J.H.SHARP

Raphaelle Peale

R. Earl

E. ERTZ.

Scherevele

a.D. Wearharasky

Frederic Remington 87–

Whistler

marin

Frank W Benson

Birge Harrison

H.p

A. Wertmuller Sued
à Lyon 1781

Walker

Mary Cassatt

Julian Story

George Luks

Raphaelle
Peale

Mantle Fielding's

Dictionary Of

AMERICAN PAINTERS,
SCULPTORS
& ENGRAVERS

Mantle Fielding's

Dictionary Of

AMERICAN PAINTERS, SCULPTORS & ENGRAVERS

Edited by Glenn B. Opitz

*Second Newly-Revised,
Enlarged and Updated Edition*

**Published By
APOLLO**

Thanks to -

Everyone involved with this significant project, especially Luane
Ballantine without whose tremendous dedication and efforts this book
would not have materialized. Special thanks to Edwin A. Ulrich and
Walter Steppacher for their continued support and encouragement,
and my regular Thursday night dinner friends.

Dedicated to -

The second and third "stringers" of artists who never really made it
with the big galleries and critics. They are the un-sung heroes of
American art.

While every effort has been made to record accurately and completely all
information contained herein, liability resulting from any errors or
omissions is disclaimed.

Apollo Book
5 Schoolhouse Lane
Poughkeepsie, NY 12603
914-462-0040

FOREWORD

Mantle Fielding's Dictionary of American Painters, Sculptors and Engravers has consistently proven to be one of the most important and basic reference works in the field of art since its original publication in 1926. Since that time, Fielding's dictionary has undergone several stages of improvement toward the goal of presenting to both scholar and novice a thorough and up-to-date source of American artists in a single volume.

In 1965, James F. Carr compiled a 93-page addendum of corrections and additions to original entries. Nine years later, Modern Books and Crafts, Inc., enlarged the dictionary, adding 2,500 two-line entries. Then, in 1983, Glenn B. Opitz greatly expanded the scope of the work by including the names of 1,000 contemporary artists and almost 5,000 other artists not included in previous editions, and expanded and updated many of the existing entries.

Replacing the now out-of-print 1983 edition, this newly-revised, enlarged and up-dated 1986 edition marks yet the highest step in meeting this goal. Almost 2,500 new names have been added, bringing the total number of artists listed to over 12,000. Existing entries have been further updated and expanded when possible, and when combined with those remaining entries in Fielding's original work for which no new information was found - and which help preserve the original character and atmosphere of the era in which the book was written - this volume becomes a highly efficient reference tool for anyone seeking information about American artists who worked during the 18th, 19th, and 20th centuries.

Even with these improvements, the editor does not claim that this volume of American artists supplies an all-encompassing list of the artists' achievements and acknowledges that some names have inevitably been omitted. However, it does supply, as far as reasonably possible, a central body of facts in compact statements and serves as a guide to further study. The improvement and completion of such an extensive reference work is a tremendous undertaking and Mr. Opitz should be commended for making available this important contribution to the study and appreciation of American art.

Dr. Martin H. Bush
Director, Edwin A. Ulrich Museum of Art and
Vice President, Academic Resource Development
Wichita State University, KS
June, 1986

PREFACE

Sixty years ago, Mantle Fielding published his classic <u>Dictionary of American Painters, Sculptors and Engravers.</u> A compilation of biographical information from a variety of sources, including Fielding's own personal experiences and contacts, this volume has remained one of the most popular and widely-used reference works throughout the years.

Some effort has been made since its original publication to improve upon and expand this dictionary. In 1965, a 93-page addendum, which corrected and supplemented original entries, was added by James F. Carr. In 1974, Modern Books and Crafts, Inc., added a 31-page index of 2,500 names, but these were only two-line entries. Recognizing the significant need that still remained for a primary source of concise biographies of American artists, I undertook the project of further expanding and updating Fielding's work, and in 1983 published a revision which included over 6,000 new entries, consisting primarily of artists of the 19th and early 20th centuries, and which included the 1929 <u>American Art Annual</u> (reprinted in 1982 as the <u>Dictionary of American Artists</u>) in its entirety.

However, a truly comprehensive dictionary of artists represents an ongoing process, a process of gathering new information and names and updating existing entries. With this in mind, we began work on the most extensive revision of Fielding's dictionary to date.

Close to 2,500 additional artists' biographies are included in this new 1986 edition, while approximately 60% of the existing entries have been updated or expanded with new information on exhibitions, collections, schooling, awards, and birth and death dates. This new edition now totals over 12,000 names, with biographical information drawn from an extensive library of source material, including both readily available and many out-of-print references, as well as resumes submitted from artists in response to our solicitation for information. Biographical information and corrections submitted by readers have also been incorporated, along with an extensive bibliography which should prove invaluable for further study. In total, the volume contains some 30% more information than our 1983 edition.

As in all such work, it is impossible to include every significant name, and there will undoubtedly be unfortunate omissions. Despite such inevitable oversights, this single volume represents our highest effort to present a comprehensive listing of American artists, paying tribute to their extensive achievements and varieties of expression, and it is my hope that it will provide dealers, collectors, and researchers with a valuable and useful resource. As always, I am grateful for the assistance of those who have worked with me on this volume and welcome any additional information, corrections, or comments.

Glenn B. Opitz

A. Aid Soc. - Artists' Aid Society
A. Bookplate S. - American Bookplate Society
A. Ceramic S. - American Ceramic Society
A. Fellowship - Artists' Fellowship, Inc. (formerly A. Aid S.)
A. Fund S. - Artists' Fund Society, New York
A. Women's A. A. of Paris - Paris American Women's Art Association
AA - Art Association (preceded by place name)
AAA - Allied Artists of America; American Art Association, when preceded by Paris
AAS - American Art Society
AC - Art Club (preceded by place name)
Acad. - Academy, Academie
ACC - Arts and Crafts Club (preceded by place name)
ACS - Arts and Crafts Society (preceded by place name)
ACD - Art Center College of Design
ADC - Art Directors' Club
AEA - Artists' Equity Association, New York
AEF - American Expeditionary Force
AFA - American Federation of Arts; Academy of Fine Arts, when preceded by place name
AFAS - American Fine Arts Society, New York
AG - Artists Guild (preceded by place name)
AGA - Art Galleries Association
AGAA - Addison Gallery of American Art, Andover, MA
AGC, Paris - Academie de la Grande Chaumiere, Paris
AI - Art Institute (preceded by place name)
AIA - American Institute of Architects
AIC - Art Institute of Chicago
AIGA, AI Graphic A. - American Institute of Graphic Arts
AL - Artists' League, Art League (preceded by place name)
Alliance - Art Alliance of America
Allied AA, All. A. - Allied Artists of America
Allied AG - Allied Artists Guild
Am., Amer. - American
Am. Acad. A.L., AAAL - American Academy of Arts and Letters
Am. APL - American Artists Professional League
Am. Soc. PS and G. - American Society of Painters, Sculptors and Gravers
Amer. PS - American Painters and Sculptors
Amer. Union Dec. A. - American Union of Decorative Artists and Craftsmen
ANA - Associate of the National Academy of Design, New York
Ann. - annual
AP - Associated Press
arch., archit. - architect, architecture, architectural
Arch. Lg. - Architectural League of New York
Artists G. - see GFLA
AS - Art Society (preceded by place name)
ASL of NY, ASL NY, NY ASL - Art Students League of New York
ASMP, A. S. Min. P. - American Society of Miniature Painters, NY
Asn., Assn., Asso., Assoc. - Association, Associate
ATA - Art Teachers' Association
AUDAC - American Union of Decorative Artists and Craftsmen
auth. - author
AV - Audiovisual
Ave. - Avenue
AWCS, AWS - American Water Color Society, New York
AWCW - Art Workers' Club for Women, New York
BAID - Beaux-Arts Institute of Design, New York
Bd. - Board
Bibliog. - Bibliography
bldg. - building
BM - Brooklyn Museum
BMA - Baltimore Museum of Art

BMFA - Boston Museum of Fine Arts
Boston GA - Guild of Boston Artists
Boston SA - Boston Society of Architects (Chapter AIA)
Boston SAC - Boston Society of Arts and Crafts
Boston SWCP - Boston Society of Water Color Painters
BPC - Brush and Palette Club (preceded by place name)
Brit. - Britain, British
Brooklyn S. Min. P. - Brooklyn Society of Miniature Painters
Brooklyn S. Modern A. - Brooklyn Society of Modern Artists
Buffalo SA - Buffalo Society of Artists
C., Cl. - Club
CA School AC, Calif. S. AC - California School of Arts and Crafts
CAA - College Art Association of America, New York
Calif. AC - California Art Club
Calif. PM - Print Makers' Society of California
Calif. PS - California Painters and Sculptors
Calif. PLH - California Palace of the Legion of Honor
Calif. SE - California Society of Etchers
Calif. WCS - California Water Color Society
CAM - City Art Museum of St. Louis
Can., CN - Canada, Canadian
CCAD - Columbus College of Art and Design
CCNY - City College of New York
Cent. - Center
Century Assoc. - Century Association of New York
CGA - Corcoran Gallery of Art
Char. C. - Charcoal Club, Baltimore
Chicago AD - Chicago Academy of Design
Chicago AFA - Chicago Academy of Fine Arts
Chicago Gal. A. - Chicago Galleries Association
Chicago NJSA - Chicago No-Jury Society of Artists
Chicago PS - Painters and Sculptors of Chicago
Chicago SAC - Chicago Society of Arts and Crafts
Chicago SE - Chicago Society of Etchers
Chicago S. Min. P. - Chicago Society of Miniature Painters
CI - Carnegie Institute, Pittsburgh, PA
Cleveland Arch. C. - Cleveland Architectural Club
Cleveland PC - Cleveland Print Club
C.L.W. Art C. - Catherine Lorillard Wolfe Art Club
CM- Cincinnati Museum Association
CMA - Cleveland Museum of Art
Co. - Company, County
C. of C. - Chamber of Commerce
Col., Coll. - College, Collegiate, Collection(s)
Columbus PPC - Columbus Pen and Pencil Club
comn. - commission(s)
comp. - competition
Cong. - Congress
Conglist. - Congregationalist
contemp. - contemporary
Contemporary - Contemporary Group
Copley S. - Copley Society of Boston
Corcoran AS - Corcoran Art School
corp. - corporate, corporation(s)
coun. - council
Ct. - Court
CT AFA, Conn. AFA - Connecticut Academy of Fine Arts, Hartford
Ctr. - Center
CU - Cooper Union
CUA Sch. - Cooper Union Art School, New York
Czech. - Czechoslovakia

Detroit S. Women P. - Detroit Society of Women Painters
Dir. - Director
Dr. - Drive
Duveneck S. - Duveneck Society (of Painters and Sculptors)
EAA - Eastern Arts Association
East. - Eastern
Eng. - England, English (also engineer, engineering)
Eur., Europ. - Europe, European
Exh., Exhib. - Exhibit(s), Exhibition(s)
Exp., Expo. - Exposition(s)
F. - Fellow
FA - Fine Arts
FAA - Fine Arts Association
FAS - Famous Artists School
Fellowship PAFA - Fellowship of the Pennsylvania Academy of the Fine Arts
Fed., Fedn. - Federation
Fel. - Fellow, Fellowship
FIT - Fashion Institute of Technology
FMA - Fogg Museum of Art
Found. - Foundation
FR, Fr. - France, French
GA - Guild of Artists (preceded by place name)
GAG - Graphic Artist Guild
Gal. - Gallery(ies)
GB - Great Britain
GCSA - Grand Central School of Art
Gen., Gen'l. - General
Ger. - Germany, German
GFLA - Artists Guild of the Authors' League of America, New York
GGE - Golden Gate Exposition, San Francisco, CA, 1939
Grand Cent. AG - Grand Central Art Galleries
h. - home address
Hartford ACC - Hartford Arts and Crafts Club
hist. - history
hon. - honorable, honorary
Hoosier Salon - Hoosier Salon, Chicago
H.S. - High School
I., Illus., Illustr. - Illustration, Illustrator
incl. - including
Indust. - Industry(ies), Industrial
Inst. - Institute, Institution
Int., Inter., Int'l. - International
Int. Soc. Paris SP - International Society of Paris Sculptors and Painters
Inter. Soc. A.L. - International Society of Arts and Letters (also given as Soc. Inter. des Beaux Arts et des Lettres)
Inter. Soc. SPG - International Society of Sculptors, Painters and Gravers
KCAI - Kansas City Art Institute
LC - Library of Congress
lect. - lecturer, lecture(s)
League Amer. PW - National League of American Pen Women
League of AA - League of American Artists
LFA - League of Fine Arts (preceded by place name)
Lg. - League
Lib., Libr. - Library
lit. - literary, literature
lith., litho. - lithograph, lithographer
MA - Museum of Art
MacD. C., MacDowell C. - MacDowell Club, New York
mem. - member, membership(s)
men. - mention
Mex. - Mexico
Min. - Miniature

Min. PS and G Soc. - Miniature Painters, Sculptors and Gravers Society
Minneapolis AL - Minneapolis Artists' League
MMA, Met. Mus. Art - Metropolitan Museum of Art, New York
mod. - modern
Modern AA - Modern Artists of America, New York
MOMA, M. Mod. A. - Museum of Modern Art, New York
mun., munic. - municipal
Municipal AS - Municipal Art Society (preceded by place name)
Mural P. - National Society of Mural Painters, New York
Mural PS - Mural Painters Society
Mus. - Museum(s), Musee, Museo
Mystic SA - Society of Mystic (Conn.) Artists
NA - Academician of the National Academy of Design, New York
NAC - National Arts Club, New York
NAD - National Academy of Design, New York (used chiefly for school)
NAS - Normal Art School
Nat., Nat'l. - National (also Natural)
Nat. AAI - National Alliance Art and Industry
Nat. Inst. A.L. - National Institute of Arts and Letters
Nat. L. Am. Pen Women, NL Am. Pen Women - National League of American Pen Women
Nat. Ser. Soc. - National Serigraph Society, New York
NA Women PS - National Association of Women Painters and Sculptors, New York
NCFA - National Collection of Fine Arts, Washington, DC
New Eng. - New England
New Haven BPC - New Haven Brush and Palette Club
New Haven PCC - New Haven Paint and Clay Club
New Soc. A. - New Society of Artists, New York
NGA, Nat. Gal. - National Gallery of Art, Washington, DC
NJSA - No-Jury Society of Artists (preceded by place name)
NL Am. Pen Women - National League of American Pen Women
N.O. - New Orleans
NOAA - Art Association of New Orleans
NO ACC - New Orleans Arts and Crafts Club
North. - Northern
North Shore AA - North Shore Arts Association, Gloucester, MA
NSMP - National Society of Mural Painters, New York
NSS - National Sculpture Society, New York
NY Arch. Lg. - Architectural League of New York
NYPL - New York Public Library
NYSC - New York Society of Craftsmen
NYSP - New York Society of Painters
NYSWA - New York Society of Women Artists
NYU - New York University
NYWCC - New York Water Color Club
Ohio WCS - Ohio Water Color Society, Columbus
PAFA - Pennsylvania Academy of the Fine Arts, Philadelphia
Paris AAA - American Art Association of Paris
Paris Groupe PSA - Groupe des Peintres et Sculpteurs Americains de Paris
Pais Women's AAA - Paris American Women's Art Association
Paris SAP - Paris Society of American Painters
Pa. S. Min. P. - Pennsylvania Society of Miniature Painters
Pastelists - Society of Pastelists, New York
PBC- Pen and Brush Club of New York
PCC - Paint and Clay Club (preceded by place name)
Phila. ACG - Arts and Crafts Guild of Philadelphia
Phila. Alliance - Art Alliance of Philadelphia
Phila. Sketch C. - Philadelphia Sketch Club
Phila. Soc. AL - Philadelphia Society of Arts And Letters
Philadelphia Soc. AA - Philadelphia Society of American Art
Photo. Sec. - Photo-Secession, New York

PI - Pratt Institute, Brooklyn, New York
PIA Sch. - Pratt Institute Art School, Brooklyn, NY
Pittsburgh AA - Associated Artists of Pittsburgh
Pittsburgh AS - Pittsburgh Art Society
Plastic C. - Plastic Club of Philadelphia
PM, Pr. M. - Print Maker's Society (preceded by place name)
PM of Am. - Print Makers of America
PMA - Philadelphia Museum of Art
PMG - Phillips Memorial Gallery
port. - portrait(s)
Port. P. - National Association of Portrait Painters, New York
P.-P. - Panama-Pacific
PPC - Pen and Pencil Club (preceded by place name)
PR - Puerto Rico
pres. - present, president
prof. - professor, profession, professional
Providence HC - Providence Handicraft Club
PS - Painters and Sculptors (preceded by place name)
PSA - Portland Society of Artists
PSC - Painters and Sculptors Club
PSD - Parsons School of Design
PS Gallery Assoc. - Painters' and Sculptors' Gallery Association, New York
ptg., ptgs. - painting(s)
ptr. - painter
publ. - published, publisher, publication(s)
PW League - National League of American Pen Women
RISD - Rhode Island School of Design
Rd. - Road
RD - Rural Delivery
rep. - represented, representative
Rome Acad. Alumni - Alumni Association American Academy in Rome
RSA - Royal Scottish Academician
s. - summer address
SA - Society of Artists (preceded by place name)
SAA - Society of American Artists, New York
SAC - Society of Arts and Crafts (preceded by place name)
SAGA - Society of American Graphic Artists, New York
Salma. C., SC - Salmagundi Club, New York
SAM - Seattle Art Museum
Scarab C. - Scarab Club, Detroit, MI
Sch. - School(s)
sci. - science
SE - Society of Etchers (preceded by place name)
SFA - Society of Fine Arts (preceded by place name)
SFMA - San Francisco Museum of Art
SI (S of I) - Society of Illustrators
S. Indp. A. - Society of Independent Artists
S. Min. P. - Society of Miniature Painters (preceded by place name)
SMPF West - Society of Men who Paint the Far West
Soc. - Society
Soc. AC - Society of Arts and Crafts (preceded by place name)
Soc. Am. E. - Society of American Etchers
Soc. of Med. - Society of Medalists
SP - Society of Painters (preceded by place name)
SPNY - Society of Painters, New York
SPS - Society of Painters and Sculptors (preceded by place name)
SSAL - Southern States Art League
St. - Street, Saint
St. Louis AG - St. Louis Artists' Guild
SVA - Society of Visual Arts

SWA - Society of Women Artists (preceded by place name)
SWCP - Society of Water Color Painters (preceded by place name)
Switz. - Switzerland
S. Women P. - Society of Women Painters (preceded by place name)
2x4 Soc. - Two by Four Society, St. Louis
tech., techn. - technology, technical, technique
Ten Am. P. - Ten American Painters
Ten Phil. P. - Ten Philadelphia Painters
TID - The Institute of Design
UCLA - University of California at Los Angeles
Univ. - University(ies)
US - United States
USA - United States of America, United States Army
USAF - United States Air Force
USMC - United States Marine Corps
USN - United States Navy
USPO - United States Post Office
var. - various
Vet. - Veteran(s)
VMFA - Virginia Museum of Fine Arts, Richmond, VA
WAA - Western Arts Association
WC - Watercolor
WCC - Water Color Club (preceded by place name)
WCP - Water Color Painters (preceded by place name)
WCS - Water Color Society (preceded by place name)
West. - Western
WFNY - World's Fair, New York, 1939
Wilmington SFA - Wilmington Society of Fine Arts
Wis. PS - Wisconsin Painters and Sculptors
WMA - Worcester Museum of Art, Worcester, MA
WMAA - Whitney Museum of American Art
Woman's AC - Woman's Art Club (preceded by place name)
WW I - World War I
WW II - World War II
Yugos., Yugosl. - Yugoslavia

CITY AND STATE ABBREVIATIONS

AK - Alaska
AL, Ala. - Alabama
AR, Ark. - Arkansas
AZ, Ariz. - Arizona
CA, Calif. - California
Chic. - Chicago
CO, Colo. - Colorado
CT, Conn., Ct. - Connecticut
CZ - Canal Zone
DC, D.C. - District of Columbia
DE, Del. - Delaware
FL, Fla. - Florida
GA, Ga. - Georgia
HI - Hawaii
IA, Ia. - Iowa
ID, Id. - Idaho
IL, Ill. - Illinois
IN, Ind. - Indiana (Ind. - also Indianapolis)
KS, Kans. - Kansas
KY, Ky. - Kentucky
LA, L.A. - Louisiana, Los Angeles
MA, Mass. - Massachusetts
MD, Md. - Maryland
ME, Me. - Maine
MI, Mich. - Michigan
MN, Minn. - Minnesota
MO, Mo. - Missouri
MS, Miss. - Mississippi
MT, Mont. - Montana
NC, N.C. - North Carolina
ND, N.D., N. Dak. - North Dakota
NE, Neb., Nebr. - Nebraska
NH, N.H. - New Hampshire
NJ, N.J. - New Jersey
NM, N.M., N. Mex. - New Mexico
NO, N.O. - New Orleans
NV, Nev. - Nevada
NY, N.Y. - New York
NYC - New York City
NYS - New York State
OH, Oh. - Ohio
OK, Okla. - Oklahoma
OR, Ore. - Oregon
PA, Pa., Penn., Penna. - Pennsylvania
Phila., Phil. - Philadelphia
RI, R.I. - Rhode Island
SC, S.C. - South Carolina
SD, S.D. - South Dakota
S.F., S. Fran., San Fran., San F. - San Francisco
TN, Tenn. - Tennessee
TX, Tex. - Texas
UT, Ut. - Utah
VA, Va. - Virginia
VT, Vt. - Vermont
WA, Wash. - Washington
WI, Wis., Wisc. - Wisconsin
WV, W.V., W. Va. - West Virginia
WY, Wyo. - Wyoming

AACH, HERB.
Painter and writer. Born Cologne, Ger., March 24, 1923; US citizen. Pupil, Art Acad., Cologne; Pratt Inst.; Stanford U.; Escuela di Pintura Y Escultura, Mex.; Brooklyn Mus. Art School. Exhibited at Academy of Arts and Letters; Martha Jackson Gal., NYC; Albright-Knox Museum. Taught at Pratt; Brooklyn Mus.; Skowhegan School. Represented by Martha Jackson and Aaron Berman Galleries in NYC.

AARONS, GEORGE.
Sculptor. Born in Lithuania, April 6, 1896; US citizen. Pupil of Museum of Fine Art School, Boston; Beaux-Arts Institute of Design, NYC. In collections of Art Museum, Ein Harod, Israel; Fitchburg (MA) Art Museum; Museum de St. Denis, France; others. Exhibitions: Philadelphia Museum; Institute of Contemporary Art, Boston; Whitney; MIT. Member of National Sculpture Society. Living in Gloucester, MA, in 1976. Died in 1980.

ABADI, FRITZIE.
(Mrs. Al Hidary). Sculptor and painter. Born in Aleppo, Syria, in 1915. Studied at Art Students League in NY. Exhibited: Whitney Museum of American Art, NY; Annual Print Invitational, Library of Congress, Washington, DC. Awards: Acrylic Painting Award; National Association of Women Artists, 1974; and the American Society of Contemporary Artists, 1978. Member: National Association of Women Artists; American Society of Contemporary Artists; NY Society of Women Artists. Represented by Phoenix Gallery, NYC. Address in 1982, 201 West Phoenix Gallery, 30 West 70th St., NYC.

ABANAVAS, CONSTANTINE E.
Sculptor and painter. Born in Newark, NJ. Spent formative years in Greece. One-man shows: Several in NYC; University of Pittsburgh; Ohio State University; Oberlin College; Museum of Albany, NY; Athens Museum, Athens, GA; Manhattanville College. Group exhibitions: Throughout US, Austria, Germany, and England.

ABANY, ALBERT CHARLES.
Painter, printmaker and teacher. Born in Boston, Mass., March 30, 1921. Study: School of Mus. of Fine Arts, Boston, Longstreth Scholar, 1942, diploma, 1948; Tufts Univ., BS educ., 1949. Exhib.: Carl Siembab Gal., Boston; Clark Univ.; Northeastern Univ.; Wessell Lib., Tufts Univ.; Art Inst., Boston. Teaching: Boston Center for Adult Education, 1949-51; Art Institute of Boston, 1965-75; Brockton Art Center, MA, 1975-77; others. Media: Oil, graphics, mixed media. Address in 1982, 42 MacArthur Rd., Natick, MA.

ABBATE, PAOLO S.
Sculptor and lithographer. Born in Villarosa, Italy, April 9, 1884. Educated in Italy and in the US. Member of International Fine Arts Society. Exhibited at National Sculpture Society, NY. Works: Dante monument, Newburgh, NY; "Fiat Voluntas Tua," Brown University, Providence, RI; "People without Vision Perish," terracotta, Evangelical Church, Cliffside Park, NJ. Busts: Professor L. Carnovale, Stilo, Italy; H. Husserl, Dr. Husserl College, Newark, NJ; Enrico Caruso, NYC; Dante monument, RI; Ruvolo memorial, Torrington, CT; David monument to Joyce Kilmer, France. Address in 1934, 1931 Broadway, New York City. Died in 1972.

ABBATT, AGNES DEAN.
Painter. Born 1847; died 1917. Elected member of National Academy, 1902. Studied art at Cooper Union and the National Academy of Design. Painted in oils and watercolors, also wax modelling. She painted landscapes, coast scenes, and flowers. Medal at Cooper Union, and first prize in oil painting at San Antonio, Texas. Address in 1926, New York.

ABBE, ELFRIEDE MARTHA.
Sculptor, engraver and illustrator. Born in Washington, DC, in 1919. Studied: Cornell University and Syracuse University. Awards: Cornell University, 1938, 1940; Tiffany Foundation Fellowship, 1948; gold medal, National Arts Club, 1970, and Academy of Artists Association, Springfield, MA, 1976; E. Liskin Cash Award, Salmagundi Club, 1979. Work: World's Fair, New York, 1939; Memorial panels, Ellis Room, Wiegand Herbarium, 1953 and Mann Library, 1955, Cornell University; Cincinnati Art Museum; and Boston Museum of Fine Arts. Exhibited: San Diego Fine Arts Gallery, 1960; Carnegie-Mellon University, 1968; National Academy of Design; National Arts Club, NY, 1969 and 70. Commissions: Bronze sculptures, Clive McCay memorial, 1967; Napoleon (bronze head), McGill University Library; The Hunter (large statue), NY World's Fair, 1939. Member: National Sculpture Society (fellow); National Arts Club. Medium: Wood. Address in 1982, Manchester Center, VT.

ABBETT, ROBERT K.
Sculptor and painter. Born in Hammond, IN, January 5, 1926. Studied: BA, University of Missouri and Chicago Academy of Fine Arts. Works: Over twenty

editions of limited prints, two editions of bronze, "Outdoor Paintings of Robert K. Abbett," Bantam Books; "Fall Colors of Robert K. Abbett," KTVY, Oklahoma City. Exhibited: Group and Gallery shows since 1970. Member: Society of Animal Artists; Who's Who in the East; Who's Who in Art; Society of Illustrators. Collections: Cowboy Hall of Fame, Oklahoma City; Parker Collection, Tulsa; Jernigan Collection, Oklahoma City; Dangerfield Collection, Ardmore, Oklahoma. Media: Paintings, oil; Sculpture, wax. Address in 1983, Bridgewater, CT.

ABBEY, EDWIN AUSTIN.
Painter, illustrator and mural decorator. Born in Philadelphia, 1852; died in London, 1911. He studied at the Penna. Academy of Fine Arts. His "King Lear" is at the Metropolitan Museum, NY, and his "Quest of the Holy Grail" at the Boston Public Library. His illustrations for Shakespeare's Works, Herrick's Poems, and "She Stoops to Conquer" are among his best known illustrations. Elected member of National Academy, 1902. See "Life of Edwin Abbey", by E. V. Lucas, 2 vols., London. Died in 1911.

ABBEY, IVA L.
Painter. Born in Chester, Conn., in 1882. Pupil of Hale, Benson, and C. J. Martin. Member of Hartford Art Society. Address in 1926, Wilkes-Barre Institute, Wilkes-Barre, Penna.

ABBOT, SAMUEL NELSON.
Illustrator. Born in Illinois, 1874. He studied in Paris under Laurens and Constant. His first illustration assignment was for Hart Schaffner and Marx, where he continued to design and illustrate their fashion catalogues for the next 25 years. During this period he also did illustration for *Ladies' Home Journal, The Saturday Evening Post* and *Collier's*. Died in 1953.

ABBOTT, ANNE FULLER.
Painter. Born Brandon, VT. Pupil of Chase; Douglas Volk; Francis Jones; ASL of NY; Corcoran Art School; NAD. Member: Wash. AC; Wash. WCC; AFA; PBC. Work: "Yeomanette," Navy Department, Washington, DC. Director of the Abbott School of Fine and Commercial Art, Washington, DC. Address in 1929, 1624 H. St. N.W.; h. 1028 Connecticut Ave., Washington, D.C.

ABBOTT, BERENICE.
Sculptor and photographer. Born in Ohio, 1898. Studied: Berlin and Paris with Bourdelle and Brancusi. She began her career as a sculptor, but is best known as a photographer. Was photographic assistant to Man Ray, 1923. Had own studio in Paris. From 1923 to 1925 photographed expatriates and celebrities in Paris. Returned to NY in 1929 to photograph the City. Worked in experimental photography from 1940. Collections: Museum of the City

of NY. Taught: New School for Social Research, 1938, for more than twenty years.

ABBOTT, ELEANORE PLAISTED.
Painter. Born at Lincoln, Maine, 1875; married Yarnall Abbott. Pupil of Penna. Academy of Fine Arts, Phila., and Simon and Cottet in Paris. Member: Phila. WCC; Plastic C.; Fellowship PAFA. Address in 1926, The Gladstone, 11th and Pine Sts., Philadelphia. Died 1935.

ABBOTT, EMILY.
Painter. Born in Minneapolis, Minnesota, in 1900. Studied: University of Minnesota; Minneapolis School of Art. Awards: Minnesota State Fair, 1937; Minneapolis Institute of Art, 1938, 1944. Collections: Walker Art Center. Exhibited mostly in the Minneapolis area.

ABBOTT, FRANCIS R.
Painter. Pupil of the Penna. Academy of Fine Arts, and the Julian Academy in Paris. He was born in Philadelphia and was an Artist Member of the Art Club for twenty years. He died in Philadelphia in 1925.

ABBOTT, YARNALL.
Painter. Born in Philadelphia, 1870. Pupil of Thos. Anschutz at Penna. Academy of Fine Arts and Collin and Courtois in Paris. Exhibited at the Penna. Academy of the Fine Arts, 1924-25. Address in 1926, 1612 Latimer Street, Philadelphia, PA. Died 1938.

ABDY, ROWENA MEEKS.
Painter and illustrator. Born in Austria, 1887, of American parents. Came to San Francisco, California, and studied under Arthur F. Mathews. Awarded medal by California Museum of Art, 1920. Exhibited watercolor, "Old Fashioned Room," at Penna. Academy of Fine Arts, Phila., 1924. Address in 1926, 1050 Lombard Street, Russian Hill, San Francisco, California. Died 1945.

A'BECKET, MARIA J. C.
Landscape painter. Born in Portland, Maine. Studied in the White Mountains with Homer Martin in 1865, and in 1875-78 with William Hunt in Boston. She also spent a summer painting in France with Daubigny. She died in New York, September 6th, 1904. She exhibited in Boston, Baltimore, Philadelphia and Washington.

ABEL, JEAN (CHRISTINE JEANNETTE).
Sculptor, painter, and educator. Born Maxwell, CA, in 1890. Studied: California Schools of Fine Arts, 1915; graduate art studies at California School of Arts and Crafts, Oakland, University of California at Berkeley, University of California at Los Angeles, University of Southern California, Columbia; Chouinard Art Center; worked with Armin Hansen

Monterey, Xavier Martinez, and Ramos Martinez. Exhibit in retrospect at Glendale College Library, 1950, Santa Barbara Artists Work Shop, 1959; one-man show, Los Angeles Museum of History, Science, and Art, 1928; produced 11 original ballets for Glendale High School shown at Greek Theatre, Los Angeles, Pasadena Community Play House, Occidental Bowl, Redlands Bowl, Los Angeles Allied Arts. Awards: California School of Fine Arts, San Francisco, 1915; water color prize, Palace of Fine Arts, San Francisco, 1924; Glendale Art Association, 1951. Member: Santa Barbara Art Association, Santa Barbara Museum of Natural History, Santa Barbara Historical Society, Music Academy of West, Glendale Art Association, Art Teachers Association of Southern California (president 1928-29, treasurer 1930-31), Pacific Arts Association (council member 1939-40), The Fine Arts Foundation (president 1943-44), Santa Barbara Botanical Gardens, Council of Arts, Santa Barbara Delta Epsilon. Taught: Glendale (CA) High School, 1921-38; art instructor, Glendale College, 1938-43, 46-56; Toll Jr. High, Glendale, 1943-45. Address in 1962, Santa Barbara, CA.

ABEL, LOUISE.
Sculptor. Born in Wurttemberg, Germany, Sept. 7, 1894. Studied: Cincinnati Art Academy; Art Students League; Kunstgewerbe Schule, Stuttgart. Work: Cincinnati Museum Association; Trail Side Museum, Cincinnati; Employees Country Club, Endicott, NY. Exhibited: Cincinnati Museum, 1925, 45; Penna. Academy of Fine Arts, 1925, 45; Art Institute of Chicago, 1926, 40; National Ceramic Exhibition, 1937, 41; Andrews Gallery, 1942; others. Position: Sculptor, designer, Rockwood Pottery, 1921-32. Address in 1953, Cincinnati, OH.

ABEL, M.
Painter. Exhibited at Cincinnati Museum in 1925. Address in 1926, 939 Richmond Street, Cincinnati, Ohio.

ABELL, MARGARET NOEL.
Sculptor, cartoonist, and craftsman. Born in New York City, December 3, 1908. Studied: Art Students League, with Alexander Archipenko; Breckenridge School, Gloucester, Mass. Member: National Association of Women Artists, New York; American Artists Professional League. Exhibited: Provincetown Art Association; National Association of Women Artists. Address in 1953, Georgetown, Conn.

ABERNETHIE.
An early American engraver of maps, Masonic prints and book plates who worked in Charleston, SC, about 1780.

ABRAHAMSEN, CHRISTIAN.
Painter and illustrator. Born in Norway, 1887. Represented in AIC by "Winter." Died January 24, 1983.

ABRAM, PAUL JR.
Sculptor and painter. Born in Bloomington, IN, 1933. Employed in commercial and billboard art work until 1974, when began painting exclusively. More recently began sculpture. Paintings have appeared on covers of *Western Horseman* and other magazines. Awards: Gold, for mixed media, Geo. Phippen Memorial Day Show; American Indian and Cowboy Artist Show. Member: American Indian and Cowboy Artists. Specialty: Historic American West. Media: Watercolor, mixed media, oil; bronze. Represented: Overland Trail Galleries, Scottsdale, AZ; Newsom's Gallery, Las Vegas, NV. Address since 1975, Scottsdale, AZ.

ABRAMOFSKY, ISRAEL.
Painter and etcher. Born Kiev, Russia, Sept. 10, 1888. Pupil of Jean Paul Laurens, Joseph Berges. Member: Salon Artist, France. Award: Hon. mention, Salon Artist, 1928. Work: "Winter Scene on Mt. Blanc," Luxembourg Galleries, Paris, France; "Street Scene, Paris," Museum, Jaffe, Jerusalem; "Fountain of the Luxembourg Garden," Toledo Museum of Art. Address in 1926, 78 Quai de La Rapee, Paris, France; h. 1616 Adams St., Toledo, Ohio.

ABRAMOVITZ, ALBERT.
Painter. Member of Society of Independent Artists. Address in 1926, 336 East 17th Street, New York.

ABRAMOVITZ, CARRIE.
Sculptor. Born: New York City, in 1913. Studied: Brooklyn College and Columbia University. Lived in Paris, 1962-63. Awards: Morrison medal, Oakland Museum in 1960. Exhibited: Mostly in San Francisco area.

ABRAMS, ELEANOR.
Painter. Born in Karns City, PA. Pupil of Elliott Daingerfield and Henry B. Snell. Address in 1926, 10 East 9th Street, New York.

ABRAMS, LUCIAN.
Painter. Born at Lawrence, Kansas, 1870. Pupil of Laurens, Constant, and Whistler in Paris. Member of Society of Independent Artists. Represented by "Sandy Bay," Dallas Art Association. Address in 1926, Lyme, Conn. Died 1941.

ABRAMSON, ROSALIND.
Painter and etcher. Born in Norfolk, VA, 1901. Pupil of Art Students League of New York under Bridgman, Henri, Bellows, and DuMond. Address in 1926, 59 West 59th Street, New York, or 706 Riverside Drive, New York.

ACHERT, FRED.
Painter. Member Cincinnati Art Club. Address in 1926 10 East 3d Street, Cincinnati, Ohio.

ACHESON, ALICE S(TANLEY).
Painter and illustrator. Born Charlevoix, Mich., August 12, 1895. Pupil of Howard Smith and Richard Meryman. Illustrated "New Roads in Old Virginia." Address in 1926, 2805 P St., Washington, DC; summer, Harewood Farm, Sandy Spring, MD.

ACHESON, GEORGINA ELLIOTT.
Miniature and water-color artist. Exhibited at the Penna. Academy of Fine Arts, Philadelphia, 1924-25. Address in 1926, Ardsley on Hudson, New York City.

ACKER, HERBERT V(AN) BLARCOM.
Painter. Born Pasadena, Calif., October 4, 1895. Pupil of Cecilia Beaux, Frank V. DuMond. Member: Pasadena SA; NAC; AFA. Address in 1926, 8320 Fountain Ave., Hollywood, Calif.

ACKERSON, F(LOYD) G(ARRISON).
Painter. Born Portage, Kalamazoo Co., Mich., Jan. 1, 1883. Pupil at Carnegie Tech. Art School. Member: Pittsburgh AA. Award: 2nd prize, Pittsburgh AA., 1920. Address in 1929, 103 Colonial Apts., Wilkinsburg, PA.

ACOSTA, MANUEL GREGORIO.
Sculptor, contemporary painter, illustrator, and muralist. Born in Villa Aldama, Chihuahua, Mexico, 1921; raised in El Paso, TX. Studied: University of Texas at El Paso; University of California; Chouinard Art Institute in Los Angeles; and with Urbici Soler, sculptor. Apprenticed in 1952 to Peter Hurd. Work in Museum of New Mexico; El Paso Museum; West Texas Museum; Time Collection; murals in Western banks. Commissions: Southwest History (aluminum mural), Casa Blanca Motel, Logan, NM, 1956; aluminum fresco mural and history panels, Bank of Texas, Houston; fresco mural, First National Bank, Las Cruces, NM, 1957. Specialty: Western and Mexican subjects. Represented by Baker Collector Gallery, Lubbock, TX. Address in 1982, El Paso, TX.

ADAM, DAVID LIVINGSTON.
Portrait painter. Born in Glasgow, Scotland, in 1883; died in Chicago, Ill., 1924. He studied in Glasgow, Brussels, and the Art Institute of Chicago. He was a member of the Palette and Chisel Club, The Chicago Society of Artists, and the Alumni of the Art Institute of Chicago. In 1920 he was awarded a gold medal by the Palette and Chisel Club.

ADAM, WILBUR G.
Painter and illustrator. Born Cincinnati, Ohio, July 23, 1898. Pupil of Duveneck, L. H. Meakin, James R. Hopkins, H. H. Wessel, C. A. Lord. Member: Tiffany Foundation; Cincinnati AC. Award: Augustus S. Peabody prize, AIC, 1925. Address in 1929, Malabry Court, 675 North Michigan Ave., Chicago, Ill.

ADAM, WILLIAM.
Painter of landscapes. Born in England, studied at Glasgow and Paris. Address in 1926, 450 Central Ave., Pacific Grove, California.

ADAMS, ALICE.
Sculptor. Born in NYC, November 16, 1930. Studied at Columbia University, BFA, 1953; Fulbright travel grant, 1953-54; French government fellowship, 1953-54; L'Ecole Nationale d'Art Decoratif, Aubusson, France. Exhibited: Sculptures in wood and metal at the Whitney Museum of American Art, 1970-71, 73; Penthouse Gallery Exhibit, at the Museum of Modern Art, NYC, 1971; American Women Artists, Kunsthaus, Hamburg, West Germany, 1972; 1955 Mercer, NY, 1970, 72, 73, and 75; Neuberger Museum, Purchase, NY, 1979-80. Awards: National Endowment for the Arts Grant, 1979; a fellowship in the Humanities from Princeton University in 1980. Noted for her constructions. Address in 1982, 55 Walker Street, NYC.

ADAMS, BERTRAND R.
Taxidermist. Born November 29, 1907, Webster City, Iowa. Studied taxidermy with local taxidermist, 1925; enrolled in a commercial art correspondence course, 1928; entered University of Iowa, where he majored in art and economics, 1934; began work on Iowa State College Library murals as assistant, under Public Works of Art Project. Has worked in most mediums, with exception of lithography and fresco. Has prepared plaster casts for bronze tablets and modelled heads.

ADAMS, CHARLES PARTRIDGE.
Painter of landscapes. Born 1858, at Franklin, Mass. Self-taught. Member: Denver AC; Laguna AA, (life). Awards: Gold Medal, National Mining and Industrial Exp., Denver; hon. mention, Pan-Am. Exp., Buffalo, 1901. Work: In State University, Boulder, Colo.; Normal School, Greeley, Colo.; Kansas City, MO; San Diego, Calif.; Woman's Club, and Denver Art Association, Denver, Colo. Address in 1926, 3935 Dalton Ave., Los Angeles, California.

ADAMS, CHAUNCEY M.
Painter, etcher and teacher. Born Unadella Forks, NY, Mar. 28, 1895. Pupil of Daniel Garber, PAFA. Member: Utica ASL. Work: "The Willows," Converse College, Spartanburg, SC. Address in 1929, Chamber of Commerce, Utica, NY; summer, Unadilla Forks, NY.

ADAMS, DUNLAP.
Engraver. Working in Philadelphia in 1764. He engraved on gold, silver, copper and brass, and seems to have been more of a silversmith and die sinker than a copper-plate engraver. See announcement in *Pennsylvania Gazette* for September 6, 1764.

ADAMS, HERBERT.
Sculptor. Born January 28, 1858, Concord, VT. Studied at Mass. Institute of Technology, Mass. Normal School, and pupil of Mercie in Paris. Awards: Honorable mention, Paris Salon, 1888 and 89; gold medal, Phila. Art Club, 1892; gold medals, Charleston Exp., 1902, and Louisiana Purchase Exp., St. Louis, MO, 1904; hors concours, Pan-American Exp., Buffalo, NY, 1901; medal of honor, P.-P. International Exp., San Francisco, 1915; gold medal, NY Architectural League, 1916; Elizabeth N. Watrous gold medal, National Academy of Design, 1916. Member: American Academy of Arts and Letters; National Academy of Design; National Sculpture Society; NY Municipal Art Society; Federal Commission of Fine Arts. Works: Fountain, Fitchburg, MA; Pratt memorial, Emmanuel Baptist Church, Brooklyn, NY; Hoyt memorial, Judson Memorial Church, NYC; bronze doors, statue of Joseph Henry and other works, Library of Congress, Washington, DC; Joseph Smith, Fairmount Park, Philadelphia, PA; W. E. Channing, Boston, MA; bronze doors and marble tympanum, St. Bartholomew's Church, New York; Matthias Baldwin, Philadelphia, PA; Gen. Joseph Hawley memorial, State Capitol, Hartford, CT; A. A. Humphreys, Fredericksburg, VA; Michigan State monument, Vicksburg National Military Park, Vicksburg, Mississippi; John Marshall, Rufus Ranney, Simon de Montfort and Stephen Lagton, County Court House, Cleveland, Ohio; Statues, Painting, Sculpture, Oratory, Philosophy, Brooklyn Museum, Brooklyn; MacMillan Fountain, Washington, DC; William Cullen Bryant, Bryant Park, New York City; Welch memorial, Theological Seminary, Auburn, NY; portrait relief, Joseph Choate, Union League Club, New York; portrait bust, Julia Marlowe, Cleveland Museum, Cleveland, OH; bust, Jeunesse, in pink Milanese Marble, Metropolitan Museum, New York; and other works. Exhibited at National Sculpture Society, 1923. Address in 1934, 131 West 11th St., New York. Died in 1945.

ADAMS, J. HOWARD.
Painter. Member of Providence Art Club. Address in 1926, 1217 Turks Head Bldg., Providence, RI.

ADAMS, JOHN OTTIS.
Painter of landscapes. Born 1851 at Amitz, Ind. Pupil of John Parker, London, and Loefftz in Munich. Among his works: "Summer Afternoon" at Richmond, Ind.; also "The Road to Town," "The Pool" and "Late Autumn." Address in 1926, The Hermitage, Brookville, Ind.

ADAMS, JOHN WOLCOTT.
Born 1874, Worcester, Mass. Student of Art Mus., Boston; Art Students League, New York. Began work in New York, 1899; illustrator of books, poems, etc., for *Harper's, Scribner's, Century* and other magazines. Illustrator: *Hoosier Romance* (by James Whitcomb Riley), 1910; known for drawings in connection with old songs, Colonial incidents, etc. Address in 1926, 360 West 22d Street, New York City.

ADAMS, JOSEPH ALEXANDER.
Born 1803 in New Germantown, NJ. An early American wood engraver, largely self-taught. He was elected an Associate member of the National Academy of Design in 1841. His Bible illustrations are well known; his "Last Arrow" was engraved in 1837 for the *New York Mirror*. He also worked for the *Treasury of Knowledge* and other publications. See "History of Wood Engraving in America," by W. J. Linton. Died Sept. 16, 1880 in Morristown, NJ.

ADAMS, KATHERINE LANGHORNE.
Painter. Born Plainfield, New Jersey. Member of the Association of Women Painters and Sculptors, New York. Exhibited: "Gloss of Satin and Glimmer of Silk," "The Blue House." Address in 1926, 142 East 18th Street, New York.

ADAMS, KENNETH M.
Painter and graphic artist. Born August 6, 1897, Topeka, Kansas. Studied art under George M. Stone, 1916; at Chicago AI, 1916; ASL of NY in 1919 under Bridgman, Speicher and Sterne; and at Summer Art School, Woodstock, NY, under Dasburg. In 1921, went to France and spent some months in Paris in various sketch classes. Painted landscapes in south of France, later returning to Paris. Spent some months in Italy studying frescoes of Giotto, Piero della Francesca and Masaccio. In 1924, painted in Taos, New Mexico. Revisited France, but soon returned to Southwest. In 1934, worked under Public Works of Art Project. Has exhibited in national exhibitions and held several one-man shows. Work owned by Los Angeles Museum; Mulvane Art Museum, Topeka, Kansas; University of New Mexico; Honolulu Academy of Fine Arts; Kansas State Agricultural College; San Francisco Art Museum. Awards: Hon. Men. for oil painting, Denver (Colo.) Museum, 1928; Hon. Men. for Graphic arts, Denver, 1930; 1st Hon. Men., 4th Exh. of Am. Litn., Print Club of Phila.; Purchase Prize, New Mexico AL, 1932; Clark Prize and Hon. Men., Corcoran Gallery. Died in 1966.

ADAMS, LINDA.
Graphics. Born in Massachusetts in 1948. Studied: Worcester Art Museum; Boston University School of Fine Arts. She has exhibited mostly in the Boston area. Noted for life-size representational nudes of women.

ADAMS, MARJORIE NICKLES.
Painter. Born: Shippensburg, Pennsylvania. Studied: Shippensburg Teachers College; Philadelphia Museum School of Industrial Art; Pennsylvania

Academy of Fine Arts; Chester Springs Academy of Fine Arts. Awards: Fellowship, Pennsylvania Academy of Fine Arts, 1922, 1923; Cresson traveling scholarship for study in Europe, 1924; Philadelphia Plastic Club, 1929. Collections: In the United States and abroad.

ADAMS, NORMAN.
Illustrator. Born in Walla Walla, Washington, 1933. He was trained at the ACD. In 1960 his first illustration, watercolor, ran on the cover of *Today's Living* in the *Herald Tribune* magazine section. He has since done covers for *Sports Afield*, *Field and Stream*, *True* and *Reader's Digest*. His editorial work has been published in *Holiday* and *The Saturday Evening Post*, among others. A participant in the S of I Annual Exhibitions, he received the Mystery Writers' Raven Award.

ADAMS, PAT.
Painter. Born in Stockton, California, July 28, 1928. Studied: University of California. Awards: Fulbright to France, 1956; Yaddo Foundation residency; National Council for the Arts, 1968. Extensive exhibitions throughout the United States and Europe. Collections: Whitney Museum of American Art, New York City; University of Michigan; University of California at Berkeley; University of North Carolina at Greensboro. Media: Oil, isobutyl and methacrylate.

ADAMS, PHILIP.
Painter. Born 1881, in Honolulu. Pupil of Bridgman, Paxton, and Hale, Benson and Woodbury in Boston. Member of Copley Society. Address in 1926, 1310 Massachusetts Ave., Washington, D.C.

ADAMS, WAYMAN.
Portrait painter. Born September 23, 1883, Muncie, Ind. Student of John Herron Art Institute, Indianapolis, 1905-09, also studied in Italy, 1910, Spain, 1912. Elected Associate Member of National Academy, 1926. Among his portraits are Joseph Pennell, Samuel Rabston, Thomas R. Marshall, and Edward W. Redfield, the painter. Member: ANA; Salma. C.; Port. P.; Phila. Sketch C.; Phila. AC; Phila. WCC; Ind. AC; Allied AA; NYWCC; AWCS; NAC; Century C.; Hoosier Salon; AFA. Awards: Proctor portrait prize, NAD, 1914; Foulke prize, Richmond (Ind.) AA, 1915; Holcomb prize, Herron AI, 1916; Logan Medal, AIC, 1918; Newport AA prize, 1918; Greenough Memorial prize, Newport AA, 1925; Shaffer prize, Hoosier Salon, Chicago, 1926; Silver medal, Sesqui-Cent. Exp., Phila., 1926; 1st Altman prize, NAD, 1926; portrait prize, Springfield (Mass.) AA, 1926; Indianapolis star portrait prize, Hoosier Salon, Chicago, 1929. Represented in Herron Art Institute; State Library, Indiana; Harrison Gallery, Los Angeles Museum; Lafayette (Ind.) Art Association; Texas Art Association; Nashville Art Associa-

tion; Harvard University; John Hopkins University; University of Pennsylvania; Indiana University; New York Chamber of Commerce; Indiana State Capitol; Pennsylvania State Capitol; Butler Art Institute; Texas State Capitol; Louisiana State University. Address in 1929, Rodin Studios, 200 West 57th St., New York, NY. Died in 1959.

ADAMS, WINIFRED BRADY.
(Mrs. John Ottis Adams). Painter. Born May 8, 1871, in Muncie, Ind. Studied in Philadelphia at Drexel Inst. and at ASL of NY. Among her works, "Marigolds" at Art Inst. of Indianapolis, and several studies in still life painting. Member: Cin. Woman's AC; Ind. AC; C. L. Wolfe AC; Portfolio C., Indianapolis, Ind.; AFA. Awards: Fine Arts prize, Herron AI, 1926; Buckingham prize, Hoosier Salon, 1926. Address, The Hermitage, Brookville, Ind. Died 1955.

ADAMS, WOODHULL.
Painter. Exhibited oil painting, "At Miss Florence's," Penna. Academy of Fine Arts, Phila., 1924. Address in 1926, Lyme, Conn.

ADDAMS, CLIFFORD ISAAC.
Painter and etcher. Born in 1876. Pupil of Whistler, and studied in Belgium, Holland, Spain, France, Italy, British Isles. Member: Chicago SE; Brooklyn SE. Awards: Cresson engraving scholarship, PAFA. Exhibited miniatures at Exhibition Academy of Fine Arts for water-colors and miniatures, 1924-25. Works: "Portrait of the Artist's Wife" and "Decoration," Pennsylvania Academy of the Fine Arts, Philadelphia; "Cottages in Wales" and many etchings, Chicago Art Institute. Address in 1926, London, England, and 71 Washington Square, New York.

ADDAMS, INEZ.
(Mrs. Clifford Addams). Painter. Address in 1926, 71 Washington Square, New York.

ADDISON, WALTER NICHOLS.
Sculptor, illustrator, and muralist. Born in Spokane, WA, March 15, 1914. Studied at National Academy of Design, 1932-35. Worked as staff illustrator for Bronx Zoo, 1937-38. Works: Animal murals such as watering hole at Gov. Clinton Hotel, NYC; fountain, ten Haitian mermaids; murals for August Schmeidigen, in Haiti, 1949-51; Polar Bear (marble); and all the animal figures for the General Motors Exhibition Hall, "The World of Tomorrow," New York World's Fair, 1964. Exhibited: Feragil Gallery, NYC, 1950; Burr Gallery, NYC. Awards: Bok Sculpture Fellowship, Tiffany Foundation Award, 1940. Died September 9, 1982.

ADICKES, DAVID PRYOR.
Sculptor and painter. Born in Huntsville, TX, January 19, 1927. Studied at Kansas City Art Institute,

1948; Sam Houston University, Huntsville, TX, BS, 1948; Atelier Fernand Leger, Paris, 1948-50. Exhibited: Museum of Fine Art, Houston, 1951; New Works, Witte Museum of Art, San Antonio, 1957; Laguna Gloria Art Museum in Austin, 1957; and a retrospective of his works at Ft. Worth Art Center, 1966. Awards: First Purchase Prize, Houston Artists, Contemporary Arts Association, Museum of Fine Arts, in Houston, 1955; Seix y Barral, Barcelona, Spain, 1962. Taught: Painting at the University of Texas, at Austin, 1955-57. Media: Bronze and oil. Address in 1982, Houston, TX.

ADLER, SAMUEL (MARCUS).
Painter. Born in New York City, July 30, 1898. Study: NAD, with Leon Kroll, Charles Louis Hinton. Work: Whitney Mus., New York City; Nat'l. Collection Fine Arts, Smithsonian; Hirshhorn Mus., Wash. DC; Brooklyn Mus.; Munson-Williams-Proctor Ins., Utica, NY; and others. Exhib.: PAFA, 1948-68; Univ. of Ill., 1949-71; Met. Mus., New York City, 1950; Whitney Mus., 1951-57; many others. Awards: Scheidt Mem. Prize, PAFA; purchase award, Whitney; Audubon Artists; Ford Foundation; others. Teaching: Visiting Prof. of Art at Univ. of IL, 1959-60; Visiting Prof. of Art at Univ. of IL, 1964; NYU, from 1948; others. Media: Oil, collage. Died Nov. 12, 1979. Address in 1976, 27 E. 22nd St., New York City.

ADNEY, EDWIN TAPPIN.
Artist and illustrator. Born at Athens, Ohio, 1868. Studied at Art Students League, New York. Illustrated *Harper's Weekly* and *Collier's Weekly*. Died 1950.

ADOLPHE, ALBERT JEAN.
Painter and mural decorator. Born 1865 in Phila. Studied with Gerome and Whistler in Paris; De Vriendt, Antwerp; Eakins, Phila. School of Ind. A. Member: Alumni Assn. School of Ind. A., Phila.; Graphic Sketch C. Awards: Hon. mention, Columbian Exp., Chicago 1894; hon. mention, Paris Salon, 1899; gold medal, Phila. AC, 1904; Stotesbury Prize, Phila., 1916, "Americanization Through Art" Exhibition; Hon. mention, Phila. AC, 1921. Work: Decorations in Marlborough-Blenheim Hotel, Atlantic City, NJ, and for steamships "St. Louis" and "St. Paul." Instructor at the La France Art Institute, Philadelphia. Address in 1926, 2616 Montgomery Ave., Philadelphia, PA. Died 1940.

ADOMEIT, GEORGE G(USTAV).
Painter. Born Germany, Jan. 15, 1879. Pupil of F. C. Gottwald. Member: Cleveland SA; Al Graphic A.; Cleveland Print C.; AFA. Awards: Prize, Ohio State Fair, 1922; prize, Cleveland Museum of Art, 1923, 1927. Address in 1929, Caxton Bldg.; h. 2054 East 102nd St., Cleveland, Ohio.

ADRIANCE, MINNIE H.
Painter. Member of Society of Independent Artists. Address in 1926, 51 East 53d Street, New York City.

AFROYIM, BEYS (EPHRAIM BERNSTEIN).
Sculptor and painter. Born Ryki, Poland, January 2, 1893. Studied: Art Institute of Chicago; National Academy of Design; and with Boris Anisfeld. Member: Artists League of America. Work: Moscow Museum of Art; U.S. public buildings. Position: Director and teacher, Afroyim Experimental Art School, 1927-46. Address in 1953, 1 West 95th St., New York City.

AGAM, YAACOV.
Sculptor, painter, multi-media artist, and lecturer. Born Israel, 1928. Studied at Bezalel School of Art, Jerusalem. Went to Paris, 1951. Deeply influenced by Hebrew conception that reality cannot be represented in a graven image, seeks to create an image which cannot be seen completely at any one time. Has expressed these concepts in monumental architectural works: "Jacob's Ladder," ceiling of National Convention House, Jerusalem; "Double Metamorphosis II," Museum of Modern Art, NY; mural for passenger ship "Shalom;" visual environment, Civic Center at Leverkusen, 1970; Environmental Salon, Elysee Palace, Paris, 1972, which includes all the walls, kinetic ceiling, moving transparent colored doors and a kinetic tapestry on the floor; mural, President's Mansion, Jerusalem, 1972; monumental musical fountain, Paris, 1977; mural, Eye Foundation Hospital, Birmingham, AL, 1982. One-man shows: Craven Gallery, Paris, 1953, (first one-man show of kinetic art); Marlborough-Gerson Gallery, NY, 1966; Tel Aviv Museum, 1973; Gallery Attali opening in Paris, first worldwide presentation of video researches by Agam, 1974; Jewish Museum, NY, 1975; Janus Gallery, Washington DC, 1977; S. African National Gallery, 1977; and many other solo and group shows, US and abroad. Group shows: First group show of kinetic movement, Galerie Denise Rene, Paris, 1955; Gallery Attali, Paris, 1976. Retrospectives: National Museum Modern Art, Paris, 1972; exhibition traveled to Stedelijk Museum, Amsterdam, 1972, and Dusseldorfs Kunsthalle, 1973. Awards: First prize for creative research, Biennial, Sao Paulo, 1963; Chevalier de l'Ordre des Arts et Lettres, 1974; Honorary Doctorate of Philosophy, Tel Aviv University, 1975; Medal of Council of Europe, 1977. Guest-lecturer, theory of advanced visual communication, Harvard University, 1968.

AGATE, ALFRED.
Miniature painter. Born Feb. 14, 1812. Brother of Frederick S. Agate. He received his instruction from the artist Thomas S. Cummings. Elected Associate Member of National Academy. Died Jan. 5, 1846 in Wash., DC.

AGATE, FREDERICK S.
Painter. Born 1807, in Sparta, Westchester Co., NY. He first studied art with the engraver Rollinson, and later with John R. Smith and S. F. B. Morse. He painted an excellent portrait of Rollinson, also of the actor Forrest as "Metamora." He was elected an Associate of the National Academy of Design and an Academician in 1826. Died May 1, 1844 in Sparta, NY.

AHL, HENRY HAMMOND.
Sculptor and painter. Born in Hartford, Conn., December 20, 1869. Studied: Royal Academy, Munich, Germany, with Alexander Wagner, Franz Stuck; Ecole des Beaux Arts in Paris, with Gerome. Work: Worcester Museum of Art; Springfield (Mass.) Art Museum; L.D.M. Sweat Memorial Museum, Portland, ME; Whistler Memorial Home, Lowell, Mass.; Vanderpoel Collection; Wellesley College; church murals in Boston, Mass.; Providence, RI. Exhibited: National Academy of Design; American Watercolor Society of New York; Washington Art Club; Penna. Academy of Fine Arts; Boston Museum of Fine Arts; Boston Art Club; Worcester Museum of Art; Hartford Atheneum; Corcoran Gallery of Art; North Shore Art Association. Address in 1953, Newbury, Mass. Died in 1953.

AHLGREN, ROY B.
Printmaker and instructor. Born in Erie, PA, July 6, 1927. Study: Erie (PA) Tech. Sch.; Villa Maria College; Univ. of Pittsburgh, BS ed.; Penn State Univ. Work: US Info. Agency, Wash. DC; Butler Art Inst., Youngstown, OH; etc. Comn.: Serigraphs, Assn. Am. Artists, NYC; WQLN Publ. TV; others. Exhibitions: National Academy of Design Annual, NY; Penna. Academy of Fine Arts; 1969 Nat'l Exhib. of Prints, Library of Congress; Silvermine Guild Print Exhib.; Int'l. Exhib. of Graphic Art, Frechen, Ger.; others. Awards: Merit, 4th Miami Int'l. Graphic Biennial; etc.; 21 national and regional prizes. Teaching: Tech. Memorial HS, Erie, PA, 1970. Member: Boston Printmakers; Phila. Print Club; World Print Council, San Francisco. Media: Serigraph. Address in 1982, 1012 Boyer Rd., Erie, PA.

AHRENS, ELLEN WETHERALD.
Painter of portraits and miniatures, illustrator. Born 1859 in Baltimore, MD. Member of Penna. Society of Miniature Painters. Awarded prizes at Penna. Academy of Fine Arts and Carnegie Institute, Pittsburgh. Address in 1926, Lansdowne, PA. Died 1953.

AID, GEO. C.
Miniature painter, etcher. Born 1872, in Quincy, Ill. Medal at St. Louis Exposition, 1904. Pupil of Laurens, and Benjamin Constant, in Paris. Address in 1926, 3660 Blaine Ave., St. Louis, MO. Died 1938.

AIKEN, CHARLES A.
Mural painter. Born 1872 in Georgia, VT. Pupil of Boston Museum of Fine Arts School. Exhibited water colors, Penna. Academy of Fine Arts, Phila., 1925. Address in 1926, 57 West 57th Street, New York. Died 1965.

AIKMAN, WALTER MONTEITH.
Artist. Born 1857, New York. Studied engraving in NY under Frank French and J. G. Smithwick, drawing and painting under Boulanger and Lefebvre, Paris. Work and Awards: Medal for engraving, Paris Exp., 1889, and Chicago Exp., 1893; exhibited at Paris, 1900; silver medal for original engravings on wood, Buffalo Exp., 1901; wood and copper engravings at Carnegie Inst., Pittsburgh and NY Public Library. Address in 1926, 133 Macon Street, Brooklyn, NY.

AIMAN, PEARL.
Painter. Exhibited "Fishing Pier, Provincetown," at Penna. Academy of Fine Arts, 1920. Address in 1926, East Willow Grove Ave., Chestnut Hill, Phila., PA.

AITKEN, PETER.
Wood engraver. Born June 16, 1858, Dundas, Can. Studied engraving under Timothy Cole several years, visited Europe 1887 and 1891, and studied in Paris, 1895. Awarded medal, Chicago Expn., 1893, and exhibited Paris Expn., 1900. Address in 1926, Hart Street, Brooklyn, NY. Died in 1912.

AITKEN, ROBERT.
Engraver and illustrator. Born 1734, in Scotland; died 1802, in Philadelphia. Aitken issued the Pennsylvania Magazine in 1776, and engraved the vignette on the title page after a design by Pierre E. duSimitiere, and a number of the illustrations; among the latter were some of the first views of military operations in the revolution ever engraved.

AITKEN, ROBERT INGERSOLL.
Sculptor. Born May 8, 1878, in San Francisco. He studied at the Mark Hopkins Institute of Art in San Francisco, under Arthur F. Matthews and Douglas Tilden. Professor of sculpture, Mark Hopkins Inst. of Art (University of California), 1901-04. Worked in Paris, 1904-07. Instructor, National Academy of Schools Sculpture Class. Taught at Art Students League. Awards: Phelan gold medal for sculpture; Helen Foster Barnett prize, National Academy of Design, 1908, for the G.R. Clark monument, University of Virginia, Richmond, VA; gold medal of honor for sculpture, New York Architectural League, 1915; silver medal of sculpture, P.-P. International Exposition, San Francisco, CA, 1915; Elizabeth N. Watrous gold medal, National Academy of Design, 1921. Member: National Sculpture

Society, 1902; Associate, National Academy of Design, 1909; National Academy of Design, 1914; New York Architectural League, 1909; National Institute of Arts and Letters; Allied Artists of America; National Arts Club. Works: Busts, Mme. Modjeska, D. Tilden, Dr. J. L. York, C. J. Dickman, CC. R. Peters, A. Thomas, D. Warfield, R. F. Outcault, G. Bellows, ex-President Taft, H. A. Jones; monuments, to W. McKinley at St. Helens, CA, 1902, and Golden Gate Park, San Francisco, 1903; to Bret Harte, 1904, to Hall McAllister, 1904, and to the American Navy, San Francisco, CA; Tired Mercury; Dancing Faun; Burrill memorial, New Britain, CT; George Rogers Clark monument, University of Virginia, Richmond, VA; doors for Greenhut and John W. Gates Mausoleums, Woodlawn cemetery, NY; The Fountain of the Earth and The Four Elements, P.-P. Exposition, 1915; "The Flame," Metropolitan Museum, NY. He designed the $50 dollar gold piece for the exposition and the half-dollar for the Missouri Centennial, 1921. Exhibited at National Sculpture Society, 1923. Worked in Paris, 1904-7. Address in 1934, 154 West 55th Street, NYC. Died January 3, 1949.

AKAMU, NINA.
(Nina Akamu Sheppard). Sculptor. Born in Midwest City, OK, July 11, 1955. Studied at Maryland Institute of Art, BFA, 1976. Exhibited: Game Conserve International, San Antonio Conservation Center, in TX, 1980; Annual Society of Animal Artists, Salmagundi Club, NY, 1981; Society of Animal Artists and Wildfowl Carvers Exhibit, Museum of Natural Science, Philadelphia, PA, 1981; National Sculpture Society Annual, NY, 1982; one-woman show, National Aquarium, Baltimore, 1981; National Academy, NY, 1982. Member: National Sculpture Society; Society of Animal Artists. Media: Bronze, clay, and terra cotta. Address in 1982, Florence, Italy.

AKAWIE, THOMAS FRANK.
Painter. Born in New York City, Feb. 22, 1935. Study: Los Angeles City College, 1953-56; Univ. of Calif., Berkeley, BA, 1959, MA, 1963. Work: Milwaukee Art Center, Wis.; Ithaca College; Oakland Mus., Calif.; Williams College; private collections. Exhib.: 1969 annual, Whitney, NYC; San Fran. Mus. of Mod. Art, 1976; Nat'l. Collection of Fine Arts, Smithsonian, 1977; La Jolla Mus. (Calif.) of Art, 1967; Calif. Palace of Legion of Honor, San Fran., 1972; San Jose Museum, 1977; Japan, 1978; and others. Awards: Anne Downey Mus. Invit., Calif.; Jack London Art Exhib., Oakland, Calif.; others. Teaching: San Fran. Art Inst.; others. Address in 1982, Berkeley, Calif.

AKED, ALEEN.
Sculptor, painter, craftsman, and lecturer. Born in England. Studied: Ontario College of Art; Ringling School of Art; and with Sydney March, Abbott Graves, Robert Brackman. Member: Sarasota Art Association. Awards: Prizes, Ontario College of Art; Ringling Museum of Art, 1938. Exhibited: Canadian National Exhibition, 1936-38; Royal Canadian Academy, 1938; Allied Artists of America, 1939; Southern States Art League, 1938-40; Sarasota Art Association; Studio Guild, 1939, 40; New York Public Library, 1940; St. George Public Museum, 1940; Ontario Society of Artists, 1938; Toronto Golf Club, 1946-52 (one-woman). Address in 1953, Ontario, Canada.

AKELEY, CARL ETHAN.
Sculptor, naturalist, and inventor. Born in Claredon, NY, in 1864, and was a member of the National Sculpture Society, 1914; Architectural League of NY; National Institute of Social Sciences; Franklin Institute. He became associated with the American Museum of Natural History in 1909 and was in Africa collecting specimens for that institution at the time of his death. He was chiefly noted as a collector and mounter of wild life specimens and as a sculptor, but he also had a notable record as an engineer. He is represented by a bronze, "The Chrysalis," in the West Side Unitarian Church, NY; two animal studies in the Brooklyn Institute Museum; and numerous groups in the American Museum of Natural History, NY. Address in 1926, NYC. Died in Kabale, Uganda, Central Africa, November 17, 1926.

AKERS, BENJAMIN PAUL.
Sculptor, painter, and author. Born July 10, 1825, in Westbrook, ME. Studied painting in Portland, ME, and in 1849 studied plaster casting with Carew in Boston. Made his first visit to Europe, visiting Florence, Italy, where he remained during the year 1852, and studied under Powers. He travelled to Europe again in 1855-57 and in 1859. Among his works are: "Peace," "Una and the Lion," "Girl Pressing Grapes," "Isaiah," "Schiller's Diver," "Reindeer," "The Lost Pearl Diver," "St. Elizabeth of Hungary," "Milton," "Diana and Endymion;" portrait busts of Tilton, Longfellow, Samuel Appleton, Edward Everett, Prof. Cleveland, Gerrit Smith, Sam Houston, and Justice John McLean. Died May 21, 1861, in Philadelphia, PA.

AKERS, CHARLES.
Sculptor. Born near Hollis, Maine, October 15, 1835 or 36. He also worked as a crayon portrait draughtsman. He went to Rome in 1855 to study art with his brother, Benjamin Paul Akers, sculptor. His studio was in New York, 1860-69. In 1875 he was working in Waterbury, Conn., and in 1879 he had returned to New York. Died Sept. 16, 1906, in New York City.

AKERS, GARY.
Painter. Born Pikeville, KY, Feb. 22, 1951. Study: Morehead (KY) State University, BA, 1972; MA, 1974. One-man exhibition: Claypool-Young Art Gallery, Morehead, KY, 1978. Exhibitions: KY Water Color Soc., 1978, 1981; Am. Water Color Soc., NY, 1979, 1982; Nat'l. Acad. Galleries, NYC, 1979, 1982; S. Water Color Soc., Denton, TX, 1979, and Asheville, NC, 1983; 4th Invitational Water Color Exhib., Springfield (Ill.) AA, 1980; AAA, NY, 1981, 1982. Awards: Grant, Greenshields Foundation, Montreal, Canada, 1976; Friends of KY WC Soc. Award, 1978. Included in Am. WCS 115th traveling exhib. Media: Egg tempera, water color. Dealer: McBridge Gallery, 117 Main St., Annapolis, MD. Gary Akers Art Studio, Union, KY, opened 1980.

AKIN, JAMES.
Born 1773, in Charleston, South Carolina. His earliest engraved work is found in Drayton's "Views of South Carolina," Charleston, SC, 1802. In 1804 he was working in Salem, Mass.; in 1808 he returned to Phila., where he drew caricatures, and engraved book plates. He also published prints in connection with William Harrison, Jr. Died July 16, 1846, in Philadelphia.

AKIN, LOUIS.
Painter. Was born 1868, in Portland, ME; died 1913, in Flagstaff, Arizona. He studied in New York City under Chase and DuMond. His specialty was painting the life of the American Indian, and the American Museum of Natural History in New York commissioned him to decorate their room devoted to Indians of the Southwest.

AKIN, MRS.
She is supposed to have been the wife of James Akin, and engraved membership certificates. Her work was done in Newburyport, Mass., in 1806-08.

ALAJALOV, CONSTANTIN.
Illustrator. Born in Rostov-on-the-Don, he was brought up in pre-revolutionary Russia and by the age of 15 was illustrating a book of poetry by Baudelaire as well as the *Lives of Savanarola*. He attended the University of Petrograd, enjoyed a brief stay as a court painter and was a member of their new artists' guild. Having fled from Constantinople, Alajalov arrived in New York in 1923 and found work painting murals for Russian cabarets. Three years later he began a 20-year relationship with *The New Yorker* doing cover art and in 1945 he began working for *The Saturday Evening Post*, in addition to illustrating children's books.

ALBEE, GRACE THURSTON ARNOLD.
Painter and engraver. Born in Scituate, Rhode Island, July 28, 1890. Studied: Rhode Island School of Design and with Paul Bornet in Paris. Awards:

National Academy of Design; Providence Art Club; Society of American Graphic Artists, 1951; Connecticut Academy, 1955, 1958; Hunterdon County Art Center, 1958; Boston Printmakers; Audubon Artist; Artists fellowship. Work: Met. Mus. of Art; NYC; Carnegie Institute; Cleveland Museum of Art; Okla. Agricultural and Mechanical College; John Herron Art Institute; Rhode Island School of Design; Library of Congress; National Museum, Stockholm; National Academy of Design; Philadelphia Museum of Art; Cleveland Printmakers Club; Marblehead Art Association; New York Public Library; Newark Public Library; Boston Public Library; Culver Military Academy; National Museum, Israel; Collection of King Victor Emmanuel, Italy. Address in 1929, 7 Rue Campagne Premiere, Paris, France.

ALBEE, PERCY F.
Painter. Born 1883, in Bridgeport, Conn. Pupil of Penna. Academy of Fine Arts and Providence School of Design. Address in 1926, 235 Benefit Street, Providence, RI. Died in 1959.

ALBERS, ANNI.
Designer, graphic artist, weaver and teacher. Born in Berlin, Germany, June 12, 1899. US citizen. Study: Bauhaus, Weimar, Germany, dipl.; Hon. Doctorates: Maryland Col. of Art, 1972; York Univ., Toronto, 1973; Phila. Coll. of Art, 1976; Univ. of Hartford, 1978. Work: Met. Mus. of Art; MOMA; Monmouth (NJ) Mus.; Art Inst. of Chicago; Univ. of Calif. at Riverside; and others. Comn.: Memorial to Nazi victims; comn. by List Family for Jewish Mus.; Ark Curtain, Dallas. Exhib.: MOMA; Brooklyn Mus., NY; Katonah Gallery, NY; Univ. of Hartford Art Sch.; Queens Coll. Library, NY; Monmouth (NJ) Mus.; Univ. of Calif., Riverside; Carnegie Inst.; Yale Univ. Art Gal; and others. Awards: Phila. Coll. of Art, 1962; Tamarind Lithog. Workshop Fellow, Los Angeles, 1964; gold medal, American Craft Council, 1981. Teaching: Black Mtn. College, 1933-49; lecturer at univ. and museums. Author: *Anni Albers: On Designing*, Wesleyan Univ. Press, 1962, 71; *On Weaving*, same press, 1965, 72; *Anni Albers: Pre-Columbian Mexican Miniatures*, Praeger, 1970. Media: Textile. Address in 1982, 808 Birchwood Dr., Orange, CT.

ALBERS, JOSEF.
Painter, printmaker and teacher. Born in Bottrop, Germany, March 19, 1888. US citizen. Study: Royal Art Sch., Berlin; Art Acad., Munich; Bauhaus, Weimar, Ger. Work: Met. Mus. Art; Guggenheim; MOMA; Whitney; Chicago Art Inst. Comn.: Brick mural, Harvard Univ., 1950; glass mural, Time & Life Bldg., NYC, 1961; plastic mural, Pan Am Bldg., NYC, 1963; Rochester Inst. Tech., 1969; Yale Univ. Art Bldg. Exhib.: Homage to the Square, MOMA, S. Am., & US travelling show 1964-66; Los Angeles Co. Mus., 1966; Kunsthalle, Dusseldorf, Ger., 1970;

Princeton Univ. Art Mus., 1971; Met. Mus. Art, 1971-72. Teaching: Bauhaus, Weimar, Dessau and Berlin, 1923-33; Black Mtn. College, NC, 1933-46; Yale Univ., 1950-60. Awards: Commander's Cross, Order of Merit, Ger. Fed. Rep., 1968; Fine Arts Medal, Am. Inst. Architects, 1975; Ford Found. Grant. Mem.: Am. Abstract Artists; Am. Inst. Graphic Arts; Print Council of Am.; Nat'l. Inst. Arts and Letters. Bibliog.: Extensive. Author: *Interaction of Color*, Yale Univ., 1963; *Formulation: Articulation*, Abrams, 1972; others. Died in 1976. Address in 1976, 808 Birchwood Dr., Orange, CT.

ALBERT, CALVIN.
Sculptor. Born November 19, 1918, Grand Rapids, MI. Studied: Grand Rapids Art Gallery with Otto Bach; Institute of Design, Chicago, with Lazlo Moholy-Nagy, Gyorgy Kepes, Alexander Archipenko. Taught at Institute of Design, Chicago; NYU; Brooklyn College; Pratt. Exhibited: Paul Theobald Gallery, Chicago, 1941; Puma Gallery, NYC, 1944; Calif. Palace, 1947; Laurel Gallery, NYC, 1950; Grace Borgenicht Gallery Inc., 1952, 54, 56, 57; The Stable Gallery, 1959; Galleria George Lester, Rome, 1962; Metropolitan Museum of Art, 1952; University of Nebraska, 1955; Walker, 1954; Jewish Museum, 1960; Museum of Modern Art, Recent Drawings USA, 1956; Whitney Annuals, 1954, 55, 56, 58, 60, 62; Brooklyn Museum, Golden Year of American Drawing, 1956; Art Institute of Chicago; Penna. Academy of Fine Arts, 1949, 53, 64. Awards: Detroit Institute, The Haass Prize, 1944; Tate, London, International Unknown Political Prisoner Competition, Honorable Mention, 1953; Audubon Artists, First Prize, 1954; Fulbright Fellowship, 1961; L. C. Tiffany Grant, 1963, 65; Guggenheim Foundation Fellowship, 1966. Commissions for churches and temples, including Park Avenue Synagogue, NYC. Collections: Brooklyn Museum; Art Institute of Chicago; Detroit Institute; Jewish Museum; Metropolitan Museum of Art; University of Nebraska; Provincetown, Chrysler; Whitney. Address in 1983, 325 W. 16th St., New York City.

ALBERT, E. MAXWELL.
Painter. Born 1890, in Chicago, Ill. Pupil of Art Students League of New York. Address in 1926, New Canaan, NY.

ALBERT, ERNEST.
Painter. Born 1857, in Brooklyn, NY. Pupil of Brooklyn Art School. Elected Associate, National Academy of Design. Address in 1926, New Canaan, Conn. Died in 1946.

ALBERTS, JOHN B.
Painter. Born 1886, at Louisville, KY. Pupil of Cincinnati Art Academy.

ALBRECHT, CLARENCE JOHN.
Sculptor, lecturer and teacher. Born Waverly, IA, September 28, 1891. Pupil of H. R. Dill, James A. Wehn, Charles Eugene Tefft. Works: Grizzly Bear Group, California Academy of Sciences; Sea Lion Group, American Museum of Natural History; Deer, Bear and Goat Groups, State Museum, University of Washington. Address in 1929, American Museum of Natural History, New York, NY.

ALBRECHT, MARY DICKSON.
Sculptor and painter. Born in Dothan, AL, June 4, 1930. Studied at University of Houston; Texas Woman's University, BS, (sculpture, with honors), 1970. Exhibited: Dallas Museum of Fine Arts, 1971; 61st Annual National Exhibit, 1972; Laguna Gloria Museum, Austin; Joslyn Art Museum, Omaha, NE, 1976; Del Mar College, Corpus Christi, TX, 1976. Awards: Juror's choice and circuit merit awards, Texas Fine Arts Association State Citation Show, 1971 and 72; Purchase award, art acquisition committee, University of Texas, Arlington, 1972. Media: Steel, bronze, metal, and plastic. Address in 1982, Dallas, TX.

ALBRIGHT, ADAM EMORY.
Artist. Born 1862, at Monroe, Wis. Student of Art Inst. of Chicago, 1881-3; Pa. Acad. Fine Arts, Philadelphia, 1883-6; Munich and Paris, 1887-8. Painter of Am. country children; exhibited at Chicago Exp., in 1893, and later in New York, Philadelphia, Boston, Washington, Chicago, Paris Salon. Member, Soc. Western Artists; Fellowship of PAFA; Chicago Soc. Artists (pres., 1915-16); Chicago WCC (dir., pres.); Chicago Acad. Design; Am. Water Color Soc., New York; Am. Federation of Arts. Died in 1957. Address in 1926, Hubbard Woods, Ill.

ALBRIGHT, GERTRUDE PARTINGTON.
Painter. Born in England. Among her paintings, "Portrait of an Actress," owned by the city of San Francisco, is the best known. Address in 1926, 737 Buena Vista Ave., San Francisco, Cal.

ALBRIGHT, H. OLIVER.
Painter. Born 1876 in Mannheim, Germany. Member of San Francisco Art Association. Address in 1926, 737 Buena Vista Ave., San Francisco, Cal.

ALBRIGHT, HENRY JAMES.
Sculptor and painter. Born July 16, 1887, in Albany, NY. Pupil of Wm. St. John Harper, John F. Carlson, C. W. Hawthorne, S. L. Huntley, and C. L. Hinton. Member: American Federation of Arts; Society of Independent Artists. Designer and Sculptor; bronze tablets marking Gen. Knox Highway, Ticonderoga to Boston. Director of Troy Art Institute. Address in

1933, Glenmont, Albany Co., New York. Died in January, 1951.

ALBRIGHT, IVAN LE LORRAINE.
Sculptor, painter, and lithographer. Born in North Harvey, IL, Feb. 20, 1897. Studied at Ecole Regionale Beaux-Arts, Nantes, France, 1919; Art Institute of Chicago, 1920-23, Ph.D., 1977; National Academy of Design, NYC, 1924; Penna. Academy of Fine Arts; and others. In collections of National Gallery, Washington, DC; Metropolitan Museum of Art, Museum of Modern Art, Guggenheim, Whitney, in NYC; others. Exhibited at Carnegie Institute; NY and Brussels World's Fairs; Museum of Modern Art; Art Institute of Chicago; Corcoran Gallery, Washington, DC; National Academy of Design and Whitney, NYC; and many more. Awards: Honorable mention, Art Institute of Chicago, 1926, and Shaffer prize, 1928; medal, painting, 1942, and Metropolitan Museum prize, 1952, at Metropolitan Museum of Art; Silver medal, Corcoran Gallery, 1955; others. Member of National Institute of Arts and Letters; American Water Color Society; American Academy of Arts and Letters; Academician, National Academy of Design; fellow, Penna. Academy of Fine Arts. Represented by Kennedy Galleries, NYC. Working at Albright Studios in Warrenville, IL, in 1929. Living in Woodstock, VT, in 1982.

ALBRIGHT, MALVIN MARR.
Sculptor and painter. Born Chicago, IL, Feb. 20, 1897. Studied at Art Institute of Chicago; Penna. Academy of Fine Arts; Beaux Arts Institute of Design, NYC; with Albin Polasek, Charles Grafly. Work: San Diego (CA) Fine Arts Gallery; Corcoran Gallery, Washington, DC; Toledo (OH) Museum of Art; Butler Institute, Youngstown, OH; Penna. Academy of Fine Arts; and others. Exhibited at National Academy of Design, Whitney, Museum of Modern Art, all in NYC; Penna. Academy of Fine Arts; Carnegie Institute and more. Awards: Fountain prize, Chicago Daily News, 1922; Jenkins prize, Art Institute of Chicago, 1929; Altman prize, National Academy of Design, 1942 and 62; Corcoran Silver Medal; Dana Medal, Penna. Academy of Fine Arts, 1965; and others. Member: Fellow, Penna. Academy of Fine Arts; Art Institute of Chicago Alumni; Laguna Beach Art Association; National Academy of Design; fellow, Royal Society of Arts; International Institute of Arts and Letters; National Sculpture Society; and others. Working at Albright Studios in Warrenville, IL, in 1929. Address in 1982, Chicago, IL.

ALBRIZIO, CONRAD A.
Draughtsman. Born, October 20, 1894, NYC. Studied architectural drawing, Cooper Union night classes, 1911; Beaux Arts under Frederick Hirons, 1918; NY ASL under Luks and DuMond, 1923; also studied in Paris, learned fresco in Rome, Italy, under Paperi and encaustic in Pompy; American Assembly and Fontainebleau School, France. Worked during studies as draftsman in New Orleans, 1919, and designer in NY. Work: Frescoes, Governor's reception room and court rooms, Louisiana State Capitol, 1932; Murals for Richmond Hill High School, under Public Works of Art project, and church of St. Cecilia, Detroit, MI. Organized Fresco Guild. Taught Fine Arts, Louisiana St. U., Baton Rouge, 1936.

ALBRIZIO, HUMBERT.
Sculptor. Born in New York City, December 11, 1901. Studied: Beaux-Arts Institute of Design; New School Social Research. Member: National Sculpture Society; Sculptors Guild; Audubon Artists; Minnesota Sculptor Group. Awards: Medal, National Sculpture Society, 1940; prizes, Walker Art Center, 1945, 46, 51; Des Moines, Iowa, 1946; Denver Museum of Art, 1947; Audubon Artists, 1947; Joslyn Art Museum, 1949. Work: Walker Art Center; United States Post Office, Hamilton, NY; State University of Iowa; Joslyn Art Museum; Worcester Museum of Art. Exhibited: Metropolitan Museum of Art; Whitney Museum of Art; Brooklyn Museum; National Academy of Design; Philadelphia Museum of Art; Carnegie Institute; Penna. Academy of Fine Arts; Albany Institute of History and Art; Art Institute of Chicago. Associate Professor, Sculpture, at State University of Iowa, Iowa City, Iowa. Address in 1953, State University of Iowa; h. Iowa City, Iowa. Died 1970.

ALCOTT, ABIGAIL MAY.
Painter. Born July 26, 1840 in Concord, Mass. Studied at Boston School of Design and abroad. Her professional life was spent in Boston, London, and Paris. Illustrator for books of her sister, Louisa May Alcott, author of *Little Women* and other classics. Best known for still life compositions. She exhibited in America and Europe. Died 1889 in Paris, France.

ALDEN, LOWELL WAVEL.
Sculptor, painter, etcher, and lecturer. Born in Jonesboro, LA, July 16, 1911. Studied: Louisiana Polytechnic Institute, B.A. Member: Associated Artists of Houston; Southern States Art League. Exhibited: Museum of Fine Arts of Houston; Dallas Museum of Fine Arts; Southern States Art League. Address in 1953, Houston, Texas.

ALDRICH, F(RANK) H(ANDY).
Painter, illustrator, craftsman, lecturer, and teacher. Born Wauseon, Ohio, Mar. 29, 1866. Pupil of Metcalf, Twachtman, Knaufft. Member: Toledo Artklan. Custodian of Ancient Books and Manuscripts, Toledo Museum of Art. Address in 1929, Toledo Mus. of Art.

ALDRICH, GEORGE AMES.
Painter and etcher. Born 1872, in Worcester, Mass. Address in 1926, 155 East Ohio Street, Chicago, Ill. Died in 1941.

ALDRICH, MARY AUSTIN.
(Mrs. Malcolm Fraser). Sculptor and craftsman. Born in NYC, February 22, 1884. Studied with Partridge, Lober, Fraser. Works: Altar piece, "Christ Child," and panels, St. Anne's Convent, Kingston, NY; bronze memorial figure, Christ Child, National Cathedral, Washington, DC; various figures in concrete and bronze in private schools and gardens. Member: National Association Women Painters and Sculptors; National Arts Club; NY Society of Craftsmen. Address in 1933, Brookhaven, Long Island, NY.

ALDRIDGE, ADELE.
Painter/graphics. Studied: Silvermine College of Art; Parsons School of Design; Chicago Art Institute. Exhibitions: Bodley Gallery, New York City, 1970; Metamorphosis Gallery, Ridgefield, Connecticut, 1971; Three Interpretations of the I Ching, Greenwich Library, 1972. Currently working on interpreting the *I Ching* in 64 separate portfolios of seven prints each.

ALEXANDER, A(RTHUR) H(ADDEN).
Etcher, landscape artist. Born Decatur, Ill., Oct. 27, 1892. Member: Am. Soc. Ldscp. A.; Cleveland SA; Cleveland Print C. Address in 1929, 4500 Euclid Ave.; h. 2572 Kemper Road, Cleveland, Ohio.

ALEXANDER, CLIFFORD GREAR.
Painter, illustrator and teacher. Born 1870, in Springfield, Mass. Pupil of School of Boston Museum of Art. Address in 1926, 6 Upland Road, Faneuil Station, Brighton, Mass.

ALEXANDER, COSMO.
Born c. 1724. Scottish painter who visited this country in 1770 and remained in Newport, RI, for a year or so; went on to South Carolina and then to Edinburgh. He died shortly after reaching home. He painted portraits of Dr. William Hunter's family of Newport, and a number of his countrymen residing in this country. On his return to Scotland he took young Gilbert Stuart with him. Died Aug. 25, 1772.

ALEXANDER, FRANCIS.
Born Feb. 3, 1800 in Connecticut. Began painting in water color, and studied under Alexander Robinson in New York. Later he went to Providence, and then opened his studio in Boston, where he had many sitters, the most famous being Daniel Webster, of whom he painted several excellent portraits. In 1831 he visited Europe, finally settling in Florence, where he remained until his death. Alexander wrote a short autobiography published in Dunlap's "History." He went to New York for a brief period in 1820 and again the following year for study. He then went to Boston with a letter to Gilbert Stuart from John Trumbull, where he advanced rapidly in his painting under Stuart's influence. In 1831 he first visited Italy.

He did not in his final years continue his profession as an artist. He drew on stone the earliest attempts at portrait lithography in America. For full account see *Boston Magazine*, 1825. He painted Charles Dickens, Benjamin R. Curtis, John Odin, Baron Stow, Mrs. Fletcher Webster and Master Lord, and many others. Died March 27, 1880.

ALEXANDER, JACQUES.
Painter. Born Berlin, Germany, Dec. 15, 1863. Pupil of Laurens and Constant in Paris. Member: Soc. of Deaf Artists. Address in 1929, 436 Fort Washington Ave., New York, NY.

ALEXANDER, JOHN WHITE.
Artist. Born 1856, in Allegheny City, PA; died in 1915 in New York City. Educated in the schools of his native city, he early manifested a talent for sketching and at sixteen went to New York, where he soon obtained employment with Harper & Brothers as an illustrator. In 1877 he went abroad and studied at the Munich Royal Gallery and later in Venice, Florence, Holland and Paris. On his return to this country in 1881 he won immediate recognition as a portrait painter; many eminent men, including Walt Whitman, Joseph Jefferson, Oliver Wendell Holmes, John Burroughs, Grover Cleveland and Robert Louis Stevenson, sat for him. In 1891 he went to Europe for health reasons and during the course of his travels made a series of portraits of distinguished authors. Three of his portraits of women were accepted by the Paris Salon of 1893, marking the beginning of his international reputation and winning him election as an associate of the Societe Nationale des Beaux Arts. He also achieved distinction in mural painting. The six decorative panels representing "The Evolution of the Book," which adorn the Congressional Library, were done by him in 1895. Later he painted the titanic series of murals surrounding the grand staircase of the Carnegie Institute, Pittsburgh, and in 1906 was engaged to do a series depicting "The Industrial Development of Pennsylvania" for the State Capitol, which he never completed. He was one of the most active members of the National Academy of Design, and its president from 1909 until shortly before his death. Among his paintings, "The Pot of Basil," painted in 1856, is owned by the Boston Museum of Fine Arts; "The Blue Bowl" is owned by the Rhode Island School of Design; and his portrait of the Norwegian painter Thaulow is owned by the Penna. Fairmount Park, Wilstach Collection.

ALEXANDER, JON H.
Sculptor, painter, and illustrator. Born in Rochester, NY, December 8, 1905. Studied: Mechanics Institute, Rochester, NY; National Academy of Design, with Robert Aitken, Charles Hawthorne; University of Rochester, School of Medicine. Works: Pittsford, NY; Rochester Memorial Art Gallery. Taught: Diorama Artist, Sculptor, Model Builder, Archaeology Divi-

sion, Rochester Museum, 1941-52. Address in 1953, Rochester Museum, Rochester, NY.

ALEXANDER, JULIA STANDISH.
Sculptor, craftsman, writer, and teacher. Born Springfield, Mass. Pupil of Art Students League of NY; Victor Brenner. Member: Alliance; NY Society of Craftsmen; American Federation of Arts. Director, Art and Craft Department, Heckscher Foundation for Children, New York City. Address in 1934, Mount Vernon, New York.

ALEXANDER, MARIE DAY.
(Mrs. Ernest R. Alexander). Painter and sculptor. Born in Greenfield, MA, October 31, 1887. Pupil of Augustus Vincent Tack, Philip Hale, William Paxton. Work: "Green River in Autumn," Mass. Federation of Women's Clubs, Boston. Member: North Shore Art Association; National Association of Women Painters and Sculptors. Address in 1934, Greenfield, MA.

ALEXANDER, MARY LOUISE.
Sculptor, writer, and teacher. Pupil of Meakin, Duveneck, Barnhorn, Grafly, Nowottny. Member: Cincinnati Women's Art Club; MacDowell Society, Cincinnati; Pen and Brush Club. Work: Vincent Nowottny tablet, Cincinnati Art Academy. Address in 1934, Cincinnati, Ohio.

ALEXANDER, NINA.
Painter and illustrator. Born in Auburn, Kansas. Pupil of Penna. Academy of Fine Arts. Student under Chase, and under Henri and Brangwyn in London. Address in 1926, 1315 Clifton Street, Washington, DC.

ALFANO, VICENZO.
Italian sculptor. Born in Naples, Italy, 1854. Exhibited in 1902 at the Sculpture Society in New York, "Cicerone." Died in 1918.

ALGER, JOHN HERBERT.
Painter. Born 1879 in Boston, Mass. Member of the Society of Independent Artists. Address in 1926, 210 East 17th Street, New York.

"ALJAMAN" (CHAPMAN, ALTON JAMES).
Painter and teacher. Born in River Junction, Florida, May 21, 1926. Study: Art Inst., Pittsburgh, diploma; Ad-Art Studio School, diploma; Merlin Enabnit Color Study Course; with Roy Hilton, Raymond Symboli, Robert Brackman. Work: Raymond Eyes, Ed Sullivan, Frankie Laine, Mae West, Gene Autry, David Freedman; Governor's Palace, Vera Cruz, Mexico; Ligoa Duncan Gallery, NYC; Atterbury Acad. Fine Arts, Miami; others. Exhibitions: R. Duncan Galleries Prix de Paris, 1969; Salon of the 50 States, NY, 1969; numerous other shows in Florida and throughout US. Awards: Prix de Paris Award,

Ligoa Duncan Galleries, NY, 1969; Antoni Gaudi Cornet Medal Award, Barcelona, Spain, 1970; John C. Meyers Art Scholarship. Teaching: North Miami Beach Artists Guild; Atterbury School, Art dir., Whitman and Shoop, Pittsburgh; creative advertising, Ashland, OH; etc. Mem.: Am. Artists Prof. Lg.; Fla. Artist Group, Inc.; Allied Artists of America; etc. Media: Oil, acrylic, foil. Rep.: Ambassador Galleries Ltd., Inc., 1990 N.E. 163rd St., North Miami Beach, Fla. 33162. Address in 1976, Aljaman's Art Clinic and Gallery, 921 N.E. 157th Terrace, North Miami Beach, Fla.

ALKE, STEPHEN.
Painter. Born in 1874. Exhibited landscapes in the annual exhibition of Cincinnati Museum, 1925. Address in 1926, New Richmond, Ohio. Died in 1941.

ALLAIRE, LOUISE.
Painter. Member of National Association of Women Painters and Sculptors. Address in 1926, 646 St. Marks Ave., Brooklyn, New York.

ALLAN, MRS. CHARLES BEACH.
Painter. Born 1874 in Detroit, Mich. Address in 1926, 542 Park Ave., Kansas City, MO.

ALLEN, ANNE HUNTINGTON.
(Mrs. Thomas W. Allen). Painter. Born New York, 1858. Student, Cooper Institute; pupil of Wyatt Eaton and Carolus Duran. Address in 1926, 230 Southern Ave., Mt. Auburn, Cincinnati, Ohio.

ALLEN, CHARLES CURTIS.
Painter. Born Dec. 13, 1886. Instructor in water color painting, Worcester Art Museum. Exhibited at Penna. Academy of Fine Arts, Philadelphia, 1925. Address in 1926, 41 Commonwealth Ave., Chestnut Hill, Mass. Died in 1950.

ALLEN, COURTNEY.
Illustrator, etcher and craftsman. Born Norfolk, VA, Jan. 16, 1896. Pupil of C. W. Hawthorne, C. C. Curran, Felix Mahony, W. H. W. Bicknell. Member: New Rochelle AA; Beachcombers C.

ALLEN, FRANK (LEONARD).
Painter, lecturer, and teacher. Born in Portland, Maine, Nov. 14, 1884. Pupil of Tarbell, Major, Deman Ross, Henry B. Snell. Member: Salma. C.; Yonkers AA.; AWCS; Artist's Fund Society; Alliance; Artists Fellowship. Director, Boothbay Studios Summer School of Art. Address in 1929, Pratt Inst.; 220A Willoughby Ave., Brooklyn, NY; summer, Boothbay Studios, Boothbay Harbor, ME.

ALLEN, FREDERICK WARREN.
Sculptor and teacher. Born North Attleboro, MA, May 5, 1888. Pupil of Pratt, Landuski, Bartlett. Member: Boston Guild of Artists; Boston Sculpture

Society; National Sculpture Society; Concord Art Association. Work: "Toreo" at Penna. Academy of Fine Arts, 1924; in Boston Museum of Fine Arts; Boston Art Club; Boston City Hall; New England Historic Genealogical Society; Metropolitan Museum, NY; Boston Public Library; Trinity Church; Concord Museum; WWI Veteran Memorial, Mt. Hope Cemetery, Boston; and others. Instructor, Museum of Fine Arts Schools, Boston. Address in 1934, Boston, MA; h. Concord, MA; summer, North Haven, ME. Died 1961.

ALLEN, GREGORY SEYMOUR.
Sculptor. Born in Orange, NJ, July 8, 1884. Pupil of G. Borglum, Shrady, P. Martini, and H. N. Bushbrown. Major work in Los Angeles Museum of Art. Address in 1933, Glendale, CA. Died in 1935.

ALLEN, GRETA.
Portrait painter. Born in Boston. Pupil of DeCamp and Benson. Member of Copley Society. Address in 1926, 755 Boylston Street, Boston.

ALLEN, HAROLD A.
Painter. Exhibited water colors at the Penna. Academy Exhibition, 1925. Address in 1926, 142 Oakdale Ave., Pawtucket, RI.

ALLEN, HAZEL LEIGH.
Sculptor. Born Morrilton, Ark., December 8, 1892. Pupil of Art Institute of Chicago and Ferdinand Koenig. Exhibited: Penna. Academy of Fine Arts, 1929; Milwaukee Art Institute, 1923, 29, 31, 33, 38; Walrus Club, Milwaukee, 1946-52; Layton Art Gallery, 1941, 49. Member: Wisconsin Painters and Sculptors Society; Walrus Club; Southern States Art League. Address in 1953, Milwaukee, Wis.

ALLEN, JAMES E.
Painter, etcher, and illustrator. Born Louisiana, MO, Feb. 23, 1894. Pupil of Harvey Dunn, Nicholas Fechin. Member: SI; Arch. LA; Salma C. Address in 1929, 49 East 9th St., New York, NY; h. 41 Mayhew Ave., Larchmont, NY.

ALLEN, JOEL.
Engraver. Born 1755 at Farmington, Conn. He engraved plates for "Maynard's" edition of Josephus, pub. 1792. Died 1825 in Middletown, Conn.

ALLEN, LENNOX.
Sculptor, painter and writer. Born in Glenview, KY, December 20, 1911. Studied: Rollins College, with Pfister, Able; Cincinnati Art Academy. Member: Southern States Art League; National Arts Club. Exhibited: National Arts Club; Louisville, KY, 1945; Ky.-Ind. Exhibition, 1946. Address in 1953, Louisville, KY; h. Glenview, KY.

ALLEN, LOUISE.
(Mrs. Louise Allen Hobbs). Sculptor. Born Lowell, MA. Studied: RI School of Design and Boston Museum Fine Arts. Member: National Association Women Painters and Sculptors; Copley Society of Boston; National Sculpture Society; Boston Sculptors Society; North Shore Art Association; Providence Art Club. Exhibited at Penna. Academy of Fine Arts; National Academy, NY; Art Institute Chicago; Albright Galleries, Buffalo; Museum Fine Arts, Providence, RI; National Sculpture Society, 1923. Represented in Cleveland Museum. Works include: World War Memorial, East Greenwich, RI; World War Tablet, Gloucester, MA; memorial tablet, Bancroft Hall, Annapolis, MD; also ideal bronzes, portraits, and garden sculptures. Address in 1928, Boston, MA; summer, East Gloucester, MA.

ALLEN, LUTHER.
Engraver. Born at Enfield, Conn., June 11, 1780; died at Ithaca, NY, Nov. 27, 1821. He was the son of Moses Allen of Enfield, Conn., a soldier in the Revolution. Luther Allen married Sally P. Abbe on November 17, 1802, and soon after that date removed to Ithaca, NY, where he is referred to as an engraver, portrait painter, and a musician of some ability. The only engravings of Luther Allen noted are a quarto mezzotint portrait of the Rev. Stephen Williams, D. D., a view of New Port, NJ, and a book-plate engraved by him, either for his father, Moses Allen, or for a brother by the same name.

ALLEN, MARGO.
(Mrs. Harry Shaw). Sculptor and painter. Born in Lincoln, MA, December 3, 1894. Studied: Boston Museum of Fine Arts; British Academy, Rome; marble carving at Gelli Studio, Italy; pupil of Frederick Allen, Charles Grafly, Bela Pratt. Award: Junior League, Boston, 1929; Delgado Museum of Art. Collections: Busts; bas-reliefs; US Frigate "Constitution;" HMS "Pragon;" Cohasset War Memorial; Church, Winchester, MA; Clearwater Art Museum; Butler Art Institute; Cincinnati Museum Association; Von Pagenhardt Collection; Museum of New Mexico, Santa Fe; National Museum, Mexico and Dallas Museum of Fine Art. Commissions include 34 terra-cotta reliefs for the First National Bank of Lafayette, LA; bronze eagle, New Iberia Bank, LA. Exhibited at National Academy of Design, NY; Penna. Academy of Fine Arts; NY Architectural League; and others. Member: National Sculpture Society; National League of American Pen Women; Boston Sculptors Society; and others. Lived in Louisiana in 1953; summer, Cohasset, ME. Address in 1982, Longboat Key, FL.

ALLEN, MARION BOYD.
(Mrs. William A. Allen). Painter. Born in Boston, Mass., Oct. 23, 1862. Pupil of Tarbell and Benson at School of Boston Museum of Fine Arts. Member:

Copley S.; Conn. AFA; NAC; NA Women PS; PBC; Buffalo SA. Awards: Hon. Men., Conn. AFA, 1915, 1921; People's Prize, Newport AA, 1919; Hudson Prize, Conn. AFA, 1920; Fellowship prize, Buffalo SAC, 1920; and others. Specialty, portraiture and landscapes. Address in 1926, Fenway Studios, Boston, Mass.

ALLEN, MARTHA.
Sculptor and craftsman. Born in Appleton, Tenn., September 22, 1907. Studied: Alabama College, AB; Teachers College, Columbia University, MA. Member: Birmingham Art Club; Alabama Watercolor Society; Alabama Art League. Exhibited: Alabama Watercolor Society; Birmingham Art Club; Junior League Gallery. Taught: Associate Professor of Art, Alabama College, Montevallo, Alabama, from 1932. Address in 1953, Montevallo, Ala.

ALLEN, MARY COLEMAN.
Painter. Born Troy, OH, Aug. 9, 1888. Pupil of Duveneck. Miniatures exhibited at Penna. Academy of Fine Arts, Philadelphia, 1924. Member of American Society of Miniature Painters. Address in 1926, 125 East 10th Street, New York City.

ALLEN, MARY GERTRUDE.
Sculptor and painter. Born Mendota, IL, October 7, 1869. Pupil of Anna Hills, Michel Jacobs, Dudley Pratt. Member: Seattle Art Institute; Women Artists of Washington; Laguna Beach Art Association. Work: "Portrait of Narcissa Prentiss Whitman," Prentiss Hall, Whitman College, Walla Walla, WA; frieze, convalescent childrens ward, Everett General Hospital, Everett, WA; altar pieces, First Lutheran Church, Portland, OR, and Cedarholme, WA. Address in 1934, Lake Stevens, WA.

ALLEN, MRS. P(EARL) W(RIGHT).
(Mrs. J. G. Allen). Painter and teacher. Born Kossuth, Miss., Apr. 9, 1880. Pupil of Anna Hills, Walter Gotz, John F. Carlson. Member: Muskogee AC; Okla. AA. Works: "Laguna Beach" and "Sunlit Rocks," Muskogee Public Library; in conjunction with Nola Jean Sharp, Baptistry Painting, First Baptist Church, Muskogee; First Baptist Church, Bristow; First Christian Church, Bristow, Okla. Address in 1929, 1412 Baltimore St., Muskogee, Okla.

ALLEN, SARAH LOCKHART.
Miniature painter. Also drew portraits in crayon. Born in Salem, Mass., Aug. 12, 1793. In Felt's "Annals of Salem," there is the following note under the year 1820: "Portraits of full size are executed by Miss Sarah Allen in crayons. She is a native of this City." Died July 11, 1877 in Salem.

ALLEN, THOMAS.
Born in St. Louis, 1849. Studied in France and Germany and exhibited at the Salon in Paris and the National Academy of Design in 1877. Awarded medals, Boston and Buffalo. Among his paintings are "Maplehurst at Noon," "Toilers of the Plains," "Upland Pastimes," and "Moonlight Landscapes." The Boston Museum of Fine Arts owned his "Portals of the Mission of San Jose, Texas." He was elected an Associate Member of the National Academy. Died 1924.

ALLEN, THOMAS B.
Illustrator. Born in Nashville, Tennessee in 1928. He studied at Vanderbilt University and received his BFA from the AIC. His work has appeared in *Esquire, Sports Illustrated, McCall's, Life, Redbook* and *Playboy*. He has also done illustrations for CBS, Harper & Row and *Signet Classics*. Gold medals have been awarded to him by the New York ADC and the S of I. From 1958 - 1964 he taught at the SVA in New York.

ALLEN, WILLARD.
Painter. Born in Woodstock, NY, 1860. Pupil of Academy of Fine Arts, Philadelphia, PA, under Chase and Carlesen. Address in 1926, Woodstock, New York.

ALLEN & GAW.
Engravers who signed a "Chart of Boston Harbor, Surveyed in 1817." It was published by John Melish in Philadelphia in 1819. The Gaw of the above firm was R. M. Gaw, who was employed by Peter Maverick of Newark, New Jersey, in 1829.

ALLER, GLADYS.
Painter. Born in Springfield, Massachusetts in 1915. Studied: Otis Art Institute; Chouinard Art Institute; Art Students League and with George Grosz. Awards: California Watercolor Society, 1936; Los Angeles Museum of Art, 1942. Work: Metropolitan Museum of Art.

ALLERDICE, SAMUEL.
Engraver. Was a pupil and later a partner of Robert Scot of Philadelphia. He engraved many copperplates for book illustrations. Scot and Allerdice made many of the plates for Dobson's edition of *Rees' Encyclopedia*, published in Philadelphia, 1794-1803.

ALLIS, C. HARRY.
Painter. Born Dayton, Ohio. Studied at Detroit Museum of Art. Exhibited "November in the Ozarks" at National Academy of Design, 1925. Address in 1929, 15 Gramercy Park, New York. Died in 1938.

ALLISON, W(ILLIAM) M(ERIE).
Illustrator. Born Kansas, Jan. 27, 1880. Pupil of John Herron Art Inst., and Chicago Art Academy. Member: SI. Illustrated "Heroes of Liberty" and "Women in American History," published by The Bobbs-

Merrill Co. Specialty, historical and western subjects. Address in 1929, 118 East 28th St., New York; h. 8916 Cherokee Ave., Hollis, LI, NY.

ALLSTON, WASHINGTON.
Painter. A South Carolinian, born at Waccamaw, on November 5, 1779, was sent to Rhode Island as a child, his native climate not agreeing with him. He was educated at Harvard, and returned to South Carolina, where he painted some religious compositions. In 1801 he went with Malbone to England and studied under West at the Royal Academy. In the following year he exhibited three pictures at Somerset House and sold one of them. Three years later he accompanied Vanderlyn to France, reveling there in the art treasures Napoleon had accumulated from all Europe, and developing the richness of color that came to characterize many of his paintings. He visited Italy, came back to America and married, and again in 1811 returned to England, taking with him S. F. B. Morse as a pupil. After a few years he returned home, a success on both sides of the ocean. He died at Cambridge, Mass., July 9, 1843. His "Uriel in the Sun" and "Jacob's Dream" are owned in England. His best known paintings in the United States are "Jeremiah," "Belshazzar's Feast" and "Witch of Endor." Among his portraits, Wm. Ellery Channings; Sam'l T. Coleridge and his self-portrait are owned by the Boston Museum of Fine Arts. The "Dead Man Revived" is in the Penna. Academy of Fine Arts, Philadelphia. See "Life and Letters of Washington Allston," by Jared B. Flagg. Also see "Artist Biographies," Allston (Boston 1879.). Died in 1843.

ALLWELL, STEPHEN S.
Sculptor. Born in Baltimore, MD, October 15, 1906. Study: MD Institute, Baltimore. Work: Metromedia Permanent Collection, private collections, including commissions. Exhibitions: Miniature Painters, Sculptors and Gravers Society, Washington, DC, 1967-71. Awards: Miniature Painters, Sculptors and Gravers Society, 1969; etc. Member: Artists Equity Association; MD Federation of Art; Rehoboth Art League; and others. Address in 1982, Baltimore, MD.

ALSTON, CHARLES HENRY.
Sculptor, painter and teacher. Born in Charlotte, NC, November 28, 1907. Studied: Columbia University, B.A., M.A. Awards: Dow Fellowship, Columbia University, 1930; Rosenwald Fellowship, 1939-40, 1940-41; prizes, Atlanta University, 1941; Dillard University, 1942. Work: Metropolitan Museum of Art; Detroit Institute of Art; Ford Collection; IBM; murals, Golden State Mutual Life Insurance Co., Los Angeles; portrait, Louis T. Wright Memorial Library, Harlem Hospital, NY. Exhibited: Metropolitan Museum of Art, 1950; Whitney Museum of Art, 1952-53; Penna. Academy of Fine Arts, 1952; High Museum of Art, 1938; Baltimore Museum of Art,

1937; Downtown Gallery, 1942; Museum of Modern Art, 1937; Corcoran Gallery of Art, 1938; Art Students League, 1950-52; Museum of Modern Art, 1970. Illustrator for leading publishers. Contributor illustrator to *Fortune, New Yorker, Reporter,* and other magazines. Instructor, Art Students League, NYC, from 1949; Joe and Emily Lowe Art School, NYC, from 1949. Address in 1976, c/o Kennedy Galleries, 20 East 56th St., NYC. Died in 1977.

ALTEN, MATHIAS J.
Painter. Born in Germany, 1871. Pupil of Constant, Laurens, and Whistler in Paris. Member of Grand Rapids (Mich.) Art Association. Address in 1926, 1593 E. Fulton Street, Grand Rapids, Michigan. Died in 1938.

ALTMANN, AARON.
Painter. Born San Francisco, Cal., 1872. Student of Constant, Laurens, and Gerome, Paris. Address in 1926, 2298 Green Street, San Francisco, California.

ALTORFER, GLORIA FINCH.
Painter and designer. Born in Peoria, Ill., April 19, 1931. Study: Bradley Univ., BA; with H. Kosak, R. Weidenaar. Exhibitions: Greater Fall River Art Assn., MA, 1970; Miniature Painters, Sculptors and Gravers Soc., Wash. DC, 1970; 73rd Annual Nat'l. Exhib. for Prof. Women, Catharine Lorillard Wolfe Art Club, NAD, NYC, 1970; and others. Mem.: Ill. Art Lg.; Fine Arts Soc.; Peoria (Ill.) Art Guild; others. Teaching: Private and studio classes, YMCA and galleries. Int. designer, E. G. Lehmann Assns. Media: Acrylic, oil, watercolor, collage. Dealer: Collectors Upstairs Gallery-Lakeview Ctr., 1125 W. Lake St., Peoria, Ill. Address in 1976, 2923 W. Vassar Ct., Peoria, Ill.

ALTSCHULER, FRANZ.
Illustrator. Born in Mannheim, Germany, 1923. He was educated in New York City at CU and TID. His professional career began in 1951 and he has since illustrated over 30 books. The recipient of awards in New York and Chicago, he has shown his work in galleries in Denver and Baltimore. His illustrations have been used as posters for the Chicago newspapers as well as for major magazines, including *Playboy* and *Skeptic.*

ALTVATER, CATHERINE THARP.
Painter. Born in Little Rock, Arkansas, July 26, 1907. Study: Grand Central Sch. of Contemp. Arts and Crafts; Art League of Long Island, with F. Spradling, E. Whitney; Nat'l. Acad. of Fine Arts, with Mario Cooper, Ogden Pleissner, Louis Bouche, Robert Phillips. Work: Many private collections and museums in US, Europe, Japan, Canada, and South America. Exhibitions: National Academy of Design; National Arts Club; Royal Water Color Soc., London; Audubon Artists, Metropolitan Museum of Art;

Mexico City Museum; numerous one-man shows and traveling exhibits. Awards: Over 70 awards including 20 first prizes. Mem.: Am. Watercolor Society; Nat. Art League; Allied Artists of America. Medium: Watercolor. Rep.: Lord & Taylor, 39th & 5th Avenue, New York, NY. Address in 1982, 505 Douglas St., New Smyrna Beach, Fla.

ALVAREZ, MABEL.
Painter. Born in Hawaii. Studied with Cahill and McBurney. Awards: California Exposition, San Diego, 1916; California Art Club, 1918, 1919, 1933; Federation of Women's Club, 1923; Laguna Beach Art Association, 1928; Ebell Club, 1933-35; Honolulu Printmakers, 1939; Oakland Art Gallery, 1838; Madonna Festival, Los Angeles, 1954; Palos Verdes Annual, 1957. Collections: Honolulu Art Academy; San Joaquin Museum; University of Southern California. Address in 1926, 2180 West 25th Street, Los Angeles, California.

AMANS, JACQUES.
Painter. Born in 1801; died in Paris in 1888. Painted portraits in New Orleans from 1828 till 1856. Address in 1838, 163 Royal Street; 1840, 184 Royal Street; 1854-56, Bienville and Customhouse Streets.

AMATEIS, EDMOND ROMULUS.
Sculptor. Born in Rome, Italy, February 7, 1897. Son of Louis Amateis. Pupil of Beaux-Arts Institute of Design and Julian Academy in Paris. Member: Alumni Association American Academy in Rome; National Sculpture Society; NY Architectural League; American Federation of Arts; National Institute of Arts and Letters; Academician, National Academy of Design. Award: Penna. Academy of Fine Arts, 1933; Morris prize, National Sculpture Society; Prix de Rome, 1921 to 1924; Avery prize, Architectural League, 1929. Work: Sculptured groups for Baltimore War Memorial; Metopes for Buffalo Historical Building; colossal relief for Rochester Times-Union; Brookgreen Gardens, SC; George Washington University; medal for Society of Medalists; many others. Exhibited: National Academy of Design; Penna. Academy of Fine Arts; National Sculpture Society. Address in 1953, Brewster, NY. Died in 1981.

AMATEIS, LOUIS.
Sculptor. Born in Turin, Italy, December 13, 1855. Educated in the schools of Turin, and a graduate of the Institute of Technology and the Academy of Fine Arts of Turin, where he was awarded a gold medal upon his graduation. His first sculptural work of importance was a bas-relief purchased by a committee of sculptors for the Art Gallery of Turin. In a competition he was awarded the commission for the sculptural decorations for the Palace of Fine Art of Turin. In 1884 he came to the United States and became a naturalized citizen of this country. He was

the founder of the School of Architecture and Fine Arts of the Columbian University, Washington, DC, and a member of the National Sculpture Society. Among his works are many portraits, busts, and the bronze doors in the Capitol, Washington, DC. Address in 1910, Washington, DC. Died in West Falls Church, VA, March 18, 1913.

AMEIJIDE, RAYMOND.
Illustrator. Born in Newark, New Jersey, 1924. He attended PI. After a seven-year stint at Ross Advertising he went free-lance and later formed AKM Studio. His paper sculpture and felt constructions have appeared in *Art Direction* and *Graphic* as well as being shown at the ADC and the Society of Illustrators of New York.

AMEN, IRVING.
Sculptor, painter, and engraver. Born in New York City, July 25, 1918. Studied: Art Students League; Pratt Institute Art School; Academy Grande Chaumiere, Paris. Commissions include a Peace Medal (in honor of the Vietnam War); 12 stained glass windows, 16 ft. high, Agudas Achim Synagogue, Columbus, OH; others. Member: Society of American Graphic Artists; Artists Equity Association. Awards: F. H. Anderson Memorial prize, 1950; Erickson award, 1952. Work: Metropolitan Museum of Art; Library of Congress; Museum of Modern Art; Smithsonian Institute; US National Museum; Phila. Museum of Art; Pennell Collection; NY Public Library; Bibliotheque Nationale, Paris; Bibliotheque Royale, Brussels. Exhibited: Society of American Graphic Artists, 1949-52; Library of Congress, 1947-52; Brooklyn Museum, 1948-52; Museum of Modern Art, 1949; Penna. Academy of Fine Arts, 1948; National Academy of Design, 1949. One-man shows: New School for Social Research, 1948; US National Museum, 1948; Argent Gallery, 1949, 51; Tribune Gallery, 1950; Pratt Institute, 1950. Publication: *Irving Amen Woodcuts 1948-1960, Irving Amen: 1964, Amen: 1964-1968,* and *Amen: 1968-1970.* Address in 1983, Boca Raton, FL.

AMEN, WILL RICE.
Painter. Exhibited water colors at the Penna. Academy of Fine Arts, Philadelphia, 1925. Address in 1926, 17 Gramercy Park, New York.

AMENT, ROBERT SELFE.
Painter and etcher. Born in New York, 1879. Pupil of Ward, Chase and Henri. Address in 1926, 2380 Grand Avenue, New York City.

AMES, DANIEL.
New York miniature painter, active from 1841-1852.

AMES, EZRA.
Portrait painter. Born May 5, 1768 in Framingham, MA. Little is known of his life except that he

commenced work as a coach painter in Albany. Later he turned his attention to portrait painting, and gained recognition in 1812, by a portrait of Gov. Geo. Clinton, exhibited at the Penna. Academy of Fine Arts. For many years after this he painted in Albany and western New York, painting most of the New York legislators. He also painted miniatures. Died Feb. 23, 1836 in Albany, NY.

AMES, FRANCIS.
(Mrs. Linwood P. Ames). Painter. Born Massena, NY, 1868. Pupil of Chase, New York; also studied in Paris. Specialty: portraiture. Address in 1926, "The Twinpike," Fort Plain, New York.

AMES, JOSEPH ALEXANDER.
Portrait painter. Born 1816 in Roxbury, MA. Elected an Associate of National Academy of Design in 1869 and Academician, 1870; had his studio in Boston, Baltimore and later in New York. He also studied in Rome. His best known work is "The Death of Webster," which has been engraved. His portraits of Prescott, Geo. Southward, Ristori, Gazzaniga, Felton and his portrait of Brady are at the Metropolitan Museum. Died Oct 30, 1872 in New York City.

AMES, JULIUS R.
Born in 1801 in Albany, NY. He was a son of Ezra Ames, the portrait and miniature painter. Julius Ames worked in Albany, New York, and flourished from 1834 to 1850. Died June 5, 1850 in Albany.

AMES, MAY.
Painter, teacher, lecturer, and etcher. Born in Cleveland, Ohio. Pupil of Cleveland School of Art, RI School of Design, Johonnot, and abroad. Member: Women's Art Club of Cleveland; Cleveland School of Art Alumni A.; Buffalo SA; Ohioborn Women A. Address in 1926, 9315 Miles Ave., Cleveland, Ohio. Died in 1946.

AMES, POLLY SCRIBNER.
Sculptor and painter. Born in Chicago, IL, in 1908. Studied at University of Chicago, Ph.D.; Art Institute of Chicago; Chicago School of Sculpture, scholar; also with Jose De Creeft and Hans Hofmann, NY; Hans Schwegerle, Munich, Germany. Exhibitions: One-woman shows, Cultural Center, Netherlands, West Indies, 1947, Galerie Chardin, Paris, 1949, Cercle Universite, Aix-en-Provence, 1950 and Esher-Surrey Gallery, The Hague, Holland, 1950; also Closson Gallery, Cincinnati and many others. Awards: Bronze award for Young Satyr and Friend, Illinois State Museum, 1962. Address in 1982, Chicago, IL.

AMES, SARAH FISHER CLAMPITT.
(Mrs. Ames). Sculptor. Born in Lewes, Delaware, August 13, 1817. Studied art in Boston, and Rome, Italy. She was the wife of Joseph Ames, portrait painter. She was personally acquainted with President Lincoln and her bust of him is considered excellent. Among her other portrait busts are General Grant and Ross Winans. Died in Washington, DC, March 8, 1901.

AMICK, ROBERT WESLEY.
Painter and illustrator. Born in Canon City, Colo., in 1879. Pupil of Art Students League, New York. Address in 1926, 63 Washington Square, New York. Died in 1969.

AMORE, JOHN.
Sculptor. Born in Genoa, Italy, February 28, 1912. Studied: Beaux-Arts Institute of Design, NYC; Fontainebleau School of Fine Arts; National Academy of Design. Member: American Academy in Rome. Awards: Beaux-Arts Institute of Design, NY, 1935, Rome prize, 1937; Competition gold medal design for City of New York, 1948; National Sculpture Society, 1951. Work: Zodiacal spheres, lobby of Louisville Times-Courier Journal Building; figures, St. Francis College, Biddeford, ME; St. Claire's Hospital, New York; decorations, SS "Independence" and SS "Constitution;" medallions, Alvey Ferguson Co., Cincinnati; Northwestern University. Address in 1953, 156 East 39th St., New York, NY.

AMUNDSEN, RICHARD.
Sculptor and painter. Born in the Sacramento Valley, CA, 1928. Initially worked as an illustrator for an art service in San Francisco. Began free lancing in 1963. Obtained commissions from Golden Books, Random House, *Field and Stream, Reader's Digest, Outdoor Life.* Turned to fine arts painting while living in Cody, WY, and later Bozeman, MT. Awarded Presidential Seal for commissioned painting of Theodore Roosevelt, presented to Pres. Nixon. Has exhibited with Northwest Rendezvous group; and at Trailside Galleries, Scottsdale, AZ. Specializes in wildlife, both in painting and bronze statuettes. Address in 1982, Bozeman, MT.

ANACREON, JOAN.
Painter. Studied: Pratt Institute, New York; Rowayton Art Center; The Wooster Community Art Center. Exhibitions: Women in the Arts Show, Community Church Gallery, New York City; The Stamford Museum; Women's Interarts Co-op. Collections: Van Summer and Weigold, New York City; Hamilton Press, Danbury, Connecticut; Connecticut Savings Bank, New Haven, Connecticut.

ANARGYROS, SPERO.
Sculptor. Born in New York, NY, January 23, 1915. Studied with William Zorach, NY, 1934-35; assistant to Mahonri Sharp Young, Salt Lake City, Utah, 1944-47. Exhibited at the National Academy of Design; De Young Memorial Museum; National Sculpture Society; others. Awards: National Sculp-

ture Society. Member: Art Students League; National Sculpture Society; International Institute of Arts and Letters. Works in bronze, marble, and stone. Address in 1982, San Francisco, CA.

ANCORA, PIETRO.
Italian painter and drawing-master. Had an art school and gave instructions in drawing in Philadelphia early in 1800; he taught John Neagle.

ANDERSEN, ROY H.
Illustrator. Born in Chicago, in 1930. He studied at the Academy of Fine Arts and the ACD. Associated with Jack O'Grady's Studio for a number of years, he came to New York in 1976. His illustrations have appeared in *National Geographic, Boy's Life, Sports Illustrated* and *Ladies' Home Journal*. He is a member of the S of I, and his work has been selected for its Annual Exhibitions; it has also been exhibited at the ADCs of Tucson and Washington and is part of the permanent collection of the LC.

ANDERSON, ABRAHAM ARCHIBALD.
Artist. Born in New Jersey, 1847. Studied painting under Cabanel, Bonnat, Carmon, Godin and Collin. Exhibited at Paris Salon, Universal Expn., Paris, 1899, etc. Work: Portraits of Gen. O. O. Howard, Gov. Morgan, H. B. Claflin, Thomas A. Edison, Bishop Cleveland Coxe, Elihu Root, Charles Stewart Smith, John Wanamaker, etc., also "Morning after the Ball," "The Convalescent," "Neither Do I Condemn Thee," etc. Address in 1926, 80 West 40th Street, New York.

ANDERSON, ALEXANDER.
Born in New York City, Jan. 21, 1775; died in Jersey City, NJ, April 18, 1870. Anderson early became interested in copperplate engraving and was self-taught; but, yielding to the wishes of his family, he studied medicine, and in 1796 was graduated from the Medical Department of Columbia College as an MD. He was again engraving on copper in New York in 1797, and the next year he permanently abandoned medicine for the burin. He engraved a number of copperplates and attained very considerable proficiency in that branch of his art. In 1820 Dr. Anderson became interested in the wood-engravings of Bewick and his followers, and he so much improved upon the work of his predecessors in this country that he is generally recognized as the Father of Wood-Engraving in the United States. His use of the "white line" in wood-engraving was successful and effective. He made many pencil and wash drawings and painted portraits. The New York Historical Society has a small portrait painted by him in 1820. See "Life and Works of Alexander Anderson" by Frederick M. Burr, and a "Memorial of Alexander Anderson," by Benjamin J. Lossing.

ANDERSON, CARL (THOMAS).
Painter, illustrator and etcher. Born Madison, Feb. 14, 1865. Pupil at Penn. Museum and Sch. of Ind.

Art. Member: Am. Artists P. L. Work: Illustrations in *Life, Judge, Saturday Evening Post, Colliers Weekly, The American Kennel Gazette;* author *Dusty, the Story of a Dog and his Adopted Boy;* animated cartoons for the screen. Address in 1929, 834 Prospect Pl., Madison, Wis. Died in 1948.

ANDERSON, DAVID PAUL.
Sculptor and instructor. Born in Los Angeles, Calif., February 3, 1946. Studied at San Francisco Art Institute; assistant to Peter Voulkos, 1972-73. Has exhibited at San Francisco Museum of Art; Oakland Museum, California; Whitney Museum, NY; San Francisco Art Institute; and others. Received National Endowment Arts Fellowship Grant, 1974 and 1981. Works in welded steel. Address in 1982, Santa Fe, New Mexico.

ANDERSON, DOROTHY VISJU.
Painter. Born in Oslo, Norway. Pupil of AIC; W. M. Chase. Member: AIC Alumni; Chicago AG; Chicago AC; S. Indp. A.; San Diego FAS. Awards: Fine Arts Building Prize, Chicago AG, 1918; first, second and third prizes, Illinois Artists, Springfield. Represented in Vanderpoel Memorial Collection, G. W. Tilton School, Chicago; Elks Club, Los Angeles, Women's Club, Hollywood, Calif. Exhibited: Salon d'Automne, Paris; Art Institute of Chicago; San Diego Fine Art Society; Tilton School, Chicago; Los Angeles Museum of Art, and extensive exhibitions abroad. Among many portraits are those of President Franklin D. Roosevelt; Countess du Nord, Paris, France; and Lt. Col. Percy, Chicago. Address in 1953, Hollywood, CA.

ANDERSON, ELLEN G.
Painter and illustrator. Born in Lexington, VA. Pupil of Charles Guerin; studied also in Paris. Address in 1926, 39 Charles Street, New York.

ANDERSON, ELMER G.
Painter. Exhibited a "Landscape," at the Penna. Academy of Fine Arts, Philadelphia, 1920. Address in 1926, 2545 North Chadwick Street, Philadelphia.

ANDERSON, ERNFRED.
Sculptor. Born in Esperod, Sweden, August 28, 1896. Studied: Societe Industrielle de Lausanne. Member: Brooklyn Painters and Sculptors; Brooklyn Art Society; Scandinavian American Artists; Elmira Art Club. Awards: Prize, Swedish Club, Chicago. Work: Monuments, Elmira, Horseheads, NY. Exhibited: National Sculpture Society, 1935-40; National Academy of Design, 1933-35; Rochester Memorial Art Gallery; Swedish Club. Author: "Public Art in Elmira," 1941. Position: Director, Arnot Art Gallery, from 1943. Taught: Instructor, Elmira College, Elmira, NY. Address in 1953, Elmira, NY.

ANDERSON, F. W.
Sculptor, painter, and craftsman. Born Sweden, August 28, 1896. Member: Brooklyn Painters and Sculptors; Brooklyn Society of Artists; Scandinavian American Artists. Address in 1929, Brooklyn, NY.

ANDERSON, FREDERIC A.
Illustrator. Exhibited at the Penna. Academy of Fine Arts, 1922. Address in 1926, 1520 Chestnut Street, Philadelphia.

ANDERSON, G. ADOLPH.
Painter. Born Rochester, Minn., May 21, 1877. Pupil of Robert Henri, Julian Academy. Member of National Arts Club, New York; Wash. AC; AFA. Address in 1926, 522 Franklin Ave., Ridgewood, New Jersey.

ANDERSON, GENEVIEVE DILLAYE.
Painter. Born in Avon, New York in 1900. Studied: Skidmore College; Columbia University; Hillyer College; University of Guadalajara, Mexico; University of Hawaii; Alfred University, New York. Award: Connecticut Watercolor Society, 1944.

ANDERSON, GEORGE M.
Painter. His watercolor at Pas Christian was loaned to the Cincinnati Museum by Mrs. Larz Anderson for their 33d Annual Exhibition, 1925.

ANDERSON, HEATH.
Painter and illustrator. She was born San Francisco, Jan. 1, 1903. Pupil of Calif. Sch. of Arts and Crafts; Geneve Rixford Sargeant. Member: All Arts C., Berkeley; Calif. S. Women A. Awards: Hon. mention, State Exhibition, Santa Cruz, 1928; 1st prize, Nat'l. American Humane Assoc., 1928.

ANDERSON, HELGE.
Painter. Exhibited at Penna. Academy of the Fine Arts, Philadelphia, 1921. Address in 1926, 152 Huntingdon Ave., Boston, Mass.

ANDERSON, HENDRICK CHRISTIAN.
Sculptor. Born Bergen, Norway, 1872; family moved to United States, settling at Newport, RI, 1873; studied art and architecture at Boston, Paris, Naples, Rome. Principal works: "Fountain of Life," "Fountain of Immortality," "Jacob Wrestling with the Angel," "Study of an Athlete," etc.

ANDERSON, HUGH.
Engraver. Born 1790 in Scotland. Listed in the Philadelphia Directory from 1811 to 1824. He engraved a number of plates for S. F. Bradford's Philadelphia edition of the Edinburgh Encyclopedia. He also engraved portraits and book illustrations. Died in 1830.

ANDERSON, JACOB S.
Figurehead carver. In NYC, 1830-57. Partner, Jacob Anderson & Co., 1830-33; Dodge & Anderson, 1845; J. S. Anderson & Son, 1856-57. Died probably in 1857.

ANDERSON, KARL.
Painter. Born in Oxford, Ohio, Jan. 13, 1874. Student of Chicago Art Institute and Colarossi Academy in Paris. Painted in Holland, Italy and Madrid. Elected Member of National Academy of Design. Also illustrated for many publications. Among his works, "The Idlers," "Sisters," "Apple Gatherers," and "The Heirloom." Address in 1926, Westport, Conn. Died in 1956.

ANDERSON, LYMAN MATTHEW.
Illustrator. Born in Chicago in 1907. He was educated at the AIC, GCSA and in private classes under Walter Biggs, Pruett Carter and Harvey Dunn. Acceptance in the 1939 *Art Directors Club Annual* started his career. He did a great many dry brush illustrations for the pulps until 1935, when he produced a syndicated strip for three years. Though his work appeared in major publications, he was most active in the field of advertising art until 1963 when he became an instructor for the FAS. He is a Life Member of both the S of I and Joint Ethics Committee.

ANDERSON, MARTINUS.
Painter and illustrator. Born in Peru, Ind., 1878. Pupil of Herron Art Institute, Indianapolis. He also did mural decorations in City Hospital, Indianapolis. Address in 1926, 135 West 44th Street, New York.

ANDERSON, OSCAR.
Painter. Born in Sweden in 1873. Pupil of Charles N. Flagg, Hartford. Address in 1926, 78 Rocky Neck Avenue, Gloucester, Mass.

ANDERSON, PERCY E.
Illustrator. Member: Salma. C. Address in 1929, Westport, Conn.; 58 East 56th St., New York, NY.

ANDERSON, PETER BERNARD.
Sculptor. Born in Sweden in 1898. Pupil of J. K. Daniels. Address in 1926, St. Paul, Minn.

ANDERSON, RAYMOND H.
Painter. Born at Bradford, Penna., in 1884. Pupil of Stevenson Art School. Address in 1926, R. D. No. 1, Saltsburg Road, Verona, Penna.

ANDERSON, RONALD.
Painter and illustrator. Born at Lynn, Mass., in 1886. Student at Chicago Art Inst. Pupil of Eric Pape. Address in 1926, 54 West 37th Street, New York.

ANDERSON, RUTH A.
(Mrs. Sam'l Temple). Painter. Born in Carlisle, Penna. Pupil of Penna. Academy of Fine Arts.

Member of National Association of Women Painters and Sculptors, and the Fellowship of the Penna. Academy of Fine Arts. Address in 1926, 53 Charles Street, Boston, Mass.

ANDERSON, RUTH BERNICE.
Painter. Born in Indianapolis, Indiana in 1914. Studied: John Herron Art Institute. Awards: Allied State Exhibition, Tucson, Arizona, 1937; L. S. Ayers and Company award, 1954; Edward Gallahue prize, 1955. Work: Daily Memorial Collection, Indiana University; DePauw University.

ANDERSON, TENNESSEE MITCHELL.
Sculptor. Born Jackson, Mich. Member: Art Club of Chicago; Chicago NJ Society of Artists; Romany Club. Address in 1929, Chicago, Ill.

ANDERSON, WILLIAM.
Born c. 1834 in IN. About 1855, this excellent engraver of portraits and landscapes was working for the engraving firm of C. A. Jewett & Co. of Cincinnati, Ohio. Much of his work will be found in the *Ladies' Repository*, published in that city.

ANDERTON, G.
Engraver. Born in London about 1826, he was engraving in the United States as early as 1850. He was in the employ of J. M. Butler of Philadelphia and was a good engraver of portraits in both the stipple and mezzotint manner. Died c. 1890.

ANDRADE, MARY FRATZ.
Painter, illustrator and teacher. Born Philadelphia. Pupil of Robert Vonnoh, Henry Thouron, Thomas Anshutz and Mucha in Paris. Member: Fellowship PAFA; Phila. Alliance; Art Teachers A. of Phila. Address in 1929, Studioshop, Old York Road; h. 503 West Ave., Jenkintown, PA.

ANDREI, GIOVANNI.
Sculptor. Born in Carrara, Italy, 1770. Worked: Washington, Baltimore, 1806-c. 1815. In Italy c. 1815. Died in Washington, 1824.

ANDREW, JOHN.
Wood engraver. Born 1815 in Hull, England. Working for publishers in New York and Boston from 1850. Died in Boston in 1870.

ANDREW, RICHARD.
Portrait painter. Born in Ireland. Exhibited at the Penna. Academy of Fine Arts, Philadelphia, 1921. Pupil of Laurens and Gerome in Paris. Mural painting in State House, Boston. Address in 1926, Fenway Studios, Boston, Mass.

ANDREWS, AMBROSE.
Portrait painter in oils and miniature. Flourished 1824-59. From 1829 to 1831 he was in Troy, New York. He later moved to St. Louis and then to New York. He painted a portrait of Gen'l Sam. Houston.

ANDREWS, ELIPHALET F.
Painter. Born at Steubenville, Ohio, June 11, 1835. Portrait and general painter; studied in Paris under Bonnat. Director of Corcoran Art School for twenty-five years. He painted several portraits hanging in the White House, including those of Martha Washington, Dolly Madison, Jefferson and others. He died in Washington, DC, March, 1915.

ANDREWS, HELEN FRANCIS.
Painter. Born in Farmington, Conn., in 1872. Pupil of Art Students League, New York. Student of Laurens and Constant in Paris. Address in 1926, Westover School, Middlebury, Conn.

ANDREWS, J. W.
Painter. Born in Newtonville, Mass., in 1879. Pupil of DuMond, Hamilton, and DeCamp. Address in 1926, Yonkers, New York.

ANDREWS, JOSEPH.
Engraver. Born in Hingham, Mass., 1806; he was apprenticed to Abel Bowen, a wood engraver of Boston, and learned copper plate engraving from Hoogland. In 1835 he went to London and studied under Goodyear, and in Paris he engraved the head of Franklin by Duplessis. Returning to the United States he engraved many fine portraits and did considerable work for the book publishers. His portrait of Washington after Stuart is one of his best plates; he also engraved "Plymouth Rock in 1620." He died in 1873. For a life of this engraver and a list of his work see *Pennsylvania Magazine* for 1908, "Joseph Andrews and His Engravings," by Mantle Fielding.

ANDREWS, MRS. M. MINNIGERODE.
Painter and illustrator. Born in Richmond, VA, 1869. Pupil of Andrews and Chase. Represented by portraits owned by University of Virginia. Address in 1926, 1232 Sixteenth Street, Washington, DC.

ANDRIEU, JULES.
Sculptor and painter. Born in New Orleans, LA, March 1844. Pupil of Ernest Ciceri of Paris, France. Address in 1910, P.O. Box 74, Pass Christian, Miss.

ANDRUS, ZORAY.
Sculptor, painter, designer, craftsman, and illustrator. Born in Alameda, CA, April 27, 1908. Studied at California College Arts and Crafts, BA; University California, with Hans Hofmann; Mills College, with Alexander Archipenko. Member: California Water Color Society. Awards: Prize, Denver Art Museum, 1942. Exhibited: Reno, Nevada, 1943; Virginia City, Nevada, 1945; San Francisco Art Association, 1943-45; Denver Art Museum, 1941, 42; California Water

Color Society, 1942-44; Elko, Nevada, 1948; Carson City, Nevada, 1952. Work: Murals, Veterans Hospital, Reno, Nevada. Address in 1953, Virginia City, Nevada.

ANGAROLA, ANTHONY.
Painter. Born in Chicago, 1893. Pupil of Minneapolis School of Art. He exhibited paintings at Academy of Fine Arts, Philadelphia, 1921, and Carnegie Institute, Pittsburgh, PA. Address in 1926, 1318 Rosedale Avenue, Chicago, Ill.

ANGEL, JOHN.
Sculptor, teacher, lecturer, and illustrator. Born in Newton Abbott, Devon, England, November 1, 1881. Studied at Albert Memorial, Cheltenham and Royal Academy Art Schools, England. Member: Academician of National Academy of Design; F., Royal Society British Sculpture; Artist Workers Guild; National Sculpture Society; Architectural League. Awards: Landseer Scholarship, two silver medals, gold medal and traveling scholarship, 1907, 1911; Litt. D., honorable degree, Columbia University, 1936. Work: Sculpture, St. John the Divine Cathedral, NY; statues: Vincennes, IN, Chicago, IL, St. John's Church, Youngstown, OH (5), Archbishop Williams H. S., Braintree, MA; St. Patrick's Cathedral, NY, and others at Concord, NH, Austin, TX, Rice Institute, Houston, TX; panels: East Liberty Presbyterian Church, Pittsburgh, PA; St. Paul's School, Concord, NH. War memorials at Exeter, Bridgewater and Rotherham, England. Exhibited: Royal Academy London, 1912-27; Penna. Academy of Fine Arts, 1938. Illustrated article on Cathedral Sculpture in "The Cathedral Age." Lectures on sculpture. Address in 1953, Sandy Hook, CT. Died in 1960.

ANGELA, EMILIO.
Sculptor. Born in Italy, July 12, 1889. Studied at Cooper Union, Art Students League, National Academy of Design, and was pupil of A. A. Weinman. Membership, National Sculpture Society, American Federation of Fine Arts, New York Architectural League. Works: "Goose Boy," "Barking Seals," "Boxer," "Goose Girl," "Baby Angela," "Mirthfulness," figures, bronzes, fountains. Awards: First prize for composition, second prize for sculpture, National Academy of Design. Exhibited at National Sculpture Society, 1923. Address in 1953, Chatham, NJ. Died 1970.

ANGELO, VALENTI.
Sculptor, painter, illustrator, engraver, designer, and writer. Born in Massarosa, Italy, June 23, 1897. Member: American Institute of Graphic Arts. Work: Library of Congress; NY Public Library; Daniel Estate, Bristol, VA. Exhibited: Penna. Academy of Fine Arts; Gump's Gallery, San Francisco; Dalzell-Hatfield Gallery, Los Angeles; Ferargil Gallery.

Author, I., *Nino; Golden Gate; Paradise Valley; Look Out Yonder; The Rooster Club; The Bells of Bleecker Street; The Marble Fountain*, 1951; *A Battle in Washington Square*. Address in 1953, Bronxville, NY.

ANGMAN, ALFONS JULIUS.
Sculptor, painter, and writer. Born in Stockholm, Sweden, January 14, 1883. Self-taught. Member: College Art Association; American Federation of Arts. Address in 1933, Oklahoma City, Okla.

ANGULO, CHAPPIE.
Painter and illustrator. Born March 3, 1928. US citizen. Study: Los Angeles City Col.; U. of Calif., Los Angeles; Kahn Art School; Esmeralda, Inst. Nac. Bellas Artes, Mex. City; London Art Center. Work: Mus. Cultures, Mex. City; Art Mus., Chilpantzingo Guerrero, Mex. Comn.: Nat. Mus. of Anthropology, Moneda, Mex., 1957, 1958; Ballet Nacional, Mexico, 1959. One-man shows: Olympic Cult. Prog., 1969; Mus. Fronterizo, Juarez, Mex., 1971; La Ciudadela, Monterrey, 1974; Gentes y Lugares Mus. de las Cult., Mex; retrospective, Museo Las Culturas, Mex., 1976; others. Exhib.: La Mujer en la Plastica Bellas Artes, Mex., Anglo Mexicano, 1981. Mem.: La Muerte-Unam. Illustrations: "Teotihuacan-un autoretrato cultural," 1964; "Relieves de Chalcatzingo;" "The Cuauhnahuac Museum — A Hist. Recompilation;" "A Guide to Chalcatzingo;" "Arqueology Zunes;" and others. Media: Fiber, paper; acrylic, oil. Address in 1982, Cuernavaca, Morelos, Mex.

ANKENEY, JOHN SITES.
Painter. Born at Xenia, Ohio, in 1870. Pupil of Twachtman, Chase and Saint Gaudens; also studied in Paris. Address in 1926, 906 Conley Ave., Columbia, MO. Died in 1946.

ANNAN, ABEL H.
Painter. Member of Washington (DC) Watercolor Club. Address in 1926, Carnegie Studios, West 57th Street, New York.

ANNAN, ALICE H.
Painter. Born in New York. Member of Art Students League, pupil of Snell, and Ben Foster. Address in 1926, Carnegie Studios, West 57th Street, New York City.

ANNELLI, FRANCESCO.
He painted historic compositions, portraits and miniatures. Very little of his work is known. He flourished in New York from 1841 to 1878.

ANNIBALE, GEORGE OLIVER.
Portrait sculptor. Born about 1829. Executed medallion heads and cameos. He had a studio in the Hoppin Building in Providence, RI, and in 1850 cut a cameo portrait of Dr. Nathan B. Crocker, the rector of St.

John's Church. In 1852 cameos were exhibited by Annibale and were described as "capital likenesses and finely executed." He received a silver medal, the highest premium for portrait busts in marble and cameos. Besides the portraits of Dr. Chapin, Mr. Chapin, and Dr. Crocker, Annibale cut a cameo likeness of James S. Lincoln, the portrait painter. Annibale's cameo portraits are cut in shell and were usually about an inch and a half tall. Died April 22, 1887, in Brooklyn, NY.

ANNIN, WILLIAM B.
This engraver was a pupil of Abel Bowen of Boston; he was working for him in 1813. As early as 1823 he was associated with George Girdler Smith. The firm of Annin & Smith did a general engraving business and were for some time also engaged in lithography in Boston.

ANSBACHER, JESSIE.
Painter. Portrait of Miss Tait. Exhibited at Penna. Academy of Fine Arts, Philadelphia, 1921. Pupil of William Chase, Joseph Pennell and Auerbach-Levy. Address in 1926, 1 West 81st Street, New York City. Died in 1964.

ANSHUTZ, THOMAS POLLOCK.
Painter and teacher. Born Newport, Kentucky, October 5, 1851; died, Fort Washington, Pennsylvania, June 16, 1912. Pupil of National Academy of Design, PAFA and of Doucet and Bouguereau, Paris. Awards: Gold Medal of Honor, PAFA, 1909. Lippincott Prize, PAFA, 1909. Member of Fellowship, and also of Faculty, of PAFA; Philadelphia WCC; New York WCC. Elected an Associate Member, NAD, 1910. Represented in collection of PAFA.

ANTHONY, ANDREW VARICK STOUT.
Artist. He was born Dec. 4, 1835 in New York City, and studied drawing and engraving under the best teachers. Anthony was an original member of the American Water Color Society. His illustrations for the works of Whittier, Longfellow and Hawthorne are of considerable merit. He passed part of his professional life in New York and California, but settled in Boston in 1878. He died July 2, 1906 in West Newton, MA.

ANTHONY, CAROL.
Illustrator. Born in New York, 1943. Educated at Stephens College, Missouri, and graduated from RISD. An exhibition of her three-dimensional figures at the Museum of Contemporary Crafts was the beginning of a successful career leading to assignments for *Redbook*, *Vintage Books* and *The New York Times*. Her intriguing characters often develop from a prop as simple as a pair of old shoes. Her work is part of the Hirshhorn collection in Washington and the Museum of New Orleans. A member of the S of I, she works out of her home in Greenwich, Connecticut.

ANTONAKOS, STEPHEN.
Sculptor. Born November 1, 1926, in Greece. Came to USA in 1930. Studied: Brooklyn (NY) Community College. Work: Finch College; University of Maine; Miami Museum of Modern Art; Milwaukee; University of North Carolina; Aldrich; Museum of Modern Art; Guggenheim; Whitney. Exhibited: Avant Garde Gallery, NYC, 1958; Schramm Galleries, Fort Lauderdale, Fla., 1964; Fischbach Gallery, New York City, 1967-70, and 72; Eindhoven, Holland, Kunst-Licht-Kunst, 1966; Kansas City, Sound, Light, Silence, 1966; Whitney, 1966, 68-70; Carnegie, 1967; Trenton, NJ, Focus on Light, 1967; UCLA, 1969; A Shade of Light, San Francisco Museum of Art, 1978; Minimal Tradition, Aldrich Museum of Contemporary Art, Ridgefield, CT. Received the NY State Creative Artists Public Service Program Award; Individual Artist's Grant, National Endowment for the Arts. Address in 1982, 435 West Broadway, New York City.

APEL, BARBARA JEAN.
Printmaker and educator. Born in Falls City, Nebraska June 16, 1935. Studied: Kansas City Art Institute, Missouri; University of Illinois, Urbana. Awards: Lincoln College, Illinois, 1966; Springfield Art League Annual, Massachusetts, 1968; Boston Printmakers, 1974. Collections: Worcester Fine Arts Museum; The University of Wisconsin; The University of Illinois. Exhibitions: Surreal Images, De Cordova Mus., Lincoln, MA, '68; Boston Vis. Artists' Group Show, NY, 76 and many others. Address in 1980, 235 Rawson Road, Brookline, MA.

APEL, CHARLES P.
Painter. Born in Brooklyn, New York, in 1857. Pupil of Chase and Mora. Address in 1926, 57 Eby Place, East Orange, New Jersey.

APEL, MARIE.
Sculptor. Born in England, 1888. Member of National Association of Women Painters and Sculptors; Societe International des Beaux-Arts et des Lettres, Paris. Exhibited at National Sculpture Society, 1923. Work: Bronze portrait statue of Chin Gee Hee, Hong-Kong, China; stone spandrel figures, Bagshot Park, England; fountain group in stone, England; P. T. Morgan memorial, San Francisco, Calif.; Sleicher memorial, Troy, NY; Langdon memorial, Augusta, GA; Gardner memorial, Easthampton, LI; Malo memorial, Denver, CO.; marble and bronze fountain, Pasadena, Calif.; Hodges Memorial, St. Paul's Church, Baltimore, MD. Address in 1926, 3 Washington Square, New York.

APPEL, KAREL.
Sculptor and painter. Born in Amsterdam, Holland, April 25, 1921. Study: Royal Academy of Fine Arts, Amsterdam, 1940-43. Work: Tate Gallery, London; Museum of Modern Art, NYC; Stedelijk Museum,

Amsterdam; Museum of Fine Arts, Boston. Comn.: Numerous in Amsterdam, Rotterdam, The Hague, Holland. Exhibition: Studio Fachetti, Paris, 1954; Stedelijk Museum, Amsterdam, 1962; Guggenheim Foundation Works, NYC, 1969; Kunsthalle, Basel, Switzerland, 1969; various Canadian museums, 1972-73; retrospectives in Mexico City, Caracas, Venez., Bogota, Colombia, Germany, and Holland. Awards: UNESCO Prize, International Biennale, Venice, 1954; International Painting Prize, 5th Sao Paulo Biennale, 1959; 1st Prize, Painting, Guggenheim International Exhibition, NYC, 1960. Media: Acrylic; aluminum, and wood. Address in 1982, c/o Martha Jackson Gallery, NYC.

APPEL, MARINNE.
Painter. Born in New York in 1913. Studied: Woodstock School of Painting. Awards: Keith Memorial, Woodstock Art Association, 1938; Carville, Louisiana, 1940; Dutchess County Fair, 1935. Collections: Metropolitan Museum of Art; Marine Hospital, Carville, Louisiana; United States Post Office, Middleporte, New York and Wrangell, Alaska.

APPLEGATE, FRANK G.
Sculptor and painter. Born in Atlanta, Ill., Feb. 9, 1882. Studied under Frederick at the University of Illinois, under Grafly at the Penna. Academy of Fine Arts, and in Paris under Verlet. Exhibited water colors at Penna. Academy of Fine Arts, Philadelphia, 1925. Member: New Mexico Painters; Santa Fe Artists. Address in 1926, Santa Fe, New Mexico. Died in 1931.

APPLETON, ELIZA B.
(Mrs. Everard Appleton). Sculptor. Born November 9, 1882. Studied with M. Ezekiel in Rome. Member of the Providence Art Club. Address in 1933, Providence, RI.

APPLETON, THOMAS G.
Art patron and painter. Born in Boston, March 31, 1812. He studied in America and England. He exhibited many paintings on his return from Egypt in Boston that attracted much attention. He was deeply interested in the Boston Museum of Fine Arts. Died April 17, 1884 in New York City.

ARAKAWA, (SHUSAKU).
Painter. Born July 6, 1936, in Tokyo, Japan. In New York City since 1959. Work: In private collections; MOMA, NYC; Basel Mus., Switz.; Japan Nat'l. Mus., Tokyo; others. Exhib.: Museum of Mod. Art; Nat. Mus., Tokyo, 1958; Schmela Gallery in Dusseldorf; Kennedy Center for Perf. Arts, Wash., DC; Met. Mus. of Art, 1974; U. of Wisconsin; Toronto; many other international exhibits. Awards: DAAD Fellowship, West Berlin. Address in 1982, 124 W. Houston St., NYC.

ARBEIT, ARNOLD A.
Painter. Born in New York City, Oct. 1, 1916. Work: Columbus Museum, Columbus, GA; numerous private collections. Comn.: Ptg., Lobby, 20 Vesey St. Bldg., New York City, 1960. Exhibitions: Cooper Union Art School, NY, 1966-67; Isaac Delgado Museum, New Orleans; Esperanto Gallery, NYC, 1967; Scarsdale Gallery, many years. Awards: Beaux Arts Inst. of Design F. B. Morse Medal for Des.; Cert. of Honor for Des. NYSA; Armstrong Memorial Medal. Mem.: Am. Inst. Architects; Mil. Gov't. Assn. Monuments, Fine Arts and Archives; etc. Teaching: Cooper Union, architecture, 1947-64; City College, NY, architecture, 1964-68. Media: Oil, watercolor. Address in 1976, Scarsdale Gallery.

ARCHAMBAULT, ANNA MARGARETTA.
Portrait and miniature painter. Born in Philadelphia. Pupil of PAFA, and Julian Academy. Painted miniature of Warren G. Harding, at White House, Washington. Also Mrs. Jasper O. Nicolls, Master William Jasper Nicolls, and Mrs. William I. Moseley. Member: PA S. Min. P.; Fellowship PAFA; Plastic C.; Phila. Alliance; Fairmount Park AA. Address in 1926, 1714 Chestnut Street, Philadelphia.

ARCHER, DOROTHY BRYANT.
Painter and teacher. Born in Hampton, Virginia, April 18, 1919. Study: Richmond Prof. Inst.; Kansas City Art Inst., with Wilbur Niewald; Honolulu Acad. of Art, with John Young. Exhibitions: Honolulu Academy of Arts, Hawaii, 1962; Laguna Gloria Museum, Austin, Texas, 1965; Inst. Relaciones Culturales, Chihuahua, Mex., 1969; El Paso Museum of Art, El Paso, Texas, 1971, 73, 74. Awards: El Paso Art Assn., 1970; El Paso Mus. Art award, 1973. Teaching: Staff Instructor, El Paso Museum of Art; national acrylic workshop. Media: Acrylic, oil. Address in 1980, 8717 Marble Drive, El Paso, Texas.

ARCHER, JAMES.
Engraver. He did the majority of the large plates illustrating "Hinton's History of the United States" published in Boston in 1834.

ARCHIPENKO, ALEXANDER.
Sculptor, painter, illustrator, etcher, craftsman, and teacher. Born Kiev, Ukraine, May 30, 1887. Studied at Ecole des Beaux-Arts, Kiev, 1902-05; Moscow, 1906-08. Exhibited in Moscow, 1906; at Salons in Paris, where he arrived in 1908; and in major cities in Europe and US until his death. Travelled to Berlin, 1920-23; came to US in 1924. Founded Archipenko Art School, NYC; Ecole d'Art in NY, 1924; also taught at Art Students League, NYC; Chouinard Art Institute, LA, CA, 1933; Mills College, 1933, 34; Bauhaus, Chicago, 1937. Invented "animated painting," known as "Archipentura;" figured significantly in Cubist movement in his early years. Represented in Museums in Osaka, Japan; Frankfort, Mannheim,

Leipzig, Hanover, Essen, Hamburg, Germany; Vienna; Rotterdam; Kiev; Moscow; National Gallery, Berlin; Brooklyn, NY; Guggenheim, NYC; Museum of Modern Art, Paris; and others. Address in 1953, 1947 Broadway; h. 624 Madison Avenue, NYC; summer, Woodstock, NY. Died February 25, 1964.

ARENSBACH, HARAL.
Artist. Exhibited water color paintings at the Academy of Fine Arts, 1921-25. Address in 1926, 121 North 21st Street, Philadelphia, PA.

ARMAN (ARMAND FERNANDEZ).
Sculptor. Born in Nice, France, November 17, 1928. US citizen. Studied at Ecole de Louvre; Ecole Nationale des Arts Decoratifs. Co-founder, Groupe des Nouveaux Realistes, 1960, and L'Ecole de Nice, 1961. In collections of Stedelijk Museum, Amsterdam; Brussels; Albright-Knox; Museum of Modern Art; museums in Cologne, Eindhoven (Holland), Paris, Helsinki, Copenhagen, Munich, Rome, Stockholm, Venice. Exhibited in many galleries in US and abroad, including Galerie du Haut Pave, Paris, 1956; Gallera Apollinaire and Galleria Schwarz, Milan; Cordier and Warren, NYC, 1961; Dwan Gallery, Los Angeles; Janis Gallery, NYC; Feigen Gallery, Chicago; XXXIV Venice Biennial, 1968; retro. at Stedelijk Museum, Palais des Beaux-Arts, Brussels; galleries in Paris, Gstaad and Lausanne in Switzerland, Venice, Stockholm, Brussels. Awards: IV International Biennial Exhib. of Prints, Tokyo, 2nd prize, 1964; Premio Marzotto, 1966. Address in 1982, 380 West Broadway, NYC.

ARMBRUSTER, A. E.
Scenic painter. Member of League of Columbus Artists. Address in 1926, 3102 North High Street, Columbus, Ohio.

ARMFIELD, MAXWELL.
Painter and illustrator. Born in England. Studied abroad. He did mural painting and illustrated for *Century* and other magazines. Address in 1926, 104 West 40th Street, New York City.

ARMIN, EMIL.
Sculptor and painter. Born in Radautz, Rumania, April 1, 1883. Studied at Art Institute Chicago. Award: Silver medal, Chicago Society of Artists, 1932. Member: Chicago Society Artists; Chicago No-Jury Society Artists; Ten Artists (Chicago). Address in 1933, Chicago, Ill.

ARMINGTON, CAROLINE H(ELENA).
Painter and etcher. Born Brampton, Ontario, Canada, Sept. 11, 1875. Pupil of Julian Academy in Paris. Member: AFA; Chicago SE; Societe Nationale des Beaux Arts; Societe de la Gravure Originale en Noir; Societe des Gravures Francais. Work: "St. Pol-de-Lyon," painting purchased by French Government.

Etchings in the New York Public Library; the Library of Congress, Washington; Luxembourg and Petit Palais, Paris; British Museum and South Kensington Museum, London; National Gallery, Ottawa, and Art Gallery, Toronto, Canada; Cleveland Museum; Syracuse Museum, Dayton Art Institute; Bibliographie de Belgique, Brussels. Address in 1929, 70 Blvd. du Montparnasse (XIVeme), Paris, France. Died in 1939.

ARMINGTON, FRANK M(ILTON).
Painter and etcher. Born Frodwich, Ontario, Canada, July 28, 1876. Pupil of Jean Paul Laurens and Henri Royer at Julian Academy in Paris. Member: Societe Nationale de la Gravure Originale en Noir. Work: "Portrait of Yetta Rianza," "La Vallee a Bizy" and "Pont Louis Philippe, Paris," Luxembourg Gallery, Paris; "La Rue Royale, Pluie." Address in 1929, 70 Blvd du Montparnasse, (XIVeme), Paris, France. Died in 1941.

ARMS, ANNELI.
Born New York City, 1935. Study: BA, Painting and Sculpture, U. of Mich., 1958; scholarship, ASL NY, Morris Kantor, 1956-58. Exhibitions (Solo): Camino Gallery, NYC, 1962; Studio, Greene St., 1968; Benson Gal., Bridgehampton, NY, 1971; Phoenix Gal., NYC, 1978, 81, 83; Westtown Art Center, PA, 1978; Edw. Wms. College, Fairleigh-Dickinson U., 1981; Hudson Highlands Mus., Cornwall, NY, 1983. 3-Person: Avant-Garde Gal., NYC, 1959; Camino Gal., NYC, 1960; Phoenix Gal., NYC, 1977. Other: Detroit Inst. of Art, 1955; Riverside Mus., NYC, 1959, 60; U. of Mich., Rackham & Slusser Galleries, 1955-56, 59, 75; Miami Mus. of Mod. Art, 1960; 2nd Int'l Pan-Pac., Tokyo, 1961-62; Benson Gal., Bridgehampton, NY, 1974, 77, 82-83; Heckscher Mus., Huntington, NY, 1975; Guild Hall, East Hampton, NY, 1977-80; Landmark Gal., NYC, 1977-78; OIA Constructs Exhib., NYC, 1978; Ingber Gal., NYC, 1978-79, 1983; Sculpturesites, Amagansett, NY, 1981-82; Thorpe Intermedia Gal., Sparkill, NY, 1981-82. Reviewed in *Art News*, 1960, 62, 68; *Arts*, 1978, 81; *NY Times*, 1959, 78, 81, 82. Media: Oil; polyurethane, wire and acrylic sculpture; monoprint etching. Address in 1983, 113 Greene St., New York City.

ARMS, JOHN TAYLOR.
Etcher. Born in Washington, DC, in 1887. Trained as an architect, in 1919 he devoted himself to the graphic arts. His aquatints were most successful. Pupil of Ross Turner, D. A. Gregg, Felton Brown and Despradelles. Member: Calif. PM; Royal Soc. Canadian Painter-Etchers; Salma. C.; Chicago SE; Brooklyn SE; Print S. of England; Wash. WCC; North Shore AA; AA of Newport; Springfield AA; Boston AC; S. Indp. A; AFA; Associe de la Societe des Beaux Arts (France); Baltimore WCC; Cleveland Print C.; Century A. Work in Congressional Library; Brooklyn Museum; U. S. National Museum; Peabody

Museum, Salem; British Museum; Toronto Art Gallery; Cleveland Museum; Delgado Museum, New Orleans; Bibliotheque Nationale, Paris; Musee de Rouen (France). Address in 1929, Greenfield Hill, Fairfield, Conn. Died in 1953.

ARMSTRONG, ARTHUR.
Portrait, landscape and historic painter. Born 1798 in Manor Township, Lancaster County. In 1820 he opened a studio in Marietta, Lancaster County, and there began his career as artist and teacher. In 1849 he opened a studio and gallery for exhibition of paintings in Mechanics' Institute, Lancaster, and later had a large studio on Orange Street, Lancaster, built by himself and with the second story fitted up as a gallery to exhibit paintings. He painted there some very large canvases, "Hamlet and Ophelia" and the "Assassination of Caesar." At some time in his career he resorted to "pot-boilers," painting signs and banners, and made and gilded frames. One silk banner which was painted for the Washington Fire Company of Louisville, Kentucky, represented the Washington Family under the portico of their mansion at Mount Vernon, with the Potomac dotted with sails seen in the background. He was a prolific painter, and while many of his works are in the vicinity of Lancaster, others are widely scattered. Died June 18, 1851.

ARMSTRONG, BARBARA.
Painter. Born in Bellaire, Ohio, 1896. Pupil of Hamilton E. Field. Address in 1926, Ogunquit, Maine.

ARMSTRONG, DAVID MAITLAND.
Painter. Born April 15, 1836 in Danskammer, NY. Graduate of Trinity College. He was an early member of the American Artists Society, founded in 1877, and was elected an Associate Member in 1906 of the National Academy of Design. He died in 1918.

ARMSTRONG, ESTELLE MANON.
Painter. Member of National Association of Women Painters and Sculptors and exhibited at 33d Annual (1924). Address in 1926, 603 Bloomfield Avenue, Nutley, NJ.

ARMSTRONG, HELEN MAITLAND.
Mural painter and designer. Born in Florence, Italy, 1869. Student of Art Students League, New York. Address in 1926, Maitland Armstrong Co., 58 West 10th Street, New York.

ARMSTRONG, JANE BOTSFORD.
Sculptor. Born in Buffalo, NY, February 17, 1921. Studied at Middlebury College; Pratt Institute; Art Students League, with Jose De Creeft. Works: Hayden Gallery, Mass. Institute of Technology; Columbus Gallery of Fine Arts, OH; New Britain Museum of American Art, CT; Worcester Polytechnic Institute, MA; Montefiore Hospital, Bronx. Commissions: Three marble animals, World of Birds, NY Zoological Society, Bronx, 1972; large white marble free-form, Research Triangle Institute, Research Triangle Park, NC, 1974. Exhibitions: One-woman shows, Frank Rehn Gallery, NY, 1971, 73, and 75, Columbus Museum of Fine Arts, OH, 1972, North Carolina Museum of Art, Raleigh, 1974, and Columbia Museum of Art, SC, 1975; Critics Choice, Sculpture Center, NY, 1972. Awards: Gold Medal, National Arts Club, NY, 1968, 69, and 72; Medal of Honor, Audubon Artists, NY, 1972; Council of American Artists Society Prize, National Sculpture Society, NY, 1973. Address in 1983, Highland Beach, FL.

ARMSTRONG, SAMUEL JOHN.
Painter and illustrator. Born Denver, Colorado, 1893. Address in 1926, Steilacoorn Lake, Pierce Co., Washington.

ARMSTRONG, VOYLE N.
Painter and illustrator. Born in Dobbin, West Virginia, Nov. 26, 1891. Pupil of Duveneck at Cincinnati Art Academy. Member: Cincinnati AC; SSAL. Address in 1926, 717 North 1st Street, Bedford, Ind.

ARMSTRONG, WILLIAM G.
Engraver, portrait painter in water color, and portrait draughtsman. Born 1823, Montgomery Co., PA. Lived in Philadelphia. Armstrong was a pupil of Longacre in Philadelphia, drew small portraits and finally became a line engraver. He engraved several portraits for Longacre's "National Portrait Gallery." He also devoted a large part of his professional life to bank-note engravings. Died in 1890.

ARMSTRONG, WILLIAM T. L.
Painter and artist. Born Belfast, Ireland, Sept. 10, 1881. Member: AIA; NY Arch. Lg.; Society of Beaux-Arts Architects; AWCS; NYWCC. Work: Milwaukee (Wis.) County General Hospital; Nutley (NJ) Public Library; Grace Episcopal Church, Nutley, NJ; Brooklyn Presbyterian Church. Associate in Design, School of Architecture, Columbia University; instructor, architecture, NY University. Address in 1929, 122 East 25th St., New York, NY; h. 603 Bloomfield Ave., Nutley, NJ. Died 1934.

ARNO, PETER.
Illustrator. Born in New York City, 1904. He was a student at Yale University from 1922 to 1924, but had no formal art training at the time. 1925 marked the beginning of his long-standing relationship with *The New Yorker*, where his cartoons and covers appeared with great frequency. The consummate New Yorker, he brought his style and wit to his books of cartoons: *Dearie, Peter Arno's Parade* and *Peter Arno's Circus*. Died in 1968.

ARNOLD, CLARA MAXFIELD.
Painter. Born East Providence, RI, 1879. Member of Providence Art Club. Specialty, flower and fruit paintings. Address in 1926, 22 Highland Avenue, East Providence, RI.

ARNOLD, HARRY.
Painter. Born in England. Member of the Society of Independent Artists. Address in 1926, 208 Gillette Avenue, Waukeegan, Ill.

ARNOLD, JOHN K.
Portrait painter. Born in 1834; died in 1909. He painted the portraits of many prominent men of the state of Rhode Island.

ARNOLD, NEWELL HILLIS.
Sculptor, craftsman, teacher, etcher, and lithographer. Born in Beach, North Dakota, July 10, 1906. Studied at University Minnesota, BA; Minneapolis School of Art; Cranbrook Academy of Art, with Carl Milles. Member: St. Louis Artists Guild; Minn. Sculptors Group; Artists Equity Association; Group 15, St. Louis. Work: City Art Museum of St. Louis; Walker Art Center; Monticello College; University Minnesota; Minn. Dept. Health; US Post Office, Abingdon, IL; World War II Memorial, St. Louis, MO; St. Anne's Church, Normandy, MO. Exhibited: Architectural League, 1937; NY World's Fair, 1939; City Art Museum of St. Louis; Wichita, KS; Artists Guild. Taught: Institute, Sculpture, Ceramics, Monticello College, Godfrey, IL, from 1938. Address in 1953, Godfrey, IL.

ARNOLDI, CHARLES.
Sculptor. Born in Dayton, OH, 1946; came to Los Angeles, 1965; lived in NY, 1970. Studied: Chouinard Art Institute, Los Angeles, 1968. Has exhibited at Riko Mizuno Gallery, Los Angeles, 1971; Nicholas Wilder Gallery, Los Angeles, 1974, 1975; Robert Elkon Gallery, NY, 1975; Fifteen Los Angeles Artists, Pasadena Art Museum, CA, 1972; Documenta 5, Kassel, Germany, 1972; Fifteen Abstract Artists, The Santa Barbara Museum of Art, CA, 1974; San Francisco Museum of Modern Art; Smithsonian (National Collection of Fine Arts). Address in 1977, Venice, CA.

ARONSON, CYRIL (MISS).
Sculptor, painter, designer, teacher, and lecturer. Born in Boston, MA, June 13, 1918. Studied at Wayne University, BA, MA. Member: Detroit Society of Women Painters and Sculptors; Detroit Water Color Society. Awards: Prizes, Detroit Society of Women Painters and Sculptors, 1941, 43. Exhibited: Art Institute of Chicago, 1941; Michigan Art, 1940, 41, 44, 45; Detroit Society of Women Painters and Sculptors, 1941-45. Address in 1953, Detroit, MI.

ARONSON, DAVID.
Sculptor and painter. Born in Shilova, Lithuania, October 28, 1923. US citizen. Study: School of Museum of Fine Arts, Boston, with Karl Zerbe, 1945; National Society of Arts and Letters Grant, 1958; Guggenheim Fellow, 1960. Work: Atlanta University; Museum of Fine Arts, Boston; Bryn Mawr; Art Institute of Chicago; Whitney Museum; Metropolitan Museum of Art; Smithsonian Institute Exhibition; Metropolitan Museum of Art, Museum of Modern Art, Whitney, NYC; Zappeion, Athens; Musee d'Arte Moderne, Paris; 1964 World's Fair; and others. Awards: Boston Institute of Contemporary Art, 1944; Boston Arts Festival, 1952-54; National Academy of Design, 1973-75. Teaching, Boston Museum of Fine Arts School, 1943-54; Boston University, 1954-63. Medium: Bronze. Address in 1982, Sudbury, MA.

ARONSON, SANDA.
Sculptor. Born NYC, February 29, 1940. Study: SUNY Oswego, BS, 1960; with Jose De Creeft, Paul Pollaro, New School for Social Research, NYC; Tulane University, New Orleans; Art Students League, NY. Exhibitions: Women Self Image, Women's Interart Center, NYC, 1974; Women Showing/Women Sharing, US Military Academy, West Point, NY, 1975; Works on Paper, Brooklyn Museum, NY, 1975. Exhibited for Women Artists, Manhattan Community College for Performing Arts, 1975; travelling show, Fairleigh Dickinson University, Chatham College, SUNY Binghamton, 1976; Four Artists, Women in the Arts Foundation, NYC, 1976; Nine/Plus or Minus, US Military Academy, 1977, and Arsenal Gallery of NYC, 1978; NY/Artists Equity Association, NYC, 1980; Artists in Res. Gallery, NYC, invitation show, 1981. Awards: Honorable mention, Sculpture, Women Showing/Women Sharing, US Military Academy, West Point, NY, 1975. Member: Women in the Arts Foundation, Board Member-at-large, NYC, 1975-76; NY Artists Equity Association. Commission: Handprinted editions, woodcuts by Clem Haupers, 1982. Published: Frontispiece, *Hear the Wind Blow*, John Beecher, International Publishers, NYC, 1968, woodcut. Teaching: Artist-in-Residence, New York Foundation for the Arts, 1977-79. Media: Assemblage and Construction, collage, woodcut, handmade paper. Address in 1983, 70 West 95th St., NYC.

ARP, HILDA.
Work: Norfolk Museum, Norfolk, VA; Wagner College, NY; collections in the US and Europe. Exhibitions: Brooklyn Museum; Norfolk Museum; Musee de Cognac, France; Int. Exh., Cannes, France. Art Positions: Dir. of the Colorama Gal., NY; NY World's Fair 1965. Address in 1970, 4516-7th Avenue, Brooklyn, NY.

ARPA, JOSE.
Painter. Born in Spain, 1868. Exhibited water color painting at the Penna. Academy of the Fine Arts,

Philadelphia, 1925. Address in 1926, 418 Oakland Street, San Antonio, Texas.

ARTER, CHARLES J.
Painter. He died in Alliance, Ohio, in 1923. He had his studios in Venice, London and New York. He painted many people of distinction and was decorated by the King and Queen of Italy for portraits he had made of them.

ARTHUR, ROBERT.
Painter. Born in Philadelphia, 1850; he died in New York, 1914. His early work was mainly decorative, and his later work was largely marine painting. He was a close friend of Robert Louis Stevenson; his studio was at Ogunquit, Maine.

ARTHURS, STANLEY MASSEY.
Mural painter. Born in Kenton, Del., 1877. Pupil of Howard Pyle. Among his works, "Landing of De Vries," at Delaware College, Newark, Delaware, "The Crusaders" at the State Capitol, Dover, Delaware. Address in 1926, 1305 Franklin Street, Wilmington, Delaware.

ARTIS, WILLIAM ELLISWORTH.
Ceramist and teacher. Born Washington, NC, Feb. 2, 1914. Study: Alfred Univ.; Syracuse Univ.; Chadron State College; Penn. State Univ. Work: Walker Art Ctr., Minneapolis; IBM; Slater Mem. Mus., Norwich, CT; Nat'l. Portrait Gallery, Wash. DC; others. Comn.: Chadron State College. Exhib.: Nat'l. Sculpture Soc.; Whitney Mus. of Am. Art; Colleges and Universities. Awards: Rosenwald Fellow, 1947; nine Purchase Awards, Atlanta Univ., 1944-65. Teaching: Prof. Art, Mankato State College, Minn. Mem.: Am. Ceramic Soc.; Nat'l. Sculpture Soc.; etc. Rep.: Gallery 500 Mankato, Minn. Died in 1977. Address in 1976, Sch. of Arts and Sci., Mankato State College, Minn.

ARTSCHWAGER, RICHARD ERNEST.
Sculptor and painter. Born December 26, 1924, in Washington, DC. Studied: Privately with Amedee Ozenfant; Cornell University, BA. Work: Nelson Gallery, Kansas City; Museum of Modern Art; Milwaukee; Aldrich; Art Institute of Chicago; Whitney. Received National Endowment for the Arts Award, 1971. Exhibited: Leo Castelli Inc., 1965, 67; Albright, 1964; Dwan Gallery, Boxes, 1964; Guggenheim, 1966; Whitney, Contemporary American Sculpture, 1966, Sculpture Annual, 1966, 68; Museum of Modern Art, The 1960's, 1967; Documenta IV, Kassel, 1968 and 72; Berne, When Attitudes Become Form, 1969; Herron, 1969; York University, Toronto, 1969; Hayward Gallery, London, 1969; Milwaukee, Aspects of a New Realism, 1969; La Jolla Museum of Contemporary Art, CA, 1980. Represented by Leo Castelli Gallery, New York City. Living in Charlotteville, NY, in 1982.

ARTZYBASHEFF, BORIS.
Illustrator. Born in Kharkov, Russia, 1899. He received his art training at the Prince Tenisheff School in St. Petersburg. In 1919 he fled to the United States, where he worked as an engraver's apprentice while illustrating books by Balzac and Aesop. A longstanding relationship with *Time* magazine resulted in his production of over 200 covers. Among a number of citations awarded him was the prestigious Newberry Medal. Died 1965.

ASANGER, JACOB.
Painter and etcher. Born in Bavaria in 1887. Member of Society of Independent Artists. Address in 1926, 12 East 15th Street, New York City.

ASBJORNSEN, SIGVALD.
Sculptor. Born in Christiania, Norway, 1867. Pupil of B. Bergslieu and M. Skeibrok, Middeltun. Address in 1910, Chicago, IL.

ASCHENBACH, (WALTER) PAUL.
Sculptor and educator. Born in Poughkeepsie, NY, May 25, 1921. Studied at Rhode Island School of Design, 1940-41; with Randolph W. Johnson, Deerfield, MA, 1942-45; I. Marshall, Philadelphia, 1946-48. Work in Sculpture Park, St. Margarethen, Austria; De Cordova, Lincoln, MA; Bundy Art Gallery, Waitsfield, VT; forged mild steel crucifix, Trinity College, Burlington, VT; and others. Teaching art at University of Vermont, from 1956. Works in steel and marble. Address in 1982, Charlotte, VT.

ASCHER, MARY.
Painter and printmaker. Born in Leeds, England. US citizen. Study: NY School of Applied Design for Women; Hunter College; ASL; with Will Barnet, Vaclav Vytlacl, Morris Kantor. Work: Ein Harod Museum, Israel; Nat'l Collection of Fine Arts, Smithsonian Inst., Wash. DC; Norfolk Museum of Fine Arts; US Nat'l Museum of Sport, NYC; Butler Inst. of Am. Art, Youngstown, many public and private collections. Comn.: 12 Women of the Old Testament and Apocrypha, Wizo Bldg., Tel Aviv. Exhib.: Exch. Exhib. with Japanese Women Artists, 1960; with Argentine Artists, 1963; Silvermine Guild, New England Ann., 1967; 30 year Retro., Nat'l. Arts Club, NYC, 1973; Met. Mus. of Art, 1979; etc. Awards: Huntington Hartford Foundation Fellowship, 1960; Medal of Honor, Nat'l Painters & Sculp. Soc.; Nat'l Assn. of Women Artists; Nat'l League of Am. Penwomen, Prof. Art; Int'l. Women's Year Award, 1975-76; First prize-oil, Womanart Gallery, NYC, 1977; and others. Mem.: Royal Soc. of Arts, fellow, London; Am. Soc. of Contemp. Artists; ASL (life); Nat'l. Assn. Women Artists; Chaplain, Nat'l. Soc. Arts and Letters (Empire State); etc. Author: *Twelve Women of the New Testament and Early Church*, with 25 portfolios; and more. Media: Oil, watercolor, prints. Address in 1982, 116 Central Park South, New York, NY.

ASHBROOK, PAUL.
Painter. Born in New York, 1867. He exhibited in oil, water color and etching at the Cincinnati Museum, 1925. Address in 1926, No. 2 Hedgerow Lane, Cincinnati, Ohio.

ASHE, EDMUND M.
Painter, illustrator and teacher. Member: NYWCC; SI, 1901; Pittsburgh AA. Address in 1929, care of Carnegie Institute of Technology, Pittsburgh, PA; Westport, Conn.

ASHER, ELISE.
Sculptor. Born in Chicago, Illinois, January 15, 1914. Studied at Art Institute of Chicago; Bradford Junior College; Boston College, BS, summers. Works: NY University Art Collection; University of Calif. Art Museum, Berkeley; Rose Art Museum, Brandeis University; Geigy Chemical Corporation; First National Bank of Chicago. Commissions: Oil on Plexiglas window, commission by Dr. John P. Spiegel, Cambridge; cover for *Poetry Northwest*, autumn-winter, 1964-65; cover for *The Chelsea*, No. 27, 1970; jacket for Stanley Kunitz, *The Testing-Tree* (poems), Little, Brown, 1971. Exhibitions: One-woman retrospective, Bradford Junior College, 1964; one-woman shows, the Contemporaries, NY, 1966, and Bertha Schaefer Gallery, NY, 1973; Lettering, traveling show, Museum of Modern Art, NY, 1967; The Word as Image, Jewish Museum, NY, 1970; plus many other one-woman and group shows. Media: Multi-layered densities in oil and enamel. Address in 1982, 37 West 12th Street, NYC.

ASHFORD, PEARL J.
Painter and illustrator. Born in Phila., PA. Study: Pratt Inst., NY; Tyler Sch. of Art, Temple Univ.; with Morris Blackburn, Phoebe Shih. Exhib.: 1st NY Int'l. Art Show, NY Coliseum, 1970; Plastic, Women's Art Club, Phila., 1971; Int'l. Art Show, Rotunda Gallery, London, 1972; Urban League Guild Ann., Phila., 1972, 74; Gallerie Paula Insel, NY, Ann. Group Show, 1976, 77. Awards: Second prize for Geraniums (painting), Willingboro Art Alliance, 1973. Mem.: Nat'l. Forum Prof. Artists; Equity Assn. Illustrator-general, US Army Ord., Phila., 1955-60. Media: Oil, watercolor. Address in 1980, 2400 Chestnut St., Apt. 1007, Phila., PA.

ASHLEY, CLIFFORD WARREN.
Painter. Born in New Bedford, Mass., 1881. Pupil of Howard Pyle. Among his works, "The Whaling Industry," "Outfitting the Whaler." Address in 1926, 31 Eighth Street, New Bedford, Mass.

ASHLEY, SOLOMON.
Sculptor. Born in Deerfield, MA, 1792. Portrait in marble, Col. Oliver Partridge, at Hatfield, MA. Specialty was gravestone portrait sculptures.

ASHLEY, WILLIAM JOHN.
Born in England in 1868. He was successful as a landscape painter. He died at Mt. Vernon, NY, October, 1921, having lived and painted for the previous ten years in this country.

ASMAR, ALICE.
Painter and printmaker. Born in Flint, Mich. Study: Lewis and Clark College; with Edward Melcarth, Archipenko, Univ. of Wash., MFA; Woolley Fellow, Ecole Nat. Superieure des Beaux-Arts, Paris, with M. Souverbie; Huntington Hartford Found. residence fellowships, 1961-64. Work: Franklin Mint, PA; Smithsonian Inst.; Public Interest Mus., Gabrova, Bulgaria; etc. Comn.: Jos. Magnin's, 1964; Security Pacific Int'l. Bank, NYC, 1970; lithographs, Artists Profusions, NYC, 1980; others in US and abroad. Exhib.: West Assn. of Art Museum Circulating Banner Exhib., 1970-72; West 79/The Law, Minn. Museum of Art, 1979-80; Portland (OR) Art Museum, 1979-80; other one-person and group shows. Awards: Menzione Onorevole, Biennale Delle Regione, 1968-69; purchase award, Seattle Art Mus.; 1st prize Southern Calif. Expos. Mem.: Am. Federation of Arts; Artists Equity; and others. Eng. draftsman, Boeing Aircraft, 1952-54; engraver, Nambe Mills, Santa Fe, NM, 1968-present. Media: Casein, oil, india ink, lithograph. Rep.: Hatfield Dalzell Galleries, Los Angeles; Gallery G Fine Arts, Wichita, KS. Address in 1982, 1125 N. Screenland Dr., Burbank, CA.

ATCHISON, JOSEPH ANTHONY.
Sculptor. Born Washington, Feb. 12, 1895. Pupil of George Julian Zolnay, Richard Edwin Brooks. Work: "Round the World Flight Memorial," National Museum, Washington; allegorical frieze, Cleveland Public Auditorium. Address in 1934, Belasco Theatre, Washington, DC.

ATHERTON, EZRA.
Miniature painter. Mentioned in the Boston directories for 1841-1842.

ATHERTON, JOHN.
Illustrator. Born in Brainerd, Minnesota, 1900. He studied art at the College of the Pacific and the School of Fine Arts in San Francisco. His advertising and editorial illustrations led to a One-Man Show in New York in 1936. He was an award winner in the 1943 Artists for Victory show for his piece, "Black Horse," which is now owned by the Metropolitan Museum of Art. His first job was a cover for *The Saturday Evening Post* and later he produced three of their Franklin anniversary covers. A founding member of the FAS. Died in New Brunswick, Canada, 1952, while on a fishing trip.

ATHEY, RUTH.
See Vivash.

ATKINS, ALBERT HENRY.
Sculptor. Born Milwaukee, Wis., 1899. Studied at Cowles Art School, Boston, 1896-98; Academie Julien and Academie Colarossi, Paris, 1893-1900. Member of faculty, RI School of Design, Dept. of Sculpture, from 1909. Member: National Sculpture Society; Architectural League of NY; Copley Society of Boston; American Art Association (Paris); Providence Art Club; Boston Architectural Club. Principal works: Copenhagen Memorial Fountain, City of Boston; Lapham Memorial, Milwaukee, WI; Architectural sculptures, Christ Church, Ansonia, Conn., All Saints Church, Dorchester, MA; WWI Memorial, Roslindale, MA; also portraits, ideal sculptures, fountains and garden sculptures. Exhibited at National Academy of Design (New York); Penna. Academy of Fine Arts, Philadelphia; Albright Galleries (Buffalo); Art Institute (Milwaukee); National Sculpture Society, (1923). Awards: Silver medal, Milwaukee Art Institute, 1917. Address in 1933, Boston, MA; summer, Gloucester, MA. Died March 10, 1951.

ATKINS, FLORENCE ELIZABETH.
Sculptor. Born in Pleasant Hill, Louisiana. Pupil of H. Sophie Newcomb Art School, Ellsworth, and William Woodward. Exhibited "Frogs," "Rabbit," at the Penna. Academy of the Fine Arts, Philadelphia, 1921. Address in 1926, San Francisco, California. Died in 1946.

ATKINSON, E. MARIE.
See Hull, Marie Atkinson.

ATKINSON, LEO F.
Painter. Born at Sunnyside, Washington, Sept. 23, 1896. Pupil of Seattle Art Club. Mural paintings in Columbian Theatre, Baton Rouge, LA., and American Theatre, Bellingham, Washington. Represented at Seattle Fine Arts Gallery, "On Cedar Drive." Address in 1926, 1122 36th St., Seattle, Washington.

ATKYNS, (WILLIE) LEE (JR.).
Sculptor, painter, teacher, graphic artist, lecturer, and illustrator. Born in Washington, DC, September 13, 1913. Member: Society of Washington Artists; Washington Water Color Club; Puzzletown Artists Guild; All. A. Johnstown; Indiana (PA) Art Association; Washington Art Club; Newport Art Association. Awards: Prizes, Society Washington Artists, 1947; Washington Art Club, 1946; All. A. Johnstown, 1948, 49, 50. Exhibited: Butler Art Institute; Carnegie Institute; University Chicago; American Watercolor Society; National Academy of Design; Washington Art Club; Smithsonian Institute; Corcoran Gallery; Phillips Memorial Gallery; Whyte Gallery; Toledo Museum of Art; Springfield Art Association; L.D.M. Sweat Memorial Art Museum; Utah State Institute; Terry Art Institute; Catholic University; Indiana State Teachers College; Baltimore Museum of Art; and many one-man exhibitions. Work: Phillips Memorial Gallery; All. A. Johnstown; Hospital, Lexington, KY. Position: Director, Lee Atkyns Studio School of Art, Washington, DC and Duncansville, PA. Address in 1982, Lee Atkyns Puzzletown Art Studio, Duncansville, PA.

ATROBUS, JOHN.
Painter. Died in Detroit, Michigan, October 18, 1908. He had lived in Chicago, and Washington, DC.

ATWOOD, JESSE.
Philadelphia portrait painter in 1860. He painted several portraits of President Lincoln.

ATWOOD, JR.
Was a map engraver working in Philadelphia about 1840.

ATWOOD, WILLIAM E.
Painter. Born at Killinoly, Conn. Member of National Arts Club, New York. Address in 1926, East Gloucester, Mass.

AUBIN, BARBARA.
Sculptor and painter. Born in Chicago, IL, January 12, 1928. Studied art at Carleton College, 1949, BA; Art Institute of Chicago, 1954; and during a George D. Brown foreign travel fellowship to France and Italy, 1955-56. Noted for her sculpture utilizing fiber, feathers, and beads in assemblages. Exhibited: Butler Institute of American Art, OH, 1961, 62; Norfolk Museum of the Arts and Sciences, 1963; 10th Annual National Prints and Drawings Exhibitions, Oklahoma Art Center, 1968; Fairweather-Hardin Gallery, Chicago, 1975, 78, and 81. She is also involved in writing for various magazines such as *Artists News*, 1977, 78; also an art critic. Has received numerous art awards. Taught: Assistant professor of painting, drawing, and watercolor at the Art Institute, Chicago, 1960-68; and Loyola University, Chicago, 1968-71; at St. Joseph's College, 1971-74; and at Chicago State University from 1971. Member: College Art Association of America; American Association Museums; Women's Caucus for Art. Address in 1982, Chicago, IL.

AUDUBON, JOHN JAMES.
Born April 26, 1785, Haiti, West Indies; died in January 27, 1851, New York City. The celebrated ornithologist and artist Audubon was the son of Captain Jean Audubon and a Creole woman named Rabin. He was legally adopted in France by both his father and his father's legal wife, Anne Moynet Audubon. He was in America from 1804 to 1805, visiting France in 1806. It was probably at this time that he received the instruction in drawing from Louis David of which he speaks in his "Journal." In 1807 he returned to America. He traveled extensively in United States and Canada, making notes and drawings for his "Birds of North America" and

"Quadrupeds of North America." John James Audubon came to New York in August 1824, Sully having given him letters to Stuart, Allston and Trumbull. At this time Audubon met John Vanderlyn and stood for him for the figure of Vanderlyn's portrait of General Jackson. Audubon visited Meadville, Penna., in 1824, and while in that city painted several portraits. Late in 1824, he went to Louisiana. He remained in the South until May 1826, when he again started to Europe, landing at Liverpool on July 21. Was in Eng. for much of the time between 1826-39. He was at once invited to show his drawings at the Royal Academy. He made several trips to the United States between 1829 and 1839. See "Life of Audubon," edited by his widow; "Audubon, the Naturalist," by F. H. Herrick; also *Scribner's* for March, 1893.

AUDUBON, VICTOR GIFFORD.
Son of John J. Audubon, was born June, 1809, in Louisville, KY. He was elected in 1864 an Academician of the National Academy in New York. His brother, J. W. Audubon, was elected as associate member of the National Academy in 1847. Died Aug. 1862 in New York City.

AUERBACH-LEVY, WILLIAM.
Painter and etcher. Born in Russia, Feb. 14, 1889. Pupil of NAD; Julian Academy in Paris under Laurens. Member: ANA, 1926; Salma. C.; Chicago SE. Awards: Mooney traveling scholarship, NAD, 1911; first figure prize, Chicago SE, 1914; bronze medal, P.-P. Exp., San F., 1915; Logan prize ($25), Chicago SE, 1918; third Hallgarten prize, NAD, 1921; bronze medal, Calif. PM, 1923; Shaw prize ($100), Salma C., 1923; 2nd Lewis caricature prize ($100), PAFA, 1924; Isaac N. Maynard prize ($100) for portrait, NAD, 1925; Isidor prize, Salma. C., 1925; prize, Jewish Centre Exhib., 1926; Lewis first prize (caricature), PAFA, 1927; Fellow, Guggenheim Mem. Foundation, 1928. Represented in AIC; Worcester Museum; New York Public Library; Carnegie Institute of Pittsburgh; "Corner of my Studio," Detroit Institute of Arts. Address in 1929, 46 Washington Sq., South, New York, NY.

AUGUR, HEZEKIAH.
Sculptor. Born February 21, 1791, in New Haven, Conn. He was self-taught, his artistic studies being carried out in New Haven, Conn. His group "Jephthah and his Daughter" is in the Yale College Gallery; also represented at U.S. Supreme Court. Exhibited at the National Academy, 1827-28; Penna. Academy of Fine Arts, 1831; Boston Athenaeum, 1832. He died in New Haven, January 10, 1858.

AULT, GEORGE COPELAND.
Painter. Born in Cleveland, Ohio, 1891. Member of Society of Independent Artists. Address in 1926, 11 Charles Street, New York, NY. Died Dec. 30, 1948.

AUNIO, IRENE.
Painter. Born in Finland, 1919. Studied: Art Students League. Awards: National Association of Women Artists, 1952, 1958; Pen and Brush Club, 1953; Ranger purchase prize, National Academy of Design, 1953; Catherine L. Wolfe Art Club, 1955, 1957; Art Students League, Johnson Merit Scholarship, 1954-55; Michael Engel award, 1958. Collections: Art Students League; National Academy of Design; Seton Hall University.

AUNSPAUGH, V(IVIAN) L(OUISE).
Painter, lecturer, and teacher. Born Bedford, VA. Pupil of Fitz and Twachtman; Weld in Rome; Mucha in Paris. Founder and director of Aunspaugh Art School, Dallas, Tex. Address in 1929, 3405 Bryan St., Dallas, Tex.

AUS, CAROL.
Painter. Born Norway, March 27, 1878. Pupil of Julian Academy, Paris, France. Work: Portrait of Governor Scofield, State Capitol, Madison, Wisc.; portraits in courthouses and libraries in Fort Wayne, Ind. and Madison, Wisc. Address in 1929, 2635 Hampden Court, Chicago, Ill. Died in 1934.

AUSTIN, AMANDA PETRONELLA.
Sculptor. Born in Carrolton, Missouri, in 1856. Exhibited: Societe des Artistes Francais, 1911. Died in 1917.

AUSTIN, CHARLES P.
Painter. Born in Denver, Colo., 1883. Pupil of Twachtman in New York and Castelluche, Paris. Address in 1926, San Juan Capistrano, California.

AUSTRIAN, BEN.
Painter. Died in Kempton, Penna., Dec. 9, 1921. He was self-taught and first achieved distinction in depicting barnyard subjects and later for landscapes. He also had a studio at Palm Beach, Florida.

AUSTRIAN, FLORENCE H(OCHSCHILD).
(Mrs. Charles Robert Austrian). Painter. Born Baltimore, MD, Sept. 8, 1889. Pupil of Hugh Breckenridge, John Sloan, Charles Hawthorne and Leon Kroll. Member: AFA. Address in 1929, 1417 Eutaw Pl., Baltimore, MD.

AUTH, ROBERT R.
Painter and printmaker. Born in Bloomington, Illinois, Oct. 27, 1936. Study: Ill. Wesleyan Univ., BFA; Wash. State U., MFA. Work: Salt Lake Art Center; Washington State University; others. Exhib.: Intermountain Painting and Sculpture, Salt Lake Art Center, 1969; Springville Mus. of Art, Utah, 1972; others. Awards: Intermountain Ptg. and Sculpture, 4th Biennial award, 1969; Allied Arts Council Artist of Year Award, 1972. Art Positions: Boise High School, 1961; bd. dir., Boise Art Gallery, 1969; etc.

Mem.: Idaho Art Assn.; Boise Art Assn. Medium: Acrylic. Rep.: Brown's Gallery, Boise, Idaho. Address in 1982, 530 Hillview Drive Boise, Idaho.

AVAKIAN, JOHN.
Painter and teacher. Born in Worcester, MA. Study: Yale Univ. School of Art and Architecture, BFA, MFA; Boston Mus. School. Work: Bucknell University Coll.; Kansas State University; Western Mich. University; others. Exhibitions: "New Talent," De Cordova Museum, Mass., 1965; 38th International Printmakers Exhib., Seattle Art Mus., 1967; Worcester (MA) Art Mus., solo, 1971; others. Awards: Boston Museum, Travel Grant '69; Providence Art Club, 1968; Art Patrons Lg. of Mobile award, 1972; Mem.: Col. Art Assn. of America; Boston Visual Artists Union. Teaching: Worcester (MA) Art Mus. School, from 1965, Mt. Ida Jr. College, 1965-pres. Media: Acrylic, serigraph. Rep.: Assn. Am. Artists, NYC. Address in 1982, 43 Morse St. Sharon, Mass.

AVENT, MAYNA TREANOR.
(Mrs. Frank Avent). Painter. Born Nashville, Tenn., Sept. 17, 1868. Pupil of Julian Academy and Lasar in Paris. Member: Nashville AA; SSAL. Award: Gold medal, Nashville AA. Address in 1929, 2811 Belmont Blvd., Nashville, Tenn.

AVERY, HOPE.
Painter. Exhibited portrait of Mr. Baker, in 33d Annual Exhibition of National Association of Women Painters and Sculptors, 1924. Address in 1926, Pittsford, VT.

AVERY, MILTON.
Painter. Born in Altmar, NY, March 7, 1893. Studied at Conn. League of Art Students, briefly 1913, with C. N. Flagg. Exhibited at numerous New York City galleries, including P. Rosenberg and Co., Bertha Schaefer Gallery, Knoedler and Co., Grace Borgenicht (many in the 1950's); Baltimore Museum of Fine Arts; Boston Museum of Fine Arts; Museum of Modern Art; Philadelphia Art Alliance; American Federation of Arts, NYC (retro.); Carnegie; Pennsylvania Academy of Fine Arts; Art Institute of Chicago; Corcoran; Whitney Museum; Albright, Buffalo, NY; many more. Awards: Logan prize, Art Institute of Chicago, 1929; Atheneum prize, Connecticut Academy of Fine Arts, 1930; Baltimore Watercolor Club, first prize, 1949; Boston Arts Festival, second prize, 1948; ART:USA:59, NYC. In collections of Addison Gallery, Andover, Mass.; Baltimore; Brandeis Univ.; Brooklyn; Albright-Knox; Dayton Art Institute; Houston Museum of Fine Arts; Atlanta (GA) Art Association; Metropolitan Museum of Art; Newark; Penna. Academy of Fine Arts; Philadelphia Museum of Art; Tel-Aviv; Whitney; Walker; many more. Died in NYC, January 3, 1965.

AVEY, MARTHA.
Painter, craftsman and teacher. Born Arcola, Ill. Pupil of J. H. Vanderpoel; Martha Walter; Cecilia

Beaux; Maurice Braun; AIC; NY School of Fine and Applied Art; Am. School of Art, Fontainebleau, France. Member: Okla. AA; North Shore AA; SSAL. Represented John H. Vanderpoel Art Assn., Okla. Art League. Head of Art Department, Oklahoma City University. Address in 1929, Oklahoma City University; 1325 North Kentucky St., Oklahoma City, Okla. Died in 1943.

AVINOFF, A(NDREW N.).
Painter and etcher. Born in Russia, Feb. 1, 1884. Studied in Russia. Member: NY WCC. Director, Carnegie Museum. Address in 1929, Napanoch, NY. Died in 1948.

AVISON, GEORGE.
Painter and illustrator. Born Norwalk, Conn., May 6, 1885. Pupil of William M. Chase, Robert Henri, etc. Member: GFLA; Silvermine GA. Illustrated *Pirate Tale from the Law*, published by Little, Brown and Co.; *Lost Ships and Lonely Seas*, published by Century Co., *Jimmy Makes the Varsity*, Bobbs Merrill Co.

AVRAM, NATHANIEL.
Sculptor. Born in Roumania, 1884; came to NY when eighteen years of age. Worked with H. A. MacNeil and Karl Bitter. Died in NY in November, 1907.

AYER, J(AMES) C.
Painter. Born Lowell, Mass., Oct. 13, 1862. Pupil of Cullen Yates, New York, L. Cohen Michel, Paris. Member: NY Physicians AC; Nassau Co. AL. Address in 1929, 2 West 67th St., New York, NY; Glen Cove, NY.

AYLWARD, IDA.
(Mrs. W. J. Aylward). Painter, illustrator and craftsman. Born Fairport, NY. Pupil of Kenyon Cox; Howard Pyle; Edmund Tarbell. Work: Mosaic glass window, Madison Ave. M. E. Church, New York; six mosaic glass windows, Pro- Cathedral of St. John, Milwaukee, Wis.; illustrations for *Woman's Home Companion*. Address in 1929, Longview Rd., Port Washington, LI, NY.

AYLWARD, WILLIAM J.
Painter and illustrator. Born in Milwaukee, Wis., 1875. Pupil of Howard Pyle. Exhibited at the Paris Salon, 1924, and National Academy of Design, New York, 1925. Address in 1926, 51 West 10th Street, New York City.

AYRES, MARTHA OATHOUT.
Sculptor. Born in Elkader, Iowa, April 1, 1890. Studied: Carleton College. Awards: Art Institute of Chicago, 1914; Los Angeles County Fair, 1915. Collection: Forest Lawn Cemetery, Glendale, California. Statues and bas-reliefs in many high schools and colleges in the United States. Address in 1934, Inglewood, Calif.

AZADIGIAN, MUNUEL.
Painter. Exhibited "Still Life" at Penna. Academy of the Fine Arts, Philadelphia, 1921. Address in 1926, 1834 North Darien Street, Philadelphia, PA.

AZARA, NANCY J.
Sculptor and painter. Born in New York City, October 13, 1939. Studied: Finch College, NY, AAS, 1957-59; Lester Polakov Studio of Stage Design, NYC, 1960-62; Art Students League, NYC, sculpture with J. Hovannes, painting and drawing with E. Dickinson, 1964-67; Empire State College, BS, 1974. Has exhibited at Sonraed Gallery, NYC; Fourteen Sculptors Gallery, NYC; Brooklyn College; Bard College, all solos; Brooklyn Museum; Azuma Gallery, NYC; Fourteen Sculptors Gallery, NYC; "Whitney Counterweight," NYC; Gallery 10 Ltd., Washington, DC; Sculpture Center, NYC; A.I.R. Gallery, NYC; Jack Tilton Gallery, NYC; others. Has worked in theatrical costume design, NYC; art consultant; faculty of Brooklyn College, Brooklyn Museum Art School; New York Feminist Art Institute (also board of Directors); and others. Address in 1984, 46 Great Jones Street, NYC.

AZUMA, NORIO.
Painter and serigrapher. Born in Kii-Nagashimacho, Japan, Nov. 23, 1928. Study: Kanazana Art College, Japan, BFA; Chouinard Art Inst., Los Angeles; ASL. Work: Whitney Museum; Philadelphia Museum of Art; Art Institute of Chicago; Smithsonian Institute, Nat'l Coll. of Fine Arts; Brooklyn Museum. Exhibitions: 28th Biennial of Corcoran Gallery, 1963; Original Graphics, Grenchen, Switz., 1964; Mus. Mod. Art, Tokyo, 1965; 1966 Annual of Whitney Museum of American Art; Phila. Mus. of Art, 1972. Awards: International Print Exhibition, Seattle, Wash., 1960; Soc. of Am. Graphic Artists Exh., 1968; Boston Printmakers, 1970. Mem.: Soc. Am. Color Prints; Print Club; Soc. Am. Graphic Artists; Print Council of Am. Medium: Oil. Rep.: Associated American Artists, NYC Azuma Gallery, NYC. Address in 1982, 276 Riverside Dr., NYC.

AZZI, MARIUS A.
Sculptor. Born in NJ, in 1892. Studied under Karl Bitter and A. Stirling Calder; Art Students League, NY; also in Rome, and at the Royal Academy in Milan, Italy, and in France. Works: Portrait busts of Lincoln, Roosevelt, Harding; The Fisherman; On-sentry-go; fountain, Sesquicentennial Exposition, Philadelphia. Exhibited statuettes at the Penna. Academy of the Fine Arts, Philadelphia, 1921. Awards: Municipal silver medal for sculpture, Milan, 1910. Taught sculpture at the American University, established by the American Expeditionary Forces at Beaune, Cote d'Or, France, 1919. Address in 1926, 120 West 11th St., New York. Died 1975.

B

B., J. W.
These initials as "J. W. B. del. et sc." are signed to a quarto line print representing an engagement between the Georgia militia under Gen. John Floyd and a force of Creek Indians at Antossee, Ala.

B., S. P.
Engraver. The initials "S.P.B." are signed to a heading of the fire insurance policy of "The Mutual Assurance Society against Fire in Virginia." There is no indication of date but the work would suggest about the year 1825.

B., W.
These initials "W.B. 1825" are signed to a number of plates illustrating "Pug's Tour through Europe," published in Baltimore about 1826.

BAAR, STANFIELD MARION.
Painter. Born in New York City, Sept. 22, 1895. Pupil of Johansen and Henri. Member: NA Women PS; MacD. C. Address in 1929, 310 West 80th St., New York, NY.

BABCOCK, DEAN.
Painter. Born in Canton, Ill., Jan. 14, 1888. Pupil of John Vanderpoel, Robert Henri and Helen Hyde. Member: Denver AA; AFA. Address in 1929, Longs Peak, Colorado.

BABCOCK, E(LIZABETH) J(ONES).
(Mrs. J. W. Babcock II). Painter and illustrator. Born Keokuk, Iowa, July 19, 1887. Pupil of Duveneck and Chase. Member: National Academy of Women Painters and Sculptors; Guild of Free Lance Artists. Illustrator for *Scribner's*, *Harper's*, etc. Address in 1929, 172 East 71st., NYC. Died Sept. 13, 1963.

BABCOCK, RICHARD.
Mural painter. Born in Denmark, 1887. Member of Art Students' League, New York. Address in 1926, Woodland Road, Pittsburgh, PA. Died 1954.

BABCOCK, WILLIAM P.
Painter. Born in Boston in 1826; died in 1899, in Bois d'Arcy, France. Studied under Couture in Paris. His works "The Red Hat," "Susanna and the Elders," "Still Life," "Fish," and "Landscape, with Figures" are at the Boston Museum of Fine Arts.

BABOT, AMY W.
Painter. Exhibited at Penna. Academy of Fine Arts, 1924. Address in 1926, 72 Chestnut St., Boston, Mass.

BABSON, R.
Engraver of stipple portraits. About 1860 he was apparently in the employ of Joseph Andrews of Boston as we find plates signed "Eng'd at J. Andrews by R. Babson."

BACH, FLORENCE JULIA.
Sculptor and painter. Born Buffalo, NY, June 24, 1887. Member of Art Students League; National Association of Women Painters and Sculptors. Pupil of William M. Chase and DuMond at Art Students League. Represented in the Buffalo Fine Arts Academy. Address in 1933, Buffalo, NY.

BACHELER, FRANCES HOPE.
Painter and teacher. Born Lebanon, Conn., in 1889. Member of Hartford Art Club. Address in 1926, 39 Hopkins St., Hartford, Conn.

BACHER, OTTO HENRY.
Painter, etcher, and illustrator. He was born in Cleveland, Ohio, in 1856. Pupil of Duveneck, in Cincinnati; and of Duvan, Boulanger, and Lefebvre in Paris. He spent some time with Whistler in Venice. He died in New York in 1909, having received many honors and medals. He was an Associate of the National Academy of Design.

BACHER, WILL LOW.
Painter and etcher. Born Bronxville, NY, Jan. 9, 1898. Pupil of George Bridgman and G. Maynard. Member: MacD. C.; Salma. C. Address in 1929, Rock Tavern, Orange Co., NY.

BACHMAN, HENRY.
Sculptor and engraver. Born in Germany, about 1838. Listed as working in Philadelphia, June 1, 1860. Exhibited "Silenus" at the Penna. Academy, 1861-63, executed in ivory.

BACHMANN, MAX.
Sculptor. Born 1862. Died in New York City, January 13, 1921. He designed the allegorical figures of the continents for the Pulitzer Building in New York City.

BACHMURA, BARBARA LEE.
Painter. Born in Detroit, Michigan, in 1925. Studied: Wayne University; University of Mexico; Mexican Art Workshop; University of Oslo. Award: Fulbright Award, 1952. Collections: Wayne University; Denison University; Motive Magazine; Vanderbilt Hospital; Nashville Art Guild, Tennessee; Crandall Art Gallery, Alliance, Ohio.

BACHOFEN, MAX ALBIN.
Painter. Born Neubrunen, Switzerland, Aug. 25, 1903. Pupil of Paul Bough Travis. Awards: Hon. mention for landscape, Cleveland, 1927; first prize for landscape, Cleveland, 1928; hon. mention for landscape, Cleveland, 1929. Work: "Sun Shine in New Hungary," City of Cleveland. Address in 1929, Castroville, Tex.; h. R.F.D. No. 1, Alliance, Ohio; summer, 11340 Mayfield Rd., Cleveland, Ohio.

BACKSTROM, FLORENCE J.
Painter and designer. Born in New York. Study: Cooper Union with V. Perard; ASL, NY, with Robert Bev. Hale, Frank Reilly. Exhibitions: Smithsonian Inst.; Washington Water Color Club; Miniature Painters and Sculptors Soc.; American Artists Prof. League Cherry Blossom Festival, Wash., DC; Diamond Jubilee Art Students League; Penna. Academy of Fine Arts. Awards: Garden State Plaza Gold Cup and many other first prizes and awards. Teaching: Teacher, adult classes, Bergenfield H.S., NJ; private classes. Member: ASL (life); Am. APL; NJ Painters and Sculptors Soc. Media: Watercolor. Address in 1976, 84 Carletondale Road Ringwood, NJ.

BACKUS, ALBERT E.
Painter. Born in Ft. Pierce, FL, January 3, 1906. Studied at the Parsons School of Applied Art in New York, 1922-23. First employed in behalf of a movie theater to paint posters and displays during the Depression for five dollars a week. Enlisted as an apprentice seaman after Pearl Harbor where he was given the opportunity to sketch at every port and develop his sketches aboard ship. Returned to Florida after the war where he has dedicated his time ever since to painting Florida landscapes. His "Everglades National Park" is part of the permanent collection of the Johnson Library, and a permanent collection of his works is on display in the Thomas F. Fleming Gallery of Albert E. Backus Paintings at Boca Raton, FL. Received an honorary doctorate from Florida Atlantic University. Lives and has studio in Fort Pierce, FL, in 1984.

BACKUS, J(OSEFA) C(ROSBY).
Painter. Born Brooklyn, NY, Oct. 13, 1875. Member: AFA. Work: "Young Lincoln," Vardy School, Tennessee. Address in 1929, 2416 Tracy Pl., Washington, DC; summer, Beech Hill, Dublin, NH.

BACON, CHARLES ROSWELL.
Painter. Born in New York, 1868. Pupil of Constant, Lefebvre and Collin in Paris. Paintings in Union Trust Co., New York. He died October 9, 1913, in New York City.

BACON, GEORGE.
An excellent music-engraver working in the city of Philadelphia about 1815. The firm was Bacon &

Hart, and Bacon was a near relative of the senior member of the firm.

BACON, HENRY.
Painter. Born in Haverhill, Massachusetts, 1839; died Cairo, Egypt, March 13, 1912. Painted in oils and water colors. Made a specialty of Egyptian subjects. Visited Paris in 1864, where he became a pupil of the Ecole des Beaux Arts and of Cabanel; and in 1866-67 studied under Edouard Frere at Ecouen. Represented at the Corcoran Art Gallery by "The Nile-Evening" (water color) and in Boston Museum of Fine Arts by "On Shipboard."

BACON, IRVING R.
Sculptor, painter, illustrator, and teacher. Born in Fitchburg, MA, November 29, 1875. Pupil of Chase in NY; Carl von Marr and Heinrich von Zugel in Munich. Work: "Village Street Scene," Louisville Association; "The Little Old Man of the Woods," D. & C. Steamer, Detroit; "The Conquest of the Prairie," Book Tower Building, Detroit; Hotel Irma, Cody, WY; Fellowcraft Club, Detroit. Sculptor of automobile radiator mounts, "Grayhound" for Lincoln and "Quail" for Ford. Exhibited: National Academy of Design; Penna. Academy of Fine Arts; Chicago Art Institute. Address in 1953, Miami, Fla.

BACON, KATE L.
See Kate B. Bond.

BACON, LOUIS.
Sculptor. At San Francisco, 1856-60.

BACON, PEGGY.
Painter. Born in Ridgefield, Conn. Pupil of James Lie. Member of Society of Independent Artists. Address in 1926, 152 West 55th Street, New York.

BADGER, JAMES W.
Miniature painter working in Boston from 1845 to 1846.

BADGER, JOHN C.
Crayon portrait artist. Born c. 1822 in NH. Exhibited at the Pennsylvania Academy in 1855. Must not be confused with Joseph W. Badger who painted miniatures in New York from 1832 to 1838, nor with the two artists who painted portraits in Boston. Thomas Badger lived there from 1836 to 1859 and James W. Badger lived there from 1845 to 1846.

BADGER, JOSEPH.
Painter. Born 1708 in Charleston, Mass. He died in Boston, and was an early colonial portrait painter. His work was not as good as Copley, Smibert and Feke. An excellent life of Joseph Badger with a description of about a hundred of his portraits was written by Laurence Park and published by the Massachusetts Historical Society, Dec. 1917. His

work is owned by Worcester Art Museum, Bowdoin College and many private collections in Boston. Died 1765.

BADGER, JOSEPH W.
Miniature painter, working in New York 1832-1838.

BADGER, THOMAS.
Miniature painter. Born Dec. 1792 in MA. Working in Boston from 1836 to 1859. Died Feb. 3, 1868 in Cambridge, MA.

BAEHR, FRANCINE.
Painter and etcher. Born Chicago, Ill., July 21, 1898. Member: Art Alliance; MacDowell Club. Address in 1929, 170 East 78th St., New York, NY; summer, Westport, Conn.

BAER, HERBERT M.
Painter and engraver. Born in New York, 1879. Honorable mention at Paris Salon 1905. Address in 1926, 655 Fifth Ave., New York.

BAER, JO.
Painter. She is known for her minimalist paintings. First major showings of her minimalist paintings in the 1960's in New York City.

BAER, LILLIAN.
Sculptor. Born New York City, 1887. Student of Art Students League, pupil of Jas. E. Fraser and K. H. Miller. Works: "The Dance," shown at International Exhibition at Rome, 1911. Exhibited at National Sculpture Society, NY, 1923. Specialty, statuettes, book-ends, etc. Address in 1926, 601 Madison Ave., New York City.

BAER, WILLIAM JACOB.
Artist. Born Cincinnati, Jan. 29, 1860. Pupil of Munich Royal Academy, 1880. Received 4 medals, with one of his works being purchased by the Directors for the Academy. Painted pictures in genre and portraits in oil and taught 1885-92; then confined himself to miniature painting, in which he is a pioneer of the modern school. Awarded 1st medal for miniatures and ideal paintings, New York, 1897; 1st class medals, Paris Exp. Among his better known works in miniature are: "Aurora," "The Golden Hour," "Summer," "Daphne," "Nymph," "In Arcadia," "Madonna with the Auburn Hair," "Primavera." Treas., Am. Soc. of Miniature Painters; ANA, 1913. Address in 1926, West 59th Street, New York. Died in 1941.

BAERER, HENRY.
Sculptor. Born in Kirchheim, Germany, in 1837, he came to the United States as a young man in 1854. Among his best known works are his statue of Beethoven in Central Park, General Fowler in Fort Green Park, and General Warren in Prospect Park,

Brooklyn; also represented in New York Historical Society; National Academy of Design, 1866-89. He was a member of the National Sculpture Society. He died in New York, December 7, 1908.

BAHLS, RUTH (KATHERINE).
Painter. Born Lafayette, March 23, 1901. Pupil of William Forsyth. Address in 1929, 502 Perrin Ave., Lafayette, Ind.

BAHNC, SALCIA.
Sculptor, painter, etcher, and teacher. Born Dukla, Austrian Poland, Nov. 14, 1898. Pupil of Art Institute of Chicago; Chicago Academy of Fine Arts. Work: "Torso," Arts Club, Chicago, IL. Exhibited at Art Institute of Chicago; Penna. Academy of Fine Arts; Salon des Tuileries, Paris; others. Address in 1953, 101 West 85th Street, NYC.

BAILEY, BEN P., JR.
Sculptor, painter, illustrator, and educator. Born in Houston, TX, December 28, 1902. Studied at University of Texas; Columbia University; Colorado State College of Education; Claremont Graduate School of Education, and with Gutzon Borglum, Charles Lawler, and others. Member: Texas Fine Arts Society; Texas Water Color Society; Southern States Art League; South Texas Artists League. Awards: Prizes, Texas Water Color Society, 1951; GI Exhibition, San Antonio; Corpus Christi Art Foundation, 1946-48, 1950. Work: IBM; Texas Memorial Museum, Austin, Texas. Exhibited: Texas Water Color Society, 1950-52; Texas Fine Art Society; Corpus Christi Art Foundation Institute, "The Adventures of Prince Leandro," 1945; "Padre Island," 1951. Taught: Associate Prof., Texas College of Art and Industry, Kingsville, TX. Address in 1953, Kingsville, TX.

BAILEY, C. FOSTER.
Painter. Was awarded honorable mention, Carnegie Institute, 1923.

BAILEY, HARRY LEWIS.
Painter, illustrator, and etcher. Born St. Louis, MO, Dec 2, 1879. Pupil of St. Louis School of Fine Arts. Member: Calif. AC; Calif. PM. Address in 1926, 175 North Almont Dr., Beverly Hills, Calif.

BAILEY, HENRIETTA D(AVIDSON).
Painter, craftswoman, and teacher. Born New Orleans, LA. Pupil of Newcomb Art Schools, New Orleans; Arthur W. Dow in New York. Member: NOAA; Baltimore Handicraft C. Represented in Delgado Museum, New Orleans, LA; City Art Museum, St. Louis. Address in 1929, Newcomb Pottery, Audubon Pl. and Plum St.; h. 3315 De Soto St., New Orleans, LA.

BAILEY, HENRY LEWIS.
Etcher. Member of Print Makers Society of California. Address in 1926, Mortgage Guarantee Bldg., Los Angeles, California.

BAILEY, HENRY TURNER.
Illustrator, craftsman, teacher, writer and lithographer. Born in Mass., 1865. Student of Mass. Normal Art School. Member: Cleveland AA; College AA; Cleveland SA; Cleveland AIA; AFA. Was Dean of the Cleveland School of Art 1917 and the John Huntington Polytechnic Inst., Cleveland, 1919. Represented in Vanderpoel AA. Address in 1926, Cleveland School of Art, Cleveland.

BAILEY, JAMES E(DWARD).
Painter. Born Baltimore, MD, Dec. 13, 1885. Member: AL of Phila.; Graphic Sketch C. Awards: Prizes, Wanamakers, Phila., 1915-16; gold medal, World Fair Poster, Chicago, 1923. Address in 1929, 1933 West Norris St., Philadelphia, PA; summer, 117 East St., Easton, MD.

BAILEY, LA FORCE.
Painter and artist. Born Joliet, Ill., Apr. 17, 1893. Pupil of William M. Hekking; John L. Frazier; Charles W. Hawthorne. Member: AIA; Provincetown AA; Wash. WCC: Scarab C. Address in 1929, Architectural Bldg., University of Illinois; h. 205 West University Ave., Urbana, Ill.; summer, care of Gray Inn, Provincetown, Mass.

BAILEY, MINNIE M.
Painter and illustrator. Born in Oberlin, Kans., in 1890. Address in 1926, 3908 Swiss Ave., Dallas, Tex.

BAILEY, R. O.
Painter. Member: Cleveland SA. Address in 1929, 2114 East 96th St., Cleveland, Ohio.

BAILEY, VERNON HOWE.
Artist. Born in Camden, NJ, April 1, 1874. Student of PA Mus. Sch. of Art, and PA Acad. Fine Arts, Philadelphia. Studied in London and Paris. Staff artist, *Philadelphia Times*, 1892-4; *Boston Herald*, 1894-01-spl. artist for latter at coronation of Edward VII; artist contbr. to *Graphic, Mail and Express*, London, 1902, and after to leading Am. mags., *The Studio*, London. Exhibited at PA Acad. Fine Arts, Philadelphia, 1891; Architectural League, New York, 1903-12. Represented in permanent collections, Detroit Mus. of Art, Minn. State Art Soc., St. Paul. Illustrator: "Lady Baltimore," "Charleston, the Place and Its People," "The Story of Harvard," etc. Mem. Soc. of Illustrators. Address in 1926, The Players, 16 Gramercy Park, New York, NY.

BAILEY, WALTER A.
Painter, illustrator, and etcher. Born Wallula, Wyandotte Co., Kan., Oct. 17, 1894. Pupil of Charles A.

Wilimovsky and John D. Patrick. Member: Kansas City SA. Address in 1929, care of the "Kansas City Star;" h. 3864 East 60th St., Kansas City, MO.

BAILLY, JOSEPH ALEXIS.
Sculptor and wood carver. Born in Paris in 1825. Settled in Philadelphia in 1850 and followed his occupation of carving on wood and marble. Later became instructor at the Penna. Academy of Fine Arts. He produced a statue of Washington, at Independence Hall, Phila., also portrait busts of Gen. Grant and Gen. Meade. Member of Penna. Academy, academician, 1856; taught there in 1876-77. Died June 15, 1883, in Phila., PA.

BAIN, HARRIET F.
Painter. Born Kenosha, Wis. Pupil of John Vanderpoel; E. A. Webster; Collin; Garrido. Member: Wis. PS; Chicago AC; Provincetown AA; Salons of America. Represented in Vanderpoel Art Assn. Collection, Chicago. Address in 1929, 112 East 10th St., New York, NY; h. 6328 7th Ave., Kenosha, Wis.

BAIN, LILIAN PHERNE.
Sculptor, painter, etcher, and teacher. Born Salem, Oregon. Pupil of F. V. DuMond, Guy Rose, Joseph Pennell. Member: Pennell Graphic Arts Society. Address in 1933, 3917 49th Street, Long Island City, NY; summer, Portland, OR. Died c. 1947.

BAINS, ETHEL FRANKLIN BETTS.
Illustrator and painter. Member: Fellowship PAFA, Phila. WCC. Award: Bronze medal, P.-P. Exp., San F., 1915. Exhibited at PAFA, 1922. Address in 1929, 1018 Westview St.; 104 Harvey St., Germantown, Philadelphia, PA.

BAIRD, EUGENE Q(UENLIN).
Painter. Born Straits Settlements, Asia, May 6, 1897. Pupil of Pratt Inst.; ASL of NY; Jane Peterson. Member: NYWCC; Art Director's C. Address in 1929, 98 Newfield St., East Orange, NJ.

BAIRNSFATHER, A. L.
Painter and illustrator. Born 1883. Member: Salma. C.; NAC. Address in 1929, 119 East 19th St.; 53 West 37th St., New York, NY; Rockport, Mass.

BAISDEN, FRANK.
Painter. Born 1904. Exhibited at the Penna. Academy Annual Water Color Exhibition, Philadelphia, 1925. Address in 1926, Care of Penna. Academy of the Fine Arts, Philadelphia.

BAIZERMAN, SAUL.
Sculptor. Born December 25, 1889, Vitebsk, Russia. Came to US in 1910. Studied: Imperial Art School, Odessa; National Academy of Design; Beaux-Arts Inst. of Design, NYC. Fire in studio in 1931 destroyed most of his work. In collections of Univ. of Minnesota;

Univ. of Nebraska; Penna. Academy of Fine Arts; Whitney; Walker. Exhibited: Dorien Leigh Galleries, London, 1924; Eighth St. Gallery, NYC, 1933; Artists' Gallery, NYC, 1938, 48, 57; Phila. Art Alliance, 1949; The New Gallery, NYC, 1952, 54; World House Galleries, NYC, 1963; The Zabriskie Gallery, 1967. Retrospective: Walker, 1953; Institute of Contemporary Art, Boston, 1958; Heckscher, 1961. Awards: Penna. Academy of Fine Arts, hon. mention, 1949; American Assoc. of Arts and Letters grant, 1951; Guggenheim Foundation Fellowship, 1952; Penna. Academy of Fine Arts, Steel Memorial prize, 1952. Taught at American Artists School, NYC; Univ. of Southern Calif.; Baizerman Art School, 1934-40. Died August 30, 1957, in NYC.

BAKER, ADELAIDE CLARISSA.
Painter and craftswoman. Born Cleveland. Pupil of George Elmer Browne; Max Bohm, Cleveland School of Art. Member: Washington Art Center; Cleveland AA; Cleveland School of Art Alumni. Address in 1929, 1437 East 115th Street, Cleveland, Ohio.

BAKER, BRYANT.
Sculptor. Born in London, July 8, 1881. Studied at London Royal Academy of Arts; City and Guilds Technical Institute. Came to US in 1915 or 16. His works include bust and heroic statue of King Edward VII; bust of Prince Olav of Norway; many notable persons in England and US, including Grover Cleveland, City Hall, Buffalo; Lincoln, Delaware Park; figure, Brookgreen Gardens, SC. Exhibited at Royal Academy, London; Paris Salon; Corcoran; in NYC. Address in 1953, 222 West 59th Street, New York City. Died 1970.

BAKER, BURTIS.
Painter. Exhibited 1921 at Penna. Academy of the Fine Arts, and in 1923 at Carnegie Inst. with "Interior with Figure." Address in 1926, Fenway Studios, Boston, Mass.

BAKER, CATHERINE (ISABELLE).
Painter and teacher. Born 1905 in Columbus. Pupil of Alice Schille. Member: Columbus AL. Award: Hon. Mention, Columbus Art League, 1928. Address in 1929, 2590 Glenmour Ave., Columbus, Ohio.

BAKER, CHARLES.
Painter. Born in 1844. He was the son of Charles Baker, one of the founders of the Art League. His home was in Brooklyn, NY. Died Aug. 19, 1906, in Hague, Lake George, NY.

BAKER, DORIS WINCHELL.
Painter. Born: Washington, DC, in 1905. Studied: Chouinard Institute of Art; Otis Art Institute. Awards: Art in National Defense, 1943, Palos Verdes, California, 1955; Women Painters of the West, 1941, 1946, 1949.

BAKER, ELIZABETH GOWDY.
Portrait painter. Born in Xenia, OH, 1860. Specialized in children's portraits in water color. Student of New York School of Art and Penna. Academy of Fine Arts. Studied also in Rome, Florence, and Paris. Address in 1926, 24 Gramercy Park, New York. Died Oct. 11, 1927.

BAKER, ELLEN KENDALL.
Painter. Born in New York State; she lived for years in Buffalo, New York. She married Harry Thompson, the English artist, and exhibited in the Paris salons and at many exhibitions in this country. Died in Chalfant, St. Giles, England, in 1913.

BAKER, FREDERICK VAN VLIET.
Artist and teacher. Born in New York, Nov. 6, 1876. Educated, Pratt Inst., Brooklyn; Ecole des Beaux Arts, Courtois in Paris. Instr. in life drawing, painting and composition, Pratt Inst. Exhibited in salons, Paris, 1901-2-3; also at Ghent, Vienna, Chicago, New York, etc. Address in 1926, 39 West 67th Street, New York.

BAKER, GEORGE A.
Portrait painter. Born in New York City, 1821; died there 1880. His first portrait work was in miniature painting, but he soon became an excellent portrait artist. He studied in Europe; elected to the National Academy in 1851. Noted for his portraits of women and children. His portrait of the artist John F. Kensett is in the Metropolitan Museum, New York, and an Ideal Head is in the Corcoran Gallery, Washington, DC.

BAKER, GEORGE HERBERT.
Painter. Born in Muncie, Ind., Feb. 14, 1878. Studied at Cin. AA. Member: Richmond Art Assoc.; Indiana Artists' Club; S. Indp. A.; Wayne County S. Indp. A. Address in 1926, 605 Main St., Richmond, Ind.

BAKER, GEORGE O.
Painter and illustrator. Born in Mexico, MO, 1882. Pupil of Laurens, and Miller in Paris. Address in 1926, Care of Chas. E. Johnson, 941 Glengyle Place, Chicago.

BAKER, GRACE.
Painter. Born in Riverdale, New York. Study: Finch College; with William Oden-Waller. Exhib.: Art Graphic Gallery, one-man show; Chrysler Mus., Norfolk, VA; UN Postage Stamp Design Comp. Awards: Todd Ctr. Arts Fest.; Peninsula Arts Assn.; etc. Mem.: Am. APL; etc. Media: Oil. Address in 1980, Williamsburg, Virginia.

BAKER, GRACE M.
Painter and teacher. Born Annawan, Ill., Oct. 18, 1876. Pupil of AIC. Member: Nat. Educational A; Western AA; College AA of Am. Head of Art Dept.,

Colorado State Teachers' College. Address in 1929, Guggenheim Hall, Colorado State Teachers' College, Greeley, Colo.

BAKER, HORACE.
Wood engraver. Born Nov. 12, 1833, in North Salem, NY. He studied engraving in his brother's firm in Boston, of which he afterwards became a partner. For many years he was connected with the engraving department of *Harper's Magazine*. Died March 2, 1918, in Great Neck, LI, NY.

BAKER, I. H.
A good engraver of stipple portraits working in Boston, about 1860.

BAKER, JOHN.
Engraver. He designed and etched in line a large plate of the "Battle of Bunker's Hill." About 1832, he also executed two separate plates of "Washington Crossing the Delaware."

BAKER, JOSEPH E.
Etcher and caricature illustrator. He was a native of Boston and drew many of the caricatures of the Civil War period.

BAKER, M. K. (MISS).
Painter. Born in New Bedford, Mass. Specialty, figure painting and portraits. Works have been at Boston Art Club and New York Academy of Design.

BAKER, MARIA MAY.
Painter. Born in Norfolk, VA, 1890. Pupil of Penna. Academy of Fine Arts and Corcoran Art Gallery. Member: Norfolk SA. Work: "Open the Gates as High as the Sky," Norfolk SA. Address in 1926, 408 Raleigh Ave., Norfolk, VA.

BAKER, MARTHA SUSAN.
Miniature painter. Born Dec. 25, 1871, in Evansville, Ind. Also painted in oil and water color, and has done some mural work. Pupil of Chicago Art Institute. Died Dec. 21, 1911, in Chicago, Ill.

BAKER, MARY FRANCES.
Painter. Born in New Orleans, LA, in 1879. Student of Penna. Academy of Fine Arts; Newcomb Art School. Member: New Orleans Art Assn. Award: Silver medal, New Orleans Art Assn. Address in 1926, 2263 Carondelet Street, New Orleans, LA. Died 1943.

BAKER, MINNIE (MITCHELL).
Sculptor, painter, teacher, and lecturer. Born in Ardmore, OK, 1901. Studied at Southeastern State College, BA; University of Iowa, MA; Oklahoma University; Ohio State University; and with Tarbell, Merryman, Guston. Member: Oklahoma Art Association; Oklahoma Education Association. Awards:

Prizes, Oklahoma State Fair, 1929, 30, 31. Work: Oklahoma Art Center; Robertson Jr. High School, Muskogee, OK; Wilburton High School, Oklahoma. Exhibited: Corcoran Gallery; Oklahoma Art Center; Philbrook Art Center. Associate Professor of Art, Southeastern State College, Durant, OK. Address in 1953, Durant, OK.

BAKER, PERCY BRYANT.
See Baker, Bryant.

BAKER, ROBERT P.
Sculptor. Born London, June 29, 1886. He studied at the Lambeth School of Art, the City and Guilds Technical Institute and the Royal Academy, London; also in Paris and Rome. Awards: First medal for portraiture and first medal for sculpture, Royal Academy. Member: Chelsea Arts Club, London; National Sculpture Society; Salmagundi Club. Work: 42 statuettes for the 15th Century stalls, Beverly Minster, England; collaborated with Adrian Jones on the colossal Quadriga on the Inigo Jones Arch, Hyde Park, London; The Soul Struggle, Belgium; The Kiss, and others in the United States. Exhibited at National Sculpture Society in 1923. Address in 1929, Woods Hole, Mass. Died 1940.

BAKER, S(AMUEL) B(URTIS).
Painter. Born Boston, Sept. 29, 1882. Pupil of Major, De Camp and Edward H. Barnard. Member: Boston AG; Salma. C.; Wash. AC; Wash. SA. Awards: 2nd William A. Clark prize ($1,500), and Corcoran medal, 1922; bronze medal, Sesqui-Centennial Exposition, Phila., 1929. Work: "The Black Mantilla," Macon Art Inst., Macon, GA; Portraits in the Massachusetts State House and Girls High School, Boston; Harvard Law School, Cambridge, Mass.; Pinkerton Academy, Derry, NH; New Hampshire State House; US Marine Corps headquarters, Washington, DC. Theological Seminary, Alexandria; seven portraits in Boston schools; portrait in Lawrence School, Brookline, Mass.; Framingham (Mass.), Normal School; National Academy of Design, NY. Instructor at Corcoran School of Art; Asst. Professor, Dept. of Arts and Sciences, George Washington University, Washington. Died 1967.

BAKER, SARAH MARIMDA.
Painter. Born Memphis, Tenn., Mar. 7, 1899. Pupil of Hugh Breckenridge; Arthur Charles; Andre L'hote. Member: Fellowship, PAFA; Wash. SA. Award: Fellowship gold medal, PAFA, 1926. Work: Altar decoration, St. John's Church, McLean, VA. Address in 1929, McLean, VA.

BAKER, WILLIAM BLISS.
Painter. Born 1859. Died at about the age of thirty, but painted some excellent landscapes.

BAKER, WILLIAM H.
Painter. Born in 1825; died in Brooklyn, NY, Mar. 29, 1875. He was brought up in mercantile pursuits in New Orleans; he devoted his spare time to the study of art and became a portrait and genre painter. He had a studio from 1853 to 1861 at 123 Canal Street; moved to New York in 1865, where he taught art and painted portraits and ideal subjects. He was a conscientious artist. Among his works, "Cupid Disarmed," "Floral Offering," "Red Riding Hood," and "Morning Glories."

BAKERVILLE, CHARLES, JR.
Illustrator. Born Raleigh, NC, Apr. 16, 1869. Member: GFLA. Work: Illustrations for *Scribner's*, *Life*, *Judge*, *Theatre*, *Vogue*, *Vanity Fair*, *Harpers Bazaar*, etc., also lacquer screens and murals. Address in 1929, 113 East 34th St., New York, NY.

BAKKE, LARRY.
Painter and teacher. Born in Vancouver, BC, Jan. 16, 1932. Study: Univ. Wash., BA, MFA; Syracuse Univ., PhD., with L. Schmeckebier. Work: Syracuse University Collection; Everett College; and private collections. Exhibitions: U. New Mex.; Watercolor Soc., NYC, annual; other univ. galleries. Awards: Watercolor, Seattle Art Museum; Painting, Spokane-Northwest; Kinorn Gallery, Seattle; Center Show-Syracuse, NY. Teaching: Univ. Victoria, 1958-71; Everett College, 1959-63; Syracuse Univ., from 1963; and more. Media: Oil, collage. Address in 1982, Syracuse, NY.

BAKOS, JOSEPH G.
Sculptor, painter, and teacher. Born Buffalo, NY, September 23, 1891. Pupil of J. E. Thompson. Member: Santa Fe Society of Artists. Award: Honorable mention, Denver Annual Exhibition, 1931. Represented in Brooklyn Museum; Whitney Museum of American Art, NY. Address in 1953, Santa Fe, New Mexico. Died 1977.

BALANO, PAULA HIMMELSBACH.
(Mrs. Cosme Balano). Painter and illustrator. Born in Leipzig, Germany, May 10, 1878. Pupil of Penna. Academy of Fine Arts under Chase and of Mucha in Paris. Awarded gold medal for her work in water color. Work in fellowship PAFA collection. Member of the Phila. Sch. of Design for Women. Address in 1926, 54 Linden Ave., Landsdowne, Penna.

BALCH, VISTUS.
Engraver. Born in Williamstown, Mass., in 1799; he died at Johnstown, NY, in 1884. Balch worked in Utica, Albany, and New York; he engraved a number of book illustrations, and several plates for the *New York Mirror*. About 1825 Balch drew on stone a portrait of Dr. Samuel L. Mitchell, for Imbert, who was the pioneer lithographer of New York City.

BALCIAR, GERALD G.
Sculptor. Born Medford, WI, August 28, 1942. Self-taught. Member: Society of Animal Artists; National Sculpture Society. Awards: Honorable Mention, Colorado Celebration of the Arts, 1975; Honorable Mention, Youth Awards, National Sculpture Society, 1977; Dr. Hexter Prize, National Sculpture Society, 1978; Bronze Medal, National Sculpture Society, 1979; Commendation, Youth Awards, National Sculpture Society, 1979. Work: Wildlife World Museum, Monument, Colorado. Exhibitions: National Academy of Design; Allied Artists of America; National Sculpture Society; National Academy of Western Art; North American Sculpture Exhibitions; Society of Animal Artists; and several wildlife conservation shows. Media: Bronze and stone. Address in 1983, Arvada, CO.

BALCOM, LOWELL LEROY.
Painter, illustrator and etcher. Born in Kansas City, MO, 1887. Studied at Kansas City Art Inst.; pupil of J. D. Patrick. Member of the GFLA. Represented in Kansas City Public Lib. Painted officers' portraits, WWI; visited Virgin Islands; travelled Orient and Mediterranean on commission from US Shipping Board; editorial work appeared in "American Legion," "Hearst's International." Member: Silvermine Guild. Address in 1926, 136 65th Street, New York. Died 1938.

BALDAUGH, ANNI.
(Mrs. Von Westrum). Miniature painter. Born in Holland, 1886. Pupil of Arendsen in Holland, Zasehke in Vienna, von Kunowsky in Munich. Member: Conn. AFA; Beaux-Arts, Paris; Bookplate Assn. Inst.; San Diego FAS; Calif. WCC. Awards: Gold medal, Los Angeles Museum, 1922; Water color prize, Phoenix, Ariz., 1923; Balch prize, Calif. Soc. Min. Painters, 1929. Exhibited the miniature of the "Washburn Children" at Miniature Exhibition, Penna. Academy of the Fine Arts, Philadelphia, 1924. Address in 1926, Los Angeles, California.

BALDREY, HAYNSWORTH.
Sculptor and etcher. Born Cortland, NY, August 24, 1885. Pupil of C. T. Hawley, Charles Grafly, Ephriam Keyser. Member: American Federation of Arts; Baltimore Water Color Club; Handicraft Club of Baltimore; National Sculpture Society; American Artists Professional League; Art Center of the Oranges. Awards: Rinehart prize, Baltimore, 1908, 1909, 1910; first award in sculpture, Art Center of the Oranges Exhibition, 1932, 33. Address in 1933, Newton, NJ. Died in 1946.

BALDRIDGE, CYRUS LEROY.
Illustrator, painter and writer. Born in Alton, NY, 1889. Pupil of Frank Holme. Illustrated "I Was There," "The Spy," by Cooper, 1924 edition (Minton Balch & Co.); "Turn to the East," by Caroline Singer,

1926 (Minton Balch & Co.). Member: GFLA. Address in 1926, Harmon-on-Hudson, NY.

BALDWIN, BARBARA.
Sculptor, painter, and writer. Born: Portland, Maine, Jan. 13, 1914. Studied: Portland School of Fine Arts; Pennsylvania Academy of Fine Arts; National Academy of Design; Art Students League; with Bower, Kroll, Du Mond, Laessle, McCartan, and others. Collections: Deering High School, Portland, ME; World's Fair, New York, 1939; Pathe News. Exhibited at National Academy of Design; Society of Independent Artists; others. Address in 1953, Monroe, NY.

BALDWIN, BURTON CLARKE.
Illustrator. Born in Danville, Ill., 1891. Pupil of Chicago Academy of Fine Arts. Member: Palette and Chisel C. Address in 1926, 805 Junior Terrace, Chicago, Ill.

BALDWIN, GEORGE.
Painter. A native of Thompson, Conn., born about 1818. He received a common school education and went to Norwich where he studied portraiture. George Baldwin painted many portraits of men prominent in his native state of Connecticut.

BALDWIN, JOSEPHINE K(NIGHT).
Painter. Born Harrisburg, July 4, 1888. Pupil of PAFA. Member: Harrisburg AA. Address in 1929, 236 North Second St., Harrisburg, PA.

BALDWIN, WILLIAM.
Born c. 1808. Flourished 1827-1846. New Orleans miniature painter.

BALFOUR, HELEN.
Painter and illustrator. Born July 11, 1857, in England. Member of California Art Club. Illustrated "Sunset Highways." Address in 1926, 310 Mt. Washington Drive, Los Angeles, California.

BALINK, HENDRICUS C.
Painter and etcher. Born 1882. Exhibited landscapes entitled "The Portuguese Hill" and "Gloucester" at Penna. Academy of the Fine Arts, Philadelphia, 1921. Address in 1926, West Monument Street, Baltimore, MD. Died 1963.

BALL, CAROLINE PEDDLE.
Sculptor. Born in Terre Haute, Ind., November 11, 1869. Pupil of Augustus St. Gaudens and Kenyon Cox, New York. Member: Indiana Sculptors Society. Award: Honorable mention, Paris Exposition, 1900. Work: Sculptor of figure of "Victory" in quadriga on the US building, at Paris Exposition, 1900; memorial corbels, Grace Church, Brooklyn; memorial fountains at Flushing, LI, and Auburn, NY; SPCA Memorial Fountain, Westfield, NJ. Address in 1933, Westfield, NJ. Died 1938.

BALL, L. CLARENCE.
Landscape painter. Born July 4, 1858, in Mt. Vernon, Ohio. Member of Chicago Society of Artists. His specialty was landscapes with cattle and sheep. Died October 10, 1915, in South Bend, IN.

BALL, LINN B.
Painter and illustrator. Born in Milwaukee, Wis., in 1891. Member: GFLA; Soc. of Illus. Address in 1926, 163 West 23d Street, New York.

BALL, ROBERT.
Painter and illustrator. Born in Kansas City, MO, in 1890. Pupil of Richard Miller in Paris and Brittany. Award: OH Dean Prize, Artists of Kansas City, 1915. Mural decorations in State Capitol, Jefferson, MO. Address in 1926, 9 West 47th Street, New York.

BALL, RUTH NORTON.
Sculptor. Born in Madison, WI. Pupil of J. Liberty Tadd in Phila.; St. Louis School of Fine Art; Cincinnati Art Acad. Member: Cincinnati Woman's Art Club; Three Arts Club and Crafters Company, Cincinnati; San Diego Artists Guild. Awards: First honorable mention, Calif. Society of Artists, San Diego, 1931. Work: Marston Memorial Fountain, Greenwood Cemetery; bronze "Mother and Child," Fine Arts Gallery, San Diego; City Art Museum, St. Louis; Cincinnati Art Museum; Marine Base, bronze tablet, Boy Scout Headquarters, San Diego, Calif. Represented in City Art Museum, St. Louis. Address in 1933, San Diego, CA.

BALL, THOMAS.
Sculptor. Born in Charlestown, MA, June 3, 1819. His art studies began with silhouette-cutting, miniature and portrait painting; studied sculpture in Italy, 1854-57. Had studio in Boston, MA, 1837-53; also in Boston 1857-64; in Italy again until 1897. After 1851 he devoted himself to sculpture. His prominent works are the Washington monument in Boston, Forrest as "Coriolanus," Emancipation Group, Washington. For his life, see "My Three Score Years and Ten," by Thomas Ball, Boston. Died December 11, 1911, in Montclair, NJ.

BALL, THOMAS WATSON.
Painter. Born in New York City, 1863. Pupil of Art Students' League, New York. Studied with Beckwith and Mowbray. He has also done mural decorations. Ceiling decoration in Chapel of the Intercession, NYC; ceiling decoration in Trinity Chapel, Buffalo, NY; figure panels in front, St. Thomas' Church, NYC; figure panels in reredos, Chapel of Newman School, Hackensack, NJ. Address in 1926, Old Lyme, Conn. Died 1934.

BALLANTINE, EDWARD J.
Painter. Born in Scotland in 1885. Member of the Society of Independent Artists. Address in 1926, 36 Grove Street, New York.

BALLANTYNE, KENNETH M.
Painter, illustrator and etcher. Born Gisborne, New Zealand, Jan. 27th, 1886. Pupil of C. F. Goldie. Member: SI. Address in 1929, 22 West 49th St.; h. 1 Oakmere Drive, Baldwin's, LI, NY.

BALLATOR, JOHN R.
Painter. Born, February 7, 1909 in Portland, Oregon. In 1928, studied painting and sculpture at University of Oregon under Kenneth Hudson and Harry Camden. In 1929; entered Yale School of Fine Arts. Studied sculpture under Robert G. Eberhart, and painting under Edwin C. Taylor, Eugene Savage and Deane Keller. In 1934, received B.B.A. from Yale. Collaborated in executing seven panel mural in oil for Nathan Hale School, New Haven, Connecticut, under Public Works of Art Project, having at different times about seven assistants. In October, supervised a mural undertaking for Franklin High School, Portland, Oregon, consisting of one panel in oil and two over-door panels in tempera. Has painted number of portraits and pictures for private individuals, receiving commissions both in the East and in Portland, Oregon.

BALLIN, HUGO.
Artist. Born New York, 1879. Studied at Art Students' League, New York, and in Rome and Florence. Awarded Scholarship, Art Students' League; Shaw Prize Fund, 1905; Thomas B. Clarke Prize, 1906; Architectural League Medal, 1906 and 1907. Elected Associate Member of National Academy. Specialty, mural decorations. Works: Executive chamber, Madison, Wis.; room in home of Oliver Gould Jennings, NY City, and E. D. Brandegee of Boston; decorative pictures in many pvt. collections; also represented in National Museum, Washington, DC; Montclair Museum, NJ; Ann Mary Memorial, RI; etc. Address in 1926, 662 Lexington Ave., New York. Died Nov. 27, 1956, in CA.

BALLING, OLE P. H.
Painter. Born April, 1828, in Norway. A painter of the Civil War, his "Heroes of the Republic," a group of twenty-seven Union generals on horseback, has been much praised. Died May 1, 1906.

BALLINGER, H(ARRY) R(USSELL).
Illustrator. Born in Port Townsend, Wash., 1892. Pupil of Maurice Braun, Art Students' League of NY, and Harvey Dunn. Illustrations for *Cosmopolitan, Good Housekeeping, Saturday Evening Post, McClure's*, etc. Address in 1926, Studio, 1947 Broadway; Home, 15 West 67th Street, New York, NY.

BALLOU, BERTHA.
Sculptor, painter, etcher, and teacher. Born in Hornby, New York, on February 14, 1891. Pupil of DuMond, Tarbell, Meryman, Bosley, and Grafly. Studied at Art Students League; Randolph-Macon Woman's College; Corcoran Gallery of Art; Boston Museum of Fine Arts School. Member: Spokane Art Association; Women Artists of Washington. Awards: Second honorable mention, Spokane Art Association, 1929; third prize, Island Empire Fair, 1930. Work: "The Old Opera Singer," Grace Campbell Memorial Museum, Spokane. Address in 1953, Spokane, WA.

BALLOU, P. IRVING.
Painter. Exhibited water colors at the Penna. Academy of the Fine Arts, Philadelphia, 1925. Address in 1926, 1015 Prospect Place, Brooklyn, NY.

BAMA, JAMES ELLIOTT.
Illustrator. Born in the Bronx, New York, 1926. He attended the High School of Art and Design and the ASL as a pupil of Frank Reilly. His career began in 1949 and has included illustrations for hundreds of books and magazines such as the *Saturday Evening Post, Argosy* and *Reader's Digest*, as well as posters for a number of advertising firms. His artwork has been shown in galleries across the country and is part of the permanent collections of many museums. He retired from illustration in 1971 to live and work as a Western painter in Wyoming. The results of his efforts were recently recorded in a book, *Paintings by Jim Bama*, published by Ballantine Books.

BAMBOROUGH, WILLIAM.
Miniature painter. An Englishman who worked on portraits in 1830 at Shippenport.

BANASEWICZ, IGNATIUS.
Painter and etcher. Born Leningrad, Russia, Dec. 5, 1903. Pupil of W. A. Levy; A. Ostrowsky; Clinton Peters; C. C. Curran. Member: Brooklyn SE; Salons of Am.; S. Indp. A.

BANCROFT, HESTER.
Painter and sculptor. Born in Ithaca, NY, 1889. Exhibited National Academy of Design, 1925. Address in 1926, Ithaca, New York.

BANCROFT, MILTON HERBERT.
Painter. Born at Newton, Mass., 1867. Student of Mass. State Normal Art School, 1883-86; continued studies irregularly at PAFA; Supt. Schools and instr. in Penna. Academy Fine Arts, 1892-94; studied in Colorossi, Delacluse and Julien Academies, Paris, 1894-99. Exhibited in Societe des Artists Francais, and in all large exhibitions of New York, Philadelphia, Boston, Washington and Chicago. Specialty, portraits; also executed mural decorations for Court of the Seasons, Panama-Pacific Expn., San Francisco. Instr. Mechanics Inst., New York. Address in 1926, 58 W. 57th Street, New York, NY.

BANKSON, G(LEN) P(EYTON).
Painter and craftsman. Born Mount Hope, Wash., Sept. 7, 1890. Self-taught. Work: Murals in Fidelity

National Bank, Spokane; mantel-piece, University of Idaho, Moscow. Address in 1929, 824 Riverside Ave.; South 222 Lacey St., Spokane, Wash.

BANNERMAN, J.
Engraver. He produced two portraits of Franklin, one in line and the other in stipple, about 1800; they were published in the "Works of Franklin" and are rather crude.

BANNERMAN, WILLIAM W.
Engraver of book illustrations for the publishers in Baltimore, MD. He etched in a rather crude manner a series of full-length portraits of statesmen for the *United States Magazine* and *Democratic Review* in 1840-45. Died c. 1846.

BANNING, WILLIAM J.
Painter. Born in Conn., in 1810. Pupil of National Academy under Sam'l Waldo. His specialty was portrait painting. He exhibited in the National Academy of Design in 1840 and 1841. He died in 1856.

BANNISTER, EDWARD M.
Artist. Born in St. Andrews, New Brunswick, in 1833. He studied art at the Lowell Institute in Boston, and spent the greater part of his professional life there. In 1871 he moved to Providence, RI. He contributed regularly to the Boston Art Club exhibitions. His picture "Under the Oaks" was awarded a first-class medal at the centennial exhibition of 1876 in Philadelphia. Died Jan. 9, 1901.

BANNISTER, ELEANOR CUNNINGHAM.
Painter. Born in New York, NY. Pupil of Whittaker in Brooklyn; Constant and Lefebvre in Paris. Member: Brooklyn Society of Artists. Work: "Portrait of Rev. R. S. Storrs," Brooklyn Museum. Died 1939. Address in 1929, 109 Cambridge Place, Brooklyn, New York.

BANNISTER, JAMES.
Engraver. Was born in England in 1821. He came to New York at an early age and was apprenticed in the engraving establishment of A. L. Dick in New York. He also became interested in bank-note work, but his chief production was portraits for book-illustrations. Died Oct. 11, 1901 in Brooklyn, NY.

BANVARD, JOHN.
Painter. Born in 1815 and died in 1891. Educated in New York schools. At an early age he supported himself with selling his pictures in New Orleans. He painted a panorama of the Mississippi River that was exhibited in this country and abroad. He also painted the picture from which the first chromo made in America was taken. It was entitled "The Orison" (New York, 1861).

BARANCEANU, BELLE.
Painter. Born Chicago, Illinois, in 1905. Studied at Minneapolis School of Art and in Chicago. Pupil of Richard Lahey, Morris Davidson, Cameron Booth and Anthony Angarola. Painted and taught in Chicago, where she was member of Chicago Society of Artists and served on Board of Directors, Chicago No-Jury Society of Artists. Has exhibited at Art Institute of Chicago, Los Angeles Museum, Kansas City Art Institute, John Herron Art Institute of Indianapolis, Nebraska Art Association, Des Moines, and San Diego Fine Arts Gallery. Has painted four murals, including one in Palace of Education, Balboa Park, and one which was executed in true fresco in the San Diego Fine Arts Gallery Garden.

BARBAROSSA, THEODORE C.
Sculptor. Born in Ludlow, VT. Studied at Yale University School of Art and Architecture, BFA; under Cyrus Dallin, Robert Eberhard, and Heinz Warneke. Exhibited: Whitney Museum in NYC, 1940; National Sculpture Society; National Academy of Design; Allied Artists; Audubon Artists. Awards: Lindsay Morris Memorial prize from the National Sculpture Society, 1949; gold medal for sculpture from Allied Artists, NYC, 1955; Henry Herring Citation for sculpture from the National Sculpture Society, 1961, and the Hexter Prize, 1977. Member: National Sculpture Society; Audubon Artists; Allied Artists; International Institute of Arts and Letters; and academician of the National Academy of Design. Executed many works in stone for the Catholic Church of the Assumption, Baltimore, 1957; five relief panels for the Museum of Science, Boston; two chapels and ten figures for the Catholic Shrine, Washington, DC, 1962-65; others. Address in 1982, Belmont, MA.

BARBEE, HERBERT.
Sculptor, son of William R. Barbee the sculptor. Born in 1848. He studied in Florence, Italy.

BARBEE, WILLIAM RANDOLPH.
Sculptor. Born January 17, 1818, near Luray, VA. His "Fisher Girl" and "The Coquette" were his best known works. Exhibited them in Richmond, Baltimore, NYC, 1858-59; also exhibited bust of Speaker Orr, Pennsylvania Academy, 1859-60. Died June 16, 1868, in Virginia.

BARBER, ALICE.
Painter. Born in Illinois. Studied: Indiana University. Exhibitions: University of Texas at Austin; Corcoran Gallery, Washington, DC; American Women's Show in Hamburg, Germany. Collections: Museum of Modern Art, New York City; Whitney Museum of American Art, New York City; San Francisco Museum of Art, California.

BARBER, CHARLES E.
Engraver. Born in London in 1840; he came to this country early in his career. Studied with his father, Wm. Barber. In 1869 he was appointed assistant engraver in the United States Mint in Philadelphia. His best work is found in the medals struck for Presidents Garfield, Arthur, and the Great Seal of the United States. Died Feb. 19, 1917, in Philadelphia, PA.

BARBER, JOHN WARNER.
Engraver. Born 1798. He was apprenticed to Abner Reed, who was then established as a bank-note engraver. Reed soon turned his attention to engraving historical scenes, both on copper and wood. Barber engraved on wood the illustrations for "Easy Lessons in Reading" and the "History of New England." His engraving establishment was in New Haven, Conn. See "Linton's Wood Engraving." Died June 22, 1885, in New Haven, CT.

BARBER, WILLIAM.
Engraver. Born in London, May 2, 1807, in London, Eng. Came to US in 1853. Became silver-plate engraver and later Chief Engraver of US Mint (1869-1879). Died Aug. 31, 1879 in Phila.

BARCLAY, EDITH LORD.
Painter. Exhibited "The May Basket" at 33d Annual of National Association of Women Painters and Sculptors. Address in 1926, 229 Williamsburg Ave., Brooklyn, NY.

BARCLAY, JAMES EDWARD.
Portrait painter. Born 1846. At one time occupied a studio in this city, during which time his portrait of Mr. S. H. Kauffman was painted from life. Died 1903.

BARCLAY, McCLELLAND.
Painter, illustrator. Born St. Louis, MO, 1891. Pupil of H. C. Ives, George R. Bridgman, Thomas Fogarty. Member: Art Students' League of New York; Chicago Art Club; Art Service League, Chicago. Awards: Navy poster prize, Committee on National Preparedness, 1917; first prize U.S.M.C. Recruiting poster; first prize for allegorical painting of Commerce of Chicago from Chicago Association of Commerce. Died 1943. Address in 1929, 730 Fifth Ave., 350 East 57th St., New York, NY.

BARD, JAMES.
Marine painter. Born in Chelsea, (now part of NYC) NY, 1815. Twin brother to John Bard, both of whom were self-taught and specialized in depicting small sailing ships and steamboats of the Hudson River and NYC. Over 300 of their paintings are recorded. Bard's work is represented in the collections of the NY Historical Society, Cooperstown, NY; and at the Mariner's Museum, Norfolk, VA; Brooklyn Muse-

um, NY; Shelburne Museum, Shelburne, VT; and the Wadsworth Athenaeum, Hartford, CT. His first painting is dated 1827; his last known attributed painting is dated 1897. He died at White Plains, NY, March 26, 1897.

BARD, JOELLEN.
Sculptor and painter. Born in Brooklyn, New York, June 19, 1942. Studied: Pratt Institute with Gabriel Laderman, Dore Ashton, Mercedes Matter; Syracuse University, with Robert Goodenough; Brooklyn Museum Art School. Exhibitions: The Brooklyn Museum Little Gallery, 1973; Gallery 91, 1974; Gallery 26, 1975; Pleiades Gal., NYC, 1975, 77, 79. Address in 1982, 1430 East 24th St., Brooklyn, NY.

BARD, JOHN.
Marine painter. Born in Chelsea, (now part of NYC) NY, 1815. Twin brother to James Bard. Self-taught. Worked with his brother James until 1849. He was destitute twice in his life, once in 1855 and again in 1856, when he was forced to enter Blackwell's Island. Their work is very similar and difficult to distinguish; both artists used the signature "J. Bard" at different times. His works are represented in the Brooklyn Museum, NY; NY State Historical Association, Cooperstown, NY; Mariner's Museum, Newport News, VA; Peabody Museum, Salem, MA; Shelburne Museum, Shelburne, VT; and Wadsworth Athenaeum, Hartford, CT. Died on Blackwell's Island, Oct. 18, 1856.

BARD, SARA (FORESMAN).
Painter and teacher. Born Slippery Rock, PA. Pupil of Henry B. Snell, George Pearse Ennis, Sigourd Skou. Member: NA Women PS; AWCS; NYWCC; Wash. WCC. Awards: Prize, NYWCC, 1928; prize, Balto. WCC, 1928; Lloyd C. Griscom prize, NYWCC, 1929; Clemant Studebaker prize, Hoosier Salon, Chicago, Ill., 1929. Address in 1929, 40 West St. Joe St., Indianapolis, Ind.

BARENSFELD, MARK.
Illustrator. Born in Cleveland, 1947. He attended Ohio University and Memphis State. His career began with an illustration for *St. Anthony's Messenger* in 1970 and his illustrations have since appeared in *Cincinnati Magazine* and *Writer's Digest*. He has produced posters for Ohio universities and his works have been shown at several Ohio museums and Art Directors' Clubs.

BARGER, RAYMOND GRANVILLE.
Sculptor. Born in Brunswick, MD, August 27, 1906. Study: Carnegie-Mellon University, BA; Winchester Fellow, Europe; Yale University, BFA; Special Academy Rome, 2 years. Works include Column of Perfection, H. J. Heinz Co., New York World's Fair, 1939; J.C. Penney, NYC, 1965; J. Mitchelle Collection, NYC, 1968; Bicentennial Bronze, 1975-76.

Awards: Title of Cavaliere, San Marino, Italy. Teaching: Rhode Island School of Design, 1939-40; Cooper Union, New York, NY, 1940-45. Member: National Sculpture Society, NYC; Architectural League of New York. Works in welded bronze, wood and stone. Address in 1980, The Mill, Carversville, PA.

BARHYDT, JEAN K.
(Mrs. George Weed Barhydt). Painter. Born Brooklyn, NY, 1868. Pupil of G. A. Thompson. Member: National Academy Women Painters and Sculptors; Conn. Association of Fine Arts. Address in 1926, The Belnord, 548 Orange Street, New Haven, Conn.

BARILE, XAVIER J.
Painter, illustrator, etcher. Born in Italy, March 18, 1891. Pupil of Chapman, Mora, Sloan, and Dodge. Member: Art Students' League of New York and the Kit Kat C. Address in 1929, 7 W. 14th St., h. 2126 Hughes Avenue, New York, NY.

BARKER, ALBERT WINSLOW.
Illustrator, writer, lecturer, etcher and teacher. Born Chicago, Ill., in 1874. Director of Art Education, Public Schools, City Bldg., Wilmington, Del.; Watch Hill, RI; Maylon, PA. Pupil of PAFA; Phila. School of Industrial Art. Member: Wilmington SFA; Phil. PC. Died in 1947.

BARKER, KATHERINE.
Painter. Born Pittsburgh, PA, 1891. Pupil of Breckenridge, Anshutz, Carlson, Hale, Beaux, and Vonnoh. Member: Fellowship, Penna. Academy of Fine Arts. Address in 1926, The Avondale, 39th and Locust Streets, Philadelphia, PA.

BARKER, M.
Miniature painter, working in New York about 1820.

BARKLEY, BRUCE E.
Illustrator. Born in New York City, 1950. He attended the ASL and received his BFA from the School of Visual Arts. A pupil of Steven Kidd, Jack Potter and Robert Weaver, he had his first illustration, *Boston Tea Party*, published in 1973. His work is owned by the United States Department of Interior, USAF, Walsh Galleries in Yonkers and the Pentagon.

BARKSDALE, GEORGE (EDWARD).
Painter. Born Charlotte County, VA, Aug., 13, 1869. Pupil of William L. Shepherd, Herman Sodersten, PAFA. Member: SI; SSAL.

BARLOW, JOHN NOBLE.
Painter. Born 1861 in Manchester, Eng. He was a member of the Providence Art Club and is represented by three landscapes in the Rhode Island School of Design. Died March 24, 1917 in St. Ives, Cornwall, England.

BARLOW, MYRON.
Born in 1873 in Ionia, Mich. Pupil of Art Institute Chicago and Ecole des Beaux Arts in Paris. Member of the Paris American Artists' Association. Works: "Mother's Love," Penna. Academy of Fine Arts; "Pecheuse," Detroit Museum of Art. Address in 1926, 362 Woodland Ave., Detroit, Mich.

BARNARD, EDWARD HERBERT.
Painter. Born July 10, 1855, in Belmont, MA. Studied at Boston Museum of Fine Arts, and with Boulanger and Collin in Paris. Awarded many honorable mentions and medals. Address in 1926, 603 Belmont Street, Belmont, Mass. Died April 16, 1909 in Westerly, MA.

BARNARD, ELINOR M.
(Mrs. Manuel Komroff). Painter. Born Kensington, London, England, Aug. 29, 1872. Member: National Academy of Women Painters and Sculptors. Specialty, portraits in water color. Address in 1926, 601 Madison Ave., New York, NY.

BARNARD, GEORGE GREY.
Sculptor. Born in Bellefonte, PA, May 24, 1863. Studied at Art Institute of Chicago, Ecole Nationale des Beaux Arts, 1884-87, with Carlier. Exhibited in Paris Salon, 1894; National Sculpture Society, 1923. Awarded Gold Medal, Paris Exposition, 1900; Gold Medal, St. Louis Exposition, 1904; others. Professor Sculpture, Art Students League, NY; Associate Member of National Academy of Design, and Societe Nationale des Beaux-Arts, Paris; Member of National Institute of Arts and Letters. Work in Metropolitan Museum of Art; Central Park, NYC; heroic-size statue group, State Capitol, Harrisburg, PA; sculpture group, Norway, Sweden; busts of A. S. Hewitt, C. P. Huntington, Dr. Leeds, the latter at Stevens Institute, Hoboken, NJ; Boston Museum; Carnegie Institute; Venus & Cupid, Paris; bronze statues of A. Lincoln, Lytle Park, Cincinnati, OH, Louisville, KY, and Manchester, England; Memorial Fountain, Tampa, FL; marble group Adam & Eve, Tarrytown, NY. He formed the collection of medieval sculpture at the Cloisters, owned by the Metropolitan Museum of Art, NYC. Address in 1933, 454 Fort Washington Ave., NYC. Died in NYC, April 24, 1938.

BARNARD, JOSEPHINE W.
Painter. Born in Buffalo, NY, 1869. Pupil of Dow, Snell and Carlson. Address, 117 Waverly Place, NY, or 26 Middagh Street, Brooklyn, NY.

BARNARD, W. S.
Born c. 1809 in CT. Engraver of book illustrations, working in New York about 1845. He was associated with A. L. Dick and was probably in his employ in his engraving establishment. Other engravings are signed "Tuthill & Barnard, Sc."

BARNES, BURT.
Painter, illustrator, writer, and teacher. Born Manitowoc, Wisc., June 30, 1879. Pupil of AIC. Member: Wisc. PS. Award: Water Color prize, Milwaukee, 1925. Work: "Under the Viaduct" and "The Lagoon," Milwaukee Art Institute, Milwaukee, Wisc. Address in 1929, 528 Clyde Ave., Wauwatosa, Wisc.

BARNES, ERNEST HARRISON.
Landscape painter and teacher. Born Portland, NY, 1873. Exhibited at National Academy of Design, 1925. Pupil of Art Students' League, Howe Foote, Charles H. Davis and Henry R. Poore New York. Teacher of freehand drawing and painting, Univ. of Mich. Address in 1926, Detroit, Mich.

BARNES, GERTRUDE JAMESON.
(Mrs. Henry N. Barnes). Painter. Born at Tyngsboro, Mass., 1865. Pupil of Minneapolis School of Fine Arts. Specialty, landscapes. Work: "In the Orchard," "Trees by the Sea." Address in 1926, 1812 Emmerson Ave., Minneapolis, Minn.

BARNES, HIRAM PUTNAM.
Artist, illustrator. Born in Boston, 1857. Public school education; studied drawing and painting with Fernand Lungren and F. Childe Hassam. Began as engraver making designs for Waltham Watch Co., also engraved on wood; became illustrator for leading Boston publishers. Exhibited water colors, Boston Art Club. Address in 1926, Waltham, Mass.

BARNES, JOHN P.
Painter. Exhibited pastels at the Annual Water Color Exhibition at the Penna. Academy of Fine Arts, Philadelphia, 1922. Address in 1926, 518 Parker Ave., Collingsdale, Penna.

BARNET, WILL.
Painter and printmaker. Born in Beverly, MA, May 25, 1911. Work: In the permanent collections of the Metropolitan Museum of Art, the Museum of Modern Art, the Whitney Museum of American Art, The Guggenheim Museum, New York; The Corcoran Gallery of Art, Washington; the Pennsylvania Academy of Fine Arts, Philadelphia; the Museum of Fine Arts, Boston. Exhibitions of his prints: Associated American Artists in 1972, 79, 82. Taught at the Art Students League from 1934-78, at Cooper Union from 1944-77, and he continues to teach at the Pennsylvania Academy of Fine Arts. Academician, NAD, 1982; Am. Acad. of Arts and Letters, 1982. Living in New York City.

BARNETT, EUGENE A.
Sculptor, illustrator, painter, etcher, and writer. Born Atlanta, GA, March 18, 1894. Pupil of Edward Penfield. Member: Society of Illustrators. Address in 1933, 1 West 67th St., New York, NY.

BARNETT, TOM P.
Painter. Exhibited oil painting entitled "Old Coal Pocket" at Penna. Academy of the Fine Arts, Philadelphia, 1921. Student of Paul Carnoyer. Born in St. Louis, MO, in 1870. Address in 1926, Lindell Boulevard, St. Louis, Missouri.

BARNEY, ALICE PIKE.
Painter and writer. Born Cincinnati, Ohio, in 1860. Pupil of Carolus Duran and Whistler. Represented by portraits of Whistler (used in illustrating) and of Natalie Barney, owned by the French Government. Address in 1926, Studio House, Washington, DC.

BARNEY, FRANK A.
Painter. Born Union Springs, NY, Dec. 7, 1862. Work: "Gray Day" and "April Morning," Syracuse Museum of Fine Arts. Address in 1929, 4 Howard St., Auburn, NY.

BARNEY, JOHN STEWART.
Landscape painter. Born 1869. He exhibited a collection of Scottish and American landscapes at the Ehrich Galleries, New York, in 1924. He died in New York City, Nov. 22, 1925, in his 57th year.

BARNEY, MARIAN GREENE.
(Mrs. W. Pope Barney). Painter and architect. Born St. Paul, Minn. Pupil of Cecilia Beaux, Violet Oakley, Emil Carlsen, Phillip Hale, Pearson. Member: Fellowship PAFA; Phila. Alliance; Print C. Address in 1929, "Wychwood," Moylan, PA.

BARNHORN, CLEMENT JOHN.
Sculptor. Born in Cincinnati, OH, in 1857. Pupil of Rebisso in Cinn.; Bouguereau, Peuch, Merc, Ferrier at Julien Academy in Paris. Member: National Sculpture Society, Cinn. Art Club. Works: Fountain figures, Hartford, Conn., and Prince George Hotel, NY; "Magdalen," Cinn. Art Museum; Theodore Thomas, Music Hall, Cinn., Ohio; fountain, Shortridge Hill School, Indianapolis, IN; portrait bust, Public Library, Cinn., OH; Madonna and Child, Cathedral facade, Covington, KY; eleven panels, Court House, Cinn., OH; five panels - war memorials, Hughes High School, Cinn., OH; portrait, Maj. C. R. Holmes, Cinn. General Hospital; bas-relief, Dr. P. S. Connor, Good Samaritan Hospital, Cinn., OH; Maenads, relief panel, Queen City Club, Cinn., OH; fountains, Hughes High School, and Conservatory of Music, Cinn., OH; fountain figure, Hartford, Conn. Exhibited at National Sculpture Society, 1923. Awards: Hon. mention, Paris Salon, 1895; bronze, silver medals, International Exposition, Paris, 1900; honorable mention, Pan-American Exposition, Buffalo, 1901; silver medal, Louisiana Purchase Exposition, St. Louis, MO, 1904. Address in 1933, Art Museum, Cincinnati, Ohio. Died in 1935.

BARNITZ, MYRTLE TOWNSEND.
Sculptor, painter, craftsman, writer, and teacher. Born Greensburg, PA. Pupil of Charles Francis Browne, Thomas Hovenden, Thomas Eakins, William Gilchrist, Thomas P. Anshutz, Hugh Breckenridge. Member: Fellowship, Penna. Academy of Fine Arts; Chicago No-Jury Society of Artists. Work: "Help Belgium" and "Boy Scout," Red Cross, Chicago. Address in 1933, Glen View, IL.

BARNS, CORNELIA.
Painter and illustrator. Born in New York, 1888. Pupil of Twachtman and Chase. Illustrated for the "Liberator." Address in 1926, Morgan Hill, California.

BARNUM, EMILY KEENE.
Painter. Born in New York, 1874. Pupil of Vibet in Paris and Irving Wiles in New York. Member of Art Students' League, New York. Founder and editor of "The Swiss Monthly," published at Lausanne. Specialty is water colors. Address in 1929, Les Tourelles, Mousquines 2, Lausanne, Switzerland.

BARNUM, J. H.
Painter and illustrator. Member: GFLA; SI. Address in 1929, Silvermine, Norwalk, Conn.

BARONE, ANTONIO.
Painter. Born 1889. Member of Oakland Art Association, Oakland, Calif. Awarded Gold Medal, Philadelphia Art Club, 1917. Exhibited "Grazia" at the Carnegie Institute, 1920, and "Lady with Muff" at the Penna. Academy of the Fine Arts, 1921. Address in 1926, 771 Lexington Ave., New York City.

BARR, PAUL E.
Painter, writer, lecturer, and teacher. Born near Goldsmith, Ind., Nov. 25, 1892. Pupil of AIC. Member: Tipton AA; S. Indp. A.; Chicago AC; Indiana AC; Hoosier Salon; AFA. Work in Goldsmith Public Schools. Died 1953.

BARR, ROGER.
Sculptor and painter. Born in Milwaukee, WI, September 17, 1921. Studied at University of Wisconsin; National University of Mexico; Pomona College, B.A.; Claremont College, M.F.A.; Jepson Art Institute, Atelier 17. Work in Hirshhorn Museum and Sculpture Garden of Smithsonian Instit., Washington, DC; Boston Museum of Fine Arts; Art Museum of Goteborg, Sweden; and others. Has exhibited at M. H. de Young Memorial Museum, San Francisco; Esther Robles Gallery, Los Angeles; Feingarten Gallery, NY; International Sculpture Exhibition, Museum Rodin; and others. Member of Artists Equity Association; American Federation of Arts. Address in 1982, c/o Smith Andersen Gallery, Palo Alto, CA.

BARR, WILLIAM.
Painter and illustrator. Born in Scotland, April 26, 1867. Among his works are "Paisley Cross," portrait of Provost Peter Eadie, and portrait of Thomas Boyle at City Hall, San Francisco. Address in 1926, 311 Lyon Street, San Francisco, Calif. Died 1933.

BARRALET, JOHN JAMES.
Painter and engraver. Born in Ireland, 1747. He died in Philadelphia, 1815. He painted portraits, engraved a few plates, painted landscapes in water color, and designed a number of plates for other engravers.

BARRATT, LOUISE BASCOM.
Illustrator. Member: SI. Address in 1929, 2 West 67th St., New York, NY.

BARRATT, THOS. E.
Miniature painter. Born c. 1814 in Eng. Flourished 1837-1854, Philadelphia. May have been a relative of Edward Barratt, who painted miniatures in Dublin in 1790.

BARRATT, WATSON.
Illustrator and mural painter. Born in Salt Lake City, Utah, in 1884. Pupil of Howard Pyle and Henri. Represented by "Canton Street" in Corcoran Art Gallery, and mural painting in Burham Library, Art Institute, Chicago. Address in 1926, 330 West 39th St., New York.

BARRET, LAURA A.
Painter, illustrator, etcher and craftsman. Born West New Brighton. Pupil of Alfred Stevens in Paris; Weir; Clarkson. Member: Society of Independent Artists; National Arts Club; Art Workers' Club for Women. Work: Landscape in Lincoln Memorial, Knoxville, TN. Address in 1926, 15 Gramercy Park, New York, NY; s. West New Brighton, S.I., NY.

BARRETT, ELIZABETH HUNT.
(Mrs. Edward N. Barrett). Painter. Born New York, NY, 1863. Pupil of NAD. Address, Amherst, VA.

BARRETT, LAWRENCE LORUS.
Sculptor, painter, illustrator, printmaker, teacher, and writer. Born in Guthrie, OK, 1897; raised in Hutchinson, KS. Studied: Broadmoor Art Association beginning 1920, the pupil of Robert Reid, Randall Davey, Ernest Lawson, J. F. Carlson, and Boardman Robinson. Work in Metropolitan Museum of Art, Colorado Springs Fine Arts Center, Brooklyn Museum, Carnegie Institute, Library of Congress. Instructor in lithography at Broadmoor and Colorado Springs Fine Arts Center. Award: Guggenheim Fellowship, 1940. Co-author with Rudolph Dehn, 1946, text on lithography. Died in Colorado Springs, CO, 1973.

BARRETT, OLIVER O'CONNOR.
Sculptor, illustrator, educator, and writer. Born in London, England, January 17, 1908. Studied at Fircroft College, England. Member: Sculptors Guild. Awards: Prize, Audubon Artists, 1948, medal, 1950. Work: Birmingham City Museum, England. Exhibited: Penna. Academy of Fine Arts, 1945; Royal Academy, London, 1933; Audubon Artists, 1946, 48, 50; New Orleans Art Association, 1942, 43; Sculpture Center; Whitney. Illustrated, "Anything For a Laugh;" "Little Benny Wanted a Pony," 1951. Contributor to *Town and Country* and other magazines. Position: Instructor of Sculpture at Cooper Union Art School, Museum of Modern Art, NYC. Address in 1970, 313 W. 57th St., NYC.

BARRIE, ERWIN (S.).
Painter. Born Canton, Ohio, June 3, 1886. Pupil AIC. Member: Chicago AC; Business Men's AC of Chicago. Address in 1926, 1188 Asbury Ave., Hubbard Woods, Ill.

BARRINGTON, AMY L.
Painter. Born Jersey City, NJ; pupil of Cox, Brush, and Chase. Member: National Academy of Women Painters and Sculptors. Lectured and wrote in magazines on interior decoration, art objects, and archaeology. Address in 1926, 3089 Broadway, New York, NY.

BARRON.
A little-known genre painter noted in Tuckerman's "Book of the Artists."

BARRY, CHARLES A.
Portrait and genre painter. Born July, 1830, in Boston. Among his best remembered work was "Motherless," "Evangeline," and a head of the poet Whittier. He flourished in Boston, 1851-1859. Died 1892.

BARRY, EDITH CLEAVES.
Sculptor, painter, illustrator, and designer. Born in Boston, MA. Studied at Art Students League; NY Institute of Fine Arts; Paris, France. Member: National Association of Women Artists; Conn. Academy of Fine Arts; Art Students League; American Federation of Arts; Montclair Art Association; American Artists Professional League; Art Centre of Oranges; Washington Water Color Society; National Arts Club; Allied Artists of America; National Society of Mural Painters. Awards: Two honorable mentions, Hudson prize, Whitney Studio; Conn. Academy of Fine Art, 1916, 21, 22, 38; medal, Montclair Art Museum, 1928. Work: Three portraits, Mountain Side Hospital, Montclair, NJ; Hospitals and Schools, NJ; Dartmouth College; Dyer Library, York National Bank, Saco, ME; US Post Office, Kennebunk, ME; Mary Wheeler School, Providence, RI; American Artist Professional League; Soldier and Sailors Club, NY. Position: Founder and Director, Brick Store Museum, Kennebunk, ME. Address in 1970, 116 East 66th St., NYC.

BARRY, GERARD M.
Painter. Born in County Cork, Ireland, 1864. Began to study art at Paris, France, in 1885 at the Academie Julien, and studied under Le Febre, Boulanger, and Carolus Duran. Exhibited in the Paris Salons of 1885 and 1886, and at the Royal Academy, London, England, in 1887. Came to the United States in 1888, and after remaining for 18 months returned to study under Carmon. Returned to United States.

BARRY, JOHN J(OSEPH).
Etcher. Born Hamilton, Ontario, Canada, 1885. Pupil of Ernest Haskell; Joseph Pennell; Frank Short in London. Member: California Society of Etchers; Calif. Print-Makers. Address in 1926, Burton Arms Apts., 680 Witmer Street, Los Angeles, Calif.

BARSE, GEORGE RANDOLPH, JR.
Artist. Born Detroit, 1861. Studied art at Ecole des Beaux Arts and Academie Julien, Paris, 1879-85; pupil of A. Cabanel, Boulanger and Lefebvre. Academy prize, Paris, France, 1882; New England prize, Boston, 1885; 1st prize Nat. Acad. Design, 1895; Academy of National Arts, 1898; National Academy, 1899. Member: Architectural League of New York. Work: Eight panels in Library of Congress, Wash., DC; Represented in the Vanderpoel Art Assn. Collection, Chicago. Address in 1926, Katonah, NY. Died 1938.

BARTH, EUGENE FIELD.
Sculptor, painter, illustrator, and teacher. Born St. Louis, March 4, 1904. Pupil of Fred C. Carpenter. Member: Art Students League of New York. Award: Halsey Ives prize, St. Louis Artists Guild, 1928. Address in 1933, Teaneck, NJ; summer, St. Louis, MO.

BARTHOLDI, FREDERIC AUGUSTE.
French sculptor. Born in 1834. Known in this country from his gigantic statue of "Liberty Enlightening the World" on Bedloes Island in New York harbor. He was a commissioner in 1876 of the French government, at the Centennial Exposition in Philadelphia. His statue of "Lafayette Arriving in America" is in Union Square, New York. Died 1904.

BARTHOLOMEW, EDWARD SHEFFIELD.
Sculptor and painter. Born in Connecticut, July 8, 1822. He studied at the National Academy and in Italy. A collection of his work is in Hartford, Conn. His full-length statue of Washington belonged to Noah Walker and his "Eve Repentant" to Jos. Harrison of Philadelphia. Exhibited at National Academy; Boston Atheneum; Philadelphia Academy, 1859, 63, 96. He died in Naples in 1858.

BARTLE, GEORGE P.
Wood engraver. Born in 1853. He studied wood engraving with H. H. Nichols. Much of his best work was done for the *Century Magazine*. He died in 1918.

BARTLE, SARA N(ORWOOD).
Miniature painter. Born Washington, DC. Pupil of Carroll Beckwith, Art Students' League of NY; Art Students' League of Washington. Address in 1926, 2300 18th Street, Washington, DC.

BARTLETT, DANA.
Painter, illustrator, and teacher. Born Ionia, Mich., Nov. 19, 1878. Pupil of ASL of NY and William M. Chase; Coussens in Paris. Member: Calif. AC; Calif. WCS; Decorative AS; Laguna Beach AA; Painters and Sculptors C. Represented in Sacramento (Calif.) State Library; "Nocturne" and "California Landscape," Los Angeles Museum of Art; Southwest Museum; "The Lake of Enchantment," Huntington Collection, San Gabriel, Calif.; "California," permanent collection, Los Angeles Public Library; "California Landscape," Lafayette Park Branch, Los Angeles Public Library; "The Blue Hill," Gardena School Coll.; "Seven Poplars," Hollywood High School; "Pacific Coast," Garfield High School, Los Angeles; "Venetian Boats," permanent print department, Public Library, Boston, Mass. Illustrations for "The Bush Aflame." Address in 1929, 101 South Virgil Ave., Los Angeles, Calif. Died 1957.

BARTLETT, ELIZABETH M. P.
Painter and teacher. Member: Society of Independent Artists. Pupil of Comins; Breckenridge; Naum Los in Rome. Address in 1926, 136 Hemenway Street, Boston, Mass.

BARTLETT, FREDERIC CLAY.
Artist. Born at Chicago, June 1, 1873. Educated, Harvard School, St. Paul's School, Concord, NH, Royal Academy Art, Munich, Germany, and studied art in Paris under Collin, Aman-Jean, Whistler, etc. Professionally engaged as artist in mural decorations in Council Chamber of Chicago City Hall. Address in 1926, The Players, 16 Gramercy Park, New York. Died 1953.

BARTLETT, MADELEINE ADELAIDE.
Sculptor, painter, and writer. Born in Woburn, MA. Pupil of Cowles Art School and Henry H. Kitson. Specialty, small bas-reliefs. Exhibited at National Sculpture Society, 1923; portraits at Penna. Academy of the Fine Arts, 1924. Member of CT Academy of Fine Arts. Address in 1953, Boston, Mass.

BARTLETT, PAUL.
Painter. Born Taunton, Mass., July 8, 1881. Pupil of John Sloan. Member: S. Indp. A. Awards: Hon. mention, Chicago SA, 1919. Work: "Landscape," Cincinnati Museum, Cincinnati, O.; "Landscape," Lux-

embourg Museum, Paris, France. Address in 1929, 1965 East 60th St., New York, NY.

BARTLETT, PAUL WAYLAND.
Sculptor and painter. Born New Haven, Conn., 1865. Went to France in childhood. Pupil of Cavelier at Ecole des Beaux Arts, Fremiet at Jardin des Plantes, and Rodin. Represented by statue of General Joseph Warren in Boston, equestrian statue of Lafayette in Louvre, Paris, statue of Columbus in Washington. Elected member of National Academy of Design, 1917; American Academy of Arts & Letters; American Art Association of Paris; etc. Painting "The Pond above the Sea" at Carnegie Institute, 1923; exhibited at National Sculpture Society, 1923. Also in collections of Metropolitan Museum of Art; Hartford State Capitol; Penna. Academy of Fine Arts; and Library of Congress. Received awards at Paris Salon, 1887; Metropolitan Museum of Art; Paris Exposition, 1889; Pan-American Exposition, Buffalo, 1901. Died September 20, 1925. in Paris, France.

BARTLETT, TRUMAN HOWE.
Sculptor and teacher. Born in Dorset, VT, 1835. Pupil of Fremiet in Paris. Work: "Wells," bronze statue, Hartford, Conn.; "Benedict," cemetery monument, Waterbury, Conn.; "Clark," cemetery monument, Hartford, Conn.; many busts and statuettes. Writings: "Life of Dr. William Rimmer," "Physiognomy of Abraham Lincoln." Exhibited at National Academy, 1866-80. Instructor of Modelling, MIT, for many years. He died in 1923.

BARTLETT, WILLIAM F.
Sculptor, painter, and illustrator. Studied: Cooper Union. Member: Society of Animal Artists. Illustrator of 15 childrens' and educational books on nature and science. Prizes: Mrs. John Newington Award, Hudson Valley Art Association. Specialty: Ceramic figures of nature. Media: Painting, oil, watercolor and graphics; sculpture, stone, wood and tin. Address in 1983, White Plains, NY.

BARTOL, E. H. (MISS).
Painter. A disciple of William M. Hunt. Had her studio in Boston.

BARTON, CATHERINE GRAEFF.
Sculptor. Born in Englewood, New Jersey, July 22, 1904. Studied in Cooper Union Art School, NY; Art Students League; and with Archipenko; Despiau, Gimond, in Paris. Member: New Haven Paint and Clay Club; National Association of Women Artists, NY. Awards: Prizes, Fine Arts Commission, Washington, DC, 1930; National Association of Women Artists, 1931. Work: Dwight School for Girls, Englewood, NJ. Exhibited: National Academy of Design, 1926; Architectural League, 1926; Penna. Academy of Fine Art, 1927; National Sculpture Society, 1940-43; New Haven Paint and Clay Club, 1944-46; others. Address in 1962, Hamden, Conn.

BARTON, DONALD B(LAGGE).
Painter. Born Fitchburg, Aug. 23, 1903. Pupil of Michael Jacobs, Philip Hale, A. T. Hibbard, Gifford Beal, Hans Hoffman. Member: NYWCC; North Shore AA; Rockport AA; Gloucester SA. Address in 1929, 61 Fox St., Fitchburg, Mass.; summer, Rockport, Mass.

BARTON, GEORGIE READ.
Sculptor and painter. Born in Summerside, Prince Edward Island, Canada; became a US citizen. Studied at Mount Allison School of Fine Arts, 1924-27; Art Students League, 1929-34, under Frank V. DuMond, Arthur Lee, and Edward McCartan. Exhibited: Exposition Internationale, in France, Monaco, and US, 1967-68; Academy of Artists, Springfield, MA; American Artists Professional League, NY; Hudson Valley Art Association, White Plains, NY. Awards: Bronze medal from the IBM Corp., 1941; gold medal and citation, Hudson Valley Art Association, 1972; American Artists Professional League Award, 1979. Member: Hudson Valley Art Association; Salmagundi Club; fellow of the Royal Society of Arts; fellow of the American Artists Professional League. Art director of Ottawa Ladies College, Ontario, 1934-40; art director at St. Agnes' School in Albany, NY, 1940-44. Address in 1982, Summerside, Prince Edward Island.

BARTON, LOREN ROBERTA.
Painter and Etcher. Born Oxford, Mass. Member of California Art Club. Her dry point of Geo. Arliss as Disraeli, and her study of the Spaniards of California are well known. Address in 1926, 993 South Wilton Place, Los Angeles, Calif.

BARTON, RALPH.
Painter and illustrator. Born Kansas City, MO, 1891. Worked for *Kansas City Star*; moved to New York City in 1910, where he did satirical drawings, caricatures for *Harper's Weekly, Puck, Judge, Liberty, Vanity Fair, The New Yorker*, Anita Loos' *Gentlemen Prefer Blondes* and his own *Science in Rhyme Without Reason* and *God's Country*. Died in 1931.

BARTOO, CATHERINE R.
Born Williamsport, Penna. Pupil of Henri and Mora. Address in 1926, 102 Oak Street, Binghamton, NY.

BARTRAM, ROBERT J.
Sculptor, painter, and illustrator. Studied: Chouinard Art Institute of Los Angeles. Awards: Faculty Award of Merit in Oil Paintings. Member: Society of Animal Artists, National Woodcarvers Association, Society for the Protection of Old Fishes (SPOOF), University of Washington, School of Fisheries. Taught: The New School, Parsons School of Design. Media: Painting, oil, watercolor, acrylic; sculpture, wood. Author and illustrator, *Fishing for Sunfish*. Address in 1983, East 83 Street, New York City.

BASING, CHARLES.
Painter. Born in Australia in 1865. Pupil of Bougereau. Executed museum decorations in Columbia College, New York, and Carnegie Institute, Pittsburgh. Address in 1926, 163 Clymer Street, Brooklyn, NY.

BASKIN, LEONARD.
Sculptor, painter, and graphic artist. Born in New Brunswick, NJ, August 15, 1922. Studied at NYU, 1939-41; apprenticed to sculptor M. Glickman; Yale School of Fine Arts, 1941-43; Tiffany Foundation Fellowship, 1947; New School for Social Research, AB, 1949, DFA, 1966; Academie de la Grande Chaumiere, Paris, 1949; Academia di Belle Arti, Florence, 1950. Illustrated *Auguries of Innocence*, by Wm. Blake, in 1959. In collections of Museum of Modern Art, Metropolitan Museum of Art, Brooklyn Museum, National Gallery in Wash., Fogg Art Museum; others in US and abroad. Exhibited at New School for Social Research, 1967; Sao Paulo, Brazil; Museum of Modern Art, Paris; and others in US and abroad. Received Guggenheim Foundation Fellowship, 1953; medal, American Institute of Graphic Artists, 1965; medal, National Institute of Arts and Letters, 1969; and others. Taught at Smith College, 1953-74. Member: National Institute of Arts and Letters; American Institute of Graphic Artists. Represented by Kennedy Galleries, NYC. Address in 1982, Devon, England.

BASSETT, CHARLES PRESTON.
Sculptor, painter, designer, lithographer, teacher, lecturer, and craftsman. Born in Pittsburgh, PA, June 27, 1903. Studied at Carnegie Institute, BA; and with Wilfred Readio, Joseph Bailey Ellis, Emil Grapin. Member: Association of Art, Pittsburgh; Pittsburgh Water Color Society. Awards: Prizes ($11,000), Westinghouse Electric Co., 1933; Brunswick-Balke Co., 1934; 1st prize, design for public fountain, Pittsburgh, PA, 1938. Exhibited: Association of Art, Pittsburgh; Carnegie Institute, 1938-44; Arts and Crafts Center, Pittsburgh, 1945. Address in 1953, Bethel Boro, Library, PA.

BASSETT, REVEAU MOTT.
Painter. Born 1897. Exhibited at National Academy of Design, New York, 1925. Member: Dallas AA; SSAL. Address in 1926, Dallas, Texas.

BASSETT, W. H.
Engraver. His plates occur in "The Poetical Works of John Trumbull," published in Hartford, Conn., in 1820, the designs by E. Tisdale.

BASSFORD, WALLACE.
Painter and illustrator. Born St. Louis, MO, Jan. 2, 1900. Pupil of Wuerpel, Carpenter, Gleeson, Goetch, George Elmer Browne, and the St. Louis School of FA. Member: Alliance. Address in 1929, Louderman

Bldg.; h. 6 Shaw Pl., St. Louis, MO; summer, Provincetown, Mass.

BASTIAN, LINDA.
Painter. Born in Ayer, Mass., Nov. 7, 1940. Studied at Antioch College, Ohio; Boston Mus. School; NYU, Ph D art educ. Head, dept. of art educ., School of Visual Arts, NYC. Work in collections of Port Authority of NY and NJ; UN Children's Fund, Reader's Digest, and others. Exhibited at SOHO 20 Gallery, Ellen Sragow Gallery, Jane Baum Gallery, others in NYC; Durmont-Landis Gallery, New Brunswick, NJ; and other locations. Member of SOHO 20 Gallery. Works depict flowers; media include oil, watercolor, painting on silk. Living in New York City in 1983.

BATCHELDER, MRS. E. B. L.
See Longman, (Mary) Evelyn Beatrice.

BATCHELLER, FREDERICK S.
Sculptor and painter. Born in 1837. Worked: Providence. Executed marble busts; turned to painting in 1860. Died in Providence, Rhode Island, March 17, 1889.

BATCHELOR, CLARENCE DANIEL.
Illustrator. Member: SI. Address in 1929, 12 West 8th St.; 226 Fifth Ave., New York, NY. Died 1977.

BATE, RUTLEDGE.
Painter. Born 1891. Exhibited portrait at Annual Exhibition of the National Academy of Design, 1925. Address in 1926, Brooklyn, NY.

BATEMAN, CHARLES.
Painter. Born in Minneapolis in 1890. Pupil of Art Students League of New York. Address in 1926, Woodstock, Ulster Co., NY.

BATEMAN, JOHN.
Sculptor. Born Cedarville, NJ, 1887. Studied at Penna. Academy of Fine Arts; also studied in Paris. Pupil of Charles Grafly. Works: One hundred year Anniversary Fountain and Soldier's Memorial Fountain, Doylestown, PA; large group machinery and three historical bas relief panels for Pennsylvania Building, Sesqui-Centennial Exposition, Philadelphia. Address in 1926, Haddonfield, NJ.

BATEMAN, WILLIAM.
Engraver on "stone, steel, silver, and copper." Is known only from his advertisement in the *New York Mercury* for Dec. 1, 1774.

BATES, BERTHA DAY (MRS.).
Painter and illustrator. Born Aug. 20, 1875. Pupil of Howard Pyle. Member: Plastic C. Born in Philadelphia in 1875. Address in 1926, Chestnut Hill, Philadelphia.

BATES, DEWEY.
Painter. Born 1851. Specialized in landscape painting, portraiture, genre. He studied in Paris, under Gerome.

BATES, EARL KENNETH.
Painter. Born 1895. Exhibited oil paintings "The Waning Year" "The Hills of Pennsylvania" in the Penna. Academy of the Fine Arts, Philadelphia, 1921, also 1924; "Experience," Beach Memorial Collection, Conn. State College; "Boundaries," Penn. Academy of the FA. He was born in Haverhill, Mass., in 1895. Pupil of Penna. Academy of Fine Arts. Address in 1926, North 21st Street, Philadelphia; Studio, Hopewell, NJ.

BATES, GLADYS (BERGH).
Painter and illustrator. Born London, England, of American parents, July 19, 1898. Pupil of New York School of Fine and Applied Art; Felicie Waldo Howell; Howard Giles. Member: Alliance; NA Women PS; North Shore AA; Cath. L. Wolfe AC. Died 1944.

BATES, GLADYS EDGERLY.
Sculptor. Born in Hopewell, NJ, July 15, 1896. Studied: Corcoran School of Art, 1910-21; Penna. Academy of Fine Arts, 1916-21; and with Grafly; Cresson European scholarship, 1920. Exhibited: Art Institute of Chicago; Carnegie; National Association of Women Artists; others. Awards: Penna. Academy of Fine Arts, 1931; National Association of Women Artists, 1934; Conn. Academy of Fine Arts, 1933; Art Institute of Chicago, 1935; Pen and Brush Club, 1944; National Association of Women Artists, 1948; others. Collections: Metropolitan Museum of Art; Penna. Academy of Fine Arts. Member: National Sculpture Society; National Association of Women Artists; Pen and Brush Club. Address in 1982, Mystic, CT.

BATES, JOHN EVERTS.
Painter and teacher. Born Brooklyn, NY, Dec. 22, 1891. Pupil of Henry Lee McFee. Address in 1929, Architects Bldg.; h. 1412 Pontiac Rd., Ann Arbor, Mich.

BATHER, GEORGE.
Engraver. Born in England, he came to the United States in 1851. He was employed in book illustrating in New York by J. C. Buttre & Co. His son, George Bather, Jr., was employed by the same firm. Died in Brooklyn in 1890.

BATHER, W. T.
An engraver of portraits in a mixed and rather mechanical manner, working in Chicago in 1897, and residing in Brooklyn, NY. He was probably a son of the engraver George Bather.

BATHURST, CLYDE C.
Sculptor. Born in Mount Union, Penna., 1883. Pupil of Grafly at Penna. Academy of Fine Arts. Address in 1933, Rockport, MA. Died in 1938.

BATTIN (or BATTON, BALLIN), JOHN T.
Sculptor. Born in England c. 1805. Worked: New York City, 1841-45; Philadelphia, from c. 1847. Exhibited: Artists' Fund Society, 1840; National Academy. Died after 1860.

BATTLES, D. BLAKE.
Painter, craftsman, and teacher. Born Wellington, Ohio, Dec. 25, 1887. Pupil of Henry Keller, F. C. Gottwald, Herman Matzen. Member: Cleveland SA. Address in 1929, Art and Color Section, General Motors Corp'n, Detroit, Mich.

BAUER, THEODORE.
Sculptor. Active in New York in 1925. Exhibited at the National Sculpture Society in New York.

BAUER, WILLIAM.
Painter, illustrator and craftsman. Born in St. Louis, MO, on June 13, 1888. Awarded 1921 prize for landscapes. Represented in Kansas City Art Inst. Address in 1926, 709 Pine Street, St. Louis, MO.

BAUGHMAN, MARY BARNEY.
Sculptor. Born in Richmond, VA. Pupil of Colarossi Academy. Address in 1926, Richmond, Virginia.

BAULCH, A. V.
Engraver. Did some excellent line engraving for the Appletons of New York in 1869 after designs by F. O. C. Darley.

BAUM, WALTER EMERSON.
Painter and illustrator. Born in Penna., Dec. 14, 1884. Pupil of the Penna. Academy of Fine Arts and of T. Trego. Exhibited at the PAFA, 1924. Address in 1926, Sellersville, Bucks County, PA. Died July 12, 1956 in PA.

BAUMANN, GUSTAVE.
Woodcarver, figure and landscape painter, woodblock printmaker, and writer. Born in Magdeburg, Germany, 1881; came to US (Chicago) in 1891. Studied drawing and printmaking at the Kunstgewerbe Schule in Munich; Art Institute of Chicago. Awarded gold medal for engraving at San Francisco in 1915. Settled in Santa Fe in 1918, one of the colony's founders. From 1931, carved small figures for Marionette Theater. Author, illustrator, *Frijoles Canyon Pictographs*. Work in Metropolitan Museum of Art; NY Public Library; Art Institute of Chicago; Museum of New Mexico; Boston Museum of Fine Arts; National Gallery of Art; National Gallery of Canada. Died in Santa Fe, New Mexico, 1971.

BAUMBER, JULIUS H.
Portrait painter. Born in Germany in 1848, he came to America in 1869, and died in Chicago in 1917.

BAUR, THEODORE.
Sculptor and decorator. Born in Wuerttemberg, Germany, 1835; in NY, 1894, Germany, 1902. Work includes sculptured ornament, Parliament Houses, Ottawa, Canada, and on NYC mansions; bronze head after the Indian Sitting Bull; "Head of Indian Chief," cast by Bonnard Bronze Co., NYC. Represented in Denver Art Museum. Member: Fellowcraft Club, NY, 1894. (Havlice gives death date of 1894.)

BAUS, S(IMON) (PAUL).
Painter. Born in Indianapolis, Sept. 4, 1882. Pupil of Adams, Forsyth and Stark. Member: Ind. SS; Hoosier Salon. Awards: First Wanamaker prize, Philadelphia, 1909; Holcomb prize ($100), Indianapolis Art Assoc., 1919; Indianapolis Art Assn. prize, 1921; hon. mention in portraiture, Chicago Exhibition of American Painters and Sculptors, 1923; Foulke prize, Richmond, Ind. Art Association, 1924; Studebaker prize for portraiture, Hoosier Salon, Chicago, 1925; Muncie AL prize, Hoosier Salon, Chicago, 1926; Griffiths prize, Hoosier Salon, Chicago 1927; Kittle portrait prize, Hoosier Salon, Chicago, 1928. Represented in John Herron Art Inst. and the Richmond Art Gallery, Richmond, Ind. Address in 1929, 47 Union Trust Bldg., 116 East Market St.; h. 26 de Qunicy St., Indianapolis, Ind.

BAUSMAN, MARIAN D.
See Walker, Marian D. Bausman.

BAXTER, BERTHA E.
Painter. Exhibited oil paintings "Evening Tide" and "Sails Drying" at the Penna. Academy of Fine Arts, 1921, Philadelphia, and "Down by the Sea" at National Academy, NY, 1925. Address in 1926, Gramercy Park, New York City.

BAXTER, ELIJAH, JR.
Painter. Born in Hyannis, Mass., Sept. 1, 1849. Studied in the Antwerp Academy from 1871-73, after that his studio was in Providence, RI. Painted landscapes with figures, and occasional fruit and flower pieces. He exhibited at the Boston Art Club and the Academy of Design in New York. Address in 1929, "The Rocks," Ocean Ave.; h. Ocean Ave., Newport, RI.

BAXTER, MARTHA WHEELER.
Sculptor and miniature painter. Born at Castleton, VT, in 1869. Studied at Penna. Academy of Fine Arts and Art Students League of NY, under Mowbray, Cox, Beckwith, and DuMond; also studied miniature painting under Mme. de Billemont-Chardon, and Mlle. Schmitt in Paris, and Mme. Behenna in Lon-

don; others. Represented by "The Girl in Red," at Penna. Academy Fine Arts in 1924; "Lieut. L. E. Bray, USN," National Gallery, Wash., DC; "Girl with Black Hat," Museum of History, Science and Art, Los Angeles, CA; "Late and Fifth Earl of Chichester," Staumer Park Collection, England; Frick Collection, NYC. Exhibited at Penna. Academy of Fine Arts; Golden Gate Expo., San Francisco, 1939; Los Angeles Museum of Art; others. Received honorable mention at the Paris Exhibition of 1900; and many others. Address in 1953, Hollywood, CA. Died in 1955.

BAYARD, CLIFFORD ADAMS.
Painter and etcher. Member of the Associated Artists of Pittsburgh. Curator of Exhibitions, Carnegie Inst., 1921-1922. He exhibited "The Road to Ripples," at the Carnegie Institute, Pittsburgh, PA. Address in 1929, 433 Thirtieth Ave., McKeesport, Penna.

BAYARD, ELEANOR.
Painter. Member: NA Women PS. Address in 1929, 44 Morningside Drive; 411 West 114th St., New York, NY.

BAYHA, EDWIN F.
Illustrator. Member: Fellowship PAFA. Address in 1929, Glenside, PA.

BAYLINSON, A. S.
Painter. Born in Moscow, Russia, Jan. 6, 1882. Pupil of Robert Henri. Member of Society of Independent Artists. Represented in Newark Museum and Public Library and New York Univ. Address in 1926, 1947 Broadway, New York. Died 1950.

BAYLISS, LILLIAN.
Miniature painter.

BAYLOR, EDNA ELLIS.
(Mrs. Armistead K. Baylor). Painter. Born Hartford, Conn., May 9, 1882. Pupil of Boston Art Museum, Frank Benson, Edmund Tarbell, Ross Turner, Henry Rice. Member: NAC; North Shore AA; Springfield AL; Nat'l. Lg. Amer. Pen Women; Amer. Artists Prof. Lg; Copley S. Award: First hon. mention, Nat'l. Lg. Amer. Pen Women, New York, 1929. Address in 1929, 15 Park Ave., New York, NY; summer, Ipswich, Mass.

BAYLOS, ZELMA.
Sculptor, painter, lithographer, and writer. Born in Butka, Hungary. Pupil of National Academy of Design; C. Y. Turner; Courtois; Prinet; Girardot in Paris; Will Low. Painted portrait of General Geo. R. Doyer; "Spirit of Democracy" owned by the American Red Cross; "Reflections after Sunset," Standish Hall, NY; and others. Member: American Artists Professional League. Address in 1933, Lake Mahopac, NY. Died c. 1947.

BAYMAN, LEO.
Sculptor. Exhibited a portrait at the Penna. Academy of Fine Arts, Philadelphia, 1920. Address in 1926, 10 East 14th Street, New York.

BEACH, CHESTER.
Sculptor. Born San Francisco, CA, May 23, 1881. Pupil of Verlet and Roland in Paris; studied in Rome. Member: National Academy of Design, 1924; American Academy of Arts & Letters; New York Architectural League; National Sculpture Society; American Numismatic Society; National Arts Club; New Society of Art; American Federation of Arts. Exhibited at National Sculpture Society, 1923. Awards: Gold medal, Julian Academy, 1905; Barnett prize, National Academy of Design, 1907; silver medal, P.-P. Exposition, San Francisco, 1915; 1st prize, National Arts Club, 1923; gold medal, New York Architectural League, 1924; Potter Palmer gold medal ($1,000), Art Institute of Chicago, 1925; gold medal and prize, National Arts Club, 1926; Watrous gold medal, National Academy of Design, 1926. Works: Three large groups on the Main Tower, Court of Abundance, P.-P. Exposition; "The Sacred Fire," Academy of Arts & Letters; marble reredos, St. Mark's Church, NY; "Cloud Forms," Brooklyn Museum; marble portrait head, Art Institute of Chicago; "Dawn," Cleveland Art Museum; "Beyond," California Palace of the Legion of Honor, San Francisco; "Spirit of the Barnard Greek Games," Barnard College; "Fountain of the Waters and Signs of Zodiac," terrace, Gallery of Fine Arts, Cleveland, OH; "Surf," Newark Art Museum; bronze, "Service," with marble figures in relief, Messages of Peace and War, American Telephone and Telegraph Building, NY; portraits of Peter Cooper, Asa Gray, Eli Whitney, S.F.B. Morse, Hall of Fame, NY; Henry Fairfield Osborn, American Museum of Natural History, NY; Augustus Juilliard, Juilliard Musical Foundation, NY; Adolph Lewisohn, Lewisohn Stadium, NY; US Coins, Monroe-Adams half dollar, Lexington-Concord half dollar, Hawaiian dollar. Address in 1953, 207 East 17th St., New York, NY. Died in 1956.

BEACHAM, NOBLE F.
Painter. Exhibited water color at the Penna. Academy of the Fine Arts, Philadelphia, 1925. Address in 1926, Lansdowne, Penna.

BEACHAM, OLIVER C(ONLEY).
Painter and etcher. Born Xenia, Ohio, Oct. 4, 1862. Member: Dayton SE; Dayton Fine AG; Am. APL. Address in 1929, 215 Oakwood Ave., Dayton, Ohio.

BEAL, GIFFORD.
Painter. Born in New York City, 1879. Pupil of William Chase, Du Mond, and Ranger. Elected Associate Member of National Academy 1908, and Academician 1914. Represented at Metropolitan

Museum by "Mayfair" and "The Albany Boat;" at Chicago Institute by "A Puff of Smoke." Also at Syracuse Museum and San Francisco Art Institute. Address in 1926, 230 West 59th Street, New York. Died Feb. 5, 1956 in New York City.

BEAL, REYNOLDS.
Painter. Born in New York City, Oct. 11, 1867. Pupil of William Chase, and studied in Europe, especially at Madrid. Elected Associate Member of National Academy, 1909; also member of New York Water Color Club. Address in 1929, 80 Middle Street, Gloucester, MA. Died 1951.

BEALES, ISAAC B.
Painter. Born Great Yarmouth, England, 1866. Pupil of E. J. Poynter, Woodhouse Stubbs. Address in 1926, 356 Harrison Ave., Hasbrouck Heights, NJ.

BEALS, GERTRUDE.
See Bourne, Gertrude Beals.

BEAMES, STEPHEN.
Sculptor and teacher. Born Multan, India, March 3, 1896. Pupil of Boston School of Fine Arts and Crafts; Albin Polasek; Beaux-Arts Institute of Design in New York. Work: War Memorial, Evanston, Ill.; sculpture for Chicago Theological Seminary. Instructor: Rockford College, Rockford, Ill. Address in 1933, Evanston, IL.

BEAN, CAROLINA VAN HOOK.
(Mrs. Algernon H. Binyon). Painter, writer, and teacher. Born Washington, DC. Pupil of Harry Thompson, Paris; Chase, New York; John Sargent, London. Member: National Academy of Women Painters and Sculptors. Address in 1926, 3012 O Street, Washington, DC.

BEARD, ADELIA BELLE.
Artist. Born Painesville, Ohio. Went to New York; studied drawing at Cooper Union and Art Students' League; portrait painting with Wyatt Eaton and William Chase. Taught classes in drawing and painting; exhibited at National Academy Design; illustrated books and magazines. Died Feb. 16, 1920 in Flushing, NY.

BEARD, DANIEL CARTER.
("Dan Beard"). Painter and illustrator. Born Cincinnati, OH, June 21, 1850; son of James Henry Beard, NA. Pupil of Sartain and Beckwith at ASL of NY. Member: SI; Ind. SS; ASL (hon.). Specialty, animals and illustrating books on outdoor life; cartoonist, historial Americana. Illustrated for *Cosmopolitan, Harpers, Century, Scribners, Life, Puck, Judge* and works of Mark Twain. Address in 1929, Suffern, NY. Died 1941.

BEARD, FRANK.
Born in Cincinnati, OH, in 1842, the third son of the artist James Henry Beard was a special artist for Harper & Bros. during the Civil War. He was for a time Professor of Fine Arts in Syracuse University. Died Sept. 28, 1905 in Chicago, IL.

BEARD, GEORGE.
Miniature painter. Flourished 1840, Cincinnati, Ohio.

BEARD, HENRY.
The second son of the artist James Henry Beard. He painted genre subjects in oil and water colors and made designs for many of Prang's publications.

BEARD, JAMES HENRY.
Painter. Born in 1812 in Buffalo, New York; died at Flushing, LI. He lived in Cincinnati during the earlier part of his life at a time when he devoted himself almost exclusively to portrait painting. He is known to have made portraits of Henry Clay, and Presidents John Q. Adams, Taylor, and Wm. H. Harrison. He came to New York in 1846 and was one of the originators and charter members of the Century Club. In his later years he devoted his time chiefly to animal painting. In 1872 he was elected a full member of the New York School of Design.

BEARD, LINA.
Illustrator. Born Cincinnati, Ohio. Sister of Daniel C. Beard. Pupil of Cooper Union and ASL of NY. Author and illustrator, with her sister Adelia, of "Little Folks Handy Book," etc. Address in 1929, Flushing, NY.

BEARD, WILLIAM HOLBROOK.
Painter. Born in Painesville, Ohio, April 13, 1824. Began his career as a traveling portrait painter after some instruction from his elder brother, James H. Studio in Buffalo, NY, 1850. Went to Europe in 1857. Studied and painted in Dusseldorf, Switzerland, Italy and France. Settled in New York City, 1860. National Academy 1862. Represented at Chicago Art Institute by "The Bear's Temperance Question." Died Feb. 20, 1900 in New York City.

BEATTY, HETTY BURLINGAME.
Sculptor, designer, illustrator, craftsman, and writer. Born in Canaan, Conn., October 8, 1906. Studied at Boston Museum of Fine Art School, and with Charles Grafly, Albert Laessle, George Demetrios. Work: US Post Office, Farmington, ME. Exhibited: Penna. Academy of Fine Arts, 1931-37; Art Institute of Chicago, 1935-37; Macbeth Gallery, 1934; Worcester Museum of Art, 1941 (one-man); Gloucester Festival of Art, 1952. Author and illustrator, "Topay," 1946; "Little Wild Horse," 1948; "Little Owl Indian," 1951; "Bronto," 1952. Address in 1953, Rockport, MA.

BEATTY, JOHN WESLEY.
Painter and etcher. Born Pittsburgh, PA, 1851.
Pupil of Royal Bavarian Academy, Munich. Has
been represented at several exhibitions. Member of
jury on painting, Columbian Exp., Chicago, 1893;
National Advisory Board, Paris Exp., 1900; Fine
Arts Committee, Pan-American Exp., Buffalo,1901;
National Advisory Committee, St. Louis Exp., 1904;
International Jury of Awards, Panama-Pacific In-
ternational Exp., San Francisco, 1915. Member:
Pittsburgh Art Society; Pittsburgh Photographers'
Society; Royal Society of Arts, London. Director,
Department of Fine Arts, Carnegie Institute, Pitts-
burgh. Represented by "Plymouth Hills," at Na-
tional Gallery, Washington, DC. Address in 1926,
Richland Lane, Pittsburgh, PA. Died Sept. 29, 1924
in Clifton Springs, NY.

BEAU, JOHN ANTHONY.
Engraver and chaser. He was a drawing teacher and
a silver-plate engraver and advertised in the *New
York Journal* for Dec. 13, 1770.

BEAUCHAMP, ROBERT.
Painter. Born Nov. 19, 1923, in Denver, Colo. Study:
Colo. Springs Fine Arts Center and Univ. of Denver;
Hans Hofmann School of Fine Arts; BFA from
Cranbrook in Michigan. Taught at Brooklyn College
and School of Vis. Arts. Work: Carnegie Inst.;
Denver Art Museum; Whitney; Met. Mus. of Art;
private collections. Exhib.: Tanager, Green, Hansa,
March Galleries, NYC; MOMA; Whitney; Carnegie
Inst.; AIC; others. Awards: Fulbright, 1959; Guggen-
heim Fellowship, 1974. Address in 1982, c/o Knowl-
ton, New York City.

BEAULEY, WILLIAM JEAN.
Painter. Born Joliet, Ill., Sept. 15, 1874. Pupil of
Henri and Maratta in New York; Yvon in Paris.
Member: New York Arch. League; Philadelphia Art
Club; Art Fund Society. Award: Arch. League prize
awarded 1912. Represented in Vanderpoel AA Col-
lection, Chicago. Address in 1929, 16 Gramercy
Park, New York.

BEAUMONT, ARTHUR.
Painter. Born Bradford, Eng., April 7, 1879. Pupil of
Bouguereau in Paris; Olsson in London. Member:
Society of Independent Artists, United Scenic Art-
ists' Association. Award: Gold medal, Julien Acad-
emy, Paris, 1905. Address in 1926, 112 Rhine Ave.,
Stapleton, NY. Died 1956.

BEAUMONT, HENRIETTA (E.).
Painter and teacher. Born York, England, Feb. 19,
1881. Pupil of H. Locke in England; A. J. Bagdanove
in New York. Member: NA Women PS. Address in
1929, 112 Rhine Ave., Stapleton, SI, NY.

BEAUMONT, LILIAN A(DELE).
Painter. Born Jamaica Plain, Mass. Pupil of School
of Boston Museum of Fine Arts under Benson,
Tarbell and Philip Hale. Member Copley Society.
Died 1922. Address in 1926, 23 Alveston Street,
Jamaica Plain, Boston, Mass.

BEAUX, CECILIA.
Painter and teacher. Born 1863 in Philadelphia.
Pupil of Wm. Sartain, the Julien School and the
Lazar School, Paris. Awarded the Mary Smith Prize,
Penna. Academy Fine Arts, 4 times; gold medal,
Philadelphia Art club; Dodge Prize, National Acad-
emy of Design. Represented at PA Academy Fine
Arts; Toledo Art Museum; Metropolitan Museum,
New York; Brooks Memorial Gallery, Memphis;
John Herron Art Institute, Indianapolis. Exhibited
at Champs de Mars, 1896; National Academy, 1902;
Soc. des Beaux Arts of American Federation of Arts.
Address in 1926, Gloucester, Mass.; (Dec.-May) 132
E. 19th Street, New York, NY. Died 1942.

BEAVER, PEGGY.
Sculptor. Born in Greensboro, North Carolina, in
1931. Studied: University of North Carolina at
Greensboro; University of South Carolina, Columbia.
Awards: South Carolina Craftsmen, 1973; Bigelow
Sanford Award of Merit, Guild of South Carolina
Artists, 1973; Dutch Folk Art Association, 1974.
Collections: Middle Tennessee State University,
Murfreesboro; University of South Carolina; As-
sociated Distributing Company, Columbia, South
Carolina.

BEBIE, W.
Portrait and landscape painter who flourished about
1845. His work is not well known; an excellent
portrait-group of a lady and her two daughters is in
the Gallery of the Minneapolis Institute of Arts.

BECHDOLT, JACK.
Painter. Exhibited water color at Annual Exhibition
of Penna. Academy, 1922. Address in 1926, 404 West
20th Street, New York City, NY.

BECHER, ARTHUR E.
Painter, pupil of Louis Mayer and Howard Pyle.
Born in Germany, 1877. Address in 1926, Hopewell
Junction, NY.

BECK, CAROL H.
Portrait painter. Born in Philadelphia, PA, in 1859.
She was a pupil of Penna. Academy of Fine Arts; also
studied in Dresden and Paris. Among her best
known portraits are "Governor Patterson" for the
State Capitol, and her brother, "Hon James M.
Beck." Died Oct. 15, 1908, in Philadelphia.

BECK, GEORGE.
An American landscape painter. Born in 1748 or
1750 in England and died in 1812 in Kentucky. He

was the first painter who worked beyond the Alleghenies.

BECK, J. AUGUSTUS.
Sculptor and painter. Born in 1831 in Lititz, PA. Student of H. Powers and Thomas Crawford in Italy. The Penna. Historical Society has several copies of portraits that were made by this artist from original pictures. Independence Hall also has several copies by this artist. Died c. 1915.

BECK, MINNA McLEOD.
Painter. Born in Atlanta, GA, 1878. Pupil of Arthur Dow in New York. Head of Art Dept., Alabama College, Montevallo, Alabama. Address in 1926, 121 Chestnut Street, Harrisburg, Penna.

BECK, RAPHAEL.
Sculptor, painter, and illustrator. Studied at Julien Academy in Paris. Address in 1926, 78 Delaware Avenue, Buffalo, New York.

BECK, ROSEMARIE.
(Rosemarie Beck Phelps). Painter and educator. Study: Oberlin College; Columbia Univ.; NYU. Work: Whitney Mus. of Am. Art, New York City; Vassar College Art Gallery, Poughkeepsie, NY; SUNY New Paltz; Hirshhorn Collection, Wash., DC; Nebr. Art Mus. Exhib.: PAFA; Nat'l. Inst. Arts and Letters; Whitney Mus. of Am. Art; Art Institute of Chicago; one-man shows at Peridot Gallery and Poindexter Gallery, NYC. Awards: Ingram-Merrill Grant, 1967 and 79. Teaching: Vassar College, 1957-58, 61-62 and 63-64; Middlebury College, 1958-60 and 63; Queens College, from 1968. Media: Oil. Rep.: Ingber Gallery, New York City.

BECK, WALTER.
Sculptor, painter, and etcher. Born in Dayton, OH, March 11, 1864. Pupil of Isaac Broome of Trenton; Munich Academy under Gysis and Loefftz; sculpture under Ruemann. Member: New York Architectural League, 1902; National Arts Club (life); Washington Art Club; American Artists Professional League. Awards: First prize, National competition for mural decorations for the City Hall, Cincinnati, 1897; silver medal, Sesqui-Centennial Exposition, Philadelphia, 1926. Work: "The Life of Christ" (20 pictures) and "Portrait of a Lady," Brooklyn Institute Museum; two paintings illustrating the "Life of Christ," and ten pictures comprising 80 portraits, illustrating the Civil War, National Gallery, Washington, one at Newark Art Association and one in Montclair Museum; "The Way," Phillips Memorial Gallery, Washington, DC. Author: "Self-Development in Drawing as interpreted by the genius of Romano Dazzi and other Children," Putnam's. Address in 1933, Millbrook, NY.

BECKER, FREDERICK.
Painter. Born at Vermillion, SD, March 24, 1888. Pupil of H. Breckenridge and Daniel Garber. His paintings, the "Gray Day" and "After the Shower," are in the Gallery of University of Oklahoma; "Cliffs at Laguna," Oklahoma City Art League; mural decoration, First Christian Church, Oklahoma City. Address in 1926, 511 East 7th Street, New York.

BECKER, HERMAN ALBERT.
Sculptor and craftsman. Born in Essen, Germany, October 7, 1909. Studied at National Academy of Design; Beaux-Arts Institute of Design; Columbia University, with Maldarelli. Member: Palm Beach Art League. Awards: Prizes, National Academy of Design, 1939; Beaux-Arts Institute of Design, 1939-41; Palm Beach Art League, 1946. Exhibited: Palm Beach Art League, 1946. Address in 1953, Miami, FL.

BECKER, MAURICE.
Painter and cartoonist. Born in Russia, 1889. Pupil of Robert Henri and Home Boss. Exhibited drawing at 1913 Armory Show. Address in 1926, Tioga, Tioga County, Penna.

BECKHOFF, HARRY.
Illustrator. Born in Perth Amboy, New Jersey, 1901. He studied art under Harvey Dunn and George Bridgman at the ASL and GCSA. In 1925 he began his career at *Country Gentleman* and has since worked for *Collier's, American, Woman's Home Companion, Reader's Digest*, and others. His illustrations have been published in several books and exhibited at the Grand Central Art Galleries.

BECKINGTON, ALICE.
Painter and teacher. Born St. Louis, July 30, 1868. Studied at Art Students' League, New York; Academie Julien, Paris; and with Charles Lazar, Paris. Has exhibited at Paris Salons, and Paris Expn., 1900, Society of American Artists; honorable mention, Buffalo Expn., 1901; bronze medal, St. Louis Expn., 1904. A founder and president of American Society Miniature Painters. Work: Miniature, "Mrs. Beckington," Met. Museum of Art, NY. Address in 1926, 156 Carnegie Hall, New York. Died 1942.

BECKMAN, JESSIE MARY.
Painter and teacher. Born Upper Sandusky, Ohio. Pupil of Meakin, Satler, Chase, Henri, Webster, Colarossi Academy, Paris. Member: Calif. AC; West Coast AC; MacDowell C. of Allied Arts. Awards: Prizes for portraits, Tri State Fair. Address in 1929, 2401 West Sixth St., Los Angeles, Calif.; summer, Laguna Beach, Calif.

BECKMAN, WILLIAM.
Painter. Born in Minnesota. Studied at Univ. of Minnesota, philos. and anthrop.; graduated from

State Univ. at St. Cloud; graduate work at Univ. of Iowa, completed 1969. Moved to NYC in 1969. Exhibitions at Allan Stone Gallery, NYC; AT&T, Basking Ridge, NJ; Allan Frumkin Gallery, NYC; others. Works are chiefly portraits and landscapes, in oil or pastel. Also makes "trompe l'oeil" boxes. Currently living in New York City.

BECKWITH, ARTHUR.
Painter. Born in London Jan. 24, 1860. Among his paintings, "Sunlight and Shadow" is in Golden Gate Park Museum, and "Foggy Morning on the Coast" in San Francisco Gallery. Address in 1926, 438 Montgomery Block, San Francisco, California. Died 1930.

BECKWITH, HENRY.
Engraver. Born in England. His best work is of animals after paintings by Landseer; he also engraved landscapes after American artists. He was working in New York, 1842-43.

BECKWITH, JAMES CARROLL.
Painter. Born Hannibal, MO, 1852. Pupil of Carolus Duran and Ecole des Beaux Arts in Paris. Honorable mention Paris Exp., 1889; gold medal, Atlanta Exp., 1895; bronze medal, Paris Exp., 1900; gold medal, Charleston Exp., 1902; National Academy, 1894. Member: American Water Color Society; Art Students' League, New York; National Institute Arts and Letters. Specialty, portraits and genre pictures. Represented by "The Blacksmith" at National Museum, Washington, DC. Portrait Mrs. R. H. McCurdy, Academy Exhibition, 1789. Portrait Capt. Jos. Lentilhon, Paris Salon, 1889. His works include "Judith" and the "Falconer" sent to the Paris Exposition of 1878. Died Oct. 24, 1917 in New York City.

BEDFORD, CORNELIA E.
Illustrator and writer. Born New York City, June 17, 1867. Pupil of School of Industrial Art of the Pennsylvania Academy of the Fine Arts, Phila. Author and illustrator of "Views and Interviews in Germany." Dresden correspondent of *New York Herald*, published in Paris. Address in 1929, Girard Trust Co., Philadelphia, PA; Hotel Continental, Dresden A, Germany. Died 1935.

BEDFORD, HENRY EDWARD.
Sculptor, painter, writer, and lithographer. Born Brooklyn, March 3, 1860. Pupil of William Anderson; Heatherly Art School in London. Member: Salmagundi Club. Address in 1926, 2744 Broadway, New York.

BEDNAR, JOHN JAMES.
Sculptor, painter, educator, and designer. Born in Cleveland, Ohio, July 1, 1908. Studied at University of Notre Dame, AB; Art Institute of Chicago, BFA, MFA. Awards: Prize, Hoosier Salon, 1945. Work: Murals, St. Edward's University; Architectural

Society, University Notre Dame. Exhibited: Hoosier Salon, 1941, 1942, 1945. Taught: Instructor, Head of the Department of Art, University Notre Dame, 1943-45. Address in 1953, South Bend, IN.

BEDORE, SIDNEY NELSON.
Sculptor. Born in Stephenson, MI, March 5, 1883. Pupil of Beaux-Arts Institute of Design, New York; Art Institute of Chicago. Work: Theodore Roosevelt monument, Benton Harbor, Michigan; fountain at T. Roosevelt School, Chicago. Address in 1953, Lake Geneva, WI. Died 1955.

BEEBE, DEE.
Painter and teacher. Born New Orleans, LA. Member of National Association of Women Painters and Sculptors. Pupil of Chase, Cox, Snell in New York; Duveneck in Cincinnati. Address in 1926, 18 Gramercy Park, New York.

BEECHER, HILDA.
Painter. Exhibited at National Association of Women Painters and Sculptors, 1924. Address in 1926, 939 Eighth Ave., New York.

BEECHER, LABAN S.
Figurehead carver. Born c. 1805. He worked in Boston, c. 1822-39. In 1834 he was commissioned to carve the Andrew Jackson figurehead for the *Constitution*. Moved to the West, about 1843, settling near Sharon, WI.

BEEK, ALICE D. ENGLEY (MRS.).
Sculptor, painter, writer, and lecturer. Born in Providence, RI, June 17, 1876. Pupil of Sidney Burleigh, RI School of Design; Wheeler Art School; Academie Delecluse, Lazar, L'Hermitte, Puvis de Chavannes, and Edward Ertz in Europe. Member: American Artists Professional League. Awards: Grand prix; 2 croix d'honneur; 2 gold medals and 1 silver medal from Expositions Internationales Francaises; grand prize and gold medal at Seattle Exposition, 1909. Represented in European Galleries. Address in 1933, Tacoma, WA.

BEEKMAN, HENRY RUTGERS.
Painter and etcher. Born in New York City, 1880. Pupil of Hawthorne, Bredin and Lathrop. He exhibited his etching "The Gallery" at the Penna. Academy of Fine Arts, Philadelphia, 1924. Address in 1926, 38 East 76th Street, New York. Died 1938.

BEELER, JOE NEIL.
Sculptor and painter. Born in Joplin, MO, 1931. Studied: Tulsa University; Kansas State, B.F.A.; Art Center School, Los Angeles. Work in Gilcrease; National Cowboy Hall of Fame; Phoenix Art Museum; others. Exhibitions: Gilcrease Museum, oneman, 1960; Trailside Galleries, Scottsdale, AZ; National Cowboy Hall of Fame; Heard Museum;

others. Won Best of Sculpture, Cowboy Artists of America show, also silver medal for sculpture. Co-founder of Cowboy Artists of America, 1965. Specialty: Western American. Address in 1982, Sedona, AZ.

BEEM, PAUL EDWARD.
Sculptor, painter, designer, illustrator, and lithographer. Born in Indianapolis, IN, January 12, 1908. Studied at John Herron Art Institute; Art Institute of Chicago, and with Elmer Taflinger, R. L. Coats. Member: Society Typographic Arts; Art Directors Club; Hoosier Salon; Art Institute of Chicago. Awards: Prizes, Herron Art Institute, 1930-34; Hoosier Salon, 1929-40; Cincinnati Museum Association, 1929; Art Institute of Chicago, 1932, 38. Work: John Herron Art Institute; Univ. North Dakota; Indiana Univ.; mural, Orphan's Home, Indianapolis, IN. Exhibited: Art Institute of Chicago, 1932, 38; John Herron Art Institute, 1929-36; Hoosier Salon, 1929-40; Cincinnati Museum Association, 1932; Dayton Art Inst., 1932; Detroit Inst. of Art, 1933; Carnegie Inst., 1934; Delgado Museum of Art; numerous one-man and group shows in Chicago since 1933. Contributor to art magazines and other publications. Position: Art Director, W. E. Long Co., Chicago, IL. Address in 1953, Chicago, IL.

BEERS, ALEXANDER R.
Painter. Born in Titusville, 1882. Student of Art Institute, Chicago. Address in 1926, Auditorium Theatre, Chicago.

BEERY, ARTHUR O.
Painter. Born in Marion, Ohio, March 4, 1930. Work: Butler Institute of American Art, Youngstown, Ohio; Erie Art Center, Erie, PA; J. M. Katz Collection. Exhibitions: PA Academy of Fine Arts 1968 Annual; Galerie 8, Erie, PA, 2nd Nat'l Watercolor; one-man show, Ruth Sherman Gallery, NYC; Columbus Art League, Columbus, Ohio; Contemp. Am. Art, Paris; etc. Awards: Butler Inst. of American Art; Columbus Ohio Art Fest. Address in 1982, c/o Cernuschi Galleries, NYC.

BEEST, ALBERT VAN.
Born in Holland in 1820. In 1845 he came to New York where he made a reputation as a marine and landscape painter and teacher. He lived mainly in Boston and New York. Among his pupils were William Bradford and R. Swain Gifford. He died in 1860, in NYC.

BEGG, JOHN ALFRED.
Sculptor, painter, and designer. Born in New Smyrna, FL, June 23, 1903. Studied at Columbia University, BS, and with Arthur Wesley Dow, Charles Martin. Member: American Institute of Graphic Arts. Work: Indiana Museum of Modern Art; Addison Gallery of American Art; bronze plaque for Readerscope award, 1945; others. Exhibited: Whit-

ney Museum of American Art, 1945, 50; Brooklyn Museum, 1935, 37; Buchholz Gallery, 1943, 45; Wakefield Gallery, 1942 (one-man); Nierndorf Gallery, 1945; New School for Social Research 1948, 49; Worcester Museum of Art, 1948; American Watercolor Society, 1952. Author, technical book reviews; "Form and Format;" "Two Little Tigers and How They Flew." Position: E. Editor, American Book Co., 1932-37; Director of Design and Production, Oxford University Press, from 1939-68. Lectured on typography and design, NYU, 1950-58. Address in 1970, Hastings-on-Hudson, NY. Died in 1974.

BEHAR, ELY MAXIM.
Painter and illustrator. Born France, Aug. 15, 1890. Exhibited water colors at the Penna. Academy of the Fine Arts, Philadelphia, 1925. Pupil of John F. Carlson and C. W. Hawthorne. Illustrations for newspapers and magazines. Address in 1926, 880 West 181st Street, NY.

BEHNCKE, NILE J(URGEN).
Painter. Born Oshkosh, June 4, 1893. Member: Balt. WCC; Wisc. PS. Director, Oshkosh Public Museum. Address in 1929, 123 Mt. Vernon St., Oshkosh, WI.

BEIN, CHARLES W.
Painter. Born New Orleans, Aug. 1, 1891. Studied in New York. Member: ACC. Address in 1929, 510 Lowerline St., New Orleans, LA.

BELASKI, STEPHEN J.
Born, March 25, 1909. Enrolled in International Correspondence Schools, Scranton, Pennsylvania. Studied at Vesper George School of Art in Boston. Won a school scholarship for free tuition for one year, and later won a foreign scholarship for three months study at Fontainebleau School, France. Studied with Jean Despujols, Andre Strauss and Gaston Balande. Work includes group of murals for foyer, Bellows Falls High School; large mural executed for the American Legion, Bellows Falls; and a number of paintings commissioned by various private individuals. Died in New York City.

BELAUME, J.
Seal engraver. In 1825 this name as "J. Belume Sculpt." appears on a dry-point etching in New Orleans, on a print representing the triumphal arch erected to commemorate the visit of General Lafayette to New Orleans.

BELCHER, HILDA.
Painter and illustrator. Born in Pittsford, Vermont, September 20, 1881. Studied: New York School of Art; and with Chase, Henri, Bellows and Luks. Awards: Strathmore Competition, 1908; New York Watercolor Club, 1909, 1915; American Watercolor Society, 1918; National Academy of Design, 1926, 1931; Pennsylvania Academy of Fine Arts, 1932;

Brown-Bigelow Company, 1925; Philadelphia Watercolor Club, 1935; Middlebury College, 1941. Collections: "Scarlet and Blue," Montclair Museum of Art; "Aunt Jennifer's China," Museum of Fine Arts of Houston; Wood Museum of Art; High Museum of Art; Dumbarton House, Washington, DC; Vassar College; Laurence Museum, Williamstown, Massachusetts; American Unitarian Association Headquarters, Boston, Massachusetts; Pennsylvania Academy of Fine Arts; Newark, New Jersey, Museum of Art; "The Mother," Maryland Institute. Address in 1926, 939 Eighth Ave., NYC. Died April 26, 1963.

BELCHER, MARTHA WOOD.
Painter, etcher, teacher. Born in England, 1844. Pupil of Cooper Institute, New York; Flugen, Lietzenmeyer, and Lindenschmidt in Munich. Member of National Association of Women Painters and Sculptors; New York Water Color Club Association. Address in 1926, Van Dyke Studios, 939 Eighth Ave., New York.

BELINE, GEORGE.
Sculptor, painter, and teacher. Born in Minsk, Russia, July 23, 1887. Studied: National Academy of Design; Julian Academy, Beaux-Arts, Lycee Charlemagne, Ecole Superieure des Places de Vosges, Paris; and with Jean Paul Laurens. Member: Allied Artists of America; Hudson Valley Art Association; American Artists Professional League; Salmagundi Club. Exhibited: National Academy of Design; Penna. Academy of Fine Arts; American Artists Professional League; and others. Address in 1970, 370 Central Park West, NYC; summer, Frenchtown, NJ.

BELKNAP, ZEDEKIAH.
Portrait painter. Born in 1781 in Vermont. Graduated from Dartmouth College 1807, and died in Weathersfield, VT in 1858.

BELL, CLARA LOUISE.
Painter. Born Newton Falls, Ohio, 1886. Pupil of Edith P. Stevenson, Cleveland School of Art, Art Students' League of New York. Award: Penton medal for miniature painting, Cleveland Museum, 1919. Address in 1926, 3226 Euclid Ave., Cleveland, Ohio.

BELL, EDITH (MARION).
Painter and teacher. Born Cushing, IA. Pupil of Charles A. Cumming, George W. Maynard, Francis C. Jones, Ivan G. Olinsky, Richard Miller. Member: Iowa AG. Awards: First prize, annual exhibit of Des Moines Artists, Women's Club, Des Moines, 1916; gold medal, Women's Club, Des Moines, 1925, 1926. Represented in the F. L. Owen Collection, Des Moines, IA. Address in 1929, 317 Physics Bldg.; h. 1338 - 22nd St., Des Moines, IA.

BELL, EDWARD AUGUST.
Painter. Born in New York, Dec. 18, 1862. Pupil of National Academy of Design and Bavarian Royal Academy, Munich. Member of Art Students' League. Elected an Associate Member of the National Academy of Design. Represented in Art Association, Indianapolis; Cincinnati Museum; Smith College. Work: "Ready for a Walk," Art Assn., Indianapolis; "The Statuette," Cincinnati Museum; "The Rose," Smith College, Northampton, MA. Address in 1926, 226 West 59th Street, New York.

BELL, WENONAH.
Painter. Born Trenton, SC. Pupil of PAFA; H. Hofmann of Munich. Member: Fellowship PAFA. Awards: Mary Smith prize, PAFA, 1926; first prize, Georgia-Alabama Artists Exhibition, Nashville, Tenn., 1926. Represented in the Virginia High School, Bristol, VA. Address in 1929, Greenville, GA.

BELLAMY, JOHN HALEY.
Wood carver, amateur poet, and inventor. Born in Kittery Point, ME, April 16, 1836. Studied art in Boston and NYC; apprenticeship as a wood carver in Boston. Worked for the Boston and Portsmouth Navy Yards, also commercial ship carving; did decorative work for public buildings and private homes. Known for his "Bellamy" or "Portsmouth Eagles." Died at Portsmouth, NH, April 5, 1914.

BELLEW, FRANK HENRY TEMPLE.
Born in 1828 in India. Came to US in 1850. Illustrator for Harper Bros., also drew caricatures for the magazines. In 1866 he issued a book on the "Art of Amusing." His son, F. P. W. Bellew ("Chip"), illustrated for *Life*. Died June 29, 1888 in New York City.

BELLOWS, ALBERT F.
Landscape and genre painter. Born in Milford, Mass., 1829. Studied in Paris and Antwerp Royal Academy. Painted in England and Wales. Associate member of National Academy, 1859; National Academy, 1861. "A Village Scene" (New England?), signed A. F. Bellows, 1876. Lent by W. T. Carrington, Art Institute, Chicago. "Forest Life," painted in 1860. Owned by New York Public Library. Died in 1883.

BELLOWS, GEORGE WESLEY.
Painter, lithographer, cartoonist, portrait painter. Born in Columbus, OH, Aug. 12, 1882. Studied in NY School of Art, under Robert Henri. Elected an associate member of National Academy in 1908, and Academician in 1918. Among his works: "Riverfront," "Gramercy Park," "Ringside Seats," "Crucifixion," and many portraits. Represented in Metropolitan Museum, Penna. Academy of Fine Arts and Brooklyn Museum. He was one of the founders of the Soc. of Independent Artists. Died Jan. 8, 1925 in New York City.

BELMONT, IRA JEAN.
Painter. Born in Kaunas, Lithuania, 1885. Studied: Konigsberg, Paris, New York. Collections: Brooklyn Museum; University of Georgia; Tel-Aviv Museum, Israel; Crocker Collection, San Francisco; Musee du Jeu de Plume, Paris; Denver Museum of Art; Heckscher Foundation. Exhibited widely nationally and internationally.

BELSEN, JACOBUS.
Sculptor, painter, and printmaker. Born in Patkino, Russia, in 1870. Studied at St. Petersburg (Leningrad) Academie. Professor at Craftsman School, St. Petersburg; positions at Alexander Lyceum, University for Architects and Engineers, Craft School of Imperial Society for the Benefit of Arts. Created murals for Humanistisches Gymnasium, stained glass windows for Hotel d'Europe, St. Petersburg; other works for churches, public and private buildings; also painted landscape watercolors, created woodcuts representing Russian aristocracy. Fled to Germany in 1917 or 18, arriving in July 1919. In Berlin he worked in metal, blockprint, oils; painted miniatures, designed furniture for architects Friedmann and Weber. Became a sculptor, and created caricatures and political cartoons for newspapers, magazines, some published in Hanfstaengel's *Hitler in the Caricature of the World*. Also published *Russian Winter Pictures, Figures of the Russian Revolution, Illustration of Norwegian and Finnish Tales, Illustrations of Russian Children's Tales*; plus a monogram of his work by F. Paul Schmidt (Ottens, Berlin). In 1924 and 1931, travelled to Holland and the East to sketch. Fled Germany in 1936, arriving in New York City. Commissioned by Metropolitan Opera Co. to paint clouds, water, fire effects on mica for special stage effects. Died September 12, 1937.

BELSKIE, ABRAM.
Sculptor. Born in London, England, Mar. 24, 1907. Studied at Glasgow School of Art, Scotland, with Alexander Proudfoot, Archibald Dawson. Member: Fellow, National Sculpture Society, 1951. Awards: Prize and scholarship, Glasgow, Scotland, 1925-27; prizes, National Sculpture Society, 1951. Work: Brookgreen Gardens, SC; Mariners Museum, Newport News, VA; American Museum of Natural History; Field Museum; Cleveland Health Museum; NY Academy of Medicine. Exhibited: National Academy of Design, 1936, 46. Co-author, "Birth Atlas," 1940. Specializes in medical sculpture, primarily for medical teaching. Position: Sculptor Associate, NY Academy of Medicine, 1939-46. Address in 1953, NY Medical College, Fifth Ave. at 106th St., NYC; h. Closter, NJ.

BELZONS, M.
French miniature painter working in Charleston, SC; was the first instructor of Thomas Sully in 1799, whose sister he married. Dunlap notes "he was a very poor painter." He flourished about 1779 in Charleston, SC.

BEMELMANS, LUDWIG.
Illustrator. Born in Austria, 1898. He studied in Germany until 1914; he then emigrated to the United States where he became a citizen four years later. Besides doing magazine illustrations for *The New Yorker, Vogue* and *Holiday*, he worked extensively in book illustration. As an author and artist he produced the *Madeline* series beginning in 1939. Very popular in the 1930's he illustrated such books as *My War with the United States* and *Life Class*. Died 1962.

BEMENT, ALON.
Painter, photographer and teacher. Born Ashfield, Mass., Aug. 15, 1878. Pupil of Boston Museum School; Bonnat and Constant in Paris; Naas School, Sweden; Ecole Des Beaux Arts, Paris. Prof. of Fine Arts, Teachers Coll., Columbia University, since 1906. Instructor, College of City of New York. Director, Maryland Institute, Baltimore. Address in 1926, 210 West 59th Street, New York, NY, or care of Maryland Institute, Baltimore, MD.

BEMIS.
Painter. Flourished about 1850. The Worcester Art Museum owns a "View in Worcester or Vicinity."

BEMUS, MARY B.
Painter, teacher. Born Leicester, New York, Aug. 17, 1849. Pupil of L. M. Wiles. Address in 1926, 401 S. Hope Street, Los Angeles, Calif.; 2130 Emerson Ave., Santa Barbara, Calif.

BEN-ZION.
Sculptor, painter, and teacher. Born in the Ukraine (Soviet Union), July 7, 1897. Self-taught, painting since 1931. Studied in Vienna. Emigrated to US in 1920, and became a US citizen in 1931. He is one of the founders of the expressionistic group, "The Ten," with whom he exhibited in Paris and NY. Other exhibitions: Advancing American Art, State Department Traveling Show, 1947; Bezalel Museum, Jerusalem, Israel, 1957; a major retrospective at the Jewish Museum in NYC, 1959; Whitney Museum of American Art Review, 1960-61; Collector's Choice, Denver Art Museum, Colorado, 1961; another retrospective in 1975, Museum of Haifa. Taught: Instructor of painting at Ball State Univ., the summer of 1956; also at the University of Iowa, the summer of 1959. Produced a four-volume set of etchings of Biblical themes published by Curt Valentin and printed in Paris, the first two volumes of which appeared in 1952. Address in 1982, 329 West 20th St., NYC.

BENBRIDGE, HENRY.
Portrait painter and miniature artist. Was born in Philadelphia, 1743, and as early as 1758 was painting

pictures. In 1759 he was sent to Italy to study with Battoni and Mengs. On his way to Italy he stopped in London long enough to paint portraits of Dr. Franklin (at Carnegie Institute) and Rev. Thomas Coombs. Benbridge painted many portraits in the South. His work has frequently been attributed to Copley. He lived for years in Charleston, SC, and died in 1812.

BENDA, RICHARD R.
Painter and collage artist. Study: Chic. Acad. Fine Arts, Art Inst. Chic. Work: Illinois Bell Telephone; Borg-Warner, Chicago; Illinois Bar Center; Columbia College, Chicago, Ill.; Immaculate Conception Church, Chicago, Ill.; St. John's Church, Brooklyn, NY; Temple B'rith Sholom, Springfield, Ill.; Rod McKuen, the Episcopal Bishop of Chicago and many private collections. Exhibitions: Knickerbocker Artists, NYC; Arts Club, Chicago; B. Russell Centenary, London; and more. Awards: Annual Knickerbocker Artists Exbn., Grumbacher; Union League Club Exbn., Purchase Award; Nat'l Soc. of Painters in Casein, First Award; Slidell Nat'l Art Exbn., 1st Award. Mem.: Audubon Artists Soc., NYC; Arts Club, Chic. Media: Acrylic, collage. Address in 1982, c/o Verzyl Gallery, Northport, NY.

BENDA, WLADYSLAW T.
Illustrator. Born in Poznan, Poland, in 1873. Studied at Krakow College of Technology and Art; Vienna. Came to New York in 1900; illustrated for magazine, book publishers. Painted East European scenes such as *A Russian Grandmother's Wonder Tales*, Scribner's, 1906. Also worked as a designer, creating the highly decorative Benda Masks worn by actors. Member: Arch. League, 1916; Player's Club, 1905. Mural Painter Award, silver medal, at Panama and Pacific Exposition. Died 1948. Address in 1926, 140 Wadsworth Ave., 1 Gramercy Park, New York, NY.

BENDELL, MARILYN.
Painter and instructor. Born in Grand Ledge, Mich., Sept. 19, 1921. Study: Am. Acad. Art; with Arnold Turtle and Pierre Nuytens. Work: Hadley School for Blind, Winnetka, Ill.; Huntington Mus. Fine Arts, W. VA. Comn.: Portrait, Hellen Keller, Hadley Sch.; and others. Exhibitions: 3-man show, Chicago Galleries; Select Group Oelschlaeger Gal., Sarasota, Fla.; One-man show Florida Fed. of Art, De Bary. Elected member Royal Soc. of Arts, London, England. Awarded First in Portrait for Jeri, Springfield Mus. Fine Arts, 1964, and First in Portrait and Figure, Portrait of a Young Woman, 1970. Media: Oil. Address in 1982, 6832 Pine, Longboat Key, Florida.

BENDER, BEVERLY STERL.
Sculptor and environmental artist. Born in Washington, DC, January 14, 1918. Studied: Knox College, BA, Galesburg, Ill.; Art Students League; Sculpture Center, NYC; Museum of Natural History, NYC. Work: Bell Museum of Natural History, Minnea-

polis; memorial commission, Mystic Seaport, Conn. Exhibitions: National A.F. Club, New York City, 1969-81; Smithsonian; National Academy of Science, Philadelphia; Metropolitan Museum of Art; Society of Animal Artists Museum Tours; others. Awards: Catharine Lorillard Wolfe gold medal, 1969, merit certificate, 1979; Anna Hyatt Huntington cash prize; founders prize and merit award, Pen and Brush Club; Knickerbocker Artists; Society of Animal Artists. Member: Society of Animal Artists; Knickerbocker Artists; Pen and Brush Club; American Artists Professional League; others. Early work, children modeled in miniature; best known for stone animal carvings. Also works in wood. Address in 1983, Pound Ridge, NY.

BENDER, RUSSELL THURSTON.
Illustrator. Born in Chicago, 1895. Pupil of Chicago Academy of Fine Arts. Member: Palette and Chisel Club. Address in 1926, 333 South Dearborn Street; Home, 2717 Jackson Blvd., Chicago, Ill.

BENEDICT, J. B.
Painter. Exhibited water color landscape at Annual Exhibition, Penna. Academy of Fine Arts, 1922. Address in 1926, 1669 Broadway, Denver, Colorado.

BENEDUCE, ANTIMO.
Painter. Born Italy, March 28, 1900. Pupil of Cleveland School of Art. Exhibited water colors in annual exhibition of Water Colors, Penna. Academy of Fine Arts, Philadelphia, 1925. Address in 1926, 1959 East 73d Street, Cleveland, Ohio.

BENEKER, GERRIT A.
Painter and illustrator. Born Grand Rapids, Mich., Jan. 26, 1882. Pupil of John Vanderpoel and Frederick Richardson in Chicago; F. V. Du Mond, Henry Reuterdahl in New York; Charles W. Hawthorne in Provincetown. Member: Provincetown Art Association; Cleveland Art Students' Association. Award: New York Herald Easter prize, 1905; Scarab Club 3d prize, Detroit, 1916; Penton medal for industrial painting, Cleveland Museum, 1919. Represented in permanent collection of Provincetown Art Association, and Grand Rapids Central High School; Youngstown Museum of Art. Author of Victory Liberty Loan Poster, "Sure, We'll Finish the Job." Address in 1926, Provincetown, Mass.

BENGELSDORF, ROSALIND.
Painter. Born April 30, 1916, in New York City. Studied at the Art Students' League with Anne Goldthwaite, George Bridgman, John Steuart Curry and Raphael Soyer; Arnot School of Art; New York School on 57th St. with Hans Hofmann. Employed as art teacher by the WPA Fed. Art Proj. in 1935-36. Married avant-garde painter George Byron Browne. Changed her emphasis to art critic and columnist in 1947. Ed. Assn. for *Art News* until 1972. She lives in New York City.

BENGLIS, LYNDA.
Sculptor and painter. Born in Lake Charles, Louisiana, October 25, 1941. Studied: Newcomb College; Tulane University with Ida Kohlmeyer, Pat Travigno, Zolton Buki; and Harold Carney. Awards: Yale-Norfolk fellowship in 1963 and Max Beckman scholarship, Brooklyn Museum, in 1965; and National Endowment for the Arts grant. Exhibited: Milwaukee Art Center; Mass. Institute of Technology; Art Institute of Chicago; Whitney; Guggenheim; and many more. Work: Guggenheim; Museum of Modern Art, NYC; Walker; others. Address in 1980, Paula Cooper Gallery, 155 Wooster St., NYC.

BENGOUGH, WILLIAM.
Painter and illustrator. Born Whitby, Ontario, Canada, Oct. 14, 1863. Pupil of Ontario Society of Artists, Toronto; ASL of NY. Member: NAC. Work: Figure illustrations for *Harper's*, *Longon Graphic* and *Collier's*; portrait painting and drawings for *Cyclopaedia of American Biography*. Address in 1929, Kiamesha, NY.

BENJAMIN, LUCILE JULLIN.
Painter. Born at Genesco, Ill., in 1876. Pupil of John Vanderpoel and Art Institute of Chicago. She painted under the name of Lucile Joullin. She died in San Francisco, Calif., on June 5, 1924. Represented by the "Algerian Slave," in the Bohemian Club, San Francisco, Calif.

BENJAMIN, SAMUEL GREENE WHELLER.
Marine painter. Born in Argos, Greece, Feb. 13, 1837. Graduated from Williams College in 1859, became a member of Boston Art Club, which owns his painting "Daybreak off the Corbiere." He died in Burlington, VT, in 1914.

BENN, BEN.
Painter. Born in Russia, Dec. 27, 1884. Pupil at National Academy of Design. His portrait of Judge J. Planken is in the Municipal Court House, New York; "Still Life," Kroeller Collection, The Hague, Holland. Address in 1926, 244 East 23d Street, New York. Died 1983.

BENNERS, ETHEL ELLIS DE TURCK.
Painter. Pupil of Wm. F. Chase, Cecilia Beaux. Member: PAFA, Phila. Alliance, NA Women PS, College Art Assoc.

BENNETT, BELLE.
Sculptor. Born in New York City in 1900. She studied under Solon Borglum, and at the School of American Sculpture. Address in 1926, 152 East 63d Street, New York.

BENNETT, EMMA DUNBAR.
(Mrs. Harrison Bennett). Sculptor. Born in New Bedford, Mass. Pupil of British Academy in Rome. Member: Copley Society of Boston; MacDowell Club, NY; Lyceum Club of Paris. Address in 1933, Paris, France.

BENNETT, EMMA-SUTTON (CARTER).
Painter, illustrator and etcher. Born Aug. 26, 1902, in Albany, GA. Pupil of Hayley Lever; ASL of NY. Member: ASL of NY; Three Arts C; Salons of America. Specialty, drypoints, etchings and book covers for magazines. Address in 1929, 613 Jackson St., Albany, GA.

BENNETT, FRANCIS I.
Painter. Born in Philadelphia, March 8, 1876. Pupil of Anshutz, Chase, and Henri. Address in 1926, 72 Whitford Ave., Nutley, NJ.

BENNETT, FRANKLIN.
Painter and etcher. Born Greenport, Jan. 5, 1908. Pupil of ASL of NY. Member: NAC; New Rochelle AA; Amer. Artists Prof. Lg. Award: Mortimer L. Schiff purchase prize ($100), NAC, 1928. Work: "Maine Woods," National Arts Club, New York. Address in 1929, care of The Holt Gallery, 630 Lexington Ave., New York, NY; summer, Greenport, LI, NY.

BENNETT, HARRY R.
Illustrator. Born in Lewisboro, New York. He studied at the AIC and American Academy of Art. His first illustration appeared in *Woman's Day* in 1950, but most of his work since then has been for book publishers, as demonstrated by the 982 paperback covers he has illustrated over the last 20 years. His works have been shown at the NYPL, the New York Historical Society and several Annual Exhibitions of the S of I.

BENNETT, PHILOMENE.
Painter and editor. Born in Lincoln, Nebraska, Jan. 2, 1935. Studied: University of Nebraska. Awards: Mid-American Exhibition, Nelson Gallery, Kansas City, Missouri, 1956 and 1962. Collections: Hallmark Collection, Kansas City; Missouri Historical Society, Columbia, Missouri; University of Nebraska, Lincoln. Media: Oil and acrylic. Address in 1980, 616 Central St., Kansas City, MO.

BENNETT, REGINALD (OSBORN).
Painter and teacher. Born Devils Lake, ND, Feb. 20, 1893. Pupil of J. P. Wicker; J. Despujols; Othon Friesz. Member: Scarab Club. Address in 1929, Scarab Club, 217 Farnsworth; h. 645 Merrick, Detroit, Mich.

BENNETT, RICHARD.
Wood Engraver. Born Ireland, July 22, 1899. Pupil of Walter Isaacs, Ambrose Patterson. Illustrations for *N.Y. Times Magazine*, *Bookman*, *Theatre Arts Monthly*, *Forum*, *Survey* and *Graphic*. "England and

Ireland - Twelve Woodcuts," published by the University of Washington in 1927; "Winter," "Donkey Stable, Clovelly," "Thomas Hardy's Cottage," Baltimore Museum.

BENNETT, RUTH M.
Painter and craftsman. Born Momence, Ill., Feb. 11, 1899. Pupil of George Bridgman, John Carlson, E. Vysedal, R. Shraeder, Armin Hansen. Member: Calif. AC; Younger Painters C. Awards: Hon. mention, Calif. AC Exh., Los Angeles Museum, 1925; hon. mention, Pomona Fair, 1926; Minnie Tingle prize ($200), Calif. AC, 1926; hon. mention, Fine Arts Gallery of San Diego, 1927. Address in 1929, 5449 Sunset Blvd.; h. 1746 McCadden Pl., Hollywood, Calif.

BENNETT, WILLIAM JAMES.
Born in England, 1789, he died in New York, 1844. He came to that city in 1816 as a landscape painter in water color and an engraver in aquatint. He was elected an associate member of the National Academy of Design in 1827 and an Academician in 1828; for some years he was the curator of the Academy.

BENNEY, ROBERT L.
Painter and illustrator. Born in New York City in 1904. Study: Cooper Union; NAD; Grand Central Art Sch.; ASL; with Harry Wickey, Frank Nankivell, Harry Sternberg, Harvey Dunn. Work: Corcoran Gallery; de Young Museum, Calif.; IBM; Chrysler Coll.; USAF, US Navy, US Army, U.S.M.C.; Mariners Museum, VA; etc. Comn.: Readers Digest; Vietnam combat art, U.S.M.C. Exhibitions: National Gallery, Wash., DC; Metropolitan Museum; Brooklyn Museum; de Young Museum, San Francisco; Corcoran Gallery; Carnegie Institute; and many others. Teaching: Pratt Institute; School of Visual Arts; Dutchess Community College. Awards: Phila. Museum of Art 1st Award; USAF official artist; Certif. of Commendation, USN. Mem.: Soc. Illustrators; Artists Equity Assn.; ASL (life); Artists and Writers Assn.; Appraisers Assn. of Am. Media: Oil, acrylic, tempera, watercolor, etching, aquatint. Address in 1982, 50 West 96 St., New York City.

BENSELL, GEORGE F.
Portrait and genre painter. Born 1837, died in 1879. Flourished 1855-1868, Philadelphia.

BENSON, EDA SPOTH.
Sculptor and painter. Born in Brooklyn, NY, March 25, 1898. Studied: Art Students League; Beaux-Arts Institute of Design, NYC; with Eugene Steinhof, Leon Dabo, and Alexander Hofer. Award: Prizes, Miami State Exposition, 1929; Palm Beach Art League, 1933, 34; Lime Rock Art Association, 1932; first prize for landscape, Florida Federation of Arts, Miami, 1930. Member: Brooklyn Society Artists; Lime Rock Art Association; Kent Art Association;

Palm Beach Art League; and others. Work: Hartford Library; murals, Pine Villa Hotel, West Cornwall, Conn. Exhibited: Library of Congress, 1943-45; American Federation of Arts traveling exhibition, Brooklyn Museum, 1933-46; National Academy of Design, 1942, 43; Albany Institute of History and Art, 1932 (one-man); and others. Address in 1953, West Palm Beach, FL.

BENSON, EUGENE.
Painter and art critic. Born in 1839 in Hyde Park, NY. He was best known for his writing and was considered the best art critic in America. He was most successful in his portraits, elected to the Artists' Fund in 1861. In 1873 Mr. Benson went abroad for study and resided there. Among his works are "Bazaar at Cairo," "Slaves Tower," "Reverie," "Ariadne," and "Strayed Maskers."

BENSON, FRANK WESTON.
Painter and etcher of portraits, interiors, birds and landscapes with figures; also teacher. Born Salem, Massachusetts, March 24, 1862. Pupil of Boston Museum School; Boulanger and Lefebvre, in Paris. Temple Gold Medal, Penna. Academy of the Fine Arts, 1908; Harris Silver Medal, Art Institute of Chicago, 1909; Palmer Medal and Prize, Art Institute of Chicago, 1910; Associate National Academy, 1897; National Academy, 1905; Ten American Painters; National Institute of Arts and Letters. Represented by "My Daughter," in Corcoran Art Gallery and "Still Life Decoration," Art Institute of Chicago. Died in 1951.

BENSON, JOHN HOWARD.
Sculptor, painter, etcher, craftsman, and teacher. Born Newport, RI, July 6, 1901. Pupil of National Academy of Design; Art Students League of New York under Joseph Pennell. Member: Newport Art Association; Art Students League of New York. Work: Sculpture, Cold Spring Harbor, NY; South Natick, Mass.; Portsmouth, NH. Co-author: "The Elements of Lettering," 1940; Author: "Lettering Portfolio," Boston Museum of Fine Arts; and others. Position: Instructor, Lettering, 1931-44, Head of the Department of Sculpture, 1936-46, Rhode Island School of Design. Address in 1953, Newport, Rhode Island.

BENSON, JOHN P.
Painter. Born Salem, Mass., Feb 8., 1865. Member: AFA; Boston GA. Work: Eight murals of the Sea and Sealife, Hall of Ocean Life, New York City; ten murals, Early Ships of New England, Providence Institution For Savings, Providence, RI. Address in 1929, Kittery, ME.

BENSON, LESLIE LANGILLE.
Illustrator. Born at Mahone, NS, March 15, 1885. Pupil of School of Boston Museum of Fine Arts, Erie

Pape School, Fenway School. Member: GFLA. Address in 1926, 602 West 190th Street, New York.

BENSON, STUART.
Sculptor and writer. Born in Detroit, Michigan, January 3, 1877. Studied at University of Michigan; studied art at the Joseph Gies School of Art in Detroit. Exhibited: Salon d'Automne, 1932; Tuileries, 1935; National Academy of Design; Carnegie Institute; Penna. Academy of Fine Arts; World's Fair of New York, 1939; Art Institute of Chicago. Notable work: "The Woman Who Came from Siberia" (bronze), 1938. Member: National Sculpture Society. Editor of *Collier's Magazine* in NYC. Died in 1949 at sea.

BENTLEY, JOHN W.
Painter. Born in Patterson, NJ, Jan. 3, 1880. Pupil of Bridgeman, Du Mond, and Henri. Member: AFA; Salfolo SA, 1921. Address in 1926, Woodstock, Ulster Co., NY.

BENTON, HARRY STACY.
Painter and illustrator. Born Saratoga Springs, NY, Oct. 11, 1877. Pupil of AIC. Member: Salma. C., 1905. Address in 1929, South Norwalk, Conn.

BENTON, SUZANNE E.
Sculptor. Born in NYC, January 21, 1936. Studied: Queens College, NYC, Columbia University; Brooklyn College; Brooklyn Museum of Art School; Silvermine, Conn. Awards: The International Susan B. Anthony Hall of Fame; Grant from the Connecticut Commission on the Arts. Exhibitions: Metal Masks Sculpture for the Performing Arts, Lincoln Center; Touching Ritual, Wadsworth Atheneum; many others in US and abroad. Creates metal masks for narrative theatre; mask rituals examining stories and ancient tales, such as "Sarah and Hagar," from Genesis, and others. Commissions: Sculptured theatre sets, Viveca Lindfors I Am a Woman Theatre Company, 1973; The Sun Queen, bronze and corten steel, Art Park, Lewiston, NY, 1975. Member of Artists Equity; American Crafts Council; others. Address in 1982, Ridgefield, CT.

BENTON, THOMAS HART.
Painter, lithographer, illustrator. Born 1889. Studied at AIC and Academie Julian in Paris. Taught at ASL (1926-35) and at Kansas Art Inst. (1930-41). Exhibited at PAFA. Work: U. of Indiana; Whitney; New School for Soc. Research. Address in 1926, 102 East 29th St., New York City. Died in 1975.

BENTZ, JOHN.
Painter, etcher and teacher. Born Columbus, Ohio. Pupil of Robert Blum; Kenyon Cox; W. M. Chase. Member: ASL of NY; PA S. Min. P.; Am. S. Min. P. Address in 1929, 171 Lakeview Ave., Leonia, NJ.

BENZ, LEE R.
Painter and printmaker. Born in Neponset, Ill. Study: Bradley Univ., BA and MA; Salzburg Col., Austria. Exhib.: Prix de Paris; Bradley Univ.; West Ill. Univ.; Colorprint, USA; Springfield (Ill.) Art Mus. Awards: Printmaking Salon of 50 States Award, NYC, etc. Mem.: Nat'l. Soc. Lit. and Arts; Int'l. Soc. of Artists; etc. Media: Intaglio, collagraph, watercolor. Address in 1982, 1125 Fond Du Lac Dr., East Peoria, Ill.

BENZIGER, AUGUST.
Portrait painter. Born at Einsiedein, Switzerland, 1867. Art Studies, Royal Academy, Vienna, Academie Julien and Ecole des Beaux Arts, Paris. Engaged as portrait painter, 1891; painted portraits of Presidents McKinley, Roosevelt and Taft; of Popes Leo XIII and Benedict XV; President Diaz, Mexico; Sir Stuart Knill, Lord Mayor of London; Leon Bourgeois, Prime Minister of France; Presidents Hauser, Forrer and Deucher, of Switzerland; J. Pierpont Morgan, Robert S. Brookings, St. Louis, Charles F. Brooker, Charles M. Schwab; Cardinals Gibbons, Farley, and O'Connell, and many other notables, United States and abroad. Address in 1926, Villa Gutenberg, Brunnen, Switzerland; 140 W. 57th Street, New York, NY.

BERDANIER, PAUL F.
Painter, etcher, and illustrator. Born Frackville, PA, March 7, 1879. Pupil of Charles Hope Provost in New York; Gustave Wolff and School of Fine Arts in St. Louis; Albert Gihon in Paris. Member: 2x4 Soc.; AL Nassau Co., NY. Awards: 2nd Prize, Thumb Box Exhibition, St. Louis Art League, 1919; 1st Prize, Missouri State Fair, Sedalia, MO, 1920; St. Louis Chamber of Commerce Prize, St. L. AG, 1920; 2nd prize, Missouri State Fair, Sedalia, 1922. Represented in permanent collection of Jefferson Memorial, St. Louis; and by landscape "Sur la Canal a Morte," permanent collection, Art Museum, Moret, France. Designer of historical costumes and stage settings. Address in 1929, 57-86th St., Jackson Heights, NY.

BERDICK, VERONICA.
Painter. Born in Chicago, Illinois, in 1915. Studied: Art Institute of Chicago. Awards: Renaissance Society; Art Institute of Chicago; Northwest Printmakers; Pennsylvania Library of Congress (2 purchase awards); Huntington Hartford Study grant, 1955. Collections: Art Inst. of Chic.; Lib. of Congress; NY Public Lib.; Mus. of Lyon, France; Bibliotheque Nat'le., Paris; Victoria and Albert Mus., London.

BERG, GEORGE LOUIS.
Painter. Born Oct. 27, 1870, McGregor, Iowa. Pupil of Art Students' League, New York. Member: Salmagundi Club; Guild of Seven Arts, Darien, CT; Hinckley Art Gallery; NY Fed. of Women's Clubs.

Address in 1926, Stony Creek, Conn. Died July, 1941 in CA.

BERGE, EDWARD.
Sculptor. Born in Baltimore, MD, 1876. He studied at the Maryland Institute, the Rinehart School of Sculpture, Baltimore, MD; the Academie Julien; under Verlet and Rodin, in Paris. Awards: Bronze medal, Pan-Am. Expo., Buffalo, NY, 1901; bronze medal, and gold medal, Louisiana Purchase Expo., St. Louis, MO, 1904; bronze medal, Santiago Expo., South America, 1910; bronze medal, P.-P. International Expo., San Francisco, CA, 1915; Clark prize, Allied Artists of America, Paris. Member: National Sculpture Society; Charcoal Club; National Arts Club. Work: Watson monument and Tattersall monument, Baltimore; Pieta, St. Patrick's Church, Washington, DC; The Scalp, Museum of Honolulu, HI; Gist mem., Charleston, SC; Latrobe and Armistead monuments, Baltimore; On the Trail, an Indian mem., Clifton Park, Baltimore; memorials, Rev. Wynne Jones, Thomas Hayes, Baltimore; garden and fountain figures; garden figure, Wild Flower, Melbourne, Australia. Exhibited at National Sculpture Society, 1923. Died in Baltimore, MD, October 12, 1924.

BERGER, C(HARLES) F.
Painter. His full-length portrait of President Polk with his hand extended is signed C. F. Berger.

BERGER, MARIE.
Painter and printmaker. Born in Fort Worth, Texas. Study: Texas Christian University; St. Louis School of Fine Art, Washington Univ., Missouri. Exhib.: Bateau Lavar Gallery, Rome; Rassagna permanente d'arte contemporanea, Veterbo, Italy; Oklahoma Art Mus.; Wittie Mus., Texas; Fort Worth Art Mus., Texas; Laguna Gloria, Austin, Texas. Awards: Benedictine Award, NY; Texas Fine Arts Jurors Award. Mem.: Reg'l. dir., Texas Fine Arts Assn.; Texas WC Soc. Media: Oil, acrylic, watercolor; etching, lithograph, collograph. Currently living in Texas.

BERGER, WILLIAM MERRITT.
Illustrator. Born Union Springs, NY, Feb. 14, 1872. Pupil of William M. Chase; George DeForest Brush; Bashet. Work: Illustrations for "Scribner's." Address in 1929, 534 West 147th St., New York, NY.

BERGIER, ARNOLD HENRY.
Sculptor, designer, craftsman, and teacher. Born in Cincinnati, OH, October 22, 1914. Studied at Ohio University; New School for Social Research; and with Joseph Du Be, Robert Gwathmey, Camilo Egas. Member: Artists Equity Association; Sculpture Center. Work: US Navy Combat Art Section; portraits of John Dewey, Toscanini, Admirals Halsey, Nimitz and Turner, James Forrestal and others. Sculpture, in Baltimore Synagogue, 1951. Exhibited: National Academy of Design; Whitney Museum of American Art, 1951; Decatur Museum Naval Historical Foundation, Washington, DC, 1951; Newport Art Association; Honolulu Academy of Art, 1946; Guildhall, East Hampton, LI, 1948; Jewish Museum, 1952. Instructor, Sculpture and ceramics, Lenox Hill Neighborhood Association, NYC. Address in 1953, 447 East 83rd St.; h. 1573 York Ave., NYC.

BERGLUND, HILMA L. G.
Painter. Born Stillwater, Minn., Jan. 23, 1886. Pupil, St. Paul School of Art; Handicraft Guild, Minneapolis. Member: Artists' Society, St. Paul, Minn. Address in 1926, 1860 Feronia Ave., St. Paul, Minn.

BERGMAN, FRANK.
Painter. Born on August 6, 1898. Studied at National Academy, Vienna, for seven years. Exhibited at Kuenstlerhaus, Vienna. Worked with Josef Urban and Willy Pogany, New York. Has exhibited at Architectural League, New York; Chicago Art Institute; Los Angeles Museum; Palace of Legion of Honor, San Francisco; and annual exhibitions of San Francisco Art Association. Work includes mural executed under Public Works of Art Project; murals for San Francisco Board of Education; two well-known steamships (won in local competition); and for a number of buildings in San Francisco, including the Sir Francis Drake Hotel, the San Jose Pacific Loan Associations and a number of other prominent buildings.

BERKAN, OTTO.
Portrait painter. Born in 1834. He lived in Philadelphia for many years, many of his pictures being in the Catholic Cathedral of that city. He died in his studio at Passaic, NJ, on Oct. 3, 1906.

BERKEY, JOHN CONRAD.
Illustrator. Born in Edgley, North Dakota, 1932. His work has included advertising, editorial posters, calendars and book covers. He has been an illustrator for the past 20 years.

BERKMAN-HUNTER, BERNECE.
Painter. Born in Chicago, Illinois. Studied: Art Institute of Chicago; New School for Social Research; Hunter College; Columbia University. Award: Seattle Art Museum, 1946. Collections: Evansville State Hospital; Kelly High School, Chicago; Art Institute of Chicago; Carnegie Institute; Seattle Art Museum; University of Iowa; University of Michigan. Exhibited extensively throughout the United States.

BERKOWITZ, HENRY.
Painter and designer. Born in Brooklyn, NY, Feb. 5, 1933. Study: Brooklyn Mus. Art Sch. with Sidney Simon; Workshop Sch. of Advertising and Ed. Art; NY Sch. Visual Arts. Work: Gutenberg Mus., Ger. Exhibitions: Brooklyn Museum; Lever House; Burr Gallery; Galleries Raymond Duncan, Paris; Art

Fest., Tours, France; many more. Awards: Merit, NY Coliseum; Am. Vet. Soc. for Artists; Palmas de Oro, Int. Art Fest., Pans, etc. Address in 1982, 11701 NW 29th Manor, Sunrise, Fla.

BERMAN, EUGENE.
Painter and designer. Born Nov. 4, 1899, in St. Petersburg, Russia. Studied in Russia, Switzerland, France, Italy, Germany. Awarded Guggenheim Fellowship (1947 and 1949). Designed scenery, costumes for the Met, City Center Opera, Ballet Russe de Monte Carlo, La Scala, and Sadler's Wells Ballet. Work in collections of Met. Mus. of Art; MOMA; Vassar College, Poughkeepsie, NY; Wash. Univ.; Phil. Museum of Art; Smith College; Mus. Fine Arts, Boston; Wadsworth Atheneum, Hartford; Musee d'Art Moderne, Paris; Graphische Sammlung Albertina, Vienna. Died Dec. 15, 1972.

BERMAN, HARRY G.
Painter in oils and water colors. Born Phil., PA, June 1, 1900. Pupil of PAFA. Fellowship Penna. Academy of Fine Arts, 1924. Works: "Late Afternoon Winter, The Waterfall." Address in 1926, North 15th Street, Philadelphia.

BERMAN, SAUL.
Painter. Born Russia, March 18, 1899. Pupil of Charles Hawthorne. Worked in Brooklyn, NY; and Provincetown, Mass.

BERMINGHAM, DAVE.
Sculptor, painter, and illustrator. Born in Plainfield, NJ, 1939. Self-taught. Employed initially in commercial art and illustration. Member: Society of Illustrators; Northern Plains Artist Association (founding member). Specializes in contemporary Western subjects. Represented by Big Horn Gallery, Cody, WY; Art Eclectic, Billings, MT. Address in 1982, Cody, Wyoming.

BERNARD, EDWARD H.
Painter. Born in Belmont, Mass., in 1855; died in 1909. Student of Boston Museum of Fine Arts.

BERNARD, FRANCISCO.
Nothing is known of this artist except that he painted portraits and landscapes of merit in New Orleans at intervals from 1848 until 1867, having a studio in the latter year at 146 Customhouse Street.

BERNAT, MARTHA MILIGAN.
Sculptor. Born in Toledo, Ohio, August 5, 1912. Studied: Cleveland School of Art; Syracuse University; Budapest School of Industrial Art, Hungary, and with Alexander Blazys, Ivan Mestrovic. Member: Liturgical Art Society; Los Angeles Art Association; Council Allied Artists. Awards: Prizes, Cleveland Museum of Art, 1935; Toledo Museum of Art, 1936, 47; Mansfield Fine Arts Guild, 1947, 48;

Rochester Memorial Art Gallery, 1948. Work: Panels, St. Peter's Church, Mansfield, OH; in churches in Hollywood, CA, Pacific Palisades, CA, Norwalk, CA. Exhibited: Cleveland Museum of Art, 1935, 42; Toledo Museum of Art, 1936; Los Angeles Art Association, 1949, 50; Greek Theatre, Los Angeles, 1949, 50; Artists of the Southwest, 1950; Los Angeles Museum of Art, 1950; annual "Madonna" exhibition, Los Angeles, 1949, 50. Address in 1953, Van Nuys, CA.

BERNATH, SANDOR.
Painter. Born in Hungary in 1892. Pupil of National Academy of Design. Member of New York Water Color Club. Address in 1926, 341 West 22d Street, New York.

BERNEKER, LOUIS F(REDERICK).
Painter. Born Clinton, MO. Pupil of St. Louis School of Fine Arts; Laurens in Paris. Member: NYWCC; AWCS; Allied AA; Salma. Club; NAC (life); NYSP. Work: Murals in church of St. Gregory the Great, New York City; Chicago Theatre, Chicago; Public School No. 60, Bronx, NY; Dallas (Tex.) Art Association. Instructor, Mechanics Institute.

BERNEKER, MAUD F(OX).
Painter. Born Memphis, Tenn., April 11, 1882. Pupil of NAD. Member: NA Women PS; Allied AA. Address in 1929, 53 East 59th St., New York, NY; summer, 65 East Main St., East Gloucester, Mass.

BERNEY, THERESA.
Painter and illustrator. Born Baltimore, Dec. 4, 1904. Pupil of Henry A. Roben, C. H. Walther, C. W. Hawthorne. Member: Balto. WCC; MD Inst. Alumni Assoc. Address in 1929, 2400 Linden Ave., Baltimore, MD.

BERNINGHAUS, J. CHARLES.
Painter. Born St. Louis, MO, May 19, 1905. Awards: Hon. mention, St. Louis Artists Guild, 1926; hon. mention, St. Louis Art League, 1925, 1926. Address in 1929, Taos, NM.

BERNINGHAUS, OSCAR E.
Painter, illustrator. Born St. Louis, Oct 2, 1874. Pupil of St. Louis School of Fine Arts. Member: Salma Club and the Taos Students' Association. Awards: Dolph prize, St. Louis, 1907; share of Chicago Fine Arts Bldg. prize; Chamber of Commerce prize. Works: Two lunettes, Jefferson City, MO, State Capitol Bldg.; "Winter in the West," City Art Museum, St. Louis; and in various libraries and schools. Specialty, Western subjects. Address in 1926, Clayton, Missouri. Died April 27, 1952.

BERNSTEIN, GERDA MEYER.
Painter. Born in Hagen, Germany, in 1925. Studied: London, England; Art Institute of Chicago. Awards:

Parke-Bernet Gallery; New Horizon Exhibition, 1975. Exhibitions: Roosevelt University; Old Orchard Art Festival; Springfield Museum, 1975; ARC Gallery, Chicago, Illinois.

BERNSTEIN, THERESA F.
Painter and printmaker. Born in Philadelphia, Pennsylvania. Studied: Philadelphia School of Design; Pennsylvania Academy of Fine Arts; Art Students League. Awards: Philadelphia Plastic Club; French Institute of Art and Science; National Association of Women Artists, 1949, 1951, 1955; Society of American Graphic Artists, 1953; Library of Congress (purchase prize), 1953; North Shore Art Association; American Color Printmakers Society. Collections: Art Institute of Chicago; Library of Congress; Boston Museum; Princeton University; Harvard University; Dayton Art Institute; Whitney Museum of American Art; Bezalel Museum, Jerusalem; Tel-Aviv and Ain Harod Museum, Israel; Metropolitan Museum of Art. Address in 1980, 54 W 74th St., New York, New York.

BERNSTROM, VICTOR.
Wood engraver. Born in Stockholm, Sweden, in 1845. Worked in London on the staff of the *Grafic*; he came to New York and became associated with the Harpers. He joined the Society of American Wood Engravers, and received a medal at the Columbian Exposition, Chicago, in 1893, and at the Pan-American and Buffalo Expositions. Later he devoted his time to landscapes in water colors. He died in Europe on March 13, 1907.

BERRY, CAROLYN.
(Carolyn Berry Becker). Painter and writer. Born in Sweet Springs, Missouri, June 27, 1930. Studied: Christian College for Women, University of Oklahoma; University of Missouri. Awards: University of Missouri, 1950; Yakima, Washington, 1974; Monterey Peninsula Museum of Art, 1974. Collections: Brandeis University; Marist College; Albrecht Gallery, St. Joseph, Missouri; Monterey Peninsula Museum of Art. Address in 1980, 78 Cuesta Vista, Monterey, CA.

BERRY, WILSON REED.
Painter, illustrator, lithographer and teacher. Born Indiana, April 22, 1851. Work: "Dominion Parliament Bldgs. at Ottawa, Canada," owned by King of Gt. Britain. Address in 1929, 216 Fourth St.; h. Island Home, Logansport, Ind.

BERRYMAN, CLIFFORD KENNEDY.
Illustrator and lithographer. Born Versailles, KY, April 2, 1869. Author "Cartoons of 58th House of Representatives;" originator of "Teddy Bear." On staff of Washington *Evening Star* since 1907. Died in 1949. Address in 1926, 1754 Euclid St., NW, Washington, DC. Died Dec. 11, 1949.

BERSON, ADOLPHE.
Painter. Born San Francisco, Calif. Pupil of Lefebvre and Robert-Fleury in Paris. Address in 1926, 1037 Fillmore Street, San Francisco, Calif.

BERT, CHARLES H.
Painter. Born in Milwaukee, Wis., 1873. Pupil of Cincinnati Art Academy, and Art Students' League of New York, also Julien Academy, Paris. Address in 1926, Lyme, Conn.

BERTHELSEN, JOHANN.
Painter. Born in Copenhagen, Denmark, on July 25, 1883. Member: AWCS. Address in 1929, Rodin Studios, 200 W. 57th St., New York, NY.

BERTOIA, HARRY.
Sculptor and graphic artist. Born March 10, 1915, in San Lorenzo, Italy. Came to USA 1930; became a citizen 1946. Studied: School of Arts and Crafts, Detroit; Cranbrook Academy of Art. Work: Albright; Dallas Public Library; Denver Art Museum; MIT; Museum of Modern Art; San Francisco Museum of Art; Utica; Va. Museum of Fine Arts; plus many commissions for corps., banks; Kodak Pavilion, New York World's Fair, 1964; and Phila. Civic Center, 1967. Exhibited: Karl Nierendorf Gallery, NYC, 1940; Staempfli Gallery, NYC; Fairweather-Hardin Gallery, Chicago; Museum of Non-Objective Art, NYC; Smithsonian; Whitney Museum; Museum of Modern Art; Battersea Park, London, International Sculpture Exhibition, 1963. Awards: New York Architectural League, Gold Medal; Graham Foundation Grant ($10,000), 1957. Taught: Cranbrook, 1937-41. Worked in copper and bronze. Living in Barto, Pennsylvania, in 1976. Died in 1978.

BERTSCH, FRED S.
Designer. Born in Michigan in 1879. Pupil of AIC. Member: Palette and Chisel Club. Address in 1926, 15 East Huron Street; h., 1629 Granville Ave., Chicago, Ill.

BERZEVIZY, J(ULIUS).
Painter. Born Hormonna, Hungary, Dec. 14, 1875. Pupil of Conrad Svestka. Member: Rochester AC; Buffalo SA; The Geneseeans. Address in 1929, 356 Maryland St., Buffalo, NY.

BESNER, FRANCES.
Sculptor and designer. Born in NYC, April 15, 1917. Studied at New York School of Fine and Industrial Arts; Parsons School of Design. Awards: Medal, New York School of Fine and Industrial Arts, 1939. Exhibited: New School for Social Research, 1939; ACA Gallery, NYC, 1940; Tribune Art Gallery, 1946. Address in 1953, Bronx, NY.

BESSIRE, DALE P(HILLIP).
Painter. Born Columbus, Ohio, May 14, 1892. Member: Indiana AC; Brown Co. Art Gallery Assn.;

Hoosier S. Patrons Assn. Address in 1929, Nashville, Ind.

BEST, EDWARD S.
Engraver. Born in London in 1826, he came to this country about 1850 and received employment in J. M. Butler's publishing establishment in Philadelphia. His best engraved plate is "Washington at Valley Forge" after the painting by C. Scheussele. Died in 1865.

BETSBERG, ERNESTINE.
Painter. Born in Bloomington, Illinois, in 1909. Studied: Art Institute of Chicago. Awards: Raymond Traveling fellowship; Art Institute of Chicago. Exhibited extensively in the United States, Japan, France and Italy.

BETTIS, CHARLES HUNTER.
Illustrator, designer. Born in Texas in 1891. Pupil of AIC. Member: Palette and Chisel, Chicago Arch., T Square, and Palette Clubs. Address in 1926, 127 North Dearborn Street; Home, 1429 Sherwin Ave., Chicago, Ill.

BETTS, ANNA WHELAN.
Illustrator, painter, teacher. Born in Philadelphia. Pupil of Howard Pyle and of Vonnoh. Member: Philadelphia Water Color Club. Award: Bronze medal, P.-P. Expn. Work: Illustrations in color for *Century*, *Harper's* and other magazines.

BETTS, E. C.
Landscape painter. Born in Hillsdale, Mich., in 1856; he died in Denver, Colo., 1917. His best known painting was "The Valley of the Housatonic."

BETTS, EDWIN D.
Painter. Born in 1847. He was the father of Louis Betts, and several other members of the family are artists. His best known work is an idealized "Birth of Christ." Died Feb., 1915, in Chicago, IL.

BETTS, LOUIS.
Portrait painter. Born in Little Rock, Ark., 1873. Pupil of his father, E. D. Betts, Sr., Wm. Chase; AIC. Member: Academy of National Arts, 1912; National Academy, 1915. Works: "William M. R. French" and "Apple Blossoms," Art Institute of Chicago. Died in 1961. Address in 1926, 19th St., New York.

BEVERIDGE, KUHNE.
Sculptor. She was born in Springfield, Ill., 1877. Pupil of William Rudolph O'Donovan, New York; Rodin, Paris. Exhibited at National Academy of New York; Royal Academy London; Salon Champs de Mars, Paris; Paris Exposition, 1900. Honorable mention, Paris, 1900.

BEVIN, ALICE CONKLIN.
Born East Hampton, Conn., Aug. 21, 1898. Pupil of Philip Hale, Charles Hawthorne, George Bridgman and Frank Du Mond. Address in 1929, Grue Leon Bonnat, Paris.

BEWLEY, MURRAY P.
Painter. Born Fort Worth, Tex., June 19, 1884. Pupil of AIC; Chase, Beaux and Henri in New York. Member: Paris American Arts Association; Salma. C. Awards: Hon. mention, Paris Salon, 1910; first prize, Salma. C., 1921. Works: "Buds," and "Portrait of Mrs. Percy V. Pennybacker," Ft. Worth (Tex.) Museum, and in the Pennsylvania Academy of the Fine Arts, Philadelphia.

BEYER, GEORGE ALBERT.
Painter, illustrator and designer. Born Minneapolis, Aug 30, 1900. Award: Minneapolis Inst. of Arts, 1925. Address in 1929, 215 Northwestern Bldg., South Minneapolis, Minn.

BICKFORD, NELSON N.
Sculptor and painter. Born in 1846. Pupil of Lefebvre, Boulanger and Bouguereau in Paris. Specialty, animals. Address in 1926, New York City. Died in 1943.

BICKNELL, ALBION HARRIS.
Painter. Born March 18, 1873, in Turner, ME. Died April 23, 1915, in Malden, Maine. He painted chiefly portraits and historical subjects. His portrait work included "Lincoln," "Webster," and "Horace Mann." Two of his historical paintings are "Lincoln at Gettysburg" and the "Battle of Lexington."

BICKNELL, EVELYN M.
Painter. Born in New York, 1857. Address in 1926, 18 West 27th Street, New York.

BICKNELL, FRANK ALFRED.
Sculptor and painter. Chiefly painter. Born in Augusta, ME, February 17, 1866. Pupil of Julian Academy in Paris under Bouguereau and Robert-Fleury; also under H. Bicknell at Malden, MA. Work: "October Morning," National Gallery, Wash., DC; "Mountain Laurel," Montclair, NJ, Museum; "Pirate's Cove," Denver Art Museum; others. Member of American Art Association of Paris; Society of American Artists; Associate of National Academy of Design; National Arts Club, NY; Chicago Water Color Society; and others. Address in 1933, Old Lyme, CT. Died in 1943.

BICKNELL, WILLIAM HARRY WARREN.
Etcher. Born in Boston, Mass., July 12, 1860. Pupil of Otto Grundmann and Boston Museum School. Member: Copley S., 1880; Chicago SE; Boston SE; Provincetown AA. Award: Bronze medal, St. Louis Exp., 1904. Represented in Art Institute of Chicago;

Rochester Memorial Art Gallery; Boston Museum of Fine Arts; New York Public Library; Congressional Library, Washington, DC. Address in 1926, Arlington Street, Winchester, Mass.

BIDDLE, GEORGE.
Sculptor, painter, and graphic artist. Educated at Groton School and Harvard College, receiving A.B. in 1908 and LLD in 1911. Studied one year at Julian Academy, Paris, and two years at PAFA; also studied with Ole Nordmark. Paintings owned by Whitney Museum, NY; PAFA; Dallas Museum. Works: "Tahitian Family," Penna. Academy of Fine Arts; table with design in marquetry, Art Institute of Chicago; lithographs, permanent collections of Metropolitan Museum, Public Library, NY; Newark Public Library; Palace of Legion of Honor, San Fran., CA; and Kaiser Friedrich's Museum, Berlin; Galeria d'Arte Moderna, Venice; Museum of Fine Arts, Boston; John Herron Art Institute, Indianapolis; painting, Whitney Museum of American Art, NY. Wrote and illustrated with fifty drawings "Green Island," Coward-McCann, 1930. Published articles in *Scribner's*, *Creative Arts*, *Am. Mag. of Art*, *Parnassus*, and *The Arts*. Illustrated with ten original lithographs Alexander Block's "The Twelve" (William E. Rudge). Former Vice-Pres., Society of Painters, Sculptors and Gravers; President, Society of Mural Painters. Address in 1970, Croton-on-Hudson, NY. Died in 1973.

BIEDERMAN, CHARLES (KAREL JOSEPH).
Sculptor. Born August 23, 1906, Cleveland, Ohio. Studied: Chicago Art Institute School, 1926-29, with Henry Poole, van Papelandam, John W. Norton. Resided Prague, Paris, New York. Work: Museum of Modern Art; Phila. Museum of Art; Rijksmuseum; University of Saskatchewan; Tate; Walker. Exhibited: Chicago Art Institute School; Pierre Matisse Gallery, 1936; Arts Club of Chicago, 1941; St. Paul Gallery, 1954; Rochester (Minn.) Art Center, 1967; Albright, 1936; Reinhardt Galleries, NYC, 1936; Galerie Pierre, Paris, 1936; Kunstgewerbemuseum, Zurich, 1962; Marlborough-Gerson Gallery Inc., 1964; Walker; Grace Borgenicht Gallery, NYC; others. Awards: Amsterdam (Stedelijk), Sikkens Award, 1962; Ford Foundation, 1964; National Council on the Arts, 1966; Walker Biennial, Donors Award, 1966; Minnesota State Arts Council, 1969; others. Represented by Grace Borgenicht Gallery, NYC. Address in 1982, Red Wing, MN.

BIERSTADT, ALBERT.
Landscape painter. Born Jan. 7, 1830, in Duesseldorf, Germany. Brought by his parents in 1831 to New Bedford, Mass., where his youth was spent. Began painting in oils in 1851; returned to Duesseldorf in 1853, and studied four years there and in Rome. On his return to the United States in 1857 he made a sketching tour in the Rocky Mountains, and from this and other visits to the West gathered materials for his most important pictures. He again visited Europe 1867, 1878 and 1883. Elected National Academy, 1860; Legion of Honor, 1867. Medals: Austria, Germany, Bavaria and Belgium, and various orders. Represented in the Metropolitan Museum, New York, and Corcoran Art Gallery of Washington, DC, and The Hermitage, St. Petersburg, Russia. Died Feb. 18, 1902 in New York City.

BIESEL, CHARLES.
Painter. Born New York City, Oct. 20, 1865. Member of the Art Club of Providence, RI. Died 1945. Address in 1926, 30 East Ontario Street, Chicago, Ill.

BIESEL, H. FRED.
Painter and illustrator. Born in Philadelphia, 1903. Pupil of the Rhode Island School of Design. Address in 1926, 5249 Calumet Ave., Chicago.

BIESIOT, ELIZABETH KATHLEEN GALL.
Sculptor, etcher, and craftswoman. Born in Seattle, Wash., October 8, 1920. Studied at University of Washington, BA, with Maldarelli; Columbia University; and with Archipenko, Paul Bonifas. Member: Northwest Crafts Workshop; Springfield Art League; American Artists Professional League; Society Ceramic Artists; Lincoln Artists Guild. Awards: Craftsman Guild, 1940; University of Washington, 1942; Denver Art Museum, 1945; Seattle Art Museum, 1945. Exhibited: San Francisco Art Association, 1944, 45; American Artists Professional League, 1945; Springfield Art League, 1944, 45, 46; Oakland Art Gallery, 1945, 46; Denver Art Museum, 1945; Mint Museum Art, 1946; Audubon Artists, 1945; Seattle Art Museum, 1940-45; Lincoln Artists Guild, 1945. Position: Instructor, University Nebraska, 1945. Address in 1953, Seattle, Washington.

BIESTER, ANTHONY.
Portrait and landscape painter. Born in Cleves, Germany, in 1840; he came to America early in life; died March 26, 1917, in Madisonville, Ohio. He was a member of the Cincinnati Art Club. He painted portraits of Archbishop Purcell and Bishop Henri, and decorations in St. John's Church, Lewisburg, KY.

BIGELOW, CONSTANCE.
Painter. Exhibited in Annual Water Color Exhibition, Penna. Academy of the Fine Arts, Philadelphia, 1925. Address in 1926, Provincetown, Mass.

BIGELOW, DANIEL FOLGER.
Landscape painter. Born in 1823, in Peru, IN. He was a friend of the portrait painter G. P. A. Healy, and with him organized the Academy of Design; later it became the Art Institute of Chicago. He died in Chicago in July, 1910.

BIGELOW, FOLGER ALLEN.
Painter. Born in Chicago in 1868; he died there in 1891.

BIGELOW, I. W. (or JAMES W.)
Portrait painter. His portrait of Miss Lillian Pullen, of White Plains, was painted about 1840 and exhibited in New York.

BIGELOW, OLIVE.
Painter. Born in Mountain Station, New Jersey, in 1886. Studied: Art Students League and in Paris, France. Awards: Royal Drawing Society, London, 1902, 1904; Newport Art Association, 1901. Collections: Providence Museum; Vienna Military Museum; Norwich Museum of Art, England; Naval Museum, Annapolis; New York Historical Society; St. John's Hospital, London; St. Elizabeth's Hospital, London; Palmella Palace, Portugal; Portuguese Embassy, London; Vassar College, New York; Oakwood School, Poughkeepsie, New York; Chinese Embassy, Washington, DC. She has designed covers for *Vogue, Harper's Weekly* and other magazines. Also known for her condensed version of King James Old and New Testaments, "Olive Pell Bible," 1952-55, now in 6th edition.

BIGGERS, JOHN THOMAS.
Sculptor and painter. Chiefly painter. Born in Gastonia, NC, April 13, 1924. Studied at Hampton Institute, with Victor Lowenfield; Penna. State College, M.A. Work: Murals, Naval Training School, Recreation Center, Hampton, VA; Eliza Johnson Home, Houston, Texas; Dallas Museum of Fine Arts; Reader's Digest Collection. Commissions: Seasons of Want and Plenty; and others. Awards: Prizes, Museum of Fine Art of Houston, 1950; Dallas Museum of Fine Art, 1952; Art Fellowship in Africa, UNESCO, 1957. Exhibited: Museum of Modern Art, 1943; City Art Museum of St. Louis; San Fran. Museum of Art; Portland Art Museum; Boston Museum of Fine Arts; Seattle Art Museum, 1945; Virginia Museum of Fine Arts traveling exhibition, 1945, 46; Brooklyn Library, 1946; M. Knoedler & Co., NYC, 1952; one-man show, Houston Museum of Fine Arts, 1968; and others. Teaching: Texas Southern University, from 1949. Address in 1982, Houston, TX.

BIGGS, WALTER.
Illustrator. Born 1866, in Elliston, VA. Studied at Chase School, NYC, with Edward Penfield, Lucius Hitchcock, Robert Henri. Illustrations in *Harper's, Scribner's, The Century, Ladies' Home Journal, Good Housekeeping, McCall's, Cosmopolitan.* Taught at ASL, Grand Central School of Art. Elected to Hall of Fame by Soc. of Illus., 1963. Died in 1968.

BIGOT, TOUSSAINT FRANCOIS.
Painter. Born France, 1794. Settled in New Orleans in 1816. Painted mostly landscapes and portraits; in 1841 he had a studio at 45 St. Philip Street, New Orleans, LA. Died 1869.

BILL, CARROLL.
Painter. Exhibited water colors at the Annual Water Color Exhibitions, at Penna. Academy of Fine Arts, Philadelphia, 1922. Address in 1926, 132 Riverway, Boston, Mass.

BILL, SALLY CROSS.
(Mrs. Carroll Bill). Painter and teacher. Born Lawrence, Mass. Pupil of DeCamp and Ross Turner in Boston. Member: PA S. Min. P.; NYWCC; Am. S. Min. P.; G. Boston A. Award: Silver medal for miniatures, P.-P. Exp., San. F., 1915. Work: Murals in three steamers of Bethlehem Ship Co.; Elks Bldg., Boston, and St. James Church, New Bedford (in collaboration with Carroll Bill); represented in Philadelphia Museum of Art, and Woman's City Club, Boston, Mass. Address in 1929, 132 Riverway, Boston, MA.

BILLIAN, CATHEY R.
Sculptor, painter, and instructor. Born: Chicago, Illinois, February 24, 1946. Studied: University of Arizona; Temple University; The Art Students League; The Art Institute of Chicago; Pratt Institute. Exhibitions: Larry Aldrich Museum of Contemporary Art, Ridgefield, Connecticut, 1974; Hudson River Museum, 1975; Elsie Meyer Gallery, 1980, 82; others. Work in Philadelphia Museum of Art; others. Address in 1982, 456 Broome Street, New York, NY.

BILLINGS, A.
Engraver. His work was chiefly book-plates and some crude book-illustrating; his book-plate for Richard Varick, an officer in the Revolution and Mayor of New York in 1801, is signed "A Billing, Sculpt."

BILLINGS, EDWIN T.
Portrait painter. Born in 1893. He painted a portrait of Stephen Salisbury that is signed and dated 1885. Several of his paintings are owned by the Worcester Art Museum, Worcester, Mass. Died Oct., 1893, in Dorchester, Mass.

BILLINGS, JOSEPH.
Engraver, on silver plate; was also a silversmith and watchmaker. According to a proclamation of 1770, he was a forger and counterfeiter of bills of credit of the Province of Pennsylvania.

BILLINGS, MARY HATHAWAY.
Painter. Born Brooklyn, NY. Pupil of Rhoda Holmes Nicholls, Cullen Yates, Pape, Whittaker. Member: NAC; Brooklyn SA. Address in 1926, 373 Grand Avenue, Brooklyn, NY; Round Hill, Northampton, MA.

BILLOUT, GUY R.
Illustrator. Born in Decize, France, in 1941; he studied art at the Ecole des arts Appliques for four years. He has received two Gold Medals from the S of I since 1969 when his first illustration appeared in *New York Magazine. Esquire, Redbook, Ms., McCall's, Money, Town and Country* and *Vogue* have all published his charming illustrations.

BILOTTI, SALVATORE F.
Sculptor. Born in Cosenza, Italy, February 3, 1879. He studied in Phila., Paris and Rome, studying successively with Charles Grafly, Injalbert and Verlet. Awards: Cresson travelling scholarships, Pennsylvania Academy of Fine Arts, Philadelphia, PA, 1906-1907; collaborative prize, New York Architectural League, 1914. Member: New York Architectural League; National Sculpture Society. Works: Marble statue, Our Lady of Lourdes, Chapel of the Little Sisters of the Poor, New York. The Art Museum of St. Louis, MO, contains examples of his works. His specialty was portrait busts and statuettes. Exhibited at National Sculpture Society, 1923; Penna. Academy of Fine Arts, 1924. Address in 1933, 9 MacDougal Alley, NYC. Died in 1953.

BINFORD, JULIEN.
Sculptor and painter. Born in Fine Creek Mills, VA, December 25, 1908. Studied at Emory Univ., GA; Art Institute of Chicago. Awards: Fellow, Art Institute of Chicago; Fellow, Virginia Museum of Fine Art, 1940; awarded National Competition for mural in Virginia State Library, Richmond, 1951; Rosenwald F. Work: Phila. Museum of Art; IBM; Boston Museum of Fine Arts; Addison Gallery of American Art; Virginia Museum of Fine Art; New Britain Museum; Springfield Museum of Art; Oberlin College; Univ. Nebraska; W. R. Nelson Gallery Art; others. Exhibited: Salon des Tuileries, Paris; Audubon Artists; Southern Museum Circuit; City Art Museum of St. Louis; Virginia Museum of Fine Arts; Art Institute of Chicago; Penna. Academy of Fine Arts; Corcoran Gallery Art Biennial, Wash., DC; National Academy of Design; Carnegie Institute; Los Angeles Museum of Art; Toledo Museum of Art. Position: Instructor, Mary Wash. College, Fredericksburg, VA. Address in 1980, Powhatan, VA.

BINGHAM, GEO. CALEB.
Portrait and genre painter. Born 1811 in VA. Friend of Chester Harding, the artist. He went to Duesseldorf in 1857, and in 1877 was made professor of art in University of Missouri at Columbia, Missouri. Died July 7, 1879, in Kansas City, MO.

BINNS, ELSIE.
Sculptor. Exhibited at Penna. Academy of Fine Arts, Philadelphia, 1924. Address in 1926, Alfred, NY.

BINON, J. B.
Sculptor. Born in France. Active in Boston in 1820. Educated in France and studied art there. When in Boston he executed a bust of John Adams. He was an early instructor of the sculptor Horatio Greenough.

BIRCH.
Engraver. In 1789, a portrait was published of "Mr. Tho. Gurney" signed "Birch Sculp." It is well engraved in line; it occurs in an Essay on "The System of Short Hand," written by Thomas Sarjeant.

BIRCH, B.
Flourished 1784. Portrait draughtsman in crayons, seal engraver, and miniature painter. He inserted an advertisement in the *N. Y. Packet*, 1784, "Likenesses are painted in crayon at one guinea each, with elegant oval, gilt frames included." By B. Birch from London.

BIRCH, GERALDINE.
(Mrs. G. R. Duncan). Painter and etcher. Born Forest Row, Sussex, England, Nov. 12, 1883. Pupil of Desvallieres, Menard, Prinet in Paris; W. W. Russell. Member: Calif. PM; Calif. AC; AFA. Work: "The Bookworm," State Library, Sacramento; "Aubrey and his Hen," Oakland Art Gallery; "The Sacred Garden," San Juan Capistrano Mission; etching, State Library, Sacramento, Calif. Address in 1929, 1550 Garfield Ave., Pasadena, Calif.

BIRCH, REGINALD B.
Illustrator. Studied in Paris, Antwerp, Munich. Noted for pen-and-ink drawings for children's books such as *Little Lord Fauntleroy* in 1886. Illustrated for many magazines. Active in later years in Massachusetts. Born in London, 1856; came to America, 1872. Died there in 1943. Address in 1926, Box 636, Dover, NJ.

BIRCH, THOMAS.
Artist. Was born in London in 1779, son of William Birch; emigrated to the United States in 1793. He established himself in Philadelphia about the year 1800, and commenced the painting of profile likenesses. A visit, made in a pilot-boat, to the capes of the Delaware in the year 1807, turned his attention to marine views, in the delineation of which he acquired a high reputation. During the war of 1812, he executed a series of historical paintings representing the naval victories of the United States. He also painted many landscapes which are highly prized, particularly those representing snow scenes. His views of Philadelphia are excellent. He died in 1851, at the age of seventy-two years.

BIRCH, WILLIAM.
Born in Warwickshire, England, 1755; died in Philadelphia, 1834. Birch was an enamel painter and engraver. For a time he was working in Bristol, and

in 1788-91 he was engraving prints and publishing them at Hampstead Heath, near London, and he was later living in London. In 1794, he came to Philadelphia with a letter of introduction from Benjamin West to the Hon. William Bingham, and in that city he painted landscapes in water colors and miniatures in enamel; among the latter were several portraits of Wash. done after the Stuart head. The earlier engraved work of Birch was executed in stipple and was much more finished than that published in this country. His one known portrait, that of Mrs. Robinson, engraved after a portrait by Sir Joshua Reynolds, belongs to this period and is an excellent piece of work. In 1791 he published in London a quarto volume entitled "Delicies de la Grande Bretagne," a collection of views of places in the neighborhood of London, and well done in stipple. His reputation as an American engraver is founded upon his Views of Philadelphia, drawn and engraved in 1798-1800 in connection with his son Thomas Birch, later well known as a landscape and marine painter. In 1808 he also issued a smaller series of plates showing the country seats of the United States. These views are now chiefly valued for their historical interest. His Philadelphia views were republished by him in 1802 and again republished by Robert Desilon in 1841. Extracts from an unpublished autobiography of William Birch are published in Anne Hollingsworth Wharton's "Heirlooms in Miniatures."

BIRDSALL, AMOS, JR.
Painter. Exhibited "The Coast" at the Penna. Academy of Fine Arts, Philadelphia, 1921. Born in New Jersey, 1865. Address in 1926, Melrose Park, Penna.

BIRDSEYE, DOROTHY CARROLL.
Painter. Born New York City. Pupil of George Bridgman, Hugh Breckenridge. Member: North Shore AA; Fellowship PAFA. Address in 1929, 11 West 90th St., New York, NY; summer, Gloucester, Mass.

BIRELINE, GEORGE.
Painter. Born Aug. 12, 1923, in Peoria, Ill. Studied at Bradley Univ. (BFA) and U. of North Carolina (MA). Taught at School of Design, NC State, 1957-75. In collections of NC Mus.; Prentice-Hall, Inc., NJ; Fayetteville Mus. of Art; Fed. Reserve Bank, Richmond, VA. Exhibited at PAFA, 1950; NC Mus. of Art; LA County Mus.; Butler Inst. in Youngstown, Ohio; Southeastern Center for Contemp. Art, Winston-Salem, 1979. Received awards from NC Mus. of Art, Ford Foundation, Winston-Salem Gallery of Fine Arts, Guggenheim, and Nat. Council on Arts Grant. Works in oil, watercolor, colored pencil. Living in Raleigh, NC, in 1982.

BIRGE, MARY THOMPSON.
Painter. Born in New York, 1872. Pupil of Yale School of Fine Arts. Address in 1926, 1914 North Pennsylvania Street, Indianapolis, Ind.

BIRGE, PRISCILLA.
Photographic media. Studied: Putney School, Vermont; Brown University; University of California, Elisha Benjamin Andrews Scholar, 1955, 1956. Exhibitions: Lucien Labaudt Gallery, San Francisco, 1965; Brown University, Providence, Rhode Island, 1975; Joan Peterson Gallery, Boston, 1975. Collections: E. B. Crocker Art Gallery, Sacramento, California; Joslyn Art Museum, Omaha, Nebraska; Pembroke College, Providence, Rhode Island.

BIRMELIN, ROBERT.
Painter and draftsman. Born Nov. 7, 1933, in Newark, NJ. Studied at Cooper Union, ASL, Yale (BFA, MFA), and U. of London. Taught at Yale; at Queens College since 1964. In collections of Brooklyn Mus.; Whitney; Addison Gallery; MOMA; Mus. of Art, San Fran.; and Chase Manhattan Bank. Exhibited at Am. Fedn. of Arts, 1960; Silvermine Guild, 1960; Whitney; MOMA; PAFA; Nat'l. Inst. of Arts and Letters. Awarded Fulbright, 1960; Am. Acad. fellowship; Schiedt Prize, PAFA; Nat'l. Inst. Arts and Letters; Tiffany Grants. Address in 1982, Leonia, NJ.

BIRNBAUM, MEG.
Illustrator. Born in Greenwich, Connecticut, 1952. She studied for two years in Massachusetts at the Montserrat School of Visual Art and Vesper George School of Visual Art. She began free-lance illustrating in 1972 with a piece in *Of Westchester Magazine* and presently works for *The Real Paper* in Cambridge, Massachusetts. Her artwork has been shown at the Beaux Arts Gallery, Mamaroneck Artist Guild Gallery, and in the Annual Exhibition of the S of I.

BIRREN, JOSEPH P.
Painter and lithographer. Born in Chicago; studied in Philadelphia, New York, Paris, and Munich. Member: Chicago AC (life); Palette and Chisel C.; AIC Alumni Assoc.; Chicago PS, and others. Exhibited at the Penna. Academy of the Fine Arts, Philadelphia, 1924. Address, 49 Elm Street, Chicago, Ill.

BISBEE, JOHN.
Artist and lithographer. He is recorded by Dunlap as a good draughtsman.

BISBING, H. SINGLEWOOD.
Painter. Born in 1849 in Phila., PA. Studied at PA, in Paris, and Brussels. Lived abroad. Exhibited in the Paris Salon, and at PAFA. Died in 1933.

BISCHOFF, ELMER NELSON.
Born July 9, 1916, in Berkeley, Calif. BA, Univ. Cal/Berkeley, 1938, and MA, 1939. In collections of Whitney; Oakland Art Museum; MOMA; Art Inst. of Chicago; San Francisco Mus. Art. Exhibited at Tate

Gallery, London; Osaka World's Fair (1970); Carnegie Inst; Whitney; and others. Awarded Ford Foundation grant, 1959; award from Art Inst. of Chicago, 1964. Teaching, San Fran. Art Inst.; Univ. of California, Berkeley, from 1963. Address in 1982, Berkeley, Calif.

BISCHOFF, ILSE M(ARTHE).
Illustrator and etcher. Born New York, NY, Nov. 21, 1903. Pupil of Joseph Pennell; George Buchner. Member: ASL of NY. Award: Boericke prize, Phila. PC, 1927. Address in 1929, 27 Mt. Morris Pk., West, New York, NY.

BISHOP.
A little-known portrait and genre painter, working about 1850.

BISHOP, HUBERT.
Painter and etcher. Born in Norwalk, Conn., in 1869. Address in 1926, 87 East Ave., Norwalk, Conn.

BISHOP, ISABEL.
(Mrs. Harold G. Wolfe). Painter and etcher. Born March 3, 1902, in Cincinnati, Ohio. Studied at Wicker Art School, Detroit; NY School of Applied Design for Women; Art Students League, NYC; Moore Inst., Hon. DFA. Taught at Yale; Art Students League; and Skowhegan School, Maine. In collections of Boston Mus. of Fine Arts; Whitney; Met. Mus. of Art; Philips Mem. Gallery, Wash., DC; Victoria and Albert Mus., London; Herron Mus. of Art, Indianapolis; the Newark Mus.; Munson-Williams-Proctor Inst., Utica, NY. Exhibited at Berkshire Museum; Whitney; Midtown Galleries, NYC; Venice Biennials; and others. Awards from Am. Artists Group, etching; Nat'l. Acad. of Design; Corcoran Gallery of Art, Wash., DC. Mem.: Am. Soc. of Graphic Artists; Nat'l. Arts Club; Audubon Artists; Royal Society of Arts, London. Address in 1982, 355 W. 246th St., New York City.

BISHOP, RICHARD E(VETT).
Etcher. Born Syracuse, NY, May 30, 1887. Graduated from Cornell University; studied at Graphic Sketch Club, and with Ernest D. Roth. Specialty, bird studies; his "Canada Geese" was awarded the Charles Lea prize in Philadelphia, 1924. Address in 1926, Springback Lane, Mt. Airy, Penna.

BISHOP, THOMAS.
Miniature painter. Born 1753 and died 1840. He lived in London and Paris and came to Philadelphia about 1811; he took a studio in Germantown, PA and painted miniatures. One of his enamels of a Venus was much admired. He exhibited at the Penna. Academy in 1811.

BISONE, EDWARD GEORGE.
Painter. Born in Buffalo, NY, Nov. 19, 1928. Study: Univ. of Buffalo, with Seymour Drumlevitsch. Ex-

hibitions: Nat'l Academy of Design; Albright-Knox Art Gal., Buffalo; plus many others. Mem.: Artists Equity Assn.; Nat'l. Soc. Lit. and Arts. Media: Mixed. Address in 1982, Cheektowaga, NY.

BISPHAM, HENRY COLLINS.
Born in Philadelphia, 1841. He studied there with William T. Richards, and later with Otto Weber in Paris. He died in 1882. "The Lion Sultan," signed "H. C. Bispham Paris 1879," exhibited at the Salon, 1879, and Royal Academy, 1880, was presented in 1883 to Penna. Academy of Fine Arts, Philadelphia.

BISSELL, EDGAR J.
Painter. Born in Aurora, Ill., 1856. Studied in Boston, Mass., and with Boulanger and Lefebvre in Paris. Address in 1926, 3016 Bartold Ave., St. Louis, MO.

BISSELL, GEORGE EDWIN.
Sculptor. Born New Preston, Litchfield Co., Conn., February 16, 1839. In marble business with his father and brother at Poughkeepsie, NY, 1866; studied art in Paris, Rome, and Florence. Public monuments and statues: Soldiers' and Sailors' Monument, and statue of Col. Chatfield, Waterbury, Conn.; portrait statue of Gen. Horatio Gates on Saratoga Battle Monument; Chancellor John Watts and Col. Abraham de Peyster, New York; Abraham Lincoln, Edinburgh, Scotland; Chancellor James Kent, Congressional Library; bronze statues, Admiral Farragut and Gen. Sherman; statue of Lincoln, Clermont, IA; marble bust and bronze statuette in Metropolitan Museum, New York. Died August 30, 1920, in Mt. Vernon, New York.

BISTTRAM, EMIL.
Born April 7, 1895. In 1906, came to America; was naturalized as US citzen. Studied in night classes, National Academy of Design, Cooper Union and New York School of Fine and Applied Art. Became commercial artist and opened an art service which employed from eighteen to twenty men. Was Associate Instructor, New York School of Fine and Applied Art, and later taught for five years at Master Institute, Roerich Museum, New York. In 1931; won Guggenheim Fellowship award for study of fresco abroad. Worked for short time with Diego Rivera in Mexico. In 1932; founded Taos School of Art, Taos, New Mexico.

BITTENBENDER, BEN.
Painter. Exhibited "Twilight, Susquehanna Valley" at Annual Exhibition of National Academy of Design, New York, 1925. Address in 1926, Nescopeck, Penna.

BITTER, KARL THEODORE.
Sculptor. Born in Vienna in 1867. He came to America in 1889 after studying in Vienna at the School of Applied Arts. Member of National Institute

of Arts & Letters, National Academy of Design, and President of National Sculpture Society at the time of his death. Works: Statue of General Sigel, Riverside Drive, NYC; panels in Trinity Church gates, NYC; figures in facade of Metropolitan Museum of Art; statue, Dr. William Pepper, Phila.; statue of facade of Brooklyn Museum; statues on Vanderbilt and Rockefeller estates; and the battle group for Dewey Architecture, NYC. See "Karl Bitter, A Biography," by Schevill, pub. in Chicago, 1917. Died in 1915.

BITTINGER, CHARLES.
Artist. Born Washington, June 27, 1879. Student, Mass. Institute Tech., 1897-99; Ecole des Beaux Arts, Paris, 1901-5. Has exhibited at Paris Salon; Societie Nationale des Beaux Arts; New York, Philadelphia, Washington, etc. Received medal, St. Louis Expn., 1904; 2nd Hallgarten prize, National Academy Design, 1909; Clark prize, same, 1912; silver medal, San Francisco Expn., 1915; 1st prize, Duxbury Art Assn., 1919. Elected Associate Member of National Academy. Address in 1926, 1 West 81st Street, New York.

BIXBEE, WILLIAM JOHNSON.
Painter, illustrator, and teacher. Born Aug. 31, 1850. Died July 14, 1921 in Lynn, MA. He was secretary of the Boston Society of Water Color Artists. Designer of the seal of the city of Lynn. His painting of "Morning" has been exhibited.

BJORKMAN, OLAF.
Sculptor. Born in Scandinavia in 1886. Among his best known works: "Beethoven," "The Titan," and heads of Lincoln and Edgar Allan Poe. Address in 1926, New York. Died in 1946.

BJURMAN, ANDREW.
Sculptor, craftsman, and teacher. Born in Sweden, April 4, 1876. Member: California Art Club; Southern California Sculptors Guild. Awards: Bronze medal, San Diego Exposition, 1915; second prize, California Liberty Fair, 1918; popular prize, Southwest Museum, 1923; honorable mention, Los Angeles Museum, 1924; first prize, Pomona, California, 1924 and 1927; honorable mention, Los Angeles Museum, 1927; gold medal, Southwest Exposition, Long Beach, California, 1928. Address in 1933, Alhambra, California. Died in 1943.

BLACK, ELEANOR SIMMS.
(Mrs. Robert M. Black). Painter. Born in Washington, DC, 1872. Exhibited at the Penna. Academy of the Fine Arts, 1924. Pupil of Corcoran School. Address in 1926, 3732 Dawson Street, Pittsburgh, PA. Died 1949.

BLACK, KATE ELEANOR.
Painter. Born London, 1855. Pupil of Cincinnati Academy. Member: Cincinnati Woman's Art Club.

Award: Bronze medal, Provincial Exhibition, New Westminster, British Columbia, Canada. Address in 1926, 4168 Forest Ave., South Norwood, Ohio. Died Dec. 14, 1924.

BLACK, LAVERNE NELSON.
Sculptor, painter, and illustrator. Born in Viola, Kickapoo Valley, WI, 1887. Moved to Chicago, studied at the Academy from 1906 to 1908. Worked as an illustrator in Minneapolis and as a newspaper artist in Chicago and NYC. Painted on commission; sculpture sold through Tiffany's. Work in Anschutz Collection, Denver, CO; Harmsen Collection; murals, US Post Office, Phoenix; Treasury Department (DC). Specialty, Southwest Indian genre, Arizona pioneers and later cattle and mining industries, Indian bronzes. Lived in Taos, NM, 1925-37, and Phoenix, AZ. Died in Chicago, IL, 1938.

BLACK, LISA.
Painter. Born in Lansing, Michigan, on June 19, 1934. Studied: University of Paris, Sorbonne; University of Michigan. Awards: Rowayton Arts Center, 1971; New Rochelle Art Association, 1971; Springfield Museum National Annual, Time-Life Building; *Smithsonian* Magazine. Exhib.: New Haven Paint and Clay Club Art Exhib., CT, 1971 and 1972. Media: Acrylic.

BLACK, MARY C. W.
(Mrs. Clarence A. Black). Painter. Born Poughkeepsie, NY. Pupil of W. L. Lathrop, Art Students' League of New York, Mora and Glenn Newell. Member: National Academy of Women Painters and Sculptors; California Art Club; National Art Club; Society of Independent Artists. Address in 1926, "El Cerrito," Santa Barbara, California.

BLACK, MRS. NORMAN I.
Painter. Born Providence, RI, 1884. Pupil of Eric Pape School, Boston; Julien Academy in Paris; studied in Munich. Member: Providence Art Club. Address in 1926, 414 West 154th Street, New York, NY.

BLACK, NORMAN I.
Painter and illustrator. Born in Chelsea, Mass., Nov. 8, 1883. Pupil of Eric Pape School, Boston; Julien Academy and Beaux Arts, Paris. Address in 1926, 414 West 154th Street, New York, NY.

BLACK, OLIVE P(ARKER).
Painter. Born Cambridge, Mass., July 22, 1868. Pupil of H. Bolton Jones, Chase, Art Students' League of New York, and National Academy of Design in New York. Member: National Academy of Women Painters and Sculptors. Address in 1926, 242 West 56th Street, New York.

BLACK, WILLIAM THURSTON.
Flourished 1850-1851, Philadelphia and New York. Portrait painter and portrait draughtsman in pastel and crayon.

BLACKBURN, JOSEPH.
He was born and trained in Great Britain, and painted in this country from 1754 to 1762. His portraits were painted in Bermuda in 1753. From 1754 to 1761 he was working in Boston. There are about eighty portraits by Blackburn in America, most of them signed. He painted a number of his figures "knee-length" with rather awkwardly posed legs. His portrait of Thomas Dering and his wife Mary are owned by the Metropolitan Museum, Theodore Atkinson, Jr., owned by the Rhode Island School of Design, and Col. Theodore Atkinson, owned by the Worcester Art Museum. The Boston Museum of Fine Arts owns the portrait of Jonathan Simpson and his wife Margaret.

BLACKBURN, M(ORRIS) ATKINSON.
Painter and engraver. Born Philadelphia, Oct. 13, 1902. Pupil of PAFA. Member: Fellowship PAFA. Address in 1929, 211 Oakmont Ave., Oakmont, Delaware Co., PA.

BLACKMAN, CARRIE HORTON.
(Mrs. George Blackman). Painter. Born Cincinnati, Ohio. Pupil of St. Louis School of Fine Arts; Chaplin in Paris. Specialty, children's portraits.

BLACKMAN, WALTER.
Painter. Born in New York. Studied in Paris under Gerome. Exhibited with the Society of American Painters in 1878 and in the Paris Salon of the same year.

BLACKMORE, ARTHUR E(DWARD).
Painter. Born Bristol, England, Feb. 8, 1854, and died Dec. 15, 1921. Pupil of South Kensington Museum, London. Member: Arts Aid Society; Art Fund Society; NY Architectural League, 1914; Washington Art Club; and Society of Independent Artists. Executed many mural decorations.

BLACKSHEAR, ANNE LAURA E(VE).
Painter, illustrator, lithographer and teacher. Born Augusta, GA, Oct. 30, 1875. Pupil of Twachtman, Chase, Gifford, Breckenridge, Garber. Member: Athens AA; Ga. AA; SSAL. Work: Portrait of President Spence, Piedmont College, Demorest, GA. Bulletin, "Charts for Visual Instruction in Extension Work," owned by the Georgia State College of Agriculture. Lectures, "Rediscovered Principles of Greek Design," "Delineation and Aid in Education" and "Class Room Practice in Design," owned by the Georgia Education Association. Writer and director of pageants and plays staged for the GA State College of Agriculture and the University of GA Summer School. Address in 1929, Georgia State College of Agriculture; h. 165 Willcox Park, Athens, GA.

BLACKSTONE, HARRIET.
Painter. Born New Hartford, NY. Pupil of Julien Academy in Paris; Chase Summer Schools; Pratt Institute, Brooklyn. Member: Chicago Society of Artists; American Women's Art Association, Paris. Represented in Vincennes Art Association; San Francisco Museum; National Gallery of Art, Washington. Died in 1939. Address in 1929, 222 West 23rd St., New York, NY.

BLACKWELL, GARIE.
Illustrator. Born in Los Angeles in 1939, she attended the Chouinard Art Institute for three years. Her first illustration was done for *Seventeen* in 1967 and she has since worked for *Cosmopolitan, Ladies' Home Journal, Mademoiselle* and Allied Chemical Corporation. She is now working in Cambridge, Massachusetts, and researching the possible health hazards to artists resulting from the use of certain products used in the profession.

BLAGDEN, ALLEN.
Painter and printmaker. Born in Salisbury, Conn., Feb. 21, 1938. Studied at Cornell Univ., BFA; travelled in Egypt and Greece for a year; summer painting fellowship, Yale Univ. Work at Garvan Collection, Peabody Mus., New Haven, Conn.; Berkshire Mus., Pittsfield, Mass. Exhibited at Silvermine Guild Artists; St. Gaudens Mus., NH; Wadsworth Atheneum; Albright-Knox Gallery, Buffalo, NY; others. Received Allied Artists Award, 1963; NAD; Century Club Art Prize, 1971. Member: Century Assn., NYC. Address in 1982, Salisbury, Conn.

BLAI, BORIS.
Sculptor, lecturer, and teacher. Born in Rowno, Russia, July 24, 1893. Studied at Imperial Academy of Fine Arts, Leningrad; Ecole Beaux-Arts, Paris; student of Rodin. Member: Phila. Alliance; Fairmount Park Art Association. Work: Rhythm of the Sea (bronze), Philadelphia Museum of Art, PA; busts of all five presidents and other portraits, Temple University, Philadelphia; others. Exhibited: First Open Air Show, Rittenhouse Square, Philadelphia, 1927; Chicago Art Institute, 1932; Philadelphia Academy Annual, 1940; retrospectives, Long Beach Island Foundation of Arts and Science, NJ, 1968, and Harcum Jr. College, PA, 1969. Awards: Page One Award, Philadelphia, 1960; Philadelphia Art Alliance Medal, 1960; Samuel S. Fels Medal, 1962. Founder, professor of art, and dean at Tyler School of Fine Arts, Temple University, 1930-60; founder, Blai School of Fine Arts, PA, from 1972. Address in 1982, Philadelphia, PA.

BLAINE, NELL.
Painter. Born in Richmond, VA, July 10, 1922. Study: Richmond Prof. Inst., 1939-42; Hans Hofmann School of Fine Arts, 1942-43; Atelier 17, etching and engraving with Wm. S. Hayter, 1945; New School for Soc. Research, 1952-53. Work: Whitney Museum of Art, NY; Virginia Museum of Fine Arts; MOMA; Met. Mus. of Art; murals in Tishman Bldg., NYC; plus numerous public and private collections. Exhibitions: Art in the White House Program; Corcoran Gallery; MOMA, NY; Museum of Modern Art, Rome; Palais de Beaux-Arts de la Ville de Paris; and many other group and one-man shows in USA and abroad. Awards: VA Mus., Fine Arts Fellowship; Guggenheim Fellow; Nat'l Endowment award. Mem.: Artists Equity Assn. Media: Oil and watercolor. Rep.: Fischbach Gal., NYC. Address in 1982, 210 Riverside Drive, NYC.

BLAIR, CARL RAYMOND.
Painter and art dealer. Born in Atchison, Kansas, Nov. 28, 1932. Study: Univ of Kans., BFA, 1956; Kans. City Art Inst.; Sch. of Design, MFA, 1957. Work: Greenville College, Greenville, Ill.; Old Dominion College, Norfolk, VA; SC State Art Collection; etc. Exhibitions: International Platform Assoc., Wash. DC; 33rd Butler Ann.; others. Awards: State, regional and national. Media: Oil. Address in 1982, 1 Oakleaf Rd, Greenville, SC.

BLAIR, E. R.
Illustrator. Member: Cleveland SA. Address in 1929, 2248 Euclid Ave., Cleveland, Ohio.

BLAIR, ROBERT NOEL.
Sculptor, painter, etcher, and illustrator. Born in Buffalo, NY, August 12, 1912. Studied at Boston Museum of Fine Arts School; Buffalo Art Institute. Member: Phila. Water Color Club; Portland Water Color Society; El Paso Art Association; Baltimore Water Color Society. Awards: Prizes, Albright Art Gallery, 1940; Art Institute of Chicago, 1948; Buffalo Society of Artists, 1951; med., Buffalo Society of Artists, 1947, 50; Guggenheim Fellow, 1946, 51. Work: Metropolitan Museum of Art; Munson-Williams-Proctor Institute; murals, chapel and hospital, Ft. McClellan, AL. Exhibited: Brooklyn Museum, 1939; Art Institute of Chicago, 1942-44, 48; Metropolitan Museum of Art; Riverside Museum; Albany Institute of History and Art, 1934-46; Baltimore Museum of Art; Albright Art Gallery, 1942 (one-man); Penna. Academy of Fine Arts; numerous others. Illustrator, "Captain and Mate" 1940, and other children's books. Taught: Instructor painting, Art Institute Buffalo, 1938-55, State University of New York College at Buffalo, 1971. Address in 1982, Holland, New York.

BLAKE, DONALD.
Illustrator. Born Tampa, Fla., 1889. Pupil of Henry McCarter. Award: Cresson Traveling Scholarship.

Fellow, Penna. Academy of Fine Arts. Address in 1926, 244 West 14th Street, New York.

BLAKE, JAMES HENRY.
Painter, illustrator and teacher. Born in Boston, Mass., July 8, 1845. Pupil of Hollingsworth and Rimmer in Boston; Moore in Cambridge. President, Cambridge Art Circle. Specialty, scientific subjects. Address in 1926, 117 Elm Street, West Somerville, Mass.

BLAKE, PETER.
Illustrator. Born 1932. Presently living and illustrating in Somerset, England, he has worked for Standard Oil Company and Exxon Corporation. His work has been exhibited in Tate and other major galleries.

BLAKE, WILLIAM W.
Engraver of business buildings, working in New York in 1848; he then had his work rooms at 167 Broadway.

BLAKELOCK, RALPH (ALBERT).
Landscape painter. Born Oct. 15, 1847, in New York City. Son of Dr. R. A. Blakelock, who intended him to pursue med. career. Blakelock was self-taught, going west to study Am. Indians. Paintings were noted for rich, vibrant color. Awarded first Hallgarten Prize in 1899, and hon. men. (1892) from PA. After a change in his style, his work was no longer popular until after his death. Work: "From St. Ives to Lelant" (St. Louis Mus.); and at Whitney and MMA. Died Aug. 9, 1919, in a mental hospital, after suffering extreme poverty.

BLAKELY, JOYCE C.
Painter. Born in New Orleans, LA, July 1, 1929. Study: Delgado Art Mus.; S. Georgia College; with Bill Hendrix, John Pellew, Zoltan Szabo, Edmond Fitzgerald. Comn.: Presby. Church, Hendersonville, NC; Pardee Hosp, Hendersonville; and more. Exhibitions: Hendrix Gal., St. Simons Island, Georgia; Butler Inst. Am. Art, Youngstown, OH; others in US and London. Mem.: Nat. Lg. Pen Women. Media: Oil. Address in 1980, Zirconia, North Carolina.

BLANCH, ARNOLD.
Painter, printmaker and teacher. Born in Mantorville, MN, June 4, 1896. Studied: Minneapolis School of Art, 1914-16; ASL, under Mora, Henri, Sloan, Miller, and Robinson, 1916-17, 19-21. One-man exhibitions: Dudensing Galleries, 1926, 28, 30; Frank K. M. Rehn Gallery, 1930, 32, 35, 39; Associated American Artists Galleries, 1940, 45, 46, 50, 54; Krasner Galleries, NYC, 1958, 61, 62, 65, 67; Univ. of Minnesota, retrospective, 1952; Des Moines Art Center, retrospective, 1952; Walker Art Center, retrospective, 1953; Philadelphia Art Alliance, retrospective, 1961; Woodstock Art Association Mus., memorial

exhibition, 1970; Ulrich Mus. of Art, Wichita, KS, retrospective, 1985; others. Group exhibitions: AIC, 1933; New Horizons of American Art, 1937; Golden Gate Expo., San Francisco, 1936; NY World's Fair, 1936; ASL, 1967; Vassar College Art Gallery, 1977; others; regular exhibitor at Corcoran, Whitney, PAFA, Carnegie, MMA, MOMA, and others. Awards: AIC, 1929, 32, 39; San Francisco Art Association, 1931; Guggenheim Fellowship, 1933; Carnegie, 1938; PAFA, 1938; Syracuse Mus. of Fine Arts, 1949, 52; Silvermine Guild, 1961; Ford Foundation Grant, 1964; others. Member: Society of American Painters, Sculptors, and Gravers; American Artists Group; American Artists Congress; Woodstock Artists Association. Taught at California School of Fine Arts, 1930-31; ASL, 1935-39, 47-68; Florida Gulf Coast Art Center, 1951-53; Des Moines Art Center, 1952; Minneapolis School of Art, 1955; Norton School of Art, 1961-62; others. In collections of AIC; Brooklyn Mus.; Butler Institute; Carnegie; Cranbrook Academy of Art; Detroit Institute of Art; Library of Congress; MMA; Philadelphia Academy of Fine Arts; Smithsonian Mus.; Ulrich Museum, KS; Whitney; many others. His designs have been used on Hallmark Cards, Castleton China, Stonelain Ceramics, others. Represented by Apollo, Poughkeepsie, NY. Died October 23, 1968, in Woodstock, NY.

BLANCHARD, WASHINGTON.
Miniature painter. Born 1808. Portrait of Wm. Ellery Channing exhibited at Boston Atheneum in 1834. Painted John C. Calhoun and Henry Clay.

BLANEY, DWIGHT.
Painter. Born in Brookline, Mass., Jan. 24, 1865. Exhibited at Penna. Academy of the Fine Arts, Philadelphia, 1921. He worked in both oil and water colors. Member: Copley S., 1892; Boston GA. Represented in Cleveland Mus. of Art. Address in 1926, 308 Fenway, Boston, Mass.

BLANKE, ESTHER.
Painter and craftswoman. Born Chicago, Ill., Feb. 2, 1882. Pupil of Chicago Art Inst., studied in London and Munich. Member: Chicago AG; Cordon Club. Address in 1926, 1200 Steinway Hall, 64 East Van Buren Street; Home, 418 Deming Place, Chicago, Ill.

BLANKE, MARIE ELSA.
Painter. Born in Chicago. Pupil of Chicago Art Inst., and studied in Munich and London. Member: Chicago Society of Artists; Chicago Art Club. Instructor in art, Lewis Institute, Chicago. Address in 1929, 1236 N. Dearborn St., Chicago, Ill.

BLASHFIELD, EDWIN HOWLAND.
Artist. Born New York, Dec. 15, 1848. Studied Paris, 1867, under Leon Bonnat, also receiving advice from Gerome and Chapu; exhibited at Paris Salon, yearly, 1874-79, 1881, 1892; also several years at Royal Academy, London; returned to America, 1881; has exhibited genre pictures, portraits and decorations. Among his paintings are "Christmas Bells" and "Angel with Flaming Sword." Decorated great Central Dome, Library of Congress; decorative panel, Bank of Pittsburgh. Elected member of Academy in 1888. Author, with Mrs. Blashfield, of "Italian Cities;" editor, with Mrs. Blashfield and A. A. Hopkins, of Vasari's "Lives of the Painters;" author, "Mural Painting in America," 1914. Address in 1926, Carnegie Hall, New York City.

BLASY, ALEXANDER.
Sculptor. Exhibited at Penna. Academy of Fine Arts, 1924. Address in 1926, 31 Bank Street, New York.

BLAU, DANIEL.
Painter, etcher and teacher. Born Dayton, Ohio, Feb. 2, 1894. Pupil of Art Academy of Cincinnati; Dayton Art Inst. Member: Dayton SE. Address in 1929, Dayton Art Inst.; h. 27 Yale Ave., Dayton, Ohio.

BLAUVELT, CHARLES F.
Painter. Born in New York in 1824, he was elected an Academician of the National Academy in New York in 1859. He died April 16, 1900 in Greenwich, CT. Represented in Wilstach Collection in Fairmount Park, Philadelphia.

BLAZEY, LAWRENCE E.
Painter and teacher. Born Cleveland, April 6, 1902. Member: Cleveland SA. Address in 1929, Carnegie Hall, 1221 Huron Rd.; h. 2017 Bunts Rd., Cleveland, Ohio.

BLEIL, CHARLES GEORGE.
Painter and etcher. Born in San Francisco, Dec. 24, 1893. Among his works are "Autumn Road" and the "Green House" at California Artists' Gallery. Member: San F. AA; Calif. SE. Awards: First prize graphic arts, San Francisco Art Assoc., 1924.

BLENNER, CARLE JOAN.
Painter. Born Richmond, VA, Feb 1, 1864. Educated Marburg, Germany, and special course, Yale; 6 years at Julien Academy, Paris. Exhibited Paris Salon, 1887, 88, 89, 91; Chicago Exposition, 1893; medal at Boston, 1891; Hallgarten Prize, National Academy of Design, 1899; represented at exhibitions in New York since 1889; bronze medal, St. Louis Expn., 1904. Address in 1926, 58 W. 57th Street, New York.

BLISS, ELIZABETH STURTEVANT (MRS.).
See Theobald, Elizabeth Sturtevant.

BLOCH, ALBERT.
Painter, etcher, writer, lecturer and teacher. Born St. Louis, MO, Aug. 2, 1882. Studied at the St. Louis

School of Fine Arts and abroad. Represented in Phillips Memorial Gallery, Washington, DC. Address in 1926, School of Fine Arts, University of Kansas.

BLOCH, JULIUS T(HIENGEN).
Painter. Born in Germany, May 12, 1888. Studied at Penna. Academy of Fine Arts. Exhibited at Penna. Academy of Fine Arts, 1924. Work: "Tulips and Anemones," Penna. Acad. of F.A. Address in 1926, 10 South 18th St., Philadelphia.

BLOCH, LUCIENNE.
Painter. Born Jan. 5, 1909, in Geneva. In 1917, she and her family moved to US. Studied at Cleveland School of Art, 1924-25; Paris with Antoine Bourdelle and Andre Lhote; anatomy and drawing classes at the Ecole Nat. des Beaux Arts. Assisted Diego Rivera in 1932-34 at Det. Inst. of Arts, Rockefeller Ctr. and New Worker's School in New York City. One of her assignments on the WPA project, entitled "The Evolution of Music," at the Music Room of George Washington High School in Upper Manhattan, was warmly received.

BLOCK, ADOLPH.
Sculptor. Born New York City, January 29, 1906. Pupil of Hermon A. MacNeil; Edward F. Sanford; Gregory; A. Stirling Calder; Edward McCartan; Beaux-Arts Institute of Design in New York; Fontainebleau School of Fine Arts, Paris. Exhibited: National Academy of Design; Penna. Academy of Fine Arts; Architecture League of New York; National Sculpture Society; Whitney Museum of American Art; plus others. Award: Third Award, National Aeronautic Trophy Competition; prize, Otis Elevator dial design competition; Tiffany Foundation Fellowship; architects' silver medal, Beaux Arts Institute, 1926; Fontainebleau Fellowship, 1927; Paris Prize, Beaux-Arts Institute, 1927; award for most Notable Service, 1970, National Sculpture Society; and others. Member, National Academy of Design (academician); National Sculpture Society (fellow); others. Worked in bronze. Address in 1976, 319 West 18th Street, New York, NY. Died 1978.

BLOCK, HENRY.
Painter, illustrator, etcher and teacher. Born Lithuania, March 11, 1875. Pupil of ASL of NY. Member: Plainfield AA. Address in 1929, 1103 Lebanon St., New York, NY; summer, 200 Third St., Dunellen, NJ.

BLOCK, JOYCE.
Painter and calligrapher. Born in Chicago, Ill. Study: Univ. Calif. at LA; Columbia Univ. Teachers College; Tenshin Calligraphy Institute, Tokyo, with Kakei Fujita. Exhibitions: Ann. Callig. Exhib., Nihon Shodo Bijutsuin, Tokyo, 1963 to 80; Yokohama Shodo Renmei, 1968-75; and others in Japan and US.

Awards: Nihon Shodo Bijutsuin, Tokyo; Yokohama Shodo Renmei. Teaching: Yokohama, Japan, 1960-79; US and Italy. Mem.: Nat'l. Ed. Assn.; Am. Assn. of Univ. Women. Media: Sumi ink, dyes. Address in 1982, 360 Alcatraz Ave., Oakland, CA.

BLONDEL, JACOB D.
Portrait painter. Born 1817 and died 1877. He was elected an Associate Member of the National Academy in 1854.

BLONDHEIM, ADOLPHE W.
Painter, etcher, illustrator and teacher. Born in Maryland, Oct. 16, 1888. Pupil of Maryland Institute, and Penna. Academy of Fine Arts. Represented in Chicago Art Institute, California Public Library, and State House, MO. Address in 1926, Provincetown, MA.

BLOODGOOD, ROBERT FANSHAWE.
Sculptor, painter, illustrator, etcher, and teacher. Born New York, October 5, 1848. Pupil of National Academy of Design; Art Students League of New York. Member: Salmagundi Club; Calif. Society of Etchers; National Arts Club. Address in 1929, 64 East 56th St; 112 Park Ave., New York, NY; summer, Setauket, LI, NY.

BLOOMER, H. REYNOLDS.
Painter. Born in New York, studied in Paris, and exhibited in the Salon of 1877.

BLOSSOM, DAVID J.
Illustrator. Born in Chicago, 1927, the son of illustrator Earl Blossom. He studied at the Yale School of Fine Arts and ASL under Reginald Marsh. In 1947 he became an art director at the J. Walter Thompson advertising agency, but upon publication of his first illustration in 1961, he turned his talents to painting and drawing. Since that time he has illustrated several books and his work has appeared in *The Saturday Evening Post, McCall's, Good Housekeeping* and *Outdoor Life*. He received Awards of Excellence from the S of I Annual Exhibitions in 1962 and 1963 and the Hamilton King Award in 1972.

BLOSSOM, EARL.
Illustrator. Born 1891 in Siloam Springs, Missouri, he attended the AIC in 1920 and began his career drawing men's fashions, illustrating for the *Chicago American* newspaper and working on staff for Charles Daniel Frey Studio. He later worked for Pete Martin of *The Saturday Evening Post* where he began his inventive and often humorous style of fiction illustration. When Martin left the *Post*, Blossom moved to *Collier's* and subsequently appeared in *True, Bluebook, Liberty* and *American Legion Magazine*, among others. His work was seen in many ADC Annual Shows and is part of the collection of the New Britain Museum of American Art. His son, David, is presently a successful illustrator in New York.

BLUEMNER, OSCAR.

Painter. Born in Preuzlau, Germany, 1867. Later emigrated to Chicago in 1893. Before he left Germany, he won a royal medal for a painting of an architectural subject, 1892. Came to Chicago to seek work at the World's Columbian Exposition, in 1893. In 1900, his Beaux-Arts design won the competition for the Bronx Courthouse. Made a trip abroad in 1912. Noted for his paintings after 1912; especially "Old Canal Port," 1914, at the Whitney Museum of American Art, NYC. Died in 1938.

BLUM, ALEX A.

Etcher and painter. He exhibited dry point etchings at the Penna. Academy of Fine Arts in the exhibition of 1924. Address in 1926, 1520 Chestnut Street, Philadelphia.

BLUM, JUNE.

Painter and curator. Born Dec. 10, 1939. Studied: Brooklyn College, New York; Brooklyn Museum Art School; The New School;Pratt Graphic Art Center. Exhibitions: Fleisher Memorial Art Gallery, Philadelphia Museum, 1974; Bronx Museum, "Year of the Woman," New York, 1975; Queens Museum, "Sons and Others, Women See Men," New York City, 1975. She is represented in the collection of Brooklyn College. Membership: Women's Caucus for Art; Col. Art Assoc. of Am; Artists' Equity Assoc. Media: Oil.

BLUM, ROBERT FREDERICK.

Painter, illustrator, and mural decorator. Born July 9, 1857, in Cincinnati, Ohio, and died June 8, 1903, in New York City. He worked in oil and pastel and studied lithography and etching. He traveled in Europe and in Japan and did much illustrating. Blum painted many Japanese street scenes, his "The Amega" being in the Metropolitan Museum, NY. He also executed the long wall-panels for the old Mendelssohn Glee Club Hall in New York City. Elected Member of National Academy, 1893.

BLUM, ZEVI.

Illustrator. Born in Paris, 1933. He received a degree in architecture from Cornell University in 1957. After several years as a practicing architect, he began a career in illustration and is presently acting chairman of the Fine Arts Department at Cornell. A book illustrator with works published by *Doubleday* and *Pantheon Books*, he is a frequent contributor to the Op-Ed page of *the New York Times. Intellectual Digest, Rolling Stone* and *Atlantic Monthly* have also used his work.

BLUME, MELITA.

Landscape painter. Born in Germany. Pupil of Art Students' League of New York, Nat. Acad, Munich. Address in 1926, Brookhaven, LI, NY.

BLUME, PETER.

Painter. Born in Russia, Oct. 27, 1906. Came to US in 1911; later became a US citizen. Studied at the Educational Alliance School of Art, 1919-24; Beaux Arts Institute of Design; and the Art Students League. Exhibited: Boston Museum of Fine Arts; Whitney Museum of American Art; Metropolitan Museum of Art; Museum of Modern Art; others. First attracted notice by his painting in 1931 called "South of Scanton," held now by the Museum of Modern Art, which won him the prize at the Carnegie International Exhibition of Painting in 1934. Another celebrated work is his "The Eternal City," 1937, held now at the Museum of Modern Art, a piece inspired by his experience of Italy under rule of Mussolini, 1932-33. Blume also painted government sponsored murals, the post offices in Geneva, NY, 1941, and Canonsburg, PA; also a mural in the Courthouse in Rome, GA, 1941. Artist-in-residence at the American Academy in Rome. Many of his paintings deal with Italian themes. Member: National Academy of Design; National Institute of Arts and Letters; and the American Academy of Arts and Letters. Address in 1982, Rte 1, Box 140, Sherman, CT.

BLUMENSCHEIN, ERNEST L.

Painter. Born in Pittsburgh, May 26, 1874. Pupil Art Students' League and Academy Julien, Paris; illustrator for *Century, Scribner's, McClure's, Harper's, American,* and other magazines and books. Chiefly engages in portrait work. Elected Associate Member of the National Academy, 1910. Represented in Cincinnati Art Museum; Harrison Collection, Los Angeles Art Museum; Kansas City Library; Wichita Museum; Pratt Institute, Brooklyn; Dayton Art Institute; Ft. Worth Museum of Art; Milwaukee Institute; five murals, Missouri State Capitol, Jefferson City; National Museum, Washington, DC; NAC, New York; Brooklyn Museum; Toronto Art Gallery. Address in 1926, Taos, New Mexico.

BLUMENSCHEIN, HELEN GREENE.

Painter. Born in New York City in 1909. Awards: New Mexico and Arizona State Fairs. Collections: New York Public Library; Library of Congress; Newark Public Library; Carnegie Institute; Cincinnati Museum Association.

BLUMENSCHEIN, MARY SHEPARD GREENE.

(Mrs. E. L. Blumenschein). Sculptor, painter, and craftswoman. Born September 26, 1869, in New York City. Pupil of Herbert Adams in NYC; Collin in Paris. Member: National Academy of Design, 1913; National Association Women Painters & Sculptors, NYC; Society of Illustrators, 1912. Awards: Third medal in the Paris Salon, 1900; second medal, Paris Salon, 1902; silver medal, St. Louis Exposition, 1904; Julian Shaw Memorial ($300), National Academy of

Design, 1915; Denver Art Museum, 1934. Represented in Brooklyn Museum. Address in 1953, Taos, New Mexico. Died in 1958.

BLUMENTHAL, M(OSES) L(AURENCE).
Illustrator and teacher. Born Wilmington, NC, July 13, 1879. Studied at Pennsylvania Museum School, and in Munich. Member: Guild of Free Lance Artists; Philadelphia Sketch Club. Illustrated for *Saturday Evening Post, The Ladies' Home Journal, Collier's, McClure's, Scribner's,* etc.

BLYTH, BENJAMIN.
Engraver and portrait draughtsman in pastel. Born 1746, Salem, Mass.; died after 1787. The son of Samuel Blyth. He was admitted to the Essex Lodge of Masons in Salem on March 1, 1781. In Felt's "Annals of Salem" under the date 1769, there is the following entry: "Benjamin Blyth draws crayons at his father's house in the great street leading to Marblehead." Many of his portraits are extant in the old families of New York. His only work as an engraver is found in a Mezzotint Allegorical Composition entitled "Sacred to Liberty, or Emblem of Ye Rising Glory of Ye American States" signed "Cole del-Blyth Facit." On the portrait of Martha Washington engraved by John Norman his name appears "B. Blythdel."

BLYTHE, DAVID GILMOUR.
Sculptor, portrait and genre painter, carver, panoramist, illustrator, and poet. Born near East Liverpool, OH, May 9, 1815. Was apprenticed to Joseph Woodwell, a carver in Pittsburgh, 1832-35. Worked as a carpenter and house painter at Pittsburgh from 1835-36; went to New Orleans in 1836. While serving in the US Navy as a ship's carpenter, travelled to Boston and the West Indies, 1837-40. Became an itinerant portrait painter in western Penna. and eastern Ohio (1841-45); settled at Uniontown, PA, 1846-51; toured to Cumberland and Baltimore, MD, Pittsburgh, PA, and Cincinnati and East Liverpool, OH. Carved a statue of Lafayette for the County Courthouse at Uniontown. Represented by Kennedy Galleries, NYC; Carnegie Institute; Rochester Museum; Brooklyn Museum; and National Baseball Museum, Cooperstown, NY. Best known for satirical genre paintings of 19th century society. Address in 1865, Pittsburgh, PA. Died in Pittsburgh, PA, May 15, 1865.

BOARDMAN, RICHARD A.
Collector and administrator. Born in Phila., PA, June 18, 1940. He studied at the Ecole des Louvre, Sorbonne in Paris, 1961; Brown Univ., AB, 1962; John Hopkins School of Advanced International Studies, Bologna, 1973. He was a Special Assistant Director at the Corcoran Gal., Wash., DC, 1974-1975; the Fine Arts Advisor at the International Communications Agency, Wash., DC, 1975. He was awarded the Special Commendation from the US Information Agency, 1978. Memberships include the Friends of Corcoran (board member); New Museums (advisory board). Collections of his work include African and Oriental art and furniture; contemporary American Art; Haitian painting and metal work. Address in 1980, 2236 Decatur Pl., NW Washington, DC.

BOARDMAN, ROSINA COX.
Painter. Born in New York City. Studied: Art Students League; Chase School of Art with William Chase, DuMond and Mora. Awards: Boardman prize, New York; Pennsylvania Society of Miniature Painters, 1949; American Society of Miniature Painters, 1952; Nat'l. Assn. of Women Artists, 1932, 58; Los Angeles Soc. of Miniature Painters; Boston Museum of Fine Arts. Collections: Metropolitan Museum of Art; Brooklyn Museum; City Art Museum of St. Louis; Corcoran Gallery of Art; Fairmont Museum of Art, Philadelphia.

BOBBS, HOWARD.
Sculptor and painter. Born in Pennsylvania, 1910; raised in California. Studied: Otis Art Institute, Los Angeles, California; Hollywood Art Institute; Phoenix Art Institute; National Academy of Design School; Art Students League. Early in career designed terrazzo floors in St. Louis, MO; later as WPA supervisor taught art in NYC. Subjects include scenes from the American Southwest and from the countries of his travels (England, Mexico, France, Italy, Scotland). Reviewed in *Southwest Art*, September 1973, April 1979; *Artists of the Rockies*, Spring 1979. Represented by own Howard Bobbs Gallery. Address since 1949, Santa Fe, New Mexico.

BOBBS, RUTH PRATT.
Painter. Born Indianapolis, Ind., Sept. 3, 1884. Pupil of Wm. M. Chase. Member: National Arts Club; National Academy Women Painters and Sculptors; Pen and Brush Club; Indiana Art Club. Work: "The Spanish Shawl," Herron Art Institute, Indianapolis. Address in 1926, 10 Gramercy Park, New York.

BOCCINI, MANUEL (FIORITO).
Sculptor, painter, etcher, and lithographer. Born in Pieve di Teco, Italy, September 10, 1890. Studied at Grande Chaumiere, Paris; Art Students League; Grand Central Art School; and with Andre Favory, Andre Derain. Exhibited: Anderson Gallery, 1927; Gallery Barrero, Paris, 1929, 30; Salon d'Automne; Boccini Gallery, NY, 1938; Society of Independent Artists; Salons of America. Address in 1953, 988 Second Ave., NYC; h. 470 Midland Ave., Rye, NY.

BOCK, CHARLES PETER.
Painter. Born in Germany, 1872. Pupil of Art Institute of Chicago; Simon in Paris. Member: Dallas Painters; Overland Landscape Outfit. Work: "Where Sand and Water Meet," Dallas Public Library. Address in 1926, Manvel, Texas.

BOCK, RICHARD W.
Sculptor. Born in Germany, July 16, 1865; came to America at age of five. Pupil of Schaper, Berlin Academy; Falguiere, Ecole des Beaux Arts, Paris. Work: Ill. State Soldiers' and Sailors' Monument at Shiloh; Lovejoy Monument at Alton, Ill.; bronze group on Public Library at Indianapolis; Soldiers' Monument at Chickamauga, for Lancaster, PA; pediments, Rail Road Station, Omaha, Neb.; many bronze busts; etc. Received medal at Columbian Exposition, Chicago, 1893; first award, American Artists' Professional League, Portland, Oregon, 1932. Member of the Chicago Society of Artists; American Artists' Professional League. Address in 1933, The Gnomes, River Forest, Ill.

BODMER, KARL.
Painter and etcher. Born 1809 in Switzerland. He traveled in America in 1832. He made water color sketches of his travels, also executed the copper plates in the atlas published in Maximilian's "Journey through North America" (1838-1842).

BODO, SANDOR.
Sculptor, painter, and conservator. Born in Szamos-szeg, Hungary, February 13, 1920; US citizen. Study: College of Fine and Applied Arts, Budapest, Hungary. Commissions: Bronze reliefs, Hungarian Reformed Federation of America; portrait of Andrew Jackson, Royal Palace, Copenhagen. Exhibitions: National Housing Center, Wash., DC; Smithsonian Institution; Tenn. Fine Art Center, Nashville; Butler Institute of American Art, Youngstown, OH; National Academy Galleries, NYC; others. Awards: American Artists Professional League, gold medal, watercolor; National Arts Club, NY, gold medals, sculpture and oil painting; Smithsonian Institution; others. Member: National Arts Club; American Artists Professional League (fellow); Allied Artists of America. Works in oil, watercolor, bronze. Address in 1982, Nashville, Tennessee.

BOEBINGER, CHARLES WILLIAM.
Painter, illustrator, teacher. Born Cincinnati, Ohio, June 17, 1876. Pupil of Cincinnati Art Academy; Art Students' League of New York. Member: Western Drawing and Manual Teachers' Association. Address in 1926, Walnut and Central Parkway, Cincinnati, Ohio.

BOECKMAN, CARL L.
Painter. Born Christiania, Norway. Studied at Christiania, Copenhagen and Munich. Award: Silver medal for portrait, Columbian Exposition, Chicago, 1893. Work: "Battle of Killdeer Mountain," Capitol, St. Paul, Minn. Address in 1929, 3500 - 3rd Ave., South Minneapolis, Minn.

BOERICKE, JOHANNA MAGDALENE.
Sculptor and painter. Born in Philadelphia on February 13, 1868. Pupil of Penna. Academy of Fine Arts, studied in Rome and Paris. Member: Penna. Society of Miniature Painters; Philadelphia Alliance; Fellowship, Penna. Academy of Fine Arts; Baltimore Water Color Club; American Federation of Arts. Address in 1933, Philadelphia, PA.

BOGARDUS, JAMES.
Engraver and diesinker. Born 1800 in Catskill, NY. He was a skillful mechanic and invented a machine for producing bank-notes from separate dies. He died in 1874 in New York City.

BOGARDUS, MRS. JAMES.
Miniature painter. Was born in 1804, and died in 1879. She exhibited portraits at the National Academy, New York, 1842 to 1846.

BOGART, GEORGE HIRST.
Landscape painter. Born New York in 1864. Pupil of the National Academy of Design; also studied in Paris. Elected an associate member of the National Academy in 1899; also member of the Society of American Artists. Represented at Metropolitan Museum, NY, by "Moonlight," at Corcoran Art Gallery by "Sunset," and at Brooklyn Institute by "Dordrecht." He died in New York City in 1944.

BOGATAY, PAUL.
Sculptor, educator, designer, and craftsman. Born in Ava, OH, July 5, 1905. Studied at Cleveland School of Art; Ohio State University, with Arthur E. Baggs. Member: Columbus Art League; American Ceramic Society. Awards: Fellow, Ohio State University, 1930-33; Tiffany Foundation Scholarship, 1928-30; prizes, Cleveland Museum of Art, 1930, 31; Syracuse Museum of Fine Arts, 1935, 36, 40, 46, 49; Columbus Art League, 1933, 35, 36, 39-41, 43, 46-51. Work: Columbus Gallery of Fine Arts; IBM; Butler Art Institute; Ball State Teachers College. Exhibited: Syracuse Museum of Fine Arts; Phila. Allied Artists; Whitney Museum of American Art; Toledo Museum of Art; American Federation of Arts, Paris; Columbus College of Art and Design; Columbus Art League; Cleveland Museum of Art; Butler Art Institute, etc. Professor of Art, Ohio State University, Columbus, OH. Address in 1953, Columbus, OH.

BOGDANOVE, ABRAHM JACOBI.
Painter and teacher. Born Minsk, Russia, Aug. 11, 1887. Pupil at National Academy under Marnard and F. C. Jones. Member: Society of Independent Artists, New York. Work: Mural decoration in Hebrew Sheltering Guardian Society, Pleasantville, NY; two mural decorations in the Brooklyn Commercial High School. Address in 1926, 145 East 23d Street, New York, NY.

BOGEN, BEVERLY.
Painter. Born in Jersey City, NJ. Study: Syracuse Univ.; ASL; Pratt Graphic Art Ctr.; with Victor

Perard, Benton Spruance, Harry Sternberg, Leo Manso. Work: More than 500 private collections, US and abroad; Bank of VA, Wash., DC. Exhibitions: Silvermine Guild Ann.; Allied Artists, Nat'l. Acad. Galleries, NYC; Yellow Hse. Gal., Huntington, NY; others. Mem.: Artists Equity Assn.; Am. Fedn. of Arts. Works in acrylic. Address in 1976, Jericho, NY.

BOGER, FRED.
Painter and illustrator. Born Baltimore, MD, Oct. 12, 1857. Pupil of Frank Duveneck in Cincinnati. Member: Cincinnati Art Club. Work: "Judge Alphonso Taft," Superior Court, Hamilton County, Ohio; portraits of George B. Cox and August Herrman at Blaine Club, Cincinnati, Ohio. Address in 1926, 2440 Jefferson Ave., S. Norwood, Ohio.

BOGGS, FRANKLIN M.
Sculptor. Born in Springfield, Ohio, 1855; lived in Paris. Studied at the Ecole des Beaux-Arts and under Gerome in Paris. "A Rough Day, Harbor of Honfleur, France" is owned by Boston Museum of Fine Arts. Died August 11, 1926, in Meudon, France.

BOGHOSIAN, VARUJAN.
Sculptor. Born June 26, 1926, New Britain, Conn. Studied: Yale University, BFA, MFA (with Josef Albers); Vesper George School of Art. Work: Museum of Modern Art; New York Public Library; Rhode Island School of Design; Whitney Museum; Worcester Art Museum. Exhibited: The Swetzoff Gallery, Boston, (many); The Stable Gallery, 1963-66; Cordier & Ekstrom, Inc., NYC, 1969; Museum of Modern Art; Art Institute of Chicago Annual, 1961; Whitney Museum Annual, 1963, 64, 66, 68; Yale University, 1965; Institute of Contemporary Art Boston, 1966; others. Awards: Fulbright Fellowship (Italy), 1953; Brown University, Howard Foundation Grant for Painting, 1966; New Haven Arts Festival, First Prize, 1958; Portland (ME) Arts Festival, 1958; Boston Arts Festival, 1961; Providence Art Club, First Prize, 1967; National Institute of Arts and Letters award. Taught: Cooper Union, 1959-64; Pratt Institute, 1961; Yale University, 1962-64; Brown University, 1964-68; American Academy, Rome, 1967; Dartmouth College, from 1968. Address in 1982, Art Department, Dartmouth College, Hanover, NH.

BOGLE, JAMES.
Portrait painter. Born in South Carolina in 1817. He moved to New York in 1836, where he studied under Morse. He was elected an Associate of the National Academy in 1850, and an Academician in 1861. He painted many portraits in the south, Calhoun, Clay, Webster; his portraits of John Dix and Henry Raymond were among his later works. He died in 1873 in Brooklyn, NY.

BOHLAND, GUSTAV.
Sculptor. Born Austria, January 26, 1897. Pupil of A. A. Weinman; Cooper Union; National Academy of Design; Beaux Arts Institute of Design. Exhibited: Nationally, one-man: Sterner Gallery, New York, 1934; World's Fair, New York, 1939; Penna. Academy of Fine Arts, 1933, 40, 49, 51; Florida Southern College, 1952. Work: Corcoran; Carl Graham Fisher Memorial, Miami Beach; Public Library and Art Center, Miami Beach; bronzes, Froedtert Grain and Malting Company, Milwaukee, Wisconsin, and in private collections. Address in 1953, Miami Beach, Florida. Died in 1959.

BOHM, C. CURRY.
Painter. Born Nashville, Tenn., Oct. 19, 1894. Pupil of AIC; Edward F. Timmins. Member: Palette and Chisel C., Chicago; Brown County SA; Hoosier Salon; Ill. AFA; Amer. Artists Prof. Lg. Award: Municipal Art League prize ($100), Palette and Chisel Club. Address in 1929, Palette and Chisel Club, 1012 North Dearborn St.; h. 4121 North Lincoln St., Chicago Ill.

BOHM, MAX.
Painter. Born in Cleveland, Ohio, in 1868. Travelled to Europe in 1886; studied at Julien School, Paris, with Constant, Lefebvre, Boulanger, Mosler, and others; travelled in Eng., Holland, Ger., Italy, and France to study works of the Old Masters. In collections of the Nat'l. Gallery, Wash., DC; San Diego Mus., Calif.; Wichita Art Mus., Kans.; Luxembourg Mus., Paris; Met. Mus. of Art, NYC; Butler Inst., Youngstown, Ohio; Smithsonian, Wash., DC; and many others, including private collections in US, France, England. Exhibited at Paris Salon from 1888; Royal Academy, London; Met. Mus. of Art, Brooklyn Mus., NYC; Luxembourg Gallery, Paris; Nat'l. Gallery, Wash., DC; Macbeth and Grand Central Galleries, NYC; others, including retrospective, Castellane Galleries, NYC. Awarded Gold Medal, Salon of 1898, Paris; Gold Medal, Panama-Pacific Int'l. Expo., San Fran., 1915; Clark prize, Figure composition, NAD, 1917; and many others. Opened school of painting, Etaples, France, in 1895; continued school in London during winters; ceased teaching in 1911 to concentrate on own painting. Lived in France, England, and briefly in the US until he settled near NYC in 1919. Elected National Academician, 1920; member, Arch. Lg.; vice pres., National Mural Painters Society; life member, National Arts Club. Died in Provincetown, MA, in 1923, where he had become one of the early forces in creation of art colony there.

BOHNERT, HERBERT.
Painter and illustrator. Born Cleveland, Ohio, 1888. Pupil of Cleveland School of Art. Address in 1926, 2258 Euclid Ave., Cleveland, Ohio.

BOHROD, AARON.
Born November 21, 1907 in Chicago Ill. Studied two years at Chicago Art Institute; two years at Art Students' League, New York, under John Sloan, Boardman Robinson and Kenneth Hayes Miller. In 1936, won Guggenheim Fellowship award in creative painting. Work owned by Chicago Art Institute and Whitney Museum of American Art, New York. Awards: Clyde M. Carr Prize, 1933; Joseph Eisendrath Prize, 1934; William H. Tuthill Prize, 1934; Watson F. Blain Prize, 1935; Chicago Artists' Prize, 1935.

BOILEAU, PHILIP.
Painter. Born in Quebec, Canada, in 1864, he died in New York on Jan. 18, 1917. He lived in Baltimore for some years and painted many pictures of fashionable women.

BOIT, EDWARD DARLEY.
Painter in water colors. Born in 1840, he graduated from Harvard in 1863 and died April 22, 1916. He was an intimate friend of John S. Sargent and held several joint water color exhibitions with him in Boston and New York. Represented in Boston Museum of Fine Arts by forty water color paintings.

BOIX, RICHARD.
Painter. Exhibited in Philadelphia in 1921. Address in 1926, 49 West 8th Street, New York.

BOLANDER, KARL S.
Painter. Born in Marion, Ohio, May 3, 1893. Pupil of Dow and Walter Sargent, Ensign, MacGilvary, Walter Beck, Lemos, Ohio State Univ., Pratt Inst., Berkshire Summer School of Art, Univ. of Chicago. Member: Columbus AL; Ohio WCS; Eastern AA; Western AA; Assn. Art Museum Directors. Instructor in Applied Arts School, Chicago; Snow-Froehlich School of Industrial Art, NY. Director, Fort Wayne Art School and Museum, 1922-26; director and lecturer, FA Department, Ohio State Fair; Director, Columbus Gallery of Fine Arts and Columbus Art School. Address in 1929, 478 East Broad St., Columbus, Ohio.

BOLEN, JOHN GEORGE.
This engraver's work is unknown except for an armorial book-plate of Charles M. Connolly, signed "J. G. Bolen, 104 B'way."

BOLINSKY, JOSEPH ABRAHAM.
Sculptor. Born in NYC, January 17, 1917. Studied: Columbia University; Stourbridge College of Art, England; Skowhegan School of Painting and Sculpture, with Jose De Creeft; Iowa University. Work: Newark (NJ) Museum; Museum of Art, Tel-Aviv, Israel; Albright-Knox; Skowhegan School; others; Synagogue, Waterloo, Iowa; Temple Sinai, Amherst, NY; and more. Exhibitions: Columbia University;

Gallery West, Buffalo, NY; Brock University, Canada; Albright-Knox; Skowhegan School; Rome; others. Awards: Des Moines Art Center; Albright-Knox Art Gallery, Buffalo, NY; Rochester Festival of Religious Art; others. Professor of Fine Arts, SUNY Buffalo, sculpture, from 1954; others. Works in bronze and stone. Address in 1982, Tonawanda, NY.

BOLLES, IDA RANDALL.
Painter. Pupil of George C. Hopkins, Duveneck, ASL of Washington, Corcoran AS. Member: Laguna Beach AA. Award: Purchase prize, comp. ex. Southern Calif. Orange Assoc., 1923. Specialty, marines. Address in 1929, Laguna Beach, Calif.

BOLMAN, CAROLINE.
Amateur miniature painter, flourished in Philadelphia about 1827. Exhibited miniature of Madame Murat, Penna. Academy, 1827.

BOLMAR, CARL P(IERCE).
Painter, illustrator and writer. Born Aug. 28, 1874. Pupil of PAFA; Spring Garden Inst. Member: Topeka AG. Art critic and staff artist for the Topeka State Journal. Illustrated "Overland Stage to California," and books by Margaret Hill McCarter. Address in 1929, Topeka State Journal, 800 Kansas Ave.; h. 1726 West St., Topeka, Kan.

BOLMER, M. DeFORREST.
Landscape painter. Born 1854 in Yonkers, NY. He died July 7, 1910. His painting, "Cold and Gray," was sold in auction at New York, 1923.

BOLOTOWSKY, ILYA.
Sculptor, painter and educator. Born July 1, 1907, Petrograd, Russia. Came to USA in 1923. Studied: College St. Joseph, Constantinople, Turkey; National Academy of Design, with Ivan Olinsky. Work: Bezalel Museum; Calcutta; Museum of Modern Art; Phila. Museum of Art; Phillips; Chrysler; Rhode Island School of Design; Aldrich; San Fran. Museum of Art; Guggenheim; Slater; Whitney Museum; Walker; Yale University; Williamsburgh Housing Project, NYC, 1936 (one of the first abstract murals); New York World's Fair, 1939; Hospital for Chronic Diseases, NYC, 1941; Cinema I, NYC, 1962. Exhibited: G.R.D. Studios, NYC, 1930; J. B. Neumann's New Art Circle, NYC, 1946, 52; Rose Fried Gallery, 1947, 49; Pratt Institute, 1949; Grace Borgenicht Gallery Inc., (many), NYC; Federation of Modern Painters and Sculptors Annuals; Whitney Annuals; New York World's Fairs, 1939, 1964-65; Seattle World's Fair, 1962; Corcoran, 1963; Albright, Plus by Minus, 1968; Guggenheim, 1974; and others. Awards: Guggenheim Fellowship, 1941; Yaddo Fellowship, 1935; L. C. Tiffany Grant, 1930, 31; National Academy of Design, Hallgarten Prize for Painting, 1929, 30; National Academy of Design, First Prize Medal for Drawing, 1924, 25; The University of Chicago, Mid-

west Film Festival, First Prize (for "Metanois"); State University of New York Grant, for film research, 1959, 60; Abstract Painting Award, National Institute of Arts and Letters, 1971. Member: Co-founder, American Abstract Artists; co-founder of Federation of Modern Painters and Sculptors; and others. Produced 16 mm experi-mental films and in 1961 began constructivist painted columns. Taught: Black Mountain College, 1946-48; University of Wyoming, 1948-57; Brooklyn College, 1954-56; Hunter College, 1954-56, 1963-64; New Paltz/SUNY, 1957-65; Long Island University, 1965-74. Represented by Grace Borgenicht Gallery in NYC. Address in 1980, Sag Harbor, NY. Died in 1981.

BOLTON, J. B.
Engraver of letters and script. He was located in Boston, Mass., in 1841 and worked in connection with D. Kimberly.

BOLTON, ROBERT FREDERICK.
Painter, illustrator, etcher and craftsman. Born in New York City, March 19, 1901. Studied with Curran, Maynard and Bridgman. Pupil of Charles C. Curran; Francis C. Johen; Edwin H. Blashfield; Ivan Olinsky. Work: Series of mural decorations, Consolidated Gas Co., NY; series of decorative panels, NY Winter Garden Theatre. Address in 1926, 502 West 139th Street, New York.

BOMAR, BILL.
Painter. In collections of Ft. Worth (TX) Art Ctr. Mus.; Brooklyn Mus.; Guggenheim; Houston Fine Arts Mus.; others. Exhibitions at Wayne Gallery, NYC, and many others. Address in 1970, 222 W. 23rd St., NYC.

BONA-PARTE.
This fictitious signature appears on a crude portrait of James Madison. The portrait is printed from the plate of Benjamin Rush, engraved by James Akin; this is a case of the engraver Akin disclaiming his own work.

BONAR, T.
Engraver of stipple portraits. About 1850 he was working for the Methodist Book Room. About the same time the firm of Bonar and Cummings were producing portraits for the *Methodist Magazine*.

BOND, GWENDOLINE (MAPLESDEN).
Sculptor, painter, etcher, teacher, writer, and lecturer. Born in India, September 3, 1890. Studied at Columbia University, BA, MA; New York University, D. Education; New York School of Applied Design; Penna. Academy of Fine Arts, with Daniel Garber; Art Students League, with DuMond, Bridgman. Member: National Arts Club; American Federation of Arts. Exhibited: National Academy of Design, 1944; National Association of Women Artists, 1946; National Arts Club; Society of American Graphic Artists; New York Society of Craftsmen. Address in 1953, c/o National Arts Club, 15 Gramercy Park, NYC.

BOND, KATE LEE BACON.
Painter and teacher. Born Topeka, Kan., Nov. 18, 1890. Pupil of AIC. Member: Chicago SA; Chicago S. Min. P. Address in 1929, 899 Ash St., Winnetka, Ill.

BOND, ORIEL E.
Painter and illustrator. Born in Altus, Okla., July 18, 1911. Study: Rockford College, with Marquis Reitzel, Einar Lundquist, Alice McCurry. Work: Private collections. Exhibitions: Rockland (IL) Art Assn., 1956-63; Am. APL, NYC, 1971, 72; others. Chief artist, J. L. Clark Mfg. Co., Rockford, Ill., 1938-77. Mem.: Am. APL; Nat'l. Soc. of Literature and Arts. Works in oil, polymer. Address in 1982, Roscoe, Ill.

BONE, HENRY.
An English miniaturist of note. Likely to have painted in America, as portraits of prominent Americans by him are known.

BONEVARDI, MARCELO.
Sculptor and painter. Born May 13, 1929, in Buenos Aires, Argentina. In US since 1958. Studied architecture, painting, sculpture at University of Cordoba. In collections of Museum of Modern Art; Ciba-Geigy Corp.; Brooklyn Museum; NYU; Tel Aviv; U.N.; University of Texas; and Moderno Museum in Buenos Aires. Exhibited at Argentinian Galleries; Pan American Union, Wash., DC; Latow Gallery, NYC; Center for Inter-American Relations, NYC, 1980. Awards: Guggenheim fellowship, 1958; New School for Social Research 1964, 65; Biennal, Sao Paulo. Address in 1982, 799 Greenwich St., NYC.

BONFIELD, GEORGE R.
Marine and landscape painter. Born in England in 1802; came to Philadelphia as a youth and became a stone carver. Encouraged by Joseph Bonaparte of Bordentown, NJ, became one of the leading marine painters of America. An early member of the Penna. Academy of Fine Arts; he died in Philadelphia in 1898. Represented in Wilstach Collection, Fairmount Park, Philadelphia.

BONGART, SERGEI R.
Painter and teacher. Born in Kiev, Russia. Study: Kiev Art Academy. Work: National Academy of Design; Kiev Academy of Fine Arts, Russia; Charles and Emma Frye Art Museum, Seattle; Theater Museum, Kiev, Russia; Laguna Beach Art Assn. Gallery; Cerritos College, Norwalk, Conn.; Sacramento State Art Collection; others in US and abroad. Exhibitions: Metropolitan Museum of Art, NY; National Academy of Design; Museum of Russian Art, Kiev, Russia; American Water Color Society; M. H.

De Young Memorial Museum, San Fran., Calif.; and many other group and one-man shows. Awards: Gold medal, Am. APL, NY, 1959; silver medal, Am. Watercolor Society, 1969; Watercolor USA, 1974. Teaching: Founder and Instructor, Sergei Bongart School of Art, Santa Monica, Calif., from 1949. Mem.: NAD; Nat'l. Acad. Western Art; Am. Watercolor Soc.; Royal Soc. of Arts; Society of Western Artists. Media: Oil, acrylic. Address in 1982, Santa Monica, Calif.

BONHAM, HORACE.
Genre painter. Born West Manchester, Penna., 1835; died 1892. Pupil of Bonnat, in Paris. Represented by "Nearing the Issue at the Cockpit," at the Corcoran Gallery, Washington, DC.

BONSALL, ELIZABETH F.
Painter. Born in Philadelphia in 1861. Pupil of Penna. Academy of Fine Arts, under Eakins and Howard Pyle. Studied in Paris under Collin and Courtois. Represented at Penna. Academy of Fine Arts by "Hot Milk" (purchased 1897). Address in 1926, 3430 Walnut Street, Philadelphia.

BONSALL, MARY W.
Painter and illustrator. Has exhibited miniatures at the Penna. Academy of Fine Arts. Born at Fernwood, Penna. Pupil of Cecilia Beaux, Chase, and Vonnoh. Address in 1926, 3430 Walnut Street, Philadelphia.

BONTA, ELIZABETH B.
Painter. Born in Syracuse, NY. Received medal for water color, "The Pale Moon," St. Paul Institute, 1916. Address in 1926, 290 Adelphi Street, Brooklyn, NY.

BONTECOU, LEE.
Sculptor. Born January 15, 1931, Providence, RI. Studied: Bradford Junior College, with Robert Wade; Art Students League, 1952-55, with William Zorach, John Havannes. Work: Amsterdam (Stedelijk); Albright; Art Institute of Chicago; Corcoran; Cornell Univ.; Houston Museum of Fine Arts; Museum of Modern Art; Penna. Academy of Fine Arts; Wash. (DC) Gallery of Modern Art; Whitney; New York State Theatre, Lincoln Center, NYC. Exhibited: Leo Castelli Inc., 1960, 62, 66; Ileana Sonnabend Gallery, Paris, 1965; Whitney Museum of American Art Annuals; Carnegie; Museum of Modern Art, 1961, 63-64; VI Sao Paulo Biennial, 1961; Seattle World's Fair, 1962; Art Institute of Chicago, 1962, 63, 1967; Corcoran, 1963; Albright, Mixed Media and Pop Art, 1963; Jewish Museum, Recent American Sculpture, 1964; Museum of Modern Art, The 1960's, 1967. Awards: Fulbright Fellowship (Rome), 1957, 58; L. C. Tiffany Grant, 1959; Corcoran, 1963. Represented by Leo Castelli Inc., NYC. Address in 1970, NYC.

BOOG, CARLE MICHEL.
Painter. Born in Switzerland, June 27, 1877. Pupil of Art Students' League of New York and of Bonnat in Paris. Drawings in Historical Museum, Bennington, VT. Address in 1926, 206 Parkville Ave., Brooklyn, NY.

BOOGAR, WILLIAM F. JR.
Sculptor and painter. Born Salem, New Jersey, August 12, 1893. Pupil of Charles Hawthorne; Penna. Academy of Fine Arts. Exhibited at Penna. Academy of Fine Arts; National Academy of Design; Paris International Exhibition, 1937. Work: Tablets, Pilgrims Landing, Provincetown, MA; children's fountain, Wawbeek, Wisconsin; Frederick Waugh memorial; and memorial to Henry Major, painter. Address in 1953, Provincetown, Mass. Died in 1958.

BOONE, CORA.
Painter. Exhibited water colors at Annual Exhibition of Water Colors, 1922, Penna. Academy of Fine Arts, Philadelphia. Address in 1926, Oakland, Calif.

BOOTH, CAMERON.
Painter. Born Erie, PA, Mar. 11, 1892. Pupil of H. M. Walcott; Andre L'hote, Paris; Hans Hofmann, Munich. Awards: John Quincy Adams Foreign Traveling Scholarship, AIC, 1917; first prize, Minnesota State AS, 1922; first prize, Twin City Artists, 1925 and 1926. Work: "Horses," Pennsylvania Academy of the Fine Arts, Philadelphia; "Early Mass," Newark Museum Association, Newark, NJ. Address in 1926, 2525 - 5th Ave. S., Minneapolis, Minn.

BOOTH, EUNICE ELLENETTA.
Painter and teacher. Born Goshen, NH. Pupil of Mass. School of Art, Boston; NY School of Fine and Applied Art; Handicraft Guild, Minneapolis, under Batchelder; William Chase; Julian Academy and Academie Delecluse in Paris. Member: College AA of America; Calif. State AA. Director, Dept. of Graphic Arts and Prof. of Drawing and Painting, College of the Pacific. Address in 1929, Weber Hall, College of the Pacific, Stockton, Calif.; summer, Norton, Mass. Died 1942.

BOOTH, FRANKLIN.
Illustrator. Born in Carmel, Indiana, in 1874. Copied intricate wood and steel engravings from magazines in pen-and-ink. In 1925, published book of 60 drawings in the decorative style he often used to illuminate poetry and articles. Member: SI, 1911; Salma C. Died in 1943. Address in 1929, 58 West 57th St., New York, NY.

BOOTH, HANSON.
Painter and illustrator. Born at Noblesville, Ind., May 19, 1886. Pupil of Bridgman in New York, also Vanderpoel. Work: Illustrations for *Harper's Monthly*. Address in 1926, Woodstock, Ulster County, NY.

BOOTH, T. DWIGHT.
Engraver. Said to have been born in Albany, NY. He was for a time engaged in bank-note work, but is chiefly known for illustrating for the publishing firm of G. P. Putnam and Co. of New York.

BOOTT, ELIZABETH.
Painter. Born in Cambridge, Mass. She studied in Europe. Some of her paintings were exhibited in Boston in 1877, and in 1878 she exhibited "Head of a Tuscan Ox" and "Old Man Reading." At the National Academy Exhibition of 1886 she had "Hydrangeas" and "Old Woman Spinning."

BORCHARDT, NORMAN.
Illustrator. Born Brunswick, GA, Jan. 21, 1891. Pupil of John Vanderpoel and John Norton. Member: GFLA. Works: Illustrations for *Century Co.; Harper's Bros.; Collier's;* etc. Address in 1929, 82 West 12th St., New York, NY.

BORDEWISCH, FERDINAND F.
Etcher and illustrator. Born Kettlersville, Ohio, June 2, 1889. Pupil of Bridgman, Fogarty and Mora. Member: Dayton SE; ASL. Address in 1929, 4001 East Third St., Dayton, Ohio.

BORDLEY, JOHN BEALE.
Portrait painter. Born in "Wye Island," Talbot County MD, in 1800. He was the grandson of Judge Bordley. After a period of legal study in Philadelphia, Bordley took up painting. He worked in Baltimore from 1834-51, appearing in the directories variously as John Beale Bordley, Beale Boardley, and Peale Boardley. He exhibited at the National Academy in 1843 as B. Boardley, and at the Penna. Academy in 1832. After 1851 Bordley retired to a farm in Harford County, MD, where he continued to paint. He later moved to Bel Air and then to Baltimore, where he died in 1882.

BORDLEY, JUDGE JOHN BEALE.
Artist. Born February 11, 1727, and spent the greater part of his life in Maryland. Jurist, agricultural experimenter and publicist, founder of the Philadelphia Society for Promoting Agriculture, amateur artist. He was an early patron of Charles Willson Peale, and shared a painting-room in Phila. with him in 1776. In 1791, he moved to Philadelphia where he was prominent as a promoter of agricultural improvements. He died on January 26, 1804. His drawing of wheat-harvesting in Maryland in 1787 is owned by the Philadelphia Society for Promoting Agriculture.

BOREIN, EDWARD.
Etcher of Western life. Born in California, Oct. 21, 1872. His work is well known for its truth as well as artistic merit. He is a member of the Print Makers' Society of California and Art Students' League of New York City. Pupil of Hopkins' Art Sch., San Francisco. Address in 1926, El Patio, Santa Barbara, Calif. Died May 19, 1945, in CA.

BOREN, JAMES ERWIN.
Painter. Born in Waxahachie, TX, Sept. 26, 1921. Studied at the Kansas City Art Institute and School of Design, B.F.A. and M.F.A.; University of Kansas City. Exhibited: National Cowboy Hall of Fame, 1969; Texas Art Gallery, Dallas, 1969-81; Cowboy Artists of America, National Cowboy Hall of Fame, 1970-72; Whitney Museum, Cody, Wyoming, 1973; and others. Awards: Excellence Award, from the Society of Technical Writers and Publishers, 1964; nine gold and eight silver awards, from Cowboy Artists of America (secretary-treasurer, 1969-70; president, 1973-74 and 1979-80). Works executed in watercolor and oil. Address in 1982, P.O. Box 533, Clifton, TX.

BORG, CARL OSCAR.
Painter. Born in Sweden, March 3, 1879. Self-taught. Member of California Art Club. Represented in University of California, Golden Gate Museum, LA Museum and LA Public Library. Address in 1926, Santa Barbara, Calif. Died May 8, 1947.

BORGATTA, ISABEL CHASE.
Sculptor and teacher. Born in Madison, WI, Nov. 21, 1921. Studied at Smith College, 1939-40; Yale University School of Fine Arts, BFA, 1944; Art Students League, 1946; New School for Social Research, 1944-45; studio of Jose De Creeft, 1944-45. Works: Wadsworth Atheneum, Hartford, CT; others. Awards: Village Art Center, 1946; National Association of Women Artists, 1952; Village Art Center, 1951; Jacques Lipchitz award, 1961. Exhibited: Penna. Academy of Fine Arts Annual, Philadelphia, 1949-55; Whitney Museum of American Art, 1951-52; NY Cultural Center, 1973; Brooklyn Museum; and many others. Works in stone and wood. Address in 1982, 617 West End Avenue, NYC.

BORGATTA, ROBERT EDWARD.
Sculptor and painter. Born in Havana, Cuba, January 11, 1921; later became a US citizen. Studied at National Academy of Design, 1934-37; NY University, School of Architecture and Allied Arts, BFA, 1940; Institute of Fine Arts, 1946-53; Yale University School of Fine Arts, MFA, 1942. Exhibited: Audubon Artists Annual, 1953-72; Whitney Museum of American Art Prizewinners Show, 1954; Schettini Gallery, Milan, Italy, 1957; Corcoran Gallery of Art, 1968; including one-man shows such as Babcock Galleries, 1964 and 68; and Southern Vermont Art Center, 1977. Member: Audubon Artists; American Watercolor Society; National Society of Painters in Casein. Taught: City College of NY as professor of painting and drawing, 1947-80. Most of his works are executed in marble and oil. Address in 1982, 366 Broadway, NYC.

BORGHI, GUIDO R.
Sculptor and painter. Born in Locarno, Switzerland, March 29, 1903. Worked as apprentice scenery painter for Famous Players Motion Picture Studios, New York City. Works: Mural, "Circus," for the Lexington School for the Deaf and Dumb, New York City, 1937; mural for Minadoka Co., Grange, Idaho, 1940; Melrose, NM, 1971; numerous private homes. Exhibited: Corcoran Museum, 1939; The World's Fair, New York City, 1939; National Academy of Design, New York City, 1940; Society of Independent Artists, 1937; Boise Art Museum, Idaho, 1941; Heyburn Art Institute, Idaho, 1940; Yonkers Museum, NY, 1946; Massillon Museum, OH, 1962; Atlanta High Museum, Atlanta, Georgia, 1962; others. Teaching: Art Instructor for Shell Oil Art Class, Equitable Life Assurance Co., Rockefeller Recreation Center Art Class, and for the Rockettes at Radio City Music Hall. Member: Society of Animal Artists (founder); Society of Independent Artists. Address in 1970, City Island, NY.

BORGLUM, JOHN GUTZON.
Sculptor. Born March 25, 1867, in Idaho. He studied in San Francisco, and with Virgil Williams and William Keith in Kansas; went to Paris in 1890 where he attended the Academie Julien and the Ecole des Beaux-Arts. He exhibited as painter and sculptor in London and Paris where he resided for long periods. Settled in NYC in 1902. Exhibited at National Sculpture Society, 1923. In collections of Metropolitan Museum of Art; and Los Angeles Museum. Awards: Gold medal, Western Art Association; gold medal, Louisiana-Purchase Exp., St. Louis, MO, 1904. Member: Societe Nationale des Beaux-Arts, associate; NY Architectural League; Royal Society of British Artists. Works: Gen. Phil Sheridan Monument, Washington, DC; 12 apostles, Cathedral of St. John the Divine, NY; colossal head of Abraham Lincoln, rotunda of Capitol, Washington, DC; Mares of Diomedes, and Ruskin, Metropolitan Museum, NY; statue of Lincoln, Newark, NJ; Henry Ward Beecher, Brooklyn, NY; Thomas Paine, Paris; numerous marble figures; colossal bronze equestrian statue of Sheridan, Chicago, IL; colossal group, 42 heroic figures in bronze, Newark, NJ; colossal bas-relief on the face of Stone Mountain, near Atlanta, GA, involving several hundred figures; best known for heads of Presidents on Mt. Rushmore. Died March 6, 1941 in New York City.

BORGLUM, SOLON HANNIBAL.
Sculptor. Born Dec. 22, 1868, in Ogden, UT. Studied with his brother, Gutzon Borglum; at Cincinnati Art Academy; and with Fremiet and Puech in Paris. Member of National Sculpture Society; Associate, National Academy of Design, (1911). Exhibited at National Sculpture Society, 1923. Received awards at Paris Salon, 1899; Pan-Am. Exp., Buffalo, 1901; Louisiana Purchase Exp., St. Louis, MO, 1904; Buenos Aires Exp., 1910. In collections of Metropolitan Museum of Art; Detroit Institute; University of Iowa; and National Gallery of Canada. Works: Statue of Gen'l. Gordon (Atlanta, GA); Soldiers and Sailors Monument (Danbury, CT); statues "Inspiration" and "Aspiration;" and 8 colossal portrait busts of Civil War generals. Made a specialty of Western life. Died Jan. 31, 1922, in Stamford, CT.

BORGORD, MARTIN.
Sculptor and painter. Born Gausdal, Norway, February 8, 1869. Pupil of Laurens in Paris; and William M. Chase. Member: Allied Artists of America; Paris American Art Association; St. Lucas Society, Amsterdam, Holland; Salmagundi Club; American Artists Professional League; American Federation of Arts. Award: Medal, Paris Salon, 1905. Work: "Laren Weaver," Carnegie Institute, Pittsburgh; "Romeo and Juliette," Luxembourg Museum, Paris; "Portrait of Walter Griffen, N.A.," and "Portrait of William H. Singer, Jr., N.A.," National Academy of Design; others. Address in 1933, Riverside, CA. Died in Riverside, CA, 1935.

BORIE, ADOLPHE.
Artist. Born Philadelphia, 1877. Studied at Penna. Academy of Fine Arts, Royal Academy, Munich, Bavaria. Awards: Carol Beck gold medal, Penna. Academy Fine Arts, 1910; silver medal, San Francisco Expn., 1915; Isaac N. Maynard prize, National Academy of Design, 1917. Fellow, Penna. Academy of Fine Arts. Member: National Society Portrait Painters. Died 1934, in Philadelphia. Address in 1926, 4100 Pine Street, Philadelphia, PA.

BORKMAN, GUSTAF.
Wood engraver. Born in Sweden, 1842; died Feb. 19, 1921, in Brooklyn, New York. Worked for *Graphic*, *Harper's Weekly*, and for *Harper's Monthly*.

BORNE, MORTIMER.
Sculptor, painter, etcher, educator, and lecturer. Born in Rypin, Poland, Dec. 31, 1902. Studied at National Academy of Design; Art Students League; Beaux-Arts Institute of Design; and with Hinton, Charles Hawthorne, F. Jones. Member: Society of American Graphic Artists, 1939, 43. Work: Library of Congress; National Gallery of Art; NY Public Library; Syracuse Museum of Fine Art; Rochester Memorial Art Gallery; NJ State Museum. Exhibited: Art Institute of Chicago, 1931; American Institute of Graphic Arts, 1937; Sweden, 1937; NY World's Fair, 1939; 100 Prints, 1940; Metropolitan Museum of Art, 1942; Museum of Modern Art, 1940; Corcoran Gallery of Art, 1941 (one-man); Montreal Museum of Fine Art, 1942 (one-man); NY Public Library (one-man); Currier Gallery of Art, 1945;

Brooklyn Museum, 1950; Wichita Art Association, 1952; NY State Fair, 1950, 51; Carnegie Institute, 1947. Position: Art Lecturer, New School, NY, 1945-67. Author: Idiomatic Specialization, 1952; New Art Techniques, 1969; others. Address in 1982, Nyack, NY.

BOROCHOFF, (IDA) SLOAN.
Painter. US citizen. Study: High Mus. of Art, 1939; Univ. of Georgia, 1939-40; GA State Univ., 1940; Chic. Sch. of Interior Decorating, 1966; Atlanta Art Inst., 1968. Work in Georgia collections. Exhib.: Many in Georgia, including Atlanta Art Mus.; High Mus.; GA State College; others. Has held numerous art-related positions in design and artistic direction in Georgia. Address in 1982, Atlanta, Georgia.

BORONDA, BEONNE.
Sculptor and educator. Born in Monterey, CA, May 23, 1911. Studied at Art Students League with Arthur Lee. Awards: National Association of Women Artists, 1938; NJ Society of Painters and Sculptors, 1945, 46; Pen and Brush Club, 1945; Norwich Art Association, 1953; Silvermine Guild Association, 1955. Exhibitions: Whitney Museum, 1940; Pen and Brush Club, 1944, 45; Penna. Academy of Fine Arts, 1935-45; National Academy of Design, 1935, 37, 41, 44, 45, 48-51; Art Institute of Chicago, 1937, 38, 40; National Association of Women Artists, 1932-46, 48; World's Fair of NY, 1939; Metropolitan Museum of Art, 1942; Conn. Academy of Fine Arts, 1933-46, 1949-51; Architectural League of NY, 1941, 44; Addison Gallery of American Art, 1950; others. Member of National Sculpture Society; others. Instructor, sculpture, Montclair Art Museum, 1944-45. She is noted for her animal sculpture. Address in 1953, Mystic, CT.

BORONDA, LESTER D.
Painter. Born in Nevada, 1886. Exhibited at the Penna. Academy of Fine Arts, 1924. Address in 1926, 131 Waverly Place, New York City.

BORST, GEORGE H.
Sculptor. Born Philadelphia, Feb. 9, 1889. Studied: Penna. Academy of Fine Arts, pupil of Charles Grafly, Albert Laessle; Itallo Vagnetti in Florence, Italy; Julian Academy, Paris. Member: Alliance, American Federation of Arts, Fellowship Penna. Academy of Fine Arts, American Artists Professional League. Awards: Stewartson prize and Stimson prize, Penna. Academy of Fine Arts, 1927. Exhibited: Penna. Academy of Fine Arts, 1930-46; National Academy of Design; National Sculpture Society; Philadelphia Art Alliance, 1937 (one-man). Address in 1953, Philadelphia, PA.

BORZO, K(AREL).
Painter. Born Hertogenbosch, Holland, April 3, 1888. Self taught. Member: Seattle Art Inst. Award:

First prize, Washington State Fair, 1928. Address in 1929, 3025 East Madison St., Seattle, Wash.

BOSE, NEAL.
Painter, illustrator and etcher. Born Columbia, Tenn., May 22, 1894. Pupil of Leopold Seyffert; Audubon Tyler and Leon Kroll. Member: GFLA. Specialty, advertising illustration. Address in 1929, Wrigley Bldg., 410 North Michigan Blvd., Chicago, Ill.; h. 836 Hinman Ave., Evanston, Ill.

BOSLEY, FREDERICK ANDREW.
Born at Lebanon, NH, Feb. 24, 1881. Pupil of the Museum of Fine Arts School, Boston. Represented by "The Dreamer." Signed "F. Bosley, 1911." Owned by Boston Museum of Fine Arts. Address in 1926, 162 Newbury Street, Boston.

BOSS, HOMER.
Painter. Born 1882; died 1956. Exhibited at 1913 Armory Show and at Philadelphia in 1921. Address in 1926, 37 West 16th St., New York.

BOSTICK, ALMA.
Painter and teacher. Born Monroe, LA, Oct. 1, 1891. Pupil of Catherine Critcher; E. Ambrose Webster. Member: Wash. SA; SSAL. Instructor, Critcher School of Painting. Specialty, portraits. Address in 1929, 604 Copley Courts, 1514 Seventeenth St., NW, Washington, DC.

BOSTON, FREDERICK J(AMES).
Painter. Born Bridgeport, Conn., 1855. Pupil of Whittaker in Brooklyn; Carolus Duran in Paris. Member: Brooklyn Society of Artists. Address in 1926, Carnegie Hall, New York City.

BOSTON, JOSEPH H.
Painter. Born Bridgeport, Conn. Associate Member of the National Academy of Design and the Brooklyn Art Club, New York. Member of the Allied Artists of America, New York. Representation, Brooklyn Institute of Arts and Sciences, New York. Died in New York City in 1954. Address in 1926, Carnegie Hall, NY.

BOSWORTH, WINIFRED.
Painter and etcher. Born Elgin, Ill., 1885. Studied at Boston Museum of Fine Arts; Art Students League of New York; Laurens in Paris; Eisengruber in Munich. Member: Chicago Water Color Club; Society of Independent Artists. Address in 1926, Woodland, Elgin, Ill.

BOTH, ARMAND.
Painter and illustrator. Born in Portland, Maine, in 1881; died in New York, Feb. 1, 1922. Studied in Boston, and with Laurens in Paris. Illustrator for magazines and books.

BOTH, WILLIAM C.
Illustrator. Born Chicago, Ill., Feb. 18, 1880. Pupil of J. Francis Smith and Laurens. Member: Palette and Chisel C. Address in 1929, Meyer Both Co., 1935 South Michigan Ave.; h. 6714 Bennett Ave., Chicago, Ill.

BOTKE, CORNELIUS.
Painter. Born Leenwarden, Holland, July 6, 1887. Pupil of Chris Le Beau. Member: Chicago Society of Artists. Awards: Fine Arts Bldg. Prize, 1918; Hon. mention for landscapes, American Exhibition, Chicago, 1921. Work: "The Golden Tree," Public School, Chicago; "The Last Snow," Oak Park High School; "Lifting Clouds," Public Library, Ponca City, Okla.

BOTKE, JESSIE ARMS (MRS.).
Painter and illustrator. Born Chicago, Ill., 1883. Pupil of Johansen, Woodbury and Herter. Member: Chicago Society of Artists. Awards: Englewood Woman's Club prize, 1917; bronze medal, Peoria Society of Allied Arts, 1918; medal, Chicago Society of Artists, 1919. Work: "White Swans," Municipal Gallery, Chicago; mural decoration for Ida Noyes' Hall, University of Chicago; "Geese," Chicago Art Institute. Address in 1926, Carmel-by-the-Sea, Calif.

BOTTUME, GEO. F.
Painter. Born in Baltic, Conn., 1828. Painted many portraits in the eastern part of the state. He was still living in Springfield, Mass., in 1878.

BOUCHE, LOUIS.
Born March 18, 1896, in New York City. From 1910 to 1915, studied in Paris with Desvailliers, Lucien Simon, Prinet and Bernard Naudin; Ateliers-Colarossi, La Grande Chaumiere and L'Ecole des Beaux Arts. From 1915 to 1916, studied at Art Students League, New York, with Du Mond and Luis Mora. Exhibited in American and European shows and held one-man exhibitions. Work owned by New York University Gallery of Living Art, Phillips Memorial Gallery, Whitney Museum of American Art, Ferdinand Howald Collection and private collectors. Executed decorations for Radio City Music Hall, New York City, and various private residences. Member: Society of Painters, Sculptors and Gravers, and member of the National Society of Mural Painters.

BOUCHE, MARIAN WRIGHT.
Painter. Born New York, Dec. 8, 1895. Pupil of Henry Matisse and Walt Kuhn. Member: Penguin Club, Society of Independent Artists. Address in 1926, care of Daniel Gallery, 2 West 47th Street, New York, NY.

BOUCHE, RENE ROBERT.
Illustrator. Born in Prague, Czechoslovakia, in 1906. He studied briefly at the universities of Munich and Paris. He was a frequent contributor to *Vogue*, which assigned him to paint an editorial series on the 1948 Republican and Democratic conventions. Best known for the fluid elegance of his drawings, he greatly influenced future styles and modes of fashion illustration.

BOUCHER, GRAZIELLA V.
Painter and writer. Born Detroit, Mich., Oct. 31, 1906. Specialty, paintings of animals. Feature writer for newspapers and magazines. Director, Nat. Pub. Campaigns and Art exhibitions.

BOUDIER.
Engraver of portraits in the same style as St. Memin. He was evidently of French birth and probably was only in this country for a short time, as only one plate of his is known and that was engraved in Philadelphia.

BOUGHTON, GEORGE H.
Painter. Born Norwich, England, 1833. Lived for years in New York City. His specialty was landscapes. Boughton was elected a member of the National Academy of Design in 1871; he died in London, England, Jan. 19, 1905. Represented at Boston Museum of Fine Arts by "Sea Breeze."

**BOUGUEREAU,
ELIZABETH JANE GARDINIER.**
Born in Exeter, NH, 1837. Studied in Paris and married her teacher, W. A. Bouguereau; she survived him, dying Jan. 1922, in St. Cloud, France. Her specialty was ideal figure-pieces. She received a medal at the Philadelphia Centennial in 1876.

BOULTON, JOSEPH LORKOWSKI.
Sculptor and painter. Born in Ft. Worth, Texas, May 26, 1896. Studied at National Academy of Design, Art Students League, Beaux-Arts Institute of Design, and with Hermon A. MacNeil. Works: Memorial tablet representing old Ft. Worth, Ft. Worth DAR; "The Devil Dog," Marine Barracks, Washington, DC; "Hop" (bronze mouse), Detroit Institute of Arts. Exhibitions: Penna. Academy of Fine Arts, 1924; National Sculpture Society, 1923; many shows, Hudson Valley Art Association, 1951-68; National Academy of Design, 1953; Allied Artists of America; plus others. Commissions: Coins and medals for Medical Society, State of Penna., Franklin Mint, series of American wildlife, American Sculpture Society, Westport, CT; plus many plaques and busts. Member: League of American Artists; Salmagundi Club; Philadelphia Art Association; American Federation of Arts; Allied Artsts of America. Awards: Helen Foster Barnett prize, National Academy of Design, 1921. Address in 1982, c/o Allied Artists of America, 15 Gramercy Park S., NYC.

BOUNTHEAU, HENRY BRINTNELL.
Miniature painter. Born 1797 in Charleston, VA. He painted a miniature of a descendant of the patriotic family of Manigault of South Carolina. Died Jan. 31, 1877 in Charleston.

BOURDON, DAVID.
Portrait painter and musician flourishing about 1810, Pittsburgh, PA.

BOURKE-WHITE, MARGARET.
Photographer. Born June 14, 1906, in New York City, Margaret White studied at Columbia Univ., Univ. of Michigan, and Cornell Univ., where she graduated in 1927. In 1929 to 1933 she was an associate editor for *Fortune* magazine. Several extensive tours of the Soviet Union resulted in the picture-and-text books *Eyes on Russia*, 1931, *Red Republic*, 1934, and *U.S.S.R., A Portfolio of Photographs*, 1934. In 1936 she became a member of the original staff of *Life* magazine. She remained an editor for 33 years and contributed photographs and photo-essays. In 1939, she travelled extensively in Europe, the Near East and the Soviet Union (where in 1941 she photographed Josef Stalin in the Kremlin); covered political and military events. In 1942, she became the first woman to be accredited as a war correspondent to the US Army. Accompanied Gen. George S. Patton's Third Army into Germany in 1944, where she recorded on film the opening of Buchenwald and other concentration camps. Other books of her photographs and text included *Shooting the Russian War*, 1942, *They Called It Purple Heart Valley*, 1944, *Dear Fatherland, Rest Quietly*, 1946, and *Halfway to Freedom: A Study of the New India*, 1949. Later published works included *A Report on the American Jesuits*, 1956, volume of autobiography, *Portrait of Myself*, 1963. Died in Stamford, CT, on August 27, 1971.

BOURNE, GERTRUDE BEALS.
(Mrs. Frank A. Bourne). Painter. Specialty, water colors. Member of National Association of Women Painters and Sculptors. Address in 1926, 130 Mt. Vernon Street, Boston.

BOURQUIN, J. E.
Painter, Yonkers, NY.

BOUTELLE, DE WITT CLINTON.
Painter. Born in Troy, 1820, and died 1884. He early came under the influence of Cole and Durand. After painting in New York and Philadelphia, he moved to Bethlehem, Penna. He painted a portrait of Asa Packer, presented to Lehigh University. He was elected an associate to the National Academy in 1853, and a member of the Pennsylvania Academy in 1862.

BOUTWOOD, CHARLES E.
Painter and teacher. Born in England; naturalized in. United States, 1892. Pupil of Royal Academy in London; later studied in Paris. Member: Chicago SA; Chicago WCC. Award: Silver medal, Chicago SA, 1913. Represented in Vanderpoel Art Asso. collection, Chicago. Address in 1929, care of F. A. Bryden and Co., Chicago, Ill.

BOUVE, ELISHA W.
Engraver and lithographer (of Bouve and Sharp, who had their lithographic establishment at Graphic Court, Boston, Mass.). Born in Boston, 1817, and died there April 13, 1897. He printed many rare views of Boston, as well as the scarce, colored print representing *S. S. Britannia* leaving her dock.

BOUVE, ROSAMOND SMITH.
Painter. Member: Boston GA; Conn. AFA; NA Women PS. Award: Bronze medal, P.-P. Expo., San F., 1915. Address in 1929, 334 East 57th St., New York, NY.

BOWDISH, EDWARD ROMAINE.
Painter, illustrator, and etcher. Born Richfield Springs, NY, May 26, 1856. Pupil of his father and August Schwabe. Member: Yonkers AA; AFA. Address in 1929, Skaneateles, NY.

BOWDITCH, MARY O.
Sculptor. Exhibited at the Penna. Academy of Fine Arts, Philadelphia, 1920. Address in 1926, Boston, Mass.

BOWDOIN, HARRIETTE.
Painter and illustrator. Born in Mass. Pupil of Elliott Daingerfield. Address in 1926, 1947 Broadway, NY.

BOWEN, ABEL.
Engraver. Born in Sand Lake Village, Greenbush, NY, 1790; died in Boston, 1850. Bowen was engraving upon wood as early as 1811, and in August, 1812, he was in business as a printer in Boston. In 1816, Bowen published in Boston "The Naval Monument," illustrated by copper and woodcut views of naval combats, a number of which were engraved by Bowen himself. He was certainly engraving upon copper in 1817 in both line and stipple; in 1821, he was in business with Alexander McKensie, a copperplate printer, and in 1825 he published Shaw's "History of Boston," illustrated by Bowen. He illustrated an edition of the lectures of Sir Astley Paston Cooper, published by Pendleton, who established the first lithographic press in Boston. Mr. W. G. Linton, in his "History of Wood Engraving in America," says that in 1834 Abel Bowen, in association with the wood-engravers Alonzo Hartwell and John C. Crossman, established the American Engraving and Printing Co. This company later became the "Boston Bewick Co.," the publishers of the *American Magazine*, a publication devoted to the encouragement of wood-engraving in America. The two volumes of this magazine contain about 500 woodcuts, generally

coarse and crude in execution. In 1836, their printing establishment was burned down and the company failed.

BOWEN, ALEXANDER.
Painter. Born in New York in 1875. Pupil of Penna. Academy of Fine Arts. Address in 1926, Salmagundi Club, 45 Fifth Ave., New York.

BOWEN, BENJAMIN JAMES.
Painter. Born in Boston, Feb. 1, 1859. Studied abroad, studio in Paris. Pupil of Lefebvre and Robert-Fleury in Paris. Exhibited in the Salon, and in America.

BOWEN, DANIEL.
Wax modeler and museum proprietor. Born in 1760. Modeled wax portraits of Benjamin Franklin and George Washington. Exhibited a panorama of New Haven in Philadelphia, Pennsylvania, in 1818. He was best known as one of the first museum proprietors in America and for his waxworks in New York City, Philadelphia, and Boston. Died in Philadelphia on February 29, 1856.

BOWEN, JOHN.
Engraver of maps, and some rather crude stipple portraits and illustrations. He was working in Philadelphia, 1810-19.

BOWEN, THOMAS.
Portrait painter. He died in 1790.

BOWER, LUCY SCOTT.
Painter and writer. Born Rochester, IA, 1864. Pupil of Robert-Fleury, Lefebvre, Simon and Menard in Paris. Member: NYSA; North Shore AA; NA; Women PS; PBC. Award: Gold prize, Arc-en-Ciel Exhibition, Paris, France, 1917; prize ($100) exhibition artist members Nat. L. Amer. Pen Women, 1929. Work: "The Knitters," Museum of Vitre, France; "The Red Roofs," Pen and Brush Club, New York; "Fishermen Mending Nets," Long Branch Club of the New Jersey Federation of Women's Clubs, "Port of La Rochelle," Museum, Warrenton, NC. Author of poems, "In a Minor Vein." Address in 1929, care of the Pen and Brush Club, 16 East 10th St., New York, NY. Died in 1934.

BOWER, MAURICE L.
Illustrator. Member: SI. Address in 1929, 1520 Chestnut St., Philadelphia, PA.

BOWERS, BEULAH SPRAGUE.
Sculptor, painter, and craftswoman. Born in Everett, MA, Nov. 5, 1892. Studied at Mass. Institute of Technology, with W. F. Brown; South Boston Art School; Mass. School of Art, B.S. (education), M. (education); Cooper Union Art School; University of New Hampshire. Member: Meriden Arts and Crafts Association; Conn. Art Association. Awards: Prizes, Arts and Crafts Association, Meriden, CT. Exhibited: Meriden Arts and Crafts Association, 1939-46; Kansas Water Color Society; Kansas Art Association; Artists Guild, annually. Lectures: Color; Design. Position: Assistant Professor of Art, University of Wichita, 1929-37; Supervisor of Art, Meriden, CT, from 1939. Address in 1953, Meriden, CT.

BOWERS, EDWARD.
Painter in oils, and crayon portrait draughtsman. Born in Maryland in 1822. He was working in Philadelphia in 1855-58.

BOWES, JOSEPH.
Engraver in line and stipple and architect. He was living in Philadelphia as early as 1796. His work appears in the *American Universal Magazine* and the *Monthly Magazine of Philadelphia.*

BOWES, JULIAN.
Sculptor and teacher. Born in New York City, March 7, 1893. Pupil of Jay Hambidge. Member: NY Society of Craftsmen; Society of Independent Artists; fellow, Royal Hellenic Society; associate, British School of Archaeology. Work in Metropolitan Museum of Art; Columbia University; American Museum of Natural History; Navy Yard, NY. Director, School of Dynamic Symmetry. Author of "Proportions of the Ideal Human Figure," "The Lost Canon of Polykleitos," and "Scripta Mathematica." Address in 1953, Saybrook, CT.

BOWLER, JOSEPH, JR.
Illustrator. Born in Forest Hills, New York, in 1928. He started working at Cooper Union Studios in 1948. His first published illustration was for *Redbook* in 1949. He was acclaimed Artist of the Year in 1967 by the AG in New York, and his work appears at the Sanford Low Collection and the Hartford Museum. He has illustrated for all the major magazines and currently all his covers and illustrations are portraits.

BOWMAN, DOROTHY.
Painter and serigrapher. Born in Hollywood, CA, Jan. 20, 1927. Studied: Chouinard Art Institute; Jepson Art Institute. Awards: Los Angeles County Fair, 1952, 1953; National Serigraph Society, 1952; Brooklyn Museum, 1954; Library of Congress, 1954; University of Illinois, 1956; Boston Printmakers, 1956, 1958; California Artists, 1957; Wichita, Kansas, 1957. Collections: New York Public Library; Immaculate Heart College, Los Angeles; Brooklyn Museum; Crocker Art Gallery, Sacramento, California; Metropolitan Museum of Art; Library of Congress; San Jose State College; Boston Museum of Fine Arts; Rochester Memorial Art Gallery; University of Wisconsin. Address in 1980, Los Angeles, CA.

BOWMAN, F. G.
According to Dunlap a painter by this name was born in Pennsylvania and had a studio in Boston. He was said to have exhibited in the early days of the Boston Athenaeum, and was working in Maryland about 1800.

BOWNE, J. C.
A line engraver of this name made a number of landscape plates for *Peterson's Magazine* of Philadelphia about 1854.

BOYCE, RICHARD.
Sculptor. Born June 11, 1920, in NYC. Studied at Boston Museum School, with Paige fellowship in painting, Bartlett grant in sculpture. Taught at Boston Museum School, at Boston University, and at UCLA from 1963. In private collections, and in Rhode Island School of Design Museum; Wellesley; Harvard; Whitney; Hirshhorn Foundation, Washington, DC. Exhibited at the B. Mirski Gallery, Boston, 1952; Swetzoff Gallery, Boston; Art Institute of Chicago; Penna. Academy Fine Arts; Landau Gallery, NYC; Smithsonian Institute; European travelling exhibition; Whitney; and others. Living in Santa Monica, CA, in 1976.

BOYCE, RICHARD A(UDLEY).
Painter, illustrator, etcher and craftsman. Born Brooklyn, NY, July 24, 1902. Pupil of O'Neil and Pennel. Member: S. Indp. A. Address in 1929, 598 Prospect St., Ridgewood, NJ; summer, 4710 Fifteenth St., N.W., Washington, DC.

BOYD, BYRON BEN.
Born Jan. 22, 1889, Wichita, KS. Attended public schools, Denver, CO. Studied painting in high school under Jean Manheim, and under various instructors in schools and universities. Attended Univ. of Colorado for three years; Northwestern Univ. for one year, receiving A.B. Four years later received M.A. in architecture from Columbia Univ., 1914. Moved to Des Moines. Became designer in architectural firm., 1916; organized firm of Boyd and Moore and practiced architecture for fourteen years, building some of most important stuctures in Iowa. During World War headed division designing submarine bases, Navy Dept., Bureau of Yards and Docks. Attended National Academy for two seasons, later studying with Henry Leith Ross and Henry Hensche. Painted during extended trips to Europe, Africa and the Near East. Has exhibited in galleries and museums in NYC, Boston, Phila., Wash., Chicago and in most national exhibitions.

BOYD, EVERETT C.
Painter. Exhibited a "Grey Day" at Cincinnati Museum, Annual Exhibition of 1925. Address in 1926, 1322 Arlington Street, Cincinnati, Ohio.

BOYD, FISKE.
Born Philadelphia, PA, in 1895. In 1913-16, studied at PAFA under Grafley, Garber, Pearson and Breckenridge. In 1921-24, studied at Art Students League, NY, under John Sloan, Boardman Robinson and Kenneth Hayes Miller. Has held one-man exhibitions in leading galleries in New York and Boston. Painted landscapes under Public Works of Art Project. Awarded Woodblock Prize, Philadelphia Print Club, 1931. Represented by woodcuts and etchings in Print Collection of Metropolitan Museum; Whitney Museum of American Art; New York Public Library; Boston Museum of Fine Arts; John Herron Art Institute, Indianapolis; Addison Gallery of American Art, Andover, Massachusetts; paintings in Phillips Memorial Gallery, Washington, DC; Whitney Museum of American Art; Newark Museum. Was one of the painters exhibiting regularly with the group which came into prominence soon after the famous "Armory" show.

BOYD, JOHN.
Engraver of stipple portraits and book-illustrations for the Philadelphia publishers from 1811 to 1827.

BOYD, RUTHERFORD.
Illustrator. Member: Salma. C. Address in 1929, 112 Prospect St., Leonia, NJ.

BOYD, WILLIAM.
Painter and artist. Born Glasgow, Scotland, Aug. 24, 1882. Studied in Paris. Member: Pitts. AA; FAIA. Award: Water color prize, Pitts. AA, 1921. Address in 1929, 1213 Empire Bldg., Pittsburgh, PA; h. Edgeworth, Sewickley, PA; summer, Medomak, Lincoln Co., ME.

BOYDEN, DWIGHT FREDERICK.
Landscape painter. Born in Boston, 1865. Pupil of Boulanger in Paris. Gold medal of Paris Salon, 1900. Address in 1926, Algonquin Club, Boston, Mass.

BOYER, HELEN KING.
Engraver. Born in Pittsburgh, PA, in 1919. Studied: With Boyd Hanna, Wilfred Readio and Samuel Rosenberg. Awards: Society of American Graphic Artists, 1943; Library of Congress, 1943; Tiffany Foundation grant, 1949; New Jersey Federation of Women's Club, 1952, 1953, 1954. Collections: Library of Congress; Carnegie Institute; Metropolitan Museum of Art; Henning Company, 1955.

BOYER, RALPH.
Painter, etcher and illustrator. Born Camden, NJ, July 23, 1879. Pupil of Anshutz, Breckenridge, Beaux and Chase. Member: NY Arch. Lg.; Salma. C.; Fellowship PAFA. Specialty, portrait painting. Address in 1929, Westport, Conn.

BOYLE, CHARLES WASHINGTON.
Painter. Born in New Orleans, LA. Pupil of Art Students League of New York. Represented by "Afternoon Light," Delgado Museum, and "Oak on Bayou," New Orleans Art Association. Died Feb. 9, 1925, in New Orleans, LA.

BOYLE, FERDINAND THOMAS LEE.
Painter. Born in Ringwood, England, 1820, and died 1906. He came to this country in childhood and studied painting under Inman. He settled in St. Louis in 1855, and organized the Western Academy of Art. In 1866, he came to New York, where he painted portraits of Chas. Dickens, Archbishop Hughes, Gen'l Grant (Union League Club of Brooklyn), Edgar Allan Poe and other celebrities. For many years he was professor at Brooklyn Institute of Art.

BOYLE, JOHN J.
Sculptor. Born Jan. 12, 1851/52, in New York City. He began life as a stonecarver and studied at the Penna. Academy of Fine Arts under Eakins; Ecole des Beaux-Arts under Dumont; Thomas and E. Millet in Paris. He was elected an Associate of the National Academy and was also a member of the National Sculpture Society; NY Architectural League; National Arts Club; NY Municipal Art Society; and the Societe des Artistes Francais. Represented by sculpture in Lincoln Park, Chicago, and "Plato" in the Library of Congress. Awarded medals, Columbia Expo., Chicago, 1893; Paris Expo., 1900; Pan-American Expo., Buffalo, 1901; St. Louis Expo., 1904. In 1902 he moved to NYC, where he died on Feb. 10, 1917.

BOYLE, SARAH YOCUM McFADDEN.
Mrs. Frederick A. Boyle). Miniature painter. Born in Germantown, PA. Studied at Drexel Institute. Pupil of Howard Pyle. Exhibited at the Penna. Academy of Fine Arts in 1924-25. Address in 1926, 94 South Munn Ave., Orange, NJ.

BOYNTON, G. W.
Engraver of maps, apparently located in Boston in 1842.

BOYNTON, GEORGE RUFUS.
Painter. Born at Pleasant Grove, Wis., 1928. Student, National Academy Design (medalist), and Art Students League, and under Walter Shirlaw, C. Y. Turner and J. G. Brown, NY. Portraits are hung in Union League Club; 7th Regt. Armory; 71st Regt. Armory; New York Yacht Club; Larchmont Yacht Club; US District Court, etc. Has painted portraits of Gen. F. D. Grant, Gen. Alexander S. Webb, Gen. Stewart L. Woodford, Gen. James Grant Wilson. Address in 1926, 58 W. 57th Street, New York, NY.

BOYNTON, RAY.
Born Iowa, 1883. In 1904, studied at Chicago Academy of Fine Arts under William P. Henderson, John W. Norton and W. J. Reynolds. In 1913, moved to Spokane, Washington, where he did first mural decoration in that city. He moved to California in 1914, and in 1917 made first experiments in fresco. Has taught drawing and painting at University of California since 1920, and fresco at California School of Fine Arts, San Francisco, since 1927. Work: Council Chamber, Spokane City Hall; lunette for dining room in a San Francisco hotel; ceiling in Mills College, Oakland, California; and frescos and murals for various private and public buildings, including California School of Fine Arts, University of California Faculty Club, and Coit Memorial. Exhibited continuously for many years.

BOZZO, FRANK EDWARD.
Illustrator. Born in Chicago, IL, in 1937. He was a pupil of Robert Shore and Eugene Karlin at SVA with classmates Paul Davis and Paul Giovanopoulos. In 1959 *Harper's* magazine gave him his first assignment, a pen and ink drawing which accompanied the article "How Much Poison Are You Breathing?" He has illustrated a number of children's books and worked for most major periodicals, including *Playboy, Esquire, Seventeen*, and *New York Magazine*. Some of the organizations that have given him awards are the S of I, the ADC's of New York, Chicago, and Detroit, AIGA and the Society of Publication designers. His work hangs in many private collections.

BRABAZON, THOMAS.
Painter. Member of the Connecticut Academy of Fine Arts, Hartford. Address in 1926, 21 Pavilion Street, Hartford, Conn.

BRACH, PAUL HENRY.
Painter. Born March 13, 1924, in NYC. BFA and MFA from State Univ. of Iowa. In collections of St. Louis Museum; Smith College; MOMA; Whitney; and private collections. Exhibited at Castelli Gallery, NYC; Dwan Gallery, LA; MOMA; Baltimore; Corcorcan Gallery, Wash., DC; Whitney, NY; Lerner-Heller Gallery; many more. Awarded Tamarind Fellowship, 1964. Taught at Univ. of Missouri; New School for Social Research, NYC; NYU; Parsons Sch. of Design; Cooper Union; Cornell Univ.; Univ. of CA, San Diego; dean, Calif. Inst. of Art, 1969-75; chairman, arts div., Fordham Univ. at Lincoln Ctr. Living in NYC in 1982.

BRACKEN, CLIO HINTON.
(Mrs. Wm. B. Bracken). Sculptor. Born in Rhinebeck, NY, July 25, 1870. Daughter of Lucy Brownson Hinton, and cousin of Roland Hinton Perry. Studied with Chapu, Carpeaux, and A. Saint-Gaudens. Resided in Boston and Conn. Had studio in New York City. Work: Statues of Gen. Fremont in California; bust of Gen. Pershing; "Chloe," Brookgreen Gardens, SC. Died Feb. 12, 1925, in New York City.

BRACKEN, JULIA M.
(Mrs. William Wendt). Sculptor and painter. Born at Apple River, IL, June 10, 1871. Studied: Art Institute of Chicago under Taft. Her best known work, "Illinois Welcoming the Nations," a souvenir of the Columbian Exposition, stands in bronze in the capitol at Springfield, IL. Considered a leading western woman sculptor by her contemporaries. Member: Chicago Society of Artists; Chicago Municipal Art League; California Art Club; National Arts Club; others. Awards: Sculpture prize, Chicago, 1898; Chicago Municipal Art League prize, 1905; Harrison prize, gold medal, Pan.-Calif. Exp., San Diego, 1915; California Art Club, 1918. Address in 1933, Laguna Beach, CA. Died June 22, 1942.

BRACKER, M. LEONE.
Illustrator. Born in Cleveland, Ohio, in 1885. He was best known for his World War I posters, particularly "Keep 'em Smiling." Accidental drowning caused his death in Rye, New Hampshire, in 1937.

BRACKET, H. V. (MISS).
Engraver. Probably the earliest woman engraver in the United States. Her name appears on a large Bible plate of "Ruth and Boaz," published in 1816.

BRACKETT, EDWARD AUGUSTUS.
Sculptor. Born in Vassalboro, Maine, Oct. 1, 1818. Work: Portrait busts, among which are "President Harrison," "W. C. Bryant," "Wendell Phillips." Exhibited: National Academy, NYC, 1841, 50, 66; Athenaeum Gallery, many times 1843-66; Apollo Association, 1840-41. His group of the "Shipwrecked Mother" is at Mount Auburn, and another of his groups was purchased by the Boston Athenaeum. Died in Winchester, MA, March 15, 1908.

BRACKETT, WALTER M.
Painter. Born 1823 in Unity, ME, and died March 8, 1919, in Boston. A native of Maine, he painted portraits and fancy heads; made a specialty of game fish.

BRACKMAN, ROBERT.
Painter. Born 1898 in Odessa, Russia. In US since 1908. Studied in San F. and at NAD under Bellows and Henri. Taught at ASL. Member of ASL; NA; Audubon Soc.; CT Acad.; Allied Artist of Am.; and AWCS. He exhibited "Life and Still-Life" in Annual Exhibition of National Academy of Design, 1925. Address in 1926, 67 West 52nd Street, New York.

BRADBURY, C. EARL.
Painter and illustrator. Born at North Bay, NY, May 21, 1888. Pupil of Laurens and Academie Julien, Paris. Exhibited at Penna. Academy of Fine Arts, Philadelphia, 1924. Address in 1926, 610 So. Prairie Street, Champaign, Ill.

BRADDOCK, EFFIE FRANCES.
Sculptor. Born Philadelphia, PA, May 13, 1866. Studied: Penna. Academy of Fine Arts, Student of J. Liberty Tadd, Emily Sartain; School of Industrial Art and School of Design for Women, Philadelphia, PA. Member: American Federation of Arts; Fellowship, Penna. Academy of Fine Arts; Plastic Club. Address in 1933, Warren, PA.

BRADFIELD, ELIZABETH V. P.
Sculptor. Exhibited at National Academy of Design, 1925. Address in 1926, Pontiac, Mich.

BRADFORD, FRANCIS S(COTT).
Painter. Born Appleton, Wis., Aug. 17, 1898. Pupil of NAD. Member: NY Arch. Lg. (asso.), 1924; Mural P. Award: Prix de Rome, American Academy in Rome, 1923; Mooney Traveling Scholarship, NAD, 1923. Address in 1929, 1947 Broadway, New York, NY.

BRADFORD, WILLIAM.
American marine painter with specialty of Arctic Scenes. Born in New Bedford, Mass., 1830. Self-taught but influenced by Van Beest, whose studio at Fairhaven he shared for two years. Accompanied several exploring expeditions towards the North Pole. "Arctic Whaler Homeward Bound," signed "Wm. Bradford, NY," is in Chicago Art Institute. Died 1892 in New York City.

BRADISH, ALVAH.
Portrait painter. Born September 4, 1806, in Geneva, New York. He is noted in Dunlap as painting portraits in Detroit. Died April 20, 1901, in Detroit, MI.

BRADLEY, CAROLYN G(ERTRUDE).
Painter, illustrator and craftsman. Born Richmond, Ind. Pupil of Victor Julius, William Forsyth, Henry B. Snell, Herron Art Inst. Member: Alumni, Herron Art Inst.; Indiana AC; Richmond Palette C; NA Women PS; NYWCC; AWCS (assn.); Cincinnati WAC. Represented, permanent collection Richmond Art Association. Address in 1929, 215 North 16th St., Richmond, Ind.

BRADLEY, SUSAN H.
Landscape painter. Born Boston, 1851. Pupil of Thayer, Edward Boit, Chase, and School of Boston Museum. Member: Philadelphia Water Color Club; Boston Water Color Club; New York Water Color Club; Society of Independent Artists. Represented in Herron Art Institute, Indianapolis. Address in 1926, 20 Brimmer Street, Boston, Mass.

BRADLEY, WILL (WILLIAM H.).
Illustrator. Born Boston, Mass., July 10, 1868. Member: SI, 1910; NY Arch. Lg., 1914 (assoc.); Players, 1905. Art director of *Collier's Magazine*, 1907-09; *Good Housekeeping*, 1911-13; *Metropolitan*, 1914-16;

and *Century*, 1914-16. Author and illustrator of "Toymaker to the King" and "The Wonder Box." Address in 1926, Short Hills, NJ.

BRADSHAW, GEORGE A.
Etcher and teacher. Born Trenton, NJ. Pupil of John Ward Stimson and the Trenton School of Industrial Arts. Member: Brooklyn SE; Chicago SE; North Shore AA. Address in 1926, School of Industrial Arts, West State and Willow Sts.; h. Hutchinson Rd., Trenton, NJ.

BRADSTREET, EDW. D.
Painter. Born in Meriden, Conn., 1878; died there Jan. 14, 1921. Member of Connecticut Academy of Fine Arts.

BRADT, DELPHINE.
Painter. Exhibited flower-pieces at the Penna. Academy of Fine Arts, Philadelphia, 1924. Address in 1926, 1820 Spruce Street, Philadelphia.

BRADWAY, FLORENCE DOLL.
Painter. Born in Philadelphia, Oct. 16, 1898. Exhibited at Penna. Academy of Fine Arts, Philadelphia, 1924. Address in 1926, Philadelphia Art Alliance Bldg.

BRADY, MABEL CLAIRE.
Sculptor, teacher, and craftsman. Born in Homer, NY, Oct. 28, 1887 (1877?). Studied at Pratt Institute Art School; NY University; NY School of Fine and Applied Arts; and with Winold Reiss, Henry B. Snell, Maude Robinson. Member: Public Buildings Administration; Keramic Society and Design Guild. Awards: Prizes, Design Guild, 1930. Exhibited: Public Buildings Administration, 1941 (one-man), 1942-45; Argent Gallery, 1945. Lectures: "Creative Expression Through Medium of Clay." Taught ceramics at Haaren High School, NY, 1930-46. Address in 1953, Dryden, NY; h. 50 Central Park West, NYC.

BRAINARD, ELIZABETH H.
Portrait painter. Born in Middleboro, and after studying in Boston went to Italy. On her return to this country she had her studio in New York and Boston. Several of her portraits are owned by Boston College. She died in Boston in 1905.

BRALL, RUTH.
Sculptor and teacher. Born in NYC, Dec. 3, 1906. Studied at Columbia University; and with Charles Hafner, Joseph Nicolosi, Oronzio Maldarelli. Works: Columbia University; NY School for Social Work; Paine College, Atlanta, Georgia. Awards: Prizes, NJ Painters and Sculptors Society; medal, Wanamaker bronze medal; Hudson Valley Art Association; and Pen and Brush Club. Member: Allied Artists of America; NJ Painters and Sculptors Society; American Artists Professional League; Pen and Brush

Club; Hudson Valley Art Association; Artists Equity Association. Address in 1953, 67 West 67th St., h. 45 Park Terrace, West, NYC.

BRAMNICK, DAVID.
Painter. Born Kishineff, Russia, 1894. Pupil of the Penna. Academy of the Fine Arts, Philadelphia. Work in Graphic Sketch Club. Address in 1926, Mark Bldg., 721 Walnut St., Philadelphia, PA.

BRANCH, GROVE R.
Painter, teacher. Instructor of Jewelry Department, School of the Worcester Museum; also at Commonwealth School of Art, Boothbay Harbor, ME. Director of Manual Arts, Worcester Academy. Member: Arts and Crafts Society of Boston. Address in 1926, 64 Fruit St., Worcester, Mass.

BRANCHARD, EMILE (PETER).
Painter. Born New York, NY in 1881. Member: Society of Independent Artists. Address in 1926, 61 South Washington Square, New York, NY. Died in 1938.

BRANDEGEE, ROBERT B.
Painter. Born in Berlin, Conn., 1848. He studied in Paris at the Ecole des Beaux Arts. He painted portraits and landscapes, also executed a number of notable mural decorations. Died March 5, 1922, in Farmington, CT.

BRANDNER, KARL C.
Painter and etcher. Born Berwyn, Jan. 17, 1898. Pupil of AIC; Chicago AFA; Detroit School of Art. Member: Palette and Chisel C; Hoosier Salon; Austin, Oak Park and River Forest AL; Ill. AFA. Award: Hon. mention, Austin, Oak Park and River Forest AL, 1929. Work: "Old Red Mill," State Museum of Fine Arts, Springfield, Ill.; "June," Plymouth High School, Plymouth, Ill. Address in 1929, 1219 Kenilworth Ave., Berwyn, Ill.

BRANDON, WARREN EUGENE.
Painter. Born in San Fran., Calif., Nov. 2, 1916. Study: Milligan College; with Raymond Brose, Jack Feldman, Jack Davis, Eliot O'Hara. Work: Didrichsen Art Found., Helsinki; plus commissions. Exhibitions: Frye Museum, Seattle; Victoria Museum, Brit. Columbia; de Young Mus., San Fran.; Knickerbocker Nat'l. Ann., NYC; etc. Awards: Elected Life Fellow of the Royal Soc. of Artists, one of four Americans; etc. Media: Oil, acrylic. Living in San Fran. in 1976; died in 1977.

BRANDT, CARL L.
Sculptor and painter. Born in Hamburg, Germany, 1831; he came to America in 1852. He painted portraits of John Jacob Astor, Mr. and Mrs. William Astor, and many other prominent people. Exhibited at the National Academy, 1855, 60, 62-84. He was

elected a member of the National Academy of Design in 1872. He died Jan. 20, 1905, in Savannah, GA.

BRANDT, REXFORD ELSON.
Born in San Diego, Calif., Sept. 12, 1914. Study: Univ. Calif., Berkeley; Stanford Univ. Work: San Diego Fine Arts Gal.; Currier Gallery, Andover, NH; NAD Galleries, NYC; and more; plus numerous commissions. Exhibitions: Int'l. Watercolor Exhib., Chic. Art Inst., 1936 and 1937; Calif. Palace of Legion of Honor, San Fran.; Nat'l. Gallery, Wash., DC; Royal Soc. Painters in WC, London; Am. WC Ann., 1960-75; plus many more. Awards: NAD Ann., 1968 and 1970; Am. WC Soc., 1970; others. Mem.: Am. WC Soc.; NAD; etc. Rep.: Challis Galleries, Laguna Beach, Calif. Address in 1982, 405 Goldenrod, Corona Del Mar, CA.

BRANNAN, SOPHIE MARSTON.
Sculptor and painter. Born in Mountain View, CA. Studied: Mark Hopkins Institute of Art, and in Paris. Member: National Association of Women Painters and Sculptors; American Watercolor Society; Conn. Academy of Art; American Federation of Arts; NY Society of Painters; Society Medalists. Awards: Prizes, National Association of Women Artists; Conn. Academy of Fine Art. Work: National Academy of Design; Corcoran Gallery of Art; Art Institute of Chicago; Syracuse Museum of Fine Art; Penna. Academy of Fine Arts; Museum of Fine Art, Toronto, Canada; Nebraska Art Association; Kansas Art Association; Brooklyn Museum; Vanderpoel Collection; American Watercolor Society; Union League; Macbeth Gallery; Maryland Institute of Art and Science; and in South America. Exhibited: American Watercolor Society; Syracuse Museum of Fine Art; Art Institute of Chicago; Nebraska Art Association; Penna. Academy of Fine Arts; Corcoran Gallery of Art; Macbeth Gallery; Brooklyn Museum; Toronto, Canada, etc. Address in 1953, San Francisco, CA.

BRANNAN, WILLIAM PENN.
Painter. He opened his studio in Cincinnati, OH, about 1840 and became known as a portrait painter. Died 1866 in Cincinnati.

BRANNIGAN, GLADYS.
(Mrs. Robt. A.). Painter. Born in Hingham, Mass. Pupil of Corcoran Art School, Washington, DC. Member of National Association of Women Painters and Sculptors. Exhibited at Penna. Academy of Fine Arts, Philadelphia, 1924. Address in 1926, 145 West 55th St., New York City. Died in 1944.

BRANSOM, PAUL.
Painter and illustrator. Born Washington, DC, 1885. Member: Society of Illustrators, 1911; New York Zoological Society. Illustrated: "The Call of the Wild," "The Wind in the Willows," "Neighbors Unknown," "The Feet of the Furtive," "Hoof and Claw," "The Sandman's Forest," "The Sandman's Mountain," "Over Indian and Animal Trails," "More Kindred of the Wild," "The Secret Trails," "Children of the Wild," etc. Address in 1926, Green Lake PO, Fulton Co., NY.

BRANSON, LLOYD.
Painter. Born in 1861; he died in Knoxville, Tenn., on June 12, 1925.

BRANTLY, BEN(JAMIN) (D.).
Painter and teacher. Born Little Rock, Ark. Pupil of Maryland Inst.; St. Louis School of Fine Arts. Member: St. Louis AL; NO AA; SSAL; FAC of Ark. Awards: First prizes for water color and oil, Arkansas State Fair, 1923-24-25. Work: Landscape, "Southern Memories," Scottish Rite Consistory, Little Rock; mural, Baptist Church, Little Rock. Address in 1929, 501 East 8th St., Little Rock, Ark.

BRASZ, ARNOLD FRANZ.
Sculptor, painter, illustrator, and etcher. Born in Polk County, WI, July 19, 1888. Pupil of Minneapolis School of Fine Arts; Henri in New York. Member: Wisconsin Painters and Sculptors. Address in 1926, Oshkosh, WI.

BRAUGHT, ROSS EUGENE.
Painter. Born in Carlisle, PA, on Aug. 6, 1898. Pupil of Penna. Academy of Fine Arts. Exhibited landscape, "Provincetown," at Penna. Academy of Fine Arts, Philadelphia, 1924. Work: "In the Valley," "Dear Chestnut." Address in 1926, Carlisle, Penna.

BRAUN, CORA FISHER.
Painter. Born Jordon, Minn., 1885. Pupil of Garber, Hale, Joseph Pearson, Breckenridge, Chase, Blashfield and Beaux. Acting Associate Professor of Art, University of Nebraska; Acting Assistant Professor of Art, Ohio State University; Director, Dept. of Applied and Fine Arts, University of Tennessee. Address in 1926, Department of Fine and Applied Arts, University of Tennessee, Knoxville, Tenn.

BRAUN, M(AURICE).
Painter. Born Nagy Bittse, Hungary, Oct. 1, 1877. Pupil of E. M. Ward, Maynard and Francis C. Jones at National Academy of Design in New York. Member: California Art Club. Represented in Municipal Collection, Phoenix, Ariz.; San Diego Museum. Awards: Hallgarten prize, National Academy of Design; gold medal, Panama-California Exp., San Diego, 1910; gold medal, Panama-California Int. Exp., San Diego, 1916. Address in 1926, Point Loma, California.

BRAUNER, OLAF.
Sculptor, painter, and teacher. Born Christiania, Norway, Feb. 9, 1869. Pupil of Benson and Tarbell in Boston. Member: Gargoyle Society; Central NY Chapter of American Institute of Architects, (hon.); League of American Artists. Work: "Come Unto

Me," altar piece in Church of Our Saviour, Chicago; portraits in the Kimball Library, Randolph, VT; in Cornell University Library, Ithaca; in Girls' High School, Boston; in Amherst College, Amherst, MA; sculpture, "Dane Memorial" in Walnut Hill Cemetery, Brookline, MA; war memorial, Kappa Sigma Fraternity, Cornell University; Clifton Beckwith Brown medal, College of Architecture, Cornell University; fountain at Seal Harbor, ME. Taught: Professor of painting, Cornell University, since 1900. Address in 1933, Ithaca, NY.

BRAUNHOLD, LOUIS.
Etcher. Member of Chicago Society of Etchers. Address in 1926, 35 North Dearborn St., Chicago, Ill.

BRAXTON, WILLIAM ERNEST.
Painter and illustrator. Born in Washington, DC, Dec. 10, 1878. Member of League of New York Artists, and Society of Independent Artists.

BRAYMER, L. E.
Illustrator. Born Chicago, Ill., June 2, 1901. Member: Palette and Chisel C.; Phila. AC. Address in 1929, 804 Pine St.; h. 1826 Spruce St., Philadelphia, PA.

BRCIN, JOHN DAVID.
Sculptor. Born Gracac, Yugoslavia, Aug. 15, 1899. US citizen. Pupil of Chicago Art Institute under Albin Polasek, B.F.A., 1922; Ohio State University, M.A., 1949. Member: American Federation of Arts; Chicago Gallery of Art. Awards: Bryan Lathrop European Travelling Scholarship (Art Institute of Chicago); Certificate of Merit, (Art Institute of Chicago); Shaffer Prize (Art Institute of Chicago); French Memorial gold medal (Art Institute of Chicago); Spaulding prize, Hoosier Salon. Work: Portrait bust of Judge Gary, Commercial Club, Gary, IN; Memorial Relief of Newton Mann, First Unitarian Church, Omaha, NE; Memorial Relief of Benjamin Franklin Lounsbury, Washington Blvd. Hospital, Chicago, IL; Joslyn Memorial Art Museum, NE. Exhibited: National Academy of Design; Penna. Academy of Fine Arts; Art Institute of Chicago; Detroit Institute of Art; Albright Art Gallery; Dayton Art Institute. Address in 1982, Denver, CO.

BRECHT, GEORGE.
Sculptor, painter, assemblagist, and conceptualist. Born in NYC, 1926. Studied: Philadelphia College of Pharmacy and Science, B.Sc.; Rutgers University; New School for Social Research, with John Cage, 1958-59; Samuel S. Fleisher Art Memorial, Philadelphia. In collection of Museum of Modern Art. Commissions for James Waring Dance Comp., NYC (music and sets). Happenings and Theatre Pieces prepared for Fluxus International Festival, NYC, 1962-63; Smolin Gallery, NYC, Yam Festival, A Series of Events, 1963; Arman's Key Event, NYC,

1965. Exhibited: Reuben Gallery, NYC, 1959; Fischbach Gallery, NYC, 1965; Galleria Schwarz, Milan, 1967, 69; Mayer Gallery, Stuttgart, 1969; Los Angeles County Museum of Art, 1969; Martha Jackson Gallery, NYC, New Media - New Forms, I & II, 1960, 61; Stockholm Art in Motion, 1961; Museum of Modern Art; Albright, Mixed Media and Pop Art, 1963; Wadsworth Atheneum, Black, White, and Gray, 1964; Smith College, Sight and Sound; Tate, Pop Art, 1969; Guggenheim, Eleven from the Reuben Gallery, 1965; Chicago Museum of Contemporary Art, 1969; Berne, Art after Plans, 1969. Living in W. Germany in 1982.

BRECK, GEORGE WILLIAM.
Artist. Born Washington, DC, 1863, and died Nov. 22, 1920 in Flushing, NY. Studied Art Students League, NY; first winner, Lazarus Scholarship for study of mural painting (offered through Metropolitan Museum) and thereby became student of American Academy Fine Arts, Rome, Italy. Director, Academy of Fine Arts, Rome. Located in New York, 1910. Mural decorations, University of VA; Watertown, N.Y. Member: Century Club; Architectural League of New York; National Society of Mural Painters; Municipal Art Society.

BRECK, JOSEPH.
Painter and illustrator. Awarded gold medal for painting, Minnesota State Art Society, 1916. Address in 1926, Metropolitan Museum of Art, New York.

BRECKENRIDGE, HUGH H(ENRY).
Painter. Born Leesburg, 1870. Pupil of Penna. Academy of Fine Arts and of Bouguereau, Ferrier and Doucet in Paris. Member: New York Water Color Club; Philadelphia Water Color Club; Art Club of Philadelphia. Instructor in Penna. Academy of Fine Arts since 1894. Member of Municipal Art Jury of Philadelphia. Awards: Hon. mention, Paris Exp., 1900; gold medal, Fellowship, PAFA, 1920, etc. Work: Portraits in University of PA and in Art Club, Philadelphia. "Still Life," San Francisco Art Museum; Court House, Reading, PA; State Normal School, West Chester, PA, etc. Elected Associate Member of National Academy of Design. Address in 1926, Fort Washington, Penna.

BREDIN, C(HRISTINE) S.
Painter and illustrator. Pupil of Cincinnati Art Academy, and Colarossi in Paris. Address in 1926, 5450 Delancey St., Philadelphia.

BREDIN, R. SLOAN.
Painter. Born in Butler Co., PA, Sept. 9, 1881. Pupil of Chase, Du Mond, and Beckwith. Elected Associate of National Academy. Among his works, "Midsummer" and "By the River." Address in 1926, New Hope, PA. Died in 1933.

BREGLER, CHARLES.
Sculptor and painter. Born in Philadelphia. Studied at the Penna. Academy of Fine Arts. Pupil of Thomas Eakins. Address in 1953, Philadelphia, PA.

BREGY, EDITH.
Painter. Born in Philadelphia. Studied at Penna. Academy of Fine Arts, pupil of Beaux and Carlsen. Represented at Herron Art Inst., Indianapolis, Ind., by "Pink Roses." Exhibited at Penna. Academy of Fine Arts, Philadelphia, 1924. Address in 1926, 1627 Sansom St., Philadelphia, PA.

BREHM, GEORGE.
Illustrator. Born in Indiana, 1878. Pupil of Twachtman, Bridgman, DuMond at ASL. Well known for depiction of children in everyday life. Assignments for *Reader's Magazine*, published by Bobbs-Merrill Co.; illustrated for *The Saturday Evening Post*, *Delineator*. Died in 1966. Address in 1926, 15 West 67th St., New York.

BREHM, WORTH.
Illustrator. Born in Indianapolis in 1883. His career was launched by *Outing Magazine*, which first bought his drawings. He is perhaps best known for his illustration of *Adventures of Tom Sawyer* and *Huckleberry Finn*, which were published by *Harper's*. He produced an abundance of artwork for *Cosmopolitan*, *Good Housekeeping* and *The Saturday Evening Post*. Died in 1928.

BREIDVIK, MONS.
Painter, illustrator, etcher, craftsman, writer, lecturer and teacher. Born Sogn, Norway, Jan. 15, 1881. Pupil of Erik Werenskiold, Harriet Backer. Member: S. Indp. A; Scandinavian Amer. A. Award: Norwegian National League prize, Chicago, 1926. Work: "Children Bathing," "The Artist's Mother," and "The Princess," Brooklyn Museum, Brooklyn, NY. Address in 1929, 867 Union St., Brooklyn, NY.

BREIN, JOHN DAVID.
Sculptor. Born in Servia in 1899. Exhibited at Penna. Academy of Fine Arts, Philadelphia, 1924. Address in 1926, Chicago, IL.

BREITMAYER, M. V.
Etcher. Exhibited etchings at the Annual Water Color Exhibition, 1922, Penna. Academy of Fine Arts, Philadelphia. Address in 1926, Pomona, New York.

BREMER, ANNE.
Painter and mural decorator. Born in San Francisco and died there Nov. 1923. Pupil of Art Students League of New York, and member of the San Francisco Art Association. She is represented by mural panels in many of the cities in California.

BREMER, HESTER.
Sculptor. Born Alsace, July 8, 1887. Pupil of Hudler; Murdach; Art Institute of Chicago. Member: Chicago Society of Artists. Award: Eisendrath prize, Art Institute of Chicago, 1922. Address in 1929, Chicago, IL.

BRENDEL, BETTINA.
Painter. Born in Luneburg, Germany; US citizen. Study: Hamburg, Germany, BA, 1940; Kunstschule Schmilinsky, Hamburg, 1941-42; Landes Hochschule Bildende Kunste, Hamburg, 1945-47, with Erich Hartmann; Univ. So. Calif., 1955-58; New Sch. for Soc. Research, 1968-69. Work: Pasadena Art Museum; San Francisco Museum; Santa Barbara Museum of Art; Mr. & Mrs. Joseph Hazen, NYC; Mr. Michael Tapie, Paris, France, etc. Exhibitions: Int'l. Center, Turin, Italy; Los Angeles County Museum; Spectrum Gallery, NYC; Esther Robles Gallery, LA; San Francisco Museum; Santa Barbara Museum; others. Awards: Long Beach Museum of Art; San Francisco Museum of Art; La Jolla Art Center. Media: Acrylic. Author, *The Painter and the New Physics*; also research on relation of theoretical physics to the arts. Living in New York City in 1970; address in 1982, Los Angeles, Calif.

BRENNAN, ALFRED LAURENS.
Painter and illustrator. Born 1853; died in New York, 1921. He worked in pen and ink, and water colors.

BRENNER, VICTOR DAVID.
Sculptor. Born in Shavely, Russia, June 12, 1871; came to NY 1890. He went to Paris in 1898, and became a pupil of Louis Oscar Roty, 1898-1901, and also of the Academie Julien, under Peuch, Verlet, and Dubois. Awards: Bronze medal, Paris Exposition, 1900; honorable mention, Paris Salon, 1900; bronze medal, Pan-American Exposition, Buffalo, NY, 1901; silver medal, Louisiana Purchase Exposition, St. Louis, MO, 1904; gold medal, Universal Exposition, Brussels, Belgium, 1910; silver medal, P.-P. International Exposition, San Francisco CA, 1915; J. Sanford Saltus silver medal of the American Numismatic Society, for achievement in medallic art, 1922. Member: National Sculpture Society; New York Architectural League; National Arts Club; American Numismatic Society. Works: American Numismatic Society; Boston Museum of Fine Arts; Art Institute of Chicago; Schenley memorial fountain, Pittsburgh, PA; set of medals, Metropolitan Museum, NY; Luxembourg, Paris; plaques, Carl Schurz; Collis P. Huntington; Fridtjof Nansen; J. Sanford Saltus; James McNeill Whistler; John Paul Jones; Abraham Lincoln Centennial; medal, C. P. Daly prize medal for research, American Geographical Society, NY; George William Curtis; J. Sanford Saltus award medal, National Academy of Design; Panama Canal; New York Historical Society Cen-

tennial; Abraham Lincoln; Samuel Putnam Avery; Theodore Roosevelt; Ambrose Swasey; John Hay; Twenty-fifth Anniversary, Clark University; Wilbur and Orville Wright, Aero Club of America; and numerous other plaques and medals. He also designed the model for the US cent, 1909. Exhibited at National Sculpture Society, 1923. Address in 1918, 18 East 8th Street, NYC. Died in NYC, April 5, 1924.

BRENNERMAN, GEORGE W.
Painter and illustrator. Born in New York in 1856. He studied with Chase and Duveneck in Munich. Landscapes and animals, especially horses in action, were his favorite subjects. He died in New York on Feb. 4, 1906.

BRETT, HAROLD M.
Painter and illustrator. Born Middleboro, Mass., Dec. 13, 1880. Pupil of Walter Appleton Clark, H. Siddons Mowbray, and Howard Pyle. Member: Boston Art Club. Address in 1926, Fenway Studios, 30 Ipswich St., Boston, Mass.

BREUER, HENRY J.
Landscape painter. Born in Philadelphia in 1860. He has painted many California views. Address in 1926, Lone Pine, Inyo County, Calif.

BREUL, HAROLD G(UENTHER).
Illustrator. Born 1889. Pupil of Henry McCarter. Awarded Cresson Scholarship, P.A.F.A. Illustrated for *Collier's* and McGraw-Hill publications. Address in 1926, 57 West 10th St., New York City, NY.

BREULL, HUGO.
Painter. Born in Saalfeld, Germany, on May 27, 1854. Pupil of William M. Chase in New York, and of Boulanger and Lefebvre in Paris. His studio was in Providence, RI. He died on Aug. 7, 1910 in Providence.

BREVOORT, JAMES RENWICK.
Landscape painter. Born in Westchester County, NY, in 1832. Studied with Thomas Cummings; also sketched in England, Holland and Italy. Elected an associate member of National Academy in 1861 and full member in 1863. Among his pictures are "English Moor" (1882), "New England Scene," and "Morning in Early Winter." He died on Dec. 15, 1918 in Yonkers, NY.

BREWER, ADRIAN L(OUIS).
Painter. Born St. Paul, Minn., Oct. 2, 1891. Pupil of N. R. Brewer. Member: Minneapolis Art Club. Awards: Bronze medal, St. Paul Institute, 1917; silver medal for oils, St. Paul Institute, 1918. Work: "In a Bluebonnet Year," Lotus Club, NY; "Portrait of Senator Joe T. Robinson," State Capitol, Little Rock, Ark.; "Ozark Valley in the Autumn," Municipal Art

Gallery, Little Rock. Address in 1926, 448 River Blvd., St. Paul, Minn.

BREWER, ALICE HAM.
(Mrs. F. Layton). Miniature painter. Born Chicago, Ill., March 14, 1872. Pupil Art Students League of New York; Art Institute of Chicago. Address in 1926, 241 Midland Ave., Montclair, NJ.

BREWER, B(ESSIE) M(ARSH).
Painter, illustrator, etcher and teacher. Born Toronto, June 1, 1883. Pupil of Henri, Pennell, Sloan, and Chase. Address in 1929, Quintard Bldg., 140 Atlantic Sq.; h. Long Ridge Rd.; summer, Box 1123, Stamford, Conn.

BREWER, MARY LOCKE.
Painter. Studied in Rome in 1911, under Signor Tanni, and later in Paris under Henri, Martin and Ernest Laurent. Among her best known pictures are "The Lagoon" in Jackson Park, Chicago, "The Sun Dial," "The Seine Boat," and "High and Dry."

BREWER, NICHOLAS RICHARD.
Painter. Born in Olmsted County, Minn., 1857. Pupil of D. W. Tryon and Charles Noel Flagg in New York. Member: Chicago Society of Artists, 1891. Represented in collection of portraits of governors of Rhode Island, Wisconsin, South Dakota and Minnesota; state portrait collections of Maine, Iowa, North Dakota; Salmagundi Club, New York; Art Institute of Chicago.

BREWSTER, ANNA RICHARDS.
(Mrs. William T. Brewster). Sculptor, painter, and illustrator. Born Germantown, PA, April 3, 1870. Studied: Cowles School of Art, Boston; Metropolitan School of Art; Art Students League; pupil of William Chase, William T. Richards, Dennis Bunker, and H. Siddons Mowbray in America; Constant and Laurens in Paris. Member: National Academy of Women Painters and Sculptors. Award: Dodge prize, National Academy of Design, 1889. Address in 1953, Scarsdale, NY.

BREWSTER, EDMUND.
Philadelphia portrait and landscape painter, working there about 1818.

BREWSTER, EUGENE V.
Painter. Born Bay Shore, NY, 1870. Self-taught. Salmagundi Club. Address in 1926, 175 Duffield St., Brooklyn, New York; home, Roslyn, NY.

BREWSTER, GEORGE THOMAS.
Sculptor. Born Kingston, MA, February 24, 1862. Pupil of Mass. State Normal Art School; Ecole des Beaux Arts, under Du Mond; and of Mercie in France. Member: National Sculpture Society, 1898; Architectural League of New York, 1897; New York

Municipal Art Society; National Arts Club; New York Society of Craftsmen; others. Instructor, Rhode Island School of Design, 1892-93; instructor at Cooper Union from 1900. Work: Portraits of "Thomas R. Proctor," Utica, NY; "J. Carroll Beckwith," Library of New York University and National Academy of Design; "Robert E. Lee," for Hall of Fame, NYC; "J. S. Sherman," Utica, NY; "Indiana," Crowning statue at Indianapolis; "Hope," crowning statue, State House, Providence, RI; "Greek Statesman" and "Greek Drama," Brooklyn Institute Museum; mural portrait tablets of Judge Andrews and Judge Bischoff, Supreme Court, New York, NY. Address in 1933, Cos Cob, CT. Died 1943.

BREWSTER, JOHN.
Portrait painter in oils and miniatures, born 1766, flourishing in Boston about 1802.

BRICHER, ALFRED THOMPSON.
Marine painter. Born in Portsmouth, NH, on April 10, 1837. He was elected an Associate Member of the National Academy of Design in 1879, also of the American Water Color Society. He died in Staten Island, NY, in 1908. He painted "Rocky Shore, Off Shelter Island," and "Grand Manan, Monhegan Island." Died Sept. 30, 1908, in Staten Island.

BRIDGE, EVELYN.
Miniature painter and etcher. Born Chicago, Ill. Pupil of Ethel Coe, Fursman and Senseney. Member: Chicago AG; AIC Alumni. Address in 1929, 218 East Huron St.; 619 North Michigan Blvd., Chicago, Ill.; summer, Provincetown, Mass.

BRIDGES, CHARLES.
An Englishman, painted in Virginia from 1730 to 1750. Most of the portraits in the South attributed to Sir Godfrey Kneller were by Bridges. He painted as late as 1750. Many of his portraits are extant and almost always, in case of women, may be known by a lock of hair resting on or in front of the shoulder. Bridges was trained in the British School and shows by his work the influence of Lely and Kneller. Portrait of Mrs. John Page, in the collection at William and Mary College.

BRIDGES, FIDELIA.
Artist. Born in Salem, Mass., May 19, 1835. Moved to Brooklyn, in 1854, and to Philadelphia, 1859, where she studied art under William T. Richards. Has painted and exhibited many noteworthy landscapes; earlier work principally in oil; later work mostly in water colors. Academy of National Arts, 1869. Member of American Water Color Society. Died in New Canaan, CT, March 1924.

BRIDGHAM, ELIZA H.
See Appleton, Eliza Bridgham.

BRIDGMAN, FREDERIC ARTHUR.
Artist. Born at Tuskegee, Ala., 1847. Apprentice in American Bank Note Co., New York; meanwhile studied in Brooklyn Art School and National Academy of Design; pupil under J. L. Gerome at the Ecole des Beaux Arts, Paris; had studio in Paris, occasionally visiting New York. Painter of figures and of oriental and archaeological pictures. Elected member of National Academy in 1881. Represented at Corcoran Art Gallery of Washington, DC., by "Procession of the Sacred Bull, Apis-Osiris." The Art Institute of Chicago has "Awaiting His Master," "Cafe in Cairo," "A Street in Algiers," and "The Neighbors." Address in 1926, 5 Impasse de Guelma, Paris, France. Died January 13, 1928, in Rouen, France.

BRIDGMAN, GEORGE B.
Painter, teacher, writer and lecturer. Born Bing, County of Monk, Canada, Nov. 5, 1864. Pupil of Gerome, Boulanger. Author: *Bridgman's Constructive Anatomy; Bridgman's Life Drawing; Bridgman's Book of Hundred Hands*. Instructor at Art Students League of New York. Address in 1926, 8 Park Place, Pelham, NY. Died Dec. 16, 1943, in NYC.

BRIDPORT, GEORGE.
Painter. Brother of Hugh Bridport. He was associated with his brother as instructor in an art school in Philadelphia in 1818. He also did the ceiling decorations in the old Hall of the House of Representatives in Washington, burned by the British in 1814. He died in Havana, Cuba, in 1819.

BRIDPORT, HUGH.
Painter and miniaturist. Born in London, 1794, and died Philadelphia, c. 1868. He was induced by Thomas Sully to come to this country in 1816. He opened a drawing academy in 1817, in Philadelphia. He was one of the instructors of the deaf-mute lithographer, Albert Newsam. Bridport gained a great reputation in Philadelphia as a portrait painter. The Penna. Academy of Fine Arts has a collection of seven miniatures by Bridport; he also painted a number of oil portraits.

BRIDWELL, HARRY L.
Painter. Born in Leesburg, Ohio, in 1861. Member Cincinnati Art Club. Address in 1926, 287 McCormick Place, Cincinnati, Ohio.

BRIGGS, AUSTIN.
Illustrator. Born in Humboldt, Minnesota, in 1909. He studied at the Wicker Art School and briefly at Detroit City College. At age 16, he went to work in a studio doing Rickenbaker Auto advertisements, as well as local editorial work for the *Dearborn Independent*. Two years later he came to NY and soon after appeared in *Collier's*. During the Depression he was able to do some movie posters for Fox Studios

and attend the ASL. From the 1940's on, his work drew acclaim in *The Saturday Evening Post, Redbook*, and *Cosmopolitan*. A Gold Medal winner in the S of I exhibitions, he is a member of their Hall of Fame. A constant innovator, he was always ahead of his imitators. Having lived most of his life in Connecticut, he moved to Paris, where he died in 1973.

BRIGGS, CLARE A.
Cartoonist. Member: SI. Address in 1929, care of New York Tribune, New York, NY; Wykagyl Park, New Rochelle, NY.

BRIGHAM, CLARA RUST.
(Mrs. W. E. Brigham). Painter and craftsman. Born Cleveland, Ohio, July 25, 1879. Pupil of Blanche Dillaye, William Brigham. Member: Prov. AC; Needle and Bobbin Club; Handicraft Club, Providence; AFA. Director: Industrial Dept., Federal Hill House. Address in 1929, 460 Rochambeau Ave., Providence, RI.

BRIGHAM, W. COLE.
Painter, craftsman and teacher. Born Baltimore, MD, Jan. 11, 1870. Pupil of ASL of NY. Member: ASL of NY. Specialty, marine mosaics. Address in 1929, Oak Lodge, Shelter Island Heights, Suffolk Co., NY.

BRIGHAM, WILLIAM EDGAR.
Painter and illustrator. Born North Attleboro, Mass., in 1885. Pupil of Henry Hunt Clark and Denman Ross. Address in 1926, 460 Rochambeau Ave., Providence, RI.

BRINDESI, OLYMPIO.
Sculptor. Born in Abruzzi, Italy, February 7, 1897. Pupil of Chester Beach; A. Phimister Proctor; Beaux-Arts Institute of Design; and Art Students League. Exhibited at National Sculpture Society, 1923; Penna. Academy of Fine Arts, Philadelphia, 1924; Architectural League of NY; Art Institute of Chicago; Hispanic Society; Baltimore Museum of Art; Rochester Memorial Art Gallery; Brooklyn Museum; Whitney Museum of American Art. Sculpted many animal and human figures in marble. Award: Prize, Architectural League of New York, 1927. Address in 1953, 27 West 15th St.; h. 201 Prince St., NYC. Died in 1965.

BRINGHURST, ROBERT PORTER.
Sculptor, craftsman, and teacher. Born at Jerseyville, IL, March 22, 1855. Studied at St. Louis School of Fine Arts and at Ecole des Beaux Arts, Paris. Principal works: "Awakening Spring," Art Institute of Chicago; "Kiss of Immortality," destroyed at Portland Fair; statue of General Grant, City Hall Park, St. Louis; Minnesota's monument at Gettysburg; Pennsylvania's monument at Shiloh. Awards: First class medal, Columbian Exposition, Chicago,

1893; cash prize, Tennessee Centennial, Nashville, 1897; silver medal, St. Louis Exposition, 1904; medal ($500), St. Louis Art Guild, 1915. Member: St. Louis Art Guild; Two by Four Society, St. Louis. Address in 1918, University City, MO. Died in University City, MO, March 22, 1925.

BRINKERHOFF, ROBERT MOORE.
Illustrator. Born in Toledo, Ohio, May 4, 1879. Pupil of Art Students League, New York. Colarossi Academy in Paris. Member: SI, 1912. Illustrations in *Saturday Evening Post, Red Book*, etc. Author of short story series, "Dear Mom," "Little Mary Mixup in Fairyland" (Duffield), 1926. Cartoons in *New York Evening World, Evening Mail*, etc. Studied in Florence and Paris. Address in 1926, 50 West 67th St., New York.

BRINLEY, DANIEL P.
Landscape painter. Born in Newport, RI, March 8, 1879. Pupil of ASL of NY; studied in Florence and Paris. Member: NAC (life); MacD. C.; N.Y. Arch Lg; Mural P.; Silvermine GA.; PS Gallery Asso. Work: Decoration for Y.M.C.A. Convention Bldg., 1919; decorations for the Hudson Motor Car Bldg., New York, NY; Borglum Memorial, New Canaan, Conn; Maillard's Restaurant, Chicago; decoration war maps, Liberty Memorial, Kansas City; stained glass windows, Fordham Lutheran Church, New York. Died July 30, 1963.

BRINTON, CAROLINE P.
Born in Pennsylvania. Student at the Penna. Academy of Fine Arts. Address in 1926, Androssan Park, West Chester, Penna.

BRISCO, FRANKLIN D.
Marine painter. Born in Baltimore, MD, 1844. Exhibited: Penn. Academy of Fine Arts in 1863; and at the Brooklyn Art Association, in 1873. Died in Philadelphia, PA, 1903.

BRISTOL, JOHN BUNYAN.
Painter. Born in Hillsdale, NY, 1826. Pupil of Henry Ary, in Hudson, NY. He became an Associate of the National Academy in 1861, and an Academician in 1875. His landscapes received medals in the exhibitions at Philadelphia in 1876 and Paris in 1889. He died Aug. 31, 1909 in NYC.

BRITT, RALPH M.
Painter. Born in Winchester, Ind., July 19, 1895. Pupil of William Forsyth. Works: "Melting Snow," "Wood Cutters," and "November Weather." Address in 1926, 456 West South St., Winchester, Ind.

BRITTON, EDGAR.
Born April 15, 1901, Kearney, Nebraska. In 1921, first worked with small group in Cedar Rapids, Iowa, drawing and painting landscapes. Moved to Chicago;

spent several years studying and working with Edgar Miller, using many mediums. Executed series of nine panels in tempera for Deerfield-Shields High School, Highland Park, Illinois, under Public Works of Art Project, and six frescoes for Bloom Township High School, Chicago Heights, IL. Exhibited at Chicago Art Institute, Whitney Museum of American Art and Brooklyn Museum, New York.

BRITTON, JAMES.
Painter, illustrator and engraver. Born in Hartford, Conn., in 1878. Pupil of C. N. Flagg, and Geo. de F. Brush. Represented at Morgan Museum at Hartford, Conn., by portrait of William G. Bunce. Address in 1926, Holbein Studios, 107 West 13th St., New York City, NY.

BROBECK, CHARLES I.
Born in Columbus, Ohio, in 1888. Pupil of Columbus Art School and Detroit School of Fine Arts. Address in 1926, 893 Locburn Ave., Columbus, Ohio.

BROCK, EMMA L.
Illustrator. Born in Fort Shaw, Mont., in 1886. Pupil of George Bridgman. Address in 1926, Fort Snelling, Minn.

BROCKMAN, ANN.
Born Alameda, California, 1898. Studied at Art Students League, New York, with John Sloan and Gifford Beal. Has exhibited extensively.

BRODEAU, ANNA MARIA.
Amateur miniature painter. Born 1775, Philadelphia. Died 1865, Washington.

BRODERSON, MORRIS.
Painter. Born on Nov. 4, 1928, in Los Angeles, CA. Studied at Pasadena Art Mus. with de Erdetey; Jepson Art Inst. and UCLA. Travelled Orient. In collections of Whitney; Stanford Univ.; S.F. Mus. of Art; Kalamazoo Inst. of Art; Yale; Mus. of Fine Arts, Boston; Hirshhorn Collection, Washington DC; and others. Exhibited at de Young Mem. Mus., San Fran.; Staempfli Gallery, NYC; Carnegie Inst. Int'l.; NAD Annual; Minn. Mus., St. Paul; and others. Awards from *Art in America* magazine; L.A. County Mus.; the Whitney and Phil. Art Directors Club. Reviewed in *Time Magazine; Christian Science Monitor*; the *NY Times*. Address in 1982, c/o Ankrum Gallery, Los Angeles, CA.

BRODERSON, ROBERT.
Painter. Born in West Haven, Connecticut, July 6, 1920. B.A. from Duke University, Durham, North Carolina, 1950; M.F.A., State College of Iowa, Iowa City, 1952. Recipient of a grant from the National Institute of Arts and Letters, New York, in 1962; a fellowship from the John Simon Guggenheim Memorial Foundation in 1964; a Summer Research

Grant from Duke University. Taught at Duke University. Awards: Childe Hassam Fund Foundation; Gallery of Fine Arts, Winston-Salem, 1949; Des Moines Art Fund Foundation; Gallery of Fine Arts, Winston-Salem, 1949; Des Moines Art Center, 1951; North Carolina State Art Society, Raleigh, 1953; Eastern Illinois University, Charleston, 1954; Atlanta Art Association Galleries, 1958, 1960. Exhibitions: Mint Museum of Art, Charlotte; Allied Arts, Durham; North Carolina State Art Society, Raleigh; Catherine Viviano Gallery, New York; Atlanta Art Association Galleries; PAFA; Butler Institute of American Art, Youngstown; Metropolitan Museum of Art, New York; Corcoran Gallery; Whitney; Museum of Modern Art, New York; others. In collections of Wadsworth Atheneum; Whitney; National Institute of Arts and Letter; others. Living in Raleigh, NC.

BRODHEAD, GEORGE H(AMILTON).
Painter. Born in Boston, Mass., 1860. Member of Rochester Art Club. Address in 1926, 194 Harvard St., Rochester, NY.

BRODIE, HOWARD.
Illustrator. Born in Oakland, California, in 1916. He studied at the California School of Fine Arts. He earned fame doing reportage during World War II in which, as an enlisted man, he worked for *Yank Magazine*. His drawings of the Pacific battles were most striking, as were his later sketches in Korea and Vietnam. His work as a staff artist in San Francisco eventually led to a weekly feature in the Associated Press with assignments such as the Watergate hearings.

BRODY, LILY.
Painter. Born in Budapest, Hungary, in 1905. Studied: With Leopold Herman; Hungarian Art Academy; Colarossi Academy in Paris. Exhibitions: Museum of Modern Art, New York City, 1962-64; International Drawing Exhibition, Rijeka Museum, Yugoslavia, 1970; Whitney Museum of American Art, 1972; New York Cultural Center, 1973.

BRODY, NANCY.
Painter. Born Chicago, IL, Dec. 1, 1949. Study: MOMA children's classes, 1961-64; High School of Performing Arts, 1964-67; Carnegie Mellon U., 1967-69; Royal Acad. of Dramatic Art, London, 1970-72; ASL of NY, 1978-80. Shows: The Montauk Club, Brooklyn, solo, 1982; Muse Gallery, Clearwater, IL, group, 1981; Keane Mason Gallery, NYC, group, 1983. Comn.: Portraits of King Hassan Durani I of Afghanistan, King Amanullah, and Mohammed Ali; auctioned and proceeds donated to refugee relief, Afghanistan. Media: Oil, watercolor, pastel, charcoal, pen and ink. Address in 1983, 1653 President St., Brooklyn, NY.

BRODZKY, H(ORACE).
Painter, illustrator and etcher. Born Melbourne, Australia, 1885. Studied in Melbourne and London. Member: Allied Artists' Association, London. Address in 1926, 141 East 27th St., New York, NY.

BROEDEL, MAX.
Illustrator. Born June 8, 1870, in Leipzig, Germany. Pupil of Leipzig Academy of Fine Arts. Associate professor of art as applied to medicine, Johns Hopkins University.

BROEMEL, CARL WILLIAM.
Painter. Born Cleveland, Ohio, Sept. 5, 1891. Pupil of H. G. Keller, Cleveland, Ohio; Robert Engels in Munich. Member: Cleveland SA. Awards: First prize for water colors, Cleveland Museum of Art, 1924 and 1925; second prize, 1926. Work: "Air and Sunshine" and "St. George, Bermuda," Cleveland Museum of Art; "Royal Palms, Barbados," Brooklyn Museum. Address in 1929, 849 Hanna Bldg.; h. 3471 Warren Road, Cleveland, Ohio.

BROKAW, IRVING.
Painter. Born New York, NY, March 29, 1871. Pupil of Bouguereau, Ferrier, Julien Academy. Member: S. Ind. A; Salons of America. Work: "The Skating Girl" Luxembourg Museum, Paris. Address in 1926, 522 Fifth Ave., New York, NY.

BROMWELL, ELIZABETH HENRIETTA.
Sculptor, painter, teacher, and writer. Born Charleston, IL. Studied in Denver and Europe. Member: Denver Art Association. Address in 1928, Denver, CO.

BRONSON, JONATHAN.
Sculptor. Born in Chihuahua, MX, 1952. Studied: University of Utah; Wasatch Bronze Foundry assistant. Self-taught. Spent many years sketching and in field study cataloging in the Uintah and Rocky Mountains; studied wolves in Alaska. Exhibited: World Wildlife Fund, Toronto, Canada; Western Heritage Show, Shamrock Hilton, Houston, TX; Game Conservation International, San Antonio, TX; Audubon Society Show, AL; Safari International, Las Vegas, NV; Society of Animal Artists Show, NYC; others. Member: Society of Animal Artists. Many noted works: "Golden Eagles," bronze; "Spring Winds," bronze; "Woolly Mammoth," bronze and mammoth tusk; "Silver Tip," bronze; numerous other pieces. Specialty is wildlife. Medium: Bronze. Represented by Nola Sullivan. Address in 1984, Pleasant Grove, UT.

BROOK, ALEXANDER.
Painter. Born New York, July 14, 1898. Member: Society of Independent Artists. Address in 1926, care of Mrs. C. R. Bacon, Ridgefield, Conn.

BROOKE, RICHARD NORRIS.
Artist. Born in Warrenton, VA, 1874. Studied at the Penna. Academy of Fine Arts; pupil of Bonnat and Constant in Paris. Vice-principal, Corcoran School of Art; president, Society of Washington Artists. Member: American Federation of Arts; council, Washington Society of Fine Arts. Represented at Corcoran Art Gallery of Washington, DC, by "A Pastoral Visit" and "Incoming Tide." Died in 1920.

BROOKINS, JACOB BODEN.
Sculptor and consultant. Born in Princeton, MO, August 28, 1935. Studied at Boise Jr. College; University of Oregon, B.S. (ceramics), M.F.A. (metalsmithing and sculpture); also with Jan Zach, Max Nixon, James Hanson, and Robert James. Exhibited: Southwestern Invitational, Yuma, AZ, 1972-73; Museum of Northern Arizona, 1977-79; Coconino County Arts Center, 1980-81; others. Positions: Instructor, jewelry, University of Oregon, 1967-68; instructor, sculpture, Northern Arizona University, 1969-75; instructor, ceramics, Yavapai College, 1979-80; director, Museum of Northern Arizona Art Institute, 1975-79; founder, Cosnino Foundation. Member: World Crafts Council; American Crafts Council; Arizona Designer Craftsmen; National Sculptors Conference; others. Address in 1984, Cosnino Foundation Research Center, Flagstaff, AZ.

BROOKS, ADELE R(ICHARDS).
Painter, craftsman, writer and teacher. Born Buffalo, Kan., Sept. 22, 1873. Pupil of Simon; Mme. La Forge; Richard Miller; Henry Snell; Hough Breckenridge; New York School of Fine and Applied Art; Pratt Inst.; Art Inst. of Chicago. Member: Western AA; St. Louis A. Lg; S. Indp. A.; AFA. Work: "Cahokia Mounds," and "Red Mound," owned by the University of Illinois; "Monks Mound," Phillips Academy, Andover, Mass. Specialty, Miniatures on ivory, landscapes and craftwork. Address in 1929, 4411 McPherson Ave., St. Louis, MO.

BROOKS, ALDEN FINNEY.
Sculptor and painter. Born West Williamsfield, OH, April 3, 1840. Pupil of Edwin White in Chicago; Carolus-Duran in Paris. Member: Chicago Society of Artists. Awards: Yerkes prize, Chicago Society of Artists, 1892; Illinois State Fair prize, 1895. Work: "Boys Fishing," Union Club, Chicago; "Gen. George H. Thomas" and "Judge Kirk Hawes," Public Library, Chicago; "Gov. J. R. Tanner," Capitol, Springfield, IL; "Isaac Elwood" and "James Glidden," State Normal School, De Kalb, IL; "Vice-President Sandison," State Normal School, Terre Haute, IN; Vanderpoel Art Association Collection, Chicago. Address in 1933, Chicago, Ill.; summer, Fennville, MI.

BROOKS, AMY.
Painter, illustrator. Born Boston, Mass. Pupil of Boston Museum School. Illustrated own books, such

as *The Dorothy Dainty Books, The Randy Books,* and *At the Sign of the Three Birches.* Address in 1926, 2 Colliston Road, Brookline, Mass.

BROOKS, ARTHUR D.
Painter. Born Cleveland, May 23, 1877. Pupil of Henry Keller. Member: Cleveland SA. Award: Second prize in decoration, Cleveland Museum of Art, 1926. Address in 1929, 11936 Carlton Road, Cleveland, Ohio; summer, Chatham, Mass.

BROOKS, CAROLINE SHAWK.
Sculptor and modeler. Born in Cincinnati, April 28, 1840. First known by her modelling in butter, exhibited in Paris World's Fair, 1878. She subsequently opened her studio in New York and executed portrait marbles of Garfield, George Eliot, Thomas Carlyle, and a portrait group of five figures representing "Mrs. Alicia Vanderbilt and Family." Died after 1900.

BROOKS, CORA S(MALLEY).
Painter. Pupil of Phila. Sch. of Design for Women, Daingerfield, Snell. Member: NAC.; N. A. Women PS; Plastic C.; Phila. Sch. of Design Alumni; Phila. Alliance; Ten Philadelphia P.; AFA. Awards: Hon. mention, Plastic C., 1920; 1st hon. mention, N. A. Women PS., 1922. Represented in Pennsylvania State College, permanent collection of Phila. School of Design Alumnae Assn., and permanent collection of the Twentieth Century Club, Lansdowne, PA. Address in 1926, North Lansdowne Ave., Lansdowne, PA.; summer, Boothbay Harbor, ME.

BROOKS, ERICA MAY.
Sculptor, painter, illustrator, craftsman, writer, lecturer, and teacher. Born London, England, July 9, 1894. Pupil of Myra K. Hughes, Norman Garstin, Charles Woodbury. Member: National Association of Women Painters and Sculptors; Paint and Brush Club; National League of American Pen Women. Exhibited: National Association of Women Artists, 1939; Studio Club, 1944, 46, 47; Albany Institute of History and Art, 1950; Hudson Valley Art Association, 1948-52; San Francisco Museum of Art, 1936; others. Award: Honorable mention, National League of American Pen Women, NY, 1928. Address in 1953, St. Agnes School; h. 257 State St., Albany, NY.

BROOKS, HENRY H(OWARD).
Painter. Born Bedford, Mass., Feb 8, 1898. Pupil of W. M. Paxton. Member: Boston GA; AFA. Address in 1929, Concord, Mass.

BROOKS, ISABEL.
Painter. Born "Cloverdale," Baltimore. Pupil of Hugh Newell, Rhoda Holmes Nicholas and A.P.C. de Haas. Exhibited in Annual Water Color Exhibition at Penna. Academy of the Fine Arts, Philadelphia, 1925. Specialty, water colors. Address in 1926, 1506 Park Ave., Baltimore, MD.

BROOKS, JAMES.
Painter. Born on Oct. 18, 1906, in St. Louis, MO. Studied at So. Methodist Univ.; Dallas Art Inst., with Martha Simkins; ASL, with Kimon Nicolaides, Boardman Robinson; private study with Wallace Harrison. Taught at Columbia, Pratt, Yale, American Acad. in Rome, Cooper Union. In collections of Yale; MOMA; Fordham; Wadsworth Atheneum; Met. Mus. of Art; Guggenheim; Tate Gallery, London; and others. Exhibited at Peridot Gallery, NYC, 1950-53; Kootz Gallery, NYC; Whitney; Sidney Janis Gallery, NYC; Carnegie; Guggenheim; Brandeis; The Tate; MOMA; many more. Awards from Carnegie Inst.; Art Inst. of Chicago; Ford Foundation; Guggenheim Found. Fellowship, 1967; others. Living in East Hampton, NY, in 1976.

BROOKS, LOU.
Illustrator. Born in Abington, PA, in 1944. He has won awards from Art Directors' Clubs of New York and Philadelphia and the Amer. Inst. of Graphic Arts. He illustrated for *Oui, Viva, National Lampoon* and *Scholastic's Bananas,* for whom he illustrated the poster "The World's Gone Bananas" in 1977.

BROOKS, RICHARD.
Born in Haverhill, MA, in 1894. Spent early life in Montana. Attended Virginia Military Institute. Studied at Boston Museum School, five years; Art Students League, New York; and various night classes in drawing. Served twenty months in France during World War. Worked for commercial painters, assisted mural painters, and did some easel painting. From 1929-33 he worked and studied abroad. Exhibited in National Academy and Architectural League Shows, New York. Work includes decoration of public buildings in New York, Montreal and the Middle West; collaborated with Eric Gugler, Architect, on maps and ceiling decorations, State Board of Education Building, Harrisburg, Pennsylvania.

BROOKS, RICHARD EDWIN.
Sculptor. Born in Braintree, MA, 1865. Pupil of T. H. Bartlett, Boston, MA, and Jean Paul Aube and Antonin Injalbert, Paris. Works: Busts of Gov. William E. Russell (bronze) and Col. Gardener Tufts (marble), Boston Statehouse; O. W. Holmes, 1897; and Gen. F. A. Walker, Boston Public Library. Awards: Honorable mention, Paris Salon, 1895. Is also represented by statues of Charles Carroll and John Hanson in Statuary Hall, Capitol Building, Washington, DC; "The Bather" and "Song of the Wave," Metropolitan Museum, NY; figures on State Capitol, Hartford, CT. Member: National Sculpture Society, 1907; National Institute of Arts and Letters; Society of Washington Artists. Awards: Honorable mention at the Paris Salon, 1895; third class medal, Paris Salon, 1899; gold medal, Paris Exposition, 1900; gold medal, Panama-Pacific Exposition, San

Francisco, 1915. Address in 1918, Washington, DC; Quincy, MA. Died in Boston, MA, May 2, 1919.

BROOKS, SAMUEL.
Medallist, miniature and profile painter, flourishing in Boston in 1790.

BROOME, ISAAC.
Sculptor. Born May 16, 1836, in Valcartier, Quebec. In 1838, arrived in Philadelphia. Studied at Penna. Academy of Fine Arts. Worked with Hugh Cannon. Member of Penna. Academy of Fine Arts. Exhibited at Penna. Academy of Fine Arts, 1855, 59; Washington Art Association, 1857, and won award at Philadelphia Centennial Exposition of 1876. Specialty: Ceramics. In collection of Penna. Academy of Fine Arts. Address in 1910, Trenton, NJ. Died in Trenton, NJ, May 4, 1922.

BROSS, ALBERT L., JR.
Painter. Born in Newark, NJ, June 29, 1921. Studied: ASL with DuMond, Bridgman, and McNulty. Work: Springville Art Museum, Utah; New Jersey State Museum; Roebling Collection; others. Exhibitions: Nat'l. Arts Club Print Show, NYC, 1972; Acad. Artists Assn., Springfield, MA, 1972; others. Awards: Newark Museum; Hudson Valley Art Assn; Montclair Museum; Springfield, Mass., Art Museum; others. Mem.: ASL (life); Hudson Valley Art Assn.; Acad. Artists Assn.; others. Media: Oil. Address in 1982, New Vernon, NJ.

BROUN, AARON.
Illustrator. Born London, England, 1895. Pupil, New York School of Design, Beaux Arts Society. Member: American Bookplate Society; Society of Poster Friends; Alliance. Address in 1926, Pocono Bldg., 229 4th Ave., New York City, NY.

BROWERE, ALBURTIS DELL ORIENT.
Painter. Born March 17, 1814 in Tarrytown, NY. Son of John Henri Isaac Browere, the artist who made life-masks of Jefferson, Gilbert Stuart, and other prominent Americans. Browere painted still life and landscapes, esp. mining scenes in Cal. Exhibited at Am. Acad., AAU and NA. Died Feb. 17, 1887 in Catskill, NY.

BROWERE, JOHN HENRI ISAAC.
Sculptor and painter. Born in New York City, November 18, 1790. Pupil of Archibald Robertson. He also studied in Italy. On his return to America, he modeled several busts and perfected a method of making casts from the living model. Subjects include Jefferson and Lafayette. Represented in New York State Historical Association, Cooperstown, New York Historical Society. Died in NYC, September 10, 1834.

BROWN, ABBY MASON.
Miniature painter. Flourished 1800-1822. She painted a miniature portrait of C. F. Herreshoff, Newport, RI.

BROWN, ABIGAIL K(EYES).
(Mrs. Roy H. Brown). Painter. Born Rockford, Mar. 29, 1891. Pupil of Marques E. Reitzel, Carl Krafft, William Owen. Member: Rockford AA; Oak Park, Austin and River Forest AL. Awards: Hon. mention, 1926, first prize for landscape, 1927, prize for most original composition, 1928, Rockford AA. Work: "Open Water," Illinois Academy of Fine Arts, Chicago, Ill. Address in 1929, 620 John St., Rockford, Ill.

BROWN, AGNES.
Born at Newburyport, Mass. Wife of J. Appleton Brown. Specialty: oil landscapes, flowers, and cats. Exhibited at the Boston Art Club.

BROWN, ALICE VAN VECHTEN.
Painter. Born Hanover, NH, 1862. Pupil of Art Students League of New York. Professor of Art, Wellesley College, since 1897. Author, with William Rankin, of "Short History of Italian Painting."

BROWN, ARTHUR WILLIAM.
Illustrator. Born Hamilton, Canada, Jan. 26, 1881. Pupil of H. Siddons Mowbray, Kenyon Cox, Walter Appleton Clark, F. V. DuMond, at ASL. Member: SI; GFLA. Illustrated "Seventeen," "The Magnificent Ambersons" and "Alice Adams," all by Booth Tarkington. Also illustrated for F. Scott Fitzgerald, O'Henry. Illustrator for *The Saturday Evening Post* and other major magazines. Was on staff of *The Saturday Evening Post*. Spent most of his life in New York City, where he died in 1966. Address in 1926, 116 West 87th St.; h. 290 West Eng Ave., New York, NY.

BROWN, BENJAMIN.
Engraver. The earliest known plate signed by B. Brown is an excellent stipple portrait of Sir Philip Francis, the frontispiece to "The Identity of Junius," by John Taylor, published in New York in 1812. Line illustrations to a botanical work, also published in New York, signed "B. Brown Sc. New York." The New York directory for 1819 contains the name of "Benjamin Brown, engraver and printer of bookplates, maps, visiting-cards, etc., in the first style of elegance." The name only appears for this one year. Died in 1942.

BROWN, BENJAMIN C.
Landscape painter and etcher. Born in Marion, Ark. Pupil of Paul Harney and John Fry, in St. Louis; Laurens and Benjamin Constant in Paris. Awards: Bronze medal for etching, Panama Pacific Exp., San Francisco, 1915. Represented in Oakland Art Gallery; Public Library, Pasadena, Calif.; British Mu-

seum; Smithsonian Institute, Washington, DC. Illustrations in *The Saturday Evening Post* and other magazines. Was on staff of *The Saturday Evening Post*. Address in 1926, 120 N. El Molino Ave., Pasadena, Calif.

BROWN, BOLTON (COI T).
Painter and etcher. Born Dresden, NY, 1865. Died 1936. Instructor, Cornell University; Head of Art Dept., Leland Stanford University. Work: "The Bather," National Arts Club, New York; "Monterey Fishing Village," Indianapolis Art Association; "Sifting Shadows" and "Farmhouse in Winter," Brooklyn Institute Museum; 1913 Armory Show; lithographs in Brooklyn Museum and New York Public Library. Address in 1926, National Arts Club, 15 Gramercy Park, New York, NY.

BROWN, BRUCE ROBERT.
Sculptor and painter. Born in Philadelphia, PA, July 25, 1938. Studied: Tyler School of Art, Temple University, BFA 1962, MFA 1964. Work: Museum of Fine Arts, Savannah, GA; Erie Summer Festival; American Academy of Arts. Exhibitions: Penna. Academy of Fine Arts National; American Academy of Arts and Letters, NY; Butler Institute, Youngstown, OH; 21st Annual International Exhibition, Beaumont, TX; plus more. Awards: Carnegie Institute; Ford Foundation; Hallmark Co. purchase award; American Academy of Arts and Letters. Teaching: Monroe Community College of the State University of New York in Rochester. Member: Artists Equity Association, NY; Southern Sculptors Association; Rochester Print Club. Address in 1982, Honeoye, NY.

BROWN, CAROLEEN ACKERMAN.
(Mrs. Egbert Guernsey Brown). Painter. Born New York City. Pupil of ASL of NY and M. Seymour Bloodgood. Member: Brooklyn SA. Address in 1929, 445 Macon St., Brooklyn, NY.

BROWN, CHARLES V.
Portrait painter. Son of J. Henry Brown, born in Philadelphia in 1848. Pupil of Thos. Eakins, and Prof. Schussele, at the Pennsylvania Academy of Fine Arts.

BROWN, CHARLOTTE HARDING.
(Mrs. James A. Brown). Illustrator. Born Newark, NJ, Aug. 31, 1873. Pupil of Philadelphia School of Design for Women. Member of Phila. WCC; Plastic C; Fellowship, PAFA. Awards: Silver medal, Woman's Exp., London, 1900; silver medal, St. Louis Exp., San Francisco, 1915. Also illustrated for *The Century*. Address in 1926, Smithtown, LI, NY.

BROWN, DOROTHY H.
Painter. Member of Providence Art Club. Address in 1926, Arlington Ave., Providence, RI.

BROWN, ETHEL P.
Painter and illustrator. Born in Wilmington, Del. Pupil of Twachtman and Howard Pyle. Student at the Penna. Academy of Fine Arts. Address in 1926, Frederica, Delaware.

BROWN, FRANCIS F.
Painter and teacher. Born in Glassboro, NJ., in 1891. Pupil of J. Ottis Adams and William Forsyth; John Herron Art Inst. Represented in Richmond Art Gallery and Herron Art Institute. Address in 1926, 126 W. 7th St., Richmond, VA.

BROWN, FRANK.
Painter. Born Beverly, Mass., April 21, 1876. Pupil of Julian Academy in Paris. Member: AWCS; Salma. C; Societe Internationale d'Aquarellistes, Paris. Work: "Ponte del Cavallo-Venise," French National Museums; "Gitanes a la foire de Seville," Wanamaker Collection, New York. Address in 1929, 47 Fifth Ave., New York, NY; 6 bis Villa Brune (XIV), Paris, France.

BROWN, G.
Two portraits were exhibited at the Penna. Academy in Oct. 28, 1847. They were miniatures by G. Brown and may be the work of the English artist by that name who exhibited at the Royal Academy from 1825 to 1839.

BROWN, GEORGE BACON.
Painter, born in Ogdensburg, NY, 1893. Pupil of Chicago Art Institute. Also painted mural decorations. He died in 1923 in Mankato, MN.

BROWN, GEORGE LORING.
Born in Boston, Mass., 1814; died at Malden, Mass., 1889. Brown was originally apprenticed to Abel Bowen, wood-engraver, and woodcuts are found signed by him. Studied in Rome from 1853-55 and became a landscape painter. His work upon copper is a series of admirably produced etchings of views of Rome, in 1860. He returned to America as a landscape painter. His "View at Amalfi" is in the Metropolitan Museum of New York. He was a pupil of Isabey in Paris.

BROWN, GLENN MADISON.
Painter and etcher. Born in Hartford, Conn., in 1854; died 1932. Member of Art Students League of New York, and Julien Academy, Paris. Pupil of Laurens and Colarossi.

BROWN, GRACE EVELYN.
Painter and illustrator, also writer of poems, articles and essays. Born Beverly, Mass., on Nov. 24, 1873. Pupil of Joseph De Camp, Albert H. Munsel and Vesper L. George. Address in 1926, Trinity Bldg., 168 Dartmouth St., Boston, Mass.

BROWN, HAROLD HAVEN.
Artist. Born Malden, Mass., 1869. Studied Ecole des Beaux Arts, Paris, under Gerome, and Academy Julien, Paris, under Laurens. Became director of Art Museum and teacher in School of Art of The John Herron Art Institute, Indianapolis, in 1913.

BROWN, HARRISON PAUL.
Painter. Born in Waterloo, Ind., 1889. Member of Indiana Art Club. Address in 1926, 42 Macomb St., Mt. Clemens, Michigan.

BROWN, HENRY B.
Landscape and marine painter. Born in Portland, Maine in 1839, died 1860. Best known picture is "On the Coast of Maine." Exhibited in England and America.

BROWN, HENRY I.
Miniature painter. Flourished in Boston, 1844-1851.

BROWN, HENRY KIRKE.
Sculptor and portrait painter. Born in Mass., February 24, 1814. Beginning as a portrait painter, he took up sculpture early, and after five years' study in Italy, established himself in New York. Work: "Washington" in Union Square, NY; "Lincoln" in Union Square, NY; "General Scott" and "Nathaniel Greene," Stanton Square, Washington, DC. Elected Member of National Academy in 1851. Exhibited: National Academy; Boston Athenaeum; Penna. Academy of Fine Arts; Washington Art Association. Died in Newburgh, NY, July 10, 1866.

BROWN, HORACE.
Painter. Born at Rockford, Ill., on Oct. 23, 1876. Pupil of John Carlson and Johansen. Member of the Allied Artists of America. Exhibited landscapes at Penna. Academy of Fine Arts, Philadelphia, 1924, and at the Art Institute of Chicago. Address in 1926, Springfield, VT.

BROWN, HOWARD V.
Painter and illustrator. Born Lexington, KY, July 5, 1878. Student of Art Students League of New York. Address in 1926, 131 West 23d St., New York.

BROWN, HOWELL C(HAMBERS).
Etcher. Born Little Rock, Ark., July 28, 1880. Member of the California Society of Etchers. Specialty, western scenes of the Indian country; "Edge of the Desert". Represented in the Museum of History, Sc. and Art, Los Angeles, CA. Address in 1926, Molino Ave., Pasadena, Calif.

BROWN, IRENE.
Sculptor and painter. Born Hastings, Michigan in 1881. Pupil of William M. Chase, Hawthorne, and Johansen. Member of National Association of Women Painters and Sculptors. Address in 1926, South Orange, NJ. Died in 1934.

BROWN, J.
This name, as engraver, is signed to a Biblical plate published in New York about 1810, but nothing else of his work has been found.

BROWN, JAMES FRANCIS.
Painter. Born at Niagara Falls, NY. Pupil of National Academy of Design, New York, and of Collin and Bouguereau in Paris. Address in 1926, 51 West 10th St., New York City, NY.

BROWN, JOHN APPLETON.
Painter of apple orchards. Born in West Newbury, Mass., July 24, 1844, and died on Jan. 8, 1902 in NYC. He came to Boston in 1865, where he opened his first studio; in 1867 he went to Paris for study. Exhibited frequently in the Salon in Paris, and had exhibitions of his landscape and figure work in the US. Several of his landscapes are in the collection of the Museum of Fine Arts in Boston. Elected Associate Member of National Academy in 1896.

BROWN, JOHN GEORGE.
Genre painter. Born Durham, England, Nov. 11, 1831; died Feb. 8, 1913 in New York City. Studied first at Newcastle-on-Tyne, then at Edinburgh Academy, and in 1853 at the schools of the National Academy of Design, New York. Elected Associate of National Academy, 1862, and to the National Academy in 1863. Represented in Metropolitan Museum, NY, and Corcoran Art Gallery, Washington, DC.

BROWN, JOHN HENRY.
Painter. Born in Lancaster, 1818. In 1836 he studied painting under Mr. Arthur Armstrong. In 1839 he went into business for himself in the same line as that of Mr. Armstrong, viz., portrait, historical, landscape, sign and fancy painting, to which he also added miniature painting on ivory. In the fall of 1845 he moved to Philadelphia, where he continued to follow the choice of his profession until his death, in 1891. He painted a miniature on ivory of Abraham Lincoln at Springfield, Ill., 1860, at the request of Judge John M. Read of Philadelphia. The miniature was in possession of Hon. Robert T. Lincoln.

BROWN, JOSEPH.
Sculptor and educator. Born in Philadelphia, PA, March 20, 1909. Studied at Temple University, B.S., and with R. Tait McKenzie. Member: National Sculpture Society; American Association of University Professors; American Federation of Teachers; Penna. Academy of Fine Arts; Artists Equity Association. Awards: Medal, Montclair Art Museum, 1941; prize, National Academy of Design, 1944. Work: MacCoy Memorial, Princeton, NJ; Leroy Mills Memorial; Rosengarten Trophy; Raycroft Trophy; Clarke Intra-mural Trophy; Firestone Library; Penna. Academy of Fine Arts; Rhode Island School of Design Museum of Art; Clarence Irvine Memorial,

Collingwood, NJ; Lehigh University; and others. Exhibited: National Academy of Design, 1934, 35, 40, 44; Art Institute of Chicago, 1941, 42; Philadelphia Public Library, 1949-51; Philadelphia Museum of Art, 1949; Firestone Library, Princeton, NJ; Woodmere Art Gallery, 1950; Exposition, Montreal, 1967. Taught sculpture at Cleveland (Ohio) College; Western Reserve University, 1950. Address in 1982, Princeton, NJ.

BROWN, LAURENCE.
According to the Selectmen's Records of the Town of Boston, July 31st, 1701, "Laurence Brown, a Limner, was granted admittance to this Towne."

BROWN, LILIAN CUSHMAN.
(Mrs. Charles Lyman Brown). Painter, teacher and lithographer. Member of Art Students League of New York. Address in 1926, 8 Ellsworth Terrace, Pittsburgh, PA.

BROWN, LYDIA M.
Painter and teacher. Born Watertown, NY. Pupil of ASL of NY. Member: New Orleans AA; New Orleans ACC; SSAL.

BROWN, MARGARETTA (GRATZ).
Painter. Born St. Louis. Pupil of E. Ambrose Webster. Member: St. Louis AG; Provincetown AA. Address in 1929, Provincetown, Mass.; h. 421 Lake Ave., St. Louis, MO.

BROWN, MATHER.
Portrait painter. Born in Massachusetts, 1761. Was the son of a noted clock-maker. Studied in London under Benjamin West. His portraits were in the manner of Gilbert Stuart and West. He was appointed portrait painter to the Duke of York, and painted George III and others of the Royal family. He is also said to have painted miniatures while in the US. His portraits are owned by the National Portrait Gallery, London, and in collections in America. Among his portraits are Mrs. James Madison, William V. Murray, John Howard, and his self-portrait once owned by Mrs. Frederick L. Gay. Died in 1831 in London.

BROWN, PAMELA V.
Miniature painter. Exhibited portrait miniatures at Exhibition of Miniatures, Penna. Academy of Fine Arts, Philadelphia, 1922-25. Address in 1926, 51 West 12th St., New York City, NY., or Woodstock, New York.

BROWN, ROY.
Landscape painter and illustrator. Born Decatur, Ill., 1879. Pupil of Art Students League of New York; Rafaelli and Menard in Paris. Member: Academy of National Artists, etc. Work: "The Dunes," Art Institute of Chicago; "Landscape," Northwestern Univer-

sity, Evanston, Ill.; "Pines and Poplars," National Arts Club, New York. Elected Associate Member of National Academy. Address in 1926, 45 Washington Square, New York. Died May 15, 1956.

BROWN, SOLYMAN.
Sculptor and portraitist. Born in Litchfield, CT, November 17, 1790. Exhibited: National Academy, 1842. Died at Dodge Center, MN, February 13, 1876.

BROWN, SONIA F.
(Mrs. Gordon Brown). Sculptor, painter, and teacher. Born in Moscow, Russia, on January 11, 1890. Came to US in 1914. Studied under Seroff and Nicolas Andrieff. Later went to Paris and worked with Antoine Bourdelle. Works: Rheims, private collection in Belgium; Saint Therese, California; The Negress; Virgin; and a great number of portraits, including one of Eleanora Duse. Exhibited: National Sculpture Society, 1923. Member: New York Society of Women Artists, president, 1927. Address in 1933, 6 MacDougal Alley; h., 70 West 11th St., NYC; summer, Siasconset, MA.

BROWN, THOMAS E.
Painter. Born Wilmington, NC, May 31, 1881. Pupil of Corcoran School of Art, Washington; Fred Wagner, PAFA, W. Lester Stevens, Edgar Nye. Member: Wash. SA; Wash. WCC; SSAL; AFA. Award: First prize landscape, Society Washington Artists medal, 1928. Address in 1929, 3358 - 18th St., NW, Washington, DC.

BROWN, URIEL or URIAH.
According to Dunlap, a portrait painter of that name was working in Salem, Mass., in 1805.

BROWN, WALTER.
A little-known genre painter, best known for his miniatures; he was the son of John Henry Brown, the Lancaster artist.

BROWN, WALTER FRANCIS.
Painter, illustrator. Born Providence, RI, Jan. 10, 1853. Pupil of Gerome and Bonnat in Paris. Member: Providence Art Club. Work: "The Acropolis" and "The Parthenon," Hay Library, Providence. Illustrated "A Tramp Abroad," by Mark Twain, "Roger Williams," by Charles Miller. Address in 1926, Palazzo da Mula, San Vio 725, Venice, Italy.

BROWN, WILLIAM ALDEN.
Landscape painter. Born Providence, March 15, 1877. Pupil of E. M. Bannister; RI School of Design. Member: Providence Art Club; Providence Water Color Club. Work: "Beside Still Waters," Pen and Pencil Club, Providence, RI; "The Oaks," Alpha Delta Psi Fraternity, RI State College, Kingston, RI. Address in 1926, 120 Dora St., Providence, RI.

BROWN, WILLIAM MASON.
Landscape and still-life painter. Born in Troy, New York, 1828. Studied with local artist for several years then moved to Newark, NJ. "Fruit and Art Objects," signed "W. M. Browne," was purchased in 1889, Penna. Academy of Fine Arts. Died Sept. 6, 1898 in Brooklyn, NY.

BROWNBACK, LOUIS U.
Painter, landscapes and harbor scenes. Represented in Brooklyn Museum by "The Harbor." Address in 1926, 7 East 12th St., New York.

BROWNE, ALDIS B.
Born, August 2, 1907, Washington, DC. In 1928 entered Yale School of Fine Arts, studying under Taylor, Savage and York; spent one year in tempera class. In 1934, received B.F.A. from Yale. Worked under Public Works of Art Project. Did two panels for Fairhaven Junior High School in collaboration with Vincent Mondo. Interested in water color, imaginative composition and decoration. His work further includes portraits which have been carried out in various mediums.

BROWNE, BELMORE.
Sculptor, painter, illustrator, and teacher. Born in Tompkinsville, Staten Island, NY, 1880. Studied with Chase, Carrol Beckwith, and in Paris at the Julien Academy. Worked as an illustrator, 1902-12; began easel painting in 1913; wrote and illustrated "The Conquest of Mt. McKinley." Director of the Santa Barbara School of Arts, from 1930. Work in National Gallery of Art, American Museum of Natural History (diorama), Albright Art Gallery, Santa Barbara Museum of Natural History, California Academy of Sciences. Associate, National Academy, 1928. Specialty, mountain landscapes and animals. Died probably in Marin Co., CA, 1954.

BROWNE, FRANCES E.
Painter. Member: Cincinnati Woman's Art Club. Address in 1926, 11 "The Westminster," Walnut Hills, Cincinnati, Ohio.

BROWNE, GEORGE ELMER.
Born Gloucester, Mass., May 6, 1871. Studied at School of Drawing and Painting, Museum of Fine Arts, and Cowles Art School, Boston; Julien Academy, Paris, under Lefebvre and Robert-Fleury. Member: Artists' Fund Society; American Art Association, Paris. Associate member of National Academy of Design, New York. Work: "The White Cloud," and "Edge of the Grove," Toledo Museum; "The Wain Team," National Gallery, Washington; "The Port Douarnenez, Brittany," Art Institute, Chicago; "Coast of Brittany," Montclair (NJ) Museum; "Autumn in Finistere," Omaha (Neb.) Public Library; "Evening in Brittany," Erie (PA) Art Club; "La Guidecca," Union League Club, Chicago; "The

Church, Montreuil," Kansas Univ.; "After the Rain," Milwaukee Art Inst.; "Moonrise in Holland," Univ. Club, Milwaukee, "Les Contrabandiers," Harrison Gal., Los Angeles Museum of History, Science and Art; "Bait Sellers of Cape Cod," purchased by French Govt. from Salon.

BROWNE, HAROLD PUTNAM.
Painter. Born Danvers, Mass., April 27, 1894. Son of George Elmer Browne. Pupil of Caro-Delvaille at Colarossi Academy; of Jean Paul Laurens and Paul Albert Laurens at Julien Academy in Paris; Heymann at Munich; George Elmer Browne and F. Luis Mora in New York. Professor, School of Fine Arts, University of Kansas. Address in 1926, School of Fine Arts, University of Kansas, Lawrence, Kans.

BROWNE, LEWIS.
Illustrator, writer and lecturer. Born London, Eng., June 24, 1897. Award: Prize, AI Graphic A, 1926. Author and illustrator of *Stranger Than Fiction* (Macmillan), 1925; *The Story of the Jews* (Jonathan Cape, Ltd.), 1926; *This Believing World* (Macmillan), 1926. Address in 1929, 60 Fifth Ave., New York, NY; summer, Westport, Conn.

BROWNE, MARGARET F.
Painter. Born in Boston, MA, in 1884. Studied: Massachusetts Normal Art School; Boston Museum of Fine Arts School; also with Frank Benson and Joseph De Camp. Awards: North Shore Art Association, 1925; Brooklyn Museum, 1928; Ogunquit Art Center, 1941; Rockport Art Association, 1955; Connecticut Academy of Fine Arts. Collections: Massachusetts Institute of Technology; Boston University; Harvard University; Bureau of Standards, Washington, DC; Buckley School, New York; Powers School, Boston; Driscoll School, Brookline, Massachusetts.

BROWNE, MATILDA.
(Mrs. Frederick Van Wyck). Sculptor, painter and teacher. Born in Newark, NJ, May 8, 1869. Studied at Julian Academy, Paris; and with Bouguereau, La Haye, C. M. Dewey, H. S. Bisbing and Julien Dupre. Work: Museum City of New York; Corcoran Gallery; Bruce Museum of Art, Greenwich, CT. Member: National Association of Women Painters and Sculptors; American Federation of Arts; American Water Color Society; Society of Animal Painters and Sculptors; Conn. Academy of Fine Arts; National Arts Club; New York Society of Artists; Allied Artists of America; Greenwich Art Association. Awards: Honorable mention, Columbian Exposition, Chicago; Dodge Prize, National Academy of Design; Conn. Academy of Fine Arts, 1919; Greenwich Art Association. Exhibited at National Sculpture Society, 1923. Executed small animal sculpture. Illustrator, "Recollections of an Old NY," 1932. Address in 1953, Greenwich, CT.

BROWNELL, CHAS. DE WOLF.
Landscape and still life painter. Born in Providence, RI, 1822. Studied in Hartford, Conn. In 1860 moved to New York; studied abroad 1861 to 1867 and afterwards settled in Bristol, RI. Painted many pictures of the Connecticut Valley.

BROWNELL, MATILDA A.
Painter. Born May 8, 1869, New York. Pupil of Chase and MacMonnies. Represented in Yale Univ., Barnard College. Awards: Hon. Mention, Columbia Exp., Chicago, 1893. Address in 1926, 1110 Carnegie Studios; home, 322 West 56th St., New York.

BROWNELL, ROWENA P.
Painter. Member, Providence Art Club. Address in 1926, 368 Thayer St., Providence, RI.

BROWNING, AMZIE D(EE).
Painter, illustrator, craftsman, writer and teacher. Born Kent, Wash., Feb 29, 1892. Pupil of George T. Heuston. Member: Tacoma Fine AA. Address in 1929, 932 Commerce St.; h. 5044 South Union Ave., Tacoma, Wash.

BROWNING, COLLEEN.
Painter. Born in County Cork, Ireland, in 1929; US citizen. Studied at Slade School of Art, London, scholarship. In collections of Detroit Art Inst.; Butler Art Inst; Columbia (SC) Mus.; Wichita (KS) Art Mus.; others. Has exhibited at Little Gallery, London, 1949; contemp. annual, Whitney, 1951-63; Art Inst. of Chicago, 1954; annuals, NAD, NYC, 1957-78; solos, Kennedy Galleries, 1968, 72, 76, 79, 82; others. Has received awards in Figure Composition, Stanford Univ., 1956; 2nd prize, oils, Butler Inst., 1960, 74; Obrig prize, NAD, 1970. Taught at City College, NY, 1960-76; NAD, 1979-81. Member of Audubon Artists; Academician, NAD. Paints in oil. Represented by Kennedy Galleries, NYC. Living in NYC.

BROWNING, G. W(ESLEY).
Painter and illustrator. Born Salt Lake City, 1868. Member: Society Utah Artists. Awards: First prize for water color, Utah Art Institute. Illustrations on nature study. Address in 1926, 730 Third Ave., Salt Lake City, Utah.

BROWNLOW, C(HARLES).
Painter. Born in England, 1863. Pupil of J. W. Whymper. Address in 1926, 435 Hansberry St., Philadelphia, PA.

BROWNLOW, WILLIAM J(ACKSON).
Illustrator. Born Elmira, NY, Jan. 22, 1890. Pupil of Bridgman, Fogarty and Dufner. Member: Cleveland SA; Cleveland Print C. Address in 1929, 416-417 Cleveland Clinic Bldg., Euclid at 93rd St.; h. 3296 Grenway Road, Shaker Heights, Ohio.

BROWNSCOMBE, JENNIE (AUGUSTA).
Painter. Born Honesdale, PA, 1850. Pupil of L. E. Wilmarth, NAD; Henry Mosier in Paris. Work: "First Thanksgiving," Museum of Pilgrim Hall, Plymouth, Mass.; "The Peace Ball," Newark Museum. Specialty, historical figure subjects. Address in 1926, 96 Fifth Ave., NYC.

BRUBAKER, JON O.
Painter and illustrator. Born in Dixon, Ill., Oct. 5, 1875. Pupil of Bridgman and Julien. Address in 1926, 32 West 47th St., New York City.

BRUCCINI (or BRUCCIANI), NICOLAO.
Modeler in plaster. Bruccini exhibited four figures made of plaster at the American Institute. Worked 1844 in New York City.

BRUCE, BLANCHE CANFIELD.
Painter and lecturer. Born Wells, Minn., Sept. 29, 1880. Pupil of Charles W. Hawthorne, Susan Ricker Knox, Hayley Lever and AIC. Member: AIC Alumni; Terre Haute PBC; Hoosier Salon. Works: "Sand Dune Group," Natural History Museum, Chicago; "Trees in Sunlight," Indiana State Normal, Terre Haute. Specialty, landscapes. Address in 1929, 2108 North 10th St., Terre Haute, Ind.

BRUCE, EDWARD.
Painter. Born Dover Plains, NY in 1879. Exhibited in the Cincinnati Museum Annual Exhibition of 1925. Work: "A Sawoie Farm," Luxembourg Gallery, Paris, France. Address in 1926, Care of Scott & Fowles, New York.

BRUCKNER, C. W.
Portrait painter. Portrait of Gen'l Robert E. Lee, signed and dated 1865.

BRUEN, R. C.
Engraver. He was apprenticed to Maverick and Durand. After his apprenticeship, he drowned in the Hudson River. He engraved book-illustrations, published by Wm. Durell of New York about 1820.

BRUESTLE, BERTRAM G.
Sculptor, painter, writer, lecturer, and teacher. Born New York City, April 24, 1902. Pupil of National Academy of Design with Charles C. Curran, Francis Jones. Work in Ames Memorial Gallery, New London, CT. Exhibited: Lyme Art Association; Salmagundi Club; New Haven Paint and Clay Club. Member: Salmagundi Club; Lyme Art Association; New Haven Paint and Clay Club. Address in 1953, New Haven, CT.

BRUESTLE, GEORGE M.
Landscape painter. Born in New York, 1872. Pupil of Art Students League, New York; also studied in Paris. Represented by "Afternoon Landscape," in

Gibbes Museum, Charleston, SC., and "Brown Hillside," Reading Museum, PA. Address in 1926, 132 East 23d St., New York.

BRUFF, CHARLES OLIVER.
Bruff advertised in the *New York Mercury* of 1770, and possibly earlier, as a goldsmith and jeweler. In 1775 he added an engraving department to his business, then established at the sign of "The Teapot, Tankard and Ear-ring," between Maiden Lane and Crown Street, near the Fly Market; and he adds to his notice, "Where he engraves all sorts of arms, crests, cypher & fancies, in the neatest manner and greatest expedition, with heads of Lord Chatham, Shakespeare, Milton, Newton, etc., with Mason's arms and all emblems of Liberty."

BRULS, MICHELSON GODHART DE.
Probably chief engraver doing business in New York in the period 1759-64, though Elisha Gallaudet was engraving in that city as early as 1759. Engraved book-plates, maps and views. The earliest work was well executed "Plan of Niagara with the Adjacent Country, surrendered to the English Army under the Command of Sir Will'm Johnson, Bart., on the 28th of July 1759." The *New York Mercury*, for May 3, 1762, stated this plan and a companion plate were to be published by subscription by "Michael de Bruls, Engraver and an Inhabitant of this City." The second plate was "A Plan of the Landing, Encampment and Attack against Fort Niagara, on Lake Ontario. The plans were engraved "on two large copperplates" and "would form a print 2 ft. 11 in. by 1 ft. 1 in." Although presumed both plates were published, the second plate is unknown.

BRUMBACK, LOUISE UPTON.
Painter. Born Rochester, New York. Pupil of William M. Chase. Member of National Association of Women Painters and Sculptors. Address in 1926, 118 East 19th St., New York.

BRUMIDI, CONSTANTINO.
Painter. Born in Rome, 1805. Died in Washington, DC, in 1880. He came to this country in 1852, and was naturalized in Washington, DC. The rapid progress of the Capitol extension under the superintendency of Capt. Meigs suggested to him the idea that the solid construction of this national building required a superior style of decoration in real fresco, like the Roman palaces. Meigs accepted the service of Brumidi. "The committee room on Agriculture, in the south wing of the Capitol, was painted in 1885 as the first specimen of real fresco introduced in America."

BRUMME, CARL LUDWIG.
Sculptor, painter, writer, and craftsman. Born in Bremerhaven, Germany, September 19, 1910. Studied with Leo Amino. Exhibited: Massillon Museum of Art, 1942-45; Museum Non-Objective Paint-

ing, 1943, 44; Pinacotheca, 1944, 45; Dartmouth College, 1944; Whitney Museum of American Art, 1947-51; Worcester Art Museum, 1951; Delaware Art Center, 1948; Munson-Williams-Proctor Institute, 1947; Fairmount Park, Philadelphia, 1949; Penna. Academy of Fine Arts, 1949; Am-British Art Center, 1947; Sculpture Center, NY, 1945-51; l'Institut Endoplastique, Paris, France, 1952. Address in 1953, c/o Hacker Gallery, 24 West 58th St., NYC.

BRUNDAGE, WILLIAM TYSON.
Painter. Born in New York, 1849. He was a pupil of Walter Shirlaw at the Art Students League, New York. His specialty was marine subjects. He died on February 6, 1923.

BRUNNER, BRUCE CHRISTIAN.
Sculptor, painter, etcher, illustrator, lecturer, teacher. Born in NY, November 4, 1898. Studied at Cooper Institute of Science and Art; Grand Central School of Fine and Applied Arts. Member: Honolulu Association of Professional Artists Murals; scientific artist, painting coral reefs and marine life on the ocean floor, for larger models and exhibits. Artist for the Department of Lower Invertebrates, American Museum of Natural History, NYC. Address in 1933, Flushing, Long Island, NY.

BRUNNER, FREDERICK SANDS.
Illustrator. Born in Boyertown, PA, on July 27, 1886. Pupil of Herman Deigendesch. Address in 1926, 6033 Webster St., Philadelphia, PA.

BRUNNER-STROESSER, RUTH.
Illustrator. Born in Pittsburgh, PA, in 1944. She attended the Ivy School of Professional Art and has since had exhibitions and received awards in the Pittsburgh area, including the Pittsburgh ADC and the Humane Society. Her illustrations have appeared in *Fortune*, *Newsweek*, *Time*, *Sports Illustrated* and local Pittsburgh magazines, as well as in exhibitions at the Carnegie Museum and Three Rivers Art Festival.

BRUNTON, RICHARD.
Engraver and diesinker. He advertised in 1781 in the *American Journal and Daily Advertiser* of Providence, RI. A memoir of Richard Brunton, by A. C. Bates, librarian of the Connecticut Historical Society at Hartford, states that he was imprisoned for making counterfeit money. Died Sept. 8, 1832 in Groton, CT.

BRUSH, GEORGE DE FOREST.
Painter. Born Shelbyville, Tennessee, 1855. Figure painter and painter of Indian subjects. Pupil of the National Academy of Design, and of Gerome in Paris. Awards: First Hallgarten Prize, National Academy of Design, 1888; Medal, Columbian Exposition, Chicago, 1893; Temple Gold Medal, Pennsyl-

vania Academy of the Fine Arts, Philadelphia, 1897; Gold Medal, Paris Exposition, 1900. Elected Society of American Artists, 1880; Associate National Academy, 1888; National Academy, 1901. Work: "In the Garden," and "Henry George," Met. Mus. of NY; "Mother and Child," Corcoran Gallery, Wash; "Portrait of a Lady," Carnegie Inst., Pitt., PA; "Mother and Child," Museum of Fine Art, Boston; "The Moose Chase," Nat. Gallery, Wash.; "Young Violinist," Worcester Art Museum. Address in 1926, Studio, New York and Dublin, NH. Died 1941, Hanover, NH.

BRYANT, EVERETT LLOYD.
Painter. Born in Galion, Ohio, Nov. 13, 1864. Pupil of Couture in Paris, Herkomer in London, and Anshutz, Chase and Breckenridge in Philadelphia. Member of the Penna. Academy of Fine Arts. Specialty, flower painting and mural painting. Work: "Asters," Penn. Acad. of the F.A., Phil.; "A Study," St. Paul Inst. Address in 1926, Care of Alley and Trask, 52 East 53d St., New York City.

BRYANT, HENRY.
Painter and engraver. Born in East Hartford, Conn., 1812. Painted portraits and landscapes; in 1837 he was elected an Associate Member of the National Academy of Design. He died in 1881 in Hartford, CT.

BRYANT, MAUD DREIN.
Painter. Born in Wilmington, Del., on May 11, 1880. Studied at Penna. Academy of Fine Arts under Anshutz, Chase and Breckenridge; also at Colarossi Academy in Paris. Work: "Calendula and Aster," Penn. Acad. of FA; "Pomons and Doll," Fellowship PAFA; Phila. Address in 1926, Hendricks, Penna.

BRYANT, NANNA MATTHEWS (MRS.).
Sculptor. Born in 1871. Exhibited at Academy of Fine Arts, Philadelphia, 1924. Member: National Association of Women Painters and Sculptors; Newport Art Association. Address in 1929, Boston, Mass. Died in Waltham, MA, 1933.

BRYANT, WALLACE.
Portrait painter. Born in Boston, Mass. Pupil of Constant, Laurens, Robert-Fleury and Bouguereau in Paris. Address in 1926, Cosmos Club, Washington, DC.

BUBERI (or BUBERL), CASPAR.
Sculptor. Born 1834 in Bohemia; came to US in 1854. Exhibited at the National Academy, 1860's and 1870's. Member of National Sculpture Society. Died August 22, 1899, in New York City.

BUCHANAN, ELLA.
Sculptor. Born in Preston, Canada. Studied: Art Institute of Chicago. Member of the Chicago Society of Artists; California Art Club; Sculptor Guild of

Southern California; Hollywood Art Association. Work: "Martha Baker Memorial," Chicago; "Pete" and "Dry Water Hole," Southwest Museum, Los Angeles, CA; drinking fountain, Olive Hill, Los Angeles. Represented in Vanderpoel Art Association Collection, Chicago. Awards: Prizes, California Art Club, 1918; California Liberty Fair, 1918; Ebell Exhibition, 1934. Address in 1953, Hollywood, CA.

BUCK, CHARLES CLAUDE.
Sculptor and painter. Born in New York City. Pupil of Emil Carlsen. Address in 1926, 495 East 188th St., New York City.

BUCK, CLAUDE.
Painter. Born New York City, July 3, 1890. Pupil of Emil Carlsen, DeForest Brush, Francis Jones. Member: Chicago PS. Awards: Prizes, $400, 1926, $300, 1927, $1,000, 1928, Chicago Galleries Assn.; Shaffer prize, AIC, Chicago, 1929. Address in 1929, 5637 Lawrence Ave., Chicago, Ill.

BUCK, EMMA G.
Sculptor and painter. Member of Chicago Art Club. Born in Chicago, Ill., in 1888. Work: Wisconsin, Perry's Centennial Medal. Address in 1926, Chicago, IL.

BUCK, WILLIAM H.
Painter of landscapes. Born in Norway in 1840; died in New Orleans, 1888. Studied under Clague and also in Boston; opened a studio as a professional painter in 1800 at 26 Carondelet St., New Orleans, where he remained until his death. Many of his paintings are of the Louisiana landscape.

BUCKLIN, WILLIAM SAVERY.
Painter. Born in Phalanx, NJ., 1851. Member of Art Students League, New York. Mural paintings in Library, Westminster, Mass. Address in 1926, Riverside, Conn. Died May 3, 1928, in Phalanx, NJ.

BUDD, CHARLES JAY.
Painter and illustrator. Born S. Schodack, Rensselaer County, NY, 1859. Pupil of P.A.F.A. under Eakins; Art Students' League of New York. Member: Philadelphia Sketch Club. Specialty, children's books. Died April 25, 1926 in NYC.

BUDD, D(ENISON) M.
Illustrator. Born Burlington, IA, June 10, 1893. Pupil of AIC. Member: SI; NY Art Directors C. Specialty, drawings for advertising. Address in 1929, 247 Park Ave., New York, NY; h. 163 Radford St., Yonkers, NY.

BUDD, KATHERINE COTHEAL.
Painter and illustrator. Pupil of William M. Chase. Address in 1926, 527 Fifth Ave., New York, NY.

BUDDINGTON, JONATHAN.
Painting portraits in New York City about 1798 to 1812.

BUDELL, ADA.
Painter and illustrator. Born Westfield, NJ, June 19, 1873. Pupil of Art Students League of New York. Member: National Association of Women Painters and Sculptors. Illustrated numerous books for children. Address in 1926, 76 Washington Place, New York, NY.

BUDELL, HORTENSE.
Landscape painter and sculptor. Born Lyons, France. Exhibited at National Association of Women Painters and Sculptors in 1924. Address in 1934, Westfield, New Jersey.

BUDWORTH, WILLIAM S(YLVESTER).
Painter. Born Brooklyn, NY, Sept. 22, 1861. Self-taught. Awards: Silver medals, American Art Society, Philadephia, 1902 and 1903. Work in Rochester Museum, NY. Address in 1926, 615 South Eighth Ave., Mt. Vernon, NY.

BUEHLER, LYTTON (BRIGGS).
Painter. Born Gettysburg, 1888. Pupil of PAFA. Member: Fellowship, PAFA. Award: European traveling scholarship, PAFA, 1908. Work: "Portrait Major Richardson" in Canandaigua, NY, Public Library. Address in 1926, 346 W. 58th St., New York, NY.

BUEHR, KARL ALBERT.
Painter. Born in Germany. Studied in England, France and Holland. Pupil of Art Institute, Chicago. Awards: Bronze medal, St. Louis Exp., 1904; Hon. mention, Paris Salon, 1910; silver medal, Chicago Society of Artists, 1914. Associate Member of National Academy of Design. Address in 1926, 1727 Chase Ave., Chicago, Ill.

BUEHR, MARY G. HESS.
(Mrs. Karl Albert Buehr). Miniature painter. Born in Chicago, Ill. Studied in Holland and in France. Pupil of Art Institute, Chicago. Address in 1926, 1727 Chase Ave., Chicago, Ill.

BUELL, ABEL.
Engraver. Born in 1742 in CT. Engraver on silver plate and type metal. It is said he was imprisoned for having altered a Colonial note. He engraved a plan of Boston, published by Romans in 1775, and a diploma-plate for Yale College prior to 1775. Died March 10, 1822 in New Haven, CT.

BUERGERNISS, CARL.
Painter. Member: Fellowship, Penna. Acad. of Fine Arts. Address in 1926, 2819 West Girard Ave., Philadelphia, PA.

BUFANO, BENIAMINO.
Sculptor. Born in San Fele, Italy, October 14, 1898. Studied: National Academy of Design; Beaux-Arts Institute of Design; Art Students League; and with Paul Manship, James L. Fraser, Herbert Adams. Award: First prize for "Soul of the Immigrant," Whitney Competitive Exhibition; Art Students League, 1914-16. Work: Metropolitan Museum of Art; San Francisco Museum of Art; Sun Yat Sen statue, St. Mary's Park, San Francisco; peace memorial, San Francisco; others. Position: Art Commissioner, City of San Francisco. Address in 1918, 54 Washington Mews, NYC. Address in 1953, San Francisco, CA. Died in 1970.

BUFF, CONRAD.
Mural painter. Born Switzerland, Jan. 15, 1886. Studied in Munich. Member: Calif. AC; Chicago Gal. A. Awards: Mrs. Henry E. Huntington prize, Los Angeles Museum, 1925; award for best display of paintings, Sacramento State Fair, Calif., 1924; First Fine Arts Prize, San Diego Museum, 1926. Work: "Romance," William Penn Hotel, Whittier, Calif.; six murals, Church of Latter Day Saints. Los Angeles, Calif. Address in 1929, 1225 Linda Rosa St., Eagle Rock, Los Angeles, Calif.

BUFFORD, JAMES A.
Engraver. About 1850 he engraved upon copper, and published a few views of Boston. Later he is listed as a lithographer with an office at No. 313 Washington St., Boston, Mass. His work was chiefly on the covers of sheet music.

BUFFUM, KATHARINE G.
Illustrator. Born Providence, RI, Sept 2, 1884. Pupil of P.A.F.A. Work: Illustrated "The Secret Kingdom," "Mother Goose in Silhouette," "Silhouettes to Cut in School," "Songs of Schooldays," etc. Specialty, silhouettes. Died Jan. 1922 in Phila., PA.

BULL, CHARLES LIVINGSTON.
Illustrator and painter. Born New York State, 1874. Pupil of Harvey Ellis and M. Louise Stowell; studied at Phila. Art Sch. Member: New York Water Color Club; National Arts Club. Worked as taxidermist, Nat'l. Mus., Wash., DC. Well known for animal illustrations such as "Under the Roof of the Jungle", his collection of stones and drawings based on trip to Guiana. Worked for US Biological Survey banding birds and drawing preservation posters, chiefly of Am. eagle. Died in 1932. Address in 1926, Oradell, NJ.

BULL, MARTIN.
Engraver. Born 1744 and died 1825. Engraver of early American bookplates. He was probably born in Farmington, Conn. Bull engraved the book-plate for the Monthly Library of Farmington, Conn.

BULL-TEILMAN, GUNVOR (MRS.).
Sculptor, painter, illustrator, writer, and lecturer. Born in Bodoe, Norway, March 14, 1900. Studied at Grande Chaumiere, Julian Academie, Paris; Academy of Fine Arts, Leipzig, with A. Lehnert, A. Miller. Member: American-Scandinavian Foundation. Awarded prizes from the Albany Institute of History and Art, 1935; Am-Scandinavian Art National Group, 1936. Work: Murals, Waldorf-Astoria Hotel, NY; US Time Corp., NY. Exhibited: Europe, 1922-31; Ferargil Gallery, 1943 (one-man); Brooklyn Museum; Albany Institute of History and Art; Harvard University. Illustrator, Undset's "Sigurd and His Brave Companions," 1943. Contributor to: Magazines with articles on art. Lectures: "Art in Occupied Norway." Address in 1953, 3 Washington Square, North, NYC.

BULLARD, MARION R.
Painter. Born Middletown, NY. Exhibited "The Apple Tree" at Penna. Academy of Fine Arts, Philadelphia, 1920. Wrote and illustrated "The Sad Garden Toad;" "The Somersaulting Rabbitt" (Dutton), 1927; "Travels of Sammiethe Turtle," and "The Cow Next Door," 1928 and 1929. Address in 1926, Woodstock, New York.

BULLARD, OTIS A.
Portrait, genre, historical, and panoramic painter. Born in Howard, NY, on February 25, 1816; died in New York City, October 13, 1853. He received instruction in portrait painting from the Hartford artist Philip Hewins. In 1840 he was at Amherst (Mass.), painting portraits of the family of Emily Dickinson. Bullard exhibited at the National Academy (1842-53) and at the American Art Union (1847-48), but his chief work was a panorama of New York City, painted with the assistance of several other artists between 1846 and 1850.

BUMSTEAD, ETHEL QUINCY.
Painter. Born London, England, 1873. Pupil of Boston Museum School, of Abbot Graves and of A. Buhler. Member: Copley Society, 1893. Address in 1926, 12 Berkeley St., Cambridge, Mass.

BUNCE, WILLIAM GEDNEY.
Landscape painter. Born in Hartford, CT, Sept 19, 1840, and died Nov. 5, 1916 in Hartford. Studied with William Hart. In 1867 he sailed to Europe, where lived in Paris. Member National Academy of Design. Among his works are "Watch Hill, RI," "Sautucket, New England," and "Venetian Night." He was noted for his landscapes.

BUNDY, GILBERT.
Illustrator. Born in Centralia, Illinois, in 1911. He spent his childhood in Oklahoma and Kansas. As a teenager he worked in an engraving house in Kansas City before coming to New York in 1929, where his first cartoons appeared in *Life* and *Judge*. Editorial illustrations for *Esquire* in the 1930's led to advertising work for such clients as Munsingwear and Cluett Peabody. During World War II he reported on the Pacific theater for King Features Syndicate.

BUNDY, JOHN ELWOOD.
Landscape painter. Born Guilford County, NC, May 1, 1853. Awards: Holcomb prize, Herron Art Institute, 1917. Member: Richmond Art Association. Work: "Blue Spring" and "Old Farm in Winter," Public Gallery, Richmond, Ind.; "Wane of Winter" and "Beech Woods in Winter," Art Association of Indianapolis. Address in 1926, 527 West Main St., Richmond, Ind.

BUNKER, DENNIS M.
Painter. Born in New York City in 1861; he died in Boston in 1890. Pupil of National Academy of Design in New York, and Herbert and Gerome in Paris. The portrait of his wife is in the Metropolitan Museum, NY. "Jessica," painted in 1890, is owned by the Boston Museum of Fine Arts, and "The Mirror" by the Philadelphia Art Club. His specialty was portraying feminine charm in portrait and figure paintings.

BUNN, KENNETH.
Sculptor. Born in Denver, CO, June 1, 1938. Studied: University of Maryland; apprenticed at Smithsonian Institute, Washington, DC, 1953, 54; worked in Denver with taxidermist Coleman Jonas; operated own business producing sculpture for commercial clients and wax museum until late 1960's. Exhibited at dealer Sandra Wilson's gallery in Santa Fe, NM, and Denver, CO; Kennedy Galleries and Graham Gallery, NYC; 145th-149th Annuals, National Academy of Design; Forrest Fenn Galleries, Santa Fe; 36th-41st Annual, National Sculpture Society; Stremmel Galleries, Reno, NV; Mongerson Gallery, Chicago; Bishop Galleries, Scottsdale, AZ. Elected Associate of National Academy of Design, 1973, and member, National Sculpture Society, 1973; member of National Academy of Western Art; Society of Animal Artists. Received Barnett Prize and an Award of Merit in competition. Address in 1976, Denver, CO.

BUNN, WILLIAM L.
Born, May 29, 1910, Muscatine, Iowa. In 1933, received B.A. in Graphic and Plastic Arts, University of Iowa. In 1934, made summer tour with own Punch and Judy Puppet Theatre in rural Iowa and Missouri, performing in town squares, sketching meanwhile. Returned to University of Iowa; became Graduate Assistant in Dramatic Arts. Engaged for two years in art and technical activities of University Theatre; studied mural design under Grant Wood. Held Carnegie Fellowship in Art; assisting in designing frescoes for University theatre.

BUNNER, RUDOLPH F.
Painter and illustrator. Member: New York Water Color Club. Address in 1926, Ridgefield, Conn.; or Great Kills, SI, New York.

BUNT.
A little-known landscape painter; has only left a record of his name as painting landscapes.

BUONGIORNO, DONATUS.
Mural painter. Born Solofra, Italy, 1865. Pupil of Roil Institute of Fine Arts, Naples. Work: "Apotheosis of the Evangelist," in Church of St. Leonard of the Franciscan Fathers, Boston, Mass.; "St. Charles Borromeo," in Church of Sacred Heart, Boston; "Fall of the Angels," in Church of St. Peter, Boston. Address in 1926, Maddaloni, Caserta, Italy.

BURBANK, ADDISON BUSWELL.
Illustrator and writer. Born Los Angeles, Calif., June 1, 1895. Studied Art Institute of Chicago, and Grande Chaumiere, Paris. Member: Cliff Dwellers, Chicago; GFLA; SI. Address in 1929, 120 East 39th St., New York, NY.

BURBANK, E(LBRIDGE) A(YER).
Painter. Born Harvard, Ill., 1858. Pupil of Academy of Design in Chicago; Paul Nauen in Munich. From 1897 made portraits of over 125 types of North American Indians. Represented in Field Museum and Newberry Library, Chicago, and Smithsonian Institute, Washington, DC.

BURCHFIELD, CHARLES E.
Painter. Born in Ashtabula Harbor, Ohio, in 1893. Won scholarship to study at Nat'l. Acad. of Design; also studied at Rhode Island Sch. of Design and Cleveland Art School. Had first important one-man show in NYC in 1920; major retrospective, Whitney Mus., 1956. Elected member of Nat'l. Inst. of Arts and Letters in 1943. Became known for his American scene paintings; depicted sites west of the Alleghenies, in Ohio and Western NYS. Acknowledged interest in 1920's American realist writers such as Sherwood Anderson, Willa Cather, Sinclair Lewis; and in Oriental art, particularly Hiroshige and Hokusai. Worked chiefly in watercolor. Died in 1967. Represented by Kennedy Galleries, NYC.

BURD, CLARA MILLER.
Painter and illustrator. Born in New York; studied there and in Paris. Member: GFLA. Illustrated in "In Memoriam," and numerous children's books; designed covers for magazines; painted portraits of children; designed and executed numerous memorial windows. Address in 1926, 18 West 34th St., New York City.

BURDICK, HORACE ROBBINS.
Portrait painter. Born in East Killingly, Conn., Oct. 7, 1844. Pupil of Boston Museum School. His portraits are in crayon and oil. Member of Boston Art Club. Address in 1926, 16 Park Ave., Malden, Mass.

BURGDORFF, FERDINAND.
Painter. Born in Cleveland, Ohio, Nov. 7, 1881. Student at Cleveland School of Art. Represented at Memorial Museum, San Francisco, by "Old Wharf," "Grand Canyon," Cleveland Museum of Art; and "Venus," at the Hotel del Monte, Del Monte, Calif.

BURGER, I., JR.
In the *New York Magazine* for May 1790, a plate of well-engraved music is signed "Burger Jun. Sc." This may have been a son or relative of the John Burger silversmith of New York, with whom Cornelius Tiebot served his apprenticeship about 1790. One of the plates is signed as "printed by I. Burger, Jun'r." This is probably the music engraver noted above.

BURGESS, ALICE L.
Painter. Born in St. Louis, MO, 1880. Pupil of W. M. Chase, A Shands, Anton Fabres, Kenneth H. Miller and W. L. Lathrop. Address in 1926, 1268 Quinnipiac Ave., New Haven, Conn.

BURGESS, GELETT.
Illustrator and writer. Born Boston, Mass., Jan. 30, 1866. Member: SI. Illustrator and author of *Lady Mechante*, *The Burgess Nonsense Book*, the *Goop* books, etc. Address in 1929, 203 Blvd. Raspail, Paris, France; h. 16 Gramercy Park, New York, NY.

BURGESS, HENRIETTA.
Painter, craftsman, writer, lecturer and teacher. Born Auburn, Calif., May 14, 1897. Pupil of Wong of Tsing Hua, Peiping, China. Member: Northwest PM; Seattle AI. Specialty, Oriental design, symbolism and textiles. Address in 1929, Grover Cleveland High School, Seattle, Wash.; h. Alderwood Manor, Wash.

BURGESS, IDA J.
Painter. Born in Chicago, Il!. Pupil of Chase and Shirlaw in New York, and Mason in Paris. Executed decorations and mural painting. Work: "Youth Enquiring of the Sphinx," "The Libation Power," "The Law," "Inspiration," mural decorations in the Orington Lunt, Lib., NW. Univ., Evanston, IL. Designed many stained glass windows and has written on the subject. Address in 1926, Washington Square, New York and Woodstock, NY.

BURGESS, RUTH PAYNE.
(Mrs. John W. Burgess). Artist. Born in Montpelier, VT. Studied at Art Students League, New York, and in Germany and Italy. Ex. Pres. of Art Students League; Patron of Metropolitan Museum of Art, New York; member of Providence Water Color Club. Painted portraits of Hon. A. B. Hepburn, Judge Pierson, Professor March, Dr. Daniel Bliss and his

Royal Highness, Prince August William. Address in 1926, Rhode Island Ave., Newport, RI.

BURGIS, WILLIAM.
Engraver. His work was chiefly in line, though he did attempt mezzotint engraving. He was a publisher of American maps and views as early as 1717. Burgis also published views of the College at Cambridge, Mass., and of the New Dutch Church in New York.

BURINE.
This name as "Burine sc." is signed to a large sheet of "shells," engraved for Resse's Encyclopedia, published by S. F. Bradford of Philadelphia, 1805 to 1818.

BURKE, FRANCES.
Painter. Resided in Richmond, Virginia. She made several copies of the Washington portrait painted by William Joseph Williams in 1792. It was owned by the Masonic Lodge of Alexandria, VA, and shows Washington in Masonic Dress. The copy of this picture in the Philadelphia Masonic Hall was made by Miss Burke from the original painting.

BURKE, MAY CORNELLA.
Painter and illustrator. Born Brooklyn, NY, Aug. 30, 1903. Pupil of F. R. Bruger. Member: SI. Address in 1929, 430 Greenwich St.; h. 1086 Ocean Ave., Brooklyn, NY.

BURKE, ROBERT E.
Painter, lecturer and teacher. Born Winsted, Conn., Sept. 14, 1884. Pupil of Pratt Inst., Brooklyn, NY. Member: College AA; Brown County (Ind.) AA. Professor of Fine Arts, Indiana University. Address in 1929, 1220 Atwater Ave., Bloomington, Ind.; summer, Nashville, Ind.

BURKE, SELMA HORTENSE.
Sculptor, teacher, writer, and lecturer. Born in Mooresville, NC, January 1, 1907. Studied at Columbia University; with Maillol in Paris; Hans Reiss in New York. Awards: Rosenwald Fellow, 1940, 41; Boehler Fellow, 1938, 39; prize, Atlanta University, 1943. Work: New York Public Library; New York Public School; Bethune College; Teachers College, Winston-Salem, NC; Recorder of Deeds Building., Washington, DC; and US Government. Exhibited: New York World's Fair, 1939; ACA Gallery, 1945; Downtown Gallery, 1939; MacMillen Theatre, 1940; Village Art Center, 1941-46; New York University, 1943; Brooklyn Museum of Art; Newark Museum; Virginia State College; Albany Institute of History and Art; Hampton Institute; Atlanta University; Modernage Gallery, 1945 (one-man). Contributor to: Magazines and newspapers. Lectures: African sculpture. Position: Director, Student's School of Sculpture, New York City, 1943-46. Address in 1953, 67 West 3rd Street; h. 88 East 10th Street, New York, NY.

BURKHARD, HENRI.
Painter. Born New York City, Feb. 17, 1892. Pupil of ASL of NY; Julian Academy, Colarossi Academy and Grand Chaumiere in Paris. Address in 1929, 35 Jane St., New York, NY; h. 54 Hawthorne Terrace, Leonia, NJ.

BURKO, DIANE.
Painter, graphic artist and teacher. Born in New York City, Sept. 24, 1945. Studied: Skidmore College; University of Pennsylvania. Awarded the Scott Paper Company Award in Earth Space Art 73. Exhibitions: Wm. Penn. Memorial Museum, Harrisburg, Pennsylvania, 1971; Philadelphia Museum of Art, Fleischer Art Memorial, 1972; Bronx Museum of the Arts, "Year of the Women," 1975; Phil. Art Alliance, 1973; Pennsylvania Academy of FA, 1980; "Objects and...," Univ. Mass., Amherst, 1973. Media: Oil, acrylics, pencil drawing.

BURLEIGH, CHARLES C.
Painter. Born in Pennsylvania in 1848, he lived in Plainfield, Conn. as a young man and later painted portraits at Northampton, Mass.

BURLEIGH, SYDNEY R(ICHMOND).
Born in Little Compton, RI, 1853. Pupil of Laurens in Paris. Among his pictures are "Landscape" and "Luxembourg Garden." Address in 1926, "Fleur-de-Lys," Providence, RI.

BURLEIGH-CONKLING, PAUL.
See Conkling, Paul Burleigh.

BURLIN, PAUL.
Artist. Born in New York City, 1886. Studied in New York, and London, England. Landscape, mural and figure painter; spent much time in the Southwest; exhibited at Salon des Independents, Paris, and annual exhibitions in U. S. Associate member of Societe International des Arts et Lettres, Salon D'Automne, Paris. Address in 1926, 106 West 57th St., New York City.

BURLIN, RICHARD.
Miniature painter. Flourished 1845-1863, New York. He also painted small portraits in oils.

BURLING, GILBERT.
Painter in oil and water colors. Born in 1843; he died in 1875. He excelled in the portrayal of game birds. His last works exhibited in 1875, "Normandy Sketches," "Beach below East Hampton, LI," "Canadian Lake," and the "Old Harness-Maker."

BURLINGAME, CHARLES A.
Painter and illustrator. Born at Bridgeport, Conn., 1860. Pupil of Edward Moran. Address in 1926, Nanuet, New York.

BURLINGAME, SHEILA.
Sculptor and painter. Born in Lyons, KS, April 15, 1894. Pupil of Art Institute of Chicago; Art Students League of NY; Grande Chaumiere, Paris, and with Carl Milles, Zadkine, John Sloan. Member: St. Louis Art Guild; St. Louis Art League; American Federation of Arts; Pen and Brush Club; National Sculpture Society; Architectural League; National Association of Women Artists; Audubon Artists; American Artists Professional League. Awards: Second prize, St. Louis Art League, 1922, 27; gold medal, Kansas City Art Institute, 1922; honorable mention, St. Louis Art League, 1926; prizes, St. Louis Art Guild, 1921, 22, 26-28; Pen and Brush Club; American Artists Professional League; National Association of Women Artists. Work: Woodcuts for St. Louis Post Dispatch, 1923-24; twenty-three woodcuts for "From the Days Journey," by Harry Burke, 1924. Exhibited: Penna. Academy of Fine Arts; National Academy of Design; Art Institute of Chicago; others. Address in 1953, Provincetown, MA. Died in 1969.

BURLIUK, DAVID.
Painter. Born in Kharkov, Ukraine, July 22, 1882. Studied at art schools in Kazan, 1898-1902, Odessa, 1911, Munich, Moscow, 1914; Bayerische Akademie der Schonen Kunst, Munich; Academie des Beaux-Arts, Paris. Came to US in 1922. In collections of Boston Museum of Fine Arts; Brooklyn Museum; Met. Mus. of Art; Whitney; Phillips Gallery, Washington, DC; Yale University. Exhibited in Russia, 1904, 1907; Societe Anonyme, J. B. Neumann Gallery, Morton Gallery, Dorothy Paris Gallery, Leonard Hutton Gallery, all NYC; Galerie Maeght, Der Blaue Reiter, Paris; Brooklyn; Philadelphia; others. Co-founder of Futurist art movement in Russia, 1911; art magazine *Color Rhyme*, 1930; founder-member of Der Blaue Reiter and Der Sturm groups, 1910-14. Died in Southampton, NY, January 15, 1967.

BURNAP, DANIEL.
Engraver. His chief work was on brass clockfaces. He was working in East Windsor, Conn., before 1800.

BURNHAM, ANITA WILLETS.
(Mrs. Alfred Newton Burnham). Painter, craftsman, writer, lecturer and teacher. Born Brooklyn, NY, Aug. 22, 1880. Pupil of Chase, Freer, Vanderpoel, Du Mond, Cecilia Beaux, John Johansen, Castellucho in Paris, Lawton Parker, etching under Ralph Pearson, ASL of NY, PAFA. Member: The Cordon, Chicago; Chicago AC; Chicago SA; Ill. AFA; North Shore AA. Awards: First water color prize, 1903 and 1905, and Goodman prize, 1916, AIC. Work: School frieze, Chicago Public School; painting in Children's Hospital, Chicago; altar decoration, All Angels Church, Chicago. Address in 1929, 1407 Tower Road, Hubbard Woods, Ill.

BURNHAM, LEE.
Sculptor and painter. Born in NYC, February 16, 1926. Studied at Cranbrook Academy of Art, 1943-45, sculpture with Carl Milles; Art Students League, 1946-47, sculpture with W. Zorach; Syracuse University, 1947-51, sculpture with Ivan Mestrovic; Porta Romano Scuola, Firenze, Italy, 1951-52; Reinhold School of Art, Baltimore, MD, with Sidney Waugh and Cecil Howard. Work includes bronze crucifix, Visitation Convent, St. Paul, MN; bronze head, Daytona Historical Society, FL; St. Joseph's Catholic Church, Zephyrhills, FL; others. Has exhibited at Firenze, Italy; Gallerie St. Placide, Paris; Bicentennial Medal Design Competition, Franklin Mint. Member of the National Sculpture Society. Received Museum of Modern Art Award, 1940; others. Media: Bronze, stone, ceramics, wood, and synthetics. Address in 1982, Hawthorne, FL.

BURNHAM, ROGER NOBLE.
Sculptor, lithographer, and teacher. Born in Boston, MA, August 10, 1876. Studied: Harvard University, and with Caroline Hunt Rimmer. Work: Four colossal figures, City Hall Annex, Boston; panels on main doors, Forsyth Dental Infirmary for Children, Boston; "Uncle Remus" memorial tablet, Atlanta; medallion, "Johann Earnest Perabo," Boston Art Museum; Carrington Mason Memorial, Memphis; figure of Centaur, head of Athena and Tritons on Germanic Art Museum, Harvard; Will Rogers memorial tablet, 20th Century-Fox Studios, Los Angeles. Exhibited: Architectural League; Penna. Academy of Fine Arts; San Francisco Museum of Art; and in Paris, Rome, Ghent, Hawaii; others. Member: American Federation of Arts; California Art Club; others. Instructor in school architecture, Harvard University, 1912 to 1917. Awards: Prizes, Architectural League, 1904; University of California, 1911; Long Beach International Exp., San Francisco Museum of Art; Los Angeles Museum of Art, 1944. Address in 1953, Los Angeles, CA.

BURNHAM, WILBUR HERBERT.
Painter, craftsman, writer and lecturer. Born Boston, Mass., Feb. 4, 1887. Studied at Massachusetts Art School, and abroad. Member: Boston AC; Boston Arch. C.; Soc. of Arts and Crafts, Boston; AFA. Works: Chancel War Memorial window, Central M. E. Church, Lawrence, Mass.; channel window, Trinity M. E. Church, Springfield, Mass.; transept window, Church of Our Saviour, Middleboro, Mass.; War Memorial window, St. Paul's Episcopal Church, Peabody, Mass.; clerestory window, St. John's Cathedral, Denver, Colo.; aisle windows, Princeton University Chapel; window, St. Mary's Church, Detroit; clerestory windows, First Presbyterian church, Harrisburg; chancel windows, First Presbyterian Church, Jamestown, NY. Address in 1929, Fenway Bldg., Boylston St., Boston, Mass.; h. 14 Overlook Rd., Melrose Highlands, Mass.

BURNS, BONNIE PHELPS.
Painter, designer, and teacher. Study: Berkshire Community College; North Adams State College. Work: The Gallery, Williamstown; The Gallery, Stockbridge, MA; collections in US and abroad. Exhibited: Boston Globe Art Exhib.; Univ. of Chic. Art Exhib.; Berkshire Art Assn. Exhib.; Williams College; Fox Hollow Festival; Int'l. Artists in Watercolor Competition; many more. Commercial Design Work: Pine Cobble Summer School, 1976-83; Schaeffer-Eton Co., Inc., Pittsfield, MA; H. George Caspari Co., Inc., NYC. Awards: Northern Berkshire Painting Award, 1968; Waterford Crystal Expressive Design Competition, 1980; Strathmore-Hallmark Competition First Prize; and others. Teaching: Pine Cobble Summer School and private lessons, drawing and watercolor. Media: Watercolor. Address in 1983, 79 Linden St., Williamstown, MA.

BURNS, JOSEPHINE.
Painter. Born in Wales, Great Britain, July 2, 1917. Studied: Cooper Union; the Art Students League, New York City. Exhibitions: The National Academy of Design; Audubon Artists; National Arts Club. Collections: C. W. Post College Museum; Oklahoma Museum; The Lanza Corporation, NJ. One-woman show, Alonzo Gallery, New York, 1966; Comm. Gallery, Brooklyn Museum, 1976 and 1977. Address in 1980, 248 Garfield Pl., Brooklyn, NY.

BURNSIDE, CAMERON.
Painter. Born in England, July 23, 1887. Studied in Paris. Paintings owned by French Government. Exhibited at the Penna. Academy of Fine Arts, Philadelphia, 1924. Official painter to American Red Cross in France, 1918-19. Address in 1926, 7637 Thirty-First St., Washington, DC.

BURPEE, WILLIAM P(ARTRIDGE).
Painter. Born in Rockland, Maine, on April 13, 1846. Represented in Boston Art Club, Springfield Museum, and Rockland Public Library. Work: "Gloucester-Evening," Boston Art Club; "Almond and Olive," Springfield Museum; "Vulcan's Forge," Rockland Pub. Library. Address in 1926, 43 Park St., Rockland, Maine.

BURR, EDWARD EVERETT.
Sculptor, painter, and teacher. Born in Lebanon, OH, January 18, 1895. Studied at Art Institute of Chicago, with Leopold Seyffert, Albin Polasek. Member: All-Illinois Society of Fine Arts; Society for Sanity in Art. Awards: Prizes, Society for Sanity in Art; All-Illinois Society of Fine Art; Art Institute of Chicago, 1933. Work: Design, Arkansas Centennial Half-Dollar. Exhibited: Society for Sanity in Art, Chicago, 1938, 41; Art Institute of Chicago, 1926, 27, 31; Illinois Academy of Fine Arts, 1927. Address in 1953, Urbana, IL.

BURR, FRANCES.
(Mrs. Frances Burr Ely). Sculptor and painter. Born Boston, MA, November 24, 1890. Studied: Art Students League; Provincetown School of Art, with Chase and Hawthorne; Fontainebleau School. Member: American Artists Professional League; American Federation of Arts; Art Students League of New York; National Association of Women Painters and Sculptors; Mural Painters. Exhibited: Rochester Memorial Art Gallery; Architectural League; Brooklyn Museum; Metropolitan Museum of Art; Art Institute of Chicago; others. Specialty, panels in gesso relief, painted. Address in 1953, Long Island, NY.

BURR, G(EORGE) BRAINERD.
Painter. Born Middletown, Conn. Pupil of Berlin and Munich Academies FA; Art Students League of New York; Colarossi Academy in Paris. Member: Allied Art Association. Address in 1926, Old Lyme, Conn.

BURR, GEORGE ELBERT.
Etcher and water colorist. Born Cleveland, Ohio. His plates for his etchings and aquatints are generally small and his work shows the miniaturist's precise delicacy. Illustrations for the Metropolitan Museum Collection. Address in 1926, Denver, Colorado.

BURR-MILLER, CHURCHILL.
Sculptor. Born in 1904. Exhibited portrait bust at Penna. Academy of Fine Arts. Lived in Wilkes-Barre, PA.

BURRAGE, MILDRED G(IDDINGS).
Painter. Born Portland, ME, May 18, 1890. Pupil of Richard Miller. Member: International Art Union, Paris. Address in 1926, Kennebunkport, ME.

BURRELL, LOUISE.
Painter. Born London, England. Pupil of Herkomer. Member: California Art Club. Address in 1926, 1189 West Adams St., Los Angeles, California.

BURROUGHS, BRYSON.
Artist. Born Hyde Park, Mass., Sept. 8, 1869. After general education, studied at Art Students League, New York, where he won Chanler Scholarship, 1891; also studied in Paris with Puvis de Chavannes and in Florence. Engaged professionally as artist since 1889; silver medal, Buffalo Expn., 1901; Pittsburgh Expn., 1903; 3d prize, Worcester Expn., 1904; Curator of paintings, Metropolitan Museum Art, New York. Member: Association of National Artists. Work: "Danae in the Tower," Brooklyn Museum; "The Consolation of Ariadne," Metropolitan Museum, New York; "The Fishermen," Chicago Art Inst.; "The Princess and the Swineherd," Denver Art Museum; "The Age of Gold," Newark Museum Association; "Hippocrene," Luxembourg, Paris. Address in 1926, Metropolitan Museum, New York City, NY. Died 1934.

BURROUGHS, EDITH WOODMAN.
(Mrs. Bryson Burroughs). Sculptor. Born October 20, 1871 in Riverdale, NY. Studied at Art Students League; with Kenyon Cox (drawing) and Saint-Gaudens (modeling); and in Paris with Injalbert. Traveled in Europe. Associate member of National Academy of Design (1913), and National Sculpture Society. Works: Bust of John La Farge, "At the Threshhold" (Metropolitan Museum of Art) and "Fountain of Youth." Died in Long Island, January 6, 1916.

BURROWS, HAROLD L.
Painter and etcher. Born in Salt Lake City in 1889. Pupil of Young and Henri. Address in 1926, 469 Fifth Ave., New York.

BURT, BEATRICE MILLIKEN.
Miniature painter. Born New Bedford, Mass., 1893. Pupil of Delecluse and Mme. Laforge in Paris; Mrs. Lucia F. Fuller, Mrs. Elsie Dodge Pattee and Miss Welch in New York.

BURT, CHARLES.
Born in Scotland, 1823. He came to New York in 1836. He was employed for a time by A. L. Dick of that city, and engraved and etched a number of portraits and book illustrations. His later work was bank-note engraving. For some years he was one of the chief engravers for the Treasury Department at Washington, DC. Several of his larger plates were made for the American Art Union in 1851-52. Died in 1892 in Brooklyn, NY.

BURT, LOUIS.
Painter. Born in New York, NY, July 20, 1900. Pupil of Henri, George Bellows, John Sloan. Awards: Hon. mention, MacDowell Club, 1916,17,18. Address in 1926, 3835 White Plains Ave., Bronx, New York, NY.

BURT, MARY THEODORA.
Painter. Born Philadelphia. Pupil of PAFA; Julien Academy in Paris. Member: Plastic Club, Philadelphia. Address in 1926, 1203 Walnut St., Philadelphia, PA.

BURTIS, MARY E(LIZABETH).
Painter. Born Orange, NJ, 1878. Pupil of Mme. Christine Lumsden. Member: Society of Independent Artists. Address in 1926, 406 Claredon Place, Orange, NJ.

BURTON, GLORIA.
Sculptor and painter. Born in NYC. Studied at Mt. Holyoke College, MA; Art Students League; University of California, Los Angeles. Works: Holyoke Museum of Art, MA. Commissions: Aluminum-bronze sculpture, Stanley Folb Building, Hollywood, 1968; bronze, brass and copper sculpture, Empire Savings & Loan, Santa Ana, CA, 1969; Bronze sculpture, Danmour & Assoc. (in mall), Reseda Village Green, Reseda Village, CA; 2 bronze sculptures, Security Pac Bank, Oxnard, CA, 1972. Exhibitions: Sacramento State Fair; San Francisco Museum of Art; two-person shows, Machinations, Museum of Science & Industry, Los Angeles, 1973 and Chicago, 1975; and Of Art and Medicine, Museum of Science and Industry, Los Angeles, 1975. Awards: Awards for People of the City, Southland Annual, Del Mar, CA, 1969, Decent, Westwood Art Association and Revelation, Santa Monica Annual. Media: Bronze and watercolor. Address in 1980, Los Angeles, CA.

BURTON, SAMUEL CHATWOOD.
Sculptor, painter, illustrator, etcher, educator, and writer. Born Manchester, England, February 18, 1881. Pupil of Laurens in Paris; Lanteri in London. Member: Minneapolis Art Association; American Federation of Arts; Beachcombers' Club, Provincetown; Chicago Society of Etchers; Art Masters of England. Awards: Third prize for painting, 1917; second prize for etching, Minneapolis Institute, 1921. Work: Metropolitan Museum of Art; University of Minnesota; Art Institute of Chicago; others. Professor of architecture and fine arts, and lecturer on art, University of Minnesota. Address in 1953, Minneapolis, MN.

BURTON, VIRGINIA LEE.
Author and illustrator. Born August 30, 1909, in Newton Centre, MA. She studied at the California School of Fine Arts; Boston Museum School. In 1929 she became a sketch artist for the *Boston Transcript*. In 1937 she published her first book, a children's story written, designed, and illustrated by herself and entitled *Choo*. In 1939 she published *Mike Mulligan and His Steam Shovel*, in 1941 *Calico, The Wonder Horse*, and in 1942 *The Little House*, which won the Caldecott Medal for best illustrated children's book of the year. She also illustrated *Song of Robin Hood* by A. B. Malcolmson, 1947, and an edition of Hans Christian Andersen's *The Emperor's New Clothes*, 1949. During the 1940s she taught graphic design and organized the Folly Cove Designers. She died on October 15, 1968, in Boston.

BUSBEE, JACQUE.
Painter. Born in Raleigh, NC, in 1870. Student of National Academy of Design, and Art Students League, New York. Painted a number of portraits; later became interested in pottery.

BUSCH, CLARENCE F(RANCIS).
Painter. Born Phila., PA, Aug. 28, 1887. Exhibited "Nude," Annual Exhibition of the National Academy of Design, 1925. Address in 1926, 58 West 57th St., New York.

BUSENBARK, E. J.
Painter. Member: Guild of Free Lance A. Address in 1926, 117 East 27th St., New York, NY.

BUSENBENZ-SCOVILLE, V(IRGINIA).
Painter and etcher. Born Chicago, April 26, 1896. Pupil of W. J. Reynolds in Chicago; Ehrlict in Munich. Member: Chicago AG; Chicago SE; GFLA. Work: Screen in Lake Shore Athletic Club, Chicago; "Old Sailor," Bibliotheque Nationale, Paris. Address in 1929, 14 East 75th St., New York, NY; Salisbury, Conn.

BUSEY, NORVAL H.
Painter. Born in Christiansburg, VA, 1845. Studied in Paris under Bouguereau. Member: Salma. Club. Address in 1926, 39 West 67th St., New York, NY.

BUSH, AGNES S(ELENE).
Painter. Born Seattle, Washington. Pupil of Ella S. Bush and Paul Morgan Gustin. Address in 1926, 529 Belmont, North, Seattle, Washington.

BUSH, BEVERLY.
Sculptor and painter. Born in Kelso, WA. Studied at University of Washington, B.A.; National Academy of Design School of Fine Arts; Art Students League. Executive Secretary of Artists Equity Association since 1958. Exhibitions: National Association of Women Artists, 1958; Art: USA, 1959; Audubon Artists, 1959; Seattle Art Museum, 1964; plus others. Awards: Youth Friends Association Scholar, National Academy of Design, 1954-55; Joseph Isador Merit Scholar, 1955-57. Address in 1982, Seattle, WA.

BUSH, ELLA SHEPARD.
Miniature painter. Born Galesburg, Ill. Pupil of J. Alden Weir, Kenyon Cox, Robert Henri, Theodore W. Thayer. Member: Painters, Sculptors, Miniature Painters; Art Students League of New York; California Art Club; Seattle Fine Arts Society. Award: Prize, Seattle Fine Arts Society, 1920.

BUSH, JOSEPH H.
Painter. Born 1794 in Frankfort, KY. At seventeen he became a student of Thomas Sully in Philadelphia. Studio at Frankfort but spent winters at Natchez and New Orleans. He painted Gen'l Zachary Taylor, Gov. John Adair, Judge Thos. B. Monroe and Gen. Martin D. Hardin. He died in Lexington, KY, in 1865.

BUSH, NORTON.
Painter. Born in Rochester, NY, 1834. He became a student of Jasper F. Cropsey in New York. Among his works are "Lake Tahoe," "Summit of the Sierras," and "Lake Nicaragua." In 1874 he was elected a member of the San Francisco Art Association, and in 1878 a director. Died in 1894, in San Francisco, CA.

BUSH-BROWN, HENRY KIRKE.
Sculptor. Born Ogdensburg, NY, April 21, 1857. Studied art at National Academy of Design; Paris at Academie Julien and Italy, 1886-89. Pupil of Henry Kirke Brown. Prominent works: Equestrian Statues Gen. G. G. Meade and Gen. John F. Reynolds, Gettysburg, PA; statues, "Justinian," Appellate Court, NY; "Indian Buffalo Hunt," Chicago Exposition, 1893; equestrian statue, Gen. Anthony Wayne for Valley Forge, PA; memorial architecture, Stony Point, NY; The Lincoln Memorial, Gettysburg, 1911; Union Soldiers' Monument, Charleston, W. VA, 1912; equestrian statue, Gen. John Sedgwick, Gettysburg, PA. Exhibited at National Sculpture Society, 1923. Represented in Metropolitan Museum of Art; Atlanta (GA) Museum; National Museum, Washington, DC. Member: National Sculpture Society; Architectural League; National Arts Club; American Federation of Arts. Address in 1933, Ambler, PA; 1730 Euclid St., Washington, DC. Died in 1935.

BUSH-BROWN, MARGARET LESLEY.
(Mrs. Henry Kirke Bush-Brown). Portrait painter. Born in Philadelphia, May 19, 1857. Pupil of Penna. Academy of Fine Arts, and Julien Academy in Paris. Represented by portraits of Lincoln, Lee, and Professor Lesley. Also painted miniatures. Address in 1926, 1729 G. St., Washington, DC.

BUTENSKY, JULES LEON.
Sculptor. Born in Stolvitch, Russia, December 13, 1871. Pupil of Hellmer and Zumbusch at Imperial Academy of Fine Arts in Vienna; Mercie and Alfred Boucher in Paris. Work: "Universal Peace," Metropolitan Museum, NY; portrait of former president, First National Bank, Brooklyn; "Jacob M. Gordin Memorial," Seward Park, NY; "Exile," White House, Washington, DC; "Ames Prize Medal," Harvard Law School; "Goluth," group at Hebrew Institute, Chicago. Address in 1935, Ramah, Pomona, Rockland Co., NY.

BUTLER.
Engraver of Baltimore. Engraving of a man and a lion signed "Butler Sc. Balto." was published prior to 1835.

BUTLER, ANDREW R.
Painter and etcher. Born Yonkers, NY, May 15, 1896. Pupil of Frank DuMond, Eugene Speicher, F. Luis Mora, Joseph Pennell.

BUTLER, EDWARD BURGESS.
Painter. Born in Lewistown, ME, in 1853. Pupil of F. C. Peyraud. Member of Chicago Art Club. Among his works are "Misty Morning," City of Chicago; "October Mist," Chicago Art League; "California Wheat," Los Angeles Museum; and Cleveland Museum of Art, "Early Springs." Address in 1926, 1608 Monroe Bldg., Chicago, Ill. Died February 20, 1928, in Pasadena, Calif.

BUTLER, EDWARD SMITH.
Painter. Born in Cincinnati, 1848. Member of the Cincinnati Art Club. Address in 1926, 1001 Chapel St., Walnut Hill, Cincinnati, Ohio.

BUTLER, FRANK.
Painter. Exhibited in Annual Water Color Exhibition at Penna. Academy of the Fine Arts, Philadelphia, 1925. Address in 1926, Care of A. R. Thayer, 126 Moss Ave., Boston, Mass.

BUTLER, GEORGE BERNARD.
Portrait painter. Born Feb. 8, 1838 in New York. Pupil of Thomas Hicks, and of Couture. Served in the Civil War. In 1873 he was elected a member of the National Academy, his last painting being exhibited there in the year of his death. Represented in the Metropolitan Museum by "The Gray Shawl." He died in May 4, 1907 at Croton Falls, NY.

BUTLER, HELEN SHARPLESS.
Painter. Born in West Chester, PA. Pupil of Chase and Anshutz. Member of Fellowship of Penna. Academy of Fine Arts.

BUTLER, HOWARD RUSSELL.
Painter. Born New York, 1856. Honorable mention Paris Salon, 1886; medals Paris Expn., 1889. Elected Associate member of National Academy, 1898, and Academician, 1902. Member of New York Water Color Club. Died in 1934. Address in 1926, Santa Barbara, California, and Princeton, NJ.

BUTLER, J. M.
Engraver, or rather a publisher of prints, as there is no evidence that he engraved himself. He was active in Philadelphia about 1850.

BUTLER, M.
Working in Boston 1821, he engraved in line five humorous copperplate illustrations for "The Songster's New Pocket Companion, etc.," published by T. Swan, Boston, 1821. This may be the same Butler who was working in Baltimore at a somewhat later date.

BUTLER, MARY.
Painter. Born in Philadelphia. Pupil of Chase, Henri and Redfield. Member of Fellowship of Penna. Academy of Fine Arts, Philadelphia. Among her paintings: "Goatfell Mountain," Penna. Academy of Fine Arts, Philadelphia; "Ogunquit Dunes," West Chester State Normal School; and "Maine Headlands," Williamsport High School. Address in 1926, 2127 Green St., Philadelphia, PA.

BUTLER, THEODORE E.
Painter. Born in 1876; died in 1937. Member of Society of Independent Artists. Address in 1926, 75 Washington Place, New York, NY.

BUTTERSWORTH, JAMES EDWARD.
Marine painter. Born in England in 1817. Pupil of his father, the painter Thomas Buttersworth. Came to US c. 1845/47, settling in West Hoboken, NJ. Painted for N. Currier and Currier and Ives, who published his work, approximately 1847-1865. Exhibited at American Art-Union, 1850-52. Represented in US Naval Academy Museum, Annapolis; Bath Marine Museum, ME; Newark Museum, NJ; Yale Centre for British Art; Mariner's Museum, Newport News, VA; Museum of the City of NY; Portland Museum of Art, ME; VA Museum of Fine Arts, Richmond; Peabody Museum of Salem; Butler Institute, Youngstown, Ohio; others. He painted ships in NY Harbor, yachts, steamships, warships; also painted landscapes and portraits. Died in West Hoboken, NJ, March 2, 1894.

BUTTERWORTH, A. H.
He engraved the frontispiece and vignette title page for "The Life and Adventures of Robinson Crusoe," published by Silas Andrews, Hartford, NJ, about the year 1828.

BUTTON, ALBERT PRENTICE.
Painter and illustrator. Born in Lowell, Mass., 1872. Pupil of Boston Art Club. Address in 1926, 44 Boyleston St., Boston, Mass.

BUTTRE, JOHN CHESTER.
Engraver. Born 1821 and died 1893. He did portrait painting, but soon became a line engraver of reputation, and established an extensive engraving business in New York.

BUZBY, ROSELLA T.
Painter and illustrator. Born in Philadelphia in 1867. Pupil of Penna. Academy of Fine Arts. Address in 1926, Fuller Building, 10 South 18th St., Philadelphia, PA.

BYE, ARTHUR E.
Painter and teacher. Born in Philadelphia, 1885. Pupil of John Carlson; studied in Paris. Member of Art Alliance, Philadelphia. Address in 1926, Langhorne, Philadelphia.

BYER, SAMUEL.
Painter. Born in Poland, 1886. Pupil of Art Institute of Chicago, Ill. Address in 1926, 439 South Halstead St., Chicago.

BYERS, EVELYN.
Painter. Exhibited water colors at Penna. Academy of Fine Arts, Philadelphia, 1922. Address in 1926, 1102 Bagby St., Houston, Texas.

BYERS, MARYHELEN.
Painter and teacher. Born Seattle, March 23, 1902. Pupil of Andre L'hote in Paris. Member: Seattle

SFA. Address in 1929, University of Washington; h. 1651 Windemere Dr., Seattle, Wash.

BYFIELD, N.
Portrait painter. Born in Boston, 1677, and probably the son of Nathaniel and Deborah Byfield. Portrait of Richard Middleton, signed and dated 1713.

BYRAM, RALPH SHAW.
Painter and illustrator. Born in Philadelphia, 1881. Member of Philadelphia Sketch Club. Address in 1926, Lena and Church Lane, Germantown, Philadelphia.

BYRD, HENRY.
Portrait painter. Lived in New Orleans in the 40's and 50's; travelling portrait painter until 1867. Died in 1883.

BYRNE, ELLEN A(BERT).
Painter. Born Fort Moultrie, SC, 1858. Pupil of Corcoran School of Art in Washington; William M.

Chase; Simon and Menard in Paris. Member: Society of Washington Artists.

BYRON-BROWNE, GEORGE.
Sculptor and painter. Born in Yonkers, NY, June 26, 1908. Studied with Karfunkle, Aiken, Zorach. Award: Third Hallgarten prize, National Academy of Design, 1928. Member: Allied Art Association; Yonkers Art Association. Address in 1933, 35 Jane St., NYC; summer, Lakewood, NJ.

BYRUM, RUTHVEN H(OLMES).
Painter and teacher. Born Grand Junction, Mich., July 10, 1896. Pupil of AIC. Member: Ind. AC; Hoosier Salon; Anderson SA; Terre Haute AL. Awards: Second prize for still life, Indiana State Fair, 1928; second prize, figure composition, third in landscape, Indiana State Fair, 1929. Work: "The Old Timer," Richmond Art Association, Richmond, Ind.; "Portrait of Mr. J. C. Black," High School, Anderson, Ind. Address in 1929, 520 Eagle St., Terre Haute, Ind.; h. 419 Union Ave., Anderson, Ind.

C

CABALLERO, EMILIO.
Painter and educator. Born in Newark, NJ, July 5, 1917. Studied at Amarillo Coll.; W. TX State U.; Columbia U. Exhibited at 104th Ann. Am. WCS Exhib., NY; 9th Ann. Southwestern Exhib., Prints & Drawings, Dallas, TX; many others. Prof., W. TX State U., from 1949. Member, Royal Soc. of GB (fellow). Works, watercolor and enamel. Address in 1982, Amarillo, TX.

CABLE, MAXINE ROTH.
Sculptor. Born in Philadelphia, PA. Studied at Tyler School of Fine Art, Temple University, Associate of Arts; Corcoran School of Art; George Washington University, AB; American University, with Hans Hofmann. Work in National Academy of Science, Washington, DC; Wolf Trap Farm of Performing Arts, VA, sculpture, 1973; and others. Has exhibited at the Corcoran Gallery of Art, 1955-67; Gallery Ten, Washington, DC, 1975, 76 and 79; and others. Received sculpture award, David Smith, Corcoran Gallery of Art, 1955; First Prize in Painting, Smithsonian Institution, 1967; and others. Address in 1982, Bethesda, MD.

CABOT, AMY W.
Painter. Member: NA Women PS; Boston MA. Address in 1929, 72 Chestnut Street, Boston, MA.

CABOT, HUGH.
Sculptor and painter. Born in Boston, MA, March 22, 1930. Studied at Vesper George School of Fine Arts; Boston Museum of Fine Arts School; College of Americas, Mexico City; Asmolean, Oxford University, Cambridge, England. Work in The Pentagon and National War Museum, Washington, DC; Harwood Foundation of Art, Taos, New Mexico. Has exhibited in Mitsubishi Gallery, Tokyo, Japan; Museum de la Marine, Paris, 1963; National Gallery of Art; and others. Received awards from the Texas Tri State, First, Second, and Third Prizes, 1969; Scottsdale, Arizona, Artist of the Year, 1978. Works in oil, watercolor, and bronze. Was official Navy combat artist in Korean War. Has contributed newspaper and magazine illustrations. Specialty is Southwestern American and Mexican frontier subjects. Address in 1982, Tubac, AZ.

CADE, J. J.
Engraver. Was born in Canada. He was a good engraver of portraits and worked for the New York publishers. In 1890 he was living in Brooklyn, NY.

CADMUS, EGBERT.
Painter. Born Bloomfield, NJ, May 26, 1868. Pupil of Charles E. Moss, C. Y. Turner, E. M. Ward and Robert Henri. Member: AWCS (assoc.); AFA. Address in 1929, 150 West 95th Street, New York, NY. Died in 1939.

CADMUS, PAUL.
Painter and engraver. Born New York City, December 17, 1904. Pupil of Francis C. Jones, William Auerbach Levy and Charles C. Curran. Member: Tiffany Foundation AG; Brooklyn SE. Award: Fellowship, Tiffany Foundation. Address in 1929, 150 West 95th Street, New York, NY.

CADORIN, ETTORE.
Sculptor. Born in Venice, Italy, March 1, 1876. Studied in Venice. Member: National Sculpture Society. Award: First medal, Royal Academy, Venice. Work: Two colossal statues, St. Mark's Square, Venice; Wagner memorial, Venice; war memorial, Edgewater, NJ; bronze statue, "Junipero Serra," for California in Statuary Hall, U.S. Capitol, Washington, DC; three large stone statues of the patron saints, Washington Cathedral; large group and two statues for Court House, Santa Barbara, CA. Address in 1933, Santa Barbara, CA. Died June 18, 1952.

CADWALDER, LOUISE.
Painter and craftsman. Born Cincinnati, Ohio. Pupil of Carlson; William M. Chase; John Rich Cahill; Winold Reiss; Ralph Johonnot; Rudolph Scaeffer; ASL of NY; Cincinnati Art Acad. Member: San Francisco S. Women A; Boston SAC; Alliance. Address in 1929, 3120 Eton Ave., Berkeley, CA.

CADY, EDWIN A. (MRS.).
Painter. Member: Providence Art Club; Providence Water Color Club. Address in 1926, Warren, RI.

CADY, HENRY N.
Painter. Born Warren, RI, July 8, 1849. Pupil of NAD. Member: Providence AC. Address in 1929, 81 Union Street, Warren, RI.

CADY, WALTER HARRISON.
Illustrator. Born Gardner, MA, June 17, 1877. Member: Salma. C.; SI 1911; AWCS; NY Arch. L.; North Shore AA; GFLA; NYWCC. Illustrated *Rackety Packety, Queen Silver Bell, The Spring Cleaning, The Cosy Lion,* by Frances Hodgson Burnett, etc.; contributor to *Life, St. Nicholas, Saturday Evening Post, Country Gentleman, Ladies Home Journal,* etc.

Author of *Caleb Cottontail* and other children's stories. Died in 1970.

CAESAR, DORIS.
Sculptor. Born NYC in 1892. Studied: Art Students League; Archipenko School of Art; also under Rudolph Belling. Work: Addison Gallery of American Art; Chapel of Our Redeemer, Chappaqua, NY; Conn. College; Daytona Institute of Art; Fort Worth Art Association; Philadelphia Museum of Art; Minneapolis Institute of Art; Newark Museum of Art; University of Iowa; University of Minn.; Utica Public Library; Wadsworth Atheneum; Whitney Museum of American Art; Penna. Academy of Fine Arts; Wellesley College; Atlanta Art Center; Erhard Weyhe, whose collection of Caesar's sculpture was shown at Weyhe Gallery, NYC, 1959; many others. Member: Federation of Modern Painters and Sculptors; Sculptors Guild; NY Architectural League; Audubon Artists; others. Exhibited: Metropolitan Museum of Art, 1955; New Burlington Gallery, London, 1956; American Federation of Arts traveling exhibit, 1953-54; Weyhe Gallery, 1933, 35, 37, 47, 53, 57, 59, 61; Brooks Memorial Museum, 1960; Wadsworth Atheneum, Hartford, CT, 1960. Noted works, "Madchen," 1958; "Annunciation," 1958; "Homage," 1958; "St. Francis Receiving the Stigmata," 1958; "Wings," 1962; "Ellipse," 1962; all bronze. Particulary known for her sensitive and repeated artistic treatment of the female form. Address in 1970, Litchfield, Conn. Died c. 1971.

CAFARELLI, MICHELE A.
Painter. Born in 1889. Member: Society Independent Artists. Address in 1926, 24 West 60th Street, New York, NY.

CAFFERTY, JAMES H.
Painter. Born in Albany, in 1819. Portrait and still life painter. He became an Academician, National School of Design, in 1853. His most notable paintings are "My Girl," "Brook Trout," and several studies of "Fish." With L. M. Wiles, painted a graveyard scene from Hamlet. Died Sept. 7, 1869.

CAGE, ROBERT FIELDING.
Sculptor and painter. Born Charlotte Co., Virginia, October 7, 1923. Study: De Bourgos School of Art, Wash., DC; Salisbury School of Art, Rhodesia; American Student and Arts League, Paris. Exhibitions: Contemporary Gallery of Art, Wash., DC; Smithsonian Institution; National Gallery of Rhodesia; Norfolk Museum of Art; others. In collections of commercial and private organizations in US, France, and Africa. Works: "Free Form," and "Moby Dick." Awards: Mariners Museum Top Sculpture Award, Great Atlantic Realtor, 1971; Award, North Carolina Museum of Art. Address in 1976, South Boston, Virginia.

CAHAN, SAMUEL GEORGE.
Illustrator. Member: SI. Address in 1929, 644 Riverside Drive, New York, NY. Died in 1974.

CAHILL, ARTHUR JAMES.
Painter and illustrator. Born in San Francisco, 1879. Pupil of California Art School. Member: California Artists' Association; Bohemian Club, San Francisco. Work: "Governor Hiram Johnson of California," State Capitol, CA; "Congressman Kent of California," "Templeton Crocker" in Crocker Art Gallery, Sacramento; "Chief Justice Irwin," Bohemian Club, San Francisco. Address in 1926, San Anselmo, California.

CAHILL, KATHARINE KAVANAUGH.
Painter. Born Four Oaks, Kentucky. Pupil of Wm. V. Cahill and S. MacDonald Wright. Member: Phoenix FAA. Award: First prize for still life, AZ State Fair, 1926. Address in 1929, 562 South New Hampshire Ave., Los Angeles, CA; summer, 708 Heard Bldg., Phoenix, AZ.

CAHILL, WILLIAM VINCENT.
Painter. Born Syracuse, NY. Pupil of Howard Pyle. Member of Art Students League of New York. Professor of drawing and painting, University of Kansas, 1918-19. Work: "Thoughts of the Sea," Museum of History, Science and Art, Los Angeles; "Summer," Municipal Collection, Phoenix, Arizona. He died in Chicago, Aug. 1924.

CAIN.
An American portrait painter who flourished about 1760 in Maryland.

CALDER, ALEXANDER (MILNE).
Sculptor. Born Aberdeen, Scotland, August 23, 1846. Pupil of John Rhind in Edinburgh. Studied in England; came to United States in 1868. Pupil of Penna. Academy of Fine Arts under J. A. Bailly and Thomas Eakins. Work: Equestrian statue of Gen. George G. Meade in Fairmount Park, Philadelphia, PA; colossal statue of William Penn, and groups on City Hall, Philadelphia, PA; three portrait busts in Union League Club, Philadelphia; represented in Penna. Academy of Fine Arts and Drexel Institute. Died in Philadelphia, PA, June 14, 1923.

CALDER, ALEXANDER (called SANDY).
Sculptor. Born in Philadelphia, PA, July 22, 1898. Study: Stevens Institute of Technology, ME, 1919; Art Students League, 1923-26, with G. Luks, G. du Bois, Boardman Robinson, J. Sloan. Work: Museum of Modern Art, Metropolitan Museum of Art, NYC; Wadsworth Atheneum; Museum of Western Art, Moscow, USSR; Philadelphia Museum of Art; others. Commissions: Gen. Motors Corp., 1954; New York International Airport, 1958; UNESCO, Paris, 1958; many others. Exhibits: In leading museums throughout US and abroad. Awards: First prize

sculpture, International Exhibition of Contemporary Painting & Sculpture, Pittsburgh, 1958; gold medal award, National Institute of Arts & Letters, 1971; Commander, Foreign Legion of Honor, 1973. Member: National Institute Arts and Letters. Died in NYC, November 11, 1976.

CALDER, ALEXANDER STIRLING.
Sculptor and painter. Born Phila., PA, January 11, 1870; son of Alexander Milne Calder. Pupil of Penna. Academy of Fine Arts; Chapu and Falguiere in Paris. Member: Associate, National Academy of Design, 1906; National Academician, 1913; National Sculpture Society, 1896; Phil. Art Club; Society of American Artists, 1905; New York Municipal Art Society; New York Architectural League, 1910; Century Association; Players'; National Institute Arts and Letters; National Arts Club (life); National Association of Portrait Painters; New Society of Artists. Instructor, National Academy of Design; Art Students League of New York. Had studio in NYC after 1908. Awards: Gold medal, Phila. Art Club, 1893; honorable mention, Pan-American Exposition, Buffalo, 1901; silver medal, St. Louis Exposition, 1904; Lippincott prize, Penna. Academy of Fine Arts, 1905; grand prize, Alaska-Yukon-Pacific Exposition, 1909; designer's medal, San Francisco, CA, 1915; silver medal, Sesqui-Centennial Exposition, Phila., 1926. Work: Statues of Witherspoon, Marcus Whitman and Davies, Presbyterian Building, Phila.; marble sun dial, Fairmount Park, Phila.; monumental archways, Throop Institute, Pasadena, CA; Lea Memorial, Laurel Hill Cemetery, Phila.; Fountain of Energy, etc., P.-P. Exposition, San Francisco, 1915; "The Star," Herron Art Institute, Indianapolis; "Washington Group," Washington Arch, NY; Depew memorial fountain, Indianapolis, IN; "The Island," Viscaya, FL. Represented in permanent collection, Penna. Academy; St. Louis Museum of Art; Franklin Inn Club; Smithsonian Institution grounds, Washington, DC; Metropolitan Museum, NYC; Reading Museum; Telfair Academy, Savannah, GA. Exhibited at National Sculpture Society, 1923. Acting Chief, Department of Sculpture, P.-P. Exposition, San Francisco, 1915. Address in 1933, 11 E. 14th St., NYC. Died in 1945.

CALDER, JOSEPHINE ORMOND.
Painter. Member: National Academy of Women Painters and Sculptors. Address in 1926, 1861 Parkwood Avenue, Toledo, OH.

CALDER, RALPH M.
Painter. Born Philadelphia, PA, 1884. Pupil of Penna. Academy of Fine Arts. Address in 1926, Care Paul Chalfin, 597 Fifth Avenue, New York, NY.

CALEWAERT, LOUIS H.S.
Sculptor, painter, and etcher. Born Detroit, Mich., August 18, 1894. Pupil of Detroit School of Fine Arts

under Wicker, and studied in Italy, Sicily, France, and Belgium. Member: Chicago Society of Etchers. Work: Toledo Museum of Art. Address in 1926, Chicago, IL.

CALFEE, WILLIAM HOWARD.
Sculptor and painter. Born in Wash., DC, February 7, 1909. Studied: Ecole des Beaux-Arts, Paris, with Paul Landowski; Cranbrook Academy of Art, with Carl Milles. Member: Wash. Art Guild. Work: Cranbrook Academy of Art; Phillbrook Art Center; Baltimore Museum of Art; Metropolitan Museum of Art; and others. Exhibited: Penna. Academy of Fine Arts; Metropolitan Museum of Art; Whyte Gallery, Wash., DC, 1952 and Corcoran Gallery, (one-man); Carnegie; National Academy of Science, Wash., DC; and others. Collaborator on and Introduction to: "Tradition and Experiment in Modern Sculpture," text by Charles Seymour. Commissions: Eight murals and two sculptures, US Treasury Department, 1936-41; font, altar, and candlesticks, St. Augustine Chapel, Wash., DC, 1969; sculpture, Civic Center, Rockville, MD, 1979. Taught: Chairman, Dept. Painting and Sculpture, American Univ., Wash., DC, 1946-54; Instructor, drawing and painting, Phillips Gallery, Wash., DC. Address in 1982, Chevy Chase, MD.

CALHOUN, FREDERIC D.
Painter. Born Minneapolis, MN, 1883. Pupil of Art Students League of New York; Minneapolis School of Art. Member: Minneapolis Art Club.

CALIGA, ISAAC HENRY.
Painter. Born Auburn, IN, March 24, 1857. Pupil of William Lindenschmidt; studied in Munich. Member: S. Indp. A. Work: "Portrait of H. F. Waters," New England Historical and Genealogical Society; "Portrait of Matthew Robson," Salem (MA) YMCA; "James B. Colgate," New York Chamber of Commerce; "Gov. Alexander H. Rice," MA State House; "Rev. Alfred W. Putnam," Danvers, MA, Historical Society. Address in 1929, Provincetown, MA.

CALKINS, LORING GARY.
Engraver and teacher. Born Chicago, IL, June 11, 1884. Pupil of Vanderpoel; Charles Francis Brown; Freer. Member: AIC Alumni Assoc.; ASL of Chicago. Illustrated "Land and Sea Mammals of Middle America and West Indies." Represented in Field Columbian Museum. Address in 1929, 101 Avalon Rd., Waban, MA. Died in 1960.

CALLE, PAUL.
Illustrator. Born in New York City in 1928. He studied at PI for four years. Following his first illustration for *Liberty Magazine* in 1947, he produced many campaigns for major advertising agencies. He has recorded the NASA space program, beginning with the Mercury Program, and in 1975 he covered the Apollo-Soyuz training team. Assign-

ments for commemorative United States postal stamps followed and his works are in collections of the Phoenix Art Museum, NASA and the Northwest Indian Center in Spokane. A Hamilton King Award winner, he has also exhibited illustrations and won awards in the S of I Annual Exhibitions.

CALLENDER, BENJAMIN.
Engraver. Born March 16, 1773, in Boston, MA. His engraved work chiefly consists of maps and charts. He was engraving for Boston publishers as early as 1796. Callender engraved some of the maps in the "American Gazetteer" by Jedediah Morse, Boston, 1897. Died Feb. 22, 1856.

CALLENDER, JOSEPH.
Born in Boston, MA, 1751; died there Nov. 10, 1821, and was buried in the Old Granary Burying Ground. He was the son of Eleazer Callender and Susanna Hiller. Joseph Callender was employed for some time as a die-sinker for the Massachusetts Mint. With Paul Revere, he engraved a number of line-plates for the *Royal American Magazine*, published in Boston in 1774.

CALLERY, MARY.
Sculptor. Born June 19, 1903, in NYC. Studied at New York Art Students League with Edward McCartan, and with Jacques Loutchansky in Paris, where she lived many years. Was commissioned to create work for NYC schools and Lincoln Center. Exhibited at Art Club of Chicago; Brussels World's Fair, 1958; Museum of Modern Art; Virginia Museum of Fine Arts; Knoedler & Co., NYC; Salon de Tuileries, Paris. In collections of Museum of Modern Art; Toledo Museum of Art; Cinn. Art Museum; San Francisco Museum of Art; Wadsworth Atheneum; Whitney; and Alcoa. Address in 1977, Paris, France. Died in Paris, February 12, 1977.

CALOGERO, EUGENE D.
Illustrator. Born in New York City in 1932. He attended the School of Industrial Arts in 1950 and had his first piece published in 1951. He has since illustrated several posters, most recently a poster for the Smithsonian Inst. His works have received many awards from the AIGA, the ADC, Type Designers Club and the Society of Magazine and Publication Designers.

CALVERLEY, CHARLES.
Sculptor. Born in Albany, NY, November 1, 1833. Apprenticed to a marble cutter in Albany at 13 for a period of over six years. Later employed and studied under E. D. Palmer in Albany from 1853-1868. During this period, he modelled numerous portrait medallions, busts, tablets, and two full statues in marble. Member: Associate, National Academy of Design in 1872, 1875. Executed many groups and figures; especially known for his portrait busts in

bronze of Horace Greeley, John Brown, Peter Cooper, and Elias Howe. Represented in Metropolitan Museum of Art by bust of Robert Burns. Died in Essex Fells, NJ, on February 24, 1914.

CALVERT, BERTHA W.
Painter. Born in Nashville, TN, in 1885. Specialty, ivory miniatures. Address in 1926, Fourth Avenue and Union Street, Nashville, TN.

CALVERT, E.
Painter. Born in England, 1850. Painted portraits in Mercer University, Lake Geneva, WI. Address in 1926, 238 Fourth Avenue, Nashville, TN.

CALVERT, PETER R.
Painter. Born in England, 1855. Pupil of John Snowden. Specialty, ivory miniatures. Address in 1926, Fourth Avenue and Union Street, Nashville, TN.

CALYO, NICOLINO.
Painter. Born in 1799. Italian portrait and miniature painter. In 1837 he lived in New York with other refugees, among them Napoleon III. He died there Dec. 9, 1884. (see *NY Tribune*, December 14, 1884).

CAMERON, EDGAR SPIER.
Painter and writer. Born Ottawa, Ill., May 26, 1862. Pupil of Chicago Academy of Design; ASL of NY; Cabanel, Constant and Laurens in Paris. Member: Cliff Dwellers. Awards: Silver medal, Paris Exp., 1900; Grower prize, AIC, 1909; Butler Purchase prize, AIC, 1914; Carr prize, AIC, 1914; Rosenwald purchase prize, AIC, 1917; Carr prize, AIC, 1917; Officier, Beaux Arts et Instruction Publique, Paris, 1920; purchase prize ($500), Municipal AL of Chicago, 1926; prize ($200), Chicago Gallery Assoc., 1927. Work: Chicago Historical Soc.; Chicago Union League Club; Supreme Court Library, Springfield, IL; "Youth and Moonlight," Chicago Commission purchase, City Hall, 1915; "Cabaret Breton," Art Institute of Chicago; mural decoration, Genesee Co. Court House, Flint, Mich. Address in 1929, 10 East Ohio Street, Chicago, IL. Died in 1944.

CAMERON, ELIZABETH WALLACE.
Painter and teacher. Born in Woodland, PA. Pupil of Christian Walter, Ossip Linde and Hugh Breckenridge. Member: Pitts. AA; Pitts. Teachers Assoc. Address in 1929, 4145 Windsor Street, Squirrel Hill, Pittsburgh, PA.

CAMERON, MARIE GELON.
Painter. Born Paris, France. Pupil of Moreau de Tours, Cabanel, Laurens and Constant in Paris; AIC. Awards: Prize, AIC, 1902; Julius Rosenwald purchase prize, AIC, 1922. Represented in Historical Society, Chicago; portrait, "Maj. Gen. Joseph B. Sanborn," First Regiment Armory, Chicago; portraits of "Judges Cutting and Kohlsaat," Cook Co.

Probate Court. Address in 1929, 10 East Ohio Street, Chicago, IL.

CAMERON, WILLIAM ROSS.
Illustrator, writer and engraver. Born in New York City, June 14, 1893. Pupil of F. L. Meyer, Xavier Martinez, Nahl, E. Spencer Mackey, Martin Griffin. Studied in London and Paris. Member: San F. AA; CA SE; Roxburgh C. Address in 1929, 55 Borica Street, Ingleside Terraces, San Francisco, CA.

CAMERON-MENK, HAZEL.
Sculptor, writer, and lecturer. Born in St. Paul, Minn., November 3, 1888. Studied: Ringling School of Art; George Washington University; Corcoran Art School; and with Eugene Weiss, Richard Lahey, Lesley Posey. Member: Washington Art Club; National Arts Club; Sarasota Art Association; League of American Pen Women. Awards: Prizes, League of American Pen Women, 1933, 1935-37; medal, Society of Independent Artists, 1933; Arlington Women's Club, 1934. Work: Clarendon Library, Arlington, VA. Contributor to: Arlington (VA) Chronicle. Exhibited: Sarasota Art Association, 1947-52; Terry Art Institute, 1952. Address in 1953, Sarasota, FL.

CAMFFERMAN, MARGARET GOVE.
Painter. Born in Rochester, MN, in 1895. Pupil of Henri. Award: Hon. mention, Seattle FAS, 1921. Address in 1929, "Brackenwood," Langley, Washington.

CAMFFERMAN, PETER MARIENUS.
Painter, sculptor, etcher, lithographer, blockprinter, lecturer, teacher, and writer. Born at The Hague, Holland, February 6, 1890. Studied at Minneapolis School of Fine Arts; pupil of Andre L'Hote, Robert Koehler, and MacDonald-Wright. Awards: Prizes, Seattle Art Museum, 1933, 35, 37, 41, 55; Pacific Coast Painters, Sculptors and Writers, 1939. Exhibited: Hathaway House, 1952 (one-man); Golden Gate Expo., 1939; Museum of Modern Art, 1933; Seattle Art Museum, 1932-46; California Palace of the Legion of Honor, 1933; Henry Art Gallery, 1950-52, 53, 55; others. Work: Seattle Art Museum; University of Washington. Member: Society of Independent Artists. Address in 1957, Brackenwood, Langley, WA.

CAMINS, JACQUES JOSEPH.
Painter and printmaker. Born Odessa, Russia, Jan. 1, 1904; US citizen. Study: Paris; ASL; with Jean Liberty and Byron Browne; Pratt Graphics Ctr., with Matsubara Naoka and Carol Summer. Work: Isreal Museum, Jerusalem; The Negev Museum; Memorial Art Museum, Czechoslovakia; Hebrew University, Jerusalem; Cooper-Hewitt Mus.; and others. Exhibitions: National Academy Galleries, NYC; Crypt Gallery, Columbia University; Provincetown, MA, Art Assn.; etc. Mem.: Artists Equity Assn.; Provincetown (MA) Art Assn; ASL; etc.

Media: Oil. Address in 1982, 1065 98th St., Studio G, Bay Harbor Islands, Fla.

CAMMEYER, W.
Engraver, working in Albany, NY, about 1812. He engraved a number of book-illustrations.

CAMPBELL.
An American portrait painter, said to have flourished about 1776. Washington writes at that date of a portrait painted of himself, but states that he never saw the artist.

CAMPBELL, ANNA BARRAND.
Miniature painter. Born in Nelson County, VA, 1879. Pupil of Art Students League of New York, and Corcoran Art Gallery, Washington, DC. Address in 1926, 1977 Biltmore Street, Washington, DC. Died March 24, 1927, in NYC.

CAMPBELL, BLENDON REED.
Painter and illustrator. Born St. Louis, MO, July 28, 1872. Pupil of Constant, Laurens and Whistler in Paris. Member: SI, 1905; Paris AAA; NY Arch. Lg., 1911. Award: Third prize, Paris AAA, 1900. Represented in Chicago Art Institute, Smithsonian Institution and Wichita AA. Address in 1929, 3 Washington Square, North, New York, NY.

CAMPBELL, C. ISABEL.
Sculptor and painter. Born Brooklyn, NY. Pupil of Phila. School of Design for Women, and with Daniel Garber, Henry B. Snell, and Samuel Murray. Member: Plastic Club; American Federation of Artists. Awards: Silver medal for miniature model and mural decorations, Sesqui-Centennial Exposition, Phila., 1926; Fellowship, Philadelphia School of Design for Women. Work: Miniature models and mural decorations, Commercial Museum. Address in 1953, Commercial Museum, Philadelphia, PA.

CAMPBELL, CORA A.
Painter, etcher, and teacher. Born in Philadelphia in 1873. Pupil of J. Frank Copeland; Charles W. Hawthorne; Earl Horter; Henry Pitz. Member: Plastic C.; Phila. Alliance; AFA. Address in 1929, 2231 N. 22nd St., Philadelphia.

CAMPBELL, DOROTHY BOSTWICK.
Sculptor and painter. Born March 26, 1899, in NYC. She studied with Eliot O'Hara, Wash., DC, and Marilyn Bendell, Cortez, FL. Exhibitions: Cooperstown Art Association, both group and one-woman shows, 1965; Sarasota Art Association, FL; Pioneer Gallery, Cooperstown; Cortez Art School, FL, 1972. Awarded Purchase Prize for Watercolor, Cooperstown Art Association, 1965; First Prize for Watercolor, Collectors Corner, Wash., DC. Member of American Art League; American Federation of the Arts. Address in 1982, Sarasota, FL.

CAMPBELL, EDMUND S.

Painter. Born in Freehold, NJ, in 1884. Pupil of Mass. Inst. of Technology; Ecole des Beaux Arts. Member of Associated Artists of Pittsburgh; Chic. Soc. of Artists; NY WC Club; Am. WC Soc. Exhibited water color paintings at Penna. Academy of Fine Arts, 1922. Address in 1926, Care of Chicago Art Institute. Died in 1950.

CAMPBELL, ELIZABETH.

Painter. Born in 1893 in Iowa Falls, Iowa. Studied with Alexander Nepote, at Marian Hartwell's School of Design, San Fran.; and San Fran. Art Inst., one year scholarship. Taught privately. Received grant from Montalva Foundation, Cal. Exhibited at Cal. Palace, San Fran.; Louis Terah Haggin Mem. Galleries, Stockton; and San Fran. Museum of Art. Living in San Francisco in 1965.

CAMPBELL, FLOY.

Painter, illustrator, writer, teacher and lecturer. Born Kansas City, MO, September 30, 1875. Pupil of ASL of NY; Colarossi Academy, Garrido, and Cottet in Paris. Member: Kansas City SA. Represented in Jefferson College, Philadelphia. Author and illustrator of "Girls in Camp Aready." Address in 1929, Kansas City, MO.

CAMPBELL, HARRIET DUNN.

Sculptor, painter, and teacher. Born Columbus, OH, August 16, 1873. Studied at Columbus Art School; Ohio University; Art Students League, with Robert Henri; William M. Chase; Arthur W. Dow; Kenneth Miller; George Bridgman; Charles Hawthorne. Member: Columbus Art League; Ohio Water Color Society; Ohio-Born Women Painters. Awards: Honorable mention for oil, 1920, 1921, for water color, 1923, Columbus Art League; honorable mention, Ohio State Fair, 1922; Robert Wolf water color prize, Columbus Art League, 1927. Exhibited: American Water Color Society, NY, 1934; Boston Art Club, 1934; Art Institute of Chicago, 1935; Columbus Art League; and others. Address in 1953, Columbus, OH.

CAMPBELL, HELENA EASTMAN OGDEN.

Painter, writer, and teacher. Born Eastman, GA. Pupil of William M. Chase School and Robert Henri in New York; Grande Chaumiere School in Paris. Member: NA Women PS; S. Indp. A.; Alliance; Municipal Art Committee, New York; SSAL. Work: Portrait of Rt. Rev. Frederick F. Reese, Bishop of Georgia, owned by the Diocese of Georgia; portrait of Henry Carr Pearson in Horace Mann School, Columbia University, New York; portrait of Pres. William F. Quillian, owned by Wesleyan College, Macon, GA; portrait sketch of Prof. William H. Kilpatrick of Teachers College, Columbia University, owned by Mercer University, Macon, GA. Address in 1929, 419 W. 119th St., The Kingscote, NYC.

CAMPBELL, HEYWORTH.

Painter, writer, lecturer, teacher. Born Philadelphia, PA, June 20, 1886. Member: Grolier C.; Salma. C.; Art Directors' C.; Advertising Club. Specialty, advertising art. Address in 1929, care of Batten Barton, Durstine and Osborn, 383 Madison Ave.; h. 325 East 72nd Street, New York, NY; summer, Oakland, NJ.

CAMPBELL, ISABELLA GRAHAM.

(Mrs. Henry Munroe Campbell, Jr.) Painter. Pupil of Chase and Bourdelle. Member: Detroit S. Women P. Address in 1929, "Greystone," Klingle Road, Washington, DC.

CAMPBELL, KENNETH.

Sculptor and painter. Born April 14, 1913, in West Medford, MA. Studied at Mass. School of Art, with E. Major, C. Darlin, R. Andrews, W. Porter; National Academy of Design, with L. Kroll, G. Beal; Art Students League, with Arthur Lee. Taught at Erskine School, Boston; Silvermine, New Canaan; Queens College; Columbia University; and others. Received awards from Longview Foundation, NYC, 1962; Ford Foundation; Audubon; and 1965 fellowship, Guggenheim. Exhibited at Stable Gallery, NYC; Art Institute of Chicago; Whitney; Penna. Academy of Fine Arts; others. In collections of Dillard University (New Orleans); Whitney; Walker Art Center (Minn.); and private collections. Member: Artists Club; Art Students League; Sculptors Guild; Audubon Artists; Boston Society of Independent Artists. Address in 1976, 79 Mercer St., New York City.

CAMPBELL, ORLAND.

Portrait painter. Born Chicago, IL, November 28, 1890. Pupil of Henry McCarter; Penna. Acad. of the Fine Arts. Member: Century Club. Work: "Anna Bartlett Warner," U.S.M.A. Museum, West Point, NY; "Davis Rich Dewey," Walker Memorial Hall, Cambridge, MA; "Dr. Miller," Walker Memorial Hall, Cambridge, MA; "Blewett Lee," University of Chicago. Address in 1929, 21 MacDougal Alley, New York, NY. Died in 1972.

CAMPBELL, ROBERT.

Engraver. Working in Philadelphia about 1806-1831.

CAMPBELL, SARA WENDELL.

Painter and illustrator. Born St. John, N. B., Canada. Pupil of Eric Pape, Chase, Penfield and Miller. Member: GFLA; SI. Specialty, story illustration and advertising in magazines. Address in 1929, 1 West 67th Street, New York, NY. Died in 1960.

CAMPBELL, WANDS.

Painter. Exhibited in the 1925 Annual Exhibition of the National Academy of Design. Address in 1926, Athens, PA.

CAMPOLI, COSMO P.
Sculptor. Born in South Bend, IN, March 21, 1922. Study: Art Institute of Chicago, grad. 1950; Anna Louise Raymond traveling fellow to Italy, France, Spain, 1950-52. Work: Museum of Modern Art, NYC; Richmond Museum, VA; Unitarian Church, Chicago; many private collections. Exhibition: New Images of Man, Museum of Modern Art, 1959; US Information Agency Show, Moscow & Petrograd; Chicago School Exhibition, Galerie du Dragone, Paris; sculpture exhibition, Spoleto, Italy; 30-year retrospective, Museum of Contemporary Art, Chicago, 1971; plus many more. Awards: Bronze medal, Deleg. National Education - Fisica, Madrid, 1969; Automotive Association of Spain award, 1969; etc. Teaching: Contemporary Art Workshop, Chicago, 1952-pres.; Inst. of Design, Illinois Institute of Technology, from 1953. Address in 1982, Chicago, IL.

CANADE, VINCENT.
Painter. Born Albanese, Italy, 1879. Self-taught. Represented in Phillips Memorial Gallery, Washington, DC. Address in 1929, care of E. Weyhe, 794 Lexington Ave., New York, NY.

CANDEE, GEO. EDWARD.
Painter. Born in New Haven, CT., 1838. Pupil of Joseph Kyle in New Haven, and also studied in Italy. Painted landscapes, portraits and figure pieces.

CANE, ALICE NORCROSS.
Painter and teacher. Born Louisville, KY. Pupil of Charles Hawthorne, James Hopkins, Van Deering Perrine, Jonas Lie. Member: Louisville AA; Louisville AC; Louisville Handicraft G. Address in 1929, Cortlandt Hotel, Louisville, Kentucky; summer, Provincetown, MA.

CANFIELD, JANE (WHITE).
Sculptor. Born in Syracuse, NY, April 29, 1897. Studied at Art Students League; James Earle and Laura Gardin Fraser Studio; Borglum School; also with A. Bourdelle, Paris, France. Works: Whitney Museum of American Art; Cornell University Museum of Art. Commissions: Six animals in lead for gate posts, commissioned by Paul Mellon, Upperville, VA, 1940; animals in lead for gym entrance, Miss Porter's School, Farmington, Conn., 1960; St. John Apostle in stone, Church of St. John of Lattington, Locust Valley, NY, 1963; herons in stone, Memorial Sanctuary, Fishers Island, 1969; Canadian geese in bronze for pool, Long Lake, Minn., 1971. Exhibitions: Sculpture Pavilion, NY World's Fair, 1939; one-man show, Brit-Am Art Gallery, NY, 1955 and Far Gallery, NY, 1961, 65, and 74; Country Art Gallery, Locust Valley, 1971. Awards: Armstrong Award, Art Institute Chicago, 1971. Media: Stone and bronze. Address in 1982, Bedford, NY.

CANNON, BEATRICE.
Painter. Born in Louisville, KY, in 1875. Pupil at Art Institute of Chicago. Address in 1926, 1115 East 61st Street, New York.

CANNON, FLORENCE V.
Sculptor, painter, engraver, lecturer, and teacher. Born in Camden, NJ. Pupil of Charles Grafly, Henry McCarter; School of Industrial Art, Phila.; Academy of Fine Art, Phila; Penna. Academy of Fine Arts; Academie Chaumiere, Paris. Member: National Association of Women Painters and Sculptors; American Artists Professional League; Washington Watercolor Club; Phila. Alliance; Phila. Plastic Club; Phila. Print Club; Alum. School of Industrial Arts; Fellowship Penna. Academy of Fine Arts; and others. Awards: President's prize for sketching, Penna. Academy of Fine Arts, 1928, 29; first Toppan prize ($300); special watercolor prize; prizes, Northwest Printmakers, 1933; Southern Printmakers, 1937; gold medal for oil, Plastic Club, 1933; special Gimbel anniversary prize, watercolor, 1933; National Association of Women Artists, 1936. Exhibited: Penna. Academy of Fine Arts; National Association of Women Artists; Corcoran; American Federation of Arts; Art Institue of Chicago; American Watercolor Society; and many others. Work owned by Fellowship of the Penna. Academy of the Fine Arts; New Jersey Federation of Women's Clubs. Address in 1953, Camden, NJ.

CANNON (CANNAN), HUGH.
Sculptor. Born in Ireland or Pennsylvania c. 1814. He settled in Phila. and there did considerable modelling and carving. Exhibited: Artists' Fund Society, bust of Chief Justice Marshall, 1840; Apollo Association, busts of Henry Clay and Edwin Forrest, 1841; and Penna. Academy of Fine Arts, Maryland Historical Society.

CANNON, JENNIE VENNERSTROM.
Painter, writer, lecturer, and teacher. Born Albert Lea, MN, August 31, 1869. Pupil of Bolton Brown, Edgar Ward and William M. Chase; and London School of Art. Member: San F. AA; Laguna Beach AA; Berkeley Lg. of Fine Arts; San F. Soc. Women A.; Carmel AA; Oakland AA; Galerie Beaux Arts, San Fran. Address in 1929, 1621 La Vereda Street, Berkeley, CA; summer, Carmel-by-the-Sea, CA.

CANTER, ALBERT M.
Painter. Born at Norma, Salem County, NJ, 1892. Member of Fellowship of the Penna. Academy of Fine Arts, Philadelphia. Among his best known paintings are "Virginia Road," and "Landscape" at the Graphic Sketch Club Gallery. Address in 1926, 721 Walnut Street, Philadelphia, PA.

CANTIN, KATHLEEN MARIE.
Printmaker. Born in 1951. Study: Univ. of New Hampshire. Work: Phila. Public Library; Decordova

Mus.; Fairbanks Mus.; Fed. Reserve Bank of Phila.; various corporations; commissions by New Hampshire Graphics Society, President and Mrs. Derek Bok of Harvard Univ., the Franklin Mint, Collector's Guild. Exhib.: 23rd Berkshire Mus. Exhib.; 2nd US Int'l. Graphics Annual; Boston Printmakers 30th Annual Exhib.; 39th Annual Exhib. of Miniature Painters, Sculptors and Engravers Soc. of Wash., DC. Awards: Helen Slottman Graphics Award, Pen & Brush Club, NYC. Currently living in Vermont.

CANTRALL, HARRIET M.
Painter. Born near Springfield, IL. Pupil of Pratt Institute, Dow, Woodbury, Townsley, Poore, Van Laer. Member: Western Arts Association; St. Louis AG; Springfield AA; AFA. Co-editor with J. C. Boudreau of "Art in Daily Activities," Mentzer Bush Co. Address in 1926, 853 Grand Blvd., Springfield, IL.

CAPARN, RHYS.
Sculptor. Born July 28, 1909, Onteora Park, NY. Studied: Bryn Mawr College; privately in Paris with Edouard Navellier; privately in NY with Alexander Archipenko. Work: Barnard College; Bryn Mawr College; Colorado Springs Fine Arts; Corcoran; Dartmouth College; Harvard University; La Jolla; Riverside Museum; City Art Museum of St. Louis; Whitney Museum; Butler; Yale University Art Gallery. Exhibited: Delphic Studios, NYC, 1933, 1935; Architectural League of NY, 1941; NY Zoological Park (Bronx), 1942; Wildenstein & Co., NYC, 1944, 47; John Heller Gallery, NYC, 1953; Doris Meltzer Gallery, NYC, 1956, 59, 60; Riverside Museum, 1961; Museum of Modern Art; Whitney Museum, 1941, 53, 54, 56, 60; Musee du Petit Palais, Paris, 1950; Penna. Academy of Fine Arts, 1951-53, 60, 64; Tate, 1953; Silvermine Guild, 1956; National Institute of Arts and Letters, 1968, 76. Awards: Metropolitan Museum of Art, American Sculpture, Second Prize, 1951; NY State Fair, First Prize for Sculpture, 1958; National Association of Women Artists, Medals of Honor for Sculpture, 1960, 61. Member: Federation of Modern Painters and Sculptors; Sculptors Guild; American Abstract Artists; New York Architectural League; International Institute of Arts and Letters. Commissions for Brooklyn Botanic Garden; Wollman Library, Barnard College; private portrait commissions. Taught: Dalton School, NYC, 1946-55, 1960-72. Address in 1982, Newtown, CT.

CAPELLANO, ANTONIO.
Sculptor. Born in Italy; possibly a pupil of Canova. As early as 1815 he was in NY, going from that city to Baltimore, MD, at the request of Max Godefroy, the architect of the Battle Monument of that city. Prior to his work on the Battle Monument, Capellano secured a commission for the execution of two panels in bas-relief upon the front of St. Paul's Church, of which Robert Cary Long was the architect. These two works, "Moses with the Tables of the Law" and "Christ Breaking Bread," were executed for the sum of $1,000 and completed before he began the Battle Monument. Exhibited "The Peace of Ghent," presumably a clay group, at the American Academy, 1816; a marble bust, "Chloris," at the Pennsylvania Academy, 1824. In September, 1817, Capellano, writing from Baltimore to James Madison at Montpelier, solicited a commission for a marble bust of James Madison, an arrangement which he was unable to complete. Capellano was then employed as a sculptor at the Capitol. In 1827 he offered to execute a statue of Washington for the Washington Monument at Baltimore. Rembrandt Peale met Capellano while in Baltimore in 1815, and again in the Boboli Gardens in Florence in 1830, when the latter resided there. His work is represented in the U.S. Capitol by a relief of Pocahontas and John Smith.

CAPERS, HAROLD HARPER.
Painter and illustrator. Born Brooklyn, NY, April 21, 1899. Pupil of F. Tadema, J. Allen St. John and Wellington Reynolds. Member: GFLA. Specialty, commercial art and advertising. Address in 1929, 30 North Michigan Avenue; h. 1345 Kenilworth Avenue, Chicago, IL.

CAPLAN, JERRY L.
Sculptor. Born Pittsburgh, PA, August 9, 1922. Study: Carnegie-Mellon University; Art Students League; University of North Carolina. Work: Raleigh State Art Gallery, NC; Westinghouse Corp.; many private collections. Commissions: Friendship Federation Plaza, Pittsburgh; Westinghouse Ceramic Division, Derry, PA; Kossman Associates, Pittsburgh; Rockwell Corp., Pittsburgh; others. Exhibitions: Butler Institute American Art, Youngstown, Ohio, 1955-75; Carnegie Institute, 1971; others. Awards: Society of Sculptors; Associated Artists of Pittsburgh Annual; Kent State University Invitational Sculpture Show; others. Teaching: Chatham College; Professor in Art at Rochester Institute of Technology, Temple University, Carnegie Mellon University and others. Medium: Terra-cotta. Address in 1982, Pittsburgh, PA.

CAPOLINO, JOHN JOSEPH.
Painter. Born in Philadelphia, PA, Feb. 22, 1896. Studied with Henry McCarter at the PAFA, and abroad. Member: Fellowship PAFA. Awards: Two European traveling scholarships, PAFA, 1924. Work: Fourteen mural decorations; "History of the U.S. Marine Corps," in the US Marine Corps bldg., Philadelphia, PA. Address in 1929, 1515 Arch Street; h. 1646 South 13th Street, Philadelphia, PA.

CARAVIA, THALIA FLORA.
Painter. Exhibited at Annual Exhibition of the National Academy of Design in 1925. Address in 1926, Paterson, NJ.

CARBEE, SCOTT CLIFTON.
Painter. Born Concord, VT, April 26, 1860. Pupil of Hugo Breul in Providence; Bouguereau and Ferrier in Paris; Max Bohm in Florence. Founder and director, Fine Arts Dept., University of Vermont Summer School, Burlington, VT. Address in 1929, director of Scott Carbee School of Art, Massachusetts Avenue at Boylson Street; h. Massachusetts Chambers, Boston, MA.

CARDELLI, GEORGIO.
Sculptor and painter. Born in Florence, Italy, 1791; came to US in 1816. About 1818 he was commissioned by Trumbell, the artist, to model busts of himself and his wife. He turned his attention to portrait painting and did considerable work in New England. Cardelli worked for some time on the decorations for the Capitol in Washington, DC.

CARDOSO, ANTHONY A.
Painter. Born in Tampa, Fla., Sept. 13, 1930. Study: Univ. of Tampa; Art Inst. of Minn.; U. of Southern Fla. Work: Minn. Mus. of Art, St. Paul; and others. Comn.: Sports Authority, Tampa Stadium office; many others in schools and institutions in Tampa, Florida. Exhibitions: Duncan Gallery, NY & Paris; Smithsonian Inst.; Brussels Int'l; Accademia Italia Exhib., Terme, Italy; many more. Awards: Latham Foundation Int'l; Smithsonian XXII Biennial; Prix de Paris Award, 1970; Gold medal, Acad. Italia Exhib.; etc. Mem.: Florida Arts Council; Tampa Realists Artists; etc. Media: Oil, acrylic. Address in 1982, 3208 Nassau Street, Tampa, Florida.

CAREW, BERTA.
Painter. Born in Springfield, MA, 1878. Pupil of Blashfield, Mowbray and Chase in New York; Carlandi in Rome; Mme. Richarde in Paris. Member National Academy Women Painters and Sculptors. Address in 1926, Care Kidder, Peabody Co., 17 Wall Street, New York City.

CAREY, CONSTANCE BEDDOE.
Painter. Born Birmingham, England. Pupil of ASL of NY. Member: Plastic C. Address in 1929, 242 South 51st Street, Philadelphia, PA.

CAREY, HENRY.
Early to mid-century American. "Landscape and Cattle."

CAREY, PEYTON.
At the Exhibition of Early Engraving in America, held at the Museum of Fine Arts, Boston, 1904, a seal of the University of Georgia was shown. A note says that this seal was designed and cut by "Mr. Peyton Carey, a graduate of 1810."

CAREY, ROSALIE MACGILL.
Painter and engraver. Born in Baltimore, MD, June 8, 1898. Pupil of C. Y. Turner, H. McCarter, H.

Breckenridge, Friez, F. Leger, Ozenfant, and Andre L'hote. Member: Balto. WCC; S. Indp. A. of NY, and of Balto. Address in 1929, Riderwood, Baltimore, MD.

CARIANI, VERALDO J.
Painter. Born in Italy in 1891. Pupil of National Academy of Design, and Art Students League of New York. Address in 1926, 148 Bemis Place, Springfield, MA.

CARIATA, GIOVANNI.
Sculptor. Born in Rome in 1865, he lived for some years in New York and died there in 1917. He made the bronze medallion presented to Gen'l Joffre.

CARIO, MICHAEL.
The American Weekly Mercury, Philadelphia, July 8-15, 1736, advertises the arrival from London of "Michael Cario, Jeweller." After detailing his various wares, in the form of rings, buttons for sleeves, snuff boxes, etc., he adds the following: "N.B. The said Michael Cario buys all sorts of old Diamonds, or any other Stones, and performs all sorts of Engraving Work, either in Gold or Silver."

CARIOLA, ROBERT J.
Sculptor and painter. Born in Brooklyn, NY, March 28, 1927. Study: Pratt Institute Art School; Pratt Graphic Center. Work: Fordham University; Topeka Public Library; and various church, school and private collections. Commissions: St. Gabriel's Church, Oakridge, NJ; Walker Memorial Baptist Church, Bronx, NY; Mt. St. Mary Cemetery, Queens, NY. Exhibitions: Corcoran Gallery; Penna. Academy; National Academy of Design; Boston Museum; Silvermine Guild; others. Awards: John F. Kennedy Cultural Center Award; Silvermine Guild; etc. Member: Professional Artists Guild; Cath. Fine Arts Society (honorary). Media: Painting - acrylic; sculpture - electric arc and gas welded metals. Address in 1982, Merrick, NY.

CARL, JOAN STRAUSS.
Sculptor and graphic artist. Born in Cleveland, OH, March 20, 1926. Studied at Cleveland School of Art; Chicago Art Institute; Mills College; with Dong Kingman, Boardman Robinson, Carl Morris, and Albert Wein; New School of Art, with Arnold Mesches and Ted Gilien. Works: North Carolina Museum of Art, Raleigh; International Cultural Center for Youth, Jerusalem, Israel. Commissions: Carved walnut pulpit, Methodist Church, Palm Springs, CA, 1967; brazed welded steel Menorah, Eternal Light and Candlesticks, Temple Adat Ariel, Los Angeles, 1969; bonded bronze relief, Capital National Bank, Cleveland, 1972; poly bronze and welded steel relief, Republic Savings & Loan, Los Angeles, 1974; mosaic wall, Mt. Sinai Memorial Park, Los Angeles, 1975. Exhibitions: American

Institute Architects Design Center, Los Angeles, 1968; one-woman show, Bakersfield College, 1967; Laguna Beach Art Museum, 1969; Fresno Art Museum, 1971; Muskegon Community College, 1973; Chai (graphics), National and International Traveling Show, 1947-75. Awards: Honorable Mention, National Orange Show, San Bernardino, 1958 and Calif. State Fair, Sacramento, 1970 and 72. Media: Stone, wood, and medal. Address in 1980, Sherman Oaks, CA.

CARL, KATHARINE AUGUSTA.
Artist. Born in New Orleans. Studied art under Bouguereau and Gustave Courtois, Paris. Painted portrait of Empress Dowager of China; also "At the Mirror," "Cupid and Psyche," "Iris", etc. Member: Societe Nationale des Beaux Arts, Paris; International Society Women Painters, London. Member of International Jury of Fine Arts, International Jury of Applied Arts, St. Louis Expn., 1904. Orders of Double Dragon and Manchu Flaming Pearl, China, etc. Died in 1938.

CARLES, ARTHUR BEECHER.
Painter. Born 1882. Member: Fellowship PAFA. Awards: Harris bronze medal ($300), AIC, 1913; silver medal, P.-P. Exp., San F., 1915; Lippincott prize, PAFA, 1917; Stotesbury prize, PAFA, 1919; Logan medal and prize, $1,500, AIC, 1928. Work: "An Actress as Cleopatra," Pennsylvania Academy of the Fine Arts, and at MMA. Died June 18, 1952.

CARLES, SARAH.
Painter. Exhibited at Penna. Academy of Fine Arts, Philadelphia, 1924. Address in 1926, 2007 Girard Avenue, Philadelphia, PA.

CARLETON, CLIFFORD.
Illustrator. Born Brooklyn, NY, 1867. Pupil of Arts Students League of New York under Mowbray. Member, Society of Illustrators, 1901. Illustrated: "Pembroke," by Julian Ralph; "Their Wedding Journey," by Howells. Address in 1926, 52 West 94th Street, New York, NY. Died in 1946.

CARLIN, JOHN.
Born June 15, 1813 in Philadelphia. A deaf mute, graduate of the Penna. Institution for the Deaf and Dumb, 1825. Studied drawing under J. R. Smith and portrait painting under John Neagle; went to London, 1838, and made studies from the antiques in the British Museum; afterwards became a pupil of Paul Delaroche in Paris. Returned to America, 1814, taking up his permanent residence in New York, and devoting himself to miniature painting for many years until interfered with by the progress of photography. After that his attention was turned to landscape and genre subjects, and the painting of portraits in oil. Loan Ex. Philadelphia, 1887. Died April 23, 1891 in NYC.

CARLISLE, MARY HELEN.
Painter. Born in Grahamstown, South Africa. Member, National Academy of Painters and Sculptors. Award: McMillin prize, National Academy of Women Painters and Sculptors, 1914. Address in 1926, 24 West 40th Street, New York, NY. Died March 17, 1925 in NYC.

CARLSEN, DINES.
Born in New York, NY, 1901. Pupil of Emil Carlsen. Award: Third Hallgarten prize, National Academy of Design, 1919. Elected an Associate Member of National Academy. Work: "The Brass Kettle," Corcoran Gallery of Art, Washington, DC. Address in 1926, 43 East 50th Street, New York, NY. Died in 1966.

CARLSEN, EMIL.
Painter. Born in Copenhagen, Denmark, 1853; came to United States in 1872. Elected Associate Member of National Academy, 1904; Academician, 1906. Work: "The Open Sea" and "Still Life," Metropolitan Museum, New York; "Moonlight on the Kattegat," Albright Art Gallery, Buffalo; "Morning," Rhode Island School of Design, Providence; "The South Stand," National Gallery, Washington; "The Lazy Sea," Brooklyn Institute Museum; "Summer Clouds," Pennsylvania Academy of the Fine Arts, Philadelphia; "Moonlight on a Calm Sea," Corcoran Gallery of Art, Washington, DC. Died Jan. 2, 1932. Address in 1926, 43 East 59th Street, New York, NY.

CARLSEN, FLORA BELLE.
(Mrs. Harold). Sculptor and painter. Born in Cleveland, OH, March 7, 1878. Pupil of F. C. Jones; Du Bois; Matzen; Solon Borglum; Lentelli. Exhibited: Paint and Brush Club, 1937 (one-man); National Academy of Design. Member: National Association of Women Painters and Sculptors; Paint and Brush Club. Award: Prize, Literary Digest cover, 1932. Address in 1953, West 183rd Pinehurst, New York, NY.

CARLSEN, JOHN H.
Painter and etcher. Born Arendal, Norway, 1875. Member: Palette and Chisel Club; Chicago Society of Artists. Address in 1926, 5230 West Congress Street, Chicago, IL.

CARLSON, CHARLES.
Painter. Born Eskilstuna, Sweden, Jan. 16, 1866. Self-taught. Member: Salons Am.; Scandinavian Am. A. Address in 1929, 606 Carlton Avenue, Brooklyn, NY.

CARLSON, EDWARD W.
Painter. Born Chicago, May 4, 1883. Pupil of AIC. Member: Chicago SA; Hoosier Salon; Swedish Amer. AA. Awards: Prize, Hoosier Salon, Chicago, 1928; prize, Swedish American Art Association, Chicago,

1929. Address in 1929, 7413 Evans Avenue, Chicago, IL.

CARLSON, JEAN.
Illlustrator. Born in Burlington, Vermont, in 1952. She attended the University of Vermont and RISD. In 1975 she won third place in the S of I Annual Student Scholarship Competition and has won various awards at New England Art Shows. She is presently teaching art at South Burlington High School in Vermont.

CARLSON, JOHN FABIAN.
Landscape painter, and teacher. Born in Sweden, 1875. Member: ANA, 1911; NA, 1925; NY WCC; AWCS; Salma. C.; Wash. WCC; Conn. AFA; PS Gal. Assoc.; NAC; Fellowship PAFA. Awards: Vezin and Isidor prizes, Salma. C., 1912; silver medal, Wash. SA, 1913, silver medal, P.-P. Exp., San F., 1915; Carnegie prize, NAD, 1918; Shaw water color prize, 1923, and Isidor prize, Salma. C., 1925; Ranger Fund purchase prize, NAD, 1923. Work: "Woods in Winter," Corcoran Gallery, Washington, DC; "Woodland Response," Toledo Mus.; "Passing Winter," Oberlin Col., Oberlin, OH.; "Morning Mists," Brooks Mem. Gal., Memphis, TN; "Autumn Beeches," Public Art Gal., Dallas, Texas; "Winter Dream Days," Art Assoc., Lincoln Neb.; "Winter Rigor," Toledo Club, Toledo, OH.; "Forest Pool," Fort Worth Art Assoc.; "Winter Beeches," Randolph Macon Women's College, Lynchburg, VA. Author of "Elementary Principles of Landscape Painting." Died in 1945.

CARLSON, MARGARET GODDARD.
Painter. Born Plainsfield, NJ, 1882. Member: National Academy of Women Painters and Sculptors. Address in 1926, Woodstock, NY.

CARLSON, MARGARET MITCHELL.
Illustrator. Born Deming, WA, 1892. Address in 1926, 393 Throckmorton Avenue, Mill Valley, CA.

CARLTON, HARRY.
Painter. Born Brooklyn, June 9, 1895. Pupil of ASL of NY. Member: Scandinavian Am. A.; Salons Am. Address in 1929, 62 Washington Square, New York, NY; h. 606 Carlton Avenue, Brooklyn, NY.

CARMEN, EVA L.
Miniature painter. Member: PA S. Min. P.; NA Women PS. Address in 1929, 939 Eighth Avenue, New York, NY.

CARMICHAEL, DONALD RAY.
Painter. Born Elnora, Indiana, Dec. 26, 1922. Study: Herron Art Inst.; Univ. of TN; with John Taylor, David Friedenthal, NY; with Edwin Fulwider, Ford Times and Garo Antreasian, New Mexico. Work: Cheekwood Fine Arts Ctr., Nashville; Enjay Chemical, New Jersey; Dyersburg Public Library, TN; and other public and private coll. Comn.: Numerous in Jackson, TN. Exhibitions: Lynn Kottler Gal., NYC; 23rd Grand Prize Int'l., Deauville, France, and Palace of Fine Arts, Rome; Water Color USA, Springfield Art Mus.; etc. Awards: Hoosier Salon; Enjay Chemical National, purchase award; TN Arts Commission, purchase award. Mem.: Artists Equity Assn.; Tenn. Watercolorist; So. WC Soc., Tenn.WC Soc. Media: Watercolor, oil. Address in 1982, Tarble Art Ctr., Eastern IL Univ., Charleston, IL.

CARMIENCKE, JOHN HERMANN.
Painter. Born in Germany, Feb. 9, 1810. He came to America in 1848 and settled in Brooklyn. He was an early member of the Brooklyn Academy and of the Artists' Fund Society of New York. Yale owns "Poughkeepsie Iron Works." Belongs to the Hudson River School of Painting. Died in 1867.

CARNELL, ALTHEA J.
Painter and illustrator. Member of the Plastic Club, Philadelphia. Address in 1926, 1907 North 7th Street, Philadelphia, PA.

CARNELL, JAMES L.
Painter. Member of the Society of Independent Artists. Address in 1926, 80 Columbia Heights, Brooklyn, NY.

CARPENTER, A. M.
Painter, craftsman, and teacher. Born Jan. 4, 1887. Pupil of D. C. Smith. Member: Western AA; College AA. Work: "Judean Hills and Mount Hermon," First Baptist Church, Abilene, Texas. Address in 1929, Fine Arts Bldg., Simmons University, Abilene, Texas.

CARPENTER, B.
Carpenter was a line-engraver of landscapes and buildings, apparently working in Boston in 1855.

CARPENTER, BERNARD V.
Painter and teacher. Born Foxboro, MA. Studied in Europe. Pupil of MA Normal Art School, Boston. Member: Buffalo SA. Head of Dept. of Design, School of Fine Arts, Buffalo Fine Arts Academy. Address in 1929, The Algon, 76 Johnson Park, Buffalo, NY; summer, Nantucket, MA. Died in 1936.

CARPENTER, DUDLEY S.
Painter and illustrator. Born in Nashville, TN, 1880. Pupil of Art Students League of New York, and of Julien, Laurens and Constant in Paris. Member of Denver Art Association. Address in 1926, Mining Exchange Building, La Jolla, CA.

CARPENTER, ELLEN MARIA.
Born Nov. 23, 1836 in Killingly, CT. She visited Europe and studied in Paris under Lefebvre and Fleury. Among her works are "The Yosemite Valley" and numerous portraits. Died 1909.

CARPENTER, FLETCHER H.
Painter and teacher. Born Providence, RI, June 27, 1879. Pupil of Ernest Major. Graduate of MA Art School, Boston. Member: Rochester AC. Address in 1929, 97 Middlesex Road, Rochester, NY.

CARPENTER, FRANCIS BICKNELL.
Painter. Born in Homer, NY, Aug. 6, 1830. In 1844 he became a pupil of Sanford Thayer at Syracuse, NY. In 1851 he removed to New York City and painted portraits of many prominent people: Lincoln, Fillmore, Greeley, Asa Packer, Lieut. Gov. Woodford, Ezra Comell, Geo. Wm. Curtis, James Russel Lowell, Lewis Gass and many other. His most celebrated work, "The Emancipation Proclamation," was exhibited in the large cities in 1864 - 1865 and was later in the House of Representatives, Washington, DC. Died May 23, 1900 in NYC.

CARPENTER, FRED GREEN.
Painter. Born in Nashville, TN, 1882. Art study at St. Louis School of Fine Arts and later in Julien Academie, Paris. Pupil of Lucien Simon and Richard Miller. Instructor, drawing and printing, St. Louis School of Fine Arts. Represented in permanent collection of St. Louis City Art Museum, and John Herron Institute, Indianapolis, and Penna. Academy of Fine Arts. Honorable mention par droit, Salon des Artistes Francais, Paris, 1910; silver medal, Panama Exp., San Francisco, 1915. Member: Society Western Artists. Address in 1926, Washington University, St. Louis, MO.

CARPENTER, HELEN K.
Illustrator. Born in Philadelphia, 1881. Pupil of Penna. Academy of Fine Arts under Chase, Breckenridge and Anshutz. Address in 1926, 75 West 55th Street, New York.

CARPENTER, HORACE T.
Pupil of Penna. Academy of Fine Arts and member of League of American Artists, New York. Portrait painter, also specialized in copies of early American historical pictures.

CARPENTER, MILDRED BAILEY.
Painter and illustrator. Born St. Louis, MO, June 19, 1894. Pupil of St. Louis School of Fine Arts. Member, St. Louis AG. Address in 1929, 416 Woodlawn, Webster Groves, MO; summer, Wyalusing, Wis.

CARR, ALICE ROBERTSON.
Sculptor. Born in Roanoke, VA, 1899. Pupil of A. Stirling Calder. Exhibited: Salon d'Automne, Salon de la Nationale, 1927. Member of Art Students League of New York. Address in 1926, Santa Barbara, CA.

CARR, GENE.
Illustrator. Born in New York, 1881. Was illustrator on staff of *New York World* and other papers from 1903. Address in 1926, "The World," New York City.

CARR, J. GORDON.
Painter and architect. Born in Batavia, NY, Feb. 20, 1907. Study: MIT, BS architecture; Howard U.; with Gordon Grat, Herb Olsen, and John Pike. Work: Grand Central Galleries, NYC; Silvermine Artists Guild; Navy Dept., Wash. DC; and others. Exhibitions: NAD; AWS; Knickbocker Artists, NYC; one-man shows at Grand Central Art Galleries, NYC; and many others. Awards: Salmagundi Club; Alvord mem. award, Hudson Valley Art Assn.; John Kellam award, N. Engl. Artists Exhib., Silvermine Guild. Mem.: Am. WC Soc.; Silvermine Guild; Hudson Valley Art Assn.; Salmagundi Club; Conn. WC Soc. Media: Watercolor. Address in 1976, 46 Beechcroft Road, Greenwich, CT.

CARR, MICHAEL C.
Painter and engraver. Born in San Francisco, CA, 1881. Pupil of Wilson Steer, Fred Brown and Gordon Craig. Awarded Slade Scholarship. Address in 1926, 711 Missouri Avenue, Columbia, MO.

CARRIGAN, WILLIAM L.
Painter. Born San Francisco, CA., 1868. Pupil of Emil Carlsen. Address in 1926, Falls Village, CT. Died 1939.

CARROLL, HARRIET I.
Painter and teacher. Born Erie, PA, 1872. Pupil of Birge Harrison, John Carlson, Hugh Breckenridge; NY School of Applied Design for Women. Member: Erie AC; AFA. Address in 1929, 401 Peach Street, Erie, PA.

CARROLL, JOHN WESLEY.
Painter. Born Wichita, Kansas, August 14, 1892. Pupil of Frank Duveneck. Taught at ASL, and Detroit Society of Arts and Crafts. Award: Harris silver medal and prize ($500), AIC, 1927; Guggenheim Fellow. Work: "Agatha," Pennsylvania Academy of the Fine Arts; "Lady in Blue," Harrison Gallery, Los Angeles Museum. Address in 1929, Woodstock, NY. Died in 1959.

CARROTHERS, GRACE NEVILLE.
Painter. Born: Abington, Indiana. Studied: with John Carlson, Anthony Thieme. Awards: Oklahoma State Exhib., 1938. Collections: New York Public Library; Gibbes Art Gallery, Charleston, South Carolina; Nat'l Gallery of Art; British Museum; Library of Congress; Royal Ontario Museum, Toronto; Bibliotheque Nationale, Paris, France; Philbrook Art Center.

CARRUTHERS, ROY.
Illustrator. Born in South Africa in 1938. He studied art there for many years at Port Elizabeth Technical College. Beginning his career in London with an illustration for *Woman's Mirror* in 1966, he has since had illustrations published in *Redbook, Ladies Home*

Journal, New York, Playboy and *Oui*. His works are in the collections of the Ponce Museum and the Galeria de las Americas in Puerto Rico.

CARRY, MARION KATHERINE.
Painter and lithographer. Born Newport, RI, Jan. 31, 1905. Pupil of John R. Frazier. Member: Newport AA. Work: "The Constellation," Museum of the Rhode Island School of Design, Providence. Address in 1929, Art Association of Newport, Bellevue Avenue; h. 12 Friendship Street, Newport, RI.

CARSON, C. W.
This man was a line-engraver of maps and vignettes, located in Albany, NY, in 1843.

CARSON, FRANK.
Painter. Born Waltham, MA, Sept. 8, 1881. Pupil of MA Normal Art School; Fenway School; ASL of NY. Member: Copley S.; Providence WCC; Provincetown AA; Boston AC; Berkeley Lg. of FA. Award: First Schneider Prize, Boston Art Club, 1924. Work: "Cedar and Palmettos," Boston Art Club; "Provincetown," Berkeley Lg. of FA; "Arboretum," John Vanderpoel Art Association, Chicago. Director, Provincetown School of Art. Address in 1929, 168 Dartmouth Street, Boston, MA; summer, "Anchorite," 11 Conwell Street, Provincetown, MA.; winter, Hamilton, Bermuda.

CARSPECKEN, GEORGE LOUIS.
Painter. Born in Pittsburgh, PA, July 27, 1884. Studied at Carnegie Institute, and abroad. Awarded first prize in 1902 at Worcester Art Museum. He died July 15, 1905 in Burlington, IA.

CARTER, A. HELENE.
Illustrator. Born Toronto, Canada in 1887. Member: GFLA; SI. Illustrated, "Three of Salu," "The Little Misogynists." Address in 1929, 112 West 11th Street, New York, NY. Died in 1960.

CARTER, CHARLES MILTON.
Painter, writer, and teacher. Born North Brookfield, MA, Dec. 9, 1853. Pupil of MA Normal Art School in Boston. Studied in European schools. Member: Boston AC; Denver AC; Ex-Director of Art, Public Schools of Denver; former State Supervisor of Drawing for MA; Hon. Pres., US Section, International Congress for the Teaching of Drawing, Paris Exp., 1900; International Jury of Awards, Dept. of Education, St. Louis Exp., 1903; delegate, Dept. of Interior to Art Congress, London, 1908. Author of "Some European Art Schools;" "Arts, Denver Public Schools." Died in 1929.

CARTER, CLARENCE HOLBROOK.
Painter. Born Portsmouth, OH, March 26, 1904. Pupil of Henry G. Keller, William J. Eastman, Paul B. Travis, Hans Hofmann. Member: Cleveland Art Center. Awards: Third prize for portrait, Ninth annual exhibition of work by Cleveland artists and craftsmen, Cleveland Museum of Art, 1927; 1st prize for water color, 3rd prize for figure composition, Cleveland Museum of Art, 1928. Work: "The Patient Cow," water color, and "A Women of the Sabines," oil, Cleveland Museum of Art; water color, "Sommer Bros. Stoves and Hardware," Brooklyn Institute of Arts and Sciences, Brooklyn, NY.

CARTER, DENNIS MALONE.
Born in Ireland, 1827. He was accompanied by his parents to America in 1839. He painted portraits and historical pictures. He settled in New York City and was one of the original members of the Artists's Fund Society, founded in 1859. He painted "Washington's Reception" (to Alex. Hamilton after his marriage to the daughter of Gen'l Schuyler) and numerous portraits. Died July 6, 1881 in NYC.

CARTER, DUDLEY CHRISTOPHER.
Sculptor and craftsman. Born in New Westminster, B. C., Canada, May 6, 1891. Studied with Dudley Pratt. Work: "Rivalry of the Winds," wood sculpture, Seattle Art Museum, Seattle, Wash.; Golden Gate Park, San Francisco; Evergreen East, Bellevue, Washington. Award: Times first prize, Seattle Art Institute, 1931; Sculpture, Music and Art Foundation, Seattle, 1948; Achievement Award for Sculpture, Past President Assembly, 1962; International Sculpture, US Department of Housing and Urban Development, 1973. Exhibited: Golden Gate Expositions, San Francisco, 1939; Seattle World's Fair, 1961; US Department Housing and Urban Development, 1973; and others. Member: Seattle Art Museum, Artists Equity Association, British Columbia Sculptors. Address in 1982, Bellevue, WA.

CARTER, GRANVILLE W.
Sculptor. Born in Augusta, ME, Nov. 18, 1920. Studied at Portland School of Fine and Applied Art; NYC School of Industrial Art; National Academy School of Fine Arts; Grande Chaumiere, Paris, France; Scuolo Circolare International, Rome, Italy; American Academy in Rome. Work in Smithsonian Institution, Washington, DC; Maine State Museum, Augusta; monumental bust of Alexander Stewart, Garden City, NY; West Texas Pioneer Family Monument (heroic bronze), Lubbock, TX; Brig. Gen. Casimir Pulaski Equestrian Monument (heroic bronze), Hartford, CT; and others. Has exhibited at American Academy of Rome Annual, 1955; National Sculpture Society, Lever House, NY; American Artists Professional League Annual, NY, 1970. Member of the National Sculpture Society; National Academy of Design (academician); others. Received the Lindsey Morris Memorial Prize, 1966; Henry Hering Memorial medal, 1968; Therese and Edwin H. Richard Memorial Prize, 1980, all National Sculpture Society; gold medals, American Artists

Professional League; others. Teaching sculpture at National Academy of Design, from 1966; lecturer on sculpture at Hofstra University, from 1966. Address in 1982, Baldwin, NY.

CARTER, MARC (MARCELLUS CARTER).
Sculptor, painter, cartoonist, and craftsman. Born in North Tarrytown, NY, March 19, 1918. Studied: Art Students League; Westchester Workshop; and with Ruth Nickerson, Ruth Yates. Member: Art Students League; Artists Equity Association; Westchester Arts and Crafts Guild. Work: Altoona Museum of Art. Exhibited: Wellons Gallery, 1951; Arthur Brown Gallery, 1951; Westchester Arts and Crafts Guild, 1947-51. Address in 1953, White Plains, NY.

CARTER, MARY MELN.
(Mrs. James Newman Carter.) Miniature painter and craftsman. Born Philadelphia, Aug. 16, 1864. Pupil of Carl Weber and C. Faber Fellows. Member: Plastic C.; Phila. Alliance; AFA. Address in 1929, "Westover," Chadds Ford, Del. Co., PA; 1832 Spruce Street, Philadelphia, PA.

CARTER, PRUETT A.
Illustrator. Born in Lexington, Missouri, in 1891. He was reared on an Indian reservation until his family moved to California where he attended the Los Angeles Art School. His first job was with the *NY American* and he later worked at the *Atlanta Georgian*. Moving closer to his chosen field, he became art editor for *Good Housekeeping* where he gave himself his first magazine illustration assignment. He moved to California in 1930, mailing his finished pieces to such NY publications as *Woman's Home Companion, Ladies Home Journal* and *McCall's*. His tasteful illustrations showed his particular understanding of women, whom he portrayed as gentle and elegant without pretension. Greatly respected by his students, he taught at the GCSA in New York and Chouinard Art Institute in Los Angeles. Died in 1955.

CARTOTTO, ERCOLE.
Painter and teacher. Born Valle Mosso, Piemonte, Italy, Jan. 26, 1889. Pupil of Bosley, Paxton, Benson, Tarbell, Hale. Member: Alumni, School of the Museum of Fine Arts, Boston; Florida Soc. A. and S.; AFA. Awards: Second Hallgarten prize, NAD, 1919; Jones prize, Balto. WCC, 1924. Work: "Mater Divina Gratia," The Vatican; "Portrait of Dr. H. C. Jones," Johns Hopkins University, Baltimore, MD; "Beatrice," "Portrait of Wm. A. Burnet," and "Harmony in Blue and Rose," Amherst, (MA), Art Gallery; "Mary Catherine" and "Portrait of Marion Ryder," MMA, New York; "Profile," San Diego Art Gallery; "Reveries," Cleveland Museum of Art; "Portrait of President Calvin Coolidge," "Portrait of Judge William H. Moore," "Portrait of Prof. John Mason Tyler," Amherst College; "Portrait of Dr. H. Hitch-

cock," Alpha Delta Phi, Amherst MA, "Portrait of Attorney General John G. Sargent" and "Portrait of Justice Harlan F. F. Stone," Department of Justice, Washington, DC; "Portrait of President Calvin Coolidge," Phi Gamma Delta Club, New York; "Portrait of C. M. Pratt," Pratt Institute, Brooklyn; "Portrait of Dean Frederick J. E. Woodbridge," Columbia University, New York. Died Oct. 3, 1946.

CARTWRIGHT, ISABEL BRANSON.
Painter. Born Coatesville, PA, Sept. 4, 1885. Pupil of Daingerfield, Henry B. Snell, and Frank Brangwyn. Member: Phila. Alliance; Plastic C.; NA Women PS; AFA. Awards: European Fellowship from Philadelphia School of Design, 1906; Phila. AC Gold Medal for water color, 1906; hon. mention, Buffalo SA, 1920; hon. mention, Plastic C., Phila., 1921; Mary Smith prize, PAFA, 1923; first prize ($1,500), cotton-field scene, San Antonio AL, competitive exhibition, 1928; fourth prize ($1,750), wild flowers, San Antonio AL, competitive exh., 1929. Represented in permanent collection of Philadelphia School of Design Alumnae Association. Address in 1929, The Studios, 2107 Walnut Street, Philadelphia, PA.

CARUGATI, ERALDO.
Illustrator. Born in Milan, Italy, in 1921. He was educated at the Scuola Superiore D'arti Applicate for four years and began his career in Italy in 1948, producing many posters until 1970. He illustrated for the *Enciclopedia dei Ragazzi* in 1965 and in the United States has done work for *Playboy, Oui, Skeptic* and *Psychology Today*. His works are in the collection of the Oklahoma Historical Society.

CASARIN, ALEXANDER.
Sculptor and painter. Born in Mexico and educated in France. Studied with Messonier. Served in Franco-Prussian War. Became interested in sculpture and came to the United States. Specialty was portrait busts. Executed bust of Pres. McKinley. Died May 26, 1907, in NYC.

CASCIERI, ARCANGELO.
Sculptor and instructor. Born in Civitaquana, Italy, February 22, 1902; US citizen. Studied at School of Architecture, Boston Architecture Center, 1922-26; Boston University, 1932-36. Work in Boston College; American War Memorial World War I, Belleau Woods, France and World War II, Margraten, Holland; sculpture on fountain, Parkman Plaza, Boston; others. Has exhibited at Boston Museum of Fine Arts, sculpture exhibit; New England Sculpture Association; others. Member: Fellowship, American Institute of Architects; Dante Alighieri Society; Naples Association of Institute of Architects and Engineers; New England Sculptors Association. Address in 1982, Lexington, MA.

CASE, ELIZABETH.
Painter, illustrator, teacher and designer. Born Philadelphia, Sept. 29, 1867. Pupil of Weir, Metcalf, Brush, Low, Chase. Member: C. L. Wolfe AC. In charge of fashion department, Gatchel and Manning; for 5 years fashion artist on "Women's Wear." Address in 1929, 330 West 15th Street, New York, NY.

CASEAU, CHARLES HENRY.
Painter, and illustrator. Born Boston, MA, 1880. Pupil of Boston Museum School of Fine Arts; Denman Ross. Address in 1929, 133 East 34th Street, New York, NY.

CASELLAS (or CASELLAR), FRENANDO.
Sculptor. Born in Valencia, Spain, in 1842. Came to US in 1876. He designed a statue of Columbus and other decorations for the St. Louis Exposition. He was President of the American Sculpture Society. Died February 12, 1925, in NYC.

CASER, ETTORE.
Painter and etcher in Venice, 1880. Pupil of de Maria in Venice, he went to Boston, MA, in 1908. Exhibited at Penna. Academy of Fine Arts, 1924. Address in 1926, 1931 Broadway, New York, NY. Died in 1944.

CASEY, F. DeSALES.
Illustrator. Member, Society of Illustrators. Address in 1926, Care of Life Publishing Co., 598 Madison Avenue, New York, NY.

CASEY, JOHN J.
Illustrator and painter. Born in San Francisco, 1878. Pupil of Tarbell and Benson in Boston; Laurens, Julien and Lazar in Paris. Address in 1926, 278 West 11th Street, New York, NY.

CASEY, JOHN JOSEPH.
Sculptor and educator. Born in New London, CT, June 27, 1931. Studied at University of Oregon, B.A.; California College of Arts and Crafts, M.F.A. with Nathan Oliveira. Work in Coos Art Museum, OR; others. Has exhibited at Denver Art Museum; Oakland Art Museum; Oregon Artists Annual, Portland Art Museum; others. Teaching drawing, painting, and sculpture, West Oregon State College, Monmouth, from 1965. Address in 1982, Monmouth, OR.

CASEY, L. W.
Painter. Member Society of Washington Artists. Address in 1926, Stoneleigh Court, Washington, DC.

CASH, HAROLD CHENEY.
Sculptor. Born Chattanooga, TN, September 26, 1895. Studied: Stanford University; University of Virginia, BA; New York School of Fine and Applied Arts; Beaux Arts Institute of Design, New York. Member: National Sculpture Society; Sculptors Guild. Awards: Guggenheim Fellowship, 1930, 31. Exhibited: Penna. Academy of Fine Arts, 1941-43; Whitney Museum of American Art, 1935; Museum of Modern Art, 1930-34; Art Institute of Chicago, 1932-38; Brooklyn Museum, 1931; San Francisco Museum of Art; Metropolitan Museum of Art. Address in 1953, 14 Bank Street, NYC. Died in 1977.

CASHWAN, SAMUEL ADOLPH.
Sculptor. Born in Cherkassi, Russia, December 26, 1900. Studied: City College, Detroit, Michigan; New York Architectural League; and with Bourdelle in Paris. Member: Scarab Club; Metropolitan Art Association, Detroit. Work: Detroit Institute of Art; Vassar College; Jackson Memorial, Jackson, Michigan; and others. Exhibited: Salon d'Automne, 1923; nationally, 1920-46. Address in 1953, Detroit, MI.

CASILAER, JOHN W.
Engraver and painter. Born June 25, 1811 in NY. At the age of 15 apprenticed to the engraver Peter Maverick, and after a time he became an excellent line engraver; his large plate of "A Sibyl," after the painting by Daniel Huntington, was an admirable example of pure line work. Having studied banknote engraving under Maverick and A.B. Durand, he was engaged in that business for some yrs., and about 1854 he became a member of the banknote engraving firm of Carpenter, Casilaer and Co., of NY. Studied painting in Europe in 1840, and by 1857, Casilaer had become a landscape painter of reputation. He was an Associate of the National Academy in 1835, and a full Academician in 1851. The Metropolitan Museum owned his "View of the Catskills," painted 1891; and the Corcoran Gallery of Washington, DC, owned his painting of Lake George. Member of the Hudson River School of Painting. Died Aug. 17, 1893 in Saratoga, NY.

CASON, MERRILL.
Illustrator. Born in Marshall, Texas, in 1929. He worked for 15 years doing display, television, graphic design and illustration in Oklahoma City. Presently a free-lance illustrator in NY, he has taught in a number of schools and has had One-Man Shows in Texas, Oklahoma and Missouri. His Artwork has been selected to hang in several S of I Annual Exhibitions.

CASSATT, MARY.
Figure painter and etcher. Born 1845 in Pittsburgh, PA. Pupil of PAFA. Elected Associate of National Academy of Design, 1910; Legion of Honor, 1904. Miss Cassatt was associated with the modern French School of Monet, Renoir, Pissario and Degas. She exhibited in the Paris Salon after 1872; her paintings are from child life, many of her groups being "Mother and Baby." Her work is represented in the principal American Museums. Died June 14, 1926 in Paris, France.

CASSELL, JOHN HARMON.
Cartoonist. Born in Nebraska City, Neb., 1873. Pupil of AIC. Member: SI, 1905; Salma. C.; GFLA. Address in 1929, "Evening World," Park Row; h. 2 West 67th Street, New York, NY.; Silvermine, CT. Died c. 1960.

CASSIDY, I. D. GERALD.
Painter and illustrator. Born 1879 in Cincinnati, OH. Pupil of Cincinnati Academy; National Academy of Design of New York. Work: Decorations on Indian Arts Building, San Diego, CA; decorations, "Last of the Indians," Hotel Gramatan, Bronxville, NY; "Reflections," Freer Collection, Washington, DC. Address in 1926, 541 El Camino del Canon, Santa Fe, NM. Died in 1934.

CASSIDY, LAURA E.
Painter. Member: Cincinnati Woman's AC; Calif. WCS. Address in 1929, 6426 Desmond Avenue, Madisonville, OH.

CASTAING, CAMILLE K.
Sculptor, designer, and craftsman. Born in French Guiana, August 16, 1899. Studied: Cooper Union Art School. Member: Society of Plastic Industry. Awards: Prizes, Anderson Gallery, 1931; medal, Plastics Contemporary, 1937-41; Museum of Modern Art, 1939; Philadelphia Art Alliance, 1940. Address in 1953, Huntington Beach, Calif.

CASTANIS, MURIEL.
(Julia Brunner). Sculptor. Born in NYC, September 27, 1926. Self-taught. Exhibitions: Women Artists at SOHO, New York City; "Feminine Perceptions," Buffalo State University, NY; "Unmanly Art," Suffolk Museum; Portland Museum of Art, Maine; Women in Art, Stamford Museum, Conn.; Contemporary Reflections, Aldrich Museum, Ridgefield, Conn.; Women Choose Women, New York Cultural Museum; and many others. Collections: Andrew Dickson White Museum, NY; Joe and Emily Lowe Museum, Florida. Awards: Tiffany Foundation sculpture grant, 1977; Award for Outstanding Design, Show Business, 1977; Award of Distinction, Virginia Museum of Fine Arts, 1979. Media: Cloth and resins. Address in 1982, 444 Sixth Avenue, New York, NY.

CASTANO, GIOVANNI.
Sculptor and painter. Born in Calabria, Italy, October 2, 1896. Pupil of School of the Boston Museum of Fine Arts; Philip L. Hale, Lesley P. Thompson, Huger Elliot, F. M. Lamb, Henry James. Work includes: "Threatening," Springfield Art Association; "Painted Stage Settings," Boston Opera House; murals, First Baptist Church, Covington, KY; St. Peter's Church, Boston; others. Member: Society of Arts and Crafts, Brockton; Boston Art Club; Cincinnati Art Club. Awards: Honorable mention, Penna.

Acadmey of Fine Arts, 1918; honorable mention, Springfield Art Association, 1926. Address in 1953, Boston, MA; h. Needham, MA.

CASTELLO, EUGENE.
Sculptor, painter, and writer. Born Philadelphia, January 12, 1851. Pupil of Penna. Academy of Fine Arts under Eakins. Member: Fellowship Penna. Academy of Fine Arts; Salmagundi Club 1904; Philadelphia Print Club (honorary); Arts and Crafts Guild of Philadelphia (honorary); Philadelphia Chapter American Institute of Architects 1871; International Society of Arts and Letters; Philadelphia Art Club; Washington Art Club. Awards: Bronze medal, American Art Society, 1904; prize, Philadelphia Arts and Crafts Guild, 1906; exhibitors bronze medal, Ghent Exposition, 1913. Work in: Historical Society of Pennsylvania; University of Pennsylvania. Correspondent, "The Studio," London. Writer in art magazines. Address in 1926, Philadelphia, PA. Died in Philadelphia, March 3, 1926.

CASTELLON, FEDERICO.
Painter and printmaker. Born in 1914 in Almeria, Spain, and came to the US in 1921. Self-taught. Awarded a fellowship from the Ministry of State of the Spanish Republic. Participated in the Exhibition of Spanish Artists, including Picasso, Gris, and Miro, held at the Cite de Universitaire, Paris, 1935. Won numerous awards including two Guggenheim Fellowships; the Nat'l Inst. of Arts and Letters Grant and membership; First prize from the Lib. of Congress; and Membership in the Nat'l Acad. More than forty one-man shows. Work is in the permanent collections of most major American museums. A retrospective of his prints was held at AAA in 1978. Died in 1971.

CASTERTON, EDA NEMOEDE.
Minature painter. Born Brillion, WI, April 14, 1877. Pupil of Virginia Reynolds, Lawton S. Parker and Chicago Academy of Fine Arts; Minneapolis School of Fine Arts; AIC; Chicago School of Illustration; Ralph Clarkson; Students' Hostel, Paris. Member: Am., Chicago, and PA S. Min. P. Awards: Hon. mention, International Art Union, Paris, 1907 and 1908; silver medal, P.-P. Exp., San F., 1915; bronze medal, Sesqui-Centennial Exposition, Phila., 1926. Address in 1929, Fine Arts Bldg.; 1915 Berteau Ave., Chicago, Ill.

CASTILEDEN, GEORGE F(REDERICK).
Painter, illustrator, etcher, and craftsman. Born Canterbury, Kent, England, December 4, 1861. Pupil of Sidney Cooper. Member: NOACC; SSAL. Work: Mural in Hot Spring Sanitarium, Coffeeville, Kansas. Address in 1929, Andrew Jackson Building, 622 St. Peter Street, New Orleans, LA.

CASTLE, MONTAGUE.
Painter. Member: Mural Painters. Address, 247 West 36th Street, New York, NY.

CASTRO-CID, ENRIQUE.
Born 1937 in Santiago, Chile. Came to US after attending University of Chile. Awarded Guggenheim in 1964. Exhibited in Santiago; Pan Am. Union, Wash., DC (1961); Feigen galleries in NYC, Chicago, and L.A. (1964); Carnegie; Inst. of Contemp. Arts, Wash., DC. In collections of Guggenheim; MOMA; and in private collections.

CASWELL, EDWARD C.
Illustrator. Born New York City, Sept. 12, 1879. Pupil of Francis C. Jones. Member: GFLA. Works: Illustrated "Old New York," by Edith Wharton; "Coasting Down East," by Ethel Hueston and Edward C. Caswell; the "Patty" books, by Carolyn Wells; "Viola Gwyn," by George Barr McCutcheon; "Spanish Towns and People" and "Towns and People of Modern Germany" by Robert M. McBride; illustrated for Vickery and Hill publications; illustrated and decorated "The Corsairs of France," Norman. Address in 1929, 402 West 22nd Street, New York, NY; h. Yonkers, NY.

CATALANO, GUISEPPI.
Etcher. Member of Chicago Society of Etchers. Address in 1926, Chiesannova, Province of Trapani, Sicily.

CATAN-ROSE, RICHARD.
Sculptor, painter, teacher, etcher, lithographer, and illustrator. Born in Rochester, NY, October 1, 1905. Studied: Royal Academy of Fine Arts, Italy, MFA; Cooper Union Art School, New York; and with Pippo Rizzo, Antonio Quarino, J. Joseph, A. Shulkin. Member: American Federation of Arts; Royal Academy of Fine Arts, Italy. Work: Our Lady Queen of Martyrs Church, Forest Hills, LI, NY. Won Royal Academy of Fine Arts, Italy; murals, Trabia, Sicily. Exhibited: Allied Artists of America, 1939, 40; Vendome Gallery, 1939, 40, 41; Forest Hills, LI, NY, 1944-46 (one-man); Argent Gallery, 1946 (one-man); and in Europe. Taught: President, Catan-Rose Institute of Fine Arts, Forest Hills and Jamaica, LI, NY; Gold Medal, Accademia Delli Arti, 1981. Address in 1982, Flushing, NY.

CATCHI, (CATHERINE O'CHILDS).
Sculptor and painter. Born in Philadelphia, PA, August 27, 1920. Studied at Briarcliff Jr. College, 1937; Commercial Illustration Studios, 1938-39; Paul Wood Studio, 1949-55; with Leon Kroll, Harry Sternberg, and Hans Hofmann; also with Angelo Savelli, Positano, Italy. Works: Hofstra University, Hempstead, NY. Exhibitions: Rayburn Hall (by Congressional invitation), Washington, DC, 1968 and 1976; Alfredo Valente Gallery, NY, 1968; Lever

House, NY, four times; Royal Academy Galleries, Edinburgh, Scotland; Royal Birmingham Society of Artists Galleries, England. Awards: Grumbacher Award, 1963; Lillian Cotton Memorial Award and Medal of Honor, National Association of Women Artists, 1966; Irene Sickle Feist Memorial Prize, 1971. Media: Stone, cast metals; oil and watercolor. Address in 1980, Manhasset, NY.

CATLIN, GEORGE.
Painter. Born in Wilkes-Barre, PA. Catlin was noted for his portraits of American Indians. He lived and painted in Louisiana in the late 1840's and early 1850's. His collection of painting of Indians was in the United States National Museum of Washington, DC. Died Dec. 23, 1872 in Jersey City, NJ.

CATTON, CHARLES.
Painter. Born Dec. 30, 1756 in London, England. Painter of genre and still-life. Died April 24, 1819 in New Paltz, NY.

CAULDWELL, LESLIE GIFFEN.
Artist. Born in New York, 1861. Studied art in Julien Academy, Paris 1884. Pupil of Boulanger, Lefebvre, Carolus-Durant. Had pictures admitted to Paris Salon, 1886 and 1888; also Paris Expn., 1889; Salon, Champs de Mars, 1890-96; also to Society British Artists, and Royal Academy, London. Exhibited at Liverpool and Berlin, at NAD, and SAA, New York; later exhibited his painting in various American cities and at World's Fair. Died in 1941. Specialty, portraits in pastel. Address in 1926, 58 West 57th Street, New York.

CAUSICI, ENRICO.
Sculptor. Born in Verona, Italy. Working in US about 1822-32. Sculpted "Washington" for the monument at Baltimore, and several subjects for Congress at Washington. Worked on the U.S. Capitol at Washington about 1823-25; modelled an equestrian statue of Washington at New York, which was erected in 1826. He died in Havana.

CAVACOS, EMMANUEL A.
Sculptor and painter. Born Island of Kythera, Greece, February 10, 1885. Pupil of Ephraim Keyser in Baltimore; Jules Coutan and V. Peter in Paris. Member: Baltimore Watercolor Club; Association des Anciens Eleves de l'Ecole Nationale des Beaux-Arts de Paris; Institut Social de l'Enseignement. Awards: Rinehart Paris Scholarship, 1911-1915; honorable mention, Paris Salon, 1913; silver medal, International Exposition of Decorative Arts, Paris, 1925; "Officier de l'Academie," French Government, 1927. Works: "Aspiration," Enoch Pratt Free Library; "Penseur," Peabody Institute, Baltimore; "Grief," Collection of Queen of Roumania. Address in 1933, Paris, France.

CAVALLITO, ALBINO.
Sculptor. Born in Cocconato, Italy, February 24, 1905. Studied at Trenton School of Industrial Arts; Beaux-Arts Institute of Design; Fontainebleau School of Fine Arts; and with H. R. Ludeke, Lejeune, J. De Creeft. Member: Fellow, National Sculpture Society; Sculptors Guild; Audubon Artists; Allied Artists of America. Awards: Prizes, National Institute of Arts and Letters, 1953; Architectural League, 1954; National Academy of Design, 1954; Hudson Valley Art Association, 1955; National Sculpture Society, 1957; gold medal, Allied Artists of America, 1954. Exhibited: National Academy of Design; Art Institute of Chicago; Whitney Museum; Brooklyn Museum; National Institute of Arts and Letters; Metropolitan Museum of Art; and others. Address in 1966, 261 Mulberry Street, NYC. Died in 1966.

CAVANAGH, J. ALBERT.
Painter. Member: Salma. Club. Address in 1926, 25 East 26th Street, New York, NY.

CAVERLEY, CHARLES.
(See Calverley).

CAWEIN, KATHRIN.
Etcher. Born: New London, CT, in 1895. Studied: Art Students League. Awards: Society of American Graphic Artists, 1936; Village Art Center, 1944; National Association of Women Artists, 1947; Pleasantville Woman's Club, 1949, 1953; Westchester Museum of Art; St. Mark's Church, Van Nuys, California.

CECERE, ADA RASARIO.
Painter. Born New York City. Pupil ASL; NAD. Member: Alliance; AFA. Address in 1929, 412 West 33rd Street; h. 344 West 28th Street, New York, NY.

CECERE, GAETANO.
Sculptor. Born in NYC, November 26, 1894. Studied: National Academy of Design, under Hermon A. MacNeil; Beaux-Arts Institute of Design; American Academy, Rome. Travelled in Europe in 1920. Represented in Metropolitan Museum, NYC; Numismatic Museum, NYC; Brookgreen Gardens, SC; others. Works include "Kneeling Girl," "Mother and Child," "The Hunters," "Persephone," "Roman Peasant," "Boy and Fawn," "Eros and Stag;" statue of John Frank Stevens, Summit, MT; architectural decorations, Stambaugh Auditorium, Youngstown, OH; band of warriors, relief, around flagpole, Plainfield, NJ. Commissions include "Lincoln," Lincoln Memorial Bridge, Milwaukee; "Rural Free Delivery Mail Carrier," Post Office Dept. Building, Washington, DC. Awarded fellowship, American Academy in Rome, 1920-23; Barnett Prize, National Academy of Design, 1924; Garden Club of America Prize, 1929; McClees Prize, Penna. Academy of Fine Arts, 1930; Lindsey Morris Memorial Prize, National Sculpture Society, 1935; National Arts Club award in sculpture, 1968; Audubon Artists sculpture award; Allied Artists of America, 1970; and many others. Was director of Dept. of Sculpture, Beaux-Arts Institute of Design; was on faculty of National Academy of Design. Member of National Academy of Design, academician; National Sculpture Society, fellow; NY Architectural League. Address in 1982, 41 Union Square, NYC.

CERRACCHI, ENRICO FILIBERTO.
Sculptor. Born in Italy, 1880; came to America in 1900, and settled at Houston, Texas. Principal works: Monument to John A. Wharton, State Capitol, Austin, Texas; "The American Doughboy" for Italian Government. Address in 1926, Houston, Texas.

CERRACCHI, GUISEPPE.
Sculptor. Born in Corsica, July 1751. Visited US about 1790 and 1793. He executed a bust of Washington, and also made portrait busts of Jefferson, Clinton, Hamilton, Jay Benson, Paul Jones, and others. His portrait was painted in miniature by Trumbull, Yale Museum. On returning to France he was guillotined for his conspiracies against Napoleon. Died January 30, 1802, in Paris.

CERUTTI-SIMMONS, TERESA.
Etcher and writer. Born Sarigliano, Italy. Pupil of J. McNeil, Whistler, Will Simmons. Member: Brooklyn SE. Address in 1929, New Milford, 3, CT.

CHACE, DOROTHEA.
Painter and sculptor. Born in Buffalo, NY, February 3, 1894. Pupil of the Art School of the Albright Art Gallery; ASL of NY. Instructor of Art at Bennett School, Millbrook. Address in 1929, 6 East 15th Street, New York, NY.

CHADEAYNE, ROBERT OSBORNE.
Painter and teacher. Born Cornwall, Dec. 13, 1897. Pupil of C. K. Chatterton, George Lux, John Sloan, George Bridgman. Member: Columbus AL. Awards: John Lambert purchase prize, PAFA, 1919; Norman Wait Harris bronze medal and cash prize, AIC, 1920; 1st prize, Columbus AL, 1928, 1929. Work: "Back Yards," Lambert Collection, PAFA, Philadelphia, PA. Address in 1929, Columbus Gallery of Fine Arts, East Broad Street; h. 207 Marshall Ave., Columbus, OH; summer Cedar Lane, Cornwall, NY.

CHADWICK, ARCH D.
Painter, craftsman, and teacher. Born Ovid, NY, May 18, 1871. Pupil of Ithaca Conservatory of Music and Art. Member: AFA. Scenic artist and designer in theatrical and motion picture studio productions. Instructor, scenic arts, Ithaca Conservatory of Music and Affiliated Schools. Address in 1929, 945 Cliff Street, Ithaca, NY.

CHADWICK, CHARLES WESLEY.
Engraver. Born in Red-Hook-on-the-Hudson, NY, 1861. Studied wood-engraving under Frederick Jeungling, William Miller. Work appeared mostly in *Century Magazine* and *Scribner's Magazine*; engaged in finishing and engraving half-tone plates. Exhibited at Paris Expn., 1900. Awards: Bronze medal, Buffalo Expn., 1901; St. Louis Expn., 1904; silver medal, Panama Expn., San Francisco, 1915. Has lectured on wood-engraving. Address in 1926, 137 East 150th Street, New York. Died in 1948.

CHADWICK, WILLIAM.
Painter. Exhibited at Penna. Academy of Fine Arts, 1924. Address in 1926, Blackhall, Lyme, CT.

CHAFFEE, OLIVER HOLBERT.
Painter. Born in Detroit, MI, 1881. Pupil of Wm. M. Chase, Robt. Henri and Miller. Address in 1926, 141 East 21st Street, New York City. Died in 1944.

CHALFANT, JEFFERSON DAVID.
Painter. Born in PA, 1846. Pupil of Bouguereau and Lefebvre in Paris. Address in 1926, "Ashley," Wilmington, DE. Died in 1931.

CHALFIN, PAUL.
Mural painter. Born in New York City, 1874. Awarded Lazarus Scholarship for mural painting, 1905. Address in 1926, 597 Fifth Avenue, New York.

CHALMERS, HELEN AUGUSTA.
Painter. Born New York City, March 29, 1880. Pupil of Henry A. Loop, NA.; William J. Whittemore and Irving Wiles. Member: Laguna Beach AA. Work: "Maker of Tales: An Impression of Robert Louis Stevenson," Stevenson Memorial, Saranac Lake, NY. Address in 1929, "Trailsend," Laguna Beach, CA; summer, Camp Running Waters, Bear Lake, CA.

CHAMBELLAN, RENE PAUL.
Sculptor and architect. Born in 1893. Studied at Julian Academy in Paris and with Solon Borglum. Collaborated with Solon Borglum on dedication panel, Pershing Stadium, Vincennes, France; and with Grosvenor Atterbury on sculptural panels, Russell Sage Foundation Building, NY. Designed John Newbury medal for American Library Association; memorials, groups, figures, plaques: Catholic Cemeteries, Chicago; Princeton University; Naval Hospital, Beaufort, SC; others. Member of National Sculpture Society. Address in 1953, Cliffside Park, NJ. Died in 1955.

CHAMBERLAIN, ARTHUR B.
Painter. Born Kitchener, Ontario, Canada, Jan. 18, 1860. Member of Rochester Art Club. Address in 1926, 16 Gladstone Street, Rochester, NY.

CHAMBERLAIN, JOHN ANGUS.
Sculptor. Born April 16, 1927, Rochester, Ind. Studied: Chicago Art Institute School, 1950-52; University of Illinois; Black Mt. College, 1955-56. Work: Albright; Los Angeles County Museum of Art; Museum of Modern Art; University of North Carolina; Rome (Nazionale); Whitney Museum. Rep. by Leo Castelli Inc. in Rye. Exhibited: Wells Street Gallery, Davida Gallery, Chicago; Martha Jackson Gallery, NYC, 1960; Dilexi Gallery, Los Angeles, and San Francisco, 1962; Leo Castelli Inc.; Robert Fraser Gallery, London; Contemporary Arts Center, Cincinnati, 1968; Museum of Modern Art; Buenos Aires Museum of Modern Art, International Sculpture Exhibition, 1960; Whitney Museum of American Art Annuals, 1960, 62, 65, Sculpture Annuals, 1966, 68; Galerie Rive Droite, Paris, Le Nouveau Realisme, 1961; VI Sao Paulo Biennial, 1961; Art Institute of Chicago, 1961, 67; Carnegie, 1961, 67; Guggenheim; Battersea Park, London, International Sculpture Exhibition, 1963; Musee Cantonal des Beaux-Arts, Lausanne, I Salon International de Galeries Pilotes, 1963; Tate, Painting and Sculpture of a Decade, 1954-64, 1964; XXXII Venice Biennial, 1964; Jewish Museum, 1964; Herron; NJ State Museum, Trenton, Soft Art, 1969; many more. Awards: Guggenheim Fellowships, 1966 and 1977. Address in 1982, c/o Leo Castelli Inc., 4 East 77th Street, NYC.

CHAMBERLAIN, JUDITH.
Painter. Born in San Francisco, CA, in 1893. Pupil of Max Weber. Address in 1926, 728 Montgomery Street, San Francisco, CA.

CHAMBERLAIN, NORMAN S(TILES).
Painter and teacher. Born Grand Rapids, MI, March 7, 1887. Pupil of Mathias Alten and Alson Clark. Member: CA PS; Laguna Beach AA. Award: Mrs. Henry Huntington prize, Los Angeles Museum of History, Science and Art, 1923. Work: "Adobe Flores," Los Angeles Museum. Address in 1929, Laguna Beach, CA. Died in 1961.

CHAMBERLAIN, SAMUEL.
Etcher, writer, and teacher. Born Cresco, IA, Oct. 28, 1895. Pupil of Edouard Leon in Paris, Malcolm Osborne in London. Member: Chicago SE. Awards: Hon. mention, Paris Salon, 1925; Medaille de Bronze, Paris Salon, 1928. Author of "Domestic Architecture in Rural France" and "Tudor Homes of England." Address in 1929, Rue Jean Dolent; care of Guaranty Trust Co., 3 rue des Italiens, Paris, France. Died in 1975.

CHAMBERLIN, EDNA W.
Sculptor. Exhibited "The Muff" at the Penna. Academy of Fine Arts, Philadelphia, 1925. Address in 1926, Summit, NJ.

CHAMBERLIN, FRANK TOLLES.

Sculptor, mural painter, etcher. Born in San Francisco, CA, March 10, 1873. Pupil of D. W. Tryon in Hartford; George de Forest Brush and George Bridgman of Art Students League of New York. Member: Beaux-Arts Institute of Design (honorary); California Water Color Society; California Printmakers; Mural Painters; Guild of Bookworkers; New York Architectural League, 1913; MacDowell Memorial Association; Calif. Art Club; Beaux-Arts (honorary); Pasadena Fine Arts Club; Los Angeles Museum Patrons Association; American Federation of Arts. Awards: Lazarus Scholarship in mural painting, American Academy in Rome, 1913; Avery prize, New York Architectural League, 1914; 1st prize and commission for mural panel, 1915; Pasadena Art Institute, 1934. Represented in Peabody Institute, Baltimore, New Rochelle (NY) Public Library and Detroit Art Institute. Exhibited: Architectural League, 1913, 14, 20; National Academy of Design; Penna. Academy of Fine Arts; Art Institute of Chicago; California Water Color Society; and many more. Former instructor, University of Southern California; Chouinard School of Arts, Los Angeles; and others. Address in 1953, Pasadena, CA. Died in 1961.

CHAMBERLIN, HELEN.

Illustrator. Born Grand Rapids, MI. Pupil of AIC. Member: Ill. Acad. of FA; South Side AA; Art Institute Alumni Assoc. Specialty, juvenile illustration. Address in 1929, Auditorium Tower, 56 East Congress Street, h. 4640 Lake Park Avenue, Chicago, IL.

CHAMBERS, C. BOSSERON.

Painter, illustrator, and teacher. Born St. Louis, MO, May 1882. Pupil of Louis Schultze at the Berlin Academy; Alois Hrdliezka at the Royal Academy of Vienna. Member: Salma. C.; SI; Alliance. Work: decoration and altar pieces in St. Ignatius' Church, Chicago; portraits in Missouri Historical Soc., St. Louis, and Osceola Club, St. Augustine, Fla.; illustrated "Quentin Durwood," by Sir Walter Scott (Scribner's).

CHAMBERS, CHARLES EDWARD.

Illustrator. Born in Ottumwa, IN. Pupil of AIC, and ASL of New York. Member: SI, 1912; Salma. C., 1915; GFLA. Award: Shaw prize, Salma. C., 1918. Illustrated for *Harper's* magazine. Address in 1926, Waldo Avenue, Riverdale-on-Hudson, NY.

CHAMBERS, HALLIE WORTHINGTON.

Painter. Born Louisville, Oct. 27, 1881. Pupil of A. Margaretta Archambault and Hugh Breckenridge. Member: North Shore AA; Louisville AC; Louisville AA. Awards: Prize for still life, Kentucky State Fair, 1921; prizes for landscape, marine and flowers, 1923, and prize for best group of paintings (ivory minia-

tures), Kentucky State Fair, 1924. Address in 1929, 100 East Main Street; h. "Kenwood Hill," Louisville, KY.

CHAMBERS, R.

Engraver, about 1820-26. His best work is a bust of Thomas Jefferson, in an oak-garlanded circle, heading a facsimile of a letter written by Jefferson to R. C. Weightman, Mayor of Baltimore, dated June 24, 1826.

CHAMBERS, ROBERT WILLIAM.

Painter. Born in Brooklyn, 1865. Student in Julien Academy, Paris, 1886-93. First exhibited in Salon, 1889. Illustrator for *Life, Truth, Vogue*, etc. Address in 1926, 43 East 83d Street, New York.

CHAMBERS, WILLIAM.

Illustrator. Born in Chicago in 1940. He graduated from the American Academy of Art in 1961 and later attended Northeastern Illinois Univ. His art career began in 1965 with an educational book illustration; he has since been a frequent contributor to Ballantine Books and Playboy Press. He has produced several posters and his illustrations have been accepted for the S of I Annual Exhibitions and the AG shows of Chicago.

CHAMPLAIN, DUANE.

Sculptor. Born in Black Mountain, NC, April 20, 1889. Student of Art Students League of New York, National Academy of Design, Beaux-Arts Institute of New York; and with I. Konti, A. A. Weinman, A. Stirling Calder, Hermon A. MacNeil. Exhibited at National Sculpture Society, 1923. Member: National Sculpture Society, fellow; Lyme Art Association; Essex Art Association. Awards: Prize, National Academy of Design, 1913; medal, Pan-Pacific Exposition, 1915; Beaux-Arts Institute of Design. Work: Memorial tablet, Peekskill, NY and Jamaica, NY; United States Post Office, Forest City, North Carolina. Address in 1953, Essex, CT. Died in 1964.

CHAMPLIN, ADA BELLE.

Painter. Born in St. Louis, MO. Pupil of Art Institute, Chicago, and Art Student's League, New York. Address in 1926, 640 Prospect Avenue, Pasadena, CA. Died c. 1954.

CHAMPNEY, BENJAMIN.

Painter. Born Nov. 17, 1817 in New Hampshire. Worked on Litho. with Pendleton firm in Boston. Studied in Europe then returned to the U.S. to paint landscapes. Member: Boston AC (pres.). Died Dec. 11, 1909 in Woburn, MA.

CHAMPNEY, JAMES WELLS.

Painter. Born in Boston in 1843. Pupil of Lowell Institute, he studied wood-engraving. In 1866 went to Europe, studying in Paris and Antwerp. Returned

and opened his studio in Boston. He painted genre subjects in oil and pastel. Elected an Associate Member of National Academy in 1882. He died in 1903.

CHANDLER, ELISABETH GORDON.
Sculptor. Born in St. Louis, MO, June 10, 1913. Studied privately with Edmondo Quattrocchi; Art Students League, anat. Works: Columbia University School of Law; Princeton University School Public and International Affairs; Aircraft Carrier USS Forrestal; Governor Dummer Academic Library; Storm King Art Center, Mountainville, NY. Commissions: Forrestal Memorial Award Medal, National Security Industrial Association, 1954; portrait bust of James L. Collins, commissioned by estate for James L. Collins Parochial School, Corsicana, TX, 1955; Timoshenko Medal for Applied Mechanics, American Society of Mechanical Engineers, 1956; Benjamin Franklin Medal, New York University Hall of Fame, 1962; bust of Owen R. Cheatham, Founder, Georgia Pacific Corp., Entrance Hall, Portland, OR, 1970; bust of Albert A. Michelson, Hall of Fame for Great Americans, NYU, 1973. Exhibited: Mattituck Museum, Waterbury, CT, 1949; National Academy of Design Annual, NY, 1950-72; National Sculpture Society Annual, 1953-79; Academy of Artists, Springfield, MA, 1961; Smithsonian Institution, Washington, DC, 1963. Awards: First Prize, Brooklyn War Memorial Competition, 1944; Thomas R. Proctor Prize, National Academy of Design, 1956 and Dessie Greer Prize, 1960 and 1979; Gold Medal, 1975 and Huntington Award, 1976, American Artists Professional League. Media: Bronze and marble. Address in 1982, Old Lyme, CT.

CHANDLER, GEORGE W.
Etcher. Born in Milwaukee, WI. Pupil of Julien Academy in Paris. Work in the Petit-Palais, Paris, Victoria and Albert Museum, London, and Congressional Library, Washington, D.C.

CHANDLER, HELEN C.
Painter, illustrator and etcher. Born in Wellington, Kansas, in 1881. Pupil of MacMonnies and Birge Harrison. Member of San Francisco Art Association. Address in 1926, 543 North Heliotrope Drive, Los Angeles, CA.

CHANDLER, WINTHROP.
Painter. Born April 6, 1747. Early American portrait painter who studied art in Boston. Several of his portraits are preserved in Woodstock and Thompson, CT, and in Worcester and Petersham, MA. Died July 29, 1790 in Woodstock, CT.

CHANLER, ROBERT WINTHROP.
Painter. Born New York City, Feb. 22, 1872. Pupil of Ecole des Beaux-Arts, Paris. Member: NY Arch. Lg., 1914 (Assoc.); Mural P.; S. Indp. A. Work:

"Porcupine," screen, Metropolitan Museum, NY; "Giraffes," Luxembourg Museum, Paris. Address in 1929, 147 East 19th Street, New York, NY. Died in 1930.

CHAPEL, GUY MARTIN.
Painter. Born in Detroit, MI, in 1871. Pupil, Art Institute of Chicago. Address in 1926, 3919 North Kenneth Avenue, Chicago, IL; summer, Fox Lake, Ill.

CHAPIN, ARCHIBALD B.
Illustrator and cartoonist. Born at Mt. Vernon, OH, in 1875. Address in 1926, 435 Clay Avenue, Kirkwood, MO.

CHAPIN, CORNELIA VAN AUKEN.
Sculptor. Born: Waterford, CT, in 1893. Studied: in Paris with Hernandez. Member: National Academy of Design; National Sculpture Society; Allied Artists of America; National Arts Club. Awards: National Association of Women Artists, 1936; Paris International, 1937; American Artists Professional League, 1939; Pen and Brush Club, 1942-1945; Meriden, Conn., 1951. Collections: Cathedral St. John the Divine, NY; Rittenhouse Square, Philadelphia; International Business Machines; Dumbarton Oaks, Washington, DC; Brookgreen Gardens, SC; Corcoran Gallery of Art; Brooklyn Museum; Springfield Art Museum; Penna. Academy of Fine Arts; National Zoological Gardens, Washington, DC. Exhibited: World's Fair of New York, 1939; Penna. Academy of Fine Arts, 1938-46; National Academy of Design, 1933-45; San Francisco Museum of Art; Whitney, 1940-42; Metropolitan Museum of Art, 1942; and others. Address in 1953, 166 East 38th Street, NYC. Died 1972.

CHAPIN, HENRY.
An artist of that name was said to be painting pictures in America, flourishing towards the late 18th or early 19th centuries.

CHAPIN, JAMES ORMSBEE.
Painter. Born in West Orange, NY, July 9, 1887. Pupil of Antwerp Royal Academy and Society of Independent Painters of America. Address in 1926, 232 West 14th Street, New York City.

CHAPIN, JOSEPH HAWLEY.
Painter. Born Hartford, Ct., Nov. 9, 1869. Pupil of Charles Noel Flagg. Member: AI Graphic Arts; Art Directors C.; Players; SI; Century Assoc. Art Director, Charles Scribner's Sons. Died in 1939.

CHAPIN, LUCY GROSVENOR.
Painter and teacher. Born Syracuse, NY. Pupil of Baschet, Merson, Collin and Prinet in Paris. Member: AA Syracuse; Nat'l Lg. Am. Pen Women; AFA. Award: Hiram Gee Fellowship in painting. Works:

Portraits of Chief Justices Ezekiel Whitman and Prentiss Mellen, in State Gallery, Capitol, Augusta, ME; Portrait of Bishop Eveland, Dickinson Seminary, Williamsport, PA. Address in 1929, 410 W. Y. Foote Bldg.; 947 Lancaster Ave., Syracuse, NY. Died in 1939.

CHAPIN, WILLIAM.
Engraver. Born in Phila., PA, Oct. 17, 1802. William Chapin was a lineal descendant of Deacon Samuel Chapin, who settled at Springfield, CT, in 1642. In 1817, William Chapin was apprenticed to John Vallance of the engraving firm of Tanner, Vallance, Keany & Co. of Philadelphia. He remained with this firm until 1822, when he began business for himself as an engraver. In December of the same year he made a contract with the Baltimore publisher, Fielding Lucas, and in 1824 he accepted a similar engagement with a New York firm. About 1827, Mr. Chapin turned his attention to projecting and engraving maps, and in time he established an extensive map business in New York. Chapin's large map of the United States is said to be the first map engraved upon steel in this country. In 1838 Mr. Chapin became much interested in the education of the blind, and in 1840 he permanently abandoned engraving and map publishing to become principal of institutions for the blind in Columbus, and later Phila., work to which he was to devote the remainder of his life. Died Sept. 20, 1888 in Phila., PA.

CHAPLIN , CARLTON THEODORE.
Painter and illustrator. Born in New London, OH, in 1860. Student of National Academy, Art Students League of New York and Julien Academy in Paris. Specialty, marines and landscapes. Represented in Brooklyn Institute by "Gloucester Harbor" and at Toledo Museum by "Rocky Coast." He died in 1925.

CHAPLIN, CHRISTINE.
Painter. Born in Bangor, ME, in 1842. Studied in London, Paris. Specialty: painting wild flowers in water color.

CHAPLIN, ELISABETH.
Painter. Born Fontainbleau, France. Member: Societe Nationale des Beaux-Arts. Awards: Gold medal from the Minister of Public Instruction, Rome; traveling scholarship from the French State; silver medal from the City of Florence. Works: "Mia Sorella," Galerie Moderne, Florence; "Demeter and Persephone," owned by the French Government; "Vendange," owned by the City of Paris. Address in 1929, 111 Avenue Victor Hugo, Paris, France; h. Villa Chaplin, San Domenico di Fiesole, Florence, Italy.

CHAPLIN, JAMES.
Painter. Address in 1926, Care of Seattle Fine Arts Society, Seattle, WA.

CHAPLIN, MARGARET.
Painter. Member: National Academy of Women Painters and Sculptors. Address in 1926, 346 West 22d Street, New York, NY.

CHAPMAN, CHARLES SHEPARD.
Painter. Born in Morristown, NY, 1879. Pupil of Chase and W. Appleton Clark. Member: Salma. Club; Academy of National Artists. Elected an Associate Member of the National Academy. Awards: First Shaw prize, Salmagundi Club; Saltus gold medal, National Academy of Design. Work: "In the Deep Woods," Metropolitan Museum, New York. Address in 1929, 156 Sylvan Avenue, Leonia, NJ or Salmagundi Club, NYC. Died in 1962.

CHAPMAN, CONRAD WISE.
Painter. Born 1842 in Rome, Italy. Son and pupil of the artist John Gadsby Chapman. When the Civil War started he joined the Confederate troops and made many pictures of army life. After the war he lived in Virginia where he died. His painting of "Fort Sumter" was in Richmond, with a collection of his paintings of the war. Died in 1910.

CHAPMAN, CYRUS DURAND.
Painter. Born Irvington, NJ, 1856. Pupil of Wilmarth and J. G. Brown in New York; Cormon and Constant in Paris. Address in 1926, 3323 Wisconsin Avenue, Washington, DC. Died in 1918.

CHAPMAN, ESTHER I. E. McCORD.
Painter. Born Richardson CO, Neb. Pupil of Corcoran School of Art. Member: Wash. WCC. Address in 1929, 1600 Q Street, Washington, DC.

CHAPMAN, JOHN GADSBY.
Painter and engraver. Born Dec. 8, 1808 in Alexandria, VA. Little of Mr. Chapman's early life is known except that he studied art in Italy and in 1836 opened a studio in NY. For sometime thereafter he was largely employed by the Harper Bros. and by others as a designer for book-illustrations, a wood-engraver, and an etcher after his own designs. He did not engrave upon copper in line or stipple. In 1848 Mr. Chapman returned to Italy and devoted himself entirely to painting, maintaining a studio in Rome until his death. Two of Mr. Chapman's sons, Conrad Wise and John Linton Chapman, were painters and artist etchers. A daughter, Mary Chapman, married Count Cerovitch, one time private secretary to Victor Emanuel, King of Italy. John Gadsby Chapman had his studio for several years in Wash., DC, during which period he painted "The Baptism of Pocahontas" for the rontunda of the Capitol. Died Nov. 28, 1889 in Brooklyn, NY.

CHAPMAN, KENNETH MILTON.
Painter. Born Ligonier, IN, 1875. Pupil of Art Institute of Chicago; New York Art Students League.

Work: Three murals, Museum of New Mexico; illustrator of works on natural sciences; writer and lecturer on Indian Art. Address in 1926, Museum of New Mexico. Died c. 1968.

CHAPMAN, MINERVA JOSEPHINE.
Painter. Born Altmar, NY, December 6, 1858. Pupil of AIC and Annie Shaw; Robert-Fleury, Bouguereau, Bourtois and Chas. Lazar in Paris. Assoc. Soc. Nat. des Beaux-Arts, Paris, 1906. Member: CA S. Min. P. Awards: Two gold medals, San Diego (CA) Exp., 1915 and 1916; first prize, California Society of Miniature Painters, 1929. Work: "Brittany Woman," miniature owned by the French Government. Address in 1929, Stanford University, CA; 420 Amherst Street, Palo Alto, CA.

CHAPMAN, W. E.
Painter. Address in 1926, 18 East 90th Street, New York, NY.

CHAPPELL, BILL.
Sculptor, painter, and a craftsman in leather. Born in Van Zandt County, TX, 1919. Self-taught. Worked as a cowboy; operated saddle and boot shop. Began painting and sculpture in 1953, when he moved to Colorado. Subjects are cowboys and Indians of the Old West. Works in bronze; paints in oil. Member of Texas Cowboy Artists. Reviewed in *The Western Horseman*, Sept. 1971; *Cowboy in Art; Bronzes of the American West*. Works include leatherwork portrait of Will Rogers in National Cowboy Hall of Fame; illustrations for magazine covers, *Western Horseman, Paint Horse Journal*, and *Craftsman*. Address since 1972, South Fork, CO.

CHARD, LOUISE CABLE.
Painter. Member: Society Independent Artists. Address in 1926, 54 Melrose Place, Montclair, NJ.

CHARD, WALTER GOODMAN.
Sculptor. Born Buffalo, NY, April 20, 1880. Pupil of Charles Grafly; School of the Museum of Fine Arts, Boston; Beaux Arts Institute of Design. Address in 1926, Fenway Studios, Boston, MA; h. Cazenovia, NY.

CHARLES, H.
He signed a number of copper-plates published in Philadelphia in 1810. As William Charles did not establish himself in Philadelphia until 1816, he cannot be connected with him.

CHARLES, SAMUEL M.
Miniature painter. Flourished about 1836. Work: Portrait, "Andrew Jackson" (miniature), signed "S. M. Charles."

CHARLES, WILLIAM.
Engraver. Born 1776 in Edinburgh, Scotland. Came to New York in 1801, and in 1807 was established there as an engraver and publisher at "Charles Repository of Arts." The directories of Philadelphia locate him in that city from 1816 to 1820, inclusive; he was in business there as copper-plate engraver, as a bookseller and as a publisher and stationer. Engraved in line-stipple and in aquatint. Best known for series of caricatures, chiefly of events connected with the War of 1812, or with local politics. These war etchings were issued in 1813, with engraver S. Kennedy. Died in Philadelphia, Aug. 24, 1820.

CHARLOT, JEAN.
Painter. Born: Paris, France, in 1898. Studied: Lycee Condorcet, Paris. Awards: Guggenheim fellowship, 1945-1947; Grinnell College, 1946; St. Mary's College, 1956; Yale University, 1948; Los Angeles County Fair, 1949; Honolulu Acad. of Art. Collections: Museum of Modern Art; Rochester Memorial Art Gallery; Dallas Museum of Fine Arts; San Francisco Museum of Art; Metropolitan Museum of Art; Art Inst. of Chicago; San Diego Fine Arts Society; University of Georgia Fine Arts Building; Arizona State College; Univ. of Hawaii; churches in Hawaii, Notre Dame, Indiana, and Lincoln Park, Michigan; murals, Des Moines Fine Arts Ctr.; St. Catherine's Church, Kauai; Hawaiian Village Hotel, Waikiki; St. Leonard Friary, Centerville, Ohio.

CHARMAN, LAURA B.
(Mrs. Albert H. Charman). Sculptor. Member: Fellowship Penna. Academy of Fine Arts. Address in 1926, Magnolia, NJ.

CHARMAN, MONTAGUE.
Painter. Exhibited water colors at Annual Exhibition of Water Colors at PAFA, Philadelphia, 1925. Address in 1926, 615 Walnut Avenue, Syracuse, NY.

CHARMATZ, WILLIAM.
Illustrator. Born in New York City in 1925. He attended the High School of Industrial Art with Henry Wolf and Helmut Krone. Beginning his career in 1946 with pen and ink illustrations for *Harper's Bazaar*, he has since worked for several magazines and illustrated many books, including *The Cat's Whiskers, The Little Duster, Endearments* and *Horse Bus Stop*.

CHARPENTIER, AUGUSTE.
A French-American portrait painter. Born in Paris, 1815, and died in Besancon in 1880. He was a pupil of Ingres and exhibited in the Paris Salon of 1833. He lived and had his studio for many years in New Orleans, where he painted numerous fine portraits.

CHASE, ADELAIDE COLE.
Portrait painter. Born in Boston, 1868, daughter of the artist J. Foxcroft Cole. Pupil of Tarbell in Boston, and Carolus Duran in Paris. Elected an Associate of the National Academy of Design, 1906. Represented

by "The Violinist" in the Boston Museum of Fine Arts. Died in 1944.

CHASE, CLARENCE M(ELVILLE).
Painter. Born Auburn, ME, July 13, 1871. Pupil of George B. Gardner and Carl Gordon Cutler. Member: Copley S.; East Gloucester SA; New Indp. S., Boston. Address in 1929, 268 Savin Hill Avenue, Boston, 25, MA.

CHASE, EDWARD L.
Illustrator. Address in 1926, Woodstock, NY.

CHASE, ELLEN WHEELER.
Painter. Born Faribault, MN. Studied in Buffalo, New York City, Boston, under Tarbell, and Rene Menard and Lucien Simon in Paris. Member: Buffalo Society of Artists. Address in 1926, The Meyer Studios, 1110 Elmwood Avenue, Buffalo, NY. Died Aug. 1, 1948.

CHASE, ELSIE ROWLAND.
Painter, illustrator, etcher, writer and craftsman. Born Saratoga Springs, NY, Feb. 10, 1863. Pupil of Yale School of Fine Arts. Member: Hartford Art Club; NAC; Society of Independent Artists; New Haven PCC; AFA. Address in 1926, 165 Grove Street, Waterbury, CT. Died in 1937.

CHASE, FRANK SWIFT.
Painter and teacher. Born St. Louis, MO, March 12, 1886. Member: Allied AA; Salma. C.; CT AFA; Woodstock AA. Awards: Richard Greenough Memorial prize, Newport AA, 1921; Peabody prize, Chicago A. Lg., 1922. Work: "Morning Shadows," South Carolina Art Association, Charleston, SC; "Landscape," Mechanics Institute, Rochester, NY. Address in 1929, Woodstock, NY. Died in 1958.

CHASE, HARRY.
Born in Woodstock, VT, 1852, and died 1889. He studied at The Hague, and in Paris. On his return he opened his studio in New York. He was elected an associate of the National Academy in 1883. His principal work: "The Harbor of New York," at the Corcoran Art Gallery; "Low Tide," "Outbound Whaler," "The North River," and "Bringing the Fish Ashore."

CHASE, JESSIE KALMBACK.
Landscape painter. Born Bailey's Harbor, WI, Nov. 22, 1879. Pupil AIC and Frederick Fursman. Member: WI Painters and Sculptors; Madison AG. Award: Hon. mention, Milwaukee Art Inst., 1925; Madison Art Guild prize, Milwaukee Art Inst., 1928. Address in 1929, 2009 Adams Street, Madison, WI.

CHASE, JOSEPH CUMMINGS.
Portrait painter. Born Kents Hill, ME, 1878. Studied art at Pratt Institute, New York; Penna. Academy

Fine Arts; Academie Julien, Paris, under Jean Paul Laurens. Exhibited in Paris Salon; won 1st and 2nd prizes, Grunwald poster competition, Paris 1904. As war artist, painted at the front 142 portraits of officers of A.E.F., including General Pershing and staff; also many "Doughboys" who had been cited for extraordinary heroism in action, and several officers of the Allies, including Marshal Foch. Address in 1926, 22 West 23d Street, New York, NY. Died in 1965.

CHASE, MARION MONKS.
Painter. Born Boston, MA, in 1874. Pupil of G. L. Noyes. Address in 1926, 144 Brattle Street, Cambridge, MA.

CHASE, SIDNEY MARCH.
Painter, illustrator, and writer. Born Haverhill, MA, June 19, 1877. Pupil of Woodbury, Tarbell, Pyle and Pape. Member: Salma. C.; North Shore AA. Address in 1929, 4 Mt. Vernon Street, Haverhill, MA. Died in 1957.

CHASE, SUSAN BROWN.
Painter. Born St. Louis, MO. Pupil H. B. Snell, C. E. Messer, Bertha Perrie, R. E. James, Chester Springs Summer School. Member: Wash. WCC; NA Women PS; S. Wash. A. Address in 1929, care of the Arts Club, 2017 I Street, N.W. Washington, DC.

CHASE, WENDALL W.
Painter and etcher. Born in Foxcroft, ME, in 1875. Pupil of Geo. L. Noyes and Hawthorne. Address in 1926, 9-A Park Square, Boston, MA.

CHASE, WILLIAM MERRITT.
Painter. Born Nov. 1, 1849 in Franklin, IN. A pupil of B. F. Hayes, of Indianapolis, he was a local portrait painter for a time, but came East to study under J. O. Eaton and in the schools of the Acad. in NY. In 1872 he went to Munich. His masters there were Alexander Wagner and Karl Von Piloty. Taught at ASL. Mr. Chase was for 10 yrs. pres. of the Society of Am. Artists, and was most successful with his work in portraiture; his "Carmencita" and his "James McNeil Whistler" were owned by the Metropolitan Museum of New York. The Cleveland Museum owned "Alice in Her Grandmother's Gown" and his portrait of Miss Dora Wheeler. Elected a member of the National Academy in 1890. Died Oct. 25, 1916 in NYC.

CHASE-RIBOUD, BARBARA DEWAYNE.
Sculptor and draftsman. Born in Phila., PA, June 26, 1939. Initiated studies in ceramics and sculpture at the Fletcher Art Memorial School, Phila., 1946-47; Phila. Museum School of Art, PA, 1947-54; Tyler School of Art, at Temple University, Phila., PA, 1954-57; Yale University School of Art and Architecture, New Haven, CT, under Josef Albers and Paul

Rudolph, 1958-60, MFA, 1960; American Academy in Rome, 1957-58. Work: Museum of Modern Art; Metropolitan Museum; Museum of Modern Art, Paris; and others. Exhibitions: Cadron Salon, Paris, 1966; Bertha Schaefer Gallery, NYC, 1970; Mass. Institute of Technology, Cambridge, 1970; Carnegie Institute, Pittsburgh, PA, 1965; Boston Museum of Fine Arts, Boston, 1970; Whitney Museum of American Art, NYC, 1971; Museum of Modern Art, Paris; American Cultural Center, Iran, 1975; and others. Awards: National Endowment Arts Individual Grant, 1973; US State Department Traveling Grant, 1975; Outstanding Alumni Award, Temple University, 1975. After travelling to Egypt in 1957, settled in Paris, where she became the promotional art director for the *New York Times*, Paris, 1961. Travelled widely in Asia and Africa. In 1965, travelled to People's Republic of China. Began to publish poetry in 1974. Media: Bronze and aluminum. Address in 1982, Paris, France.

CHATTERTON, C. K.
Painter and teacher. Born in Newburgh, NY, Sept. 19, 1880. Study: NY School of Art under W. M. Chase, Robert Henri, Luis Mora, Kenneth Hayes. His paintings combine plein-air tradition with forthrightness about homely subject matter, chiefly in Hudson Valley and Maine. Work: Brooklyn Mus.; Nat'l. Coll. of FA (Smithsonian Inst.); Sheldon Mus., Omaha, Neb.; Hackley Gal., Muskegan, MI; Canajoharie (NY) Gal.; Taylor Hall Art Gal., Vassar Coll., Poughkeepsie, NY; private collections. One-man shows: Wildenstein Gal., MacBeth Gal., Chapellier Galleries, NYC. Group shows: Carnegie Inst's. Int'l. exhibitions; Corcoran Gal. of Art, Wash. DC; Toledo Mus. of FA; PAFA; Albright Galleries, Buffalo; NAD, NYC; Art Inst. of Chic.; Rhode Island School of Design. Member: Salma. C.; Chicago WCC. Award: Isidor prize, Salma. C., 1913. In 1910, painting "Snow Clad Town" included in first showing of US Art in So. America. In 1926, painting "Clinton Square, Newburgh" was selected for Tri-Nat'l. Exhib. sent abroad under sponsorship of Wildenstein Gallery. Teaching: Artist-in-Residence, Vassar College, 1915; Professor Emeritus of Art, Vassar, retired 1948. Died New Paltz, NY, July 2, 1973.

CHATTIN, LOU ELLEN.
(Mrs. Lou Ellen Showe). Painter. Born Temple, TX, Nov. 16, 1891. Pupil of John F. Carlson, F. V. Du Mond, George Bridgman, Ossip Linde, Kathryn C. Cherry, Hugh Breckenridge. Member: SSAL; Buffalo SA; Hoosier Salon; Ind. AC. Address in 1929, 870 26th Avenue, North, St. Petersburg, Florida; summer, The Tree Top, Box 115, Chautauqua, NY. Died in 1937.

CHAUDHURI, PATRICIA M.
Sculptor and painter. Born in NYC, July 6, 1926. Studied at Simmons College, BS; Boston Museum of

Fine Arts, five year certificate, painting with Karl Zerbe and David Aronson; Skowhegan School of Painting and Sculpture, summer scholar, 1951; Yale Summer Art School, scholar, 1952; also sculpture with George Demetrios. Exhibitions: Painting, Boston Arts Festival, 1955 and sculpture, 1963; New England Sculpture Association, 1969-71. Awards: Louis T. Comfort Tiffany Award for Sculpture, 1961. Address in 1976, Harvard, MA.

CHAVEZ, EDWARD ARCENIO.
Sculptor and painter. Born in Wagonmound, NM, March 14, 1917. Studied at Colorado Springs Fine Art Center under Frank Mechau, Boardman Robinson, Peppino Mangravite, and Arnold Blanch. Exhibited: National Institute of Arts and Letters in NYC; Whitney Museum of American Art, NYC; National Academy of Design, NYC; Metropolitan Museum of Art, NYC. Awards: Childe Hassam Award for painting at the National Institute of Arts & Letters, 1953. Member: Woodstock Art Association (chairman, from 1949) and the National Academy of Design. Taught: Painting at the Art Students League, 1954-58; visiting professor of art at Colorado College, Colorado Springs, 1959-60; professor of art at Syracuse Univ. School of Art, 1960-62. Commissions: Murals for the post offices in Center, TX; Glenwood Springs, CO; Geneva, NE; for the Government Art Commission, 1938; and the West High School in Denver; and a mural for the 200th State Hospital, Recife, Brazil. Address in 1982, Woodstock, NY.

CHEFFETZ, ASA.
Painter, illustrator, and etcher. Born Buffalo, NY, August 16, 1897. Pupil of Philip Hale, Ivan Olinsky, William Auerbach-Levy. Award: Eyre gold medal, PAFA, 1928. Work: "Summer Sun," "Noonday Shadows," "Ramshackle Barn," "Afterglow," Baltimore Museum of Art, Baltimore, MD; "Country Lane" "Abdul Baha" and "The Open Door," Newark Museum of Art, Newark, NJ. Address in 1929, 484 White Street, Springfield MA. Died in 1965.

CHEN, ANTHONY.
Illustrator. Born in Kingston, Jamaica, in 1929. He attended ACD and graduated cum laude from PI in 1955, having studied under Richard Lindner and Dong Kingman. In 1957, he first illustrated for *My Baby Magazine* and began children's book illustration in 1966 with *Too Many Crackers* for Lothrop, Lee and Shepard. He has since illustrated books for *Reader's Digest* and *Better Homes and Gardens* as well as others. He has had numerous One-Man Shows in NY, Washington, Richmond and at the Delaware Museum. He was an instructor at Nassau Community College, 1974.

CHENEY, HELEN M.
Scuptor. Born in Wiarton, Ontario, Canada, 1932. Studied: Wayne State University, BFA; Eastern

Michigan University, MFA candidate. Exhibitions: Detroit Artists Market; Willis Gallery, Detroit; Eastern Michigan University; Saginaw Art Museum ("Woman Art Show"); University of Michigan ("Detroit Now"); Detroit Institute of Arts, Works by Michigan Artists, 1974-75. Awards: First prize, Saginaw Art Museum ("Woman Art Show"). Address in 1975, Grosse Ile, MI.

CHENEY, JOHN.
Engraver. Born Oct. 20, 1801 at South Manchester, CT. Line-engraver of small heads and book illustrations working as an engraver in Boston in 1829. In 1833 he went to Europe to study art, supporting himself there by engraving for American publishers. Died Aug. 20, 1885 in his home town.

CHENEY, MARY MOULTON.
Painter, designer, and teacher. Born Minneapolis, MN. Graduate of University of Minnesota; School of Boston Museum of Fine Arts. Pupil of Denman W. Ross, George Elmer Browne. Award: Hon. mention, MN State Fair, 1917. Director, Minneapolis School of Art, 1917-1926. Address in 1929, 1912 South Third Avenue, Minneapolis, MN.

CHENEY, RUSSELL.
Painter. Born South Manchester, CT, Oct. 16, 1881. Pupil of Kenyon Cox, Chase, Woodbury, ASL of NY; Laurens in Paris. Member: CT AFA; Colorado Springs AS; Century C. Work: "Skungimaug Morning," Morgan Memorial Museum, Hartford, CT; "Ute Pass," San Francisco Museum of Art; "Colleone," Newark Museum Association. Address in 1929, 22 Forest Street, South Manchester, CT. Died in 1945.

CHENEY, SETH WELLS.
Painter and engraver. Born Nov. 26, 1810 at South Manchester, CT. In 1829 S. W. Cheney joined his brother, John Cheney, in Boston, and with him learned to engrave. He accompanied John Cheney to Europe in 1833, and studied in Paris under Isabey, Delaroche, and other French masters. Seth W. Cheney returned home in 1834; he again went to Europe in 1837 and resumed his art studies in France, Italy and Germany. In 1841 he opened a studio in Boston and began to draw portraits in crayon, and he was first among American artists to effectively work in "black and white." His line-engravings are comparatively few in number. His life was written by Ednah D. Cheney, and published in Boston, 1881. A memorial exhibition of the work of John and Seth Wells Cheney at the Boston Museum in 1893 included 338 engravings, paintings, drawings and two or three objects of sculpture. Died Sept. 10, 1856 in South Manchester, CT.

CHENEY, WARREN.
Sculptor, lecturer, writer, and teacher. Born in Paris, France, September 19, 1907. Studied at University of Calif.; Ecole des Beaux Arts, and with Hans Hofmann. Awards: Honorable mention, Los Angeles County Fair, Pomona, 1930; honorable mention, Ebell Sculpture Exhibition, May 1933. Exhibited: Gumps Gallery (one man), San Francisco, 1934; Metropolitan Museum of Art, 1934; Weyhe Gallery, 1934-36; San Francisco Museum of Art, 1936, 37; Philadelphia Museum of Art, 1940. Stage sets: "Liliom" and "The Mad Hopes," 1938; "Le Sacre du Printemps," 1938. Position: Instructor, sculpture and design, University of California, Los Angeles, 1937-38; Chairman of Art Department, Adjunct Professor of Art, Randolph-Macon Women's College, 1939-40; City College of New York, 1947-48. Member: California Art Club. Instructor in sculpture and lecturer at Mills College; instructor, Cheney-Wessels School of Art, San Francisco. Address in 1953, Flushing, LI, NY.

CHERMAYEFF, IVAN.
Illustrator. Born in London, England, in 1932. He studied at Harvard Univ., the Inst. of Design in Chicago and graduated with a BFA from Yale Univ., School of Art and Architecture. His many clients have included IBM, Philip Morris USA, Westinghouse Electric Corp., and others. Vice-president of Yale Art Association and a member of the Yale Council Committee on Art and Architecture, Industrial Designers Society of America, Architectural League of New York and the Alliance Graphique Internationale. He is author of *Observations on American Architecture* published by The Viking Press in 1972.

CHERNEY, MARVIN.
Painter. Born in Baltimore, MD, in 1925. Studied drawing at Maryland Inst. of Art; scholarship, School of Art Studies, NYC. Initially influenced by work of German Expressionists Kokoschka, Kollwitz; also work of Titian, Rembrandt; travelled to France, Italy, for five months. Lived and worked in NYC. Painted portraits and still lifes; worked primarily in oil, lithography, painting in oil on paper. Received many prizes and awards. Died in 1967. Represented by Kennedy Galleries, NYC.

CHERRY, EMMA RICHARDSON.
Painter, teacher and lecturer. Born Aurora, IL, Feb. 28, 1859. Pupil of ASL of NY; Chase; Cox; McCarter; Breckenridge; Zanetti Zilla in Venice; Merson, Andre L'Hote, Julien Academy in Paris. Member: ASL of NY; Denver AA; Houston AL; San Antonio AL. Awards: Gold medal, Western Art Assoc., Omaha; landscape prize, SSAL, Birmingham; still life prize, Nashville, TN; portrait prize, Austin, TX. Work: In Elizabet Ney Museum, Austin, TX; Soc. of Civil Engineers Club, New York City; San Antonio Art League; Houston Art Museum; Denver Art Museum. Director, Texas Fine Arts Association. Address in 1929, 608 Fargo Avenue, Houston, Texas;

care of American Express, 11 Rue Scribe, Paris, France.

CHERRY, KATHRYN E.
Painter and teacher. Born Quincy, IL, in 1880. Pupil of St. Louis Art School, New York Art School, Richard Miller and Hugh Breckenridge; studied abroad. Member: St. Louis AG; Chicago AC; NA Women PS; North Shore AA; Rockport AS; PBC; 8 Women P. of Phila.; Atlan. C. (hon.); Chicago Galleries Assoc.; AFA. Awards: St. Louis A. Lg. ($500), 1919, Hugo Kohler Landscape prize, St. Louis AG, 1920; John Liggett Scott memorial prize, St. Louis AG, 1921; Kansas City Art Institute gold medal, for painting, 1922; purchase prize ($350), St. Louis Chamber of Commerce, 1923; hon. mention, Phila. Artists Week Ex., 1923; hon. mention, NA Women PS, 1923; Bixby landscape prize, St. Louis, 1924; hon. mention, NA Women PS, 1927; prize ($200), Chicago Gal. A., 1927. Work: "Inner Harbor," and "Nisbit Hills," St. Louis High Schools; also represented in Soldan High School; Principia Academy, St. Louis; South Eastern Missouri State Teachers College, Cape Girardeau; Laura Davidson Sears Academy of Fine Arts Club, Quincy, IL. Address in 1929, 5504 Delmar Street, St. Louis, MO; summer, East Gloucester, MA.

CHESKIN, L(OUIS).
Painter and teacher. Born Russia, Feb. 17, 1907. Pupil of F. Tkatch; Frederic M. Grant. Member: Ill. AFA; Chicago NJSA. Address in 1929, 25 East Superior Street; h. 3576 Lyndale Street, Chicago, IL.

CHESNEY, LETITIA.
Painter, craftsman, and teacher. Born Louisville, KY, Feb. 14, 1872. Pupil of Natilia Sawyer Bentz, Paul Sawyer. Member: Seattle AI. Work: "Daniel Boone," Historical Society, Kentucky State House, Louisville; "Shawondassee," Queen Anne Hill Branch Library, Seattle, WA. Address in 1929, Winslow, Bainbridge Island, WA.

CHESNEY, MARY.
Painter, craftsman, and teacher. Born Louisville, KY, Jan. 6, 1872. Pupil of Mary Harbough. Award: First prize, North West Independent Salon, 1928. Address in 1929, Winslow, Bainbridge Island, WA.

CHESSE, RALPH.
Painter. Born New Orleans, Jan. 6, 1900. Member: Oakland AA; Modern Gallery Group. Award: Second Anne Bremer prize, San Francisco Art Association, 1928. Address in 1929, 7 Blackstone Ct., San Francisco, CA.

CHICAGO, JUDY.
Painter and writer. Born in Chicago, Illinois on July 20, 1939. Until 1970, she exhibited under the name of Judy Gerowitz. Studied: UCLA, received her MA in

1964. She is currently involved in the development of teaching methods for the education of young women in the arts. Exhib.: Jewish Mus., NY, 1966; Whitney Mus. Am. Art, 1970; MMA, 1979. Address in 1980, 1651 B 18th St., Santa Monica, CA.

CHICHESTER, CECIL.
Painter, illustrator, and teacher. Born New York City, April 8, 1891. Pupil of Maratta and Birge Harrison. Instructor, Art Students Lg. of NY, and Woodstock School of Landscape Painting. Address in 1929, Woodstock, Ulster Co., NY.

CHILD, EDWIN BURRAGE.
Painter. Born Gouverneur, NY, May 29, 1868. Studied art ASL, New York, 1891, and was a pupil of John La Farge. Asst. of John La Farge in glass work and mural painting for several years. Exhibited regularly in Society of American Artists, and National Academy of Design, and other important annual exhibitions. Illustrator of many articles in *Scribner's* and other periodicals and contributor to magazines. Later engaged chiefly in portrait painting. Address in 1926, 42 West 93d Street, New York, NY. Died in 1937.

CHILD, LOUIS.
Portrait painter, working in New York about 1800. His portrait of Micah Hawkins is inscribed on back of canvas, "Retouched from memory by Wm. S. Mount, 1856."

CHILD, THOMAS.
Early American portrait painter, noted as being in Boston in 1688. Died Nov. 10, 1706.

CHILDS, BENJAMIN F.
Wood engraver. Born at Cambridge, 1814, and died 1863. In 1850 he became superintendent of engraving for the Tract Society. He engraved the illustrations after drawings by Darley for Irving's "Knickerbocker's History of New York," published by Wiley and Putnam of New York in 1853.

CHILDS, CEPHAS G.
Engraver. Born in Bucks Co., PA, 1793; died in Philadelphia, 1871. Childs was taught to engrave by Gideon Fairman in Philadelphia. Childs issued his "Views of Philadelphia" in 1826-33, many of these being engraved by himself. After a visit to Europe, he associated himself with the artist Henry Inman, under the firm name of Childs & Inman. This firm, which was in existence from 1831 to 1835, brought P. S. Duval from Europe and placed him at the head of the lithographic department; this added to their general engraving business. Inman drew upon the stone himself, and their deaf and dumb apprentice, Albert Newsam, executed some of his best work for the firm of Childs & Inman, and became the foremost lithographic artist of his day. About 1845 Childs

abandoned engraving and interested himself in newspaper work in Philadelphia. Along with Walter Colton he was one of the editors of *The Commerical Herald*, John R. Walker being the publisher. He was afterward commercial editor of *The North American*, published by Thomas R. Newbold. Childs was a soldier in the War of 1812.

CHILDS, LILLIAN E.
Miniature painter. Born in Little Silver, NJ. Pupil of William M. Chase in New York and Art Institute of Chicago. Address in 1926, 85 Washington Place, New York City.

CHILLMAN, JAMES, JR.
Painter, artist, writer and teacher. Born in Philadelphia, PA, Dec. 24, 1891. Pupil of P. P. Cret; George Walter Dawson. Member: AIA; Amer. A. of Museums; SSAL; AFA. Award: Fellowship in architecture, American Acad. in Rome, 1919; water color prize, SS Art League, 1926. Author of articles on architecture in "Journal AIA," "Memoirs of American Academy in Rome." Address in 1929, Museum of Fine Arts of Houston; h. 2242 Stanmore Drive, River Oaks, Houston, Texas; summer, School of Fine Arts, University of Pennsylvania, Philadelphia, PA.

CHILTON, WILLIAM.
Painter. Born in Washington, DC, Dec. 15, 1856. Pupil of Washington ASL. Member: S. Wash. A.; Wash. WCC; Wash. AC; AFA. Address in 1929, 1961 Biltmore Street, N.W. Washington, DC. Died in 1939.

CHIMES, THOMAS.
Painter. Born in Philadelphia, Pennsylvania, in 1921. Studied at the Art Students League of New York. Taught at the Drexel Institute of Technology in Philadelphia. Exhibitions: Avant Garde Gallery, Bodley Gallery, and The Museum of Modern Art, New York. Work in private collections.

CHINNI, PETER ANTHONY.
Sculptor and painter. Born March 21, 1928, Mt. Kisco, NY. Studied: Art Students League, 1947, with Edwin Dickinson, Kenneth Hayes Miller, Julian Levi; Academy of Fine Arts, Rome, 1949-50, with Emilio Sorrini. Work: Denver Art Museum; St. Louis City Art Museum; Whitney Museum. Exhibited: Galleria San Marco, Rome, 1955; Kipnis Gallery, Westport, Conn., 1956; R. R. Gallery, Denver, 1957; Galleria Schneider, Rome, 1957; Janet Nessler Gallery, NYC, 1959, 61; Albert Loeb Gallery, NYC, 1966; Audubon Artists Annuals, 1958, 59, 61, 62; Festival of Two Worlds, Spoleto, 1960; Boston Arts Festival, 1960, 62; Conn. Academy of Fine Arts, 1960, 62; Whitney Museum of American Art Annuals, 1960, 62, 64, 65; Corcoran, 1962; Sculptors Guild, 1963, 64, 66, 68; Carnegie, 1964-65; Heseler Gallery, Munich, 1968; Rome (Nazionale) 1968.

Awards: Art Students League, Daniel Schnackenberg Scholarship, 1948; Silvermine Guild, 1st Prize, 1958, 60, 61; Denver Art Museum, 2nd Prize, 1960. Member of Sculptors Guild; Artists Equity, New York. Address in 1983, Katonah, New York.

CHISOHN, MARY B.
Painter. Exhibited at National Association of Women Painters and Sculptors, 1924. Address in 1926, 1337 Lexington Avenue, New York.

CHITTENDEN, ALICE BROWN.
Painter and teacher. Born Brockport, NY, Oct. 14, 1860. Pupil of CA School of Fine Arts under Virgil Williams. Member: AFA. Awards: Gold medal for flower painting, San F. Exp. of Art and Industries, 1891; silver medals, Lewis-Clark Exp., Seattle, 1909. Work: Portrait, Rt. Rev. William Ford Nicholls, Bishop of CA, in Episcopal Divinity School, San Francisco; six portraits for CA Society of Pioneers. Instructor of Art, Sarah Dix Hamlin School; member of faculty, CA School of Fine Arts, San Francisco. Address in 1929, 1351 Sutter Street, San Francisco, CA. Died in 1934.

CHIVERS, HERBERT CHELSEY.
Sculptor, painter, etcher, and writer. Born Windsor, England. Pupil of Luks, Sloan, Robinson, Lever, Young, Preissig, and Pennell. Address in 1929, 16 Morningside Avenue, New York, NY.

CHOATE, NATHANIEL.
Sculptor. Born in Southboro, MA, December 26, 1899. Went to Paris in 1923 to study painting; then to Italy. Returning to Paris, he worked at the Carlo Rossi, Delacleuse, and Roman schools. After visiting Greece in 1924, he decided finally to become a sculptor. Returned to Boston and worked under John Wilson, instructor of sculpture for the Harvard Architectural School and the Mass. Institute of Technology. In 1927 and 28, he went again to Europe and returned to the US in 1929. Studied: Harvard University; Julian Academy; Grande Chaumiere. Member: National Sculpture Society; Associate of the National Academy of Design; Architectural League; New York Ceramic Society. Works: Statuette, Theseus; Minotaur, companion piece to preceding; Brookgreen Gardens, SC; Harvard University. Address in 1953, 96 East 10th Street, NYC. Died in 1965.

CHORLEY, JOHN.
Line-engraver of portraits and book illustrations, working in Boston as early as 1818. Upon a well-executed Bible print the name is signed "I. P. Chorley Sc."

CHOUINARD, NELBERT MURPHY.
Painter and designer. Born Montevideo, MN, Feb 9, 1880. Pupil of Arthur Dow, Ernest Batchelder,

Ralph Johonnot, and of Pratt Institute. Member: CA AC; Alliance. Director of the Chouinard School of Art of Los Angeles. Address in 1929, 2606 West Eighth Street, Los Angeles, CA; 1114 Garfield Avenue, South Pasadena, CA. Died in 1969.

CHRISTENSEN, GARDELL DANO.
Sculptor, painter, illustrator, and designer. Born in Shelley, ID, August 31, 1907. Studied: Sculpture with Alice Craze, Max Kalish. Member: American Association of Museums; Salmagundi Club. Work: African Hall, North American Hall and Boreal Hall, of the American Museum of Natural History, NY; Museum of Ocmulgee National Park, Macon, GA; Custer Battle Field, MT; Colonial Museum, Nairobi, British East Africa. Exhibited: National Academy of Design; Georg Jensen Co., 1939. Illustrated, "Wapiti the Elk," "Animals of the World," "Big Cats," and others. Contributor of articles and illus. to *Era*, *Audubon*, and other nature magazines. Exhibits Designer, American Museum of Natural History, 1928-41; Assistant Producer and Manager, McArthur 3-Dimensional Adv. Corp., 1947-49; Sculptor, National Park Museum Laboratories, 1950-51; Exhibit Designer, Montana Historical Society, 1952, 53; Hagley Museum, Wilmington, DE, 1956-59; Cabrillo Beach Marine Museum. Address in 1970, San Pedro, CA.

CHRISTENSEN, INGEBORG.
Painter, writer, lecturer, and teacher. Born Chicago. Pupil of Pauline Palmer; AIC. Member: Chicago AC; Chicago PS; Alumni AIC. Award: Municipal Art League prize, AIC, 1925. Work: "Pals," John Marshall High School, Chicago. Address in 1929, Studio 21, 4 East Ohio Street; h. 5357 Wayne Ave., Chicago, IL.

CHRISTENSEN, RALPH A.
Painter, craftsman, etcher, writer, lecturer, and teacher. Born in Chicago, IL, April 4, 1886. Pupil of Vanderpoel, Ufer, Mucha. Member: Alumni AIC; AFA; CA AC. Address in 1929, Boudeman Bldg., 122 West South Street, h. R. 4 Pomeroy Park; summer, 1133 Reycraft Drive, Kalamazoo, MI. Died in 1961.

CHRISTIE, RUTH VIANCO.
Painter, craftsman, and teacher. Born Rochester, Aug. 23, 1897. Pupil of Mechanics Inst. Member: Rochester AC. Awards: Second Wiltsie water color prize, 1917; first Wiltsie water color prize, 1918. Address in 1929, 74 Harding Road, Rochester, NY.

CHRISTY, HOWARD CHANDLER.
Illustrator and portrait painter. Born in Morgan County, Ohio, 1873. In his youth studied under Chase, NY, ASL. He was employed as an illustrator on *Harper's* and *Scribner's* magazines. His reporting on the Spanish-American war from Cuba for the latter publication brought much acclaim. He later devoted his time to painting portraits; among his best known pictures are the portrait of Mrs. William Randolph Hearst of New York, Secretary of State Hughes, Crown Prince Humbert of Italy, Amelia Earhart, and others. His masterpiece is "Signing of the Constitution," Rotunda, US Capitol. Address in 1926, Hotel des Artistes, West 67th Street, New York City. Died March 3, 1952.

CHRYSSA, VARDEA.
Sculptor and painter. Born in Athens, Greece, in 1933; US citizen. Studied: Grande Chaumiere, Paris, and at California School of Fine Art. Collections: Museum of Modern Art; Whitney Museum of American Art; Albright-Knox Art Gallery, Buffalo, NY; and The Solomon R. Guggenheim Museum. Actively exhibiting in major galleries and museums during the 1960's, including Guggenheim, Museum of Modern Art, Carnegie, and Whitney Museum. Address in 1982, 15 East 88th Street, New York City.

CHUBB, T. Y.
Engraver. About 1860 Chubb was an engraver of portraits in mezzotint and worked for book publishers.

CHUBBUCK, THOMAS M.
Engraver of portraits and landscapes in line and stipple. He was located in Springfield, MA.

CHURBUCK, LEANDER M.
Painter. Born Wareham, MA, Feb. 19, 1861. Pupil of Copley S. and Boston Art Students' Assoc. Member: Copley S. 1905; Brockton AL. Awards: Gold medal, Dallas Exp., 1903; first prize for water colors, Denver Exp., 1909. Work: "On the Cape Ann Shore," "In Old Marblehead," Municipal Gallery, Brockton, MA; copy of L'hermette's "Friend of the Humble," Library, Brockton, MA. Address in 1929, 270 Green Street, Brockton, MA.

CHURCH, ANGELICA SCHUYLER.
Sculptor, painter, teacher, lithographer, and craftsman. Born Briarcliff, NY, April 11, 1878. Pupil of New York School of Applied Design; Alphonse Mucha. Member: Alliance; New York Salma. Club; Ossining Historical Society. Work: Statue of the Savior, Calvary Church, NY; Mark Twain portrait tablet, at his boyhood home, Hannibal, MO; Seal of Bienville D'Hiberville, Louisiana State Library, New Orleans; four miniature medallions, Louisiana State Museum, New Orleans; "The Rescue," equestrian group, in action, New York City Police Department. Exhibited: New York Municipal Art Society, 1910; Ossining Historical Society. Address in 1953, Ossining, NY.

CHURCH, CHARLES F.
Painter. Member: Chicago SA; GFLA. Represented in the Vanderpoel Art Assoc. Collection, Chicago.

Address in 1929, 64 East Lake Street; 9244 South Winchester Ave.; London Guarantee Bldg., Chicago, IL.

CHURCH, FREDERICK EDWIN.
Painter. Born Hartford, CT, May 4, 1826. Landscape painter. Pupil of Thomas Cole at Catskill, where he worked for several years before opening a studio in New York. Was elected a member of the National Academy of Design in 1849. Traveled in South Labrador and the West Indies, and in 1868 made his first trip through Europe, which also extended to Palestine. Received a second-class medal at the Paris Exposition, 1867. His best known work is "The Falls of Niagara," owned by the Corcoran Gallery of Art; also the "Aurora Borealis." Died April 7, 1900 in NYC.

CHURCH, FREDERICK STUART.
Painter. Born 1842, Grand Rapids, MI. Pupil of Chicago Academy of Design, L.E. Wilmarth, Walter Shirlaw, National Academy of Design and Art Students League of New York. Silver medal, St. Louis Exp., 1904. Painter in oil and water color, illustrator and etcher. Elected to National Academy, 1885. Member: AWCS; New York Etching Club; Society of Illustrators, New York. Studio, New York. Work: "Moonrise," Metropolitan Museum, New York, Hudson River School of Painting. Died Feb. 18, 1924 in NYC.

CHURCH, HENRY.
Sculptor and painter. Born in 1836. Worked: Chagrin Falls, Ohio. Carved large bas-relief in rock over the Chagrin River. Exhibited "Group of Owls" in stone and "Greyhound" in cast iron at the Museum of Modern Art. Died in 1908.

CHURCHILL, ALFRED VANCE.
Painter and teacher. Born Oberlin, OH, Aug. 14, 1864. Pupil of Julian Academy in Paris. Member: Union Internationale des Beaux Arts; College AA; North Shore AA. Dir. Art Dept., Iowa College, 1891-93; Dir. Art Dept., Teachers College, Columbia University, New York, 1897-1905; lecturer, Johns Hopkins University, Baltimore, 1902-03; University of Chicago, 1914, 1916 and 1917; Professor of the History and Interpretation of Art, Smith College, Northampton, MA, after 1907; Director, Smith College Museum of Art, after 1920; editor, Smith College Art Museum Bulletin. Address in 1929, Smith College Museum of Art; h. 38 Franklin Street, Northampton, MA. Died in 1949.

CHURCHILL, FRANCIS G.
Painter, illustrator and etcher. Born in New Orleans in 1876. Pupil of Cincinnati Academy. Address in 1926, Canal-Commercial Building, New Orleans, LA.

CHURCHILL, LETHA E.
Painter. Address in 1926, 3919 Wyandotte Street, Kansas City, MO.

CHURCHILL, WILLIAM WORCESTER.
Painter. Born in Jamaica Plains, MA, in 1858, and lived in Boston. Pupil of Bonnat in Paris. "Leisure" (girl dressed in white), signed and dated 1910, in Boston Museum of Fine Arts Collection. Address in 1926, Fenway Studios, Boston, MA. Died Feb. 15, 1926 in Wash., DC.

CHURCHMAN, E. MENDENHALL.
Painter. Born Brooklyn, NY. Pupil of Penna. Academy of Fine Arts, Tarbell and Benson in Boston. Member: Fellowship Penna. Academy of Fine Arts; Plastic Club; Society of Independent Artists. Address in 1926, Union Lane, Brielle, NJ. Died in 1939.

CHURCHMAN, ISABELLE SCHULTZ.
Sculptor, craftsman, and teacher. Born in Baltimore, MD, April 20, 1896. Studied: Teachers College, Columbia University, BS in Education; Maryland Institute; Rinehart School of Sculpture; and with Ephraim Keyser, Maxwell Miller. Member: San Diego Art Guild; La Jolla Art Center. Work: Tuskegee Institute; Medical Building, Baltimore, MD. Exhibited: Penna. Academy of Fine Arts, 1920-22; San Diego Fine Arts Society, 1930, 40, 46; La Jolla Art Center, 1945, 46. Taught: Ceramics, Adult Education, San Diego City Schools, 1945-46. Address in 1953, San Diego, California.

CHWAST, SEYMOUR.
Designer and illustrator. Born Aug. 18, 1931, in NYC. Studied at Cooper Union under Leon Friend. Work: Mus. of Mod. Art, NY; Greengrass Gal., NYC. Exhibitions: The Louvre, Paris, France, 1971; Lincoln Ctr., NYC; Brooklyn Mus.; Art Mus., Amsterdam; throughout Italy. Teaching: Instr. design and illustr., Cooper Union, 1975. Known for his numerous poster designs as well as animated commercials, book and children's book designs. Received many awards from ADC, AIGA, Cooper Union. Address in 1982, c/o Push Pin Studios, 67 Irving Place, New York, NY.

CIAMPAGLIA, CARLO.
Painter. Born in Italy, March 8, 1891. Pupil of Cooper Union; NAD. Member: Allied AA; Arch. Lg of NY; NS Mural P. Award: American Academy in Rome Scholarship, 1920. Instructor, Cooper Union Art School. Address in 1929, 1193 Broadway, New York, NY. Died in 1875.

CIANFARANI, ARISTIDE BERTO.
Sculptor and designer. Born in Agnone, Italy, August 3, 1895. Studied: Rhode Island School of Design, with Arthur William Heintzelman in France, and in Italy, with Dazzi, Zanelli, Selva. Member: Provi-

dence Art Club; Architectural League; Salma. Club; Audubon Artists; International Art Association, Rome. Awards: Prizes, Architectural League, 1942; Allied Artists of America; medal, Bologna, Italy. Work: Brown University; war memorial, Meriden, CT; Northborough, MA; Ogden, Utah; Fall River, MA; Providence, RI; statues, Muhlenberg College, PA; Our Lady of Providence Seminary, RI; Worcester, Mass. Exhibited: Penna. Academy of Fine Arts; Whitney Museum of American Art; World's Fair, New York, 1939; Audubon Artists; Architectural League; Ogunquit Art Association; Contemporary American Art; Providence Art Club; Newport Art Association; Rhode Island School of Design. Address in 1953, Providence, RI. Died 1960.

CIARDIELLO, JOSEPH G.
Illustrator. Born in Staten Island in 1953, he graduated from PSD in 1974, having illustrated for the Parsons Catalogue while still a student. He has illustrated books, including *The Great Houdini* and *Buffalo Bill*, as well as major magazines. He won a National Parks Purchase Prize in 1974 and his work is part of the collection of Mauro Graphics in Staten Island.

CIAVARRA, PIETRO.
Sculptor. Born Philadelphia, PA, June 29, 1891. Pupil of Charles Grafly, Guiseppe Donato, Charles T. Scott, Penna. Academy of Fine Arts, Philadelphia School of Industrial Art, Alfred Bottiau, Paris. Member: Fellowship Penna. Academy of Fine Arts; American Federation of Arts; Philadelphia Alliance. Represented in Fellowship of the Penna. Academy of the Fine Arts and Samuel Fleisher Galleries. Address in 1933, Germantown, Philadelphia, PA.

CICERI, EUGENE M.
Painter, working in New Orleans about 1850.

CICERO, CARMEN LOUIS.
He was born 1926 in Newark, NJ. Earned B.S., Newark State Col. Studied under Motherwell. Taught at Sarah Lawrence, now at Montclair State Col. Awarded Guggenheim (1957 & 1963); Ford Foundation Purchase Prize, (1965). Exhibited at Newark Museum; Brooklyn Museum; MOMA; Whitney; Art Inst. of Chicago; PAFA; University of Colorado. In collections of Guggenheim; University of Michigan; MOMA; Art Gallery of Toronto; Worcester Art Museum; and Whitney.

CIMINO, H(ARRY).
Wood engraver and illustrator. Born in Marion, IN, Jan. 24, 1898. Pupil of AIC; ASL of NY. Illustrated: "Gifts of Fortune," by Tomlinson (Harper); "Sutter's Gold," by Cendrars (Harper); "The King's Henchman," by Millay (Harper). Address in 1929, 2 East 23rd Street; h. 102 East 22nd Street, New York, NY; summer, Falls Village, CT.

CIMIOTTI, GUSTAVE.
Painter. Born in New York, Nov. 10, 1875. Pupil of ASL of NY under Mowbray, Cox, J. Alden Weir and Robert Blum; Constant in Paris. Member: Salma. C., 1908; Grand Cent. AG; Montclair AA. Address in 1929, 51 West 10th Street, New York, NY.

CIRINO, ANTONIO.
Painter, craftsman, writer, teacher. Born Serino, Italy, March 23, 1889. Pupil of A. W. Dow. Member: Rockport AA; Providence AC; Springfield AL; North Shore AA; Eastern AA; Salma. C. Award: Prize, Springfield Art League, 1926. Author of "Jewelry Making and Design." Address in 1929, 108 Vinton Street, Providence, RI; summer, Granite Street, Rockport, MA.

CITRON, MINNA WRIGHT.
Painter and printmaker. Born Oct. 15, 1896. Studied painting at the Brooklyn Inst. of Arts and Sc. with Benjamin Kopman; commercial art at the NY School for Applied Design; Art Students League with Kenneth Hayes Miller, H. Sternberg, and K. Nicolaides. Exhib.: Solo at Brownwell-Lawbertson Gallery in 1932; "Feminaries," Midtown Cooperative Galleries, 1935. Address in 1982, 145 Fourth Ave., New York, New York.

CLAGHORN, JOSEPH C.
Painter, etcher, and teacher. Born Philadelphia, Sept. 4, 1869. Pupil of Anshutz; PAFA. Member: S. Wash. A; Fellowship PAFA; Landscape Club of Wash. Instructor in arts and crafts, Central High School, Washington. Address in 1929, Cabin John, MD.

CLAPP, WILLIAM HENRY.
Painter, etcher, and teacher. Born Montreal, Canada in 1879. Pupil of Jean Paul Laurens. Member: Royal Canadian Academy; CA AC; Montreal AC; Oakland AL; Pen and Pencil C., Montreal. Work: Canadian National Gallery; Montreal Art Gallery; Oakland Art Gallery; Montreal Arts Club and in possession of various Provincial Governments of Canada. Director, Oakland Municipal Art Gallery. Address in 1929, Oakland Art Gallery, Civic Auditorium, Oakland, CA. Died in 1954.

CLARK.
As "Clark Sculpt," this man signed three copperplates of buildings in Lancaster, PA. The work was evidently done between 1813 and 1820.

CLARK, ADELE.
Painter. Pupil of D. J. Connah, Kenneth Hayes Miller, Henri and Chase. Member: Richmond Art Club. Work: "Portrait of R. A. Dunlop," Richmond Chamber of Commerce.

CLARK, ALLAN.
Sculptor. Born June 8, 1896/98, in Missoula, MT. Studied at Puget Sound College. Pupil of Polasek at Art Institute of Chicago; R. Aitken at National Academy of Design, NY; Japanese and Chinese Masters. Member of National Sculpture Society; Society of Independent Artists; American Institute of Arts and Letters; Society of Santa Fe Painters and Sculptors. Taught at Beaux-Arts Inst. Traveled in Orient. Painted in Santa Fe, NM. Award: Rosenwald Memorial prize ($500), Grand Central Art Galleries, 1930. Work: Bronze statue, "The Antelope Dance," marble bust; "Mme. Galli-Curci." In collections of Metropolitan Museum of Art; Honolulu Academy of Arts; Whitney; and Seattle. Exhibited at National Sculpture Society. Address in 1933, Grand Central Galleries, NYC; summer, Santa Fe, NM. Died April 27, 1950.

CLARK, ALSON SKINNER.
Painter, illustrator, craftman, etcher, and teacher. Born Chicago, March 25, 1876. Pupil of Simon, Cottet, Whistler, Mucha and Merson in Paris; Chase in New York. Member: Paris AAA; Chicago SA; Allied AA; Chicago Cliff Dwellers; Calif. PM; Calif. AA; Laguna Beach AA. Awards: Bronze medal, St. Louis Exp., 1904; Cahn prize, AIC, 1906; bronze medal, P.-P. Exp., San F., 1915; hon. mention, Los Angeles Museum, 1922; Grand Museum prize, Southwest Museum, Los Angeles, 1923; Huntington prize, Los Angeles Museum, 1924. Work: Municipal commission purchase; "The Coffee House," Art Institute of Chicago; lithographs in Hackley Gallery, Muskegon, MI, Victoria Museum, London; Union League C., and University C., Chicago; Municipal collection, Watertown, NY; State Library, Sacramento, CA; curtains, New Community Theater, Pasadena; murals, Carthay Circle Theatre, Los Angeles; murals, First Nat. Bank, Pasadena; panels, Town Club, Pasadena. Represented in Pasadena High School collection of paintings; Woman's Athletic Club, Los Angeles; Chic. Athletic Club, Chicago. Died 1949.

CLARK, ALVIN.
Painter and engraver. Born March 8, 1804 in Ashfield, MA. He was an engraver and was employed for a short time in Boston, where he made watercolors and India ink portraits. He also painted in Providence, RI, New York and Fall River, MA. In 1835, at forty years of age, Clark became interested in telescopes and made the first achromatic lenses manufacured in this country. Died Aug. 19, 1877 in Cambridge, MA.

CLARK, C. H.
Painter. Pupil of Julian and Delecluse Academies in Paris. Address in 1926, 432 Baldwin Street, Meadville, PA.

CLARK, ELIOT C(ANDEE).
Painter, teacher, lecturer, and writer. Born New York, March 27, 1883; son of Walter Clark. Member: ANA, 1917; NAC; SPNY; AWCS; Allied AA; Conn. AFA; Salma. C.; Int. Soc. AL; MacD.C.; A. Fund S.; NYWCC. Awards: Third Hallgarten prize, NAD, 1912; Ranger purchase prize, NAD, 1922; Edgar B. Davis prize, San Antonio, Texas, 1929. Work: "March," Maryland Institute, Baltimore; "Santa Maria delle Salute," Bloomington (Ind.) Art Assoc.; "Rolling Country," owned by estate of Woodrow Wilson; "Winds of Destiny," Dayton Museum; "Autumn Twilight," Fort Worth (Texas) Museum; "Golden Autumn," Woman's Forum, Wichita Falls; "Landscape," NAC. Teacher, Art Students League, 1912-1914. Author "Alexander Wyant"; "J. Francis Murphy"; "John Twachtman"; "Theodore Robinson," and writer for art magazines. Address in 1929, Kent, CT. Died in 1980.

CLARK, ELIZABETH L.
Painter. Member: Balto. WCC. Address in 1929, 1025 North Calvert Street, Baltimore, MD.

CLARK, ELSIE S.
Painter. Born in Providence, RI, 1881. Studied in Paris. Address in 1926, Rodin Studios, 200 West 57th Street, New York.

CLARK, EMELIA M. GOLDSWORTHY.
Painter and teacher. Born Platteville, WI, June 3, 1869. Pupil of AIC; Otis Art Inst., Los Angeles; Pratt Inst.; Dow, Forsyth, Snell, Batchelder, Mannheim, Fursman, Vanderpoel and Townsley. Member: Calif. AC; West Coast Arts, Inc.; Calif. WCS; MacDowell C. of Allied Arts; Artland C. Formerly art director, Western State Normal College, Kalamazoo, Mich. Author and art editor, "Public School Methods," Chicago. Address in 1929, 114 West 42nd Street, Los Angeles, CA. Died c. 1955.

CLARK, FREEMAN.
Painter. Born Holly Springs, MS. Pupil of Chase; Wiles; ASL of NY; NY School of Art; Shinnicock School of Art. Represented in Riverside Branch Public Library, New York, NY. Address in 1929, Freeman Place, Holly Springs, MS.

CLARK, (GEORGE) FLETCHER.
Sculptor and illustrator. Born in Waterville, KS, November 7, 1899. Studied: University of California, BA; Beaux-Arts Institute of Design; in Europe. Illustrated, "Penny Puppets, Penny Theatre and Penny Plays," 1941. Work: Wood Memorial Gallery, Montpelier, VT; private collections. Exhibited at Calif. Palace of Legion of Honor, 1933; Avant-Garde Gallery, NYC, 1959; Gilbert Gallery, San Francisco, 1968; others. Address in 1953, 7 East 9th St., NYC. Address in 1982, San Francisco, CA.

CLARK, HARRIETTE A.
Miniature painter. Born in De Pere, WI, 1876. Pupil of Laurens and Blaschet in Paris. Painted miniatures of Ex-President Diaz and Madame Diaz. Address in 1926, 27 West 67th Street, New York City, NY.

CLARK, HERBERT F.
Painter and illustrator. Born Holyoke, MA, 1876. Pupil of Rhode Island School of Design, Providence, RI, and the School of the Corcoran Art Gallery, Washington, DC. Specialty, landscapes. Address in 1926, 3034 R Street, NW, Washington, DC.

CLARK, HERBERT WILLIS, JR.
Sculptor. Born in Providence, Rhode Island, 1877. Studied sculpture at Rhode Island School of Design. Employed as designer by Gorham Company which made small decorative bronzes. Work: "Saddle Horse" (bronze), 1911. Died in 1920.

CLARK, JAMES.
Engraver. In 1840, James Clark was an engraver of bank-notes, cards, etc., with an establishment at 67 Broadway, New York City.

CLARK, JAMES LIPPITT.
Sculptor, craftsman, and lecturer. Born Providence, RI, November 18, 1883. Pupil of Rhode Island School of Design. Traveled Africa, Europe, and Orient. Member: Animal Painters and Sculptors; New York Zoological Society; and National Sculpture Society. In collections of Museum of Natural History; Rhode Island School of Design; Ohio State University; and National Museum, Washington, DC. Award: Speyer Memorial prize, National Academy of Design, 1930. Address in 1933, 705 Whitlock Avenue, Bronx, NY; care of the American Museum of Natural History, 77th Street and Central Park; h. 40 West 77th Street, NYC. Died in 1957.

CLARK, JOHN DEWITT.
Sculptor. Born in Kansas City, Missouri. Studied: Kansas City Art Inst.; San Diego State Col.; with Lowell Houser, Everett Jackson, John Dirks. Work: The Mexican North Am. Cultural Inst., Mexico; Palomar College; Southwestern College; La Jolla Museum of Contemporary Art. Exhibitions: Findlay Gallery, NY; Eleven Calif. Sculptors, Western Museum Assn.; Santa Barbara West Coast Invitational; San Diego Fine Arts Gallery; Mex.- North Am. Cult. Inst., Mexico City. Media: Black granite, bronze. Address in 1982, c/o Art Dept., Southwestern College, Chula Vista, CA.

CLARK, MATT.
Illustrator. Born in Coshocton, Ohio, in 1903. He was educated at the National Academy Art School in New York. *College Humor* published his first illustration in 1929 which led to a career with *The Saturday Evening Post*, other major magazines of the time. He was well known for his watercolor and pen and ink drawings of the early West, with particular attention to horses and cowboys.

CLARK, ROLAND.
Painter and etcher. Born New Rochelle, NY, April 2, 1874. Address in 1929, 49 West 12th Street; h. 37 Madison Ave., New York, NY; summer, "Breezewood," Peconic P.O., NY. Died in 1957.

CLARK, ROY C.
Landscape painter. Born Sheffield, MA, April 3, 1889. Pupil of Edgar Nye; Irving Wiles; William Judson. Member: S. Indp. A.; Wash. Landscape C; Wash. SA; Wash. WCC. Address in 1929, 144 Uhland Terrace, Washington, DC; summer, 8 Pine Street, Pittsfield, MA.

CLARK, SARAH L.
Painter, illustrator, and teacher. Born Philadelphia, PA, Aug. 22, 1869. Pupil of Chase and Carlson; PAFA. Specialty, pathological and surgical drawings. Address in 1929, 642 North 42nd Street, Philadelphia, PA. Died in 1936.

CLARK, VIRGINIA KEEP.
Portrait painter. Born New Orleans, LA, Feb. 17, 1878. Pupil of William Forsyth, J. C. Beckwith, Howard Pyle. Member: NA Women PS. Address in 1929, 4 East 66th Street, New York, NY; summer, "Windy Meadow," Oyster Bay, LI, NY.

CLARK, WALTER.
Landscape painter. Born in Brooklyn, March 9, 1848. Pupil of Innes. He became an Associate of the National Academy in 1898 and an Academician in 1909. Among his paintings were "In Early Leaf" and "Gloucester Harbor." He died March 12, 1917 in Bronxville, NY.

CLARK, WILLIAM BULLOCK (MRS).
Painter. Member: Baltimore WCC. Address in 1929, 3 Upland Road, Baltimore, MD.

CLARKE, FREDERICK BENJAMIN.
Sculptor. Born Mystic, CT, in 1874. Pupil of Augustus Saint-Gaudens. Member: Beaux-Arts Institute of Design. Works: "Loton Horton" tablet, "Alfred E. Smith," NY; "Angeline Elizabeth Kirby" tablet, Wilkes-Barre, PA; "Over Door Panel," Grace Dodge Hotel, Washington, DC. Address in 1933, 304 East 44th Street, New York, NY. Died in 1943.

CLARKE, GLADYS DUNHAM.
(Sylvanna Warren). Sculptor, painter, and writer. Born in Southington, Conn., August 24, 1899. Studied with Dickinson, Du Mond, Fogarty, Gruger, Lentelli, Calder, and Bridgman. Member: National Association Women Painters and Sculptors. Address in 1933, Weston, Conn.

CLARKE, JOHN LOUIS.
Sculptor, painter, and woodcarver. Born in Highwood, Montana, 1881. Attended Indian school, then schools for the deaf beginning 1894. Worked in a Milwaukee factory carving altars around 1900. In 1913, established his studio in East Glacier. Work in Art Institute of Chicago, Montana Historical Society, Museum of Plains Indians (Browning). Specialty was wildlife, preferably bears and mountain goats. Worked in cottonwood, among other materials. Died in Cut Bank, Montana, in 1970.

CLARKE, RENE.
Painter and illustrator. Member: NYWCC; Phila. WCC. Address in 1929, 46 Bayley Avenue, Yonkers, NY; 250 Fifth Avenue, New York, NY.

CLARKE, THOMAS.
Engraver. The name of this engraver in the stipple manner first appears in 1797, when he was engraving portraits and subject plates of the *American Universal Magazine* of Philadelphia, and illustrations for an edition of "Telemachus," published by David Longworth of New York. He was apparently in both cities in this year, as he signed his plates respectively, "T. Clarke, Sculp.," Philadelphia, 1779, and "Engraved by Thos. Clarke, NY." Clarke was engraving in New York at least as late as 1800.

CLARKE, THOMAS SHIELDS.
Sculptor and painter. Born in Pittsburgh, PA, in 1860. Studied painting and sculpture at Ecole des Beaux Arts, Paris, and in Rome and Florence, for 11 years. Exhibited works and won many medals at London, Madrid, Berlin, Paris, Chicago Exposition, and at Exposition of San Francisco and Atlanta, GA. He executed many large works in bronze and marble for New York, San Francisco, Chicago, and other cities. Pictures in Museums of Boston and Philadelphia. Member: Royal Society of Arts, London; National Sculpture Society; Metropolitan Museum of Art; American Museum Natural History; Architectural League; Associate National Academy of Design; National Arts Club. Among his best known paintings is "Night Market, Morocco," owned by the Philadelphia Art Club. Address in 1917, 7 West 43rd street, NYC; h. Lenox, MA. Died November 15, 1920, in NYC.

CLARKSON, RALPH ELMER.
Portrait painter and teacher. Born Amesbury, MA, Aug. 3, 1861. Pupil of School of Boston Museum; Julian Academy under Lefebvre and Boulanger in Paris. Member: ANA, 1910; Chicago SA; Municipal Art Lg. of Chicago; NYWCC; Port. P.; AFA; Chicago WCC; Chicago PS; Municipal Art Commission; Chicago AC. Instructor, AIC. Awards: Cahn prize, AIC, 1909; hors concours (jury of awards), P.-P. Exp., San F., 1915. Work: "A Daughter of Armenia," Art Institute of Chicago. Address in 1929, 410 South Michigan Avenue; h. 255 Dearborn Street, Chicago, IL; summer, Oregon, IL. Died in 1942.

CLASSEN, WILLIAM M.
Engraver. This name is signed to a few well-engraved line-plates of Bldgs. and book-illustrations as "Wm. M. Classen, Eng. No. 1 Murry Street, Corner of B. Way" (New York). The apparent date of these plates is about 1840-50. On one plate seen, the name is signed "J. M. Classen Sc.," though the work seems to be the same.

CLAUS, MAY AUSTIN.
Painter. Born in Berlin, NY, Aug. 18, 1882. Pupil of School of Boston Museum and of W. A. J. Claus. Member: Penna. S. Min. P. Address in 1929, 410 Boylston Street, Boston, MA; summer, Provincetown, MA.

CLAUS, WILLIAM A. J.
Portrait painter. Born Maintz, Germany, June 14, 1862. Pupil of Grundmann in Boston; Julian Academy in Paris; Henri Quyton in Belgium. Work: "Old Pioneer," Boston Art Club; "Gov. Greenhalge," State House, Boston; "Carl Faelten," Faelten Hall, Boston; "Dr. Eben Tourjee," N.E. Conervatory, Potsdam College, Potsdam, NY; altar pieces at the Church of St. Francis de Sales, Boston; portraits of prominent natives painted in India, 1884 to 1887. Director, Claus Art School. Address in 1929, 410 Boylston Street, Boston, MA.

CLAY, EDWARD WILLIAMS.
Engraver. Born April 9, 1799 in Phila., PA. Clay is said to have been a midshipman under Commodore Perry, but he later studied law and was admitted to the Phila. bar in 1825. He had, however, a decided leaning toward art; he drew some of the plates engraved for Child's "Views of Philadelphia," and he drew upon stone for the lithographing firm of Childs & Inman. Clay was a merciless caricaturist, and some of his lampoons of fellow-citizens are said to have caused him much personal inconvenience. In the Philadelphia directories of 1835-36, his profession is given as "Artist." He engraved several fairly well-executed plates in the stipple manner, the best of these being a portrait of the Rev. Joseph Eastburn. His caricatures were etched. Died Dec. 3, 1837, in NYC.

CLAY, MARY F. R.
Sculptor and painter. Exhibited: Pennsylvania Academy of Fine Arts, 1924. Member: Fellowship, Penna. Academy of Fine Arts, Philadelphia; sign; National Association of Women Painters and Sculptors; North Shore Art Association; Plastic Club. Awards: Proctor prize, National Academy of Design, 1923; Kohnstamm prize ($250), Art Institute of Chicago, 1925. Address in 1933, Bar Harbor, ME. Died in 1939.

CLAYPOOLE, JAMES.
Painter. Was the earliest native artist of Pennsylvania. He was born in Philadelphia, 1720, and died in the West Indies about 1796. He was the son of Joseph Claypoole of Philadelphia and of Edith Ward. Joseph Claypoole was the First Warden of Christ Church, Philadelphia, and was "concerned in the promoting and assisting of the building of Christ Church, and contributed much toward it." Joseph Claypoole, the artist's father, was born in 1677, and died before May 3, 1744. He was the son of James Claypoole, friend of Penn, Patentee of PA, and Register General of the Colony. The first James Claypoole was a wealthy merchant. His son Joseph, father of the artist, was also a man of wealth, as he was a large property owner in Philadelphia. James Claypoole painted portraits in Philadelphia before 1750; little is known of his paintings, but he was the instructor of his nephew, Matthew Pratt, whose autobiographical notes state that he was apprenticed "To my uncle James Claypoole, limner and portrait painter in general" in 1749. His work shows that he was guided by a painter of no mean acquirements. Claypoole abandoned art for public life and was High Sheriff of Philadelphia during the Revolutionary War. His daughter, Elizabeth, married Timothy Matlack, the soldier and patriot of Phila., whose portrait was painted by Charles Willson Peale. His daughter Mary married James Peale, the artist, brother of Charles Willson Peale, and his cousin John Claypoole was the husband of the celebrated Betsy Ross. There is a portrait inscribed on the back of the canvas "Margaret Allen drawn and colored by Claypoole, Philadelphia, 1746." Charles Willson Peale, in a letter, mentions "James Claypoole," whose painting he examined at his home in Philadelphia in 1762.

CLAYTON, (HENRY) CHARLES.
Sculptor, painter, educator, and lecturer. Born in Goodman, Wis., September 11, 1913. Studied: University Wisconsin, BA, MA, with Wolfgang Stechow, Oskar Hagen, John Kienitz, James Watrous. Member: Artists Equity Association. Awards: Wisconsin Salon, 1947; Wisconsin Annual, 1939. Work: IBM; City of Milwaukee; University of Wisconsin; Beloit College; Gimbel's Wisconsin Collection; North Carolina State Art Society. Exhibited: Grand Central Art Gallery, 1947; Art Institute of Chicago, 1949; Wis. Salon, 1939-42, 1948-50; Milwaukee Art Institute, 1939-42, 47; Gimbels, 1949. Taught: Education Director, Milwaukee Art Institute, 1946-47; Associate Professor, 1947-49, Chm. Department of Art, 1949-51, Beloit College; Professor, Chairman of Department of Art, University Miami, Coral Gables, Florida, from 1951. Address in 1953, University of Miami, Coral Gables, Fla.; h. South Miami, Fla.

CLEAR, CHARLES VAL.
Sculptor, painter, lecturer, and teacher. Born in Albion, IN, in 1910. Pupil of John A. Herron Art School; Corcoran School of Art; sculpture with Myra Richards, J. Maxwell Miller, Seth Velsey. Member: Indianapolis Art Association; Elkhart Art League; Society of Washington Artists; Washington Art League; Columbia Water Color Society; American Federation of Arts, NY. Work: Phillips Memorial Gallery, Washington, DC; Society of Washington Artists; John Herron Art Institute; Mt. Rainier Public Library. Director, Art League of Washington. Address in 1953, Akron, OH. Died c. 1968.

CLEAVER, ALICE.
Painter and teacher. Born Racine, WI, April 11, 1878. Pupil of Vanderpoel, Chase, Beaux, Biloul; Lucien Simon in Paris. Member: Lincoln AG; Omaha SFA. Award: John L. Webster prize, Omaha SFA, 1922. Address in 1929, Falls City, NE.

CLEAVER, MILDRED DAY.
(Mrs. Chester H.). Sculptor. Born in Newark, NJ, November 7, 1888. Studied: Norton School of Art; and with Genevieve Karr Hamlin. Member: Palm Beach Art League; American Artists Professional League. Exhibited: Palm Beach Art League, 1944, 45, 46. Address in 1953, West Deal, NJ.

CLEAVES, MURIEL MATTOCKS.
(Mrs. H. H. Cleaves). Sculptor, illustrator, and teacher. Born in Hastings, NE. Pupil of M. C. Carr, John S. Ankeney, Birger Sandzen, Art Institute of Chicago. Member: Staten Island Institute, Art and Sculpture; Kansas City Society of Artists. Awards: Second and third prizes, water colors, Pueblo, 1922; honorable mention, Kansas City Art Institute, 1923. Address in 1933, Staten Island, NY. Died in 1947.

CLELAND, THOMAS MAITLAND.
Painter, illustrator, and writer. Born New York, NY, Aug. 18, 1880. Member: Boston SAC. Awards: Medal, Boston SAC, 1920; 2 gold medals and bronze medal, Am. Inst. of Graphic A., 1920. Address in 1929, 70 Fifth Avenue, New York, NY; h. Route 2, Danbury, CT. Died in 1964.

CLEMENS, ISAAC.
Engraver. The *New York Gazette*, 1776, contains the following advertisement: "Isaac Clemens, Engraver (who lately arrived with his Majesty's Fleet from Boston, in New England) informs the Gentlemen of the Navy and Army and the Public in general, that he now carries on the Engraving Business at his shop near the French Church, 1 King Street, New York." This advertisement disappears in a very short time, and Mr. Clemens probably went back to England, as nothing more is known about him.

CLEMENT, EDWARD H.
Painter. Born in Chelsea, MA, 1843. Pupil of Boston Art Students' Association.

CLEMENTS, GABRIELLE de VEAUX.
Painter and teacher. Born in Philadelphia, PA, 1858. Pupil of Robert-Fleury and Bouguereau in Paris. Member: Fellowship PAFA; Wash. WCC; S. Wash. A.; Chicago SE; North Shore AA; Charleston EC. Awards: Second Toppan prize, PAFA; Mary Smith prize, PAFA, 1895. Work: Painting in St. Patrick's Church, Washington, DC; mural paintings: St. Paul's Chapel, Baltimore; St. Matthews Church, Sparrow Point, MD; etchings in National Museum, Washington, DC. Address in 1929, 1673 Columbia Road, Washington, DC; summer, Lanesville, Gloucester, MA. Died March 26, 1948.

CLEMENTS, GEORGE HENRY.
Painter. Member: New York Water Color Club. Born in Louisiana. Landscape and genre painter. He exhibited a portrait of Frank Duveneck at Cincinnati Museum in 1925. Address in 1926, 33 West 67th Street, New York City, NY. Died in 1935.

CLEMENTS, ROSALIE.
Painter. Born Washington, DC, Jan. 5, 1878. Pupil of E. F. Andrews in Washington; F. Luis Mora and Thomas Fogarty in New York. Member: PBC; S. Indp. A. Address in 1929, Wiccopee, Hopewell Junction, Dutchess Co., NY.

CLEPHANE, LEWIS PAINTER.
Painter. Born Washington, DC, Feb. 8, 1869. Pupil of Birge Harrison; Alexander Robinson in Holland. Member: S. Wash. A.; Wash. AC; S. Indp. A.; AFA. Address in 1929, 1824 Ontario Place, Washington, DC.

CLEVENGER, SHOBAL VAIL.
Sculptor. He was born October 22, 1812, near Middleton, OH. Largely self-taught, he executed many busts of prominent men and was enabled to go abroad for study. Travelled to Philadelphia, Washington, Boston, NYC. Work at the Maryland Historical Society and the NY Historical Society. Died Sept., 1843, at sea.

CLEWS, HENRY, JR.
Sculptor and painter. Born in New York City in 1876. Studied at Amherst College and Columbia University; also at Lausanne and Hanover Universities. Worked independently in Paris and New York City. Several exhibitions held in New York City, 1903-14; memorial exhibition, Metropolitan Museum of Art, 1939. Works: "Frederick Delius," English composer (bronze), 1916-17. Address in 1918, 27 West 51st Street. Died in 1937.

CLIFFORD, JUDY DEAN.
Illustrator. Born in Orange, California, in 1946. She attended the University of Washington in Seattle and studied art at the Academy of Art in San Francisco for four years. Her career began with a series for the Simpson Lee Paper Co., and she has since won awards at the Western ADC Show and exhibited in the S of I Annual Exhibitions in New York and Los Angeles. She has worked for magazines and produced posters for Levi's and the San Francisco Ballet.

CLIFTON, ADELE ROLLINS.
Painter, illustrator, etcher, writer and teacher. Born Brooklyn, NY, July 27, 1875. Pupil of Alexander W. Dow; William M. Chase. Member: Plastic C; Phila. Alliance. Address in 1929, 1830 Rittenhouse Square, Philadelphia, PA; summer, Whitefield, NH.

CLIME, WINFIELD SCOTT.
Painter. Born Philadelphia, PA, Nov. 7, 1881. Pupil of Corcoran Art School, Washington; ASL of NY. Member: S. Wash. A.; Wash. WCC; Wash. AC; Landscape C., Washington; NAC; Salma. C.; Allied AA; AFA; Tiffany Foundation. Represented in the Los Angeles Museum of Art. Address in 1929, Old Lyme, CT. Died in 1958.

CLINEDINST, BENJAMIN WEST.
Painter. Born Woodstock, VA, Oct. 14, 1859. Studied at Ecole des Beaux Arts, Paris. Pupil of Cabanel and Bonnat. Specialty, genre pictures and portraits; illustrator of books. Painted portraits of Theodore Roosevelt, Admiral Peary, Gen. Curtis Lee, Edward Echols, Gen. E. W. Nichols. Elected Member of the National Academy of Design, 1898. Awards: Evans prize, AWCS, 1900; silver medal, Pan-Am. Exp., Buffalo, 1901; silver medal, Charleston Exp., 1902. Address in 1926, Pawling, NY. Died Sept. 12, 1931 in Pawling, NY.

CLIVE, RICHARD R.
Painter. Born in NYC, Jan. 8, 1912. Study: NAD; NYU; with Dan Greene, Harold Wolcott. Work: Navy Combat Art Collection; Municipal Coll., Ossining, NY; Arts and Sci. Ctr., Nashua, NH; others, inc. commissions for Navy. Exhibitions: Salma Club Annual, 1961-82; Am. Artists Professional Lg.; Am. Veterans Soc. of Artists; Naval Art Coop, 1963-72; Stevens Inst. of Technology; etc. Awards: New Rochelle Art Assn., portrait and graphics; Am. Legion, Lt. Breng award; Miniature Art Soc. of NJ. Mem.: Salma. C. (hon.); Am. APL; Acad. Artists Assn.; Pastel Soc. of America; etc. Media: Oil, pastel, watercolor. Address in 1982, 29 Holly Street, Yonkers, NY.

CLIVETTE, MERTON.
Sculptor, painter, etcher, writer, lecturer, and teacher. Born in Wisconsin, June 11, 1868. Pupil of Chase, La Farge, Twachtman, Art Students League of NY; Rodin in Paris. Address in 1929, 92 Fifth Avenue, New York, NY; summer, Stamford, CT.

CLOAR, CARROLL.
Painter. Born in Earle, Ark., Jan. 18, 1913. Study: Southwestern at Memphis, BA; Memphis Acad. of Arts; ASL, MacDowell fellowship, 1940. Work: Met. Mus. of Art, MOMA, Whitney, NYC; Brooks Mem. Art Gallery, Memphis; Hirshhorn Mus., Wash., DC. Exhib.: Pittsburgh Int'l.; Whitney Annual; PAFA; Brooks Mem. Art Gallery, Memphis; others. Awards: Guggenheim Fellow, 1946; Am. Acad. of Arts and Letters Prize, 1967; Southwestern College, 1977. Rep.: Forum Gallery, NYC. Address in 1982, Memphis, TN.

CLONNEY, JAMES GOODWYN.
Genre and miniature artist. Born Jan. 28, 1812 in Liverpool, England. Started painting miniatures in New York, 1834, and exhibited in the National Academy, 1841-1852. Also exhibited at PAFA. Was elected an Associate Member of the National Academy in 1867. Died Oct. 7, 1867 in Binghamton, NY.

CLOPATH, HENRIETTE.
Painter. Born in Switzerland. Award: Gold medal, University of Okla., 1916. Writer and lecturer on modern painting. Address in 1926, Chalet Art Studio.

CLOSSON, WILLIAM BAXTER PALMER.
Painter and engraver. Born Thetford, VT, 1848. Pupil of Lowell Institute; travelled in Europe. Followed engraving on wood, 1872-94; then painted in pastel and oil. Awards: For wood engraving: Gold, silver, and bronze medals, Mass. Charitable Mechanics Assoc.; third class medal, Paris Salon, 1882; silver medal, Paris Expn., 1889; medal, Columbian Expn., Chicago, 1893; silver medal, Pan-Am. Exp., Buffalo, 1901; St. Louis Exp., 1904. Member: Boston Art Club; Copley Society; Society Washington Artists; Union Internationale des Beaux Arts et des Lettres; Conn. AFA; Allied AA; AI Graphic A; North Shore AA; NAC (life); PS Gallery Assoc. Proofs of his engravings are in many galleries, libraries, and museums. Paintings in Evans collection, National Gallery and Gallaudet College, Washington, DC; National Arts Club, NY. See "History of Wood Engraving in America," by W. J. Linton. Address in 1926, Newton, MA. Died May, 1926.

CLOUGH, JANE B.
Sculptor. Born Chicago, IL, March 30, 1881. Pupil of Solon Borglum, Mahonri Young, J. E. and Laura Fraser, Anna V. Hyatt. Member: National Sculpture Society (life); Kansas City Society of Artists. Address in 1933, 1 West 67th Street, New York, NY; h. Kansas City, MO.

CLOVER, LEWIS P., JR.
Born in New York, Feb. 20, 1819. He studied painting and engraving under Asher B. Durand. He had his studio for some years in New York and Baltimore. Exhibited at AAU and NA. Later he entered the church and, afterward, the priesthood. Among his paintings are "The Rejected Picture," "The Idle Man," and "The Phrenologist." Died Nov. 9, 1896 in NYC.

CLOVER, PHILIP.
Portrait painter. Born in 1842. He was formerly of Columbus, OH, but painted many Chicago politicians. Works: "Fatima," and "The Criminal." He died in 1905.

CLUSMANN, WILLIAM.
Painter. Born in North Laporte, IN, 1859. Pupil of Benczur at Royal Academy in Munich. Member: Chicago Society of Artists; Chicago Water Color Club. Awards: Hon. mention, Stuttgart, Germany, 1885. Died Sept. 28, 1927 in Chicago, IL.

CLUTE, BEULAH MITCHELL.
Painter, illustrator, and lecturer. Born Rushville, IL, March 24, 1873. Pupil of ASL of NY; AI Chicago. Member: Artists Guild, Chicago; AIC Alumni Assoc.; Cal. Book Plate Soc. Designer for the Three Redwoods Studio, Berkeley. Specialty, bookplates and illuminated parchments. Address in 1929, 2614 Channing Way, Berkeley, CA.

CLUTE, CARRIE E(LISABETH).
Painter, etcher, and teacher. Born Schenectady, NY, July 3, 1890. Pupil of Henry B. Snell. Member: AWSC; PBC; NA Women PS. Address in 1929, 67 Bedford St., New York, NY; summer, Rhinebeck, NY.

CLUTE, WALTER MARSHALL.
Painter and illustrator. Born in Schenectady, NY, Jan. 9, 1870. He was a pupil of the Art Students League of New York, and of Constant and Laurens in Paris. He received the 1910 prize of Art Institute of Chicago, and was vice-president of the Society of Western Artists at the time of his death. Died Feb. 13, 1915 in North Cucamonga, CA.

CLYMER, EDWIN SWIFT.
Painter. Born Cincinnati, Ohio, 1871. Pupil of PAFA. Member: Phila. Sketch C.; Phila. WCC. Work in Reading, PA, Museum of Art. Address in 1929, Lanesville P.O., Gloucester, MA.

CLYMER, JAMES FLOYD.
Painter. Born in 1893. Exhibited, Penna. Academy of Fine Arts, 1924, Philadelphia. Address in 1926, Provincetown, MA.

CLYMER, JOHN.
Illustrator. Born in Ellensburg, Washington, 1907. He studied in Vancouver and Port Hope, Canada, as well as in Wilmington and New York. He illustrated several Chrysler advertisements before painting a

cover for *The Saturday Evening Post* in 1947. In addition to illustrations in many major magazines, he has had special assignments for a number of Canadian publications and the Marine Corps.

COALE, GRIFFITH B.
Illustrator. Born in Baltimore, May 21, 1890, he studied art in Italy and Spain; also studied with M. Heymann in Munich; and with Richard Miller and Laparra in Paris. His career as a muralist and portrait artist was interrupted by World War II, during which time he founded the Navy's Combat Artists Corps and served as a Lieutenant Commander. Member: Charcoal C.; Mural P. His murals can be seen in public buildings in New York City and his portraits of famous Americans are in the collections of Johns Hopkins University and the Maryland Historical Society. Address in 1929, 125 West 11th Street, New York, NY. Died in 1950.

COAN, C. ARTHUR.
Painter, writer, and lecturer. Born Ottawa, IL, Dec. 16, 1867. Author of "History of an Appearance." "Southlumberland's Yule Tide," "The Fragrant Note Book" "Proportional Form," etc. Lecturer on art and archaeology. Address in 1929, Piermont Avenue, Nyack, NY.

COAN, FRANCES CHALLENOR.
Painter and illustrator. Born East Orange, NJ. Pupil of Henry B. Snell and E. M. Scott; Metropolitan Art School. Illustrator of "The Fragrant Note Book," etc. Designer and painter of stage settings. Address in 1929, Piermont Avenue, Nyack, NY.

COAN, HELEN E.
Painter, illustrator and teacher. Born Byron, NY. Studied: Art Students League of New York; pupil of Frederick Freer and William M. Chase. Member: California Art Club. Awards: Medals for oil and watercolor, Alaska-Yukon-Pacific Exposition, Seattle, 1909; medal and diploma, San Diego Exposition, 1915. Address in 1929, 204 North Burlington Avenue, Los Angeles, CA.

COAST, OSCAR REGAN.
Painter. Born Salem, OH, 1851. Studied with Yewell, Thomas Hickes and Fallers in Paris and Rome. Member: Salma. C., 1897; Wash. AC; Santa Barbara AC; AFA. Specialty: Landscapes. Address in 1929, 802 Union Title Bldg.; h. 418 East 19th Street, Indianapolis, IN. Died in 1931.

COBB, CYRUS.
Sculptor, painter, and musician. Born in Malden, MA, August 6, 1834. His twin brother, Darius Cobb, also noted as a painter. Pupil of John A. Jackson. Works: "Soldiers' Monument" on Cambridge Common; "America," "Paul Revere," at Boston; produced

many works of sculpture and painting of a national character, besides directing choruses and lecturing on art; wrote and illustrated "Sonnets to the Masters of Art." Member: Boston Art Club. Died in Allston, MA, January 29, 1903.

COBB, DARIUS.
Portrait painter and sculptor. Born at Malden, MA, Aug. 6, 1834. Twin brother of Cyrus Cobb, with whom he studied and worked until 1870. They worked near Boston. He painted portraits, some landscapes and figure pieces; he also cut several busts in marble. Lectured on art. Died April 23, 1919 in Newton Upper Falls, MA.

COBB, GERSHAM.
A book-plate engraver working about 1800. Worked in Boston at later date. He was most probably an American, as the only plate signed by him is of the pictorial type, with an American eagle bearing an oval frame, once containing a name, later carefully erased; there is a scratchy landscape at the base.

COBB, KATHERINE M.
Painter. Born Syracuse, Jan. 5, 1873. Pupil of Charles Hawthorne; Carlson; Webster. Member: PBC; Associated Artists of Syracuse. Address in 1929, 602 Comstock Avenue, Syracuse, NY.

COBER, ALAN E.
Illustrator. Born in NYC in 1935. He began law studies at the Univ. of Vermont, then returned to NY to attend SVA. His reputation as a top line and half-tone artist grew as his work appeared in books and magazines. The pen and ink drawings from his book *The Forgotten Society*, published by Dover Press, have been exhibited in galleries and museums nationwide. Named Artist of the Year in 1965 by the AG, he has received five gold medals, four Awards of Excellence and the Hamilton King Award from the S of I as well as two gold medals from the ADC. In addition, *The New York Times* has twice placed his children's books on their 10-Best list. Pres. of the Illustrators Workshop, he collects folk art.

COBURN, FREDERICK WILLIAM.
Illustrator and writer. Born Nashua, NH, Aug. 6, 1870. Pupil of ASL of Washington, DC, and NY. Member: Copley S.; Lowell AA; Concord AA. Address in 1929, 722 East Merrmack Street, Lowell, MA. Died in 1953.

COCHRAN, ALLEN D.
Painter. Born Cincinnati, OH, Oct. 23, 1888. Pupil of Kenyon Cox and Birge Harrison. Member: Salma. C. Address in 1929, Woodstock, NY.

COCHRAN, DEWEES.
(Mrs. Dewees Cochran Helbeck). Sculptor, painter, teacher, designer, and craftsman. Born in Dallas,

TX, April 12, 1902. Studied: Philadelphia Museum School of Industrial Art; University of Pennsylvania; Penna. Academy of Fine Arts, with Henry McCarter. Member: American Craftsmen's Education Council; honorary member, Doll Collectors of America Inc., Boston; National Institute of American Doll Artists (president, 1967-69, director, from 1975). Creator of the "Portrait Doll," "The Look-Alikes," "The Grow-Up Dolls." Exhibited: Marie Sterner Gallery, 1931; Philadelphia Print Club, 1931; Carpenter Art Gallery, Dartmouth College, 1952; Women's International Exp., 71st Armory, NY, 1959. Contributor to craft magazines. Taught: Design Director, Instructor, School for American Craftsmen, Hanover, NH, 1946-47; Director, Dewees Cochran Dolls. Address in 1982, Felton, CA.

COCHRANE, CONSTANCE.
Painter and teacher. Born Pensacola, Florida. Pupil of Elliot Daingerfield and Henry B. Snell. Member: Phila. School of Design for Women Alumnae; NA Women PS; Phila. AL; Ten Phila. P.; AFA. Represented in Twentieth Century Club, Lansdowne, PA; Bywood Public School, Upper Darby, PA. Address in 1929, 7103 Pennsylvania Avenue, Bywood, Upper Darby, PA.

COCHRANE, JOSEPHINE G.
Painter. Member: NA Women PS; Conn. AFA. Address in 1929, 123 West Monument Street, Baltimore, MD.

COCKCROFT, EDITH VARIAN.
Painter. Born in Brooklyn, NY, 1881. Member of National Association of Women Painters and Sculptors. Address in 1926, 17 East 39th Street, New York City.

COCKRELL, DURA (BROKAW).
Painter, craftsman, writer, lecturer, and teacher. Born Liscomb, Iowa, Feb. 16, 1877. Pupil of William M. Chase and Kenneth Hayes Miller. Member: Ft. Worth AA; Ft. Worth Painters Club. Award: Bronze medal, Woman's Forum, Dallas, TX, 1919; silver medal, Dallas Woman's Forum, 1926. Head of art dept, Texas Christian University. Fort Worth, 1900-1924; head of art dept. William Woods College, from 1925. Address in 1929, William Woods College, Fullton, MO.

COCONIS, CONSTANTINOS (TED).
Illustrator. Born in Chicago in 1937. He spent a year at the American Academy of Art and three months at the AIC, before the appearance of his first illustration in *Sunset* in 1954. His distinctive style and intricate technique have earned him a reputation resulting in the publication of his work by almost every major magazine, including *Redbook*, *Cosmopolitan*, *Playboy* and *Time*, as well as by many publishers such as Fawcett, The Viking Press and

Random House. Among his advertising assignments are movie campaigns and record covers. An award winner in the S of I Annual Exhibitions, he owns and drives formula race cars.

CODEZO, THOMAS.
Spanish-American painter. Born in Havanna in 1839. Studied in Paris with Henri Regnault. He came to the United States in 1869; worked in oil and crayon.

CODMAN, EDWIN E.
Painter. Member of Providence Art Club. Address in 1926, 166 Ontario Street, Providence, RI.

CODNER, WILLIAM.
Sculptor of gravestones. Born in Boston, Mass., July 24, 1709. Introduced portraits in mortuary art. Sons, Abraham and John, followed same specialty. Died in Boston, Mass., September 12, 1769.

COE, ETHEL LOUISE.
Painter, illustrator, lecturer, writer, and teacher. Born Chicago, IL. Pupil of AIC; Hawthorne and Sorolla. Member: Chicago PS; Chicago AC; Cordon C.; Chicago GA; NAC. Award: Young Fortnightly prize, AIC, 1911. Work: In Sioux City Art Museum; Vanderpoel AA Collection, Chicago. Director, Dept. of Art, Sarah Lawrence College, Bronxville, New York. Lecturer, AIC and Clubs. Address in 1929, care of Art Institute, Chicago, IL; 1223 Elmwood Avenue, Evanston, IL. Died 1938.

COE, THEODORE DEMEREST.
Painter. Born Suffern, NY, April 13, 1866. Pupil of John Twachtman and Carlo Rossi Academy in Paris. Member: Boston AC. Address in 1929, East Sandwich, MA.

COFFEE, THOMAS.
Sculptor. Born in England, c. 1800. Worked: NYC, 1830-69. Exhibited: Bust of Judge Hitchcock of Mobile, AL, Apollo Gallery, 1839; busts, including "Osceola," National Academy, 1841-42; statue of Henry Clay, American Institute, 1844, 56.

COFFEE, THOMAS, JR.
Sculptor. Born in NYC, c. 1839. Worked: NYC with father, Thomas Coffee.

COFFEE, WILL.
Painter. Exhibited water colors at Annual Exhibition of Water Colors at Penna. Academy of Fine Arts, Philadelphia, 1925. Address in 1926, 729 Walnut Street, Philadelphia.

COFFEE, WILLIAM JOHN.
Sculptor and painter. Born in England, c. 1774. Worked: Derby; London; NYC, 1816-1826; Albany, NY, 1827-45. Exhibited: Royal Academy, 1833;

Apollo Gallery, 1839. In 1818 he executed busts of Thomas Jefferson, his daughter, and granddaughter; also bas-reliefs for City Hall, Albany, NY. Died c. 1846.

COFFIN, GEORGE ALBERT.
Marine painter. He was born 1856, and died Feb. 3, 1922 in NYC.

COFFIN, ROBERT P. TRISTRAM.
Illustrator, writer, lecturer, and teacher. Born Brunswick, ME, March 18, 1892. Illustrations for "Crowns and Cottages," Yale University Press; "An Attic Room," Doubleday, Doran & Co.; pen and ink illustrations for "The Forum" and "The Bookman." Address in 1929, Aurora-on-Cayuga, NY; summer, Pennellville, Brunswick, ME.

COFFIN, SARAH TABER.
Painter. Born Vassalboro, ME, June 1, 1844. Pupil of Dr. Rimmer, R. Swain Gifford, W. Sartain, Frank Duveneck and Charles Woodbury; ASL of NY under C.Y. Turner, and Ross Turner in Boston. Member: Copley S; North Shore AA. Work: In Moses Brown School, Providence, RI. Address in 1929, Chestnut Hill, MA.

COFFIN, W. HASKELL.
Painter. Studied at Corcoran Art School, Washington, DC, and in Paris. Member: SI. Died 1941. Address in 1926, 80 West 40th St., NYC.

COFFIN, WILLIAM ANDERSON.
Landscape and figure painter. Born in Allegheny, PA, in 1855. Studied in New York and Paris. Elected an associate member of the National Academy of Design in 1898, and National Academy in 1912. Represented in collection of Metropolitan Museum, New York, and National Collection at Washington, DC. Died Oct. 26, 1925 in NYC.

COGDELL, JOHN STEPHANO.
Sculptor and painter. Born in Charleston, SC, Sept. 19, 1778. He was largely self-taught, but received some help from Washington Allston, and studied abroad. From about 1820 modelled a few busts of distinguished Americans. Exhibited at the National Academy; Penna. Academy; Artists' Fund Society; Boston Athenaeum; and American Academy. Died Feb. 25, 1847.

COGSWELL, RUTH McINTOCH.
Illustrator and teacher. Born Concord, NH, Aug. 17, 1885. Pupil of Yale School of Fine Arts; Henry B. Snell. Member: New Haven PCC; New Haven BPC. Address in 1929, 301 Alden Avenue, New Haven, CT.

COGSWELL, WILLIAM.
Painter. Born in Fabius, NY, 1819. He died in Pasadena, CA., 1903. He was practically self-taught

as a portrait painter. He resided at times in NY, Phila., Chicago, St. Louis, and Calif. His list of portraits inc.: Presidents Lincoln, Grant and McKinley. His "President Grant and Family" was in the Nat. Gallery, portraits of Gen'l Grant and Salmon P. Chase were in the Capitol, Washington, DC.

COHEN, ADELE.
Sculptor, painter. Born in Buffalo, NY. Studied at Art Institute Buffalo; Albright School of Buffalo; Parsons School of Art, NY. Works: Albright-Knox Art Gallery, Member's Gallery, Buffalo, NY; Museum Arts and Science, Evansville, IN; Univ. of Mass., Amherst; Towson College, Baltimore, MD. Commissions: Stage sets sculpted of polyester resins and fibres for the play, "Fando," Buffalo Fine Arts Academy and Workshop Repertory Theater, NY State Theater, 1967. Exhibitions: Art Across America, Institute of Contemporary Art, Boston, 1965; Western NY Exhibition, Buffalo Fine Arts Academy, 1957-71; Patteran Artists, NY State travel tour, 1975-77; Unordinary Realities, Xerox Corp, Rochester, NY, 1975; Michael C. Rockefeller Arts Center Gallery, State Univ. College, Fredonia, NY, 1975. Awards: Best of Show, Western NY Exhibition, 1964; Painting Award, Annual New England Exhibit, Silvermine Guild Artists, 1965 and 66; Paul Lindsay Sample Memorial Award, Chautauqua Exhibition of American Art, 1967. Member of Nat. Assoc. of Women Artists, Inc. Address in 1982, Snyder, NY.

COHEN, GEORGE.
Born 1919 in Chicago, IL. Educated at the School of the Art Inst. (Chicago-BFA) at Drake University and at University of Chicago. Taught at Northwestern since 1948. Awards from Art Inst., and Copley Foundation (1956). Exhibited at Bordelon Gallery (Chicago-1950); Alan Gallery, NYC; Feigen galleries in Chicago, LA and NYC; MOMA; Carnegie; SF Museum of Art. In collections of Lipman Foundation, and in many private collections.

COHEN, HY.
Painter. Born London, England, June 13, 1901. Pupil of NAD; William Starkweather. Address in 1929, 991 Carroll Street, Brooklyn, NY.

COHEN, ISABEL.
Painter. Born, Charleston, SC, April 12, 1867. Pupil of Elliott Daingerfield and Henry S. Rittenberg in NY; Joseph Noel, Rome, Italy; British Acad. of Art. Member: NA Women PS; PBC; NAC; Yonkers AC; Springfield AA; SSAL; AA of Charleston. Awards: Prize, St. Louis Exp.; first portrait prize, Charleston Exp. Address in 1929, The Colonial Studios, 39 West 67th Street, New York, NY; h. Gilbes Art Bldg., Meeting Street, Charleston, SC.

COHEN, KATHERINE M.
Sculptor and painter. Born in Philadelphia, March 18, 1859. Pupil of Penna. Academy of Fine Arts, Art

Students League of NY; under Augustus Saint-Gaudens, and with Mercie in Paris. Among her best known works: Statue of General Beaver, bronze of Abraham Lincoln, "Dawn of Thought," and "Vision of Rabbi Ben Ezra." She died in Philadelphia, Dec. 14, 1914.

COHEN, LEWIS.
Painter. American. Born June 27, 1857 in London. Pupil of Alphonse Legros, J. Watson Nicholl, and A. S. Cope. Elected an Associate Member of the National Academy. He painted "Puente San Martin, Toledo." Died 1915 in New York.

COHEN, NESSA.
Sculptor. Born in NYC, in 1885. Pupil of James E. Fraser, NY; and with Despiau and Charles Malfrey in Paris. Studied at Cooper Union and Art Students League. Among her work: "Sunrise," Havana, Cuba; and groups of Indians of the Southwestern United States, American Museum of Natural History. Exhibited at National Sculpture Society, 1923; Penna. Academy of Fine Arts, Philadelphia, 1924. Member of NY Architectural League, National Association of Women Painters and Sculptors, Society of Independent Artists. Address in 1953, Newark, NJ.

COHILL, CHARLES.
A portrait painter born in 1812 in PA. A painting of a Shakespearean character was shown in Philadelphia at Barr & Co. in 1923. It was inscribed on the back of the canvas "Charles Cohill, 1838."

COINER, CHARLES TOUCEY.
Painter. Born Santa Barbara, CA, August 21, 1898. Address in 1929, 271 East Meehan Avenue, Mt. Airy, Philadelphia, PA.

COLBORN, JANE TAYLOR.
Sculptor and educator. Born in Rochester, NY, July 13, 1913. Studied at University of Rochester, NY, B.A. (English), 1934; Cornell University, Ithaca, summer school, drama and speech, 1935; Silvermine Guild School of Arts, Westport, CT. Work in Springfield Art Museum, MA. Has exhibited at Silvermine Guild of Artists; Wadsworth Antheneum. Received awards from Springfield Art League, purchase award, Best in Show; New England Exhibition, Renaissance Art Foundry, award for metal sculpture; New Haven Paint and Clay Club, Jay Johnston Award Metal Sculpture. Member of National Association of Women Artists; Artists Equity Association, New York; Silvermine Guild Artists; New Haven Paint and Clay Club. Taught at Silvermine Guild of Artists. Works in metal. Address in 1982, New Canaan, CT.

COLBURN, ELANOR (ELEANOR R.).
Sculptor and painter. Born in Dayton, OH, 1866. Pupil of Art Institute of Chicago. Member: Laguna Beach Art Assoc.; San Diego Artists Guild. Awards: Second prize, Laguna Beach Art Association, 1927; third prize, 1928, first prize, 1929, Los Angeles Painters and Sculptors; Lesser Farnum prize, San Diego, 1930; gold medal, Laguna Beach Art Association, 1932. Represented in Chicago Municipal Art League. Among her paintings, "An Off-Shore Wind" was owned by the Chicago Art Institute. Address in 1933, Laguna Beach, CA. Died in 1939.

COLBY, GEORGE W.
Painter and illustrator. Exhibited at the Penna. Academy of Fine Arts, Philadelphia, 1922, pastel, "Study of a Woodcock." Address in 1926, 25 Cedar Street, Malden, MA.

COLBY, HOMER WAYLAND.
Illustrator, etcher, and craftsman. Born North Berwick, ME, April 30, 1874. Pupil of George H. Bartlett. Illustrations for *Classic Myths* (Gayley); Virgil's *Aeneid* (Kittredge); *English and American Literature* (Long); *Ancient History* (Myers); *Stories of Heroism* (Mace); *Civilization in Europe* (Schapiro and Morris). Address in 1929, 66 Maynard Street, Arlington, MA. Died in 1950.

COLBY, JOSEPHINE WOOD.
Painter. Born in NY, NY, Jan. 26, 1862. Pupil of ASL of NY; NAD; Will Low, Carroll Beckwith, William Sartain, John W. Alexander. Member: NYWCC; NY Soc. C.; NAC (life); SPNY. Work in Pennsylvania Academy of the Fine Arts, Phila.; Walker Gallery, Liverpool, Eng.; Manchester Art Gallery, Eng. Address in 1929, The Tamaracks, Andover, NJ.

COLE, ALPHAEUS PHILEMON.
Painter. Born Jersey City Heights, NY, July 12, 1876. Pupil of Constant and Laurens in Paris. Member: Conn. AFA; NYWCC; Salma. C.; AWCS; Allied AA; NY Soc. P.; AFA; NAC (life). Awards: Hon. mention, Pan-Am Exp., Buffalo, 1901; hon. mention, Conn. AFA, 1919; Isidor prize, Salma. C., 1926. Work: "Dr. Richard Whitehead," Historical Society, Raleigh, VA, and University of Virginia; "Mrs. Isaac Gates," Huntington Library, Oneonta, NY; "Mr. Manning," Chamber of Commerce, New York. Address in 1929, 33 West 67th Street, New York, NY.

COLE, ANNIE ELIZABETH.
Painter. Born Providence, RI, Dec. 9, 1880. Pupil of Corcoran School of Art, Washington, DC. Member: Wash. WCC. Address in 1929, 2941 Tilden Street, N.W., Washington, DC.

COLE, CHARLES OCTAVIUS.
Portrait painter. Born July 1, 1814, in MA. He was working in New Orleans, LA, about 1835.

COLE, EMILY BECKWITH.
Sculptor. Born New London, CT, Jan. 2, 1896. Pupil of Louis Gudebrod. Address in 1926, Hartford, CT.

COLE, FRANCES.
Water-colorist. Born: St. Louis, MO, Sept. 2, 1910. Studied: Antioch College; Univ. of Mich.; Univ. of Dayton. Exhibited at Water-color Soc., NYC; Nat'l. Acad. of Design Galleries, NYC; and throughout the US. Living in Phoenix, Arizona.

COLE, GEORGE TOWNSEND.
Painter. Born in Calif.. Pupil of Bonnat in Paris. Address in 1929, 1103 El Centro Ave., Los Angeles, Calif.

COLE, JACQUES MOYSE DUPRE.
(Moses D. Cole). Was born in France, in 1783. He came to Newburyport, MA, from the West Indies with his father in 1795, and on the death of his father took the name of Moses Dupre Cole. He remained in Newburyport where he painted many portraits.

COLE, JESSIE DUNCAN SAVAGE.
Painter. Born Pass Christian, MS, 1858. Pupil of Wyatt Eaton; John La Farge. Died Oct. 27, 1940. Address in 1926, 81 Wickes Avenue, Nepperham, Yonkers, NY.

COLE, JOSEPH FOXCROFT.
Painter. Born in ME, Nov. 9, 1837. He studied abroad and was a pupil of Charles Jacque in 1867. He exhibited in the Salon, 1866-67-73-74, the Royal Academy of 1875. Rep. in the Boston Museum of Fine Arts. Died May 2, 1892 in Winchester, MA.

COLE, JOSEPH GREENLEAF.
Painter. Born in Newburyport CT 1803, son of Moses D. Cole. After studying with his father a few years, he established himself in Boston where he died in 1858. He painted portrait of Geo. R. T. Hewes, belonging to the Bostonian Society, and hanging for years in the Old State House, Boston.

COLE, MARGARET WARD.
(Mrs. Alphaeus). Sculptor. Born Haslington, England, in 1874. Pupil of Injalbert and Rollard in Paris. Member: Allied Artists of America. Work: Memorial tablet of Dr. Clinton L. Bagg, Metropolitan Hospital, Welfare Island, NYC; Meorial Tablet, Akron Univ., Akron, OH. Address in 1933, 33 West 67th Street, New York, NY; summer, Lower Montville, NJ.

COLE, THOMAS.
Landscape painter. Born Feb. 1, 1801 in England. In 1819 his father, James Cole, emigrated to America and settled in Ohio where he studied the rudiments of his art; later Thomas studied abroad, but lived the greater part of his life in New York City. Elected member of National Academy in 1826. He is represented by "Catskill" in the Metropolitan Museum, New York, and in the Corcoran Museum, Washington, by "The Departure and the Return." Died Feb. 1848 near Catskill, NY.

COLE, THOMAS CASILAER.
Portrait painter. Born Staatsburg-on-Hudson, NY, July 23, 1888. Pupil of Tarbell, Benson and Hale at Boston Museum of Fine Arts School; Julian Academy under Baschet and Laurens in Paris. Address in 1929, Hotel Chelsea, 222 West 23rd Street, New York, NY.

COLE, TIMOTHY.
Wood-engraver. Born London, England, 1852. Burned out by Chicago fire of 1871; went to New York; entered employment of *Century* Magazine, then *Scribner's*. Went to Europe to engrave the Old Masters, 1883; finished 1st Italian series, 1892; Dutch and Flemish series, 1896; English series, 1900; Spanish series, 1907; French series, 1910; engraved "Old Italian Masters." Awards: Honorable mention, Society of Sculptors, Painters and Engravers, London; National Academy, 1908. Member: American Academy Arts and Letters; honorable mention, Brotherhood of Engravers of Chicago. Represented in Carnegie Institute, Pittsburgh, and City Art Museum, St. Louis; Chicago Art Institute; Metropolitan Museum; Boston Art Museum; Washington National Gallery, etc. Died 1931. Address in 1926, Ferris Lane, Poughkeepsie, New York.

COLE, VIRGINIA THURMAN.
Painter and teacher. Born Columbus, OH. Pupil of George Elmer Browne; Alice Schill; Columbus Art School. Member: Ohio WCS; Columbus AL. Address in 1929, 389 Library Park, South, Columbus, OH.

COLEMAN, CHARLES CARYL.
Painter. Born Buffalo, NY, Apr. 25, 1840. Studied in Paris and Rome. Member: ANA, 1865; Players C.; NAC; London AC. Awards: Bronze medal, Columbian Exp., Chicago, 1893; silver medal, Pan Am. Exp., Buffalo, 1901. Work: "Early Moonlight - Capri," "The Antiquary," and "The Capri Girl," Buffalo Fine Arts Acad.; "Vesuvius from Pompeii," and "Music in the Moonlight," Detroit Inst.; "Oil Press, Anacapri-Capri," and "In the Garden of Villa Castello," Buffalo Academy of Fine Arts; "The Return from the Crucifixion" and "Vesuvius Eruption of 1906," Brooklyn Museum; "Christ Walking on the Sea," Seamen's Institute of New York, the drawings for which are in the St. Louis Museum; "A Decorative Pane" and "A View of the Castello of Capri," Louisville Museum of Fine Arts. Address in 1929, Villa Narcissus, Island of Capri, Italy; and "The Players," 16 Gramercy Park, New York, NY. Died Dec. 4, 1928 in Capri, Italy.

COLEMAN, GLENN O.
Painter. Born Springfield, OH, July 18, 1887. Pupil of Henri. Member: S. Indp. A; Whitney Studio C; New Soc. A. Award: Third prize, Carnegie Institute, 1928. Work: "Manetta Lane," Luxembourg Museum; "Coenties Slip," Newark Museum, Newark, NJ.

Address in 1929, Glenco Studios, 414 National Blvd., Long Beach, LI, NY. Died May, 1932 in Long Beach, NY.

COLEMAN, RALPH PALLEN.
Illustrator. Born Philadelphia, PA, June 27, 1892. Pupil of the Philadelphia School of Ind. Art. Illustrated "The Man with Three Names" and "Drums of Jeopardy" by McGrath; "The Loring Mystery" and "Sir John Dering," by Jeffery Farnol; "The Panther," by Richard Washburn Child; "A Speaking Likeness," by Julian Street; "Nobody's Man," by Oppenheim, etc., and for many magazines. Address in 1929, 234 Walnut Street, h. 203 Rodman Avenue, Jenkintown, PA. Died in 1968.

COLEMAN, SAMUEL, JR.
Painter. Born in Portland, ME, March 4, 1832. He moved to New York and became a pupil of Asher B. Durand. He studied in France and Spain. He became an associate member of the National Academy in 1860, and a full member in 1862. He was a founder of the American Society of Painters in Water Colors. Among his works are "Bay of Gibraltar, " "Market Day in Brittany," and "The Arab Burying-Ground." Died March 26, 1920 in New York City.

COLES, ANN CADWALLADER.
Painter. Born Columbia, SC, 1882. Pupil of C. A. Whipple, A. V. Tack and F. Luis Mora. Member: Society of Independent Artists. Work: "Gen. M. C. Butler," Confederate Museum, Richmond, VA. Address in 1926, 164 Waverly Place, New York, NY.

COLES, JOHN, JR.
Born c. 1778. Son of John Coles, heraldic painter, a student with Frothingham under Gilbert Stuart. He painted portraits from 1807 to 1820 in Boston. His scenes were always on panels w. lead color b.g. Died Sept. 6, 1854 in Charlestown, MA.

COLETTI, JOSEPH ARTHUR.
Sculptor. Born in San Donato, Italy, Nov. 5, 1898. Studied with John Singer Sargent. Works: Chapel of St. George's School, Newport, RI; Tympanum Chapel of Mercersburg Academy, Mercersburg, PA; Eugene Dodd Medal, Harvard Architectural School and Edward W. Bok gold medal, Harvard Advertising Award, Cambridge, MA; Coolidge Memorial, Widener Library, Harvard University; Harvard War Memorial, "Columbia" and "Alma Mater," also candelabra, Cambridge, MA; Brookgreen Gardens, SC; St. Theresa of Avila statue, Washington Cathedral; Vatican Library, Rome; portrait busts and fountains; many others. Awards: Sachs Fellow, Harvard University, 1924-26; two gold medals, Tercentenary Fine Arts Exhibition, Boston, 1930; Henry Hering medal, National Sculpture Society; others. Exhibited: Penna. Academy of Fine Arts, 1929-31; Museum of Modern Art, 1933; World's Fair of NY,

1939; Philadelphia Museum of Art, 1939; Metropolitan Museum of Art, 1942; Whitney, 1940; Audubon Artists, 1946. Member: National Sculpture Society; Architectural League of NY. Address in 1970, Fenway Studios, Boston, MA. Died in 1973.

COLL, JOSEPH CLEMENT.
Illustrator. Born June 2, 1881 in Phila., PA. Exhibited at PAFA, 1922. Pen and Ink Drawings. Died Oct. 19, 1921 in Phila.

COLLARD, W.
Line-engraver of portraits, working for magazines about 1840-45.

COLLAS, LOUIS ANTOINE.
Painter. Born 1775 in Bordeaux, France. Painted miniatures and larger portraits in oil in and about New Orleans, from 1820 til 1828. He was listed in the directory, 1822, as "portrait and miniature painter, 44 St. Peter Street." Nothing is recorded of him after 1828.

COLLES, GERTRUDE.
Painter. Born Morristown, NJ, 1869. Pupil of Laurens in Paris; George de Forest Brush and B. R. Fitz in New York. Work: "Former Senator Jacob Miller," State House, Trenton, NJ. Address in 1926, 939 Eighth Avenue, New York, NY. Died in 1957.

COLLES, JOHN.
Profile miniature painter. Born 1751. Flourished 1778-1780, New York. His advertisement is recorded in the *New York Gazette* for May 10, 1780. Died 1807.

COLLIDGE, BERTHA.
Miniature painter. Born Lynn, Mass., August of 1880. Pupil of Boston Museum School under Tarbell and Benson; Bourgeois in Paris; Grueber in Munich. Member: Soc. de La Min., Paris; PA Soc. Min. P. Address in 1929, 133 East 40th St., NY. Died in 1934.

COLLIER, CHARLES MYLES.
Marine painter. Born in Hampton, VA, in 1836. Died Sept. 14, 1908 in Gloucester, MA.

COLLIER, ESTELLE E(LIZABETH).
Painter and writer. Born Chicago, IL, Aug. 1, 1881. Pupil of F. W. Southworth. Member: Tacoma FAA. Several awards received at Washington State Fairs. Work: "Lake Cachelus, Washington," Stadium High School, Tacoma, Wash.; "The Resolute," Seattle, (Wash.) Yacht Club. Address in 1929, R. 1, Box 267, South Tacoma, Wash.

COLLIER, JOHN.
Illustrator. Born in Dallas, Texas, in 1948. He attended Central College in Kansas for two years. He began illustrating Christmas cards in 1967. His career has blossomed in NY as illustrations for

Redbook and *McCall's* have won him gold medals and an Award of Excellence at the Annual Exhibitions of the S of I. He has had exhibitions in Oklahoma City, Little Rock, Tulsa and New York.

COLLIER, NATE.
Illustrator. Born Orangeville, IL, Nov. 14, 1883. Pupil of J. H. Smith and G. H. Lockwood. Member: SI. Work: Illustrations for *The Saturday Evening Post; Life; Judge; The Country Gentleman; Ladies' Home Journal; Bystander; Passing Show; London Opinion; London Humorist;* McNaught Newspaper Syndicate of New York; and the *Illiterate Digest,* by Will Rogers. Address in 1929, 140 Paulin Blvd., Leonia, NJ. Died in 1961.

COLLINS, FRANK H.
Painter and teacher. Director of drawing, elementary public schools of New York. Address in 1929, 500 Park Avenue, New York, NY.

COLLINS, FRED L.
Illustrator. Born Prince Edward Island, Jan. 1, 1876. Pupil of Hamilton Art School; S. J. Ireland. Member: Columbus PPC (Secy.-treas. from 1903). Manager of Art Dept., Bucher Engraving Co. Address in 1929, Franklin Avenue, Columbus, Ohio; summer, Ancaster, Ont., Canada.

COLLINS, JIM.
Sculptor and educator. Born in Huntington, WV, September 12, 1934. Studied at Marshall University, A.B., 1957; University of Michigan, Ann Arbor, M.P.H., 1961; Ohio University, M.F.A., 1966. Work in Wichita Art Association, KS; Milwaukee Art Center, WI; outdoor sculpture, St. Augustine Church Signal Mountain, TN, 1970; series of five wall reliefs, St. Jude Catholic Church, Chattanooga, 1978. Has exhibited at Arkansas Arts Center, Little Rock, 1973; painting, J. B. Speed Art Museum, Louisville; Southern Association Sculptors Traveling Exhibition; invitational, Mississippi Museum of Art, Jackson, 1978; others. Works in wood and metals. Address in 1982, Signal Mountain, TN. Living in Ohio in 1984.

COLLINS, JULIA ALICE.
Painter. Born Savannah, GA. Pupil of the Telfair Academy, Savannah, GA; St. Louis School of Fine Arts. Awards: Three first prizes and two second prizes for portraits in the Tri-State Expositions of 1921 and 1923. Works: The Fourteen Stations of the Cross in the John Flannery Memorial Chapel, St. Joseph's Hospital, Savannah, GA. Address in 1929, 217 Gordon Street, East, Savannah, GA; summer, 81 Charlotte Street, Asheville, NC.

COLLINS, MARJORIE S.
Miniature painter. Exhibited portrait miniatures at Penna. Acad. of Fine Arts, Philadelphia, 1922. Address in 1926, 701 Nottingham Rd., Wilmington, DE.

COLLINS, MARY SUSAN.
Painter, craftsman, and teacher. Born in Bay City, MI, June 1, 1880. Pupil of Museum of Fine Arts, Boston; Columbia Univ.; Art Students League of NY. Member: Cleveland Art Assn.; Cleveland Woman's Art Club; American Federation of Arts. Awards: Prizes, Cleveland Museum, 1921, 22, 24, 25, 29, 36; prize ($200), Chicago Galleries Assn., 1927; first prize, oil, still-life, Cleveland, 1929. Exhibited: Penna. Academy of Fine Arts; American Federation of Arts; Allied Artists of America; Cleveland Museum of Art; others. Work: "Primrose," Cleveland Museum of Art. Address in 1962, Easton, PA.

COLLINS, WALTER.
Painter, illustrator, lecturer, and teacher. Born Dayton, OH, Sept. 26, 1870. Pupil of Julian and Colarossi Acad. in Paris; Hyman's School of Illustration, Munich; Martz Weinholdt, Walter Thor, Royal Acad. in Munich; Adolf von Menzel in Berlin; Cincinnati Art Academy. Member: SSAL; Tampa Art Inst. Address in 1929, Lykes Hall, 302 North Boulevard, Tampa, FL; h. Seffner, FL.

COLLOW, JEAN.
Painter. She exhibited water colors in Cincinnati Museum in 1925. Address in 1926, Art Academy, Cincinnati.

COLLVER, ETHEL BLANCHARD.
Painter. Born Boston, MA. Pupil of Tarbell, Benson, and Hale in Boston; Academie Colarossi, Naudin, Guerin, in Paris. Member: Copley Society, 1901. Address in 1926, Fenway Studios, 125 Commonwealth Avenue, Boston, MA. Died in 1955.

COLMAN, R. CLARKSON.
Painter. Born Elgin, IL, Jan 26, 1884. Studied in Chicago, and with Laurens and Julian in Paris. Member: Calif. AC; San Diego Art Guild; Laguna Beach AA. Awards: Texas Cotton Place Exposition, 1910; gold medal, Riverside Fair, 1917; popular prize, Laguna Beach Assoc. 1920, 1922; cash prize, Sacramento State Fair, 1920. Represented in Public Library, Ajo, Arizona; Public Library, Waco, Texas; Santa Monica Woman's Club; three murals, Junior High School, Santa Ana, CA. Address in 1929, Studio-by-the-Sea, Laguna Beach, CA.

COLSON, FRANK V.
Painter, illustrator, etcher, and teacher. Born Boston, Oct. 24, 1894. Pupil of Boston Museum of Fine Arts School. Member: North Shore AA; Boston SE. Instructor, North Shore Summer School of Art. Address in 1929, 98 Everett Street, East, Boston, MA.

COLT, MARTHA COX.
Sculptor, painter, and teacher. Born in Harrisburg, PA, Sept. 16, 1877. Pupil of Philadelphia School of Design for Women; Penna. Academy of Fine Art;

NY School of Art; Moore Institute; University of Pennsylvania; and with Kenneth Hayes Miller, Henry B. Snell, and Calder Penfield. Member: Harrisburg Art Association; Plastic Club, Philadelphia. Work: Bronze bust of Dr. Charles Hatch Ehrenfeld, York Collegiate Institute, York, PA; Philadelphia Museum of Art. Exhibited: Plastic Club; Harrisburg Art Association. Address in 1953, Shiremanstown, PA.

COLT, MORGAN.
Painter. Born in Summit, NY, 1876. Member of Rochester Art Club. Address in 1926, New Hope, PA. Died April 12, 1926.

COLTMAN, ORA.
Sculptor and painter. Born Shelby, OH, Dec. 3, 1860. Pupil of Art Students League of NY; Julian Academy in Paris; Magadey Schule, Munich. Member: Cleveland Society of Artists; Cleveland Printmakers. Represented in Cleveland Museum of Art. Address in 1933, Cleveland, OH.

COLTON, MARY RUSSELL FERRELL.
(Mrs. Harold S.). Sculptor, painter, teacher, serigrapher, writer, and museum curator. Born in Louisville, KY, March 25, 1889. Studied: Moore Institute; Philadelphia School of Design for Women; pupil of Daingerfield; Henry B. Snell. Member: National Association of Women Artists; American Artists Professional League; Philadelphia Watercolor Club; American Watercolor Society of New York; Washington Watercolor Club; American Federation of Arts; Plastic Club. Author: "Indian Art and Folk Lore." Contributor to "Plateau," published by Museum of Northern Arizona. Curator, Museum of Northern Arizona, Flagstaff, AZ, 1928-46. Address in 1953, Museum of Northern Arizona; h. Flagstaff, AZ.

COLWELL, ELIZABETH.
Painter, etcher, illustrator, and craftsman. Born in Michigan in 1881. Pupil of Vanderpoel and Olson-Nordfeldt in Chicago. Member: Chicago SE; NY SE; Chicago Cordon C. Award: Hon. mention, P.-P. Exp., San F., 1915. Represented in Print Dept., Chicago Art Institute. Designer of typeface called "Colwell Hand Letter," put out by American Type Foundry Co. Address in 1929, 1373 East 57th Street, Chicago, IL.

COLYER, VINCENT.
Painter. Born 1825 in Bloomingdale, NY. In 1849 he was elected an associate of the National Academy. Before the Rebellion he painted "Freedom's Martyr," representing the burial of Barber by John Brown. He also painted a number of Indian pictures from sketches he had made in the West. He was born in New York, but lived most of his life in Connecticut. Died July 12, 1888, near Darien, CT.

COMAN, CHARLOTTE BUELL.
Painter of landscapes. Born at Waterville, NY, 1833. Pupil of James Brevoort in New York, and Vernier in Paris. Elected an Associate Member of National Academy of Design in 1910. Represented in Metropolitan Museum, New York, and National Gallery, Washington, DC. She died in Yonkers, New York, Nov. 11, 1924.

COMBS, FRANCES HUNGERFORD.
Painter. Member: Wash. WCC. Address in 1929, The Wellinton, 3820 Kanawha Street, Washington, DC.

COMEGYS, GEORGE H.
Painter. Born in Maryland. Died in the PA Hospital for the Insane, in Philadelphia. He was a pupil of Neagle and member of board of the Artists' Fund Society in 1845. Work: "The Ghost Story", "Little Plunderers", Penna. Academy of Fine Arts.

COMES, MARCELLA RODANGE.
Painter. Born Pittsburgh, Sept 3, 1905. Pupil of Giovanni Romagnoli. Member: Associated Artists of Pittsburgh. Award: Art Society prize for best portrait, Associated Artists of Pittsburgh, 1929. Address in 1929, 3242 Beechwood Blvd., Pittsburgh, PA.

COMINS, ALICE R.
Painter. Member: Concord AA; NA Women PS. Address in 1929, care of Old Colony Trust Co., 22 Boylston Street, Boston, MA; Carmel, California; Cape Neddick, ME.

COMINS, EBEN F.
Portrait painter, lecturer, and teacher. Born Boston, MA in 1875. Pupil of Beaux-Arts in Paris, Denman Ross and Art Museum School in Boston. Member: Boston S. Indp. A.; Boston AC; Copley S.; Boston SWCP; CT AFA; Wash. AC; X Painters of Wash.; AFA. Awards: Hon. mention, CT AFA, 1919; first prize, Hartford Exhibition, 1921. Address in 1929, 1611 Connecticut Avenue, Washington, DC; summer, East Gloucester, MA.

COMSTOCK, ANNA BOTSFORD.
Naturalist and illustrator. Born near Otto, Cattaraugus County, New York, on September 1, 1854. Attended schools in her native town and the Chamberlain Inst. and Female College. In 1879-1881, when her husband was chief entomologist in the US Department of Agriculture, she was formally appointed his assistant and prepared the drawings for his *Report of the Entomologist* (on citrus scale insects) of 1880. She studied wood engraving at Cooper Union, New York City, in order to prepare illustrations for her husband's *Introduction to Entomology*, 1888. In 1888 she was one of the first four women admitted to Sigma XI, national honor society for the sciences. She made engravings for the more than 600 plates in Prof. Comstock's *Manual for*

the Study of Insects, 1895, and for *Insect Life*, 1897, and *How to Know the Butterflies*, 1904. Her engravings were also widely exhibited in major expositions and won several prizes. Books written and illustrated by herself included *Ways of the Six-Footed*, 1903, *How to Keep Bees*, 1905, *Confessions to a Heathen Idol*, a novel, 1906, *The Handbook of Nature Study*, which went through more than two dozen editions, 1911, *The Pet Book*, 1914, and *Trees at Leisure*, 1916. She was a contributing editor for *Nature-Study Review* in 1905-1917 and editor in 1917-1923, and was on the staff of *Country Life in America*. In 1923 she was chosen one of the twelve greatest living American women in a poll by the League of Women Voters. She died in Ithaca, New York, on August 24, 1930.

COMSTOCK, ENOS B(ENJAMIN).
Painter, illustrator, and writer. Born Milwaukee, Dec. 24, 1879. Pupil John H. Vanderpoel, Frederick W. Freer. Author and illustrator of "Tuck-Me-In Stories," "When Mother Lets Us Tell Stories," "Fairy Frolics," etc. Illustrated "She and Allan," "When the World Shook," "The Ancient Allan," etc. Address in 1929, 178 Highwood Avenue, Leonia, NJ. Died in 1945.

COMSTOCK, FRANCES BASSETT.
Sculptor, painter, and illustrator. Born Elyria, OH, Oct. 16, 1881. Pupil of Gari Melchers, Frederick W. Freer, and John Vanderpoel. Member: NY Water Color Club. Address in 1929, Leonia, NJ.

CONACHER, JOHN C.
Illustrator. Lived from 1876 to 1947. Though classically trained, he developed a style, full of comic detail, which appeared in his many pen and ink drawings for magazines in the early 1900's. *Everybody's* and *Judge* published his illustrations, and his work for the Seaboard National Bank advertisements was selected for the ADC Annuals of Advertising Art.

CONANT, ALBAN JASPER.
Painter. Born Chelsea, Sept. 24, 1821. Painted portraits of Lincoln, Sherman, Anderson at Sumter; judges of Ct. of Appeals and Supreme Ct. of US, and cabinet secretaries; 4 portraits of Henry Ward Beecher, Dr. James McCosh, Bishop H. C. Potter, "Burial of De Soto," etc. Author: "Footprints of Vanished Races in the Mississippi Valley," "My Acquaintance with Abraham Lincoln," etc. Died Feb. 3, 1915 in NYC.

CONANT, MARJORIE.
Painter. Born Boston, MA, Sept. 14, 1885. Pupil of Hale, Benson and Tarbell. Member: Atlanta AA; NA Women PS. Address in 1929, 67 Peachtree Place, N.W., Atlanta, GA.

CONARD, GRACE DODGE.
Painter, craftsman, and teacher. Born Dixon, IL, April 10, 1885. Pupil of AIC. Member: Chicago ASL; Chicago AG. Instructor, AIC. Address in 1929, Art Institute, Chicago; h. 297 Keystone Avenue, River Forest, IL.

CONARROE, GEORGE W.
Born in 1803 and died 1882. He was a portrait painter in Philadelphia about 1825. A self-portrait of the artist is owned by the PA Historical Society in Philadelphia. In 1829 he exhibited paintings in the PA Academy of Fine Arts. At that time he was living in Salem, NJ. He then lived in Philadelphia until his death.

CONAWAY, GERALD.
Sculptor and painter. Born in Manson, WA, Feb. 15, 1933. Studied at Everett Jr. College, Washington, A.B.A.; University of Washington, Seattle, B.A. (art education) and M.F.A. (sculpture) with George Tsutakawa and Everett Dupen. Work in Anchorage Fine Arts Museum, Alaska; marble monument, Mutual Insurance Co., NY and Anchorage Centennial, Anchorage; concrete wall sculptures, Raymond Lawson, AIA. Has exhibited at Sculpture Northwest, Seattle, 1968. Works in wood, stone steel, plastics. Address in 1982, Anchorage, AK.

CONDAK, CLIFFORD ARA.
Illustrator. Born in Haverhill, MA, in 1930. He attended the Inst. of Applied Arts and Sciences and the New School for Social Research in NYC. His first illustration, a tempera, appeared in *Therapeutic Notes*, a Parke Davis and Company publication, in 1954. Since then his pieces have appeared in publications such as *Seventeen*, *Nugget*, *Playboy* and *Sports Illustrated*. His artwork and illustrations have been shown at the Museum of Modern Art in NY, Gallery of Modern Art in Washington, DC, and San Francisco Museum of Modern Art.

CONDIT, CHARLES L. (MRS.).
Painter, craftsman, and teacher. Born Perryburg, OH, Nov. 29, 1863. Pupil of Maud Mason. Member: Texas FAS; Austin AL. Specialty, conventional decoration of china. Address in 1929, 2308 San Antonio Street, Austin, Texas.

CONDON, GRATTAN.
Illustrator. Born Eugene, OR, June 10, 1887. Pupil of Los Angeles School of Art and Design; Los Angeles ASL; Walter Biggs. Illustrated for the *Ladies' Home Journal* and the *Saturday Evening Post*. Address in 1929, 15 West 67th Street, New York, NY.

CONE, JOSEPH.
Engraver in both stipple and line, was chiefly engaged upon portrait work. Joseph Cone was engraving over his own name in Philadelphia, 1814-19,

inclusive. From 1820-24 he was engraving prints and publishing them in Balt., MD. He also worked for Boston publ., and from 1829-30 his name reappears in the Philadelphia directories as an "Engraver."

CONE, MARVIN D.
Painter and teacher. Born Cedar Rapids, Oct. 21, 1891. Pupil of AIC; Ecole des Beaux-Arts, Montpellier, France. Work: "Cloud Bank," Cedar Rapids Art Association. Address in 1929, 1721 Fifth Avenue, Cedar Rapids, IA. Died in 1964.

CONGDON, ADAIRENE VOSE.
Painter. Born in New York City. Pupil of Art Students League of New York. Represented in Petit Palace, Paris; Library of Congress; New York Public Library; and Boston Art Club. Address in 1926, Villa Vose Studios, Campbell, NY.

CONGDON, THOMAS RAPHAEL.
Painter and etcher. Born in Addison, NY, in 1862. Pupil of Art Students League of New York, also studied in Paris. Represented by prints in Library of Congress, New York Public Library, and Boston Art Club. Died Nov. 15, 1917 in Boston, MA.

CONGDON, WILLIAM.
Sculptor, painter. Born in Providence, RI, April 15, 1912. Studied: Yale University, B.A.; Demetrios School of Sculpture; Provincetown School of Art, with Henry Hensche. Awards: Temple gold medal, Penna. Academy of Fine Arts, 1951; prizes, Rhode Island Museum of Art, 1949, 50; Clark Award, Corcoran Gallery, 1953. Work: City Art Museum of St. Louis; Univ. of Illinois; Detroit Institute of Art; RI Museum of Art; Boston Museum of Fine Arts; Phillips Collection, Washington, DC; Whitney; Museum of Modern Art; Metropolitan Museum of Art; others. Exhibited: National Academy of Design, 1939; Penna. Academy of Fine Arts, 1937-39, 1950; Carnegie Institute, 1940, 52, and 58; Whitney Museum of American Art, 1941, 51, 52, 55; Rhode Island Museum of Art, 1948, 49; Addison Gallery of American Art, Andover, MA, 1941; Art Institute of Chicago, 1952; Toledo Museum of Art, 1952; Albright Art Gallery, 1952; Calif. Palace of Legion of Honor, 1952; Contemporary Art Society, Boston, 1951; Los Angeles Museum of Art, 1951; Venice Biennale, 1952; Metropolitan Museum of Art, 1950; Wildenstein Gallery, 1950; Betty Parsons Gallery, 1949, 50, 52; Margaret Browne Gallery, 1951; Duncan Phillips Gallery, 1952; Contemp. Art, 1951; Ferrara, Italy, 1981; others. Illustrated articles in *Life Magazine* and others. Address in 1953, Venice, Italy; h. Providence, RI. Living in Milan, Italy, in 1982.

CONKEY, SAMUEL.
Sculptor and painter. Born in NYC, 1830. Worked: Chicago; New York City. Exhibited: National Academy, 1867-90. Died in Brooklyn, NY, Dec. 2, 1904.

CONKLING, MABEL.
(Mrs. Paul B. Conkling). Sculptor. Born in Boothbay, ME, November 17, 1871. Studied in Paris under Bouguereau and Collin until 1899. In 1900 she studied sculpture under MacMonnies. Work: "The Lotus Girl," "Song of the Sea," and portrait reliefs of Dr. George Alexander, Mrs. James A. Garland, and Hope Garland. Member of National Association of Women Painters and Sculptors; American Federation of Arts; American Numismatic Society; Society of Medalists; Art Workers' Club. Exhibited at National Sculpture Society, 1923. Address in 1933, 26 West 8th St., NYC; summer, Boothbay, ME.

CONKLING, PAUL BURLEIGH.
Sculptor and painter. Born in New York City, October 24, 1871. Pupil of MacMonnies, Falguiere, and Ecole des Beaux-Arts, Paris; and Kensington School of Art, London. Member of Society of American Artists; Society of Independent Artists. Exhibited at National Sculpture Society, 1923. His specialty was portraiture. Address in 1926, 5 MacDougal Alley; 26 West 8th St., NYC; summer, Boothbay, ME. Died March, 1926.

CONLEY, SARAH WARD.
Sculptor, painter, illustrator, craftsman, writer, and teacher. Born Nashville, TN, Dec. 21, 1861. Pupil of Bouguereau, Julian and F. A. Bridgman in Paris; Ferrari in Rome. Member: Nashville Art Association. Work: Woman's Building, Centennial Exp., Nashville, TN; mural decorations in Battle Creek Sanitarium. Address in 1929, Nashville, TN.

CONLON, GEORGE.
Sculptor. Born in Maryland in 1888. Pupil of Injalbert and Bartlett in Paris. Address in 1926, Baltimore, MD. Died in 1980.

CONN, JAMES.
Engraver and writing-master at Elizabethtown, NJ, advertised in 1771 his "intention to teach writing, arithmetic, mathematics, geography," etc., and adds to his notice the following: "Futhermore, the said Conn at leisure hours, engraves Shop Bills, Bills of Parcels, Bills of Exchange, or any kind of Writing for the Rolling-Press, in the neatest Manner."

CONNAWAY, INA LEE WALLACE.
Sculptor and painter. Born in Cleburne, TX, December 27, 1929. Studied at Baylor University; also with Rhinhold Ewald, Hanau, Ger and Junicero Sekino, Alaska; Famous Artist Course, University of Alaska; Corcoran School of Art; George Washington University, B.A. Work: John F. Kennedy Elementary School, Ft. Richardson, AK; Alaskan State Museum, Juneau; P.E. Wallace Jr. High School, Mt. Pleasant, TX; Cora Kelly Elementary School, Alexandria, VA; Kate Duncan Smith DAR School, Alabama. Exhibitions: Lasting Americana, A Series

on the US, Ft. Richardson, Juneau, and Anchorage, AK, 1962-65; American Artists Professional League Grand National, 1966; Sovereign Exhibitions Ltd., VA, NC, and SC, 1970-71; US Military Academy Library Exhibition, 1970; DAR Army and Navy Chapter Exhibition, 1971. Awards: Prizes Beaux Arts Ball, Artist of the Month and American Art Week, Anchorage, 1963; Alaska State Fair, Palmer, 1964. Media: Oil, stone, wood, and bronze. Address in 1976, c/o Lynn Kottler Gallery, 3 East 65th Street, NYC.

CONNAWAY, JAY HALL.
Painter. Born Liberty, IN, Nov. 27, 1893. Member: ASL of NY; Allied AA; Salma. C. Work: "Winter," Herron Art Institute, Indianapolis, IN; "The Everlasting Cliffs," permanent collection, Springfield (IL) High School. Award: Hallgarten prize ($200), NAD, 1926. Address in 1929, care of The Macbeth Gallery, 15 East 57th Street, New York, NY. Died in 1970.

CONNELL, EDWIN D.
Painter. Born New York, NY, Sept. 3, 1859. Pupil of Bouguereau, Robert-Fleury and Julien Dupre in Paris. Member: Societe Internationale des Beaux-Arts; Paris AAA. Awards: Hon. mention, Paris Salon, 1899; medal, second class, Orleans Exp., 1905; first class medal, Toulouse Exp., 1908; silver medal, P.-P. Exp., San F., 1915. Work: "Cattle," Toledo Museum of Art. Address in 1929, 56 Rue de Sevres, Clamart, France.

CONNELLY, EUGENE L.
Painter. Member Pittsburgh Academy of Artists. Address in 1926, Davis Theatre, Pittsburgh, PA.

CONNELLY, MARC.
Illustrator. Member: Society of Illustrators. Address in 1926, 159 East 83rd Street, New York, NY.

CONNELLY, PIERCE FRANCIS.
Sculptor and landscape painter. Born in Southern City, Louisiana, c. 1841; raised in England. Studied art in Paris and Rome; took a studio as a sculptor in Rome about 1860. Visited the U.S. in 1876; exhibited in the Centennial at Philadelphia. Went to New Zealand and became a well-known mountain climber and landscape painter. Died in 1902.

CONNER, BRUCE G.
Sculptor, painter, and film maker. Born in McPherson, KS, Nov. 18, 1933. Went to California in 1957. Studied at University of Wichita, KS, with David Bernard; University of Nebraska, with Rudy Pozzatti; Brooklyn Museum Art School, with Reuben Tam; University of Colorado at Boulder. Taught: California College of Arts and Crafts, Oakland, 1965-66; San Francisco Art Institute, 1972; California State at San Jose, 1974. In collections of Museum of Modern Art; Art Institute of Chicago; Los Angeles Co. Art Museum; Guggenheim; Whitney. Exhibited at East and West Gallery, San Francisco; Allan Gallery, New York City; Batman Gallery, San Francisco; Ferus Gallery, Los Angeles; San Francisco Art Institute; Robert Fraser Gallery, London; de Young Museum, San Francisco; Museum of Modern Art, Whitney, New York City; Los Angeles Co. Museum; Dallas Museum of Fine Arts; Oakland Museum; National Galerie, Berlin; National Museum of Modern Art, Paris; many others. Awards: Copley Foundation Award; gold medal, Milan Biennale Nuovo Techniques in Arts; Guggenheim Fellowship. Address in 1982, San Francisco, California.

CONNER, CHARLES.
Landscape painter. Born in Richmond, Indiana, in 1857. His best known canvas was "Wet Night in February," shown at St. Louis Exposition. Died February 14, 1905 in Richmond.

CONNER, JEROME.
Sculptor. Born in Ireland, October 12, 1875. Self-taught. Member: Society of Washington Artists. Work: Bronze tablet, "Nuns of the Battlefield," Washington, DC. Address in 1929, Washington, DC.

CONNER, JOHN RAMSEY.
Painter. Born Radnor, Pennsylvania in 1867. Pupil of PAFA. Award: Bronze medal, P. P. Exp., San Francisco, 1915; silver medal, Sesqui-Centennial Exposition, Philadelphia, 1926. Work: "The Fisherman," Pennsylvania Academy of Fine Arts, Philadelphia; "Under the North Light," Des Moines Assoc. of Fine Arts; "A Cottage Interior," California Coast, Los Angeles. Address in 1929, 1718 East Ocean Blvd., Long Beach, California. Died September 12, 1952.

CONNICK, CHARLES J.
Craftsman and draftsman. Born in Springboro, PA, Sept. 27, 1875. Studied in Pittsburgh, Boston, England and France. Member: Mural P.; Boston SAC; Boston Arch. C.; Boston AC; Boston SA (hon.); AFA. Awards: Gold medal, P.-P. Exp., San F., 1915; Logan medal, AIC, 1917; Soc. of Arts and Crafts medal, Boston, 1920; American Institute of Architects, craftsmanship medal, 1925. Work: Stained glass windows in Fourth Presbyterian Church, Chicago; Chapel and Synod House, St. John the Divine Cathedral, Seattle, Wash.; All Saints' Church, Peterboro, NH; Christ Church, Glendale, Ohio; St. John's Church, Beverly Farms, MA; Trinity College Chapel, Washington, DC; St. Agatha's Church, Philadelphia, PA. Represented in Vanderpoel AA Collection, Chicago. Address in 1929, 9 Harcourt Street, Boston MA, h. 157 Webster Street, West Newton, MA. Died in 1945.

CONNOR, J. STANLEY.
Sculptor. Born in 1860. Self-taught initially; later visited Italy to study sculpture. Most notable sculpture was the marble bust of "Cain."

CONNY, JOHN.
Engraver. Born 1655 in Boston. Was a prominent gold and silversmith of Boston at least as early as 1700. The MSS. Archives of MA, under date of March 12, 1702-3, note the indebtedness of the Colony "To John Conny for graving 3 Plates for Bills of Credit," and on Nov. 26, 1706, the same records show that, to prevent counterfeiting, the plate for the bills was to be provided with, "eight blazons and put on by the engraver." This MA currency of 1702 included little more than the engraved script and the seal of the Colony, and the earlier bills of 1690 approach it so closely in general design and execution, especially in the character of the decoration at the top of the note, that there is a strong possibility that both plates were made by the same man. If this assumption were correct, John Conny would be the first American engraver upon copper on record. Died 1722 in Boston.

CONOVER, CLAUDE.
Sculptor and ceramist. Born in Pittsburgh, PA, December 15, 1907. Studied at Cleveland Institute of Art. Work in Cleveland Museum of Art, OH; Everson Museum of Art, Syracuse, NY; others. Has exhibited at Cleveland Museum of Art; Everson Museum of Art; Butler Institute of American Art, Youngstown, OH; Objects USA, traveling exhibition to some 35 museums in US and Europe; others. Received awards from Everson Museum of Art; Columbus Museum of Art; Cleveland Museum of Art; others. Member of American Crafts Council. Address in 1982, Cleveland, OH.

CONRADS, CARL H.
Sculptor. Born in Germany, 1839, came to New York in 1860. He served in the Union Army. Among his works are statues of Alexander Hamilton, Central Park; "General Thayer," West Point; and "Daniel Webster" for the Capitol at Washington. He resided in Hartford, Conn., after 1866.

CONREY, LEE F.
Illustrator. Born St. Louis, MO, 1883. Pupil of St. Louis School of Fine Arts. Member: Society of Illustrators. Illustrations for *Cosmopolitan*, *McClure's*, *Munsey's* magazines.

CONROW, WILFORD S(EYMOUR).
Painter, lecturer, and writer. Born South Orange, NJ, June 14, 1880. Pupil of Jean-Paul Laurens, Morisset, P. Tudor-Hart, Hambidge. Member: Salma. C.; Wash. AC; NYSC.; Art Center, New York; Barnard C; Brooklyn SA; Grolier C; Cosmos; Century; Am. APL. Work: "Portrait of Cephas Brainerd," Y.M.C.A., New York City; Portraits of Henry Clay Cameron, Karl A. Langiotz, Howard Crosby Butler, Princeton University, Princeton, NJ; Portrait of Dr. Wm. H. Dall, Cosmos Club, Washington, DC; mural painting of George Washington, George Washington Life Insurance Co. Building., Charleston, WV; portraits of Prof. Wm. H. Goodyear, Brooklyn Museum; Dr. Charles R. Gillett, Dr. Charles Cuthbert Hall, Dr. Francis Brown, Union Theological Seminary, New York; Gov. J. Franklin Fort, State House, Trenton, NJ. Address in 1929, 130 Carnegie Hall; 154 West 57th Street, New York, NY. Died Nov. 24, 1957 in NYC.

CONROY, GEORGE I.
Painter. Member: Salma. Club. Address in 1926, 793 Gravesend Avenue, Brooklyn, NY.

CONSTANT, GEORGE.
Painter, illustrator, etcher, and teacher. Born Aijon, Greece, April 18, 1892. Pupil of Charles Hawthorne, George Bellows, R. Davy, Wolcott. Member: Dayton SE; S. Indp. A. Address in 1929, 51 West 8th Street, New York, NY; summer, 867 N. Dearborn Street, Chicago. Died in 1978.

CONSTANT, MARJORIE.
Painter. Exhibited at National Association of Women Painters and Sculptors, New York, 1924. Address in 1926, Duxbury, MA.

CONTENT, DAN.
Illustrator. Born in 1902. He received training at PI and the ASL. A pupil of Dean Cornwell, his illustrations for various adventure stories reflected Cornwell's teachings. His editorial work appeared in *Cosmopolitan, Good Housekeeping, Liberty, Ladies Home Journal, Collier's* and *McCall's* as early as 1923. He taught at the Workshop School of Art in the 1940's.

CONTI, GINO EMILIO CESARA.
Sculptor, painter, and teacher. Born in Barga, Italy, July 18, 1900. Studied: Rhode Island School of Design; Ecole des Beaux-Arts, Julian Academy, Paris. Awards: Prizes, IBM, 1941; Providence Art Club, 1950. Work: Murals, Rhode Island State College; Rhode Island Public School; "French School Boy," Rhode Island School of Design Museum; mural decorations, Corvese Hospital, Providence, RI. Exhibited: Paris, 1925; Architectural League, 1929, 30; National Academy of Design, 1929; Penna. Academy of Fine Arts, 1929; City Art Museum of St. Louis, 1930; Providence Museum of Art; Worcester Museum of Art, Worcester, MA; Cincinnati Museum Association; Newport Art Association; Doll & Richards, Boston; Argent Gallery, 1950, 51; Providence Art Club, 1950, 51; Des Moines Art Center, 1951; Addison Gallery of American Art, 1951; Wadsworth Atheneum, 1950; Silvermine Guild

Artists, 1952; Ogunquit Art Center, 1951, 52; Springfield Museum of Art, 1952. Member: Architectural League of NY; Providence Art Club; Providence Water Color Club. Address in 1953, Providence, RI.

CONVERSE, LILLY S.
Painter. Born Petrograd, 1892. Pupil of Kenneth Hayes Miller. Address in 1926, Rue Desbordes, Valmore, Paris, France.

CONWAY, JOHN SEVERINUS.
Sculptor and painter. Born in Dayton, Ohio, in 1852. Pupil of Conrad Diehl, Jules Lefebvre, Boulanger, and Millet in Paris. Work: Mural decorations in Chamber of Commerce, Milwaukee. Sculptor for "Soldiers' Monument," Milwaukee. Member: NY Architectural League, National Sculpture Society. Died Dec. 25, 1925, in Tenafly, NJ.

CONWAY, WILLIAM JOHN.
Sculptor and painter. Born in St. Paul, Oct. 26, 1872. Pupil of Colarossi Academy under Collin, Courtois and Prinet in Paris. Member: Whistler Club; Art Workers' Guild; Minnesota State Art Society; Artists' Society, St. Paul Institute. Address in 1933, St. Paul, MN.

COOK, CHARLES B.
Painter. Exhibited "Mountain Building" at the Penna. Academy of Fine Arts, 1924. Address in 1926, Woodstock, New York.

COOK, DANIEL.
Painter. Born Cincinnati, 1872. Pupil of Nicholas Gysis, Cincinnati Art Academy. Member: Munich Art Club; Cincinnati Art Club. Instructor at University of Cincinnati. Work: "A Rainy Day," University of Cincinnati; mural decorations, Cincinnati Music Hall. Address in 1926, 104 Saunders Street, Cincinnati, OH.

COOK, FRANCES KERR.
Illustrator. Born West Union, Iowa. Pupil of AIC; Chicago AFA. Member: ASL; AIC Alumni. Work: Illustrated *Today's Stories of Yesterday, Red and Gold Stories, The Alabaster Vase;* cover designs and illustrations for books of Scott, Foresman and Co., A. Flannagan and Co., Albert Whitman and Co.; illustrations for *Youth's Companion, Child Life, Little Folks, Woman's Home Companion, Designer, Craftsman,* and *McCalls.* Specialty, illustration of children's stories. Address in 1929, 200 River Bluff Road, Elgin, IL.

COOK, HOWARD (NORTON).
Illustrator and etcher. Born Springfield, July 16, 1901. Pupil of ASL of NY. Award: Hon. mention for woodcut, Philadelphia Print Club, 1929. Represented by etchings and woodcuts in the print collection of the Metropolitan Museum of Art, New York; Fogg

Art Museum, Harvard University, Cambridge, MA; Baltimore Museum of Art, Baltimore, MD. Address in 1929, Rue Du Vallonnet, Cagnes-sur-mer, Alpes-Maritimes, France; h. 100 Washington Road, Springfield, MA.

COOK, ISABEL VERNON.
Painter. Born Brooklyn, NY. Pupil of Art Students League of New York and Chase; Blanche and Simon in Paris. Member: National Academy of Women Painters and Sculptors. Address in 1926, 39 West 67th Street, New York, NY.

COOK, JOHN A.
Painter. Born Gloucester, MA, March 14, 1870. Pupil of DeCamp, E. L. Major and Douglas Volk. Member: S. Indp. A.; North Shore AA; Boston AC; New Haven PPC; AFA. Address in 1929, 16 Sayward Street; h. 8 Highland Street; summer 67 E. Point Road, Gloucester, MA. Died in 1936.

COOK, MAY ELIZABETH.
Sculptor. Born Chillicothe, OH, Dec. 1881. Pupil of Paul Bartlett; Ecole des Beaux-Arts and Colarossi Academy in Paris. Member: Columbus League of Artists; American Ceramic Society (associate); Plastic Club; National Sculpture Society; National Arts Club; National Association of Women Painters and Sculptors; Philadelphia Alliance; Gallery of Fine Arts, Columbus; American Federation of Arts; Union Internationale des Beaux-Arts des Lettres, Paris. Represented in Carnegie Library, Columbus OH; Ohio State University, Columbus, OH; National Museum, Washington, DC; memorial panels, Colorado Springs; Chillicothe, OH. Awards: Hon. mention, Int. Painters and Sculptors, Paris; medal, Paris Salon, for war work (600 life masks and 500 models for reconstruction of faces of American soldiers). Address in 1933, Columbus, OH; National Arts Club, 15 Gramercy Park, NYC. Died in 1951.

COOK, PAUL RODDA.
Painter. Born Salina, Kansas, Aug. 17, 1897. Pupil of H. D. Pohl, Birge Harrison, H. D. Murphy. Member: SSAL; San Antonio AL; Amer. Artists Prof. Lg. Awards: First prize, Waco Cotton Palace, 1st prize, San Angelo, 2nd prize, Lockhart State Fair and hon. mention, Davis Competition, all in 1929. Address in 1929, 409 West Park Avenue, San Antonio, TX.

COOK, ROBERT HOWARD.
Sculptor and medalist. Born in Boston, MA, April 8, 1921. Studied at Demetrios School, 1938-42; Beaux Arts, Paris, under Marcel Gaumont, 1945. Works in Whitney Museum of American Art, NY; Penna. Academy of Fine Arts, Philadelphia; Hirshhorn Collection, Washington, DC; Thespis (12 ft. long bronze), Canberra Theatre Center, Australia, 1965; others. Has exhibited at Institute of Contemporary Art, Boston; Mint Museum of Art, Charlotte, NC;

Virginia Museum of Fine Art, Richmond; Penna. Academy of Fine Arts; Whitney Annual; National Academy of Design; others. Received second prize, Prix de Rome, American Academy of Rome; National Academy of Arts and Letters, Cash Award and Best-of-Show; Tiffany Award; others. Member of Sculptors Guild. Works in bronze and wood. Address in 1982, Rome, Italy.

COOK, T. B.
Engraver. In 1809-16 T. B. Cook was engraving portraits in stipple for Wm. Durell and other book publishers of New York.

COOK-SMITH, JEAN BEMAN.
Sculptor and painter. Born in New York, March 26, 1865. Pupil of Art Institute of Chicago; Chase. Studied in Holland, France, and Italy. Member: National Academy of Women Painters and Sculptors. Work: "The Maya Frieze," San Diego Museum, CA. Address in 1933, San Diego, CA.

COOKE, ABIGAIL W.
Painter. Pupil of Rhode Island School of Design. Member of Providence Art Club. Address in 1926, 15 Pitman Street, Providence, RI.

COOKE, CHARLES H.
Painter. Born Toledo, Ohio, July 31, 1859. Pupil of AIC. Member: Palette and Chisel C.; AIC Alumni Assoc.; S. Indp. A.; Chicago NJSA; Am. APL; Ill. Acad. FA. Address in 1929, 6329 Glenwood Avenue, Chicago, IL.

COOKE, EDNA.
Illustrator. Born in Philadelphia, 1891. Pupil of Breckenridge and McCarter at the Penna. Academy of Fine Arts. Address in 1926, Care of 235 South 11th Street, Philadelphia.

COOKE, GEORGE.
Engraver and portrait-painter. Born in St. Marys County, MD, March 1793. He studied art in Europe in 1826-30, and established himself in New York on his return to this country. It is not known that this man ever attempted to engrave, and the plates signed by George Cooke as "engraver" are too well done to be ascribed to any prentice hand. Died in 1849.

COOKE, JESSIE DAY.
Painter, illustrator, and teacher. Born Atchison, Kansas, May 16, 1872. Pupil of Vanderpoel, Freer, Pauline Dohn. Member: Alumni Assoc. AIC; Chicago NJSA; Ill. Acad. FA; Am. APL. Address in 1929, 6329 Glenwood Avenue, Chicago, IL.

COOKE, JOSEPH.
Engraver. In the *Pennsylvania Gazette*, Philadelphia, 1789, Joseph Cooke advertises himself as goldsmith, jeweler and hair-worker. Advertises "Church,

State or County Seals, Coats of Arms, and all manner of Engraving on steel, silver, gold, or metal, executed in the best manner and at the lowest prices."

COOKE, KATHLEEN McKEITH.
Sculptor and painter. Born in Belfast, Ireland, Sept. 30, 1908; US citizen. Studied with Arthur Schweider, Samuel Adler, Madeleine Gekiere, Collette Roberts, and Theodoros Stamos. Works: University of Utah, Cornell University, Arts Council Northern Ireland, Bank Ireland, and University of Notre Dame; plus others. Exhibitions: One-woman shows, Betty Parsons Gallery, 1970 and 75, David Hendriks Gallery, Dublin, Ireland, 1971 and 73; Kunstmuseum, Odense, Denmark, 1973; Carstens Gallery, Copenhagen, 1973; Compass Gallery, Glasgow, 1973; Galerie Rivolta, Lausanne, 1973; Arts Council Gallery, Belfast, 1973; Philadelphia Museum Art, 1971; Hillsborough Art Center, Northern Ireland, 1971; Drawings by Living Americans, National Endowment for the Humanities Traveling Exhibition, 1972; Gordon Lambert Collection, Municipal Gallery of Modern Art, Dublin, 1972; plus others. Media: Clay, stone; oil and dry point. Address in 1976, 95 Lexington Ave., NYC. Died in 1978.

COOKINS, JAMES.
Landscape painter. Born in Terre Haute, IN, 1825. After study abroad he opened his studio in Cincinnati in 1861, but finally settled in Chicago, IL.

COOKMAN, CHARLES EDWIN.
Painter. Born in Columbus, OH, in 1856; died in 1913.

COOLEY, GARY.
Illustrator. Born in Jackson, Michigan, in 1947. He studied for four years at the Society of Arts and Crafts. Since 1969, when he entered the field of illustration doing black and white art for Detroit newspapers, his work has appeared in books, magazines and on posters. The Graphic Artists Guild of Detroit has awarded him three gold medals and he received a First Honor from the 1973 Ace Awards in Pittsburgh.

COOLIDGE, DAVID W.
Painter. Born in Lincoln, Neb. Study: Drake Univ.; with John Falter; PAFA; Tyler Sch. Art, Rome. Work: US Nat'l. Bank, Omaha; Arthur Anderson & Co., Phila. Exhibitions: Wm. Penn. Mem. Mus., Harrisburg, PA; Hazleton (PA) Art Mus.; Phila. WC Club Ann.; Phila. Art Alliance; etc. Mem.: Phila. WC Club; assoc. mem., Am. WC Society. Media: Watercolor, oil. Address in 1982, Box 359, Bryn Mawr, Pennsylvania.

COOLIDGE, JOHN.
Painter, illustrator, and writer. Born Pennsylvania, Dec. 6, 1882. Pupil of Chase, Cecilia Beaux, T. P.

Anshutz; J. Francis Smith. Member: California AC. Address in 1929, 930 Central Building; h. 959 South Arlington Avenue, Los Angeles, California. Died in 1934.

COOLIDGE, MOUNTFORT.
Painter. Born in Brooklyn, NY, in 1888. Pupil of Robert Henri. Address in 1926, 126 Pennsylvania Street, Brooklyn, New York. Died in New York.

COONSMAN, NANCY.
Sculptor. Born at St. Louis, MO, in 1888. Pupil of Zolnay and Grafly. Address in 1926, 6171 Delmar Blvd., St. Louis, MO.

COOPER, ALICE.
Sculptor. Born in Denver, CO. Among her best known works, "Summer Breeze," "Dancing Fawn," and "Frog Girl."

COOPER, B. Z.
Painter. Exhibited water colors at Penna. Academy of the Fine Arts, Philadelphia, 1922. Address in 1926, 1947 Broadway, New York.

COOPER, BROTHER ETIENNE.
Sculptor, painter, and teacher. Born in Altoona, PA, July 11, 1915. Studied: University of Notre Dame, A.B.; Catholic University. Exhibited: Hoosier Salon, 1950. Work: Mural, Children's Room, Sts. Peter and Paul Cathedral, Indianapolis. Illustrated "Young Prince Gonzaga," 1944. Taught art at Cathedral High School, Indianapolis, Ind. Address in 1953, Notre Dame, IN.

COOPER, COLIN CAMPBELL.
Painter. Born Philadelphia. Pupil of PAFA; Julian and Delecluse Academies in Paris. Member: ANA, 1908; NA, 1912; NYWCC; AC Phila; Phila. WCC; AWCS; Fellowship PAFA; Lotos C.; NAC; SPNY; AFA. Specialty: Street scenes. Awards: Bronze medal, Atlanta Exp., 1895; Wm. T. Evans prize, AWCS, 1903; Senan prize, PAFA, 1904; gold medal, ACP, 1905; silver medal, Buenos Aires Exp., 1910; Beal prize, NYWCC, 1911; gold medal for oil painting and silver medal for water colors, P.-P. Exp., San F., 1915; Hudnut prize, NYWCC, 1918; Lippincott prize, PAFA, 1919. Work: "Broad Street, New York," Cincinnati Museum; "The Flatiron, New York," Dallas (TX) Art Association; "Grand Basin, World's Fair," and "The Plaza, New York," St. Louis Museum of Fine Arts; "Basilika, Quebec," Boston Art Club; "Procession at Bruges," Art Club of Philadelphia; "The Rialto," Lotos Club, New York; "Broadway in War Time," PAFA, Philadelphia; "Fifth Avenue, New York," owned by the French Government; "Lotos Pool, El Encanto, Santa Barbara," Reading Museum. Address in 1929, 222 West 59th Street, New York, NY; Santa Barbara, California. Died Nov. 6, 1937.

COOPER, ELIZABETH.
Sculptor. Born in Dayton, OH, 1901. Studied with Sally James Farnham and at American School of Sculpture. Exhibited at National Sculpture Society, 1923. She made a specialty of animals. Address in 1926, Stamford, CT.

COOPER, EMMA LAMPERT.
Painter. Born Nunda, NY. Studied New York, Cooper Union, and Art Students League, and with Miss Agnes D. Abbatt in water colors; later went abroad several times for study in Paris and to sketch in Holland, Italy, etc. Member: NY WCC; AWCS; NA Women PS; New York Society of Painters; (pres.) Women's Art Associaton of Canada; Philadelphia Water Color Club. Died July 30, 1920 in Pittsfield, NY.

COOPER, FRED G.
Illustrator. Born McMinnville, OR, Dec. 29, 1883. Member: SI, 1910; Salma. C.; AI Graphic A.; Phila. Sketch C.; GFLA. Illustrations for *Collier's*, *Life*, and *Liberty*. Cartoonist and advertising designer. Theater posters for Food Administration. Originator of the Cooper Letter. Address in 1929, care of Life, 598 Madison Avenue; h. 101 West 55th Street, New York, NY. Died in 1962.

COOPER, GEORGE VICTOR.
Sculptor, portraitist, landscapist, lithographer, illustrator, and cameo cutter. Born in Hanover, New Jersey, Jan. 12, 1810. Worked: New York City, 1835-36; California, from 1849. Exhibited: Apollo Association, 1839; National Academy, 1839. Worked with J. M. Lett, *California Illustrated*, 1853; Cooper made the illustrations. Noted work: Portrait of Abraham Lincoln. Died in New York City, Nov. 12, 1878.

COOPER, JAMES.
Miniature painter. Flourished in Philadelphia, 1855. He exhibited at the Penna. Academy in 1855.

COOPER, LUCILLE BALDWIN.
Sculptor and painter. Born in Shanghai, China, Nov. 5, 1924; US citizen. Studied at University of California, Los Angeles; University of Hawaii; Honolulu Academy of Art. Works: Painting, Hawaii Loa College. Commissions: 48 colleges, Polynesian Hotel, Honolulu, Hawaii, 1960; oil painting, Fiji Hotel, 1971. Exhibitions: 3 Plus 1 Show, Ala Moana, Honolulu; Honolulu Academy of Art Annual; Easter Art Festival; Hawaii Painters and Sculptors League Annual; Honorary Retrospective, Hawaii Loa College, 1970. Awards: Best in Show for Watercolor, Watercolor and Serigraph Society; honorable mention for Watercolor. Member: Hawaii Painters and Sculptors League (sec.); Hawaii Potters Guild; Hawaii Craftsmen (pres.); honorary member Windward Art Guild (pres.). Media: Clay, acrylic; oil, and watercolor. Address in 1980, Shanghai, China.

COOPER, MARGARET MILLER.
Painter. Born Terryville, Connecticut, March 4, 1874. Pupil NAD; PAFA at Chester Springs, PA; Henry B. Snell; Guy Wiggins. Member: NAC (Assoc.); NA Women PS; AFA; CT AFA. Address in 1929, 169 Vine Street, New Britain, Connecticut; summer, Lyme, Connecticut.

COOPER, MARIO RUBEN.
Sculptor, painter, and illustrator. Born in Mexico City, Mexico, Nov. 26, 1905. Study: Otis Art Institute, Los Angeles, 1924; Chouinard Art School, Los Angeles, 1925; Grand Central Art School, NYC, 1927-37; Columbia University; with F. Tolles Chamberlin, Louis Trevisco, Pruett Carter, Harvey Dunn. Work: Metropolitan Museum of Art; Butler Institute; NASA; and others. Commissions for USAF: painting of Atlas ICBM, planes, capitals of Europe; invited by National Gallery to document Apollo 10 & 11 flights. Exhibitions worldwide. Illustrations in *Collier's, Woman's Home Companion, American, Cosmopolitan.* Head, team of artists to Japan, Korea, Okinawa, USAF, 1956, and to Japan, 1957; art consultant, USAF, 1960; teacher, Art Students League, from 1957, and at National Academy of Design School of Fine Arts, City College of NY, 1961-68, and Grand Central School of Art. Received Audubon Artists Guild Medal of Honor, 1974; Samuel F. B. Morse Gold Medal, National Academy of Design; American Water Color Society High Winds Medal, 1979, 81. Member: Honorary member Royal Water Color Society of Great Britain; Century Association; Audubon Artists (president, 1954-58); Academician, National Academy of Design; American Water Color Society (president from 1959). Works in watercolor. Address in 1982, 1 W. 67th St., NYC.

COOPER, PEREGRINE F.
Painter. He worked in oil portraits, miniatures, also drawing in pastels. He flourished in Philadelphia from 1840 to 1890. In 1863 he published a book on miniature painting. He exhibited for a number of years at the Pennsylvania Academy of the Fine Arts, Philadelphia.

COOPER, PETER.
Painter. Painted a view of Philadelphia. The records of the "Philadelphia City Council" read: "Peter Cooper, painter, was admitted a freeman of the city in May 1717."

COOTES, FRANK GRAHAM.
Painter and illustrator. Born Staunton, VA, April 6, 1879. Pupil of Kenneth Hayes Miller, Robert Henri and F. V. Du Mond in New York. Member: SI, 1910. Illustrations for "The Shepherd of the Hills," etc. Designed covers for magazines. Address in 1929, 50 West 67th Street, New York, NY. Died in 1960.

COPE, MARGARETTA PORTER.
Painter. Born Philadelphia, Feb. 17, 1905. Pupil of A. Margaretta Archambault and PAFA. Address in 1929, 1928 Panama Street; h. 2418 Spruce Street, Philadelphia, PA; summer, 839 Kearney Avenue, Cape May City, NJ.

COPELAND, ALFRED BRYANT.
Painter. Born in Boston, 1840. He studied abroad and on returning to this country he became professor in the University of St. Louis. He later opened his studio in Paris, exhibited in the Salon, and sent a collection of his paintings to Boston. He died Jan. 30, 1909 in Boston, MA.

COPELAND, CHARLES.
Painter. Born Thomaston, ME, 1858. Engaged as illustrator and painter in water color; exhibited at Society American Artists; Penna. Academy Fine Arts; Boston Art Club, etc. Member: Boston Art Club, Boston Society Water Color Painters. Address in 1926, 110 Tremont Street, Boston, MA.

COPELAND, JOSEPH FRANK.
Painter, craftsman, and teacher. Born St. Louis, MO, Feb. 21, 1872. Member: Phila. Sketch C.; Phila. WCC; Phila. Alliance. Instructor, Pennsylvania Museum School of Industrial Art. Address in 1929, 320 South Broad Street, Philadelphia, PA; h. 58 Forest Avenue, Drexel Hill, PA.

COPELAND, M. BAYNON.
Portrait painter. Born El Paso, Texas. Pupil of Kenyon Cox in New York; Ferdinand Humbert and R. Miller in Paris; Shanon in London. Address in 1929, 73 Longridge Road, S.W. 5, London, England.

COPLEY, JOHN SINGLETON.
Portrait painter. Born in Boston, July 3, 1738. This famous American portrait painter was the stepson of the English portrait painter and mezzotint engraver Peter Pelham, who died in Boston in 1751. On May 22, 1748, his first wife having died, Pelham married Mary Singleton Copley, the widow of Richard Copley and the mother of the subject of his sketch. John Singleton Copley doubtless received instructions from his step-father in both portrait painting and in engraving. As evidence of the latter statement there exists a small but creditably executed mezzotint plate of the Rev. Mr. William Welsted of Boston in New England. This plate is signed "J.S. Copley pinxt. et fecit." William Welsted died 1753, and this plate was probably engraved soon after this date. Copley sent over to London, for exhibition at the Royal Academy in 1760, a picture of "The Boy and the Flying Squirrel." In 1775 after a successful career as a portrait painter in Boston he established himself in London. His masterpieces, "The Death of Major Pierson," and "The Death of Lord Chatham" are both in the Nat'l Acad. See "Life of John

Singleton Copley," by Augustus T. Perkins. Also "The Life and Works of John Singleton Copley," by Frank W. Bayley. The Boston Mus. of Fine Arts owns his portraits of Samuel Adams, Gen'l Jos. Warren, Mrs. Warren, John Quincy Adams, and "Watson and the Shark." Died Sept. 9, 1815 in London, England.

COPP, ELLEN RANKIN.
Sculptor. Born in Atlanta, IL, 1853. Pupil of Art Institute of Chicago; Fehr School in Munich. Address in 1903, Chicago, IL.

COPPEDGE, FERN ISABELL.
Painter. Born Decatur, IL, July 28, 1888. Pupil of William M. Chase, John Carlson, and ASL of NY; AIC; PAFA. Member: NA Women PS; Plastic C.; Phila. Alliance; Fellowship PAFA; ASL of NY; Ten Phila. P.; North Shore AA; Gloucester SA. Awards: H. O. Dean prize, Artists of Kansas City and vicinity, 1927; E. Shield prize, 1918; hon. mention, NA Women PS, 1922; first prize, Plastic Club, 1924; silver medal, Kansas City AI, 1924. Work: "The Thaw," Detroit Institute of Art; "Winter on the Schuylkill," Pennsylvania State Capitol; "Snow Covered Hills," PAFA; "From the Hill Top," American Embassy, Rio de Janeiro, Brazil; "The Frozen Canal," DeWitt Museum, San Antonio, TX; "A Village on the Delaware," Thayer Museum, Kansas University, Lawrence, Kansas. Address in 1929, 4011 Baltimore Avenue, Philadelphia, PA; summer, Lumberville, Bucks Co., PA.

COPPINI, POMPEO.
Sculptor and painter. Born Moglia, Italy, May 19, 1870. Pupil of Academia de Belle Arti and Augusto Rivalta in Florence; came to America in 1896; citizen of US in 1901. Represented in the US by 36 public monuments, 16 portrait statues and about 75 portrait busts, and in Mexico City by the Washington Statue, gift from Americans to Mexico. Address in 1953, San Antonio, TX; 210 West 14th Street, NYC. Died Sept. 27, 1957, in San Antonio, TX.

COPPOLINO, JOSEPH.
Sculptor and designer. Born in New York, NY, November 3, 1908. Studied: Cooper Union Art School, New York; Beaux-Arts Institute of Design, New York; National Academy of Design; with Piccirilli, Lee Lawrie, Gaetano Cecere; industrial design with Dreyfuss, Barnhardt. Awards: Prizes, Beaux-Arts Institute of Design, New York, 1929, 35; Cooper Union Art School, New York; Prix de Rome, 1937, 38. Prosthetic work with Veteran's Administration, New York, NY. Address in 1953, Veteran's Administration, 252 Seventh Avenue, New York, NY; h. 217-09 120th Avenue, St. Albans, NY.

CORAM, THOMAS.
Portrait and landscape painter. He was born in Bristol, England, April 25, 1757. He came to

Charleston, SC, at an early age. He was a self-taught artist and attempted engraving (see "Stauffer's American Engravers"). Died May 2, 1811 in Charleston, SC.

CORBETT, EDWARD M.
Born August 22, 1919 in Chicago, IL. Studied at Cal. School of Fine Arts, S.F. Taught there and at S.F. State Teachers College; UC/Berkeley; Mount Holyoke (1953-62); Santa Barbara. Received Rosenberg fellowship (1951), and award from Nat. Inst. of Arts and Letters. Exhibited at Art Inst. of Chicago; Riverside Museum, NYC; G. Borgenicht Gallery, NYC; MOMA; Tulane; Whitney, others. In collections of the Tate; Newark Museum; Bankers Trust; Whitney; MOMA; and many others, incl. private collections. Died June 6, 1971 in MA.

CORBETT, GAIL SHERMAN.
(Mrs. H. W. Corbett). Sculptor. Born in Syracuse, NY, in 1871. Studied modeling with Caroline Peddle (Ball); Art Students League with Augustus Saint-Gaudens, H. Siddons Mowbray, George de Forest Brush. Taught drawing and modeling for 2 years at Syracuse University, 1898-1899. Worked in Paris under the guidance of Saint-Gaudens, and at the Ecole des Beaux-Arts. Awards: Honorable mention for sculpture, and bronze medal for medals, P.-P. International Exp., San Francisco, 1915. Member: National Sculpture Society; American Numismatic Society; National Association of Women Painters and Sculptors. Works: Hamilton S. White memorial, and Kirkpatrick memorial fountain, Syracuse, NY; tablet to Dean Vernon, Syracuse University, and bust of Dr. Calthrop, May Memorial Church, Syracuse, NY; bronze doors for Auditorium, Municipal Building and Tower, and large bronze zodiac and compass in front of Tower, Springfield, MA; garden fountains, sun-dials, and low relief portraits. Exhibited at National Sculpture Society, 1923. Address in 1933, 443 West 21st St., NYC. Died Aug. 26, 1952.

CORCOS, LUCILLE.
Painter and illustrator. Born in NYC in 1908. Studied: Art Students Lg. Awards: Pepsi-Cola, 1944; Grumbacher award, 1956. Collections: Whitney Museum of American Art; US Gypsum Company; Upjohn Pharmaceutical Company; Columbia Broadcasting System; Museum of Art, Tel-Aviv; mural, North Shore Hospital, Manhasset, New York; *Life Magazine*; mural, Waldorf-Astoria, New York. Her first illustration assignments came in 1929 from Conde Nast's *Vanity Fair*. She became well known for her children's book illustrations, inc. *Grimm's Fairy Tales*, published by Limited Editions Club, and *Ungskah* and *Oyaylee*. Died in 1973.

CORISH, JOSEPH R.
Painter. Born Somerville, MA, April 9, 1909. Study: Boston Univ.; Harvard Univ.; Bridgewater State

College. Work: US Naval Acad. Mus.; US Naval War College; state capitols; foreign embassies; ships of US, Brit., Japan, Ger., Spain and Portugal. Exhibitions: Boston Museum of Fine Arts; Busch Reisinger Museum; Jordan Exhib. of Contemp. N. Eng. Artists; Harvard, Yale, Boston U., Conn. College; museums in US, Germany, Spain, Norway, and Japan. Mem.: Am. Soc. of Marine Artists; Salmagundi Club; Am. APL; also US Navy Combat Artist; lecturer at Harvard, Univ. of Conn. and others. Media: Oil. Address in 1982, Somerville, MA.

CORNE, MICHAEL FELICE.
Italian marine and portrait painter in oil. Born 1752 on Elba, came to US in 1799. He also drew portraits in India ink, several being in Essex Institute at Salem, MA. During the War of 1812 he painted a series of naval engagements. Died July 10, 1845 in Newport, RI.

CORNELIUS, MARTY.
Painter and illustrator. Born in Pittsburgh, PA in 1913. Studied: Carnegie Inst.; and with Reginald Marsh, Alexander Kostellow. Awards: Association Art Pittsburgh, 1939, 1945, 1953; Martin Leisser School of Design, 1946-1949; Butler Institute of American Art, 1948; Corcoran Gallery of Art, 1941, 1947; others. Collections: Pitts. Public Schools; MOMA, NYC; others. Exhib. at Whitney, NYC; Corcoran, Wash., DC; Carnegie, from 1937; Pal. of Legion of Hon., San Fran.; others. Died in 1979.

CORNELL, JOSEPH.
Sculptor. Born in Nyack, NY, Dec. 24, 1903. Studied at Phillips Academy at Andover, MA. Settled in NYC, 1929. Exhibited at Peggy Guggenheim's "Art of this Century" Gallery (1944-45); Egan Galleries (1947-53); Stable Gallery (1953); Allen Frumkin Gallery (1953), Chicago; Museum of Modern Art, 1936, 61; Whitney Annuals, 1962, 66; Galerie des Beaux Arts, Paris, 1938; Carnegie, 1958; others. Assoc. with the Julien Levy Galleries, exhibiting there from 1932-42. Awards: Chicago Art Inst. 1959; Ada S. Garrett Prize, 1959; American Academy of Arts and Letters, Award of Merit, 1968. Many of his works are now held by the Hirshhorn Museum. Address in 1971, Flushing, NY. Died in 1972.

CORNER, THOMAS C.
Painter. Born Baltimore, MD, 1865. Pupil of Weir and Cox in New York; Lefebvre and Constant in Paris. Member: Charcoal Club. Represented in Virginia State Library, Richmond, by portrait of Gov. F. W. Mackey Holliday, painted in 1897. Died in 1938.

CORNETT, ROBERT FRANK.
Painter. Born Lafayette, LA, July 27, 1867. Pupil of George Essig; Corcoran School of Art. Member: S. Wash. A.; Wash. Landscape C. Address in 1929, 2944 Taver Street, N.W., Woodridge, DC.

CORNOYER, PAUL.
Painter. Born St. Louis, MO, 1864. Pupil of Lefebvre, Constant and Louis Blanc in Paris. Work: "After the Rain," Brooklyn Institute Museum; "Madison Square," Art Association, Dallas, Texas; St. Louis Art Museum; "Rainy Day, Columbus Circle," Newark Art Association. Died June 17, 1923 in East Gloucester, MA.

CORNWELL, DEAN.
Illustrator. Born Louisville, KY, Mar. 5, 1892. Pupil of Harvey Dunn; Charles S. Chapman. Member: SI; GFLA; Players C.; Chelsea Arts C., London; London Sketch C.; Salma. C.; Arch. L. of NY. Awards: First illustration prize, Wilmington SFA, 1919 and 1921; two awards of merit, AIC Alumni, 1922; Isidor water color prize, Salma. C., 1927. Illustrated: "Torrent," "Kindred of the Dust," "Rivers End," "Valley of Silent Men," "Find the Women," "The Desert Healer," "The Garden of Peril," "Never the Twain Shall Meet," "The Enchanted Hill," "Exquisite Perdita." Author of "City of the Great King," (Cosmopolitan Book Corp.). Address in 1929, 206 East 33rd St., New York, NY; Mamaroneck, NY. Died in 1960.

CORNWELL, MARTHA JACKSON.
Sculptor and painter. Born West Chester, PA, Jan. 29, 1869. Studied at Philadelphia School of Design; Penna. Academy of Fine Arts; and Art Students League of New York; and with Saint-Gaudens, H. Siddons Mowbray, and George de Forest Brush. Member: Art Students League of NY; Fellowship Penna. Academy of Fine Arts. Specialty, portrait bronzes. Exhibited at Penna. Academy of Fine Arts, Philadelphia, 1924. Died before 1926.

CORNWELL, WILLIAM CARYL.
Painter. Born Lyons, NY, Aug. 19, 1851. Pupil of Lefebvre, Boulanger, and Julian Acad., Paris. Member: Salma. C.; NAC; AFA. Inventor of the Cornwell luminos. Address in 1929, 434 Lafayette Street, New York, NY.

CORSO, SAM.
Sculptor and designer. Born in Montevago, Italy, March 6, 1888. Studied: Cooper Union Art School. Member: Union Scenic Art. Awards: Prizes, Cooper Union Art School, 1920, 21. Exhibited: Models of Army, Navy, and Aviation Units of Allied Armed Forces at Grand Central Palace and Museum of Science and Industry, Rockefeller Center, NY. Art Director, Fox Films, Paramount Studios, 1925-32; West Coast Sound Studio, New York, NY, 1953. Address in 1953, 510 West 57th Street, New York, NY; h. Forest Hills, LI, NY.

CORSON, KATHERINE LANGDON.
(Mrs. Walter H. Corson). Landscape painter and illustrator. Born Rochdale, England. Pupil of Emil

Carlsen, H. Bolton Jones and F. C. Jones in New York. Member: National Academy of Women Painters and Sculptors: Fellowship Penna. Academy of Fine Arts; Plastic Club. Award: Medal, Atlanta Expn., 1895. Work: "Across the Cove," Hamilton Club. Died Feb. 12, 1937.

CORTIGLIA, NICCOLO.
Painter and teacher. Born New York City, April 7, 1893. Pupil of William Forsyth; Academy of Arts, Florence, Italy. Member: Florence (Italy) SFA. Award: First prize, Florence, Italy, "Primaverile," 1920. Address in 1929, 900 Coal Exchange Bldg.; h. 61 West Union Street, Wilkes Barre, PA.

CORTRIGHT, HAZEL PACKER.
Painter. Member: Plastic Club. Address in 1926, St. Martin's, Philadelphia, PA; Saunderstown, RI.

CORWAINE, AARON H.
Born in Kentucky, Aug. 31, 1802; died in Philadelphia in July, 1830. Studied with Thomas Sully. His studios were in Phila. and later in Cincinnati.

CORWIN, CHARLES ABEL.
Painter. Born in Newburgh, NY, Jan. 6, 1857. Pupil of Frank Duveneck. Member: Chicago SA; Salma. C. 1905; Bronx AG. Awards: Cahn prize, AIC 1900; hon. mention, Chicago SA; participant in Fine Arts Bldg. prize, AIC 1914. Work in Piedmont Gallery, Berkeley, CA. Address in 1929, Salmagundi Club, 47 Fifth Ave.; 2486 Grand Concourse, New York, NY. Died in 1938.

CORWIN, SOPHIA M.
Sculptor and painter. Born in New York. Studied at Art Students League; National Academy School of Fine Arts; Hofmann School; Archipenko School; Phillips Gallery Art School, Washington, DC, with Karl Knaths; NYU. Awards: Phillips Gallery of Art, Washington, DC; Creative Arts Gallery; National Sculpture Competition Award, US Department of Housing and Urban Development. Collection: New York University. Exhibitions: Corcoran Gallery; Baltimore Museum; NYU; Capricorn Gallery, NYC; others. Living in Yonkers, NY, in 1982.

CORY, KATE T.
Sculptor, painter, and muralist. Born in Waukegan, IL, 1861. Studied: Cooper Union, NYC; Art Students League; pupil of Cox and Weir. From 1905 to 1912, lived among Hopis at Oraibi and Walpi. Moved to Prescott, AZ, 1913. Member: National Academy of Women Painters and Sculptors; Society of Independent Artists. Work in Smithsonian Institution; Public Museum, Prescott; University of Arizona, Tucson; Tuzigoot Museum, Clarkdale, AZ. Specialized in portraying the Hopi people and Arizona landscape. Address in 1957, Prescott, AZ. Died in 1958.

COSIMINI, ROLAND FRANCIS.
Painter and illustrator. Born Paris, France, May 1, 1898. Pupil of Richard Andrews and Ernest L. Major. Decorations and publicity for Raymond & Whitcomb Co.; illustrations and jacket designs for Houghton Mifflin Co. Address in 1929, 28 St. Botolph Studios, Boston, MA.

COSTA, HECTOR.
Sculptor and painter. Born Caltanessetta, Italy, March 6, 1903. Pupil of Prior, Hinton, Nicolaides, Olinsky, and Ellerhusen. Member: Penna. Academy of Fine Arts; Art Students League. Award: Bronze medal, first prize, design, Italian-American Art Exhibition 1928; Tiffany Foundation Fellowship, 1931. Address in 1933, 242 East 83rd Street, New York, NY.

COSTAGGINI, FILIPPO.
Painter. Born in Rome, Italy, 1839; died at Upper Falls, Baltimore County, MD, April 15, 1904. Began his artistic career in Rome, where he won distinction as an historical painter. He came to America in 1870 and engaged in the painting of historical and religious pictures, as well as portraits; among his notable portraits is one of the late Senator Justin S. Morrill of Vermont. His works can be found in the large cathedrals and churches of the US, especially in NY, Phila., and Baltimore. He was given the commission to complete the historical frieze in the Rotunda of the Capitol representing American History, commenced by Constantino Brumidi. The work of Costaggini began at the three Indians in the group, representing Penn's Treaty, and continued the historical events in chronological order to the period of the Discovery of Gold in California, this being two thirds of the frieze. He died before completing the work.

COSTELLO, VAL.
Painter. Member: Calif. AC; Calif. WCS; Laguna Beach AA. Address in 1929, 518 West 53rd Street, Los Angeles, CA.

COSTIGAN, IDA.
Sculptor. Born in Germany in 1894. Came to US at early age. Self-taught. Exhibited at National Academy of Design, 1922; National Sculpture Society, 1923; Penna. Academy of Fine Arts, 1924. Address in 1926, Orangeburg, NY.

COSTIGAN, JOHN E.
Painter. Born Providence, RI, Feb. 29, 1888. Self-taught. Member: ANA, 1926; NA, 1928; AWCS; NYWCC; Salma. C.; Allied AA; Am. Soc. Animal PS; Guild of American Painters; NAC. Awards: Third Hallgarten prize, NAD, 1920; Isidor prize, Salma. C. 1920; Peterson purchase prize, AIC, 1922; Charles E. Kramer purchase prize, 1923; Vezin prize ($200), Salma. C., 1923; W. H. Tuthill purchase prize,

AIC, 1924; Shaw purchase prize ($1,000), Salma. C., 1924; Saltus medal, NAD, 1925; medal ($300), NAC, 1925; bronze medal, Sesq. Expos., 1926; Logan medal ($1,500), AIC, 1927; Clark prize ($300), NAD, 1927; second Altman, NAD, 1927; Plimton ($100), Salma. C., 1928; Speyer ($300), NAD, 1928; Lloyd Griscom P.-P., WCC, 1928; Mrs. Julius Rosenwald prize ($500), Grand Cent. Art Gallery Members' Exp., 1928; John McGowan P.-P. WC Exhibition, 1929. Represented in Art Institute, Chicago; Duncan Phillips Gallery, Los Angeles Museum; Vanderpoel AA Collection, Chicago; Delgado Museum, New Orleans; Museum, Nashville, Tennessee; Rhode Island School of Design; Connecticut Agricultural College; NAC Collection; Salma. C. Thumb Box Collection; Montclair Museum. Address in 1929, care of Grand Central Galleries, 15 Vanderbilt Avenue, New York, New York, Orangeburg, New York. Died in 1972.

COTHARIN, KATE LEAH.
Painter. Born Detroit, Michigan, October 27, 1866. Pupil of J. M. Dennis in Detroit. Member: Copley S. Represented in Springfield Art Museum. Specialty, pastel landscapes in miniature. Address in 1929, 279 Dartmouth Street, Boston, Massachusetts; summer, Rockport, Massachusetts.

COTHER, DOROTHY McVEY.
Painter and teacher. Born Crossville, TN. Pupil of M. L. Weatherford, Henry B. Snell, Pratt Institute; Ecole des Beaux Arts, Fontainebleau. Member: NA Women PS; L. C. Tiffany Foundation. Awards: Holland prize, AWCS and NYWCC, 1926; Memorial Fellowship Award ($1,000), AA of Pratt Institute, 1927. Address in 1929, 309 Washington Avenue, Brooklyn, NY.

COTTON, JOHN WESLEY.
Painter, etcher, and lecturer. Born Ontario, Canada, October 29, 1868. Pupil of E. Marsden Wilson in London; AI Chicago. Member: Ontario SA; Chicago SE; California PM; California AC; California WCC; Calif. PS. Awards: DeWolf prize, Chicago SE, 1915; hon. mention for etchings, P.-P. Exp., San Francisco, 1915; gold medal, Pac. Southwest Expos., Long Beach, 1928; hon. mention, PS Club, Los Angeles, 1928. Etchings in: New York Public Library; Congressional Library, Washington; Art Institute of Chicago; National Gallery, Ottawa; Art Museum, Toronto; State Library, Sacramento, California; Oakland Public Library; Los Angeles Art Museum. Address in 1929, Glendale, California. Died in 1931.

COTTON, WILLIAM HENRY.
Portrait painter. Born Newport, RI, July 22, 1880. Studied Cowles Art School, Boston, under Andreas Anderson and Joseph De Camp, also Julien Academy, Paris, under Jean Paul Laurens. Exhibited at National Academy of Design, New York; Corcoran Art Gallery, Washington; Art Institute of Chicago; PAFA; Saint Louis Art Museum; Carnegie Institute, Pittsburgh; etc. Award: First Hallgarten prize, NAD, 1907. Has painted portraits of Honorable Willard Bartlett, George Barr McCutcheon, Harrison Rhodes, and Miss Chrystal Herne; mural painting in the Capitol Theatre, New York; represented in the exhibition of American Artists at Luxembourg Museum, at The Government Academy of National Artists; a founder National Association Portrait Painters. Member: Newport Art Association. Address in 1926, 132 East 19th Street, New York City, New York. Died in 1958.

COUARD, ALEXANDER P.
Painter. Born in New York City, 1891. Pupil of George Bridgman and F. V. DuMond. Address in 1926, R. D. 42, Norwalk, Ct.

COUDERT, AMALIA KUSSNER.
Miniature painter. Born 1876. Painted King Edward, Czar and Czarina, Cecil Rhodes, and many of the English aristocracy.

COUGHLIN, MILDRED MARION.
Etcher. Born in Pennsylvania, July 16, 1895. Pupil of M. Waltner; Beaux Arts School of Design in Paris. Member: Brooklyn SE; Chicago SE. Address in 1929, Roslyn Estates, Long Island, NY.

COULON, GEORGE DAVID.
Portrait painter, born c. 1823 in France. Studio at 103 Conde Street in 1850. Continued to paint in New Orleans for fifty years. His last residence, given shortly before his demise, was at 1536 North Claiborne Street. Died in 1904.

COULTER, MARY J.
Painter, etcher, craftsman, and lecturer. Born Newport, Kentucky. Pupil of Cincinnati Art Academy under Duveneck, Nowottny and Meakin, AI Chicago; Lionel Walden and C. W. Hawthorne; studied in Florence, Italy; University of Chicago. Member: San Francisco AA; Provincetown AA; Chicago SE; California SE; California PM; AFA; San Diego AG; Santa Barbara AG; North Shore AA. Awards: Silver medal for pottery and overglaze at the Lewis and Clark Expedition, Portland, Oregon, 1905; Atlan Ceramic prize, AI Chicago, 1909; bronze medal for porcelain, bronze medal for jewelry and honorable mention for textiles, P.-P. Exp., San Francisco, 1915; Los Angeles Museum of Art; Huntington Library and Art Gallery, San Marino, California. Represented in Art Institute of Chicago; Cooke Collection, Honolulu, Hawaii; Commercial Club and Fitzhugh Collections, San Francisco; Metropolitan Museum of Art, New York; Boston Museum of Fine Arts; University Club, San Diego; Charles M. Lea Collection, Philadelphia, Print Department, New York

Public Library, Los Angeles Public Library, and Library of Congress, Washington; one hundred and sixty-eight prints on the "S.S. Malolo," Matson Navigation Company, San Francisco; Chalcographie du Louvre, Paris; British Museum, London; Huntington Library and Art Gallery; John Herron Art Institute; California State Library, Sacramento; University Club, San Diego; California Society of Pioneers, San Francisco; National Gallery of Art. Assistant Director, Fine Arts Gallery of San Diego, 1926; Director and Curator, North Shore Arts Association of Gloucester, 1927. Address in 1929, "de la Guerra Studios," Santa Barbara, California.

COUPER, B. KING (MRS.).
Sculptor and painter. Born Augusta, Georgia, February 23, 1867. Pupil of Chase, Daingerfield, Du Mond, Breckenridge, and Cox. Member: North Shore Art Association; Columbia (SC) Art Association; Southern States Art League; National Association of Women Painters and Sculptors; Boston Art Club; National Arts Club, NY. Represented in permanent collection, Spartanburg, South Carolina; Currier Gallery of Art, Manchester, New Hampshire; Brooklyn Museum of Art; High Museum of Art, Atlanta, Georgia. Exhibited: Salon d'Automne, Paris, 1930; University of Georgia; Greensboro College, North Carolina. Address in 1953, Tryon, North Carolina.

COUPER, WILLIAM.
Sculptor. Born Norfolk, Virginia, Sept. 20, 1853. Pupil of Thomas Ball and Cooper Institute in New York; studied in Munich and Florence, where he lived 22 years. Member: National Sculpture Society; New York Architectural League. Award: Bronze medal, Pan-Am. Exp., Buffalo, 1901. Work: "A Crown for the Victor," Art Museum, Montclair, New Jersey; statues, Henry W. Longfellow and Dr. John Witherspoon, Washington, DC; Capt. John Smith, Jamestown Island, Virginia; Morris K. Jesup, Natural History Museum, and John D. Rockefeller, Rockefeller Institute, New York; John A. Roebling, City Park, Trenton, New Jersey; thirteen heroic portrait busts of scientists, foyer Natural History Museum, New York. Address in 1933, Montclair, New Jersey. Died in 1942.

COURSEN, LOUISE.
Painter and writer. Born Canton, IL, Feb. 26, 1866. Pupil of AIC; Minneapolis AI. Member: S. Indp. A; Salons of America; Chicago NJSA. Specialty, exhibit talks. Address in 1929, 123 South Adams Street, Lewiston, IL.

COURTNEY, LEO.
Block printer. Born Hutchinson, Kansas, August 11, 1890. Pupil of C. A. Seward. Member: Wichita AA; Wichita AG. Address in 1929, 502 Butts Building.; h. 342 North Volutsia Avenue, Wichita, Kansas.

COURTRIGHT, ROBERT.
Born October 20, 1926 in Sumter, SC. Studied at St. John's College, Annapolis (1943-5), American Art School, New York City, and Art Students League. Lived in France. Works in collage art. Exhibited at New Gallery, New York City (many since 1951); Galerie du Fleuve, Paris (1963); MOMA; Smithsonian; and MMA. In collections of Wadsworth; Phillips collection, Washington, DC; MMA and many private collections.

COUSE, EANGER IRVING.
Painter. Born Saginaw, Minnesota, September 3, 1866. Pupil of NAD in New York; Bouguereau, Robert-Fleury and Ecole des Beaux-Arts in Paris. Member: ANA, 1902; Lotos C. (life); NAC (life); Taos SA; SPNY; Allied AA; AFA. Awards: Shaw prize for black and white, Salma. C., 1890; 2nd Hallgarten prize, NAD, 1900; Proctor prize, Salma. C., 1900; honorable mention, Paris Exp., 1900; honorable mention, Pan-Am. Exp., Buffalo, 1901; 1st Hallgarten prize, NAD, 1902; Osborne competition prize ($500), 1903; 2 bronze medal, St. Louis Exp., 1904; Lotos C. Purchase prize, 1910; Isidor Gold Medal, NAD, 1911; Carnegie prize ($500), NAD, 1912; silver medal, P.-P. Exp., San Francisco, 1915; Altman prize, NAD, 1916; Isidor prize ($100), Salma C., 1917; Ranger Fund purchase prize, NAD, 1921; Lippincott prize, PAFA, 1921. Specialty, Indians. Work: "Elkfoot," National Gallery, Washington; "The Forest Camp," Brooklyn Institute Museum; "Medicine Fires," Dallas (TX) Museum; "Under the Trees," Smith College, Northhampton, Massachusetts; "The Tom Tom Maker," Lotos Club, New York; "Sheep at Evening," St. Paul, (MN) Museum; decoration, "Adoration of the Shepherds," Grace Church, Harrisburg, Pennsylvania; "Shappanagons, Chippewa Chief," and "San Juan Pottery," Detroit Inst.; "Song of the Flute," NAC, NY; "Indian Courtship," Art Museum, Montclair, NJ; "Indian Love Song," Brooklyn Institute Museum; "Making Pottery," Fort Worth (TX) Museum; "The Peace Pipe," Metropolitan Museum, New York, NY; "A Vision of the Past," "Making Medicine," and "The Water Shrine," Butler Art Institute, Youngstown, Ohio; "Wild Turkey Hunters," Santa Barbara (CA) Museum; "Shrine of the Rain Gods," Toledo Museum; "Apache Water Bottle," Nashville (TN) Museum; "Sacred Birds," Cleveland Museum; "The Waterfall," Milwaukee Art Inst.; three lunettes, Missouri State Capitol, Jefferson City, Missouri; "Indian Moonlight," San Diego Museum. Address in 1929, Taos, New Mexico. Died in 1936.

COUSINS, CLARA LEA (MRS.).
Sculptor. Born in Halifax Cty., VA, Apr. 6, 1894. Studied: Cincinnati Art Academy; Corcoran Art School; Penna. Academy of Fine Arts; Grand Central Art School w/Ennis, Snell, and Cecilia Beaux. Works: Stratford College, Danville, Virginia. Exhibited:

Danville Art Club; Richmond Art Center; Morton Gallery; Southern States Art League; National Gallery of Art; others. Member: American Artists Professional League; American Federation of Arts; So. States Art League; New Orleans Art Association; Mississippi Art Association. Address in 1953, Bremo Bluff, VA.

COUSINS, HAROLD.
Sculptor. Born in Washington, 1916. Studied at Art Students League, NY, under William Zorach. Associated with Zadkine's studio in Paris from 1949 to 1950, working in stone. After 1950, worked primarily with metal, modelling large figurative works.

COUTTS, GORDON.
Painter. Born in Scotland, 1880. Pupil of Lefebvre in Paris. Address in 1926, 406 Pacific Avenue, Piedmont, California. Died 1937.

COUTURIER, HENRI.
Portrait painter. Born in Holland. He is said to have painted a portrait of Frederick Philipse (owner of Philipse manor, Yonkers) in New Orange in 1674. He resided for some years in Delaware, where he became councillor or burgomaster of the Province. He died in 1684 in Eng. Some of his portraits are signed by the monogram of the artist.

COVE, ROSEMARY.
Sculptor and painter. Born in NYC, January 11, 1936. Studied at Parsons School of Design, 1954-56; Art Students League, 1964-65; with Knox Martin, 1966-70. Work in collection of CIBA Geigy, NY. Has exhibited at Brooklyn Museum, Works on Paper; Ball State University, 22 Drawings and Small Sculptures; Weatherspoon Gallery of Art, NC, Small Sculpture Show, 1977; others. Member of Women in the Arts. Works in terra-cotta, corten steel; oil and ink. Address in 1982, 128 Ft. Washington Avenue, NYC.

COVELL, MARGARET.
A little-known portrait and genre painter.

COVERT, JOHN.
Painter. Exhibited "Resurrection" and "Temptation of St. Anthony" at exhibition of "Paintings Showing the Later Tendencies in Art," at the Penna. Academy of Fine Arts, 1921. Address in 1926, 15 West 29th Street, New York City. Died in 1960.

COVEY, ARTHUR SINCLAIR.
Painter and etcher. Born Bloomington, IL, June 13, 1877. Pupil of Vanderpoel, Karl Marr, Frank Brangwyn. Member: ANA; Salma. C.; Mural P.; Arch. Lg. of NY. Awards: First, second and third Shaw prizes, Salma. C., 1910, 1911, 1912; bronze medal for etching, P.-P. Exp., San F., 1915; medal for decorative painting, NY Arch. L., 1925. Works:

"The Spirit of the Prairies" and three mural panels, Wichita Public Library; "The Great Wheel," etching in Library of Congress; mural decorations, Orange Hospital; "Spirit of Modern Industry," Administration Building, Kohler Co., Kohler, WI; 13 decorative mural paintings, Memorial Hall Administration Building, The Norton Company, Worcester, MA. Address in 1929, 115 East 40th Street, New York, NY; Torrington, Connecticut. Died in 1960.

COVINGTON, WICKLIFFE C(OOPER).
Painter and teacher. Born Shelby County, KY, July 2, 1867. Pupil of Kenyon Cox, William M. Chase; ASL of NY. Member: Louisville AA; SSAL; AFA; Miss. State AA; Carmel AA. Work: "Flower Study," Louisville Art Association Collection. Address in 1929, Bowling Green, KY; summer, Carmel, CA. Died in 1938.

COWAN, R. GUY.
Sculptor and craftsman. Born East Liverpool, OH, August 1, 1884. Pupil of N.Y.S. School of Ceramics. Member: American Ceramic Society; Cleveland Society of Artists. Awards: 1st prize for pottery, 1917, and Logan medal for applied design, 1924, Art Institute of Chicago; 1st prize for pottery, Cleveland Museum, 1925. Address in 1929, c/o Cowan Pottery, Rocky River, Ohio; h. Lakewood, Ohio.

COWAN, SARAH EAKIN.
Miniature painter. Born 1875. Member: NA Women PS; Am. S. Min. P.; PA S. Min. P.; PBC. Address in 1929, 125 E. 10th Street; 35 West 10th Street, NY, New York. Died in 1958.

COWELL, JOSEPH GOSS.
Sculptor and painter. Born Peoria, Illinois, December 4, 1886. Studied: University of Illinois; George Washington University; Boston Museum of Fine Arts School; Bradley Polytechnic Institute; Julian Academy, Paris; pupil of Bridgman, DuMond, Tarbell, and Benson; Laurens in Paris. Member: Boston Art Club, Boston Architectural Club. Work: Murals in Universalist Church, YMCA, Peoria, Illinois; theatre, Holyoke, Massachusetts; theatres in Boston, and Tower Theatre, Philadelphia; stained glass windows, St. Mary's Cathedral, Peoria, Illinois; War Memorial flagstaff base, Wrentham, Massachusetts; murals in churches in Boston, Nashua, New Hampshire, Whitman, Massachusetts, Bridgeport, Connecticut; murals, altars, screens, and altar figures, St. Mary's Cathedral, Peoria, Illinois, and St. James' Church, New York. Exhibited: Paris Salon, 1920; Architectural League, 1923, 24, 31; Boston Art Club, 1922-26; Rockport Art Association, 1939. Associate Director, Designers Art School, Boston; Director, National Art School, Washington, DC, 1940-42. Address in 1953, Washington, DC; h. Wrentham, Massachusetts.

COWEN, A. MARIAN.
Painter. Member: Pitts. AA. Address in 1929, 5818
Rippey Street, E.E., Pittsburgh, PA.

COWLES, EDITH V.
Painter and illustrator. Born Farmington, Ct., 1874.
Pupil of John T. Niemeyer; Bruneau and Mme.
Laforge in Paris. Illustrated: *House of Seven Gables*,
by Hawthorne; "Old Virginia," by Thomas Nelson
Page; "Friendship," by Emerson. Has five stained
glass windows in St. Michael's Church, Brooklyn.
Director of Craft Work at the Lighthouse for the
Blind. Address in 1926, 152 W. 57th St., NY, NY.

COWLES, GENEVIEVE A(LMEDA).
Painter, illustrator, craftsman, writer, and lecturer.
Born Farmington, CT, Feb. 23, 1871. Pupil of
Niemeyer and Brandegee. Work: Mural of the
"Charge to St. Peter," Conn. State Prison; windows of
the seven parables, Grace Church, NY; altar piece,
St. Peter's Church, Springfield, MA; stained glass
windows in honor of Eliezer Ben Jehvdah, Talpioth,
Palestine. Illustrated *The House of the Seven Gables*,
Litte Folk Lyrics, and for *Scribner's* and *McClure's*.
Author of "The Prisoners and their Pictures,"
McClure's, 1922; "The Camouflage of Crime,"
Psychology Magazine. Lecturer on the prison ques-
tion and on Palestine. Address in 1929, 123 East 28th
St., New York, NY.

COWLES, MILDRED.
Painter. Born in Farmington, CT, 1876. Pupil of Yale
Art School. Address in 1926, 102 West 57th Street,
New York, NY.

COWLES, RUSSELL.
Painter. Born Algona, IA, Oct. 7, 1887. Pupil of
NAD; ASL of NY. Member: NAC; Century Assn.
Award: American Academy in Rome fellowship,
1915-1920; Harris silver medal ($500), AIC, 1925.
Address in 1929, care of the Century Association, 7
West 43rd Street, New York, NY. Died in 1978.

COX, ALBERT SCOTT.
Painter and illustrator. Born Randolph, ME, 1863.
Studied at Academy, Paris. Painter of figures and
landscapes; much illustrating and many caricatures.

COX, ALLYN.
Painter. Born New York, June 5, 1896. Pupil of his
father, Kenyon Cox; NAD; George Bridgman. Mem-
ber: NY Arch. Lg.; Mural P. Awarded: Fellowship
American Academy in Rome, 1916. Work: Over-
mantel in Public Library, Windsor, VT. Address in
1929, 123 E. 63rd St.; 130 E. 67th St., NY, NY.

COX, CHARLES BRINTON.
Sculptor. Born in Philadelphia in 1864. Fielding
noted that his modeling of animals showed beauty
and power. He died in 1905.

COX, DOROTHY E.
Painter. Exhibited at Penna. Academy of Fine Arts,
Philadelphia, 1924. Address in 1926, 107 South Front
Street, Harrisburg, PA.

COX, ELEANOR.
Sculptor and illustrator. Born Montrose, CO, April
12, 1914. Student of Abbott School of Fine and
Commercial Arts, Washington, 1933-35, Corcoran
School of Fine Arts, with Hans Schuler, 1934-37,
Yard School of Fine Art, with William Marks
Simpson, 1937-38, Temple University Art School,
with Raphael Sabatini, Boris Blai, 1940-41. One-man
sculpture exhibits at Central High School, Washing-
ton, 1939, National League of American Pen Women,
1947, Woman's City Club of Washington, 1948, Silver
Spring (MD) Gallery, 1954; exhibited in group shows
at Corcoran Art Gallery, National Museum Art
Gallery, Statler Hotel, International Galleries, Cen-
tral Branches Public Library and Arts Club, Penna.
Academy of Fine Arts, and others. Member: Society
of Washington Artists; Society of Miniature Painters,
Sculptors, and Gravers of Washington (secretary
from 1956); National League of American Pen Wom-
en; D.A.R. Awards: Prizes, Corcoran School of Art,
1936; League of American Pen Women, 1946. Ad-
dress in 1962, McLean, VA; office, Dept. Air Force,
Washington.

COX, GEORGE J.
Sculptor. Exhibited "The Zodiac" at Annual Exhibi-
tion of National Academy of Design, 1925, New
York. Address in 1926, 509 West 121st Street, New
York.

COX, JAMES.
Artist. Born in England, 1751, and died 1834. He
came to this country as a young man and settled in
Philadelphia where he was the fashionable drawing-
master for many years. He collected over 5,000
volumes on the fine arts which he sold to the Library
Co. of Philadelphia; he did much to advance the arts
in that city. He excelled in flower painting.

COX, KENYON.
Sculptor, painter, illustrator, teacher, writer, and
lecturer. Born in Warren, OH, October 27, 1856.
Studied in Paris under Carolus-Duran and Gerome.
Member: Associate member of the National Acad-
emy of Design, 1900; Academician, 1903; Society of
American Artists of NY; Mural Painters; NY Archi-
tectural League; National Institute of Arts and
Letters; American Academy of Arts and Letters;
Fellowship of the Penna. Academy of Fine Arts;
Art Students League; Lotus Club. Awards: Second
Hallgarten prize, National Academy of Design, 1889;
two bronze medals, Paris Exp., 1889; Temple silver
medal, Penna. Academy of Fine Arts, 1891; medal,
Columbian Exp., Chicago, 1893; gold medal, St.
Louis Exp., 1904; medal of honor for mural painting,

NY Architectural League, 1909; Isidor medal, National Academy of Design, 1910. Represented by a portrait of Augustus Saint-Gaudens and "The Harp Player," Metropolitan Museum, NY; portrait of Henry L. Fry, Cincinnati Museum; mural paintings: "Venice," Bowdoin College, Brunswick, ME; "Art and Science," Library of Congress, Washington, DC; "The Reign of Law," Appellate Court, NY; "Contemplative Spirit of the East," Minn. State Capitol; "The Progress of Civilization," Iowa State Capitol; "The Beneficence of the Law," Essex Co. Court House, Newark, NJ; "The Judicial Virtues," Luzerne Co. Court House, Wilkes-Barre, PA; "The Light of Learning," Public Library, Winona, MN; "Passing Commerce Pays Tribute to the Port of Cleveland," Federal Building, Cleveland; "The Sources of Wealth," Citizens' Bldg., Cleveland; statue, "Greek Science," Brooklyn Institute Museum; three drawings in Rhode Island School of Design, Providence; eleven sketches and "Tradition," Cleveland Museum; "Peace and Plenty," Manhattan Hotel, NYC; two lunettes in Oberlin College; "The Marriage of the Atlantic and the Pacific" and four mosaics in the Wisconsin State Capitol; "Plenty," National Gallery, Washington, DC; decorations on corner pavilions, Hudson Co. Court House, Jersey City, NJ; drawings in Carnegie Institute, Pittsburgh. Author of "Mixed Beasts," "Old Masters and New," "Painters and Sculptors," "The Classic Point of View," "Artist and Public," "Winslow Homer," and "Concerning Painters." Specialty, portraits, figure pieces, mural decoration. Address in 1917, 130 E. 67th St., NYC; summer, Windsor, VT. Died in NYC, March 17, 1919.

COX, LOUISE (HOWLAND KING).
Painter. Born San Francisco, CA, June 23, 1865. Pupil of NAD, ASL under Kenyon Cox in New York. Member: ANA, 1902; SAA, 1893; Mural P., 1919. Awards: Third Hallgarten prize, NAD, 1896; bronze medal, Paris Exp., 1900; silver medal, Pan-Am. Exp., Buffalo, 1901; Shaw Memorial prize, SAA, 1903; silver medal, St. Louis Exp., 1904. Specialty, children's portraits. Work: "May Flowers," National Gallery, Washington. Address in 1929, 130 East 67th Street, New York, NY. Died Dec. 11, 1945.

COX, LYDA MORGAN.
Painter, craftsman, and teacher. Born De Pere, WI, May 15, 1881. Pupil of Cullen Yates, Gottwald, Johonnot; Cleveland School of Art. Member: Seattle FAS; Woman's AC of Cleveland; S. Indp. A.; Western Traveling Artists. Award: Second hon. mention, Seattle FAS, 1923. Work: Wall decorated tile in the Cleveland Orphan Asylum. Address in 1929, 8333 46th Avenue, South, Seattle, Wash.; summer, 1887 Hillside Avenue, East, Cleveland, OH.

COX, PALMER.
Illustrator. Born in Quebec, Canada, in 1840. In 1875 he settled in New York, where he followed his artistic and literary pursuits. His illustrated work was well known. Died July 24, 1924 in Quebec, Canada.

COX-McCORMACK, NANCY.
Sculptor. Born Nashville, TN, Aug. 15, 1885. Pupil of Victor Holm, St. Louis; Charles Mulligan, Chicago. Member: National Association of Women Painters and Sculptors; Chicago Art Club; Cordon Club; Nashville Art Association; National Sculpture Society. Work: "Harmony," Nashville Museum; Carmack Memorial, Nashville; bronzes of Rev. John Cavanaugh, University of Notre Dame, South Bend, IN; Dean Craven Laycock, Dartmouth College, Hanover, NH; Perkins Memorial, Perkins Observatory, Wesleyan University, Delaware, OH; "H. E. Benito Mussolini," The Capitol, Rome, copy in Fine Arts Museum, Philadelphia; "Senator Giaccomo Boni," Campedoglio, Rome; Primo de Rivera, Madrid, Spain. Address in 1933, 16 East 8th Street, NYC.

COXE, R. CLEVELAND.
Painter and engraver. Born Baltimore, MD, 1855. Pupil of Bonnat and Gerome in Paris. Address in 1926, 1320 Fifth Avenue, Seattle, Washington.

COY, ANNA.
Painter and teacher. Born Rockford, IL. Pupil of Chase, Henri and Alexander Robinson. Member: Rockford AA; Am. APL. Work: Portrait of the first president of Rockford Womans Club. Address in 1929, 127 No. 3d Street, Rockford, IL.

COY, C. LYNN.
Sculptor. Born Chicago, IL, Oct. 31, 1889. Pupil of Art Institute of Chicago; F. C. Hibbard; Albin Polasek; Lorado Taft. Member: Alumni Art Institute of Chicago; Chicago Society of Artists; Illinois Academy of Fine Arts; Chicago Art Club; Chicago Painters and Sculptors; LaGrange Art League. Work: George H. Munroe Memorial, Joliet, IL. Represented in Vanderpoel Art Association Collection, Chicago. Exhibited: Art Institute of Chicago, 1915, 17, 19, 21; Chicago Painters and Sculptors, 1948, 50; Chicago Art Club, 1952. Address in 1953, Chicago, IL; h. Riverside, IL.

COYLE.
Painter and designer; came to New York from England. He died in New York City in 1824.

COYLE, JAMES.
Painter. He was elected a member of National Academy of Design, New York, in 1826. He died in New York City July 22, 1828.

COYNE, ELIZABETH K(ITCHENMAN).
Painter. Born Philadelphia, PA. Pupil of Leopold Seyffert and Cecilia Beaux. Member: Fellowship PAFA; Phila. Alliance; AFA. Award: Cresson Traveling Scholarship, PAFA. Work: "Along the

Neshaminy," Lambert Collection, Penn. Academy of the Fine Arts. Address in 1929, Wall Bldg., 1716 Chestnut Street; h. 508 Spring Ave., Elkins Park, Philadelphia, PA.

COYNE, JOAN JOSEPH.
Sculptor, painter, craftsman, and writer. Born Chicago, IL, June 16, 1895. Pupil of George Mulligan, Leonard Crunelle, and Albin Polasek. Member: Chicago Society of Artists; Society of Independent Artists. Address in 1929, Germantown, Philadelphia, PA.

COYNE, WILLIAM VALENTINE.
Painter, illustrator, and etcher. Born New York, Feb. 14, 1895. Pupil of Henri, Beaux Arts Inst. Member: S. Indp. A.; Beaux-Arts Inst. Represented in the New York Public Library. Illustrations for "New York Evening Post," "The Bookman." Address in 1929, 123 East 88th Street, New York, NY.

COZZENS, FREDERIC SCHILLER.
Marine painter. Born in NYC, October 11, 1846. Attended Rensselaer Polytechnic Inst., Troy, NY, 1864-67; no information available on course of study. He was painting in NYC by 1874; from mid-1870's to 1898, his illustrations appeared in NY's *Daily Graphic* and *Harper's Weekly*. Most famous work is series of watercolors for Kelley's *American Yachts: Their Clubs and Races*, published by Scribner's in 1884. Did book and magazine illustrations until about 1906: "Yachts and Yachting," *Outing* magazine (1886-87), *Rushton's Portable Canoes* (1891), *The Rudder* magazine (1903, 06); 24 paintings for *Our Navy: Its Growth and Achievements* were reproduced as chromolithographs by Am. Publishing Co., Hartford. Also executed many paintings; from 1870 through 1920, he depicted every match in America's Cup, held off of NY Harbor. Also painted fishing vessels and scenes, and warships. Painted scenes of North American Indians, 1920, 21. First major exhibit, Mystic Seaport Museum, 1983. In many private collections; Mariner's Museum (Newport News, VA), MIT, NY Yacht Club, Peabody Museum of Salem (MA), US Coast Guard Academy, Kennedy Galleries (NYC). Died in NYC August 29, 1928.

CRAFT, KINUKO YAMABE.
Illustrator. Born in Japan in 1940. She spent four years at the Kanazawa Municipal College of Fine Arts and one and a half years at the AIC. The winner of various awards and selected to show her work in S of I Annual Exhibitions, she has had assignments from *Psychology Today*, Science Research Associates and Scott, Foresman and Company. She currently lives and works in Chicago.

CRAIG, ANDERSON.
Painter, teacher. Born Iowa City, IA, April 15, 1904. Pupil of Randall Davey. Director, Experimental School of Art. Address in 1929, 20 West Eighth Street, New York, NY.

CRAIG, ANNA BELLE.
Painter. Born Pittsburgh, PA, March 13, 1878. Pupil of Pittsburgh School of Design; ASL of NY, Chase, Shirlaw, Henry G. Keller, Martin G. Borgord, and Howard Pyle. Member: Pittsburgh AA; Cordova C. of Women P., Pittsburgh. Illustrated in *Harper's*, *St. Nicholas*, *Metropolitan*, and books for children. Address in 1929, Pennsylvania College for Women, Woodland Road; h. 5806 Walnut Street, Pittsburgh, PA.

CRAIG, CHARLES.
Painter. Born Morgan County, OH, 1846. Educated Penna. Academy of Fine Arts, Philadelphia. Painter of Indians, cowboys, plains, and mountains. Exhibited at American Water Color Society, New York; Denver, 1883; Minneapolis Expn., 1886-8; St. Louis, 1889; Omaha, 1894-6. Awards: Honorable mention, Western Artists' Association. Represented by Indian paintings in many fine private collectons in US and abroad. Address in 1926, Colorado Springs, CO. Died in 1931.

CRAIG, EMMETT JUNIUS.
Sculptor. Born DeWitt, MO, March 3, 1878. Pupil of Merrill Gage and Wallace Rosenhomer. Member: Kansas City Society of Artists. Awards: Silver medal, 1924, and bronze medal, 1925, Kansas City Art Institute. Address in 1933, 1040 Argyle Building; McMillian Building; h. Kansas City, MO.

CRAIG, ISAAC EUGENE.
Painter. Born near Pitts., in 1830. After studying art in Phila. he went to Paris. He returned to this country in 1855, but returned to Europe some ten years later. He painted a portrait of Joel T. Hart, the Kentucky sculptor, and some striking views of Venice.

CRAIG, MARTIN.
Sculptor and restorer. Born in Paterson, NJ, November 2, 1906. Studied at City College of New York, B.S. Works in Nelson A. Rockefeller Collection; Kalamazoo Art Institute, MI; ark and two candelabra, Fifth Avenue Synagogue, NY; sculpture, Temple Beth El, Providence, RI; others. Has exhibited at Salon Jeune Sculpture Annual, Paris, 1950-54; Salon Mai, Paris, 1952-54; Museum of Modern Art, NY; others. Received first prize, Organic Design Competition, Museum of Modern Art, 1940; Mark Rothko Award, 1971; others. Lectured on sculpture at Cooper Union Art School; New York University; others. Works in welded metals; plastics. Address in 1982, East Hampton, NY.

CRAIG, THOMAS BIGELOW.
Painter. Born in Philadelphia, 1849. Exhibited at Penn. Acad. of Fine Arts, and NAD. Represented at

the Boston Art Club and PA Academy of Fine Arts. Elected Associate Member of National Academy. Died 1924 in Woodland, NY.

CRAIG, WILLIAM.
Born in Dublin, Ireland, 1829; in 1863 he settled in this country. He was one of the original members of the American Society of Water Color Painters. Among his paintings are "Mount Washington," "Hudson River, near West Point," and many landscapes of peculiar transparency in coloring. He died in 1875 in Lake George, NY.

CRAM, ALLEN G(ILBERT).
Painter, illustrator, and teacher. Born Washington, DC, Feb. 1, 1886. Pupil of William Chase, Charles H. Woodbury. Member: Santa Barbara AL. Award: Ruth Payne Burgess prize, Art Association of Newport, 1914. Work: "A Lady in Fiesta Costume," Court House, Santa Barbara. Illustrations for *Old Seaports of the South*, *Fifth Avenue*, and *Greenwich Village* (Dodd Mead). Address in 1929, 2317-A Rancheria Street; h. 124 Oceana Avenue, Santa Barbara, CA. Died in 1947.

CRAMER, FLORENCE BALLIN.
Painter. Born Brooklyn, NY in 1884. Pupil of DuMond, Brush and Harrison. Member: NA of Women PS. Address in 1926, 163 E. 72d St., NY, NY.

CRAMER, S. MAHREA.
(Mrs. Paul Lehman). Sculptor, painter, etcher, designer, and illustrator. Born Fredonia, Ohio, March 21, 1896. Studied: John Herron Art Institute; Otto Stark Academy of Fine Arts; Art Institute of Chicago; and with Elmer Forsberg. Member: Assn. Chicago Painters and Sculptors; American Watercolor Society of New York; Ohio Watercolor Society; Chicago Galleries Association. Exhibited: American Watercolor Society of New York, 1942-44, 46; Hoosier Salon, 1941-46; Indiana Art Exhibition, 1943, 44; Chicago Galleries Association, 1943, 45 (one-man). Address in 1953, Chicago, Ill.

CRAMPTON, ROLLIN McNEIL.
Painter and illustrator. Born New Haven, CT, March 9, 1886. Pupil of Thomas Benton, Yale Art School, ASL of NY. Work: "Portrait of Frau Busnell" in Union League Club. Address in 1929, Madison, CT. Died in 1970.

CRANCH, CAROLINE A.
Painter. Daughter of Christopher P. Cranch, and pupil of her father and the Cooper Institute of New York, under William Hunt. Specialty, figurepieces. Address in 1926, Cambridge, MA.

CRANCH, CHRISTOPHER PEARSE.
Painter. Born in Alexandria, VA, on March 8, 1813. He studied abroad, returned to NY and in 1864 was elected a member of the National Academy. He later moved to Cambridge, MA. He was a portrait, landscape and still life painter. The son of Wm. Cranch, Chief Justice of the US circuit court of the Dist. of Columbia, he studied divinity at Harvard and was a Unitarian minister until he turned to painting in 1842. In 1844 he published a volume of poems. Among his paintings are "Washington Oak, at Newburg, NY;" "Venice" and "Forest of Fountainebleau." Represented in the Boston Museum of Fine Arts. He died Jan. 20, 1892 in Cambridge, MA.

CRANCH, JOHN.
Portrait painter. Born in Washington, DC, Feb. 2, 1807. Student of King, Harding, and Sully, he commenced painting portraits in Washington, DC in 1829. In 1830 he studied in Italy, and in 1834 returned to this country, where he painted many portraits and original compositions. He was elected an Associate of the National Academy in 1853. He was the brother of Christopher Pearse Cranch. Died Jan. 1, 1891 in Urbana, OH.

CRANDELL, BRADSHAW.
Illustrator. Born in Glens Falls, New York in 1896. He was educated at Wesleyan University and the AIC. In 1921 his first cover appeared on *Judge*, marking the beginning of his career which concentrated on cover design. His art graced the front of such magazines as *Collier's*, *Redbook*, *American*, *Ladies Home Journal* and *The Saturday Evening Post*. For 12 years in the 1930's and 1940's he worked on *Cosmopolitan* covers doing a series of pastels of beautiful women, often using Hollywood stars for models. He was a member of the Dutch Treat Club, the Artists and Writers Association, and the S of I. Died in 1966.

CRANE, ANN.
Painter. Born in New York City. Pupil of Twachtman in New York and of Merson in Paris. Died Jan. 26, 1948. Address in 1926, Arcade, Bronxville, NY.

CRANE, BRUCE.
Landscape painter. Born New York, NY, Oct. 17, 1857. Pupil of A. H. Wyant. Member: ANA, 1897; NA, 1901; SAA, 1881; AWCS; A. Fund S.; Salma. C., 1888; Lotos C.; Union Internationale des Beaux-Arts et des Lettres; NAC. Awards: Webb prize, SAA, 1897; bronze medal, Paris Exp., 1900; Inness medal, NAD, 1901; silver medal, Pan.-Am. Exp., Buffalo, 1901; silver medal, Charleston Exp., 1902; gold medal, St. Louis Exp., 1904; third prize, C.I. Pittsburgh, 1909; Saltus medal, NAD, 1912; silver medal, P.-P. Exp., San F., 1915; Shaw prize ($500), Salma. C., 1917; Ranger Purchase Fund, NAD, 1919. Work: "Autumn Uplands," Metropolitan Museum, New York; "November Hills," Carnegie Institute, Pittsburgh; "Autumn," National Gallery, Washington; "March," Brooklyn Institute Museum; "Autumn

Hills," Montclair (NJ) Gallery; "Springtime," Peabody Institute, Baltimore; "November Hillsides," Corcoran Gallery, Washington, DC; "Last of Winter," Fort Worth (TX) Museum; "Autumn Meadowland," Hackley Art Gallery, "December Uplands," Syracuse (NY) Museum of Art; "The Wilderness," Museum, Oshkosh, WI. Address in 1929, Studio Arcade, Bronxville, NY. Died in 1937.

CRANE, FREDERICK.
Painter of mountain scenery. Born in Bloomfield, NJ, in 1847. He was awarded the bronze medal in 1904 of the St. Louis Exposition. He died in New York City, Jan 25, 1915. Represented in Worcester Art Museum by "London from the Thames."

CRANE, WILBUR.
Painter. Born New York City, Dec. 18, 1875. Pupil of William M. Chase, Robert Henri. Member: Salma. C.; Arch. Lg.; New Rochelle AS. Address in 1929, 1674 Broadway, New York, NY; h. 6 Ormond Place, New Rochelle, NY; summer, Lake Hill, Ulster Co., NY.

CRANK, JAMES H.
Illustrator. Member: GFLA. Address in 1929, Interlaken, Asbury Park, NJ.

CRASKE, LEONARD.
Sculptor. Born in London, 1882, he came to America in 1910 and made his home in Boston and Gloucester. Studied at City of London School and London University. Studied medicine and anatomy, St. Thomas Hospital, London; art with the Dicksees; assistant to Paul R. Montford. Exhibited at National Sculpture Society, 1923. Address in 1926, Boston, MA. Died on Aug. 29, 1950.

CRATZ, BENJAMIN ARTHUR.
Painter. Born Shanesville, Tuscarawas Co., Ohio, May 1, 1886. Pupil of George Elmer Browne; Julian in Paris. Member: Toledo Artklan; Provincetown AA; Beachcombers Club; Springfield (IL) AA; Salma. C; AFA. Address in 1929, 2150 Parkwood Avenue, Toledo, OH; summer, Provincetown, MA. Died c. 1951.

CRAVATH, RUTH.
Sculptor and teacher. Born in Chicago, IL, Jan. 23, 1902. Studied at Art Institute of Chicago; Grinnell College; California School of Fine Art. Works: San Francisco Museum of Art; Stock Exchange, San Francisco; Vallejo, CA; Chapel at the Archbishop Hanna Center for Boys, Sonoma, CA; marble group, Starr King School, San Francisco, CA. Exhibited: San Francisco Art Association, 1924, 26-28, 30, 32, 35, 37; San Francisco Museum of Art, 1941; World's Fair of NY, 1939; Seattle Art Museum, 1929; San Francisco Society of Women Artists, 1926-28, 32, 34, 38-41, 44. Member: San Francisco Art Association;

San Francisco Society of Women Artists; Artists Equity Association. Awards: San Francisco Art Association, 1924, 27; San Francisco Society of Women Artists, 1934, 40. Position: Instructor of Art, Dominican Convent, San Rafael, CA. Address in 1953, San Francisco, CA.

CRAWFORD, ARTHUR ROSS.
Painter, craftsman. Born Marilla, Manistee Co., MI, July 29, 1885. Pupil of Chicago Academy of Fine Arts under W. J. Reynolds and W. P. Henderson. Member: ASL of Chicago (life). Manager of Crawford Decorating Co. Specialty, landscape and decorative painting. Address in 1929, Jaruis Avenue, Niles, IL.

CRAWFORD, BRENETTA HERMANN.
(Mrs. Earl Stetson Crawford). Painter, illustrator, and teacher. Born Toledo, OH, Oct. 27, 1875. Pupil of ASL of NY; Colarossi and Carmen Academies in Paris. Member: Am. S. Min. P.; NA Women PS. Address in 1929, 41 "The Enclosure," Nutley, NJ; care of Guaranty Trust Co., Paris, France.

CRAWFORD, EARL STETSON.
Painter. Born Philadelphia, PA, June 6, 1877. Studied at School of Industrial Art, Philadelphia, PA; PAFA; Delacluse and Julien Academies; Ecole Nationale des Beaux Arts, Paris; also in Munich, London, Rome, Florence and Venice. Connected with School of Applied Design for Women, NY, 1912-17. Portrait painter and mural decorator, also designer of stained glass windows in various churches; mural work in US Gov't Bldgs., San Francisco. Fellow, Society of American Illustrators; member, National Association of Portrait Painters. Address in 1926, "The Enclosure," Nutley, NJ.

CRAWFORD, ESTHER MABEL.
Painter, craftsman, and teacher. Born Atlanta, GA, April 23, 1872. Pupil of Whistler, Dow, Beck. Member: Calif. AC; West Coast Arts. Award: Bronze medal, San Diego Exp., 1915. Address in 1929, 716 North Avenue 66, Los Angeles, CA.

CRAWFORD, RALSTON.
Painter, lithographer, and photographer. Born in St. Catharines, Ontario, Can., 1906. Lived in Buffalo between 1910-26. Studied art at the Otis Art Institute, in LA, CA; Phila. Academy of Fine Arts, 1927-30; Academie Colarossi; and Academie Scandinave, Paris, 1932-33. Also worked at the Walt Disney studio, 1926. First photographic works were photos of New Orleans, 1937-38. Work in lithography, 1951-52, in Paris. A characteristic work of his painting is his "Grain Elevators from the Bridge," 1940, at the Whitney Museum of American Art, NYC. Exhibited: Whitney; Metropolitan Museum of Art; Art Inst. of Chicago; Penna. Academy of Fine Arts; Corcoran; Seattle Art Museum; many others. Address in 1976, New York City.

CRAWFORD, THOMAS.
Sculptor. Born Mar. 22, 1811/1814, in NYC. In 1835 he went to Rome, studied with Thorwaldsen. His best known works are the bronze doors and work on the Capitol at Wash., DC; the equestrian statue of Washington at Richmond, VA; and his statue of Adam and Eve. His son was Francis Marion Crawford, the well-known author. Died Oct. 10, 1857, in London.

CRAWFORD, WILL.
Illustrator. Born in Washington, DC, in 1869. He was a self-taught artist who worked on staff for the *Newark Daily Advertiser* and the *Sunday Call* while still in his teens. He illustrated for the *New York World* before establishing a studio with John Marquand and Albert Levering, later to be shared by Charles M. Russell. He was a successful free-lancer for *Life, Munseys, Puck* and *Cosmopolitan,* after which he worked in Hollywood as an expert on Indian costumes. Died in 1944.

CRAWLEY, IDA JOLLY.
Sculptor, painter, writer, lecturer. Born in Pond Creek, London Co., E. TN, Nov. 15, 1867. Pupil of Corcoran Art School; Johannes Oertell in Germany; Sir Frederic Massi in Paris. Member: Amer. Art Union, Paris; Amer. Fed. of Arts. Awards: Gold medal, Appalachian Exp., Knoxville; silver medal, East Tenn. Art Assoc.; loving cup and bronze medal, Kenilworth Inn Galleries; bronze medal, Asheville (NC) Gallery. Represented by paintings (fifteen), First Nat. Bank, Champaign, IL; Gayosa Hotel, Peabody Hotel, University School, Memphis, TN; University, Fayetteville, AR; Baptist Church, Mansfield, OH; City Hall, Gardners Hospital and (three hundred) Crawley Museum of Art and Archaelogy. Pres., Crawley Museum of Art and Archaeology, Asheville, NC. Address in 1933, Asheville, NC.

CRAWLEY, JOHN.
Painter. Born in England, 1784, he was brought over to this country by his parents when very young and settled at Newark, NJ. He studied with the artist Savage. Crawley painted portraits at Philadelphia and exhibited at the first opening of the Penna. Academy of Fine Arts.

CRAWLEY, JOHN, JR.
Draughtsman. Son of the artist John Crawley, he is recorded in Dunlap's "History of Art" as an excellent draughtsman, much interested in lithography. He was engaged at Endicott's and Swett's lithographic establishment and executed some beautiful specimens of work on the title pages of the music of that day.

CRAWSHAW, LUKE.
Sculptor. Born in St. Louis, MO, Oct 15, 1856. Pupil of Lorado Taft, Art Institute of Chicago; Julian Academy in Paris. Address in 1918, Ogden, UT.

CREAL, JAMES PIRTLE.
Painter and etcher. Born Franklin, Kentucky, September 5, 1903. Pupil of Walter Ufer. Member: Louisville AA. Award: Purchase prize, Speed Memorial Museum, Louisville, 1927. Work: "New Mexico," public schools, Louisville, KY. Address in 1929, 1927 West 10th Street, Los Angeles, California; h. Altawood, Anchorage, Kentucky; summer, 521 South Coronado Street, Los Angeles, California. Died in 1934.

CREIFELDS, RICHARD.
Painter. Born New York City, May 26, 1853. Pupil of NAD; Barth, Wagner and the Royal Academy in Munich. Works: Altar piece, St. Andrews Church, equestrian portrait of Col. Daniel Appleton, 107th Regiment Armory and portrait of William B. Dana, Chamber of Commerce, all in New York City; portrait of Judge Brown, Court of Appeals, Albany, NY; portrait of W. H. English, Montauk Club, Brooklyn, NY. Address in 1929, Broadway Studios, 70th St. and Broadway; h. 209 West 107th Street, New York, NY. Died in 1939.

CREMEAN, ROBERT.
Sculptor. Born September 28, 1932, Toledo, Ohio. Studied: Alfred University, 1950-52; Cranbrook Academy of Art, BA, 1954, MFA, 1956. Work: Cleveland Museum of Art; Detroit Institute; Los Angeles Museum of Art; University of Miami; University of Michigan; University of Nebraska; St. Louis City Art Museum; Santa Barbara Museum of Art; UCLA. Exhibited: Toledo Museum of Art, 1955; Esther Robles Gallery, LA, 1960-66; The Landau-Alan Gallery, NYC, 1968; Detroit Institute, 1956; Houston Museum of Fine Arts; Art Institute of Chicago, 1960, 61; San Francisco Museum of Art, Bay Area Artists, 1961; Whitney Museum; Western Association of Art Museum Directors, Light, Space, Mass, 1962; XXXIV Venice Biennial, 1968. Awards: Fulbright Fellowship (Italy), 1954-55; Tamarind Fellowship, 1966-67. Position: Instructor, Detroit Institute of Arts; instructor, University of California, Los Angeles, 1956-57; instructor, La Jolla Art Center, California, 1957-58. Address in 1976, c/o Esther Robles Gallery, Los Angeles, CA.

CRENIER, HENRI.
Sculptor. Born Paris, France, Dec. 17, 1873. Pupil of Falguiere, and Ecole des Beaux-Arts, Paris. Member: National Sculpture Society, 1912; NY Architectural League, 1913. Awards: Honorable mention, Paris Salon, 1897, Society of French Artists, 1907, and P.-P. Exp., San Francisco, 1915. Work: "Boy and Turtle," Metropolitan Museum of Art; pediments and caryatides, City Hall, San Francisco; Fenimore Cooper Memorial, Scarsdale, NY; "Boy and Turtle," Mt. Vernon Place, Baltimore, MD. Exhibited at National Sculpture Society, 1923. Address in 1933, Shore Acres, Mamaroneck, NY.

CRESSON, CORNELIA.
(Mrs. Cornelia Cresson Barber). Sculptor and engraver. Born in New York, NY, February 15, 1915. Studied: With Genevieve Karr Hamlin, Mateo Hernandez. Member: Artists Equity Association, New York. Exhibited: Allied Artists of America, 1938; Art Institute of Chicago, 1940; Ellen Phillips Samuel Memorial, Philadelphia, PA, 1940; Whitney Museum of American Art, 1940; Metropolitan Museum of Art, 1942; Grand Rapids Art Gallery, 1940; Albany Institute of History and Art, 1939, 40; Municipal Art Gallery, NY, 1938; ACA Gallery, 1943; Riverside Museum, 1946; Penna. Academy of Fine Arts, 1947; Silvermine Guild Artists, 1952; Artists Equity Association, New York, 1952. Address in 1953, 496 Avenue of the Americas; h. 59 West 12th Street, New York, NY.

CRESSON, MARGARET FRENCH.
Sculptor and writer. Born Concord, MA, August 3, 1889. Pupil of D. C. French and Abastenia St. L. Eberle; NY School of Applied Design for Women. Member: National Sculpture Society (secretary, 1941-42); National Association of Women Painters and Sculptors; American Federation of Arts; Grand Central Art Galleries; Washington Society of Artists; National Academy; Architectural League of New York (vice president, 1944-46). Awards: Shaw memorial prize, National Academy of Design, 1927; honorable mention, Junior League Exhibition, 1928; honorable mention, Society of Washington Artists, 1929. Exhibited at Penna. Academy of Fine Arts, 1922, 25, 27-29, 37, 40-42; National Sculpture Society, 1923; National Academy of Design, many times; Art Institute of Chicago, 1928, 29, 37, 40; World's Fair of New York, 1939; Whitney, 1940; Carnegie, 1941; others. Work: Portrait bust of "President James Monroe," National Museum, Washington, DC; bronze bust of "Daniel C. French," Trask Foundation, Saratoga Springs, NY; bronze relief of "F. F. Murdock," Mass. State Normal School; bronze relief of "William E. Barker," YWCA, Washington DC; bronze memorial to Mrs. Alvin Klein, St. Paul's Church, Stockbridge, MA; Baron Serge A. Korff Memorial prize, Georgetown School of Foreign Service; bust, Com. Richard E. Byrd, Corcoran Gallery, Washington, DC; NYU; Rockefeller Institute; and many portrait busts and reliefs held privately. Contributor to *American Artist, NY Times, American Heritage, Reader's Digest.* Address in 1970, Stockbridge, MA. Died in 1973.

CRESSY, SUSAN.
Painter. Award: Hon. mention, WI PS, 1922. Address in 1929, 222-18th Street, Milwaukee, WI.

CREW, MAYO.
Painter, illustrator, craftsman, and teacher. Born Memphis, TN, June 30, 1903. Pupil of Clara Schneider; Newcomb School of Art; ASL of NY.

Member: Memphis AA. Awards: First prizes in water color, pottery and design, Memphis Tri-State Fair. Address in 1929, 295 South Bellevue Blvd.; h. 1512 Court Avenue, Memphis, TN.

CRIMI, ALFREDO DIGIORGIO.
Painter. Born San Fratello, Messina, Italy, Dec. 1, 1900. Pupil of NAD. Member: Louis Comfort Tiffany Foundation; Arch. Lg. of NY. Address in 1929, 9 West 14th Street, New York, NY; h. 1962 Pilgrim Avenue, Bronx, NY.

CRISP, ARTHUR WATKINS.
Mural painter. Born Hamilton, Canada, April 26, 1881. Pupil of ASL of NY. Member: ANA; NY Arch. Lg., 1911; Mural P.; Players' C.; NYWCC; AWCS; Allied AA; NYSC; Century A. Awards: Collaborative prize, NY Arch. Lg., 1914; bronze medal, P.-P. Exp., San F., 1915; first Hallgarten prize, NAD, 1916; gold medal, NY Arch. Lg., 1920. Work: *Hamlet, As You Like It, Taming of the Shrew,* and four allegorical paintings in Belasco Theatre, NY; two allegorical lunettes, The Playhouse, NY; two mural paintings in Robert Treat Hotel, Newark, NJ; mural panel, Mark Twain Hotel, Elmira, NY; picture in Nat. Gal., Ottawa, CN; mural decoration for auditorium of Greenwich House, NY; wall hanging for Hotel Du Pont, Wilmington, DE; picture for Canadian War Records; mural paintings, Houses of Parliament, Ottawa, CN; "The Garden Party," owned by Edward, Prince of Wales; decorations in Mt. Vernon (NY) High School; Clover Garden Dance Hall; Peddie School, Hightstown, NJ. Formerly Instructor at ASL of NY; Cooper Institute; Beaux Art School of Design; NAD. Address in 1929, 308 East 51st Street, New York, NY.

CRISSEY, THOMAS HENRY.
Painter. Born Stamford, CT, 1875. Pupil of George Bridgman, Walter Florian, Edward Dufner. Member: Society of Independent Artists; New York Society of Artists. Address in 1926, Powers Street, New Canaan, Ct.

CRITCHER, CATHERINE CARTER.
Painter and teacher. Born Westmoreland Co., VA in 1868. Pupil of Cooper Union; Corcoran Art School; Richard Miller and Charles Hoffbauer in Paris. Member: S. Wash. A.; Wash. WCC; NA Women PS; Provincetown AA; Sail Loft C.; Wash. AC; Taos SA; SSAL. Award: Bronze medal, Wash. AC, 1914, 1922. Represented in Boston Arts Club. Address in 1929, 1 Dupont Circle; 3 St. Matthews' Alley; h. 1836 S Street, N.W., Washington, DC.

CRITTENDEN, ELIZABETH C.
Painter. Exhibited at National Association of Women Painters and Sculptors, New York, 1924. Address in 1926, 76 North 30th Street, Flushing, Long Island, NY.

CROASDALE, E.
Portrait painter. He painted a portrait of Abraham Lincoln, and on the back of the canvas is inscribed "Painted by E. Croasdale, and retouched by S. J. Ferris, 1863."

CROCKER, J. DENISON.
Landscape and portrait painter. He was born in Salem, Connecticut, November 25, 1823. With exception of some instruction from Charles Lanman, he was self-taught.

CROCKER, MARION E.
Painter. Born Boston, MA. Pupil of Tarbell in Boston; Kenyon Cox in New York; Constant and Laurens in Paris; George Hitchcock in Holland. Member: Copley S., 1888. Address in 1929, 40 Webster Place, Brookline, MA.

CROCKER, MARTHA E.
Painter. Born in South Yarmouth, Massachusetts, May 3, 1883. Pupil of Benson, Tarbell, Cottet, Simon and Hawthorne. Member: NA Women PS, Boston S. Indp. A, Provincetown AA. Address in 1929, 107 Fenway Studios, 30 Ipswich Street, Boston, MA.; h. Channing Place, Cambridge, Massachusetts; summer, Provincetown, Cape Cod, MA.

CROCKER, W. H.
Painter. Born in New York City, 1856. Pupil of Robert Vonnoh and Charles Rosen. Address in 1926, 50 Hamilton Terrace, New York, NY.

CROM, LILLIAN HOBBES.
Painter. Member: Fellowship PA Academy of Fine Arts. Address in 1926, Schwenksville, Pennsylvania.

CROMARTY, MARGARET A.
Painter and designer. Born Canada, Aug. 7, 1873. Pupil of Scranton School of Design. Member: Pensacola AC. Awards: First prize for water color, Pensacola Tri-County Fair, 1911; 1st prize for tapestry, Lagrange, IN, 1923. Address in 1929, 314 South Fla. Blanca Street, Pensacola, FL.

CROMWELL, JOANE (CHRISTIAN).
Painter, illustrator, and teacher. Born Lewistown, Illinois. Pupil of AIC; Anna A. Hills. Member: Laguna Beach AA. Work: "Driver's Point," Laguna Beach Chamber of Commerce; "The Emerald Pool," Cal-Acres Co., Los Angeles; "Beyond the Arch," Laguna Beach Art Gallery. Address in 1929, 1900 Parry Avenue, Laurel Canyon, Hollywood, CA.

CRON, NINA NASH.
Miniature painter. Born Spokane, Wash., April 28, 1883. Pupil of Elsie Dodge Pattee, Mabel Welch and Amelia Fuller. Address in 1929, 3302 McKinley Street, Washington, DC.

CRONBACH, ROBERT M.
Sculptor. Born February 10, 1908, St. Louis, MO. Studied: St. Louis School of Fine Arts, 1925, with Victor Holm; Penna. Academy of Fine Arts, 1927-30, with Charles Grafly, Albert Laessle; assistant in Paul Manship Studio, NYC and Paris, 1930. Work: University of Minnesota; St. Louis City; Springfield (MO) Art Museum; Walker; and many architectural commissions including Social Security Bldg., Wash., DC; Cafe Society Uptown, NYC; 240 Central Park South, NYC; Temple Israel, St. Louis, etc. Exhibited: Hudson D. Walker Gallery, NYC, 1939; The Bertha Schaefer Gallery, NYC, 1951, 52, 60, 67; New York World's Fairs, 1939, 1964-65; Sculptors Guild; Metropolitan Museum of Art; Denver Art Museum; Whitney Annuals, 1948, 1956-59; Riverside Museum, 1957; Silvermine Guild, 1957, 58, 60; Brussels World's Fair, 1958; Penna. Academy of Fine Arts; Architectural League of New York; Brooklyn Museum; Museum of Modern Art. Awards: Penna. Academy of Fine Arts, Stewardson Prize, 1938; Penna. Academy of Fine Arts, Cresson Fellowship, 1929, 30; National Sculpture Competition for Social Security Building, Washington, DC, First Award, 1939. Taught: Adelphi College, 1947-62; North Shore Community Art Center, 1949-54; Skowhegan School, summers, 1959, 60, 64. Member: Sculptors Guild; Architectural League of New York; Artists Equity. Address in 1982, 420 East 86th St., New York City.

CRONENWETT, CLARE.
Engraver. Address in 1926, 641 O'Farrell Street, San Francisco, CA.

CRONYN, RANDOLPH E.
Painter. Born New York City, Feb. 25, 1901. Pupil of Edmund Greacen, John Costigan, George Pearse Ennis. Member: Salma. C.; NAC; New Rochelle AA. Address in 1929, 6 Minetta Street, New York, NY; summer, 210 Lyncroft Road, New Rochelle, NY.

CROOKS, FORREST C.
Illustrator. Born Goshen, IN, Oct. 1, 1893. Pupil of George Sotter and Arthur Sparks. Illustrated for *Scribner's Pictorial Review, Collier's Weekly, Woman's Home Companion, Century*. Address in 1926, Carversville, PA.

CROOME, WILLIAM.
Wood engraver; was a pupil of Bowan's. He illustrated a number of books. Later in life he gave his time to designing bank-notes. He is also said to have been a very good painter in water colors. See "History of Wood Engraving in America," by W. J. Linton.

CROPSEY, JASPER F.
Painter. Born Feb. 18, 1823 at Rossville, LI, New York. Pupil of National Academy of Design in New York City; traveled in Europe. At first an architect; later painted landscapes, chiefly Hudson River

scenery including landscapes owned by the Metropolitan Museum, New York. Elected member of National Academy in 1851. Died June 22, 1900 in Hastings, NY.

CROSBY, KATHARINE VAN RENSELLAER.
See Gregory, Katharine V. R.

CROSBY, PERCY L.
Painter and illustrator. Born in 1891. Member: SI; Salma. C. Best known for comic strip "Skippy". His work, executed almost exclusively in black and white line, hung in Paris, Rome, and Luxembourg Galleries. Address in 1929, 54 East 59th Street, 131 East 93rd Street, New York, NY. Died in New York City, 1964.

CROSS, A. B.
This engraver of landscapes was a pupil of A. L. Dick in 1840. He is said to have abandoned engraving early in his life for some other business.

CROSS, AMY.
Painter and teacher. Born Milwaukee, WI, April 5, 1856. Pupil of Cooper Inst., R. Swain Gifford, William Sartain and ASL of NY; Hague Academy under Fritz Jansen, Jacob Maris and Albert Neuhuys in Holland; Julian Academy in Paris. Member: NYWCC; AFA. Awards: Silver medal at Hague Academy, 1893; silver medal, Atlanta Exp., 1895; bronze medal, Charleston Exp., 1902. Address in 1929, 15 West 67th Street, New York, NY.

CROSS, ANSON KENT.
Painter, teacher, and writer. Born Lawrence, MA, Dec. 6, 1862. Pupil of MA Normal Art School. Member: AFA; Boston AC; Copley S. (hon.) Awards: Bronze medal, MA Charitable Mechanics Assoc., Boston, 1892. Received medal, P.-P. Exposition, San Francisco, 1915, for new vision training method of teaching drawing and painting. Author of several books on art education. Director of classes in drawing and painting, Home Study Dept., Columbia University; Director, The Vision Training Art School, Boothbay Harbor, ME. Address in 1929, Boothbay Harbor, ME. Died in 1944.

CROSS, LOUISE.
Sculptor. Born in Rochester, MI, November 14, 1896. Studied at Wellesley College; Minneapolis School of Art; Art Institute of Chicago; University of Chicago; and with Harriet Hanley. Works: Memorial reliefs, Minnesota State Capitol; Todd Memorial Hospital, University of Minnesota. Exhibited: World's Fair of New York 1939; Philadelphia Museum of Art, 1934, 40; Metropolitan Museum of Art, 1942; National Sculpture Society; Whitney; Artists Equity Association; Sculptors Guild traveling exhibition, 1940, 41; Franklin Institute, Philadelphia, PA. Award: Minneapolis Institute of Art. Contributor to: Art magazines.

Address in 1953, 505 East 82nd Street, New York, New York.

CROSS, P. F.
Engraver. Born in Sheffield, England; died in Philadelphia in 1856. Cross was a die-sinker and served in that capacity in the Mint of England before he came to Philadelphia in about 1845 and became an assistant to James B. Longacre, chief engraver of the U.S. mint. Cross engraved the adverse of the Ingraham medal.

CROSS, SALLY.
Painter. Born Lawrence, MA. Pupil of De Camp and Ross Turner in Boston. Member: Penna. Society of Miniature Painters; New York Water Color Club. Address in 1926, 120 Riverway, Boston, MA.

CROSSMAN, ABNER.
Painter. Born St. Johnsbury, VT, June 14, 1847. Pupil of William Hart in New York; F. W. Moody in London. Member: Chicago Water Color Club. Address in 1926, 658 Woodland Park, Chicago, IL.

CROSSMAN, WILLIAM HENRY.
Painter and etcher. Born New York, NY, Aug. 7, 1896. Pupil of Henri, Lie, Bridgman and Hawthorne. Member: Salma. C.; ASL of NY. Represented in the NY Stock Exchange, Hotel Barclay and the Harvey School, NY; College of William and Mary and in the Wythe Museum, Williamsburg. Address in 1929, Colonial Studios, 39 W 67th St., New York, NY.

CROUCH, EMILY H.
Painter. Member: Providence Water Color Club. Address in 1926, 102 George Street, Providence, RI.

CROW, CAROL (WILSON).
Sculptor. Born in Christiansburg, VA, July 31, 1915. Studied at Columbia University, with Oronzio Maldarelli, 1958; Beartsi Foundry, Italy, 1965; University of California, with Peter Voulkos, 1968. Has exhibited at Ft. Worth Art Center, TX; Museum of Fine Arts, CA, 1970; Invitational Sculpture Show, San Francisco Museum, CA, 1970; Houston Museum of Fine Arts, TX; others. Member: Artists Equity of Houston; Texas Society of Sculptors; others. Works in clay and bronze. Address in 1982, Houston, TX.

CROW, J. CLAUDE.
Sculptor. Born in Stillwell, Okla., November 30, 1912. Studied: American Art School, with H. Glintenkamp. Member: Art League of America. Work: Brooklyn Public Library; Ft. Hamilton High School, Brooklyn, NY. Exhibited: World's Fair, New York, 1939; Springfield Museum of Art, 1938; Whitney Museum of American Art, 1939; Brooklyn Museum, 1946; ACA Gallery, 1939, 40; New School for Social Research, 1940; Hudson Walker Gallery, 1940; Critic's Choice, 1945. Address in 1953, Brooklyn, NY.

CROWE, AMANDA MARIA.
Sculptor. Born in Cherokee, North Carolina, in 1928. Studied: Art Institute of Chicago; Instituto Allende San Miguel, Mexico; De Paul University, Chicago. Awards: John Quincy Adams traveling scholarship, Art Institute of Chicago, 1952; Art Institute of Chicago, scholarship, 1946. Collections: Container Corporation of America; Cherokee Indian School in North Carolina; Museum of the Cherokee Indian, North Carolina.

CROWELL, MARGARET.
Sculptor, illustrator, and painter. Born in Philadelphia, PA. Pupil of Penna. Academy of Fine Arts. Member: Fellowship Penna. Academy of Fine Arts. Address in 1926, Avondale, PA.

CROWN, JOHN.
Painter. Member: GFLA. Address in 1929, 303 Fifth Avenue; 381 Fourth Avenue, New York, NY.

CROWNINSHIELD, FREDERIC.
Painter. Born Boston, Nov. 27, 1845. Studied art in France and Italy. Specialty, mural painting and stained glass windows; also landscape in oils and water colors. Instructor of drawing and painting, Museum of Fine Arts, Boston, 1879-85. Director, American Academy in Rome. Academy of National Arts. Member: National Society Mural Painters; National Institute Arts and Letters. The Boston Museum of Fine Arts owns his "Perugia," painted 1911, "Taormina," 1913, and "Capri Cliff," 1916. Elected Associate Member of National Academy in 1905. Died Sept. 3, 1918 in Capri, Italy.

CRUMB, CHARLES P.
Sculptor. Born Bloomfield, MO, Feb. 9, 1874. Pupil of O'Neill, Verlet, Barnard, Taft, Lanteri, Bringhurst, Grafly. Address in 1933, Beechwood Park, Delaware Co., PA.

CRUMB, R.
Illustrator. Born in the eastern United States in 1945. His interest in comic art began at the age of eight when he wrote, drew and sold his own comic books. A self-taught artist, he has had his work published in many books and magazines. His book *Fritz the Cat* was the basis for the popular animated movie and his "Mr. Natural" appeared weekly in the *Village Voice*. Presently living in California, he works for such comic book publishers as Print Mint and Last Gasp.

CRUMBLING, WAYNE K.
Painter. Exhibited at Penna. Academy of Fine Arts, Philadelphia, 1920. Address in 1926, Wrightville, PA.

CRUMMER, MARY WORTHINGTON.
Sculptor, painter, etcher, craftsman. Born in Baltimore, MD. Studied: Maryland Institute; Rinehart School of Sculpture, with Denman Ross; Harvard University. Award: Weyrich Memorial prize, Charcoal Club, 1923; purchase prize, Maryland State Fair, 1928; prizes, Peabody Institute, 1923; Baltimore Museum of Art, 1939. Member: Baltimore Water Color Club; Maryland Inst. Alumni Association; Maryland Historical Society; American Federation of Arts. Address in 1953, Baltimore, MD.

CRUMP, LESLIE.
Painter, illustrator, and teacher. Born Saugerties, NY, Jan. 7, 1894. Pupil of F. Luis Mora, Charles S. Chapman, Julian Academy in Paris. Member: NYWCC; Brooklyn WCC; ASL of NY. Address in 1929, 503 Central Avenue, Cranford, NJ. Died in 1962.

CRUMPACKER, GRACE DAUCHY.
Painter. Born Troy, NY, Oct. 4, 1881. Pupil of AIC. Member: Hoosier Salon, Artists League of Northern Ind. Award: Prize, Artists League of Northern Indiana, South Bend, 1929. Address in 1929, 1121 Riverside Drive, South Bend, Ind.; summer, R. F. D. No. 1, Wanatah, Ind.

CRUNELLE, LEONARD.
Sculptor. Born Lens, France, July 8, 1872. Pupil of Lorado Taft and Art Institute of Chicago. Member: Chicago Society of Artists; Cliff Dwellers Club; State Art Commission; Chicago Painters and Sculptors. Awards: Medal and diploma, Atlanta Exposition, 1895; special prize, Art Institute of Chicago, 1904; bronze medal and diploma, St. Louis Exposition, 1904; Chicago Society of Artists medal, Art Institute of Chicago, 1911. Work: "Squirrel Boy," Art Institute of Chicago. Address in 1929, Chicago, IL. Died in 1944.

CRUZ, RAYMOND.
Illustrator. Born in New York City in 1933. He studied art for five years at Cooper Union and PI. His first illustration was published in 1964 for the New York Graphic Society. Besides working for *Seventeen* and *McCall's*, he has illustrated several books for Atheneum Press and Four Winds Press. His works have been exhibited at the Museum of Contemporary Crafts in Houston and the S of I Annual Exhibitions.

CSAKANY, GABRIEL S.
Illustrator. Born in Budapest, Hungary, in 1938. He emigrated to Canada in 1956, attended the Toronto College of Art and studied under local professionals as an apprentice. He has had several magazine assignments in the United States and in Canada. As a designer and illustrator, he has won awards in Canada, the United States and Germany.

CSOSZ, JOHN.
Painter and etcher. Born Hungary, Oct. 2, 1897. Pupil of Gottwald and Keller. Member: Cleveland

SA. Work: "End of a Perfect Day," Public School Collection; portrait, Dr. Henderson, Memorial Library; mural decorations, Holy Ghost Church, Cleveland, OH; "Atlanta," University Club, Akron, OH. Address in 1929, 14918 Superior Road, Cleveland, Ohio.

CUCUEL, EDWARD.
Painter and illustrator. Born San Francisco, CA, Aug. 6, 1875. Pupil of Constant, Laurens and Gerome in Paris; Leo Putz in Munich. Member: Soc. Nat. des Beaux Arts (Assoc.), Paris; Isaria and Aussteller Verbund Munchner Kunstler, Der Ring, Munich. Award: Silver medal, P.-P. Exp., San Francisco, 1915. Represented in Detroit Art Inst.; Birkenhead Museum, Liverpool. Work: "The Art of Edward Cucuel," by Baron von Ostini, with 100 plates; "Color Plates of Edward Cucuel," E. W. Savory, Ltd., Publishers; "Color plates by Stehli Freres, Zurich" (Zehrfeld and Co., Leipzig Amalthea Pub. Co., Vienna). Address in 1929, 1 West 67th Street; h. 575 Riverside Dr., NY; 5 Klarstrasse, Munich, Germany; 16 Kreuzplatz, Zurich, Switzerland; 19 Rue Vavin, Paris, France.

CULBERTSON, JOSEPHINE M.
Painter, etcher, and teacher. Born Shanghai, China, May 4, 1852. Pupil of William M. Chase, Arthur W. Dow, George H. Smillie. Member: San Francisco S Women A; Carmel AA; Laguna Beach AA; Berkeley Lg. FA. Award: Hon. mention, Alaska Yukon Exposition, Seattle, Wash., 1909. Address in 1929, cor. Lincoln and 7th Sts.; Box 53, Carmel, CA.

CULBERTSON, LINN.
Painter and teacher. Born Princeton, IA, Sept. 29, 1890. Pupil of Charles Atherton Cumming. Awards: First prize ($100), Des Moines Women's Club, 1914; gold medal, Des Moines Women's Club, 1922; bronze medal, 1924, silver medal, 1928, and purchase prize, 1929, Des Moines Women's Club. Address in 1929, 1131-22d Street, Des Moines, IA.

CULBERTSON, QUEENIE.
Painter and illustrator. Born San Angelo, Texas. Pupil of Frank Duveneck; William DeL. Dodge. Member: Cincinnati Woman's AC. Address in 1929, 4120 Forest Avenue, Norwood, Cincinnati, Ohio.

CULIN, ALICE MUMFORD ROBERTS.
Painter. Born Philadelphia, PA, Jan. 30, 1875. Pupil of Joseph De Camp, Carl Newman and Robert Henri. Awards: Mary Smith prize, PAFA, 1906 and 1910; bronze medal, P.-P. Exp., San Francisco, 1915. Address in 1929, 137 West 12th Street, New York, NY.

CULTER, RICHARD.
Illustrator. Member: SI. Address in 1929, Ridgefield, CT, 211 Secor Lane, Pelham Manor, NY.

CUMING, BEATRICE LAVIS.
Painter. Born Brooklyn, NY, March 25, 1903. Pupil of Henry B. Snell. Member: NYWCC; NA Women PS; AWCS; Allied AA. Address in 1929, 245 Fulton Street, Brooklyn, NY. Died in 1975.

CUMMENS, LINDA.
(Linda Talaba Cummens). Sculptor and graphic artist. Born Detroit, MI, July 15, 1943. Studied: Detroit Institute of Technology; private instruction with Lois Pety; Illinois Wesleyan University, B.F.A.; Southern Illinois University, M.F.A. Awards: Birmingham (MI) Art Association, 1963; Royal Oak Art Association, Michigan, 1966; Illinois State Museum Craftsman's Award, 1975; Ball State University, 1975; others. Exhibited: One-man, Renee Gallery, Detroit, 1968, and Lewis Towers Gallery, Loyola University, 1975; Library of Congress Print Show, 1965; North Shore Artists, 1980; others. Commissions: Bronze door ornaments, Little Grassy Museum, Southern Illinois University, 1970; bronze sculpture, Directory and Bureau of Budget, State of Illinois, Springfield, 1975; other individual commissions. Member: Women's Caucus for Art; American Association of University Women; Auburn Art Association. Collections: Henry Ford Traveling Print Collection; J. L. Hudson Collection, Grosse Point, MI; McLean County Bank, Bloomington, IL; Albion University Print Collection; Detroit Art Institute Rental Gallery and Collection. Address in 1982, Deerfield, IL.

CUMMING, ALICE McKEE.
(Mrs. Charles A.). Sculptor, painter, lecturer, and teacher. Born in Stuart, IA, March 6, 1890. Studied: State University of Iowa; Cumming School of Art. Member: Iowa Art Guild; Society for Sanity in Art; Des Moines Art Forum. Awards: Medal, Iowa State Fair; prize, Des Moines Women's Club, 1925; medal, Art Institute of Chicago, 1942. Work: Des Moines Women's Club; State Historical Gallery, Des Moines. Exhibited: Society for Sanity in Art, Chicago, 1941; Ogunquit Art Association, 1943-46; Des Moines Art Forum, 1945, 46; Iowa Art Guild traveling exhibit. President, Director, Cumming School of Art, Des Moines, Iowa, from 1937. Address in 1953, Des Moines, Iowa.

CUMMING, CHARLES ATHERTON.
Painter, lecturer, and teacher. Born in Illinois, March 31, 1858. Pupil of Boulanger at Julian Academy, Lefebvre and Constant in Paris. Member: Iowa AA; College AA of America. Founder and Director, Cumming School of Art, Des Moines; and head of department of graphic and plastic arts, State Iowa City, IA; founder, Iowa Art Guild. Work: Mural painting, "Departure of the Indians from Fort Des Moines," in Polk County Court House; in the State Historical Gallery, Des Moines, IA; portraits, memorial collection, State Univ. of Iowa, Iowa City;

landscapes in Des Moines Woman's Club Gallery and Cedar Rapids Gallery of Art Association. Author of "Classification of the Arts of Expression," "The White Man's Art Defined," "The Psychology of the Symbolic Pictorial Arts" and "My Creed." Address in 1929, The Cumming School of Art, Des Moines, IA; h. P.O. Box 345, San Diego, CA. Died in 1932.

CUMMINGS, JAMES HOYT (MRS.).
Sculptor and painter. Born in Lyons, Kansas, April 15, 1905. Student of Kalamazoo College, University of Kansas, Art Students League, NYC, 1940, Grande Chaumiere, Paris, France, 1930. Exhibited in group and one-man shows, including Chicago Art Institute, Penna. Academy of Fine Arts, Buffalo Museum, National Academy, NY, St. Louis Art Museum; represented in permanent collections, including Liomberger Davis Little Museum. Received 1st prize, St. Louis Artists Guild, 1928; sculptor prize, St. Louis Artists League, 1921-22; 1st prize, Midwestern Artists, 1922; Graphic Art prize, National Association of Women Artists, 1946; sculptor prize, Professional Artists NYC, 1947; sculptor prize, Pen and Brush Club, NYC, 1948. Member: National Sculpture Society, Audubon Artists, Cape Cod Art Association, Provincetown Art Association, Chi Omega.

CUMMINGS, MELVIN EARL.
Sculptor. Born Salt Lake City, Utah, August 13, 1876. Student of Mark Hopkins Art Institute, San Francisco; pupil of Douglas Tilden; Mercie and Noel in Paris. Executed numerous statues in and around San Francisco, notably 11 ft. statue of Robert Burns, Golden Gate Park; also Conservatory Fountain; National Monument to Commodore Sloat, Monterey, CA; etc. Instructor of modeling, University of CA, 1904; instructor at San Francisco Art Institute since 1905. Member: San Francisco Art Association. Address in 1926, San Francisco, California. Died in 1936.

CUMMINGS, THOMAS SEIR.
Painter. Born in Bath, England, August 26, 1804, he came to America at an early age and became one of the most successful miniature painters in the country. He was one of the founders of the National Academy in 1826 and an early vice-president. Among his many beautiful portraits are those of Miss O'Bryan, Mrs. Cummings, Henry Inman and Mr. Hatch. Died September 24, 1894 in Hackensack, NJ.

CUNNINGHAM, JOE.
Writer, cartoonist, and lecturer. Born Philadelphia, PA, June 22, 1890. Member: PPC; Amer. Assoc. Cartoonists and Caricaturists. Designer of "Coat of Arms" for the U.S. Tank Corps. Creator of "Rufus McGoofus," the cartoon calendar. Address in 1929, Philadelphia Record; Melrose Park, Philadelphia, PA.

CUNNINGHAM, MILDRED C.
Painter. Born St. Paul, MN, Aug. 23, 1898. Pupil of Charles A. Cumming. Member: Iowa AG; Ill. AFA; All-Ill. SFA; Rockford AA. Address in 1929, 1718 Camp Avenue, Rockford, IL.

CUNNINGHAM, PATRICIA.
Sculptor, painter, teacher, designer, writer, and critic. Born in California. Studied: University of California, A.B., M.A.; and with Hans Hofmann, Andre L'Hote. Awards: Fellow, University of California. Work: Murals, Sea View School, Monterey, California. Taught: Art Center, Carmel Pine Cone-Cymbal, 1942-46; Instructor of Painting, Carmel Art Institute, Carmel, CA, 1940-46. Address in 1953, Carmel, CA.

CUNNINGHAM, ROBERT MORRIS.
Illustrator. Born in Herington, Kansas, in 1924. He attended the University of Kansas, KCAI and ASL. His first illustration was done for American Cyanamid Company in the 1960's. The recipient of Gold Medals in 1966 and 1967 from the S of I, he has shown his paintings at the Brooklyn Museum and the Smithsonian Inst. of Washington, DC.

CUPRIEN, FRANK W.
Painter. Born Brooklyn, NY, 1871. Pupil of Carl Webber in Philadelphia; ASL of NY; studied in Munich, Dresden, Leipzig, Italy and Paris. Member: Leipzig AA; California AC; Laguna Beach AA; Dallas AA; Denver AA; Munich P.; SSAL; New Haven PCC; PSC of Los Angeles. Awards: Gold medal, Berliner Ausstellung; silver medal, Galveston, Texas, 1913; silver medal, San Diego Exp. 1915; silver medal, San Diego Exp., 1916; hon. mention, Phoenix (Ariz.) State Fair, 1916; bronze medal, Sacramento State Fair, 1918; prize, Sacramento fair, 1920; popular prize, Laguna Beach Art Assoc., 1921; Skidmore prize ($50), Laguna Beach AA, 1922; prize ($100), Pac. Southwest Exp., Long Beach, CA; prize ($100), Laguna Beach AA, 1928. Work: "Homeward Bound," del Vecchio Gallery, Leipzig. Address in 1929, The Viking Studio, Laguna Beach, CA. Died June 21, 1948.

CUREL-SYLVESTRE, ROGER.
Painter. Born Nice, France, 1884. Pupil of A. Stevens and Noel. Member: Societe Royale des Beaux Arts, Bruxelles (Assoc.); Salons of America. Work: "Autumn," Milwaukee Art Inst. Address in 1929, 1 rue Chàrles Dickens, Paris, France.

CURRAN, CHARLES COURTNEY.
Painter. Born Hartford, KY, Feb. 13, 1861. Pupil of Cincinnati School of Design; ASL and NAD in NY; Julian Academy under Constant, Lefebvre and Doucet in Paris. Member: ANA, 1888; NA, 1904; NYWCC; AWCS; SAA, 1888; Salma. C.; Lotos (life); NAC (life); Allied AA; Mac D. C. Awards: Third

Hallgarten prize, NAD, 1888; hon. mention, Paris Salon, 1890; Clark Prize, NAD, 1893; silver medal, Atlanta Exp., 1895; medal, Columbian Exp., Chicago, 1893; second Hallgarten prize, NAD, 1895; hon. mention, Paris Exp., 1900; silver medal, Pan-Am. Exp., Buffalo, 1901; Carnegie prize, SAA, 1904; silver medal, St. Louis Exp., 1904; first Corcoran prize, S. Wash. A., 1905; Altman prize, ($1,000), NAD, 1919. Work: "Perfume of the Roses," National Gal., Washington; "The Breezy Day," Pennsylvania Academy, Philadelphia; "The Golden Hour," Museum of Art, Columbus; "Noon Sunshine," Art Association, Richmond, IN; "The Jungfrau" and "The Swimming Pool," Toledo (OH) Museum of Art; "Children Catching Minnows," Buffalo (NY) Fine Arts Academy; "Imprisoned Jewel," Art Museum, Montclair, NJ; "The Hawk," San Antonio Art Museum; "The Carnelian Necklace," Fort Worth Art Museum; "Pine Needles and Sunlight," Dallas Art Association; "Rita," Witte Memorial Museum, San Antonio, TX; "Cathedral Interior, Verona," Metropolitan Museum. Address in 1929, 39 West 67th Street, New York, NY. Died in 1942.

CURRIER, CHARLES.
Lithographer. Born 1818. Brother of Nathaniel (of Currier & Ives, 1862-1901), had a lithographic establishment for years at 33 Spruce Street, New York City. He did a large amount of work on the sheet music illustrations of the day. Died Jan. 4, 1887.

CURRIER, CYRUS BATES.
Painter and illustrator. Born Marietta, OH, Dec. 13, 1878. Pupil of Julian Academy, Bouguereau, Constant, Mucha, Paris. Member: Salma. C. Address in 1929, 1347 Lucile Avenue, Los Angeles, CA. Died c. 1951.

CURRIER, JOSEPH FRANK.
Painter. Born Nov. 21, 1843. He is represented in the permanent collection in Herron Art Gallery, IN, and the St. Louis Museum. He studied in Munich, and in 1878 sent to the Society of American Artists "A Bohemian Beggar" and two landscapes. Died in Jan. 1909.

CURRIER, NATHANIEL.
Lithographer. Born March 27, 1813 in Roxbury, MA. The firm of Currier and Ives, 1862-1901, issued for years lithographic portraits, views and pictorial records of sporting events and other happenings. For a number of years in the 1850's and 60's work in lithographic stone crowded out the wood block. Currier productions were often crudely executed, but some very beautiful prints did come from his presses. The shooting, fishing and racing prints furnish us today with a pictorial idea of American sports of the period, which is of great interest to the modern sportsman. Died November 20, 1888 in New York City.

CURRIER, WALTER BARRON.
Painter, etcher, craftsman, writer, lecturer, and teacher. Born Springfield, MA, May 3, 1879. Pupil of Dow, Eben Comins, Kenyon Cox. Member: Calif. AC; Calif. PM; Laguna Beach AA; Santa Monica AA. Award: First prize Annual Art Exhib., Santa Monica AA. Work: "California the Golden," "The Land of the Afternoon" and "Dalton Canyon," Lincoln High School, Los Angeles; "Sunset Glow from Bigbear," "The Phantom," "Sunrise in San Leandro Hills," Exposition Park Galleries, Los Angeles; "California," Cecil B. de Mille Home for Girls, Hollywood, CA. Writer and lecturer on Art Education. Head of Fine and Vocational Art Depts., Lincoln High School, LA, CA. Director Currier Creative Art School, Santa Monica, CA. Address in 1929, 432-15th St., Santa Monica, CA. Died in 1934.

CURRY, JOHN STEUART.
Painter, sculptor, and lithographer. Born in Dunavant, KS, November 14, 1897. Studied: Art Institute of Kansas; Art Institute of Chicago; Geneva College; pupil of Norton, Reynolds, Shoukheiff. Member: Art Students League. Awards: Purchase prize, Northwest Print Maker, fifth annual exhibition, 1933; second prize, Thirty-first International Exhibition, Carnegie Institute, 1933; gold medal, Penna. Academy of Fine Arts, 1941; prize ($3,0000), Artists for Victory Exhibition, Metropolitan Museum of Art, 1941. Work: "Baptism in Kansas," "Kansas Stockman," and "The Flying Codonas," Whitney Museum of American Art, NY. Address in 1933, Westport, CT. Died in 1946.

CURTIS, CALVIN.
Painter. Born in Stratford, CT, 1822. He began his studies under Daniel Huntington in 1841, also working at the Academy of Design. His work was largely portrait painting. To a limited degree he extended his work to landscapes.

CURTIS, CONSTANCE.
Painter. Born Washington. Pupil of Art Students League of New York and William M. Chase. Exhibited Paris Expn., 1900; St. Louis Expn., 1904. Pres. Art Workers' Club for Women. Member: Art Students League; Women Painters and Sculptors. Address in 1926, 1199 Park Avenue, New York, NY. Died in 1959.

CURTIS, DOMENICO DE.
Sculptor. Born in Roslyn, New York. Exhibited: Salon des Artistes Francais, 1930; Salon des Independents, 1931.

CURTIS, ELIZABETH.
Painter. Born New York, NY. Pupil of Twachtman and Chase. Member: PBC; AFA. Address in 1929, 127 East 10th St.; 399 Park Ave., New York, NY. summer, Watertown, NY

CURTIS, GEORGE.
Painter. Born in Southampton, England, in 1859. Pupil of Legros, Benjamin Constant. Member: Society of Independent Artists. Represented in Musee de Melun; large mural paintings in the Church Villemomble. Address in 1926, 5 West 16th Street, New York. Died in 1943.

CURTIS, IDA MAYNARD.
Painter. Born Lewisburg, PA, in 1860. Pupil of Hawthorne, Ross, Maynard, Simon, Jolley. Member: San Diego AA; Laguna Beach AA; Carmel AA; Provincetown AA; NAC. Award: Landscape prize, Catherine L. Wolfe C., 1923. Address in 1929, care of Back Bay Branch of Old Colony Trust Co., Boston, MA; R.F.D. No. A, Box 60, Carmel, Calif.

CURTIS, LELAND.
Painter. Born Denver, Colo., Aug. 7, 1897. Member: Calif. AC; Artland C; PSC of Los Angeles; AFA; Am. APL. Awards: Bronze medal, PSC of Los Angeles, 1924; cash prize, Calif. State Fair, 1926; Los Angeles Co. Fair, 1926; silver medal, PSC of Los Angeles, 1928. Work: "Sierra Gold," Artland Club, Los Angeles; "The Everlasting Mountains," permanent collection, Hollywood Athletic Club; "High Sierras," purchased by City of Los Angeles, 1929. Address in 1929, 560 South New Hampshire Street; h. 3871 South Hobart Blvd., Los Angeles, CA.

CURTIS, LEONA.
Sculptor. Born in Plainfield, NJ, January 26, 1908. Studied: Art Students League; and with Robert Laurent, Jose de Creeft, Concetta Scaravaglione. Member: New York Society of Women Artists; National Association of Women Artists. Awards: Medal, Montclair Art Museum, 1935; prize, National Association of Women Artists, NY, 1941. Work: Bas-relief, Clark High School, Roselle, NJ. Exhibited: Penna. Academy of Fine Arts, 1935; Philadelphia Museum of Art, 1940; National Academy of Design, 1942; World's Fair, NY, 1939; Metropolitan Museum of Art, 1942; Montclair Art Museum, 1935, 36; Newark Museum, 1939; American-British Art Center, 1941; Bonestell Gallery, 1943. Address in 1953, 295 Adelphi Street, Brooklyn, NY.

CURTIS, NATHANIEL CORTLANDT.
Painter, architect, writer, lecturer, and teacher. Born Smithville, NC, Feb. 8, 1881. Pupil of William R. Ware. Member: AIA; N.O. AA; Arts and Crafts Club of N.O. Designed buildings for Alabama Polytechnic Inst., Auburn, Ala. Author: "Architectural Graphics," "Architectural Composition." Address in 1929, 1105 Hibernia Bldg.; h. 1423 Calhoun Street, New Orleans, LA.

CURTIS, SIDNEY.
Painter. Member: Salmagundi Club. Address in 1926, 112 Hicks Street, Brooklyn, NYC.

CURTIS, WILLIAM FULLER.
Painter, sculptor, and worker in applied arts. Born in Staten Island, NY, February 25, 1873. Pupil of Julius Rolshoven, Lefebvre and Robert-Fleury in Paris. Awards: Third Corcoran prize, Society of Washington Artists, 1902; first Corcoran prize, Washington Water Color Club, 1903; silver medal, St. Louis Exposition, 1904. Member: New York Architectural League, 1902; Society of Washington Artists; Washington Water Color Club; Boston Society of Arts and Crafts. Work: Altar panels, Church of St. Michael and All Angels, Geneseo, NY; decorative panels, Cosmos Club, Washington, DC. Address in 1933, Brookline, MA; summer, Ashfield, MA.

CURTIS-BROWN, MARY SEYMOUR.
Painter. Born Norwalk, CT, July 28, 1888. Pupil of Albert Sterner. Member: NAC. Address in 1929, Whitney Point, NY; h. Peck Farm, Lisle, NY.

CURTIS-HUXLEY, CLAIRE A.
Sculptor. Born in Palmyra, NY. Exhibited: Salon des Artistes Francais; Salon de la Nationale; Salon des Artistes Independent. Awards: Honorable mention, Exposition Universalle, 1900. Works held: Luxembourg Museum, Paris.

CUSHING, HOWARD GARDINER.
Portrait painter. Born in Boston, 1869. He studied for five years in Paris at the Julien Academy; was also pupil of Laurens and Constant. Represented at Metropolitan Museum, New York, by portrait of Mrs. Ethel Cushing. He exhibited "A Woman in White," "Woman in Silver Dress," and "Sunlight." He also painted a series of murals for Mrs. H. P. Whitney's studio, on Long Island. Elected Associate Member of National Academy in 1906. Died April 26, 1916 in NYC.

CUSHMAN, ALICE.
Landscape painter. Born Philadelphia, Sept. 27, 1854. Pupil of NAD in New York, Ross Turner in Boston. Member: Plastic C.; Phila. WCC; Fellowship PAFA (assoc.). Award: Woman's Exposition of the Carolinas, 1897. Specialty, water colors. Address in 1929, 919 Pine Street, Philadelphia, PA.

CUSHMAN, GEORGE H.
Engraver and painter. Born June 5, 1814 in Windham, CT. Cushman was a pupil of Asaph Willard, the Hartford engraver, and became an admirable line-engraver of landscapes and book illustrations. He was chiefly known as a miniature painter. Died Aug. 3, 1876 in Jersey City, NJ.

CUSHMAN, HENRY.
Sculptor and craftsman. Born London, England, December 16, 1859. Work: Carved ivory cup, Windsor Castle. Specialty, carved wood and stonework. Address in 1933, Los Angeles, CA.

CUSHMAN, THOMAS HASTINGS.
Born at Albany, NY, June 6, 1815. He was apprenticed in the engraving establishment of A. L. Dick in New York. He is well known as a bank-note engraver. Died Nov. 7, 1841 in Albany, NY.

CUSTIS, ELEANOR PARKE.
Painter. Born Washington, DC, 1897. Pupil of Corcoran Art School; Henry B. Snell. Member: Wash. WCC; S. Wash. A.; NA Women PS; Wash. AC; PBC; NYWCC; AWCS; AFA. Address in 1929, 626 East Capitol Street, Washington, DC.

CUSUMANO, STEFANO.
Born Febuary 5, 1912, in Tampa, Florida. Studied at Met. Art School, NYC; Cooper Union; and with Arthur Schwieder. Taught at Cooper Union, NYU, and Cornell. Awarded Ford Foundation Purchase Award (1962), Am. Acad. Arts and Letters award (1962, 1968, 1971). Exhibited at Montross Gallery, NYC (1942); George Binet Gallery (1946-50); Oregon State University; Tampa Art Inst.; Terry Dintenfass (1967); MOMA; Corcoran, Washington, DC. In collections of Newark Museum; Whitney; Nat. Gal. (Washington, DC); Brooklyn Mus.; Johns Hopkins; University of Illinois; Florida State University; and others. Died November 18, 1975.

CUTLER, CARL GORDON.
Painter. Born Newtonville, MA, Jan. 3, 1873. Pupil of Boston Museum School; Constant and Laurens in Paris. Member: Boston AC; Copley S.; Boston SWCP; (assoc.) NYWCC. Address in 1929, Fenway Studios, Boston, MA; h. 24 Central Avenue, Newtonville, MA. Died in 1945.

CUTLER, CHARLES GORDON.
Sculptor. Born in Newton, Mass., January 17, 1914. Studied: Baltimore Museum of Fine Art School. Work: Addison Gallery of American Art, Andover, Mass.; IBM; Fitchburg Art Center; Springfield Museum of Art; Virginia Museum of Fine Arts, Richmond, VA; Cleveland Museum of Art. Exhibited: Penna. Academy of Fine Arts, 1942, 46; Art Institute of Chicago, 1942; Buchholz Gallery, 1943; New England Sculpture, 1942; Rhode Island School of Design, 1938; Fitchburg Art Center, 1946; Whitney Museum of American Art; Fogg Museum of Art; New London, Conn.; Worcester Museum of Art; Corcoran Gallery of Art; one-man: Grace Horne Gallery; Vose Gallery, Boston; Cincinnati Museum Association; Detroit Institute of Art; Framingham, Mass. Taught: Head, Sculpture Dept., Cincinnati Art Academy, from 1952. Address in 1953, South Brooksville, ME; h. Cincinnati, OH.

CUTLER, JERVIS.
Engraver. Born Sept. 19, 1768 in Martha's Vineyard, MA. In 1812 he engraved, on copper, illustrations for a book, including the earliest view of Cincinnati. Died June 25, 1846 in Evansville, IN.

CYPRYS, ALLAN.
Sculptor. Studied: The New School for Social Research, NYC; Sarah Lawrence College, Bronxville, NY. Exhibited: Nexus Gallery, Philadelphia, Pennsylvania, 1978; New Jersey Institute of Technology, 1981; 14 Sculptors Gallery, New York City, 1978, 80, 83, all group shows; one-man shows include The Bronx Council on the Arts, Bronx, New York, 1975; Mamaroneck Artist Guild, Larchmont, New York, 1981, 83; others. Commissions: The Grand Hyatt Hotel, New York City, wall relief; numerous others. Position: Instructor at Christopher Columbus High School, Bronx, NY. Noted work: "Growth Patterns," 1981, wood; "Enclosure," 1982, wood; others. Address in 1984, New Rochelle, NY.

CZERMANSKI, ZOLZISLAW.
Illustrator. Born in Krakow, Poland, in 1900. He became a pupil of the famous Polish caricaturist Kazimierz Sichulski and later had his first exhibit, "Caricatures of Personalities of the Arts," held in the Tatra mountains. He moved to Paris to study art with Fernand Leger and there began his career as a painter of everyday Parisian life. In 1931 he was invited to the US to work for the newly founded magazine *Fortune*. His paintings have appeared in Warsaw, Paris, London, Geneva, Vienna, New York, Washington, and Philadelphia. Died in 1970.

D

DABO, LEON.
Landscape and mural painter, writer, and lecturer. Born Detroit, MI, July 9, 1868. Pupil of Daniel Vierge, Pierre Galland, Ecole des Beaux-Arts and Julian Academy in Paris. Member: Pastellists; Hopkin C. of Detroit; NAC; Allied Artists, London, England; Royal Society of Arts and Sciences, London, England; Les Mireilles, Avignon, France; Les Amis des Arts, Arles, France; Societe des Amis du Louvre, Paris, France; School Art League of NY; Brooklyn SA; PS; Mural P.; Three Arts C. Cincinnati. In collections of: MMA; Luxembourg Museum, Paris; Nat'l Gallery, Washington, DC; Imperial Museum of Art, Tokyo, Japan; Nat. Gal., Ottawa, CN; Boston; Brooklyn; Herron Art Inst., Indianapolis; St. Louis; Detroit; Toledo; Museum of Art, Montclair, NJ; Poland Springs (ME) Museum; Art Assoc., Milwaukee; Art Assoc. Muncie, IN; Hackley Art Gallery, Muskegon, MI; Art Assoc., Saginaw, MI; Nat. Arts Club, NY; Arbuckle Inst., Brooklyn, NY; Baltimore, MD; Newark, NJ; Museum of Art, Fort Worth, Texas; Beloit College, Beloit, Wisc.; Delgado Museum, New Orleans; Memorial Art Gallery, Rochester, NY; Reading Art Gallery, Reading, PA; Museum of Art, Minneapolis, MN; Mus. Avignon, France; Montreal Art Assoc.; Tuskogee Inst., Ala.; Mus. of Lyons, France; Mural, "Ascension," ceiling-triforium gallery (16 panels) and altar (4 panels) Church of St. John the Baptist, Brooklyn, NY; ten historical paintings, Flower Memorial Library, Watertown, NY. Address in 1929, 222 West 22nd Street, New York, NY. Died in 1960.

DABO, THEODORE SCOTT.
Painter. Born in New Orleans, LA, 1877. Painted in Ecole des Arts, Paris; traveled extensively and studied painting independently. Ceased painting 1890, owing to irreconcilable views of teachers and his own ideas; studied natural law and optics, and made discoveries in atmosphere, luminosity and vibration. Returned to New York 1900, and entered various exhibitions; subsequently, exhibitions at London, Paris and elsewhere. Address in 1926, Billancourt (Seine), France.

DABOUR, JOHN.
Artist. Born in Smyrna, Asia, in 1837. Pupil of Academy of Fine Arts in Paris. Fifteen years of his professional life were spent in the U.S. painting portraits which are found in the principal cities in the U.S., but chiefly in Baltimore, MD. Among his most prominent sitters were Archbishop Spaulding, Senator Cameron, Senator Davis and Governor Groome of Maryland. He died in NY in 1905.

DAGGETT, ALFRED.
Line engraver of portraits, and bank-note vignettes, was the uncle and the first preceptor of the American artist J. F. Kensett. Daggett was born in New Haven, CT, 1799, and died there 1872. He was a member of the engraving firms of Daggett and Ely, and Daggett, Hinman and Co. The work signed by these firm names, however, is usually executed in stipple.

DAGGETT (OR DAGGET), MAUD.
Sculptor. Born Kansas City, MO, February 10, 1883. Pupil of Lorado Taft. Member: California Art Club. Award: Silver medal, Pan. California Exp., San Diego 1915. Work: Fountain, Hotel Raymond, Pasadena; drinking fountain; medallion and Memorial Fountain, Castelar St. Creche Building, City of Los Angeles; "Peter Pan Frieze," Pasadena Public Library; Bertha Harton Orr Memorial Fountain, Occidental College, Los Angeles; four works, American Exhibition of Sculpture, National Sculpture Society, San Francisco, 1933. Address in 1929, Pasadena, CA.

DAGGY, RICHARD S.
Painter, illustrator, and etcher. Born Chatham, NJ, Feb. 17, 1892. Pupil of Augustus S. Daggy. Member: Silvermine Guild of Artists; Darien Guild of the Seven Arts; S. Indp. A. Address in 1929, Seir Hill, Norwalk, CT.

DAHLER, WARREN.
Sculptor, painter, and craftsman. Born in New York, NY, October 12, 1897. Studied: National Academy of Design; University of Chicago; and with George Grey Barnard. Member: Silvermine Guild of Art; National Society of Mural Painters, New York. Awards: Prize, Architectural St. Francis Hotel, San Francisco, League, 1915. Work: Murals, Capitol Building, Missouri; CA; Somerset (VA); stage sets for Broadway plays. Exhibited: National Academy of Design, 1920, 22; Silvermine Guild of Art, 1932 (one-man). Address in 1953, Norwalk, Conn. Died in 1961.

DAHLGREEN, CHARLES W.
Landscape painter, etcher, and teacher. Born Chicago, Sept. 8, 1864. Pupil of AIC. Member: ASL of Chicago; Art Service League; Chicago PS; Chicago SE; Chicago Gal. A. Awards: Hon. mention, P.-P. Exp., San F., 1915; Rosenwald and Carr prizes, AIC, 1919; Chicago Municipal Art Lg. purchase prize, 1920; first prize for landscape in oil, Indiana Hoosier Salon, 1925 and landscape prize, 1928; purchase prize, Chicago Gal. A., 1927 and 1928. Represented: Library of Congress, Washington, DC and Smithsonian Institution; Chicago AG; Inter. Soc. AL;

Museum of History, Science and Art, Los Angeles; Vanderpoel AA. Collection, Chicago; and NY Public Library. Address in 1929, 409 North Cuyler Ave., Oak Park, IL.

DAILEY, CHUCK.
Painter & museologist. Born in Golden, CO, May 25, 1935. Studied: Univ. of CO; western Europe, 1962-63. Exhibitions: Fine Arts Mus. of NM; Univ. of CO Museum; Gallery 5, Santa Fe; others. Work: Mus. of NM; permanent collection, Santa Fe; others. Member: Am. Assoc. of Mus.; Am. Indian Mus. Assoc.; others. Curator, Exhibitions Division, Mus. of NM. Address in 1982, Santa Fe, NM.

DAILEY, EVELYNNE B.
Painter and printmaker. Born Indianapolis, IN, Jan. 8, 1903. Studied: Herron School of Art of Indiana Univ.; The Bauhaus; Butler University. Exhibitions: Brooklyn Museum; Chicago Art Inst.; Nat'l Acad. of Design. Her work is in the collection of the Library of Congress, Washington, D.C.

DAINGERFIELD, ELLIOTT.
Painter, illustrator, teacher, writer and lecturer. Born Harper's Ferry, VA, March 26, 1859; came to NY in 1880. Studied in NY. Member: ANA, 1902; NA, 1906; NYWCC; SAA, 1903; Lotos C.; NAC. Awards: Silver medal, Pan-Am. Exp., Buffalo, 1901; Clarke prize, NAD, 1902. Work: "Christ Stilling the Tempest," and "Slumbering Fog," Metropolitan Museum, NY; "Storm Breaking Up," Toledo Museum; "The Child of Mary," National Gallery, Washington; "The Midnight Moon," Brooklyn Inst. Museum; mural decorations in Lady Chapel of Church of St. Mary the Virgin, NY; "An Arcadian Huntress" and "Swirling Mists," City Art Mus., St. Louis; "The Valley of the Dragon," Chicago Art Inst.; "Sunset Hour," "West Glow," Butler Art Inst., Youngstown, OH; "Little Town of Bethlehem," Harrison Gallery, Los Angeles Museum. Address in 1929, 222 West 59th Street, New York, NY.

DAINGERFIELD, MARJORIE.
Sculptor. Born in New York City. Studied: School of American Sculpture; Grand Central School of Art; and with James Fraser, Edmond Amateis, Mahonri Young, Solon Borglum. Award: Pen & Brush Club, 1956, Anna Hyatt Huntington Award for Bronze; Catherine Lorillard Wolfe Art Club Award. Collections: School of Tropical Medicine, San Juan, Puerto Rico; Hobart College, Geneva, NY; Queens College, Charlotte, NC; Georgetown University. Exhibited: National Sculpture Society; Pen and Brush Club; Catherine Lorillard Wolfe Art Club; National Academy of Design; Duke University, NC. Member: Pen and Brush Club; Catherine Lorillard Wolfe Art Club; National Sculpture Society, fellow. She is perhaps best known for her statuette-emblem for Girl Scouts of America. Address in 1976, 1 West 67th Street, NYC. Died in 1977.

DAINTY, S.
This man was engraving landscapes in mixed manner, about 1840, in Philadelphia. John Dainty was a copperplate printer in Philadelphia, working as early as 1817, and this S. Dainty may have been his son.

Dal FABBRO, MARIO.
Sculptor and writer. Born in Cappella Maggiore, Italy, October 6, 1913; US citizen. Studied: Institute of Industrial Art, Venice. Work: Kemerer Museum, Bethlehem, PA; Museum of Art, Science, & Industry, Bridgeport, CT; Allentown (PA) Art Museum. Exhibitions: Triennial International of Milan, Italy; Allentown (PA) Art Museum; New England Exhibition, Silvermine Guild; Museum of Art, Science, and Industry, Bridgeport, CT; etc. Awards: Sculpture, first prize, City of Vittorio Veneto, Italy; first prize, sculpture, Lehigh Art Alliance; and others. Member: International Academy Tommaso Campanella, Rome; Silvermine Guild. Medium: Wood. Address in 1982, Fairfield, CT.

DALAND, KATHERINE.
Illustrator. Born in Boston, MA, 1883. Illustrated *Lyrics of Eliza*, and many other books.

DALE, BENJAMIN M.
Illustrator. Member: SI. Address in 1929, 15 West 37th Street, New York, NY; 111 Meteor St., Forest Hills, LI, NY.

DALLAM, ELIZABETH FORBES.
Painter and teacher. Born in Philadelphia, PA, Feb. 9, 1875. Pupil of Anshutz, Breckenridge, and McCarter. Awards: Two European traveling scholarships, PAFA. Member: Fellowship PAFA; North Shore AA. Address in 1929, 2224 Pine St., Philadelphia, PA; summer, Rocky Neck, Gloucester, MA.

DALLIN, CYRUS EDWIN.
Sculptor, teacher, and writer. Born in Springville, UT, November 22, 1861. Pupil of Chapu and Dampt in Paris; also of Ecole des Beaux-Arts and Academie Julien, Paris. Member: National Academy of Design, 1930; National Sculpture Society, 1893; New York Architectural League; Art Club of Philadelphia, 1895; Boston Art Club; St. Botolph Club, 1900; Royal Society of Arts, London; Boston Guild of Artists; Boston Society of Sculptors; American Federation of Arts. Instructor, Museum of Art, Normal Art School Association, NY, 1888. Awards: Honorable mention, Paris Salon, 1890; first class medal and diploma, Columbian Exposition, Chicago, 1893; silver medal, Mass. Charitable Mechanics Association, 1895; silver medal, Paris Exposition, 1900; silver medal, Pan-Am. Exposition, Buffalo, 1901; gold medal, St. Louis Exposition, 1904; third class medal, Paris Salon, 1909; gold medal, P.-P. Exposition, San Francisco, 1915. Work: Lincoln Park, Chicago; Library of

Congress, Washington; Salt Lake City; Fairmount Park, Philadelphia; "Soldiers and Sailors Monument," Syracuse, NY; marble relief "Julia Ward Howe," Museum of Fine Arts, Boston; "The Hunter," Arlington, MA; "Alma Mater," Washington University, St. Louis, MO; Kansas City, MO; Cleveland School of Arts; "Memorial Relief," Provincetown, MA; Storrow Memorial, Lincoln, MA. Address in 1933, Arlington Heights, MA. Died 1944.

DALLISON, KEN.
Illustrator. Born in Hounslow, Middlesex, England, in 1933. He attended the Twickenham School of Art for two years. He began his career in 1956 with *Liberty* in Toronto, Canada. He lived in NY for many years and as a free-lance illustrator won several awards including a Gold Medal from the S of I. Presently he lives near Toronto and is represented in the Ontario Gallery of Art.

DALRYMPLE, AMY FLORENCE.
Landscape painter. Born in Boston. Studied at Massachusetts Normal Art School; and in Italy. Member: Boston SAC; Copley S. Address in 1929, Blue Ship Studio; h. 27 T. Wharf, Boston, MA.

DALRYMPLE, LUCILE STEVENSON.
Painter. Born Sandusky, OH, on Oct. 19, 1882. Pupil of AIC, and J. Francis Smith Acad., Chicago. Member: Cordon C; AIC Alumni; Chicago S. Min. P.; South Side AA; Renaissance Soc. U. of C.; AFA; IL AFA. Work: Portrait of "Mr. J. T. Gillick," director's room, Union Station, Chicago; "I. C. Elston," Elston Bank, Crawfordsville, IN; "Betsy Gates Mills," Betsy Mills Club, Marietta, OH; portrait of Presidents of Wabash College, Dr. J. F. Tuttle, Dr. G. S. Burroughs, Dr. William P. Kane, Dr. George L. Mackintosh, Dr. Charles White, Theodore H. Ristine, in Trustees Room, Wabash College, Crawsfordsville, Indiana; Dr. Alfred Tyler Perry, Marietta College, Marietta, OH. Miniature, "Youth," purchased by IL AFA, for Permanent Gallery, Springfield, IL. Address in 1929, Fine Arts Bldg.; h. 4704 Drexel Blvd., Chicago, IL; summer, "Marais du Cygne," R. D. No. 1, Port Clinton, OH.

DALSTROM, GUSTAF O(SCAR).
Painter. Born Gothland, Sweden, Jan. 18, 1893. Pupil of AIC; George Bellows; Randall Davey. Member: Chicago SA; Chicago NJSA. Adress in 1929, 645 Kemper Place, Chicago, IL.

DALTON, E.
Miniature painter, who flourished in 1827 in Philadelphia.

DALTON, PETER C.
Sculptor. Born in Buffalo, NY, December 16, 1894. Studied: Art Students League; Beaux-Arts Institute of Design, NY; National Acad. of Design. Member: Associate, National Academy of Design; National Sculpture Society; Audubon Artists; National Institute of Arts and Letters. Awards: Allied Art Association, 1935; American Academy of Arts and Letters, 1945; gold medal, National Academy of Design, 1950, 1951. Work: USPO, Carthage, Miss. Exhibited: Penna. Academy of Fine Art, 1936, 1941, 1943, 1945, 1950, 1951; Fairmount Park, PA; Carnegie Institute, 1941; Museum of Modern Art, 1951; National Academy of Design, 1950, 1951. Address in 1953, Grandview-on-Hudson, NY. Died 1972.

DALY, MATT A.
Painter. Born Cincinnati, OH, on Jan. 13, 1860. Pupil of Duveneck, Noble and Lutz. Member: Cincinnati AC.; Am. APL. Represented in Cincinnati Art Museum; University of Cincinnati. Address in 1929, Apts. 7 and 9, 127 East 3rd St., Norwood, OH.

DAMINAKES, CLEON.
Painter and etcher. Born Berkeley, CA. Member: Calif. SE; Chicago SE. Award: Logan medal, Chicago SE, 1922. Work: Mural decorations, Berkeley High School Auditorium. Address in 1929, 11 West 52nd St., New York, NY; h. 327 Lenox Ave., Oakland, Calif.

DAMMAT, WILLIAM T.
Painter. Born at New York, 1853. Pupil of Munich Academy, and Munkacsy. Represented by "The Woman in Red" and "The Contrabandist" in the Luxembourg Museum, Paris; "A Quartette," Metropolitan Museum, New York; "Eva Haviland," Boston Museum. Address in 1926, 45 Avenue de Villiers, Paris.

DAMON, LOUISE WHEELWRIGHT.
Sculptor and painter. Born in Jamaica Plain, Mass., October 29, 1889. Studied: Boston Museum of Fine Art School; and with Charles Hawthorne. Member: Providence Art Club; Newport Art Association. Address in 1953, Providence, RI; summer, Annisquam, Mass.

DAMROSCH, HELEN T(HERESE).
See Tee-Van, Mrs. John.

DANA, CHARLES E.
Painter. Specialty, water colors. Born in Pennsylvania in 1843, he received the gold medal of the Philadelphia Art Club for his water colors in 1891. He died in Philadelphia in 1924.

DANA, WILLIAM PARSONS WINCHESTER.
Painter. Born Boston, 1833. Went to sea in early life; studied art at Ecole des Beaux Arts, and under Le Poittevin, Paris, 1854-62. Had studio in NY 1862-70, residing abroad from 1870. Member of Academy of Nat. Artists, 1862; Nat. Academy, 1863. Painted marine, landscape and figure pictures. Received

medals at Paris International Expn., 1878 and 1889; 1st prize marine painting at Penna. Academy of Fine Arts, 1881. Address in 1926, 57 Onslow Gardens, London, S.W., England.

DANAHER, MAY.
Painter, craftsman, and teacher. Born La Grange, TN. Pupil of PAFA, Hugh Breckenridge and George Elmer Browne. Member: SSAL; Miss. AA.; North Shore AA; S. Indp. A., NY; AFA. Awards: First prizes for miniature on china, enamel vase and gold brooch, second prizes for collection and landscape in oil, Tri-State Fair, Memphis, TN; first prizes for collection of oils, 1923, 1924; second prizes for flower paintings and portraits, Arkansas State Fair. Director, Fine Arts Club, Little Rock. Address in 1929, 2022 Izard St., Little Rock, AR.

DANBY, J.
"Paulson's Advertiser," Philadelphia, May 29, 1822, contains the advertisement of "J. Danby, Engraver in General, from London." This notice says that he engraves on "Gold, Silver, Copper, Brass, Wood, etc. in a superior manner," but no signed work by Danby was known to Fielding in 1926.

DANDO, SUSIE MAY.
Painter and teacher. Born Odell, IL, on Sept. 6, 1873. Pupil of William L. Judson in California. Member: Calif. AC.; Laguna Beach AA.; West Coast Arts. Award: Silver medal, Panama-Calif. Exp., San Diego, 1915. Address in 1929, 126 Brooks Ave., Venice, CA.

D'ANDREA, ALBERT PHILIP.
Sculptor, painter, engraver, and educator. Born in Benevento, Italy, October 27, 1897. Studied: City College of New York, B.A., 1918; University Rome; National Academy of Design; Pratt. Member: Brooklyn Society of Art; College Art Association of America, Fellow; Royal Society of Art, England; Honorary Academician, Accademia di Belle Arti, Perugia; National Sculpture Society; Audubon; others. Awards: Prizes, City College of New York, 1933; Library of Congress, 1944; National Sculpture Society, 1963; others. Work: Library of Congress; City College of New York; Museum of the City of New York; New York Historical Society; Smithsonian; Vatican Library; Jewish Museum, NYC; medals for commissions. Exhibited: National Sculpture Society, 1951, 52, 72; American Artists Professional League, NYC, 1972; Audubon Artists 30th Annual Exhibition, NY, 1972; National Academy of Design. Director, Architectural and Engineering Unit, Board of Education, NY, 1947-51; art faculty, City College of New York, 1918-48, professor and chairman of Art Department, 1948-68. Assistant Editor, Theatre Annual, from 1946. Address in 1982, Brooklyn, NY.

DANENHOWER, DOROTHY SCUDDER.
Sculptor, painter, craftsman, lecturer and teacher. Born in Princeton, NJ, March 18, 1880. Pupil of Pyle, Grafly, etc. Awarded poster prize, Cleveland Electrical Exposition, May, 1914. Address in 1918, Newark, NJ.

DANFORTH, MARIE.
See Page, Marie Danforth.

DANFORTH, MOSELY ISAAC.
Engraver. Born Hartford, CT, in 1800; died in New York in 1862. In 1818 Danforth was an apprentice to Asaph Willard of the Graphic Company, of Hartford, and he became a meritorious line-engraver of portraits and bank-note vignettes. He established himself in business in New Haven in 1821, but soon after moved to New York. Danforth was one of the founders of the Drawing Association of 1825, and of the National Academy of Design in 1826. Danforth went to London in 1827 and remained there about 10 yrs. and some of his largest and best plates were engraved in that city. Upon his return to NY he became interested in bank-note engraving as a business. He was a member of the firm of Danforth, Underwood & Co. about 1850; about 1858 this firm was merged into the American Banknote Co., and he was vice-president of the latter company at the time of his death. While abroad in 1827 he began to study art at the Royal Academy in London. He was chiefly successful as a painter in water colors, and some of his sketches became very popular and brought high prices.

DANIEL, LEWIS C.
Illustrator and etcher. Born in New York on Oct. 23, 1901. Pupil of Harry Wickey. Work: "He That is Without Sin Among You Let Him First Cast a Stone at Her," La Bibliotheque Nationale. Address in 1929, 119 West 57th St.; h. 506 Fort Washington Ave., New York, NY.

DANIELE, FRANCESO.
Painter. Exhibited water colors in Annual Exhibition at Penna. Academy of Fine Arts, Philadelphia, 1925. Address in 1926, 2021 Randon Road, Cleveland, OH.

DANIELI, FIDEL ANGELICO.
Painter and art critic. Born in Ironwood, MI, June 15, 1938. Pupil of Pasadena City College, Leonard Edmondson; UCLA, Jan Stussy, William Brice. Lives and exhibits in California.

DANIELL, WILLIAM SWIFT (or DANIEL).
Painter. Born San Francisco, CA, on April 26, 1865. Pupil of Julian, Delecluse and Vitti Academies and Laurens in Paris. Member: Calif. AC.; Laguna Beach AA.; Beach Combers, Provincetown, MA. Address in 1929, Daniell Studio, Laguna Beach, CA.

DANIELS, ELMER HARLAND.
Sculptor and craftsman. Born Owosso, MI, on October 23, 1905. Pupil of Myra Richards, Edward McCarten, Williams, Amateis, Derejenski, Flanagan. Studied at John Herron Art Institute; Beaux-Arts Institute of Design, NY; and in Europe. Work: Indiana University; Lincoln Memorial, Lincoln City, IN; State Capitol Bldg, IN; others. Award: Honorable mention, Indiana Art Assoc.; prize for portrait, Indiana State Fair, 1928; prizes, Hoosier Salon, 1938; Indiana Art Club, 1940. Member: Indiana Art Association; Art Students League; Nat. Sculpture Society; Architectural League; Hoosier Salon, others. Address in 1953, Ann Arbor, MI.

DANIELS, J. B.
Painter. Born New York, NY, 1846. Pupil of Lindsay. Member: Cincinnati Art Club. Address in 1926, 619 Walnut Street, Cincinnati, Ohio.

DANIELS, JOHN KARL.
Sculptor. Born in Norway, May 14, 1875. Pupil of Andrew O'Connor and Knut Okerberg. Honorary member of American Institute of Architects. Work: Bronze portrait statues, Minnesota State Capitol, St. Paul; monuments in five U.S. national cemeteries; flagstaff, City of Minneapolis; others. Awards: Gold medal, St. Louis Exposition, 1904; first prize, Minnesota State Art Commission, 1913 and 1914. Address in 1933, Minneapolis, MN.

DANIELS, JULIA.
Illustrator. Member: SI. Address in 1929, 145 East 47th Street, New York, NY.

DANIELSON, PHYLLIS I.
Painter. Born in 1932. Studied: Ball State Univ.; Michigan State Univ.; Indiana University. Exhibitions: Mint Museum of Art, Charlotte, North Carolina, 1971; Matrix Gallery, Bloomington, Indiana, 1971; South Bend Art Center, Indiana, 1975. Medium, Fabric. Living in Grand Rapids, MI.

DANNER, SARA KOLB.
(Mrs. W. M. Danner, Jr.). Painter. Born New York City on Oct. 2, 1894. Pupil of Phila. School of Design for Women, MA Normal Art School, G. L. Noyes, Henry Snell. Member: Chicago SA; IN AC; Phila. Alliance; IL AFA; All-Ill. SFA; Santa Barbara AL. Address in 1929, Las Tunas Road, Santa Barbara, California.

DANTE, GIGLIO RAPHAEL.
Sculptor and painter. Born in Rome, Italy, September 4, 1916. Studied: Academy of Rome, Italy. Work: Springfield Museum of Art; Savoy Collections, Naples, Italy; Michelangelo Auditorium, Boston, Mass. Exhibited: Critic's Choice, Cincinnati Museum Association, 1945; Penna. Academy of Fine Arts, 1934-36; Golden Gate Expo., San Francisco,

1939; Boris Mirski Gallery, 1944, (one-man), Brandt Gallery, 1945, 46 (one-man). Address in 1953, 128 East 16th Street, New York, NY.

DAPHNIS, NASSOS.
Sculptor, painter. Born July 23, 1914, Krockeai, Greece. Came to USA in 1930. Self-taught. Work: Baltimore Museum of Art; Albright; Norfolk, Museum of Mod. Art; Chrysler; RI School of Design; Tel Aviv; Carnegie Inst.; Whitney Museum. Rep. by Leo Castelli Gallery, NYC. Exhibited: Contemporary Arts Gallery, NYC, 1938, 47, 49; Galerie Colette Allendy, Paris, 1950; Leo Castelli Inc., 1959-61, 63, 65, 68; Franklin Siden Gallery, Detroit, 1967; Albright, 1969; Syracuse (Everson), 1969, 77; Carnegie, 1970; Corcoran Biennial, 1959, 63, 69; Whitney Museum of American Art Annual, 1960-65, 67; Walker, Purist Painting, 1961; Guggenheim Abstract Expressionists and Imagists, 1961; Seattle World's Fair, 1962; Lausanne, I Salon Inter. de Galeries Pilotes, 1963; DeCordova, 1965; University of Illinois, 1969; Birmingham Museum of Art, 1976. Awards: Ford Foundation, 1962; National Council on the Arts, 1966; Guggenheim Memorial Foundation Fellowship, 1977. Member: American Abstract Artists. Taught: Horace Mann School, Riverdale, NY, 1953-58. Address in 1982, 362 W. Broadway, NYC.

DARBY, HENRY F.
An American portrait painter, born about 1831. From 1853 to 1859 he resided in NY and Brooklyn and painted portraits exhibited at the National Academy of Design. His grief at the loss of his wife in 1859 caused him to abandon his profession and live in England. His last exhibited portraits were "Henry Clay" and "John Calhoun," and these paintings are in the Capitol at Washington, DC.

DARBY, J. G.
This name, as engraver, is signed to a view of Niagara Falls, and to a map of the region about the falls, both published in Buffalo, NY, 1838.

DARLEY, EDWARD H.
Philadelphia portrait painter, and a brother of F.O.C. Darley the illustrator. He painted a portrait of the poet, Edgar Allen Poe.

DARLEY, FELIX O. C.
Illustrator and draughtsman. Born in Philadelphia 1822 and died 1888. He soon became known as an accomplished pen and ink artist; his fine drawings in outline for Irving, Cooper, and other authors place him in the front rank of the illustrators. Darley traveled in Europe and made many sketches and drawings, also a few compositions in color.

DARLEY, JOHN CLARENDON.
Portrait painter, exhibiting in Philadelphia between 1830 and 1840. Represented in loan exhibition of Penna. Academy in 1887.

DARLING, JAY NORWOOD.
(J. N. Ding). Illustrator. Born Norwood, MI, on Oct. 21, 1876. Member: NAC; SI. Cartoonist for Des Moines Register, New York Herald Tribune. Address in 1929, 2320 Terrace Road, Des Moines, IA.

DARNAULT, FLORENCE MALCOLM.
Sculptor. Born in New York City December 24, 1905. Studied: Radcliffe College; National Academy of Design; Art Students League; and in Europe. Awards: Pen & Brush Club; National Arts Club. Collections: City College of New York; US Naval Academy; American Institute of Engineers; Whitehead Metals Company; New York University Medical School; American Telephone & Telegraph Company; Harvard University, Army Officers Club, Governor's Island, NY; statue, Mexico City; Colombian Government, Cartagena, Colombia. Exhibited: Pen and Brush Club; National Arts Club, NY; National Academy of Design; Allied Artists of America. Member: National Arts Club; Pen and Brush Club. Address in 1953, 222 West 23rd Street, NYC.

DARRAGH, MARIAN R. A.
Miniature painter. Exhibited at the Annual Miniature Exhibition of the Penna. Academy of Fine Arts, Philadelphia, 1925. Address in 1926, 1830 Manning Street, Philadelphia, PA.

DARRAH, MRS. S. T.
Painter. A native of Pennsylvania, her professional life was spent in Boston. She painted landscapes and marines. Among her paintings are "Rocks at Manchester, MA" and "Gathering Kelp." She died in Boston in 1881.

DASBURG, ANDREW (MICHAEL).
Painter. Born Paris, France, on May 4, 1887. Pupil of Cox, Harrison, and Henri. Member: New Mexico P. Award: Second prize Pan-Am. Exhib., Los Angeles, CA, 1925. Address in 1929, Santa Fe, NM.

D'ASCENZO, MYRTLE GOODWIN.
(Mrs. Nicola D'Ascenzo). Painter. Born North Tunbridge, VT, Dec. 31, 1864. Pupil of PA School of Industrial Art. Member: Phila. WCC; Plastic C. Address in 1929, 425 West Price Street, Germantown, PA.

D'ASCENZO, NICOLA.
Painter and craftsman. Born Torricella, Italy, Sept. 25, 1871. Pupil of Mariani and Jacovacci in Rome. Member: Fellowship PAFA; T. Sq. C.; Phila. Sketch C.; NY Arch. Lg., 1902; Mural P.; AC Phila.; Phila. A. Crafts G.; NAC; AIA (hon); AFA. Awards: Columbian Exp., Chicago, 1893; gold medal, T. Sq. C.; prize, Americanization through Art Exhib., Phila., 1916; gold medal, Arch. L. of NY, 1925; gold medal, Alumni Assn. of the Penn. Museum and School of Industrial Art. Work: Stained glass, St.

Thomas PE Church, NY; mural decoration, Municipal Bldgs., Springfield, MA; stained glass, Wash. Memorial Chapel, Valley Forge; mosaic frieze, Cooper Library, Camden, NJ; stained glass, chapel at Mercersburg, PA; great west window, chapel at Princeton University. Specialty, mural decoration and stained glass and mosaics. Address in 1929, 1602 Summer St.; h. 425 West Price St., Germantown, PA.

DATZ, A. MARK.
Sculptor, painter, and etcher. Born in Russia, Oct. 27, 1889. Studied: National Academy of Design; Cooper Union Art School; Beaux-Arts Inst. of Design, NY. Member: Federation of Painters and Sculptors; Society of American Graphic Artists, NY; Artists Equity Association, NY; Salons Am.; S. Indp. A. Work: Whitney Museum; Rochester Memorial Art Gallery; Oshkosh Museum of Art; Los Angeles Museum of Art; New York Public Library; State Teachers College, Indiana, Pennsylvania; Tel-Aviv Museum, Israel. Exhibited: (One-man) New School for Social Research, 1927; J.B. Neumann Art Circle, 1928; Eighth St. Gallery, 1933, 34; Dorothy Paris Gallery, 1936; Passedoit Gallery, 1938; Montross Gallery, 1941; George Binet Gallery, 1946. Address in 1953, 50 E 56th St., New York, NY. Died in 1968 (?).

DAUB, MATTHEW.
Painter. Born in NYC. Studied at Pratt; BA in painting, Southern IL Univ., Carbondale. Work at St. Louis (MO) Neurological Inst.; Dobrick Gallery, Chicago; others. Solo exhibitions at Far Gallery, NYC; Signet Fine Arts/Kemp Gallery, St. Louis; Dobrick Gallery, Chicago, 1983; and Evansville (IN) Museum of Arts and Sciences. Selected for the Am. Watercolor Society's 111th Annual; the 46th National Midyear Show at the Butler Inst., Youngstown, OH; Watercolor USA. Works in watercolor. Currently living in Illinois.

DAUGHERTY, JAMES HENRY.
Painter, illustrator and engraver. Born Asheville, NC, 1886. Pupil of Frank Brangwyn; also Penna. Academy of Fine Arts. Member: Mural Painters; Modern Artists of America; New York Architectural League. Work: Murals in State Theatre, Cleveland; decoration in Safety Institute, New York; recruiting posters for US Navy. Address in 1926, 59 South Washington Square, New York, NY.

DAUGHERTY, NANCY LAURIENE.
Painter, illustrator, writer, lecturer, teacher. She was born at Kittanning, PA, on June 21, 1890. Studied under Irving Wiles, Douglas Connah, Frank A. Parsons; Simon and Billeau in Paris, France. His work is represented in the Federal Court, Pittsburgh, PA; Armstrong County Court of Pennsylvania. Address in 1933, 130 Vine Street, Kittanning, PA.

DAVENPORT, E(DITH) FAIRFAX.
Painter. Born Kansas City. Pupil of Collin, Laurens, and Ecole des Beaux Arts in Paris. Member: SSAL; New Orleans AA; North Shore AA; AFA. Awards: Medal of Queen Elizabeth of Belgium for war poster; Press prize, SSAL, 1925. Work: Portrait, "Achille Perretti," Cabildo, New Orleans, LA; portrait "Helen R. Parsons," Public Library Bldg., Kansas City, MO. Address in 1929, Zellwood, Orange Co., Fla.; 15 East 38th St., New York, NY.

DAVENPORT, HENRY.
Painter, lecturer, and teacher. Born Boston, MA, on April 1, 1882. Pupil of Ecole des Beaux Arts, Dechenaud, Charles Hawthorne, George Elmer Browne. Member: Paint and Clay Club; S. Indp. A. Address in 1929, 7 Cite Martignac, rue de Grenelle, Paris, France.

DAVENPORT, JANE.
(Mrs. Jane Davenport de Tomasi). Sculptor, painter, and teacher. Born Cambridge, MA, on September 11, 1897. Studied at University of Chicago; Art Students League; Grande Chaumiere, Paris; pupil of Stirling Calder, Antonio Bourdelle, and Jacques Louchansky. Member: Art Students League of New York; Society of Independent Artists; American Federation of Arts. Work: "Erbia," American University Union, Paris, France; wall fountain, The Biological Laboratory, Cold Spring Harbor; tablet (low relief), Buckley School, NYC; statue, Carnegie Institution, Washington, DC; medal; George Lane Nichols, Buckley School, New York City. Address in 1929, Cold Spring Harbor, LI, NY.

DAVEY, RANDALL.
Painter. Member: Portrait Painters; S. Indp. A.; New SA; Painter-Graver's S; Indp. S.; New Mexico SA; Kansas City SA; Taos SA. Awards: Second Hallgarten prize, NAD, 1915; hon. mention, P.-P. Exp., San F., 1915. Work: Art Inst. of Chicago; Kansas City Art Inst.; Corcoran Gallery, Wash., DC; Cleveland Museum; Detroit Institute of Arts; Santa Fe Museum of Art and Archeology. Address in 1929, 29 West 14th St., New York, NY; Santa Fe, NM.

DAVIDSON, CLARA D.
(Mrs. Simpson). Painter and illustrator. Born St. Louis, MO, Jan. 16, 1874. Pupil of ASL and Dow in New York; Blanche and Mucha in Paris. Member: NA Women PS.; CT AFA; CT SA; Silvermine GA. Work in Art Museum, Rockford, IL. Address in 1929, 3 Park St., Norwalk, CT.

DAVIDSON, FLORENCE A.
Painter. Born Baltimore County, MD, on Aug. 30, 1888. Pupil of AIC; ASL of NY; School of the Boston Museum of Fine Arts. Member: NA Women PS; PBC; Catherine Lorillard Wolfe AC; New Rochelle AA; Balto. WCC. Awards: Gertrude Hoyt water

color prize, 1926, and Mary Landon portrait prize, 1927, Catherine Lorillard Wolfe AC, New York. Address in 1929, 261 West 22nd St., New York, NY.

DAVIDSON, GEORGE.
Painter. Born Butka, Russian Poland, on May 10, 1889. Pupil of F. C. Jones and Douglas Volk. Member: Mural P.; Arch. L. of NY. Award: Medal of Honor for mural painting, Arch. L. of NY, 1926. Work: Decorations for Barnard College; ten panels, Palm Room, Hotel Mt. Royal, Montreal; two historical paintings, Buffalo Savings Bank, Buffalo, NY. Instructor, mural painting, Cooper Union, NY. Address in 1929, 11 East 14th Street, New York, NY.

DAVIDSON, HARRY.
Wood engraver. Born in Philadelphia in 1857, he went to New York in 1878 and entered the employ of the Century Company. He died in New York in 1924.

DAVIDSON, JO.
Sculptor. Born in NYC March 30, 1883. Pupil of George de Forest Brush and Herman A. MacNeil. He studied at the Art Students League, NY, and the Ecole des Beaux-Arts, Paris. Exhibited at National Sculpture Society, 1923. Works: Bust of Feodor Chaliapine; panel of dancing figures, Neighborhood Playhouse, New York City; busts, Marshall Foch, President Wilson, marshal Joffre, Clemenceau, Gen. John J. Pershing, Anatole France, Emile Coue; figure, Gertrude Stein; bronze heads, Joseph Conrad, Bernard Baruch; figure, Ida Rubenstein; bronze statuette, Japanese girl; marble head, The Artist's Wife; bronze statuette, Supplication. Designed US War Industries Badge; designed heroic group for French Government to commemorate first victory of the Marne. Address in 1933, 8 West 8th Street, NYC. Died January 2, 1952.

DAVIDSON, JOSEPH.
Sculptor. Born in Moscow, Russia, April, 1884. Pupil of Geo. de Forest Brush, H. A. MacNeil. Address in 1910, American Art Association, Paris, France; h. 1267 Fifth Ave., NYC.

DAVIDSON, MORRIS.
Painter. Born Rochester, NY, on Dec. 16, 1898. Pupil of AIC, Harry Walcott. Member: Provincetown AA. Address in 1929, 76 Horatio St., New York, NY; summer, Provincetown, MA.

DAVIDSON, OSCAR L.
Painter. Born in 1875; died in Indianapolis, IN, in 1922. He was a member of Society of Indiana Artists and of the Indiana Illustrators' Club. He made a speciality of reproducing historic ships.

DAVIDSON, ROBERT WILLIAM.
Sculptor and educator. Born Indianapolis, IN, on May 13, 1904. Studied at John Herron Art Institute;

State Academy of Fine Arts, Munich, Germany; Chicago Art Institute; pupil of Myra R. Richards, Albin Polasek, A. Iannelli, Edmond R. Amateis, R. A. Baillie, O. L. Davidson, Ernst Melaun, and Anton Bauer. Member: Indiana Art Association; Chicago Art Association. Awards: First prizes, Indiana State Fair, 1923 and 1924, Grand Prize, 1928; Art Association prize, Herron Art Institute, Indianapolis, 1925 and 1928; Spaulding first prize, Hoosier Salon, Chicago, 1927; Muncie Star prize, Hoosier Salon Chicago, 1928. Work: Indianapolis Museum of Art; University of North Carolina, Greensboro; "Adam," owned by the Colony Artists Association of Chicago; portrait busts, Mr. and Mrs. S. E. Raub, Raub Memorial Library, Indianapolis; Peace and War reliefs, exterior Shortridge High School, Indianapolis; bronze medal, Indiana Society of Architecture; Lint on A. Cox Memorial Tennis trophy, Hawthorne Tennis Club, Indianapolis; *many portrait heads privately owned.* Exhibited: National Academy, NY, 1933; Whitney Museum, 1937; New York World's Fair, 1939. Teaching: Resident sculptor, Skidmore College, Saratoga Springs, NY, 1933-72, professor of art, sculpture, and drawing, 1940-72. Address in 1982, Rock City Falls, NY.

DAVIES, ARTHUR BOWEN.
Sculptor, painter, and patron. Born in Utica, New York, Sept. 26, 1862. Studied at the Academy of Design; worked as an engineering draftsman in Mexico, 1880-82; Art Institute of Chicago; Art Students League in New York; Gotham Art Students School; Italy, 1893, under the sponsorship of William Macbeth and Benjamin Altman. Noted for organizing of Armory Show, 1913. Specialty, landscapes with figures. Represented in Metropolitan Museum and Chicago Institute. One-man show at Macbeth Gal., NYC, 1896. Awarded Silver Medal, ptg., Pan Am. Expo., Buffalo, 1901; hon. men., Carnegie Inst., 1913. Important in collection of European art and founding of MOMA, NYC. Memorial exhibition held at Metropolitan Museum of Art, 1930. Noted work in sculpture: "Nude" (bas-relief). Also worked as a designer of rugs and tapestries. Address in 1926, 53 West 39th Street, New York. Died in Florence, 1928.

DAVIES, CHARLES, WILLIAM.
Engraver. Born at Whitesboro, NY, 1854. Davies learned to engrave upon copper and steel in Utica, NY, was in partnership with his preceptor for two years and then went into business for himself in Syracuse, NY. He was burned out after a short time, and after working at his business in various places, in 1881 he established himself in Minneapolis, MN, as the pioneer engraver of that city. No signed work of this engraver is known to Fielding.

DAVIES, MARIA T.
Painter. Born in Harrodsburg, KY, 1872. Pupil of Blance, Mucha, and Delecluse. Member of the Nash-

ville Art Club. Died in 1924 at Acklen Avenue, Nashville, TN.

DAVIES, THEODORE PETER.
Printmaker and painter. Born in Brooklyn, NY, Oct. 9, 1928. Studied: Sch. of Mod. Photography, NYC, in 1952; ASL, with George Grosz, Harry Sternberg, 1957-60, John Sloan, merit scholar, 1958. Work: Photograms, MOMA, NYC; woodcuts, Nat'l. Gallery of Art, Wash., DC, and Phila. Mus. Art; ASL; etc. Exhib.: Print Club of Phila. Annual; Silvermine Guild Annual; Boston Printmakers Ann.; MOMA; SUNYA; others. Awards: Hon. men., Boston Printmakers; Creative Artists Public Service Fellowship in Graphics, 1973-74. Mem.: ASL (life); Print Council of AM.; Print Club of Phila.; Jamaica Art Mobilization; etc. Media: Woodcut, serigraph. Address in 1982, Hollis, NY.

DAVIS, CECIL CLARK (MRS.).
Painter. Born Chicago on July 12, 1877. Member: Chicago SA; Chicago AC; Colony Club; NA Women PS; AFA. Award: Portrait prize, Municipal AL, 1918; gold medal, Salon, Rio de Janeiro, 1920; gold medal, Philadelphia AC, 1925; portrait prize, NA Women PS, 1926. Address in 1929, 7 West 51st Street; h. 969 Park Avenue, New York, NY; summer, Marion, MA.

DAVIS, CHARLES H(AROLD).
Landscape painter. Born Amesbury, MA, on Jan. 7, 1856. Pupil of Otto Grundmann and Boston Mus. School; Boulanger and Lefebvre in Paris. Member: SAA, 1886; ANA, 1901, NA, 1906; Copley S.; Lotos C; NAC; Mystic SA; AFA. Awards: Gold medal, American Art Assoc., New York, 1886; hon. mention, Paris Salon, 1887; $2,000 prize, Am. Art Assoc., NY, 1887; silver medal, Paris Exp., 1889; hors concours, Paris Salon; Palmer prize, AIC, 1890; medal, Mass. Charitable Mechanics Assoc., Boston, 1890; medal, Columbian Exp., Chicago, 1893; grand gold medal, Paris Exp., 1900; Lippincott prize, PAFA, 1901; second Corcoran prize, S. Wash. A., 1902; silver medal, St. Louis Exp., 1904; Harris bronze medal ($300), AIC, 1914; gold medal, P.-P. Exp., San F., 1915; Altman prize ($1,000), NAD, 1917; Sesnan gold medal, PAFA, 1919; second W. A. Clark prize ($1,500), and Corcoran silver medal, Corcoran Gallery, Washington, 1919; Saltus medal, NAD, 1921. Work: MMA; Corcoran Gallery; Carnegie Inst.; Boston Mus. FA; Art Museum, Worcester, MA; Nat. Gal. Wash., DC; PAFA; AIC; Hackley Art Gal., Muskegon, MI; Minneapolis Inst.; St. Louis; Syracuse; Butler; Bruce Art Museum, Greenwich, CT; and Harrison collection, LA. Address in 1929, Mystic, CT.

DAVIS, CHARLES PERCY.
Painter, illustrator, craftsman, and teacher. Born Iowa City, IA. Pupil of Chase and Beckwith in NY; Bouguereau, Ferrier and Robert-Fleury in Paris.

Member: Boston SAC. Curator, City Art Museum since 1914. Address in 1929, City Art Museum, St. Louis, MO.

DAVIS, CORNELIA CASSADY.
Painter. Born 1870, died 1920. Pupil of Cincinnati Art Academy. She is represented in London by her portrait of President Wm. McKinley. She also painted pictures of American Indian life.

DAVIS, DAVID.
Sculptor. Probably at Charleston, South Carolina, c. 1845. Noted work: Bust of John Belton O'Neall.

DAVIS, EARL R.
Painter. Born Jan. 17, 1886. Member: Providence AC; Providence WCC; S. Indp. A.; AFA. Address in 1929, P.O. Box 1532, Providence, RI.

DAVIS, EMMA EARLENBAUGH.
(Mrs. William John Davis.). Painter, illustrator. Born Altoona, PA, Sept. 8, 1891. Pupil of Walter Everett, J. Frank Copeland, and Daniel Garber. Member: Phila. Alliance. Work: Illustrations for *Ladies Home Journal, Saturday Evening Post, Country Gentlemen*. Illus., *Ann of Sea Crest High, Romee Ann Sophomore, Romee Ann Junior*. Address in 1929, 144 Edgehill Rd., Bala-Cynwyd, PA.

DAVIS, EMMA LU.
Sculptor. Born in Indianapolis, IN, November 26, 1905. Studied: Vassar College, BA; Penna. Academy of Fine Arts. Work: Museum of Modern Art; Whitney; others. Exhibited: Penna. Academy of Fine Arts, 1931, 33, 38, 39; Museum of Modern Art, 1942; Whitney, 1951; Terry Art Institute, 1952. Awarded prize and traveling scholarship, Penna. Academy of Fine Arts, 1930. Member of Artists Equity Association. Address in 1953, Chapel Hill, NC.

DAVIS, FAITH HOWARD.
Sculptor, painter, illustrator. Born Chicago, IL, July 29, 1915. Studied: Sarah Lawrence College, B.A.; and with Peppino Mangravite, Bradley Tomlin, Kurt Roesch. Awards: Prize, Buffalo, NY, 1946. Exhibited: Albright Art Gallery, 1939-46; The Patteran, traveling exhibition. Address in 1953, Snyder, NY.

DAVIS, FLOYD MacMILLAN.
Illustrator. Born in 1896. While still very young he began illustrating for small advertising firms. He is known for his depiction of southern people and he illustrated books by such famous authors as William Faulkner, Glenn Allan and Sigmar Byrd. During World War II, he was a correspondent-artist for the War Department and many of his paintings were reproduced in *Life* magazine. His war paintings are owned by the Pentagon, and over the years he won several ADC Medals. Died in 1966.

DAVIS, GLADYS ROCKMORE.
Painter. Born in New York City in 1901. Studied: Art Institute of Chicago with John Norton. Awards: Corcoran Gallery of Art, 1939; Art Institute of Chicago, 1937; Virginia Museum of Fine Arts, 1938; Pennsylvania Academy of Fine Arts, 1938, gold medal, 1952; National Academy of Design, 1944, gold medal, 1955; Pepsi-Cola, 1946. Collections: Metropolitan Museum of Art; PAFA; Nebraska Art Assn.; Toledo Mus. of Art; Butler Art Inst.; Swope Art Gallery; Cranbrook Acad. of Art; Dayton Art Inst.; Nelson Gal. of Art; Univ. of Arizona; Univ. of Nebraska; Baltimore Mus. of Art; Kent State University; Miami Univ.; Atlanta Museum of Art; Davenport Municipal Museum; Birmingham Museum of Art; Encyclopedia Britannica Collection.

DAVIS, HALLIE.
Painter. Exhibited at the Pennsylvania Academy of Fine Arts in 1924. Address in 1926, 1620 Summer Street, Philadelphia, PA.

DAVIS, JACK.
Illustrator. Born in Atlanta, GA, in 1924. He attended the University of Georgia and studied at the ASL. His first illustration was published in the Georgia Tech *Yellow Jacket*, a humor magazine. His distinctive caricatures have been seen in many TV film spots and movie posters for the major studios as well as in *Time, TV Guide, Audubon, Ladies Home Journal*, and *Life*.

DAVIS, JESSIE FREEMONT SNOW.
Sculptor, painter and teacher. Born Williamson County, Texas, February 22, 1887. Studied: Art Students League with George Bridgman, John Knott, Frank Reaugh. Member: Southern States Art League; National Association of Women Artists, New York; Dallas Art Association; Dallas Craftsman Guild. Awards: Prizes, Dallas Museum of Fine Arts, 1948, 49; San Antonio Craftsman Guild, 1948; Oak Cliff Society of Fine Arts, Dallas, Texas. Work: Dallas Museum of Fine Arts; Oak Cliff Gallery; Technical High School, Dallas; San Angelo (Tex.) Public Library. Exhibited: National Association of Women Artists, New York, 1944; Museum of Fine Arts of Houston, 1945; Dallas Allied Artists, 1943, 44; Southern States Art League, 1946. Taught: Instructor of Art, Dallas (Tex.) Public Evening School. Address in 1953, Dallas, Texas.

DAVIS, JOHN PARKER.
Wood engraver. Born on March 17, 1832. His work appeared in the *American Art Review* and *Harper's Monthly*. Among his best engravings is "Eager for the Fray" after Shirlaw. See "History of Wood Engraving in America" by W. J. Linton. Davis was one of the founders of the Society of American Wood Engravers. Died in 1910 and was the last Secretary of the Society of American Wood Engravers.

DAVIS, LEONARD M.
Landscape painter. Born Winchendon, MA, May 8, 1864. Pupil of ASL of NY; Julian Academy under Laurens, Lefebvre and Benjamin-Constant, and of Ecole des Beaux-Arts in Paris. Member: AFA. Specialty, since 1898, Alaska scenes. Award: Silver medal for 127 Alaska paintings, P.-P. Exp., San F., 1915. Work: Washington State Art Assoc. Mus., Seattle; "Peril Straits," Municipal Art Gal., Seattle, Wash.; "The Aurora Borealis," Museum of New Mexico, Santa Fe, N.M.; "The Edward Prince Ranch, Alberta, Canada," purchased by the Prince of Wales for St. James Palace, London, England; 23 paintings of the Edward Prince Ranch, purchased by the Canadian Gov't for the Mus. of The Public Archives of Canada. Address in 1929, care of NY Camera Club, 121 West 68th St., NY.

DAVIS, PAUL.
Illustrator. Born in Cetrahoma, OK in 1938. He came to New York and studied with Robert Weaver, Tom Allen and George Tacherny at SVA. His first illustration was published in *Playboy* and he then joined Push Pin Studios with Milton Glaser and Seymour Chwast. In 1975 and 1976 the Paul Davis Exhibition was shown in Japan at a number of art museums. He has received more than 50 awards of distinctive merit for typography, design and illustration.

DAVIS, RICHARD.
Sculptor. Born in New York City Dec. 7, 1904. Studied with Jose De Creeft, John Flanagan, Ahron Ben-Shemeul, Bourdelle. Exhibited NY World's Fair, 1939; Museum of Modern Art; Whitney; Art Institute of Chicago; others. Member: American Art Congress; Society of Independent Artists; National Sculpture Society. Address in 1953, 17 East 96th Street, NYC.

DAVIS, RONALD WENDEL.
Painter and printmaker. Born June 29, 1937, in Santa Barbara, CA. Studied at U. of Wyoming; San Fran. Art Inst.; Yale U.-Norfolk Summer School on grant, 1962. Awarded grant from Nat. Endowment for the Arts, 1968. Exhibited S. F. Arts Festival, 1961-3; Biennial in Argentina; Stanford U.; J. Hellman Gallery, 1972; U. of Nevada; Whitney Mus.; Corcoran Biennial, 1975; others. In collections of MOMA; L.A. County Mus.; Albright-Knox, Buffalo; Tate; others. Living in Malibu, CA, in 1982.

DAVIS, SAMUEL P.
Sculptor. Born in Schenectady, New York, 1864. Worked: Brooklyn, New York. Exhibited: Berlin, 1891; Exposition Universale, Paris, 1900; Chicago, 1893; Buffalo, 1901.

DAVIS, STARK.
Painter. Born Boston, MA, May 13, 1885. Member: Palette and Chisel C. of Chicago; Chicago PS;

Chicago Gal. A. Work: Overmantel decoration, Office of the President, Bell Telephone Co., NY. Award: Eisendrath prize, AIC, 1924. Address in 1929, 1012 North Dearborn, St. Chicago, IL; Flossmoor, IL.

DAVIS, STUART.
Painter, illustrator, and teacher. Born Philadelphia, PA, on Dec. 7, 1894. Pupil of Robert Henri. Member: Modern AA; Brooklyn S.A. Represented by "In Cuba," Harrison Gallery, Los Angeles Museum, and in collections of Albright; MMA; Cranbrook Acad. of Art; Whitney; LA; and PAFA. Address in 1929, 356 West 22nd Street, New York, NY; summer, 51 Mt. Pleasant Ave., East Gloucester, MA. Died in 1964.

DAVIS, W. TRIPLETT.
Painter and illustrator. Born in Washington, DC. Pupil of Corcoran Gallery School of Arts and of Lucien Powell. Member: Society Washington Artists. Address in 1926, 3521 13th Street, N.W., Washington, DC.

DAVIS, WARREN B.
Painter. Awards: Inness prize, 1905; Evans prize, 1906; Isidor prize, 1911. Address in 1926, 7 East 42nd Street, New York City.

DAVIS, WILL.
Painter, etcher, craftsman, and teacher. Born in Boston, MA, on April 7, 1879. Pupil of De Camp, Tarbell, Benson. Member: Copley S; AFA; North Shore AA. Address in 1929, 18A, 53 Aldworth St., Jamaica Plain, MA.

DAVIS, WILLIAM STEEPLE.
Marine painter, etcher and writer. Born in Orient, NY, on May 7, 1884. Member: Brooklyn SA; AFA. Work: Etchings in print collection of the Toledo Museum of Art; block prints and one etching, Los Angeles Museum of History, Science and Art. Address in 1929, Orient, LI, NY.

DAVISON, L(UCIEN) A(DELBERT).
Painter, writer, lecturer, and teacher. Born Clay, NY, June 15, 1872. Pupil of College of Fine Arts, Syracuse. Member: S. Indp. A. Address in 1929, 325 East 31st St., New York, NY; h. Waverly Pl., Syracuse, NY; summer, Brewerton, N.Y.

DAVISSON, H(OMER) G(ORDON).
Painter and teacher. Born Blountsville, IN, on April 14, 1866. Pupil of PAFA; Corcoran School of Art in Washington; ASL of NY; Szbe School in Munich. Director, Fort Wayne Art School, 1911-1917. Member: Brown Co. AGA; Indiana AC; Hoosier Salon. Award: Indiana University prize, Hoosier Salon, Chicago, 1927. Represented in the Hamilton Club, Brooklyn; public libraries in Marion, Tipton and Peru, IN; Fort Wayne Art Museum; Fort Wayne

Women's Club; and numerous private collections. Address in 1929, Fort Wayne, IN.

DAVOL, JOSEPH B.
Painter. Born Chicago, IL, 1864. Pupil of Benjamin Constant and Laurens in Paris. Member: Fellowship, Penna. Academy of Fine Arts. Died in 1923.

DAVY, JAMES BENJAMIN.
Sculptor, painter, and etcher. Born in San Francisco, CA, Feb. 25, 1913. Studied: Randolph Schaeffer School of Design. Exhibited: Golden Gate Expo., San Francisco, 1939; San Francisco Art Assoc., 1941, 42, 45; Oakland Art Gallery, 1943, 44; Library of Congress, 1943. Address in 1953, San Francisco, CA.

DAWES, DEXTER B.
Painter. Born Englewood on June 15, 1872. Pupil of ASL of NY. Member: New Haven PSS; NAC. Address in 1929, 221 Lydecker St., Englewood, NJ.

DAWES, E(DWIN) M.
Painter. Born Boone, IA, Apr. 21, 1872. Self-taught. Member: CA AC. Awards: Hon. mention, 1909, gold medal, 1913, second award, 1914, all given by Minnesota State Art Society; bronze medal, St. Paul Inst. of Art, 1915. Works: "By the River," State Art Society, St. Paul, MN; "Dawn in Sweet Grass Mountains," Public Library, Owatonna, MN; "Channel to the Mills," Minneapolis Institute. Address in 1929, Fallon, Nevada.

DAWES, H. M.
Book-plate engraver. Was probably a member of the Massachusetts family of that name. He engraved a book-plate for Rev. Wm. Emerson (1769-1811), the father of Ralph Waldo Emerson. Dawes must thus have been working prior to 1811.

DAWKINS, HENRY.
One of the earlier engravers in the American Colonies, described himself as an engraver and silversmith. In NY by 1754, he engraved a book-plate for Burnet, an attorney. In 1775 Dawkins advertised in the *New York Mercury* that he had set up business opposite the Merchants Coffee House in NY. Worked with James Turner in Phila. in 1758, and in 1761, engraved a music book published by James Lyon. Remained in Philadelphia until 1774, when he returned to NY. Dawkins was chiefly occupied in the production of book-plates, bill-heads, map ornamentation, etc. This work is executed in line. His large plate of Nassau Hall, at Princeton, is probably his best work, and his one known portrait plate is that of Benjamin Lay, an eccentric Quaker of Phila., the latter plate being poorly engraved.

DAWLEY, HERBERT M.
Sculptor and writer. Born Chillicothe, OH, March 15, 1880. Pupil of Art Students League of Buffalo,

New York. Member: Buffalo Society of Artists. Award: Fellowship prize, 1915, Buffalo Society of Artists. Address in 1933, Chatham, NJ.

DAWSON, ARTHUR.
Painter. Born in England in 1857, he studied at South Kensington Schools; in 1857 he came to this country. He was a founder of the Chicago Society of Artists. He had charge of the restoration of the pictures belonging to the Public Library, New York, and the United States Military Academy at West Point, New York. He died at Richmond, VA, in 1922.

DAWSON, DIANE.
Illustrator. Born in Galveston, TX, in 1952. She attended Stephens College and RISD, studying under Tom Sgouros. She graduated from the SVA in 1975 and began her career that year with illustrations for Ginn and Company. She has illustrated several children's books and the cartoon strip *Burdseed* for Scholastic's *Bananas*.

DAWSON, GEORGE WALTER.
Painter and teacher. Born Andover, MA, on March 16, 1870. Pupil of MA Normal Art School in Boston; PAFA. Member: Phila. WCC; Fellowship PAFA; Phila. Alliance; T. Sq. C.; NYWCC; Chicago WCC; AFA. Professor of Drawing at Univ. of PA. Specialty, landscapes and flowers. Address in 1929, Dept. of Architecture, University of Pennsylvania; h. University Dormitories, West Philadelphia, PA.

DAWSON, JOHN W(ILFRED).
Painter and craftsman. Born Chicago, IL, on Aug. 23, 1888. Pupil of William Rice, Arthur Dawson, and Julian Academy, Paris. Member: Providence AC. Address in 1929, 3 Church Lane, Wickford, RI.

DAWSON-WATSON, DAWSON
(or WATSON, DAWSON).
Painter, woodcarver, engraver, designer, teacher. Born London, England, July 21, 1864; came to US in 1893. Pupil of Mark Fisher in Steyning, England; Carolus-Duran, Chartran, Collin, Aime Morot and Leon Glaize in Paris. Painted in New England 1893-97; briefly back in England; Canada for three years; the Woodstock (NY) art colony; the St. Louis Society of Fine Arts, 1904-15; in Boston, 1926; finally established a studio in San Antonio. Member: San Antonio Art League. Specialty: Texas Landscapes. Awards: Silver medal, Lewis and Clark Exp., Portland, OR, 1905; silver and gold medals, Sedalia, MO; three first prizes and one second, IL State Fair, 1916; Austin, TX, 1926; Nat'l prize ($5,000), TX Wildflower Competitive Exhib., 1927; special first prize, Nashville AA, 1927; hors concours, TX Wildflower Comp. Exhib., 1928; first and fifth prizes, TX Wildflower Comp. Exhib., 1929; popularity prize, Southern States Art League, 1929. Work: "Light Breeze," painting and also mezzotint,

City Art Museum, St. Louis; "The Open Book," decorative panel, Wichita High School; "Rainbow in Winter," Central High School and Barr Branch Library, St. Louis; Oakland (CA) Museum; library, Houston, TX; "The Wheatfield," Springfield (IL) Art Assoc.; "Grand Canyon," St. Louis Club; "The Glory of the Morning," Lotus Club, NY. Teacher at St. Louis School of Fine Arts, 1904-1915. Author and director of pageant at Brandsville, MO, 1916. Director, San Antonio Art Guild, 1918-19. Art director, Missouri Centennial. Art director, St. Louis Industrial Exhib., 1920, and City of St. Louis Homecoming of Soldiers. Art director, designer and scenic constructor of the St. Louis Junior Players, 1920-23. Address in 1933, San Antonio, TX. Died there in 1939.

DAY, BENJAMIN.
Sculptor. Worked: Lowell, Massachusetts, 1835-55. He was also a gravestone manufacturer and proprietor of a marble yard. Died August 30, 1916, in Summit, NJ.

DAY, BERTHA C.
See Mrs. D. M. Bates.

DAY, FRANCIS.
Painter. Born LeRoy, NY, on August 12, 1863. Pupil of ASL of NY; Ecole des Beaux-Arts, Herbert and Merson in Paris. Member: SAA, 1891; ANA, 1906; Salma. C., 1888. Award: Third Hallgarten prize, NAD, 1895. Work: "Fairyland," Art Museum, Montclair, NJ. Address in 1929, Lanesboro, MA.

DAY, HOWARD D. (MRS.).
See Willson, Martha Buttrick.

DAY, JOHN.
Painter. Born May 27, 1932, in Malden, MA. Studied at Yale Univ., BFA 1954, MFA 1956; with Josef Albers, Burgoyne Diller, James Brooks. Taught at Univ. of Bridgeport, CT; William Patterson College, NJ, since 1970. In collections of Lyman Allyn Mus., CT; MOMA; Met. Mus. of Art; Montclair (NJ) Art Mus.; and others. Exhibited at Lyman Allyn Mus.; Whitney; Found. Maeght, St. Paul de Vence, France; Mus. Pompidou, Paris; Contemp. Arts Association, Houston; Parrish Art Mus., Southampton, NY; and others. Received Ford Foundation purchase award; fellowships to MacDowell Colony, 1960-64; first prize Silvermine Guild Artists, 1969. Address in 1982, 22 E. 89th St., NYC.

DAY, MABEL K.
Painter. Born Yarmouth, Nova Scotia, on July 7, 1884. Pupil of Robert Henri, Kenneth Hayes Miller, Henry Snell, and Homer Boss. Member: Pitts. AA. Awards: 1st prize Pitts. AA., 1913; prize for best picture by a woman, Pitts. AA., 1923; second prize, Pitts, AA., 1927. Address in 1929, Union College,

Schenectady, New York; summer, Lake Annis, Nova Scotia, Canada.

DAY, WORDEN.
Sculptor and printmaker. Born in Columbus, OH, June 11, 1916. Studied at Randolph-Macon Woman's College, B.A.; New York University, M.A.; Art Students League; also with Jean Charlot, Emilio Amero, Maurice Sterne, Vaclav Vytacil, Hans Hofmann, and Stanley William Hayter. Work in National Gallery of Art and Library of Congress, Washington, DC; Philadelphia Museum of Art; Virginia MFA; University of MN; Bradley U.; Brooks Mem. Gallery; Corcoran; Yale U.; University of Louisville; Mills College; and others. Has exhibited at Library of Congress; Brooklyn Museum; Philadelphia Museum of Art; Abstract Painting and Sculpture in America, Museum of Modern Art, NY; and others. Received Guggenheim fellowship, 1951-52 and 61-62; traveling fellowship, Virginia Museum of Fine Arts, 1940-42; Rosenwald Fellowship, 1942-44. Member of Fed. of Mod. Painters and Sculptors; MacDowell Colony; Art Students League; Sculptors Guild. Taught multimedia at Art Students League, from 1966-70. Address in 1982, Montclair, NJ.

DAYTON, F. E.
Illustrator. Member: SI. Address in 1929, 33 West 67th St.; 259 West 11th Street, New York, NY.

DAYTON, HELENA SMITH.
Illustrator. Member: SI. Address in 1929, 33 West 67th Street; 259 West 11th St., New York, NY.

De BELLIS, HANNIBAL.
Sculptor and medalist. Born in Accadia, Italy, Sept. 22, 1894; US citizen. Studied at University of Alabama, MD, 1920; also with Gaetano Cecere, Jean De Marco, and George Lober. Work in Navy Art Museum, Navy Combat Museum, the Pentagon, Smithsonian Institution, Washington, DC; portrait medallions; bronze plaques for St. Vincent's Hospital and Medical Center, NY; Salmagundi Club Honor Award Medal; and others. Received Salmagundi Sculpture Prizes, 1960 and 71; American Artists Prof. League Award, 1964. Member of Medalist Society; National Sculpture Society; American Artists Professional League; Salmagundi Club. Works in bronze. Address in 1982, Forest Hills, NY.

De BEUKELAER, LAURA HALLIDAY.
Sculptor. Born Cincinnati, OH, 1885. Pupil of Cincinnati Art Academy; St. Louis School of Fine Arts. Member: Cincinnati Woman's Art Club. Work: State Normal School, Geneseo, NY; Washburn College, Topeka, KS. Address in 1926, Topeka, KS.

De BOTTON, JEAN PHILIPPE.
Sculptor and painter. French and US citizen. Studied: Ecole Beaux-Arts, Paris; Sorbonne, Paris;

Rollins College; with Antoine Bourdelle, George Braque, Jules Romains. Work; Metropolitian Museum, NY, Chester Dale Collection; National Museum of Modern Art, Paris; Museum of Art, Atlanta; Fogg Museum, Harvard; and many other museums in Geneva, France, Vienna, US. Commissions: French Government commissions; H. M. King George VI coronation, England; America at War, City of San Francisco; plus many others. Exhibitions: Carnegie; Knoedler & Wildenstein Galleries, NYC & Paris; many others. Awards: Grand prix, Salon d' Honneur Beaux-Arts, French Government; many more. Teaching: Academy Montmartre, Paris and NYC. Member: Salon d' Automne, Paris; Salon Modern Paris; Salon France Novelle; American Federation of Arts. Address in 1976, 930 Fifth Avenue, New York, NY. Died in 1978.

De BOYEDON, OSCAR HUGH.
Sculptor and craftsman. Born Porto Alegre, Brazil, on June 13, 1882. Pupil of Bourdelle in Paris. Member: Boston Society of Arts and Crafts. Address in 1929, care of Ainslie Galleries, 677 Fifth Ave., New York, NY; Florence, Italy; Paris, France.

De BRENNECKE, NENA.
Sculptor and painter. Born in Argentina, May 7, 1888. Studied: University of London; and with Henri Matisse, W. Wulff. Work: Denver Art Museum; Denver National Bank; United States Post Office, Paulsboro, NY; Coraopolis, PA; Hamlet, NC; Windsor, CT. Exhibited: Brooklyn Museum, 1935; Architectural League, 1924; Denver Art Museum; Museum of New Mexico, Santa Fe; London, England, 1914, 17, 20; Paris Salon, 1914. Address in 1953, 320 East 59th St., New York, NY.

De COUX, JANET.
Sculptor. Bron in Niles, MI. Studied: Carnegie Institute of Technology; New York School of Industrial Design; Rhode Island School of Design; Art Institute of Chicago; assistant to C. Paul Jennewein, A. B. Cianfarani, Gozo Kawamura, James Earl Fraser, and Alvin Meyer. Awards: Guggenheim Fellowship, 1938-39, 1939-40; Widener medal, Penna. Academy of Fine Arts, 1942; Carnegie award; Lindsay Memorial Prize, National Sculpture Society; American Academy of Arts and Letters, grant. Collections: College of New Rochelle; US Post Office, Girard, PA; St. Mary's Church, Manhasset, NY; Society of Medalists; Sacred Heart School, Pittsburgh; St. Vincent's, Latrobe, PA; St. Scholastica, Aspinwall, Penn.; Crucifixion Group, Lafayette, NJ; altar, St. Margaret's Hospital Chapel, Pittsburgh; Christ King Church of Advent, Pittsburgh; doors, St. Anne, Palo Alto, California; Charles Martin Hall Memorial, Thompson, OH; Brookgreen Gardens, SC. Resident art instructor, Cranbrook Academy, 1942-45. Member of National Academy of Design; National Sculpture Society. Works in stone and wood. Address in 1982, Gibsonia, PA.

De CREEFT, JOSE.
Sculptor. Born in Guadalajara, Spain, November 27, 1884; US citizen. Settled in NYC. Studied at Academie Julien, 1906; Maison Greber, 1911-14. In collections of Whitney; Metropolitian Museum of Art; Philadelphia Museum of Art; Miro Foundation, Barcelona; others. Commissions in Puy de Dome, France, soldier of war memorial; Mallorca, Spain, 200 stone sculptures; Central Park, NYC, Alice in Wonderland bronze group; Bronx (NY) Municipal Hospital; Bellevue (NY) Hospital. Exhibitions at Paris Salons, 1919-28; Ford Foundation Traveling Show, US, 1959-60; Festival of Arts, White House, Washington, DC, 1965; New School of Art Center, 1974; Kennedy Gallery, NYC, 1979; traveling retrospective, 1980, 81, Spain; others. Received Widener Memorial gold medal, Penna. Academy of Fine Arts, 1945; Brevoort-Eyckemeyer Prize, Columbia University; others. Taught at New School for Social Artists; Fellow, Nat. Sculpture Soc.; Academician, National Academy of Design; founding member, Sculptors Guild; Fellow, National Institute of Arts and Letters. Media: Lead, quartz, ebony, onyx, marble, wood, terra-cotta, serpentine. Represented by Kennedy Galleries in NYC. Address in 1982, c/o Kennedy Galleries, 40 West 57th Street, NYC. Died in 1983.

De FRANCISCI, ANTHONY.
Sculptor. Born in Italy on June 13, 1887. Pupil of George T. Brewster at Cooper Union; National Academy of Design; James E. Fraser at Art Students League; and with A. A. Weinman in NY. Member: National Sculpture Society; New York Architectural League; American Numismatic Society (Associate); Allied Artists of America; National Academy. Award: Saltus medal, American Numismatic Society, NY, 1927; Penna. Academy of Fine Arts, 1936; gold medal, Allied Artists of America, 1950; others. Exhibited at National Sculpture Society, 1923. Represented: Cincinnati Museum Association; Numismatic Society Galleries; Metropolitian Museum, NY; Union Square Memorial, NY. Instructor at Columbia University. Address in 1953, 246 West 80th Street; h. 230 West End Avenue, NYC. Died in 1964.

De FRASSE, AUGUSTE.
Sculptor. Born in France, c. 1821. He worked in Santa Cruz, CA, and New Orleans, LA, 1854-60.

De GRAZIA, ETTORE (TED).
Sculptor, painter, and printmaker. Born in Morenci, AZ, 1909. Lived in Italy, 1920-24. Studied music and art, University of Arizona, B.A., 1944, B.S. and M.A., 1945. Exhibited in Mexico City (1942) and elsewhere since 1932. Commissions include UNICEF greeting card, 1960. Specialty is religious and Mexican figures. Printmaking media include serigraphy, lithography, etching. Author of numerous books.

Represented by DeGrazia Gallery in the Sun; Buck Saunders Trading Post and Gallery, Scottsdale, AZ. Address in 1982, Tucson, AZ.

De KOSENKO, STEPAN.
Sculptor and designer. Born in Tiflis, Caucasus, Russia, 1865. Pupil of Ecole des Arts Decoratifs, Paris. Member: Salmagundi Club; National Sculpture Society; MacDowell Club; Architectural League of New York. Designer in decorative art. Address in 1933, 160 West 73rd St., NYC; h. 18 E 40th St., NYC.

De LAITTRE, ELEANOR.
(Mrs. Eleanor de Laittre Brown). Sculptor, painter, craftsman, illustrator, and designer. Born in Minneapolis, Minnesota, April 3, 1911. Studied at Boston Museum of Fine Arts School; and with George Luks and John Sloan. Works: Walker Art Center; University of Minnesota. Exhibited: American Abstract Artists, 1940-46; World's Fair of New York, 1939; Art Institute of Chicago, 1937-41; Contemporary Art Gallery, 1939 (one-man); others. Member: American Abstract Artists. Address in 1953, 44 West 56th Street, NYC.

De LAP, TONY.
Sculptor. Born in Oakland, CA, November 4, 1927. Studied: Menlo Jr. College, CA; California College of Arts and Crafts, Oakland; Claremont Graduate School, Claremont, CA. In collections of Whitney; Walker Art Institute, Minneapolis; Museum of Modern Art; Tate Gallery, London; others. Exhibited at Whitney Sculpture Annual, 1964 and 66; Jewish Museum, NYC, 1966; Los Angeles Co. Museum of Art, 1967; La Jolla (CA) Museum of Art, 1973; Art Institute of Chicago; others. Awarded American Federation of Arts and Ford Foundation Grants, Artists in Residence Program; Nealie Sullivan Award, San Francisco Art Institute; Los Angeles Dept. of Airports, first prize, sculpture. Fine arts lecturer, University of California, Davis; professor, University of Calif., Irvine, from 1965. Represented by Janus Gallery, Venice, CA; Robert Elkon Gallery, NYC. Address in 1982, Del Mar, CA.

De LISIO, MICHAEL.
Sculptor. Born in NYC, January 22, 1911. Studied at NYC High School. Served in the US Navy in Cuba, 1942-45; later a film press agent for MGM, 1945-57. Work: Hirshhorn Collection; Minneapolis Institute; Wichita Museum; others. Exhibited: Nova Scotia College of Art, Halifax, 1969; Hanover Gallery, London, 1970; Minneapolis Institute of Arts, MN, 1971; Wichita Art Museum, KS, 1972; Long Beach Museum of Art, 1973; Princeton University Library, NJ, 1973; The Grolier Club, NYC, 1974; Smith College Museum of Art, Northhampton, MA, 1974; Greenwich Library, CT, 1976; Philadelphia Art Alliance, PA, 1976. Media: Bronze and terra cotta. Address in 1982, 32 East 64th Street, NYC.

De LUE, DONALD.
Sculptor. Born in Boston, MA, October 5, 1897. Studied at Boston Museum of Fine Arts School. Received awards from Architectural League, 1942, prizes, 1951, medal; National Sculpture Society, 1942, 46, gold medal; Guggenheim Fellow, 1943-44; National Institute of Arts and Letters, 1945; medal, Allied Artists of America, 1946; American Artists Professional League, gold medal; Sculptors of the Year Award, American Numismatic Association, 1979; medal, Brookgreen Gardens, 1979; others. Work: Heroic figures, State of LA, Memorial; Thomas Jefferson, bronze figure, Jefferson parish, LA, Bicentennial; Court House, Philadelphia, PA; University of Penna.; American Exporter Memorial, NYC; chapels at West Point and Arlington, VA; Harvey Firestone Memorial; Federal Reserve Bank, Boston and Philadelphia; US Military Cemetery Memorial, Omaha Beach, St. Laurent, Normandy, France; The Alamo, San Antonio, TX; bronze sculpture, Plaza of the Astronauts, New York World's Fair, 1964-65; and others. Member of National Academy of Design, Academician, Associate; National Scultpure Society; National Institute of Arts and Letters; Royal Society of Arts; American Artists Professional League; others. Media: Bronze, marble, and granite. Address in 1982, Leonardo, NJ.

De LUNA, FRANCIS P.
Sculptor. Born New York, Ocotober 6, 1891. Studied: National Academy of Design; Beaux-Arts Institute of Design; Cooper Union Art School. Pupil of Herman A. McNeil. Member: National Sculpture Society; Architectural League of New York. Address in 1953, 11 West 29th Street, New York, NY. Died 1975.

De MARCO, JEAN ANTOINE.
Sculptor. Born in Paris, France, in 1898; US citizen. Studied at Ecole Nationale des Arts Decoratifs, Paris. Works: Whitemarsh Park Memorial, Prospectville, PA; War Department Building, Washington, DC; US Post Office, Weldon, NC; Danville, PA; US Capitol, Washington, DC; Joslyn Memorial Museum; Memorial, Notre Dame University; Metropolitian Museum of Art; reliefs, Cathedral of the Assumption, Baltimore, MD; Brooklyn Museum. Awards: New Rochelle Art Association, 1940; American Academy of Arts and Letters, 1959; National Academy of Design, 1946; Architectural League, 1958; National Sculpture Society, 1945, 48, 54. Exhibitions: Penna. Academy of Fine Arts (many); National Academy of Design; Metropolitian Museum of Art; World's Fair, NY, 1939; Boston Museum of Fine Arts; Fairmount Park, Philadelphia, PA; others. Member: National Academy of Design; National Sculpture Society. Taught at Columbia University; National Academy of Design; Iowa State University. Address in 1982, Prov.-Frosinone, Italy.

DE NESTI, ADOLFO.
Sculptor. Born in Florence, Italy, 1870. Exhibited "Dancing Faun" at Penna. Academy of Fine Arts, 1914. Address in 1926, Philadelphia, PA.

De NIKE, MICHAEL NICHOLAS.
Sculptor and writer. Born in Regina, Sask., Canada, September 14, 1923; US citizen. Studied: National Academy of Fine Arts; with Jean de Marco, Carl Schmitz. Commissions: Young St. Francis (bronze), St. Davids, Kinnelon, NJ; many more. Exhibited: National Academy of Design, NYC, 1964; Audobon Artists, 1965; Knickerbocker Artists, 1965; National Sculpture Society Annual, 1966; American Artists Professional League, 1974; others. Awards: Dr. Ralph Weiler award, National Academy of Design, 1964; Allied Artists of America award, 1975; others. Member: American Artists Professional League. Teaching: Instructor of woodcarving, Fair Lawn Adult Education, 1968-74; Passaic Co. College, 1976-80. Media: Wood, stone. Address in 1982, Wayne, NJ.

De ORLOV, LINO S. LIPINSKY.
See Lipinsky, Lino S.

De RIVERA, JOSE.
Sculptor. Born September 18, 1904, West Baton Rouge, LA. Studied: Studio School, Chicago, with John W. Norton, 1928-30. Work: Art Institute of Chicago; Metropolitan Museum of Art; Museum of Modern Art; Newark Museum; Univ. of Rochester; San Francisco Museum of Art; St. Louis City; Utica; Virginia Museum of Fine Arts; Whitney Museum; Smithsonian, Washington, DC; Tate; and many commissions including Moore-McCormack Lines, SS Argentina, and Soviet Pavilion, New York World's Fair, 1939. Exhibited: Mortimer Levitt Gallery, NYC, 1946; Grace Borgenicht Gallery Inc., 1952, 56, 57, 58, 59, 60; Walker, 1957; Brooklyn Museum; Art Institute of Chicago; "The Twelve Americans," Museum of Modern Art; Brussels World's Fair, 1958; American Painting and Sculpture, Moscow, 1959; Whitney Annuals, 1934-68; La Jolla, 1972. Awards: Art Institute of Arts and Letters Grant, 1959; Brandeis Univ., 1969. Taught: Brooklyn College, 1953; Yale University, 1954-55; North Carolina School of Design, Raleigh, 1957-60. Address in 1982, c/o Grace Borgenicht Gallery, NYC.

De SOTO, MINNIE B. HALL.
(Mrs. Emilio Dominguez De Soto). Sculptor, painter, writer, lecturer, and teacher. Born in Denver, CO, May 2, 1864. Studied at Art Students League of New York, Art Institute of Chicago, Henry Read. Member: National Art Club; Denver Art Club. Address in 1933, Denver, CO.

De WELDON, FELIX GEORGE WEIHS.
Sculptor, painter, teacher, and lecturer. Born in Vienna, Austria, April 12, 1907. US citizen. Studied:

Marchetti College, B.A.; University of Vienna School of Architecture, M.A., M.S., Ph.D.; and in Italy, France, England. Member: American Fed. of Arts, NY. Awards: Prizes, Vienna, Austria, 1925, 27; St. Andrews, Canada, 1939. Work: Busts, King George V and King George VI, London; Museum, City of Vienna; Nat. Portrait Gallery, London; American Embassy, Canberra, Australia; Naval War College, Newport, RI; White House, Wash., DC; State Capitol, Little Rock, AR; Dallas, TX; St. Augustine, FL; Museum, Brisbane, Australia; U.S. Naval Academy, Annapolis, MD; many portrait busts of prominent officials in Scotland, England, and US. Exhibited: Vienna, 1925-28; Paris Salon, 1929, 30, 38; Cairo, Egypt, 1932, 33; Royal Academy of London, 1934-37; Montreal Museum of Art, 1938; Architectural League, New York, 1939; Museum, Montreal, Canada, 1940; Art Assoc., Newport, RI, 1946; others. Lectures: History of Painting, 12th Century; etc. Director of Newport (RI) Acad. of Fine Arts, 1952-60. Comm. of Arts and Science for Pres. Eisenhower, 1952-60; others. Address in 1982, Washington, DC.

De YONG, JOE.
Sculptor and painter. Born in Webster Grove, MO, 1894. Worked in Russell's studio in Montana from 1916 to 1926, when Russell died. Honorary member, Cowboy Artists of America. Work in Free Public Library, Santa Barbara, CA; mural, "Up the Trail," Texas Post Office. Grew up roping and cowboying. Later turned to art; became interested in Indians, learned Indian sign language; served as technical advisor on Indians for movie industry. Specialty was Western subjects in traditional style. Died in Los Angeles, CA, 1975.

de ZORO—dei CAPPELLER, (ETTORE) E.
Sculptor. Born in Cibiana, Italy, January 27, 1894. Studied: Moci College, Italy; Imperial Art Academy, Germany; Andhra Research University, India, D.F.A. Member: Los Angeles Art Association; California Art Club; Societe Academique d'Histoire International; College of Heraldique de France; Atheneum National Science and Art, Mexico; Hon. Comite Coltural, Argentina; Academia Hispano-Americana de Cicencias y Artes, Spain; Society of Fine Arts, Brazil. Awards: Cross Academic Honor, International Academic Council, Washington, DC, 1938; medal, Hispano-Americana Academy of Science and Art, Spain, 1932; Grand Prix, Belgium, 1937; Pacific International Exposition, 1935, etc. Work: Busts, figures, reliefs, San Francisco; Carmel, CA; University of Southern California; Italy, Ecuador, Bulgaria, Mexico, Washington, DC, etc. Exhibited: Pacific International Exposition, 1935; Golden Gate Exposition, San Francisco, 1939; Los Angeles Museum of Art; Palos Verdes, CA, 1935-37; California Art Club, 1936; Santa Barbara, CA, 1935-38; Ebell Salon, Los Angeles, 1940-41. Address in 1953, Santa Barbara, CA.

DEAKIN, EDWIN.
Painter. Born in England in 1840. He came to America and settled in Berkeley, Ca. His specialty was the Spanish Missions.

DEAN, ELIZABETH M.
Painter. Born Cambridge, MA. Pupil of Ludovici in London; Lazar in Paris; Duveneck and H. D. Murphy in Boston. Member: Copley Society, 1896. Address in 1926, 107 Winthrop Street, Roxbury, MA.

DEAN, GRACE RHOADES.
Sculptor and etcher. Born in Cleveland, OH, on January 15, 1878. Pupil of Cleveland School of Art; Kenyon Cox; Arthur W. Dow; also studied in Munich. Member: National Association of Women Painters and Sculptors; Cleveland Woman's Art Club; Toledo Athena Society; Ohio Water Color Society; American Federation of Arts; Dayton Society of Etchers. Awards: Prize for etching, Toledo Art Museum, 1918; second prize for landscape decoration, 1920, and first water color prize, 1924, Toledo Federation of Art Societies; prize, Ohio State Fair, 1922. Address in 1933, Toledo, OH.

DEAN, J(AMES) ERNEST.
Painter, etcher and teacher. Born East Smithfield, PA, on Feb. 23, 1871. Pupil of Twachtman, Beckwith, Chase, and McCarter; Hayek, Brockhoff, and Groeber in Munich. Member: Toledo Artklan. Address in 1929, 1064 Oakwood Ave., Toledo, Ohio.

DEANE, L(ILLIAN) REUBENA.
Miniature painter. Born in Chicago on Sept. 24, 1881. Pupil of AIC, J. Wellington Reynolds and Virginia S. Reynolds. Address in 1929, 1446 Stanley Ave., West Hollywood, Los Angeles, CA.

DEARBORN, NATHANIEL.
Engraver. Born in New England, 1786. Died in South Roadway, MA, 1852. Nathaniel was the son of Benjamin Dearborn, a man of some scientific attainments. At an early age he was apprenticed to Abel Bowen, in Boston, to learn wood engraving; and in 1814 Dearborn was in business for himself as an engraver on wood, with an office on School Street, Boston. He also engraved upon copper, in the stipple manner, a few portraits and views which were of little merit. Dearborn published several books, among them *The American Text-book for making Letters, Boston Notions* (1848), *Reminiscences of Boston and a Guide through the City and its Environs* (1851), and a *Guide through Mount Auburn.*

DEARTH, HENRY GOLDEN.
Painter. Born in Bristol, RI, 1864. He spent most of his professional life in Paris. He painted landscapes and figures. Is represented at Metropolitan Museum by "Cornelia;" "The Old Church at Montreuil" is in the National Gallery at Washington, DC; and the "Black Hat" at Art Institute, Indianapolis. Elected an Associate of the National Academy of Design, 1902; Academician in 1906. He died in New York City, March 27, 1918.

DEAS, CHARLES.
Painter. Born in Philadelphia in 1818; grandson of Ralph Izard. Visits to the Penna. Academy and Sully's painting-room fostered his artistic propensities. He was also a great sportsman and traveled among the Indians, his best known work being his painting of Indian character. Elected Associate Member of the National Academy of Design in 1829. He died in 1867.

DEATON, HERMAN L.
Sculptor and painter. Born in Iowa, February 4, 1928. Self-taught; also studied with Dimitar Krustev at the Des Moines Art Center, IA. Joined brother's museum exhibit firm in 1964, with clients such as the Smithsonian. At this time learned to model and cast. Set up own studio in 1974. Exhibited: Deaton Museum Studio, Newton, IA; Smithsonian Institution, Washington, DC; St. Paul Science Museum, MN; Herbert Hoover Pres. Library, IA; New York State Museum, Albany; Society of Animal Artists Annuals; many others. Works at Husberg, Sedona, AZ; Gallery of the Southwest, Houston, TX; others; and include foundry bronzes "Down on the Farm;" special small-scale commissions, rodeo sculptures for Hesston Corporation, "Bullfighter Clown and Bull," "World Champion All-Around Cowboy." Member: Society of Animal Artists. Noted for anatomical accuracy. Specialty is animals and figures in bronze and other material. Address in 1983, Newton, Iowa.

DEATON, NORMAN (NEAL).
Sculptor and painter. Born in Des Moines, IA, about 1930. Self-taught. Exhibited: Mitchell Museum, Mt. Vernon; Illinois Gallery Exhibition. Awards: Certificate of Award, Smithsonian. Began own studio in 1959, specializing in "sculpture taxidermy," rather than stuffing, and anatomical modeling for museums worldwide. Work can be seen at Museum of Westward Expansion, St. Louis, MO. Member: Society of Animal Artists, Honorary Life Membership in Art Directors Association of Iowa. Taught: Museum Exhibits Seminars and other various museums and technical organizations. Media: Paintings, oil and acrylic; sculpture, bronze and other mixed media. Specialties: Animal life, human, landscapes of natural wildlife. Address in 1983, Newton, Iowa.

DeBECK, WILLIAM MORGAN.
Cartoonist, caricurist, and writer. Born Chicago, on April 16, 1890. Pupil of Chicago AFA. Member: SI; Author's L; Club Ormesson, Paris. Work: In over 300 US and foreign newspapers. Originator of Barney Google and Spark Plug, Parlow Bedroom and Sink,

Bughouse Fables. Address in 1929, King Features Syndicate, 2 Columbus Circle, New York, NY. Died in 1942.

DeBEET, CORNELIUS.
Painter a number of landscapes in Baltimore, MD, in 1812; he also painted fruit and flower pieces.

DEBEREINER, GEORGE.
Painter, etcher, and craftsman. Born Arzberg, Germany, on Sept. 28, 1860. Studied AIC; Holland and Germany. Member: Cincinnati AC. Work: Mural, "Labor and Commerce," Union Savings, Bank, Cincinnati, OH; murals in Elk Club, Indianapolis, IN. Died in 1939. Address in 1929, 347 Wood Ave., Clifton, Cincinnati, Ohio.

DeBLOIS, FRANCOIS B.
Painter. Born in 1829 in Canada. Active in and near Montreal and Boston. Exhibited at the Boston Athenaeum, 1867-73, including "Dead Game," 1867, and "Grapes," 1873; "The Poor Relations," Brooklyn Art Association, 1874. Died in 1913.

DEBONNET, M(AURICE) G.
Painter and writer. Born Paris, France, on Dec. 24, 1872. Member: Brooklyn S. Modern A.; Brooklyn WCC; NYWCC; AWSC; Nassau Co. AL; Am. APL; Salma. C. Died in 1946. Address in 1929, 4340-215th St., Bayside, NY.

DeBRA, MABEL MASON.
Painter, illustrator, and teacher. Born Milledgeville, OH, on Oct. 24, 1899. Pupil of Henry B. Snell, Will S. Taylor, and Walter Beck. Member: NYWCC; Wash. WCC; Ohio WCS; Columbus AL. Award: Robert Wolfe water color prize, Columbus Art League, 1929. Work: Mural, "Crystal Springs," Ohio State Archeological Museum. Address in 1929, Dept. of Fine Arts, Ohio State Univ.; h. 2084 Neil Ave., Columbus, Ohio.

DeBREHAN, MARCHIONESS.
Miniature painter. The Marchioness De Brehan was the sister of Count de Moustier, French minister to the United States. She visited Mount Vernon in 1788 with her brother, and painted several profile miniatures of George Washington and Nelly Custis.

DeCAMBREY, LEONNE.
Painter, craftsman, teacher, lecturer, and writer. She was born in Southern Sweden on March 7, 1877. Pupil of Alfred Jansson, Walter Sargent, Vanderpoel, etc. Member: Chicago NJSA; Chicago AA. Author of "Lapland Legends" and "A Girl in Sweden." Specialty, color psychology. Address in 1929, 6582 Sheridan Road, Chicago, IL.

DeCAMP, JOSEPH RODEFER.
Painter. Born at Cincinnati, OH, 1858. Pupil of Duveneck at Cincinnati Academy; Royal Academy

in Munich; Florence, and Italy. Represented in Wilstach Collection, Philadelphia, by "The New Gown;" Cincinnati Museum, by "Women Drying her Hair;" Portrait of "Dr. Horace Howard Furness" at Pennsylvania Academy of Fine Arts; Portrait of "Frank Duveneck" at Cincinnati Museum; "Daniel Merriman" at Worcester Museum. Died in 1923.

DECKER, E. BENNET (MRS.).
Miniature painter and illustrator. Born Washington, DC, on Feb. 28, 1869. Pupil of William H. Whittemore in miniature painting. Member: Wash. AC. Microscopic drawings for Smithsonian Institution and the National Museum, Washington, DC. Address in 1929, 3111 Hawthorne St., N. W., Washington, DC.

DECKER, JOSEPH.
Painter. Born in Germany, 1853; came to United States in 1867. Studied in the schools of the National Academy of Design and abroad. He died in Brooklyn, NY, in 1924.

DECKER, LINDSEY.
Sculptor. Born 1923, in Lincoln, NE. Studied: American Academy of Art, Chicago, 1942-43; State University of Iowa, 1946-50, BFA, MFA. Work: Albion College; Cranbrook; Detroit Institute. Commissions for Eastland Center, Detroit, 1957; Atomic Energy Commission, Oak Ridge, TN. Exhibited: Chiku-Rin Gallery, Detroit; Michigan State University; Kalamazoo Institute; The Zabriskie Gallery, 1959, 60; Art Institute of Chicago, Exhibition Momentum, 1950-54; Philadelphia Art Alliance, 1954; Whitney Museum of Art Annuals, 1956, 60; Houston Museum of Fine Art; Museum of Modern Art, Recent Sculpture USA, 1959; Penna. Academy of Fine Arts, 1960; Cincinnati Art Museum, Midwest Sculpture, 1960; Prince St. Gallery, NYC, 1969; others. Awards: Detroit Institute, Cantor Prize, 1956; Italian Government Fellowship for work in creative sculpture, 1957; Fulbright Fellowship (Italy), 1957. Address in 1982, 78 Greene St., NYC.

DECKER, RICHARD.
Illustrator, cartoonist and designer. Born in 1907. He studied at the Philadelphia Museum School of Industrial Art. In 1939 he illustrated an *Evening Bulletin* series and was a regular contributor to *The New Yorker* and advertisers in the Philadelphia area. He designed sets for seven major plays for Connecticut Playmakers, Inc.

DeCORDOBA, MATHILDE.
Painter and etcher. Born in New York City. Pupil of Whittenmore, Cox and Mowbray in New York, and Aman-Jean in Paris. Represented by prints in Luxembourg, Paris and Library of Congress, Washington, DC. Address in 1926, "The Rembrant," 152 West 57th Street, New York.

DeCOSSEY, EDWIN.
Illustrator. Member: SI. Address in 1929, Care of Hanff-Metzger, Inc., 95 Madison Ave., New York, NY.

DEELEY, S.
Engraver. All that was known to Fielding of this man was that he engraved in line a fairly well-executed plate showing the "New Hampshire Granite Ledge at Concord, NH." The plate is signed "C. Deeley Sc., Boston." The apparent date is about 1835-40.

DEEM, GEORGE.
Painter. Born Aug. 18, 1932, in Vincennes, IN. BFA from School of Chicago Art Inst., with Paul Wieghardt and Boris Margo; also studied calligraphy, Christian symbolism, and drawing and painting for one year at St. Meinard Archabbey. Lived in Eng. and Italy. Taught at School of Visual Arts, NYC; Leicester Polytech., Eng.; Univ. of Penn. In collections of Neue Galerie, Aachen, Ger.; U. of Rochester; Oberlin; Indianapolis Mus. Art; Albright-Knox Gallery, Buffalo, NY; others. Exhibited at Allan Stone Gallery, NYC; Art Inst. of Chicago; MOMA; Albright-Knox, Buffalo; Corcoran; MMA; Whitney; PAFA; others. Awarded: MacDowell Colony Fellowship (1977). Rep.: Allan Stone Gallery, NYC. Address in 1982, 10 W. 18th St., NYC.

DeFOE, ETHELLYN BREWER.
(Mrs. Louis DeFoe). Miniature painter. Born in New York City. Pupil of Whittemore and Mowbray in New York. Member: NA Women PS. Address in 1929, 250 West 88th Street, New York, NY.

DeFOREST, GRACE EMILY BANKER.
Painter, illustrator, and teacher. Born on Dec. 5, 1897. Pupil of Joseph W. Gies; John P. Wicker; and Francis P. Paulus. Member: Detroit S. Women P; Am. APL. Address in 1929, 610 Parkview Manor, Apt. 404, Jefferson Ave. and Parkview, Detroit, MI.

DeFOREST, LOCKWOOD.
Landscape painter, architect, and writer. Born in NY, on June 23, 1850. Pupil of Corrode in Rome; F. E. Church in NY. Member: ANA, 1891, NA, 1898; A. Fund A.; Artists Aid S.; NY Arch. Lg.; NY Soc. C.; Boston SAC; Century Assoc.; NAC; AFA. Founded Assoc. Artists with L. C. Tiffany and Mrs. C. Wheeler, 1878. Awards: Medal for Indian Carvings, Colonial Exp., London, 1886; medal, Columbian Exp., Chicago, 1893; bronze medal, St. Louis Exp., 1904. Founded workshops at Ahmedabad, India, for revival of woodcarving. Work: "The Rameseum Thebes," Smith College, Northampton, MA; "Mission Canyon, Santa Barbara," Herron Art Inst., Indianapolis. Published "Indian Domestic Architecture," 1885; "Illustrations of Design," 1912. Died April 4, 1932 in Santa Barbara, CA. Address in 1929, 1815 Laguna St., Santa Barbara, CA.

DeFOREST, ROY.
Painter. Born Feb. 11, 1930, in North Platte, NE. MA from S. F. State College (1958). Also attended Cal. School of Fine Arts. In collection of S. F. Mus. of Art; Oakland Mus.; Joslyn (Omaha) Art Mus.; MOMA; Whitney; others. Exhibited at East and West Gallery, S. F. (1955, 58); S. F. Mus. of Art; Whitney; Albright-Knox; Reed College; Wash. State Univ.; and many galleries, incl. Hansen-Fuller (1971-78) and Alberta (Can.) Inst., Calgary, (1974). Received Nat'l Endowment for the Arts Award (1972) and others. Rep.: Hansen-Fuller Gallery, San Fran.; Allan Frumkin Gallery, NYC. Address in 1982, Port Costa, California.

De FOREST, CORNELIUS WORTENDYKE (MRS.)
See Morrow, Julie.

DeFRANCA, MANUEL J.
Painter. One of the original members of the Artists' Fund Society of Philadelphia; member of its Council, 1835-36; Controller, 1837. Painted portrait of Mrs. Sartain (John) in 1836.

DeGAVERE, COR.
Painter. Born Batavia, Java, of Dutch parents, on Jan. 25, 1877. Pupil of Janssen and Guerin. Member: Santa Cruz AL; West Coast Arts; San Francisco SWA; Berkeley AL. Address in 1929, 452 East Cliff Drive, Seabright, Santa Cruz, CA.

DEGEN, IDA DAY.
Sculptor. Born in San Francisco, CA, October 10, 1888. Studied: California School of Fine Arts; Art Students League; and with Ralph Stackpole, William Zorach. Member: San Francisco Art Association; National Association of Women Artists, New York; San Francisco Women Artists; Marin Society of Artists. Awards: Prizes, Marin Co. Garden Center, 1948, 50; Frances Young Gallery, 1949, 50, 51; San Rafael, CA, 1941; Oakland Art Gallery, 1942, 46; San Francisco Museum of Art, 1942, 43, 50, 51. Work: S. Grace Cathedral; de Young Memorial Museum; Palace of the Legion Honor, all in San Francisco, CA. Exhibited: San Francisco Museum of Art, 1941-45; Conn. Academy of Fine Arts; Denver Art Museum, 1941, 43, 45; Penna. Academy of Fine Arts, 1942, 52; National Association of Women Artists, New York, 1942, 43, 45, 46; Pomona CA, 1941; Delgado Museum of Art, 1942; Oakland Art Gallery, 1941, 42, 44, 46; San Francisco Women Artists, 1941-46; California Palace of the Legion of Honor, 1949; California State Fair, 1950. Address in 1953, Mill Valley, CA.

DEGENHART, PEARL C.
Sculptor, painter, and teacher. Born in Philipsburg, MT, in 1904. Studied: University of Montana, B. A.; Columbia University, M.A.; University of California; University of Oregon; University of New Mexico.

Award: Prize, University of Montana, 1919. Exhibited: San Francisco Art Association, 1932, 37, 40; Contemporary Art Gallery, 1939; Spokane, Washington, 1948; Oakland Art Gallery, 1948; Topeka, KS, 1950; Denver, CO, 1938; Humboldt State College, 1935, 45, 48. Contributor to: School Arts magazine, on arts and crafts. Taught: Instructor of Art, Arcata High School, Arcata, CA, 1928-46. Address in 1953, Arcata, CA.

DeGROOT, ADRIAAN M.
Portrait painter. Born in Holland in 1870. His portrait of Col. Roosevelt is owned by "The Outlook," New York. Address in 1926, 92 Fifth Avenue, New York.

DeHASS, M. F. H.
Marine painter. Born in Rotterdam in 1832. He came to New York and during the Civil War painted several naval actions for Admiral Farragut. He was elected a member of the National Academy in 1867; he died in 1895. His "Rapids Above Niagara" was exhibited at the Paris Exposition of 1878.

DeHAVEN, FRANKLIN.
Landscape painter. Born Bluffton, IN, on Dec. 26, 1856. Pupil of George H. Smillie in NY. Member: ANA, 1902; NA, 1920; Salma. C., 1899; NAC; Allied AA. Awards: Inness prize, Salma. C., 1900; Show prize, Salma. C., 1901; hon. mention, Pan-Am. Exp., Buffalo, 1901; silver medal, Charleston Exp., 1903; silver medal, St. Louis Exp., 1904; Vezin prize, 1916; silver medal and cash prize, NAC, 1921; Plimpton prize, Salma. C., 1925. Work: "The Gleaming" and "Indian Camp near Custer," Brooklyn Inst. Museum; "Castle Creek Canyon, South Dakota," National Gallery, Washington, DC; "Silvery Waters," Butler Art Inst., Youngstown, Ohio. Died Jan. 10, 1934 in NYC. Address in 1929, 257 West 86th St., New York, NY.

DEHN, ADOLPH (ARTHUR).
Lithographer. Born Waterville, MN, on Nov. 22, 1895. Pupil of MN Art School; ASL of NY. Represented in British Museum; Metropolitan Museum; Minneapolis Museum. Died in 1968. Address in 1929, 98 Joralemon St., Brooklyn, NY; summer, Waterville, MN.

DEHNER, DOROTHY.
Sculptor and printmaker. Born in Cleveland, OH, in 1908. Studied at UCLA; Skidmore College, BS; Art Students League, with Nicolaides, K. H. Miller, Jan Matulka; Atelier 17, New York City; Yaddo Foundation Fellow, 1971. In collections of Metropolitan Museum of Art; Museum of Modern Art; Seattle Art Museum; commission, bronze wall sculpture, Rockefeller Center, New York City; others. Exhibited at Whitney Museum; Museum of Modern Art; Hirschhorn, Washington, DC; Guggenheim; Carnegie Insti-

tute; Dallas Museum of Contemporary Art; San Francisco Museum of Art; Los Angeles County Museum of Art; others. Awarded Tamarind Lithography Institute Artist in Residence, 1970-71; Sculpture Prize, Art USA, 1968; others. Member of Sculptor's Guild; Federation of Modern Painters and Sculptors; Artists Equity Association. Works in bronze and wood. Represented by Associated American Artists, New York City; Parsons-Dreyfuss, New York City. Address in 1983, 33 Fifth Ave., New York City.

DEHNER, WALTER LEONARD.
Painter, landscaper and teacher. Born Buffalo, NY, on Aug. 13, 1898. Pupil of ASL of NY at Woodstock, and PAFA. Director of Art, University of Puerto Rico. Address in 1929, Whitehouse, Ohio.

DEIGAN, JAMES THOMAS.
Illustrator. Born in Monongahela, PA, in 1934. He was educated at Temple University and Carnegie Institute of Technology. A resident of Pittsburgh for many years, he has been awarded prizes from the ADC there.

DEIGENDESCH, HERMAN F.
A painter, etcher, and teacher. He was born in Philadelphia in 1858 and was a pupil of the Munich Academy. For many years he was an instructor at the School of Industrial Art in Philadelphia. He was a member of the Philadelphia Society of Etchers. Represented at Independence Hall, Philadelphia, by his copy of the portrait of "John Hart" by Copley. He died at Southampton, PA, May 9, 1921.

DEIKE, CLARA L.
Painter and teacher. Born Detroit, MI. Pupil of H. G. Kellery; F. C. Gottwald; H. H. Breckenridge; Hans Hofmann in Munich. Member: Woman's AC, Cleveland; Cor Ardens, Chicago. Awards: 2nd prize Cleveland Museum, 1922; 1st prize and 1st hon. mention, Cleveland Museum, 1923; 2nd prize, Cleveland Museum, 1925; 3rd prize, Cleveland Museum, 1926; hon. mention group drawings, 1927, and first prize, Cleveland Museum, 1928. Work: "Italian Fishing Boats, Gloucester, MA," and "Through the Trees," Central High School, Cleveland; "Flowers," Public School Art Collection, Cleveland Board of Education. Address in 1929, 1309 West 111th St., Cleveland, Ohio.

DeIVANOWSKY, SIGISMUND.
Painter, illustrator, architect, and writer. Born in Poland on April 17, 1874. Pupil of Petrograd Academy; Constant, Laurens, and Corman in Paris. Member: Petrograd Academy; SI. Awards: Gold medal, Petrograd Academy; silver medal, Societe des Artists, Paris. Series of heroines of the stage and heroines of fiction for *Century Magazine*. Illustrated for the *Ladies Home Journal*. Address in 1929, Westfield, NJ; summer, Martha's Vineyard, MA.

DeKAY, HELENA.
(Mrs. R. Watson Glider). She exhibited since 1874 flower-pieces and decorative panels at the National Academy of Design. In 1878 she exhibited the "Young Mother" and "The Last Arrow" (figure-piece).

DeKOONING, WILLEM.
Painter. Born in Rotterdam, Holland, April 24, 1904. Studied: Acad. Beelende Kunsten ed Technische Wetenschappen, Amsterdam, 1916-24. Work: Art Inst. of Chic.; Met. Mus. of Art, MOMA, Whitney in NYC; Walker Art Ctr., Minneapolis, MN; plus others. Comn.: Murals, NY World's Fair, 1939; French Line Pier (with Fernand Leger), NYC. Exhib.: Melbourne Nat'l., 1967; Frankfurter Kunstverein, Kimpass, NYC, 1968; Stedelijk Mus., retrospective, Amsterdam, 1968; MOMA, retrospective, exhib. 1969; Whitney, Am. Art Annual, 1969 & 70; Carnegie Inst., 1979; many others. Awards: Logan medal, Art Inst. of Chic.; President's medal; Mellon prize; others. Teaching: Black Mtn. College, 1948; Yale Univ., 1950-51. Mem.: Nat'l Inst. Arts and Letters. Address in 1982, c/o Fourcade Droll Inc., 36 E. 75th St., NYC.

DeKRUIF, HENRI G(ILBERT).
Painter and etcher. Born Grand Rapids, MI, on Feb. 17, 1982. Pupil of Gifford Beal, F. Luis Mora, Frederick Richardson, DuMond, Vanderpoel, and Ernest Haskel. Member: Calif. AC; Los Angeles Modern AS; Laguna Beach AA; ASL of NY; Calif. PM.; Calif. WCS; Group of Eight. Awards: $100, Los Angeles County Fair, 1923; first prize, Southern California Painters and Sculptors, Los Angeles Museum,1925; cash honorarium, Pan-Am exhibit of oil paintings, Los Angeles Museum, 1926; first prize for water colors, Orange Co. Fair, 1926. Represented in permanent collection of Los Angeles Museum. Address in 1929, 2324 Miramar St.,Los Angeles, CA. Died in 1944.

DeKRYZANOVSKY, ROMAN.
Painter. Born Balta, Russia, 1885. Pupil of E. Renard, E. Tournes and P. Gouzguet. Member: Scarab Club, Detroit. Work: "Kismet," Detroit Institute of Arts. Address in 1926, 48 Adams Avenue, West Detroit, MI.

Del PIATTA, BEGNI.
Sculptor. Exhibition at the Pennsylvania Academy of Fine Arts, Philadelphia, in 1924. Address in 1926, 12 West 8th Street, New York.

DeLAMOTTE, CAROLINE J(ONES).
(Mrs. Octave John DeLamotte). Painter and teacher. Born Pikesville, MD, on Sept. 3, 1889. Pupil of C. Y. Turner, Ephraim Keyser, and Charles H. Webb. Awards: First prize for charcoal drawing and first prize for watercolor, LA State Fair, Shreveport, LA,

1917; first prize for charcoal portrait, first prize for original design, and first prize for watercolor collection at Donaldsonville, LA, 1917. Work: In M. E. Church, Le Compte, LA. Address in 1929, McNary, Arizona.

DeLAND, CLYDE OSMER.
Illustrator and painter. Born Union City, PA, on Dec. 27, 1872. Pupil of Drexel Inst. under Howard Pyle in Philadelphia. Member: Phila. Alliance. Work: Painting, "First American Flag," City of Somerville, MA; "First Continental Congress," Carpenters' Hall, Philadelphia; "The First Steamboat," "The First Automobile," "The First Street Railway," National Museum, Washington, DC; illustrated, "The Count's Snuffbox," etc. Address in 1929, 603 Baker Bldg., 1520 Chestnut Street; h. 22 N. St. Bernard Street, Philadelphia, PA. Died in 1947.

DELANEY, JOSEPH.
Painter and writer. Born Knoxville, TN, Sept. 13, 1904. Studied: ASL with Thomas Denton, Alexander Brook, 1929-35; NYU, writing, with Horace Coohn; also with George Bridgman. Work: Huntington Hartford Collection; Truman Library, Independence, MO; Nat'l. Gallery, Smithsonian, Wash., DC; NYC Museum; others. Exhibitions: Metropolitan Museum; Brooklyn Museum; Riverside Museum; Krashauer Gallery; ACA Art Gallery; Whitney Museum; Studio Museum, Harlem, NYC; others. Awards: Rosenwald Fellowship; Greenwich Village Art Center. Art Positions: Instr., researcher, WPA Fed. Art Project, 1934-40; researcher, Am. Wing. Met. Mus of Art, 1936-39. Media: Oil. Address in 1982, PO Box 383, New York City.

DELANEY, JOSEPH E.
This man was a line engraver of portraits and landscape, working for magazines about 1850.

DELANO, ANNITA.
Painter, writer, lecturer and teacher. Born Hueneme, Calif., on Oct. 2, 1894. Member: Calif. AC, Calif. WCS. Award: Henry E. Huntington prize ($250), Los Angeles Museum. Work: "Virgins of the Red Rocks," Los Angeles Museum. Address in 1929, University of California at Los Angeles; h. 2332½ Miramar Street, Los Angeles, CA.

DELANOY, ABRAHAM JR.
Painter. Born in NY, probably in 1740, and died in the same city about 1786. He visited England about 1766 to 1769, and was instructed for a time by West. There is a reference to his being in London in a letter from Charles Willson Peale, published in John Sartain's "Reminiscences of a Very Old Man," where he mentions going with West in 1769 to the rooms of Mr. Delanoy, who expected soon to "return to his native place, New York". One of the students in the painting by Pratt, "The American School," is sup-

posed to be Abraham Delanoy. Dunlap mentions several portraits of members of the Beekman family by this painter, and he himself remembered the man from 1780 to 1783 in "the sear and yellow leaf both of life and fortune; consumptive and poor, his only employment being sign-painting." In 1772 he painted a portrait of Peter Livingston (1737-1794).

DELAUNAY, PAUL.
Sculptor and painter. born in Paris, France, 1883. Director, Birmingham Academy of Fine Arts, Alabama. Member: American Artists Professional League.

DELBOS, JULIUS (M.).
Painter, etcher, and teacher. Born London, July 22, 1879. Member: AWCS; NYWCC; Soc. of Graphic A.; Old Dudley Art Society, London; Salma. C.; NAC. Exhibited at National Academy of Design, NY, 1925. Address in 1929, Salmagundi Club, 47 Fifth Ave., New York, NY.

DELBRIDGE, THOMAS JAMES.
Painter, etcher, craftsman, and teacher. Born in Atlanta on Sept. 16, 1894. Pupil of Charles Hawthorne. Member: NAC; Alliance; L. C. Tiffany Foundation. Award: Fellowship, L. C. Tiffany Foundation, 1922; first water color prize, NAC, Junior Exhib., 1928. Work: "Indian Still Life," Tiffany Foundation. Address in 1929, National Arts Club, 15 Gramercy Park, New York, NY.

DeLEON, AMANDA.
Painter. Born in Madrid, Spain, in 1908. Studied: San Jose de Tarbes Convent, Caracas, Venezuela. Collections: Musee d'Art Moderne, Paris; National Gallery Modern Art, Rome; Glasgow Art Gallery, Scotland; Museum Modern Art, Barcelona; Musee de Beaux Arts, Lausanne; Municipal Gallery Modern Art, Dublin; Municipal Gallery Modern Art, Genoa; Art Gallery of Toronto, Canada; Denver Museum of Art; Butler Art Inst.; University of California; Museum of Delhi, India; National Museum of Modern Art, Tokyo; Municipal Art Museum, Dusseldorf, Germany; Neue Galerie der Stadt Linz, Austria; Hamburger Kunsthalle, Germany.

DeLESLIE, ALEXANDER.
Painter, lecturer, and teacher. Born Moscow, Russia, Dec. 14, 1892. Pupil of Bridgman, Bellows, and Maynard. Author of: *How France Built Her Cathedral* (Harpers); *A Childhood in Brittany* (Century). Art director, Stirling Press, NY. Instructor in Design, Mechanics Inst., New York. Address in 1929, Springfield Gardens, LI, NY; summer, Longmeadow, MA.

D'ELIA, TERESA ILDA.
Sculptor, painter, illustrator and teacher. Born in Greenwich, Conn., November 18, 1918. Studied: Art Students League; New School for Social Research; and with Simkovitch, Charlot, Picken, Sternberg. Member: Springfield Art League. Awards: Medal, San Francisco Art Association, 1943; prizes, Douglas Aircraft Exhibit, 1943; Springfield Art League, 1945, 46. Exhibited: Penna. Academy of Fine Arts, 1942; American Artists Professional League, 1942; San Francisco Museum of Art, 1943; Northwest Print Maker, 1943; Philadelphia Print Club, 1945; Los Angeles Museum of Art, 1945; Springfield Art League, 1945, 46; Greenwich Society of Artists, 1945; Douglas Aircraft Exhibit, 1943; Palace of Legion of Honor, 1946. Address in 1953, Greenwich, Conn.

DELLA-VOLPE, RALPH.
Painter and educator. Born in NJ, May 10, 1923. Study: NAD; ASL. Work: NY Cultural Center; ASL; Wichita (KS) AA; Lib. of Congress, Pennell Collection; Chase Manhattan Bank Coll.; Treasury Bldg., Wash., DC; Slater Mus., Norwich, CT. One-man shows: Berkshire Mus., Pittsfield, MA; Artist Gal., NYC, 1959; Babcock Gal., NYC, 1960, 62, 63; The Gal., West Cornwall, CT, 1974; Anderson (IL) Fine Arts Center, 1975; Wolfe St. Gal., Wash., DC, 1974, 77; retrospective, Columbia (SC) Mus. of Art, 1975; and many others. Group shows: PAFA; Lib. of Congress; Nat'l Inst. of Arts and Letters, NYC; Parke-Bernet Gal., NYC; Butler Art Inst. Ann., Youngstown, OH; Contemp. Gal., NYC; Wadsworth Atheneum, Hartford, CT; Soc. of Am. Etchers, Chicago, IL; Brooklyn Mus., NY; Corcoran Gal., Wash., DC; MOMA Lending Lib.; Am. Color Print Soc., Phila., PA; and many others. Awards: Mac Dowell Fellowship, 1963; purchase award, Lib. of Congress; Wichita (KS) AA; NY ASL; hon. mention, Wash. WCC; Nat'l Vet. Art Exhib.; drawing prize, Berkshire Mus.; finalist, Nat'l Inst. Arts & Letters, 1963, 64. Teaching: Chairman, prof., Art Dept, artist in res., Bennett College, Millbrook, NY, 1949-77; prof. drawing/painting, Marist College, Poughkeepsie, from 1977. Style: Realistic and abstract landscapes, figures, and portraits. Address in 1982, South Road, Box 51, Millbrook, N.Y.

DELLEKER, GEORGE.
With the profession of "engraver" appended, this name appears in the Philadelphia directories from 1817-24, inclusive. He was possibly engraving in that city earlier than the first-named date, as we find portraits of naval heroes of the War of 1812 executed by him and evidently intended for popular distribution. He was later associated with the engraver G. H. Young, under the firm name of Delleker & Young, in the general engraving business in Philadelphia.

DELLENBAUGH, FREDERICK SAMUEL.
Painter. Born in McConnelsville, Ohio, 1853. Pupil of Carolus Duran and Academie Julien, Paris. Engaged in art and literary pursuits; librarian, American Geographical Society, 1909-11; artist and topog-

rapher with Major Powell's 2nd expedition down Colorado River 1871-3; with Harriman expedition to Alaska and Siberia, 1899; voyages to Iceland, Spitzbergen, Norway, West Indies and S. A., 1906; several personal expeditions to the Southwest in early days.

DelMAR, FRANCES.
Painter, teacher, writer and lecturer. Born Washington, DC. Pupil of Collin, Fleury, and Bouguereau in Paris; Rolshoven in London. Work: Mural decorations at Caroline Rest (hospital), Hartsdale, NY; paintings of New Zealand and South Sea Islands for the American Museum of Natural History. Author of *A Year Among the Maoris* (London). Died May 8, 1957 in NYC. Address in 1929, Barnard Club, 221 West 57th Street, New York, NY.

DelMUE, M(AURICE) (AUGUST).
Painter. Born Paris, France, on Nov. 4, 1878. Member: San F. AA; Am. APL. Award: Silver medal, Panama Pacific Exp., San Francisco, 1915. Work: "Late Afternoon in the Sierras," Comparative Museum of Art; "West Winds," Golden Gate Park Museum, San Francisco, CA; "Forest Knolls," Walters Collection, San Francisco. Address in 1929, Forest Knolls, Marin Co, CA.

DELNOCE, LUIGI.
Engraver. Born in Italy; died in New York about 1888. Delnoce was an admirable engraver of book-illustrations, appearing in New York publications of 1855-60, but he was chiefly engaged in bank-note work.

DELSON, ELIZABETH.
Painter and printmaker. Born in New York, NY, Aug. 15, 1932. Studied: Smith College; Hunter College; Pennsylvania Acad. of Fine Arts. Awarded the Audubon Artists Medal of Honor for Graphics. Exhibited in several NY galleries and is in the for-sale collection of Associated American Artists and the Landmarks Collection. Media: Oils on 3 dim. surfaces; etchings. Address in 1980, 625 Third St., Brooklyn, NY.

DeLUCE, PERCIVAL.
Painter. Born in New York, 1847, and died 1914. Pupil of Antwerp Academy, Joseph Portaels, Brussels; Sonnat, Paris. Specialty, portrait and genre painting; exhibited at all principal exhibitions, especially in New York. Silver medal, S. C. Inter-State Expn.; Academy of National Artists. Member: American Water Color Society, Artists' Fund Society, S.C.

DELUIGI, JANICE CECILIA.
Sculptor and painter. Born in Indianapolis, IN, November 27, 1915; Italian and American citizen. Works: Illinois Bell Telephone Co., Chicago; Art Institute of Chicago; Civic Museum Revltella,

Trieste, Italy. Commissions: Sculpture in memory of John F. Kennedy and Robert F. Kennedy, Community of Milano, Italy, 1969; stained glass windows, San Giorgio Maggiore, Benedictine Monastery, 1973 and Cini Foundation and Benedictine M. Nuovalese, 1973; artistic glass sculpture of Murano for the best film presented at the VII Festival International School of Film and Fiction, Trieste, 1969. Exhibitions: Gallery Art, Muova Spazio, Folgaria, Italy, 1975; Gallery Art, San Marco, Venice, 1975; La Capella, Art Center, Trieste, 1975; Engravings, International Center Graphics, Venice, 1975. Awards: First Prize International Painting and Sculpture, Fruili-Venezia Guilia, 1971; Silver Medal for Painting, Pope Paul Vi, 1973. Media: Glass; oil, watercolor. Address in 1982, Venice Italy.

DelVALLE, HELEN.
Painter. Studied: The Art Inst. of Chicago; PAFA. Awards: Chicago, NLAPW, 1971, 1973; Municipal Art Lg. of Chicago, 1973. Exhibitions: Chicago Public Library, 1969; American Society of Artists, 1973; Balzekas Museum, Chicago, 1973. Past-president of the American Society of Artists. Her work is included in collections throughout the world.

DeMAINE, HARRY.
Painter. Born Liverpool, England on Dec. 23, 1880. Pupil of Castellucho in Paris; F. V. Burridge in London. Member: Salma. C.; AWCS.; NYWCC. Address in 1929, care of Salmagundi Club, 47 Fifth Ave., New York, NY.

DeMANCE, HENRI.
Painter. Born Hamburg, Germany, on Oct. 5, 1871. Pupil of Lenbach. Member: S. Indp. A. Work: "Portrait of a Man," "Grapes of the Hudson," Schiller Museum, Marbach. Address in 1929, 332 East 69th Street, New York, NY; summer, Sorrento, Italy. Died in 1948.

DeMARIS, WALTER.
Illustrator. Born Cedarville, NJ, Aug. 24, 1877. Pupil of ASL of NY. Address in 1929, 34 Pierce St., New Rochelle, NY.

DeMERS, JOSEPH.
Illustrator. Born in San Diego, CA, in 1910. He attended the Chouinard Art School and, as a fine artist, exhibited work at the Museum of Modern Art in 1933. After ten years as a production illustrator for Warner Brothers Studios, he became a successful book publisher in California. Ultimately, he moved to NY in the late 1940's to work at Cooper Studio. His free-lance work was seen in *The Saturday Evening Post, Ladies Home Journal* and *McCall's*. Good business sense prompted him, Coby Whitmore and Joe Bowler to form a corporation through which they retained world rights for many European reprints to their artwork. His paintings have been shown and

are owned by many museums and galleries. A member of S of I, he currently runs a gallery on Hilton Head Island in South Carolina.

DEMETRIOS, GEORGE.
Sculptor. Born in Greece, April 1, 1896. Studied with Charles Grafly and Antoine Bourdelle. Exhibited at the Pennsylvania Academy of Fine Arts, Philadelphia, in 1924. Member: Associate, National Academy of Design; National Sculpture Society and Boston Society of Independent Artists. Died in 1974. Address in 1970, Gloucester, MA.

DeMILHAU, ZELLA.
Etcher. Born New York City on April 3, 1870. Pupil of ASL of NY. Member: NAC; NA Women PS; Phila. Print C; Chicago SE; Calif. PM. Represented in NY Public Library; National Museum, Washington, DC; Brooklyn Museum. Address in 1929, Southhampton, LI, NY.

DEMILLIERE.
Portrait painter in oils and miniatures. Flourished in New York in 1796.

DEMING, ADELAIDE.
Landscape painter. Born Litchfield, CT, on Dec. 12, 1864. Pupil of ASL of NY; Pratt Inst., Chase, Lathrop, Dow, and Snell. Member: NA Women PS; New Haven PCC; NYWCC; CT AFA. Awards: Beal prize, NYWCC, 1908; Burgess prize, NY Woman's AC, 1908. Represented in Litchfield Public Library and Pratt Inst. Address in 1929, Litchfield, CT.

DEMING, EDWIN WILLARD.
Sculptor, painter, muralist, writer and illustrator. Born Ashland, OH, on August 26, 1860. Pupil of Art Students League of New York; Lefebvre and Boulanger in Paris. Member: Mural Painters; Washington Art Club; (life) National Arts Club. Awards: Silver medal, American Art Society, 1892; bronze medal, St. Louis Exposition, 1904; bronze medal for sculpture, P.-P. Exposition, San Francisco, 1915. Work: Two mural paintings, Morris High School, NYC; "Braddock's Defeat" and "Discovery of Wisconsin," mural decorations, Wisc. Historical Society, Madison, WI; "The Fight" and "Mutual Surprise," two bronzes, Metroplitan Museum, NY; "The Watering Place," "Pueblo Buffalo Dance" and "Sioux War Dance," Art Museum, Montclair, NJ; "Mourning Brave," National Museum, Washington, DC; "Attacked by Bears," gouache; "Bighorn Sheep," bronze; "The Herder," Milwaukee Museum; and others in collections; represented in American Museum of Western Art; murals of Indian life, Museum of the American Indian; Brooklyn Museums; Whitney Museum of American Art. Traveled in West studying Indians. Wrote and illustrated articles about Indians with artists DeCost Smith and Frederick Remington. Painting, "Landfall of Jean Nicholet," selected for commemorative US stamp. Modeled bronzes, 1905-1910; primarily painter and illustrator. Specialty, Indian and animal subjects of the West. Address in 1933, 15 Gramercy Park, NYC. Died in NYC, 1942.

DeMOLL, MARY HITCHNER.
(Mrs. Carl DeMoll). Illustrator. Member: Fellowship PAFA; Plastic C. Address in 1929, 135 Rutger's Ave., Swarthmore, PA; 282 West Rittenhouse St., Germantown, Philadelphia, PA.

DEMUTH, CHARLES.
Painter. Born Lancaster, PA, 1883. Pupil of PAFA; studied in Paris. Member: Fellowship PAFA. Award: Silver medal, Sesqui-Centennial Exp., Phila., 1926. Represented by water colors in the Metropolitan Museum of Art, New York; Art Inst. of Chicago; Fogg Art Museum; Cambridge, MA; Brooklyn Museum; Cleveland Museum; Rochester Museum; Barnes Foundation, Merion, PA; Phillips Memorial Gallery, Wash., DC; Harrison Gallery, Los Angeles Museum. Died in 1935. Address in 1929, Lancaster, PA; care of Daniel Gallery, 600 Madison Ave., New York, NY.

DENGHAUSEN, FRANZ H.
Sculptor and teacher. Born in Boston, Mass., April 8, 1911. Studed at Boston Museum Fine Arts School, with Charles Grafly; Child-Walker School of Design, with Arnold Geissbuhler. Member: Copley Society; Boston Art Club; North Shore Art Association, Rockport Art Association; others. Exhibited: Penna. Academy of Fine Arts, 1931; National Academy of Design, 1931; World's Fair of New York, 1939; Cincinnati Museum Association, 1935; Addison Gallery, 1939, 51; Wadsworth Atheneum, 1951; many others. Instructor of sculpture, Cambridge Center for Adult Education, Cambridge, MA. Address in 1953, Roslindale, MA.

DENGLER, FRANK.
Sculptor. Born in Cincinnati, Ohio, in 1853. He studied abroad, and on his return to this country was for a time instructor in modeling in the Boston Museum. He resigned in 1877 and moved to Covington, KY, and afterwards to Cincinnati. Among his works are "Azzo and Melda," an ideal head of "American," and several portrait busts. Died in 1879.

DENISON, HAROLD (THOMAS).
Painter, illustrator and etcher. Born Richmond, MI, Sept. 17, 1887. Pupil of Art Students League, NY; Chicago Academy of Fine Arts. Specialties: Etchings, water colors and illustration. Member: SI; Salma. C. Died in 1940. Address in 1929, Boston Corners, NY.

DENMAN, HERBERT.
Painter. Born in New York in 1855. Student at the Art Students League, New York, and with Carolus

Duran in Paris. His "Trio" received Honorable Mention at the Paris Salon, 1886. He decorated Mr. Fred Vanderbilt's Ball Room. He died in California in 1903.

DENNING, CHARLOTTE.
Miniature painter. Flourished about 1834, Plattsburgh, New York.

DENNIS, CHARLES W(ARREN).
Portrait painter and illustrator. Born in New Bedford on Feb. 25, 1898. Pupil of Harold Brett, Howard E. Smith, and Frederick Bosley. Member: S. Indp. A.; Boston AC; Business Men's AC of Boston. Address in 1929, 1269 Great Plain Ave., Needham, MA.

DENNIS, MORGAN.
Illustrator and etcher. Born Boston, MA, on Feb. 27, 1891. Pupil of W. H. W. Bicknell. Member: Beachcombers; North Shore AA; New Haven PCC. Illustrated "The Champion," "Themselves," "What's Up," and "The Black Watch." Address in 1929, 412 Eighth Ave.; h. 258 West Fourth St., New York, NY; summer, Provincetown, MA.

DENNISON, DOROTHY.
Painter. Born in Beaver, PA, on Feb. 13, 1908. Awards: Cresson European Traveling Scholarship; Butler Inst. of American Art; Ohio State Fair. Collections: PAFA; Columbus Art Gallery, Canton Art Inst.; Marine Midland Bank; Lawrence Fleishman; Olsen Foundation. Address in 1980, 915 Walker Mill Road, Poland, OH.

DENNISON, GEORGE AUSTIN.
Sculptor and painter. Born in New Boston, Illinois, 1873. Exhibited sculptured enamels in the Louvre Museum, Paris. Address in 1926, Cathedral Oaks, Alma, CA.

DENNISON, LUCY.
Painter. Born in Youngstown on April 5, 1902. Pupil of Butler AI; James R. Hopkins; Daniel Garber. Member: Youngstown S. Women A; Mahoning SP. Address in 1929, Women's City Club, Wick Ave.; h. 33 Scott St., Youngstown, Ohio.

DENNY, MILO B.
Painter. Born Waubeek, IA, April 21, 1887. Pupil of AIC; NY ASL; Cornell Coll. School of Art. Address in 1929, 901 Chateau Ave., Cincinnati, OH; summer, Taos, NM.

DENSLOW, DOROTHEA HENRIETTA.
Sculptor. Born in NYC, Dec. 14, 1900. Studied at Arts Students League of New York. Member: Conn. Academy of Fine Arts; American Federation of Arts. Work: Foundation sculpture (Richmond, VA); memorial plaque, Beth Moses Hospital, NYC; Brookgreen Gardens, South Carolina Exhibited: Syracuse Brookgreen Gardens, SC. Exhibited: Syracuse Museum of Fine Art, 1938; Berkshire Museum of Art, 1941; others. Position: Founder and Director, Sculpture Center, NYC, 1928-53. Address in 1970, 167 East 69th St., NYC. Died in 1971.

DePEYSTER, GERARD BEEKMAN.
Several portraits of the DePeyster family are in the collection of the New York Historical Society and are painted by Gerard Beekman DePeyster.

Der HAROOTIAN, KOREN.
Sculptor and painter. Born in Ashodavan, Armenia, April 2, 1909. Studied at Worcester Museum Art School. Works: Metropolitan Museum of Art; Worcester Museum of Art; Whitney; Penna. Academy of Fine Arts; Arizona State College Museum, Tempe; marble eagle, US Pavilion, Brussels World's Fair, 1958; Fairmount Park Association, Philadelphia, PA. Awards: Springfield Art League, 1945; Audobon Artists, 1950, medal, 1949; gold medal, Penna. Academy of Fine Arts, 1954; American Academy of Arts and Letters, 1954. Exhibited: Whitney, 1956 and prior; Penna. Academy of Fine Arts, 1946-56; Art Institute of Chicago, 1951, 54; Phila. Art Alliance, 1950; Detroit Institute of Art, 1960; Museum of Jamaica, B.W.I., 1942; Cranbrook Academy of Art; Royal Academy, London, 1964; The Contemporaries Gallery, NY, 1967; University of Nebraska; and others. Address in 1970, Orangeburg, NY.

DERCUM, ELIZABETH.
Painter. Exhibited at the Penna. Academy of Fine Arts, Philadelphia, in 1924. Address in 1926, 1719 Walnut Street, Philadelphia, PA.

DERGANS, LOUIS S.
Painter. Born in Laiback, Austria, on Nov. 4, 1890. Pupil of Richard S. Meryman and S. Burtis Baker; Calif. School of Fine Arts. Member: S. Wash. A; Wash. Landscape C; Wash. AC; AFA. Specialty: portraits. Address in 1929, "The Lombardy," 2019 Eye St., NW, Washington, DC.

DeRIBCOWSKY, DEY.
Marine painter. Born in Rustchuk, Bulgaria, on Oct. 13, 1880. Studied in Paris, Florence and Petrograd. Member: Art Assoc. of Newport; Buenos Aires Society of Fine Arts. Awards: Gold medal, Petrograd, 1902; gold medal, Uruguay Exhibition, Montevideo, 1908; gold medal, Rio de Janeiro Exp., 1909; Kuznezoff prize, Odessa, 1909; Orloff prize, Moscow, 1910; first prize, Sofia Nat'l Gallery, 1910; first grand prize, Southwestern Int. Fair and Exp., El Paso, Texas, 1924. Inventor of the Medium "Reflex." Work: "Aurora Bureale," Mus. Alexander III, Petrograd; "Winter Sunset at Volga," Tretiacof Gal., Moscow; "After Glow at Yalta," Odessa Mus.; "President William," Uruguay Mus. Montevideo; "Pres. Quintana," Buenos Aires Mus.; "The Fleet," National

Palace, Montevideo; "Brazilian High Sea Fleet," Nat'l. Palace, Rio de Janeiro; "Balantia," Governor's Palace, Barbados; "Monterey at Moonlight," "Grand Canyon," Manchester (NH) Memorial.

DeROSE, ANTHONY LEWIS.
Painter. Born in NYC in 1803. He studied under J. R. Smith and was an early student at the National Academy School. He was elected an Academician in 1833, his specialty being portraiture and historical composition. He died in NY in 1836.

DERRICK, WILLIAM R(OWELL).
Painter and craftsman. Born San Francisco, CA. Pupil of Bonnat, Boulanger and Lefebvre in Paris. Member: ANA; NAC; CT AFA; Lotos C.; Chicago AG; SPNY. Awards: Prize ($100), CT AFA, 1916. Work: "The Plaza," National Gallery, Washington. Address in 1929, 58 West 57th Street, New York, NY.

DERUJINSKY, GLEB W.
Sculptor, painter, lecturer, craftsman, and teacher. Born Smolensk, Russia, on August 13, 1888. Pupil of Verlet, Injalbert in France and of the Russian Academy. Member: National Sculpture Society; New York Architectural League; National Academy of Design; Allied Artists of America. Exhibited at National Sculpture Society, 1923. Award: Silver medal, Encouragement of Art, Petrograd, 1909; gold medal, Sesqui-Centennial Exposition, Philadelphia, 1926; National Academy of Design, 1938, 68; medal, National Arts Club, 1961, 64; Lindsey Memorial prize, 1954, 65; Allied Artists of America, 1958, gold medal, 1966; others. Work: "Theodore Roosevelt," Roosevelt Memorial House, New York. In collections of Metropolitan Museum of Art; Cranbrook and San Diego Fine Art Gallery; others. Address in 1970, 29 West 65th Street, NYC. Died in 1975.

DESCH, FRANK H.
Painter. Born Philadelphia, PA, on Feb. 19, 1873. Pupil of Chase and Hawthorne and of Biloul, Paris. Member: Allied AA; Fellowship PAFA; Salma. C.; Provincetown AA. Awards: F. A. Thompson prize and $1,000 purchase prize, Salmagundi Club, 1924. Work: "The Blue Chinese Coat," Butler Art Inst., Youngstown, OH; "La Robe de Boudoir," Salmagundi Club, NY; "Alice in Wonderland," Bloomington Art Association, Bloomington, IL. died in 1934. Address in 1929, Provincetown, MA.

DESSAR, LOUIS PAUL.
Painter. Born Indianapolis, IN, on Jan. 22, 1867. Pupil of NAD in NY; Bouguereau, Robert-Fleury and Ecole des Beaux-Arts in Paris. Member: SAA, 1898; ANA, 1900, NA, 1906; Salma. C., 1895; Lotos C.; A. Fund S. Awards: Third class medal, Paris Salon, 1891; medal, Columbian Exp., Chicago, 1893; hon. mention, CI Pittsburgh, 1897; second Hall-

garten prize, NAD, 1899; first Hallgarten prize, NAD, 1900; bronze medal, Paris Exp., 1900; silver medal, Pan-Am. Exp., Buffalo, 1901; silver medal Charleston Exp., 1902. Work: " Return to the Fold" and "The Watering Place," National Gallery, Washington; "Wood Cart," Metropolitan Museum, NY; "Early Morning" and "Evening at Longore," Art Museum, Montclair, NJ. Died on Feb. 14, 1952. Address in 1929, 58 West 57th St., Lotos Club, 110 West 57th St., 331 West 24th St., New York, NY; summer, Becket Hill, Lyme, CT.

DESVARREAUX, LARPENTEUR JAMES.
Painter. Born Baltimore, MD, on Oct. 20, 1847. Pupil of Van Marcke and Ecole des Beaux-Arts in Paris. Award: Gold medal, Alaska Yukon Exp., 1909. Specialty, landscapes with cattle or sheep. Address in 1929, 26 rue de Fleurus, VI, Paris, France.

DETHLOFF, PETER H(ANS).
Painter. Born Barnsdorf, Germany, on Sept. 8, 1869. Pupil of William Gaethe and Christian von Schneidau; Calif. Art Inst. Awarded three first prizes at Utah State Fair Association. Work: Fresco ceiling, St. Mary's Academy Chapel, Salt Lake City, Utah. Address in 1929, 1555 North Harvard Blvd., Hollywood, Calif.

DeTHULSTRUP, THURE.
Painter and illustrator. Member: SI, 1901 (hon.); AWCS; Century Assoc.; GFLA. Awards: Hon. mention for drawings, Pan-Am. Exp., Buffalo, 1901. Address in 1929, 1060 Amsterdam Ave; 33 West 67th St., New York, NY.

DETWILLER, F(REDERICK) K(NECHT).
Painter, illustrator, etcher, and artist. Born Easton, PA, on Dec. 31, 1882. Pupil of Ecole des Beaux Arts, Paris; Inst. di Belle Arti, Florence; Columbia U., NY. Member: Paris Am. Students C.; Paris AAA; Brooklyn WCC; AFA; Allied AA; Phila. SE; Artists Fellowship, Inc.; Lotos C; CT AFA; Guild of Am. Painters; Phila. Print C.; Salma. C.; S. Indp. A.; Brooklyn SE; Brooklyn S. Mod. A.; Salons of Am. (Dir., 1922-25). Award: Medal, Society of Beaux Arts Arch., NY, 1910; Shaw prize for etching, Salma. C., 1920. Represented in the Nat. Gal.; Lib. of Congress; Smithsonian Inst., Wash.; Imperial War Mus., London; Print Div., NY Pub. Lib.; Peabody Mus., MA; CT State Lib., Hartford; Farnsworth Art Mus., Wellesley College, MA; Vanderpoel Art Assn. Coll., Chicago; Lafayette College, Easton, PA; Bibliotheque Nat., Paris, France. Address in 1929, Carnegie Hall, 56th St. and 7th Ave., NY. Died in September, 1953.

DeVEAUX, JACQUES MARTIAL.
Born in 1825 and died in 1891. Painted portraits.

DeVEAUX, JAMES.
Born in Charleston, SC, in 1812. In 1829 he visited Phila. and received help and instruction from Henry Inman and Thomas Scully. In 1836 he visited Europe for study, returning to America in 1838 where he painted many portraits, one of the best being his portrait of his friend, Col. John S. Manning, of South Carolina, painted in Clarendon, SC, about 1839. He died in Rome 1844. (See life of James DeVeaux in *Artists of America* by C. E. Lester, NY, 1846.

DEVILLE, J.
Portrait painter who had a studio about 1840 to 1855. Address in 1926, 66 Saint Ann Street, New Orleans.

DEVINE, BERNARD.
Painter. Born in Portland, ME, in 1884. Pupil of Bridgeman in New York and Laurens in Paris. Member of the Paris American Artists' Association. Address in 1926, Willard, ME.

DeVOLL, F. USHER.
Painter. Born Providence, RI, Dec. 15, 1873. Pupil of RI School of Design; Chase, Hawthorne, Henri, Mowbray; Laurens in Paris. Member: Providence AC; Salma C.; Providence WCC; CT AFA; Wash. AC; AFA. Award: Silver medal, P.-P. Exp., San. F., 1915. Work: "Autumn Landscape," and "NY Waterfront Winter," RI School of Design, Providence; "Spring," Art Club, St. Johns, New Brunswick; "Winter in New England," Delgado Mu., New Orleans, LA; "Winter in the Berkshires," Newcomb College, New Orleans, LA; "Studies of New York Street and Harbor Scenes," Milwaukee Art Inst.; "Twixt Day and Night Madison Sq., NY," Vanderpoel Art Assn., Chicago. Address in 1929, 19 Arcade Building, Providence, RI.

DeVOS, FLORENCE M(ARIE).
Painter. Born Cook Co., IL, on Oct. 13, 1892. Pupil of Henry Mattson. Address in 1929, P. O. Box 287, Woodstock, NY.

DEWEY, CHARLES (MELVILLE).
Landscape painter. Born Lowville, NY, July 16, 1849. Pupil of Carolus-Duran in Paris. Member: ANA, 1903, NA, 1907; Nat. Inst. A. L.; Lotos C.; NAC. Awards: Silver medal, Pan-Am. Exp., Buffalo, 1901; silver medal, St. Louis Exp., 1904. Work: "Edge of Forest," Corcoran Gallery, Washington; "The Grey Robe of Twilight," Fine Arts Academy, Buffalo; "The Harvest Moon" and "The Close of Day," Nat. Gallery, Washington; "Old Fields," PA Academy, Phila.; "Amagansett from the Fields," "Evening Landscape" and "November Sunset," Brooklyn Inst. Museum; "The Valley Road," Art Museum, Monclair, NJ; "Homeward," Minneapolis Inst. of Arts; "The Sun Shower," Metropolitan Museum of Art, New York. Address in 1929, 222 West 23rd Street, New York, NY.

DEWEY, CHARLES S.
Painter. Born in Cadiz, Ohio, in 1880. Member of Chicago Society of Artists. Address in 1926, 2708 Lake View Avenue, Chicago.

DEWEY, JULIA HENSHAW.
(Mrs. Charles M. Dewey). Painter and illustrator. Born in Batavia, NY. Member of National Association of Women Painters and Sculptors. Address in 1926, 222 West 23d Street, New York City, NY.

DEWEY, KENNETH FRANCIS.
Illustrator. Born in Brooklyn, NY, in 1940. He studied under Robert Weaver and Phil Hays at the SVA. His first illustration was done for a magazine in Phoenix, AZ, in 1967. Three years later he wrote and illustrated a book entitled *Onyamarks*. His illustrations have been selected to appear in the S of I Annual Exhibitions of 1974, 1975 and 1976.

DEWEY, S.
Silhouettist and miniature painter. Flourished 1800-1810 in Baltimore. There was a Silas Dewey, a portrait painter, in Baltimore, 1814-1815.

DEWING, FRANCIS.
Engraver. A Boston newspaper heralds the arrival of this early American engraver in New England as follows: "Boston, July 30, 1716. Lately arrived from London, Francis Dewing, who Engraveth and Printeth Copper Plates, Likewise Coats of Arms and Cyphers on Silver Plate. He likewise Cuts neatly in wood and "Printeth Callicoes". In 1722, Dewing engraved and printed a large map of "The Town of Boston in New England, By John Bonner, 1722, Aetatis Suae 60". The plate is signed as "Engraved and Printed by Fra. Dewing, Boston N. E. 1722. Sold by Captain John Bonner and William Price, against ye Town House where may be had all sorts of Prints, Maps etc."

DEWING, MARIA OAKEY.
Painter. Born at New York, 1857. Studied at National Academy, New York, and under John LaFarge and Thomas Couture. Specialties are figures, flower pieces and portraits. Address in 1926, 12 West 8th Street, New York City.

DEWING, T(HOMAS) W(ILMER).
Painter. Born Boston, May 4, 1851. Pupil of Boulanger and Lefebvre in Paris. Member: ANA, 1887, NA, 1888; Ten American Painters; Nat. Inst. A. L. Specialty, small figures. Awards: Clarke prize, NAD, 1887; silver medal, Paris Exp., 1889; gold medal, Pan-Am. Exp., Buffalo, 1901; gold medal, St. Louis Exp., 1904; gold medal, International Exp., Munich, 1905; Lippincott prize, PAFA, 1906; first medal, C.I. Pittsburgh, 1908. Work: "Summer," Nat. Gal., Wash; twenty-two oil paintings, two screens,

silver point, a pastel, Freer Collection, National Gallery, Wash., D.C.; "The Recitation," and "Lady in Green and Gray," Art Inst., Chicago; "The Letter," "Tobit and the Angel," and "Girl at Desk," Metropolitan Mus., New York; "Lady with a Mask," Corcoran Gal., Wash., DC; "Writing a Letter," Toledo Mus.; "Lady with a Macaw," Fine Arts Acad., Buffalo; "Lady in Gold," Brooklyn Inst. Museum; "Lady in Gray," RI School of Design, Providence; "Lady in Yellow," "Lady in Green," and "Lady with Lute," City Art Museum, St. Louis; "Lady in Black and Rose," Carnegie Inst., Pittsburgh; "A Musician," Luxembourg Museum, Paris. Died on Nov. 5, 1938 in NYC. Address in 1929, 12 West 8th Street, New York, NY.

DeWITT, JEROME PENNINGTON.
Painter, illustrator, craftsman, lecturer, and teacher. Born Newark, NJ, May 27, 1885. Pupil of G. A. Williams; G. Lunger; Pratt Inst. under Prellwitz, Beck, Moschcowitz and Paddock. Member: Art Centre of the Oranges. Instructor, Fawcett Art School, Newark, NJ; Hunter College, NY; Newark College of Technology; Berkshire Summer School of Art; Cartaret Academy, Orange, NJ. Address in 1929, Van Dyck Studios, 939 8th Ave., Cor. 56th St., New York, NY; h. 94 Berkeley Ave., Bloomfield, NJ.

DeWOLF, WALLACE L.
Painter, etcher, and writer. Born Chicago, IL, on Feb. 24, 1854. Self-taught. Member: AIC; Chicago SA; Municipal A. Lg.; Chicago SE; Calif. AC; Calif PM; Chicago Art Commission; Chicago PS; Los Angeles PS; Pasadena SA; AFA. Work: "Lake Louise," Springfield Art Assoc.; "Coast Scene, Santa Barbara," Union League Club, Chicago; "Hermit Range," Glacier, B. C. South Park Commission; "Mojave Desert" and "Among the Redwoods," Art Inst. of Chicago. Represented in Vanderpoel AA. Collection, Chicago. Address in 1929, 105 West Monroe St., Chicago, IL. Died in 1930.

DEXTER, HENRY.
Sculptor. Born in Nelson, New York, October 11, 1806. Self-taught. Among his portrait busts are those of Charles Dickens, Longfellow, Agassiz, Henry Wilson, and Anson Burlingame. His statues include "The Backwoodsman," "The Cushing Children," "Gen'l. Jos. Warren at Bunker Hill," and "Nymph of the Ocean." Exhibited: Boston Athenaeum, 1834. Also executed a series of busts of the governors of the US, 1859-60. Died in Cambridge, MA, June 23, 1876.

DEXTER, MARY L.
Painter. Member: Society Independent Artists. Address in 1926, 526 Astor Street, Milwaukee, WI.

DeYOUNG, H(ARRY) A(NTHONY).
Landscape painter and teacher. Born Chicago, IL, Aug. 5, 1893. Pupil of AIC, F. de Forrest Schook and

John W. Norton; Edward Lake at University of Illinois. Member: Chicago Gal. A.; Chicago PSA; All-Ill. SA; San Antonio AA. Former instructor, Glenwood Sketch classes; National Academy of Art, Chicago, and Midwest Summer School of Art, Coloma, MI; Founder and Director, San Antonio Acad. of Art. Awards: Fine Arts Bldg., Purchase Prize ($500), AIC, 1925; hon. mention, AIC, 1925; members prize ($200), Chicago Gallery of Art, 1927; hon. mention ($100), Davis Comp., San Antonio, Texas, 1929. Represented in Chicago Public Schools. Died in 1956. Address in 1929, Pabst Galleries, 222 Losoya St., San Antonio, Texas.

DeZAYAS, G(EORGE).
Illustrator. Born Mexico City, Mexico, on Nov. 30, 1895. Pupil of Jean Paul Laurens in Paris. Illustrations in *Collier's*, *The Mentor*. Illustrated *Strange Bedfellows* and *How to Get Rid of a Woman*. Address in 1929, 15 West 51st St., New York, NY.

DEZAYAS, MARIUS.
Portrait painter. Exhibited at the "Exhibition of Paintings Showing the Later Tendencies in Art," at the Penna. Academy of Fine Arts, Phila., 1921. Address in 1926, 549 Fifth Ave., New York City.

DHAEMERS, ROBERT AUGUST.
Sculptor. Born in Luverne, MN, November 24, 1926. Studies: California College of Arts and Crafts, B.F.A., 52, M.F.A., 54. Work: First Christ Lutheran Church, Burlingame, CA; Mills College; others. Commissions: Jerry's Restaurant, San Leandro, CA; First Lutheran Church; science complex, Mills College; Holy Cross Hospital, San Fernando, CA; others. Exhibitions: New York Museum of Contemporary Crafts; Addison Gallery of Amercian Art, Andover, MA; De Young Museum, San Francisco, CA; Brigham Young University; Civic Art Gallery, San Jose; etc. Awards: Gold medal, sculpture, Oakland Museum of Art; first prize, metal work, California State Fair; Mills College faculty research grant. Teaching: Mills College, Oakland, CA, 1957-1980. Member: Western Association Schools & Colleges; Accrediting Commission Senior Colleges & Universities; others. Media: Metal, stainless steel, galvanized painted steel; etching, lithography, silk screen. Address in 1982, Oakland, CA.

Di BONA, ANTHONY.
Sculptor. Born Quincy, MA, on October 11, 1896. Pupil of Philip L. Hale, Charles Grafly, L. P. Thompson, Bela Pratt, and School of the Museum of Fine Arts, Boston; also American Academy of Rome and Paris. Member: Boston Art Club and Boston Sculpture Society; Gloucester Society of Artists; North Shore Art Association. Work: Portrait of Thomas Allen, School of the Boston Museum of Fine Arts; Fountain, War Memorial, Woburn, Massachusetts. Address in 1935, Trudeau, NY. Died in 1951.

Di MEO, DOMINICK.
Sculptor and painter. Born February 1, 1927, in Niagara Falls, New York. B.F.A. from Art Institute of Chicago; M.F.A. from University of Iowa (1953). Awarded Guggenheim Memorial Foundation Fellowship in Graphics, 1972-73. In collections of Whitney; University of Mass., Amherst; Art Institute of Chicago; others. Exhibited at Albright-Knox, Buffalo, New York; Art Institute of Chicago; Whitney Museum; International Drawing Competition, Barcelona; and others. Award: Guggenheim Memorial Foundation Fellowship for Graphics, 1972-73. Address in 1982, 429 Broome St., NYC.

Di SPIRITO, HENRY.
Sculptor. Born in Castleforte, Italy, July 2, 1898. Studied: Munson-Williams-Proctor Institute and with Richard Davis. Awards: Prize, Cooperstown Art Association, 1947, 48, 50, 51. Work: Munson-Williams-Proctor Institute; Sherburne (NY) Public Library; Addison Gallery of American Art, Andover, MA. Exhibited: Whitney Museum of Art, 1951; Art Institute of Chicago, 1951; Museum of Modern Art, 1951; Sculpture Center, 1949; Cortland State Fair, 1948; Cooperstown Art Association, 1947-52; Albany Institute of History and Art, 1951; St. Lawrence University, 1952; Addison Gallery of American Art, Andover, 1952; one-man: Colgate University, 1947; Munson-Williams-Proctor Institute, 1949; Cazenovia Jr. College, 1949; Sherburne Public Library, 1950. Address in 1953, Utica, NY.

Di SUVERO, MARK.
Sculptor and painter. Born in Shanghai, China. Studied at University of California. In collections of Wadsworth Atheneum; New York University. Exhibited at Art Institute of Chicago; Peace Tower, Los Angeles; American Sculpture of the Sixties, Los Angeles County Museum; Whitney; San Francisco Museum of Art; 20th National Print Exhibition; etc. Received Longview Foundation Grant; Walter K. Gutman Foundation Grant; Art Institute of Chicago Award. Address in 1982, 195 Front St., NYC.

Di VALENTIN, LOUIS.
Sculptor and painter. Born in Venice, Italy, November 21, 1908. Studied: California School of Fine Arts; Corcoran School of Art; Art Students League; and in Italy. Award: Prize, National Academy of Design. Work: Catholic University, National Cathedral, St. Matthews, all in Washington, DC. Exhibited: Corcoran Gallery of Art, 1945; Carnegie Institute, 1942-45; National Academy of Design, 1942-45; Toledo Museum of Art, 1943-45; Springfield (Mass.) Museum of Art, 1943-45; Cambridge, Mass., 1944, 45. Address in 1953, 74 East Locust Avenue, White Plains, NY.

DIAMOND, HARRY O.
Illustrator. Born in Los Angeles in 1913. He attended Los Angeles City College in 1932 and 1933 and

Chouinard Art Inst. in 1934 and 1935. He has received numerous awards as both illustrator and art director. His first published illustration was done for *Westways* magazine in Los Angeles in 1932 and he is presently the art director at Exxon Corporation.

DIAMONDSTEIN, DAVID.
Painter, illustrator, craftsman, and writer. Born in Kurenitz, Vilna Province, Russia, on April 14, 1883. Pupil of Robert Henri, Jerome Myers, Sigismund de Ivanowsky. Member: S. Indp. A. Author of "Spirits of the Storm and other Poems." Address in 1929, 2347 Pitkin Ave., Brooklyn, NY.

DIBBLE, THOMAS (REILLY) (JR).
Engraver. Born Haddonfield, NJ, April 19, 1898. Pupil of Van Deering Perrine. Member: Palisade AA; AFA. Address in 1929, 4 Dean St.; h. 25 East Demarest Ave., Englewood, NJ.

DICK, ALEXANDER L.
Engraver. Born in Scotland about 1805. He was a pupil of Robert Scott, a reputable engraver of Edinburgh; he came to the US in 1833 and in time established an extensive engraving business in New York City. He employed many engravers, and since all plates issued from his business bore his name, it is practically impossible to identify his individual work.

DICK, GEORGE.
Sculptor and painter. Born in Manitowoc, WI, 1916; moved to Albuquerque, NM, 1947. Studied at University of Michigan, forestry, 1939; University of New Mexico, M.F.A., 1950 (with Randall Davey, Kenneth Adams). Worked for US Wildlife Service and travelled extensively in the West. Work published in magazines such as *Arizona Highways, Saturday Evening Post, New Mexico Stockman*; on Christmas cards. Exhibited nationally. Represented by Woodrow Wilson Fine Arts, Santa Fe, NM. Specialty was wildlife and Western subjects. Bibliography, *Western Painting Today*, Hassvick; *Cowboys in Art*, Ainsworth. Died in 1978 in Albuquerque, NM.

DICK, JAMES T.
Artist. Born in 1834 and died 1868. He was the son of A. L. Dick, the engraver. James T. Dick was one of the originators of the Brooklyn Art School and founder of the Academy of Design. Among his best efforts are "Cooling Off," "Leap Frog," and "At Mischief."

DICKERSON, GRACE LESLIE.
Sculptor and painter. Born in Fort Wayne, IN, August 27, 1911. Studied: Ft. Wayne Art School; Art Institute of Chicago; and with Guy Pene duBois. Member: Indiana Art Club; Hoosier Salon. Awards: Prizes, Ft. Wayne Museum, 1938, 40, 44; Indiana State Fair, 1940, 46; Hon. degree, B.A., Wayne

University, 1950. Work: Cathedrals in Ft. Wayne, Evansville, South Bend, IN. Exhibited: Women's National Exhibition, Cincinnati, Ohio, 1933; Hoosier Salon, 1936, 38, 40, 46; Herron Art Institute, 1938, 39, 41, 44; Ft. Wayne Museum, 1938-46; Indiana Artists, 1939-45; one-woman: Canterbury College, Danville, IN; Civic Theatre, Ft. Wayne. Address in 1953, Fort Wayne, IN.

DICKEY, DAN.
Sculptor, painter, and teacher. Born in New York, NY, March 17, 1910. Studied: Carleton College, B.A.; Nat. Academy of Design; Art Students League; and with Kroll, Covey, Bridgman, Hofmann. Member: San Diego Art Guild. Awards: Prizes, San Diego Fine Art Society, 1937, 38; San Diego Art Guild, 1945. Work: San Diego Fine Art Society; Otis Art Institute; Carville (La.) Marine Hospital. Exhibited: Cincinnati Museum Assoc., 1936; San Francisco Museum of Art, 1938, 39; Oakland Art Gallery, 1937, 38, 42; National Gallery of Art, Washington, 1941; San Diego Fine Art Society, 1937, 40, 41; Los Angeles Museum of Art, 1938, 1945; San Diego Art Guild, 1940-46; Los Angeles Art Association, 1941, 46. Address in 1953, San Diego, CA.

DICKEY, ROBERT (LIVINGSTON).
Illustrator. Born Marshall, MI, on May 27, 1861. Pupil of J. Francis Smith and AIC. Member: SI; The Players. Creator of "Mr. and Mrs. Bean" in *Saturday Evening Post*, "Buddie and His Friends," Metropolitan Newspaper Service. Address in 1929, Hotel Chelsea, 222 West 23rd St., New York, NY; winter, St. Petersburg, Florida. Died in 1944.

DICKINSON, ANSON.
Portrait painter in oils and miniatures. Born Litchfield, CT, in 1780. He was a brother of the artist Daniel Dickinson. In 1811 he was considered the best miniature painter in New York; in 1818 he went to Canada, and in 1840 settled in New Haven, CT. He worked for a time in Boston. He died in 1852 at New Haven, CT.

DICKINSON, DAISY OLIVIA.
Sculptor, painter, craftsman, and lecturer. Born June 3, 1903, in Bellingham, Washington. Studied at Chouinard Art Institute; Santa Barbara School of Fine Arts; and with Chamberlin, MacDonald-Wright, and Fletcher. Award: Los Angeles County Fair, 1941. Exhibited: Los Angeles Museum of Art, 1929, 33, 39, 40; California State Fair, 1930, 31, 34; Pasadena Art Institute, 1930, 31. Instructor of Drawing and Painting, Children's Class, Santa Barbara (Calif.) School of Fine Arts. Address in 1953, La Crescenta, CA.

DICKINSON, DANIEL.
Painter. Born in 1795 and died after 1840. He was a portrait painter in oils and miniatures and was a contemporary of Jocelyn in New Haven, CT. He moved to Philadelphia in 1820 and in 1830 he started painting in oils. He was a brother of Anson Dickinson. He exhibited six miniatures at the Penna. Academy, 1827-1831, several being after paintings of Sully.

DICKINSON, EDWIN W.
Painter and teacher. Born in Seneca Falls, NY, on Oct. 11, 1891. Pupil of DuMond, Chase, Hawthorne. Address in 1929, 46 Pearl St., Provincetown, MA.

DICKINSON, PRESTON.
Painter. Born NY, 1891. Pupil of ASL of NY. Award: Bronze medal, Sesqui-Centennial Expo., Phila., 1926. Represented in Museum of Art, Cleveland, Ohio; Brooklyn Museum; Albright Gallery, Buffalo, NY; Fogg Museum, Cambridge, MA; Omaha; Hartford; Phillips Memorial Gallery, Washington, DC. Died in 1930 in Spain. Address in 1929, care of Daniel Gallery, 600 Madison Ave., New York, NY.

DICKINSON, SIDNEY E(DWARD).
Painter. Born Wallingford, CT, on Nov. 28, 1890. Pupil of Bridgman, Volk and Chase. Member: NA; NAC; Century C; Allied AA. Awards: Third Hallgarten prize, NAD, 1917; Philadelphia prize, PAFA, 1923; popular prize, Corcoran Gallery, Washington, DC., 1924; Carol Beck gold medal, PAFA, 1924; first Hallgarten prize, NAD, 1924. Work: "Self Portrait," Corcoran Gallery, Washington; "Unrest," Chicago Art Inst.; "The Young Painter," "The Black Cape," City Art Museum, St. Louis; Portrait of the Artists, Houston Museum, Houston, TX. Instructor, ASL of NY, 1920-21; NAD Art Schools, 1928. Address in 1929, 78 West 55th Street, New York, NY.

DICKMAN, CHARLES J(OHN).
Painter. Born Demmin, Germany, on May 14, 1863. Pupil of Laurens and Constant in Paris. Member: San F. AA. Mural decoration in Syndicate Bldg., Oakland, Calif.; mural decoration, Steamship Co. Offices, San Francisco, CA. Address in 1929, 628 Montgomery St.; h. Bohemian Club, Post and Taylor Sts., San Francisco, CA. Died in 1943.

DICKSON, H. E.
Painter. Exhibited water colors at the Annual Exhibition of Water Colors at the Penna. Academy, Philadelphia, 1925. Address in 1926, Pugh Street, State College, PA.

DIEBENKORN, RICHARD.
Painter. Born in Portland, OR, April 22, 1922. Studied at Stanford Univ., 1940-43; Univ. of California, 1943-44; California School of Fine Arts, 1946; Univ. of New Mexico, M.A., 1952. Exhibited five times at the Whitney Museum of American Art, 1955-70; one-man shows inc. the DeYoung Memorial Musuem, in San Francisco, 1963; Jewish Museum,

1965; and the Los Angeles County Museum, Los Angeles, 1969 and 72; Venice Biennale, 1968; 20th National Print Exhibit, 1977; plus numerous others. Awards: Albert M. Bender fellowship, 1946; gold medal, PAFA, 1968; Purchase prize, Olivet College, 1968. Member: American Academy of Arts and Letters. Early work, realism; later work, abstract expressionism, such as "Woman in a Window," 1957, at the Albright-Knox Art Gal., Buffalo, New York. Authored a book on drawing in 1965. Address in 1982, c/o Knoedler Gallery, 19 East 70th Street, NYC.

DIEDERICH, (WILHELM) HUNT.
Sculptor. Born in Hungary on May 3, 1884. Studied sculpture in Philadelphia, PA, Rome, and Paris. Member: Salon d' Automne, Paris, and Salon des Tuileries. Exhibited at National Sculpture Society, 1923. Award: Gold medal, Architectural League, pottery, 1927. Specialty, animals and figurines for monuments. Address in 1933, c/o Milch Gallery, 108 West 57th St., New York, NY; summer, Cagues A. M. France; Burgthaun, Bavaria, Germany.

DIEDRICKSEN, THEODORE.
Etcher and illustrator. Born New Haven, on may 30, 1884. Pupil of Yale School of Fine Arts; Baschet and Gervais in Paris. Member: New Haven PCC. Instructor in drawing, Yale School of Fine Arts, New Haven, CT. Address in 1929, 24 Wilkins Street, Hamden, CT.

DIELMAN, ERNEST BENHAM.
Painter. Born New York City, 1893. Pupil of Volk. Address in 1926, 154 West 55th Street, New York City, NY.

DIELMAN, FREDERICK.
Painter, illustrator, craftsman, etcher, and teacher. Born Hanover, Germany, on Dec. 25, 1847; came to the US in childhood. Pupil of Diez at the Royal Academy in Munich. Member: ANA, 1881, NA, 1883; AWCS; SAA, 1905; SI (hon.), 1910; Mural P.; Nat. Inst. AL; Century Assoc.; Salma. C (hon.); Pres. NAD, 1899-1910; Pres. Fine Arts Fed. of NY, 1910 to 1915. Professor of Art in the College of the City of NY, 1903-18. Director, Art Schools of Cooper Union. Work: Two mosaic panels, "Law," "History," Library of Congress, Washington, DC; mosaic panel, "Thrift," Albany (NY) Savings Bank; six mosaics in Iowa Capitol, Des Moines; seven paintings, "Star" Office, State Washington, DC. Died in 1935. Address in 1929, 41 West 10th St., New York, NY; h. Ridgefield, CT.

DIEMAN, CLARE SORENSEN.
Sculptor. Born Indianapolis, IN. Pupil of Art Institute of Chicago; Columbia University; and architects in architectonic sculpture; forty-five models, Denver National Bank; models for Gulf

Building, Houston, Texas. Exhibited: Art Institute of chicago, 1917; Penna. Academy of Fine Arts, 1943, 45; National Association of Women Artists, 1945, 46; others. Member: National Association of Women Artists; Phila. Art Alliance; Sante Fe Painters and Sculptors. Taught: Shipley School for Girls, Bryn Mawr, PA. Address in 1953, 205 East 19th St., NYC.

DIENES, SARI.
Sculptor, painter, and teacher. Born in Debreen, Hungary, October 8, 1898. US citizen. Studied: Ozenfant School of Art, London, England; and with Andre L'Hote, Fernand Leger, in Paris; Henry Moore, in London. Work: Brooklyn Museum; Museum of Modern Art Print Collection; numerous commissions including stage sets and costume designs. Exhibited: Mortimer Brandt Gallery; Norlyst Gallery; Vendome Gallery; New School for Social Research, 1942, 75; Bronx Museum of Art, 1975; Heckscher Museum, 1979; many others. Taught: Assistant Director, Ozenfant School, 1936-41; Instructor, Parsons School of Design, NYC; Director, Sari Dienes Studio, NYC. Received American Federation of Art Grant, 1971; Rothko Foundation Grant; International Women's Year Award, 1976. Address in 1980, Stony Point, NY.

DIERINGER, ERNEST.
Painter. Born July 6, 1932, in Chicago, IL. Studied at Art Inst. of Chicago on Nat. Scholastic Scholarship, 1950-54. Taught at Hyde Park Center, 1958. Work: Montana Hist. Society. Exhibited: Wells St. Gallery, Chicago, 1959; Art Gallery in Toronto; Art Inst. of Chicago; L. A. County Museum.

DIETERICH, LOUIS P.
Portrait painter. Born in Germany, 1842. Address in 1926, 347 North Charles Street, Baltimore, MD.

DIETERICH, WALDEMAR F(RANKLIN).
Portrait painter, illustrator, and teacher. Born Baltimore, MD, November 10, 1876. Pupil of Constant, L'Hermite and Laurens in Paris. Member: Charcoal C., Baltimore; ASL of NY. Instructor, Maryland Inst., Baltimore. Address in 1929, 347 North Charles Street, Baltimore, MD.

DIETRICH, GEORGE ADAMS.
Sculptor, painter, illustrator, and teacher. Born Clark County, IN, April 26, 1905. Pupil of Charlotte R. Partridge, Garolomo Picolli, Viola Norman; Layton School of Art; Art Institute of Chicago. Member: Wisconsin Painters and Sculptors; Hoosier Salon. Awards: Culver Military Academy prize ($200), Hoosier Salon, 1927; Clement Studebaker water color prize ($100), Hoosier Salon and the Currie Monon prize ($100), Hoosier Salon, 1928; Milwaukee Art Inst. Medal and $50 for sculpture, Wisconsin Painters and Sculptors, 1929. Exhibited: Art Institute of Chicago, 1928, 30, 31; Hoosier Salon,

1927-32; Penna. Academy of Fine Arts, 1929-30. Head of sculpture department, Layton School of Art, 1929-37. Taught: Professor, Sculpture and Painting, University of Michigan, 1937-38. Address in 1953, Milwaukee, WI.

DIETSCH, CLARENCE PERCIVAL.
Sculptor and painter. Born in NYC on May 23, 1881. Studied at New York School of Art; American Academy in Rome; and with William M. Chase, Beckwith, Attilto Piccirilli. Member: Alumni, American Academy in Rome; National Sculpture Society, 1910; NY Architectural League, 1911. Awards: Rinehart Scholarship in sculpture, American Academy in Rome, 1906-1909; honorable mention, P.-P. Exposition, San Francisco, 1915. Work: Besso Memorial Monument in Rome; panels for Rice Institute, Houston, Texas; "Athlete," Peabody Inst. Baltimore. Exhibited: Penna. Academy of Fine Arts, 1907; American Academy in Rome, 1906-10; National Academy of Design. Address in 1953, Palm Beach, FL. Died in 1961.

DiFLIPPO, ANTONIO.
Sculptor. Exhibited at the PAFA, Philadelphia, in 1924. Address in 1926, 126 East 75th Street, New York.

DIGGS, ARTHUR.
Painter. Born Columbia, MO, on Nov. 16, 1888. Pupil of AIC. Member: Chicago AL. Award: James Mac Veagh prize, Chicago AL. Address in 1929, 1239 West 109th St., Chicago, IL.

DILLAWAY, THEODORE M.
Painter, writer, lecturer, and teacher. Born Somerville, MA, in 1874. Pupil of MA NAS; Delacluse Acad., Paris. Member: Phila. Sketch C; Phila. Alliance; EAA; AFA. Works: "Autumn in the Fells" and "Spring in the Fells," O. W. Holmes School, Boston; "Bald Mt., N.H.," John Story Jenks School, Phila.; "Spring Blossoms," Hackett School, Phila.; "Boothbay Harbor Scene," LaFrance Inst., Phila. Author: *Decoration of School and Home*, Milton Bradley Co.; *American Renaissance Craft and Picture Texts for Teachers*, Brown Robertson Co. Director of Art, Philadelphia Public Schools. Address in 1929, Dept. of Art Education, Grant Bldg., 17th and Pine Sts., Philadelphia, PA; h. 332 Wellsley Road, Mt. Airy, Philadelphia; summer, Acad. of Fine Arts Country School, Chester Springs, PA.

DILLAYE, BLANCHE.
Painter, illustrator, and etcher. Born Syracuse, NY. Pupil of PAFA; etching under Stephen Parrish; painting under Garrido in Paris. Member: NYWCC; Phila. WCC; Fellowship PAFA; Plastic C.; NA Women PS; Phila. AC. Awards: Silver medal for etching, Atlanta Exp., 1895; silver medal, AAS, 1902; silver medal for etchings, International Exp.,

at Lorient, France, 1903; gold medal for water color, Conservation Exp., Knoxville, TN, 1913. Work: "Still Evening in the Little Street," W. C. Art Collection, Univ. of Syracuse, NY; "Arrangement in Green" (oil), Syracuse Museum of Fine Arts. Address in 1929, 24 South 17th St., Philadelphia, PA.

DILLON, FRANK H.
Painter. Born Evanston, IL, on Oct. 11, 1886. Pupil Art Inst., Chicago. Member: GFLA. Address in 1929, 180 N. Michigan Ave., Chicago, IL; h. 1108 Spruce St., Winnetka, IL; summer, Glen Haven, MI.

DILLON, LEO AND DIANE.
Illustrators. Born in the same year, 1933, Leo in NY and Diane in CA, they studied together at PSD and SVA in NY under John Groth and Leo Leonni. As a team they have illustrated many children's books, including *The Hundred Penny Box*, 1974, *Why Mosquitoes Buzz in People's Ears*, 1975 and *Ashante to Zulu*, 1976. Their illustrations have appeared in *Ladies Home Journal*, *The Saturday Evening Post* and others. Their work has been exhibited at Gallery 91 in Brooklyn, and they often travel to schools on the East Coast as guest speakers.

D'IMPERIO, DOMINIC.
Sculptor. Born in Italy on August 31, 1888. Pupil of Grafly and Leasoly. Member: Penna. Academy of Fine Arts; Philadelphia Alliance. Award: Bronze medal, Spring Garden Institute, 1916. Work: "Sinclair Memorial," Church of St. James, Phila.; "Pan," Graphic Sketch Club, Philadelphia. Address in 1929, Philadelphia, PA.

DINE, JAMES.
Sculptor and painter. Born in Cincinnati, OH, June 16, 1935. Studied: Univ. of Cincinnati; Boston Mus. School. Work: The Museum of Modern Art, NYC; Tate Gallery, London; Stedelijk Museum, Amsterdam; Whitney, NYC; Albright-Knox, Buffalo, NY. Exhibitions: Guggenheim, NYC, 1963; Venice Biennial, 1964; Whitney Museum, NYC, 1966; Milwaukee Art Center, 1979; many more. Awards: Norman Harris silver medal & prize, Art Institute of Chicago, 1964. Teaching: Visiting professor, Oberlin College, 1965; Cornell University, 1967. Address in 1982, c/o The Pace Gallery, NYC.

DINNEEN, ALICE.
Painter. Born in New York City in 1908. Studied: New York School Applied Design for Women; Art Students League; with Furlong. Collections: Carville, Louisiana; La Fortaliza, San Juan, PR; NY Hospital; mural, US Post Office, Warrenton, NC; Corbin, Kentucky; Dept. of Labor, Washington, DC.

DINNERSTEIN, HARVEY.
Illustrator. Born in Brooklyn, NY, in 1928. He attended Tyler Art School of Temple University for

four years. His first illustration to be published was for a medical advertisement, followed by many assignments for advertising and editorial clients. He has illustrated several books, including *Tales of Sherlock Holmes*, *Remember the Day* and *At the North Wind*. Since 1946, when he won the Conde Nast Award, he has received numerous awards and his paintings are in the collections of major museums and universities throughout the United States.

DIRK, NATHANIEL.
Painter. Born Brooklyn, NY, on Dec. 21, 1895. Pupil of Max Weber, Kenneth H. Miller, Boardman Robinson. Member: S. Indp. A.; ASL of NY. Died in 1961. Address in 1929, 15 East 14th St., New York, NY.

DISMUKES, ADOLYN GALE.
(Mrs. George). Sculptor, painter, writer. Born in Memphis, TN, May 14, 1865. Studied: Bethany Col. Specialized in tropical and Arctic landscapes. Author: "A Norse Idyll." Contributor to newspapers and magazines. Awards: Honorable mention, Tenth Annual Exhibition of Tennessee Artists, Nashville, 1928; second and third prizes, Mississippi Art Association, 1929. Address in 1953, Biloxi, Miss.

DISMUKES, MARY ETHEL.
Painter, craftsman, writer, and lecturer. Born Pulaski, TN. Pupil of ASL of NY; Twachtman, Kenyon Cox, Loeb and Carleton. Member: New Orleans AA; Miss. AA; Gulf Coast AA; Nashville AA; SSAL; New Orleans ACC. Awards: First Nat'l Bank of Biloxi gold medal, Gulf Coast AA, 1927; first prize for painting of place of historic interest in MI, first and second prizes for pictorial photography and second prize for flower study, State Fed. of Women's Clubs, Jackson, 1927; first prize, State Fair, Jackson, 1926; first prize, Guild Coast Fair, Gulfport, 1926; prizes at District and State Convention, M.F.W.C., for most popular picture and best colored photographs. Died in 1952. Address in 1929, 113 Lameuse St., Biloxi, MI.

DIX, CHARLES T.
Artist. Born in Albany in 1838, died in Rome 1873. Served on his father's staff in the Civil War. Later he won a name for his marine and landscape painting. In 1866-67 he exhibited at the Royal Academy, London. His "Sunset at Capri" is a spirited study of sea and shore.

DIX, EUABEE.
(Mrs. Alfred Le Roy Becker). Miniature painter. Born Greenfield, IL, on Oct. 5, 1879. Pupil of St. Louis School of Fine Arts. Studied in NY, London and Paris. Member: Penna. S. Min. P.; A. S. Min. P.; NA Women PS. Address in 1929, 58 West 57th St., New York, NY; care of Morgan and Co., 14 Place Vendome, Paris, France.

DIXEY, GEORGE.
Sculptor. Son of John Dixey, an Irish-American sculptor; was born in Philadelphia and studied under his father. He executed "Theseus Finding his Father's Sword," "Saint Paul in the Island of Malta," and "Theseus and the Wild Boar." Exhibited at the American Academy, 1817-20; Penna. Academy, 1818. Followed in his father's gilding and carving business, 1821-32. Died c. 1854.

DIXEY, JOHN.
Sculptor. Born in Dublin, Ireland, c. 1760-1770; settled in Philadelphia towards the close of the eighteenth century. Studied: Royal Academy; Italy, 1789. Did some modeling and stone cutting. Noted works: "Hercules and Hydra;" "Ganymede;" the figures of "Justice" on the NYC Hall and the Albany State House; bust of Alexander Hamilton. Exhibited at Royal Academy, 1788; American Academy; and Penna. Academy. Died in 1820.

DIXEY, JOHN V.
Sculptor and painter. The youngest son of the Irish-American sculptor John Dixey. He was born in Philadelphia and received instruction from his father. In 1819 he modeled "St. John writing the Revelations." Gave up sculpture after 1827. He painted several landscapes in oil that were exhibited at the gallery of the National Academy of Design, the Apollo Association, and the American Academy.

DIXON, FRANCIS S(TILLWELL).
Painter. Born in New York City on Sept. 18, 1879. Pupil of ASL of NY. Member: Allied AA; CT AFA; Salma. C. Work: "The Leaning Tree," Morgan Memorial, Hartford, CT. Died in 1962. Address in 1929, 241 Franklin Place, Flushing, NY.

DIXON, MABEL E(ASTMAN).
Painter. Born Auburn, IA. Pupil of Arthur W. Dow, Andre Strauss. Member: Iowa AC. Work: "The Viaduct, Moret," Fontainebleau Museum, Fontainebleau, France. Address in 1929, 4330 Harwood Drive, Des Moines, IA.

DIXON, MAYNARD.
Mural painter and illustrator. Born Fresno. CA, Jan. 24, 1875. Self taught. Member: San F. AA; Bohemian C.; Southwest Soc.; Painters of the West; Club Beaux Arts; Chicago Gal. A; Commonwealth C; Oakland AL. Specialty, Western life and scenes. Work: Decorations for dining salons *SS Silver State* and *SS Sierra*; murals for "Room of the Dons," Mark Hopkins Hotel, San Francisco (Frank van Sloun collaborating); mural, Technical HS, Oakland, CA; panel, "India," Oakland Theatre; So. Wall Main Reading Rm., CA State Lib., Sacramento; "Legends of Earth and Sun," dining room, Arizona Biltmore, Phoenix, Ariz. Died Nov., 1946. Address in 1929, 728 Montgomery St.; h. 1637 Taylor St., San Francisco, CA.

DOBLER, MAUD A.

(Mrs. George Dobler). Painter and teacher. Born Rockford, IL, on Feb. 3, 1885. Pupil of Marquis E. Reitzel, Carl Krafft, and H. A. Oberteuffer. Member: Rockford AA; Austin, Oak Park and River Forest AL; Illinois AFA; All-Ill. SFA. Award: First hon. mention, Rockford Art Assoc., 1929. Address in 1929, 1507 Harlem Blvd., Rockford, IL.

DOBSON, MARGARET (ANNA).

Painter and teacher. Born Baltimore, MD, on Nov. 9, 1888. Pupil of PAFA under Weir, Vonnoh, Breckenridge, Garber, Pearson, and Cecilia Beaux; Baudouin and St. Hubert in fresco decoration. Member: Md. Inst. Alumni A.; Provincetown AA. Represented in Mississippi Art Collection and Syracuse Art Museum; fresco decoration in Hospital of St. Vincent de Paul at Fontainebleau, and in the Fontainebleau Palace, France.

DODD, MARK DIXON.

Painter and etcher. Born in St. Louis, MO, 1888. Pupil of Art Students League of New York. Address in 1926, 106 Columbus Heights, Brooklyn, NY.

DODD, SAMUEL.

Engraver. Born in Bloomfield, NJ, 1797; he died in Aug. 7, 1862. He was little known. The only signed plate of Samuel Dodd is a portrait of "Washington in Uniform" (Hart, 690) signed "S. Dodd Set. New Ark." The plate was probably engraved about 1820.

DODGE, CHARLES J.

Sculptor. Born in NYC, 1806. Began as a figurehead and ship carver in 1828, working for his father Jeremiah Dodge. His first known work is a bust of his father in pine, painted white, donated to the New York Historical Society in 1952. He carved a head for the damaged head of President Andrew Jackson for the frigate *Constitution*. Continued independently as a carver, setting up his studio on South Street; later incorporated his father's carving business after his death in 1860. Attributed wood sculptures of larger than life "Jim Crow," in the Shelburne Museum, Vermont, and a seated Indian figure used at a cigar store. Indian now in the Long Island Historical Society. Gave up sculpture in 1874; died twelve years later, in 1886.

DODGE, CHESTER L.

Painter and illustrator. Born Salem, ME, on May 21, 1880. Studied at RI School of Design and ASL of NY. Member: Providence AC; Providence WCC. Instructor at RI School of Design. Address in 1929, The Fleur-de-Lys, 7 Thomas St.; h. 29 Waterman St., Providence, RI.

DODGE, FRANCES F.

(Mrs. A. C. Dodge). Landscape painter and etcher. Born Lansing, MI, Nov. 22, 1878. Pupil of Duveneck, Meakin, Wessel, Joseph Pennell. Member: NA Women PS; Chic. So. Side AA; Cincinnati Woman's AC. Address in 1929, 5844 Stoney Island Ave., Chicago, IL.

DODGE, JEREMIAH.

Sculptor. Born in 1781. Worked in NYC as a ship and figurehead carver. He studied ship carving with Simeon Skillin, 1798; partner from 1806-1811. Formed a partnership with Cornelius N. Sharpe, from 1815-1828. Later took into the partnership his son, Charles J. Dodge, with whom he worked until 1838. Known works: "Hercules" for the U.S.S. *Ohio*, 1820; heads for the *Lexington* and the *Vincennes*, 1825; and the well-known "Andrew Jackson" for the U.S.S. *Constitution*, 1835. Died in 1860.

DODGE, JOHN WOOD.

Miniature painter. Born on Nov. 4, 1807 and died on Dec. 16, 1893. His portrait miniature of General Jackson executed in 1842 was engraved for the postage stamp of 1863. He was elected an associate member of the National Academy of Design in 1832.

DODGE, OZIAS.

Painter and etcher. Born in Morristown, VT, in 1868. Pupil of Yale School of Fine Arts and under Gerome in Paris. Represented by etchings in Congressional Library, Art Institute Chicago, and New York Public Library. He died in 1925.

DODGE, W. DeLEFTWICH.

Mural painter. Born Liberty, VA, on March 9, 1867. Studied in Munich and with Gerome in Paris. Member: Mural P. Award: Gold medal, Prize Fund Exhib., NY, 1886; third medal, Paris Exp., 1889; medal, Columbian Exp., Chicago, 1893. Work: Majestic Theatre, Boston; Empire Theatre, NY; Academy of Music, Brooklyn; Orpheum Theatre, Kansas City, MO; hotels Astor, Algonquin, Devon and Waldorf-Astoria, NY; "Ambition," ceiling in Library of Congress, Wash.; Mosaics, Hall of Records, NY; mural paintings, Panama-Pacific Exp., San Francisco, 1915; 5 mural paintings, Teachers Col., Cedar Falls, IA; 21 mural paintings, Flag Room, Albany, NY; Memorial panel, Kenosha Co. Court House, Wis. Died in 1935. Address in 1929, 52 West 9th Street, New York, NY.

DODSON, RICHARD W.

Engraver. Born in Cambridge, MD, Feb. 5, 1812; died in Cape May, NJ, 1867. Dodson was an excellent line-engraver of portraits and book-illustrations. He was pupil of the Philadelphia engraver James B. Longacre, and he made some of the best portraits in the National Portrait Gallery, published by Longacre & Herring. Dodson is said to have abandoned engraving for another business in 1845. Died on July 25, 1867.

DODSON, SARAH PAXTON BALL.
Landscape and figure painter. Born in Philadelphia, PA, 1847; died Brighton, England, 1906. Pupil of M. Schussele in Philadelphia; later of Evariste Vital Luminais and Jules Lefebvre in Paris; also criticisms by Boutet de Monvel. Was an exhibitor at the Paris Salon.

DOELGER, FRANK J.
Painter. Member: Society of Independent Artists. Address in 1926, 430 Irving Avenue, Brooklyn, NY.

DOHANOS, STEVAN.
Illustrator and painter. Born in Lorain, OH in 1907. He attended the Cleveland School of Art, after which he embarked on a long, successful career. His first assignment was a watercolor done for *McCall's* in 1934 and within four years he had won the Award for Distinctive Merit from the ADC of NY. From 1943 to 1959, his tightly rendered paintings, usually depicting everyday incidents in small town America, appeared on over 120 covers of *The Saturday Evening Post*. He has also designed 25 United States postage stamps and his artwork is owned by the Whitney Museum in New York City. A founding faculty member of the FAS, he was elected to the S of I's Hall of Fame in 1971. Received awards from the Phila. WCC and ADC. Address in 1982, Westport, CT.

DOHERTY, MRS. LILLIAN C.
Painter. Pupil of Corcoran School of Art, Wash., DC; Rhoda H. Nicholls; C. W. Hawthorne; also studied in Europe. Member: Washington Society of Artists. Address in 1926, 12 Rhode Island Avenue, N.W., Washington, DC.

DOHN, PAULINE.
See Mrs. Pauline Dohn Rudolph.

DOKE, SALLIE GEORGE.
(Mrs. Fred Doke). Painter. Born Keachie, LA. Pupil of Cincinnati Academy and Chicago Academy of Fine Arts. Member: Society of Independent Artists. Award: Gold medal at Dallas, 1916. Address in 1926, Lometa, Texas.

DOLAN, ELIZABETH HONOR.
Painter, illustrator, and teacher. Born in Fort Dodge, IA, on May 20, 1887. Pupil of La Montague; St. Hubert; Paul Baudoin; F. Luis Mora; George Bridgman; Thomas Fogarty. Work: Mural decorations, Morrill Hall, State Museum, Lincoln, NE. Address in 1929, Room 315 Liberty Bldg.; h. 1608 E. St., Lincoln, NE.

DOLE, MARGARET FERNALD.
Painter. Born Melrose, MA, on May 5, 1896. Pupil of School of MFA, Boston; FA Course, Radcliffe Coll.; Charles Woodbury, and Philip L. Hale. Member: Providence AC; AFA. Address in 1929, 133 Prospect St., Providence, RI; summer, Nauset Hghts., Orleans, MA.

DOLE, WILLIAM.
Painter. Born in Angola, IN, Sept. 2, 1917. BA from Olivet College, Mich.; MA from U. of Calif., Berkeley, 1947; studied with Moholy-Nagy and Gyorgy Kepes. Taught at Berkeley; U. of Calif., Santa Barbara, since 1949. In collection of Walker Art Center, Minneapolis; Santa Barbara Mus. of Art; PAFA; Fogg Art Mus., Boston; others. Exhibited at de Young Mus., San Fran.; Staempfli Gallery, NYC, 1974, 76, 78, 80; Hirshhorn Collection, Wash., DC; and others. Received Art Award from Am. Acad. and Inst. of Arts & Letters, 1978. Works in collage. Rep. in NYC, Staempfli Gal.; in Los Angeles, Mekler Gal. Address in 1982, Dept. of Art, Univ. of Calif., Santa Barbara.

DOLINSKY, NATHAN.
Painter and teacher. Born in Russia on Aug. 9, 1889. Pupil of NAD. Member: Salma C.; NY Arch. Lg.; Mural P. Address in 1929, 9 East 12th St., New York, NY; 709 Willoughby Ave., Brooklyn, NY; summer, Hunter, NY.

DOLPH, JOHN HENRY.
Painter. Born on April 18, 1835. Elected a Member of the National Academy in 1898. He died in Sept. 28, 1903. Represented at Penna. Academy of Fine Arts by his portrait of the artist Charles Loring Elliott. His specialty was the painting of cats and dogs.

DOMBECK, BLANCHE M.
Sculptor. Born in New York City in 1914. Studied: Graduate Training School of Teachers; with Zeitlin and Amino. Exhibited: Sculpture Center, New York Sculptors Guild, 1980; Canton Art Institute, Ohio, 1981; St.-Gaudens Memorial, National Historical Site, Cornish, NH, 1981; others. Awards: Fellowship, MacDowell Colony, 1981; others. Collections: Brooklyn Museum; Randolph-Macon Woman's Col. Address in 1982, Hancock, NH.

DOMVILLE, PAUL.
Painter and teacher. Born Hamilton, Canada, on June 16, 1893. Pupil of PAFA; School of Fine Arts, Univ. of PA. Member: Phila. Alliance; T-Square C., Phila.; Mural P.; (assoc.) Arch. L. of NY. Work: Murals in Mutual Trust Company of Phila. Asst. Professor of Drawing, Univ. of Penna. School of Fine Arts. Head of Dept. of Interior Decoration, Phila. School of Design for Women. Address in 1929, 2037 Moravian St., Philadelphia, PA; summer, Woodstock, Ulster Co., NY.

DONAHEY, JAMES H(ARRISON).
Illustrator, craftsman, writer, lecturer, and cartoonist. Born in Westchester, OH, on April 8, 1875. Pupil

of Cleveland School of Art. Member: Cleveland AA. Address in 1929, "Plain Dealer," Cleveland, OH; h. Aurora, OH.

DONAHEY, WILLIAM.
Painter. Born in Westchester, Ohio, 1883. Artist for children's papers, magazines, and books. Died c. 1953. Address in 1926, 2331 Cleveland Avenue, Chicago, IL.

DONAHUE, WILLIAM HOWARD.
Painter. Born in New York City on Dec. 21, 1881. Pupil of Henry R. Poore and E. L. Warner. Member: Brooklyn S. Modern A.; Allied A.; The New York Group; Salma C.; Nanuet PS. Address in 1929, Lyme, CT; 47 Fifth Ave., New York, NY.

DONALDSON, ALICE WILLITS.
Painter, illustrator, and craftsman. Born in Illinois, September 28, 1885. Pupil of Cincinnati Academy; PA Museum School. Member: NYWCC; Alliance; GFLA; American Union Dec. Artists and Craftsmen. Address in 1929, 313 West 20th Street, New York, NY.

DONATI, ENRICO.
Sculptor and painter. Born in Milan, Italy, February 19, 1909; United States citizen. Studied at University of Pavia, Italy; Art Students League, 1940; New School for Social Research. In collections of Albright-Knox Art Gallery, Buffalo, New York; Museum of Modern Art; Whitney; Baltimore Museum; Corning Glass, New York; University of Michigan; others. Exhibited at Carnegie International Exhibits, 1945-61; Museum of Modern Art, 1953-54; Guggenheim, 1954-55; Whitney; Penna. Academy of Fine Arts; Staempfli Gallery, New York City, 1962-80; Grand Palais, Paris, 1980; and others, including museums in Rome, Milan, Brussels, Munich, Sao Paulo. Served on advisory board, Brandeis University; Yale Univ. President's Council on Arts and Architecture; others. Also taught at Yale, 1962-72. Rep. by Staempfli Gallery, New York City. Address in 1982, 222 Central Park South, New York City.

DONATO, GUISEPPE.
Sculptor. Born Maida, Calabria, Italy, on March 14, 1881. Pupil of Philadelphia Industrial Arts School under Grafly and J. Liberty Tadd; Penna. Academy of Fine Arts under Grafly; Ecole des Beaux-Arts; Julian and Colarossi Academies in Paris; and under Auguste Rodin. Member: National Sculpture Society, 1909; NY Architectural League; American Art Association of Paris; Union Internationale des Beaux-Arts et des Lettres; Fellowship Penna. Academy of Fine Arts; American Federation of Arts. Awards: Stewardson scholarship, Penna. Academy of Fine Arts, 1900 (first time awarded). Exhibited at National Sculpture Society, 1923. Work: City Hall, Philadelphia, PA. Died in 1965.

DONDO, MATHURIN M.
Painter, writer, lecturer, and teacher. Born on March 8, 1884. Pupil of Hawthorne, Henri, Bellows, and Schumacher. Member: Berkeley Lg. FA; S. Indp. A. Address in 1929, University of California, Berkeley, CA.

DONELSON, MARY HOOPER.
(Mrs. P. T. Jones). Sculptor. Born in Hermitage, Tennessee, January 3, 1906. Studied at Vanderbilt University; Art Institute of Chicago; and with Emil Zettler, Guy Pene duBois, and Albin Polasek. Works: Tennessee State Capitol; University of Tennessee; Davidson County Court House. Awards: Art Institute of Chicago, 1928; Proctor & Gamble Company, 1928; Public Health Association, 1929. Exhibited: Penna. Academy of Fine Arts, 1931; National Academy of Design, 1938; Art Institute of Chicago, 1930; Southern States Art League, 1934; Nashville Museum of Art, 1945. Address in 1953, Old Hickory, TN.

DONER, MICHELE OKA.
Sculptor. Born in Miami Beach, FL, 1945. Studied: University of Michigan, B.F.A., M.F.A. Collections: Johnson Wax Collection; John Michael Kohler Arts Center, Sheboygan, WI; Steelcase Collection of Contemporary Art; private collections. Exhibitions: Michigan Artists Exhibition, The Detroit Institute of Arts, 1970; All Michigan, The Flint Institute of Arts, 1971; Gertrude Kasle Gallery, Detroit (two-persons), 1971; MacGilman Gallery, Chicago, 1972; John Michael Kohler Arts Center Invitational (Ceramic Sculpture), 1973; Richard Nash Gallery, Seattle, WA, 1974; Works by Michigan Artists, Detroit Institute of Arts, 1974-75. Awards: Dr. and Mrs. Barnett Malbin Prize, 20th Exhibition for Michigan Artists-Craftsmen; Standard Ceramic Company Award, 2nd Invitational Exhibition; Ceramic Award, 2nd Michigan Craftsmen's Council Exhibition. Address in 1975, Franklin, MI.

DONEY, THOMAS.
Engraver. This capital engraver of portraits in mezzotint came to Canada from France, and after working for some time in IL and Ohio, he est. himself in business in NY about 1845. Doney engraved a number of meritorious portrait plates for the *Democratic Review* and other NY and Phila. periodicals.

DONIPHAN, DORSEY.
Painter and teacher. Born Washington, DC, on Oct. 8, 1897. Pupil of Tarbell, R. S. Meryman, Burtis Baker, and A. R. James, Corcoran School of Art; and School of the Mus. of Fine Arts, Boston. Member: S. Wash. A.; Am. APL. Address in 1929, 1462 Harvard St., N.W., Washington, DC.

DONLEVY, ALICE H.
Painter and illustrator. Born Manchester, England, 1846. Pupil of Women's Art School of Cooper Union,

New York. Address in 1926, 308 East 17th Street, Bronx, New York, NY.

DONLON, LOUIS J.
Painter. Member: Conn. Academy of Fine Arts. Address in 1926, Care of Connecticut Academy of Fine Arts, 904 Main Street, Hartford, CT.

DONLY, EVA BROOK.
Painter. Born in Simcoe, Ontario, Canada, on April 30, 1867. Pupil of F. M. Bellsmith and John Ward Stimson. Member: NYWCC; NAC; Gamut Club; NA Women PS; Pen and Brush C.; Wash. AC; Lyceum Club of London; Wash. WCC; Brooklyn SA; AFA. Award: Hon. mention for water color, NA Women PS, 1923; first prize for water colors, Great Western Fair, London, 1926 and 1927. Works: "Arrival of U-Boat Deutschland at Norfolk, VA," owned by US Government; "Elba Beach, Bermuda," "Beach Lake Erie," National Gallery, Ottawa, CN. Address in 1929, Simcoe, Ontario, CN.

DONNESON, SEENA.
Sculptor, printmaker, teacher, and lecturer. Born in New York City. Studied: Pratt Institute; Pratt Graphics Center, New York; The Art Students League, New York City; New School for Social Research. Awarded ten nat. competition awards. Exhibited: "Refractions/Reflections," Ft. Lauderdale Museum of Art; "Museum in the Mall," Bridgeport, CT, sponsored by Sculptors League of NY; New School for Social Research, NY; "Art in the Park," Battery Park, Central Park, Rutgers Univ., New York University; "Games," Women's Inter-Art Center, NY; 15th and 19th Biennial, Brooklyn Museum, 1965 and 75; Finch College, 1971; San Diego Museum, CA, 1975; others. One-woman shows: University of California; LI University; Terrain Gallery, NYC; Tennessee Fine Arts Center, Maryville College, TN; Portland Museum of Art; many other colleges and universities. Collections: Brooklyn Museum; Finch College, New York; Norfolk Museum, Virginia; Museum of Modern Art, New York; Los Angeles County Museum of Art, CA; plus many others. Member: National Association of Women Artists; Artists Equity Association; Women in Art. Received fellowships from Creative Artists Public Service, NYS Council on the Arts; Edward McDowell Foundation (twice); Tamarind Lithography Workshop; Municipal Art Society. Media: Clay, handmade paper, heavily embossed collographs and etching. Represented by Associated American Artists and Grippi Gallery in NYC. Address in 1982, 319 Greenwich St., NYC.

DONOGHUE, JOHN.
Sculptor. Born in Chicago in 1853. Pupil of Academy of Design; also studied in Paris. Principal works: "Young Sophocles," 1885, "Hunting Nymph," 1886, and "St. Paul," at Congressional Library, Wash., DC;

"St. Louis of France," Appellate Court House, NYC; "Egyptian Ibis." Awarded first prize, Columbian Expo., Chicago, 1893 ("Sophocles Leading the Chorus after Battle of Sallis"); hon. mention, Paris Salon of 1886. Died July of 1903, Lake Whitney, CT.

DONOHO, GAINES RUGER.
Sculptor and landscape painter. Born in Church Hill, MI, in 1857. He died in NYC, 1916. Pupil of Art Students League and R. Swain Gifford in NY; also studied in Paris at Julian Academy under Lefebvre, Boulanger, Bouguereau, Robert-Fleury. Awards: Silver medal, Paris Exposition, 1889; Hors Concours, Paris Salon, 1890; Webb prize, Society of American Artists, 1892; medal, Columbian Exp., Chicago, 1913; Carnegie Institute, 1911; gold medal, Panama-Pacific Exp., San Francisco, 1915. Represented in Brooklyn Institute Museum by "La Marcellerie."

DONOHUE, WILLIAM H.
Painter. He exhibited at Annual Exhibition, Acad. of Design, NY, 1925. Address in 1926, Nanuet, NY.

DOOLITTLE, AMOS.
Engraver. Born in Cheshire, CT, 1754; died in New Haven, Conn., 1832. Doolittle learned early to engrave upon metal. His artist friend Ralph Earle made some rather curious drawings of the engagement at Lexington and Concord, and these Doolittle engraved on copper and published in New Haven in 1775. Doolittle engraved a considerable number of portraits, views, Bible illustrations, book-plates, etc., all executed in line. Mr. Barber credits Doolittle with engraving the first historical plates done in America. Mr. Barber overlooked Paul Revere's plate of the Boston Massacre, published in 1770, and Roman's "Exact View of the Late Battle at Charleston," which was published in Philadelphia in Sept. 1775, or about three months before the appearance of Doolittle's views of Lexington and Concord.

DOOLITTLE, EDWIN S.
Painter. Born in Albany, 1843. He had a studio in 1867 in New York; in 1868 he went to Europe for study. In 1869 he painted his "Shadow of a Great Rock in a Weary Land." His painting comprised landscapes and marine subjects. Mr. Doolittle also executed illustrations for books, and has designed book covers. He died in 1900.

DOOLITTLE, HAROLD L.
Etcher. Born Pasadena, CA, on May 4, 1883. Member: Chicago SE; Brooklyn SE; Calif. SE; Calif. PM; AFA. Prints owned by Los Angeles Museum; Calif. State Library; Art Inst. of Chicago. Address in 1929, 1520 Rose Villa St., Pasadena, CA.

DOOLITTLE, SAMUEL.
Engraver. A "Goodwin" book-plate, signed "S. D. Sct. 1804," is assigned to this name in the descriptive

catalogue of the late exhibition of early American engravings held under the auspices of the Museum of Fine Arts, in Boston.

DOOLITTLE & MUNSON.
Engravers. This firm was engraving portraits, banknotes, etc., in 1842, in Cincinnati, Ohio. The second member of this firm may have been S. B. Munson, living, earlier, in New Haven. Some good line work of about this period, signed "A. Doolittle Sc.," may be the work of the first member of this firm. The work referred to is too well done to have been engraved by Amos Doolittle, of New Haven, and this latter Amos died in 1832. A view of the engraving establishment of Doolittle & Munson is to be found in a work entitled "Cincinnati in 1842," published in that city. The sign shown calls them "bank note engravers."

DOONER, EMILIE ZECKWER.
(Mrs. Richard T. Dooner). Painter and etcher. Born Philadelphia, on Aug. 31, 1877. Studied at PAFA and abroad. Member: Fellowship PAFA; Plastic C.; Phila. Alliance; Print C. Address in 1929, 523 Kenilworth Road, Merion, PA.

DOONER, RICHARD T.
Painter and teacher. Born in Philadelphia on May 19, 1878. Pupil of Anshutz and Thouron. Member: Philadelphia Art Week Assoc.; Philadelphia Alliance; Philadelphia Sketch C.; Fairmount Park AA.; Fellowship PAFA; Philadelphia Print C; AFA. Awards: Gold medals at expositions in Dresden, 1909; Paris, 1910; Budapest, 1912; Royal Photographic Society of Great Britain, 1923; International gold medal, American Arts and Crafts Association, 1923. Address in 1929, 1822 Chestnut Street, Philadelphia, PA; h. Merion, PA.

DORAN, ROBERT C.
Painter and etcher. Born Dallas, Texas, 1889. Pupil of Kenneth Hayes Miller in New York. Address in 1926, 304 West 52d Street, New York, NY.

DORNE, ALBERT.
Illustrator. Born in New York City in 1904. He learned his trade, after leaving school at an early age, by taking odd jobs in art studios and advertising agencies. He worked under Saul Tepper in NY while supporting himself as a clerk and a professional boxer. He started his career with sheet music cover illustrations; rose to the top of his profession, receiving the Horatio Alger Award for his achievement. His superb draftsmanship and strong compositions were seen in most major magazines in the 1930's and 1940's. He was President of the S of I, founding director of the FAS and co-founder of the *Code of Ethics and Fair Practices*. He received an honorary degree from Adelphi University and the First Gold Medal from the NY ADC for his distinguished career. Died in 1965.

DORSEY, JOHN SYNG.
Born in Philadelphia on Dec. 23, 1783; died there on Nov. 12, 1818. This eminent American surgeon published, in 1813, his "Elements of Surgery," with plates by "John Syng Dorsey, M.D." These plates are etched and sometimes finished in stipple; they are excellently done. Dr. Dorsey also etched several good book-plates.

DOSKOW, ISRAEL.
Painter and illustrator. Born Russia, on Nov. 30, 1881. Pupil of PAFA. Member: Salma. C.; SI. Address in 1929, 150 East 41st Street; 219 East 39th St.; 452 Fifth Ave., New York, NY.

DOTY, ROY.
Illustrator. Born in Chicago, IL, in 1922. He received his art training at CCAD. After service with US Army in World War II, when he worked with *Yank* and *Stars and Stripes*, he began his free-lance career. His illustrations have appeared in over 50 books and in advertising and editorial journals. Two of his longstanding clients are *Consumer Reports* and *Popular Science*. His work, ranging in style from decorative to cartoon, has also been seen in advertisements for Macy's, The Bowery Savings Bank and in the comic strip *Laugh-In* based on the TV series.

DOUGAL, W. H.
Engraver. Born in New Haven, CT, about 1808; was living in Washington, SC, in 1853. Mr. Alfred Jones says that his name was originally Macdougal, and he was so known for a time, but for some reason he later dropped the "Mac." He was a good engraver of landscapes and portraits, the latter being executed in a mixed manner. In 1853 he was in the employ of the US Treasury Dept. at Washington, DC.

DOUGHERTY, ELIZABETH ZAVARZINA.
Sculptor. Born in St. Petersburg, Russia, in 1898. Came to US (California) in 1922. Studied at California School of Fine Arts, San Francisco, in the 1920's and 30's; Mills College, Oakland, California, 1950, with F. Carlton Ball; Richmond Art Center, c. 1958-61. Exhibited at Golden Gate International Exposition, San Francisco, 1939; San Francisco Art Association Annuals; San Francisco Society of Women Artists; Oakland Art Museum; others. Died in Piedmont, California, in 1977.

DOUGHERTY, LOUIS R.
Sculptor. Born Philadelphia, 1874. Pupil of Penna. Academy of Fine Arts and Drexel Institute. Member: The Scumblers, Philadelphia; Fellowship Penna. Academy of Fine Arts. Address in 1926, Stapleton, NY.

DOUGHERTY, PARK C.
Painter. Born Philadelphia, PA, 1867. Pupil of Penna. Academy of Fine Arts; Julien Academy in

Paris. Member: Art Club, Philadelphia; Fellowship Penna. Academy of Fine Arts, 1916. Address in 1926, 49 Boulevard du Montparnasse, Paris, France.

DOUGHERTY, PAUL.
Marine painter. Born Brooklyn, NY, on Sept. 6, 1877. Studied alone in Paris, London, Florence, Venice, and Munich. Member: SAA, 1905; ANA, 1906, NA, 1907; Nat. Inst. A. L.; Lotos C.; Salma. C., 1907; AWCS; Century Assoc.; NAC; New Soc. A. Award: Osborne prize ($500), 1905; second prize, CI Pitts., 1912; Innes gold medal, NAD, 1913; gold medal, P. P. Exp., San F., 1915; Carnegie prize, NAD, 1915; Altman prize ($1,000), NAD, 1918. Work: "The Land and the Sea," Corcoran Gal., Wash.; "Flood Tide," Carnegie Inst., Pitts.; "Moonlight Cove," Toledo Museum.

DOUGHTY, THOMAS.
Landscape painter. Born in Philadelphia on July 19, 1793; died in New York on July 22, 1856. Self-taught. Represented at the Metropolitan Museum by "On the Hudson" and "A River Glimpse."

DOUGLAS, CHESTER.
Painter and craftsman. Born Lynn, on Oct. 6, 1902. Pupil of John Sharman. Address in 1929, 233 Lynnfield St., Lynn, MA.

DOUGLAS, HALDANE.
Painter and etcher. Born Pittsburgh, PA, on Aug. 13, 1893. Pupil of Armin Hansen. Member: Calif. AC; Calif. PS; Laguna Beach AA; Calif. PSC. Award: Hon. mention, Pomona, 1925. Address in 1929, 212 South Catalina St., Los Angeles, CA; 704 Alpine Drive, Beverly, CA; summer, Monterey, Calif.

DOUGLAS, HAROLD.
Painter. Member: CT AFA; Salma. C. Address in 1929, Farmington, CT.

DOUGLAS, LAURA GLENN.
Painter. Born in Winnsboro, SC. Studied: College for Women, Columbia, SC; Corcoran School of Art; Art Students League; NAD with Hawthorne; and abroad. Awards: Metropolitan Museum of Art, 1926; Art Institute of Chicago, 1942. Collections: Rochester Memorial Art Gallery; Gibbes Art Gallery; United States Treasury Department, Washington, DC; United States Post Office, Camilla, GA.

DOUGLAS, LUCILLE SINCLAIR.
Painter and illustrator. Born Tuskegee, AL. Pupil of ASL of New York, Lucien Simon, Richard Miller, and Alexander Robinson in Paris; studied in Spain and Holland. Member: Societe des Artistes Independentes, Paris; NA Women PS; SSAL. Work: Illustrated *The Autobiography of a Chinese Dog*, by Florence Ayscough (Houghton Mifflin). Address in 1929, care of Millie Higgins Smith, 489 Park Avenue,

New York; American Woman's Club, 66 Synchwan Road, Shanghai, China.

DOUGLAS, WALTER.
Painter. Born in Cincinnati, OH, on Jan. 14, 1868. Pupil of Chase, NAD, and Aslin, NY. Member: AWCS; Salma, C., 1904; Art Center of the Oranges. Work: "In the Shade," Dallas (TX) Art Association. Specialty, poultry. Address in 1929, 264 West 19th St., New York, NY; summer, Block Island, RI.

DOULBERRY, FRANK R.
Painter. Member: GFLA. Address in 1929, 145 East 42nd St., New York, NY.

DOULL, MARY ALLISON.
Miniature painter, craftsman, and teacher. Born Prince Edward Island, Canada. Pupil of C. Y. Turner, NAD in NY; Julian Acad. in Paris. Member: PBC; Catherine Lorillard Wolfe C.; NY. Soc. Ceramic Art. Address in 1929, 150 East 34th St., 77 Irving Place, NY, NY; summer, Cape Traverse, Prince Edward Island, Canada.

DOVE, ARTHUR G.
Painter and illustrator. Born Canandaigua, NY, on Aug. 2, 1880. Work: "Golden Storm," and "Waterfall," Phillips Memorial Gallery; "Cow," "Rain," and "Fishing Nigger," Intimate Gallery, New York, NY. Address in 1929, Halesite, NY.

DOVE, LEONARD.
Illustrator. He was a frequent contributor of cartoons and covers to *The New Yorker* in the 1940's and 1950's. He worked in pen and ink and watercolor.

DOW, ARTHUR WESLEY.
Painter. Born 1857, in Ipswich, MA. Studied art in Boston and at Paris. Pupil of Boulanger and Lefebvre. Pictures in Salon, Paris, 1886-87. Instructor of Art, Pratt Institute, Brooklyn, 1895-1904; instructor of Composition at Art Students League, New York, 1897-1903. Member: Society of Independent Artists; American Federation Arts. Died in 1922.

DOW, LELIA A.
Painter, craftsman, and teacher. Born Cooksville, Wis., on Apr. 2, 1864. Pupil of AIC; John Vanderpoel; F. W. Fursman. Member: Madison AG; Wis. PS; AFA. Address in 1929, 301 Forest St., Madison, Wisc.

DOWIATT, DOROTHY.
Painter. Born Pittsburgh, PA, on Oct. 9, 1903. Pupil of Edouard Vysekal; E. Roscoe Shrader. Member: Calif. AC; Younger Painters C. (Pres.). Awards: First prize for figure composition and 2nd prize for still life, Arizona State Fair, 1928. Address in 1929, 421 North Greenleaf Ave., Whittier, CA.

DOWLING, JACQUES MacCUISTON (MRS.).
Sculptor. Born in Texarkana, TX, October 19, 1906.
Studied art at Loyola University, Frolich's School of
Fine Art, Los Angeles, National Academy of Design,
Art Students League, NYC, and with Robert Aitken,
Robert Laurent, William Zorach, and others. One
man shows held at Federation of Dallas Artists, 1950,
Rush Gallery, 1958, Sartor's Gallery, 1958; exhibited
in group shows at Dallas Museum of Fine Arts,
Museum of New Mexico, Shuttles Gallery, Feder-
ation of Dallas Artists, Sartor's Galleries, Ney Art
Museum, Oak Cliff Society of Fine Arts, and others.
Represented in permanent collections of several
corps., many private homes. member: St. Catherine's
Business and Profile Guild (past president), Dallas
Art Association, U.D.C. (board member), Federation
of Dallas Artists (1st vice president), American
Federation of Arts, Oak Cliff Society of Fine Arts.
Recipient 1st sculpture, Fed. of Dallas Artists, 1950-
54, and many others. Address in 1962, Dallas, TX.

DOWNES, J(OHN) IRELAND HOWE.
Landscape painter. Born Derby, CT, in 1861. Pupil of
Yale School of Fine Arts and J. Alden Weir; Merson
in Paris. Member: New Haven PCC; CT AFA;
Rockport AA. Work: "Destruction of S.S. *Emden* off
the Cocos Islands," War Memorial Collection, Nation-
al Gallery, Washington, DC. Died on Oct. 16, 1933.
Address in 1929, 254 Lawrence St.; h. 345 Whitney
Ave., New Haven, CT.

DOYLE, ALEXANDER.
Sculptor. Born in Steubenville, Ohio, January 28,
1857. He studied sculpture with Nicoli, Dupre, and
Pellicia; and at the Nat. Academies at Carrara and
Florence, Italy. Returned to the US in 1878. Among
his works are: Bronze equestrian statue of Gen.
Albert Sidney Johnston; bronze statue of Gen. Robert
E. Lee; marble statue of Margaret Haugherty, for
New Orleans, LA; Nat. Revolutionary Monument,
Yorktown, VA; bronze statue of Gen. Philip Schuyler,
Saratoga, NY; marble statue of Gen. Garfield, Cleve-
land, OH; bronze statue of Gen. James B. Steedman,
Toledo, OH; marble statue of Senator Benjamin H.
Hill, Atlanta, GA; bronze statue of Horace Greeley,
NY; bronze statue and monument to Henry W.
Grady, Atlanta, GA; and statues of Benton, Blair,
and Kenna, in Statuary Hall, Capitol; others. Ad-
dress in 1918, Dedham, MA; summer, Squirrel
Island, ME. Died in Boston, Dec. 21, 1922.

DOYLE, MARGARET BYRON.
(Mrs. John Chorley). She was a daughter of W.M.S.
Doyle, and became the wife of John Chorley the
engraver. She painted many excellent portraits in
Boston between 1820 and 1830.

DOYLE, WILLIAM M. S.
Portrait painter. Born in Boston, MA, in 1796. Was
the son of a British army officer who was stationed

there. He associated as a young man with Daniel
Bowen the silhouettist, at the "Bunch of Grapes
Tavern," and in 1805 the Boston directory states he
was a "miniature painter". He died in 1828 and at the
time was proprietor of the Columbian Museum in
Boston. Among his portraits are those of Gov. Caleb
Strong, Isaiah Thomas and John Adams. Died May,
1828.

DRABKIN, STELLA.
Painter. Born in New York City in 1906. Studied:
NAD; Phila. Graphic Sketch Club, with Earl Horter.
Awards: American Color Printmaker Society, 1944;
Phila. Printmaker Club, 1955. Collections: PAFA;
Phila. Museum of Art; Nat'l. Gal. of Art; Metro-
politan Museum of Art; PA State College; Library of
Congress; Atwater Kent Museum; Tel-Aviv Mu-
seum, Israel; Bazalel Museum, Jerusalem.

DRADDY, JOHN G.
Sculptor. Born in 1833. Working in Cincinnati, 1859-
60; later became a partner in the firm of Draddy and
O'Brien. He executed many notable church altars
including the August Daly altar and the "Coleman
Memorial" in St. Patrick's Cathedral, New York
City. He died in Italy, 1904.

DRAKE, WILL H.
Painter and illustrator. Born in New York, 1856.
Pupil of Julien Academy under Constant and Doucet.
Elected Associate Member of National Academy,
1902. Specialty, animals. Address in 1926, 362 West
9th Street, Los Angeles, CA.

DRAYTON, EMILY.
See Mrs. J. Madison Taylor.

**DRAYTON, GRACE GEBBIE
WIEDERSHEIM.**
Sculptor and illustrator. Born Philadelphia, PA, on
October 14, 1877. Member: Fellowship Penna. Acade-
my of Fine Arts; Alliance; Society of Illustrators;
Artists Guild of the Authors' League of America.
Author and illustrator of *Fido, Kitty Puss* and other
children's books. Originator of Campbell's Soup
Kids. Address in 1933, 145 East 52nd St., New York,
NY. Died in 1936.

DRAYTON, JOSEPH.
Engraver of landscape in aquatint, and an expert
print colorist. At least as early as 1820 he was
working in Philadelphia. He was later employed for
some years as a draftsman in one of the Government
departments in Washington. Drayton engraved a
few book illustrations in line.

DREIER, KATHERINE SOPHIE.
Painter, writer, and lecturer. Born Brooklyn, NY, on
Sept. 10, 1877. Pupil of Walter Shirlaw. Member:
Societe Anonyme (founder and pres.). Work: "The

Good Shepherd," St. Paul's School, Garden City, LI; "Mother and Child," pastel, Houston Museum of Fine Arts. Translator of, with critical essay, "Personal Recollections of Van Gogh," by Elizabeth D. Van Gogh, 1913; "Western Art and The New Era" or "An Introduction to Modern Art," Brooklyn Museum, with forward and 104 biographical sketches, 1926. Died in 1952. Address in 1929, 88 Central Park, West, New York, NY.

DREIFOOS, BYRON G(OLDING).
Painter and teacher. Born in Philadelphia, on Jan. 30, 1890. Pupil of Fawcett School of Industrial Arts. Member: Art Centre of the Oranges; APL. Address in 1929, 268 So. Centre St., Orange, NJ.

DRENNAN, VINCENT J(OSEPH).
Painter and writer. Born in New York, on Jan. 5, 1902. Pupil of NAD; Cooper Union. Address in 1929, 1044 East 36th St., Brooklyn, NY.

DRESHER, A.
Dresher was a landscape engraver of little merit, working in New York about 1860.

DRESSLER, BERTHA MENZIER.
See Menzler-Peyton.

DREW, CLEMENT.
Sculptor, marine painter, figurehead carver, photographer, and art dealer. Born in Boston or Kingston, Mass., in 1807 or 1810. Worked in Boston from 1841 at least until 1860. Working in and around Gloucester, Mass., during the 1880's; possibly living in Maine as late as 1889.

DREWES, WERNER.
Painter, printmaker, teacher. Born in Canig, Ger., July 27, 1899; US citizen, 1936. Studied: Charlottenburg Techn.-Hochschule, Berlin; Stuttgart Sch. Arch.; Stuttgart Sch. Arts & Crafts; Weimar Staatliches Bauhaus, with Johannes Itten, Paul Klee, 1921-22; travelled to Italy and Spain to study Old Masters, 1923; Dessau Staatliches Bauhaus, with Wassily Kandinsky, Lyonel Feininger, 1927-28. Work: MOMA; Met. Mus. Art, NYC; Guggenheim Mus. Art, NYC; Brooklyn Mus. of Art, NY; Boston Mus. FA; Wadsworth Atheneum, Hartford, CT; Yale Univ. Art Gal.; Nat'l Gal. of Art, Wash. DC; Nat'l Mus. of Am. Art; Art Inst. Chicago; Cleveland Mus. of Art; Achenbach Found. for Graphic Arts, San F.; Mus. in Frankfurt, Cologne, Hamburg, Karlsruhe, Stuttgart, Berlin, Paris, London & Jerusalem. One-man shows: Cleveland Mus. Art, 1961; Achenbach Found., San. F., 1962; Wash. U., St. Louis, 1965; Nat'l Collection Fine Arts, Wash. DC, 1969; Wash. U., St. Louis, 1979; Associated American Artists, NY, 1983; other shows in US and abroad. Teaching: Columbia U., 137-40; Inst. of Design, Chicago, 1946; prof. design & dir. first yr. prog.,

School of Fine Arts, Wash. U., St. Louis, 1946—65. Member: Founding member, Am. Abstract Artists, NY, 1937—1946; Wash. Soc. Printmakers. Awards: Plexiglass Sculpture Competition, MOMA, 1939; painting, "Autumn Harvest," St. Louis City Art Mus., 1959. Media: Oil, watercolor, woodcut. Rep.: Assoc. Am. Artists, 653 Fifth Ave., NYC; Princeton (NJ) Gallery of Fine Art, 9 Spring St. Address in 1982, 11526 Links Drive, Reston, VA.

DREXEL, FRANCIS MARTIN.
Painter and banker. Born in Dornbirn, Austrian Tyrol, 1792; died in Philadelphia, 1863. After studying in Italy, came to America to settle in Philadelphia. Here he achieved success as a portrait painter, taking up residence at the southwest corner of Sixth and Chestnut Streets, where he established his studio. After several years, hearing that South America offered a profitable field for an ambitious artist, he sailed for Valparaiso. On his return home he brought with him a large collection of curiosities for Peale's Museum, then in the State House. Having accumulated some capital, he decided to settle down and become a broker, in order to open a career for his sons. In this field he made an auspicious beginning in Louisville, KY, but on his wife's desire to return to Phila. he opened an office on Third Street, below Market, on January 1, 1838, the beginning of the noted house of Drexel & Co.

DREYER, MARGARET WEBB.
Painter. Born in East St. Louis, IL, in 1917. Awards: Houston Artists Annual; Texas Watercolor Society. Collections: Inst. of International Education; Witte Museum; Thomas P. Creaven. Media: Acrylic, watercolor. Address in 1980, 4713 San Jacinto, Houston, TX.

DREYFOUS, FLORENCE.
Painter. Born New York, NY. Pupil of Robert Henri. Member: NYS Women A. Address in 1929, 235 West 102nd Street, New York, NY.

DREYFUS, ISIDORA C.
Miniature painter and teacher. Born Santa Barbara, CA, on Aug. 8, 1896. Pupil of Delecuse, Mme. de Billemont-Chardon and Sonia Routchine. Address in 1929, 60 East 42nd Street, New York, NY; h. Santa Barbara, CA.

DREYFUSS, ALBERT.
Sculptor, painter, and writer. Born NYC, 1880. Pupil of George Grey Barnard, Harper, Twachtman, DuMond, Pratt Institute; Art Students League of New York. Member: Salons of America; Society of Independent Artists; League of New York Artists. Work: Arsenal Park Memorial, Pittsburgh, PA. Awards: Pioneer Monument for Albion, Orleans Co., NY, 1911. Assisted in studios of R. Hinton Perry, Tonetti, and Victor Ciani on sculpture for public bldgs.

and monuments. Contributor of art criticism and essays to newspapers and magazines. Address in 1929, 232 West 14th Street, New York, NY.

DRIGGS, ELSIE.
Painter. Born Hartford, CT. Pupil of ASL of NY; Maurice Sterne in Italy. Member: NY S. Women A. Address in 1929, care of Daniel Gallery, 600 Madison Ave., New York, NY.

DROGSETH, EINSTEIN OLAF.
Painter. Exhibited "Rough Country" at Penna Academy of Fine Arts, 1920. Address in 1926, 190 Beniteau Avenue, Detroit, Michigan.

DROUET, (BESSIE) CLARKE.
(Mrs. Henry Drouet). Sculptor and painter. Born in Portsmouth, NH, January 18, 1879. Pupil of Philip Hale and George Bellows. Member: Nat. Association of Women Painters and Sculptors. Address in 1933, Skywood Studio, 430 East 86th St., NYC.

DROWNE, SHEM.
Sculptor. Born in Kittery, Maine, in 1683. Made weather vanes, carved figureheads and ornamental pieces. Worked in Boston. Some of his copper weather vanes still exist. Died in 1774.

DRUGGER, MARIE R. (MRS.).
See Duggar.

DRUMMOND, A(RTHUR) A.
Painter and illustrator. Born Toronto, on May 28, 1891. Pupil of C. M. Manly. Member: AWCS; Canadian Soc. of Graphic A. Address in 1929, 63 Inglewood Drive, Toronto, CN.

DRUMMOND, (I. G.).
Sculptor and painter. Born in Edmonton, Alberta, Canada, April 11, 1923; US citizen. Studied: Penna. Academy of Fine Arts, University of Penna., B.F.A., 1951, M.A., 1952; also with George Harding. Work: Commissions for New York World's Fair Trade Center, 1963-64; Aeromatic Travel Corp., 1969; Art Club Camera, Grand Central Sta.; Ahi Ezer Synagogue, Brooklyn, 1971, many more. Exhibitions: Penna. Academy of Fine Arts, 1950; Silvermine Guild, 1964; East Hampton Gallery, NY, 1968-69; Art Image, Manhattan, 1969-70. Media: Colored concrete and wire lathe. Address in 1980, Astoria, NY.

DRURY, HERBERT R.
Painter. Born Cleveland, OH, on Aug. 21, 1873. Pupil of Carlson and DuMond. Member: Cleveland SA. Address in 1929, Drury Lane, Willoughby, OH.

DRURY, HOPE CURTIS.
(Mrs. William H. Drury). Painter. Born Pawtucket, RI, on June 14, 1889. Pupil of RI School of Design.

Member: Providence AC; Providence WCC. Address in 1929, Paradise Road, Newport, RI.

DRURY, JOHN H.
Painter. Born in Washington, DC, on June 30, 1816. A follower of the French school, and pupil of Thomas Couture of Paris. Member: Chic. Acad. of Design; spent most of his professional life in Chic.

DRURY, WILLIAM H.
Marine painter. Born Fitchburg, MA, on Dec. 10, 1888. Pupil of RI School of Design; Boston Museum of Fine Arts School; Tarbell and Woodbury. Member: Providence WCC; Newport AA; Brooklyn SE; Calif. PM. Award: Gillespie prize, Newport AA, 1916. Represented in RI School of Design; Nat. Gallery of Art, Wash.; Brooklyn Museum; Calif. State Library. Address in 1929, St. George's School; Paradise Rd., Newport, RI.

DRYDEN, HELEN.
Illustrator and draftsman. Born Baltimore, MD, on Nov. 26, 1887. Pupil of PAFA. Member: S. Indp. A.; SI, 1914 (assoc); GFLA; Alliance; AFA. Award: Second prize ($500), Newark poster competition, 1915. Designed covers for magazines, posters, stage costumes, and scenery. Address in 1929, 9 East 10th St., New York, NY.

DRYFOOS, NANCY PROSKAUER.
Sculptor. Born in New Rochelle, NY, March 25, 1918. Studied: Sarah Lawrence College, sculpture with Oronzio Maldarelli, painting with Curt Roesch; Columbia University School of Architecture, with Maldarelli, sculpture with Jose De Creeft; Art Students League. Member: Fellow, Nat. Sculpture Society; Knickerbocker Artists; Western Arts and Crafts Guild; others. Awards: Prizes, Nat. Arts Club, NY, 1947; Painters and Sculptors Society, NJ, 1950; Village Art Center, 1950; Westchester Arts and Crafts Guild, 1950, 51; gold medal of honor, Allied Artists of America, 1958; Knickerbocker Artists, 1960; American Society of Contemporary Artists, 1970. Work: Salmagundi Club; Columbia University Library; Evanston Museum of Fine Arts; Brandeis University; Sarah Lawrence College; numerous commissions. Exhibited: Allied Artists of America, 1947-51; Aubudon Artists, 1947; Syracuse Museum of Art, 1948, 51; Penna. Academy of Fine Arts, 1950; National Academy of Design, 1951; National Association of Women Artists, NY, 1952; Painters and Sculptors Society of NJ, 1950, 51; Knickerbocker Artists, 1951, 52; Hudson Valley Art Association, 1952; Contemporary Art., 1949-52; Brooklyn Museum; National Sculpture Society Annual, 1965-80. Address in 1982, 45 East 89th St., NYC.

DRYSDALE, ALEXANDER JOHN.
Painter and illustrator. Born in Marietta, GA, on March 2, 1870. Pupil of Paul Poincy in New Orleans;

ASL of NY, under Curran and DuMond. Member: New Orleans AA. Award: Gold medal, New Orleans AA, 1909. Represented in Delago Museum, New Orleans, and Louisana State Museum. Address in 1929, 320-322 Exchange Place; h. 1323 Louisiana Ave., New Orleans, LA.

Du MOND, HELEN SAVIER.
(Mrs. F. V. Du Mond). Sculptor and painter. Born in Portland, OR, August 31, 1872. Pupil of Art Students League, Robert Brandegee and F. V. Du Mond in NY; Collin and Merson in Paris. Member: National Arts Club (life); Art Workers Club; Catherine L. Wolfe Art Club. Address in 1933, 27 West 67th St., NYC; summer, Lyme, CT.

Du PEN, EVERETT GEORGE.
Sculptor. Born in San Francisco, CA, June 12, 1912. Studied at University of Southern California, with Merrell Gage; Louis Comfort Tiffany Fellowship, summer, 1935 and 36; Chouinard Art Institute; Yale University School of Fine Arts, B.F.A.; and with Lukens, Sample, Snowden, Fulop, Eberhard, and Archipenko. Work: Bronze sculptures, Seattle World's Fair, 1962; Seattle Art Museum; others. Awards: Tiffany scholarship, 1935-36; fellowship, European study, 1937; Saltus gold medal, National Academy of Design. Exhibited: American Academy in Rome, 1935-37; National Academy of Design; Kansas City Art Museum, 1942; City Art Museum of St. Louis, 1941, 42; San Francisco Art Association, 1943; Seattle Art Museum; Penna. Academy of Fine Arts; National Sculpture Society. Member: Fellowship, National Sculpture Society; Academician, National Academy of Design. Works in wood and bronze. Lectures: Modern Sculpture. Taught: Prof. of Sculpture, University of Washington School of Art, Seattle, Washington, from 1945. Address in 1982, Seattle, WA.

DUBLE, LU.
Sculptor. Born Oxford, England, January 21, 1896. Studied: Art Students League; National Academy of Design; Cooper Union Art School; and with Archipenko, De Creeft, Hofmann. Member: Associate of the National Academy of Design; National Sculpture Society; National Association of Women Artists; Architectural League; Audubon Artists. Awards: Guggenheim Fellowship, 1937, 38; Fellow, Institute of International Education; prize, Nat. Association of Women Artists, 1937; Audubon Artists, 1947, gold medal, 1958. Work: Newark Museum of Art. Exhib.: Phila. Museum of Art, 1940; Carnegie Institute; Montclair Art Museum, 1941;l Museum of Modern Art, 1942, 1952; Penna. Academy of Fine Art, 1942-46; Whitney Museum of American Art, 1946, 1947; National Academy of Design, annually; Audubon Artists, annually; Sculptors Guild; National Association of Women Artists, annually; Marie Sterner Gallery, 1938 (one-man). Instructor at Greenwich

House, NYC. Address in 1970, 17 East 9th Street, NYC. Died in 1970.

DUBOIS, CHARLES E.
Landscape painter. Born in New York, 1847. He studied in Paris; also painted in Venice and Rome. Among his paintings, "Willows at West Hampton" and "Palisades, Hudson River," were exhibited at the Phila. Exposition. His "Evening at East Hampton" was in the Exhibition of Society of American Artists in 1878. He died in 1885.

DuBOIS, GUY PENE.
Painter and writer. Born Brooklyn, NY, on Jan. 4, 1884. Pupil of Chase, DuMond and Henri. Taught at ASL. Member: New Soc. A.; NIAL; and NA. Work: "The Doll and the Monster," Metropolitan Museum; two paintings in Phillips Memorial Gallery, Washington. Died in 1958. Address in 1929, Kraushaar, 680 Fifth Ave., New York, NY; summer, Garnes, par Dampierre, Seine et Oise, France.

DUBOURJAL, SAVINIEN EDME.
Painter in oils and miniatures. He was born in Paris on Feb. 12, 1795, and died there on Dec. 8, 1853. Pupil of Girodet. He exhibited at the Salon in 1814. In 1846, he was working in Boston and 1847 to 1850 he was in New York, where he exhibited frequently at the National Academy of Design Exhibitions. He was a friend of the artist G.P.A. Healy; see the "Life of Healy" by Healy's daughter.

DuBRAU, GERTRUD (MARGARETE).
Painter, illustrator, craftsman, and teacher. Born in Germany on June 1, 1889. Pupil of Maryland Inst., Baltimore, and Royal Academy, Leipzig, Germany. Member: S. Indp. A. Work: Murals in Masonic Temple, Cumberland, MD; "Entry of Gen. Braddock into Fort Cumberland, 1794," City Hall Rotunda, Cumberland, MD; "Tea Burning at Bridgeton, NJ" New Cumberland Hotel, Bridgeton, NJ. Manager, DuBrau Art Studio. Address in 1929, Piedmont and Columbia Avenues, Cumberland, MD.

DUBUFE, CLAUD MARIE.
French portrait painter who had his studio in New Orleans, LA, about 1837, and painted portraits of many of the members of the Old French Families of Louisiana. Born in Paris, Oct., 1790, he studied under David. He died in 1864. His portraits painted when he was in the United States are remarkable for their forceful character and their firm, strong modeling.

DUBUQUE, EDWARD W(ILLIAM).
Painter and teacher. Born Moosup, CT, on Nov. 5, 1900. Pupil of Heintzelman; Gorguet, Laurens and Bauduin in Paris. Member: Providence AC. Work: "In Memoriam" (in collaboration with Auguste F. Gorguet), Morris High School, NY; 3 panels in Seaman's Bank, NY (in collaboration with Ernest

Peixotto); pure fresco, Chancel of Christ Church, Birmingham, MI (in collabration with Katherine McEwen), redecorated St. Joseph's Church, North Grosvenordale, CT. Address in 1929, 31 Vicksburg St., Providence, RI.

DUCASSE, MABLE LISLE.
(Mrs. C. J. Ducasse). Painter. Born in Colorado in 1895. Pupil of Walter Isaacs, F. DuMond, Will S. Taylor, George Bridgman, Luis Mora, Charles Chapman and Yasushi Tanaka. Member: Providence WCC. Awards: Third prize, 1919, first prize, 1924, and second prize, 1925, Seattle SFA. Address in 1929, 261 Benefit Street, Providence, Rhode Island.

DUCHAMP, MARCEL.
Sculptor and painter. Born in Blainville, France, July 28, 1887. Studied at the Academie Julian, Paris, 1904. Came to US in 1915, staying with art patrons Louise and Walter Arensberg. In 1955 he became a US citizen. Exhibited: Montross Gallery, NYC, 1916 (four-man); Arts Club of Chicago, 1937; Rose Fried Gallery, 1952; Galerie de l'Institute, Paris, 1957; Sidney Janis Gallery, 1958, 59; La Hune, Paris, 1959; Eva de Buren Gallery, Stockholm, 1963; Walker, 1965; Tate Gallery, 1966; Galerie Rene Block, Berlin, 1971; L'Uomo e l'Arte, Milan, 1973. Retrospectives of his work include: Galeria Solaria, Milan, 1967; Paris-Moderne, 1967. Co-founder, along with Man Ray and Francis Picabia, of the DADA group in New York City, 1917. Famous for his "Ready-mades" or commonplace objects raised to the level of artistic appreciation, an example being his celebrated "Fountain," which was a urinal presented upside down in 1917 at the Society of Independent Artists. Also published one issue of *New York Dada* in 1921 and produced a film in 1925 entitled "Anemic Cinema." Died in Neuilly, France, Ocotober 1, 1968.

DUCHE, THOMAS SPENCE.
Painter. Born in Philadelphia in 1763. He went to England and studied painting under Benjamin West, and while there he painted the portrait of Bishop Seabury now at Trinity College, Hartford, CT. He also painted a portrait of Bishop Provost, which is owned by the New York Historical Society. He died in England in 1790.

DUCLORY LEPELITIER.
Portrait painter; a creole of Martinique, West Indies. He came to New Orleans in the first half of the nineteenth century, and remained there about ten years, painting portraits.

DUDENSING, BIBI.
Painter. Born in San Francisco in February of 1901. Pupil of Richard Miller, Louis Wilson, Colarossi and Julian Academies of Paris. Member: S. Indp. A.; AIC; NAC. Award: Gold medal, Paris, 1914; hon.

mention, AIC. Address in 1929, 119 East 19th St.,New York, NY; care of Victor Charreton, 8 Blvd. Chicey, Paris, France.

DUDENSING, F. VALENTINE.
Painter. Born in San Francisco, CA, 1901. Member: Society of Independent Artists. Address in 1926, 116 East 19th Street, New York, NY.

DUDENSING, RICHARD.
Engraver of portraits and landscapes, in stipple and in line. Came to the US from Germany about 1857. About 1880 he established a book publishing house in New York which was still in existence in 1926. He died on Sept. 4, 1899, during a visit to the old home in Germany.

DUDLEY, DOROTHY.
Painter. Born in Somerville, MA, on Dec. 23, 1892. Pupil of Henry R. Snell. Member: NA Women PS. Award: Prize for landscape, NA Women PS., 1927. Address in 1929, 83 State St., Brooklyn, NY.

DUDLEY, FRANK V.
Painter and lecturer. Born Delavan, WI, 1868. Studied at AIC. Member: AIC Alumni Assoc.; Chic. AC; Chic. AG; Chic PS; Union Internationale des Beaux Arts et des Lettres, Paris. Awards: Chic. Municipal Art Lg. prize, 1907; Municipal Art Lg. purchase prize, 1914; Butler purchase prize, AIC, 1915; Cahn Prize, AIC, 1919; Logan Medal and Prize, AIC, 1921; prize ($300), Chic. Gal. A., 1927 and 1929. Represented in Chic. Art Inst. collection; Municipal collection of Owatonna, MN; collection of Cedar Rapids Art Assoc.; Public School collections of St. Louis and Chicago. Address in 1929, 6356 Greenwood Ave., Chicago, IL; summer, Chesterton, IN.

DUER, DOUGLAS.
Painter. Member: Society of Illustrators. Address in 1926, 51 West 10th Street, Brooklyn, NY.

DUER, HENRIETTA A.
Painter. Pupil of S. Edwin Whiteman, Courtois Castaign and Giradot. Member: Balto. Mus. of A; Balto. WCC; North Shore AA; Am. APL. Address in 1929, Sudbrook Park, Baltimore Co., MD.

DUESBERG, OTTO.
Painter. Member: Society of Independent Artists. Address in 1926, 10 Eldert Street, Brooklyn, NY.

DUFFIELD, EDWARD.
Engraver, and a clock and watch-maker of Philadelphia. Born in 1730, and died 1805. He was also a diesinker and engraver of medals. He engraved the silver medal presented to Col. John Armstrong, in 1756, as a memorial of the destruction of the Indian village of Kittanning by Armstrong; he also made the dies for the medals prepared in 1762 for distribution

among the Indians by The Friendly Association for Preservation of Peace among the Indians. The dies for this latter medal cost 15L; they were cut upon punches fixed in a socket, and the impression was made by the stroke of the sledge-hammer.

DUFFY, EDMUND.
Illustrator. Born in Jersey City, NJ, in 1899. Pupil of ASL of New York, also studied in Paris. Cartoonist for *The Baltimore Sun*. Address in 1929, care of the Baltimore Sun; h. 901 Cathedral Street, Baltimore, MD.

DUFFY, RICHARD H.
Sculptor. Born New York, NY, January 22, 1881. Pupil of Art Students League of New York; Mercie in Paris. Associate, National Sculpture Society, 1914. Address in 1928, 14718 Ferndale Avenue, Jamaica, NY. Died in 1953.

DUFNER, EDWARD.
Painter. Born Buffalo, NY, on Oct. 5, 1872. Pupil of ASL of Buffalo, under Bridgman; ASL of NY, under Mowbray; Whistler and Laurens, in Paris; studied in Spain and Italy. Member: ANA, 1910; NA, 1929; NYWCC; AWCS; Salma. C., 1908; Paris AAA; Lotos C; NAC; Allied AA; Patron, Montclair Art Mus. Awards: Albright prize and scholarship, 1893, Buffalo Fine Arts Acad.; hon mention and first Wanamaker prize, Paris AAA, 1899; bronze medal, Pan-Am. Exp., Buffalo, 1901; hon. mention, Paris Salon, 1902; prize, Soc. of Artists, Buffalo, 1904; Julius Levy prize, Peabody Inst., 1921; Walter Lippincott prize, PAFA, 1924; gold medal, National Art Competition, New York, 1925. Work: "In the Studio," Buffalo Fine Arts Academy; "By the Window," Milwaukee Art Soc.; "Meadow Brook," Rochelle Public Library; "End of the Day," Art League, Seymour, IN; "Gladys by the Window," Lotos Club, NY; "Song of the Thrush," National Arts Club, NY; "Youth," Fort Worth Mus.; "Sunlight a Joy," Montclair Art Mus.; "Margaret by the Window," permanent coll., National Acad. of Design. Instructor, ASL of Buffalo, 1903 to 1906; ASL of NY, 1908 to 1917; Carnegie Inst. Tech., Pittsburgh, 1920. Address in 1929, 939 Eighth Ave., New York.

DUFRENE, THOMAS.
Painter. Born in Ireland. Worked in Philadelphia from 1841 to 1853, from 1849 as proprietor of an ornament works.

DUGGAN, PETER PAUL.
Painter. Born in Ireland. He came to America in 1810 and settled in New York, where he taught in the New York Academy. He drew a head of Washington Allston for the American Art Union Medal. He later left America and went to England, and finally to Paris, where he died in 1861.

DUGGAR, MARIE R. (MRS.).
Sculptor. She died in St. Louis, MO, May 5, 1922. She made a specialty of bas-relief portraits of children. (Listed as Drugger, Marie R. in Mallett's).

DULIN, JAMES HARVEY.
Painter and etcher. Born in Kansas City, MO, on Oct. 24, 1883. Pupil of AIC; Laurens, Naudin, Avy in Paris. Address in 1929, 9 Rue des Acacias, Paris, France; h. 1330 Sheridan Road, Wilmette, IL.

DULL, CHRISTIAN L(AWTON).
Painter. Born in Philadelphia, PA, on May 24, 1902. Pupil of Daniel Garber, George Harding. Member: Phila. Alliance; Amer. Artists Prof. Lg. Work: "Studio Reflected," Smedley Junior High School, Philadelphia. Address in 1929, 5853 Willows Ave., Philadelphia, PA.

DULL, JOHN J.
Painter and sculptor. Born Phila., PA, 1862. Pupil of PAFA. Member: Fellowship PAFA; T. Sq. C.; Phila. Sketch C.; Phila. WCC; AFA. Award: Gold medal, Plastic C., 1903. Address in 1929, 1524 Chestnut St., 5853 Willows Ave., Philadelphia, PA.

DUMLER, M(ARTIN) G(EORGE).
Painter. Born in Cincinnati, OH, on Dec. 22, 1868. Pupil of Edward H. Potthast, M. Rettig, and R. Busebaum. Member: Salma. C.; Cincinnati AC. Address in 1929, 127 East 3rd St.; h. 1607 Dexter Ave., Cincinnati, OH.

DUMMER, H. BOYLSTON.
Painter, illustrator, and teacher. Born in Rowley, MA, in Oct. 19, 1878. Pupil of Eric Pape, George Noyes, Ambrose Webster, and John Carlson. Member: Salma C; North Shore AA; Boston S. Indp. A; Rockport AA. Work: Illustrated nature books for Ginn and Co.; World Book Co.; American Book Co. Address in 1929, 6 Mill Lane, Rockport, MA.

DUMMER, JEREMIAH.
Portrait painter. A noted goldsmith and engraver of Boston in the seventeenth century; son of Richard and Frances Curr Dummer of Newbury, and the father of William Dummer was born in 1645, and died in 1718. The portraits of himself and his wife are the property of direct descendants of the heirs of Samuel Dummer of Wilmington, MA. On the back of the self-portrait of Jeremiah Dummer is inscribed: "Jeremiah Dummer pinx. Del in Anno 1691. Mei Efflgles, Aetat 46".

DUMMETT, LAURA DOW.
Painter, draftsman, and teacher. Born in Allegheny, PA, on Aug. 17, 1856. Pupil of Pittsburgh School of Design for Women; Julian Academy and Desgoffe in Paris. Member: Pittsburgh AA. Address in 1929, Glendora, Chews P.O., Gloucester Co., NJ.

DuMOND, F(RANK) V(INCENT).
Painter, illustrator, and teacher. Born Rochester, NY, 1865. Pupil of Boulanger, Lefebvre, and Constant in Paris. Member: SAA, 1905; ANA, 1900, NA, 1906; ASL of NY; NY Arch. Lg., 1904; Mural P.; Lotos C.; Salma. C., 1900; Century Assoc.; Players C.; Rochester AC; Yonkers AA. Awards: Third class medal, Paris Salon, 1890; gold medal, Boston, 1892; gold medal, Atlanta Exp., 1895; silver medals for painting and illustration, Pan-Am Exp., Buffalo, 1901; silver medal, St. Louis Exp., 1904; hors concours (jury of awards), P.—P. Exp., San F., 1915. Director, Dept. of Fine Arts, Lewis and Clark Exp., Portland, 1905. Instructor at ASL of NY. Work: "At the Well," Public Gallery, Richmond, IN; two murals in San Francisco Public Library. Died Feb. 6, 1951 in NYC. Address in 1929, 27 West 67th St., NY; Grassy Hill, Lyme, CT.

DUNBAR, DAPHNE FRENCH.
Lithographer and painter. Born in Port Colban, Canada, in 1883. Studied: Boston Museum of Fine Arts School; with Ross, Zerbe, and Kenneth H. Miller. Awards: San Diego, California, 1941; Institute of Modern Art, Boston, 1945. Collections: Colorado Springs Fine Art Center; Boston Museum of Fine Art; Addison Gallery of American Art; Los Angeles Museum of Art; Detroit Inst. of Art; Library of Congress.

DUNBAR, HAROLD.
Painter and illustrator. Born in Brockton, MA, on Dec. 8, 1882. Pupil of MA Normal Art School under E. L. Major, DeCamp and Tarbell; Colarossi in Paris. Member: Boston SWCP; Boston AC; NYWCC; Copley S.; Concord AA; AWCS. Award: Hon. mention, AWCS, 1917. Work: "Spring Evening," Boston Art Club; "Portrait of Arthur Gilman," Radcliffe College; "Portrait of Gov. Woodbury," State House, Vermont; "The Morning Letter," Municipal collection, McPherson, Kansas; "Portrait of Chief Justice Watson," Supreme Court, VT; portraits of Buechner Family, Buechner Hospital, Youngstown, OH. Director, Chatham Summer School of Painting, Cape Cod, MA. Address in 1929, Box 494, Chatham, MA.

DUNBAR, ULRIC STONEWALL JACKSON.
Sculptor. Born January 31, London, Ontario, Can., in 1862, and was a pupil of Frederick A. T. Dunbar and the Art School of Toronto, Canada. He was a member of the Washington Arts Club. His awards include a bronze medal at the Columbian Exposition, Chicago, 1893; prize, Pan-American Exposition, Buffalo, 1901; prize, Atlanta Exposition, 1902; St. Louis Exposition, 1904; prize, Seattle, WA., 1906; silver medal, Panama-Pacific Exposition, San Francisco, 1915. He is represented in Washington by a bronze statue of Gov. Alexander M. Shepherd; "Singleton Monument," Oak Hill Cemetery; bust of G. G. Hubbard, Hubbard Memorial Hall; statue of Col. Hammond, Atlanta, GA; Ross memorial bronze, "Grief," Norwich, CT; bronze busts of Albert Pike, Scottish Rite Temple, Washington, DC; Little Rock, AR; Dallas, TX; St. Louis, MO; and Baltimore, MD. Address in 1926, Washington, DC. Died in Wash., DC, in May 1927.

DUNBIER, AUGUSTUS WILLIAM.
Painter, teacher, and lecturer. Born in Osceola, NE, on Jan. 1, 1888. Pupil of Royal Acad., Dusseldorf; and AIC. Member: Omaha SA; Salma. C.; S. Indp. A. Awards: Hon. mention, Northwestern Ex., 1918; C. N. Dietz prize ($100), Nebraska Ex., 1922. Work: "Clouds," in Public Library, Omaha. Address in 1929, Education Dept. YMCA, Omaha, NE.

DUNCAN, FLORIDA.
Painter. She was born near London, Ontario, Can. Self-taught. Member: NYWCC; Wash. WCC. Address in 1929, Provincetown, MA.

DUNCAN, FREDERICK (ALEXANDER).
Sculptor and painter. Born in Texarkana, Ark., May 11, 1881. Pupil of Art Students League of New York; George Bridgman, Howard Chandler Christy. Address in 1933, 54 West 68th St., NYC.

DUNCAN, G(ERALDINE) R(OSE).
See Birch, Geraldine.

DUNCAN, JEAN.
Painter, craftsman, and teacher. Born in St. Paul, MN, on Dec. 26, 1900. Pupil of George Bridgman, Clarence Chatterton and Charles Hawthorne. Member: St. Paul ASL; S. Indp. A. Award: Second prize, Minneapolis Art Inst., 1925. Address in 1929, 482 Laurel Ave., St. Paul, MN.

DUNCAN, WALTER JACK.
Illustrator. Born Indianapolis, IN, 1881. Student of Art Students League of NY. Pupil of John Twachtman. Began with *Century Magazine*, 1903; sent to England by *Scribner's*, 1905; became connected with *McClure's*, 1907; with *Harper's*, 1912-13. Illustrated books by Booth Tarkington, Robert C. Holliday, Christopher Morley, etc. Died in 1941. Address in 1926, 7 East 8th Street, New York, NY.

DUNDAS, VERDE VAN V.
Sculptor, writer, and lecturer. Born in Marlin, TX, August 31, 1865. Pupil of Lorado Taft. Member of the Chicago Municipal Art League; Chic. Art Students League; American Art Soc., Philadelphia; Western Art Society. Work: "Baby Buntin'," Arche Club, Chicago. Address in 1926, Chicago, IL; summer, Art Institute of Chicago, IL.

DUNKERLEY, JOSEPH.
Miniature painter. Flourished 1784-85 in Boston, MA. He advertised in the *Independent Chronicle*, Boston, December 1784, saying that he "Still carries on his Profession of Painting Miniatures at his house in the North Square."

DUNLAP, HELENA.
Painter. Born in Los Angeles, CA. Work: San Diego Fine Arts Gallery; Los Angeles Museum. Address in 1929, Los Angeles, CA; Paris, France.

DUNLAP, JAMES BOLIVER.
Sculptor, painter, lithographer, engraver, and cartoonist. Born in Indianapolis, IN, May 7, 1825. Worked: San Francisco, 1850-60; Indianapolis. Died in Indianapolis, IN, Sept. 4, 1864.

DUNLAP, WILLIAM.
Painter and engraver. Born in Perth Amboy, NJ, on Feb. 18, 1766. In 1784 Dunlap went to London to study art with Benjamin West, and as early as 1783 he had made a crayon portrait from life of George Washington. He engraved a portrait of the actor Wignell in the character of Darby. He painted a number of portraits, settled in NY, and was elected president of the National Academy of Design. The Metropolitan Museum owns his portraits of Mr. and Mrs. John A. Conant. He was the author of the *History of the Arts of Design, in the United States* (1834). Died in New York, Sept. 18, 1839.

DUNLAP, ZOE F.
Miniature painter. Born in Cincinnati, OH, 1872. Pupil of Cincinnati Academy; also studied in Paris. Address in 1926, Cincinnati, OH.

DUNN, ALAN CANTWELL.
Painter. Born in Belmar, NJ, Aug. 11, 1900. Pupil of NAD; Fontainebleau School of Fine Arts, France; visiting fellow, Amer. Acad. in Rome, 1923-24. Member: NYWCC; Tiffany Foundation; AWCS (assoc.). Address in 1929, New York, NY.

DUNN, CHARLES A. R.
Painter. Born in Washington, DC, Dec. 9, 1895. Pupil of Edgar Nye and C. W. Hawthorne. Member: S. Wash. A.; Wash. WCC; Wash. Lndsp. C.; Ten Painters of Washington. Award: First prize, S. Wash. A., 1925. Address in 1929, 3810 Eighth St., N.W., Washington, DC.

DUNN, DELPHINE.
Painter, craftsman, and teacher. Born in Rushville, IN. Address in 1929, Westerville, OH.

DUNN, EMELENE ABBEY.
Sculptor, painter, and architect. Born in Rochester, NY, May 26, 1859. Established the NY Normal Art School, 1905; American Art Club, 1913. Address in 1929, New York, NY.

DUNN, HARVEY HOPKINS.
Illustrator and draftsman. Born in Philadelphia, PA, July 9, 1879. Pupil of Univ. of Penna.; PAFA; PSIA; Denman Ross at Harvard Univ. Member: GFLA; AI of Graphic A.; Phila. Alliance; Fellowship PAFA; Phila. Sketch C.; Amer. Soc. of Illustrators; The Stowaways, NY; AFA. Awards include first prizes in Poster Competitions, Jewelry Fashion Show, Phila., 1918, the Phila. Chapter AIA, and the T-Square Club, 1927. Work includes trademarks for La Fayette Motor Car Co., Alexander Bros., Hoover Co., and General Motors Export Co. Address in 1929, New York, NY; Philadelphia, PA.

DUNN, HARVEY T.
Painter, illustrator, and teacher. Born in Manchester, SD, March 8, 1884. Pupil of AI Chicago and Howard Pyle. Member: SI, 1913; Salma. C.; GFLA. Opened school with Charles Chapman in Leonia, NJ, in 1906; later taught at ASL and Grand Central School of Art, NYC. Worked for all major magazines; official war artist during WWI. Represented in Smithsonian Inst., International Art Gallery, National Gallery, Washington, DC. Address in 1929, Tenafly, NJ.

DUNN, LOUISE M.
Painter. Born in East Liverpool, OH, 1875. Pupil of H. G. Keller and Cleveland SA; AFA. Award: Second prize for watercolor, Cleveland Museum, 1923. Address in 1929, 1541 Crawford Road, Cleveland, OH.

DUNNEL, E. G.
Engraver. He was a student in the National Academy of Design, NY, in 1837, and in that year secured the third prize for drawing. He became a good engraver of landscape and book illustrations, and in 1847 he was in the employ of Rawdon, Wright, and Hatch, an engraving firm of NY. Soon after this he is said to have abandoned engraving for the pulpit.

DUNNEL, WILLIAM N.
This clever engraver in line and stipple was one of the many pupils of A. L. Dick of NY. Dunnel was engraving for the magazines about 1845, but he contracted bad habits and disappeared.

DUNPHY (DUMPHY, DURPHY), RICHARD L.
Sculptor. Worked: NYC, from 1856.

DUNSMORE, JOHN WARD.
Painter. Born near Cincinnati, OH, Feb. 29, 1856. Pupil of Cincinnati Art Acad.; Couture in Paris. Member: ANA; NY Arch. Lg., 1903; Salma. C., 1903; Boston AC, 1881; AWCS; A. Fund S.; Cincinnati AC; AFA. Awards: Medal, Mass. Charitable Mechanics Assoc., Boston, 1881; Evans prize, Salma C., 1914. Work: Ohio Mechanics Inst., Cincinnati; Lassell Seminary, Auburndale, MA. Represented in Salma.

Club and National Academy of Design, NY; Cincinnati Art Museum. Address in 1929, 96 Fifth Ave., New York, NY.

DUNTON, W. HERBERT.
Painter and writer. Born in Augusta, ME, Aug. 28, 1878. Pupil of A. M. Anderson, DeCamp, F. V. DuMond, W. L. Taylor, E. L. Blumenschein, and L. Gaspard. Member: AFA; Salma. C.; S. Indp. A.; Springfield AA. Awards: Gold medal, Nashville, 1927; hon. men., San Antonio, 1928; cash prize, Pac. S.W. Expo., 1929; cash prize, San Antonio, 1929. Work: Peoria (IL) Society of Applied Arts; Witte Mem. Mus. Fine Arts, San Antonio; Mus. of New Mexico, Santa Fe; U. Club, Akron, OH; Missouri State Capitol, Jefferson City, MO. Specialty: Paintings of the West. Address in 1929, Taos, NM.

DUNWIDDIE, CHARLOTTE.
Sculptor and patron. Born in Strasbourg, France, 1907. Studied: Academy of Arts, with Wilhelm Otto, Berlin; Mariano Benlluire y Gil, Madrid, Spain; and in Buenos Aires. Awards: Speyer Award, National Academy of Design, 1969; Lindsey Memorial Prize, National Sculpture Society, 1970; Pen & Brush Club, 1958; and 15 gold medals. Exhibited: Salon Bellas Artes, Buenos Aires, 1940-45; Allied Artists of America, 1956-72; National Sculpture Society, 1958-72; National Academy of Design, 1959-80. Was president of Pen and Brush Club, 1966-70; vice-president, National Sculpture Society, from 1979. Address in 1982, 35 East Ninth Street, NYC.

DUPAS, JEAN-THEODORE.
Illustrator. Born in Bordeaux, France, 1882. He studied under Carolus-Duran and A. Besnard. A member of the Artists of France, he won the Prix de Rome in 1910 and, in 1941, received the Chevalier de la Legion d'Honneur from the French Art Institute. Died in 1964.

DUPHINEY, WILFRED ISRAEL.
Painter, illustrator, and teacher. Born in Central Falls, RI, Sept. 16, 1884. Pupil of ASL of NY; W. C. Loring and Albert F. Schmitt. Member: Prov. AC; Prov. WCC. Work: Portraits in Central Falls, RI; State House, Providence, RI; City Hall, Providence, RI. Illustrations for magazines. Address in 1929, Providence, RI.

DUQUE, FRANCIS.
Painter. Born in 1832. Studied in Paris and Rome. He came to the U.S. about 1865 and became a popular portrait painter. He died in NYC in 1915.

DURAND, ASHER BROWN.
Engraver and painter. Born in 1796. In 1812 he was apprenticed to the engraver Peter Maverick, and in 1817 he became a partner of his preceptor, under the firm name of Maverick & Durand. The reputation of Asher B. Durand as an engraver in pure line was established by his large plate of the "Declaration of Independence," after the painting by John Trumbull. In 1925 he was, for a time, interested in the business of bank-note engraving, in connection with his brother, Cyrus Durand, and in the same year he was a member of the firm of Durand, Perkins and Co. About 1836, A. B. Durand abandoned engraving for the brush and palette, and he soon became as famous a painter of landscapes as he had been an engraver; to this branch of art he devoted the remainder of his life. In 1895 the Grolier Club of NY published a very full check-list of the engraved work of Asher B. Durand. He was a charter member of the National Academy and was president from 1845 to 1861. His biography was written by John Durand. The NY Historical Society has a set of early presidents painted by Durand from originals by Gilbert Stuart. The Metropolitan Museum owns his "Judgement of God" and five of his landscapes. Durand has been called the "Father of American Landscape Painting." He died in 1886.

DURAND, CYRUS.
Engraver. Born in Jefferson, NJ, Feb. 27, 1781. He was the elder brother of Asher B. Durand. In 1814 Cyrus Durand was in business as a silversmith in Newark, NJ. He was a most ingenious mechanic, and among his earlier inventions was a machine constructed for Peter Maverick, then of Newark, for ruling straight and wavy lines in connection with bank-note work. This was the first of a long series of improvements and inventions intended for use in notes, and Cyrus Durand is credited with having made the first American geometrical lathe. Though not an engraver himself, Cyrus Durand devoted his life to the invention and perfection of machinery used in bank-note work, and his services were so important in this connection that his name cannot be omitted from the present record. Died at Irvington, NJ, Sept. 18, 1868.

DURAND, JOHN.
Engraver. Two well-engraved vignettes on the title-pages of the works of William Cowper and Thomas Gray, published in NY by R. & W. A. Bartow, but undated, are signed "Engraved by J. Durand." In answer to a query, Mr. John Durand, of Nice, Italy, son of Asher B. Durand, writes that these vignettes were engraved by John Durand, a younger brother of A. B. Durand, who died about 1820, aged 28 years. Mr. Durand says that his father always maintained that his brother John was the most talented member of the family at the time of his death.

DURAND, WILLIAM.
The nephew of A. B. Durand was a man of very considerable mechanical ability. He was engraving for note work in NY in 1850.

DURANT, J. WALDO.
Portrait painter. Born in 1774. The Worcester Art Museum owns a portrait of John Waldo, signed by Durant, dated 1791. Died in Philadelphia, 1832.

DURKEE, HELEN WINSLOW.
(Mrs. C. J. Mileham). Miniature painter. Born in New York, NY. Studied: Art Students League of NY; pupil of Chase, DuMond, George Bridgman and Mora. Member: Penna. Society of Miniature Painters; National Association of Women Painters and Sculptors; American Society of Miniature Painters. Award: C. D. Smith Memorial prize, Baltimore Water Color Club, 1921. Address in 1947, New York, NY.

DURLACHER, RUTH.
Painter. Born in Springfield, MA, Jan. 11, 1912. Exhibited: Springfield Art League, 1937; National Arts Club, 1938; Allied Artists of America, 1939. Address in 1940, New York, NY.

DURRIE, GEORGE H.
Painter. Born in New Haven, CT, 1820. He was a pupil of Jocelyn and painted portraits, but was better known for his farmscenes. The Yale Art School owns his "Winter in the Country." Died in 1863.

DURRIE, JOHN.
Painter. Born in Hartford, CT, 1818. He passed most of his life at New Haven, CT, and painted landscapes and a few portraits.

DUSHINSKY, JOSEPH.
Painter. Exhibited at the Annual Exhibition of Water Colors at the Penna. Academy of Fine Arts, 1925. Address in 1926, 64 East 88th Street, New York, NY.

DuSIMITIERE, PIERRE EUGENE.
Artist, antiquary, and naturalist. Born in Geneva, Switzerland, about 1736. In 1768 he was elected a member of the American Philosophical Society, and in 1777 one of the curators of the society. He designed the vignette for the title page of Aitken's *Pennsylvania Magazine* in 1775, and the frontispiece for the *United States Magazine* in 1779. He painted portraits in oils and miniature, also maps and views. See "Memoir of DuSimitiere" in the *Pennsylvania Magazine*. His collection of manuscripts, drawings, and broadsides is in the Philadelphia Library Co., Philadelphia. Died in Philadelphia in 1784.

D'USSEAU, LEON.
Painter and sculptor. Born in Los Angeles, CA, 1918. Exhibited: Metropolitan Mus. of Art; Audubon Artists; Palace of Legion of Honor; California Watercolor Soc.; Los Angeles Museum of Art. Address in 1953, Hollywood, CA.

DUSTIN, SILAS S.
Landscape painter. Born in Richfield, OH. Pupil of National Academy of Design and William M. Chase. Member: Artists Fund Society; Salma. Club; Laguna Beach Art Assoc.; California Art Club. Represented in Seattle Museum of Art; Portland, OR, Museum of Art; Berkshire Athenaeum and Museum, Pittsfield, MA. Address in 1940, Los Angeles, CA.

DUTHIE, JAMES.
Engraver. He was born in England and was taught there to engrave. Duthie was engraving book illustrations on steel in NY between 1850-55. Some of his best line work appears in the illustrations of an edition of Cooper's works, published in NY in 1860.

DUVAL, AMBROSE.
Flourished 1827-1830 in New Orleans, LA, as a miniature painter. His miniature of Gov. William C. C. Claiborne of Louisiana has often been reproduced and copied. It is signed "A. Duval." He also painted Lelande de Ferrier.

DUVAL, P. S.
Lithographer. Worked in Philadelphia where his firm executed the title for "Godey's."

DUVALL, FANNY ELIZA.
Painter and teacher. Born in Port Byron, NY, September 8, 1861. Pupil of Sartain in NY; Mlle. Olga de Boznanska and F. Auburtin in Paris. Member: California Art Club; West Coast Arts, Inc.; Laguna Beach Art Association; American Federation of Arts. Awards: Bronze medal, Lewis and Clarke Centennial Expo., 1905; gold medal, Alaska-Yukon-Pacific Expo., 1909. Work: "Large Rose," Jonathan Club, Los Angeles; "Pont Neuf, Paris," Friday Morning Club, Los Angeles; "Sycamore Tree in Spring," Ruskin Art Club, Los Angeles. Address in 1929, 4547 Marmion Way, Los Angeles, CA. Died about 1939.

DUVENECK, FRANK.
Painter, sculptor, etcher, and teacher. He was born at Covington, KY, in 1848, and received his early training at a monastery near Pittsburgh. He also studied in Munich under Diez. He was an Associate of the National Academy in 1905, an Academician in 1906, and was also a member of the Society of American Artists of NY, Cincinnati Art Club, and the National Institute of Arts and Letters. Taught at Art Students League, 1898-99, and Academy of Fine Arts, Cincinnati. Represented at the Cincinnati Museum Association; Art Association of Indianapolis; Penna. Academy of Fine Arts; National Gallery of Art, Washington, DC. Awarded medal, Columbian Expo., Chicago, 1893; honorable mention, Paris Salon, 1895; silver medal, Pan-American Expo., Buffalo, 1901; prize, P.-P. Expo., San Francisco,

1915. Address in 1910, Art Academy of Cincinnati; h. Covington, KY. Died January 2, 1919.

DUVIVIER AND SON.
Portrait painters, flourishing in Philadelphia about 1796. Their advertisement in Claypoole's *American Daily Advertiser*, Philadelphia, is as follows: "Academy of Drawing and Painting, Duvivier & Son, No. 12 Strawberry Street, between Second & Third Streets, Near Market, Philadelphia."

DUYCKINCK, EVERT.
Portrait painter. Born in 1621. Came to New Amsterdam in 1638 from Holland. He is described as a limner, painter, glazier, and burner of glass. In 1693 he painted the portrait of Stephanus Van Cortland, Mayor of New York City in 1677. Died in 1702.

DUYCKINCK, EVERT, III.
Portrait painter. Born in 1677. He painted in 1725 the portrait of his cousin Ann Sinclair Crommelin. He is also said to have painted a portrait of Lieut.-Governor William Stoughton. The Duyckincks were the most important family of painters in Colonial America. Died in 1727.

DUYCKINCK, GERARDUS.
Portrait painter. Born in 1695. He was the son of Gerret Duyckinck. He was admitted as freeman of the city in 1731, and there described as a limner. Died in 1742.

DUYCKINCK, GERRET.
Portrait painter of the early Dutch families in New York State. Born in 1660. He painted Anne Van Cortland, who married Stephen de Lancey in 1700. The portrait is signed and dated "Gt. Duyckinck, 1699." Died about 1710.

DWIGGINS, WILLIAM ADDISON.
Illustrator and writer. Born in Martinsville, OH, on June 19, 1880. Exhibited at the American Institute of Graphic Arts, NY, 1929, where he was awarded a gold medal. Address in 1947, Hingham, MA.

DWIGHT, JULIA S. L.
Painter. Born in Hadley, MA, December 2, 1870. Pupil of Tryon and Tarbell in Boston; Brush in New York. Address in 1926, 1651 Beacon Street, Brookline, MA.

DWIGHT, MABEL.
Painter and lithographer. Born in Cincinnati, OH, on January 29, 1876. Studied: Hopkins Art School, San Francisco; pupil of Arthur Mathews. Work: Lithographs in Metropolitan Museum; Museum of Fine Arts, Boston; Cleveland Museum of Art; Art Institute of Chicago; Victoria and Albert Museum, London; Bibliotheque Nationale, Paris. Address in 1929, 34 Grove St., New York, NY.

DYE, CLARKSON.
Painter. Born in San Francisco, CA, June 30, 1869. Pupil of Virgil Williams, Burridge, and Michelson. Work: Mural decorations in Cathedral of Los Angeles, Durango, Mexico; Grand Opera House, Waco, TX. Address in 1926, 2595 Union Street, San Francisco, CA.

DYER, AGNES S. (MRS.).
Painter. Born in San Antonio, TX, February 14, 1887. Studied: Art Students League of NY; pupil of Julian Onderdonk, Arthur Dow, and John Carlson. Address in 1926, 483 North Grove Street, East Orange, NJ.

DYER, CHARLES GIFFORD.
Painter. Born in Chicago, 1851. Studied art in Paris. Died January 26, 1912, in Munich, Germany.

DYER, H. ANTHONY.
Landscape painter and lecturer. Born in Providence, RI, on October 23, 1872. Studied in Holland and France. Member: Providence Art Club; Providence Water Color Club; Boston Society of Water Color Painters; American Federation of Arts; Newport Art Association. Work: Corcoran Gallery, Washington, DC; Providence, RI, Art Club; Rhode Island School of Design. Address in 1940, Providence, RI. Died August 24, 1943.

DYER, HARRY W.
Painter and illustrator. Born in Portland, ME, on November 16, 1871. Studied: Art Students League of NY; pupil of Charles L. Fox in Portland, Ross Turner, Frank W. Benson, Voitz Preissig, and Despradelle. Member: Architectural Club; Salma. Club. Award: 2nd prize, Beaux Arts, 1896. Address in 1929, 90 Morningside Drive, New York, NY; East Stroudsburg, PA. Died January 28, 1936.

DYER, NANCY A.
Painter. Born in Providence, RI, Oct. 20, 1903. Work: Providence Art Club, Providence, RI. Address in 1929, Providence, RI.

EAKINS, MRS. THOMAS.
Mrs. Eakins copied and restored Sully's portrait of Dr. Philip Syng Physick at the University in 1889.

EAKINS, THOMAS COWPERTHWAIT.
Sculptor and painter. Born in Philadelphia, Penna., July 25, 1844. Pupil of Penna. Academy of Fine Arts; Ecole des Beaux-Arts under Gerome, Bonnat, and Du Mond in Paris. Work: Reliefs for Trenton Battle monument; horses of Grant and Lincoln on the Soldiers' and Sailors' monument, Brooklyn; assisted in modelling figures of prophets adorning Witherspoon Building. Awards: Medal, Columbian Exposition, Chicago, 1893; honorable mention, Paris Exposition, 1900; gold medal, Pan-American Exposition 1901; gold medal, St. Louis Exposition, 1904; Temple gold medal, Penna. Academy of Fine Arts, 1904; Proctor prize, Nat. Acad. of Design, 1905. Member: Nat. Acad. of Design. Prof. of painting and dir. of schools, Penna. Acad. of Fine Arts. A mem. exhibit of 150 paintings was held at PAFA, 1917-18. Address in 1910, 1729 Mt. Vernon St., Phila., PA. Died June 25, 1916, Philadelphia.

EARHART, JOHN FRANKLIN.
Landscape painter. Born in OH, Mar. 12, 1853. Member: Cin. AC. Award: Landscape prize ($100), Cin. AC, 1903. Address 1929, Fernbank, Cin., OH.

EARL (or EARLE), JAMES.
Painter. Born in Mass., May 1, 1761. Brother of Ralph Earl. He painted portraits in Charleston, and died suddenly of yellow fever on Aug. 18, 1796. His portrait of Charles Pinckney is owned by the Worcester Art Museum.

EARL (or EARLE), RALPH.
Painter of portraits and historical scenes. Born in Leicester, Mass., May 11, 1751. He was the author of "Four Scenes of the Battle of Lexington," and was present at the famous march. Amos Doolittle later engraved the subjects. After the war he went to London, where he studied with Benjamin West. He returned to America in 1786. Died in Bolton, Conn., Aug. 16, 1801. (Also signed "Earle.")

EARL (or EARLE), RALPH ELEASER.
Painter. Son of Ralph Earl, the well-known portrait painter, who died in 1801. Ralph Jr. was born in England, c. 1785, while his father was studying art in that country, and came to the United States with him when he was a child. He studied first with his father, and then went to London in 1809, where he continued his art studies, and to Paris in 1814. He returned

from Europe in 1815, arriving in Georgia. From there he went to Tennessee, where he married Miss Caffery, a niece of General Andrew Jackson. He painted in New Orleans and died there Sept. 16, 1838. He was buried at the "Hermitage."

EARL (or EARLE), THOMAS.
A little-known American painter who lived at Cherry Valley, Mass. Born 1737, and died 1819. He was a cousin of Ralph Earl, the artist, gunmaker, and soldier of the Revolutionary War. He painted portraits in Connecticut in 1775 and in Charleston, SC, in 1792. His full-length portrait of Dr. Dwight and his wife is in Copley's manner with black shadows.

EARLE, AUGUSTUS.
Artist, and son of James Earle, was admitted as a student at the Royal Academy in 1793. From 1815 to 1832 he traveled in North and South America. When in New York he spent his time with Thomas Cummings the well-known painter of miniatures. Died in 1838.

EARLE, CORNELIA.
Painter and teacher. Born Huntsville, AL, Nov. 25, 1863. Pupil of G. L. Noyes. Member: Columbia AA; Southern SAL; Carolina AA; North Shore AA. Award: First prize, Columbia AA, 1922. Address in 1929, 1703 Laurel St., Columbia, SC.

EARLE, EDWIN.
Painter. Born Somerville, Mass., Dec. 9, 1904. Pupil of Mass. Sch. of Art; ASL of NY; Pruett Carter. Address in 1929, 51 West 16th St., New York, NY; summer, Derby Line, VT.

EARLE, ELINOR.
Painter. Born Philadelphia. Pupil of PAFA. Member: Plastic C.; Fellowship PAFA; Phila. Alliance. Award: Mary Smith prize, PAFA, 1902; bronze medal, St. Louis Exp., 1904. Address in 1929, 8840 Stenton Ave., Chestnut Hill, Philadelphia, PA.

EARLE, J.
He was engraving portraits in Philadelphia in 1876, in connection with James R. Rice.

EARLE, LAWRENCE CARMICHAEL.
Painter. Born New York City, Nov. 11, 1845; died at Grand Rapids, Nov. 20, 1921. He studied in Munich, Florence and Rome. He was an Associate of the National Academy of Design, and a member of the

American Water Color Society, Artists' Fund Society, Art Institute of Chicago (honorary), and the New York Water Color Club. Represented in the Art Institute of Chicago and in the Chicago National Bank. He made a specialty of portraits.

EARLE, OLIVE.
Painter. Born London, Dec. 27, 1888. Work: "Marine Life," Trade Development Board, Bermuda. Address in 1929, 416 West 20th St., New York, NY; summer, Jefferson Valley, NY.

EARLEY, JAMES FARRINGTON.
Sculptor. Born in Birmingham, England, Sept. 27, 1856. American citizen, 1882. Pupil of Royal Academy. Papal medal, Leo XIII; silver medal, St. Louis Exposition, 1904. Member: Washington Architectural Club; Society of Washington Artists. Address in 1910, rear 175 East S St.; h. 1348 T St., NW, Washington, DC.

EAST, NATHANIEL S., JR.
Sculptor and designer. Born in Delaware Co., PA, March 21, 1936. Studied at Phila. College of Art; with Herman Cohen. In collections of Glassboro College, NJ; University City Arts League, Phila.; Phila. School System; Bell Telephone Company, Phila. Exhibited at Allentown, PA; Antonio Souza Gallery, Mexico City, 1969; Grabar Gallery, Phila., 1968; National Forum of Professional Artists, Phila.; etc. Received National Ornamental & Miscellaneous Metals Association awards, 1978, 80. Member: University City Arts League (vice-president, 1965-66); National Forum of Professional Artists; etc. Author and teacher. Works in pre-used metal objects. Address in 1982, Hatfield, PA.

EASTERDAY, SYBIL UNIS.
Sculptor. Born in San José, California, in 1876. Studied with Juan Buckingham Wandesforde, Hayward, California, c. 1892; with Arthur Mathews and Douglas Tilden at Mark Hopkins Institute of Art, San Francisco, mid-1890's. Had studio in San Francisco c. 1897-1903. Worked in Mexico City, 1903-05, on portrait commissions. Her works include portrait of Porfirio Diaz, President of Mexico, 1903; plaster panel of "Memory Unveiling the Past;" "Despair;" "Reverie." Active for 10-year period; much celebrated in local and national press. Little of her work has survived, except through photos. Died in Tunitas Glen, San Mateo Co., Calif., in 1961.

EASTMAN, CHARLOTTE FULLER.
Painter. Born in Norwich, CT. Studied at PAFA; ASL; Art Inst. of Chicago; Boston Mus. of Fine Arts School; and with Wayman Adams.

EASTMAN, RUTH.
Illustrator. Member: Society of Illustrators, New York; Artists Guild of the Authors' League of America. Address in 1929, 80 West 40th St., New York, NY.

EASTMAN, SETH.
Painter. Born in Brunswick, Maine, Jan. 24, 1808. He graduated from the Military Academy at West Point in 1831, and taught drawing there from 1830-40. He was afterwards stationed with his regiment in the Western states, where he became greatly interested in the Indians. Nine paintings of Indian life and 17 paintings of U.S. forts are in the Capitol Bldg., Washington, DC. He died Aug. 31, 1875, in Wash., DC.

EASTMAN, W(ILLIAM) JOSEPH.
Painter, craftsman, writer and teacher. Born Nov. 14, 1888. Member: Cleveland SA; Cleveland AA. Award: First prize, Penton medal, Cleveland Museum of Art, 1919. Died in 1950. Address in 1929, 1868 East 82nd St., Cleveland, Ohio.

EASTON, LINWOOD.
Etcher. Born Portland, ME, May 17, 1892. Pupil of Albert E. Moore, Alexander Bower. Member: Salma. C.; Portland SA. Died 1939. Address in 1929, 518 Brighton Ave., Portland, ME.

EASTWOOD, R(AYMOND) J(AMES).
Painter and teacher. Born Bridgeport, Conn., May 25, 1898. Pupil of F. V. Du Mond, W. S. Kendall, E. C. Taylor. Member: ASL of NY; Provincetown AA. Address in 1929, 317 East Administration Bldg.; h. 1135 Ohio St., Lawrence, Kansas; summer, 53 Sedgwick St., Bridgeport, Conn.

EATON, CHARLES FREDERICK.
Painter. Born in Providence, RI, 1842. Lived in Europe until 1886; settled in Santa Barbara, 1886; occupied in painting, wood carving and landscape architecture; made rare collection of antique carved furniture and tapestries. An advocate of the arts and crafts movement in America. Address in 1926, Santa Barbara, Calif.

EATON, CHARLES HARRY.
Painter. Born Dec. 13, 1850, and died Aug. 4, 1901. First exhibited at National Academy of Design, NY. Gold medal at the Philadelphia Art Club, 1900, exhibiting "The Willows." Elected an Associate Member of the National Academy of Design in 1893. He exhibited "The Willows" at the Paris Exposition in 1889 and at the World's Fair, Chicago, in 1893.

EATON, CHARLES WARREN.
Landscape painter. Born Albany, NY, Feb. 22, 1857. Pupil of NAD and ASL of NY. Member: AWCS; NYWCC; Salma. C., 1897; A. Fund S.; Lotos C. Awards: Hon. mention, Paris Exp., 1900; Proctor prize, Salma. C., 1901; silver medal, Charleston Exp., 1902; Inness prize, Salma. C., 1902; Shaw prize,

Salma. C., 1903; gold medal, Phila. AC, 1903; Inness gold medal, NAD, 1904; silver medal, St. Louis Exp., 1904; gold medal, Paris Salon, 1906; silver medal, Buenos Aires Exp., 1910. Work: "Dunes at Knocke, Belgium," Cincinnati Museum; "Gathering Mists," National Gallery, Washington; "Connecticut Pines," B'klyn Ins. Museum; "The Strip of Pines," Art Museum, Montclair, New Jersey; "Snow Scene" and "Landscape," Hackley Gallery, Muskegon, Mich.; "The Tall Pines," Nashville, Tenn., Museum; "An Autumnal Mood," Arnot Art Gallery, Elmira, NY. Died Sept. 10, 1937. Address in 1929, 63 Monroe Pl., Bloomfield, NJ.

EATON, HUGH McDOUGAL.
Painter and illustrator. Born in Brooklyn, NY, in 1865. Pupil of Cox and Chase. Specialty, illustrations and lead block prints. Died Sept. 14, 1924, at Halsey St., Brooklyn, NY.

EATON, JOSEPH ORIEL.
Painter. Born Feb. 8, 1829, in Licking Co., Ohio. Genre and portrait painter in oil and water colors. He was an Associate of the National Academy, and a member of the Society of Painters in Water Colors. He visited Europe in 1873. Exhibited at National Academy in 1868, "View on Hudson." He died in New York on Feb. 7, 1875.

EATON, LOUISE HERRESHOFF.
Painter. Born Providence. Pupil of Mary C. Wheeler; Constant, Laurens and Collin in Paris. Member: Providence AC; Providence WCC; North Shore AA; Gloucester SA. Address in 1929, 11 Charles Field St., Providence, RI; summer, East Gloucester, Mass.

EATON, MARGARET FERNIE.
(Mrs. Hugh M. Eaton). Painter, illustrator and craftsman. Born Leamington, England, April 22, 1871. Pupil of J. B. Whittaker in Brooklyn; ASL of NY under Cox and Mowbray. Member: NY WCC; ASL of NY (life). Address in 1929, 339 Halsey St., Brooklyn, New York, NY; summer, "The Fircone," Montville, NJ.

EATON, WILLIAM S(YLVESTER).
Painter and etcher. Born in Waltham, Mass., Dec. 12, 1861. Member: S. Indp. A; Salma. C.; PBC. Address in 1929, Eaton Bldg., Jermain Ave.; h. The Terrace, Sag Harbor, LI, NY.

EATON, WYATT.
Painter. Born in Philipsburg, Canada, 1849; died in Newport, RI, in 1896. Figure and portrait painter. Pupil of J. O. Eaton, the National Academy of Design, and later of Gerome at the Ecole des Beaux Arts. He was the first secretary of the Society of American Artists. He painted "Ariadne" and is represented at the Boston Museum of Fine Arts by "Mother and Child."

EBBELS, VICTORIA.
Painter. Born in Hasbrouck Heights, NJ, in 1900. Pupil of George Luks and Robert Henri. Member of the Society of Independent Artists. Address in 1926, 1213 Carrier St., Denton, Texas.

EBERBACH, ALICE KINSEY.
Painter. Born in Philadelphia, June 16, 1872. Pupil of Courtois, Girardot, Henri, Chase. Member: Fellowship PAFA. Address in 1929, 441 West Stafford St., Germantown, Philadelphia, PA.

EBERHARD, ROBERT GEORGE.
Sculptor, craftsman, lecturer, museum curator, and teacher. Born Geneva, Switzerland, June 28, 1884. Pupil of MacNeil at Art Students League, Mercie, Carlier, Peter, Rodin at Ecole des Beaux-Arts, Lycee Montaigne, Paris; Pratt Institute Art School; Yale University, BFA, MA. Member: Societe des Artistes Francais; Artistes du Cher; New Haven Paint and Clay Club; National Sculpture Society. Head of Department of Sculpture at Yale University. Work: War Memorial tablets, White Plains (NY) High School; flagstaff base, Public School No. 9, Brooklyn; war memorial, Rosedale, NY. Received Lissignol prize, Geneva, Switzerland; silver medal, Artistes du Cher, Vierzon, France; honorable mention, Paris Salon. Exhibited at National Sculpture Society, 1923. Positions: Curator at Yale University Gallery of Fine Art and taught at Yale, from 1952. Address in 1953, Newcastle, ME.

EBERLE, ABASTENIA ST. LEGER.
Sculptor. She was born in Webster City, IA, April 6, 1878. Pupil of Art Students League of New York; George Grey Barnard. Member: Associate, National Academy of Design; National Sculpture Society; Allied Artists of America; American Federation of Arts. Awards: Bronze medal, St. Louis Exposition, 1904; Barnett prize, National Academy of Design, 1910; bronze medal, P.-P. Exposition, San Francisco, 1915; prize, Garden Club of America, 1929; hon. mention, Allied Artists of America, 1930; Lindsay Morris Sterling prize, National Sculpture Society, 1931. Work: "Girl on Roller Skates" and "Mowgli," Metropolitan Museum, New York; "Windy Doorstep," Worcester Art Museum; Peabody Art Institute; Baltimore; Newark Museum; Carnegie Institute, Pittsburgh; "Little Mother," Chicago Art Institute; "The Dancer," Venice, Italy; Twentieth Century Club, Buffalo, NY; "Rag Time," Toledo Art Museum; "Hurdy Gurdy," Detroit Institute; general excellence trophy, "Iron May," Pacific and Asiatic Fleet. Address in 1933, 204 West 13th Street, New York, NY; summer, Green Farms, CT. Died Feb. 26, 1942, in New York City.

EBERT, CHARLES H.
Painter. Born Milwaukee, Wis., July 20, 1873. Pupil of Cincinnati Art Academy; ASL of NY; Julian

Academy in Paris. Member: Greenwich SA; Salma. C.; Lyme AA; Wis. PS. Awards: Bronze medal, Buenos Aires Exp., 1910; silver medal, P.-P. Exp., San F., 1915; Milwaukee Sentinel prize, 1927. Address in 1929, Lyme, Conn.; summer, Monhegan Island, ME.

EBERT, MARY ROBERTS.
(Mrs. Charles H. Ebert). Painter and craftsman. Born Titusville, PA, Feb. 8, 1873. Pupil of ASL of NY; Twachtman; Hunt in Boston. Member: AWCS; N.A. Women P.S. Address in 1929, Lyme, Conn.; summer, Monhegan Island, ME.

EBY, KERR.
Illustrator. Born in Japan in 1889. The son of Can. Methodist missionaries, he came to America at age 18 to study at PI and the ASL. He produced a very popular volume entitled *War*, from his sketches of France in World War I, which was published by *Yale University Press* in 1936. He spent most of World War II in the Pacific where he produced many sketches. Other illustrations of his appeared in books and magazines such as *Life* and *The Century*. An extensive collection of his work is housed at the New York Public Library. Died in 1946.

ECHERT, FLORENCE.
Painter and craftsman. Born Cincinnati, Ohio. Pupil of Cincinnati AA; ASL of NY; W. M. Chase. Member: Cincinnati Woman's AC. Address in 1929, The Valencia, 276 St. George Street, St. Augustine, Fla.; summer, "Little Chalet," Intervale, White Mts., NH.

ECKE, BETTY TSENG YU-HO.
See Tseng, Yu-Ho.

ECKFORD, JESSIEJO.
Painter. Born Dallas, Texas, Nov. 21, 1895. Pupil of Aunspaugh Art School, Hale Bolton, Frank Reaugh, and Felicie Waldo Howell. Member: Dallas Art Assoc.; S. Indp. A.; Highland Park SA; SSAL; Tex. S. FA; AFA. Awards: Bronze medal, 1916, gold medal, 1919, Dallas Woman's Forum Exhibit; prize, Davis wildflower comp., San Antonio. Address in 1929, Wallnut Hill Lane, Dallas, Texas.

ECKHARDT, EDRIS.
Sculptor, lecturer, and educator. Born in Cleveland, Ohio, January 28, 1906. Studied at Cleveland School of Art and with Alexander Blazys. Member: American Ceramic Society. Awards: Prizes, Cleveland Museum of Art, 1935-37, 43-45; National Ceramic Exhibition, Syracuse Museum of Fine Art, 1933; Butler Art Institute, 1946. Work: Mall, Cleveland, Ohio; ceramics, Cleveland Pub. Library and School; Cleveland Museum of Art; Akron Public School; Queens (NY) Library; Ohio State Univ.; Phila. Art Alliance; Columbus Public School; Cleveland Board of Education. Exhibited: Syracuse Museum of Fine

Art, 1933-41; Paris Exposition, 1936; International Ceramic Exhibition, Scandinavian countries, 1939, 40; New York World's Fair, 1939; Golden Gate Expositions, 1939; College Art Assoc. of America traveling exhibition, 1933-36; Cleveland Museum of Art, 1933-46; Toledo, Ohio, 1939, 40; Butler Art Institute 1946; Wichita Art Association, 1946; Akron, Ohio, 1937; Phila. Art Association, 1944. Address in 1953, Cleveland, Ohio.

ECKSTEIN, FREDERICK.
Sculptor and drawing master. Born c. 1775, probably in Berlin. Studied at the Academy in Berlin. Son of Johann Eckstein; moved to US in 1794. Worked: Philadelphia, 1794-1817; Harmony, Penna.; Wheeling, West Virginia; Cincinnati, 1823-30, 1838-40; Kentucky. Johann and Frederick co-founded Penna. Academy. Frederick taught Hiram Powers, Shobal Clevenger. Died Feb. 10, 1852, Cincinnati.

ECKSTEIN, JOHANN.
Sculptor, modeler in wax, portrait and historical painter, and engraver. Probably born in Mecklenburg, Germany, c. 1736. Historical painter and sculptor at Prussian Court, c. 1772 to 1794. Executed a death mask and plaster bust of Frederick the Great in 1786. Exhibited at the Royal Academy (London) and Berlin Academy. Emigrated to the US in 1794, settling in Philadelphia. Worked there as a limner and "statuary" with his son, Frederick Eckstein. An organizer of the Columbian Soc. of Artists (1795), the Penna. Academy (1805), and the Soc. of Artists (1810). Exhibited a design for an equestrian statue of Washington in Roman costume, Soc. of Artists, 1811-12. Died in Havana, Cuba, June 27, 1817/1818.

ECKSTEIN, JOHN.
Portrait painter, modeler and engraver. Born in Germany 1750 and died 1817. In proposals for a "Representation of a Monument of Gen. Washington," he is referred to as "formerly historical painter and statuary to the King of Prussia." His name was in Phila. directories of 1796-97 and 1805-06 as "Limner and Statuary;" 1811-16 was listed as "Engraver." Was still painting and engraving in 1822. Eckstein's few portrait plates are inscribed "Painted and Engraved by John Eckstein," and executed in combination of stipple and roulette work, hard in effect. In 1806 he modeled statue of Washington for above proposed monument, and engraved the plate of that subject for the Soc. of the Cincinnatus. In 1809 he was the engraver for illustrations for Freneau's poems, which were published by Lydia R. Bailey, of Philadelphia, PA. John Eckstein may be the same as Johann Eckstein, listed above.

EDDY, HENRY B.
Illustrator. Born New York, NY, Sept 16, 1872. Member: Society of Illustrators, 1914; New Rochelle Art Association. Died in 1935. Address in 1929, care

of N.Y. Sunday American, 2 Duane St., New York, NY; h. Mamaroneck, NY.

EDDY, HENRY S(TEPHENS).
Painter. Born Rahway, NJ, Dec. 31, 1878. Pupil of Volk, Cox, Twachtman, ASL of NY, Alphonse Mucha and Geo. E. Browne. Member: Salma. C.; Beachcombers of Provincetown; Artists Fellowship; A. Fund S.; Provincetown AA; Guild of Am. Painters; Allied AA; Guild of Am. Painters; Allied AA; Westfield AA; Amer. Assn. of Museums; Lotos C; Plainfield AA; New Haven PCC; Phila. Alliance; Am. APL; AFA. Work: "In from the Nets," Milwaukee Art Inst.; "St. Michaels at Passaic," Reid Memorial Library, Passaic, NJ; "Finse in June," Arnot Art Gallery, Elmira; "A Nantucket Doorway," Junior Art League of Miss Hutchinson's School, Memphis, Tenn.; "Cranford River," Free Public Library, Cranford, NJ; "Winter," Westfield High School; "The Path through the Woods," First National Bank, Plainfield, NJ; "Ravello, Italy," Lotos Club, NY. Died in 1944. Address in 1929, Springfield Road, Westfield, NJ.

EDDY, ISAAC.
Engraver. Born in Weathersfield, VT, Feb. 17, 1777. He engraved some crude plates for the "First Vermont Edition of a Bible," published at Windsor, VT, by Merifield & Cochran. Mentioned as an engraver or possibly as a land-surveyor. Was probably connected with Pendleton's engraving establishment in Boston. Died July 25, 1847, in Waterford, NY.

EDDY, JAMES.
Engraver. Born May 29, 1806; was living in Providence, RI, 1881. He was a good engraver of portraits in the stipple manner, and was working as early as 1827 to 1830 in Boston. Died May 18, 1888, in Providence.

EDDY, OLIVER TARBELL.
Engraver. A folio map of New Hampshire with an inset view of Bellows Falls engraved in line is signed "O. T. Eddy, engraver, Walpole (N.H.) Aug. 1817."

EDDY, SARAH JAMES.
Sculptor. Born in Boston, 1851. Exhibited portrait bust of Samuel S. Fleisher at the Penna. Academy of Fine Arts, Philadelphia, 1914. Address in 1926, Bristol Ferry, RI.

EDELSON, MARY BETH.
Lecturer, mixed media and conceptual artist. Studied: The Art Institute of Chicago; DePauw University; New York University. Awarded a National Endowment Grant, 1973. Exhibitions: Indianapolis Museum of Art, formerly John Herron Museum, 1968; Corcoran Gallery of Art, Wash., DC, 1973; Ringling Mus. of Art, Sarasota, FL, 1974.

Collections: Corcoran Gallery of Art; Joe Cantor Collection; Sheldon Swope Gallery. Media: Conceptual works, sculpture, photos, books, performance art, drawings, posters. Address in 1980, 110 Mercer Street, New York, NY.

EDENS, ANNETTE.
Painter, craftsman and teacher. Born Guemos, Wash., April 16, 1892. Pupil of Dow, Hawthorne. Member: Seattle FAS. Address in 1929, University of Washington, Seattle, Wash.; summer, Eldridge Farm, Bellingham, Wash.

EDERHEIMER, RICHARD.
Portrait painter. Born Frankfurt, Germany, 1878. Died 1934 in New York. Member: League of New York Artists; Society of Independent Artists. Address in 1926, 18 East 57th St., New York.

EDGERLY, MIRA.
See Korzybska, Mira Edgerly.

EDHOLM, C(HARLTON) L(AWRENCE).
Painter, illustrator and writer. Born Omaha, Neb., Mar. 21, 1879. Pupil of Ludwig Herterich in Munich. Address in 1929, 7 Main St., Dobbs Ferry, NY.

EDMISTON, ALICE R.
Painter. Born Monroe, Wis. Pupil of AIC; ASL of NY; and studied in Paris. Award: Prize ($100), Omaha SFA, 1923. Represented in Vanderpoel AA Collection, Chicago. Address in 1929, 1900 South 40th St., Lincoln, Neb.

EDMOND, ELIZABETH.
Sculptor. Born 1887, in Portland, ME. Exhibited at the Penna. Academy of Fine Arts, Philadelphia, 1914. Died June 22, 1918, in Pasadena, Calif.

EDMONDS, ESTHER TOPP.
Painter. Born in NYC, 1888. Daughter of A. Edmonds, she began her art studies with her father; also studied at Cooper Union and Art Students League of NY, graduated with honors. After completing her studies, she became assoc. with her father. In 1910 he opened a studio in Columbia, SC, where she continued to work with him. After his death, she cont. her profession of portrait painter, and painted portraits of many prominent men.

EDMONDS, FRANCIS WILLIAM.
Painter. Born in Hudson, NY, Nov. 22, 1806. He was a genre painter who had little art education. He was employed as a cashier in a New York bank. In 1840 he was elected a member of the National Academy. He died Feb. 7, 1863, in New York City.

EDMONDSON, WILLIAM JOHN.
Painter. Born Norwalk, Ohio, 1868. Pupil of Academy of the Fine Arts, Phila., under Vonnoh and Chase;

Julian Academy, Paris, under Lefebvre; Aman-Jean Academy, Paris. Member: Fellowship PAFA; Cleveland SA; Cleveland AA. Awards: Second Toppan prize, PAFA; European traveling scholarship, PAFA; first prize, figure painting; popular vote prize and Penton medal, Cleveland Museum of Art, 1919; 1st prize for decorative and mural painting, Cleveland Museum, 1923. Work: Delgado Art Museum, New Orleans; Cleveland Museum; Western Reserve University; Society for Savings, Cleveland; Fellowship PAFA, Philadelphia; State House, Columbus, Ohio; Municipal Collection, Cleveland. Address in 1929, 2362 Euclid Ave., Cleveland, Ohio; h. 2812 Scarborough Rd., Cleveland Heights, Ohio.

EDMUNDSON, CAROLYN.
Painter. Born in Pittsburgh, PA, 1906. Studied: Carnegie Institute, College of Fine Arts; Columbia University. Awards: Nevada Art Association, 1952; Society Western Art, 1954. Collections: Nevada State Museum, Carson City; still life paintings, advertising illustrations for Cannon Mills, Forstmann Woolens, Yardleys of London and many others.

EDROP, ARTHUR (NORMAN).
Painter and illustrator. Born Birmingham, Eng., May 15, 1884. Pupil of Whittaker in Boston. Member: Phila. Sketch C.; SI; Art Directors C. Illustrator for *Life, Collier's Weekly, Ladies Home Journal*, etc. Specialty, Advertising art. Address in 1929, "Topping," Hilaire Rd., St. David's, PA.

EDSTROM, DAVID.
Sculptor, writer, lecturer, and teacher. Born Hvetlanda, Sweden, March 27, 1873. Pupil of Borjison, Royal Academy, Stockholm; Injalbert in Paris. Member: Los Angeles Painters and Sculptors; South Calif. Sculptors Club; Scandinavian Artists of NY; Calif. Painters and Sculptors Club. Award: Silver medal, World's Fair, St. Louis, 1904. Work: "Soldiers' Monument," Ottumwa, Iowa; "Isis" and "Nepthys," Masonic Temple, Washington, DC; War memorial relief, Montreal, Canada; Statue of Judge G. F. Moore, Scottish Rite Temple, Dallas, Texas; "Cry of Poverty," "Caliban," "Portrait of Baron Beck-Frus" and "Portrait of Dr. Romdahl" in Gothenburg Mus., Sweden; reliefs in the Faehrens Gallery, Stockholm; "Portrait of the Crown Prince of Sweden," and "Portrait of the Princess Patricia of Connaught," in the Royal Palace, Stockholm; Statue of "Gen. P. Cochran," Dallas, Texas; Statue, M. H. Whittier, Los Angeles; Strickland Memorial, Dallas, Texas; "The Hunchback," "Caliban," "February," "Peasant," "Old Italian Soldier," "Two Souls," "Grotesque," "Ernest Thiel," "Prometheus," "Athlete," National Museum, Stockholm. Address in 1933, Los Angeles, Calif. Died in 1938.

EDWARDS, EDWARD B.
Painter, illustrator, draughtsman. Born Columbia, PA, Feb. 8, 1873. Studied in Paris and Munich.

Member: NY Arch. Lg., 1892; A.L. Graphic A.; Salma. C.; GFLA.

EDWARDS, ELLENDER MORGAN.
Graphic artist and photographer. Born in Hagerstown, MD. Studied: The Maryland Institute of Art; George Washington University, Washington, DC; ASL. Awards: Rockville, Maryland, N.L.A.P.W.; Shepherd Col., West Virg.; Waterford Foundation, Inc., Virginia. Exhibitions: University of Arizona; De Young Museum, Calif.; Montgomery College, Maryland. Address in 1980, Rockville, MD.

EDWARDS, GEORGE WHARTON.
Painter, illustrator and writer. Born Fair Haven, CT, in 1869. Studied in Antwerp and in Paris. Member: NYWCC; AWCS; (life) NAC; SI; Am. Inst. of Arts and Letters; PS. Awards: Bronze and silver medals, Boston, 1884 and 1890; bronze medal, Pan-Am. Expo., Buffalo, 1901, for painting, and hon. mention for drawing; silver medal, Charleston Expo., 1902; medal, Barcelona, Spain, 1902; medal of King Albert, 1920; Golden Palms of French Acad., 1921; Knight Chevalier, Legion d'Honneur, France, for "Eminent Services in Art," 1925; Knight Chevalier, Order de la Couronne Belge, for "Distinction in Art," 1927; Royal Order of Knight Chevalier (Isabella) from Alfonso XIII, Spain, 1928, for "Eminent Distinction in Art." Manager, art dept. at Collier's, 1898-1903; Amer. Bank Note Co., since 1904. Work: Mural decoration, "Henrik Hudson," U.S. Military Academy; illustrated Austin Dobson's "Sun Dial;" "Old English Ballads," "The Last Leaf," by O. W. Holmes, etc. Author of "Alsace-Lorraine," "Vanished Towers and Chimes of Flanders," "Vanished Halls and Cathedrals of France," "Holland of Today," "Belgium, Old and New," "Paris," "London," "Spain," "Rome." Died in 1950. Address in 1929, Greenwich, Conn.

EDWARDS, HARRY C.
Painter and illustrator. Born Philadelphia, PA, Nov. 29, 1868. Pupil of Adelphi College, Brooklyn, under J. B. Whittaker; Art Students League of New York under Mowbray. Member: Brooklyn Soc. of Artists. Illustrated "The Gun Brand," "Blackwater Bayou," etc. Died in Brooklyn, NY, May 9, 1922.

EDWARDS, KATE F(LOURNOY).
Painter. Born Marshallville, GA, in 1877. Pupil of AIC; Simon in Paris. Member: The Cordon, Chicago; Atlanta AA; Atlanta FAC; Atlanta Studio Club. Awards: 1st prize, Southeastern Fair Expo., 1916, Atlanta, GA; 1st prize, Atlanta AA, 1921. Work: Portraits of Judge Barbour, property of U.S. Gov., Wash., DC, Gov. Slaton, property of State of Georgia; Senator A. S. Clay, Georgia State Capitol; Jos. Clisby, Clisby Sch., Macon, GA; Gov. M. B. Wellborn, Fed. Reserve Bank, Atlanta; Dr. I. S. Hopkins and Dr. William H. Emerson, Georgia Sch. of Technology,

Atlanta; Judge Cincinnatus Peeples, Fulton Co. Courthouse, Atlanta; Dean Robert J. Sprague, Rollins College, Winter Park, FL; Dr. John E. White, Wake Forest College, NC; George Muse, Geo. Muse Clothing Co., Atlanta; Stanley M. Hastings, O'Keefe Jr. High School, Atlanta, GA. Address in 1929, Pershing Point Apts., Atlanta, GA.

EDWARDS, ROBERT.
Painter and illustrator. Born Buffalo, NY, Oct. 4, 1879. Pupil of ASL of Buffalo; ASL of NY; Chase School; Eric Pape School and Cowles School in Boston. Member: SI, 1910; Salons of Am.; S. Indp. A. Illustrated "Eve's Second Husband;" composed "The Song Book of Robert Edwards." Died in 1948. Address in 1929, 144 Macdougal St., New York, NY.

EDWARDS, SAMUEL ARENT.
Engraver. Born in 1862 in Somersetshire, England; living in New York in 1905. Mr. Edwards was a student at the Kensington Art School in 1877-81 and was then taught to engrave in mezzotint by Appleton, Josey & Alais, of London. He first exhibited examples of his engraving in the Royal Academy in 1885. In 1890 Mr. Edwards came to the United States, established himself in New York, and made book illustrations, portraits, and subject plates. He successfully revived the art of printing in colors from mezzotinto plates, and deservedly achieved a reputation. His color plates were issued without touching up with water colors, as was often the custom in prints of this description. Died in 1935.

EDWARDS, THOMAS.
Silhouettist, and portrait painter in oils and miniatures. Flourished 1822-56 in Boston, Mass. He was a frequent exhibitor in the early years of the Boston Athenaeum and also contributed drawings to the first lithographic press in Boston, established in 1825 by the Pendleton Brothers.

EDWARDS, WILLIAM ALEXANDER.
Illustrator. Born in NYC in 1924. Studied: Whitney Art School in Manor Haven under Alfred Freundeman. His first published illustration was a cover, entitled "Big Nickelodeon," for Bantam Books. Since 1962, he has illustrated for magazines and books, the most notable being his covers for Herman Hesse's novels *Demian, Steppenwolf,* and *Magister Ludi: The Glass Bead Game.* A prolific portrait artist, he has had work exhibited in galleries in Bridgeport and Waterbury, CT.

EDWIN, DAVID.
Engraver. Born in Bath, England, in Dec., 1776. He was a son of John Edwin, an English actor. David Edwin was apprenticed to a Dutch engraver, Jossi, who was residing in England, but who returned to Holland, with Edwin. Edwin disagreed with his master and went to Philadelphia in 1797. He found a

friend and employer in T. B. Freeman, for whom he engraved the title-page for "Scotch Airs," by Benjamin Carr. He was later assistant to Edward Savage. Lack of tools, poor quality of obtainable plates and rude printing led him to totally change his method. For 30 years he was the most prolific workman in America. Failing health and overwork impaired his sight, and about 1830 he ceased work. In 1835 he became treasurer of the newly formed "Artists' Fund Society of Philadelphia" and also received a bequest from a friend which made his last years comfortable. These details are from a biographical sketch in "Catalogue of the Engraved Work of David Edwin," by Mantle Fielding, Phila., 1905. His engravings were in stipple and were beautifully finished. Among his best known plates are Thomas McKean, Thomas Jefferson, Dolly Madison, and a number of General Washington. Died in Phila., Feb. 22, 1841.

EGAS, CAMILO.
Sculptor, painter, etcher, lithographer, and teacher. Born in Quito, Ecuador, December 10, 1899. Studied at Academia de las Bellas Artes, Ecuador; Royal Institute des Beaux-Arts, Rome; San Fernando Academia de Bellas Artes, Madrid. Awards: Fellowships to Rome and Paris from Ecuador; prize, International Exhibition, Quito. Work: Museum of Modern Art; Newark Museum of Art; IBM; National Museum, Ecuador; murals, New York World's Fair, 1939; New School for Social Research, NY; Jijon Library, Quito. Exhibited: Salon d'Automne, Salon de Tuileries, Salon des Independentes, all in Paris; Galeria Nacional de Rome; Salon del Retiro, Madrid. Position: Director, Art Department, New School for Social Research, NYC. Address in 1953, 248 West 14th St., NYC; h. Orwigsburg, PA. Died in 1962.

EGGELING, HERMAN.
Painter and teacher. Born New York, NY, Aug. 17, 1884. Pupil of Bridgman and Sloan. Member: Bronx AG. Illustrated "Encyclopedia of Foods," by Artemas Ward. Specialty, landscape painting. Address in 1929, 106 Pleasant Ave., Tuckahoe, NY.

EGGEMEYER, MAUDE KAUFMAN.
Painter. Born New Castle, Ind., Dec. 9, 1877. Pupil of J. E. Bundy; Gifford Beal; Cincinnati Art Academy. Member: Chicago Gal. A; Ind. AC; Richmond Palette C.; Cincinnati Women's AC. Awards: Beaumont Parks prize, Hoosier Salon, 1924; Crilly prize, Hoosier Salon, 1927; Salon Patrons Assn. prize, 1928. Address in 1929, "Twin Oaks," Richmond, Ind.

EGGENHOFER, NICK.
Sculptor, painter, and illustrator. Born Gauting, Southern Bavaria, Germany, 1897; came to US (New York City) in 1913. Studied at Cooper Union; apprenticeship at the American Lithography Company. Member: Cowboy Artists of America, National

Academy of Western Art. Painted "Making Friends" in 1923, reproduced on cover of *Western Story Magazine*, 1923. Illustrated for many books and magazines. Produced series of bronzes of scale model Western vehicles he had made. Specialty is Western subjects, wagon-train era. Lived in Milford, NJ; later moved to Cody, WY. Living there in 1976.

EGGERS, GEORGE WILLIAM.
Lithographer, writer and lecturer. Born Dunkirk, NY, Jan. 31, 1883. Pupil of Pratt Institute. Member: Chic. AC; Denver Cactus Club; Worcester C; Assn. Art Mus. Directors. Director, Worcester Museum of Art. Died in 1958. Address in 1929, 76 West St., Worcester, Mass.

EGGLESTON, BENJAMIN.
Painter. Born Belvidere, Minn., Jan. 22, 1867. Pupil of Minneapolis School of Fine Arts under Douglas Volk and studied in Paris. Member: Brooklyn AC; Brooklyn WCC; Salma. C., 1903; Brooklyn SA; Allied A.A.; PS; AFA; Scandinavian Am. A. Died in Feb., 1937. Address in 1929, 164 East 22nd St., Brooklyn, NY; summer, West Stockbridge, Mass.

EGGLESTON, EDWARD M.
Painter, illustrator. Born Ashtabula, OH, Nov. 22, 1887. Pupil of John N. Piersche, Albert Fowley, Alice Schilly, Harvey Dunn. Member: GFLA; SI. Address in 1929, 59 W 35th St., NY, NY; h. 109-61-198th St., Hollis, Long Is., NY; summer, Twin Lakes, CT.

EGRI, TED.
Sculptor and painter. Born in NYC, May 22, 1913. Studied at Master Institute Roerich Museum, dipl., 1931-34; Duncan Phillips Memorial Gallery Art School, 1942; Hans Hofmann School of Art, New York, and Provincetown, MA, 1948. Work in Museum of New Mexico, Santa Fe; others. Has exhibited at Colorado Springs Fine Arts Center; Penna. Academy of Fine Arts Annual; Shidoni 6th and 7th Annual Outdoor Show. Received awards from Museum of New Mexico, top award for sculpture and honorable mention for drawing. Member: Artists Equity Association; Taos Art Association. Address in 1982, Taos, NM.

EHNINGER, JOHN WHETTEN.
Painter. Born July 22, 1827, in New York. He studied abroad and afterwards painted a number of genre studies of American life. His best known paintings are "New England Farmyard," "Yankee Peddler," "Lady Jane Grey." He also produced illustrations in outline and a series of etchings. Elected a member of the National Academy in 1860. Died Jan. 22, 1889, in Saratoga, NY.

EHRICH, WILLIAM.
Sculptor. Born in Koenigsberg, Germany, July 12, 1897. Studied at State Art School of Koenigsberg;

with Erich Schmidt-Kestner, Stanislaus Cauer, and Franz Thryne. Exhibited: Finger Lakes Exhibition, Rochester, NY; Albright Art Gallery; Syracuse Museum of Fine Arts. Award: Honorable mention, wood sculpture, Buffalo Society of Artists, 1932; prizes, Albright Art Gallery, 1935, 38, 40, 41, 45; Rochester Memorial Art Gallery. Member: Buffalo Society of Artists. Address in 1953, Carnegie Hall; University of Rochester; h. Rochester, NY.

EICHHOLTZ, JACOB.
Painter. Born Nov. 2, 1776, of an old family of German origin in Lancaster, PA. He was an expert coppersmith who developed a talent for portrait drawing. Early in the century he was aided by visiting artists, and when Thos. Sully visited Lancaster, before his departure for Europe in 1809, he directed him to the instruction of Gilbert Stuart in Boston. He took with him his best known portrait (of Nicholas Biddle, with the US Bank in the background). He later settled in Phila. as a portrait painter for 10 years. In the style of Sully and Stuart, he painted over 250 portraits and some landscapes and hist. groups, between 1810 and his death in 1842. Among his subjects were Chief Justices Marshall and Gibson; Govs. Shulze, Porter and Ritner; Attys. Gen. Elder, Franklin and Champneys; Nicholas Biddle and many of the foremost people of his day in Phila., Baltimore, Harrisburg and Lancaster.

EIDE, PALMER.
Sculptor, painter, educator, and craftsman. Born in Sioux Falls, Minnehaha County, SD, July 5, 1906. Studied at Augustana College, BA; Art Institute of Chicago; Harvard University; Yale University; Cranbrook Academy of Art; St. Olaf College, DFA. Member: College Art Assoc. of America; American Oriental Society. Awards: Scholarships, Harvard University, 1936-37; Fellow, Yale University, 1940, 41; Painting, Sioux City Art Center, 1966; Governor's Award in Arts for Creative Achievement, South Dakota, 1976. Work: City Hall Broadcasting Station KSOO, Sioux Falls, SD; Trinity Lutheran Church, Rapid City, SD; mural, University of South Dakota, etc. Position: Professor of Painting, Augustana College, Sioux Falls, SD, 1931-71. Exhibited: Sioux City Art Center, 1961, 62, and 66; Fine Arts in Service of Church, Seattle, WA, 1963; Lee Fine Arts Center, University of South Dakota, 1977; Dahl Fine Arts Center, Rapid City, SD, 1977; others. Address in 1982, Sioux Falls, SD.

EILERS, EMMA.
Painter and craftsman. Born in NY. Pupil: ASL. Member: ASL; NY Woman's AC. Address in 1929, Brooklyn, NY; summer, Sea Cliff, LI, NY.

EILSHEMIUS, L(OUIS) M(ICHEL).
Painter, illustrator, craftsman and writer. Born Laurel Hill, Arlington, NJ, Feb. 4, 1864. Pupil of

Schenker, Robert C. Minor, Van Luppen, Julian in Paris. Member: Modern AA; AFA; Salons of America; Societe Anonyme. Died in 1941. Address in 1929, 118 East 57th St., New York, NY.

EIMER, ELSA.
Painter. Member: S. Indp. A. Address in 1929, 209 East 19th St., New York, NY.

EINSEL, NAIAD.
Illustrator. Born in Philadelphia in 1927. Graduated from PI in 1947, beginning her career the next year with an illustration for *Seventeen*. Since 1950, her work has appeared in many major magazines and in exhibitions at the S of I, ADC and Greengrass Gallery. Among her many poster assignments was the Westport Bicentennial Quilt in 1976 which she designed and which 33 Westport women hand-stitched, under the guidance of J.L. McCabe.

EINSEL, WALTER.
Illustrator. Born in NY in 1926. Attended PSD and graduated from the ASL and the Brooklyn Museum School. In 1953, his first work was published in *The New York Times Magazine*. He has since illustrated many magazines and books. His pen and ink and three-dimensional artwork has been exhibited at the Museum of Contemporary Crafts, Montreal Expo, and the Fairtree and Greengrass Galleries in NY.

EISENBACH, DOROTHY L.
Painter and teacher. Born Lafayette, Ind. Pupil of William Forsyth, Felicie Waldo Howell. Award: J. I. Holcomb prize ($100), Indiana Artists Exhibition, 1929. Address in 1929, John Herron Art Institute, Indianapolis, Ind.; h. 627 Owen St., Lafayette, Ind.

EISENLOHR, E. G.
Painter, lecturer and teacher. Born Cincinnati, Ohio, Nov. 9, 1872. Pupil of R. J. Onderdonk and F. Reaugh in Texas; Academy Karlsruhe, Germany, under G. Schoenleber. Member: Salma. C; AFA. Work: "The Sentinel of the Canyon," Dallas Public Art Gallery; Elisabet Ney Mus., Austin, TX. Author of "Study and Enjoyment of Pictures," "Tendencies in Art and Their Significance," "Landscape Painters." Died in 1961. Address in 1929, 324 Eads Ave., Station A, Dallas, Tex.

ELAND, JOHN SHENTON.
Painter, illustrator and etcher. Born Market Harborough, England, March 4, 1872. Pupil of Sargent. Member: AFA. Medalist of the Royal Academy, England. Represented by etching in Brooklyn Museum. Died in 1933. Address in 1929, 205 West 57th St., New York, NY.

ELDER, ARTHUR J(OHN).
Painter, etcher, teacher and craftsman. Born London, England, March 28, 1874. Pupil of Walter

Sickert, Theodore Roussel, Charles Huard, David Muirhead, James Pryde. Member: Chelsea AC;. Junior Art Workers Guild, London. Award: Medal, Crystal Palace, London, 1901. Died c. 1951. Address in 1929, Westport, Conn.

ELDER, JOHN ADAMS.
Painter of portraits and battle subjects. Born Fredericksburg, VA, Feb. 3, 1833. In his early youth he was a cameo carver. Pupil of the Duesseldorf Academy and of Emanuel Leutze. Won prize at Dusseldorf Academy. He painted portraits of General Robert Edward Lee and General T. J. Jackson. Died Feb. 24, 1895.

ELDRED, L. D.
Marine artist and etcher. Was born in Fairhaven, Mass. He studied in Julien Studio in Paris. On his return to this country he opened his studio in Boston, where his work has been much sought after.

ELDRIDGE.
Engraver. A line engraving of a residence, "Hickory Grove," is signed as "Drawn by J. Collins, Engraved by Eldrige." It is a good work and appears in "The Miscellaneous Writings of Samuel J. Smith, of Burlington, NJ," Philadelphia, 1836.

ELDRIDGE, CHARLES W.
Miniature painter. Born in New London, Conn., in Nov., 1811. He lived for years in Hartford, Conn. He also painted many miniatures in the South. He was a member for years of the old firm of miniature painters, Parker & Eldridge. Died in 1883.

ELIA, ALBERT.
Illustrator. Born in Beirut, Lebanon, in 1941. Studied for five years at the Beaux Arts in Paris and PSD in NY. *Mademoiselle* published his first illustration in 1964 and he has since worked for *Harper's Bazaar*, *The New York Times*, and *Seventeen*. Since 1970, he has been involved in film and photography.

ELISCU, FRANK.
Sculptor, lecturer, and teacher. Born in NYC, July 13, 1912. Studied with Rudolph Evans and Paul Fjelde. Commissions: War memorial, Cornell Medical College; Presidential Eagle, Oval Office, White House; inaugural medal, President Ford, Vice President Rockefeller, plus others. Exhibited: Penna. Academy of Fine Arts; Conn. Academy of Fine Arts; Cleveland Museum of Art; Detroit Institute of Art; plus others. Member: Fellowship National Sculpture Society (president, 1967-70); National Academy of Design (academician); Architectural League of New York. Awards: Prize, Architectural League of New York, 1955, Silver Medal, 1958; Henry Hering Award, 1960; and others. Address in 1982, Sarasota, FL.

ELKINS, HENRY ARTHUR.
Painter. Born in Vershire, VT, in 1847. He moved to Chicago in 1856 and taught himself to paint. Among his pictures are "Mount Shasta," "New Eldorado," and the "Crown of the Continent." Died in Colorado in 1884.

ELLERHUSEN, F(LORENCE) COONEY.
Painter and teacher. Born Canada. Pupil of Chase, George Luks, Vanderpoel; AIC; ASL of NY. Member: Allied AA; NA Women PS. Died in 1950. Address in 1929, 939-8th Ave., New York, NY; summer, Towaco, NJ.

ELLERHUSEN, ULRIC HENRY.
Sculptor and teacher. Born in Germany, April 7, 1879; came to America at age of 15. Pupil of Art Institute of Chicago; Lorado Taft; Art Students League of NY; Karl Bitter. Member: National Sculpture Society, 1912; NY Architectural League, 1914; Beaux-Arts Institute of Design (honorary), 1916; Allied Artists of America; American Federation of Arts; Associate National Academy of Design, 1932. Exhibited at National Sculpture Society, 1923. Awards: 1st prize in competition for medal for St. Louis Art League; medal of honor for sculpture, NY Architectural League, 1929; Allied Artists of America, 1934. Work: "Contemplation," "Wonderment," "Meditation" and "Frieze of Garland Bearers," exterior decorations, Fine Arts Building, San Fran.; Schwab Memorial Fountain, Yale University Campus, New Haven, Conn.; medal for St. Louis Art League; Penna. Memorial medal to employees of the Penna. Rail Road in military service; peace monument and allegorical portraits of "Confucius," "Columbus," "Pocahontas," and "Life of Douglass," Elmwood Park, East Orange, NJ; 3 reliefs illustrating F. Douglass Memorial Home, Wash., DC; Edward Austin Abbey II, Memorial, University of Penna.; portrait of Very Rev. Walter G. Moran, St. Vincent Ferrer Church, NY; Communion Rail, Church of St. Gregory the Great, NY; portrait of Prof. Alexander Smith, University of Chicago; St. Michael Relief, St. Mary's College, Notre Dame, Ind.; "The March of Religion," South Front Chapel, University of Chicago; also "Morning," "Evening," "Prophet," "Priest," "Learning," "Science," portraits of "Bach," "Wilson," "Roosevelt;" exterior of Christ Church, Cranbrook, Mich.; buttress finial statues of Gutenberg, Pasteur, W. Wright, Renan, Pere Marquette, Phillips Brooks, Bishop Williams, Bishop Page, Dr. Samuel Marquis; "They came and stood at the Cross," (John and Mary); Church of the Heavenly Rest, NY, Symbolism, main entrance, "Moses" and "St. John Baptist;" others. Address in 1953, Towaco, NJ. Died in 1957.

ELLERTSON, HOMER E.
Painter and illustrator. Born River Falls, Wisc., Dec. 23, 1892. Pupil of Pratt Inst., Brooklyn, NY; M. de la Cluse, Naudin and Miller in Paris. Member: Scandinavian American SA; SSAL; AFA. Work: "The Encore" and "The Ebro," Phillips Memorial Gallery, Washington, DC. Died in 1935. Address in 1929, "El-Taarn," Tryon, NC.

ELLICOTT, HENRY JACKSON.
Sculptor. Born in Anne Arundel County, MD, 1848. Studied drawing at the National Academy of Design; also studied under Brumidi, Powell, and Leutze. Died in Washington, DC, February 11, 1901.

ELLIOT, GEORGE.
A little-known American portrait painter born in 1776; he died in 1852. His portrait of Mr. Van Dusen, of Connecticut, was signed. He was said to have been an Academician, but the published lists of the National Academy of Design do not note his name.

ELLIOTT, BENJAMIN F.
Landscape and portrait painter. Born Sept. 26, 1829, in Middletown, Conn. He painted many portraits for Kellogg Brothers, in Hartford. He died Sept. 6, 1870.

ELLIOTT, CHARLES LORING.
Portrait painter. Born in Scipio, NY, Oct. 12, 1812. He came to New York City about 1834 and became the pupil of John Trumbull. In 1846 he was elected a member of the National Academy of Design. He was said to have painted more than seven hundred portraits of prominent men of his time. His portraits are in all the prominent galleries. He died in Albany, NY, Aug. 25, 1868.

ELLIOTT, ELIZABETH SHIPPEN GREEN.
(Mrs. Huger Elliott). Illustrator. Born Philadelphia, PA. Pupil of PAFA and of Howard Pyle. Member: Phila. WCC; NYWCC; SI (assoc.), 1903; Fellowship PAFA; Plastic C; Providence AC; Concord AA; Phila. Alliance; AFA. Awards: Second Corcoran prize, Wash. WCC, 1904; bronze medal, St. Louis Exp., 1904; Mary Smith prize, PAFA, 1905; Beck prize, Phila. WCC, 1907; silver medal, P.-P. Exp., San F., 1915. Work: Magazine and book illustrations; exclusively on staff of *Harpers Magazine*, 1902-11; illustrated edition of *Lambs Tales from Shakespeare*, 1922; *Old Country House*, 1902; *Aurelie*, 1912; *The Book of the Little Past*, 1908; *Riverland*, 1904; *Rebecca Mary*, 1905; *A Daughter of the Rich*, 1924; *Bred in the Bone*, 1925, *Little Hop Skippel*, 1926; Bryn Mawr Coll. May Day Program, 1924 and 1928. Address in 1929, 114 East 90th St., New York, NY.

ELLIOTT, HANNAH.
Painter, miniature painter, illustrator and teacher. Born Atlanta, GA, Sept. 29, 1876. Studied in America and Europe. Award: Third prize for Miniature, All Southern Exhibition, Charleston, SC., 1921. Address in 1929, 2036-13th Ave., South, Birmingham, AL.

ELLIOTT, JOHN.
Painter. Born in England, 1858. Student in Julien Academy. Pupil of Carolus Duran, Paris; Jose di Villegas at Rome. Subjects were chiefly portraits and mural decorations, some of the more notable in America being "The Vintage," frieze and ceiling in house of Mrs. Potter Palmer, Chicago; "The Triumph of Time," ceiling decoration in Boston Public Library; "Diana of the Tides," mural painting in new National Museum, Washington. Represented in permanent collection of Old State House, Boston, and collection of H. M. the Dowager Queen of Italy. Died May 26, 1925.

ELLIOTT, RONNIE.
Sculptor, painter, etcher, and lithographer. Born in NYC, December 16, 1916. Studied at NY University; Hunter College; Art Students League; and with William Zorach, Alexander Brook, Hans Hofmann, Francis Luna. Member: Art League of America. Exhibited: Penna. Academy of Fine Arts, 1933, 34, 39; Honolulu Academy of Art, 1936; Golden Gate Exposition, 1939; New York World's Fair, 1939; Carnegie Institute, 1941; Corcoran Gallery of Art, 1939; Nat. Academy of Design, 1941; Bennington College, 1943; San Francisco Museum of Art, 1945, 46; Western College, Oxford, OH, 1945; Marquie Gallery, 1942, 44 (one-man); Art of This Century, 1943-45; Metropolitan Museum of Art, 1942; Museum Non-Objective Painting, 1946, 47; Norlyst Gallery, 1947; Carlebach Gallery, 1947; Museum of Modern Art, 1948; Galerie Creuze, Paris, 1948; Realites Nouvelles, Paris; 1948-51, Polo Gallery, Washington, DC, 1976; Andre Zarre Gallery, NYC, 1977; Nardin Gallery, NYC, 1979. Work: Museum of Modern Art; Whitney Museum; Carnegie Institute; Cornell University; and others. Awards: Wellesley College Purchase Award, Jewett Arts Center, 1970. Address in 1982, 68 East Seventh Street, New York City.

ELLIS, EDMUND L(EWIS).
Painter, etcher and artist. Born Omaha, Neb., Oct. 30, 1872. Pupil of G. B. Post, McKim, Mead and White. Member: NY Arch. Lg.; Bronx AG; NSS; AIA; AFA. Work: Marble reredos and church decorations, St. James Protestant Episcopal Church, Fordham, and interiors of Park Central Hotel, New York City. Address in 1929, 25 West 43rd St.; h. 2341 Andrews Ave., New York, NY.

ELLIS, EDWIN M.
Born 1841. This engraver of portraits and landscape, working both in stipple and in line, was in business in Philadelphia in 1844. Died in 1895.

ELLIS, FREMONT F.
Painter, etcher and teacher. Born Virginia City, Mont., Oct. 2, 1897. Pupil of ASL of NY. Member: Calif. AC; Santa Fe Art Club; Los Cinco Pintores.

Address in 1929, Camino del Monte Sol, Santa Fe, NM.

ELLIS, GEORGE B.
Engraver. In 1821 Ellis was a pupil of the Phila. engraver Francis Kearny, and in 1825-37, inclusive, he was in business for himself in the same city. His name disappears from the Philadelphia directories in 1838. Ellis first attracted attention as an engraver by his excellent copies of English engravings, which he made for an edition of "Ivanhoe." He produced some very good portraits, but his best work is found among his small "Annual" plates.

ELLIS, HARRIET.
Painter and draughtsman. Born Springfield, Mass., April 4, 1886. Pupil of Hawthorne, Mabel Welch, Johonnot, Albertus Jones, Cecilia Beaux, Pratt Inst. Member: NA Women PS; Springfield AL; Springfield AG. Specialty: Portraits in oil, sepia-pencil, silhouette. Address in 1929, 158 Sherman St., Springfield, Mass.

ELLIS, JOSEPH BAILEY.
Sculptor and teacher. Born North Scituate, Mass., May 24, 1890. Pupil of Albert H. Munsell, Bela Pratt; Peter and Injalbert in Paris. Member: Copley Society; Boston Architectural Club; Pittsburgh Art Association; Salma. Club. Address in 1933, College of Fine Arts, Carnegie Institute of Technology; h. Pittsburgh, PA; summer, Boothbay, Maine. Died January 24, 1950.

ELLIS, MAUDE MARTIN.
Painter and illustrator. Born Watseka, Ill., Feb. 7, 1892. Pupil of J. Wellington Reynolds. Address in 1929, Beil Bldg., 19 East Pearson St., Chicago, Ill.

ELLIS, SALATHIEL.
Sculptor, cameo portraitist, and designer of medals. Born in Vermont or Toronto, Canada, 1860. Began his career as a cameo-cutter in St. Lawrence Co., NY. Worked in NYC 1842 to at least 1864. Executed medals for the US Mint; in 1864 contributed two medallions to the Metropolitan Fair.

ELLIS, VERNON.
Sculptor, painter, etcher, writer, and teacher. Born in Columbia, PA, December 5, 1885. Pupil of Chase. Address in 1918, Plainfield, MA. Died in 1944.

ELLIS, WILLIAM H.
Line-engraver. He was a good line-engraver of landscape and book illustrations. His work appears in Philadelphia publications of 1845-47.

ELLSWORTH, CHERYL (LAWTHER).
Sculptor. Born in Dubuque, Iowa, in 1911. Studied at University of Wisconsin. Has exhibited in New York and Penna.

ELLSWORTH, JAMES SANFORD.
Miniature painter. Born in Windsor, Conn., in 1802. Moved to the West. He painted "A Wounded Grecian Racer" and made several copies of Gilbert Stuart's full-length portrait of Washington, one being in the Wadsworth Gallery. Died in Pittsburgh, PA, in 1874.

ELMENDORF, STELLA.
See Tylor, Stella Elmendorf (Mrs.).

ELMORE, ELIZABETH TINKER.
Painter, etcher and writer. Born Clinton, Wis., Aug. 7, 1874. Pupil of William Merritt Chase, Charles Mielatz; George De Forest Brush, and portrait study in Rome, Italy. Member: NA Women PS; PBC; Catherine Lorillard Wolfe Art Club. Awards: First prize for portrait, 1918, first prize for etching, 1919, Catherine Lorillard Wolfe Art Club. Specialty, marines, portraits and etchings. Died in 1933. Address in 1929, 17 East 67th St., New York, NY.

ELOUIS, JEAN PIERRE HENRI.
(Henry Elouis). Painter. Born in Caen, France, Jan. 20, 1755. He studied art under the French painter Jean Barnard Restout and went to London in 1783. Exhibited at the Royal Academy 1785-87. At the beginning of the French Revolution he emigrated to Baltimore. Charles Wilson Peale met him in 1791 at Annapolis, calling him "Mr. Louis," mentioning that "he paints in a new style." In 1792 Elouis moved to Phila. and his name appears in the Directories for 1793 as "limner, 201 Mulberry St." He remained in Phila. until 1799, where he taught drawing to Eleanor Custis and painted miniatures of Washington and Mrs. Washington. Elouis travelled the U.S., Mexico, and South America. Returned in 1807 to France. His portraits are noted for their simplicity and directness. Died in Caen on Dec. 23, 1840.

ELSHIN, JACOB (ALEXANDROVITCH).
Painter and illustrator. Born in Leningrad, Russia, Dec. 30, 1891. Pupil of Zemin, Roussanoff, Andriev, Dimitrieff. Member: Seattle AI; Seattle AG. Work: Stage setting, "Chinese Street Scene," "Buddhist Temple Scene," Seattle Civic auditorium; "Ruins of Troy," Cornish School of Art and Music, Seattle; settings for "Theatre Russe de Miniature," "Chopiniana Ballet" and "Danse Macabre Ballet," Metropolitan Theatre, Seattle. Address in 1929, 1326 Sixth Ave.; h. 517 27th Ave., South, Seattle, Wash.

ELWELL, FRANCIS (or FRANK) EDWIN.
Sculptor. Born in Concord, Mass., June 15, 1858. He was a pupil of Daniel Chester French; Falguiere and Ecole des Beaux-Arts in Paris. His works include "Dickens and Little Nell," in Philadelphia; "The Flag" at Vicksburg, Miss.; equestrian statue of General Hancock at Gettysburg, Penna.; and "New Life," cemetery, Lowell, MA; "Greece" and "Rome," New York Custom House; "Lincoln Monument,"
Orange, NJ; "Egypt Awaking," Paris; "The New Life," Penna. Academy, Philadelphia; others. Awards: gold medal, Philadelphia Art Club, 1891 and 97; silver medal, Pan-Am. Exposition, Buffalo, 1901; medal, Columbian Exposition, Chicago, 1893. Received a silver medal for architecture from the King of Belgium. Died in Darien, Conn., January 23, 1922.

ELWELL, JOHN H.
Etcher and draughtsman. Born Marblehead, Mass., March 10, 1878. Pupil of Vesper L. George, Reuben Carpenter, Evening Art School, Boston. Member: Boston AC. Specialty, designing, etching and engraving Ex Libris labels. Address in 1929, 30 Bromfield St., Boston, Mass.; h. 33 Brewster Rd., Newton Highlands, Mass.; summer, Naugus Head, Marblehead, Mass.

ELWELL (or ELLWELL), ROBERT FARRINGTON.
Sculptor, painter and illustrator. Born near Boston, Mass., 1874. Self-taught as an artist. Worked as newspaper artist in Boston about 1890; in 1896 became ranch manager, a job he held for 25 years, for Colonel Cody. Sketches earned him commissions for Western illustrations. Painted for *Harper's, Century, American,* and other 1930's magazines. Specialty was Western subjects. Primarily painter and illustrator. Died in Phoenix, Arizona, in 1962.

ELY, A.
Engraver. Ely engraved the script title-page, the music, and a curious "musical" vignette for "The Songster's Assistant, etc.," by T. Swan, Suffield, Conn.; printed by Swan and Ely. The work is undated but is probably c. 1800. The only copy known is in the Watkinson Library, Hartford, Conn.

ELY, RICHARD.
Illustrator. Born in Rochester, NY, in 1928. Attended the Kunst Akademie in Munich and studied under Jack Potter at SVA. He has worked for magazines and publishing companies since the 1950's and his works are in the collections of the NY Public Library, the private collection of the late Princess Grace of Monaco, and the Museum of Afro-American Heritage in Phila. His paintings of Elizabeth Rethberg and George Cehanovsky hang in the Founder's Hall of the Met. Opera House in NY.

EMEREE, BERLA LYONE.
Painter and teacher. Born Wichita, Kan., Aug. 7, 1899. Pupil of Frank B. A. Linton; Jose Arpa. Member: SSAL; San Antonio AG; El Paso AG. Awards: Three blue ribbons, Kendall County Fair, Boerne, Tex., 1926, 1927. Work: "New Mexico Ranch Life," State Museum, Santa Fe, NM; "On the River, San Antonio," Carnegie Public Library, Fort Worth, Tex. Address in 1929, 2315 Byron St., El Paso, Tex.

EMERSON, ARTHUR W(EBSTER).
Painter, illustrator, etcher and teacher. Born Honolulu, Hawaii, Dec. 5, 1885. Pupil of John C. Johansen; ASL of NY. Member: ASL of NY; Salons of America; AFA; Berkeley Lg. FA. Address in 1929, 139 South School St., Honolulu, Hawaii.

EMERSON, CHARLES CHASE.
Illustrator and painter. Member: Society of Illustrators, 1912; Boston Art Club. Died in 1922.

EMERSON, EDITH.
Painter. Born Oxford, Ohio, 1888. Pupil of AIC, PAFA and Violet Oakley. Member: Fellowship PAFA; Phila. Print C; Phila. Alliance; Mural P.; Phila. WCC; Alumni AIC. Work: Mural decorations in the Little Theatre, Philadelphia; Roosevelt memorial window, Temple Keneseth Israel, Phila., PA; Moorestown Trust Co., Moorestown, NJ. Represented in the Pennsylvania Academy of the Fine Arts; Vanderpoel AA Collection, Chicago; illustrations in "Asia" and "The Century." Address in 1929, "Lower Cogslea," St. George's Rd., Mt. Airy, Philadelphia, PA.

EMERSON, SYBILL DAVIS.
Sculptor, painter, decorator. Born in Worcester, MA, 1892. Exhibited: Salon d'Automne, 1928. Awards: First prize, San Francisco Art Association, 1924.

EMERSON, W. C.
Painter and architect. Member: Chicago SA; Chicago WCC; NYWCC; New Canaan SA. Award: Englewood Club prize. Address in 1929, New Preston, Conn.; New Canaan, Conn.

EMERTON, JAMES H.
Illustrator. Born Salem, Mass., 1847. Member: Copley S., 1894. Illustrated zoological publications. Specialty, Amer. spiders. Address in 1929, Fenway Studios, 30 Ipswich St., Boston, Mass.

EMMES, THOMAS.
The earliest known attempt of a portrait engraved upon copper by an American engraver is the work of Thomas Emmes, of Boston. This is a portrait of the Rev. Increase Mather and appears as a frontispiece to "The Blessed Hope, etc.," published in Boston, New England, 1701, by Timothy Green for Nicholas Boone. The plate itself is a very rough attempt at a copy of a London portrait engraved either by Sturt or Robert White, and is little more than scratched upon the copper in nearly straight lines; it has a strongly cross-hatched background. The plate is signed "Tho. Emmes Sculp. Sold by Nicholas Boone 1701."

EMMET, ELLEN G.
See Rand, Ellen G. Emmet.

EMMET, LESLIE.
Painter. Exhibited at the National Association of Women Painters and Sculptors, New York, 1924. Address in 1926, Salisbury, Conn.

EMMET, LYDIA FIELD.
Portrait painter and illustrator. Born New Rochelle, NY, Jan. 23, 1866. Pupil of Chase, Mowbray, Cox and Reid in New York; Bouguereau, Collin, Robert-Fleury and MacMonnies in Paris. Member: ANA, 1909, NA, 1912; ASL of NY; NYWCC; Port. P.; Conn. AFA; NA Women PS; AFA. Awards: Bronze medal, Columbian Exp., Chicago, 1893; bronze medal, Atlanta Exp., 1895; hon. mention, Pan-Am. Exp., Buffalo, 1901; silver medal, St. Louis Exp., 1904; Shaw prize, SAA, 1906; Proctor prize, NAD, 1907; Clarke prize, NAD, 1909; hon. mention, City of Pittsburgh, 1912; Bok prize (first award), PAFA, 1915; pop. prize, Corcoran Gall. of Art, Washington, 1917; Maynard portrait prize, NAD, 1918; Hudson prize, Conn. AFA, 1919; popular prize, Newport AA, 1921, 23; Philadelphia prize, PAFA, 1925. Died Aug. 16, 1952. Address in 1929, 535 Park Ave., New York, NY; summer, Stockbridge, Mass.

EMMET, ROSINA.
See Sherwood, Rosina Emmet.

EMMONS, ALEXANDER HAMILTON.
Portrait painter. Born in East Haddam, Conn., on Dec. 12, 1816. He painted in oil and executed numerous miniatures. In 1843 he opened his studio in Hartford. His only absence for any length of time from this country was an extended trip through Europe to study the work of the old masters. He finally settled in Norwich, Conn., where he died in 1879.

EMMONS, C(HANSONETTA) S(TANLEY).
Miniature painter and craftsman. Born Kingfield, ME, Dec. 30, 1858. Pupil of Enneking and Alice Beckington. Member: Boston SAC. Represented in SAC collection, Boston Museum and Museum of Fine Arts, Newport, RI. Died in 1937. Address in 1929, 21 Bennington St., Newton, Mass.

EMMONS, DOROTHY STANLEY.
Painter and etcher. Born Roxbury, Mass., June 14, 1891. Pupil of Woodbury, G. E. Browne, G. A. Thompson, Aldro T. Hibbard, and G. L. Noyes. Member: New Haven PCC; Am. APL. Address in 1929, 21 Bennington St., Newton, Mass.

EMMONS, NATHANIEL.
Painter. Born in Boston, 1704. A little-known American painter of considerable merit. He painted a portrait of Judge Sewall (engraved by Pelton), William Clarke, Andrew Oliver and Rev. John Lowell (painted 1728). He died May 19, 1740, in Boston.

EMORY, HOPPER.
Illustrator and etcher. Born Baltimore, MD, May 8, 1881. Member: Balto. Charcoal C. Address in 1929, 17 East 22nd St., Baltimore, MD; summer, Towson, MD.

EMPIE, HAL H.
Sculptor, painter, cartoonist, and illustrator. Born in Safford, AZ, March 26, 1909. Studied with Frederic Taubes. Member: El Paso Sketch Club; Arizona Artists Guild. Work: Panels, Methodist Church, Duncan, Ariz. Exhibited: Museum of Modern Art; Pepsi-Cola, 1944, 45; Calif. Water Color Society, 1945; El Paso, TX. Contributor, illustrator and cartoonist for Western magazines. Position: Instructor, Cloudcroft, New Mexico, Art Colony. Address in 1953, Duncan, AZ.

ENDEWELT, JACK.
Illustrator. Born in NYC in 1935. Studied under Jack Potter and Daniel Schwartz at SVA, where he has been an instructor of book illustration and drawing since 1968. He has illustrated educational books as well as many covers for Dell and Avon, and his work has often been included in the S of I Annual Exhibitions.

ENDRES, LOUIS J.
Painter. Exhibited at Cincinnati Art Museum in 1925. Address in 1926, 4206 Ballard Ave., Cincinnati.

ENGEL, RICHARD DRUM.
Painter and writer. Born Washington, DC, Dec. 25, 1889. Largely self taught. Studied in France. Member: Soc. Wash. A. Address in 1929, 806 Farragut St., N.W., Washington, DC.

ENGELMANN, C. F.
Engraver. An elaborate, curiously designed, and crudely engraved Birth and Baptismal Certificate, published about 1814, is signed "Eng. and sold by C. F. Englemann on Pennsmount near Reading, PA." The design closely follows similar work emanating from the community of Seventh Day Baptists at Ephrata, Lancaster Co., PA, which is in the vicinity of Reading.

ENGLAND, PAUL GRADY.
Sculptor, painter, and writer. Born in Hugo, OK, January 12, 1918. Studied at Carnegie Institute, BA, 1940; Zadkine Studio, Paris, 1948-49; University of Tulsa, MA, 1959; Art Students League, with George Grosz, William Zorach, Jose De Creeft. Member: Artist Equity Association; Art Students League. Exhibited: ACA Gallery, 1945, 46; Penna. Academy of Fine Arts, 1947, 52; Contemporary Art Gallery, 1944-46; Riverside Museum, 1946; one-man: Le Centre d'Art, Port-au-Prince, Haiti, 1947; RoKo Gallery, 1948; Galerie Creuze, Paris, 1949; Bodley Gallery, NY, 1950; Hugo Gallery, 1951; Grand

Central Moderns, NYC, 1955; Philbrook Art Center, Tulsa, 1971; St. Mary's College, MD, 1972. Work: NY Public Library Print Collection; Philbrook Art Center; Staten Island Museum; State Collection, Oklahoma City; and others. Awards: Grand Awards, Philbrook Art Center, 1957 and 63; Graphics Award, Joslyn Museum of Art, 1957; Award of Excellence, Smithtown Arts Council, LI, 1981. Position: Associate professor of painting, Hofstra University, 1959-81; professor, from 1981. Address in 1982, 359 Soundview Drive, Rocky Point, NY.

ENGLE, BARBARA JEAN.
Painter, graphic artist, jeweler. Born in Grandin, ND. Studied at Honolulu Acad. of Arts, Honolulu; Chouinard Art Institute, Los Angeles, California; Otis Art Institute, Los Angeles. Exhibitions: Nat. Print Exhib., Honolulu Acad. Arts, 1971-79, Silk Screen Prints (one-woman), 71, 10 Hawaii Printmakers, 78; Barbara Engle, Jewelry, Santa Barbara, CA, 1972 and Kauai Museum, 73; Hawaii Artists League Ann., Paintings, 1978; Womens Exhib., Paintings and Prints, Downtown Gallery, 1979; others. Collections: Honolulu Academy of Arts; State Foundation on Culture and Arts, Hawaii; Dept. of Education, Hawaii. Teaching: Instructor of drawing, silkscreen printing and painting, Honolulu Acad. Arts, from 1964. Media: Oil. Address in 1980, 2231 Noah Street, Honolulu, HI.

ENGLE, H(ARRY LEON).
Landscape painter. Born Richmond, Ind., 1870. Pupil of Art Inst. of Chicago. Member: Palette and Chisel C.; Chicago PS. Award: Palette and Chisel Club prize, 1917. Work: "Old Lyme Road," purchased by Chicago Art Commission, 1914; "Laurel Blossoms," Long Beach (Calif.) Public Library. Address in 1929, 1544 Arthur Ave., Chicago, Ill.; summer, Yorkville, Ill.

ENGLE, NITA.
Illustrator. Born in Marquette, MI, in 1925. Attended Northern Michigan Univ. and the AIC. After nine years as an art director in a Chicago agency, she decided to start free-lancing. She began illustrating children's books at Chicago Text publishers and later for such magazines as *Reader's Digest* and *Playboy*. A member of the AWS, she has exhibited in Illinois, Michigan, California, and England.

ENGLER, ARTHUR.
Engraver. Born Jersey City, NJ, 1885. Pupil of Francis Clarke. Address in 1926, 150 Nassau St., New York, NY.

ENGLERT, GEORGE.
Painter. Self-taught artist. He is a current member of the American Watercolor Society, Allied Artists of America, Audubon Artists, National Soc. of Painters

in Casein and Acrylic, Rockport Art Association, and other numerous memberships. He has won almost a hundred awards in national shows. Principal medium: Acrylic. Currently resides in Tivoli, NY.

ENGLISH, FRANK F.
Painter. Born in Louisville, KY, in 1854. Pupil of Penna. Academy of Fine Arts; he also studied in England. Address in 1926, Point Pleasant, Bucks County, Penna.

ENGLISH, MABEL BACON PLIMPTON.
(Mrs. J. L. English). Painter. Born Hartford, Conn., Feb. 18, 1861. Pupil of Chase and D. W. Tryon. Member: Hartford AS; Hartford AC; Conn. AFA; Hartford Arts and Crafts C. Address in 1929, 210 Fern St., Hartford, Conn.; summer, Weekapaug, RI.

ENGLISH, MARK F.
Illustrator. Born in Hubbard, TX, in 1933. Attended the Univ. of Texas for one year before going to Los Angeles to study under John LaGatta at the ACD. His first job was in Detroit in an advertising studio and soon his editorial illustrations were appearing in *Redbook, Ladies' Home Journal,* and *McCall's.* He has been awarded many medals from the S of I where he is currently a member. Named Artist of the Year in 1969 by the AG, he received awards from several ADC's in the U.S. He has been a contributor to the National Park Service Art Prog. and has exhibited at the Brandywine Gallery.

ENNEKING, JOHN JOSEPH.
Painter. Born in Ohio on Oct. 4, 1841. He came to Boston in 1865. In 1872 he went abroad to study and afterwards returned to this country and settled in Boston. His landscapes and cattle pictures have decided merit. His "Hillside" is in the Boston Museum of Fine Arts, and "Autumn in New England" is owned by the Worcester Art Museum. Died Boston, MA, Nov 16, 1916.

ENNEKING, JOSEPH ELIOT.
Painter. Born Hyde Park, Mass. Pupil of De Camp, Benson and Tarbell in Boston. Member: Boston AC; Copley S.; Salma. C.; Conn. AFA. Died in 1916. Address in 1929, 17 Webster Square, Hyde Park, Mass.; summer, Mystic, Conn.

ENNIS, GEORGE PEARSE.
Painter and craftsman. Born St. Louis, MO, 1884. Pupil of Chase. Member: Salma. C.; AWCS; Allied AA; A. Aid S.; NY Arch. Lg.; NYWCC; Guild of Amer. Painters; A. Fund S.; NYSP; Aquarellists; Boston AC. Awards: Shaw prize, Salma. C., 1922; Kramer purchase prize, AIC; Isidor prize, Salma. C., 1923 and 1925; William Church Osborn prize, 1926; R. Horace Gallatin prize, 1927. Work: 15 large canvases, 31 pencil drawings (material gathered Bethlehem Steel Co.) executed at dir. of Ordinance

Dept., US Govt., 1917-18; three victory windows in NY Military Acad.; mem. windows, NY Athletic Club; Church of All Nations, NYC; mural decorations and stained glass windows, Unitarian Ch., Eastport, ME; Presbyterian Ch., Cornwall, NY; Calvary Methodist Ch., Bronx, NY; First Baptist Ch., Jamaica, LI, NY. Represented at the Art Inst. of Chicago; U. of Arkansas, Fayetteville. Died in 1936. Address in 1929, 67 West 87th St., NY; summer, Eastport, ME.

ENNIS, GLADYS ATWOOD.
Block printer. Born Natick, Mass. Pupil of Henry B. Snell; George Pearse Ennis. Member: AWCS; NYWCC; Three Arts C; NA Women PS. Address in 1929, 67 West 87th St., New York, NY; summer, Eastport, ME.

ENO, HENRY C.
Engraver. Active in New York c. 1885. Member of New York Etching Club. Died in 1914.

ENOS, CHRIS.
Photographer and art administrator. Born in Calif., Aug. 21, 1944. Studied: Foothill College, Los Altos, CA; San Francisco State University; San Francisco Art Institute. Exhibitions: Photography and Film Center West, Berkeley, CA, 1972; Focus II Gal., NYC, 1974; Bibliotheque Nationale, Paris, France, 1975. Collections: San Francisco Museum of Art, California; San Francisco Art Institute, CA; Fogg Museum, Harvard University, Cambridge, MA. Address in 1980, P.O. Box 507, Boston, MA.

ENOS, RANDALL.
Illustrator. Born in New Bedford, MA, in 1936. Studied at Boston Museum for two years. He began illustrating for *Harper's* and has since worked for many other major magazines. He illustrated the children's book *It's Not Fair* in 1976 as well as other books for Simon and Schuster and Harper & Row. He has done a considerable amount of film animation for NBC and for other companies, winning an award at the Cannes Film Festival in France.

ENQUIST, MARY B.
Sculptor. Member: Washington Water Color Club. Address in 1929, Washington, DC.

ENRIGHT, WALTER.
Illustrator. Born Chicago, Ill., July 3, 1879. Pupil of AIC. Member: SI, 1910; Players; NYAC. Award: Harmon Cartoon, 1929. Address in 1929, 1 West 67th St., New York, NY.

ENSIGN, RAYMOND P.
Draughtsman, lecturer and teacher. Born River Falls, Wisc., Aug. 4, 1883. Pupil of Pratt Institute and Ralph Robertson. Member: Western AA; AFA; Fed. Council on Art Ed.; EAA. Award: Medal,

Cleveland Society of Artists, 1921. Director, Newark School of Fine and Industrial Art; Dir., Berkshire Summer School of Art. Address in 1929, Newark School of Fine and Industrial Art, 55 Academy St., Newark, NJ; summer, Berkshire Summer School of Art, Monterey, Mass.

ENTE, LILY.
Sculptor, painter, printmaker. Born in Ukraine, Russia, May 20, 1905. Works mostly in black and white marble. Exhibitions: Claude Bernard Galerie, Paris, France; Great Burlington Gallery, London, England; Whitney Museum of American Art; International Exhibition 84 Artists, Bundy Art Gallery, Waitsfield, VT; Riverside Museum, NY; Stable Gallery, NY; Univ. of Illinois. Collections: Phoenix Art Museum; Riverside Museum; Safad Museum, Israel. Member: Nat. Assoc. of Women Artists; Artists Equity Assoc.; Brooklyn Soc. of Artists. Address in 1982, 400 Riverside Dr., NY, NY.

ENTERS, ANGNA.
Sculptor, painter, illustrator, cartoonist, and writer. Born in NYC, April 28, 1907. Studied in US, Europe, Greece, Egypt, Near East. Awards: Guggenheim Fellow, 1934, 35. Work: Metropolitan Museum of Art; Honolulu Academy of Art; mural, Penthouse Theatre, University of Washington. Exhibited: Newhouse Gallery, 1933-45; Warren Gallery, London, England; Met. Museum of Art, 1943; Honolulu Academy of Art; Rochester Memorial Art Gallery; Worcester Museum of Art; Minneapolis Institute of Art; Detroit Institute of Art; Rhode Island School of Design; San Francisco Museum of Art; Wadsworth Atheneum; Renaissance Soc., University of Chicago; Baltimore Museum of Art; Bloomington (Ill.) Art Museum; Colorado Springs Fine Art Center; Denver Art Museum; Albany Institute of History and Art; Pasadena Art Institute; Santa Barbara Museum of Art; Addison Gallery of American Art; Los Angeles Museum of Art, 1945; Art Institute of Chicago, 1939-41, 49; Museum of Fine Art of Houston, 1950; Brook Art Gallery, London, England, 1950; Museum of Modern Art, 1933, 44. Author and illustrator, "First Person Plural," 1937; "Love Possessed Juana," 1939; "Silly Girl," 1944; illustrated, "Best American Short Stories of 1945." Contributor to art and theatre publications on painting and arts. Represented by American Theatre, International Berlin Art Festival, 1951. Address in 1953, c/o Newhouse Galleries, 15 E 57th St.; h. 113 W 57th St., NYC.

ENTZING-MILLER, T. M.
Born in 1804. This man was a designer for engravers and an engraver of portraits in line. He did good work and was located in Philadelphia and in New York in 1850-55. Died 1855 in New York.

EPPENSTEINER, JOHN J(OSEPH).
Painter and illustrator. Born St. Louis, MO, Feb. 14, 1893. Pupil of St. Louis School of Fine Arts. Member:

St. Louis AG; St. Louis A. Lg.; St. Louis Two-by-Four SA. Awards: First landscape prize, 1923, and prize for best small painting, 1924 and 1926, St. Louis Artists Guild; bronze medal, Midwestern Artists' Exh., Kansas City Art. Inst., 1927; first modern painting prize ($100), St. Louis AG., 1928; bronze medal for black and white, Kansas City AI, 1929; first prize, black and white ($250) Post Dispatch, 1929. Address in 1929, 3831 Nebraska Ave., St. Louis, MO.

EPPING, FRANC.
Sculptor. Born in Providence, RI, in 1910. Studied at Otis Art Institute, Los Angeles; Corcoran Gallery of Art, Wash., DC; Academy of Fine Arts, Munich, Germany; also with Joseph Wackerle and Bernhard Bleeker. Works: Washington College; Nebraska Art Association; Berea College; High Museum of Art, Atlanta, Georgia; Public Buildings Administration, Wash., DC; US Post Office, Alabama City, Alabama; Oakmont, Penn. Awards: Academy of Fine Arts, Munich, Germany, 1933; Conn. Academy of Fine Arts, 1954; Silvermine Guild, 1955.

EPSTEIN, JACOB.
Sculptor. Born in NYC, 1880. Work: Oscar Wilde monument, Pere Lachaise, Paris; figures in London Medical Association Building. Address in 1916, care of Med. Assoc., London, Eng. Died in 1959.

ERBAUGH, RALPH (WALDO).
Painter. Born Peru, Miami Co., Ind., June 29, 1885. Member: S. Indp. A.; Chicago No-Jury Society of Artists. Address in 1929, "The Avon," 6109 Dorchester Ave., Chicago, Ill.

ERDMANN, R(ICHARD) FREDERICK.
Painter. Born Chillicothe, Ohio, Feb. 12, 1894. Pupil of L. H. Meakin, James Hopkins, Herman Wessel, Paul Jones, Charles Curran, Frank DuMond, George Luks, Frank Duveneck. Address in 1929, 405 South Cornell St., Albuquerque, NM.

ERICKSON, CARL O. A.
Illustrator. Born in Joliet, IL, in 1891. Studied for two years at the Chicago Acad. of Arts and began his career working for depart. stores in Chic. (Marshall Field and Lord and Thomas) as well as for advertisers. Arriving in NYC in 1914, he cont. doing advertising illustrations until 1920 when he began a very successful career as a fashion artist. Shortly thereafter he moved to Paris where for 20 years he reigned supreme in the fashion field. His elegant illust., often the final draft of 20 or more preliminary sketches, first appeared in *Vogue* in 1923. He returned to America in 1940, after the Nazi takeover of France, to continue his work for *Conde Nast*.

ERICSON, DAVID.
Painter. Born Motala, Sweden, April 15, 1873. Pupil of Chase, Whistler and Prinet. Member: Provincetown

AA; Paris AAA. Awards: Silver medal, St. Louis Exposition, 1904; hon. mention, Carnegie Institute, International Exp., 1904; 1st prize, Minnesota Art Exp., St. Paul, 1911. Work: "Nativity," Duluth Art Assn.; "Moonlight, Provincetown," La Crosse Art Asso.; "Barley Field, Etaples," Commercial Club, Duluth. Address in 1929, care of the American Express Co., 11 Rue Scribe, Paris, France.

ERIKSEN, GARY.
Sculptor. Born in Jackson, Michigan, September 11, 1943. Studied: Oberlin College, AB, 1966; Kent State Univ., MA, 1968; Univ. of Chicago, 1971-73; Accademia delle Belle Arti di Roma, Italy, 1973-77; Mechanics Institute, NYC, 1979-81; assistant to Steve Daley, foundry of American Academy in Rome, 1974. Work: Medals, National Gallery, Budapest; medals, Smithsonian Institution; Cooper-Hewitt, NYC; American Numismatic Society, NYC; others, including commissions. Exhibitions: Nat. Gallery, Budapest, 1977; National Sculpture Society, NYC, 1978; Salma. Club, NYC, 1982; Palazzo Medici Riccardi, Florence, 1983; Cooper-Hewitt, 1983; American Medallic Sculpture Association, NYC, 1983; others. Awards: First prize, Salma. Club, 1982; fountains project grant, NYS Council on the Arts, 1982. Member: American Medallic Sculpture Assoc., co-founder and pres.; NY Artists' Equity Assn.; Fed. Internationale de la Medaille. Media: Bronze, terra cotta. Address in 1983, 280 Mott St., NYC.

ERLA, KAREN.
Painter and printmaker. Born Pittsburgh, PA, Nov. 17, 1942. Study: Carnegie Inst. of Technology; Boston Univ.; CA State College; Geo. Wash. Univ., Washington, DC; Pratt Inst; Parsons School of Design. Work: IBM; Reuben Donnelly Co. Exhibitions: Corcoran Gallery, Wash. DC; New School for Social Research, NYC; Saddle River (NJ) Group; Multi-Cultural Arts Inst., San Diego, CA; NJ Printmaking Society (mono print etchings); Cork Gal., Avery Fisher Hall, Lincoln Center, NYC; Manhattanville College (solo). Rep.: Phoenix Gallery, 30 W. 57th St., NYC; Rye (NY) Art Center. Technique: Collage, mixed media, etching, monoprint, other. Address in 1983, Old Orchard St., North White Plains, NY.

ERLANGER, ELIZABETH N.
Painter. Born in Baltimore, Maryland, 1901. Studied: with Ralph M. Pearson, Umberto Romano, Liberte and Hans Hofmann. Awards: National Association of Women Artists, 1952, 1953, 1956; Brooklyn Society of Art, 1953, 1955, 1958; Village Art Center, 1953, 1955, 1956. Collections: Florida So. College; University of Maine; Colby College; NY Public Library; Evansville, IN, Museum of Art.

ERSKINE, HAROLD (PERRY).
Sculptor. Born Racine, Wis., June 5, 1879. Pupil of Ecole des Beaux-Arts, Paris; Sherry E. Fry;

Colorado University School of Fine Arts. Member: Beaux Arts Society and Century Club, New York. Work: Portrait bust, Carl Akeley, American Museum Nat. History, NY; Walter J. Travis Memorial, Garden City Golf Club, NY; War memorial, St. Anthony Club, NYC; Wilton Merle-Smith Memorial, Central Presbyterian Church, NYC; Founders Memorial, National Chi Psi Fraternity, Ann Arbor, Mich.; numerous garden sculptures. Address in 1933, 251 East 61st Street, New York, NY; summer, Roxbury, Conn. Died January 6, 1951.

ERTZ, BRUNO.
Painter. Born Manitowoc, Wis., March 1, 1873. Self taught. Painted birds and insects. Address in 1929, 701 South 16th St., Manitowoc, Wis.

ERTZ, EDWARD (FREDERICK).
Painter, illustrator, etcher and teacher. Born Canfield, Tazewell Co., Ill., March 1, 1862. Pupil of Lefebvre, Constant and Delance in Paris. Member: Royal Soc. of British Artists; Soc. of Arts, London; Imperial Arts League; British WCS; Essex AC; Aberdeen AG; Societe Inter. d'Aquarellistes, Paris; Societe des Cinquante; Union Inter. des Beaux-Arts; Chicago SE; Chicago AG; Cal. SE. Awards: Diploma of honor, Inter. Exp., St. Etienne; gold medal, Exp. d'Angiers; grand prix, Inter. Exp., Rouen, France; medal, Soc. des Amis des Arts de la Somme, 1899; medal, Ville d'Elboeuf, France; two awards, Bristol (Eng.) Arts and Crafts; medal, AAS Phila., 1902; medal, Festival of Arts and Letters, London, 1927. Work: "The Gardener," Alexander Palace Mus., London; "Spanish Water Carrier," Public Gall., Liverpool; Print Dept., Library of Congress, Wash., DC, and Calif. State Library; NY Pub. Library; Boston Mus. of Fine Arts; "The Vacation Girl," "Sunset, Grand Canyon," American Consulate, London; "Normandy Cider Mill," Alexander Palace Museum, London. Address in 1929, Pulborough, Sussex, England.

ESCHERICH, MRS. ELSA F.
Painter. Born Davenport, IA, March 20, 1888. Pupil of Vanderpoel, Hawthorne and Walcott. Member: Calif. AC; West Coast Arts, Inc.; Los Angeles AL. Address in 1929, 3333 No. Marengo Ave., Pasadena, Calif.

ESHERICK, WHARTON HARRIS.
Sculptor, painter, craftsman, designer, and wood engraver. Born Phila., PA, July 15, 1887. Studied at Phila. Museum School of Industrial Art; Penna. Academy of Fine Arts; and student of Chase, Beaux, and Anshutz. Member: Artists Equity Association; Phila. Alliance; Phila. Art Club. Awards: Prize, Penna. Academy of Fine Arts, 1951; one of eleven winners in an International Sculpture Competition, awarded two prizes for "The Unknown Political Prisoner;" gold medal, Architectural League, 1954;

Phila. Museum School of Art, 1957. Work: Penna. Academy of Fine Arts; Whitney Museum of Amer. Art; Phila. Museum of Art; University Penna.; Hedgerow Theatre, Moylan, PA. Exhibited: World's Fair NY, 1939; 20th Century Sculpture Show, 1952-53; Museum of Modern Art, 1953; Addison Gallery of Amer. Art, Andover, MA, 1964; Phila. Museum of Art, 1949; Penna. Academy of Fine Arts, 1951, 52; Whitney Museum of Amer. Art, 1952; Phila. Art Alliance, 1952; others. Address in 1970, Paoli, PA. Died in 1970.

ESKRIDGE, ROBERT LEE.
Painter, etcher and draughtsman. Born Philipsburg, PA, Nov. 22, 1891. Pupil of Los Angeles College of Fine Arts; AIC; Chicago Academy of Fine Arts; George Senseney. Member: Chicago SE; Brooklyn SE; Chicago AC. Awards: Bronze medal for water color, Pan.-Cal. Exp., San Diego, 1915; Martin B. Cahn prize, AIC, 1928. Address in 1929, Philipsburg, PA; 115 East Chestnut St., Chicago, Ill.; Coronado Beach, Calif.

ESSIG, GEORGE EMERICK.
Painter and illustrator. Born in Philadelphia, Sept. 2, 1838. Pupil of Edward Moran and James Hamilton. Student at Penna. Academy of Fine Arts, Phila. Specialty, marines. Address in 1926, Ventnor, Atlantic City, NJ.

ESTABROOK, FLORENCE C.
Painter and teacher. Born Sewell, Mass. Pupil of School of the Museum of Fine Arts, Boston. Member: Lg. of Amer. Pen and Brush Women. Address in 1929, 1236 Eleventh St., NW, Washington, DC.

ESTE, FLORENCE.
Painter. Born in Cincinnati, Ohio, in 1860. Her water colors won the Penna. Academy of the Fine Arts prize, 1925. Address in 1926, Paris, France. Died there on April 25, 1926.

ETTER, DAVID RENT.
Born in Philadelphia, 1807; he lived there until his death in 1881. He was interested in the city and state politics. An artist of fair ability, best known for his copies of Gilbert Stuart's paintings. The city of Philadelphia owns his copy of the Stuart-Washington "Lansdowne" portrait.

ETTL, ALEX J.
Sculptor. Born Fort Lee, NJ, December 12, 1898. Pupil of his father, John Ettl, and Robert Aitken. Studied: National Academy of Design; Columbia University; City College of New York. Member: Fellow, National Academy of Design. Work: "Katrina Trask Memorial," Yaddo, Saratoga Springs, NY; Wolf and Jacobs Memorial, Friars' Club, New York City; marble bench historical site, Hackensack, NJ; sculpture, Pennsylvania Building,

Philadelphia, PA; Elsie the Borden Cow, and numerous industries in U.S. Address in 1933, 304 West 42nd Street, NYC; h. Princeton, NJ.

ETTL, JOHN.
Sculptor. Born Budapest, Hungary, August 1, 1872. Studied in Budapest, Paris, Munich, and Vienna. Work: "Abraham Lincoln," State Arsenal, NY; "War Memorial," East Rutherford, NJ; sculpture in Palace of Justice, Berne, Switzerland; Soldiers Monument, Haverstraw; "Chief Oratam," Bergen County Historical Society; sculpture, Pennsylvania Building, Philadelphia, PA. Exhibited at National Sculpture Society, 1923. Address in 1933, 227 West 13th Street, NYC; h. Port Washington, NY. Died in 1940.

EUWER, ANTHONY HENDERSON.
Illustrator. Born in Allegheny, Penna., in 1877. Illustrated many American and English periodicals and papers. Address in 1926, 508 Aspen Road, Portland, Oregon.

EVANS, ANNE.
Painter. Member: Denver AC; AFA. Address in 1929, 1320 Hannock St., Denver, Colo.

EVANS, DeSCOTT.
Born in Wayne Co., Ind., 1847. He studied in Paris, returned to Cleveland and became inst. and co-dir. in the Acad. of Fine Arts there. He was very skillful in painting draperies. He painted numerous portraits and among his genre paintings are "The First Snow-Storm," "Grandma's Visitors," and "Day Before the Wedding." He died July 4, 1898, at sea.

EVANS, DULAH MARIE.
See Krehbiel, Dulah Evans.

EVANS, EDWIN.
Painter and teacher. Born Lehi, Utah, Feb. 2, 1860. Pupil of Laurens, Lefebvre and Benjamin-Constant in Paris. Died in 1946. Address in 1929, 1261 Emerson Ave., Salt Lake City, Utah.

EVANS, ELIZABETH H.
Painter. Exhibited at National Assoc. of Women Painters and Sculptors. Address in 1926, 204 Clay St., Baltimore, MD.

EVANS, GRACE (LYDIA).
Painter and teacher. Born Pittston, PA, Feb. 19, 1877. Pupil of PAFA under Chase, Anshutz and Breckenridge; Drexel Inst. Member: Phila. Alliance; Fellowship PAFA; Conn. AFA. Work: Portrait of Dr. Francis March, March High School, Easton, PA. Specialty, portraits. Address in 1929, 1551 Shakespeare Ave., New York, NY; 510 Presser Building, 1714 Chestnut St.; h. 218 - 32nd St., Philadelphia, PA.

EVANS, GRACE FRENCH.
Painter. Born Davenport, IA. Pupil of Hermon More, Kenneth Hayes Miller. Member: AFA; NA Women PS; Woodstock AA. Address in 1929, 20 Forest Rd., Davenport, IA; summer, Woodstock, NY.

EVANS, JESSIE BENTON.
Painter, etcher and teacher. Born Akron, Ohio, March 24, 1866. Pupil of AIC and William Chase in Chicago; Zanetti Zilla in Venice. Member: Chicago SA; Chicago AC; Phoenix AC; AFA; Salvator Rosa, Naples. Awards: 1st prize landscape, 1913 and 1923, 2nd portrait prize, 1923, Arizona State Fair. Works: "On the way to McDowel," Municipal coll.; "Morning," Country Club, Phoenix, Ariz.; "On the Verde River" and "Gray Day," Arizona Club. Represented in the College Club, Chicago; Public School Art Societies, Chicago, Phoenix and Mesa, Ariz; Vanderpoel AA Collection, Chicago; Art Institute, Akron, Ohio. Died in 1954. Address in 1929, 1517 East 61st St., Chicago, Ill.; winter, Scottsdale, Ariz.

EVANS, JOHN T.
Flourished in 1809 in Philadelphia as a landscape, portrait and miniature painter. He exhibited his miniatures and water colors at the Penna. Academy of the Fine Arts.

EVANS, JOHN W(ILLIAM).
Wood engraver. Born Brooklyn, March 27, 1855. Pupil of P. R. B. Pierson. Awards: Bronze medal, Pan-Am. Exp., Buffalo, 1901; bronze medal, St. Louis Exp., 1904; silver medal, P.-P. Exp., San F., 1915. Represented in NY Public Library; Carnegie Institute; Brooklyn Inst. of Arts and Sciences. Address in 1929, 4 Carlton Place, Baldwin, LI, NY.

EVANS, MARGARET.
Painter, craftsman, lecturer and teacher. Born Youngstown, Ohio. Pupil of Birge Harrison and John Carlson at the ASL of NY, Woodstock; Columbia Univ., Arthur Dow; sp. course in Europe. Director of the Butler Art Institute. Address in 1929, care of Butler Art Inst.; h. 810 Glenwood Ave., Youngstown, Ohio.

EVANS, RAY O.
Illustrator. Born in Columbus, Ohio, 1887. Made illustrations for daily papers and *Puck*. Address in 1926, *The Columbus Dispatch*, Columbus, Ohio.

EVANS, RUDULPH.
Sculptor. Born Wash., DC, February 1, 1878. Pupil of Falguiere and Rodin; studied at Corcoran Art Gallery, Wash., DC; Art Students League of New York; Academie Julien and Ecole des Beaux-Arts, Paris. Member: Associate National Academy of Design, 1919; National Academy, 1929; Paris Art Association; Allied Artists of America; National Sculpture Society; National Institute of Arts Letters, 1926. Awards: Bronze medal, Paris Salon, 1914; Watrous gold medal, National Academy of Design, 1920; Legion of Honor, Paris; Crown of Italy, Rome. Work: Marble portrait, Gen. Bolivar, Bureau American Republics, Wash.; statue, James Pierce, NY; bronze portrait, John Greenleaf Whittier, Hall of Fame, NY; Jean Webster McKinney Memorial, Greenwich, Conn.; Corcoran Gallery; Kiernan Memorial, Green Bay, Wis.; Woolley Memorial, Detroit, Mich.; bronze portrait, Joseph French Johnson, New York University. Decorated by King Victor Emanuel for exhibition in Rome. Statue of "The Golden Hour" acquired by French Government for Luxembourg; replica of same in Metropolitan Museum, NY. Exhibited extensively in U.S. and abroad. Address in 1953, Washington, DC. Died in 1960.

EVANS, W. G.
A map designed to illustrate the geography of the Heavens is fantastically designed by E. H. Burnett and is engraved by W. G. Evans. It was published at Hartford, Conn., in 1835.

EVENS, THEODORE A.
A good line map of Cincinnati published in 1838 is signed as "Drawn & Engraved by T. A. Evens."

EVERDELL.
This name as "Everdell Sct. 1816" is signed to a business card, in line and script. It is an advertisement of the business of "Elijah Lewis, Saddle, Harness & Trunk Maker," New York, 1816.

EVERETT, ELIZABETH (RINEHART).
Sculptor, painter, illustrator, etcher, and craftsman. Born Toledo, Ohio. Studied: Pratt Institute Art School, Brooklyn, NY; University of Washington, Seattle, BA; also pupil of Walter Isaacs. Exhibited: Marshall Field, Chicago, IL, 1946. Awards: Sweepstake prize, 1926; first prize, 1927, 1928, Western Washington Fair; Women Painters of Washington, 1933. Member: Women Painters of Washington, (President); Seattle Photographic Society. Address in 1953, Seattle, Washington.

EVERETT, FLORENCE.
Painter and teacher. Born Ontario, Can. Member: St. Louis AS; St. Louis AG. Address in 1929, Harris Teachers College, Park and Theresa Aves., St. Louis, MO; 3935 Castleman Ave., St. Louis, MO.

EVERETT, HERBERT EDWARD.
Sculptor and teacher. Born Worcester, Mass. Pupil of Boston Museum School; Julian Academy in Paris; Penna. Academy of Fine Arts. Member: Phila. Water Color Club. Address in 1933, Philadelphia, PA. Died in 1935.

EVERETT, JOSEPH ALMA FREESTONE.
Painter, etcher, lecturer, and teacher. Born in Salt Lake City, UT, Jan. 7, 1884. Pupil of J. T. Harwood. Member: Utah Art Colony. Address in 1929, Salt Lake City, UT. Died in 1945.

EVERETT, LOUISE.
Painter and sculptor. Born in Des Moines, IA, April 9, 1899. Pupil of Fursman, Hawthorne, Julia Bracken Wendt, Otis Art Inst.; Fontainebleau School of Fine Arts, 1925; Julian Academy, Paris, 1926. Member: California Art Club; Laguna Beach Art Association; West Coast Arts. Awards: Second prize, West Coast Arts, 1923; marine prize, Laguna Beach Art Association, 1923; silver medal, sculpture, Pacific Southwest Expo., 1928. Address in 1929, 980 South Manhattan Place, Los Angeles, CA.

EVERETT, MARY O.
(Mrs. H. G. Everett). Painter. Born in Mifflinburg, PA, 1876. Address in 1929, Los Angeles, CA; summer, Laguna Beach, CA. Died in 1948.

EVERETT, RAYMOND.
Painter, sculptor, book-plate designer, and teacher. Born in Englishtown, NJ, August 10, 1885. Studied at Drexel Inst.; Harvard; pupil of Howard Pyle, Joseph L. Smith, and Denman Ross; in Paris at the Julien Academy; in Rome. Award: Silver medal, Southern States Art League, San Antonio, 1929. Represented in Detroit Public Library; Elisabet Ney Museum, Austin, TX; Univ. of Colorado Museum. Member: Texas FAA; Southern States Art League; Amer. Inst. of Architects. Taught at the Univ. of Pennsylvania and the Univ. of Michigan; Univ. of Texas from 1917. Address in 1941, Austin, TX.

EVERGOOD, PHILIP HOWARD FRANCIS.
Painter, sculptor, illustrator, lecturer, writer, and teacher. Born in NYC, October 26, 1901. Pupil of Cambridge Univ.; Slade School in London; under von Schlegell and Luks at Art Students League, NYC; Julian Academy in Paris. Awards: Prizes, Art Inst. of Chicago, 1935, 46; Carnegie Inst., 1945, 50; Hallmark Award, 1950; Corcoran Gallery, 1951; gold medal, Penna. Academy of Fine Arts, 1950, 58; others. Work: Metropolitan Museum of Art; Museum of Modern Art; Whitney; Boston Museum of Fine Arts; Los Angeles Museum of Art; Art Inst. of Chicago; Brooklyn Museum; others. Exhibited: Carnegie Inst., 1938, 39; World's Fair of New York, 1939; Tate Gallery, London, 1946; others. Illustrator for *Fortune* and *Time* magazines. Member: Art Students League New York; Artists Equity Association; National Inst. of Arts and Letters. Address in 1970, Bridgewater, CT.

EVERS, IVAR EILS.
Painter. Born in Sweden, 1866. Pupil of Napoleon Caesar in Sweden; De Camp in Boston; Twachtman in New York. Member: Society of Independent Artists. Address in 1926, Tillson, Ulster County, New York.

EVERS, JOHN.
Miniaturist and painter of theater scenery. Born August 17, 1797, in Newtown, Long Island, NY. Founder of the National Academy of Design. Died May 3, 1884, in Hempstead, Long Island, NY.

EWBANK, JAMES L.
Engraver. Born in New York. Working in New York City in 1850.

EXILIOUS, JOHN G.
Engraver. This reputable line engraver of landscapes and buildings was working in Philadelphia between 1810-14. He was, in 1810, one of the founders of the Society of Artists in Philadelphia, but nothing more is known about him. His largest and best plate is a view of the Pennsylvania Hospital, engraved in 1814 after his own drawings.

EYDEN, WILLIAM ARNOLD.
Painter and lecturer. Born in Richmond, IN, Feb. 25, 1893. Studied with William A. Eyden, Sr.; T. C. Steele; Charles Hawthorne. Exhibited at PAFA; Richmond AA, 1915-1944; Hoosier Salon, 1941-1946; Indianapolis Art Club, 1930-1946; John Herron Art Inst., 1946. Work: Ball State Teachers College; Indiana Univ.; Richmond AA; various public schools. Awarded prizes, Richmond AA, 1928; Indiana Art Club, 1945; Hoosier Salon, 1945. Member of Richmond AA; Indiana Art Club; Society of Independent Artists; Indianapolis AA. Address in 1953, Indianapolis, IN.

EYRE, LOUISA.
Sculptor. Born in Newport, RI, January 16, 1872. Pupil of Augustus Saint-Gaudens, Charles Grafly, Thomas Anshutz, Kenyon Cox; also studied at Penna. Academy of Fine Arts and Art Students League of NY. Exhibited at Nat. Sculpture Soc., 1923; Palace of the Legion of Honor; Penna. Academy of Fine Arts, 1896-1945. Work: Tablet to Gen. George Sykes for Mem. Hall, West Point, NY; decorative reliefs, Univ. Museum, Philadelphia, PA; Dennison Bldg., NY; Washington Cathedral, Washington, DC. Address in 1953, Franklin, NH. Died in 1953.

EZEKIEL, MOSES.
Sculptor. Born in Richmond, VA, October 28, 1844. Member of the National Sculpture Soc. Received a gold medal from the Royal Art Assoc., Palermo; silver medal, St. Louis Expo., 1904. Address in 1910, Rome, Italy; Cincinnati, OH. Died in Rome, March 27, 1917.

F

FABER, LUDWIG E.
Painter and etcher. Born in Philadelphia, Oct. 21, 1855. Studied at Penna. Academy of the Fine Arts. Painted portraits and miniatures. Died May 16, 1913, in Philadelphia.

FABIAN, LYDIA DUNHAM.
Painter. Born Charlotte, MI, March 12, 1857. Pupil of the ASL of NY; AIC; Ossip Linde and Henry Henshall. Member: Santa Fe Society of Artists; Alumni of the Chicago Art Institute. Address in 1929, 3918 Lake Park Ave., Chicago, IL.

FABION, JOHN.
Sculptor and painter. Born in Vienna, Austria, October 31, 1905. Studied at Art Institute of Chicago, with Boris Anisfeld; and abroad. Member: Artists Equity Association. Awards: Prizes, Art Institute of Chicago, 1933, 36, and 60. Work: Statler Hotel, Washington, DC, and Los Angeles, Calif.; United States Naval Academy; St. Mary's Hospital, Anderson, IN; United States Post Office, Bedford, IN; monument, Chopin School, Chicago, IL. Exhibited: Art Institute of Chicago; Golden Gate Exposition, 1939; National Museum, Washington, DC; Pennsylvania Academy of Fine Arts; others. Taught: Professor of Art, Art Institute of Chicago, 1946-70, professor emeritus, from 1970. Address in 1982, Chicago, IL.

FABRI, RALPH.
Painter, etcher and teacher. Born Budapest, Hungary, April 23, 1894. Pupil of Royal Hungarian Academy of Fine Arts. Address in 1929, 45 Washington Sq., South, New York, NY.

FACCI, DOMENICO (AURELIO).
Sculptor, painter, teacher, and craftsman. Born in Hooversville, Penna., February 2, 1916. Studied at Roerich Academy of Art, and with Pietro Montana, Louis Slobodkin, William Zorach. Member: Artists Equity Association; Audubon Artists; Sculptors League; National Sculpture Society (fellow); others. Awards: Audubon Artists, 1956-61, and 1978; Knickerbocker Artists, 1978; and many others. Work: Florida Southern College. Exhibited: Artists Equity Association Lighthouse Exchange, 1950; Whitney Museum of American Art; National Academy of Design; First International Art Exhibition, Florida Southern College; Butler Institute of American Art; Audubon Artists, 1978. Position: Instructor of sculpture, Roerich Academy of Art, NYC. Address in 1982, 248 West 14th St., NYC.

FACKERT, OSCAR WILLIAM.
Painter and illustrator. Born Jersey City, NJ, July 29, 1891. Pupil of Schook, Grant, Gottwald, Bentley. Member: Palette and Chisel C. Awards: First prizes, 1923 and 1925, and second prize, 1924, Northern Indiana Exhibition; hon. mention, Midwest Exhibition, Kansas City AI, 1924. Work: Mural decoration in the Oliver Hotel, South Bend, IN. Address in 1929, 1558 Juneway Ter., Chicago, IL.

FAGG, KENNETH S.
Painter, illustrator and etcher. Born Chicago, IL, May 29, 1901. Pupil of Pennell, Bridgman, Du Mond, Garber, Vysekal. Member: ASL of NY. Address in 1929, 3926 Packard St., Sunny Side, LI, NY.

FAGGI, ALFEO.
Sculptor. Born Florence, Italy, September 11, 1885. Pupil of Accademia Belle Arts, Florence. Member: Salons of America. Work: War Memorial "Pieta" and fourteen reliefs "Stations of the Cross," St. Thomas Church, Chicago; "The Doubting St. Thomas," Chapel at the University of Chicago; lifesize figure of St. Francis, Museum of Santa Fe, NM; bronze head of Japanese poet, Art Institute of Chicago; head of Noguchi, Phillips Memorial Gallery, Washington, DC; statue of Eve, Arts Club of Chicago; bronze door, episodes in life of St. Francis, University of Chicago. Address in 1929, Woodstock, NY.

FAGNANI, JOSEPH (GUISEPPE).
Sculptor and portrait painter. Born in Naples, December 24, 1819; died in New York, May 22, 1873. He came to America in 1851 and lived in Washington and then in New York. His painting of the "Nine Muses," in the Metropolitan Museum of Art, New York, attracted much attention, as well-known American beauties had served as models. Exhibited at National Academy; Boston Atheneum; Penna. Academy.

FAHNESTOCK, WALLACE WEIR.
Painter. Born Harrisburg, PA, Jan. 15, 1877. Pupil of Chase, Mowbray, DuMond and Dow. Member: Salma. C.; Painters of So. Vermont. Work: "Wilderness Music," B. and B. Academy, Manchester, VT; "Late Afternoon," Boston City Club. Address in 1929, Dorset, VT.

FAIG, FRANCES WILEY.
Painter. Pupil of Duveneck, Grover, and Hawthorne. Member: MacD. C. of Cincinnati; Cin. Woman's AC. Work: Mural decorations in Engineering Library, University of Cincinnati. Address in 1929, 3345 Whitfield Ave., Clifton, Cincinnati, OH.

FAILLE, C(HARLES) A(RTHUR).
Painter, etcher, and lecturer. Born Detroit, MI, Feb. 17, 1883. Self-taught. Member: Calif. AC. Work: "The Hum of the Mill," Society of Fine Arts, Omaha, NE. Address in 1929, 1854 Ft. Stockton Dr., San Diego, CA; 396 Blenheim Road, Columbus, OH.

FAIR, ROBERT.
Painter. Born in Ireland in 1847, he came to America in 1876 and established himself in New York City. He later moved to Philadelphia and painted several pictures of note, some of which gained places in the Pennsylvania Academy of Fine Arts. He died in Philadelphia in May, 1907.

FAIRBANKS, AVARD TENNYSON.
Sculptor. Born Provo, UT, March 2, 1897. Pupil of Art Students League of New York under James E. Fraser; Beaux-Arts in Paris, under Injalbert; Grande Chaumiere and Ecole Modern, Paris; Yale University, BFA; University of Wash., MFA; University of Mich., MA and PhD; Fellow, Guggenheim Memorial Foundation, 1927. Member: National Sculpture Society; American Federation of Arts. Work: "The Indian," "The Pioneer," Salt Lake City Public Schools; monument, "The Blessing of Joseph," and fountain in honor of Hawaiian motherhood, Laie, HI; "Doughboy of Idaho," Service Memorial, Oregon Agricultural College, Corvallis; "Old Oregon Trail Marker" and "War Memorial," Jefferson High School, Portland, OR; bronze doors, US National Bank, Portland, OR; "Fountain of Aphrodite," Washburne Gardens, Eugene, OR; Memorial to the Pioneer Mothers, Vancouver, WA; the Three Witnesses Memorial, Salt Lake City; Tabernacle Door for Altar, St. Mary's Cathedral, Eugene, OR; "Heat and Power," Power House, University of Oregon. Exhibitions: Paris Salon, 1914; National Academy of Design; National Sculpture Society; Pan-Pacific Exhibition, 1915; Carnegie; Art Institute of Chicago; San Francisco Museum of Art; others. Taught: University of Oregon, 1920-27; Seattle Institute of Art, 1928-29; University of Michigan, 1927-47; University of Utah, from 1947; University of North Dakota, from 1965. Address in 1929, University of Oregon, Eugene, OR; address in 1976, Salt Lake City, UT.

FAIRBANKS, FRANK PERLEY.
Painter and architect. Born in Boston, 1875; died 1939. Pupil of Tarbell and De Camp in Boston. Member: NY Arch. Lg., 1913; Mural P.; Fellow, American Academy in Rome. Awards: Sears prize and Page traveling scholarship from the Boston Museum of Fine Arts; Academy at Rome scholarship, 1909-12; annual professor in the School of Fine Arts of the Amer. Academy in Rome, 1922; professor in charge of the School of Fine Arts, 1923. Work: Public Library, St. Paul, Minn.; University of Cincinnati; Memorial Apse, Tivoli-on-the-Hudson; etc.

Address in 1929, American Academy in Rome, Porta San Pancrazio, Rome, Italy.

FAIRBANKS, J. LEO.
Sculptor, painter, lecturer, teacher, and writer. Pupil of Julian Academy, Paris. Member: American Artists Professional League; American Federation of Arts; Society of Oregon Artists; Park and Garden Sculptor Society; Associated Artists of Salt Lake City; Utah A. Inst.; Salt Lake City Art Commission. Designed and executed sculpture frieze on Mormon Temple, Hawaii; mural paintings, Salt Lake Temple; Library Building, Oregon State College; State War Memorial, ID; Arizona Temple and Logan Temple, Mesa, AR; mural decorations and two stained glass windows, Hall of Religion, Century of Progress Exposition, Chicago, IL. Professor of Art and Architecture, Oregon State College, Corvallis, OR. Address in 1933, Corvallis, OR.

FAIRBANKS, JOHN B.
Painter and teacher. Born Payson, UT, Dec. 27, 1855; died in 1940. Pupil of Constant, Lefebvre and Laurens in Paris. Member: Paris AA; S. Utah A.; Assoc. Artists Salt Lake City. Awards: First prize, Utah State Fair, 1899; first prize for marine, Utah State Fair, 1913; second prize for marine, Utah State Fair, 1917; second prize for landscape, Utah State Fair, 1918; first, second and third prizes, Utah State Fair, 1920; first prize, Payson High School Exhibit, 1926. Address in 1929, Springdale, Mouth of Zion Canyon, UT.

FAIRCHILD, (CHARLES) WILLARD.
Illustrator. Born Marinette, WI, Nov. 18, 1886. Pupil of Chicago AFA; ASL of NY. Member: SI; Art Directors C. Address in 1929, care Batten, Barton, Justine and Osborn, 383 Madison Ave.; h. 1 West 67th St., New York, NY.

FAIRCHILD, LOUIS.
Engraver. Born in Farmington, Conn., in 1800; was living in New York in 1840. Fairchild learned to engrave with Asaph Willard, in New Haven, and became an etcher and line-engraver of landscape. He also painted portraits in miniature and excelled in that branch of art, though he did little work as a painter. Died c. 1840.

FAIRCHILD, MARY.
See Low, Mary Fairchild.

FAIRCHILD, MAX.
Painter. Exhibited at the National Association of Women Painters and Sculptors, New York, 1924. Address in 1929, 58 West 57th St., NY.

FAIRCHILD, MAY.
(Mrs. Charles Nelson Fairchild). Portrait and miniature painter. Born Boston, MA. Pupil of Cowles Art

School in Boston; ASL of NY; John F. Carlson. Member: NA Women PS; PBC; ASL of NY; Brooklyn Min. S.; C. L. Wolfe AC. Taught miniature painting at ASL of NY. Work: "Miss Evelyn Hall," Northfield (MA) School; "Col. Livingston," State Normal School, Plattsville, WI. Address in 1929, Rhinebeck, NY.

FAIRFAX, D. R.
Portrait painter who flourished early in the nineteenth century. The collection of paintings at Independence Hall, Philadelphia, has a portrait of Johnston Blakeley, 1781-1814, painted by D. R. Fairfax.

FAIRMAN, DAVID.
A brother of Gideon Fairman. He is mentioned as an engraver, though none of his work has been found. David was born in 1782 and died in Philadelpia, Aug. 19, 1815. His obituary refers to him as "A respectable Artist."

FAIRMAN, GIDEON.
Engraver. Born in Newtown, CT, June 26, 1774. Died in Philadelphia, March 18, 1827. In 1796 he opened an office in Albany as an engraver, and in 1810 he moved to Philadelphia and became a member of the bank note engraving firm of Murray, Draper, Fairman & Co. About 1824 he entered into partnership with Cephas G. Childs, and in 1826 he was a member of the firm of Fairman, Draper, Underwood & Co.

FAIRMAN, RICHARD.
Born in 1788. Died in Philadelphia, 1821. Mr. C. Gobrecht says that Richard was a brother of Gideon Fairman, and in 1820 he was working in the establishment of the latter engraver. He was engraving subject plates in line in Philadelphia as early as 1812.

FALCONER, JOHN M.
Painter and etcher. Born in Edinburgh, Scotland, May 22, 1820. He came to America in 1836 and became an honorary member of the National Academy in 1856. He painted in oils and water colors; etched on copper from his own works and designs of other artists. Member of New York Etching Club. Died March 12, 1903, in New York City.

FALLS, CHARLES BUCKLES.
Illustrator. Born Fort Wayne, IN, Dec. 10, 1874; died in 1959. Member: SI, 1909; GFLA; Mural P. Award: Beck prize, Phila. WCC, 1918. Work: Illustrated *An Alphabet Book*, by Rachel Field (Doubleday, Page & Co.); *The East Window*, by Bert Leston Taylor (Knopf). Address in 1929, 2 East 23d St., New York, NY.

FALLS, D(e) W(ITT) C(LINTON).
Painter and illustrator. Born New York, Sept. 29, 1864. Pupil of Walter Satterlee. Specialty, military subjects, portraits, comic illustrating. Address in 1929, 449 Park Ave., New York, NY.

FALTER, JOHN PHILIP.
Illustrator. Born in Plattsmouth, NE, Feb. 28, 1910. Studied: Kansas City Art Institute and in NY at the ASL. Beginning his career in 1929 at *Youth Magazine*, he has since illustrated for many major magazines and book publishers, including Macmillan and *Reader's Digest*. He served in the Navy in World War II as a special artist, producing some 180 posters. A member of the Player's Club, the Philadelphia Sketch Club, and S of I, he was elected to the latter's Hall of Fame in 1976.

FANNING, RALPH.
Painter, artist, writer, lecturer and teacher. Born New York, Nov. 29, 1889. Pupil of Cornell and Univ. of IL. Member: Ohio Soc. WCP; Columbus A. Lg. Lecturer for Bureau of University Travel. Professor of History of the Fine Arts, Ohio State University. Address in 1929, Dept. of Fine Arts, Ohio State Univ., Columbus, OH.; summer, Riverhead, LI, NY.

FANNING, SOLOMON.
Painter. Born in Preston, CT, in 1807. In 1833 he went to New York and studied portrait painting, and in 1840 he settled in Norwich, CT, where he practiced his profession. His portraits were said to have been good likenesses.

FANNING, WILLIAM S(ANDERS).
Painter and artist. Born Detroit, May 10, 1887. Pupil of Francis Paulus, Joseph Gies, John P. Wickes, Othon Friesz, Jean Marchand. Address in 1929, 5470 Trumbull Ave., Detroit, MI.

FANSHAW, SAMUEL RAYMOND.
Miniature painter. Born Dec. 21, 1814, in New York City. He exhibited at the National Academy from 1841 to 1847. He was elected an Associate of the Academy in 1881. Died Dec. 15, 1888, in New York City.

FARINA, PASQUALE.
Painter. Born Naples, Italy, Nov. 2, 1864. Studied at the Academy of Fine Arts, Naples. Directed manufacture of artistic ceramics and a class in sculpture at "Aversa," near Naples, Italy, 1885-87. Professor of drawing and perspective in the Normal School for Girls, at Tucuman, Argentine Republic, 1888-90. In 1890, founded a school of drawing, painting and sculpture at Tucuman. Member: Phila. Art Alliance; Fellowship PAFA; S. Indp. A.; AFA; Am. APL; Fairmount Park Association; Fairmount Art Assn. Award: Bronze medal, World's Fair, Chicago, 1893. Represented by: Allegorical painting of Italy in Council Hall, Atessa, Italy; National Museum, Buenos Aires, Argentina. Expert on "Old Masters" work. Address in 1929, 1350 South 51st St., Philadelphia, PA.

FARIS, BEN(JAMIN) HOWARD.
Painter. Born July 21, 1862; died 1935. Pupil of Cincinnati Academy. Member: Cincinnati AC. Specialty, newspaper art. Address in 1929, "Com.-Tribune"; h. Newlands Hotel, Cincinnati, OH.

FARJEON, ELIOT EMANUEL.
Portrait painter. Born in New York City. Studied at Cooper Union; NAD; ASL of NY; with Bonnat, Bouguereau, Robert-Fleury and Lefebvre in Paris. Member: Pittsburgh AA. Address in 1929, Rosenbaum Bldg., Pittsburgh, PA.

FARLEY, R(ICHARD) B(LOSSOM).
Painter. Born Poultney, VT, Oct. 24, 1875. Pupil of Whistler, Chase, Cecilia Beaux. Member: AFA; Salma. C.; Fellowship PAFA; Phila. Sketch C.; Phila. Alliance. Awards: Fellowship prize, PAFA, 1912; gold medal, Phila. AC., 1912; fourth W. A. Clark prize ($500), Corcoran Gallery, 1914; silver medal, P.-P. Exp., San F., 1915. Work: "Morning Mists," Pennsylvania Academy of the Fine Arts; "Fog," Corcoran Gallery, Washington, DC.; "Blue and Gold," "The Passing Cloud," Reading (PA.) Museum. Address in 1929, 1520 Chestnut St., Philadelphia, PA.

FARLINGER, JAMES S(HACKELTON).
Painter. Born Buffalo, NY, July 8, 1881. Address in 1929, 99 Claremont Ave., Verona, NJ; summer, 88 Mary St., Pembroke, Ontario, Canada.

FARLOW, HARRY.
Painter. Born Chicago, IL, April 11, 1882. Pupil of Duveneck, Benson, and Tarbell. Member: Salma. C.; MacD. C. Portraits in Hunter College, Lawyers' Club, Yale Club, Board of Education, Princeton Club, Calumet Club, New York; Manufacturers' Club, and Neff College, Philadelphia. Address in 1929, 55 Continental Ave., Forrest Hills, NY.

FARMER, BIRGITTA MORAN.
(Mrs. Thomas P. Farmer). Miniature painter. Born Lyons, NY; died 1939. Pupil Syracuse Univ.; Academie de la Grande Chaumiere, Paris. Member: AFA; Penn. S. Min. P.; NA Women PS. Address in 1929, 912 North Alvord St., Syracuse, NY.

FARMER, JOHN.
Engraver. Born Feb. 9, 1798, in Half Moon, Saratoga County, NY. Farmer was educated near Albany, NY, and taught school in that city. In 1821 he moved to Michigan, became a surveyor, and drew the first published map of Michigan. He later published a number of maps of Michigan, Wisconsin, Lake Superior, Detroit, etc. It is stated that he engraved most of these maps. Held many important city offices in Detroit. Died March 24, 1859, in Detroit, MI.

FARNDON, WALTER.
Painter. Born in England, March 13, 1876. Pupil of NAD under Edgar M. Ward. Member: ANA, 1928; Salma. C.; AWCS; NYWCC; Allied A. A.; NYSP. Award: Turnbull prize, Salma. C., 1919; Paul H. Hammond prize, AWCS, 1925; Vezin prize, Salma. C., 1926; Isidor prize, Salma. C., 1929. Address in 1929, Douglaston, Long Island, NY.

FARNHAM, JESSICA SHIRLEY.
Sculptor and painter. Born in New Rochelle, NY. Studied with Lorado Taft and Charles Mulligan. Work: "Park Scene," painting, Woodlawn High School, Birmingham; medallion, Montgomery Museum of Fine Arts, Montgomery, Ala. Member: Southern States Art League; Ala. Artists' League; Birmingham Art Club. Head of Art Department, Woodlawn High School, Birmingham, Ala. Address in 1933, 45 Woodlawn Station, Birmingham; h. Citronelle, Ala.

FARNHAM, SALLY JAMES.
(Mrs. Paulding Farnham). Sculptor. Born in Ogdensburg, NY, November 26, 1876. Studied at Wells College. Work: Equestrian statue of Gen. Bolivar, New York, NY; war memorial, Fultonville, NY; statue of Sen. Clark, Corcoran; Soldiers and Sailors Monument, Ogdensburg, NY; frieze in Pan Am Bldg, Wash., DC; Vernon Castle mem., Woodlawn Cemetery, NYC. Exhibited at NSS, 1923. Died April 28, 1943, in New York City. Address in 1929, 57 West 57th St., New York, NY.

FARNSWORTH, JERRY (MRS.).
See Sawyer, Helen Alton.

FARNSWORTH, JERRY.
Painter. Born Dalton, GA, Dec. 31, 1895. Pupil of C. W. Hawthorne, Clinton Peters. Member: Provincetown AA; Salma. C.; Wash. AC.; Wash. SA; Ten Painters of Wash. Awards: Second prize, Wash. SA, 1924; third Hallgarten prize, NAD, 1925; Hallgarten prize ($100), NAD, 1927; Golden State prize ($500), Grand Cent. Gal., 1928. Work: "Helen," Delgado Museum, New Orleans; "Three Churches," Penn. Academy of the Fine Arts, 1929. Address in 1929, North Truro, MA.

FARNUM, HERBERT CYRUS.
Painter. Born Gloucester, RI, Sept. 19, 1866. Pupil of RI School of Design; Julian Academy in Paris. Member: Providence AC; Providence WCC. Work: "Flood Tide," Rhode Island School of Design. Address in 1929, Olney Ave., North Providence, RI.

FARNUM, ROYAL B(AILEY).
Art designer, writer, lecturer and teacher. Born Somerville, MA, June 11, 1884. Pupil of Massachusetts Normal Art School. Member: Fed. Council on Art Education; Eastern Arts Assn.; Boston AC;

Design and Industries Assn. of Great Britain; Mass. Art Teachers A.; Inter. Fed. A. Tea.; AFA. Author of "Present Status of Drawing and Art in the Elementary and Secondary Schools in the United States," 1914, for the Bureau of Education, Washington; "Manual Arts in New York State," 1917; "Decoration for Rural Schools," Cornell Leaflet, 1914; "Syllabi on Drawing and Art;" "Practical Drawing Books—Art Education Series," 1924; "Education Thru Pictures," 1928. Writer of articles on art education in various magazines. On editorial staff, Practical Drawing Co., Dallas, TX. Educational Director, Rhode Island School of Design. Address in 1929, Rhode Island School of Design, 11 Waterman St., Providence, RI.

FARNUM, SUZANNE SILVERCRUYS.
(Mrs. Henry W. Farnum). Sculptor, writer, and lecturer. Born in Maeseyck, Belgium, May 29, 1898. Studied with Eberhardt, at Yale School of Fine Arts. Works: Herbert Hoover's bust, Louvain Library, Belgium, and copy to Mrs. Herbert Hoover; "Princess Josephine Charlotte of Belgium," property of Queen Elizabeth; Baptismal Font, Lutheran Church, New Haven, CT; plaque and medals of Dr. William Gillman Thompson, Reconstruction Hospital, NY; bust, Dr. Carmalt, New Haven Hospital, New Haven, CT. Awards: Beaux Arts prize, best composition of year, 1927; alumni prize, Academy of Rome, 1928. Member: National Association Women Painters and Sculptors; Paint and Clay Club. Address in 1933, 37 West 10th Street, NYC; home, 92 Cottage Street, New Haven, CT.

FARNUNG, HELEN M.
Painter and etcher. Born in Jersey City, NJ, in 1896. Pupil of Art Students League, New York. Address in 1926, 413 West 147th St., New York.

FARNY, HENRY.
Born in Ribeauville, Alsace, 1847. He came to this country in 1853 and later lived in Cincinnati. In 1867 he worked for Harper Bros. in New York, illustrating their publications; he visited Europe, and in Rome met Regnault, who gave him employment. He returned to America in 1870. Died Cincinnati, OH, on Dec. 24, 1916.

FARR, FRED W.
Sculptor. Born August 9, 1914, St. Petersburg, Fla. Studied: University of Oregon; Art Students League; American Artists School, NYC. Work: Ball State Teachers College; Detroit Institute; University of Illinois; Phillips; Portland (ME) Museum of Art. Rep. by P. Rosenberg and Co., NYC. Commissions for Moore-McCormack Lines Inc., SS Argentina (mural). Exhibited: The Bertha Schaefer Gallery, NYC; Museum of Modern Art; Springfield (Mass.) Museum of Fine Arts; Walker; Utica; Rhode Island School of Design; Whitney Museum; Port-au-Prince

(Haiti) Bicentennial Exposition; Walters Art Gallery, Baltimore; ART:USA:59; and many universities. Awards: Port-au-Prince Bicentennial Exposition, 1950, Haiti, Silver Medal. Member: Artists Equity. Taught: Brooklyn Museum School; Museum of Modern Art School, 1947; Hunter College, 1954; Dalton Schools, NYC, 1950; University of Colorado; Dayton Art Institute School; University of Oregon, 1948. Address in 1970, 155 Ridge St., NYC. Died in 1973.

FARRELL, A. T.
Illustrator. Member: SI. Address in 1929, 1910 Forster Ave., Brooklyn, NY.

FARRELL, KATHERINE LEVIN.
(Mrs. Theo. P. Farrell). Painter and etcher. Born Philadelphia, PA; died in 1951. Pupil of School of Design, School of Industrial Art, and of PAFA. Member: Plastic C.; Fellowship PAFA; Phila. Alliance; NA Women PS. Awards: Silver medal, 1922, and gold medal, 1923, Plastic Club. Represented in Pennsylvania State College Art Gallery; Trenton AA. Address in 1929, 330 South 43rd St., Philadelphia, PA.

FARRER, HENRY.
Painter and etcher in oil and water colors. Born March 23, 1843, in England. He attained distinction as a landscape painter. His principal works are "On the East River," "November Day," "A Hot Day." Member of the New York Etching Club and the American Society of Painters in Water Colors. Died Feb 24, 1903, in Brooklyn, NY.

FARRER, THOMAS CHARLES.
Painter and etcher. Born in England, 1838. He came to America in 1858 and served in the Union Army during the Civil War. He was the brother of Henry Farrer. Among his works exhibited at the National Academy in New York were "Twilight on the Hudson," "Sunset," and "Coming through the Lock." Member of the New York Etching Club. Died in 1901.

FARRINGTON, KATHERINE.
Painter in St. Paul, MN, in 1877. Pupil of De Camp, and Art Students League of New York. Address in 1926, 483 Field Point Road, Greenwich, CT.

FARROW, W(ILLIAM) M(cKNIGHT).
Painter, etcher, writer, lecturer and teacher. Born Dayton, OH, April 13, 1885. Pupil of AIC. Member: Alumni, AIC; All-Ill. SFA; Chicago Art Lg. Awards: Eames MacVeagh prize for etching, Chicago Art League, 1928; Charles S. Peterson prize, Chicago Art League, 1929. Work: "Christmas Eve," Woman's Club, Western Springs, IL; "Mother Nature's Mirror," Phillips Junior High School, Chicago; portrait of Abraham Lincoln, Stewart Community House,

Gary, IN. Address in 1929, Art Institute of Chicago; h. 6038 South Racine Ave., Chicago, IL.

FASANO, CLARA.
Sculptor. Born in Castellaneta, Italy, in 1900; US citizen. Studied: Cooper Union Art School; Art Students League; Adelphi College, Brooklyn, NY; Academy Julien and Colarossi, Paris; also in Rome with Dazzi. Awards: National Association of Women Artists, 1945, 50, 55; Audubon Artists, 1952; National Institute of Arts and Letters, 1952; Daniel Chester French medal, National Academy of Design, 1965, and Greer prize, 1968; scholarship abroad, 1922-1923. Exhibitions: Whitney Museum of American Art, NY; Metropolitan Museum of Art; National Academy of Design; Penna. Academy of Fine Arts, Philadelphia. Collections: US Post Office, Middleport, OH; Technical High School, Brooklyn, NY; Port Richmond High School, Staten Island, NY; Metropolitan Museum of Art; Smithsonian, Wash., DC. Taught sculpture at the Industrial and Fine Arts School of New York and Adult Ed., 1946-56; Manhattanville College, 1956-66. Address in 1982, Italy.

FASOLINO, TERESA.
Illustrator. Born in Port Chester, NY, in 1946. Attended the SVA where she studied under Robert Weaver. She also attended PI and ASL. Her career began at *Ingenue* and she has worked for *Travel and Leisure, Playboy, Redbook*, and *The New York Times*.

FASSETT, CORNELIA ADELE STRONG.
Painter. Born Nov. 9, 1831, in Owasco, NY. Daughter of Judge Strong. Studied abroad under Meissonier and moved to Washington, DC, in 1875. Her large portrait of the Supreme Justices in 1876 was exhibited at the Centennial. Painted many portraits of men and women in public life of Washington. She had eight children. Several of her paintings are in the Capitol Bldg., Washington, DC. Died Jan. 4, 1898, in Wash., DC.

FASSETT, TRUMAN E.
Painter and teacher. Born Elmira, NY, May 9, 1885. Pupil of Boston Museum School; Richard Miller; Lucien Simon. Member: Salma. C.; NAC; AFA. Address in 1929, 47 Washington Square, South, New York, NY; h. Woodmere, LI, NY.

FAUGHT, ELIZABETH J(EAN).
(Mrs. Ray Clinton Faught). Sculptor. Born in Richmond, Virginia, November 2, 1883. Studied at Rinehart School of Sculpture and with Ephraim Keyser. Member: Maryland Institute Alumni Association; Baltimore Museum of Art. Address in 1933, "Aqua Vista," 201 Athol Gate Lane, Carroll P.O., Baltimore, Maryland.

FAULKNER, BARRY.
Mural painter. Born Keene, July 12, 1881. Pupil of Abbott H. Thayer and George de F. Brush. Member:

ANA, 1926; Mural P.; NY Arch. Lg., 1911; Nat'l Inst. of Arts and Letters; NAD (assoc.). Awards: American Academy in Rome Scholarship, 1908-1911; medal of honor for painting, NY Arch. Lg., 1914. Work: Panels in foyer of Washington Irving High School, New York City; Pictorial Maps in Cunard Bldg., New York, NY; Eastman School of Music, Rochester; decorations in University of Illinois Library. Address in 1929, 319 East 72nd St., New York, NY, and 61 Summer St., Keene, NH.

FAULKNER, HERBERT WALDRON.
Painter, illustrater, engraver, writer, and lecturer. Born Stamford, CT, Oct. 8, 1860. Pupil of ASL of NY under Beckwith and Mowbray; Collin in Paris. Member: Salma. C., 1897; Syndicat de la Presse Artistique. Award: Hon. mention, Pan-Am. Exp., Buffalo, 1901. Work: "Gondolier's Kitchen," Dallas (Tex.) Art Association; "Palace on Grand Canal," St. Louis Museum; "Une Fete qui finit mal," Minneapolis Museum; "San Georgio, Venice, at Sunset," Herron Art Institute, Indianapolis. Died in 1940. Address in 1929, Washington, CT.

FAULKNER, SARAH M. (SALLY).
Sculptor, painter, designer, teacher, and craftswoman. Born in Lowell, Mass., May 8, 1909. Studied at Boston Museum of Fine Arts School; Army Air Force Photo. School. Member: Lowell Art Association; Boston Photo. Society. Position: Instructor, Lowell Art Association, Lowell, Mass. Address in 1953, Lowell, Mass.

FAUR, AUREL-SEBASTIAN.
Sculptor and painter. Born in Romania, January 30, 1918. Studied at School of Beaux Arts, Bucharest, 1934-37; School of Ceramics, Sevres, France. Worked at Manufacture National de Sevres, Iser, Despiaux, Maillol. Exhibited: Salon d'Automne, Salon des Independants, Salon des Tuileries, Grandes Galeries d'Art Contemporain, all in Paris; Musee de Peinture Moderne, Wauxhall, Bruxelles. Awards: 1st prize for portrait sculpture, School of Beaux Arts, Bucharest, 1939. Collections: Simu and Dona State Museums, Bucharest. Specialty is portrait sculpture cast in bronze and alabaster. Paints on porcelain in oils and watercolor. Address in 1983, 91-41 71st Road, Forest Hills, New York City.

FAUST, DORBERT C.
Painter. Exhibited a water color at Cincinnati Museum, 1925. Address in 1926, 552 Mt. Vernon Road, Newark, OH.

FAWCETT, GEORGE.
Illustrator and etcher. Born London, April 8, 1877. Studied in England. Member: Canadian Soc. P.E.; Chicago SE. Work: Three etchings, National Gallery, Ottawa, Canada. Address in 1929, 828 Valencia Ave., Coral Gables, FL; h. Old Branchville Road, Ridgefield, CT.

FAWCETT, ROBERT.
Illustrator. Born in London in 1903. Moved to Canada as a child and in 1924, after studying at the Slade School of Art, London, began his career in NY. He went on to produce illustrations for magazines and advertising clients, as well as to paint murals for the Commonwealth Institute and to write a book on the art of drawing, demonstrating his superb draftsmanship and mastery of composition. His intricate, atmospheric illustrations were published in *Look*, *Collier's*, and *The Saturday Evening Post*, appearing in the latter for the first time in 1945. A founding faculty member of the FAS, he was President of the Westport Artists and later elected to the S of I Hall of Fame. Died in 1967.

FAXON, WILLIAM BAILEY.
Painter. Born Hartford, CT, 1849. Pupil of Jacquesson de la Chevreuse. Member; SAA, 1892; ANA, 1906; AFAS; A. Aid S.; Century Assoc. Address in 1929, 7 West 43rd St., New York, NY.

FAY, NELLIE.
Painter. Born Eureka, CA, 1870. Pupil of Arthur F. Mathews and Emil Carlsen. Address in 1926, 1612 Washington St., San Francisco, CA.

FeBLAND, HARRIET.
Sculptor and painter. Born in NYC. Studied at Pratt Institute; NY University; Art Students League; American Artists School. Work in New School Art Center, NY; Cincinnati Art Museum; Tweed Gallery, Univ. of Minnesota; others. Has exhibited at Silvermine Guild, CT; Museum of Modern Art, Paris; Hudson River Museum, Yonkers; Women Choose Women, NY Cultural Center; others. Member of NY Artists Equity Association; Silvermine Guild of Artists; National Association of Women Artists. Taught at NY Univ., 1960-62; Harriet FeBland's Advanced Painters Workshop, Pelham, NY, 1962. Works in acrylic, sculpture in steel and other metals, plexiglas, marble and wood. Address in 1982, 245 E. 63rd St., NYC.

FECHIN, NICOLAI IVANOVICH.
Sculptor and painter. Born Kazan, Russia, 1881; came to US after World War I, living first in NYC; moved to Taos, NM, in 1927. Studied at Art School of Kazan; Imperial Academy of Art in St. Petersburg, with Ilya Repin; awarded a traveling scholarship through Europe. Member of Imperial Academy of Fine Arts, Russia. Work in Imperial Academy of Fine Arts (Petrograd); Kuingi Galleries (Petrograd); Museum of Kazan; Albright Art Gallery (Buffalo, NY); Art Institute of Chicago; Museum of New Mexico; Colorado Springs Fine Art Center; National Cowboy Hall of Fame; Harrison Eiteljorg Collection. Received first prize for portraits from the National Academy in 1924. Specialty was Indian figures and Southwestern subjects. Titles include "Young Indian Girl," "Old Indian," others. Died in Santa Monica, CA, in 1955.

FEDERE, MARION.
Painter and graphic artist. Born in Vienna, Austria. Studied: Vienna, Austria; Brooklyn Museum; Seide's Workshop; San Miguel De Allende, Instituto, Mexico; Pratt Graphic Center. Exhibitions: Village Art Center; National Academy of Design; Brooklyn Museum; Brandeis University. Awards: 19th Ann. Drawing Award, Village Art Ctr., 1964; Floyd Bennett Field First Prize, First Place Prof. Awards, 1969; Contemp. Awards, Am. Society of Contemp. Artists, 1981. Address in 1980, 2277 E. 17th St., Brooklyn, NY.

FEHRER, OSCAR.
Portrait painter. Born New York City in 1872. Studied in New York, Paris and Munich. Member: Allied AA; Salma. C.; NAC (life); Brooklyn SA; Brooklyn PS. Represented in Memorial Hall City Library, Lowell, MA. Address in 1929, care of the National Arts Club, 15 Gramercy Park, New York, NY; h. Lyme, CT.

FEININGER, LYONEL.
Painter and printmaker. Born Elizabeth, NJ, in 1871. Studied at the Berlin Academy; in Paris attended classes at Colarossi. Newspaper illustrator in Berlin, Chicago and Paris. Taught painting and graphic arts at the Bauhaus in Dessau. A member of the Exhibition Group, the Blau Vier, which included Klee, Kandinsky, and Jawlensky. Retrospective exhib., Nat'l. Gal., Berlin, 1931. His first major show in the US was held in 1944 at the Museum of Modern Art. Died in 1956.

FEITELSON, LORSER.
Painter. Born Feb. 11, 1898 in Savannah, GA. Studied in New York City and Paris. Taught at Art Center School in L.A. Exhibited at Cal. Palace (SF), 1928-29; S. F. Mus. of Art; Scripps College; MOMA (1936-37); Brooklyn Mus.; MMA; L.A. County Mus.; Whitney, and abroad. In collections of Brooklyn; MOMA; San Francisco Mus. of Art; Long Beach Mus. of Art; The Art Inst. of Chicago, 1947; Univ. of IL, 1950, 51, 52; Met Mus. of Art, 1953; many private collections. Died May 24, 1978.

FEKE, ROBERT.
Early American portrait painter. Born c. 1707 at Oyster Bay, Long Island. Married Eleanor Cozzens in 1742 at Newport, RI. Worked there and in Boston, New York and Philadelphia. The earliest date on his painting is 1741, and the latest is 1748. Made several sea trips; was possibly captured and taken to Spain. Went to Bermuda. His portraits are in Harvard University and the Redwood Library, Newport, RI. Portraits of the Bowdoins owned by Bowdoin College, Brunswick, ME. The Rhode Island School of Design

has his "Pamela Andrews," and the Cleveland Museum owns his portrait of Charles Apthorp. Died in 1750 in Bermuda.

FELCH.
This name is signed to some poorly executed landscape work published in 1855, with no indication of place.

FELDMAN, BARUCH M.
Painter. Born in Russia, 1885. Pupil of Anshutz. Member: Fellowship, Penna. Academy of Fine Arts. Address in 1926, 320 Harmony St., Philadelphia, PA.

FELDMAN, CHARLES.
Painter, writer and lecturer. Born Lublin, Russia, Jan. 27, 1893. Pupil of NAD; Robert Henri; George Bellows. Member: Salons of America; S. Indp. A. Address in 1929, 66 West 9th St., New York, NY; summer, 123 Beach 86th St., Rockaway Beach, NY.

FELDMAN, HILDA.
Painter, craftsman and teacher. Born Newark, NJ, Nov. 22, 1899. Pupil of Ida Wells Stroud, Anna Fischer. Member: NA Women PS. Address in 1929, 507 Richmond Ave., Maplewood, NJ.

FELKER, RUTH KATE.
(Mrs. W. D. Thomas). Painter. Born St. Louis, MO, May 16, 1889. Pupil of School of Architecture at Washington University; St. Louis School of Fine Arts; ASL of NY; Society of Beaux-Arts Architects; studied in Europe. Member: Soc. of Ancients of St. Louis; Wash. Univ. Arch. Soc. (hon.); St. Louis AG. Awards: Mallinckrodt prize, St. Louis AG, 1915, 1916, 1917, 1919. Work: Mural decoration in St. John's Hospital, St. Louis. Paintings in St. Louis Art League Gallery. Address in 1929, 7530 Harter Ave., Richmond Hgts., St. Louis Co., MO.

FELL, OLIVE.
Sculptor, painter, etcher, muralist and caster of life masks. Born at Big Timber Creek, at the foot of the Crazy Mountains in Montana, about 1900. Studied at Wyoming University; Art Institute of Chicago; Art Students League. Work in Buffalo Bill Museum (Olive Fell Room), Cody, WY, "100 Best Prints of the Year." Specialty, western scenes and wildlife; titles include "Fenced Sagebrush," "The Lone Rider," "Wading Moose." Address in 1949, Four Bear Ranch, near Cody, Wyoming.

FELLOWS, ALBERT P.
Painter and etcher. Born Selma, AL, 1864. Pupil of School of Industrial Art and of Drexel Inst., Philadelphia; PAFA; ASL of NY. Member: Phil. Soc. of Etchers; Phila. Sketch C.; Phila. Print C. Address in 1929, 112 South 52nd St., Philadelphia, PA; h. 127 Chatham Rd., Stonehurst, Del. Co., PA.

FELLOWS, CORNELIA FABER.
(Mrs. A. P. Fellows). Portrait painter. Born Philadelphia. Pupil of Penna. Academy of Fine Arts, and Drexel Institute. Member: Fellowship, Penna. Academy of Fine Arts; Plastic Club. Address in 1926, 3203 Summer St., Philadelphia, PA.

FELLOWS, FRED.
Sculptor and painter. Born in Ponca City, OK, August 15, 1934. Competed in rodeos; worked as saddlemaker and then commercial artist. Has done commissions for Winchester Firearms and Armco Steel Corp. Exhibited at Cowboy Artists of America show since 1968; Cowboy Hall of Fame; Russell Museum; Montana Historical Society; Los Angeles Co. Museum of Art; others. Awarded gold medal, Phippen award, 1975, and silver medal, 1978, Cowboy Artists of America Exhibition; Grumbacher. Member of Cowboy Artists of America. Specialty is the contemporary West. Bibliography, *Western Painting Today*, Hassrick; *Artists of the Rockies* magazine and *Print* magazine. Represented by The Peacock Galleries Limited, Jackson, WY; Flathead Lake Galleries, Bigfork, MT. Address in 1982, Bigfork, MT.

FELLOWS, LAWRENCE.
Illustrator. Born in Ardmore, PA. He attended the Philadelphia Academy of Fine Arts, followed by studies in England and France. Upon his return he did many humorous drawings for *Judge* and *Life*. His tasteful line drawings, utilizing large areas of white space, were suited to fashion illustration and appeared often in *Vanity Fair*, *Apparel Arts*, and *Esquire*. He was best known for his Kelly-Springfield Tire advertisements in the 1920's.

FELTON, ROBERT.
Engraver and one of the early American die-sinkers, according to the Colonial Records of Pennsylvania. At a meeting of the Governor's Council, held in Philadelphia, 1663, Charles Pickering and others were accused of coining silver "in imitation of Spanish pieces with too great an alloy of copper in it." From the minutes of the trial it appears that Robert Felton testified that he "made the Seals and the bills, viz-the Spanish Bills." He further speaks of the "Stamping of New Bills" and "Striking on the Stamp," and he says he worked several weeks in "Cutting the Seals."

FENDERSON, ANNIE M.
(Mrs. Mark Fenderson). Painter. Born Spartansburg, PA. Member: NA Women PS; Pa. S. Min. P. Specialty, miniatures. Address in 1929, 144 West 23rd St., New York, NY.

FENDERSON, MARK.
Illustrator. Member: SI, 1913. Address in 1929, 144 West 23d St., New York, NY.

FENN, HARRY.
Painter, illustrator and engraver. Born in England on Sept. 14, 1845. In 1864 he came to America. He was a founder of the American Water Color Society, the Society of Illustrators, and the Salmagundi Club. Specialty: Landscapes. Died in Montclair, NJ, April 21, 1911.

FENNER, MAUDE RICHMOND.
(Mrs. Albert Fenner). Painter, craftsman and writer. Born Bristol, RI, May 24, 1868. Pupil of Burleigh, Mathewson and RI School of Design. Member: Providence AC; Providence WCC. Address in 1929, 78 Oriole Ave., Providence, RI.

FENTON, BEATRICE.
Sculptor. Born Philadelphia, PA, July 12, 1887. Pupil of School of Industrial Art, Philadelphia, and Penna. Academy of Fine Arts. Member: Fellowship Penna. Academy of Fine Arts; Plastic Club; Philadelphia Art Alliance; National Association of Women Painters and Sculptors; National Sculpture Society, fellow. Exhibited at National Sculpture Society, 1923; Philadelphia Art Alliance, 1924-65; Penna. Academy of Fine Arts, 1920-68; Woodmere Art Gallery, 1958-68; others. Awards: Stewardson sculpture prize, Penna. Academy of Fine Arts, 1908; Cresson Traveling Scholarship, Penna. Academy of Fine Arts, 1909-1910; honorable mention, P.-P. Exposition, San Francisco, 1915; honorable mention, Plastic Club, 1916; Widener medal, Penna. Academy of Fine Arts, 1922; Fellowship prize, Penna. Academy of Fine Arts, 1922; Shillard silver medal, Plastic Club, 1922; bronze medal, Sesqui-Centennial Exposition, Philadelphia, 1926; Owens Memorial Award, 1967; others. Represented in permanent collection, Philadelphia Art Club; Fairmount Park, Philadelphia; Charles M. Schmitz Memorial, Academy of Music; "Fairy Fountain," Wister Park, Philadelphia; Brookgreen Gardens, SC; Philadelphia Museum of Art; others. Taught sculpture at Moore Institute of Art, Science and Industry, Philadelphia, 1942-53. Address in 1982, Philadelphia, PA.

FENTON, HALLIE CHAMPLIN.
Painter and teacher. Born in St. Louis, MO, Oct. 1980. Pupil of Jacques Blanche in Paris. Member: NA Women PS. Died in 1935. Address in 1929, Sagamore Park, Bronxville, NY.

FENTON, JOHN WILLIAM.
Painter and teacher. Born Conewango Valley, NY, July 6, 1875. Pupil of NY School of Fine and Applied Art; Cullen Yates and Howard Giles. Member: Salma. C.; New Rochelle AA. Award: First hon. mention, New Rochelle AA, 1923; E. Irving Hanson prize, 1927, New Rochelle AA. Work: "Bittersweet," Literary Digest cover. Teacher of art in New York City High Schools. Died in 1939. Address in 1929, 244 State St., East Westport, CT; summer, "Fenton Farms," Conewango Valley, Catteraugus Co., NY.

FERBER, HERBERT.
Sculptor and painter. Born April 30, 1906, NYC. Studied: City College of New York, 1923-26; Columbia University School of Dental and Oral Surgery, 1927, BS, 1930, DDS; Beaux-Arts Institute of Design, NYC, 1927-30; National Academy of Design, 1930. Work: Bennington College; Brandeis University; Albright; Cranbrook; Detroit Institute; Metropolitan Museum of Art; Museum of Modern Art; NYU; Newark Museum; Whitney Museum; Walker; Williams College; Yale University. Exhibited: The Midtown Betty Parsons Gallery, The Kootz Gallery, Andre Emmerich Gallery, all in NYC; Whitney Museum; San Francisco Museum of Art; Walker; National Academy of Design; Brooklyn Museum; Penna. Academy of Fine Arts; Corcoran; Philadelphia Art Alliance; Sculptors Guild; Golden Gate International Exposition, San Francisco; New York World's Fair, 1939; Art Institute of Chicago; Metropolitan Museum of Art; Sao Paulo; Museum of Modern Art; Brussels World's Fair, 1958; Tate; Carnegie; Documenta II, Kassel; Baltimore Museum of Art; Cranbrook; Battersea Park, London, International Sculpture Exhibition; Musee Rodin, Paris; plus numerous commissions, including B'nai Israel Synagogue, Millburn, NJ; Brandeis University; Whitney; J. F. Kennedy Federal Office Building, Boston, 1969. Awards: Beaux-Arts Institute of Design, NYC, Paris Prize, 1929; L. C. Tiffany Grant, 1930; Metropolitan Museum of Art, Artists for Victory, $1,000 Prize, 1942; Tate, International Unknown Political Prisoner Competition, 1953; Guggenheim Foundation Fellowship, 1969. Taught: University of Pennsylvania, 1936-64; Columbia University School of Dental and Oral Surgery; Rutgers University, 1965-67. Rep. by Knoedler Gallery, NYC. Address in 1982, 44 MacDougal St., NYC.

FERG, FRANK X.
Painter. Member: Penna. Academy of Fine Arts. Address in 1926, 6026 Webster St., Philadelphia, PA.

FERGUSON, ALICE L. L.
(Mrs. H. G. Ferguson). Painter. Born Washington, DC. Pupil of Corcoran School in Washington; and of Hawthorne and Breckenridge. Member: Wash. WCC; S. Wash. A; SSAL; NA Women PS; AFA. Address in 1929, 2330 California St., Washington, DC.

FERGUSON, DOROTHY H.
Painter and etcher. Born Alton, IL, Dec. 9, 1896. Pupil of Charles Hawthorne. Award: First prize, St. Louis Artists Guild, 1928. Work: "Goin' Home," Public Schools, St. Louis, MO. Address in 1929, 628 East 15th St., Alton, IL; summer, care of Provincetown Art Association, Provincetown, MA.

FERGUSON, DUNCAN.
Sculptor. Born Shanghai, China, January 1, 1901. Pupil of A. H. Atkins, Robert Laurent. Member:

Society of Independent Artists; Salons of America. Work: "Anatol" and "Mimi," Newark Museum, Newark, NJ; male figure, life-sized bronze, Whitney Museum of American Art, NYC. Address in 1929, 11 Minetta St., NYC; address in 1933, Cape Neddick, ME.

FERGUSON, EDWARD L.
Engraver. Born in Illinois in 1859. He lived in New York; his specialty was steel engraving. He died in New York City in 1915.

FERGUSON, ELEANOR M.
Sculptor. Born Hartford, June 30, 1876. Pupil of C. N. Flagg in Hartford; D. C. French, G. G. Barnard and Art Students League of New York. Member: Conn. Academy of Fine Arts. Address in 1933, 847 Prospect Ave.; 123 Vernon St., Hartford, CT.

FERGUSON, ELIZABETH F.
Illustrator. Born in Omaha, NE, 1884. Pupil of Penna. Academy of Fine Arts. Address in 1926, 1039 Fine Arts Bldg., Chicago, IL.

FERGUSON, HENRY.
Painter. Born 1842. Elected an Associate member of the National Academy in 1884. He died in 1911 in New York. His painting "In Venice" was exhibited in the Centennial of the National Academy in 1925.

FERGUSON, LILLIAN.
Painter and craftsman. Born Windsor, Ont., Canada, Aug. 18, 1877. Pupil of Lefebvre and Julian Academy in Paris; Alexander Robinson in Holland; William Chase. Member: Calif. AC; Laguna Beach AA; San Diego FAS; West Coast Arts, Inc. Award: Cash prize, Calif. State Fair, Sacramento, 1926; Tingle Memorial Fund prize, West Coast Arts, Inc., Los Angeles, 1926. Address in 1929, 1841 No. Highland Ave., Hollywood, CA.

FERGUSON, NANCY MAYBIN.
Painter. Born in Philadelphia, PA. Studied: Philadelphia School of Design; Pennsylvania Academy of Fine Arts; and with Daingerfield, Breckenridge, Chase, and Hawthorne. Awards: Fellowship, Pennsylvania Academy of Fine Arts; traveling scholarships, Pennsylvania Academy of Fine Arts and the Philadelphia School of Design; Philadelphia Sketch Club; National Association of Women Artists; Gimbel Brothers Exhibition; Reading Museum of Art; Woodmere Art Gallery; Germantown Art Exhibit; Moore Institute Art School and Industry. Collections: Friends Central School, Overbrook, Pennsylvania; Reading Museum of Art; Barnes Foundation; Woodmere Art Gallery; Pennsylvania Academy of Fine Arts; Moore Institute of Art and Science; Sellersville, Pennsylvania, Art Museum. Exhibitions: Toledo Mus. Art, 1927, 36, 38, 44; PAFA, 1945-52; Corcoran; Art Inst. Chicago; Detroit Inst. Art;

Carnegie Inst.; Buffalo FA Academy; Arch. League; Nat. Academy of Design; others. Member: Philadelphia Art All.; Provincetown Art Assoc.; Fellowship, Penna. Academy of Fine Arts. Address in 1953, Philadelphia, PA.

FERGUSON, WILLIAM HUGH.
Etcher. Born Reading, PA, 1905. Exhibited at the Annual Exhibition of Water Colors at the Penna. Academy of Fine Arts, Philadelphia, 1925. Died in Reading in 1964. Address in 1926, Perkiomen Ave., Reading, PA.

FERNALD, HELEN E(LIZABETH).
Painter, writer and lecturer. Born Baltimore, MD, Dec. 24, 1891. Pupil of ASL of NY. Member: Plastic C.; Phila. Alliance; Am. Oriental S. Author of articles and lectures on Chinese art. Address in 1929, The University Museum, Philadelphia, PA; h. 27 Central Ave., Bryn Mawr, PA; summer, 44 Amity St., Amherst, MA.

FERNBACH, A(GNES) B.
Etcher. Born New York City, June 29, 1877. Pupil of ASL of NY; Cooper Union; NY School of Applied Design for Women; Alphonse Mucha and Ernest Haskell. Member: Brooklyn SE. Address in 1929, 320 West 89th St., New York, NY.

FERNE, HORTENSE T.
Painter and etcher. Born New York, NY. Pupil of Chase, Hawthorne, Browne, Wagner and Auerbach-Levy; Breckenridge; NAD; School of Industrial Art, Phila. Member: Phila. Alliance; Print C.; AWCS; (sec.-treas.) Phila. SE; North Shore AA; Art Centre, NY; (Chm.) New Group Phila. A.; Plastic C.; NA Women PS. Award: First hon. mention, Plastic C., 1927. Work: "Indian Study" and "White Cloud," Lanape Club, Philadelphia; Cardinal portrait, Rome; Republican Club, New York. Address in 1929, 10 South 18th St.; 1901 Walnut St., Philadelphia, PA.

FERNIE, MARGARET.
See Eaton, Margaret Fernie.

FERNOW, BERNICE PAUAHI ANDREWS.
(Mrs. B. E. Fernow, Jr.). Painter. Born Jersey City, NJ, Dec. 17, 1881. Pupil of Olaf M. Brauner and Theodora Thayer. Member: ASL of NY; A.S. Min. P. Specialty: Portraits and miniatures. Address in 1929, Clemson College, SC.

FERRANA, JOSEPH.
Figure maker. Born in Italy c. 1800. Lived and worked in Baltimore, 1860. Worked in plaster.

FERRANA, PILARENE.
Figure maker. Born in Tuscany c. 1841. Son of Joseph Ferrana. Lived and worked in Baltimore, 1860. Worked in plaster.

FERRARI, FEBO.
Sculptor. Born in Pallanza, Italy, Dec. 4, 1865. Pupil of Royal Academy, Turin. Member: New Haven PCC. Specialty, architectural sculpture. Address in 1929, Onahill Cottage, Short Beach, CT.

FERREN, JOHN.
Sculptor, painter, designer, and teacher. Born in Pendleton, OR, October 17, 1905. Studied at Sorbonne, Paris; University Florence, Italy; University Salamanca, Spain. Work: Museum of Modern Art; Wadsworth Atheneum; Phila. Museum of Art; San Fran. Museum of Art; Detroit Institute of Art; Scripps College; Museum of Non-Objective Painting, NY. Exhibited: Corcoran Gallery of Art, 1937; Penna. Academy of Fine Arts, 1937, 40, 45; Calif. Palace of the Legion of Honor, 1945, 49, 52; Detroit Institute of Art, 1946; City Art Museum, 1946; Kleemann Gallery, 1947-49; Museum New Mexico, 1950; Santa Barbara Museum of Art, 1952; San Fran. Museum of Art, 1952; Stanford University, 1952; one-man: Matisse Gallery, 1936-38; Willard Gallery, 1941; Minneapolis Institute of Art, 1936; San Fran. Museum of Art, 1937; Putzel Gallery, Hollywood, Calif., 1936. Position: Instructor, Cooper Union Art School, NYC. Address in 1953, 52 East 9th St., NYC; h. Los Angeles, Calif. Died in 1970.

FERRER, RAFAEL.
Sculptor and painter. Born in Santurce, Puerto Rico, 1933. Studied at Staunton Military Academy, Virginia, 1948-51; Syracuse University, NY, 1951-52; University of Puerto Rico, Mayaquez, 1952-54, under E. Granell. Exhibitions: University of Puerto Rico Museum, Mayaquez, 1964; Pan American Union, Washington, DC, 1966; Penna. Academy of Fine Arts, Philadelphia, 1967; Leo Castelli Gallery, NYC, 1968; Kunsthalle Bern, Switzerland, 1969; Stedelijk Museum, 1969; Museum of Modern Art, NYC, 1970; Corcoran Gallery, 1971; Whitney Museum, NYC, 1973. Taught: Philadelphia College of Art, Penna., 1967. Lived in Hollywood, Calif. and Europe. Was associated with the Surrealist Group, Paris, 1953. In 1959, took up painting professionally. Address in 1982, c/o Nancy Hoffman Gallery, 429 West Broadway, NYC.

FERRER, VERA L.
Miniature painter. Born New York, NY, Jan 13, 1895. Pupil of Lucia Fairchild Fuller and J. B. Whitaker; NAD. Member: NA Women PS. Address in 1929, Little Neck, NY.

FERRIS, BERNICE BRANSON.
(Mrs. Warren W. Ferris). Illustrator. Born Astoria, IL. Pupil of J. C. Leyendecker, F. Goudy, Lawton Parker; Chicago AI; Chicago Academy of F.A. Member: Lincoln AG; Wash. AC. Died in 1936. Address in 1929, Russell Rd., Alexandria, VA.

FERRIS, EDYTHE.
(Mrs. Raymond Ferris). Painter, illustrator and teacher. Born Riverton, NJ, June 21, 1897. Pupil of Philadelphia School of Design for Women. Member: Phila. Alliance; Philadelphia School of Design for Women, Alumnae; AFA. Address in 1929, 3741 Locust St., Philadelphia, PA.

FERRIS, JEAN LEON GEROME.
Historical painter. Born Philadelphia, Aug. 8, 1863. Pupil of S. J. Ferris and Christian Schuessele in Philadelphia; Bouguereau and Gerome in Paris. Member: A. Fund S. of Phila.; Phila. SE, 1881; Phila. AC, 1890. Loan collection of seventy paintings of American History, Museum of Independence Hall, Philadelphia. Died in 1930. Address in 1929, 8 No. 50th St., Philadelphia, PA.

FERRIS, STEPHEN JAMES.
Portrait painter. Born in Plattsburgh, NY, Dec. 25, 1835. He received the Fortuny prize for the best portrait of the artist in Rome, 1876. He painted about 2000 portraits and made a number of etchings. He died in Philadelphia, July 9, 1915.

FERRIS, STEPHEN, JR.
Etcher and crayon portrait draughtsman. Flourished 1857-60, Philadelphia. He was a close friend of the engraver John Sartain of Philadelphia.

FERRIS, WARREN W(ESLEY).
Painter and illustrator. Born Rochester, NY, June 22, 1890. Pupil of John Norton; AIC; Le Mans in France. Member: Wash. AC; Wash. WCC. Award: First prize, Decorative Art League, New York, 1923. Address in 1929, Russell Rd., Alexandria, VA.

FERRISS, HUGH.
Illustrator, architect designer. Born St. Louis, MO, July 12, 1889. Pupil Sch. FA, St. Louis; Arch. Sch. Washington Univ. Member: NY Arch. Lg.; NYAG. Illustrations for *Harpers, Century, Pencil Points, Monitor, Arts and Decoration, McCalls*, etc. Contr. article on "Architectural Rendering," Encyclopaedia Brittannica, 1929. Consultant to Arch. Comm. World's Fair, Chicago, 1933; Spec. Lecturer on Design and Illustration, Columbia (1926), Yale (1928), U. of Penn. (1928); Hon. Master of Arch., Wash. U. (1928). Address in 1929, 101 Park Ave., New York, NY.

FERRY, ISABELLE H.
Painter and teacher. Born Williamsburg, MA. Pupil of Tryon, Henri, Bouguereau, Boutet de Monvel, Fleury, etc. Member: Springfield, MA, Art Lg.; Conn. AFA; Holyoke A. Lg. Died in 1937. Address in 1929, Skye Studio, Boothbay Harbor, ME; h. 189 East St., Easthampton, MA.

FERSTADT, LOUIS.
Sculptor, painter, illustrator, designer, teacher, and lecturer. Born in Ukraine, Russia, October 7, 1900. Work: Walker Art Center; Whitney Museum of American Art; Tel-Aviv Museum, Palestine; Biro-Bidjan, Russia; murals, Hunter College; radio station WNYC; RCA Building, NY. Exhibited: Whitney Museum of American Art; Metropolitan Museum of Art; Museum of Modern Art; Brooklyn Museum; Carnegie Institute; National Academy of Design; Penna. Academy of Fine Arts; and in international exhibitions. Illustrator, *Peek-a-Boo*, juvenile book, 1931. Position: Art Staff, *Chicago Tribune*; Art Director, Fox Features Syndicate; Art Director, Ed., Writer, comic books. Address in 1953, 147 Fourth Ave.; h. 510 West 124th St., NYC. Died in 1954.

FETERS, W. T.
A crudely done stippled portrait of the Rev. John Davenport, of Connecticut, is signed "W. T. Feters," though this may be a mistake of the letter-engraver for Peters. The plate has no indication of its origin, and the only reasons for ascribing it to an American are the poor quality of the work and the fact that the subject is American. The date of publication is about 1820.

FETSCHER, CHARLES W.
Painter and architect. Member: Soc. Deaf A. Address in 1929, 323 Guion Ave., Richmond Hill, LI, NY.

FETTE, HENRY GERHARD.
Portrait painter in oils and miniature. Flourished in Boston, 1842-51.

FIELD, EDWARD LOYAL.
Landscape painter. Born Jan 4, 1856, in Galesburg, IL, and died March 22, 1914, in New York City. He also painted in water color.

FIELD, ERASTUS SALISBURY.
Painter. Born 1805 in Leverett, MA. Self-taught; briefly a student of Samuel F. B. Morse in 1824. Field was an itinerant painter, painting portraits in W. Mass. and Conn. In 1845 and 1847 works were exhibited at Am. Inst. of NYC. Died in 1900.

FIELD, HAMILTON EASTER.
Painter and etcher. Born in Brooklyn, 1873; died there, 1922. Pupil in Paris of Gerome, Gollin, Courtois, Fantin-Latour, and Lucien Simon. He was also an art editor, writer and teacher.

FIELD, LOUISE BLODGETT.
Painter. Born in Boston. Pupil of Ross Turner, Fred D. Williams, William Morris Hunt and Tomasso Juglaris in Boston. Member: Boston WCC; Copley S., 1896. Address in 1929, 32 Cottage St., Wellesley, MA.

FIELD, MARY.
(Mrs. Herman Field). Painter and craftsman. Born Stoughton, MA, Jan. 14, 1864. Pupil of AIC. Member: Chicago SA; Chicago AC. Award: Bronze medal, Alaska Yukon Pacific Exp., Seattle, 1909; prize for portrait, Chicago AC, 1918. Address in 1929, 4826 Kimbark Ave., Chicago, IL.

FIELD, ROBERT.
Portrait painter and engraver. Probably born in Gloucester, England, and came to New York c. 1793. Went to Halifax, after painting very good miniatures in Boston, Phila., Baltimore, and NY. Field was in Phila., 1795, and on August 1st he published his portrait of Washington in NYC. He engraved stipple portraits of Washington, Jefferson, Hamilton and Shakespeare, but was chiefly occupied in painting miniatures. Subjects of miniatures include Washington and Jefferson, after Stuart, Charles Carroll of Carrollton, both of the latter engraved by Longacre and William Cliffton, and J. E. Harwood, engraved by Edwin. Painted portraits of Mrs. Allen, of Boston, and Mrs. Thornton, of Washington, DC. About 1808, Field moved to Halifax, Nova Scotia, to paint portraits; there he engraved at least one large plate, a full-length portrait of Governor-General Sir John Coape Sherbrooke, published in Halifax in 1816. He painted this and several of other governors for the Government House in Halifax. A number of Field's portraits in that city were those of Bishop Charles Ingles, now in the National Gallery in London, and portraits of Adam Dechezean, John Lawson, Michael Wallace, and William Bowie, of Halifax. He probably returned to England for a short time, as Algernon Graves, in his "Dictionary of Artists," mentions R. Field as "a portrait painter of Halifax, NS." He later went to Jamaica. In a letter of Field's, in the Pennsylvania Historical Society, addressed to Robert Gilmor, Jr., Baltimore, Field refers to the Robertson portrait of Washington which he engraved "with some ornaments to surround and make it more interesting." Died Aug. 9, 1819, in Jamaica.

FIELDING, MANTLE.
Architect, designer and author of books relating to painting and engraving. Born in New York, 1865. Member of Philadelphia Art Club and Penna. Academy of Fine Arts. Author of *American Engravers*, and "Gilbert Stuart, and his Portraits of Washington." Address in 1926, 520 Walnut St., Philadelphia, PA.

FIELDS, FREDERICA HASTINGS.
Stained glass artist and glass engraver. Born in Philadelphia, PA, Jan. 10, 1912. Studied: Landscape painting with Frank M. Fletcher, 1930, and Frank Logan, 1931; Wellesley College, 1930-32; The Art Students League, NY, with Nicolaides, 1933; stained glass with Mrs. Orin Skinner, 1938-39, and with George Sotter, 1951. Exhibitions: Nat. Collection of

Fine Arts, Washington, DC, 1953, 57, 58; Corcoran Gallery of Art, 1955, 56; Nat. Conference on Religious Art, NY, 1967; First Presbyterian Church, Stamford, CT, 1976. Awards: Corcoran Gallery of Art, 1955, 1956; 4th and 6th International Exhibition of Ceramic Arts, Nat. Collection of Fine Arts, 1953, 57. Collections: Washington Cathedral, Washington, DC; Greenwich Library, CT; Y.M.C.A., Greenwich, CT. Member: Greenwich Art Soc.; Stained Glass Assoc. of America. Address in 1984, Greenwich, CT.

FIELDS, MITCHELL.
Sculptor. Born in Belcesti, Rumania, September 28, 1901. Studied at National Academy of Design; Beaux-Arts Institute of Design. Member: Nat. Sculpture Society; Associate of the National Academy of Design. Awards: Guggenheim Fellow, 1932, 35; prize, National Academy of Design, 1929; Widener Memorial gold medal, Penna. Academy of Fine Arts, 1930; National Academy of Design, 1949, prize, 1950. Work: Brooklyn Museum; Gorki Literary Museum; Museum of Modern Western Art, Moscow. Exhibited: Museum of Modern Art; Whitney Museum of American Art; Brooklyn Museum; Metropolitan Museum of Art; National Academy of Design; Penna. Academy of Fine Arts. Died in 1966. Address in 1953, 3 Great Jones St.; h. 38 Morton St., NYC.

FILARDI, DEL.
Sculptor. Member of Society of Animal Artists; Catharine Lorillard Wolfe Art Club; Salma. Club. Has exhibited at National Sculpture Soc.; Catharine Lorillard Wolfe Art Club, NYC; Society of Animal Artists, NYC; "Birds of Prey," Museum of Science, Boston; Blue Herron Gallery. Address in 1983, c/o Blue Herron Gallery, Wellfleet, MA.

FILKOSKY, JOSEFA.
Sculptor. Born in Westmoreland City, PA, June 15, 1933. Study: Seton Hall College; Carnegie-Mellon University; Cranbrook Academy of Art; Art Institute of Chicago, Summer Sculpture Seminar. Exhibitions: Art Image in All Media, NYC, 1970; Indiana University, 1972; Bertha Schaefer Gallery, NYC, 1973 (all solos); Pittsburgh Plan for Art, 1971, 73, 75; Sculpture in the Fields, Storm King Art Center, Mountainville, NY, 1974-76; Sculpture on Shoreline Sites, Roosevelt Island, NY, 1979-80. Awards: Three Rivers Purchase Prize, 1972; Associated Artists of Pittsburgh Award, 1976. Teaching: Professor of Art, Seton Hall, from 1956. Member: Associated Artists of Pittsburgh; others. Works in aluminum, plexiglas. Address in 1983, Seton Hall Col., Greensburg, PA.

FILMER, JOHN.
Engraver and book illustrator.

FILTZER, HYMAN.
Sculptor. Born in Zitomir, Russia, May 27, 1901. Studied at Yale School of Fine Arts; Beaux-Arts

Institute of Design; and with Gutzon Borglum, Paul Manship. Member: Fellow, National Sculpture Soc. Awards: Prize, National Aeronautic Association, Washington, DC, 1922. Work: Public Schools, New York, Bronx, and Queens; Bellevue Hospital, New York; Ft. Wadsworth, New York; Russell Sage Foundation; United States Army Soldier's Trophy. Exhibited: National Academy of Design, 1926, 1936, 40; Philadelphia Museum of Art, 1940; New York World's Fair, 1939; Architectural League, 1938; Whitney Museum of American Art, 1940; Metropolitan Museum of Art, 1942; New York Historical Society, 1943; Penna. Academy of Fine Arts, 1953; others. Position: Restorer of Sculpture, Metropolitan Museum of Art, New York City, from 1945. Address in 1967, c/o Metropolitan Museum of Art, NYC; h. 1639 Fulton Ave., Bronx, NY. Died in 1967.

FINCH, ELINOR G.
Miniature painter. Exhibited portrait miniatures at the Penna. Academy of the Fine Arts, Philadelphia, 1922. Address in 1926, 22 Terrace Park, Spokane, WA.

FINCKEN, JAMES H(ORSEY).
Engraver and etcher. Born Bristol, England, May 9, 1860. Member: Phila. Sketch C.; Phila. Alliance; Phila. Print C.; AFA. Address in 1929, 1012 Walnut St.; h. 909 South Saint Bernard St., Philadelphia, PA. Died in 1943.

FINE, PERLE.
Painter. Born in Boston, MA, May 1, 1908. Studied with Hans Hofmann and printmaking with William Hayter. Collections: Whitney Museum of American Art; Smith College Museum; Rutgers University; Munson-Williams-Proctor Institute; Los Angeles Museum of Art; Guggenheim Museum of Art; The Miller Company Collection; Brandeis University; Brooklyn Museum. Exhibited at Carnegie Inst., Pittsburgh; Art of the Century, Peggy Guggenheim Gallery, NY; Geometric Abstraction in Am. and Nature in Abstractions, Whitney Mus. of Am. Art, NY. Media: Oil, acrylic, wood collage, and collage. Address in 1980, 538 Old Stone Highway, The Springs, NY.

FINK, DENMAN.
Painter and illustrator. Born Springdale, PA, Aug. 29, 1880. Pupil of Benson, Hale and Walter A. Clark. Member: SI. Illustrated *Mace's History of United States*; *The Barrier* and *The Lost Girl*, by Rex Beach; *Post Borders*, by Mary Austen, etc. Illustrations for *Harper's*, *Scribner's*, *Century*, etc. Address in 1929, Haworth, NJ.

FINK, FREDERICK.
Genre and portrait painter. Born Dec. 28, 1817 in Little Falls, NY. Studied under Morse. The subjects of the few pictures he lived to execute are "An Artist's

Studio," "The Shipwrecked Mariner," "The Young Thieves," "A Negro Woodsawyer," and a portrait of W. S. Parker, painted when the artist was eighteen years old. Fink died Jan. 23, 1849.

FINK, SAMUEL.
Illustrator. Born in NYC in 1916. Studied: NAD and ASL in the mid-1930's. His first work appeared in *The New York Times* in 1938. He has spent most of his career at Young and Rubicam as an art director and is author and illustrator of the book *56 Who Signed* for E.P. Dutton. He is represented in the collection of the Brooklyn Museum.

FINKELNBURG, AUGUSTA.
Painter. Born Fountain City, WI. Pupil of AIC; Pratt Inst., Brooklyn; studied in Paris, Italy, Holland and England and with Robert Reid, Willard Metcalf, Henry B. Snell, Herbert Adams and Arthur W. Dow. Awards: Three first prizes at Missouri State Fair. Member: St. Louis AG; St. Louis AL. Work: Landscape, St. Louis High Schools. Address in 1929, Kimmswick, MO.

FINKLE, MELIK.
Sculptor. Born in Rumania in 1885. Studied at Cincinnati Art Academy. Work in Cincinnati Museum; US Post Office, Sylvania, OH; City College of NY; others. Address in 1953, NYC.

FINN, HENRY JAMES.
Miniature painter, actor and author. Born June 17, 1787, in Sydney, NS, Canada. Painted miniatures in Boston, 1833. Died Jan. 13, 1840.

FINNEY, BETTY.
Painter. Born in Sydney, Australia, in 1920. Studied: Royal Art Society, Sydney; Academie des Beaux-Arts, Brussels; Otis Art Institute; also with Paul Clemens, Ejnar Hansen and Norman Rockwell. Awards: Scholarship, Royal Art Society, Sydney; Los Angeles, Stacy award, 1952; Traditional Art Show, Hollywood, 1955; Friday Morning Club.

FINTA, A(LEXANDER).
Sculptor, illustrator, teacher, and writer. Born Turkeve, Hungary, June 12, 1881. Studied at Columbia University and in Europe. Member: American Fed. of Arts; Painters and Sculptors Club of Southern California. Work: Marble bust of His Eminence Cardinal Hayes, Metropolitan Museum of Art, New York; bronze portrait of Count Apponyi, National Museum of Budapest, Hungary; "Strength," granite monument, City of Rio de Janeiro, Brazil; 30-foot high marble War Monument, City of Nyitra, Czechoslovakia; 15-foot high granite War Monument, City of Maniga, Czechoslovakia; 12-foot high marble monument of Adolf Merey, City of Budapest, Hungary; monument of Honveds, City of Hatvan, Hungary; Numismatic Society, NYC. Ex-

hibited: National Museum of Fine Arts, Budapest; Metropolitan Museum of Art; Brooklyn Museum; National Academy of Design; Library of Congress; others. Sculptor for Twentieth Century Fox Film Corporation, 1944, 45. Address in 1953, Los Angeles, CA. Died in 1958 (?).

FIORATO, NOE.
Sculptor. Address in 1921, 308 West 56th Street, New York, NY.

FIORE, ANTHONY JOSEPH.
Sculptor. Born in New York City, September 10, 1912. Studied at the National Academy of Design. Member: Larchmont Art Society. Address in 1933, 4601 Murdock Avenue, New York, NY.

FIORE, GEORGIA ELEANORA.
Sculptor. Born in Philadelphia, PA. Exhibited at the Salon des Artistes Francais in 1934.

FIORE, ROSARIO RUSSELL.
Scuptor. Born in NYC, January 5, 1908. Studied at National Academy of Design; Beaux Arts Institute of Fine Arts; Mech. Institute. Work includes bronze sculptures, Interior Dept., Washington, DC; White House, Washington, DC; heroic size bronze statue of Gen. George C. Marshall, Leesburg, VA; others. Has exhibited at Grand Central Art Gallery, NYC; Architectural League, NY; Corcoran Art Gallery, Wash., DC. Received National Academy Prize; Anna V. Huntington Award, National Academy. Member of National Sculpture Society. Address in 1982, Jekyll Island, GA.

FIRESTONE, I(SADORE) L(OUIS).
Painter, illustrator and teacher. Born in Austria-Hungary, April 13, 1894. Pupil of Carnegie Inst. of Tech., Pittsburgh; NY Evening School of Ind. A.; ASL of NY. Member: Pittsburgh AA. Address in 1929, 148 East 34th St., New York, NY; h. 246 Dinwiddie St., Pittsburgh, PA.

FISCHER, ANTON OTTO.
Painter and illustrator. Born Munich, Bavaria, Feb. 23, 1882. Pupil of Jean Paul Laurens, Julian Academy, Paris. Member: SI; AFA. Illustrated for *Harper's Weekly*, *Saturday Evening Post*, *Everybody's Life*, and Scribner's. Best known for marine paintings; author, illus. of *Fo'cs'le Days*, publ. by Scribner's. Died in 1962. Address in 1929, 164 Elmendorf St., Kingston, NY; summer, Shandaken, Ulster Co., NY.

FISCHER, H.
Painter. Member: Society of Independent Artists. Address in 1926, 48 West 90th Street, New York, New York.

FISCHER, J. F.
Work: Portrait of Albert Pike, born in 1809 and died in 1891. American lawyer, author, and Confederate commissioner appointed to treat with the Indians. Half length to left, long white locks and white beard. Size 29 in. x 23 in. Signed "J. F. Fischer." Sold, American Art Association, NY, Dec., 1921.

FISCHER, MARTIN.
Painter, writer and lecturer. Born Kiel, Germany, Nov. 10, 1879. Member: Duveneck Soc. of Painters; Cincinnati AC. Worl: Murals, Physiological Laboratories, College of Medicine and Assembly Hall, Col. of Pharmacy, Cin., OH. Address in 1929, College of Medicine, Eden Ave.; h. 2236 Auburn Ave., Cincinnati, OH.

FISCHER, MARY ELLEN SIGSBEE.
(Mrs. Anton O. Fischer). Illustrator. Born New Orleans, LA, Feb. 26, 1876. Member: SI (assoc.), 1912. Address in 1929, 402 Albany Ave., Kingston, NY; Shandaken, Ulster Co., NY.

FISH, GERTRUDE ELOISE.
Sculptor. Born in Roselle Park, NJ, Sept. 28, 1908. Studied with Georg Lober, Charles Grafly, and Laessle. Awards: Penna. Academy of Fine Arts, Exhibitions by Women Artists, Gimbel Bros., Philadelphia, 1932. Member: Fellowship Penna. Academy of Fine Arts; Westfield Art Association. Address in 1933, 420 Chestnut St., Roselle Park; summer, Cranberry Lake, NJ.

FISHER, A. HUGH.
Painter, etcher and writer. Born London, Feb. 8, 1867. Pupil of Jean Paul Laurens, Benjamin Constant, Sir Frank Short. Member: Chicago SE; Calif. PM. Represented in Wash. Public Library, Washington, DC; British Museum, National Art Gallery of Victoria, London. Address in 1929, The Print Corner, Hingham Center, Mass.; h. 46 Aldridge Rd. Villas, Bayswater, London, England.

FISHER, ALVAN.
American portrait and genre painter. Born Aug. 9, 1792, in Needham, MA. In 1825 he visited Europe for study and travel. He established his studio in Boston, where he painted many portraits. One of his best works is a portrait of Spurzheim painted from recollection in 1832. Died in Feb. 1863 in Dedham, MA.

FISHER, ANNA S.
Painter. Born Cold Brook, NY. Member: ANA; AWCS; NYWCC; NA Women PS; SPNY; Allied AA. Awards: National Arts Club prize, NA Women PS, 1919; Harriet B. Jones prize, Balt. WCC., 1922. Work: "The Orange Bowl," National Academy of Design, New York, NY. Died in 1942. Address in 1929, 939 Eighth Ave., New York, NY.

FISHER, BUD.
Cartoonist. Born in 1885. Address in 1926, 258 Riverside Drive, New York.

FISHER, EMILY KOHLER.
Painter. Member: Fellowship, Penna. Academy of Fine Arts. Address in 1926, Manheim Apartments, Queen Lane, Germantown, Philadelphia.

FISHER, FLAVIUS J.
Portrait painter. Born in 1832 in Virginia. He studied in Philadelphia; also abroad. In Washington he painted portraits of many prominent people; also some landscapes. He died May 9, 1905, in Wash., DC.

FISHER, GEORGE HAROLD.
Sculptor, writer, craftsman, and educator. Born in Detroit, MI, September 14, 1894. Studied at Detroit School of Fine Arts and with John Wicker. Awards: Prizes, Grosse Pointe, Michigan, 1934-36. Work: Murals, Westlake Professional Bldg., Los Angeles; Flint Ridge Biltmore Hotel; US Post Office, Chelsea, MI. Exhibited: Detroit Institute of Art, 1919, 1931-33; Los Angeles Museum of Art, 1924-26; Painters and Sculptors Society, 1926, 27; California Water Color Society, 1926; Calif. Mod. Art Workers, Hollywood, 1924; San Diego Fine Art Soc., 1926; Scarab Club, Detroit, MI, 1936. Address in 1953, Detroit, MI.

FISHER, GEORGE V.
Painter. Member: Society of Independent Artists. Address in 1926, 858 52d St., New York, NY.

FISHER, HARRISON.
Illustrator. Born Brooklyn, NY, July 27, 1875. Studied in San Francisco. Member: SI, 1911. Illustrated *The Market Place*, by Harold Frederic; *Three Men on Wheels*, by Jerome K. Jerome; for *Life*, etc. Died in 1934 in New York City. Address in 1929, 80 West 40th St., New York, NY.

FISHER, HUGH ANTOINE.
Landscape painter. Born 1867; died in 1916 in Alameda, California. He was the father of the illustrator Harrison Fisher.

FISHER, HUGO MELVILLE.
Painter. Born in Brooklyn, NY, Oct. 20, 1876. Pupil of Whistler, Laurens, Constant in Paris. Member: Paris AAA. Address in 1929, 344 West 28th St., New York, NY.

FISHER, IRMA.
Exhibited water colors at the Exhibition of the Penna. Academy of Fine Arts, 1925, in Philadelphia. Address in 1926, 7621 Star Ave., Cleveland, OH.

FISHER, JOHN.
The Journals of the Continental Congress, under date of June 26, 1773, note "that there is due to John

Fisher, for re-newing two copper-plates for loan-office certificates, and making two letters in the device of the thirty dollar bills, 20 dollars."

FISHER, KENNETH L.
Sculptor. Born in Tacoma, WA, April 28, 1944. Studied: University of Oregon, Eugene. Exhibited extensively; national exhibitions include Henry Korn Gallery, Eugene, OR, 1970; Int. Art Gallery, Pitts., PA, 1971; Jewish Community Center, Portland, OR, 1971; Portland Art Museum Sales Gallery, Portland, OR, 1980; Howell Street Gallery, Seattle, WA, 1981; 41st Annual, Braithwaite Fine Arts Gallery, So. Utah State College, UT, 1982; Goldsboro's 3rd Annual Juried Exhibition, NC, 1982; Painter and Sculptors Society of NJ, 49th National, Bergen Community Museum, NJ, 1982; Louisiana Art and Arts Guild 13th Annual River Road Show, Guild Gallery, LA, 1982; Cooperstown Art Association 47th Annual, NY, 1982; Galerie Triangle 3rd Annual National Exhibition, Washington, DC, 1982; Audubon Artists 41st Annual National Arts Club, NY, 1983; 2nd Annual Non-Member Open Juried Exhibition, Salmagundi Club, NYC, 1983; Knicker-bocker Artists 33rd Annual Exhibition, Salmagundi Club, NYC, 1983; and others. Awarded: Honorable Mention, Terrance Gallery Nat. Juried Exhibition, Palenville, NY, 1982; M. Grumbacher Bronze Medallion, Southport's 2nd Annual Art Exhibit, Southport, NC, 1982; First and Second Place, 8th Annual, J. K. Ralston Museum, Sidney, First and Second Place, 8th Annual, J. K. Ralston Museum, Sidney, MT, 1982; First Place, Joseph A. Cain Memorial Sculpture Purchase Award for the Del Mar College Permanent Collection, Corpus Christi, TX, 1982; Cert. of Recognition, 10th International Art Exhibition, Georgia Tech., Georgia, 1983; numerous others. Media: Bronze, aluminum, chrome and applied color. Address in 1983, Portland, OR.

FISHER, LEONARD EVERETT.
Illustrator. Born in NY, June 24, 1924. Attended Yale Univ. and received a Pulitzer Prize for painting in 1950. His illus. for over 200 children's books have earned him many awards. The des. of ten U.S. postage stamps, he has prod. a poster series of the bicentennial and of great comp. in 1976. Many mus. have exhibited his works, which are also in the col. of the LC, NAD, New Brit. Museum of Amer. Art and several univ. He has been on the fac. of the Paier School and Dean of the Whitney Art School.

FISHER, VAUDREY.
Painter. Born Staffordshire, England, 1889. Pupil of von Herkomer; Castellucho; Brangwyn. Address in 1926, 1730 Broadway, New York, NY.

FISHER, WILLIAM EDGAR.
Illustrator and designer. Born Wellsville, NY, Oct. 24, 1872. Pupil of AIC; Cornell Univ. Member: A.

Bookplate S.; Salma C. On "Judge" Editorial Staff; Art Director, William Green Printing Co. Specialty, bookplate designs. Address in 1929, 627 West 43rd St.; h. 611 West 36th St., New York, NY.

FISHER, WILLIAM MARK.
Landscape painter. Born in Boston, 1841. Studied at the Lowell Institute, Boston, and in Paris. He was elected an Associate of the Royal Academy in 1913. He died in London in 1923. Represented at Boston Museum of Fine Arts by "Road to Menil," painted in 1869.

FISK, EDWARD.
Landscape painter. Exhibited at the "Exhibition of Paintings Showing the Later Tendencies in Art," at the Penna. Academy of the Fine Arts, Philadelphia, 1921. Address in 1926, Care of Daniel Galleries, New York City.

FISKE, CHARLES ALBERT.
Painter. Born in MA, 1837. He graduated from Dartmouth College, lived in New York City, and exhibited at the National Academy of Design. He died May 13, 1915, in Greenwich, CT.

FISKE, GERTRUDE.
Painter and etcher. Born Boston, April 16, 1879. Pupil of Tarbell, Benson, Hale and Woodbury. Member: ANA; Boston GA; NA Women PS; Boston SE; Concord AA; Conn. AFA; New Haven PCC; AFA. Awards: Silver medal, P.-P. Exp., San F., 1915; Hudson prize, Conn. AFA, 1918; Samuel Bancroft, Jr., prize, Wilmington, SFA, 1921; Thomas B. Clarke prize, NAD, 1922; Shaw Memorial prize, NAD, 1922; Clerici prize, NA Women PS, 1925; figure prize, New Haven PCC, 1925; Clarke prize, NAD, 1925; prize, Springfield AL, 1925; Conn. Acad. Flagg prize, 1925; portrait prize, Conn. AFA, 1926; New Haven PCC prize, 1929. Address in 1929, 132 Riverway, Boston, MA.

FISKEN, JESSIE.
Painter. Born in Row, Scotland, 1860. Pupil of Glasgow School of Art. Address in 1926, 1607 Minot Ave., Seattle, WA.

FITCH, BENJAMIN HERBERT.
Painter. Born Lyons, NY, 1873. Self-taught. Member: Rochester Art Club; Rochester Society of Artists. Address in 1926, 217 West 33rd Street, Philadelphia, PA.

FITCH, JOHN.
Engraver. Born in South Windsor, CT, Jan. 21, 1743; died in Bardstown, KY, July 2, 1798. Also inventor of the steamboat, he was apprenticed to a clock-maker at an early age. After some service in the Revolutionary War as a gunsmith, he was appointed a deputy-surveyor by the State of Virginia in 1780. In

1785 Fitch made a map of the northwest country for explorers, based on maps of Hutchins and Morrow and his own explorations. This he crudely engraved on copper, hammered out and printed on a press of his manufacture. According to his advertisement in the *Pennsylvania Packet* of 1785, he sold it for "a french crown," and he apparently disposed of a considerable number. With $800 raised, he formed a steamboat company in 1787 and built a 60-ton boat.

FITCH, JOHN LEE.
Born in Hartford, CT, 1836; died in 1895. He studied abroad, and spent his professional life in Hartford and New York City. He was an Association of the National Academy and Treasurer of the Artists' Fund Society of New York. His works include "In the Woods," "Gill Brook Willows on the Croton," "Near Carmel, NY."

FITE, FRANK E. (MRS.).
See Peck, Anne Merriman.

FITE, HARVEY.
Sculptor. Born in Pittsburgh, PA, Dec. 25, 1903. Studied at St. Stephen's College; Woodstock School of Painting; with Corrado Vigni, Florence, Italy. Exhibited in numerous one-man shows in Rome, Italy, Paris, and NY, 1949-51; US State Dept. traveling group shows in Europe and Africa, 1953, 54; Opus 40, Woodstock, NY, monumental landscape structure on 6½ acres of bluestone quarry; Whitney. Received Asia Foundation Grant for Cambodia, 1956. Member of Woodstock Artists Association. Taught at Bard College (professor of sculpture, 1932-69; emeritus from 1969). In collections of Whitney; Albany Institute; restoration of Mayan sculpture in Carnegie Inst., Washington, DC. Died in Saugerties, NY, in 1976.

FITLER, MRS. W. C.
See Hirst, Claude Raguet.

FITLER, WILLIAM C.
Painter. Born Cincinnati, OH, c. 1897. Specialty, landscapes in watercolor. Studio in New York City. Died c. 1926.

FITSCH, EUGENE C(AMILLE).
Painter and etcher. Born Alsace, France, Dec. 11, 1892. Pupil of Mahonri Young, Frank V. DuMond; Joseph Pennell; Albright Art School; ASL of NY; Beaux Arts School of Sculpture. Member: S. Indp. A.; ASL of NY; Alliance. Instructor of the Graphic Arts, Art Students League of New York. Address in 1929, 143 West 4th St., New York, NY; summer, Grassy Hill, Lyme, CT.

FITTS, CLARA ATWOOD.
(Mrs. F.W. Fitts). Illustrator. Born Worcester, MA, Oct. 6, 1874. Pupil of School of the Boston Museum of Fine Arts. Member: Copley S; AFA. Work: Altarpiece, three panels, St. John's Church, Roxbury, MA. Illustrated books for children, etc. Address in 1929, 40 Linwood St., Roxbury, MA.

FITZ, BENJAMIN RUTHERFORD.
Painter. Born in 1855 in New York. Pupil of National Academy and Art Students League from 1877 to 1881; studied in Munich under Loefftz and returned to American in 1884. He died in Peconic, LI, NY, in 1891. He was a member of the Society of American Artists and is represented in the Metropolitan Museum, New York.

FITZ-RANDOLPH, GRACE.
Sculptor, painter, and teacher. Born in NY. Pupil of J. Alden Weir and Augustus Saint Gaudens in New York; Benjamin-Constant, Girardot and Puech in Paris. Bronze medal, Atlanta Exposition, 1895. Member: Art Students League of New York; NY Woman's Art Club. Address in 1910, 3 Washington Square, South, New York City. Died in NYC, January 1917.

FITZER, KARL H.
Painter and illustrator. Born Kansas City, May 4, 1896. Member: Kansas City SA. Work: Pastel paintings; designer of fine year books. Address in 1929, 700 Graphic Arts Bldg.; h. 7341 Terrace, Kansas City, MO.

FITZGERALD, HARRINGTON.
Landscape and marine painter. Born in Phila., April 5, 1847. Pupil of Fortuny and Gerome in Paris; George Nicholson in Philadelphia. Member: Fairmount Park AA; Phila. Sketch C.; Pen and Pencil C., Phila.; Newspaper Artists' Assn.; AAS Artist member, Art Jury, Philadelphia, 1908-12. Awards: Gold medal, AAS, 1902; bronze medal, Charleston Exp., 1902. Represented in Smithsonian Institution and National Gallery of Art, Wash., DC; Albright Art Gallery, Buffalo; Detroit Museum of Art; Commercial Museum, Phila.; State College, Penn.; etc. Died in 1930. Address in 1929, 918 Spruce St., Philadelphia, PA.

FITZGERALD, PITT L(OOFBOURROW).
Painter and illustrator. Born Washington C.H., O., Oct. 3, 1893. Pupil of PAFA and N. C. Wyeth. Member: Columbus PPC; Columbus AL. Died in 1971. Address in 1929, 515 Grove Ave., Columbus, OH.

FITZPATRICK, DANIEL ROBERT.
Cartoonist. Born Superior, WI, March 5, 1891. Pupil of AIC. Member: St. Louis AG. Awards: Lewis first caricature prize, PAFA, 1924; Pulitzer cartoon prize; Harmon-Survey prize. Address in 1929, Post-Dispatch Bldg, 12th and Olive St.; H. 5624 Cabanne Ave., St. Louis, MO.

FITZPATRICK, JOHN C.
Painter, illustrator and writer. Born Washington, DC, Aug. 10, 1876. Pupil of ASL of NY. Member: Wash. WCC; Washington AC. Address in 1929, 135 A Street, NE, Washington, DC.

FITZPATRICK, JOHN KELLY.
Painter and teacher. Born Wetumpka, AL, Aug. 15, 1888. Pupil of AIC. Member: NOAA; SSAL. Awards: Special mention, SSAL, Houston, TX, 1926; popular prize ($75), State Fair, Montgomery, AL, 1927. Work: "Portrait of Gov. Parons" and "Pioneer Cabin," State of Ala. Address in 1929, Wetumpka, AL.

FJELDE, PAUL.
Sculptor and educator. Born Minneapolis, MN, Aug. 12, 1892. Studied at Minneapolis School of Art; Beaux-Arts Institute of Design and Art Students League, NY; under Lorado Taft in Chicago; Royal Academy, Copenhagen; Academie de la Grande Chaumiere, Paris. Exhibited at National Sculpture Society, 1923. Awards: Honorable mention, St. Paul Institute, 1918; American Artists Professional League; National Sculpture Society. Member: Society of Western Sculptors; Chicago Society of Artists; National Sculpture Society (fellow); National Academy of Design, Academician. Works: Lincoln monument, Christiania, Norway; J. S. Bradstreet memorial, Minneapolis Art Institute; Irwin memorial, Auburn, ME; Gjertsen memorial, Minneapolis, MN; Lincoln monument, Hillsboro, ND; Pioneers memorial, Council Bluffs, IA; Donnersberger memorial, McKinley Park, Chicago, IL; decorations for Washington School, McKeesport, PA; Brookgreen Gardens, SC. Taught: Pratt Institute from 1929; instructor at National Academy School of Fine Arts, NYC; editor of *National Sculpture Review*, 1951-55; etc. Address in 1970, Brooklyn, NY.

FLACK, ARTHUR W.
Painter. Born in San Francisco, 1878. Pupil of Rochester Fine Arts Institute; also studied in London and Paris. Address in 1926, Atlas Building, Rochester, NY.

FLAGG, CHARLES NOEL.
Portrait painter. Born in Brooklyn, Dec. 25, 1848; died in Hartford, CT, Nov. 10, 1916. He studied for years in Paris. His principal portraits were of Mark Twain, Charles Dudley Warner, and a series of seven governors of Conn. He was elected an Associate of the National Academy in 1908.

FLAGG, GEORGE WHITING.
Painter. Nephew of Washington Allston, born in New Haven, CT, June 26, 1816; he spent his childhood in South Carolina. In 1830 he went to Boston as a portrait painter. He was assisted by Luman Reed, patron of art and artists, and many of his works are to be found in the Reed collection (New York Historical Society). In 1851 he was elected a member of the National Academy of New York. Represented at the New York Historical Society by the "Wood-chopper's Boy," "Match Girl," "Lady and Parrot," and "The Nun." He died Jan. 5, 1897, in Nantucket, MA.

FLAGG, H. PEABODY.
Painter. Born Somerville, MA, 1859. Pupil of Carolus-Duran in Paris. Member: NY Arch. Lg., 1899; Boston AC; Salma. C., 1904. Work: Two hist. paintings in Flower Mem. Library, Watertown, NY. Address in 1929, 26 E 23rd St., NY, NY.

FLAGG, HENRY C.
Marine painter. Nephew of Washington Allston, and brother of George W. Flagg, born in New Haven, CT, on Dec. 10, 1811. He painted many marines and later joined the United States Navy. Died Aug. 23, 1862, in Jamestown, NY.

FLAGG, J(AMES) MONTGOMERY.
Painter and illustrator. Born Pelham Manor, NY, June 18, 1877. Pupil of ASL of NY; Herkomer in England; Victor Marec in Paris. Member: SI, 1911; Lotos C.; GFLA. Illustrations for *Liberty*, *Cosmopolitan*, *College Humor* and other magazines; *City People*, *Kitty Cobb* and books of satire; travel book, *Boulevards all the Way-Maybe*. Collection of drawings published as "The Well-Knowns." Appointed military artist for New York State in World War I and made forty-six posters, which were used for U.S. Gov. Died in 1960. Address in 1929, 108 West 57th St.; 1 West 64th St., New York, NY.

FLAGG, JARED BRADLEY.
Painter. A younger brother of Geo. W. Flagg, the artist. Born in New Haven, CT, 1820. He studied with his brother and also received some instruction from 1849. He died on Sept. 25, 1899.

FLAGG, JOSIAH.
Engraver. Born c. 1737. Charles E. Goodspeed, of Boston, notes the following book as containing 70 pages of copper-plate music engraved by Josiah Flagg -- *Sixteen Anthems*, "collected from Tan'sur Williams, Knapp, Ashworth & Stephenson, etc. Engraved and printed by Josiah Flagg, and sold by him at his house near the Old North Meeting House and at his shop in Fish Street. Also by the Booksellers in Boston, New England." Died in 1795.

FLAGG, JOSIAH (JR.).
Miniaturist. Born c. 1763. Flourished in Boston about 1783. He advertised in the *Boston Gazette*, Feb. 10, 1783, "Copying of Miniature Painting in Hair."

FLAGG, MONTAGUE.
Painter. Born in 1842 in Hartford, CT; died Dec. 24, 1915, in New York City. Pupil of Jacquesson de la

Chevreuse in Paris. Most of his professional life was spent in New York. Elected a member of the National Academy in 1910. He painted "Portrait of My Wife." The figure is seen to the waist; the hair is parted and drawn over the ears; she wears a simple black dress, slightly open at the throat. Painting owned by the Metropolitan Musem of Art, New York.

FLANAGAN, JOHN.
Sculptor. Born Newark, NJ, in 1865. Pupil of Saint-Gaudens in NY; Chapu and Falguiere in Paris. Member: National Academy of Design, 1911; Nat. Sculpture Society, 1902; NY Architectural League, 1914; Conn. Academy of Fine Arts; Salmagundi Club; American Numismatic Society; Society of Illustrators; New Society of Artists. Exhibited at National Sculpture Society, 1923. Awards: Silver medal, Paris Exp., 1900; silver medal, Pan-Am. Exp., Buffalo, 1901; silver medal, St. Louis Exp., 1904; medal of honor for section medals, P.-P. Exp., San Francisco, 1915; Saltus medal, American Numismatic Society, 1921; Chevalier of Legion of Honor, 1927; Watrous gold medal, National Academy of Design, 1932. Work: Clock, Library of Congress, Washington, DC; bronze relief, "Antique Education," Free Public Library, Newark, NJ; tinted marble relief, "Aphrodite," Knickerbocker Hotel, NYC; bronze memorial portrait of Samuel Pierpont Langley, Smithsonian Institution, Washington, DC; Bulkley memorial, Aetna Life Insurance Bldg., Hartford, CT; Alexander memorial medal for School Art League of NY; Carnegie Institute, Pittsburgh; Newark Art Museum; war medal for the town of Marion, MA; medal for the Garden Club of America; "Medaille de Verdun," voted by Congress, and presented by the President of the United States to the City of Verdun. Address in 1933, 116 West 65th St., NYC. Died March 28, 1952.

FLANAGAN, JOHN RICHARD.
Illustrator. Born in Sydney, Australia, in 1895. He was an apprentice to a lithographer while studying art. He came to the U.S. and worked on *Everyweek* magazine, illustrating Chinese stories, soon establishing himself as an authority on the Orient. His illustrations also appeared in *Blue* and *Collier's*. Working almost exclusively in pen and ink, both in color and black and white, he later decided to design stained glass windows. He served as a instructor at New York Academy of Arts for many years. Died in 1964.

FLANIGEN, JEAN NEVITT.
Painter. Born Athens, GA, Feb. 7, 1898. Pupil of Wagner, Breckenridge, Garber, McCarter and Pearson; PAFA. Member: Fellowship PAFA; SSAL. Represented in Fellowship PAFA Collection. Art editor of University of Georgia Annual. Address in 1929, 424 Prince Ave., Athens, GA.

FLANNAGAN, JOHN.
Sculptor. Born April 7, 1895, in Fargo, ND. Studied: Minneapolis Institute School, 1914-17, with R. Koehler. Work: Andover (Phillips); Cincinnati Art Museum; Cleveland Museum of Art; Det. Institute; Harvard University; Honolulu Academy; Metropolitan Museum of Art; Vassar College; Whitney Museum; Wichita Art Museum. Exhibited: Whitney Studio Club, NYC, 1925; Weyhe Gallery, 1927, 28, 30, 31, 34, 36, 38; Arts Club of Chicago, 1934; Vassar College, 1936; Bard College, 1937; Buchholz Gallery, NYC, 1942; Museum of Modern Art; Whitney Museum; Metropolitan Museum of Art; Brooklyn Museum. Awards: Guggenheim Foundation Fellowship, 1932; Metropolitan Museum of Art, Alexander Shilling Prize, 1940. Died Jan. 6, 1942, in NYC.

FLECK, JOSEPH A.
Painter. Born Vienna, Austria, Aug. 25, 1892. Pupil of Vienna AFA. Member: IL Acad. FA; Taos S. Awards: Bronze medal, Kansas City AS, 1923; Rosenwald prize ($300), AIC, 1927; prize (figure), Phoenix, AZ, 1928; silver medal, K.C.A.I., 1929. Work: "Indian Motherhood," Kansas City Public Library; "Little Wolf," St. Joseph Art Collection, St. Joseph, MO; portrait of General Paxton, Confederate Museum, Richmond, VA; "Their Domain," Wesleyan College, Salina, Kan.; "Survivors," Fort Worth Art Museum, Fort Worth, TX. Address in 1929, Taos, NM.

FLEISHBEIN, FRANCOIS.
Portrait painter. Born in Germany c. 1804. Came to New Orleans in 1833. He had a studio at 135 Conde Street, New Orleans, from 1840 to 1860.

FLEISHER, LILLIAN B.
Painter. Exhibited at the Pennsylvania Academy of Fine Arts, Philadelphia, in 1924. Address in 1926, 237 Wyncote Road, Jenkintown, PA.

FLEMING, H(ENRY) S(TEWART).
Sculptor, painter, illustrator, and craftsman. Born in Philadelphia, July 21, 1863. Pupil of Lefebvre and Benjamin-Constant in Paris. Member: Society of Illustrators, 1901. Address in 1929, 1 Broadway, New York, NY; Eton College, Scarsdale, NY.

FLEMMING, JEAN ROBINSON.
(Mrs. Ralston Flemming). Painter. Born Charleston, SC, Sept. 22, 1874. Pupil of Elliott Daingerfield, H. B. Snell, John Carlson, F. S. Chase, Castelluche. Member: Carolina AA; Jackson AA; Southern SAL; Norfolk SA. Address in 1929, York Apts., 429 West York St.; Talbot Bldg., 105 West Main St., Norfolk, VA.; summer, Virginia Beach, VA.

FLERI, JOSEPH C.
Sculptor. Born Brooklyn, NY, May 20, 1889. Member: National Sculpture Society; Architectural

League of NY. Work: "Crucifixion and Twelve Apostles," Holy Cross Church, Philadelphia, PA; other sculpture in churches in Bethlehem and Northampton, PA; garden sculpture, Syosset, NY; statues at Brookgreen Gardens, SC; others. Address in 1953, 461 Sixth Avenue, NYC. Died in 1965.

FLETCHER, ANNE.
Painter and teacher. Born Chicago, IL, June 18, 1876. Pupil of Hawthorne, Bridgman, ASL of NY; Simon and Lasar in Paris. Work: Paintings and decorations in the Confederate Museum, Governor's Mansion, U.S. District Court, Westmoreland Club, Richmond, VA; U. of VA, Charlottesville. Address in 1929, 211 E Franklin St., Richmond, VA.

FLETCHER, CALVIN.
Sculptor, painter, architect, craftsman, writer, lecturer, and teacher. Born in Provo, Utah, June 24, 1882. Pupil of Pratt Institute; Columbia University; Art Institute of Chicago; Central School Arts and Crafts in London; Colarossi and Biloul in Paris; Morse in Chicago. Works: Two murals in Latter Day Saints Temple in Logan, Utah; Utah St. Collection; Utah State Agricultural College; J. H. Vanderpoel Collection, Chicago; Smoky Hill Art Club, KS. Award: First prize, Utah State Fair Association. Former president, Utah Art Institute. Address in 1933, Agricultural College; h. Logan, Utah.

FLETCHER, FRANK MORLEY.
Painter, craftsman, writer, lecturer and teacher. Born Whiston, Lancashire, England, April 25, 1866. Pupil of Cormon in Paris. Member: Art Worker's Guild and Graver-Printer's Society, London; Calif. P.M. Awards: Medals for oil painting, World's Columbian Exposition, Chicago, 1893, and for prints, Milan International, 1906. Works: Woodblock prints in British Museum and Victoria and Albert Museum, London, and in galleries at Dresden and Budapest and the Boston Museum of Fine Arts. Author of textbook on woodblock printing. Director Santa Barbara School of the Arts. Address in 1929, 2626 Puesta del Sol, Santa Barbara, CA.

FLETCHER, G(ILBERT).
Illustrator and block printer. Born Mankato, MN, March 24, 1882. Pupil of PAFA. Work: "Ship at Wave Crest," Metro. Museum of Art; "The Village," Newark Museum of Art; illustrations for *Ladies' Home Journal*. Address in 1929, Towners, NY.

FLETCHER, GODFREY B.
Painter. Born at Watsonville, CA, Dec. 16, 1888. Pupil of Armin Hansen. Frequently worked in water color. Died in Dec. 1923, at Watsonville, CA.

FLETCHER, WILLIAM BALDWIN.
Sculptor. Born in Indianapolis, IN, August 18, 1837. He was a physician and amateur sculptor. Work in Indiana State House. Died in Orlando, Florida, on April 25, 1907.

FLEURY, ALBERT.
Mural painter. Born in Havre, France, 1848. Member of Chicago Water Color Club. Address in 1926, 1133 North Dearborn St., Chicago, IL.

FLISHER, EDITH E.
Painter, craftsman and teacher. Born Cleveland, OH, Sept. 26, 1890. Pupil of PAFA. Member: Nashville AA; Nashville Des. Club. Work: "Portrait of Gov. Tom Rye," State Capitol, Nashville; "Portrait of Dr. J. A. Crook," Union Univ., Jackson, Tenn. Address in 1929, 167 Eighth Ave., North; h. 8 West End Apartments, Nashville, TN.

FLOEGEL, ALFRED E.
Painter. Born Leipzig, Germany, Sept. 4, 1894. Pupil of C. C. Curran, F. C. Jones, Ivan G. Olinsky; NAD; Beaux-Arts Inst. of Design; American Academy in Rome. Member: Arch. Lg. of NY; Mural P. Work: Decoration on organ doors, church, Cranbrook, MI; stained glass windows, church, Kalamazoo, MI. Address in 1929, 160 Fifth Ave., New York, NY; h. 5906 Woodbine St., Brooklyn, NY.

FLOET, LYDIA.
Painter. Exhibited at National Association of Women Painters and Sculptors, New York, 1925. Address in 1926, Wilton, CT.

FLOOD, EDWARD C.
Sculptor and painter. Born in 1944. Studied at Art Institute of Chicago. Work in National Collection of Fine Arts, Washington, DC; Art Institute of Chicago, IL. Has exhibited at Indianapolis Museum of Art, IN; Art Institute of Chicago; others. Received Cassandra Foundation Grant, 1970; National Endowment Artists Fellowship Grant, 1978; others. Works in acrylic and wood. Address in 1982, Brooklyn, NY.

FLORANCE, EUSTACE LEE.
Painter. Born in Philadelphia. Member: St. Botolph C; Wash. AC. Address in 1929, 10 Frisbie Pl., Cambridge, MA; 1090 Washington St., Dorchester, MA.

FLORENTINO-VALLE, MAUDE RICHMOND.
Painter and illustrator. Pupil of Art Students League of New York under Cox, Chase, Brush and Beckwith; Academie Julien under Lefebvre, Constant and Beaury-Sorel, in Paris. Address in 1926, 1136-1140 Corona St., Denver, CO.

FLORIAN, WALTER.
Painter. Born 1878 in New York City; died there, April 1, 1909. Pupil of Metropolitan Museum Art School under Twachtman and Herbert Morgan; Art Students League of New York; Julien and Colarossi

in Paris. He painted Jozef Israels, Dutch painter, life size; seated figure, with palette and brushes held in his left hand, a characteristic pose, painted in Israel's studio. Signed "Walter Florian." Owned by the Metropolitan Museum, New York.

FLORIMONT, AUSTIN.
Portrait draughtsman in crayon, and miniature painter. Flourished in Philadelphia, 1781.

FLORIO, SALVATOR ERSENY.
Sculptor. Born in Messina, Italy, in 1890 (or 1895?). He studied at the National Academy of Design and assited in the studios of Hermon A. MacNeil, A. Stirling Calder and James E. Fraser. Awards: Silver medal for nude figure, National Academy of Design; bronze medal for service as sculptor, Panama-Pacific International Exposition, San Francisco, CA, 1915. Works: Reliefs, Springtime; Adam and Eve; The Tribute; head of Minerva, San Francisco Museum of Art, San Francisco, CA; portrait, Rear-Admiral C. J. Peoples. Exhibited at National Sculpture Society in 1923.

FLORSHEIM, RICHARD A.
Sculptor, painter, educator, writer, printmaker and lecturer. Born in Chicago, IL, October 25, 1916. Studied at University of Chicago; Museum of Modern Art; Met. Museum of Art; Musee Nationale d'Art Moderne, Paris; and with Aaron Bohrod. Member: Chicago Society of Artists; Artists Equity Association; National Academy of Design; Audubon Artists; Soc. Amer. Graphic Artists; others. Awards: Prizes, Art Institute of Chicago, 1946, 50; Pennell Fund Award, Library of Congress, 1956; Chicago Newspaper Guild Artists, 1959. Work: Musee du Jeu de Paume, Paris; Art Institute of Chicago. Exhibited: Penna. Academy of Fine Arts, 1934, 35; Los Angeles Museum of Art, 1934; San Francisco Museum of Art, 1935, 48; Art Institute of Chicago, 1940-43, 45, 47-51, 70; Salon des Refuses, 1935; Toledo Museum of Art, 1942; Philadelphia Print Club, 1946, 48, 51; Whitney Museum of American Art, 1947; Zanesville Art Institute, 1948; Baltimore Museum of Art, 1948; Delgado Museum of Art, 1948; Chicago Society of Etchers, 1948; University of Nebraska, 1950; Milwaukee Art Institute, 1950; Akron Art Institute, 1951; Decatur Art Center, 1951; National Academy of Design, 1972; and many more. Address in 1976, Chicago, IL. Died in 1979.

FLOWER, SHERWOOD.
Painter. Born Oakwood, Cecil County, MD, 1878. Address in 1926, Evesham Ave., Baltimore, MD.

FOGARTY, THOMAS.
Illustrator. Born New York, 1873. Pupil of ASL of NY under Mowbray, Beckwith. Member: SI, 1901; Salma. C., 1908. Illustrated *The Making of an American*, by Riis; *On Fortune's Road*, by Will Payne, etc. Taught at ASL, 1903-1922; pupils included Norman Rockwell. Works in collections of Met. Mus. of Art, NYC; Brooklyn Mus., NY. Died in 1938. Address in 1929, 38 E 22nd St., New York, NY.

FOLAWN, THOMAS JEFFERSON.
Painter. Born Youngstown, OH. Pupil of C. S. Niles, CO Sch. FA; van Waeyenberge in Paris; J. M. Waloft in NY. Member: Denver Art Assoc.; Brush and Pencil Club, St. Louis; S. Indp. A.; Boulder AA; AAPL; Boulder AG. Award: Honorable mention, oil painting, Springville, UT, AA. Died in 1934. Address in 1929, 1805 Marine St., Boulder, CO; summer, Santa Fe, NM.

FOLEY, MARGARET.
Sculptor and cameo portraitist. Biographers differ as to where Margaret Foley, (Margaret E. Foley) was born. Some give her birthplace as Vermont, others as New Hampshire. Largely self-taught. Worked in Boston and later went to Rome. Some of her works were exhibited at the Centennial Exposition at Philadelphia in 1876. Tuckerman wrote of her that she "achieves new and constant success in her relievos." Her medallions of William and Mary Howitt, of Longfellow, and of William Cullen Bryant, and her ideal statues of Cleopatra, Excelsior, and Jeremiah are considered to be the best specimens of her cameo work. The cameo portrait of William Cullen Bryant, in the New York Historical Society, is said to be cut by Margaret Foley. Exhibited at Boston Atheneum; Penna. Academy; Nat. Academy; Centennial Exhibition, Philadelphia. She died in 1877 at Meran in the Austrian Tyrol.

FOLGER, L.
Portraits signed "L. Folger" are found in the southern states; one known to Mantle Fielding, author, was so signed, and dated 1837.

FOLINSBEE, JOHN FULTON.
Painter. Born Buffalo, NY, March 14, 1892. Studied with Birge Harrison, John F. Carlson and Du Mond. Member: ANA, 1919; NA, 1928; Salma. C.; Allied AA; Conn. AFA; NAC. Awards: Third Hallgarten prize, NAD, 1916; second Hallgarten prize, NAD, 1917; Greenough memorial prize, Newport AA, 1917; hon. mention, AIC, 1918; hon. mention, Conn. AFA, 1919; Isidor prize, Salma. C., 1920; Carnegie prize, NAD, 1921; J. Francis Murphy prize, NAD, 1921; 3rd Wm. A. Clark prize and Corcoran bronze medal, Corcoran Gallery, 1921; 3rd prize, NAC, 1922; hon. mention, Phila. AC, 1922; 1st Hallgarten prize, NAD, 1923; Phila. Sketch Club medal, 1923; Charles Noel Flagg prize, Conn. Academy of the Fine Arts, 1924; purchase prize, Phila. Art Club, 1924; Plimpton prize, Salma. C., 1924; Gedney Bunce prize, Conn. AFA, 1925; Thompson prize, Salma. C., 1926; bronze medal, Sesqui-Centennial Expo., Phila., 1926; Murphy prize, NAD, 1926. Represented in

Syracuse (NY) Museum of Fine Arts; Corcoran Gallery, Wash,; Nat. Arts Club, NY; Grand Rapids Art Assn.; Phila. Art Club; RI School of Design, Providence; Public Museum and Art Gallery, Reading, PA. Address in 1929, New Hope, PA.

FOLLETT, JEAN.
Sculptor and painter. Born in St. Paul, MN, June 5, 1917. Studied at Univ. of Minnesota; Hans Hofmann School of Art, NY; and the School of Fernand Leger, in Paris, France, 1946-51. Works: Museum of Modern Art; Whitney; "Lady with the Open-Door Stomach" (1956) and "Many Headed Creature" (1958). Exhibited: Four one-man shows at the Hansa Gallery, NY, 1951-59; Guggenheim Museum, 1954; Soho Gallery, NY, 1977, plus many more. Awards: Cash award, National Foundation of the Arts & Humanities, 1966. Her style is noted for use of "found" objects (pieces of wood, metal, string, etc.) Paintings are distinguished by extremely thick application of paints, giving appearance of relief. Address in 1982, St. Paul, MN.

FOLSOM, MRS. C. A.
Born in New York City, Dec. 27, 1812. Flourished in New York, 1837-38, painting miniatures. Died Feb. 1899, Westfield, NJ.

FOLTZ, LLOYD C(HESTER).
Painter and etcher. Born Brown Co., KS, Sept. 24, 1897. Pupil of Chicago AFA. Member: Wichita AG; Calif. PM. Address in 1929, Western Lithograph Bldg.; h. 1320 Woodrow Ave., Wichita, KS.

FOLWELL, SAMUEL.
Born c. 1767; died in Phila., 1813. Possibly from New England. Engraved bookplates in 1792 for residents of New Hampshire. In 1798 came to Phila. as min. painter, silhouette cutter, "worker in hair." Conducted a school in Philadelphia. Few examples of his work have been seen, and his 2 portraits are a combination of aquatint and stipple, pleasing in effect, though showing an unpracticed hand. His studio in 1795 was at No. 2 Laetitia Court, and he exhibited portraits that year at the "Columbianum" in Philadelphia. Profile portrait of Geo. Washington, owned by Penn. Hist. Soc., is inscribed "S. Folwell, Pinxt. 1795," and is said to have been taken from life on a public occasion, the Pres. being unaware of the fact. It is drawn on paper, painted in India ink, with certain lights touched in, and declared at the time a correct likeness. Reproduced on wood and published in Watson's "Annals and Occurrences of NYC and State in the Olden Time," 1846.

FON, W. W.
Painter. Exhibited water colors at Penna. Academy of Fine Arts, Philadelphia, 1922. Address in 1926, Care of Penna. Academy of Fine Arts, Philadelphia, PA.

FOOTE, MARY ANNA HALLOCK.
(Mrs. Arthur De Wint Foote). Painter and engraver. Born in Milton, NY, Nov. 19, 1847, where she continued to live. Attended Poughkeepsie Female Collegiate Seminary. Studied at the Cooper Institute, and with William J. Linton, the wood engraver. Many of her illustrations were published by Scribner & Co. The Worcester Art Museum owns a pencil drawing, "Spring Whistles." Died in 1938.

FOOTE, WILL HOWE.
Painter and teacher. Born Grand Rapids, MI, June 29, 1874. Pupil of AIC; ASL of NY; Julian Academy in Paris under Laurens and Constant. Member: ANA, 1910; Salma. C.; Lyme AA; Grand Rapids AA; Century C. Awards: Hon. mention, Pan-Am. Exp., Buffalo, 1901; third Hallgarten prize, NAD, 1902; bronze medal, St. Louis Exp., 1904; silver medal, P.-P. Exp., San F., 1915; Eaton purchase prize, Lyme AA, 1926. Died in 1965. Address in 1929, Old Lyme, CT.

FORAKIS, PETER.
Sculptor and painter. Born October 2, 1927, Hanna, Wyoming. Studied: San Francisco Art Institute, with Bud Dixon, Thomas Hardy, Nathan Oliveira, 1954-57, BA. Work: Aldrich; commissions for Williams College, Denver City Park, Univ. of Houston, TX. Exhibited: Gallery Six, San Francisco; Spasta Gallery, San Francisco; David Anderson Gallery, NYC; Tibor de Nagy Gallery, NYC; Uiano Museum, Tokyo; San Francisco Museum of Art; Oakland Art Museum; Martha Jackson Gallery, NYC; Guggenheim, Drawings and Prints, 1964; Jewish Museum, Primary Structures, 1966; Los Angeles County Museum of Art. Taught: San Francisco Art Institute, 1958; Brooklyn Museum School, 1961-63; The Pennsylvania State Univ., 1965; Carnegie, 1965; Univ. of Rhode Island, 1966. Address in 1982, Putney, VT.

FORBELL, CHARLES.
Illustrator. Member: Salma. C.; GFLA. Address in 1929, Park Lane, Douglas Manor, LI, NY.

FORBES, BART JOHN.
Illustrator. Born in Altus, OK, in 1939. Studied under John LaGatta at the ACD and also attended the Univ. of North Carolina. He has received 34 Certificates of Merit from the S of I Annual Exhibitions. His first illustration was done for Bell Helicopter in Dallas, TX, in 1965. Periodicals such as *McCall's, TV Guide, Saturday Review, Time, Redbook, Penthouse,* and *Money* have published his illustrations.

FORBES, EDWIN.
Painter and etcher. Was born in New York, 1839. At first he devoted himself to animal painting. During the Civil War he was a special artist of Frank Leslie's

Illustrated Newspaper. His studio was in Brooklyn, and from 1878 he devoted himself to landscape and cattle pictures. In 1877 he was elected an Honorary Member of the London Etching Club. He died March 6, 1895, in New York City.

FORBES, HELEN (KATHARINE).
Painter. Born San Francisco, Feb. 3, 1891. Pupil of Van Sloun, Hansen, Groeber and L'hote. Member: San F. AA; San F. S. Women A; Palo Alto AC. Address in 1929, 712 Montgomery St., San Francisco, CA; summer, 1151 University Ave., Palo Alto, CA.

FORBES, LIONEL C. V.
Painter. Born in Australia in 1898. Member of California Water Color Society. Address in 1926, Los Angeles, CA.

FORCE, CLARA G.
Miniature painter. Born Erie, PA, Nov. 30, 1852. Pupil of Lucia F. Fuller, Alice Beckington, Maria Strean, Mabel Welsh, Elsie D. Pattee, Theodora Thayer, Du Mond, Seyffert. Member: Calif. S. Min. P.; Calif. AC. Represented in Art Gallery, Erie Public Library, Woman's Club, Erie, PA. Died in 1939. Address in 1929, 1800 East Mountain St., Pasadena, CA.

FORD, L. W. NEILSON.
(Mrs. Wm. B. Ford). Painter. Born Baltimore, MD. Pupil of Leonce Rabillon in Paris; Hugh Newell in New York; B. West Clinedinst in Philadelphia; Lippish in Berlin; Henry Snell; William Nickerson; Fred Jackson, Manchester, England; Richard Luy, Vienna; Colarossi Academy, Paris. Member: Baltimore WCC; Plastic C. Died in 1931. Address in 1929, Woodbrook, Govans P.O., MD.

FORD, LAUREN (MISS).
Painter. She was born in New York City, Jan. 23, 1891. Pupil of George Bridgman; Frank DuMond. Member: AWCS; Mural P. Address in 1929, Ford Farm, Milton Rd., Rye, NY.

FORD, RUTH VANSICKLE.
Painter. Born in Aurora, IL, Aug. 8, 1897. Studied: Chicago Academy of Fine Arts; Art Students League; with George Bellows, Guy Wiggins and John Carlson. Awards: Art Institute of Chicago, 1931; Chicago Woman's Aid, 1932; Connecticut Academy of Fine Arts, 1932; Professional Art Show, Springfield, IL, 1958. Collections: Aurora College; Lafayette College, IN; Aurora Public Library. Exhibited a one-man show, Chicago Art Inst., 1934; Watercolor USA, Springfield, 1962-63; Nat. Academy of Design; Chicago Art Inst. and many more. Media: Watercolor and oil. Address in 1980, 69 Central Ave., Aurora, IL.

FORESMAN, ALICE C(ARTER).
Miniature painter and teacher. Born Darien, WI, July 24, 1868. Pupil of Lucia Fairchild Fuller and Elsie Dodge Pattee. Member: Calif. S. Min. P.; West Coast Arts, Inc. Address in 1929, 7002 Hawthorn Ave., Los Angeles, CA; summer, 893 East 28th St., North, Portland, OR.

FORINGER, A(LONZO) E(ARL).
Mural painter and illustrator. Born Kaylor, Armstrong Co., PA, Feb. 1, 1878. Pupil of H. S. Stevenson in Pittsburgh; Blashfield and Mowbray in New York. Member: Mural P.; NY Arch. Lg., 1911; AFA. Award: Third prize ($300), Newark poster competition, 1915. Work: 11 panels, Council Chamber, City Hall, Yonkers, NY; Baptistry and Organ Walls, Church of the Savior, Philadelphia; panel, County Court House, Mercer, PA; panel, House of Representatives, Utah State Capitol; two panels, Kenosha Co. Court House, Kenosha, WI; bank note designer for European and Canadian banks; Red Cross war poster "The Greatest Mother in the World," and the post-war poster "Still the Greatest Mother in the World;" 4 panels in the Home Savings and Loan Company Bldg., Youngstown, OH. Illustrations for *Scribner's* and other magazines. Address in 1929, Saddle River, NJ.

FORKNER, EDGAR.
Painter. Born Richmond, IN. Pupil of C. Beckwith, Irving Wiles, F. DuMond, ASL of NY. Member: Seattle Art Institute; Chicago Gallery Association; Hoosier AP Association, Chicago. Awards: First prize, Hoosier Salon, 1916; Owsley prize, Hoosier Salon, 1917; first prize, Seattle FAS, 1918, 1923. Address in 1929, 319 White Bldg.; 2615 East Cherry St., Seattle, WA.

FORMAN, ALICE.
Painter. Born in NYC, June 1, 1931. Study: ASL, NYC, Sat. classes with Ethel Katz, 1944-48; Cornell Univ., BA, 1952; Mex. Art Workshop, Taxco, Mexico, summer, 1950; Brooklyn Mus. Art Sch., summer, 1951; NYU, fall, 1952; ASL, NYC, with Harry Sternberg, Morris Kantor, 1954-56. Work: J. Walter Thompson Co.; Cornell U.; Inst. for Rehabilitation, Houston. One-Man Shows: Camino Gallery, NYC, 1960, 62; Phoenix Gallery, NYC, 1966, 68, 71, 74, 76; Marist College, Poughkeepsie, NY, 1965, 68, 73; Kornblee Gallery, NYC, 1977, 79; etc. Exhibitions: Whitney, 1960; Kornblee Gallery, D'Arcy Gallery, NYC; Contemp. Arts Mus., Houston; Butler Inst. Biann., 1972; "Tenth Street" Exhibition, NYC; Westmoreland Co. Mus. of Art, Greensburg, PA, "New American Still Life;" others. Awards: Nat'l. Stud. Assn. Reg'l. Awards; Daniel Schnackenberg Merit Scholar, ASL, 1955-56. Visiting Prof. of Art, Vassar Col., 1980-81; free lance writer. Represented by Kornblee Gallery, NYC. Address in 1983, Poughkeepsie, NY.

FORMAN, HELEN.
Etcher. Born London, England, June 9, 1892. Pupil of Allen Philbrick; AIC. Member: Calif. AC; San Francisco AA. Address in 1929, Art Dept., Chicago Public Library; h. 1360 East 49th St., Chicago, IL.

FORMAN, KERR S(MITH).
Painter and illustrator. Born Jacksonville, IL, Oct. 26, 1889. Pupil of John Douglas Patrick, Charles A. Wilimovsky. Member: Iowa AC; Des Moines Sketch C. Awards: Prize, Des Moines Women's Club, 1925; gold medal, Des Moines Women's Club, 1929. Work: "Silent Mesas," Des Moines Women's Club. Address in 1929, 308 Insurance Exchange Bldg.; h. 213 Argonne Apts., Des Moines, IA.

FORNELLI, JOSEPH.
Sculptor, painter and illustrator. Born in Chicago, IL, May 21, 1943. Studied: Art Institute of Chicago. Exhibited: Leigh Yawkey Woodson Mus., Wausau, WI; Cleveland Museum of Natural History; Reflexes and Reflection - N.A.M.E. Gallery, Chicago; Nat. Wildlife Art Show, Kansas City; Brookfield Zoo Spec. Exhibit Building, one man show. Awards: Chicago Municipal Art League's 1979 Gold Medal; 1st Place Blue Ribbon, National Wildlife Art Show; Honorable Mention, Italian American Artists in the U.S.A. Member: Chicago Municipal Art League Board Member; National Wildlife Art Collectors Society; Ducks Unlimited; Vietnam Veterans Arts Group Board Member; Society of Animal Artists. Work includes life size portrait bust, Columbus Hospital, IL; illustrations for *Main Street*, Sinclair Lewis, 1970; numerous magazine illustrations. Media: Bronze and stone; oil and watercolor. Address in 1983, Park Ridge, IL.

FORREST, IAN B.
Engraver and painter. Born in Aberdeenshire, Scotland, about 1814; died in Hudson County, NJ, in 1870. Forrest was an apprentice to the London engraver Thomas Fry, and he remained in his employ until he was induced to come to Philadelphia in 1837 to engrave for the National Portrait Gallery. He later turned to miniature painting. Forrest was a good engraver of portraits in the stipple manner, but some of his best work is found in the form of small fancy heads and vignettes.

FORSBERG, ELMER A.
Painter, lecturer and teacher. Born Gamlakarleby, Finland, July 16, 1883. Pupil of AIC. Member: Chicago PS; Cliff Dwellers; Swedish C. Address in 1929, The Art Institute of Chicago; h. 3730 Rokeby St., Chicago, IL; summer, Covington, MI.

FORSTER, JOHN.
Lithographer. Born in 1825. Worked with the firm Kimmel & Forster, executed a number of lithographs of the Civil War period. Died in 1900.

FORSYTH, CONSTANCE.
Painter, illustrater, etcher and teacher. Born Indianapolis, Aug. 18, 1903. Pupil of William Forsyth, George Harding, Henry McCarter. Award: Prize, Hoosier Salon, Chicago, 1928. Address in 1929, 15 South Emerson Ave., Indianapolis, IN; summer, Winona Lake, IN.

FORSYTH, (MARY) BRYAN.
Sculptor and painter. Born in Tucson, AZ, 1910. Studied at Maryland Institute of Art, 1929-30; Grand Central School of Art, NYC, 1931-32 (western art with Frank Tenney Johnson). Had studio in NYC, 1937-68; did portrait commissions, commercial art, and illustrations for newspapers, magazines, books. Moved to New Mexico in 1969. Work includes bronze of Mari Sandoz (author), Nebraska Hall of Fame, commission, 1978; bronze, "Victorio," New Mexico Museum of Fine Arts, 1981. Received *St. Nicholas* magazine medals for drawing, 1921, 1923. Represented by Shidoni Gallery and Foundry, Tesuque, NM; Sanders Galleries, Tucson, AZ. Specialty is Southwestern subjects. Address in 1982, Pecos, NM.

FORSYTH, WILLIAM.
Painter and teacher. Born Hamilton Co., OH, in 1854. Pupil of Royal Academy in Munich under Loefftz, Benczur, Gysis and Lietzenmeyer. Member: Art Assoc. of Indianapolis; AWCS. Instructor, Herron Art Inst. Awards: Medal, Munich, 1885; silver medal for water color and bronze medal for oil, St. Louis Exp., 1904; bronze medal, Buenos Aires Exp., 1910; Fine Arts Bldg. prize ($500), SWA, 1910; bronze medal for oil and silver medal for water colors, P.-P. Exp., San F., 1915; Foulke prize, Richmond, Ind., 1923; Holcomb prize, 1924, and Landon prize, 1925, Ind. AA. Work: "Autumn at Vernon," "The Constitutional Elm-Corydon," "Close of a Summer Day," "Still Life," "Old Market Woman," and "In October," Art Assoc., Indianapolis; "Autumn Roadside," and "The Smoker," Public Gallery, Richmond, Ind.; flower piece, Brooklyn Mus.; Vanderpoel AA. Collection, Chicago. Died in 1935. Address in 1929, 15 South Emerson Ave., Irvington, IN.

FORSYTHE, VICTOR CLYDE.
Sculptor, painter, illustrator and cartoonist. Born Orange, California, 1885. Studied with Louisa MacLeod at the School of Art and Design, Los Angeles; Art Students League, pupil of DuMond. Employed as staff artist for the *New York World*; did cartoons and comic strips; painted propaganda posters. On return to California, painted scenes of Western desert, mining camps, prospectors, ghost towns. Member: Painters of the West; Salma. Club; Calif. AC; Allied AA. Work in Municipal Art Guild (Phoenix); Harmsen Collection; Earl C. Adams Collection. Award: Bronze medal, Painters of the

West, 1927. Address in 1929, 520 Almansor St., Alhambra, CA. Died in California in 1962.

FORTUNATO, NANCY.
Painter and teacher. Born IL, Nov. 29, 1941. Study: Art Inst. Chic., IL; Ed Whitney, Zoltan Szabo, R. E. Wood, AWS; & others. Work: Amoco Oil; Eddie Bauer's; Pres. Libr. Coll., Wash. DC. One-person shows: Botanical Gardens, IL; others. Exhib: Am. Watercolor Soc., NY, 111th Annl.; Nat'l Lg. of Am. Pen Women, NY; Sumi-e Soc. Nat'ls; Les Etoiles, Paris; other nat'l watercolor shows. Teaching: Illinois District 211 Adult Ed., from 1972; U. of IL, Chic.; state workshops. Awards: Artists in Watercolor Comp., London, 1978; Am. Artists 1st Nat'l Art Comp., NY, 1979; M. Grumbacher Award, Int'l Soc. of Artists Show, Foothills Art Center, CO, 1979; Nat'l Miniature Show, top awards, 1978-79. Mem: Sumi-e Soc. of Am.; AWS; Old Watercolor Soc. and Soc. of Italic Handwriting, Eng. Media: Watercolor. Address in 1983, 249 N. Marion St., Palatine, IL.

FORTUNE, E. CHARLTON.
Painter. She was born Marin Co., CA, 1885. Studied at St. John's Wood School of Art in London; ASL of NY under F. V. Du Mond, Mora and Sterner. Member: Calif. AC; San Francisco AA; NY ASL; Soc. of Scottish A. Awards: Silver medal P.-P. Exp., San F., 1915; silver medal, Panama-Calif. Exp., San Diego, 1915; honorary prize, San. F. AA, 1916; Emanuel Waiter purchase prize, San Francisco AA, 1920; silver medal, Societe des Artistes Francais, Paris, 1924; first prize, Calif. State Fair, 1928. Address in 1929, The Studio, High St., Monterey, CA.

FOSDICK, GERTRUDE CHRISTIAN.
(Mrs. J. W. Fosdick). Sculptor, painter, and writer. Born in Middlesex Co., VA, April 19, 1862. Pupil of Julian Academy in Paris under Bouguereau and Lefebvre. Member: Pen and Brush Club; North Shore Art Association; Allied Artists of America; Nat. Arts Club. Work: Stacy Memorial, Gloucester, MA. Address in 1933, 33 West 67th St., New York, NY; summer, "The Nutshell," Sugar Hill, NH.

FOSDICK, J(AMES) WILLIAM.
Mural painter, craftsman, writer. Born Charlestown, MA, Feb. 13, 1858. Pupil of Boston Museum School; Julian Academy in Paris under Boulanger, Lefebvre and Collin.75). In collections of MOMA; L.A. County Mus. of Art; Stanford U.; UCLA; and many private collections.

FOSS, FLORENCE WINSLOW.
Sculptor. Born in Dover, New Hampshire, August 29, 1882. Studied at Mt. Holyoke College; Wellesley College; University of Chicago; Radcliffe College. Awards: Springfield Art Association, 1941, 43; Society of Washington Artists, 1936. Exhibited at Penna. Academy of Fine Arts; National Academy of Design; Art Institute of Chicago; Conn. Academy of Fine Arts; others. Professor of Art, Mt. Holyoke College. Address in 1953, Mt. Holyoke, South Hadley, MA.

FOSSETTE, H.
Was an engraver of landscape, working in New York about 1850, after drawings by A. Dick.

FOSTER, ALAN.
Illustrator. Born Fulton, NY, Nov. 2, 1892. Cover designs for *The Saturday Evening Post, Collier's, American Boy.* Address in 1929, 367 Fulton St.; h. 155 Henry St., Brooklyn, NY.

FOSTER, ARTHUR TURNER.
Painter and teacher. Born Brooklyn, NY, in 1877. Self taught. Member: Artland C; Los Angeles PSC; Calif. WCS. Address in 1929, 2509 West 7th St., Los Angeles, CA.

FOSTER, BEN.
Landscape painter and art writer. Born North Anson, ME, 1852. Student of Abbott H. Thayer in New York; Morot and Merson in Paris. Awards: Carnegie prize, National Academy of Design, New York, 1906; Inness gold medal, National Academy of Design, 1909. Elected Society of American Artists, 1897; Associate, National Academy, 1901; National Academy, 1904; New York Water Color Club; American Water Color Society, New York; Century Association; National Institute of Arts and Letters. Died Jan. 28, 1926, in New York. Address in 1926, 119 East 19th St., New York.

FOSTER, CHARLES.
Painter. Born North Anson, ME, July 4, 1850. Pupil of Cabanel, Ecole des Beaux-Arts and Jacquesson de la Chevreuse in Paris. Member: Conn. AFA. Died in 1931. Address in 1929, Farmington, CT.

FOSTER, ELIZABETH H(AMMOND).
Painter. Born St. Paul, MN, March 5, 1900. Pupil of Minneapolis Institute of Art; Carl L'hote in Paris; Hans Hofmann in Munich. Awards: Third prize, Minnesota State Fair; hon. mention, Minnesota State AS. Address in 1929, 117 Farrington Ave., St. Paul, MN; summer, Otisville, MN.

FOSTER, ENID.
Sculptor. Born San Francisco, CA, October 28, 1896. Pupil of Chester Beach. Work: "Three Fates," Mt. View Cemetery Association, Oakland, CA; "Reuniting of Souls," Mausoleum, Oakland; memorial pool to Sarah B. Cooper, Golden Gate Park, San Francisco. Address in 1933, Piedmont, CA.

FOSTER, GRACE.
Painter and teacher. Born Wolfe City, TX, March 9, 1879. Pupil of Elia J. Hobbs, Zella Webb, Frank Reaugh. Member: SSAL. Address in 1929, 2905 Polk St., Greenville, TX; summer, 825 Victoria St., Abilene, TX.

FOSTER, JOHN.
Born in Dorchester, MA, 1648. In 1667 Foster graduated from Harvard; in 1675 he established the first printing office in Boston. Foster was the first engraver of a portrait in this country, of whom there is any record. This is a wood-block portrait of the Rev. Richard Mather, and one of the three known impressions has written on it, in an almost contemporaneous hand, "Johannes Foster, Sculpt." This impression was found in the New York Public Library as the frontispiece to a life of Richard Mather published in Cambridge, New England, in 1670. Another copy of this portrait, framed, is in the possession of the Massachusetts Historical Society. It has the name of Richard Mather printed upon it in type, but has no indication of the engraver. Dr. Samuel A. Green, of the Massachusetts Historical Society, has made a close study of Foster as the possible engraver of this portrait. Foster is also credited with having engraved the rude woodcut map of New England issued with Rev. W. Hubbard's narrative of the troubles with the Indians in New England, published by John Foster in Boston in 1677. Died Sept. 9, 1681, in Boston.

FOSTER, O. L.
Painter. Born Ogden, IN, May 12, 1878. Pupil of Laura A. Fry, Harry Leith-Ross. Address in 1929, 24 Littleton St., Lafayette, IN.

FOSTER, RALPH L.
Illustrator and designer. Born Providence, May 20, 1881. Pupil of RI School of Design; ASL of NY. Member: Providence AC; Vice-President and Art Director, Livermore Knight Co. Address in 1929, care of Livermore & Knight Co., 42 Pine St.; h. 268 President Ave., Providence, RI.

FOSTER, W(ILLIAM) F.
Illustrator. Member: SI, 1910; Salma. C. Award: Clarke prize ($300), NAD, 1926. Address in 1929, 15 West 67th St.; care of Salmagundi Club, 47 Fifth Ave., New York, NY.

FOTE, MARY.
Painter and illustrator. Member: NA Women PS; New Haven PCC; Port. P. Work: "Portrait of an Old Lady," Art Institute of Chicago. Address in 1929, 3 Washington Square, North, New York, NY.

FOURNIER, ALEXIS J(EAN).
Painter, illustrator and lecturer. Born St. Paul, MN. Pupil of Laurens, Constant, Harpignies and Julian Academy in Paris. Member: Buffalo SA; Buffalo AC; Toledo Art Klan; Minneapolis A. Lg.; Paris AAA; Cliff Dwellers; NAC; AFA. Awards: Gold and silver medals, Minn. Industrial Soc.; Hengerer prize, Buffalo, 1911; hon. mention, Chicago AG, 1917. Work: "Clearing After a Storm," Vanderbilt Univ., Nashville, Tenn.; "The Haunts and Homes of the Barbizon Masters," twenty oil paintings. Represented in Minneapolis Inst.; St. Paul Lib.; Detroit Art Institute; PA Historical Soc.; Congressional Lib. Print Dept.; Woman's Club of Minneapolis; Progress Club, South Bend, Ind.; Public Library and Erie Co. Trust Co. Bank, East Aurora, NY; "A France Sky," Hackley Art Gallery, Muskegon, MI; Kenwood C., Chicago; Minneapolis Club and Library. Address in 1929, 142 East Elder St., South Bend, Ind.; 150 Walnut St., East Aurora, NY.

FOWLE, EDWARD A.
This man was a landscape engraver, working in line in Boston in 1843, and in New York a little later.

FOWLE, ISAAC.
Ship carver. In Boston, 1806-43. Apprenticed to Simeon Skillin, Jr., of Boston. Worked in Skillin's shop with Edmund Raymond until about 1822. Formed partnership with his sons John D. and William H. Fowle, 1833. Ex. of his work are in the Old State House, Boston, inc. the figure of a woman.

FOWLE, JOHN D.
Ship carver. In Boston, 1833-1869. With his brother William H. Fowle, formed partnership with father Isaac Fowle in 1833. Work included an eagle and coat of arms of NY for the *Surprise* (1850) and a crowing cock for the *Game Cock* (1851).

FOWLE, WILLIAM H.
Ship carver. In Boston, 1833-early 1860's. In partnership with father Isaac and brother John D. Fowle. Died in Lexington, MA, soon after 1860.

FOWLER.
Philadelphia portrait painter, living in Germantown about 1860. Painted a portrait of Miss Anna Howell, of Philadelphia, about 1860.

FOWLER, CARLTON.
Painter. Born in New York, NY, March 19, 1877. Pupil of Acad. Julian and Caro-Delvaille. Member: NAC; Salma. C. Award: Hon. ment., Pan-American Exp., Buffalo, 1901. Died in 1930. Address in 1929, 47 Fifth Ave.; 15 W 67th St., New York, NY.

FOWLER, EVA(NGELINE).
Painter, writer, lecturer and teacher. Born Kingsville, OH, in 1885. Pupil of ASL of NY; PAFA;

Delaye and Carl in France. Member: Dallas AA. Awards: Gold medal, Cotton Centennial, New Orleans, 1885; Saint-Gaudens bronze medal, World's Columbian Exposition, Chicago, 1893. Died in 1934. Address in 1929, Binkley Hall, Kidd Key College, Sherman, TX.

FOWLER, FRANK.
Portrait painter. Born July 12, 1852, in Brooklyn, NY, and died Aug. 18, 1910, in New Canaan, CT. Studied at Ecole des Beaux Arts. Member of Society of American Artists, and National Academy of Design, 1899. He exhibited a portrait at the Society of American Artists in New York in 1878; he also did some work in fresco.

FOWLER, MARY BLACKFORD.
(Mrs. Harold North). Sculptor. Born in Findlay, OH, February 20, 1892. Studied at Oberlin College, A.B.; Columbia University; Corcoran School of Art; and with George Demetrios. Member: Soc. Washington Artists; North Shore Art Association. Work: Memorial tablets, Springfield (Mass.) Public Library; Findlay, OH; sculptural reliefs, Federal Building, Newport News, VA. Exhibited: Institute Modern Art, Boston, 1945; North Shore Art Assoc.; Soc. of Washington Artists. Co-Author: *The Picture Book* of Sculpture, 1929. Address in 1953, Washington, DC.

FOWLER, MEL.
Sculptor. Born in San Antonio, TX, November 25, 1921. Studied at Southwestern University, University of Texas, University of Maryland, and Norfolk School of Art. Represented by Texas Fine Arts Permanent Col.; State Health Dept. Building, Homburg, Ger. (9-foot carrara marble sculpture); others. Has exhibited at Galveston (TX) Art League; Congressional Exhibition, DC; Galerie Monika Beck, Homburg, Germany; Art Museum, Wichita Falls, TX; International Sculpture Exhibition, Massa, Italy, Mannheim, Germany, Pietrasanta, Italy; Laguna Gloria Art Museum, Austin, TX; others. Address in 1984, Liberty Hill Texas, also in Italy.

FOWLER, TREVOR THOMAS.
Portrait painter. Born 1830. His studio was at No. 10 St. Charles St., New Orleans. Died New Orleans, 1871.

FOX, CECILIA BEATRICE BICKERTON.
See Griffith, Beatrice Fox.

FOX, FONTAINE.
Cartoonist. Born in 1884. Member: SI. Address in 1929, care of Wheeler Syndicate, 373 Fourth Ave., New York, NY; 1 Park Ave., Manhasset, LI, NY.

FOX, GILBERT.
According to Wm. Dunlap, Fox was born in London, England, about 1776. He was apprenticed to the London engraver Thomas Medland and was asked to come to Philadelphia in 1795 by James Trenchard. Fox engraved a few portraits and book illustrations for Philadelphia publishers and later became a teacher of drawing in a women's academy there. Dunlap says that he eloped with one of his pupils, lost his position, and went on the stage; the Philadelphia directory of 1798 lists his name as "A Comedian." It was for Gilbert Fox that Joseph Hopkinson wrote "Hail Columbia," and Fox sang it for the first time at his benefit, in 1798. Died c. 1806.

FOX, LORRAINE.
Illustrator. Born in Brooklyn, NY, in 1922. Published her first illustration, a gouache, in *Better Homes and Gardens* in 1951. She went to PI and the Brooklyn Museum Art School where she studied under Will Burtin and Reuben Tam. She was a lecturer and teacher at PSD in NYC and a faculty member at the FAS. She had numerous illustrations published in most of the well known magazines and won Gold Medals from the S of I and the Philadelphia ADC. Died in 1976.

FOX, MARGARET M. TAYLOR.
(Mrs. George L. Fox). Painter, illustrator, etcher, and teacher. Born Philadelphia, July 26, 1857. Pupil of Peter Moran, T. P. Anshutz. Illustrated "The Deserted Village," "The Traveller," "English Poems," published by J. B. Lippincott Co.; "Historic Churches of America." Address in 1929, Silver Spring P.O., Linden, MD.

FOX, MORTIMER J.
Painter. Born New York, Oct. 2, 1874. Address in 1929, Carnegie Hall; h. 888 Park Ave., New York, NY; summer, "Foxden," Peekskill, NY.

FOY, EDITH GELLENBECK.
Painter. Born Cincinnati, OH, Oct. 9, 1893. Pupil of Wessel, Meakin, Hopkins, Weis. Member: Cincinnati Woman's AC. Address in 1929, 6322 Grandvista Ave., Cincinnati, OH.

FOY, FRANCES M.
Painter, illustrator and etcher. Born Chicago, IL, April 11, 1890. Pupil of George Bellows; AIC. Member: Chicago SA; Chicago NJSA. Address in 1929, 645 Kemper Place, Chicago, IL.

FOY, PROSPER.
Sculptor, marble cutter, gilder, gnomist, engraver. Worked: New Orleans, 1825-38.

FOYSTER, JERRY.
Painter. Born Albany, New York, in 1932. Studied at the University of Buffalo, NY. Group Exhibitions: The Contemporary Arts Center, Cincinnati, 1964; Bianchini Gallery, New York, 1964; Leo Castelli Gallery, New York, 1964.

FRAIN, N(ELLIE) M.
Painter and medical illustrator. Born Furnessville, IN, June 25, 1887. Pupil of AIC. Illustrated: "Pathology of the Mouth," by Moorehead and Dewey; "Dental Histology," by Frederick Brogue Noyes; "Tuberculosis of Lymphatic System" by Walter B. Metcalf; "Surgical Anatomy," by Eycleschymer; "Bastin's College Botany," by W. B. Day; "Histology," by Prentiss Arey; "Physical Exercises for Invalids and Convalescents," by Edward H. Ochsner. Address in 1929, College of Dentistry, University of Ill., 1838 West Harrison St.; h. 53 West Burton Pl., Chicago, IL.

FRALEY, LAURENCE K.
Sculptor. Born in Portland, OR, May 17, 1897. Studied with H. M. Erhman. Member: American Artists Professional League; Oregon Soc. of Artists. Address in 1933, Portland, OR.

FRAME, ROBERT.
Painter. Born July 31, 1924, in San Fernando, CA. Earned BA from Pomona College in 1948; MFA (Claremont Grad. Sch.), 1951. Taught at Pasadena City Col., Pasadena School of Fine Arts, and UCLA. Awards from National Academy of Design, New York, 1950; Cal. State Fair; Pasadena Art Museum; Guggenheim fellowship (1957-58); Calif. Invitational Exhibit (1961). Exhibited at Scripps Col.; San Diego State Col.; Otis Art Inst, LA; S. F. Mus. of Arts; Carnegie; and Santa Barbara Mus. In collections of National Academy of Design; Pasadena Art Mus.; Santa Barbara Art Museum; and many private collections.

FRANCE, EURILDA LOOMIS.
Painter, illustrator and teacher. Born Pittsburgh, PA, March 26, 1865. Pupil of Julian Academy, Carolus-Duran and Ami Morot in Paris. Member: Buffalo SA; Phila. Alliance; New Haven PCC; New Haven BPC; AFA. Died in 1931. Address in 1929, 562 Orange St., New Haven, Conn.; summer, R.F.D. 2, Scarboro, ME.

FRANCE, JESSE LEACH.
Painter and illustrator. Born in Cincinnati, OH, in 1862. Pupil of Carolus-Duran, Paris. Address in 1926, 78 Pearl St., New Haven, CT.

FRANCES, HARRIETTE ANTON.
Painter/graphics. Born in San Francisco, CA in 1927. Studied: San Francisco School of Fine Arts, 1942-45; University of the Pacific, 1955-57; San Francisco Art Inst., painting with James Weeks, 1963, 65-66; Univ. of Calif., summers, 1974-76. Awards: James D. Phelan Award, 1965; Marin Society of Artists, 1973-75; San Francisco Women Artists, 1975. Collections: Aschenbach Foundation for Graphic Arts at the California Palace of the Legion of Honor, San Francisco; Fresno Arts Center.

Exhibited at the De Young Mus., San Francisco, 1963; California Printmakers, 1971; Bicentennial Exhibit, Mus. of Mod. Art, San Francisco, 1976. Media: Lithography and acrylic. Address in 1984, 105 Rice Lane, Larkspur, CA.

FRANCIS, GEORGE.
Painter. Born in Hartford, CT, in 1790, and died there in 1873. He studied drawing under Benjamin West, and coloring with Washington Allston. His father was a carriage builder and he had to carry on the business after his father's death. He designed the ornamental work for sleighs and carriages, and occasionally painted a portrait or landscape.

FRANCIS, HELEN I.
See Hodge, Helen.

FRANCIS, JOHN F.
Painter. Born in 1808 in Phila. Practiced portrait painting in Schuylkill County and elsewhere; came to Philadelphia and devoted himself to painting fruit pieces, many of which were sold from the exhibition rooms of the Art Union, 1844-1850. He painted a portrait in 1838 of William R. Smith of Philadelphia, which was exhibited in the Loan Ex. at Penna. Academy of Fine Arts in 1887. Died Nov. 15, 1886, in Jeffersonville, PA.

FRANCIS, MURIEL (WILKINS).
Sculptor, painter, teacher, and craftsman. Born in Longview, TX, Oct. 25, 1893. Studied at Shreveport School of Art and Design; Kansas City Art Institute; and with Paul Mercereau, Will Stevens, Virginia Cole, Alexander Archipenko, and others. Member: Ft. Worth Art Association. Awards: Prize, Ft. Worth Art Association. Exhibited: Texas General; Ft. Worth Art Association; Texas Fine Art Association; Southern States Art League; State of Texas traveling exhibit, 1952-53. Instructor of Art, Carswell Air Force Base, Texas. Address in 1953, Ft. Worth, TX.

FRANCIS, VIDA HUNT.
Illustrator. Born in Philadelphia in 1892. Illustrated *Bible of Amethens, Cathedrals and Cloisters of the South of France*, etc. Address in 1926, Hillside School, Norwalk, CT.

FRANCIS, WILLIAM C.
Architect and decorator. Born Buffalo, NY, May 21, 1879. Pupil of Buffalo ASL; Columbia Univ. School of Arch. Member: Alumni Acad. in Rome; Buffalo SA. Award: Fellowship prize, Buffalo SA, 1918. Address in 1929, 64 Pearl St., Buffalo, NY; h. 15 Upper Croton Ave., Ossining, NY.

FRANCISCO, J. BOND.
Painter. Born Cin., OH, Dec. 14, 1863. Pupil of Fechner in Berlin; Nauen Schule in Munich; Bouguereau, Robert-Fleury and Courtois in Paris.

Member: Laguna Beach Assn.; S. Calif. AC; Los Angeles P and SC. Address in 1929, 1401 Albany St., Los Angeles, CA.

FRANK, BENA VIRGINIA.
Painter, etcher, teacher and lecturer. Born Norfolk, VA, May 31, 1900. Pupil of Cooper Union; ASL of NY; studied abroad. Member: SSAL; Gloucester SA; Allied AA; Salons of America. Work: Portraits of Prof. and Mrs. Horace Esterbrook, University of Maine. Address in 1929, 230 East 15th St., New York, NY.

FRANK, GERALD A.
Painter. Born Chicago, Nov. 22, 1888. Pupil of Reynolds and Ufer in Chicago; Hawthorne, Webster and Nordfeldt in Provincetown, Mass. Member: Chicago PS; Chicago AC; Chicago AG; AIC Alumni; North Shore AA. Awards: Chicago AG Fine Arts prize, 1919; prize, AIC, 1921; Muncipal A. Lg. prize ($100), AIC, 1922; Peterson purchase prize, AIC, 1922. Represented in AIC; Municipal collection, Chicago. Address in 1929, Tree Studio Bldg., 4 E. Ohio St., Chicago, IL; summer, Box 8, Clifton, MA.

FRANK, JANE SCHENTHAL.
Sculptor and painter. Born in Baltimore, MD, July 25, 1918. Studied at Parsons School, NY, 1938-39; with Hans Hofmann, Provincetown, MA, 1960; Rhinehart fellowship, Maryland Institute of Art, 1961. Work in Baltimore Museum of Art; Corcoran Gallery of Art; Smithsonian Institution; others. Has exhibited at Baltimore Museum of Art; Corcoran Gallery of Art; A Decade of Sculpture, Philadelphia Art Alliance; others. Member of Artists Equity Association. Address in 1982, Owings Mills, MD.

FRANKENBURG, ARTHUR.
Illustrator. Member: SI. Address in 1929, 1947 Broadway; 33 West 67th St., New York, NY.

FRANKENSTEIN, JOHN PETER.
Sculptor and painter. Born c. 1816 in Germany. Came to Cincinnati, Ohio, in 1831; lived in Phila. from 1839; returned to Ohio in 1847 and Cincinnati in 1856, where he had a studio; moved to NYC c. 1874. Exhibited at Artists' Fund Society; the Apollo Association. Specialty was portraits, both in painting and sculpture. Died April 16, 1881, in New York City.

FRANKENTHALER, HELEN.
Painter. Born Dec. 28, 1928, in New York City. BA from Bennington College, 1949. Honor degrees from Radcliffe and Amherst. Taught at NYU, Yale, Princeton and Hunter. Awarded I Biennale (Fr.), 1959, National Conf. Christians and Jews, 1978, Bennington Alum. Award, 1979. Exhibited in Milan, London, and at MMA, Guggenheim, Whitney, Museum of Fine Arts (Boston). In collections of MMA, MOMA, Whitney, Cooper Hewitt, Guggenheim, Cleveland, and Art. Inst. (Chicago).

FRANKLIN, CHARLOTTE WHITE.
Sculptor and painter. Born in Philadelphia, PA, 1923. Studied at Tyler Art School, Temple University, BA, 1945, BS (education), 1946, MFA, 1947; Institute San Miguel Allende, Univ. Guanajuato, 1957; Mexico City College, 1958; University of Madrid, 1968; and others. Awards: Fulbright Fellowship; Philadelphia Board of Education fellowship to University of Madrid and Rome; Les Beaux Arts Exhibition, Philadelphia. Work: In private collections; commissions for St. Augustine Church, Philadelphia; and others. Exhibited: Colleges, universities, libraries, US Embassy in Madrid; Penwalt Galleries, Philadelphia; William Penn Memorial Museum; others. Address in 1982, Philadelphia, PA.

FRANKLIN, DWIGHT.
Sculptor and painter. Born New York, NY, Jan. 28, 1888. Member: American Assoc. of Museums. Work in American Museum of Nat. History; Newark Public Library; Met. Museum; Children's Museum, Brooklyn; Cleveland Museum; University of Illinois; French War Museum; 21 groups, Museum of the City of NY. Specialty, miniature groups for museums, usually of historical nature. Address in 1933, c/o The Coffee House, 54 West 45th St., New York, NY.

FRANKLIN, KATE MANN.
Painter, craftsman, writer, lecturer, and teacher. Born Flushing, NY. Pupil of Arthur Wesley Dow. Member: NA Women PS. Contributor, magazine articles; lecturer, Brooklyn Museum and Metropolitan Museum of Art; instructor, Cornell SS of Art. Address in 1929, Eagle Nest Lane, Flushing, LI, NY; summer, South Bristol, ME.

FRANTZ, MARSHALL.
Illustrator. Born Kiev, Russia, Dec. 26, 1890. Pupil of Walter Everett. Member: GFLA; SI. Illustrations for: *Saturday Evening Post, Cosmopolitan, Harper's Bazaar, Good Housekeeping, McCalls, Ladies Home Journal, American, Red Book, Colliers,* and *Liberty.* Address in 1929, 939 Eighth Ave., New York, NY.

FRANZEN, AUGUST.
Portrait painter. Born Norrkoping, Sweden, 1863. Pupil of Dagnan-Bouveret in Paris. Member: SAA, 1894; ANA, 1906; NA, 1920; Century C; Lotos C. Awards: Medal, Columbian Exp., Chicago, 1893; bronze medal, Paris Exp., 1900; hon, mention, Pan-Am. Exp., Buffalo, 1901; gold medal, AAS, 1902; portrait prize, NAD, 1924. Work: "Yellow Jessamines," Brooklyn Institute Museum; "William H. Taft," Yale University; "Admiral Robley Evans," National Gallery, Washington, DC; Toledo Museum of Art, Toledo, Ohio. Died in 1938. Address in 1929, 222 West 59th St., New York, NY.

FRANZONI, CARLO.
Sculptor. Born 1789 in Carrara, Italy; came to US. Represented in the Capitol, Washington, DC. Died May 12, 1819, in Washington, DC.

FRANZONI, GIUSEPPE.
Sculptor. Born c. 1780 in Carrara, Italy; came to US in 1806. Represented in the Capitol, Washington, DC; also worked in Baltimore. Died April 6, 1815, in Washington, DC.

FRASCONI, ANTONIO M.
Illustrator and painter. Born on Apr. 28, 1919, in Montevideo, Uruguay. Studied at the Art Students League; New Sch. for Soc. Research. Work: Met. Mus. of Art; MOMA; FA Mus., Montevideo; Bibliot. Nat'l., Paris; Arts Council of GB, London. Exhib. at PAFA; Smithsonian, etc. Teaching: SUNY Purchase. Awarded scholarships from the ASL; Nat. Inst. of Arts and Letters; Conn. Comn. of the Arts. Received top prize for book illust. from the Limited Editions Club in NY. Represented: Weyhe and Dintenfass Galleries, NYC. Living in Norwalk, CT.

FRASER, CHARLES.
Portrait painter in miniature and oils. Born Aug. 20, 1782, Charleston, SC. He entered Charleston Col. about 1792, graduated in 1798, studied in a law office until 1800, and then devoted himself for a time to art, probably encouraged by the example of his friend Malbone. He lived in Charleston most of his life except for a few visits to Boston, NY, and Columbia, SC. In 1857 his friends and admirers formed an exhibition of more than three hundred examples of his work. See the exc. illustrated article by Miss Alice R. H. Smith in *Art in America*, 1915, and "Early American Portrait Painters in Miniature," by Bolton. Died Oct. 5, 1860, in Charleston.

FRASER, DOUGLASS.
Painter. Born Vallejo, CA, Dec. 29, 1885. Pupil of Arthur Matthews at Mark Hopkins Inst. of Art; ASL of NY; Du Mond and Hawthorne. Member: Carmel AA; Bohemian C, San Fran.; AFA. Work: "Monterey Cypress Trees," Crew's Reading Room, U.S. Battleship *California*; "Greenwood Oaks," Library, Elk's Club, Vallejo, CA; two mural panels--"The Bringing of Talents to Beauty," Bohemian Club, San Francisco; "Sunny Hills," Mrs. Isadore Grigsby Memorial, George Washington Junior High Sch., Vallejo, CA; "California Oaks," library, Business Men's Club, Portland, OR; "Ships of the Navy, Old and New," Mare Island Golf Club; "Donner Lake," U.S. Submarine S-29. Address in 1929, 203 Sacramento St., Vallejo, CA; forwarding address, Bohemian Club, San Francisco, CA.

FRASER, JAMES EARLE.
Sculptor. Born Winona, MN, November 4, 1876. Pupil of Falguiere in Paris. Member: Associate,

National Academy of Design, 1912; Academician, National Academy of Design, 1917; Nat. Institute of Arts and Letters; National Sculpture Society, 1907; National Association of Portrait Painters; National Commission of Fine Arts; New Society of Artists; National Arts Club. Exhibited at National Sculpture Society, 1923. Awards: First prize, American Art Association of Paris, 1898; medal, Edison competition, 1906; gold medal for sculpture and gold medal for medals, P.-P. Expo., San Francisco, 1915; prize, National Arts Club, 1929. Knighted in Swedish order of Vasa. Represented by medals in Metropolitan Museum, NY; Ghent Museum; bust of Ex-President Roosevelt, Senate Chamber, Capitol, Washington; Fine Arts Academy of Buffalo; statue of Bishop Potter in Cathedral of St. John the Divine, NY; "End of the Trail," City of San Francisco; Buffalo nickel; U.S. Victory Medal; John Hay Memorial, Cleveland; "Alexander Hamilton," south ent. U.S. Treasury, Washington; "Victory Figure," Bank of Montreal; "Canadian Soldier," Bank of Montreal, Winnipeg; R. T. Lincoln sarcophagus, Arlington Nat. Cemetery; John Ericsson Monument, Washington, DC; bronze statue of Lincoln, Jersey City, NJ. Commissioned to do figures for Arlington Mem. Bridge. Instructor, Art Students League of New York, 1906-11. Address in 1953, Westport, CT. Died in 1953.

FRASER, LAURA GARDIN.
(Mrs. James E. Fraser). Sculptor. Born Chicago, IL, September 14, 1889. Pupil of James E. Fraser and Art Students League. Member: Associate, National Academy of Design, 1924; National Academician, 1931; National Sculpture Society; National Academy of Women Painters and Sculptors. Exhibited at National Sculpture Society, 1923; National Academy of Design; and in Paris. Awards: Helen Foster Barnett prize, National Academy of Design, 1916; Shaw Memorial prize, National Academy of Design, 1919; Saltus gold medal, National Academy of Design, 1924; Saltus gold medal, American Numismatic Society, 1926; Watrous medal, National Academy of Design, 1931. Designed medal for Society of Medalists, 1930. Work: Wadsworth Atheneum; Elks Building, Chicago; Delaware Park in Buffalo, NY; NY University; Grant memorial half dollar and gold dollar; equestrian statue, Baltimore; Brookgreen Gardens, SC; heroic allegorical groups, Theodoraris under Boulanger and Lefebvre. Member: Salma. C., 1897. Illustrated *Richard Carvel*, *Caleb West*, etc. Died in 1949. Address in 1929, care of Salmagundi Club, 47 Fifth Ave., New York, NY; h. Brookhaven, NY.

FRASER, MARY ALDRICH.
Sculptor. Born in NYC, February 22, 1884. Studied with William Ordway Partridge and Georg Lober. Works: National Cathedral, Washington, DC; St. John's Cathedral, NYC; Garden City Cathedral, Long Island, NY; St. Luke's Cathedral, Orlando, FL;

and in many other cathedrals; also in private gardens. Award: Central Florida Exp., Orlando, FL. Exhibited: Argent Gallery; National Arts Club; Central Florida Exp.; others. Address in 1962, Orlando, FL; summer, Garden City, NY.

FRAZEE, JOHN.
Sculptor. Born in Rahway, NJ, July 18, 1790. He was apprenticed as a youth to a country bricklayer, William Lawrence. His first work with the chisel was carving his employer's name upon the tablet of a bridge constructed by Lawrence over Rahway River at Bridgetown, in 1808. In 1814 he formed a partnership with a former apprentice and established a stonecutting business at New Brunswick. In 1818 he moved to NY and with his brother William opened a marble shop in Greenwich St. From that time until 1825, he made tombstones and mantels. His portrait bust of John Wells, old St. Paul's Church, Broadway, NY, is probably the first marble bust made in this country by a native American. A number of busts were executed by Frazee in 1834, seven of which are in the Boston Athenaeum. Died Feb. 24, 1852, in Crompton Mills, RI.

FRAZER, HARLAND.
Painter. Member: St. Louis AG. Awards: Mallinckrodt portrait prize, 1921, and first figure prize, 1922, St. Louis AG. Address in 1929, 2 West 67th St., New York, NY.

FRAZER, OLIVER.
Painter. Born in Fayette County, KY, Feb. 4, 1808. He was the son of Alexander Frazer, an Irish patriot. His father died while Oliver was very young. His uncle, Robert Frazer, assumed charge of his education. He early showed signs of great artistic talent, and his uncle placed him under the tuition of Kentucky's great artist, M. H. Jouett. Later he was sent to Phila. and studied with T. Sully. After his course in Phila., he spent 4 years studying in Europe, attending the art schools of Paris, Florence, Berlin and London. When he returned to the US, he opened a studio in Lexington. Frazer devoted himself principally to portraits, his group-portrait of his wife and children, and portraits of Col. W. R. McKee, Chief Justice George Robertson, M. T. Scott, J. T. Hart, the famous sculptor, and H. Clay being among his works. Many critics say his portrait of Clay is the finest ever painted of that man. Died near Lexington, KY, Feb. 9, 1864.

FRAZIER.
Nothing known of him except that he flourished about 1793, in Norfolk, VA, and painted a number of portraits.

FRAZIER, BERNARD (EMERSON).
Sculptor, museum art dir., craftsman, and lecturer. Born in Athol, KS, June 30, 1906. Studied at Univ.

of Kansas, BFA; National Academy of Art; Art Institute of Chicago; and with Lorado Taft. Member: National Sculpture Society; American Ceramic Soc.; Scarab Club. Awards: Prizes, Syracuse Museum of Fine Arts, 1941; Chicago Galleries Association, 1943; Springfield Museum of Art, 1944; Kansas City, MO, 1938; Fellow, Carnegie Foundation, 1938, 39. Work: University of Kansas; Baker University, Kansas; Philbrook Art Center; State Minerals Building, Kansas; Ft. Dearborn memorial plaque, Chicago, IL; dioramas, Dyche Mus. of Nat. History. Exhibited: Syracuse Mus. of Fine Art, 1938-41; San Francisco Museum of Art, 1939, 40; Cranbrook Academy of Art, 1946; Art Institute of Chicago, 1941; Cincinnati Museum Association, 1941; National Academy of Design, 1939, 41; Corcoran Gallery of Art, 1941; Philadelphia Art Alliance, 1939, 41; Museum of New Mexico, Santa Fe, 1942, 46; Kansas City Art Institute, 1940, 41, 43; Springfield Museum of Art, 1944; Chicago Galleries Association, 1939, 40, 42, 43. Lectures: Sculpture; Ceramic Sculpture. Position: Sculptor in Residence, 1937-38; Instructor, 1939-44, University of Kansas; Art Director, Philbrook Art Center, Tulsa, OK, 1944-50. Address in 1953, Tulsa, OK.

FRAZIER, CHARLES.
Sculptor. Born in 1930, Morris, OK. Studied at Chouinard Art Institute, Los Angeles, 1948-49 and 1952-56. Also resided in Italy. Work: La Jolla and Los Angeles Museums, and many private collections. Exhibitions: La Jolla; Ellin Gallery, Los Angeles; Kornblee Gallery, NYC; Los Angeles County Museum; Penna. Academy of Fine Arts; Dwan Gallery, Los Angeles; Art Institute of Chicago; Pasadena Art Museum. Awards: La Jolla Art Center, 1962; Long Beach Museum of Art, 1963. Address in 1970, Los Angeles, CA.

FRAZIER, JOHN R. (MRS.).
See Stafford, Mary.

FRAZIER, JOHN R(OBINSON).
Painter and teacher. Born Stonington, CT, July 29, 1889. Pupil of RI School of Design, and C. W. Hawthorne. Member: Phila. WCC; Providence AC; NYWCC; Providence WCC. Awards: Phila. WCC Prize, 1920; Dana gold medal, Phila. WCC, 1921; Harriet B. Jones prize, Baltimore WCC, 1922; Logan purchase prize, AIC, 1922; Kansas City Art Institute purchase prize, 1923. Represented in RI School of Design; Chicago Art Institute; Brooklyn Museum. Address in 1929, Rhode Island School of Design, Providence, RI.

FRAZIER, KENNETH.
Painter. Born Paris, France, June 14, 1867. Pupil of Herkomer in Eng.; Constant, Doucet and Lefebvre in Paris. Member: SAA, 1893; ANA, 1906; Century Association Award: Bronze medal, Pan-Am. Exp.,

Buffalo, 1901. Died Aug. 31, 1949. Address in 1929, 7 West 43rd St., New York, NY; Garrison-on-Hudson, NY.

FRECHETTE, MARIE MARGUERITE.
Painter. Born Ottawa, Canada, 1884. Pupil of Kenyon Cox; Charles Hawthorne; Mme. LaFarge in Paris. Member: Union Internationale des Beaux Arts et des Lettres. Work: Ten historical portraits for Chateau Frontenac, Quebec. Address in 1926, 67 Somerset St., West Ottawa, Canada.

FREDENTHAL, DAVID.
Painter. Born in Detroit, Michigan, in 1914. Studied art at Cass Tech. HS, Detroit, with Mary Davis. Studied works of Masaccio, Michelangelo, Rembrandt, Daumier; strongly influenced by work of Brueghel. Exhibited pencil drawings at Young Artists' Market, Detroit, 1933; all sold. Won Museum of Mod. Art Traveling Fellowship to Europe. Received commissions, including WPA Mural, Detroit Post Office; drawings of New England plants for defense purposes; artist correspondent for *Life Magazine* during World War II. First important show on East Coast at Whitney Museum, NYC, 1947. Received many awards and had many successful exhibitions. Worked in oil, watercolor. Died in 1958. Represented by Kennedy Galleries, NYC.

FREDER, FREDERICK C(HARLES).
Painter. Born Monroe, Orange Co., NY, July 4, 1895. Pupil of Charles Curran, Francis Jones, Ivan Olinsky, NAD, Fernand Cormon and Angel Zarraga, Ecole des Beaux Arts, Paris; also studied in Germany, Italy, and Spain. Member: Salma. C. Award: Pulitzer prize ($1,500), Columbia University, 1920. Work: "Before the Walls of Kairouan, Tunisia," Fine Arts Gallery, San Diego, California. Address in 1929, 646 East 241st Street, New York, NY.

FREDERICK, EDMUND.
Illustrator. Born Philadelphia, PA, April 2, 1870. Studied at PAFA. Member: SI, 1910. Worked in New York for the *World* and *The Morning American*. Illustrated books by Elinor Glyn, Robert W. Chambers, Joseph C. Lincoln, etc. Address in 1929, 330 West 58th St., New York, NY; 322 Fenimore St., Brooklyn, NY.

FREDERICK, FRANK FORREST.
Sculptor, painter, craftsman, teacher, writer, and lecturer. Born in Methuen, MA, October 21, 1866. Pupil of Mass. Normal Art School; Royal College of Art, Stanhope Forbes and Newlyn in London; Tom Robertson in Venice; Trenton School of Industrial Arts. Member: Society of Western Artists. Professor of Art and Design, University of Illinois; Director, Trenton School of Industrial Arts. Address in 1929, Trenton, NJ.

FREDERICK, JOHN L.
Engraver. Born c. 1798. Frederick was an engraver of buildings and book illustrations, in business in Philadelphia from 1818 until 1845. As he was engraving for Collins' Quarto Bible, published in New York in 1816, it is probable that he came from that city to Philadelphia. His one known portrait, that of the Rev. Joseph Eastburn, is an attempt in stipple, and is poorly done. He is said to have died in Philadelphia in 1880-81.

FREDERICKS, ALFRED.
Wood engraver and illustrator of books.

FREDERICKS, MARSHALL MAYNARD.
Sculptor. Born in Rock Island, IL, January 31, 1908. Studied at John Huntington Polytechnic Institute, Cleveland, OH; Cleveland School of Art, Graduate, 1930; Munich, Germany; Paris, France; Copenhagen, Rome, and London; Carl Milles Studio; Cranbrook Academy of Art. Work in Detroit Institute of Arts; Cranbrook Museum of Art; Henry Ford Memorial, Dearborn, MI; Saints and Sinners Fountain, Oakland University; others. Has exhibited at Carnegie Institute; Art Inst. of Chicago; Detroit Art Institute; Whitney Museum; others. Member Nat. Academy of Design (academician); National Sculpture Soc. (fellow); honorary member, Michigan Soc. of Architects; Royal Soc. of Arts (fellow); International Institute of Arts and Letters (fellow). Taught at Cranbrook School, 1932-38, instructor of sculpture; Cranbrook Acad. of Art, 1932-42, inst. of sculpture. Address in 1982, Birmingham, MI.

FREDERICKSON, FREDERICK LYDER.
Sculptor and painter. Born in Mandal, Norway, February 18, 1905. Studied at Art Students League, with R. Soyer, L. Kroll, Laurent; and in Norway. Work: Phila. Museum of Art. Exhibited: Penna. Academy of Fine Arts, 1937, 41; Virginia Museum of Fine Art, 1942; one-man exhibitions: Downtown Playhouse, 1936; Hudson Walker Gallery, 1937, 39; Schoneman Gallery, 1940; Marie Sterner Gallery, 1941; Marquie Gallery, 1944; and in Norway, 1939. Address in 1953, 1202 Lexington Ave., NYC.

FREE, JOHN D.
Sculptor and painter. Born in Pawhuska, OK, 1929. Initially studied pre-veterinary medicine and animal husbandry. Worked as a cowboy, in rodeos, and as a rancher. Turned to art, studying privately in Taos, NM, for four years. In collections of Gilcrease Museum, Tulsa, OK; National Cowboy Hall of Fame, Oklahoma City; others. Had one-man show at National Cowboy Hall of Fame, 1971, and National Academy of Western Art, 1973; group, Grand Central Galleries, NYC, 1973. Member of Cowboy Artists of America, 1972-75; National Academy of Western Art. Awarded second in sculpture and honorable mention, Philbrook Art Center; silver

medal, National Academy of Western Art, 1979. Has own foundry. Reviewed in *Persimmon Hill, Oklahoma Today, The Oklahoma Cowman; The Cowboy in Art* by Ainsworth. Specialty is Western animals. Media: Bronze; oil, pastel, pencil. Address in 1982, Pawhuska, OK.

FREEDLANDER, ARTHUR R.
Painter and teacher. Born in New York in 1875. Pupil of Twachtman and Mowbray in New York; Cormon in Paris. Member: Salma. C., 1905; Gld. of Amer. P. Award: Isidor portrait prize, Salma. C., 1915, Director, Martha's Vineyard School of Art. Died in 1940. Address in 1929, 1 West 67th St.; 220 West 59th St., New York, NY.

FREEDLEY, ELIZABETH C.
Painter. Exhibited at Annual Exhibition of Penna. Academy of Fine Arts, Philadelphia, 1924, and at National Assoc. of Women Painters and Sculptors. Address in 1926, New Hope, PA.

FREEDMAN, RUTH.
Painter. Born in Chicago, IL, 1899. Pupil of Chicago Academy of Fine Arts. Address in 1926, Seattle, WA.

FREELAND, ANNA C.
Painter. Born in 1837; died in 1911. She painted figure and historical scenes; her "William the Conqueror" is signed and dated "1886," and is owned by the Worcester Art Museum.

FREELON, ALLAN (RANDALL).
Painter, etcher and teacher. Born Philadelphia, PA, Sept. 2, 1895. Pupil of Pennsylvania Museum School of Industrial Art; Earl Horter, Hugh Breckenridge. Member: Alumni Assoc., PA Mus. School of Art; Phila. Art Teachers A; Eastern AA; AFA; North Shore AA. Supervisor Art Education, Philadelphia Public Schools. Address in 1929, 2220 Catherine St., Philadelphia, PA; summer, c/o Hugh Breckenridge, East Gloucester, MA.

FREEMAN, E. O.
This good line-engraver of historical subjects was working for Boston publishers about 1850.

FREEMAN, FLORENCE.
Sculptor. Born in Boston, MA, 1836. After study with Richard Greenough, she went abroad and studied with Hiram Powers. Established a studio in Rome. Executed several bas-reliefs of Dante, and many portrait busts. Also specialized in chimney pieces. She died after 1876, in Rome, Italy.

FREEMAN, GEORGE.
Miniature painter. Born April 21, 1789, at Spring Hill, CT. In 1813 he went abroad for study and remained in London and Paris for twenty-four years. He painted on ivory and porcelain, and was honored

by being allowed to paint Queen Victoria and Prince Albert, from life. He returned to the US in 1837 and died in Hartford, CT, on March 7, 1868. He painted miniatures of President Tyler, Mrs. Sigourney, Mr. and Mrs. Nicholas Biddle, Mr. and Mrs. James Brown, and Mrs. J. W. Wallace.

FREEMAN, H. A. L. (MRS.).
Sculptor. Wife of the artist James E. Freeman. Born in Augusta Latilla, Italy, 1826. For many years she had her studio in Rome. A "Group of Children," also the "Culprit Fay," of Drake's poem, were modelled with skill by Mrs. Freeman.

FREEMAN, JAMES EDWARD.
Painter. Born in Nova Scotia in 1808. He was brought to the United States in 1810. He studied in New York City and entered the School of the National Academy. He later studied abroad, and had his studio in Rome. His best known paintings are "The Beggars," "Italian Peasant Girl," "The Bad Shoe," "Girl and Dog on the Campagna," and "The Mother and Child." His self-portrait was shown in the Centennial Exhibition of the National Academy of Design, New York, 1925. Elected a Member of the National Academy in 1833. He died Nov. 21, 1884, in Rome.

FREEMAN, JANE.
Painter and teacher. Born in England, Feb. 11, 1883. Pupil of Chase, Du Mond, Henri, George E. Browne, Frank Fairbanks, Hawthorne, Bredin, Cooper Union; Academy de la Grand Chaumiere in Paris. Member: NA Women PS. Awards: Popular vote prize, Art and Industries Exhib., Hotel Astor, NY, 1928; water color prize, NA Women PS, 1928. Died in 1963. Address in 1929, 160 Carnegie Hall, NY; summer, Provincetown, MA.

FREEMAN, MARGARET (LIAL).
Illustrator. Born Cornwall-on-Hudson, NY, May 13, 1893. Pupil of Eric Pape; Richard Miller; Margaret West Kinney. Illustrated: *The Story of a Wonder Man*, by Ring Lardner (Scribner); *Father' First Two Years*, by Fairfax Downey (Minton, Balch & Co.); *Italian Fairy Tales*, by Capuana (Dutton); *The Frantic Young Man*, by Charles Samuels (Coward, McCann); *American Folk Tales*, edited by Rachel Field (Scribner); *Jane's Father*, by Dorothy Aldis (Minton, Balch and Co.). Address in 1929, 177 MacDougal St., New York, NY.

FREEMAN, MARION.
Painter. Exhibited at the National Academy of Design, 1925. Address in 1926, 123 Waverly Place, New York.

FREEMAN, W. H.
Engraver. Very little is known about this engraver or his work beyond the fact that he was a fairly good

engraver of line plates, and that he worked for New York and Baltimore publishers in 1815 and 1816. In Mr. Stauffer's work he notes that Freeman engraved a number of plates for a quarto Bible that was published in NY in 1816. Freeman also engraved "The Washington Monument at Baltimore," which was published by John Horace Pratt in 1815, in a rare publication on the laying of the corner stone of Washington Monument.

FREER, FREDERICK WARREN.
Painter and etcher. Born in Chicago, June 16, 1849; died there March 7, 1908. He was elected an Associate member of the National Academy of Design, and a member of the American Water Color Society and NY Etching Club. He was president of the Chicago Academy of Design.

FREILICHER, HY.
Sculptor, teacher, craftsman. Born in Northumberland, PA, April 13, 1907. Studied at College of the City of New York, B.S.; Beaux-Arts Institute of Design. Member: Sculptors Guild. Exhibited: Sculptors Guild, annually; New York World's Fair, 1939; American Fed. of Arts traveling exhibition; Carnegie Institute; Brooklyn Museum; Metropolitan Museum of Art. Lectures: Sculpture His., Aesthetics, Technique. Position: Inst. of Sculpture, Abraham Lincoln High School, Brooklyn, New York. Address in 1953, 2514 Avenue M, Brooklyn, New York.

FRENCH, ALICE HELM.
(Mrs. William M. R. French). Painter. Born Lake Forest, IL, March 17, 1864. Pupil of AIC. Member: AFA. Represented in St. Louis Mus.; Beloit Col. Art Museum; Doshisha Col., Kyoto, Japan; Vanderpoel AA Collection, Chicago; Colegio Internacional, Guadalajara, Mexico. Address in 1929, 37 Glen Road, Williamstown, MA.

FRENCH, DANIEL CHESTER.
Sculptor. Born Exeter, NH, April 20, 1850. Pupil of Wm. Rimmer in Boston; J.Q.A. Ward in NY; Thomas Ball in Florence. Member: Associate, Nat. Academy of Design, 1900, Academician, National Academy of Design, 1901; National Sculpture Society, 1893; Society of American Artists, 1882; NY Architectural League, 1890; American Institute of Architects, 1896; Academy San Luca, Rome; Nat. Arts Club; Century Association; National Institute of Arts and Letters; American Academy of Arts and Letters; Concord Art Assoc. Member of National Commission of Fine Arts 1910-15. Awards: Third class medal, Paris Salon, 1892; medal of honor, Paris Exp., 1900; medal of honor of sculpture, NY Architectural League, 1912; medal of honor, P.-P. Exp., San Francisco, 1915; gold medal of honor, National Institute of Arts and Letters, 1918. Work: "Death and the Sculptor," memorial to Martin Milmore, Boston; "The Minute Man," Concord, MA; "Abraham Lincoln,"

for Lincoln, Nebraska; "Continents," New York Custom House; "Gen. Devens," equestrian statue (in collaboration with E. C. Potter), Worcester, MA; "Jurisprudence" and "Commerce," Federal Building, Cleveland; "Quadriga," State Capitol, St. Paul, MN; "Alma Mater," Columbia University, NY; Parkman Memorial, Boston; "Mourning Victory," memorial to Melvin brothers in Concord, MA, and replica and "Memory," Met. Mus., NY; bust of Emerson, Art Mus., Montclair, NJ; "Spirit of Life," Trask Memorial, Saratoga, NY; "Study of a Head," Fine Arts Academy, Buffalo; "Statue of Emerson," Concord, MA; "Lafayette Monument," Brooklyn, NY; "Lincoln" in the Lincoln Memorial, Monument to First Division, Dupont Fountain, and "The Sons of God Saw the Daughters of Men that they were Fair," Corcoran Gallery, all in Washington, DC; White Memorial Fountain, Boston, MA; War Memorial, Milton, MA; War Memorial, St. Paul's School, Concord, NH. Died Oct. 7, 1931. Address in 1929, 12 West 8th St., h. 36 Gramercy Park, NYC; summer, Glendale, MA.

FRENCH, EDWIN DAVIS.
Engraver. Born in North Attleborough, MA, June 19, 1851. In 1869 he began engraving on silver with the Whiting Manfg. Co., and he moved with that establishment to NY in 1876. Studied drawing and painting at the Art Students League of NY, under William Sartain in 1883-86; later on the board of that organization until 1891, serving as pres. in 1890-91. In 1894 he began designing and engraving bookplates and similar work on copper, and achieved a well-deserved reputation. He designed and engraved 245 bookplates, chiefly for private owners; also many for clubs and public institutions. Among the latter may be noted the beautiful plates designed and engraved for the Grolier Club, Union League, and Metropolitan Museum of Art of NY; Dean Hoffman Lib., etc. For the Society of Iconophiles he engraved their first publication, a series of views of historical NY buildings, and he made a number of title-pages and certificate plates. Moved his studio to Saranac Lake in 1897. Died Dec. 8, 1906, in New York City.

FRENCH, ELIZABETH D. L.
Sculptor, painter, and writer. Born in Plymouth, PA, June 28, 1878. Studied with Charles W. Hawthorne. Works: Papier-mache figures, life size, of historical characters in Wyoming Valley, for Wilkes-Barre Sesqui-Centennial; author of original pageants, plays, and stories for children; church decorations, Grace Church, Kingston, PA; decorations, Mission Room, St. Stephens Church, Wilkes-Barre, PA. Address in 1933, 44 Reynolds St., Kingston; summer, Chase, PA. Died in 1943.

FRENCH, FRANK.
Painter. Born Loudon, NH, May 22, 1850. Mainly self-taught. Member: ANA, 1923; Soc. of American

Wood Engravers; Salma. C.; A. Fund S. Awards: bronze medal, Centennial Exp., Philadelphia, 1876; medal, Columbian Exp., Chicago, 1893; silver medal for wood engravings, Pan-Am. Exp., Buffalo, 1901; gold medal for wood engraving, St. Louis Exp., 1904. Died in 1933. Address in 1929, "The Sycamores," Reeds Ferry, NH.

FRENCH, JARED.
Sculptor and painter. Born in Ossining, NY, Feb. 4, 1905. Studied at Amherst College, MA, 1921-25; Art Students League, NYC, 1925-27, under Boardman Robinson, Kimon Nicholaides. Exhibited: Julien Levy Gallery, NY, 1939; Museum of Modern Art, NYC, 1943; Edwin Hewitt Gallery, NYC, 1950, 55; Robert Isaacson Gallery, NYC, 1962; Rochester Museum, NY, 1964; New York Cultural Center, NYC, 1972; Whitney; Carnegie. Awards: National Institute of Arts and Letters Award, 1967. Modelled numerous murals under the Federal Arts Project. Member: Mural Painters Society, NY, 1936-38. In collections of Whitney; Baltimore; others. Media: Stone, cast metals; tempera. Address in 1982, Rome, Italy.

FRERICHS, WILLIAM CHARLES A.
Painter. Born in Ghent, Belgium in 1829. Came to New York. In 1854 he became instructor in various art schools. He died March 16, 1905, in Tottenville, LI, NY.

FRESHMAN, SHELLEY A.
Illustrator. Born in NYC, in 1950. Attended PI for four years, studying under David Byrd and Alvin Hollingsworth. She began her career with a poster for the off-Broadway prod. *Geese* and illustrated the book *Cricket* for Bobbs-Merrill in 1975. Her works have appeared in the S of I and 1976 Annual Exhibitions.

FREUND, H(ARRY) LOUIS.
Painter. Born Clinton, MO, Sept. 16, 1905. Pupil of Ankeney, Carpenter, Goetsen, Wuerpel. Member: Delta Phi Delta. Awards: Wayman Crow medal, St. Louis, 1927; second portrait award, St. Louis Artists Guild, 1929. Address in 1929, St. Louis School of Fine Arts, St. Louis, MO; h. Clinton, MO.

FREUND, WILL(IAM) FREDERICK.
Sculptor and painter. Born January 20, 1916. Studied at University of Wisconsin, B.S., M.S.; University of Missouri. Member: Mid-American Artists. Awards: Fellowship and prize, Tiffany Foundation, 1940, 49; Mid-American Artists, 1950; Madison Art Salon; Milwaukee Art Inst.; Missouri Valley Artists; Addison Gallery of American Art, 1945, 46. Exhibited: Madison Library; Wisconsin Union; Milwaukee Art Institute; City Art Museum of St. Louis; William Rockhill Nelson Gallery; Springfield (MO) Art Museum; Joslyn Museum of Art;

Mulvane Municipal Art Gallery; Denver Art Museum, (one-man). Position: Instructor, Stephens College, Columbia, MO, 1946-64; Southern Illinois University, 1964-81. No longer sculpting by 1982. Address in 1984, Watersmeet, MI.

FREY, ERWIN F.
Sculptor and teacher. Born Lima, OH, April 21, 1982. Pupil of C. J. Barnhorn, James Fraser, Henri Bouchard, Paul Landowski; Lima Col.; Cincinnati Art Academy; Art Students League; Beaux-Arts Institute of Design; Julian Academy, Paris. Member: National Sculpture Society; Columbus Art League. Award: Honorable mention, Paris Salon, 1923; honorable mention, Art Institute of Chicago, 1925; others. Work: Beatty Memorial, Springfield, OH; Madonna and Child, Lamme Engineering Medal, Ohio State University; Fairmount Park, Phila.; others. Exhibited: Paris Salon, 1923; Penna. Academy of Fine Arts, 1929; Art Institute of Chicago, 1928; Architectural League, 1925; National Academy of Design, 1930; Philadelphia Museum of Art, 1943, 50. Professor of Fine Arts, Ohio State University, from 1925. Address in 1953, Ohio State University; h. Columbis, OH. Died in 1968.

FREY, GRACE EGGERS.
Sculptor. Exhibited a portrait in the Cincinnati Museum in 1925. Address in 1926, Columbus, OH.

FRIEDENBERG, KATHLEEN M.
Sculptor and medical illustrator. Studied veterinary medicine, University of London, 1965; Studio School of Art and Design, Philadelphia, PA; watercolor painting under Domenic di Stefano; sculpture under Natalie Hodes, 1974; Wayne Art Center, under Holly Silverthorne; also under Zeno Frudakis. Work: Illustrations for *Practical Horseman* magazine; two books, *The Lame Horse* and *The Sick Horse*, Dr. James Rooney (author); various anatomical and surgical drawings for *Equine Medicine* and *Surgery*; sculpture works include "Old Friends" (bronze), "Hard Day's End" (bronze), "Free at Last" (bronze); numerous others. Awards: Thouron Scholarship to study orthopedics in man and horse, University of Penna.; two 1st prizes and a silver medal from DaVinci Alliance; Coscia award for sculpture, DaVinci Alliance; Amelia prize, Woodmere. Exhibitions: Allied Artists, NYC, 1983; North American Sculpture Exhibition, Golden, CO. Member: Assoc. of Medical Illustrators; Society of Animal Artists. Specialty, animal subjects, horses. Address in 1983, Ardmore, PA.

FRIEDENSOHN, ELIAS.
Sculptor and painter. Born December 12, 1924, NYC. Studied: Tyler School of Fine Arts, Temple University, 1942-43, with Rafael Sabatini; Queens College, with Cameron Booth, 1946-48, AB; NYU, Institute of Fine Arts; privately with Gabriel Zendel

in Paris. Work: Art Institute of Chicago; Sara Roby Foundation Collection, Krannert Mus. Art, University of Illinois; Whitney; Walker; Minneapolis Museum of Art. Exhibited: Hewitt Gallery, NYC, 1955, 57, 59; Vassar College, 1958; Feingarten Gallery, NYC, San Francisco, Los Angeles and Chicago; Terry Dintenfass Inc., NYC, 1967; Audubon Artists Annual; Young American Painters, 1959, and Whitney Mus. Annuals, 1961-64, Whitney Mus. Amer. Art; Art Inst. of Chicago Annuals, 1959, 61; University of Illinois, 1957, 59, 61, 63; National Arts Club Annual, NYC, 1958; Galleria Schneider, Rome, Fulbright Annual, 1958; Corcoran Annuals, 1960, 62; Smithsonian; Albright; Phila. Art Alliance; Syracuse University; Penna. Academy of Fine Arts Annual, 1967; Minnesota Museum, 1980; and many more. Awards: Lowe Foundation Award, 1951; Fulbright Fellowship (Italy), 1957; University of Illinois, 1957; National Arts Club Annual, NYC, Stephens Award, 1958; Guggenheim Foundation Fellowship, 1960. Member: College Art Association. Taught, Queens College. Represented by Terry Dintenfass, NYC. Address in 1984, Leonia, NJ.

FRIEDLANDER, LEO.
Sculptor. Born NYC, 1889. Pupil of Art Students League of New York; Ecole des Beaux Arts of Paris and Brussels; American Academy in Rome. Member: National Sculpture Society; Alumni, American Academy in Rome; New York Architectural League; National Academy. Exhibited at National Sculpture Society, 1923; National Academy of Design; Architectural League; Art Institute of Chicago; others. Awards: American Academy in Rome Fellowship, 1913-16; Helen Foster Barnett Prize, National Academy of Design, 1918 and 1924; honorable mention, Art Institute of Chicago, 1920; silver medal, Sesqui-Centennial Exp., Philadelphia, 1926; medal, Architectural League, 1933. Work: Sculptures on Washington Memorial Arch, Valley Forge, PA, 1912; figures on altar of St. Thomas' Church, Frankfort, PA; colossal heads of Beethoven and Bach, Eastman School of Music, Rochester, NY; 3 colossal figures, entrance Masonic Temple, Detroit, MI; 28 allegorical life-sized bas-reliefs, National Chamber of Commerce, Wash., DC; 3 life-sized allegorical figures, Ann Arbor, Univ. of Michigan Museum; "Bacchante," Metropolitan Museum of Art; 8 allegorical figures for Baptismal Font, Cranbrook Church, Michigan; 3 6-feet figures, "The Three Wise Men," Chapel, Berkeley, CA; bronze doors and allegorical column caps, Goldman Memorial, Congregational Cemetery, Queens, NY; entire sculptures for Epworth Euclid M. E. Church, Cleveland, OH; designed the seal for the New York Building Congress; three marble reliefs, Amer. Bank and Trust Co., Phila., PA; 8 marble Metopes, Lee Higginson Bank, NYC; pediment, museum, City of New York, 1929; all sculptures for facades, Jefferson County Court House, Birmingham, AL,

1929-30; bronze relief, and two stone reliefs, main entrance, Genesee Valley Trust Co., 1929-30; all exterior figurative sculpture, Grosse Pointe Church, Grosse Pointe, MI, 1929-30. Address in 1953, White Plains, NY. Died in 1966.

FRIEDMAN, ARNOLD.
Painter. Born New York City, 1879. Pupil of ASL of NY; Robert Henri. Address in 1929, 53 Baylie St., Corona, LI, NY.

FRIEDMAN, MARVIN.
Illustrator. Born in Chester, PA, Sept. 26, 1930. Attended the School of Art at the Philadelphia Museum. He studied under Henry C. Pitz, Albert Gold, and Benjamin Eisenstat, and has illustrated books such as *Chewing Gum*, published by Prentice-Hall in 1976, *Pinch*, by the Atlantic Monthly Press in 1976, and *Can Do Missy*, by Follet in 1975. Work: Playboy Collection, Chicago; Ford Motor Company, Dearborne, IL; Nat. Broadcasting Co. Coll., NY. Exhibited at Pittsburgh Mus. and Brandywine Mus. in Delaware; Phila. Mus. of Art.

FRIES, CHARLES ARTHUR.
Painter, illustrator and teacher. Born Hillsboro, OH, Aug. 14, 1854. Studied at Cincinnati Art Academy. Member: San Diego AG; Laguna Beach AA; La Jolla AA; Calif. AC. Awards: Silver medal, Seattle FAS, 1911; silver medal, P.-P. Exp., 1915. Represented in San Diego Fine Arts Gallery. Died in 1940. Address in 1929, 2843 E Street; h. 2876 F. St., San Diego, CA.

FRIESEKE, FREDERICK CARL.
Painter. Born Owosso, MI, April 7, 1874. Pupil of AIC; ASL of NY; Constant, Laurens and Whistler in Paris. Member: ANA, 1912, NA, 1914; Soc. Nat. des Beaux-Arts, Paris; Paris AA; Inter. Society AL; NYWCC; Chevalier of the Lg. of Honor, France. Awards: Silver medal, St. Louis Exp., 1904; gold medal, Munich, 1904; fourth W. A. Clark prize ($500), Corcoran AG, 1908; Temple gold medal, PAFA, 1913; grand prize, P.-P. Exp., San F., 1915; Harris silver medal and prize ($500), AIC, 1916; Wm. M. R. French Gold Medal, AIC, 1920; Potter Palmer Gold Medal ($1,000), AIC, 1920; Edw. B. Butler prize ($100), AIC, 1920; gold medal, Phila. AC, 1922. Work: "Before the Mirror," Luxembourg Museum, Paris; "The Toilet," Metropolitan Museum, New York; "The Open Window," "On the Bank" and "The Toilet," Art Institute, Chicago; "Garden in June," "Wooden Bridge," Minneapolis Institute of Arts; "Nude" and "The Hammock," Telfair Academy, Savannah, GA; "Girl Sewing" and "Autumn," Modern Gallery, Venice, Italy; Museum of Odessa; "The Sun Bath," Museum of Fine Arts, Syracuse, NY; "Torn Lingerie," Art Museum, St. Louis; "Under the Willows," Cincinnati Mus.; "Memories," Toledo Museum; "The Bird Cage," New Britain (Conn.) Institute; "The Blue Gown," Detroit, Mich.

Inst.; "Dressing Room" and "Peace," Corcoran Art Gallery, Washington; "Golden Locket," Cincinnati Museum; "Lady in Rose," Arts and Crafts Guild, New Orleans, LA; "Lady in Pink," Lincoln, Nebr., Museum; "Before the Window," Cedar Rapids Art Association; "Blue Curtains," "Truth," and "Nude," Harrison Gallery, Los Angeles Museum of History, Science and Art. Died in 1939. Address in 1929, care of Macbeth Galleries, 15 East 57th St., New York, NY; and 64 Rue du Cherche Midi, Paris, France.

FRIETSCH, CHARLOTTE G.
Painter, writer and teacher. Born WI, Jan. 18, 1896. Member: S. Indp. A.; Salons of Amer. Awards: Second prize and honorable mention for design, Alliance. Address in 1929, 253 W 85th St., New York, NY; summer, "Pine Rest," Brunswick Gardens, Spotswood, NJ.

FRISCH, VICTOR.
Sculptor. Born in Vienna, Austria, in 1876. Studied painting at the Academy of Fine Arts, Munich, and then sculpture under Heinrich Zuegel and Ludwig Herterich. Also worked in Auguste Rodin's studio as pupil and assistant, and for twelve years he remained with Rodin in Paris. After the war he came to the US. Works: Garden sculpture and fountain, Long Island, NY; Lucius N. Littauer monument, Gloversville, NY; Beethoven memorial, Vienna, Austria; church figures, Lyons, France; various sculptures in European museums and cemeteries; war memorial, "Despair." Awards: Won competition for the Emil Verhaeren monument in Paris; gold medals in Paris, Vienna, and Munich. Memberships: Nat. Sculpture Society; NY Arch. League; Art Clubs of Vienna and Munich.

FRISCHKE, ARTHUR.
Painter. Born New York City, June 25, 1893. Pupil of NAD and Cooper Union. Member: Bronx AG; Am. APL. Address in 1929, 656 Eagle Ave., New York, NY.

FRISHMUTH, HARRIET WHITNEY.
Sculptor. Born in Philadelphia, PA, on September 17, 1880. Studied in Paris under Rodin and Injalbert, in Berlin under Cuno von Enchtritz, and also in NY (Art Students League) under Hermon A. MacNeil and Gutzon Borglum. Exhibited at the Paris Salon in 1903; National Sculpture Society in NYC, 1923; National Academy of Design; Academy of Fine Arts, Philadelphia; others. Awards: Augustus Saint-Gaudens Prize, Art Students League; Helen Foster Barnett prize, for Girl and Dolphin fountain, National Acad. of Design; MacMillin prize for sculpture, Nat. Association of Women Painters and Sculptors; honorable mention, for the Saki Sun-dial, P.-P. International Exp., San Francisco, 1915; National Arts Club prize, for Extase, National Association of Women Painters and Sculptors, 1921; Elizabeth N.

Watrous gold medal, for Fantaisie, Nat. Academy of Design, 1922. Member: National Sculpture Society, 1914; National Association of Women Painters and Sculptors; League of American Artists; Allied Artists of America; fellow, National Academy of Design; others. Work: Joy of the Waters, Museum of Fine Arts, Dayton, OH; Metropolitan Museum of Art, NYC; Los Angeles Museum of Art; museums in New Hampshire, Georgia, New Jersey; John Herron Art Institute; Dallas Mus. of Fine Arts; Brookgreen Gardens, SC. Address in 1976, Norwalk, CT. Died in 1979.

FRITZ, HENRY EUGENE.
Painter, etcher, writer, lecturer and teacher. Born in Germany, Oct. 12, 1875. Pupil of George Bridgman, Robert Blum, George Maynard, C. Y. Turner, Arthur W. Dow; NAD; Beaux Art Inst.; ASL, New York. Member: Eastern AA; Salons of America; New Rochelle AA. Award: Hon. mention, New Rochelle AA, 1922. Address in 1929, 4 Poplar Ave., Chester Park, Pelham, NY.

FROELICH, PAUL.
Painter. Exhibited at Annual Exhibition of Penna. Academy of Fine Arts, Philadelphia, 1924, and Water Color Exhibition, 1925. Address in 1926, 1703 Tioga St., Philadelphia.

FROLICH, FINN HAAKON.
Sculptor. Born Norway, August 13, 1868. Pupil of Ernest Barrias, Augustus Saint-Gaudens, D. C. French. Member: Southern California Sculptors Guild; Norse Studio Club; California Painters and Sculptors. Award: Silver medal, Paris Exposition, 1900; silver medal, Long Beach Exp. Work: Monuments to James Hill and Edvard Grieg, Seattle; monument to Jack London, Honolulu; Tower of Legends, Forest Lawn Cemetery, Los Angeles; monuments to R. Amundsen, Long Beach, CA; Paul Kruger, Johannesburg, South Africa. Director of Sculpture, Alaska-Yukon-Pacific Exposition, 1909; official sculptor, Pan-American Exposition, Calif., 1915. Director, Frolich School of Sculpture, Hollywood, CA. Address in 1933, Hollywood, CA. Died in 1947.

FROMAN, ANN.
Sculptor. Born in NYC, April 7, 1942. Studied: FIT, NY; Palace of Fontainebleau School of Fine Art, France; National Academy School of Fine Art; Art Students League, NYC. First worked in fashion design; turned to sculpture in 1968. Traveled in Israel and Italy; influenced by Arab women and churches. Work in Congregation Emanu-El of NY; Butler Museum of Art, Youngstown, OH; Slater Museum, Norwich, CT. Has exhibited at NY Artists, Brooklyn Museum; Judaica Museum, Phoenix, AZ; others. Received first prize for sculpture, Salmagundi Club, American Soc. of Contemporary

Artists; plus numerous others. Member of American Soc. of Contemporary Artists; Artists Equity Association. Specializes in bronze figures, often Western subjects. Work is cast in own foundry. Titles include "Women of the West," "Women of the Bible," "Nude York," "Dancing Bronzes." Represented by Gemini Gallery, Palm Beach, FL; Shorr Goodwin Gallery, Phoenix, AZ. Address in 1984, Stanfordville, NY.

FROMEN, AGNES VALBORG.
Sculptor. Born Waldermasvik, Sweden, December 27, 1868. Pupil of Art Institute of Chicago under Lorado Taft and Charles Mulligan. Member: Chicago Society of Artists; Art Institute of Chicago Alumni; Swedish American Art Association; Cordon. Exhibited at National Sculpture Society, 1923. Awards: Prize, Municipal Art League of Chicago, 1912; Swedish Exhibition, 1912; second and third prize for frieze of Illinois State Fair Building, 1914; prizes at Swedish American Exhibition, 1917, 19, 24 and 29; honorable mention, Art Institute Chicago, 1922. Work: "The Spring," Art Institute of Chicago; "Bust of Washington Irving," Washington Irving School, Bloomington, IL; memorial tablet in Hyde Park Church of Christ, Chicago; memorial fountain, Oxford, OH; fountain and greenhouse, Forest Lawn Cemetery, Omaha, NE; "Baby Jane," museum, Goteborg, Sweden. Address in 1933, Chicago, IL.

FROMKES, MAURICE.
Painter. Born Feb. 19, 1872. Pupil of NAD under Ward and Low. Member: ANA, 1927; Salma. C.; MacD. C.; Allied AA; AFA. Award: Isidor portrait prize, Salma. C., 1908; Diploma of Honor, International Expo. of Fine Arts, Bordeaux, France, 1927. Work: Painting at Delgado Museum, New Orleans; "Portrait," Newcomb Col., New Orleans; "Madonna of the Road," National Mus. of Modern Arts, Madrid; "Jacinta and her Family," Albright Gallery, Buffalo; "A Spanish Mother," RI School of Design; "Little Carmen of the Hills," Duncan Phillips Mem. Gallery, Washington, DC; "Adoration of Pepito," Randolph-Macon Women's College, Lynchburg, VA. Died in 1931 in Paris. Address in 1929, 51 W 10th St.; 108 W 57th St., New York, NY.

FROMUTH, CHARLES H(ENRY).
Marine painter. Born Philadelphia, PA, Feb. 23, 1861. Pupil of PAFA under Thomas Eakins. Member: Fellowship Pennsylvania Academy of Fine Arts; Assoc. Soc. Nat. des Beaux-Arts, Paris; London Pastel Soc.; Soc. Des Peintres de Marine, Paris; Berlin Secession Soc. of Painters (cor.). Awards: Second class gold medal, International Exp., Munich, 1897; silver medal, Paris Exp., 1900; gold medal, St. Louis Exp., 1904. Represented in Museums of Wellington and Christ Church, New Zealand; Museum of Quimper, France. Died in 1937. Address in 1929, Concarneau, Finistere, France.

FROST, ANNA.
Painter, lithographer and teacher. Born Brooklyn. Pupil of C. W. Hawthorne, George Senseney, H. B. Snell, Hugh Breckenridge, Bolton Brown. Member: Brooklyn WCS; NA Women PS; North Shore AA; PBC. Address in 1929, 152 Henry St., Brooklyn, NY.

FROST, ARTHUR BURDETT.
Illustrator. Born in Philadelphia, Jan. 17, 1851, he began illustrating early. Studied at PAFA (part-time) and in London, but primarily self-taught. In 1877 he went to England and returned in 1878. Hon. mention, Paris Expo., 1909. Illustrated *Uncle Remus*, *Tom Sawyer* and *Mr. Dooley*. Wrote and illustrated own books. Died June 22, 1928, in Pasadena, CA.

FROST, JOHN.
Painter and illustrator. Born Philadelphia, May 14, 1890. Pupil of A.B. Frost. Member: Calif. AC ; Calif. PS ; Pasadena SA. Awards: Hon. mention, Southwest Museum, 1921; landscape prize, Southwest Museum, Los Angeles, 1922; 2nd prize and popular prize, Southwest Museum, 1923; gold medal, Calif. PS , 1924. Address in 1929, 284 Madeline Drive, Pasadena, CA.

FROST, JULIUS H.
Painter, sculptor, and teacher. Born in Newark, NJ, July 11, 1867. Self-taught. Member: Soc. of Independent Artists; Art League of Washington; Salons of America; American Federation of Arts. Address in 1933, Washington, DC. Died in 1934.

FROTHINGHAM, JAMES.
Portrait painter. Born in Charleston, Mass., 1786. Coach painter; later he received some instruction from Gilbert Stuart and finally became his pupil. Frothingham painted portraits in Boston, Salem, NY and Brooklyn. Elected Member of National Academy of Design in 1831. His copies of Stuart's "Washington" are excellent, and his original portraits have fine coloring at times, resembling his master's work in color and composition. A number of his portraits were owned by the City of New York and hung in the Old Court House. Died Jan. 6, 1864, in New York City.

FROTHINGHAM, SARAH C.
Miniature painter. Born in 1821. Daughter of James Frothingham, NA. She exhibited at the National Academy, 1838-42. Died July 20, 1861, in New York City.

FRUDAKIS, EVANGELOS WILLIAM.
Sculptor and instructor. Born in Rains, UT, May 13, 1921. Studied at Greenwich Workshop, NY, with Merli and Albino Cavalitto, 1935-39; Beaux Arts Institute of Design, NY, 1940-41; Penna. Academy of Fine Arts, with W. Hancock, P. Manship, E. J. Ferris, J. F. Harbeson, D. M. Robb, and W. M.

Campbell; assistant to sculptors P. Manship and J. Davidson. Work in Penna. Academy of Fine Arts; National Academy of Fine Arts, NY; over-life size female figure in fountain, Philadelphia Civic Center; others. Has exhibited at Penna. Academy of Fine Arts Annual, 1941-62; National Academy of Design Annual, 1948-63; Philadelphia Museum of Art; Philadelphia Art Alliance; others. Received awards from National Sculpture Society; Cresson traveling scholarship; Henry Scheidt Memorial scholarship; Louis Comfort Tiffany scholarship; Amer. Academy of Rome, Italy, Prix de Rome fellowship; others. Member of Penna. Academy of Fine Arts; American Acad. of Rome; Nat. Sculpture Soc.; Academician, National Academy of Design; Allied Artists of America. Teaching at National Academy of Fine Arts, NY, from 1970, instructor; Penna. Academy of Fine Arts, Philadelphia, from 1972, senior instructor. Address in 1982, Frudakis Gallery, Philadelphia, PA.

FRUDAKIS, ZENOS.
Sculptor and painter. Born in San Francisco, CA, July 7, 1951. Studied at Penna. Academy of Fine Arts, Philadelphia, 1973-76; University of Penna., Phila., B.F.A., 1981. Works, Boy and Elephant (life size fountain sculpture), Burlington Mall, NJ; and others. Has exhibited at National Sculpture Society; National Academy of Design; Allied Artists of America; Salmagundi Club, NY. Received Certificate of Merit, National Academy of Design; award, National Sculpture Society; others. Member of Allied Artists of America; fellowship, Penna. Academy of Fine Arts; Penna. Art Alliance; others. Works in bronze; oil. Address in 1982, Philadelphia, PA.

FRUEH, (ALFRED J.).
Painter and illustrator. Born Lima, OH, 1880. Member: Society of Independent Artists. Best known for cartoon caricatures. Contributed to *New Yorker*. Lived most of life in NYC. Died in 1968.

FRY, GEORGIA TIMKEN.
Painter. Wife of the painter John H. Fry. She was born in St. Louis in 1864, and was a pupil of Harry Thompson, Aime Morot, Schenck and Cazin in Paris. She was a member of the National Association of Women Painters and Sculptors; Society of New York Artists; Society of Women Artists. She is represented by "Return of the Flock," at the Boston Art Club. She made a specialty of landscapes with sheep. She died in China in 1921.

FRY, JOHN H.
Painter. Born in IN. Pupil of Boulanger and Lefebvre in Paris. Member: Union Lg. C.; Paris AA; A. Fund S; Salma. C., 1902; SPNY; Wash. AC; AFA. Died Feb. 24, 1946. Address in 1929, 200 West 57th St., New York, NY.

FRY, M(ARY) H(AMILTON).
Illustrator and cartoonist. Born Salem, MA, April 18, 1890. Pupil of Boston Museum School. Member: Boston SAC; Copley S. Address in 1929, 106 Winthrop St., Cambridge, MA.

FRY, SHERRY EDMUNDSON.
Sculptor. Born Creston, IA, September 29, 1879. Pupil of Art Inst. of Chicago under Taft; Verlet and MacMonnies in Paris; Academie Julien and Ecole des Beaux-Arts, Paris. Member: Associate, National Acad., 1914; National Sculpture Society, 1908; NY Architectural League, 1911; National Academician, 1930. Exhibited at National Sculpture Society, 1923. Awards: Honorable mention, Paris Salon, 1906; medal, Salon, 1908; American Academy at Rome scholarship, 1908-11; silver medal, P.-P. Exp., San Francisco, 1915; Watrous gold medal, Nat. Academy of Design, 1917; honorable mention, Art Institute of Chicago, 1921; Wm. M. R. French gold medal, Art Institute of Chicago, 1922. Work: Statue, "Indian Chief," Oskaloosa, IA; "Au Soleil," fountain, Toledo Museum of Art; "The Dolphin," fountain, Mt. Kisco, NY; "The Turtle," fountain, Worcester, MA; fountain for St. George, Staten Island, NY; Capt. Abbey, Tompkinsville, CT; pediment, H. C. Frick house, NYC; pediment, Clark Mausoleum, Los Angeles; statue of Ira Allen, University of Vermont; "Modesty," Metropolitan Museum of Art, NYC. Address in 1933, Century Club, 7 West 43rd St., NYC; Roxbury, CT. Died in 1966.

FUCHS, BERNARD.
Illustrator. Born in O'Fallon, IL, in 1932. Studied at the School of Fine Art at Washington Univ. His career started in Detroit, where he produced illustrations for automobile advertisements. This success brought him recognition and assignments from such magazines as *Redbook*, *Lithopinion*, and *Sports Illustrated*. Elegance and craftsmanship are constants of the innovative style that have earned him many awards and prompted the AG to name him Artist of the Year in 1962. A Hamilton King Award winner, he is the youngest member of the S of I Hall of Fame. As a faculty member of the Illustrators Workshop, he is passing on the knowledge that has made him a cont. influence in Amer. illustration.

FUCHS, EMIL.
Sculptor, painter, and etcher. Born in Vienna, Austria, in 1866. He studied under Victor Tilguer and later at the Royal Academy in Vienna and Berlin, winning a travelling scholarship in 1890 which enabled him to study in Italy where he remained until 1899. From 1897 he made his residence in London, later moved to NY, where his paintings and sculpture were frequently shown. Awards: Gold medal, Munich Exp., 1896, for Mother Love, executed in Rome. Member: Nat. Sculpture Society; NY Architectural League. Work: Monument

to Prince Christian Victor, St. George's Chapel, Windsor, England; monuments to Queen Victoria at Balmoral and Sandringham, England; The Sisters, memorial in marble, Walker Art Gallery, Liverpool, England; bronze statue, La Pensierosa, Metropolitan Museum of Art, NY; marble busts, Lady Alice Montague, Ignace Paderewski, Sir Arthur Pinero; marble bas-relief, Sancta Cecilia, in a private collection, NY; bronze busts, Gari Melchers, Sir Johnston Forbes-Robertson, Sir David Murray; bas-relief, Mother and Child; Ashley Memorial, Ramsey Cathedral, England. Exhibited at Nat. Sculpture Society, 1923. Address in 1926, 80 West 40th Street, NYC. Died in NYC in 1929.

FUECHSEL, HERMAN.
Painter. Born in Brunswick, Germany, Aug. 1833, he came to America in 1858, and was a member of the Artists' Fund Society of New York. He died Sept. 30, 1915, in New York City.

FUERST, SHIRLEY M.
Mixed media. Born in Brooklyn, NY, June 3, 1928. Studied: Hunter College; Brooklyn Museum Art School; Pratt Ctr. for Contemporary Printmaking; Art Students League, New York City. Awards: Village Art Center, 1963; Enjay Art Competition, 1966; National Association of Women Artists, 1970. Exhibitions: "Unmanly Art," Suffolk Museum, 1972; Brooklyn Museum; Riverside Museum. She was a founding member of Floating Gallery, a women's artist group. Publ.: Author, *Health Hazards In Art*, 1975. Address in 1980, 266 Marlborough Road, Brooklyn, NY.

FUERTES, LOUIS AGASSIZ.
Painter. Born at Ithaca, NY, 1874. Painter of birds since 1896. Illustrated: *Birding on a Broncho*, 1896; *Citizen Bird*, 1897; *Songbirds* and *Water Fowl*, 1897; *Birdcraft Birds of the Rockies*, 1902; *Handbook of Birds of Western United States*; *Coues' Key to North American Birds*, 1903; *Handbook of Birds of Eastern United States*; plates for "Report of NY State Game, Forest and Fish Commission;" *Birds of New York*; several series in *National Geographic* magazines. Permanent work: Habitat groups, American Museum Natural History, New York; 25 decorative panels for F. F. Brewster, New Haven, CT; birds of New York at State Museum, Albany. Died in Unadilla, NY, Aug., 1927. Address in 1926, Cornell Heights, Ithaca, NY.

FUHR, ERNEST.
Illustrator. Born 1874 in New York. Member: SI; GFLA. Died 1933 in Westport, CT. Address in 1929, Westport, CT.

FULDA, E(LISABETH) RUNGIUS.
Sculptor, painter, and etcher. Born in Berlin, Germany, Aug. 16, 1879. Studied with Carl Rungius,

August Gaul, and Richard Friese. Work: "Spring," mural painting, Public School No. 41, NYC; "Shoe Bill Stork" and "Mother Giraffe and Baby," paintings, Bronx Zoological Park, NYC; "Dinosaur Babies," group, American Museum of Nat. History, NYC; illustrations, *Tales of Nature's Wonderland*, by W. T. Hornaday. Member: National Association of Women Painters and Sculptors. Address in 1933, 157 East 116th Street, NYC.

FULLER, GEORGE.
Born at Deerfield, MA, Jan. 17, 1822. Studied in Boston, New York, London and continental Europe. First known as a portrait painter. Elected Associate of the National Academy of Design, 1857. Original member of Society of American Artists. Since his death the exhibition of his later works has placed him in the front rank of American colorists and painters of original inspiration. He painted "Fedalma" (the Spanish gypsy), "Nydia" (the blind girl in Bulwer's *Last Days of Pompeii*); also represented at Corcoran Gallery, Washington, by "Lorette." Died March 21, 1884, in Brookline, MA.

FULLER, HENRY B(ROWN).
Painter. Born Deerfield, MA, Oct. 3, 1867; son of George Fuller. Pupil of Cowles Art School in Boston under Bunker; Cox and Mowbray at ASL of NY; Collin in Paris. Member: SAA, 1902; ANA, 1906. Awards: Bronze medal, Pan-Am. Exp., Buffalo, 1901; Carnegie prize, NAD, 1908; silver medal, P.-P. Exp., San F., 1915. Work: "Illusions," National Gallery, Washington. Died in 1934. Address in 1929, 113 Berkeley Street, Cambridge, MA; summer, Deerfield, MA.

FULLER, LUCIA FAIRCHILD.
Miniature painter. Born in Boston, 1872. Pupil of Art Students League of NY under William M. Chase and H. Siddons Mowbray. Engaged professionally as painter from 1889, chiefly doing miniatures. Bronze medal, Paris Expn., 1900; silver medal, Buffalo Expn., 1901. Member: American Soc. of Miniature Painters; Penna. Society of Miniature Painters; New York Water Color Club; etc. Died in Madison, WI, May 22, 1924.

FULLER, MARY.
(Mary Fuller McChesney). Sculptor. Born in Wichita, KS, October 20, 1922. Studied: University of California in Berkeley; California Faience Company of Berkeley. Work in San Francisco Gen. Hospital; Children's Sculpture Garden, Community Center, Salinas, CA; others. Exhibitions: Syracuse Museum, NY; San Francisco Museum of Art; San Francisco Women's Center; Bolles and Gump's Galleries, San Francisco; others. Awarded first prize for Ceramic Sculpture, Pacific Coast Ceramic Association, 1947 and 1949; Merit Award, San Francisco Art Festival, 1971; National Endowment for the Arts art critic

grant, 1975. Medium: Concrete. Also noted for her writing of short stories, novels, and articles on art. Address in 1982, Petaluma, CA.

FULLER, META V. WARRICK (MRS.).
See Warrick, Meta Vaux.

FULLER, R(ALPH) B(RIGGS).
Painter and illustrator. Born Capac, MI, Mar. 9, 1890. Member: Salma. C. Humorous drawings in *Life, Judge, Liberty, Saturday Evening Post, American Magazine*, etc. Address in 1929, 170 Ames Ave., Leonia, NJ; summer, West Boothbay Har., ME.

FULLER, RICHARD HENRY.
Painter. Born at Bradford, NH, in 1822. He was chiefly self-taught. He is represented in the Boston Mus. of Fine Arts by his painting "Near Chelsea," painted in 1847. Died in 1871 at Chelsea, MA.

FULLER, SUE.
Sculptor and printmaker. Born in Pittsburgh, PA, in 1914. Studied: Carnegie Institute; Columbia University; with Hans Hofmann, S. W. Hayter, Josef Albers, T. Tokuno. Awards: Association of Artists, Pittsburgh, 1941, 42; Northwest Printmakers, 1946; Philadelphia Printmakers Club, 1944, 46, 49; Tiffany Foundation Fellowship, 1947; National Institute of Arts and Letters, 1950; NY State Fair, 1950; Guggenheim Fellowship, 1948. Collections: NY Public Library; Library of Congress; Harvard U. Library; Carnegie Inst.; Whitney Museum of Am. Art; Ford Foundation; Art Inst. of Chicago; Museum of Mod. Art; Brooklyn Museum; Met. Museum of Art; Nat. Academy of Design; Baltimore Museum of Art; Phila. Museum of Art; Seattle Art Museum; Guggenheim; others. Exhibited at Met. Museum of Art; Museum of Modern Art; Penna. Academy of Fine Arts; Butler; Corcoran; in Paris, Brazil, Germany, and more. Media: Plastic and string. Address in 1982, Southampton, NY.

FULLER-LARGENT, LYDIA.
Painter, craftsman, lecturer, teacher. Born in CA. Pupil of CA School of Fine Arts; Rudolph Schaeffer, Ralph Johonnot. Member: PAA; Calif. Women A. Address in 1929, Moulder Bldg., Page and Gough Sts.; h. 1450 Taylor St., San Francisco, CA.

FULTON, A(GNES) FRASER.
Sculptor, painter and designer. Born Yonkers, NY, March 10, 1898. Pupil of Dow, Martin, Bement, Upjohn. Member: Yonkers Art Association. Award: Honorable mention, *House Beautiful* cover contest. Address in 1929, Teachers' College, Columbia University, New York, NY; h. Yonkers, NY.

FULTON, C(YRUS) J(AMES).
Painter. Born Pueblo, CO, June 26, 1873. Pupil of H. F. Wentz and A. H. Schroff. Work: "Sky-Line Trail," Eugene Chamber of Commerce. Died in 1949. Address in 1929, 1192 Jefferson St., Eugene, OR.

FULTON, DOROTHY.
Sculptor, painter, and teacher. Born in Uniontown, PA, October 23, 1896. Studied at Penna. Academy of Fine Arts; Phila. Museum School of Industrial Art; Univ. of Southern Calif.; Univ. of Penna.; Univ. of Kansas; also pupil of Laessle, McCarter, Breckenridge, Garber, and Hale. Award: Fellowship Penna. Academy of Fine Arts. Exhibited: Lancaster, PA, Art Association, 1937-41; Kansas City Art Institute, 1933; Pennsylvania Academy of Fine Arts, 1935, 36-38, 40, 45; Newman Gallery, Philadelphia, 1936 (one-man); and others. Address in 1953, Lindon Hall, Lititz, PA; h. Bokeelia, Lee Co., FL.

FULTON, ROBERT.
Artist, inventor, successful introducer of the steamboat. Born in Little Britain township, Lancaster County, PA, Nov. 14, 1765. Came to Philadelphia in 1872 as a portrait painter; within 4 years he earned enough to establish his widowed mother on a small farm clear of debt. He then went to London to study under Benjamin West, after establishing himself in Devonshire under the patronage of men of wealth. In 1794 he became a member of the family of Joel Barlow, author of *The Columbiad*, in Paris, where he painted the first panorama exhibited in the French capital. In 1797 he began experiments in submarine navigation and torpedo warfare. As early as 1803 he had, with the financial assistance of Chancellor Livingston, launched a steamboat on the Seine, which sank, though a partial success later achieved encouraged him to build the famous "Clermont," which, in 1807, set out on her historic voyage to Albany. Died in NY Feb. 24, 1815.

FUNK, WILHELM HEINRICH.
Painter. Born Hannover, Germany, 1866. Studied at Art Students League of New York, and in museums of Spain, Holland, France, Italy and Germany. Came to America in 1885; first attracted attention by a pen-portrait of Edwin Booth, the actor. He became the pen and ink artist on the staff of the *New York Herald*; also contributed to *Scribner's Magazine, Century, Harper's, Judge and Truth*; he devoted his attention to portrait painting. Address in 1926, 80 West 40th St., New York.

FURLONG, CHARLES (WELLINGTON).
Painter, illustrator, writer and lecturer. Born Cambridge, MA, Dec. 13, 1874. Pupil of Ecole des Beaux Arts, Bouguereau, Jean Paul Laurens. Member: Boston Art School Alumni Assoc.; Salma. C.; Boston AC. Award: Prix de concours, Academie Julian, Paris. Illustrations for Bailey's *Encyclopedia of Horticulture; Harper's; Scribners; The Gateway to the Sahara*. Address in 1929, 333 Beacon St., Boston, MA; summer, Pendleton, OR.

FURLONG, THOMAS.
Painter, craftsman, illustrator, writer, lecturer and teacher. Born in St. Louis, MO. Pupil of ASL of NY; John Vanderpoel, Max Weber. Member: ASL of NY. Work: Altar piece, Tryptich, St. Vincent de Paul's Church, Brooklyn, NY; two altar pieces, St. Bridgid's Church, Queens, New York City. Lectures at New York University on "Free Hand Drawing and Applied Art." Author of "Form: Its Analysis and Synthesis" and "Design and Its Structural Basis." Address in 1929, 3 Washington Sq., North, New York, NY; summer, Golden Heart Farm, Bolton Landing on Lake George, NY.

FURNASS, JOHN MASON.
Painter and engraver. Born on March 4, 1763, in Boston, MA. He was the nephew of the engraver Nathaniel Hurd, who bequeathed him his engraving tools. Furnass engraved book-plates and certif. for the MA Loan Soc. In 1785 he was painting portraits in Boston, and in 1834 the Boston Athen. exhibited two copies by him of paintings by Teniers. He painted two portraits of John Venal, the old schoolmaster of Boston. Died at Dedham, MA, June 22, 1804.

FURNESS, WILLIAM HENRY, JR.
Painter. Born in Phila., 1827. Son of Rev. William H. Furness. He drew many exc. portraits in crayon, and painted a number of portraits of well-known Philadelphians in oils. His work in crayon stood next to Cheney. He painted Charles Sumner, Lucretia Mott, Rev. Dr. Barnes, Hamilton Wilde, Mrs. Lathrop and Miss Emerson. Died in 1867.

FURSMAN, FREDERICK.
Painter. Born El Paso, IL, Feb. 15, 1874. Pupil of AIC; Julien Academy, Jean Paul Laurens and Raphael Collin, in Paris. Member: Cliff Dwellers; Chicago SA; Chicago Gal. A. Awards: Cahn prize ($100), AIC, 1911; Frank prize ($150), 1923; Chicago SA, silver medal, AIC, 1924. Work: "In the Garden," Museum of Art, Toledo, OH. Director, Summer School of Painting, Saugatuck, MI. Address in 1929, Saugatuck, MI.

FURST, FLORENCE WILKINS.
(Mrs. F. E. Furst). Painter. Born Delavan, WI. Pupil of Lucy Hartrath, Marquis Reitzell, Madame Armand Oberteuffer. Member: Rockford AA; Ill. AFA; All-Ill. SFA; AFA. Works: "Still Life," State permanent collection, Centennial Building, Springfield, Ill. Address in 1929, 819 West Stephenson St., Freeport, Ill.

FURST, MORITZ.
Engraver. Born at Bosing, Hungary, 1782; he was living in New York in 1834. Engraver of dies for coins and medals. In 1807 Mr. Joseph Clay, United States Consul at Leghorn, asked Furst to come to the United States, as die-sinker in the U.S. Mint at Philadelphia; in this capacity he engraved the dies for a large number of Congressional medals awarded to heroes of the War of 1812. Also engaged in business, as he advertised in 1808 as "Engraver of Seals and Dye-Sinker on Steel and other metals," in Philadelphia. In business in Philadelphia as late as September, 1820.

G., L.
The initials of this unknown engraver appear upon a reversed copy of a caricature originally etched by William Charles of Philadelphia. Also signed as "L. G. Sculpt." on a map of Sacketts Harbour, by Patrick May, published and sold by Patrick May in Bristol, CT. This map is copyrighted in 1815, indicating the date of the work.

GAADT, GEORGE S.
Illustrator. Born in Erie, Penn., in 1941. Studied: Columbus College of Art and Design. Since his first illustration, a silk-screen, appeared in 1961, he has received over 60 awards in many cities in the U.S. In addition to corporate advertising work and editorial illustration for many major magazines, he has also done children's books for Macmillan. His work has been shown in galleries in Columbus, Ohio; Pittsburgh, Pennsylvania; and at the S of I.

GABAY, ESPERANZA.
Painter. Born New York City. Pupil of Kenyon Cox, Walter Shirlaw. Member: NA Women PS. Award: Emerson McMillan Prize, NA Women PS, 1917; hon. mention, NAC, 1925. Address in 1929, 136 West 91st St., New York, NY; summer, Sheffield, MA.

GABO, NAUM.
Sculptor. Born August 5, 1890, in Briansk, Russia. Came to US in 1946. Studied: University of Munich, medical faculty, 1910, natural science, 1911; Polytechnic Engineering School, Munich, 1912. Work: Albright; Hartford (Wadsworth); Museum of Modern Art; US Rubber Co.; Whitney Museum; Yale University. Exhibited: Galerie Percier, Paris, 1924; Little Review Gallery, NYC, 1926; Arts Club of Chicago, 1934, 1952; Lefebvre Gallery, London, 1936; Musee du Jeu de Paume, 1937; Julien Levy Galleries, NYC, 1938; Hartford (Wadsworth), 1938, 53; Museum of the City of London, 1942; Baltimore Museum of Art, 1950; MIT, 1952; Pierre Matisse Gallery, NYC, 1953; Amsterdam (Stedelijk), circ., 1965-66; Museum of Modern Art; Whitney Museum; Art Institute of Chicago; Paris (Moderne). Awards: Tate, International Unknown Political Prisoner Competition, Second Prize, 1953; Guggenheim Foundation Fellowship, 1954; Art Inst. of Chicago, Logan Medal, 1954; Royal Col. of Art, London, Hon. DFA, 1967. Member: Am. Academy of Arts and Letters, 1965. Taught at Harvard Univ., 1953-54; designed sets for Ballet Russe, 1926 ("La Chatte"); executed comm. for Bijenkorf Building in Rotterdam and US Rubber Co. Bldg., NYC. Rep. by Marlborough-Gerson Gallery, NYC. Died in 1977.

GABRIEL, GABRIELLE.
Painter and craftswoman. Born Germantown, PA, Dec. 24, 1904. Pupil of Daniel Garber, Hugh Breckenridge. Member: Fellowship PAFA; Plastic C. Address in 1929, 4523 Sansom St., Philadelphia, PA; summer, Stone Harbor, NJ.

GACH, GEORGE.
Sculptor and painter. Born in Budapest, Hungary, January 27, 1909; US citizen. Studied at Hungarian Academy of Fine Art. Has exhibited at Audubon Artists; Allied Artists; National Sculpture Society; Hammer Galleries, NY; others. Received gold medals, Hudson Valley Art Association, NY; National Sculpture Society, NYC; others. Member of Allied Artists of America; National Sculpture Society; National Art League; Hudson Valley Art Association; others. Works in bronze, wood; oil, plastic. Address in 1982, Roslyn Heights, NY.

GADBURY, HARRY L(EE).
Painter, illustrator and etcher. Born Greenfield, OH, June 5, 1890. Pupil of Buchler, Meekin, Wessel, Duveneck. Member: Dayton SE. Address in 1929, 11 Westminster Apts., Dayton, OH.

GADE, JOHN.
Painter. Born Tremont, NY, Oct. 24, 1870. Self-taught. Member: S. Indp. A.; Salons of America; Chicago NJSA; Buffalo Salon IA. Address in 1929, 108 Stewart St., Floral Park, LI, NY.

GAENSSLEIN, OTTO ROBERT.
Sculptor and painter. Born in Chicago, IL, June 6, 1876. Pupil of A. Chatain, Carl Marr, and J. P. Laurens. Honorable mention, Paris Salon, 1906. Member: Paris American Art Association; Chicago Society of Artists. Address in 1910, Paris, France.

GAER, FAY.
Sculptor and craftswoman. Born London, England, April 7, 1899. Pupil of Ralph Stackpole, Leo Lentelli. Member: Art Students League of NY. Represented in Mills College Art Gallery, Mills College, CA; Temple Emanuel, San Francisco. Address in 1933, Berkeley, CA.

GAERTNER, CARL F.
Painter, illustrator, etcher and teacher. Born Cleveland, OH, April 18, 1898. Pupil of Cleveland School of Art; F. N. Wilcox and H. G. Keller. Member: Cleveland SA. Awards: Second prize, 1922, first prize, 1923, and first prize, 1924, Cleveland Museum of Art. Exhibited at Annual Exhib. of

PAFA, 1924. Works: "The Ripsaw," Cleveland Museum of Art; "The Furnace," Midday Club of Cleveland; and mural--War Memorial in Kenyon College. Died Nov. 1952. Address in 1929, 401 Prospect-Fourth Bldg., Cleveland, OH; h. 3325 Greenway Rd., Shaker Village, OH.

GAERTNER, LILLIAN V.
Painter, illustrator, etcher and craftswoman. Born New York City, July 5, 1906. Pupil of Joseph Hoffmann, Ferdinand Schmutzer. Member: Mural P; Arch. Lg. of NY; AFA. Work: Murals in Montmartre Club, Palm Beach, Fla.; Ziegfeld Theatre, New York; original sketch Ziegfeld Theatre, Vienna Museum; Metropolitan Opera Costume Designs, Vienna Museum, Chicago, IL. Address in 1929, 312 West 101st St., New York, NY.

GAETANO, NICHOLAS.
Illustrator. Born in Colorado Springs, Colorado, he attended ACD. *Art Direction* magazine published his cover in 1965 and since 1970 his editorial work has appeared in many magazines including *New Times, Travel and Leisure, Contempo,* and *Newsday.* With advertising and book illustration to his credit, he has received numerous awards from the AIGA, ADC, and S of I. He has produced posters for the Open Gallery in Los Angeles which has exhibited his work.

GAG, WANDA HAZEL.
Artist and author. Born in New Ulm, Minn., on March 11, 1893. Entered the Art Students League, where she studied under John Sloan and other noted teachers. A show of her drawings, lithographs, and woodcuts at the Weyhe Gallery in NYC in 1926 brought her first recognition as a serious artist. Represented in the Museum of Modern Art's 1939 exhibition of "Art in Our Time." She wrote and illustrated *Millions of Cats,* 1928. Other books for children included *The Funny Thing,* 1929, *Snippy and Snappy,* 1931, *A.B.C. Bunny,* 1933, *Gone Is Gone,* 1935, and *Nothing at All,* 1941. She also translated and illustrated *Tales from Grimm,* 1936, *Snow White and the Seven Dwarfs,* 1938, *Three Gay Tales of Grimm,* 1943, and *More Tales from Grimm,* 1947. *Growing Pains: Diaries and Drawings for the Years 1908-1917,* 1940, was a memoir based on her journals. Died in NYC on June 27, 1946.

GAGE, G(EORGE) W(ILLIAM).
Painter and illustrator. Born Lawrence, MA, Nov. 14, 1887. Pupil of Hale, Benson and Pyle. Member: GFLA. Designed covers for leading magazines, and illust. numerous books. Instructor of book illust., NY Evening School of Indust. Art. Died Aug. 7, 1957, in NYC. Address in 1929, 61 Poplar St., Brooklyn, NY.

GAGE, HARRY L.
Painter, draughtsman and teacher. Born Battle Creek, MI, Nov. 1887. Pupil of AIC. Member: AFA;

AI Graphic A. Secretary, Bartlett Orr Press, New York; Asst. Typographic Director, Mergenthaler Linotype Co., Brooklyn; Pres., Wm. H. Denny Co., New York. Address in 1929, 49 Brunswick Rd., Montclair, NJ.

GAGE, MERRELL.
Sculptor, lecturer, and teacher. Born Topeka, KS, December 26, 1892. Pupil of Art Students League of NY; Beaux Arts and Henri School of Art. Member: California Art Club; Calif. Painters and Sculptors. Award: Gold medal, Kansas City Art Institute, 1921; gold medal and Way Side Colony prize, Pacific Southwest Exp., 1928; honorable mention, Los Angeles Museum, 1929; prize, Los Angeles Museum of Art, 1933. Works: Lincoln Memorial and Billard Memorial, owned by the State of Kansas; Police Memorial and American Legion Mem. Fountains, Kansas City; Bar Association Memorial, Jackson Co., MO; Santa Monica World Flight Mem.; Childrens Fountain, La Jolla Public Library; figures of "Agriculture" and "Industry," Calif. State Bldg., Los Angeles; "John Brown" and "The Flutist," Mulvane Museum, Topeka, KS. Exhibited: Golden Gate Exposition, 1939; Los Angeles Museum of Art, 1945 (oneman). Position: Instructor of Sculpture, University of Southern CA, from 1945. Address in 1953, Santa Monica, CA. Died in 1981.

GAGE, ROBERT MERRELL.
Sculptor. His bronze statue of Lincoln stands in the State House Grounds, Topeka. Address in 1926, Topeka, KS.

GAGLIARDI, TOMMASO.
Sculptor. Born in Rome; employed in the studio of Thomas Crawford. Moved to US in 1855. Employed as a sculptor at the US Capitol in Washington, 1855-58; executed bust of Crawford. In Italy c. 1860-70. After 1870 he traveled to Japan; founded a school of sculpture in the Royal Academy at Tokyo. Later went to India and there executed numerous portrait busts. Died in Italy in 1895.

GAINS.
Nothing is known of this painter except that the portrait of Rev. James Honyman, executed by Samuel Oakey of Newport in 1774, records the portrait as painted by "Gains," probably a local artist. Honyman was pastor of Trinity Church, Newport, RI, from 1704 to 1750. The painting hangs in the vestry of Old Trinity Church, Newport, RI.

GAIR, SONDRA BATTIST.
Painter. Studied: School of Education, NY Univ., NYC; Univ. of Texas, Austin, TX; Univ. of Maryland, College Park, Maryland; The American Univ., Wash., DC. Awards: Wash. Watercolor Society, 1971-1972; Carnegie Institute Exhibit, PA, 1962; National Watercolor Society, 1969.

GALE, CHARLES F.
Painter. Born in Columbus, OH, in 1874; died in 1920.

GALE, GEORGE (ALBERT).
Painter, illustrator and etcher. Born Bristol, RI, Nov. 16, 1893. Pupil of RI School of Design. Member: Providence WCC; RI School Design Alumni; Newport AA; RI Shipmodel S. Represented in RI School of Design Museum. Illustrated for *Scribner's* and *Yachting*. Address in 1929, 25 Pearse Ave., Bristol, RI.

GALE, WALTER RASIN.
Painter, illustrator, lecturer and teacher. Born Worton Manor, Kent County, MD, Jan. 17, 1878. Pupil of Maryland Inst.; Charcoal C. School of Art; various art courses at Johns Hopkins Univ., Univ. of Chicago and New York Univ. Member: Arch. Inst. of A.; Eastern AA; College AA of Amer.; Baltimore WCC. Instructor, Art Dept., Baltimore City College. Died in 1959. Address in 1929, Baltimore City College; h. 233 West Lanvale St., Baltimore, MD.

GALEN, ELAINE.
Sculptor and painter. Born in NYC, July 12, 1928. Studied at Philadelphia Museum School of Art, dipl., 1950; University of Penna., B.A., 1951; Art Students League, 1955-59; NY University, M.A., 1963; major study with Morris Kantor. Works: Philadelphia Museum of Art; Museum Rigaud, France; Rey Collection, Perpignan, France; Atelier 45. Commissions: Images from the Wind (portfolio, also co-auth.), NY, 1962 and Mythic Encounters (litho suite), Chicago, 1974, Ed DuGrenier. Exhibitions: Whitney Museum of American Art Annual, NY, 1961; Brooklyn Museum International, 1963; NJ State Arts Council, 1970; one-woman show, Penna. Academy of Fine Arts, Peale House, 1972; State Museum of Illinois, 1974; numerous one-woman shows and others. Awards: Chautauqua Institute First Prize for Painting, 1963; National Print Award, Hunterdon Center, NJ, 1970; American Iron and Steel Institute. Award for Design Excellence, 1972; plus others. Media: Stainless steel; oil and pencil-ink. Address in 1982, c/o Zriny Hayes Gallery, Chicago, IL.

GALLAGHER.
An Irishman who painted portraits in Philadelphia about 1800; he also painted signs and other pictures. In 1807 he was employed in New York as a scene painter by Thomas A. Cooper, but he was not a success. In 1798 he painted a standard for the First Philadelphia Volunteer Cavalry, commanded by Capt. McKean.

GALLAGHER, GENEVIEVE.
Painter and teacher. Born Baltimore, MD, Jan. 19, 1899. Pupil of Henry Roben, Hugh Breckenridge, Leon Kroll and John Sloan. Award: Baltimore Municipal Art Society Prize, 1921. Address in 1929, 4212 Pennhurst Ave., Baltimore, MD.

GALLAGHER, SEARS.
Painter and etcher. Born in Boston, April 30, 1869. Pupil of Tomasso Juglaris in Boston; Laurens and Constant in Paris. Member: Boston GA; Boston SWCP; Chicago SE; Cal. SE; Boston SE; Concord AA; Brooklyn SE; AFA. Award: Logan prize for etching, AIC, 1922; silver medal for etching, Tenth International Exhibition Print MS, California, 1929. Etchings in Boston Museum of Fine Arts; Art Institute of Chicago; New York Public Library; Brooklyn Museum; Library of Congress. Died in 1955. Address in 1929, 755 Boylston St, Boston, MA; h. West Roxbury,

GALLAND, JOHN.
Engraver. Born April 30, 1809. The name of John Galland, "engraver," appears in the Philadelphia directories for 1796-1817, inclusive. He engraved in the stipple manner with little effect. Probably his most ambitious work is a large portrait of Washington done after a similar plate by David Edwin. A number of portraits and historical plates executed by Galland are to be found in a history of France published by James Stewart, Philadelphia, 1796-97. Died Oct. 11, 1847.

GALLAUDET, EDWARD.
Born in Hartford, CT, 1809; died there, 1847. He was the son of Peter Wallace Gallaudet, merchant. Edward Gallaudet was probably apprenticed to one of the several engraving establishments in Hartford; he then worked in Boston with John Cheney. Gallaudet was a reputable line engraver, his best work appearing in the Annuals of 1835-40. A miniature portrait of Edward Gallaudet was owned by his nephew, Mr. E. M. Gallaudet, principal of the Gallaudet College for the Deaf and Dumb, at Washington, DC.

GALLAUDET, ELISHA.
Born in New Rochelle, NY, about 1730. Elisha Gallaudet was the second son of Dr. Peter Gallaudet. Gallaudet was in business in New York as an engraver, as he advertised in the *New York Mercury* of March 5, 1759. In this issue appear proposals for printing by subscription, "Six Representations of Warriors who are in the Service of their Majesties, the King of Great Britain and the King of Prussia. Designed after life with a Description as expressed in the Proposals." Besides early bookplates his only known engraving was a portrait of the Rev. George Whitfield, issued as a frontispiece to a "Life of Whitfield," published by Hodge & Shober, New York, 1774. This plate was poorly engraved, and evidently a copy of an English print. Died in 1805 in New York City.

GALLI, STANLEY W.
Illustrator. Born in San Fran., CA, in 1912. Did a number of odd jobs in Nevada and Calif. before enrolling in the Calif. School of Fine Arts, and later studied at the ACD. He worked briefly in a San Fran. studio and later as a free-lance illustrator. He has had assignments for magazines inc. *Country Gentleman, Sports Afield, McCall's,* and *True.* Among his clients are Random House and United Airlines, for which he illustrated a series of posters in the 1960's. His works are in the collections of the USAF and the Baseball Hall of Fame.

GALLISON, HENRY HAMMOND.
Landscape painter. Born in Boston on May 20, 1850. Studied in Paris, pupil of Bonnefoy. Represented in Boston Museum of Fine Arts by "The Golden Haze" and "The Morning Shadow." He died in Cambridge, MA, on Oct. 12, 1910.

GALLO, FRANK.
Sculptor. Born in 1933 in Toledo, OH. Earned B.F.A. from Toledo Museum School, 1954; M.F.A. from University of Iowa, 1959. Teaching at University of Illinois since 1960. Received awards from Des Moines Art Center; Contemporary Arts Center, Cincinnati, OH; Guggenheim fellowship, 1966. Exhibited at Toledo Museum of Art, 1955; Gillman Galleries of NYC and Chicago; Penna. Academy of Fine Arts; Whitney; Art Institute of Chicago; Louisiana State University; Puch Gallery, NYC; Time, Inc. In collections of Museum of Modern Art; Colorado State University; Baltimore Museum of Art; Princeton; and many private collections. Address in 1982, Dept. of Art, University of Illinois, Urbana, IL.

GALLUP, JEANIE.
See Mottet, Jeanie Gallup.

GALT, ALEXANDER.
Sculptor. Born June 26, 1827, in Norfolk, VA. He studied abroad. Among his works are many portrait busts; bust of Jefferson Davis was executed from actual measurements. Died January 19, 1863, in Richmond, VA.

GALT, CHARLES FRANKLIN.
Painter. Born St. Louis, 1884. Pupil of St. Louis School of Fine Arts and of Richard Miller. Address in 1926, 4021 Washington Ave., St. Louis, MO.

GAMBERLING, GRACE THORP.
Painter. Exhibited at the Pennsylvania Academy of Fine Arts, Philadelphia, in 1924. Address in 1926, Cynwyd, PA.

GAMBLE, JOHN MARSHALL.
Sculptor and painter. Born in Morristown, NJ, Nov. 25, 1863. Studied at San Francisco School of Design; Academie Julien, Laurens and Constant in Paris. Member: San Francisco Art Association; Santa Barbara Community Art Association; American Federation of Arts; Foundation of Western Art. Awards: Medal, Alaska-Yukon-Pacific Exp., 1909. Work: Auckland (N.Z.) Museum of Art; Park Museum, San Francisco. Address in 1953, Santa Barbara, CA.

GAMBLE, ROY C.
Painter. Born June 12, 1887. Pupil of Detroit Fine Arts Academy; ASL of NY; Julian in Paris. Member: Scarab C. Awards: Second Hopkin prize for painting, Scarab C., Detroit, 1914; gold medal, 1920, Scarab C.; Herbert Munio prize, Artists Exh., MI, 1926; Founders prize, Detroit Art Inst., 1928. Work in Penna. Academy of the Fine Arts; "Freckles," Detroit Art Institute. Address in 1929, 5726 14th St.; 83 Fort St., West, Detroit, MI.

GAMMELL, R(OBERT) H(ALE) IVES.
Painter. Born Providence, RI, Jan. 7, 1893. Pupil of William M. Paxton. Member: AFA; Providence AC; Boston GA. Work: Decorations, hemicycle of Toledo Museum of Art; Women's Club, Fall River, MA; Public Library, Newark, NJ. Address in 1929, 22 St. Rotolph St., Boston, MA; h. 170 Hope St., Providence, RI; summer, Provincetown, MA.

GANDOLA, PAUL MARIO.
Sculptor, architect, and craftsman. Born Besano, Italy, August 15, 1889. Pupil of Milan Academy of Fine Art. Member: Cleveland Society of Artists; Cleveland Sculptors Society. Address in 1933, 12208-10 Euclid Avenue; care of The Cleveland Society of Artists, Cleveland, OH.

GANDOLFI, MAURO.
Engraver. Born in Bologna, Italy, in 1764; died there in 1834. This master engraver in line, and a pupil of the famous Giuseppe Longhi, was probably the first of the really prominent European engravers to visit the United States professionally, although he never engraved here. Dunlap tells us that he came to the United States under a contract to engrave, for $4,000, Col. Trumbull's large plate of the "Declaration of Independence."

GANIERE, GEORGE ETIENNE.
Sculptor and teacher. Born Chicago, IL, April 26, 1865. Pupil of Art Institute of Chicago. Member: Chicago Society of Artists; Alumni Art Institute of Chicago. Exhibited at National Sculpture Society, 1923. Award: Shaffer prize, Art Institute of Chicago, 1909. Work: "Baby Head" in John Vanderpoel Memorial Collection; "Lincoln" at Lincoln Memorial School, Webster City, IA, and at Burlington, Wis.; "Lincoln Fountain," Lincoln Highway, Chicago, IL; "Gen. Anthony Wayne," equestrian statue, Fort Wayne, IN; "Lincoln" and "Douglas," Chicago

Historical Society; "Lincoln," IL Historical Society; "Lincoln," Grand Army Memorial Hall, Chicago; "Hately Memorial," Highland Park, IL; "Lincoln Memorial," Starved Rock, State Park, IL; "Dr. Frank W. Gunsaulus Memorial," Chicago; "Head of Lincoln," "Meditation," Milwaukee Art Institute; "The Debator," Omaha Society of Fine Arts; "Head of Lincoln," Morgan Park, IL; "Tecumseh," "Little Turtle," Chicago Historical Society; "The Toilers," "Awakening Soul" and ideal figure, "Innocence," Fine Arts Gallery, De Land, FL. Former instructor and head, Sculpture Dept., Chicago Art Institute. Director and instructor, Department of Sculpture, Stetson University, De Land, FL. Died in 1935. Address in 1933, De Land, FL.

GANNAM, JOHN.
Illustrator. Born in Lebanon, in 1897. Spent his early years in Chicago and at age 14 he became the family breadwinner. One of his many odd jobs was in an engraving studio where he began his artistic training and in 1926 he moved to Detroit where for four years he worked in an art studio. Coming to NY in 1930, he quickly found assignments at *Woman's Home Companion* and later *Good Housekeeping, Ladies' Home Journal* and *Cosmopolitan*. His advertising illustrations were in high demand and although he used all media, his most prolific work was done in watercolor. A member of the AWS, NAD, and S of I, he worked most of his life from his studio on West 67th Street. He is a member of the Illustrators Hall of Fame. Died in 1965.

GANO, KATHARINE V.
Painter. Born in Cincinnati in 1884. Pupil of Duveneck. Address in 1926, Southern Railway Bldg., Cincinnati, OH.

GARBER, DANIEL.
Painter and teacher. Born N. Manchester, IN, April 11, 1880. Pupil of Cincinnati Art Academy under Nowottny; PAFA under Anshutz. Member: ANA, 1910; NA, 1913; NAC; Salma. C., since 1909. Awards: Cresson scholarship, PAFA, 1903; first Hallgarten prize, NAD, 1909; hon. mention, ACP, 1910; hon. mention, CI Pittsburgh, 1910; fourth Clark prize, Corcoran Gal., 1910; Lippincott prize, PAFA, 1911; Palmer prize ($1,000), AIC, 1911; second W. A. Clark prize ($1,500) and silver Corcoran medal, 1912; gold medal P.-P. Exp., San F., 1915; Altman prize ($500), NAD, 1915; Shaw prize, Salma. C., 1916; NAD, 1915; Shaw prize, Salma. C., 1916; Morris prize, Newport AA, 1916; Altman prize ($1,000), NAD, 1917; Stotesbury prize, PAFA, 1918; Temple gold medal, PAFA, 1919; 1st W.A. Clark prize and gold medal, Corcoran Gallery, 1921; Locust medal, PAFA, 1923; third prize ($500), Carnegie Inst., 1924; first Altman prize ($1,000), NAD, 1927; gold medal of honor, PAFA, 1929. Work: "April Landscape," and "South Room--Green Street,"

Corcoran Gallery, Wash.; "Winter—Richmont," Cincinnati Museum; "The Hills of Byram" and "Towering Trees," Art Institute, Chicago, IL; "September Fields," City Art Museum, St. Louis; "Midsummer Landscape," University of Missouri; "March," Carnegie Institute, Pittsburgh; "Down the River, Winter," Mus. of Art and Science, Los Angeles; represented in Ann Mary Brown Memorial, Providence; National Arts Club, New York; St. Paul Institute of Art; Pennsylvania Academy of the Fine Arts; Detroit Institute; Wilstach collection, Memorial Hall, Philadelphia; Phillips Gallery, Washington; Locust Club, Philadelphia; Albright Gallery, Buffalo; Swarthmore College, Swarthmore, PA; National Gallery, Washington, DC; Art Association, Topeka, Kansas; Metropolitan Museum of Art, New York. Died in 1958. Address in 1929, Lumberville, Bucks Co., PA.

GARBER, VIRGINIA WRIGHT.
Painter, lecturer and teacher. Pupil of Chase; Constant in Paris. Member: Fellowship PAFA; Plastic C.; PA Sch. Ind. A. Alumni A. Address in 1929, Bryn Mawr, PA.

GARCIA, J. TORRES.
Painter. Exhibited at the Penna. Academy of Fine Arts, 1921, at "Exhibition of Paintings Showing the Later Tendencies in Art." Address in 1926, 4 West 29th St., New York.

GARDEN, FRANCIS.
Engraver. *The Boston Evening Post*, 1745, contains the following advertisement: "Francis Garden, engraver from London, engraves in the newest Manner and at the cheapest Rates, Coats-of-Arms, Crests or Cyphers on Gold, Silver, Pewter or Copper. To be heard of at Mr. Caverly's Distiller, at the South End of Boston." "N.B. He will wait on any Person, in Town or Country, to do their work at their own House, if desired; also copperplate printing performed by him." No work of any kind signed by Garden was known to Fielding in 1926.

GARDIN, ALICE TILTON.
Painter. Born in 1859. Member: NA Women PS. Address in 1929, care J. E. Fraser, 328 East 42nd St.; 3 MacDougal Alley, New York, NY.

GARDIN, LAURA.
See Fraser, Laura Gardin.

GARDINER, ELIZA D(RAPER).
Painter, engraver and teacher. Born Providence, RI, Oct. 29, 1871. Pupil of RI School of Design. Member: Providence AC; Providence WCC; California PM. Represented in Detroit Institute; Springfield Public Library; Providence AC; Philadelphia Print Club; Bibliotheque Nationale, Paris. Address in 1929, 2139 Broad St., Providence, RI.

GARDINER, FREDERICK M(ERRICK).
Painter, etcher and writer. Born Sioux Falls, SD, June 27, 1887. Pupil of Edourd Leon in Paris; Phillip L. Hale. Member: Phila. PC. Address in 1929, Valley St., Beverly Farms, MA; h. Contoocook, NH; summer, Schooner "Evanthia II," care of Theodore Chadwick, 19 Congress St., Boston, MA.

GARDNER, CHARLES REED.
Painter, illustrator and etcher. Born Phila., Aug. 17, 1901. Pupil of Thornton Oakley, Herbert Pullinger. Member: Phila. Print C. Work: Cover and end paper for *Peder Victorious* (Harper Bros.); cover in Baltimore Museum of Art; covers for *Ecstasy of Thomas DeQuincy* (Doubleday Doran); *The Lost Child* (Longman, Green and Co.); *The Garden of Vision* (Cosmopolitan). Address in 1929, 522 Walnut Street; h. 2029 North Carlisle Street, Philadelphia, Pennsylvania; summer, 137 South Spruce St., Lititz, PA.

GARDNER, DONALD.
Illustrator. Member: GFLA; SI. Address in 1929, 12 Park Ave., North, Bronxville, NY.

GARDNER, FRED.
Painter and architect. Born Syracuse, NY, April 16, 1880. Pupil of Pratt Institute, Brooklyn; ASL of NY. Member: S. Indp. A. Address in 1929, 110 Columbia Heights, Brooklyn, NY; summer, Spring Valley, NY.

GARDNER, GERTRUDE G(AZELLE).
Painter and teacher. Born Fort Dodge, IA. Pupil of Henry B. Snell; Pratt Inst.; Fontainebleau Sch. FA, France. Member: NA Women PS; AFA. Address in 1929, 195 Union St., Flushing, LI, NY; summer, Boothbay Harbor, ME.

GARESCHE, MARIE R.
Painter, writer and lecturer. Born St. Louis, MO, July 29, 1864. Pupil of Jules Machard and Henry Mosler. Member: St. Luke AS, (founder). Author of *Art of the Ages*. Address in 1929, 4930 Maryland Ave.; h. 3622 West Pine Blvd., St. Louis, MO; summer, "Ravinedge," Douglas, MI.

GARIBALDI, MRS. PIETRO A. (LUCINDA).
Sculptor. Born in Maine, c. 1822. Statuary maker, with her husband, in Boston, 1850.

GARIBALDI, PIETRO A.
Sculptor. Born in Italy, in 1818. Statuary maker in Boston in 1850-51. Assisted in his work by his wife. Later established the firm of Garibaldi & Cordano.

GARLICK, THEODATUS.
Sculptor, wax portraitist. Born in Vermont, 1805. Died in Bedford, Ohio, 1884. Worked: Cleveland, Ohio; Youngstown, Ohio.

GARNER, CHARLES S., JR.
Painter. Born 1890. Exhibited at Annual Exhibition of the Penna. Academy of Fine Arts, Phila., 1924. Died 1933, New Hope, PA. Address 1926, 320 Harmony St., Philadelphia.

GARNER, FRANCES C.
Painter. Exhibited at the Water Color Exhibition of the Penna. Academy of Fine Arts, Phila., 1925. Address in 1926, 320 Harmony St., Philadelphia.

GARNSEY, ELMER E(LLSWORTH).
Painter. Born Holmdel, Monmouth Co., NJ, Jan. 24, 1862. Pupil of Cooper Union, ASL, George Maynard and Francis Lathrop in New York. Member: Mural P; AIA (hon.), 1899; Century Assoc.; A. Aid S.; AFA. Awards: Bronze designer's medal, Columbian Exp., Chic., 1893; hon. mention and silver medal for mural decorations, Paris Exp., 1900. Work: General color schemes--Library of Congress, Wash.; Public Library, Boston; Public Library, St. Louis; Library of Columbia Univ., New York; Memorial Hall, Yale University, New Haven; State Capitol, St. Paul, MN; State Capitol, Des Moines, IA; State Capitol, Madison, WI; U.S. Customs House, New York; Richardson Memorial Library, City Art Museum, St. Louis. Specialty, mural and landscape painting. Died in 1946. Address in 1929, care of Fifth Avenue Bank, 530 Fifth Ave., New York, NY.

GARNSEY, JULIAN E(LLSWORTH).
Mural painter. Born New York City, Sept. 25, 1887. Pupil of ASL of NY; Jean Paul Laurens in Paris. Member: Calif. AC; Calif. WCS; Los Angeles Arch. C.; Arch. Lg. of NY; Los Angeles PS. Award: Honor award in fine arts, Southern Calif. Chapter, Amer. Inst. of Architects, 1927. Work: Decoration of Library and Auditorium, University of Calif., Los Angeles; decorations in Los Angeles Public Library; Hawaiian Electric Co., Honolulu; Union Depot, Ogden, UT; Bridges Art Museum, San Diego, CA; Del Monte Hotel, Del Monte, CA. Address in 1929, 3305 Wilshire Blvd.; h. 657 North Mariposa Ave., Los Angeles, CA; summer, Hermosa Beach, CA.

GARRETSON, ALBERT M.
Painter and illustrator. Born Buffalo, NY, Oct. 12, 1877. Pupil of Laurens in Paris. Award: Inness bookplate prize, Salma. C., 1912. Address in 1929, Publicity Division, Metropolitan Life Insurance Co., 1 Madison Ave., New York; h. Beechurst, LI, NY.

GARRETSON, DELLA.
Painter. Born Logan, OH, April 12, 1860. Pupil of Detroit Art Museum; NAD; ASL of NY. Address in 1929, Dexter, MI; summer, Ogunquit, ME.

GARRETT, ANNA.
Illustrator. Member: Plastic Club; Wilmington SFA; Fellowship PAFA. Address in 1929, Lansdowne, PA; 1609 Broome St., Wilmington, DE.

GARRETT, ANNE SHAPLEIGH.
Painter. Exhibited at the Pennsylvania Academy of Fine Arts, Philadelphia, in 1924. Address in 1926, 1609 Broome Street, Wilmington, DE.

GARRETT, CLARA PFEIFER.
(Mrs. Edmund A. Garrett). Sculptor. Born Pittsburgh, PA, July 26, 1882. Pupil of St. Louis School of Fine Arts; Ecole des Beaux-Arts; Mercie and Bourdelle in Paris. Awards: Bronze medal, Louisiana Purchase Exp., St. Louis, 1904; honorable mention, National Sculpture Society, 1905; sculpture prize, Artists' Guild of St. Louis, 1915; St. Louis Art League Prize, 1916. Work: "Boy Teasing Turtle," Metropolitan Museum, New York City; "McKinley," City of St. Louis; "Children at Play," 50-ft. frieze, Eugene Field School, St. Louis. Address in 1933, Beverly Hills, CA.

GARRETT, EDMUND HENRY.
Painter, illustrator and etcher. Born in Albany, NY, 1853. Studied at Academie Julien, Paris; pupil of Jean Paul Laurens, Boulanger and Lefebvre, Paris. Medal at Boston, 1890. Exhibitor at Paris Salon and principal exhibitions in America. Died 1929 in Nedham, MA. Address in 1926, 142 Berkeley St., Boston, MA.

GARRETT, JOHN W. B.
Portraits, signed "J. W. B. Garrett," have been found in the southern states; one so signed is dated 1852.

GARRETT, THERESA A.
Etcher. Born June 8, 1884. Member: Chicago SE; GFLA. Address in 1929, 410 South Michigan Ave., Chicago, IL.

GARRIS, PHILIP.
Illustrator. Born in Maryland in 1951. He received no formal art training. In 1976, the S of I awarded him a Gold Medal for his Grateful Dead album cover. He also illustrated concert posters for Bill Graham and the 1976 album cover for Kingfish. He is presently living in Sausalito, California.

GARRISON, EVE.
Painter. Born in Boston, MA. Studied: Art Institute of Chicago. Award: Gold Medal, Corcoran Gallery of Art, 1933. Collections: Univ. of Illinois; United States Treasury Department, Wash., DC.

GARRISON, JOHN L(OUIS).
Painter and illustrator. Born Cincinnati, OH, June 14, 1867. Pupil of Nowottny and Goltz. Member: Columbus PPC. Address in 1929, 179 Clinton Place Ave., Columbus, OH.

GARRISON, ROBERT.
Sculptor. Born Fort Dodge, IA, May 30, 1895. Pupil of Pennsylvania Academy of the Fine Arts; Gutzon

Borglum. Work: 2 Bronze Mountain Lions for State Office Building, Denver, Colorado; 2 seal fountains, Voorhees Memorial; Daly Memorial; Fairmount Cemetery; Athena, Morey High School; Overseas Memorial Tablet, Post Office, Denver; Mosher Memorial, Rochester, NY; sculpture on Riverside Baptist Church, NYC; terra cotta decorations on South Side High School, National Jewish Infirmary, and Midland Building, Denver, CO; sculpture on Boston Ave. M.E. Church, Tulsa, OK; three panels, RKO Building, Rockefeller Center, NYC. Address in 1933, Chappell House, Denver, CO; 125 West 55th St., New York, NY. Died in 1945.

GARSTIN, ELIZABETH WILLIAMS.
Sculptor. Born New Haven, Jan. 12, 1897. Studied: Eberhard; Yale Art School. Member: New Haven Paint and Clay Club; Am. Fed. of Arts. Address in 1933, New Haven, CT; summer, Salisbury, CT.

GARVEY, JOSEPH M.
Painter. Born in New York, 1877. Pupil of William M. Chase. Member of Society of Independent Artists. Address in 1926, Alpine, NJ.

GARY, LOUISA M(ACGILL).
Painter. Born Baltimore, Dec. 19, 1888. Member: Baltimore WCC. Address in 1929, "Upsandowns," Catonsville, MD.

GASPARD, LEON.
Painter. Born Vitebsk, Russia, 1882. Studied at Academie Julien, Paris, France. Came to U.S. in 1916. Exhibited in Belgium; Salon d'Artistes Francaise; Salon d'Autumn, Paris; also in New York, Philadelphia, Chicago, New Orleans, etc. Awarded gold medal, National Academy, Russia. Honorable mention, Salon Francaise. Clubs: Russian (Moscow), Salmagundi, New York. Died in 1964. Address in 1926, 108 West 57th St., New York.

GASPARRO, FRANK.
Sculptor and instructor. Born in Philadelphia, PA, August 26, 1909. Studied at Penna. Academy of Fine Arts, and with Charles Grafly. Member: Society of Medalists; Fellow, Penna. Academy of Fine Arts. Awards: Cresson traveling scholarship, Penna. Academy of Fine Arts, 1930, 31. Work: Philadelphia Museum of Art; Harrisburg Museum of Art; Allentown Art Museum. Exhibited: Philadelphia Museum of Art, 1940; Penna. Academy of Fine Arts, 1946; medals at French Mint, Paris, France, 1950; Spanish International Medallic Art Exhibition, Madrid, 1952. Instructor of Sculpture, Fleisher Art Memorial, Philadelphia, PA; Sculptor-Engraver, US Mint, Philadelphia, PA, from 1942. Awards: Order of Merit, Italian Republic, 1973; Percy Owens Award, Outstanding Artist, PA, 1979; Citation for Superior Performance of the US Treasury, 1977. Address in 1983, Havertown, PA.

GASSER, HENRY MARTIN.
Painter. Born in Newark, NJ, Oct. 31, 1909. Study: Newark Sch. of Fine & Indust. Art; ASL, with Robert Brackman, John R. Grabach. Work: Met. Mus. of Art, NYC; Phila. Mus. of Art; Newark (NJ) Mus.; Dept. of War, Wash. DC; Nat'l Gal., Smithsonian, Wash. DC. Exhib.: NAD, 1971 & 75; Am. WC Soc., 1971 & 75; others. Awards: Hallgarten Prize, NAD, 1943; Phila. Watercolor Club, 1945; American Watercolor Society, 1969; Allied Artists Gold Medal; plus various awards from Audubon Artists, Conn. Academy, Salmagundi Club. Teaching: Newark School of Fine & Industrial Art, Dir., 1946-54; ASL, 1964-70. Member: NAD; Am. WC Soc.; Phila. WC Club; Audubon Artists; AAA. Medium: Watercolor. Address in 1982, So. Orange, NJ.

GAST, MICHAEL CARL.
Painter. Born in Chicago, IL, June 11, 1930. Study: School of Art Institute, Chicago, BFA, 1952; Univ. of the Americas, Mex., MFA, 1960. Exhibits: Wash. WC Assn. 66th Ann. Nat. Exhib., Smithsonian Inst., 1963; Metrop. Area Exhib., Howard Univ., Wash., DC, 1970; Soc. Wash. Artists Ann. Exhibs., Smithsonian Inst., 1963 & 64; Mickelson Gallery, Wash., DC., 1966; Foundry Gallery, Wash., DC, 1980; etc. Positions: Museum technician, Nat'l. Mus. Hist. & Technology, 1961-1964; museum specialist, Nat'l. Coll. Fine Arts, Smithsonian, 1969-71. Mem.: Artists Equity Assn.; College Art Assn. Media: Polymer, oil. Address in 1982, 5730 First St., S., Arlington, VA.

GATEWOOD, MAUD FLORANCE.
Painter. Born on Jan. 8, 1934. Studied: Univ. of North Carolina, Greensboro, AB; Ohio State Univ., MA; Univ. Vienna; Fulbright grant, 1962-63; Acad. Appl. Arts, Vienna; Harvard Summer School. Awards: National Academy of Arts and Letters, 1972; National Endowment for the Arts, 1981. Collections: Mint Museum, Charlotte, NC; Coca Cola Company, Atlanta, GA. Exhibited: NC Artists Annual, NC Museum of Art, 1961-76; Piedmont Painting & Sculpture Annual, Charlotte, 1965-71; Amer. Academy of Arts and Letters, Nat. Inst. of Arts and Letters, 1972. Medium: Acrylic. Address in 1984, Yanceyville, NC.

GATHMAN, THOMAS.
Painter. Born in Chicago, IL, in 1946. Studied at Chic. Acad. of Fine Art, BFA; painting with Gustav Likan, Chicago, 1967-68; Mayfair College, Loop College, YMCA, Roosevelt Univ., Northeastern Univ., all in Chicago. Work owned by numerous galleries in Illinois, Indiana, Iowa, Ohio, including Raffles, Inc., in Chicago, Atlanta and London. Exhibited at Chicago Academy of Fine Art, 1966; Univ. of Illinois Medical Center, 1969, Linda Graves Gal., 1974, Mary Bell Galleries, 1981, 82, 83, all in Chicago; Krasl Art Center, St. Joseph, MI, 1983; Muskegon (MI) Mus. of Art, 1983. Awarded First Prize, painting, Chicago Academy, 1967, 68; scholorship, Chicago Academy, 1967, 68; Beckman Mem. scholarship, Brooklyn Mus., NY, 1969. Represented by Mary Bell Galleries, Chicago. Address in 1983, Elmwood Park, IL.

GATTER, OTTO JULES.
Painter and illustrator. Born in Philadelphia, 1892. Pupil of Penna. Academy of Fine Arts. Illustrated for *Scribner's*, *Cosmopolitan* and *McClure's*. Died July 5, 1926. Address in 1926, 1530 Wallace St., Philadelphia.

GAUGENGIGL, I(GNAZ) M(ARCEL).
Painter and etcher. Born Passau, Bavaria, July 29, 1855; came to United States in 1880. Pupil of Academy of Munich. Member: SAA, 1895; ANA, 1906; Copley S. (hon.); Boston GA; NYEC. Awards: Medal, New Orleans Exp.; medal, Mass. Charitable Mechanics' Assoc. Work: "An Amateur," RI School of Design, Providence; "Une Question Difficile," Metropolitan Museum of Art; "Scercando," Boston Museum of Art. Died Aug. 3, 1932, in Boston. Address in 1929, 5 Otis Place, Boston, MA.

GAUK, JAMES.
The New York directories for 1795-1804 contain this name as "Engraver."

GAUL, ARRAH LEE.
(Mrs. A. L. G. Brennan). Painter. Member: Plastic C.; AWCS; NA Women PS. Address in 1929, Spruce and Sixteenth Sts.; Ludlow Bldg., 34 South 16th St., Philadelphia, PA.

GAUL, GILBERT.
Painter. Born in Jersey City, NJ, in 1855. Pupil of J. G. Brown, of the National Academy. His extensive study of the soldier's career supplemented his academic training, insight, and feeling for dramatic composition. "Charging the Battery" and "Wounded to the Rear" are among the best of his episodic compositions, and these have equally interesting, if less animated companion pieces in a host of subjects which depict the excitement and the picturesque features of army scenes on the plains of the far West. For "Charging the Battery" he was awarded a medal at Paris Exposition, 1889. In 1882 was elected National Academician. Died in 1919 in New York.

GAULEY, ROBERT D(AVID).
Painter and teacher. Born Carnaveigh County, Monaghan, Ireland, March 12, 1875; came to U.S. in 1884. Pupil of D. W. Ross in Cambridge; Benson and Tarbell in Boston; Bouguereau and Ferrier in Paris. Member: ANA, 1908; NYWCC; AWCS. Awards: Bronze medal, Paris Exp., 1900; hon. mention, Pan-Am. Exp., Buffalo, 1901; "Hors Concours," Charleston, SC, Exp., 1902; bronze medal, St. Louis Exp., 1904; Isidor prize, Salma. C., 1907; Clarke

prize, NAD, 1908; third prize, Appalachian Exp., Knoxville, TN, 1910; Isidor portrait prize, Salma. C., 1912; silver medal, P.-P. Exp., San F., 1915. Work: "The Fur Muff," National Gallery, Wash., DC; "Hon. Nathaniel Macon," Capitol, Wash., DC; "Peter Toft Mem. Portrait," Kolding, Denmark; "A Holland Lady," Pub. Lib., Watertown, NY; "Copy of a Fresco Found at Medurn, now in the Mus. at Gizeh, Egypt," "Mediterranean Coast," "Naples," "Amalfi," "Azores," "Coast of Sardinia," "Coast of Crete," "Fountain, Rome," "Mount Vesuvius from the Bay of Naples," Museum of Fine Arts, Boston; Harvard University, Dept. of Fine Arts, Cambridge. Died in 1943. Address in 1929, 26 Oakland St., Watertown, MA.

GAUSTA, HERBJORN.
Painter. Born in Norway, 1854. Pupil of Royal Academy of Munich. Member: Minneapolis Art League. Address in 1926, 1706 Elliott Ave., Minneapolis, MN.

GAVALAS, ALEXANDER BEARY.
Painter. Born in Limerick, Ireland, Jan. 6, 1945. Family moved to US in 1947. Grew up in Washington Heights, NYC. Study: School of Arts and Design, diploma, 1963; Manhattanville College, 1969-71. Largely self-taught in art. Studied paintings of Old Masters; influenced by Hudson River locations and the Cloisters, NYC. Exhibitions: Landscape paintings and drawings, Queens College Art Center, City U. of NY, 1983; exhibit first traveled to Fort Wayne Mus. of Art; Marycrest College Ebert Art Gallery, Davenport, IA; Arnot Art Mus., Elmira, NY. Has also exhibited at Krasl Art Center, St. Jos., MI; Tweed Mus. of Art, Duluth, MN; Western IL (Macomb) Univ. Style: Landscape, classical realism. Media: Pen & ink, oil. Rep: Eric Galleries, 61 East 57th St., NYC. Address in 1983, Long Island City, NY.

GAVIN, VERNONA E.
Painter. She was born in Eau Claire, WI, March 4, 1891. Pupil of Gerrit V. Sinclair, Emily Groom. Member: Wis. PS. Award: Florence B. Fawsett prize ($100), Milwaukee Art Institute, 1929. Address in 1929, 587 Marshall Street; h. 1544 23rd Street, Milwaukee, WI; summer, 855 Grand Avenue, East, Eau Claire, WI.

GAVIT, JOHN E.
Engraver. Born Oct. 29, 1817, in New York. Gavit learned his business in Albany, NY, where he established an engraving, printing and lithographing business. He later became interested in bank-note work, and in 1855 he assisted in organizing the American Bank Note Co. in New York. After serving as secretary, he was elected president in 1866 and held the office until his death. Died Aug. 25, 1874, in Stockbridge, MA.

GAW, ROBERT M.
Engraver. Born in New Jersey in 1829. Probably in employ of Peter Maverick in Newark, NJ, in 1829. Executed portrait and architectural engravings in line.

GAY, EDWARD.
Painter. Born April 25, 1837, in Dublin, Ireland. He came to America in 1848; began to study art under Lessing and Schirmer at Karlsruhe, Germany. Specialty, landscapes. He received the Metropolitan prize for the picture "Broad Acres," presented to the Metropolitan Museum of Art, New York; later works include "Washed by the Sea," "Atlantis," "The Suburbs," in Tewksberry Collection, New York; "Where Sea and Meadow Meet," Governor's Mansion, Albany, NY. Elected an Associate Member of the National Academy, 1868; National Academy, 1907. Died in 1928. Address in 1926, 434 South 2d Ave., Mt. Vernon, NY.

GAY, GEORGE HOWELL.
Painter. Born Milwaukee, WI, Aug. 2, 1858. Pupil of Paul Brown and Henry A. Elkins in Chicago. Settled in New York in 1889. Specialty, marines and landscapes. Died in 1931. Address in 1929, 100 Kraft Ave., Bronxville, NY.

GAY, INKWORTH ALLAN.
Landscape painter. Born Aug. 18, 1821, in West Hingham, MA. He studied with Robert W. Weir, and later in Paris. Represented by landscapes in the Boston Museum. He was a brother of the artist Walter Gay. Died Feb. 23, 1910, in MA.

GAY, WALTER.
Painter. Born Hingham, MA, Jan. 22, 1856. Pupil of Bonnat in Paris. Member: ANA, 1904; AFA; Societe Nouvelle; Nat. des Beaux-Arts; Societe de la Peinture a l'Eau; Royal Society Water Colors, Brussels; Nat. Inst. A. L. Member: Executive committee, Societe des Amis du Louvre, Paris; National Inst. of Arts and Letters; Committee des Amis du Musee de Luxembourg, Paris; Committee des Amis de Versailles. Awards: Hon. mention, Paris Salon, 1885; third class medal, Paris Salon, 1888; gold medal, Vienna, 1893; gold medals, Antwerp and Munich, 1894; gold medal, Berlin and Budapest, 1895; silver medal, Paris Exp., 1900; silver medal, Pan-Am. Exp., Buffalo, 1901; Chevalier of the Legion of Honor, 1894, officer, 1906, Commander, Legion of Honor, 1927. Work: Seven pictures bought by the French Government; "White and Blue" and "Las Cigarreras," Luxembourg Museum, Paris; "Interior of Palazzo Barbaro," Boston Museum of Fine Arts; "Chez Helleu," Pennsylvania Academy, Phila.; "The Spinners" and portrait of W. H. Huntington, Metropolitan Museum, New York; "Benedicite," Museum at Amiens, France. Work: Buffalo, NY; Providence, RI; Carnegie Institute, Pitts., PA; Pinacotheque,

Munich; "Interior of Petit Trianon," RI School of Design, Providence; "The Green Salon," Metropolitan Museum of Art, New York; "Interior, Chateau du Breau (La Commode)," Art Institute of Chicago; "Interior-Musee Correr, Venice," Metropolitan Museum of Art, New York; "La Console," Palace of the Elysee, Paris; represented in Boston Museum of Fine Arts; Detroit Institute of Arts. Died in 1937. Address in 1929, 11 Rue de l'Universite, Paris, France; summer, Le Breau-par-Dammarie-les-Lys, Seine et Marne, France.

GAYLOR, (SAMUEL) WOOD.
Painter, etcher and lecturer. Born Stamford, CT, Oct. 7, 1883. Pupil of NAD. Member: Penguins; Modern Artists of America; Salons of America; Brooklyn S. Modern A. Address in 1929, 10 Vannest Place, New York, NY.

GEARHART, FRANCES H(AMMEL).
Engraver and etcher. Born in Illinois. Member: Calif. PM; AFA. Prints in Toronto Museum; Rhode Island School of Design; Los Angeles Museum; Chicago Art School; Smithsonian Inst., Washington; Delgado Museum, New Orleans; State Library, Sacramento, CA. Address in 1929, 18 West California St.; h. 595 South Fair Oaks Ave., Pasadena, CA.

GEARHART, MAY.
Etcher and teacher. Born Henderson Co., IL. Pupil of Walter Shirlaw, Rudolph Schaeffer, B. C. Brown, A. W. Dow, AIC, San Francisco School FA. Member: Chicago SE; Calif. PM. Work: "Rim of the World" and "North of 64," Los Angeles Museum; etching in Calif. State Library, Sacramento; etching in Smithsonian Institution, Washington, DC. Supervisor of Art, Los Angeles City Schools. Address in 1929, 595 South Fair Oaks Ave., Pasadena, CA.

GEBER, HANA.
Sculptor and instructor. Born in Praha, Czech., February 14, 1910. US citizen. Studied at Teachers College, Prague; Art Students League; Sculpture Center, NY. Works: Yeshiva University Museum; Jewish Museum, NY; Rose Art Museum, Brandeis University; Museum Ethnography and Folklore, Ramat-Aviv, Israel; Lowe Art Museum, University of Miami. Commission: Wedding altar, Temple Emanuel, Yonkers, NY; memorial, Verona High School, NJ; statue, Riverdale Temple, Bronx; statue, Temple Sinai of LI, NY; silver wallpiece, Free Westchester Synagogue; plus others. Exhibitions: One-woman shows, Montclair Art Museum, Union American Hebrew Congregations, NY, Sculpture Center, NY, American Jewish History Society, Waltham and Boston, MA, and Penna. Academy of Fine Arts, Philadelphia; plus others. Awards: Memorial Foundation of Jewish Culture Fellowship, 1969; Gold Medal, National Association of Women

Artists; First Prize, American Society of Contemporary Artists; plus others. Media: Silver and bronze. Address in 1982, 168 West 225th Street, NYC.

GEBHARDT, C. KEITH.
Sculptor, painter, designer, lecturer, writer, and illustrator. Born in Cheboygan, MI, August 14, 1899. Studied at Univ. of Michigan; Art Inst. of Chicago. Work: Murals, paintings, sculpture, Milwaukee Public Museum. Dir. of Winnipeg School of Art, Canada, 1924-29; Associate Artists, 1932-40, Chief Artists, 1940-53, Milwaukee Public Museum, Milwaukee, WI. Address in 1953, Milwaukee, WI.

GEBHART, PAUL.
Designer. Born Greenville, PA, Jan. 2, 1890. Pupil, Cleveland SA. Member: Cleveland SA. Address in 1929, 1101 Citizens Bldg., Cleveland, Ohio; h. 41 Sagamore Rd., R.F.D. No. 4, Willoughby, OH.

GEDDENS, GEORGE.
Painter. Born in Bedford, England, in 1845. By profession an actor, he practiced painting in his leisure hours. He studied in California and at the National Academy schools in New York. His studio was in New York City. Among his works, "Twilight" was exhibited at the National Academy in 1878, and "Noontide" and "Eventide" at the Brooklyn Art Association.

GEE, YUN.
Sculptor, painter, and teacher. Born in Canton, China, Feb. 22, 1906. Studied with Chu and at California School of Fine Arts. Works: Altar Piece, "The Last Supper," St. Peter's Lutheran Church, NY. Member: Society of Independent Artists. Inventor of the Lunar Tube. Address in 1953, NYC.

GEER, GRACE WOODBRIDGE.
Portrait painter and teacher. Born in Boston, July 25, 1854. Pupil of Mass. Normal Art School, F. H. Tompkins, Triscott, Tarbell, Vonnoh and Lowell Inst. Member: AG; Nat. Lg. Am. Pen. W.; Copley S., 1900. Represented by portrait at International Institute for Girls, Madrid, Spain; Girls' High School, Boston. Died 1938 in Boston. Address in 1929, 12 Pinckney St., Boston, MA.

GEERLINGS, GERALD KENNETH.
Painter. Born 1897. Exhibited water colors at the Exhibition of Water Colors at the Penna. Academy of Fine Arts, Philadelphia, 1925. Address in 1926, 148 Central Ave., Flushing, Long Island, NY.

GEHR, JAMES L.
Sculptor and designer. Born in Green Bay, WI, Dec. 8, 1906. Studied at Layton School of Art; Goodyear Technical Institute; Frank Lloyd Wright Fellow, Taliesin, Spring Green, WI. Member: National

Sculpture Soc.; Wisconsin Painters and Sculptors; Seven Arts Society, Milwaukee, WI. Awards: Prizes, Milwaukee Art Institute, 1938, 40. Work: Animal sculpture groups, Milwaukee, WI, parks; Milwaukee Public Museum. Exhibited: Howard University, 1941; Seven Arts Soc., annually; Wisconsin Painters and Sculptors, annually. Lectures: Animal Sculpture. Address in 1953, Cedarburg, WI.

GEISEL, THEODORE (DR. SEUSS).
Illustrator. Born in Springfield, Mass., in 1904. Studied art at Dartmouth College and Oxford Univ. and traveled extensively in Europe. He wrote several screenplays and won the Academy Award in 1951 for his animated cartoon *Gerald McBoing-Boing*. In 1954 he went to Japan as a foreign correspondent for *Life* and later received an Honorary Doctorate of Humane Letters. He has illustrated over ten picture books and is currently working on elementary school readers. Some of his most famous illustrated books are *If I Ran the Circus, Scrambled Eggs Supper* and *On Beyond Zebra*, published by Random House. A number of his books have been translated into animated television programs.

GEISSBUHLER, ARNOLD.
Sculptor and teacher. Born in Delemont, Switzerland, August 9, 1897. Studied at Julian Academy, Grande Chaumiere, Paris; Zurich, Switzerland. Apprenticed with Otto Munch in Zurich, Switzerland, 1914-19. Member: Sculptors Guild, NY. Work: Art Museum, Berne, Switzerland; Fogg Museum of Art; war memorial, Somloire, France; architectural sculpture, Switzerland, France, USA. Exhibited: New York World's Fair, 1939; Salon des Tuileries, Paris, France; Philadelphia Mus. of Art; Institute of Contemporary Arts, Washington, DC; Whitney Museum of American Art; Metropolitan Museum of Art; one-man shows include Guild Farnsworth Museum of Art; Dennis (MA) Art Center; others in the US and abroad. Awards: Bronze Medal for Figure, Academy Julian, Paris, 1919; Outstanding Award, Art USA, 1958; Cambridge Centennial Award, Cambridge Art Association. Taught drawing and sculpture, NY School of Design, 1929-30; Stuart School of Design, Boston, 1936-42; Wellesley College, Wellesley, MA, from 1937. Medium: Bronze. Address in 1982, Dennis, MA.

GEISSMANN, ROBERT.
Illustrator. Born in New Washington, Ohio, in 1909. Studied art at Ohio State Univ. before serving with the Air Force in World War II as an art director with a film unit. He continued his illustration and design career in NY after the war, but maintained ties with the service as director of the USAF Art Program. An active member of the S of I, he was President from 1953 to 1955. In 1967, he helped found the NY GAG and served as its president for many years. Died in 1976.

GELERT, JOHANNES SOPHUS.
Sculptor. Born in Denmark, 1852; came to the United States in 1887. He was a member of the National Sculpture Society. Represented: Haymarket Monument, Chicago; Gen. Grant in Galena, IL; Art Institute, Chicago; museums in Denmark. Died in New York City, November 4, 1923.

GELLENBECK, ANN P.
Painter. Born Shakopee, Minn. Member: Tacoma Fine Arts Assoc.; S. Indp. A; Chicago NJSA; AFA. Address in 1929, 4415 North 8th St., Tacoma, Wash.

GELLER, TODROS.
Sculptor, etcher, engraver, block printer, writer. Born in Vinnitza, Russia, July 1, 1889. Work: "Yiddish Motivs," seven wood cuts, Buckingham Collection, Art Institute of Chicago; "Yiddish Motivs" and "Palestine," book of wood cuts, Chicago Public Library, Detroit Public Library, Milwaukee Public Library, and Hebrew Union College, Jewish Museum, Cincinnati, OH. Member: Chicago Society of Artists; Chicago No-Jury Society of Artists; Around the Palette. Address in 1933, Chicago, Ill.

GELLERT, EMERY.
Painter. Born Budapest, Hungary, July 24, 1889. Pupil of Papp, Kriesch, Ignace and Geza Udvary. Member: "Feszek," Hungarian AC. Award: Prize, Cleve. Mus., 1925. Work: "The Life of Joseph," The Temple, Cleve., OH; "Heart of Jesus," St. Margaret's Church, Cleve., OH; "Christ's Resurrection" and "Moses Receives the Ten Commandments," Greek-Cathedral Church, Det., Mich. Address 1929, 3920 Euclid Ave., Cleveland, OH.

GELLERT, HUGO.
Painter and illustrator. Born Budapest, Hungary, May 3, 1892. Pupil of NAD. Work: Mural decorations at the Workers Center, Union Square, New York. Address in 1929, Buckhout Rd., White Plains, NY.

GELON, MARIE MARTHA J.
See Cameron, Marie Gelon.

GENDROT, FELIX ALBERT.
Sculptor and painter. Born in Cambridge, MA, April 28, 1866. Studied: Mass. Normal Art School, Boston; Julian Academy in Paris under Laurens and Constant; sculpture with Puech and Verlet. Member: Boston Art Club; American Art Association of Paris; Copley Society; American Federation of Arts. Address in 1933, Roxbury, MA.

GENIN, JOHN.
Born in France, 1830; died in New Orleans, 1895. He had a studio as portrait, historical and genre painter at 150 Canal Street in 1876; he resided and painted in New Orleans for the next twenty years, and at the time of his death had a studio at 233 Royal St.

GENIN, SYLVESTER.
Painter. Born in Ohio, Jan. 22, 1822. With comparatively little training, he had a remarkable talent for composition. His painting of historical art had a spirited style. Died April 4, 1850, in Kingston, Jamaica.

GENTH, LILLIAN.
Painter. Born in Philadelphia. Pupil of Phila. School of Design for Women under Elliott Daingerfield; Whistler in Paris. Member: ANA, 1908; Assoc. Fellowship PAFA; NAC; R. Soc. Arts, London; Inter. Soc. AL; Allied AA. Awards: Mary Smith prize, PAFA, 1904; Shaw mem., NAD, 1908; bronze medal, Buenos Aires Exp., 1910; first Hallgarten prize, NAD, 1911; bronze medal, NAC, 1913. Work: "Depths of the Woods" and "Adagio," Nat. Gallery, Wash.; "Springtime," Metropolitan Mus., NY; "The Lark," Engineers' Club, NY ; "The Bird Song," Carnegie Inst., Pittsburgh; "Pastoral," Brooklyn Inst. of Arts and Sciences; "Venice" and "In Normandy," Phila. Art Club; and in Detroit (MI) Club; Grand Rapids (MI) Art Assoc.; Muncie (IN) Art Assoc.; Rochester (NY) Museum; National Arts Club, NY; Cremer Collection, Dortsmund, Germany; Nashville AA; Dallas AA; Des Moines AA; Newark Mus. Assoc. Died March 28, 1953, in NYC. Address in 1929, 50 Central Park West, NY.

GENTHE, ARNOLD.
Illustrator. Born Berlin, Germany, Jan. 8, 1869. Award: Gold medal, Paris, 1928. Illustrated *Old Chinatown, The Book of the Dance, Impressions of Old New Orleans, Isadora Duncan, The Yellow Jacket* (Geo. C. Hazleton and Benrimo), *Sanctuary* (Percy MacKaye). Died in 1942. Address in 1929, 41 East 49th St.; h. 443 East 58th St., New York, NY.

GENTLE, EDWARD.
Painter, illustrator, craftsman and teacher. Born Chicago, IL, July 20, 1890. Self-taught. Works: Cover designs for *Compton's Pictured Encyclopedia* and *Our Wonder World*. Address in 1929, Garden Studio Ohio, 3 East Ontario St., Chicago, IL; Country Studio, Grand Ave. and Ruby St., Franklin Park, IL.

GEORGE, DAN.
Sculptor. Born in Lake George, NY, July 5, 1943. Studied: State University NY, Albany; Art Students League, 1968-73; Academie v Schonekunsten, Antwerp, 1970-71; Henry Schenckenberg Merit Scholar. Work: Hyde Collection, Glens Falls, NY; Manhattan Laboratory Museum, NYC; Sculpture Space, Utica, NY. Commissions: Stewart-Scott Association, Poughkeepsie, NY; site project, Lake George, NY. Exhibitions: Lowe Art Gallery, Syracuse, NY, 1978; Prospect Mtn. Sculpture Show, Lake George, 1979; Usden Gallery, Bennington College, VT, 1979; Sculpture at Columbia Plaza, Washington, DC, 1980; and others. Awards: Grant, NYS Council on the Arts,

1978; Collaborations in Art, Science & Technology, 1978. Media: Cast metals. Address in 1982, 64 W. 21st St., NYC.

GEORGE, THOMAS.
Painter. Born July 1, 1918, in New York City. Earned B.A. from Dartmouth (1940); studied at Art Students League and at Chaumiere, Paris. Awards: Rockefeller grant to Far East; awards from Brooklyn Mus. and Whitney (1962-63). Exhibited at Carnegie; MOMA; Dartmouth; Whitney; Korman Gallery, NYC; Contemp. Gallery, NYC; PAFA; Corcoran Gallery, Wash., DC. Commissioned by US Olympic and Kennedy Galleries for poster. In collections of Dartmouth; Brooklyn Mus.; Albright Knox Gallery; Whitney; Library of Congress; Wash. (DC) Gallery of Mod. Art; MOMA; Guggenheim; and the Tate.

GEORGE, VESPER LINCOLN.
Painter and teacher. Born Boston, MA, June 4, 1865. Pupil of Constant, Lefebvre and Doucet in Paris. Member: Boston AC; NY Arch. Lg.; Mural P.; North Shore AA. Director, Vesper George School of Art, Boston. Died 1934 in Boston, Mass. Address in 1929, 116 Charles St., Boston; h. West Gloucester, MA.

GEORGI, EDWIN.
Illustrator. Born in 1896. Began his art training in an advertising agency and later free-lanced for many companies, including Hartford Fire Insurance Co., Crane Paper, and Yardley and Co. His editorial work appeared in most major magazines, *The Saturday Evening Post* being a frequent user of his paintings of beautiful women. He worked most of his life from his studio in Norwalk, Conn. Died in 1964.

GERARDIA, HELEN.
Painter. Born in Ekaterinislav, Russia, in 1903. Studied: Brooklyn Museum; Art Students League; and with Hans Hofmann, Charles Seide, Adam Garret and Nahum Tschacbasov. Awards: Boston Society of Independent Artists, 1952, 1956, 1957; Village Art Center, 1952, 1954, 1955; Fellowship Research Studios, Maitland, FL, 1952-1953; Fellowship Yaddo Found., 1955; Woodstock Art Assoc., 1956; Abraham Lincoln High School; National Association of Women Artists, 1958. Collections: Univ. of Illinois; Smith College; Univ. of Maine; Dartmouth College; Colby College; Lincoln High School; Yeshiva College; Butler Art Institute; Research Studios Art Center; Cincinnati Museum Assoc.; Fogg Museum of Art. Address in 1980, 490 West End Ave., 4C, NY, NY.

GERE, NELLIE HUNTINGTON.
Landscape painter, interior decorator and teacher. Born Norwich, CT, 1859. Pupil of AI Chicago; John Vanderpoel; Frederick Freer; Pratt Inst., Brooklyn; Ispwich Summer School under Dow. Member:

Chicago ASL; Arthur Dow A. Associate professor of Fine Art and lecturer on staff of Univ. Extension, Univ. Calif., Southern Branch, Los Angeles. Author of "Outline on Picture Study in the Elementary School." Address in 1929, 529 No. Alexandria Ave., Los Angeles, CA.

GERHARDT, KARL.
Sculptor. Born in Boston, Massachusetts, 1853. Exhibited: Paris Salon. Represented by various statues in Hartford, Connecticut; Brooklyn, New York; Pennsylvania. Died in 1940.

GERITZ, FRANZ.
Painter, etcher, craftsman, writer, lecturer and teacher. Born in Hungary, April 16, 1895. Pupil of Nahl; Van Sloun; Martinez. Member: Alumni Calif. School AC; Calif. PM; Oakland AA. Instructor of block cutting and printing, Univ. of Calif. Extension Division. Died in 1945. Address in 1929, 701-B North Belmont Ave., Los Angeles, CA; summer, R.F.D., Box 114, Berkeley, CA.

GERLACH, GUSTAVE.
Sculptor. Pupil of Karl Bitter, and sculptor of the colossal personification of "Minnesota." Active in 1900.

GERMAN, JOHN D.
Miniature painter. Flourished in New York in 1837.

GERNHARDT, HENRY F.
Painter and etcher. Born Des Moines, IA, June 30, 1872. Pupil of Charles Noel Flagg. Member: Conn. AFA. Address in 1929, Framingham, MA.

GERRER, ROBERT GREGORY.
Painter and teacher. Born Alsace, France, July 23, 1867. Pupil of Ortiz, Nobile, Gonnella, and Galliazzi. Member: AFA. Work: "Portrait of Pope Pius X," in the Vatican, Rome; portrait of Dr. J. B. Murphy, Wightman Memorial Gallery, Notre Dame, IN. Address in 1929, St. Benedict and Kickapoo Sts., Shawnee, OK.

GERRY, SAMUEL LANCASTER.
Portrait painter in oils and miniatures. Born May 10, 1813, in Boston. He was President of the Boston Art Club in 1858. Works: "The Old Man of the Mountain," "The Artist's Dream," and "Bridal Tour of Priscilla and John Alden." Also painted landscapes. He died in 1891 at Roxbury, MA.

GERSHOY, EUGENIE.
Sculptor and painter. Born in Krivoi Rog, Russia, January 1, 1901. Became a US citizen. Studied at Art Students League, with Calder; California School of Fine Arts; and in Europe with Sloan, Miller, and Robinson, 1921-22. Works: Art Institute of Chicago; Metropolitan Museum of Art; Whitney Museum of

American Art; Biggs Memorial Hospital; Astoria Public Library, NY. Awards: St. Gaudens medal; Red Cross National Competition, 1941; Metropolitan Museum of Art, 1943; Rotunda Gallery, San Fran., 1950; Fellowship, Yaddo Foun., 1951. Exhibited: Whitney Museum of American Art Annual and Biennial Exhibits, NY, from 1931; 15 Young American Sculptors and 20th Century Portraits, Museum of Modern Art, 1942; San Fran. Museum, CA, 1948-65; Women Artists of America, Newark Museum, NJ, 1964; Invitationals, Phila. Museum of Art, PA, 1940, 42; Artists for Victory, Metropolitan Museum of Art, NY, 1942; one-woman shows were held at the Brooklyn Museum, Baltimore Museum, Dallas Museum, Wichita Museum, Delgado Museum, and others. Also taught painting and drawing at New Orleans Art School, 1940-41; at the San Francisco Unified School, 1946-65; and ceramic sculpture at the California School of Fine Art, San Francisco, 1956-57. Commissions: Polychromed papier mache sculptures, Cafe Society, NY, 1942; San Francisco Art Commission, CA, 1965; papier mache portrait sculptures, Chelsea Hotel, NYC, 1967-77. Address in 1982, Hotel Chelsea, 222 West 23rd Street, NYC.

GERSTEN, GERRY N.
Illustrator. Born in NYC in 1927. Attended the High School of Music and Art and Cooper Union Art School. He studied under the painter Robert Gwathmey and fellow classmates included Milton Glaser, Seymour Chwast, Reynold Ruffins, and Edward Sorel. His first illustration was done for Sudler and Hennessey, Inc., in 1951. He illustrates for *Playboy, Esquire, Harper's, Time, McCall's, True* magazine and others. In 1975 the NY State Lottery poster was executed by this illustrator. Noted for his humorous caricatures, he is profiled in *Idea Magazine, North Light*, and in the book *The Art of Humorous Illustration*. He is an active member of the S of I and his work has appeared often in their Annual Exhibitions.

GERSTENHEIM, LOUIS.
Painter. Born in Poland, 1890. Pupil of National Academy of Design. Member of the Society of Independent Artists. Address in 1926, 344 East 57th St., New York.

GERSTLE, MIRIAM ALICE.
Painter, illustrator and etcher. Born San Francisco, CA, March 9, 1898. Work: Mural Decorations in Royal Links Hotel, Cromer, England; Royal Bath Hotel, Bournemouth, England. Address in 1929, 37 Hamilton Terrace, St. John's Wood, London, N.W. 8, England.

GERSTLE, WILLIAM L(EWIS).
Painter. Born San Francisco, Jan. 28, 1868. Pupil of George Weiss, ASL of NY; San Francisco School of

Fine Arts. Member: San Francisco AA; AFA. Address in 1929, 716 Montgomery St.; h. 310 Sansome St., San Francisco, CA.

GEST, J(OSEPH) H(ENRY).
Painter. Born Cincinnati, 1859. Member: NAC; Cin. Municipal AC; Nat. Gallery of Art Comm.; Director, Cincinnati Museum; President, Rookwood Pottery. Address in 1929, Art Museum, Eden Park; h. 2144 Grandin Road, Cincinnati, OH.

GETCHELL, EDITH LORING.
Etcher. Born in Bristol, PA. Pupil of Penna. Academy of Fine Arts. Her etchings are in the Library of Congress, Wash., DC; Boston Museum of Fine Arts, Worcester Art Museum, MA; and Walters Collection, Baltimore, MD. Member of New York Etching Club. Address in 1926, 6 Linden St., Worcester, MA. Died in 1935.

GETTIER, C. R.
Illustrator. Member: Char. C. Address in 1929, Tudor Hall, Baltimore, MD.

GETTIER, G. WILMER.
Landscape painter. Born Baltimore, MD, Feb. 23, 1877. Studied in Baltimore and Munich, and under S. E. Whitman. Member: Char. C.; Baltimore Alliance; Fine Arts C., Baltimore. Address in 1929, 855 North Howard St.; h. 1019 West Lanvale St., Baltimore, MD.

GETZ, ARTHUR.
Painter. Born in 1913, in Passaic, NJ. Studied at Pratt Inst. Painted murals for the WPA Fed. Art Proj. in 1939-42. Contr. to *The New Yorker*. He also painted under the name of Arthur Kimmel. Illustrated *Hamilton Duck*, 1972.

GETZ, PETER.
He was a silversmith and jeweler of Lancaster, Pennsylvania, in the last quarter of the eighteenth century. He was a "self-taught mechanic of singular ability," says Wm. Barton in his life of David Rittenhouse. In 1792 Getz was a candidate for the position of Chief Coiner and Engraver to the newly organized mint in Philadelphia, but the place was given to the engraver Robert Scott.

GEVELOT, NICHOLAS.
Sculptor. Worked on US Capitol, Washington, 1820's; elsewhere as late as 1850, where he executed bas-relief of W. Penn's Treaty. Other later works include busts of Lafayette and Hamilton; equestrian statue of G. Washington, 1834.

GEYER, HENRY CHRISTIAN.
Sculptor. Stonecutter and plaster caster, active in Boston 1768-70. Work included human and animal likenesses.

GHIGLIERI, LORENZO E.
Sculptor and painter. Born in Los Angeles, CA, 1931. Received scholarship from Los Angeles Art Directors Club, 1948; served as naval artist during Korean War; worked in commercial art in Chicago and NYC. Turned to sculpture in 1974. Work includes ship's portrait for official presentation to Great Britain, 1953; life-size bronze of an eagle; life-size bronze of Abraham Lincoln; 4 by 12 foot bronze, "Genesis of Love;" statuette presented by Oregon to Pres. Reagan. Reviewed in *Southwest Art*, November 1979. Specializes in dramatic Eskimo and Indian figures; wildlife. Address since 1956, near Portland, OR.

GIACOMANTONIO, ARCHIMEDES A.
Sculptor and painter. Born in Jersey City, NJ, Jan. 17, 1906. Studied at DaVinci Art School, NY, 1925; with Onorio Ruotolo, 1925-26; with Vincenzo Gemito, 1926-29; Royal Academy of Art, Rome, 1929. Work at Jersey City Museum, NJ; Columbus Monument, Jersey City, NJ; Columbus Monument, Hazelton, PA. Has exhibited at Academy of Fine Arts, Rome, Italy; Equitable Galleries, Allied Artists and National Sculpture Society, NYC, 1936-81; Theodore Roosevelt, Metropolitan Museum, NY; National Academy of Design, NY. Received medal, Montclair Art Museum, 1936; gold medal, National Academy of Design, 1980; gold medal, National Sculpture Society, 1981; Linsey Morris Memorial, Allied Artists, 1981. Member: Allied Artists of America; National Sculpture Society; American Artists Professional League; National Academy of Design; Lotus Club, NY. Address in 1982, c/o Jock Manton, 42 West 67th St., NYC.

GIBALA, LOUISE.
Painter. Born in Allegheny, PA. Awards: American Artists Professional League; National Art League; Low Ruins Gallery, Tubac, Arizona. Collections: Christ Lutheran Church, Little Neck, NY; Dutch Reformed Church, Flushing, NY. Exhibitions: NA Gal.; Smithsonian Gal.; Lever House.; etc.

GIBBS, GEORGE.
Painter and illustrator. Born New Orleans, LA, March 8, 1870. Pupil of Corcoran School and ASL in Washington, DC. Member: S. Wash. A.; Wash. WCC; Amer. Fed. of Arts; Phila. Alliance; Phila. AC. Author and illustrator of *American Sea Fights*, *Tony's Wife*, *The Yellow Dove*, and twenty-five other novels and historical tales. Address in 1929, 1520 Chestnut St., Philadelphia, PA; h. Rosemont, PA.

GIBRAN, KAHLIL GEORGE.
Sculptor. Born in Boston, MA, November 29, 1922. Studied at Boston Museum School, 1940-43, painting with Karl Zerbe. Work in Chrysler Collection, Virginia Museum, Norfolk; Penna. Academy of Fine Arts, Philadelphia; others. Has exhibited at Whitney

Museum of American Art Annual; Cambridge Art Association; Boston Athenaeum, 1981; others. Received George Widener Medal, Penna. Academy of Fine Arts, 1958; John S. Guggenheim Fellowship, 1959-61; National Institute of Arts and Letters Award and Fellowship, 1961. Member of National Sculpture Society; New England Sculpture Society; Cambridge Art Association; Provincetown Art Association; others. Works in steel. Address in 1982, Boston, MA.

GIBSON, CHARLES DANA.
Painter and illustrator. Born in Roxbury, MA, Sept. 14, 1867. Pupil of ASL, NY; George Post, architect, at St. Gaudens. Member: ANA; Soc. of Illus., 1902; Amer. Inst. Graphic Arts; Nat. Inst. AL; Port. P.; Artists Guild of Authors' Lg. of Amer.; Amer. Fed. Arts. Author and illustrator of *Education of Mr. Pipp*; *Sketches in London*; *The Social Ladder*; *A Widow*; *The Americans*. He illustrated for *Life* magazine, *Cosmopolitan*, and *Collier's* for many years. Acquired the original *Life* mag., served as editor. Died Dec. 23, 1944, in New York City. Address in 1929, Life Pub. Co., 598 Madison Ave; Carnegie Studios; h. 127 East 73d St., New York, NY.

GIBSON, FREDERICK (MRS.).
See Kremelberg, Mary.

GIBSON, LYDIA.
Painter and illustrator. Born New York City, Dec. 29, 1891. Pupil of Fraser, Bourdelle, Guerin, Varnum, Poor. Member: S. Indp. A; Salons of Am. Address in 1929, Mt. Airy Rd., Croton-on-Hudson, NY.

GIBSON, THOMAS.
Miniature painter. Notice of his death published in the *Morning Star* of New York City on December 27th, 1811: "Thomas Gibson, painter, died December 23, 1811."

GIBSON, WILLIAM HAMILTON.
Artist and illustrator. Born in Sandy Hook, CT, 1850. He worked on the *Art Journal* and *Picturesque America*. He was a member of the New York Water Color Society, and exhibited his work after 1872. He died in 1896 in Washington, DC.

GICHNER, JOANNA E.
Sculptor. Born in Baltimore in 1899. Pupil of Grafly. Address in 1926, 1516 Madison Ave., Baltimore, MD.

GIDDENS, PHILIP H(ARRIS).
Etcher. Born Cuthbert, GA, Oct. 15, 1898. Pupil of Ecole Nationale des Beaux-Arts, Paris. Member: Brooklyn SE; Chicago SE; Arch. Lg. of NY. Awards: Hon. mention, Grand Salon, Paris, 1923; first prize, Southern Artists Exhibition, Nashville, TN, 1925.

Address in 1929, 7 MacDougal Alley; h. 955 Park Ave., New York, NY.

GIDDINGS, ALBERT F.
Painter and etcher. Born in Brenham, TX, 1883. Pupil of Art Institute of Chicago; Frederick W. Freer. Decoration in Wendell Phillips High School, Chicago. Address in 1926, Hotel Del Prado, 1400 East 59th St., Chicago, IL.

GIDDINGS, FRANK A.
Painter and etcher. Born Hartford, CT, 1882. Pupil of Chase. Member: Conn. Academy of Fine Arts. Address in 1926, 74 Webster St., Hartford, CT.

GIDEON, SAMUEL EDWARD.
Painter, artist, writer, lecturer and teacher. Born Louisville, KY, Dec. 9, 1875. Pupil of Ross Turner, L'Ecole des Beaux Arts, Fontainebleau, Gorguet, Duquesne, Despradelle. Member: Texas FAA; Southern States Art Lg.; AIA; Laguna Beach AA. Address in 1929, Univ. of Texas; 2514 Pearl St., Austin, TX.

GIEBERICH, O(SCAR) H.
Painter and etcher. Born New York City, March 25, 1886. Pupil of ASL of NY; Charles Hawthorne. Member: Salma. C.; Paris Groupe PSA. Work: "B. P. Ciboure," Brooklyn Museum of Art. Address in 1929, 25 rue du Montparnasse, Paris, France; h. 1716 Ocean Ave., Brooklyn, NY.

GIES, JOSEPH W.
Painter. Born in Detroit. Pupil of Bouguereau and Robert-Fleury in Paris; Royal Academy in Munich. Work: "Lady in Pink" and "Portrait of Robert Hopkins," Detroit Institute. Address in 1926, 14 West Adams Ave., Detroit, MI.

GIESBERT, EDMUND.
Painter, illustrator, lecturer and teacher. Born Neuwied, Germany, June 1, 1893. Pupil of AIC. Member: Chicago PS; Chicago SA. Award: F. G. Logan medal and $500, AIC, 1929. Address in 1929, 6022 Woodlawn Ave., Chicago, IL.

GIESE, AUGUSTUS F.
Painter. Member: Society of Independent Artists. Address in 1926, 1852 Jerome Ave., New York, NY.

GIFFEN, LILIAN.
Painter, writer, lecturer and teacher. Born New Orleans, LA. Member: Baltimore WCC; Washington AC; Phila. Alliance; North Shore AA; NA Women PS; Rockport AA; Gloucester SA; Southern States Art Lg.; New Orleans AA; AFA. Awards: Membership prize, Baltimore WCC, 1925; prize for painting, League of American Pen Women, Baltimore, 1926. Address in 1929, 1004 North Charles St., Baltimore, MD; summer, East Gloucester, MA.

GIFFORD, FRANCES ELIOT.
Painter. Born New Bedford, MA, 1844. Received art education in Cooper Institute, New York, and in Boston, under S. L. Gerry. Painter of birds with landscapes; also magazine illustrator.

GIFFORD, ROBERT GREGORY.
Painter, illustrator and writer. Born West Medford, MA, Dec. 10, 1895. Pupil of Boston Museum School. Member: Duxbury AA; Rockford AA. Award: Second place, School of Amer. Academy in Rome competition, 1922. Work: "America's oldest Department Store," Gallery of the Duxbury His. Assoc.; "Portrait of J. Fisler," Manufacturers' Club, Philadelphia. Illustrates own stories. Designer of bookplates, stage sets, etc. Address in 1929, Fenway Studios, Boston, MA; h. Box 166, Duxbury, MA.

GIFFORD, ROBERT SWAIN.
Landscape painter and etcher. Born at Island of Naushon, MA, Dec. 23, 1840. He learned the rudiments of his art from Albert Van Beest, a Dutch marine painter at New Bedford, MA. Moved to Boston in 1864 and two years later settled in New York. First exhibited in 1864 at the National Academy of Design, of which he was elected an Associate in 1867, and an Academician in 1878. Traveled extensively, painting in Oregon and Calif. in 1869, and later in Europe, Algiers, and Egypt. Member of the Soc. of American Artists; American Water Color Society; National Arts Club; Society of London Painters; Royal Society of Painters and Etchers, London. Founder, with James D. Smillie and Leroy M. Yale, of the New York Etching Club. Painted "Near the Oceans," and is represented at the Corcoran Gallery by "October on Massachusetts Coast." Died Jan. 15, 1905, in New York.

GIFFORD, SANFORD ROBINSON.
Painter. Born at Greenfield, NY, July 10, 1823. Graduate of Brown University, 1842. Pupil of J. R. Smith and the National Academy of Design, New York. Elected National Academician, 1854. Studied in Paris and Rome, 1855-57; traveled also in Italy, Greece, Syria, Egypt and through the Rocky Mountains. He was one of the first American painters to depart from the conventions of the old school and create a broader and higher style. A Hudson River School artist. He painted "The Villa Malta," "Sunset on the Lake," "Near Palermo." Represented at the Corcoran Gallery, Washington, DC, by "Ruins of the Parthenon." Died Aug. 24, 1880, in New York.

GIFFUNI, FLORA BALDINI.
Painter. Born in Naples, Italy, Oct. 26, 1919. Study: NYU, BFA, 1942; Teachers College, Columbia Univ., MFA, 1945; Universities of Madrid, Pisa, Instituto d'Allende, NY School of Interior Design, ASL. Work: NY City Hall (portrait, Mayor V.

Impelliteri); Columbus Club (portrait, Judge DiFalco); colleges; private collections. Awards: Am. Artists Professional Lg., Lever House National, NY.; Nat'l Art Lg.; Pastel Soc. of America; Salmagundi Club; and many others. Mem.: Fellow, Am. Artists Professional Lg.; honorary member, Salma. C.; founder, pres., Pastel Society of Am.; life member, ASL; Accademia di Belle Arte, Parma, Italy; and others. Teaching: Adults, teenagers, Flora Baldini Giffuni Art Studio. Medium: Pastel. Rep.: Reyn Gallery, NYC. Address in 1983, 180-16 Dalny Road, Jamaica Estates, NY.

GIGNOUX, REGIS FRANCOIS.
Landscape and historical painter. Born in Lyon, France, in 1816. He came to America in 1844. Elected National Academician in 1851. Lived in Brooklyn, NY; in US to 1870. His best known landscapes are "Niagara Falls," "Virginia in Indian Summer," "Mount Washington," and "Spring." He died Aug. 6, 1882, in Paris.

GIHON, A(LBERT) D(AKIN).
Landscape painter and teacher. Born Portsmouth, NH, Feb. 16, 1866. Pupil of Eakins in Philadelphia; Constant, Laurens and Ecole des Arts Decoratifs in Paris. Member: Fellowship PAFA. Awards: Second prize, Paris AAA, 1900; first prize, Paris AAA, 1901. Represented in Luxembourg. Address in 1929, 59 Avenue de Saxe, Paris, France.

GIHON, CLARENCE MONTFORT.
Painter. Born Philadelphia, 1871. Pupil of Chase and Cox in New York; Laurens and Constant in Paris. Died 1929 in Paris. Address in 1926, 51 Boulevard St. Jacques, Paris, France.

GIKAS, CHRISTOPHER.
Stained glass artist. Born: Lincoln, NE, Jan. 26, 1926. Studied: OK State Univ.; Univ. of NM, stained glass with Hans Tatschl. Work: Oklahoma State U.; Museum of NM, Santa Fe; Univ. of NM, Albuquerque, NM. Comn.: Vietnam Monument, Cannon AFB, NM, and East. NM Univ. Exhibitions: University of NM Gallery. Awards: East. NM Univ. Faculty Award, 1969. Teaching: W. Tex. State Univ., 1955-62; East. NM Univ., from 1962. Mem.: NM Arts Council. Media: Stained glass. Address in 1982, Portales, NM.

GILBERT, ARTHUR HILL.
Painter and teacher. Born Chicago, IL, June 10, 1894. Member: Calif. AC; Carmel AA; Salma. Club; Laguna Beach AA. Awards: Hon. mention, Laguna Beach AA, 1921; third prize, Orange Co. Exhib., 1921, and second prize, 1928; prize, Sacramento State Fair, 1922; hon. mention, Painters of the West, 1927; hon. mention, Springville, Utah Annual, 1927; second Hallgarten, NAD, 1929. Work: "Mexican Weavers," "Spirit of Rubidoux," "Church Tower,"

Mission Inn Public Galleries, Riverside, CA. Address in 1929, Carmel by the Sea, Monterey County, CA.

GILBERT, CAROLINE.
Etcher, designer, craftswoman, teacher. Born Pardeeville, WI, Jan. 12, 1864. Pupil of Arthur Dow. Member: St. Paul Inst. Artists' S. Awards: 2nd etching prize and 1st prize for lithography, MN State Fair, 1920; 2nd prize in painting, Twin City Exhibit, 1922. Address in 1929, Mechanic Arts High School; h. 88 Arundel St., St. Paul, MN; summer, 204 Lake Ave., White Bear, MN.

GILBERT, CHARLES ALLAN.
Illustrator and painter. Born Hartford, CT, 1873. Pupil of Art Students League of New York; Constant and Laurens in Paris. Illustrated "Women of Fiction;" "A Message from Mars." Died 1929 in New York. Address in 1926, 251 East 61st St., New York, NY.

GILBERT, CLYDE LINGLE.
Painter. Born in Medora, IN, Oct. 15, 1898. Study: School of Applied Art, Battle Creek, MI; Nat'l. Acad. of Commercial Art, Chicago; Studio of Fine Arts, Brazil, IN. Work: Private collections. Exhibitions: Howe Military School, Ind, 1949; Wawasee Art Gallery, Ind., 1949; Battle Creek Sanitarium, Mich., 1966; French Lick Hotel, Ind, 1966. Awards: Irwin D. Wolf, Gold Medal, Packaging, 1938; others. Art Positions: Designer, American Coating Mills, Inc. Mem.: Indiana Federation of Art Clubs. Media: Oil, watercolor. Address in 1982, 139 Riverview Ave., Elkhart, IN.

GILBERT, GROVE SHELDON.
Born in Clinton, NY, Aug. 5, 1805. In 1834 he settled in Rochester, NY. He devoted himself to portraiture. In 1848 he was elected an honorary member of the National Academy of Design of New York. He died March 23, 1885.

GILBERT, SARAH.
Painter of flowers and several figure pieces. She was a student of the Cooper Institute, and for years had her studio in New Haven, CT, and exhibited at the New Haven Art Building.

GILBERT, SHARON.
Sculptor. Born in New York City in 1944. Studied: The Cooper Union; The Skowhegan School of Painting and Sculpture; Brooklyn Mus.. Exhibitions: Columbia University, New York, 1971; State University of New York at Albany, 1972; Whitney Museum, Art Resources Center, New York, 1974.

GILBERTSON, BORIS.
Sculptor. Born in Evanston, IL, May 7, 1907. Studied at Art Institute of Chicago. Awards: Prizes, Art Institute of Chicago, 1933, 43. Work: Sculpture reliefs, US Post Office, Fond du Lac, Janesville, WI; Dept. Interior Bldg., Washington, DC; memorial, Dubois, WY. Exhibited: Penna. Academy of Fine Arts, 1943, 44; Corcoran Gallery of Art, 1937; Whitney Mus. of American Art, 1936; Art Institute of Chicago. Address in 1953, Cornucopia, WI.

GILBERTSON, CHARLOTTE.
Painter. Born in Boston, MA. Studied: Boston Univ.; The Art Students League, and Pratt Graphics in NYC; with Fernand Leger in Paris. Exhibitions: *Galerie Mai*, Paris, France, 1949; Bodley Gallery, NYC, 1971, "Along the Yukon;" Iolas Gallery, NYC, 1972. Media: Oil and acrylic. Address in 1981, Old Schoolhouse Rd., Harwich Port, MA.

GILCHRIST, EMMA S.
Painter. Member: Carolina AA; Southern States Art Lg. Died 1929 in Charleston, SC. Address in 1929, care of Gibbes Memorial Art Gallery; 140 Broad St.; 4 Savage St., Charleston, SC.

GILCHRIST, W. WALLACE.
Painter. Born 1879. Studied at Penna. Academy of Fine Arts, and in Munich, Paris and London. Awards: Third Hallgarten prize, National Academy of Design, 1908; gold medal, Washington, DC, Society Artists, 1914. Work: "The Model's Rest," at Cincinnati Mus. Died Nov. 4, 1926, in Brunswick, ME. Address in 1926, Brunswick, ME.

GILDEMEISTER, CHARLES.
Lithographer and painter. Born Oct. 11, 1820, in Bremen, Germany. Signed a "View of the Narrows" and a "View of the Hudson River, from Fort Lee." Published by Seitz in 1851. Died Feb. 8, 1869.

GILDER, ROBERT F(LETCHER).
Painter. Born Flushing, NY, Oct. 6, 1856. Pupil of August Will in NY. Work: "Where Rolls the Broad Missouri," University Club, Omaha; "Sunshine and Shadow," Omaha Friends of Art Assoc.; "Winter Morning," St. Paul Inst.; "Desert Clouds," Philip Payne Memorial, Amherst College; "Arizona Desert" and "San Gabriel Canyon, Calif.," Omaha Public Library; "Among the Hemlocks," State Normal School, Wayne, NE; "October at Wake Robin," State Normal School, Kearney, Neb.; "October in Nebraska," South Omaha Public Library; "Winter Afternoon," Lincoln High School, Council Bluffs, IA; "Autumn Colors," High School, Lincoln, NE; "Head of Mill Hollow, Fontenelle Forest," Public Library, Fremont, NE; and others in Omaha schools. Died in 1940. Address in 1929, Omaha World-Herald, South Side Office; 2318 N St., Omaha, NE; h. Wake Robin, Sarpy Co., NE.

GILDERSLEEVE, BEATRICE.
(Mrs. C. C. Gildersleeve). Painter and craftswoman. Born San Francisco, CA, Jan. 28, 1892. Member: San

Francisco S. Women A; Santa Cruz AL. Address in 1929, Felton, Santa Cruz Co., CA.

GILE, SELDEN CONNOR.
Painter and etcher. Born Stow, ME, March 20, 1877. Pupil of Perham Nahl, Frank Van Sloun, Spencer Macky, W. H. Clapp. Member: Soc. of Six, Oakland AL, Am. Artist Prof. Lg. Award: Prize, Santa Cruz, CA, 1929. Died in 1947. Address in 1929, Belvedere, CA; h. 7027 Chabot Rd., Oakland, CA.

GILES, CHARLES T.
Engraver. Born Aug. 25, 1827, in New York; living in Brooklyn, NY, in 1900. This reputable line-engraver of landscape and historical subjects began work in New York in 1847, and was practicing his profession as late as 1898.

GILES, HOWARD.
Painter, illustrator and teacher. Born Brooklyn, NY, Feb. 10, 1876. Pupil of Jay Hambridge; ASL of NY under Mowbray. Member: Associate National Acad. Design; Amer. Water Color Soc.; A. Fund S.; Amer. Inst. Graphic Arts; Philadelphia AC; Nat. Arts Club (life); Artists Guild of Authors' Lg. of Amer.; Century Association; Philadelphia Water Color Club. Awards: Shaw Purchase Prize ($500), Salma. C., 1915; Shaw illustration prize, Salma. C., 1915; Beck prize, Phila. Water Color Club, 1917; Inness gold medal, Nat. Academy Design, 1918; hon. mention, Chicago Art Institute, 1918; Silver medal ($1,000), Carnegie Inst., 1921; Water Color Purchase Prize, AIC, 1921; bronze medal, Sesqui-Centennial Expo., Phila., 1926; Phila. WC. prize, 1928. Represented in Pennsylvania Academy of the Fine Arts; Chicago Art Institute; Brooklyn Museum; Museum of Fine Arts, Boston; Fogg Museum, Harvard University; Fine Arts Gallery, San Diego, CA; Denver Art Museum. Died in 1955. Address in 1929, 35 West 14th St., New York, NY; h. Forest Hill, NJ.

GILKISON, MRS. A. H.
Painter. Member: Pitts. Artists' Association. Address in 1926, 226 West Swissvale Ave., Pittsburgh, PA.

GILL, DeLANCEY.
Painter. Born 1859 in Chester, SC. Member: S. Wash. A. Address in 1929, Rutland Cts., Washington, DC.

GILL, PAUL LUDWIG.
Painter and illustrator. Born in New York, March 14, 1894. Pupil of Pennsylvania Academy Fine Arts, George Harding, Henry McCarter, Fred Wagner, Daniel Garber; Academy Colarossi, Paris. Member: Philadelphia Water Color Club; Sketch C.; Fellowship Penna. Academy Fine Arts; American Water Color Society; New York Water Color Club; Philadelphia Alliance. Awards: Cresson Travelling

Fellowship, Penna. Acad. Fine Arts, 1922-23; prize, Baltimore Water Color Club, 1926; Tuthill purchase prize, Chicago, 1926; silver medal, Sesqui-Centennial Expo., Phila., 1926; purchase prize, NY Water Color Club, 1927; Phila. Water Color prize, 1927; William Church Osborne prize, NY, 1928. Represented in Brooklyn Museum; La France Institute, Phila. Instructor, Phila. School of Design for Women. Died in 1938. Address in 1929, Wynnewood, PA.

GILL, S. LESLIE.
Painter. Born Valley Falls, RI, May 12, 1908. Pupil of John R. Frazier, Charles W. Hawthorne. Work: "Ice Plant," Rhode Island School of Design Museum, Providence. Address in 1929, 172 Linwood Ave., Providence, RI.

GILL, SUE MAY WESCOTT (MRS.).
Sculptor and painter. Born in Sabinal, TX, Jan. 14, 1890. Pupil of Breckenridge, Garber, McCarter, Wagner, Pearson; Penna. Academy of Fine Arts, 1920-26; Julien Academy, Paris. Member: Phila. Alliance; Penna. Academy of Fine Arts; National Association of Women Painters and Sculptors; Ten Philadelphia Painters. Awards: Cresson Traveling Scholarship, Penna. Academy of Fine Arts, 1922; first Toppan prize, Penna. Academy of Fine Arts, 1923; honorable mention, Ogunquit Art Center, 1931; Penman Memorial prize, National Association of Women Painters and Sculptors, 1932; Fellowship prize, Penna. Acad. of Fine Arts, 1933. Represented in The Little Gallery, Cedar Rapids, IA. Specialty, portraits and flowers. Inst., Summer School, Syracuse U., NY. Address in 1982, Wynnewood, PA.

GILLAM, FREDERICK VICTOR
and T. BERNARD.
Illustrators for *Harper's Weekly* and other papers and magazines. They were born in England; came to US and settled in New York. Their work suggests the work of Tenniel. Frederick died Jan. 29, 1920.

GILLAM, W(ILLIAM),
C(HARLES) F(REDERICK).
Painter, etcher, artist and craftsman. Born Brighton, England, Oct. 14, 1867. Member: Calif. SE. Work: Hambrook House, Sussex, England; Provincial Normal School, Victoria, B.C.; Queen Mary High School, Vancouver, B.C.; St. Paul's Episcopal Church, Burlingame, CA. Address in 1929, 1401 Broadway; h. 1143 El Camino Real, Burlingame, CA.

GILLESPIE, GEORGE.
Painter. Member: Pittsburgh Artists' Association. Address in 1926, 711 Penn Ave., Pittsburgh, PA.

GILLESPIE, JESSIE.
Illustrator. Born Brooklyn, NY. Pupil of PAFA. Illustrations for "Pictorial Review," "Girl Scouts," and

Keystone Publishing Co. Address in 1929, 5909 Wayne Ave., Germantown, Philadelphia, PA; summer, Henryville, Monroe Co., PA.

GILLESPIE, JOHN.
Painter. Born Malta, OH, May 15, 1901. Pupil of School of the Columbus Gallery of FA. Member: Columbus A. Lg.; Ohio Water Color Soc. Award: Walter A. Jones water color prize, 1924, at Columbus Art League. Supervisor of Art, Columbus Junior Academy, and Columbus Academy. Address in 1929, 54 South Garfield Ave., Columbus, OH; summer, McConnellsville, OH.

GILLESPIE, W.
Engraver. Engraving on steel in Pitts., PA, about 1845. He made a line map of Pitts. and vicinity, "Designating the portion destroyed by fire April 10, 1845," It is signed as "Eng'd by W. Gillespie."

GILLETTE, L(ESTER) A.
Painter and teacher. Born Columbus, Oh., Oct. 5, 1855. Pupil of Hill, Williams, Chase, Jacobs, Carlson and AIC. Member: Topeka AG; Miami AA; Gloucester SA; Amer. Fed. Arts. Address in 1929, 717 Fillmore St., Topeka, KS.

GILLIAM, MARGUERITE HUBBARD.
Painter and teacher. Born Boulder, CO. Member: Fellowship PAFA. Award: Bronze medal, Kansas City AI, 1925. Address in 1929, White Rock Lane, Boulder, CO.

GILLINGHAM, EDWIN.
A map of Boston and its vicinity, made from an actual survey by John G. Hales, is signed "Edwin Gillingham Sc."

GILMAN, J. W.
Engraver. He engraved the music and words in "The American Harmony, or Royal Melody Complete, etc.," in two volumes, by "A. William Tan'sur, Senior, Musico Theorico," and by "A. Williams, Teacher of Psalmody in London." The book was "Printed and Sold by Daniel Bayley, at his House next Door to St. Paul's Church, Newbury-Port, 1771." A study of the "Gilman Genealogy" implies that he was John Ward Dilman, born in Exeter, MA, 1741, who died there in 1823. There is no record of his career except that he was postmaster of Exeter for 40 years.

GILMORE, ADA.
Painter and wood engraver. Born in Kalamazoo, MI, 1882. Studied with Henri in New York; Art Institute of Chicago; and in Paris. Work: "Parasols," purchased by Municipal Art Commission, Chicago. Address in 1926, Provincetown, MA.

GILPIN, CHARLES ARMOUR.
Painter. Born Cumberland, MD, Oct. 7, 1867. Pupil of PAFA. Member: Pittsburgh AA; Amer. Fed.

Arts. Work: "Relic of 1824," owned by Hundred Friends of Pittsburgh Art. Address in 1929, Hotel Judson, 53 Washington Sq., New York, NY.

GIMBER, STEPHEN H.
Painter, engraver and lithographer. Born in England in 1810 where he learned to engrave. Was working at his profession in New York by 1830; in 1832-33 his name is associated on plates with that of A. L. Dick, NYC. His name is found in the New York directories until 1842. Moved to Philadelphia as an engraver and lithographer after 1856. Gimber was a good portrait engraver in stipple and mezzotint, and his early subject plates are in line; he also drew portraits upon stone, and printed miniatures. He died in Philadelphia in 1862.

GIMBREDE, JOSEPH NAPOLEON.
Born at West Point, NY, in 1820. Son of Thomas Gimbrede. Learned to engrave with his uncle, J. F. E. Prud'homme. J. N. Gimbrede was in business as an engraver in New York in 1841-45, producing portraits and subject plates. He was later a stationer with an establishment under the Metropolitan Hotel, 588 Broadway, New York.

GIMBREDE, THOMAS.
Engraver. Born in France in 1781; died at West Point, NY, Oct. 25, 1832. Gimbrede came to the United States in 1802 as a miniature painter; he was engraving some excellent portraits in the stipple manner for the New York publishers John Low and William Durell as early as 1810. In 1816 he had an office at 201 Broadway, New York. He did a considerable amount of work for the Philadelphia magazines, *The Port Folio* and *The Analectic*. On January 5, 1819, he was appointed drawing-master at the Military Academy at West Point, and was there until his death. He continued to engrave and publish portrait plates as late as 1831. He was a brother-in-law of J. F. E. Prud'homme. Also engraved portraits in stipple.

GIMENO, P(ATRICIO).
Painter, lecturer and teacher. Born Arequipa, Peru, SA, Dec. 25, 1865. Pupil of M. Rosas and Valencia in Spain. Member: Okla. Art League. Award: $500 prize for Allegorical Painting awarded by Okla. City R. R. Co. Work: Portrait of Pres. Pierola in Gov. Palace, Lima, Peru. Address in 1929, 807 Jenkins Ave., Norman, OK.

GINSBERG, RUTH PLACE.
Tapestry. Studied: New School for Social Research; Syracuse Univ. Exhibitions: Southern Illinois Univ., 1969; The Art Institute of Chicago, 1970; Albright-Knox Gallery, Buffalo, NY, 1974. Commissions: Temple B'Nai Amoona, St. Louis; Law Offices of Moldover, Strauss & Hertz, NYC. Collections: The Art Institute of Chicago; Federal Reserve Bank of Memphis.

GINSBURG, A.
Painter. Member: Painters and Sculptors. Address in 1929, Bible House, New York, NY.

GINTHER, MARY PEMBERTON.
See Heyler, Mary Pemberton Ginther.

GINTHER, WALTER K(ARL).
Painter and etcher. Born Winona, MN, April 3, 1894. Pupil of Vaclav Vytlacil, Cameron Booth, R. F. Lahey and E. Dewey Albinson. Awards: First prize, student competition, 1922, and first prize, 1924 and 1926, MN State Fair; special mention, MN State AS, 1923. Address in 1929, 407 East 7th St., Winona, MN.

GIORDANO, JOAN M.
Painter. Born in Staten Island, NY, in 1939. Awards: Museum of Modern Art.

GIOVANOPOULOS, PAUL A.
Illustrator. Born in Kastoria, Greece, in 1939. He came to America on scholarship to attend NYU School of Fine Art, and later Soc. of Visual Arts, studying under Robert Weaver. His career began with magazine illustrations for *Seventeen* in 1960. His children's book illustrations have won several awards from *The New York Times*, and his artwork has been shown at the Soc. of Illus. Annual Exhibitions, and in NY, Baltimore, Philadelphia, and Washington. He has been an instructor at Parsons School of Design and Soc. of Visual Arts.

GIRARDET, P.
Engraver. A well-engraved line and stipple plate was published in New York in 1857 entitled "Winter Scene in Broadway." The plate is signed as engraved by "P. Girardet" from a painting by H. Sebron. His works may not have been executed in the United States. The names of the engraver and painter are French, and though the scene is laid in New York, the plate may have been made abroad.

GIRARDIN, FRANK J.
Landscape painter. Born in Kentucky, 1856. Pupil of Cincinnati Art Academy. Represented by "The Hillside" and "Lingering Snow" in Public Gallery, Richmond, IN. Address in 1926, Redondo Beach, CA.

GIRAULT, LOUIS.
Miniature painter. He was flourishing in NY in 1798.

GIRSCH, FREDERICK.
Engraver and etcher. Born March 31, 1821 in Germany. Received some instruction from a local artist, Carl Seeger. Earned some money by portrait painting, and his portrait of a Princess attracted attention. A sufficient sum was raised by subscription to enable him to study at the Royal Academy of Darmstadt. Settled in NY, having learned to etch and to engrave in line. First work in

this country was done for the then *New Yorker Criminal Zeitung*. As was then the custom, this publication issued "premium" engravings, and Girsch engraved two of these — "Die Helden der Revolution" and "Niagara Falls." He improved in the quality of his line work and made portraits for publishers of NYC. It was as a bank-note engraver that he did his best work and achieved a reputation. Engraved "De Soto Discovering the Mississippi" on the back of one of the early bank-notes; the head of "Liberty" and portrait of Washington on fractional currency; engraved, in etching and line, a large plate, "Grandma's Toast," which was excellent; "The Gypsy Girl," executed for "his own pleasure," about the same time, is in pure line, and probably as meritorious a plate as was ever engraved by him. Died Dec. 18, 1895, in Mt. Vernon, NY.

GIULIANI, VIN.
Illustrator. Born in NYC in 1930. Attended Pratt Inst. He started as an industrial des., but he became best known for his assemblage technique using wood shapes. Both his editorial illust. for *Seventeen*, *McCall's*, *Redbook*, and *Time*, and his advertising work for Scovill Manuf., Exxon, and Corp. Annual Reports, earned him a reputation as a fine craftsman. His illust. were selected for several Annual Exhibitions at the Soc. of Illustrators. Died in 1976.

GIUSTI, ROBERT G.
Illustrator. Born in Zurich, Switzerland in 1937. Attended Tyler School of Fine Art and Cranbrook Academy of Art until 1961. His artwork was first published in 1956 in *American Girl* and more recently in *McCall's*, *Redbook*, *Fortune*, *Idea*, and *Penthouse*. He also illustrated many book covers and promotional posters. Exhibits of his work were held at the Cranbrook Museum of Art and the Greengrass Gallery in New York.

GLACKENS, WILLIAM J.
Painter and illustrator. Born Philadelphia, March 13, 1870. Pupil of PAFA; also studied in Europe. Member: ANA, 1906; SI, 1902; Soc. Amer. Artists, 1905; Am. PS; Port. P.; Society Independent Artists; Los Angeles Modern AS; New Soc. A; Paris Groupe PSA. Awards: Gold medal for drawings at Pan-Am. Exp., Buffalo, 1901; silver medal for painting and bronze for illustration, St. Louis Exp., 1904; hon. mention, CI Pittsburgh, 1905; bronze medal, P.-P. Exp., San F. 1915. Work: "Luks at Work," Harrison Gallery, Los Angeles Mus. Drawings in Metropolitan Museum, New York; Minneapolis Institute of Arts. Died in 1938 in New York City. Address in 1929, care Kraushaar Galleries, 680 Fifth Ave.; Daniel Gallery, 600 Madison Ave.; h. 10 West 9th St., New York, NY.

GLADDING, K. C.
Engraver. Several rather poorly engraved "Rewards of Merit" are signed "K. C. Gladding Sc." There is no

indication of the place of origin, other than that the plates are undoubtedly American. Judging from the "bank-note" ornamentation, the date of the plates is about 1825-30.

GLAMAN, EUGENIE FISH.
Painter and etcher. She was born in St. Joseph, MO, 1873. Pupil of Art Inst. Chicago; Simon, Cottet and Fremiet in Paris; Frank Calderon, Briton Reviere, London. Member: Chic. PS; Chicago WCC; Alumni Asso. Art Inst. Chicago; Chicago ASL; Chicago SE. Awards: Bronze medal, St. Louis Exp., 1904; Butler Purchase prize ($200), Art Inst. Chicago, 1913. Work: Purchased by Chic. Municipal Comm. Represented in Vanderpoel AA Collection, Chicago; etchings, permanent coll., State Museum and State Library, Springfield, IL. Specialty, animal subjects. Died in 1956. Address in 1929, 2850 Lexington St., Chicago, IL.

GLARNER, FRITZ.
Painter. Born July 20, 1899, in Zurich, Switzerland. Studied at Acad. of Fine Arts, Naples. In America after 1936. Won Corcoran award in 1957. Exhibited at Kootz Gal., NYC (1945); Cal. Palace (1950); Whitney (1950-55); Carnegie; Seattle's World Fair (1962); U. of Penn. (1971); Mus. Modern Art; Corcoran; many others here and abroad. Painted Time Life bldg. mural, NYC (1960). In collections of Brandeis; Florida State U.; Yale; Chase Manhattan Bank; NYU; Mus. of Modern Art; Rockefeller Inst.; Mus. Fine Arts, Boston; and Smithsonian. Died Sept. 18, 1972, in Switzerland.

GLASCO, JOSEPH.
Sculptor and painter. Born in Pauls Valley, OK, January 19, 1925. Studied at University of Texas, 1941-42; with Rico Lebrun, 1946; in Mexico City, 1947; Art Students League, NY, 1948. Work in Metropolitan Museum of Art and Museum of Modern Art; Hirshhorn Museum; Whitney Museum of American Art. Exhibited: Catherine Viviano Gallery, NY; Gimpel and Weitzenhoffer Gallery, NYC; Museum of Modern Art; Whitney Museum of American Art; Met. Museum of Art; Guggenheim Museum; Art Institute of Chicago, IL; Corcoran Gallery of Art; Dallas Museum of Fine Arts; Los Angeles Co. Museum of Fine Arts; others. Member of National Society of Literature and the Arts. Address in 1982, Galveston, TX.

GLASER, JOSEPHINE.
Painter. Born New York City, May 6, 1901. Pupil of Eugene Savage, Ernest Peixotto, Bridgman, Curran, Du Mond, Gorguet, St. Hubert, etc. Member: Alliance; Art Students Lg. of NY. Award: Tiffany Foundation Fellowship. Work: Three portraits at Georgetown University, Washington, DC; "Flower Study," Tiffany Foundation, Oyster Bay, NY; altar piece, Church of Our Lady of Martyrs, Auriesville, NY. Address in 1929, 135 West 84th St., New York, NY.

GLASER, MILTON.
Illustrator. Born in NYC in 1929. Attended Cooper Union Art School with classmates Edward Sorel, Seymour Chwast and Reynold Ruffins. He was awarded a Fulbright Scholarship to study etching with the late Giorgio Morandi in Italy in 1952. A co-founder of Push Pin Studios, former design director and Chairman of the Board at *New York Magazine* and designer of *Village Voice*, he co-authored *The Underground Gourmet* and is a faculty member of the Society of Visual Arts. He is also the designer of the Childcraft store and the decorative programs for the World Trade Center. His distinctive work has earned him many awards, inc. a Gold Medal from the Soc. of Illustrators and the honor of a One-Man Show at the Museum of Modern Art.

GLASS, BILL.
Sculptor. Cherokee, born in Tahlequah, OK, 1950. Studied: Central State College, with a few art classes; Institute of American Indian Art, Santa Fe; researched ancient symbolism at the Tahlequah Archaeological Society. Media: Clay, bronze. Specialty: Strong Indian women. Reviewed in *Artists of the Rockies*, Fall 1979. Exhibited at Sloan-McKinney Gal., Tulsa, OK. Address in 1982, Locust Grove, OK.

GLASS, JAMES WILLIAM.
Painter. Born in 1825. Became a student of Huntington, and afterwards painted in England for a number of years. He was particularly successful in his drawing of horses, and an equestrian portrait of the Duke of Wellington brought him into prominence. Died Dec. 22, 1855, in New York City.

GLASS, SARAH KRAMER.
Painter. Born in Troy, OH, Nov. 7, 1885. Pupil of Bertha Menzler Peyton; ASL of NY; Grand Central School of Art. Member: NA Women PS; North Shore AA; Gloucester SA. Address in 1929, 107 Mt. Pleasant Ave., East Gloucester, MA.

GLEASON, J. DUNCAN.
Painter and etcher. Born Watsonville, CA, Aug. 3, 1881. Pupil of DuMond, Vanderpoel. Member: Calif. AC; Laguna Beach AA; Los Angeles Painters and Sculptors Club; Long Beach AA. Died in 1959. Address in 1929, 2411 Edgemont Glen, Los Angeles, CA.

GLEASON, WILLIAM B.
Sculptor. One of Boston's leading figurehead and ornamental carvers of the mid-19th century. Began career in 1845 in partnership with his father, Samuel W. Gleason, and brother, Benjamin A. Gleason. Gleason was credited with many figureheads, one of

the most famous being his "Minnehaha," reproduced in Pickney. He continued to work until the 1870's.

GLEESON, ADELE SCHULENBERG.
(Mrs. Charles K. Gleeson). Sculptor. Born in St. Louis, MO, January 18, 1883. Studied with George J. Zolnay; St Louis School of Fine Arts; Grafly; and in Berlin. Member: St. Louis Art Guild. Address in 1926, Kirkwood, MO.

GLEESON, C(HARLES) K.
Painter and etcher. Born St. Louis, MO, March 5, 1878. Pupil of Theo. Steinlen; St. Louis School of Fine Arts; ASL of NY; Colarossi Academy in Paris. Member: Chicago SE; St. Louis AG. Work in: Herron Art Institute, Indianapolis; Worcester Art Museum; Chicago Art Institute; St. Louis Museum of Fine Arts; NY Public Library; Library of Congress, Washington, DC; Toledo Art Museum. Address in 1929, 115 Edwin Ave., Kirkwood, MO.

GLEESON, JOSEPH MICHAEL.
Painter, sculptor, and illustrator. Born in Dracut, MA, Feb. 8, 1861. Went to Munich to study art, 1885, and afterward made many trips to Europe, studying in France and Italy. Pupil of Bouguereau, Dagnan-Bouveret, Robert-Fleury in Paris. Member: Society of Illustrators. Settled in New York as painter and illustrator of animal life. Writer about animal life for magazines. Address in 1926, Newfoundland, NJ.

GLENNY, ALICE RUSSELL.
(Mrs. John Glenny). Sculptor and painter. Born Detroit, MI, 1858. Pupil of Chase in New York; Boulanger in Paris. Member: Buffalo Society of Artists; Art Students League of Buffalo; National Academy of Women Painters and Sculptors. Award: Prize for mural decoration, Buffalo Historical Society. Address in 1929, Raymond House, W. London, England; Buffalo, NY.

GLICENSTEIN, ENOCH HENDRYK (ENRICO?).
Sculptor and painter. Born in Tourkeck, Russia, May 24, 1870. Studied at the Academy of Fine Arts, Munich, where he received the Prix de Rome, in 1895 and 96; l'Ecole des Beaux-Arts, Lodz, Poland, 1887. Established a residence there for several years. In 1910 he became professor at the Academy of Art, Warsaw. Moved to US in 1926. Works: Melancholy, Staedel Museum, Frankfort, Germany; statue, Jeramiah, Newark Mus., NJ; Wanderer, Quirinal Palace, Rome, Italy; Maternity; Awakening; Messiah; Orpheus; Solitaria; Crucifixion; Serenata; Hyperion; Beggar; Musicians; San Francisco; busts of Hirzsenberg, and Daughter of d'Annunzio, National Museum, Krakow, Poland; Lord Balfour, Hebrew University, Jerusalem, Palestine; Prof. Orestano; Galriele d'Annunzio; Artist's Son; Count Strogonoff; portraits of Prof. Mommsen, Son, and Daughter; Dr.

Ludwig Mond, Mme. E. W.; half figure, Sibilla; statue, Stornello, Kunsthalle, Bremen, Germany; head, Artist's Conception of St. Peter; St. Francis; bust, Beppe Ciardi; statue, St. Francis. Exhibited: Salon de la Societe Nationale, 1906; mem. exhibition, Petit Palais, Paris, 1949. Awards: Silver medal, Lemberg, Poland, 1893; first prize, 1894, and Prix de Rome, 1895, 1896, Academy of Fine Arts, Munich, Germany; first and second prize, Warsaw, Poland, 1897; gold medal, International Exposition, Paris, 1900; gold medal, Munich, 1905. Membership: Sztuka in Krakow, Poland; Societe Nationale des Beaux-Arts, Paris. Died in NYC, December 30, 1942.

GLICKMAN, MAURICE.
Painter and lecturer. Born in Jassy, Romania, January 6, 1906. Studied at Art Students League; and abroad. Member: Sculptors Guild; Audubon Artists. Awards: Guggenheim Fellow, 1934. Work: Dept. Interior, Washington, DC; Binghamton Museum of Art; Howard University; James Monroe High School, NY; US Post Office, Ashburn, GA; South River, NJ; Northampton, PA; bas-reliefs for public buildings. Exhibited: Whitney Museum of American Art, 1937-51; Penna. Academy of Fine Arts, 1939-41; Philadelphia Museum of Art, 1940; Museum of Modern Art, 1935; New York World's Fair, 1939; Morton Gallery, 1931 (one-man); Women's Club, University of North Carolina, 1941 (one-man). Contributor to: Art magazines with articles on sculpture and architecture. Position: Director, The School for Art Studies, NYC. Address in 1982, 165 East 66th St., NYC.

GLINSKY, VINCENT.
Sculptor, painter, etcher, lithographer, and teacher. Born in Russia, Dec. 18, 1895. Studied at Columbia Univ.; City Col., NY. Exhibited: National Academy of Design, 1920, 23, 24, 44, 47-52; Architectural League, 1926, 44, 46, 50; Salon des Tuileries, Paris; Museum of Modern Art, 1930; Brooklyn Museum, 1930, 38; Museum Modern Art, 1942; Philadelphia Museum of Art, 1940, 49; Art Institute of Chicago, 1930, 32, 35, 38; Carnegie Institute, 1941; Penna. Academy of Fine Arts, 1931, 39, 43, 45-52; Argent Gallery, 1950-52; others. Awards: Prizes, medals, Penna. Academy of Fine Arts, 1935, 48; Guggenheim Fellow, 1935-36; grant, American Academy of Arts and Letters and National Institute of Arts and Letters, 1945. Taught: Instructor at Brooklyn College, Brooklyn, NY, from 1949; NY University, 1950-75. Address in 1970, 9 Patchin Place, NYC. Died in 1975.

GLINTENKAMP, HENDRICK.
Sculptor, painter, and illustrator. Born Augusta, NJ, Sept. 10, 1887. Pupil of Robert Henri; Nat. Academy of Design. Work: Series of twelve woodblock prints, Victoria and Albert Museum, London, England; group of seven woodblock prints, Public Library,

New York; group of three woodblock prints, Baltimore Museum of Art, Baltimore, MD. Address in 1933, Amenia, NY. Died in 1946.

GLOETZNER, JOSEPHINE P.
Painter and draughtsman. Born Wash., DC. Member: Washington WCC; Soc. Wash. Artists; Kunstlerinen Verein, Munich. Address in 1929, 1526 Corcoran St.; 1228 M St., N.W., Washington, DC.

GLOVER, DeLAY.
Engraver. Born in 1823. Glover was an engraver of portraits and subjects in line and in stipple. He was located in New York in 1850-55. Died in 1863.

GLOVER, DeWITT CLINTON.
Engraver. Born in DeRuyter, Madison County, NY, in 1817; died there Jan. 3, 1836. He was the son of Daniel and Rhoda (Gage) Glover and the brother of DeLay and Lloyd Glover. He early attempted engraving on wood and steel and to perfect himself in the art he entered the office of J. & W. Casilear in New York, where he made rapid progress; but he died at the age of nineteen.

GLOVER, LLOYD.
Engraver. Born in DeRuyter, Madison County, NY, in 1825; he was living in 1859. He was the son of Daniel Glover, and the brother of DeLay Glover, also an engraver. Lloyd Glover was taught to engrave under a Boston master and for several years he was the head of the New England branch of the Bank Note Engraving firm of Danforth, Wright & Co. of New York. He finally abandoned engraving for commerical pursuits, residing at Lynn, MA. He was said to be a man of decided literary and artistic attainments.

GLUECKMAN, JOAN.
Painting/Tapestry. Studied: Wayne State University; UCLA; University of Michigan; Detroit Institute of Arts. Exhibitions: SOHO 20 Gallery, New York City; Hobart & William Smith College, "The Eye of Woman", 1974; Women's Interart Center's "Erotic Garden," NYC. Initiated and Organized Artists' Cooperative, Feminist Gallery, SOHO 20, NYC. She also helped organize and set up the Women's Interart Center.

GNOLI, DOMENICO.
Illustrator. Born in Rome, in 1932. Lived for many years in Majorca, Spain. Self-taught, at age 18 he was designing sets for the Old Vic theater and began his career as a portrait and graphic artist with exhibits in Rome and Brussels. His works have appeared in many magazines including *Playboy*, *Sports Illustrated*, and *Holiday* and he has written several children's books. Since his death in NY in 1970 at the age of 37, his works have been acquired by National Gal. in the US.

GOATER, JOHN.
Illustrator and engraver. He worked on the *Illustrated American News*.

GOBRECHT, CHRISTIAN.
Engraver and die-sinker. Born Dec. 23, 1785, in Hanover, York County, PA; died in Phila., July 23, 1844. Apprenticed to a clockmaker of Manheim, Lancaster County, PA. He learned engraving and die-sinking, and by 1810 had engraved a creditable portrait of Washington for J. Kingston's *New American Biographical Dictionary*, published in Baltimore. About 1811 he moved to Philadelphia and while engaged in sinking dies for medals and work of that type he furnished a few good portrait plates for the publishers there. Work: Franklin Inst. medal of 1825, after a design by Thomas Sully; portrait medal of Charles Willson Peale; the Seal of St. Peter's Church, Philadelphia. In 1836 appointed draughtsman and die-sinker to U.S. Mint in Phila. Designed and made dies for the dollar of 1836. In 1840 succeeded William Kneass as chief engraver to Mint, until his death. Dies made by Gobrecht are esteemed for their artistic excellence. Was original inventor of the medal-ruling machine, a device whereby medals, etc., could be engraved directly from the relief face, and a plate thus prepared for reproduction on paper.

GODDARD, RALPH BARTLETT.
Sculptor. Born Meadville, PA, June 18, 1861. Pupil of National Academy of Design and Art Students League of New York; Dampt in Paris. Member: National Sculpture Society, 1899. Work: Statuettes of Carlyle and of Tennyson, and bronze portrait medallions, Metropolitan Museum, NY; "Premiere Epreuve," Detroit Institute; Statue of Gutenberg, Hoe Building, New York. Address in 1933, New York City; and Madison, CT. Died April 25, 1936.

GODEFROID, F.
Painter. Father of another artist of that name. In 1807 he painted a portrait of merit of M. Fortin, master of a Masonic Lodge, in the Louisiana State Museum. In 1809 he had a studio in South Burgundy Street, near Canal Street, New Orleans.

GODEFROY, LOUIS.
Painter. In the New Orleans directory of 1824 as "a painter, with his studio at 139 Tehoupitoulas street," and in 1830 at "31 Poydras, corner of Tehoupitoulas street."

GODWIN, ABRAHAM.
Engraver. Born July 16, 1763, in what is now Paterson, NJ; died there Oct. 5, 1835. Enlisted in a New York regiment as fife major; served until the close of the Revolutionary War, when he became an apprentice to A. Billings, an indifferent engraver of book-plate, etc., located in New York. As an engraver, Godwin apparently issued but few signed plates, and his work was not of high quality.

GODWIN, FRANCES BRYANT.
Sculptor. Born in Newport, Rhode Island, in 1892. Studied at the Art Students League of NY, under James Earle Fraser and George Bridgman, and at the Colarossi Academie in Paris with M. Poisson; also for a short time with A. Phimister Proctor in Rome. Works: Head, E. M.; horse, Cock Robin. Membership: National Arts Club. Her work has been chiefly animal sculptures, and more especially, horses.

GODWIN, FRANK.
Illustrator. Born Washington, DC, Oct. 20, 1889. Pupil of Corcoran School of Art. Member: Soc. of Illustrators; Darien G. of Seven Arts. Address in 1929, Riverside, CT; summer, Lake Skaneateles, Skaneateles, NY.

GODWIN, KARL.
Painter, illustrator, etcher and teacher. Born Walkerville, Canada, Nov. 19, 1893. Pupil of Charles W. Hawthorne, Sigurd Skou. Member: Salma. C; Allied AA. Address in 1929, 360 East 55th St.; Salmagundi Club, 47 Fifth Ave., New York, NY.

GOELLER, E. SHATWELL (MISS).
Sculptor and painter. Born in San Francisco, CA, July 30, 1887. Pupil of Armin Fansen and Frank Van Sloun. Member: San Francisco Art Club. Address in 1918, San Francisco, CA.

GOETHE, JOSEPH ALEXANDER.
Sculptor, painter, engraver, craftsman, and writer. Born in Ft. Wayne, IN, March 1, 1912. Studied at Dayton Art Institute. Member: Santa Monica Art Guild. Awards: Fellow, Huntington Hartford Foundation, 1952. Work: Virginia Museum of Fine Arts; Evansville Public Museum; Washington County Museum of Fine Art, Hagerstown, MD; Brooks Memorial Museum; sculpture, figures, Langston Terrace Housing Project, Washington, DC; *USS Pres. Monroe*; *USS African Meteor*. Exhibited: Cincinnati Museum Association, 1935, 36; Art Institute of Chicago, 1934; National Academy of Design, 1943; Hoosier Salon; Chicago Society of Independent Artists; Wash. Art Club; Philadelphia Museum of Art; and many one-man exhibitions. Author: "Handbook Of Commercial Woods." Address in 1929, Santa Monica, CA.

GOETSCH, GUSTAV F.
Painter, etcher and teacher. Born Minneapolis, March 15, 1877. Pupil of Koehler in Minneapolis; Chase and Beckwith in New York; Blanche and Julian in Paris. Member: SFA; St. Louis AG; Chicago SE; Calif. SE; St. Louis AL; 2 x 4 Soc. Awards: First prize ($100) for painting, Minneapolis AI; hon. mention, St. Paul Inst., 1917; first prize for best work of art, and first prize, thumb box exhibition, St. Louis AL, 1918, 1920, 1922; first prize for best work of art, and first prize for pastel, St.

Louis AG, 1918; gold medal, Kansas City AI, 1924; first prize, Missouri State Fair, 1924; first prize, second prize and hon. mention, St. Louis AG, 1926; first prize St. Louis AL, 1926; hon. mention, Kansas City AI, 1927. Work in: City Art Museum, St. Louis; Minneapolis Inst. of Arts; Chicago Art Institute; and Worcester Art Museum. Address in 1929, 20 Elm Ave., Glendale, MO; School of Fine Arts, Washington University, St. Louis, MO.

GOFF, SUDDUTH.
Painter. Born Eminence, KY, Aug. 6, 1887. Pupil of Meakin, Nowottny, Benson, Bosley and Hale; Cincinnati Art Academy (Duveneck School); School of Boston Museum of Fine Arts. Member: Alumni Boston School of Museum of Fine Arts; Louisville AC. Award: First prize and gold medal in painting, Art Colony Exhibiton, Louisville, 1924. Work: Portrait in Kentucky State Capitol, Frankfort; portrait, Standard Sanitary Mfg. Co., Pittsburgh; portrait owned by KY State Federation of Women's Clubs, Lexington Public Library; portrait owned by KY W.C.T.U. in State Historical Bldg.; portrait of Ex-Governor McCreery in Richmond, KY, City Hall; portraits in Paris, KY, and Lexington, KY, City Hall. Instructor, American Academy of Art, Chicago, IL. Address in 1929, Am. Academy of Art, Chicago, IL.

GOHL, EDWARD HEINRICH.
Painter. Born in Harrisburg, PA, 1862. Pupil of Constant, Laurens, Bashet and Schommer in Paris. Address in 1926, Pearson Bldg., Auburn, NY.

GOLBIN, ANDREE.
Painter. Born in Leipzig, Germany in 1923. Studied in Switzerland with Henri Bercher; New York School of Fine and Applied Arts; Art Students League; Hans Hofmann School of Art. Awards: National Association of Women Artists, 1950; Grumbacher prize, Laurel Gallery, 1950.

GOLD, ALBERT.
Illustrator. Born in Philadelphia, in 1916. Studied under Henry C. Pitz at the Philadelphia College of Art where he is now a professor. He joined the Army in 1943, the year his first illustration appeared in *Yank*. Examples of the artwork he did as an Army War Artist can be seen in the *James Jones New Anthology of World War II Art*, published by Grosset and Dunlap. His illustrations have appeared in *Holiday*, *The Lamp*, and in many children's books. His work, which has received many awards, has been shown at the Metropolitan Museum of Art, the New Britain Mus. of American Art, and the Philadelphia Art Museum.

GOLDBECK, WALTER DEAN.
Sculptor, painter, and etcher. Born in St. Louis, MO, 1882. Award: Cahn honorable mention, Art Institute of Chicago, 1911. Died in 1925.

GOLDBERG, REUBEN LUCIUS.
Illustrator. Born San Francisco, CA, July 4, 1883. Cartoonist on *Evening Mail* since 1907. Member: Society of Illustrators. Died in 1970. Address in 1929, care of McNaught Syndicate, Times Bldg.; *Evening Mail*, 25 City Hall Place, New York, NY.

GOLDIE, JAMES L.
Painter. Born in Dorchester, MA, in 1892. Member of Conn. Academy of Fine Arts, Springfield, MA. Address in 1926, 284 Oakland St., Springfield, MA.

GOLDNER, JANET.
Sculptor. Born in Washington, DC, 1952. Study: Asgard School, Denmark, 1971; Penland School, NC, 1972; Experiment in International Living, VT; independent study of arts in West Africa, 1973; Antioch Col., B.A. Art, 1974; NYU, M.A. Sculpture, 1981. Work: Terry Gallery, Sudbury, MA; Rockrose Development Corp., NYC; many private collections and commissions. Outdoor sculpture: Austerlitz, NY, 1981; Bethesda, MD, 1981, 82; Wilton, CT, 1982. One-person shows: Stamford Museum, CT, 1977, 80; Washington Square E. Gallery, NYC, 1978, 80; Phoenix Gallery, NYC, 1983. Exhibitions: Concord Art Association, MA, 1975; Worcester Craft Center, MA; Bell Gallery, Greenwich, CT, 1977; Phoenix Gallery, NYC, 1981, 82; Cable Artists, NYC, 1982. Award: Millay Colony for the Arts, NY; Ossabow Island Project, GA; VA Center for the Creative Arts, Sweet Briar; Yaddo, Saratoga Springs, NY. Media: Fibers, wire mesh, copper, wire, metal, found objects. Address in 1983, 77 Bleeker St., NYC.

GOLDSBOROUGH, NANNIE COX.
Died Nov. 1923 in Eastland, MD. She painted a number of portraits and exhibited at the Paris Salons.

GOLDSTEIN, GLADYS HACK.
Painter. Born in Newark, OH, in 1918. Studied: Maryland Institute; Penn. State Univ.; Columbia Univ. Awards: Penn. State Univ., 1954; Berney Memorial award, Maryland, 1956; National League of American Pen Women, 1956; Rulon-Miller award, Baltimore, 1957. Collections: Penn. State Univ.; Univ. of Arizona; Univ. of Penn.; Baltimore Museum of Art. Media: Acrylics, oil, watercolor. Address in 1980, 2002 South Rd., Baltimore, MD.

GOLDSTEIN, MILTON.
Printmaker. Born in Holyoke, MA, Nov. 14, 1914. Study: ASL, 1946-49; with Harry Sternberg, Morris Kantor, Will Barnet; Guggenheim Fellow, 1950. Work: Phila. Mus. of Art; Met. Mus. of Art & Mus. of Modern Art, NYC; Brooklyn Mus., NY; Smithsonian Nat'l. Mus., Wash., DC. Commissions: Collection of etchings, Int'l. Graphics Society, NYC, 1952; Collection of etchings, 1954. Exhibited: Library of Congress, 1948; Smithsonian Inst., 1955; Brooks

Mem. Mus., Memphis, TN, 1959; Am. Printmakers in Italy, Boston Public Lib., 1960; Queens College, NY, 1964; Brooklyn (NY) Mus., 1977. Awards: 1st and purchase award, Phila. Art Mus., 1952; 1st and purchase award, Nat'l. Print Show, West, NM Univ., 1971. Teaching: Adelphi Univ., 1953-present. Member: Soc. Am. Graphic Artists; Fellow, Royal Soc. of Arts, London; Am. Color Print Soc.; etc. Address in 1982, Bayside, NY.

GOLDSWORTHY, EMELIA M.
Painter. Born in Platteville, WI, 1869. Pupil of Art Institute of Chicago, and of Otis Art Institute, Los Angeles, CA. Address in 1926, Art Director, Western States Normal School, Kalamazoo, MI.

GOLDTHWAIT, G. H.
This man, apparently a bank-note engraver, was working in Boston in 1842. There is a "Miniature County Map of the United States, Drawn, Engraved and Published by G. H. Goldthwait, Boston 1842." The map is embellished with a border of small views of public buildings and natural scenery.

GOLDTHWAITE, ANNE.
Painter, sculptor, lithographer and etcher. Born Montgomery, AL, in 1875. Pupil of Nat. Academy of Design under Mielatz in New York; Academie Moderne in Paris. Member: NA Women PS; NYWCC; Eclectics; Calif. P.M.; Brooklyn SE; Society of Painters of NY. Awards: McMillin landscape prize, ($100), NA Women PS, 1915; bronze medal for etching, P.-P. Exp., San F., 1915. Work in National Collection of Fine Arts, Washington, DC; Metropolitan Museum of Art; New York Public Libary; Whitney; Rhode Island School of Design; Musee du rue Spontini, Paris; Brooklyn Museum; Bibliotheque Nationale, Paris. Commissions: Over two hundred prints; fired clay sculpture; murals for the state of Alabama. Taught: New York Art Students League for more than twenty-three years. Specialty: Southern scenes, portraits, still lifes, and landscapes. Address in 1933, Montgomery, AL. Died in 1944.

GOLINKIN, J(OSEPH) W(EBSTER).
Painter, illustrator and lithographer. Born Chicago, IL, Sept. 10, 1896. Pupil of Art Inst. Chicago; ASL of NY. Address in 1929, 55 East 59th St., New York, NY.

GOLTZ, WALTER.
Painter and teacher. Born Buffalo, NY, June 20, 1875. Award: Bronze medal, Sesqui-Centennial Exposition, Philadelphia, 1926. Address in 1929, Woodstock, NY.

GOLUB, LEON ALBERT.
Painter. Born in Chicago, IL, in 1922. Received his Bachelor's degree, History of Art, University of Chicago, 1942; Master of Fine Arts from The School

of The Art Institute of Chicago, 1950. Taught at the Univ. of Chicago, Univ. of Indiana, and Northwestern Univ. Exhibitions: Wittenborn and Company, NY, 1952; Institute of Contemporary Arts, London, 1957; Hanover Gallery, London, 1962, 1964. Group Exhibitions: The Solomon R. Guggenheim Museum, New York, 1954; Museum of Art, Carnegie Institute, Pittsburgh, 1955; University of Illinois, Champaign-Urbana, 1957, 1961, 1963; The Museum of Modern Art, New York, 1960, 1962; Tate Gallery, London, 1963; Kassel, Germany, 1964; Prix Marzotto, Italy, 1964; Frumkin Gal.; Temple Univ.; San Francisco Mus. of Art; School of Visual Arts, NYC; others. In collections of Art Inst. of Chicago, Mus. of Modern Art; Univ. of California; Univ. of Texas; Kent State; Tel Aviv; private and corporate owners. Awarded grant from Ford Found. in 1960; Florsheim prize at annual exhib., Art Inst. of Chicago (1954); award at Biennal, Mexico City, 1962. Living in NYC.

GONZALES, BOYER.
Painter. Born Houston, TX. Pupil of Wm. J. Whittemore in New York; Walter Lansil in Boston; ASL; Birge Harrison at Woodstock, NY; studied in Holland, Paris and Florence; painted with Winslow Homer. Member: NY Water Color Club; Salma. C.; Nat. Arts Club, NY; Southern States Art Lg.; Texas Fine Arts Assoc. Awards: Arthur Evarts gold medal, Dallas, 1921; gold medal, Dallas, 1924; hon. mention, Southern States Art Lg., 1926. Represented in Galveston Art League; Municipal Schools of Galveston; Delgado Museum, New Orleans, LA. Address in 1929, 3327 Avenue O, Galveston, TX; summer, Woodstock, NY.

GONZALES, CARLOTTA.
(Mrs. Richard Lahey). Sculptor, painter, teacher, and illustrator. Born in Wilmington, NC, April 3, 1910. Studied at Penna. Academy of Fine Arts, with Laessle; National Academy of Design, with Aitken; Art Students League, with Laurent, Karfiol. Member: Society of Independent Artists; Ogunquit Museum of Art. Exhibited: Corcoran Gallery of Art, 1939, 50, 51; Montclair Art Museum, 1952; National Academy of Design, 1931. Illustrated, "Stars in the Heavens;" "USA and State Seals." Position: Staff artist, *National Geographic* magazine, Washington, DC, from 1943. Address in 1982, Vienna, VA.

GONZALEZ, XAVIER.
Sculptor and painter. Born in Almeria, Spain, February 15, 1898. Became a US citizen. Studied at Art Institute of Chicago, 1921-23; studied at museums in Europe, 1937-38. Worked in Paris, where he came in contact with art world; assistant to the Spanish painter, Jose Arpa. Awards: Guggenheim Fellowship, 1949; Ford Foundation Grant, 1965; gold medal and the 79th Artist Annual Award, National Art Club of NY, 1978; plus others. Member: American Watercolor Society; American National

Academy; National Association of Mural Painters (president), 1968. Taught: Newcomb College for Women of Tulane University, New Orleans, LA, 1930-42; art instructor at the Brooklyn Museum, 1945; lecturer at the National College Association, 1946; Western Reserve University, 1953-54; Summer School of Art, Wellfleet, MA; lecturer at the Metropolitan Museum of Art, NY; instructor at Art Students League. Has done mural commissions in Alabama, Texas, and Louisiana. Address in 1984, 222 Central Park South, NYC.

GOOD, B(ERNHARD) STAFFORD.
Painter and illustrator. Born in England, Jan. 7, 1893. Pupil of Art Inst. of Chicago, George Bellows, N.C. Wyeth. Illustrated *The Children of the New Forest*, by Capt. Marryat (Scribner's). Illustrations in *Scribner's* magazine. Address in 1929, Folcroft, PA.

GOOD, MINNETTA.
Painter and craftsman. Born New York City. Pupil of F. Luis Mora and Cecilia Beaux. Member: NA Women PS. Died in 1946. Address in 1929, 335 East 31st St., New York, NY; summer, Middle Valley, NJ.

GOODACRE, GLENNA.
Sculptor and painter. Born in Lubbock, Texas, August 28, 1939. Studied at Colorado College, B.A.; Art Students League. Commissions: Bronze bust of Dr. W. C. Holden, Texas Technical University, 1972; bronze of Dan Blocker, City Center, Odonnell, TX, 1973; bronze of J. Evetts Haley, Haley Library, Midland, TX, 1973; bronze of C. T. McLaughlin, Diamond M. Foundation, 1973; bronze relief of Dr. Kenneth Allen, Presbyterian Hospital, Denver, CO, 1975. Exhibitions: Catharine Lorillard Wolfe Art Club, NY, 1972; Texas Fine Arts National Show, Austin, 1973; West Texas National Watercolor Show, Museum Texas Technical University, 1973; Allied Artists of America, NY, 1974; National Academy of Design, NY, 1975. Awards: Catharine Lorillard Wolfe Art Club Cash Award for Oil Portrait, NY, 1972; Allied Artists of America, Award for Sculpture, NY, 1974. Media: Oil, pastel, watercolor; bronze. Address in 1982, Boulder, CO.

GOODALL, ALBERT GALLATIN.
Engraver. Born in Montgomery, AL, Oct. 31, 1826. In 1844 he went to Havana and learned copperplate engraving. He moved to Philadelphia in 1848 and commenced to engrave bank-notes on steel. Later was with a New York company which became, in time, the American Bank Note Co. Goodall was president of this company for the last twelve years of his life. Died in New York City Feb. 19, 1887.

GOODELMAN, AARON J.
Sculptor, illustrator, etcher, lecturer, and teacher. Born in Russia, April 1, 1890. Pupil of G. T. Brewster; J. Injalbert. Member: Plastic Club; Society of

Independent Artists. Awards: Bronze medal, Soc. of Beaux Arts Architecture, 1914, 1915, 1916. Work: Portrait bust of Ansky, Classic Theatre; "The Golem," Gabel's Theatre; "Sholem Alachem," Sholem Alachem Folks' Inst.; "Relief," Hospital for Joint Diseases, all in NY. Illust. for *Kinter Journal* and *Kinter Land*. Taught: Chairman of Art Dept., inst. of sculpture, Jefferson School for Social Sciences NYC, 1946-52. Address in 1953, NYC. Died in 1978.

GOODING, WILLIAM C.
Portrait painter. Born in 1775. In the Ontario *Messenger*, published in Canandaigua, NY, 1815, Mr. William C. Gooding advertised to do "Portrait and Miniature Painting." Died in 1861.

GOODMAN, CHARLES.
Engraver. Born in Philadelphia, 1796; died there Feb. 11, 1835. Pupil of David Edwin, and a good engraver in the stipple manner. Goodman and his fellow apprentice, Robert Piggot, founded the firm of Goodman & Piggot and produced a considerable number of portraits, etc., in Philadelphia.

GOODMAN, WALTER.
Painter. Born in England in 1838. He resided in Cuba for five years. He was in the United States in 1870. He devoted himself to portrait painting and also did illustrating.

GOODRICH, J(AMES) H(ARRY).
Painter. Born Colon, St. Joseph Co., MI, Nov. 29, 1878. Pupil of Gies in Detroit; Freer in Chicago. Member: Nashville AA; Southern States Art League. Awards: Carnegie Scholarship to Harvard Univ., 1928, 1929. Instructor in art, George Peabody College for Teachers, Nashville, TN; head of art department, Fisk University. Address in 1929, Route 3, Hamilton Rd., Nashville, TN.

GOODRIDGE, SARAH.
Miniature artist. Was born in Massachusetts in 1788. She early showed a love of art, but did not have the means to study. Largely self-taught, it was not until about 1812 that she went to Boston and began painting miniatures; here she was introduced to Gilbert Stuart, who gave her the only real instruction she ever received. Her miniature of Stuart is in the Metropolitan Museum, New York; others are owned by the Boston Museum and private collectors. Memoir of Sarah Goodridge is in Mason's *Life and Works of Gilbert Stuart*. Died in 1853.

GOODWIN, ALICE HATHAWAY HAPGOOD.
(Mrs. Harold Goodwin, Jr.). Painter. Born in Hartford, CT, Nov. 5, 1893. Pupil of Hugh H. Breckenridge, Emil Carlsen, Violet Oakley. Member: Fellowship Penna. Academy of Fine Arts. Work: Reredos, Episcopal Church, Castleton, VT. Address in 1929, 118 Walnut St., Jenkintown, PA.

GOODWIN, ARTHUR CLIFTON.
Painter and illustrator. Born in Portsmouth, NH, 1866. Exhibited at Annual Exhibition of Penna. Academy of Fine Arts, Philadelphia, 1924. Address in 1926, 139 West 54th St., New York.

GOODWIN, FRANCES M.
Sculptor. Born in Newcastle, IN. She studied art in Indianapolis, IN, and later at the Chicago Art Institute, where she became interested in modeling. Later abandoned her intention of becoming a painter in order to study sculpture. She studied at the Art Students League, New York, with D. C. French as instructor. Except as stated she was self-taught. Among her works are: Statue representing Indiana, for Columbian Exposition; bronze bust of Capt. Everett, Riverhead Cemetery, NY; marble bust of Schuyler Colfax, Senate gallery; bust of Robert Dale Owen for the State House at Indianapolis, IN. Died 1929 in Newcastle, IN.

GOODWIN, GILBERTA D(ANIELS).
Painter. Born Burlington, VT, Aug. 20, 1888. Pupil of John F. Weir, Edwin Taylor, G. A. Thompson, Hayes Miller. Member: NY Water Color Club; New Haven Paint and Clay Club; Conn. Soc. of Painters. Address in 1929, 120 West 11th St., New York, NY.

GOODWIN, HELEN M.
Painter. Born New Castle, IN. Pupil of Hoffbauer and Mme. La Forge in Paris; Hawthorne. Member: Indiana AC; Provincetown AA; American Woman's AA, Paris; Hoosier Salon. Awards: First prize, miniature, Hoosier Salon, Marshall Field Galleries, 1925. Works: "The Lone Sentinel," Public School, New Castle; "Sierra Madre, California," Spiceland Academy of Indiana; "The Old Bible," Public Library, New Castle. Address in 1929, 320 South Main St.; summer, Oak Hill Lodge, New Castle, IN.

GOODWIN, MYRTLE.
See D'Ascenzo, Myrtle Goodwin.

GOODWIN, PHILIP RUSSELL.
Painter and illustrator. Born in Norwich, CT, 1882. Pupil of RI School of Design; Howard Pyle; Art Students League of New York. His editorial work appeared in many magazines and he had exhibitions in NY at the Hammer, Kennedy and Latendorf Galleries. Died in 1935. Address in 1926, Grove and Louis Sts., Mamaroneck, NY.

GOOSSENS, JOHN.
Painter. Born Norway, MI, Aug. 27, 1887. Pupil of Royal Academy of Antwerp, Belgium; Frederick Poole; George Oberteuffer; AIC. Member: Alumni AIC; Ill. AFA. Awards: Two blue ribbons, Aurora, 1927; two red ribbons, Aurora, 1928; hon. mention, Springfield, IL, 1928. Address in 1929, 1624 North Shore Ave., Chicago, Ill.; summer, care of Charles Treve, R.D. No. 1, Aurora, IL.

GORBUTT, JOHN D(ETWILER), JR.
Sculptor and painter. Born in Troy, Kansas, October 20, 1904. Studied with V. Helen Anderson. Work: "Portrait of Justice E. R. Sloan," property of the State of Kansas. Award: Kansas Free Fair, 1932. Member: Topeka Artist Guild. Address in 1933, Topeka, Kansas.

GORDIN, SIDNEY.
Sculptor. Born October 24, 1918, in Cheliabinsk, Russia. Studied: Cooper Union, 1937-41, with Morris Kantor, Wallace Harrison, Leo Katz. Work: Art Institute of Chicago; Newark Museum; Chrysler; Southern Illinois Univ.; Whitney Mus. Exhibited: Grace Borgenicht Gallery Inc., 1953, 55, 58, 60, 61; New School for Social Research, 1957; Dilexi Gallery, San Francisco, 1959, 63, 65; de Young, 1962; Los Angeles County Museum of Art, 1963; Metropolitan Museum of Art, 1951; Whitney Mus. of American Art Annuals, 1952-57; Mus. of Modern Art; Art Inst. of Chicago; Penna. Academy of Fine Arts; Brooklyn Mus.; Newark Mus.; San Francisco Mus. of Art; Tulsa (Philbrook). Taught: Pratt Inst., 1953-58; Brooklyn Col., 1955-58; New School for Social Research, 1956-58; Sarah Lawrence Col., 1957-58; Univ. of Calif., Berkeley, from 1958. Commissions for Temple Israel, Tulsa, OK, 1959; Envoy Towers, 300 East 46 Street, NYC, 1960. Address in 1982, c/o Anglim Gallery, San Francisco, CA.

GORDON, ELIZABETH.
Sculptor. Born in St. Louis, MO, in 1913. Studied: The Lenox School; sculpture with Walter Russell, Edmondo Quattrocchi. Awards: Brooklyn War Memorial Competition, 1945; Catherine L. Wolfe Art Club, 1951, 1958; Pen and Brush Club, 1954; National Academy of Design, 1956; gold medal, Hudson Valley Art Association, 1956; Pen and Brush Club, 1957. Collections: The Lenox School, NY; Aircraft Carrier "U.S.S. Forrestal;" James L. Collins Parochial School, TX; Woodstock Cemetery; Kensico Cemetery, NY; James Forrestal Research Center, Princeton University.

GORDON, EMELINE H.
(Mrs. Beirne Gordon). Painter and teacher. Born Boston, MA, June 25, 1877. Pupil of Tarbell, Frank Benson, Eliot Clark. Member: Savannah AC. Address in 1929, 304 East Huntingdon St., Savannah, GA; summer, North Hatley, Canada.

GORDON, FREDERICK CHARLES.
Painter. Born at Cobourg, Ont., 1856; died March 20, 1924, in High Orchard, NJ. Studied at Art Students League, NY and Julien and Colarossi Academies, Paris. Began work 1882, at Toronto, Canada, and came to U.S. in 1886; painter of portraits, landscapes and genre. Later devoted his attention chiefly to decorative drawings for publications. In collection of Boston Museum and private collectors.

GORDON, LEON.
Sculptor. Born in Bonsor, Russia, May 25, 1888. Pupil of Art Institute of Chicago; Art Students League, NYC; Julian Academy; Kunst Academy, Vienna. Member: Salmagundi Club; Soc. of Illustrators. Address in 1933, 80 West 40th Street, NYC.

GORE, THOMAS H.
Painter and draughtsman. Born Baltimore, MD, Oct. 1, 1863. Studied with Duveneck. Member: Cincinnati AC. Died in 1937. Address in 1929, 211 Pleasant St., Covington, KY.

GOREY, EDWARD.
Illustrator. Born in 1929. A graduate of Harvard in 1950, he worked briefly in a publishing house and began his free-lance career in 1953. Aside from many editorial assignments for *The New York Times*, *Esquire*, and *Holiday*, he has illustrated several children's books, of which the first was entitled *Unstrung Harp*. In the early 1950's he illustrated the Henry James novels for Anchor Books and has since published many albums of drawings. Presently living in Barnstable, Mass., he has had exhibitions in Minneapolis and New York.

GORI, OTTAVIANO.
Sculptor. Worked: NYC, 1841-59; San Francisco, from 1861. Exhibited: American Institute, 1842. Media: Marble and alabaster.

GORKY, ARSHILE.
Painter. Born 1905 in Khorkom Vari Haiyotz Dzor, Armenia. Emigrated in 1920 to US. He studied at the Polytechnic Inst., in Tilfis, 1916-18; New Sch. of Design, Boston, 1923; Grand Central Sch., NYC, 1925-31. Exhibitions were held at the Guild Art Gallery in NYC, 1932, 1935, 1936; Mellon Gallery, Philadelphia, 1934; and many others. In collections of the Univ. of Arizona; Albright-Knox Gallery, Buffalo, NY; Oberlin College. Died July 21, 1948, in Sherman, CT.

GORSON, AARON HARRY.
Painter. Born in Russia, July 2, 1872; came to America in 1889. Pupil of Penna. Academy of Fine Arts; Julian Academy, Constant and Laurens in Paris. Member: Pittsburgh AA; Brooklyn AS; Alliance. Represented in Newark Museum Association; American Art Museum, Worcester, MA; Heckscher Park Art Museum, Huntington, LI, NY. Died Oct. 11, 1933, in New York City. Address in 1929, 6 West 28th St.; 1995 Creston Ave., New York, NY.

GOSHORN, JOHN THOMAS.
Painter. Born near Independence, IA, 1870. Pupil of Art Institute of Chicago, and Smith Art Academy. Address in 1926, 512 Washington Bank Bldg., Pittsburgh, PA.

GOSS, JOHN.
Painter and illustrator. Born Lewiston, ME, Sept. 19, 1886. Member: Boston AC; Amer. Water Color Society. Died c. 1963. Address in 1929, Fenway Studios, 30 Ipswich St., Boston, MA; h. Walpole, MA.

GOSSELIN, LUCIEN H.
Sculptor. Born Whitefield, NH, Jan. 2, 1883. Pupil of Verlet, Bouchard, Landowski, and Mercie. Member: Societe Libre des Artistes Francais. Award: Honorable mention, French Artists Salon, 1913. Address in 1933, Paris, France; h. Manchester, NH.

GOTH, MARIE.
Painter. Born in Indianapolis, IN. Studied: Art Students League, with DuMond, Chase, and Mora. Known chiefly as a portrait painter. Awards: Evansville, Indiana Mus. of Art and History, 1939; Indiana Art Club, 1935, 1939, 1944, 1945, 1956; Brown County Art Gallery, 1933; Hoosier Salon, 1926, 1929, 1932, 1934, 1942, 1945, 1946, 1948, 1949, 1951, 1952, 1957, 1958; Nat. Acad. of Design, 1931. Collections: Hanover Col.; Franklin Col.; Purdue U; Indiana U; Butler Col.; John Herron Art Inst.; Florida State U; Honeywell Mem. Com. Center, Wabash, IN; John Howard Mitchell House, Kent, England.

GOTHELF, LOUIS.
Painter. Born Russia, Apr. 6, 1901. Pupil of Ivan Olinsky, G. W. Maynard, Nat. Acad. of Design, J. Wellington Reynolds, Art Inst. Chic. Member: Rockford AA; Artklan; United Scenic A., Chic. Work: "Portrait of Scholem Alachem," Jewish Educational Bldg., Toledo. Art dir., Orpheum Theatre, Rockford, IL. Address 1929, 119 Floyd St., Toledo, OH.

GOTO, JOSEPH.
Sculptor. Born January 7, 1920, in Hilo, Hawaii. Studied: Chicago Art Institute School; Roosevelt University. Work: Art Institute of Chicago; Indiana University; Museum of Modern Art; University of Michigan; Union Carbide Corp. Exhibited: Allan Frumkin Gallery, NYC and Chicago, 1962; Stephen Radich Gallery, NYC, 1964, 65, 67; Art Institute of Chicago; Carnegie Institute; University of Illinois; Speed Art Museum, Louisville; Whitney Museum; Rhode Island School of Design; and many more. Awards: Art Institute of Chicago, 1957; Graham Foundation Fellowship, 1957; John Hay Whitney Fellowship; Art Institute of Chicago, Watson F. Blair Prize; Art Institute of Chicago, Logan Prize; Art Institute of Chicago, Palmer Prize; J. S. Guggenheim Fellowship, 1969. Taught at Brandeis; Carnegie; Rhode Island School of Design; and others. Address in 1982, Providence, RI.

GOTTHOLD, FLORENCE W(OLF).
(Mrs. Frederick Gotthold). Painter and craftswoman. Born Uhrichsville, OH, Oct. 3, 1858. Pupil of B. R. Fitz, H. Siddons Mowbray and H. G. Dearth. Member: NY Pen and Brush C.; MacD. C.; Greenwich SA; NA Women PS; Silvermine GA; Gld. of Book Workers; Wilton SA. Died in 1930. Address in 1929, 67 W 52nd St., NY, NY; summer, Wilton, CT.

GOTTHOLD, ROZEL.
Sculptor, painter, craftsman, and writer. Born in New Orleans, LA, January 26, 1886. Inventor of palm baskets. Address in 1921, New Orleans, LA.

GOTTLIEB, ADOLF.
Painter. Born March 14, 1903, in NYC. Studied at the Art Students League, 1919, with John Sloan and Robert Henri; Parsons Sch. of Design, 1923. In 1944-45, was president of Fed. of Mod. Painters. Taught at the Pratt Inst., 1958; UCLA, 1958. Awarded Dudensing Nat. Competition, 1929; U.S. Treasury Dept., Mural Competition, 1939; Brooklyn Museum First Prize, 1944. Exhibitions: Dudensing Gallery, NYC, 1930; Uptown Gallery, NYC, 1934; Galerie Handschen, Basel, 1961.

GOTTWALD, F(REDERICK) C(ARL).
Painter and teacher. Born in 1860. Pupil of Art Students Lg. of NY; Royal Academy, Munich. Member: Cleveland SA. Work: "The Umbrian Valley, Italy," Cleveland Museum. Instructor at Cleveland School of Art. Died in 1941. Address in 1929, Cleveland School of Art, Cleveland, OH.

GOUDY, FRED W.
Type designer, craftsman, writer, lecturer, teacher. Born Bloomington, IL, March 8, 1865. Member: Grolier C.; American Institute Graphic A.; Stowaways. Awards: Bronze medal, St. Louis Exp., 1904; gold medal, American Institute Graphic A.; gold medal, Amer. Inst. of Architects; Friedsam gold medal, NY Arch. League. Author of *The Alphabet*, and *Elements of Lettering*, published by Mitchell Kennerly, NY, and John Lane, London, and editor of *Arts Typographica*. Instructor, Art Students League, NY; University of NY. Died in 1947. Address in 1929, Marlboro-on-Hudson, NY.

GOULD, CARL FRELINGHUYSEN.
Painter, architect, lecturer and teacher. Born New York City, Nov. 24, 1873. Pupil of William Sartain; Ecole des Beaux Arts; M. Victor Laloux. Member: Beaux-Arts Architects; Seattle Fine Arts Soc.; American Inst. of Architects; NY Arch. Lg. Work: Campus Bldgs., University of Washington; New Seattle Times Bldg.; formerly Head of Department of Architecture, University of Washington. Address in 1929, 710 Hoge Bldg.; h. 1058 East Lynn St., Seattle, WA; summer, Bainbridge Island, WA.

GOULD, JANET.
Sculptor. Born in Rumania, June 5, 1899. Studied with A. Finta, Charles Neilson. Member: League of

Present-Day Artists; Creative Arts; NY Ceramic Arts. Awards: Prizes, Asbury Park Art Association, 1940; Springfield Museum of Art, 1950. Exhibited: National Academy of Design, 1940, 42, 44; Asbury Park Art Association, 1940; Cincinnati Museum, 1943; Hartford, CT, 1942; Art Institute of Chicago, 1943, 47; Riverside Museum, 1944, 48; Ferargil Gallery, 1946; Barbizon Plaza (one-woman); Penna. Academy of Fine Arts, 1946, 47; Audubon Artists, 1945; Irvington Free Library, 1946; Springfield Art Museum, 1948, 50; Fairmont Art Association, 1949. Address in 1953, 315 West 36th St.; h. 235 West 22nd St., NYC.

GOULD, STEPHEN.
Sculptor and collector. Born in NYC, December 25, 1909. Studied at New School for Social Research, with Manola Pascal. Has exhibited at National Exhibition of Professional Artists, NY; Salmagundi Club; National Soc. of Arts and Letters Exhibition, Metropolitan Museum of Art, NY, 1979. Member of Royal Society of Arts; National Society of Arts and Letters; Artists Equity Association; Salmagundi Club. Works in clay. Address in 1982, Tamarac, FL.

GOULD, THOMAS RIDGEWAY.
Sculptor. Born in Boston, Nov. 5, 1818. He studied with Seth Cheney. His two colossal heads of "Christ" and "Satan" were exhibited at the Boston Athenaeum in 1863. His most celebrated statue was the "West Wind"; among his portrait busts are those of Emerson, Seth Cheney, and the elder Booth. Opened studio in Florence in 1868 where lived most of his life. He died Nov. 26, 1881, in Florence, Italy.

GOULD, WALTER.
Painter. Born in Phila. in 1829, he studied under J. R. Smith and Thomas Sully. He became a member of the Artists' Fund Soc. of Phila. His subjects are generally oriental, a reminiscence of his travels in Egypt and Asia. He visited Constantinople and painted pictures of many important persons there. Died Jan. 18, 1893, in Florence, Italy.

GOULET, LORRIE.
(Lorrie J. de Creeft). Sculptor and teacher. Born in Riverdale, NY, Aug. 17, 1925. Studied at Inwood Pottery Studios, 1932-36, with Amiee Voorhees; Black Mountain College, NC, with Josef Albers; sculpture with Jose de Creeft, 1943-44. In collections of Hirshhorn, Washington, DC; NJ State Museum; others. Commissions for NY Public Library; Bronx Municipal Hospital; Bronx Police and Fire Station. Exhibited at Clay Club Sculpture Center, NYC, 1948, 55; American Federation of Arts, 1963; World Trade Fairs, Algiers, Barcelona, Zagreb, 1964; Contemporary Gallery, NYC, 1959, 62, 66, 68; Kennedy Galleries, NYC, 1971, 73-75, 78, 80; many more. Taught at Museum of Modern Art, 1957-64; New School for Social Research, 1961-75; Art Students League, 1981; others. Awards: First Sculpture Prize, Norton Gallery, 1949, 50, and Westchester Art Society, 1964; Soltan Engel Memorial Award, Audubon Artists, 1967. Member of Sculptors Guild; Audubon Artists; founding member, Visual Artists and Galleries Association; Nat. Commission on Art Education; others. Works in wood, stone, ceramics. Represented by Kennedy Galleries, NYC. Address in 1982, 241 West 20th St., NYC.

GOVE, ELMA MARY.
Portrait artist in crayons and oils. She was working in New York in 1851-55.

GRABACH, JOHN R.
Sculptor and painter. Born in Newark, NJ, March 2, 1886. Pupil of Art Students League of NY. Member: League of NYA; Society of Independent Artists; Audubon Artists; Philadelphia Water Color Club; North Shore AA; Amer. Fed. of Arts. Exhibited: Corcoran Gallery of Art., 1931, 33, 35, 41; Art Institute of Chicago; Montclair Art Mus. Awards: Peabody prize, Art Inst. of Chicago, 1924; Sesnan gold medal, Penna. Academy of Fine Arts, 1927; Preston Harrison prize, Los Angeles Museum. Work: "Wash Day in Spring," Art Inst. of Chicago; "The Steel Rainbow," Vanderpoel AA, Chicago. Position: Instructor of Art, Newark School of Fine and Industrial Arts. Died in 1981. Address in 1953, Irvington, NJ.

GRAD, BARBARA.
Painter/graphics. Born in 1951. Studied: The School of the Art Institute of Chicago. Exhibitions: Allan Frumkin Gallery, Chicago, IL, 1973; Suburban Fine Arts Center, Highland Park, IL, 1974; Northern Illinois Univ., DeKalb, IL, 1975. She is represented in the collections of The Art Institute of Chicago Museum.

GRAF, CARL C.
Painter. Born Sept. 24, 1890. Pupil of Herron Art Inst., Indianapolis, IN, and Cincinnati Academy. Member: Ind. AC; Nashville A. Colony. Died in 1947. Address in 1929, 43 Union Trust Bldg., Indianapolis, IN; Nashville, IN.

GRAFLY, CHARLES.
Sculptor. Born Dec. 3, 1862, in Philadelphia, PA. Pupil of Penna. Academy of Fine Arts, and Chapu and Dampt, Paris. Member of International Jury of Awards, St. Louis Exp., 1904; Municipal Art Jury, Philadelphia National Academy, 1906; Nat. Institute of Arts and Letters; National Sculpture Society; Architectural League; Philadelphia Art Club; Penna. Academy of Fine Arts. Represented in permanent collections of Penna. Academy of Fine Arts; Detroit Art Museum; St. Louis Mus.; Carnegie Institute, Pittsburgh; Boston Museum. Executed a large number of notable pieces in busts, life size;

and ideal figures, groups, largely in bronze. Received awards at Paris Salon, 1891; Penna. Academy of Fine Arts, 1892; Columbian Exp., Chicago, 1893; Atlanta Exp., 1895; Penna. Academy of Fine Arts, 1899; International Exp., Paris, 1900; Pan-Am. Exp., Buffalo, 1901; Buenos Aires Exp., 1910; Philadelphia Water Color Club, 1916; George D. Widener gold medal, 1913; Watrous gold medal, Nat. Academy, 1918; and Palmer Gold Medal, Art Institute of Chicago, 1921. Exhibited at National Sculpture Society, 1923. Address in 1926, Philadelphia, PA. Died May 5, 1929, in Philadelphia, PA.

GRAFSTROM, RUTH SIGRID.
Illustrator. Born in Rock Island, Illinois, in 1905. Studied at the Art Inst. of Chicago and the Colarossi Academy in Paris. A fashion artist for *Vogue* from 1930 to 1940, she later worked for *Delineator*, *Cosmopolitan* and *Woman's Home Companion*. She won many awards and citations from the NY Art Directors' Club and the Society of Illustrators, of which she had been a member.

GRAFTON, ROBERT WADSWORTH.
Painter. Born in Chicago, IL, Dec. 19, 1876. Pupil of Art Inst. of Chicago; Julian Academy in Paris; studied in Holland and England. Awards: Mary T. R. Foulke prize, Richmond AA, 1910 and 1919; Leroy Goddard prize, Hoosier Salon, Chicago. Member: Chicago PS; Palette and Chisel C.; Chicago AC; Chicago AG. Work in Delgado Museum and New Orleans Art Assoc., New Orleans; La Fayette Art Assoc.; Union Lg. C., Chicago; Northwestern Univ; Purdue Univ.; Earlham College; Public Art Gallery, Richmond, IN; mural panels in State House, Springfield, IL; Tulane Univ., New Orleans, LA; First National Bank, Ft. Wayne, IN; two portraits, State Library, Indianapolis; portrait, State House, Lansing, MI; portrait of Ex-President Coolidge, Saddle and Sirloin Club; mural, "Coming of Pioneers," Kansas Wesleyan Univ.; official portrait, Secretary Jardine, Dept. of Agriculture, WA. Died in 1936. Address in 1929, East Coolspring Ave., Michigan City, IN.

GRAHAM, A. W.
Engraver. Born in England, he studied engraving under Henry Meyer, a well-known London engraver. He came to the United States about 1832, and in 1934 he engraved some excellent views for the *New York Mirror*. He engraved a few portraits at a later date, but his best work is to be found in the small plates executed for the "Annuals" of 1835-40. Graham was located in Philadelphia in 1838-40 and in 1844-45, according to the directories of that city; he was living in New York in 1869.

GRAHAM, CECILIA BANCROFT.
Sculptor. Born San Francisco, CA, March 2, 1905. Pupil of Louis de Jean, Oskar Thiede, Nicolo

D'Antino. Address in 1929, Berkeley, CA; summer, Stateline, Lake Tahoe, CA.

GRAHAM, ELIZABETH SUTHERLAND.
Painter. Born New York City. Pupil of NY Sch. of Applied Design for Women; M. Despujols. Member: Nat. Assoc. Women Painters and Sculptors; Brooklyn SA; Brooklyn Soc. of Miniature Painters. Died in 1938. Address in 1929, 464 Clinton Ave., Brooklyn, NY.

GRAHAM, GEORGE.
Engraver in mezzotint and in stipple. His first work appeared in 1795. Probably located in Philadelphia in 1797. Working for New York publishers in 1804. He designed and apparently engraved a frontispiece for the "Proceedings of the Society of the Cincinnati," published in Boston in 1812, and he was again engraving in Philadelphia in 1813.

GRAHAM, JOHN D.
Sculptor and painter. Born Kiev, Russia, Dec. 27, 1891. Pupil of John Sloan. Work: Sixteen paintings, Phillips Memorial Gallery, Wash., DC; painting, Spencer Kellog collection, New York; five paintings, Ben Hecht collection, New York. Author: "System and Dialectics of Art," 1937. Address in 1953, NYC. Died in 1961.

GRAHAM, MARGARET NOWELL.
(Mrs. J. L. Graham). Painter. Member: Southern States Art League; Amer. Federation of Arts. Address in 1929, 625 Summit St., Winston-Salem, NC.

GRAHAM, P. PURDON.
This name, as engraver, is signed to a well-executed line-engraving of Cadwallader Colden, after a portrait painted by Matthew Pratt, and belonging to the Chamber of Commerce of New York. The work was probably done about 1870-75, but nothing more is known about the engraver.

GRAHAM, PAYSON (MISS).
Sculptor and illustrator. She was a member of Art Students League of New York. Address in 1926, 251 West 81st St., New York.

GRAHAM, ROBERT A(LEXANDER).
Painter and teacher. Born Brooklyn, IA, June 29, 1873. Pupil of Art Students Lg. of NY; Joseph DeCamp; Twachtman; Bridgman. Member: NY Water Color Club; Salma. Club. Specialty, figure and landscape painting. Died in 1946. Address in 1929, 300 East 13th Ave., Denver, CO.

GRAHAM, WALTER.
Sculptor and painter. Born in Toledo, IL, Nov. 17, 1903; raised in Chicago. Studied at Chic. Academy of Fine Arts; Chicago Art Inst.; privately. Illustrated for Street and Smith Publishers; painted cover art

for magazines, including *Western Story, Western Life, Appaloosa News,* etc. Owner of Nugent Graham Studios (commercial art), 1939-50. Turned to fine art full-time in 1950. Work in Central Washington Museum, Wenatchee; Favell Museum, Oregon; murals for ships, State of Alaska; others. Exhibited at Russell Museum, Great Falls, MT; Society of Animal Artists Exhibition, Columbus (OH) Gallery; Art Institute of Chicago; others. Awarded first prize, Chicago Galleries; gold medal, Palette and Chisel Academy, Chicago; honorable mention, Seattle Art Director's Club. Member of Society of Animal Artists. Specialty is animals and Western historical subjects. Works in bronze; oil, watercolor. Bibliography, *Western Painting Today.* Address in 1982, Wenatchee, WA.

GRAHAM, WILLIAM.
Born in New York, but spent many years in Rome. Painted generally Roman and Venetian landscapes. "Outside the Porto del Popolo, Rome," (signed) "W. Graham, 1874, Rome," exhibited at Penna. Academy of Fine Arts.

GRAMATKY, HARDIE.
Illustrator. Born in Dallas, Texas, in 1907. Attended Stanford Univ. and Chouinard Institute under Pruett Carter. He initiated his career with a 12-page spread for *Fortune* in 1939, and went on to illustrate for major periodicals such as *Collier's, Good Housekeeping, Redbook,* and *True.* Author-illustrator of *Little Toot,* he is the creator of 12 additional children's books and recipient of 40 watercolor awards. His paintings have been in museums and galleries worldwide as well as part of many permanent collections.

GRANDEE, JOE RUIZ.
Sculptor, painter, and gallery director. Born in Dallas, TX, Nov. 19, 1929. Studied at Aunspaugh School of Art, Dallas. Operated ranch; turned full-time to art in 1956. Represented in the White House, Washington, DC; Montana State Historical Society; Xavier Univ. Museum, Cincinnati, OH; Marine Corps Museum, Quantico, VA; commissions include wedding portrait of Linda Bird and Chuck Robb; portrait of Leander H. McNelly, Texas Ranger, for Richard Nixon; portrait of Johnny Carson; and others. Has exhibited at Amon Carter Museum, Ft. Worth, TX, 1968; Norton Art Gallery Museum, Shreveport, LA, 1971; El Paso (TX) Museum of Fine Arts; US Capitol (first comprehensive exhibition of a Western artist), 1974; and many more. Selected first Official Artist of Texas; also awarded Franklin Mint gold medal in Western art; and many others. Specialty is Old West subjects. Has illustrated a number of books; biography in *The West Still Lives,* by Schultz. Media: Oil, ink. Represented by Corpus Christi Art Gallery, Corpus Christi, TX; One Main Gallery, Dallas, TX. Owner: Joe Grandee Gallery &

Museum of Old West, Arlington, TX. Address in 1984, Arlington, TX.

GRANDIN, ELIZABETH.
Painter and craftsman. Born Camden, NJ. Pupil of Henri; Guerin in Paris. Member: MacD. C.; Nat. Assoc. Women Painters and Sculptors; NYS Women Artists. Address in 1929, 25 East 11th St., New York, NY; h. Annandale, NJ.

GRANDY, WINFRED MILTON.
Sculptor. Born in Preston, CT, Sept. 20, 1899. Studied with Burdick, Yale School of the Fine Arts. Awards: Honorable mention, Univ. of Tennessee, Knoxville, TN, 1931; first prize, garden figure, Mass. Agricultural/Horticultural Show, 1932. Address in 1933, New Haven, CT; summer, "The Studio," Short Beach, CT.

GRANER, LUIS.
Portrait, genre and landscape painter of great versatility. Born in Barcelona, Spain, 1867. Came to America in 1910, and lived and painted in New Orleans from 1914 to 1922, at intervals. Received medals at Barcelona, Madrid, Berlin, Paris, and in many other places. In 1904 he was made a member of the "Societe Nationale des Beaux Arts," France. Represented in art museums, Madrid and Barcelona, Spain; Brussels, Belgium; Bordeaux, France; Berlin, Germany; and in the National Museums of Brazil, Chile, Argentina and Uruguay, and in the Papal Gallery, Rome.

GRANGER, CAROLINE GIBBONS.
Painter. Exhibited at the Penna. Academy of Fine Arts, Philadelphia, in 1924. Address in 1926, 1016 South 46th St., Philadelphia, PA.

GRANT, BLANCHE C.
Painter, lecturer and writer. Born Leavenworth, KS, in 1874. Pupil of Paxton, Hale, McCarter, Johansen. Award: Hon. mention, St. Paul Inst., 1917. Address in 1929, Taos, NM.

GRANT, CATHARINE (HARLEY).
Painter and teacher. Born Pittsburgh, PA, Jan. 27, 1897. Pupil of Penna. Academy of Fine Arts; Hugh H. Breckenridge. Member: Fellowship Penna. Academy of Fine Arts; Phila. Alliance; Plastic C. Specialty, portraits. Died in 1954. Address in 1929, 303 Walnut St.; h. 1809 Pine St., Philadelphia, PA; summer, Bellwood, PA.

GRANT, CHARLES H(ENRY).
Marine painter. Born Oswego, NY, Feb. 6, 1866. Pupil of De Haas, and Nat. Academy of Design. Member: San. F. AA; Bohemian Club; Sequoia Club. Work: "Salute to the Flag," Oswego (NY) City Hall; "Safe in Port," Syracuse Museum of Art; "After the Rain," Sequoia Club, San F.; "Arrival of Atlantic

Battleship Fleet in Golden Gate, San Francisco, 1908," Memorial Museum, San Francisco; "They Made the World Safe for Democracy," Bohemian Club, San Francisco; "Arrival" Pacific Battle Fleet in Golden Gate, San Francisco, 1919, Bohemian Club; commissioned by Bohemian Club to paint *H.M.S. Hood* and *U.S.S. California*; by Citizens Committee of the Chamber of Commerce to paint *U.S.S. California*; official artist of U.S. Navy on 1925 cruise to Australia. Died in 1939. Address in 1929, Bohemian Club, San Francisco, CA.

GRANT, CLEMENT ROLLINS.
Painter. Born in Freeport, ME, 1849. Studied abroad; on his return to this country, established his studio in Boston and became a member of the Boston Art Club. Specialty: Landscapes and portraits. Work: "Amy Wentworth," "Marguerita," and a "Normandy Fisherman."

GRANT, FREDERIC M.
Painter, illustrator, etcher and teacher. Born Sibley, IA, Oct. 6, 1886. Pupil of Chase, Miller, Vanderpoel and Snell. Member: Chicago PS; Cliff Dwellers. Awards: Goodman prize, 1914, Cahn prize and Butler prize, 1917, Municipal AL prize, 1917, Eisendrath prize, 1919, Municipal AS prize, 1919, Holmes prize, 1924, Logan medal ($500), 1926, Hearst prize ($300), 1927, all from Art Inst. of Chicago; Fine Arts Bldg. prize, Chicago AG, 1916; popular prize, Chicago AC, 1918; hon. mention, Chicago AG, 1918; Chase prize, Venice, 1918. Address in 1929, 139 East Ontario St., Chicago, IL.

GRANT, GORDON HOPE.
Painter and illustrator. Born San Francisco, CA, June 7, 1875. Pupil of Heatherley's and Lambeth's Schools, London. Member: Amer. Water Color Soc.; Society of Illustrators, 1911; Salma. C., 1901; Allied Artists of America; NYSP; Amer. Fed. of Arts. Worked on the *San Francisco Chronicle* and *The Examiner*. Reports of Boer War, Mexican border conflicts in *Harper's*. Paintings of nautical subjects in collections of Met. Mus. of Art; Libr. of Congress. Died in 1962. Address in 1929, 137 East 66th St., New York, NY.

GRANT, ISAAC H.
Painter. Member: Conn. Academy of Fine Arts. Address in 1926, 10 Olds Place, Hartford, CT.

GRANT, J.
A little known portrait painter who was working in Philadelphia in 1829.

GRANT, J. JEFFREY.
Sculptor and painter. Born in Aberdeen, Scotland, April 19, 1883. Studied in Aberdeen; Munich, Germany. Work in Springfield Museum of Art; Municipal Art League, Chicago; others. Exhibited at

Nat. Academy of Design; Corcoran; Pennsylvania Academy of Fine Arts; Art Institute of Chicago. Won awards at Art Institute of Chicago, 1922, 24, 26, 27; medal, Palette and Chisel Academy, 1917; medal, prize, Municipal Art League, 1934, 36. Member: Chicago AC; Chicago PS; Artists Guild of the Authors' League of America; North Shore AA; Palette and Chisel Club. Listed as painter in 1953. Address in 1953, Chicago, IL.

GRANT, LAWRENCE W.
Painter. Born Cleveland, OH, June 10, 1886. Pupil of Chase in New York; Laurens and Lefebvre in Paris. Member: Salma. C. Address in 1929, Provincetown, MA.

GRANVILLE-SMITH, WALTER.
See Smith, Walter Granville.

GRAVATT, SARA H(OFFECKER).
Painter. Born in Philadelphia, PA, Aug. 31, 1898. Pupil of George Harding, Henry B. Snell, Joseph Pearson. Member: Fellowship Penna. Academy of Fine Arts; Plastic C.; Graphic Sketch C. Address in 1929, 1565 Washington St., Charleston, W. VA; summer, Fairchance, PA.

GRAVES, ABBOTT (FULLER).
Painter. Born Weymouth, MA, April 15, 1859. Pupil of Institute of Technology, Boston; Cromon, Laurens and Gervais in Paris. Member: Associate National Academy of Design, 1926; Boston AC; Copley S.; Salma. Club, 1909; Paris AAA (hon.); Allied Artists of America; National Arts Club (life); Artists Fund (hon.). Specialty, paintings of gardens. Award: Medal, Exp. des Beaux Arts, Paris, 1905. Represented in National Arts Club, New York; Art Museum, Portland, ME. Died in 1936. Address in 1929, Kennebunkport, ME.

GRAVES, ELIZABETH EVANS.
Painter, illustrator, craftswoman, and teacher. Born Fort Brady, MI, March 13, 1895. Pupil of R. Sloan Bredin, Henry B. Snell, Howard Giles, etc. Member: Wash. SA; Washington Water Color Club; National Association Women Painters and Sculptors; Washington AC. Address in 1929, 3705 Harrison Street, NW, Washington, DC.

GRAVES, MARY DE B(ERNIERE).
Painter, illustrator, writer, lecturer and teacher. Born Chapel Hill. Pupil of William Chase; Henry McCarter. Member: Southern States Art League. Awards: Prize, N.C. Federation of Women's Clubs, 1926, and 1929; Silver Cup, Kenilworth Exh., Asheville, NC, 1927. Illustrated in *New York Evening Post*; *The World*; *Tribune*; *Southern Magazine*; *The Ruralist*; *Philadelphia Record*; *Country Life*. Address in 1929, 203 Battle Lane, Chapel Hill, NC.

GRAVES, MORRIS.
Painter. Born in Fox Valley, OR, August 28, 1910. Exhibited at Seattle Art Museum; Willard Art Gallery, NYC, 1942-78; Detroit Art Inst.; L.A. Co. Museum; Art Inst. of Chicago; Museum of Modern Art; National Academy of Design, NYC; and others. Received Guggenheim Foundation Fellowship, 1946; Blair Prize, Art Inst. of Chicago, 1948; Windsor Award (Duke and Duchess of Windsor), 1957. In collections of Seattle Art Museum; Museum of Modern Art; Phillips; Whitney; Metropolitan Museum of Art. Honorary member of American Watercolor Society. Works in oil and tempera. Address in 1982, c/o Willard Gallery, NYC.

GRAVES, NANCY STEVENSON.
Sculptor and painter. Born in Pittsfield, MA, Dec. 23, 1940. Studied at Vassar College, Poughkeepsie, NY, 1958-61, BA; School of Art and Architecture, Yale University, New Haven, CT, 1961-64, BFA, MFA, 1964. In 1966, she travelled to Florence, Italy, to study sculpture. Began her filming career in 1969 in NYC. Exhibited: Graham Gallery, NYC, 1968; Whitney Museum, NYC, 1969; National Gallery of Canada, Ottawa, 1970; Gallery Reese Palley, NYC; New Galerie der Stadt Aachen, Germany (for film); Vassar College, Poughkeepsie, NY; Mus. of Modern Art, NYC; Yale University, New Haven, CT; Pratt Institute, NYC, all in 1971; Inst. of Contemporary Art, University of Penna., Philadelphia, (films) 1972; Albright-Knox Art Gallery, Buffalo, 1974. Group shows include The School of Visual Arts, NYC, 1971; Corcoran Gallery of Art, Washington, DC, 1971; American Women Artists, Kunsthause, Hamburg, West Germany; Indianapolis Museum of Art, 1972; Documenta V, New Galerie, Kassel, Germany, 1972; Stadtischen Kunsthalle, Dusseldorf, West Germany; and Louisiana Museum, Vancouver Art Gallery, British Columbia, Canada, 1977; Whitney Biennale, 1983. Awards: Fulbright-Hayes Grant in painting, Paris, 1965; Vassar College Fellowship, 1971; National Endowment for the Arts Grant, 1972. Works with fetish assemblage sculpture using acrylic, fur, feathers, and metal. Member of the College Art Association and is currently on its board of directors. Address in 1982, 69 Wooster Street, NYC.

GRAY, CHARLES A.
Painter. Born in Iowa in 1857. Connected with Art Department of *Chicago Herald* and *Tribune*. He painted portraits of Presidents McKinley and Garfield, Eugene Field, Opie Read and many others. His portraits of J. Warren Keifer and M. G. Kerr are in the Capitol Bldg., Washington.

GRAY, HARRIET TYNG.
Painter. Born So. Orange, NJ, May 26, 1879. Pupil of DuMond, Beaux, Hawthorne and Howell. Member: Greenwich SA; Nat. Assoc. Women Painters and Sculptors; Amer. Federation of Arts. Address in 1929, Rock Ridge, Greenwich, CT.

GRAY, HENRY PETERS.
Painter. Born June 23, 1819, in New York. He began his art studies under Daniel Huntington, P.N.A., in 1839. He went to Europe in 1840 and studied the old masters. On his return in 1842 he was elected a Nat. Academician. From 1869-71 he was president of the National Academy. Painting portraits in New York, with an occasional figure picture, occupied the greater part of his career. "The Origin of Our Flag" was one of the last of his exhibits at the Academy, in 1875. His work shows his sound academic study, and his color is reminiscent of the golden tone of Titian or Correggio. Many of his portraits are cabinet size. He died Nov. 12, 1877, in New York.

GRAY, KATHRYN.
Painter. Born Jefferson Co., KS, 1881. Pupil of Art Students Lg. of NY; Julian Academy, Paris. Member: Amer. Artists Professional Lg.; Allied Artists of NY; Amer. Federation of Arts. Died in 1931. Address in 1929, Van Dyke Studios, New York, NY.

GRAY, MARY.
Painter. Member: Allied Artists of America; Nat. Assoc. Women Painters and Sculptors; North Shore AA; Nat. Arts Club; Amer. Federation of Arts. Address in 1929, 47 Gramercy Park; 59 West 9th St., New York, NY.

GRAY, PERCY.
Painter. Born in San Francisco, Oct. 3, 1869. Studied in San Francisco and NY. Member: Bohemian C.; Sequoia C.; San F. AA. Award: Bronze Medal, P.-P. Exp., San F., 1915. Died in 1952. Address in 1929, Monterey, CA.

GRAY, W(ILLIAM) F(RANCIS).
Painter, lecturer and teacher. Born Philadelphia, PA, May 9, 1866. Pupil of Pennsylvania Museum and Penna. Academy of Fine Arts. Member: Phila. AC; Phila. Sketch C.; Art Teachers' Assoc. of Phila.; Fellowship Penna. Academy of Fine Arts. Address in 1929, 2014 Mt. Vernon St., Philadelphia, PA.

GRAYDON, ALEXANDER.
Author, soldier and limner. Born in Bristol, PA, April 10, 1752. He served in the revolution, was taken prisoner, was exchanged, and received the appointment of Captain from Congress for raising recruits for the army. In 1811 he published "Memoirs of a Life, chiefly passed in Penna. within the Last Sixty Years." In this he notes his love of drawing and painting. He is known to have copied Stuart's portrait of Washington, painted on glass, similar to those done in China about 1800, but not as well painted. Died May 2, 1818, in Philadelphia.

GRAYHAM, WILLIAM.
Painter. Born in 1832, and died in 1911. His "Rainy Day in Venice" is signed "W. Grayham," Venezia 1885.

GRAYSON, CLIFFORD P(REVOST).
Painter. Born Philadelphia, July 14, 1857. Pupil of Penna. Academy of Fine Arts; Gerome and Bonnat; Ecole des Beaux Arts in Paris. Member: Phila. AC; Century Assoc.; Salma. C. Awards: $2,000 prize, American Art Galleries, New York, 1886; Temple gold medal, Penna. Academy of Fine Arts, 1887. Work: "Mid-Day Dreams," Corcoran Gallery, Wash.; "Rainy Day in Pont Aven," Art Institute, Chicago; "Le Toussaint," Art Club, Philadelphia. Died in 1951. Address in 1929, Box 73, Lyme, CT.

GREACEN, EDMUND W.
Painter and teacher. Born New York, 1877. Pupil of Chase and Du Mond in New York; studied in Europe. Member: Associate National Academy of Design; Salma. C., 1910; Soc. des Artistes Independents, Paris; Allied Artists of America; Nat. Arts Club (life); Amer. Water Color Society; Painters and Sculptors Gallery Assoc. Awards: Shaw Purchase Prize, Salma. C., 1921; Nat. Arts Club prize, 1923. Work: "The Lady in Blue," "Sidonie," Butler Art Institute, Youngstown, Ohio; "Hudson River Twilight," Newark Museum; "The Feather Fan," National Arts Club. Was president of Grand Central School of Art. Died Oct. 4, 1949. Address in 1929, 142 East 18th St., New York, NY.

GREASON, WILLIAM.
Painter. Born St. Mary's, Ontario, Feb. 26, 1884. Pupil of Penna. Academy of Fine Arts, Breckenridge, Julian Academy, Boschel and Laurens in Paris. Member: Scarab C.; Salma. C.; North Shore AA. Award: Hopkin 1st prize, Scarab. C., 1915; gold medal, Scarab. C., 1917. Work: "The D. A. C. at Twilight," Detroit Art Institute. Address in 1929, 1504 Broadway; h. 528 Canfield Ave., East Detroit, MI.

GREATH.
Miniature painter from Sweden who visited Phila. and, according to Chas. W. Peale, "painted for his own amusement."

GREATOREX, ELEANOR.
Painter and etcher. Born in New York City, 1854. Devoted her time to painting and illustration. Flower paintings frequently exhibited. Member of New York Etching Club.

GREATOREX, ELIZA PRATT.
Painter. Born on Dec. 25, 1820, in Ireland; she came to America in 1836. Pupil of James and William Hart in New York. In 1869 she was elected an Associate of the National Academy, being the first woman to receive that recognition. Her work was in oils, and she also illustrated a number of publications. She died Feb. 9, 1897, in Paris.

GREATOREX, KATHLEEN HONORA.
Painter. Born Hoboken, NJ, 1851. Studied art in New York, Rome and Munich. Besides decorative work and book-illustration, she painted flower pieces, etc., which she has exhibited in the Paris Salon and elsewhere. Awards: Hon. mention, Paris Salon; gold medals, Phila., Chicago and Atlanta Expos. Among her flower pieces she exhibited the panels "Thistles," "Corn," and "Hollyhocks."

GREAVES, WILLIAM A.
Painter. Born in Watertown, NY, 1847; he died in 1900. Studied under Thomas Le Clair and was a student at the Cooper Institute of New York City. Resided in Utica, NY, for several years and in 1873 moved to Warrentown. Painted portraits of S. J. Randall, G. A. Grow, Matthew S. Quay, Gov. Fenton, and Gov. Beaver. Portraits of Randall and Grow in the Capitol Bldg., Washington, DC.

GREBEL, ALPHONSE.
Painter. Member: Society of Independent Artists. Address in 1926, 174 St. Nicholas Ave., New York, NY.

GRECO, DANIEL.
Painter. Member: Pittsburgh Artists' Association. Address in 1926, 608 Fifth Ave., New Kensington, PA.

GREEN.
An English portrait painter who arrived in the Colonies about 1750 and painted portraits from then until 1785.

GREEN, BERNARD I.
Painter, etcher and teacher. Born Swerzen, Russia, Feb. 12, 1887. Pupil of Douglas Volk, Francis Jones, Edgar M. Ward and Pressig; National Academy of Design; Art Students Lg. of NY; NY Univ. (art course). Member: NY SE; Chicago AG; Bronz AG; School Art Lg.; Mystic AA. Work: "Girl Reading," Museum of Oakland, CA. Head of art dept., Thomas Jefferson High School, Brooklyn; head of art dept., Yeshivah Rabbi Isaac Elchanan, New York. Died in 1951. Address in 1929, 939 Eighth Ave., NY; h. 259 Montgomery St., Brooklyn, NY.

GREEN, DAVID OLIVER.
Sculptor and educator. Born in Enid, OK, June 29, 1908. Studied at American Academy of Art; Nat. Academy of Art. Work in Los Angeles Co. Museum of Natural History, CA. Has exhibited at Los Angeles Co. Museum Art Annual; Tucson Art Center, AZ; Laguna Beach Art Gallery, CA; others. Taught at Otis Art Institute, 1947-73, assistant professor of

sculpture. Received first prize for sculpture, Laguna Beach Art Assoc.; Pasadena Soc. of Artists. Member of International Inst. of Arts and Letters; Pasadena Society of Artists; Soc. of Italic Handwriting; Society of Calligraphy, Los Angeles. Works in stone and wood. Address in 1982, Altadena, CA.

GREEN, EDITH JACKSON.
Painter. Born Tarrytown, NY, March 22, 1876. Pupil of Twachtman, DeCamp, Raphael Collin. Work: "A Fantasy of Old Providence," Providence Plantation Club. Address in 1929, 74 North Main St.; h. 25 John St., Providence, RI; summer, Old Town, North Attleboro, MA.

GREEN, ELIZABETH SHIPPEN.
See Elliott, Elizabeth Shippen Green.

GREEN, ERIK H. (MRS.).
Painter. Member: Providence Art Club. Address in 1926, Oldtown, North Attleboro, MA.

GREEN, FLORENCE TOPPING.
(Mrs. Howard Green). Landscape and miniature painter, writer and lecturer. Born London, England, Feb. 23, 1882. Pupil of Cooper Union; R. Swain Gifford, John Carlson. Member: Amer. Artists Prof. Lg.; (asso.) NY Water Color Club; Art Div. Am. Women's Assoc., NY; Amer. Federation of Arts; Pen and Brush Club. Chairman of Arts and Crafts, General Federation of Women's Clubs, 1924-1928; Art Division, 1928-1930. Died in 1945. Address in 1929, 104 Franklin Ave., Long Branch, NJ.

GREEN, FRANCIS G.
Landscape and marine painter. Worked in New York City between 1844-60. Exhibited at the American Institute, 1844, 45; American Art-Union, 1849-50; also at the National Academy, 1850-53, 60.

GREEN, FRANK RUSSELL.
Painter. Born Chicago, April 16, 1856. Pupil of Boulanger, Lefebvre, Collin and Courtois in Paris. Member: Associate National Academy, 1897; Amer. Water Color Soc.; NY Water Color Club; Salma. C., 1887; Lotos C. Awards: Lotos Fund, Nat. Academy of Design, 1896; hon. mention, Paris Salon, 1900; Morgan prize, Salma. C., 1903; bronze medal, St. Louis Exp., 1904; Shaw prize, Salma. C., 1908. Died in 1940. Address in 1929, care of Salmagundi Club, 47 Fifth Ave., New York, NY.

GREEN, H(IRAM) H(AROLD).
Painter, illustrator and etcher. Born Paris, Oneida Co., NY, Nov. 15, 1865. Pupil of H. S. Mowbray, Cox, Bridgman. Member: Amer. Federation of Arts. Award: Albright Prize, Albright Art Academy, 1898. Work: "Grand Canon," owned by the Santa Fe R.R.; "Apache Trail," owned by the Southern Pacific R.R.; "My Soldier," U.S. Government Liberty Loan

Poster. Specialty, pictorial maps. Died in 1930. Address in 1929, Fort Erie, Ont., Canada.

GREEN, HAROLD ABBOTT.
Painter. Born Montreal, Canada, Nov. 10, 1883. Pupil of Flagg and Brandegee. Member: Conn. Academy of Fine Arts. Awards: Dunham prize, Conn. Academy of Fine Arts, 1918. Address in 1929, 284 Asylum St.; h. 50 Ashley St., Hartford, CT.

GREEN, JASHA.
Sculptor and painter. Born in Boston, MA, May 1, 1927. Studied at Boston Museum School, 1941, 46-47; with F. Leger, Paris, France, 1948-50. Work in Guggenheim Museum, NY; Brooklyn Museum; Phila. Museum of Art; Kansas City Art Institute, MO; Denver Art Museum. Has exhibited at Albrecht Museum, St. Joseph, MO; Everson Mus., Syracuse, NY; Chrysler Museum, Norfolk; Oklahoma Museum, Oklahoma City; others. Works in steel sculpture; oil painting. Address in 1982, 117 E. 18th St., NYC.

GREEN, JASPER.
Sculptor, woodcarver, and artist-correspondent. Born January 31, 1829, at Columbia, PA. Worked for *Harper's Weekly* during the Civil War. Died in Philadelphia, in March 2, 1910.

GREEN, MILDRED C.
Painter, illustrator and teacher. Born Paris, Oneida County, NY, April 18, 1874. Pupil of Bridgman, Hitchcock and Dufner. Member: Buffalo SA; Buffalo Guild of Allied Arts; Buffalo Fine Arts Academy. Instructor, Life Class, Buffalo School of Fine Arts. Address in 1929, 717 Delaware Ave., Buffalo, NY; summer, Clayville, NY.

GREEN, WILLIAM BRADFORD.
Painter, lecturer and teacher. Born Binghamton, NY, Aug. 1, 1871. Pupil of Chase, Blom and Dow. Member: Conn. Academy of Fine Arts; Brooklyn SA; Copley S. Died in 1945. Address in 1929, 133 Steele St., Hartford CT.

GREENAMYER, LEAH J.
Painter, craftswoman, writer, lecturer and teacher. Born Ashtabula, OH, April 17, 1891. Pupil of Cora B. Austin, George S. Krispinsky, Grace Williamson, John Lloyd, Butler Art Institute. Member: Youngstown Art Alliance; Columbus AL; Cleveland Art Center; Mahoning Soc. of Painters; Ohio-Born Women A. Art Editor of *Youngstown Sunday Vindicator*. Address in 1929, 117 East Warren Ave., Youngstown, OH.

GREENAWALT, FRANK F.
Painter. Member: Soc. Wash. A.; Wash. AC; Wash. Water Color Club. Address in 1929, 1719 Lanier Pl., Washington, DC.

GREENBAUM, DELPHINE BRADT.
(Mrs. William E. Greenbaum). Painter. Member: Fellowship Penna. Academy of Fine Arts. Address in 1929, Box 101, Iloilo, Phila.

GREENBAUM, DOROTHEA SCHWARCZ.
Sculptor and graphic artist. Born in NYC, June 17, 1893. Studied: NY School of Fine and Applied Arts; Art Students League. Member: Sculptors Guild; National Association of Women Artists; Audubon Artists. Works: Whitney Museum of Amercian Art; Lawrence Museum, Williamstown, MA; Oberlin College; Fitchburg, Mass., Art Center; Huntington Museum; Brookgreen Gardens, SC; Newark Museum of Art; Baltimore Museum of Art; Museum of Moscow, Russia; Puerto Rico; Ogunquit Museum of Art. Awards: Penna. Academy of Fine Arts, 1941; Society of Washington Artists, 1941; International Business Machines, 1941; Audubon Artists, 1954; Grant, American Academy of Arts and Letters, 1947; National Association of Women Artists, 1952, 54. She has had 28 one-woman shows. Address in 1983, Princeton, NJ.

GREENBERG, GLORIA.
Painter. Born on March 4, 1932. Studied: Cooper Union Art School, NYC; Yale-Norfolk Art School; The Brooklyn Museum Art School. Exhibitions: The Denver Art Museum, 1953; The Joslyn Art Museum, Omaha, Nebraska, 1953; Columbia Univ., 1965-1966; 55 Mercer, NYC, 1970-1974. Collections: Ms. Lucy R. Lippard and other private collectors. Media: Acrylic and paper works with ink. Address in 1980, 118 E 17th St., NY, NY.

GREENBERG, MAURICE.
Illustrator. Born Milwaukee, WI, in 1893. Pupil of Wisconsin School of Art; Art Institute of Chicago. Member: Palette and Chisel C. Award: Municipal AL Prize, Chicago, 1927.

GREENBERG, MORRIS.
Etcher, writer and teacher. Pupil of Birge Harrison and Maynard. Member: Municipal AS; Brooklyn SE; Amer. Federation of Arts. Died June 22, 1949. Address in 1929, 1183 Dean St., Brooklyn, NY.

GREENE, ALBERT V(AN NESSE).
Painter, illustrator and etcher. Born Jamaica, LI, NY, Dec. 14, 1887. Pupil of Corcoran Gallery, Art Students Lg. of NY, Penna. Academy of Fine Arts, Academie de la Grand Chaumiere in Paris. Member: Phila. Sketch C., Fellowship Penna. Academy of Fine Arts; Phila. Alliance; American Art Assoc. of Paris; S. Indp. A.; Salons of America. Award: Second landscape prize, Penna. Academy of Fine Arts, 1919. Represented in Collection of Fellowship of Penna. Academy of Fine Arts. Address in 1929, 704 South Wash. Sq.; Phila. Sketch Club, 235 South Camac St., Phila., PA; summer, Chester Springs, PA.

GREENE, E. D. E.
Painter. Born in 1823 in Boston. He was elected to the Nat. Academy of Design, NY, 1858. He painted several beautiful female portraits, remarkable for their exquisite finish. He died June 17, 1879, in New York City.

GREENE, FRED STEWART.
Painter. Born North Stonington, CT, June 23, 1876. Pupil of RI School of Design; Art Students Lg. of NY. Member: Alumni Assoc., RI School of Design; Providence Water Color Club. Specialty, landscapes. Died in 1946. Address in 1929, Ye Hollie Studio; h. 58 Beach St., Westerly, RI; winter, Quidnesset, Belleview, Marion Co., FL.

GREENE, HERBERT.
Collage and architect. Born in Oneonta, NY, in 1929. Studied at Syracuse University, 1947; University of Oklahoma, Bachelor of Architecture degree in 1952. Taught at the University of Oklahoma, Norman, and the University of Kentucky, Lexington. Exhibitions: University of Oklahoma, Norman, 1960; and at the OK Art Center, OK City. Group Exhibitions: Arizona State Univ., Tempe, 1961; Kansas State Univ. of Agriculture and Applied Science, Manhattan, 1962; Univ. of Kentucky, Lexington, 1963; J. B. Speed Art Mus., Louisville, 1963. Architect of bldgs. in Houston, TX, and Oklahoma.

GREENE, MARIE ZOE.
Sculptor. Born in 1911. Studied: Radcliffe College; New Bauhaus, Chicago; in France; in Italy. Award: Gold medal, Cannes, France, 1969. Collections: Roosevelt University, Chicago; Southwest Missouri State College; Radcliffe College.

GREENE, MARY SHEPARD.
See Blumenschein, Mary Shepard Greene.

GREENFIELD, E. J. FORREST.
Painter, craftsman, writer and teacher. Born London, England, June 24, 1866. Pupil of Karl Schearer. Member: S. Indp. A.; Needle and Bobbin Club. Address in 1929, The Willows Studios, Point Pleasant, NJ.

GREENING, HARRY C.
Illustrator and cartoon artist. Born in Titusville, PA, in 1876. Pupil of Art Students League of New York. Address in 1926, 350 Madison Avenue, New York.

GREENLEAF, BENJAMIN.
Painter. Born Sept. 25, 1786, in Haverhill, MA. A painter of portraits who was working in New Eng. about 1817. Died Oct. 29, 1864, in Bradford, MA.

GREENLEAF, HELEN.
Sculptor and teacher. Born in Riverside, IL, June 3, 1885. Pupil of School of Boston Museum of Fine Arts.

Member: Conn. Academy of Fine Arts. Address in 1916, 64 South Main St., Wallingford, CT; summer, Center Harbor, NH.

GREENLEAF, RAY.
Illustrator. Member: Society of Illustrators; Salma. C.; Amer. Inst. of Graphic Arts. Died in 1950. Address in 1929, 50 Union Sq.; 263 West 11th St., New York, NY.

GREENLEAF, RICHARD C(RANCH).
Painter. Born in Berlin, Germany, Nov. 15, 1887. Pupil of Collin, Courtois, Simon and Menard in Paris. Address in 1929, Lawrence, LI, NY.

GREENLEAF, VIOLA M.
Illustrator. Member: Society of Illustrators. Address in 1929, 263 West 11th St., New York, NY.

GREENMAN, FRANCES CRANMER.
(Mrs. F. C. Greenman). Painter. Born Aberdeen, SD, June 28, 1890. Pupil of Chase, Benson, Castellucho in Paris. Member: S. Washington A. Awards: Gold medal, Corcoran School, 1908; gold medal, MN State Art Com., 1915; first award, MN Inst. of Arts, 1921 and 1922. Address in 1929, 522 East 89th St., New York, NY.

GREENOUGH, BEULAH.
See Hardy, Beulah Greenough.

GREENOUGH, HORATIO.
Sculptor. Born September 6, 1805, in Boston, MA. Modeled miniature figures from chalk and plaster, from 1817; later formally studied painting, drawing, stonecutting and clay modeling with local inst.; Harvard graduate, 1825; sculpture in Italy, 1824-26, under the patronage of Washington Allston. Some of his works include bust of John Quincy Adams from life; Chief Justice John Marshall; "Chanting Cherubs," which was commissioned by James Fenimore Cooper; "The Child and the Angel"; colossal statue of "Washington," 1833-41, placed originally in the Capitol Rotunda for a short time, later moved in front of the Capitol, presently in the Smithsonian Institution; "The Rescue." Publications: *Aesthetics in Washington*, 1851, *Travels, Observations and Experience of a Yankee Stonecutter*, 1852, the latter under the pseudonym of Horace Bender. Formulated the theory of functionalism. Died in Somerville, MA, in 1852.

GREENOUGH, JOHN.
Painter. Born in November, 1801 in Boston, MA. A little known portrait painter who worked about 1840. He painted some excellent portraits. Died in Paris in November, 1852.

GREENOUGH, RICHARD SALTONSTALL.
Sculptor. Born in Jamaica Plain, MA, April 27, 1819. He was a younger brother of Horatio Greenough and

worked for some years in Paris. Had a studio in Newport, RI. His statue of Benjamin Franklin is in City Hall Square, NY; and his "Boy and Eagle" is in the Boston Athenaeum. He died on April 23, 1904, in Rome, Italy.

GREENWOOD, CORA.
Painter and craftsman. Born Waltham, MA, July 11, 1872. Pupil of Denman Ross, Alphonse Mucha. Member: Boston Society of Arts and Crafts. Address in 1929, 38 Cypress Rd., Wellesley Hills, MA; summer, Annisquam, MA.

GREENWOOD, ETHAN ALLEN.
Painter. Born in 1779 and died in 1856. He studied under Edward Savage. Settled in Boston and succeeded Savage in the ownership of the New England Mus.. Greenwood frequently signed and dated his portraits "Greenwood Pinx 18." His portrait of Isaiah Thomas is reproduced in Goodspeed's edition of "Dunlap."

GREENWOOD, JOHN.
Painter and engraver. Born in Boston, New England, in 1727; died at Margate, England, 1792. Son of Samuel Greenwood, of Boston, and nephew of Prof. Isaac Greenwood, of Harvard. In 1752 he went to Surinam, in a clerical capacity, and from there he went to Holland. In Holland he learned to engrave in the mezzotint manner. In 1763 he established himself in London as a painter and engraver of portraits. Greenwood is sometimes referred to as an early American engraver, but there is no evidence that he ever practiced that art in this country. The portrait of Thomas Prince, engraved by Pelham in Boston in 1750, was painted by John Greenwood. In 1760 he engraved a portrait of himself. Greenwood's American portraits were all painted before 1752. His portrait of Benjamin Pickman of Salem, Mass., is dated 1749. His own portrait was engraved by Pether.

GREENWOOD, JOSEPH H.
Painter. Born in Spencer, MA, 1857. Pupil of R. Swain Gifford in New York. Represented by "Autumn," Worcester Art Museum. Address in 1926, 2 Woodbine St., Worcester, MA.

GREENWOOD, MARION.
Painter and muralist. Born April 6, 1909. Studied at Art Students League with G. Bridgman, F. V. DuMond and J. Sloan, 1924-28; studied lithography with Emil Ganso and mosaic technique with A. Archipenko at Woodstock, NY, 1929-30; and the Academie Colarossi, Paris. First exhibit was at the Assoc. Amer. Artists Gallery, NY, in 1944; elected member of the National Acad. of Design in 1959. Taught Univ. of Tenn. (1954-55) and Syracuse Univ. in 1965. Died in Woodstock, NY, as a result of an auto accident.

GREENWOOD, WILLIAM RUSSELL.
Painter and etcher. Born Oxford, IN, June 25, 1906. Pupil of Sister Rufinia; Delle Miller. Member: Lafayette AA; Hoosier Salon; Ind. Acad. of Sciences. Address in 1929, 520 South Ninth St., Lafayette, IN; summer, Colorado Springs, CO; Manitou, CO.

GREER, BLANCHE.
Painter, illustrator and decorator. Born Eldora, IA, Aug. 9, 1884. Pupil of Chase and Eben F. Comins. Member; Phila. Water Color Club; Plastic C; Fellowship Penna. Academy of Fine Arts; Wash. Water Color Club; Phila. Alliance; Artists Guild of the Authors' Lg. of America. Award: Beck prize, Phila. Water Color Club, 1916. Address in 1929, 4 Franklin Place, Summit, NJ.

GREER, JEFFERSON E. (JAMES E.?).
Sculptor, painter, and muralist. Born in Chicago, IL, 1905. Studied at University of Wisconsin; Chicago Acad. of Fine Art; Loyton Art Inst. in Milwaukee. Settled on a Texas ranch in 1925. Assisted in fresco murals, El Paso School of Mines; in 1934 assisted Gutzon Borglum at Mount Rushmore; made Post Office decorations for the Federal Works Administration in Prairie du Chien. Address in 1948, Bristol, RI.

GREGORI, LUIGI.
Born in Italy, 1819. He came to the United States in 1874 and was made Art Director of the Art Department of the University of Notre Dame, IN. Historical and portrait painter; also successful in fresco work and miniatures.

GREGORY.
This name, as "Gregory Sc," is signed to a very crude line Bible print, illustrating "Zachariah's Vision." As this print was found loose, there is no indication of place or date, though the apparent date is within the first quarter of the 19th century.

GREGORY, ANGELA.
Sculptor and educator. Born in New Orleans, LA, on October 13, 1903. Studied: NY State College of Ceramics, Alfred, NY; Newcomb College of Tulane University; Parsons School in Paris and Italy; Grande Chaumiere, Paris; with Antoine Bourdelle; Charles Keck, NY. Awards: Scholarship, Newcomb College; Southern States Art League, 1930, 1931; Louisiana Painters and Sculptors, 1929; St. Mary's Dominican College Distinguished Award Medal, 1977. Collections: International Business Machines; Delgado Museum of Art; Louisiana State Museum; Criminal Courthouse, New Orleans; Louisiana State University; Louisiana Library; La Tour Caree, Septmonts, France; Louisiana National Bank, Baton Rouge; Charity Hospital, New Orleans; Silver-Burdette Publishing Co., NY; Louisiana State Univ., Baton Rouge; St. Gabriel Church, St. Gabriel, LA; McDonogh monument, Civic Center, 1938; Bienville monument, 1955, New Orleans, LA. Artist-in-Residence, Newcomb College, Tulane Univ., LA, 1940-41; sculptor-in-residence, professor of art appreciation, St. Mary's Dominican College, 1962-75; professor of art, 1975-76, emeritus professor, from 1976. Address in 1984, New Orleans, LA.

GREGORY, DOROTHY LAKE.
Illustrator and etcher. Born Brooklyn, NY, Sept. 20, 1893. Pupil of Robert Henri, Charles W. Hawthorne. Illustrator of *Early Candlelight Stories* and *Happy Hour Series*. Address in 1929, 50 Commercial St., Provincetown, MA.

GREGORY, ELIOT.
Painter and sculptor. Born in New York in 1854. He entered Yale, studied in Rome and Paris and exhibited paintings and sculpture in the Paris Salon. Work: "Soubrette," "Children," "Coquetterie," and portraits of Gen. Cullum, Admiral Baldwin, and Ada Rehan. Died in 1915.

GREGORY, FRANK M.
Born in Mansfield, Tioga County, PA, 1848. He studied at the National Academy of Design in 1871, and subsequently studied at the Art Students League, and with Walter Shirlaw. Worked in etching and design. In 1888 he illustrated "Faust."

GREGORY, JOHN.
Sculptor. Born London, England, May 17, 1879. Arrived in United States c. 1891. Pupil of Art Students League of NY; Beaux-Arts, Paris; American Academy, Rome; studied under J. Massey Rind, Geo. Grey Barnard, Hermon A. MacNeil, G. Borglum, Herbert Adams, Mercie. Member: Beaux-Arts Institute of Design (hon.); National Sculpture Society; NY Architectural League; Am. Federation of Arts. Awards: American Academy in Rome Fellowship, 1912-15; NY Architectural League medal in Sculpture, 1921; honorable mention, Art Institute of Chicago, 1921; medal, Concord Art Association, 1926. Work: "Philomela," Metropolitan Museum; "Launcelot and Sir Ector," Corcoran Gallery, Wash., DC; decorative flooring relief, Cunard Bldg., NYC; War memorials, Suresnes, Paris, France; numerous garden sculptures. Exhibited at National Sculpture Society, 1923. Address in 1953, New York City. Died in 1958.

GREGORY, KATHARINE V. R.
(Mrs. John Gregory). Sculptor and teacher. Born in Colorado Springs, CO, Sept. 1, 1897. Studied with Bourdelle and J. M. Lawson. Member: National Association of Women Painters and Sculptors; Society of Independent Artists. Award: Bryant prize for sculpture, National Association of Women Painters and Sculptors, 1933. Address in 1933, 222 East 71st St., NYC.

GREGORY, WAYLANDE.
Sculptor, designer, writer, and lecturer. Born in Baxter Springs, KS, June 13, 1905. Studied: Kansas State Teachers College; University of Chicago; Kansas City Art Institute; and in Europe. Member: National Sculpture Society; Society of Designer-Craftsman. Awards: Alfred University, 1939; Paris Exp., 1937; Syracuse Museum Fine Arts, 1933, 1937, 1940; prize, Architectural League, 1936; Cleveland Museum of Art 1929, 1931. Work: Sculpture, District Bldg., Washington, DC; fountain, Roosevelt Park, NJ; Syracuse Museum of Fine Arts; Cranbrook Museum; City Art Museum, St. Louis; others. Exhibited: Whitney Museum of American Art; Museum of Modern Art; Art Institute of Chicago; Montclair Art Museum; Worcester (MA) Museum of Art; City Art Museum, St. Louis; Richmond Academy, Arts and Sciences; San Diego, CA; many one-man shows in leading museums, and in Europe. Contributor to art magazines. Lecturer on ceramic art, etc. Address in 1953, Mountain Top Studios, Bound Brook, NJ. Died in 1971.

GREGSON, MARIE E(VANGELINE).
Painter. Born New York City, Dec. 16, 1888. Pupil of Twachtman and Cox. Member: Nat. Assoc. Women Painters and Sculptors; Amer. Artists Professional Lg. Specialty, portraits and landscapes. Address in 1929, Auburndale, LI, NY.

GREIMS, MARY HEARN.
(Mrs. Herbert S. Greims). Painter. Born in New York. Pupil of Cooper Union, and George Smillie in New York; Philadelphia School of Design for Women; Penna. Academy of Fine Arts, Phila. Member of the Fellowship of the Penna. Academy of Fine Arts, and Nat. Academy of Women Painters and Sculptors. Address in 1926, Ridgefield.

GREINER, CHRISTOPHER.
Portrait painter in oils and miniatures, flourishing in Philadelphia in 1837. Died in 1864. Portrait of "Daniel Billmeyer" is owned by the Historical Society of Pennsyvania.

GREN, TULLIO A.
Painter. Born in Genoa, Italy. Studied in Italy and U.S.; graduated from the Famous Artists School of Westport, CT. Self-taught watercolorist. Solo exhibitions: Oakland Public Library, Oakland, NJ; "La Galeria," Paramus Park, NJ; Bergen County Comm. Museum, Paramus, NJ; Sullivan Co. Art Museum and Cult. Cent., Hurleyville, NY; Orange Co. Arts Council, Middletown NY. Group exhibitions: Audubon Artists; Painters and Sculptors Soc. of NJ; New England Exhib. of P. and S., New Canaan, CT; Cooperstown Art Exhib.; NJ Watercolor Soc., Morristown, NJ; many others. Awards: Harriet Preston Award, Best in Show, Paramus, NJ; Best of Show, Art in The Park, Paramus, NJ; Best of Show,

Paskack Art Assoc., NJ; others. In collections of Bergen Co. Comm. Museum; Orange Co. Comm. College, Middletown, NY; Orange Co. Park Comm., Montgomery, NY. Address and studio in 1983, Wallkill, NY.

GRENHAGEN, MERTON.
Portrait painter. Born Orihula, WI. Pupil of Chase in Phila.; Laurens in Paris; Chicago Art Inst.. Member: Chicago SA; Wis. PS. Represented in University of Wisconsin; Wisconsin Historical Museum; Wisconsin State Capitol Bldg.; University of Illinois; University of Michigan; Milwaukee Public Library. Address in 1929, Oshkosh, WI.

GRESSEL, MICHAEL L.
Sculptor. Born in Wurzburg, Germany, September 20, 1902; US citizen. Studied: Art School, Bavaria, with Arthur Schleglmeunig; Beaux Arts Institute of Design, NYC. Work: Metropolitan Museum of Art, NY; Bruckner Museum, Albion, MI; Nat. Theatre & Academy, NYC; National Theatre, Washington, DC. Commissions: Ivory relief portrait for Gen. Eisenhower, 1962; emblem, Harvard University; Legend of Sleepy Hollow, Monument, Tarrytown, NY; and others. Exhibitions: Hudson Valley Art Association, White Plains, NY, 1946-72; Allied Artists of America; National Academy of Design, 1971; National Sculpture Society, NY, 1972; and others. Awards: Gold Medal, Hudson Valley Art Association, 1972; others. Member: Hudson Valley Art Association, director from 1952; Nat. Sculpture Society. Address in 1982, Armonk, NY.

GRIBBLE, HARRY WAGSTAFF.
Illustrator. Member: Society of Illustrators. Address in 1929, Inter-Theatre Arts, 42 Commerce St., New York, NY.

GRIDLEY, ENOCH G.
This engraver in both stipple and line was in business in New York in 1803-05 inclusive, and at a later date he was working for Philadelphia publishers. The latest date on his plates is 1818.

GRIFFEN, DAVENPORT.
Painter, lithographer and teacher. Born Millbrook, New York, Oct. 5, 1894. Pupil of John W. Norton. Member: Chicago SA. Awards: Jenkins prize, Chicago Artists Exhibition, Chicago, 1928; Chicago Womens Club prize, Chicago, 1929. Address in 1929, Douglas Arcade, 3569 Cottage Grove Avenue, Chicago, IL.

GRIFFIN, J(AMES) M(ARTIN).
Painter, etcher and teacher. Born Cork, Ireland, February 20, 1850. Pupil of James Brenan at School of Art, Cork. Member: Water Color Society of Ireland. Address in 1929, 3342 Chestnut Street, Oakland, CA.

GRIFFIN, THOMAS B.
Landscape painter.

GRIFFIN, WALTER.
Painter. Born in Portland, ME, 1861. Pupil of Collin and Laurens in Paris. Member: Associate National Academy of Design, 1912; National Academy of Design, 1922; Allied Artists of America; NY Water Color Club; American Art Assoc. of Paris; Salma. C.; American Water Color Society. Awards: Medal of honor, P.-P. Exp., San F., 1915; Sesnan gold medal, Penna. Academy of Fine Arts, 1924. Represented in Memorial Art Gallery, Rochester; Buffalo Fine Arts Academy; Brooklyn Art Museum; Luxembourg Gallery, Paris. Died in 1935. Address in 1929, care of American Express Co., Nice, Alpes-Maritime, France.

GRIFFING, MARTIN.
Painter of profiles in color. Born in 1784, died in 1859. He worked in Mass., Vermont, and New York.

GRIFFITH, BEATRICE FOX.
(Mrs. Charles F. Griffith). Sculptor and craftswoman. Born Hoylake, Cheshire, England, Aug. 6, 1890. Pupil of Grafly and Giuseppe Donato; Penna. Academy of Fine Arts. Member: Phila. Alliance; National Assoc. of Women Painters and Sculptors; Fellowship Penna. Academy of Fine Arts; Plastic Club. Work: Marble portrait of Edith Wynne Mathison, Bennett School, Millbrook, NY; marble portrait, President Ewing, Lahore Union College, Lahore, India; bronze portrait of Herbert Burke, Valley Forge Hist. Soc., Valley Forge Memorial Chapel; 75th Anniversary medal for Women's Medical College, Philadelphia; National Society of Colonial Dames of America medal for Sesqui-Centennial Exp., Philadelphia, 1926; bronze trophy, "Swan Dive," National A.A.U. Swimming Trophy, 1927; illuminated manuscripts for Board of Education, Philadelphia, Art Alliance, Philadelphia, and Valley Forge Historical Society. Address in 1929, "Lynhurst," Ardmore, PA.

GRIFFITH, CONWAY.
Painter. Member of Laguna Beach Art Association. His specialty was marine and desert scenes. He died at Laguna Beach, CA, in 1924.

GRIFFITH, J. MILO.
Sculptor. Exhibited: Royal Academy, 1883. Work: Earliest public work was done for Llandaff Cathedral. Designer of a silver shield presented by South Wales to the Prince and Princess of Wales, 1888. Exhibited: Royal Acad., 1883. Taught: Prof. of Art in a college in San Fran. Died in 1897.

GRIFFITH, JULIA S(ULZER).
Painter. Born in Chicago. Pupil of Art Inst. of Chicago; Mulhaupt, Noyes and Breckenridge. Member:

North Shore AL; Gloucester SA; Ill. AFA; Chicago No-Jury Society of Artists; Chicago SA. Died in 1945. Address in 1929, 1318 Sunnyside Ave.; h. 4223 Greenview Ave., Chicago, IL; summer, 3 Eastern Pt. Rd., Gloucester, MA.

GRIFFITH, LILLIAN.
Painter. Born Philadelphia, PA, July 11, 1889. Pupil of Elliott Daingerfield, Henry B. Snell. Award: Spec. mention, Calif. Art Club exhibition, Exposition Park, Los Angeles, 1928. Address in 1929, Bonita Ave., Azusa, CA; summer, 409 East Bay Front, Balboa, CA.

GRIFFITH, LOUIS OSCAR.
Landscape painter and etcher. Born Greencastle, IN, Oct. 10, 1875. Pupil of Frank Reaugh; St. Louis School of Fine Arts; Art Inst. of Chicago; studied in New York and Paris. Member: Chicago Gal. A.; Indiana SP; Brown Co. Art Gal. A.; Boston AG; Chic. SE; Chic. SPS. Awards: Bronze medal for etching, P.-P. Exp., San F., 1915; gold medal, Palette and Chisel C., 1921; Daughters of Indiana prize, 1924, and Ade prize, 1925, Hoosier Salon, Chicago; San Antonio AL, prize, 1929. Represented in Union League Club of Chicago; "Winter," Chic. Commission purchase; Delgado Museum, New Orleans, LA; Oakland (Calif.) Museum; Indiana State Univ. Collection; Vanderpoel AA Coll., Chicago. Died in 1956. Address in 1929, Nashville, IN.

GRIFFITH, NINA K.
Painter. Born in Wausau, WI, in 1894. Studied: Art Institute of Chicago; with Charles Rosen, Wayman Adams, and Victor Higgins. Awards: Art Institute of Chicago, Chicago Galleries Assoc. Collections: Wausau High School; Milwaukee-Downer College; Wellesley College; Illinois Veterans Orphanage.

GRIFFITH, W(ILLIAM) A(LEXANDER).
Painter and lecturer. Born Lawrence, KS, Aug. 19, 1866. Pupil of St. Louis School of Fine Arts; Lefebvre and Constant in Paris. Member: Laguna Beach AA. Awards: Wyman Crow gold medal, St. Louis, 1889; first prize, Orange Co. Fair; first prize, Southern Calif. Fair, Riverside, 1928; first prize, Calif. Artists, Santa Cruz, 1929. Represented in Mulvane Art Gal., Topeka, Kansas; State His. Soc., Topeka; State Teachers Col., Emporia, Kan.; Thayer Mem. Mus., Lawrence, KA; Univ. Club, San Diego, CA; high schools at Santa Ana, Corona, and Long Beach, CA. Died in 1940. Address in 1929, Laguna Beach, CA.

GRIFFITHS, ELSA CHURCHILL.
Miniature painter. Address in 1926, 1114 9th Ave., West, Seattle, WA.

GRIGWARE, EDWARD T.
Painter and illustrator. Born Caseville, MI, April 3, 1889. Pupil of Chicago Academy of Fine Arts.

Member: Palette and Chisel Club; Oak Park Lg.; Chicago PS. Awards: Charles Worcester prize, Palette and Chisel C., 1925; Edward Rector prize, Indiana Hoosier Salon, 1925; Art Review Prize, 1926; prize, Circle AL, Chicago, 1927; silver medal, Oak Park Lg., 1928; gold medal, Palette and Chisel C., 1928. Address in 1929, 180 North Michigan Ave., Chicago, IL; h. 162 Taylor Ave., Oak Park, IL.

GRILO, SARAH.
Painter. Born in Buenos Aires, Argentina, in 1920. Studied in Madrid and Paris from 1948 to 1950. Group Exhibitions: Stedelijk Museum, Amsterdam, 1952; Museu de Arte Moderna, Rio de Janeiro, 1952, 1963; New Delhi, 1953; Museu de Arte Moderna de Sao Paulo, 1953, 1961; Brussels World's Fair, 1958; Instituto de Arte Contemporaneo, Lima, 1958; Carnegie Institute, 1958; The Art Inst. of Chicago, 1959; Museu de Arte Moderna, Bahia, Brazil, 1961; Walker Art Ctr., Minneapolis; many more. Awarded Guggenheim Foundation fellowship, 1962; many prizes. In collections of Stedelijk Mus., Amsterdam; museums in Argentina, Venezuela, Colombia, and Wash., DC. Living in NYC in 1970.

GRIMALDI, WILLIAM.
Miniature painter. Born in England, 1750; died in London in 1830. He worked in Paris from 1777-85, and in London, 1786-1824, exhibited yearly. He is said to have visited the United States about 1794, but it is doubtful if he ever came to this country. A portrait of George Washington in military uniform somewhat similar to the Trumbull type, signed "Grimaldi," was sold in Philadelphia.

GRIMES, FRANCES.
Sculptor. Born Braceville, OH, January 25, 1869. Pupil of Pratt Institute in Brooklyn; assistant to Herbert Adams and Augustus Saint-Gaudens. Member: National Sculpture Society, 1912; National Association of Women Painters and Sculptors; American Federation of Arts. Awards: Silver medal for medals, P.-P. Exp., San Fran., 1915; McMillin sculpture prize, National Association of Women Painters and Sculptors, 1916. Work: Overmantel, Washington Irving High School, New York City; "Girl by Pool" and "Boy with Duck," Toledo Museum of Art; bust of Charlotte Cushman and Emma Willard, Hall of Fame; bust of Bishop Potter, Grace Church, NYC. Exhibited at National Sculpture Society, 1923. Address in 1953, 229 East 48th St., New York, NY. Died in 1963.

GRIMES, JOHN.
Painter. Born in 1799 at Lexington, KY. He studied under Matthew Harris Jouett, who painted his portrait, now owned by the Metropolitan Museum. Grimes painted for some time in Nashville, TN. He painted a portrait of Charles Wetherill, copied by Thomas Sully about 1853. He died Dec. 27, 1837, in Lexington, KY.

GRIMSON, SAMUEL BONARIES (MRS.).
See Hoffman, Malvina.

GRINAGER, ALEXANDER.
Painter. Born in Minneapolis, MN, in 1864. Pupil of Royal Academy, Copenhagen, Denmark; Laurens and Constant in Paris; studied also in Norway, Italy and Sicily. Member: Allied Artist of America; Salma. C., 1908; Minneapolis A. Lg.; American Federation of Arts. Died in 1949. Address in 1929, "Nordstede," Cedar Lane Road, Ossining, NY; Mohegan Heights, Tuckahoe, NY.

GRINNELL, G. VICTOR.
Painter. Member: New Haven Paint and Clay Club; Conn. Academy of Fine Arts; Mystic SA. Address in 1929, 40 East Main St., Mystic, CT.

GRIPPE, PETER J.
Sculptor and printmaker. Born August 8, 1912, Buffalo, NY. Studied: Albright Art School; Buffalo Fine Arts Acad., with E. Wilcox, Edwin Dickinson, William Ehrich; Atelier 17, NYC. Work: Andover (Phillips); Brandeis University; Brooklyn Museum; Albright; Library of Congress; Metropolitan Museum of Art; Museum of Modern Art; New York Public Library; National Gallery; Philadelphia Museum of Art; The Print Club, Philadelphia; Tel Aviv; Toledo Museum of Art; Whitney Museum; Walker. Exhibited: The Willard Gallery, The Peridot Gallery, Lee Nordness Gallery, all in NYC; Metropolitan Museum of Art; Whitney Mus. of American Art Annuals, for many years; Federation of Modern Painters and Sculptors; American Abstract Artists Annuals; Carnegie; Brooklyn Mus.; Detroit Institute; Art Institute of Chicago; American Federation of Arts; Museum of Modern Art; Penna. Academy of Fine Arts; University of Illinois; Art:USA:59, NYC, 1959; Print Council of America, NYC, American Prints Today, circ., 1959-62; Inst. of Contemporary Art, Boston; Smithsonian, Drawings by Sculptors; Boston Athenaeum; plus many more. Awards: Brooklyn Museum, 1947; Metropolitan Museum of Art, $500 First Prize, 1952; The Print Club, Phila., Charles M. Lea Prize, 1953; National Council for United States Art, $1,000 Sculpture Award, 1955; Boston Arts Festival, First Prize for Sculpture, 1955; Rhode Island Arts Festival, Sculpture Award, 1961; Guggenheim Foundation Fellowship, 1964. Taught: Black Mountain College, 1948; Pratt Institute, 1949-50; Smith College, 1951-52; Atelier 17, NYC, 1951-52; Brandeis Univ., from 1953. Address in 1982, Orient, NY.

GRISCOM, LLOYD C(ARPENTER).
Painter. Born Riverton, NJ, 1872. Pupil of Ezra Winter and George P. Ennis. Member: American Water Color Society. Address in 1929, 580 Park Ave., New York, NY; summer, Syosset, LI, NY.

GRISWOLD, CARRIE.
Painter. Born in Hartford, CT. Studied under Leutze in New York City. A skilled copyist. She died in Florida.

GRISWOLD, CASIMIR CLAYTON.
Painter. Born Delaware, OH, 1834. Studied wood engraving in Cincinnati, but moved to New York in 1850. He received some instruction in painting from a brother and in 1857 exhibited his first picture at the National Academy of Design. Specialty, landscapes and coast scenes. He lived in Rome, Italy, 1872-86. Elected Associate Member of the National Academy in 1866; National Academy in 1867. He was one of the original members of the Artists' Fund Society. His best pictures were "December," exhibited in 1864; "A Winter Morning," 1865; "The Last of the Ice," 1866. Died June 7, 1918, in Poughkeepsie, NY.

GROLL, ALBERT L(OREY).
Landscape painter. Born in New York, Dec. 8, 1866. Pupil of Gysis and Loefftz in Munich. Member: Associate National Academy of Design, 1906, National Academy of Design, 1910; NY Water Color Club; Amer. Water Color Society; Artists' Fund Soc.; Salma. C., 1900; Lotos C; National Arts Club; Allied Artists of America; Soc. of Painters of NY. Awards: Morgan Prize, Salma. C., 1903; hon. mention, Munich; Shaw prize, Salma. C., 1904; silver medal, St. Louis Exp., 1904; Sesnan medal, Penna. Academy of Fine Arts, 1906; medals, Buenos Aires and Santiago Exp., 1910; Inness gold medal, National Academy of Design, 1912; silver medal, P.-P. Exp., San F., 1915. Work: "No Man's Land —Arizona," Corcoran Gal., Washington; "California Redwoods" and "Washoe Valley, Nevada," Brooklyn Institute Museum; "Acoma Valley, New Mexico," National Gallery, Washington; "Hopi Mesa," Public Gallery, Richmond, Ind.; "Laguna River, New Mexico," Art Mus., Montclair, NJ; "Silver Clouds," Metropolitan Mus., New York; "The Milky Way," Minneapolis Institute of Arts; "On the Beach," and "The Garden of the Gods," Lotos Club; "Storm Cloud, Arizona," Fort Worth (TX) Mus.; "In New Mexico," Boston Museum; "Arizona Desert," St. Louis Museum; "Passing Shadows," National Arts Club, New York; ""In Arizona," St. Paul Museum; "Land of the Sage Brush," Carnegie Museum, Pittsburgh. Died in 1952. Address in 1929, 222 West 59th St., New York, NY.

GROOM, EMILY.
Painter. Born in Wayland, MA, March 17, 1876. Pupil of Art Inst. of Chicago; Brangwyn in London. Member: Wisconsin Painters and Sculptors; Concord AA; NY Water Color Club; Nat. Assoc. Women Painters and Sculptors; Amer. Water Color Society; Chic. Gal. Assoc. Awards: Gold Medal, St. Paul Inst., 1917; hon. mention, Milwaukee Art Inst., 1918; Medal of honor, Milwaukee Art Institute, 1920;

Fausett prize, Milwaukee Art Inst., 1925; Shortridge prize, St. Louis, 1926; Bain prize, Milwaukee AI, 1926; Wisconsin art purchase prize, 1928, Milwaukee AI. Work: "Hillside — November," St. Paul Inst.; and in Milwaukee Art Institute Represented in Vanderpoel AA Collection, Chicago. Address in 1929, Genesee Depot; h. 325 Cambridge Ave., Milwaukee, WI.

GROOME, ESTHER M.
Painter and etcher. Born York County, PA. Pupil of Fuchs, Castaigne, William M. Chase, Henri and Cecilia Beaux. Member: Fellowship, Penna. Academy of Fine Arts. Address in 1926, Library Bldg., State Normal School, West Chester, PA.

GROOMRICH, WILLIAM.
An English landscape painter who came to this country about 1800. He settled first in New York and later in Baltimore. He painted a view from Harlem Heights and other views around New York. He exhibited in 1811 at Philadelphia with the Society of Artists, giving his address as Baltimore.

GROOMS, RED.
Sculptor. Born in Nashville, TN, June, 1937, under the name Charles Roger Grooms. Studied at the Art Institute of Chicago; Peabody College for Teachers, Nashville, TN; Hans Hofmann School, NYC; and the New School for Social Research. Became involved in non-verbal spontaneous theatrical presentations called "Happenings," with Claes Oldenberg, Jim Dine, and Allan Kaprow, NYC. One of his better known "happenings" was entitled "Burning Building," 1959. Permanent works of his were assemblages of groups of objects, which in turn made environments such as his "Loft on 26th Street," 1965-66, at the Hirshhorn Museum. Collections of his works are at Rutgers Univ. and the Art Institute of Chicago. Exhibited: Art Institute of Chicago, 1966; Museum of Modern Art, NYC, 1966; Guggenheim Museum, NYC, 1972; one-man shows were held at Ft. Worth Art Musuem, in Texas, 1976; University of Miami, 1980. Co-authored a book with Allan Kaprow. Address in 1982, Marlborough Gallery Inc., 40 West 57th St., NYC.

GROOMS, REGINALD L.
Painter and teacher. Born in Cincinnati, Nov. 16, 1900. Pupil of Cincinnati Art Acad.; Laurens, Pages and Royer at Julian Academy in Paris. Member: Duveneck SPS; Cincinnati AC. Work: "The Harbor," Hughes High School; "The Tuna Fleet," College High School, Cincinnati; "The Road to the River." Address in 1929, Germania Bldg., 31 East 12th St.; h. 2211 Fulton Ave., Cincinnati, OH.

GROPPER, WILLIAM.
Painter and illustrator. Born in New York, Dec. 3, 1897. Pupil of Henri, Bellows, Giles. Awards:

MacDonald prize, 1919, for caricature; Collier prize, 1920, for illustration. Illustrated "Chinese White," "Diary of a Physician," "Munchausen, M.D.," "Literary Spotlight," "The Circus Parade," "The Golden Land," 56 drawings of U.S.S.R. Address in 1929, 50 West 10th St., New York, NY.

GROSBECK, DAN SAYRE.
Painter and illustrator. Address in 1926, care of Foster and Kleiser, 287 Valencia St., San Francisco, CA.

GROSE, HELEN M(ASON).
(Mrs. Howard B. Grose, Jr.). Illustrator. Born in Providence, RI, Oct. 8, 1880. Pupil of Frank Benson, Will Foote, Converse Wyeth, Elizabeth Shippen Green Elliott. Member: Prov. AC. Illustrated: *The House of the Seven Gables, Rebecca of Sunnybrook Farm, The Seven Vagabonds* (Houghton Mifflin Co.); *Jolly Good Times, Jolly Good Times at School* (Little Brown Co.); *Anna Karenina* (Jacobs and Co.). Address in 1929, 39 Benevolent St., Providence, RI.

GROSH, PETER LEHN.
Born near Mechanicsville, Lancaster County, PA, in 1798. Lived at same village, where he was a general utility artist and painter, as well as fruit and flower grower, until 1857. Painted a number of portraits, most of which were produced between 1820 and 1835. He was a versatile man, practically self-taught, though with much native ability in striking a likeness. He died at Petersburg, 1859. He painted Mr. and Mrs. John Beck; Peter and Samuel Grosh; Mrs. Samuel Grosh; and "King and Jester."

GROSS, ALBERT R.
Painter. Member: Charcoal Club. Address in 1926, 1230 St. Paul St., Baltimore, MD.

GROSS, ALICE (ALICE GROSS FISH).
Sculptor and painter. Born in NYC in 1913. Studied with Ruth Yates. Work in Berkshire Mus., Pittsfield, MA. Has exhibited at Audubon Artists; National Academy of Design, NY, 1968; Allied Artists of America, 1969; Knickerbocker Artists, National Arts Club, NY. Awards: Allied Artists of America; Westchester Art League; New Rochelle Art Assoc. Member of Silvermine Guild of Artists; Audubon Artists; Allied Artists of America; Knickerbocker Artists. Address in 1982, 16 Sutton Pl., NYC.

GROSS, CHAIM.
Sculptor. Born March 17, 1904, in Kolomea, East Austria. Came to USA in 1921. Studied: Kunstgewerbe Schule; Educational Alliance, NYC; Beaux-Arts Institute of Design, with Elie Nadelman; Art Students League, with Robert Laurent. Work: Ain Harod; Addison Gal., Andover, MA; Baltimore Museum of Art; Bezalel Museum; Boston Museum of Fine Arts; Brooklyn Museum; Art Institute of Chicago; Jewish Museum; Metropolitan Museum of Art; Museum of Modern Art; Penna. Academy of Fine Arts; Philadelphia Museum of Art; Queens College; Reed College; Rutgers University; Smith College; Tel-Aviv; Whitney Mus.; Walker; Worcester Art Museum; Butler; and many others, including commissions for Main P.O., Washington, DC; FTC Bldg., Washington, DC; Hadassah Hosp., Jerusalem; Temple Shaaray Tefila, NYC; and others. Exhibited: Boyer Gallery, Philadelphia, 1935; Boyer Gallery, NYC, 1937; A.A.A. Gallery, NYC, 1942, 69; Youngstown (Butler); Jewish Museum; Duveen-Graham Gallery, NYC; Whitney Museum; Sculptors Guild Annuals; Penna. Academy of Fine Arts; American Federation of Arts; Am. Painting and Sculpture, Moscow, 1959; Museum of Modern Art; Smithsonian; New York World's Fair, 1964-65. Awards: L. C. Tiffany Grant, 1933; Paris World's Fair, 1937, Silver Medal; Museum of Modern Art, Artists for Victory, $3,000 Second Prize, 1942; Boston Arts Festival, Third Prize for Sculpture, 1954; Penna. Academy of Fine Arts, Honorable Mention, 1954; Audubon Artists, Prize for Sculpture, 1955; National Institute of Arts and Letters Grant, 1956, and Award of Merit Medal, 1963. Member: Sculptors Guild (President); Artists Equity; Federation of Modern Painters and Sculptors; National Institute of Arts and Letters. Taught: Educational Alliance, NYC; New School for Social Research. Address in 1983, 526 LaGuardia Place, New York City.

GROSS, IRENE.
(Irene Gross Berzon). Painter. Born in Germany. Awards: National Assoc. of Women Artists, Bocour Artists colors prize and Goldie Paley prize. Collections: Springfield Museum of Fine Arts, MA; St. Vincent's College, Latrobe, PA. Exhibitions: Silvermine, Audubon Artists, Knickerbocker.

GROSS, J.
This reputable engraver of portraits in stipple was working for the "National Portrait Gallery," published in 1834; probably one of the group of engravers brought to Philadelphia by James B. Longacre. J. D. Gross was engraving portraits in mezzotint about the same time, but the work is so inferior in execution to the stipple work of J. Gross that it must be executed by another man.

GROSS, JULIET WHITE.
(Mrs. John Lewis Gross). Sculptor, painter, draughtsman, and writer. Born Phila., PA. Pupil of Phila. School of Des.; Penna. Acad. of Fine Arts; Edouard Leon in Paris. Member: Fellowship, Penna. Acad. of Fine Arts; Nat. Assoc. of Women Painters and Sculptors; Phila. Alliance. Awards: Mary Smith prize, PA. Acad. of Fine Arts, 1919; Fellowship PA. Acad. of Fine Arts prize, 1920; gold medal, Plastic Club, 1925; hon. men. (Soc. des Artistes Francais), Paris Salon, 1926. Address in 1929, Sellersville, PA.

GROSS, OSKAR.
Painter. Born in Vienna, Austria, 1871. Pupil of Imperial Royal Academy of Fine Arts, Vienna; studied in Munich and Paris. Member: Wiener Kunstler-Genossenschaft; Austrian Artists' Assoc. (hon.); Chicago PS; Cliff Dwellers; Palette and Chisel Club. Award: Municipal Art Lg. prize, Art Inst. of Chicago, 1928. Work: "Dreams of Future," Chicago Municipal Commission purchase; "At The Market," Municipal Gallery, Vienna; "Alonzo Stag," Univ. of Chicago; "Fred Bauman" and "Dankmar Adler," Chicago Chap., American Inst. of Architects. Died Aug. 19, 1963. Address in 1929, 19 East Pearson St., Chicago, IL.

GROSS, RICHARD.
Painter. Was born in Munich in 1848, but came to America as a child. Pupil of National Academy in New York. Among his important pictures was a portrait of "William Chambers," "Old Nuremberg," "The Savant," and "The Lady of Shalott."

GROSS, SYDNEY.
Painter, illustrator, writer and teacher. Born Philadelphia, Jan. 9, 1897. Pupil of Arthur Pope. Member: Philadelphia Sketch C; Friends of Fogg Art Museum. Author of "A Short Outline of European Painting." Address in 1929, 1109 West Lehigh Ave., Philadelphia, PA.

GROSSMAN, EDWIN BOOTH.
Painter. Born Boston, MA, April 9, 1887. Pupil of W. M. Chase and Richard Miller. Member: S. Indp. A. Died Feb. 17, 1957, in Poughkeepsie, NY.

GROSSMAN, ELIAS M.
Painter, illustrator and etcher. Born Russia, Jan. 8, 1898. Pupil of Cooper Union and Educational Alliance Art School. Address in 1929, 150 Columbia Heights, Brooklyn, NY.

GROSSMAN, ISIDORE.
Sculptor, craftsman, and teacher. Born in NYC, Feb. 23, 1908. Member: Art League of America. Exhibited: Carnegie Institute, 1939; Penna. Academy of Fine Arts, 1939-46; NY World's Fair, 1939; New School for Social Research, 1939, 40; Municipal Art Gallery, 1940; Fairmount Park, PA, 1940. Address in 1953, 604 East 9th St.; h. 389 East 10th St., NYC.

GROSSMAN, JOSEPH B.
Painter. Born in Russia, 1888. Pupil of Penna. Academy of Fine Arts. Address in 1926, 1523 Chestnut St., Philadelphia.

GROSSMAN, NANCY.
Sculptor and painter. Born in NYC, April 28, 1940. Studied at Pratt Institute. Work in Whitney Museum of American Art, NY; others. Has exhibited at Corcoran Gallery of Art; Whitney Mus. of America

Art Sculpture Annual; Figure Sculpture, Fogg Art Museum; others. Received Guggenheim Memorial Foundation Fellowship, 1965; American Academy of Arts and Letters/National Institute of Arts and Letters Award, 1974. Address in 1982, 105 Eldridge St., NYC.

GROSVENOR, THELMA CUDLIPP.
(Mrs. Charles S. Whitman). Sculptor, painter, and illustrator. Born in Richmond, VA, October 14, 1891. Studied in Royal Academy Schools, Lon., England; with Kenneth Hayes Miller, Art Students League, NY; St. John's Wood School. Member: New York Society of Women Artists; Society of Illustrators; Newport Art Assoc. Exhibited: Penna. Academy of Fine Arts; Corcoran Gallery of Art; Toledo Museum of Art; Art Institute of Chicago; Whitney Museum of American Art; Newport Art Association; National Academy of Design; Virginia Museum of Fine Art; Rhode Island School of Design; College Art Association of America traveling exhibition. Illustrated covers for *Vanity Fair, Town and Country, Saturday Evening Post, Harper's, Century,* and *McClures.* Lectures: "Pre-Columbian Sculpture." Address in 1953, 455 East 57th St., NYC.

GROTH, JOHN.
Illustrator. Born in Chicago, in 1908. Went to the Art Inst. of Chicago and the Art Students League. His first piece, a cartoon, was published in 1930 in *Ballyhoo* magazine. His ink and wash illustrations appeared in *Holiday* and *Esquire* and in several books such as *The Grapes Of Wrath* and others. He has received citations from the U.S. Army and USAF as a result of his work as a War Correspondent during World War II, in Korea, Indochina, the Congo, Santo Domingo, and Vietnam. His work has been shown and is owned by many prestigious museums including the Metropolitan Museum of Art and the Museum of Modern Art.

GROVE, DAVID.
Illustrator. Born in Wash., DC, he went to Syracuse Univ. and began a career as a photographer in the early 1960's. He settled in Paris in 1964 as a freelance illustrator. Returning to the U.S. in 1969, he presently lives in San Francisco where he is President of the Society of Illustrators of San Francisco. His artwork appears frequently in books for Ballantine, Avon, Dell, Fawcett, and Bantam, earning him awards in Los Angeles and New York.

GROVE, EDWARD RYNEAL.
Sculptor and painter. Born in Martinsburg, WV, Aug. 14, 1912. Studied at National School of Art, Washington, DC, 1933; Corcoran School of Art, Washington, DC, with Schuler and Weisz, 1934-40; also with Robert Brackman, Noank, CT, 1946. Work in Smithsonian Institution; Corcoran Gallery of Art; Washington Cathedral, DC; Museum of Medallic

Art, Poland. Has exhibited at Watercolor Annual, Penna. Academy of Fine Arts, Philadelphia; Nat. Sculpture Society, Lever House, NY; others. Sculptor-engraver of US Mint, Phila., 1962-65. Member of the Nat. Sculpture Soc.; Artists Equity Association; National Academy of Design. Awards: Lindsey Morris Memorial Prize, 1967, Mrs. Louis Bennett Prize, 1971, both from National Sculpture Society; American Numismatic Association. Works in clay, bronze, silver; oils, watercolor. Address in 1982, West Palm Beach, FL.

GROVE, JEAN DONNER.
Sculptor. Born in Washington, DC, May 15, 1912. Studied at Hill School of Sculpture; Corcoran School of Art; Catholic University of America; Wilson Teachers College, B.S., 1939; Cornell University; Philadelphia Museum of Art; travel study in Europe; also with Clara Hill, Hans Schuler, Heinz Warneke, and Fritz Janschka. Work in Rosenwald Collection, Philadelphia, PA; others. Has exhibited at Corcoran Gallery of Art, Washington, DC; Penna. Academy of Fine Arts Annual, Philadelphia; National Academy of Design; others. Received Competition Prize for Design of Artists Equity Association Philadelphia Award; Tallix Foundry Award, National Sculpture Society; others. Member of National Sculpture Soc.; Artists Equity Association; Phila. Art Alliance; Associate National Academy of Design, NY; others. Works in stone, wood, clay, bronze, and plastics. Address in 1982, West Palm Beach, FL.

GROVE, SHELTON GILBERT.
Painter. Born in Clinton, NY, 1805; died in Rochester, 1885. Studied medicine, but gave it up for painting, his work being mostly portraiture.

GROVER, OLIVER DENNETT.
Painter. Born Earlville, IL, 1861. Student of Univ. of Chicago; studied painting at Royal Academy, Munich; Duveneck School, Florence, Italy; and in Paris. Received first Yerkes prize for painting, "Thy Will Be Done," Chicago, 1892; executed mural decorations, Branford, Conn., Mem. Library, 1897; Blackstone Mem. Library, Chicago, 1903. His pictures are in many public collections. Elected Associate Member of the National Academy, 1913. Address in 1926, 9 E. Ontario St., Chicago, IL.

GROVES, DOROTHY LYONS.
Painter. Born Condersport, PA. Pupil of John Carlson; Harry Leith-Ross. Member: New Haven Paint and Clay Club; New Haven Brush and Palette Club; Amer. Artist's Professional League. Address in 1929, 80 Vista Terrace, New Haven, CT.

GROVES, HANNAH CUTLER.
Painter and teacher. Born Camden, NJ, Dec. 30, 1868. Pupil of William M. Chase and School of Design, Philadelphia. Member: Phila. Alliance;

Plastic C. Died in 1952. Address in 1929, Pressor Bldg., 1714 Chestnut St., Philadelphia, PA; h. 237 Hopkins Ave., Haddonfield, NJ.

GROW, RONALD.
Sculptor. Born 1934 in Wooster, OH. Studied at University of Colorado; earned M.A. at UCLA. Teaching at University of Mexico since 1962. Work: In private collections. Exhibitions: California State Fair, 1961; Long Beach Museum of Art; University of New Mexico; Scripps College; Syracuse Univ.; Downey Museum of Art, CA; UCLA; Brandeis University. Awards: Sculpture, California State Fair, 1961; Long Beach Museum of Art and Los Angeles and Vicinity Exhibitions, both 1962.

GRUB, HENRY.
Sculptor and painter. Born in Baltimore, MD, 1884. Pupil of Maynard, Ward, and Bridgman. Member: New York Society of Independent Artists. Address in 1926, 53 Greenwich Ave., New York.

GRUBER, AARONEL DEROY.
Sculptor and kinetic artist. Born in Pittsburgh, PA. Studied at Carnegie Institute of Technology. Work in Smithsonian Institution, Washington, DC; Rose Art Museum, Brandeis University; Butler Institute of American Art; De Cordova Museum, Lincoln, MA; plus sculpture commissions. Has exhibited at De Cordova Museum, Lincoln, MA; Biennal International de la Petite Sculpture, Budapest Museum, Hungary; Everson Museum, Syracuse, NY; others. Received six sculpture awards, Western Penna. Society of Sculptors. Works in lucite and plexiglas. Address in 1982, Pittsburgh, PA.

GRUELLE, RICHARD B.
Landscape painter. Born in 1851. Among his best known paintings are "The Passing Storm" at Indianapolis Public Library; "A Gloucester Inlet" at the Herron Art Institute; "In Verdure Clad" at Public Gal., Richmond, IN. He died in Indianapolis in 1915.

GRUENBERG, RUTH.
Painter. Exhibited at the Penna. Academy of Fine Arts, 1922 (water colors). Address in 1926, 3211 Oxford St., Philadelphia, PA.

GRUGER, FREDERIC R.
Illustrator. Born in Phila. in 1871. Studied at the Penna. Academy of Fine Arts with Wm. Glackens, Maxfield Parrish. First work in *Philadelphia Ledger*; career associated with magazines, especially *Saturday Evening Post*. Address in 1926, 57 West 57th St., New York. Died March, 1953, in NYC.

GRUMIEAU, EMILE J(ACQUES).
Painter, illustrator and teacher. Born Gosselies, Hainaut, Belgium, May 17, 1897. Pupil of Art Inst. of

Chicago. Member: Chicago SA. Address in 1929, 149 East Huron St., Chicago, IL; summer, Glenwood, IL.

GRUNEWALD, GUSTAVUS.
Painter. Born Dec. 19, 1805, in Germany. A Pennsylvania German artist who was painting landscapes in Bethlehem, PA, in 1832. Died Aug. 1, 1878, in Germany.

GRUPPE, C(HARLES) P(AUL).
Painter. Born Picton, Canada, Sept. 3, 1860. Studied in Holland; chiefly self-taught. Member: NY Water Color Club; Amer. Water Color Society; AC Phila.; Salma. C., 1893; Nat. Arts Club; Rochester AC; Amer. Federation of Arts; Pulchre Studio, The Hague. Awards: Gold medal, Rouen; gold medal, Amer. Art Society, 1902; two gold medals, Paris; silver medals for oils and for water color, St. Louis Exp., 1904; bronze medal, Appalachian Exp., Knoxville, 1910; Tuthill prize, Art Institute Chicago. Works: "A Dutch Canal," Inst. of Arts, Detroit; National Arts Club, NY; Art Club of Philadelphia; "The Meadow Brooks," Nat. Gallery, Washington, DC; "Homeward Way," Reading (PA), Museum; "It Sure is Jan," Butler Art Institute, Youngstown, OH. Died in 1940. Address in 1929, 1112 Carnegie Hall; h. 138 Manhattan Ave., New York, NY.

GRUPPE, EMILE A(LBERT).
Painter. Born Rochester, NY, Nov. 23, 1896. Pupil of John Carlson, Bridgman, Richard Miller, Charles Chapman. Member: Salma. C. Address in 1929, 138 Manhattan Ave., New York, NY; summer, Reed Studios, Gloucester, MA.

GRUPPE, KARL HEINRICH.
Sculptor and painter. Born Rochester, NY, March 18, 1893. Son of Charles Gruppe, the painter. Lived in Holland as a child; returned to US as adult. Pupil of Karl Bitter; studied at Royal Academy of Antwerp and Art Students League, NY. Member: Nat. Sculpture Soc. (assoc.); NY Architectural League (assoc.). Award: Saint-Gaudens prize, 1912, Art Students League; Avery prize, 1920, NY Architectural League; Helen Foster Barnett prize, 1926. Work: Final figure, Italian towers, P.-P. Exp., San Francisco, 1915; Memorial Tablet, City Club, NY; Memorial Tablet, Princeton Charter Club; Portrait Bust, Dean of Adelphi College, Brooklyn, NY, 1929. Exhibited at National Academy of Design Annual; Nat. Sculpture Soc., 1923, Annual Exhibition, 1977. Address in 1982, Southold, NY. Died in 1982.

GRYGUTIS, BARBARA.
Sculptor and ceramist. Born in Hartford, CT, Nov. 7, 1946. Studied: University of Arizona, Tucson, AZ, B.F.A., 1968, M.F.A., 1971; travel-study in Japan. Awards: Tucson Art Center, AZ, 1968, 1970, 1971, 1975. Exhibitions: University of Arizona Museum of Art, 1971; Graphic Arts Gallery, Tucson, AZ, 1972;

Harlan Gallery, Tucson, 1975; Renwick Gallery, Smithsonian; Museum of Contemporary Crafts, NYC, 1976; Everson Museum, Syracuse, NY, 1976. Commissions: Union Bank Branch Office, Tucson; La Placita Shopping Center, Tucson. Media: Clay and glass. Address in 1982, Tucson, AZ.

GSCHWINDT, R.
Painter. He painted some excellent portraits in New Orleans in 1859 and 1860; studio at 82 Camp Street. No date could be found regarding his birth or death.

GUARINA, SALVATOR ANTHONY.
Painter and etcher. Born in Sicily, Italy. Pupil of Whittaker and Blum, and member of the Wash. Art Club. Address in 1926, care of Salmagundi Club, New York.

GUCK, EDNA.
Sculptor and painter. Born in NYC, March 17, 1904. Studied at Art Students League, and in Paris, France. Work: Seattle Art Museum; Brooklyn Museum; Queens College; National Hospital for Speech Disorders; Halloran Hospital; New York Public School; New York Housing Projects. Awards: Prize, Essex Art Assoc., 1951. Exhibited: Riggs-Sargent, Mexico, D.F., 1952; Essex Art Association, 1950-51; Carlebach Gallery, 1950; Centre d'Art, Haiti, 1949; Bonestell Gallery, 1939-46; Am-British Art Center, 1942; AID, 1941; Metropolitan Museum of Art, 1941; New York World's Fair, 1939; New School for Social Research, 1940; Ferargil Gallery, 1939; NY Society of Women Artists, 1935-38; Newark Museum of Art, 1936; Newton Gallery, 1935; Jersey City Museum, 1935; Providence Art Assoc., 1930; Salon d'Automne, Paris, 1928. Position: Instructor at River Edge Adult Education, NJ, 1951-52; Jewish Community Center of the Rockaways, NY, 1951-52. Address in 1953, 433 West 18th St., NYC.

GUDEBROD, LOUIS ALBERT.
Sculptor. Born Middletown, CT, September 20, 1872. Pupil of Yale Art School; Art Students League of New York, under Mary Lawrence and Augustus Saint-Gaudens; Dampt in Paris. Member: Nat. Sculpture Society, 1902; New York Architectural League, 1902; Conn. Academy of Fine Arts; New Haven Paint and Clay Club; Lyme Art Association. Awards: Silver medal, Charleston Exp., 1902; gold medal, Panama-Pacific Exp., San Francisco, California, 1915. Assistant to Saint-Gaudens in Paris. Director of Sculpture, Charleston Exp., 1902. Work: Anderson Prison Monument for New York State at Andersonville, GA; "Henry Clay Work Memorial," Hartford, CT; portrait memorials in Bristol and Meriden public libraries; Weaver High School, Hartford; Grace Hospital, New Haven; Mayflower tablet in State Capitol, Hartford. Address in 1933, Meriden, CT.

GUE, DAVID JOHN.
Portrait, landscape and marine painter. Born in Farmington, New York, Jan. 17, 1836. He painted the portraits of Grant, Lincoln and Beecher. He died in Brooklyn, New York, May 1, 1917.

GUERIN, JULES.
Painter and illustrator. Born in St. Louis, MO, Nov. 18, 1866. Pupil of Constant and Laurens in Paris. Member: Associate National Academy of Design, 1916; Amer. Water Color Society; NY Water Color Club; Soc. of Illustrators, 1901; Nat. Inst. AL; The Players; NY Arch. Lg., 1911; Mural P.; NY Art Com.; Beaux Arts Inst. of Design; Am. Fed. of Arts. Awards: First Yerkes medal, Chicago; hon. mention, Paris Exp., 1900; hon. mention for drawings, Pan-Am. Exp., Buffalo, 1901; silver medal, St. Louis Exp., 1904; Beck prize, Phila. Water Color Club, 1913; gold medal, P.-P. Exp., San F., 1915. Specialty, architectural subjects and decoration. Director of color, Panama-Pacific Exp., San Francisco, 1915. Painted decorations in Lincoln Mem., Washington, DC, and Penn. Station, NY; decorations in Federal Reserve Bank, San Francisco; murals in Illinois Merchant's Trust Co., Chicago; Liberty Mem., Kansas City, MO; and Union Trust Co., Cleveland; murals, Terminal Building, Cleveland. Address in 1929, 50 E. 23rd St.; h. 24 Gramercy Park, NY.

GUERNSEY, ELEANOR LOUISE.
Sculptor. Born in Terre Haute, IN, 1878. Pupil of Art Institute of Chicago. Member: Art Students League of Chicago; Indian Sculptors' Society. Address in 1926, James Milliken University, Decatur, IL.

GUGLER, FRIDA.
Painter. Born Milwaukee, WI. Pupil of Art Inst. of Chicago; studied in Paris, Munich and Italy. Work: "Landscape," Vanderpoel Mem. Assoc., Chicago, IL; "Landscape," Milwaukee Art Institute, Milwaukee, WI. Address in 1929, 2 Washington Mews, New York, NY.

GUGLIELMO, VICTOR.
Sculptor. Born in Italy. He assisted Frank Happersburger in his work in San Francisco. Address in 1926, San Francisco, CA.

GUILD, FRANK S.
Painter. Member: Philadelphia AC; Phila. Sketch C. Died in 1929. Address in 1929, 721 Walnut St., Philadelphia, PA.

GUILD, LURELLE VAN ARSDALE.
Painter, illustrator and writer. He was born in NYC, Aug. 19, 1898. Pupil of Bridgman. Member: Soc. of Illustrators; Artists Guild of the Authors' Lg. of America; A. Directors C. Award: Hon. mention for water color, Art Directors Club, 1924. Works: Illustrations for *House and Garden, Country Life,* *Ladies' Home Journal, McCall's* and *Designer.* Author of *The Geography of American Antiques* (Doubleday, Doran and Co.). Address in 1929, 31 Park Ave., New York, NY; h. Revonah Manor, Urban St., Stamford, CT.

GUILLETT, MADAME J.
French miniature painter who flourished in New York, 1839-42. She also painted many miniatures in Virginia.

GUINNESS, BENJAMIN (MRS.).
Painter. Member: National Academy of Women Painters and Sculptors.

GUINZBURG, FREDERIC VICTOR.
Sculptor, craftsman, lecturer, and teacher. Born New York City, June 18, 1897. Pupil of J. Myers and Victor David Brenner at Art Students League; Ernesto Grazzeri in Rome; and School of American Sculpture. Member: National Sculpture Society (assoc.); NY Architectural League. Award: Hon. mention, Concord Art Association, 1924; bronze medal, Sesqui-Centennial Exp., Philadelphia, 1926. Exhibited at National Sculpture Society, 1923. Address in 1929, 21 West 89th St., New York, NY; Chiselhurst Studio, Chappaqua, Westchester Co., NY. Died in 1978.

GUISLAIN, J. M.
Painter. Born in Louvain, Belgium, 1882. Address in 1926, 725 West 172nd St., New York, NY.

GULDBERG, CHRISTIAN A(UGUST).
Painter and architect. Born Madagascar, April 13, 1879. Member: NY Arch. C; Montclair AA. Address in 1929, 7 St. Luke Pl., Montclair, NJ.

GULLAGER, CHRISTIAN.
Portrait painter. Born Mar. 1, 1759, in Copenhagen, Denmark. He painted excellent portraits in Boston from 1789. He painted portraits of President Wash., Geo. Richards Minot, Col. John May, Rev. James Freeman, Dr. Eliakin Morse, David West, Rev. Ebenezer Morse and Benjamin Goldthwait. His portraits are signed "Gullager." Died Nov. 12, 1826, in Philadelphia.

GULLEDGE, JOSEPHINE.
Painter. Member: Washington Water Color Club. Address in 1926, Fairmount Seminary, Washington, DC.

GULLIVER, MARY.
Painter and teacher. Born Norwich, CT, Sept. 9, 1860. Pupil of Boston Museum of Fine Arts School; Grundmann, Niemeyer, Vonnoh and Crowninshield; Whistler, Collin, Delance, Callot, Lazar and Prinet in Paris; Delecluse and Colarossi Academies, Paris; studied in England, Holland, Italy, Spain, Germany.

Member: Copley S, 1883. Teacher in Drawing and Painting and History of Art, Mary A. Burnham School for Girls, Northampton, MA, for 10 years; head of department of Fine Arts, Rockford College, 1911-1919. Specialty, portrait and genre painting. Address in 1929, 1115 Orange Ave., Eustis, FL.

GUMMER, DON.
Sculptor. Born in Louisville, KY, 1946. Studied at John Herron Art Institute, Indianapolis, 1964-66; School Museum of Fine Arts, Boston, 1966-70; Yale University School of Fine Arts, New Haven, B.F.A., 1971, M.F.A., 1973. Work, outdoor installations, Dag Hammerskjold Plaza, NYC; others. Has exhibited at Albright-Knox Art Gallery, Buffalo; Joe and Emily Lowe Art Gallery, Syracuse University, NY; Akron Art Mus., OH; Aldrich Mus. of Cont. Art, Ridgefield, CT; Chicago Arts Club; others. Received grant, Nat. Endowment for the Arts; grant, Tiffany Foundation. Works in wood and stone. Address c/o Sperone Westwater Fischer, 142 Greene St., NYC.

GUNDLACH, HELEN FUCHS.
(Mrs. E. Q.). Sculptor, painter, illustrator. Born in Buffalo, NY, Feb. 9, 1890. Studied with John Carlson, Charles Rosen, and Walter Everette. Award: Fellowship prize, Buffalo Soc. of Artists, 1923. Member: Buffalo Soc. of Artists; Art Dept., League of Am. Pen Women. Address in 1933, Ebenezer, NY.

GUNN, ARCHIE.
Painter, illustrator, etcher and teacher. Born in Taunton, Somersetshire, Eng., Oct. 11, 1863. Pupil of Archibald Gunn, P. Calderon in London. Address in 1929, 120 West 49th St., New York, NY; summer, Inglesea Bungalow, East Rockaway, LI, NY.

GUNN, EDWIN.
Painter. Member: Salmagundi Club, New York. Address in 1926, 252 Mt. Hope Ave., New York, NY.

GURDUS, LUBA.
Painter. Born Bialystok, Poland 1914. Studied: Art School, Lausanne, Switzerland; Acad. of Art, Warsaw, Poland; Inst. of Fine Arts, NY U.; in Ger.. Award: Warsaw Acad. of Art, 1938. Collections: Mun. Col.; Tel-Aviv, Israel; Howard U.; Jewish Mus. of NY; Israeli Consulate; Stephen West House, NY.

GUSSOW, BERNARD.
Painter and teacher. Born in Russia, Jan. 2, 1881. Pupil of Bonnat in Paris. Member: S. Indp. A.; Modern Artists of America. Represented in Newark (NJ) Mus.; Harrison Gall., Los Angeles Museum; Barnes Foundation, Philadelphia. Died in 1957. Address in 1929, 108 West 75th St., New York, NY.

GUSSOW, ROY.
Sculptor and environmental artist. Born November 12, 1918, Brooklyn, NY. Studied: NY State Institute of Applied Agriculture (Farmingdale), 1938; Institute of Design, Chicago, with Lazlo Moholy-Nagy, Alexander Archipenko. Work: Atlanta Art Association; Brooklyn Museum; California Academy of Science; Museum of Modern Art; University of North Carolina; North Carolina Museum of Art, Raleigh; Whitney Museum; Guggenheim. Represented by Borgenicht Gallery, NYC. Exhibited: Design Associates Gallery, Greensboro, NC, 1952; Penna. State University, 1959; Grace Borgenicht Gallery Inc., NYC, 1964; Art Institute of Chicago; Omaha (Joslyn); Denver Art Museum; San Francisco Museum of Art; Metropolitan Museum of Art; Penna. Academy of Fine Arts; Whitney Museum. Awards: Penna. Academy of Fine Arts, Honorable Mention, 1958; Ford Foundation, 1960, 62; National Gold Medal Exhibition for the Building Arts, NYC, 1962. Taught: Colorado Springs Fine Arts Center, 1949-51; North Carolina State Col., 1951-62; Pratt Inst., 1962-68. Commissions: United States Commerce Department Trade Fair, circ. Bangkok and Tokyo, 1956 (American Pavilion); San Francisco Museum of Science and Industry, 1962; Phoenix-Mutual Building, Hartford, CT, 1963 (8-ft. stainless steel sculpture commissioned by Max Abramovitz); Tulsa Civic Center, 1968; Xerox Corp., 1968; and others. Address in 1983, 40-40 24th Street, Long Island City, NY.

GUSTIN, PAUL MORGAN.
Painter, illustrator, etcher and teacher. Born Fort Vancouver, Wash., 1886. Member: Painters and Sculptors. Work: Group of murals, Roosevelt HS, Seattle; "Road Through Forest," Art Gallery, Univ. of Washington; "April Afternoon," Washington State College. Address in 1929, care of Grand Central Art Galleries, New York, NY.

GUSTON, PHILIP.
Painter. Born June 27, 1913, in Montreal, Canada. Studied at Otis Art Inst., LA; Hon. D.F.A. from Boston Univ. Taught at Univ. of Iowa; Washington Univ., in St. Louis; NYU; Pratt; Boston Univ.; and Brandeis Univ. Awards: Carnegie Inst. (1945); Guggenheim (1947 & 1968); Ford Foundation Grant (1959); Brandeis Award (1980). Exhibited at Univ. of Iowa; School of Mus. of Fine Arts, Boston; Munson-Williams-Proctor Inst., Utica. In collections of City Art Museum, St. Louis; Phillips Collection (Wash., DC); Worchester (MA) Art Mus.; Whitney; MOMA; and Tate Gallery, London.

GUTHERS, CARL.
Painter. Born in Switzerland in 1844. He came to America in 1851, where he received his art training. In 1868 he went to Paris. His work was mural, portrait, and genre subjects. Many portraits in the Minnesota State Capitol; mural paintings in the Library of Congress, Washington, DC. He died in 1907 in Washington, DC.

GUTIERREZ, LOUIS.
Painter and collage. Born in 1933 in Oakland, CA. Studied at San Jose State, BA, 1957; Instituto San Miguel Allende, Mexico, MFA, 1958. Work: San Fran. Mus. of Art; Diablo Valley College; San Jose State College. Exhibited: San Fran. Art Center, 1962-64; CA State Fair, 1960-64; San Fran. Mus. of Art, 1960-64. Awards: San Fran. Art Festival, 1962; Art Inst. Annual, San Fran.; Ford Foundation award. Taught at Lincoln Univ. (CA) and Acad. of Art, San Fran. Works in low relief construction.

GUTMAN, ELIZABETH.
Painter. Born in Baltimore. Pupil of Breckenridge, H. B. Snell, S. E. Whiteman. Member: Baltimore Water Color Club. Address in 1929, Pikesville, MD.

GUTMANN, BERNHARD.
Painter, etcher and craftsman. Born Hamburg, Germany, Sept. 26, 1869. Studied in Dusseldorf and Karlsruhe, Germany, and in Paris. Member: Allied Artists of America; Salma. C.; Silvermine Guild of Artists. Died in 1936. Address in 1929, Silvermine (R. F. D. No. 43), New Canaan, CT.

GUY, FRANCIS.
Born in 1760 in England. Arrived in 1795 in the US. Painted landscapes in Balt. and Phila. about 1800. He was originally a tailor, and was self-taught. His style was crude and harsh. He exhibited a number of drawings and paintings at the exhibition in 1811 of the Soc. of Artists in Phila. About 1817 he returned to Brooklyn, NY, where he died Aug. 12, 1820.

GUY, JAMES M.
Sculptor and painter. Born February 10, 1910, in Middletown, Conn. Studied: Hartford Art School, with Albertus Jones, Kimon Nicolaides. Work: Wadsworth; Guggenheim; MIT; Society of the Four Arts. Represented by Chas. Egan Gallery, New York City. Exhibited: Boyer Gallery, New York City, 1939, 40; Ferargil Galleries, NYC, 1941, 42, 44; Carlebach Gallery, NYC, 1949, 50; Paris World's Fair, 1937; New York World's Fair, 1939; Golden Gate Inter. Exposition, San Francisco, 1939; Whitney Annuals; Museum of Modern Art; Metropolitan Museum of Art; Art Institute of Chicago. Address in 1982, Moodus, CT.

GUY, SEYMOUR J.
Painter. Born in England, Jan. 16, 1824. He came to America in 1854 and settled in New York. Pupil of Ambrosino Jerome in London. He was elected a member of the Nat. Academy of Des. in 1865. His portrait of the artist Chas. Loring Elliott (1868) is in the Met. Museum. He painted many scenes and incidents drawn from childlife, among them "The Good Sister," "The Little Stranger," and "The Little Orange Girl." He died Dec. 10, 1910, in NYC.

GUYSI, ALICE V.
Painter. Born Cincinnati, OH. Pupil of Colarossi Academy, and of Harry Thompson in Paris. Address in 1926, 209 Longfellow Ave., Detroit, MI.

GUYSI, JEANNETTE.
Painter and craftswoman. Born Cincinnati, OH. Pupil of Colarossi Academy and of Harry Thompson in Paris. Died in 1940. Address in 1926, 209 Longfellow Ave., Detroit, MI.

GWATHMEY, ROBERT.
Painter. Born Jan. 24, 1903, in Richmond, VA. Studied at Maryland Inst. (Baltimore); Penna. Academy of Fine Arts (Phil.); NC State College, Raleigh. Awards from 48 States Mural Contest (1939); Carnegie; Corcoran Gallery of Art, Wash., DC, (1957). Taught at Carnegie Inst. of Tech., PA; Cooper Union; Boston Univ. Exhibited at Brooklyn Museum (1932); ACA Gallery (many times, 1933-76). In collections of Univ. of Georgia; Boston Mus. of Fine Arts; IBM; Mus. of Fine Arts, Springfield, MA; Whitney; L.A. County Mus.; Brooklyn Mus.; Univ. of Texas, Austin; Carnegie; Birmingham Mus. of Art; and Museum de Arte Moderna de Sao Paulo, Brazil.

GYBERSON, INDIANA.
Painter. She studied with Chase in LI, NY; and in Paris. In 1912 was working on painting for Salon; suffered eye injury. Later had studio in Chicago, IL. Member: Chic. PS; Chic. Gal. A.; Am. Fed. of Arts.

GYER, E. H., JR.
Painter and illustrator. Born Tacoma, Oct. 15, 1900. Pupil of G. Z. Heuston. Member: Tacoma FAA. Award: Hon. mention, Tacoma FAA, 1922. Address in 1929, 5811 South Junett St., Tacoma, WA.

GYRA, FRANCIS JOSEPH, JR.
Painter. Born in Newport, RI, Feb. 23, 1914. Study: RI Sch. of Des., Dipl.; Parsons Sch. of Des., Paris; Brighton Col. of Arts & Crafts, Sussex, Eng.; Froebel Inst.; Roehampton, Eng.; Univ. of Hawaii; McNeese State Col.; Keene State Col., BS. Work: Prov. (RI) Art Mus.; Tenn. Fine Arts Center. Exhibited: Int. Water Color Exhib., Art Inst. of Chic., 1938-40; 1st Art Ann., No. New Eng., Canaan, NH, 1969; Stratton Arts Festival, VT, 1970; and others. Awards: Art Assn. of Newport, RI, 1938; Eva Gebhard-Gourgand Foundation grants, 1966-72. Teaching: Woodstock (VT) Union & Dist. Schools, 1949-69; VT State Dept. of Educ., 1954-70; Woodstock (VT) Sch. Dist., from 1969. Member: Int'l. Inst. Arts & Letters; others. Address in 1982, Linden Hall, Woodstock, VT.

H

HAAG, C.
Miniature painter, who flourished in New York about 1848, and exhibited at the National Academy, New York.

HAAG, CHARLES (CARL) OSCAR.
Sculptor. Born Norrkoping, Sweden, 1867. Pupil of Junghaenel Ziegler and Injalbert. Awards: Bronze and silver medal, first prize, Swedish-American Exhibition. Work: "Cornerstone of the Castle" in Winnetka; "Accord," Metropolitan Museum, New York; series of fountains, among them the "American Fountain," at Johnstown, PA. Sculptor of symbolic and poetic art and series of figures and groups in wood called "the spirits from the woods;" series of stones called the "stoneworld." Address in 1933, Winnetka, Illinois. Died in 1934.

HAAPANEN, JOHN NICHOLS.
Landscape painter. Born Niantic, CT, Oct. 13, 1891. Pupil of E. L. Major, W. Felton Brown, A. K. Cross. Member: Boston AC; Copley S. Address in 1929, Boothbay Harbor, ME.

HAAS, HELEN.
(Mrs. Ruffin Haas de Langley). Sculptor. Born in NYC, 1904. Studied with Antoine Bourdelle, France. Works: Luxembourg Museum, Paris; Port Sunlight Museum, London; NY Mus. of Natural History. Exhibited: Salon Des Tuileries, Paris; Salon D'Automne, Grand Palais, Paris; a one-woman show was held at the Charpentier Gallery, Paris, Jacques Seligman Gallery, New York and Knoedler Gallery, London; and a special exhibit for the Armed Forces, in London, 1942-43. Address in 1982, 28 East 73rd Street, NYC.

HABBEN, JOSEPH E.
Painter and illustrator. Born in Britt, IA, March 25, 1895. Member: Art Students Lg. of NY. Address in 1929, care of J. M. Forkner, R. R. 2, Anderson, IN.

HABERGRITZ, GEORGE JOSEPH.
Sculptor and painter. Born in NYC, June 16, 1909. Study: National Academy of Design; Cooper Union, graduate; Academie Grande Chaumiere. Work: Butler Museum, Youngstown, OH; Safad Museum, Israel; Jewish Museum, London; Purdue Univ.; Wilberforce Univ. Exhibition: Albright Museum, Painting Annual, Buffalo, NY, 1938-40; American Watercolor Society Annual, 1947-49; National Association of Painters in Casein, 1947-74; National Academy of Design, 1948-51; others in US and Bogata, Colombia. Awards: Gold medal, drawing, National Academy of Design, 1938; Grumbacher awards, National Society of Painters in Casein, 1968, 70, 72, 74. Teaching: Director, School of Continuing Art Education, from 1968; lecturer in Africa, South Pacific, India, from 1957; Art Students League, Instructor in Painting, 1960-64; Workshop Prof. Artists, from 1967; others. Member: National Society of Painters in Casein. Media: Oil, wood, metal, collage, found material. Address in 1982, 150 Waverly Place, NYC.

HACK, GWENDOLYN DUNLEVY KELLEY.
(Mrs. Charles Hack). Painter. Born in Columbus, OH, in 1877. Educated at Art Students League of NY; in Paris studied under Mesdames Debillement and Gallet. Specialties, miniatures on ivory, pastels, bas-reliefs, etc.; painted portraits on ivory, Queen of Italy, 1895, and received decoration; exhibited paintings in Paris Salon; National Academy of Design; Chicago Art Institute; Cincinnati Art Museum; and in other cities; also in Nashville and Omaha expositions. Address in 1926, 12 West 93d Street, New York.

HACK, KONRAD F.
Illustrator. Born in Chicago in 1945. He attended the Art Inst. of Chicago and University of Chicago between 1964 and 1968. He produced movie promotion art and sports advertisements for WGN-TV in Chicago. Serving as a combat artist in Vietnam with the 19th Military History Detachment, he earned the Bronze Star and Army Commendation Medal. Recently he has illustrated books for the Franklin Library and the Hamilton Mint, for whom he also designed a set of bicentennial pewter plates.

HACKETT, GRACE EDITH.
Painter, illustrator, and craftsman. Born in Boston, Sept. 22, 1874. Pupil of MA Normal Art School in Boston; H. B. Snell in Europe. Member: Boston Soc. of Arts and Crafts; NY Water Color Club; Copley S; Eastern AA; Amer. Federation of Arts. Supervisor of drawing in public schools, Boston. Died in 1955.

HADEN, ELMER S.
Painter. Born in United States. Pupil of Flameng in Paris. Address in 1926, Nyack, NY.

HADLEY, MARY HAMILTON.
Painter. Address in 1926, 355 Willow Street, New Haven, CT.

HADLEY, PAUL.
Painter and draftsman. Born Indianapolis, IN. Pupil of PA Museum, Philadelphia. Member: Ind. AC;

Chicago Gal. A; Hoosier Salon. Work: Decoration in Eagle's Club, Indianapolis, IN; design for Indiana flag accepted by the legislature, 1917. Address in 1929, 44 Union Trust Building., Indianapolis; h. Mooresville, IN.

HADZI, DIMITRI.
Sculptor and printmaker. Born March 21, 1921, in NYC. Studied: Polytechnic Institute of Brooklyn; Cooper Union; Polytechnion, Athens; Museo Artistico Industriale, Rome; Brooklyn Museum School. Work: Albright; MIT; Museum of Modern Art; New School for Social Research; Princeton Univ.; Rhode Island School of Des.; Guggenheim; Whitney; Yale University; Fogg Art Museum; Hirshhorn. Commissions for MIT, Lincoln Center, JFK Office Bldg. (Boston). Exhibited: Galleria Schneider, Rome, 1958, 60; Seiferheld Gallery, NYC, 1959; Galeria Van der Loo, Munich, 1961; Stephen Radich Gallery, 1961; Gallery Hella Nebelung, Dusseldorf, 1962; MIT, 1963; Felix Landau Gallery, 1969; Middleheim Park, Antwerp, International Outdoor Sculpture Exhibition, 1957, 59; Carnegie, 1958, 61; Museum of Modern Art; Claude Bernard, Paris, Aspects of American Sculpture, 1960; Whitney Annuals; Boston Arts Festival, 1961; XXXI Venice Biennial, 1962; Seattle World's Fair, 1962; Battersea Park, London, International Sculpture Exhibition, 1963; New York World's Fair, 1964-65; Musee Rodin, Paris, 1966. Awards: Fulbright Fellowship (Greece), 1950; L. C. Tiffany Grant, 1955; Guggenheim Foundation Fellowship, 1957; National Institute of Arts and Letters, 1962. Address in 1983, Cambridge, MA.

HAENEL, WILLIAM M.
Painter and teacher. Born Chicago, April 26, 1885. Pupil of Walter Ufer; Leo Putz in Munich. Member: Chicago AC; Artists Guild of the Authors' Lg. of America. Award: William Ormonde Thompson prize, Art Inst. of Chicago, 1928. Address in 1929, 19 Pearson Street, h. 421 St. James Pl., Chicago, IL.

HAFFNER, J. J.
Painter. Member: Boston Soc. of Water Color Painters. Address in 1929, 26 Hillard Street, Cambridge, MA.

HAFNER, CHARLES ANDREW.
Sculptor. Born in Omaha, NE, October 28, 1888. Pupil of Edmund C. Tarbell, F. W. Benson, Philip Hale at School of Museum of Fine Arts, Boston; James Earle Fraser, Art Students League, NY; Solon Borglum, Edward McCartan, Beaux-Arts Institute of Design. Member: NY Architectural League; Allied Artists of America; Artist Fellowship, Inc.; Numismatic Society of NY; National Sculpture Society. Works: Terra cotta pediment, Rivoli Theatre, NY; marble fountain "The Dance," Albee Theatre, Brooklyn, NY; Peter Pan Fountain (bronze), Paramount Theatre, NY; three medals,

Numismatic Museum, NY; Rockefeller Center, NYC. Address in 1953, 112 W. 54th St., NYC.

HAGEN, JOAN B.
Sculptor. Studied: Vassar College, Poughkeepsie, NY; Art Barn, Greenwich, CT; Silvermine, New Canaan; Art Life Studio, New York City. Works: Six sculptures reproduced for nat. dist. through Alva Museum replicas. Exhibited: Hudson Valley Art Assoc.; Audubon Artists; and local groups. Awards: Greenwich Art Soc. Award. Member: Stone Sculpture Soc., NYC; Soc. of Animal Artists, NYC. Medium: Stone. Address in 1983, Greenwich, CT.

HAGEN, LOUISE.
Painter, lecturer, and teacher. Born Chicago, IL, March 16, 1888. Pupil of Henri. Member: Nat. Assoc. of Women Painters and Sculptors. Lectures on Contemporary American Art illustrated by paintings. Address in 1929, 51 W 10th St., New York, NY.

HAGENDORN, MAX.
Painter, draftsman, and teacher. Born Stuttgart, Germany, June 27, 1870. Pupil of Faller, Kurtz, Seubert in Stuttgart; Gebhard Fugel in Munich; Royal Academy of Fine and Industrial Arts, Stuttgart. Member: Amer. Federation of Arts. Award: Prize, St. Louis Exp., 1904. Address in 1929, 46 Bullard Street, Sharon, MA.

HAGER, LUTHER GEORGE.
Illustrator and cartoonist. Born in Terre Haute, IN, in 1885. Died 1945. Address in 1926, 655 Empire Building, Seattle, WA.

HAGGIN, BEN ALI.
Portrait and figure painter. Born in 1882. Associate Member of the National Academy. His charming portrait of Miss Kitty Gordon is now famous, and his portrait of Mary Garden as Thais sold for $25,000. It is in the painting of the nude that he has had his greatest success. Member of National Art Club, NY; Portrait Painter. Awards: Third Hallgarten prize, National Academy of Design, 1909. Address in 1929, 62 Washington Mews, NYC; Great Neck, LI; and Tannersville, NY. Died in 1951.

HAGUE, MAURICE STEWART.
Landscape painter. Born Richmond, Jefferson Co., OH, May 12, 1862. Member: S. Indp. A. Studied med. 3 yrs. before changing to art, with portrait painting and modeling, and beginning landscape painting by 1895. Exhibited at Boston, St. Louis, Minn., Buffalo, Cleveland, and Col. Work in Col. Gal. of Fine Arts, and many private collections.

HAGUE, MORTON.
Sculptor. Born in Brooklyn, New York, March 2, 1894. Studied with Wilcoxson and Fromen. Address in 1933, Chicago, IL; h. Morgan Park, IL.

HAGUE, RAOUL.
Sculptor. Born in Constantinople, Turkey, 1905. Came to US in 1921. Studied at the University of Iowa, 1921; Beaux Arts Inst. of Design, NY, 1926-27; Art Students League, 1927-28; and the Courtauld Institute, London, 1950-51. Exhibited: Museum of Modern Art, 1933, 56; Whitney Mus. of American Art, 1945-48, 52, 57, and 58. Awards: Ford Foundation Grant, 1961; Mark Rothko, 1962. Address in 1982, Woodstock, NY.

HAHN, NANCY COONSMAN (MRS.).
Sculptor. Born St. Louis, MO, August 28, 1892. Pupil of Zolnay, Eberle and Grafly; Washington Univ.; St. Louis School of Fine Arts. Member: St. Louis Artists Guild; North Shore Art League, Winnetka, IL. Work: Missouri State Memorial, presented by the State to the French Government; Kinkaid Memorial Fountain and bench ends, Daughters of American Colonists Fountain, Forest Park, City of St. Louis; "Maidenhood" and Reedy Memorial, St. Louis Art Museum; H. H. Culver Mem., Culver, IN; Barclay Memorial, New London, MO; Doughboy War Memorial, Memphis, TN; Dawson Fountain figures, Winnetka, IL; "Maidenhood," Cleveland Mus. of Art; others. Awards: Medal, St. Louis Sch. of Fine Arts. Exhibited: Penna. Acad. of Fine Arts, 1916, 18, 20-24; Architectural League, 1916-18, 20; Nat. Acad. of Des., 1916, 18; Pan-Pacific Exp., 1915; Albright, Buff.; Corcoran; Art Inst. of Chic., 1916-18, 20, 22, 24, 44, 46, 48, 49; others. Address in 1953, Winnetka, IL.

HAHS, PHILIP B.
Painter. Born in Reading, PA, in 1853. He commenced preparing for a business career in Philadelphia, but employed his leisure in artistic experiments, and about 1872 he joined the Phila. Sketch Club. Here Mr. Hahs went on with his studies and also continued to receive instruction from Mr. Thomas Eakins. Mr. Hahs was considered almost unrivaled in technique. He was a regular contributor to the exhibitions, until at the exhibition of the Philadelphia Society of Artists in 1881, in which he was represented by a landscape and four genre paintings, he was recognized as the foremost among the young artists of his period. About this time he was attacked by a severe illness, terminating, after some months, in his death, which occurred in Phila., 1882.

HAIDT, JOHN VALENTINE.
Born in Germany on Oct. 4, 1700. He emigrated to America and joined the Moravian Church. A gallery of his portraits and several other pictures are still preserved at Bethlehem, PA. He died Jan. 18, 1780. Also religious painter.

HAIG, MABEL GEORGE.
Painter. Born Blue Earth, MN, May 31, 1884. Pupil of W. L. Judson, Helena Dunlap, Anna Hills. Member: Laguna Beach AA; CA. Water Color Society.

HAIGH, ELIZA VOORHIS.
Painter. Born Brooklyn, NY., April 12, 1865. Pupil Art Students League, New York and Paris. Member: Conn. Academy of Fine Arts. Address in 1929, Winsted, CT.

HAILMAN, JOHANNA K. WOODWELL.
(Mrs. James D. Hailman). Painter. Born Pittsburgh, 1871. Member: Amer. Federation of Arts; National Academy of Design; Women Painters and Sculptors; Pittsburgh AA. Awards: Second prize, Pittsburgh AA, 1911; silver medal, P. P. Exp., San F., 1915. Represented in Fine Arts Dept. Collection, Carnegie Institute, Pittsburgh. Address in 1929, 7010 Penn Ave., Pittsburgh.

HAINES, BOWEN AYLESWORTH.
Painter and illustrator. Born in Canada, Dec. 21, 1858. Pupil of Frank Smith and Mrs. Emma Lampert Cooper. Member: Rochester AC. Address in 1929, Hilton, NY.

HAINES, FRED STANLEY.
Etcher. Born 1879. Member: Chicago SE; Calif. PM. Died 1960. Address in 1929, Thornhill, Ontario, Canada.

HAINES, MARIE BRUNER.
Painter, illustrator, craftsman, writer, lecturer, and teacher. Born in Cincinnati, OH, Nov. 16, 1885. Pupil of Noble Volk, Francis Jones, DuMond, Dimitri Romanofsky. Member: Southern States Art League; Texas Fine Arts Assoc. Awards: 1st portrait prize, Southern Artists Exhibition, Atlanta, 1917; 1st prize figure painting, Macon, 1920. Rep. in Agricultural and Mechanical College, College Station, TX; Museum of New Mexico, Santa Fe, gesso panels; decorations in theatre, Bryan, TX. Specialty, mural decoration in gesso. Address in 1929, College Station, TX; summer Taos, NM.

HAINES, WILLIAM.
This excellent engraver of portraits in the stipple manner was born June 21, 1778. He came from England to Philadelphia in 1802. He opened a studio at No. 178 Spruce Street, and advertised that he painted portraits in water colors "in a style entirely new in the United States," and his work of this description proves that Haines was a master of this branch of his art. He produced a number of good portrait plates for American publishers, and he also drew for other engravers. Haines returned to England about 1809, as his name disappears from the Philadelphia directory of 1810, and a subject plate engraved by "W. Haines" was published in London in 1809. He died July 24, 1848.

HAKE, OTTO EUGENE.
Painter and illustrator. Born in Germany, Dec. 17, 1876. Pupil of Art Inst. of Chicago; Morisset at

Colarossi's in Paris; Debschitz in Munich. Member: Palette and Chisel C.; Chicago SA; Artists Guild of the Authors' Lg. of America. Represented in Municipal Art Collection. Address in 1929, 1012 North Dearborn St., Chicago, IL.

HALBERG, CHARLES EDWARD.
Marine painter. Born Gothenborg, Sweden, Jan. 15, 1855. Member: Chicago SA; Swedish-American AS. Award: Rosenwald purchase prize ($200), Art Inst. of Chicago, 1914. Represented in Stockholm Museum and Gothenborg Museum. Address in 1929, 1114 North Parkside Ave., Austin, IL.

HALBERT, A.
Engraver. He was a nephew of J.F.E. Prud'homme and was probably a pupil of that engraver. In 1825 he was working for the Harper Bros. in New York, and in 1838 he was in the employ of the engraving firm of Rawdon, Wright & Hatch, of the same city. Halbert was a good line engraver of portraits and vignettes; as his signed plates are very few in number he was probably chiefly engaged in bank-note work.

HALBERT, SAMUEL.
Painter. Exhibited paintings at the Academy of Fine Arts, Philadelphia, 1921, in "Exhibition of Paintings Showing the Later Tendencies in Art." Address in 1926, 128 West 85th Street, New York.

HALE, ELLEN DAY.
Painter. Born Worcester, MA, Feb. 11, 1855; daughter of Rev. Edward Everett Hale. Member: Wash. SA; Wash. Water Color Club; Chicago Society of Etchers; Charleston EC; North Shore AA; Wash. AC. Award: Third Corcoran prize, S. Wash. A., 1905. Work: "The Lily," St. Paul Institute. Died in 1940.

HALE, GARDNER.
Painter. Born Chicago, IL, Feb. 1, 1894. Member: NY Arch. Lg.; Mural P.; Amer. Federation of Arts. Work: Fresco in Director's Room, Illinois Merchants Trust Bank, Chicago; church, Souverain Moulin, France; and many important works privately owned. Died 1931. Address in 1929, 23 Charlton St., New York; 20 rue Jacob, Paris, France.

HALE, (MARY POWELL) HELME.
(Mrs. William Hale). Sculptor, painter, and teacher. Born Kingston, RI, April 12, 1862. Pupil of Art Students League of NY; Rhode Island School of Design; Chase; Saint-Gaudens; Duveneck; Knowlton. Member: Alumni Association, Rhode Island School of Design; North Shore Art Association; American Artists Professional League; American Federation of Arts. Address in 1933, Gloucester, MA.

HALE, LILIAN WESTCOTT.
(Mrs. Philip L. Hale). Painter. Born Hartford, CT, Dec. 7, 1881. Pupil of Elizabth Stevens, Tarbell and Chase. Member: Associate National Academy of Design; Conn. Academy of Fine Arts; Boston GA; Concord AA; Nat. Assoc. of Portrait Painters; Amer. Federation of Arts. Awards: Bronze medal, Buenos Aires Exposition, 1910; gold medal and medal of honor, P. P. Exp., San. F., 1915; gold medal, Phila. AC, 1919; Potter Palmer Gold medal, Art Inst. of Chicago, 1919; Beck gold medal, Penna. Academy of Fine Arts, 1923; Julia S. Shaw Memorial prize, Nat. Academy of Design, 1924; first Altman prize, Nat. Academy of Design, 1927. Represented in the collection of the Pennsylvania Academy of Fine Arts and the Philadelphia Art Club; Metropolitan Museum of Art; Corcoran Gallery; Denver Art Museum; Art Association, Concord, MA; Phillips Memorial Gallery, Washington.

HALE, PHILIP LESLIE.
Painter, teacher, and writer. Born Boston, May 21, 1865; son of Rev. Edward Everett Hale. Pupil of J. Alden Weir in NY. Member: Associate National Academy of Design, 1917; Phila. Art Club; St. Botolph C.; Boston Guild of Artists; San Fran. Art Club; Fellowship Penna. Academy of Fine Arts (assoc.); Eclectics; Nat. Assoc. of Portrait Painters; National Arts Club. Awards: Hon. mention, Pan. Am. Exp., Buffalo, 1901; bronze medal, St. Louis Exp., 1904; gold medal, Buenos Aires Exp., 1910; Harris silver medal ($500), Art Inst. of Chicago, 1914; hors concurs (jury of awards), P.-P Exp., San Fran., 1915; Proctor prize, Nat. Academy of Design, 1916; Lea prize, Phila. Water Color Club, 1916; popular prize, Penna. Academy of Fine Arts, 1919. Instructor at Boston Museum School and Penna. Academy of Fine Arts. Work: "The Crimson Rambler," Phila., PA; "Spirit of Antique Art," Museum of Montevideo, Uruguay; "Girl with Muff," Corcoran Gallery, Wash., DC; "Girl with Pearls," Philadelphia Art Club. Died Feb. 2, 1931. Address in 1929, Fenway Studios, 30 Ipswich St., Boston, MA; h. Federal Hill, 213 Highland St., Dedham, MA.

HALE, SUSAN.
Painter. Born in Boston, 1834. Specialty, landscape painting in water colors. Exhibited a series of pictures of the White Mountains. Died Sept. 17, 1910 in Matunuck, RI.

HALEY, JOHN CHARLES.
Sculptor and painter. Born in Minneapolis, MN, September 21, 1905. Studied with Cameron Booth, Minneapolis; and Hans Hofmann, Munich and Capri. Work in Metropolitan Museum of Art, NY; San Francisco Museum of Art; others. Has exhibited at San Francisco Art Association Annual; Chicago Art Institute; Oil Painting, 51 and Drawing, 52, Metropolitan Museum of Art, NY; 149th Annual Painting and Sculpture, Penna. Academy of Fine Arts; M. H. De Young Memorial Museum, San Francisco. Received six painting and sculpture awards, San

Francisco Art Association, 1936-56; Watercolor Award, California Watercolor Society; Painting Award, Richmond Art Center. Teaching at University of California at Berkeley, from 1930. Works in all media in painting and sculpture. Address in 1982, Richmond, CA.

HALEY, ROBERT DUANE.
Sculptor and painter. Born Lambertville, NJ, Jan. 6, 1892. Pupil of Kenneth Hayes Miller, George Bridgman, Robert Tolman and John C. Johansen. Address in 1929, Greenwich, CT; Bridgeport, CT.

HALKIN, THEODORE.
Sculptor and painter. Born in Chicago, IL, March 2, 1924. Studied at Art Institute of Chicago, B.F.A., 1950; Southern Illinois University, M.S. (art), 1952. Work in Art Institute of Chicago; Butler Institute of American Art. Has exhibited at Corcoran Gallery; American Painting and Sculpture Annual, Penna. Academy of Fine Arts; Detroit Institute of Arts; Allan Frumkin Galleries, NY and Chicago; others. Received Purchase Prize, Butler Institute; Chicago and Vicinity Show First Prize for Sculpture, Art Institute of Chicago; others. Teaching at Art Institute of Chicago, associate professor of art. Address in 1982, c/o Phyllis Kind Gallery, Chicago, IL.

HALL, ALFRED BRYAN.
Engraver. Born in Stepney, London, England, in 1842. He was living in New York in 1900. A. B. Hall was a son of H. B. Hall, Sr., and came to New York in 1851. After serving an apprenticeship of seven years with his father, he worked as an engraver with J. C. Buttre, H. Wright Smith, A. H. Ritchie and George E. Perine, all of New York. He was later a member of the firms of H. B. Hall and Sons, and H. B. Hall Sons, until his retirement in 1899.

HALL, ALICE.
Engraver. Born at Halloway, London, England, 1847. She was living in New York in 1900. She was a daughter of H. B. Hall, Sr., and while still young she evinced considerable talent in drawing and etching. She etched portraits of Washington, after Stuart and Trumbull, among her other works.

HALL, ANNE.
Miniature painter. Born in Pomfret, CT, in 1792. When very young she received some instruction in miniature painting from S. King of Newport, who at one time had given lessons in oil painting to Washington Allston; she afterward studied painting in oil with Alexander Robertson in New York, but finally devoted herself to miniature painting. She was an exhibitor at the National Academy of Design in New York, and elected Academician in 1833. Among her best known works are a portrait of a Greek girl, which has been engraved, and a group representing Mrs. Dr. Jay with her infant child. She died in Dec., 1863.

HALL, ARNOLD.
Illustrator. Born Binghamton, March 2, 1901. Pupil of George Bridgman, Charles C. Curran, Frances C. Jones. Illustrated *The Swiss Family Robinson* (Minton Balch and Co.); *Brackie, the Fool* and *Jataka Tales Out of Old India* (G. P. Putnam's Sons.) Address in 1929, Columbia Height, Brooklyn, NY; summer, 171 Front Street, Binghamton, NY.

HALL, ARTHUR WILLIAM.
Painter. Born Bowie, TX, Oct. 30, 1889. Pupil of Art Inst. of Chicago. Address in 1929, 38 Drummond Place, Edinburgh, Scotland.

HALL, CHARLES BRYAN.
Engraver. Born in Camden Town, London, Aug. 18, 1840. C. B. Hall was the second son of H. B. Hall, Sr., and he came to NY in Spring, 1851, and commenced his studies under his father. In 1885 he was apprenticed to James Duthie, a landscape engraver then living in Morrisania, NY. After working about five years with George E. Perine, of New York, he started in business for himself as an engraver of portraits. He died in 1896.

HALL, FLORENCE S.
Painter. Born in Grand Rapids, MI. Pupil of Art Institute of Chicago, and of Johansen. Member: Chicago Art Students League. Address in 1926, 63 West Ontario Street, Chicago, IL.

HALL, FRANCES DEVEREUX JONES.
(Mrs. Frances Devereux Jones Hall). Sculptor and painter. Born New Orleans, LA. Pupil of Sophie Newcomb College, New Orleans; Henry McCarter, Howard Pyle, Charles Grafly. Member: Philadelphia Alliance; National Association of Women Painters and Sculptors, New York. Instructor of modelling, Springside School, Chestnut Hill, Philadelphia. Address in 1933, Philadelphia, PA.

HALL, FREDERICK GARRISON.
Painter and etcher. Born Baltimore, MD, April 22, 1879. Pupil of William Paxton and Henri Royer. Member: Brooklyn Soc. of Etchers; Boston AG; North Shore AA; Chic. Soc. of Etchers; Amer. Federation of Arts. Award: Bijur Prize, Brooklyn Soc. of Etchers, 1926; Lea prize, Phila. Print Club, 1926; silver medal, Sesqui-Centennial Exposition, Philadelphia, 1926; Eyre gold medal, Philadelphia, 1927. Represented in Cleveland Museum of Art; Print Dept., Library of Congress, Wash., D.C.; Art Institute of Chicago; Boston Museum of Fine Arts; Bibliotheque Nationale, Paris; Uffizi Gallery, Florence. Died in 1946. Address in 1929, Riverway Studios, 132 Riverway; h. 260 Beacon St., Boston; summer, Eastern Point, Gloucester, MA.

HALL, GEORGE F.
Painter, architect. Born Providence, RI. Member: Prov. Art Club. Address in 1929, 80 Union Trust Bldg.; h. 49 Orchard Ave., Providence, RI.

HALL, GEORGE HENRY.
Painter. Born in Boston, Sept. 25, 1825. He was largely self-taught and began painting in 1842. Elected member of National Academy in 1868. Represented by "Self-portrait," in Brooklyn Museum, painted in 1845; "The Roman Wine Cart," in Boston Museum of Fine Arts, painted in 1851. He died Feb. 17, 1913, in NYC.

HALL, GEORGE R.
Engraver. Born in London, England, in 1818. He was a brother of H. B. Hall, Sr. George R. Hall commenced engraving under the tuition of his brother, and then worked in London and in Leipzig. He came to NY in 1854, and was first employed by Rawdon, Wright, Hatch & Co., and was later engraving over his own name for the Putnams and other New York publishers.

HALL, HENRY BRYAN.
Engraver. Born in London, England, May 11, 1808; died at Morrisania, NY, April 25, 1884. Hall was a pupil of the London engravers Benjamin Smith and Henry Meyer, and he was later employed by H.T. Ryall, historical engraver to the Queen, to execute the portrait work in the large plate of "The Coronation of Victoria," after the painting by Sir George Hayter. Mr. Hall came to NY in 1850 and soon established a very extensive business as an engraver and publisher of portraits. He had very considerable ability as a portrait painter, and while in London he painted a portrait of Napoleon II, among others; among his portraits painted in the US are those of Thomas Sully and C. L. Elliott. He painted miniatures on ivory, and etched a large number of portraits of men prominent in the Colonial and Revolutionary history of this country for a private club of NY and for Philadelphia collectors. He made the drawings in pencil and wash for Dr. Thomas Addis Emmett's series of privately printed "Club" portraits of the signers of the "Declaration of Independence" and of other Revolutionary characters which he also engraved.

HALL, HENRY BRYAN, JR.
Engraver. Born in Camden Town, London, England. He was living in New York in 1900. He came to NY with his father in 1850 and served his apprenticeship with his father. In 1858 he went to London and worked under Charles Knight for about one year, and then returned and established himself in the engraving business in NY. He engraved many portraits of generals and officers of the Civil War, and also a number of historical plates, but retired from business in 1899. Among his larger plates are "The Death of Lincoln," and subjects after the painting of J. G. Brown and other American artists.

HALL, ISABEL HAWXHURST.
Painter, illustrator, and craftsman. Born NYC. Pupil of Henry Prellwitz, Frank Vincent DuMond,

Mrs. Elbert Treganza. Member: NY Soc. of Craftsmen; Amer. Artist's Prof. League. Work: Illustrated "Rubaiyat of Omar Khayyam." Designer of numerous church windows. Address in 1929, 23 Sixth Ave; h. 195 West 10th St., NYC.

HALL, JAMES.
Sculptor. Active in Charleston, South Carolina, 1803. His work has been located in both North Carolina (Wilmington) and South Carolina (Georgetown). Specialty was gravestones. Died in 1823.

HALL, JOHN H.
Wood engraver and lithographer. Was born at Cooperstown, NY. Self-taught except for a few lessons from Dr. Anderson. He began to engrave about 1826 and in 1840 he illustrated the *Manual of Ornithology*, which contains some of his best work. (See "The History of Wood Engraving in America," by W. J. Linton.) Died in CA in 1849.

HALL, MABEL B.
Painter. Member: Philadelphia Water Color Club. Address in 1929, 1211 Locust St., Philadelphia, PA.

HALL, NORMA BASSETT.
Painter and teacher. Born Halsey, OR, May 21, 1889. Pupil of Art Inst. of Chicago; Portland, OR, Art Assoc. School.

HALL, NORMAN.
Illustrator. Born Chicago, Feb. 21, 1885. Member: Artists Guild of the Authors' League of America. Address in 1929, 1013 Lake Michigan Bldg.; 180 North Michigan Avenue, Chicago, IL; h. 171 St. Charles Rd., Elmhurst, IL.

HALL, PARKER L.
Sculptor, painter, and craftsman. Born in Denver, Colorado, September 15, 1898. Award: Honorable mention, California Palace of Legion of Honor, 1931. Member: San Francisco Art Association; Bohemian Club. Address in 1933, San Francisco, CA; h. Berkeley, CA.

HALL, PETER.
Engraver. Born in Birmingham, England, in 1828. Mr. Hall came to the US in 1849 and learned to engrave in the NY establishment of the American Bank Note Co. His special work was bank-note script engraving, in which he excelled. In 1886 he went into business in NY as a bank-note engraver; later the firm became Kihn & Hall, and was later known as "Kihn Brothers." His son, Charles A. Hall, was employed at the Bureau of Printing and Engraving, at Washington, D.C. A well-executed stipple portrait of Washington, after the portrait by Mrs. E. Sharpless, is signed as "Engraved by P. Hall" and appears as a frontispiece to the *Memoirs of Thaddeus Kosciusko*. Died July 5, 1895.

HALL, SUSAN.
Sculptor. Member: National Association of Women Painters and Sculptors, New York. Address in 1929, 130 West 57th Street, New York, NY.

HALL, THOMAS.
Painter. Born in Sweden, April 23, 1883. Pupil of Freer, Wolcott, Reynolds. Member: Swedish Soc., Chicago; Scandinavian Am. Soc., NY; Chicago SA; Chicago Gal. A. Awards: Hon. mention, 1920 and 1923, and first prizes for water colors, 1924 and 1925, Swedish-American Soc. Work: "Northern Sunset," Midway Masonic Temple, Chicago; painting in Englewood (Chicago) High School. Address in 1929, 5725 South Wells St., Chicago, IL.

HALL, THOMAS VICTOR.
Sculptor, painter, illustrator, and teacher. Born Rising Sun, IN, May 30, 1879. Pupil of Nowottny, Meakin, Duveneck, Art Acad., Cincinnati. Member: Salmagundi Club; Kit-Kat Club; Cincinnati Art Club; Artists Fellowship. Address in 1933, Salmagundi Club, NYC; summer, Peekskill, NY.

HALLADAY, MILTON RAWSON.
Illustrator. Born in 1874. Member: Providence AC; Providence Water Color Club. Address in 1929, Providence Journal Co.; Providence, RI.

HALLER, ARLENE.
Sculptor. Born in Newark, NJ, Feb. 17, 1935. Study: Newark State, 1957; self-taught in art. Exhibitions: Newark (NJ) Museum; Nat. Academy of Design, NYC; Silvermine Guild, New Canaan, CT; Catherine Lorillard Wolfe Art Club, NYC; Allied Artists of America; National Arts Club; Rutgers University (solo); and others. Awards: American Association of University Women; Catherine Lorillard Wolfe Art Club, Excalibur award & Harriet Frishmuth award for traditional sculpture. Address in 1983, North Plainfield, NJ.

HALLER, EMANUEL.
Painter and printmaker. Born in Newark, NJ, Sept. 7, 1927. Study: Newark School of Fine & Industrial Art, Cert., 1949; Pratt Inst., NY. Work: NJ State Mus., Trenton; Newark Mus., NJ; Monmouth College, West Long Branch, NJ; Rosenwald Collection, Jenkintown, PA; others. Exhibited: Boston Mus. Fine Arts, MA; National Academy of Design, NYC; Penna. Academy of Fine Arts; Phila. Mus. of Art; Seattle Art Mus.; Squibb Art Gal., Princeton, NJ; Wadsworth Atheneum, Hartford, CT; and others, including several one-person shows. Media: Oil, watercolor. Address in 1983, 121 Greenbrook Road, North Plainfield, NJ.

HALLETT, HENDRICKS A.
Painter. He was born at Charlestown, MA, in 1847, and studied in Antwerp and Paris. He was well known for his pictures of various types of ships and of notable events. A member of the Boston Society of Water Color Painters. Awarded a bronze medal at MA Charitable Mechanics' Association, Boston, on March 17, 1892. He died in Boston in 1921.

HALLIDAY, MARY HUGHITT.
Painter. Born Cairo, IL, October 31, 1866. Pupil of W. M. Chase, Charles Lasar, Academie Carmen and Academie Colarossi in Paris. Member: Calif. Art Club; Chicago Galleries Assoc.; Amer. Federation of Arts. Address in 1929, 316 Adelaide Drive, Santa Monica, CA.

HALLMAN, HENRY THEODORE.
Painter, illustrator, and craftsman. Born Milford Square, PA, Sept. 17, 1904. Pupil of Thornton Oakley. Work: "Christ Entering Jerusalem," "Gethsemane," "Christ Bearing the Cross" and "Miraculous Draft of Fishes," Emmanuel Lutheran Church, Souderton.

HALLOCK, RUTH MARY.
Painter and illustrator. Born Erie, PA. Pupil of Art Inst. of Chicago; Art Students Lg. of NY. Member: North Shore AA; Pen and Brush Club; Nat. Arts Club. Died 1945. Address in 1929, 40 Gramercy Park, New York, NY; summer, Gloucester, MA.

HALLOWELL, GEORGE HAWLEY.
Born in Boston in 1871. He studied architecture and painting. His early work was making copies of the old Italian Masters. His specialty was landscapes of logging scenes and the woods. In 1906 he studied abroad. He worked in both oil and water colors. Pupil of F. W. Benson; E. C. Tarbell; and H. B. Warren. Studio, Boston, MA. Represented in the Boston Museum of Fine Arts. Address in 1926, 229 Park Avenue, Arlington Heights, MA. Died March 26, 1926 in Boston.

HALLOWELL, ROBERT.
Painter and etcher. Born Denver, CO, March 12, 1886. Work: "Afternoon Light," Brooklyn Museum; "Matterhorn," Cleveland Museum; "St. Tropez," "Wild Flowers" and "Rain," Phillips Memorial Gallery, Washington, DC; "Cassio" and "Tranquility," Lewisohn Collection, New York. Address in 1929, 408 West 20th Street, New York, NY. Died in 1939.

HALPERT, SAMUEL.
Painter. Born in Russia, Dec. 25, 1884. Member: New Soc. of Artists; (pres.) Soc. Indp. Artists of Detroit; Societare Salon d'Automne, Paris. Represented in the Pennsylvania Academy of Fine Arts; Newark Museum; San Francisco Museum; Harrison Gallery, Los Angeles Museum; Phillips Memorial Gallery, Washington, DC; Art School of the Society of Arts and Crafts. Died in 1930. Address in 1929, 47 Watson St., Detroit, MI; summer, Ogunquit, ME.

HALPIN, FREDERICK.

Engraver. Born in Worcester, England, in 1805. He was the pupil of his father, an engraver for one of the Staffordshire potteries. About 1827 Frederick Halpin was located in London, engraving historical subjects and portraits. He came to NY about 1842, and for a time was in the employ of Alfred Jones in that city. He was a good engraver of portraits and book illustrations in stipple. His name is sometimes signed to prints as "F. W. Halpin." Died Feb. 1880, in Jersey City, NJ.

HALPIN, JOHN.

Engraver. He was a brother of Frederick Halpin, and was engraving in St. Petersburg, Russia, before he reached the US, by way of Halifax. About 1850 John Halpin was engraving landscapes and a few portraits for NY publishers, until as late as 1867. Some few years later he was employed by the Ladies' Repository and the Methodist Book Concern, both of Cincinnati, OH. Also worked in watercolors.

HALSALL, WILLIAM FORMBY.

Painter. Born in Kirkdale, England, March 21, 1841; died Nov., 1919. At the age of 12 he went to sea in the ship "Ocean Rover," of Portsmouth, NH, and followed the sea for seven years. He was in the United States Navy during part of the Civil War, and afterwards became a fresco painter. He was a student in the Mass. Inst. of Tech., class of 1874. After 1877 he painted the following marine pictures: "First Fight of Ironclads, Monitor and Merrimac;" "The Mayflower" (Memorial Hall, Plymouth, MA); "Niagara Falls;" "Sheeted Ghost;" "The Winter Passage;" and "When Sleep Falleth on Men."

HALTOM, MINNIE HOLLIS.

Painter and teacher. Born Belton, TX. Pupil of Rolla Taylor; Jose Arpa in Spain; Metropolitan Art School, New York; Xavier Gonzalez. Member: San Antonio AL; Southern States Art League; Am. Salon Painters. Represented in Colorado High School and Main Avenue High School, San Antonio, TX.

HAMANN, CHARLES F.

Sculptor. Member of National Sculpture Society. Active in 1926. Address in 1910, East 37th St., Flatbush, NY.

HAMBRIDGE, JAY.

Painter and illustrator. Born in 1867 in Simcoe, Canada; he died in New York City, Jan. 20, 1924. Pupil of the Art Students League in New York and of William M. Chase. He was the discoverer of dynamic symmetry.

HAMILTON, DAVID OSBORNE.

Painter, etcher and writer. Born Detroit, MI, June 19, 1893. Member: Art Students League of NY; Brooklyn Society of Etchers. Author of *Four Gar-*

dens, book of verse published by Yale University Press in their "Younger Poets Series;" *Pale Warriors*, a novel (Scribners). Address in 1929, 1505 Astor Street, Chicago, IL; summer, Huron Mt. Club, Huron Mountain, MI. Died in 1955.

HAMILTON, EDWARD W. D.

Painter. Born in 1862. He painted "Canal, Venice" (owned by the Boston Museum of Fine Arts).

HAMILTON, ETHEL HEAVEN.

(Mrs. Ethel R. Heaven Hamilton). Painter and teacher. Born in Mexico, July 14, 1871. Pupil of Chase, MacMonnies, Colarossi School, Paris. Member: NY Water Color Club; Catherine Lorillard Wolfe Art Club; Nat. League of Amer. Pen Women (Artists Member). Died in 1936.

HAMILTON, FRANK MOSS.

Painter and architect. Born in Kansas City, MO, June 26, 1930. Study: With Eliot O'Hara; Stanford Univ.; Univ. Kansas. Work: Favell Mus., OR; others. Exhibited: Laguna Beach Festival of Arts, CA, 1949-68; Franklin Mint Yearly Western Show, 1974. Awards: First Awards, Laguna Beach Art Festival, 1963-65; Franklin Mint Bicentennial Medal Design, 1972; others. Media: Watercolor. Address in 1983, Cambria, CA.

HAMILTON, FRANK O.

Painter. Born in 1923 in Selma, TN. Earned BA from Stanford University in 1948. Taught at San Francisco Art Institute. Exhibited at Humboldt State College (CA), Richmond Art Center, both in 1959; Cal. Palace of the Legion of Honor, San Francisco; LA County Museum; Poindexter Gallery, NYC; and in Toronto.

HAMILTON, HAMILTON.

Painter and etcher. Born in England, 1847. He began his career as a portrait painter at Buffalo, NY, in 1872; specialty, landscapes. Elected Associate Member of the National Academy in 1886; National Academy, 1889. Member of American Water Color Soc.; NY Etching Club. Represented at the Fine Arts Academy, Buffalo, NY, by "The Valley of Fountains" and "Sunset After the Storm." Address in 1926, Norwalk, CT. Died 1928.

HAMILTON, HILDEGARDE.

(Mrs. L. H. Ryland). Painter. Born: Syracuse, NY, in 1908. Studied: Art Students League; John Herron Art Inst.; Cincinnati Art Acad.; Syracuse Univ.; Julian Acad., Ecole des Beaux-Arts, Paris. Collections: Wesleyan College, GA; Hall of Art, NY; Evergreen School, Plainfield, New Jersey; Eaton Gallery, NY; Nassau, Bahamas.

HAMILTON, J. M. C.

Painter. His work is said to be similar to that of Alfred Stevens.

HAMILTON, JAMES.

Marine and landscape painter. Born in Ireland, Oct. 1, 1819; he died in Philadelphia, March 10, 1878. He was particularly successful in his marine views. He also painted several views of Niagara Falls which attracted much attention.

HAMILTON, JOHN McLURE.

Portrait painter and illustrator. Born in Phila., PA, Jan. 31, 1853. Pupil of Penna. Academy of Fine Arts; Royal Academy in Antwerp; Ecole des Beaux-Arts in Paris. Member: Phila. Water Color Club (hon.); Fellowship Penna. Academy of Fine Arts; Amer. Federation of Arts; Royal Soc. of Port. P.; Pastel Soc.; Senefelder C., London. Awards: Hon. mention, Paris Salon, 1892; gold medal, Pan-Am. Exp., Buffalo, 1901; hors concours (jury of awards), P. P. Exp., San F., 1915; gold medal of honor, Penna. Academy of Fine Arts, 1918. Work: "Gladstone at Downing Street," "Hon. Richard Vaux," "George Meredith," "William R. Richards," "Henry Thouron" and "Cardinal Manning," Pittsburgh; "Gladstone," Luxembourg Museum, Paris; "Prof. Tyndall," "Aislow Ford," "Cosmo Monkhouse," "Ridley Corbet," Nat. Gallery, London. Author of "Men I Have Painted." Died in 1936. Address in 1929, Hermitage, Kingston on Thames, England.

HAMILTON, MARIANNA.

Batik and watercolorist. Born: Berkeley, CA, in 1943. Studied: University of California at Santa Barbara; San Francisco Art Inst.; University of Arizona. Exhibitions: San Francisco Museum of Art, CA, 1965; Phoenix Art Museum, AZ, 1967; Monterey Peninsula Museum of Art, CA, 1973.

HAMILTON, MARY W.

Miniature painter. Member: Detroit Soc. of Women Painters. Address in 1929, 4 Beverly Road, Grosse Pointe, MI.

HAMILTON, NORAH.

Etcher. Born Fort Wayne, IN, 1873. Pupil of Cox in New York; Whistler in Paris. Member: Chicago Society of Etchers. Address in 1929, Hull House, Chicago, IL.

HAMILTON, ROBERT.

Painter and teacher. Born County Down, Ireland. Studied in London and Paris. Member: Salma. C.; Kit-Kat Club. Work: Mural in Public School 43, the Bronx, New York City. Many portraits and landscapes are privately owned. Address in 1929, 20 West 15th Street, NYC; summer, Pontoosuc Studio, Lanesboro, MA.

HAMILTON, WILBUR DEAN.

Painter, illustrator, craftsman. Born Somerfield, OH, 1864. Pupil of Ecole des Beaux-Arts in Paris. Member: Copley S., 1903; Boston GA; St. Botolph C.

Awards: Jordan prize in Boston; medal, Atlanta Exp., 1895; gold medal, P. P. Exp., San Fran., 1915. Work: "Beacon Street, Boston," RI School of Design, Providence. Represented in Boston Museum, Boston University, American Univ., John Wesley Memorial Room, Lincoln College, Oxford, England. Instructor at Mass. Normal Art School. Address in 1929, Trinity Court, Dartmouth St., Boston.

HAMLIN, EDITH.

Painter. Born Oakland, CA, in 1902. Studied: California School of Fine Arts; and with Maynard Dixon. Collections: San Francisco Museum of Art; San Diego Fine Arts Gallery; Mission High School, San Fran., CA; United States Post Office, Tracy, CA; Coit Mem. Tower, San Fran.; Santa Fe RR Ticket Office, Chicago and Los Angeles; Arizona Biltmore Hotel, Phoenix; Plains Hotel, Cheyenne, WY; Jacome's Department Store, Tucson, AZ; St. Ambrose Church, Tucson, AZ; Old Pueblo Club, Tucson, AZ.

HAMLIN, GENEVIEVE KARR.

Sculptor and teacher. Born in New York City, July 1, 1896. Pupil of Abastenia St. L. Eberle, Henry Dropsy, Andre L'Hote, in Paris; also studied at Vassar College. Member: National Association of Women Painters and Sculptors; Am. Numismatic Society; Sculptors Guild; National Association of Women Artists. Work: Portrait Medallion of Theodore Roosevelt, Tsing Hua College, Peking, China; medals for Exposition of Women's Arts and Industries, Antique and Decorative Arts League, American Art Dealers Association. Exhibited at Penna. Academy of Fine Arts, 1923-38; National Academy of Design, 1923-38; Art Institute of Chicago, 1926; NY World's Fair, 1939; Rehn Gallery; others. Award: Fellowship, Cranbrook Academy of Art. Specialty, small sculpture, portrait heads in the round and relief, animal studies. Taught: Instructor of sculpture, Newark School of Fine and Indust. Arts, Newark, NJ, 1926-43. Address in 1953, 58 West 57th St., NYC.

HAMLIN, WILLIAM.

Engraver. Born in Providence, RI, Oct. 15, 1772; died there Nov. 22, 1869. Mr. Hamlin established himself in business as a manufacturer and repairer of sextants, quadrants, and such other nautical and mathematical instruments as were used by the navigator. As engraving upon metal was part of his business, he began experimenting upon copper, and his business card of a later date adds to his business proper that of "Engraving & Copperplate Printing." As an engraver Mr. Hamlin made his own tools and worked practically without instruction. His plates show a somewhat weak mixture of mezzotint and stipple, frequently worked over with the roulette. Good impressions of his plates, however, show that he made the best of his limited opportunities. Mr.

Hamlin saw Gen. Washington, on one of his visits to the Eastern States, and the impression made upon the engraver was so strong that his most important plates have Washington for their subject. Considering the Savage portrait as the best likeness, he followed that artist in his several portraits of Washington; but he also held Houdon's bust in high esteem and in his ninety-first year he engraved Washington after that sculptor. This was his last plate.

HAMM, PHINEAS ELDRIDGE.
Engraver. Born in Philadelphia in 1799; he died there in 1861. Hamm was probably the pupil of a Philadelphia engraver and in 1825-27 he was in business as an engraver in the city. While he usually worked in line, he engraved a few good portraits in stipple.

HAMMARGREN, FRITZ EMANUEL.
Sculptor. Born Orebro, Sweden, April 7, 1892. Pupil of Bourdelle in Paris, and Art School, Gothenborg, Sweden. Member: Scandinavian-American Art Club and National Sculpture Society. Work: "Leda and the Swan," fountain, and monument to Dr. N. A. Wilson, Orebro, Sweden; portrait, A. P. Waller, John Morton Memorial Building, Philadelphia; "Torso," in marble, Brooklyn Mus., Brooklyn, NY; numerous figures, fountains, and small sculptures. Awards: Honorable mention, Conn. Academy of Fine Arts, 1927; honorable mention, Montclair Art Museum, 1932. Address in 1933, Leonia, NJ.

HAMMELL, WILL.
Illustrator. Born Trenton, NJ, Aug. 14, 1888. Pupil of William M. Chase, R. Sloan Bredin, Frank V. Dumond. Member: Society of Illustrators; Art Dir. Club. Address in 1929, 25 West 45th Street, New York, NY; h. 180 Spring Street, Red Bank, NJ.

HAMMER, JOHN.
Painter. Member: Artists Guild of the Authors' League of America. Address in 1929, West 12th Street, New York, NY.

HAMMER, TRYGVE.
Sculpture, craftsman, and draftsman. Born Arendal, Norway, September 6, 1878. Pupil of Skeibrok, MacNeil, Calder and Solon Borglum. Member: National Sculpture Society; Society of Independent Artists; Brooklyn Society of Modern Art; Scandinavian-American Art; Architectural League of NY; Philadelphia Art Alliance. Work: Roosevelt Commons Memorial, Tenafly, NJ; memorial window, Crescent Athletic Club, Brooklyn, NY; head of a baby, Newark Museum; head of a man, Brooklyn Museum; "Good Shepherd" memorial tablet, Zion Lutheran Church, Brooklyn, NY; Humphrey Memorial Tablet, Stevens Institute, Hoboken, NJ. Exhibited at National Sculpture Society, 1923. Died in 1947. Address in 1933, Douglaston, Long Island, NY.

HAMMERSMITH, PAUL.
Painter and etcher. Born Naperville, IL, March 17, 1857. Self-taught. Member: Milwaukee Art Society; Cal. Society of Etchers; Chicago Society of Etchers; Wisconsin Painters and Sculptors. Work: New York Public Library; Newark Public Library. Awards: Bronze medal for etching, St. Paul Inst., 1916; silver medal for etching, St. Paul Inst., 1918. Died in 1937. Address in 1929, 116 Michigan St.; h. 567 Belleview Place, Milwaukee, WI.

HAMMITT, CLAWSON S. LAKESPEARE.
Painter. Born in Wilmington, DE, in 1857. Pupil of Eakins and Chase in Philadelphia, and Constant and Lefebvre in Paris. Among his portraits are those of James Latimer and Henry Latimer in the US Capitol, others in State House, Dover, DE, and State College, Newark, Delaware. Died in 1927 in Wilmington, DE. Address in 1926, 12th and Jefferson Streets, Wilmington, DE.

HAMMOND, ARTHUR J.
Painter. Born in Vernon, CT, April 3, 1875. Pupil of Eric Pape, Charles Woodbury and G. L. Noyes. Member: New Haven Pen and Pencil Club; Amer. Federation of Arts; Conn. Academy of Fine Arts. Award: Hon. mention, Conn. Academy of Fine Arts, 1919. Represented in Lynn (MA) Public Library. Address in 1929, Rockport, MA.

HAMMOND, GEORGE F.
Painter. Born in Boston, MA, Nov. 25, 1855. Pupil of Mass. Normal Art School, W. M. Chase, W. L. Sonntag and Walter F. Lansil. Member: Cleveland SA. Address in 1929, 555 Luck Avenue, Zanesville, OH.

HAMMOND, HARMONY.
Sculptor and painter. Born in Chicago, IL, February 8, 1944. Studied at Junior School of the Art Institute of Chicago, 1960-61; Milliken University, Decatur, IL, 1961-63; University of Minnesota, MN, 1963-67; Alliance Francaise, Paris, Summers of 1967, 69. Exhibited: Bottega Gallery, Minneapolis, 1964; Walker Art Center, Minneapolis, 1964; Minneapolis Institute of Arts, Minneapolis, 1965; Sarah Lawrence College, 1972; New Gallery, Cleveland, OH, 1973; New York Cultural Center, NYC, 1973; Vassar College Art Gallery, Poughkeepsie, NY, 1975; one-woman shows include Lerner-Heller Gallery, 1979, 81, Herter Gallery, Amherst College, 1981; retrospective, Glen Hanson Gallery, Minneapolis, 1981; Denver Art Museum, 1981; Haag Gementemuseum, The Hague, 1980; many others. Taught: Painting and drawing at the Art Institute, Chicago, 1973; private studio seminar for Women Artists, NYC, 1973; Richmond College, City University, NYC, 1975. Published articles, "More on Woman's Art: An

Exchange," *Art in America*, November, 1976; and "Feminist Abstract Painting—A Political Viewpoint," *Heresies*, December, 1977; and "A Sense Touch: Women Identified Sexuality in Womens Art," *Heresies*, Spring, 1981; and others. Address in 1982, 129 West 22nd Street, NYC.

HAMMOND, J. T.
A good line engraver of landscapes and subject plates in 1839. Born c. 1820. In that year he was employed in Philadelphia, but later he seems to have moved to St. Louis, MO.

HAMMOND, JANE NYE.
Sculptor. Born in New York, 1857. Exhibited: Chicago Exposition, 1893; Buffalo Exposition, 1901. Died in Providence, RI, October 23, 1901.

HAMMOND, NATALIE HAYS.
Painter. Born Lakewood, NJ, Jan. 6, 1905. Pupil of Sergei Soudekine. Member: Royal Soc. Min. Painters; Sculptors and Gravers; Guilford Soc. of England; Amer. Federation of Arts; Nat. Arts Club; Wash. Art Club. Address in 1929, 133 East 6th Street, New York, NY; summer, "Lookout Hill," Gloucester, MA.

HAMMOND, RICHARD HENRY.
Painter. Born in Cincinnati, OH, in 1854. Pupil of Noble, Weber and Duveneck. Member of Cincinnati Art Club. Address in 1926, 806 Barr St., Cincinnati, OH.

HAMPTON, BLAKE.
Illustrator. Born in Poteau, OK, in 1932. He attended North Texas State College where he received his BA. Influenced by his study with Octavio Medellin, a sculptor, he has produced many fine dimensional pieces in addition to his other work. His first illustration was done in 1946 in California and it was entitled *How the Froggy Lost His Whoop.* The Eisenhower Museum and the John F. Kennedy Library own his artwork.

HAMPTON, JAMES.
Sculptor. Born in Elloree, South Carolina, April 8, 1909. Self-taught. His only known work is entitled "Throne of the Third Heaven of the Nations Millenium General Assembly," which was begun in 1950. The piece, left unfinished at the time of his death, was said to be inspired by his mystical visions and religious convictions in the Second Coming of Christ. Died in Washington, DC, Nov. 4, 1964.

HAMPTON, JOHN WADE.
Sculptor and painter. Born in NYC, 1918. Work in Cowboy Hall of Fame. Won gold medal in sculpture, Cowboy Artists of America Show, 1977, 79-81. Co-founder of Cowboy Artists of America. Illustrations published in *Arizona Highways* and *Western Horse-*

man, others. Specializes in Old West subjects. Sculpts in bronze. Reviewed in *Southwest Art*, May 1974; *Art West*, November 1980. Address in 1982, Scottsdale, AZ.

HAN, SHARRY.
Cartoonist and journalist. Born in San Francisco, CA, Feb. 17, 1957. Study: California State at L.A., 1977; Defense Information School, Dept. of Defense, Navy Journalist/Broadcaster, 1981. Exhibited: US Naval History Museum. Cartoons sold to *OMNI* magazine, *Playgirl*, the *National Enquirer*, *Los Angeles* magazine; cartoons distributed nationwide by McNaught Newspaper Syndicate. Awards: US Navy OPSEC Poster Award; US Navy Chief of Information (CHINFO) Merit Award for a Published Graphic Art. Address in 1983, 1644 W. Little Creek Road #4, Norfolk, VA.

HANATSCEK, H.
Painter. Born Zuaim Moraira, Dec. 19, 1873. Pupil of Griepenkerl, Eisenmenger in Vienna and Munich. Address in 1929, 53 W 72nd St., New York, NY.

HANBURY, UNA.
Sculptor. Born in Kent, England, 1909; came to US (Washington, DC), 1944. Studied at Polytechnic School of Art; Royal Academy School of Art; Academie de la Grande Chaumiere, Academie Julian, Paris; with Frank Calderon, March Brothers, Jacob Epstein. In collections of National Portrait Gallery, Washington, DC; Smithsonian Institution (auditorium), Washington, DC; numerous commissions, including Julius Rudel, Kennedy Center, DC. Exhibited at National Sculpture Society; Lever House, NYC; National Portrait Gallery, Washington, DC; others. Awarded numerous prizes including Landseer prize and gold medal, Royal Academy of Art. Past member of Society of Animal Artists and National Sculpture Society. Sculpts portraits and horses in bronze. Reviewed in *Bronzes of the American West* by Broder; *Artists of the Rockies*, summer 1979; *Southwest Art*, Aug. 1980. Rep. by Munson Gallery, Santa Fe, NM; Carson Gallery, Denver, CO. Address since 1970, Santa Fe, NM.

HANCOCK, ADELAIDE D.
Painter. Born in Boston, MA. Pupil of Chicago Academy of Fine Arts; Eda N. Casterton. Address in 1929, 225 North Michigan Avenue; h. 1120 Hyde Park Blvd., Chicago, IL.

HANCOCK, JOSEPH LANE.
Landscape painter. Born in Chicago, IL, in 1864. Pupil of Art Institute of Chicago. He died in 1925.

HANCOCK, NATHANIEL.
Miniature painter and engraver. He was working in Boston from 1790 to 1802. In 1805 he moved to Salem,

MA. His miniature of Colonel William Raymond Lee is in the collection at the Essex Institute, Salem, MA.

HANCOCK, WALKER (KIRTLAND).
Sculptor. Born in St. Louis, MO, June 28, 1901. Study: St. Louis School of Fine Arts with Victor Holm; Washington University, St. Louis, 1918-20, honorary DFA, 1942; University of Wisconsin, 1920; Penna. Academy of Fine Arts, 1921-25; American Academy in Rome. Work: Penna. Academy of Fine Arts; Corcoran Gallery, National Gallery of Art, and National Portrait Gallery, Washington, DC; and many others. Commissions: Eisenhower Inaugural Medals; Penna. Railroad War Memorial, Penna. Railroad Station, Philadelphia; Army and Navy Medal; portrait statues of Douglas MacArthur, US Military Academy; John Paul Jones, Fairmount Park, Philadelphia; James Madison, Library of Congress, Madison Building; Booth Tarkington & Robert Frost, National Portrait Gallery; Field Service Memorial, Blerancourt, France; bronze bas-relief of Edwin A. Ulrich, The Edwin A. Ulrich Museum, Wichita (KS) State University; and many others. Exhibitions: National and international museums and galleries, and at National Sculpture Society, NY. Positions: Resident Sculptor, American Academy, Rome, 1956-57, 1962-63; Sculptor in Charge, Stone Mt. Memorial, GA, 1964; Head, Department of Sculpture, Penna. Academy of Fine Arts, 1929-68. Awards: Widener gold medal, Penna. Academy of Fine Arts; Fellowship prize, Penna. Academy of Fine Arts, 1931; sculpture, National Academy of Design, 1949; J. Sanford Saltus medal, American Numismatic Society, 1953; Thomas H. Proctor prize, National Academy of Design, 1959; Medal of Achievement, National Sculpture Society, 1968; Medal of Honor, 1981; and many others. Member: Exec. Comm., American Academy in Rome; National Collection of Fine Arts Commission; Academician, National Academy of Design; Fellow, National Sculpture Society; National Institute of Arts and Letters; Architectural League of NY; Benjamin Franklin Fellow, Royal Society of Arts. Media: Bronze, stone. Address in 1984, Gloucester, MA.

HAND, MOLLY WILLIAMS.
Painter, etcher, and teacher. Born Keene, NH, April 29, 1892. Pupil of Daniel Garber, Ralph Pearson, Hugh Breckenridge, Arthur Carles, George Luks, Robert Henri, John Sloan, Phillip Hale, Frank von der Lancken, Albert Heckman, George Bridgman. Member: Amer. Artists Prof. Lg.; Nat. Assoc. Women Painters and Sculptors; Art Students League of NY; Fellowship Penna. Academy of Fine Arts; Westfield Art Assoc.; Amer. Federation of Arts; Elizabeth Soc. of Artists. Work: "Still Life No. 1," Newark Museum, Newark, NJ. Address in 1929, Carteret Arms, 16 South Broad St., Elizabeth, NJ; h. 246 East Sixth Avenue, Roselle, NJ.

HANDELL, ALBERT GEORGE.
Painter. Born in Brooklyn, NY, Feb. 13, 1917. Studied at Art Students League; Grande Chaumiere, Paris. In collections of Syracuse Univ.; Brooklyn Mus., NY; Schenectady Mus., NY; Salt Lake City Mus.; Art Students League. Exhibited at Berkshire Mus., Pittsfield, MA; ACA Gallery, NYC; Eileen Kuhlik Gallery; group shows at Allied Artists of America and Audubon Artists, NY, and many more. Awards: John F. and Anna Lee Stacy Scholarship Fund, 1962-65; Ranger Fund Purchase Prize, Audubon Artists, 1968; Eliz. T. Greenshields Mem. Foundation, 1972. Extensive bibliography. Member of Allied Artists of America; Salma. C.; Art Students League. Media: Multimedia. Rep. by Eileen Kuhlik Gallery, NYC. Address in 1982, Woodstock, NY.

HANDFORTH, THOMAS SCHOFIELD.
Painter, illustrator, and etcher. Born in Tacoma, Sept. 16, 1897. Pupil of Hawthorne; Nat. Academy of Design; Art Students League; Ecole National des Beaux Arts in Paris. Member: Brooklyn Society of Etchers; Philadelphia Society of Etchers; American Federation of Arts. Awards: Emil Fuchs prize, Brooklyn Society of Etchers, 1927; Charles M. Lea prize, Philadelphia Print Club, 1929. Work: Twenty-one etchings, Metropolitan Museum of Art, New York; Pennsylvania Museum (etching); NY Public Library (six etchings); Honolulu Academy of Arts (twelve etchings); Bibliotheque Nationale (three etchings); Fogg Art Museum, Cambridge, MA (six etchings, five drawings). Represented in "Fine Prints of the Year," 1926-28. Illustrated: *Sedonie*, by Pierre Coalfleet; *Handbook on the Italian Ballet* by Luigi Albertiere; *Toutou in Bondage*, by Elizabth Coatsworth; and for the *Forum*, 1925 to 1929, and *Asia Magazine*. Died 1948. Address in 1929, The Print Corner, Hingham Center, MA.

HANDLEY, MONTAGUE.
Sculptor. His work includes busts of "Diana," "Bacchus," and "Flora."

HANDVILLE, ROBERT T.
Illustrator. Born in Paterson, NJ, in 1924. He graduated first in his class at Pratt Institute. He studied under Reuben Tam at the Brooklyn Museum Art School and went to school with Ellsworth Kelly. His first published illustration was done for *Elks Magazine* in 1948. He has done extensive work for many well-known magazines and publishing houses, and has also been an artist-reporter for *Sports Illustrated*.

HANE, ROGER.
Illustrator. Born in Bradford, PA, in 1940. He received his training in advertising design and illustration from the Philadelphia College of Art. Among his many clients were *Fortune, NY Magazine, The Times of London, Ladies Home*

Journal, Time, McCall's, Exxon Corporation, Columbia Records and others. The Swiss magazine *Graphis* in 1975 published an article on his great insight and imagination in depicting the everyday world. Also in 1975 he received an Award of Excellence from the Soc. of Illustrators as well as being elected Artist of the Year by the Artists Guild. Died in 1975.

HANEY, IRENE W.
Painter and teacher. Born Pittsburgh, Feb. 3, 1890. Pupil of Christ Walter. Member: Pittsburgh Art Assoc.; Teachers Art Club. Address in 1929, 6828 Lyric Street, Pittsburgh, PA.

HANEY, JAMES PARTON.
Painter. Born in NYC, Apr. 16, 1869. Pupil of Bell, DuMond and Mucha. Studied with Woodbury. Became art dir. and teacher. Died 1923 in NYC.

HANKS, JERVIS F.
Born in New York State in 1799. He moved with his family to Wheeling, West Virginia, in 1817, and found employment there in painting signs. In 1823 he visited Philadelphia and made some experiments in portrait painting which he continued on his return to Virginia. In 1827 he was in NY and when he could not gain sufficient employment painting portraits, he returned to his sign painting.

HANKS, OWEN G.
Engraver. Born in Troy, NY, in 1838. He studied engraving in the establishment of Rawdon, Wright & Hatch, in NY. He was a capital line engraver, both of portraits and landscapes, and was chiefly employed by the bank-note co. He died about 1865.

HANLEY, HARRIET CLARK.
Sculptor. Born in St. Louis, MO. Work: Monument to George B. Wright, Fergus Falls, MN. Address in 1933, Minneapolis, MN.

HANLEY, MEREDITH.
Painter. Member: Artists Guild of the Authors' League of America, Chicago Art Club. Address in 1929, 5810 Blackstone Avenue, Chicago, IL.

HANLEY, WILLIAM H.
Portrait draughtsman in crayon. He is known to have been working in Boston from 1850 to 1859.

HANLON, LOUIS.
Painter and illustrator. Born in 1882. Member: Society of Illustrators. Died c. 1955. Address in 1929, 9018-107th Street, Richmond Hill, LI, NY; 6525 Germantown Avenue, Philadelphia, PA.

HANNA, THOMAS KING, JR.
Painter and illustrator. Born in Kansas City, MO, April 10, 1872. Pupil of Art Students League of NY.

Member: Society of Illustrators, 1904; Salma. C.; Artists Guild of the Authors' League of America, NY. Work in National Art Gallery, Sydney, N.S.W., Australia. Died in 1951. Address in 1929, 14 Knollwood Terrace, Caldwell, NJ.

HANNAFORD, ALICE IDE.
(Mrs. Foster Hannaford). Sculptor. Born in Baltimore, MD, August 28, 1888. Pupil of Fraser and Art Students League of NY. Work: "Wigwam Dance," Brooklyn Institute Museum. Address in 1933, Winnetka, IL.

HANNELL, V. M. S.
Sculptor and painter. Born in Negaunee, MI, Jan. 22, 1896. Studied at Art Inst. of Chicago and Academy of Fine Arts, Obo, Finland. Work: "The Virgin," St. Joseph's Church, Woods Hole, MA. Member: Chicago No-Jury Society of Artists. Address in 1933, Chicago, IL; summer, Furnessville, Chesterton, IN.

HANNY, WILLIAM F.
Cartoonist. Born in Burlington, IA, in 1882. Address, Pioneer Press, St. Paul, MN.

HANSELL, GEORGE H.
Portrait painter in oils and miniatures who flourished 1844-1857 in NY. In 1844 he exhibited a "Miniature of a Little Girl" at the National Academy of Design in New York.

HANSEN, ARMIN CARL.
Painter, etcher, and teacher. Born in San Francisco, CA, Oct. 23, 1886. Pupil of Mathews; Grethe at Royal Academy, Stuttgart, Germany. Member: Associate National Academy of Design, 1926; San Fran. Art Assoc.; Calif. Society of Etchers; Salma. C.; Allied Artists of America; Wis. Painters and Sculptors; Societe Royale des Beaux-Arts, Brussels. Awards: Prize, International Exp., Brussels, 1910; silver medal, Panama-Pacific Exp., 1915; silver medal for drawing and painting, San Fran. Art Assoc., 1919; first Hallgarten prize, National Academy of Design, 1920; Los Angeles Chamber of Commerce Prize, Los Angeles Museum, 1923; William Preston Harrison Prize ($100) for etching, International Print Makers, Los Angeles, 1924; gold medal, Painters of the West, 1925; Lea prize, Print Club of Philadelphia, 1927. Represented in Memorial Museum, San Francisco; Los Angeles Museum of History, Science and Art; Palace of Fine Arts, San Francisco; Ranger Fund Purchase, National Academy of Design. Died in 1957. Address in 1929, 762 Eldorado Street; h. 621 Cass Street, Monterey, CA.

HANSEN, EJNAR.
Sculptor, painter, lithographer, and teacher. Born in Copenhagen, Denmark, Jan 9, 1884. Studied at Royal Academy of Fine Art, Copenhagen, Denmark. Member: California Water Color Society; California Art

Club; Pasadena Society of Artists. Awards: Prizes, Los Angeles Mus. of Art, 1927, 45, 46; Federation Western Art, 1934; San Diego Fine Art Society, 1941; Los Angeles Art Club, 1941; Pasadena Art Inst., 1943; California Water Color Society, 1944; Pasadena Society of Artists, 1947, 51; State Art College, 1948, 49; National Orange Show, 1951; Laguna Beach Art Association, 1951, 52; Newport Beach Union High School, 1952; Palos Verdes Annual, 1952. Work: Los Angeles Mus. of Art; San Diego Fine Art Society; Pasadena Art Inst.; Pomona, California Municipal College; California State Fair College; National Orange Show; Springville, UT, College; Santa Paula, California, Municipal College; NY Public Library; mural, US Post Office, Lovelock, NV. Exhibited: NY World's Fair, 1939; Golden Gate Exp., 1939; Corcoran Gallery of Art, 1943; Cincinnati Museum Association, 1945; Art Institute of Chicago, 1945, 46; Los Angeles Mus. of Art; National Academy of Design, 1946; Pasadena Art Institute. Position: Instructor, Los Angeles County Art Institute; Instructor, Art, John Muir College and Pasadena School of Fine Art, Pasadena, CA. Address in 1953, Pasadena, CA.

HANSEN, HANS PETER.
Painter. Born in Denmark in 1881. Member: Kunst Gewerbe Verein. Award: Mention, collaborative competition, New York Architectual League, New York. Address in 1926, 467 West 159th Street, New York, NY.

HANSEN, OSCAR J.W.F. (OSKAR III).
Sculptor. Born in 1892 to Oskar II and Josephine Maximiliana in the then dual Kingdoms of Norway and Sweden. Came to U.S. in 1910. His works are in many private and public collections, including Brooklyn Museum; American Numismatic Museum; Art Museum of Milan; Lake Forest Public Library; Rand Tower, Minneapolis; Art Institute of Rio de Janeiro; Dayton Art Institute; Chicago Zoological Park, Brookfield; and many others. His works include colossal granite "Liberty," Yorktown, VA; colossal bronze "Winged Figures of the Republic," Hoover Dam; reliefs in concrete, Hoover Dam; colossal "Wings," created in 1929 in Chicago, later displayed in Navy Museum (Washington, DC), and Brooklyn Museum; Hinsdale (Ill.) War Memorial; turquoise Stallion's Head, Smithsonian Gem Collection; bronze "Excelsior," wedding gift of people of Norway to King Olav V and Princess Martha; portrait busts of Joseph Conrad, Elijah Paris Lovejoy, David Lloyd George, Wilbur and Orville Wright, others; "Holy Figures of Christendom," faceted and sculptured from Morganite Beryl crystal, exhibited at Nat. Mus. of the Smithsonian; 4,535 carat Beryllium crystal depicting flaming Buddhist nun; "Brooding Image of God," faceted in 507 carat Morganite. Elected fellow, International Institute of Arts and Letters; eulogized by U.S. Congress in 1961

for his inspired sculpture. Author of *Beyond the Cherubim* and books on astronomy, biology, theology, and the arts. Died in Charlottesville, VA, in 1971.

HANSON, HENRY T.
Painter and illustrator. Born in Chicago, IL, in 1888. Pupil of DuMond, Bridgman, Snell and John Carlsen. Address in 1926, 225 West 39th Street, New York, NY.

HANSON, MAUDE.
Painter. Member: NY Water Color Club; Art Director's Club. Address in 1929, Woodstock, NY.

HAPGOOD, ALICE HATHAWAY.
See Goodwin, Alice Hathaway Hapgood.

HARARI, HANANIAH.
Painter. Born: Rochester, NY, in 1912. Studied: Syracuse Univ.; Fontainebleau, Paris; with Leger, L'Hote and Gromaire, Paris. Awards: Nat. Academy of Design, 1941; Audubon Artists, 1945; Art Director's Club, Chicago; Ossining, NY, 1953, 1955, 1957; Mt. Kisco, NY, 1955. Collections: Whitney Museum of American Art; University of Arizona; Philadelphia Museum of Art; Museum of Modern Art; Albright Art Gallery; San Francisco Museum of Art; Rochester Memorial Art Gallery; Iowa State University. Media: Oil. Address in 1980, 34 Prospect Place, Croton-on-Hudson, NY.

HARBAUGH, MARJORIE WARVELLE (MRS.).
Sculptor. Born in Chicago, IL, July 28, 1897. Studied at Milwaukee-Downer College, B.S.; Univ. of Wisconsin, M.S.; and with Mabel Frame, William Varnum, Franz Aust. Member: Wisconsin Society of Applied Arts. Work: Univ. of Wisconsin; Oriental Consistory Lib., Chicago, IL; Hudson Mem. Garden, Hudson, OH. Exhibited: Massillon Mus. of Art, 1945; Milwaukee Art Inst. Address in 1953, Hudson, OH.

HARBESON GEORGIANA (NEWCOMB) BROWN.
(Mrs. John F. Harbeson). Painter, illustrator, and craftsman. Born in New Haven, CT, May 13, 1894. Pupil of Hugh Breckenridge, Joseph T. Pearson, Jr., Dan. Garber, Violet Oakley. Member: Fellowship Penna. Academy of Fine Arts; Philadelphia Alliance; Plastic Club; Philadelphia Water Color Club; Nat. Assoc. Women Painters and Sculptors. Award: First prize, National Academy of Design; Women Painters and Sculptors, 1926; prize, Nat. Textile Design Comp., Art Alliance of Am., 1929. Address in 1929, 110 East 59th Street, New York, NY; h. care Caroline Drum, Westport, CT.

HARCOURT, GEORGE E.
Illustrator. Born Detroit, May 23, 1897. Pupil of John Wicker. Member: Scarab Club; Art Founders Soc.

Address in 1929, Parke Davis & Co.; h. 5775 Wabash Avenue, Detroit, MI.

HARDENBERGH, ELIZABETH RUTGERS.
Painter and craftsman. Born New Brunswick, NJ. Pupil of H. B. Snell and Mrs. E. M. Scott. Member: Nat. Assoc. Women Painters and Sculptors; NY Water Color Club; NY Soc. Ceramic Artists; Allied Artists of America; Soc. of Painters of NY; Alliance. Specialty: pottery and painting. Address in 1929, 17 E 62nd St., New York, NY; summer, Byrdcliffe, Woodstock, Ulster Co., NY.

HARDIE, FERNANDO.
Sculptor. Born in Tuscany, 1837. Employed by his father, Lorenzo Hardie, Sr., in Philadelphia, 1860. Medium: plaster.

HARDIE, LORENZO, JR.
Sculptor. Born in Tuscany, 1834. Employed by his father, Lorenzo Hardie, Sr. Active in Philadelphia in 1860. Medium: plaster.

HARDIE, LORENZO, SR.
Sculptor. Born in Tuscany, 1818. Employed numerous artists, including his sons, Fernando and Lorenzo Hardie, Jr., Francesco Barsotte, Frostino Gianelli, Michael Belli, Domenica Belli, Anato Belli, Angelo Mathedi, Lorenzo Pero, Giovanni March. Active in Philadelphia in 1860. Medium: Plaster.

HARDIE, ROBERT GORDON.
Painter. Born in Brattleboro, VT, on March 29, 1854. Studied at Cooper Institute, and National Academy of Design, New York; with Gerome in Paris. Elected to Society of American Artists in 1897. His portrait of Miss Harriet S. Walker (painted in 1900) is in the Walker Art Gallery, Bowdoin College, Brunswick, ME. He died in Brattleboro, VT, on Jan. 10, 1904.

HARDIN, ADLAI S.
Sculptor. Born in Minneapolis, MN, September 23, 1901. Studied: Art Institute of Chicago; Princeton University, A.B. Member: Associate, Nat. Academy of Design; National Sculpture Society. Awards: Prizes, Architectural League, 1941; Nat. Sculpture Society, 1950; medal, National Academy of Design, 1945. Work: Penna. Academy of Fine Arts; IBM; Moravian Church, Bethlehem, PA. Exhibited: National Academy of Design; Penna. Academy of Fine Arts, annually. Address in 1982, Darien, CT.

HARDING, CHARLOTTE.
See Brown, Charlotte Harding.

HARDING, CHESTER.
Born at Conway, MA, September, 1792. He began life as a peddler in Western New York, painted signs in Pennsylvania, and finally, although entirely self-taught, became a fashionable portrait painter. He lived at various times in St. Louis, Philadelphia, and Boston; he went to London and painted the poet Rogers, the historian Alison, and several members of the Royal Family. Among his American portraits are one of Daniel Webster, owned by the Bar Association of NY; John Randolph, in the Corcoran Gallery, Washington; Charles Carroll of Carrollton. Elected Honorary Member of National Academy in 1828. He died in 1866. (See "Autobiography of Chester Harding, Artist," edited by his daughter Margaret E. White, Boston, 1890.)

HARDING, GEORGE.
Mural Decorator, illustrator. Born in Philadelphia, PA, Oct. 2, 1882. Pupil of Penna. Academy of Fine Arts and Howard Pyle; also studied abroad. Member: Soc. of Illustrators; Salma. Club; Phila. Water Color Club; Philadelphia Art Club; Fellowship Penna. Academy of Fine Arts; NY Arch. Lg.; Philadelphia Alliance; Mural Painters. Special artist, *Harper's Magazine*, around the world, 1913. Mural decorations, Hotel Traymore, Atlantic City, NJ; Corn Exchange National Bank, Philadelphia; Earle Theatre, Philadelphia; Capitol Theatre, Trenton; Pere Marquette Hotel, Peoria, IL; American Hotel, Allentown, PA; First Nat. Bank, and Germantown Trust Co., Philadelphia; War Dept. Collection, Smithsonian Institution, Washington, DC; Imperial War Museum Library, London; Library War Museum, Paris. Official artists, A. E. F., 1918. Member of faculty of the Penna. Academy of Fine Arts, and Arch. Dept., University of PA. Died 1959. Address in 1929, 128 North Broad St., Philadelphia, PA.

HARDING, JOHN L.
Portrait painter. Working in New England. His portrait of Mrs. John Lovett is signed "J. L. Harding, 1837" and is owned in Woodstock, CT.

HARDRICK, JOHN W.
Painter and teacher. Born Indianapolis, IN, Sept. 21, 1891. Pupil of William Forsythe, Otto Stark. Member: Indiana AA. Works: Portrait of Evans Wollen, Fletcher Savings and Trust Co.; portrait of George L. Knox and H. L. Sanders, YMCA, Indianapolis; portrait of Bishop Jones, Wilberforce University; portrait of Miss Lackey, Haughville School; portrait of Rev. Lewis, Bethel, AME, Indianapolis; "Still Life," School No. 64, Indianapolis. Address in 1929, 46 North Pennsylvania Street, Rm. 314; h. 2908 Meredith Avenue, Indianapolis, IN.

HARDWICK, ALICE R.
(Mrs. Melbourne H. Hardwick). Painter, writer, and teacher. Born in Chicago, Jan. 18, 1876. Pupil of DuMond, Birge Harrison, Melbourne H. Hardwick; Art Students League of NY; studied in Holland and Belgium. Member: Springfield Art League; North Shore Arts Assoc.; Copley Society; Am. Federation

of Arts. Address in 1929, 486 Boylston Street, Boston, MA; summer, Annisquam, MA.

HARDWICK, MELBOURNE H.
Painter. Born in Digby, Nova Scotia, on Sept. 29, 1857. He died in Waverly, MA, 1916. He was a pupil of Triscott, Luyton and Blummers. Represented in Boston Museum of Fine Arts by "Mid-summer." Died Oct. 25, 1916, in Belmont, MA.

HARDY, ANNA E.
Painter. Born in Bangor, ME, Jan. 26, 1839. Pupil of Georges Jeannin, Paris; Abbott Thayer in Dublin, N. H. Specialty, flower painting. Died Dec. 15, 1934, in S. Orrington, ME.

HARDY, BEULAH GREENOUGH.
Painter. Born in Providence, RI. Pupil of Collin, Merson, Courtois and Virginia Reynolds in Paris; Sir Charles Holroya in London. Member: Society of Miniatures, London; Plastic Club; Philadelphia Alliance; Philadelphia PC; Amer. Federation of Arts. Address in 1929, 336 Meehan Avenue, Mt. Airy, Philadelphia, PA.

HARDY, CHARLES.
Illustrator. Born in England, May 29, 1888. Pupil of E. P. Kinsella. Member: Artists Guild of the Authors' League of America. Died in 1935. Address in 1929, 43 West 67th Street, New York, NY; Compo Street, Westport, CT.

HARDY, JEREMIAH.
Painter. Born Oct. 22, 1800. Pupil of S. F. B. Morse. He painted a portrait of Cyrus Hamlin (seen in profile to left, wearing spectacles), owned by Boston Museum of Fine Arts. He died in 1888. Father of Anna. E. Hardy.

HARDY, WALTER MANLY.
Painter and illustrator. Born at Brewer, ME, in 1877. Pupil of Lazar in Paris; Blum, Brush, Cox, Clark and Bridgman in NY. Address in 1926, 159 Wilson Street, Brewer, ME.

HARE, DAVID.
Sculptor. Born March 10, 1917, in NYC. Studied in New York, Arizona, Colorado (majored in experimental color photography). Work: Brandeis University; Albright; Carnegie; Wadsworth; Metropolitan Museum of Art; Museum of Modern Art; San Francisco Museum of Art; Guggenheim; Whitney Museum; Washington University; Yale University. Published portfolio of color photos on American Indian, with C. Whissler of American Museum of Natural History (1940). Exhibited: Hudson D. Walker Gallery, NYC, 1939; Julien Levy Galleries, NYC, 1946; The Kootz Gallery, NYC, 1946, 48, 51, 52, 56, 58, 59; San Francisco Museum of Art; Staempfli Gallery, 1969; Philadelphia Museum of Art, 1969; I &

IV Sao Paulo Biennials, 1951, 57; Museum of Modern Art; Musee Rodin, Paris, International Sculpture, 1956; Brussels World's Fair, 1958; Art Institute of Chicago, 1961; Seattle World's Fair, 1962; Whitney Mus. of Am. Art. Address in 1982, New York City.

HARE, J. KNOWLES.
Illustrator. Born in Montclair, NJ, Jan. 19, 1882. Member: Society of Illustrators. Designer of covers for *Saturday Evening Post, American Magazine*, etc. Died 1947. Address in 1929, 1 West 67th Street; 27 East 27th Street, New York, NY.

HARE, JEANNETTE R.
Sculptor. Born in Antwerp, Belgium, August 24, 1898. Pupil of C. C. Rumsey, A. S. Calder, H. Frishmuth. Member: National Association of Women Painters and Sculptors. Address in 1933, Forest Hills, LI, NY; summer, Ogunquit, ME.

HARER, FREDERICK W.
Etcher. Born Uhlerstown, PA, Nov. 15, 1880. Pupil of Penna. Academy of Fine Arts under Anshutz and Chase. Award: Baltimore Water Color Club, prize, 1921. Represented in Pennsylvania Academy of Fine Arts. Address in 1929, Uhlerstown, PA.

HARGENS, CHARLES.
Painter. Born in 1893. He exhibited water colors at the Penna. Academy of Fine Arts Water Color Exhibition, Philadelphia, 1925. Address in 1926, 303 Walnut Street, Philadelphia, PA.

HARHBERGER, FLORENCE E.
Painter, illustrator, and teacher. Born Freetown, Cortland Co., NY, Nov. 19, 1863. Pupil of Art Students League and Cooper Union in New York, under Brush, J. Alden Weir, Shirlaw and Frederick Freer. Member: Utica Art C.; Utica Sketch C. Address in 1929, 223 W Fayette St., Syracuse, NY.

HARKAVY, MINNA R.
Sculptor. Born in Estonia, 1895. Studied at Art Students League; Hunter College; in Paris with Antoine Bourdelle. Awards: National Association of Women Artists, 1940-1941; National Exhibition of American Science, Metropolitan Museum of Art, 1951; Project award, United States Treasury. Collections: Whitney Museum of American Art; Museum of Modern Art; Musee Municipal, St. Denis, France; Museum of Western Art, Russia; Tel-Aviv, Ain Harod Museum, Israel; United States Post Office, Winchendon, MA. Exhibited: San Francisco Museum of Art; Art Institute of Chicago; Penna. Academy of Fine Arts; others. Address in 1982, 2109 Broadway, New York City.

HARKINS, ROBERT.
Miniature painter of Brooklyn, NY. He flourished about 1841.

HARLAN, HAROLD COFFMAN.
Illustrator, etcher and artist. Born Dayton, OH,
April 5, 1890. Pupil of Max Seiffert, Carl Howell, etc.
Member: Amer. Institute of Architects; Dayton
Society of Etchers; Dayton Artists Guild; Ohio State
A. of Arch. Address in 1929, 2905 Salem Avenue, at
Benton, Dayton, OH.

HARLAND, MARY.
Painter. Born Yorkshire, Eng., Oct. 8, 1863. Studied
in London, Dresden and Paris. Member: Cal. Society
Min. Painters. Award: Silver medal, P.-P. Exp., San
Francisco, 1915. Address in 1929, 1323 14th Street,
Santa Monica, CA.

HARLAND, THOMAS.
Book plate engraver, located for a time in Norwich,
CT.

HARLES, VICTOR J.
Painter. Born in St. Louis, MO, in 1894. Pupil of St.
Louis School of Fine Arts. Address in 1926, Hanley
Road and Canton Avenue, Clayton, MO.

HARLEY, CHARLES RICHARD.
Sculptor. Born in Philadelphia in 1864. Educated at
Spring Garden Institute; Penna. Academy of Fine
Arts; in Paris at Ecole Nationale des Arts Deco-
rative, Academie Julien, Ecole des Beaux Arts, and
under Dampt and Aube; in NY under St. Gaudens
and Martiny; and in Rome and Florence. Profession-
ally engaged as sculptor since 1895. Medal, Buffalo
Exposition, 1901. Address in 1926, 709 West 169th
Street, New York.

HARLOS, STELLA.
Painter and teacher. Born Milwaukee, Aug. 6, 1901.
Pupil of Layton School of Art; G. V. Sinclair; William
Owens, Jr. Member: Wis. Soc. AC. Award: Hon.
mention, Milwaukee Art Institute, 1924. Address in
1929, 752 - 24th Street, Milwaukee, WI.

HARLOW, HARRY MERRICK SUTTON.
Painter and craftsman. Born Haverhill, July 19,
1882. Pupil of Eric Pape in Boston. Member:
Haverhill Society of Arts and Crafts. Work: Mural
decorations, Trinity Church, Haverhill, MA; St.
Martin banner, St. Augustine and St. Martin
Mission Church, Boston, MA; panels in Chapel of the
Society of the Divine Compassion, New York City;
panels in Christ Church, Portsmouth, NH. Specialty,
illumination. Address in 1929, 226 Merrimack
Street, Lowell, MA; h. 307 Dennett Street.,
Portsmouth, NH.

HARLOW, LOUIS R.
Water color artists and etcher. Born in Wareham,
MA. In 1880 he opened his studio in Boston. His work
was very popular with publishers of fine books, his
illustrations having color and brilliancy.

HARMER, THOMAS C.
Landscape painter. Born Hastings, Eng., April 29,
1865. Pupil of L. H. Meakin, Frank Duveneck.
Member Tacoma AS; Seattle Fine Arts Society.
Address in 1929, 516 North K Street, Tacoma, WA.

HARMES, ELMER E.
Painter and teacher. Born Milwaukee, WI, June 20,
1902. Pupil of George Oberteuffer, Arthur Carles,
Henry McCarten, G. Moeller. Member: Wis. Painters
and Sculptors; Fellowship Penna. Academy of Fine
Arts; Delta Phi Delta. Awards: Ramborger prize,
Penna. Academy of Fine Arts, 1924; Bain prize, Wis.
Painters and Sculptors, 1928. Address in 1929, No. 9,
1000 University Avenue, S. E. Minneapolis, MN.

HARMON, CLIFF FRANKLIN.
Painter. Born in Los Angeles, CA, June 26, 1923.
Study: Bisttram School of Fine Art, Los Angeles and
Taos, with Emil Bisttram; Black Mtn. College, NC,
with Joe Fiore; Taos Valley Art School, with Louis
Ribak. Work: Mus. of Art, Santa Fe, NM; Oklahoma
Art Center. Exhibitions: Dallas Museum; NM
Museum of Art; Joslyn Museum, Omaha; Bertrand
Russell Centennial, London. Awards: NM State Fair;
NM Museum; Phoenix Art Museum. Member: Taos
Art Assoc. Media: Acrylic, watercolor. Address in
1982, Taos, NM.

HARMON, EVELYN SHAYLOR.
Miniature painter. Born 1871. Member: Penna Soc.
Miniature Painters. Exhibited at Penna. Academy of
Fine Arts in 1925. Address in 1929, 40 Carleton
Street, Brookline, MA; 147 Pine Street, Portland,
ME.

HARMON, LILY.
Painter, lithographer, sculptor, and writer. Born:
New Haven, CT, November 19, 1912. Pupil of the
Yale University School of Fine Art; Academie Cola-
rossi, Paris; Art Students League. Collections:
Encyclopaedia Britannica; Butler Institute, Youngs-
town, OH; Tel-Aviv Museum, Israel; Whitney Muse-
um of American Art; Hirshhorn Museum; Newark
Museum of Art; New York Jewish Community
Center, Port Chester (commission); others. Exhib-
ited: Metropolitan Museum of Art, 1943; Carnegie
Institute, Pittsburgh, 1944-49; one-woman shows,
International Salon, Palace of Fine Arts, Mexico
City, 1944-73; Wichita Art Museum, 1981 (retrospec-
tive); University of Illinois, 1949; Butler Institute,
1982; others. Member: Artists Equity Association;
National Academy of Design; Provincetown Art
Association. Teaching oil painting at National Acad-
emy of Design, NY, since 1974. Address in 1984, 151
Central Park W., NYC.

HARNETT, WILLIAM MICHAEL.
Still life painter. Born in Ireland in 1848. Family
moved to Philadelphia; Harnett practiced engraving

in Philadelphia from 1865. In 1871 he moved to NYC. Studied at National Academy and Cooper Union in NYC. Returned to Philadelphia in 1876; studied at Penna. Academy of Fine Arts. In 1880, went to London to study; visited Frankfort, stayed in Munich, studying Old Masters, from 1881-1885. Returned to US via Paris and London, arriving in NYC in April 1886. He exhibited at Paris Salon c. 1885. Subjects of his first pictures, exhibited in 1875, were fruit and vegetables; from about 1876 he turned to other subjects such as beer mugs, tobacco, books, musical instruments, writing materials, money, skulls. His work is in collections of Addison Gallery, Andover, MA; Art Museum, Wichita, KS; Columbus Gallery of Fine Arts; Butler Institute, Youngstown, OH; Fine Arts Museum of San Francisco; Met. Museum of Art, NYC; Graves Art Gallery, Sheffield, Eng.; Museum of Fine Arts, Boston. He died in 1892.

HARNISCH, ALBERT E.
Sculptor. Born in Philadelphia, 1843. Studied at Penna. Academy of Fine Arts; and in Italy. Lived in Rome for eight years. Pupil of Jos. A. Bailly. He executed the Calhoun Monument and the Barclay family group. He made a specialty of portrait busts. Exhibited at Penna. Academy of Fine Arts, 1859-69.

HAROOTIAN, KHOREN DER.
Sculptor and painter. Born in Armenia, April 2, 1909; US citizen. Studied at Worcester Art Mus., MA. Work in Met. Mus. of Art; Whitney Mus. of Art; Bezalel Mus., Israel; sculpture, Fairmount Park Assoc., Phila.; bronze monument, Armenian Bicentennial Committee, Fairmount Park, Phila. Has exhibited at Whitney Mus.; Penna. Academy of Fine Arts; Fairmount Park International Exhib., Phila. Museum; Brussels World's Fair, Belgium; others. Received George D. Widener Medal, Penna. Academy of Fine Arts, 1954; Am. Academy of Arts and Letters and Nat. Institute of Arts and Letters Award and Citation, 1954; Silver Medal, Gruppo Donatello, Florence, Italy, 1962. Works in bronze, marble, and watercolor. Address in 1982, Orangeburg, NY.

HARPER, EDITH W.
Painter. Exhibited at Cincinnati Museum in 1925. Address in 1926, 2119 Alpine Place, Cincinnati, OH.

HARPER, GEORGE COBURN.
Etcher. Born Leetonia, OH, Oct. 23, 1887. Pupil of Cleveland School of Art; Art Students League of NY. Member: Scarab Club. Work: "Christmas Morning," Bibliotheque Nationale, Paris; "Mountain Home," Los Angeles Museum of Art, Los Angeles, CA. Died in 1962. Address in 1929, 116 Orchard Drive, Northville, MI.

HARPER, MARIAN DUNLAP.
Miniature painter. Studied at Art Institute of Chicago and in Paris. Member: Chicago SA; Chicago Miniature Painters; Chicago AG. Address in 1929, 578 Washington Ave.; 847 Grove St., Glencoe, IL.

HARPER, WILLIAM ST. JOHN.
Painter, etcher and illustrator. He was born in Rhinebeck, NY, Sept. 8, 1851, and first studied in the schools of the National Academy under Professor Wilmarth. Later he was a pupil of William M. Chase and Walter Shirlaw in NY and of MM. Munkacsy and Bonnat in Paris. Mr. Harper was president of the Art Students League in 1881, an Associate of the National Academy, and a member of the New York Etching Club. In 1892 he was awarded the Clarke Prize at the Academy for his picture called "Autumn." He died Nov. 2, 1910, in NYC.

HARRIS, ALEXANDRINA ROBERTSON.
Miniature painter. Born Aberdeen, Scotland, July 11, 1886. Pupil of Adelphi Art School under Whitaker; Art Students League of NY; Amer. School of Min. Painters. Member: Nat. Assoc. Women Painters and Sculptors; Brooklyn Soc. Min. Painters; Pennsylvania Soc. Min. Painters. Awards: Hon. mention, Nat. Assoc. Women Painters and Sculptors, 1922; Charlotte Ritchie Smith Memorial Prize, Baltimore Water Color Club, 1922. Address in 1929, 101 Columbia Heights, Brooklyn, New York, NY.

HARRIS, CHARLES GORDON.
Painter. Born Providence, Oct. 17, 1891. Pupil of Stacy Tolman, George A. Hays, H. Cyrus Farnum, RI School of Design. Member: Prov. Art Club; Prov. Water Color Club; South County AA. Address in 1929, 138 Smithfield Road, North Providence, RI.

HARRIS, CHARLES X.
Painter. Born Foxcroft, ME, 1856. Pupil of Cabanel in Paris. Work: Memorial Hall, Phila.; portraits in Manor Hall, Yonkers; Mercantile Library; Lambs' Club, New York; stained glass window, Doylestown, PA; Perce, Quebec, Canada. Address in 1929, 356 Mountain Road, West Hoboken, NJ.

HARRIS, GEORGE EDGERLY.
Painter and etcher. Born Milford Hundred, DE, Oct. 22, 1898. Pupil of Nat. Acad. of Design; C. C. Curran; Charles X. Harris. Member: Mural Painters; Salma. Club. Work: Portraits in the Manor Hall, Yonkers, NY. Address in 1929, 412 Eighth Avenue, New York, NY. Died before 1940.

HARRIS, JAMES.
A line engraving of a Madonna, well executed and published about 1850, is signed "Ja's Harris, Engraver, 58 Nassau Street, New York." No other plates of this engraver have been seen.

HARRIS, JOSEPH T.
Portrait painter. He exhibited at the Boston Athenaeum in 1833, "A Portrait of a Gentleman."

HARRIS, JULIAN HOKE.

Sculptor and educator. Born in Carrollton, GA, Aug. 22, 1906. Studied at Georgia Institute Technology, B.S.; Penna. Academy of Fine Arts. Member: National Sculpture Society; American Institute of Architects; Atlanta Art Association; Southern States Art League, 1939; Tri-County Exh., Atlanta, 1940; IBM, 1942; Assoc. Georgia Artists, 1951. Work: Designed and executed sculpture on 24 public buildings and 21 memorial and portrait commissions including Stone Mountain Confederate Memorial; Georgia State Office Building, Atlanta; Coca-Cola Bottling Co., Atlanta; Atlanta Constitution Building; New Georgia State Prison, Reidsville; Upson County Hospital, Thomaston, GA; Uncle Remus Library, Atlanta; Grant Park Zoo; 24 commemorative medallions including official inaugural medallion for Pres. Jimmy Carter, commemorative medals and medallions for Rich's, Atlanta; Mandeville Mills, Carrollton, GA. Position: Professor, Department of Architecture, Georgia Institute of Technology; Prof., Atlanta (GA) Art Inst. Address in 1982, Atlanta, GA.

HARRIS, LOUIS.

Painter and teacher. Born in St. Louis, MO, Nov. 7, 1902. Pupil of Kenneth Hayes Miller, Max Weber. Member: Art Students League of NY. Address in 1929, 331 East 25th Street, New York, NY.

HARRIS, MARGIE COLEMAN.

Sculptor, painter, educator, etcher, writer, and lecturer. Born in Washington, DC, March 30, 1891. Studied at Carnegie Inst.; Univ. of Pittsburgh; Univ. of Chicago; Penna. State College. Member: Eastern Art Assoc.; Nat. Education Assoc.; Associated Artists of Pitts.; Allied Artists, Johnstown; Penna. Art Education Assoc.; Phila. Print Club; NJ Painters and Sculptors; New Orleans Art Assoc.; Ligonier Valley Art League; Johnstown Art League; Cambria County Art Assoc. Awards: Prizes, Ebensburg Fair, 1935; Allied Artists Johnstown, 1933-37, 51, 52; Garden Club, 1938-45. Work: Cambria Lib.; Veteran's Hospital, Aspinwall, Bethlehem, PA; State Teachers College, Indiana, PA. Exhibited: Indiana, PA, 1944-46; Associated Artists of Pitts., 1924-53; Allied Artists, Johnstown, 1933-53; Ebensburg, PA, 1932-41; Phila. Print Club, 1950-52; Irvington Print Club, 1950-52; NJ Painters and Sculptors Soc., 1952; Norton Gal. of Art, 1952; Puzzletown Guild, 1950-52. Position: Inst. of Art, Penna. State Col., 1919-38; teacher and lecturer at Art Inst., Johnstown, PA, 1935-53; State Teachers Col., 1939; treasurer, Penna. Art Education Assoc., 1952, 53. Address in 1953, Johnstown, PA.

HARRIS, MARION D.

Painter. Born in 1904 in Phila., PA. Exhibited water colors at Annual Ex. of Water Colors, Penna. Academy of Fine Arts, Phila., 1925. Address in 1926, 920 Madison Ave., Wilmington, DE.

HARRIS, N. NEIL.

Sculptor, designer, photographer, and historian. Born in Lafayette, IN, June 9, 1940. Studied: Indiana University; El Camino Jr. College, El Segundo, CA; Purdue University, West Lafayette, IN; received diploma from American School of Photography, Chicago, IL, 1964. Member: Indiana State Numismatic Assoc. (hon. life mem.); Lafayette Numismatic Society (hon. life mem.); Token and Medal Society; Amer. Numismatic Assoc.; Allied Artists of Am.; Amer. Medallic Sculpture Assoc.; Soc. of Medalists; others. Positions: Asst. historian, Am. Numismatic Assoc., 1969-1970, historian, 1970-76; director, Token and Medal Soc., 1970-77, 1st V.P., 1976-78, 2nd V.P., 1978-80, Pres., 1980-82; others. Awarded First Annual Founder's Award, Indiana State Numismatic Assoc., 1971; Burton Saxton Award, Amer. Numismatic Assoc., 1969, Medal of Merit, 1980; Newspaper National Snapshot Awards (three), 1964, others. Designed official seals and logotypes for over 30 corporations and associations, including the annual convention medal, Indiana State Numismatic Assoc., 1965, 72, annual medals, 1973-76; 50th Anniversary Medal, Lions Club, Lafayette, IN; 8th Century Medal, Lafayette Numismatic Soc., 1969; 24 Olympic transportation tokens, So. Cal. Rapid Transit Dist., 1983; designer and sculptor for annual convention medals, Amer. Numismatic Assoc., 1977, 78, 80, and the Howland Wood Mem. Award Medal, 1980. Exhibited at First Annual Ex., Am. Medallic Sculp. Assoc., NY, Col. Springs, and San Francisco, 1983-84. Also works as an author, illustrator, editor. Address in 1984, Col. Springs, CO.

HARRIS, REGINALD G. (MRS.).

See Davenport, Jane.

HARRIS, ROBERT G.

Illustrator. Born in 1911 in Kansas City, MO. He studied under Harvey Dunn and George Bridgman. He attended the Kansas City Art Inst., Art Students League and Grand Central School of Art in New York. From 1938 to 1960 his illustrations appeared in *The Saturday Evening Post, Ladies Home Journal, Redbook, Woman's Home Companion, McCall's* and *Good Housekeeping*. In 1962 he had a one-man show entitled "Portraits," which was held at the Phoenix Museum in Arizona. He is currently working exclusively on portraits.

HARRIS, SAMUEL.

Engraver. Born in Boston, MA, May 1783. He was drowned in the Charles River, on July 7, 1810. *The Polyanthos*, Boston 1812, published a memoir of Samuel Harris, and from this we learn that he was apprenticed at an early age to his relative, the Boston engraver Samuel Hill, and the first portrait executed by Harris appeared in *The Polyanthos* for 1806. As an engraver Harris worked in both line and stipple and his plates possess merit and show great promise.

HARRIS, WILLIAM L.
Mural painter. Born in New York in 1870; he died at Lake George, NY, in 1924. Studied art at Art Students League, NY, and in Paris at Academie Julien. Worked on decorations for Congressional Library, Washington, DC, and collaborated with Francis Lathrop in decorating St. Bartholomew's Church, New York. He also lectured on art subjects. Designed decoration for Church of the Paulist Fathers, New York.

HARRISON, CATHERINE NORRIS.
See Patterson, Catherine Norris.

HARRISON, CHARLES.
Engraver. In 1840 he was working as a letter engraver in New York.

HARRISON, CHARLES P.
Engraver. Born in England in 1783, he was the son of Wm. Harrison, Sr., and was brought to Philadelphia by his father in 1794. He was probably a pupil of his father in engraving. From 1806 until 1819 he was in business in Philadelphia as a copperplate printer, but in 1820-22 Harrison combined "engraving" with his printing establishment. In 1823 he was in business in NY; he remained there until 1850 and probably later. Died 1854 in NYC. There is some very good line work signed by C. P. Harrison, but his stipple portrait work is inferior in execution. He also attempted portrait painting with very indifferent success. Charles P. Harrison was the father of Gabrial Harrison, the actor and author, born in Philadelphia in 1818.

HARRISON, DAVID R.
This bank-note engraver was for many years in the employ of the American Bank Note Co., and he continued to engrave until he was nearly ninety years of age.

HARRISON, HENRY.
Painter. Born in England in 1844. He came to America with his parents when six years old and studied under Daniel Huntington and LeClear. He has painted many portraits. His picture of Jonathan Dayton is in the Capitol Building at Washington, DC. He died in 1923 in Jersey City, NJ.

HARRISON, J. P.
Engraver. He is known as the first engraver who practiced west of the Alleghenies. He was established in Pittsburgh, PA, in 1817.

HARRISON, JEANNETTE SHEPHERD.
See Loop, Jeanette Shepperd Harrison.

HARRISON, LOWELL BIRGE.
Painter. Born in Philadelphia in 1854. Pupil of Cabanel in Paris. Elected an Associate, NAD, 1902; full membership in 1910. Represented by "The Mirror," in Wilstach Collection, Philadelphia; "Glimpse of St. Laurence," at Penna. Academy of Fine Arts; at the Luxembourg Gallery, Paris. Died in 1929 in Woodstock, NY. Address in 1926, Woodstock, NY.

HARRISON, RICHARD.
The name of "Richard Harrison, Engraver" appears in the Philadelphia directories in 1820-22 inclusive, together with that of Richard G. Harrison, noted below. Previous to that time, or in 1814, he was engraving line frontispieces, etc., for F. Lucas & J. Cushing, publishers of Baltimore, Maryland.

HARRISON, RICHARD G.
This line engraver was probably one of the "several sons" of Wm. Harrison, Sr., who came to Phila. in 1794. R. G. Harrison was engraving for the *Port Folio* in 1814 and possibly earlier than that for S. F. Bradford's Philadelphia edition of the *Edinburgh Encyclopedia* of 1805-18. After 1822 he is called "bank-note engraver" in the Philadelphia directories and in this capacity his name appears there continuously until 1845.

HARRISON, RICHARD G., JR.
This younger R. G. Harrison was a mezzotint engraver working in Philadelphia about 1860-65, chiefly upon portrait.

HARRISON, SAMUEL.
Engraver. Born in 1789. Westcott, in his "History of Philadelphia," says that Samuel Harrison was a son of William Harrison and that he was a pupil in engraving with his father before 1810, and died on July 18, 1818, aged twenty-nine years. The only example of his work seen is a good line map of Lake Ontario and Western New York, engraved in 1809.

HARRISON, THOMAS ALEXANDER.
Painter. Born in Philadelphia, PA, Jan. 17, 1853. Pupil of Penna. Academy of Fine Arts; Ecole des Beaux-Arts, Bastien-Lepage and Gerome in Paris. Member: Soc. of American Artists, NY, 1885; Associate National Academy of Design, 1898, National Academy of Design, 1901; Philadelphia Art Club; Paris Soc. of Arts and Crafts; Fellowship Penna. Academy of Fine Arts; Century Assoc.; Philadelphia Water Color Club (hon.); Cercle d'Union Artistique; Soc. Nat. des Beaux-Arts; Royal Inst. of Painters in Oil Colors, London; Soc. of Secessionists, Berlin and Munich (cor.); Nat. Inst. Arts and Letters. Awards: Hon. mention, Paris Salon, 1885; Temple silver medal, Penna. Academy of Fine Arts, 1887; gold medal, Paris Exp., 1889; second medal, Munich Salon, 1891; medal of honor, Brussels and Ghent, 1892; gold medal of honor, Penna. Academy of Fine Arts, 1894; medals of honor at Vienna and Berlin. Chevalier of Legion of Honor,

1889, Officer, 1901; Officer of Public Instruction, by French Gov. Work: "L'Arcadie" and "Solitude," Luxembourg Museum, Paris; "The Wave," Penna Academy, Philadelphia; "Crepuscule," Corcoran Gallery, Washington, DC; "Sables et Lune," Quimper Museum, France; "Les Amateurs," Art Institute, Chicago; "Nude," Royal Gallery, Dresden; "A Festival Night," "Boys Bathing," "East Hampton," "Le Grand Mirror" and "Marine," Milstack Gallery, Philadelphia; "Castles in Spain," Metropolitan Museum, New York; "Golden Dunes," St. Paul Institute. Died in 1930. Address in 1929, 6 Rue du Val de Grace, Paris, France; Century Assoc., 7 West 43rd Street, NY; Woodstock, NY; Concarneau, France.

HARRISON, WILLIAM.
Engraver. Born in England; died in Philadelphia, Oct. 18, 1803. William Harrison is said to have been a grandson of John Harrison, the inventor of the chronometer. He learned to engrave in London and was for a time in the employ of the Bank of England; he also engraved maps for the East India Company. In 1794 Wm. Harrison came to Philadelphia "with several sons" under an engagement to engrave for the Bank of Pennsylvania. He remained there until his death.

HARRISON, WILLIAM F.
Born c. 1912 in Pennsylvania. This excellent letter engraver was in the employ of New York bank-note companies, 1831-40.

HARRISON, WILLIAM, JR.
Engraver. This son of William Harrison was engraving in line in Philadelphia as early as 1797, signing himself "W. Harrison, Junior Sculp't." As an engraver his name appears in the Philadelphia directories for 1802-19, inclusive. He was a good portrait engraver in line and also worked in stipple. Very little of his signed work is seen and he was probably chiefly employed by the bank-note engraving companies.

HARRITON, ABRAHAM.
Painter and etcher. Born in Bucharest, Romania, Feb. 16, 1893. Pupil of National Academy of Design under J. W. Maynard and C. F. Mielatz. Member: Soc. Independent Artists; Salons of Am. Represented in Oakland (CA) Public Museum. Address in 1929, 3908 Gorman Avenue, Sunnyside, LI, NY.

HARRITON, DAVID M.
Sculptor, painter, designer, craftsman, and lecturer. Born in Romania, April 1, 1895. Studied at National Academy of Design; Art Students League. Member: Society of Designer-Craftsmen (Pres.). Awards: Medal, Paris Exp., 1937. Work: Glass ceiling, Clark Memorial, Vincennes, IN; Worcester War Memorial; Federal Reserve Bldg., Washington, DC; US Bureau Shipping, NYC. Exhibited: Soc. Designer-Craftsmen, annually. Lectures: Carved glass. Address in

1953, 511 East 72nd Street; h. 137-58 75th Road., Kew Gardens Hills, NY.

HARSHE, ROBERT BARTHOLOW.
Painter, etcher, teacher, and writer. Born Salisbury, MO, May 26, 1879. Pupil of Art Institute of Chicago; Art Students League of NY; University of MO; Teachers Col., New York, under Dow; Laszlo in London; Colarossi Academy in Paris. Member: California Soc. of Etchers (hon.); Brooklyn Soc. of Etchers (hon.); Amer. Ceramic Soc. (hon.); Chicago Soc. of Illustrators; NY Soc. of Etchers; Am. Com. of Three to Internat. Congr. of Art Edn. Paris; Sec. Treas., Assoc. Art Museum Directors, 1917-1922; Chic. Art Club; Cliff Dwellers Club. Advisory Council, Artistic Relations Section, Lg. of Nations Int. Institute of Intellectual Cooperation. Work: Luxembourg Museum, Paris; Brooklyn Museum; Harrison Gal., Los Angeles Mus. Asst. chief, Dept. of Fine Arts, Panama-Pac. Exp., San Francisco, 1915; ex-asst. director, Dept. of Fine Arts, Carnegie Institute, Pittsburgh, PA; Chevalier Legion of Honor (France), 1925. Director of Art Institute of Chicago. Address in 1929, 311 Belden Avenue, Chicago, IL. Died in 1938.

HARSHMAN, ARTHUR L.
Sculptor, designer, and painter. Born in Dunkirk, IN, December 29, 1910. Member: Industrial Designers Institute; Indiana Art Soc.; Indianapolis Art Assoc.; Indiana Soc. of Printmakers. Work: Mus. of Modern Art; Ball State Teachers Col. Gallery, Muncie, IN. Exhibited: Library of Congress, 1946; Laguna Beach Art Association, 1947, 48; Mint Museum of Arts, 1946, 47; Industrial Designers Institute, Good Design Exhibition, Chicago, 1950; Industrial Designers Institute, NY, 1951; Indiana Artists, 1947-49; Tri-State Print Exhibition, 1946; Ohio Valley Artist, 1949. Position: Head, Design Control Department, Indiana Glass Co., from 1937. Address in 1953, Dunkirk, IN.

HART, ALFRED.
Painter. Born in Norwich, CT, March 28, 1816; in 1848 he moved to Hartford, CT, and later to the West.

HART, GEORGE OVERBURY.
Painter and etcher. Born Cairo, IL, May 10, 1868. Self-taught. Member: Amer. Water Color Society; NY Water Color Club; Brooklyn Soc. of Etchers; Salons of America; Soc. of Independent Artists. Awards: Etching prize, Brooklyn Soc. of Etchers, 1923-24; first prize, water color, Palisade Art Association, Englewood, NJ, 1924; bronze medal, Sesqui-Centennial Expo., Phila., 1926. Represented in NY Public Library; Met. Museum of Art; Brooklyn Mus.; Smithsonian Institution, Washington, DC; Newark Mus.; Cincinnati Mus.; Mem. Gal., Rochester, NY; South Kensington and British Museums, London. Died in 1933. Address in 1929, Coytesville, NJ.

HART, JAMES MCDOUGAL.

Landscape painter. Born in Kilmarnock, Scotland, May 10, 1828. He was brought to America in 1831 and apprenticed to a coach painter. In 1851 he went to Dusseldorf, Germany, for a year's study and returning home he settled in New York City. Elected Associate of National Academy in 1857 and National Academy in 1859. Represented at Corcoran Art Gallery, Washington, DC, by "The Drove at the Ford." He died October 24, 1901 in Brooklyn, NY.

HART, JOEL TANNER.

Sculptor. Born February 10, 1810, in Clark County, KY. He went abroad for study and spent much of his life in Florence, Italy. He executed several statues of Henry Clay, 1846-48, and busts of many prominent men. Associated with Shobal Vail Clevenger after 1831. Died in Florence, Italy, March 2, 1877.

HART, JOHN FRANCIS.

Cartoonist. He was born in Germantown, Phila., in 1867. Died c. 1950. Address in 1926, 169 Hansberry Street, Germantown, Philadelphia.

HART, LEON.

Painter. Exhibited at "Exhibition of Paintings Showing Later Tendencies in Art," Philadelphia, 1921. Address in 1926, 311 West 24th Street, New York City.

HART, LETITIA BONNET.

Painter. Born in New York, April 20, 1867. Pupil of her father, James M. Hart; National Academy of Design under Edgar M. Ward. Award: Dodge prize, National Academy of Design, 1898. Work: Miss Mattie Harris, Virginia College, Roanoke. Exhibited at National Academy of Design, 1885. Address in 1929, 94 First Place, Brooklyn, New York, NY; summer, Lakeville, CT.

HART, WILLIAM HOWARD.

Painter. Born in Fishkill-on-Hudson, NY, 1863. Pupil of Art Students League and J. Alden Weir in New York; Boulanger and Lefebvre in Paris. Member: Salma. Club, 1898; Amer. Federation of Arts. Address in 1929, 131 East 66th Street, New York, NY.

HART, WILLIAM M.

Painter. Born at Paisley, Scotland, March 31, 1823; died at Mt. Vernon, NY, June 17, 1894. Specialty, landscapes with cattle. Represented at the Metropolitan Mus. by "Scene at Napanock" and "Seashore Morning." Elected to National Academy, 1858. Brother of James M. Hart. Hudson River School Artist.

HARTIGAN, GRACE.

Painter. Born in Newark, NJ, March 28, 1922. Studied: Newark College of Engineering; and with

Isaac Lane. Her subject matter is usually abstract. Collections: Museum of Modern Art; Metropolitan Museum of Art. Media: Oil on canvas, watercolor collage. Address in 1980, Baltimore, MD.

HARTING, GEORGE W.

Illustrator and painter. Born in Little Falls, MN, Dec. 11, 1877. Pupil of Henri, Chase, Mora, Miller and Koehler. Member: Society of Illustrators, 1912; Salma. Club, 1917; Pictorial Photographers, 1918; contributing member, Pittsburgh Photo Salon. Illustrations for *House and Gardens* and *Vogue*, *McCalls*, *Delineator*, etc. Address in 1929, 51 West 10th Street, New York, NY.

HARTLEY, JONATHAN SCOTT.

Sculptor. Born in Albany, NY, September 23, 1845. He studied in New England and later in Paris and Italy. His first teacher was Erastus D. Palmer, one of the early American sculptors. He married the daughter of the painter George Inness. Exhibited at London, 1884, 1889; Buffalo Exposition, 1901; National Academy, 1901. He was elected to the National Academy in 1891. Died in New York City on December 6, 1912.

HARTLEY, JOSEPH.

Sculptor. Born in Albany, New York, May 19, 1842. Member: Salmagundi Club. Address in 1921, 1442 Minford Place, New York, NY.

HARTLEY, MARSDEN.

Painter. Born in Lewiston, ME, 1878. Studied at Cleveland Art School and Art Students League. Pupil of Nina Waldeck; DuMond; Cox; Luis Mora; Francis Jones; Chase School. Represented in Phillips Memorial Gallery, Washington, DC. Exhibited at Penna. Academy of Fine Arts in 1921, at "Exb. of Paintings Showing the Later Tendencies in Art"; retrospectives at Cincinnati Museum, 1941, Museum of Modern Art, 1944, Whitney, 1980. Died Sept. 2, 1943. Address in 1929, Aix-en-Provence, France; Room 303, 489 Park Avenue, New York, NY.

HARTLEY, RACHEL.

Painter, illustrator, lecturer, and teacher. Born in New York, Jan. 4, 1884. Pupil of Art Students League of NY. Member: Art Students League of NY; National Arts Club; Pen and Brush Club, NY; Wash. Art Club; American Federation of Arts. Work: "Shrimp Gatherers," Mus. of Georgetown, British Guiana. Address in 1929, Barn Yard Studio, Southampton, LI, NY; h. 16 East 96th Street, New York, NY.

HARTMAN, BERTRAM.

Painter and decorator. Born in Junction City, KS, April 18, 1882. Studied at Art Institute of Chicago; Royal Academy, Munich; and in Paris. Member: Chicago Society of Artists; American Water Color

Society. Died c. 1960. Address in 1929, care of the Montross Gallery, 26 East 56th Street; 267 West 11th Street, New York, NY.

HARTMAN, REBER S.
Painter. He exhibited water colors at the Penna. Academy of Fine Arts, Philadelphia, 1925. Address in 1926, 1316 Spring Garden Street, Philadelphia, PA.

HARTMAN, ROBERT.
Painter. Born Dec. 17, 1926, in Sharon, PA. Educated at University of Arizona (BFA, MA), Colorado Springs with W. Mangravite, Vytlacil, Sander and Woelffer. Taught at Texas Tech. College, University of Nevada-Reno, University California at Berkeley (1961). Awarded 1st prize, Walter Fund, San Francisco Art Inst. (1967); awards from Tucson Art Center (1952 & 1957), Butler Inst., Youngstown (1955), Art Center, LaJolla (1962), Int. Young Artists, Tokyo (1967). Exhibited at Kipnis Gallery, Westport, CT (1954); Whitney Biennial (1973); Baum Gallery (1978) and Cerf Gallery (1980), in San Francisco. In collections of Univ. of Washington; Roswell Mus., New Mexico; Butler Inst., Youngstown; Smithsonian; Colorado Springs Fine Art Center; and Oakland Mus.

HARTMAN, SYDNEY K.
Painter and illustrator. Born in Germany in 1863. Pupil of Laurens and Benjamin Constant in Paris. Address in 1926, 13 W 30th St., New York, NY.

HARTRATH, LUCIE.
Painter and teacher. Born in Boston. Pupil of Rixens, Courtois and Collin in Paris; Angelo Jauk in Munich, 1906. Studied at Art Students League in 1896. Member: Chicago Painters and Sculptors; Cordon Club; Chicago Art Club; Kunstlerinen Verein, Munich; National Assoc. Women Painters and Sculptors. Awards: Butler purchase prize, Art Institute of Chicago, 1911; Young Fortnightly prize, Art Institute of Chicago, 1912; Rosenwald purchase prize ($200), Art Institute of Chicago, 1915; Carr landscape prize, Art Institute of Chicago, 1916; Municipal Art Lg. Purchase Prize; Terre Haute Star Prize ($200), Hoosier Salon, 1925 and 1928; DeFrees prize, Hoosier Salon, 1927; Trikappa prize ($200), Hoosier Salon, 1929. Head of Dept. of Drawing and Painting, Rockford (IL) College. Address in 1929, 4 East Ohio Street, Chicago, IL.

HARTSON, WALTER C.
Painter. Born in Wyoming, IA, in 1866. Member: New York Water Color Club; Society of Independent Artists. Awards: Bronze medal and honorable mention, Atlanta Exposition, 1895; third Hallgarten prize, National Academy of Design, 1898; first landscape prize, Osborne competition, 1904. Address in 1926, Wassaic, Dutchess County, NY.

HARTWELL, ALONSO.
Portrait painter in oils, and crayon portrait draughtsman. Born 1805 in Littleton, MA; died Waltham, MA, 1873. Hartwell moved to Boston in 1822, and was apprenticed to a wood engraver and practiced that art professionally from 1826 to 1851. In the latter year he started painting portraits in oils.

HARTWELL, GEORGE KENNETH.
Painter, illustrator, and craftsman. Born Fitchburg, MA, June 6, 1891. Pupil of Frank DuMond, Kenneth Miller, W. R. Leigh. Member: American Federation of Arts. Died Dec. 13, 1949. Address in 1929, 333 Fourth Avenue; h. 518 Ft. Washington Avenue, New York, NY.

HARTWELL, KENNETH.
Painter. Exhibited water colors at the Penna. Academy of Fine Arts, Philadelphia, 1925. Address in 1926, 518 Fort Washington Avenue, New York City.

HARTWICH, HERMAN.
Painter. Born in New York in 1853. He received his first instruction in drawing and painting from his father. Studied at Royal Academy, Munich; in 1877 received a medal there. Pupil of Profs. Diez and Loefftz. Specialty: Figures, landscapes, portraits, animals, etc. Has painted many subjects in Upper Bacaria in the Tyrol. Made short stays in Paris and Holland, and was painting portraits in the United States, 1893-96. Died 1926.

HARVEY, ELI.
Sculptor, painter, and craftsman. Born in Ogden, OH, September 23, 1860. Pupil of Cincinnati Academy under Leutz, Noble, and Rebisso; Julian Academy in Paris under Lefebvre, Constant and Doucet; Delecluse Academy under Delance and Callot; and Fremiet at the Jardin des Plantes Paris Zoo. Member: National Sculpture gorilla, for New York Zoological Society; medal commemorating entry of the U.S. into the war, for Am. Numismatic Society; Eagles for the Victory Arch, New York; Am. Elk for BPOE; sculpture for the Evangeline Blashfield Memorial Fountain; Brown Bear Society, 1902; NY Architectural League, 1903; American Art Association of Paris; American Society of Animal Painters and Sculptors; Allied Artists of America; Society National des Beaux Arts; California Art Club; Laguna Beach Art Association; American Federation of Arts. Awards: First class gold medal for painting, Paris-Province Exp., 1900; Wanamaker prize for sculpture, American Art Association of Paris, 1900; bronze medal for sculpture, Pan-Am. Exp., Buffalo, 1901; bronze medal, St. Louis Exp., 1904; bronze medal, P.-P. Exp., San Francisco, 1915. Work: "Maternal Caress" and American bald eagle for honor roll, Metropolitan Museum, NY; sculpture for Lion House, New York Zoo; recumbent lions for

Eaton Mausoleum; portrait of "Dinah," Mascot for Brown University, Providence; represented in museums of St. Louis, Liverpool, Newark, Cincinnati; American Mus. of Nat. History, and Metropolitan Museum of Art, New York; Brookgreen Gardens, SC. Exhibited at National Sculpture Society, 1923; and Paris Salons, 1895, 1899. Died February 10, 1957, in CA. Address in 1933, Alhambra, California.

HARVEY, GEORGE.
Born in Eng., 1800. Painter of landscapes and miniatures, flourishing 1837 to 1840. In 1836 he painted a miniature from life of Daniel Webster in the Senate Chamber, Wash., DC. Died in Eng., 1878.

HARVEY, HAROLD LeROY.
Painter and illustrator. Born in Baltimore, July 7, 1899. Pupil of Turner, McCarter, Desponjols, Baudouin and others. Member: Charcoal Club, Baltimore; Fellowship Penna. Academy of Fine Arts; Kit-Kat Club; American Art Assoc. of Paris. Address in 1929, 62 West 9th Street, New York, NY; h. 2935 St. Paul Street, Baltimore, MD.

HARVEY, PAUL.
Painter. Born in Chicago, IL. Pupil of Art Institute of Chicago; Boston Museum School. Member: Boston Art Club; California Art Club. Work: "The Cedars," Boston Art Club. Address in 1929, 268 West 40th Street, New York, NY.

HARVEY, RICHARD D.
Illustrator. Born in Meadville, PA, in 1940. He studied under John LaGatta at the Art Center College of Design and Phoenix College. Beginning in 1967 with an illustration for *Good Housekeeping*, he has since illustrated for *McCall's*, *Business Week*, *Time*, *Oui*, *Cosmopolitan* and others. Many of his illustrations have been paperback covers for Avon, Dell, Pyramid and Ballantine.

HARVEY, ROBERT.
Painter. Born in Dublin, Ireland, May 12, 1868. Pupil of George Smillie. Member: Chicago No-Jury Society of Artists; Salons of America. Address in 1929, 10 Sniffen Court, East 36th Street, New York, NY; summer, 165 Oak Street, Plattsburgh, NY.

HARWOOD, BURT S.
Painter. Born in Iowa in 1897. His specialty was painting the Indians of Taos, NM, where he died in 1924.

HARWOOD, JAMES T.
Painter and teacher. Born in Lehi, UT, 1860. Pupil of Laurens and Bonnat in Paris. Member: National Arts Club. Head of Art Department, University of Utah. Specialty, colored etching. Died in 1940. Address in 1929, University of Utah; h. 1718 Lake Street, Salt Lake City, UT.

HARWOOD, SABRA B.
Sculptor. Born in Brookline, MA, January 18, 1895. Pupil of Bela Pratt and Charles Grafly. Member: Copley Society. Address in 1933, Boston, MA.

HASELTINE, ELISABETH.
(Mrs. Frederick C. Hibbard). Sculptor. Born in Portland, OR, September 25, 1894. Studied at University of Chicago; Art Institute of Chicago; with Polasek, Bourdelle, and Mestrovic. Work: Interior sculpture, Norton Memorial Hall, Chautauqua, NY; sculpture, Illinois State Mus., Springfield. Awards: French Traveling Fellowship, Art Institute of Chicago, 1925; first prize, sculpture, 1930, third prize, 1932, Chicago Galleries Association. Member: Association of Chicago Painters and Sculptors; Chicago Gallery Assoc.; Cordon Club. Instructor in art, Univ. of Chicago. Address in 1933, Chicago, IL.

HASELTINE, HERBERT.
Sculptor. Born in Rome, Italy, April 10, 1877. Pupil of Aime Morot; studied at Royal Academy, Munich, and Julian Academy, Paris. Work: "British Champion Animals," Field Museum, Chicago, IL; Metropolitan Museum of Art; Whitney Museum; Brooklyn Museum; Addison Gallery, Andover, MA; National Gallery of Art, Washington, DC; Virginia Museum of Fine Arts; Tate, London; Rhode Island School of Design; equestrian monuments in connection with architectural work by Sir Edwin Luytens, R.A., at Jamnagar, Kathiawar, India. Address in 1953, 200 Central Park South, New York City. Died in 1962.

HASELTINE, JAMES HENRY.
Sculptor. Born in Philadelphia, November 2, 1833. He studied in Philadelphia under Joseph Bailly; in Paris and Rome. Served in the United States Army in Civil War. He executed statue of "America Honoring Her Fallen Brave," owned by Philadelphia Union League Club. He also did portraits of Longfellow, Read, General Sheridan and General Merritt. Exhibited at Penna. Academy of Fine Arts, 1855, and later. Died in Rome, Italy, Nov. 9, 1907.

HASELTINE, WILLIAM STANLEY.
Sculptor. Born June 11, 1835, in Philadelphia. Studied in Philadelphia under Webster. Elected an Academician of National Academy of Design, 1861. He had a studio in Rome, and exhibited at the "Centennial," in Philadelphia, 1876. Died February 3, 1900, in Rome, Italy. Brother of J. H. Haseltine.

HASEN, BURT STANLEY.
Painter and printmaker. Born in NYC, Dec. 19, 1921. Studied: Art Students League, 1940, 42, 46, with Morris Kantor; Hans Hofmann School of Fine Arts, 1947-48; Acad. Grande Chaumiere, Paris, 1948-50, with Ossipe Zadkine; Accad. Belli Arti, Rome, 1959-60. Work: Walker Art Center, Minneapolis; Worcester Art Mus.; Muhlenberg Col., Allentown,

PA; others. Commissions: Mural, YMHA & YWHA, NYC, 1947. Exhibited: Salon Mai, Mus. Art Mod., Paris, 1951; Metropolitan Mus., NYC, 1953; Berlin Acad., 1956; Whitney, NYC, 1963; Walker Art Center, 1966. Awards: Purchase prizes, Emily Lowe Found., 1954; Fulbright Grant to Italy, 1959-66. Teaching: School of Visual Arts, 1953-pres.; etc. Media: Oil, acrylic. Address in 1982, 7 Dutch St., NYC.

HASHIMOTO, MICHI.
Painter and illustrator. Born in Japan, July 10, 1897. Member: California Water Color Society; Arthur Wesley Dow A. Address in 1929, 1947 Sawtelle Blvd., Sawtelle, CA.

HASKELL, ERNEST.
Painter, lithographer, etcher, and writer. Born in Woodstock, CT, July 30, 1876. Member: Chicago Society of Etchers. Award: Bronze medal for etchings, P. P. Exp., San Francisco, 1915. Also resided in New Milford, CT. Died in Bath, ME, on Nov. 1, 1925.

HASKELL, IDA C.
Painter. Born in California, 1861. Studied in Chicago, Philadelphia and Paris. Died in 1932. Member: National Assoc. Women Painters and Sculptors. Address in 1929, 232 East 15th Street, New York, NY; summer, Brookhaven, LI, NY.

HASKEY, GEORGE.
Sculptor and painter. Born in Windber, PA, October 24, 1903. Studied at Carnegie Institute; and with Emile Walters, Samuel Rosenberg, Hobart Nichols. Awards: Prizes, Allied Artists, Pittsburgh, 1933, 34, 35, 38; Art League, North Kensington, PA, 1940; Fellow, Tiffany Foundation, 1935. Work: Latrobe (PA) HS. Exhibited: Allied Artists Johnstown, 1933-43; Tiffany Foundation, 1935, 36; Carnegie Institute, 1937-44; Munson-Williams-Proctor Institute, 1946. Address in 1953, Watertown, NY.

HASLER, WILLIAM N.
Painter and etcher. Born in Washington, DC., May 9, 1865. Studied at Art Students League. Address in 1929, 32 Hillside Avenue, Caldwell, NJ.

HASSAM, CHILDE.
Painter and etcher. Born in Boston, Oct. 17, 1859. Studied in Boston and Paris. Member: Associate Nat. Academy of Design, 1902; National Academy of Design, 1906; American Water Color Society; NY Water Color Club; Boston Art Club; Ten American Painters; Munich Secession; Soc. Nat. des Beaux-Arts; Nat. Institute of Arts and Letters; American Academy of Arts and Letters. Awards: Art Club, Philadelphia, 1892; Columbian Exp., Chicago, 1893; Cleveland Art Assoc., 1893; Temple medal, Penna. Acad. of Fine Arts, 1899; Paris Exp., 1901; Pan-Am.

Exp., Buffalo, 1901; St. Louis Exp., 1904; Penna. Academy of Fine Arts, 1906; Sesnan medal, Penna. Academy of Fine Arts, 1910; W. A. Clark prize ($2,000) and Corcoran gold medal, Washington, 1912; Evans prize ($300), American Water Color Society, 1912; gold medal of honor, Penna. Academy of Fine Arts, 1920; gold medal for painting, Philadelphia Art Club, 1915; Altman prize ($500), National Academy of Design, 1922; Altman prize ($1,000), National Academy of Design, 1924 and 1926; gold medal, Sesqui-Centennial Expo., Philadelphia, 1926; others. Work: Metropolitan Museum of Art, NY; Corcoran Gallery; Cincinnati Museum; Carnegie Institute; Fine Arts Academy, Buffalo; RI School of Design; Nat. Gallery, Washington, DC; Penna. Academy of Fine Arts; Art Institute of Chicago; Harrison Gallery, Los Angeles Museum; Phillips Academy, Andover, MA; many others. Died in 1935. Address in 1929, 130 West 57th Street, New York, NY.

HASSELBUSCH, LOUIS.
Painter. Born Philadelphia, Nov. 8, 1863. Pupil of Penna. Academy of Fine Arts; Academy Julian under Constant and Lefebvre in Paris; Royal Academy in Munich. Member: Philadelphia Sketch Club. Specialty: Portraits. Represented in libraries, universities, etc. Address in 1929, 1009 Lindley Avenue, Logan Station, PA; summer, Edison, Bucks Co., PA. Died before 1940.

HASSELMAN, ANNA.
Painter, lecturer, and teacher. Born Indianapolis, 1873. Pupil of Chase, Hawthorne and Forsyth. Member: Indianapolis Art Association; Portfolio. Lecturer on art appreciation. Curator of paintings, John Herron Art Institute. Address in 1929, John Herron Art Institute; h. 121 West 41st Street, Indianapolis, IN.

HASSELRIIS, MALTHE C. M.
Painter, illustrator, and craftsman. Born Skive, Denmark, Jan. 16, 1888. Address in 1929, 333 Seventh Avenue, New York, NY; Forest Hills Gardens, LI, NY.

HASTINGS, DANIEL.
Sculptor. In Massachusetts, c. 1775. Work includes portrait on slate of John Holyoke, Newton, Mass., done in 1775. Specialty was gravestones.

HASTINGS, MARION (McVEY).
Painter. Born Geneva, NY, Jan. 25, 1894. Pupil of Alethea Hill Platt, D. J. Connah, A. H. Hibbard. Member: Seattle FAS. Award: Prize, Yakima, WA, 1929. Address in 1929, 102 Marlborough House; 1220 Boren Avenue, Seattle, WA.

HASWELL, ERNEST BRUCE.
Sculptor, writer, lecturer, and teacher. Born in Hardinsburg, KY, July 25, 1889. Pupil of Barnhorn

(at Cincinnati Art Academy), Meakin, Dubois, Victor Rousseau; Academie Royale des Beaux Arts, Brussels, Belgium. Member: Cincinnati MacDowell Society; Cincinnati Art Club; Crafters' Guild. Work: "Spinoza," bas-relief, Hebrew Union College and Spinoza House, The Hague; "Northcott Memorial," Springfield, IL; Cincinnati Museum, Cincinnati MacDowell Society, Rookwood Pottery; St. Coleman's Church, Cleveland; war memorial, Bond Hill, OH; war memorial, Avondale (OH) School; portraits of Generals Greene, St. Clair, and Wayne, Greensville, OH; Nippert Memorial, University of Cincinnati Stadium; Jacob Burnett Memorial, Cincinnati; Moorman Memorial, Louisville, KY; Holmes Mem., Cincinnati, OH; Brookgreen Gardens, SC. Exhibited at National Sculpture Society in 1923. Contributor to *International Studio, Art and Archaeology,* and *Craftsman* magazines. Associate Professor, College of Applied Arts, University of Cincinnati, Ohio. Died in 1965. Address in 1953, Cincinnati, OH.

HATCH, EMILY NICHOLS.
Painter. Born Newport, RI. Pupil of John Ward Stimson, Chase, and Hawthorne. Member: National Assoc. Women Painters and Sculptors (Pres., 1922-1926); Society of Painters of NY, Pen and Brush Club of NY. Award: McMillan prize, NY Woman's Art Club, 1912. Represented in Nat. Mus. Washington. Address in 1929, 62 Washington Square, New York, NY.

HATCH, GEORGE W.
Engraver. Born about 1805, in Western New York; died at Dobbs Ferry, NY, in 1867. Hatch was one of the first students in the National Academy of Design in 1826, and for a time he was a pupil of A. B. Durand. He was a good line engraver, and in 1830 he was designing and engraving bank-note vignettes in Albany and in New York City. While he engraved portraits, landscape plates and subject plates for the "Annuals," his signed work is not plentiful. A large and well engraved portrait of Washington Irving, published in the *New York Mirror* in 1832, is signed "Engraved by Hatch and Smillie."

HATCH, L. J.
He was a bank-note engraver in the employ of the Treasury Department, at Washington, DC, about 1875.

HATFIELD, DONALD GENE.
Painter. Born in Detroit, MI, May 23, 1932. Studied: Northwestern Mich. College; Mich. State Univ.; Univ. of Wisconsin. Work: Montgomery Museum of Art, AL; Tuskegee Inst.; and others. Exhibitions: Birmingham Museum of Art; Chautauqua Art Assoc., NY; others. Awards: Purchase Award, 11th Dixie Annual, Montgomery Museum of Art, 1970; Kelly Fitzpatrick Award, 42nd Annual, Montgomery Museum of Art, Alabama Art League, 1971; and many others. Member: Alabama Art League; AL Water Color Society; Birmingham Art Assoc. Medium: Watercolor. Address in 1982, Auburn, AL.

HATFIELD, JOSEPH HENRY.
Painter. Born near Kingston, Canada, in 1863. Pupil of Constant, Doucet and Lefebvre in Paris. Awards: Silver medal, Mass. Charitable Mechanics Association, Boston, 1892; second Hallgarten prize, National Academy of Design, 1896. Work in Boston Art Club. Address in 1926, Canton Junction, MA.

HATFIELD, KARL LEROY.
Painter and etcher. Born in Jacksonville, IL, Feb. 19, 1886. Pupil of John Montgomery, Cyril Kay-Scott. Member: Southern States Art League; El Paso AG. Address in 1929, 14 Morehouse Block; h. 1508 Elm Street, El Paso, TX; summer, Chapel Studio, Santa Fe, NM.

HATHAWAY, DR. R.
Portrait artist. He was working in New England in 1793. The lithograph portrait of Col. Briggs Alden is inscribed "Dr. R. Hathaway, del 1793."

HATHAWAY, J.
Miniature painter. Flourishing in Boston about 1833. He exhibited a miniature of a lady at the Boston Athenaeum in 1833.

HATOFSKY, JULIAN.
Painter. Born 1922 in Ellenville, NY. Studied at the Art Students League, NYC (1946-50); Chaumiere, Paris; and Hofmann School of Fine Arts, NYC (1951). Exhibited at Avant Garde Gallery, NYC (1957); Egan Gallery, NYC (1963). In the collections of the Whitney and private collections.

HAUPERS, CLEMENT (BERNARD).
Sculptor, painter, lecturer, and teacher. Born in St. Paul, MN, March 1, 1900. Studied at Minneapolis School of Art; with C. S. Wells, Vaclay Vytlacil, Cameron Booth, Robert Hale; in Paris with L'Hote, Bourdelle, Jacovleff, Shukhaeff, and at the Colarossi Acad. and the Academie de la Grande Chaumiere. Member: Minnesota Art Assoc. Awards: Special mention, MN State Fair, 1920; first prize, 1925, first prize, 1926, hon. mention, 1926, MN State Fair; Minneapolis Institute of Art, 1928. Work: Brooklyn Mus.; NY Public Library; Phila. Mus. of Art; Minneapolis Inst. of Art; San Diego Soc. of Fine Art; Dallas Mus. of Fine Art. Exhibited: Art Inst. of Chicago; NY World's Fair, 1939; Milwaukee Art Inst.; Minnesota State Fair; Minneapolis Inst. of Art; Walker Art Center. Position: Supt., Fine Art Dept., Minn. State Fair, 1930-41; Instructor, St. Paul School of Art, 1931-36; State Dir., Regional Director, Assistant to Nat. Dir., Federal Art Project, 1935-42; Instructor, St. Paul Art Center, St. Paul, Minn., from 1945. Address in 1953, Rutledge, MN.

HAUPT, ERIK G.
Painter. Born in Cassel, Germany, in 1891. Pupil of Laurens and Richard Miller in Paris. Address in 1926, Care of the Charcoal Club, 1230 St. Paul Street, Baltimore, MD.

HAUSCHKA, CAROLA SPAETH.
Sculptor. April 29, 1883, in Philadelphia.

HAUSER, ALONZO.
Sculptor and educator. Born in La Crosse, WI, January 30, 1909. Studied at Layton School of Art; Univ. of Wisconsin; Art Students League, with William Zorach. Member: An American Group; Sculptors Guild; Minnesota Art Assoc.; Minnesota Sculptors Guild. Awards: Prizes, Wisconsin Painters and Sculptors, 1940-42; IBM, 1941; Minnesota Regional Sculpture Award, 1946. Work: IBM; St. Paul's Church, St. Paul, MN; Milwaukee Art Inst.; Walker Art Center; reliefs, US Post Office, Park Rapids, MN. Exhibited: Whitney Mus. of American Art; Brooklyn Mus.; NY World's Fair, 1939; Sculptors Guild; Minn. Reg. Sculpture Exhibition; ACA Gallery, 1936; Layton Art Gallery, 1942; one-man retrospective, Walker Art Center, 1946; St. Paul Gallery of Art, 1946; Las Cruces Community Art Center, NM, 1975. Position: Instructor of Sculpture, Layton School of Art, 1940-42; Carleton Col., 1944-45; Head of Art Dept., Macalester Col., St. Paul, MN, 1945-49. Address in 1982, Mesilla Park, NM.

HAUSHALTER, GEORGE M.
Painter. Born Portland, ME, Jan. 9, 1862. Pupil of Julian Acad. and Ecole des Beaux-Arts. Member: Am. Water Color Soc.; Rochester Art Club. Work: Decorations in St. Andrew's and St. Philip's Church, Rochester, NY. Address in 1929, New Hope, PA.

HAUSMANN, GEORGE E.
Painter. Born in St. Louis, MO. Pupil of Chase, Richard Miller, Laurens. Member: Artists Guild of the Authors' League of America, NY. Work: Mural "Success Crowning Industry," The Fleishman Co. Address in 1929, 33 West 67th St., New York, NY; summer, Leonia, NJ.

HAVELL, ROBERT, JR.
Born Nov. 25, 1793, in Eng. In 1839 the English engraver, Robert Havell, Jr., arrived in America; his work was well known in *Audubon's Birds of America*. He settled on the Hudson soon after his arrival, and died in Tarrytown, Nov. 11, 1878. In 1848 he published his engraving of "West Point from Fort Putnam" after a painting by himself. He also engraved a "View of the City of Hartford," and a number of views of other American cities. An excellent sketch of Robert Havell and Robert Havell, Jr., by Geo. A. Williams, will be found in *The Print-Collector's Quarterly*, Vol. 6, No. 3, 1916. Also painted landscapes.

HAVENS, BELLE.
See Walcott, Belle Havens.

HAVILAND, JOHN.
Born in 1792. An English artist and architect who was in Philadelphia soon after 1800. He designed a number of buildings, and started a school for drawing in 1818 with Hugh Bridport, the miniature painter. Died March 28, 1853.

HAVLENA, JARI.
Painter. Born in Grand Forks, ND, in 1923. Studied: Abbott School of Fine Arts, Washington, DC, De Paul University, Chicago; Art Inst. of Chicago; University of Kansas City; and with Robert von Neumann, Max Kahn and Paul Wiegert. Awards: Vandergritt scholarship, Art Inst. of Chicago; Kansas des-Craftsmen, 1954. Collection: Quigley Music Studio, Kansas City.

HAWEIS, STEPHEN.
Painter and etcher. Born in London, Eng. Pupil of Alphonse Mucha and Eugene Carriere in Paris. Work: Mural decorations in War Mem. Chapel of St. Francis Xavier, Nassau, Stone Ridge Church, NY; painted windows in St. Anselm's Church, Bronx, NY; paintings in Detroit Inst. and Toledo Mus. Address in 1926, Nassau, N.P., Bahama Is., B.W.I.

HAWKINS, BENJAMIN F.
Sculptor. Born in St. Louis, MO, June 17, 1896. Pupil of Victor Holm, Leo Lentelli, Lee Lawrie. Member: National Sculpture Society. Work: "Minerva," University of Michigan, Ann Arbor; sculptural detail, Washington Hall, United States Military Academy, West Point, NY; figures, high school, Little Rock, AR; Brookgreen Gardens, SC. Address in 1982, Pleasantville, NY.

HAWKINS, CORNELIUS H.
Portrait and landscape painter. Born near Tupelo, MI, in 1861. Studied in St. Louis School of Fine Arts; in NY, under William Chase. He is represented in the Louisiana State Museum at New Orleans, and the Alabama State Capitol.

HAWKINS, EDWARD MACK CURTIS.
Painter. Born in New York, Nov. 24, 1877. Pupil of Whistler, Cazin, Monet, and Beardsley. Member: Charcoal Club, Binghamton Society of Arts and Crafts. Awards: Silver medal, Liege, Belgium, 1899-1902; Order of Leopold of Belgium; Iron Crown, Romania. Works owned by Queen of Romania, King of Serbia and late King Leopold of Belgium. Address in 1929, 120 East State Street, Ithaca, NY; summer, "The Hawk's Nest," Frontinac, NY.

HAWKINS, GRACE MILNER.
Painter and lecturer. Born in Bloomington, WI, Oct. 20, 1869. Pupil of H. Siddons Mowbray, Kenyon Cox,

Twachtman. Member: Nat. Arts Club; American Federation of Arts; Madison Art Assoc. Award: First prize, Midland Empire Fair, Billings, MT, 1925. Work: "The Trout Stream," New Gallery, Hartford, CT. Address in 1929, Drumlinbrow, 1910 Regent Street, Madison, WI; summer, Leafy Lodge, Absarokee, MT.

HAWKINS, MAY PALMER.
(Mrs. Edward M. C. Hawkins). Painter. Born in London, Feb. 14, 1879. Pupil of Cadmus, Bernard Meyers, E. M. C. Hawkins, Ward and Stouffer. Member: American Federation of Arts. Address in 1929, 120 East State Street, Ithaca, NY; summer, "The Hawk's Nest," Frontinac, NY.

HAWKINS, THOMAS WILSON, JR.
Painter. Born in Los Angeles, CA, May 15, 1941. Studied: CA State Univ., Long Beach; CA State Univ., Los Angeles. Work: Various collections in CA. Exhibited: So. California Expos., Del Mar, 1967-77; Butler Inst., Youngstown, OH, 1970; Da Vinci Open Art Comp., NYC, 1970; Bertrand Russell Cent., London & Nottingham, England, 1973; others. Awards: So. California Expos., 1967, 70; purchase award, All City Los Angeles Art, Barnsdall, 1977; others. Member: Regional associations; Nat'l Educ. Assoc. Address in 1982, Arcadia, CA.

HAWKS, RACHEL MARSHALL.
(Mrs. Arthur L. Hawks). Sculptor and teacher. Born in Port Deposit, MD, March 20, 1879. Pupil of Maryland Institute, Rinehart School of Sculpture under Ephraim Keyser, Charles Pike. Member: Handicraft Club of Baltimore; Maryland Institute Alumni. Work: Bust of Dr. Basil Gildersleeve, Johns Hopkins University, Baltimore; numerous garden sculptures—"Boy and Dragon Fly," "Boy and Dolphins," etc., in Administration Building, Maryland Casualty Co., Baltimore. Specialty, mural decorations in relief. Exhibited at Nat. Sculpture Society, 1923. Address in 1953, Ruxton, Baltimore Co., MD.

HAWLEY, CARL T.
Painter, illustrator, etcher and teacher. Born in Montrose, PA, April 4, 1885. Pupil of Art Students League of NY; Julian and Colarossi Academies in Paris. Member: Art Students League of NY; Amer. Art Assoc. of Paris; Paris Society of Etchers. Award: Silver medal, Sesqui-Centennial. Work: Mural decoration, Court House, Pulaski, NY. Represented in Syracuse Museum. Illustrated *History in Rhymes and Jingles*; *Tanglewood Tales*. Address in 1929, 871 Ostrom Avenue, Syracuse, NY; summer, Heart Lake, PA.

HAWLEY, MARGARET FOOTE.
Miniature painter. Born Guilford, CT, June 12, 1880. Pupil of Corcoran AS; Howard Helmick; Colarossi in Paris. Member: American Society of Miniature Painters; Pennsylvania Soc. of Miniature Painters; Guild of Boston Artists; New Haven Paint and Clay Club; American Federation of Arts. Awards: Medal of honor, Penna. Academy of Fine Arts, 1918; Lea prize ($50), Penna. Academy of Fine Arts, 1920; Charlotte Ritchie Smith Memorial prize, Baltimore Water Color Club; silver medal, Sesqui-Centennial Exposition, Philadelphia, 1926. Work: Metropolitan Museum, New York, and Concord Art Association. Address in 1929, 58 W 57th St., New York, NY.

HAWLEY, THEODOSIA.
Painter. Member: National Association of Women Painters and Sculptors. Address in 1929, 141 East 40th Street, New York, NY; care of the Concord Art Association, Concord, MA.

HAWTHORNE, CHARLES WEBSTER.
Painter and teacher. Born in Maine, Jan. 8, 1872. Pupil of National Academy of Design and Art Students League in NY; Chase at Shinnecock, LI. Member: Associate National Academy of Design, 1908; National Academy, 1911; Salma. Club, 1900; National Arts Club; Lotos Club; Artists' Fund Society, NY; Players; Societe Nat. des Beaux-Arts, Paris; American Water Color Society; National Institute of Arts and Letters; Portrait Painters; Century Association. Awards: Salma. Club, 1902, 04; National Academy of Design, 1904, 06, 11, 14, 15, 24, 26; Carnegie Inst., Pittsburgh, 1908, 25; Buenos Aires Exp., 1910; Penna. Academy of Fine Arts, 1915, 23; P.P. Exp., San F., 1915; Art Inst. of Chicago, 1917, 23; Phila. Expo., 1923; Corcoran Gallery, 1923, 26; gold medal, Sesqui-Centennial Expo., Philadelphia, 1926; others. In collections of Metropolitan Museum of Art; Corcoran; Syracuse Mus. of Fine Arts; RI School of Design; Worcester Museum; Buffalo Fine Arts Academy; Detroit Institute; City Art Museum, St. Louis; Herron Institute, Indianapolis; Boston Museum of Art; Houston Museum of Fine Arts; Toledo Museum of Fine Arts; Cincinnati Mus.; Hackley Art Museum, Muskegon, MI; Dayton Art Institute; Museum of Art, Fort Worth, TX; National Academy of Design; National Arts Club, NY; Lotos Club, NYC; Denver Art Museum; Univ. of IL; Carnegie; Washburn College, Kansas; Brooklyn Museum. Died Nov. 29, 1930 in Baltimore.

HAWTHORNE, EDITH G.
Sculptor, painter, craftsman, writer, and teacher. Born in Copenhagen, Denmark, Aug. 29, 1874. Studied with Chase. Member: Laguna Beach Art Association. Address in 1933, San Francisco, California.

HAY, DE WITT CLINTON.
Engraver. Born in 1819 in or near Saratoga, NY. In 1850 he was an apprentice with Rawdon, Wright, Hatch & Smillie, in New York. He devoted himself to bank-note engraving as a member of the firm of

Wellstood, Hanks, Hay & Whiting, of New York. Contemporaries of Hay attributed the engraving of the small annual plate of "The Oaken Bucket," after the painting by Frederick S. Agate, to him; this plate was signed by his employers, Rawdon, Hatch & Smillie.

HAY, GENEVIEVE LEE.
Sculptor and teacher. Born in Cleveland, OH, September 12, 1881. Pupil of Henri; Cooper Union; Art Students League of New York. Member: Mac Dowell Club. Died in Flemington, NJ, April 7, 1918. Address in 1918, 356 West 22nd St., NYC.

HAY, GEORGE AUSTIN.
Painter and filmmaker. Born in Johnstown, PA, Dec. 25, 1915. Studied: Penna. Academy of Fine Arts; Art Students League; National Academy; Univ. of Rochester; Univ. of Pittsburgh; Columbia Univ.; also with Robert Brackman, Dong Kingman. Work: Univ. of Pittsburgh; NY Public Library; Dept. of Army; Library of Congress; Metropolitan Museum of Art, NYC. Exhibitions: Pittsburgh Playhouse; Rochester Memorial Art Gallery; Philharmonic Hall, Lincoln Center, 1965; Riverside Museum, 1970; Carnegie Institute, 1972; Duncan Galleries, NYC, 1973; American Painters in Paris, 1976; and others. Awards: Prizes in regional exhibitions. Member: American Artist's Professional League; Fed. Design Council; Allied Artists of America; others. Media: Oil, watercolor. Address in 1982, Washington, DC.

HAY, STUART.
Painter. Born in Sewickly, PA, Feb. 22, 1889. Member: Artists Guild of the Authors' League of America, NY; American Federation of Arts. Address in 1929, 242 East 19th Street, New York, NY.

HAY, WILLIAM.
This line engraver of buildings and subjects was working in Philadelphia from 1819 to 1824.

HAY, WILLIAM H.
Engraver. This name is signed to plates found in C. G. Childs' *Views of Philadelphia*, published in 1828. Both this man and the William Hay noted above were line engravers of similar subjects and were contemporaries. There is enough difference in their style of work, however, to encourage the belief that they were different men.

HAYDEN, CHARLES H.
Landscape painter. Born in Plymouth, MA, on Aug. 4, 1856; died in Belmont, MA, in 1901. Pupil of the Boston Museum School; also of Boulanger, Lefebvre and R. Collin, in Paris. Awards: Honorable mention, Paris Exposition, 1889; Jordon prize, Boston, 1895; silver medal, Atlanta Exposition, 1895; bronze medal, Paris Exposition, 1900. Member of Boston Water Color Society. Represented by "The Poplars,

Chatham, Massachusetts" at the Corcoran Art Gallery, and "Turkey Pasture," owned by Boston Museum of Fine Arts.

HAYDEN, EDWARD PARKER.
Landscape painter. Died in Haydenville, MA, Feb. 7, 1922.

HAYDEN, ELLA FRANCES.
Painter. Born in Boston, MA, March 21, 1860. Pupil of National Academy of Design; Delecluse School, Paris; National Art School, Munich; Cowles Art School, Boston. Member: Providence Art Club; Providence Water Color Club. Specialty, landscapes. Address in 1929, 70 Intervale Road, Providence, RI; summer, Pomfret, CT.

HAYDEN, SARA S.
Painter, illustrator, and teacher. Born in Chicago. Pupil of Art Institute of Chicago; Collin, Merson and Lazar in Paris; Chase and Duveneck. Member: Chicago Society of Artists. Address in 1929, 3319 Michigan Avenue, Chicago, IL.

HAYDON, HAROLD EMERSON.
Sculptor, painter, illustrator, educator, lecturer, and writer. Born in Fort William, Canada, April 22, 1909. Studied at Univ. of Chicago, Ph.D., M.A.; Art Institute of Chicago. Member: Artists Equity Association; American Association Univ. Professors. Awards: Prize, University of Chicago, 1945. Work: Mural, Pickering College, Newmarket, Ontario, Canada. Exhibited: Art Institute of Chicago, 1937, 38, 44, 45, 46-50; others. Illustrator, many educational books, monographs, etc. Taught: Instructor, Assistant Professor of Art, University of Chicago, IL, 1944-48; Associate Professor, 1944-75; visiting lecturer, murals, University of Chicago, 1975-81. Address in 1983, Chicago, IL.

HAYES, DAVID VINCENT.
Sculptor. Born March 15, 1931, in Hartford, CT. Earned A.B. at University of Notre Dame (1951), and M.F.A. from Indiana University (1955), with David Smith. Taught at Harvard University. Awards: Fulbright research grant, 1961; Guggenheim Fellowship, 1961; National Institute of Arts and Letters award. Exhibited at Smithsonian; Guggenheim; Willard Gallery, NYC; Wadsworth; Musee Rodin (American Center). In collections of Dallas Museum; Guggenheim; Addison Gallery; Museum of Modern Art, NY; Brooklyn Museum; Houston Museum of Fine Arts; and private collections. Address in 1982, Coventry, CT.

HAYES, KATHERINE WILLIAMS.
(Mrs. James A. Hayes, Jr.). Painter, illustrator, and teacher. Born Washington, DC, April 5, 1889. Pupil of Enrico Nardi, Robert Logan, Philip Hale, William James, Frederick Bosley. Address in 1929, Wallingford, PA.

HAYES, LOUISA.
Sculptor, painter, and craftsman. Born in Buffalo, NY, January 15, 1881. Pupil of Robert Reid and Albright Art School. Member: American Society of Sculptors; Buffalo Guild of Allied Arts. Address in 1918, Buffalo, NY; summer, "Shoreoaks," care of Ridgeway, Ontario, Canada.

HAYES, TUA.
Painter. Born in Anniston, AL. Studied at Converse College; Columbia Univ. Teacher's College; with Henry Lee McFee. Collections: Delaware Art Museum; University of Delaware; others. Exhibited: National Academy of Design; Baltimore Museum; others. Awards: Delaware Art Museum. Member: Philadelphia Alliance. Works in oil and watercolor. Lives in Wilmington, DE.

HAYS, AUSTIN.
Sculptor. Born in NYC in 1869; was the son of William J. Hays, Sr., member of National Academy of Design, and brother of William J. Hays, Jr., the landscape painter. Was a clerk in the Chemical National Bank, but later went to Paris and studied art for six years under Mercie and Puech. Much of his work was exhibited in the Petit Salon in Paris and the National Academy of Design, NYC. He was a member of the Salmagundi Club. Died at his country home in the White Mountains, July 24, 1915.

HAYS, ELAH HALE.
Sculptor. Born in Madisonville, TX, in 1896. She moved to San Francisco, California, in 1913. Studied at University of California at Berkeley; under Vaclav Vytlacil, 1938, and Antonio Prieto, 1946. Taught at California College of Arts and Crafts, Oakland, 1943-73. Works include bas-reliefs, facade of Giannini Hall, University of California, Berkeley; bas-reliefs, John McLaren Elementary School, San Francisco; drinking fountain, First Congregational Church, Berkeley. Exhibited at University of California, Berkeley; Oakland (California) Art Gallery; San Francisco Museum of Art; San Francisco Art Association Annuals; San Francisco Society of Women Artists; others.

HAYS, GEORGE A.
Landscape painter. Born Greenville, NH, Nov. 23, 1854. Self-taught. Member: Providence Art Club; Copley Society, 1892; Society of Independent Artists; Providence Water Color Club. Specialty: Landscapes with cattle. Address in 1929, Room 42, Woods Bldg., 19 College Street, Providence, RI.

HAYS, HENRY.
This book-plate engraver was an Englishman working in London as early as 1820 at 168 Regent Street. While working on book-plates, Fenshaw says that Hays was located in NY in 1830-55. American book-plates signed by him have been found.

HAYS, PHILIP.
Illustrator. Born in Shreveport, LA, in 1940. He studied with Jack Potter at Art Center College of Design. Shortly thereafter, his free-lance career began in New York with *Seventeen* magazine, one of his first clients. With many record covers and other advertising work to his credit, he has been awarded medals by the Art Directors' Club of NY and the Society of Illustrators. Predominantly executed in watercolor, his works have been used by *Sports Illustrated*, Seagram's Distillers and Columbia Records.

HAYS, WILLIAM JACOB, JR.
Painter. Born in Catskill, NY, July 1, 1872. Pupil of National Academy of Design in NY; Julian and Colarossi academies in Paris. Member: Associate National Academy of Design, 1909; Salma. Club, 1900; American Federation of Arts. Award: Shaw prize, Salma. Club, 1912. Address in 1929, Millbrook, NY.

HAYS, WILLIAM JACOB, SR.
Animal painter. Born in NY, Aug. 8, 1830; died March 13, 1875. He was a pupil of J. R. Smith. Elected an Associate Member of the National Academy of Design in 1852. Represented in Corcoran Art Gallery of Washington, DC, by "head" of a Bull-Dog.

HAYWARD, ALFRED.
Painter and Cartoonist. Born in 1883 in Camden, NJ. Pupil of Penna. Academy of Fine Arts. Member: Fellowship Penna. Academy of Fine Arts; Philadelphia Water Color Club; Philadelphia Sketch Club; Philadelphia Art Club; NY Water Color Club. Award: Dana gold medal, Philadelphia Water Color Club, 1919. Address in 1929, 6642 North 18th Street, Philadelphia, PA. Died in 1939.

HAYWARD, BEATRICE BURT.
(Mrs. Caleb Anthony Hayward, Jr.). Miniature painter. Born in New Bedford, MA, Dec. 17, 1893. Pupil of Delecluse and Mme. La Farge in Paris, Lucia Fairchild Fuller, Elsie Dodge Pattee and Mabel Welch in New York. Address in 1929, 17 Jenny Lind Street, New Bedford, MA.

HAYWARD, F. HAROLD.
Sculptor, illustrator, painter, and teacher. Born in Romeo, MI, June 30, 1867. Pupil of Whistler, Laurens, and Benjamin-Constant in Paris. Address in 1910, Mt. Clemens, MI.

HAYWOOD, MARY CAROLYN.
Painter and illustrator. Born in Philadelphia, PA, Jan. 3, 1898. Pupil of Violet Oakley, Elizabeth S. F. Elliott, Hugh Breckenridge. Member: Philadelphia Alliance; Fellowship Penna. Academy of Fine Arts; Philadelphia Water Color Club; American Federation of Arts. Work: Portrait in the Penna. Academy of

Fine Arts. Address in 1929, 2107 Walnut Street; h. 152 W. Wyoming Avenue, Germantown, Philadelphia, PA.

HAZARD, ARTHUR MERTON.
Painter and teacher. Born in North Bridgewater, MA, Oct. 20, 1872. Pupil of De Camp; Duveneck; Prinet and Henri Blanc in Paris. Member: St. Botolph Club; Copley Society; California Art Club; Salma. Club; Painters of the West. Awards: Medal, Mass. Charitable Mechanics' Assoc., 1892. Work: "Israel, the Light of the Nations," mural decoration, Temple Israel, Boston; "Canadian War Memorial," Houses of Parliament, Toronto; "Spirit of Service," American Red Cross Museum, Washington, DC; "Not by Might" and "Spirit of the Armistice," National Museum, Washington, DC. Died 1930. Address in 1929, Carnegie Hall, 57th Street and 7th Avenue, New York, NY.

HAZELETT, SALLY POTTER.
Painter. Born in Evanston, IL, 1924. Studied: Rollins College; Columbia University; University of Louisville; Inst. of Design, Chicago; Illinois Inst. of Technology. Awards: Fulbright award, 1952. Collection: University of Louisville.

HAZELL, FRANK.
Painter and illustrator. Born in Hamilton, CT, June 7, 1883. Pupil of Art Students League of NY, Alphonse Mucha. Member: Salma. Club; Society of Illustrators, NY Water Color Club; Guild of American Painters; American Water Color Society; Artists Guild of the Authors' League of America, NY; NY Architectural League. Address in 1929, 321 West 112th Street, New York, NY.

HAZELTINE, FLORENCE.
Painter, craftsman, and teacher. Born Jamestown, NY, April 28, 1889. Pupil of Pratt Institute; Fursman, Watson, Garber, Lever, Henry Snell, Bell Cady White. Member: Springfield (IL) AA; WAA. Award: Mallinkrodt prize, St. Louis AG, 1924. Address in 1929, 5610 Bartmer Avenue, St. Louis, MO.

HAZELTON, ISAAC BREWSTER.
Painter and illustrator. Born in Boston, Dec. 30, 1875. Pupil of Tarbell, Benson, De Camp, and W. F. Brown. Member: Artists Guild of the Authors' League of America, NY. Address in 1929, 2 East 23rd Street, New York, NY; h. 33 Rutgers Place, Nutley, NJ; summer, Isle au Haut, ME.

HAZELTON, MARY ISAAC BREWSTER.
Painter and teacher. Born in Milton, MA. Pupil of Edmund C. Tarbell. Member: Copley Society; Guild of Boston Artists; Concord Art Association; Conn. Academy of Fine Arts; American Federation of Art. Awards: First Hallgarten prize, National Academy

of Design, 1896; Paige traveling scholarship, School of Boston Museum of Fine Arts, 1899; hon. mention, Pan-Am. Exp., Buffalo, 1901; bronze medal, P. P. Exp., San Francisco, 1915; Popular Prize, Newport Art Association, 1916. Work: Decoration for chancel, Wellesley Hills Congregational Church, 1912. Address in 1929, 304 Fenway Studios, Boston; h. Wellesley Hills, MA.

HAZEN, BESSIE ELLA.
Painter, etcher, and teacher. Born in Waterford, New Brunswick, CT. Pupil of Columbia Univ., NY; University of California. Member: California Art Club; Print Makers' Society of California; West Coast Arts; California Art Teachers; Arthur W. Dow Foundation; Pacific Art Association. Awards: Second prize for water color, Arizona State Fair, 1916; Second prize for water color and prize for black and white, Arizona State Fair, 1917; second prize for water color, Arizona State Fair, 1919; first prize for realistic painting, Art Teachers Assoc., Los Angeles, 1924; gold medal for water color, West Coast Arts, Inc., 1926. Represented in City Library, Springfield, MA. Died in 1946. Address in 1929, 1042 West 36th Street, Los Angeles, CA.

HAZEN, FANNIE WILHELMINA.
(Mrs. B. F. Ledford). Sculptor and painter. Born in Murphy's Gulch, CA, August 27, 1877. Pupil of Hopkins Institute, San Francisco, and Academie Moderne, Paris. Address in 1933, Los Angeles, CA; summer, Los Gatos, CA.

HAZLEWOOD, PHOEBE W(EEKS).
Painter. Born in Ellendale, ND, Dec. 12, 1885. Pupil of Sarah Hayden. Specialty, glass painting and silhouette cutting. Address in 1929, Redford Gardens, Sackett Harbor, NY.

HAZLITT, JOHN.
Born in England in 1767. He painted portraits in Hingham, MA, and was working in Salem, MA, in 1782, painting both miniatures and large portraits in oil. In 1785 he conducted an Art School in Boston. He was of English birth and returned to England in 1787. He died May 16, 1837.

HAZZARD, SARA.
Miniature painter. Born Jamestown, NY. Pupil of Art Students League of NY; William M. Chase; American School of Miniature Painting. Member: Pennsylvania Society of Miniature Painters; National Association of Women Painters and Sculptors. Address in 1929, Commodore Hotel, New York, NY; h. 516 East Second Street, Jamestown, NY; summer, Lakewood-on-Chautauqua, NY.

HEADE, MARTIN JOHNSON.
Born August 11, 1819, in Bucks County, PA. He began his career as a portrait painter, studied in

Italy, traveled in the west and then settled in Boston as a landscape painter. His studio was later moved to New York. His best known works are "Off the California Coast" and his South American scenes. Died Sept. 4, 1904 in Florida.

HEALY, GEORGE P.A.
Portrait painter. Born in Boston, July 15, 1813; died in Chicago in 1894. Began studies in Paris in 1836. Went to Chicago about 1858 where he had a farm of 50 acres. With his family he went to Europe and remained a long time in Rome. His portraits of distinguished people are numerous. He painted many portraits in Chicago and Washington and for Louis Philippe. He was an honorary member of the National Academy of Design. (See "Reminiscences of a Portrait Painter," by George P. A. Healy.) Died June 24, 1894 in Chicago.

HEATH, EDDA MAXWELL.
Painter, illustrator, and teacher. Born in Brooklyn, NY. Pupil of Pratt Inst., New York; Wm. M. Chase. Member: Brooklyn Society of Artists; Nanuet Painters and Sculptors; Yonkers Art Association; Carmel Art Association; American Artist's Professional League; American Federation of Arts. Address in 1929, care of Babcock Galleries, 5 East 57th Street, New York, NY; h. Rockland Avenue, Park Hill, Yonkers, NY.

HEATH, HOWARD P.
Painter and illustrator. Born in Boulder, CO, Oct. 2, 1879. Pupil of Art Institute of Chicago; Art Students League of NY; Frank Nankivell. Member: Salma. Club; Society of Illustrators, 1911; NY Water Color Club. Address in 1929, Norwalk, CT.

HEATON, AUGUSTUS G(OODYEAR).
Painter. Born Philadelphia, PA, April 28, 1844. Pupil of Cabanel at Ecole des Beaux-Arts (1863) and of Bonnat (1879) in Paris. Member: Philadelphia Sketch Club; Society of Independent Artists; Salma. Club, 1908. Award: Bronze medal, Columbian Exp., Chicago, 1893. Work: "The Recall of Columbus," U.S. Capitol, Washington (engraving on fifty cent postage stamp, Columbian Exp.); "Washington's First Mission," Union League Club, Philadelphia; "Baron Steuben at Valley Forge," War College, Washington; portraits in State Dept. and Navy Dept., Washington, DC; Delaware State House; New York Historical Society; Tulane University; Cornell University; "Hardships of Emigration" engraved on ten cent postage stamp, Omaha Exp. Author: "The Heart of David," "Fancies and Thoughts in Verse," "Mint Marks," and "New National Anthem." Died in 1931. Address in 1929, 1400 South Olive Street, West Palm Beach, FL.

HEAVEN, ETHEL R.
See Hamilton, Ethel Heaven.

HEBALD, MILTON ELTING.
Sculptor and printmaker. Born May 24, 1917, in NYC. Studied: Art Students League with Ann Goldwaithe, 1927-28; National Academy of Design, with Gordon Samstag, 1931-32; Master Institute of United Arts, Inc., NYC, 1931-34; Beaux-Arts Institute of Design, NYC, 1932-35. Work: Bezalel Museum, Calcutta; Museum of Modern Art; Museum of the City of New York; Penna. Academy of Fine Arts; Philadelphia Museum of Art; Tel Aviv; Virginia Museum of Fine Arts; Whitney Museum; Yale Univ.; and commissions, including bronze fountain at 333 E. 79th St., NYC; bronze frieze at Pan-Am Terminal, Kennedy Airport; bronze group, Central Park, NYC; James Joyce Monument, Zurich; and others. Exhibited: ACA Gallery (Prize show), NYC, 1937, 40; Grand Central Moderns, NYC, 1949, 52; Galleria Schneider, Rome, 1957, 63; Lee Nordness Gallery, NYC, 1959-61, 63, 66; Penthouse Gallery, San Francisco, 1966; Gallery of Modern Art, 1966, 68; Virginia Museum of Fine Arts, 1967; Kovler Gallery, Chicago, 1967-68; London Arts; Cincinnati Art Museum; Sculptors Guild; Whitney Museum Annuals, 1937-63; Penna. Academy of Fine Arts, 1938-64; Arte Figurativo, Rome, 1964, 67; Carnegie, 1965. Awards: ACA Gallery Competition Prize, 1937; Brooklyn Museum, First Prize, 1950; Prix de Rome, 1955-59. Taught: Brooklyn Museum School, 1946-51; Cooper Union, 1946-53; Univ. of Minnesota, 1949; Skowhegan School, summers, 1950-52; Long Beach State College, summer, 1968. Address in 1982, Bracciano, Italy.

HEBER, CARL AUGUSTUS.
Sculptor. Born Stuttgart, Germany, April 15, 1875. Pupil of Art Institute of Chicago; Academie Julian, and Ecole des Beaux Arts, Paris. Member: National Sculpture Society, 1904; Philadelphia Alliance. Awards: Bronze medal, St. Louis Exposition, 1904; bronze medal, P.-P. Expos., San Francisco, 1915; prize, American Institute of Architects and T Square joint exhibition, Philadelphia. Work: "Pastoral," St. Louis Museum Fine Arts; "Champlain Memorial," Crown Point, NY; "Champlain Statue," Plattsburgh, NY; "Schiller Monument," Rochester, NY; "Benjamin Franklin," Princeton University; statue "Valor," New York City; Everett Memorial, Goshen, NY; Soldiers and Sailors Monument, Geneva, IL; World War Memorial, Wausau, WI; "Roman Epic Poetry," Brooklyn Museum; "Herald of the Dawn" erected at Batavia, NY. Exhibited at National Sculpture Society, 1923. Died 1956. Address in 1953, Philadelphia, PA.

HEBER, CLAUDIA.
See Smith, Marcella.

HECHT, VICTOR DAVID.
Painter. Born in Paris, France, May 15, 1873. Pupil of Art Students League of NY; Lefebvre and Robert-

Fleury in Paris. Member: National Association of Portrait Painters, NY. Address in 1929, 14 East 60th Street, New York, NY.

HECKMAN, ALBERT WILLIAM.
Painter, etcher and designer. Born in 1893 in Meadville, PA. Studied with Arthur W. Dow. Member: N.Y.S. Ceramic A.; American Institute Graphic A.; Alliance. Address in 1929, Woodstock, Ulster Co., NY.

HEDIAN, HELENA.
Painter. Member: Baltimore Water Color Club. Address in 1929, 2112 Bolton Avenue, Baltimore, MD.

HEE, MARJORIE WONG.
Painter. Born in Honolulu, HI. Studied: University of Hawaii; Honolulu Acad. of Arts; Columbia University Teachers College; Art Students League. Awards: Hawaii Easter Art Festival; Hawaii Ten Bamboo Studio; Hawaii Watercolor and Serigraph Society Annual. Collections: Castle Memorial Hospital; The Hawaii State Foundation on Culture and the Arts.

HEEBNER, ANN.
See McDonald, Mrs. Ann Heebner.

HEERMAN, NORBERT.
Painter and writer. Born in Frankfort-on-the-Main, Germany, May 10, 1891. Pupil of Reynolds in Chicago, Fleury in Paris, Corinth in Berlin, Duveneck in Cincinnati. Member: Cincinnati Art Club; Colorado Springs Art Society. Work: "The Continental Divide" (mural), Evanston School, Cincinnati; "Cameron's Cone, Colorado," Hughes High School, Cincinnati; "Concetta, Capri Coal Carrier," permanent collection, Art Museum, Cincinnati, OH. Author of "Frank Duveneck," a biography. Address in 1929, Woodstock, NY.

HEIDEMANS, HENRI.
Miniature painter who flourished in New York about 1841-42.

HEIL, CHARLES EMILE.
Painter, illustrator, and teacher. Born in Boston, Feb. 28, 1870. Studied in Boston and Paris. Member: Salma. Club; Boston Water Color Club; Society Independent Artists; Boston Society of Water Color Painters; Chicago Society of Etchers; Print Makers' Society of California; Bronx Artists Guild; Brooklyn Society of Etchers; American Federation of Arts. Award: Gold medal for water color, P. P. Exp., San Francisco, 1915. Represented in Worcester (MA) Art Museum; Malden (MA) Public Library; National Gallery, Washington; New York Public Library; Concord Art Association; Chicago Art Institute; Cleveland Museum of Art; Milwaukee Art Institute; Cincinnati Museum; California State Library; Los

Angeles Museum; Print Divison, State Galleries, Munich, Germany; Bibliotheque Nationale, Paris. Address in 1929, 43 Arborough Road, Roslindale, MA.

HEIMER, J. L.
Marine painter. He was known for his many excellent paintings of ships.

HEINDEL, ROBERT ANTHONY.
Illustrator. Born in Toledo, OH, in 1938. He is a graduate of the Famous Artists School. Since moving to NY, he has done illustrations for *Redbook*, *Ladies Home Jornal*, *Time*, *Good Housekeeping* and *Sports Illustrated*. His work has appeared in several books including *Psycho*, *The Grapes of Wrath*, for the Franklin Library, and *Sybil*, for which he received an Award of Excellence from the Society of Illustrators. In addition to a one-man show in NY, his illustrations have been exhibited in Cleveland and at the Smithsonian Institute. He is a founding faculty member of the Illustrators Workshop.

HEINTZ, MARION.
Painter and craftsman. Born in Buffalo, Aug. 16, 1900. Pupil of Buffalo School of Fine Arts. Member: Allied AG. Address in 1929, 80 Hodge Avenue, Buffalo, NY.

HEINTZELMAN, ARTHUR WILLIAM.
Painter, etcher, lecturer, and teacher. Born in Newark, NJ, Nov. 22, 1891. Pupil of RI School of Design; studied in Holland, France, Belgium, Spain, England and Scotland. Member: Chicago Society of Etchers; Providence Art Club; Print Makers' Society of California; California Society of Etchers; Salma. Club; American Federation of Arts; Brooklyn Society of Etchers; American Art Association of Paris; Societe Gravure Originale en Noir, Paris; Associee Societe Nationale Des Beaux Arts. Awards: Logan prize, Art Institute of Chicago, 3 yrs.; Barnett prize, Brooklyn Society of Etchers, 1920; 1st prize, California Society of Etchers, 1921; Noyes prize, Brooklyn Society of Etchers, 1924; Lea prize, Print Club, Philadelphia, 1925. Etchings in Metropolitan Museum, NY; Chicago Art Institute; NY Public Library; Milwaukee Art Institute; Los Angeles Museum; Rhode Island School of Design; Cincinnati Museum; Corcoran Gallery, Washington, DC; Bibliotheque Nationale, Paris; Victoria and Albert Museum, South Kensington, London; British Museum, London. Address in 1929, care of Frederick Keppel & Co., 16 East 57th Street, NY; 20-22 Route de la Croix, Le Vesinet (S&O), FR.

HEINZ, CHARLES LLOYD.
Painter and craftsman. Born in Shelbyville, IL, Jan. 8, 1885. Pupil of R. M. Root; St. Louis School of Fine Arts; Chicago Academy of Fine Arts; Miller and Hawthorne, Cape Cod School of Art. Member:

Illinois Academy of Fine Arts; All-Ill. Society of Fine Arts. Awards: Ten first and seven second prizes at Indiana State Fair, Indianapolis; two second prizes, State Fair, Springfield, IL. Died c. 1955. Address in 1929, Shelbyville, IL; summer, Provincetown, MA.

HEINZE, ADOLPH.
Painter. Born in Chicago, Feb. 5, 1887. Pupil of Buehr, Grant and Snell. Member: Painters and Sculptors of Chicago; Chicago Galleries Assoc.; All-Ill. Society of Fine Arts. Awards: Municipal Art League prize, 1927; prize ($200) Chicago Galleries Assoc., 1927. Work: "The Cloud Break," John Marshall High School, Chicago; "Booth Bay Harbor," Downers High School, IL; second prize award for "Mt. Wilbur," presented to America Forks High School, Utah, 1929. Address in 1929, 209 South State Street, Chicago, IL; h. 106 North Main Street, Downers Grove, IL.

HEINZMANN, SAMILLA LOVE JAMESON.
(Mrs. Heinzmann). Sculptor, painter, illustrator, and cartoonist. Born in Indianapolis, IN, April 22, 1881. Pupil of Chicago Art Institute; Detroit Fine Arts Academy; Carnegie Institute of Technology; De Lug in Vienna. Work: Thomas Paine Memorial Tablet, NYC; Henry Hudson Tablet, Amsterdam, Holland. Member: Society of Independent Artists; Institute of Arts and Sciences. Address in 1953, The Willow Bridge Studio, Princess Bay, Staten Island, NY.

HEITER, MICHAEL M.
Painter and illustrator. Born in New York City, Sept, 15, 1883. Pupil of W. L. Taylor, O. Rouland, M. H. Bancroft, Sigurd Skou. Member: Artists Guild of the Authors' League of America, NY; Bronx Artists Guild; Society of Independent Artists. Address in 1929, 116 West 39th Street, New York, NY; h. Scarsdale, NY.

HEITLAND, WILMOT EMERTON.
Painter and illustrator. Born Superior, WI, July 5, 1893. Pupil of Penna. Academy of Fine Arts, Garber, Beaux, Briggs, etc. Member: Philadelphia Water Color Club; NY Water Color Club; American Water Color Society; Aquarellists; Fellowship Penna. Academy of Fine Arts; Society of Illustrators; Darien Guild of the Seven Arts. Awards: Cresson Traveling Scholarship, Penna. Academy of Fine Arts, 1913; Art Directors medal, 1921; Dana gold medal, Philadelphia Water Color Club, 1922; Brown and Bigelow Purchase prize, Art Institute of Chicago, 1923; Logan medal, Art Institute of Chicago, 1924; prize, Philadelphia Water Color Club, 1924; prize, Baltimore Water Color Club, 1925; gold medal, Philadelphia Art Week, 1925. Work: "The Shanty, Tampa Bay" and "The Road to Chester," Art Institute of Chicago; "The Jungle, Santo Domingo" and "San Geromino, S.D.," Brooklyn Museum. Illustrator of "Ambling through Arcadia," by C. H. Towne. Illustrator for

Century, Collier's, Woman's Home Companion, McCalls, Cosmopolitan, Delineator, Ladies Home Journal, New Yorker, Liberty, and *Harper's Bazaar.* Instructor of illustration, Art Students League, New York. Address in 1929, "Buttonwood," Noroton Heights, CT.

HEKKING, WILLIAM M.
Painter, writer, lecturer, and teacher. Born Chelsea, WI, March 10, 1885. Pupil of Laurens; Richard Miller; Art Students League of NY; Julian Academy, Paris. Member: Salma. Club; American Federation of Arts. Awards: Gold medal, Kansas City Art Institute, 1922; Huntington prize ($200), Columbus Society of Artists, 1924; first prize, Wilmington Society of Artists, 1926. Director, Buffalo Fine Arts Association, Albright Art Gallery. Address in 1929, Albright Art Gallery; h. 2 Saybrook Place, Buffalo, NY; summer, Monhegan Island, ME.

HELBIG, MARGARET A.
Painter and teacher. Born Leesville, VA, Nov. 8, 1884. Pupil of John Carlson, Henry B. Snell. Member: Lynchburg Art Club. Work: "Phlox," Randolph-Macon Woman's College, Lynchburg, VA. Address in 1929, 701 Floyd Street, Lynchburg, VA.

HELCK, C. P.
Painter. Exhibited at National Academy of Design, New York, in 1925. Address in 1926, 256 West 55th Street, New York.

HELCK, PETER.
Illustrator. Born in NYC in 1893. He studied at the Art Students League and in England as a pupil of Frank Brangwyn. In 1911 he did advertising art for NY department stores and later editorial illustration for major magazines. His first love was the automobile, and he would often leave his studio in Benton Corners, NY, to take motor trips across Europe. In 1961 he published *The Checkered Flag,* a collection of his race drawings. A member of the Society of Illustrators Hall of Fame, he is also a founding faculty member of the Famous Artists School.

HELD, AL.
Painter. Born in NYC, Oct. 12, 1928. Studied at Art Students League, 1948-49; Academie de la Grande Chaumiere, 1949-52. Exhibited: Guggenheim Museum, 1966; Jewish Museum, 1967; Documenta IV, Kassel, West Germany, 1968; one-man shows at the San Francisco Museum of Art, 1968, Corcoran Gallery of Art, 1968, and the Andre Emmerich Gallery, NY, 1975; retrospective, Whitney Museum of Art, NYC, 1971, and Emmerich Gallery, Zurich, Switzerland, 1977; numerous others. Taught art at Yale University, 1962-78; as an adjunct of painting, 1978. Awards: Logan Medal, from the Art Institute, Chicago, 1964; Guggenheim Foundation Fellowship, 1966. Commissioned by NY State to paint 90-foot

wide "Albany Mural" in the Empire State Plaza, Albany, NY. Address in 1982, Dept. of Painting and Printmaking, Yale University School of Art, New Haven, CT.

HELD, ALMA M.
Painter and teacher. Born in Iowa, Dec. 16, 1898. Pupil of Charles A. Cumming; National Academy Design. Member: National Association of Women Painters and Sculptors; Iowa Artists Guild. Awards: Silver medal, Iowa State Fair and Exposition, 1925; gold medal, Iowa State Fair and Exposition, 1926. Address in 1929, 623 West Eighth Street, Waterloo, IA.

HELD, JOHN, JR.
Illustrator. Born in Salt Lake City, Utah, January 10, 1889. Pupil of M. M. Young. Work: Murals, Milton Point Casino; illustrated *Adventures of Baron Munschausen, Christopher Columbus*, etc. Moved to NYC about 1910. Began his career as sports cartoonist; illustrations of stylized flappers in 1920's, 30's; cartoon strips, "Margie" and "Ra, Ra Rosalie," 1930's. Later concentrated on sculpting and ceramics; artist-in-residence, Harvard and Univ. of Georgia. Died 1958. Address in 1929, Westport, CT; Palm Beach, FL.

HELD, PHILIP.
Painter and photographer. Born in NYC, June 2, 1920. Studied: Art Students League, 1938-42 & 46, with Kuniyoshi, Fiene, Blanch, Lee, Vytlacil; School of Art Studies, NYC, with Moses Soyer, 1947-48; Columbia Univ. Teachers Coll., serigraphy with Arthur Young, 1949. Work: Univ. of MA; The Berkshire Museum; Philadelphia Museum Lending Library; Art Students League Collection; others. Exhibitions: Berkshire Museum; Penna. Academy of Fine Arts; Philadelphia Museum; Pleiades Gallery, NYC, 1978 - 80; many more. Awards: Kleinhert Foundation Grant; Sarasota Art Assoc.; etc. Teaching: Scarborough (NY) School, 1947-52; Fieldstone School, Riverdale, NY, 1952-62; Booker-Bay Haven Sch., Sarasota, FL, 1971-78; etc. Member: Art Students League (life); Woodstock Artists Assoc.; Florida Art League; etc. Media: Oil. Address in 1982, Sarasota, FL.

HELDER, Z. VANESSA.
Painter. Born in Lynden, WA, in 1904. Studied: University of Washington; Art Students League, with Robert Brackman, George Picken and Frank DuMond. Exhibited: Seattle Art Museum, Spokane Art Center, Los Angeles Art Museum, Kramer Gallery, all one-man; Museum of Modern Art; Metropolitan Museum of Art; Whitney; Hartford Atheneum; Penna. Academy of Fine Arts; many other museums throughout the U.S. Awards: Pacific Coast Painters and Sculptors, 1936, 1939; Women Painters of Washington, 1937; Seattle Art Museum;

Women Painters of the West, 1946; Pen and Brush Club, 1947; Greek Theatre, Los Angeles, 1948; National Orange Show, 1949; Ramona High School, 1953; Glendale Art Association, 1955; California State Fair, 1949. Collections: Seattle Art Museum; Newark Museum; High Museum of Art; IBM; American Academy of Arts and Letters; Eastern Washington State College; Lynden Washington Public Library; Spokane Art and History Museum; Coulee Dam Building; Glendale Art Association. Member: International Institute of Arts and Letters (life fellow); Baltimore Water Color Society; Glendale Art Association. Address in 1961, Los Angeles, CA.

HELDNER, KNUTE.
Painter, writer, and teacher. Born June 10, 1884. Studied in Sweden, and at the Art Inst. of Chicago and Minn. School of Fine Arts. Address in 1929, 212 W 1st St.; h. 123 W Superior St., Duluth, MN.

HELENE, SISTER.
Sculptor, painter, teacher, writer, and craftswoman. Born in Alameda, CA. Studied at Siena Heights College, A.B.; Art Institute of Chicago; Claremont Graduate Art Seminar; Cranbrook Academy of Art, M.F.A.; and abroad. Member: American Artists Professional League; Stained Glass Association of America; American Federation of Arts; College Art Association of America. Work: Bronze doors, figures, stained glass and murals for churches. Exhibited: Institute of Modern Art, Boston, 1944; Detroit Institute of Art, 1939, 42, 45; Catholic Art Association, 1938-42; Cranbrook Museum; Des Moines Art Center; Springfield Museum of Art; Saginaw Museum of Art; Sioux City Art Center. Contributor to Catholic Art Quarterly; Stained Glass Quarterly; American Apostolate, research film strip for metal designers. Position: Director, Studio Angelico, Adrian, MI, from 1935; Comm. of the Arts, Association American College, 1945-52, Faculty Advisor, from 1952. Address in 1953, Adrian, MI.

HELLER, EUGENIE M.
Sculptor, painter, cartoonist, and lithographer. Born in Rushville, IL. Pupil of J. Alden Weir in New York; Aman-Jean, Grasset and Whistler in Paris. Rep. by woodcuts in the Art Gallery, Lindsborg, KS; Illinois State Art Gallery, Springfield; Grosvenor Library, Buffalo, NY; Brooklyn Museum. Award: Silver medal, Philadelphia Art Assoc., 1903. Address in 1933, Brooklyn, NY.

HELLER, HELEN WEST.
Painter, illustrator, etcher, craftsman, writer, and lithographer. Born in 1872, in Rushville, IL. Represented by woodcuts in the Art Gallery, Lindsborg, Kansas; Illinois State Art Gallery, Springfield. Author of the poem "Migratory Urge," with text cut in wood. Died 1955. Address in 1929, Wisconsin Hotel, 226 Wisconsin Street, Chicago, IL.

HELLMAN, BERTHA LOUISE.
Painter and teacher. Born in La Grange, TX, Jan. 30, 1900. Pupil of Rice Institute; Penna. Academy of Fine Arts. Member: Southern States Art League; Fellowship Penna. Academy of Fine Arts. Awards: Prize for black and white drawing, Southern States Art League, Houston, TX, 1925; silver medal, Southern States Art League, San Antonio, 1929. Address in 1929, 1616 Main Street; h. 2402 Jackson Street, Houston, TX; summer, La Grange, TX.

HELM, JOHN F., JR.
Painter, etcher, and teacher. Born in Syracuse, NY, Sept. 16, 1900. Pupil of F. Montague Charman. Member: Baltimore Water Color Society; North West Print Makers. Address in 1929, Dept. of Architecture, Kansas State Agricultural College; h. 1508 Humboldt, Manhattan, KS.

HELMICK, HOWARD.
Painter, etcher, and illustrator. Born in Zanesville, OH, in 1845. Studied in Paris and London. Member of British Artists and Royal Society of Painters and Etchers. He was a professor of art at Georgetown University. He died at Washington, DC, on April 28, 1907.

HELOK, C. PETER.
Painter, illustrator, and etcher. Born in New York City, June 17, 1893. Pupil of W. de Leftwich Dodge, Frank Brangwyn. Member: Salma. Club; American Water Color Society. Address in 1929, 206 East 33d Street, New York, NY; h. 90 Caryl Avenue, Yonkers, NY.

HELWIG, ALBERT METTEE.
Illustrator. Born in Baltimore, MD, Sept. 27, 1891. Pupil of C. Y. Turner and Henry B. Snell, and Maryland Inst. School of Art. Member: Charcoal Club. Address in 1929, 918 Equitable Bldg., Fayette and Calvert Streets; h. 1223 East North Avenue, Baltimore, MD.

HELWIG, ARTHUR.
Painter. He exhibited the "Black Canyon, Colorado," at the exhibition held at the Cincinnati Museum in 1925. Address in 1926, 323 Elland Circle, Cincinnati, OH.

HEMBERGER, ARMIN BISMARCK.
Illustrator, etcher, and lecturer. Born in Scranton, PA, April 1, 1896. Pupil of Maryland Institute; Max Brodel. Member: New Haven Paint and Clay Club. Medical illustrator, School of Medicine, Yale University. Address in 1929, School of Medicine, Yale University; h. 10 Prospect Place, New Haven, CT.

HEMENWAY, ALICE SPAULDING (MRS.).
Sculptor, painter, teacher, and lecturer. Born in Dedham, MA, April 9, 1866. Studied at Mass. School of Art; Rhode Island School of Design; and abroad. Member: Tampa Civic Art Club; American Federation of Arts; Florida Federation of Arts. Awards: Medal, Mass. School of Art. Work: Tampa Art Institute, Hillsboro Masonic Lodge, Children's Home, YWCA, Public School, all in Tampa, FL; Boston Art Club. Exhibited: Paris Salon; Rhode Island School of Design; Tampa Art Institute; Tampa Civic Art Club; Boston Art Club (one-woman). Address in 1953, Tampa, FL.

HEMING, ARTHUR.
Illustrator and writer. Born in Paris, Ontario, Canada, Jan. 17, 1870. Pupil of Frank Brangwyn, Frank V. DuMond. Member: Society of Illustrators; Arts and Letters Club of Toronto. Awards: Gold medal for best work, bronze medal for best illustrations and MacLean prize for illustration, Canadian Society of Graphic Arts, 1926. Represented in Canadian National Gallery; 10 pictures in the Royal Ontario Museum. Author and illustrator, "Spirit Lake," "The Drama of the Forests" and "The Living Forest." Address in 1929, 771 Yonge Street, Toronto, Canada; summer, Old Lyme, CT.

HEMINGWAY, GRACE HALL.
Painter, lecturer, and teacher. Born in Chicago, IL, June 15, 1872. Pupil of Art Institute of Chicago; Florida Art School; Leon Kroll; Carl Krafft; Karl Buehr; Anna Lee Stacey. Member: Chicago Society of Artists; All-Illinois Society of Fine Arts; All-Michigan Society of Fine Arts; Oak Park Art League. Address in 1929, 600 North Kenilworth Avenue, Oak Park, IL; summer, "Windemere," Walloon Lake, MI.

HEMPSTEAD, JOSEPH LESLIE.
Painter and etcher. Born in Brooklyn, NY, Feb. 3, 1884. Member: Chicago Art Club. Work: "Lincoln," owned by Illinois State Historical Library; "Coolidge," owned by Former President Coolidge; "Lincoln," "Washington," "Jefferson," "Hamilton" and "Coolidge," Congressional Library, Washington, DC; "Hamilton and "Jefferson," Chicago Historical Society. Address in 1929, Tree Studio Bldg., 10 East Ohio Street, Chicago, IL.

HENDERSON, A. ELIZABETH.
Miniature painter. Born in Ashland, KY, in 1873. Pupil of Art Students League of New York. Address in 1926, 79 Hamilton Place, NY.

HENDERSON, EVELYN.
Painter. Born in Cape Ann, MA. Pupil of Guerin; Le Beau. Member: San Francisco Society of Women Artists; Society Internat'l Des Beaux Arts et Des Lettres. Address in 1929, 133 Marion Avenue, Mill Valley, CA.

HENDERSON, HARRY V. K.
Painter and artist. Born in Poughkeepsie, NY, March 6, 1883. Pupil of Pratt Institute, Brooklyn. Member: Am. Water Color Society; Architectural League of NY; American Institute of Architects; Soc. of Beaux-Arts Arch. Address in 1929, 40 West 40th Street; h. 29 West 8th Street, New York, NY.

HENDERSON, HELEN WESTON.
Painter. Born in Philadelphia in 1874. Studied at Pennsylvania Academy of Fine Arts, 1892-97; Academie Colarossi, Paris. Art and music editor of *Philadelphia North American*, 1900-04; art editor of *Philadelphia Inquirer*, 1904-09.

HENDERSON, JOHN R.
Sculptor, painter, and printmaker. Active in Denver, Colorado, 1893-98. Charter member of the Artists Club. Work in Denver Public Library (sketches and woodblocks). Head modeled in relief exhibited in 1898.

HENDERSON, WILLIAM PENHALLOW.
Mural painter and teacher. Born in Medford, MA, 1877. Pupil of Boston Museum School under Tarbell. Holder of Paige traveling scholarship, Boston Museum School. Member: Denver Art Association. Work: "The Green Cloak;" series of Indian dance pastels, Art Institute of Chicago; Marquette and Joliet mural decorations, High School, Joliet, IL; "Felipe de los Valles," Denver Art Association. Died 1943. Address in 1929, care of the Cliff Dwellers, Orchestra Hall, Chicago, IL; Santa Fe, NM.

HENDRICKS, EMMA STOCKMON.
(Mrs. H. G. Hendricks). Painter, writer, lecturer, and teacher. Born Solano County, CA, Sept. 1, 1869. Pupil of Mon. Campoin, Gerald Cassidy, Jose Arpa. Member: Amarillo Art Association; Southern States Art League; Texas Fine Arts Association; American Federation of Arts. Award: First prize, Cotton Palace Exposition, Waco, TX, 1927. Work: "Palo Duro Canyon," Library, Amarillo, TX. Address in 1929, 2212 Polk Street, Amarillo, TX.

HENDRIX, CONNIE SUE.
(Connie Sandage Manus). Painter. Born in Mt. Ayr, IA, May 30, 1942. Studied: Drake University, Des Moines, Iowa. Awards: Tennessee Watercolor Society, 1973; National Bank of Commerce, 1973; Central South Art Exhibition, 1973. Collections: Foothills Art Center, Golden, Colorado; Union Planters National Bank; Commercial and Industrial Bank. President of the Tennessee Watercolor Society, 1975. Address in 1980, 1408 Flamingo St., Memphis, TN.

HENGLE, WALTER VANDEN.
Painter. Exhibited water colors at the Penna. Academy of Fine Arts, Philadelphia, 1925. Address in 1926, 2095 North 63rd Street, Philadephia.

HENKE, BURNARD ALBERT.
Painter and illustrator. Born Cologne, Germany, April 25, 1888. Pupil of Guy Rose. Member: California Art Club. Address in 1929, 1497 Sunset Avenue, Pasadena, CA.

HENKORA, LEO AUGUSTA.
Painter, illustrator, etcher, lecturer, and teacher. Born in Vienna, Austria, Aug. 10, 1893. Pupil of Anthony Angarola and Cameron Booth. Member: Society of Independent Artists; Nat. AA; American Artists Professional League; American Federation of Arts. Awards: First Prize, MN State Fair, 1924; second prize, portraiture, second prize, Batik decoration, MN State Fair, 1928. Address in 1929, 1435 East Franklin Street, h. 3029 Dupont Avenue, S., Minneapolis, MN.

HENNEMAN, VALENTIN.
Sculptor, painter, etcher, lecturer, and teacher. Born in Oost-Camp, Belgium, July 7, 1861. Studied in Belgium, Germany, Italy, France. Work: "The Decline of Illiteracy in Belgium," "The Shepherd," "Storm in the North Sea," "Moonlight on the Atlantic," owned by the Belgian Gov.; "Liniken Bay," Museum of Bruges; "View at Southport," City Hall, Bruges; portrait of Baron L. de Bu de Westvoorde, City Hall Oost-Camp. Three hundred portraits of noted Belgians. Known as the "Snow Sculptor." Instructor, in portrait, Bangor Society of Art. Died 1930. Address in 1929, Bangor, ME; summer, Boothbay Harbor, ME.

HENNESSY, WILLIAM JOHN.
Painter. Born July 11, 1839, in Thomastown, Ireland. Entered the National Academy in 1856, and was elected an Academician in 1861. He went to London in 1870. Genre painting and illustrating were his chief interest. Among his works, "On the Sands," "Autumn," "The Votive Offering," "Flowers of May." He died Dec. 26, 1917, in NYC.

HENNING, ALBIN.
Illustrator. Born in Oberdorla, Germany, in 1886. He was raised in St. Paul, MN. A student of Harvey Dunn at the Art Institute of Chicago, he also attended the Grand Central School of Art in NY. Adventure illustration was his specialty, resulting in many assignments for boys' stories in publications such as *American Boy* and *Boys Life*. He was most remembered, however, for his exciting paintings of World War I subjects, some of which appeared in *The Saturday Evening Post*.

HENNINGS, E. MARTIN.
Painter. Born in Pennsgrove, NJ, Feb. 5, 1886. Pupil of Art Institute of Chicago; National Academy, Munich. Member: Art Institute of Chicago; Taos Society of Artists; Painters and Sculptors of Chicago; Chicago Galleries Association; Chic. Cliff Dwellers;

Salma. Club; American Federation of Arts. Awards: Englewood Woman's Club prize, 1916, Clyde M. Carr prize, 1922, Fine Arts Building prize, 1922, 26, Cahn prize, 1923, Frank prize, 1927, all from Art Institute of Chicago; Palette and Chisel Club gold medal, 1916; Lippincott prize, Penna. Academy of Fine Arts, 1925; Isidor medal, National Academy of Design, 1926; Ranger purchase, National Academy of Design, 1926; hon. mention, Paris Salon, 1927; first prize, Texas Wild Flower Competition ($3000), 1929; prize, Chicago Galleries Assoc., 1929. Represented by "Stringing the Bow," Harrison Gallery, Los Angeles Museum; Chicago Municipal Collection; "Announcements," Temple Collection, Penna. Academy of Fine Arts; "Passing By," Museum of Fine Art; Houston, TX; "Drying Nets," State Collection, Springfield, IL. Address in 1929, Tree Studio Bldg., 4 East Ohio Street, Chicago, IL.

HENRI, MRS. ROBERT.
See Organ, Marjorie.

HENRI, PIERRE.
Miniature painter who flourished in Philadelphia about 1790-1812. He painted Mrs. Beaumont in the character of "The Grecian Daughter," Penna. Academy, 1811.

HENRI, ROBERT.
Painter. Born in Cincinnati, OH, June 24, 1865. Studied at Penna. Acad. of Fine Arts, Philadephia, 1886-88; Academie Julien and Ecole des Beaux Arts, Paris, 1888-91. He studied without instruction for years, in France, Spain, and Italy. His picture "La Neige" was purchased from the Salon, 1899, by the French Government for the Luxembourg Gallery; represented in permanent collections of Carnegie Institute, Pittsburgh; Art Inst., Chicago; Columbus, Ohio, Fine Arts Gallery; New Orleans Art Assoc.; City of Spartanburg, SC; Dallas Art Association; Penna. Academy of Fine Arts; Brooklyn Institute Museum; Art Institute, Kansas City; Carolina Art Association, Charleston, SC; Metropolitan Museum of Art, New York; San Francisco Institute of Art; National Arts Club, NY; Minnesota Institute of Arts; Fine Arts Academy, Buffalo; Cincinnati Museum; Detroit Institute; City Art Museum, St. Louis; Butler Art Institute; others. Member: Associate National Academy of Design, 1904; National Academy of Design, 1906; Society of American Artists, NY, 1903; National Association of Portrait Painters; National Arts Club (life); American Painters and Sculptors; Taos Society of Artists; Los Angeles Modern Art Society; Independent Artists; Boston Art Club; New Society of Artists; Art Students League; and National Institute of Arts and Letters. Address in 1926, 10 Gramercy Park, NY. Died in NYC in 1929.

HENRICH, JEAN MacKAY.
See MacKay, Jean V.

HENRY, ALBERT P.
Sculptor. Born Versailles, KY, in 1836. His first art work, as a boy, was a carving from marble of an Indian girl holding a dove while a wolf creeps up to snatch the bird from her grasp. He modeled small portrait busts and cast them in iron for door stoppers. At the beginning of the Civil War, young Henry recruited a company of the Fifteenth Kentucky Cavalry. He was captured and taken to Libby Prison. While in prison he devoted much of his time to carving oxen bones used for making soup. He smuggled some from the prison including "The Prisoner's Dream," showing the interior of a cell, an armed sentry at the door, while the prisoner is sleeping on the floor. Following the close of the war he was appointed consul at Anconia, Italy. Prior to his leaving the US he had executed his bust of Henry Clay, now in the Capitol at Washington, and a bust of Abraham Lincoln from life, now in the Custom House, in Louisville, KY. He studied in Florence, Italy under Powers and Joel T. Hart. His most ambitious work was an ideal bust of Genevieve. He also made one of Senator Guthrie, of Kentucky, and a bust of Senator Garrett Davis. Died Nov. 6, 1872.

HENRY, COAH.
Painter and teacher. She was born in Hamilton, MO, in 1878. Pupil of H. B. Snell. Member: Kansas City Society of Artists; National Association of Women Painters and Sculptors; American Federation of Arts. Work: "The Footbridge after Rain," Newark Museum of Art. Address in 1929, 2718 Linwood Blvd., Kansas City, MO.

HENRY, EDWARD LAMSON.
Born in Charleston, SC, Jan. 12, 1841. Pupil of Penna. Academy of Fine Arts, and of Gleyre in Paris. Lived in Paris, Rome, and Florence from 1800 to 1863. Sketched and studied with the armies in Virginia during the Civil War. Elected National Academician in 1869. His special gift lay in the line of American genre, and he painted scenes from real life with a keen eye for character. He is represented in the Metropolitan Museum in NY, and the Corcoran Art Gallery, Washington, DC. He died in Ellenville, NY, May 11, 1919.

HENRY, JOHN.
The name of "John Henry, Engraver," appears in the Philadelphia directory for the one year of 1793, and he was engraving well-executed business cards in that city. In 1818 he was working for Baltimore publishers, and in 1828 he was engraving the illustrations for Madame Mothe Guion's "Die Heilige Liebe Gottes," published in Lancaster, PA. He may have had some connection with William Henry of Lancaster, member of the Continental Congress and prominent in revolutionary affairs. In support of this suggestion we find that a John Henry was a pupil at the Franklin College, in Lancaster, in 1787.

HENSCHE, HENRY.
Painter. Born in Chicago, IL, Feb. 20, 1901. Pupil of C. W. Hawthorne. Member: Salma C. Exhibited in the Annual Exhibition (1925) of the Nat. Academy. Address in 1929, Provincetown, MA.

HENSHAW, ANNE BIGELOW.
Painter and craftsman. Born in Providence, RI. Pupil of William C. Loring, Henry Hunt Clark. Member: Providence Art Club; Newport Art Association; Boston Society of Arts and Crafts. Address in 1929, 8 Champlin Street, Newport, RI.

HENSHAW, GLEN COOPER.
Painter. Born in Windfall, IN, 1881. Pupil of Bonnat and Jean Paul Laurens in Paris. Address in 1929, 66 West 93rd Street, New York, NY.

HENSHAW, JULIA.
See Dewey, Julia Henshaw.

HENTZ, N. M.
Engraver. A large and very well executed etching of an "American Alligator" appears in Vol. 11 of the *Transactions of the American Philosophical Society,* Philadelphia, 1825. This plate is signed "N. M. Hentz Del & Sculp." and illustrates an article by Hentz on the American alligator presented to the society on July 21, 1820.

HENWOOD, MARY R.
Miniature painter. She exhibited at the Penna. Academy of Fine Arts, Philadelphia, in 1925. Address in 1926, 3219 W Penn St., Philadelphia.

HEPBURN, CORDELIA.
(Mrs. Paul Cushman). Sculptor. Member: National Association of Women Painters and Sculptors. Address in 1924, 630 Park Ave., NYC.

HEPBURN, NINA MARIA.
Painter. She exhibited water colors at the Penna. Academy of Fine Arts, Philadelphia, in 1925. Address in 1926, Freehold, NJ.

HEPWORTH, BARBARA.
Sculptor. Born in Wakefield, Yorkshire, England, in 1903. Studied at Leeds School of Art and at the Royal College of Art in London, spent three years in Italy studying carving under Ardini. Exhibitions: London, 1928; XXV Venice Biennale, 1950; Whitechapel Art Gallery, London, 1954; V Sao Paulo Biennial, 1959; numerous open air international sculpture exhibitions in London, 1949-57. Awards: Second prize in the inter. sculpture competition for the work entitled "The Unknown Political Prisoner;" and the sculpture prize at Sao Paulo in 1959. Works are represented in the Museum of Modern Art, NY; Kroller-Mueller Museum, Holland; Tate Gallery, London; and many others. Commissions: Festival of Britain,

1951; "Vertical Forms" for the Technical College at Hatfield; and "Meridian," for the State House in London.

HERBERT, JAMES DRUMMOND.
Sculptor, painter and advertising art director. Born in New York, December 26, 1896. Studied at Columbia University; Art Students League; Julian Academy, Paris. Pupil of Bridgman, DuMond, Hayes, Miller, Lentelli. Member: Art Students League of NY; National Arts Club; Society of Illustrators; National Sculpture Society. Exhibited at National Academy of Design; Penna. Academy of Fine Arts; Art Institute of Chicago; Architectural League; Art Directors Club. Address in 1953, 53 East 10 Street, New York, NY. Died 1970.

HERBERT, LAWRENCE.
Engraver. The *Pennsylvania Gazette,* in 1748, contains the following advertisement: "Engraving on Gold, Silver, Copper, or Pewter, done by Lawrence Herbert, from London, at Philip Syng's, Goldsmith, in Front Street." In 1751 Herbert apparently left Philadelphia, as on August 1st of that year he requested persons having any demands upon him to present them at the home of Peter David, in Second Street, Philadelphia.

HERBST, FRANK C.
Illustrator. Member: Society of Illustrators. Address in 1929, 152 LaFayette Street, Newark, NJ.

HERDLE, GEORGE LINTON.
Painter. Born in Rochester, NY, in 1868. Studied in Holland and in Paris. Member: Rochester Art Club; Rochester Municipal Art Commission. Director, Memorial Art Gallery of Rochester University. Address: 47 Clinton Avenue, Rochester, NY. Died Sept 22, 1922, in Rochester.

HERFORD, OLIVER.
Illustrator. Illustrated for the *Ladies Home Journal.* Died 1935. Address in 1929, 142 E 18th St., NY, NY.

HERGESHEIMER, ELLA SOPHONISBA.
Painter. Born in Allentown, PA. Pupil of Penna. Academy of Fine Arts under Cecilia Beaux and Chase; Prinet and Mucha in Paris; and in Italy and Spain. Member: Fellowship Penna. Academy of Fine Arts; Nicholson Art League, Knoxville; Nat. Arts Club; Alliance; Am. Fed. of Arts. Awarded traveling scholarship, Penna. Acad. of Fine Arts; hon. mention, So. States Art League, 1922; gold medal for portrait, Appalachian Expo., Knoxville, 1910; first prize, Tenn. State Expo., 1924; first prize, So. States Art League, 1925; first prize for portrait, first prize for still life, and first prize for flower study, Tenn. State Expo., 1926. Dir. of art schls. in Tenn. and Kentucky. Died 1943. Address 1929, 803 Board St., Nashville, TN; summer, 435 Windsor St., Reading, PA.

HERING, ELSIE WARD.
Sculptor. Born August 29, 1872, in Howard County, MO. Studied in Denver, CO, and at Art Students League. Pupil of Augustus Saint-Gaudens. She and her husband became his assistants. Member: Denver Art Club and National Sculpture Society. Exhibited at Nat. Sculpture Soc., 1923. Work: Schermerhorn memorial font in Chapel of Our Savior, Denver, CO; W.C.T.U. drinking fountain, St. Louis Museum. Received awards at SC Exposition, 1902; Louisiana Purchase Exposition, St. Louis, 1904. Specialty was portraits, busts, reliefs. Died NY, Jan. 12, 1923.

HERING, HARRY.
Painter. Born in NYC, Jan. 12, 1887. Member: Brooklyn Water Color Club; Alliance; Nat. Sculpture Soc. Address in 1929, 324 E 23rd St., NY, NY; h. 8507 Norwich Ave., Jamaica, LI, NY.

HERING, HENRY.
Sculptor. Born in New York City, February 15, 1874. Pupil of Augustus Saint-Gaudens, 1900-07; studied at Cooper Union, 1888-91; with Philip Martiny, 1891-97; at Art Students League, 1894-98; at Ecole des Beaux-Arts and Colarossi Academy, Paris, 1900-01. Member: New York Architectural League, 1910; National Sculpture Society, 1913; Am. Federation of Arts. Awards: Silver medal for medals and bronze medal for sculpture, P.-P. Expo., San Francisco, 1915. Work: Civil War Memorial, Yale University, New Haven; Robert Collyer Memorial Church of Messiah, NYC; sculpture on Field Museum of Natural History, Chicago; the two South Pylon groups, "Defense" and "Regeneration," Michigan Avenue Bridge, Chicago; "Pro Patria," Indiana State War Memorial; Federal Reserve Banks at Dallas, Kansas City, Chicago, Cleveland, Pittsburgh, and Clarksburg, West VA. Exhibited at Nat. Sculpture Society, 1923. Died January 17, 1949, in New York City. Address in 1933, Waldorf Building, 10 West 33rd Street; h. Hotel White, 37th Street and Lexington Avenue, New York, NY.

HERMAN, LEONORA OWSLEY.
Painter and etcher. Born in Chicago, July 2, 1893. Pupil of Simon, Menard, Helleu, Leon in Paris. Member: Phila. Alliance; Fellowship Penna. Academy of Fine Arts. Specialty, decorative murals. Address in 1929, 740 Beacon Lane, Merion, Philadelphia, PA.

HEROLD, DON.
Illustrator. Born in Bloomfield, IN, in 1889. Address in 1926, Bronxville, New York.

HERRICK, HUGH M.
Painter. Born Rocky Ford, CO, May 8, 1890. Pupil of William Forsyth, E. Roscoe Shrader. Member: CA. Art Club. Address in 1929, 119 So. Kingsley Dr., Los Angeles, CA.

HERRICK, MARGARET COX.
Painter. Born in San Francisco, CA, June 24, 1865. Pupil of Carlsen, Fred Yates, Arthur Mathews, and Mary C. Richardson; Art Students League of NY and San Francisco; studied in Europe. Member: San Francisco Art Association. Work: Lunette in YMCA, Oakland, CA; portrait of Rev. J. K. McLean, First Congregational Church; two canvases, Piedmont Community Church; Portrait, President Hoover, for Convention, hung in Convention Hall, Kansas City; Portrait, Col. Charles Lindbergh, Veteran's Home, Livermore, CA. Specialties, portraits, flowers, still life. Address in 1929, 312 Pacific Ave., Piedmont, CA.

HERRING, FREDERICK WILLIAM.
Son of the artist James Herring, he was born in New York City in 1821, and studied art with his father and Henry Inman. Devoted his attention to portrait painting. Died Aug. 13, 1899 in NYC.

HERRING, JAMES.
Portrait painter and engraver who was born in London, England, Jan. 12, 1794. His father emigrated to the U.S. in 1804 and settled in New York. He associated himself with James Longacre in publishing the "National Portrait Gallery." He painted a number of portraits and had a studio in Chatham Square, New York. He died October 8, 1867 in Paris.

HERRING, JAMES VERNON.
Painter and teacher. Born in Clio, SC, Jan. 7, 1887. Pupil of College of Fine Arts, Syracuse University. Member: College Art Association; Am. Federation of Arts. Address in 1929, Howard University; h. 2201 Second Street, N. W., Washington, DC; summer, 815 King St., Greensboro, NC.

HERRMANN, MAX.
Painter. Member: Salma. Club. Specialty: Cattle and Sheep. Member of Society of Animal painters and sculptors of America. Address in 1929, 246 Fulton Street, Brooklyn, NY.

HERRON, JASON (MISS).
Sculptor. Born in Denver, Colorado, September 11, 1900. Studied at Stanford University, BA; Otis Art Institute; University of Southern California, with Merrell Gage and F. Tolles Chamberlin. Works: Los Angeles Museum of Art; Browning Mus., London, England; South Pasadena High School; Belmont School, Los Angeles; Santa Monica, CA, High School. Awards: Los Angeles Co. Fair, 1934; Los Angeles Art Assoc.; Society for Sanity in Art, 1945; California Art Club, 1946. Exhibited: California Palace of Legion of Honor, San Francisco; National Academy of Design, NY; Corcoran Gallery of Art, Washington, DC; Art Institute of Chicago; plus numerous others. Address in 1976, Ventura, CA.

HERSCHEL, S. FRANCES.
(Mrs. Arthur H. Herschel). Painter. Born in Boston, MA. Pupil of Henry B. Snell, Jean L. Boyd, Corcoran AS. Member: Washington Water Color Club; Syracuse Allied Artists. Died in 1937. Address in 1929, P.O. Box 44, Albany, NY.

HERSCHFIELD, HARRY.
Illustrator. Member: Society of Illustrators. Address in 1929, Care of the *New York Journal*, New York, NY.

HERTER, ADELE.
(Mrs. Albert Herter). Painter. Born in New York, Feb. 27, 1869. Pupil of Courtois in Paris. Member: National Association of Women Painters and Sculptors; American Federation of Arts. Awarded bronze medal, St. Louis Expo., 1904, and hon. mention, Pan-Am. Exp., Buffalo, 1901. Died in 1946. Address in 1929, 1324 Garden Street, Santa Barbara, CA; h. East Hampton, LI, NY.

HERTER, ALBERT.
Mural painter and craftsman. Born in New York, March 2, 1871. Pupil of Art Students League of NY under Beckwith; Laurens and Cormon in Paris. Member: Society of Am. Artists, 1894; Associate National Academy of Design, 1906; American Water Color Society; NY Water Color Club; Mural Painters; NY Architectural League, 1901; Century Assoc. Awards: Hon. mention, Paris Salon, 1890; medal, Atlanta Expo., 1895; Lippincott prize, Penna. Academy of Fine Arts, 1897; hon. mention, Nashville Expo., 1897; Evans prize, American Water Color Society, 1899; bronze medal, Paris Expo., 1900; silver medal, Pan Am. Expo., Buffalo, 1901. Work: Painting, "Two Boys," Metropolitan Museum, NY; "Hour of Despondency," Brooklyn Inst. Museum. Specialty, mural paintings and portraits. Died Feb. 15, 1950. Address in 1929, 1324 Garden Street, Santa Barbara, CA; h. East Hampton, LI, NY.

HERTER, CHRISTINE.
Painter. Born in Irvington-on-Hudson, NY, Aug. 25, 1890. Pupil of Sergeant Kendall. Member: NY Water Color Club; New Haven Paint and Clay Club; National Assoc. Women Painters and Sculptors; Newport Art Association; American Federation of Arts. Awards: Second Hallgarten prize, National Academy of Design, 1916; popular vote prize, Newport Art Association, 1915; prize, National Association of Women Painters and Sculptors, 1922. Address in 1929, Hot Springs, VA.

HERTHEL, ALICE.
Painter. Born in St. Louis. Pupil of St. Louis School of Fine Arts; Simon and Anglada-Camarasa in Paris. Member: St. Louis Artists Guild; Am. Federation of Arts. Address in 1929, 96 Arundel Place, St. Louis, MO.

HERVIEUE, AUGUSTIN JEAN.
Painter. Born near Paris, France, in 1794. He studied in England with Sir Thomas Lawrence. He painted "The Landing of Lafayette," and a portrait of Robert Owen which is owned by the Ohio Historical Society. Exhibited at the Royal Academy, London, 1819 and 1858.

HERZ, NORA (EVELYN).
Sculptor. Born in Hipperholme, England, May 13, 1910. Studied: Pratt Institute Art School; Sculpture Center; and in Germany. Awards: Village Art Center, 1949, 1951; Montclair Art Museum, 1956; Pen and Brush Club, 1956; Hunterdon County Art Center, 1957; Bamberger Company, 1957, 1958. Collections: Bavarian Nat. Mus., Munich, Germany; Athens, GA. Exhibited: Audubon; National Academy of Design; Penna. Academy of Fine Arts; Metropolitan Museum of Art; Architectural League; Sculpture Center; Nat. Sculpture Society; others. Address in 1953, 2 West 15th Street; h. 224 Sullivan Street, New York City.

HERZEBERG, ROBERT A.
Painter, illustrator, etcher and teacher. Born in Germany, May 22, 1886. Pupil of Vanderpoel, H. M. Walcott, A. Mucha, Kenyon Cox. Member: Scarab Club. Work: "Ancient Egypt," mural decoration in Tuly High School, Chicago. Director, Detroit School of Applied Art. Address in 1929, Bonstelle Studio Bldg., 3408 Woodward Avenue; h. 425 West Seventh Street, Royal Oak, Detroit, MI.

HERZEL, PAUL.
Sculptor, painter, and illustrator. Born in Germany, August 28, 1876. Pupil of St. Louis School of Fine Arts; Beaux-Arts Institute of Design, NY. Member: National Sculpture Society (Associate); American Federation of Arts. Awards: Mrs. H. P. Whitney "Struggle" prize, 1915; Barnett prize, National Academy of Design, 1915; prize, Garden Club of America, 1929. Exhibited at National Sculpture Society, 1923. Address in 1933, Brooklyn, New York.

HERZOG, LEWIS.
Painter. Born in Philadelphia, PA, Oct. 15, 1868. Studied in London, Rome, Berlin, Dusseldorf, Munich and Venice. Member: Art Club of Phila.; National Arts Club; Salma. Club; Am. Federation of Arts. Awards: Gold medal, Munich; hon. mention, Berlin; bronze medal, St. Louis Expo., 1904. Address in 1929, 390 West End Avenue; 80 West 40th Street, New York, NY; h. Scarsdale, NY.

HESS, EMIL JOHN.
Sculptor and painter. Born in Willock, PA, Sept. 25, 1913. Studied at Duquesne University; Art Institute of Pittsburgh; Art Students League; Brooklyn Museum Art School. Work: Penna. State Museum; Mus. of Modern Art. Exhibited: National Academy

of Design, 1950; Penna. State Museum, 1950; Art Students League, 1947-50; Brooklyn Museum, 1951; Betty Parsons Gallery, 1951, 52, 68, 70 (one-man). Member: Life member, Art Students League; Am. Fed. of Arts; Inter. Platform Assoc. Media: Metal; oil. Address in 1982, 130 West Tenth St., NYC.

HESS, EMMA KIPLING.
See Ingersoll, Emma Kipling Hess.

HESS, HAROLD W.
Painter. Exhibited water colors at the Penna. Academy of Fine Arts, Philadelphia, 1925. Address in 1926, 346 South Smedley Street, Philadelphia.

HESS, MARY G.
See Buehr, Mary G. Hess.

HESS, SARA M.
Painter and teacher. Born in Troy Grove, IL, Feb. 25, 1880. Pupil of Richard Miller, Ossip Linde, AIC; Julian Academy, Paris. Member: Nat. Association Women Painters and Sculptors; Brooklyn Society of Artists; Painters and Sculptors; Alumni Art Institute of Chicago; New Haven Paint and Clay Club; New Society American Artists; Society of Painters, NY; Pen and Brush Club, NY. Represented in Public School Col., Gary, IN; Oshkosh Museum, Oshkosh, WI. Address in 1929, Hillsdale, NJ.

HESSELIUS, GUSTAVUS.
Swedish artist. Born in 1682. He arrived in America (1711) near Wilmington, DE. He painted an altarpiece of the "Last Supper" for the parish Church of St. Barnabas, Prince George's County, MD, in 1721. He was the first organ builder in America. He also painted a number of portraits of Judge William Smith of NY, and his first wife Mary Het. (Signed and dated "G. H. 1729.") He died May 25, 1755.

HESSELIUS, JOHN.
Painter. Born in 1728. He was the son of Gustavus Hesselius, the Swedish artist, and nephew of Samuel Hesselius, the Swedish missionary. He settled in Maryland, and in 1763 he married Mary, only child of Col. Richard Young of Annapolis, MD. His earliest portraits were painted in Philadelphia in 1750; he afterwards painted many portraits in Maryland. He was an early instructor of Charles Willson Peale. Died April 9, 1778.

HETZEL, GEORGE.
Painter. Born in Alsace in 1826. He studied at Dusseldorf, and lived and painted for years at Pittsburgh, PA. Represented in Wilstach Collection, Fairmount Park, Phila. He died in Pitts. in 1906.

HEUERMANN, MAGDA.
Painter, illustrator, writer, and lecturer. Born in Galesburg, IL, Sept. 10, 1868. Pupil of Art Institute

of Chicago and F. H. C. Sammons in Chicago; Roth, von Lenbach and Duerr in Munich; Mme. Richard in Paris. Member: Chicago Soc. of Miniature Painters; Chicago Artists Guild; Chicago Art Club; Chicago Woman's Club; Cordon Club; Schleswig Holstein Kunstlerbund; Chicago Society of Artists; Art Institute of Chicago Alumni; West Coast Art League; Oak Park Art League. Awards: Medals at New Orleans, Philadelphia, Atlanta, Columbian Expo., Chicago, 1893. Author of "How I Paint a Head," and "Miniatures Old and New." Represented in Carnegie Library, Joliet, IL, and in University of Iowa. Address in 1929, Fine Arts Bldg., Chicago, IL; h. 520 Fair Oak Avenue, Oak Park, IL; summer, Palisades Park, MI.

HEUSTIS, EDNA F.
See Simpson, Edna Heustis (Mrs.).

HEUSTIS, LOUISE LYONS.
Portrait painter and illustrator. Born in Mobile, AL. Pupil of Art Students League of NY under Chase and Kenyon Cox; Julian Academy, Lasar and MacMonnies in Paris. Member: National Association Women Painters and Sculptors; Newport Art Association. Awards: First prize Brown and Bigelow National Competition, 1925; prize, Newport Art Association, 1921, 1928, 1928; prize, Nashville Art Association, 1926; prize, portrait, Birmingham, AL, 1928. Address in 1929, 228 West 59th Street, New York, NY; summer, Newport, RI.

HEUSTON, FRANK ZELL.
Painter. Born in La Crosse, WI, Dec. 14, 1880. Pupil of George Maynard, George Heuston, George Bridgman. Member: National Arts Club. Address in 1929, 3226 Oxford Avenue, New York, NY.

HEWINS, PHILIP.
Portrait and religious painter. Born in Blue Hill, ME, in July, 1806. In 1834 he established his studio in Hartford, CT, where he lived until his death, May 14, 1850. His portraits were considered good likenesses.

HEWITT.
This engraver was working for the *Port Folio* and other Philadelphia magazines about 1820. He was an engraver of landscapes in line. J. Hewitt is noted as an engraver of music, published in NY, but without indication of date.

HEWITT, EDWIN H.
Artist and painter. Born in Red Wing, MN, March 26, 1874. Studied architecture at Paris Ecole des Beaux-Arts under Pascal. Member: Fellow American Institute of Architects. Awards: Hon. mention for painting, Minnesota State Art Society, 1914; gold medal in architecture. Pres., Metropolitan District Planning Committee. Address in 1929, 1200 Sec. Ave., So.; h. Silver Ridge Farm, Excelsior, MN.

HEWITT, WILLIAM K.

Portrait painter. Born in New Jersey in 1818. He commenced exhibiting at the Penna. Academy of Fine Arts about 1847. He painted many excellent portraits of Philadelphians of his day. Died in Philadelphia in 1892.

HEWLETT, JAMES MONROE.

Mural painter and architect. Born in Lawrence, LI, NY, Aug. 1, 1868. Pupil of Columbia University, McKim, Mead and White, P.V. Gailand in Paris. Member: American Institute of Architects; Mural Painters; NY Architectural League; American Federation of Arts. Work: Mural Paintings in Carnegie Technical School, Pittsburgh; Cornell Theatre, Ithaca; Columbia University Club, New York. Architect of Soldiers' and Sailors' monuments in Philadelphia and Albany, Brooklyn Hospital, Brooklyn Masonic Temple. Died in 1941. Address in 1929, 2 West 45th Street, New York, NY; h. Lawrence, LI, NY.

HEYLER, MARY PEMBERTON GINTHER.

(Mrs. M. P. G. Heyler). Painter, illustrator, craftsman, and writer. Born in Philadelphia, PA. Pupil of Penna. Academy of Fine Arts. Member: Plastic Club; Fellowship Penna. Academy of Fine Arts. Work: Stained glass windows, "St. John on Patmos," Church of the Restoration, Philadelphia; "Peter and John at the Tomb," and angel panels below, St. John's Church, Suffolk, CA. Illustrator for magazines and books. Address in 1929, Gable End, Buckingham, PA.

HIBBARD, ALDRO T.

Painter. Born in Falmouth, MA, Aug. 25, 1886. Pupil of De Camp, Major and Tarbell. Member: Associate National Academy of Design; Guild of Boston Artists; St. Botolph Club; Gloucester Art Association; Rockport Art Association. Awards: First prize at Duxbury, 1920; hon. mention, Art Institute of Chicago, 1921; first Hallgarten prize, National Academy of Design, 1922; Sesnan gold medal, Penna. Academy of Fine Arts, 1923; Stotesbury prize, Penna. Academy of Fine Arts, 1928; second Altman prize, National Academy of Design, 1928. Work: "The Moate Range," National Academy of Design; "Winter," Boston Art Museum; "Hills of Jamaica," Metropolitan Museum, New York; "Ice Pond," purchased by Ranger Fund, Nat. Academy of Design, presented to Phillips Academy Collection. Address in 1929, Fenway Studios, 30 Ipswich Street, Boston, MA; summer School, 71 A Main Street, Rockport, MA.

HIBBARD, ELISABETH HASELTINE.

Sculptor. Born in Portland, Oregon, in 1894. Studied at Portland (Oregon) Art School; University of Chicago; Art Institute of Chic.; Grande Chaumiere, Paris; also with Polasek, Bourdelle, Navellier, and de Creeft. Works: University of Chicago; Norton Memorial Hall, Chautauqua, NY; Jackson Park, Chicago. Exhibited: Art Institute of Chicago, 1924-31, 35-40, 43, 44; Women's Art Salon, Chicago, 1943-45; others. Awards: Art Institute of Chicago, 1925; Chicago Galleries Association, 1929, 30, 32; National Association of Women Artists, 1937. Address in 1953, Chicago, IL.

HIBBARD, EVERETT.

Sculptor and painter. Studied: Oklahoma, Detroit, Boston and New York City. Works published: 8 Lithographs in color (in edition of 250); 5 Lithographs in Black and White (in editions of 25). Exhibited: Tulsa, Oklahoma Gallery; Santa Fe, New Mexico; Albuquerque, NM; Sports Arts, New Orleans; Plainfield, Chatham and Ridgewood, NJ; Ellenville, NY; and Collectors Cabinet, New York City. Awards: Southwestern Art Association, Tulsa, Oklahoma; Washburn University, Topeka, Kansas; Somerset County College, NJ; Ridgewood, Fairlawn and Bergen County Art Guilds, NJ. Member: Society of Animal Artists, NYC. Taught: Philbrook Art Center, Tulsa, Oklahoma. Media: Stone; oil and watercolor. Address in 1983, Midland Park, NJ.

HIBBARD, FREDERICK CLEVELAND.

Sculptor. Born in Canton, MO, June 15, 1881. Pupil of John Vanderpoel and Lorado Taft; Art Institute of Chicago; Illinois Institute of Technology; University of Missouri. Member: Chicago Society of Artists; Cliff Dwellers; Chicago Painters and Sculptors; American Federation of Arts. Awards: Honorable mention, Art Institute of Chicago, 1913; Shaffer prize, Art Institute of Chicago, 1914; gold medal, Kansas City Art Institute, 1924. Work: "Mark Twain," Hannibal, MO; "Gen. James Shields," Carrollton, MO; "The Virginian," Winchester, VA; "U.D.C. Shiloh Memorial," Shiloh National Park, TN; "General Grant," Vicksburg, MS; "Dr. G. V. Black," Lincoln Park, Chicago, IL; "Volney Rogers," Youngstown, Ohio; "Gen. H. W. Lawton," Fort Wayne, IN; "Soldier and Sailor," Pitts.; "Doughboy," McConnellsville, OH; "Tom Sawyer" and "Hucklebury Finn," Hannibal, MO; "Champ Clark," Bowling Green, MO; "Fountains," Stevens Hotel, Chicago. Represented in Vanderpoel Collection, Chicago; University of Chicago; Illinois Inst. of Technology; Butler Art Institute; others. Exhibited at National Sculpture Society, 1923; Art Institute of Chicago, 1903, 04, 08, 11-13, 16, 18, 19, 24, 33-35, 39, 40, 43; Pan-Pacific Expo., 1915; Baltimore Museum of Art, 1923; Penna. Academy of Fine Arts, 1904; Kansas City Art Institute, 1924; others. Vice President, Municipal Art League, Chicago. Address in 1953, 923 E 60th St.; h. 6209 Ellis Ave., Chicago, IL.

HIBBEN, HELENE.

Sculptor. Born in Indianapolis, IN, November 18, 1882. Pupil of William Forsyth at Herron Art Insti-

tute; Lorado Taft at Art Institute of Chicago; Jame Earle Fraser at Art Students League of New York. Member: New York Society of Craftsmen; Indianapolis Art Association. Address in 1933, Indianapolis, IN.

HIBBEN, THOMAS.
Teacher and artist. Born in Indianapolis, IN, Oct. 22, 1893. Pupil of William Forsyth, Robinson Locke, Stark, Jaussley and Cret. Address in 1929, 124 East 40th Street, New York, NY.

HIBEL, EDNA.
Painter and lithographer. Born in Boston, MA, on Jan. 15, 1917. Studied: Boston Museum of Fine Arts School; and with Carl Zerbe and Jacovleff. Award: Boston Art Festival, 1956. Collections: Boston Museum of Fine Arts; Harvard University; Norton Gallery of Art. Media: Oil. Address in 1980, Riviera Beach, FL.

HICKEY, ISABEL.
Painter. Born in Philadelphia, PA, Oct. 24, 1872. Pupil of Chase, Pyle, Penna. Academy of Fine Arts; studied in France, Spain, Italy. Member: Plastic Club; Fellowship Penna. Academy of Fine Arts; Philadelphia Alliance; Philadelphia Print Club; American Federation of Arts; Brooklyn Society of Etchers; President, Phil. Art Teachers Association. Supervisor of art education, Philadelphia public schools. Address in 1929, 1931 Wallace Street, Philadelphia, PA.

HICKEY, ROSE VAN VRANKEN.
Sculptor. Born in Passaic, NJ, May 15, 1919. Studied: Pomona College; Art Students League; University of Iowa; and with Bridgman, Humbert Albrizio, Mauricio Lasansky, Zorach and Laurent. Awards: Los Angeles Museum of Art, 1944; Oakland Art Gallery, 1945, 46; Pasadena Art Institute 1945, 51; Joslyn Museum of Art, 1950; Walker Art Center, 1951; Des Moines Art Center, first prize, sculpture, 1953; National Association of Women Artists, 1952; portrait award for sculpture, Catharine Lorillard Wolfe National Art Exhibition, New York City, 1969; Salma. Club, 1980, 82, 83; others. Represented in Des Moines Art Center; Coventry Cathedral, England; Laguna Gloria Museum, Austin, TX; others. Exhibited at Pasadena Art Museum, 1946; National Association of Women Artists Annual, National Academy, 1951-79; Stedelijk Museum, Amsterdam, 1956-57; Audubon Artists Annual, National Academy, 1965; Salmagundi Club Annual, NYC, 1978, 79; many others. Address in 1982, Houston, TX.

HICKOK, CONDE WILSON.
Painter. Born in Batavia, IL. Pupil of Art Institute of Chicago, C. P. Browne. Member: Chicago Society of Artists; Chicago Art Club; Art Institute of Chicago

Alumni; Hoosier Salon. Work: "In the Window," City of Danville, IL; "The White Dune," Chicago College Club Address in 1929, 3106 Wenonah Avenue, Berwyn, IL.

HICKOX, ANN LENHARD.
Painter and teacher. Born in Phoenixville, PA, June 26, 1893. Pupil of Chester Springs School of Industrial Art; Penna. Academy of Fine Arts and Fred Wagner. Member: Eastern Art Association. Address in 1929, Phoenixville, PA; summer, Weekapaug, RI.

HICKS, AMI MALI.
Painter, craftsman, writer, lecturer, and teacher. Born in Brooklyn, NY. Pupil of William M. Chase; studied in Berlin and Paris. Member: Boston Society of Arts and Crafts; NY Society of Craftsmen; Alliance; Society of Independent Artists. Awards: Hon. mention, World's Fair, Chicago, 1893, and St. Louis World's Fair, 1904. Work: Memorial tablets in Bowdoin College, ME. Author, "The Craft of Hand-made Rugs" and "Everyday Art" (Dutton). Specialty: Theatrical decoration of costumes and material. Address in 1929, 141 E 17th St., New York, NY.

HICKS, HERBERT.
Painter and illustrator. Born in Columbus, OH, June 26, 1894. Pupil of Messer, Brooks, Wagner, Garber, and Harding, Corcoran School of Art; Penna. Academy of Fine Arts Chester Spings School; Penna. Academy of Fine Arts. Member: Washington Water Color Club. Address in 1929, John's Bldg., 407 Locust Street, Philadelphia, PA; h. 402 High Street, Clarendon, VA.

HICKS, THOMAS.
Painter. Born in Newton, Bucks County, PA; died Oct. 8, 1890. Began painting at the age of 15. Studied in the Penna. Academy of Fine Arts, Philadelphia, PA, and the Academy of Design, New York. His first important picture, "Death of Abel," was exhibited in 1841. In 1845 he sailed for Europe, and painted in London, Florence, Rome, and Paris. In Paris he was a pupil of Couture. In 1849 he returned to New York and entered upon a successful career as a portrait painter. Among his works are: Portraits of Dr. Kane, Henry Ward Beecher, William C. Bryant, T. Addison Richards, Bayard Taylor, Oliver Wendell Holmes, Henry W. Longfellow, Harriet Beecher Stowe, Daniel Wesley Middleton in the Capitol, at Washington; Mrs. Hicks (wife of the artist) in Metropolitan Museum, New York. He was elected a member of the National Academy in 1851. His portrait of Abraham Lincoln is known from the engraving only.

HIGGINS, EUGENE.
Sculptor, painter, and etcher. Born in Kansas City, MO, February, 1874. Pupil of Laurens, Benjamin Constant, Gerome, Ecole des Beaux-Arts, and Julian Academy in Paris. Work: "The Little Mother,"

Carnegie Institute, Pittsburgh; "Tired Out," "Man and the Setting Sun," Milwaukee Art Institute; "The Covered Wagon," Harrison Gallery, Los Angeles Museum; etchings in NY Public Library, Brooklyn Museum, and British Mus., London; Congressional Library, Washington, DC; City Art Museum, St. Louis; Bibliotheque Nationale, Paris. Member: Associate National Academy of Design; League of American Artists; NY Water Color Club; National Arts Club; American Water Color Society; Salma. Club; American Federation of Arts; Brooklyn Society of Etchers. Exhibited: National Academy of Design; Carnegie Institute; Penna. Academy of Fine Arts; Art Institute of Chicago. Died in 1958. Address in 1953, West 22nd St., NYC.

HIGGINS, W. VICTOR.
Painter and teacher. Born in Shelbyville, IN, June 28, 1884. Pupil of Art Institute of Chicago and Academy of Fine Arts in Chicago; Rene Menard and Lucien Simon in Paris; Hans von Hyeck in Munich. Member: Associate National Academy of Design; Allied Artists of America; Chicago Society of Artists; Palette and Chisel Club; Chicago Commission for Encouragement of Local Art; Taos Society of Artists; Los Angeles Modern Art Society. Awards: Gold medal, Palette and Chisel Club, 1914; Municipal Art League purchase prize, 1915; Cahn prize ($100), Art Institute of Chicago, 1915; Butler purchase prize ($200), Art Institute of Chicago, 1916; Chicago Society of Artists medal, 1917; Logan medal, Art Institute of Chicago, 1917; Hearst prize, Art Institute of Chicago, 1917; Altman prize ($1000), National Academy of Design, 1918. Work: "Moorland Piper," Terre Haute Art Association; "Moorland Gorse and Bracken," Municipal Gallery, Chicago; mural decorations in Englewood theater, Chicago; "Women of Taos," Santa Fe Railroad; "Juanito and the Suspicious Cat," Union League Club, Chicago; "The Bread Jar," City of Chicago; "A Shrine to St. Anthony," collection of Des Moines Association of Fine Arts; "Fiesta Day," Butler Art Institute, Youngstown, OH; "Pueblo of Taos," "Indian at Stream," Los Angeles Museum; etc. Instructor, Chicago Academy of Fine Arts. Address in 1929, 220 So. Michigan Ave., Chicago, IL; summer, Taos, NM.

HIGHWOOD, C.
Painter. He painted a portrait of Henry Clay (1777-1852); half length, seated; body to left; arms folded in front; large collar and cravat. Size 29 by 39 inches. Painted from life in NY in 1850. Signed "C. Highwoods." Sold by American Art Association, New York, December, 1921.

HILDEBRANDT, CORNELIA (ELLIS).
Painter. Born in Eau Claire, WI. Pupil of Art Institute of Chicago; Augustus Koopman and Virginia Reynolds in Paris. Member: National Association of Women Painters and Sculptors; American Society of Miniature Painters, NY. Address in 1929,

306 East 51st Street, New York, NY; summer, New Canaan, CT.

HILDEBRANDT, HOWARD LOGAN.
Painter. Born in Allegheny, PA, Nov. 1, 1872. Pupil of Ecole des Beaux-Arts under Constant and Laurens in Paris; National Academy of Design in New York. Member: Associate National Academy of Design; Salma. Club, 1899; NY Water Color Club; Lotos Club; American Water Color Society; National Arts Club; Pittsburgh Art Association; Allied Artists of America; Society of Independent Artists; American Federation of Arts. Awards: Evans prize, American Water Color Society, 1906; first honor, Associated Artists of Pittsburgh, 1911; purchase prize, Salma. Club; gold medal, Brown and Bigelow, Allied Artists of America. Work: "Cleaning Fish," John Herron Art Institute, Indianapolis; represented in Lotos Club, New York; Butler Art Institute, Youngstown, OH. Address in 1929, 1 West 67th Street; 306 East 51st Street, New York, NY.

HILDEBRANDT, TIM A. and GREG J.
Illustrators. Twin brothers born in Detroit in 1939. They attended Meinzinger's Art School in 1958 and began their career as an illustrating team in 1961 with *The Man Who Found Out Why.* Together they have produced several books, including *Mother Goose, Panda Book, Hippo Book* and *A Home for Tandy.* They also illustrated many book covers and the 1976-1977 J. R. R. Tolkien Calendar for Ballantine.

HILDEBRANDT, WILLIAM ALBERT, JR.
Sculptor, painter, teacher, and illustrator. Born in Philadelphia, PA, October 1, 1917. Studied at Tyler School of Fine Arts, Temple University, B.F.A., B.S. in Education, M.F.A.; Philadelphia Museum School Association; Penna. State Education Association; of Industrial Art. Member: Philadelphia Art Teachers National Education Association. Awards: Prizes, Temple University Alumni Award, 1948; Tyler Art School Alumni, 1950; Philadelphia Art Teachers Association, 1949, 50. Exhibited: Penna. Academy of Fine Arts, 1941; Temple University, 1946 (one-man); Woodmere Gallery, 1943-46; Philadelphia Art Teachers Association, 1946-52; Ragan Gallery, 1946; DaVinci All., 1948-52; Friends Central School, 1950-52. Positions: Art Supervisor, Sharon Hill, PA, 1939-44; Art Supervisor, Tyler School of Art, 1944-47; Art Consultant, Franklin Institute Lab for Research and Development, from 1947; Art, Winston Publishing Co., from 1952. Illustrated *Echoes from Mount Olympus,* 1970; author of *Aunt in the Middle Years,* 1980. Media: Oil, multiple media. Address in 1983, PA.

HILDER, HOWARD.
Mural painter. Born in London, England, September 28, 1866. Pupil of Bouguereau, Ferrier, Dagnan-

Bouveret, De la Gandara and Jacque in Paris; DeBock and Josef Israels in Holland. Member: St. Lucas Society, Amsterdam, Holland; Newport Art Association; Florida Society of Arts and Sciences. Work: Murals, King Cole Hotel, Miami Beach; "Life of Christ" series, St. Stephen's Church, Coconut Grove, FL; Woman's Club, Miami; YWCA, Miami; Scenery Viking Pageant, Newport, RI, 1922; Asbestos Drop and Stage Scenery, Miami Sr. High School auditorium, 1928. Chairman of Decorative Painting, Architectural League of Greater Miami. Address in 1929, Coconut Grove, FL; summer, "Wavan-aki," Muscongus, ME. Died in 1935.

HILDRETH, SUSAN W. (SUSY).
Painter. Born in Cambridge, MA. Pupil of Ross Turner, A. H. Thayer. Member: Allied Artists of America; NY Water Color Club. Address in 1929, 27 Everett Street, Cambridge, MA. Died in 1938.

HILGENDORF, FRED C.
Painter and craftsman. Born in Milwaukee, WI, Dec. 28, 1888. Pupil of Milwaukee School of Fine and Applied Arts. Member: Wisconsin Painters and Sculptors; Wisconsin Society Applied Arts. Address in 1929, 211 Glen Ave., Whitefish Bay, Milwaukee, WI.

HILL, ARTHUR TURNBULL
Painter. Born in New. York, April 26, 1868. Pupil of Brooklyn Institute Art School; chiefly self-taught; studied works of George Inness. Member: Artists' Fund Society; Brooklyn Art Club; Nat. Academy of Design (life); Salma. Club. Work: "The Dunes - Amagansett" and "The Marches - Amagansett," Museum of the Brooklyn Institute; "After a Storm," National Gallery, Washington, DC; "Low Tide - Amagansett," National Arts Club, New York. Address in 1929, 33 West 67th Street, New York, NY; Briar Woods, East Hampton, LI, NY.

HILL, CARRIE L.
Painter and teacher. Born in Tuscaloosa County, AL. Pupil of Elliott Daingerfield, George Elmer Browne. Member: National Association of Women Painters and Sculptors; Southern States Art League; Birmingham Art Club. Awards: Gold medal, Mississippi Art Assoc., 1925; 1st prize for flower painting, Nashville, Art Assoc., 1926. Work: "Foothills of the Pyrenees," Public Library, Birmingham; "Red Roofs," Phillips High School, Birmingham; "New England Landscape," University of Alabama. Address in 1929, 1034 South 20th Street, Birmingham, AL.

HILL, CLARA.
Sculptor. Born in Massachusetts. Pupil of Augustus Saint-Gaudens; Julian Academy under Puech and Colarossi Academy under Injalbert, in Paris. Member: Society Washington Artists; American Federation of Arts. Award: Grand prize, Seattle Expo., 1909. Represented in Trinity College, Washington, DC; Army Medical Museum, Washington, DC; Woman's Medical College, Philadelphia. Address in 1933, c/o the Arts Club, Washington, DC; h. Washington, DC. Died in Washington, DC, 1935.

HILL, J. W.
In Dunlap's *History of the Arts*, he is recorded as painting landscapes in New York.

HILL, JAMES.
In 1803 James Hill engraved some crude Bible illustrations published in Charlestown, MA. He also engraved a large plate of the "Resurrection of a Pious Family," after the painting by the English clergyman Rev. William Peters. This was published in Boston, without date, but the copy of this print sold in the Clark sale, Boston, 1901, shows a watermark of "1792" in the paper, though this paper may be older than the impression. It is executed in stipple, and a large plate of the same subject was engraved by Thomas Clarke and published in New York in 1797.

HILL, JAMES JEROME, II.
Painter, illustrator, and writer. Born in St. Paul, MN, March 2, 1905. Pupil of Louis W. Hill. Awards: Gold medal, New Haven Paint and Clay Club, 1922, 1923. Mural paintings at St. Paul Academy. Address in 1929, 260 Summit Avenue, St. Paul, MN; summer, Del Monte, CA.

HILL, JOHN.
Engraver. Born in London in 1770; died at West Nyack, NY, in 1850. John Hill engraved in aquatint a considerable number of plates published in London, the best of these being a series of views after the paintings of J. M. W. Turner, Loutherberg, and others. Hill came to New York in the summer of 1816, but soon moved to Philadelphia, and remained there until 1824. He lived in NY from 1824 until 1839. The first plates executed in the U.S. by Hill were his small magazine plates of Hadrill's Point and York Springs, PA. He later issued his American drawing-books, with colored plates; but his best work is found in *The Landscape Album*, a series of large aquantint plates of American scenery, after the paintings by Joshua Shaw, and published by Hill and Shaw in Philadelphia in 1820. His *Hudson River Port Folio* is an equally good series of still larger plates; these views on the Hudson were aquatinted by Hill after paintings by W. G. Wall. One of his last plates was a large view of Broadway, New York, published in 1836. He seems to have retired from active work soon after this date.

HILL, JOHN HENRY.
Engraver. Son of J. W. Hill, was born in 1839. He was an etcher of landscape. Member of the New York Etching Club. Died 1922.

HILL, JOHN WILLIAM.
Born in England, Jan. 13, 1812. He died in this country in 1879. He worked in aquatint and lithography. Later he painted landscapes in water color and achieved considerable reputation; he also drew upon stone for the lithographers. Son of John Hill.

HILL, MABEL BETSY.
Illustrator. Born in Cambridge, MA, May 7, 1877. Member: Artists Guild of the Authors' League of America, NY. Work: Illustrated "Bolenius," "Barnes" and "The Children's Method," readers and other books for children. Address in 1929, 436 Fort Washington Avenue, New York, NY.

HILL, PAMELA E.
Miniature painter. Born May 9, 1803 in Framingham, MA; died in 1860. Exhibited at a number of the Boston Athenaeum Exhibitions. She painted miniatures of Mrs. Joel Thayer, Miss L. B. Vose, Rev. Mr. Sharp, Rev. Mr. Croswell, and Miss Walsingham. Her studio in 1834 was at 28 Somerset Street, Boston.

HILL, (PAULINE) POLLY KNIPP.
Etcher and painter. Born: Ithaca, NY, April 2, 1900. Studied: University of Illinois; Syracuse University; and with Hawley, George Hess and Jeannette Scott. Awards: Society of American Graphic Artists, 1929, 1948; Brooklyn Society of Etchers, 1930-1933; Florida Federation of Art, 1933, 1944, 1950; Southern States Art League, 1943; Gulf Coast Group, 1946; Philadelphia Printmakers Club, 1941; Philadelphia Sketch Club, 1957; Florida Art Group, 1951; Library of Congress, 1950. Work: Etchings, "St. Cloud" and "Trianon," Syracuse Museum of Fine Art, Syracuse, NY; "Barbara," "Montmorency," "On the Stairway," "Place de la Concorde" and "St. Cloud," J. B. Speed Memorial Museum, Louisville, KY; Library of Congress; Tel-Aviv Museum, Israel; Metropolitan Museum of Art. Address in 1984, St. Petersburg, FL.

HILL, PEARL L.
Painter. Born in Lock-Haven, PA, in 1884. Pupil of Penna. Museum and School of Industrial Art. Member: Plastic Club; Fellowship, Penna. Academy of Fine Arts; Philadelphia Art Alliance. Address in 1926, 10 South 18th Street, Philadelphia, PA.

HILL, ROBERT JEROME.
Painter, illustrator, and teacher. Born in Austin, TX. Pupil of Art Students League of NY; and with Kunz-Meyer. Member: Dallas Art Association; Texas Fine Arts Association; Southern States Art League. Curator, Dallas Public Art Gallery. Address in 1929, 805 W. Jefferson Avenue, Dallas, TX.

HILL, S. W.
A little known landscape painter, who also painted fruit-pieces.

HILL, SAMUEL.
Engraver. As early as 1789 Samuel Hill was engraving in Boston, and he made many portraits and engraved early American views for the *Massachusetts Magazines*, published in that city. In 1803 Hill engraved some Bible plates for the NY Publisher, William Durell. In *Russell's Gazette*, Boston, 1794, Samuel Hill advertised as "engraver and copper-plate printer, with a shop at No. 2 Cornhill."

HILL, SARA B.
Etcher and draftsman. Born in Danbury, CT. Pupil of Alphonse Mucha. Member: American Bookplate Society; Society of Bookplate Collectors and Designers. Represented in print collection of Metropolitan Museum, NY; Grolier Club, New York; Library of Congress, Washington, DC; Harvard Library, Cambridge; Vassar College, Poughkeepsie; Carnegie Institute, Pittsburgh; National Gallery and Guild Hall, London. Specialty, bookplates. Address in 1929, 135 East 66th Street, New York, NY.

HILL, THOMAS.
Painter. Born Sept. 11, 1829, in England; he came to the United States in 1840 and settled in Taunton, MA. He later removed to Philadelphia and studied in the life class of the Penna. Academy of Fine Arts. He studied in Paris in 1866 and in 1867 opened his studio in Boston. He soon moved to San Francisco. Among his works are "Yosemite Valley," "Danner Lake," "The Heart of the Sierras," and "The Yellowstone Canon." He died June 30, 1908.

HILL, WILLIAM LEE.
Painter and sculptor. Born in Star Valley, WY, 1922. Studied at Brigham Young University, English literature and education, 1949. Specialty is animals and people of the West. Paints in oil in Impressionist style. Prints published by Western Profiles Publishing Co.; represented by Zantmann Art Gallery, Palm Desert, CA; Myer's Gallery, Park City, UT. Reviewed in *Southwest Art*, December 1979. Address in 1982, Mendon, UT.

HILLARD, WILLIAM H.
Painter. Born 1830; died in Washington, DC, in April, 1905. Among his best known paintings were "The Fight above the Clouds" and a portrait of President Garfield.

HILLBOM, HENRIK.
Painter and craftsman. Born in Sweden, April 8, 1863. Pupil of Lefebvre and Constant. Member: Conn. Academy of Fine Arts; New Haven Paint and Clay Club. Silver designer with Wallace Mfg. Co., since 1899. Address in 1929, Wallingford, CT; summer, Lyme, CT.

HILLER, J., JR.
Engraver. A close copy of the Joseph Wright etching of Washington is signed "J. Hiller Ju'r Sculp. 1794."

This Hiller portrait has only appeared on the back of playing cards and the few copies known all come from New England. It is possible that this J. Hiller, Jr., was Joseph Hiller, Jr., son of Major Joseph Hiller, an officer in the Revolution and the collector of customs at Salem, MA, in 1789-1802. The younger Hiller was born in Salem, June 21, 1777, and the "Cleveland Genealogy" says that he was lost overboard from a ship off the Cape of Good Hope, on Aug. 22, 1795.

HILLER, LEJAREN.
Illustrator and painter. Born in Milwaukee, WI, July 3, 1880. Pupil of Art Institute of Chicago; studied in Paris. Member: Society of Illustrators, 1910; American Institute of Graphic Arts; Art Directors' Club; American Federation of Arts. Illustrator for magazines and advertising. Address in 1929, Underwood and Underwood, Inc., 242 West 55th Street; h. 332 West 28th Street, New York, NY.

HILLES, CARRIE P.
Miniature painter. Exhibited at the Penna. Academy of Fine Arts, Philadelphia, in 1925. Address in 1926, 238 Allen Lane, Germantown, Philadelphia.

HILLIARD, WILLIAM HENRY.
Painter. Born in Auburn, NY, in 1836. He studied art in New York City; also studied abroad, and on his return to this country established his studio in Boston. Landscapes and marine views were his specialty, and among his best known works are views of Maine, the White Mountains, and the Atlantic Coast, including "Castle Rock," "Wind against Tide," "Allatoona Pass, GA." Died in 1905, in Washington, DC.

HILLS, ANNA ALTHEA.
Painter, lecturer, and teacher. Born in Ravenna, OH. Pupil of Art Institute of Chicago; Cooper Union; Julian in Paris. Member: California Art Club; (pres.) Laguna Beach Art Association; Washington Water Color Club. Awards: Bronze medal, Panama-California Expo., San Diego, 1915; Bronze medal, California State Fair, 1919; landscape prize, Laguna Beach Art Association, 1922 and 1923; prize, Orange Co. Fair, 1925. Address in 1929, Laguna Beach, CA.

HILLS, J. H.
Born in 1814. This line-engraver was working at his profession in Burlington, VT, about 1845-50. His plates were of considerable merit.

HILLS, LAURA COOMBS.
Painter. Born in Newburyport, MA, Sept. 7, 1859. Pupil of Helen M. Knowlton; Cowles Art School in Boston; Art Students League of NY. Member: Society of American Artists, 1897; Associate of National Academy of Design, 1906; Boston Water Color Club; Copley Society, 1892; Guild of Boston Artists;

American Society of Miniature Painters; Pennsylvania Society of Miniature Painters; American Federation of Arts. Awards: Bronze medal, Paris Expo., 1900; 2nd prize, Corcoran prize, Society of Washington Artists, 1901; silver medal, Pan-Am. Expo., Buffalo, 1901; silver medal, Charleston, Expo., 1902; gold medal, St. Louis Expo., 1904; medal of honor, P.P. Expo., San Francisco, 1915; medal of honor, Penna. Academy of Fine Arts, 1916; Lea prize ($100), Penna. Academy of Fine Arts, 1920. Work: "Persis," Metropolitan Musuem, NY. Specialty, miniatures and flowers in pastel. Address in 1929, 66 Chestnut Street, Boston, MA; summer, Sawyer Hill, Newburyport, MA.

HILLS, METTA V.
(Mrs. Elijah C. Hills). Painter. Born in Orleans, NY, April 1, 1873. Member: San Francisco Society of Women Artists. Address in 1929, 1570 Hawthorne Terrace, Berkeley, CA.

HILLSMITH, FANNIE.
Painter and collage artist. Born in Boston, MA, March 13, 1911. Studied: Boston Museum of Fine Arts School; Art Students League, with Alexander Brook, Sloan and Hayter. Awards: Currier Gallery of Art, 1952; Berkshire Museum, 1956, 1957; Boston Art Festival, 1957; Portland Museum of Art, 1958; Boston Museum of Fine Arts School, Alumni Traveling Scholarship, 1958. Collections: Museum of Modern Art; New York Public Library; Currier Gallery of Art; Fogg Museum of Art; Addison Gallery of American Art; Gallatin Collection. Address in 1980, Second Ave, New York, NY.

HILLYER, WILLIAM.
Portrait painter in oils and miniatures, flourishing in New York 1834-1861. Member of the firm of Miller & Hillyer.

HIMMELSBACH, PAULA B.
See Balano, Paula Himmelsbach.

HINCHMAN, MARGARETTA S.
Sculptor, painter, lithographer, and illustrator. Born in Philadelphia, PA. Pupil of Howard Pyle and Kenyon Cox. Member: American Federation of Arts; Plastic Club; Philadelphia Arts and Crafts Guild; Philadelphia Alliance; Fellowship Penna. Academy of Fine Arts; Print Club; Philadelphia Water Color Club; Washington Water Color Club; Mural Painters; La Musee des Arts Decoratifs and Union Centrale des Arts Decoratifs, Paris. Award: Silver medal, Plastic Club, Philadelphia, 1927. Address in 1953, Washington, CT. Died in 1955.

HINCKLEY, ROBERT.
Painter. Born in 1853 in Massachusetts. Studied art in Paris, 1864 to 1884. Graduated from Ecole des Beaux Arts. Had a studio in Washington, DC, since

1884, where he painted 350 portraits of eminent Americans. He also was the instructor of the portrait class at the Corcoran Art School for six years. His portraits of Chas. F. Crisp and John E. Rutledge are in the Capitol Building, Washington, DC. Also in collections of Annapolis & West Point. Died June 1, 1941.

HINCKLEY, THOMAS HEWES.
Painter. Born in Milton, MA, Nov. 4, 1813. He devoted himself to animal painting. In 1851 he went abroad to study the work of Sir Edwin Landseer and the Flemish masters. He painted two pictures of dogs and game in 1858, which were exhibited at the Royal Academy. Among his early works were a few portraits and landscapes. He died Feb. 15, 1896, in Massachusetts.

HINE, CHARLES.
Painter. Born in Bethany, CT, in 1827. Studied with Jared B. Flagg. His work was largely figure-pieces, and his masterpiece was nude figure, "Sleep." He died in New Haven, July 29, 1871.

HINES, NORMAN.
Sculptor. Born in Pawtucket, Rhode Island, April 8, 1926. Self-taught. Apprenticed with the former Irons & Russell Co., Providence, RI. Began sculpting full time in 1960. Exhibited twice at the National Sculpture Society in NYC. Has produced over seventy medals and commemorative seals including Pope Pius XII Portrait Plaque, Vatican; John F. Kennedy Inaugural Portrait Plaque, Young Democrats of RI; 100th Anniversary of Memorial Day Medal, Franklin Mint; St. Joseph Medal, Franklin Mint; Portrait Busts of John F. Kennedy, Lyndon B. Johnson, both for the New York World's Fair; Seals for the Depts. of Interior, Justice, Treasury, and the US Park Ranger Badge and Seal. Media: Clay, plaster, bronze, and pewter. Address in 1984, Attleboro, MA.

HINGSTON.
Line-engraver of bill-heads and work of that description, apparently working in Georgetown, near Washington, DC, as he signs his plates "Hingston ft., G. Town." One of his plates is a bill-head for the City Hotel of Alexandria, VA. The work appears to belong to the first quarter of the last century.

HINKELMAN, EDNA WEBB.
(Mrs. Edward Hinkelman). Painter and teacher. Born Cohoes, NY, Feb. 12, 1892. Pupil of C. L. Hinton; Emil Carlsen. Address in 1929, 9 Lansing Avenue, Troy, NY; summer, Navesink, NJ.

HINMAN, DAVID C.
This capital engraver of portraits in stipple was working about 1830-35, both over his own name and as a member of the firm of Daggett, Hinman & Co., of New Haven, CT.

HINOJOSA, ALBINO R.
Illustrator. Born in Atlanta in 1943. He attended Texarkana and East Texas State University, studying under Jack Unruh and Otis Lumpkin. His first published illustration appeared in the *Greenville Texas Herald* in 1968 and he has since exhibited in Tennessee, Louisiana and NY. He is a member of the Society of Illustrators of Los Angeles and NY. He lives in Ruston, LA.

HINSCHELWOOD, ROBERT.
Engraver. Born in Edinburgh in 1812. He came to the United States about 1835 and was employed as a landscape engraver by *Harpers* and other New York publishers. He also worked for the Ladies' Repository, of Cincinnati, about 1855, and was later, for a long time, in the employ of the Continental Bank Note Co. of New York. Hinschelwood married a sister of James Smillie and many of his landscape plates are engraved after Smillie's drawings.

HINSDALE, RICHARD.
Landscape and genre painter. Born in Hartford, CT, in 1825. He died early in life (1856) when his work was beginning to show great promise.

HINTERMEISTER, HENRY.
Painter and illustrator. Born in New York, NY, June 10, 1897. Pupil of Will Taylor, Otto Walter Beck, Anna Fisher. Member: NY Water Color Club; American Water Color Society; Brooklyn Society of Artists. Address in 1929, 4622-14th Avenue; h. 7920 Ft. Hamilton Parkway, Brooklyn, New York, NY.

HINTON, CHARLES LOUIS.
Painter, illustrator, and sculptor. Born in Ithaca, NY, October 18, 1869. Pupil of National Academy of Design under Will H. Low; Gerome and Bouguereau, in Paris; Ecole des Beaux-Arts, Paris, under Gumer. Exhibited at National Sculpture Society, 1923. Member: Associate National Academy of Design, 1916; Mural Painters; National Sculpture Society; Artists' Fellowship; Century Club; NY Architectural League, 1911. Award: Traveling scholarship, National Academy of Design, 1893; honorable mention, Pan-Am. Exposition, Buffalo, 1901; others. Work: Mural decoration in court house, Wilkes-Barre, PA; Cleveland Museum of Art; Smithsonian Institution. Illustrated "Emmy Lou," etc. Died in 1950. Address in 1933, Bronxville, NY.

HINTON, ERWALD STUART.
Sculptor. Born in New York, January 3, 1866. Worked in Chicago. Address in 1910, Chicago, IL.

HINTON, MRS. HOWARD.
Sculptor. Pupil of Lant Thompson. Born in 1834; died in New York City, December 19, 1921.

HIOS, THEO.
Painter and graphic artist. Born in Sparta, Greece, Feb. 2, 1910; US citizen. Studied: American Artists School; Art Students League; Pratt Institute; National University of Athens. Work: Parrish Art Museum, Southampton, NY; Riverside Museum, NY; Guild Hall Museum, Easthampton, NY; Tel Aviv Museum; Carnegie Institute, Pittsburgh; National Collection of Fine Arts, Washington, DC; National Pinokothiki Museum, Athens, Greece; and others. Exhibitions: Carnegie Institute International; Penna. Academy of Fine Arts; Brooklyn Museum; Museum of Modern Art, NYC. Awards: Silvermine Guild; Guild Hall, Easthampton, NY; Adolph & Esther Gottlieb Foundation Grant, $10,000, 1981; and others. Teaching: City College, NYC, 1958-61; Dalton School, NYC, 1962-73; New School for Social Research, 1962-present. Member: Federation of Modern Painters & Sculptors; Audubon Artists. Media: Oil, acrylic, pastel, watercolor. Address in 1982, 136 West 95th Street, New York, NY.

HIRAMOTO, MASAJI.
Sculptor and painter. Born in Fukui, Japan, Dec. 8, 1888. Pupil of Penna. Museum; Columbia University. Member: Society of Independent Artists; Japanese Art Society; Salons of America; Salon D'Automne, Societe Nationale des Beaux-Arts, Paris. Work: "The Daibutsu," Columbia University. Address in 1933, Suite 1601, 165 Broadway, New York, NY; h. Paris, France.

HIRSH, ALICE.
Painter. Born in 1888. Member: National Association of Women Painters and Sculptors; Connecticut Academy of Fine Arts. Died in 1935. Address in 1929, 53 Washington Square, New York, NY.

HIRSCH, JOSEPH.
Painter. Born in Philadelphia, PA, April 25, 1910. Studied at Pennsylvania Museum School for Industrial Art; Philadelphia College of Art, 1927-31; with Henry Hensche, Provincetown, and George Luks, NYC. In collections of Whitney; Museum of Modern Art; Corcoran Gallery, Washington, DC; Boston (MA) Museum of Fine Arts; Metropolitan Museum of Art; others, including several commissions. Exhibited at Penna. Academy of Fine Arts; National Academy of Design; numerous others in U.S. from 1934. Taught at Art Students League, NYC, 1959-67; others. Received Sch. Art League Prize, drawing, Philadelphia Sesquicentennial, 1926; municipal scholarship, Penna. Museum School for Industrial Art, 1928; Penna. Academy of Fine Arts; Altman prizes, National Academy of Design, 1959, 67, 78; Purchase Prize, Butler Institute, 1964; Carnegie Prize, 1968; many more. Member: Artists Equity Association; National Academy of Design; National Institute of Arts & Letters. Represented by Kennedy Galleries, NYC. Address in 1980, 90 Riverside Dr., NYC.

HIRSCH, STEFAN.
Painter and teacher. Born in Nuremberg, Germany, Jan. 2, 1899. Pupil of Hamilton Easter Field. Member: Modern Artists of America; Salons of America; Brooklyn Society of Modern Artists. Work: "Nightscene," Newark Museum, Newark, NJ; "New England Town," Worcester Art Museum, Worcester, MA; "Lower Manhattan," "Farmyard" and "Factory Town," Phillips Memorial Gallery, Washington, DC. Address in 1929, 110 Columbia Heights, Brooklyn, NY; h. 135 Central Park, West, New York, NY.

HIRSCH, WILLARD NEWMAN.
Sculptor. Born in Charleston, SC, November 19, 1905. Studied at College of Charleston; Beaux-Arts Institute of Design; National Academy of Design. Member: Artists Equity Association; South Carolina Art Guild. Awards: Prizes, South Carolina Art Guild, 1951. Work: Lincoln Hospital, NY; IBM; Columbia (SC) Museum of Art; Clemson College; relief, National Guard Armory, Mullins, SC. Exhibited: Syracuse Museum of Fine Arts, 1948; National Academy of Design, 1935, 42; Penna. Academy of Fine Arts, 1942; Whitney Museum of American Art, 1950; Wichita Art Association, 1949; South Carolina Art, Gibbes Art Gallery, 1947-52, one-man; Columbia Museum of Art, 1952. Member: Charleston Artists Guild; South Carolina Artists Guild (past president). Position: Instructor of Sculpture, Gibbes Art Gallery, Furman University, Greenville, SC; Ext. Div., University South Carolina, Columbia, SC. Address in 1982, 2 Queen St., Charleston, SC.

HIRSCHBERG, CARL.
Painter and illustrator. Born in Germany March 8, 1854. Pupil of Art Students League; also studied in Paris. Specialty, figure painter of genre. Founder of Salmagundi Club. Died on June 2, 1923, in Danbury, CT.

HIRSCHFIELD, MORRIS.
Primitive painter. Born in Russia-Poland in 1872. Produced religious sculpture at early age. Emigrated to US in 1890; lived in Brooklyn, NY. Worked in ladies' garment shop, later had own highly successful business. Not active again artistically until 1937. First one-man exhibition organized in 1943 for Museum of Modern Art; work shown in numerous expositions in US and Europe. In collections of Museum of Modern Art; Sidney Janis Gallery; private collections. Brooklyn Museum has photos of 74 of his 77 paintings. Considered one of the greatest primitive painters. Died in Brooklyn, NY, July 26, 1946.

HIRSHFELD, ALBERT.
Illustrator. Born in St. Louis, MO, in 1903. He traveled and studied art in NY, Paris, London and Bali. He started his career at *The New Masses*, and in 1923 his first pen and ink caricatures appeared in

The NY World. His drawing of political, television and, most notably, theater personalities have been published in magazines, books and in *The NY Times* for over 50 years. Examples of his unique drawings are owned by the Whitney Museum, Metropolitan Museum of Art, and others.

HIRST, CLAUDE RAGUET.
Sculptor and painter. Born in Cincinnati, OH, 1855. Studied: Cincinnati Art Academy with Nobel; and with Agnes D. Abbatt, George Smillie and Charles C. Curran in New York. Her husband was the landscape painter William Fitler. Exhibited: National Academy of Design, 1884. Work: Boston Art Club; Art Club of Philadelphia. Awards: First hon. mention., Syracuse, 1897; second prize, Syracuse, 1898; hon. mention, National Association of Women Painters and Sculptors, 1922 and 1927. Member: National Association of Women Painters and Sculptors; New York Watercolor Club. William Harnett's influence is seen in her similar still-lifes of books, pipes, and tobacco jars. She also worked in watercolor. Address in 1933, NYC. Died in 1942.

HITCHCOCK, DAVID HOWARD.
Sculptor, landscape painter, and illustrator. Born in Hawaii, May 15, 1861. Pupil of Virgil Williams; Bouguereau and Ferrier in Paris. Member: Salmagundi Club, 1904; Honolulu Art Society. Died in 1943. Address in 1933, Laniakeal; h. Honolulu, Hawaii.

HITCHCOCK, GEORGE.
Painter. Born in 1850 in Providence, RI. Studied painting in Paris. Exhibited "Tulip-Growing," Paris Salon, 1887. He was fond of painting subjects and places in Holland. Elected an Associate Member of the National Academy. Died Aug. 2, 1913 on Island of Maarken, Holland.

HITCHCOCK, LUCIUS WOLCOTT.
Painter and illustrator. Born West Williamsfield, OH, Dec. 2, 1868. Pupil of Art Students League of NY; Lefebvre, Constant, Laurens and Colarossi Academy in Paris. Member: Society of Illustrators, 1904; Salma. Club, 1907; New Rochelle Art Association. Awards: Silver medal for illustration, Paris, 1900; hon. mention, Pan-Am. Expo., Buffalo, 1901; silver medal for illustration and bronze for painting, St. Louis Expo., 1904. Address in 1929, Premium Point Park, New Rochelle, NY.

HITE, GEORGE H.
Born in Urbana, OH. Painted miniatures and portraits; flourished 1839-61 in New York. Died in 1880.

HITTELL, CHARLES J.
Painter. Born in San Francisco, 1861. Studied in San Francisco School of Design, 1881-83; Royal Academy of Fine Arts, Munich, 1884-88; Academie Julien,

Paris, 1892-93. Since 1893 painted Western American subjects, figures and landscapes. His landscapes are in the American Museum of Natural History, New York; and in the Museum of Vertebrate Zoology, Berkeley, CA. Address in 1926, San Jose, Santa Clara County, CA.

HITTLE, MARGARET A.
Painter, illustrator and etcher. Born in 1886. Pupil of Art Institute of Chicago. Has executed mural panels in several schools in Chicago, IL. Address in 1926, 55 Arlington Place, Chicago, IL.

HO, TIEN.
Illustrator. Born in Shanghai, China, in 1951. She attended the University of Dublin, Ireland, and the Art Students League in New York, studying under Marshall Glasier. Her first illustration was an annual report cover, done for Topps Chewing Gum in February, 1976. Her work has been shown at the Society of Illustrators. In addition to being an illustrator, she is a fabric and fashion designer, known professionally as Tien.

HOARD, MARGARET.
Sculptor. Born in Iowa in 1880. Pupil, Art Students League of NY. Member: L'Union Internationale des Beaux-Arts et des Lettres, Paris, 1914; Art Students League of New York; National Association of Women Painters and Sculptors. Award: Honorable mention, P.-P. Exposition, San Francisco, 1915. Represented in Metropolitan Museum of Art, New York, NY. Address in 1933, Mt. Vernon, New York. Died in 1944.

HOBAN, FRANK J.
Painter and designer. Born in Cincinnati, OH. Member: Palette and Chisel Club. Address in 1929, 608 South Dearborn Street; h. 5345 Winthrop Avenue, Chicago, IL.

HOBART, CLARK.
Painter and etcher. Born in Illinois. Pupil of Art Students League, New York; also studied in Paris. Address in 1926, 1371 Post Street, San Francisco, CA.

HOBART, GLADYS MARIE.
Painter and teacher. Born in Santa Cruz, CA, Aug. 28, 1892. Pupil of J. C. Johansen. Member: Palette and Chisel Club. Address in 1929, 1910 Fulton Street, San Francisco, CA.

HOBBIE, HOLLY.
Illustrator. Born in 1944. The early influence of her farm upbringing in Connecticut infused her art with a homespun, fresh quality which captured the hearts of greeting card lovers all over America. Having attended Pratt Institute and Boston University, she has been employed by the American Greeting Corpo-

ration for the past ten years. She has chosen to remain somewhat anonymous, maintaining a quiet life as a wife and mother of three.

HOBER, ARTHUR.
Painter. Born in New York City, 1854. Studied at Art Students League under Beckwith and later in Paris under Gerome. He contributed to many exhibitions and in 1909 was elected an Associate of the National Academy of Design. He died in 1915.

HODES, SUZANNE.
Painter. Studied: Radcliffe College; Brandeis University; Columbia University. Awards: Kokoschka School, 1959; Brandeis Arts Festival, 1959, 1960; Fulbright Fellowship to Paris, 1963-64; Radcliffe Institute Fellowship, 1970-72. Exhibitions: Weizman Institute, Israel, 1972; Gund Hall, Harvard Graduate School of Design, 1972. Collections: Fogg Museum, Cambridge, MA; Rose Art Museum, Waltham, MA; City of Salzburg, Austria.

HODGE, HELEN.
Painter and lecturer. Born in Topeka, KS. Pupil of Corcoran School of Art in Washington; George M. Stone; George Hopkins. Member: Topeka Artists Guild; Laguna Beach Art Association; West Coast Arts. Seven first prizes, Kansas State Fair. Represented in Mulvane Art Museum and in the Woman's Club, Topeka, KS. Address in 1929, 714 Kansas Avenue; h. 1515 Boswell Avenue, Topeka, KS.

HODGE, R. GAREY.
Painter. Born in Moweaqua, IL, July 27, 1937. Study: Eastern Illinois University; Howard University Summer School, with Wm. Georgenes. Work: Numerous private collections in IL, WI, IN, & MO. Exhibitions: Tri-State Exhibition, Evansville Museum, IN; Mississippi Valley Invitational, State Museum, Springfield, IL; IL Bell Telephone Competition, Chicago; River Roads Exhibition, St. Louis; 5th International Biennial Sport Fine Arts, Barcelona, Spain; etc. Awards: NY World's Fair Sculpture Design runner up, 1963; Second in painting, North Side Art Association, St. Louis; Grand Prize, US Hockey Hall of Fame. Member: Artists Equity Association; IL State Museum Society; Springfield Art Association; others. Media: Acrylic, graphite, watercolor. Address in 1982, Springfield, IL.

HODGELL, ROBERT OVERMAN.
Sculptor, painter, etcher, engraver, lithographer, and serigrapher. Born in Mankato, KS, July 14, 1922. Studied at Univ. of Wisconsin, B.S., M.S.; Dartmouth College; State Univ. of Iowa. Member: Society of American Graphic Artists; Art Association Museum; National Ser. Society; Mid-Am. Arts; Madison Art Association. Work: Joslyn Art Museum; Dartmouth College; Wisconsin Union; Topeka Art Guild; Kansas

State Teachers College; Kansas State College. Exhibited: Mississippi Art Association, 1947; Albany Print Club, 1947, 51; Society of American Graphic Artists, 1947, 50-52; Washington Water Color Club, 1948; Northwest Printmakers, 1949; Philadelphia Print Club, 1950; Portland Society of Artists, 1950; Butler Art Institute, 1951; Terry Art Institute, 1952; Bradley University, 1952; National Ser. Society, 1952; Library of Congress, 1948, 52; Western Arts, 1948-52; Kansas Painters, 1949-51; Mid-Am. Arts, 1950, 51; Walker Art Center, 1951; Wisconsin Salon, 1942; Kansas Free Fair, 1935-43, 47; Six States Exhibition, 1943, 44, 46, 47; Topeka Art Guild, 1947, 49, 50; Madison Art Association, 1948-52; Pell College, 1950; and others. Illustrated "The Lee Papers," 1948; "Soil Conservation," 1948. Position: Instructor, Des Moines Art Center, Des Moines, Iowa, from 1949. Address in 1953, Des Moines Art Center; h. Des Moines, IA.

HODGES, STEVE LOFTON.
Painter. Born in Port Arthur, TX, Oct. 9, 1940. Study: Univ. of TX; Lamar Univ.; Univ. of AK. Work: Delgado Museum, New Orleans; Atlanta (GA) Artists Club. Exhibited: Biennial, Delgado Museum, 1971; Galerie Simonne Stern, New Orleans, 1972; 1st St. Gallery, NYC, 1975. Awards: Atlanta Artists Club, 1970; purchase award, Delgado Museum, 1975. Member: College Art Association. Media: Acrylic. Address in 1980, c/o Gallerie Simonne Stern, New Orleans, LA.

HODGIN, MARSTON (DEAN).
Painter. Born in Cambridge, OH, Dec. 3, 1903. Pupil of F. F. Brown, R. L. Coars, J.R. Hopkins, Charles Hawthorne; Art Dept., IN University, under R. E. Burke and T. C. Steele; Walter Sargent, University of Chicago. Member: Indiana Art Club; Richmond Art Association; Oxford Art Club. Awards: Hon. mention, Indiana Painters' Exhibition, 1924-1925; first prize, still life, 1925-1926, first prize, portrait, 1927-1928, first prize, landscape, 1928-1929 at Richmond Art Association Exhibition. Work: "On Clear Creek," owned by Morton High School, Richmond, IN. Instructor Fine Arts, Miami University, Oxford, Ohio. Address in 1929, Miami University, Oxford, OH.

HOE, MABEL KENT.
Sculptor and painter. Born in Cranford, NJ, January 27, 1880. Studied at Art Students League; and with Archipenko, Arthur Lee, Bridgman, Miller, Nicolaides. Member: National Association of Women Artists; Asbury Park Society of Fine Arts. Awards: Prize, National Association of Women Artists, 1936. Exhibited: National Association of Women Artists; Montclair Art Museum; American Artists Professional League; and in Asbury Park, Spring Lake, Newark, NJ. Address in 1953, Cranford, NJ.

HOECKNER, CARL.
Painter. Born in Munich, Germany, Dec. 19, 1883. Studied in Hamburg and Cologne. Member: Chicago Society of Artists, "Cor Ardens." Address in 1929, 63 W. Ontario Street, Chicago, IL.

HOERMAN, CARL.
Painter, artist, and craftsman. Born in Babenhausen, Bavaria, April 13, 1885. Member: Laguna Beach Art Association. Awards: Englewood Womens Club prize, Art Institute of Chicago, 1927; Logan purchase prize, Illinois Academy of Fine Arts, Springfield, 1928. Work: "Mount Shasta, California," State Museum, Springfield, IL. Address in 1929, Saugatuck, MI; h. Highland Park, IL.

HOFF, GUY.
Painter and illustrator. Born Rochester, NY, May 1, 1889. Pupil of Wilcox and DuMond. Award: First Honorable mention, Albright Art Gallery, Buffalo, 1916. Address in 1929, 939 8th Avenue; h. 655 Riverside Drive, New York, NY.

HOFFBAUER, CHARLES.
Painter. Born in Paris, France, June 18, 1875. Pupil of Gustave Moreau, F. Flameng and Cormon in Paris. Member: Societe des Artistes Francais; Societe Internationale; NY Architectural League, 1912. Awards: Hon. mention, Paris Salon, 1898; second class medal, Paris salon, 1899; bronze medal, Paris Expo., 1900; Bourse de Voyage, 1902; Prix Rosa Bonheayr, 1902; Prix National du Salon, 1906; Knight of the Legion of Honor. Work: "Les Gueux," Carnegie Rouen; "The Roof Garden," Carnegie Institute, Pittsburgh; "Revolte de Flamands," Memorial Hall, Philadelphia; "Coin de Bataille," Luxembourg, Paris; "Sur les Toits," National Gallery, Sydney, N.S. Wales; mural decorations in Confederate Memorial Hall, Richmond, CA. Died July 26, 1957 in Boston, MA. Address in 1929, 70 dis Rue Notre Dame-des-Champs, Paris, France.

HOFFMAN, BELLE.
Painter and illustrator. Born in Garretsville, OH, April 28, 1889. Pupil of Henry Snell; Cleveland School of Art; Art Students League of NY. Member: National Association of Women Painters and Sculptors; American Federation of Arts; Cleveland Woman's Art Club. Award: Second landscape prize, Cleveland Museum, 1923. Address in 1929, 140 West 57th Street, New York, NY.

HOFFMAN, EDWARD FENNO, III.
Sculptor. Born in Philadelphia, PA, October 20, 1916. Studied at Penna. Academy of Fine Arts. Member: Fellow, Penna. Academy of Fine Arts. Awards: Cresson traveling scholarship, 1948; Tiffany Foundation grant, 1950; National Academy of Design, 1951. Work: Brookgreen Gardens, SC; war memorial, Penna. Hospital, and Lansdowne, PA; St.

Alban's Church, Newtown Square, PA. Exhibited: Penna. Academy of Fine Arts, 1947; National Academy of Design, 1951, 52; Philadelphia Sculpture Exhibition, 1952; Woodmere Art Gallery, 1947, 49; National Sculpture Society Annual, NYC, 1972, 79. Member: National Academy of Design; National Sculpture Society; Allied Artists. Address in 1984, Wayne, PA.

HOFFMAN, FRANK B.
Sculptor, painter, and illustrator. Born in Chicago, IL, August 28, 1888. Studied with Wellington Reynolds, Leon Gaspard, John Singer Sargeant. Exhibited: Art Institute of Chicago; Harwood Gallery, Taos, NM. Position: Art, Brown and Bigelow Calendar Co., St. Paul, MN, from 1940. Address in 1953, Taos, MN.

HOFFMAN, GRACE LeGRAND.
Painter. Born in Syracuse, NY, Nov. 11, 1890. Pupil of Arthur Dow, Walter Sargent, James Parton Haney, Despujols, Andre Strauss, Gaston Ballande, and Gorguet. Member: Society of Independent Artists. Address in 1929, 25 Davis Avenue, New Rochelle, NY.

HOFFMAN, GUSTAVE ADOLPH.
Painter, etcher, and lecturer. Born in Cottbus, Brandenburg, Germany, Jan. 28, 1869. Pupil of National Academy of Design and Royal Academy of Fine Arts, Munich. Represented by a series of etchings in the National Gallery, Berlin; Royal Gallery, Munich; National Gallery, Leipzig; Art Gallery, Frankfurt; British Museum, London; Lenox Library, New York City; two oil portraits, Capitol, Hartford, CT, and Superior Court, Rockville, CT. Address in 1933, 5 Laurel Street, Rockville, CT. Died Aug. 30, 1945.

HOFFMAN, HARRY LESLIE.
Painter. Born in Cressona, PA. Pupil of Art Students League under DuMond in New York; Julian Academy in Paris. Member: Salma. Club, 1908; Mac Dowell Club; Allied Artists of America; New Haven Paint and Clay Club; Artists Aid Society; Lotus Club; American Water Color Society; NY Water Color Club; Lyme Art Association; American Federation of Arts; Architectural League of NY. Awards: Gold medal, P.P. Exp., San Francisco, 1915; Eaton Purchase prize, Lyme Art Association, 1924; landscape prize, New Haven Paint and Clay Club, 1925. Represented at Milwaukee and Chicago Art Institute; Boston City Club; National Gallery of Art, Washington, DC; Oshkosh Public Museum, Oshkosh, WI. Address in 1929, 50 West 67th Street, New York, NY; summer, Old Lyme, CT.

HOFFMAN, HARRY ZEE.
Painter. Born in Baltimore, MD, Dec. 5, 1908. Study: University of Maryland, 1928; Maryland Institute of Fine Arts, 1937; Pratt Institute, 1947; also with

Robert Brackman, 1930-40, Aldro T. Hibbard, 1940. Exhibitions: National Museum, Washington, DC; Penna. Academy of Fine Arts; Albany Institute of History & Art; Audubon Artists, NYC; Enoch Pratt Library; Maryland Institute; Creative Gallery, NYC; others. Work: Baltimore Community College; Enoch Pratt Film Collection; Baltimore Museum of Art Film Collection. Awards: Water Color Show, Washington Co. Art Museum; Baltimore Water Color Club Show; others. Teaching: Hoffman School of Art. Member: Baltimore Water Color Club; Washington Water Color Society; Artists Equity Association; American Artists Professional League. Media: Acrylic, oil, watercolor. Address in 1976, Baltimore, MD.

HOFFMAN, MALVINA CORNELL.

(Mrs. Samuel Bonaries Grimson). Sculptor and painter. Born in NYC, June 15, 1887. Pupil of Rodin in Paris; Gutzon Borglum, Herbert Adams and J. W. Alexander in NY. Member: Associate National Academy of Design, 1925; National Institute of Social Sciences; Three Arts Club, NY (hon); National Academy of Women Painters and Sculptors; Alliance; Painters' and Sculptors' Gallery of Art; National Sculpture Society. Awards: Honorable mention, Paris, 1911; first prize, "Russian Dancers" exhibit, Paris, 1911; hon. mention, for sculpture, P.-P. Exp., San Francisco, 1915; Shaw memorial prize, National Academy of Design, 1917; Widener gold medal, Penna. Academy of Fine Arts, 1920; Barnett prize, National Academy of Design, 1921; Elizabeth Watrous gold medal, National Academy of Design, 1924; Joan of Arc gold medal, National Association of Women Painters and Sculptors, 1925; hon. mention, Concord Art Association, 1925. Exhibited at National Sculpture Society, 1923. Work: "Russian Bacchanale," Luxembourg Museum; "Bill," Jeu de Paume, annex, Luxembourg Museum, Paris; "Head of Modern Crusader," Metropolitan Museum of Art; "Ivan Mestrovic," "Martinique Woman," "Senegalese Soldier," Brooklyn Museum; "Pavlowa Mask," Carnegie Institute, Pittsburgh; "Pavlowa Gavotte," Museum of Art, Stockholm; "The Sacrifice," Cathedral of St. John the Divine, NY; "Gervais Elwes," Queen's Hall, London; "Ignace Paderewski" (the artist), Academy of Rome; "John Keats," University of Pittsburgh, Pittsburgh, PA; "Anna Pavlowa," mask, Corcoran Gallery of Art, Washington, DC; "Ignace Paderewski" (the Statesman), portrait, purchased for permanent exhibition in US. Represented at American Museum of Natural History; Detroit Museum of Art; Cleveland Museum; heroic size stone group, entrance Bush House, London. Decorated with Palmes Academique, France, 1920; Royal Order of St. Sava, III, Yugoslavia, 1921. Address in 1953, 157 East 35th Street, h. 120 East 34th Street, New York, NY. Died in 1966.

HOFFMAN, MAXIMILIAN A.

Sculptor and painter. Born in Trier, Germany, February 6, 1887. Pupil of Milwaukee Art Students League; Royal Academy, Munich. Member: Chicago Society of Artists; Society of Western Sculptors. Address in 1918, 4 East Ohio St., Chicago, IL. Died July 1, 1922.

HOFFMAN, POLLY.

(Mrs. Luther Hoffmann). Painter and craftsman. Born in Bryan, TX, Feb. 8, 1890. Pupil of Henry B. Snell. Member: Southern States Art League. Awards: First prize, Texas Oklahoma Fair, 1925, 1926, 1927. Address in 1929, 2004 Avondale, Wichita Falls, TX.

HOFFMAN, RICHARD PETER.

Painter. Born in Allentown, PA, Jan. 10, 1911. Studied: Mercersburg Academy; Parsons School of Design. Work: Butler Institute of American Art, Youngstown, OH; Moravian College, Bethlehem; other collections in PA. Exhibitions: Harry Salpeter Gallery, NY; Allentown Art Museum, PA; Woodmere Art Gallery, Philadelphia, PA; New Britain Museum of American Art, CT; and others. Awards: Woodmere Art Gallery, Philadelphia, PA; Casein Award, Knickerbocker Artists, NY; Commercial Museum Civic Center Award, Philadelphia; and more. Member: Lehigh Art Alliance; Philadelphia Watercolor Society. Address in 1982, Allentown, PA.

HOFFMAN, WILMER.

Sculptor. Born in Catonsville, MD, August 1, 1889. Studied at Princeton University; Rinehart School of Sculpture; Penna. Academy of Fine Arts. Pupil of Charles Grafly, Ephraim Keyser, and Albert Laessle. Member: Fellowship Pennsylvania Academy of Fine Arts; Guild of South Carolina Artists. Award: Cresson traveling scholarship, Pennsylvania Academy of Fine Arts, 1922, 1924; gold and silver medals, Paris Expo., 1937. Work: French Government Foreign Art Collection, Paris; Baltimore Museum of Art. Exhibited: Salon d'Automne, Salon des Tuileries, Paris; New York World's Fair, 1939; one-man shows in Paris, Amsterdam, London, Charleston, NYC. Died May 21, 1954. Address in 1953, Charleston, SC.

HOFFMANN, ARNOLD.

Landscape painter and teacher. Born in Russia, Oct. 15, 1886. Studied in Munich. Member: American Water Color Society. Exhibited at Annual Exhibition of National Academy of Design in 1925. Address in 1929, 310 Riverside Drive, New York, NY.

HOFFSTETTER, W. A.

Painter. Member: Fellowship Penna. Academy of Fine Arts; Philadelphia Water Color Club; Philadelphia Art Club. Address in 1929, 721 Walnut Street, Philadelphia, PA; Glenside, PA.

HOFFY, ALFRED.
Born in 1790 in England. Portrait painter, crayon portrait draughtsman and lithographer. Hoffy exhibited at the Pennsylvania Academy for a number of years and was working in Philadelphia, 1840-52.

HOFMAN, HANS O.
Painter and illustrator. Born in Saxony, Germany, Aug. 20, 1893. Member: Society of Independent Artists. Illustrations in *The New Yorker, Chicagoan, The Nomad, Plain Talk.* Address in 1929, 14 Christopher Street, New York, NY.

HOFMAN, RUTH ERB.
(Mrs. Burton A.). Sculptor, painter, and educator. Born in Buffalo, NY, April 13, 1902. Studied at Wellesley College, B.A.; Child-Walker School of Fine Arts and Crafts; and with Arthur Lee, Agnes Abbot, Edwin Dickinson, Charles Burchfield. Member: The Patteran. Awards: Prizes, Carnegie Institute, 1941; Terry Art Institute, 1952; Albright Art Gallery, 1939, 40, 46. Work: Sculpture, Northwestern University Hall of Fame. Exhibited: Carnegie Institute, 1941, 43, 44; Metropolitan Museum of Art (AV), 1942; Art Institute of Chicago, 1943; Riverside Museum, 1939, 42; American Federation of Arts traveling exhibition, 1939; Albright Art Gallery, 1934-52; Terry Art Institute, 1952. Address in 1953, Buffalo, NY.

HOFMANN, HANS.
Sculptor, painter, and educator. Born on March 21, 1880, Weissenberg, Bavaria, Germany. Studied: Gymnasium, Munich; Academie de la Grande Chaumiere, 1904; lived and studied in Paris, 1903-14, under the patronage of Phillip Freudenberg; associated with Henri Matisse, Pablo Picasso, Georges Braque, and Robert Delamay. One-man exhibitions: Paul Cassier Gallery, Berlin, 1910; California Palace, 1931; New Orleans/Delgado, 1940; Art of This Century, NYC, 1944; Betty Parsons Gallery, 1946, 47; The Kootz Gallery, NYC, 1947, 49, 50-55, 57, 58, 60-64, 66; Richard Gray Gallery, Chicago, 1978; Metropolitan Museum of Art, "Hans Hofmann as Teacher," 1979; numerous others. Awards: J. Henry Schiedt Memorial Prize, Penna. Academy of Fine Arts, 1952; medal, Art Institute of Chicago, 1953; honorable mention, 1963; honorary degree, University of California, 1964; others. Taught: Opened his first school in Munich, 1915-32; summer sessions at Ragusa, 1924, Capri, 1925-27; Saint-Tropez, 1928, 29; Chouinard Art Institute, Los Angeles, CA, 1930; University of California, Berkeley, 1930; Art Students League, 1932-33; established his own school in NYC, in 1933-58. Author: Search for the Real and Other Essays, 1948. Died February 17, 1966.

HOFTRUP, JULIUS LARS.
Painter. Born in Sweden, Jan. 21, 1874. Self-taught. Member: Buffalo Society of Artists; American Water Color Society; NY Water Color Club; Brooklyn Society of Modern Artists; Scandinavian-American Artists. Award: Gallatin purchase prize, 1925. Represented in Brooklyn Museum; Cleveland Museum; Cedar Rapids Museum; Phillips Memorial Gallery, Washington, DC. Died April 11, 1959 in Elmira, NY. Address in 1929, 400 West 57th Street, New York, NY; h. Munstorp, Pine City, NY.

HOGUE, ALEXANDRE.
Painter, craftsman, block printer, and writer. Born in Memphis, MO, Feb. 22, 1898. Pupil of Frank Reaugh; Minneapolis Art Institute. Member: Southern States Art League; Highland Park Society of Artists, Dallas, TX. Address in 1929, 912 Moreland Street, Dallas, TX; summer, Taos, NM.

HOHNHORST, WILL.
Painter. Member: Cleveland Society of Artists. Address in 1929, 3219 Oak Road, Cleveland Heights, Cleveland, OH.

HOIE, HELEN HUNT.
Painter and collage artist. Born in Leetsdale, PA. Studied: Carnegie Tech. Exhibitions: Guild Hall Museum, Award, 1970; Long Island Painter's Show, 1973; Babcock Galleries, New York City, 1974. Address in 1980, E. 67th St., New York, NY.

HOLBERG, RICHARD A.
Painter and illustrator. Born in Milwaukee, WI, March 11, 1889. Pupil of Alexander Mueller; Louis Wilson, E. A. Webster. Member: Salma. Club; Wisconsin Painters and Sculptors; Rockport Art Association; North Shore Art Association; Artists Guild of the Authors' League of America, NY. Awards: Hon. mention, Wisconsin Painters and Sculptors, 1920; special hon. mention, Wisconsin Painters and Sculptors, 1922. Address in 1929, 131 East 31st Street, New York, NY.

HOLBERG, RUTH LANGLAND.
Painter. Born in Milwaukee, WI, Feb. 2, 1891. Pupil of Alexander Mueller, F. F. Fursman, E. A. Webster. Member: Wisconsin Painters and Sculptors; Provincetown Art Association; Rockport Art Association; North Shore Art Association; PW League. Address in 1929, 131 East 31st Street, New York, NY.

HOLDEN, CORA MILLET.
Painter and teacher. Born in Alexandria, VA, Feb. 5, 1895. Pupil of Cyrus Dallin; Joseph DeCamp; MA School of Art; Cleveland School of Art. Mural decorations "Separation" and "Reunion" war memorials at Goodyear Hall, Akron, OH; "Steel Production," mural decoration, Federal Reserve Bank, Cleveland, OH; series of four mural decorations, Allen Memorial Medical Library, Cleveland, OH. Specialty: Portraits and murals. Address in 1929, 2049 Cornell Avenue, Cleveland, OH. Died in 1939.

HOLDSWORTH, WATSON.
Painter. Member: Providence Water Color Club. Address in 1929, Orchard Avenue, Graniteville, RI.

HOLLAND, BRAD.
Illustrator. Born in Fremont, OH, in 1944. He presently works in New York and his illustrations are seen frequently on the Op-Ed page of *The New York Times*. His magazine work for such publications as *Playboy*, *Redbook*, *Evergreen Review* and *National Lampoon*, and his book illustrations for *Simon and Schuster*, have won him two Gold Medals and an Award of Excellence from the Society of Illustrators Annual Exhibitions. His drawings were part of an American Exhibition at the Louvre in Paris.

HOLLAND, FRANCIS RAYMOND.
Painter. Born in Pittsburgh, PA, Jan. 10, 1886. Pupil of Art Students League of NY. Member: Society of Independent Artists; Silvermine Group; Connecticut Society of Artists; Pittsburgh Art Association, 1916. Work: "Marsh House," Darien, CT. Died in 1934, in NY. Address in 1929, Darien, CT.

HOLLAND, JOHN JOSEPH.
Scene-painter. Born in London in 1776, he came to Philadelphia in 1706 and worked at the Chestnut Street Theatre. He also painted landscapes in water colors; in 1797 he drew a view of Philadelphia which was engraved by Gilbert Fox. Died December 15, 1820.

HOLLAND, ROBERT A.
Painter and teacher. Born in Edgerton, MO, May 6, 1868. Pupil of Cincinnati Art Academy under Duveneck. Member: Kansas City Society of Artists; Assoc. Art Museum Directors. Ex-director, City Art Museum, St. Louis. Director, Kansas City Art Institute. Address in 1929, 4415 Warwick Blvd.; h. 4322 Warwick Blvd, Kansas City, MO.

HOLLAND, THOMAS.
Landscape artist working in New York about 1800. He exhibited in Philadelphia at the Society of Artists Exhibition in 1811.

HOLLINGSWORTH, ALICE CLAIRE.
Illustrator. Born in Indianapolis, IN, Feb. 12, 1907. Pupil of Herron Art School; Circle Art Academy. Address in 1929, 1116 West 30th Street, Indianapolis, IN.

HOLLINGSWORTH, GEORGE.
Painter of landscapes and portraits. Born in Milton, MA, in 1813. He painted a portrait of Captain Fisher of Milton (owned by the Boston Museum of Fine Arts). He died in 1882 in Massachusetts.

HOLLISTER, ANTOINETTE B.
Sculptor. Born in Chicago, IL, August 19, 1873. Pupil of Art Institute of Chicago; Injalbert and Rodin in Paris. Member: South West Sculptors; Chicago Society of Artists. Awards: Honorable mention for sculpture, P.-P. Exposition, San Francisco, 1915; Shaffer prize for sculpture, Art Institute of Chicago, 1919. Address in 1929, The All-Arts Studios, Greenwich, CT.

HOLLOWAY, EDWARD STRATTON.
Illustrator, painter, craftsman, and writer. Born in Ashland, Greene Co., NY. Pupil of Penna. Academy of Fine Arts. Award: Bronze medal, St. Louis Expo., 1904. Art director, J. B. Lippincott Co.; joint author, *The Practical Book of Interior Decoration*; author of *The Practical Book of Furnishing the Small House and Apartment*; *The Practical Book of Learning Decoration and Furniture*, and *American Furniture and Decoration: Colonial and Federal*. Address in 1929, 400 South 15th Street, Philadelphia, PA. Died in 1939.

HOLLOWAY, IDA H(OLTERHOFF).
(Mrs. George C. Holloway). Painter, illustrator, and craftsman. Born in Cincinnati. Pupil of Cincinnati Art Academy under Frank Duveneck; Henry B. Snell; also studied in Europe. Member: Cincinnati Woman's Art Club; MacDowell Club; The Crafters Club, Cincinnati. Address in 1929, 2523 Ritchie Avenue, East W. H., Cincinnati, OH.

HOLLROCK, GEORGE L.
Painter. Member: Artists Guild of the Authors' League of America, NY. Address in 1929, 70 Fifth Avenue, New York, NY.

HOLLYER, SAMUEL.
Engraver. Born on Feb. 24, 1826 in London. Died in New York City, Dec. 29, 1919. Mr. Hollyer was a pupil of the Findens in London. He came to the United States in 1851; but he twice returned to England for periods of two and six years, and finally settled in this country in 1866. Besides engraving, Mr. Hollyer was engaged here at different times in lithography, photography and the publishing business. In collection of Metropolitan Museum of Art. An excellent engraver in both line and in stipple. Produced a large number of portraits, landscapes, and historical subjects. Among his larger and best plates are "The Flaw in the Title," "Charles Dickens in His Study" and "The Gleaner."

HOLM, VICTOR S.
Sculptor and teacher. Born in Copenhagen, Denmark, December 6, 1876. Pupil of Art Institute of Chicago under Lorado Taft; Philip Martiny in NY. Member: National Sculpture Society, 1913; St. Louis Art Guild; St. Louis Art League; 2 x 4 Society of St. Louis; Municipal Art Comm.; Alumni Art Inst. of

Chicago; St. Louis Architectural Club (hon.); Ethical Culture Society; Societe Francaise (hon.). Awards: Silver medal, Missouri State Fair, 1913; Carleton prize ($100), St. Louis Art Guild, 1914, 16, 17; honorable mention, P.-P. Exp., San Francisco, 1915; St. Louis Artists' League prize ($300), 1922; silver medal, Midwestern Artists, Kansas City, 1926. Work: Parker Memorial, State Univ. Library, Rolla, MO; Ives Memorial, City Art Museum, St. Louis; Barnes Memorial, Barnes Hospital, St. Louis; Missouri State Monument at Vicksburg, MS; Gov. Carlin Monument, Carrollton, IL; Washington Fischel Monument, Bellefontaine, St. Louis, MO; "Boy With Father's Sword," St. Louis Public Library; decorations of exterior of St. Pius' Church, St. Louis; Waterloo, IA, High School; Ft. Dodge High School; "Col. Drieux" monument, New Orleans; Washington University War Memorial, St. Louis; Nelson Memorial Fountain, Le Claire, IL; Musicians Memorial Fountain, Forest Park, St. Louis; Dr. Beaumont Memorial, Beaumont High School, St. Louis; Wayman Crow Memorial, City Art Museum, St. Louis; World War Monument, Maplewood, MO; Emile Zola Memorial, W.M.H.A., St. Louis; Claude Monet Medal for 2 x 4 Society, St. Louis; Geo. W. Niedringhaus Memorial, Granite City, IL; Festus Wade Memorial, Missouri State Capitol Bldg., Jefferson City, MO; "Spirit of St. Louis," Gold Medal given by American Society of Mechanical Engineers for Aviation; Long Memorial, Long Public School, Statue of Geo. Washington, Masonic Temple, two heroic statues, Continental Life Insurance Building, Heroic Bear, Municipal Auditorium, all in St. Louis, MO; Shaw Gold Medal for Horticulture given by MO Botanical Gardens. Exhibited at National Sculpture Society, 1923. Address in 1933, School of Fine Arts, Washington University, St. Louis, MO. Died in 1935.

HOLMAN, LOUIS ARTHUR.
Illustrator. Born at Summerside, Prince Edward Island, Canada, in 1866. Illustrated "Boston, the Place and the People," in 1903, "Boston Common" in 1910; contributor also to Scribner's, Century, Printing Art, etc. Address in 1926, 9A Ashburn Place, Boston, MA. Died in 1939.

HOLMBOM, JAMES W.
Painter. Born in Monson, ME, March 3, 1926. Studied: Portland (ME) School of Art, with Alexander Bower; University of Maine; Instituto Allende, Mexico, with James Pinto and Fred Samuelson. Work: Massachusetts and Maine corp. collections; Instituto Allende. Exhibitions: Instituto Allende; Galleria San Miguel; UNICEF Invitational; Bertrand Russell Cent., and others. Awards: Portland Art Festival-Purchase Prize. Art Position: City Art Director, Montpelier, VT, 1956-59, and Marblehead, MA, 1959-71; others. Media: Acrylic, oil. Address in 1980, Hancock, ME.

HOLMES, HARRIET MORTON.
(Mrs. J. Garnett Holmes). Etcher. Born in Portland, ME. Member: California Print Makers; California Society of Etchers. Address in 1929, R.F.D. 2, Temple, AZ; 826 North Central Avenue, Phoenix, AZ.

HOLMES, RALPH.
Painter, illustrator, craftsman, writer, lecturer and teacher. Born in La Grange, IL. Pupil of Art Institute of Chicago; studied in Paris. Member: California Art Club; Los Angeles Painters and Sculptors. Award: Silver medal, Associated Artists of Pittsburgh, Carnegie Institute, 1915. Address in 1929, 6553 Colgate, Los Angeles, CA.

HOLMES, RHODA CARLETON.
See Nicholls, Rhoda Carleton Holmes.

HOLMES, WILLIAM H.
Painter. Born in Harrison Co., OH, Dec. 1, 1846. Artist to U.S. Geological Survey of the Territories, 1872; curator, 1906, and director, 1920, National Gallery of Art. Member: President, Washington Water Color Club; Hon. President, Society of Washington Artists; Washington Landscape Club (hon.); American Federation of Arts. Art Editor, *Art and Archaeology*. Awards: First Corcoran prize, Washington Water Color Club, 1900; Parsons prize, Washington Water Color Club, 1902. Work: "Midsummer," Corcoran Gallery, Washington, "The Wanderlusters' Rest," National Gallery of Art, Washington, DC. Address in 1929, National Gallery of Art, Smithsonian Institution; h. Cosmos Club, Washington, DC. Died 1933.

HOLMGREN, R. JOHN.
Painter and illustrator. Born in St. Paul, MN, Nov. 27, 1897. Pupil of Bridgman and Woodbury. Member: Society of Illustrators; Artists Guild of the Authors' League of America, NY. Address in 1929, 42 East 58th Street, New York, NY. Died 1963.

HOLSCHUH, (GEORGE) FRED.
Sculptor. Born in Beerfelden, Germany, November 19, 1902; US citizen. Studied at Penna. Academy of Fine Arts; University of Pennsylvania; also with Bauhaus founder, Walter Gropius. Work at Addison Gallery, NY; Brookgreen Gardens, SC; monument, Yugoslav Order of St. Francis, Washington, DC; others. Has exhibited at Penna. Academy of Fine Arts; National Academy of Design, NY; Regional Sculpture Show, Smithsonian Institution, Washington, DC; others. Received Stimson Prize in Sculpture, Penna. Academy of Fine Arts, 1935; European Traveling Scholars, 1935, 36; Southern Sculptors National Show. Member: Association of Southern Sculptors. Works in wood and copper. Address in 1982, Tallahassee, FL.

HOLSLAG, EDWARD J.
Painter and mural designer. Born in Buffalo, NY, in 1870. Pupil of National Academy of Design, and of John La Farge. He exhibited portraits and landscapes at the Chicago Art Institute, and is represented by murals in the Congressional Library, Washington, DC, and in many banks, theatres and public buildings. He died in De Kalb, IL, Dec. 10, 1925. He was formerly president of the Palette and Chisel Club.

HOLSMAN, ELIZABETH TUTTLE.
Sculptor and painter. Born in Brownville, NE, Sept. 25, 1873. Pupil of Art Institute of Chicago. Member: Chicago Society of Artists; Chicago Art Club; Chicago Galleries Association. Award: Silver medal, St. Paul Institute, 1916. Work: "Still Waters," Omaha Society of Fine Arts; "Portrait of David Rankin," bronze bas-relief, and "Portrait of Joseph Addison Thompson," Tarkio College, Tarkio, MO; bronze bas-relief of Dean Reese, Law School, University of Nebraska, Lincoln, NE; war memorial bas-relief "Lieut. Alexander McCornick" in US Destroyer "The McCornick;" war memorial "Victory" with honor roll in Harrison Technical High School, Chicago. Address in 1933, Chicago, IL; summer, Lotus Island, Lauderdale Lakes, WI.

HOLT, MAUD S.
(Mrs. Winfield Scott Holt). Painter. Born in Carbondale, IL, Nov. 1, 1866. Pupil of Harry Thompson and Percy Tudor; Hart in Paris; George Elmer Browne; Academie des Grandes Chaumieres. Member: Southern States Art League; Little Rock Fine Arts Club; Springfield, IL, Art Association. Awards: First prize for flower paintings, St. Louis Fair, 1890. Represented by portraits in the Arkansas State House; Public Libary, Little Rock; and a landscape in the Boys Club, Little Rock. Address in 1929, 1003 Barber Avenue, Little Rock, AR.

HOLT, PERCY WILLIAM.
Painter. Born in Mobile, AL. Pupil of Birge Harrison, John F. Carlson, Charles Rosen. Address in 1929, 2214 Broadway, Galveston, TX; summer, Woodstock, NY.

HOLT, SAMUEL.
Miniature painter. Born in Meriden, CT, in 1801. He lived in Hartford for many years.

HOLTERHOFF, IDA.
See Holloway, Ida Holterhoff.

HOLTON, LEONARD T.
Illustrator and writer. Born in Philadelphia, Sept. 6, 1900. Member: Society of Illustrators; Philadelphia Artists Guild. Address in 1929, 3501 Powelton Avenue, Philadelphia, PA.

HOLTZMAN, IRVING.
Painter. Born in Russia, Feb. 16, 1897. Pupil of Cooper Union; National Academy of Design. Member: Salons of America; Society of Independent Artists. Address in 1929, 671 Manida St., New York, NY.

HOLVEY, SAMUEL BOYER.
Sculptor and designer. Born in Wilkes-Barre, PA, July 20, 1935. Studied at Syracuse University; American University. Represented by commission, bas-relief mural, Wyoming Valley Country Club, Wilkes Barre, PA, 1962. Exhibited at Corcoran Area Show, Washington, DC; Annual Washington Area Sculpture Show; The American Genius, Corcoran Gallery; etc. Taught design and graphic design, Corcoran School of Art, Washington, DC, 1965-80; University of Maryland, 1967-78. Works in metal direct contruction, lumia. Address in 1982, Bethesda, MD.

HOLYLAND, C. I.
Engraver. He engraved on copper in New York in 1834. The only plate known is an allegorical frontispiece to "A Defense of Particular Redemption - In four letters to the Baptist Minister," New York, 1834. He signed his work "C. I. Holyland Sc."

HOLYOKE.
A little-known genre painter of some talent.

HOLZER, J. A.
Sculptor and mural painter. Born in Berne, Switzerland, in 1858. Pupil of Fournier and Bernard in Paris. His mural, "Homer," is at Princeton University, Princeton, NJ. Address in 1926, 182 East 72nd Street, New York, NY.

HOLZHAUER, EMIL EUGEN.
Painter and sculptor. Born Schwabisch Gmund, Germany, Jan. 21, 1887. Pupil of Robert Henri, Homer Boss. Member: Society of Independent Artists; Audubon Artists; Georgia Art Association; Southern States Art League. Awards: Art Institute of Chicago, 1930; North Carolina Exhibition, 1942; Southern States Art League, 1946; Carnegie grant, 1946, 49; Georgia Art Association, 1952; others. Work: Albany Institute of History and Art; Art Institute of Chicago; Newark Museum; Whitney Museum, NYC; Syracuse Museum of Fine Arts; High Museum of Art; others. Exhibited: Art Institute of Chicago, 1927-35, 37, 43; Penna. Academy of Fine Arts, 1928, 32; Corcoran, 1930, 34, 51; Carnegie, 1930; Brooklyn Museum, 1929, 33; Albright; Whitney, 1933, 34; many others. Professor of Art, Wesleyan College, Macon, GA, from 1942. Address in 1953, Wesleyan College; h. 656 College St., Macon, GA.

HOMAN, S. V.
Miniature painter, flourishing in Boston in 1844.

HOMER, WINSLOW.
This noted landscape, marine and genre painter was born in Boston, Feb. 24, 1836; died at Scarboro, ME, Sept 29, 1910. Beginning work as a lithographer when nineteen years old, he took up painting and illustrating two years later. He came to NY in 1859, and for a short time studied at the National Academy of Design and with Frederick Rondel. He was sent by Harper & Brothers to make war paintings in 1861; he subsequently painted many pictures of black American life, and a visit to the Adirondack mountains inspired him to paint camping scenes with mountain guides. Later he traveled in England and France. He is best known by his pictures of the Maine Coast, where for many years he lived the life of a recluse at Scarboro. He was elected an Associate of the National Academy in 1864, and an Academician the following year, and was a member of the American Water Color Society and the National Institute of Arts and Letters.

HONG, ANNA HELGA.
Painter, lecturer, and teacher. Born in Monona Co., IA, Feb. 21, 1894. Member: California Art Club; Chicago Society of Artists. Award: Third prize for oil painting, Northwestern Painters, Seattle Fine Arts Society, 1925; Tingle prize, Los Angeles Museum, 1926; second prize, Chicago Norske Club, 1926; first Eisteddfod prize, Los Angeles, 1926. Lecturer on art appreciation, modern art and interior decoration. Address in 1929, Dept. of Art, Northwestern University, Evanston, IL; summer, 1115 Mendocino St., Altadena, CA.

HONIG, GEORGE H.
Sculptor and portrait painter. Born in Rockport, IN, 1881. Pupil of National Academy of Design and H. A. MacNeil in New York. Member: Evansville Society of Fine Arts and History. Awards: Suydam bronze medal, National Academy of Design, 1914; Suydam silver medal, National Academy of Design, 1915. Work: Spanish-American war memorial at Salina, KS; "The Spirit of 1861" and "The Spirit of 1916," on Vanderburg County Soldiers' and Sailors' Coliseum, Evansville, IN; "The Hiker," Fairview Park, Denver, CO; portrait of Cleo Baxter Davis in Court House, Bowling Green, KY; portrait in bronze of J. B. Gresham for War Mothers of America, Evansville, IN; Service Star and Legion Memorial, Evansville, IN; Judge Thomas Towles, Sr., Memorial, Henderson, KY; Abraham Lincoln Trail Markers (portrait) Grand View, IN; six memorials of Transylvania Company, Henderson, KY; replicas in Transylvania University, Lexington, KY, and Univ. of North Carolina, Chapel Hill, NC; Rotary Hall of Fame Memorial, Fine Arts Society, Evansville; Portrait Crowder Memorial, Evansville, Indiana; war memorials in Elks House, Princeton, NJ, Evansville, IN, and Mt. Vernon, IN; in Eagles Home at Anderson and Richmond, IN; in Masonic Temple, Evansville, IN; in Court House at Bloomington, IL, and Evansville, IN; soldier group, Joliet, IL; fountain and bronze goups, Shelbyville, IN; Capello memorial, Evansville, IN; World War memorials at Evansville and Connelton, IN; bronze portrait, Rescue Mission. Address in 1933, Evansville, IN.

HONIG, MERVIN.
Painter. Born in New York, NY, Dec. 25, 1920. Studied at Brooklyn College, 1938-41, 73, B.A.; Hofstra University, M.A.; and with Francis Criss, Amadee Ozenfant, and Hans Hofmann. Exhibited: Metropolitan Museum of Art, 1944; Carnegie, 1945; Los Angeles County Museum, 1945; Whitney, 1949; Brooklyn Museum, 1960; Wadsworth Atheneum, 1965; Heckscher Museum, 1965; Butler Institute American Art Annual, 1967, 69; Oklahoma Museum of Art, Annual Drawing Exhibition, 1969; Pensacola Museum of Art, 1982; National Academy, NY Member's Annual, 1983; Hudson River Museum, Artists Annual, 1983; others. Solo exhibitions include D'Arcy Gallery, NY; NYC Community College; Frank Rehn Gallery, NY; New School, NY; many others; group exhibitions include ACA Gallery; National Academy of Design Annuals; Audubon Artists; Allied Artists, NY; Salma. Club; Knickerbocker Artists; National Arts Club; many others. Awards: Gold medal, Best in Show, American Veterans Society of Artists, 1968; Award of Excellence, Mainstreams 70, Marietta College, OH; Locust Valley Art Show, 1st prize, 1966, 2nd prize, 1967; Samuel Morton Memorial Award, Audubon Artists Annual, 1983. Work: Oklahoma Museum of Art; Colby College Museum of Art, ME; Metropolitan Museum of Art; Nassau Co. Museum; National Academy of Design; Emily Lowe Gallery, Hofstra University; William Benton Museum of Art, Storrs, CT. Member: Associate, Nat. Academy; Audubon Artists; Allied Artists; Artists Equity Association; College Art Association. Teaching: Hofstra University; The New School. Lecturer; author of numerous articles. Address in 1984, Westbury, NY.

HONORE, PAUL.
Painter, illustrator, writer, and lecturer. Born in Pennsylvania, May 30, 1885. Pupil of Brangwyn; Wicker; Penna. Academy of Fine Arts. Member: National Arts Club; Washington Art Club; Scarab Club; Detroit Arts and Crafts Society; Artists Guild of the Authors' League of America, NY; Mural PS; Michigan Academy of Fine Arts; American Artists Professional League. Awards: Prize, Museum of Art Founders Society, Detroit Art Institute, 1917; Preston prize, Detroit Art Institute, 1917; Walter Piper purchase prize, Scarab Club. Work: Murals in Department of Architecture, Univ. of Michigan; County Courthouse, Midland, MI; Highland Park High School; Student Church, East Lansing; Public Library, Dearborn, MI; Player's Club, Detroit, MI; "The Loggers," State of Michigan; wood block prints,

Detroit Art Institute. Illustrated: *Bushranger and Highwaymen* (McBride & Co.); *Tales from Silverlands, Frontier Ballads* and *The Winged Horse,* (Doubleday, Doran & Co.); *Tales Worth Telling,* (Century Co.); *The Winged Horse Anthology,* (Doubleday, Doran & Co.); *Heroes from Hakluyt,* (Henry Holt). Address in 1929, 217 Farnsworth Avenue, East, Detroit, MI; h. Royal Oak, MI.

HOOD, ETHEL PAINTER.
Sculptor. Born in Baltimore, MD, April 9, 1908. Studied: Art Students League; Julian Academy, Paris. Awards: Gold medal, Catherine L. Wolfe Art Club, 1954; Society of Washington Artists, 1939. Collections: Radio City and French Bldg., Rockefeller Center, New York City; St. Francis of the Curbs, Brookgreen Gardens, SC. Exhibited at Baltimore Museum of Art; Corcoran; National Academy of Design, NYC; Whitney; Penna. Academy of Fine Arts; Corcoran Gallery of Art, Washington, DC; others. Member: Fellowship National Sculpture Society; National Association of Women Artists. Address in 1982, 15 E. 61st Street, NYC.

HOOGLAND, WILLIAM.
Born in 1795. He was an admirable engraver in both line and stipple. He appears in NY about 1815 as the designer and engraver of vignettes. In 1826 he was working with Abel Bowen in Boston, and among his pupils there were John Cheny and Joseph Andrews. In 1841 he was again in NYC. Hoogland was one of the early American bank-note engravers.

HOOKER, MARGARET HUNTINGTON.
Sculptor, painter, and illustrator. Born in Rochester, NY, June 10, 1869. Studied at Art Students League and Metropolitan Schools of NY; also in Paris and London. Taught art in Normal School, Cortland, NY, 1893-94; illustrated for *New York Tribune,* 1897; later taught arts and crafts in Paris. Sculpture includes marble bas relief (the American Naturalist Edgar Burroughs?), exhibited at Apollo Gallery, Poughkeepsie, NY, 1974. Address in 1915, Rochester, NY; living in Paris in 1926.

HOOKER, WILLIAM.
As early as 1805 Hooker was engraving in Philadelphia, and in 1810 he was one of the organizers of the Philadelphia Society of Artists. In 1816 he removed to NY and his name appears in the directories of that city until 1840. His occupation is generally given as "Engraver," but he also appears as "map-publisher" and as "instrument maker and chart-seller to the US Navy." The *New Pocket Plan of New York,* of 1817, is "Drawn, engraved, published and sold" by Hooker. He engraved a few portraits in stipple, and subject plates in line, but he seems to have been chiefly employed in map engraving.

HOOKS, MITCHELL HILLARY.
Illustrator. Born in Detroit, MI, in 1923. He attended the Cass Technical High School there. His first illustration was done in 1942 for an advertising firm. A leader in the field of paperback cover illustration for many years, he has illustrated a great number of books and magazines as well. An active member of the Society of Illustrators, a contributor to the U.S. Air Force art program, he lives and works in New York City.

HOOPER, ANNIE BLAKESLEE.
Painter, illustrator, and craftsman. Born in Calif. Pupil of San Francisco Art School; Art Students League of NY and Charles Melville Dewey. Member: NY Water Color Club. Address in 1929, 200 Fifth Avenue, New York, NY; h. Spuyten Duyvil, NY.

HOOPER, EDWARD.
Born in England, May 24, 1829; died in Brooklyn, Dec. 13, 1870. He was an engraver and was for many years a member of the firm of Bobbett and Hooper, wood-engravers. Mr. Hooper produced several water colors remarkable for their accuracy of drawing and harmony of color. He was one of the originators of the American Water Color Society.

HOOPER, ELIZABETH.
Painter, illustrator, craftsman, and writer. Born in Baltimore, Oct. 6, 1901. Member: Baltimore Water Color Club; Baltimore Society of Independent Artists. Address in 1929, 605 The Charles Apts., 3333 North Charles St., Baltimore, MD.

HOOPER, LAURA B.
Painter. Member: Baltimore Water Color Club. Address in 1929, Shirley and Green Spring Aves., Baltimore, MD.

HOOPER, ROSA.
Painter. Born in San Francisco, CA, July 19, 1876. Pupil of San Francisco Art School; San Francisco Art League; Otto Eckhardt in Dresden; Mme. de Billemont in Paris. Member: California Society of Miniature Painters; San Francisco Society of Women Painters; Alliance. Awards: Grand Prize, Alaska-Yukon Pacific Exposition, Seattle, 1909; gold and bronze medals, Panama-Pacific Exposition, San Diego, 1915; first popular vote prize, CA. Soc. of Miniature Painters, Los Angeles CA, 1929. Address in 1929, 624 Lexington Ave., New York, NY.

HOOPER, WILL PHILLIP.
Painter and illustrator. Born in Biddeford, ME. Pupil of Benjamin Fritz and Art Students League of NY; Massachusetts Normal Art School, Boston. Member: NY Water Color Club; Salma. Club. Address in 1929, Villa Rosa Studios, Spuyten Duyvil, NY. Died in 1938.

HOOPLE, WILLIAM C.
Illustrator. Member: Society of Illustrators; Artists Guild of the Authors' League of America, NY. Address in 1929, 11 East 14th Street, New York, NY.

HOOVEN, HERBERT NELSON.
Painter. Born in Hazelton, PA, Jan 31, 1898. Pupil of Penna. Academy of Fine Arts; Beaux-Arts Institute of Design; Pennsylvania Mus. School Ind. Artists. Member: Fellowship, Penna. Academy of Fine Arts. Work: "Anthracite Coal Industry," Hazelton Public Library; mural decorations, Church of St. Louis, Waterloo, Canada; "Fleet on Narragansett Bay," Library, University of Valparaiso; "End of Winter" and "Edge of the Woods," Hazleton High School Gallery; "Morning," Civic Club, Hazleton, PA. Address in 1929, Drums, PA.

HOOVER, BESSIE M.
See Wessel, Bessie Hoover.

HOOVER, CHARLES.
Illustrator. Born in Washington, DC, April 8, 1897. Pupil of Hugh Breckenridge. Member: Washington Landscape Club. Address in 1929, 409 Evening Star Building; h. 3024 - 45th St., NW, Washington, DC.

HOOVER, MRS. LOUIS ROCHON.
Painter and illustrator. Born in Washington, DC. Pupil of Hugh Breckenridge. Work: Portraits and advertising illustrations. Address in 1929, 3024-45th Street, NW, Washington, DC.

HOPE, JAMES.
Painter. Born in Eng., Nov. 29, 1818, he accompanied his father to Canada; after the death of his parent he removed to Fair Haven, VT, and became interested in art. In 1853 he opened his studio in NY and was elected an Associate of the National Academy. His pictures include "The Army of the Potomac," "Rainbow Falls," "The Gem of the Forest," and the "Forest Glen." He died in 1892, in NYC.

HOPE, JOHN W.
Sculptor. Exhibited at National Academy of Design in 1925. Specialty, animals. Address in 1926, 65 Gun Hill Road, NY.

HOPE, THOMAS W.
Portrait and miniature painter, flourishing 1839-45 in New York.

HOPKIN, ROBERT.
Painter. Born Jan. 3, 1822, in Glasgow, Scotland. Went with his parents when eleven years old to Detroit, MI, where he grew up and became the head of the art interests of that city. His best work consists of landscape and marine painting. He died on March 21, 1909 in Detroit.

HOPKINS, C. E.
Painter and etcher. Born in Cincinnati, OH, in 1886. Pupil of Newotany and Barnhorn. Member: Cincinnati Art Club. Address in 1926, 3525 Trimble Avenue, Evanston, Cincinnati, OH.

HOPKINS, CHARLES BENJAMIN.
Painter, illustrator, writer, and teacher. Born Oct. 23, 1882. Pupil of Artklan. Illustrated *A Dog's Life*, by Tige; author and illustrator of *Comic History of our Boys in France*. Instructor in commercial art, Marysville Business College. Address in 1929, care of S. D. Johnson Co, Marysville, CA.

HOPKINS, DANIEL.
Engraver. This man engraved the music and words for "The Rudiments of Music," etc. The book is dated in 1783, and it was published in Cheshire, CT.

HOPKINS, EDNA BOLES.
(Mrs. James R. Hopkins). Engraver. Born in Michigan in 1878. Member: Societe Internationale des Graveurs en Couleurs; Societe Internationale des Graveurs sue Bois; Societe Nationale des Beaux-Arts in Paris. Award: Silver medal, P.-P. Exp., San Francisco, 1915. Work in Library of Congress, Washington, DC; Walker Art Gallery, Liverpool; National Museum, Stockholm; Kunst Gewerbe Museum, Berlin; Bibliotheque d'Art et Archaeologie, Paris; Cincinnati Art Museum; Detroit Institute of Arts. Address in 1929, Ohio State University, Columbus, OH; 55 Rue de Dantzig, Paris, France. Died in 1935.

HOPKINS, JAMES R.
Painter. Born in Ohio, 1878. Pupil of Cincinnati Art Academy. Member: Associate National Academy of Design; American Art Association of Paris; Associate, Societe Nationale des Beaux Arts, Paris. Awards: Lippincott prize, Penna. Academy of Fine Arts, 1908; bronze medal, Buenos Aires, 1910; gold medal, P.P. Expo., San Francisco, 1915; Harris bronze medal and prize ($300), Art Institute of Chicago, 1916; Clarke prize, National Academy of Design, 1920. Work: "Frivolity," Cincinnati Museum; "A Kentucky Mountaineer," Chicago Art Inst.; "Reflections," Atlanta Art Association. Address in 1929, Ohio State University, Columbus, OH; 55 Rue de Dantzig, Paris, France.

HOPKINS, MARK.
Sculptor. Born in Williamstown, MA, February 9, 1881. Pupil of Frederick MacMonnies. Member Societe des Artistes Francais; Union Internationale des Beaux-Arts. Died in 1935 in Paris, France. Address in 1910, Giverny-par-Vernon, Eure, France; and Williamstown, MA.

HOPKINSON, CHARLES SYDNEY.
Painter. Born in Cambridge, MA, July 27, 1869. Pupil of Art Students League of NY; Aman-Jean, Denman Ross, Carl G. Cutler. Member: Associate National Academy of Design; Guild of Boston Artists; Boston Water Color Club; Society of American Artists, 1898; American Water Color Society; Portrait Painters; Concord Art Association; Boston

Society of Water Color Painters. Awards: Bronze medal, Pan-Am. Expo., 1901; bronze medal, St. Louis Expo., 1904; second prize ($200), Worcester Museum, 1902 and 1905; Beck gold medal, Penna. Academy of Fine Arts, 1915; silver medal, P.P. Expo., San Francisco, 1915; silver medal, Sesqui-Centennial Exposition, Philadelphia, 1926; Logan medal ($1,000), Art Institute of Chicago, 1926. Represented in Rhode Island School of Design; Harvard University; collection of war portraits, National Gallery of Art, Washington; Brooklyn Museum; Brown University; Radcliffe College; Dartmouth College; University of Virginia; Cleveland Museum. Died in 1962. Address in 1929, Manchester, MA.

HOPKINSON, FRANCIS.
Painter and lawyer, signer of the Declaration of Independence, was born October 2, 1737. He drew and painted several portraits. He died May 9, 1791.

HOPPE, LESLIE F.
Designer. Born in Jerseyville, IL, 1889. Pupil of Chicago Academy of Fine Arts and Art Institute of Chicago. Member: Palette and Chisel Club. Address in 1929, 415 South Claremont Avenue, Chicago, IL.

HOPPER, EDWARD.
Painter and etcher. Born in Nyack, NY, July 22, 1882. Pupil of Henri; Hayes Miller; Chase. Member: American Print Makers; Brooklyn Soc. of Etchers. Awards: Bryan prize, Los Angeles Museum, 1923; Logan prize, Art Institute of Chicago, 1923. Represented in California State Library; Penna. Academy of Fine Arts; Brooklyn Museum; New Orleans Museum; Art Institute of Chicago; NY Public Library; Metropolitan Museum; British Museum; Fogg Museum, Cambridge; Phillips Memorial Gallery, Washington, DC. Died in 1967. Address in 1929, 3 Washington Square, North, New York, NY.

HOPPIN, AUGUSTUS.
Painter and wood engraver. Born in Providence, RI, July 3, 1828. He illustrated and engraved for many publications. Died April 1, 1896 in Flushing, NY.

HOPPIN, HOWARD.
Painter. Member: Providence Art Club. Address in 1929, 7032 Westminster Street, Providence, RI.

HOPPIN, THOMAS FREDERICK.
Sculptor, painter, and etcher. Born August 15, 1816, Providence, RI. Brother of Augustus Hoppin. Studied in Philadelphia and later in Paris under Delaroche. On his return to this country he opened his studio in New York and worked in that city during the late 1830's. He lived in Providence, RI, 1841-72. He produced statues in plaster, stained glass designs, and many etchings and illustrations of American life and history. The American Art Union in 1848 and 1850 published two of his etchings. Exhibited at National Academy of Design; Art-Union; Boston Athenaeum; American Institute. Honorary member of National Academy of Design, New York. Died January 21, 1872, in Providence, RI.

HOPSON, WILLIAM FOWLER.
Etcher and engraver. Born in Watertown, CT, Aug. 30, 1849. Pupil of L. Sanford in New Haven; J. D. Felter and August Will in New York. Member: Grolier Club, New York; Rowfant Club, Cleveland; American Institute of Graphic Arts; Acorn Club and Paint and Clay Club, New Haven; American Federation of Arts. Award: Hon. mention for copper engraving, Pan-Am. Expo., Buffalo, 1901. Work in Chicago Art Institute; New York Public Library; Library of Congress; Metropolitan Mus.; Harvard University; Yale University; and other collections. Specialty, bookplates. Engraved the blocks for one edition of Webster's. Died Feb. 13, 1935. Address in 1929, 720 Whitney Avenue, New Haven, CT

HOPWOOD.
A mixed copper-plate engraving is signed "Hopwood Sc." The title is "A Winter Piece" (snow scene with cottage in right background, tree in left; in the center of foreground is a man with a stick in his right hand standing by a horse with a pannier). This print was published in 1803 by J. Nicholdson, Halifax.

HORCHERT, JOSEPH A.
Sculptor. Born in Hechingen, Germany, May 4, 1874. Studied in Staedel Art Institute, Frankfurt am Main, and Royal Academie, Munich, Germany. Member: St. Louis Art League; St. Louis Art Guild. Award: Prize for Fountain, St. Louis Art League. Work: Guggenheim Memorial Fountain, St. Louis; figures on the Friedrich Bridge, Berlin; high altar, Sacrament Church, St. Louis, MO; memorial tablet, College of Pharmacy, St. Louis; pediments, high school, Jersey City, NJ, and Preparatory Seminary, St. Louis; mem. tablet, Westminster Col., Fulton, MO; portraits of Founders of Lindenwood College, St. Charles, MO. Address in 1933, St. Louis, MO.

HORD, DONALD.
Sculptor. Born in Prentice, Wisconsin, February 26, 1902. Pupil of Santa Barbara School of the Arts; University of Mexico; Penna. Academy of Fine Arts; Beaux-Arts Institute of Design. Member: National Sculpture Society; National Academy; National Institute of Arts and Letters. Work: Bronze, "El Cacique," San Diego Fine Arts Gallery, San Diego, CA; San Francisco Museum of Art; fountain, Balboa Park, San Diego; San Diego Civic Center; others. Exhibited: Museum of Modern Art, NYC, 1942; Metropolitan Museum of Art, 1942, 51; American-British exhibition, 1944. Awards: Medal, San Diego Expo., 1935, 36; National Institute of Arts and Letters, 1948; Guggenheim Fellowship, 1945, 47. Address in 1953, San Diego. Died in 1966.

HORE, ETHEL.
See Townsend, Ethel Hore.

HORIUCHI, PAUL.
Artist. Born April 12, 1906 in Yamanashiken, Japan. Primarily a self-taught artist. Works in collage (rice paper); is also a painter since youth. Lives in Seattle (created mural for Seattle World's Fair, 1962). Received awards from Washington State Fair; many from Seattle Art Museum; Ford Foundation; Seattle World's Fair; Spokane Art Board Coliseum and others. Exhibited at NY Coliseum (1959); Carnegie; Stanford University; Seattle Art Museum; Penna. Academy of Fine Arts; Yoseido Gallery, Tokyo; Oakland Art Museum; Reed College; Expo 74, Spokane. In collections of Wadsworth; Reed College; Harvard; University of Arizona; Denver Art Museum; Seattle Public Library; Museum of Modern Art in Tokyo; Mead Corporation; University of Oregon.

HORN, MILTON.
Sculptor. Born in Ukraine, Russia, September 1, 1906. Pupil of Henry Hudson Kitson, Boston; Beaux-Arts Institute of Design, New York; Educational Alliance, NYC. Work: Ceiling, Hotel Savoy-Plaza, New York; Brookgreen Gardens, SC; National Museum of Fine Arts, Washington, DC; National Academy of Design, NYC; numerous commissions including WV University Medical Center; B'nai Israel Temple, Charleston, WV; Central Water Filtration Plant, Chicago; others. Awards received from American Institute of Architects and National Sculpture Society. Exhibited: New York World's Fair, 1939; Penna. Academy of Fine Arts, 1936; Brooklyn Museum, 1930; Metropolitan Museum of Art, 1942, and 51; Philadelphia Museum of Fine Arts, 1949; National Institute of Arts and Letters, 1953, 55, 77; many others. Artist in residence, Olivet College, 1939-49, Michigan. Address in 1953, Olivet College, Michigan. Living in Chicago in 1982.

HORNBY, LESTER GEORGE.
Illustrator, painter, and engraver. Born in Lowell, MA, March 27, 1882. Pupil of Rhode Island School of Design, Providence; Pape School, Boston; Art Students League of NY; Laurens and others in Paris. Member: Providence Art Club; Providence Water Color Club; Chicago Society of Etchers; NY Society of Etchers; Salma. Club; American Art Association of Paris (Dir. 1907-1908); Boston Society of Water Color Painters; North Shore Art Association. Work: Victoria and Albert Museum, London; Library of Congress, Washington, DC; NY Public Library; Art Institute of Chicago; Detroit Institute; RI School of Design, Providence; Carnegie Institute, Pittsburgh. Illustrated "Sketch-book of London," "Edinburgh," "Paris," "Boston." Series of war etchings. Address in 1929, Boston Art Club, 150 Newbury Street; 91 Pinckney Street, Boston, MA.

HORNE, LAURA TREVITTE.
Painter. Born in Dalton, GA, in 1891. Pupil of John Carlsen; Francis Jones; Van Dearing Perrine. Member: Newport Art Association. Address in 1926, Woodstock, NY.

HORNER, T.
About 1844 Horner was living in Ossining, NY, where he engraved a large "View of New York from Brooklyn," published by W. Neale of New York.

HORNLY, LESTER GEORGE.
Painter and etcher. Born in Lowell, MA, in 1882. Student of School of Design, Providence, RI; also studied in Paris under Jean Paul Laurens and other masters. Represented by etchings in New York and Boston Public Libraries; Congressional Library; South Kensington Museum, London. Address in 1926, 9A Park Street, Boston, MA.

HOROWITZ, BRENDA.
Painter. Born in New York City. Studied: City College of NY; Cooper Union Art School; The Hans Hofmann School of Art; City University of NY. Exhibitions: Croquis Gallery, New York City; Museum Gallery, 1971; Columbia University Gallery, 1974; Westbeth Galleries, New York City.

HOROWITZ, NATHAN.
Sculptor. Born in Grand Rapids, 1947. Studied: Cranbrook Academy of Art, M.F.A. Exhibitions: National and state exhibitions; works by Michigan Artists, Detroit Institute of Arts, 1974-75. Awards: First Prize, Port Huron International. Commissions: Kappey-Nemar Corp.; City of Grand Rapids. Address in 1975, Grand Rapids, MI.

HORSFALL, CAROLYN SARAH.
Painter and craftsman. Born in Hartford, CT, July 3, 1901. Pupil of Anna Fisher, Henry B. Snell, George Pearse Ennis. Member: Springfield Art League; National Association Women Painters and Sculptors; American Water Color Society; NY Water Color Club. Address in 1929, 150 Lexington Avenue, New York, NY; h. 52 Huntington Street, Hartford, CT; summer, Boothbay Harbor, ME.

HORSFALL, ROBERT BRUCE.
Painter. Born in Clinton, IA, in 1869. Studied at Cincinnati Art Academy, 1886-89; gained European scholarship and studied at Art Academy, Munich, and in Paris, France. Has exhibited at Chicago, IL, since 1886; and at Midwinter Exposition, San Francisco. Made scientific illustrations for American Museum of Natural History, New York, 1898-1901; illustrated *Land Mammals of the Eastern Hemisphere*, 1912-13; also many books of birds, etc. Permanently represented by 12 backgrounds for Habitat Groups, American Museum of Natural History, New York. Address in 1926, Box 80, R. 6, Portland, OR. Died March 24, 1948.

HORTENS, WALTER HANS.
Illustrator. Born in Vienna, Austria, in 1924. He studied in Egypt and Austria and is a graduate of Pratt Institute and the Academie Julien in Paris. His first assignment appeared in 1948 in *The New York Times* and since then his technical illustrations have frequently been seen in *National Geographic, Life* and *Time.* A veteran of World War II, he is a contributor to the U.S. Air Force Art Program and a member of the Society of Illustrators.

HORTER, EARL.
Illustrator. Born in 1881. His etchings of large cities were of high quality. Work: "Smelters-Pittsburgh;" "Madison Square, NY;" "Old Creole Quarters, N. Orleans." Member: Soc. of Illustrators, 1910. Award: Silver medal, P.-P. Expo., San Francisco, 1915; international watercolor, Chic. Died in 1940.

HORTER, FREDERICK FORMES.
Sculptor. Born in Tremont, NY, November 1, 1869. Pupil of Cooper Union in NY. Address in 1910, Weehawken, NJ.

HORTON.
This engraver is simply mentioned in Mr. Stauffer's volume as engraving portraits and views in 1830-35 for Phila. and Baltimore publishers. He probably came from Providence, RI. He engraved a business card of the Roger Williams Hotel in that city, and the card says that this house was "Formerly kept by Mr. Horton," but whether the former innkeeper was the engraver himself, or a relative, is uncertain. Horton was certainly engraving for Providence book publishers as early as 1823. In that year he engraved ten copper plates illustrating a "Complete System of Stenography," by J. Dodge.

HORTON, DOROTHY E.
(Mrs. T. J. Stewart). Painter. Born in Poplar Bluff, MO, Oct. 14, 1898. Pupil of St. Louis School of Fine Arts; Penna. Academy of Fine Arts; Susan Ricker Knox. Award: Second prize, Eire Art Club, 1928. Address in 1929, 3919 Sassafras Street, Erie, PA.

HORTON, ELIZABETH SUMNER.
Painter. Born in Boston, June 27, 1902. Pupil of Philip Hale, Alexander and Williams James, Fred Bosley; M. Morrisset in Paris. Member: National Association of Women Painters and Sculptors. Award: First prize, Junior League, Boston, 1928. Address in 1929, 97 Lee Street, Brookline, MA.

HORTON, HARRIET H.
Portrait and miniature painter. Represented by portraits in Minnesota Historical Society. She died in 1922 in St. Paul, MN.

HORTON, WILLIAM SAMUEL.
Painter and writer. Born in Grand Rapids, MI, Nov. 16, 1865. Pupil of Art Students League and National Academy of Design in New York; Constant and Julian Academy in Paris. Member: NY Water Color Club; American Federation of Arts; Societe Moderne; Soc. Internationale; and Salon d'Automne, Paris. Awards: Gold medal, International Expo., Nantes, 1904; bronze medal, Orleans, 1905. Work: "Bathers Returning," Bradford Museum, England; "Good Friday in Seville" and "Soir d'Hives, Pontarlier," Luxembourg Museum; "General Pershing and the American Contingent Traversing the Place de la Concorde, July 14, 1919," Nat. Mus., Washington, DC; Musee Carnavalet, Paris, France; and in the Brooklyn Museum. Died in 1936. Address in 1929, 64 Rue de la Rochefoucauld, Paris, France.

HOSFORD, HARRY LINDLEY.
Etcher. Born in Terre Haute, IN. Pupil of Chase, DuMond, Beckwith, Maynard and F. C. Jones. Member: Chicago Society of Etchers. Represented in collection of the New York Public Library and the Minneapolis Institute of Arts. Address in 1929, 781 Goodrich Avenue, St. Paul, MN; summer, Lyme, CT.

HOSKIN, ROBERT.
Wood engraver. Born in Brooklyn, NY, in 1842. He studied at the Brooklyn Institute where he received the Graham medal. In 1883 he received the gold medal of the Paris Salon for engraving. He has done considerable engraving for the magazines in this country. His best known engraving is "Cromwell Visiting Milton."

HOSKINS, GAYLE PORTER.
Illustrator. Born in Brazil, IN, July 20, 1887. Pupil of Vanderpoel; AIC; Howard Pyle. Award: First prize, Wilmington Society of Fine Arts, 1920. Work: Series of war paintings for the *Ladies Home Journal*; illustrated *Kazan, Me, Smith,* etc.; magazine cover designs; advertising work, Veedol oil, Gould Batteries, Hercules Powder Co.; "Bill and Jim" series; etc. General magazine illustration. Address in 1929, 1616 Rodney Street, Wilmington, DE.

HOSMER, FLORENCE A.
Painter. Born in Woodstock, CT. Studied: Massachusetts School of Art; Boston Museum of Fine Arts School; and with Joseph DeCamp, Anson Kent Cross, Charles Woodbury. Collections: International Institute of Boston; Essex Institute, Salem, MA; Park Street Church, Boston.

HOSMER, HARRIET GOODHUE.
Sculptor. Born in Watertown, MA, October 9, 1830. Educated at Lenox, and studied drawing and modeling in Boston, and anatomy at the Medical College, St. Louis; 1852-59 in Rome under John Gibson, the English sculptor. Executed many ideal figures, among the most popular being a statue of "Puck," her "Beatrice Cenci," which is in the St. Louis public library, "Zenobia," "Sleeping Faun,"

and a statue of Thomas H. Benton cast in bronze for Lafayette Park, St. Louis. She was also noted for her writing both in prose and poetry. Died in Watertown, MA, February 21, 1908.

HOSTATER, ROBERT B.
Painter. Born in San Francisco. He lived and studied for more than twenty-five years in Paris. Exhibited at the Salon.

HOTCHKISS.
A little-known landscape painter who worked much of his time in Italy. He painted views of "Mount Aetna" and "Colosseum by Moonlight."

HOTCHKISS, WALES.
Painter. Born in Bethany, CT, in 1826. Pupil of George W. Flagg in New Haven. He painted many portraits in oils, but his forte was in water color. He lived in Northampton for years.

HOTTINGER, WILLIAM A.
Illustrator. Born in Philadelphia, PA, Oct. 11, 1890. Pupil of Carl von Marr. Member: Allied Artists of America. Address in 1929, 127 North Dearborn Street, Chicago, IL; h. Glen Ellyn, IL.

HOTVEDT, CLARENCE ARNOLD.
Painter and teacher. Born in Eau Claire, WI, April 16, 1900. Pupil of Art Institute of Chicago. Member: Alumni, Art Institute of Chicago; Wichita Artists Guild. Address in 1929, 411 Avenue C, Wichita, KS.

HOTVEDT, KRIS J.
Printmaker and instructor. Born in Wautoma, WI, in 1943. Studied: Layton School of Art, Milwaukee, WI; San Francisco Art Institute, CA; Instituto Allende, San Miguel de Allende, Mexico. Exhibited: Pembroke State University, NC, 1968; Arizona State University, Tempe, 1973; Oklahoma Art Center, Oklahoma City, 1974; Los Llanos Gal., Santa Fe, 1980, and Ledoux Gal., Taos, NM, 1981; many others. Collections: Atalya School Art Collection, Santa Fe, NM; University of Sonora, Hermosillo, Mexico; Huntington Art Alliance, CA; others. Media: Woodcut and serigraphs. Address in 1982, 125 Spruce St., Santa Fe, NM.

HOUGH, RICHARD.
Photographer and designer. Born in Roanoke, VA, March 1, 1945. Studied: Roanoke College; Rochester Institute of Technology, summer; Hotchkiss Workshop, with Minor White, summer; School of Design, Calif. Institute of Arts. Exhibited: Virginia Mus., Richmond, 1969, 71; 23rd Irish International, Dublin, 1970; Soc. of Photogr. Educ. Exhib., Univ. of Illinois, Chicago, 1971; others. Member: Soc. of Photogr. Educ. Address in 1976, Los Angeles, CA.

HOUGH, WALTER (DR.).
Sculptor, writer, and lecturer. Born in Morgantown, WV, April 23, 1859. Pupil of E. F. Andrews and W.

H. Holmes. Member: Washington Water Color Club and American Federation of Arts. Address in 1933, National Museum, Washington, DC. Died in 1935.

HOULAHAN, KATHLEEN.
Painter. Born in Winnipeg, CT, Jan. 31, 1887. Pupil of Robert Henri. Member: Nat. Arts Club; Society of Independent Artists; Seattle Fine Arts Soc. Address in 1929, 2159 Shelby St., Seattle, WA.

HOULTON, J.
A poorly designed and roughly engraved heading to a certificate of the Charitable Marine Society of Baltimore is signed "J. Houlton Sculp't." As the certificate is filled out in 1797, it must have been engraved prior to that date. The design shows Columbus handing a book to a sailor; ship in full sail; lighthouse, etc., in the background. The plate is further signed "F. Kemelmeyer Deilin't."

HOUSE, JAMES.
Born in 1775. According to Dunlap, House painted a number of portraits in Philadelphia, but gave up art and entered the United States Army. He was known as Colonel House in 1814. Died Nov. 17, 1834.

HOUSE, JAMES (CHARLES), JR.
Sculptor, illustrator and educator. Born in Benton Harbor, MI, Jan. 19, 1902. Studied at University of Michigan; Penna. Academy of Fine Arts; University of Pennsylvania, BS in Education. Work: Sculpture, Whitney Museum of American Art. Exhibited: Penna. Academy of Fine Arts, 1939, 40, 42, 45, 46; Dallas Museum of Fine Art, 1936; Brooklyn Museum, 1932; Whitney Museum of American Art, 1934, 36; Philadelphia Museum of Art, 1933, 40, 50; Carnegie Institute, 1941; New York Municipal Exhibition, 1936; Metropolitan Museum of Art (AV), 1942; Museum of Modern Art, 1942; Detroit Institute of Art, 1932, 35, 38-40; Kansas City Art Institute, 1935. Award: John Frederick Lewis first prize for caricature, Philadelphia Water Color Club, 1925. Author: "Fifty Drawings," 1930. Illustrations in *The New Yorker*, *Life*, *Collier's*, and numerous newspapers. Position: Assistant Professor, Modeling and Drawing, University of Pennsylvania, Philadelphia, PA, 1927-72, emeritus associate professor, 1972-75, visiting critic, 1976, 77, and 79; associate professor of Philadelphia Museum of Art Eve. Class, 1949-50; sculpture critic. Address in 1982, Media, PA.

HOUSE, T.
He was a bank-note engraver, chiefly employed in Boston. He engraved a few portraits for book publishers and he seemed to be working as early as 1836. He died about 1865. His full name may have been Timothy House.

HOUSER, ALLAN C.
Sculptor and painter. Born in Apache, OK, June 30, 1914. Studied at Indian Art School, Santa Fe, NM,

with Dorothy Dunn, Olaf Nordmark. Work: Murals, Dulce, NM; Dept. of Interior Building, Washington, DC; Ft. Sill Indian School, OK; Southwestern Museum, Los Angeles, CA; State Museum, Santa Fe. Exhibited: National Gallery of Art, Washington, DC, 1953; Chicago Indian Center, 1953; Art Institute of Chicago, 1953; Southern Plains Indians Museum, 1971; Gallery Wall, Phoenix, AZ, 1975-78; Outdoor Sculpture Shows, Shidoni Foundry, Santa Fe, 1976-77; Gov.'s Gallery, State Capital, Santa Fe, 1977; Jamison Gallery, Santa Fe, 1977; American Indian and Cowboy Exhibition, San Dimas, CA, 1978; Wagner Gallery, Austin, TX, 1978. Awards: Gold medal in bronze, silver medal in stone and silver medal in other metal, Heard Museum of Sculpture I Show, 1973; Best of Show and First Place in Sculpture, American Indian and Cowboy Show, San Dimas, CA, 1978. Taught: Instructor of art, Intermountain Indian School, Brigham City, UT; head, department of sculpture, Institute of American Indian Arts, Santa Fe; Lake Forest College, Chicago, 1978; University of Washington, 1978; artist-in-residence, Dartmouth College, Hanover, NH, 1979. Address in 1982, Los Angeles, CA.

HOUSKEEPER, BARBARA.
Sculptor and painter. Born in Ft. Wayne, IN, Aug. 25, 1922. Studied at Knox College, IL; Rhode Island School Design; Art Institute of Chicago. Works: Illinois Bell and Telephone, Chicago; Gould Foundation, Rolling Meadows, IL; Kemper Insurance Co., Long Grove; Mercury Rec., Chicago. Commissions: Large sculptures, executive office, Condecor Mfg., Mundelein, IL, 1972, Mr. and Mrs. Wm. Goldstandt Collection, Glencoe, IL, 1972, Mr. and Mrs. Leonard Sax Collections, Northfield, IL, 1972 and Reception Hall, Kemper Insurance Co. Home Office, Long Grove, IL, 1974; Memorial Sculpture, American Bar Association, Chicago, 1975. Exhibitions: New Horizons in Art (wide regional annual), since 1966; Theme Ecology Invitational, University Wisconsin Gallery, Madison, 1970; Springfield State Museum All Summer Show, 1973; one-person show, Michael Wyman Gallery, Chicago, 1973 and 76; 1st Chicago Sculpture Invitational, Federal Building, Chicago, 1974. Awards: First Prize, Painting, New Horizons in Art Annual, 1969 and First Prize, Painting, 1970; Second Prize, Sculpture, Old Orchard Festival Annual, 1973. Media: Acrylic sheet, stainless steel. Address in 1982, El Granada, CA.

HOUSTON, FRANCES C. LYONS.
(Mrs. William C. Houston). Painter. She was born Jan. 14, 1867, in Hudson, MI. Studied in Paris under Lefebvre and Boulanger. Painted a portrait of Ethel Barrymore. Died in 1906 in Windsor, VT.

HOUSTON, GRACE.
Painter and teacher. Born Marysville, OH. Pupil of NY School of Applied Design; Provincetown Art Colony. Member: Pittsburgh Art Association; Alliance. Art Supervisor, Pittsburgh, PA. Address in 1929, Indiana State Teachers College, Art Dept., Indiana, PA; summer, PA State College, Art Dept., State College, PA.

HOUSTON, H. H.
He was one of the earliest good stipple-engravers of portraits who worked in the United States. He probably came here from Ireland as the *Hibernian Magazine,* of Dublin, contains portraits very similar in execution of his known work and signed "H. Houston." Houston appears in Philadelphia in 1796 and as his last dated work was done in 1798, his stay here was a comparatively short one. He engraved two separate plates of John Adams, and portraits of Washington, Rittenhouse, Kemble as Richard III, Kosciusko, etc. The first state of the John Adams plates published in Philadelphia in 1797 is lettered "H. H. Houston, Sculp't."

HOUSTON, NORA.
Painter, lecturer, and teacher. Pupil of Kenneth Hayes Miller, Vonnoh, Henri and Chase; Simon, Blanche, Menard and Cottet in Paris. Award: Hon. mention, Appalachian Expo., Knoxville, 1910. Address in 1928, 100 North Fourth Street; 519 East Franklin Street, Richmond, VA.

HOUSTON, RUSSELL A.
Sculptor and architect. Born in Morgantown, West Virginia, September 28, 1914. Studied at Corcoran School of Art; University of Hawaii; and with Robert Laurent. Member: Society of Washington Artists; Art Guild of Washington; Maryland Sculptors Guild; Washington Sculptors Group; Association Fed. of Architecture. Awards: Prizes, Corcoran School of Art, 1940, 41; Society of Washington Artists, 1940, 41, 48, 49; Association Fed. Architecture, 1939, 40, 47, 48 (4); Corcoran Gallery of Art, 1947; Baltimore Museum of Art, 1947, 48. Work: Design medal for New York World's Fair, 1939; American Legion medal; sculpture, Officer's Club, Washington, DC; St. Paul's Church, Washington, DC; Carlton Hotel, Pittsburgh, PA. Exhibited: Penna. Academy of Fine Arts, 1946; Corcoran Gallery of Art, 1943 (one-man); Morgantown, West Virginia, 1938 (one-man); Society of Washington Artists, 1939-44, 48, 49; Association Fed. of Architecture, 1939, 42, 46, 47, 48; US National Museum, 1940, 48-52; Honolulu Academy of Art, 1945 (one-man); Washington Art Club, 1947-49; Home Builder's Expo., Washington, DC, 1948, 49; Virginia Museum of Fine Art, 1951; Playhouse, Washington, DC (one-man). Position: Sculpture, Architecture, Mills, Petticord and Mills Association, Washington, DC. Address in 1953, Kensington, MD.

HOVANNES, JOHN.
Sculptor and teacher. Born in Smyrna, NY, Dec. 31, 1900. Studied at Rhode Island School of Design;

Beaux-Arts Institute of Design. Member: Sculptors Guild; Audubon Artists; Westchester Arts and Crafts Guild. Awards: Guggenheim Fellow, 1940; Eugene Meyer award, 1941; Wings for Victory competition, 1942. Work: Newark Mus. Exhibited: Penna. Academy of Fine Arts, 1942, 43, 45, 46; Art Institute of Chicago, 1942, 43; Metropolitan Museum of Art (AV), 1942; National Academy of Design, 1943; Riverside Mus, 1943; Whitney Mus of American Art, 1942-46; Nebraska Art Assoc., 1945; NY World's Fair, 1939; Sculptors Guild, annually; Robinson Gal., 1941 (one-man). Position: Instructor, Cooper Union Art Schl, 1945, 46; Art Students League, NYC, 1945, 46. Address in 1953, 126-30 E 59th St.; h. 140 E 58th St., NYC. Died in 1973.

HOVELL, JOSEPH.
Sculptor and teacher. Born in Kiev, Russia, October 28, 1897. Studied at Russian Imperial Art School; Cooper Union Art School, with Brewster; National Academy of Design, with Robert Aitken. Work: New York Museum of Science and Industry; US Government; Nordacs Club; Carnegie Hall Gallery; Yeshiva College; White House, Washington, DC. Commissions: Portrait busts, bas-reliefs of numerous important persons in private collections; plaques and busts, Carnegie Hall, NY. Exhibited: Bronx Art Guild, 1927; Community House, NY, 1928, 33; National Academy of Design, 1929, 31; Brooklyn Museum, 1930; Roerich Museum, 1932; Carnegie Hall, 1934, 35, 36; Allied Artists of America, 1935; Grand Central Palace, 1937; Jewish Museum, NY, 1949, 50; Medallic Art, 1952. Address in 1982, 130 West 57th St., NYC.

HOVENDEN, MARTHA.
Sculptor. Born in Plymouth Meeting, PA, May 8, 1884. Pupil of Charles Grafly, H. A. MacNeil. Member: Fellowship Penna. Academy of Fine Arts; Plastic Club; Washington Art Club. Exhibited at Pennsylvania Academy of Fine Arts in 1924. Died in 1941. Address in 1933, Plymouth Meeting, PA.

HOVENDEN, THOMAS.
Painter and etcher. Born in 1840 in Dunmanway, County Cork, Ireland; died 1895 at Plymouth Meeting, PA. Studied at the Cork School of Design. Came to New York in 1863 and entered the school of the National Academy of Design; studied in Paris under Cabanel. He painted "Jerusalem the Golden," "Last Moments of John Brown," and "A Brittany Image Seller." Elected Member of the National Academy in 1882. Member of the NY Etching Club.

HOVEY, OTIS.
Painter. Born in 1788 in MA. Dunlap mentions him as a youthful genius. He made several copies of paintings that possessed merit. He later lived in Oxford, NY. He painted a few portraits but was not successful.

HOW, KENNETH GAYOSO.
Painter and artist. Born in Wantaugh, LI, NY, June 8, 1883. Pupil of Jane Peterson; Henry B. Snell. Member: NY Water Color Club; NY Architectural League; Salma Club; American Water Color Society; American Federation of Arts. Work: Buckwood Inn, Shawnee-on-Delaware, PA; additions to Hotel Gramatan, Bronxville, NY; "Oscela," Gramatan Inn, Daytona, FL. Address in 1929, 145 East 57th Street; h. 400 East 58th Street, New York, NY.

HOWARD, CECIL DE BLAQUIERE.
Sculptor. Born in Canada, April 2, 1888. At the age of thirteen he started working at the Art School, Buffalo, NY, where he studied under James Fraser. In 1905 he entered the Academie Julien, Paris, and exhibited at the Salon the following year. Also exhibited in NYC at National Sculpture Society. Member: Societe Nationale des Beaux-Arts, associe, 1912; National Academy of Design, NY; National Institute of Arts and Letters; National Sculpture Society; Salon d'Automne; Salon de Tuileries. Works: Two war monuments in France, one at Hautot-sur-Mer and one at Ouville-la-Riviere, both towns on the Normandy coast; Whitney; Brooklyn Mus.; Albright, Buffalo; Museum of Modern Art, Paris. Most of his work consists of nude figures of various sizes, but he also did many portrait busts and animal studies. Often worked directly in stone and marble. Died in 1956. Address in 1953, 40 West 57th Street, New York City.

HOWARD, CLARA FRANCES.
Miniature painter and teacher. Born in 1866 in Poughkeepsie, NY. Pupil of NAD and ASL of NY under Brush and Chase. Member: Nat. Association of Women Painters and Sculptors; American Society of Miniature Painters. Address in 1929, 55 South Hamilton Street, Poughkeepsie, NY. Died before 1940.

HOWARD, DAN F.
Painter. Born in Iowa City, IA, Aug. 4, 1931. Study: University of Iowa. Work: Lowe Art Museum, Miami, FL; Parthenon, Nashville, TN; Masur Museum of Art, LA; West Collection of Contemporary Art, St. Paul, MN; and others. Exhibitions: Lowe Art Museum; Arkansas Arts Center; Jocelyn Art Museum, Omaha; West 79/The Law National Exhibition, Minnesota Museum of Art, St. Paul; National Painting & Sculpture Exhibition, Oklahoma Art Center; many more. Awards: Miami National 1st Prize; Bellinger Prize, Chautauqua Exhibition of American Art, NY; Purchase award, West 79/The Law; etc. Teaching: Arkansas State University; Kansas State University; University of Nebraska, Lincoln. Member: College Art Assoc. of America; American Federation of Arts; National Council Art Administrators; others.

HOWARD, EDITH LUCILE.

Painter and teacher. Born in Bellows Falls, VT. Pupil of Philadelphia School of Design for Women under Daingerfield, Snell. Member: NY Water Color Club; Philadelphia Alliance; Plastic Club; Lyceum Club of London and Paris. Awards: Hon. mention, Plastic Club, 1915; gold medal Plastic Club, 1917. Instructor and lecturer, Philadelphia School of Design for Women. Address in 1929, 1206 Carnegie Hall, New York, NY; h. 1313 West 8th Street, Wilmington, DE.

HOWARD, ELOISE.

Painter. Member: National Association Women Painters and Sculptors. Exhibited "Summer" (decorative panel) at 33rd Annual Exhibition of National Association of Women Painters and Sculptors. Address in 1929, 57 East 59th Street, New York, NY; care of Tiffany Foundation, Oyster Bay, LI, NY.

HOWARD, LINDA.

Sculptor. Born in Evanston, IL, October 22, 1934. Studied: University of Denver, Denver, CO; Hunter College, SUNY, New York City; Chicago Art Institute, 1953-55. Awards: Creative Artists Public Service Grant, 1975; North Jersey Cultural Council, 1974; New England Artists, 1970. Exhibitions: Silvermine Guild, CT, 1971; Philadelphia Civic Center Museum, 1974; Sculpture Now Gallery, New York City, 1975, 78; Art Institute of Chicago, 1980; many others. Represented by sculpture for 1980 Winter Olympics, Lake Placid; Springfield Art Museum; others. Address in 1982, 11 Worth St., New York, NY.

HOWARD, MARION.

Landscape painter and decorator. Born in Roxbury, MA, 1883. Pupil of Boston Museum School under Tarbell, Benson and Hale; also of Chase and Edward H. Barnard. Address in 1929, North Conway, NH.

HOWARD, ROBERT BOARDMAN.

Sculptor. Born in New York, September 20, 1896. He attended the California School of Arts and Crafts, studying drawing under P. W. Wahl and painting under X. Martinez. In 1916 he entered the Art Students League, studying under Kenneth Hayes Miller. In 1918 he went to France, and after World War I studied alone in Paris for two years and elsewhere in Europe. In collections of San Francisco Mus. of Mod. Art; Oakland Mus., Calif.; commissions for San Francisco Stock Exch. (sculpture murals), Golden Gate Park in San Francisco (fountain), IBM Research Center in San Jose, others. Exhibited at Nat. Sculpture Soc., 1923; Corcoran, 1937; Carnegie, 1941; Whitney Annuals, 1948-55; Met. Museum of Art, 1951; San Francisco Mus. of Modern Art, 1976; San Francisco Art Inst.; plus many more. Instructor, sculpture, at San Francisco Art Inst., 1945-54, and Mills Col., 1946. Address in 1982, San Francisco, CA.

HOWE, ARTHUR VIRGIL.

Painter. Born in 1860. Specialty, landscape painting. Died in 1925 in Troy, NY.

HOWE, GEORGE.

Illustrator. Born in Salzburg, Austria, in 1896. He ran away to America at the age of 14. After studying in Paris for two years, he returned, making the United States his home. Before his career as a magazine illustrator began, he was forced to work at assorted odd jobs, from chauffeuring to scenery painting for movie companies. His illustrations, most of which were done in watercolor, executed in a flat, posterlike manner, were seen in *Collier's, American, Woman's Home Companion* and *Good Housekeeping*. One of his last assignments was a series of paintings that were seen as posters for the Barnum and Bailey Circus. Died in 1941.

HOWE, WILLIAM H.

Painter. Born at Ravenna, OH, in 1846. He began the study of art in 1880 at the Royal Academy of Dusseldorf, Germany, and after working there two years went to Paris. Here he studied with Otto de Thoren and F. de Vuillefroy and had a picture accepted at the Salon of 1883. For ten years thereafter he was a successful exhibitor at the Salon and other European exhibitions. Returning to the United States, he was elected a National Academician in 1897 and a member of the Society of American Artists in 1899. At the Paris Exposition of 1889 he was awarded a medal of the second class. At London in 1890 he received a gold medal, and in the same year the Temple Gold Medal at the Pennsylvania Academy of Fine Arts, Philadelphia, PA, and a gold medal at Boston. A medal was awarded to him at the Chicago World's Fair in 1893, a gold medal at San Francisco in 1894, and a gold medal at Atlanta in 1895. He was an Officier d'Academie and a Chevalier of the Legion of Honor, both by decree of the French Government. In permanent collections of the St. Louis Museum of Fine Arts and in the Cleveland Museum. Died in Bronxville, NY, in 1929.

HOWE, ZADOC.

Born 1777 in CT. This name, as "Z. Howe Sc't," is signed to a poorly engraved figure of a man used as a frontispiece to "A New Collection of Sacred Harmony, etc." by Oliver Brownson, Simsbury, CT, 1797. The music in this collection is also doubtless engraved by Howe. Died 1852 in MA.

HOWELL, FELICIE WALDO.

Painter. Born in Honolulu, Sept. 8, 1897. Pupil of Corcoran Art School, Washington, DC, under E.C. Messer; Phila. School of Design for Women; and Henry B. Snell. Member: Associate Nat. Academy of Design, 1922; Philadelphia Water Color Club; Concord Art Association; Allied Artists of America; Barnard Club; Painters' and Sculptors' Gallery

Association; NY Water Color Club; Society of Painters of NY; Washington Water Color Club; American Water Color Society. Awards: Prize, National Assoc. of Women Painters and Sculptors, 1916; first hon. mention, Concord Arts Association, 1919; silver medal, Society of Washington Artists, 1921; second Hallgarten prize, National Academy of Design, 1921; silver medal, Wash. Water Color Club, 1921; Mr. and Mrs. Augustus S. Peabody prize, Art Institute of Chicago, 1921; bronze medal, Society of Washington Artists, 1922; hon. mention, State Fair, Aurora, IL, 1922; William H. Tuthill purchase prize, international water color exhibition, Chicago Art Institute, 1927. Work: "A New England Street," Corcoran Gallery, Washington; "The Avenue of the Allies," American Legion Building, Gloucester, MA; "Gramercy Park, New York," Herron Art Inst.; "The Flower Women," Telfair Academy, Savannah; "The Pierce-Nichol House, Salem," Metropolitan Museum of Art, New York. Instructor in painting, New York School of Fine and Applied Art; summer class, Gloucester, MA. Address in 1933, 224 East 49th Street, New York, NY.

HOWELL, JAMES.
Painter. Born in Kansas City, MO, Nov. 17, 1935. Work: Private collections. Exhibitions: Butler Art Institute Mid-Year Annual; Northwest Watercolor Annual; Frye Museum Puget Sound Annual; Springfield Art Society Annual; Westchester Art Society Annual; and others. Address in 1970, Box 6773, Rt. 6, Bainbridge Island, WA.

HOWELLS, ALICE IMOGEN.
Sculptor, painter, and craftsman. Born in Pitts., PA. Pupil of Art Students League of NY; Robert Henri, William Chase. Member: Art Centre of the Oranges; Catherine Lorillard Wolfe Art Club; Provincetown Art Association. Award: Silver medal, Panama-Pacific Exposition, San Francisco, 1915. Address in 1933, East Orange, NJ; summer, Provincetown, MA. Died in 1937.

HOWES, SAMUEL P.
Portrait, landscape, and miniature painter, who flourished 1829-35 in Boston. He exhibited a portrait of S. Baker in 1833 at the Boston Athenaeum.

HOWITT, JOHN NEWTON.
Painter and illustrator. Born in White Plains, NY, May 7, 1885. Pupil of Art Students League of New York. Member: Society of Illustrators; Guild of Free Lance Artists; League of New York Artists. Died 1958. Address in 1926, 147 West 23rd Street, New York.

HOWLAND, ALFRED CORNELIUS.
Painter. Born in Walpole, NH, Feb. 12, 1838; died in Pasadena, CA, March 17, 1909. Studied art in Boston and New York and was a pupil of the Royal Academy and of Albert Flamm in Dusseldorf, and of Emile Lambinet in Paris. He became an Associate of the Nat. Academy of Design in 1874 and an Academician in 1882. He was a regular exhibitor in New York and his works were frequently seen in Paris and Munich. His studio, during the winter, was in New York, while his summer home was "The Roof Tree," Williamstown, MA. He painted "Friendly Neighbors" and "The Old Windmill."

HOWLAND, ANNA GOODHART (MRS.).
Painter. Born in Atchison, KS, May 10, 1871. Pupil of Corcoran School of Art, Washington, DC. Member: Wash. Water Color Club. Address in 1929, 2412 Pennsylvania Ave., NW, Wash., DC; summer, Beltsville, MD.

HOWLAND, EDITH.
Sculptor. Born March 29, 1863, in Auburn, NY. Studied at Vassar College, Poughkeepsie, NY. Pupil of Gustave Michel in Paris, and of Augustus Saint-Gaudens; also studied at Art Students League under Daniel C. French. Member: Art Students League of New York; National Association of Women Painters and Sculptors; Nat. Sculpture Soc. Award: Hon. mention, Paris Salon, 1913. Represented in Met. Mus. by marble group "Between Yesterday and Tomorrow;" also in Brooklyn Museum. Exhibited at the Nat. Sculpture Soc., 1923. Address in 1933, Catskill-on-Hudson, NY. Died Sept. 8, 1949.

HOWLAND, GEORGE.
Painter. Born in NYC in 1865. Pupil of Benjamin-Constant, Laurens and Collin in Paris. Awards: Hon. mention, Paris Salon, 1914; silver medal, Paris Salon, 1921. Member: Chevalier of the Legion of Honor of France. Died 1928 in France. Address in 1926, 29 Quai Voltaire, Paris, France.

HOWS, JOHN AUGUSTUS.
Painter. Born 1832 in New York City, he graduated from Columbia in 1852. He studied art and in 1862 was elected an Associate Member of the National Academy. He has been a wood engraver, landscapist, and illustrator. Among his paintings are "An Adirondack Lake," Sanctuary of St. Alban's Church, NY, and "Paul Smiths, Saint Regis." He died Sept. 27, 1874, in NYC.

HOXIE, VINNIE REAM.
Sculptor. Born in Madison, WI, on September 25, 1847. She studied under Bonnat in Paris and with Majolilin in Rome. Her statues of Abraham Lincoln, in the rotunda of the Capitol, Washington, DC, and Admiral Farragut, standing in Farragut Square, Washington, were executed under commissions from Congress. Among her other works were many portrait busts and medallions of prominent Americans and foreigners, and a number of ideal statues. Died in Washington, DC, November 2, 1914.

HOYLE, ANNIE ELIZABETH.
Painter, illustrator, and teacher. Born Charlestown, WV, April 29, 1851. Pupil of Rouzee; Uhl; George H. Story in NY; Henry Mosler and Julian Academy in Paris. Member: Washington Art Club; American Federation of Arts. Illustrated: *Forest Trees in Pacific Slope* and *Forest Trees of Rocky Mountains*, by George B. Sudworth (U.S. Gov't); *Native American Forage Plants* and *Range and Pasture Management*, by Arthur W. Sampson; *Important Western Browse Plants*, by Wm. A. Dayton (U.S. Gov't); *Important Southwestern Range Plants*, by Dayton and N. W. Talbot (U.S. Gov't); *Forest Trees of Illinois*; *Forest Trees of Texas*. Address in 1929, Atlantic Bldg., 930 F. St.; h. 3931 Huntington Street, Chevy Chase, Washington, DC.

HOYT, ALBERT G.
Painter. Born Dec. 13, 1809 in Sandwich, NH. He studied in France and Italy and on his return to this country settled in Boston where he painted many portraits. He was the first President of the Boston Art Club. His full length portrait of Daniel Webster is owned by the Union League Club of New York. Died Dec. 19, 1856 in W. Roxbury, MA.

HOYT, EDITH.
Landscape painter. Born in West Point, NY, April 10, 1890. Pupil of Charles Woodbury, E.C. Messer, Henry Moser; Corcoran School of Art. Member: Society of Washington Artists; Washington Water Color Club. Work: Painting of XVIIth Century Manor House, Museum of Society of Historic Monuments, Quebec, Canada. Address in 1929, 1301 21st Street, NW, Washington, DC.

HOYT, HETTIE J
Sculptor and painter. Born in Harvard, IL. Pupil of Carl Marr, F.W. Heine, Fred Grant. Member: Am. Artists Professional League. Work: "Fleur de Lis and Lilies," D. A. R. Continental Hall, Wash., DC; "Chrysanthemums," Woman's Club, Milwaukee; "Zinnias," Col. Woman's Club, Milwaukee. Specialty, still life and flowers. Address in 1933, Stamford, CT.

HOYT, MARGARET (HOWARD) (YEATON).
Painter and etcher. Born in Baltimore, MD, July 1, 1885. Pupil of Gabrielle DeV. Clements, Theresa Bernstein, William Meyerowitz. Member: American Federation of Arts; Gloucester Society of Artists; North Shore Art Association; Rockport Art Association; Southern States Art League. Died in 1943. Address in 1929, 206 Washington Street, Lexington, VA; summer, Lanesville, Gloucester, MA.

HSIAO, CHIN.
Sculptor and painter. Born in Shanghai, China, January 30, 1935. Study: Taipei Normal College; with Li Chun-Sen, Taipei, Taiwan. Work: Museum of Modern Art, The Metropolitan Mus., NYC; National Gallery of Modern Art, Rome; Philadelphia Museum of Art; others. Exhibitions: Carnegie; 7th Biennial Sao Paulo, 1963; 4th Salon, Galeries-Pilotes, Lausanne, Switzerland, and Paris; plus others. Awards: City of Capo d'Orlando, Italy, prize. Media: Metal construction; acrylic, ink. Living in NYC in 1970. Address in 1982, Milano, Italy.

HUBARD, WILLIAM JAMES.
Sculptor, portraitist, silhouettist. Born in Whitchurch, Shropshire, England, August 20, 1807. Immigrated, 1824. Originally worked on silhouettes as a child; gave it up for oil painting. Settled in Gloucester County, VA; later in Richmond. Had assistance and advice of Robert W. Weir and Thomas Sully. Became interested in sculpture in 1850's. Constructed a bronze foundry in Richmond, which was later converted to ammunition production during the Civil War. Hubard was killed at the foundry in an accidental explosion. Worked: NYC; Boston; Philadelphia; Baltimore; Gloucester County, VA; Richmond, from 1841. Exhibited: National Academy, 1834. Work held: Corcoran Gallery, Washington. Died in Richmond, VA, Feb. 15, 1862.

HUBBARD, BESS BIGHAM.
Sculptor. Born in Fort Worth, TX, February 18, 1896. Studied at Chicago Academy of Fine Arts; and with Boardman Robinson, Xavier Gonzalez, Alexandre Hogue, Octavio Medellin, Ernest Freed, and William Zorach. Works: Colorado Springs Fine Arts Center; Dallas Museum of Fine Arts; Texas Fine Arts Association; Elisabet Ney Museum. Awards: Dallas, Texas, 1944; Museum of Fine Arts, Abilene, Texas, 1949-1951; Fort Worth Art Association, 1950. Address in 1953, Lubbock, TX.

HUBBARD, C(HARLES) D(ANIEL).
Painter, illustrator, and teacher. Born in Newark, NJ, July 14, 1876. Pupil of Kenyon Cox and John H. Niemeyer. Member: New Haven Paint and Clay Club; Salma. Club. Died in 1951. Living in CT in 1929.

HUBBARD, FRANK MCKINNEY.
Caricaturist. Born in Bellefontaine, OH, 1868. Employed as Caricaturist on *Indianapolis News* since 1891. Died 1930 in Indianapolis, IN. Address in 1926, Indianapolis News, Indianapolis, IN.

HUBBARD, MARY W(ILSON).
Painter. Born in Springfield, MA, April, 1871. Pupil of Art Students League of NY; Constant in Paris. Member: National Association Women Painters and Sculptors; NY Water Color Club. Address in 1929, 445 East 57th Street, New York, NY.

HUBBARD, PLATT.
Painter. Born in Columbus, OH, in 1889. Pupil of Robert Henri; has also studied in Paris. Died 1946. Address, Old Lyme, CT.

HUBBARD, RICHARD W.
Painter. Born Oct. 1816 in Middletown, CT. American landscape painter; Lake George and the Conn. River are his favorite scenes. In 1858 he was elected a member of the Nat. Academy. Among his paintings are "High Peak;" "North Conway;" "Vermont Hills;" "The Adirondacks;" "Early Autumn." He died Dec. 21, 1888, in Brooklyn, NY.

HUBBARD, WHITNEY MYRON.
Painter. Born in Middletown, CT, June 18, 1875. Pupil of F. V. DuMond. Member: New Haven Paint and Clay Club; Brooklyn Water Color Club; Conn. Academy of Fine Arts. Award: Hon. mention, Connecticut Academy of Fine Arts, 1924. Address in 1929, 511 First Street, Greenport, LI, NY.

HUBBELL, HENRY SALEM.
Painter. Born in Paola, KS, Dec. 25, 1870. Pupil of Art Institute of Chicago; Whistler, Collin, Laurens and Constant in Paris. Member: Associate National Academy of Design, 1906; Paris Society of American Painters; Portrait Painters; National Arts Club (life); Allied Artists of America; Salma. Club; Florida Society of Arts and Science (President); Century Association. Awards: Hon. mention, Paris Salon, 1901; third class medal, Paris Salon, 1904; third prize, Worcester (MA) Museum, 1905; third Harris prize and bronze medal, Art Institute of Chicago, 1910. Professor of Painting and Director, School of Painting and Decoration, Carnegie Institute of Technology, Pittsburgh, PA, 1918-1921. Member: Board of Regents, University of Miami, FL. Work: "Child and Cat," Luxembourg, Paris; "The Samavar," Miniature, Museum of Lille, France; "Larkspurs," Government Collection, France; "The Brasses," Wilstack Collection, Philadelphia; "Paris Cabman," Union League Club, Philadelphia; "Women with Fan," Art Association, Grand Rapids. Died Jan. 9, 1949. Address in 1929, 1818 Michigan Ave, Miami Beach, FL.

HUDNUT, ALEXANDER M.
Painter. Born in Princeton, NJ. Member: Salma. Club; Century Association; Lotos Club; NY Water Color Club; Grolier Club. Address in 1929, 50 Broadway; h. 19 West 54th Street, New York, NY; summer, Allenhurst, NJ.

HUDNUT, JOSEPH.
Painter. Member of the Salmagundi Club of New York. Address in 1926, 44 West 10th Street, New York.

HUDSON, CHARLES BRADFORD.
Painter and writer. Born in Ontario, Canada, Jan. 17, 1865, of American parents. Pupil of Brush and Chase; Bouguereau in Paris; Columbia University, NY. Awards: Silver medals for drawings and paintings, Exposition, Bergen, Norway, 1898; Paris Exposition, 1900. Represented by etchings at Boston Museum of Fine Arts; mural paintings at the California Academy of Sciences, San Francisco. Author of *The Crimson Conquest, The Royal Outlaw*, and magazine and newspaper articles. Address in 1929, 317 Alder Street, Pacific Grove, CA. Died in 1939.

HUDSON, CHARLES WILLIAM.
Painter. Born in Boston, Aug. 21, 1871. Pupil of Boston Museum School under Grundmann, Tarbell and Benson. Member: Boston Water Color Club; NY Water Color Club (life). Died 1943. Address in 1929, 13 Hilton Street, Hyde Park, Boston, MA; summer, W. Thornton, NH.

HUDSON, ELMER F(ORREST).
Marine painter. Born in Boston, Aug. 14, 1862. Member: Boston Art Club; Copley Society, 1895; Salma. Club. Address in 1929, Monhegan Island, ME. Died before 1940.

HUDSON, ERIC.
Marine painter. Born in Boston, MA. Member: Associate National Academy of Design, 1926; North Shore Art Association; Salma. Club; National Arts Club. Awards: Silver medal, Sesqui-Centennial Expo., Philadelphia, 1926; Marine prize, North Shore Art Association, 1929. Died Dec. 22, 1932. Address in 1929, 29 East 9th Street, New York, NY; summer, Monhegan Island, ME.

HUDSON, GRACE CARPENTER.
Painter. Born in Potter Valley, California, in 1865. Studied at Hopkins Art Institute, San Francisco, 1878. Won Alvord Gold Medal for figure drawing, San Francisco Art Association, 1880. She exhibited paintings of Indians in women's department of California state building, Chicago World's Columbian Exposition, 1893. Made field trips to Hawaii to paint native children; to Oklahoma to paint Pawnee tribe. Went to Europe in 1905. Settled permanently in Ukiah, Calif. In collections of Field Mus., Chicago (Pawnee tribe paintings); Oakland (California) Museum; National Gallery of Art, Washington, DC; others. She concentrated on studying and painting the Pomo Indians of Mendocino County, California. Also did illustrations for *Sunset, Cosmopolitan*, and *Western Field*. Died in 1937.

HUDSON, HENRIETTA.
Illustrator, writer, and teacher. Born in Hudson City, NJ, May 9, 1862. Member: National Arts Club. Illustrated: "The Blue Veil" and "Roses Red." Address in 1929, Bolton Landing-on-Lake George, NY.

HUDSON, JULIEN.
Painter of miniatures. Born in New Orleans. Studied art in Paris. Had a studio from 1837 to 1844, the year of his death, at 120 Baronne Street, New Orleans.

HUDSON, ROBERT H.

Sculptor and painter. Born September 8, 1938, in Salt Lake City, UT. Studied: San Francisco Art Institute, BFA, MFA. Work: Los Angeles County Museum of Art; Oakland Art Mus.; San Francisco Museum of Art; Stedelijk Museum, Amsterdam. Represented by Allan Frumkin Gallery, NYC; Hansen-Fuller Gallery, San Francisco. Exhibited: Richmond (CA) Art Center, 1961; Batman Gallery, San Francisco, 1961; Bolles Gallery, San Francisco, 1962; San Francisco Art Institute, 1965; Allan Frumkin Gallery, Chicago, 1964, 68, NYC, 1965; Nicholas Wilder Gallery, Los Angeles, 1967; San Francisco Museum of Art; Whitney Museum; Los Angeles County Museum of Art; Art Institute of Chicago; Walker. Awards: Richmond (CA) Art Center, 1959; San Francisco Art Festival, 1961; San Francisco Museum of Art, 1963; San Jose State College, 1964; San Francisco Museum of Art, Nealie Sullivan Award, 1965; Guggenheim Fellowship. Address in 1982, Cotati, CA.

HUDSON, WILLIAM, JR.

Born in 1787. Portrait miniature and landscape artist, flourishing in Boston, 1829-1855.

HUDSPETH, ROBERT NORMAN.

Painter, craftsman, and teacher. Born in Caledonia, Ontario, Canada, July 2, 1862. Pupil of Academie Julian under Bouguereau, Ferrier, Bashet and Douvet. Work: Portrait miniature owned by the late Lord Milner, England; case owned by H. R. H. Queen Mary of England. Died 1943. Address in 1929, 49 Thoreau Street, Concord, MA.

HUELSE, CARL.

Sculptor. Exhibited at Annual Exhibition of National Academy of Design, New York, 1925. Address in 1926, Philadelphia, PA.

HUENS, JEAN LEON.

Illustrator. Born in Melsbroeck, Belgium, in 1921. He trained at La Cambre Academy prior to 1943, when his illustrations for a children's book by a Belgian publisher marked the start of his career. His illustrations have frequently been seen in America since 1962 when he began painting covers for *The Saturday Evening Post* and *Reader's Digest*. Most recently he has been a frequent contributor to *National Geographic*. The Society of Illustrators has selected his works for several of their Annual Exhibits, and in 1973 The Securite Routiere Europeenne awarded him First Prize for his poster "Against Drunkenness at the Steering Wheel."

HUESTIS, JOSEPH W.

Painter. Member of Society of Independent Artists. Address in 1926, 564 Jefferson Avenue, Brooklyn, NY.

HUEY, FLORENCE G(REENE).

(Mrs. J. Wistar Huey). Portrait painter. Born in Philadelphia in 1872. Pupil of Gabrielle D. Clements, Joseph De Camp and Cecilia Beaux; Penna. Academy of Fine Arts. Member: Pennsylvania Society of Miniature Painters; Baltimore Water Color Club. Award: Charlotte Ritchie Smith Memorial prize, Baltimore Water Color and Miniature Expo., 1927. Address in 1929, Ruxton, Baltimore Co., MD.

HUF, KARL (PHILIP).

Painter and illustrator. Born in Philadelphia, PA, Sept. 28, 1887. Pupil of Penna. Academy of Fine Arts; Chase; Breckenridge; Anshutz; Weir; Mc Carter. Illustrations for *The Ladies' Home Journal*; advertisements and illustrations in newspapers and magazines. Address in 1929, Asst. Art Director, F. Wallis Armstrong Co., 16th and Locust Sts.; h. 3850 North Smedley St., Philadelphia, PA. Died in 1937.

HUFF, WILLIAM GORDON.

Sculptor and painter. Born Fresno, CA, February 3, 1903. Pupil of B. Bufano, Edgar Walter, Arthur Lee. Awards: Second sculpture award, Palace of Fine Art, San Francisco, 1922; first sculpture prize, California Society of Fine Arts, San Francisco, 1923. Work: Civil War Monument, Bennington, VT; Prof. Fay Memorial, Tufts College, MA; Francis Marion Smith Memorial, Oakland, CA; Chief Solano Monument, Solano Co., CA. Address in 1933, Berkeley, CA; summer, Rock Tavern, NY.

HUFFAKER, SANDY.

Illustrator. Born in Chattanooga, TN, in 1943. He attended the University of Alabama and studied under Daniel Schwartz at the Art Students League. He was a political cartoonist for *The News and Observer* in Raleigh, NC before coming to NY as a free-lancer. His artwork has been seen in *Sports Illustrated*, *Business Week*, *Time* and *The New York Times*, which sponsored his nomination for a Pulitzer Prize in 1977. Exhibitions of his paintings and drawings have been held at the Greengrass Gallery, Puck Gallery and Hunter Gallery of Chattanooga. A member of the Society of Illustrators, he presently lives and works in NY.

HUGER, EMILY HAMILTON.

Painter, craftsman, writer, lecturer, and teacher. Born in New Orleans, LA, Jan. 11, 1881. Pupil of Ellsworth Woodward, Chase, W. A. Bell and Breckenridge. Member: New Orleans Art Assoc.; Western Arts Assoc.; So. States Art League; Am. Fed. of Arts; Newcomb Art Alumnae Assoc. Head of Art Dept., Southwestern LA Inst., Lafayette, LA. Died in 1946. Address 1929, 1202 Johnston St., Lafayette, LA.

HUGHES, DAISY MARGUERITE.

Painter and teacher. Born in Los Angeles, CA, 1882. Pupil of L. E. Garden Macleod, Ralph Johonnot,

Rudolph Schaeffer, George Elmer Browne, and C. P. Townsley. Member: Calif. Art Club; Art Teachers' Association of Southern California; National Association of Women Painters and Sculptors; Allied Artists of America; American Federation of Arts. Address in 1929, care of Messrs. Munroe & Co., 4 Rue Ventadour, Paris, France; 614 South Normandie Avenue, Los Angeles, CA.

HUGHES, GEORGE.
Illustrator. Born in New York City in 1907. He studied at the National Academy of Design and Art Students League. For a short time he worked in Detroit as a special designer in the auto industry. He began his long-standing career with *The Saturday Evening Post* in the 1940's and did his first cover in 1948. Living in Arlington, VT, for many years, he was a neighbor of Norman Rockwell, John Atherton and Mead Schaeffer. He now lives in Wainscott, NY.

HUGHES, ROBERT BALL
(or BALL ROBERT).
Sculptor. Born Jan. 19, 1806, in London, England, where he studied with Edward Hodges Baily of the School of Flaxman; received the silver medal of the Royal Academy. He came to the United States in 1829 and settled first in New York and later in Dorchester, MA. He modeled the groups "Little Nell," "Uncle Toby and the Widow Wadman," preserved in plaster at the Boston Athenaeum. His life-size high-relief of Bishop Hobart of New York is in the vestry of Trinity Church, New York. Executed full-length statue of Alexander Hamilton for Merchants' Exchange; wax bust of Charles Wilkes, president of Bank of New York, NY Historical Society, 1830; John Watts, bronze version at Metropolitan Museum of Art; others. Exhibited at National Academy of Design; Boston Athenaeum; Artists' Fund Society, Philadelphia. Honorary professional member of National Academy of Design, 1831. He died March 5, 1868, in Dorchester, MA.

HUGHES, ROY V.
Painter and illustrator. Born in Elmira, NY, Feb. 14, 1879. Pupil of F. V. DuMond, Art Students League of NY. Member: Pittsburgh Art Association. Address in 1929, 1517 Park Blvd., Dormont, Pittsburgh, PA.

HUGHES-MARTIN, AGNES.
Painter and illustrator. Born in Claremorris, Co. Mayo, Ireland, Dec. 11, 1898. Pupil of H. George Robertson Martin. Member: Boston Soc. of Independent Artists. Address in 1929, care of Mrs. Lyman, 111 Alexander Street, Dorchester, Boston, MA.

HULBERT, CHARLES ALLEN.
Painter and sculptor. Born in Mackinaw Island, MI. Pupil of Penna. Academy of Fine Arts; John Ward Stimson in NY; Metropolitan Museum Art School,

and Artist-Artisan Institute in NYC. Work: "The Old Trunk," Public Library, Erie, PA; "Portrait of Sec. Edward Lazansky," in the Capitol, Albany, NY. Member: Salma. Club; Brooklyn Painters and Sculptors; Pittsfield (MA) Art Association. Address in 1933, South Egremont, MA. Died in 1939.

HULBERT, KATHERINE ALLMOND.
(Mrs. Charles A. Hulbert). Painter. Born in Sacramento Valley, CA. Pupil of San Francisco School of Design, National Academy of Design and John Ward Stimson in NY. Member: National Association of Women Painters and Sculptors; Brooklyn Painters and Sculptors; Pittsfield (MA) Art League. Work: "The Old Mill," Library of Girls' High School, Brooklyn. Died in 1961. Address in 1929, South Egremont, MA.

HULL, MARIE ATKINSON.
Painter. Born in Summit, MI, Sept. 28, 1890. Pupil of Penna. Academy of Fine Arts; Art Students League of NY; John F. Carlson. Member: Mississippi Art Association; Southern States Art League; Fellowship Penna. Academy of Fine Arts; New Orleans Art Association; New Orleans Arts and Crafts Club; American Federation of Arts. Award: Mississippi Art Association gold medal, 1920; first prize, Southern States Art League, 1926; second prize ($2500), Davis Wildflower Competition, San Antonio, TX, 1929. Work: "Ancient Oaks, Biloxi," owned by Mississippi Art Association. Address in 1929, 825, Belhaven Street, Jackson, MI.

HULTBERG, JOHN.
Painter. Born in Berkeley, CA, Feb. 8, 1922. Studied: Fresno State College, BA, 1943; California School of Fine Arts, 1947-49; Art Students League, 1949-51. Exhibited: Martha Jackson Gallery, NY, 1955-72, ICA Gallery, London, 1956, Corcoran Gallery, Washington, DC, 1956, Oakland Museum, CA, 1960 (all one-man); many others. Work: Metropolitan Mus. of Art; Guggenheim; Mus. of Modern Art; Stedelijk Museum; others. Awards: Prize for landscape, National Academy of Design, 1972; National Endowment for the Arts Grant, 1981. Member of National Academy of Design. Has taught painting at the Art Students League and the San Francisco Art Institute. Address in 1984, Monhegan, ME.

HUMES, RALPH HAMILTON.
Sculptor. Born in Philadelphia, December 25, 1902. Pupil of Albert Laessle and Charles Grafly at Penna. Academy of Fine Arts; Rinehart School of Sculpture. Member: National Sculpture Soc.; Conn. Academy of Fine Arts; New Haven Paint and Clay Club; National Academy (Associate); others. Awards: Cresson Traveling Scholarship, Penna. Academy of Fine Arts, 1929, 30; prizes, National Academy of Design, 1932, 37; New Haven Paint and Clay Club, 1932, 36; fellowship, Penna. Academy of Fine Arts,

1937; others. Exhibited: Penna. Academy of Fine Arts, 1930-34, 37; National Academy of Design, 1932, 33, 35, 37, 40, 45; National Sculpture Society Shows; Art Institute of Chicago; many others. Represented in Brookgreen Gardens, SC; fountain, Coral Gables, FL; Penna. Academy of Fine Arts; commissions. Address in 1980, Leesburg, FL. Died in 1981.

HUMPHREY, DAVID W.
Painter and illustrator. Born in Elkhorn, WI, in 1872. Pupil of Art Institute of Chicago; Julian Academy, Paris; studied with Whistler in Paris. Address in 1926, 259 West 23rd Street, New York.

HUMPHREY, ELIZABETH B.
Painter. Born in Hopedale, MA, about 1850. She was a pupil at the Cooper School of Design and of Worthington Whittredge. Her professional life was devoted chiefly to designing illustrations. She made some excellent sketches and paintings during a trip to California. Her illustrations include landscape, still-life and figures.

HUMPHREY, WALTER B.
Illustrator. Member: New Rochelle Art Association. Address in 1929, 94 Mayflower Avenue, New Rochelle, NY.

HUMPHREYS, ALBERT.
Sculptor and painter. Born near Cincinnati, OH. Pupil of Gerome and Alexander Harrison in Paris. Represented by paintings in Detroit Institute of Art and Boston Public Library. Represented by sculpture in National Gallery of Art, Washington, DC, and Children's Fountain, So. Manchester, CT. Address in 1922, 96 Fifth Avenue, New York. Died in 1922.

HUMPHREYS, FRANCIS.
Born in 1815 in Ireland. Capital engraver of portraits and subject plates in both mezzotint and in line. He was employed in 1850-58 by the Methodist Book Concern, of Cincinnati, OH.

HUMPHREYS, MALCOLM.
Painter. Born in Morristown, Nov. 7, 1894. Pupil of John H. Carlson, Charles W. Hawthorne, Charles Rosen, George Elmer Browne. Member: Salma Club; Allied Artists of Am.; Society of Independent Artists; American Federation of Arts; Palm Beach Art League. Awards: Third Hallgarten prize, National Academy of Design, 1929; hon. mention, Allied Artists of America, 1929; Ranger Fund purchase award, National Academy of Design, 1929. Address in 1929, 11 Franklin Place, Morristown, NJ; summer, Care of Munroe and Co., 4 Rue Ventadour, Paris, France.

HUMPHREYS, MARIE CHAMPNEY.
Miniature painter who exhibited in Europe and America. She was born in Deerfield, MA, 1867, and was the daughter of J. Wells Champney, well known for his art works. She died in New Rochelle, NY, on Dec. 1, 1906.

HUMPHREYS, SALLIE THOMSON.
Painter, designer, lecturer, and teacher. Born in Delaware, Ohio. Pupil of Emma Humphreys; Washington, DC, Art Students League; NY School of Fine and Applied Arts; studied at Colarossi Academy in Paris; and various places in Europe. Member: College Art Association; Washington Water Color Club; Washington Art Club; American Federation of Arts. Designs for textiles, wall paper, cretonne, cotton and linen materials reproduced by leading firms. Author of lectures on "Design," "Design in Its Relation to the Home," "Textile Design," "Interior Decoration," and "The Value of Art Instruction to the College Student." Instructor in design, Washington Art Students League, 1897-1904; Baltimore Water Color Club, 1902-1903. Director, School of Fine Arts, Ohio Wesleyan University. Address in 1929, School of Fine Arts, Ohio Wesleyan University; h. 162 North Sandusky Street, Delaware, OH.

HUMPHRIES, CHARLES H.
Sculptor. Born in England, 1867. Member: National Sculpture Society, 1908; Society of Independent Artists. Address in 1929, 214 East 45th Street, New York, NY.

HUMPHRYS, WILLIAM.
Engraver. Mr. Baker, in his "American Engravers," says that William Humphrys was born in Dublin in 1794. He adds that he learned to engrave with George Murray in Philadelphia, went to England in 1823, returned to this country in 1843 and in 1845 again went abroad to remain there for the rest of his life. Mr. Baker credits him with numerous small "Annual" plates, but says that he was principally engaged in bank-note engraving. Died Jan. 21, 1865 in Genoa, Italy.

HUNT, CLYDE DU VERNET.
Sculptor. Born in Scotland in 1861. Student of Massachusetts Institute of Technology, Boston. Represented in Metropolitan Museum of Art, New York, by marble statue, "Nirvana." Exhibited at National Sculpture Society, 1923. Member: Nat. Sculpture Soc. Address 1926, Weathersfield, VT. Died in 1941.

HUNT, ESTHER.
Sculptor and painter. Born in Grand Island, NE, August 30, 1885. Pupil of Chase. Member: Laguna Beach Art Association. Award: Gold medal for sculpture, Pan-Pacific Exposition, San Diego, 1915. Address in 1933, 142 E 18th St., New York, NY.

HUNT, LEIGH HARRISON.
Etcher, teacher, writer, and lecturer. Born in Galena, IL, May 19, 1858. Pupil of Henry Farrer.

Member: Artists' Fund Society; Society of American Etchers; Arti et Amicitae, Holland (cor.). Address in 1929, 600 West 146th Street, New York, NY. Died in 1937.

HUNT, LYNN BOGUE.
Illustrator. Member: Society of Illustrators. Address in 1929, 41 Union Square, New York, NY.

HUNT, MABELLE ALCOTT.
Painter, craftsman, and teacher. Born in New York City, Sept. 1, 1898. Pupil of Whittaker and Holland at Adelphi Institute, Brooklyn, NY; Savannah Art Club. Specialty, blockprints. Address in 1929, 601-45th Street, East; h. "Chatham Crescent," Savannah, GA.

HUNT, P. C.
Painter. Member: Boston Art Club. Address in 1929, 26 Park Drive, Brookline, MA.

HUNT, SAMUEL VALENTINE.
Engraver. Born in Norwich, England, Feb. 14, 1803; died at Bay Ridge, NY, in 1893. Hunt was originally a taxidermist and was a self-taught artist and engraver. He came to the US in 1834 and was then an excellent line-engraver of landscape. He worked for New York and Cincinnati publishing houses.

HUNT, THOMAS L.
Painter. Exhibited at Penna. Academy of Fine Arts Annual Exhibition of 1924. Address, Laguna Beach, CA. Died in 1938.

HUNT, UNA CLARKE.
(Mrs. Arthur P. Hunt). Painter and illustrator. Born in Cincinnati, OH, Jan. 6, 1876. Pupil of Boston Museum School and Denman W. Ross. Member: Washington Water Color Club. Work: Reredos in St. Michael's Church, Geneseo, NY. Address in 1929, Pasaconaway, NH.

HUNT, WILLIAM MORRIS.
Sculptor, painter, cameo portraitist, and teacher. Born in Brattleboro, VT, March 31, 1824. Studied in Rome, Italy, under Henry Kirke Brown; later at Duesseldorf; Paris under Pradier. Influenced deeply by work of Thomas Couture in Paris. Returned to Boston where he taught art; noted for bringing attention to emerging art trends in Paris and Barbizon, France, in latter half of 19th Century. He painted many portraits of noted persons and was the author of many original sketches of types of Parisian life. Sculpture works were few. Works: "The Horses of Anahita" (or "The Flight of Night"), 1846, one of two large murals for the State Capitol at Albany, NY, 1878; "Landscape" and "Girl at a Fountain," Met. Museum, NYC; and "The Spouting Whale," Washington, DC. Died at Appledore, one of the Isles of Shoals, off New Hampshire coast, Sept. 8, 1879.

HUNTER, DAVID.
Sculptor. Born in England, August 1865. Pupil of Art Institute of Chicago and John Gelert in Chicago. Second prize, Architectural Club, Chicago; first prize for relief at Springfield, IL. Member Palette and Chisel Club; Chicago Architectural Club. Address in 1910, Northwestern Terra Cotta Co., Chicago, IL. Died 1927 in New York.

HUNTER, EVANGELINE D.
Miniature painter. Exhibited at the Penna. Academy of Fine Arts, Philadelphia, 1925. Address in 1926, 4205 Sansom Street, Philadelphia, PA.

HUNTER, FRANCES TIPTON.
Illustrator. Born in Howard, PA, Sept. 1, 1896. Pupil of Thornton Oakley; Penna. Academy of Fine Arts. Member: Soc. of Illustrators; Williamsport Artists Guild; Fellowship Penna. Academy of Fine Arts. Specialty, illustrations of children for magazines. Died 1957. Address in 1929, 2101 Chestnut Street, Philadelphia, PA.

HUNTER, ISABEL.
Painter and teacher. Born in San Francisco, CA. Pupil of Arthur Mathews, Emil Carlsen, Joullin; San Francisco Art Institute; Art Students League of NY. Member: San Francisco Art Assoc.; San Francisco Soc. of Women Artists. Address in 1929, Monterey, CA; h. 2050 Santa Clara Avenue, Alameda, CA.

HUNTER, JOHN YOUNG.
Painter. Exhibited water colors at the Penna. Academy of Fine Arts, Philadelphia, 1925. Address in 1926, 58 West 57th Street, New York.

HUNTER, LIZBETH C(LIFTON).
Painter. Born in Gilroy, CA, Nov. 29, 1868. Pupil of Henry B. Snell. Member: NY Water Color Club; Boston Water Color Club; National Association of Women Painters and Sculptors; Am. Federation of Arts. Address in 1929, 156 East 37th Street, New York, NY.

HUNTER, ROBERT DOUGLAS.
Painter. Born in Boston, MA, March 17, 1928. Study: Cape School of Art, Provincetown, MA, with Henry Hensche; Vesper George School of Art, Boston; also with R. H. Ives Gammell, Boston. Work: The Chrysler Art Museum, MA; The Maryhill Museum, WA; Northeastern University; Tufts University; Boston University Medical Center; MIT; others. Commissions: Mural, Church of St. Mary of the Harbor, Provincetown, MA; Emmanuel Church, West Roxbury, MA. Exhibited: Academy Artists Show, Springfield, MA; American Artists Professional League Show, NYC; New England Artists Exhibition, Boston. Awards: New England Artists Exhibition, 15 Richard Milton Gold Medals, 1954-70; American Artists Professional League, gold medal,

1962, Newington Prize, 1966, 67; many others. Teaching: Vesper George School of Art, from 1955; Worcester Art Museum; Mt. Ida Jr. College, Newton, MA. Member: Guild of Boston Artists; American Artists Professional League; Acad. Artists Assn.; Grand Central Art Gallery; others. Media: Oil. Address in 1982, 250 Beacon St., Boston, MA.

HUNTINGTON, ANNA VAUGHN HYATT.
(Mrs. Archer M.). Sculptor. Born in Cambridge, MA, March 10, 1876. Studied: Art Students League, NY, under H. MacNeil and Borglum; H. H. Kitson in Boston; self-study of wild animals at the Bronx Zoo. Exhibited: National Sculpture Soc., 1923. Member: Associate (1916) and Academician (1923), National Academy of Design, NY; National Sculpture Society, 1905; American Federation of Arts; American Academy of Arts and Letters; board member, Brookgreen Gardens, SC. Awards: Honorable mention, Paris Salon, 1910; silver medal, P.-P. Expo., San Francisco, 1915; purple rosette from French Government, 1915; gold medal, Plastic Club, 1916; Saltus medal, National Academy of Design, 1920, 1922; Legion of Honor, 1922; gold medal, Nat. Academy of Design, 1958; Grand Cross of Alfonso the Twelfth, Spanish Government; many others. Work: "Lion," (bronze) erected at Dayton, OH; "Joan of Arc," for which she was awarded honorable mention at the Paris Salon, unveiled NYC, 1915; Gloucester, MA; Blois, France; Cathedral of St. John the Divine, NY; bronze elephants, Carnegie Institute; other pieces held in collection of Brookgreen Gardens, SC: "Jaguar," (bronze), 1907; "Great Dane," (granite), 1922; "Diana of the Chase," (bronze), 1922; "Youth Taming the Wild," (limestone), 1927; "El Cid Campeador," 1934; "Mother," (bronze), 1953; "Wrong Number," (bronze), 1967; numerous others. Specialty, animal sculpture, garden sculpture, and fountains. Address in 1970, Bethel, CT. Died on October 4, 1973.

HUNTINGTON, CLARA.
Sculptor. Born in Oneonta, NY, February 2, 1878. Pupil of Arturo Dazzi in Rome. Member: National Association of Women Painters and Sculptors. Work: Portrait bas-relief of H. E. Huntington, Henry E. Huntington Library and Art Gallery, San Marino, CA; decorative bas-relief, Berkeley Women's Club, California. Address in 1933, Los Gatos, CA; Forti Di Marmi, (Lucca) Italy.

HUNTINGTON, DANIEL.
Portrait and genre painter. Born in New York, Oct. 14, 1816. Died in New York, April 18, 1906. Pupil of Professor Samuel F. B. Morse, 1835, and later of Inman; also of G. P. Ferrero in Rome. Elected Associate of the National Academy, 1839; National Academy, 1840; President of National Academy, 1862-1869 and 1877-1891; Vice-President of the Metropolitan Museum of Art, New York, 1870-1903.

HUNTINGTON, D(ANIEL) R(IGGS).
Painter and artist. Born in Newark, NJ, Dec. 24, 1871. Member: Seattle Fine Arts Soc.; Washington Chapter American Institute of Architects. Work: Firlands Hospital Group, University Bridge Piers, Seattle, WA; rose garden, Woodland Park, fountain and Harding Memorial in collaboration with Alice Carr. Address in 1929, 455-456 Empire Bldg.; h. 138 East 52nd Street, Seattle, WA.

HUNTINGTON, ELEAZER.
Engraver. Born in 1789, he resided at Hartford, CT, and was the son of Nathaniel Gilbert and Betsy (Tucker) Huntington. In 1825 he published at Hartford "The American Penman Etc.," written and engraved by Eleazer Huntington. In 1828 he engraved, in line, maps, diagrams and a series of small American views for a school atlas, published in New York. He engraved a fairly well executed portrait of himself.

HUNTINGTON, JIM.
Sculptor. Born in Elkhart, IN, January 13, 1941. Studied at Indiana University, Bloomington, 1958-59; El Camino College, 1959-60. Work in Addison Gallery of American Art, Andover, MA; Brandeis University; Whitney Museum of American Art; Storm King Art Center, Mountainville, NY; others. Has exhibited at Corcoran Gallery of Art; Whitney Museum of American Art; Mass. Institute of Technology; Max Hutchinson Gallery, NY. Received National Endowment for the Arts Fellowship, 1980-81. Works in stone, metal, and wood. Address in 1982, Brooklyn, NY.

HUNTINGTON, MARGARET WENDELL.
Painter. Born in 1867. Member: National Association of Women Painters and Sculptors. Award: Hon. mention, National Association of Women Painters and Sculptors, 1927. Died in 1955. Address in 1929, 13 East 9th Street; 7 East 12th Street; 53 Washington Square, New York, NY.

HUNTLEY, SAMANTHA LITTLEFIELD.
Painter. Born in Watervliet, NY. Pupil of Art Students League of NY under Twachtman and Mowbray; Ecole des Beaux Art, Paris, under Cuyer; Ecole Normale d'Enseignement du Dessin, Paris, under Lefebvre and Robert-Fleury. Member: National Arts Club; American Federation of Arts. Work: "Daniel S. Lamont," owned by the War Dept., Washington, DC; "William F. Vilas," owned by the State Historical Library and Court House, Madison, WI; "Archbishop John J. Glennon," Archbishop's House, St. Louis, MO; "Frank W. Higgins," Capitol, Albany, NY; "J. Townsend Lansing," "Girl in Black," and "John E. McElroy," Albany, NY Historical and Art Society; "Wm. F. Gurley," Emma Willard School Collection, Troy, NY; "Gen. John M. Schofield," Schofield Barracks, Honolulu, Hawaii;

Dr. Charles Doolittle Walcott, and Dr. Charles Greenley Abbot, Smithsonian Institution, Washington, DC. Died June 19, 1949. Address in 1929, Wildflower Haven, Kinderhook, NY.

HUNTLEY, VICTORIA H.
Lithographer. Born in Hasbrouck Heights, NJ, in 1900. Studied: Art Students League; also with John Sloan, Max Weber, William C. Palmer and Kenneth Hayes Miller. Awards: Art Institute of Chicago, 1930; Philadelphia Printmakers Club, 1933; Library of Congress, 1945, 1949; Association American Artists, 1946; grant, American Academy of Arts and Letters, 1947; Guggenheim fellowship, 1948; Society of American Graphic Artists, 1950, 1951; Art Students League, 1950, 1951. Collections: Metropolitan Museum of Art; Art Inst. of Chicago; Boston Museum of Fine Arts; Philadelphia Museum of Art; Cleveland Museum of Art; Whitney Museum of American Art; International Business Machines; Library of Congress; Brooklyn Museum; University of FL; University of Michigan; Albany Printmakers Club; Rochester Memorial Museum; Art Students League; Cincinnati Museum Association; Paris, France, 1954; also touring Italy, 1955-56, 1956-57; Museum of Fine Arts of Houston; Penna. Academy of Fine Arts; New York Public Library; Newark Public Library; Philadelphia Printmakers Club; University of Glasgow; Italian Government; United States Post Office, Springville, NY; Greenwich, CT.

HUNTOON, MARY.
Sculptor, painter, etcher, and teacher. Born in Topeka, KS, November 29, 1896. Pupil of Joseph Pennell and Henri, Art Students League; and studied in Paris. Exhibited: Brooklyn Society of Artists, 1930; Salon d' Automne, 1929; Women Painters of America, 1936-38; others. Member: National League of American Pen Women; Prairie Water Color Painters. Address in 1953, Paris, France; summer, Topeka, KS.

HURD, E.
A line-engraver of buildings, etc., working about 1840. His work possessed little merit.

HURD, ELEANOR HAMMOND.
Painter. Born in Kalamazoo, MI. Pupil of Charles Hawthorne, Hugh Breckenridge, Charles Woodbury. Member: Baltimore Water Color Club; Friends of Art.; Baltimore Institute of Arts. Address in 1929, 4407 Keswick Road, Baltimore, MD; summer, Seal Harbor, ME.

HURD, NATHANIEL.
Engraver. Born in Boston, MA, 1730; died there in 1777. Nathaniel Hurd advertised his business as follows: "Nathaniel Hurd Informed his Customers he has remov'd his shop from MacCarty's corner, on the Exchange, to the Back Part of the opposite Brick Building where Mr. Ezekiel Pirce Kept his Office. Where he continues to do all sorts of Goldsmith's Work. Likewise engraves in Gold, Silver, Copper, Brass and Steel, in the neatest, Manner, and at reasonable Rates." But Hurd was engraving upon copper at an earlier date than this, as a bookplate of Thomas Dering is noted as engraved by Hurd in 1749. In 1762 he engraved a rare caricature portrait of Dr. Seth Hudson, a notorious character, and in 1764, a portrait of Rev. Joseph Sewall. With these exceptions and that of a Masonic notice engraved about 1764, numerous book-plates constitute the known engravings of Nathaniel Hurd.

HURD, PETER.
Painter and illustrator. Born Rosewell, Feb. 22, 1904. Pupil of N.C. Wyeth; Penna. Academy of Fine Arts. Member: Fellowship Penna. Academy of Fine Arts; Wilmington Society of Fine Arts. Illustrated *The Last of the Mohicans* (David McKay); *American History*, by T. S. Lawler (Ginn and Co.). Address in 1929, Roswell, NM.

HURLEY, EDWARD TIMOTHY.
Painter, illustrator, etcher, and craftsman. Born in Cincinnati, OH, Oct. 10, 1869. Pupil of Cincinnati Art Academy under Frank Duveneck. Member: Cincinnati Art Club; Chicago Society of Etchers; Richmond Art Association; Crafters Company of Cincinnati. Awards: Gold medal for originality in art workmanship, St. Louis World's Fair, 1904; Logan Medal, Art Institute of Chicago, 1921; landscape prize, Columbus, 1921. Work: "Midnight Mass," Cincinnati Mus.; etchings in Richmond (IN) Art Association; Art Association of Indianapolis; Detroit Institute; Toledo Museum of Art; NY Public Library; Library of Congress, Washington, DC; Chicago Art Institute; British Museum, London, England. Illustrated with etchings and published seven books on Cincinnati. Died 1950. Address in 1929, Rookwood Pottery; h. 2112 St. James Avenue, W. H., Cincinnati, OH.

HURRY, LUCY WASHINGTON.
Painter, craftsman and decorator. Born in Hagerstown, MD, in 1884. Pupil of Art Students League of NY under Kenyon Cox; Marshall Fry; Fayette Barnum. Member: NY Water Color Club; National Association of Women Painters and Sculptors. Address in 1929, 60 Greenwich Street, Hempstead, LI, NY.

HURST, CLARA SCOTT.
Painter and teacher. Born in Kirwin, Dec. 27, 1889. Pupil of Katherine L. Perkins, George M. Stone, Birger Sandzen. Awards: First prize in landscape and second in oil, State Fair, Topeka, KS, 1927; first prize in design and first prize in miniature, State Fair, Topeka, 1926; prizes, Hutchinson, KS, 1927. Address in 1929, Kirwin, KS.

HURST, EARL OLIVER.
Illustrator. Born in Buffalo, NY, in 1895. He studied at the Albright Art School, Cleveland School of Art and later at the University of Beaune in France. His work appeared on the cover of *Judge* as early as 1924 and very often in *Collier's* in the early 1930's. He was an active illustrator for magazines, working until 1956. He has had exhibits at the Silvermine Gallery, Society of Illustrators and a One-Man Show at the Boothbay Harbor Gallery.

HURST, RALPH N.
Sculptor and educator. Born in Decatur, IN, Sept. 4, 1918. Studied at Indiana University, Bloomington, B.S. and M.F.A.; Ogunquit School of Painting and Sculpture, ME, with Robert Laurent. Work in Evansville Museum of Arts and Science, IN; Columbus Museum of Arts and Crafts, GA; others. Has exhibited at Metropolitan Museum, NY, American Sculpture, 1951; National Liturgical Art Exhibition, San Francisco, 1960; High Museum, Atlanta, GA, 1967. Member of Artists Equity Association; National Art Education Association; Southeastern Sculptors Association. Works in alabaster and wood. Address in 1982, Tallahassee, FL.

HURTT, ARTHUR R.
Painter and illustrator. Born in Wisconsin, Oct. 31, 1861. Pupil of Douglas Volk, Irving Wiles, Art Students League of NY. Studied in France. Member: California Art Club; Minnesota Art League. Award: Bronze medal, Pan.-California Expo., San Diego, 1915. Painter of stage scenery, murals and panoramas. Work in State Building, Exposition Park, Los Angeles. Address in 1929, 1518 Mohawk Street, Los Angeles, CA.

HUSE, MARION.
Painter. Born in Lynn, MA. Studied: New School of Design, Boston; Carnegie Institute of Technology; also with Charles Hawthorne. Awards: Springfield Art League, 1925, 1936, 1941; Connecticut Academy of Fine Arts, 1933; Albany Institute of History and Art, 1938, 1944. Collections: Lawrence Museum of Art, Williamstown, MA; Wood Gallery of Art, Montpelier, VT; Bennington, Vermont, Museum of History and Art; Boston Museum of Fine Arts; Alabama Polytechnic Institute; American Association of University Women; University of Wisconsin; Library of Congress; United States State Department; Howard University; Virginia Museum of Fine Arts; Victoria and Albert Museum, London, England; Nelson Gallery of Art; Tel-Aviv Museum; State Teachers College, Albany, NY; Munson-Williams-Proctor Institute.

HUTAF, AUGUST WILLIAM.
Painter and illustrator. Born in Hoboken, NJ, Feb. 25, 1879. Pupil of W.D. Streetor. Member: American Numismatic Society; Society of Illustrators. Work includes posters, book covers and decorations. Created poster, "The Spirit of the Fighting Tanks," 5th Liberty Loan. Died 1942. Address in 1929, 1-31st Street, Woodcliff-on-Hudson, NJ.

HUTCHENS, FRANK TOWNSEND.
Painter and lecturer. Born in 1869 in Canandaigua, NY. Pupil of Art Students League of NY, under Wiles, DuMond, Mowbray and George de Forest Brush; Julian Academy under Constant and Laurens, and Colarossi Academy in Paris. Member: National Arts Club; Aquarellists; Allied Artists of America; American Art Association of Paris; Salma. Club; American Water Color Society; Am. Federation of Arts. Work: "Betrayal of Christ," Carnegie Library, Sioux Falls, South Dakota; portrait of Gen. Edgar S. Dudley, Museum at West Point, NY; "Autumn Afternoon," Art Club, Erie, PA; "A Winter Morning," Herron Art Institute, Indianapolis; "Twilight in Picardie," Toledo Museum; "Hon. James W. Wadsworth," Capitol, Albany; "Olive Garden, Capri," Sioux Falls Art Association; "Old Cafe in Sidi-Bou-Said," Memorial Art Gallery, Rochester; "Street Market, Tunis" and "Old Arab Quarter, Tunis," Syracuse Museum of Fine Arts; "Bab Menara at Sunset," High Museum of Art, Atlanta; "Returning Home," Buckner Collection, Milwaukee Art Institute; portrait, "Gov. Chas. M. Floyd," Capitol, Concord, NH; "The Dunes," Warren Art Association, Warren, PA. Address in 1929, 47 Fifth Avenue, New York, NY; h. Norwalk, CT. Died in 1937.

HUTCHINS, JOHN E.
Painter. Born in Wyoming, PA, in 1891. Address in 1926, 709 Putnam Avenue, Brooklyn, NY.

HUTCHINS, MAUDE PHELPS McVEIGH.
Sculptor. Born in New York City, February 4, 1899. Pupil of Robert G. Eberhard; Yale School of Fine Arts. Exhibited: Grand Central Art Galleries; University of Chicago; others. Member: New Haven Painters and Sculptors Society; National Academy of Women Painters and Sculptors. Award: Floyd Warren prize, Beaux-Arts Institute of Design, New York, 1925. Address in 1953, Chicago, IL.

HUTCHINS, WILL.
Painter, writer, lecturer, and teacher. Born Westchester, CT, June 11, 1878. Pupil of Yale School of Fine Arts; Laurens in Paris. Head of Art Department, American University, Washington, DC. Address in 1929, American University; h. 1348 Euclid Street, Washington, DC.

HUTCHINSON, ALLEN.
Sculptor. Born in England, January 8, 1855. Pupil of Jules Dalou. Works: "King Kalakana," Hawaiian types and figures and busts of Hawaiian notables, etc., Bishop Museum, Honolulu; "Sir Alfred Stephen,"

National Art Gallery, Sydney, Australia; busts of Robert Louis Stevenson, Honolulu Academy of Arts and the Stevenson Society of America, Saranac Lake, NY; Auckland Art Museum, New Zealand. Address in 1929, 25 Dongan Place, New York, NY.

HUTCHINSON, ELLEN WALES.
Painter and teacher. Born in East Hartford, CT, June 12, 1868. Pupil of C. E. Porter; Geo. Thomson; Guy Wiggins. Member: Connecticut Academy of Fine Arts; New Haven Paint and Clay Club; New Haven Brush and Palette Club. Address in 1929, 866 Elm Street, New Haven, CT. Died in 1937.

HUTCHINSON, FREDERICK W.
Painter. Born in Montreal, Canada. Pupil of Jean Paul Laurens, Benjamin Constant. Member: Associate National Academy of Design; Allied Artists of America; Salma. Club. Represented in Cleveland Museum of Art; Art Gallery, Toronto, Canada. Address in 1929, care of the Salma. Club, 47 Fifth Avenue, New York, NY.

HUTCHINSON, JOSEPH SHIELDS.
Sculptor, painter, educator, and museum director. Born in Mt. Pleasant, PA, October 15, 1912. Studied at Ohio State University, B.F.A., M.F.A.; Western Reserve University; and with James Hopkins, Edward Frey. Member: American Association of University Professors. Awards: Prize, Columbus (OH) Art League, 1937. Work: Sculpture, Ohio Wesleyan University. Position: Instructor, Dept. of Fine Arts, Ohio State University, Columbus, OH, 1935-37; Assistant Professor, Ohio Wesleyan University of Delaware, OH, 1937-40; former director, Mint Museum of Art, Charlotte, NC. Address in 1953, Charlotte, NC.

HUTSALIUK, LUBO.
Painter. Born in Lvov, Ukraine, April 2, 1923; US citizen. Studied: Cooper Union Art School. Work: Palm Springs Desert Museum, CA; Vermont Art Center, Manchester; Bibliotheque Nat'l., Paris. Exhibited: Galerie Norval, Paris, 1959; Angle de Faubourg, Paris, 1963; Hilde Gerst Gallery, NYC, 1966; Galerie Royale, Paris; 1976; 25 yrs. retrospective, USOM Gallery, NYC, 1980; and others. Member: Audubon Artists. Media: Watercolor, oil. Address 1982, 260 Riverside Dr., New York, NY.

HUTSON, CHARLES WOODWARD.
Painter, writer, and teacher. Born in McPhersonville, SC, Sept. 23, 1840. Pupil of Ethel Hutson. Member: New Orleans Arts and Crafts Club; Southern States Art League; Art Association of New Orleans; Gulf Coast Art Association. Died in 1936. Address 1929, 7321 Panola St., New Orleans, LA.

HUTSON, ETHEL.
Painter, illustrator, writer and teacher. Born in Baton Rouge, LA, April 19, 1872. Pupil of Mrs. J. P.

McAuley, Arthur W. Dow, Ellsworth Woodward, etc. Member: Art Association of New Orleans; New Orleans Arts and Crafts Club; Southern States Art League. Address in 1929, 7321 Panola Street, New Orleans, LA.

HUTT, HENRY.
Illustrator. Born in Chicago, IL, in 1875. Pupil of Chicago Art Institute. His studio was in New York City and he illustrated for the leading magazines and periodicals.

HUTT, JOHN.
Engraver. In Rivington's *New York Gazette* for 1774 is the following: "John Hutt, Engraver in general, from London, at Mr. Hewitt's directly opposite the Merchants' Coffee House, in Dock Street, New York. Engraves-Coats of Arms, Crest, Seals and Cyphers, Bills of Exchange, Bills of Lading, Shop Bills, Bills of Parcels, Card Plates, etc. Architecture, Frontispieces, Doorplates, Compliment Cards, Plate Dog-Collars, Etc., Stamps, etc. Gentlemen disposed to employ him may depend on the utmost neatness and dispatch." The only examples of Hutt's work known are some book-plates and a few diagrams engraved in connection with John Norman and published in Philadelphia in 1775.

HUTTBUG, CHARLES E.
Painter. Born in Sweden, May 16, 1874. Pupil of Talmadge and Oslen in England. Member: Gulf Coast Art Association. Award: Gold medal, Gulf Coast Art Association, 1927. Address in 1929, 429 Porter Ave., Biloxi, MI.

HUTTON, DOROTHY WACKERMAN.
Painter and designer. Born in Cleveland, OH, Feb. 9, 1899. Pupil of Minnesota School of Art, Mary Moulton Cheney, Richard Lahey, Anthony Angarola, Andre L'hote. Member: Alliance. Address in 1929, 3964 Packard Street, Long Island City, NY.

HUTTON, ISAAC AND GEORGE.
Engravers. This firm of jewelers and silversmiths, of Albany, NY, working about 1796, made dies for seals; one for Union University, at Schenectady, NY. But as this firm employed engravers, among them Gideon Fairman (about 1795), the actual work was probably done by someone in their employ. Issac was born in 1767 and died Sept. 8, 1855, in NYC.

HUTTON, J.
A fairly well-engraved line plate of a battle scene is signed "J. Hutton, Sc't Alb'y." The print was apparently made about 1825-30, but no other work by Hutton is known.

HUTTY, ALFRED HEBER.
Painter and etcher. Born in Grand Haven, MI, Sept. 16, 1877. Pupil of St. Louis School of Fine Arts; Art

Students League of NY under Chase and Birge Harrison. Member: Salma. Club; Woodstock Art Association; Society of Washington Artists; Washington Water Color Club; North Shore Art Association; Chicago Society of Etchers; National Arts Club; Brooklyn Society of Etchers; British Society of Graphic Arts, London; Allied Artists of America; Rockport Art Association; American Water Color Society; Print Society of England. Awards: City Art and Design Committee prize, Scarab Club, Detroit, 1921; hon. mention, Kansas City Art Institute, 1922; Scarab Club, gold medal, Detroit Institute of Art, 1923; first medal for etching, Michigan Art Institute, 1923; Logan prize and medal, Chicago Society of Etchers, 1924; Shaw Prize, Salma. Club, 1924; Clark prize, Detroit Institute of Art, 1925; Landscape prize, New Haven Paint and Clay Club, 1925; Howe Prize, Detroit Institute of Art, 1926. Represented in Gibbes Memorial Art Gallery, Charleston, SC; Art Institute of Chicago; Detroit Institute; Library of Congress, Washington, DC; Cleveland Museum; NY Public Library; Los Angeles Museum; Municipal Gallery, Phoenix, AZ; Gov.'s Mansion, Jackson, Mississippi; United States National Museum; California State Library; University of Michigan; Colorado State Library; John Herron Art Institute, Indianapolis; Bibliotheque Nationale, France. Made 1924 Associate Plates for the Printmakers of California and the North Shore Art Association. Address in 1929, Broadview, Woodstock, New York; 46 Tradd Street, Charleston, SC.

HUYSSEN, ROGER.
Illustrator. Born in Los Angeles in 1946. He attended the University of California at Santa Barbara and the Art Center College of Design. After working briefly for a design firm in California, he moved to NY in 1974 as a free-lance illustrator for advertising and editorial clients. His airbrush and watercolor work has been seen on Columbia Records covers and several movie posters. He is a member of the Society of Illustrators.

HYATT, ANNA VAUGHN.
See Huntington, Anna Vaughn Hyatt.

HYATT, HARRIET RANDOLPH.
See Mayor, Harriet R. Hyatt (Mrs.).

HYDE, DELLA MAE.
Painter and teacher. Born in Oakland, MD. Pupil of National Academy of Design, Art Students League of NY; Henri, Mora, Bridgeman. Member: Brooklyn Society of Modern Artists; Salons of America; Art Students League of NY; Gloucester Society of Artists; Washington Art Club. Address in 1929, 1517 H. Street, NW; h. "The Ritz," 1631 Euclid Street,

NW, Washington, DC; summer, Rockaway Inn, East Gloucester, Massachusetts.

HYDE, HALLIE CHAMPLIN.
See Fenton, Hallie Champlin.

HYDE, HELEN.
Painter and etcher. Born April 6, 1868 in Lima, NY, in 1863. Member of the Chicago Society of Etchers and California Society of Etchers. Represented in Library of Congress, Washington; New York Public Library; Boston Museum. She died in Pasadena, CA, on May 13, 1919.

HYDE, MARIE A. H.
Sculptor, painter, illustrator, writer, and craftswoman. Born in Sidney, OH, October 12, 1882. Studied at Cleveland School of Art; Art Students League; National Academy of Design; and with William Chase, Frank Parsons. Awards: Prize, Cleveland School of Art, 1905. Work: Metropolitan Museum of Art; Southwest Museum of Los Angeles, CA; Museum of New Mexico, Santa Fe. Illustrator, technical handbooks, Lockheed-Connors-Joyce, 1943-46. Author, illustrator, and craftswoman, national magazines and art publications. Address in 1943, Arizona Studios, 508 West 114th St., NYC.

HYDE, RUSSELL TABER.
Painter, etcher, lecturer, and teacher. Born in Waltham, MA, July 14, 1886. Pupil of Laurens, Baschet, Richer. Member: Associated Artists of Pittsburgh. Associate Professor, Fine Arts Dept., Carnegie Institute of Technology, Pittsburgh. Address in 1929, 2 Roselawn Terrace, Waltham, MA.

HYDT, WILLIAM HENRY.
Portrait painter. Born in New York, Jan. 29, 1858. Pupil of Boulanger, Lefebvre, Doucet and Alexander Harrison in Paris. Member: Associate National Academy of Design, 1900; Society of American Artists, NY, 1893; Century Association. Awards: Hon. mention, Paris Expo., 1900; bronze medal, Pan-Am. Expo., Buffalo, 1901; hon. mention, P.-P. Expo., San Francisco, 1915. Died in 1943. Address in 1929, 829 Park Avenue, New York, NY.

HYETT, WILL J.
Painter. Born in Cheltenham, England, Jan 10, 1876. Pupil of Sir Alfred East. Member: Associated Artists of Pittsburgh; Pittsburgh Architectural Club. Awards: Bronze medal, P.P. Exposition, San Francisco, 1915; third honor, Associated Artists of Pittsburgh, 1917. Address in 1929, care of Gillespie Galleries, 639 Liberty Avenue, Pittsburgh, Pennsylvania; h. Gibsonia, PA.

I

IACOVLEFF, ALEXANDRE.
See Jacovleff, Alexandre.

IANNELLI, ALFONSO.
Sculptor, painter, craftsman, writer, lecturer, and teacher. Born Andretta, Italy, February 17, 1888. Studied: Newark Technical School; Art Students League; pupil of Gutzon Borglum; George B. Bridgman; William St. John Harper. Represented by sculpture in Sioux City Court House, Sioux City, IA; design and sculpture, Immaculata High School, Chicago; Midway Gardens, Chicago; St. Francis Xavier Church, Kansas City, MO; Church of St. Thomas the Apostle, Chicago; "Youth," Art Institute of Chicago; sculpture and stained glass, St. Thomas Aquinas High School, Racine, WI; St. Patrick's Church, Racine, WI. Exhibited: Art Institute of Chicago, 1921, 25 (one-man), 1948-52; National Sculpture Society; Grand Central Gallery. Member: Cliff Dwellers. Awards: honorary degree, M.F.A., Art Institute of Chicago, 1928; Saint-Gaudens prize in sculpture. Address in 1953, Park Ridge, IL.

IARDELLA (or JARDELLA), ANDREW B.
Sculptor. Worked: Philadelphia, 1803-31. Exhibited: Bust of Alexander Hamilton, Penna. Academy, 1811.

IARDELLA, FRANCISCO.
Sculptor. Born in Carrara, Italy, 1793; came to US in 1816. Died in Washington, January 23, 1831. Worked on U.S. Capitol, Washington.

IARDELLA (or JARDELLA), GIUSEPPE.
Sculptor. Born in Italy. Worked: Philadelphia, 1790's-1803.

IARICCI, A(RDUINO).
Painter. Born in Italy, May 2, 1888. Self-taught. Member: Society of Independent Artists; Salons of America; Bronx Artists Guild. Address in 1929, 57 West 175th St., New York, NY.

ICKES, PAUL A.
Painter and illustrator. Born in Laclede, MO, April 2, 1895. Pupil of Bridgman, N. Fechin, Leith-Ross. Member: Artists Guild of the Authors' League of American, NY; Society of Illustrators. Address in 1929, 32 West 10th St., New York, NY; summer, Center Lovell, ME.

IDE, ALICE STEELE.
See Hannaford, Alice Ide.

IHRIG, CLARA LOUISE.
Sculptor, painter, and illustrator. Born in Oakland, Pittsburgh, PA, October 31, 1893. Pupil of Sparks, Zeller, and Sotter. Member: Associated Artists of Pittsburgh. Address in 1933, Pittsburgh, PA.

ILLAVA, KARL.
Sculptor. Pupil of Gutzon Borglum. Member: National Sculpture Society; Architectural League of New York (associate). Work: War Memorial, 66th St. and Fifth Ave., New York; War Memorial, Gloversville, NY; memorial to Dr. Henry Franenthal, foyer, Joint Disease Hospital, NYC; memorial to Veterans of All Wars, Whitestone, NY; others. Address in 1934, Bronxville, NY.

ILLIAN, GEORGE (JOHN).
Illustrator. Born in Milwaukee, WI, Nov. 29, 1894. Pupil of Milwaukee Art Inst.; Art Inst. of Chicago; Art Students League of NY. Member: Soc. of Illustrators; Players; Artists Guild of the Authors' League of Am., NY; Salma. Club. Address in 1929, 140 E 39th St.; 16 Gramercy Park, New York, NY.

ILLMAN, THOMAS.
Born in England. He was engraving in London in 1824, and about six years later he came to NY, and at once formed the engraving firm of Illman & Pilbrow. He worked in stipple and in mezzotint, and was a good engraver. Illman Sons, about 1845, engraved portraits for both NY and Phila. publishers.

ILSLEY, FREDERICK J(ULIAN).
Painter. Born in Portland, ME, Mar. 6, 1855. Self taught. Member: Portland Society of Artists; Salma. Club; Rockport Art Association; American Artists Professional League; Hayloft Club; American Federation of Arts. Address in 1929, 15 Powsland St., Portland, ME; summer, Rockport, MA.

IMBERT, ANTHONY.
Lithographer and marine painter. A French naval officer. He was the proprietor of an early lithographic establishment in New York. He was located at 79 Murray St., and in 1831 he had moved to 104 Broadway. Died before 1838.

IMLER, E(DGAR).
Painter and etcher. Born in St. Clairsville, PA, Jan. 31, 1894. Pupil of Art Institute of Chicago; Penna. Academy of Fine Arts. Member: Art Students League of NY; Louis Comfort Tiffany Foundation. Address in 1929, 131 West 23rd St., New York, NY; summer, Osterburg, PA.

IMRIE, HERBERT DAVID.
Etcher. Born in Napa, CA, Mar. 8, 1886. Pupil of Piazzoni. Member: California Society of Etchers. Address in 1929, 782 San Luis Rd., Berkeley, CA.

INDIANA, ROBERT.
Sculptor and painter. Born in New Castle, IN, September 13, 1928. Studied at John Herron School of Art; Munson-Williams-Proctor Institute; Art Institute of Chicago, B.F.A.; Skowhegan School of Painting and Sculpture; University of Edinburgh and Edinburgh College of Art, Scotland; others. Work in Museum of Modern Art; Whitney Museum of American Art; Carnegie Institute of Arts; Stedelijk Mus., Amsterdam; others. Has exhibited at Museum of Modern Art, NY; Tate Gallery, London; Whitney Mus. of American Art; Virginia Museum of Fine Arts, Richmond; Corcoran Gallery of Art; others. Works in oil and steel. Address in 1982, c/o Star of Hope, Vinalhaven, ME.

INDICK, JANET.
Sculptor. Born in Bronx, NY, March 3, 1932. Studied at Hunter College, with Robert Motherwell and Dong Kingman, B.A. (art), 1953; The New School, with Gregorio Prestopino and Richard Pousette-Dart, 1961. Work in Bergen Community Museum of Art and Science, Paramus, NJ; steel sculpture, The Jewish Center, Teaneck, NJ; sculpture (brass), Tree of Life, Temple Beth Rishon, Wyckoff, NJ; includes "Small Gallery," stainless steel and wood. Has exhibited at 94th Annual Exhibition of National Association of Women Artists, 1983. Awards: National Association of Women Artists, sculpture prize, 1974; National Association of Painters and Sculptors, sculpture prize, 1978, 80; others. Member of National Association of Women Artists. Address in 1983, Teaneck, NJ.

INGELS, FRANK LEE.
Painter and sculptor. Born in Tomara, Nebraska, in 1886. Member: Chicago Society of Artists; California Art Club. Exhibited: Art Institute of Chicago, 1915. Received honorable mention, Art Inst. of Chicago, 1915. Address in 1934, 1500 Lowell Ave., Los Angeles, CA.

INGERLE, RUDOLPH F.
Painter. Born in Vienna, Austria, April 14, 1879. Member: Cliff Dwellers; Palette and Chisel Club; Bohemian Art Club; Municipal Art League; North Shore Art Association; Alumni, Art Inst. of Chicago; Chicago Painters and Sculptors. Awards: Brower prize ($300), Art Inst. of Chicago, 1927; Hearst prize ($300); gold medal, Assoc. Chicago Painters and Sculptors, 1928. Work: "After the Storm," City of Chicago; "Moonrise," Arche Club, Chicago; represented in Mun. Art League Collection, Chicago. Address in 1929, 339 Laurel Ave., Highland Park, IL; 218 South Wabash Ave., Chicago, IL.

INGERSOLL, ANNA.
Painter. Exhibited at the Penna. Academy of Fine Arts in 1924. Address in 1929, 1815 Walnut St., Philadelphia, PA.

INGERSOLL, EMMA KIPLING HESS.
(Mrs. D. W. Ingersoll). Painter and teacher. Born in Chicago, IL, Jan. 18, 1878. Pupil of Art Institute of Chicago. Member: Designers' Alumni of Art Institute of Chicago; Pennsylvania Society of Miniature Painters. Award: Bronze medal for miniatures, St. Louis Expo., 1904. Address in 1929, Chestertown, MD.

INGHAM, CHARLES CROMWELL.
Painter. Born in 1796 in Dublin. He studied in the Academy there and obtained a prize for "The Death of Cleopatra"; settled in New York in 1817; was one of the founders of the National Academy of Design and its Vice-President, 1845-50. His best-known picture, "The White Plume," was engraved by A. B. Durand. Among his well-known portraits are those of Edwin Forrest, Lafayette, De Witt Clinton, Gulian C. Verplank and Catharine M. Sedgwick. Specialty was portraits of women and children. Died Dec. 10, 1863, in NYC.

INGHAM-SMITH, ELIZABETH.
(Mrs. E. Ingham-Smith). Sculptor and painter. Born in Easton, Pennsylvania. Pupil of Pennsylvania Academy of the Fine Arts, Philadelphia; Henry B. Snell; Whistler in Paris; Alex Jameson in London. Member: Phila. Water Color Club; Washington Water Color Club; New York Water Color Club. Address in 1934, Old Inn, North Shirley, MA.

INGLIS, JOHN J.
Painter, illustrator, and craftsman. Born in Dublin, Ireland, Aug. 26, 1867. Pupil of Gerome, Courtois, and Collin in Paris, and studied in London. Member: Royal Hibernian Acad. of Arts, Dublin; Rochester Art Club; Genesseans. Award: Taylor Scholarship for painting, Dublin Acad.; gold medal, Rochester Exposition, 1925. Died in 1946. Address in 1929, 83 Reynolds Arcade; h. 320 Inglewood Dr., Rochester, NY.

INGRAHAM, GEORGE H.
Etcher. Born in New Bedford, MA, in 1870. Address in 1926, 1127 Guardian Bldg., Cleveland, OH.

INGRAHAM, KATHERINE ELY.
Etcher. Born in Minneapolis, MN, in 1900. Studied: University of Wisconsin; Art Students League; and with Joseph Pennell. Awards: Madison Art Association, 1944, 1946. Collection: Library of Congress.

INMAN, HENRY.
Portrait, genre, miniature, and landscape painter. Born Oct. 28, 1801, in Utica, NY. Studied under John

Wesley Jarvis in New York City. He went to Europe in 1845, remaining about a year. He painted Wordsworth, Macaulay, Dr. Thomas Chalmers and others. Among his sitters in this country were many distinguished men, whose portraits are preserved in public collections in Boston, New York, Philadelphia and elsewhere. He was, between 1831 and 1835, associated with Col. Cephas G. Childs in a lithographic printing and publishing business carried on in this city, and was a Director of the Penna. Academy of Fine Arts in 1834. His portrait of Chief Justice Marshall was lithographed by A. Newsam and engraved by A. B. Durand. He was vice-president of the National Academy from 1820 to 1830 and again from 1838 to 1844. From 1831 to 1835 he lived at Mt. Holly, NJ, and in Philadelphia. In 1843 he sailed for England; returned to US late in 1845; died Jan. 17, 1846. Tuckerman gives a long account of Inman in his *Book of Artists*.

INMAN, J. O'BRIEN.
Painter. Born June 10, 1826, in NYC. Son of Henry Inman. As a young man he painted portraits in the Western States; later he moved his studio to New York. In 1866 he went to Europe and opened his studio in Rome. He was elected an associate of the National Academy of Design in 1865. He died May 28, 1896, in Fordham, NY.

INNES, CHARLES.
Sculptor. At New York City, 1854-56. Exhibited: Busts of Huges, Brady, and Fremont, American Institute, 1856.

INNESS, GEORGE.
Landscape painter. Born in Newburgh, NY, May 1, 1825. Except for some elementary instruction in his youth in Newark, NJ, and a few months' study under Regis Gignoux in NY, he received no academic art education. Through a long course of patient study from nature, he learned to express his ideals on canvas. His work is distinctly divided into two periods, the first covering the years during which, in conscientious, analytical fashion, he painted scenes in this country, Italy and other parts of Europe; the second embracing the time from about 1878 to his death, during which he became more and more a synthesist. In this latter period his work evoked such power, individuality and beauty of color and composition as to place his work among that of the greatest artists of the nineteenth century. There are points of similarity in his development and that of two great Frenchmen, Corot and Rousseau. Both had more academic training than Inness, but both, in their landscape work, went through the analytical stages that mark the earlier pictures of Inness. The landscapes of George Inness show the same sort of grasp as those of the two masters mentioned above, the same intensity of purpose, the same general conception of nature, and they possess a great quality of

tone, and an unusual depth and variety of color. His pictures are in galleries and museums, and his "Georgia Pines" is in the William T. Evans Collection. In 1868 he was elected to the National Academy and was also a member of the Art Students League. Died in Scotland, while on a trip, Aug. 3, 1894.

INNESS, GEORGE, JR.
Painter. Born in Paris, France, in 1853. He was a pupil of his father in Rome, Italy; studied one year in Paris. Lived in Boston and New York, where he occupied a studio with his father (1878). He resided with his family in Montclair, NJ, after 1880, but had a studio in Paris; exhibited annually at Paris Salon; honorable mention, Paris Salon, 1896, and gold medal, 1900. Officer, Academie des Beaux Arts, Paris, 1902. Elected Associate Member of the National Academy, 1895; National Academy, 1899. Art signature always "Inness, Jr." Author of "Life and Letters of George Inness," 1917. His painting "Shepherd and Sheep" is in the Metropolitan Museum. Address in 1926, Care of Century Co., 353 Fourth Ave., New York. Died July 27, 1926, in Cragsmoor, NY.

INOUYE, CAROL.
Illustrator. Born in Los Angeles, in 1940. She attended Chouinard Art Institute and UCLA. She began her career as a graphic designer and art director for several publishing houses. Her first published piece, entitled *Creative Living*, appeared in 1975. She wrote and illustrated the book *Naturecraft* and has done editorial illustrations for *Reader's Digest*, *Gallery* and *Guideposts*. Presently living in NYC, she is a member of the Society of Illustrators.

INSLEY, WILL.
Sculptor and painter. Born October 15, 1929, Indianapolis, Indiana. Studied: Amherst College, BA, 1951; Harvard University Graduate School of Design, M. Architecture, 1955. Work: Brandeis University; Colby College; University of No. Carolina. Exhibited: Amherst College, 1951; The Stable Gallery, 1965-68; Walker, 1968; Albright; Cornell Univ.; Whitney; Riverside Museum; Guggenheim; VI International Art Biennial, San Marino (Europe), 1967; Aldrich; New Delhi, First World Triennial, 1968; Museum of Modern Art, 71; Museum of Contemporary Art, Chicago, 1976. Awards: National Foundation on the Arts, 1966; Guggenheim Foundation Fellowship, 1969. Taught: Oberlin College Artist-in-Residence, 1966; University of North Carolina, 1967-68; Cornell University, 1969; School of Visual Arts, NYC, 1969-78. Represented by Max Protech Gallery, NYC. Address in 1982, 231 Bowery, NYC.

INUKAI, KYOHEI.
Painter. Award: Maynard prize ($100), National Academy of Design, 1926. Exhibited self-portrait at

National Academy and at Penna. Academy of Fine Arts in 1925. Address in 1929, 200 West 57th St.; 46 Washington Sq., New York, NY.

INVERARITY, ROBERT BRUCE.
Sculptor, painter, illustrator, etcher, lithographer, block painter, craftsman, lecturer, teacher, and writer. Born in Seattle, Washington, July 5, 1909. Studied: University of Washington, B.A., 1946; Fremont University, M.F.A., 1947, PhD, 1948; and with Kazue Yamagishi, Blanding Sloan, and Mark Tobey. Work at University of Washington, two mosaics; Washington State Museum, six panels. Exhibited at one-man shows and numerous group exhibitions. Director, Philadelphia Maritime Museum, 1969-76; Museum of International Folk Art, 1949-54; Adirondack Museum, 1954-65. Taught: University of Washington, 1933-37. Author and illustrator of *Block Printing and Stenciling, The Rainbow Book* (Art of Batik), yearly article in *Puppetry, A Yearbook of Marionettes*. Address in 1982, La Jolla, CA.

INVERNIZZI, PROSPER.
Painter. Exhibited at Penna. Academy of Fine Arts in 1924. Address in 1926, 500 West 178th St., New York.

IORIO, ADRIAN J.
Painter, illustrator, writer and lecturer. Born in New York, NY, May 13, 1879. Illustration and decoration; technical, biological, microscopical designs and diagrams for textbooks, etc. Faculty member, Massachusetts School of Art. Died in 1957. Address in 1929, 383 Boylston St., Boston, MA; Laboratory, 28 Park St., Randolph, MA.

IPPOLITO, ANGELO.
Painter and educator. Born in Arsenio, Italy, on Nov. 9, 1922; US citizen. Studied: Ozenfant School of Fine Arts; Brooklyn Museum School of Art; Instituto Meschini, Rome, Italy. Collections: Whitney Museum of American Art; Phillips Collection, Wash., DC; Munson-Williams-Proctor Institute; Sarah Lawrence College. Exhibited: Carnegie; Whitney; Museum of Modern Art; Sao Paulo Biennial, Brazil; others. Awards: Fulbright Fellowship, Florence; Tiffany Grant; others. Represented by Grace Borgenicht Gallery, NYC. Address in 1982, Binghamton, NY.

IPSEN, ERNEST L.
Portrait painter. Born in Malden, MA, Sept. 5, 1869. Pupil of Boston Museum School; Royal Academy at Copenhagen. Member: Associate National Academy of Design; Academician Nat. Academy of Design, 1924; National Arts Club (life); Allied Artists of America; Salma. Club; Century Association; American Water Color Society; NY Water Color Club; American Federation of Arts. Award: Proctor Prize, National Acad. of Design, 1921; Isaac N. Maynard

Prize, National Academy of Design (best portrait), 1929. Represented in Chicago Art Inst.; Massachusetts Institute of Technology; Boston State House; Trenton State House; New Bedford City Hall; Johns Hopkins Univ.; Butler Art Inst., Youngstown, OH; "Judge John W. Hogan," Court of Appeals, NY; "Dr. Warfield," Princeton Theological Seminary; "Dr. John Bates Clark," Carnegie Endowment for International Peace; "A. Nathan Meyer," Barnard College, Columbia University; "Dr. John Bates Clark," Columbia University; "Hon. Elihu Root," Century Assoc., NY; "Edwin Howland Blashfield," National Academy of Design, NY; "Thomas U. Slocum," Harvard Club, NY; "Rev. Henry Van Dyke," Princeton Club, NY; "Dr. William F. Whitney," Harvard Medical School, Boston; "Hon. Abram I. Elkus" and "Justice Hogan," Court of Appeals, Albany, NY; "Lee Kohns," NY Board of Trade and Transportation; "Dr. Arthur Cushman McGiffert," Union Theological Seminary; "George A. Plimpton," Amherst Col., MA; "Irene Sutliffe," Director's Room, NY Hospital; "Hon. Wm. Howard Taft," Chief Justice US Supreme Court, for US Supreme Court, Wash.; many others. Died in 1951. Address in 1929, 119 E 19th St., New York, NY.

IREDELL, RUSSELL.
Sculptor, painter, etcher, illustrator, and designer. Born February 28, 1889. Studied: Penna. Academy of Fine Arts, and with Henry McCarter, Cecilia Beaux, Daniel Garber. Member: Laguna Beach Art Association. Awards: Cresson Traveling scholarship, Penna. Academy of Fine Arts. Work: Many private portrait commissions. Exhibited: Laguna Beach Art Association, 1943-46, and later; Festival of Art, Laguna Beach; one-man: Los Angeles, Pasadena, La Jolla, Coronado, Santa Ana, Huntington Beach, San Francisco, Palm Springs, all in California; Nassau; Lake Forrest, IL; and others. Author, illustrator, "Drawing the Figure." Address in 1953, Laguna Beach, California. Died in 1959.

IRELAND, LEROY.
Painter. Born in Phila., PA, Dec. 24, 1889. Pupil of Penna. Acad. of Fine Arts; Wm. M. Chase; Daniel Garber; Emil Carlsen in NY. Member: Salma. Club; Fellowship, Penna. Acad. of Fine Arts; Artists' Fund Soc., NY. Work: "God of the Snake Dance," Dallas Art Assoc.; "Osiris," Mus., San Antonio, TX. Address in 1929, 140 W 57th St., New York, NY.

IRELAND, WILLIAM ADDISON.
Illustrator. Born in Chillicothe, OH, Jan. 8, 1880. Member: Columbus Pen and Pencil Club. Died in 1935. Address in 1929, Columbus Evening Dispatch; h. 264 Woodland Ave., Columbus, OH.

IRISH, MARGARET HOLMES.
Painter. Born in Blenheim, Canada, in 1878. Pupil of St. Louis School of Fine Arts. Member: Alliance;

Society of Independent Artists; Twentieth Century Club, St. Louis; American Federation of Arts. Award: Prize, State Fair, St. Louis, 1912. Address in 1929, No. 79 South Rock Hill Rd.; h. R. 6, Box 98, Webster Groves, MO.

IRVIN, REA.
Illustrator. Born in San Francisco, CA, Aug. 26, 1881. Pupil of Hopkins Art Institute, San Francisco. Member: Soc. of Illustrators, 1913. Work: Illustrated *Opera Guyed*, by Newman Levy (Knopf). Died in 1972. Address in 1929, Spuyten Duyvil, NY.

IRVIN, SISTER MARY FRANCIS.
Sculptor, painter, teacher, and engraver. Born in Canton, Ohio, October 4, 1914. Studied: Seton Hill College; Carnegie Institute, B.F.A.; Art Institute of Chicago; Cranbrook Acad. of Art, M.F.A. Member: Associated Artists of Pittsburgh; Greensburg Art Club; College Art Association of America, New York; Catholic Art Association. Awards: Associated Artists of Pittsburgh, 1944; Greensburg Art Club, 1944, 45, 55, 57. Work: Carnegie Institute; St. Charles Borromeo Church, Twin Rocks, PA. Exhibited: Library of Congress, 1944; Associated Artists of Pittsburgh, 1943-46, 54, 57; Carnegie Institute, 1944, 56; Greensburg Art Club, 1944-52, 54, 57, 59-64; Pittsburgh Playhouse, 1950, 53; Allegheny Art League, 1951. Taught: Professor of Art, Seton Hill College, Greensburg, PA. Address in 1970, Greensburg, PA.

IRVIN, VIRGINIA H.
Painter. Born in Chicago, IL, in 1904. Studied: Art Institute of Chicago; and with Elsie Dodge Pattee. She is a miniature painter. Awards: American Society of Miniature Painters, 1944; Calif. Society of Miniature Painters, 1947, 1949; Pennsylvania Society of Miniature Painters, 1950; National Association of Women Artists, 1954, 1958. Collection: Philadelphia Museum of Art.

IRVINE, LOUVA ELIZABETH.
Artist and filmmaker. Studied: Hans Richter Film Institute, CCNY; School of Visual Arts; Art Students League. Films: "Sophie Newman, J. Skiles, NYC;" "Elegy for My Sister;" "Rain." Exhibitions: Festival of Women's Films, 1972; Second International Festival of Cinema, Montreal, 1972; Women's Interart Center, 1973; Whitney Museum, 1972. New Film: "Portrait of Thomas Messer" (Director of the Guggenheim Museum).

IRVINE, WILSON HENRY.
Landscape painter. Born in Byron, IL, Feb. 28, 1869. Pupil of Art Institute of Chicago. Member: Associate National Academy of Design, 1926; Chicago Society of Artists; Chicago Water Color Club; Cliff Dwellers; Palette and Chisel Club, Chicago; Salma. Club; Allied Artists of America. Awards: Cahn prize ($100), Art Institute of Chicago, 1912; Carr prize ($100), Art Institute of Chicago, 1915; silver medal, P.-P. Expo., San Francisco, 1915; medal, Chicago Society of Artists, 1916; Palette and Chisel Club prize, Art Institute of Chicago, 1916; Grower prize, Art Institute of Chicago, 1917. Work: "The Road" and "Autumn," Art Institute of Chicago, Municipal Art League purchase, 1911; "Early Spring," Sears Memorial Museum, Elgin, IL. Represented in Rockford, IL, Art Association. Died in 1936.

IRVING, JOAN.
Sculptor and painter. Born in Riverside, California, March 12, 1916. Studied: Riverside City College, with Richard Allman, 1933-35; Art Center School, Los Angeles, California; with Edward Kaminski and Barse Miller, 1935-37. Awards: Festival of Art, Laguna Beach, 1951; California Watercolor Society, 1951; National Orange Show, 1951; Watercolor West, 1975. Membership: American Watercolor Society; life fellow, Royal Society of Arts; honorary life member, Watercolor West; honorary life member, San Diego Watercolor Society. Collections: Metropolitan Museum of Art; Newport Harbor School Collection. Exhibited: American Water Color Society, National Academy, New York City; California Watercolor Society, Los Angeles County Museum of Arts, 1950, 51, 52, 53, and 55. Address in 1982, Corona Del Mar, California.

IRVING, JOHN BEAUFAIN.
Painter. Born Nov. 26, 1825, in Charleston, SC. He studied in Charleston, and, in 1851, he went to Europe and studied with Leutz. On his return he had a studio in Charleston and later in New York. Elected an Associate of the National Academy and an Academician in 1872. His portraits and historical subjects are spirited and rich in color. He also painted genre subjects. Died in NYC, April 20, 1877.

IRWIN, BENONI.
Painter. Born in 1840 at Newmarket, Canada. Pupil of the National Academy of Design in New York; Carolus Duran in Paris. Represented at the Metropolitan Museum, New York, by a life-size bust portrait of Charles H. Farnham. Represented at the Corcoran Art Gallery, Washington, DC, by a portrait of Edward C. Messer. Died in 1896 at South Coventry, CT.

ISAACS, BETTY LEWIS.
Sculptor. Born in Hobart, Tasmania, Sept 2, 1894. Studied at Cooper Union Art School; Art Students League; Alfred University; Kunstgewerbe Schule; private study at Warsaw (Poland) and in Vienna (Austria). Exhibited: National Alliance of Art in Industry; Audubon Artists; National Association of Women Artists; Brooklyn Society of Artists; Cooper Union; Ferargil Galleries; Argent Galleries; etc. Works: Cooper Union Mus.; Church of St. Anselm,

Tokyo, Japan. Awards: National Association of Women Artists, 1955, 57, 60. Taught: Cooper Union Art School, Greenwich House, NYC, 1930-36. Address in 1970, 21 E. 10th St., NYC. Died in 1971.

ISAACS, WALTER F.
Painter, writer, lecturer and teacher. Born in Gillespie, IL, July 15, 1886. Pupil of Chase, DuMond, Guerin, Friesz. Member: Western Assoc. of Museum Directors; Pacific Arts Assoc. Address in 1929, University of Washington, Seattle, WA.

ISELIN, LEWIS.
Sculptor. Born in New Rochelle, New York, June 22, 1913. Studied: Harvard University; Art Students League, 1934-38, with Mahonri Young, John Stuart Curry, George Bridgman and Gleb Derujunshy; Guggenheim Fellowship, 1952. Member: Century Association. Awards: Prize, National Academy of Design, 1938; Penna. State College, 1950; Guggenheim Fellow, 1951-52. Work: American Military Cemetery, Suresnes, Paris, France (Mem., figure, reliefs); Fogg Art Mus., Cambridge, MA; Columbus Gal. of Fine Arts, OH; Rockland Art Museum, ME. Exhibited: Nat. Academy of Design, 1938, 43; Penna. Academy of Fine Arts, 1940-60; Mus. of Modern Art, 1942; World's Fair, New York, 1939; Metropolitan Museum of Art, 1945; Whitney Museum of Art, 1940-60; Penna. State College, 1950. Medium: Bronze. Address in 1982, Camden, Maine.

ISHAM, RALPH.
Portrait and landscape painter. Born about 1820 in Connecticut. He was connected with the Wadsworth Athenaeum Gallery when it was first opened. He died early in life.

ISHAM, SAMUEL.
Painter. Born in NYC on May 12, 1855. Pupil of Julien Academy, Paris, under Jacquesson de la Chevreuse, Boulanger and Lefebvre. He exhibited at Paris Salons and in most of the larger American exhibitions. He was a member of the jury of the Pan-American Exposition, Buffalo, 1901, and received a silver medal at the St. Louis Exposition, 1904. He was elected an Associate of the National Academy in 1900 and an Academician in 1906, and also held membership in the New York Water Color Club; NY Architectural League; and the Nat. Institute of Arts and Letters. He was the author of *A History of American Painting*, 1905. He died in Easthampton, Long Island, NY, June 12, 1914.

ISNARD, JEAN JACQUES.
Sculptor and engraver. Worked in New Orleans from 1818-46. Medium, marble.

ISRAEL, NATHAN.
Painter. Born in Brooklyn, NY, in 1895. Pupil of Max Weber; K. H. Miller; B. Robinson. Member: Art Students League of NY; Soc. of Independent Artists. Address 1926, 15 Kossuth Place, Brooklyn, NY.

ITALIANO, JOAN MYLEN.
Sculptor and educator. Born in Worcester, MA. Studied: Siena Heights College, Adrian, MI, PhB; Studio Angelico, M.F.A.; Barry College, Miami, FL. Awards: Toledo Annual, 1950; Best of Show, Artists' Guild Show, Palm Beach, 1955; Palm Beach Art League, 1955, 1956. Collections: The Navy Base Chapel, Key West, FL; The Holy Ghost Seminary, Ann Arbor, MI; St. Thomas Aquinas High School, Chicago, IL; Mary Manning Walsh Home, NYC. Exhibited: Detroit Inst. of Art, 1950 and 56; Fitchburg Art Mus.; others. Media: Metal, wood, clay, and enamel. Member: International Sculpture Center; So. Assoc. of Sculptors. Taught: Instructor of sculpture, Barry College, Miami, FL, 1956-58; associate prof. of sculpture and ceramics, College of the Holy Cross, 1969, chairman of the fine arts dept., 1977-80. Address 1982, West Boylston, MA.

IVERD, EUGENE.
Painter, illustrator and teacher. Born St. Paul, MN, Jan. 31, 1893. Pupil of Penna. Academy of Fine Arts. Cover designs for *The Saturday Evening Post*. Died in 1938. Address in 1929, 15 West 7th St.; h. 1318 West 30th St., Erie, PA.

IVES, CHAUNCEY BRADLEY.
Sculptor. Born December 14, 1810, in Hamden, Connecticut. Worked in NYC, 1840-44. Had a studio for seven years in Florence; later settled in Rome, with many visits to the US. His best known statues are "Pandora," "Rebecca," "Bacchante," and his statues of Roger Sherman and Jonathan Trumbull are in the Capitol at Washington, DC. Largely a portrait sculptor. Died Aug. 2, 1894, in Rome.

IVES, HALSEY COOLEY.
Landscape painter. Born Oct. 27, 1847, in Montour Falls, NY. He taught in St. Louis and became director of the Museum of Fine Arts. He received medals for his landscapes. He died in England, May 5, 1911.

IVES, NEIL MCDOWELL.
Painter. Born in St. Louis, MO, in 1890. Pupil of DuMond, Carlsen and Dasburg. Address in 1926, Woodstock, NY. Died Sept. 12, 1946.

IVES, PERCY.
Portrait painter. Born in Detroit, MI, in 1864. Studied at Penna. Academy of Fine Arts and in Paris, France. Exhibited in Paris, New York, Boston, Philadelphia, Cincinnati, Chicago, etc.; painted portrait of Grover Cleveland, Secretary of War Alger, Postmaster-General Dickinson, etc. Received honorable mention, Buffalo Exposition, 1901; member of Jury of Admission, Art Dept., St.

Louis Exposition, 1904. Member: Detroit Museum of Art; Society of Western Artists; Fine Arts Society, Detroit; Archaeology Institute of America. Address in 1926, 502 Cass Ave., Detroit, MI.

IVONE, ARTHUR.
Sculptor. Born in Naples, Italy, May 29, 1894. Pupil of Achille D'Orsi and Mossuti, Naples; Ettene Ferrari, Rome; C. J. Barnhorn, Cin. Art Acad. Member: Cinc. Art Assoc. Work: Ohio St. War Mem.; Springfield (OH) Mus.; panels, Birmingham, AL; Stephen C. Foster Mem. bronze bust, Music Hall, Cinc., OH; others. Address 1953, Cincinnati, OH.

IVORY, P. V. E.
Illustrator. Pupil of Howard Pyle. Member: Salma. Club; Society of Illustrators. Address in 1929, 51 West 10th Street, New York, New York; Harriman, New York.

IZOR, ESTELLE PEELE.
Painter. Pupil of Forsyth and Steel in Indianapolis; Freer and Vanderpoel in Chicago; Chase and Herter in New York; H. D. Murphy in Boston. Member: Indianapolis Art Club. Address in 1926, "The Wellington," West Michigan Street, Indianapolis, Indiana.

J

JACKSON, ANNIE HURLBURT.
Painter. Born in Minneapolis, MN, Aug. 19, 1877. Pupil of Eric Pape; Murphy; Woodbury. Member: Copley Society; Guild of Boston Artists; Pennsylvania Society of Miniature Painters; American Society of Miniature Painters; American Federation of Arts. Award: Gold medal, Sesqui-Centennial Expo., Philadelphia, 1926. Specialty, miniatures. Address in 1929, 329 Tappan St., Brookline, MA.

JACKSON, EVERETT GEE.
Painter and teacher. Born in Mexia, TX, Oct. 8, 1900. Pupil of Art Institute of Chicago. Member: Southern States Art League. Awards: First Anne Bremer Prize, San Francisco Art Association, San Francisco, 1929; hon. mention, Bohemian Club, San Francisco, 1928. Work: "Spring in Coyoacan," Houston Museum of Fine Arts, Houston, TX. Address in 1929, 638 South McKinney St., Mexia, TX; summer, Sul Ross State Teachers College, Alpine, TX.

JACKSON, HARRY ANDREW.
Sculptor and painter. Born in Chicago, IL, April 18, 1924. Studied at the Art Institute, 1931-38; with Ed Grigware in Cody, WY, 1938-42; with Hans Hofmann at the Brooklyn Museum Art School, 1946-48. Exhibited: Nat. Collection of Fine Arts, Washington, DC, 1964; National Academy of Design, NYC, 1964, 65, 67, 68, and 70; National Cowboy Hall of Fame, Oklahoma City, 1966 and 70-72; a retrospective of works was held at the Buffalo Bill Historical Center, Cody, WY, 1981. Awards: Samuel Finley Breese Morse Gold Medal from the National Academy of Design, 1968, and the silver medal, from the National Cowboy Hall of Fame, 1971. Member: Cowboy Artists of America; National Sculpture Society; fellow, Am. Artists Professional League; Bohemian Club; National Academy of Western Art; and the National Academy of Design (associate). He was official combat artist for the US Marine Corps, 1944-45; the youngest combat artist in World War II. He is the author of a volume entitled *Lost Wax Bronze Casting*, 1972. Subject matter of his works draws upon the life of the American West and his own experience as a cowboy. Address in 1982, Cody, WY.

JACKSON, HAZEL BRILL.
Sculptor. Born in Philadelphia, PA, December 15, 1894. Studied: School of the Museum of Fine Arts, Boston; Scuola Rosatti, Florence, Italy; also under Bela Pratt, Charles Grafly; Angelo Zanelli in Rome. Exhibitions: National Academy of Design; National Academy of Rome; National Academy, Firenze, Italy; Corcoran Gallery. Member: Circolo Artisco of Rome; L. C. Tiffany Foundation; fellow, National Sculpture Society; Boston Society of Sculptors. Works: Vassar College; Calgary Museum, Canada; bronzes, Wellesley College; "The Starling" and "The Pelican," Concord, MA, Art Museum. Address in 1982, Twin Oaks, 83 Balmville Rd., Newburgh, NY.

JACKSON, JOHN ADAMS.
Sculptor and artist (crayon). Born in Bath, Maine, November 5, 1825. Pupil of D. C. Johnston, Boston; Suisse, Paris. Worked: Boston; NYC; Italy, 1860-79. Died in Italy, August 30, 1879.

JACKSON, JOHN EDWIN.
Painter and illustrator. Born in Eagleville, TN, Nov. 7, 1876. Pupil of National Academy of Design; Art Students League of NY. Member: Salma. Club; Society of Illustrators; Artists Guild of the Authors' League of America, NY. Award: Prize, Nashville Art Club, 1923. Work: "Wall Street," National City Bank, New York; "Broadway," Nashville Art Club, Nashville, TN; "Lower New York," New York Public Library. Illustrated *Land of Journeys Ending* (Century Co.). Illustrations in *Harper's, Scribner's*. Address in 1929, 256 West 12th St., New York, NY.

JACKSON, LESLEY.
Painter and etcher. She was born Rochester, MN. Pupil of Washington Art Students League; Edmund C. Messer; Charles W. Hawthorne; Henry B. Snell. Member: Society of Washington Artists; Washington Water Color Club; NY Water Color Club; American Federation of Arts. Awards: Second Corcoran prize, Washington Water Color Club, 1905; figure painting prize, New Haven Paint and Clay Club, 1924. Specialty, watercolors and etching. Address in 1929, "The Concord," Washington, DC.

JACKSON, MARTIN J(ACOB).
Painter. Born in Newburgh, NY, April 12, 1871. Pupil of Cooper Union and National Academy of Design under Edgar M. Ward in New York; Comelli in London; also studied in Paris, Brussels and Antwerp. Member: Society of Independent Artists; Buffalo Independent Artists; Art League of Los Angeles. Awards: Silver medal for oil painting and silver medal for water colors, Alaska-Yukon Expo., Seattle, 1909. Designer of costumes and illuminator. Address in 1929, Bradbury Bldg., Los Angeles, CA.

JACKSON, MAY HOWARD (MRS.).
Sculptor. Born in Philadelphia, PA, May 12, 1877. Pupil of Penna. Academy of Fine Arts. Member: Society of Independent Artists. Award: Harmon,

sculpture, 1928. Work: "William P. Price," St. Thomas' Church, Philadelphia; "Paul Lawrence Dunbar," Dunbar High School, Washington, DC; William H. Lewis, ex-Asst. Attorney General; Kelly Miller, Howard University, Washington, DC. Address in 1929, Washington, DC. Died 1931 in Washington, DC.

JACKSON, NIGEL LORING.
Painter and art administrator. Born in Kingston, Jamaica, Jan. 23, 1940. Studied: Manhattan Community College; New School for Social Research; Art Students League, 3-year scholar, 1971. Work: NY Harlem Music Center; Ministerial Interfaith Association; others. Commission: NY Harlem Music Center. Exhibited: Interracial Council on Bus. Opp., NYC; NY International Art Show; Act of Art, NYC; and others. Awards: Silver award, NY International Art Show. Reviews: *NY Times*. Member: Art Students League. Medium: Oil. Address in 1976, 403 W. 21st St., NYC.

JACKSON, ROBERT FULLER.
Painter, illustrator, artist, and teacher. Born in Minneapolis, MN, July 22, 1875. Member: Boston Architectural Club. Award: Special prize for painting of Indian Hunter by Cyrus Dallin, at Arlington, MA, Boston Architectural Club. 1924. Represented in Brookline Public Library; Huntington Hall, Massachusetts Institute of Technology, Boston. Address in 1929, 9 Cornhill, Boston; h. 329 Tappan St., Brookline, MA.

JACOBS, HAROLD.
Sculptor and painter. Born in NYC, October 29, 1932. Studied at Cooper Union, 1953; New York Univ.; New School for Social Research; Sorbonne, Fulbright scholar, 1961. Work in Whitney Museum of American Art; Portland Art Museum, OR; Penna. Academy of Fine Arts. Works in mixed media; inflatable structures. Address in 1982, Philadelphia, PA.

JACOBS, LEONEBEL.
Sculptor, portrait painter, and teacher. Born in Tacoma, Washington. Pupil of Brush, Hawthorne. Member: National Association of Women Artists; American Watercolor Society; Pen and Brush Club; American Federation of Arts. Work: Portraits of Mrs. Calvin Coolidge, Sir John Lavery, Mrs. William B. Meloney, Prince de Ligne, Dean Hubert E. Hauks, Gutzon Borglum, Dr. Frances Carter Wood. Author of *Portraits of Thirty Authors*. Address in 1953, 322 East 57th Street, NYC.

JACOBS, MICHEL.
Sculptor, portrait painter, writer, and teacher. Born in Montreal, Canada, September 10, 1877. Studied: Ecole des Beaux-Arts, Paris; pupil of Laurens in Paris; E. M. Ward at National Academy of Design;

and in Berlin, Germany. Member: Salma. Club; Society of Independent Artists; Artists Fellowship; Artists Guild of the Authors' League of America. Exhibited at National Sculpture Society, 1923; National Academy of Design; Allied Artists of America; Paris Salon; Montreal Museum of Art; Washington Society of Artists. Work: "Portrait of Champ Clark," in the Capitol, Washington; 26 portraits in Barone de Hirsch Institute, Montreal, Canada; medal for "Military Order of World War;" bas-relief at National Portrait Gallery, Washington, DC. Author of *The Art of Color* (1946), *The Art of Composition* and *The Study of Color*. Director of the Metropolitan Art School. Address in 1953, Rumson, NJ.

JACOBSEN, ANTONIO NICOLO GASPARO.
Marine Painter. Born in Copenhagen, Denmark, Nov. 2, 1850; son of a violin maker. Studied art at the Royal Academy, in Copenhagen, although these studies ended abruptly with the advent of the Franco-Prussian War in 1871, when he fled to America to avoid conscription. In NYC he was employed in painting the ships of the Old Dominion Steamship Line. Moved to West Hoboken, NJ, in 1880, where he continued to specialize in steamer portraits. Later in his life, his three children Helen, Carl, and Alphonse aided him in painting cloud and sky backgrounds in many of his paintings. He is said to be the most prolific of all American marine painters and is well represented in the Mass. State House, Boston, MA; India House, NYC; Mariner's Museum, Newport News, VA; Mystic Seaport Museum, Mystic, CT; Nation Scheepvaart Museum, Antwerp, Belgium; Peabody Museum, Salem, MA; Philadelphia Maritime Museum, Philadelphia, PA; Penobscot Marine Museum, Searsport, ME; and the Seamen's Bank for Savings. Jacobsen died February 2, 1921.

JACOBSEN, MRS. E. M. P.
See Plummer, Ethel M'Clellan.

JACOBSON, ARTHUR ROBERT.
Painter and printmaker. Born in Chicago, IL, on Jan. 10, 1924. Husband of Ursula Jacobson, painter and sculptor. Studied at University of Wisconsin; Madrid Print Workshop, Spain; London. In collections of Dallas Museum of Art; Penna. Academy of Fine Arts. Exhibitions: Corcoran Biennial of Painting; Library of Congress; Watercolor USA, Springfield, IL; others. Awards: Purchase award, Penna. Academy of Fine Arts, and Dallas Museum of Art; others. Address in 1982, Phoenix, AZ.

JACOBSON, OSCAR B(ROUSSE).
Painter, lecturer, writer and teacher. Born in Westervik, Sweden, May 16, 1882. Pupil of Birger Sandzen, Weir, Albert Thompson and Neimeyer; Yale Art School. Member: College Art Association; Oklahoma Art Association; Society of Independent

Artists; American Federation of Arts. Work: "Prayer for Rain," McPherson Art Gallery, KS; "Voices of the Past," Bethany Art Gallery, Lindsborg, KS; "Portrait of Gov. Williams," State Capitol, Oklahoma City, OK; "Rio Grande," Hayes Normal School. Director, University of Oklahoma School of Art. Represented in collection of the University of Oklahoma, Norman. Address in 1929, University of Oklahoma; h. 609 Chautauqua St., Norman, OK.

JACOBSON, URSULA MERCEDES.
Sculptor and painter. Born in Milwaukee, WI, March 26, 1927. Wife of Art Jacobson, who is also a painter. Studied: Univ. of Wisconsin-Milwaukee, B.S., 1948; Western Reserve University; Cleveland Museum and School of Art; University of Wisconsin-Madison, M.S., 1950, graduate study, 1950-51. Awards: Wisconsin Designer Craftsmen, Milwaukee, 1948; Weatherspoon Annual, NC, 1967; Phoenix Art Museum, 1974. Exhibitions: Yares Gallery, AZ, 1965; Bolles Gallery, San Francisco, 1966; Four Corners Biennial, Phoenix Art Museum, 1971-75; Palace of the Legion of Honor, San Francisco. Address in 1982, Phoenix, AZ.

JACOBSSON, STEN WILHELM JOHN.
Sculptor, painter, teacher, and craftsman. Born in Stockholm, Sweden, March 28, 1899. Studied with Carl Milles; in Germany, Sweden, US, France. Awards: First Prize in Sculpture and First Prize in Medalist Competition, U.S. Government; Prize, Barbeur Memorial Competition, Detroit, Michigan. Work: Murals, First Swedish Baptist Church, NY; First Lutheran Church, Arlington, NJ; Metropolitan Museum of Art; Detroit Institute of Art; Sculpture, United States Post Office, Forest Hills, New York. Instructor of Sculpture, painting, and design, Wayne State University; instructor, Detroit Country Day School; Henry Ford Art School; Cranbrook Academy of Arts. Membership: Society of Medalists. Address in 1982, Detroit, MI.

JACOVLEFF, ALEXANDRE.
Painter and illustrator. Born in St. Petersburg (Leningrad) on June 13, 1887. Studied: Imperial Academy of Fine Art in Moscow under Professor Kardovsky. Received a traveling scholarship from the Academy in 1913 in Italy and Spain. Traveled extensively after 1917 to Mongolia and Japan. Produced numerous life-size ethnological portraits in sanguine and pastel. In 1922, published limited editions of his sketches and paintings of Far East; also a book on the Chinese and Japanese theaters. In 1925, Official Artist for the Citroen sponsored expedition to Africa, during which he produced more than 500 drawings and paintings. Published album of prints, *Pictures of Asia*, highly celebrated. Taught at the Boston Museum School, 1934-37, as head of the Painting Department. Underwent radical change in style, towards free-drawn, fanciful and symbolic

work. Exhibitions of his work were held in China, Europe, Australia. American Exhibitions: National Geographic Soc., Washington, DC, 1934; Carnegie Institute, Pittsburgh, PA, 1924, 1938; Knoedler's in NYC, 1936; Boston Museum of Fine Arts, 1937; Dayton Art Institute and Minnesota Institute of Art, 1938; Memorial exhibition held in his honor at the Grand Central Art Galleries, NYC, 1939; Apollo Gallery, Poughkeepsie, NY, 1979-83. He died suddenly of cancer in 1938 in Paris.

JACQUES, BERTHA E.
Etcher. Born in Covington, OH. Studied: Chicago Art Institute. Collections: NY Public Library; Congressional Library, Washington, DC.

JAEGERS, ALBERT.
Sculptor. Born in Elberfeld, Germany, in 1868. He came to Cincinnati, OH, while a boy and was apprenticed to his father, a wood-carver, who was engaged in ecclesiastical work. Studied: Sculpture at the Cincinnati Art Academy under Louis J. Rebisso, and architecture in the office of Lucien Plymton. Also studied in the art centers of Europe. Member: New York Architectural League; National Institute of Arts and Letters; National Sculpture Society. Works: Statues, New York Custom House and Fine Arts Building, St. Louis, MO; commissions for Pan-American Exposition, Buffalo, NY, and Louisiana Purchase Exposition, St. Louis, MO; monument to General von Steuben, Washington, DC, 1910, replica presented by US Government to Germany, 1911; marble monument to the Founders of Germantown, PA, 1920. Exhibited at National Sculpture Society, 1923. Awarded bronze medal, St. Louis Exposition, 1904. Died in Suffern, NY, 1925.

JAEGERS, AUGUSTINE.
Sculptor. Born in Barmen, Germany, March 31, 1878. Brought to America in 1882. Pupil of Art Students League of New York; National Academy of Design; Ecole des Beaux-Arts in Paris, under Mercie. Member: National Sculpture Society, 1909. Awards: Collaborative and Avery prize, Architectural League of New York, 1909. Work: Sculpture on arches in Court of Four Seasons, San Francisco Exposition, 1915; Frey and Lopez Mem., NY. Address in 1933, 3225 30th St., Long Island City, NY.

JAFFE, NORA.
Sculptor and painter. Born in Urbana, OH, Feb. 25, 1928. Studied at Dayton Art Inst., OH; also with Samuel Adler and David Hare, NY. Work in Brooklyn Mus., NY; Penna. Academy of Fine Arts, Phila.; others. Has exhibited at Mus. of Modern Art, NY; Baltimore Mus. of Art; Penna. Academy of Fine Arts; Vassar College, Poughkeepsie, NY. Received MacDowell Colony Residency, 1969-70; others. Works in plaster, wood; and oil. Address in 1982, 285 Central Park W., NYC.

JAMAR, S. CORINNE.
Miniature painter. Born in Elkton, MD, 1876. Pupil of Art Institute of Chicago; Drexel Institute, Philadelphia; Maryland Institute, Baltimore. Award: 1st prize, Southern States Art League, 1921-22. Address in 1929, Elkton, Cecil Co., MD.

JAMBOR, LOUIS.
Painter. Born in Nagyvarad, Hungary, Aug. 1, 1884. Pupil of Academi of Art, Budapest. Awards: First prize, City of Budapest, 1919; Baron Kohner prize, Budapest, 1921. Work: Main altar painting, St. Stephen Church, New York, NY. Address in 1929, 200 West 57th St., New York, NY; summer, Southampton, LI, NY.

JAMES, ALEXANDER R.
Painter. Born in Cambridge, Mass., 1890. Pupil of Museum of Fine Arts, Boston, A. H. Thayer. Member: Guild of Boston Artists. Work: "Portrait of Prof. William James" and "Portrait of a Girl," Museum of Fine Arts, Boston. Died in February, 1941. Address in 1929, Dublin, NH.

JAMES, ALFRED EVERETT.
Sculptor, painter, etcher, designer, teacher, and craftsman. Born in Edgewood, RI, April 17, 1908. Studied: RI School of Design; Thurn School of Modern Art; and with Hans Hofmann. Member: Scarab Club. Awards: Prizes, West Palm Beach Army Exchange, 1943; Montgomery Museum of Fine Arts, 1945, 47, 50. Work: Birmingham Museum of Art; murals, Providence Public Lib. Exhibited: U.S. Army Exchange, West Palm Beach, Florida, 1943; High Museum of Art, 1950; Montgomery Museum of Fine Arts, from 1940, 43, 45, 47, 50. Taught: Instructor of Art, Alabama Polytechnic Institute, Auburn, Alabama, 1937-46. Address in 1953, Auburn, AL.

JAMES, AUSTIN.
Sculptor. Born in Philadelphia, PA, March 12, 1855. Pupil of California School of Fine Arts; Bufano; Stackpole; Mora. Member: Carmel Art Association; Los Angeles Painters and Sculptors; Pasadena Art Institute. Address in 1934, Pasadena, CA; summer, Pebble Beach, CA.

JAMES, EVA GERTRUDE (MRS.).
Sculptor, painter, craftsman, writer, and teacher. Born in Morgan County, IN, July 18, 1871. Studied in Indiana Univ.; St. John's Academy; and with Robert E. Burke. Member: Indiana Art Club; Hoosier Salon. Award: Prizes, Indiana State Fair, 1924 and 1925. Exhibited: Soc. of Indiana Artists; Indiana State Fair Brazil, IN. Address in 1953, Brazil, IN.

JAMES, EVALYN GERTRUDE.
Painter, illustrator, craftsman, writer, lecturer, and teacher. Born in Chicago, IL, May 22, 1898. Pupil of

Rhoda E. Selleck; William Forsyth; R. E. Burke. Member: Indiana Art Club; Herron Art School Alumni; Hoosier Salon; Western Arts Association; Survey Com., Indiana Federation of A. C.; Chairman, State Com. Art Courses for Schools of Indiana. Awards: Indiana State Fair, 1920, 1924-25. Head of Art Department, Indiana State Teachers College. Illustrated numerous books on scientific subjects. Represented in Shortridge High School, Indianapolis, IN. Address in 1929, 526 Eagle St., Terre Haute, IN; 1048 W. 28th St., Indianapolis, IN.

JAMES, H(AROLD) FRANCIS.
Painter, writer, lecturer, and teacher. Born in Drayton, England, Nov. 9, 1881. Pupil of Jean Paul Laurens in Paris. Member: Western Art Association. Author of "Color Tables for High Schools," "Grade Color Tablet." Address in 1929, Ft. Wayne Art School and Museum; h. 904 West Berry, Fort Wayne, IN; summer, Lorient, Hardin, IL.

JAMES, JOHN WELLS.
Painter. Born in Brooklyn, NY, Feb. 22, 1873. Pupil of James Knox. Member: Salma. Club; American Federation of Arts. Address in 1929, 1239 Dean St., Brooklyn, New York, NY.

JAMES, ROY HARRISON.
Illustrator. Born in Zalma, MO, May 10, 1889. Member: St. Louis Artists Guild. Specialty, cartoons. Address in 1929, St. Louis Star Bldg., 12th and Olive St.; h. 8103 Madison St., Vinita Terrace, St. Louis, MO.

JAMES, ROY WALTER.
Sculptor, painter, writer, and teacher. Born in Gardena, CA, September 23, 1897. Self taught. Member: California Art Club; Laguna Beach Art Association; Long Beach Art Association; Artists Guild of the Authors' League of America. Work: "Sentinel by the Sea," Long Beach Public Library; "Sunset," Long Beach High School; "Old Baldy," Public Library, Covina; "Light the Crown of Beauty," High School, Covina, CA. Exhibited: Oakland Art Gallery; Palace of the Legion of Honor; Los Angeles Museum of Art. Contributor to various art periodicals and newspapers. Address in 1953, Los Angeles, CA.

JAMES, WILL.
Painter, illustrator, etcher, and writer. Born in Great Falls, MT, June 6, 1892. Award: Newberry medal, Amer. Lib. Assoc. (novel), 1927. Author and illustrator of: *The Drifting Cowboy; Cowboys, North and South; Smoky; Country; Sand;* (Chas. Scribner's). Died in 1942. Address in 1929, Pryor, MT.

JAMES, WILLIAM.
Painter and teacher. Born in Cambridge, MA, June 17, 1882. Pupil of Benson and Tarbell. Member:

Guild of Boston Artists. Award: Silver medal, P.-P. Expo., San Francisco, 1915; Beck gold medal, Penna. Academy of Fine Arts, 1925. Represented in Fenway Court, Boston; Rhode Island School of Design, Providence. Address in 1929, Riverway Studios, Boston, MA; h. 95 Irving St., Cambridge, MA.

JAMESON, DEMETRIUS GEORGE.
Painter and printmaker. Born in St. Louis, MO, Nov. 22, 1919. Studied: Corcoran School of Art, Washington, DC; Washington University School of Fine Arts; University of Illinois School of Fine and Applied Arts, Urbana. Work: Victoria & Albert Museum, London; Denver, Portland (OR), Seattle Art Museums; Amer. Embassy, Athens; others. Exhibited: Guggenheim Mus.; Seattle World's Fair; Corcoran; 4th International Print Show, Italy; Butler Institute, Youngstown, OH; many others. Awards: Portland, Denver, Seattle Art Museums; St. Louis City Art Museum; etc. Teaching at Oregon State University from 1950. Member: Portland (OR) Art Association; Artists Equity Association; others. Works in oils. Address in 1982, Corvallis, OR.

JAMESON, MINOR S(TORY).
Painter. Born in New York, NY, Aug. 26, 1873. Pupil of Cullen Yates and John F. Carlson. Member: Society of Washington Artists (pres.); Washington Landscape Club. Award: First Prize (silver medal), Washington Society of Artists, 1924. Address in 1929, 13 Oxford St., Chevy Chase, MD.

JAMESON, SAMILLA LOVE.
See Heinzmann, Samilla Love Jameson.

JAMIESON, BERNICE (EVELYN).
Painter, etcher, and teacher. Born in Providence, RI, April 18, 1898. Pupil of RI School of Design. Member: Providence Art Club. Address in 1929, 41 North St., Meshanticut Park, Cranston, RI.

JAMIESON, MITCHELL.
Illustrator. Born in Kensington, MD, in 1915. Attended the Abbott School of Fine Arts and studied at the Corcoran School of Art. During World War II, as an official combat artist, he began reporting on naval operations in the Pacific. These illustrations were reproduced in *Fortune* and *Life*, among others.

JAMISON, CECILIA VIETS DAKIN HAMILTON.
Author and artist. Born in Yarmouth, Nova Scotia, in 1837. Educated privately in Boston, NY, and Paris. She traveled to Rome to continue her studies and remained there for three years. Among her best known portraits were one of Longfellow (now at Tulane University) and one of naturalist Louis Agassiz (now at the Boston Society of Natural History). During the 1880's, Mrs. Jamison became well known as a writer of juvenile literature as well as of adult romances. A frequent contributor to *St. Nicholas*, many of her novels were serialized in *Harper's*, *Scribner's* and *Appleton's*. Her books included *The Story of an Enthusiast*, 1888, *Lady Jane*, 1891, *Toinette's Philip*, 1894, *Seraph, the Little Violiniste*, 1896, *Thistledown*, 1903, and *The Penhallow Family*, 1905. She died in Roxbury (now part of Boston) on April 11, 1909.

JAMPEL, JUDITH.
Illustrator. Born in London, England, in 1944. Attended Hunter College and SVA in NY. Her first published illustration was a self-promotional booklet entitled, *Sorry but we don't hire women because*. She works with nylon fabric, polyester fabric, real hair, and props to create her three-dimensional figures. She received the Hamilton King Award and Award of Excellence from the Society of Illustrators in 1975. Her artwork has been shown at the Greengrass Gallery in NYC.

JANOWSKY, BELA.
Sculptor and instructor. Born in Budapest, Hungary, in 1900. Studied: Ontario College of Art; Penna. Academy of Fine Arts; Cleveland School of Art; Beaux-Arts Institute of Design; and with Alexander Blazys and Charles Grafly. Commissions: Bronze reliefs, US Department of Commerce Building, Washington, DC; bronze 150th anniversary plaque of New York Naval Shipyard, Naval Historical Museum, Washington, DC; Royal Society of Canada. Exhibited: Ontario Society of Artists; Allied Artists of America Annual, from 1939; National Academy of Design; National Sculpture Soc.; Penna. Academy of Fine Arts; Chicago Art Institute. Member: Modelers and Sculptors League of America; Allied Artists of America; National Sculpture Society. Award: Allied Artists of America, Lindsey Morris Memorial Prize, 1951 and 64. Taught: Instructor of sculpture, Craft Students League. Address in 1982, 52 W. 57th St., NYC.

JANSSON, ALFRED.
Painter. Born in Sweden, 1863. Studied in Stockholm, Christiania, and Paris. Member: Palette and Chisel Club; Chicago Society of Artists; Chicago Art Club; Chicago Artists Guild; Swedish American Artists. Awards: Swedish American Artists 3rd prize, 1911; second prize, 1913, first prizes, 1915, Rosenwald purchase prize ($200), 1912, Carr landscape prize, 1914, Art Institute of Chicago. Work: "Icy Rocks," Municipal Commission purchase. Address in 1929, 1851 Byron St., Chicago, IL.

JANTO, PHYLLIS.
Sculptor. Born in Philadelphia, PA, April 20, 1932. Studied: Moore Institute of Art, Philadelphia, 1952-54; Hunter College, BFA, 1962; Pratt Institute, MFA, 1965. Work in private collections. Exhibitions: Pratt Institute, 1965 (solo); Lowe Gallery, Hudson

Guild, NYC, 1975 (solo); Atlantic Gallery, NYC, 1983 (solo), 1981, 83 (group); Brooklyn Museum, 1974, 75; Lincoln Center, 1975; Bowdoin College, Maine, 1980; Nexus Gallery, Philadelphia, 1983; Port of History Museum, Philadelphia, 1983; many other galleries in NYC, Washington, DC, and Maine. Awards: Scholarship to Sculpture Center; Wm. Graf Scholarship for Graduate Study (Hunter College); grant, National Endowment for the Arts, 1980. Member: Artists' Equity Association; Women's Caucus for the Arts; Atlantic Gallery. Medium: Wood. Address in 1983, 48 West 20th St., NYC; summer, Washington, ME.

JANVIER, ALBERT WILSON.
Crayon-portrait draughtsman. He was doing portrait work in Philadelphia about 1858.

JANVIER, CATHERINE ANN (MRS.).
Painter. Born in Philadelphia. Her early life was passed in China; studied in the Penna. Academy of Fine Arts and Art Students League, New York. Pictures: "Geoffrey Rudel and the Countess of Tripoli," "The Princess Badroulbadour," "Daniel at Prayer," "The Violinist," etc. Member: Art Students League; Fine Arts Soc. of NY. Died Dec. 12th, 1923.

JAQUES, BERTHA E.
Etcher, printer, writer, and teacher. Born in Covington, OH. Pupil of Art Institute of Chicago. Member: Chicago Society of Artists; Chicago Society of Etchers; Calif. Society of Etchers; Calif. Print Makers. Award: Bronze medal, P.-P. Expo., San Francisco, 1915. Work: Art Institute of Chicago; NY Public Library; Library of Congress, Smithsonian Insti., Washington, DC; St. Paul Institute of Art. Address in 1929, 4316 Greenwood Ave., Chicago, IL.

JAQUES, F(RANCIS) L(EE).
Painter. Born in Geneseo, IL, on Sept. 28, 1887. Pupil of C. C. Rosenkranz. Member: Salma. Club. Work: Background of flying bird group (dome), murals of reptiles, groups and backgrounds, American Museum of Natural History, New York. Address in 1929, 515 Edgecombe Ave., New York, NY.

JARVIS, CHARLES WESLEY.
Portrait, miniature, and historical painter. The second son of John Wesley Jarvis, he was born in NYC, probably in 1812, and brought up by his mother's family, the Burtises of Oyster Bay, Long Island. About 1828 he was apprenticed to Henry Inman, with whom he worked in NYC and Philadelphia until 1834. Returning to NYC, the younger Jarvis established himself as a portrait painter and worked there until his death, which occurred at his home in Newark, NJ, on February 13, 1868.

JARVIS, JOHN WESLEY.
Portraitist, miniaturist, sculptor, and engraver. Born in England in 1780. A nephew of John Wesley.

He was brought to Philadelphia at five years old, and educated there; spent much of his time out of school with Pratt, Paul, Clark and other minor painters. He met Gilbert Stuart, who "occasionally employed Paul to letter a book" in one of his pictures; was apprenticed to Edward Savage, to learn engraving, and with him went to NY. He learned to draw and engrave from D. Edwin, who was employed by Savage on his first arrival in this country; finally engraving on his own account. Taught Henry Inman and John Quidor. He made several trips South, with Henry Inman as his assistant on his first trip to New Orleans, where he finished six portraits a week, probably in 1833. It was after this that he painted his most important works, the full-length portrait of military and naval heroes for the City of NY. Worked: New York City, 1802-10, painting portraits and miniatures in conjunction with Joseph Wood; Baltimore, 1810-13; New York City, 1813-40; New Orleans; Richmond, VA; Washington. While Jarvis was in NY he published the prints of other engravers, notably those of Robert R. Livingston, published in 1804 and engraved by George Graham. He died in extreme poverty Jan. 12, 1840 in NYC.

JARVIS, W. FREDERICK.
Painter, lecturer, and teacher. Born in Monroe County, Ohio. Pupil of Silas Martin, Charles Bullette, and Madam Schille. Member: So. States Art League; Soc. of Independent Artists. Award: Gold medal, Tri-State Fair, 1926. Address in 1934, Dallas, TX.

JAY, CECIL (MRS.).
Miniature painter and portrait painter in oil. Member of New York Water Color Club.

JEANFIL, HENRI (JACQUES).
Sculptor, painter, etcher, and lecturer. Born in North Tonawanda, NY, June 8, 1909. Studied with D. Campagna, Richardson, K. Green, and F. Bach. Work: "La Ballet Russe," "Valkyries," "Street Scene, Sicily," "Les Muses," paintings, "Old Log Cabin," etching, Buffalo School of Fine Arts. Member: Buffalo Society of Artists; Boston Art Club; Penna. Academy of Fine Arts; Nat. Sculpture Soc. Address in 1933, 642 Oliver St.; Jeanfil Studios, 350 Gibson St., Buffalo; summer, North Rushford Lake, NY.

JECT-KEY, ELSIE.
Painter. Born in Koege, Denmark. Studied: Art Students League, with Frank DuMond, George Bridgman, and Homer Boss; National Academy of Design, with Murphy, Olinsky, and Neilson; Beaux-Arts Institute of Design. Exhibited widely in the US and abroad. Media: Oil and watercolor. Address in 1980, 333 E. 41st St., NY, NY.

JEFFERSON, JOSEPH.
Painter and actor. Born February 20, 1829 in Philadelphia. Died at Palm Beach, Florida, on April

23, 1905. He painted "The Coast of Maine" and "Massachusetts Bay."

JEFFREYS, LEE.
Painter, writer, lecturer, and teacher. Born in New York City, on Jan. 24, 1901. Pupil of Art Students League of NY; Julian Academy in Paris. Member: National Arts Club; Grand Central Gallery; Society of American Artists in Paris. Address in 1929, 915 First Bank Bldg.; h. Sherman Drive Extension, Utica, NY; summer, R.F.D No. 2, Barneveld, Herkimer Co., NY.

JEFFRIES, L(ULU) R(ITA).
(Mrs. H. P. Jeffries). Painter, illustrator, writer, and teacher. Born in Nova Scotia. Pupil of Paul Moschowitz and Pratt Institute. Member: Newport Art Association. Address in 1929, Sussex Corners, N.B., Canada.

JEMNE, ELSA LAUBACH.
Painter and illustrator. Born in St. Paul, Minnesota, in 1888. Pupil of Violet Oakley, Cecilia Beaux, Daniel Garber, Emil Carlsen, and Joseph Pearson. Member: St. Paul Art Soc.; Fellowship Penna. Acad. of Fine Arts; Mural Painters. Awards: Silver medal, St. Paul Insti., 1911; J. J. Hill gold medal, St. Paul Institute, 1915; Cresson European Scholarship, Penna. Academy of Fine Arts, 1914 and 1915; gold medal for painting, St. Paul Insti., 1916; gold medal for painting, Minn. State Fair, 1921; first prize for painting, Minneapolis, Minn. Mural decorations in Central HS, Minneapolis; Stearns County C.H., St. Cloud, Minnesota; Leamy Home, Phila.; Nurses Home, St. Luke's Hosp., St. Paul, Minn. Address in 1929, 212 Mt. Curve Blvd., St. Paul, Minnesota.

JENCKES, JOSEPH.
Born in England in 1602, he emigrated to America in 1642. He was an inventor and die-sinker. He was employed by the Lynn Iron Works to make the dies for the "pine-tree shilling." He built the first American fire-engine. He died in 1683.

JENKINS, F. LYNN.
Sculptor. Born in Devonshire, England, 1870. He studied at the Royal Academy Schools in London, Paris, and Rome. Member: Royal Society of British Sculptors; National Sculpture Society; New York Architectural League. Works: Portrait busts, King Edward VII; Secretary Mellon; John McFadden; George J. Gould; and many others; decorative sculptures, Lloyd's Registry of British Shipping; UK Provident Insti.; public libraries, town halls and other public and private bldgs in London and elsewhere; garden decorations and fountains, Luton Hoo and Knowsley, Eng.; fountains and pedestal sculpture, Chestnut Hill, PA; statuette, Diana, Met. Museum of Art, NY; numerous others. Exhibited at Nat. Sculpture Society 1923. Died in NY 1927.

JENKINS, H(ANNAH) T(EMPEST).
Painter, writer, lecturer and teacher. Born in Philadelphia, PA. Pupil of Spring Garden Institute, School of Industrial Art and Penna. Academy of Fine Arts in Philadelphia; Robert Fleury and Constant in Paris; Tackouchi Seiho in Kyoto, Japan. Member: Plastic Club; Fellowship Penna. Academy of Fine Arts; Southern California Art Club; Laguna Beach Art Association. Award: Diploma, Alaska-Yukon-Pacific Expo., Seattle, 1909. Professor Emeritus of Art Department of Pomona College, Claremont, California. Died in 1927. Address in 1929, Sumner Hall, Pomona College, Claremont, Los Angeles Co., California.

JENKINS, MATTIE M(AUD).
Miniature painter and illustrator. Born in South Abington, Massachusetts, on July 29, 1867. Pupil of Henry Cook, Ethel B. Colver and Charles W. Reid. Member: Brockton Art Club. Address in 1929, 704 Washington St., Whitman, MA.

JENKINS, PAUL.
Born July 12, 1923 in Kansas City, MO. Studied at Kansas City Art Institute, and Art Students League of NYC. Awarded Hon. DH, Linwood College (1973), Officier des Arts Et Lettres (1980). Lived in Paris. Exhibited at Studio Paul Fachelti, Paris (1954); Martha Jackson Gallery, NYC (multiple); A. Tooth & Sons, London; Museum of Modern Art; Whitney; Carnegie; Osaka & Tokyo (1959); Guggenheim; Louvre, Paris; and Corcoran Gallery, Washington, DC. In collections of Museum of Modern Art; Guggenheim; University of California/Berkeley; Brooklyn Museum; Chrysler Art Museum, Provincetown; Whitney; Tate Gallery, London; Stedelijk Museum, Amsterdam. Received Golden Eagle Film Award (1966) for "Ivory Knife," (autobiography).

JENKS, PHOEBE PICKERING HOYT.
(Mrs. Lewis E. Jenks). Portrait painter. Born in Portsmouth, NH, July 28, 1847. She came to Boston to live when sixteen and made it her home. Her best portraits have been of women. Among her many sitters were Mrs. Ellis L. Mott and daughter, Mrs. S. A. Bigelow, Mrs. Harrison Gardiner, Mrs. C. C. Walworth, Mrs. Edward Taylor, Mrs. Henry Landcaster, and a large portrait of the two Lovering boys. She died in New York City on Jan. 20, 1907.

JENNEWEIN, CARL PAUL.
Sculptor. Born on December 2, 1890, in Stuttgart, Germany. In US since 1907. Studied at Art Students League, with Buhler and Lauter, 1907-09, with Clinton Peters, 1910. Opened his studio in 1921. Member: National Sculpture Society; New York Architectural League; (hon.) American Institute of Architects; American Academy in Rome Alumni. Awards: Collaborative prize for sculpture and Avery prize, NY Architectural League, 1915; American

Academy in Rome Fellowship in sculpture, 1916-19; honorable mention, Art Institute of Chicago, 1921; Medal of Honor, Architectural League of New York, 1972; Benjamin Clinedinst Memorial Medal for Achievement, Exceptional Artistic Merit in Sculpture, 1967; American Numismatic Association Art Award, 1970; Daniel Chester French Award Medal, 1972 and 150th Anniversary Gold Medal, 1975; numerous others. Represented in Metropolitan Museum of Art; Corcoran Gallery, Washington; Penna. Academy of Fine Arts; Baltimore Museum of Art; Darlington memorial fountain, Washington, DC; frieze, Eastman School of Music, Rochester, NY; Dante Tablet, Ravenna, Italy; Philadelphia Museum of Art; Barre, VT, war memorial; Lincoln Life Insurance Building, Ft. Wayne, IN; portrait of G. B. McClellan, Caruso Memorial, Metropolitan Opera House; Cunard Building decoration; Woolworth Building, NY; Plymouth, MA, memorial fountain; Levi tomb, Mt. Pleasant, NY; Providence War Memorial; mural decorations, Church of the Ascension, Kingston, NY. Exhibited at National Sculpture Society, 1923. Address in 1976, 538 Van Nest Avenue, Bronx, NY. Died in 1978.

JENNEY, EDGAR WHITFIELD.
Painter and interior decorator. Born in New Bedford, MA, on Dec. 11, 1869. Pupil of Major in Boston; Laurens, Emmanuel and Cavaille Coll., Paris. Member: Mural Painters; NY Architectural League; American Federation of Arts. Work: Decorations in Wisconsin State Capitol; Union Central Life Ins. Co., Cincinnati, Ohio; Senate Chamber and House of Commons, Ottawa, Canada; Hibernia Bank, New Orleans, LA; Standard Oil Building, Hotel Roosevelt, and Equitable Insurance Building in New York City; Palmer House, Chicago, IL. Address in 1929, 13 Vestal St., Nantucket, MA. Died in Nantucket, MA, July 21, 1939.

JENNINGS, DOROTHY (MRS.).
Sculptor and painter. Born in St. Louis, MO, on November 19, 1894. Pupil of Nancy Hahn, Victor Holm, G. Goetsch, W. Ludwig, F. Conway, and W. Wuerpel. Member: St. Louis Art League; St. Louis Independent Artists. Award: Prize for sculpture, St. Louis Artists Guild, 1928. Address in 1934, St. Louis, MO.

JENNINGS, FRANCIS A.
Sculptor, painter, and teacher. Born in Wilmington, Delaware, February 27, 1910. Studied: Wilmington Academy of Art; Fleischer Memorial School of Art; Philadelphia Graphic Sketch Club. Work: Mural, Delaware Industrial School for Boys. Exhibited: Penna. Academy of Fine Arts, 1939, 42, 43; Whitney, 1962; Wilmington Art Center, 1935-37, 1939-43; Pyramid Club, Philadelphia, 1950-52; Ellen Donovan Gallery, Philadelphia, 1952, (one-man); Baltimore Museum of Art, MD, 1963; four shows, Makler

Gallery, Philadelphia and Rose Fried Gallery, NYC, 1960-66; Ward Nasse Gallery, NYC, 1977; Landmark Gallery, 1977; others. Taught: Lecturer, National Art Teachers Association Conv., April, 1969. Address in 1982, 55 Greene Street, New York City.

JENNINGS, LOUISE B.
(Mrs. H. S. Jennings). Painter. Born in Tecumseh, Michigan, on Nov. 6, 1870. Pupil of William M. Chase, Hugh Breckenridge, DeNeal Morgan, and Bryant. Member: Baltimore Water Color Club; Baltimore Society of Independent Artists; American Federation of Arts; Fellowship Penna. Academy of Fine Arts. Address in 1929, 505 Hawthorn Rd., Roland Park, Baltimore, MD; summer, Woods Hole, MA.

JENNINGS, SAMUEL.
Painter. Native of Philadelphia. In 1792 he painted a large and imposing allegorical picture which he presented to the Philadelphia Library, called "The Genius of America Encouraging the Emancipation of the Blacks." Jennings went to London, and Dunlap says that he was there in 1794. Created portraits and miniatures in crayon and oil media.

JENNINGS, WILLIAM.
Portrait painter. One of his pictures is signed and dated 1774.

JENNYS, J. WILLIAM.
Painter. He painted portraits of Col. and Mrs. Constant Storrs, which are dated 1802 and owned by John F. Lewis, Philadelphia. (May be William Jennings, above).

JENNYS, RICHARD, JR.
Engraver. A well-executed mezzotint portrait of the Rev. Jonathan Mayhew is signed by Richard Jennys, Jr., as engraver. It was published in Boston about 1774 and was "Printed and Sold by Nat. Hurd, Engraver, on ye Exchange."

JENSEN, H(OLGER) W.
Painter. Born in Denmark, on Jan. 6, 1880. Pupil of Art Institute of Chicago; Chicago Academy of Fine Arts. Member: Chicago Painters and Sculptors; Austin, Oak Park and River Forest Art League; Palette and Chisel Club, Chicago; Chicago Galleries Association. Address in 1929, Route No. 3 Grand Detour, Dixon, IL.

JENSEN, LEO (VERNON).
Sculptor and painter. Born in Montevideo, MN, July 10, 1926. Studied at Walker Art Center, scholar, 1946-48. Work in New Britain Museum of American Art, Connecticut; Phillip Morris, NY; bronze musicians, United Artists Corp., NY; and others. Has exhibited at New Britain Museum, Far Gallery, NY; Arras Gallery, NY; Butler Institute of Amer.

Art, Ohio; Milwaukee Art Center. Received first prize for wood carving, Silvermine Guild Artists Annual; first prize for sculpture, John Slade Ely House Invitational. Works in bronze, wood; acrylic, watercolor. Address in 1982, Ivoryton, CT.

JENSEN, THOMAS M.
Portrait painter. Born in Apenrade, Denmark in 1831. He came to this country in 1870. He painted many of the portraits of the New York judges which are now in the Kings County Court House and the City Hall of New York City. Among his best known portraits were those of Roswell C. Brainard; Michael McGoldrick; and Hamilton W. Robinson. He died March 6, 1916 in Bay Ridge, NY.

JEPSON, MRS. W. R.
See Wiles, Gladys (Lee).

JEROME, ELIZABETH GILBERT.
Painter. Born Dec. 18, 1824, in New Haven, Conn. Studied in the National Academy, New York, under E. Leutze. Also worked in crayon. She exhibited in the National Academy in 1866, and excelled in ideal figure painting. Died Apr. 22, 1910 in New Haven, CT.

JEROME, IRENE ELIZABETH.
Painter and illustrator. Born in New York State in 1858, and with the exception of a few lessons was self-taught in art. In 1882 she exhibited eighteen sketches of Colorado which had decided merit. Among her work was considerable illustrating for books and other publications.

JERRY, SYLVESTER.
Painter. Born in Woodville, Wisconsin, on Sept. 20, 1904. Pupil of Layton School of Art; Art Students League of NY. Member: Wisconsin Painters and Sculptors; Art Students League of NY. Address in 1929, 190 Concordia Ave., Milwaukee, Wisconsin; summer, Woodstock, NY.

JETTER, FRANCES.
Illustrator. Born in NY, in 1951. Attended Parsons School of Design. In 1974 her career began with illustrations for a psychology book by John Wiley and Sons. She has designed bookjackets as well as editorial illustrations for *The New York Times*, *Institutional Investor*, *The Independent* (a United Nations publication), and others. Her illustrations have appeared in the Annual Exhibitions of the Society of Illustrators and in *Graphis Annual*.

JEWELL, FOSTER.
Painter. Born in Grand Rapids, on July 21, 1893. Pupil of Mathias J. Alten. Address in 1929, 447 College S. E., Grand Rapids, Michigan.

JEWETT, CHARLES A.
Engraver. Born in Lancaster, MA, in 1816; died in NY in 1878. This good line-engraver of subject plates was engraving in New York in 1838. He later removed to Cincinnati, OH, and about 1853 he was conducting an extensive engraving business in that city. In 1860 he was again located in NY.

JEWETT, FREDERICK STILES.
A marine and landscape painter. Born Feb. 26, 1819, in Simsbury, CT. He moved to the West Indies when 22, and visited Europe, but lived most of his life in his native state Connecticut. One of his best paintings is in the Wadsworth Athenaeum. Died Dec. 26, 1864, in Cleveland, OH.

JEWETT, MAUDE SHERWOOD.
(Mrs. Edward H. Jewett). Sculptor. Born in Englewood, NJ, on June 6, 1873. Pupil of Art Students League of New York. Member: National Association of Women Painters and Sculptors; Alliance; American Federation of Arts; Am. Artists Professional League. Exhibited at National Sculpture Society, 1923. Work: Fountain in Cleveland Mus.; Soldiers and Sailors War Memorial, East Hampton, LI, NY. Specialty: Sun-dials and portrait statuettes. Was living in New York City in 1926. Address in 1933, Easthampton, LI, NY. Died in Southampton, LI, April 17, 1953.

JEWETT, WILLIAM.
Portrait, genre and landscape painter. Born in East Haddam, Conn., Jan. 14, 1790. He was apprenticed to a coach maker and, when eighteen years of age, he met Samuel Waldo, and going to New York with him he formed the partnership of Waldo & Jewett, with whom he collaborated in painting many excellent portraits of prominent men. He was elected an associate member of the Nat. Academy of Design in 1847. He died Mar. 24, 1874, in Bergen, New Jersey.

JEWETT, WILLIAM S.
Painter. Born in South Dover, NY, 1812. He came to New York City as a very young man and studied at the Schools of the National Academy of Design. In 1845 he was elected an Associate Member. He sailed in 1849 from New York for San Francisco where he resided for years and painted a number of pictures, and prospected for gold. He died Dec. 3, 1873, in Springfield, MA.

JEX, GARNET W.
Painter. Member: Society of Washington Artists; Southern States Art League; American Federation of Arts. Address in 1929, 631 Orleans Place, NE, Washington, DC.

JEYNES, PAUL.
Sculptor. Born in Millburn, NJ. Studied: Yale University, 1949; also studied with Frank Eliscu,

1974-75. Work: Numerous private collections, plus commissions. Exhibited: Abercrombie and Fitch, NYC; Sculpture Center, NYC Caravan House, NYC; Audubon Artists; Cincinnati Zoo International Wildlife Art Show, 1983. Awards: 1st prize ($2,500), Cincinnati Zoo International Wildlife Art Show, 1983. Member: Board of Directors, Art Founder's Guild of America, Inc. Editor of "The Artist's Foundry," Modern Art Foundry, Long Island City, NY. Medium: Bronze. Address in 1983, 305 East 70th St., New York, NY.

JIRAK, IVAN.
Painter. Born in Allegheny, PA, on Nov. 5, 1893. Pupil of Christian Walter. Member: Pittsburgh Art Association; American Federation of Arts. Awards: $100 prize, Pittsburgh Art Association, 1922. Work: "Peonies," Public Schools of Pittsburgh. Address in 1929, 408 Fairywood Ave., Pittsburgh, PA.

JIROUCH, FRANK LUIS.
Sculptor and painter. Born in Cleveland, OH, on March 3, 1878. Studied: Cleveland School of Art; Penna. Academy of Fine Arts; Julian Academy, Paris, France; pupil of Matzen, Ludikie, Grafly, Garber, Pearson, Landowski, Bouchard. Member: National Sculpture Society; Cleveland Society of Artists; Fellowship Penna. Academy of Fine Arts. Work: Bronze relief in Church of Lady of Lourdes; "Diana of Ephesus," Union National Bank; Stone pediment, United Savings and Trust Bank; Chapman Memorial, Cleveland Ball Park; Altar of Sacrifice, Cleveland; Spanish War Monument, Columbus, OH; "Day and Night," Wade Park, Cleveland; Maine Memorial Tablet, Havana, Cuba; "Portrait of Victor Herbert," bronze, 1905. Exhibited: Penna. Academy of Fine Arts, Paris Salon; Art Institute of Chicago; Architectural League; Los Angeles Museum of Art. Address in 1953, Cleveland Heights, OH. Died in 1970.

JOB, ALICE E.
Painter and writer. Born Alton, Ill. Pupil of Lefebvre, Constant and Puvis de Chevannes in Paris. Member: National Association of Women Painters and Sculptors; National League of American Pen Women. Address in 1929, 70 Fifth Ave.; h. Hotel Albert, 65 University Pl., New York, NY.

JOCELYN, NATHANIEL.
Portrait painter and engraver. Born in New Haven, CT, in Jan. 31, 1796; died there Jan. 13, 1881. Nathaniel Jocelyn was the son of a watchmaker. At the age of eighteen years he was apprenticed to an engraver, and when he was twenty-one he entered into partnership with Tisdale, Danforth and Willard, in the Hartford Graphic and Bank-Note Engraving Company; he later, with Mr. Danforth, virtually founded the Nat. Bank-Note Engraving Company. Dissatisfied with engraving, Jocelyn gave it up in 1820 and became a painter of portraits, and exhibited at the National Academy in 1826. He went abroad with S. F. B. Morse in 1829-30, and became a meritorious portrait painter. He was made an Academician of the National Academy on May 13, 1846. Brother of Simeon Jocelyn.

JOCELYN, SIMEON S.
Engraver and painter. Born in New Haven, CT, Nov. 21, 1799; died in Tarrytown, NY, Aug. 17, 1879. S. S. Jocelyn was engraving line portraits in New Haven, after drawings by N. Jocelyn, as early as 1824, and in 1827 the engraving firm of N. & S. S. Jocelyn was in business in that city. S. S. Jocelyn and S. B. Muson were also associated as engravers. He also painted miniatures and oils. The latter part of his life was passed in New Haven, CT.

JOHANSEN, ANDERS D.
Painter and illustrator. Born in Denmark. Pupil of Anna Fisher, Walter Beck, W. S. Taylor, Max Herrmann and Pratt Institute. Member: Scandinavian-American Artists; Tiffany Foundation; American Water Color Society (assoc.). Award: Pratt Art Alumni European Fellowship, 1924. Address 1929, 309 Washington Ave., Brooklyn, NY.

JOHANSEN, JOHN C(HRISTEN).
Painter. Born in Copenhagen, Denmark, Nov. 25, 1876. Pupil of Art Institute of Chicago; Duveneck, Julian Academy in Paris. Member: Associate National Academy of Design, 1911; Academician National Academy of Design, 1915; Portrait Painters; Players; National Arts Club; Salma. Club, 1906; MacDowell Club; American Fed. of Arts. Awards: Municipal League purchase prize and Young Fortnightly prize, Art Institute of Chicago, 1903; honorable mention, Arts Club of Chicago, 1903; silver medal, Chicago Society of Artists, 1904; bronze medal, St. Louis Expo., 1904; gold medal, Buenos Aires Expo., 1910; Saltus gold medal, National Academy of Design, 1911; Harris silver medal ($500), Art Institute of Chicago, 1911; hon. mention, Carnegie Institute, Pittsburgh, 1912; H. S. Morris prize, Newport Art Association, 1915; gold medal, P.-P. Expo., San Francisco, 1915; silver medal, Sesqui-Centennial Expo., Phila., 1926; Wm. M. R. French memorial gold medal, Art Insti. of Chicago, 1928. Represented in Nat. Gallery, Santiago, Chili; Penna. Academy of Fine Arts; "Piazza San Marco," Art Inst. of Chicago; "Fiesole," Public Gallery, Richmond, IN; Mus., Dallas, TX; Conservative Club, Glasgow; Art Mus., Syracuse, NY; Union League of Chicago; Proteus Club, Des Moines, IA; Arche Club, Chicago; Univ. Club, Chicago; Gallery of Vincennes, IN; State Normal School, Terre Haute, IN; Herron Art Insti.; Masonic Temple, NY, NY; Wisconsin, Cornell and Clark Universities; Nat. and Corcoran Galleries of Art, Washington, DC; Wells College. Died in 1966. Address in 1929, 12 W 9th St., New York, NY.

JOHANSEN, M. JEAN MCLANE.
See McLane, M. Jean.

JOHANSON, PATRICIA.
Landscape-sculptor and architect. Born in NYC, September 8, 1940. Studied: Bennington College; Hunter College; City College School of Architecture; Brooklyn Museum Art School; Art Students League. Awards: Guggenheim Fellowship, 1970-71; first prize, Environmental Design Competition, Montclair State College, 1974; Artists Fellowship, National Endowment for the Arts, 1975. Work in Detroit Institute of Art; Metropolitan Museum of Art; Museum of Modern Art; gardens, *House and Garden*, 1969; Cyrus Field, 1970-75; Con Edison Indian Point Visitors Center, 1972; projects for Columbus East High School, Columbus, IN, 1973. Exhibited: Museum of Modern Art, 1968-69, 79; Penna. Academy of Fine Arts, 1975; Brooklyn Museum, 1977, 80; Newark Museum, 1979; others. Represented by Rosa Esman Gallery, NYC. Address in 1982, Buskirk, NY.

JOHN, FRANCIS COATES.
Painter. Born in Baltimore, in 1857. Studied at Ecole des Beaux Arts in Paris, under Yvon, Lehmann, Boulanger and Lefebvre. He opened a studio in New York in 1882. Specialty: Figure painting. He won the Clarke prize, National Academy of Design. Elected member of the National Academy in 1894. Member: National Institute of Arts and Letters; American Federation of Arts. Address in 1926, 33 W. 67th St., New York.

JOHN, GRACE SPAULDING.
Painter, writer, and lecturer. Born in Battle Creek, Michigan, on Feb. 10, 1890. Pupil of Charles Hawthorne, Daniel Garber, Fred Weber. Work: Portrait of Aloysius Larchmillar, Statehouse, Oklahoma City, Oklahoma; "The Onion Cart, France," Museum of Fine Arts, Houston, TX. Died in 1972. Address in 1929, 808 Louisiana St.; h. 1306 Barbee St., Houston, Tex.

JOHNS, CLARENCE M.
Painter. Born in Pittsburgh, PA, in 1843. Pupil of Penna. Academy of Fine Arts, and later studied in Paris. He was widely known for his animal pictures. He served for years on the jury of awards for the Carnegie Art Exhibitions at Pittsburgh. He died in 1925.

JOHNS, JASPER.
Sculptor and painter. Born in Augusta, GA, May 15, 1930; grew up in Allendale and Sumter. Studied at University of South Carolina, 1947-48. Represented in Wadsworth Atheneum; Whitney; Albright-Knox; Museum of Modern Art, New York and Paris. Works: "The Critic Sees," 1961; "Double White Map," 1965, which sold at an auction in NY for $240,000, highest price ever paid at that time for a 20th century American piece of art; "Book," 1957 and "Drawer," 1957, which are examples of the attachment of objects to paintings. Exhibited: Retrospective, San Francisco Museum of Modern Art, 1978; Museum of Modern Art, NY, 1968, 70, and 72; The Second Breakthrough, 1959-64; University of California, Irvine, 1969; Museum of Contemporary Art, Chicago, 1971-72; Seattle Art Museum, Wash., 1973; Art Institute of Chicago, 1974; numerous other group and one-man shows, some of which were held at the Gallery d'Arte del Noviglio, in Milan, 1959, the Gabrie Rive Droite, in Paris, and the Whitechapel Gallery, London, 1964. Executed numerous sculpted objects consisting of mass produced objects such as beer cans, flashlights, and lightbulbs. He was drafted into the Army in 1949. Address in 1982, c/o Leo Castelli, 420 W. Broadway, NYC.

JOHNSEN, MAY ANNE.
Painter. Born in Port Chester, NY, in 1921. Studied with John Carroll. Awards: Silvermine Art Guild; Columbia Fair; Hamilton, OH, Miniature Painters. Exhibitions: Miniature Painters, Sculptors, Gravers Society of Washington, 1962-72; Catharine Lorillard Wolfe National Art Show, NYC, 1964; others. Works in silver point and oil. Lives in Brainard, NY.

JOHNSON, ADELAIDE (MRS.).
Sculptor. Born in Plymouth, IL, 1860. Studied with Monteverde and Fabi Altini in Rome. Work: Portrait bust of Susan B. Anthony, Metropolitan Museum, NY; portrait bust of Hiram W. Thomas, Chicago Historical Society; largest work was the "Memorial to the Pioneers of the Women's Suffrage Movement," presented by the Women of the US to the Joint Committee on the Lib., February 15, 1921. It is now placed in the Crypt on the first floor of the Capitol beneath the Dome; the work consists of a group setting of Elizabeth Cady Stanton, Susan B. Anthony, and Lucretia Mott in Carrara. Address in 1933, 230 Maryland Avenue, NE, Washington, DC. Died in 1949.

JOHNSON, ARTHUR A(LOYSIUS).
Illustrator, designer, lecturer, and teacher. Born in Joliet, IL, on June 29, 1898. Work: Posters for Chicago Rapid Transit Co., Chicago North Shore Milwaukee Railroad and Chicago South Shore South Bend Railroad. Address in 1929, 59 East Adam St., 410 So. Michigan Ave., Chicago, IL; 202 Herkimer St., Joliet, IL.

JOHNSON, ARTHUR C(LARK).
Painter and teacher. Born in Hyde Park, MA, on Sept. 5, 1897. Pupil of Tarbell, Meryman, Hale, Bosley, E. L. Major, and F. W. Brown. Instructor, School of Art, Springfield, IL. Director, Springfield Art Association. Address in 1929, 56 Harvard Ave., Hyde Park, MA; summer, Hampton, NH.

JOHNSON, BELLE.
Sculptor. Exhibited at Penna. Academy of Fine Arts, Philadelphia, in 1925. Address in 1926, 200 Claremont Ave., NY.

JOHNSON, BUFFIE.
Painter and lecturer. Born in NYC on Feb. 20, 1912. Studied: University of California at Los Angeles; Art Students League. Collections: Boston Museum of Fine Arts; Baltimore Museum of Art; Newark Museum of Art; Walker Art Center, Minneapolis, MN; Metropolitan Museum of Art; Cincinnati Museum Association. Address in 1980, 102 Green St., NY, NY.

JOHNSON, BURT W.
Sculptor and teacher. Born April 25, Flint, OH, in 1890, and was a pupil of Louis Saint-Gaudens, J. E. Fraser, Robert Aitken, and George Bridgman. He was a member of the Laguna Beach Art Association and the New York Architectural League. He is represented by "Spanish Music Fountain" and "Greek Tablet" at Pomona College, Claremont, CA; panel, "Christ" at St. Francis Hospital, La Crosse, WI; memorial fountain, Huntington Park, CA; Pomona Valley memorial monument, Pomona; Dimick statue, West Palm Beach, CA; memorial statue, Woodside, NY; Anna I. Young memorial panel, Agnes Scott College, Decatur, GA; World War Memorial Panel, College Park, Atlanta, GA; four heroic architectural figures and two heroic panels on facade of building, fountain, "High Note," two copies of "Kneeling Cynthia," "Little Sculptor Boy" and "Pottery" in lobby, Fine Arts Building, Los Angeles, CA. Address in 1926, 86 Grove St., Flushing, NY; summer, Claremont, CA. Died in Claremont, CA, March 27, 1927.

JOHNSON, C. EVERETT.
Painter, illustrator, writer, and lecturer. Born in Gilroy, CA, on Dec. 7, 1866. Pupil of Art Institute of Chicago; Richard Miller in Paris. Member: Cliff Dwellers; Chicago Art Club. Work: Advertising illustration for Washburn Crosby Co.; Quaker Oats Co.; California Fruit Growers Exchange. Address in 1929, 2656 Tanoble Dr., Altadena, CA.

JOHNSON, CLARENCE R.
Painter. Member: Fellowship Penna. Academy of Fine Arts. Awards: Hallgarten prize ($300), National Academy of Design, 1925; bronze medal, Sesqui-Centennial Expo., Philadelphia, 1926, Peabody prize ($200), Art Institute of Chicago, 1926. Address in 1929, Lumberville, PA; 15 Windermere Ave., Lansdowne, PA.

JOHNSON, CONTENT.
Painter. Born in Bloomington, IL. Pupil of Julian Academy under Constant and Laurens in Paris; NY School of Art under Chase. Member: Society of

Painters of NY; Pen and Brush Club, NY. Died Nov. 9, 1949. Address in 1929, 200 West 57th St., New York, NY.

JOHNSON, CORDELIA.
Painter. Born in Omaha, Nebraska, July 11, 1871. Pupil of J. Laurie Wallace. Member: Omaha Art Guild. Address in 1929, 2346 South 34th St., Omaha, NE.

JOHNSON, DAVID.
Painter. Born May 10, 1827, in New York. At the beginning of his artistic career he received a few lessons from J. F. Cropsey. He studied the works of the great European masters of landscape painting, but his professional life passed entirely in New York, and he had never been abroad. He was elected a National Academician in 1861, and was one of the founders of the Artists' Fund Society. At the Centennial Exhibition at Philadelphia in 1876, he exhibited "Scenery on the Housatonic," "Old Man of the Mountains," and "A Brook Study, Orange County, NY," and received one of the first awards. His pictures are notable for fine color and excellent drawing. He died Jan. 30, 1908, at Walden, NY.

JOHNSON, DAVID G.
Painter and line-engraver of portraits and views of little merit, who was working in New York in 1831-35, and again in 1845.

JOHNSON, DOUGLAS.
Illustrator. Born in Toronto, CN, in 1940. Studied at the Ontario College of Art for three years. The start of his career in Toronto in 1960 led to his success as an illustrator, his distinctive style being in great demand among magazine and book publishers. His work has been exhibited at the Art Gallery of Ontario, the Brooklyn Museum, and the Society of Illustrators, for which he produced the *Illustrators 13* exhibition poster. He was an instructor at Society of Visual Arts until 1974 and creative director of The Chelsea Theatre Center. He lives in NY and co-directs Performing Dogs, an advertising consultant group.

JOHNSON, EASTMAN.
Genre and portrait painter. Born Jonathan-Eastman Johnson in Lovell, ME, July 29, 1824; died in New York, April 5, 1906. He studied in Dusseldorf, Rome, Paris and The Hague, and settled in New York, becoming a member of the National Academy of Design in 1860. He was the son of Philip C. Johnson, Secretary of State for Maine. He worked in a lithographic establishment in Boston in 1840 and after a year went to Augusta, ME, where he commenced making portraits in black crayon. He also visited Newport. In 1845 the family moved to Washington, DC, and young Johnson drew many crayon portraits, working in the Senate Committee

Rooms at The Capitol. In 1858 he moved to New York, where he remained the rest of his life, except for a period spent in Boston and in visits to Europe in 1885, 1891 and 1897.

JOHNSON, EDYTH A. B.
Miniature painter. Born Portsmouth, NH, Jan. 26, 1880. Pupil of Twachtman, Alice Beckington, Carroll Beckwith. Member: Plastic Club; Print Club; Fairmount Park Art Association. Address in 1929, Hamilton Court, 39th and Chestnut Sts., Phila., PA.

JOHNSON, ELENA MIX.
(Mrs. Alexander L. P. Johnson). Painter. Born in Nogales, AZ, Aug. 19, 1889. Pupil of Daniel Garber, Henry McCarter, Joseph T. Pearson, Charles Grafly. Member: Fellowship Penna. Academy of Fine Arts; American Federation of Arts; American Artists Professional League. Address in 1929, 2045 Park Rd., NW, Washington, DC. Died in 1939.

JOHNSON, F.
Painter. Member: Boston Art Club. Address in 1929, 22 Kensington Ave., Bradford, MA.

JOHNSON, FRANK EDWARD.
Painter, writer, and lecturer. Born in Norwich, CT, July 6, 1873. Pupil of Laurens and Constant in Paris. Member: Washington Water Color Club. Died in 1934. Address in 1929, 31 General Lee, Marianao, Cuba; summer, Norwich, CT.

JOHNSON, FRANK TENNEY.
Painter and illustrator. Born near Big Grove, IA, June 26, 1874. Pupil of Lorenz, Heinie and Henri, Art Students League of NY; NY School of Art. Member: Associate National Academy of Design; NY Water Color Club; Allied Artists of America; Salma. Club; American Federation of Arts; Society of Painters, NY; Laguna Beach Art Associaton; California Art Club; Painters of the West; American Water Color Society. Awards: Hon. mention, Wisconsin Painters and Sculptors, 1919; Shaw purchase prize ($1,000), Salma. Club, 1923; Edgar B. Davis prize ($1,250), Texas Wild Flower Competition, 1929; silver medal, Brown and Bigelow, Allied Artists of America, 1929. Represented in National Gallery, Washington, DC; Dallas Art Association; main drop curtain and murals, Carthay Circle Theatre, Los Angeles, CA. Died in 1939. Address in 1929, 48 Charles St., New York, NY; 22 Champion Pl., Alhambra, CA.

JOHNSON, GRACE MOTT.
Sculptor. Born in New York City, July 28, 1882. Pupil of Gutzon Borglum; H. A. MacNeil; Art Students League. Also studied in Paris. Member: National Acad. of Women Painters and Sculptors; Grand Central Gallery; National Sculpture Society; Society Independent Artists; Society of Animal Painters and Sculptors. Awards: McMillin Sculpture prize, National Academy of Women Painters and Sculptors, 1917, Joan of Arc medal, 1927, prizes, 1935, 36. Exhibited at the National Sculpture Society, 1933. Specialty, animals. Work: New York Public Library; Public Library, Pleasantville, New York. In collections of Whitney and Brookgreen Gardens. Address in 1953, Pleasantville, NY.

JOHNSON, HARRY LEROY.
Miniature painter. Member: Penna. Soc. of Miniature Painters; Am. Society of Miniature Painters. Address in 1929, 3030 Park Ave., Swarthmore, PA.

JOHNSON, HELEN LESSING.
(Mrs. Frank Edgar Johnson). Painter, illustrator, and etcher. Born in Poughkeepsie, NY, May 31, 1865. Pupil of Charles Melville Dewey. Member: Yonkers Art Association. Died in 1946. Address in 1929, 16 Amackassin Terrace, Yonkers, NY.

JOHNSON, HELEN SEWELL.
Painter, illustrator, and etcher. Born in Cambridge, MD, Sept. 1, 1906. Pupil of Charles Hawthorne; Richard Meryman; National Academy of Design. Address in 1929, 806 Ambassador Apts.; h. 220 Portner Apts., Washington, DC.

JOHNSON, HERBERT.
Illustrator and cartoonist. Born in Sutton, NE, Oct. 30, 1878. Member: Society of Illustrators, 1913; Philadelphia Art Club; Philadelphia Sketch Club; Philadelphia Print Club; Philadelphia Alliance; Society of Allied Artists; Artists Guild of the Authors' League of NY. Former connections with *Denver Republican*; *Kansas City Journal*; Philadelphia. North American Staff Cartoonist for *Saturday Evening Post* since 1912. Died in 1946. Address in 1929, Morningside Farm, Huntingdon Valley, PA.

JOHNSON, HORACE C.
Portrait painter. Born in Oxford, CT, in 1824. He was a student of the National Academy, also of the English Life Schools. He settled in Waterbury, CT. Among his pictures are the "Roman Mother," "Rebecca at the Well," and "Italian Girls at the Fountain."

JOHNSON, IRENE CHARLESWORTH.
Sculptor. Born in Gering, NE, September 27, 1888. Pupil of Zolnay. Work in Nashville Museum of Art. Member: Southern States Art League; Nashville Art Association. Awards: Second prize for sculpture, All Southern Exhibition, 1921; first prize for sculpture, Southern States Art League, 1925. Address in 1953, Nashville, TN.

JOHNSON, J. THEODORE.
Sculptor, painter and teacher. Born in Oregon, IL, November 7, 1902. Studied: Art Institute of Chicago; and with Andre L'Hote, Aristide Maillol, Leopold G.

Seyffert, and Leon Krollin. Awards: Lathrop European Scholarship, 1925; Eisendrath prize, Art Institute of Chicago, 1928; Logan gold medal and prize of $2,500, Art Institute of Chicago, 1928; first prize and first popularity prize, Swedish Club, Chicago, 1929; prize ($750), Chicago Galleries Association, 1929; Guggenheim Fellowship, 1929; Minn. Institute of Art, 1943, 44; Minneapolis State Fair, 1944. Work: Art Institute of Chicago; Toledo Museum of Art; Vanderpoel Collection; IBM Collection; Minneapolis Institute of Art; University of Chicago; Field Museum; murals, Garden City, LI, NY; Oak Park, IL; Morgan Park, IL; Western Illinois State Teachers College. Exhibited: Corcoran Gallery of Art, 1928, 30, 37; Carnegie Institute, 1929, 30; Penna. Academy of Fine Arts, 1929, 37; Art Institute of Chicago, 1928-30, 32, 40; Brooklyn Museum, 1932; National Academy of Design, 1936; Golden Gate Exposition, 1939; Toronto, Canada, 1940; National Gallery, Canada, 1940; Montreal Art Association, 1941; Minneapolis Institute of Art, 1938-44; San Francisco Museum of Art, 1946; Minnesota State Fair, 1941-44; Whitney Museum of American Art; etc. Taught: Instructor, Head of Dept., Minneapolis School of Art, 1938-45; Associate Professor, San Jose College, San Jose, California, from 1945. Address in 1953, Art Department, San Jose State College; h. Cupertino, CA.

JOHNSON, JEANNE PAYNE.
(Mrs. Louis C. Johnson). Painter. Born near Danville, OH, April 14, 1887. Pupil of Art Students League of NY; Mme. LaForge, Richard Miller and Lucien Simon in Paris. Exhibited at Penna. Academy of Fine Arts in 1925. Died in 1958. Member: Brooklyn Society of Miniature Painters; National Association of Women Painters and Sculptors. Address in 1929, 39 Remsen St., Brooklyn, New York, NY; summer, Stony Brook, LI, NY.

JOHNSON, JESSAMINE INGLEE.
Painter and teacher. Born in Delphi, IN, Dec. 2, 1874. Pupil of Herron Art Institute, Indianapolis. Member: Indiana Art Club. Award: "Friend of Art" prize ($100), Hoosier Salon, Chicago, 1929. Address in 1929, 1221 Central Ave., Connersville, IN.

JOHNSON, JOSEPH HOFFMAN.
Portrait painter. Born in 1821; died in 1890. He painted several portraits for the City of New York.

JOHNSON, LESTER.
Sculptor and painter. Born in Detroit, MI, Sept. 28, 1937. Studied: Wayne State University; University of Michigan, B.F.A., M.F.A. Exhibitions: Michigan Artists Exhibition, The Detroit Institute of Arts, 1964-66, 70, 72; Michigan Watercolor Society, 1965-67, 71; Butler Institute, Youngstown, OH, 1966; Springfield Art Museum, MO, "Watercolor USA," 1966; Detroit Artists Market, "Seven Black Artists," 1969; Gallery 7, Detroit (one-man), 1970; California

National Watercolor Society, Laguna Beach, 1970; The Whitney Mus. of Am. Art, NY "Contemporary Black Artists in America," 1971, 73; Carnegie Institute, Pittsburgh, 1971-72; Cranbrook Academy of Art, 1972; The Flint Institute of Arts (one-man), 1973; Works by Michigan Artists (sculpture), The Detroit Institute of Arts, 1974-75. Collections: The Detroit Institute of Arts; The Flint Institute of Arts; Sonnenblich-Goldman, NY. Awards: John S. Newberry Prize, Michigan Artists Exhibition, The Detroit Institute of Arts; Mrs. Albert Kahn Award Museum Purchase, 1964; Harlem Gallery Square, 1969, 71, 72; 1st Prize in Painting, Michigan State Fair, 1969, 73. Address in 1975, Detroit, MI.

JOHNSON, MARIE RUNKLE.
Painter. Born in Flemington, NJ, Dec. 21, 1861. Pupil of Collin, Girardot, Courtois and Prinet, in Paris; Chase, in NY. Member: CA Art Club. Award: Medal, Pan.-Cal. Expo., San Diego, 1915. Address in 1929, 255 So. Fair Oaks Ave., Pasadena, CA.

JOHNSON, MARSHALL.
Painter. Born in Boston. Pupil of Lowell Institute. Painter of the United States Frigate, "Constitution." Died in 1915 in Boston, MA.

JOHNSON, MARY ANN.
Painter. She excelled in still-life subjects. She died in New London, CT, where much of her best painting was done.

JOHNSON, MERLE DeVORE.
Illustrator. Born in Oregon City, OR, Nov. 24, 1874. Member: Artists Guild of the Authors' League of America, NY. Died in 1935. Address in 1929, 243 West 34th St., New York, NY.

JOHNSON, NEOLA.
Sculptor, painter, illustrator, and teacher. Born in Chicago, IL. Pupil of Anthony Angarola and Cameron Booth. Member: Gary Pen and Pencil Club. Address in 1929, 1300 West Fifth Ave., Gary, IN; summer, Lindstrom, MN.

JOHNSON, SAMUEL FROST.
Painter. Born in New York City, Nov. 9, 1835. He studied in the life schools of the National Academy and afterwards in the Academies of Brussels and Paris. He painted for some time in London, and on his return to this country accepted a professorship in the Metropolitan Museum. His works include "Les Pommes" shown at the Salon in 1869; "Moorland Landscape;" portraits of Cardinal McCloskey and Lady Helen Blackwood.

JOHNSON, SARGENT CLAUDE.
Sculptor. Born in Boston, Mass., October 7, 1889. Studied at California School of Fine Arts; and with

Stackpole, Bufano. Work: "Esther," terra cotta head, Fine Arts Gallery of San Diego; San Francisco Museum of Art; porcelain enamels, Richmond (CA) City Hall. Awards: Gold medal, California Palace of the Legion of Honor, 1925; Kahn prize, 1927, bronze medal, 1929, prize of $150, 1933, Harmon Foundation; first prize, sculpture, California Legion of Honor, 1931, Ogden prize, 1933. Member: San Francisco Art Association. Taught: Instructor of sculpture, Mills College, Oakland, CA. Address in 1953, San Francisco, California. Died in 1967.

JOHNSON, THOMAS.
Wood-engraver. He engraved a series of portraits of musicians in 1878.

JOHNSON, WILLIAM T.
Engraver and/or watercolorist. W. T. Johnson was listed by Stauffer as engraver of subject plates for *Sartain's Magazine*, c. 1850. This may have been the William T. Johnson of Philadelphia who exhibited a water color drawing at the American Institute in 1849.

JOHNSTON, BARRY WOODS.
Sculptor. Born in Florence, AL. Studied at Georgia Institute of Technology, B.S., 1969; Art Students League, with Jose De Creeft; Penna. Academy of Fine Arts, with Walker Hancock, Harry Rosen, and Tony Greenwood; National Academy of Fine Arts, with Michael Lantz; also studied in Italy, with Enzo Cardini and Madame Simi. Has exhibited at National Sculpture Society Annual Group Show, NY, 1980 and 1981; others. Received Stewardson Award, Penna. Academy of Fine Arts; Honorable Mention, National Academy of Design; others. Member: National Sculpture Society. Works in clay and bronze. Address in 1982, Washington, DC.

JOHNSTON, DAVID CLAYPOOLE.
Engraver. Born in Philadelphia, PA, in March 1799; died at Dorchester, MA, Nov. 8, 1865. In 1815, Johnston was a pupil of the Philadelphia engraver Francis Kearney, and in 1819 he was in business for himself etching caricatures of Phila. celebrities. The complaints of some of his victims finally became so loud that the publishers and print-sellers declined to handle his plates. Johnston engraved a few good portraits in stipple and some line illustrations for the Boston publishers, and he also drew upon stone for lithographers. He is best known, however, by his annual publication of "Scraps," first issued in 1830. This Annual was usually made up of four to six sheets, each containing from nine to twelve small etched caricatures of local, social, or political significance, all designed and etched by Johnston. The character and general excellence of these etchings gained for Johnston the name of "The American Cruikshank."

JOHNSTON, HENRIETTA.
Artist. Of her earlier life nothing is known. Emigrated to America in 1707 and settled in Charles Town (now Charleston), SC. Untrained, she employed native talent to produce portraits of frank, unadorned directness. They were small, generally 9 by 12 inches and never larger than 14 by 16, and were done in pastels, a technique only then coming into widespread use. She was almost certainly the earliest woman artist in America. Some 40 portraits by her are known, most done between 1707 and 1720. A number of portraits done in NY as late as 1735 have been attributed to her. She died in Charleston on March 9, 1728 or 1729.

JOHNSTON, JOHN.
Painter. Born in Boston in 1753; died June 29, 1818. He was the son of Thomas Johnston, who kept a shop in Brattle Street, where he sold colors, made charts, painted coats of arms, and engraved portraits, music plates, etc. John Johnson had military service in the Revolution, reaching the rank of Major, and was an original member of the "Cincinnati." He painted many portraits of public men of Massachusetts, and his pictures, although deficient in drawing, possessed talent. Also used pastels.

JOHNSTON, JOHN BERNARD.
Landscape painter. Born in Boston in 1847. He was a pupil of William Morris Hunt, and died in 1886. Represented in Boston Museum of Fine Arts by "Landscape with Cattle."

JOHNSTON (JOHNSON), JOHN R.
Sculptor and painter. Born in Ohio, during the 1820's. Worked: Cincinnati, 1842-53; Baltimore, 1857-72.

JOHNSTON, MARY G.
Painter and etcher. Born in Evansville, IN, Nov. 16, 1872. Pupil of Chautauqua Summer Schools; Charles W. Hawthorne, Richard Miller, and James Hopkins. Member: Louisville Art Association; Louisville Art Club; Louisville Handicraft Guild. Address in 1929, Pewee Valley, KY.

JOHNSTON, M(ARY) VIRGINIA DEL C(ASTILLO).
Painter. Born in Puerto Principe, Cuba, Aug. 16, 1865. Pupil of E. H. Andrews, E. C. Messer, and Robert Henri. Member: Society of Washington Artists; League of American Pen Women. Address in 1929, 563 41st Ave., San Francisco, CA.

JOHNSTON, RANDOLPH W.
Sculptor and etcher. Born in Toronto, Canada, February 23, 1904. Studied: Ontario College of Art; University of Toronto; Central School of Arts and Crafts, London; Royal Canadian Academy. Member: Clay Club; Soc. of Gold. Awards: Prize, Springfield

(MA) Art League, 1937. Work: Memorial tablets, Toronto and Montreal, Canada; reliefs, Smith College; member panels, Eagle Brook School; University of Nebraska. Exhibited: Royal Canadian Academy, 1925, 26; National Gallery, Ottawa, 1927; Society of Independent Artists, 1942; AV, 1942; Audubon Artists, 1945; Clay Club, 1944 (one-man), 1945; Springfield Art League, 1937, 38; Whitney Museum of Art, 1949; Smith College, 1948-51; Pittsfield Art League, 1936; George Walter Vincent Smith Art Gallery, 1945 (one-man). Author, illustrator, *The Country Craft Book*, 1937; illustrated *The Golden Fleece of California*. Contributor to art magazines. Taught: Assistant Professor, Smith College, Northampton, MA, from 1940. Address in 1953, Bahamas.

JOHNSTON, ROBERT E.
Illustrator. Born in Toronto, Canada, Sept. 14, 1885. Pupil of Harvey Dunn; Walter Sickert in London. Member: Society of Illustrators; Arts and Letters Club of Toronto. Address in 1929, 490 Broad Ave., Leonia, NJ.

JOHNSTON, RUTH.
Painter, illustrator, writer, lecturer, and teacher. Born in Sparta, GA, April 26, 1864. Pupil of Cos, Beckwith, and Blum. Member: Baltimore Water Color Club; Art Students League of NY. Illustrator for magazines and children's calendars. Formerly instructor, Maryland Institute, Baltimore. Address in 1929, Pen Lucy, Catonsville, MD.

JOHNSTON, SCOTT.
Sculptor, painter, and illustrator. Born in Sac City, IA, December 5, 1903. Studied at Art Institute Chicago, with Alfonso Iannelli. Address in 1933, 224 East Ontario St., Chicago, Ill.

JOHNSTON, THOMAS.
Engraver. Born in Boston, MA, in 1708; died there May 8, 1767, and was buried in King's Chapel burying ground. *The Boston Evening Post* 1767 says: "Last Friday Morning, died here Mr. Thomas Johnston, Japanner, Painter and Engraver, after a short illness, being seized with an Apoplectic Fit a few days before." Johnston was a fairly good engraver of maps, buildings, book-plates, sheet music, etc., and he was also a heraldic painter. His plan of Boston, signed as "Engraven by Thos. Johnson, Boston, N.E.," is dedicated "to His Excellency William Burnet, by the publisher, William Burgis." He was also an organ builder of some reputation in his day. Among his eleven children were William and John, both portrait painters. His engravings are listed in Stauffer's and Fielding's books on American Engraving.

JOHNSTON, THOMAS MURPHY.
Portrait draughtsman in crayons and oils. Born in 1834. The latter part of his life he lived in Dorchester.

He was the son of David C. Johnston, and was working in Boston, MA, in 1856-1868.

JOHNSTON, WINANT P.
Sculptor, painter, and writer. Born in NYC, July 2, 1890. Pupil of Charles Grafly. Member: Independent Society of Sculptors. Address in 1926, Washington, DC.

JOHNSTON, YNEZ.
Painter and printmaker. Born in Berkeley, CA, on May 12, 1920. Studied: University of California at Berkeley. Awards: Guggenheim fellowship, 1952-53; Tiffany Foundation grant, 1955; Metropolitan Museum of Art, 1952. Collections: Santa Barbara Museum of Art; Metropolitan Museum of Art; City Art Museum of St. Louis; Los Angeles Museum of Art; Philbrook Art Center; University of Michigan; University of Illinois; Wadsworth Atheneum; Philadelphia Museum of Art; Whitney. Address in 1980, 579 Crane Blvd., Los Angeles, CA.

JOHNSTONE, JOHN HUMPHREYS.
Painter. Born in New York in 1857. Pupil of John La Farge in New York, and of Lefebvre and Doucet in Paris. His paintings are in the Luxembourg in Paris; Wilstach Gallery, Philadelphia; Carnegie Institute, Pittsburgh. Address in 1926, Paris, France.

JOHNSTONE, WILL.
Illustrator. Member: Society of Illustrators. Address in 1929, care of the Evening World, Pulitzer Bldg., New York, NY.

JOINER, HARVEY.
Painter. Born in Charlestown, IN, April 8, 1852. Self-taught. Member: Louisville Artists League. Specialty, Kentucky beechwoods. Address in 1929, 405 Equitable Bldg., Louisville, KY; h. Prather, IN.

JONAS, LOUIS PAUL.
Sculptor. Born in Budapest, Hungary, July 17, 1894. Studied with Carl E. Akeley. Work: "Indian Elephant Group," "The Last Stand," American Museum of Natural History; group in bronze, City of Denver, Colorado; Memorial Fountain for Humane Society, New Rochelle, NY. Member: New Rochelle Art Association of Museums; Museum Association of Great Association; New York Architectural League; American Britain. Address in 1933, 62 Flandreau Ave., New Rochelle, NY.

JONES, A. L.
Plates so signed are really engraved by W. S. Lawrence, an apprentice to Alfred Jones, and were finished by Mr. Jones. A further notice of Lawrence will be found in its proper place.

JONES, ALBERTUS EUGENE.
Painter and teacher. Born in South Windsor, CT, Oct. 31, 1882. Pupil of Charles Noel Flagg. Member:

Connecticut Academy of Fine Arts; Salma. Club; Paint and Clay Club. Award: Dunham prize, Connecticut Academy of Fine Arts, 1912 and 1927. Instructor of drawing and painting, Hartford Art Society School. Died in 1957. Address in 1929, South Windsor, CT.

JONES, ALFRED.
Engraver and painter. Born April 7, 1819, in Liverpool, England. Accidentally killed in New York, April 28, 1900. Mr. Jones came to the United States as a very young man and in 1834 he was apprenticed to the engraving firm of Rawdon, Wright, Hatch & Edson, of Albany, NY. He later studied at the National Academy of Design, in New York, and in 1839 he was awarded the first prize in drawing. Mr. Jones was made an Academician of the National Academy in 1851. About 1841 Alfred Jones began engraving over his own name, and in 1843 he engraved in line his first large plate, "The Farmers' Nooning," after the painting by W. S. Mount; this plate was executed for the American Art Union. As a line-engraver, Mr. Jones had few, if any, superiors in this country, and his large plate of "The Image Breaker," published by the American Art Union in 1850, is deservedly recognized as one of the best engravings ever produced in the United States. Among other fine examples of his work published by the Art Union are "Mexican News" (1851), "The New Scholar" (1850), and "The Capture of Major Andre." Mr. Jones continued to engrave with undiminished skill up to the time of his death, his late portraits of Washington, A. B. Durand and Thomas Carlyle being admirable examples of a combination of line work with etching.

JONES, ANTHONY W.
Sculptor and carver. Worked: New York City, 1818-61. Exhibited: Bust of General James Tallmadge, American Institute Fair, 1844. Died in 1868.

JONES, BAYARD.
Illustrator. Born in Rome, GA, in 1869. Pupil of Laurens and Constant in Paris. Address in 1926, 40 West 28th St., New York.

JONES, BENJAMIN.
Engraver. Located in Philadelphia in 1798-1815, inclusive. He engraved in line subject-plates possessing little merit, and Dunlap says that he was living in 1833.

JONES, CARMINTA DE SOLMS.
Painter. Exhibited in Penna. Academy of Fine Arts, Philadelphia, 1925. Address in 1926, 1822 Chestnut St., Philadelphia.

JONES, C(ORA) ELLIS.
Painter. Born in Aurora, IL, May 14, 1875. Pupil of Roderick Mackenzie and George Elmer Browne.

Member: Birmingham Art Club; Southern States Art League; Gloucester Society of Artists; American Federation of Arts. Works: "Mount Hood" and "The Pool," Library of Birmingham Southern College. Address in 1929, 2420 Arlington Ave., Birmingham, AL.

JONES, (CHARLES)
DEXTER (WEATHERBEE), III.
Sculptor and designer. Born in Ardmore, PA, December 17, 1926. Studied at Penna. Academy of Fine Arts, Philadelphia, 1947-49; Charles Rudy and Walker Hancock, 1951-52; Accademia della Belle Arti, Florence, Italy, 1955-56. Work at National Academy of Design; Woodmere Art Gallery; Penna. Academy of Fine Arts; Smithsonian Institution; others. Has exhibited at Penna. Academy of Fine Arts; National Academy of Design, NY; National Sculpture Society, NY; Philadelphia Museum of Art; Allied Artists of America, NY; Penna. Society of Architects; others. Received Helen Foster Barnett Prize, National Academy of Design; John Gregory Award, Therese and Edwin Richard Prize, Mrs. Louis Bennett Prize, all National Sculpture Society. Member: National Sculpture Society, fellow; American Institute of Architects; Allied Artists of America; National Arts Club; others. Works in bronze and stone. Address in 1982, Philadelphia, PA.

JONES, DOROTHY B.
Painter. Born April 27, 1908. Member: Connecticut Academy of Fine Arts. Awards: Prize, Springfield Art League, 1926; hon. mention, Connecticut Academy of Fine Arts, 1929. Address in 1929, 34 East 11th St., New York, NY; h. South Windsor, CT.

JONES, ELIZABETH A. B.
Sculptor and medalist. Born in Montclair, NJ, May 31, 1935. Studied at Vassar College, B.A., 1957; Art Students League, 1958-60; Scuola Arte Medaglia, The Mint, Rome, Italy, 1962-64; Academy Brasileira Belas Artes, Rio de Janeiro, honorary diploma, 1967. Works: Creighton University. Commissions: Portrait of Albert Schweitzer, Franklin Mint, PA, 1966; gold sculptures with precious stone, Government of Italy, 1968; portrait of Picasso, commissioned by Stefano Johnson, Milan, Italy, 1972; Gold Medal Award for Archeology, University Museum, University PA, 1972; Holy Year Jubilaeum; gold portrait medallion, Pope John Paul II, gift of State to the Pope by Italy, 1979; many others. Exhibited: Tiffany & Co., NY, Houston, Los Angeles, Chicago, and San Francisco, 1966-68; Montclair Art Museum, NJ, 1967; many international medallic art shows, Rome, Madrid, Paris, Athens, Prague, and Cologne; Smithsonian Institution and National Sculpture Society, NY, 1972; USIS Consulate, Rome, Italy, 1973. Awards: Outstanding Sculptor of the Year, American Numismatic Association, Colorado Springs, CO, 1972; Louis Bennet Award, National Sculpture

Society, 1978. Media: Wax, plaster, silver and gold. Address in 1982, Philadelphia, PA.

JONES, ELIZABETH SPARHAWK.
See Sparhawk-Jones, Elizabeth.

JONES, EMANUEL.
Painter. Born in Frankfurt, Germany. Worked: Charleston, SC, 1806-22. Died in 1822.

JONES, EMERY.
Carver of ship figureheads. Worked: Newcastle, South Freeport, ME, 1856-60. Sculpted figure of Samuel Skolfield, which is reproduced in Pinckney.

JONES, EUGENE ARTHUR.
Painter. Born in Brooklyn, NY. Pupil of J. H. Boston, Frederick J. Boston. Member: Brooklyn Society of Artists; Allied Artists of America; Salma. Club. Work: "Moonlight," Newark Museum, Newark, NJ; "Brooklyn Bridge Twilight," Fort Worth Art Museum, Fort Worth, TX. Address in 1929, 61 Poplar Ave., Brooklyn, NY.

JONES, FITZEDWARD.
This good engraver of subject-plates and portraits in mezzotint and in stipple was originally a printer in Carlisle, PA. It is not known where or when he learned to engrave, but in 1854 he was in business in Cincinnati, OH, as a "practical portrait, historical and landscape engraver, and Plain and color printer," according to his business-card. He also worked for many years for the Western Methodist Book Concern, of Cincinnati.

JONES, FRANCES DEVEREUX.
See Hall, Frances Devereux Jones.

JONES, FRANCIS C(OATES).
Painter and teacher. Born in Baltimore, MD, July 25, 1857. Pupil of Boulanger and Lefebvre at Ecole des Beaux-Arts in Paris. Member: Associate National Academy of Design, 1885; Academician National Academy of Design, 1894; Society of American Artists, 1882; American Water Color Society; NY Architectural League, 1888; Mural Painters; National Institute of Arts and Letters; National Arts Club; Artists' Aid Society; Century Association; Society of Illustrators; Lotos Club; Salma. Club; American Federation of Arts. Awards: Clarke prize, National Academy of Design, 1885; silver medal, Pan-Am. Expo., Buffalo, 1901; silver medal, St. Louis Expo., 1904; Isidor medal, National Academy of Design, 1913; silver medal, P.-P. Expo., San Francisco, 1915. Address in 1929, 33 West 67th St., New York, NY.

JONES, GLADYS MOON.
(Mrs. Harry LeRoy Jones). Sculptor and writer. Born in Colfax, IL, December 28, 1892; LL.B., Northwestern University, 1921; student at Corcoran School of Art, 1952-54; studied sculpture under Innocenti, in Florence, Italy; MFA, Catholic University of America, 1958. Admitted to Illinois bar, 1922; editorial staff of Science Service, 1927; Sunday Features for National Education Association, 1928; published five articles, *Ladies Home Journal*, 1928-29; founder of All States Publicity News Bureau, 1929; expert consultant Administration Export Control, 1941-42; information specialist, Bd. Econ. Warfare, 1942-44; analyst, Foreign Econ. Administration, 1944-45; sales representative, Woman's National News Service, 1946. Taught sculpture and ceramics, YWCA Adult Education Program, 1959-60. Exhibited in artists' group shows in Washington, Corcoran Area shows. Address in 1962, 1310 34th St.; studio, 3316 P St. Rear, Washington, DC.

JONES, GRACE CHURCH.
("Jonzi"). Painter and teacher. Born in West Falls, NY. Pupil of Colarossi Academy; Academie de la Grande Chaumiere in Paris; Art Students League of NY. Member: American Federation of Arts; Denver Art Museum. Address in 1929, 2295 E. Louisiana Ave., Denver, CO.

JONES, HOWARD W.
Sculptor. Born June 20, 1922, Ilion, NY. Studied: Toledo University; Syracuse University, BFA Cum Laude, 1948; Columbia University; Cranbrook. Work: Albright; Kansas City (Nelson); Milwaukee Art Institute; Aldrich; St. Louis Art Museum; Walker. Exhibited: Mitchell Gallery, Woodstock, NY; Fairmont Gallery, St. Louis, 1961; Kansas City (Nelson); The Howard Wise Galley, NYC; Worcester Art Museum; Walker and Milwaukee, Light, Motion, Space, 1967; Whitney Museum, Light: Object and Image, 1968; Jewish Museum, Superlimited, 1969; Aldrich, Boston and Newark Museum of Fine Arts, NJ, 1969 and 70; Wadsworth Atheneum; Forbes Foundation Museum, NJ. Awards: *Art in America* (Magazine), New Talent, 1966; Graham Foundation Fellowship and Grant, 1966-67; Syracuse University, Roswell S. Hill Prize; Syracuse University, four-year scholarship; National Endowment for the Arts Fellowship and Grant, 1977. Taught at Yale University, 1967; Washington University, St. Louis, from 1957. Rep. by Howard Wise Gallery, NYC. Address in 1980, St. Louis, MO.

JONES, HUGH BOLTON.
Painter. He was born in Baltimore in 1848 and began his art studies in that city. He went to France in the seventies, and became a member of the artist colony at Pont Aven, in Brittany. Many good pictures from his easel date from that period. Later on he travelled in Spain and in Northern Africa, but for ten or fifteen years he found all his subjects in the United States, whether in picturesque fields and forests of New Jersey, or along the Massachusetts coast. He was elected a National Academician in 1833, and became a member of the Society of American Artists, and the

American Water Color Society. Mr. Jones had a studio in New York, but, like many of our landscape painters, spent more months of the year in the country than in town. Address in 1926, 33 West 67th St., New York. Died in 1927.

JONES, JESSIE BARROWS.
Painter and craftsman. Born in Cleveland, OH, March 15, 1865. Pupil of Twachtman, Chase, Hitchcock. Member: Cleveland Art Association; Alumni Association Cleveland School of Art. Died in 1944. Address in 1929, 11896 Carlton Road, Cleveland, OH; 432 South Beach St., Daytona, FL.

JONES, KEITH.
Illustrator. Born in Cardiff, Wales, Jan. 10, 1950. Studied: Kingsway-Princeton College and Camden Arts Centre, London, 1974; Livingston College, Rutgers University, BA, 1982. Work: Jane Voorhees Zimmerli Art Museum & Old Queens Gallery; private collections in England, Germany, Greece, Italy, US, Wales. Exhibited: Society of Illustrators, NYC, 1981; Arts NW Gallery, Seattle, solo, 1981; 13th Annual International Exhibition, Louisiana Water Color Society, New Orleans, 1983; others in NJ, NY. Awards: Certificate of merit, Society of Illustrators, 1981; honorable mention, West '82 Art and the Law; Pres. Award for graphics, Knickerbocker Artists 32nd Annual. Address in 1983, 1050 George St., New Brunswick, NJ.

JONES, LEON FOSTER.
Painter. Born in Manchester, NH, Oct. 18, 1871. Pupil of Cowles Art School in Boston under Major and DeCamp. Member: Salma. Club; Artists' Fund Society. Award: Silver medal, P.-P. Expo., San Francisco, 1915. Represented in the Boston Museum of Fine Arts. Died in 1940. Address in 1929, Port Jefferson, LI, NY.

JONES, LOIS MAILOU.
(Mrs. V. Pierre-Noel). Painter. Born in Boston, MA, in 1906. Studied: Boston Normal Art School; Boston Museum of Fine Arts School; Columbia University; Designers Art School; Harvard University; Howard University, AB; Acad. Julien in Paris with Berges, Montezin, Adler, and Maury; Acad. Grand Chaumiere in Paris; Colorado State Christian College, Hon. PhD, 1973; Suffolk University, Boston, LHD, 1981. Awards: Fellowship, General Education Board, 1937-38; prizes, Boston Museum of Fine Arts School, 1926; National Museum, Washington, DC, 1940, 47, 54, 60, 64; Corcoran Gallery of Art, 1941, 49, 51; Atlanta University, 1942, 49, 52, 55, 60; Chevalier, National Order Merit of Honor, Haitian Government, 1955; Lubin award, 1958; Alumni Award, Howard University, 1978; others. Collections: Brooklyn Museum; Palais National, Haiti; Atlanta University; Howard University; West Virginia State College; Rosenwald Foundation; Retreat

for Foreign Missionaries, Washington, DC; Metropolitan Museum of Art; Hirshhorn Museum; Corcoran Gallery; others. Exhibited: Penna. Academy of Fine Arts; American Water Color Society; ACA Gallery; Grand Central Art Galleries; Corcoran; National Academy of Design; Trenton Museum, NJ; San Francisco Museum of Art; Baltimore Museum of Art; Salon Artistes Francais, Gran Palais Champs-Elysees, Paris; plus 50 one-man shows. Member: Artists Equity Association; Washington Water Color Society; Society of Washington Artists; fellow, Royal Society of Arts. Media: Oil, acrylic. Address in 1984, Washington, DC.

JONES, LOUIS E(DWARD).
Painter. Born in Rushville, PA, Mar. 7. 1878. Pupil of Penna. Academy of Fine Arts; Birge Harrison, John F. Carlson. Member: Fellowship Penna. Academy of Fine Arts; American Federation of Arts. Address in 1929, Woodstock, NY.

JONES, MARGUERITE M(IGNON).
Painter and illustrator. Born in Chicago, IL, Dec. 12, 1898. Pupil of Chicago Academy of Fine Arts. Member: Artists Guild of the Authors' League of America. Illustrated *The Brownie Twins in Pancake Town* by E. B. Neffies (Albert Whitman). Address in 1929, 1466 Pensacola Ave., Chicago, IL.

JONES, MARTHA M(ILES).
Painter, craftsman, and teacher. Born in Denison, IA, April 28, 1870. Pupil of Vanderpoel; and studied in Paris. Member: California Art Club; San Diego Artists Guild; Laguna Beach Art Association; La Jolla Art Club; California Society of Miniature Painters. Died in 1945. Address in 1929, 4380 Valle Vista, San Diego, CA.

JONES, NANCY C(HRISTINE).
Painter and teacher. Born in Providence, RI, May 7, 1888. Pupil of RI School of Design, Charles Hawthorne, Harry Leith-Ross and Fontainebleau School of Fine Arts, Paris. Member: Providence Art Club; Providence Water Color Club; American Federation of Arts. Address in 1929, Diamond Hill, Manville, RI.

JONES, NELL CHOATE.
Painter. Born in Hawkinsville, GA. Pupil of Fred J. Boston, John Carlson, Ralph Johonnot; Gorguet. Member: Brooklyn Society of Artists; National Association of Women Painters and Sculptors; Southern States Art League; Catherine Lorillard Wolfe Art Club. Represented in High Museum, Atlanta, GA, and Fort Worth Art Museum, Fort Worth, TX. Address in 1929, 61 Poplar St., Brooklyn, NY; summer, Woodstock, NY.

JONES, PAUL.
Painter. Born in Harrodsburg, KY, June 9, 1860. Pupil of Flameng, Courtois, Laurens, and others in

Paris. Member: Cincinnati Art Club (president); Duveneck Society; Cincinnati MacDowell Club. Author of "Marco Polo" and librettist of Grand Opera, "Paoletta." Specialty, portraits. Address in 1929, 2611 Essex Place, Cincinnati, OH.

JONES, R. S.
A line-engraver working in Boston in 1873.

JONES, ROBERT.
Illustrator. Born in Los Angeles, CA, in 1926. Attended the University of Southern California and Art Center College of Design. He had practical training as an animator at Warner Brothers Studios before coming to NY in 1952 to join Charles E. Cooper Studio with whom he was associated for 12 years. Many magazines have published his work, most notably *The Saturday Evening Post*, and among his many advertising clients is Exxon Corporation, for whom he developed the Exxon Tiger as their symbol. A member of the Society of Illustrators for 20 years, he was awarded a Gold Medal from their 1967 Annual Exhibition.

JONES, S. K.
Born in Clinton, CT, in Feb., 1825. After 1861 he painted in New Haven, his specialty being portraits.

JONES, SETH C.
Painter, illustrator, and teacher. Born in Rochester, NY, July 15, 1853. Pupil of Wm. H. Holmes and Thomas Moran. Member: Rochester Art Club; Picture Painters Club; Municipal Art Com.; Chicago Artists Guild. Address in 1929, Municipal Bldg.; h. 137 Frost Ave., Rochester, NY; summer, Linden, NY.

JONES, SUSAN.
Painter, illustrator, and teacher. Born in Philadelphia, PA, Dec. 12, 1897. Pupil of Penna. Academy of Fine Arts. Member: Fellowship, Penna. Academy of Fine Arts. Work: Portrait covers for "Mary," "Marge," and "Michael" by Nelia Gardner White; still-life illustrations for "Wearever Aluminums" catalogue. Address in 1929, 3845 North Park Ave., Philadelphia, PA.

JONES, THOMAS.
Painter. Exhibited at the Penna. Academy, Philadelphia, in 1924. Address in 1926, 5113 Chester Ave., Philadelphia, PA.

JONES, THOMAS DOW.
Sculptor and medallionist. Born December 11, 1811, in Oneida Co., NY. Little is known of him except from letters written by him in October and November, 1857, to Honorable Lewis Cass and Capt. Meigs. The letters refer to a bust of the Honorable Lewis Cass executed nine years previous to this time. They also refer to a bust of Honorable John C. Brecken-

ridge, on which Jones was then engaged, and to the fact that he himself was a western sculptor. Moved to Ohio in 1830's. Worked in Cincinnati as stonemason; 1842, began sculpting portrait busts. In November, 1857, he resided in Cincinnati, OH. Also worked in Boston, NYC, Detroit, and Nashville. He was elected an Associate Member of the National Academy in 1853. Best known works include bust of Lincoln, 1861; Salmon P. Chase, 1876. Died in Columbus, OH, February 27, 1881.

JONES, THOMAS HUDSON.
Sculptor. Born in Buffalo, NY, July 24, 1892. Studied: Albright Art Gallery; Carnegie Institute; Boston Museum Fine Art School; American Academy, Rome, Italy. Award: Prix-de-Rome, 1919-22. Work: "Gen. U. S. Grant," Hall of Fame, NY; portrait figure, "Dr. Moore," park in Rochester, NY; medal, Columbia University, NY; Skinner Memorial Relief, Holyoke, MA; Munger Relief, Birmingham, AL; figure, "Christ," St. Matthews Church, Washington, DC; Eno Memorial, Trinity College, Hartford, CT; Trowbridge Portrait, American Academy, Rome, Italy; William Rutherford Mead Portrait, NYC; Meldrum Memorial Relief, Library, Houston, TX; Morton Memorial, Burlington, Wisconsin; awarded sculpture for Tomb of Unknown Soldier, Arlington National Cemetery. Executed many medals including: World War II; The Freedom Medal; Women's Army Corps; For Humane Service (German Airlift); and others. Taught: Instructor of Sculpture, Albright Art Gallery; Columbia University. Address in 1970, Washington, DC.

JONES, WILLIAM FOSTER.
Born 1815 in Pennsylvania. An American portrait and historical painter working in Philadelphia about 1850. He also painted miniatures, several being signed and dated 1847-1849, and worked in crayon.

JONES, WILLIAM R.
Engraver of portraits in the stipple manner. Born in the United States. He first appears in Philadelphia in 1810, when he was an Associate of the Society of Artists of the United States, organized in Philadelphia in that year. As an engraver his name appears in the directories of Philadelphia in 1811-24, inclusive.

JONGERS, ALPHONSE.
Portrait painter. Born in France, Nov. 17, 1872. Pupil of École des Beaux-Arts under Delaunay and Gustave Moreau; studied two years in Spain. Came to US in 1897. Member: Society of American Artists, NY, 1905; Associate National Academy of Design, 1906; Lotos Club. Awards: Silver medal, St. Louis Expo., 1904; third class medal, Paris Salon, 1909. Work: "William T. Evans," National Gallery, Washington, DC; "Louise" and "Arthur H. Hearn," Metropolitan Museum, New York, NY. Died Oct. 2, 1945.

JONNIAUX, ALFRED.
Painter. Born in Brussels, Belgium; US citizen. Studied: Acad. Beaux Arts, Brussels; Calvin Coolidge College of Liberal Arts. Work: de Young Memorial Museum, San Francisco; Palais des Beaux Arts, Brussels; Royal Society Portrait Painters, London; US Capitol, Washington; Brandeis University; plus others. Exhibitions: Smithsonian Institution Invitational; Royal Academy, London; Kennedy Galleries, NYC; and others. Address in 1976, 712 Bay Street, San Francisco, CA.

JONSON, C. RAYMOND.
See Jonson, Raymond.

JONSON, JAMES.
Illustrator. Born in St. Louis, MO, in 1928. Attended Washington University and the Jepson Art School of Los Angeles. His first work appeared in *Westways* in 1948 and he has since won awards from the Los Angeles Art Directors' Club, the Society of Illustrators, and First Prize at the National Art Museum of Sport Competition. He has illustrated several sports books and many magazines, including *Look*, *The Saturday Evening Post*, *Seventeen*, *Playboy*, *Boys' Life*, *Ski* and *Sports Illustrated*. His works are in the collections of Circle Galleries, Ltd. Currently he is producing lithographics at the American Atelier.

JONSON, JON MAGNUS.
Sculptor. Born in Upham, ND, December 18, 1893. Studied with Albin Polasek and Lorado Taft. Work: Sculpture for International House, Chicago. Award: Garden sculpture prize, Hoosier Salon, 1931. Address in 1933, Frankfort, IN.

JONSON, RAYMOND.
Painter. Born in Chariton, IA, July 18, 1891. Pupil of W. J. Reynolds and B. J. O. Nordfeldt. Member; MacDowell Colony. Work: "The Bur Reed," a decoration, City of Chicago; "Irony," University of Oklahoma, Norman; "Mountain Vista," Mississippi Art Association, Jackson, MS; "The Temple," Milwaukee Art Institute; "Earth Rhythms No. 1," Corona Mundi, New York; "Light," Museum of Mexico, Santa Fe. Address in 1929, Camino Atalaya, Sante Fe, NM.

JOPLING, FREDERIC WAISTEL.
Sculptor, painter, illustrator, and etcher. Born in Kensington, London, England, April 23, 1860. Studied at Art Students League of New York; pupil of Walter Shirlaw; Sartain; Penfold; Chase. Member: Print Makers' Society of California. Represented in the National Gallery of Canada at Ottawa. Address in 1926, The Men's Hotel, Buffalo, NY.

JORDAN, DAVID W(ILSON).
Landscape painter. Born in Harrisburg, PA, June 2, 1859. Pupil of Penna. Academy of Fine Arts under Schussele and Eakins. Member: Philadelphia Sketch Club; Fellowship Penna. Academy of Fine Arts. Address in 1929, 43 West 87th St., New York, NY.

JORDAN, FREDD ELMER.
Sculptor and craftsman. Born in Bedford, IN, November 25, 1884. Award: Prize ($200), Hoosier Salon, Chicago, 1928. Address in 1934, 559 Hendrie Street, Detroit, MI.

JORDAN, HENRY.
Born in England. Came to the United States about 1836, and was for a time in the employ of Alfred Jones, in New York City. Jordan was good line-engraver of landscape, and was later a member of the engraving firm of Jordan & Halpin. He returned to England for a time, but ultimately settled in the United States.

JORDAN, MILDRED C.
Miniature painter. Born in Portland, ME. Pupil of Yale School of Fine Arts. Member: New Haven Paint and Clay Club. Address in 1926, 129 Whalley Ave., New Haven, CT.

JORGENSEN, JORGEN.
Sculptor, painter, and etcher. Born in Denmark, December 6, 1871. Member: American Artists' Professional League; Society of Independent Artists; Newark Outdoor Sketch Club. Etchings in the Newark Museum. Address in 1933, 10 Fernwood Road, Maplewood, NJ.

JOSEPH, ADELYN L.
Sculptor, painter, craftsman, and writer. Born in Chicago, June 16, 1895. Pupil of Mulligan, Grafly, and Polasek. Member: Chicago Society of Artists; Society of Women Sculptors; Chicago Artists' Guild. Address in 1928, 1311 East 53rd Street, Chicago, IL.

JOSEPH, JOAN A.
Sculptor. Pupil of Mulligan, Crunelle, and Polasek. Member: Chicago Society of Artists; Society of Independent Artists. Exhibited "The Art Student" at the Academy of Fine Arts, Philadelphia, 1924. Address in 1926, 4320 Drexel Boulevard, Chicago, IL; Green Lake, WI.

JOSEPHI, (ISAAC).
Miniature painter and landscape painter. Born in New York. Pupil of Art Students League of NY; Bonnat in Paris. Member: American Society of Miniature Painters; American Water Color Society; Royal Society of Miniature Painters, London; Lotos Club. Awards: Hon. mention, Paris Expo., 1900; silver medal, Charleston Expo., 1902. Address in 1929, 924 West End Ave.; 2178 Broadway, New York, NY.

JOSEPHS, WALTER W.
Painter. Born in Philadelphia, PA, Feb. 11, 1887. Pupil of Penna. Academy of Fine Arts; Daniel

Garber. Member: Philadelphia Art Club. Address in 1929, 200 South 15th St., Philadelphia, PA.

JOSHI, SATISH.
Painter. Born in India on Feb. 28, 1944. He emigrated to US in 1969. Studied at New Delhi College of Art, India. In collections of Pratt Institute; Whitney, NYC; CBS; Lalitkela Academy of India; others. Exhibited at galleries in India, 1966, 1967, 1968; Columbia Univ., NYC, 1975; Gallery One, NYC, 1975; Silvermine Guild, 1977; Bronx Museum of Arts, NY, 1981; Phoenix Gallery, NYC, 1982; Cygnus Gallery, San Diego, CA, 1983; many other group and solo shows. Received Royal Drawing Society of London special achievement award, 1963. Teaches at Riverdale (NY) Country School. Lives and works in NYC. Represented by The Phoenix Gallery, NYC; Corporate Art Source, Chicago; Cygnus Gallery, San Diego.

JOSIMOVICH, GEORGE M.
Painter. Born in Mitrovica, Srem, Yugoslavia, May 3, 1894. Pupil of Art Institute of Chicago; George Bellows, Randall Davy. Member: Chicago Society of Artists; No-Jury Society of Artists; Society of Independent Artists. Address in 1929, 1460 East 57th St.; h. 5509 Everett Ave., Chicago, IL.

JOSLYN, FLORENCE BROWN.
Painter and illustrator. Pupil of John Carlson. Member: Association of Oklahoma Artists. Address in 1929, 628 West 9th St., Oklahoma City, OK.

JOSSET, RAOUL (JEAN).
Sculptor. Born in Tours, France, December 9, 1900. Studied with Injalbert and Bourdelle. Work: Fifteen war memorials in France; "Colossal Christ of Jussy," Aisne, France; two Indians carved on pylons, George Rogers Clark Memorial, Vincennes, IN; at Century of Progress Exposition, Chicago, Ill., figure of executive over main entrance and four bas-reliefs inside Federal Building, three statues and finial on Agricultural Building. Awards: Medals, Salon of Paris, 1922 and 1923. Address in 1953, 139 West 54th Street, NYC. Died in 1957.

JOUETT, MATTHEW HARRIS.
Portrait painter. Born in Mercer County, KY, Apr. 22, 1787; died in Lexington KY, Aug. 10, 1827. After studying with Gilbert Stuart in Boston, he returned to Lexington, KY, and there painted many portraits. He also worked in Natchez, Louisville, and New Orleans. About 350 portraits have been recorded as painted by him. He is represented in the Metropolitan Museum of New York by his portrait of John Grimes.

JOULLIN, AMEDEE.
Painter. Born in San Francisco on June 13, 1862. Studied there and in France. Her specialty was Indian pictures. She is represented in many galleries in California. She died in San Francisco on Feb. 3, 1917.

JOULLIN, LUCILE.
See Benjamin, Lucile Jullin.

JOURDAIN, JEAN.
(Dorothy Jean Jordan). Painter. Born in New London, CN, May 13, 1912. Study: Art Students League, NYC, under Oscar Van Young, Francis de Erdley, Leonard Edmondson. Work: Represented in numerous collections in the US, Canada, Europe. One-woman shows: Pasadena Art Museum; Occidental College; Palos Verdes Art Association; Cowie Gallery, Los Angeles; Amerson Gallery, Tucson, AZ; and many others. Exhibited: National Gallery of Canada, Ottawa; Museum of Modern Art, NYC; Metropolitan Museum of Art, NYC; Honolulu Academy of Arts, HI; Toronto Museum of Art, Canada; Cleveland Museum of Art; Marion Koogler McNay Museum, San Antonio, TX; de Young Museum, San Francisco, CA; Palace of Legion of Arts, San Francisco; San Diego Museum; Santa Barbara Museum; and many others. Awards: Pasadena Art Museum; Los Angeles County Museum; California State Fair; Laguna Festival of Arts; California Watercolor Society. Member: Pasadena Society of Artists; California Water Color Society; board of Pasadena Art Museum. Address in 1983, 3726 Canyon Crest Road, Altadena, CA.

JOUVENAL, JACQUES.
Sculptor-portraits. Born in Germany, March 18, 1829. Worked: NYC, 1853-55; Washington, 1855-1905. Work held: US Capitol. Died in Washington, March 8, 1905.

JU, I-HSIUNG.
Painter and educator. Born in Kiangsu, China, Sept. 15, 1923. Studied: National University of Amoy, China; University of Santo Tomas, Manila. Work: Philippine Cultural Center, Manila; National Museum of History, Taipei, Taiwan; International Center, University of Connecticut; DuPont Art Gallery, Washington & Lee University; and others. Commissions: Gulf States Paper Co., Tuscaloosa, AL; many more. Exhibitions: Asian Arts Festival, University of Philippines; 10th Japan Nan-ga-in Exhibition, Tokyo, Kyoto, and Osaka Museum; National Painting & Calligraphy Exhibition, National Gallery, Taipei; etc. Awards: South-East Asia Art Exhibit; Chinese Artists' League; Art Educator of the Year, Taiwan; Contributor to the Arts award, National Museum of History, Taipei; etc. Teaching: University of Virginia and Washington & Lee University, 1969 to present; plus others. Member: Virginia Museum of Fine Arts; College Art Association of America. Media: Ink, acrylic, watercolor. Address in 1982, Washington & Lee University, Lexington, VA.

JUDKINS, MISS E. M.
Portrait artist in crayons, who worked in New England about 1847.

JUDSON, ALICE.
Painter. Born in Beacon, NY. Pupil of Art Students League of NY and J. H. Twachtman. Member: National Association of Women Painters and Sculptors; Eclectics; Pittsburgh Art Association; North Shore Art Association; Gloucester Society of Artists; Plastic Club; Pen and Brush Club; Washington Water Color Club; American Artists Professional League. Award: Russell Memorial Prize, Pittsburgh Art Association. Work: Over mantle decoration, Administration Building, Matteawan State Hospital, Beacon, NY; "The Day's Done," Pittsburgh Friends of Art. Died April 3, 1948. Address in 1929, 58 West 57th St., New York, NY; h. 9 Leonard St., Beacon, NY.

JUDSON, ALMIRA.
Painter. Born in Milwaukee, WI. Pupil of Woman's Academy, Munich; Colarossi and Garrido Studios in Paris; Henri in New York. Member: San Francisco Society of Women Artists. Address in 1929, 123 Edgewood Ave., San Francisco, CA; summer, Los Gatos, CA.

JUDSON, MINNIE LEE.
Landscape painter. Born in Milford, CT, Oct. 20, 1865. Pupil of Yale School of Fine Arts. Member: Connecticut Academy of Fine Arts; New Haven Paint and Clay Club; American Federation of Arts. Died in 1939. Address in 1929, Main St., Stratford, CT.

JUDSON, SYLVIA SHAW.
Sculptor. Born in Chicago, IL, June 30, 1897. Studied at Art Institute of Chicago with Albin Polasek; Grande Chaumiere, Paris, France, with Antoine Bourdelle. Works: Art Institute of Chicago; National Academy of Design; Philadelphia Museum of Art; Springfield Museum of Art; Davenport, Iowa; Dayton Art Institute. Awards: Art Institute of Chicago, 1929; Carr prize, 1947; International Sculpture Show, Philadelphia, 1949; Municipal Art League, 1957; Lake Forest College, 1952; Chicago Chapter of American Institute of Architects, 1956; Garden Clubs of America, 1956. Exhibited: Art Institute of Chicago, 1938; Arden Gallery, NYC, 1940 and the Sculpture Center, NYC, 1957; International Sculpture Exhibition, Philadelphia Museum; American Shows, Art Institute of Chicago, Museum of Modern Art, NYC, and the Whitney Museum of American Art, NY. Also taught sculpture at the American University, Cairo, Egypt, 1963; Vice President of the women's board for the Art Institute of Chicago, 1953-54. Address in 1976, Lake Forest, IL. Died in 1978.

JUDSON, WILLIAM LEES.
Painter. Born in Manchester, England, in 1842. Came to America in 1852. Pupil of J. B. Irving in New York, and of Boulanger and Lefebvre in Paris. Address in 1926, 212 Thorne St., Los Angeles, CA. Died in 1928.

JUENGLING, FREDERICK.
Engraver and painter. Born in New York City in 1846. He studied art there and attained high rank as an engraver. He was a founder of the American Society of Wood-Engravers. He received honorable mention at the Paris Salon. Among his works are "The Professor," engraved after Duveneck, and "The Voice of the Sea." His paintings include "The Intruder," "Westward Bound," and "In the Street." He died in 1889.

JUERGENS, ALFRED.
Painter. Born in Chicago, August 5, 1866. Pupil of Chicago Academy of Design; Munich Royal Academy, under Gysis and Diez. Member: Chicago Society of Artists; Munich Artists Association; Artists Association of Germany; Soc. Inter. des Beaux-Arts. Awards: Silver medal, Madrid and Munich; Cahn prize ($100), Art Institute of Chicago, 1914; bronze medal, P.-P. Expo., San Francisco, 1915; William Randolph Hearst $300 prize, Art Institute of Chicago; Business Men's Art Club Prize ($200), Art Institute of Chicago, 1923. Work: "John the Baptist at the River Jordan" and "Suffer Little Children to Come Unto Me," St. Paul's Church, Chicago; "November Afternoon," Cliff Dwellers Club, Chicago; "Afternoon in May," Municipal Gallery, Art Institute, Chicago, 1913; "Lilac Time," Union League Club, Chicago; "A Lilac Bush," Clark Gallery, Grand Rapids, MI; "Field Flowers," Women's City Club; "The Lilac," West End Woman's City Club, Chicago, IL; "A Ravine in Winter," Oak Park Club, IL. Address in 1929, 213 South Grove Ave., Oak Park, IL.

JULIO, E. B. D. FABRINO.
Painter. Born on the Island of St. Helena, of an Italian father and a Scotch mother, in 1843. He died in Georgia in 1879. Specialty, portraits, genre and landscape. Julio came to the United States in 1861, and to New Orleans in the latter part of the 60's, where he resided the greater part of the time during the remainder of his life, except the year 1872, which he spent in Paris as a student of Leon Bonnat. His "Diana," "Harvest Scene," and several Louisiana landscapes were exhibited at the Centennial at Philadelphia in 1876.

JULIUS, OSCAR H.
Painter. Member: Salma. Club; American Water Color Society; Allied Artists of America. Address in 1929, 67 West 87th St., New York, NY.

JULIUS, VICTOR.

Painter, illustrator, and teacher. Born in Boston, MA, July 26, 1882. Pupil of National Academy of Design, Art Students League of NY. Member: NY Water Color Club; Salma. Club; Artists Fellowship. Address in 1929, 67 West 87th St., New York, NY; Malvern, LI, NY. Died before 1940.

JUNGE, CARL S(TEPHEN).

Painter and illustrator. Born in Stockton, CA, June 5, 1880. Pupil of Hopkins Art Institute, San Francisco; Chicago Art Institute; School of Art in London; Julian Academy in Paris. Member: Chicago Allied Artists of America; Oak Park and River Forest Artists Guild; Chicago Writers Guild. Awards: Prizes, 1916, 1917, 1922, and 1925 from American Bookplate Society; 1926 from the Bookplate Association International. Author and illustrator of *Book-plates*; author and designer of *Junge Decorators*. Represented in Library of Congress, Washington; Museum of Fine Arts, Boston; Metropolitan Museum of Art; British Museum. Address in 1929, 143 South Harvey Ave., Oak Park, IL.

JUNGWIRTH, LEONARD D.

Sculptor, etcher, and lecturer. Born in Detroit, Michigan, October 18, 1903. Studied: University of Detroit, Bachelor of Arch. Eng.; Wayne University, MFA, and in Germany. Member: Michigan Academy School of Arts and Letters. Work: Detroit Institute of Art; Kalamazoo Institute of Art; Richard Memorial, Detroit; Grosse Pointe (Michigan) Church; reliefs, Michigan State College, Grand Haven (Michigan) High School; St. Thomas Aquinas Chapel, East Lansing, Michigan. Exhibited: Detroit Institute of Art, annually; Flint Institute of Art, 1951. Lectures on Techniques of Sculpture. Taught: Instructor, Wayne University, 1936-40; Associate Professor, Michigan State College, East Lansing, Michigan, from 1940. Address in 1953, East Lansing, Michigan. Died in 1964.

JUNJEL & BARRET.

Marble and stone partners in sculpture. Worked: New Orleans, 1850-51. The team was Barthol Junjel and Anthony Barret.

JUNKIN, MARION MONTAGUE (MR.).

Sculptor, painter, and etcher. Born Chungju, Korea, August 23, 1905. Studied: Washington and Lee University, BA, 1927; Art Students League, 1927-30; and with Randolph Johnston, George Luks, George Bridgman, Edward McCarten. Awards: Prize, Virginia Museum of Fine Arts, 1946; Butler Institute of American Art, 1946; Richmond Academy of Fine Arts; others. Work: Virginia Museum of Fine Arts; IBM. Exhibited: Art Institute of Chicago; Penna. Academy of Fine Arts, 1933; Corcoran Gallery of Art, 1935; Virginia Museum of Fine Arts, 1942, 44; Carnegie Institute; Whitney Museum of American Art; World's Fair, New York, 1939; IBM; Pepsi-Cola, 1946; Butler Institute of American Art, 1946; Tennessee annual exhibition. Taught: Professor, Head of Art Department, Vanderbilt University, Nashville, Tenn., 1941-46. Died 1977.

JURECKA, CYRIL.

Sculptor. Born in Moravia, Czechoslovakia on July 4, 1884. Pupil of Academy of Fine Arts, Prague. Member: California Art Club. Died in 1960. Address in 1934, Claremont, CA.

JUSTICE, JOSEPH.

Engraver. In 1804 Justice was working in New York in connection with Scoles, and the directories of Philadelphia locate him in that city as an engraver from 1810 until 1833. His plates show an ineffective combination of etchings and stipple work, poorly done.

JUSTICE, MARTIN.

Illustrator and painter. Member: Society of Illustrators, 1911. Address in 1929, 945 Orange St., Los Angeles, CA; 1832 Ivar Ave., Hollywood, CA.

JUSTIS, LYLE.

Illustrator. Born in Manchester, VA, in 1892. He was considered a master of pen and ink despite his lack of formal art training. His first published works were sheet music illustrations which led to assignments from major magazines and several advertising clients. Among his best known illustrations were those done for the Grosset and Dunlap 1930 edition of Robert Louis Stevenson's *Treasure Island*. Noted for his historical drawings, he was a member of the Sketch Club and Pen and Pencil Club. Died in 1960.

JUSZKO, JEAN (or JENO).

Sculptor. Born in Ungvar, Hungary, November 26, 1880. He studied at the National School of Ceramics in Hungary and Ecole des Beaux-Arts, Paris. Member: National Sculpture Society; Salma. Club; American Numismatic Society; New York Architectural League. Work: Monument of Archbishop Samy, Santa Fe, NM. Exhibited at National Sculpture Society, 1923; "Portrait Bust," at the Annual Exhibition of the National Academy of Design, New York, 1925. Address in 1935, NYC. Died in 1954.

K

KACERE, JOHN.
Painter. Born on June 23, 1920 in Walker, Iowa. Earned B.F.A. and M.F.A. from State University of Iowa. Taught at University of Manitoba; University of Florida; Cooper Union; Parsons; and University of New Mexico. Exhibited at Labriskie Gallery, Allan Stone Gallery (both NYC); Museum of Modern Art; Corcoran; Yale; University of Colorado; Walker Art Center; Museum of Contemporary Art, Chicago; Byron Gallery, NYC. In collections of Yale; Mt. Holyoke College; Wadsworth; Brandeis University; and Stedelijk Museum, Amsterdam.

KAELIN, CHARLES SALIS.
Painter. Born in Cincinnati, OH in 1858. Pupil of Cincinnati Art School; Art Students League of New York; Cincinnati Museum Association. Exhibited at Paris Exposition, 1900. Member: Society Western Artists; Cincinnati Art Club. Address in 1926, Rockport, MA.

KAESELAU, CHARLES ANTON.
Painter. Born in Stockholm, Sweden, June 25, 1889. Pupil of Charles W. Hawthorne. Member: American Scandinavian Foundation; Provincetown Art Association. Work: "Mother and Child," Zachau Gallery, Uddevalla, Sweden; "Ice Floes," Provincetown Art Museum. Address in 1929, Court St.; h. 530 Commercial St., Provincetown, MA.

KAGY, SHEFFIELD HAROLD.
Painter, sculptor, and educator. Primarily painter. Born in Cleveland, OH, October 22, 1907. Studied at Cleveland School of Art; Corcoran School of Art; John Huntington Polytechnic Institute, Cleveland; and with Henry Keller, Paul Travis, Oley Nordmark, Ernest Fiene, others. Member: Artists Guild of Washington; Society of Washington Artists; Landscape Club, Washington, DC; Washington Printmakers. Awards: Prizes, White Sulphur Springs, WV, 1936; Cleveland Museum of Art, 1933, 35; medal, Washington Landscape Club, 1950. Work: Murals, US Post Office, Walterboro, SC; Luray, VA; map, Presidential Yacht "Williamsburg." Exhibited: Art Institute of Chicago, 1934; Whitney Museum of American Art; Penna. Academy of Fine Arts; PMG; American Federation of Arts; National Museum, Washington, DC; Cleveland Museum of Art; Corcoran Gallery of Art; Palm Beach Art Center; Norfolk Museum of Art; New York World's Fair, 1939; Golden Gate Exposition, 1939. Position: Instructor, National School of Art, Washington, DC, 1946-56. Address in 1982, Washington, DC.

KAHAN, SOL B.
Sculptor. Born in Zitomir, Russia, December 23, 1886. Studied at Art Students League, with Robert Laurent. Exhibited: National Academy of Design; Whitney Museum of American Art; College Art Association of America; Brooklyn Museum; Architectural League. Address in 1953, 1717 Bryant Ave., Bronx, NY.

KAHILL, JOSEPH B.
Portrait painter. Born in Alexandria, Egypt, May 15, 1882. Pupil of Charles L. Fox, Richard Miller, Collin and Prinet in Paris. Member: American Art Association of Paris; Painters and Sculptors Association of Portland. Represented in Walker Art Gallery of Bowdoin College and the Sweat Memorial Museum, Portland, ME. Died in 1957. Address in 1929, 562 Congress St.; h. 2 Crescent St., Portland, ME.

KAHILL, VICTOR.
Sculptor. Exhibited "A Study" at the Penna. Academy of Fine Arts, Philadelphia, 1924. Member: Penna. Academy of Fine Arts. Address in 1926, 3610 Spring Garden St., Philadelphia, PA.

KAHLE, JULIE.
Painter. Member: National Association of Women Painters and Sculptors; American Society of Miniature Painters; Pennsylvania Society of Miniature Painters. Address in 1929, 325 West End Ave., New York, NY. Died in 1937.

KAHLER, CARL.
Painter. Exhibited at Philadelphia, 1921, Academy of Fine Arts, exhibition of "Paintings Showing the Later Tendencies in Art." Address in 1926, 49 West 8th St., New York City.

KAHN, ISAAC.
Sculptor and painter. Born in Cincinnati, August 16, 1882. Pupil of Duveneck and Lindsay. Member: Cincinnati Art Club; Ceramic Society. Address in 1929, 4609 Eastern Avenue; h. 327 Kemper Lane Apts., Cincinnati, Ohio.

KAIN, FRANCIS.
Sculptor and marble cutter. Born c. 1786. Worked: NYC, 1811-39. Died in Eastchester, NY, 1844.

KAIN, JAMES.
Sculptor and marble cutter. Worked: NYC, 1827-38; New Orleans, 1829, 1832. Died in NYC, 1838.

KAINZ, LUISE.
Sculptor, etcher, engraver, and teacher. Born in NYC, May 3, 1902. Studied at Teachers College, Columbia University; Munich Academy of Fine and Applied Arts. Exhibited: Weyhe Gallery; National Arts Club; Brooklyn Society of Etchers; Dudensing Gallery. Contributor to *Design* magazine. Position: Chairman of the Art Department, Bay Ridge High School, Brooklyn, NY. Address in 1953, 208 East 15th St., NYC.

KAINZ, MARTIN.
Painter and etcher. Born in Dachau, Bavaria, Germany, May 7, 1899. Pupil of Munich Academy. Member: New Rochelle Art Association. Address in 1929, 1071 Clay Ave., Pelham Manor, NY.

KAISER, AUGUST.
Painter, illustrator and etcher. Born in Germany in 1889. Address in 1926, 11 East 35th St., New York.

KAISER, CHARLES.
Illustrator. Member: Society of Illustrators; Artists Guild of the Authors' League of America, NY. Address in 1929, 119 East 34th St., New York, NY; 175 Beechwood Ave., Mt. Vernon, NY.

KAISH, MORTON.
Painter. Born January 8, 1927, in Newark, NJ. Earned B.F.A. from Syracuse; studies at Chaumiere, Paris and Institute d'Arte, Florence. Taught at Everson Museum of Art, Syracuse; Dartmouth; and Columbia. Received H. T. Leavenworth award at Syracuse, 1949; also received awards from Everson, 1950; and American Printmakers, 1962. Exhibited at Staempfli Gallery, 1964; Museum of Modern Art; Art Institute of Chicago, 1964; University of Nebraska; New School for Social Research; Whitney; and American Institute of Arts & Letters (multiple). In collections of Syracuse; Philadelphia Print Club; Brooklyn Museum; and private collections.

KAJIWARA, TAKUMA.
Painter. Born in Japan, Nov. 15, 1876. Member: St. Louis Artists Guild; 2 x 4 Society, St. Louis; American Federation of Arts. Award: First portrait prize, St. Louis Artists Guild, 1922; Carl Weimar prize, St. Louis Artists Guild, 1924; silver medal, Kansas City Art League, 1926; Mallinckrodt portrait prize, 1926; Baldwin portrait prize, 1928. Exhibited at Penna. Academy of Fine Arts, 1925. Died in 1960. Address in 1929, 750 Century Bldg.; h. Jefferson Hotel, St. Louis, MO.

KALB, MARTY JOEL.
Painter. Born in Brooklyn, NY, April 13, 1941. Study: Michigan State University; Yale University; University of California, Berkeley. Work: Speed Museum, Louisville, KY; Ohio Wesleyan; University of Massachusetts. Exhibited: Columbus (OH) Gallery

of Fine Art Invitational; Canton (OH) Art Institute; others. Awards: Ohio Arts Council Grant. Teaching: Ohio Wesleyan University, 1967 to present. Member: College Art Association of America. Medium: Acrylic. Dealer: Allan Stone Gallery, NYC. Address in 1982, 165 Griswold St., Delaware, OH.

KALDENBERG, FREDERICK ROBERT.
Sculptor. Born in New York in 1855. Self-taught in art. Took up carving in meerschaum at ten years of age, and at fourteen commenced ivory carving, being the first native American to do this work. Some of his productions were in the possession of the late Russian Emperor, the King of Belgium and the Presidents of Venezuela and Mexico, and among the relics of General U. S. Grant; also in the gallery of George W. Vanderbilt, the Smithsonian Institution, and the palace of Li Hung Chang, etc. Member of National Sculpture Society; New York Architectural League; New York Society of Craftsmen. Awarded bronze medal, American Institute, 1869; gold medal, Cincinnati, 1884. Died in NYC, October, 1923.

KALISH, MAX.
Sculptor. Born in Poland, March 1, 1891. Pupil of Matzen, Adams, Calder, Injalbert. Member: American Federation of Arts; National Academy (Associate); National Sculpture Society. Awards: First prize for sculpture, Cleveland Museum of Art, 1924 and 1925. Work: "Laborer at Rest" and "Torso," Cleveland Museum of Art; also represented in Amherst College, MA; National Gallery, Washington, DC; Newark, NJ, Museum. Died in 1945.

KALLEM, HERBERT.
Sculptor. Born in Philadelphia, PA, November 14, 1909. Studied at National Academy of Design; Pratt Institute; Hans Hofmann School of Fine Arts. Work in Whitney Museum of American Art, NY; Wadsworth Atheneum, Hartford, CT; Chrysler Museum, Provincetown, MA; others. Has exhibited at Whitney Museum of American Art; Carnegie Institute; others. Member of Sculptors Guild; Audubon Artists. Taught at School of Visual Arts and NY University, sculpture. Address in 1982, 45 W. 28th St., NYC.

KALLEM, MORRIS J.
Painter. Exhibited portraits at Annual Exhibition, 1925, National Academy of Design, New York. Address in 1926, 1916 Grand Concourse, New York.

KALLMAN, KERMAH.
Sculptor. Born in Sweden, April 11, 1905. Studied with Aaron Goodelman, Saul Berman. Member: Audubon Artists; New York Society of Women Artists; National Association of Women Artists; Artists Equity Association. Exhibited: Am-British Art Center; Riverside Museum; National Academy of Design; ACA Gallery; Bonestell Gallery; Peikin Gallery; Chappellier Gallery; Norlyst Gallery; Na-

tional Arts Club; Argent Gallery; American Academy of Arts and Letters; Contemporary Art Gallery; DeMotte Gallery; Laurel Gallery; Penna. Academy of Fine Arts, 1947, 49, 52. Position: Director, New York Society of Women Artists, NYC, 1943, 50-51. Address in 1953, 161 East 88th St., NYC.

KALLOS, ARPAD.
Painter. Born in Hungary, Sept. 9, 1882. Pupil of Edward Ballo and Julius Benczur. Member: Society of Hungarian Artists; Cleveland Society of Artists. Awards: Prize for nude, 1916, and Countess Nadanyl prize, 1917, at the Hungarian National Exhibition. Work: "Nude in Violet" and "Nude in Red," Hungarian Andrassy Museum, Budapest; "Briedermeyer," owned by the former Hapsburg Dynasty of Austria-Hungary.

KALTENBACH, LUCILE.
Painter, illustrator and writer. Born in Durban, South Africa. Pupil of Art Institute of Chicago; John Norton; Allen St. John; Andre L'hote in Paris. Member: Alumni Art Institute of Chicago; Art Students League of Chicago. Award: Municipal Art League prize, Art Students League of Chicago, 1927; Rogers Park Woman's Club prize, Art Institute of Chicago, 1928. Specialty, water color painting. Address in 1929, 4101 Grace St., Chicago, IL.

KAMENSKY, THEODORE.
Sculptor. Born in St. Petersburg, Russia, 1836. Pupil of St. Petersburg Academy. Came to US in 1872. Member: St. Petersburg Academy of Fine Arts, 1863. Awards: Medals at London International Exposition and Vienna Exposition. Work: Crowning statue and two reliefs for Capitol, Topeka, KS; "The Little Sculptor" and "The Widow and Child," St. Petersburg Academy. Address in 1913, Clearwater, FL. Died in Florida, 1913.

KAMMERER, HERBERT LEWIS.
Sculptor. Born in NYC, July 11, 1915. Studied at Yale University, B.F.A.; American Academy in Rome; National Academy of Design; Art Students League; apprentice to Charles Keck and C. Paul Jennewein; assistant to Paul Manship. Member: National Sculpture Society; American Academy in Rome. Work: Medals, memorial tablets and portraits of prominent persons. Exhibited: National Academy of Design, 1942, 49, 51, 52; Penna. Academy of Fine Arts, 1941, 47-49, and from 52; Palazzio Venezia, Rome, 1950, 51; and many more. Awards: George D. Widener Gold Medal, Penna. Academy of Design Annual, 1948; Prix d'Rome, American Academy Rome, 1949; Grant in Sculpture, National Institute of Arts and Letters, 1952, Fulbright, 1949-51. Professor of sculpture, SUNY, New Paltz, NY, from 1962. Address in 1982, New Paltz, NY.

KAMP, GLINTEN.
Painter. Exhibited water colors at the Penna. Academy of Fine Arts, 1925. Address in 1926, 19 East 16th St., New York City.

KAMPF, MELISSA Q.
Painter and teacher. Born in Philadelphia, May 1, 1867. Pupil of Chase, Poore, Carolus Duran. Member: Society of Independent Artists; Norfolk Society of Artists. Award: Gold medal, Norfolk Society of Artists, 1922. Address in 1929, 722 Virginia Ave., Norfolk, VA; summer, Chenango Lake, South New Berlin, NY.

KANE, JOHN.
Painter. Born in 1860 in Scotland. Emigrated to US with parents in 1871, settling in Pittsburgh. Worked in coal mines since the age of 9 and at numerous other laboring jobs with the railroad and steel mills. Lost a leg in a train mishap in 1891. As a result, he took up his childhood passion of painting. Untrained artist. Painted pictures for pleasure, painted railroad cars, portraits on beaverboard. Did portraiture for working class people in Pittsburgh, PA. At age 67, 1927, 1st exhibit at Carnegie Institute's Pittsburgh International. His most famous work is entitled "Self-Portrait," painted in 1929. Medium: Oil.

KANE, MARGARET BRASSLER.
Sculptor. Born in East Orange, NJ, May 25, 1909. Studied: Syracuse University; Art Students League; and with John Hovannes. Awards: National Association of Women Artists, 1942, 1951; New York Architectural League, 1944. Exhibited at Art Institute of Chicago; Metropolitan Museum; Whitney; Pennsylvania Academy of Fine Arts; others. Collections: US Maritime Commission; Limited Editions Lamp Company. Address in 1982, Cos Cob, CT.

KANTOR, MORRIS.
Painter. Born in Russia, April 15, 1896. Arrived in US in 1911. Studied and taught at Art Students League. Pupil of Homer Boss. Member: Society of Independent Artists. Represented at the Art Institute of Chicago; Metropolitan Museum of Art; Museum of Modern Art; and the Detroit Institute of Art. Address in 1929, 1947 Broadway, New York, NY. Died in 1974.

KAPLAN, MURIEL.
Sculptor. Work includes "Paul Mocsanyi," terra cotta, exhibited at 94th Annual Exhibition of National Association of Women Artists, NYC, 1983. Member: National Association of Women Artists. Address in 1983, Palm Beach, FL.

KAPPEL, PHILIP.
Painter, illustrator and etcher. Born in Hartford, CT, Feb. 10, 1901. Pupil of Pratt Institute; Philip Little.

Member: North Shore Art Association; Marblehead Art Association; Chicago Society of Etchers; Mac Dowell Club of NY; American Federation of Arts. Awards: First prize, Marblehead Art Association, 1925; Bijur prize, Brooklyn Society of Etchers, Brooklyn Museum, 1926. Illustrated: The Story of Man's Work, and Lord Timothy Dexter (Minton Balch & Co.). Represented in "Fine Prints of the Year," 1926 and 1927; and Bibliotheque Nationale, Paris. Address in 1929, 500 Fifth Ave., New York, NY; summer, care of Philip Little, Salem, MA.

KAPPEL, R. ROSE.
(Mrs. Irving Gould). Painter. Born in Hartford, CT, in 1910. Studied: Pratt Institute Art School; NY University; Harvard University; Fordham University; Washington University. Award: National Academy of Design, 1956. Collections: Library of Congress; Gloucester Art Association; Boston Museum of Fine Arts; Cleveland Museum of Art; Fogg Museum of Art; Culture & Health School, Brooklyn. Address in 1980, 35-36 76th St., Jackson Heights, NY.

KAPPES, KARL.
Painter and teacher. Born in Zanesville, Ohio, May 28, 1861. Pupil of William M. Chase in New York; Benjamin Constant in Paris; Carl Marr in Munich. Member: Scarab Club; American Federation of Arts. Died in 1943. Address in 1929, 410 Monroe St., Toledo, Ohio; summer, Liberty Center, Ohio.

KAPPES, WALTER.
Painter of Black American life.

KARASZ, ILONKA.
Painter, illustrator, craftsman, and teacher. Born in Budapest, July 13, 1896. Studied at Royal School of Arts and Crafts, Budapest. Member: American Union Dec. Artists. Address in 1929, 140 East 34th St., New York, NY; summer, Brewster, NY.

KARAWINA, ERICA.
(Mrs. Sidney C. Hsiao). Sculptor, painter, stained glass artist, designer, and lithographer. Born in Wittenberg, Germany, January 25, 1904. Studied in France and with Charles J. Connick, Frederick W. Allen. Work: Addison Gallery of American Art; Los Angeles Museum of Art; Biro-Bidjan Museum, Russia; Museum of Modern Art; Les Archives International de la Danse, Paris, France; Metropolitan Museum of Art; Boston Museum of Fine Arts; Worcester Museum of Art; stained glass in churches in San Francisco, CA; Denver, CO; Chicago, IL; Cincinnati, OH; New York, NY; Paris, France. Exhibited: Boston Art Club; Society of Independent Artists, Boston; Penna. Academy of Fine Arts; Rockefeller Center, NY, 1937; New York World's Fair, 1939; Oklahoma Art Center; Grand Rapids Art Gallery, 1940. One-man exhibitions include Grace Horne Gallery, Boston; University of New Hampshire, Durham, NH, 1937; Lancaster (PA) Art Club, 1937; Wadsworth Atheneum, 1938; Texas State College, 1939. Commissions: Crux Gemmata (glass in concrete), Manoa Valley Church, Honolulu, HI, 1967; six windows of sculptured glass, St. Anthony's Church, Oahu, HI, 1968; translucent glass mosaic murals, Hawaii State Office Bldg., Honolulu, HI, 1975; others. Address in 1982, Honolulu, HI.

KARCHIN, STEVE.
Illustrator. Born in Brooklyn, NY, in 1953. Attended Pratt Institute from 1971 to 1974 where he studied under Jerry Contreras and David Byrd. His first work appeared in *Guideposts* in 1974. Selected for every Annual Exhibition of the Society of Illustrators since 1973, his editorial illustrations have been published in *Redbook*, *American Way* and *Guideposts* and he has done several covers for Avon.

KARFIOL, BERNARD.
Painter. Born May 6, 1886 in Brooklyn NY. Awards: Hon. Mention, Pan-American Expo., Los Angeles, 1925; hon. mention, International Exhibition, Carnegie Institute, Pittsburgh, 1927; W. A. Clark first prize and Corcoran gold medal, 1928, Washington, DC. Represented in Corcoran Gallery and Phillips Memorial Gallery, Washington, DC, and Newark Museum, Newark, NJ. Author of many non-fiction books, including *Wilderness: A Journal of Quiet Adventure in Alaska*, and *Greenland Journal*. Elected hon. member of U.S.S.R. Academy of Art. Died Aug. 16, 1952. Address in 1929, 136 West 77th St., New York, NY; summer, Ogunquit, ME.

KARFUNKLE, DAVID.
Sculptor, painter, and etcher. Born in Austria, June 10, 1880. Pupil of National Academy of Design, New York, with Francis Jones, Edgar Ward; Royal Academy, Munich, Germany; and with Bourdelle, in Paris. Work: Newark Museum; Cleveland Museum of Art; murals, Grace Church, Jamaica, Long Island, New York. Exhibited: Carnegie Institute; Penna. Academy of Fine Arts; Art Institute of Chicago; National Academy of Design; others abroad. Address in 1953, 20 East 14th Street, New York City.

KARL, MABEL FAIRFAX (SMITH) (MRS.).
Sculptor, etcher, and blockprinter. Born in Glendale, Oregon, June 27, 1901. Studied with Leo Lentelli, Joseph Pennel, George Bridgman, and Archibald Dawson. Work: "Fawn," drypoint, Fine Arts Gallery, San Diego, California; California Trophy, sculpture, US Marines, San Diego; "Woodrow Wilson" and "Memorial," bronze reliefs, Wilson Memorial High School, San Diego. Awards: Honorable mention for sculpture, Museum of Fine Arts, Houston,

1932; honorable mention for sculpture, Fine Arts Gallery, San Diego, 1933. Member: Art Students League of New York; Artists Guild; Fine Arts Society, San Diego; American Federation of Arts. Address in 1933, 4119 Voltaire Ave., Ocean Beach, CA; 1207 Willard St., Houston, TX.

KARLIN, EUGENE.
Illustrator. Born in Kenosha, Wisconsin in 1918. He received scholarships from the Chicago Professional School of Art, Art Institute of Chicago and Art Students League. He is presently a teacher at the Society of Visual Arts and has won numerous awards from the Art Directors' Club, Art Institute of Chicago, Society of Illustrators and American Institute of Graphics Arts. He has illustrated for all the major magazines and done extensive book illustration for such publishing houses as Macmillan, Golden Press, Random House, Houghton Mifflin, Bantam, and many others.

KARST, JOHN.
Wood engraver. Born in Germany in 1836; died in De Bruce, NY, in 1922, having lived his entire professional life in this country.

KASE, PAUL G(EORGE).
Painter and craftsman. Born in Reading, PA, Nov. 4, 1896. Pupil of Breckenridge and Penna. Academy of Fine Arts. Member: Fellowship Penna. Academy of Fine Arts; American Federation of Arts. Work: "Rocks, Bluff Point," Reading Museum of Art.

KASSOY, HORTENSE.
Sculptor and painter. Born in Brooklyn, NY, on February 14, 1917. Studied: Pratt Institute; Columbia University; University of Colorado; Columbia University Teachers College, with Oronzio Maldarelli, B.S. and M.A.; American Artists School, with Chaim Gross. She was awarded a prize at Painter's Day at the New York World's Fair; sculpture award, American Society of Contemporary Artists. Exhibitions: Toledo Museum, Ohio, 1947; ACA Gallery, 1940, 1954; National Academy of Design; Brooklyn Museum, 1974; Lincoln Center, 1975; International Sculpture Exhibition, Forte dei Marmi, Italy, 1976, and Pietrasanta, Italy, 1976; others. Member of Artists Equity; others. Media: Wood, marble, batik, watercolor. Address in 1982, 130 Gale Place, Bronx, New York.

KASTEL, ROGER K.
Illustrator. Born in White Plains, NY, in 1931. Attended the Art Students League and Frank Reilly School of Art for six years. His first published work appeared in 1962 for Pocket Books at which time he was also free-lancing for advertising agencies. Included among the many paperback covers which he has illustrated is the much publicized *Jaws*, published by Bantam. His works have been exhibited at the Salmagundi Club and the Grand Central Gallery in New York.

KAT, WILLIAM.
Painter and etcher. Born in Holland, April 27, 1891. Pupil of School van Kunstnyverheid, Holland. Member: American Water Color Society (associate); American Federation of Arts. Work: "Peat Ships," Oberlin College, Oberlin, Ohio. Address in 1929, 89 Seaman Ave., New York, NY.

KATCHAMAKOFF, ATANAS.
Sculptor, painter, and craftsman. Born in Leskovetz, Bulgaria, January 18, 1898. Studied at the Academy of Fine Arts, in Sofia, Bulgaria, in 1919 and 1920; first prize for statue, "Grief," International Sculpture Exhibition, Berlin, Germany, 1920; first prize for "Egyptian Thought," International Sculpture Exhibition, Venice, Italy, 1921; first prize, "Madonna and Child," California State Fair, 1929; first prize ($1,500), for "Indian Woman with Papoose," Art Alliance of America, 1931; prize, 13th annual Los Angeles Exhibition, 1932. Address in 1933, Palm Springs, California.

KATES, HERBERT S.
Illustrator and etcher. Born in New York City, Jan. 12, 1894. Member: Society of Illustrators. Works: Illustration for *Harper's Magazine, Arts and Decoration, The Sketch Book Magazine*, etc. Address in 1929, 48 West 48th St., New York, NY; h. 33 Halcyon Terrace, New Rochelle, NY.

KATO, KENTARO.
Painter. Born in Japan in 1889. Won second Hallgarten prize, National Academy of Design, 1920. Address in 1926, 680 Fifth Avenue, New York, NY.

KATOAKA, GENJIRO.
Painter. Born in Japan in 1867. Came to America and studied with Twachtman in New York. Member of New York Water Color Club. Address in 1926, Tokyo, Japan.

KATZ, EUNICE.
Sculptor and painter. Born in Denver, CO, January 29, 1914. Studied at Art Students League, with Harry Sternberg; Sculpture Center, with Dorothea Denslow; also with Angelo di Benedetto, Frederick Taubes, Donald Pierce, and Edgar Britton. Works: US State Department Art for Embassies Program, Washington, DC; Temple Emanuel Collections, Denver, CO; Hillel House, Boulder; Children's Hospital, Pittsburgh, PA; four figure sculpture (bronze), Beth Israel Hospital, 1970; others. Exhibitions include Allied Artists of America, National Academy, 1949-66; National Society of Painters and Sculptors, NJ, 1964; one-woman shows, Pietrantonio Gallery, NY, 1965; others. Awards: Award of Merit, Rocky

Mountain Liturgical Arts, 1958; Patron's Award, Art Museum New Mexico Biennial, 1966; First Place Award, American Association of University Women, 1966. Media: Bronze and Oil. Address in 1982, Denver, CO.

KATZ, HILDA.
(Hilda Weber). Painter. Born June 2, 1909. Studied: National Academy of Design; New School for Social Research. She is also a graphic artist. Awards: National Association of Women Artists, 1945, 1947; Mississippi Art Association, 1947; Society of American Graphic Artists, 1950. Collections: Library of Congress; Baltimore Museum of Art; Fogg Museum of Art; Santa Barbara Museum of Art; Colorado Springs Fine Arts Center; Society of American Graphic Artists; Pennell Collection; Syracuse University; California State Library; NY Public Library; Addison Gallery of American Art; Newark Public Library; Pennsylvania State Teachers College; Springfield, Missouri, Art Museum; Pennsylvania State University; Metropolitan Museum of Art; Bezalel Museum, Israel. Address in 1980, 915 West End Ave., New York, NY.

KATZ, MORRIS.
Painter. Born in Poland, March 5, 1932. Studied: Ulm, West Germany and Gunsburg; with Hans Facler; Art Students League. Work: Evansville Museum of Arts & Science, Indiana; Butler Institute of American Art, Youngstown, Ohio; St. Lawrence University Art Center, Canton, NY; and many more. Exhibitions: Instant Art Shows worldwide. Member: American Guild of Variety Artists; International Platform Association; Artists Equity Association; International Arts Guild, Monaco. Technique: Instant art — use of palette knife with tissue paper and liberally applied paint. Media: Oil, pencil. Address in 1982, 406 6th Avenue, New York, NY.

KATZEN, LILA PELL.
Sculptor and educator. Born in NYC. Studied: The Art Students League, NYC; Cooper Union, NY; also with Hans Hofmann, NYC, and Provincetown, MA. Awards: Goodyear Fellow, Foxcroft School, Virginia; Creative Arts Award, The American Association of University Women; Corcoran Gallery of Art, Washington, DC, 1959; Fellowship, Tiffany Foundation, 1964. In collections of Smithsonian; Everson, Syracuse, NY; National Gallery of Art, Washington, DC; others. Exhibited: Biennial of Contemporary Painting and Sculpture, Whitney Museum of Art, NYC, 1973; Baltimore Museum, 1975; Fordham University, Lincoln Center, 1978; University of North Carolina, Chapel Hill, 1979; Metropolitan Museum Art Center, Coral Gables, Florida, 1980; others. Taught: Maryland Institute College of Art, from 1962. Media: Steel and other metals, concrete. Address in 1982, 345 Broadway, New York, NY.

KATZIEFF, JULIUS D.
Painter and etcher. Born in 1892. Pupil of Boston Museum of Art and Penna. Academy of Fine Arts. Address in 1926, 126 Dartmouth St., Boston, MA.

KAUBA, CARL.
Sculptor. Born in Vienna, Austria, in 1865. Studied at Vienna academies under Carl Waschmann, Stefan Schwartz. Although he probably never visited U.S., collectors rank him in a class with Remington and Russell as one of the great portrayers of American Western subjects. Executed his detailed, small to medium size bronzes in Vienna studio from photos, illustrations and artifacts sent from US. Work exported to US, 1895-1912; not fully appreciated until 1950's. In Harmsen Collection of American Western Art. Died in 1922.

KAUFFMAN, (CAMILLE) ANDRENE.
Painter, sculptor, and educator. Born in Chicago, IL, April 19, 1905. Studied at Art Institute of Chicago, B.F.A.; University of Chicago, M.F.A.; and with Andre L'Hote. Member: Chicago Society of Artists; American Association of University Professors. Awards: European scholarship, Art Institute of Chicago, 1926. Work: Murals and sculptures, public building; murals, US Post Office, Ida Grove, Iowa; medal, Rockford (IL) College; mural, Science Building, Rockford College. Exhibited: Art Institute of Chicago, annually; Whitney Museum of American Art, 1934; Brooklyn Museum, 1934; Chicago Society of Artists, 1926-46. Position: Instructor, Art Institute of Chicago, Chicago, IL, 1927-67, chairman, division of fine arts, 1963-66, emeritus professor, from 1967; professor, Rockford (IL) College, from 1943. Address in 1982, Elmhurst, IL.

KAUFFMANN, ROBERT C.
Painter and illustrator. Born in Chicago, Jan. 23, 1893. Pupil of Art Institute of Chicago. Member: Artists Guild of the Authors' League of America, NY. Address in 1929, 2 West 67th St., New York, NY.

KAUFMAN, JEAN FRANCOIS.
Sculptor, painter, etcher, and writer. Born in Uznach, Switzerland, October 31, 1870. Naturalized citizen of the United States. Pupil of Gerome, Ecole Nationale des Beaux-Arts, Paris. Award: Hon. mention, Paris Salon, 1927. Works: "Portrait Hon. Asa Bird Gardner," War Department, Washington, DC; decorations in Monumental Church, Richmond, VA; monumental bronze bust, Poughkeepsie, NY. Address in 1929, 94 West Houston St., New York, NY.

KAUFMAN, THEODORE.
Painter. Born in Nelson, Hanover, in 1814. He studied abroad, and returning to this country fought in the National Army during the Civil War. Subsequently he resided in Boston. His works include

"Genl. Sherman near the Watchfire," "On to Liberty," "Farragut in the Rigging."

KAUFMANN, FERDINAND.
Painter. Born in Oberhausen, Germany, Oct. 17, 1864. Pupil of Laurens, Constant and Bouguereau in Paris. Member: American Art Association of Paris; Pittsburgh Art Association; North Shore Art Association. Address in 1929, 9 Wood St., Pittsburgh, PA.

KAULA, LEE LUFKIN.
(Mrs. W. J. Kaula). Painter. Born in Erie, PA. Pupil of C. M. Dewey in New York; Aman-Jean in Paris. Member: National Association of Women Painters and Sculptors. Award: Honorable mention, Connecticut Academy of Fine Arts, 1925. Address in 1929, 311 Fenway Studios, 30 Ipswich St., Boston, MA; summer, New Ipswich, NH.

KAULA, WILLIAM J(URIAN).
Landscape painter. Born in Boston, MA, 1871. Pupil of Normal Art School and Cowles Art School in Boston; Collin in Paris. Member: Boston Art Club; NY Water Color Club; American Art Association of Paris; Boston Water Color Club; Guild of Boston Artists; Boston Society of Water Color Painters. Awards: Bronze medal, P.-P. Expo., San Francisco, 1915; hon. mention, Buffalo Society of Artists, 1924; hon. mention, Connecticut Academy of Fine Arts, 1924. Address in 1929, 311 Fenway Studios, 30 Ipswich St., Boston, MA.

KAVANAUGH, KATHARINE.
See Cahill, Katharine Kavanaugh.

KAVANAUGH, MARION.
See Wachtel, Marion Kavanaugh.

KAWACHI, J(OSEPH) B(UNZO).
Painter and craftsman. Born June 26, 1885, in Toyoaka Tajima, Japan. Studied in Japan. Member: Society of Independent Artists. Address in 1926, 170 Fifth Ave., New York, NY.

KAWAMURA, GOZO.
Sculptor. Born in Japan, August 15, 1886. Pupil of MacMonnies; studied in Paris at Ecole des Beaux-Arts; also studied in studios of Kitson in Boston, Remington in NY, A. A. Weinman, J. E. Fraser, and others. Member: American Numismatic Artists. Work: Memorial tablet of World War I, American Jersey Cattle Club; "Portrait of Prince Katcho," Japanese Imperial Family; ideal type of cow and bull for Holstein-Friesian Association of America, to be placed in every college of agriculture in the United States. Exhibited at National Sculpture Society, 1923. Address in 1933, 96 Fifth Avenue; 5 West 16th Street, NYC. Died in 1950.

KAY, GERTRUDE A(LICE).
Illustrator. Born in Alliance, Ohio, July 8, 1884. Pupil of Howard Pyle. Member: Artists Guild of the Authors' League of America, NY; Plastic Club; National Arts Club; National Association of Women Painters and Sculptors. Illustrations for *Ladies' Home Journal*, etc., and juvenile books. Address in 1929, 133 South Union Ave., Alliance, Ohio. Died in 1939.

KAY-SCOTT, CYRIL.
Painter and teacher. Born in Westport, MO, Jan. 3, 1879. Pupil of Colarossi Academy, Paris. Director, School of Painting, El Paso, and Summer School of Painting, Santa Fe. Address in 1929, 1429 East Yandell Blvd.; h. 801 Austin St., El Paso, TX; summer, 415 San Francisco St., Santa Fe, NM.

KAYE, ELIZABETH GUTMAN.
Painter. Born in Baltimore, MD, in 1887. Pupil of S. Edwin Whiteman, Hugh Breckenridge and H. B. Snell. Address in 1926, 856 Park Ave., Baltimore, MD.

KAZ, NATHANIEL.
Sculptor. Born in NYC, March 9, 1917. Studied at the Art Students League with George Bridgeman, Samuel Cashwan, William Zorach. Work: "Danse Espagnole" (bronze), 1955; in collections of Brooklyn Museum; Whitney; Metropolitan Museum of Art; others. Exhibited: Downtown Gallery, NYC, 1939; Chicago Art Institute, 1937, 38; New York World's Fair, 1939; Penna. Academy of the Fine Arts, Philadelphia, 1953; Whitney Museum of American Art, NY; American Museum of Natural History, NY; Sculptors Guild Exhibition, 1954; Metropolitan Museum; others. Member: Sculptors Guild; The Woodstock Society of Artists; the Brooklyn Society of Artists; others. Awards: First prize, Detroit Art Institute, 1929. Address in 1983, 160 West 73 Street, NYC.

KEANE, THEODORE J.
Painter. Born in San Franciso in 1880. Pupil of California School of Design and Art Institute of Chicago. Member: Palette and Chisel Club; Chicago Society of Artists; Cliff Dwellers; National Arts Club; Attic Club of Minneapolis. Specialty: Animal etchings. Formerly director of Minneapolis Society of Fine Arts and dean of School of the Chicago Art Institute. Address in 1929, 220 South Michigan Ave., Chicago, IL.

KEARFOTT, ROBERT RYLAND.
Sculptor, painter, and illustrator. Born in Martinsville, VA, December 12, 1890. Studied at University of Virginia, B.A.; Art Students League; and with Bridgman, Miller, Hawthorne. Member: Salma. Club; Artists Guild; Studio Guild. Work: Cover designs, advertising illustrations for national magazines. Address in 1953, Mamaroneck, NY.

KEARL, STANLEY BRANDON.
Sculptor. Born December 23, 1913, in Waterbury, CT. Studied: Yale University, 1941, BFA, 1942, MFA; State University of Iowa, 1948, Ph.D.; also studied in Rome. Work: Marbach Galerie; University of Minnesota; Rome (Nazionale); Stockholm (National); Sweden (Goteborg). Exhibited: L'Obelisco, Rome, 1950; Galerie d'Art Moderne, Basel, 1951; Samlaren Gallery, Stockholm, 1951; Marbach Galerie, Berne, 1952; Beaux Arts Gallery, London, 1956; Galleria Selecta, Rome, 1957; Obelisk Gallery, Washington, DC, 1958; Wakefield Gallery, NYC, 1961; D'Arcy Gallery, NYC, 1962; Grand Central Moderns, NYC, 1965, 68; XXVI Venice Biennial, 1952; Penna. Academy of Fine Arts; Museum of Modern Art; Whitney Museum Annual, 1962; Hudson River Museum, Yonkers, NY. Awards: Fulbright Exchange Professor to Rome University, Italy, 1949-50; Institute of Contemporary Arts, Florence, Italy, 1952; Connecticut Academy Sculpture Prize, 1959; Silvermine Guild Association Annual award, 1967. Taught: Pratt Institute, 1967. Address in 1982, Scarsdale, NY.

KEARNEY, FRANCIS.
Engraver. Born in Perth Amboy, NJ, about 1780. Kearney is said to have been a nephew of Commodore James Lawrence, and Westcott, in his *History of Philadelphia*, says that he learned drawing with Archibald and Alexander Robertson, and engraving with Peter R. Maverick, in New York City. Kearney was in business in New York in 1798-1801, as an engraver. In 1810 he appeared in Philadelphia and remained there continuously until 1833. Kearney founded his fame as an engraver upon a faithful copy of "The Last Supper," after Raphael Morghen. He did considerable work in line, stipple, and aquatint for the magazines, *Annuals*, and book publishers, and in 1820-23 he was interested in bank-note work as a member of the firm of Tanner, Vallance, Kearney & Co., of Philadelphia.

KEARNEY, JOHN (W.).
Sculptor and art administrator. Born in Omaha, NE, August 31, 1924. Studied at Cranbrook Academy of Art, Bloomfield Hills, MI, 1945-48; University Stranieri, Perugia. Work in Norfolk Art Museum, VA; Edwin A. Ulrich Museum of Art, Wichita, KS; others. Has exhibited at Corcoran Biennial, Washington, DC; Painting and Sculpture Today, John Herron Museum, Indianapolis; ACA Galleries Biennial, NY; Art Institute of Chicago; Ulrich Museum, KS; and others. Received Fulbright Award, 1963-64; others. Works in bronze and steel. Address in 1982, Chicago, IL.

KEARNS, JAMES JOSEPH.
Sculptor and painter. Born in Scranton, PA, August 7, 1924. Studied at Art Institute of Chicago, B.F.A, 1951. Work in Museum of Modern Art; Whitney Museum of American Art, NY; National Collection of Fine Arts, Smithsonian Institution; others. Has exhibited at National Institute of Arts and Letters; Whitney Museum of American Art Annual; Penna. Academy of Fine Arts; others. Received National Institute of Arts and Letters Grant. Teaching at School of Visual Arts, from 1960, drawing, painting, and sculpture. Works in bronze and fiberglas. Address in 1982, Dover, NJ.

KEASBEY, HENRY T(URNER).
Painter. Born in Philadelphia, PA, Sept. 23, 1882. Pupil of Herkomer, Brangwyn, Swan, Talmage. Member: North Shore Art Association. Address in 1929, Hotel Chelsea, West 23rd St., New York, NY; summer, 6 Lookout Court, Marblehead, MA.

KEAST, SUSETTE SCHULTZ.
(Mrs. Susette S. Keast). Painter. Born in Philadelphia in 1892. Pupil of Breckenridge, Anshutz and Chase. Member of Fellowship of Penna. Academy of Fine Arts. Address in 1926, 1928 Rittenhouse Square, Philadelphia.

KEATS, EZRA JACK.
Illustrator. Born in Brooklyn, NY, in 1916. He had no formal art training, yet in 1948 his first illustration appeared in *Collier's*. A well-known children's book illustrator, he received the Horn Book Award from the *Boston Globe* and two Caldecott Awards. The five UNICEF cards he contributed in 1965 raised $500,000 for medical aid for needy children. All of his manuscripts and illustrations are owned by Harvard University.

KECK, CHARLES.
Sculptor. Born in NYC, September 9, 1875. Pupil of National Academy of Design; Art Students League of New York; Philip Martiny; Augustus Saint-Gaudens; American Academy in Rome; studied further in Greece, Florence, and Paris. Member: Associate, National Academy of Design; National Sculpture Society, 1906; New York Architectural League, 1909; Numismatic Society; Allied Artists of America; American Federation of Arts; Alumni Association, American Academy in Rome. Award: Rinehart Scholarship to Rome, 1901-05; gold medal, Architectural League of New York, 1926. Work: "Stonewall Jackson," Charlottesville, VA; "Booker T. Washington," Tuskegee, AL; George Washington Monument, Palermo Park, Buenos Aires; Sloane Tablet, Robert College, Constantinople; Lewis and Clark Monument, Charlottesville, VA; Citizen Soldier, Irvington, NJ; Mohammed Statue, Institute of Arts and Sciences, Brooklyn, NY; Soldiers' Memorial, Brooklyn; "George F. Johnson," Binghamton, NY; "George Rogers Clark," Springfield, OH; Liberty Monument, Ticonderoga, NY; Memorial Tablet and Friendship Panel, Yale University Club, NYC; Soldiers' Memorial, Harrisonburg, VA; War

Memorial, Montclair, NJ; Columbia University, pylons, NYC; Wrenn Tablet—Tennis Champion, Forest Hills Stadium, LI; Mitchell Monument, Scranton, PA; Pittsburgh Soldiers' Monument, Pittsburgh; Swope Memorial, Kansas City, MO; Soldiers' Monument, Lynchburg, VA; Souvenir Gold Dollar, San Francisco Exposition; Souvenir Half Dollar, Sesqui-Centennial Exposition, and United States Steamship "Maine" Memorial Tablets, for United States Government; sculpture on the New York State Education Building, Albany, NY; Manchester Bridge, Pittsburgh; Pittsburgh City Hall; Wilmington City Hall; Oakland City Hall; busts of Patrick Henry, James Madison, Hall of Fame, NY; statue of Lincoln, Wabash, IN. Address in 1933, 40 W. 10th Street, NYC. Died in 1951.

KEEFER, ELIZABETH E.
Etcher and teacher. Born in Houston, TX, Nov. 4, 1899. Pupil of Art Institute of Chicago; Joseph Pennell. Member: Art Students League of Chicago; Art Students League of NY; Pen and Brush Club, NY. Address in 1929, Avenue D; h. Avenue C, Alpine, TX.

KEELER, CHARLES BUTLER.
Painter and etcher. Born in Cedar Rapids, IA, April 2, 1882. Pupil of Art Institute of Chicago; Johansen Stevens. Member: Chicago Society of Etchers; Print Makers' Society of California; New Haven Paint and Clay Club. Awards: Silver medal for etchings, St. Paul Institute, 1915; hon. mention, P.-P. Expo., San Francisco, 1915. Represented in St. Paul Institute; Los Angeles Museum; American Institute of Graphic Arts, "Fifty Prints of the Year," 1927. Address in 1929, Fin del Viaje, Glendora, Los Angeles Co., CA.

KEELER, (LOUIS BERTRAND) ROLSTON.
Painter. Born in New York in 1882. Pupil of National Academy of Design. Address in 1929, Sammis Ave., Huntington, Suffolk County, NY.

KEELER, (R.) BURTON.
Painter. Born in Philadelphia, PA, April 5, 1886. Pupil of Penna. Academy of Fine Arts. Member: NY Architectural League; Artists Guild of the Authors' League of America, NY. Awards: Cresson Traveling Scholarship, Penna. Academy of Fine Arts, 1911 and 1912. Address in 1929, 50 Gramatan Ave., Mt. Vernon, NY.

KEEN, LILA MOORE.
Painter. Born in Cleveland, GA, in 1903. Studied: Agnes Scott College; and with Wayman Adams. Noted for her portraits, and flowers in watercolor, especially camellias and magnolias. Awards: National Gallery, 1945, 1946, 1947. She exhibited widely in the southeastern US. Died in 1963.

KEENAN, WILLIAM.
This etcher of portraits, and line-engraver of vignettes and subject-plates, was working for the magazine and book publishers of Philadelphia in 1830-33. He then apparently located himself in business in Charleston, SC, as we find an aquatint view of Charleston, engraved by Keenan and published by him at "132 King St., Charleston, SC," and other plates executed for book publishers in that city, in 1835. Some of these latter plates are inscribed as "Drawn, Engraved and Printed by W. Keenan."

KEENER, ANNA E(LIZABETH).
Painter and writer. Born in Flagler, CO, Oct. 16, 1895. Pupil of Birger Sandzen. Member: New Orleans Arts and Crafts Club. Awards: Bronze Medal for wood engraving, Kansas-Missouri-Oklahoma Exhibition; hon. mention for linoleum cut, Kansas-Missouri-Oklahoma Exhibition, 1923. Work: "Barn on the Hill," San Francisco Public Library; "Oxen and Carts," Bethany College, Lindsborg, KS; "Wyoming Landscape," Oklahoma University, Norman, OK; "Bird's Mine," Sul Ross State Normal, TX; represented in Smoky Hill Art Club, Lindsborg, KS; Pawhuskee, OK, Schools; author of "Spontaneity in Design," 1923.

KEENEY, ANNA.
Sculptor. Born in Falls City, OR, 1898. Pupil of Avard Fairbanks, Harry P. Camden. Work: "Fallen Aviator," First National Bank, Condon, OR; "Eve," University of Oregon. Address in 1933, University of Oregon; h. 1380 Beech, Eugene, OR; summer, Olex, OR.

KEEP, HELEN ELIZABETH.
Painter, illustrator and craftsman. Born in Troy, NY. Pupil of Art Institute of Chicago; Detroit Art Museum School; Frederick W. Freer. Member: Detroit Women Painters; Detroit Society of Arts and Crafts; Founders Association of Detroit Art Institute. Address in 1929, 2247 Jefferson Ave., East, Detroit, MI.

KEFFER, FRANCES.
Painter and teacher. Born in Des Moines, IA, Jan. 6, 1881. Pupil of Pratt Institute, Alex. Robinson, Frank Brangwyn, Ossip Linde. Member: National Association Women Painters and Sculptors; Nanuet Painters; Brooklyn Society of Artists; Brooklyn Society of Painters and Sculptors; Pen and Brush Club of NY. Award: $100 prize, Woman's Club, Des Moines, Iowa, 1912. Died in 1954.

KEHM, BIMEL.
Sculptor, designer, and writer. Born in Dayton, OH, February 4, 1907. Studied at University of Illinois; Julian Academy, Paris, France; Yale School of Fine Art; Beaux-Arts Institute of Design. Member: Architectural League. Work: Brooklyn (NY) Technical

High School. Exhibited: Architectural League; National Academy of Design; Allied Artists of America. Contributor to *House and Garden, Architectural Forum* magazines. Address in 1953, New Canaan, CT.

KEHRER, F. A.
Illustrator. Member: Pen and Pencil Club, Columbus. Address in 1926, 24 W. Maynard Ave., Columbus, Ohio.

KEISTER, ROY C.
Illustrator. Born in Ohio in 1886. Pupil of Art Institute of Chicago. Address in 1926, 1906 Republic Bldg., Chicago, IL.

KEITH, DORA WHEELER.
(Mrs. B. Keith). Painter, illustrator and craftsman. Born in Jamaica, LI, NY, March 8, 1857. Pupil of Art Students League of NY and of Chase; studied in Paris. Member: Associate National Academy of Design, 1906; Society of American Artists, 1886. Awards: Prang prize ($500), 1885; Prang prize ($200), 1886; hon. mention, Pan-Am. Expo., Buffalo, 1901. Died in 1940. Address in 1929, 33 West 67th St., New York, NY; and Onteora, Catskill, NY.

KEITH, WILLIAM.
Landscape and portrait painter. Born in Scotland in 1839; died in California in 1911. Pupil of Achenbach and Carl Marr. Represented in Corcoran Art Gallery by portrait of Irving M. Scott, builder of ships for the United States Navy.

KELLEHAR, DANIEL JOSEPH.
Painter. Born in Erie, PA, Nov. 15, 1930. Studied: Edinboro State College; Syracuse University. Work: Washington & Jefferson College, PA; Hemingway Collection, NY; Erie Public Library, PA; others. Exhibitions: National Society of Painters in Casein, NY; Butler Institute of American Art, Youngstown, Ohio; Audubon Artists, NYC; Watercolor USA, Springfield, Missouri; others. Awards: Mainstreams '69 Marietta College Award of Excellence; Washington & Jefferson College; others. Member: Erie Art Center; Chautauqua Institute of Art, NY; Pennsylvania Art Education Association. Media: Acrylic and collage. Address in 1980, 427 E. 8th Street, Erie, PA.

KELLER, ARTHUR I.
Painter and illustrator. Born in 1867; died in 1924. Pupil of National Academy of Design; also studied in Munich. Member of American Water Color Society and New York Water Color Club. He is represented by a painting,"The Mass," in the Munich Academy.

KELLER, CLYDE LEON.
Painter and teacher. Born in Salem, OR, Feb. 22, 1872. Pupil of E. W. Christmas, R. B. A., in London. Member: Society of Oregon Artists; Palette Club.

Work: "After the Shower" and "California Marshes," Liberty Theatre, Portland, OR; "Columbia River," B.P.O.E. Club, Portland; "The Tualatin," Portland Press Club. Died in 1941. Address in 1929, 450 Washington St.; h. 512 East 55th St., North, Portland, OR.

KELLER, DEANE.
Painter. Born in New Haven, Dec. 14, 1901. Pupil of Edwin C. Taylor, Eugene F. Savage. Awards: American Academy in Rome prize, Grand Central Galleries, New York, 1926; figure composition prize, New Haven Paint and Clay Club, 1926. Address in 1929, Yale School of the Fine Arts; h. 55 Huntington St., New Haven, CT.

KELLER, GRACE.
(Mrs. John M. Keller). Painter. Member: Baltimore Water Color Club. Address in 1929, Chadford Apts., Roland Park, Baltimore, MD.

KELLER, HENRY GEORGE.
Painter. Born in Cleveland, April 3, 1870. Pupil of Bergman at Dusseldorf; Balsche at Karlsruhe; Zugel at Munich. Awards: Silver Medal, Munich, 1902; special awards for maintained excellence, Cleveland Museum; also represented in the Phillips Memorial Art Gallery, Washington, DC. Instructor of composition and design, Cleveland School of Art. Died in 1949. Address in 1929, 1381 Addison Road, Cleveland, Ohio.

KELLER, BURTON (MRS.).
See Southwick, Katherine.

KELLEY, GARY R.
Illustrator. Born in Algona, Iowa, in 1945. Studied: University of Northern Iowa and was a pupil of John Page, a print-maker. *Better Homes and Gardens* published his first illustration in 1970. His artwork is owned by the Artworks Gallery in Keokuk, Iowa, and the Three-Rooms-Up Gallery in Minneapolis. Private collectors in Iowa, California, Florida, Arizona, and Washington, DC, own his paintings, drawings, and prints.

KELLEY, MAY McCLURE.
(Mrs. William Fitch Kelley). Sculptor and painter. Pupil of Cincinnati Art School, Herbert Vos, Charles W. Hawthorne, Brenda Putnam, G. J. Zolnay, Jo Davidson, Antoine Bourdelle. Member: Washington Art Club; Society of Washington Artists. Works: Bas-relief portrait, Grace Coolidge, the White House; "Adoration," Woman's Universal Alliance, Washington, DC. Address in 1933, 2207 Massachusetts Ave., Washington, DC; Knole, Rockville Pike, MD.

KELLNER, CHARLES H(ARRY).
Painter. Born in Kasa, Czechoslovakia, Sept. 13, 1890. Pupil of W. Reynolds, Victor Higgins, Harry

Lachman, Pierre Bonnard. Member: Chicago Society of Artists; New York Society of Artists; Illinois Academy of Fine Arts; All-Illinois Society of Fine Arts; Chicago Palette and Chisel Club; Springfield Art Association; American Artists Professional League. Award: 1st prize, Bellevue, France, Academy, in portrait and landscape. Work: "Sunny Morning, St. Cloud, Paris," owned by the United States Government; "Reflecting Pool, Villa D'Esti, Tivoli," Phi Sigma Sigma Sorority House, University of Illinois, Champaign; "Mme. R.," Vanderpoel Art Association, Chicago. Address in 1929, Kellner Studios, 1022 Argyle St.; h. 5059 Kenmore Ave., Chicago, IL.

KELLNER, MARY.
Sculptor. Born in NYC, June 16, 1900. Studied at Ogunquit School of Art; Clay Club; and with Robert Laurent, Chaim Gross. Member: National Association of Women Artists; Brooklyn Society of Artists; Art League, Guilford, CT; Artists Equity Association; Meriden Arts and Crafts; Silvermine Guild of Artists. Awards: Prizes, Brooklyn Society of Artists, 1949, 51; Silvermine Guild of Artists, 1952. Work: Bezabel National Museum, Israel. Exhibited: National Association of Women Artists, 1946-52; ACA Gallery, 1948 (one-man); Brooklyn Museum, 1945-48, 50, 52; Artists of America, 1945; Audubon Artists, 1947; Meriden Arts and Crafts, 1949-52; Argent Gallery; New York Historical Society; Silvermine Guild Artists, 1952; Riverside Museum, 1950. Address in 1953, 105 Lincoln Rd., Brooklyn NY; summer, Stony Creek, CT.

KELLOG, MINER KILBOURNE.
Painter. Born in Cincinnati, Ohio, August 22, 1814. He resided abroad. He painted a portrait of General Scott, in the City Hall, New York; also a replica of the head. During a visit to this country he sold many excellent examples of his work. He has also painted miniatures. Died 1889.

KELLOGG, EDMUND P(HILO).
Painter, illustrator and teacher. Born in Chicago, Sept. 11, 1879. Pupil of Freer, Duveneck, Chase and Albert Herter. Member: Designers Alumni of Art Institute of Chicago; Chicago Art Club; Chicago Architecture Club. Represented in St. Paul Institute; "Ready for Flight," Chicago Athletic Association; "A French Garden," Indianapolis Athletic Club; mural paintings in Metropolitan Theatre, Boston, MA; mural decoration, Church of the Sacred Heart, Rochester, NY. Instructor at the Academy of Fine Arts, Chicago, IL. Address in 1929, 4332 Oakenwald Ave., Chicago, IL.

KELLOGG, J. G.
Engraver of portraits in line, working in New Haven, CT, about 1850. He was born in Tolland, CT, in 1805, and died in Hartford, CT, in 1873.

KELLOGG, JANET REID.
Painter and illustrator. Born in Merrill, WI, Jan. 19, 1894. Pupil of George Elmer Browne. Member: Wisconsin Painters and Sculptors. Award: Medal, Milwaukee Art Institute, 1929. Address in 1929, 31 Bayley Ave., Yonkers, NY.

KELLY, ANNIE D.
Painter. Member: Washington Water Color Club; Society of Washington Artists; Washington Art Club. Address in 1929, 1919 N. St., N.W., Washington, DC.

KELLY, EDNA.
Sculptor. Born in Bolivar, NY, July 23, 1890. Pupil of Cincinnati Art Academy, Ella Buchanan. Member: California Art Club; Long Beach Art Association; Laguna Beach Art Club. Awards: Prize, Pomona-Los Angeles County Fair, 1927; medal and award, Panama Pacific Exposition, Long Beach, 1928. Address in 1929, 1539 North Edgemont, Hollywood, CA; h. 112 East Broadway, Long Beach, CA.

KELLY, ELLSWORTH.
Sculptor and painter. Born in Newburgh, NY, May 31, 1923. Studied at Pratt Institute, 1941-42; Boston Museum School, 1946-48; Ecole des Beaux-Arts, 1948-49. Exhibited: Betty Parsons Gallery, NYC, many times; Museum of Modern Art, NY; Paintings, Sculpture, and Drawings by Ellsworth Kelly, Washington Gallery of Modern Art, 1963; Venice Biennale International Art, 1966; NY Painting and Sculpture, 1940-1970, Metropolitan Museum of Art, NY, 1969; Recent Painting and Sculpture, Stedelijk Museum, Amsterdam, Holland, 1979-80; Guggenheim; Whitney; many more. Numerous sculpture commissions, including the lobby of the Transportation Building, Philadelphia, in 1956; a wall sculpture for New York World's Fair, New York Pavilion, 1964; mural, UNESCO, in Paris, 1969; mural, Central Trust Company, Cincinnati, OH, 1981. Represented in Whitney; Guggenheim; Metropolitan; Carnegie; Museum of Modern Art; others. Noted for his hard-edged, multi-paneled modular paintings also.

KELLY, GRACE VERONICA.
Painter, illustrator, writer and teacher. Born in Cleveland, Jan. 31, 1884. Pupil of H. G. Keller. Awards: Second prize for water color, 1924; second prize for landscape and hon. mention for water color, Cleveland Museum of Art, 1925. Work: "Sunset on the Cuyahoga River," Cleveland Heights Public Schools; "Back Yard Activities," owned by the City of Cleveland. Illustrates for papers and magazines. Art critic for *Cleveland Plain Dealer*. Address in 1929, Standard Theatre Bldg., 811 Prospect Ave.; h. 1835 Wadene St., East Cleveland, Ohio.

KELLY, J. E.
This engraver in 1851 had an office at 141 Fulton St., New York City. He engraved portraits in a mixed manner.

KELLY, J. REDDING.
Portrait painter and teacher. Born in New York, Aug. 5, 1868. Pupil of National Academy of Design. Member: Salma. Club, 1898. Work: Portrait of Abraham Lincoln, reproduced in New York Sunday *Times*, 1929. Professor in Art Department, College of the City of New York. Died in 1939. Address in 1929, 55 West 95th St., New York, NY.

KELLY, JAMES EDWARD.
Sculptor. Born in NY, July 30, 1855. Pupil of National Academy of Design and Art Students League of New York; Theodore Robinson and Carl Hirschberg. Work: "Monmouth Battle Monument;" equestrian Gen. Sherman; "Col. Roosevelt at San Juan Hill;" etc. Illustrated for *Scribner's; Harper's; St. Nicolas*, until 1881; since then exclusively sculptor. One of the founders of New York Art Students League. Address in 1929, 318 West 57th St., NYC. Died in NY, 1933.

KELLY, LOUISE.
(Mrs. Edward P. Kelly). Painter and lecturer. Born in Waukon, IA, June 14, 1879. Pupil of Art Institute of Chicago; Penna. Academy of Fine Arts; George Elmer Browne. Member: American Federation of Arts; National Association of Women Painters and Sculptors; Chicago Galleries Association; Provincetown Art Association; Minneapolis Society of Fine Arts. Address in 1929, Apt. 902, Leamington Hotel, Minneapolis, MN; summer, Provincetown, MA.

KELLY, THOMAS.
Born in Ireland about 1795; died in the almshouse in New York City about 1841. The professional career of this very good engraver in line and in stipple is difficult to trace. He was working for Boston publishers in 1823, but was in Philadelphia in 1831-33, and in New York in 1834-35. Kelly was associated for a short time with Joseph Andrews in Boston. Besides his portraits he engraved a considerable number of good plates for the *Annuals* and magazines.

KELMAN, BENJAMIN.
Painter and illustrator. Born in 1890. Pupil of Penna. Academy of Fine Arts and National Academy of Design. Address in 1926, 1692 Park Ave., New York City, NY.

KEMBLE, E(DWARD) W(INDSOR).
Illustrator. Born Sacramento, CA, Jan. 18, 1861. Self-taught. Specialty, Black American subjects. Illustrated: *Uncle Tom's Cabin, Huckleberry Finn*; author of *Kemble's Coons*. Died in 1933.

KEMEYS, EDWARD.
Sculptor. Born in Savannah, GA, in 1843. He studied in New York and later in Paris. He made a specialty of the wild animals of the American continent. His "Fight between Buffalo and Wolves" was exhibited in the Salon of 1878. Among his works: "Panther and Deer," "Coyote and Raven;" he also made the colossal head of a buffalo for the Pacific Railroad station at St. Louis. A collection of some fifty of his small bronzes is at the National Gallery in Washington, DC. He died at Georgetown Heights, Washington, DC, in 1907.

KEMMELMYER, FREDERICK.
Painter. He was an active painter in Baltimore, MD about 1788 to 1803. He advertised himself as a portrait painter. An artist by that name made a sketch from life of Washington on Oct. 2nd, 1894, when the latter was reviewing the Western troops at Cumberland, MD.

KEMP, OLIVER.
Painter, illustrator and writer. Born in Trenton, NJ, May 13, 1887. Pupil of Howard Pyle, Chase, Gerome. Illustrations for *Scribner's, Harper's, Century, Saturday Evening Post*. Director, School of Industrial Arts, Trenton, NJ. Member: Wilmington Society of Artists. Died in 1934. Address in 1929, 922 Transportation Bldg., Detroit, MI; summer, Bowerbank, Piscataquis Co., ME.

KEMPER, RUBY WEBB.
Painter and craftsman. Born in Cincinnati, OH, Dec. 8, 1883. Pupil of T. E. Noble, L. H. Meakin, W. H. Fry, Frank Duveneck, Anna Riis. Member: Cincinnati Ceramic Club; Cincinnati Woman's Art Club; The Crafters Society. Address in 1929, Milford, OH.

KEMPSTER, RUTH.
Painter. Born in Chicago, IL, in 1904. Studied: Los Angeles County Art Institute; Art Students League; Academie des Beaux-Arts; National Academy, Florence, Italy. Awards: California State Fair, 1931, 1932, 1936; Pasadena Society of Art, 1936, 1940, 1944, 1951; Women Painters of the West, 1951; International Olympics Games, Exhibition, 1932. Collections: Pasadena Art Institute; Huntington Memorial Hospital, Pasadena. Toured Korea as portrait artist for Armed Forces, Far East Command, 1953.

KEMPTON, ELMIRA.
Painter and craftsman. Born in Richmond, IN, Aug. 9, 1892. Pupil of James R. Hopkins; H. H. Wessel; C. J. Barnhorn. Member: Indiana Artists' Club; Richmond Palette Club. Address in 1929, 75 South 17th St., Richmond, IN.

KENDAL, H. H.
Painter. Member: Boston Art Club. Address in 1929, 142 Berkeley St., Boston, MA.

KENDALL, BEATRICE.
Painter, craftsman and teacher. Born in New York City, Jan. 14, 1902. Pupil of Sergeant Kendall. Member: American Federation of Arts. Award:

Winchester Fellowship, Yale University, 1922; Landscape prize, New Haven Paint and Clay Club, 1926. Work: Three portraits, Lawrenceville School, Lawrenceville, NJ. Specialty: Screens and decorations. Address in 1929, Hot Springs, VA.

KENDALL, ELISABETH.
Sculptor, painter, and illustrator. Born in Gerrish Island, Maine, September 22, 1896. Pupil of Yale School of the Fine Arts. Address in 1924, 58 Trumbull St., New Haven, CT.

KENDALL, KATE.
Painter, of Cleveland, Ohio. Exhibited water colors at the Penna. Academy of Fine Arts. Deceased 1915.

KENDALL, MARGARET (STICKNEY).
Miniature painter. Born in Staten Island, NY, Nov. 29, 1871. Pupil of J. Alden Weir and Julius Rolshoven. Member: American Society of Miniature Painters; New Haven Paint and Clay Club. Award: Bronze medal, St. Louis Expo., 1904. Address in 1929, Simsbury, CT.

KENDALL, MARIE B(OENING).
Painter and teacher. Born in Mt. Morris, NY, Aug. 16, 1885. Pupil of William M. Chase and Jean Mannheim, Los Angeles College of Fine Arts. Member: California Art Club; West Coast Arts; Society of Independent Artists; Laguna Beach Art Association; National Association of Women Painters and Sculptors. Work: Three paintings in the Virginia Hotel, painting in Seaside Hospital, and Polytechnic High School, Long Beach, California; Teachers College, Mt. Pleasant, MI; has also done magazine covers. Address in 1929, 2306 Lime Ave., Long Beach, CA; summer, Laguna Beach, CA.

KENDALL, (WILLIAM) SERGEANT.
Sculptor and painter. Born in Spuyten Duyvil, NY, January 20, 1869. Pupil of Art Students League of New York; Eakins in Philadelphia; Ecole des Beaux-Arts and Merson in Paris. Member: Society of American Artists, 1898; Associate, National Academy of Design, 1901; Academician, National Academy of Design, 1905; National Institute of Arts and Letters; New York Water Color Club; Connecticut Academy of Fine Arts; Century Association; New Haven Paint and Clay Club. Dean, School of Fine Arts of Yale University, 1913 to 1922. Awards: Honorable mention, Paris Salon, 1891; medal, Columbian Exposition, Chicago, 1893; Lippincott prize, Penna. Academy of Fine Arts, 1894; honorable mention, Tennessee Centennial Exposition, Nashville, 1897; second prize, Worcester Museum, 1900; bronze medal, Paris Exposition, 1900; bronze medal, Carnegie Institute, Pittsburgh, 1900; second prize, Worcester Museum, 1901; silver medal for painting, bronze medal for drawing and honorable mention for sculpture, Pan-American Exposition, Buffalo, 1901;

Shaw prize, Society of American Artists, 1901; Shaw Fund Purchase, Society of American Artists, 1903; gold medal, St. Louis Exposition, 1904; Isidor medal, National Academy, 1908; Harris prize, Art Institute of Chicago, 1908; Palmer gold medal, Art Institute of Chicago, 1910; gold medal for painting and silver medal for sculpture, P.-P. Exposition, San Francisco, 1915; Butler prize, Art Institute of Chicago, 1918; gold medal, Mississippi Art Association, 1926; Isidor medal, National Academy of Design, 1927. Work: "Beatrice," Pennsylvania Academy, Philadelphia; "The Seer," and "Psyche," Metropolitan Museum, New York; "An Interlude," National Gallery, Washington, DC; "Narcissa," Corcoran Gallery, Washington; "Crosslights," Detroit Institute of Arts; "Intermezzio," RI School of Design, Providence; and many private collections. Address in 1929, Hot Springs, VA. Died in 1938.

KENNEDY, JAMES.
Engraver in line and stipple. In 1797 he was working for the New York publisher, John Low. He remained in that city until 1812, and then went to Philadelphia, as he was later employed by the publishers S. F. Bradford and T. W. Freeman, both of that city.

KENNEDY, LAWRENCE.
Painter. Born in Pittsburgh, PA, Oct. 31, 1880. Pupil of Art Institute of Chicago. Member: Chicago Society of Artists; Cliff Dwellers. Address in 1929, 30 North Michigan Blvd., Chicago, IL; h. 29 N. Oak St., Hinsdale, IL.

KENNEDY, OWEN W.
Painter. Born in Washington, DC, May 26, 1891. Pupil of Worcester, MA, Art Museum School. Member: Business Men's Art Club of Boston. Address in 1929, Boylston, MA.

KENNEDY, S.
Engraver. Working in Philadelphia in 1813 with William Charles, who was best known by his series of caricatures of the War of 1812.

KENNEDY, SAMUEL J.
Painter. Born in Mt. Pleasant, MI, in 1877. Pupil of Henri Martin. Work: "Young Genius," Mt. Pleasant Public Gallery; "The Marshes," Library of Michigan Agricultural College. Address in 1926, 4 East Ohio St., Chicago, IL.

KENNEDY, SYBIL.
Sculptor. Born in Quebec, Canada, August 13, 1899. Studied at Montreal Art School and with Alexander Archipenko. Works: National Gallery, Canada; Montreal Museum of Fine Arts. Awards: Huntington prize, National Association of Women Artists, 1941; Amelia Peabody prize, 1948. Exhibited: National Academy of Design; Art Institute of Chicago; Weyhe Gallery (solo), NYC, 1949; others. Address in 1953, 55 East 86th Street, NYC.

KENNEL, LOUIS.
Painter. Born in North Bergen, NJ, May 7, 1886. Pupil of George Bridgman, Wm. H. Lippincott, Charles Graham, Ernest Gros. Member: Society of Independent Artists. Designed stage scenery. Address in 1926, New Durham, NJ.

KENNY, THOMAS HENRY.
Painter and printmaker. Born in Bridgeport, CT, Jan. 12, 1918. Studied: Knox College; Ohio Christian University; largely self-taught as an artist. Work: Metropolitan Museum of Art, NYC; Philadelphia Museum of Art; Stedelijk Museum, Amsterdam; Museum of Modern Art, Mexico City; numerous others in US and abroad. Exhibited: Boston Athenaeum; Modern Art Museum, Haifa; Stedelijk Museum; Museum of Modern Art, Mexico City; Fine Arts Museums in Sao Paulo, Rio de Janeiro, Ireland, Belgium, Helsinki, Israel, France, and many others throughout the world. Member: Life fellow, Royal Society of Arts, London; College Art Association of America; American Federation of Arts; Institute of Contemporary Arts, London. Living in Roslyn, NY in 1970. Address in 1984, Cuba, KS.

KENSETT, JOHN FREDERICK.
Born in Cheshire, CT, in 1818; died in New York City in 1872. In 1840 he went to England to study art, and during his five years' stay in that country he partially supported himself by engraving. Kensett continued his studies in Rome and returned to the United States in 1848. He opened a studio in New York and established a reputation as a painter of landscape. In 1850 he sent a painting to the Royal Academy for exhibition, which was highly praised. He was elected a National Academician in 1849. He is represented in the Metropolitan Museum by his painting "Lake George," also a number of landscapes painted in 1871. He is considered one of the most distinguished landscape painters of the last generation. Died in 1872.

KENSETT, THOMAS.
Engraver. In 1812 Thomas Kensett was a member of the engraving and print-publishing firm of Shelton & Kensett, located at Cheshire, Connecticut. As evidence that he was an engraver himself, we have a well-executed map of Upper and Lower Canada, published in 1812, and signed "Kensett Sculp. Cheshire, Conn't." Another large plate entitled "Brother Jonathan's Soliloquy on the Times" is signed "Kennsett, Paint. et Sculp." Mr. H. W. French, in his "Art and Artists in Connecticut," says that Thomas Kensett came from England to Cheshire in 1812, and had previously been an engraver at Hampton Court, in England, and Mr. James Terry says that he was born in England in 1786 and died in 1829.

KENT, ADA HOWE.
Painter. Born in Rochester, NY. Pupil of Brush, Abbott Thayer and Whistler. Member: New York Water Color Club. Address in 1926, 29 Atkinson St., Rochester, NY.

KENT, ROCKWELL.
Painter and illustrator. Born in Tarrytown Heights, NY, June 21, 1882. Pupil of Chase, Henri, Hayes Miller, Thayer. Work: "Marine," in Metropolitan Museum, New York, NY; "Lone Woman," "Mother and Children," Brooklyn Museum; murals, US Post Office and Federal Building, Washington, DC. Kent was the first American to have been given an exhibition at the Hermitage in Leningrad. Author and illustrator of *Voyaging* (G. P. Putnam's Sons), and *Wilderness*. Address in 1929, Ausable Forks, NY. Died in 1971.

KENYON, HENRY R.
Painter. Member: Providence Art Club; North Shore Art Association. Work: "Landscape, Holland," "November Twilight," and "Venice," Rhode Island School of Design, Providence. Address in 1929, Ipswich, MA.

KEPES, GYORGY.
Painter. Born Oct. 4, 1906 in Selyp, Hungary. Earned master's from Royal Academy of Fine Arts, Budapest, 1928; Rhode Island School of Design, Hon. PhD, 1981. Resides in United States. Taught at New Bauhaus, 1937-38; Institute of Design, Chicago, 1938-43; MIT as Professor of Visual Design, 1946-80; Center for Advanced Visual Studies, director, 1967-74, prof. emer., from 1971; Harvard University, visiting professor, 1964-66, 79. Awarded Guggenheim Fellowship, 1960-61; Fine Arts Award, American Institute of Architects, 1968. Exhibited at Art Institute of Chicago, 1944; San Francisco Museum of Art; National Collection of Fine Arts, Washington, DC; Everson Museum, Syracuse; Baltimore; Dallas; Museum of Fine Arts, Houston; Whitney; Museum of Modern Art; Dartmouth College, 1977 (one-man); Alpha Gallery, Boston, 1980, 81, 83 (one-man); and others. In collections of Museum of Fine Arts, Boston; Addison; Museum of Modern Art; Harvard; Whitney; Brooklyn; Albright-Knox Art Gallery; San Francisco Museum of Art; Brandeis; and University of Illinois. Many mural commissions. Member: Fellow, American Academy of Arts and Science; National Institute of Arts and Letters. Address in 1984, Cambridge, MA.

KEPLINGER, LENA MILLER.
Painter. Member: Washington Water Color Club; Washington Society of Artists. Address in 1929, Bethesda, MD.

KEPPLER, GEORGE.
Sculptor. Born in Germany, January 22, 1856. He came to America, and lived in Providence, RI. Studied in Baden and Berlin. Address in 1926, 56 Wesleyan Avenue, Providence, RI.

KEPPLER, JOSEPH.
Illustrator and caricaturist. Born in Vienna in 1838.
He came to America about 1868. In 1873 he was in
New York as a cartoonist for *Frank Leslie's Weekly.*
He also was successful with lithography. He died in
New York in 1894.

KER, MARIE SIGSBEE.
See Fischer, Mary Ellen Sigsbee.

KERKAM, EARL.
Painter. Born 1890 in Washington, DC. Studied at
Chaumiere, Paris; Institute of Art, Montreal; Art
Students League; Penna. Academy of Fine Arts.
Taught at Chaumiere; NY Studio School; and pri-
vately. Exhibited in Paris; Bonestell Gallery, 1944;
Charles Egan Gallery, many times; World House
Gallerie, NYC. In collection of Philadelphia Museum
of Art and many private collections. Died in January,
1965.

KERMES, CONSTANTINE JOHN.
Painter and printmaker. Born in Pittsburgh, PA,
Dec. 6, 1923. Studied: Carnegie-Mellon University,
with Victor Candell, Leo Manso, Frank Lloyd
Wright. Work: Storm King Art Center, Mountain-
ville, NY; Pennsylvania State University; Hershey
Medical Center, PA; others. Commissions: Icon paint-
ings, Holy Cross Greek Orthodox Church, Pitts-
burgh; Pennsylvania Hist. & Mus. Commission,
Cornwall Museum; murals, Sperry Rand Corp., PA,
& Brussels, Belgium; and others. Exhibited: Butler
Institute of American Art, Youngstown, OH, 1964;
Smithsonian Institution, Washington, DC, 1969;
Grimaldis Gallery, Baltimore, 1979; Pennsylvania
Water Color Society, 1979, 80; many more. Awards:
Annual Design Review Awards; Industrial Design
Magazine, 4 years; American Iron & Steel Institute,
4 years; others. Media: Oil, acrylic; woodcut, litho-
graph. Dealer: Jacques Seligmann Gallery, NYC.
Address in 1984, Lancaster, PA.

KERNAN, F. G.
This man was an engraver of portraits, in a mixed
style, located in New York in 1870.

KERNAN, JOSEPH F.
Painter and illustrator. Born in Brookline, MA, Sept.
13, 1878. Pupil of Eric Pape. Member: Artists Guild
of the Authors' League of America, NY; American
Artists Professional League. Specialty, national ad-
vertising and magazine covers. Address in 1929, 875
West 181st St., New York, NY.

KERNS, FANNIE M.
Painter, illustrator, designer and teacher. Born in
Los Angeles, CA. Pupil of Arthur Dow, Frank
Ingerson, Ralph Johonnot. Member: Boston Society
of Arts and Crafts; Southern California ACS; South-
ern California Art Teachers Association. Awards:

First Prize for landscape, Los Angeles Museum,
1924. Address in 1929, 916 Grattan St., Los Angeles,
CA.

KERR, GEORGE.
Illustrator. Member: Society of Illustrators, 1913.
Address in 1929, Art Department, N.Y. Journal;
Kamac Products Co., 249 West 34th St., New York,
NY.

KERR, IRENE WAITE.
Painter. Born in Pauls Valley, OK, 1873. Pupil of
Walcott, Clarkson, William M. Chase, James Fraser,
DuMond and F. L. Mora. Address in 1926, 144 East
14th St., Oklahoma City, OK.

KERR, JAMES W(ILFRID).
Painter and etcher. Born in New York City, Aug. 7,
1897. Pupil of Howard Giles. Member: American
Federation of Arts. Address in 1929, 736 West 173rd
St., New York, NY.

KERR, KENNETH A.
Painter. Born in Pittsburgh, PA, February 10, 1943.
Exhibitions: National Watercolor Society; others.
Awards: American Institute of Fine Arts; National
Society of Art Directors. Media: Watercolor. Address
in 1970, 1015 W. Palm St., San Diego, CA.

KERSHAW, J. M.
This engraver of buildings, etc., was working in St.
Louis, MO, in 1850.

KERSWILL, J. W. ROY.
Painter. Born in Bigbury, England, Jan. 17, 1925;
US citizen. Studied: Plymouth College of Art, Eng-
land; Bristol College of Art. Work: Wyoming State
Art Gallery; Mountain Man Museum, Wyoming;
Grand Teton Natural History Association; Depart-
ment of Interior; others. Commissions: Alpenhof,
Teton Village, Wyoming; etc. Member: American
Artists Professional League; Artists Equity Associa-
tion. Media: Watercolor, oil. Address in 1982, Jack-
son Hole, WY.

KETCHAM, AUSTIN.
Painter and teacher. Born in Richmond Hill, LI, Oct.
29, 1898. Pupil of Art Institute of Chicago; Lewis
Institute; Bertha E. Perrie. Member: Alumni Chica-
go Art Institute; Kansas City Society of Artists.
Award: J. B. Irving portraiture prize, Missouri
Kansas Oklahoma Exhibition, 1923. Address in
1929, Kansas City Art Institute; 2615 Troost Ave.,
Kansas City, MO; summer, Art Institute, Chicago,
IL.

KETCHAM, SUSAN M.
Painter. Born in Indianapolis, IN. Pupil of Art
Students League of NY, under Chase and Bell; Art
Institute of Chicago. Member: Art Students League

of NY; National Association of Women Painters and Sculptors. Award: Elling prize, NY Woman's Art Club, 1908. Work: "A Young Student," "Beatrix," "The Restless Sea, Oqunquit, ME," Herron Art Institute, Indianapolis. Address in 1929, 1010 Carnegie Hall, New York, NY; summer, Ogunquit, ME. Died in 1937.

KETTEN, MAURICE.
Painter, illustrator and cartoonist. Born in Florence, Mar. 2, 1875. Pupil of Cabanel, Delaunay, Moreau, Ecole des Beaux Arts, Paris. Member: Society of Illustrators. Work: "Can You Beat It," "Such Is Life," and "The Day of Rest" daily cartoons in the *Evening World*. Address in 1929, care the New York World, 63 Park Row; h. Hotel St. Regis, 2 East 55th St., New York, NY; summer, West Outlet, ME.

KETTERER, GUSTAV.
Painter and craftsman. Born in Germany, May 20, 1870. Pupil of Penna. Academy of Fine Arts. Member: Philadelphia Art Club; Philadelphia Alliance; T. Square Club; Arts and Trades Club, NY. Work: Interior decorator of Detroit Museum of Art; Indianapolis Library; Hartford County Court House; murals of Keneseth of Israel Temple; decoration, exterior and interior, Persian Building, Sesqui-Centennial.

KEUHNE, MAX.
Painter. Born in New York, 1880. Pupil of Kenneth Hayes Miller, Chase and Henri. Address in 1926, 18 Bank St., New York, NY.

KEY, F. C.
The firm of F. C. Key & Sons, of No. 123 Arch St., Philadelphia, was engaged in die-sinking and embossing, about 1850. A fairly well-executed head of Millard Fillmore was published by this firm. It is embossed on white paper, surrounded by an oval in gold, with the name and publisher also printed in gold.

KEY, JOHN ROSS.
Painter. Born July 16, 1837, in Maryland. Studied in Paris. Studio in Chicago and Boston. Principal paintings: "Marblehead Beach"; "Newport"; "Golden Gate, San Francisco." He was also successful in his work in black and white. He died in Baltimore, March 24, 1920.

KEY, MABEL.
Painter. Born in Paris, France, 1874, of American parents. Awards: Honorable mention for water color, St. Paul Institute, 1915; silver medal, St. Paul Institute, 1916; silver medal, Wisconsin Painters and Sculptors. Instructor in Milwaukee Art Institute. Address in 1926, Fullerton Parkway, Chicago, IL.

KEY, WILLIAM H.
Engraver. Born in Brooklyn, NY; was living in 1892. From 1864 until 1892, and possibly later, Key was an assistant engraver for the US Mint at Philadelphia. Key engraved the dies for the Kane Expedition medal, and a medal for Archibishop Wood.

KEY-OBERG, ELLEN B.
Sculptor. Born in Marion, Alabama, April 11, 1905. Studied at Cooper Union Art School. Works: University of Wisconsin; Norfolk Museum, Virginia. Awards: Audubon Artists, 1944; National Association of Women Artists, 1949. Exhibited at National Academy of Design, NY; Pennsylvania Academy of Fine Arts; Whitney. Taught sculpture and painting, Chapin School, 1937-70; sculpture workshop, Newark (NJ) Museum, 1955-65. Address in 1982, La Jolla, CA.

KEYS, HARRY J.
Illustrator. Member: Pen and Pencil Club, Columbus. Address in 1926, "Columbus Citizen," Columbus, OH.

KEYSER, EPHRAIM.
Sculptor and teacher. Born in Baltimore, MD, October 6, 1850. Pupil of Royal Academies in Munich and Berlin. Member: National Sculpture Society, 1907; Charcoal Club of Baltimore; American Federation of Arts. Awards: Silver medal, Munich Academy; first class medal, New Orleans Exposition, 1885. Work: Major General Baron de Kalb, Annapolis, MD; memorial to President Chester A. Arthur, Rural Cemetery, Albany, NY; "Psyche," life size marble, Cincinnati Art Museum; "Bust of Sidney Lanier," Johns Hopkins University. Taught at Rinehart School for Sculpture, Maryland Institute. Address in 1929, 20 Overhill Road, Roland Park, Baltimore, MD. Died in 1937.

KEYSER, ERNEST WISE.
Sculptor and painter. Born in Baltimore, MD, December 10, 1876. Pupil of Maryland Institute Art School in Baltimore; Art Students League of New York; Julian Academy in Paris; Augustus Saint-Gaudens. Member: National Sculpture Society, 1902; American Art Association of Paris; New York Architecture League, 1908. Award: Gold medal, New York Society of Architecture, 1923. Work: "Enoch Pratt Memorial," Baltimore; Adm. Schley statue, Annapolis; "Sir Galahad" for Harper memorial, Ottawa, Canada; fountain, Newark Museum; memorial at Troy, OH. Exhibited at National Sculpture Society, 1923. Address in 1929, 59 West 12th St.; 249 West 74th St., New York, NY. Address in 1953, Atlantic Beach, FL. Died in 1959.

KIBBEY, ILAH MARIAN.
Landscape painter. Born in Geneva, Ohio. Pupil of Hugh Breckenridge; Charles Wilimovsky; Henry B.

Snell; Lester Stevens; Kansas City Art Institute; Art Institute of Chicago. Member: National Association of Women Painters and Sculptors; North Shore Art Association; Rockport Society of Artists; Kansas City Society of Artists. Awards: J. B. Irving prize, for small oil painting, Kansas City Art Institute, 1921; silver medal in graphic arts, bronze medal for water color, Midwestern Art Association, 1921; silver medal in graphic arts, bronze medal for water color, Midwestern Art Association, 1921; silver medal, water colors, Midwestern Art Association, 1923; silver medal, Midwestern Art Association, 1927; purchase prize, Midland Theatre, Kansas City, 1928; purchase prize, Missouri State Fair, 1928. Died in 1958. Address in 1929, 4415 Warwick Blvd., Kansas City, MO; summer, Rockport, MA.

KIDD, REBECCA MONTGOMERY.
Painter and illustrator. Born in Muncie, IN, Nov. 29, 1942. Studied: Famous Artists Schools (correspondence course, commercial art and illustration, 1960-64). Exhibited: Bethesda, MD; Potomac, MD; Ft. Meade; The Pentagon; invitational exhibition, Queens College, University of Cambridge, England, July, 1982. Member: Visual Artists and Galleries Association, Inc., NYC; Eastern Shore Art League, constitution and bi-laws chairman, 1979, board of directors, from 1982; Arts Council of the Eastern Shore. Media: Specialty, oils and pastels. Address in 1983, 9 Lake St., Onancock, VA.

KIDD, STEVEN R.
Illustrator. Born in Chicago in 1911. Studied at the Art Institute of Chicago and later at the Art Students League, Grand Central School of Art, and Pratt Institute in NY. His instructors, including Harvey Dunn, George Bridgman, and Henry Varnum Poore, were some of the best known artists of their day. He started working in 1926 in Chicago and has since illustrated many books and magazines such as *Cosmopolitan*, *Redbook*, *Forbes*, and *Argosy*. He is currently teaching at the Art Students League.

KIDDER, FRANK HOWARD.
Painter. Born in Litchfield, CT, in 1886. Pupil of Kenneth Hayes Miller and Denys Wortman. Address in 1926, 210 South Main St., New Canaan, CT.

KIDDER, HARVEY W.
Illustrator. Born in Cambridge, MA, in 1918. Graduated from the Child-Walker School of Design, having studied with Lawrence Beal Smith and Arthur Lougee. His long career in editorial and book illustration began with *Houghton Mifflin* in 1939, and his artwork has since been used by *Reader's Digest*, *Ford Times*, *True*, *Argosy*, *Lithopinion*, *Golf Digest*, and many others. A member of the Society of Illustrators, he has participated in the U.S. Air Force Art Program and the National Park Service Art Program.

KIDDER, JAMES.
The *Polyanthos*, Boston, June, 1813, refers editorially to an aquatint, "View on Boston Common," contained in the number, and says it is "a specimen of the talents of Master J. Kidder, a youth of Boston, and also his first essay in aquatinta." Kidder's few plates, all in aquatint, represent views in and about Boston. Kidder designed plates engraved by Abel Bowen about 1823.

KIEFER, SAM P.
Painter. Member: Pen and Pencil Club, Columbus, Ohio. Address in 1926, 147 West Maynard Ave., Columbus, Ohio.

KIENBUSCH, WILLIAM.
Painter. Born April 13, 1914 in NYC. Earned B.A. from Princeton, 1936, attended Art Students League following year; studied with Henry Varnum Poor, Abraham Rattner, and Stuart Davis. Taught at Brooklyn Museum Art School. Received awards from Brooklyn Museum; Metropolitan Museum of Art; NY State Fair; Boston Arts Festival; Ford Foundation. Exhibited at University of Maine; Cornell; Princeton; Whitney; Carnegie; Albright-Knox; Walker; Museum of Modern Art; Metropolitan Museum of Art. In collections of Portland Museum; Montelau (NJ) Art Museum; Boston; Dartmouth; University of Nebraska; Wichita Art Museum; Penna. Academy of Fine Arts; Wadsworth; Carnegie; Munson-Williams-Proctor Institute; Museum of Modern Art; and others.

KIESLER, FREDERICK JOHN.
Sculptor and architect. Born on September 22, 1896, in Vienna, Austria. Came to US in 1926 and became a US citizen in 1936. Studied architecture at the Institute of Technology and the Academy of Fine Arts in Vienna. Designed Vienna's International Exhibition of New Theater Technique, 1924, and also the Austrian Theater Exhibit at the Paris World's Fair, 1925. As a registered architect he later designed and built the Art of the Century Gallery, NY, in 1940; Galerie Maeght, Paris, 1947; World House Galleries, NYC, 1957; and Kamer Gallery, NYC, 1959. During the late 30's and 40's associated with the Surrealists and designed the International Surrealist Exhibition in Paris, 1947. Some works include his wood construction entitled "Galaxy," 1947-48, second version, 1951; "Universal Theater," commissioned in 1961; and the "Shrine of the Book," a sanctuary in Jerusalem, 1965. In collection of Museum of Modern Art. Exhibited at Museum of Modern Art; Leo Castelli Inc., NYC, 1961, 62; The Howard Wise Gallery, NYC, 1969; Andre Emmerich Gallery, NYC, 1979, 1980; Guggenheim; Whitney; others. Noted for environmental sculpture, integrating plastic arts into an environmental context. Scenic director of the Juilliard School of Music, 1933-57; director of the Columbia University School of Archi-

tecture's Laboratory for Design Correlation, 1936-42. Died in NYC, December 27, 1965.

KIHN, W(ILFRED) LANGDON.
Painter. Born in Brooklyn, Sept. 5, 1898. Pupil of Homer Boss; Art Students League of NY; F. W. Reiss. Member: Brooklyn Society of Artists; Salma. Club; Philadelphia Water Color Club; Lyme Art Association; Century Club; Fellow, Royal Society of Artists; others. Work: Two portraits of Indians, and "Prairie, Montana," Litchfield (Conn.) Museum; 4 Indian portraits, Ohio State University, Columbus, OH; Indian portrait, Seattle Fine Arts Society; Indian portraits, Provincial Museum of British Columbia, Victoria; 8 Indian portraits and landscapes, Montreal Gallery of Art; Indian portrait and landscape, National Gallery of Art, Ottawa, Canada; Indian portraits and landscape, Royal Ontario Museum, Toronto; Indian portraits, Museum of Winnipeg, Canada; 15 Indian portraits, David Thompson Memorial, British Columbia; Indian portraits and landscape, Art Center, Vancouver, B.C. Exhibited: National Academy of Design; Corcoran; Architectural League; Brooklyn Museum; National Museum of Canada; others. Contributor to *Woman's Day; Natural History; Scribner's*; and other national magazines; also illustrated numerous books. Instructor, Kihn-Ten Eyck Art School, Stamford, CT. Address in 1953, Hadlyme, CT.

KILBERT, ROBERT P.
Painter, lecturer and teacher. Born in Germany, Sept. 14, 1880. Pupil of J. Francis Smith. Member: Paint and Clay Club. Address in 1929, 58 West Washington St.; h. 3741 North Kildare Ave., Chicago, IL; summer, Treasure Hill Art Academy, Bridgman, MI.

KILBRUNN, L.
See Kilburn, Laurence.

KILBURN (OR KILBRUNN), LAURENCE.
Painter. Born in 1720. He arrived from London in 1754, and advertised in the New York papers soliciting business. There are a number of portraits in New York by Kilburn which show him to have had some skill as a portrait painter; a bunch of flowers at the breast or a flower held in the hand were two of the characteristics of his style. He died June 28, 1775 in NYC. (See portrait of Mrs. Philip Schuyler, at New York Historical Society.)

KILENYI, JULIO.
Sculptor and medalist. Born in Arad, Hungary, February 21, 1885. Studied: Royal Academy of Art School, Budapest, Hungary; and in France and Germany. Designer of distinguished service medal of the US Navy Department; Lindbergh medal of St. Louis; Commander Byrd North Pole medal; Thomas A. Edison medallion for Edison Pioneers; General

Pershing medallion for American Legion; Judge E. H. Gary for U.S. Steel Corporation; medal for 150th anniversary Battle of Bunker Hill; and many more. Represented in the Metropolitan Museum of Art and Numismatic Museum, NY; Cleveland Museum of Art; Boston Museum of Fine Arts; Massachusetts Historical Museum; and others. Member: National Sculpture Society; Architectural League of New York; American Numismatic Society; Audubon Artists; Allied Artists of America; and others. Exhibited at National Sculpture Society, 1923; National Academy of Design; Albright Art Gallery; Penna. Academy of Fine Arts. Address in 1953, 1 West 67th St., NYC. Died in 1959.

KILHAM, JANE HOUSTON.
Painter. Born in Modesto, CA, Feb. 22, 1870. Pupil of Emil Carlsen, Raphael Collin, Paul Serusier. Member: North Shore Art Association; Gloucester Society of Artists; Boston Society of Independent Artists, president. Award: Schneider Prize, Boston Art Club, 1925. Address in 1929, h. 42 West Cedar St., Boston, MA; summer, "The Clearing," Tamworth, NH.

KILHAM, WALTER H.
Painter and artist. Born in Beverly, MA, August 30, 1868. Member: American Institute of Architects. Address in 1929, 9 Park St.; h. 42 West Cedar St., Boston, MA. Died 1948.

KILMER, DAVID L.
Illustrator. Born in Waterloo, Iowa, in 1950. Attended the Colorado Institute of Art in 1968 and 1969. His first published illustration was in 1970 for the Testor Corp., and he has since received awards from the Curtis Paper Co., Art Direction, and the Chicago '75 exhibit. From 1973 through 1976, his work has been selected to hang in Society of Illustrators Annual Exhibitions.

KILPATRICK, AARON (EDWARD).
Painter. Born in St. Thomas, Canada, April 7, 1872. Pupil of William Wendt. Member: California Art Club; Painters of the West; Laguna Beach Art Association. Awards: Silver and bronze medals, at the Panama-Calif. Expo., San Diego, 1915. Work: "Blue Gums," owned by the Los Angeles Athletic Club. Address in 1929, 5199 Ellenwood Drive, Eagle Rock, CA.

KILPATRICK, DeREID GALLATIN.
Sculptor and painter. Born in Uniontown, PA, September 21, 1884. Pupil of Lucien Simon, Rene Prinex, Emil Menard, Antoine Bourdelle, Raphael Collin. Studied in Paris. Work: Statue of Young George Washington, Lincoln Highway at Waterford, PA; statue of Colonel William Crawford, Connellsville, PA; bas reliefs, Methodist Episcopal Church, Greensburg, PA; old portraits, Court House, Uniontown, PA. Address in 1929, c/o Dr. A. G. Morgan, 45

Prospect Place, NYC; home, care of Dr. J. J. Kilpatrick, Bellefonte, PA; summer, The White Swan Hotel, Uniontown, PA.

KILVERT, B. CORY.
Illustrator. Born in 1881. A graduate of the Art Students League, he was a prolific illustrator of children's books. His illustrations, often of golf scenes, appeared in *Life*. He devoted himself to watercolor and seascape painting in his later years. Died in 1946 in NYC.

KIMBALL, ALONZO MYRON.
Painter and illustrator. Born in Green Bay, WI, in 1874; died in Evanston, IL, in 1923. He was a pupil of the Art Students League, New York, and of the Julien Academy, Paris, under Lefebvre and Whistler. He was a member of the Society of Illustrators, 1911.

KIMBALL, ISABEL MOORE.
Sculptor. Born in Wentworth, Mitchell Co., IA. Studied: Pratt Institute Art School, Brooklyn, New York; also a pupil of Herbert Adams. Member: Society of Painters of New York; National Association of Women Painters and Sculptors; Brooklyn Society of Artists; Painters and Sculptors; American Federation of Arts. Work: "Wenonah," Fountain in Central Park, Winona, MN; gold medal, YMCA swimming and life saving; Richards memorial tablet, Vassar College, Poughkeepsie, NY; Barrett memorial, Historical Society, Des Moines, IA; war memorial tablet for Essex, CT; war memorial tablet, Mountainville, NY; Burnett memorial tablet, Central High School, Kalamazoo, MI; Brooklyn Botanical Gardens; Riceville, IA. Address in 1953, Elgin, IL.

KIMBALL, KATHARINE.
Etcher and illustrator. Born in New Hampshire. Pupil of National Academy of Design in New York; Royal College of Art, London. Member: Assoc. Royal Society of Painter-Etchers and Engravers, London; Societaire Section de Gravure, Salon d'Automne, Paris; Chicago Society of Etchers; Print Makers' Society of California. Award: Bronze medal, P.-P. Expo., San Francisco, 1915. Illustrated: Okey's *Story of Paris*; Gialliat-Smith's *Brussels*; Stirling Taylor's *Canterbury and Rochester*, etc. Work: Bibliotheque d'Art et d'Archeologie, Paris. Work in Victoria and Albert Museum and British Museum, London; New York Public Library; Boston Museum of Fine Arts; Library of Congress, Washington, DC; Oakland (CA) Public Museum; Public Reference Library, Bath, Somerset, England. Address in 1929, care of Brown, Shipley & Co., 123 Pall Mall, London, SW, England.

KIMBERLY, CORA DRAPER.
Painter. Born in St. Louis, MO, in 1876. Studied: Washington University; Boston Museum of Fine Arts; Art Institute of Chicago; Chicago Academy of Art; and with Farnsworth, Vanderpoel, Messer, and Hawthorne. Award: Society of Washington Artists. Collections: Interiors of White House, Arlington House, Dumbarton House, and Mt. Vernon.

KIMBERLY, DENISON.
Engraver and painter. Born in Guilford, CT, in 1814. Kimberly was a fellow-student with George H. Cushman in the engraving establishment of Asaph Willard, and as a line-engraver of portraits he achieved considerable success. He was working in 1830 for S. Walker, the Boston publisher, and was later connected with the Franklin Print Company, of Boston. In 1858 Kimberly abandoned engraving for painting; he studied in Boston, and in 1862 he opened studios in Hartford and in Manchester. He was chiefly engaged in portrait work, producing good likenesses, strong and free in outline, yet remarkably soft in feature. The portrait of his friend Seth W. Cheney is one of his best works. Died in 1863.

KIMBERLY, JAMES H.
Miniature artist, flourishing 1841-43, in New York.

KIMBLE, RICHARD M.
Painter. Born in New York City. Member: Allied Artists of America; Salma. Club; National Arts Club. Work: "The Old Antique Shop," Pennsylvania Academy of Fine Arts. Address in 1929, 30 East 14th St.; h. 616 West 116th St., New York, NY; summer, Banff, Alberta, Canada.

KIMMEL, LU.
Illustrator. Born in Brooklyn, NY, in 1908. He was a pupil of Will Taylor, Pruett Carter, George Luks, Max Hermann, and Michel Jacobs at Pratt Institute. In 1933, he won an award from the National Red Cross Poster Competition while illustrating regularly for *The Saturday Evening Post, Country Gentleman, Household Magazine, Field and Stream,* and others. A member of the Society of Illustrators, he lectured at the Queensboro Teachers' Association and was an art instructor at the Commercial Illustrations Studios in NY. Died in 1973.

KIMMEL, P. K.
Engraver of vignettes and portraits working in New York about 1850; later a member of the engraving firm of Capewell & Kimmel, of the same city. There was also an engraving firm of Kimmel & Foster. May be same as Christopher Kimmel, born 1830, in Germany.

KIMURA, SUEKO M.
Painter. Born in Hawaii in 1912. Studied: University of Hawaii, B.A. and M.F.A.; Chouinard Art Institute, Los Angeles, CA; Columbia University; Brooklyn Museum Art School. Awards: Artists of Hawaii; Easter Art Show, 1962, 65, 68; Wichita Art Museum,

Kansas; purchase prizes, State Foundation on Culture and the Arts, 1968, 69, 72; others. Collections: State Foundation on Culture and the Arts; Contemporary Arts Center; Department of Education Artmobile; Bilger Hall, University of Hawaii; Honolulu Academy of Art. Exhibited: Brooklyn Museum; Kyoto Museum of Modern Art; Contemporary Arts Center (one-man); others. Member: Honolulu Printmakers; Hawaii Painters and Sculptors League. Taught: University of Hawaii, emeritus professor of art, from 1952. Address in 1984, Honolulu, HI.

KINDLER, ALICE L. RIDDLE.
(Mrs. Hans Kindler). Painter. Born in Germantown, PA, Oct. 3, 1892. Studied at Penna. Academy of Fine Arts. Works: "The Yellow Still Life," Penna. Academy of Fine Arts, Philadelphia; mural, "The Canterbury Pilgrimage," West Philadelphia High School. Address in 1929, Hotel du Chateau, Chantilly, France.

KING, ALBERT F.
Painter. Born in Pittsburgh, PA, Dec. 6, 1854. Self-taught. Member: Pittsburgh Art Association; Pittsburgh Art Society. Work: Portrait in Homeopathic Hospital and in Duquesne Club, Pittsburgh, PA. Address in 1929, Fifth Ave. Arcade Bldg.; 815 South Braddock Ave., Pittsburgh, PA.

KING, CHARLES B.
Painter and etcher. Born in California in 1869. Pupil of Laurens in Paris, and of Brangwyn in London. Represented in New York Public Library, and Library of Congress, Washington, DC. Address in 1926, 814 Jefferson Ave., Detroit, MI.

KING, CHARLES BIRD.
Born in Newport, RI, in 1785. He first studied with Edward Savage, and in 1805 he went to London where he continued his studies. He returned in 1812, had a studio in Philadelphia, and in 1816 moved to Washington, DC. He died in Washington, March 18, 1862, leaving a number of his pictures and several thousand dollars to the Redwood Library of Newport, RI. His portrait of John C. Calhoun is in the Corcoran Art Gallery, Washington, DC. Hon. member of National Academy.

KING, DAISY B.
Sculptor and painter. Born in Washington, DC, September 8, 1875. Studied at Corcoran School of Art, with E. F. Andrew; Boston Museum of Fine Arts School, with Bela Pratt; and with H. J. Ellicott. Awards: Medal, Corcoran School of Art. Work: St. Paul's Church, Stockbridge, MA; mural, Gurley Memorial Church, Washington, DC; and many portraits. Exhibited: Architectural League; National Academy of Design; Society of Independent Artists. Address in 1953, 39 Gramercy Park, NYC.

KING, ELIZABETH D. (BESSIE).
Painter. Born August 14, 1855. Pupil of Candler School of Art, Detroit. Member: Atlanta Art Association. Represented in the Detroit Museum of Art, Detroit, MI. Address in 1929, 384 Dargan Pl., S. W., Atlanta, GA.

KING, EMMA B.
Painter. Born in Indianapolis, IN. Pupil of Cox, Beckwith, Chase and Art Students League in New York; Boulanger, Lefebvre, Carolus-Duran and Edwin Scott in Paris. Member: Art Students League of NY; Indiana Art Club. Address in 1929, 2118 North Talbot St., Indianapolis, IN.

KING, FRANCIS SCOTT.
Painter. Born in Auburn, ME, in 1850. Designer and engraver on copper. Designer of "Libris" of the printer's devil; designed the "Sylvester" bronze tablet for Johns Hopkins University; also seal for The Rockefeller Institute for Medical Research, New York; designed and engraved copper plates for *The Boston Port Bills*, published by Grolier Club, New York; designed and engraved on copper numerous important plates for the Society of Iconophiles, New York. Member: Society of American Wood Engravers. Address in 1926, 106 South 7th St., Newark, NJ.

KING, FRANK S.
Engraver. Well known as a wood engraver, and later turned to copper plate engraving. He executed a series of wood engravings after the work of Burne-Jones. Possibly the Francis Scott King listed above.

KING, F(REDERIC) L(EONARD).
Painter and illustrator. Born in New York, August 31, 1879. Pupil of Bridgman; Chase; Cox; Arthur W. Dow. Member: Salma. Club; Boston Art Club; North Shore Art Association; Rockport Art Association. Address in 1929, 4 Champney Pl., Boston, MA; summer, The Forecastle, Rockport, MA.

KING, GEORGE B.
This line-engraver produced some portraits and book illustrations of lesser merit for the New York publishers of 1830-34.

KING, GERTRUDE.
(Mrs. L. H. Colville). Painter, craftsman and teacher. Born in Newark, NJ. Pupil of R. H. Johonnot, I. W. Stoud. Member: National Association of Women Painters and Sculptors. Address in 1929, Mendham, NJ.

KING, GILLIS.
Painter. Born in Dewville, TX, Feb. 8, 1904. Pupil of S. E. Gideon, Michel Jacobs, George Bridgman. Member: Texas Fine Arts Association; Southern States Art League; American Federation of Arts.

Work: "Sugar Maples," Austin Art League, Austin, TX; "The Road," San Angelo Art League, San Angelo, TX. Address in 1929, 618 North Second, Ft. Worth, TX; h. 2702 East Ave., Austin, TX.

KING, HAMILTON.
Painter and illustrator. Born in Lewiston, ME, Dec. 21, 1871. Pupil of Julian Academy in Paris. Member: Society of Illustrators, 1915; American Federation of Arts. Died in 1952. Address in 1929, 200 West 57th St., New York, NY; East Hampton, LI, NY.

KING, JAMES.
Painter, etcher and engraver. Born in New York in 1852. Pupil of Art Students League, New York; also of Ecole des Beaux Arts under Gerome. He made a specialty of portraits and marine views. Member of the New York Etching Club. Died in Montclair, NJ, in 1925.

KING, JAMES S.
Engraver. The *Ladies Repository*, published in Cincinnati in 1852, contains some good line subject-plates signed by James S. King as engraver.

KING, JOHN.
Portrait painter of the Civil War period. (See his portrait of Gen. Henry Lee, Gov. of Virginia.)

KING, JOHN CROOKSHANKS.
Sculptor. Born October 11, 1806, in Kilwinning, Ayrshire, Scotland. Came to United States in 1829. Worked as machinist in New Orleans, Louisville, and Cincinnati until 1833. Met Hiram Powers in Cincinnati. After 1840, moved to Boston. Executed marble busts and cameo likenesses. Among his best known busts are: "Daniel Webster," "John Quincy Adams," "Louis Agassiz" and "Emerson." Died in Boston, April 22, 1882.

KING, LOUISE H.
See Cox, Louise Howland King.

KING, MARION PERMELIA.
Sculptor. Born in Ashtabula, OH, October 7, 1894. Pupil of Charles Grafly. Member: Cleveland School of Art Alumni; Fellowship Penna. Academy of Fine Arts; Allied Artists of America; Society of Independent Artists; American Federation of Arts. Awards: Cresson Traveling Scholarship, Penna. Academy of Fine Arts, 1923-25; Stimson Prize, 1925. Address in 1929, 14 Sherman St., Ashtabula, OH.

KING, PAUL.
Painter. Born in Buffalo, NY, Feb 9, 1867. Pupil of Art Students League of Buffalo; Art Students League of NY under Mowbray. Member: Associate National Academy of Design; Salma. Club; Art Club of Philadelphia; Artists' Fund Society; Artists' Aid Society; National Arts Club; International Society of Arts and Letters; Painters' and Sculptors' Gallery Association; Fellowship Penna. Academy of Fine Arts; Allied Artists of America; American Federation of Arts. Awards: Shaw prize, Salma. Club, 1906, Inness Prize, 1906; hon. mention, Philadelphia Art Club, 1911, gold medal, 1913; silver medal, P.-P. Expo., San Francisco, 1915; Philadelphia prize, Penna. Academy of Fine Arts, 1918; first Altman prize ($1,000), National Academy of Design, 1923; Isidor prize, Salma. Club, 1928. Work: "A Cool Retreat," Engineers Club, New York; "Boulder Pass," Art Club of Philadelphia; "Sailing Boats," Reading Museum; "The Old Farm," Albright Gallery, Buffalo; "Hauling Logs," Butler Art Institute, Youngstown, OH; "Passing of Winter," Harrison Gallery, Los Angeles Museum; "Landscape," Art Museum, Houston, TX; "Autumn," "Winter," "Autumn Trees," New Pantheon, Nashville, TN; "Winter Woods," Buffalo Athletic Club; "Nearing Home," Quinnipiack Club, New Haven. Represented in National Gallery, Washington, DC. Address in 1929, Stony Brook, LI, NY; 275 Pawling Ave., Troy, NY.

KING, S. CECILIA COTTER.
(Mrs. W. A. King). Sculptor and painter. Born in Tipperary, Ireland, October 30, 1874. Pupil of Cincinnati Art Academy, under Sharp, Meakin, and Nowottny in painting and Rebisso in sculpture. Associate member, Society of Western Artists. Address in 1910, 147 Bead Ave., Central Park, Buffalo, NY.

KING, SAMUEL.
Portrait painter in oils and miniature. Born on Jan. 24, 1749 in Newport, RI. He painted a miniature of Rev. Ezra Stiles, president of Yale University, in 1770, and a portrait in oil in 1771. In the winter of 1771-72 he was painting in Salem, MA. In 1780 King made a copy of Peale's portrait of Washington, belonging to John Hancock, which was sent to France. King had as pupils Stuart, Allston, Malabone and Charles B. King. He died Dec. 30, 1819, in Newport, RI.

KING, VIRGINIA MORRIS.
(Mrs. Sylvan King). Sculptor. Born in Norfolk, VA, October 16, 1879. Pupil of Solon Borglum and of Harriet Frishmuth. Awards: Florence K. Sloane prize and Elsie Stegman prize, Norfolk Society of Artists, 1921. Member: Norfolk Society of Artists. Address in 1926, Keokuk St., Chevy Chase, Washington, DC; summer, 596 Mowbray Arch, Norfolk, VA.

KING, WILLIAM DICKEY.
Sculptor. Born February 25, 1925, in Jacksonville, Florida. Studied: University of Florida, 1942-44; Cooper Union, 1945-48, with Milton Hebald, John Hovannes; Brooklyn Museum School, 1948-49; Central School of Arts and Crafts, London, 1952; others. Taught at Brooklyn Museum School, 1953-60;

Berkeley; Art Students League, 1968-69. Awards: Cooper Union, 1948, 64; Fulbright, 1949; others. Exhibited at Philadelphia Museum of Art; Museum of Modern Art; Guggenheim; Cooper Union; Whitney; Terry Dintenfass, NYC; and many others. In collections of Addison; Syracuse University; Cornell; Bankers Trust in NYC; mural commission, SS *United States*; others. Address in 1984, 17 E. 96th Street, New York, NY.

KING, WYNCIE.
Illustrator. He was born Covington, GA, Sept. 21, 1884. Address in 1929, College Inn, Bryn Mawr, PA.

KINGMAN, DONG M.
Painter and illustrator. Born in Oakland, CA, on Mar. 31, 1911. Studied at Lingnan School, Hong Kong, with Sze-To-Wai, 1926; Fox and Morgan Art School, Oakland. In collections of Metropolitan Museum of Art, Museum of Modern Art, Whitney, in NYC; Boston Museum of Fine Arts; de Young Museum, San Francisco; plus commissions in NYC, San Francisco, and Hong Kong. Exhibited at American Water Color Society; San Francisco Art Association; Metropolitan Museum of Art Water Color Exhibition; Whitney Annual; others. Received awards: San Francisco Art Association Annual, 1936; Metropolitan Museum of Art Water Color Exhibition; and American Water Color Society Annual. Taught at Art Students League; Columbia University, 1946-1954; Hunter College, 1948-1953; Famous Artists School, Westport, CT, from 1954. Member of American Water Color Society; others. Media: Watercolor and lacquer. Represented by Hammer Galleries, NYC. Address in 1982, 21 W. 58th St., NYC.

KINGSBURY, EDNA (A.).
Painter. Born in Xenia, Ohio, May 5, 1888. Pupil of J. Otis Adams, Otto Stark, William Forsythe. Member: Springfield Art Association; Society of Independent Artists. Address in 1929, 1128 East Ohio St., Indianapolis, IN.

KINGSBURY, EDWARD R(EYNOLDS).
Painter. Born in Boston. Pupil of Massachusetts Normal Art School and Boston Museum School; studied in Paris. Member: Boston Art Club; Salma. Club; American Federation of Arts. Work: "Time and the World," mural painting in Charlestown (MA) High School, etc. Died in 1940. Address in 1929, Boston Art Club, 150 Newbury St., Boston, MA; summer, Ogunquit, ME.

KINGSLEY, ELDRIDGE.
Wood engraver and painter. Born in 1842; died in New York in 1918. Pupil of Cooper Institute of New York. Awarded gold medal at the Paris Exposition of 1889. Many examples of his work are in the Print Department of the New York Public Library. He was a member of the Society of American Wood Engravers.

KINGSLEY, NORMAN WILLIAM.
Sculptor, portrait painter, engraver, and dentist. Born in St. Lawrence Co., NY, October 26, 1829. Practiced dentistry in Elmira and Troy, NY; moved to NYC in 1852. Member: Lotos Club. Work includes a bust of Whitelaw Reid at the Lotos Club, NYC. He exhibited at the National Academy, 1859-80. Address in 1909, Warren Point, NJ.

KINNEY, BENJAMIN HARRIS.
Sculptor and marble cutter. Born February 7, 1821, in Massachusetts; raised in Sunderland, VT. Became established in Worcester, MA, after 1843, with a sojourn in Rutland, VT, in 1850. His bust of Isaiah Thomas is owned in Worcester, MA. Also represented at American Antiquarian Society. Died December, 1888, in Worcester, MA.

KINNEY, MARGARET WEST.
(Mrs. Troy Kinney). Illustrator. Born in Peoria, IL, June 11, 1872. Pupil of Art Students League of NY; Julian Academy in Paris under Robert-Fleury, Collin, Merson and Lefebvre. Member: Associate, Society of Illustrators, 1912. Address in 1929, R.F.D. No. 1., Falls Village, CT.

KINNEY, TROY.
Painter, illustrator, etcher. Born in Kansas City, MO, Dec. 1, 1871. Pupil of Art Institute of Chicago. Member: Chicago Society of Etchers; Brooklyn Society of Etchers; NY Architectural League; Philadelphia Paint Club. Work in Chicago Art Institute; Cleveland and Brooklyn Museums; New York Public Library; Library of Congress, Washington, DC. Specialty, etchings. Died in 1938. Address in 1929, R.F.D. No. 1, Falls Village, CT.

KINSELLA, JAMES.
Painter. Born in New York in 1857; died in 1923. Pupil of National Academy of Design; Ecole des Beaux Arts in Paris. Member: National Arts Club. Work: "Seven O'Clock from Manasquan," Museum of Newark, NJ, Technical School.

KINSEY, ALBERTA.
Painter. Native of West Milton, OH, and studied art in the Cincinnati Art Academy and in the Chicago Art School. Instructor of art in Lebanon University, Lebanon, Ohio. Member: Women's Art Club, Cincinnati; Art Association, and Arts and Crafts Club, New Orleans. Architectural work, and landscapes in oil and water colors. Represented in Cincinnati Art Museum and in the Delgado Museum.

KINSEY, HELEN F(AIRCHILD).
Painter, illustrator, writer and teacher. Born in Philadelphia, Aug. 12, 1877. Pupil of Thouron; W. M.

Chase; Beaux; Anshutz; Breckenridge; Grafly; Dr. James P. Haney; Arthur W. Dow. Member: Plastic Club; Fellowship Penna. Academy of Fine Arts; Eastern Art Association; Philadelphia Art Teachers Association; Philadelphia Alliance; American Federation of Arts. Address in 1929, 1301 Spring Garden St.; h. 1015 So. St. Bernard St., Philadelphia, PA.

KINSEY, NATHANIEL, JR.
Engraver. Born 1829 in Delaware. In 1854-55 this good landscape engraver was employed by the Western Methodist Book Concern, of Cincinnati, Ohio.

KINSMAN-WATERS, RAY.
Painter, craftsman and teacher. Born in Columbus, OH, July 21, 1887. Pupil of Columbus Art School; Alice Schille. Member: NY Water Color Club; League of Columbus Artists; Ohio Water Color Club. Awards: Water color prize, League of Columbus Artists, 1923. Address in 1929, 1143 Lincoln Rd., Columbus, OH.

KINZINGER, ALICE FISH.
Sculptor, painter, educator, and craftswoman. Born in Grand Rapids, MI, November 6, 1899. Studied at University of Michigan, A.B.; Art Institute of Chicago; Baylor University, M.A.; and with Hans Hofmann. Member: Texas Fine Arts Association. Work: Francis Parker School, Chicago, IL; murals, public school, Grand Rapids, MI. Exhibited: Minneapolis Institute of Art; Grand Rapids Art League; West Texas Exhibition, Ft. Worth, TX. Position: Instructor, Baylor University, Waco, TX, 1935-46. Address in 1953, 1621 South 9th Street, Waco, TX.

KIPP, LYMAN.
Sculptor. Born December 24, 1929, in Dobbs Ferry, NY. Studied at Pratt Institute, 1950-52; Cranbrook Academy of Art, 1952-54. Work: Albright; University of California; Cranbrook; Dartmouth College; MIT; University of Michigan; High Museum of Art, Atlanta, GA; Whitney Museum. Exhibited: Cranbrook, 1954, Betty Parsons Gallery, NYC, 1954, 56, 58, 60, 62, 64, 65, 68, Pensacola Art Center, 1958, Albright-Knox Gallery, 1967, all one-man; RI School of Design; Baltimore Museum of Art, 1955, 59, 67; Whitney Museum Annuals, 1956, 60, 62, 66, 68; Brooklyn Museum, 1960; Claude Bernard, Paris; Art Institute of Chicago; Carnegie; Jewish Museum; Los Angeles County Museum of Art; Museum of Modern Art; others. Awards: Guggenheim Foundation Fellowship, 1966; Fulbright Grant, 1966; others. Member: American Association of University Professors. Taught: Harvey School, Hawthorne, NY; Cranbrook Academy of Art; Bennington College, 1960-63; Hunter College, assistant professor of sculpture, 1963-67, professor and department chairman, 1975-78; Herbert Lehman College, professor of sculpture and department chairman, 1966-75; Dartmouth College, 1969. Address in 1984, Somers, NY.

KIRALFY, VERONA A(RNOLD).
Portrait painter. Born in New York City, Oct. 1, 1893. Pupil of Chase and Art Students League of NY. Member: Pittsburgh Art Association. Award: 1st honor, Pittsburgh Art Association, 1922. Address in 1929, Central Athletic Bldg., Craig and Filmore Sts., Pittsburgh, PA.

KIRBY, C. VALENTINE.
Craftsman, writer, lecturer and teacher. Born in Canajoharie, NY, July 19, 1875. Pupil of Art Students League of NY; Chase School of Art, NY; studied in Europe. Member: Eastern Art Association; Western Art Association; Philadelphia Alliance; Philadelphia Sketch Club. Instructor of fine and industrial arts, Manual Training H.S., Denver, CO, 1900-10; director of art instruction, Buffalo, 1911, 1912; Pittsburgh, PA, 1912-20; State Director of Art Education for Pennsylvania, since 1920. Lecturer at Carnegie Institute of Technology, University of Pittsburgh, Pennsylvania State College. American representative and speaker, International Art Congress, Dresden, 1912. Assisted in survey of art in American Industry, 1920; Committee International Art Congress, Prague, 1928; Advisory Committee, Carnegie Corporation; Art Committee, National Congress of Parents and Teachers; Federated Council on Art Education. Author: *The Business of Teaching and Supervising the Arts.* Address in 1929, State Dept. of Public Instruction; h. 219 State St., Harrisburg, PA.

KIRCHNER, EVA LUCILLE (EO).
Sculptor, ceramist, designer, educator, and lecturer. Born in Rich Hill, MO, September 25, 1901. Studied at Denver Art Academy; Denver University; University of Chicago; Columbia University; University Southern California; Alfred University. Member: Colorado Society of Ceramists; 15 Colorado Artists. Exhibited: Denver Art Museum (one-woman). Work: Sculpture and panels, City and County Building, Denver, CO; garden sculpture, St. Anne's Orphanage, Denver. Position: Instructor, Museum of Art School, Denver Art Museum, Denver, CO. Address in 1953, 2921 East 14th Ave., Denver, CO.

KIRK, FRANK C.
Sculptor and painter. Born in Zitomir, Russia, May 11, 1889. Studied at Penna. Academy of Fine Arts, with Hugh Breckenridge, Daniel Garber, Cecilia Beaux, Philip Hale; and in Paris. Member: Philadelphia Alliance; Society of Independent Artists; Salons of America; Grand Central Art Galleries; National Academy of Design; Connecticut Academy of Fine Arts; Society of Washington Artists; Artists Equity Association; Audubon Artists; Boston Art Club; Allied Artists of America; Washington Art Club; North Shore Art Association; Copley Society, Boston; Springfield Art League. Awards: Fellowship, Penna. Academy of Fine Arts; Cresson traveling scholar-

ship, Penna. Academy of Fine Arts; prizes, Connecticut Academy of Fine Arts, 1934, 39, 51; Ogunquit Art Center, 1935; Allied Artists of America, 1943, 45; Springfield Art League, 1943; North Shore Art Association, 1947, 48, 51. Work: Museum Western Art, Moscow, Russia; Binghamton Museum of Art; Cayuga Museum of History and Art; Philadelphia Museum of Art; Biro-Bidjan Museum, Russia; five paintings owned by the Graphic Sketch Club, Philadelphia; "Tuscanian Vase," Trenton Museum, Trenton, NJ; murals, Victoria Theatre, Mahanoy City, PA; Royal Theatre, Felton Theatre, Bronson Theatre, Philadelphia; Grand Theatre, Norfolk, VA; theatres at Reading and Phoenixville, PA. Exhibited nationally. Address in 1953, 38 Union Sq., NYC. Died in 1963.

KIRK, JOHN.
Engraver. Born 1823, in England; died in the United States about 1862. Kirk came to the United States about 1841, and was largely employed by the publishers G. P. Putnam, and by A. B. Hall and other New York engravers. He did some admirable work in line.

KIRK, MARIE LOUISE.
Painter and illustrator. Born in Philadelphia, PA. Student of Philadelphia School of Design and of the Penna. Academy of Fine Arts. Received the Mary Smith prize at the Penna. Academy of Fine Arts in 1894.

KIRKBRIDE, E(ARLE) R(OSSLYN).
Painter and illustrator. Born in Pittsburgh, March 11, 1891. Pupil of Vanderpoel; Buehr; Clarkson. Member: Cliff Dwellers; Palette and Chisel Club. Illustrated: *Sunny Sam* (Reilly and Lee Co.); *Myself and Fellow Asses*, by Thos. Temple Hoyne; stories for *Red Book*. Died in 1968. Address in 1929, Fine Arts Bldg., 410 South Michigan Blvd.; h. 5493 Cornell Ave., Chicago, IL; summer, Eagles Nest Camp, Oregon, IL.

KIRKHAM, CHARLOTTE BURT.
Painter and teacher. Born in East Saginaw, MI. Pupil of Douglas Volk, Burtis Baker, Lefebvre in Paris. Member: Washington Society of Artists; Springfield Art League; Springfield Artists Guild. Address in 1929, 66 Harrison Ave.; h. 107 Maplewood Ter., Springfield, MA.

KIRKLAND, VANCE H.
Painter, lecturer and teacher. Born in Convoy, OH, Nov. 3, 1904. Pupil of Henry G. Keller, Frank N. Wilcox. Member: Cleveland Art Center. Award: Hon. mention, Cleveland Museum of Art, 1927. Gives gallery talks at Denver Art Museum. Director, Chappell School of Art. Address in 1929, 1300 Logan St.; h. 970 Pearl St., Denver, CO.

KIRKPATRICK, FRANK LE BRUN.
Painter. Exhibited water colors at the Penna. Academy of Fine Arts, Philadelphia. Died in 1917.

KIRKPATRICK, MARION POWERS.
See Powers, Marion.

KIRKPATRICK, W(ILLIAM) A(RBER-BROWN).
Painter and illustrator. Born in England, Nov. 7, 1880. Studied under Laurens in Paris; and London. Member: Artists Guild of the Authors' League of America, NY; St. Botolph Club. Address in 1929, 30 Ipswich St., Boston, MA; summer, Friendship, ME.

KIRKUP, MARY A.
Painter, writer and lecturer. Born in Fort Atkinson, IA. Pupil of Art Students League of NY; Lasar in Paris. Member: League of American Pen Women; New Rochelle Art Club; Yonkers Art Association. Award: Adolph Grant prize, New Rochelle Art Association, 1926; landscape prize, Catherine Lorillard Wolfe Art Club, New York, 1927.

KIRMSE, MARGUERITE.
Sculptor, painter, illustrator, and etcher. Born in Bournemouth, England, December 14, 1885. Pupil of Frank Calderon. Member: Philadelphia Painters Club; Springfield Art Association. Illustrated *Bob, Son of Battle*, by Ollivant. Address in 1929, 231 East 48th St., New York, NY; summer, Bridgewater, CT. Died in 1954.

KIRPAL, ELSA.
See Peterson, Elsa Kirpal.

KIRSCH, AGATHA (BEATRICE).
Painter, illustrator, craftsman and teacher. Born in Creston, IA, May 9, 1879. Pupil of Arthur V. Frasier; Seattle Art School under Ella Shepherd Bush; Johonnot; Art Department, University of Washington. Award: Hon. mention, Seattle Fine Arts Society. Address in 1929, 503 Washington Mutual Savings Bank Bldg., cor. Second Ave. and Spring St.; h. 7582 -45th Ave., SW, Seattle, WA.

KIRSHNER, RAPHAEL.
Painter and illustrator. Born in Vienna in 1876; died in New York City in 1917. He painted a series of prominent American women.

KIRSTEN, RICHARD CHARLES.
Sculptor, graphic artist, and painter. Primarily painter and graphics. Born in Chicago, IL, April 16, 1920. Studied at Art Institute of Chicago; University of Washington; and in Japan. Member: American Federation of Arts; Northwest Water Color Society; Northwest Printmakers; Artists Equity Association. Awards: Prizes, Seattle Art Museum, 1949, 50; Music and Art Foundation, 1951; Northwest Water

Color Society, 1952. Exhibited: Seattle Art Museum, 1945, 47-52; Western Washington Fair, 1949-51; Music and Art Foundation, 1949-52; Pacific Northwest exhibition, Spokane, Washinton, 1949-51; Northwest Printmakers, 1950, 51; Buffalo Print Club, 1951; Artists Equity Association (Seattle Chapter), 1952. One-man exhibitions: Seattle Art Museum, 1943; Studio Gallery, 1949, Millard Pollard Association, 1952, Hathaway House, 1952, all in Seattle. In collections of Metropolitan Museum; Seattle Art Museum; Tokyo Museum of Modern Art. Position: Specialist (Artist), US Navy, Chicago, 1944-46; artist, Kirsten Pipe Co., 1946-48; Ed. Art, Seattle Post-Intelligencer, from 1948. Address in 1982, Seattle, WA.

KISELEWSKI, JOSEPH.
Sculptor. Born in Browerville, MN, February 16, 1901. Studied at Minneapolis School of Art, 1918-21; National Academy of Design, 1921-23; Beaux-Arts Institute of Design, NY, 1923-25; American Academy in Rome; Academie Julian, Paris. Member: National Academy of Design; National Sculpture Society; Architectural League; American Academy in Rome. Awards: Prix de Rome, 1926-29; Watrous gold medal; prize, Beaux-Arts, Paris; and others. Work: Statue, Milwaukee, WI; groups, Bronx County Court House, NY; fountain at Huntington Museum, SC; pediment, Commerce Building, Washington, DC; George Rogers Clark memorial, Vincennes, IN; plaques, Capitol Building, Washington, DC, Covington, KY, John Peter Zanger School, NY; reliefs, General Accounting Building, Washington, DC; statue, Harold Vanderbilt, Nashville, TN; statue, Moses, Syracuse University Law School; others. Address in 1982, Browerville, MN.

KISER, VIRGINIA LEE.
Painter, etcher and craftsman. Born in Virginia. Pupil of William M. Chase, F. Vincent DuMond, F. Luis Mora, Joseph Pennell. Member: Columbus Art League; Pittsburgh Associated Artists; American Federation of Arts; Ohio Water Color Painters. Address in 1929, 81 Miami Ave., Columbus, Ohio.

KISHI, MASATOYO.
Born: Sakai, Japan, in 1924. Graduated from the Sakai Middle School in 1941 and completed his studies in the science course at the Tokyo Physical College in 1945. He organized the Tekkeikai Group in 1958. Exhibitions: Sogo Art Gallery, Osaka, 1956; Maruzen Gallery, Tokyo, 1957; Hakuho Gallery, Osaka, 1957, 1960; Takasnimaya Art Gallery, Osaka, 1958; Thibaut Gallery, New York, 1961; Museum of Art, Carnegie Institute, Pittsburgh, 1961; Bolles Gallery, San Francisco, 1961. Came to US in 1960; lives in San Francisco.

KISSACK, R. A.
Painter. Born in St. Louis, MO, March 4, 1878. Pupil of St. Louis School of Fine Arts and studied in Paris.

Member: St. Louis Artists Guild. Awards: Gold medal, St. Louis School of Fine Arts; George Warren Brown prize for figure painting, St. Louis Artists Guild. Work: Decoration in Missouri State Capitol, portraits. Director of Art Education, New York University. Address in 1929, 15 West 11th St., New York, NY.

KISSELL, ELEONORA.
Painter and etcher. Born in Morristown, NJ, Oct. 23, 1891. Member: National Association of Women Painters and Sculptors. Address in 1929, 159 East 61st St., New York, NY; summer, Morristown, NJ.

KITCHELL, JOSEPH GRAY.
Painter and writer. Born in Cincinnati, Ohio, in 1862. Photographic editor of *Quarterly Illustrator*. In 1900 he produced the Ketchell "Composite Madonna," a merging of the most important madonnas painted by the great masters during 300 years, which attracted wide attention in America and Europe. In 1915 he invented and patented a new method of reproducing pictures known as "Sub-Chromatic Art," examples of which were accepted by the Metropolitan Museum; National Academy of Design; Congressional Library; British Museum; Bibliotheque Nationale, Paris, etc. Address in 1926, Mountain Lakes, NJ.

KITSON, HENRY HUDSON.
Sculptor. Born in Huddersfield, England, April 9, 1865. Pupil of Ecole des Beaux-Arts in Paris under Bonnaissieux. Member: Copley Society, 1899; Boston Society of Arts and Crafts; Boston Art Club; Eclectics. Awards: Three gold medals, Massachusetts Charitable Mechanics' Association, New York, 1886; bronze medal, Paris Exposition, 1889; medal, Columbian Exposition, Chicago, 1893; decoration from King of Rumania; medal, Paris Exposition, 1900. Work: "The Minute Man," Lexington, MA; Cedar Rapids, IA; Dyer Memorial Fountain, Providence; W. M. Hunt Memorial, Boston; "Music of the Sea," Boston Museum; "Viscount James Bryce," bronze bust, National Gallery, Washington, DC; National Gallery, London, England; Newark Museum; "Admiral Selfridge," Vicksburg, MS; "Roger Conant" statue, Salem, MA; "Patrick A. Collins Monument," "Robert Burns Monument," "Henry B. Endicott Memorial," "Gov. Banks Monument," Boston, MA; "Farragut Statue"; "Lt. Gen. Stephen D. Lee," "Gen. Martin L. Smith," "Iowa State Memorial," Vicksburg, MS; "Thomas A. Doyle Statue," Providence, RI; "Walt Whitman," bust, London, England; "Elizabeth, Queen of Rumania (Carmen Sylva)," "Carol, King of Rumania," Bucharest, Rumania; "Christ," Drexel Memorial Chapel, Philadelphia, PA; "Haynes Memorial," Newark, NJ. Address in 1929, 4 Harcourt St., Boston, MA. Died in 1947.

KITSON, SAMUEL JAMES.
Sculptor. Born in England in 1848, he came to America in 1878, having studied in Italy. He pro-

duced such work as the "Sheridan Monument" and the portrait of Gov. Greenhalge in the State House at Boston. He died in New York in 1906.

KITSON, THEO ALICE RUGGLES.
(Mrs. H. H. Kitson). Sculptor. Born in Brookline, MA, 1871. Pupil of H. H. Kitson in Boston; Dagnan-Bouveret in Paris. Member: Copley Society; National Sculpture Society. Awards: Hon. mention, Paris Salon, 1890; two medals, Massachusetts Charitable Mechanics' Association; bronze medal, St. Louis Exposition, 1904. Work: "Minute Man of '76," Framingham, MA; soldier monuments at Goshen, NY; Walden, NY; Vicksburg, MS; Minneapolis, MN; Pasadena, CA; Providence, RI; Little Falls, RI; Ashburnham, MA; North Andover, MA; North Attleboro, MA; Sharon, MA; Topsfield, MA; Spanish War monuments at Schenectady, NY, and Lynn, MA; World War memorials, Dorchester, MA; Brookline, MA; Francestown, NH; Equestrian Statue of Victory, Hingham, MA; portrait statue of "Gen. Kosciuszko," Public Gardens, Boston, MA; memorial statue, Mt. Auburn, Cambridge, MA. Address in 1929, Framingham, MA.

KITT, KATHERINE F(LORENCE).
Painter, illustrator and teacher. Born in Chico, CA, Oct. 9, 1876. Pupil of Richard Miller, Henri Morrisot. Member: Cincinnati Woman's Art Club; National Arts Club; American Federation of Arts. Head of art department, University of Arizona, since 1925. Address in 1929, 319 South Fourth Ave., Tucson, AZ.

KITTS, J(ESSIE) De L(ANCEY).
(Mrs. L. T. Kitts). Painter and craftsman. Born in Knoxville, TN, Oct. 9, 1869. Pupil of Minn. School of Fine Arts; San Francisco School of Fine Arts. Member: San Francisco Society of Women Artists. Address in 1929, 1248 25th Ave., San Francisco, CA.

KIYOKAWA, TAIJI.
Painter. Born in 1919 in Hamamatsu, Japan. Graduated from Keio University, Tokyo; studied in France and U.S. Taught at Tokyo University of Arts; residing in San Francisco, CA. Received awards from National Western Museum in Tokyo. Exhibited at many Tokyo galleries; Zen Center, San Francisco, 1964; San Francisco Art Center; California Palace; and Triangle Gallery, San Francisco. In collections of International Theatre of Tokyo and San Francisco Museum of Art.

KLAGES, FRANK H.
Painter and illustrator. Born in Philadelphia in 1892. Pupil of Penna. Academy of Fine Arts. Address in 1926, 2027 North 31st St., Philadelphia, PA.

KLAGSTAD, AUGUST.
Painter. Born in Bingen, Norway, Aug. 14, 1866. Pupil of Feudell; W. J. Reynolds; Art Institute of Chicago; and Chicago Academy of Fine Arts. Member: Scandinavian Art Society of America; American Federation of Arts. Award: Hon. mention, Minneapolis Institute, 1915. Specialty, portraits and church paintings.

KLAR, WALTER H(UGHES).
Painter, writer, lecturer and teacher. Born in Westfield, MA, March 20, 1882. Pupil of Ernest L. Major, Joseph DeCamp, Richard Andrews. Member: Springfield Art League. Award: First honor, Pittsburgh Associated Artists, Pittsburgh, PA, 1919. Address in 1929, 41 Dartmouth St., Springfield, MA.

KLASS, DAVID.
Sculptor. Born in Washington, DC, 1941. Studied: Pratt Institute, School of Architecture, 1959-62, Art School, B.F.A., 1962-66; under Theodore Roszak, 1966-68; Columbia College of Physicians and Surgeons, 1973-74. Exhibitions: Riverside Museum, NYC, 1962; National Academy of Design Annual, NYC, 1971; NJ Painters and Sculptors Society, Jersey City, NJ, 1971, 72, 73, 74, 75; First Street Gallery, NYC, 1977; National Sculpture Society Annual, NYC, 1981; Salmagundi Annual, NYC, 1983; others. Awards: New Jersey Painters and Sculptors Society, Honorable Mention, 1975; National Academy of Design, Helen Foster Barnett Prize, 1976; Salmagundi Annual, The Phillip Isenberg Award, 1983. Membership: President of Society of Artists and Anatomists. Taught: Pratt Institute, 1968-69; University of Bridgeport, CT, 1971; Educational Alliance Art School, NYC, 1972-75; Bennington College, VT, 1978; Parsons School of Design, NYC, 1978-79; Sculpture Center School, NYC, 1983; private classes in anatomy, from 1974. Noted for his Judaica sculptures such as the Rochester Holocaust Memorial, Rochester, NY. Other noted works include "Spirit of Dance" and "Pegasus." Media: Metals. Address in 1984, 136 West 24th Street, NYC.

KLASSEN, JOHN P.
Sculptor, painter, educator, and craftsman. Born in Ukraine, Russia, April 8, 1888. Studied at Ohio State University; and in Germany. Member: Columbus Art League. Awards: Prize, Columbus Gallery of Fine Art, 1945. Exhibited: Syracuse Museum of Fine Art, 1939; Columbus Gallery of Fine Art, 1939-46. Lectures: Mennonite Art. Position: Professor of Art, Bluffton College, Bluffton, OH, 1924-46. Address in 1953, Bluffton, OH.

KLASSTORNER, SAMUEL.
Sculptor and teacher. Born in Russia, February 25, 1895. Pupil of Art Institute of Chicago. Member: Chicago Painters and Sculptors; Chicago Society of Artists. Awards: Adams Foreign Traveling Fellowship, Art Institute of Chicago; Englewood Woman's Club prize, 1921, from Chicago Society of Artists; Frank G. Logan medal and $200, Chicago Society of

Artists; honorable mention, Painters and Sculptors, 1923, Art Institute of Chicago. Address in 1933, Chicago, IL.

KLAUBER, ALICE.
Painter. Born in San Diego, May 19, 1871. Pupil of Chase; Henri. Award: Prize, Fine Arts Gallery, San Diego, 1927. Chairman of Art Dept., San Diego Expo., 1915-16. Designed and directed finish and furnishings, for the "Persimmon Room" of the Exposition, for the living rooms of the Community Center in Balboa Park, for the new Y.W.C.A. in San Diego, and for the San Diego Wednesday Club House. Address in 1929, 2429 Fifth St., San Diego, CA.

KLAUDER, MARY.
Sculptor. Exhibited "A Study" at the Penna. Academy of the Fine Arts, Philadelphia, 1914. Address in 1926, Bala, PA.

KLAVANS, MINNIE.
Sculptor and painter. Born in Garrett Park, MD, May 10, 1915. Studied at Wilson Teachers College, B.S. Ed., 1935; private instructor in silversmithing, 1951-55; painting with Laura Douglas, 1958-60; American University, 1960-64; with Luciano Penay, 1965-70; Corcoran Gallery of Art, plastics with Ed McGowin, 1970-71. Represented in National Collection of Fine Arts, Smithsonian Institution, White House, Corcoran Gallery of Art and National Endowment for the Arts, all in Washington, DC; Museum of Contemporary Art, Madrid, Spain; Baltimore Museum of Art, MD. Exhibited at Corcoran Gallery of Art, 1965 and 67; Baltimore Museum of Art, MD, 1967 and 72; Cisneros Gallery, NY, 1967; Museum of Modern Art, Bilbao, Spain, 1969; Chrysler Museum of Art, Norfolk, VA, 1972. Awards: First Prize for silversmithing, Smithsonian Institution, 1953 and 55; Special Award, Baltimore Museum of Art, 1967. Member: Artists Equity Association. Address in 1982, Washington, DC.

KLAW, ALONZO.
Painter. Born in Louisville, KY, April 15, 1885. Pupil of New York School of Art; Art Students League of NY. Member: Salma. Club; American Water Color Society; NY Water Color Club. Address in 1929, Carmel, NY.

KLEIMINGER, A. F.
Painter. Born in Chicago, IL, Dec. 4, 1865. Pupil of Henri Martin. Member: Chicago Society of Artists; Society of Independent Artists; New Bedford Society of Artists. Address in 1929, 4164 Lake Park Ave., Chicago, IL; summer, Nonquitt, MA.

KLEIN, BENJAMIN.
Painter, illustrator and etcher. Born in Austria-Hungary, Sept. 4, 1898. Pupil of Margaret and Troy Kinney; National Academy of Design; and Europe.

Award: Honorable mention, Eberhard Faber Competition, and Van Dyke Contest for Drawing, 1927. Illustrations for many magazines. Address in 1929, 130 West 95th St., New York, NY.

KLEIN, FRANK ANTHONY.
Sculptor and craftsman. Born in Trier, Germany, June 23, 1890. Studied in Germany, with Van de Velde, Grasseger, Sobry. Member: Allied Artists of America. Work: Statues, portraits, memorials, monuments: Court St., Brooklyn, NY; St. Nicolas Cemetery, Passaic, NJ; St. Catherine of Siena Church, NY; Brooklyn Technical High School; Richmond Hill, NY; St. Stephens Church, Arlington, NJ; Our Lady of Angels Church, Brooklyn, NY; also work in ceramics. Exhibited: Architectural League; National Sculpture Society; Whitney Museum of American Art; Brooklyn Museum; Penna. Academy of Fine Arts; New York Historical Society. Contributor: Articles and illustrations, newspapers and magazines. Address in 1953, 1244 East 45th St., Brooklyn, NY.

KLEIN, ISIDORE.
Painter and illustrator. Born in Russia, Oct. 12, 1897. Pupil of National Academy of Design. Member: Society of Independent Artists. Illustrations in *The New Yorker, Life, Judge, New Masses*. Address in 1929, 145 West 14th St., New York, NY.

KLEIN, NATHAN.
Painter. Exhibited in 1925, at Annual Exhibition of National Academy of Design, New York. Address in 1926, 1841 61st St., Brooklyn, NY.

KLEITSCH, JOSEPH.
Painter, lecturer and teacher. Born in Banad, 1885. Studied in Chicago, Budapest, Munich and Paris. Member: Chicago Painters and Sculptors; Palette and Chisel Club; Chicago Society of Artists; Laguna Beach Art Association. Awards: Gold medal, Palette and Chisel Club; silver medal, Painters and Sculptors Club; first prize, State Fair, Sacramento, California; grand prize and figure prize, Laguna Beach Art Association; purchase prize, Arche Club, Chicago. Address in 1929, Laguna Beach, CA.

KLEMPNER, ERNEST S.
Painter. Born in Vienna, Austria, July 26, 1867. Pupil of L'Allemand. Member: American Federation of Arts. Work: "Portrait of an Actor," City of Vienna; "Francis Burley, Esq.," Chicago Historical Society; "Dr. Otto C. Schmidt," Dr. Archibald Church Library, Chicago. Etchings of King George V, Lord Northcliffe and others. Illustrated for *Punch, Illus. London News, Graphic*, etc. Address in 1929, 410 South Michigan Ave., Chicago, IL; h. Lake Bluff, IL.

KLEPPER, FRANK L.
Painter and teacher. Born in Plano, Texas, May 3, 1890. Pupil of Art Institute of Chicago; Harry Lachman in Paris. Member: Southern States Art League; Dallas Art Association. Award: Hon. mention, Texas State Artists, 1916; Everts gold medal, Texas State Artists, 1920; Woman's Forum medal, Texas State Artists, 1922; purchase prize, Texas Artists, 1928; hon. mention, Davis Competitive exhibition, 1929. Represented in Collection of Woman's Forum, Dallas; high schools, McKinney, and Plano, TX. Died in 1950. Address in 1929, McKinney, TX.

KLEPPER, MAX FRANCIS.
Painter. Born in Germany in 1861. Came to America in 1876 and settled in Toledo, Ohio. Established himself in New York, working on magazine illustration. He also specialized in animal pictures. He died in Brooklyn, NY in 1907.

KLINE, FRANZ.
Painter. Born in Wilkes-Barre, PA, in 1910. Studied: School of Fine and Applied Art, Boston University, 1931-35; Heatherly's Art School, London, 1937-38. Exhibited: Institute of Design, Chicago; National Academy of Design, NY; Museum of Modern Art, NY, 1956. One-man shows include the Margaret Brown Gallery, Boston, 1952; Egan Gallery, NY, 1950, 51, 54; and the Sidney Janis Gallery, NY, 1956. Work: Museum of Modern Art, NY; Albright Art Gallery, Buffalo; Carnegie Institute, Pittsburgh; Guggenheim Museum, NY; others. Award: National Academy Award, 1943-44. Has taught at Black Mountain College, 1952; Pratt Institute, 1953-54; and Philadelphia Museum School of Art, 1954.

KLINE, GEORGE T.
Lecturer and teacher. Born in Baltimore, MD, Aug. 22, 1874. Pupil of S. E. Whiteman. Member: St. Louis Art League; American Federation of Arts. Illustrated scientific articles. Died in 1956. Address in 1929, St. Louis University School of Medicine, 1402 South Grand Ave., St. Louis, MO.

KLINE, HIBBERD VAN BUREN.
Painter, illustrator and etcher. Born in Auriesville, NY, Nov. 8, 1885. Pupil of College of Fine Arts, Syracuse University; and Art Students League of NY under Chase and Mora. Member: American Federation of Arts; Professor of illustration, Department of Art, Syracuse University. Address in 1929, 523 Clarendon St., Syracuse, NY; summer, Fort Hunter, NY.

KLINE, WILLIAM F(AIR).
Mural painter, illustrator and craftsman. Born in Columbia, SC, May 3, 1870. Pupil of National Academy of Design under Low and Ward, and of John La Farge in New York; Julian Academy under Bouguereau and Constant, and Colarossi Academy in Paris. Member: Associate National Academy of Design, 1901; National Society of Mural Painters; NY Water Color Club, 1918; American Water Color Society, 1919; American Federation of Arts. Awards: Lazarus traveling scholarship, 1894; silver medal, Pan-Am. Expo., Buffalo, 1901; Clarke prize, National Academy of Design, 1901; second Hallgarten prize, National Academy of Design, 1903; bronze medal for painting and gold for window, St. Louis Expo., 1904. Work: Crerar Memorial Window, Second Presbyterian Church, Chicago, IL. Died July 30, 1931 in Anniston, AL. Address in 1929, 244 West 14th St., New York, NY.

KLING, BERTHA.
Sculptor. Born in Philadelphia, PA, August 8, 1910. Studied at Boston Museum of Fine Arts School; Fontainebleau School of Fine Art, France; Penna. Academy of Fine Arts. Member: Philadelphia Art Alliance. Awards: Fellowship, Penna. Academy of Fine Arts; Hunt traveling scholarship, Boston, 1933; prizes, RI Chronicle, 1936; Penna. Academy of Fine Arts, 1940. Exhibited: New York World's Fair, 1939; Penna. Academy of Fine Arts, 1935, 36, 38, 43; National Sculpture Society, 1935, 38, 40, 42; Philadelphia Art Alliance, 1935-45; Newport Art Association, 1938, 39, 40; Providence Art Club, 1935-39, 41. Lectures: Techniques of Sculpture and Bronze Casting. Address in 1953, 1676 Margaret St., Philadelphia, PA.

KLIROS, THEA.
Illustrator. Born in NYC in 1935. Attended Bennington College and Yale University before beginning her career in 1953 with a woodcut for *Seventeen*. Best known for her fashion illustrations, she has had her artwork exhibited in Washington, DC, and in Spain.

KLITGAARD, GEORGINA.
Painter. Born in NYC on July 3, 1893. Studied: Barnard College. Awards: Pennsylvania Academy of Fine Arts, 1930; Pan-American Exposition, 1931; Guggenheim fellowship, 1933; Carnegie Institute; Art Institute of Chicago. Collections: Metropolitan Museum of Art; Whitney Museum of American Art; Newark Museum; Dayton Art Institute; New Britain Art Institute; Brooklyn Museum; Wood Gallery of Art, Montpelier, Vermont; United States Post Office, Poughkeepsie, NY, Goshen, NY, Pelham, Georgia. Address in 1980, Bearsville, NY.

KLOPPER, ZANWILL D.
Painter and illustrator. Born in Russia, in 1870. Pupil of Julian Academy in Paris. Specialty, anatomical drawings. Represented by "Immaculate Conception," and mural decorations in "St. Mary's of the Woods." Address in 1926, 1642 West Division St., Chicago, IL.

KLOTZ, ISIDORE E.
Painter. Exhibited "The Rose Bower" at the Penna. Academy of Fine Arts, Philadelphia, 1925. Address in 1926, East Gloucester, MA.

KLOUS, ROSE M.
(Mrs. Isidore P. Klous). Painter and etcher. Born in St. Petersburg, Petrograd, Russia, May 28, 1889. Pupil of Art Students League of NY; Grand Central School of Art; Julian Academy, Paris. Member: Art Students League of NY; Gloucester Society of Artists; Society of Independent Artists. Address in 1929, 205 West 57th St., New York, NY; summer, 7 Marble Rd., East Gloucester, MA.

KLUMPKE, ANNA ELISABETH.
Painter. Born in San Francisco, CA, in 1856. Pupil of Rosa Bonheur, Robert-Fleury, Lefebvre and Julian Academy in Paris. Member: Copley Society, 1893. Awards: Hon. mention, Paris Salon, 1885; silver medal, Versailles, 1886; Temple gold medal, Penna. Academy of Fine Arts, 1889; bronze medal, St. Louis Expo., 1904. Author of *Rosa Bonheur, sa vie son oeuvre.* Work: "In the Wash House," Pennsylvania Academy of the Fine Arts, Philadelphia. Died in February, 1942. Address in 1929, Chateau-de-By, 12 Rue Rosa Bonheur, Thomery, Seine-et-Marne, France.

KLUTH, ROBERT.
A marine and landscape painter. Born in Germany in 1854. He came to America at the age of seven years. He studied art in America, Germany and Norway. He was one of the founders of the Brooklyn Society of Artists. Many of his paintings of Norwegian fjords were purchased by Andrew Carnegie, for public libraries. He died in Brooklyn, New York, in September, 1921.

KNAP, J(OSEPH) D(AY).
Painter, illustrator and etcher. Born in Scottdale, PA, June 7, 1875. Pupil of J. H. Holden. Address in 1929, Villa Charlotte Bronte, 2501 Palisades Ave., New York, NY.

KNAPP, CHARLES W.
Painter of landscapes. Born in Philadelphia in 1823; he died there May 15, 1900.

KNAPP, GRACE Le DUC.
(Mrs. C. C. Knapp). Painter and illustrator. Born in Minnesota, Jan. 28, 1874. Pupil of Art Students League of NY; Corcoran Art School, Washington, DC. Member: Washington Water Color Club. Address in 1929, 2471 Mohawk St., Pasadena, CA.

KNAPP, SADIE MAGNET.
Sculptor and painter. Born in NYC, July 18, 1909. Studied at New York Training School for Teachers, lic.; City College of New York; Brooklyn Museum Art School; Atelier 17; Sculpture Center. Works: Georgia Museum Art, Athens; Norfolk Museum Art, VA; Riverside Museum, NY; others. Exhibitions: Corcoran Gallery Art, Washington, DC; Baltimore Museum; Penna. Academy of Fine Arts, Philadelphia; Butler Institute of Art, Youngstown, Ohio; plus others in Canada, England, France, Switzerland, Argentina, Mexico, Japan, India, Scotland and Italy. Received Awards for Painting, Baltimore Museum, 1956, 58, and 61; Award for Painting, Silvermine Guild Artists, 1965; Grumbacher Award for Painting, National Academy of Design, 1968; Cramer Prize, 1980. Member: National Association of Women Artists; National Society of Painters in Casein and Acrylics; Artists Equity Association; others. Address in 1982, West Palm Beach, FL.

KNAPP, WILLI.
Sculptor, painter, and etcher. Born in Hofeld, Germany, April 4, 1901. Studied at Art Institute Chicago. Awards: First prize, Wisconsin State Exhibition, 1929 and 1930; sculpture prize, Milwaukee Art Institute, 1930; prize, applied art, Wisconsin Applied Art Association, 1931; medal, Milwaukee Art Institute, 1932, second prize, applied arts, 1932, first prize, applied arts, 1933. Represented in State Teachers College, Milwaukee, Wisconsin. Address in 1933, 419 East Townsend St., Milwaukee, WI.

KNATHS, (OTTO) KARL.
Painter. Born in Eau Claire, WI, Oct. 21, 1891. Pupil of Art Institute of Chicago. Award: Harris silver medal ($500), Art Institute of Chicago, Chicago, 1928. Represented in the Phillips Memorial Gallery, Washington, DC. Died in 1971. Address in 1929, 8 Commercial St., Provincetown, MA.

KNAUBER, ALMA JORDAN.
Painter and lecturer. Born in Cincinnati, Ohio, Aug. 24, 1893. Pupil of F. Duveneck, L. H. Meakin, C. J. Barnhorn, Hopkins, and Hawthorne, and studied in France and England. Member: Cincinnati Woman's Art Club; American Artists Professional League; Tau Sigma Delta, hon. arch. frat.; College Art Association; Columbus Art League; Ohio Water Color Society; Western Art Association. Address in 1929, School of Household Administration, University of Cincinnati; 3331 Arrow Ave., Cincinnati, Ohio.

KNEASS, WILLIAM.
Engraver. Born Sept. 25, 1780 in Lancaster, PA; died in Philadelphia, Aug. 27, 1840. It is not known with whom Kneass learned to engrave, but he worked continuously in Philadelphia as an engraver from 1805 to the time of his death. On Jan. 29, 1824, he was appointed engraver and die-sinker at the US Mint, succeeding Robert Scot. His work is usually in line, though he produced some good aquatint views. He was a member of the firm of Kneass & Dellaker, general engravers.

KNECHT, FERN (ELIZABETH) EDIE.
Painter. Born in Du Bois, NE. Pupil of John Carlson, Charles Hawthorne. Award: John Beverly Robinson prize, St. Louis Artists Guild, 1925. Address in 1929, 906 A.O.U.W. Bldg.; h. Capitol Hill Apt. Hotel, Little Rock, AR.

KNECHT, K(ARL) K(AE).
Cartoonist and illustrator. Born Iroquois, SD, Dec. 4, 1883. Pupil of Art Institute of Chicago. Member: Hoosier Salon; Cartoonists of America. On staff of *Evansville Courier*. Address in 1929, Courier Bldg.; 111 Adams Ave., "The Jae-Kae," Evansville, IN.

KNEELAND, HORACE.
Sculptor. Born c. 1808 in New York City. Worked in New York City, 1839-51. Exhibited: National Academy; American Art Union. Work possibly includes bas-relief of a "Trotting Horse," owned in Washington, DC. Died c. 1860.

KNIFFIN, H(ERBERT) R(EYNOLDS).
Painter and teacher. Studied at Cooper Union; National Academy of Design; School of Design and Teachers College, Columbia University; and in Paris and Munich. Instructor, Pope Pius Art and Industrial School, 1906-07; Greenwich Handicraft School, 1908; Assistant Director of Art Instruction, Newark, NJ; Instructor, University of Pittsburgh, 1912-17; director of art, Ethical Culture School since 1918, and Fieldstone Professional Art School. Author of "Elements of Art Appreciation," "Fine Arts and Education," etc. Address in 1929, 3902 Spuyten Duyvil Parkway, New York, NY.

KNIGHT, AUGUSTA.
Painter, craftsman and designer. Born in Augusta, IL. Pupil of St. Louis School of Fine Arts; Art Students League of NY; Pratt Institute, Brooklyn; Art Institute of Chicago; and Charles Hawthorne. Member: Omaha Artists Guild. Award: Hon. mention for water colors, St. Paul Institute, 1916; Robert Morsman prize, Nebraska Artists, 1922; hon. mention, water color, Midwestern Artists, Kansas City Art Institute, 1924. Director of Art, University of Omaha. Address in 1929, 4216 Harney St., Omaha, NE. Died in 1937.

KNIGHT, CHARLES.
Miniature painter, flourishing in Philadelphia 1811-16. He exhibited at Exhibition of Society of Artists, Philadelphia, 1811.

KNIGHT, CHARLES R(OBERT).
Painter, sculptor, and illustrator. Born in Brooklyn, NY, October 21, 1874. Studied: Art Students League; Brooklyn Polytechnic Institute. Pupil of Brush and DuMond. Work: Mural decorations of prehistoric animals and men, American Museum of Natural History, New York; Los Angeles Museum; Field Museum, Chicago. Specialty, animals and birds, modern and fossil. Member: New York Architectural League, 1912. Address in 1953, 24 West 59th Street, New York City. Died in NYC, April 1953.

KNIGHT, CLAYTON.
Painter and illustrator. Born Rochester, NY, March 30, 1891. Pupil of Von der Lancken, Henri, and Bellows. Member: Artists Guild of the Authors' League of America; Soc. of Illustrators. Illustrates for magazines. Address in 1929, 680 Madison Ave., New York, NY; h. Roslyn, LI, NY.

KNIGHT, DANIEL RIDGWAY.
Painter. Born March 15, 1840, in Philadelphia. Died in France in 1924. Pupil of Penna. Academy of Fine Arts, and of Meissonier in Paris. Officer of the Legion of Honor of France. He is represented in the Penna. Academy of Fine Arts by "Hailing the Ferry," and in the Brooklyn Institute Museum by "The Shepherdess." Died March 9, 1924.

KNIGHT, E. H.
Engraver. Born in Brooklyn, NY, in 1853. He died there in 1896. In 1867 E. H. Knight studied engraving with H. B. Hall; he was then in the employ of H. B. Hall & Sons, and was later a partner in this firm. As an engraver, his individuality was lost in the signed work of the firm, but his name appears on a fine portrait of Charles Dickens.

KNIGHT, KATHERINE STURGES.
Illustrator. Member: Society of Illustrators. Address in 1929, Roslyn, LI, NY.

KNIGHT, L(OUIS) ASTON.
Landscape painter. Born Paris, France, 1873. Pupil of Lefebvre, Robert-Fleury and of his father, Ridgway Knight, in Paris. Member: Rochester Art Club. Awards: Bronze medal, Paris Expo., 1900; hon. mention, Paris Salon, 1901; gold medal, Rheims Expo., 1903; gold medal, Lyons Expo., 1904; gold medal, Nantes Exhibition, 1904; gold medal, Geneva Exhibition, 1904; third class medal, Paris Salon, 1905; second class medal, Paris Salon, 1906; gold medal, American Art Society, 1907; Knight of the Legion of Honor, 1920. Work: "The Torrent," Toledo Museum of Art; "The River Wharf," "Sous le Moulin," Luxembourg Museum, Paris. Represented in Rochester Memorial Art Gallery. Died May 8, 1948, in NYC. Address in 1929, 147 Rue de la Pompe, Paris, France; Beaumont le Roger Eure, France.

KNIGHT, T.
Engraver. In 1856, and possibly earlier, Knight was a partner of George Girdler Smith, of Boston, along with W. H. Tappan, the firm name being Smith, Knight & Tappan. His name is signed to some very good portraits executed in both line and stipple.

KNOCHE, LUCILLE (MORLEY).
Designer, sculptor, and painter. Born in Mt. Vernon, NY, March 23, 1899. Studied at Art Institute of Chicago; Illinois Institute of Technology; and in Germany. Member: Inter-Society Color Council; American Society for Aesthetics; Industrial Designers Institute. Awards: All American Packaging award, 1942. Work: San Francisco Museum of Art; Typographical Art Society, Chicago; New York World's Fair. Exhibited: Industrial Designers Institute traveling exhibition. Co-editor, *Descriptive Color Names Dictionary*, 1950. Contributor to *Better Homes and Gardens, Good Housekeeping, Forum, Interior Design,* and other national magazines. Arranged exhibitions for Fashion Group, Chicago; Marshall-Fields; Container Corporation of America; Inter-Society Color Council. Positions: Color and Fabric Stylist, Montgomery Ward Co., NY; Color Technician, Montgomery Ward, Chicago, 1942-46, Butler Bros., 1946-48, Sears Roebuck Co., 1953. Address in 1953, Chicago, IL.

KNOPFE, NELLIE A(UGUSTA).
Painter, lecturer and teacher. Born in Chicago, in 1875. Pupil of Art Institute of Chicago under Vanderpoel and Freer; Charles H. Woodbury; John F. Carlson; Birger Sandzen. Member: American Water Color Society; Art Institute of Chicago Alumni; College Art Association; National Association of Women Painters and Sculptors; Chicago Galleries Association; Illinois Academy of Fine Arts; Society of Independent Artists. Director, School of Fine Arts and Professor of Art, Illinois Woman's College. Represented in John H. Vanderpoel memorial collection; permanent collection, Lafayette, IN, Art Association, and private collections. Address in 1929, Illinois Woman's College, Jacksonville, IL; h. 435 Robinson St., West Lafayette, IN.

KNOTT, ARTHUR HAROLD.
Painter. Born in Toronto, Canada, May 22, 1883. Pupil of Birge Harrison, George Bridgman, Hermon Dudley Murphy, Pratt Institute. Address in 1929, Morro Bay, CA.

KNOWLES, ELIZABETH McGILLVRAY.
Painter. Exhibited at 33rd Annual Exhibition of National Association of Women Painters and Sculptors. Address in 1926, 19 East 49th St., New York City.

KNOWLES, FARQUAR MCGILLVRAY.
Painter, illustrator, writer, lecturer and teacher. Born in Syracuse, NY, May 22, 1860. Studied in the United States, England, France and Canada. Member: R.C.A.; Allied Artists of America; Brooklyn Society of Miniature Painters. Awards: Hon. mention, Pan-Amer. Expo., Buffalo, 1901; medal, Louisiana Purchase Expo., St. Louis, 1904; medal, Panama-Pacific Expo., San Francisco, 1915. Repre-

sented in National Galleries of Ottawa, Toronto, Winnipeg, Edmonton, Regina and Chicago. Died in 1932. Address in 1929, care of Babcock Art Gallery, 5 East 47th St., New York, NY.

KNOWLTON, HELEN MARY.
Born in Littleton, MA, Aug. 16, 1832. Pupil of William M. Hunt, she opened a studio in Boston in 1867. She has exhibited many charcoal sketches as well as landscapes and portraits in oil. Some of her most effective work is in charcoal. She has also published "Talks on Art," of William M. Hunt. The Boston Museum of Fine Arts owns her "Haystacks." She died in 1918.

KNOX, JAMES.
Painter. Born in Glasgow, Scotland, April, 1866. Member: NY Water Color Club; Allied Artists of America; American Federation of Arts. Work: "First Attack of the Tanks," U.S. National Museum, Washington, DC. Address in 1929, Hotel St. George, Brooklyn, New York, NY.

KNOX, SUSAN RICKER.
Painter. Born in Portsmouth, NH. Studied in Philadelphia, New York and Europe. Member: National Arts Club; Pen and Brush; Society of Painters, NY; National Association of Women Painters and Sculptors; Connecticut Academy of Fine Arts; Buffalo Society of Artists; Chicago Galleries Association; New Haven Paint and Clay Club; North Shore Art Association; Springfield (MA) Art League. Award: Hon. mention, Connecticut Academy of Fine Arts, 1927. Specialty, portraits. Address in 1929, 119 East 19th St., New York, NY; summer, York Harbor, ME.

KNUDSON, HELEN ELIZA.
Painter. Born in Farmingdale, IL. Member: American Federation of Arts; WAA; Illinois Academy of Fine Arts; Springfield Art Association. Address in 1929, 1141 Williams Blvd., Springfield, IL.

KNUTESON, OSCAR.
Painter. Member: Laguna Beach Art Association. Address in 1929, 125 Rotdale Trail, Laurel Canyon, Hollywood, CA; Laguna Beach, CA.

KOBBEE, MARIE O(LGA).
Painter. Born in New Brighton, SI, NY, 1870. Member: NY Water Color Club. Specialty: Pastel portraits and portrait drawings. Address in 1929, 77 East 89th St., New York, NY; Stockbridge, MA.

KOBMAN, CLARA H.
Painter. Member: Cincinnati Woman's Art Club. Address in 1929, 5 Marguerite Bldg., Main and Foraker Terrace, Norwood OH; 3 Eden Park Terrace, Cincinnati, OH.

KOCH, HELEN C.
Painter, craftsman, teacher and designer. Born in Cincinnati, Ohio, March 2, 1895. Pupil of L. H. Meakin, James Hopkins, Henry B. Snell. Member: Western Art Association; Cincinnati Woman's Art Club; Crafters. Address in 1929, 253 Hearne Ave., Cincinnati, OH.

KOCH, JOHN.
Painter. Born in Toledo, Ohio, Aug. 18, 1910. Pupil of A. Valerio, L. Makielski, Richard Miller. Member: Michigan Academy of Science, Arts and Letters. Died in 1978. Address in 1929, 2003 Day St., Ann Arbor, MI; summer, 16 bis Rue Bardinet, Studio 20, Paris, France.

KOCH, PETER.
Painter, illustrator, lecturer and teacher. Born in Saint Marys, Ohio, Dec. 25, 1900. Pupil of Duveneck, Hopkins, John Norton. Member: Illinois Society of Fine Arts; Minn. Art Institute. Address in 1929, 112 Locust St., Chicago, IL.

KODA-CALLAN, ELIZABETH.
Illustrator. Born in Stamford, CT, in 1944. Attended Siena Heights College in Michigan; University of Dayton in Ohio; and Society of Visual Arts in NYC. She studied under James McMullan and has done extensive work for *Scholastic Magazine* and *New York Magazine*. Her first published illustration was done for Arista Records in October 1974.

KOECHL, PAUL.
Painter and teacher. Born in Brooklyn, NY, July 27, 1880. Pupil of Homer Boss. Member: Society of Independent Artists. Address in 1929, 1947 Broadway; h. 270 Park Ave., New York, NY.

KOEHLER, P. R.
Landscape painter. Exhibited "Early Evening" in New York.

KOEHLER, ROBERT.
Painter. Born in Hamburg, Germany, in 1850; died in 1917. He was brought to the United States in 1854. Studied at Milwaukee, Wisconsin, and there learned lithography, which he practiced in Pittsburgh, PA, and in New York; studied drawing in night classes at National Academy in 1877. Organized the American department of the art exhibition, Munich, 1883 and 1888. Director of Minneapolis School of Fine Arts since 1893. Principal paintings; "Holiday Occupation;" "Her Only Support;" "The Socialist;" "The Strike;" "Violet;" "Judgment of Paris;" "Love's Secret;" "The Family Bible;" "Father and Son;" "Salve Luna." Member: Society of Western Artists; Minneapolis Society of Fine Arts; Minneapolis Art League; City Art Commission, Minn.; State Art Society.

KOEHLER, SYLVESTER R.
Painter. Born in Germany in 1837; died at Littleton, NH, on Sept. 10th, 1900.

KOEN, IRMA RENE.
Painter, writer, lecturer. Born in Rock Island, IL. Pupil of C. F. Brown, Lathrop, Snell; studied abroad. Member: NY Water Color Club; Painters and Sculptors of Chicago; National Association of Women Painters and Sculptors; Illinois Academy of Fine Arts; Chicago Art Club. Represented in Toledo Museum; Pennsylvania Academy of the Fine Arts; Peoria Art Association. Address in 1929, care the Chicago Galleries Association, Chicago, IL; h. 3637 Twelfth St., Rock Island, IL; summer, Boothbay Harbor, ME.

KOENIGER, WALTER.
Painter. Born in Germany, May 6, 1881. Pupil of Duecker; von Gebhard. Member: Salma. Club. Work: "The Silent Places," Toledo Museum; author of "Koeniger Painter of Snow" in International Studio, June, 1925. Address in 1929, 222 West 59th St., New York, NY, summer, Woodstock, NY.

KOEPNICK, ROBERT CHARLES.
Sculptor and teacher. Born in Dayton, OH, July 8, 1907. Studied at Dayton Art Institute; Cranbrook Academy of Art; and with Carl Milles. Member: Dayton Society of Painters and Sculptors. Awards: Prizes, College Art Association of America, 1931; National Academy of Design, 1940, 41; National Catholic Welfare Competition, 1942; National Gallery of Art, 1945. Work: Sculpture, County Court House, St. Paul's Church, Parker Cooperative School, Roosevelt High School, all in Dayton, OH. Exhibited: Penna. Academy of Fine Arts, 1936-38, 40; National Academy of Design; Art Institute of Chicago, 1937; Syracuse Museum of Fine Art, 1938; Cincinnati Museum Association, 1935-37, 39, 40; Dayton Society of Painters and Sculptors, 1937-45; Metropolitan Museum of Art, NYC. Position: Head, Sculpture and Ceramic Department, School of Dayton Art Institute, Dayton, OH, 1936-41, 46-74, emeritus professor, from 1974. Address in 1982, Lebanon, OH.

KOERNER, HENRY.
Painter and lecturer. Born on Aug. 28, 1915, in Vienna, Austria. Studied at the Academy of Applied Art, Vienna. Also studied with Theodore Slama in Vienna. His work has been exhibited at Museum of Modern Art, 1942, in the National War Poster Competition; Philadelphia Museum Art, 1950; Artist of the Year, Pittsburgh, 1963. Taught at the Munson-Williams-Proctor Institute, 1947-48; artist in residence, Chatham College, 1952-53; Washington University, 1956. Awards include the National War Poster Competition, 1942; Museum of Modern Art Temple Award; Art Institute of Philadelphia; and First Prize at the National Cancer Association, 1939.

Commissioned for 65 *Time* magazine portraits. Media: Ink, watercolor and oil. Living in Pittsburgh, PA.

KOEVOETS, H. & C.
This firm was engraving and publishing portraits in New York about 1870.

KOHLER, ROSE.
Sculptor and painter. Born in Chicago, IL. Pupil of Cincinnati Academy under Duveneck and Barnhorn. Member: Cincinnati Woman's Art Club; American Artists Professional League. Died in 1947. Address in 1929, 2 West 88th St., New York, NY.

KOHLMAN, RENA TUCKER.
See Magee, Rena Tucker Kohlman.

KOHLMEYER, IDA R.
Painter. Born on Nov. 3, 1882. Studied: Newcomb College; Newcomb Art Department, Tulane University. Awards: Southeastern Annual Exhibition, Atlanta, Georgia; Biennial Exhibition of Contemporary American Painting, Washington, DC. Address in 1980, 9811 Madison Ave., NY, NY.

KOHN, GABRIEL.
Sculptor. Born 1910, in Philadelphia, PA. Studied: Cooper Union, 1929; Beaux-Arts Institute of Design, NYC, 1930-34; Zadkine School of Sculpture, Paris, 1946. Work: Albright; Cranbrook; Museum of Modern Art; Ringling; Whitney Museum. Exhibited: Atelier Mannucci, Rome, 1948; Galleria Zodiaco, Rome, 1950; Cranbrook, 1953; Leo Castelli Inc., NYC, 1959; Otto Gerson Gallery, NYC, 1963; Salon de la Jeune Sculpture, Paris, 1950; Los Angeles County Museum of Art; Metropolitan Museum of Art, National Sculpture Exhibit; Penna. Academy of Fine Arts; Whitney Museum; Museum of Modern Art; Claude Bernard, Paris, Aspects of American Sculpture; New School for Social Research; Seattle World's Fair, 1962. Awards: Augustus Saint-Gaudens Medal from Cooper Union, 1925; Beaux-Arts Institute of Design, NYC, 14 awards in sculpture, 1929-32, and a silver medal, 1932; Cranbrook, George A. Booth Scholarship, 1952; Tate, International Unknown Political Prisoner Competition, 1953; Ford Foundation Grant, 1960. Address in 1970, N. Hollywood, CA. Died in 1975.

KOHN, IRMA.
Landscape painter. Born in Rock Island, IL. Represented in Toledo Museum and Penna. Academy of Fine Arts, Philadelphia.

KOLIN, SACHA.
Sculptor and painter. Born in Paris, France, May 9, 1911. Studied at School of Applied Arts, Academy of Fine Art, Vienna; Studio Naoum Aronson and Societe Nationale des Beaux-Arts in Paris. Work in Smithsonian National Galleries; Everson Museum (commission); others. Member: Artists Equity Association; League Present-Day Artists. Awards: Prizes, Societe Nationale des Beaux-Arts, Paris, 1934, 35. Exhibited: Vienna, Austria, 1934; Paris, France, 1934-36; Mercury Gallery, NY, 1938-41; New York World's Fair, 1939; ACA Gallery; Whitney Museum of American Art; Burliuk Gallery; Contemporary Art Gallery; ANTA Theatre; Everson; Brooklyn Museum; Salon des Realites Nouvelles, Paris, others. Sculpted in metal, wood, and formica. Address in 1953, 777 West End Ave., NYC. Died in 1981.

KOLLER, E. LEONARD.
Sculptor, illustrator, writer, lecturer, and teacher. Born in Hanover, PA, December 8, 1877. Studied under Pyle, Morse and Willett. Member: Eastern Art Association; American Federation of Arts. Work: "Soldiers Memorial Monument," near Gettysburg battlefield; and memorial windows in Pittsburgh and Philadelphia. Author of text books on design, illustration and lettering. Address in 1933, 633 Jefferson Ave., Scranton, PA.

KOLLOCK, MARY.
Sculptor, landscape, still life and portrait painter. Born in Norfolk, VA, in 1840 (the *Artists Year Book* says August 20, 1832); lived in NYC. Studied at the Penna. Academy of Fine Arts; the Art Students League; and at the Julian in Paris. Exhibited at the Penna. Academy from 1864; and at the National Academy from 1866. Member of the Art Students League. Among her works are "A November Day"; "Glimpse of the Catskills"; "Midsummer in the Mountains," which was exhibited in 1876 at the "Centennial," Philadelphia, PA. Died on January 12, 1911, in NYC.

KOLSKI, GAN.
Painter, illustrator and teacher. Born in Poland. Award: Silver and bronze medal, National Academy of Design, 1922, 1923. Address in 1929, 23 Minetta Lane, New York, NY.

KOMINIK, GERDA.
Painter. Born in Vienna, Austria. Awards: Riverdale Outdoor Show; Reilly's School of Fine Arts; Romanofsky's gold medal; San Miguel de Allende, Mexico. Collections: In Canada, Austria, England, Mexico, and the US. Exhibitions: Art Students League; Allied Artists of America; Academician National Academy of Design; NYC galleries.

KOMODORE, BILL.
Painter and photographer. Born Oct. 23, 1932, in Athens, Greece. Became U.S. citizen (1947). Earned BA and MFA (1957) from Tulane University. Studied with Hans Hofmann. Taught at Commercial Art School, Dallas; Florida School for Deaf and Blind (St. Augustine); and at his own school in St. Augus-

tine, FL. Awarded Carnegie Scholarship, 1956, and awards from Dallas Museum of Fine Arts (1960); Texas Commission on Arts grant (1980); others. Exhibited at Chrysler Art Museum; 1961 Texas State Fair; Albright-Knox; Whitney, many others. In private collections, and in those of the National Gallery of Art; Whitney; and Walker Art Center.

KOMROFF, MANUEL (MRS.).
See Barnard, Elinor M.

KONI, NICOLAUS.
Sculptor and lecturer. Born in Hungary, May 6, 1911; US citizen. Studied: Academy of Fine Art, Vienna; Masters School, Paris; Masters School, Florence, Italy. Work: Oklahoma Art Center, Oklahoma City; Forrestal Building; Metropolitan Opera House; Kennedy Center, Washington, DC; many others. Exhibitions: Whitney, NYC; Birmingham (AL) Museum of Fine Art; Parrish Art Museum, Southampton, NY; Milch Galleries, NYC; International Sculpture Expo., Paris; many others. Awards: First prize in Art, Parrish Art Museum. Member: National Sculpture Society; Quilleis Art Society. Media: Wood, marble, bronze, jade, gold. Living in New York City in 1970. Address in 1982, Palm Beach, Florida.

KONRATY, LOLA.
Sculptor and painter. Born in Riga, Russia, February 24, 1900. Studied abroad and with Serge Soudeikine, William Ehrich. Work: Rochester Memorial Art Gallery. Exhibited: Buffalo, NY; Syracuse Museum of Fine Art; Rochester Memorial Art Gallery, 1935-46. Address in 1953, Pittsford, NY.

KONTI, ISIDORE.
Sculptor. Born in Vienna, Austria, July 9, 1862. Pupil of Imperial Academy in Vienna under Helmer and Kundmann. Came to US in 1890. Member: Associate, National Academy of Design, 1908, Academician, 1909; National Arts Club; Yonkers Art Association; League of American Artists; National Sculpture Society, 1897; New York Architectural League, 1901; Salma. Club, 1904; Allied Artists of America; American Federation of Arts. Award: Gold medal, St. Louis Exposition, 1904. Work: "Genius of Immortality," Metropolitan Museum of NY, and Detroit Institute; "Illusion," owned by the Italian government; "South America," group for Bureau of American Republics Building, Washington, DC; medal, "Landing of Jews in America," Minneapolis Institute; "Orpheus," Peabody Institute, Baltimore, MD; monument of Kit Carson and Lt. Beal, National Museum of Art, Washington; statues of Justinian and Alfred the Great, Court House, Cleveland; three fountains, Audubon and City Park, New Orleans; "Rev. Morgan Dix," Trinity Church, NY; memorial to heroes of World War, Yonkers, NY; "The Despotic Age," St. Louis Museum and Corcoran Gallery; memorial, St. John's Cathedral, NYC; "Dancer," Museum, Newark, NJ; Lincoln and Hudson-Fulton Memorials, Yonkers, NY; McKinley Memorial, Philadelphia; fountain figure, NYC. Address in 1933, 314 Riverdale Ave., Yonkers, NY. Died in 1938.

KONZAL, JOSEPH.
Sculptor. Born in Milwaukee, WI, in 1905. Studied: Art Students League, with Weber, Kuhn, Laurent, 1926-30; Layton School of Art, 1927; Beaux-Arts Institute of Design, NYC, 1928-30. Work: New School for Social Research; Storm King Art Center, Mountainville, NY; Tate; Whitney Museum. Exhibited: Eighth St. Playhouse, NYC, 1938; Contemporary Arts Gallery, NYC; The Bertha Schaefer Gallery, NYC; Art Institute of Chicago; Museum of Modern Art; New York World's Fair, 1939; Brooklyn Museum, 1950, 52, 54, 56, 58, 60; Penna. Academy of Fine Arts, 1953-54, 58, 64; Federation of Modern Painters and Sculptors Annuals; Sculptors Guild Annuals; Silvermine Guild Annuals, 1954-63; Whitney Museum Annuals, 1960, 62, 63, 64, 66, 68; Carnegie; Newark Museum; New York World's Fair, 1964-65; Boston Museum; Aldrich Museum; others. Awards: Brooklyn Museum Biennial, two first prizes; Guggenheim Fellow. Member: Sculptors Guild; Federation of Modern Painters and Sculptors. Taught at Brooklyn Museum School; Adelphi University; Newark Public School of Fine and Industrial Art; Queens College. Address in 1982, 360 West 21st Street, NYC.

KOONS, DARELL J.
Painter. Born in Albion, MI, Dec. 18, 1924. Studied: Bob Jones University; Western Michigan University; Eastern Michigan University. Work: Butler Institute of American Art, Youngstown, Ohio; South Carolina State Art Collection, Museum of Art, SC. Teaching: Bob Jones University, from 1955 to present. Exhibitions: Acquavella Galleries, NY; Southeastern Exhibits, Atlanta, GA; Ohio State College Invitational, CA; and others. Awards: Realistic Artist Association, Springfield, MA; Society of Four Arts, FL; Guild South Carolina Artists; others. Member: Greenville Art Association and Guild; Guild of South Carolina Artists. Media: Watercolor, acrylic. Address in 1982, 6 Yancy Drive, Greenville, SC.

KOOPMAN, AUGUSTUS.
Painter and etcher. Born in Charleston, SC, in 1869. Studied at the Penna. Academy of Fine Arts and later in Paris. Represented in Philadelphia Art Club by "The Old Troubadour"; his dry-points and etchings are in the Congressional and New York Public Libraries. He died in 1914.

KOOPMAN, JOHN R.
Painter. Born in Falmouth, MI, June 5, 1881. Pupil of Chase, Henri, K. H. Miller, Wiles. Member: Salma.

Club; NY Water Color Club. Exhibited water colors at Penna. Academy of Fine Arts. Awards: First water color prize, annual exhibition Michigan Artists, Detroit, 1924; water color purchase prize, Michigan State Fair, 1924; Isidor prize, NY Water Color Club, 1929. Instructor in Drawing and Painting, Brooklyn Institute of Arts and Sciences, and Grand Central School of Art. Died in Sept. 16, 1949. Address in 1929, 257 West 86th St., New York, NY.

KOPMAN, BENJAMIN D.
Painter. Born in New York. Member of the Allied Artists of America, New York. Represented in Brooklyn Institute of Arts and Sciences; and by "Portrait of a Young Man" at Penna. Academy of Fine Arts. Address in 1926, 8 East 15th St., New York. Died in 1965.

KOPMAN, KATHARINE.
Native of New Orleans. Studied under Molinary, Newcomb School of Art, and with Dodge Mac-Knight. Instructor of drawing and design, Newcomb High School; Newcomb School of Art; supervisor of art, Alexandria Grammar Schools, Alexandria, LA. Specialty, landscapes.

KORAS, GEORGE.
Sculptor. Born in Florina, Greece, April 1, 1925; US citizen. Studied at School of Fine Arts, Athens, Greece; studied in Paris and Rome, 1955; Art Students League, 1957; with Jacques Lipchitz, 1955-59. Work in W. P. Chrysler Collection; Provincetown (MA) Museum; Norfolk (VA) Museum; National Museum of Athens, Greece; plus commissions for Board of Education, Queens and Bronx, NY. Exhibitions include Panhellenios Zapeion, Athens, Greece; Brooklyn Museum; Penna. Academy of Fine Arts; Silvermine Guild of Artists; Consulate General of Greece. Awards: Brooklyn Museum; Penna. Academy of Fine Arts; Hofstra University. Teaching at SUNY Stony Brook, from 1966. Member of Audubon Artists, director of sculpture, 1963-66, 68-71. Works in bronze. Address in 1982, Flushing, NY.

KORBEL, MARIO J.
Sculptor. Born in Osik, Czechoslavakia, March 22, 1882. Came to U.S. at the age of 18, returned to Europe to study in Paris and Munich. Later established a studio in Prague. Member: Chicago Society of Artists; National Sculpture Society. Award: Shaffer prize, Art Institute of Chicago, 1910; Goodman Prize ($500), Grand Central Galleries, 1929. Work: Dancing group, Cleveland Museum; "Andante," Met. Museum of Art; "Minerva," Univ. of Havana, Cuba; marble bust in Chicago Art Inst.; McPhee Mem. monument, Denver. Also in collections of the Vatican; Cranbrook Academy of Art; Nat. Gallery of Canada; Whitney; and many private collections. Exhibited at Nat. Sculpture Society, 1923. Died in 1954. Address in 1933, 54 West 74th St., New York, NY.

KORMENDI, EUGENE (JENO).
Sculptor and teacher. Born in Budapest, Hungary, October 12, 1889. Studied at Art Academy of Budapest; and in Paris. Member: Society of Fine Arts, Budapest; Society Four Arts, Palm Beach, FL; Audubon Artists. Awards: Society Four Arts, Palm Beach, 1945; Hoosier Salon, 1946; medal, Barcelona Institute Exposition. Work: Heeres Museum, Vienna; Budapest Museum; memorials, monuments, statues, Valparaiso, IN; University of Notre Dame; Mt. Mary College, Milwaukee; Boys Town, NE; Washington, DC; Ft. Wayne, IN; and many works abroad. Exhibited: One-man exhibitions: Milwaukee Art Institute, 1940, 45; Norton Gallery, 1944; Renaissance Society, University of Chicago, 1941; Oak Park Art League, 1941; Herron Art Institute, 1943; also, Hoosier Salon, 1946; Audubon Artists, 1946; Art Institute of Chicago, 1946; and abroad. Position: Artist in Residence, Univ. of Notre Dame, South Bend, IN, from 1941. Address in 1953, 1009 West Washington Ave., South Bend, IN. Died in 1959.

KORNHAUSER, DAVID E.
Painter. Studied at Penna. Academy of Fine Arts. Represented at Penna. Academy of Fine Arts by "Along the Schuylkill River."

KORZYBSKA, MIRA EDGERLY.
(Countess Alfred de Korzybska). Painter, writer and lecturer. Born Aurora, IL, Jan. 16, 1879. Work: "Mrs. Lawrence Drummond with Jim," Metropolitan Museum, New York; "Alfred Skarbek de Korzybska," Chicago Art Institute. Address in 1929, care of the Fifth Avenue Bank, New York, NY; h. 66 Weleza St., Warsaw, Poland.

KOSCIUSZKO, TADEUSZ ANDRZEJ BONAWENTURA.
Portrait artist. He was born in the Polish section of Lithuania in Feb. 12, 1746 and died in Solothurn, Switzerland, Oct. 15, 1817. Came to America in 1776, joined the Continental Army, and fought in the American Revolution. Returned to Europe in 1784; revisited the U.S. in 1797-98. He drew a portrait of General Gates and several of the other Revolutionary soldiers. Worked in both crayon and oils.

KOSH, A. E.
Born in Germany in 1838; died in this country in 1897. Kosh was an engraver of landscape and subject-plates for magazines, and came to the United States in 1868.

KOSICKI, C(ATHERINE) W(ATHA).
Painter. Born May 12, 1890. Pupil of Frederick Mozitz, Riga, Latvia. Member: Detroit Society of Women Painters; Society of Independent Artists; Detroit Society of Independent Artists. Award: First prize, Michigan State Fair, 1928. Address in 1929, 3779 Collingwood Ave., Detroit, MI.

KOSLOW, HOWARD.
Illustrator. Born in Brooklyn, NY, in 1924. Attended Pratt Institute and the Cranbrook Academy of Art in Michigan. His career began in 1946 with a Hilton Hotel advertising series and went on to include book, poster, and editorial illustration. Some of his clients are *Boys' Life, Popular Science, Reader's Digest,* and the *United States Postal Service.* The Smithsonian Institution and the National Park Service own his work and his illustrations have been shown in galleries nationwide.

KOSSIN, SANFORD.
Illustrator. Born in Los Angeles, California, in 1924. Studied at the Jepson Art Institute before coming to New York in 1952. Early in his career he was a frequent contributor to Galaxy Magazine, illustrating science fiction stories. He has recently been painting for paperback book publishers and has had exhibits in the Society of Illustrators Annual Exhibitions several times. He illustrated a series on the Bay of Pigs for *Life* in 1963 and his work has appeared in *Argosy* and *The Saturday Evening Post.* His works are in the US Air Force Museum and the Douglas MacArthur Memorial.

KOST, FREDERICK W.
Landscape painter. Born in New York, in 1861. Student of National Academy of Design, NY, and studied later in Paris and Munich. Elected National Academician in 1906. Received honorable mention at Paris Exhibition, 1900. Represented at Penna. Academy of Fine Arts, Philadelphia, and in the Brooklyn Institute. He died at Brookhaven, LI, in 1923.

KOTZ, DANIEL.
Landscape painter. Born near South Bend, IN, March 21, 1848. Pupil of Henry F. Spread. Member: Salma. Club; Nanuet Painters. Address in 1929, 3779 Collingwood Ave., Detroit, MI.

KOWAL, DENNIS J.
Sculptor and writer. Born in Chicago, IL, September 9, 1937. Studied at Art Institute of Chicago; University of Illinois, Chicago; Southern Illinois University. Work in Gillette Corporation, Boston; Brockton Art Center; MBTA Station, Prudential Auditorium, Boston; monuments, Milton Academy, MA; commissions for numerous corporations, banks, etc. Has exhibited at 66th Chicago Artists Annual, Art Institute of Chicago; Robert Freidus Gallery, NYC; Mead Art Museum, Amherst College, MA; Gilbert Gallery Ltd., Chicago; many others. Member: Boston Visual Artists Union; New England Sculptors Association, Boston; others. Author: *Casting Sculpture,* 1972; *Artists Speak,* New York Graphic Society, 1976. Address in 1982, Cohasset, MA.

KOWNATZKI, HANS.
Sculptor and painter. Born in Koenigsberg, Germany, November 26, 1866. Pupil of Neide, Knorr, Koner and Lefebvre in Paris. Award: First prize for sculpture, Society of Washington Artists, Washington, DC, 1929. Member: Society of Independent Artists. Address in 1933, Peconic, Long Island, NY. Died in 1939.

KRAFFT, CARL R.
Painter. Born in Reading, Ohio, Aug. 23, 1884. Pupil of Art Institute of Chicago; Chicago Fine Arts Academy. Member: Painters and Sculptors of Chicago; Painters' and Sculptors' Gallery Association, NY; Cliff Dwellers; Society of Ozark Painters; Austin, Oak Park and River Forest Art Leagues; Chicago Galleries Association; Illinois Academy of Fine Arts; Grand Central Art Galleries. Awards: Englewood Woman's Club prize, Art Institute of Chicago, 1915; Municipal Art League purchase prize, 1916; hon. mention, Chicago Artists Guild, 1916; Fine Arts Building prize, Artists Guild, 1917; second ($200) Logan Medal, Art Institute of Chicago, 1920; bronze medal, Illinois Artists Exposition, 1920; silver medal, Chicago Society of Artists, 1921; bronze medal, Central States exhibition, Aurora, 1922; first Logan medal and $500, Art Institute of Chicago, 1925; Medal of Honor, Allied Artists of America, 1925; Harry Frank prize for figure composition, Art Institute of Chicago, 1925. Represented by "Charms of the Ozarks," Municipal Art League Collection, Chicago; collection of Peoria (IL) Society of Allied Arts; "Ozark Zephyrs," Englewood Woman's Club; "Cliff at Morning, Ozarks," Harrison Gallery, Los Angeles Museum; "The Bridge" and "The Squatter's Shack," Art League, Aurora, IL; "Quiet of Evening," Arche Club, Chicago; "Morning Fog," and "Mill Creek in Winter," City of Chicago; "Day after Christmas" and "Woods in Snow," in Oak Park Art League; "Tree Tapestry," South Shore Country Club, Chicago; "November Snow," Wichita Falls, TX; "The Red Sleigh," Lincoln School, River Forest, IL; "Ozark Palisades," University of Illinois; "Morning Light," Illinois State Museum; series of murals, First National Bank, Elmhurst, IL; "Autumn Spirit," Richmond, Indiana Art Association; "December Day," Howe School, Austin; "Winter," Faulkner School, Chicago; "Afternoon," Holmes School, Oak Park; "Triad of Life," Y.M.C.A. Austin. Address in 1929, 416 North Harvey Ave., Oak Park, IL. Died in 1938.

KRAMER, REUBEN ROBERT.
Sculptor and teacher. Born in Baltimore, MD, October 9, 1909. Studied: Rinehart School of Sculpture, European traveling scholarship, 1931, 33; American Academy in Rome; Acad. Grand Chaumiere; and in London. Member: Artists Equity Association; Alumni, American Academy in Rome. Awards: Rinehart traveling scholarship, 1931, 1933; Prix de

Rome, 1934; Brooklyn Museum of Art, 1940, 1946, 1948, 1949, 1951, 1952; Peale Museum, 1949; Maryland Sculptors Guild, 1947; National Institute of Arts and Letters Grant, 1964; others. Work: Brooklyn Museum of Art; IBM; Martinet College; U.S. Post Office, St. Albans, WV; relief, St. Mary's Seminary, Alexandria, VA; Baltimore Museum; Corcoran; Portland (OR) Art Museum; others, including 8 1/2 ft. statue of Justice Thurgood Marshall (commission). Exhibited: Baltimore Museum of Art, 1939, 51, 59, 66, retrospective, 1978; Philadelphia Museum of Art, 1940, 1949; Penna. Academy of Fine Arts, 1949-53, 57, 58, 60; Brooklyn Museum of Art, 1940, 1941, 1943-1952; American Academy in Rome; Grand Central Art Galleries; Corcoran, 1951-57, and 1960 (one-man). Taught: Instructor, Baltimore City College and Polytechnical Institute; head of sculpture department, American University, Washington, DC; director, Evening and Saturday School, Baltimore Art Center, MD, 1953. Works in bronze. Address in 1982, Baltimore, MD.

KRAMER, SCHEIRE B.
Portrait painter. His portrait of William L. Strong, Mayor of New York, is in the City Hall. It is signed and dated 1898.

KRASNER, LEE.
Painter. Born in Brooklyn, NY, in 1911. Studied: Cooper Union Art School; National Academy of Design; Hans Hofmann School of Art. Collections: Whitney Mus. of Am. Art; Philadelphia Museum of Art. Address in 1980, The Springs, E. Hampton, NY.

KRASNOW, PETER.
Sculptor and painter. Born in the Ukraine, Russia, c. 1887-90; in Los Angeles, California, from 1922. Studied at Art Institute of Chicago until 1916. Exhibited at Whitney Studio Club, NYC, 1922; Los Angeles County Museum, 1922, 27; Stendahl Art Gallery, Los Angeles; California Palace of the Legion of Honor, San Francisco, 1931; Galerie Pierre, Paris, 1934; Pasadena Art Institute, California, 1954; California-Pacific International Exposition, San Diego, 1935; Museum of Modern Art, Sao Paulo, Brazil; Los Angeles Institute of Contemporary Art; San Francisco Museum of Modern Art; Rutgers University, NJ; many others in California. Carved directly in wood. Died in Los Angeles in 1979.

KRATINA, JOS(EPH) M.
Sculptor and teacher. Born in Prague, February 26, 1872. Pupil of L'Ecole des Beaux Arts and Julian Academy in Paris. Member: Art Alliance of Am.; Brooklyn Soc. of Artists. Address 1933, 109 Berkeley Pl., Brooklyn, NY; summer, Mt. Tremper, NY.

KRATOCHVIL, STEPHEN.
Painter. Born in Czechoslovakia, June 8, 1876. Pupil of P. Albert Laurens; J. Pierre Laurens; H. Royer in Paris. Member: Cleveland Society of Artists. Address in 1929, 1898 East 82nd St., New York, NY.

KRAUS, ROBERT ADOLF (or ADOLPH F.).
Sculptor. Born in Zeulenroda, Germany, August 5, 1850. Settled in America in 1881. Works: Theodore Parker and the "Crispus Attucks" monuments; winged figures of "Victory," Machinery Hall, Columbian Exposition, Chicago, 1893. Award: Grand Prize of Rome. Died in Danvers, MA, November 7, 1901.

KRAUS, ROMUALD.
Sculptor and teacher. Born in Itzkany, Austria, February 7, 1891. Studied in Europe, with Langer, Kleimsch, Wackerle. Awards: Prize, Golden Gate Expo., 1939. Work: Sculpture, Court House, Newark, NJ; Howard University; Evander Childs High School, Bronx, NY; Newark Museum; Court House, Covington, KY; US Post Office, Ridgewood, NJ; Williamstown, NY. Exhibited: Metropolitan Museum of Art; Cincinnati Museum Association, 1946; Penna. Academy of Fine Arts, 1935, 36; Golden Gate Expo., 1939. Position: Instructor, Art Center, Louisville, KY; Cincinnati Museum Association, Cincinnati, OH. Address in 1953, Cincinnati, OH.

KRAVJANSKY, MIKULAS.
Painter, printmaker, and teacher. Born in Czechoslovakia, May 3, 1928. Left Europe in 1968. Studied: Academy of Arts, Bratislava, Czechoslovakia, Faculty of Scenography, 1957. Design work: Scenic Artist and Technical Producer, State Theatre, Presov, Czechoslovakia; Chief Set Designer, Czechoslovak Television, Bratislava; over 450 productions for Nat. Theatre and Nat. Film Board of Czechoslovakia, including opera, ballet & drama, 1957-68. Exhibited: Designs and paintings exhibitions in Prague, Budapest, Vienna, Warsaw, Paris, Berlin, Cairo, Brennala of Fine Art at Sao Paulo, Fine Art Gallery in Toronto, & NYC. Teaching: Lecturer, Academy of Arts, Bratislava; Assistant Professor, University of Bratislava, 1965-68; Assistant Master, Humber College, Toronto, 1969-75.

KREHBIEL, ALBERT H.
Painter and teacher. Born in Chicago, IL. Pupil of Art Institute of Chicago and Frederick Richardson; Laurens in Paris. Member: Painters and Sculptors of Chicago; Chicago Water Color Club; Cliff Dwellers; National Society of Mural Painters, NY. Instructor, Art Institute of Chicago; architecture department, Armour Institute. Work: Mural decorations for Supreme Court, Springfield, IL. Died in 1945. Address in 1929, Park Ridge, Chicago, IL.

KREHBIEL, DULAH EVANS.
(Mrs. Albert Krehbiel). Painter and illustrator. Pupil of Art Institute of Chicago; W. Appleton Clark; and Art Students League in NY. Member: Chicago Art

Club; Cordon Club; Chicago Society of Artists. Designer and publisher of Ridge Craft cards. Address in 1929, Park Ridge, Chicago, IL.

KREIGHOFF, W(ILLIAM) G(EORGE).
Painter. Born in Philadelphia, Aug. 31, 1875. Pupil of Chase, Meakin, Sharp. Member: Phila. Alliance; Philadelphia Society AA. Work: "Portrait of Judge J. M. Patterson," Philadelphia Law Assoc.; "Portrait of President Bigell," State College, TX. Address in 1929, 10 South 18th St.; h. 1915 Rittenhouse St., Philadelphia, PA.

KREIS, HENRY.
Sculptor. Born in Essen, Germany, 1899; came to US in 1923. Studied under Paul Wackerle in Munich at the State School of Applied Art. Studied also with Paul Manship at the Beaux-Arts Institute of Design, NYC. Works: "Indian Summer" (brownstone), 1937; Medal of the Wise and Foolish Virgins (bronze), 1947. Died in Essex, CT, in 1963.

KREMELBERG, MARY.
(Mrs. Frederick Gibson). Painter. Member: National Association of Women Painters and Sculptors; Fellowship Penna. Academy of Fine Arts; Baltimore Water Color Club. Address in 1929, 1007 No. Charles St., Baltimore, MD.

KRENTZIN, EARL.
Sculptor and silversmith. Born in Detroit, Michigan, December 28, 1929. Graduated from Cass Technical High School, 1948; Wayne State University, BFA, 1952; Cranbrook Academy, Michigan, MFA, 1954; Royal College of Art, London, 1957-58. In collections of Detroit Institute of Art, MI; Cranbrook Galleries, MI; St. Paul (MI) Art Center; Jewish Museum, NYC; others, including commissions. Exhibited at Museum of Contemporary Crafts, NYC, 1963, 65; one-man shows, Kennedy Galleries, NYC, 1968-75, Detroit Institute of Art, 1978, Oshkosh Museum, 1982. Awarded prize at Detroit Institute of Arts, 1952; Fulbright Fellowship, 1957-58; Tiffany Grant, 1966; Wichita Arts Center, Kansas, 1966. Works in fiber, clay, metal, silver. Rep. by Kennedy Galleries, NYC. Address in 1982, Grosse Pointe, Michigan.

KRETSCHMAN, EDWARD A.
Sculptor and teacher. Born in Germany, Aug. 27, 1849. Came to the U.S. in 1856. Pupil of J. A. Bailey and George Starkey. Diploma, American Institute, 1875. Address in 1910, Philadelphia, PA.

KRETZINGER, CLARA JOSEPHINE.
Painter. Born in Chicago. Pupil of Art Institute of Chicago and Chicago Acad. of Fine Arts; Lefebvre, Robert-Fleury, Laurens, Congdon and Richard Miller in Paris. Member: Chicago Society of Artists; Chicago Art Club; American Federation of Arts. Award: Hon. mention, Paris Salon. Represented in

Beloit Art Museum. Address in 1929, 11 Rue Schoelcher, Paris, France; h. 917 Monadnock Bldg., Chicago. IL.

KREUTZBERG, MARGUERITE G.
Painter. Born in Elgin, IL, Sept. 14, 1880. Pupil of W. P. Henderson. Member: Chicago Art Club. Award: Butler Purchase Prize, Art Institute of Chicago, 1923. Work: "A Little Venus of the Steppes," Chicago Public Schools; mural decoration in public school, Lake Bluff, IL. Address in 1929, Graham Ave., Bethlehem, PA.

KRIENSKY, MORRIS E.
Painter, sculptor, illustrator, and designer. Born in Glasgow, Scotland, July 27, 1917. Studied at Professional Design School; Art Students League; Boston Museum of Fine Arts School; and with Alma O. Le Brecht. Member: American Watercolor Society. Work: M. Knoedler and Co.; Pushkin Museum, Moscow; others. Exhibited: American Watercolor Society, 1946; Dept. of the Interior, Washington, DC; White House, Washington, DC; Art Institute of Chicago; Hackley Art Gallery; Wilmington Society of Fine Art; Dartmouth College; M. Knoedler and Co.; National Academy of Design; others. Address in 1982, 463 West St., NYC.

KRIMMEL, JOHN LEWIS.
Portrait and genre painter. Born 1789 in Wurtemberg, Germany. He came to this country in 1810 to join his brother who was a merchant of Philadelphia. Disliking trade, he continued the course he had begun in Germany, and painted small portraits. In 1812, he exhibited at the Penna. Academy of Fine Arts a picture of Centre Square, Philadelphia, containing numerous small figures, and painted many other works of like character, two of which are owned by the Penna. Academy. He was President of the Society of American Artists. He drowned in Wissahickon Creek, Philadelphia, on July 15, 1821.

KRIZE, EMILIE M.
Painter. Born in Luzerne, PA, in 1918. Studied: Maryland Institute; Penna. Academy of Fine Arts; Johns Hopkins University; Norfolk Division of William and Mary College; and with Maroger. Award: Traveling scholarship, Maryland Institute. Collections: Planters Nut and Chocolate Company Club; Norfolk Naval Shipyard Library; State House, Annapolis, Maryland.

KROLL, LEON.
Painter and teacher. Born in New York, Dec. 6, 1884. Pupil of Art Students League of NY and National Academy of Design; Laurens in Paris. Instructor at National Academy of Design, 1911-18. Member: Academician, National Academy of Design, 1927; National Arts Club (life); Society of Independent Artists; New Society Etchers; New Society Artists;

Philadelphia Art Club; New York Society of Etchers; Boston Art Club. Awards: Porter prize, Salma. Club, 1914; bronze medal, P.-P. Expo., San Francisco, 1915; Logan prize, Art Institute of Chicago, 1919; Purchase prize, Art Institute of Chicago, 1919; first prize, Wilmington Society of Fine Arts, 1921; Clarke prize, National Academy of Design, 1921; first Altman prize, National Academy of Design, 1922; Potter Palmer gold medal and $1,000, Art Institute of Chicago, 1924; honorable mention, International Exhibition, Carnegie Institute, 1925; Temple gold medal, Penna. Academy of Fine Arts, 1927. Work: "A Basque Landscape," Pennsylvania Academy of Fine Arts, Philadelphia; "North River Front," "Leo Ornstein at the Piano," Art Institute of Chicago; "In the Country," Detroit Institute; "Broadway and 42nd St.," Harrison Gallery, Los Angeles Mus.; "Sleep," St. Louis Museum; "Study for Sleep," and "Central Park, Winter," Cleveland Museum; drawings, Metropolitan Museum, New York; four drawings, Art Institute of Chicago. Visiting critic, Maryland Institute, 1919-23; Art Institute of Chicago, 1924-25. Died in 1974. Address in 1929, care W. S. Budworth and Son, 424 West 52nd St., New York, NY.

KRONBERG, LOUIS.
Painter and teacher. Born in Boston, MA, Dec. 20, 1872. Pupil of Museum of Fine Arts, Boston; Art Students League of NY; Julian Academy under Benjamin-Constant, Laurens and Collin in Paris. Member: Boston Art Club; Guild of Boston Artists; Copley Society of Boston; Salma. Club; Assoc. Salon Nat.; American Water Color Society; NY Water Color Club; Boston Society of Water Color Painters. Awards: Longfellow traveling scholarship, Boston Museum, 1894-97; silver medal, P.-P. Expo., San Francisco, 1915; Shaw prize, Salmagundi Club, 1919. Work: "Pink Sash," Metropolitan Museum, New York; "Behind the Footlights," Pennsylvania Academy of the Fine Arts, Philadelphia; "Ballet Girl Preparing for the Dance," Boston Museum of Fine Arts; "Oriental Dancer," Herron Art Institute, Indianapolis; "Ballet Girl in White," "La Guitana," "At the Window," and others, Gardner collection, Boston, MA; "The Ballet Girl," Butler Art Institute, Youngstown, Ohio; "Spanish Dancer," Albright Art Gallery, Buffalo; "Ballet Girl," San Diego Fine Arts Gallery. Died in 1964. Address in 1929, Salmagundi Club, 47 Fifth Ave., NY, NY; care of Boston Art Club, Newbury and Dartmouth Sts., Boston, MA.

KRUELL, GUSTAVE.
Wood engraver. Born in Germany, in 1843. He organized the American Wood Engravers' Society, of which he was president. He received many honorable mentions and medals for his work. His engraved portraits include those of Darwin, Wm. Lloyd Garrison and Lincoln. He published "A Portfolio of National Portraits." He died in California in 1907. (See "History of Wood Engraving," by W. J. Linton.)

KRUGER, LOUISE.
Sculptor and designer. Born in Los Angeles, CA, in 1924. Studied: Scripps College, CA; Art Students League; also with Capt. Sundquist, shipbuilder; F. Guastini, Pistoia, Italy; Chief Opoku Dwumfour, Kumasi, Ghana. Collections: Museum of Modern Art; New York Library Print Collection; Modern Museum, Sao Paulo; Brooklyn Museum. Exhibitions: Metropolitan Museum; Whitney; Museum of Modern Art; Art Institute of Chicago; Kunsthaus, Zurich. Works in wood, bronze. Address in 1982, 30 East Second Street, New York City.

KRUGMAN, IRENE.
Sculptor. Born in NYC. Studied at Kansas City Art Institute; New York University; New School for Social Research, with Yasuo Kuniyoshi. Work in NJ State Mus., Trenton; Newark Mus., NJ; others. Has exhibited at Brooklyn Mus., NY; Riverside Mus., NY; Summit Art Center, NJ; others. Works in wire and plaster. Address in 1982, Morristown, NJ.

KRUPKA, JOSEPH.
Sculptor. Born in Czechoslovakia, Jan. 1, 1880. Pupil of Hermon MacNeil. Member: NY Architectural League, 1914 (associate). Address in 1916, 510 East 77th St., NYC; summer, Greycourt, NY.

KRUPP, LOUIS.
Painter and designer. Born in Miesbach, in West Germany, Nov. 26, 1888; US citizen. Studied: Art Inst. of Chic.; Art Students League, with Wellington J. Reynolds, Karl Buehr, Charles Schroeder, Elmer Forsberg, George B. Bridgman. Work: Inst. Zacatecano Bellas Artes, Mexico. Exhibited: El Paso Art Mus.; Am. Artists Professional League Grand Nat. Awards: Hon. mention, Art Inst. of Chicago; 1st prizes, El Paso Art Association. Member: Am. Artists Professional League; El Paso Art Association; Nat. Soc. of Arts and Letters; others. Media: Oil, watercolor, charcoal. Address in 1976, El Paso, TX.

KRUSCHKE, HERMAN.
Woodcarver. Birth and death dates unknown. Active in Ashland, Wis., approx. 1888-1901. Executed church dec., scroll sawings, newels, railings. Carved "Chief Sitting Bull," c. 1882, at tobacco shop in Ashland.

KRUSH, JOSEPH.
Painter. Exhibited: Penna. Academy of Fine Arts, 1937, 38; Art Institute of Chicago, 1939. Address in 1940, Camden, NJ.

KRYZANOVSKY, ROMAN.
Painter. Born in Balta, Russia, January 22, 1885. Pupil of E. Renard, E. Townes, P. Gorquet. Work: "Kismet," and "Still Life," Detroit Institute of Arts. Represented in State of Michigan collection; Detroit Public Library; Kiev, Russia, City Mus. Awards:

Rolshoven prize, 1915, and Frank Scott Clark prize, 1918, 19, Detroit Institute of Arts; Founders prize, Detroit Institute, 1920; Marvin Preston prize, 1921. Member: Scarab Club, Det. Address in 1925, Detroit, MI. Died in Detroit, MI, 1929.

KRYZANOVSKY, SARI.
Painter. Born in Lexington, KY. Pupil of Roman Kryzanovsky. Award: First water color prize, Detroit Institute of Art, 1925. Address in 1929, 2156 East Jefferson Ave., Detroit, MI.

KUCHARYSON, PAUL.
Sculptor, etcher, engraver, craftsman, designer, and illustrator. Chiefly graphic artist. Born in Utica, NY, July 2, 1914. Studied at John Huntington Institute of Art; Cleveland School of Art. Awards: Prizes, New York World's Fair, 1939; Cleveland Museum of Art; Dayton, OH; Oakland, CA. Position: Artist, Inter-Collegiate Press, Kansas City, MO, from 1946. Address in 1953, Kansas City, MO.

KUEMMEL, CORNELIA A.
Sculptor, painter, and teacher. Born in Glasgow, Howard Co., MO. Pupil of St. Louis School of Fine Arts, under John Fry and E. Wuerpel. Member: St. Louis Art Guild. Died in 1937. Address in 1933, Pritchett College, Glasgow, MO.

KUHLMAN, G. EDWARD.
Painter, writer and lecturer. Born Woodville, Ohio, Sept 26, 1882. Pupil of Penna. Acad. of Fine Arts; Art Inst. of Chicago. Studied abroad. Represented in Public Mus., Oshkosh, WI. Specialty: Altar paintings for churches and landscape. Address in 1929, 107 W First St., Oil City, PA.

KUHLMAN, WALTER EGEL.
Painter and educator. Born in St. Paul, MN, Nov. 16, 1918. Studied: St. Paul School of Art, with Cameron Booth; University Minn., BA; California School Fine Arts; Academie de la Grande Chaumiere. Exhibited: NY World's Fair, 1940; San Francisco Museum of Art, 1955; California Palace of the Legion of Honor, 1967; Butler Institute of American Art, 1970; one-man shows include Walker Art Center, MN, Stanford University and Charles Campbell Gallery, 1981, 83. Work in San Francisco Museum of Art; Phillips Memorial Gallery, Washington, DC; Museum of Modern Art, Sao Paulo, Brazil; others. Awards: Graham Foundation Fellowship, 1957; California Arts Council Fellowship, 1983; others. Has taught at Stanford University; California School of Fine Arts; University of New Mexico; University of Santa Clara; Sonoma State College (presently). Media: Oil, monoprints. Address in 1984, Sausalito, CA.

KUHN, HARRY P(HILLIP).
Painter and craftsman. Born in Zurich, Switzerland, Nov. 27, 1862. Award: Gold medal, Louisiana Purchase Expo., St. Louis, 1904. Address in 1929, Colt Bldg., Paterson, NJ; summer, Wheelerville, PA.

KUHN, ROBERT J.
Sculptor. Exhibited at National Academy of Design, 1925. Address in 1929, Richmond Hill, NY.

KUHN, WALT.
Painter. Born Oct. 27, 1880, in NYC. Studied abroad and taught at Art Students League and NY School of Art. Exhibited in Philadelphia, 1921, at "Exhibition of Paintings Showing the Later Tendencies in Art," Penna. Academy of Fine Arts. Address in 1926, 11 East 13th St., New York City. Died July 13, 1949 in NYC.

KUMM, MARGUERITE ELIZABETH.
Painter, engraver, and etcher. Born in Redwood Falls, MN. Studied: Minneapolis School of Art, with Cameron Booth and Anthony Angarola; Corcoran School of Art, with Eugene Weisz and Richard Lahey. Collections: Library of Congress; Boston Museum of Fine Arts; Valentine Museum; Virginia Museum of Fine Arts; Oregon State College; Society of American Graphic Artists; Washington County Museum of Fine Arts, Hagerstown, Maryland; Pennsylvania State University; Metropolitan Museum of Art; Smithsonian Institution; Lowry Hill Children's Clinic, Minn., MN; others. Exhibited: National Academy of Design, NY, 1942-44, 49; Artists for Victory, Metropolitan Museum of NY, 1942; Virginia Museum of Fine Arts, Richmond, VA, 1945; one-woman shows include Smithsonian Institution, 1950, Mint Museum, Charlotte, NC, 1951, Butler Art Institute, Youngstown, OH, 1952, Witte Memorial Museum, San Antonio, TX, 1953; others. Awards: International Award, Art Directors' Club, NY, 1925, Boston, 1926; Society of American Graphic Artists, 1943; Pennell Fund Purchase Award, Library of Congress, 1951, 53; 25 Selected Miniature Prints Award, Society of American Etchers, 1940, 45, Henry B. Shope Prize, 1943. Member: Society of American Graphic Artists. Media: Oil, acrylic. Address in 1984, Falls Church, VA.

KUMME, WALTER (HERMAN).
Painter and teacher. Born in Philadelphia, PA, Dec. 16, 1895. Pupil of Penna. Academy of Fine Arts. Member: Fellowship Penna. Academy of Fine Arts; T. Square C.; Wilmington Society of Fine Arts. Award: Cresson traveling scholarship, 1914, Penna. Academy of Fine Arts. Address in 1929, 130 Charles St., New York, NY.

KUNIYOSHI, KATHERINE SCHMIDT.
Painter. Born in Xenia, Ohio, Aug. 15, 1898. Pupil of Kenneth Hayes Miller. Member: Soc. of Independent Artists. Address in 1929, Ardsley Studios, 110 Columbia Heights, Brooklyn, New York; summer, Ogunquit, ME.

KUNIYOSHI, YASUO.
Painter and lithographer. Born in Okayama, Japan, Sept. 1, 1893. Pupil of Kenneth Hayes Miller; Los Angeles School of Art and Design; Nat. Academy of Design; Independent Artists School; Art Students League. Member: Brooklyn Modern Artists; Salons of America; Modern Artists; An American Group; hon. associate, National Institute of Arts and Letters; Artists Equity Association (president). Awards: Prizes, Los Angeles Museum of Art, 1934; Golden Gate Expo., San Francisco, 1939; Guggenheim Fellowship, 1935-36; Carnegie Institute, 1939, 44; medal, Penna. Academy of Fine Arts, 1934; Virginia Museum of Fine Arts; Metropolitan Museum of Art, 1950; Harris medal, Chicago, 1945; others. Work: Metropolitan Museum of Art; Museum of Modern Art; Carnegie Institute; Whitney; Brooklyn Museum; Newark Museum; Albright Art Gallery; Columbus Gallery of Fine Arts; Virginia Museum of Fine Arts; Addison Gallery of American Art, Andover, MA; University of Arizona; Detroit Institute of Art; Cranbrook Academy of Art; Art Institute of Chicago; Wichita Art Museum; Walker Art Center; others. Exhibited nationally and internationally. Taught at Art Students League. Address in 1953, 30 East 14th Street, New York, NY; h. Woodstock, NY. Died in 1953.

KUNSTLER, MORT.
Illustrator. Born in Brooklyn, in 1931. Studied at Brooklyn College, UCLA, and Pratt Institute. In 1949 he published his first illustration, a black and white line drawing, for Handy Football Library. He is best known for his intricate and realistic historical paintings. His works are owned by the Daytona Beach Mus. of Arts and Sciences, Air Force Mus. in Colorado, Favell Mus. in Oregon, and others.

KUNTZE, EDWARD J.
Sculptor and etcher. Born in Pomerania, Germany, 1826. Studied in Stockholm, Sweden. Came to the US in 1852. Worked in Philadelphia in the mid-1850's; in NYC from 1857. Resided in London from 1860 to 1863. Associate of the National Academy, 1869-70. Among his works are statuettes of Irving, Lincoln, and a statue of "Psyche" and one of "Puck." He also exhibited three etchings at the National Academy in 1868. Died in NY, 1870.

KUPER, ROSE.
Painter. Studied: Hunter College; in France; and with Hans Hofmann, Abraham Rattner. Awards: National Association of Women Artists, 1952; Brooklyn Society of Art, 1954; Village Art Center. Collections: San Diego Fine Arts Society; Philbrook Art Center; Dallas Museum of Fine Arts; Santa Barbara Museum of Art; Jewish Museum, NY; Hunter College; Long Island University; Fashion Institute of Technology; Ashlawn, Virginia (home of James Monroe); Riverside Mus.; Des. Center, NY.

KUPFER, R.
Engraver. Line-engravings of some merit, published in New York magazines about 1865, after drawings by Thos. Nast and other American designers, are so signed. Among other prints engraved by Kupfer is a folio plate of a view of New York, published in 1867.

KUPFERMAN, MURRAY.
Painter. Born in Brooklyn, NY, March 10, 1897. Pupil of Pratt Institute; National Academy of Design; Beaux Arts Institute of NY. Represented in National Academy of Design; New York Water Color Club; Architectural League; Corcoran Gallery; Penna. Academy of Fine Arts; Brooklyn Museum; also private collections abroad. Scenic decorations, "America's Answer," Military Park Building, Newark, NJ. Specialty: Landscapes. Address in 1929, 2003 E. 22nd St., Brooklyn, NY.

KURTZ, BENJAMIN TURNER.
Sculptor. Born in Baltimore, MD, January 2, 1899. Pupil of Charles Grafly, Albert Laessle. Member: Fellowship Penna. Academy of Fine Arts; National Sculpture Society; Philadelphia Art Alliance; others. Work: Public Library, Fort Worth, TX; Curtis Institute Museum, Philadelphia; Public Library, Camden, ME; Brookgreen Gardens, SC; Johns Hopkins Hospital, Baltimore; Peale Museum, Baltimore; Hochild Kohn Department Store, Baltimore; fountain, Norton Gallery, West Palm Beach, Florida; Baltimore Museum of Art; National Gallery; others. Awards: Cresson traveling scholarship, Penna. of Fine Arts, 1922; bronze medal, Sesqui-Centennial Exposition, Philadelphia, 1926; Spalding prize ($1,000), Art Institute of Chicago, 1926; others. Address in 1953, Baltimore, MD.

KURTZ, JULIA WILDER.
Painter and teacher. Born in Harrodsburg, KY. Pupil of Art School of the Buffalo Fine Arts Academy, Richard E. Miller, Charles Hawthorne. Member: Buffalo Society of Artists; Buffalo Guild Allied Arts; American Federation of Arts. Address in 1929, 269 Richmond Ave., Buffalo, NY.

KURTZ, WILBUR G.
Painter and illustrator. Born in Oakland, IL, Feb. 28, 1882. Pupil of Art Institute of Chicago. Member: Atlanta Art Association. Represented in Atlanta Woman's Club; Atlanta Federal Reserve Bank; five murals in Nat. Bank of Abbeville, SC; proscenium decoration, auditorium, Macon, GA. Address in 1929, 907 Penn Ave., NE, Atlanta, GA.

KURTZWORTH, H(ARRY) M(UIR).
Painter, designer, lecturer, writer and teacher. Born in Detroit, MI, Aug. 12, 1887. Pupil of Detroit Museum School of Art under Paulus and Gies; Detroit Academy of Fine Arts under Wicker; Columbia Univ., NY, under Dow; Pennsylvania

School of Industrial Art; and with Julius Melchers. Member: Fourth International Art Congress, Dresden, 1912; Detroit Society of Arts and Crafts. Award: Hon. mention, Kansas City Art Institute, 1923. Organizer and director, Grand Rapids School of Art and Industry, 1916-20; director, Michigan Art Institute, 1918-24; associate dir., Chicago Academy of Fine Arts, from 1926; director, Kansas City Art Institute, 1921-24; director, Modern Home Bureau. Author of "Genius, Talent or Mediocrity," 1924; "International Art," 1937; "Motion Picture Handbook," 1946; editor, *Western Art Annual*, 1922. Address in 1953, Los Angeles, CA.

KURZ, DIANA.
Painter and educator. Born in Vienna, Austria. Studied: Brandeis University, B.A.; Columbia University, M.F.A. Awards: Yaddo Fellowship, 1968, 69; US Government Fulbright Grant in Painting to France, 1965-1966; MacDowell Fellowship, 1977; others. Exhibitions: University of Michigan, 1965; Green Mountain Gallery, NYC, 1972, 74, 77, 79; Brooklyn College, 1974; Boston Museum School Gallery, 1980; Weatherspoon Art Gallery, NC, 1981; others. Member: Women's Caucus Art; College Art Association. Taught: Philadelphia College of Art, 1968-72; Pratt Institute, 1973; Univ. of Colorado, 1978; State University of NY at Stony Brook, 1979; Virginia Commonwealth University, 1980; Cleveland Institute of Art, 1980-81. Media: Oil and watercolor. Address in 1984, 152 Wooster Street, New York, NY.

KURZ, LOUIS.
Mural painter and one of the founders of the Chicago Art Institute. He was born in Austria in 1833, and came to America in 1848. He fought for the North in the Civil War, and he was a personal friend of Lincoln. His sketches of the Civil War were the first to be issued after the close of the conflict. He died in Chicago, IL, March 21, 1921.

KUTCHIN, LOU.
Painter. Exhibited water colors at the Penna. Academy of Fine Arts, Philadelphia, 1925. Address in 1926, 2038 Spruce St., Philadelphia.

KYLE, JOSEPH.
Painter. Born in 1815, in Ohio. His work was portraiture, genre subjects and still-life. In 1849 he was elected an Associate Member of the National Academy of Design. He died in 1863 in NYC. His painting, "A Family Group," is owned by the Academy of Fine Arts, Elgin, Illinois.

L

LaBRUCE, FLORA M(cDONALD).
Painter, craftsman, writer, and teacher. Born in New York City. Pupil of Cooper Institute; John McNevins. Member: Carolina Art Association; Sketch Club; Southern States Art League. Address in 1929, Gibbes Art Building, 176 Meeting St., Charleston, SC; summer, "Gleneden," Edneyville P.O., NC.

LACEY, BERTHA J.
Painter. Born in Perrysville, IN, 1878. Pupil of Vanderpoel, Meakin and Duveneck. Member: Art Students League of Chicago; Indiana Artists; Cincinnati Woman's Art Club; National Arts Club; The Cordon, Chicago. Award: Prize for group of miniatures, Hoosier Salon, Chicago, 1927. Died in 1943. Address in 1929, Perrysville, IN.

LaCHAISE, GASTON.
Sculptor. Born in Paris, March 19, 1882. Came to US in 1906. Pupil of Bernard Palissy; Ecole des Beaux Arts under Gabriel Jules Thomas, also a sculptor. Worked with Lalique; H. H. Kitson in Boston. Work: "Seagull," National Coast Guard Memorial; decoration frieze, American Telephone and Telegraph Building, NY; Cleveland Museum of Art; Newark Museum; Penna. Museum; Morgan Memorial Museum, Hartford, CT; Phillips Memorial Gallery, Washington; Smith College Art Mus., Northampton, MA; Whitney Museum of Art, NY; Toledo Art Museum; Wichita Art Museum; Rockefeller Center and many private collections. Exhibitions held at Joslyn Museum of Art, Brummer Gallery, NYC; Philadelphia Art Association; Brooklyn Museum; Weyhe Gallery, NYC; Museum of Modern Art; R. Schoelkopf Gallery, NYC; Wadsworth Atheneum; others. Published *Gaston Lachaise: Sixteen Reproductions in Collotype*, with introduction by A. E. Gallatin. Address in 1933, 58 West 8th St., NYC. Died in NYC, October 19, 1935.

LaCHANCE, GEORGE.
Painter. Born in Utica, NY, Oct. 13, 1888. Pupil of Old St. Louis Art School. Member: Hoosier Salon; Society of Independent Artists; Am. Federation of Arts. Work: Historical mural, County Court House, Vincennes, IN; 14 industrial murals, New Toledo Scale Auditorium, Toledo; portrait, Donors Gallery, DePauw University, Greencastle, IN.

LACHER, GISELLA LOEFFLER.
Painter. Born in Vienna, Austria, Sept. 24, 1900. Pupil of Mary McCall, Hugh Breckenridge. Member: St. Louis Artists Guild; Alliance; Boston Society of Arts and Crafts. Awards: First prize for water color,

Artists Guild of the Authors' League of America, NY, 1919 and 1920, decoration prize, 1927, special prize, 1928; hon. mention, Kansas City Art Institute, 1923. Works: "The Offering," Soldan HS, St. Louis; "Wonder," Cleveland HS; painting, Community HS. Address in 1929, Rt. 12, Box 192a, Kirkwood, MO.

LACHMAN, HARRY.
Painter. Born in La Salle, IL, June 29, 1886. Member: Societe Inter. des Artistes et Sculpteurs; Societe Paris Moderne; Chevalier of the Legion of Honor, France. Work: "Toledo," Delgado Museum of Art, New Orleans, LA; "St. Nicolas du Chardonnet," "Uzerche," "Antibes" and "The Valley of Les Andelys," in Musee du Luxembourg; "Printemps Parisien," Musee du Petit Palais, Paris; "Old Tower" and "Old Church," Chicago Art Institute; "Notre Dame," Memphis Women's Club. Address in 1929, Riviera Studios, St. Andre, Nice, France.

LADD, ANNA COLEMAN.
(Mrs. Maynard Ladd). Sculptor. Born in Bryn Mawr, PA, July 15, 1878. Studied in Paris and Rome. Member: Concord Art Association; Nat. Sculpture Society, 1915 (assoc.); Boston Guild of Artists; North Shore Art Association; American Federation of Arts; Art Institute of Chicago; National Academy of Design. Award: Hon. mention, P.-P. Expo., San Francisco, 1915. Work: Bronzes in Boston Art Museum; bronze medal, "The Spirit of Serbia," Rhode Island School of Design; "Bronze Lady," Gardner collection, Boston; "Wind and Spray," Borghese Collection, Rome; Boston Public Gardens Fountain; "Fountain of Youth," Torresdale, PA; Soldiers' Memorials, Hamilton and Manchester, MA, Beverly Farms, South Bend, Brookline, and Grand Rapids; fountains in Boston Public Library gardens. Founded American Red Cross Studio of Portrait Masks, France, 1917-19. Exhibited: National Sculpture Society, 1923. Address in 1933, Boston, MA; summer, Beverly Farms, MA. Died in 1939.

LADD, LAURA D. STROUD.
Painter. Born in Philadelphia, PA, July 1, 1863. Pupil of Phila. School of Design for Women and Penna. Acad. of Fine Arts. Member: Fellowship Penna. Acad. of Fine Arts; Plastic Club; Phila. Water Color Club; Alliance; Nat. Assoc. of Women Painters and Sculptors; North Shore Arts Assoc.; Am. Fed. of Arts. Died in 1943.

LAESSLE, ALBERT.
Sculptor. Born in Philadelphia, PA, March 28, 1877. Pupil of Spring Garden Institute; Drexel Institute;

Penna. Academy of Fine Arts; C. Grafly; and studied in Paris. Member: Associate, National Academy Design; National Sculpture Society, 1913; Fellowship Penna. Academy of Fine Arts; Nat. Institute of Arts and Letters; Philadelphia Alliance; American Numismatic Society; New Society Artists of New York; Societe des Amis de la Medaille d'Art, Brussels; Society Animal Painters and Sculptors, NY. Awards: Stewardson prize, 1902, and Cresson traveling scholarship, Penna. Academy of Fine Arts, 1904; bronze medal, Buenos Aires, 1910; Penna. Academy of Fine Arts Fellowship prize ($100), 1915, Widener gold medal, 1918, gold medal, 1923; gold medal, P.-P. Expo., San Francisco, 1915; first sculpture prize, Americanization through Art, Philadelphia, 1916; honorable mention, Art Institute of Chicago, 1920; gold medal, Sesqui-Centennial Expo., Philadelphia, 1926; prize ($300), best outdoor decorative group, Philadelphia Art Alliance, 1928; James E. McClees prize, 1928; Saltus medal, American Numismatic Society, 1951. Work: "Turtle and Lizards," "Blue Eyed Lizard," and "Chanticleer," Penna. Academy of Fine Arts, Philadelphia; "Heron and Fish," Carnegie Institute, Pittsburgh; 3 small bronzes, "An Outcast," "Locust and Pine Cone," "Frog and Katydid," Peabody Institute, Baltimore; "Victory" and "Turning Turtle," Metropolitan Museum, NY; "The Bronze Turkey," Philadelphia Art Club; "Penguins," Philadelphia Zoological Gardens; "Billy," Rittenhouse Square, Philadelphia; "Hunter and First Step," Concord Art Association, Concord, MA; "Dancing Goat," "Pan," "Billy," "Duck," "Turtle," "Frogs" for fountain, Camden, NJ. Exhibited: Nat. Sculpture Society, 1923. Instructor, Penna. Acad. of Fine Arts Country School, Chester Springs, PA. Address in 1953, Miami, FL. Died in 1954.

LAESSLE, MARY P. MIDDLETON.
(Mrs. Albert Laessle). Sculptor. Born in Phila., PA, May 1, 1870. Member: Fellowship, Penna. Academy of Fine Arts. Address in 1910, Germantown, PA.

LaFARGE, BANCEL.
Painter and craftsman. Member: Mural Painters; NY Water Color Club; Century Association; American Art Association of Paris; National Institute of Arts and Letters; New Haven Paint and Clay Club; American Fed. of Arts. Work: Mural paintings "Crucifixion," "Madonna Enthroned," "Christ in Glory," "Christ Blessing Children," in Church of Blessed Sacrament, Providence, RI; mosaics, "Crowning of the Virgin," "The Trinity," St. Charles College, Catonsville, MD. Died in 1938. Address in 1929, Edgehill, Mt. Carmel, CT.

LaFARGE, JEAN.
Miniature painter. Father of the artist John La Farge. He was a French refugee from Santo Domingo, and came to NY and painted miniatures in the early part of the nineteenth century.

LaFARGE, JOHN.
Sculptor, landscape and figure painter, decorator, and glass painter. Born March 31, 1835, in New York. Pupil of Couture in Paris and William M. Hunt. Member: Society of American Artists, 1877; National Arts Club; Mural Painters (hon. pres.); National Academy, 1869; National Institute of Arts and Letters; American Institute of Architects; and Century Association. The year 1876 marked an artistic shift from flower studies and landscapes to stained glass and murals. Awarded gold medal, Pan-Am. Expo., Buffalo, 1901; diploma and medal of honor, St. Louis Expo., 1904; medal of honor, Architectural League of NY, 1909. Represented in Metropolitan Museum, NY, and Boston Museum of Fine Arts. (See *American Painting and Its Tradition*, by John C. Van Dyke.) Address in 1910, 51 West 10th Street, NYC. Died in Providence, RI, Nov. 14, 1910.

LaFARGE, MABEL.
(Mrs. Bancel La Farge). Painter. Born in Cambridge, MA, June 26, 1875. Pupil of John La Farge. Member: New Haven Paint and Clay Club. Award: Member prize, New Haven Paint and Clay Club, 1927. Died in 1944. Address in 1929, Mt. Carmel, CT.

LaFAVOR, WILL.
Sculptor. Born in Frankfort, NY, 1861. Exhibited "Herr Meisner," at the Penna. Academy of Fine Arts, Phila., 1914. Address in 1929, Washington Park Field House, Pittsburgh, PA.

LaFONTAINE, RACHEL ADELAIDE.
Painter and author. Born in Zonnemaine, Holland, 1845. Took course at Art Students League, New York; afterward studied under Charles Melville Dewey, J. H. Beard, Sr., and Harry Chase, New York. Traveled in England, France and Holland, 1878. Specialty, sundowns and marines. First exhibited in National Academy of Design, 1885. Illustrated several deluxe editions. Address in 1926, Care Thomas Whittaker, Inc., New York.

LAGANA, FILIPPO.
Sculptor. Born in Italy, April 27, 1896. Pupil of Beaux-Arts Institute of Design. Member: Darien Guild of Seven Arts; Silvermine Guild of Artists. Work: Portrait, "Clarence Roe," Pennsylvania Museum of Art, Philadelphia. Address in 1934, Darien, CT. Died in 1963.

LaGATTA, JOHN.
Painter and illustrator. Born in Naples, Italy, May 26, 1894. Pupil of Howard Giles, Kenneth Hayes Miller, Frank Parsons, NY School of Fine and Applied Art. Member: Society of Illustrators; Artists Guild of the Authors' League of America, NY. Illustrated covers for most major magazines, 1920's and 30's. After many years in NYC, moved to Los Angeles, taught at Art Center College of Design.

Died in Pasadena, CA in 1977. Address in 1929, 12 Band St.; 80 West 40th St., New York, NY; h. Baldwin Harbor, LI, NY.

LAGUNA, MARIELLE.
Painter and instructor. Born in NYC. Studied: NY University; The New School; Brooklyn Museum Art School with Reuben Tam and Manfred Schwartz; Adelphi University; Pratt Graphic Center. Awards: Long Island Festival Competition, 1958; medal of honor, National Association of Women Artists, 1967; Grace F. Lee Memorial Prize, 1967; gold medal, Hofstra Univ., 1961; several fellowships, including Yaddo and Edward MacDowell Colony, 1965, 69, 73, 75, and 77. Exhibitions: NY Center Gallery; Chatham College, Pittsburgh, PA; Penna. Academy of Fine Arts Annual, Philadelphia; National Academy of Design Annual; others. Member: Nat. Association of Women Artists; Artist Equity of New York; New York Society of Women Artists. Media: Oil and acrylic. Address in 1984, 324 Christopher St., Oceanside, NY.

LAHEY, RICHARD (FRANCIS).
Portrait painter, etcher and teacher. Born in Jersey City, NJ, June 23, 1893. Pupil of Bridgman, Henri, K. H. Miller. Member: Society of Independent Artists; Century Association; American Fine Arts Society, NY; Art Students League of NY. Award: Tuthill prize, Art Institute of Chicago, 1925; Beck gold medal, Penna. Academy of Fine Arts, 1929. Work: "Down by the River," Penna. Academy of Fine Arts; "Pont Neuf," Brooklyn Museum; "Fourteenth of July," Detroit Museum; etchings, Metropolitan Museum, Newark (NJ) Public Library, Detroit Museum. Instructor, Art Students League of NY. Died in 1979. Address in 1929, 2695 Boulevard, Jersey City, NJ.

LAIDLAW, JENNIE L.
Painter. Born in Milwaukee, WI, Sept. 28, 1861. Member: National Association of Women Painters and Sculptors; National Arts Club. Address in 1929, Spuyten Duyvil, New York, NY.

LAISNER, GEORGE ALOIS.
Sculptor, painter, craftsman, educator, and lecturer. Born in Czechoslovakia, May 5, 1914. Studied at Art Institute of Chicago, B.A.E.; University of Chicago, B.A.E.; and with Chapin, Polasek, Anisfeld. Member: Northwest Art Assoc. Awards: Prizes, Puyallup, Washington, 1939; Seattle Art Museum, 1943, 44; San Francisco Museum of Art, 1943. Work: Seattle Art Museum; San Francisco Museum of Art; Northwest Printmakers. Exhibited: Art Inst. of Chicago, 1937, 40, 46; Library of Congress, 1943; Seattle Art Museum, 1940-45; Northwest Printmakers, 1938-45; Golden Gate Expo., 1939; San Francisco Museum of Art, 1939, 41, 44; San Francisco Art Association, 1940-44; Oakland Art Gallery, 1940-45. Position:

Instructor of Art, 1937-41, Professor of Fine Arts, 1942-46, State College of Washington, Pullman, Washington. Address in 1953, Pullman, WA.

LAITE, GORDON.
Illustrator. Born in NYC in 1925. Attended Beloit College in Wisconsin and the Art Institute of Chicago. Though he has used several media throughout his career, his work is predominantly in line. His children's book illustrations have been published by Holt and Abingdon Press, for whom he illustrated *Good King Wenceslas* and *The Story of Saint Nicholas*. He has lived most of his life in Gallup, New Mexico.

LAKEMAN, NATHANIEL.
Painter. Born in 1756. He painted quite a number of portraits, many of them in Salem, MA, about 1820.

LAKEY, EMILY JANE.
Painter. Born in Quincy, NY, June 22, 1837. She studied art in Ohio and Tennessee, and exhibited at Chicago and in the National Academy. In 1877 she studied in Paris under Emile Van Marcke. Her best known paintings are the "Leader of the Herd" and "An Anxious Mother." Died on Oct. 24, 1896 in Cranford, NJ.

LALANNE, MARY E.
Miniature painter, flourishing in Boston, 1833. Exhibited several miniatures at the Boston Athenaeum in 1833.

LALIBERTE, NORMAN.
Illustrator. Born in Worcester, MA, in 1925. Studied: Montreal Museum of Fine Art, Cranbrook Academy of Art and Institute of Design in Chicago. He received a Masters in Art Education from Illinois Tech. An author and illustrator, he has had over 50 one-man exhibitions and has designed many banners. Among the books he has illustrated is *The Rainbow Box*, a book of poems by Joseph Pentauro.

LALONDE, JOSEPH WILFRID.
Sculptor and painter. Born in Minneapolis, MN, March 19, 1897. Pupil of Gustave Goetsch, F. Luis Mora, F. V. Du Mond, Stanislas Stickgold. Award: First painting prize, Minnesota State Art Society, 1923. Work: Mural of Joan of Arc and St. Louis, St. Louis Church, St. Paul, MN; over altar, St. Adelbert's Church, St. Paul, MN. Address in 1933, 53 Greenwich Ave., New York, NY; h. St. Paul, MN.

LAMAR, JULIAN.
Painter. Born in Augusta, GA, Oct. 14, 1893. Pupil of Chase in Florence; Marr in Munich; Corcoran Gallery; Penna. Academy of Fine Arts. Member: National Arts Club; Newport Art Association; Salma. Club; American Federation of Arts. Work: "Prof. Henry Fairfield Osborn," Administration Building,

Zoological Gardens, New York, NY; "Cornelius Dewitt Willcox" and "Major General Fred W. Sladen," Military Academy, West Point, NY; "George M. Plimpton," Barnard College, New York City; "President John Grier Hiben," Nassau Hall, Princeton University; "President C. C. Cuyler," Princeton Club, New York City; "President Franklin H. Martin," American College of Surgeons, Chicago. Address in 1929, 15 Gramercy Park, New York, NY.

LAMB, ANTHONY.
Engraver. The *New York Mercury*, of Dec. 1, 1760, contains the following advertisement: "Maps, Plans, Coats of Arms, Shop Bills, Monthly Returns and other Engraving neatly done on Silver, Copper, etc., with Care and Dispatch, and all sort of Copper Plate Printing done in the best manner and at Reasonable Rates, at Anthony Lamb's, at Sir Isaac Newton's Head, New York."

LAMB, CHARLES R(OLLINSON).
Painter, craftsman, and architect. Born in New York. Pupil of Art Students League of NY. Member: National Society of Mural Painters; Nat. Sculpture Society (lay); NY Municipal Art Soc.; Art Students League of NY; National Arts Club; NY Architectural League; American Fine Arts Soc.; National Society Craftsmen. Specialty: Religious, historical and municipal art. Address in 1929, 23 Sixth Ave.; h. 360 West 22d St., New York, NY.

LAMB, ELLA CONDIE.
(Mrs. Charles R. Lamb). Sculptor, painter, illustrator, and craftsman. Born in New York. Pupil of Wm. M. Chase and C. Y. Turner in New York; Hubert Herkomer in England; Collins and Courtois in Paris. Work: National Arts Club; mosaic frieze, Sage Chapel, Cornell University, Ithaca, NY; murals, Flower Library, Watertown, NY; mosaic reredos, St. Mary's Church, Wayne, PA; others. Member: Mural Painters; National Arts Club. Awards: Dodge prize, National Academy of Design, 1889; hon. mention, Columbia Expo., Chicago, 1893; medal, Atlanta Expo., 1895; honorable mention, Pan-Am. Expo., Buffalo, 1901. Represented in collection of the National Arts Club. Specialty: Mural decorations, stained glass and portraits. Living in Cresskill, NJ, in 1933. Died in 1936.

LAMB, F. MORTIMER.
Painter. Born in Middleboro, MA, 1861. Pupil of Massachusetts Normal Art School; School of Boston Museum of Fine Arts; Julian Academy in Paris. Member: NY Water Color Club; American Water Color Society; Washington Water Color Club; New Haven Paint and Clay Club; Boston Society of Water Color Painters; Boston Art Club. Awards: Gold medal, 20th Century Expo., Boston, 1900; silver medal, P.-P. Expo., San Francisco, 1915. Work:

Memorial corridor, City Hall, Brockton, MA; "The Good Samaritan," Universalist Church, Stoughton, MA; "Spring," Chicataubut Club, Stoughton, MA; two landscapes and five portraits in Christian Science Students' Library, Brookline, MA; portrait of "Dean Bennett," Boston University Law School; four murals, First Baptist Church, Montclair, NJ. Died in 1936. Address in 1929, Stoughton, MA.

LAMB, FREDERICK STYMETZ.
Painter. Born in New York in 1863. Brother of Charles Rollinson Lamb. Student of Art Students League, New York; pupil of Lefebvre, Boulanger and M. Millet in Paris. Honorable mention, Chicago Exposition, 1893; gold medal, Atlanta Exposition, 1895; received gold medal from French Government. Member: National Society of Mural Painters; National Arts Club; Art Students League. Address in 1926, 23 6th Ave., New York.

LAMB, JOHN.
A New York silversmith. In the *Mercury* of 1756, he advertises "Engraving in gold, silver, copper and other materials, by John Lamb."

LAMB, KATHERINE S(TYMETS).
Painter, illustrator, craftsman, and teacher. Born in Alpine, NJ, June 3, 1895. Pupil of National Academy of Design; Art Students League of NY; Woman's Art School of Cooper Union. Member: National Arts Club; Mural PS; Art Student League of NY. Work: Froehlich memorial stained glass window, Newark Museum, Newark, NJ; "Adoration of the Cross," three murals in reredos, Christ Church, Hackensack, NJ; "Christ in Glory," mosaic reredos, Christ Lutheran Church, New York. Specialty, designs for stained glass and mosaic and decorative illustrations. Address in 1929, 23 Sixth Ave.; h. 346 West 22nd St., New York, NY; summer, Cresskill, NJ.

LAMB, THOMAS B.
Illustrator. Member: Society of Illustrators. Address in 1929, 156 Fifth Ave., New York, NY.

LAMBDEN, HERMAN.
Painter. Born in New Rochelle, NY, Jan. 4, 1859. Pupil of Rondel, Hartman and Yates. Member: New Rochelle Art Association; American Federation of Arts. Died in 1935. Address in 1929, 115 Paine Ave., New Rochelle, NY.

LAMBDIN, GEORGE COCHRAN.
Painter. Son of James R. Lambdin. He was born in Philadelphia in 1830. He painted portraits, but was better known for his flower painting, his flower pieces and roses being much sought after at the time. He was elected a National Academician of the National Academy of Design in 1868. He died in Germantown, PA, on Jan. 28, 1896.

LAMBDIN, JAMES REID.
Painter. Born in Pittsburgh, May 10, 1807. He came to Philadelphia in 1823 to study painting, working under E. Miles for six months, and afterwards under Sully for a year. Also painted in miniature. Returned to Pittsburgh, where, about 1828, he established a Museum and Gallery of the Fine Arts, the first public exhibition of works of art in the West. About four years later he removed with his collection to Louisville. He lived in Philadelphia after 1838, in which year he was made Corresponding Secretary of the Artists' Fund Society. He was Vice-President of the same Society, 1840-43; Corresponding Secretary again in 1844; President in 1845-67. He painted many portraits in Washington, including several of the presidents, one of Webster and one of Chief Justice Marshall. He was an active officer of the Pennsylvania Academy of the Fine Arts. He died in Philadelphia, Jan. 31, 1889.

LAMBERT, CHARLES.
Stonecutter. Born in Kirk Deighton, Yorkshire, England, August 30, 1816; moved to Nauvoo, IL, 1844; settled in Utah in 1849. Joined Mormons, 1843. Carved sun-face capitals of the Nauvoo Temple of the Latter Day Saints, Nauvoo, IL, about 1844. Died in Salt Lake City on May 2, 1892.

LAMBERT, GERTRUDE A.
Painter. Born in South Bethlehem, PA, Aug. 10, 1885. Pupil of Philadelphia School of Design for Women and Penna. Academy of Fine Arts. Member: Fellowship Penna. Academy of Fine Arts; Plastic Club; National Association of Women Painters and Sculptors. Awards: Cresson traveling scholarship, Penna. Academy of Fine Arts, 1912-13; Mary Smith prize, Penna. Academy of Fine Arts, 1915; silver medal, P.-P. Expo., San Francisco, 1915. Work: "The Little Market, Baveno," Penna. Academy of Fine Arts. Instructor in water color, Philadelphia School for Women, 1910-11. Address in 1929, 12 East 15th St., New York, NY; h. 215 So. Center St., Bethlehem, PA.

LAMBERT, NORA SARONY.
Painter. Born in England, Feb. 24, 1891. Pupil of George de F. Brush, Kenneth Miller, George Breck, Francis Jones. Address in 1929, Rouses Point, Clinton Co., NY.

LAMBERT, SAUL.
Illustrator. Born in NYC in 1928. Attended Brooklyn College and studied under Ad Reinhardt. His first published work appeared in *Esquire* in 1960 and his paintings have since appeared in most major publications. He has illustrated many books and produced posters for ABC and Columbia records. His works have been exhibited at the Bolles Gallery and the City Center Gallery in NY.

LAMIS, LEROY.
Sculptor and teacher. Born Sept. 27, 1925, in Eddyville, IA. Earned B.A. from New Mexico Highlands University, 1953; M.A., Columbia University, 1956. Taught at Cornell College (IA), 1956-60, and Indiana State University, from 1961. Awarded residency, Dartmouth, 1970, and received awards from Des Moines Art Center, 1958, and NYS Council on the Arts. Work in Albright-Knox Museum; Whitney; Hirshhorn; others. Exhibited at Clarke College, 1957 and 1961; City Art Museum of St. Louis; Seattle Art Museum; State University of Iowa; Albright-Knox; Denver Art Museum; Museum of Modern Art; Smithsonian Institution; La Jolla; Whitney Museum; Rhode Island School of Design; Scripps Club; and others. In collections of Whitney; Albright-Knox; Staempfli Collection; Hirshhorn Collection; and many private collections. Member: American Abstract Artists. Media: Plastics. Address in 1984, Terre Haute, IN.

LAMONT, DANIEL G.
Historical painter and portrait painter in oils and miniatures, flourishing in New York, 1846-47.

LAMONT, FRANCES KENT (MRS.).
Sculptor. Pupil of Solon Borglum and Mahonri Young. Represented in Cleveland Museum of Art; memorial to the wars of America, New Canaan, CT; Spanish-American war memorial, New Rochelle, NY; Metropolitan Museum of Art; Denver Art Museum; Cranbrook Museum of Art; Albright Art Gallery; others. Exhibited: Salon des Tuileries, Paris, 1937-39; Whitney, 1941-51; Philadelphia Museum of Art, 1940-49; Penna. Academy of Fine Arts, 1940, 48, 49; Allied Artists of America, 1958, 59, 60; one man: George W. V. Smith Museum, 1950; Denver Art Museum, 1952; traveling exhibition, 1952-53; Albright, 1953. Awards: Allied Artists of America, 1958; National Sculpture Society, 1969. Member: National Sculpture Society. Address in 1970, 21 West 10th Street, NYC. Died in 1975.

LAMPKIN, R(ICHARD) H(ENRY).
Painter. Born in Georgetown, KY, June 11, 1866. Pupil of H. D. Fulhart; Cincinnati Art Academy. Address in 1929, 146 W. McMillan St., Cincinnati, OH.

LANDAU, JACOB.
Illustrator. Born in Philadelphia in 1917. He attended the Museum Art School and the New School for Social Research and later studied in Paris. His career in magazine illustration began with the editorship of *At Ease*. He has worked extensively in advertising design for IBM, Steuben Glass, and others. An instructor at the Philadelphia Museum Art School, he has also served as chairman of the design department at Pratt Institute.

LANDEAU, SANDOR L.

Painter. Born in Hungary, 1864. Pupil of Laurens and Constant in Paris. Member: American Art Association of Paris. Awards: Second Wanamaker prize, American Art Association of Paris; hon. mention, Pan-Am. Expo., Buffalo, 1901; hon. mention, Paris Salon, 1905; third class medal, Paris Salon, 1907. Address in 1929, care of Paul Foinet, 21 Rue Brea, Paris, France.

LANDECK, ARMIN.

Painter and engraver. Born in Wisconsin, June 4, 1905. Trained as an architect at Columbia University. Studied etching with Stanley William Hayter in NY. Member of the National Academy of Design; American Institute of Arts and Letters; and the International Institute of Arts and Letters. Collections: Metropolitan Museum of Art; Museum of Modern Art; Swedish National Museum; and others. Works and lives in Litchfield, CT.

LANDER, LOUISA.

Portrait sculptor. Born in Salem, MA, September 1, 1826. Began her art career by modeling likenesses of members of her family; went to Rome, 1855, and studied under Thomas Crawford. Studio in Washington, DC, after 1855. Among her first notable works were figures of marble, "Today" and "Galatea." Among her later works are a bust of Governor Gore, of Massachusetts; bust of Hawthorne; statues of "Virginia Dare;" "Undine;" "Virginia;" "Evangeline;" "Elizabeth;" "The Exile of Siberia;" "Ceres Mourning for Proserpine;" "A Sylph Alighting;" "The Captive Pioneer;" also many portrait busts. Address in 1923, 1608 19th St., Washington, DC. Died November 14, 1923.

LANDIS, LILY.

Sculptor. Born in NYC. Studied at Sorbonne, France; Art Students League; also with Jose De Creeft. Exhibited group shows at Sculptors Guild; Audubon Artists; National Academy of Design; Art Institute of Chicago; Corcoran Gallery; Sculpture Center; Penna. Academy of Fine Arts; Whitney Museum of American Art; and others. Works: Noma Electric Company; David Doniger Company; Hirsch & Company; and also many private collections. Address in 1983, 400 E. 57th St., NYC.

LANE, CHRISTOPHER.

Painter. Born June 7, 1937, in NYC. Studied at High School of Music and Art, NYC; Goddard College, VT; School of Painting and Sculpture, Mexico City. In Mexico and Paris from 1957 to 1962. Exhibited at Beaux Arts Gallery, London (1962); Osborne Gallery, NYC (1958); City Center Gallery, NYC; II Biennale, Paris; Museum of Modern Art; Yale; University of Illinois; and in many private collections.

LANE, FITZ HUGH.

Painter and lithographer. Born in Gloucester, MA, December 19, 1804. No formal art training until 1832 when apprenticed to lithography firm of William S. and John Pendleton, Boston. In 1845 formed own litho firm with John W. A. Scott. In the 1840's he turned increasingly to oil painting. Returned to Gloucester in 1848. His paintings were primarily of that city and environs and the Maine coast; also of NY Harbor, Baltimore, and Puerto Rico (St. John's). Subjects were harbor views, wharf scenes, sailing and steamships, landscapes. Exhibited frequently in Gloucester, Boston, Albany (NY), and NYC. Many works purchased and sold by American Art-Union. Most of his works are in collections of Cape Ann Historical Association, Gloucester, MA; Karolik Collection, Museum of Fine Arts, Boston. Also represented in Butler Institute, Youngstown, Ohio; Shelburne (VT) Museum; Mariner's Museum, Newport News, VA; RI School of Design; Richmond (VA) Museum of Fine Arts; Newark (NJ) Museum; Farnsworth Museum, Rockland, ME; Berry-Hill Galleries, NYC; others, including private collections. Died in Gloucester, MA, August 18, 1865.

LANE, KATHARINE WARD.

Sculptor. Born in Boston, MA, Feb. 22, 1899. Pupil of Anna Hyatt Huntington, Charles Grafly, Brenda Putnam. Member: Guild of Boston Artists; National Association of Women Painters and Sculptors; North Shore Art Association; Boston Sculptors Society; National Sculpture Society. Awards: Bronze medal, Sesqui-Centennial Exposition, Philadelphia, 1926; Widener Memorial gold medal, Penna. Academy of Fine Arts, 1927; Joan of Arc gold medal, National Association Women Painters and Sculptors, 1928, and Anna Hyatt Huntington prize, 1931; Paris Salon, France, 1928; Grover prize, North Shore Art Association, 1929; Speyer prize, National Academy of Design, 1931; Barnett prize, 1932. Works: Museum of Fine Arts, Boston, MA; Reading Museum, PA; entrance doors and brick carvings, Harvard University, MA. Address in 1933, Boston, MA; summer, Manchester, MA.

LANE, MARIAN.

Painter and craftsman. Born in Great Gransden, Huntingdonshire, England. Member: Washington Water Color Club; Washington Society of Arts and Crafts; NY Guild of Bookworkers. Address in 1929, care Arts Club, 17th and I Streets, NW, Washington, DC.

LANE, MARION JEAN ARRONS.

Sculptor, painter, and teacher. Studied: Brooklyn Museum Art School, with Manfred Schwartz and Reuben Tam; The Art Students League, NYC, with Morris Kantor; Pratt Institute; William Paterson College, NJ, B.A.; Rutgers University, M.F.A. Exhibitions: Brooklyn Museum; Montclair Museum;

Edward Williams College, 1971; Kraushaar Gallery, NYC, 1975; Pleiades Gallery, NY, 1976, 77. Awards: Brooklyn Museum, 1958; Montclair Museum, 1960, 1964; Atlantic City Annual, 1963. Taught: Instructor, drawing and painting, Riverdell Adult School, Oradell, NY, 1961-71; Edward Williams College, 1972; Bergen Community College, 1980-81. Life member, Art Students League. Address in 1976, Ridgewood, NJ.

LANE, MARY COMER.
Painter. Member: Baltimore Water Color Club; Southern States Art League. Address in 1929, 26 Gaston St., Savannah, GA.

LANE, SUSAN MINOT.
Painter. Born in Cambridge, MA, in 1832. She was a pupil of William Morris Hunt. She is represented by a painting in the Boston Museum of Fine Arts. She died in 1893, in Cambridge, MA.

LANE, THOMAS HENRY.
Painter. Worked in portraits and miniatures. He was born Feb 14, 1815, and died Sept. 27, 1900, at Elizabeth, NJ.

LANE, WILLIE BAZE.
Painter, lecturer and teacher. Born in Mason, TX, March 16, 1896. Pupil of Nordfeldt in Santa Fe. Member: Oklahoma Art Association; Chickasha Art League; Oklahoma City Art League; Oklahoma Traveling Exhibitors. Work: Murals in First Christian Church and First Baptist Church, Chickasha. Address in 1929, 1121 Florida Ave., Chickasha, OK; summer, Santa Fe, NM.

LANG, CHARLES M.
Sculptor, painter, illustrator, craftsman, and teacher. Born in Albany, NY, Aug. 26, 1860. Pupil of Julius Benzur, Prof. Lofftz; studied in Venice and London. Member: Salmagundi Club. Work: "Gov. David B. Hill," "Gov. Roswell P. Flower," Albany, NY; "Hugo Flagg Cook," Capitol, Albany; Judges Parker and Houghton, Court House, Albany; bust of James Ten Eyck, Masonic Temple, Albany; "Gen. Joseph B. Carr," "Cuett" and "Warren," Troy, NY; "Morgan J. O'Brien," Manhattan Club, New York City; "Bishop Rooker," "Gen. C. P. Easton," "Prof. Robinson," Albany High School, Ithaca, NY. Address in 1933, Miller Building Studio, 1931 Broadway; 47 Fifth Ave., New York, NY. Died in 1934.

LANG, GEORGE S.
Engraver. Born in Chester County, PA, in 1799; living in Delaware County, PA, in 1883. Baker said that Lang was a pupil of George Murray, the Philadelphia engraver, in 1815, and that he abandoned engraving early in life. The Philadelphia directories, however, contain his name as "engraver" until 1833, and as his signed work is scarce, he was probably employed in bank-note work. He was a good line-engraver.

LANG, LOUIS.
Painter. Born in Wurtemberg, Germany, March 29, 1824. He came to America in 1838, and settled in Philadelphia. He was elected a National Academician in 1852, and was a member of the Artists' Fund Society. His work was portraits and historical scenes. Work: "Maid of Saragossa," "Blind Nydia" and "Romeo and Juliet" in the Century Club, New York. He died May 6, 1893, in NYC.

LANGE, KATHARINE GRUENER.
(Mrs. Oscar J. Lange). Sculptor. Born in Cleveland, OH, Nov. 26, 1903. Studied at Smith College, B.A., 1924; Cleveland Institute of Art, 1933. Works: Cleveland Museum of Art; Republic Steel Corporation, Cleveland. Exhibited: Architectural League; Whitney; Metropolitan Museum of Art; Cleveland Museum of Art; others. Awards: Cleveland Museum of Art, 1936, 1937, 1940-43, 1945, 1946, 1948-50, 1952, 1953-55, 1957. Member: Cleveland Institute of Art; Cleveland Art Association. Address in 1962, Shaker Heights 22, OH.

LANGENBAHN, AUGUST A.
Sculptor. Born in Germany, August 28, 1831. Came to US c. 1852; settled in Buffalo, NY, c. 1885. Works held: Buffalo Historical Society; Buffalo Public Library; Buffalo Museum; NY Historical Society. Died in Buffalo, NY, June 7, 1907.

LANGERFELDT, THEODORE O.
Painter. Born in Germany in 1841. He came to Boston, MA, in 1868. He painted chiefly in water colors, and one of his architectural paintings was awarded a prize at the Centennial Exhibition in Philadelphia in 1876.

LANGHORNE, KATHERINE.
See Adams, Katherine Langhorne.

LANGLEY, ELIZABETH.
Painter and etcher. Born in Chicago, IL, May 20, 1907. Pupil of Arthur Carles, Hugh Breckenridge; Art Students League of NY. Address in 1929, 2038 Spruce St., Philadelphia, PA; summer, High Point, NJ.

LANGLEY, SARAH.
(Mrs. Earl Mendenhall). Sculptor, painter, illustrator, writer, and teacher. Born in Texas, July 12, 1885. Pupil of Penna. Academy of Fine Arts. Member: Fellowship Penna. Academy of Fine Arts. Works: "Jewels," Penna. Academy of Fine Arts. Address in 1933, Philadelphia, PA; summer, Forest Inn, Eagles Mere Park, PA.

LANGS, MARY METCALF.
Sculptor. Born in Burford, Ontario, Canada, March 12, 1887. Studied sculpture with Bourdelle, Despiau, Gimond in Paris. Awards: Albright Art Gallery, 1938, 41, 45, 50. One man shows at Schenectady and Niagara Falls, NY; exhibited at Salon de Printemps, Paris; Salon d'Autumn, Paris; National Academy of Design; Penna. Academy of Fine Arts; Audubon Artists, NYC; Artists Western NY, Buffalo; and others. Member: Patteran Society; Artists Equity; International Institute of Arts and Letters (life fellow). Address in 1962, Niagara Falls, NY.

LANGTON, BERENICE FRANCES.
(Mrs. Daniel W. Langton). Sculptor. Born in Erie Co., PA, September 2, 1878. Pupil of Augustus Saint-Gaudens in NY; Rodin in Paris. Member: Pen and Brush Club; National Association of Women Painters and Sculptors. Exhibited at National Sculpture Society, 1923; Metropolitan Museum of Art, 1942; Penna. Academy of Fine Arts; National Academy of Design; Salon des Beaux-Arts, and Salon des Tuileries, Paris, France; Pen and Brush Club. Awards: Bronze medal, St. Louis Expo., 1904; Helen Foster Barnett prize for sculpture, National Association of Women Painters and Sculptors, 1915; medal, Pen and Brush Club, 1948. Works: Lawrence memorial, New London, CT; Rathborne tablet, NY Athletic Association, Travers Island, NY; Triton fountain, Oakdene, Bernardsville, NJ; vari-colored marble fountain, Cleveland, OH; swan fountain, Hempstead, LI; marble sun-dial, Morristown, NJ. Exhibited: Metropolitan Museum of Art, 1942; Penna. Academy of Fine Arts; Walters Gallery, Baltimore, MD; Salon des Beaux-Arts, Salon des Tuileries, Paris, France. She executed numerous small marbles, bronzes, and portrait medals. Address in 1953, 122 East 27th Street, NYC. Died in 1959.

LANGTRY, MARY.
Painter. Member: NY Water Color Club; National Association of Women Painters and Sculptors. Address in 1929, Box 41, Tompkins Cove, NY; 241 Ryerson St., Brooklyn, New York, NY.

LANGZETTEL, GEORGE H(ENRY).
Painter and teacher. Born in Springfield, MA, April 3, 1864. Pupil of Yale School of Fine Arts. Member: New Haven Paint and Clay Club. Instructor in Drawing and Secretary, Yale School of Fine Arts. Address in 1929, Yale School of Fine Arts; h. 725 Whitney Ave., New Haven, CT.

LANKES, JULIUS J.
Painter, sculptor, illustrator, etcher, artist, craftsman, and writer. Born in Buffalo, NY, August 31, 1884. Studied: Art Students League, Buffalo, NY; Boston Museum of Fine Arts School; pupil of Mary B. W. Coxe; Ernest Fosbery; Philip Hale; W. M. Paxton.

Member: Associate of the National Academy of Design; American Artists Professional League; Print Society of England; Society of American Graphic Artists; Print Makers' Society of California. Represented in permanent print collections of the Boston, NY, and Newark Public Libraries; Metropolitan and Brooklyn Museums; Carnegie Institute, Pittsburgh; Library of Congress, Washington, DC; British Museum. Exhibited: Carnegie; Corcoran; Albright; Baltimore Museum of Art; Rochester Memorial Art Gallery; Richmond Academy of Fine Arts. Illustrations for "New Hampshire" and "Westrunning Brook," by Robert Frost; "Homes of the Freed," by Rossa B. Cooley; "Marbacka," by Selma Lagerlof; "May Days," ed. by Genevieve Taggard; "Spring Plowing," by Charles Malan. Address in 1953, Durham, N.C. Died in 1960.

LANMAN, CHARLES.
Painter. Studied with Asher Durand. Born in Monroe, MI, 1819. He was elected an Associate Member of the National Academy in 1847. His largest picture, "View of Filziyama," was purchased by the Japanese government. Published *The Private Life of Daniel Webster*. He died March 4, 1895.

LANSIL, WALTER F.
Born in Bangor, ME, in 1846. He early became familiar with ships and the sea. He studied abroad and on his return to this country set up his studio in Boston, where he became well known in his style of painting. Among his works are "Crossing the Georges" and "View of Charlestown, with Shipping."

LANSNER, FAY.
Painter and tapestry artist. Born in Philadelphia, PA, in 1921. Studied: Tyler School of Fine Arts, Temple University, 1945-47; Columbia University with Susanne Langer; Art Students League, 1947-48; Hans Hofmann School, 1948-50; with Fernand Leger, Andre L'hote, Paris, 1950. Work: Newsweek, NYC; Ciba-Geigy Corp., Ardsley, NY; Cite des Arts, Paris; Neuberger Museum, SUNY Purchase; Corcoran Gallery, Washington, DC; Metropolitan Museum, NYC; Philadelphia (PA) Museum of Art; and many other museums, corporations, and private collections. One-woman shows: Galerie 8, Paris, 1951; Hansa Gallery, NYC, 1954, 56, 58; Kornblee Gallery, NYC, 1964, 66; Benson Gallery, Bridgehampton, LI, NY, 1970, 72, 76, 78, 80, 82; Ingber Gallery, NYC, 1980; Phoenix Gallery II, Washington, DC, 1982; and many more. Exhibited: Davis Gallery, NYC; Zabriskie Gallery, NYC; Tibor de Nagy Gallery, NYC; Contemporary Art Museum, Houston, TX; School of Visual Arts, NYC; Weatherspoon Art Gallery, Greensboro; Corcoran Gallery, Washington, DC; Museum of Modern Art, NYC (lending service); 17th Brooklyn Museum Print Annual; La Demeure Tapestry, Paris; American Federation of Arts, Museum Section, Guild Hall, East Hampton, LI, NY;

University of North Dakota; Cite des Arts, Paris; Metropolitan Museum of Art; Denver (CO) Art Museum; and many others. Member: Co-founder, Women in the Arts, with Ce Roser. Bibliography: Numerous reviews in *Art News*, *Art in America*, *Craft Horizons*, *NY Times*, etc.; books; broadcasts; taped interviews. Media: Oil, pastel, charcoal, pencil, lithograph, collage, watercolor, tapestry. Represented: Marlborough Graphics, and Arras Gallery, NYC. Address in 1983, 810 Broadway, NYC.

LANTZ, MICHAEL.
Sculptor. Born in New Rochelle, NY, April 6, 1908. Studied at the National Academy of Design, 1924-26; under Lee Lawrie, 1926-35; and at the Beaux-Arts Institute of Design, 1928-31. Exhibited: Philadelphia Museum of Art, PA, 1940 and 48; National Sculpture Society, National Academy of Design, and the Lever House, NY. Member: National Sculpture Society (president, from 1970-73, chairman of honors and awards committee); National Academy of Design (council member, 1970 to present, 1st vice president, 1975 to present); American Academy of Achievement (board of governors); and the Fine Arts Federation of NY (vice president, 1970). Taught: Professor of Sculpture in adult education in New Rochelle, 1936-38; Instructor at the National Academy of Design, from 1965 to the present. Commissioned works: Sculptural Outlines for the Architect's Building in Albany, NY, 1968; Thomas Jefferson Bicentennial Medal, US Mint, 1976; New Rochelle Bicentennial Medal, 1976; a four foot bronze eagle for the Peoples Bank for Savings, 1977; and others. Published numerous articles in the *National Sculpture Review*. Address in 1982, New Rochelle, NY.

LAPLANTE, LOUISE A.
Painter. Born in Dover, NH, in 1950. Studied: With Ralph Della Volpe; Art Institute of Boston, B.F.A., 1974; College of New Rochelle, M.A., 1976; State University of NY at Albany. Work: Private collections. One-woman shows: University of Vermont & SUNY Albany, 1976; Albany (NY) Institute of History and Art, 1979; Gallery on Paper, Lenox, MA, 1982, and others. Exhibited: 20th Annual National Exhibition of Prints & Drawings, Oklahoma Art Center, Oklahoma City, 1978; Adirondack Regional Art Exhibition, Hyde Collection, Glens Falls, NY, 1978; New England Arts Festival & Showcase, Northampton, MA, 1981; The Main Artery, Northhampton, MA, 1982; other exhibitions in Massachusetts and Vermont. Address in 1983, 66 Franklin St., Northhampton, MA.

LAPSLEY, ROBERT ERNEST.
Illustrator. Born in Memphis, TN, in 1942. Attended: North Texas State University for three years before leaving for Los Angeles where he studied at the Art Center College of Design until 1970. He has exhibited his work at the Society of Illustrators Annual Exhibitions.

LARNED, MARGUERITE YOUNGLOVE.
Painter. Member: National Association of Women Painters and Sculptors; Pen and Brush Club; Elizabeth Society of Artists. Address in 1929, 62 Washington Sq., New York, NY.

LARSEN, B(ENT) F(RANKLIN).
Painter and teacher. Born in Monroe, UT, May 10, 1882. Pupil of Walter Sargent, Lee R. Randolph, Henri Royer, Paul Albert Laurens, Jules Pages. Member: American Society of Independent Artists; American Artists Professional League; Pacific Art Association; Western Art Association; American Federation of Arts. Awards: Utah prize, Springville National Exhibition, 1926; first prize, Utah County Exhibition, 1927. Work: "The Mother Tree" and "Belgium Fields," Springville Gallery, Springville, Utah; "In Dragon Land" and "Sunlit Mountain," Alice Art Collection, State Capital, Salt Lake City; "Rock Canyon," Utah County Collection, County Gallery, Provo; "The Joshua," Gila College, Thatcher, Arizona. Died in 1970. Address in 1929, 733 North Fifth West, Provo, UT.

LARSEN, (CHARLES) PETER.
Painter, etcher and craftsman. Born in Philadelphia, March 7, 1892. Pupil of Penna. Academy of Fine Arts. Member: Chicago Society of Etchers. Represented in Chicago Art Institute. Address in 1929, 27 West 8th St., New York, NY; h. 662 Madison Ave., York, PA.

LARSEN, MAY SYBIL.
Painter. Born in Chicago, IL. Pupil of Art Institute of Chicago; Sloan; Davey. Member: Society of Independent Artists; Chicago No-Jury Society of Artists. Died 1953. Address in 1929, 4437 North Francisco Ave., Chicago, IL.

LARSEN, MORTEN.
Sculptor, painter, and wood carver. Born in Saal Sogan, Jutland, Denmark, in 1858 or 1859. Later lived in California. Studied at Industrial Art School and Royal Academy, probably in Denmark. Exhibited at Mechanics' Institute of Industrial Exhibitions, San Francisco, 1890's. Executed "Deer in the Forest" (1893), sculpted in high relief. His work departed from the academic tradition and was inspired more by the European folk-art traditions. His pieces were among the few landscape-inspired sculptures of the period.

LARSH, THEODORA.
(Mrs. Francis Dane Chase). Miniature painter and teacher. Born Crawfordsville, IN. Pupil of Art Students League of NY; Art Institute of Chicago; Beaux; Vanderpoel; Bridgman; George Luks; Hawthorne; Johansen; Mme. La Forge in Paris. Member: National Association of Women Painters and Sculptors; Art Students League of Chicago; Alliance;

Indiana Art League; Art Students League of NY; Hoosier Salon; American Artists Professional League; Crawfordsville (Ind.) Art League (hon.). Award: Griffith prize, miniatures, Hoosier Salon, 1926. Director, NY League of Business and Professional Women. Died in 1955. Address in 1933, 152 Carnegie Hall, New York, NY; summer, 4 Montrose Ave., Argyle Park, Babylon, LI, NY.

LARSON, FRED T.
Painter. Born in Chicago, April 19, 1868. Pupil of Art Institute of Chicago. Member: Palette and Chisel Club. Specialty, woodcuts and color block prints. Address in 1929, 55 E. Washington St.; 2935 North Whipple St., Chicago, IL.

LARTER, JOSENIA ELIZABETH.
(Mrs. W. H. D. Cox). Painter, illustrator, etcher and teacher. Born in Newark, NJ, April 6, 1898. Pupil of Gruger, Rosen, Henri, Du Mond, Bridgman, Pennell, Ida W. Stroud, Van Sloun, Charles S. Chapman. Member: American Federation of Arts. Awarded $1,000, trademark contest, 1922, Lawyers Mortgage Company. Specialty: Figure composition. Address in 1929, 395 Parker St., Newark, NJ.

LASCARI, HILDA K.
Sculptor. Born in Sweden, 1886. Member: National Sculpture Society. Address in 1934, New York. Died in 1937.

LASKY, BESSIE.
Painter. Born in Boston, MA, April 30, 1890. Pupil of Felicie Waldo Howell. Member: National Association of Women Painters and Sculptors; North Shore Art Association; New Haven Paint and Clay Club; American Federation of Arts. Work: "Interior," Newark Museum. Address in 1929, 910 Fifth Ave.; summer, 609 Palisades Beach Blvd., New York, NY.

LASSAW, IBRAM.
Sculptor. Born May 4, 1913, in Alexandria, Egypt; US citizen. Studied with Dorothea H. Denslow at Sculpture Center, NYC (1926-30); at Beaux-Arts Institute and City College, NYC. Founder of American Abstract Artists. Exhibitions include those at Kootz Gallery (many since 1951); MIT; Duke University; Museum of Modern Art; Carnegie; Art Institute of Chicago; Philadelphia Art Alliance; Albright-Knox; Seattle World's Fair (1962); University of Illinois; Two Hundred Years of American Sculpture, and Recent Acquisitions, Whitney Museum of American Art, NYC; numerous others. Taught: Instructor of sculpture, American University, 1950; artist-in-residence, Duke University, 1962-63; visiting artist, University of California, Berkeley, 1965-66; adjunct faculty, Southampton College, from 1966; visiting professor, Brandeis University, Waltham, NY, 1972; Mt. Holyoke College, 1978. In collections of Harvard University; Washington University;

Newark Museum; Wadsworth Atheneum; Baltimore Museum; Cornell University; Whitney Museum; Museum of Modern Art, NY; Museum of Modern Art, Rio de Janeiro, Brazil; Kneses Tifereth Israel Synagogue, Port Chester, NY; Beth El Temples of Providence and Springfield; Carnegie; Albright; and others. Address in 1982, East Hampton, NY.

LASSELL, CHARLES.
Illustrator. Member: Society of Illustrators. Address in 1929, Westport, CT.

LATHROP, DOROTHY PULIS.
Painter and illustrator. Born in Albany, NY, April 16, 1891. Pupil of A. W. Dow; Henry McCarter; F. Luis Mora. Member: Fellowship Penna. Academy of Fine Arts; National Association of Women Painters and Sculptors. Illustrated *The Three Mulla-Mulgars, Down-Adown-Derry* and *Crossings*, by Walter de la Mare; *A Little Boy Lost*, by W. H. Hudson; *The Grateful Elephant*, translated by E. W. Burlingame; and *Silverhorn*, by Hilda Conkling; *Made-to-Order Stories*, by Dorothy Canfield; *The Light Princess*, by George MacDonald; *Tales from the Enchanted Isles*, by Ethel May Gate. Illustrated for magazines. Address in 1929, 151 South Allen St., Albany, NY.

LATHROP, ELINOR L.
Sculptor and painter. Born in Hartford, CT, Sept. 26, 1899. Pupil of Hale, Logan, Calder, Mora, and Jones. Member: Hartford Art Society. Address in 1926, West Hartford, CT; summer, Old Lyme, CT.

LATHROP, FRANCIS.
Painter. Born at sea, June 22, 1849. He was educated in New York City and in Germany. He exhibited at the Society of American Artists in 1878, portraits of Ross R. and Thomas Winans. He devoted himself chiefly to mural painting and designing of stained glass. He executed wall paintings at Bowdoin College Chapel; Metropolitan Opera House, New York; and decorations for Trinity Church, Boston. Elected an Associate Member of the National Academy in 1906, three years before his death. He was also a member of the Society of American Artists. He died Oct. 18, 1909, in Woodcliffe Lake, NJ.

LATHROP, GERTRUDE KATHERINE.
Sculptor. Born in Albany, NY, Dec. 24, 1896. Studied: Art Students League, School of American Sculpture. Pupil of Solon Borglum and Charles Grafly. Sister of illustrator Dorothy Pulis Lathrop; mother was a painter. In collections of Brookgreen Gardens; National Collection of Fine Arts, Washington, DC; Albany Public Library; Houston Public Library; Smithsonian Institution, Washington, DC. Exhibited: National Sculpture Society, 1923; Albany Institute of History and Art, 1957, 66; Woodmere Art Gallery, Philadelphia, 1963. Member: Society of Animal Painters and Sculptors; National Academy

of Design; National Institute of Arts and Letters; National Association of Women Painters and Sculptors; National Sculpture Society (Assoc.). Awards: Hon. mention, Art Institute of Chicago, 1924; Helen Foster Barnett prize, National Academy of Design, 1928, and Saltus Gold Medal for merit, 1970; Medal of Honor, Allied Artists of America, 1964; Silver Medal, Pen and Brush Club, 1967; others. Address in 1982, Falls Village, CT.

LATHROP, IDA PULIS.
(Mrs. Cyrus Clard Lathrop). Painter. Born in Troy, NY, Oct. 27, 1859. Self-taught. Member: National Association of Women Painters and Sculptors. Work: "Still Life," Prendergast Art Gallery, Jamestown, NY. Specialty, portraits and still life. Died in 1937. Address in 1929, 151 South Allen St., Albany, NY.

LATHROP, W(ILLIAM) L(ANGSON).
Painter and etcher. Born in Warren, IL, March 29, 1859. Member: Associate National Academy of Design, 1902; Academician National Academy of Design, 1907; NY Water Color Club; Rochester Art Club; NY Etching Club. Awards: Evans prize, American Water Color Society, 1896; gold medal, Art Club of Philadelphia, 1897; Webb prize, Society of American Artists, 1899; bronze medal, Pan-Am. Expo., Buffalo, 1901; third prize ($500), Carnegie Institute, Pittsburgh, 1903; second prize, Worcester, 1904; bronze medal, St. Louis Expo., 1904; gold medal for oil painting and silver medal for water colors, P.-P. Expo., San Francisco, 1915. Work: "The Meadows," Metropolitan Museum, New York; "Clouds and Hills," Minneapolis Museum; "Three Trees," National Museum of Art, Washington; "Abandoned Quarry," Carnegie Institute, Pittsburgh; "Old Covered Bridge," Hackley Art Gallery, Muskegon, MI. Died in 1938. Address in 1929, New Hope, Bucks Co., PA; care of the Ferargil Galleries, 607 Fifth Ave., New York, NY.

LATILLA, EUGENIO.
Painter. Born in 1808. He lived in Italy for years, but later moved his studio to New York. His portraits were excellent; he painted many of the most eminent American clergymen. Latilla taught for some years in the School of Design in New York. Died Oct. 30, 1861 in Chappaqua, NY.

LAUBER, JOSEPH.
Sculptor, mural painter, etcher, craftsman, and teacher. Born in Meschede, Westphalia, Germany, Aug. 31, 1855; came to US at age of nine. Pupil of Karl Muller, Shirlaw and Chase; worked with La Farge. Member: Mural Painters; NY Architectural League, 1889; Artists' Fellowship, Inc. (president); Salma. Club, 1902; NY Etching Club. Awards: Hon. mention for mosaics and glass, Columbian Expo., Chicago, 1893; gold and bronze medals for mosaic and mural designs, Atlanta, 1895; medals, for etch-

ings and mural work, Midwinter Fair, California. Specialty, stained glass, mosaics and murals. Work: Paintings—sixteen symbolic figures, Appellate Court, NY; portrait of ex-speaker Pennington, House of Representatives, Washington, DC; windows in Church of the Ascension, NY; Trinity Lutheran Church, Lancaster, PA; painting of Christ, Euclid Ave. Baptist Church, Cleveland, Ohio. Instructor of art at Columbia University, NY. Address in 1933, 371 West 120th St., New York. Died Oct. 19, 1948.

LAUCK, ANTHONY JOSEPH.
Sculptor and educator. Born in Indianapolis, IN, December 30, 1908. Studied at John Herron Art School, Indianapolis; Corcoran School of Art, Washington, DC; also with Oronzio Maldarelli, Ivan Mestrovic, Carl Milles, Hugo Robus, and Heinz Warneke. Work in Penna. Academy of Fine Arts; Corcoran Gallery of Art; Butler Institute of Fine Arts; Indianapolis Museum of Art; others. Has exhibited at Fairmount Park Art Association International Exhibition, Philadelphia; Penna. Academy of Fine Arts; Audubon Artists, National Academy of Arts, NY; others. Received awards from Fairmount Park Art Association, 1948; Penna. Academy of Art, 1953; Indianapolis Museum of Art, 1954. Taught drawing and sculpture at University of Notre Dame, 1950-73. Works in wood and stone. Represented by Bodley Gallery, NYC. Address in 1982, Notre Dame, IN.

LAUDER, JAMES.
Sculptor. Born in NJ, c. 1825. Worked: NYC, 1846-61.

LAUDERDALE, URSULA.
(Mrs. Edward Seay Lauderdale). Painter, lecturer and teacher. Born in 1880. Pupil of Henri; Reaugh; Art Students League of NY; Devol; Maurice Braun. Member: Dallas Art Association; Fort Worth Art Association; Dallas Woman's Forum; Southern States Art League; American Federation of Arts. Work: Stained glass window, "Ruth," City Temple, Dallas, Texas. Died in 1933. Address in 1929, 3401 Princeton Ave., Dallas, TX.

LAUGHLIN, ALICE D(ENNISTON).
Painter, illustrator and engraver. Born in Pittsburgh, PA, Oct. 19, 1895. Member: Art Students League of NY; American Federation of Arts; National Arts Club. Represented by woodcuts in the Rochester Memorial Gallery, Rochester, NY; New York Public Library; Phillips Memorial Gallery, Washington, DC. Died in 1952. Address in 1929, 133 East 64th St., New York, NY; summer, Hyannisport, MA.

LAUNE, PAUL SIDNEY.
Painter and illustrator. Born in Milford, NE, May 5, 1899. Pupil of Chicago Academy of Fine Arts.

Award: Silver medal for graphic arts at Midwestern Exhibition, 1924, Kansas City, MO, Art Institute. Represented in High School Collections, McPherson, KS.

LAUNITZ, ROBERT EBERHARD SCHMIDT VON DER.
Sculptor. Born in Riga, Latvia, Nov. 4, 1806. Studied sculpture under Thorwaldsen in Rome. In 1828 he came to America; worked in marble shop of John Frazee, later formed a partnership with Frazee, 1831, in NY. Elected a member of the National Academy in 1833. Mainly a sculptor of mantels and gravestones. Also among his productions are the Pulaski monument in Savannah, GA; the Battle monument in Frankfort, KY; and the monument to General George H. Thomas in Troy, NY. Taught many American sculptors, including Thomas Crawford. Died in NYC, Dec. 13, 1870.

LAURENCE, SIDNEY.
Painter. Born in NY, Oct. 14, 1865. Member: Salma. Club. Address in 1929, Anchorage, AK.

LAURENT.
A little known genre painter who worked in America with some success.

LAURENT, ROBERT.
Sculptor and educator. Born in Concarneau, France, June 29, 1890. Came to US in 1902. Pupil of Hamilton Easter Field; Maurice Sterne; Frank Burty; British Academy in Rome. Member: Artists Equity Association; New England Sculptors Association; Salons of America; Modern Artists of America; Brooklyn Society of Modern Artists; National Sculpture Society; Audubon Artists. Awards: Logan medal, prize, Art Institute of Chicago, 1924, 38; Fairmount Park, Philadelphia, International Sculpture Competition, 1935 (monument); Brooklyn Museum, 1942; Herron Institute, five 1st prizes; Audubon Artists, 1945; medal of honor and prize, 1967; many others. Received commission from Radio City Music Hall, NYC; and others. Represented in Art Institute of Chicago; Newark Museum; Brooklyn Museum; Vassar College; Whitney Museum; Museum of Modern Art; Penna. Academy of Fine Arts; Wadsworth Atheneum; Metropolitan Museum of Art; Whitney; others. Exhibited at Daniel Gallery, Salons of America, Whitney, Metropolitan Museum of Art, all in NYC; Art Institute of Chicago; Brooklyn; Corcoran; Penna. Academy of Fine Arts; John Herron Art Institute; and many more. Director of Ogunquit (ME) School of Painting and Sculpture. Taught: Art Students League; Vassar; Goucher; Corcoran School of Art; Indiana University, Bloomington, IN, from 1942, Emeritus, from 1960. Address in 1970, Indiana University, Bloomington, IN; h. Cape Neddick, ME. Died in Cape Neddick, ME, April 20, 1970.

LAURIE, ALEXANDER.
See Lawrie, Alexander.

LAURIE, LEE O.
See Lawrie, Lee O.

LAURIE-WALLACE, JOHN.
Sculptor, painter, illustrator, lecturer, and teacher. Born in Garvagh, Ireland, July 29, 1863. Pupil of Thomas Eakins; Penna. Academy of Fine Arts; Art Institute of Chicago. Member: Omaha Artists Guild, President; Chicago Society of Artists. Work: Joslyn Memorial; Lincoln Art Gallery. Address in 1953, Omaha, NE.

LAURITZ, PAUL.
Painter. Born in Larvik, Norway, April 18, 1889. Member: CaliforniaArt Club; Los Angeles Painters and Sculptors; Artland Club. Awards: Second prize, 1920, first prize, 1922, first prize, 1923, second prize, 1924, hon. mention, 1925, third prize, 1926, State Fair, Sacramento, California; hon. mention, State Fair, Arcadia, California, 1923; first prize, State Fair, Santa Ana, California, 1923; hon. mention, State Fair, Phoenix, Arizona, 1925. Died in 1975. Address in 1929, 3955 Clayton Ave., Los Angeles, CA.

LAUTER, F(LORA).
Painter. Born in New York in 1874. Pupil of Henri, Chase and Mora in New York. Member: Women's International Art Club, London; Salons of America; Buffalo Society of Independent Artists; Society of Independent Artists; Independent Artists of Chicago; Hoosier Salon; Indianapolis Artists Guild; Alliance; East Gloucester Art Club; North Shore Art Association. Address in 1929, 612 East 13th St., Indianapolis, IN.

LAUTZ, WILLIAM.
Sculptor. Born in Unstadt, Germany, on April 20, 1838, and came to the US in 1854. Since that time he was a resident of Buffalo. He was an actor and for sixteen years confined himself entirely to Shakespearean roles. He then found expression in sculpture and modeling, and some of his work is in the Buffalo Historical Society Building. Died in Buffalo, NY, June 24, 1915.

LAUX, AUGUST.
Painter. Born in the Rhine Pfaiz, Bavaria, in 1847; died in Brooklyn, NY, July 21, 1921. Removed with his parents to New York in 1863, and studied at the National Academy of Design. Exhibited in spring of 1870 at National Academy, and became notable for decorative work, but after 1880 gave his attention to genre and still-life pictures.

LAVALLE, JOHN.
Painter. Born in Nahant, MA, June 24, 1896. Pupil of Philip Hale and Leslie Thompson; School of Boston

Museum of Fine Arts; Julian Academy in Paris. Member: Boston Guild of Artists; Boston Society of Water Color Painters; Copley Society; Grand Central Art Galleries Association; Gloucester Art Association; St. Botolph Club, Boston. Represented in Brooklyn Museum, Columbia University Club, New York. Address in 1929, Fenway Studios, 30 Ipswich St., Boston, MA; h. 32 Bates St., Cambridge, MA.

LaVALLEY, J(ONAS) J(OSEPH).
Painter. Born in Rouses Point, NY, August, 1858. Member: Springfield Art League; Connecticut Academy of Fine Arts. Work: "Birth of Springfield," owned by City of Springfield. Represented in Springfield Art Museum; Massachusetts Agricultural College. Address in 1929, 1537 Main St.; h. 101 Allen St., Springfield, MA.

LAVIGNE.
Engraver. The few known plates signed by Lavigne are well executed in stipple, and appear in the "Polyanthos," published in Boston in 1914.

LAW, MARGARET MOFFETT.
Painter and teacher. Born in Spartanburg, SC. Pupil of Chase; Henri; Mora; Hawthorne; and Andre L'hote. Member: Baltimore Water Color Club; Southern States Art League; New Haven Paint and Clay Club; Society of Independent Artists; National Association of Women Painters and Sculptors; Washington Water Color Club; Kenilworth Art Club; Baltimore Handicraft Club; American Federation of Arts; American Artists Professional League. Work: "Feeding Chickens," Kennedy Library, Spartanburg, SC; "Wayside Chat," Converse College, SC; "A Short Crop," Phillips Memorial Gallery, Washington, DC; "Under the Mimosa," Art Club, Spartanburg, SC; "The Road to Town," Clifton Park High School, Baltimore, MD. Died in 1958. Address in 1933, 1 East Hamilton St., Baltimore, MD; h. 364 Spring St., Spartanburg, SC.

LAW, PAULINE ELIZABETH.
Printer. Born in Wilmington, DE, Feb. 22, 1908. Studied: Art Students League; Grand Central Art School; and with Carlson, Hibbard, and Snell. Awards: Hudson Valley Art Association, 1955, 1957; Pen and Brush Club; Catherine L. Wolfe Art Club. Collection: Athens, Greece, Museum of Art. Address in 1980, 15 Gramercy Park, NY, NY.

LAWFORD, CHARLES.
Painter. Member: Attic Club, Minneapolis; Minneapolis Art League. Awards: First prize ($100), Minneapolis Institute, 1915; bronze medal, St. Paul Institute, 1917; gold medal, Minnesota State Art Commission, 1917.

LAWGOW, ROSE.
Painter, illustrator, and craftsman. Born in Portland, OR, Jan. 20, 1901. Member: Seattle Fine Arts Society. Address in 1929, R. 7, Box 285, Seattle, WA.

LAWLESS, CARL.
Painter. Born in IL, Feb. 20, 1896. Pupil of Penna. Academy of Fine Arts; Chicago Academy of Fine Arts. Member: Philadelphia Sketch Club; Fellowship Penna. Academy of Fine Arts; Philadelphia Alliance; Philadelphia Art Club; Connecticut Academy of Fine Arts. Awards: Cresson Traveling Scholarship, Penna. Academy of Fine Arts, 1921; Fellowship prize, Penna. Academy of Fine Arts, 1923; Murphy memorial prize, National Academy of Design, 1923; hon. mention, Connecticut Academy of Fine Arts, 1925. Represented in National Academy of Design, New York; Springfield, Massachusetts, Art Association; Columbus Academy of Art; Art Institute of Chicago. Address in 1929, 20 Orchard Lane, Mystic, CT.

LAWLOR, GEORGE W(ARREN).
Painter. Born in Chelsea, MA, Oct. 21, 1878. Pupil of Julian and Colarossi Academies and Ecole des Beaux-Arts in Paris. Member: Boston Art Club. Address in 1929, Poplar Street Studios, Brooklyn, NY.

LAWMAN, JASPER HOLMAN.
Landscape and portrait painter. Born in Cleveland, OH, in 1825. Studied abroad. He painted many of the leading families in western Pennsylvania. He died April 1, 1906, in Pittsburgh, PA.

LAWRENCE, CHARLES B.
Painter. Born in Bordentown, NJ. He removed to Philadelphia about 1813. He was a pupil of Rembrandt Peale, and is said also to have studied with Stuart. He finally abandoned art for commerce. His portrait of Jose Francisco Correa de Serra, the distinguished Portuguese botanist, is owned by the American Philosophical Society, Philadelphia. He also painted some landscapes.

LAWRENCE, EDNA W.
Painter and teacher. Born in Concord, NY, Nov. 27, 1898. Pupil of RI School of Design; Aldra Hibbard. Member: Providence Art Club; Providence Water Color Club. Address in 1929, 98 Jenkins St., Providence, RI; summer, 332 Center St., Richmond, SI, NY.

LAWRENCE, HELEN (CHRISTOPHER).
Painter and teacher. Born in Red Oak, IA, July 12, 1895. Pupil of Art Students League of NY; Grand Central School of Art; Mafori-Savini Academy, Florence. Member: National Association of Women Painters and Sculptors; American Water Color Society; Silvermine Guild of Artists. Address in 1929, "Ashlands," Darien, CT.

LAWRENCE, RUTH.
(Mrs. James C.). Sculptor, craftsman, writer, lecturer, educator, and museum director. Born in

Clarksfield, Ohio, June 9, 1890. Studied: Ohio State University; Akron University; University of Minnesota; and in Italy. Member: College Art Association of America; Western Art Association; American Museum Directors Association; Sculptors Guild; American Society for Aesthetics. Work: University of Minnesota; Walker Art Center. Contributor to art magazines and educational journals. Taught: Instructor, 1934, Curator, Gallery of Art, 1934-40; Director of University Gallery, Assistant Professor, University of Minnesota, Minneapolis, from 1940. Address in 1953, 310 Northrop Auditorium; h. Minneapolis, MN.

LAWRENCE (or LAURENCE), SAMUEL.

Portrait painter. Born in Surrey, England in 1812. In 1854 he was living in the United States, where he painted or drew the portraits of a number of prominent men. Died Feb. 28, 1884, in London.

LAWRENCE, W. S.

This landscape engraver was an apprentice with Alfred Jones in 1840, and in 1846 he was engraving over his own name for New York publishers. Plates signed "A. L. Jones" were executed by Lawrence when an apprentice with Jones, and were finished by the latter.

LAWRENCE, WILLIAM RODERICK.

Painter. Born March 3, 1829. His figure paintings were all of a peculiarly imaginative tendency, but most carefully drawn. There are two in the Wadsworth Gallery in Hartford, CT, "The Royal Children" and "Napoleon at Waterloo." He spent his entire life in Hartford, CT, and died there Oct. 9, 1856.

LAWRENCE-WETHERILL, MARIA.

Painter and etcher. Born in Philadelphia, PA, Dec. 11, 1892. Pupil of Clinton Peters, Guillomet, Bashet and Pagess. Member: National Association of Women Painters and Sculptors; National Arts Club; Philadelphia Print Club; American Artists Professional League; American Federation of Arts. Address in 1929, National Arts Club, New York, NY; Palm Beach, FL.

LAWRIE, ALEXANDER.

(A.K.A.: Laurie). Portrait painter, engraver and crayon portrait draughtsman. Born in New York City, Feb. 25, 1828. He exhibited a crayon portrait of Thomas Sully at the Pennsylvania Academy in 1854. He studied both at the National Academy and at the Pennsylvania Academy of Fine Arts. Later he was a pupil of Leutze in Dusseldorf, and of Picot in Paris. Appleton's *Cyclopaedia* notes that "He has made upward of a thousand crayon heads, including likenesses of Richard H. Stoddard and Thomas Buchanan Read." Among his best portraits in oil is the likeness of Judge Sutherland, painted for the New York Bar Association. He also painted land-scapes. In 1866 he was elected an Associate Member of the National Academy of Design. He died Feb. 15, 1917.

LAWRIE (or LAURIE), LEE O.

Sculptor. Born in Rixford, Germany, October 16, 1877. Pupil of Saint-Gaudens and Martiny. Instructor in sculpture, Harvard University, 1910-12; Yale University, 1908-18. Member: Associate of National Academy of Design; National Institute of Arts and Letters; National Sculpture Society; National Arts Club; New York Architectural League; Century Association; (hon.) American Institute of Architects. Award: Gold medal, American Institute of Architects, 1921 and 1927; hon. award, Southern California Chapter, American Institute of Architects, 1926; medal, Architectural League, 1931. Work: Decorations in US Military Academy, West Point; Church of St. Vincent Ferrer, and reredos of St. Thomas' Church, NY; Harkness Memorial Tower and Archway, Yale University; sculpture for National Academy of Sciences, Washington, DC; sculpture for Nebraska State Capitol; small marble head of woman, Metropolitan Museum of Art, NY; Los Angeles Public Library; Bok Carillon Tower, FL; Goodhue Memorial, NY; memorial, Octagon House Garden, Washington, DC; peace memorial, Gettysburg, PA; others. Exhibited at National Sculpture Society, 1923. Address in 1953, Locust Lane Farm, Easton, MD. Died in 1963.

LAWSON, ADELAIDE J.

Painter. Born in New York, NY, June 9, 1890. Studied at Art Students League of NY. Member: Society of Independent Artists; Salons of America; NY Society of Women Artists. Address in 1929, 10 Vannest Pl., New York, NY.

LAWSON, ALEXANDER.

Engraver. Born in Ravenstruthers, Lanarkshire, Scotland, Dec. 18, 1773; died in Philadelphia, Aug. 22, 1846. An extended memoir of Alexander Lawson was read before the Pennsylvania Historical Society, in 1878, by the late Townsend Ward and from this paper the following brief sketch is compiled. Alexander Lawson was left an orphan at the age of fifteen years and was cared for by an elder brother residing in Liverpool. As he sympathized deeply with the Revolutionary movement in France, in 1793 Lawson determined to seek his future in that country, and as he could not obtain a direct passage from England, he sailed for the United States, expecting to return on a French vessel. He landed at Baltimore on July 14, 1794, and was so well pleased with the social and political conditions existing in this country that he changed his plans and concluded to cast in his lot with the Americans. He went to Philadelphia, and as he seemed to have some knowledge of engraving, he first found employment with the engravers "Thackara & Vallance." Some time after this he commenced

business for himself, and first attracted attention by his admirable plates for an edition of Thomson's *Seasons*. In 1798 Lawson met his fellow countryman, Alexander Wilson, and a firm and lasting friendship resulted. Lawson engraved the best plates in Wilson's famous *Ornithology*, the first volume of which was issued in 1808, and also those in its continuation, by Charles Lucien Bonaparte.

LAWSON, ERNEST.
Landscape painter. Born in California, 1873. Studied in Kansas City; Art Students League of NY; and in Paris. Member: Associate National Academy, 1908; National Academy, 1917; Institute of Arts and Letters; National Arts Club; New Society of Artists, NY. Awards: Silver medal, St. Louis Expo., 1904; Sesnan medal, Penna. Academy of Fine Arts, 1907; gold medal, American Art Society, 1907; first Hallgarten prize, National Academy of Design, 1908; gold medal, P.-P. Expo., San Francisco, 1915; Altman prize ($500), National Academy of Design, 1916; second W. A. Clark prize ($1,500), and Corcoran silver medal, 1916; Inness gold medal, National Academy of Design, 1917; Temple gold medal, Penna. Academy of Fine Arts, 1920; Altman prize ($1,000), National Academy of Design, 1921; first prize, Pittsburgh International Expo., 1921. Work: "An Abandoned Farm," National Gallery, Washington; "The Swimming Hole," Art Museum, Montclair, NJ; "Winter," Metropolitan Museum, New York; "Landscape" and "Winter," Brooklyn Museum; "Road at the Palisades," City Art Museum, St. Louis; "Boat House, Harlem River, Winter," Corcoran Gallery, Washington, DC; "Spring" and "Ploughed Field," Harrison Gallery, Los Angeles Museum; and in museums at Worcester, MA; Chicago, IL; San Francisco, CA; Pittsburgh, PA; Youngstown, OH; Savannah, GA. Died on Dec. 18, 1939. Address in 1929, care of Ferargil Gallery, 37 East 57th St., NYC.

LAWSON, HELEN E.
Engraver. This daughter of Alexander Lawson made the drawings for her father's illustrations in the works of Prof. Haldeman and Dr. Binney, and she also engraved several plates of birds for a publication of about 1830. She showed decided talent in this work.

LAWSON, KATHARINE STEWART (MRS.).
Sculptor. Born in Indianapolis, IN, May 9, 1885. Pupil of Lorado Taft, Hermon A. MacNeil. Award: Shaw prize, National Academy of Design, 1921. Member: National Association of Women Painters and Sculptors; Independent Society of Sculptors. Address in 1933, Saugatuck, CT; "Lone Pine Studio," Westport, CT.

LAWSON, OSCAR A.
Engraver. Born in Philadelphia, Aug. 7, 1813; died there Sept. 6, 1854. This son of Alexander Lawson

was probably a pupil of his father, and he became an accomplished line-engraver. Also painted landscapes and portraits. He furnished a number of small plates for the *Annuals*; but about 1840 he entered the service of the U. S. Coast Survey, at Washington, as a chart engraver, and he remained there until failing health compelled him to resign in 1851.

LAWSON, THOMAS BAYLEY.
Painter. Born in Newburyport, MA, Jan. 13, 1807. He drew from the Antique in the National Academy of Design, NY, for six months in 1831; returned to Newburyport, and commenced painting portraits in 1832. In 1844 he painted a portrait of Daniel Webster. Lawson died Jan. 4, 1888 in Lowell, MA.

LAWSON-PEACEY, JESS M. (MRS.).
Sculptor. Born Edinburgh, Scotland, February 18, 1885. Studied at College of Art, Edinburgh, and the Royal College of Art, London. Member: British Institute; Associate Royal College of Art, London; Art Alliance of America; National Sculpture Society; National Association of Women Painters and Sculptors; ARBS, London. Awards: Helen Foster Barnett prize, National Academy Design, 1918; Widener gold medal, Penna. Academy of Fine Arts, 1919; medal, International Exp., Paris, 1926; McClees prize, Penna. Academy of Fine Arts, 1927. Exhibited at National Sculpture Society, 1923. Address in 1933, 114 East 71st St., NYC. Died in 1965.

LAX, DAVID.
Painter. Born in Peekskill, NY, May 16, 1910. Studied: Ethical Cultural School, scholarship, 1924-28, with H. R. Kniffen, Victor D'Amico, Victor Frisch; Archipenko Art School, with Alexander Archipenko. Work: Gallery Modern Art, NYC; Clearwater Museum, FL; Pentagon War Art Collection; SUNY Collection; others. Commissions: Many for Irving Mills Collection, 1932-42; combat paintings for Pentagon, 1942-50; NY in the 50's, Dutchess Community College, Poughkeepsie, NY; others. Exhibitions: Corcoran; Carnegie Institute; National Arts Club Annual, NYC; National Gallery; Philadelphia Art Alliance; many others. Awards: Mills Artists Fellow, 1932-42; bronze star, War Art, 1945; silver medal, International Institute of Arts & Letters. Teaching: Chairman, department of art, 1958-73, professor, 1973-77, Dutchess Community College, Poughkeepsie, NY; emeritus professor, from 1977, State University of NY. Member: Association of American Artists; Dutchess Co. Art Association, NY; International Institute of Arts & Letters; etc. Represented: Washington Irving Gallery, NYC. Address in 1984, Box 94, Red Hook, NY.

LAY, OLIVER INGRAHAM.
Painter. Born in New York City in 1845. He died there in 1890. He studied at the Cooper Institute, and the National Academy, and was also a pupil of

Thomas Hicks. Elected an Associate Member of the National Academy in 1876. He painted many portraits, and some genre subjects. His copy of Stuart's portrait of Chief Justice John Jay was owned by the New York Historical Society.

LAYBOURNE-JENSEN, (LARS PETER).
Sculptor and painter. Born in Copenhagen, Denmark, in 1888. Pupil of Danish Academy. Member: Society of Independent Artists. Address in 1926, Roselle Park, NJ.

LAZARD, ALICE ABRAHAM.
Painter. Born in New Orleans, LA, in 1893. Pupil of Charles Sneed Williams and of the Art Institute of Chicago. Member: Springfield, IL, Art Association; Art Club of Chicago; Art Institute of Chicago Alumni Association. Address in 1926, Klaubers, Louisville, KY.

LAZAREE (or LAZZAREE), JOSEPH.
Sculptor. Worked: New York City, 1843-50. Died c. 1850.

LAZARUS, JACOB HART.
Portrait painter. Born in New York City in 1822; he died there in 1891. He studied portraiture with Henry Inman, whose portrait he painted; it was given by the artist's widow to the Metropolitan Museum, NY. He also painted miniatures and the one he painted of Chas. A. May was exhibited at the Centennial of the National Academy in 1925. He was elected an Associate Member of the National Academy of Design in 1849.

LAZARUS, M(INNIE) RACHEL.
Painter, craftsman and teacher. Born in Baltimore, MD, Dec. 4, 1872. Pupil of Dewing Woodward; Julian Academy, Paris; Louis DesChamps. Member: Blue Dome Fellowship; Baltimore Water Color Club; Handicraft Club of Baltimore. Award: First prize for portrait, Florida Federation of Arts, 1928. Director, Blue Dome Fellowship, Coral Gables, Florida. Address in 1929, 3650 S. W. 23rd St., Coral Gables, Miami, FL.

LAZZARI, PIETRO.
Sculptor, painter, lithographer, illustrator, and etcher. Born in Rome, Italy, May 15, 1898; US citizen. Studied: Ornamental School of Rome. Member: National Society of Mural Painters; Art Guild of Washington; Washington Watercolor Society; Artists Equity Association. Awards: Prize, Ornamental School, Rome; Fulbright Scholarship; Baltimore Museum Lord Prize. Work: Art Institute of Chicago; Whitney; National Collection of Fine Arts, Washington, DC; San Francisco Museum of Art; others, including many commissions. Exhibited: Metropolitan Museum of Art, 1942; Whitney Museum of Art, 1934; Art Institute of Chicago, 1943; National Academy of Design, 1944, 45; Contemporary Art Gallery, 1939; Whyte Gallery, 1943; Crosby Gallery, 1945; Paris, France, 1945; Corcoran; National Collection of Fine Arts, 1970. Taught: Instructor, sculpture and drawing, American University, Washington, DC, from 1948-50; Corcoran School of Art, 1965-69. Media: Concrete, bronze; oil. Address in 1976, Washington, DC. Died in 1979.

LAZZELL, BLANCHE.
Painter and etcher. Born in Maidsville, Monongalia Co., WV. Pupil of Chase, Schumacher, Charles Guerin, Andre L'hote and Albert Gleizes. Member: Society of Independent Artists; Provincetown Printers; Provincetown Art Association; Societe Anonyme; NY Society of Women Artists. Works: Wood block-prints, "The Violet Jug," Detroit Art Institute; "Tulips," "The Monongahela," "Trees" and "Fishing Boat," WV University Library. Died in 1956. Address in 1929, Provincetown, MA; h. Morgantown, WV.

LEA, TOM.
Illustrator. Born in El Paso, TX, in 1907. Studied at the Art Institute of Chicago and under John Norton. His work for *Life* during World War II brought him considerable recognition and throughout his career he has illustrated over 50 books about the American West and the war, seven of which he also wrote. His works are in the collections of the University of Texas and the Dallas Museum of Fine Art. He exhibited his artwork at the Whitney Museum in 1938.

LEACH, BERNARD.
Painter and etcher. Born in Hong Kong, China, 1887. Pupil of Slade School of London and of Frank Brangwyn. Member: Chicago Society of Etchers. Address in 1926, Care of Dr. W. E. Hoyle, Crowland, Liandaff, Cardiff, Wales.

LEACH, ETHEL P(ENNEWILL) B(ROWN).
Painter, illustrator, and etcher. Born in Wilmington, DE. Pupil of Twachtman, Howard Pyle. Member: Philadelphia Plastic Club; Philadelphia Alliance; Fellowship Penna. Academy of Fine Arts; Wilmington Society of Fine Arts; American Federation of Arts. Work: "Totin' Clo'es," Mississippi Art Association, Jackson; portrait of "Gov. Wm. D. Denney," State House, Dover, DE; illustrated "Catching Up with the Circus," by Gertrude Crownfield. Address in 1953, Frederica, DE; summer, Rehoboth Beach, DE.

LEACH, LOUIS LAWRENCE.
Sculptor. Born in Taunton, MA, May 4, 1885. Studied: Massachusetts School of Art; and with Cyrus Dallin. Work: Monuments, memorials, bas-reliefs, Taunton, MA; Massachusetts State House; Garden City, NY; Brighton, MA; Sioux City, IA; Tufts College; Tufts Medical School, Boston. Address in 1953, Taunton, MA. Died in 1957.

LEACH, SAMUEL.
Engraver. The *Pennsylvania Gazette* of Dec. 1741 advertises that "Samuel Leach, from London, performs all sorts of Engraving, such as Coats of Arms, Crests, Cyphers, Letters and SC, on Gold, Silver or Copper. Also engraving of all kinds for Silversmiths. N. B. The said Leach may be heard of at Mr. Samuel Hazard's, Merchant, opposite the Baptist Meeting House, in Second Street, or at Andrew Farrels, Tanner, in Chestnut St., Philadelphia."

LEAKE, GERALD.
Painter. Born in London, England, Nov. 26, 1885. Member: Salma. Club; Allied Artists of America; Architectural League of NY; Mural Painters; American Water Color Society; National Arts Club. Awards: Prize ($1,000), Salma. Club, 1923; Plympton prize, Salma. Club, 1926; Shaw prize, Salma. Club, 1927; gold medal, Allied Artists of America, 1929. Died in 1975. Address in 1929, 51 West 10th St., New York, NY.

LEALE, MARION.
Miniature painter. Born in New York, NY. Pupil of Art Students League of NY; Lucia Fairchild Fuller. Member: Society of Independent Artists; NY Society of Craftsmen; National League American Pen Women; Baltimore Water Color Club. Address in 1929, 1261 Madison Ave., New York, NY.

LEAMING, CHARLOTTE.
Painter and teacher. Born in Chicago, IL, Jan. 16, 1878. Pupil of Freer, Chase, Duveneck, Herter. Member: Chicago Society of Artists; Chicago Art Students League; Colorado Springs Art Society. Award: Corona Mundi Prize ($100), 1924. Address in 1929, Parkins Fine Arts Bldg., Cache le Poudre; h. 1614 Wood Ave., Colorado Springs, CO.

LEARNED, ARTHUR G(ARFIELD).
Painter and illustrator. Born in Chelsea, MA, Aug. 10, 1872. Studied in Munich; Vienna; and under Laurens, Steinlen and others in Paris. Member: National Arts Club; MacDowell Club. Work: New York Public Library; Brooklyn Institute Museum; Library of Congress, Washington, DC; University of Pennsylvania. Specialty: Portraits and decorations. Address in 1929, 36 Gramercy Park, New York, NY; summer, Brucehaven, Stamford, CT.

LEAVITT, D(AVID) F(RANKLIN).
Illustrator and decorator. Born in St. Louis, MO, August 28, 1897. Studied in Paris. Award: Third prize, St. Louis Artists Guild, 1927. Address in 1929, 5603 Cabanne Ave., St. Louis, MO.

LEAVITT, EDWARD C.
Painter. Born in 1842. Exhibited at the National Academy of Design in NYC, 1875. His specialty was fruit and flower still life oil paintings, often in conjunction with opulent backgrounds of highly polished tables, costly antiques, etc., rich in color, sharp detail. Most celebrated works characteristic of the artist are those of the 1880's to early 1890's. 1892 marks a rapid decline in quality of his work. Died in Providence, Rhode Island, November 20, 1904.

LEAVITT, W. H.
Painted portraits in New Orleans in 1904, and afterwards had a studio at 622 Commercial Place.

LEBDUSKA, LAWRENCE H.
Painter. Born in Baltimore, MD, September 1894. Studied in Leipzig, Germany, and with Fleider, Schneider, Swoboda. In collections of Museum of Modern Art, NYC; Whitney, NYC; Newark (NJ) Museum; Albright Art Gallery, Buffalo, NY; University of Arizona. Exhibited at the Art Center of NY in 1926; Brandenmeyer Gallery, Buffalo, NY; other galleries in NYC and nationally. Received award at Leipzig International Art Exposition, 1912. Member of Audubon Artists. Paints in the primitive style. Address in 1953, 230 East 52nd St., NYC.

LeBLANC, MARIE de HOA.
Painter, illustrator and teacher. Born in New Orleans, LA, Nov. 23, 1874. Pupil of Art Institute of Chicago; D. W. Ross; Martin Heyman in Munich. Member: New Orleans Art Association; Southern States Art League. Award: Gold medal, New Orleans Art Association, 1914. Work: "Paysage d'Automne," Delgado Museum of Art, New Orleans. Address in 1929, 905 Dumaine, New Orleans, LA.

LEBRUN, RICO (FREDERICO).
Sculptor, painter, printmaker, and teacher. Born in Naples, Italy, Dec. 10, 1900. Studied: Beaux-Arts Academy, Academy of Arts and National Technical Institute, Naples. After moving to US in 1924, returned frequently to Italy to study Renaissance and Baroque masters. Lived in Springfield, IL, 1924; moved to NYC in 1925, where he became a successful advertising artist; taught at Art Students League. Settled in California in 1938. Represented in Los Angeles Museum of Art; Metropolitan Museum of Art; Museum of Modern Art; Munson-Williams-Proctor Institute; Boston Museum of Fine Arts; Rhode Island School of Design; Whitney; others. Has exhibited at City Art Museum of St. Louis, 1945; Los Angeles Museum of Art, 1945, 48-51; Carnegie Institute, 1945; Whitney, 1948-50, 52; Art Institute of Chicago, 1947, 48, 51; Metropolitan Museum of Art, 1950; Penna. Academy of Fine Arts, 1951, 52; others. Awards include prizes, Art Institute of Chicago; Guggenheim Fellowship; Metropolitan Museum of Art; American Academy of Arts and Letters. Member of Artists Equity Association. Highly influential artist on West Coast. Also taught in Mexico at Escuela de Bellas Artes, San Miguel de Allende; in Italy at American Academy, Rome. Represented by

Kennedy Galleries, NYC. Address in 1953, Los Angeles, CA. Died in 1964.

Le CASTRO, A.
Miniature painter. A miniature painted on ivory of a gentleman evidently of the southern states is signed "A. Le Castro."

LeCLEAR, THOMAS.
Portrait painter. Born in Owego, NY, March 11, 1818. He was elected a member of the National Academy, 1863. He is represented by a portrait of "William Page," in the Corcoran Gallery, Washington, DC. Died Nov. 26, 1882, in Rutherford Park, NJ.

LeCOUNT & HAMMOND.
Engravers. Well-engraved landscape plates published in 1840 are thus signed. The second member of the firm was probably J. T. Hammond, who was in business as an engraver in Philadelphia in 1839.

LEDDEL, JOSEPH, JR.
Engraver. The *New York Weekly Post Boy*, in 1752, contains the advertisement of Joseph Leddel, Jr., for the sale of all manner of pewterwork. At the end of this advertisement he says that "He also engraves on Steel, Iron, Gold, Silver, Copper, Brass, Pewter, Ivory or Turtle Shell, in a neat manner very reasonably."

LEDERER, ESTELLE MacGILL.
Sculptor, painter, lecturer, and teacher. Born in Cleveland, Ohio, April 7, 1892. Address in 1933, Studio 5, New Haven, CT; summer, Estelle MacGill Lederer Art Colony, Pine Orchard, CT.

LEDGERWOOD, ELLA RAY.
(Mrs. H. O. Ledgerwood). Painter and teacher. Born in Dublin, TX. Pupil of Irving Wiles, Kenneth Hayes Miller. Member: Ft. Worth Art Association; Painters Club; Ft. Worth Art Comm. Address in 1929, Central High School; h. 2808 Hemphill St., Ft. Worth, TX.

LeDUC, ALICE SUMNER.
Painter, illustrator, and craftsman. Born in Hastings, MN. Address in 1929, 2512 Humboldt Ave., South, Minneapolis, MN; summer, Hastings, MN.

LeDUC, A(RTHUR CONRAD).
Painter. Born in Washington, DC, March 23, 1892. Pupil of John Sloan; Corcoran School; Academie Julian; Colarossi. Member: Society of Independent Artists; Salon d'Automne; Society of Modern Arts. Address in 1929, King's Highway, Haddonfield, NJ.

LEE, AMY FREEMAN.
Painter and lecturer. Born in San Antonio, TX, in 1914. Studied: University of Texas; Incarnate Word College. Awards: San Antonio Artists, 1949, 1956; Smith College, 1950; Boston Society of Independent Artists; Charles Rosen award, 1950; Texas Fine Arts Association, 1950, 1958; Texas Watercolor Society, 1955; Neiman-Marcus award, 1953; Grumbacher award, 1953; Hall Memorial, 1954; Rosengren award, 1953; Silvermine Guild, 1957; Beaumont Museum, 1957; "Artist of the Year," San Antonio, 1958; Theta Sigma Phi Headliner award, 1958. Collections: Witte Memorial Museum; Smith College; Baylor University; Baltimore Museum of Art; Dallas Republic National Bank. Address in 1980, 127 Canterbury Hill, San Antonio, TX.

LEE, ARTHUR.
Sculptor. Born in Trondheim, Norway, May 4, 1881. Studied at Art Students League; Ecole des Beaux-Arts, Paris; and in London and Rome. Awards: Guggenheim Fellowship; American Academy of Arts and Letters grant; honorable mention for sculpture, P.-P. International Expo., San Francisco, 1915; Widener Memorial gold medal at Penna. Academy of Fine Arts, 1924. Work: "Eureka," torso, Cooper Union, NY; "Volupte," torso, Metropolitan Museum, NY; Whitney Museum of American Art; Brooklyn Museum; Valentine Museum, Richmond, VA. Exhibited at National Sculpture Society, 1923; Art Institute of Chicago; others. Taught: Instructor, Greenwich House, NYC. Address in 1953, 1947 Broadway; h. 160 Waverly Pl., NYC. Died in 1961.

LEE, BERTHA STRINGER.
Painter. Born in San Francisco, CA, Dec. 6, 1873. Pupil of Wm. Keith in San Francisco; Joseph Mathews in New York; studied abroad. Member: San Francisco Art Association; California Art Club; Arts and Crafts Club. Awards: Chicago Expo., 1893; Seattle Expo., 1909; San Francisco Art Association; Sacramento State Fair. Work: "Monterey Coast," Del Monte Art Gallery; "In the Gloamings," Golden Gate Park Museum, San Francisco. Died in 1937. Address in 1929, 2744 Steiner St., San Francisco, CA.

LEE, DORIS EMRICK.
Painter and illustrator. Born in Aledo, IL, on Feb. 1, 1905. Studied: Rockford College, AB, 1927, LLD, 1948; Kansas City Art Institute, 1928-29; in Europe, 1931; California School of Fine Arts, with Arnold Blanch, 1931; with Andre L'hote in Paris; Russell Sage College, 1954. Awards: Art Institute of Chicago, 1935, 1936; Penna. Academy of Fine Arts, 1944; Rockford College; Russell Sage College; Carnegie Institute, 1943; Library of Congress, 1947; Art Directors Club, NY, 1946, 1950, gold medal, 1957; Worcester Museum of Art, 1938; first prize, Art and Science Exhibition, 1966. Collections: US Post Office, Washington, DC; Art Institute of Chicago; Metropolitan Museum of Art; Library of Congress; Albright-Knox Art Gallery; University of Nebraska; Cranbrook Museum; Encyclopedia Britannica Collection; Penna. Academy of Fine Arts; Lowe Gallery, Miami;

Honolulu Academy of Fine Arts; Rhode Island School of Design; University of Arizona; Rockford College; Mt. Holyoke Museum; Florida Gulf Coast Art Center. Exhibited: Whitney Museum; Carnegie Museum, Pittsburgh; New York and San Francisco World's Fairs; Association of American Artists; others. Member: An American Group; American Society of Painters; Sculptors and Gravers; Woodstock Art Association. Address in 1982, Woodstock, NY.

LEE, GEO(RGE) D.
Painter and teacher. Born in St. Louis, MO, Dec. 1, 1859. Member: American Federation of Arts; Louisville Art Association; Southern States Art League. Died in 1939. Address in 1929, Kenyon Bldg., 112 South Fifth St.; h. 163 Crescent Ave., Louisville, KY.

LEE, HENRY C.
Painter, writer and lecturer. Born in New York City, May 3, 1864. Pupil of Josef Israels and George Holston. Member: Lotos Club; Salma. Club; Groupe des Peintres et Sculpteurs Americains de Paris; Society of Illustrators. Work: "French Dunes," Bohemian Club, San Francisco, CA. Address in 1929, Cornwall, NY.

LEE, HENRY J.
Painter and illustrator. Member: Society of Illustrators. Address in 1929, Harmon-on-Hudson, NY.

LEE, HOMER.
Engraver. Born May 18, 1855 in Mansfield, OH. He was the son of John Lee, an engraver, and received some instruction from his father in this art. He was later regularly apprenticed to a steel-engraver in New York City, but his master having failed before the expiration of his apprenticeship, he began business for himself as Homer Lee & Co. He was successful, and in 1881 he founded the Homer Lee Bank Note Co. of New York. Later he was vice-president and director of the Franklin-Lee Bank Note Co., of the same city. Mr. Lee studied art in Canada and in Europe, and received honorable mention for one of his paintings at the Vienna Exposition of 1873. He also received honorable mention in the Paris Exhibition of 1900, and the bronze medal at the Charleston Exposition, 1902. He died Jan. 26, 1923, in NYC.

LEE, LAURA.
Painter. Born in Charlestown, MA, March 17, 1867. Pupil of School of Boston Museum of Fine Arts; Julian Academy in Paris. Member: Copley Society; National Association of Women Painters and Sculptors; Boston Society of Arts and Crafts; American Federation of Arts. Address in 1929, 56 William St., Stoneham, MA.

LEE, M(ANNING) de V(ILLENEUVE).
Painter and illustrator. Born in Summerville, SC, March 15, 1894. Pupil of Penna. Academy of Fine Arts under Garber, Breckenridge, Pearson and Harding. Member: Fellowship Penna. Academy of Fine Arts; Southern States Art League. Award: Cresson Traveling Scholarship, Penna. Academy of Fine Arts, 1921; second Toppan prize, Penna. Academy of Fine Arts, 1923. Work: Portrait of Freas Styer, US Mint, Philadelphia; series of five marine paintings, US Naval Academy. Illustrated: *The Blue Fairy Book* and *The Red Fairy Book*, by Lang (Macrae-Smith); *Spanish Dollars and The Overland Trail*, Reginald Wright Kauffman (Penn Publishing Co.); *Historic Ships, Historic Railroads, Historic Airships*, Rupert Sargent Holland (Macrae-Smith Co.); and others. Address in 1929, 5835 Wissohickon Ave., Philadelphia, PA.

LEE, ROBERT J.
Illustrator. Born in Oakland, CA, in 1921. Attended the Academy of Art College in San Francisco for four years. He served in the Air Force as a special service artist and later taught at the Academy Art College, Pratt Institute, and is presently assistant professor of Fine Arts at Marymount College. His first work appeared in *Western Advertising* in 1946 and he has since had several one-man shows and group exhibitions in NY, Chicago, St. Louis, and San Francisco. His paintings have been exhibited in the Smithsonian Institution and several university museums.

LEE, SELMA.
Painter, etcher and teacher. Born in New York, Nov. 5, 1879. Pupil of Mielatz, Robert Henri, Charles Curran. Member: Brooklyn Society of Etchers; Chicago Society of Etchers; Broadmoor Art Association. Address in 1929, 271 Madison Ave., care of Louis F. Lee, New York, NY.

LEEDY, LAURA A.
Painter and teacher. Born in Bloomington, IL, Oct. 26, 1881. Pupil of Anthony Angarola and George Elmer Browne. Member: St. Paul Art Students League. Award: Hon. mention, Minnesota State Fair, 1925 and 1928. Address in 1929, 713 Fairmount Ave., St. Paul, MN.

LEEPER, DORIS MARIE.
Sculptor and painter. Born in Charlotte, NC, April 4, 1929. Studied: Duke University, B.A. in Art History, 1951; self-taught as an artist. Collections: National Collection of Fine Arts, Washington, DC; 180 Beacon Collection, Boston; Chase Manhattan Bank; Wadsworth Atheneum, Hartford, CT; Columbus Museum of Art, OH; Reserve Insurance, Orlando, FL; Bank of NY; Jacksonville Art Museum, Florida. Exhibited: Contemporary Women Artists, National Arts Club, NY, 1970; Mississippi Museum of Art, Jackson, 1979; High Museum of Art, Atlanta, 1975; Museum of Arts

and Science, Daytona Beach, 1980. Awarded an individual grant from the National Endowment for the Arts, 1972; Artist in Residence Fellowship, Rockefeller Foundation, 1977; others. Media: Oil; fiberglas, metal, and concrete. Address in 1982, New Smyrna, FL.

LEEPER, VERA B(EATRICE).
Painter, craftsman, designer, teacher and lecturer. Born in Denver, CO, March 13, 1893. Pupil of Eben S. Comins; Denver University; NY University; Boston Museum School; and studied in Paris. Member: National Society of Mural Painters, NY; American Federation of Arts; Hudson Valley Art Association; Chappaqua Artists Guild. Award: Prizes, C. L. Wolfe Art Club, 1920; NY Water Color Club, 1926; first prize, Art Center of the Oranges, 1927; National Academy of Design, 1929; Kansas City Art Institute, 1934. Work: Murals in Roger Sherman Restaurant, New Haven, CT; Garde Theatre, New London, CT; Commodore Hull Theatre, Derby, CT; Old English Room, Morene Products Co., NYC; Denver Art Museum. Exhibited: Paris Salon; Metropolitan Museum of Art; National Society of Mural Painters; Grand Central Art Galleries; C. L. Wolfe Art Club; Hudson Valley Art Association; others. Specialty: Murals and portraits. Address in 1953, Los Angeles, CA.

LEES, HARRY H.
Illustrator. Member: Society of Illustrators; Artists Guild of the Authors' League of America, NY. Died in 1959. Address in 1929, 334 West 22nd St., New York, NY.

LEFF, RITA.
Painter and printmaker. Born in NYC, in 1907. Studied: Art Students League; Brooklyn Museum School of Art; Parsons School of Design; and with George Picken, Louis Schanker, Abraham Rattner and Adja Yunkers. Awards: Audubon Artists, 1955-1958; Brooklyn Society of Artists, 1950, 1953, 1957; Brooklyn Museum Alumni Association, 1955-1957; Boston Printmakers, 1954; Society of American Graphic Artists, 1954; Village Art Center, 1953-1955; Creative Graphic Exhibition, 1958; National Association of Women Artists, 1964, 66, 68, 69; Norton Gallery, Palm Beach, FL, 1971, 72. Collections: Metropolitan Museum of Art; Library of Congress; University of Maine; Pennsylvania State University; Dallas Museum of Fine Arts; Abraham Lincoln High School; Contemporary Gallery, 1956. Exhibited: Library of Congress Print Annual; Penna. Academy of Design Print and Watercolor Annual; Esterhazy Gallery, 1971, and Gallery Cassell, 1973, Palm Beach, FL (both one-man). Member: Audubon Artists; National Association of Women Artists; Society of American Graphic Artists. Media: Oil, watercolor; collage. Address in 1984, West Palm Beach, FL.

LEFFERTS, WINIFRED E(ARL).
Painter and illustrator. Born in Newtonville, MA, Oct. 9, 1903. Member: American Water Color Society; NY Water Color Club; National Association Women Painters and Sculptors; Brooklyn Society of Artists. Address in 1929, 311 Washington Ave., Brooklyn, NY.

LEGGETT, R.
This good line-engraver of landscapes was working about 1870 and signed plates from "No. 4 John St., New York."

LEHMAN, GEORGE.
Painter and engraver. Born in Lancaster County, PA; died in Philadelphia in 1870. About 1829 Lehman painted, engraved aquatint, and hand-colored a series of admirable views of Pennsylvania towns. He also aquatinted a number of smaller plates and drew for engravers. In 1835-37 he was in the lithographing business in Philadelphia, and was later a member of the print publishing firm of Lehman & Baldwin, of the same city. In 1830 he painted a number of landscapes in Philadelphia.

LEHMAN, HAROLD.
Sculptor, painter, and teacher. Born in New York City, October 2, 1913. Studied: Otis Art Institute; and with Fettelson, Siqueiros. Member: Art League of America; Woodstock Art Association. Awards: Prizes, Los Angeles Museum of Art, 1933; Municipal Art Gallery, NY, 1937. Work: Newark Museum; Museum of Modern Art; murals, Rikers Island, NY; United States Post Office; Renovo, PA. Exhibited: World's Fair, New York, 1939; Whitney Museum of Art, 1940; Museum of Modern Art, 1943; National Academy of Design, 1943; Woodstock Art Association, 1942-45; National Gallery of Art, 1943. Taught: Instructor, YMCA, New York, NY, 1947-50. Address in 1953, 46 West 21st Street, New York, NY.

LEICH, CHESTER.
Painter and etcher. Born in Evansville, IN, Jan. 31, 1889. Studied in Florence, Munich, Berlin, and with Siebelist in Hamburg. Member: Chicago Society of Etchers; Brooklyn Society of Etchers. Address in 1929, 117 Christie St., Leonia, NJ; h. 610 Riverside Ave., Evansville, IN.

LEIGH, HOWARD.
Painter, etcher, and craftsman. Born in Cecilia, KY, Aug. 9, 1896. Pupil of Paul Mauron and John Albert Seaford. Award: Hon. mention, Paris Salon, 1927. Work: Lithographs of the Great War in Musee de la Guerre, Paris; New York Public Library; Boston Public Library; Henry Co. Historical Society, New Castle, IN. Address in 1929, Hoosier Art Patrons Assn., 211 W. Wacker Dr., Chicago, IL.

LEIGH, WILLIAM ROBINSON.
Sculptor, painter, illustrator, writer, lecturer, and teacher. Born in Berkeley County, WV, September 23, 1866. Studied: Maryland Institute, with Hugh Newell; Royal Academy, Munich, with Raupp, Gysis, Loefftz, and Lindenschmid. Member: Allied Artists of America; Salmagundi Club; American Water Color Society; Author's League. Awards: Medals, Royal Academy, Munich; Appalachian Expo., Knoxville, TN, 1911. Work: Frank Phillips Museum, Bartlesville, OK; African Hall, American Museum of Natural History; 3 portraits, Washington and Lee University; "Getting Acquainted," Nayasset Club, Springfield, MA; "The Great Spirit," "The Poisoned Pool," "The Maya Historian," "The Stampede," "Hunting with the Boomerang-Hopi Reservation," Fine Arts Museum, Huntington, LI, NY; and in Munich. Exhibited: Babcock Gallery; Grand Central Art Gallery, 1939, 41, 44; Gumps Gallery, San Francisco, CA, 1944; Washington County Museum of Fine Arts, 1950, 52; Maryland Institute, Baltimore, 1950. Author, illustrator, *Frontiers of Enchantment*, 1938; and other books. Contributor to: *Scribners, Natural History*, and *Colliers*. Lectures: Art; Africa. Address in 1953, 1680 Broadway; h., 200 West 57th St., NYC. Died March 11, 1955.

LEIGHTON, CLARE.
Engraver and writer. Born in London, England, April 12, 1901. Came to the United States in 1939; became a citizen in 1945. Member of the National Institute of Arts and Letters, an academician of the National Academy of Design, and a fellow of the Royal Society of Painters, Etchers, and Engravers, London. Awarded an honorary Doctor of Fine Arts by Colby College, Maine. Collections: Museum of Modern Art, Metropolitan Museum of Art, New York; Library of Congress, Washington, DC; Art Institute of Chicago; Cleveland Museum of Art; British Museum, Victoria and Albert Museum, London; National Gallery, Stockholm; National Gallery, Ottawa. Major retrospective at the Boston Public Library in 1977. Living in Woodbury, CT.

LEIGHTON, KATHERINE W(OODMAN).
Painter. Born in Plainfield, NH, March 17, 1876. Pupil of Boston Normal Art Society. Member: California Art Club; West Coast Arts; Artland Club. Died in 1952. Address in 1929, 1633 West 46th St., Los Angeles, CA.

LEIGHTON, SCOTT.
Animal painter. Born in Auburn, ME, in 1849. His best work is as a painter of horses. Mr. Leighton's horses are always technically good in drawing. He was a member of the Art Club of Boston. His death occurred in 1898.

LEISENRING, L. MORRIS.
Painter and architect. Born in Lutherville, MD, Oct. 29, 1875. Pupil of Maryland Institute; Drexel Insti-tute; Penna. Academy of Fine Arts; University of Pennsylvania; Duquesne in Paris; American Academy in Rome. Member: Washington Art Club; Washington Water Color Club; Washington Chapter American Institute of Architects. Address in 1929, 1320 New York Ave.; h. 177 Church St., Washington, DC.

LEISENRING, MATHILDE MUEDEN.
(Mrs. L. M. Leisenring). Portrait painter. Born in Washington, DC. Pupil of Art Students League of NY and Washington; Laurens, Constant and Henner in Paris. Member: Society of Washington Artists; Washington Water Color Club; Washington Art Club. Awards: Third Corcoran prize, Society of Washington Artists, 1903; second Corcoran prize, Washington Water Color Club, 1903; second honor, Appalachian Expo., Knoxville, TN, 1910. Instructor, Corcoran Gallery, Washington, DC. Address in 1929, 1777 Church St., Washington, DC.

LEITH-ROSS, HARRY.
Painter. Born in Mauritius, Jan. 27, 1886. Pupil of Birge Harrison and J. F. Carlson; Laurens in Paris. Member: Associate of National Academy of Design; Salma. Club; Connecticut Academy of Fine Arts; Allied Artists of America; American Federation of Arts. Awards: Porter prize, Salma. Club, 1915; Charles Noel Flagg prize, Connecticut Academy of Fine Arts, 1921; second prize, Duxbury, MA, Art Association, 1921; hon. mention, Connecticut Academy of Fine Arts, 1922; hon. mention, Society of Washington Artists, 1924; landscape prize, New Haven Paint and Clay Club, 1924; Ranger purchase, National Academy of Design, 1927; Burton Mansfield prize, New Haven, 1928. Address in 1929, Woodstock, Ulster Co., NY.

LEITNER, L(EANDER).
Painter, illustrator, and craftsman. Born in Delphos, OH, April 30, 1873. Pupil of Art Students League of NY; J. B. Whittaker, Henry Prellwitz, Joseph Boston and F. V. DuMond. Member: Society of Independent Artists; Alliance. Address in 1929, 348 East 50th St., New York, NY; summer, Edgemoor, DE.

LEKAKIS, MICHAEL NICHOLAS.
Sculptor. Born March 1, 1907, in NYC. Self-taught. Work: Dayton Art Museum; Greece (National); Wadsworth, Hartford, CT; Museum of Modern Art; Portland (OR) Art Museum; Guggenheim; Seattle Art Museum; Tel Aviv; Whitney Museum. Exhibited: Philadelphia Museum of Art, 1977; Artists' Gallery, NYC, 1941; The Bertha Schaefer Gallery, New York City; Dayton Art Museum; Whitney Annuals, 1948-52, 1958, 60, 62; Guggenheim, Sculpture and Drawings, 1958; Cleveland Museum of Art, 1961; Boston Arts Festival, 1961; Wadsworth Atheneum; Seattle World's Fair, 1962; Museum of Modern Art. Address in 1982, 345 West 29th Street, New York City.

LELAND, CLARA WALSH.
(Mrs. D. R. Leland). Painter. Born in Lockport, NY, June 2, 1869. Pupil of Penna. Academy of Fine Arts; Whistler School, Paris; William Chase, Cecilia Beaux. Works: "The Garden," Lincoln Public Schools; "Copper and Gold," Prescott School, Lincoln. Address in 1929, 325 North 14th St., Lincoln, NE.

LELAND, ELIZABETH.
(Mrs. Ernest E. Morenon). Sculptor. Born in Brookline, MA, April 6, 1905. Studied at Julian Academy, Paris, 1926-27; Ecole Nationale Superieur des Beaux Arts, Paris, 1927, 28, 30, 32; Fontainebleau School of Fine Arts, France, 1927, 1928. Exhibitions: One-man show, Jr. League, Boston, Brookline, MA, 1934; group shows, Independent Artists, Boston; Penna. Academy of Fine Arts; Merrimack Valley Art Association. Awards: Honorable mention, Jr. League regional show, New Haven; 2nd prize, national show, San Francisco, 1934. Member: Social Science Club, Newton; National Society of Colonial Dames of America. Director of Merrimack Valley Artists, 1935-38. Address in 1962, Newton, MA; studio, Boston, MA; summer, Sandwich, MA.

LELAND, HENRY.
Painter. Born in Walpole, MA, in 1850. His early death was the result of an accident. In 1876 he exhibited the portrait of Mlle. D'Alembert at the Paris Salon, and in 1877 "A Chevalier of the Time of Henry III" and "An Italian Girl." He died in 1877.

LELLA, CARL.
Painter. Born in Bari, Italy, Feb. 4, 1899. Pupil of Barry Faulkner. Member: National Society of Mural Painters, NY; Architectural League of NY. Work: Four mural panels, Farmers National Bank, Reading, PA; mural, "The Arts and Sciences," Bushwick High School, Brooklyn, NY. Address in 1929, 11 West 29th St., New York, NY; h. Colonia, NJ.

LEM, RICHARD DOUGLAS.
Painter. Born in Los Angeles, CA, Nov. 24, 1933. Studied: University of California, Los Angeles, BA; California State University, Los Angeles, MA; Otis Art Institute; California Institute of Arts; with Rico LeBrun and Herbert Jepson. Work: San Diego Fine Arts Gallery; numerous private collections. Exhibitions: Phoenix Art Museum, 1961; San Diego Fine Arts Gallery, 1965; Palos Verdes Art Gallery, 1968; Kottler Galleries, NYC, 1973; Galerie Mouffe, Paris, 1976; and others. Awards: Los Angeles Fine Arts Society and Art Guild Award for painting, 1965. Media: Oil, watercolor. Address in 1982, 1861 Webster Avenue, Los Angeles, CA.

LEMET, LOUIS.
Engraver. Born in 1779. He was a close follower of the methods of St. Memin, producing portraits by the same means, and identical in appearance and size.

Also worked in crayon. He was located in Philadelphia in 1804. Died Sept. 30, 1832.

LEMLY, BESSIE CARY.
Painter, craftsman and teacher. Born in Jackson, June 4, 1871. Pupil of Art Students League of NY, Pedro J. Lemos, E. A. Webster and Maud M. Mason. Member: Mississippi Art Association; Art Study Club; director, Southern States Art League; College Art Association; American Federation of Arts. Represented by "The Meadow," collection of the Mississippi Art Association. Address in 1929, Belhaven College; h. 620 North St., Jackson, MS.

LEMON, FRANK.
Sculptor. Born in Washington, DC, Nov. 10, 1867. Pupil of Corcoran School of Art. Awarded diploma, Pan-American Expo., Buffalo, 1910, for work in National Museum exhibit. Member of NY Architectural League, 1902. Address in 1918, East Point, GA.

LEMOS, PEDRO J.
Painter, etcher, illustrator, craftsman, writer, and teacher. Born in Austin, NV, May 25, 1882. Pupil of Mary Benton; Arthur Dow; San Francisco Institute of Art. Member: California Society of Etchers, director; Chicago Society of Etchers; Bohemian Club; Carmel Art Association, president. Awards: Hon. mention for etching, P.-P. Expo., San Francisco, 1915; gold medal for prints, California State Fair, 1916. Director, Museum of Fine Arts, Leland Stanford University; editor, School Arts Magazine. Director, American Art Aid. Author of "Print Methods;" "Art Simplified;" "Applied Art;" "Color Cement Handicraft;" "The Bird in Art;" "The Tree in Art;" "Principles of Beauty in Design;" "Plant Form in Design;" "Indian Decorative Designs;" "Oriental Decorative Designs." Died in 1945. Address in 1929, Museum of Fine Arts, Leland Stanford Junior University, Stanford University, CA; h. 460 Churchill Ave., Palo Alto, CA.

LENEY, WILLIAM SATCHWELL.
Engraver. Born in London, England, Jan. 16, 1769; died at Longue Pointe, near Montreal, Canada, Dec. 31, 1831. Leney was of Scotch descent. He is said to have been a pupil of the well-known English engraver Peltro W. Tompkins, and Leney's work bears evidence of a careful training in the art of stipple engraving. About 1805 Leney was induced to come to the United States; he settled in New York and seems to have had abundant employment. One of Leney's early plates executed in this country is that of "Moses in the Bulrushes," done for Collins' Bible, published in 1807; for this plate he is said to have received a gold medal.

LENGHI, MOSES G.
Sculptor. At NYC, 1848-49. Exhibited: American Institute, 1849. Medium: Marble.

L'ENGLE, LUCY.
Painter. Born in NY, Sept. 28, 1889. Member: NY Society of Women Artists; Provincetown Art Association. Address in 1929, 151 East 53rd St.; h. 535 Park Ave., New York, NY; summer, Truro, MA.

L'ENGLE, W(ILLIAM) JOHNSON, JR.
Painter. Born in Jacksonville, FL, April 22, 1884. Pupil of Richard Miller, J. P. Laurens, Collin and Louis Biloul. Member: Society of Independent Artists; Provincetown Art Association. Died in 1957. Address in 1929, 151 East 53rd St., New York, NY.

LENSKI, LOIS.
(Mrs. Arthur Covey). Painter and illustrator. Born in Springfield, OH, October 14, 1893. Pupil of Kenneth H. Miller; Walter Bayes in London. Award: Logan medal, Art Institute of Chicago, 1923. Author and illustrator of *Skipping Village, A Little Girl of 1900 (Stokes); Jack Horner's Pie, Alphabet People* (Harpers); *The Wonder City* (Coward-McCawn); and illustrator of numerous other children's books. Work: Mural decorations for Children's Orthopedic Hospital, Orange, NJ; Lord and Taylor's, New York. Address in 1929, Harwinton, CT.

LENT, MARGARETE.
Painter and teacher. Born in Washington, DC, Oct. 6, 1896. Pupil of Corcoran School of Art, Washington, DC; NY School of Fine and Applied Art; Hawthorne; Snell. Member: American Water Color Society; National Association of Women Painters and Sculptors; Washington Water Color Club; Washington Art Club; NY Water Color Club. Awards: Helen Willoughby-Smith prize, NY Water Color Club, 1928; NY Water Color Club prize, 1929. Address in 1929, 1528 Corcoran St., Washington, DC.

LENTELLI, LEO.
Sculptor and painter. Born in Bologna, Italy, Oct. 29, 1879; came to US in 1903. Works: Saviour and sixteen angels, reredos, Cathedral of St. John the Divine, NY; group over entrance of Mission Branch Library, San Francisco, CA; five figures, facade, San Francisco Public Library; decorations, Orpheum Theatre, St. Louis, MO; decoration, Sixteenth Street Bridge, Pittsburgh, PA; panel, Corning Free Academy, Corning, NY; flagpole base and panels for Mothers House, Rice Memorial playfield, Pelham, NY; six equestrian figures and sculptural decorations, Panama-Pacific International Expo., San Francisco, CA; groups, Sullivan Gates, Denver, CO; panels, entrance doorway and top of tower, Straus Bank Building, NY; lunette, Steinway Piano Building, NY; group, Sesquicentennial Expo., Philadelphia, PA; fountain, Breakers Hotel, Palm Beach, FL; Diana, Leda, Park Central Hotel, NY; R. E. Lee, Charlottesville, VA (with H. M. Shrady); Cardinal Gibbons, Washington, DC; Brookgreen Gardens. Awards: Henry O. Avery prize, NY Architectural League, 1911, 21; collaborative and Avery prize, NY Architectural League, 1913; purchase prize, San Francisco Art Association, 1916; gold medal, NY Architectural League, 1922; Elizabeth N. Watrous gold medal, National Academy of Design, 1927. Membership: National Sculpture Society; NY Architectural League; National Academy of Design. Taught: California School of Fine Arts, San Francisco, 1913-18; instructor, Art Students League, NYC. Address in 1953, 51 West 10th Street, NYC. Died in 1962.

LENZ, ALFRED (DAVID).
Sculptor. Born in Fond du Lac, WI, May 20, 1872. Began studying as a jeweler's apprentice; then studied engraving, chasing, metal founding, all operations necessary to produce an object of art in metal. Specialty: Bronze statuettes. Member of National Scupture Society; Art Workers Club. Exhibited at National Sculpture Society, 1923. Works include "Pavlowa," Metropolitan Museum of Art; "Star Dust" and "Senorita Hootch," Cleveland Museum of Art; "Senorita Hootch," Newark Museum of Art. Address in 1925, Flushing, Long Island, NY. Died in Havana, Cuba, Feb. 16, 1926.

LENZ, FRANCES H.
Painter and teacher. Born in Elmira, NY, February, 1899. Pupil of George Bridgman, Von Schlegell, and Charles Martin. Member: Society of Independent Artists. Address in 1929, 120 West 12th Street, New York, NY; summer, Provincetown, MA.

LENZ, OSCAR.
Sculptor. Born in Providence, RI, in 1874. Studied under Saint-Gaudens in New York and under Saulievre in Paris. After his return to this country, he executed the Colonial Group at Charleston, SC, and some of the groups in the Pennsylvania Railroad Station in New York. Died June 25, 1912.

LEONARD, BEATRICE.
Painter. Born in Marion, IN, July 11, 1889. Pupil of Chicago Academy of Fine Arts. Member: Hoosier Salon; Bronx Artists Guild; Society of Independent Artists. Address in 1929, 57 West 175th Street, New York, NY.

LEONARD, GEORGE HENRY.
Landscape painter and writer. Born in Boston, MA, May 3, 1869. Pupil of Gerome, Bouguereau and Aman-Jean in Paris. Member: American Art Association of Paris; Boston Art Club; Copley Society; American Federation of Arts. Address in 1933, Northampton, MA.

LEONARD, JAMES.
Portrait painter. At Jefferson County (VA), 1820.

LEONARD, WILLIAM J.
Painter. Born in Hinsdale, NH, in 1869. Pupil of Laurens and Constant in Paris. Address in 1926, Norwell, MA.

LEPELLETIER, MICHAEL.
Engraver. Maps and plans published by T. C. Fay, of New York, in 1814, are signed "Lepelletier, Sculpt., New York."

LEPPER, ROBERT LEWIS.
Sculptor and educator. Born in Aspinwall, PA, September 10, 1906. Studied at Carnegie Institute of Technology, B.A.; Harvard University Graduate School of Business Administration, cert. Work in Butler Museum of American Art, Youngstown, OH; Carnegie Museum of Art; Museum of Modern Art, NY; Stedelijk Museum, Amsterdam. Received medal, Penna. Society of Architects; Purchase Award, Carnegie Museum. Taught design at Carnegie-Mellon University, 1930-75. Address in 1982, Pittsburgh, PA.

LEPPERT, RUDOLPH E.
Illustrator. Born in New York City, December 20, 1872. Pupil of George de Forest Brush and Baron deGrimm. Member: Salma. Club; American Federation of Arts. Address in 1929, Art Director, Funk and Wagnalls Co., 354 Fourth Ave., New York, NY; 2 Wagner Ave., Mamaroneck, NY.

LeROY, ANITA.
Painter. Born in Philadelphia. She studied at the Penna. Academy of Fine Arts. Specialized in Dutch scenes.

LeROY, HAROLD M.
Painter. Born in NYC, Dec. 12, 1905. Studied: Columbia University; Brooklyn Museum of Art School; Art Students League; Hans Hofmann Art School. Work: Butler Institute of American Art, Youngstown, OH; Chrysler Museum at Norfolk, VA; Slater Memorial Museum, Norwich, CT; Smithsonian; others. Exhibitions: Museum of Modern Art, Paris, guest of Societe de L'Ecole Francaise, 1969, 70; National Academy Galleries, Audubon Artists Annual Exhibitions, 1970-77; American Society of Contemporary Artists 57th Annual, Lever House, NYC, 1975; Brooklyn Museum, 1979, 80; and others. Awards: Heydenryk Award, Graphic Art, 1977; American Vet. Award, oil painting, 1979; Binney & Smith award, oil painting, 1981. Member: Artists Equity Association; Metropolitan Painters and Sculptors; American Vet. Society Artists; American Society of Contemporary Artists; etc. Media: Oil, serigraph. Address in 1982, 1916 Avenue K, Brooklyn, NY.

LESHER, MARIE PALMISANO.
Sculptor. Born in Reading, PA, September 20, 1919. Studied: Art Students League, NYC; Berte Fashion Studio in Philadelphia; Museum of Fine Arts School and University of Houston, TX. Awards: International Exhibition, Berwick, PA, 1970; Beaumont Art Museum, 1971-1973; Del Mar College, Corpus Christi, TX, 1972; Texas Fine Arts Association, 1973; Prix de Paris, 1978; others. Collections: Carver Museum, Tuskegee, AL; Art Guild, Shreveport, LA; Laguna Gloria Art Museum, Austin, TX. Exhibited: 7th Annual Eight State Exhibition, Oklahoma Art Center, 1965; Butler Institute of American Art, Youngstown, OH, 1970; Catharine Lorillard Wolfe Art Club Annual, NYC, 1973, 79, 81; National Sculpture Society 40th and 41st Annuals, NYC, 1973, 74; 14th Biennial, Joslyn Museum of Art, Omaha, NE, 1976; many others. Member: Artists Equity, NY and Philadelphia; Texas Society of Sculptors International. Taught sculpture at Sculptors Workshop, Houston, 1972-73. Media: Bronze, clay, and wood. Address in 1982, Houston, TX.

LESLIE, ANNE.
Portrait artist. Born in 1792. Sister of the artist Charles Robert Leslie. She showed considerable artistic talent. In 1822 she copied several portraits, and drew original crayon portraits of her friends. She also copied a number of her brother's paintings; her copy of the "Duchess and Sancho," exhibited at the Penna. Academy of the Fine Arts in Philadelphia in 1847, was admirably executed. Still living in 1860.

LESLIE, CHARLES ROBERT.
Born in London, England, of American parents on Oct. 19, 1794; brought by his parents to Philadelphia in 1800, and apprenticed to Bradford & Inskeep, booksellers, but developed a taste for art, as evinced by three early water color sketches of noted actors in character, later hung in the print room of the Penna. Academy of Fine Arts. These drawings so interested his employer, Mr. Bradford, that he obtained subscriptions for sending young Leslie to London. Mr. Bradford was at that time a Director of the Academy, and at a special meeting of the Board held in 1811 he introduced the following resolutions, which were adopted: "Resolved, that this Academy, having examined the drawings produced at the exhibition by master Leslie, are of the opinion that such rare talents evinced so early in life, give promise of great celebrity and usefulness, if fostered by the smiles of public patronage." Leslie arrived in London, in December of 1811, and studied at the Royal Academy and with West and Allston. He was elected to the Royal Academy in 1826. He was appointed in 1833 Professor of Drawing at the U. S. Military Academy at West Point, NY. He returned to London and died there on May 5, 1859. His works include "Uncle Toby and the Widow," "Anne Page and Master Slender," and "The Murder of Rutland by Clifford," owned by the Penna. Academy of Fine Arts, Philadelphia.

LESLIE, ELIZA.
Authoress and artist, and sister of Anne Leslie and Charles Robert Leslie. Was born in Philadelphia, Nov. 15, 1787; died in Gloucester, NJ, on Jan. 1, 1858. She made a few crayon portraits.

LESNICK, STEPHEN WILLIAM.
Painter. Born in Bridgeport, CT, March 22, 1931. Studied: Silvermine College of Art; Art Career School; with Revington Arthur, John McCleand, Jack Wheat, Carl Symon. Work: Gov. Paul Laxalt, NV; Burndy Library, Norwalk, CT; Boulder City Hospital Art Collection, NV. Exhibitions: All New England Art Exhibition, CT, 1955; Layout and Design, International Competition, Japan, 1963; Annual American Watercolor Society Show, 1968; and many others. Awards: International Industrial Design Show, Japan; Franklin Mint; others. Member: Nevada State Water Color Society. Address in 1982, 1127 Westminister Ave., Las Vegas, NV.

LESSHAFFT, FRANZ.
Painter. Born in Berlin, Germany, March 8, 1862. Pupil of Royal Academy of Fine Arts, Berlin, under Anton V. Werner, Thumann and Meyerheim. Member: Philadelphia Sketch Club; Fellowship Penna. Academy of Fine Arts; Society of Independent Artists; Philadelphia Art Club; Art Teachers Association. Awards: Hon. mention, Berlin; hon. mention for water color, American Art Society, 1902. Address in 1929, 1020 Chestnut St., Philadelphia, PA.

LESTER, WILLIAM H.
Illustrator and etcher. Born in Valparaiso, Chile, S.A., 1885. Pupil of Art Institute of Chicago. Member: Chicago Society of Etchers; Brooklyn Society of Etchers. Address in 1926, 121 South Hill St., Los Angeles, CA.

LESUEUR, ALEXANDER CHARLES.
(Name may be Charles Alexander Lesueur.) Watercolorist, illustrator, engraver, and lithographer. Born Jan. 1, 1778 at Havre de Grace, France; died there Dec. 12, 1846. In 1800 he began his career as a naturalist-artist with a French expedition exploring the coasts of Australia. Upon his return, he spent ten years in France working on the reports of the discoveries made in Australia. In 1815 he came to Philadelphia on the invitation of William Maclure, the geologist, and assisted him in a study of American Zoology. He finally settled in Philadelphia where he taught drawing and painting, and became a prominent member of the American Philosophical Society, and of the Academy of Natural Sciences. The *Journal of the Academy of Natural Sciences* for 1818 contains a number of plates illustrating papers on natural history beautifully etched by Lesueur. He remained in Philadelphia for nine years and then moved to New Harmony, IN, in 1825, where he taught drawing and engraved scientic plates for

conchologist Thomas Say for twelve years. He returned to France in 1837 and there took up lithography, and was for a time curator of the Museum of Natural History at Havre, until his death in 1846. His work is in the Museum at Havre and the American Antiquarian Society, Worcester, MA.

LEUSCH, FRANZISKA A.
Painter. Born in Philadelphia, PA. Pupil of Fred Wagner. Instructor in Philadelphia Normal School. Address in 1926, 114 Wharton Ave., Glenside, PA.

LEUTZE, EMANUEL.
German historical painter. He was born in the village of Emingen, near Reutlingen, in Wurtemburg, May 24, 1816. He went as a child to Philadelphia, where he was instructed by John A. Smith, a portrait painter. In 1841 he returned to Europe and pursued his studies at Dusseldorf under Lessing; but as he did not hold with the views of that academy, he established an atelier of his own. In 1842 he visited Munich, Venice and Rome, and returned to Dusseldorf in 1845, and there executed a considerable number of paintings. He obtained in 1850 the gold medal at Berlin for his "Washington Crossing the Delaware," in the Kunsthalle at Bremen (replica at the Metropolitan Museum, New York). After having been in America in 1851, and again in 1859, he established himself there in 1863, and died in Washington, DC, July 18, 1868.

LEVEE, JOHN.
Painter and sculptor. Born April 10, 1924, in Los Angeles, CA. Earned B.A. from UCLA; also studied at New School for Social Research and Academie Julian, Paris. Taught as visiting professor at University of Illinois; NYU; Washington University; USC. Awarded grand prize at I Biennial, Paris (1959); Ford fellow (1969). Awards from Salon de Deauville and Academie Julian, Paris, and Woolmark Foundation. Exhibited at Corcoran Museum; Carnegie Institute; Aldrich Museum, Ridgefield, CT; Museum of Modern Arts; Brooklyn Museum; Whitney Museum; Haifa of Art, Israel; Walker Museum; others. In collections of Guggenheim; Cincinnati Art Museum; Washington University; Museum of Massachusetts; Whitney Museum; Washington Gallery of Modern Art; and others internationally.

LEVER, HAYLEY.
Painter, etcher and teacher. Born in Adelaide, South Australia, Sept. 28, 1876. Studied in Paris, London, New York. Member: Associate National Academy of Design, 1925; Royal British Artists, London; Royal Institute of Oil Painters, London; Royal West of England Academy; National Arts Club (life); Contemporary; New Society Artists. Awards: Honorable mention, Carnegie Institute, Pittsburgh, 1913; silver medal, National Arts Club, 1914; Carnegie prize, National Academy of Design, 1914; gold medal, P.-P.

Exposition, San Francisco, 1915; gold medal, National Arts Club, 1916; Sesnan gold medal, Penna. Academy of Fine Arts, 1917; Philadelphia Water Color Club prize, 1918; fourth prize ($200), National Arts Club, 1922; bronze medal, Sesqui-Centennial Exposition, Philadelphia, 1926; Temple gold medal, Penna. Academy of Fine Arts, 1926. Work: "Port of St. Ives," Sydney Art Gallery, Australia; "Fishing Boats," Adelaide Art Gallery, Australia; "Winter, St. Ives," Brooklyn Institute Museum; "Sunshine, St. Ives, Cornwall," Pennsylvania Academy of the Fine Arts, Philadelphia; "Dawn," Corcoran Gallery, Washington, DC; "Smeaton's Quay, St. Ives," Fort Worth (TX) Museum; "Boats, Gloucester," and "Changing Nets, Gloucester," Detroit Institute; "Gloucester, Mass.," and "Fishing Boats at St. Ives," Harrison Gallery, Los Angeles Museum; "Fishermen's Quarters," Dallas Art Museum; "Hudson River," National Arts Club; "Herring Boats," Phillips' Memorial Gallery, Washington; "Dancing Boats," Des Moines Art Museum, IA; "French Crabbers," Lincoln University, Lincoln, NE; "Gloucester," Telfair Museum, Savannah; "Boats," etching, Baltimore Museum, MD; Presidential Yacht "Mayflower," The White House, Washington, DC; "Tuna Boats and Sails," Metropolitan Museum, NY; three watercolors, Brooklyn Museum; "Midday in the Harbor," City Art Museum, St. Louis; "Fishing Boats, Gloucester, Mass.," Museum of Fine Arts, Syracuse, NY; "Bathing Beach," Art Museum, Montclair, NJ. Instructor at Art Students League of NY. Address in 1929, 215 West 57th St., New York, NY.

LEVEY, JEFFREY KING.
Painter and sculptor. Born in NYC, Sept. 25, 1908. Studied with Ivan Olinsky, David Karfunkle, Daniel Garber. Member: National Arts Club; MacDowell Colony. Address in 1933, 67 West 52nd St., NYC; summer, MacDowell Colony, Peterboro, NH.

LEVI, JOSEF.
Painter and sculptor. Born February 17, 1938, in NYC. Studied: University of Connecticut, with Walter Meigs, BA; Columbia University. Work: Albright; Des Moines; J.B. Speed Art Museum, Louisville, KY; Museum of Modern Art; Aldrich. Exhibited: The Stable Gallery; Arts Club of Chicago; J.B. Speed Art Museum, Louisville, KY; Walker Art Center, Light, Motion, Space, 1967; Museum of Modern Art, The 1960's; Flint Institute; Herron; Whitney Museum; Aldrich; Nelson Atkins Gallery, Kansas City. Received Purchase Award, University of Illinois, Urbana, 1966. Address in 1982, 171 West 71st Street, NYC.

LEVI, JULIAN CLARENCE.
Painter, etcher, and architect. Born in New York City, Dec. 8, 1874. Pupil of William R. Ware at Columbia University; Scellier de Gisors at the Ecole des Beaux-Arts in Paris. Member: American Institute of Architects; French Institute in America; Societe Architects Diplomes par le Gouvernement Francais; Beaux-Arts Institute of Design; American Federation of Arts; Architectural League of NY; National Sculpture Society; National Society of Mural Painters, NY. Awards: French Government Diploma, 1904; hon. mention, Paris Salon, 1904; Chevalier, Legion of Honor, 1921, also Officier de l'Instruction Publique, 1927; gold medal, Santiago di Chili, 1923; hon. mention, Turin, Italy, 1926; silver medal, Societe des Architectes Diplomes par le Gouvernement Francais, 1927. Address in 1953, Tilden Bldg., 105 W. 40th St; h. 205 West 57th St., New York City.

LEVIN, ALEXANDER B.
Painter and illustrator. Born in Russia, Feb. 19, 1906. Pupil of Daniel Garber, Pearson, George Harding. Member: Fellowship Penna. Academy of Fine Arts. Award: First Packard prize, Penna. Academy of Fine Arts, 1927. Address in 1929, Pennsylvania Academy of the Fine Arts, Chester Springs, PA.

LEVINE, JACK.
Painter. Born in Boston, MA, Jan. 3, 1915. Study: Children's classes, Boston Museum of Fine Arts; with Denman Ross, 1929-31; with Harold Zimmerman; Colby College, hon. DFA, 1946. In collections of Metropolitan Museum of Art; Museum of Modern Art; Whitney; Walker Art Center, Minneapolis; Art Institute of Chicago; others. Exhibited at Fogg Art Museum (during high school); Institute of Contemporary Art, Boston, 1953; Whitney, 1955; Palacio Bellas Artes, Mexico City, 1960; annually, Carnegie Institute and Art Institute of Chicago; Corcoran; Museum of Modern Art; Penna. Academy of Fine Arts; many others. Won Guggenheim Fellowship, 1945, 46; Corcoran Award, 1959; Altman Prize, National Academy of Design, 1975; others. Has taught at Art Institute of Chicago; Penna. Academy of Fine Arts; American Art School, NYC; others. Member of National Institute of Arts and Letters; Artists Equity Association; American Academy of Arts and Science; National Academy of Arts and Letters; others. Represented by Kennedy Galleries. Address in 1982, 68 Morton Street, NYC.

LEVINE, SAUL.
Painter and sculptor. Born in NYC, June 11, 1915. Studied at Syracuse University; Yale University, B.F.A.; Corcoran Art School, with Heinz Warneke. Awards: Prize, Art Institute of Chicago, 1943. Work: Brooklyn Museum; murals, US Post Office, Ipswich, MA; South Hadley, MA. Exhibited: Penna. Academy of Fine Arts, 1946; Pepsi-Cola, 1944; Whitney Museum of American Art, 1943; Art Institute of Chicago, 1943; New York World's Fair, 1939; Carnegie Institute, 1940; Virginia Museum of Fine Arts, 1946; Artists Guild of Washington, 1945; Society of

Washington Artists, 1946. Address in 1953, Washington, DC.

LEVINSON, MON.
Sculptor and painter. Born in NYC, Jan. 6, 1926. Studied economics at the University of Pennsylvania, Philadelphia, 1943-44, 1946-48. Self-taught in the field of art. Work: Whitney; Hirshhorn; commission for Museum of Modern Art; others. Exhibited: Kornblee Gallery, NYC, 1961, 63-66, 68; Franklin Siden Gallery, Detroit, 1965-67, 69; Museum of Modern Art, 1963; Sidney Janis Gallery, NYC, 1964; Obelisk Gallery, Boston, 1968; Milwaukee Art Center, 1969-70; Whitney, 1970, 73; Storm King Arts Center, Mountainville, NY, 1972 and 75; Whitney Museum, NYC, 1970, 73; Hirshhorn, 1974; Rosa Esman Gallery, NYC, 1976, 77; 55 Mercer St. Gallery, 1980; Getler Pall Gallery, NY, 1981; and numerous others. Awards: Astor Foundation Grant, NYC, 1967; Fulbright Award for Sculpture, Washington, DC, 1970, 71, 74; Cassandra Foundation Award, NYC, 1972; National Endowment for the Arts Fellowship, 1976. Taught: Visiting artist at C. W. Post College, 1970-72 and 76-77. Address in 1982, 309 West Broadway, NYC.

LEVITT, JOEL J.
Painter and etcher. Born in Kiev, Russia, Feb. 1, 1875. Pupil of Odessa Art School; Academy of Design, Petrograd; Ilia Repin. Member: Salma. Club; North Shore Art Association; Allied Artists of America; American Artists Professional League. Represented in the Petrograd Museum; Wilna Museum, Russia; National Gallery of Canada, Ottawa; Museum of Broadmoor Art Academy, Colorado Springs, CO. Died in 1937. Address in 1929, 39 West 67th St., New York, NY.

LEVITZ, EBBITT A.
Painter. Born in New Haven, CT, Sept. 17, 1897. Pupil of Sargeant Kendall; Yale Art School. Member: Queensboro Art Association; Society of Independent Artists. Address in 1929, 20 Canal St., Jamaica, NY; h. 120-86 Lincoln Ave., South Ozone, NY; summer, 10 Scranton St., New Haven, CT.

LEVONE, ALBERT JEAN.
Illustrator. Born in Russia, Oct. 25, 1895. Pupil of Thornton Oakley and J. R. Sinnock. Illustrated for *The Designer, Century*, etc. Address in 1929, 2461 North 30th St., Philadelphia, PA.

LEVY, ALEX(ANDER) O(SCAR).
Painter and illustrator. Born in Bonn, Germany, May 26, 1881. Pupil of Duveneck, Chase, Linde and Henri. Member: Buffalo Society of Artists; Buffalo Art Club; Society of Independent Artists; Salons of America; Art Directors. Awards: First hon. mention, Buffalo Society of Artists, 1922; hon. mention, Buffalo Society of Artists, 1923; Fellowship prize, Buffalo

Society of Artists, 1924. Address in 1929, 41 Berkeley Place, Buffalo, NY.

LEVY, BEATRICE I.
(Mrs. Maurice D. Levy). Sculptor. Born in NYC, July 28, 1918. Studied at Art Students League, NYC, 1945. Exhibitions: One-man show, ACA Gallery, 1954; group shows, Audubon Artists, 1952, 56, 58; National Academy of Design, 1952; National Association of Women Artists annuals; Long Island Art League, 1955, 56; Brooklyn Museum, 1958; Silvermine Guild Artists, 1959; Jersey City Museum. Awards: Rose Metzger Memorial prize, National Association of Women Artists, 1957; other prizes. Member: Art Students League; Artists Equity Association; National Association of Women Artists. Address in 1962, Great Neck, Long Island, NY.

LEVY, BEATRICE S.
Painter and etcher. Born in Chicago, April 3, 1892. Pupil of Art Institute of Chicago; Voyt Preissig and Charles Hawthorne. Member: Chicago Society of Etchers; Chicago Art Club; Chicago Society of Artists. Awards: Hon. mention for etching, P.-P. Expo., San. Francisco, 1915; Jenkins prize, Art Institute of Chicago, 1923; gold medal, Chicago Society of Artists, 1928; prize, Illinois Academy, Springfield, 1928. Work: Chicago Art Institute; Los Angeles Museum; Smithsonian Institution, Washington, DC; Corona Mundi Collection, New York; Bibliotheque Nationale, Paris. Died in 1974. Address in 1929, 1504 East 57th St., h. 5724 Blackstone Ave., Chicago, IL.

LEVY, MARGARET WASSERMAN.
Sculptor. Born on December 13, 1899; US citizen. Studied at Wellesley College, B.A., 1922; Bryn Mawr College, 1923; Philadelphia School of Occupational Therapy, 1923-24; Stella Elkins Tyler School of Art; Penna. Academy of Art. Work in Penna. Academy of Fine Arts; Philadelphia Museum of Fine Arts. Has exhibited at Detroit Institute of Arts; Penna. Academy of Fine Arts; Philadelphia Museum of Art; National Academy of Design 138th, NY, 1963 and 1981; others. Member of Artists Equity, Philadelphia; Philadelphia Art Alliance. Address in 1982, Philadelphia, PA.

LEVY, WILLIAM AUERBACH.
Painter and etcher. Born in Brest-Letovsk, Russia, in 1889. Studied at National Academy of Design, and Academie Julian, Paris. Represented in permanent collection of Carnegie Institute, Pittsburgh; Art Institute, Chicago; Art Museum, Boston; Public Library, New York; and in important private collections. Awarded Mooney traveling scholarship, 1911; 1st prize, Chicago Society of etchers, 1914; bronze medal, San Francisco Exposition, 1915. Instructor of etching, National Academy of Design, and in the Educational Alliance, New York. Member: Painters-Gravers of America; Chicago Society of Etchers. Address in 1926, 230 East 15th St., New York, NY.

LEWICKI, JAMES.
Illustrator. Born in Buffalo in 1917. Attended Pratt Institute and the Art School of the Detroit Society of Arts and Crafts. While attending Pratt Institute he illustrated his first book, *New York: From Village to Metropolis*, by Robert Swan. Winner of first prizes from Hallmark Cards and the Audubon Artists, in 1969 he illustrated *The Golden Bough* by Fraser for Limited Editions. He taught art for 15 years at CW Post College and later was department chairman and director of their graduate art program.

LEWIS, ALICE L.
Painter and teacher. Born in Providence, RI, Dec. 6, 1872. Pupil of Collin in Paris; J. L. Tadd in Philadelphia; RI School of Design; Douglas Donaldson, Hollywood, CA. Member: Boston Society of Arts and Crafts; Pittsfield Art League. Art Instructor, Berkshire School for Crippled Children. Address in 1929, 472 West St., Pittsfield, MA; h. 62 Benevolent St., Providence, RI.

LEWIS, (ARTHUR) ALLEN.
Painter, etcher, illustrator and teacher. Born in Mobile, AL, April 7, 1873. Pupil of George Bridgman in Buffalo; Gerome in Paris. Member: Associate National Academy of Design; Chicago Society of Etchers; American Institute of Graphic Arts; Stowaways; Print Makers' Society of California. Awards: Bronze medal, St. Louis Expo., 1904; Logan prize, Chicago Society of Etchers, 1915; gold medal, P.-P. Expo., San Francisco, 1915; Barnett prize, Brooklyn Society of Etchers, 1917; silver medal, Sesqui-Centennial Exposition, Philadelphia, 1926; Nathan I. Bijur prize, Brooklyn Society of Etchers, 1928; John J. Agar prize, National Arts Club, 1928. Work: New York Public Library; Brooklyn Institute Museum; Herron Art Institute, Indianapolis; Chicago Art Institute; Oakland (CA) Public Museum; Newark Public Library; Detroit Institute of Arts; Metropolitan Museum of Art; Cleveland Museum; Columbia University Library, New York; British Museum. Teacher of wood engraving, color printing, etching and illustration, Art Students League of New York. Illustrated *Short Stories*, by Walt Whitman (Columbia University Press); *Journeys to Bagdad*, by Charles Brooks (Yale Univ. Press); *Paul Bunyon*, by James Stevens (Alfred A. Knopf); *Jesus Christ in Flanders*, by Honore de Balzas; *Divers Proverbs*, by Nathan Bailey (Yale Univ. Press). Died in 1957. Address in 1929, 41 Union Sq., New York, NY; h. 211 Lafayette Ave., Brooklyn, NY.

LEWIS, DAVID.
Portrait painter. In 1805 he had his studio at 2 Tremont St., Boston, MA.

LEWIS, EDMOND DARCH.
Landscape painter. Also painted marine views. Born Oct. 17, 1835, and lived in Philadelphia. Tuckerman mentions his paintings as having decided merit. Among his works are "Queen of the Antilles," "Fairmount Park," "Bass Rocks, after a Storm" and "Casino at Narragansett Pier." He died Aug. 12, 1910, in Philadelphia, PA.

LEWIS, EDMONIA.
Sculptor. Born near Albany, NY, July 4th, 1843/45. She was part Indian by birth. Her work shows considerable ideality and talent, and her chief patronage was from abroad. Exhibited in Boston in 1865. She also executed portrait busts of Henry W. Longfellow, Charles Summer, John Brown, and Abraham Lincoln.

LEWIS, HELEN V(AUGHAN).
Painter. Born in New York City, March, 1879. Pupil of Cox, Du Mond and Beckington. Member: Pennsylvania Society of Miniature Painters. Address in 1934, Irvington-on-Hudson, NY.

LEWIS, H(ERBERT) T(AYLOR).
Painter and teacher. Born in Chicago, Dec. 30, 1893. Pupil of Art Institute of Chicago; Julian and Delecluse in Paris. Member: Chicago No-Jury Society of Artists. Instructor, Rockford College. Address in 1929, Rockford College, Rockford, IL.

LEWIS, J.
This engraver signs his name "J. Lewis Sculpt." to several maps illustrating a bible published by S. Etheridge, of Charlestown, MA, 1813. The same man probably engraved the book-plate of Dr. Peter Middletown, who died in New York in 1781. This plate bears evidence of American origin and would thus locate Lewis in New York at a considerably earlier date than that above mentioned.

LEWIS, JAMES OTTO.
Born Feb. 3, 1799 in Philadelphia, PA. This engraver in the stipple manner first appears in books published in Philadelphia in 1815. Engraved the portrait of Lewis Cass, Secretary of War under President Jackson, in 1831. There is no record of such an engraver in the Philadelphia directories, and in the New York directory the nearest approach to this name is "Joseph Lewis, engraver and sealcutter" in 1816-23. Lewis probably spent some time in the western country, as he published in Philadelphia, in 1835, "The North American Aboriginal Portfolio," a collection of lithographic portraits of Indians; some of these are inscribed as "Painted from life by J. O. Lewis, at Detroit, 1833." His engraving of Commodore Decatur, full-length, standing on deck of ship, after G. Strickland, is a creditable piece of stipple engraving. Died in 1858, in NYC.

LEWIS, J(EANNETTE) MAXFIELD.
Painter. Born in Oakland, CA, April 19, 1894. Pupil of Gottardo Piazzoni, Winold Reiss, Armin Hansen.

Member: San Francisco Society of Women Artists; Oakland Art League. Address in 1929, 3136 Huntington Blvd., Fresno, CA; summer, General Delivery, Monterey, CA.

LEWIS, JOSEPHINE M(ILES).
Painter. Born in New Haven, CT. Pupil of John F. Weir and John H. Niemeyer at Yale School of Art; Frederick MacMonnies and Aman-Jean in Paris. Member: National Association of Women Painters and Sculptors; New Haven Paint and Clay Club; NY Society of Painters; Allied Artists of America. Awards: Shaw memorial prize, National Academy of Design, 1916; 1st prize, New Haven Paint and Clay Club, 1923. Address in 1929, Carnegie Studios, 154 West 57th St., New York, NY.

LEWIS, LAURA C. (MRS.).
Painter. Born in Philadelphia, PA, Aug. 21, 1874. Pupil of Philadelphia School of Design for Women; Penna. Academy of Fine Arts; Elliott Daingerfield; W. L. Lathrop; William M. Chase. Member: Plastic Club. Address in 1929, 2004 Ontario St., Philadelphia, PA.

LEWIS, MARY.
Sculptor and illustrator. Born in Portland, Oregon, June 18, 1926. Studied at University of Oregon, 1945-50, B.S. (sculpture), 1949; Oregon Division of American Association of University Women Mabel Merwin fellowship, 1950, Syracuse University, with Ivan Mestrovic, technical assistant to Mestrovic, 1951-53, M.F.A., 1953. Works: In private collections. Commissions: Four-ft mahogany and hammered copper bird and 28 inch Carrara marble skunk cabbage, commissioned by Joseph Stein and Waterbury Club, CT, 1964; small stone carving, Prouty Garden, Children's Hospital Medical Center, Boston, 1965; Madonna and Child (maple relief from half round log 20 by 30 inches), St. Louis de Montfort Sem. Chapel, Litchfield, CT, 1966. Exhibitions: Artists of Oregon, Portland Museum Art, 1951 and 69; 12th and 14th Annual New England Exhibitions, Silvermine Guild Artists, New Canaan, CT, 1961 and 63; 62nd and 63rd Annual Exhibitions, New Haven Paint and Clay Club, John Slade Ely Center, New Haven, 1963 and 64. Awards: Tiffany Travel Scholar, 1953; Fulbright Lecturer, 1958-59; Associate, National College Arts, Pakistan, 1959. Co-Author of *The Little Yellow Dinosaur*, 1971; illustrated *In the Beginning - The Bible Story of Creation, Adam and Eve, Cain and Abel*; others. Media: Most sculpture media; ink, watercolor. Address in 1982, Rainier, OR.

LEWIS, PHILLIPS F(RISBLE).
Painter. Born in Oakland, CA, Aug. 26, 1892. Pupil of California School of Arts and Crafts and Armin C. Hansen. Member: San Francisco Art Association; Oakland Art League; San Francisco Galerie Beaux Arts; American Federation of Arts. Awards: Hon.

mention, Palace of Fine Arts, San Francisco, 1922; hon. mention, Berkeley League of Fine Arts, 1924; hon. award, Springville, Utah, 1926; second prize, State Fair, Phoenix, AZ, 1927. Represented in Oakland Public Art Gallery. Died in 1930. Address in 1929, 5233 Broadway Terrace, Oakland, CA.

LEWIS, WILLIAM.
Born 1788 in Salem, MA. He was painting portraits there in 1812. His work appeared frequently in the early exhibitions at the Boston Athenaeum. Also a miniaturist.

LEWIS, YARDLEY.
The following appeared in the *Boston Weekly Journal* of Dec. 13, 1737: "Yardley Lewis of London, late from Ireland, dwelt lately in widow Howard's house near the north market place. Draws family pictures by the Life, also surveys and draws maps."

LEY, MARY HELEN.
Sculptor, painter, and teacher. Born in Leadville, CO, April, 1886. Studied with Sterba and Dudley Crafts Watson. Member: Colorado Art League; Hoosier Salon. Address in 1933, 606 East Wayne St., Ft. Wayne, IN.

LEYENDECKER, FRANK X.
Painter and illustrator. Born in Montabour, Germany in 1877. He came to America in 1883. Studied at Chicago Art Institute and Julian Academy; pupil of Laurens and Constant. He was also a designer and painter of stained glass windows. He died April 19, 1924, in New Rochelle, NY.

LEYENDECKER, JOSEPH CHRISTIAN.
Painter and illustrator. Born in Montabour, Germany, March 23, 1874. Pupil of Art Institute of Chicago; Julian Academy in Paris, 1896. Member: Salma. Club. Opened Chicago studio with brother, Francis, in 1897. Illustrated *Saturday Evening Post* cover, May, 1899; many other paintings for the *Post*. Worked for Cluett, Peabody & Co., originated Arrow Shirt Collar Man. Advertised apparel of B. Kuppenheimer, Hart Schaffner & Marx. Died July 26, 1951. Address in 1929, Mt. Tom Road, New Rochelle, NY.

LIBERMAN, ALEXANDER.
Sculptor and painter. Born 1912 in Kiev, Russia. Studied with Andre L'Hote (in Paris), 1929-31; architecture with August Perret; Ecole des Beaux Arts, Paris 1930-32; Rhode Island School of Design, DFA (hon.), 1980. U.S. citizen, 1946. Art Director of Vogue magazine, 1943; Art Director of Conde Nast Publ., USA and Europe, 1944; Editorial Director of same, 1962. Exhibited at Milwaukee Art Center, 1956; Museum of Modern Art, 1960, 62, 64, 65, 67-69; NY World's Fair, 1964; Bennington College; Guggenheim and Whitney Museum, NYC; Los Angeles County Museum; Corcoran Gallery of Art, Washing-

ton, DC; Tokyo Biennial, 1962; Philadelphia Museum of Art, 1969; Emmerich Gallery, NYC, 1967-69, 73, 74, 78-81. Award: Chevalier, Legion of Honor, France. In collections of Art Institute of Chicago; Smith College; Whitney Museum; Addison Gallery; Chase Manhattan Bank; Albright-Knox; Yale University; Washington Gallery of Modern Art; Museum of Modern Art; Tate Gallery, London. Living at 173 E. 70th St., NYC, in 1982.

LIBHART (or LIEBHART), JOHN JAY.
Modeller in clay; portrait, miniature, landscape, historical, and still life painter. Born in York County, PA, 1806; raised and lived in Marietta, on the Susquehanna. Studied painting with Arthur Armstrong. Active in Marietta, Harrisburg, Lebanon, Lancaster, and other central Pennsylvania towns. Died after 1860.

LICHTEN, FRANCES M.
Painter, illustrator and etcher. Born in 1889, in Bellefonte, PA. Member: Philadelphia Water Color Club; Philadelphia Print Club. Died in 1961. Address in 1929, 1709 Sansom St., h. 633 North 17th St., Philadelphia, PA.

LICHTENAUER, JOSEPH MORTIMER.
Sculptor and painter. Born in NYC, May 11, 1876. Studied at Art Students League; Julian Academy, Paris; with Mowbray; Merson and Laurens in Paris; and in Italy. Member: Art Students League of NY; Washington Art Club; National Society of Mural Painters; Architectural League, 1902; Silvermine Guild of Artists; Salmagundi Club; Art Fellowship; American Artists Professional League. Awards: Medal, Architectural League, 1903, 05; Paris Salon, 1937. Work: Smithsonian Institution; Metropolitan Museum of Art; Brooklyn Museum; American Academy of Arts and Letters; ceiling, Shubert Theatre, NY; triptychs, US Army. Exhibited: National Society of Mural Painters, annually; National Academy of Design, 1945; Salmagundi Club; Silvermine Guild of Artists; Argent Gallery, 1946 (oneman). Specialty: Murals. Address in 1953, Westport, CT.

LICHTENSTEIN, ROY.
Sculptor and painter. Born in NYC, October 27, 1923. Studied at Ohio State University, Columbus, BFA, 1946, MFA, 1949; Art Students League, NYC, under Reginald Marsh. Work: Albright-Knox; Art Institute of Chicago; Museum of Modern Art; Whitney; Walker. Exhibited: Carlebach Gallery, NYC, 1951; John Heller Gallery, NYC, 1952-54; Ferus Gallery, Los Angeles; Galleria II Punto, Turin, 1964; Leo Castelli Gallery, NYC; Art Institute of Chicago; Guggenheim Museum, NYC; Gallery of Modern Art, Washington; Whitney; Institute of Contemporary Arts, London, 1963; Detroit Institute of Arts, 1973; Museum of Modern Art, NYC, 1974; Blum-Helman

Gallery, NY, 1981; others. Taught: Instructor of art at Ohio State University, 1946-51; State University of New York, College at Oswego, 1957-60; Rutgers University, 1960-63. Many articles, including "What is Pop Art?" in *Art News*, NYC, November, 1966; "Metamorphoses: l'Ecole de NY," in *Quadram*, Paris, March, 1966; "Le Classicism du Hot Dog," in *La Quinzaine* Litteraire, Paris, January, 1968; plus other interviews with the artist. Address in 1982, Southampton, NY.

LICHTIN, ROSA.
(Mrs. Aaron Lichtin). Painter. Born in Russia, Dec. 31, 1898. Pupil of Penna. Academy of Fine Arts. Member: Fellowship Penna. Academy of Fine Arts; Graphic Sketch Club. Work: "Portrait of Dr. Theodor Herzl," Headquarters of North Philadelphia Zionist District. Address in 1929, 1545 South 7th St., Philadelphia, PA; summer, Wildwood Crest, Wildwood, NJ.

LICHTNER, (F.) SCHOMER.
Painter and illustrator. Born in Peoria, IL, March 18, 1905. Pupil of Gustave Moeller, Boardman Robinson. Member: Wisconsin Painters and Sculptors. Address in 1929, 1104 - 49th St., Milwaukee, WI.

LIDDELL, KATHARINE (FORBES).
Painter. Born in Montgomery, AL. Pupil of E. Ambrose Webster. Member: Provincetown Art Association; NY Society of Women Artists. Address in 1929, 259 Bradford St., Provincetown, MA.

LIDOV, ARTHUR HERSCHEL.
Painter, sculptor, designer, and illustrator. Born in Chicago, IL, June 24, 1917. Studied at University of Chicago, BA, 1936, studied art history, 1938-39. Awards: Prizes, University of Chicago, 1933; Art Directors' Club, Chicago, 1946; Art Directors' Club, NY, 1948; Art Directors' Club, Detroit, 1952; American Institute of Graphic Arts Award, 1963. Work: Public School, Chicago; US Post Office, Chillicothe, IL; Monsanto Chemical Co.; Coca-Cola Co.; Wright Aeronautics; Radio Corp. of America; Reynolds Aluminum Corp.; Lederle Pharmaceutical Co.; NY Central RR; US Playing Cards; US Army; Schenley Distillers; National Distilleries; Chase National Bank; and many other leading U.S. firms. Exhibited: University of Chicago, 1933; Art Institute of Chicago, 1933, 34; National Academy of Design, 1946-48; Milwaukee Art Institute, 1945; national traveling exhibition, *Fortune* magazine, 1948; Art Directors' Club, Chicago, 1946, NY, 47, 49, 50, Detroit, 52; Museum of Modern Art. Contributor illustrator to national magazines. Living in Poughquag, NY, in 1982.

LIE, JONAS.
Landscape painter. Born in Norway, April 29, 1880. Pupil of National Academy of Design and Art

541

Students League of NY. Member: Associate National Academy of Design, 1912; Academician National Academy of Design, 1925; Salma. Club; New Society of Artists; National Arts Club; Century Club; American Federation of Arts; (hon.) Boston Art Club; (hon.) Three Art Club. Awards: Silver medal, St. Louis Expo., 1904; first Hallgarten prize ($300), National Academy of Design, 1914; silver medal, P.-P. Expo., San Francisco, 1915; Greenough memorial prize, Newport, RI, 1916; gold medal, Art Week, Philadelphia, 1925; first prize, Chicago Norske Klub, 1925 and 1927; first prize, High School Art Association, Springville, UT, 1927; Carnegie prize, National Academy of Design, 1927; Maida Gregg memorial prize, National Arts Club, 1929. Work: "Fishing Boats at Sunrise," Carnegie Institute, Pittsburgh; "The Conquerors," Metropolitan Museum, NY; "Culebra Cut," Detroit Museum; "Afterglow," Art Institute of Chicago; "Ice Harvest," Luxembourg Museum, Paris; also represented in Peabody Institute, Baltimore, MD; Memorial Art Gallery, Rochester, NY; Museum of Art, Syracuse, NY; Art Association of Dallas, TX; Art Association of Lafayette, IN; Boston Museum of Fine Arts; Cleveland Museum; Brooklyn Institute of Art and Science; Albright Art Gallery, Buffalo; Telfair Academy, Savannah, GA; Corcoran Gallery, Washington, DC; Cedar Rapids Art Association, Cedar Rapids, IA; Elmira Art Association, Elmira, NY; RI School of Design, Providence. Series of paintings of Panama Canal was presented as memorial to Gen. Goethals, 1929, to US Military Academy, West Point, NY. Died in 1940. Address in 1929, 40 West 59th St., NYC.

LIEBERMAN, LOUIS (KARL).
Sculptor. Born in Brooklyn, NY, May 7, 1944. Studied: Brooklyn Museum Art School, with Isaac Soyer, 1961-64; Brooklyn College, B.A., 1962; Rhode Island School of Design, with Richard Merkin, B.F.A., 1969. One-man exhibitions: Vancouver Art Gallery, Vancouver, B.C., Canada, 1969; James Yu Gallery, NYC, 1973, 74; Renneth Gallery, West Hampton Beach, NY, 1979; John Davis Gallery, Akron, OH, 1983; Columbus Museum of Art Collectors Gallery, OH, 1984. Group exhibitions: Gary Mansion Gallery, Rhode Island School of Design, Providence, 1970; Aldrich Museum of Contemporary Art, Ridgefield, CT, 1973, 74; M. Knoedler & Co., NYC, 1976; Getler/Pall Gallery, NYC, 1980, 81; Cleveland Institute of Art, 1982; Metropolitan Museum of Art, NYC, 1983; others. Collections: Metropolitan Museum of Art, NYC; Philadelphia Museum of Art, PA; Aldrich Museum of Contemporary Art, Ridgefield, CT; Staten Island Museum, Richmond, NY; others. Awards: Creative Artists Public Service Foundation of the New York State Council on the Arts, for graphics, 1980-81, for sculpture, 1972; National Endowment for the Arts, Visual Arts Fellowship, 1972. Teaching: Adjunct lecturer, drawing, Brooklyn College, NY, 1971-78; adjunct lecturer, sculpture and design, Lehman College, Bronx, NY, 1972-75; others. Member: International Sculpture Center, NYC. Address in 1984, 16 Greene St., NYC.

LIGGET, JANE STEWART.
Sculptor, painter, and teacher. Born in Atlantic City, NJ, Sept. 4, 1893. Studied at Penna. Academy of Fine Arts, with Beatrice Fenton; and in Paris, France. Member: National Association of Women Artists; American Artists Professional League; Philadelphia Art Alliance; American Federation of Arts; Plastic Club. Awards: Fellowship, Penna. Academy of Fine Arts; Cresson traveling scholarship, Penna. Academy of Fine Arts, 1915. Exhibited: Woodmere Art Gallery, 1941-45; Penna. Academy of Fine Arts, 1941-46; Allied Artists of America, 1943; Philadelphia Art Alliance, 1942-46; National Association of Women Artists, 1942. Position: Instructor, sculpture, Valley Forge General Hospital, Phoenixville, PA, 1944-45. Address in 1953, Merion, PA; studio in Philadelphia, PA.

LILLIE, ELLA FILLMORE.
Lithographer. Born in Minneapolis, MN. Studied: Minn. School of Fine Arts; Art Institute of Chicago; NY School of Fine Arts; Cincinnati Art School. Awards: Southern Printmakers, 1938; Hoosier Salon, 1945, 1950, 1956, 1958; John Herron Art Institute, 1956; Northwest Printmakers, 1940; Springfield, Missouri, 1941, 1942; Library of Congress, 1945; Indiana Printmakers, 1947; Boston Printmakers, 1948; Society of American Graphic Artists, 1951. Collections: Seattle Art Museum; Library of Congress; Dayton Art Institute; California State Library; Fleming Museum; Boston Museum of Fine Arts; Wesleyan College, Macon, GA; Metropolitan Museum of Art; Pennsylvania State University; Colt, Avery, Morgan Memorial; Carnegie Institute; Art Institute of Chicago; Toledo Museum of Art; Telfair Academy; High Museum of Art; Brooks Memorial Art Gallery; Honolulu Institute of Art; Minn. Art Institute.

LIMBACH, RUSSELL T.
Painter, illustrator, etcher and teacher. Born in Massillon, OH, Nov. 9, 1904. Awards: First prizes in lithography and illustration, 1926, 2nd prizes, 1927; 1st prize in lithography, 2nd prize for water color, 3rd prize for illustration, 1928, Cleveland Museum of Art. Work: "Spring Night," Los Angeles Museum of Art, Los Angeles, CA; "The Bathers," "Fraternity House" and "The Iron Fence," Cleveland Museum of Art. Address in 1929, 305 Union Trust Co.; h. 10115 Superior Ave., Cleveland OH.

LIMERICK, J(AMES) ARTHUR.
Painter, sculptor, craftsman, lecturer and teacher. Born in Philadelphia, PA, July 19, 1870. Pupil of Boyle, Grafly, Anshutz, Thouron. Member: Baltimore Friends of Art; Baltimore Water Color Club.

Awards: Medal awarded by City of Baltimore for execution of bronzes supplied to the city; gold medal of honor, Maryland Institute, Baltimore, 1921. Founded statues of "Benjamin Franklin," Waterbury, CT, "Alexander Agassiz," Calumet, MI, and "Robert Morris," Philadelphia, PA, all by Paul W. Bartlett. Address in 1929, 960 North Howard St., Baltimore, MD; h. 102 Longwood Road, Roland Park, MD.

LINCOLN, AGNES HARRISON.
Painter. Born in Minneapolis, MN. Pupil of Alden Weir and Edmund Tarbell. Award: Fawsett prize ($100), Milwaukee Art Institute. Died in 1950. Address in 1929, 2509 Irving Ave., South, Minneapolis, MN.

LINCOLN, F. FOSTER.
Illustrator. Member: Society of Illustrators, 1910. Address in 1929, Union Village, RFD, Woonsocket, RI.

LINCOLN, JAMES SULLIVAN.
Born in Taunton, MA, May 13, 1811. He came to Providence, RI, at the age of ten and was apprenticed to an engraver. At 17 he chose the profession of portrait painting and established his studio at Providence. He became the first president of the Providence Art Club. Died Jan. 18, 1888.

LINDBERG, ARTHUR H.
Painter and illustrator. Born in Worcester, MA, Sept. 29, 1895. Pupil of Walter Beck; Pratt Institute; Frank Du Mond; George Bridgman; Art Students League of NY. Member: Scandinavian-American Artists.

LINDBERG, T(HORSTEN) (HAROLD) (FRED).
Painter, illustrator and craftsman. Born in Stockholm, Sweden, Jan. 13, 1878. Pupil of Higher Art Industrial School, Stockholm, Sweden. Member: Wisconsin Painters and Sculptors; Scandinavian-American Artists; American Federation of Arts. Address in 1929, 2701 Camden Ave., Omaha, NE.

LINDBORG, CARL.
Sculptor and painter. Born in Philadelphia, PA, Nov. 27, 1903. Studied at Philadelphia Museum School of Industrial Art; Penna. Academy of Fine Arts; Julian Academy, Paris, and with Andre L'Hote. Awards: Fellow, Penna. Academy of Fine Arts; medal, Philadelphia Art Club, 1937. Work: Penna. Academy of Fine Arts; Friends Central School Gallery; Allentown Museum. Exhibited: Corcoran Gallery of Art, 1931; Penna. Academy of Fine Arts; Whitney Museum of American Art; Friends Central School Gallery, annually; Fellow, Penna. Academy of Fine Arts; Philadelphia Museum of Art; Philadelphia Art Club; Philadelphia Art Alliance; Am-Swedish Museum, Philadelphia, PA; Military Preparatory School and College; Wellons Gallery, NY, 1952. Address in 1953, Newtown Square, PA.

LINDE, OSSIP L.
Painter. Born in Chicago. Pupil of Art Institute of Chicago; Laurens in Paris. Member: Allied Artists of America; Salma. Club; Society of Painters, NY. Awards: Hon. mention, Paris Salon, 1907; third class medal, Paris Salon, 1910. Represented in Oakland Museum. Died in 1940. Address in 1929, care of Guaranty Trust Co., 1 Rue des Italiens, Paris, France; Westport, CT.

LINDENMUTH, MRS. TOD.
See Warren, Elisabeth Boardman.

LINDENMUTH, TOD.
Painter. Born in Allentown, PA, May 4, 1885. Pupil of Henri, Webster and Browne. Member: Salma. Club; Provincetown Art Association. Work: "Mending Nets" and "Provincetown Wharf," Toledo Museum; "Garden Near the Dunes," Pennsylvania State College Museum; "The Runway," Rochester Memorial Art Gallery; "The Red Sail," Pennsylvania Academy of the Fine Arts; and represented in the New York Public Library. Address in 1929, 159 Commercial St.; h. 56 Commercial St., Provincetown, MA.

LINDER, C. BENNETT.
Painter. Born in Helsingfors, Finland, April 6, 1886. Member: Salma. Club. Address in 1929, Carnegie Hall; h. 143 West 57th St., New York, NY.

LINDER, HENRY.
Sculptor. Born in Sept. 26, 1854, in Brooklyn, NY. Pupil of Professor Knabl. Exhibitor at the National Sculpture Society of numerous busts; also the sitting figures "Music" and "Spring." Awarded bronze medal, St. Louis Expo., 1904. Member of National Sculpture Society; National Society of Craftsmen. Died Jan. 7, 1910, in Brooklyn, NY.

LINDER, JEAN.
Sculptor. Born in Berkeley, CA, in 1939. Studied: University of California at Berkeley; San Francisco Art Institute. Exhibitions: Oakland Museum, 1962; Richmond Museum, 1963; Whitney Museum of American Art, 1966, 1970; 55 Mercer, NYC, 1972. Collections: San Francisco Museum, CA; Rose Art Museum of Brandeis University; Trenton State Museum, NJ.

LINDIN, CARL (OLOF) (ERIC).
Painter. Born in Sweden, 1869. Pupil of Laurens, Constant and Aman-Jean in Paris. Member: Woodstock Art Association. Awards: First prize, 1919, and second prize, 1925-28, Swedish Club, Chicago. Decorations in Hull House, Chicago, IL. Died in 1942. Address in 1929, Woodstock, Ulster Co., NY.

LINDING, HERMAN M.
Sculptor, painter, and craftsman. Born in Sweden, June 1, 1880. Pupil of Callmander, Carl Wilhelmson, and of Colarossi. Member: Society of Independent Artists; Whitney Studio Club; Alliance. Address in 1926, Grant's Corners, Ossining, NY; 154 East 64th St., New York, NY.

LINDNER, RICHARD.
Painter. Born in Hamburg, West Germany, 1901. Raised in Nuremberg. Studied at the Hamburg School of Fine and Applied Arts in 1922 and the Academy of Fine Arts in Munich, 1924. In 1933, he left for Paris, emigrating to the U.S. in 1941, where he illustrated for *Vogue* magazine, from 1941-50. Taught at Pratt Institute, NYC, 1951-65. Characteristic of his work are his "The Meeting," 1953, Museum of Modern Art; and "Rock-Rock," 1963, Dallas Museum. Painting subjects concentrate on women and precocious children. Died in 1978.

LINDNEUX, ROBERT O(TTAKAR).
Painter. Born in New York, NY, Dec. 11, 1871. Studied in Dusseldorf, Germany, with Benjamin Vautier. Specialty: Indians, animals and scenes of western outdoor life. Died in 1970. Address in 1929, 3039 East Colfax Ave., Denver, CO; summer, Pahaska Tepee, Lookout Mountain, CO.

LINDSLEY, E(MILY) E(ARLE).
Painter, illustrator and teacher. Born in New Rochelle, NY, Feb. 25, 1858. Pupil of W. Chase, John Weir, C. Ferrari. Member: National Association of Women Painters and Sculptors. Died in 1944. Address in 1929, 23 Chatsworth Ave., Larchmont, NY; winter, "Amber Beach," St. Cloud, FL.

LINEN, GEORGE.
Painter. Born in Greenlaw, Scotland in 1802. He was a student of the Royal Scottish Academy in Edinburgh. In 1843 he settled in New York, and painted portraits in oil, of a small size. He died in New York, in 1888.

LINES, C(HARLES) M(ORSE).
Painter and artist. Born in Angola, IN, Dec. 15, 1862. Member: Cleveland Society of Artists; Cleveland Print Club; American Federation of Arts. Address in 1929, 1827 Cadwell Ave., Cleveland Heights, OH; summer, Rockport, MA.

LINFORD, CHARLES.
Landscape painter. Born in Pittsburgh, PA, in 1846; he died in 1897. His painting "Lowland Woods" was owned by the Penna. Academy of Fine Arts, Philadelphia.

LINK, B. LILLIAN.
Sculptor. Born in New York, 1880. Pupil of Mrs. Charles Sprague-Smith, George Grey Barnard and Herbert Adams. Member: MacDowell Club; Alliance; National Association of Women Painters and Sculptors. Awards: Avery prize, NY Architectural League, 1907; sculpture prize, NY Woman's Art Club, 1912. Address in 1934, Boston, MA; 260 West 76th St., NYC.

LINN, WARREN.
Illustrator. Born in Chicago in 1946. Received his BFA from the Art Institute of Chicago in 1968. His editorial illustrations have appeared often in *Playboy* since 1967. *Rolling Stone* and *The New York Times*, among others, have used his work. As a book illustrator, he has painted covers for St. Martin's Press and Scott, Foresman and Co. The Chicago Artists Guild awarded him prizes in 1972 and 1973.

LINQUIST, MARLENE.
Painter. Studied: University of Rochester; Ohio University, Athens; NY University. She was awarded a prize for painting at the Miami Museum of Modern Art. Exhibitions: Rockefeller Art Gallery, State University College, Fredonia, NY; Joe and Emily Lowe Art Gallery; Design Center, Miami, FL.

LINSON, CORWIN KNAPP.
Painter, illustrator, craftsman, and writer. Born in Brooklyn, NY, Feb. 25, 1864. Pupil of Ecole des Beaux Arts; Academie Julian; Gerome and Laurens in Paris. Member: NY Water Color Club; Salma. Club; Allied Artists of America. Work: Portrait of "Hon. Edmund Wilson," Mon. Co. Court House, Freehold, NJ; "Mark Hopkins," Williams College; "Col. C. J. Wright," New York Military Academy; "Dr. Hunter McGuire," St. Luke's Hospital, Richmond, VA; "A Summer Chautauqua," Swathmore Chautauqua Association; five memorial windows, Baptist Temple, Brooklyn, NY. Illustrated: "I.N.R.I.," by Rosegger; "The Lost Word," by Dr. H. Van Dyke; "Life of the Master," by Dr. Watson; "Modern Athens," by Geo. Horton; own articles in *Scribner's, Century, Cosmopolitan, The House Beautiful*, etc., inc. "Pont Aven Vignettes," "Color at Vesuvius," "Sunset at Jerusalem." Died in 1934. Address in 1929, Atlantic Highlands, NJ.

LINTON, FRANK BENTON ASHLEY.
Painter and sculptor. Born in Philadelphia, PA, Feb. 26, 1871. Pupil of Thomas Eakins in Phila.; Gerome, Benjamin-Constant, Bouguereau, Bonnat and Laurens in Paris. Member: Internationale Union des Beaux-Arts et des Lettres, Paris; Philadelphia Art Club. Awards: Medaille de Bronze, Paris Salons, 1927; "Officier d'Academie," French Government, 1928. Represented in Johns Hopkins Univ., Baltimore, MD; Girard College, Hahnemann College, College of Physicians, and the Baldwin Locomotive Works, all in Philadelphia; "La derniere retouche," owned by the French Gov. Address in 1933, Philadelphia, PA. Died in 1944.

LINTON, ROLAND (MRS.).
Sculptor. Born in NYC, February 21, 1904. Studied at Brooklyn Academy; Art Students League, 1919-1920; also with R. Laurent, and J. De Creeft. Works: Daphne, Mother and Child, Magdalena; in collections of International Business Machines, Harry Kriendler, Harold Hedges. Exhibitions in leading museums and galleries in US. Awards: International Business Machines, 1946, 47; National Association of Women Artists, 1945; Long Island Art Festival; gold medal of honor, Audubon Artists, 1946; Sculpture House award, Painters and Sculptors Society of NJ, 1st prize sculpture, 1958. Member: NY Society of Women Artists (president); National Association of Women Artists (assistant gallery director); Dutchess County Art Association; Audubon Artists. Address in 1962, 880 Fifth Ave., NYC.

LINTON, WILLIAM JAMES.
Wood engraver, designer, and water color painter. Born in London, England in 1812. He came to the United States in 1866. He was elected a member of the National Academy of Design in 1882; was also author of *History of Wood Engraving in America.* Member of Society of Painters in Water Colors. Died Dec. 29, 1897 at "Appledore," New Haven, CT.

LION, HENRY.
Sculptor. Born in Fresno, CA, Aug. 11, 1900. Studied at Otis Art Institute and with S. MacDonald-Wright. Work: "The Pioneer," bronze fountain; De Anga Mem.; "Felipe De Neve, Founder of Los Angeles," bronze; bronze doors and chandelier panels, City Hall (all the property of the City of Los Angeles). Exhibited: Los Angeles Co. Fair; Painters and Sculptors Society; Pacific Southwest Expo.; Golden Gate Expo., 1939, San Francisco; one-man, Los Angeles Museum of Art, 1937, 45. Author of "Sculpture for Beginners." Awards: Sculpture award, Los Angeles Co. Fair, 1922, 33, 34, 39; $1,000 prize for fountain design, 1923; prizes, Otis Art Institute, 1923, 40, 41; Nat. Sculpture Competition, 1923; purchase prize, Los Angeles Woman's Club, 1925; sculpture award, Pacific Southwest Expo., Long Beach California, 1928; Ebel Salon, 1937, 42; California Art Club, 1938. Member: California Art Club. Address in 1953, Los Angeles, CA.

LION, JULES.
Lithographer. Born 1816 in France. He opened a studio in New Orleans in 1839, bringing with him the first daguerreotype outfit used in that city. He had exhibited in the Salon, Paris, 1831 and 1836. He remained in New Orleans making lithograph portraits of the leading statesmen of the South until 1865, after which no record of him is found. Also painted miniatures and portraits.

LIONNI, LEO.
Sculptor and painter. Born in Amsterdam, Holland, May 5, 1910; U.S. citizen. Studied at University of Genoa, Italy, Ph.D. Work in Philadelphia Museum of Art; Museum of Modern Art and Metropolitan Museum of Art, NYC. Has exhibited at Museum of Modern Art, NYC; Staempfli Gallery, NYC; others. Was art director for *Fortune* from 1948-60. Works in bronze; oil. Address in 1982, c/o Staempfli Gallery, NYC.

LIPCHITZ, JACQUES.
Sculptor. Born in Druskieniki, Lithuania, August 22, 1891. Came to U.S. in 1941. Studied: Academie des Beaux-Arts, Paris, 1909-11, with Jean Antonine Ingalbert and Dr. Richet; Academie Julian, Paris, with Raoul Verlet; Academie Colarossi, Paris; Columbia University, Hon. LHD, 1968. Work: Museum Modern Art, Paris; Museum Grenoble, France; Museum of Modern Art, Guggenheim, and Metropolitan Museum Art, NYC; Albright-Knox Art Gallery, Buffalo, NY; Philadelphia Museum of Art; Tate; Tel Aviv; Art Institute of Chicago; Cleveland Museum of Art; and many others. Commissions: Five bas-reliefs, Barnes Foundation, Merion, PA, 1922; "Prometheus," Paris World's Fair, 1937; sculpture, Fairmount Park Association, Philadelphia, 1958; Presidential Scholars Medallion, 1964; others. One-man exhibitions: Brummer Gallery, NYC, 1935; Paris World's Fair, 1937; Buchholz Gallery, NYC, 1942, 43, 46, 48, 51; Galerie Maeght, Paris, 1946; San Francisco Museum of Art, 1951, 63; Cincinnati Art Museum, 1951; Museum of Modern Art, 1954; Walker Art Center, 1954, 63; Cleveland Museum of Art, 1954, 72; Rijksmuseum, 1958; Paris/Moderne Museum, 1959; Tate, 1959; Albright-Knox, 1963; Marlborough-Gerson Gallery Inc., 1964, 66; others. Group exhibitions: Whitney; Museum of Modern Art; Art Institute of Chicago; Tate; others. Awards: Sculptures, Academy Julien, Paris, 1909; gold medal, Paris World's Fair, 1937; Widener gold medal, Penna. Academy of Fine Arts, 1952; gold medal, sculpture, American Academy of Arts and Letters and National Institute of Arts and Letters, 1966. Among his many noted works: "Prometheus," 1937; "Rape of Europa," 1938; "Peace on Earth," 1969. Member: American Academy of Arts and Letters; National Institute of Arts and Letters. Address in 1970, Fine Arts Associates, 44 Walker St., NYC; h. Hastings-on-Hudson, NY. Died in 1973.

LIPINSKY de ORLOV, LINO SIGISMONDO.
Sculptor, painter, etcher, and conservator. Born in Rome, Italy, January 14, 1908. Studied at British Academy of Arts; Lipinsky Art Academy, Rome; Accademia Belle Arti, Rome. Member: Soc. of American Graphic Artists; Audubon Artists; Chicago Society of Etchers; Calcografia Romana, Rome, Italy; others. Awards: Medal, Rome, Italy, 1928, 31; Paris Salon, 1937; Budapest, Hungary, 1936; prizes, Chicago Society of Etchers, 1941; Society of American Graphic Artists, 1942; Library of Congress, 1942; Detroit Insti. of Art, 1943; Kosciuszko Foundation

1948; Westchester Co. Historical Society, 1979; others. Work: Severance Music Hall, Cleveland, OH; St. Patrick's Cathedral, NY; Boston Symphony Hall; NY Public Library; Library of Congress; Detroit Institute of Art; Cranbrook Academy of Art; Metropolitan Museum of Art; Vassar College; Florida State University; Yale University; Radcliffe Music Building; many churches in U.S. and abroad. Exhibitions: Los Angeles Museum of Art, 1927, 28, 32; Art Institute of Chicago, 1934; Chicago Soc. of Etchers; Society of American Graphic Artists; Grand Central Art Gallery; Library of Congress; National Academy of Design; Cleveland Mus. of Art; Detroit Institute of Art; Albany Institute of History and Art. One-man exhibitions inc. Vose Gallery; Symphony Hall, Boston; Jr. League, Boston; Knoedler Gallery; Audubon Artists; Carnegie Institute; Mills College, Oakland, CA; Albright Art Gallery; and abroad. Co-author, *Anatomy for Artists*, 1931; author, *Pocket Anatomy in Color for Artists*, 1947. Curator, John Jay Homestead, Katonah, from 1967. Media are primarily oil and etching. Address in 1982, Katonah, NY.

LIPMAN-WULF, PETER.
Sculptor and printmaker. Born in Berlin, Germany, April 27, 1905; U.S. citizen. Studied at State Academy of Fine Arts, Berlin, with Ludwig Gies. Work in Metropolitan Museum of Art; Whitney Museum of American Art; National Gallery of Art, Washington, DC; British Museum, London; bronze busts of Bruno Walter and Karl Bohm, Metropolitan Opera, NY; bronze bust of Pablo Casals, Corcoran Gallery of Art, Washington, DC; others. Has exhibited at Penna. Academy of Fine Arts; Whitney Museum of American Art; Jewish Museum, NY; Guild Hall, East Hampton, NY; others. Received Guggenheim Fellowship, 1949-50; Olivetti Award, Silvermine Guild of Artists, 1962. Member of Guild Hall, East Hampton, NY; Silvermine Guild of Artists. Taught as professor of sculpture, Adelphi University, from 1961. Address in 1982, Sag Harbor, NY.

LIPPERT, LEON.
Painter. Born in Bavaria, March 15, 1863. Pupil of Cincinnati Art Academy, under Nowottny and Duveneck, and studied abroad. Member: Cincinnati Art Club. Died in 1950. Address in 1929, 119 E. Fifth St., Government Sq., Cincinnati, OH; h. 658 Nelson P., Newport, KY.

LIPPINCOTT, MARGARETTE.
Painter. Born in Philadelphia in 1862. Student of the Penna. Academy of Fine Arts, Philadelphia. Her specialty was flower painting. Died Sept., 1910.

LIPPINCOTT, WILLIAM HENRY.
Painter and etcher. Born in Philadelphia on Dec. 6, 1849. Began study of art in Penna. Academy of Fine Arts; became designer of illustrations, later, scenic artist; was a pupil of Leon Bonnat, 1874. Remained in Paris 8 years, regularly exhibiting at Paris Salons. He returned to the U.S. in 1882; established a studio in New York. He was a professor of painting, National Academy of Design. Painted portraits, figure compositions and landscapes; was a regular contributor to American art exhibitions. "The Duck's Breakfast," "Love's Ambush," and "Pleasant Reflections" are his most important pictures. Elected an Associate of the National Academy of Design, 1884; Academician National Academy of Design, 1896. Member: American Water Color Society; Society of American Etchers; Century Association; New York Etching Club. Died March 16, 1920 in NYC.

LIPPOLD, RICHARD.
Sculptor. Born on May 3, 1915, Milwaukee, WI. Studied: The University of Chicago; Chicago Art Institute School, 1933-37, BFA (industrial design); University of Michigan. Work: Addison, Andover, MA; Detroit Institute of Art; Wadsworth; Metropolitan Museum of Art; Museum of Modern Art; Newark Museum; Utica; Virginia Museum of Fine Arts; Whitney Museum; and commissions, including Metropolitan Mus. of Art; Four Seasons Restaurant, NYC; Chateau Mouton Rothschild, Pauillac, France; Pan-Am Building, Lincoln Center. Exhibited: The Willard Gallery, NYC, 1947, 48, 50, 52, 68; Museum of Modern Art; Philadelphia Museum of Art; Tate; Whitney Museum; France (National); Brooklyn Museum, Sculpture in Silver; Newark Mus., Abstract Art; Art Institute of Chicago. Awards: Tate, International Unknown Political Prisoner Competition, Third Prize, 1953; Brandeis University, Creative Arts Award, 1958; American Institute of Architects, Fine Arts Medal, 1970; Municipal Art Society of NY, Citation, 1963; Architects League of NY, Silver Medal, 1960; elected to the National Institute of Arts and Letters, 1963. Taught: Layton School of Art, Milwaukee, 1940-41; University of Michigan, 1941-44; Goddard College, 1945-47; Trenton Junior College (head of art dept.), 1947-52; Queens College, 1947-48; Black Mountain College, 1948; Hunter College, 1952-65. Address in 1984, Locust Valley, NY.

LIPTON, SEYMOUR.
Sculptor. Born November 6, 1903, in NYC. Studied: City College of New York, 1921-22; Columbia University, 1923-27. Work: Brooklyn Museum; Albright; Cornell University; Des Moines; Detroit Institute; Metropolitan Museum Art; Museum of Modern Art; University of Massachusetts; University of Michigan; New School for Social Research; Phillips Gallery, Washington, DC; Santa Barbara Museum of Art; South Mall, Albany; Tel Aviv; Toronto; Utica; Whitney Museum; Yale University; Hirshhorn; many commissions, including IBM, Yorktown Heights, NY; Inland Steel Building, Chicago; Dulles International Airport, Washington, DC; Lincoln Center,

NYC; Milwaukee Center for Performing Arts. Exhibited: Whitney Museum Annuals; IV Sao Paulo Biennial, 1957; XXIX Venice Biennial, 1958; Carnegie, 1958, 61; Brussels World's Fair, 1958; Seattle World's Fair, 1962; New York World's Fair, 1964-65; Art Institute of Chicago, 1966; Museum of Modern Art, Dada, Surrealism and Their Heritage, 1968; Penna. Academy of Fine Arts Annual, 1968; Smithsonian, 1968; Museum of Modern Art, The New American Painting and Sculpture, 1969; MIT; numerous galleries. Awards: Prizes, Art Institute of Chicago, first prize, 1957; IV Sao Paulo Biennial, Top Acquisition Prize, 1957; National Institute of Arts and Letters, 1958; Guggenheim Foundation, 1960; New School for Social Research, 1960; Ford Foundation Grant, 1962; awards, Architectural League, 1961, 63; Penna. Academy of Fine Arts, Widener Memorial Gold Medal, 1968. Taught: Cooper Union, 1942-44; Newark State Teachers College, 1944-45; Yale University, 1957-59; New School for Social Research, 1940-64. Represented by Marlborough Gallery, NYC. Address in 1982, 302 W. 98th St., NYC.

LISIESKI, PETER.
Painter, illustrator, printmaker. Born in Worcester, MA, 1956. Studied: Boston Museum of Fine Arts School, 1974; Rhode Island School of Design, BFA, 1978; University of Massachusetts, MFA, 1982. Exhibited: Woods-Gerry Gallery, RI School of Design, Providence, RI, 1976; Worcester Art Museum, Worcester, MA, 1977; Boston Society of Illustrators, Boston, 1979; Artworks Gallery, Worcester, MA, 1980; Hampden Gallery, Univ. of Massachusetts, Amherst, 1980; Augusta Savage Gallery, Amherst, 1981; Leverett Craft Center, Leverett, MA, 1982; others. Awards: Art Award, Windsor Mt. School, 1974; scholarship, RI School of Design, 1974-78; exhibition poster, Boston Society of Illustrators, 1979. Member: NY Society of Illustrators; Art Director's Club, Boston; Boston Soc. of Illustrators; College Art Association; fellowship, Millay Colony for the Arts, Austerlitz, NY, MacDowell C., Peterborough, NH. Positions: Teaching at University of Massachusetts, various classes; Art Director for newpapers and publishers. Has published numerous books and articles. Address in 1983, Sunderland, MA.

LITLE, ARTHUR.
Illustrator. Member: Society of Illustrators, 1912; American Institute of Graphic Arts; Salma. Club. Address in 1929, 27 West 67th St.; care of Salmagundi Club, 47 Fifth Ave.; 15 West 29th St., New York, NY.

LITTLE, EDITH TADD (MRS.).
Sculptor, painter, illustrator, architect, craftsman, writer, lecturer, and teacher. Born in Philadelphia, June 27, 1882. Studied: Penna. Academy of Fine Arts; pupil of Chase, Beaux, Grafly. Member: Fellowship Penna. Academy of Fine Arts; Florida Association of Architects. Former chairman of art, Florida Fed. of Women's Clubs. Chairman of Fine Arts, Pinellas Co. Fed. of Women's Clubs. Address in 1933, Florida Art School; h. St. Petersburg, FL.

LITTLE, GERTRUDE L.
Painter. Born in Minneapolis, MN. Pupil of Seattle Art Society; Art Students League of NY; School of American Society of Miniature Painters of NY; William M. Chase. Member: California Society of Miniature Painters; West Coast Arts; Pennsylvania Society of Miniature Painters. Awards: 1st prize, for miniature, Seattle Fine Arts Society, 1921; 1st prize, 1923, hon. mention, 1924, first prize and popular vote prize, 1925, second prize and popular prize, 1928, California Soc. of Miniature Painters; hon. mention, Los Angeles Museum, 1925; second special prize, San Diego Fine Arts Society, 1926; silver medal, Pac. Southwest Expos., 1928; first prize, Los Angeles County Fair, 1928. Address in 1929, 4417 Prospect St., Los Angeles, CA.

LITTLE, JOHN WESLEY.
Landscape painter. Born in Forksville, PA, in 1867. Studied at National Academy of Design, New York, 1888-94, and with Leonard Ochtman; went abroad for travel and study, 1899-1900 and 1905. He exhibited at the St. Louis Exposition; Penna. Academy of Fine Arts; Philadelphia Art Club; American Water Color Society; NY Water Color Club; Chicago Art Institute; Washington Water Color Club; International Exhibition, Montevideo, 1911; Panama, P.I., Exposition, etc. Awards: Silver medal, American Art Society, 1901. Member: Phila., Washington and Chicago Water Color Clubs; Philadelphia Sketch Club. Died in 1923 in Williamsport, PA.

LITTLE, NAT(HANIEL) (STANTON).
Illustrator. Born in Helena, MT, Feb. 18, 1893. Pupil of Art Students League of NY; Penna. Academy of Fine Arts. Member: Fellowship Penna. Academy of Fine Arts; Philadelphia Sketch Club. Awards: Beck prize, Phila. Water Color Club, 1923; gold medal, Fellowship Penna. Academy of Fine Arts, 1925. Address 1929, 1010 Clinton St., Philadelphia, PA.

LITTLE, PHILIP.
Painter and etcher. Born in Swampscott, MA, Sept. 6, 1857. Pupil of Boston Museum School. Member: Guild of Boston Artists; Chicago Society of Etchers; Portland (ME) Art Association (life); Brooklyn Society of Etchers; National Arts Club (life); Boston Society of Water Color Painters; American Federation of Arts. Awards: Hon. mention, Art Institute of Chicago, 1912, for "The Brook;" silver medal, P.-P. Expo., San Francisco, 1915. Work: "In the Wake of the Moon," Pennsylvania Academy, Philadelphia; "Where Hawthorne Wrote and Derby Traded," City

Art Museum, St. Louis, MO; "The Upper Ipswich River," Minneapolis Society of Fine Arts; "Seining at Dawn," Bowdoin College Art Gallery, Brunswick, ME; "Gulls in Fog," Portland (ME) Society of Art; "Surf at Sunset," Nashville Art Assoc.; "Awakening of the Day," Milwaukee Art Association; "The Old Wharf," Dubuque Art Association; "A Relic of History," Essex Institute, Salem; "Transport Going East off Marblehead, 1917," RI School of Design; "February Thaw," Boston Museum; etchings in Congressional Lib., Washington; NY Public Library; "Salem's Old Wharves," Bibliotheque Nationale, Paris; and other places. Curator of Art, Essex Institute, Salem, MA. Died in 1942. Address in 1929, Daniel's Street Court; h. 10 Chestnut St., Salem, MA; summer, MacMahan Island, ME.

LITTLE, TRACEY M(AY) (BATES).
Etcher. Born in Whitehall, IL, May 24, 1879. Pupil of Frank DuMond. Member: Provincetown Art Association; Art Centre of the Oranges. Address in 1929, 3 Brookside Rd., South Orange, NJ; summer, 349-A Commercial St., Provincetown, MA.

LITTLEFIELD BROTHERS.
Ship carvers. Active in Portland, ME, 1858-70's. The brothers were Charles H. and Francis A., sons of Nahum Littlefield. Executed figurehead of the *Ocean King*, 1874.

LITTLEFIELD, NAHUM.
Ship carver. Active in Portland, ME, in 1830's. Father of Charles and Francis Littlefield.

LITTLEJOHN, C(YNTHIA) (PUGH).
Painter. Born in Assumption Parish, LA. Pupil of Ellsworth Woodward and A. A. Dow. Member: Nat. Arts Club; Newcomb Art Alumnae; Southern States Art League; American Soc. of Bookplate Collectors and Designers. Address in 1929, 1221 Leontine, New Orleans, LA.

LITTLEJOHN, MARGARET (MARTIN).
Painter, sculptor, illustrator, and teacher. Born in Jefferson, Texas, Dec. 12, 1887. Pupil of Paxton, Hale, Chase, and Carlson. Member: Ft. Worth Art Association. Address in 1919, Ft. Worth, Texas.

LITZINGER, DOROTHEA M.
Painter and etcher. Born in Cambria County, PA, Jan. 20, 1889. Pupil of National Academy of Design. Illustrated for "County Life in America;" well known for her flower painting. Died Jan. 4, 1925 in NYC.

LIVERMORE, MARY SPEAR MASON.
Miniature painter. Born in 1806. Flourished 1847 to 1848 in Boston, MA.

LIVEZEY, WILLIAM E.
Sculptor, painter, and illustrator. Born near Unionville, MO, April 12, 1876. Illustrated "The Days of

Long Ago," by W. E. Comstock, etc. Address in 1921, 538 South Dearborn Street; h. 2320 Cleveland Avenue, Chicago, IL.

LIVINGSTON, CHARLOTTE.
Painter. Born in New York City. Pupil of George Maynard; Ivan Olinsky. Member: Bronx Artists Guild; American Artists Professional League; Bronx Institute of Art; Ixia Society; American Federation of Arts. Address in 1929, 2870 Heath Avenue, Kingsbridge, Bronx, New York, NY.

LIVINGSTON, HARRIET.
Amateur miniature painter. She became the wife of Robert Fulton, 1808, and painted a miniature of her father, Walter Livingston, repro. in C. W. Bowen's "Centennial of the Inauguration of Washington." Died in 1824.

LLERENA, CARLOS ANTONIO.
Illustrator. Born in Peru in 1952. Worked as an illustrator in South America before coming to the U.S. in 1971. He studied at the Ringling School of Art and Society of Visual Arts, where he is presently an instructor. In addition to editorial art for magazines and children's books which he has illustrated, his works have also appeared on the Op-Ed page of *The New York Times*. While working in pen and ink for the most part, he has recently been doing woodcuts.

LLOYD, CAROLINE ALMA (NEE GOODMAN).
Sculptor. Born in Ft. Wayne, IN, March 7, 1875. Studied voice and piano in Chicago and Denver, 1894-97; and in Berlin 1909-10; also taught voice. Later studied drawing and miniature painting in Paris; studied sculpture there after 1929. From 1929-1939 she exhibited regularly at the Salon d'Automne, the Tuileries, the Salon des Beaux-Arts, and other galleries in Paris; also exhibited at New York World's Fair, 1939; Golden Gate International Expo., San Francisco. Received medal for sculpture, Paris International Expo., 1937; French Gov. purchased work for exhibit at Musee Jeu de Paume, 1939. Associate member of Societe Nationale des Beaux-Arts, Paris. Died Los Angeles, CA, Dec. 30, 1945.

LLOYD, LUCILE.
Mural painter. Born in Cincinnati, Aug. 20, 1894. Pupil of Frank Fairbanks and Eugene Savage. Member: American Bookplate Society. Work: "The Madonna of the Covered Wagon," South Pasadena Jr. High School, CA. Address in 1929, 1125 East Raleigh St., Glendale, CA.

LLOYD, SARA A. W.
Painter. Pupil of Swain Gifford, Volk and Chase in NY. Among her paintings are "Sunshine and Shadow" and portraits of W. J. Morehead, John Jones, and Miss Slade. Address 1926, Hamilton, NY.

LOBER, GEORGE JOHN.

Sculptor. Born in Chicago, IL, November 7, 1892. Pupil of Calder, Borglum, and Longman; National Academy of Design; Columbia College; Beaux Arts Insti. Member: NY Architectural League; National Sculpture Society; Connecticut Academy of Fine Arts; Salmagundi Club; Allied Artists of America; National Arts Club; Academician, Nat. Academy of Design; others. Awards: Avery collaborative prize, NY Architectural League, 1911; honorable mention, Art Institute of Chicago, 1918, 1920; first prize, Connecticut Academy of Fine Arts, 1924; prize, Art Centre of the Oranges, 1926; medal, prizes, National Arts Club; Nat. Sculpture Soc., 1952. Represented in Corcoran Gallery, Washington, DC, and Montclair Museum, Montclair, NJ. Work: Permanent exhibition medals, Numismatic Museum, NY; bronze statue, "Eve," Metropolitan Museum, NY; Byzantine Madonna in silver, Brooklyn Museum, NY; Eleanor T. Woods, "Peace Memorial," Norfolk, VA; nineteen Lincoln Memorial Tablets, State of Illinois; John Wells James Mem., MA; "Mother's Memorial," 71st Regiment Armory, NYC; Caleb Thomas Winchester Memorial, Wesleyan College, Middletown, CT; marble Baptistry, First Baptist Church, Plainfield, NJ; St. Peter and St. Paul Church of Our Lady of Consolation, Pawtucket, RI; memorial, Central Park, NYC, to honor NYC employees; bronze portrait, Frank Bacon, Golden Gate Museum, San Francisco, CA; also important portraits. Exhibited at National Sculpture Society, 1923; National Academy of Design, annually; Penna. Academy of Fine Arts; Allied Artists of America; National Arts Club; Montclair Art Museum; others. Address in 1953, 33 West 67th Street, NYC. Died in 1961.

LOCHRIE, ELIZABETH DAVEY.

Sculptor and painter. Born in Deer Lodge, MT, July 1, 1890. Studied at Pratt Institute Art School, B.A.; Stanford Univ.; and with Winold Reiss, Dorothy Puccinelli, Nicholas Brewer, Victor Arnitoff. Member: Life fellow, International Institute of Arts and Letters; Montana Institute of Arts; American Artists Professional League; Northwest Association of Arts. Work: Murals, US Post Office, Burley, ID; Dillon, MT; St. Anthony, ID; State Hospital, Galen, MT; bronze panels, Finlen Hotel, Butte, MT; Ford Motor Co. Collection; IBM Collection; bronze bas-relief portrait, James Finlen, Fort Lauderdale, 1970. Exhibited: Association of American Artists, 1939-45; NY World's Fair, 1939; Baltimore Art Association, 1945; Northwest Art Association, 1944-46; Rhodes Gallery, Tacoma, WA, 1940; Findlay Gallery, 1945; Montana Art Association; Bozeman (MT) College; Whitney Museum of Art, Cody, WY, 1968; one-woman shows include Arthur Newton Gallery, 1951, 59; Town Hall Gallery, NY, 1952; State History Gallery, Helena, MT, 1944, 73. Lectures: Art in Montana; War Art; etc. Address in 1980, Ojai, CA. Died in 1981.

LOCKE, ALEXANDER S.

Mural painter. Born in New York, Feb. 14, 1860. Pupil of John La Farge. Member: NY Architectural League, 1894; National Society of Mural Painters, NY; National Arts Club. Address in 1929, 103 Pineapple St.; h. 87 Winthrop St., Brooklyn, New York, NY.

LOCKE, ALICE G.

Painter and teacher. Born in Lexington, MA, Sept. 18, 1883. Pupil of Henry B. Snell. Member: National Association of Women Painters and Sculptors; Gloucester Art Association; Brooklyn Society of Artists; North Shore Art Association. Address in 1929, 183 Union St., Flushing, NY; summer, Rocky Neck Road, East Gloucester, MA.

LOCKE, CHARLES (WHEELER).

Painter, illustrator, etcher, and teacher. Born in Cincinnati, OH, August 31, 1899. Pupil of Joseph Pennell, H. H. Wessel, John E. Weis, etc. Member: Duveneck S. Represented in Metropolitan Museum, New York; British Museum, London; Cincinnati Museum. Address in 1929, 78 Columbia Heights, Brooklyn, NY; summer, 3906 Hazel Ave., Norwood, OH.

LOCKE, LUCIE H.

Painter. Born in Valdosta, GA, in 1904. Studied: Newcomb College, Tulane University; San Antonio School of Art; and with Charles Rosen, Xavier Gonzales, Increase Robinson, Frederic Taubes, and others. Awards: Corpus Christi Art Foundation, 1946, 1949, 1954, 1955. Collections: Montgomery Museum of Fine Arts; Del Mar College; Corpus Christi Art Foundation; Corpus Christi Civic Center.

LOCKMAN, DeWITT McCLELLAN.

Painter. Born on July 30, 1870 in NY. Pupil of James H. Beard, Nelson N. Bickford and William Sartain. Studied in Europe 1891-1892, 1901-1902. Represented in the permanent collections of the Metropolitan Museum of Art, NY; National Academy of Design, NY; Numismatic Society, NY; Yale University, New Haven, CT; and numerous others. Notable portraits include Gen. John Pershing and F. D. Roosevelt. Member: Associate National Academy of Design, 1917; Academician National Academy of Design, 1921; Nat. Association of Portrait Painters, NY; Salma. Club; Allied Artists of America; American Federation of Arts. Award: Silver medal, P.-P. Expo., San Francisco, 1915; Lippincott prize, Penna. Academy of Fine Arts, 1918. Died July 1, 1957. Address in 1929, 58 West 57th St., New York, NY.

LOCKPEZ, INVERNE.

Sculptor. Born in Havana, Cuba, in 1941. Studied: The National Academy of San Alejandro, Havana; Atelier of Lolo Soldeville, Paris. Living and working in NYC since 1966. Grants: Cintas Foundation, NY,

1970-1971; New York State Council on the Arts, 1973. Commissions: Latin-American Theater, NY, 1969; sculpture, NYC Public Arts Council, McKenna Square, 1972.

LOCKSPEISER, (ELEANORE).
Painter. Born in NYC June 16, 1900. Studied: With Max Weber; Louvre Print Room; Slade School, London. Work: Smithsonian Archives; Museum of the City of NY; Franklin Marshall College Art Center; Sperry Modern Art; private collections in Paris, London, NY, Philadelphia, Los Angeles, Chicago. Exhibited: Whitney Museum Annual; Los Angeles Fine Arts Museum; Jewish Museum First International Show; London Group and Redfern Gallery, London; solo shows at Feigl Gallery; Phoenix Gallery; Whittenberg Etching Show; Woodstock Historical Society; Hudson Art Consortium Retrospective, 1951-83; wall in New Paltz (NY) Gallery - CETA project; panels in Legislative Office Building, Albany, NY; etc. Address in 1983, 120 W. 86th St., NYC.

LOCKWOOD, J. W(ARD).
Painter. Born in Atchison, KS, Sept. 22, 1894. Pupil of Department of Fine Arts, University of Kansas; Penna. Academy of Fine Arts; Ransom Academy in Paris. Member: Fellowship Penna. Academy of Fine Arts. Died in 1963.

LOCKWOOD, WILTON (ROBERT).
Portrait painter. Born Sept. 12, 1862, in Wilton, CT. He was also known for his flower painting. Pupil of John LaFarge; also studied for ten years in Paris. Elected an Associate of the National Academy in 1906, and Academician, 1912. He died in Brookline, MA, on March 20, 1914. His portrait of John LaFarge was placed in the Boston Museum of Fine Arts; his flower piece "Peonies" was purchased by the Corcoran Art Gallery of Washington, DC.

LODBERG, AGNES C. L.
Sculptor, painter, craftswoman, writer, and teacher. Born in Denmark, April 8, 1875; came to America in 1906. Pupil of the Royal Academy of Fine Arts, Copenhagen, Denmark. Work: Portrait medallion of President Wilson owned by American Numismatic Society; Christian X, King of Denmark; portrait bust of Admiral F. E. Chadwick, University Library, Morgantown, WV. Member: Scandinavian American Society, NY. Address in 1919, Newport, Rhode Island.

LODIGENSKY, THEODORE.
Illustrator. Born in Paris, France, in 1930. Attended the Society of Arts and Crafts School in Detroit for four years, studying under Guy Palazzola. He began his career in Michigan in 1953 and has since illustrated for such magazines as *Automobile Quarterly, Car Classic, Playboy, Rod and Gun* and *Mechanics*

Illustrated. An industrial designer as well as an artist, his works have been shown at the Detroit Museum of Art and the Society of Illustrators Annual Exhibitions.

LODWICK, AGNES.
Painter and teacher. Born in Bergen Point, NJ. Pupil of St. Louis School of Fine Arts; Frank Swift Chase. Member: West. Art Assoc.; St. Louis Artists Guild; St. Louis Alliance; Players. Address 1929, 4 rue de Chevreuse, Paris, France; summer, Nantucket, MA.

LOEB, DOROTHY.
Painter and etcher. Born in Bavaria in 1887 of American parents. Pupil of Art Institute of Chicago; studied in Paris and Munich. Member: Provincetown Art Association. Address in 1929, Litchfield, CT; summer, Provincetown, MA.

LOEB, LOUIS.
Painter. Born Nov. 7, 1866, in Cleveland, OH. He studied in Paris under Gerome. Elected a member of the Nat. Academy in 1906. Specialty: Figure painting. He was a member of the Soc. of American Artists. He died July 12, 1909 in Canterbury, NH.

LOEBL, FLORENCE WEINBERG.
Painter. Born in New York in 1894. Pupil of Kenneth Hayes Miller. Member: Society of Independent Artists; League of New York Artists. Address in 1926, 135 West 79th St., New York, NY.

LOEFFLER, GISELLA.
See Lacher, Gisella Loeffler.

LOEHER, ALOIS.
Sculptor. Born in Paderborn, Germany. Worked: NYC, 1883; Milwaukee, 1889. Works held: Chicago Art Inst. Died Silver Spring, Maryland, 1904.

LOEWENGUTH, FREDERICK M.
Painter and craftsman. Born in Rochester, NY, April 18, 1887. Studied in London and Paris. Member: Rochester Art Club. Address in 1929, 401 Powers Building, Rochester, NY.

LOFTING, HUGH.
Illustrator, writer, lecturer. Born in Maidenhead, Eng., Jan. 14, 1886. Illustrated *Story of Doctor Doolittle; Voyages of Doctor Doolittle; Doctor Doolittle's Post Office; Doctor Doolittle's Circus; Doctor Doolittle's Zoo; Doctor Doolittle's Caravan; Doctor Doolittle's Garden; Dr. Doolittle in the Moon; The Story of Mrs. Tubbs; Porridge Poetry; Noisy Norah;* etc. Address in 1929, care of F.A. Stokes Co., 443 4th Ave., NY, NY.

LOGAN, HERSCHEL C.
Engraver, etcher, block printer. Born in Magnolia, MO, April 19, 1901. Pupil of Chicago Academy of

Fine Arts; Federal Schools, Inc. Member: Wichita Artists Guild. Awards: Bronze medal, Kansas City Art Institute, 1926 and 1927. Work: Three woodcuts owned by The Century Co. Address in 1929, 440 North Madison Ave., Wichita, KS.

LOGAN, ROBERT FULTON.

Painter, etcher, and teacher. Born in Lauder, Manitoba, Canada, March 25, 1889. Pupil of Boston School of the Museum of Fine Arts; Art Institute of Chicago; Philip L. Hale. Member: National Arts Club; Connecticut Academy of Fine Arts; Chicago Society of Etchers; Soc. Int. Gravure Originale en Noir; American Art Association of Paris; Salma. Club. Award: Logan medal, Chicago Society of Etchers, 1922. Work: "Spanish Iris," Art Society of Hartford; "Les Molineaux-Billancourt," Luxembourg Museum, Paris. Etchings in Chicago Art Institute; Library of Congress, Washington, DC; Metropolitan Museum of Art; New York Public Library; Morgan Memorial Art Museum, Hartford; Connecticut State Library; Ann Arbor Art Museum; British Museum, London; Fitzwilliam Mem. Art Mus., Cambridge, Eng.; Luxembourg Mus.; Bibliotheque Nationale, Paris. Assistant Director, Atelier of Painting, Bellevue Art Training Centre, A.E.F., 1919. Died in 1959. Address in 1929, Villa Adrien, 33 Route des Gardes, Bellevue, Seine et Oise, France.

LOGGIE, HELEN A.

Etcher. Born in Bellingham, WA. Studied: Smith College; Art Students League; and with John Taylor Arms, Mahonri Young. Awards: Northwest Print-makers, 1939; Library of Congress, 1943; Pacific Northwest Arts and Crafts Assoc., 1950; Florida Southern College, 1952; Albany Printmakers Club, 1953; National Academy of Design, 1955, 60, 64, Samuel Morse Medal, 1969; American Artists Professional League, gold medal, 1960; others. Collections: University of Nebraska; Library of Congress; Museum of Fine Arts of Houston; Seattle Art Museum; Western Washington College of Education; Springfield Museum of Art; Metropolitan Museum of Art; Pennsylvania State University; National Museum, Stockholm; Glasgow University, Scotland; British Museum, England; Lyman Allyn Museum; International Business Machines; Albany Institute of History and Art; Philadelphia Museum of Art. Exhibited: National Academy of Design, 1969, 1965 and prior; Penna. Academy of Fine Arts; Denver Art Museum; Society of American Graphic Artists, NY; Seattle Art Museum; San Francisco Museum of Art; Carnegie Institute; Whitney; Philadelphia Water Color Club; Audubon Artists; Wichita Art Association; Chicago Society of Etchers; American Academy of Arts and Letters; Connecticut Academy of Fine Arts; Washington Water Color Club; Art Institute of Chicago; Corcoran Gallery of Art; many others. Member: Associate National Academy of Design; Society of American Graphic Artists, NY; California

Print Makers; Connecticut Academy of Fine Arts; Northwest Print Makers; Audubon Artists; Philadelphia Water Color Club; Washington Water Color Club; others. Address in 1970, Bellingham, WA.

LOMBARD, JAMES.

Sculptor. Born in Baldwin, ME, June 26, 1865. Carved his first works in wood while at school in Baldwin, ME. Later moved to Bridgton, ME, where he farmed and made furniture and weathervanes during the 1880's. Noted for his silhouettes of hens and roosters in pine. Died in Bridgton, ME, Feb. 27, 1920.

LOMBARD, WARREN P(LIMPTON).

Etcher. Born in West Newton, MA, May 29, 1855. Member: Ann Arbor Art Association; American Federation of Arts. Died in 1939. Address 1929, 805 Oxford Rd., Ann Arbor, MI; summer, Monhegan, ME.

LO MEDICO, THOMAS GAETANO.

Sculptor and designer. Born in New York City, July 11, 1904. Studied at the Beaux-Arts Institute of Design. Exhibited at the Metropolitan Museum of Art; Whitney Museum of American Art; Penna. Academy of Art; National Academy of Design; plus numerous others. Awards: J. Stanford Saltus Medal, from the Numismatic Society, 1956; Mrs. Louis Bennet Prize and the Lindsey Morris Memorial Prize from the National Sculpture Society. Member: American Numismatic Society; National Sculpture Society, fellow; National Academy of Design; and the New York Architectural League. Taught: Instructor at the National Academy of Design School of Fine Arts, NY. Address in 1982, Tappan, NY.

LONDON, FRANK (MARSDEN).

Painter. Born in Pittsboro, NC, May 9, 1876. Pupil of Arthur Dow, William Chase, Kenyon Cox. Award: Hon. mention, International Exhibition, Bordeaux, France, 1927. Died in 1945. Address in 1929, 317 East 51st St.; h. 215 East 48th St., New York, NY.

LONDONER, AMY.

Painter. Born in Lexington, MO, in 1878. Pupil of Robert Henri and of John Sloan. Member: Art Students League of NY; Society of Independent Artists; League of NY Artists. Address in 1926, 1947 Broadway, NY. Died in 1953.

LONE WOLF.

(Hart Meriam Schultz). Sculptor, painter, illustrator, and commercial artist. Born on the Blackfoot Reservation, Montana, 1882. Studied at Indian schools; Los Angeles Art Students League in 1910; in Chicago, 1914-15; encouraged by Thomas Moran. Work in Harmsen Collection; University of Nebraska Art Gallery; Santa Fe Railroad (Chicago). Illustrated books of his father, James Willard Schultz. Specialty

was Western subjects, including statuettes of horses, buffalo, deer. Style in the school of Remington and Russell. Died probably in Tucson, Arizona, about 1965.

LONG, ADELAIDE HUSTED.
(Mrs. George T. Long). Painter, teacher, and writer. Born in New York. Pupil of Art Students League of NY, John Twachtman, Ernest Knaufft and George T. Collins; Anglade in Paris. Member: National Arts Club; American Federation of Arts. Address in 1929, 57 North Broadway, White Plains, NY.

LONG, DANIEL A.
Illustrator. Born in Columbus, OH in 1946. Attended Southwestern College and the Art Center College of Design. He now works for the U.S. Navy, Xerox, American Express, Panasonic, Merrill Lynch, the *New York Daily News* and London Records. His first illustration was done for Columbia Records in 1975. He illustrated the book *Human Sexuality*, published by McGraw-Hill in 1976.

LONG, ELLIS BARCOFT.
Sculptor and painter. Born in Baltimore, MD, October 30, 1874. Pupil of Andre Castaigne and E. S. Whiteman in Baltimore; of Cox, Mowbray, Saint Gaudens, and D. C. French in New York. Member: Charcoal Club. Address in 1926, 127 Baltimore, MD.

LONG, FRANK WEATHERS.
Sculptor, painter, engraver, and jeweler. Born in Knoxville, TN, May 7, 1906. Studied at Art Institute of Chicago; Penna. Academy of Fine Arts; New Mexico State Teachers College; Julian Academy in Paris. Work: IBM Collection, NY; Smithsonian Institution; Berea College Collection; US Post Office, Berea, Morehead, Louisville, KY; Drumright, OK; Hagerstown, MD; others. Exhibited: World's Fair, NY, 1939; Golden Gate Expo., San Francisco, 1939; American Federation of Arts traveling exhibition; one-man exhibitions include Speed Memorial Museum, 1940; Berea College, 1938-40; Ashland (KY) Art Association, 1939; University of New Mexico Gallery, 1968; Mus. of Albuquerque, 1979. Member of So. Highlanders Handicraft Guild; Albuquerque Chapter of New Mexico Designer-Craftsmen (president 1969). Position: Dir., Alaska Office of Indian Arts and Crafts Board, Juneau, AK, 1951-57. Media: Gem material; metal. Address 1953, Berea, KY.

LONG, HUBERT.
Sculptor. Born in Sydney, Australia, February 2, 1907; US citizen. Studied at Newark School of Fine and Industrial Art, NJ. Work in Guild Hall Museum Collection, East Hampton, NY; Phoenix Art Museum, AZ; others. Has exhibited at Andrew Crispo Gallery, NY, 1974 and 76; Guild Hall, East Hampton, NY, 1976; Indianapolis Museum; others. Works in wood. Address in 1982, East Hampton, NY.

LONGACRE, JAMES BARTON.
Engraver. Born in Delaware County, PA, Aug. 11, 1794; died in Philadelphia, Jan. 1, 1869. Longacre was taught to engrave by George Murray, in Philadelphia. His earliest work was done for S. F. Bradford's Encyclopedia, but he first attracted attention by his admirable large plate of Andrew Jackson, after the portrait by Thomas Sully, published in Philadelphia in 1820. He soon found abundant employment in engraving portraits in the stipple manner, many of them done after his own drawings from life. About 1830, in connection with James Herring, Longacre conceived the idea of publishing "The American Portrait Gallery," a series of biographical sketches of statesmen, military and naval heroes. These were to be illustrated by portraits, and Longacre engraved a number of these himself and drew the originals for other engravers; taken as a whole it was the best series of portraits engraved in the United States up to that time. The large plates of Longacre are remarkable for their faithfulness as portraits, and for the beauty of their execution. The majority of them are done in the stipple manner, but his large plate of Charles Carroll, after the painting by Chester Harding, proves him to have been an accomplished line-engraver. In 1844 Mr. Longacre was appointed engraver to the U.S. Mint, succeeding C. Gobracht, and he held the position until his death. Longacre painted, in oil, many of the originals of the engraved portraits; they are cabinet size and carefully painted.

LONGACRE, LYDIA E(ASTWICK).
Miniature painter. Born in New York, Sept. 1, 1870. Pupil of Art Students League of NY, under Chase and Mowbray; Whistler in Paris. Member: American Society of Miniature Painters; Pennsylvania Society of Miniature Painters; National Association of Women Painters and Sculptors. Died in 1951. Address in 1929, 27 West 67th St., New York, NY.

LONGFELLOW, ERNEST WADSWORTH.
Painter. Born in Cambridge, MA, in 1845. Studied art in Paris under Hebert Bonnat and Couture. His best known landscapes and compositions are: "Misty Morning;" "The Choice of Youth;" "Italian Pifferari;" "Morning on the Aegean;" "The Matterhorn;" "Evening on the Nile;" "First Love;" Portrait of H. W. Longfellow; etc. "Marine" (signed "Ernest Longfellow 1875") is owned by the Boston Museum of Fine Arts. Died Nov. 23, 1921 in Boston, MA.

LONGFELLOW, MARY KING.
Painter. Member: Boston Water Color Club. Address in 1929, 116 State St., Portland, ME.

LONGLEY, BERNIQUE.
Sculptor and painter. Born in Moline, IL, in 1923. Studied: Art Institute of Chicago; with Francis Chapin and Edouard Chassaing; Bryon Lathrop

traveling fellowship, 1945; Institute de Allende, Mexico, 1971; Santa Fe School of Arts and Crafts, 1975. Collections: Museum of New Mexico; Dallas Art Museum; mural, La Fonda Del Sol Restaurant, NY; mural, Alexander Girard Home, Santa Fe. Exhibitions: Art Institute of Chicago; New Mexico Museum of Fine Arts; Santa Fe Festival of Arts, 1977-81; Denver Art Museum; one-woman exhibitions include the San Francisco Museum of Art; Van Dieman-Lilienfeld Gallery, NY; Denver Art Museum; others. Awards: Lathrop traveling scholarship, Art Institute of Chicago, 1945, honorable mention, 1948; Museum of New Mexico, purchase prize, 1953, honorable mention, 1965; honorable mention, Denver Museum of Art Regional Sculpture Show, 1948; Mexico State Fair. Address in 1982, Santa Fe, NM.

LONGMAN, (MARY) EVELYN BEATRICE.
(Mrs. N. H. Batchelder). Sculptor. Born in Winchester, OH, Nov. 21, 1874. Pupil of Art Institute of Chicago under Taft; French in NY; Olivet College, M.A. Member: National Sculpture Society, 1906; Associate of the National Academy of Design, 1909; Academician, National Academy of Design, 1919; American Numismatic Society; Concord Art Association; Connecticut Academy of Fine Arts; American Federation of Arts; National Arts Club. Awards: Silver medal, St. Louis Expo., 1904; silver medal, P.-P. Expo., San Francisco, 1915; Shaw memorial prize, National Academy of Design, 1918 and 1926, Watrous gold medal, 1924; W.M.R. French gold medal, Art Institute of Chicago, 1920; Widener gold medal, Penna. Academy of Fine Arts, 1921; Flagg prize, Connecticut Academy of Fine Arts, 1926. Work: Bronze doors of Chapel, US Naval Academy, Annapolis; bronze door of Library, Wellesley College, Wellesley, MA; Ryle memorial, Public Library, Paterson, NJ; "Torso," bust of Henry Bacon, and "Victory," Metropolitan Museum, NY; "Victory," and "Electricity," Toledo Museum; Allison monument, Des Moines, IA; "Electricity," American Telephone and Telegraph Building, NY; centennial monument, Chicago; Naugatuck War Memorial, Naugatuck, CT; Theodore C. Williams Memorial, All Souls' Church, NY; Spanish War Memorial, Hartford, CT; also represented in Metropolitan Museum of Art; Wadsworth Atheneum; Art Institute of Chicago; City Art Museum, St. Louis; Cincinnati Museum of Art; Cleveland Museum; Herron Art Institute, Indianapolis. Exhibited at National Sculpture Society, 1923. Address in 1953, Osterville, MA. Died in 1954.

LONGPRE, PAUL De.
Painter. Born in France in 1855, he came to the United States in 1890 and died in Hollywood, Los Angeles, CA, in 1911. His specialty was floral painting, and his first exhibition in New York in 1896 was composed entirely of floral subjects.

LONGYEAR, WILLIAM LLOWYN.
Illustrator, writer and teacher. Born in Shokan, NY, June 17, 1899. Pupil of Frank DuMond; Art Students League of NY. Member: College Art Association; Eastern Art Association. Author of *Practical Folio of Lettering*; illustrated *Industrial and Applied Arts Drawing Books* and *Practical Drawing Books*. Address in 1929, 253 Washington Ave., Brooklyn, NY; summer, Berkshire Summer School of Art, Monterey, MA.

LOOMIS, CHESTER.
Painter. Born Oct. 18, 1852 near Syracuse, NY; died in Englewood, NJ, in Nov. 1924. Painted portraits and landscapes. Pupil of Harry Thompson and Bonnat in Paris. He was elected an Associate Member of the National Academy in 1906. He also executed several mural paintings.

LOOMIS, MANCHUS C.
Painter. Born at Fairview, PA. Studied at San Francisco School of Design under Virgil Williams, and at the Chicago Art Institute under Vanderpoel, Grover and Boutwood. Member: Palette and Chisel Club; Art Institute of Chicago Alumni. Address in 1929, 30 East Randolph St.; 3919 North Kenneth Ave., Chicago, IL.

LOOMIS, (WILLIAM) ANDREW.
Illustrator, designer, painter, writer, and teacher. Born in Syracuse, NY, June 15, 1892. Pupil of Frank DuMond, George Bridgman, Leopold Seyffert, John Carlson, George Oberteuffer; NY Art Students League; Art Institute of Chicago. Member: Artists Guild of the Authors' League of America, NY; Association of Arts and Industries, Chicago; Art Institute of Chicago; Palette and Chisel Club; Society of Illustrators; American Federation of Arts; Chicago Freelance Artists Guild. Awards: $1,000, Harvard Awards for advertising; first prize for poster from the U.S. Shipping Board. Specialty: Advertising illustrations. Taught at American Academy of Art in Chicago. Author and illustrator of "Fun With a Pencil," 1939; "Figure Drawing for All It's Worth," 1943. Died in 1959. Address in 1953, Los Angeles, CA; h. North Hollywood, CA.

LOOP, HENRY AUGUSTUS.
Distinguished portrait and figure painter. He was born in Hillsdale, NY, Sept. 9, 1831. He studied with Henry Peters Gray; also with Couture in Paris. One of his best portraits was that of Judge Skinner of Buffalo. In 1861 he was elected to the National Academy, and in 1863 to the Century Club. He died Oct. 20, 1895, at Lake George, NY.

LOOP, JEANETTE SHEPPERD HARRISON.
(Mrs. Henry A. Loop). Painter. Born March 5, 1840 in New Haven, CT. A portrait and figure painter, she was a pupil of Henry Loop, whom she married c.

1865. She was a sister of Judge Lynde Harrison. Specialized in children's portraits. Had studio in NYC. Elected an Associate of the National Academy of Design in 1875. Died April 17, 1909 in Saratoga, NY.

LOOP, LEOTA WILLIAMS.
Painter and teacher. Born in Fountain City, IN, Oct. 26, 1893. Pupil of Olive Rush; William Forsyth; R. L. Coats. Member: Indiana Art Club; Hoosier Salon; Kokomo ASL; Kokomo Art Association; American Federation of Arts; Art League of North Indiana; Society of Independent Artists; Salons of America. Represented in Elwood High School; Tipton Library, Milwaukee Children's Home; High School and Woman's Department Club, Kokomo, IN. Address in 1929, 1423 West Sycamore, Kokomo, IN; summer, R.R. No. 2, Martinsville, IN.

LOPEZ, CHARLES ALBERT.
Sculptor. Born in Matamoras, Mexico, Oct. 19, 1869. He came to New York when a youth and studied with Ward of New York, afterwards at the Ecole des Beaux Arts in Paris. Awarded first prize for McKinley Monument, Philadelphia. He was elected in 1906 as an Associate of the National Academy. Died the same year in NYC on May 18.

LORAN, ERLE.
Painter and writer. Born Oct. 3, 1905 in Minneapolis, MN. Studied at University of Minn.; at Minneapolis School of Art; Chaloner Foundation Scholarship for Study in Europe; Minneapolis School of Art and Design, Hon. MFA; and with Hans Hofmann. Taught at Berkeley, 1936-81, chairman of art department, 1952-56, emeritus professor of art, from 1981. Awarded Paris Prize from Chaloner Foundation, NYC, 1926; prize, San Francisco Museum of Art, 1956; California Palace, San Francisco awards, 1956 and 1963; Purchase Prize, Krannert Art Museum, 1965. Exhibited at Kraushaar Gallery, NYC, 1931; San Francisco Museum of Art, many times since 1939; Santa Barbara Museum; Museum of Modern Art; Carnegie; Cranbrook Academy of Art, Michigan; Whitney; Art Institute of Chicago; Carnegie Institute, Pittsburgh; Metropolitan Museum of Art; others. In collections of Brigham Young University; U.S. State Department; Denver Art Museum; Fine Arts Gallery, San Diego; University Art Museum, University of California, Berkeley; University of Minn.; IBM; Smithsonian Institution; San Francisco Museum of Art; and many private collections. Media: Acrylic, oil. Address in 1984, Berkeley, CA.

LORD, CAROLINE A.
Painter and teacher. Born in Cincinnati, OH, March 10, 1860. Pupil of Cincinnati Art Academy; Art Students League of NY; Julian Academy in Paris. Member: Cincinnati Woman's Art Club (hon.). Instructor in Cincinnati Art Academy. Awards:

Bronze medal, Columbian Expo., Chicago, 1893; Fellowship Prize, Buffalo Fine Arts Society, 1925. Work: "First Communion" and "Old Woman," Cincinnati Museum. Address in 1929, 975 E. McMillan St., Cincinnati, OH.

LORD, EVELYN RUMSEY.
Painter. Born in Buffalo, NY. Pupil of Buffalo Art School, C. W. Hawthorne, Charles Woodbury. Member: Buffalo Society of Artists. Award: Fellowship prize, Buffalo, 1916 and 1925. Address in 1929, 18 Tracy St., Buffalo, NY.

LORD, HARRIET.
Painter, etcher, craftsman and teacher. Born in Orange, NJ, March 7, 1879. Pupil of Edmund Tarbell, F. W. Benson, Joseph de Camp, W. L. Lathrop. Member: National Arts Club; National Association of Women Painters and Sculptors; American Federation of Arts. Died in 1958. Address in 1929, 25 East End Ave., New York, NY; summer, Nantucket, MA.

LORD, JAMES BROWN.
Painter. Born in 1859. He died in 1902.

LORD, PHOEBE GRIFFIN.
(Mrs. P. G. L. Noyes). Miniature painter in water color. Born in 1831. Died in 1875.

LORENSEN, CARL.
Sculptor. Born in Klakring, Denmark, in 1864. He was a pupil of Kroyer, studying at the Copenhagen Academy. Went to Chicago in 1890 and did a number of sculptures for the World's Fair. He was a regular exhibitor at the Art Institute of Chicago and the Field Museum, Chicago. Died January 17, 1916, in Chicago, IL.

LORENZ, RICHARD.
Painter. Born in Germany in 1858. He came to this country as a young man. In 1905 he was awarded the "Osborne prize." He was a member of the Society of Western Artists. Among his works were "A Critical Moment;" "Burial on the Plains;" "Plowing in Saxony." He died in Milwaukee, WI, in 1915.

LORENZANI, ARTHUR EMANUELE.
Sculptor and teacher. Born in Carrara, Italy, Feb. 12, 1886. Came to the U.S. in 1913. Pupil of Academia Belle Arti, Carrara, 1904; Rome Prize and three year pension. Member: National Sculpture Society; NY Architectural League; Allied Artists of America. Exhibited at National Academy of Design; Penna. Academy of Fine Arts; Albright-Knox Art Gallery; National Sculpture Society, 1923. Commissions: John F. Kennedy (bronze portrait), M. Labetti Post Veterans of Foreign Wars, Staten Island, 1964. Award: $200 prize at International Expo., Parma, Italy; Mrs. H. P. Whitney Prize for war competition;

Special Silver Medal, National Sculpture Society, 1968. Specialty: Portraits and home and garden fountains. Media: Bronze, marble. Address in 1982, Staten Island, NY.

LORING, CHARLES GREELEY.
Painter. Born in 1828. He died in 1902.

LORING, FRANCIS WILLIAM.
Painter. Born in Boston, MA, in 1838. He studied in Europe and died in Meran, Austria, in 1905. His painting "The Bridge of Chioggia" is dated 1886, and is owned by the Boston Museum of Fine Arts.

LORING, WILLIAM CUSHING.
Painter and teacher. Born in Newton Center, MA, Aug. 10, 1879. Studied in New York, Boston, London and Paris. Member: Boston Art Club; American Federation of Arts; Prov. Art Club. Represented in Brown University; Rhode Island State House; Rhode Island School of Design; Harvard University; and numerous institutions in New York City. Contributor of articles to magazines on subjects related to American Art. Address in 1929, Kirkside, Wayland, MA; 687 Boylston St., Boston, MA.

LORNE, NAOMI.
Painter. Born in NYC. Studied: City College of NY; Hunter College; and with A.T. Hibbard, George Bridgman and Frederick J. Waugh. Work: Staten Island Hospital; General Steel Corporation; American Cyanamid Company; Ain-Harod Museum, Israel; Maryknoll Teachers College; Society of Independent Artists; Everhart Museum; Architectural League; Argent Galleries; National Arts Club; NY Public Library; National Academy of Design; Brooklyn Museum; Penna. Academy of Fine Arts; American Academy of Arts and Letters; Carnegie Institute; others. Exhibitions: Canton Art Institute; Butler Art Institute; Pennsylvania State Museum; High Museum of Art, Atlanta; Brooks Memorial Art Gallery, Memphis; Albany Institute of History and Art; Riverside Museum; Stedelijk Museum; museums in Amsterdam, Brussels, Antwerp and Ostand; many others. One-woman exhibitions: Vendome Galleries, NY; Beryl Lush Galleries, NYC and Philadelphia, PA; Long Ridge Gallery, Stamford, CT; Kent State University; others. Awards: Cooper prize, National Association of Women Artists, 1947, Rose Metzger Award, 1956; bronze medal, Audubon Artists, 1944, 47; Heydenryk Award, Silvermine Guild of Connecticut, 1956. Member: Fellow, International Institute of Arts and Letters; NY Society of Women Artists (director); National Association of Women Artists; Audubon Artists; Artists Equity Association (director of NY chapter, 1953-54); Silvermine Guild of Connecticut; others. Address of studio in 1962, 124 E. 24th Street, NYC; 8 E. 23rd Street, NYC.

LORRAINE, ALMA ROYER.
Painter and teacher. Born in Randolph, OH. Pupil of Art Institute of Chicago; Alexandra Harrison; Bouguereau in Paris; Molinari in Rome. Award: Silver medal, Alaska-Yukon-Pacific Expo., Seattle, 1909. Work: "Aqueducts of Claudius," West Chester Seminary. Specialty: Oil portraits and studies of animals. Address in 1929, 1617 California Ave., Seattle, WA.

LORRAINE, HELEN LOUISE.
Medical illustrator. Born in Webster Grove, MO, June 23, 1892. Pupil of Nora Houston, Adele Clark and Max Brodel; Richmond School of Art; Johns Hopkins Medical School, Department of Art as applied to Medicine. Work: College of Physicians, Philadelphia, PA. Exhibited: Southern Surgical Association; American Medical Association; Medical Society of Virginia; Exhibition by Modern Medicine, medical illustrators. Illustrated numerous medical, operative, and surgical publications. Head of Medical Illustration Department, St. Elizabeth's Hospital, Richmond, VA, 1915-45. Member: Association of Medical Illustrators; honorary member of Medical Artists Association of Great Britain; Art Center Club. Address in 1953, Richmond, VA.

LOS, NAUM MICHEL.
Sculptor and teacher. Born in Novomoskovsk, Russia, Oct. 19, 1882. Studied: Royal Academy of Fine Arts, Berlin, Germany; University of Lausanne, Switzerland; pupil of Paul Du Bois and Victor Rousseau. Work: Bust of Oscar Browning, Kings College, Cambridge, England; bronze portrait bust and portrait plaquette, President of French Institute in U.S., Museum of French Art, NY; other portrait busts in Rome and U.S. Exhibited: Golden Gate Expo., 1939, San Francisco; National Academy of Design; National Sculpture Society; Penna. Academy of Fine Arts. Taught: Instructor of sculpture, drawing, painting, and anatomy, Naum Los School of Art, NYC, in 1953. Address in 1953, 22 East 60th Street, NYC.

LOSSING, BENSON JOHN.
Illustrator. Born Feb. 12, 1813 in Beekman, NY. He made numerous drawings for illustrating his *Field Book of the Revolution*. He died in Dover Plains, NY, June 3, 1891. Was editor of *Poughkeepsie Casket*, and was taught wood engraving by his engraver, J. A. Adams. (See "Biographical Notice" of Lossing, prepared for the Worcester Society of Antiquity in 1892.)

LOTARE, CARL.
Painter. Died in 1924. Painter of American Indian subjects; he also did some mural painting.

LOTHROP, KRISTIN CURTIS.
Sculptor. Born in Tucson, AZ, Feb. 8, 1930. Studied: Bennington College, BA; sculpture with George Demetrios, 4 years. Exhibitions: Hudson Valley Art

Association, 1968; National Sculpture Society, 1967-71; National Academy of Design, 1968-71; Allied Artists of America, 1969. Awards: Mrs. Louis Bennett Award, National Sculpture Society, 1967; Thomas R. Proctor Award, National Academy of Design, 1968; Daniel Chester French Award, 1970. Member: New England Sculptors Association; National Sculpture Society. Media: Bronze, wood, and stone. Address in 1982, Manchester, MA.

LOUD, H. C.
Crayon portrait draughtsman who was working in Philadelphia about 1850.

LOUD, MARION V.
Painter, writer, lecturer and teacher. Born in Medford, MA, Oct. 6, 1880. Pupil of Denman Ross; Eben Comins; John Wicker; H. H. Clarke; Deborah Kallen; Lawrence Grant. Member: Detroit Society of Women Painters; Society of Arts and Crafts. Award: Hon. mention, Detroit Federation of Women's Clubs, Independent Show, 1924. Illustrated "A Picnic On a Pyramid," by M. V. Loud. Address in 1929, 2555 Burns Ave.; h. 46 Davenport St., Detroit, MI.

LOUDERBACK, WALT.
Illustrator. Born in Valparaiso, IN, in 1887. Pupil of Art Institute of Chicago. Member: Salma. Club; National Arts Club; Artists Guild of the Authors' League of America, NY. Died in 1941. Address in 1929, care of Will Perrin, Hearst's International Magazine, 119 West 40th St.; 266 West 12th St., New York, NY.

LOVE, G.
Engraver. This name as engraver is appended to a frontispiece to Watts' "Divine Songs," published in Philadelphia in 1807 by L. Johnson.

LOVE, G(EORGE) PATERSON.
Painter, illustrator, and etcher. Born in Providence, RI, March 28, 1887. Pupil of Edmund C. Tarbell and Frank W. Benson. Member: Boston Art Club; Copley Society; Providence Art Club; Providence Water Color Club; American Federation of Arts. Address in 1929, 270 Boylston St., Boston, MA; h. 29 Waterman St., Providence, RI.

LOVEGROVE, STANLEY D.
Painter, illustrator, and etcher. Born in East Orange, NJ, Feb. 19, 1881. Pupil of Thomas Anshutz at Penna. Academy of Fine Arts. Member: Philadelphia Sketch Club; Philadelphia Alliance; Philadelphia Water Color Club; Philadelphia Printmakers Club. Address in 1929, Evening Bulletin, City Hall Sq.; h. Philadelphia Sketch Club, 235 S. Camac St., Philadelphia, PA.

LOVELAND, JOHN WINTHROP.
Sculptor and painter. Born in West Pittston, PA, Oct. 1, 1866. Pupil of Swain Art School, New Bedford, MA, under Harry Neyland. Member: Washington Society of Artists. Address in 1933, Wardman Park Hotel, Washington, DC; summer, Nantucket, MA.

LOVELL, KATHARINE ADAMS.
Painter. Born in New York City. Pupil of Pratt Institute; W. M. Chase, C. W. Hawthorne, John Carlson. Member: National Association of Women Painters and Sculptors; Pen and Brush Club of NY; Brooklyn Society of Artists; Brooklyn Painters and Sculptors. Address in 1929, 32 St. Paul's Pl., Brooklyn, NY.

LOVELL, TOM.
Illustrator. Born in NYC in 1909. Received his BFA in 1931 from Syracuse University. In 1930 his first illustrations were published in a book entitled *Gangster Stories.* He has illustrated for all the major magazines and has won two gold medals from the Society of Illustrators, two from the National Cowboy Hall of Fame, and the Syracuse Centennial Gold Medal in 1970. His works are owned by the New Britain Museum of American Art, USMC Headquarters, and the National Cowboy Hall of Fame in Oklahoma City.

LOVEN, FRANK W.
Painter and illustrator. Born in Jersey City, NJ, Oct. 2, 1868. Pupil of Birge Harrison, F. V. Du Mond and John Carlson. Member: Salma. Club. Represented in Hoboken Public Library. Address in 1929, 3435 Boulevard, Jersey City, NJ.

LOVET-LORSKI, BORIS.
Sculptor. Born in Lithuania, December 25, 1894. Studied: Academy of Art, St. Petersburg, Russia. Member: Academician, National Academy; fellow, National Sculpture Society; Lotos Club. Awarded: Knight of the Legion of Honor, 1948. Work: British Museum, London; Metropolitan Museum of Art; Dumbarton Oaks; San Diego Fine Arts Association; Los Angeles Museum of Art; Seattle Art Museum; San Francisco Museum of Art; sculpture and mosaics for Chapel of American War Memorial, Manila, Philippines; bronze head of Gen. DeGaulle, for City Hall, Paris, France, 1959-60; heroic size bronze head of John Foster Dulles, for Washington International Airport; others. Had exhibited at Salon d'Automne; Tuileries; also one-man in NYC, London, Manila, Philadelphia, and Caracas. Address in 1970, 131 East 69th Street, NYC. Died in 1973.

LOVETT, ROBERT.
Born 1796 in NYC. According to *Poulson's Advertiser,* Lovett was an engraver upon metal and stone, located in Philadelphia in 1816-22, inclusive. He was principally engaged in engraving seals and dies. He moved to New York about 1825, but later returned to Philadelphia.

LOVETT, WILLIAM.
Portrait and miniature painter of Boston, MA. Born in 1773. His work was excellent, as shown by his miniature of Rev. John Clarke, at one time owned by the Essex Institute of Salem, MA. He died in 1801.

LOVINS, HENRY.
Painter, craftsman, writer, lecturer and teacher. Born in New York City, March 12, 1883. Pupil of Jean Mannheim, William M. Chase, Robert Henri, Edgar L. Hewett; College of City of New York, BS; NY School of Fine and Applied Arts. Member: American Federation of Arts; California Art Club; Los Angeles Painters and Sculptors; International Artists Club, Los Angeles; Artland Club, Los Angeles. Work: Mayan Indian murals and windows, San Diego Museum, San Diego, CA; "City of the Sun," Mayan Priests and figure glyphs, Santa Fe Museum, Santa Fe, NM; "The Miracle Man," Southwest Museum, Los Angeles; Aztec, Mayan, American Indian, Chinese, Egyptian, Persian murals and decorations, Whitley Park Country Club, Hollywood; marine decorations and windows, Sea Breeze Beach Club, Santa Monica, CA; San Diego Fine Arts Society; Museum of New Mexico, Santa Fe; others. Exhibited: Los Angeles Museum of Art; Los Angeles Art Association; Pan.-Pacific Expo., 1915; Golden Gate Expo., San Francisco, 1939; Denver Art Museum; Laguna Beach Art Association; others. Contributor to art and architectural magazines. Address in 1953, Hollywood, CA.

LOW, MARY FAIRCHILD MacMONNIES.
(Mrs. Will H. Low). Painter. Born in New Haven, CT, Aug. 11, 1858. Pupil of St. Louis School of Fine Arts; Carolus-Duran and Julian Academy in Paris. Member: Society of American Artists, 1896; Associate National Academy of Design, 1906; International Woman's Art Club, London; Assoc. Soc. Nat. des Beaux Arts. Awards: Paris, three years' scholarship from St. Louis School of Fine Arts; medal, Columbian Expo., Chicago, 1893; bronze medal, Paris Expo., 1900; bronze medal, Pan-Am. Expo., Buffalo, 1901; gold medal, Dresden, 1902; Julia Shaw prize, Society of American Artists, 1902; gold medal, Normandy Expo., Rouen, 1903; gold medal, Marseilles, 1905. Represented in Museum at Rouen, France; Union League Club, Chicago; City Art Museum, St. Louis; Museum of Vernon, France; Art Institute of Chicago. Died May 23, 1946. Address in 1933, Bronxville, NY.

LOW, WILL H(ICOK).
Painter, illustrator, teacher, writer, and lecturer. Born in Albany, NY, May 31, 1853. Pupil of Ecole des Beaux-Arts, under Gerome, and of Carolus-Duran in Paris. Member: Associate National Academy of Design, 1888, Academician National Academy, 1890; Society of American Artists, NY, 1878; National Society of Mural Painters, NY; NY Architectural League, 1889; Century Association; Lotos Club; National Institute of Arts and Letters. Member: International Jury of Awards, St. Louis Expo., 1904. Awards: Silver medal for drawing, Paris Expo., 1889; medal, Columbian Expo., Chicago, 1893; Lotos Club Fund, National Academy of Design, 1895; silver medal, Pan-Am. Expo., Buffalo, 1901. Work: "The Orange Vender" and 60 drawings, Art Institute of Chicago; "Christmas Morn," National Gallery, Washington; "Aurora," Metropolitan Museum, New York, NY; mural decorations, ceiling of reception room and ballroom, Waldorf-Astoria Hotel, New York; panels in Essex Co. Court House, Newark, NJ; Luzerne Co. Court House, Wilkes-Barre, PA; Federal Building, Cleveland; St. Paul's P.E. Church, Albany, NY; "The Sylvan Year," Art Museum, Montclair, NJ; 32 panels in State Education Building, Albany, NY; Frieze in Legislative Library, NY State Capitol; decorative painting, "Victory 1918," Columbia University. Author: *A Chronicle of Friendship* and *A Painter's Progress.* Delivered Scammon course of lectures, Art Institute of Chicago, 1910. Died in 1932. Address in 1929, Lawrence Park, Bronxville, NY.

LOWDON, ELSIE MOTZ.
Miniature painter. Born in Waco, TX. Pupil of Art Students League of NY; American School of Miniature Painters. Member: National Association of Women Painters and Sculptors; Southern States Art League. Award: Balch prize ($200) and popular vote award, Los Angeles Museum, 1927. Address in 1929, 424 East 57th St., New York, NY.

LOWE, ALICE LESZINSKA.
See Ferguson, Alice L. L.

LOWE, R.
This man was working as a commercial engraver on copper in 1851, his office being at 104 Broadway, NY. He engraved diplomas, etc.

LOWELL, NAT.
Etcher, lecturer and teacher. Born in Riga, Latvia, Nov. 3, 1880. Pupil of Carroll Beckwith, Siddons Mowbray. Represented by etchings in the Metropolitan Museum of Art, New York; New York Public Library. Address in 1929, Monsey, NY.

LOWELL, ORSON BYRON.
Illustrator and cartoonist. Born in Wyoming, IA, Dec. 22, 1871. Pupil of Vanderpoel and Grover at Art Institute of Chicago, 1887-1893. Member: Society of Illustrators, 1901; Artists Guild of the Authors' League of America, NY; New Rochelle Art Association. Work: Illustrations in a number of American periodicals; original drawings in Cincinnati Museum; La Crosse (WI) Art Association; Maryland Institute, Baltimore; Mechanics' Institute, Rochester. Best known for his social cartoons, drawings, paint-

ings and posters. Illustrated *The Court of Boyville*, W.A. White (Doubleday, 1899), and *Love in Old Clothes*, H. C. Brunner (Scribner's, 1896). Died in 1956. Address in 1953, Rochelle Park, New Rochelle, NY.

LOWELL, SHELLEY.
Sculptor and painter. Born in 1946. Studied: Pratt Institute, Brooklyn, NY. Exhibitions: The Erotic Art Gallery, NYC; International Museum of Erotic Art, San Francisco, CA; The Bronx Museum of Art, Bronx, NY, 1975. In the collection of Memorial Sloan-Kettering Cancer Center, NYC.

LOWENGRUND, MARGARET.
Painter and etcher. Born in Philadelphia, PA. Pupil of Joseph Pennell. Member: Art Students League of NY. Died in 1957. Address in 1929, 19 East 59th St., New York, NY.

LOWENHEIM, F(REDERICK).
Illustrator. Born in Berlin, Germany. Pupil of Kunst-Schule, Berlin; Art Institute of Chicago. Member: Society of Illustrators, 1911; Salma. Club, 1911; Artists Guild of the Authors' League of America, NY; New Rochelle Art Association; American Federation of Arts. Address in 1929, 38 Premium River Road, Hazelhurst, New Rochelle, NY.

LOWERY, ROBERT S.
Illustrator. Born in Birmingham, AL, in 1950. Received a scholarship to the Art Students League to study under Steven Kidd and Leslie Willett. He began his career as a sports artist with a pen and ink drawing of Muhammand Ali for *The New York Times*. Madison Square Garden has subsequently commissioned him to produce fight posters and his works have appeared in *Ring Magazine* as well as in NFL and NBA stories for *The New York Times*. His work is in the collections at the NY Jazz Museum, Madison Square Garden and Art Students League.

LOWNES, CALEB.
Engraver. The *Pennsylvania Magazine*, Philadelphia, 1775, contains a fairly well-engraved line plate of a "New Plan of Boston Harbour," signed C. Lownes, Sculp. This Caleb Lownes was a die-sinker and sealcutter in business in Philadelphia, and was a prominent citizen of that city. In 1779, according to the Minutes of the Supreme Executive Council, he cut a seal for the Pennsylvania Board of Admiralty.

LOWREY, ROSALIE.
Painter and illustrator. Born in Dayton, OH, February 27, 1893. Pupil of Art Students League of NY; Dayton Art Institute; Penna. Academy of Fine Arts. Member: Ohio Water Color Society. Work: "Portrait of Leola Clark," Patterson School, Dayton; "Portrait of Grace Greene," Dayton Junior Teachers' College, Dayton. Illustrated *Our Little Folks* (U. B. Publish-

ing House). Address in 1929, 1035 Harvard Blvd., Dayton, OH.

LOZOWICK, LOUIS.
Painter, illustrator, etcher, writer, and lecturer. Born in Russia, January, 1892. Studied: National Academy of Design; Ohio State University; in France and Germany. Exhibitions:Carnegie Institute, Pittsburgh; Penna. Academy of Fine Arts; Museum of Modern Art; retrospective, Whitney, 1972; first one-man show held in Berlin, 1923. Member: National Academy of Design. Work in Library of Congress, Washington, DC. Author of *Modern Russian Art*. Illustrations in *Nation, Theatre Arts Monthly*, and *Herald-Tribune*. Died in 1973. Address in 1929, 792 Lexington Ave., New York, NY.

LUCAS, ALBERT PIKE.
Sculptor and painter. Born in Jersey City, NJ, in 1862. Pupil of Hebert, Boulanger, Dagnan-Bouveret and Courtois in Paris. Member: Academician, National Academy Design, 1927; Societe Nationale des Beaux-Arts, Paris; National Arts Club; Lotos Club; Allied Artists of America; Salmagundi Club; National Sculpture Society; Fine Arts Federation of NY; Society of Painters of NY. Awards: Honorable mention, Paris Expo., 1900; bronze medal, Pan-Am. Expo., Buffalo, 1901; Isidor prize, Allied Artists of America, 1931. Work: "October Breezes," National Gallery, Washington; "Ecstasy," marble bust, Metropolitan Museum, NY. Address in 1933, 1947 Broadway, NYC. Died in 1945.

LUCAS, JEAN W(ILLIAMS).
Painter and teacher. Born in Hagerstown, MD, August 5, 1873. Pupil of Henri, Daingerfield and Whittemore. Member: National Association of Women Painters and Sculptors; Pennsylvania Society of Miniature Painters. Award: Honorable mention for miniature, P.-P. Expo., San Francisco, 1915. Address in 1929, Penn Hall School, Chambersburg, PA; 20 Broadway, Hagerstown, MD.

LUCCEARINI, JOHN.
Statue moulder. Born in Italy in 1830. Living with his brother Andrew Luccearini in Washington, DC, in June, 1860.

LUCCHESI, BRUNO.
Sculptor. Born in Lucca, Italy, July 31, 1926; U.S. citizen. Studied at Institute Arte, Lucca, M.F.A., 1953. Work in Penna. Academy of Fine Arts; Dallas Museum of Fine Arts; Hirshhorn Museum; Whitney Museum of American Art, NY; others. Has exhibited at Whitney Museum of American Art; Penna. Academy of Fine Arts; Corcoran Gallery of Art; Brooklyn Museum, NY. Member of Sculptors Guild; Artists Equity Association; National Academy of Design; National Sculpture Society. Received Watrous Gold Medal, National Academy of Design, 1961; gold

medal, National Arts Club, 1963; S. F. B. Morse Medal, National Academy of Design, 1965; others. Teaching at New School for Social Research, from 1962, instructor. Address in 1982, 14 Stuyvesant Street, NYC.

LUCE, LAURA H.
Landscape painter, teacher, and lecturer. Born in Salem, NY, June 19, 1845. Pupil of A. H. Wyant, C. B. Coman and H. B. Snell in New York. Member: National Association of Women Painters and Sculptors. Address in 1929, 120 East Main St., Titusville, PA.

LUCE, LEONARD E.
Painter and illustrator. Born in Ashtabula, OH, Sept. 27, 1893. Pupil of Gottwald, Keller and DuMond. Member: Cleveland Society of Artists. Address in 1929, Keith Bldg., Euclid at 17th St.; h. 3291 Yorkshire Road, Cleveland, OH.

LUCE, MARIE HUXFORD (MRS.).
Painter. Born in Skaneateles, NY. Pupil of J. S. H. Keever in Holland; Mr. and Mrs. Charles H. Woodbury in Boston. Member: NY Water Color Club; American Federation of Arts. Address in 1929, Viale Duca di Genova, 36, Florence, Italy; Skaneateles, NY.

LUCE, MOLLY.
(Mrs. Alan Burroughs). Painter. Born in Pittsburgh, PA, Dec. 18, 1896. Pupil of Kenneth Hayes Miller. Member: NYS Women Artists; Art Students League of NY. Died before 1940. Address in 1929, 27 Wellington Lane, Belmont, MA.

LUCHTEMEYER, EDWARD A.
Painter and illustrator. Born in St. Louis, MO, Nov. 19, 1887. Self-taught. Member: St. Louis Art League; St. Louis Artists Guild; Oakland Art League. Represented in all branch libraries in St. Louis; also St. Louis Art League. Address in 1929, 817 Newport Ave., Webster Groves, MO.

LUCIONI, LUIGI.
Painter and etcher. Born in Malnate, Italy, Nov. 4, 1900. Pupil of William Starkweather. Member: Allied Artists of America; Brooklyn Society of Etchers. Awards: Bronze medal, L. C. Tiffany Foundation, New York, 1928; medal of honor, Allied Artists of America, New York, 1929. Work: "Interior," High Museum, Atlanta, GA. Address in 1929, 64 Washington Sq., South, New York, NY; h. 403 New York Ave., Union City, NJ.

LUDEKENS, FRED.
Illustrator. Born in Huoneme, CA, in 1900. Grew up in Canada and studied art briefly in California. He began as an artist for a San Francisco ad agency and went on to become an art director for Lord and Thomas. In 1931 he came to NY and launched a second career as an editorial illustrator for the major magazines, among them *The Saturday Evening Post*. His illustrations of Western towns were particularly popular, as well as his more recent science fiction work. He headed the Famous Artists School in the 1960's while holding a creative position at Foote, Cone and Belding.

LUDOVICI, ALICE E.
Painter. Born in Dresden, Germany, Nov. 7, 1872. Pupil of Julius Ludovici in NY; studied in Europe. Member: California Society of Miniature Painters; American Federation of Arts. Awards: Silver medal for miniatures, Alaska-Yukon-Pacific Expo., Seattle, 1909; gold medal for miniatures, California Society of Miniatures Painters, 1914; gold medal, Pan.-Calif. Expo., San Diego, 1915, for miniatures. Specialty, pastel portraits and miniatures on ivory. Address in 1929, 167 North Orange Grove Ave., Pasadena, CA.

LUFKIN, LEE.
See Kaula, Lee Lufkin.

LUGANO, INES SOMENZINI.
Painter. Born in Verretto, Pavia, Italy. Studied: Academy of Fine Arts, Pavia, Italy; and with Romeo Borgognoni. Known as a miniature and portrait painter. Awards: National Exhibition, Milano, Italy; California Society of Miniature Painters, 1935; New Orleans Art Association, 1939. Collections: Tulane University; Delgado Museum of Art.

LUINI, COSTANZO.
Sculptor and craftsman. Born in Milan, Italy, August 31, 1886. Pupil of Aitken and MacCartan. Member: New York Architectural League; American Federation of Arts; Boston Society of Arts and Crafts; Art League of Nassau County. Works: Medals, Walter Scott, T. Edison, T. Vail, Societe des Femmes de France of NY; Gen. Pershing; Wall Tablet for U.S. Naval Academy. Exhibited: National Academy of Design, Annual Exhibition, 1925. Address in 1933, Elmhurst, Long Island, NY.

LUISI, JERRY.
Sculptor and instructor. Born in Minneapolis, MN, October 7, 1939. Studied at National Academy of Design; Art Students League. Work in National Academy of Design, NY; others. Has exhibited at National Academy of Design; Allied Artists of America; National Sculpture Society; Salmagundi Club; others. Received Greenshields Foundation Grant, 1972 and 75; Anna Hyatt Huntington Award, Hudson Valley Art Association, 1980; John Gregory Award, National Sculpture Society, 1980; others. Member of National Sculpture Society; life member of Art Students League; Artists Equity Association. Teaching sculpture at Fashion Institute of Technology, from 1972, and at National Academy of Design, from 1979. Address in 1982, 37 E. 28th St., NYC.

LUKE, WILLIAM.

Figurehead carver. Born in Portsmouth, VA, 1790. Active in 1822. A noted work is his figure of "Tamanend." Reportedly worked in the Gosport Navy Yard and carved for many Navy ships.

LUKEMAN, (HENRY) AUGUSTUS.

Sculptor. Born in Richmond, VA, Jan. 28, 1872. Pupil of Launt Thompson and D. C. French in NY; Ecole des Beaux-Arts in Paris, under Falguiere. Member: Associate, National Academy of Design, 1909; NY Architectural League, 1898; National Sculpture Society, 1898. Award: Bronze medal, St. Louis Expo., 1904. Work: "McKinley," Adams, MA, and Dayton, OH; "Manu," Appellate Court, NY; four figures, Royal Bank Building, Montreal; four figures, Brooklyn Institute Museum; Columbus Custom House; "Professor Joseph Henry," Princeton University; "Kit Carson," Trinidad, CO; Straus Memorial, NY, 1915; U. S. Grant Memorial, San Diego, CA; Soldiers' monument, Somerville, MA; statue, "Franklin Pierce," Concord, NH; "Women of the Confederacy," monument, Raleigh, NC; "Gen. Wm. Shepard," Westfield, MA; "Honor Roll," Prospect Park, Brooklyn, NY; "Soldiers' Memorial," Red Hook Park, Brooklyn, NY; Equestrian Statue, Francis Asbury, WA; Francis Asbury, Drew Seminary, Madison, NJ; General Gregg, Reading, PA; War Memorial, Pittsfield, MA; Masonic War Memorial, Elizabeth, PA; War Memorial, Wilmington, DE; Statues of Sen. James George and Jefferson Davis for Statuary Hall, Capitol, Washington; Stone Mountain Confederate Memorial, GA. Exhibited at National Sculpture Society, 1923. Address in 1933, 160 West 86th St., NYC; summer, Stockbridge, MA. Died in NY, 1935.

LUKIN, SVEN.

Painter and sculptor. Born on February 14, 1934, in Riga, Latvia. Studied architecture at University of Pennsylvania. Awarded Guggenheim fellowship, 1966. Exhibited at Nexus Gallery, Boston, 1959; Stedelijk Museum, Amsterdam, Holland, 1966; Betty Parsons Gallery, Martha Jackson Gallery, Whitney Museum, Guggenheim Museum, all in NYC; Des Moines Art Center, IA, 1968; Los Angeles County Museum of Art, 1978. In collections of Los Angeles County Museum; Albright-Knox Gallery, Buffalo, NY; University of Texas; Allentown (PA) Art Museum; Whitney, NYC; and Larry Aldrich Museum, Ridgefield, CT. Address in 1982, 807 Ave. of the Americas, NYC.

LUKITS, THEODORE NIKOLAI.

Painter, sculptor, illustrator and teacher. Studied: Art Institute of Chicago; St. Louis School of Fine Art. Member: International Art Club, Los Angeles; American Institute Fine Arts Society, CA; Laguna Beach Art Association; Riverside (CA) Art Association; Los Angeles Art Association; California Art Club; Society for Sanity in Art; American Artists Professional League. Awards: Brand Memorial Prize, 1918; Bryan Lathrop scholarship, 1919; prizes, Art Institute of Chicago, 1926, 27, 29; Los Angeles Museum of Art, 1937; medals, Painters and Sculptors of Los Angeles, 1942. Restored masterpiece (El Greco), 1925, at the Santa Barbara, CA, Mission. Position: President and Director of Lukits Academy of Fine Arts, Los Angeles. Address in 1953, Los Angeles, CA.

LUKS, GEORGE (BENJAMIN).

Painter. Born in Williamsport, PA, August 13, 1867. Pupil of Penna. Academy of Fine Arts and Dusseldorf Academy; studied in Paris and London. Member: National Association of Portrait Painters, NY; American Painters and Sculptors; NY Water Color Club; Boston Art Club. Awards: Fourth W. A. Clark prize ($500), and Corcoran hon. mention, 1916; Hudnut prize, NY Water Color Club, 1916; Temple gold medal, Penna. Academy of Fine Arts, 1918; Logan Medal, Art Institute of Chicago, 1920 and 1926; Locust Club gold medal, Philadelphia, 1927. Represented in Metropolitan Museum, NY; Delgado Museum, New Orleans; Milwaukee Art Institute; Detroit Art Institute; Cleveland Museum; Harrison Gallery, Los Angeles; Phillips Memorial Gallery, Washington, DC; New York Public Library; Barnes Museum, Philadelphia; Library, and murals for Neco Allen Hotel, Pottsville, PA. War Correspondent in Cuba, 1895-96. Died October 30, 1933 in NYC. Address in 1929, 141 East 57th St.; 693 Fifth Ave., New York, NY.

LUM, BERTHA.

Painter and etcher. Born in Iowa. Pupil of Art Institute of Chicago; Frank Holme and Anna Weston. Member: Boston Society of Arts and Crafts; California Society of Etchers; Asiatic Society of Japan; Alumni Art Institute of Chicago; California Print Maker's Society. Award: Silver medal, P.-P. Expo., San Francisco, 1915. Specialty: Wood block prints. Address in 1929, 136 St. Anne Alley, Chinatown; h. 3665 Washington St., San Francisco, CA; 44 Chiang Tsa, Hu Tang, Peking, China.

LUMIS, HARRIET R(ANDALL).

(Mrs. Fred W. Lumis). Painter. Born in Salem, CT, May 29, 1870. Pupil of Willis S. Adams; Leonard Ochtman; NY Summer School of Art; Hugh Breckenridge; E. P. Hayden. Member: Connecticut Academy of Fine Arts; Springfield Art League; Philadelphia Alliance; National Association of Women Painters and Sculptors; Gloucester Society of Artists. Award: Hon. mention, Connecticut Academy of Fine Arts, 1925. Work: "Autumn Woodland," Springfield Art Museum, Springfield, MA; "Spring in New England," Paseo High School, Kansas City, MO. Died in 1953. Address in 1929, 28 Bedford Road, Springfield, MA.

LUMPKINS, WILLIAM THOMAS.

Sculptor, painter, designer, and craftsman. Born in Marlow, OK, April 8, 1909. Studied at University of New Mexico; Colorado State College; University of California at Los Angeles; Texas Christian University. Work: Murals, Native Market, Santa Fe, NM; designed school, trade, and industrial buildings in Southwest. Exhibited: Palace of Legion of Honor, 1934; Southwest Annual, 1934-40, 46; Chappell House, Denver, CO, 1938; NY World's Fair, 1939; Paris Salon; Memphis, TN, 1945. Author, illustrator, "Modern Pueblo Homes." Address in 1953, Santa Fe, NM.

LUMSDON, CHRISTINE MARIE VOSS.

Painter, writer, lecturer, and teacher. Born in Brooklyn, NY. Pupil of Carolus-Duran, Henry Mosler, Childe Hassam and George de Forest Brush. Member: National Association of Women Painters and Sculptors; National Academy of Design (life); Society of Independent Artists; Brooklyn Institute of Art and Science. Award: Salon, Paris, 1904. Work: "Ideal Head of Our Lord," exhibited and reproduced; over 2,287 copies sold. Author, *La Belle Feroniere*, copyright drama. Lecturer on art subjects. Died in 1937. Address in 1933, Carnegie Studios, 154 West 57th St., New York, NY.

LUND, BELLE JENKS.

Painter. Born in Alexandria, SD, August 22, 1879. Pupil of F. F. Fursman; E. A. Rupprecht; E. Cameron; Art Institute of Chicago. Member: Indiana Art Club; Hoosier Salon; Alumni, Art Institute of Chicago. Work: "Dune Country," Kappa Sigma House, LaFayette, IN; "Lily Pond," Elk's Club, Hammond, IN; "Norwegian Landscape," Lake-Hills Country Club, Lake Co., IN. Address in 1929, 160 Waltham St., Hammond, IN.

LUND, THEODORE F.

Miniature painter. Flourished in NY, 1841-44. Exhibited 1836-37 under names H. Lund and F. Lund.

LUNDBERG, A. F.

Painter. Exhibited "Lawn Party" at the Penna. Academy of Fine Arts, Philadelphia, 1914. Address in 1926, 48 North Grant Ave., Columbus, OH.

LUNDBORG, FLORENCE.

Painter and illustrator. Born in San Francisco, CA. Studied at Mark Hopkins Institute of Art, and in Paris and Italy. Member: National Association of Women Painters and Sculptors; San Francisco Art Association; Gamut Club. Awards: Gold medal, San Francisco Art Association; bronze medal, P.-P. Expo., San Francisco, 1915. Work: Mural decorations for California building at Panama-Pacific Exposition; "Queen of Hearts," at Henriettes, Paris; Wadleigh High School, NYC. Illustrated *Rubaiyat, Yosemite Legends, Honey Bee, Odes and Sonnets,* etc. Died in 1949. Address in 1933, 12 East Eighth St., New York, NY.

LUNDEBERG, HELEN.

Painter. Born June 24, 1908 in Chicago. Studied with Lorser Feitelson, whom she married. Exhibited at Pasadena Art Museum, 1953; Long Beach Museum of Art; Scripps College; Museum of Modern Art; Carnegie Institute; Brooklyn Museum; Denver Art Museum; University of Illinois; Seattle Art Museum; San Francisco Museum of Fine Art; Museum of Art in Sao Paulo, Brazil. In collections of Los Angeles Co. Museum, Santa Barbara Museum and Chaffey College, all in California; Hirshhorn Museum and National Collection of Fine Arts, both in Washington, DC; San Francisco Museum of Art.

LUNDEEN, GEORGE W.

Sculptor. Born in Holdrege, Nebraska, in 1948. Studied art at Hastings College; University of Illinois, MFA sculpture; in Italy on Fulbright-Hays grant. Taught briefly in Nebraska; artist in residence, Texas A & M. Has exhibited at National Sculpture Society; National Academy of Design, New York City. Member of National Sculpture Society. Specialty is statuettes of people; works in bronze and terra-cotta. Reviewed in *Artists of the Rockies*, spring 1981. Represented by Driscol Gallery, Denver, CO; O'Brien's Art Emporium, Scottsdale, AZ. Address in 1982, Loveland, Colorado.

LUNDGREN, MARTIN.

Mural painter. Born in Sweden in 1871. Pupil of Art Institute of Chicago, and Louis Betts. Member: Palette and Chisel Club; Chicago No-Jury Society of Artists. Address in 1929, 5242 Bernard St., Chicago, IL.

LUNDIN, EMELIA A.

Painter. Born in Stockholm, Sweden, Jan. 16, 1884. Pupil of Paul Gustin, F. Tadema. Member: Seattle Fine Arts Society. Address in 1929, 8741 Dayton Ave., Seattle, WA.

LUNDQUIST, EINAR.

Painter. Born in Shovde, Sweden, August 4, 1901. Pupil of Daniel Garber; Art Institute of Chicago. Member: American Artists Professional League; Swedish-American Art Association. Awards: First prize for water color, Swedish-American Art Association, Chicago, 1929; 1st prize for water color, Swedish Club, Chicago, 1929. Address in 1929, 1512 Sixth St., Rockford, IL.

LUNG, ROWENA CLEMENT.

Sculptor and painter. Born in Tacoma, WA, March 27, 1905. Pupil of Parshall, Herter, Cooper, Armstrong, Cadorin, and Fletcher. Member: Society of Independent Artists; Tacoma Civic Art Association; Women Artists of Washington; others. Represented

in State Historical Building, College of Puget Sound, and Lowell School, Tacoma, WA. Director of Armstrong School of Art. Taught: Professor of art, College of Puget Sound, Tacoma, WA. Address in 1933, Tacoma, WA; summer, Vashon Island, WA.

LUNGREN, FERNAND HARVEY.
Painter and illustrator. Born in Toledo, OH, or Hagerstown, MD, Nov. 13, 1857/59. Attended the University of Maryland and the University of Michigan (engineering); studied art briefly in Cincinnati and then at the Penna. Academy of Fine Arts, with Thomas Eakins, and the Academie Julian in Paris. Sketched for the Santa Fe railroad in 1892, and in Arizona in 1893. Since that time, he devoted himself to desert scenes and the folklore of the Navajo, Moquis, and Apache. Moved to California in 1903 and settled in Santa Barbara in 1907. Lungren was one of the founders of the Santa Barbara School of Art. His most famous work is entitled "Thirst," published in 1896. Member: Santa Barbara Art League; Community Art Association (director); American Federation of Arts. Work: Stenzel collection; Earl C. Adams collection; Santa Barbara State College. Has illustrated for *Scribner's Magazine; Harper's; Century; St. Nicholas.* Address in 1929, Mission Canyon Road, Santa Barbara, CA. Died in Santa Barbara, CA, 1932.

LUPORI, PETER JOHN.
Sculptor and educator. Born in Pittsburgh, PA, December 12, 1918. Studied at Carnegie-Mellon University, B.F.A., 1942; University of Minnesota, M.S. (education), 1947; with Joseph Bailey Ellis and John Rood. Work in Walker Art Center, Minneapolis; Holy Childhood Church, St. Paul, MN; others. Has exhibited at Carnegie Institute of Art; Walker Art Center; Minneapolis Institute of Arts; St. Paul Museum of Art; others. Received 2nd award in sculpture, Prix de Rome, NY, 1941; Carnegie Institute Prize for Sculpture, Associated Artists of Pittsburgh, 1949; 2nd prize for sculpture, Local Artists Exhibition, Minneapolis Institute of Arts, 1953. Member of Artists Equity Association; Society of Minnesota Sculptors. Works in ceramic, wood, and welded metal sculpture. Address in 1982, c/o Dept. of Art, College of St. Catherine, St. Paul, MN.

LUPTON, FRANCES PLATT TOWNSEND (MRS.).
Sculptor, miniaturist, and landscape painter. According to Dunlap, in his "History of the Arts," a Mrs. Lupton modeled and presented a bust of Governor Throop to the National Academy of Design. Also exhibited at the National Academy of Design in 1828, 29, and 31.

LUQUIENS, ELIZABETH KOLL.
Painter. Born in Salem, Ohio, Jan. 19, 1878. Pupil of Albert G. Thompson; Delecluse and Mucha in Paris.

Member: New Haven Paint and Clay Club; Connecticut Academy of Fine Arts. Address in 1929, 189 East Rock Road, New Haven, CT; summer, Waterville, NH.

LUQUIENS, HUC MAZELET.
Painter and etcher. Born in Auburndale, MA, June 30, 1881. Pupil of Bonnat and Merson in Paris. Member: Chicago Society of Etchers; Connecticut Academy of Fine Arts; New Haven Paint and Clay Club; California Society of Etchers; Honolulu Art Association. Award: Winchester fellowship, Yale Art School, 1904; first prize, New Haven Paint and Clay Club, 1925. Represented by etchings in the New York Public Library; National Museum, Washington, DC; Yale School of the Fine Arts Museum, New Haven, CT; Academy of Arts, Honolulu, HI. Instructor of art, University of Hawaii. Died in 1961. Address in 1929, 1646 Bingham St., Honolulu, HI.

LUSH, VIVIAN.
(Mrs. Vivian Lush Piccirilli). Sculptor. Born in NYC, August 3, 1911. Studied: Leonardo da Vinci Art School; National Academy of Design; Art Students League; also with Attilio Piccirilli, Charles Keck, and Robert Aitken. Award: National Association of Women Artists. Collections: Riverside Church, NY; Rockefeller Center, NY; Port Richmond High School; Unity Hospital, Brooklyn, NY; Roosevelt High School, Bronx, NY; Children's Wing, Public Library, Trinidad, British West Indies. Member: National Association of Women Artists. Address in 1953, Bronx, NY.

LUTHER, JESSIE.
Sculptor, painter, craftsman, writer, lecturer, and teacher. Born in Providence, RI, Nov. 3, 1860. Pupil of S. R. Burleigh; Paul Bartlett and Raphael Collin in Paris. Member: Providence Art Club; Boston Society of Arts and Crafts; Providence Handicraft Club; Philadelphia Arts and Crafts Guild; Boston Weavers Guild. Address in 1929, East Providence, RI; h. Providence, RI.

LUX, GWEN (CREIGHTON).
(Gwen Lux Creighton). Sculptor. Born in Chicago, IL. Studied: Maryland Institute of Arts; Boston Museum of Fine Arts School; later in Paris; and with Ivan Mestrovic, in Yugoslavia. Awards: Guggenheim fellowship, 1933; Detroit Institute of Art, 1945, 1956; National Lithograph prize, 1947; National Association of Women Artists, 1947; Audubon Artists, 1954; Architectural League, 1958; others. Collections: Association of American Artists; Radio City, NY; McGraw-Hill Building, Chicago; University of Arkansas; Victoria Theatre, NY; Bristol (TN) Hospital; Steamship *United States*; Texas Petroleum Club, Dallas; Northland Shopping Center, Detroit; General Wingate School, Brooklyn; General Motors Research Center, Detroit; Socony Building, NYC; R. H. Macy-

Roosevelt Field, NY; Public School 19, NYC; Aviation Trades High School, Long Island, NY; Detroit Museum; Country Day School, Lake Placid, NY. Member: Hawaii Artists and Sculptors League. Exhibited: Whitney, 1935; Detroit Museum, 1948; Pomeroy Galleries, San Francisco, 1968; Contemporary Arts Center, Honolulu, 1970; Downtown Gallery, Honolulu, 1976; others. Media: Concrete, various metals, polyester resin. Address in 1982, Honolulu, HI.

LUZAK, DENNIS.
Illustrator. Born in Chicago in 1939. Received his B.F.A. from the University of Notre Dame in 1961. He began his career as a designer for Chrysler and Ford Motor Co., but in 1969 joined the staff of Jack O'Grady Studios in Chicago. Later he moved to NY where his illustrations have appeared in major magazines and books as well as in the Society of Illustrators Annual Exhibition.

LYBRAND, JACOB.
Engraver. About 1820, J. Lybrand neatly engraved in line a view of the Gilpin paper-mill, on Brandywine Creek, PA, after a drawing by B. K. Fox. Possibly a little earlier than this he was engraving in connection with R. Campbell, of Philadelphia; these latter plates were also in line, but very simple in character.

LYE, LEN.
Sculptor. Born July 5, 1901, in Christchurch, New Zealand. Came to U.S. in 1948. Studied: Wellington Technical College; Canterbury College of Fine Arts. Began work in kinetic construction in 1920's. Work: Albright; Art Institute of Chicago; Whitney Museum. Exhibited: London Film Society, 1928; Museum of Modern Art, Motion Sculpture, 1961, and Albright, 1965; Stedelijk, Art in Motion, 1961-62; Whitney Museum Annual, 1962; The Howard Wise Gallery, NYC, On The Move, 1963. Taught: City College of New York (film technique); NYU. Received international awards for experimental films, Brussels, Belgium, 1958; National Endowment for the Arts Grant, 1979. Address in 1982, 41 Bethune St., NYC.

LYFORD, CABOT.
Sculptor and painter. Born in Sayre, PA, May 22, 1925. Studied at Skowhegan School of Art, summer 1947; Cornell University, B.F.A., 1950; Sculpture Center, NY, 1950-51. Work in Addison Gallery of American Art, Andover, MA; Wichita Museum, Kansas; Harbor Sculpture (black granite), Portsmouth, NH; others. Has exhibited at Payson Museum, Portland, ME; Addison Gallery, Andover, MA; Fitchburg Art Museum; others. Teaching sculpture at Phillips Exeter Academy, NH, from 1963. Works in stone and metal; watercolor. Address in 1982, Exeter, NH.

LYMAN, JOSEPH.
Painter. Born in Ravenna, OH, on July 17, 1843. He visited Europe for study, and on his return to New York was elected an Associate of the National Academy of Design, 1866. His most important paintings are "Summer Night," "Moonlight," "Sunset on the Maine Coast," and "Waiting for the Tide." He died March 5, 1913 in Wallingford, CT.

LYMAN, MARY ELIZABETH.
Painter. Born in Middlefield, CT, Dec. 2, 1850. Pupil of Bail, Yale School of Fine Arts, and John H. Niemeyer. Member: New Haven Paint and Clay Club. Address in 1929, Middlefield, CT.

LYMAN, SYLVESTER S.
Born in Easthampton, MA, Sept. 24, 1813. He first painted portraits, and later landscapes. He worked largely in Hartford, CT.

LYNCH, ANNA.
Miniature painter. Born in Elgin, IL. Pupil of Art Institute of Chicago; Bouguereau, Simon, Cottet and Mme. Debillemont in Paris. Member: Alumni Art Institute of Chicago; Chicago Painters and Sculptors; Pennsylvania Society of Miniature Painters; Chicago City Commission for Public Art; Paris American Woman's Art Association; Chicago Art Club; Chicago Society of Miniature Painters; Cordon Club; Chicago Galleries Association. Awards: Miniature prize, Chicago Art Club; bronze medal, P.-P. Expo., San Francisco, 1915; hon. mention, Art Institute of Chicago; award of merit, Chicago Art Institute Alumni; purchase prize, Arche Club; three purchase prizes, Chicago Galleries Association, 1927. Work: Portrait of Judge Joseph E. Gary, Chicago Court House; portrait of Judge Arba E. Waterman, Memorial Hall, Chicago; two paintings, City Commission, Chicago. Address in 1933, Tree Studio Annex, 9 E. Ontario St., Chicago, IL; h. 54 South Crystal St., Elgin, IL.

LYNCH, MARY BRITTEN.
Painter. Born in Pruden, KY, on Sept. 30, 1933. Studied: University of Tennessee at Chattanooga. Awards: National Association of Women Artists Annual, National Academy Galleries, NYC; Tennessee All-State, Nashville, TN; 4th Annual Print and Drawing Exhibitions, Arkansas Art Center, Little Rock. She has exhibited widely in the Southeastern U.S. and has been very active in the Tennessee Watercolor Society. Media: Acrylic and watercolor. Address in 1980, 1505 Woodnymph Trail, Lookout Mountain, TN.

LYNCH, VIRGINIA.
Painter, writer, lecturer, and teacher. Born in New York City. Pupil of Julius Schledorn; Art Students League of NY; studied in China and Japan. Member: National Arts Club; National Association of Women

Painters and Sculptors; C. L. Wolfe Art Club. Award: Watercolor prize, C. L. Wolfe Art Club, 1922. Instructor, Columbia University. Address in 1929, 270 East 142nd St., New York, NY.

LYND, J. NORMAN.
Illustrator. Born in Northwood, Logan County, OH, Nov. 15, 1878. Member: Society of Illustrators, 1913; Artists Guild of the Authors' League of America, NY. Address in 1929, 300 Denton Ave., Lynbrook, LI, NY.

LYNN, KATHARINE N. (MRS.).
Painter. Born in Philadelphia, May 13, 1875. Pupil of Penna. School of Industrial Art; Art Students League of NY; Colarossi School; Constant and Mme. Richard in Paris. Member: National Association of Women Painters and Sculptors; Philadelphia Alliance; Pennsylvania School of Industrial Art Alumni; Washington Water Color Club; Washington Art Club. Address in 1929, Nantucket, MA.

LYNN-JENKINS, FRANK.
Sculptor. Born in Torquay, England, in 1870, and was a pupil of Lambeth School of Modeling and the Royal Academy of Art in London. His awards included a silver medal at the International Paris Exposition in 1900. He is represented by a marble Madonna and Child at the Metropolitan Museum of Art in NY. Died in NYC, September 1, 1927.

LYON, EDWIN.
Sculptor. Worked: Natchez, Mississippi. Exhibited: Penna. Academy, 1848, 1853.

LYON, JEANNETTE AGNEW.
(Mrs. William T. Lyon). Landscape painter. Born in Pittsburgh, PA, Dec. 3, 1862. Pupil of Robert C. Minor of New York; Mesdag at the Hague; Constant in Paris. Member: Cleveland Woman's Art Club; North Shore Art Association. Address in 1929, 2330 Euclid Blvd., Cleveland, OH.

M

M., (J.) AE.
14 Sculp. 1758. This early American engraver can not be identified by the compiler. The only evidence of his existence is a small quarto portrait of Frederick III of Prussia, "folded and inserted" in the NY Almanac for 1759, printed and sold by Hugh Gaine at the Bible and Crown in Hanover Square. This print may be described as follows: Exceedingly rude line work with an attempt at stipple in the face. Vignette; half length in uniform, standing to right, face front, right hand on hip, left hand on hilt of sword resting on point; muzzle of cannon in right base. Inscription: "J.M. AE 14 Sculpt 1758 Frederick the Third The Great King of Prussia, Sold by J. Turner in Arch Street, Philadelphia."

MAAS, JACOB.
Engraver. Born 1800 in Pennsylvania. The only mention found of Jacob Maas is in connection with the engraving and sale of "Lafayette and Washington Badges" in 1824. The Philadelphia newspapers of that year contain conditions of sale of "their plates;" and this notice is signed jointly by "J. L. Frederick and Jacob Maas, Engravers."

MACARAY, LAWRENCE RICHARD.
Painter. Born in Elsinore, CA, May 8, 1921. Studied: Whittier College; California State University, Long Beach. Work: Bowers Museum, Santa Clara, CA; Thompson Industries, Los Angeles; Bertrand Russell Peace Foundation, Nottingham, England; others. Exhibitions: Annual Palos Verdes; Museum of Art; All California Art Exhibition, San Bernadino; Bertrand Russell Centenary Art Exhibition, Nottingham, England; etc. Awards: Southern California Expo. Prize, Del Mar; others. Medium: Oil. Address in 1982, 628 N. Buttonwood St., Anaheim, CA.

MaCARTNEY, CATHERINE (NAOMI).
Painter and teacher. Born in Des Moines, IA. Pupil of Charles A. Cumming, Richard Miller, Henry Hunt Clark; Colarossi Academy, Paris. Member: Iowa Artists Guild (president); National Association of Women Painters and Sculptors; College Art Association; L.C. Tiffany Foundation. Awards: Second prize, Des Moines Women's Club, 1912; first prize, Des Moines Women's Club, 1914; gold medal for design, Iowa State Fair, 1916; gold medal for painting, Iowa State Fair, 1921. Work: "Late Summer," F. L. Owen Collection, Des Moines, IA. Address in 1929, 318 Physics Hall; H. Burkley Place, Iowa City, Iowa.

MACAULAY, DAVID ALEXANDER.
Illustrator and designer. Born in Burton on Trent, England, Dec. 2, 1946. Study: RI School of Design, B. Architecture. Work: Cooper Hewitt Museum, NYC. Exhibited: Children's Book Illus., Museum of Contemporary Art, Houston, TX, 1975; SPACE Gallery of Architecture, NYC, 1976; Annual International Exhibition of Children's Book Illus., Bologna, Italy, 1976 & 1977; 200 years of American Illus., Museum of Hist. Soc. of NY, 1977; Children's Book Art, Monterey (CA) Peninsula Museum of Art, & Triton Museum of Art, Santa Clara, 1978-79. Awards: First runner-up, Caldecott Medal, American Library Association, 1974-78; Deutscher Jugenbuchpreis, Germany, 1975; Medal, American Institute of Architects, 1978. Media: Pen and ink. Author and illustrator of numerous books on architecture. Address in 1982, 27 Rhode Island Ave., Providence, RI.

MACAULEY, CHARLES RAYMOND.
Illustrator. Born in Canton, Ohio, in 1871. Executed cartoons and illustrations in the leading publications. Address in 1926, 82 West 12th Street, New York. Died in 1934.

MacCAMERON, ROBERT LEE.
Figure and portrait painter. Born in Chicago, Jan. 14, 1866; died in N.Y., Dec. 29, 1912. Pupil of Gerome and Collin in Paris. Awards: Hon. mention, Paris Salon, 1904; Third Class medal, Paris Salon, 1908; Legion of Honor, 1912. Elected Associate of the National Academy, 1910. Member: Paris Society of American Painters; International Society of Painters, Sculptors and Gravers, London; National Society of Portrait Painters, NY. Represented by "Groupe D'Amis," painted 1907, and "The Daughter's Return," at the Metropolitan Museum in NY.

MacCHESNEY, CLARA TAGGART.
Painter. Born in Brownsville, CA. Pupil of Virgil Williams, San Francisco; H. S. Mowbray and J. C. Beckwith, NY; also of Courtois and Girardot at Colarossi School, Paris, France. Exhibited: Paris Salon, 1896, 1898; Paris Exposition, 1900; bronze medal, Buffalo Exposition, 1901; St. Louis Exposition, 1904. Member: NY Water Color Club. Died in 1938. Address in 1926, 15 W. 67th Street, New York.

MacCORD, CHARLES WILLIAM.
Painter. Born in Allegheny City, PA, Feb. 3, 1852. Self-taught. Work: "Light on the Hills," Bridgeport Public Library; "The Last Ray," Sea Side Club, Bridgeport. He died Jan. 7, 1923, in Bridgeport, CT.

MacCORD, MARY NICHOLENA.
Painter. Born in Bridgeport, CT. Member: National Arts Club; National Association of Women Painters

and Sculptors; American Water Color Society; Connecticut Academy of Fine Arts; NY Water Color Club; New Haven Paint and Clay Club; NY Society of Painters; Washington Water Color Club; Allied Artists of America; American Federation of Arts. Award: Harriet Brooks Jones prize, Baltimore Water Color Club, 1923. Exhibited at Penna. Academy of Fine Arts in 1925. Address in 1929, 839 West End Ave., New York, NY.

MacCUISTON, JACQUES (JAX) (MISS).
Sculptor. Born in Texarkana, Texas, October 19, 1906. Studied with Haakon Frolich and George Demont Otis. Award: Sixth Annual Allied Arts exchange, Dallas Public Art Gallery, 1933. Address in 1933, 5122 Gaston Ave., Dallas, Texas.

MacDERMOTT, STEWART SINCLAIR.
Painter and etcher. Born in New York, July 14, 1889. Pupil of Art Students League of NY; Beaux Arts Institute of Design, NY; Ecole des Beaux Arts, Fontainebleau, France. Member: Alliance. Represented in print collection of the Metropolitan Museum of Art. Address in 1929, 51 West 10th Street, h. 323 West 84th Street, New York, NY.

MacDONALD, FRANK E.
Painter and illustrator. Born in Kansas City, Feb. 8, 1896. Pupil of Roland Thomas, G. V. Millett, J. D. Patrick. Member: Kansas City Artists Guild. Address in 1929, 4420 Norledge Place, Kansas City, MO.

MacDONALD, GENEVA A.C.
Painter, craftsman, graphic artist, and teacher. Born Aug. 28, 1902, in Natick, MA. Studied at Massachusetts School of Art; Boston Museum of Fine Arts School; Des. Workshop, NY; Harvard Univ.; and with R.M. Pearson, E. Thurn, and U. Romano. Member: Society of Independent Artists, Boston; National Association of Women Artists; Copley Society; Gloucester Society of Artists; others. Exhibited: Jordan Marsh Gallery, 1945, 46; National Academy of Design; National Association of Women Artists; Stuart Gallery, Boston; DeCordova and Dana Museum, 1952; Library of Congress, 1952; others. Address in 1953, Boston, MA.

MacDONALD, HAROLD L.
Sculptor, painter, illustrator, and teacher. Born in Manitowoc, WI, May 13, 1861. Pupil of Boulanger and Lefebvre in Paris. For many years he resided in Washington, DC, where he maintained a high standard as a portrait painter. Work: Portrait of William Griffith, Capitol, Washington, DC. Member: Society of Washington Artists. Address in 1921, Purcellville, VA.

MacDONALD, JAMES WILSON ALEXANDER.
Sculptor, painter, writer, and lecturer. Born in Steubenville, OH, August 25, 1824. Was in the publishing business in St. Louis, but from his thirtieth year he devoted himself to art. He made the first portrait bust cut in marble west of the Mississippi, that of Senator James T. Benton of Missouri. After the Civil War he came to NY, and his bust of Charles O'Connor is in the Appellate Court, and that of James T. Brady in the Law Library; his bronze statue of Fitz-Greene Halleck is in Central Park, and his Washington Irving in Prospect Park, Brooklyn. Died in Yonkers, NY, August 14, 1908.

MACDONALD-WRIGHT, STANTON.
Painter. Born in Charlottesville, VA, July 8, 1890. Went to France in 1907; studied at the Sorbonne and at the Beaux-Arts, Colarossi, and Julian Academies, Paris. Returned to the U.S. in 1916; studied at the Art Students League with W. T. Hedges and J. Greenbaum. Founded Synchromist movement in Paris with Morgan Russell, 1913. Taught at University of California, 1942-50; Fulbright Exchange Professor, Japan, 1952-53; others. In collections of Boston Museum of Fine Arts; Brooklyn; Carnegie; Art Institute of Chicago; Corcoran; Denver Art Museum; Detroit Art Institute; Los Angeles County Museum of Art; Metropolitan Museum of Art; Museum of Modern Art; Philadelphia; Toledo; Santa Barbara; Whitney; Walker; Newark Museum; others. Exhibition at Salon d'Automne, Paris; The Synchromist, Munich and Paris, 1913; Photo-Secession, NYC, 1917; Stieglitz's 291 Gallery, NY, 1917 (one-man); Stendahl Gallery, Los Angeles; Duveen-Graham Gallery, NYC; Los Angeles County Museum; Metropolitan Museum of Art; Brooklyn; Rose Fried Gallery, 1955 (one-man); others. Author of *A Treatise on Color*. Died in 1973. Address in 1971, Pacific Palisades, California.

MacDONALL, ANGUS.
Painter and illustrator. Born in St. Louis in 1876. Illustrator and cartoonist for: *Life; Scribner's; American; Red Cross Magazine; Ladies' Home Journal; Harper's*. Address in 1926, Westport, CT.

MacDOWELL, SUSAN HANNAH.
Painter. Born in Philadelphia in 1851. Student at Pennsylvania Academy of Fine Arts. Pupil of Prof. C. Schussele and of Thomas Eakins. Her paintings are largely portraits, and are generally owned in Philadelphia where her professional life was spent.

MacFARLAN, CHRISTINA.
Painter. Born in Philadelphia. Pupil of Chase and Breckenridge at Penna. Academy of Fine Arts. Address in 1926, Studio, 1805 Chestnut Street, Philadelphia, PA.

MacFARLANE, SCOTT B. (MRS.).
Illustrator. Born in Santa Barbara, CA, Sept. 23, 1895. Pupil of Dante Ricci in Rome; Arthur

Musgrave. Address in 1929, 3255 N. Street, Washington, D.C.

MacGILVARY, NORWOOD HODGE.
Painter. Born in Bangkok, Thailand, Nov. 14, 1874. Pupil of Davidson College; Mark Hopkins Institute, San Francisco; Myron Barlow; Laurens in Paris. Member: NY Water Color Club; American Water Color Society; Allied Artists of America; Providence Art Club; NY Architectural League; Salma. Club; Pittsburgh Architectural League. Awards: Silver medals, Panama-Pacific Expo., San Francisco, 1915. Work: "Twilight After Rain," National Gallery of Art, Washington, D.C. Died in 1950. Address in 1929, Carnegie Institute of Technology; h. 8 Roselawn Terr., Pittsburgh, PA.

MacGINNIS, HENRY R.
Painter and teacher. Born in Martinsville, IN, Sept. 25, 1875. Pupil of J. O. Adams and T. C. Steele, Indiana; Collin and Courtois in Paris; Royal Academy, Munich. Member: Society of Independent Artists; Beachcombers. Award: Hon. mention, Royal Academy, Munich. Work: Mural painting, Mem. Room, Gregory School, Trenton, NJ; portraits in Customs House, NY and Masonic Temple, Trenton, NJ; faience tile mural, St. Thomas' Church, Woodhaven, LI, NY. Address in 1929, School of Industrial Arts, State and Willow Streets; h. 38 West State Street, Trenton, NJ; summer, Wentworth, N.H.

MacGREGOR, SARA JULIA NEWLIN.
(Mrs. Donald MacGregor). Painter, sculptor, illustrator, and teacher. Born in Pennsylvania. Pupil of William M. Chase, Ben Gilman, Cecilia Beaux and Henry Thouron. Member: Fellowship Penna. Academy of Fine Arts; Plastic Club. Award: Bronze medal, American Art Society, 1902. Address in 1933, Princeton, NJ.

MacHARG, KATHERINE.
Painter, sculptor, designer, and teacher. Born in Biwabik, MN, October 5, 1908. Studied: Pratt Institute Art School; Penna. Academy of Fine Arts; University of Arizona; Duluth State Teachers College. Member: Minn. Sculpture Group; American Federation of Arts. Awards: Penna. Academy of Fine Arts. Exhibited: Chester Springs traveling exhibition; Minnesota State Fair, 1940; Duluth Arrowhead Exhibition. Contributor to *School Arts Magazine*. Address in 1953, 205 Superior Street; h. Duluth, MN.

MACHETANZ, FRED.
Painter and lithographer. Born in Kenton, Ohio, 1908. Studied: Ohio State University, B.A., 1930, M.A., 1935; Chicago Art Institute, 1930-32; American Academy, Chicago, 1930-32; Art Students League, 1945; University of Alaska, Hon. DFA, 1973.

Work: University of Alaska Museum; Alberta (Canada) Museum, Calgary; Anchorage Historical & Fine Arts Museum; Frye Art Museum, Seattle; and others. Commissions: Scripps Institute Research Ship, 1963; Dept. of Interior, 1969; The Tender Arctic, Frye Museum, Seattle, 1973; North Slope Borough, Fairbanks, 1981; and others. One man exhibitions: University of Alaska, 1964 & 72; Anchorage Historical & Fine Arts Museum, 1968, 74, 80; Frye Museum, Seattle, 1972; Tryon Gallery Ltd., London, 1979. Awards: Silver Medal, North American Wild Animals Art Exhibition, 1979; Artist of the Year, American Artist Magazine, 1981. Teaching: University of Alaska, 1964-present. Member: Society of Animal Artists; Explorers Club. Media: Oil, lithograph.

MacINTOSH, MARIAN T.
Painter. Born in Belfast, Ireland. Pupil of Heinrich Knirr and Henry B. Snell. Member: Philadelphia Alliance; Plastic Club; National Association of Women Painters and Sculptors; American Federation of Arts. Address in 1929, 291 Nassau Street, Princeton, NJ.

MACK, STANLEY.
Illustrator. Born in Brooklyn, New York in 1936. He attended the RI School of Design. His drawings have appeared on the Op-Ed page of *The New York Times* where he was art director of their Sunday magazine section. His pen and ink work also appears in "Stan Mack's Real Life Funnies" in the *Village Voice*.

MacKALL, R. McGILL.
Painter, etcher, and craftsman. Born in Baltimore, April 15, 1889. Pupil of Laurens and Richard Miller in Paris; Art Students League of NY; Royal Academy in Munich. Member: Salon d'Automne, Paris; Charcoal Club; Washington Art Club: National Society of Mural Painters, NY; NY Architectural League. Work: Mural decorations in First English Lutheran Church; St. Luke's Church, Baltimore; stained glass window, Christ P. E. Church, Luray, VA; murals, State of Maryland, City of Baltimore; War Memorial Building, Baltimore; Lobby Decorations, Woodrow Wilson Hotel, New Brunswick, NJ. Address in 1929, Hampden Hall, 3553 Roland Ave.; h. Cecil Apts., 1117 North Eutaw Street, Baltimore, MD.

MacKAY, EDWIN MURRAY.
Painter. Born in Detroit, MI. Pupil of Laurens, Blanche and Kenyon Cox. Member: Connecticut Society of Artists. Work: Portaits of "Ex-Gov. Sleeper," Michigan State Capitol Building; "Justice Ostrander," Michigan Supreme Court, Lansing, MI. Drawings in NY Public Library. Address in 1926, 241 East Euclid Ave., Detroit, MI. Died Feb. 28, 1926.

MacKAY, JEAN V.
(Mrs. Jean MacKay Henrich). Sculptor, teacher, lecturer, and engraver. Born in Halifax, N.S., Canada, September 19, 1909. Studied: Antioch College, B.A.; Art Institute of Chicago; Art Institute of Buffalo, NY; and abroad. Member: Buffalo Print Club; The Patteran. Work: Library of Congress; Veterans Memorial, Geneva, NY. Exhibited: Penna. Academy of Fine Arts, 1942; Butler Art Institute, 1941; Seattle Art Museum, 1942; San Francisco Museum of Art, 1942; Denver Art Museum, 1942; Albright Art Gallery, 1936-46. Taught: Instructor of Sculpture, Art Institute of Buffalo, NY, 1937-43, 1944-46. Address in 1953, 155 St. James Pl., Buffalo, NY.

MACKAY, FRANCES I.
Sculptor. Born in Baltimore, MD, in 1906. Studied at the Maryland Institute, Baltimore, under J. Maxwell Miller, and at the Penna. Academy of Fine Arts, under Albert Laessle. Works: Bust, Carl; relief, Helen; figure, Terino; Diane. Awards: Rinehart traveling scholarship, 1926.

MacKAY, WILLIAM ANDREW.
Mural painter and illustrator. Born in Philadelphia, PA, July 10, 1878. Pupil of Constant and Laurens in Paris; Acad. in Rome; Robert Reid in NY. Member: Society of Illustrators, 1910; National Society of Mural Painters, NY; NY Architectural League, 1911; Players Club; American Art Association of Paris. Work: Mural paintings in Senate Reading Room, Congressional Library, Washington, DC; House of Representatives, St. Paul, MN; Supreme Court Room, Essex County Court House, Newark, NJ; Castlegould, Port Washington, LI, NY; decoration and painting, Knickerbocker 42nd St. Bldg., New York, NY; Illinois Merchants Trust Co., Chicago, IL; St. Georges Church, Stuyvesant Square, New York. Died in 1939. Address in 1929, 345 East 33rd Street, "The Players," 16 Gramercy Park, New York, NY; summer, Coytesville, Fort Lee, NJ.

MacKENSIE, E.
This accomplished engraver of portraits in the stipple manner came from England in 1833-34 to engrave for the "National Portrait Gallery." He remained in the United States, and was later employed doing portrait work for the Methodist Book Concern of New York.

MacKENZIE, RODERICK D.
Sculptor, painter, illustrator, etcher, writer, lecturer, and teacher. Born London, England, April 30, 1865. Pupil of the School of the Museum of Fine Arts, Boston; Constant, Laurens, Jules Lefebvre, Chapu and the Ecole Nationale des Beaux-Arts in Paris. Member: Royal Society of Arts, London; American Federation of Arts. Award: Curzon gold medal, India. Work: "State Entry Delhi, Durbar, 1903,"

Museum at Calcutta; "The Chitor Elephants," gate to Fort, Delhi, India; "Afghans" and "Beluchis;" series of night pictures of steel works, Birmingham, AL; eight murals and bas-relief panels, Rotunda and Dome, State Capitol, Montgomery, AL. Address in 1933, The Art Studio, Mobile, AL.

MacKILLOP, WILLIAM.
Painter. Born in Philadelphia, PA. Pupil of St. Louis School of Fine Arts; Jean Paul Laurens and Ernest Laurent in Paris. Member: Allied Artists of America; Salma. Club. Award: Silver medal, P.-P. Expo., San Francisco, 1915. Address in 1929, Van Dyck Studios, 939 Eighth Avenue, New York, NY.

MacKINNON, MARY (MRS.).
Painter and illustrator. Born in New York City, March 23, 1890. Member: Society of Illustrators; Artists Guild of the Authors' League of America, NY. Represented by portrait and fashion work in *Harper's Bazaar*; advertising work for Lux, MacCallum Hosiery. Address in 1929, 25 West 11th Street, New York, NY; summer, Easthampton, L.I., NY.

MacKINSTRY, ELIZABETH (CONKLING).
Sculptor, illustrator, and teacher. Born in Scranton, PA, March 31, 1879. Pupil of Arthur Dow and Pratt Institute in New York; Gerome in Paris. Address in 1918, 1118 Elmwood Ave.; h. 1046 Elmwood Ave., Buffalo, NY.

MacKLOW, J.
A well-engraved portrait of Martha Washington, after the painting by Woolaston, is signed by this man about 1835; it is further inscribed as "Engraved expressly for the Christian Family Annual."

MacKNIGHT, DODGE.
Painter. Born in Providence, RI, Oct. 1, 1860. Pupil of Cormon in Paris. Member: New Society of Artists, NY. Work: Thirty water colors, Museum of Fine Arts, Boston; "The Almond Tree," Institute of Arts, Detroit; "The Bed of the Brook," RI School of Design, Providence; ten water colors, Fogg Museum, Cambridge, MA; collection of pastels and water colors in "Macknight Room," Gardner Museum, Boston; water colors in Brooklyn Museum and Worcester Museum. Address in 1929, East Sandwich, MA.

MacKUBIN, FLORENCE.
Portrait and miniature painter. Born in 1866 in Florence, Italy. She studied in France and Italy. Her portraits include "Gov. Lloyd Lowndes," Prof. Basil Gildersleeve and Prof. Marshall Elliot. Her miniatures are in the Walters Art Gallery, Baltimore. She died in Baltimore, MD, Feb. 1, 1918.

MACKWITZ, WILLIAM.
Engraver. Born in Germany in 1831. Worked in St. Louis, MO, 1856-1916. Died August 6, 1919.

MacLAUGHLIN, DONALD SHAW.
Etcher and painter. Born in Boston in 1876. Awarded medals for etching. Address in 1926, 569 Fifth Avenue, New York. Died in 1938.

MacLEAN-SMITH, ELIZABETH.
Sculptor and lecturer. Born in Springfield, MA, February 18, 1916. Studied at Wellesley College, A.B.; Belgian-American Education Foundation traveling fellowship, Belgium, 1937; Boston Museum School, with Frederick Warren Allen and Sturdivant traveling fellowship, Mexico, 1941. Work: Museum of Fine Arts, Boston; Museum of Fine Arts, Springfield, MA; Williams College, Williamstown, MA. Commissions: Polyester murals, Dini's Sea Grill, Boston, 1962-70; fountain and garden sculptures and portraits in private collections. Exhibitions: New England Sculptor's Association, Prudential Center, Boston, 1968 and 70; one-woman shows, G. W. V. Smith Museum, Springfield, 1950, Tufts College, Medford, MA, 1952, Crane Museum, Pittsfield, MA, 1956, and McIver-Ready Gallery, Boston, 1968. Media: Wood, stone, and clay. Taught: Instructor of Sculpture, Boston Museum School, 1940-53; Bradford Jr. College. Served as president for five terms, New England Sculptor's Association. Address in 1982, Charlestown, MA.

MacLEARY, BONNIE.
Sculptor. Born in San Antonio, Texas, 1898. Pupil of New York School of Art; Julian Academy, Paris; Art Students League of New York; James E. Fraser; Frank Du Mond. Member: National Sculpture Society; Associate of the National Academy of Design; National Academy of Women Painters and Sculptors; National Arts Club of NY; Allied Artists of America; American Artists Professional League. Work: "Aspiration," Metropolitan Museum of Art, New York; "Ouch!" Children's Museum, Brooklyn, NY; Munos Rivera Monument, Rio Piedras, Puerto Rico; World's War Memorial Monument, San Juan, Puerto Rico. Exhibited: National Academy of Design; National Association of Women Artists; Penna. Academy of Fine Arts; Architectural League; Allied Artists of America. Received award, Women's Art and Industrial Exhibition, 1928, 29. Address in 1953, New York City. Died in 1971.

MacLEISH, NORMAN.
Painter and graphic artist. Born August 29, 1890, in Glencoe, IL. Studied: Art Institute of Chicago; with P. Vignal in Paris. Member: Chicago Society of Artists. Exhibited: Art Institute of Chicago, 1938, 39; World's Fair of NY, 1939; Golden Gate Expo., 1939. Address in 1940, Glencoe, IL.

MacLELLAN, CHARLES A.
Painter and illustrator. Born in Trenton, Ontario, Canada, June 22, 1885. Pupil of Art Institute of Chicago; Howard Pyle. Member: Wilmington Soc. of Fine Arts. Address 1926, 1305 Franklin St., Wilmington, DE; summer, Trenton, Ontario, Canada.

MacLEOD, ALEXANDER S.
Painter and etcher. Born in Orwell, Prince Edward Island, Canada, April 12, 1888. Pupil of Van Sloun. Member: CA Society of Etchers. Address in 1929, 5974 Vine St., Kerrisdale P.O., B. C., Canada.

MacMILLAN, HENRY JAY.
Painter, decorator and designer. Born January 13, 1908, in Wilmington, NC. Studied: Art Students League, with Y. Kuniyoshi, G. Bridgman, and A. Woelfle; NY School of Fine and Applied Arts; and with J. Smith. Member: North Carolina Professional Artists Club. Work: Coq Rouge Restaurant, NYC; Sperry Corp. R.C.A. Building, NYC. Director, Wilmington Museum Art School. Address in 1940, Wilmington, NC; Wrightsville Beach, NC.

MacMILLAN, MARY.
Painter. Member of Chicago Society of Artists. Address in 1915, Chicago, IL.

MacMONNIES, FREDERICK WILLIAM.
Sculptor and painter. Born in Brooklyn, NY, September 28, 1863. Pupil of National Academy of Design; Art Students League of New York; Augustus Saint-Gaudens; Falguiere, Ecole des Beaux Arts and Mercie in Paris. Member: Society of American Artists, 1891; New York Architectural League, 1892; Associate National Academy of Design, 1901; Academician National Academy of Design, 1906; National Institute of Arts and Letters; National Arts Club, NY. Awards: Second class medal, Paris Salon, 1891; medal, Columbian Expo., Chicago, 1893; first class gold medal, Antwerp, 1894; medal, Philadelphia Art Club, 1895; medal, Atlanta Expo., 1895; grand prize of honor, Paris Expo., 1900; medal, Munich; first prize, Boston Art Club; Honorable mention for painting, Paris Salon, 1901; gold medal for sculpture, Pan-Am. Expo., Buffalo, 1901; Chevalier of the Legion of Honor, 1896; Chevalier Order of St. Michael of Bavaria. Work: "Army," "Navy," "Horse Tamers," "J. S. T. Stranahan," "General Slocum," Brooklyn, NY; "Bacchante," Metropolitan Museum of Art, New York, and Luxembourg, Paris; "Victory," West Point, NY; "Sir Henry Vane," Boston Public Library; central bronze door and statue of "Shakespeare," Library of Congress, Washington, DC; "Gen. McClellan," Washington, DC; "Pioneer Monument," Denver; "Pan of Rohalion," Fine Arts Academy, Buffalo, NY; "Nathan Hale," "Civic Virtue," fountain, New York; "Washington at Princeton," Princeton, NJ; Lindbergh Medal for Society of Medalists. Exhibited at National Sculpture Society, 1923. Address in 1933, 20 West 10th Street, New York, NY; Giverny-par-Vernon, Eure, France. Died in 1937.

MacMONNIES, MARY FAIRCHILD.
See Low, Mary Fairchild MacMonnies.

MacMORRIS, LEROY DANIEL.
Painter, illustrator, and etcher. Born in Sedalia, MO, April 1, 1893. Pupil of Pennell; Leon Gaspard; Gorguet; Despujols. Member: L. C. Tiffany Foundation Artists Guild; Art Students League of NY; Kansas City Art Association. Address in 1929, 906 Carnegie Hall, New York, NY; care of Hastings and Sells, 43 Rue La Chaussee D'Antin, Paris, France.

MacNEIL, CAROL BROOKS.
(Mrs. H. A. MacNeil). Sculptor. Born in Chicago, IL, January 15, 1871. Pupil of Art Institute of Chicago under Lorado Taft; MacMonnies and Injalbert in Paris. Member: National Sculpture Society, 1907; National Association of Women Painters and Sculptors. Exhibited: National Sculpture Society, 1923. Awards: Honorable mention, Paris Expo., 1900; bronze medal, St. Louis Expo., 1904. Executed busts, statuettes, fountains. Address in 1933, College Point, LI, NY. Died in 1944.

MacNEIL, HERMON ATKINS.
Sculptor. Born in Everett, MA, February 27, 1866. Pupil of Massachusetts Normal Art School in Boston; Chapu at Academie Julian and Falguiere at Ecole des Beaux-Arts in Paris. Member: National Sculpture Society, 1897; Associate National Academy of Design, 1905; Academician National Academy of Design, 1906; Society of American Artists, 1901; New York Architectural League, 1902; Century Association; New York Municipal Art Society; National Academy of Arts and Letters; American Federation of Arts. Exhibited at National Sculpture Society, 1923. Awards: Columbian Expo., Chicago, 1893; Atlanta Expo., 1895; Paris Expo., 1900; Pan-Am. Expo., Buffalo, 1901; Charleston Expo., 1902; St. Louis Expo., 1904; Jewish Settlement in America; P.-P. Expo., San Francisco, 1915; medal of honor for sculpture, NY Architectural League, 1917. Designer of Pan-Am. medal of award; New York Architectural League medal of honor; U.S. Government quarter dollar. Sculptures at City Park, Portland, OR; Albany, NY; State Capitol at Hartford, CT. In collections of: Metropolitan Museum of Art; Corcoran; Art Institute of Chicago; Montclair (NJ) Art Museum; Northwestern University; Cornell; Hall of Fame, New York University. Taught at Cornell University; Art Institute of Chicago; Pratt; American Academy in Rome. Address in 1953, College Point, LI, NY.

MacNUTT, J. SCOTT.
Painter. Born in Fort D. A. Russell, WY, Jan., 11, 1885. Pupil of Woodbury; School of the Boston Museum. Member: St. Louis Artists Guild; American Federation of Arts. Instructor, St. Louis School of Fine Arts, 1927-28. Address in 1929, 72 Vanderventer Place, St.Louis, MO; summer, Ogunquit, ME.

MACOMBER, MARY L.
Painter. Born in Fall River, MA, Aug. 21, 1861. Student of Boston Museum Art School, and pupil of Duveneck. Member of the Boston Guild of Artists. She died in Boston on Feb. 6, 1916.

MACOMBER, STEPHEN.
Painter. Member: Providence Water Color Club; Mystic Society of Artists. Address in 1929, 187 High Street, Westerly, RI.

MacRAE, ELMER LIVINGSTON.
Painter. Born in New York, July 16, 1875. Pupil of Art Students League of NY under Twachtman, Beckwith, Blum and Mowbray. Member: NY Water Color Club; American Painters and Sculptors; Pastelists; Greenwich Society of Artists. Award: Second hon. mention for "Calla Lilies," Greenwich Society of Artists, 1929. Address in 1929, 12 West 69th Street; care Montross Gallery, 26 East 56th Street, New York, NY; Cos Cob, CT.

MacRAE, EMMA FORDYCE.
(Mrs. Homer Smith). Painter. Born in Vienna, Austria, April 27, 1887. Pupil of Luis Mora, Robert Reid, Kenneth Hayes Miller; Art Students League; NY School of Art. Member: MacDowell Club, NY; National Association of Women Painters and Sculptors; North Shore Arts Association; Gloucester Society of Artists; Allied Artists of America; National Arts Club; National Association of Women Artists; American Federation of Arts; National Society of Mural Painters, NY; Pen and Brush Club; others. Awards: Hon. mention, National Association of Women Painters and Sculptors, 1927, Gould prize, 1928; medal, National Arts Club, 1930; Allied Artists of America, 1942; National Association of Women Artists, 1945; Pen and Brush Club, 1946, 50. Work: Wesleyan College; Cosmopolitan Club; National Academy of Design. Exhibited: Art Institute of Chicago, 1930; Carnegie Institute, 1930; Corcoran, 1935, 37; Penna. Academy of Fine Arts, 1934-36; Museum of Fine Arts of Houston; de Young Memorial Museum; Newport Art Association; Seattle Art Museum; National Academy of Design; Allied Artists of America; National Association of Women Artists; others. Address in 1953, 12 West 69th Street, New York, NY; h. 888 Park Ave., New York, NY.

MacRUM, GEORGE H.
Painter and teacher. Pupil of Art Students League of NY. Member: Allied Artists of America; Salma. Club; Philadelphia Art Club. Awards: Gold medal, Appalachian Expo., Knoxville, TN, 1911; Turnbull prize, Salma. Club, 1914; silver medal, Panama-Pacific Expo., San Francisco, 1915. Work: "The Pile Driver," Penna. Academy of Fine Arts; "The Pardon on the Mountain," Canadian National Gallery, Toronto, Canada. Address in 1929, 1320 Pacific St., Brooklyn, NY.

MacSOUD, NICOLAS S.
Painter. Born in Zahle, Mt. Lebanon, Syria, March 7, 1884. Pupil of National Academy of Design. Member: Brooklyn Society of Miniature Painters; Brooklyn Society of Artists; Salma. Club; Washington Water Color Club; Painters and Sculptors (president). Work: "The Holy Sepulchre," Brooklyn Museum, Brooklyn, NY. Address in 1929, 320 Fifth Ave., NYC; h. 566 Fifth St., Brooklyn, NY; summer, New Monterey Hotel, Asbury Park, NJ.

MACY, HARRIET.
Painter. Born in Des Moines, IA, in 1883. Pupil of Cumming School of Art, Des Moines; Art Students League of NY. Member: Iowa Artists Guild. Awards: Des Moines Women's Club, 1915, gold medal, 1923, purchase prize, 1924, gold medal, 1927. Address in 1929, 1321-28th St., Des Moines, IA.

MACY, WILLIAM STARBUCK.
Born in New Bedford, MA, in 1853. He studied art at the National Academy in NY, and at Munich. His best work represents familiar New England effects. He had studios in New York and New Bedford. Among his works are "Edge of the Forest," "Winter Sunset," and "The Old Mill." He died in 1916.

MADEIRA, CLARA N.
Painter. Exhibited water colors at the Penna. Academy of Fine Arts, Philadelphia, 1925. Address in 1926, 2300 Pine Street, Philadelphia, PA.

MADSEN, OTTO.
Painter and illustrator. Born in Germany, April 30, 1882 of Danish parents. Pupil of Wilimovsky, Berninghaus, Tolson, and Ivan Summers. Member: St. Louis Pen and Brush Club; Kansas City Society of Artists. Work: "Baptism of Christ in the Jordan," First Baptist Church, St. Louis; decorative panels in the California State Building and Transportation Building, Panama-Pacific Expo., San Francisco, 1915. Address in 1929, 922 Broadway; h. 825 E. 42nd St., Kansas City, MO.

MADSEN, VIGGO HOLM.
Printmaker and craftsman. Born in Kaas, Denmark, April 21, 1925, U.S. citizen. Studied: Anderson College, Syracuse University, B.F.A., 1951, M.F.A., 1952; NYU; Columbia University Teachers College; Adelphi University; Inst. Allende, San Miguel, Mexico; Det Danske Selskab, Denmark. Work: Philadelphia Center for Older People, PA; C. W. Post College, Brookville, NY; and others. Exhibited: National Academy of Design Show, NYC; Drawing USA II, Smithsonian; Oregon State University; Silvermine Guild of Artists Print Show; and others. Awards: Award of Excellence, C. W. Post College; Cover Design Award, NYS Teachers Association; and others. Teaching: Roslyn High School, NY, 1960-82; Nassau Community College, 1966-present; etc.

Member: L.I. Craftsmen's Guild; NYS Art Teachers Association; American Crafts Council; and others. Address in 1982, 5 Meldon Avenue, Albertson, NY.

MAESCH, FERDINAND.
Painter. Born in Muhlhausen, Germany, June 21, 1865. Studied in Germany and France. Work: Portrait of Hon. Herbert T. Ketcham, Surrogate Court, Kings County, NY. Died in 1925, in Yonkers, NY.

MAFFIA, DANIEL J.
Illustrator. Born in Nevers, France in 1937. He attended the School of Industrial Art where he was a pupil of Vogel. Among his clients are *Esquire, Limited Editions Club* and the National Park Service. His evocative paintings have been featured in *Idea* magazine's edition of New York illustrators and selected for inclusion in the Society of Illustrators Annual Exhibitions.

MAGAFAN, ETHEL.
Painter. Born in Chicago, Illinois, Oct. 10, 1916. Studied: Colorado Springs Fine Arts Center; and with Frank Mechau, Boardman Robinson and Peppino Mangravite. Awards: Stacey scholarship, 1947; Tiffany scholarship, 1949; Fulbright fellowship, 1951; prizes, National Academy of Design, 1951, 56, 64, 67; Hallmark award, 1952; American Watercolor Society, Pomona, California, 1955, 62; Norfolk Museum of Art, 1957; Ball State Teachers College, 1958, 64; Albany Institute of History and Art, 1962; NY State Fair, 1962; Springfield (MO) Museum of Art, 1966; Connecticut Academy of Fine Arts, 1966; others. Collections: Metropolitan Museum of Art; Denver Art Museum; World's Fair, New York, 1939; Wilmington Society of Fine Arts; Norfolk Museum of Art; Des Moines Art Center; murals, Senate Chamber, Recorder of Deeds Building, Social Security Building, all in Washington, DC; Ball State Teachers College; Munson-Williams-Proctor Institute Museum of Art; Weatherspoon Gallery, University of North Carolina; United States Post Office, Auburn, Nebraska; Wynne, Arkansas; Madill, Oklahoma; South Denver Branch, Colorado; others. Exhibited: Carnegie Institute; Art Institute of Chicago; National Academy of Design; Audubon Artists; SUNY Albany; Flint Institute of Art; Connecticut Academy of Fine Arts; Metropolitan Museum of Art; Penna. Academy of Fine Arts; San Francisco Museum of Art; Corcoran; Whitney; Brandeis University; Boston Museum of Fine Arts; many others. Member: National Academy of Design. Address in 1970, Woodstock, NY.

MAGAGNA, ANNA MARIE.
Illustrator. Born in Wilkes-Barre, Pennsylvania in 1938. She attended Marywood College in Scranton; Art Students League and Society of Visual Arts in NY. She has been on the faculty of Pratt Institute since 1971. Her free-lance art career began in 1958

with the children's book *Christmas Miniature* by Pearl S. Buck, which she illustrated for John Day Co. She has since worked for magazines such as *Vogue* and *Harper's Bazaar*. A member of the Society of Illustrators since 1971, she lives in New York City.

MAGEE, ALAN.
Illustrator. Born in Newtown, PA, in 1947. He attended the Tyler School of Art and Philadelphia College of Art. His first published illustration was seen on the cover of *Scholastic Magazine* in 1969. Since then his work has appeared in *McCall's, Good Housekeeping, Penthouse, Viva, New York Magazine* and *The New York Times*. He has illustrated several book covers for Ballantine, Fawcett, Bantam, Pocket Books and Random House, and won a New York Book Publishers Award in 1976.

MAGEE, JAMES C.
Landscape painter. Born in Brooklyn in 1846. Pupil of Penna. Academy of Fine Arts; Chase in New York; Robert Henri in Paris. He died Jan. 15, 1924. Represented in the Johnson collection in Philadelphia and the Lord Richmond collection, London.

MAGEE, RENA TUCKER KOHLMAN.
(Mrs. Franklin Magee). Sculptor, painter and writer. Born in Indianapolis, IN, November 29, 1880. Pupil of Joseph De Camp, H. Siddons Mowbray, Charles H. Woodbury, and George Gray Barnard. Member: National Sculpture Society; Independent Society of Sculptors. Director of Exhibitions, Milch Galleries. Contributor to various magazines on topics of art. Address in 1953, New York, NY.

MAGENIS, H.
Portrait painter. He worked in Philadelphia in 1818.

MAGER, (CHARLES A.) GUS.
Painter, writer, and cartoonist. Born in Newark, NJ, Oct. 21, 1878. Member: Modern Artists of America; Salons of America. Represented in Whitney Museum of American Art, NY. Address in 1933, 204 Prospect Street, South Orange, NJ.

MAGIE, GERTRUDE.
Painter. Born in Trenton, NJ, Oct. 1, 1862. Pupil of Chase, Hawthorne, Martin, Morriset, Guerin, Bridgman, Leon. Member: National Association of Women Painters and Sculptors; Washington Art Club; American Federation of Arts; National Arts Club; Art and Archeology of America; Assoc. professionelle des Graveurs a l'eau forte, Paris (associate). Represented by four etchings in Metropolitan Museum, NY; two etchings, New York Public Library; nine etchings, Museum of Historic Art, Princeton, NJ. Address in 1929, 321 Nassau Street, Princeton, NJ; care of Bankers Trust Co., 16 Wall St., New York, NY; 49 Boulevard du Montparnasse, Paris, France.

MAGNER, DAVID.
Sculptor and carver. Born in Massachusetts c. 1835. At Boston, 1860.

MAGNUSSON, KRISTJAN H.
Painter. Born in Isafjord, Iceland, March 6, 1903. Pupil of John Sharman. Address in 1929, 46 Meddow Croft Road, Winchester, MA.

MAGONIGLE, EDITH M.
Mural painter. Born in Brooklyn, NY, May 11, 1877. Member: National Association of Women Painters and Sculptors (president; hon. vice-president); National Society of Mural Painters; American Federation of Arts. Work: Frieze on Administration Building, Essex County Park Commission, Newark, NJ; "Tragedy" and "Comedy," The Playhouse, Wilmington, DE. Address in 1929, 829 Park Avenue, New York, NY.

MAGONIGLE, H. VAN BUREN.
Sculptor, architect, painter, and writer. Born in Bergen Heights, NJ, October 17, 1867. Member: Associate, National Academy of Design; Fellow, American Institute of Architects; New York Architectural League (president); Alumni American Academy in Rome (past president); National Sculpture Society (vice-president); Salma. Club; American Federation of Arts; Society Beaux-Arts; New York Chapter American Institute of Architects (president). Awards: Gold medal, New York Architectural League, 1889; Rotch Traveling Scholarship, 1894. Work: McKinley National Memorial, Canton, OH; National Maine monument, and Firemen's Memorial, both in New York City; Liberty Memorial, Kansas City, MO; Arsenal Technical Schools, Indianapolis. Author of *The Nature, Practice and History of Art; The Renaissance*, etc. Address in 1933, 101 Park Avenue; h. 829 Park Avenue, New York, NY.

MAGRAGH, GEORGE.
Wood carver. Born in Philadelphia. Exhibited: Pennsylvania Academy of Fine Arts, 1811 and 1813.

MAGRATH, WILLIAM.
Born in Ireland, on March 20, 1838. He came to America in his youth. Member of National Academy of Design. His first studio was in NYC, and later he established his studio in Washington, D.C. Among his works are "Irish Peasantry," "Courtyard with Donkey," and the "Irish Interior." He died in 1918, in Brighton, NY.

MAHIER, EDITH.
Painter. Born in Baton Rouge, LA. Pupil of NY School of Fine Arts. Taught in Department of Art, University of Oklahoma, Norman, OK.

MAHLER, REBECCA.
Painter and teacher. Born in New York City. Pupil of William M. Chase. Address in 1929, 320 West 83rd Street, New York, NY.

MAHON, JOSEPHINE.
Sculptor, painter, craftsman, writer, and teacher. Born in Caldwell, NJ, October 31, 1881. Pupil of Charles W. Hawthorne, Richard Hayley Lever; New York School of Fine and Applied Arts; Pratt Institute; Columbia University. Member: American Artists' Professional League; Catharine Lorillard Wolfe Art Club. Address in 1933, Bloomfield Avenue, West Caldwell, NJ; summer, "Wateredge," Nantucket, MA.

MAHONY, FELIX.
Painter, illustrator, lecturer, and teacher. Born in New York, NY. Pupil of Steinlen in Paris; Corcoran School of Art, Washington, DC; New York School of Fine and Applied Arts in NY; and Paris. Member: Washington Art Club; Beachcombers; Provincetown Art Association; Society of Washington Artists. Director, National School of Fine and Applied Art, Washington, D.C. Address in 1929, Conn. Ave. and M. St.; h. The Champlain, 1424 K Street, Washington, D.C.

MAILMAN, CYNTHIA.
Painter. Born on Dec. 31, 1942, in Bronx, NY. Studied: Pratt Institute, Brooklyn, New York, B.S., 1964; The Art Students League; Brooklyn Museum Art School. Exhibitions: Sequoia Gallery, Los Altos, California, 1971; SOHO 20, NYC, 1974; Queens Museum, Flushing Meadow, NY, 1975. Some of her work is in the collection of the Prudential Life Insurance Company. Medium: Acrylic on canvas. Address in 1980, Staten Island, NY.

MAIN, WILLIAM.
Engraver. Born in 1796 in New York City. He practiced engraving there between 1821 and 1833. According to Wm. Dunlap, Main, as a young man, was taken to Italy by Mauro Gandolfi, who came to this country in 1817 under contract to engrave Col. Trumbull's "Declaration of Independence." Gandolfi broke his contract and returned home the same year, and took Main with him under promise of teaching him engraving. For some reason not stated, Main was abandoned in Florence, and he then applied to Morghen, was admitted, and spent three years in the studio of that great master. This statement of Dunlap is supported by the fact that the peculiar engraving table brought by Main from Florence was for many years in the possession of James Smillie, in NY, and was always known among engravers as the "Morghen table." In 1820 William Main returned to NY full of enthusiasm for his art. He eventually found employment and engraved a few portraits and book illustrations. William Main was one of the founders of the National Academy of Design in 1826, and a member of the class of engravers which included Durand, Danforth, Peter Maverick and C. C. Wright. He seems to have left NY in 1833, but returned and died there in 1876.

MAININI, TROVATORE.
Painter and craftsman. Born in Barre, VT. Pupil of Carlo Abate, Leslie Thompson and C. J. Connick. Member: Boston Society of Arts and Crafts and Boston Art Club. Address in 1929, 9 Harcourt Street, Boston, MA; h. 56 Liberty Square, Quincy, MA.

MAJOR, ERNEST L.
Painter and teacher. Born in Washington, D.C., 1864. Pupil of Art Students League of NY, and Boulanger and Lefebvre in Paris. Member: Boston Art Club; Guild of Boston Artists. Awards: Silver medal, P.-P. Expo., San Francisco, 1915; Bok prize, Penna. Academy of Fine Arts, 1917. Instructor in Massachusetts School of Art, Boston. Address in 1929, Fenway Studios, Boston, MA.

MAJOR, JAMES PARSONS.
Engraver. Born at Frome, Somersetshire, England, in 1818. Mr. Major came to the U.S. as a bank-note engraver in 1830. He resided in Brooklyn until 1872, and for over fifty-five years was in charge of the engraving and modeling department of what is now the American Bank-Note Co., of NY. He died at Somerville, NJ, Oct. 17, 1900.

MAKARENKO, ZACHARY PHILIPP.
Sculptor and painter. Born in North Caucasus, Russia, February 20, 1900; U.S. citizen. Studied: State University Academy of Fine Arts, Kiev; in Germany and Italy. Work: Public & private collections worldwide. Exhibition: Angelicum, Regional Ital. IV Religious Exhibition, Milan, 1947; USA Religious Exhibition, Burr Gallery, NYC, 1958; American Artists Professional League Grand National, NYC, 1966; National Academy of Design Galleries, NYC, 1971; others. Awards: American Artists Professional League, 1966; medal of honor, Painter and Sculptor Society Exhibition, Jersey City (NJ) Museum, 1971; Allied Artists of America Gold Medal of Honor, for sculpture, National Academy of Design Galleries, 1971; others. Member: Fellow, American Artists Professional League. Address in 1980, North Bergen, NJ.

MAKIELSKI, BRONISLAW A.
Painter and teacher. Born in South Bend, IN, Aug. 13, 1901. Pupil of Art Institute of Chicago; Leon A. Makielski. Member: Alumni Art Institute of Chicago; Delta Phi Delta; Scarab Club. Work: Altar piece, Church of the Holy Comforter, Charlottesville, VA; Lincoln School, Ypsilanti, MI; Royal Oak High School, MI; Michigan State College; McDonald School, Dearborn, MI. Exhibited: Hoosier Salon; Detroit Institue of Art, 1926-45. Address in 1953, Charlottesville, VA.

MAKIELSKI, LEON A.
Painter. Born in Morris Run, PA, May 17, 1885. Pupil of Art Institute of Chicago; Julian Academy

and Grande Chaumiere Academy in Paris; and of Lucien Simon, Rene Menard, and Henri Martin. Member: Scarab Club; American Federation of Arts. Awards: John Quincy Adams Traveling Scholarship, Art Institute of Chicago, 1908; prizes, Detroit Institute of Art, 1917, 19, 21, 23, 25; Michigan State Fair, 1925; Scarab Club, 1929. Work: Murals, McDonald School, Dearborn, MI; Lincoln School, Ypsilanti, MI; Fordson High School, Dearborn, MI; portrait, University of Michigan. Exhibited in U.S. and abroad. Instructor in arch., University of Michigan; instructor in portrait painting, Detroit School of Applied Arts. Address in 1953, Detroit, MI.

MALBONE, EDWARD G.

Minature painter. Born in Newport, RI, in Aug. 1777. Received some instruction from a local scene painter. Established himself in Boston as a miniature painter when about nineteen, and formed a close friendship with Washington Allston; afterward opened studios successively in NY and Philadelphia. Removed with Allston, in the winter of 1800, to Charleston, SC, where some of his best works were produced. Accompanied Allston to London in May 1801, and while there painted his largest and most celebrated miniature, "The Hours," in the Providence Athenaeum - a group of three beautiful young girls representing the Past, the Present, and the Future. On returning to the U.S., he chose Charleston for his permanent residence, visiting the North periodically. In 1806, travelled to Jamaica for his health. Died in Savannah, GA, May 7, 1807, on his way to Newport, RI. Malbone was the foremost American miniature painter. He also occasionally painted in oils and drew pastel portraits. One hundred and fifty-seven miniatures by him are listed in "Early American Portrait Painters in Miniature," by Theodore Bolton, NY, 1921.

MALCOM, JAMES PELLER.

Engraver and draftsman. Born in Philadelphia in August, 1767. Malcom began to engrave in Philadelphia prior to 1786, as he designed and engraved the frontispiece of the "Lyric Works of Horace" by John Parke, Philadelphia, 1786. Attended the Royal Academy, England. Worked for the *Gentleman's Magazine* and other English periodicals. As an engraver and upon his earlier prints he signed his name Malcom, but as an author and upon his later prints he used the signature of "James Peller Malcolm F.A.S." Died in London, England, April 5, 1815.

MALCOM, THALIA WESTCOTT.

(Mrs. Donald Malcom). Painter. Born in New York City, Sept. 10, 1885. Pupil of Randall Davey and Albert Andre. Member: NY Water Color Club; Society of Independent Artists; Alliance; French Institute in U.S. (life); Metropolitan Museum of Art (life); American Association of Museums; American Artists Professional League; American Federation of Arts. Address in 1933, 104 Rue de L'Universite, Paris, France.

MALCYNSKI, ELIZABETH P.

Illustrator. Born in Brooklyn, New York in 1955. She studied art for four years at the Parsons School of Design. She illustrated the cover for *Day Care Magazine* in 1976 and has since illustrated for Bantam and Columbia Records. She is a descendant of George Luks of the Ashcan School.

MALDARELLI, ORONZIO.

Sculptor. Born September 9, 1892, in Naples, Italy. Came to U.S. in 1900. Studied: Cooper Union, 1906-08; National Academy of Design, 1908, with Leon Kroll, Ivan Olinsky, Hermon McNeil; Beaux-Arts Institute of Design, NYC, 1912, with Solon Borglum, Jo Davidson, John Gregory, Elie Nadelman. Work: Art Institute of Chicago; Dallas Museum of Fine Arts; Fairmount Park Association; Metropolitan Museum of Art; Newark Museum; Ogunquit; Penna. Academy of Fine Arts; Sara Roby Foundation; Utica; Virginia Museum of Fine Arts; Whitney; commission for St. Patrick's Cathedral, NYC. Exhibited: National Academy of Design, 1922, 23, 58, 62, 63; California Palace, 1930; Art Institute of Chicago, 1935, 36, 40, 42, 57; Whitney Museum, 1936, 56, 62; University of Minnesota, 1937; Society of Independent Artists, NYC, 1941; Penna. Academy of Fine Arts, 1943; Sao Paulo, 1951; Museum of Modern Art, 1953; University of Illinois, 1953, 55; Wadsworth, Hartford, CT, 1957. Awards: Fairmount Park Association, Philadelphia, First Prize, Sculpture, 1930; J. S. Guggenheim Fellowship, 1931-33; Art Institute of Chicago, Logan Medal, 1941; National Institute of Arts and Letters; National Academy of Design; Architectural League of New York; National Sculpture Society; Artists Equity Association. Taught at Sarah Lawrence College, 1933-61; professor of sculpture, Columbia University, NYC. Address in 1953, 8 West 13th Street, NYC. Died in NYC, January 4, 1963.

MALHAUPT, FREDERICK J.

Painter. Exhibited at National Academy of Design, New York, 1925. Address in 1926, Gloucester, MA.

MALLARY, ROBERT.

Sculptor. Born December 2, 1917, in Toledo, OH. Studied with John Emmett Garrity and at Escuela de las Artes del Libro, Mexico City. Taught at University of New Mexico, Pratt, and Amherst. Exhibited at Allan Stone Gallery, 1961-62; Seattle World's Fair, 1962; Museum of Modern Art Sao Paulo Biennial, Brazil, 1963; and Institute of Contemporary Art, London, 1968. In collections of Museum of Modern Art; Albright-Knox; Houston Museum of Fine Arts; Smith College; Brandeis; Whitney; Los Angeles County Museum; and Berkeley. Address in 1982, Conway, MA.

MALLISON, EUPHAME CLASON.
Painter, craftsman, and teacher. Born in Baltimore, MD, April 30, 1895. Pupil of Gamba de Preydour. Member: Southern States Art League; Baltimore Water Color Club. Represented at Pennsylvania State College. Address in 1929, Box 512, University, Virginia.

MALLONEE, MISS JO.
Painter. Born in Stockton, NY, in 1892. Pupil of G. Bridgeman.Member: Art Students League of New York; League of New York Artists. Address in 1926, 39 West 39th Street, New York, NY.

MALLORY, RONALD.
Sculptor. Born June 17, 1935, in Philadelphia, PA. Studied: University of Colorado, 1951; University of Florida, B.Arch., 1952; School of Fine Arts, Rio de Janeiro, with Roberto Burle Marx, 1956; Academie Julian, Paris, 1958. Work: University of California at Berkeley; Museum of Modern Art; Museum of Modern Art, Munich, Germany; Aldrich; Whitney Museum; and others. Exhibited: The Stable Gallery, 1966, 67; Esther Robles Gallery, 1968; Palais des Beaux-Arts, Brussels, 1965; Museum of Contemporary Art, Houston, TX, 1966; Carnegie; Flint Institute; Worcester Art Museum; UCLA, Electric Art, 1969; Torcuato di Tella, Buenos Aires, 1969; Museum of Modern Art; Whitney. Address in 1982, c/o Galeria Bonino Ltd., NYC.

MALM, GUSTAV N.
Painter, illustrator, craftsman and writer. Born in Svarttorp, Sweden, Jan. 20, 1869. Studied in Sweden. Member: Smoky Hill Art Club. Author and illustrator of "Charlie Johnson," a study of the Swedish Emigrant. Address in 1929, Malm Studio, Lindsborg, KS.

MALMSTROM, MARGIT.
Sculptor. Born in Stockholm, Sweden, in 1943. Studied: Bard College, sculpture with Harvey Fite; in NYC with sculptor Bruno Lucchesi; later as a scholarship student at the National Academy of Design. Work has been exhibited since 1977 in numerous galleries in NYC. Awards: Helen Foster Barnett Prize from the National Academy show in 1978. Taught: Sculpture at Barrett House, Dutchess County Art Association, Poughkeepsie, NY; The Chelsea School of Fine Art, NYC; The Sculpture Center, NYC, currently. Has also conducted demonstrations and workshop classes at Sculpture Associates, NYC. Co-author, with Bruno Lucchesi, of three books on sculpture technique: *Terracotta: The Technique of Fired Clay Sculpture; Modeling the Head in Clay*; and *Modeling the Figure in Clay*. Address in 1984, 36 West 21st Street, NYC.

MALONE, BLONDELLE.
Painter. Member: National Association of Women Painters and Sculptors; American Federation of Arts. Address in 1929, 1741 Rhode Island Avenue, Washington, D.C.

MALONE, LAETITIA HERR.
(Mrs. John E. Malone). Painter and illustrator. Born in Lancaster, PA, in 1881. Pupil of Chase, Mora, Beaux, Anshutz, and McCarter at Penna. Academy of Fine Arts. Member: Penna. Academy of Fine Arts; Philadelphia Art Alliance. Address in 1926, Lancaster, PA.

MALONE, ROBERT JAMES.
Etcher, caricaturist. Born in Birmingham, AL, March 14, 1892. Work published in *New York Times, Cosmopolitan, International Book Review, Review of Reviews, The London Graphic*. Address in 1929, St. James, LI, NY.

MALONE, ROBERT R.
Painter and printmaker. Born in McColl, SC, August 8, 1933. Studied: Furman University; University of NC; University of Chicago; State University of Iowa. Work: Smithsonian Institution; Library of Congress; NY Public Library; Philadelphia Museum of Art; California Palace of Legion of Honor, San Francisco; others. Commissions: International Graphic Arts Society. NYC; Ferdinand Roten Galleries, Baltimore; Lakeside (MI) Studio; many more. Exhibited: 15th National Print Exhibition, Brooklyn Museum; New Talent in Printmaking 1968, AAA Gallery, NYC; Biennal International De L'Estampe, Paris. Awards: Purchase Award, Colorprint USA, Texas Tech. University; Recent American Graphics Purchase Award, University of Wisconsin, Madison; Southern Illinois University Sr. Resident Scholar Award. Teaching: Southern Illinois University, 1970-present; others. Member: College Art Association of America. Media: Oil, lithography, etching. Address in 1984, Edwardsville, IL.

MANATT, WILLIAM WHITNEY.
Sculptor. Born in Granville, OH, March 2, 1875. Pupil of Broutos of Athens; Saint Gaudens at Art Students League of NY. Address in 1915, Berkeley, CA.

MANBERT, BARTON.
Painter and etcher. Born in Jamestown, NY. Pupil of George Bridgman, Lucian Hitchcock and Reynolds. Member: California Art Club; Glendale Art Association. Award: Bronze medal, San Diego Expo., 1915. Address in 1929, 621 South Columbus Avenue, Glendale, CA; summer, Balboa Island, CA.

MANCA, ALBINO.
Sculptor. Born in Tertenia, Sardinia, Italy, January 1, 1898. Studied: Royal Academy of Fine Art, Rome, Italy, with Ferrari and Zannelli. Member: National Sculpture Society (fellow); National Academy of Design; American Artists Professional League;

Allied Artists of America. Awards: Prizes, Royal Academy of Fine Art, Rome, Italy, 1926, 27; Montclair Art Museum, 1941; American Artists Professional League, 1941; Allied Artists of America, 1943; prizes, National Academy of Design, 1964, 66; Smithsonian Institution, 1965. Work: Monument Cagliari, Sardinia; The Gate of Life, entrance gate, Queens Zoo, 1968; Brookgreen Gardens, SC; Henry Hering Memorial Medal, 1959; sculpture, Fairmount Park Association, Philadelphia, PA; commemorative medals in numismatics collections of Smithsonian Institution, American Numismatic Society, Metropolitan Museum of Art. Exhibited: American Artists Professional League, 1941; Newark Museum, 1941; Montclair Art Museum, 1941; Allied Artists of America, 1943; Museum of Modern Art (AV), 1942; Italian Salon, Rockefeller Center, NY, 1940 (oneman); World's Fair, New York, 1939. Address in 1980, 131 West 11th Street, New York, NY.

MANCHESTER, ARTHUR WILLIAMS (MRS.).
See Waite, Emily Burling.

MANCINI, JOHN.
Sculptor. Worked: New York City, 1841-57.

MANDEL, HOWARD.
Sculptor, painter, and illustrator. Born in Bayside, NY, February 24, 1917. Studied: Pratt Institute Art School, Brooklyn; New York Sculpture Center; Art Students League; Atelier Fernand Leger, Paris; Atelier Andre L'Hote, Paris; Ecole Beaux Arts, Sorbonne, France. Member: Audubon Artists; Clay Club; Woodstock Art Association. Awards: Tiffany Fellow, 1939, 49; Fulbright Scholarship to Paris, 1951, 52. Work: Whitney; Butler Institute, Youngstown, OH; Norfolk Museum of Arts and Science, VA; Lexington, KY; Marine Hospital, Ft. Stanton, NM; mural, Arthur Studios, NY. Exhibited: American Watercolor Society of New York, 1937-40; New York Watercolor Club, 1937-40; Clay Club, 1940-46; Philadelphia Museum of Art, 1940-42; Toledo Museum of Art, 1941; Utah State Institute of Fine Arts, 1941; Vendome Gallery, 1942; Woodstock Art Association, 1946; Whitney, 1948-59; Metropolitan Museum of Art, 1950; National Institute of Arts and Letters, 1955, 61. Illustrated many national magazines. Address in 1982, 285 Central Park West, NYC.

MANDELMAN, BEATRICE M.
Painter. Born in Newark, New Jersey in Dec. 31, 1912. Studied: Art Students League; Newark School of Fine and Industrial Arts. Collections: Metropolitan Museum of Art; Museum of New Mexico; University of Omaha. Media: Acrylic and collage. Address in 1980, Taos, NM.

MANDL, A.
Painter. Born in Munich in 1894. Pupil of Daniel Garber and LeRoy Ireland. Member: Fellowship, Penna. Academy of Fine Arts.

MANDZIUK, MICHAEL DENNIS.
Painter and serigrapher. Born in Detroit, MI, January 14, 1942. Work: Minn. Museum of Art, St. Paul; Borg Warner Corp., Chicago; Art Center Collection, Park Forest, IL. Exhibited: Minn. Museum Art Drawing Biennial, St. Paul, 1973; Butler Institute of American Art, Youngstown, OH, 1973-74; Ukranian Institute of Modern Art, Chicago, 1975; Battle Creek Art Center, Michigan; others. Medium: Silk screen. Address in 1982, Allen Park, MI.

MANGER, HEINRICH (HENRY).
Sculptor. Born in 1833. Active in Philadelphia c. 1862 to 1871. Exhibited a bust of Lincoln at the Pennsylvania Academy, 1865-67.

MANGRAVITE, PEPPINO.
Painter. Born in Lipari, Italy, June 28, 1896. Pupil of E. Guastini. Member: Society of Independent Artists; Salons of America; Brooklyn Society of Modern Artists. Award: Gold medal, Sesqui-Centennial Expo., Philadelphia, PA, 1926. Represented in the Phillips Memorial Gallery, Washington, DC. Art director, Avon College, Avon, CT; Birch-Walthen Schools, NY. Address in 1929, 7 Oakland Street, Rye, NY.

MANGUM, WILLIAM (GOODSON).
Sculptor and painter. Born in Kinston, NC. Studied: Corcoran School of Art, Washington, DC; Art Students League; University of NC, Chapel Hill. Work: Carl Sandburg Memorial, Flat Rock, NC; "Lamp of Learning" Monument, Greensboro, NC; NC Museums; private collections, including R. Phillip Hanes. Exhibitions: Isaac Delgado Museum; Galerie Paula Insel Exhibition and Bodley Gallery National, NYC; NC Museum of Art; Museum of Art, Springfield, MA; Virginia Museum of Fine Art; Southeast Center of Contemporary Art, Winston-Salem, NC. Awards: Virginia Museum of Fine Art; Delgado Museum Award, NC Museum of Art. Member: Southern Association of Sculptors. Teaching: Sculpture and art history at Salem College, from 1982. Address in 1982, Salem College, Winston-Salem, NC.

MANHOLD, JOHN HENRY.
Sculptor. Born in Rochester, NY, August 20, 1919. Studied at University of Rochester, B.A.; Washington University, St. Louis, M.A.; New School, with Chaim Gross and Manolo Pasqual; also with Ward Mount. Work in City of West Orange, NJ; Memorial Sloan-Kettering Hospital, NY; others. Has exhibited at Allied Artists of America; Audubon Artists of America; Grover M. Hermann Fine Arts Center, OH; National Sculpture Society; others. Member of American Artists Professional League (fellow); Painters and Sculptors Society, NJ; National Arts Club; Knickerbocker Artists. Awards: Second prize, Partons Award, Painters and Sculptors Society of NJ, 1971; John Subkis Award, National Arts Club,

1971; others. Work in marble and bronze. Address in 1982, Chatham, NJ.

MANIATTY, STEPHEN GEORGE.
Painter. Born in Norwich, CT, Sept. 5, 1910. Studied: Massachusetts School of Art. Work: Holyoke Museum, MA; Historical Murals, Franklin Trust Co., Greenfield, MA. Exhibited: Hudson Valley Art Association, White Plains, NY, 1972; American Artists Professional League, NYC, 1972; Guild of Boston Artists, 1975; others. Awards: Hudson Valley Art Association, NY; Rockport Art Association, MA, Gold Medal of Honor, 1968; American Artists Professional League, NY, Gold Medal, 1970; and many others. Member: Salmagundi Club; Guild of Boston Artists; Hudson Valley Art Association; American Artists Professional League; Southern Vermont Art Association. Medium: Oil. Address in 1976, Deerfield, MA.

MANIEVICH, ABRAHAM.
Painter. Born in Russia, Nov. 25, 1882. Pupil at Government Art School, Kiev; Art Academy, Munich. Work: "Through the Branches," Luxembourg Museum, Paris; "Rome, Italy," and "Spring, Capri, Italy," Horvatt Gallery, Geneva; "Paris, Parc de Montsouris," Imperial Academy of Art, Petrograd; "Autumn Symphony," Fund Museum, Moscow; "Miestetchks" and "My Birthplace," Museum of Art, Kiev; landscape and "Birch," Brooklyn Museum of Art. Address in 1929, 3751 Giles Place, Bronx, NY.

MANIGAULT, EDWARD MIDDLETON.
Painter. Born in London, Ontario, CN, June 14, 1887. Pupil of Kenneth Hayes Miller. Address in 1926, 130 West 57th Street, New York, NY. Died Sept. 4, 1922, in San Francisco, CA.

MANKOWSKI, BRUNO.
Sculptor and medalist. Born in Germany, October 30, 1902. U.S. citizen. Studied art at the Munich Art School; State Art School, Berlin; Beaux-Art Institute, NY. Exhibited: National Academy of Design Annual, 1940-78; Penna. Academy of Fine Arts Annual, 1947-54; National Sculpture Society Annual, 1947-78; American Academy of Arts and Letters, 1949-50; Allied Artists of America Annual, 1952-77. Awards: Daniel Chester French Award, Allied Artists of America, 1964; Herbert Adams Memorial Medal, 1972, and gold medal, at the Bicentennial Exhibition, 1978; National Sculpture Society; Gold Medal from the American Numismatic Association, Colorado Springs, 1980. Member: National Academy of Design, 1971-73; fellow, National Sculpture Society (council member, 1953-58, 71-78, chairman of the exhibit committee, 1956-58); a life fellow of the American Numismatic Society. Commissions: Sculptured panel, by U.S. Government Society of Fine Arts, Chesterfield, SC, 1939; memorial plaque, Macombs Junior High School, NY, 1949; numerous

designs for Steuben Glass, Corning, NY, 1954-55. Address in 1982, De Bary, FL.

MANLEY, F.
Sculptor. Active mid-19th century. Made portrait busts in NY.

MANLEY, THOMAS R.
Painter and etcher. Born in Buffalo, NY, Nov. 29, 1853. Pupil of Penna. Academy of Fine Arts. Member: National Arts Club; NY Water Color Club. Award: Bronze medal for etchings, St. Louis Expo., 1904. Work: Montclair Art Association; Yale Club, New York, NY. Address in 1929, 38 St. Luke's Place, Montclair, NJ.

MANLY, JOHN.
The only evidence of this man as an engraver is found in an etched portrait of Washington, executed after 1789. Manly is said to have been a die-sinker, and apparently flourished about 1800. In an advertisement in the *Freeman's Journal*, Philadelphia, 1790, "an Artist" proposes "a subscription for a medal of George Washington." Subscriptions were received at Wilmington by Peter Rynberg, and in Philadelphia by J. Manly, "in the care of Robert Patton, Postmaster." This would indicate that Manly was then in Philadelphia - if he were not the "artist" referred to. In 1772 he was painting portraits in Virginia.

MANN, JACK.
Painter. Exhibited at National Academy of Design, New York, in 1925. Address in 1926, 15 East 14th Street, New York.

MANN, PARKER.
Painter. Born in Rochester, NY, July 6, 1852. Studied at Ecole des Beaux Arts, Paris. Engaged as landscape painter in Washington most of the time from 1887-98; in NY, 1899-1906. Spent several years painting in England, France, Holland, Switzerland, Italy, and Spain. He died on Dec. 15th, 1918 in Princeton, NJ.

MANNHEIM, JEAN.
Painter. Born in Krevznach, Germany, Nov. 18, 1863. Pupil of Ecole Delecluse, Colarossi, London School of Art. Member: California Art Club; Laguna Beach Art Association. Awards: Gold medal, Seattle Expo., 1909; gold and silver medals, San Diego Expo., 1915. Represented in Denver (CO) Museum. Address in 1929, 500 Arroyo Drive, Pasadena, CA.

MANOIR, IRVING (K.).
Painter, sculptor, craftsman, lithographer, block-printer, lecturer, teacher, and writer. Born in Chicago, IL, April 28, 1891. Pupil of Wellington Reynolds; H. M. Wollcot; Art Institute of Chicago; Chicago Academy of Fine Arts; Penna. Academy of Fine Arts; and studied abroad. Award: Goodman Prize,

Art Institute of Chicago, 1915; Prize of $500, Speed Memorial Museum, Louisville, KY, 1931; first landscape prize, Laguna Beach Art Association, 1925. Work: "Blue Hills," in Joliet (IL) Public Library; mural decoration in Vincennes (IN) High School; "Fairytale Land of New Mexico," Speed Memorial Museum, Louisville, KY; "Still Life," Milwaukee Art Institute, Milwaukee, WI; "Decorative Birds," Brooks Memorial Art Museum, Memphis, TN; "Where D. H. Lawrence Lived in Taos," and "Decorative Trees," Commission for the Encouragement of Local Art, Art Institute of Chicago, Chicago, IL. Member: Painters and Sculptors of Chicago; Art Institute of Chicago Alumni; Chicago Art Club; Chicago Galleries Association; St. Petersburg Art Club; Laguna Beach Art Association; Artland Club. Exhibited: Corcoran; Penna. Academy of Fine Arts; Art Institute of Chicago; Los Angeles Museum of Art; Laguna Beach Art Association; City Art Museum of St. Louis; others. Address in 1953, Corona del Mar, CA.

MANON, ESTELLE REAM.
Painter. Born in Lincoln, IL, in 1884. Pupil of William M. Chase and Charles W. Hawthorne. Member: St. Joseph Art League; Oklahoma Art League. Head of art department, Oklahoma City High School. Address in 1926, 716½ Tely Street, St. Joseph, MO.

MANOR, FLORENCE.
Sculptor. Born in Santa Cruz, CA, October 29, 1881. Award: Gold medal, Alaska-Yukon-Pacific Exposition, 1909. Address in 1916, 2529 Union Street; h. 2245 Green Street, San Francisco, CA.

MANSFIELD, BLANCHE McMANUS.
(Mrs. Francis Miltoun Mansfield). Illustrator and painter. Born in East Feliciana, LA, Feb. 2, 1870. Studied in Paris. Specialty, book and periodical illustration. Author *The American Woman Abroad, Our French Cousins*, etc. Address in 1929, 9 Rue Falguiere, Paris, France.

MANSFIELD, LOUISE BUCKINGHAM.
Painter and illustrator. Born in Le Roy, NY. Pupil of Art Students League of NY. Member: Association of Women Painters and Sculptors; Brooklyn Society of Artists; Brooklyn Water Color Club; Art Students League of NY; American Federation of Arts. Address in 1929, 368 Hancock Street, Brooklyn, NY.

MANSHIP, PAUL HOWARD.
Sculptor. Born on December 25, 1885, St. Paul, MN. Studied at St. Paul School of Art; Penna. Academy of Fine Arts; Art Students League; American Academy in Rome. Work: American Academy in Rome; Addison Gallery, Andover, MA; Art Institute of Chicago; Cochran Memorial Park; Detroit Institute; Harvard University; League of Nations; Metropoli-

tan Museum of Art; Minneapolis Institute; New York Coliseum; Pratt Institute; Rockefeller Center; City Art Museum of St. Louis; Corcoran; Luxembourg, Paris; Fairmount Park, Philadelphia; Phillips Academy, Andover, MA; others. Exhibited: Architectural League of New York, 1912; American Federation of Arts, 1914; 37 Leicester Gallery, London, 1921; Philadelphia Museum of Art, 1926; Tate, 1935; Century Association, 1935; Virginia Museum of Fine Arts, 1936; Arden Gallery, NYC, 1941; American Academy of Arts and Letters, 1945; Walker, 1948; Smithsonian, 1958; St. Paul Gallery, 1967; Penna. Academy of Fine Arts; National Academy of Design; Whitney Museum; Metropolitan Museum of Art; National Sculpture Society; many others in U.S. and abroad. Member: National Sculpture Society, 1912; Associate National Academy of Design, 1914; Academician National Academy of Design, 1916; American Institute of Arts and Letters, 1918; Chevalier, Legion d'Honneur, 1929; Century Association; National Arts Club. Awards: American Academy in Rome scholarship, 1909-12; Barnett prize, National Academy of Design, 1913; Widener gold medal, Penna. Academy of Fine Arts, 1914; gold medal, P.-P. Expo., San Francisco, 1915; Barnett prize, National Academy of Design, 1917; gold medal, American Institute of Architects, 1921; medal, American Numismatic Society, 1924; gold medal, Philadelphia Art Association, 1925; gold medal, Sesqui-Centennial Expo., Philadelphia, 1926; Legion d'Honneur, 1929; National Sculpture Society, 1943; National Institute of Arts and Letters, gold medal, 1945. Address in 1953, 319 East 72 St., NYC; Lanesville, Gloucester, MA. Died February 1, 1966, in NYC.

MANSO, LEO.
Painter and educator. Born April 15, 1914 in NYC. Studied at National Academy of Design; New School for Social Research. Exhibited at Norlyst Gallery, NYC, 1947; Whitney Museum of American Art Annual, 1947-66; Grand Central Moderns, many times, 1957-64; National Institute of Arts and Letters, 1961, 69; Museum of Modern Art, 1961, 65; Babcock Galleries, NYC; Penna. Academy of Fine Arts, 1968; University of Nebraska; Walker; Montclair Museum, NJ, 1979; others. In collections of Boston Museum of Fine Arts; Corcoran Gallery; University of Illinois; Whitney; Penna. Academy of Fine Arts; Brandeis University; Nebraska Art Association; Brooklyn Museum; Museum of Modern Art; Worcester (MA) Museum; and many private collections. Received awards from Audubon Artists, 1952; Wesleyan University, IL, 1954; American Academy of Arts and Letters, 1969; Penna. Academy of Fine Arts; University of Illinois; Ford Foundation; Guggenheim Fellowship in Printmaking, 1982; others. Member: Century Club; American Abstract Artists; National Academy of Design. Taught at Columbia University; Smith College; University of Michigan;

Cooper Union; NY University; Art Students League; American Academy in Rome. Co-founder of the Provincetown Workshop, 1959. Address in 1984, 460 Riverside Drive, New York, NY.

MANUEL, BOCCINI.
Sculptor, painter, and etcher. Born in Pieve di Teco, Italy, September 10, 1890. Pupil of Andri Favory, Andre Derain. Member: Art Students League of New York; Society of Independent Artists; Salon d'Artistes Francais Independants, Paris; Chicago No-Jury Society of Artists; Salons of America. Address in 1933, 485 Madison Avenue; h. 470 Midland Avenue, Rye, NY.

MANUEL, MARGARET.
Etcher. Born in Hawick, Scotland. Pupil of Ernest Haskell and NY School of Applied Design for Women. Member: Brooklyn Society of Etchers; National Association of Women Painters and Sculptors; American Federation of Arts. Work: "On the Edge of the Cumberlands - Tennessee," Chicago Art Institute; "Logan-Lee, Pentland Hills," National Museum, Washington, D.C.; "On The Edge of the Cumberlands - Tennessee" and "Maine Seascape," Corona Mundi, International Art Center, New York City; "In the Heart of the Cumberlands - Tennessee," Bibliotheque Nationale, Paris, France (permanent collection). Address in 1929, Harperley Hall, 1 West 64th Street, New York, NY.

MANY, ALEXIS B.
Painter. Born in Indianapolis, IN, August 10, 1879. Member: Salma. Club; Washington Society of Artists; Washington Art Club. Awards: Bronze medal, Society of Washington Artists, 1921; Corcoran prize, Society of Washington Artists, 1921; 1st prize, California Art Club, 1921. Address in 1929, 1710 Third Street, N.E., Washington, D.C.

MAPES, JAMES JAY.
Amateur miniature painter. Born in Maspeth, L.I. 1806. He is noted by William Dunlap in his "History of the Arts of Design." From 1835 to 1838 he was "Professor of Chemistry and Natural Philosophy of Colors," at the National Academy, and was an hon. member of the National Academy. He died Jan. 19, 1866, in NYC.

MA-PE-WI (VALINO SHIJE HERRERA).
Painter. Pueblo Indian of the Pueblo Zia, Jenez Valley, NM. Born in 1900. Represented in the Santa Fe Museum, Santa Fe, NM. Address in 1929, care of Mrs. Van Stone, Santa Fe, NM.

MAPLES, THOMAS.
Sculptor. Born in England, c. 1803; came to U.S. c. 1850. Worked: Philadelphia, 1850-70's.

MAPLESDEN, GWENDOLINE ELVA.
Painter, sculptor, illustrator, writer, lecturer, and teacher. Born in Secunderabad, India, September 3, 1890. Pupil of Daniel Garber, George Bridgman, Vincent Du Mond. Member: National Association of Women Painters and Sculptors; Fellowship, Penna. Academy of Fine Arts; Alliance; NY Society of Craftsmen; Art Students League of NY; American Artists Professional League; National Arts Club, NY; American Federation of Arts. Author of *A Comparison Between Eastern and Western Ideals of Art*. Address in 1933, 523 West 121st Street; h. 435 West 119th Street, New York, NY; summer, Suffield, CT.

MARAFFI, LUIGI.
Sculptor and craftsman. Born in Aversa, Italy, December 4, 1891. Pupil of Grafly. Member: Graphic Sketch Club, Philadelphia; Fellowship, Penna. Academy of Fine Arts. Awards: Stewardson prize and two Cresson Scholarships, Penna. Academy of Fine Arts. Work: Bronze portrait of Edward T. Stotesbury, Drexel Bank, Philadelphia. Address in 1933, 1311 Christian St., Philadelphia, PA.

MARANS, MOISSAYE (MR.).
Sculptor. Born in Chisinau, Roumania, October 11, 1902. U.S. citizen. Studied: Technical Institute, Bucharest; University Jassy, Roumania; Cooper Union Institute, New York, with Brewster; National Academy of Design, with Aitken; Penna. Academy of Fine Arts, with Grafly; Cincinnati Academy of Fine Arts; Beaux-Arts Institute of Design, NY; New York University. Member: National Academy of Design; Architectural League of New York; Audubon Artists; National Sculpture Society; American Artists Professional League. Awards: Prizes, Penna. Academy of Fine Arts, 1928; United States Post Office competition, York, PA, 1941; American Federation of Arts traveling exhibition, 1951; Football Coach of the Year plaque competition, 1946; 1953 Medal for Reflection, Architectural League of New York, 1953; medal, National Academy of Design, 1967. Work: Norfolk Museum of Fine Arts; Smithsonian Institution, Museum of Natural History, Washington, DC; Brooklyn Botanical Gardens; West Baden (IN) College; United States Post Office, Boyertown, PA; Chagrin Falls, Ohio. Exhibited: National Academy of Design; Los Angeles Museum of Art; Corcoran Gallery of Art; World's Fair, New York, 1939; Whitney Museum of American Art; Philadelphia Museum of Art; Penna. Academy of Fine Arts; National Sculpture Society; American Federation of Arts traveling exhibition; Brooklyn Museum; Jewish Museum, NY. Media: Wood and stone. Address in 1976, 93 Court Street, Brooklyn, NY. Died in 1977.

MARAS, M.
French miniature artist who flourished in NY from 1800 to 1802; he later went to Constantinople and became painter to the Sultan.

MARBLE, JOHN NELSON.
Painter. Born in 1855. He studied in France and Italy. He painted portraits of Bishop Phillips Brooks, Judge Henry E. Howland and Mary Baker Eddy. He died in Woodstock, VT, April 1, 1918.

MARCHAND, JOHN NORVAL.
Painter, sculptor and illustrator. Born in Leavenworth, KS, 1875. Studied at the Harwood Art School, St. Paul, MN; at the Munich Academy, 1897-99. Worked as staff artist for *New York World*, and as a book and magazine illustrator in New York City. Illustrated *Girl of the Golden West; Arizona: A Romance of the Great Southwest*; many other books and magazines. Executed portrait bust of Charles M. Russell, 1905. Specialty was western subjects. Member of Society of Illustrators. Work in Earl C. Adams Collection, Anschutz Collection, Harmsen Collection. Died in Westport, CT, in 1921.

MARCHANT, B.
The only engravings known by Marchant are line illustrations in "The Narrative of Capt. James Riley," published in NY in 1816.

MARCHANT, EDWARD DALTON.
Born in Edgartown, MA, Dec. 16, 1806. He painted portraits in Philadelphia and NY for many years. He also resided in Nashville, TN, and settled in Philadelphia in 1845. He first exhibited in 1829 at the National Academy of Design. He was a member of the Union League Club of Philadelphia where several of his portraits are owned and in 1833 he was elected an Associate Member of the National Academy. He died in Asbury Park, NJ, Aug. 15, 1887.

MARCHANT, G. W.
See Merchant, G. W.

MARCHESCHI, (LOUIS) CORK.
Sculptor and teacher. Born in San Mateo, CA, April 5, 1945. Studied at the College of San Mateo, CA, 1963-66; California State College, Hayward, 1966-68; Graduate School, California College of Arts and Crafts, Oakland, 1969-70, M.F.A., 1970; also with Mel Ramos and Paul Harris. Became involved in Experiments in Art and Technology, San Francisco and Berkeley, 1968-69. Exhibited: Egor Meade Gallery, San Francisco, 1968; Museum of Art, Oakland, CA, 1970; Louis K. Meisel Gallery, NYC, 1973; Galerie M. Bochum Weitmar, West Germany, 1974; Ulrich Museum, Wichita, KS, 1975; Hanson-Cowles Gallery, Minneapolis, MN, 1977; Tubingen Museum, Germany, 1978; numerous others. Awarded Minnesota State Arts Council Grant, 1975; and Bush Foundation Grant, 1978. Taught: Minneapolis College of Art and Design, from 1970. Author of several books and articles, including *Heat, Light, and Motion*, 1974, *Neon*, 1975. Address in 1982, Minneapolis, MN.

MARCHINO, FREDERICK.
Sculptor. At New York City, 1850.

MARCUS, MARCIA.
Painter. Born in New York on Jan. 11, 1928. Studied: NY University; Cooper Union Art School; Art Students League; and with Edwin Dickinson. Collections: Whitney Museum of American Art; Newark Museum. Address in 1980, New York City.

MARCUS, PETER.
Painter, etcher, and writer. Born in New York City, Dec. 23, 1889. Pupil of Ecole des Beaux Arts, Ecole des Beaux Arts Decoratifs in Paris; Charles H. Davis; Henry W. Ranger. Member: NY Architectural League; Connecticut Academy of Fine Arts; Lotos Club; Salma. Club; New Haven Paint and Clay Club; Brooklyn Society of Etchers; Mystic Society of Artists. Award: Hon. Mention, Connecticut Academy of Fine Arts, 1918. Author and illustrator of *New York, the Nation's Metropolis*. Address in 1929, 155 West 58th Street, 30 West 59th Street, New York, NY; Water Street, Stonington, CT.

MARDON, ALLAN.
Illustrator. Born in Welland, Ontario in 1931. He graduated from the Ontario College of Art and studied at the Edinburgh School of Art and Slade School of Fine Art. His editorial illustrations are in great demand and are seen regularly in *Time* and *Sports Illustrated*. His *Time* covers have been exhibited overseas and he has shown work in the Society of Illustrators Annual Exhibitions, the General Electric Gallery, and Circle Gallery which has issued his NBA lithographs as part of its 1977 Official Fine Art Sports Collection.

MARE, JOHN.
Portrait painter. Born 1739 in NYC. He is recorded in the city of New York as a "Limner." He painted the portrait of Robert Monckton, Governor of NY in 1761; he signed his portrait of John Ketelas "Jno. Mare Pinxt, 1767." Three other portraits painted by him in 1766, 1767 and 1768 have been identified. Died in 1795.

MARE, JOHN De.
Engraver. Born in Belgium, he belonged to a noble and ancient family, and was himself a highly cultivated man. It is not known where he learned to engrave, but he appeared in NY about 1850, and engraved in line a few admirable book illustrations. He is said to have returned to Europe about 1861.

MARGOLIES, ETHEL POLACHECK.
Painter. Born in Milwaukee, WI, August 1, 1907. Studied: Smith College, A.B., 1929; Silvermine Guild of Artists; Umberto Romano School, East Gloucester, MA; University of Vermont, summer school; and with Revington Arthur, Gail Bymon, and Robert

Rocher. Awards: Burndy Engineering award, Silvermine Guild, 1957, other awards for industrial painting, 1954, 60, and 64; Electric Regulator Corporation, 1954; New Haven Paint and Clay Club, 1955, 75; Springfield Museum, MA, 1957; Chautauqua Art Association, 1958. Collections: Burndy Library, Norwalk, CT; Springfield Museum of Art; New Haven Paint and Clay Club. Exhibited: Silvermine Guild, New England Exhibition, New Canaan, CT, 1954-57, 60-68, 74-75; Connecticut Academy of Fine Arts; Audubon Artists; Connecticut Watercolor Society. Member: Silvermine Guild of Artists; Connecticut Academy of Fine Arts; Artists Equity Association; New Haven Paint and Clay Club; Connecticut Watercolor Society. Address in 1984, New Canaan, CT.

MARGOULIES, BERTA.
(Berta Margoulies O'Hare). Sculptor. Born in Lovitz, Poland, September 7, 1907; U.S. citizen. Studied at Hunter College; Art Students League; Academies Colarossi and Julian, Paris; Ecole des Beaux-Arts, Paris. Works: Willamette University, Salem, OR; Des Moines Art Institute, IA; College, City of New York; Washington, DC; Monticello, AR; U.S. Post Office, Canton, NY; Whitney; Metropolitan Museum of Art; several US government commissions. Exhibitions: Whitney; Metropolitan Museum of Art; Penna. Academy of Fine Arts; Art Institute of Chicago; National Academy of Design; Corcoran; others. Awards: Avery Prize for Sculpture, New York Architectural League, 1937; American Academy of Arts and Letters, 1944; Guggenheim fellowship, 1946; Society of Four Arts, 1947; Penna. Academy of Fine Arts, 1951; Montclair Art Museum, 1952, 53. Founding member of Sculptors' Guild and Artists Equity. Address in 1984, Flanders, NJ.

MARGULIES, ISIDORE.
Sculptor and kinetic artist. Born in Vienna, Austria, April 1, 1921. Studied at Cooper Union Art School, NY, 1940-42; State University of NY, Stony Brook, B.A. (liberal arts), 1973; C. W. Post College, M.A.A., 1975; with Robert White, James Kleege, and Alfred Van Loan. Work in Brookgreen Gardens, SC. Has exhibited at National Academy of Design, NY; National Sculpture Society; Nelson Rockefeller Collection, 1980-81. Member of National Sculpture Society. Received Council of American Artists Award, National Sculpture Society, 1979; gold medal, National Sculpture Society, 1980. Address in 1982, Plainview, NY.

MARGULIES, JOSEPH.
Painter and etcher. Born in Austria, July 7, 1896. Pupil of Joseph Pennell; National Academy of Design; Art Students League of NY; Ecole des Beaux Arts, Paris. Member: Art of NY; Louis Comfort Tiffany Guild; Alliance. Work: Portrait of Judge Garvin, Federal Court, Brooklyn; Portrait, Morris Raphael Cohen, College of City of New York; Portrait, Dr. Frederick Paul, De Witt Clinton High School; Portrait, Attorney General Albert Ottinger of New York, State Capitol, Albany, NY. Address in 1929, 310 West 75th Street, New York, NY.

MARGULIES, PAULINE.
Sculptor. Born in New York, September 1, 1895. Studied with Fraser, Brewster, and Eberle. Address in 1919, Cooper Hall, 20 East Seventh Street, New York City.

MARIE-TERESA, (SISTER).
Painter and teacher. Born in Stillwater, MN, April 27, 1877. Pupil of New York School of Art; Art Students League of NY; Penna. Academy of Fine Arts; Robert Henri. Studied in Florence and Munich. Awards: Hon. mention for painting, St. Paul Institute, 1916; bronze medal for oil, St. Paul Institute, 1918; hon. mention, Minnesota State Art, 1919; silver medal and prize, Minnesota Art Association, 1920; hon. mention, Minnesota State Fair, 1922; special mention, Minnesota State Art Society, 1923. Member: St. Paul Art Society. Address in 1929, The College of St. Catherine, St. Paul, MN.

MARIL, HERMAN.
Painter and printmaker. Born in Baltimore, MD, Oct. 13, 1908. Studied: Maryland Institute of Fine Arts. Work: Whitney Museum; Metropolitan Museum of Art, NYC; Baltimore Museum; National Collection of Fine Arts, Smithsonian Institute; Scranton, PA, Post Office Murals; and others. Exhibited: San Francisco Golden Gate Expo., 1939; Carnegie Institute Annual, 1940-45; retrospective, Baltimore Museum, 1967; Penna. Academy of Fine Arts; Corcoran Gallery Biennials; Everson Museum, Syracuse, NY, 1977; and many others. Awards: Stefan Hirsch Memorial Award, Audubon Artists, 1972; Institute of Arts and Letters, Academy of Arts and Letters, NYC, 1978. Teaching: University of Maryland, 1947-present; Philadelphia Museum College of Art, 1955-56. Member: Baltimore Museum of Art; College Art Association; Artists Equity Association; Associate National Academy of Design. Media: Oil, acrylic; casein. Represented: Forum Gallery, NYC. Address in 1984, Baltimore, MD.

MARIN, JOHN.
Painter and etcher. Born in Rutherford, NJ, 1870. Pupil of Art Students League of NY; Penna. Academy of Fine Arts. One of the "291" group of the "Seven Americans" at the Intimate Gallery, New York. Represented in the Metropolitan Museum of Art, New York; Brooklyn Museum of Art; San Francisco Museum of Art, San Franciso, CA; Phillips Memorial Gallery, Washington, DC. Address in 1929, 253 Clark Terrace, Cliffside, NJ.

MARINSKY, HARRY.
Sculptor, painter, designer, and illustrator. Born in London, England, May 8, 1909. U.S. citizen. Studied: Rhode Island School of Design; Pratt Institute Art School, Brooklyn. Member: Artists Equity Association, NY; National Sculpture Society. Awards: Prizes, Art Directors Club, 1945; Silvermine Guild Sculpture Award, 1956. Commissions: Large bronze bird for scent and touch garden, Stamford Museum, CT, 1960; bronze figures, Harlequin Plaza, Denver, CO, 1981. Exhibited: Rhode Island Museum of Art, 1940-42; Montross Gallery, 1941; Museum of Modern Art, 1943; American-British Art Center, 1943-45; Madison Square Garden, NY, 1946 (one-man); Art Institute of Chicago, 1947; Eggleston Gallery, 1951 (one-man); Rolly-Michaux Galleries, Boston and NY; National Home Furnishing Show, 1952; Hammer Galleries, NY. Illustrated *Mexico in Your Pocket*, 1936; *Judy at the Zoo*, 1945; and other books. Contributor to national magazines. Media: Bronze; watercolor. Address in 1984, Pietrasanta (Lucca) Italy.

MARIONI, TOM.
Sculptor, environmental artist, and museum director. Born in Cincinnati, OH, May 21, 1937. Moved to San Francisco, CA, in 1959. Studied at Cincinnati Conservatory of Music, 1954; Cincinnati Art Academy, 1955-59. Curator, Richmond (CA) Art Center, 1968-71; founder and director, Museum of Conceptual Art, San Francisco, from 1970; editor, *Visions* magazine, from 1975. In collections of Oakland Museum and Richmond Art Center, CA; Student Cultural Center, Belgrade, Yugoslavia; City of San Francisco; plus commissions. Exhibited at Columbus, GA; Richmond (CA) Art Center; Oakland (CA) Museum; Whitechapel Gallery, London; M.H. de Young Memorial Museum, San Francisco; Los Angeles Institute of Contemporary Art; San Francisco Museum of Modern Art; and many galleries including those in San Francisco, Los Angeles, Bologna (Italy), Vienna (Austria), Bern (Switzerland), and Edinburgh (Scotland). Has published extensively. Awarded National Endowment for the Arts award, 1976-79; Guggenheim Grant, 1980. Address in 1982, San Francisco, CA.

MARISOL, ESCOBAR.
Sculptor. Born May 22, 1930, Paris, France. Studied: Art Students League, 1950, with Yasuo Kuniyoshi; Hofmann School, 1951-54; Academie des Beaux-Arts, Paris, 1949; New School for Social Research, 1951-54; Moore College of Art, Philadelphia, hon. degree, 1970. Work: Arts Club of Chicago; Brandeis University; Albright; Museum of Modern Art; Whitney Museum; and others. Exhibited: Leo Castelli Inc., NYC, 1957; Festival of Two Worlds, Spoleto, 1958; Dallas Museum of Fine Arts; Art Institute of Chicago; Carnegie; University of Illinois, 1961; American Federation of Arts, Wit and Whimsey in

20th Century Art, circa, 1962-63; Whitney Museum Annuals, 1962, 64, 66; Arts Club of Chicago, 1965; Sidney Janis Gallery, 1966, 67; Museum of Modern Art; Tate, Painting and Sculpture of a Decade, 1954-64; The Hague, New Realism; Los Angeles County Museum of Art, American Sculpture of the Sixties, 1967; Houston Festival of Arts, 1967; and many more. Contributor to *Pop Art; The Art of Assemblage*; others. Address in 1982, c/o Sidney Janis Gallery, NYC.

MARK, LOUIS.
Painter. Born in Hungary, August 25, 1867. Pupil of Bouguereau in Paris. Member: National Arts Club. Work: "Trinquets," Royal Museum, Budapest; "Explorer Robert Peary," Brooklyn Museum, Brooklyn, NY; "Tvyll," Albright Art Gallery, Buffalo, NY. Address in 1929, 200 West 57th Street, New York, NY; h. Benczur-Ucca - 7, Budapest, Hungary.

MARK, PHYLLIS.
Sculptor. Born in NYC. Studied: Ohio State University; New School for Social Research; sculpture with Seymour Lipton. Exhibitions: Drew University, 1969; Morris Museum, NJ, 1970; The Hudson River Museum, 1971-72; Women Choose Women, New York Cultural Center, 1973; Institute Contemporary Art, Los Angeles and Boston; Brooklyn Museum; Albright-Knox; many more. Collections: Dickerson-White Museum, Cornell University; The RCA Corporate Collection; Syracuse University; Corcoran. Works with motorized or wind propelled sculpture, metal, Dacron sails. Address in 1982, 803 Greenwich St., New York City.

MARKELL, ISABELLA BANKS.
Painter, sculptor, and etcher. Born in Superior, WI, December 17, 1891. Studied: Fontainebleau, FR, 1930; Maryland Institute; Penna. Academy of Fine Arts; Ecole des Beaux-Arts, Paris, France; also with O'Hara, Brackman, and Farnsworth. Member: Society of American Graphic Artists, NY; Pen and Brush Club; Miami Art Association; others. Awards: Prize, Southern States Art League, 1945; Boston Printmakers; Pen and Brush Club, 1953, 55, 64; Providence, Rhode Island, 1953, 1955; Wilmington Society of Fine Arts, 1958; prizes, National Association of Women Artists, 1956, 58-60, 64; three gold medals, American Artists Professional League, 1960, prize, 1964; many others. Work: New York Public Library; New York Historical Society; Museum, City of New York; Northwest Printmakers; Metropolitan Museum of Art; Philadelphia Free Library; Philadelphia Printmakers Club; New York Hospital; Providence Museum of Art; many others. Exhibited: Newark Museum; Northwest Printmakers; Philadelphia Print Club; Baltimore Museum of Art; Birmingham Art Museum; High Museum of Art; Allied Artists of America; New York Historical Society; American Watercolor Society of New York; Society of Ameri-

can Graphic Artists, NY; Museum, City of New York; DeMotte Gallery; Argent Gallery; Library of Congress; California Palace of the Legion of Honor; Laguna Beach Art Association; New Haven Paint and Clay Club; Ringling Museum of Art; Irvington Art Museum; Toronto Art Gallery; Miami Beach, FL; New Jersey Painters and Sculptors Society. Address in 1984, 10 Gracie Square, NYC.

MARKHAM, CHARLOTTE H.
Painter. Born in Wisconsin in 1892. Pupil of Art Institute of Chicago. Address in 1926, 704 Marshall Street, Milwaukee, WI.

MARKHAM, MARION E.
Painter. Born in Syracuse, NY, in 1875. Pupil of Chase. Represented by "Girl in Red" and "Portrait of a Child," at Syracuse Museum of Fine Arts. Address in 1926, 430 La Fayette Street, New York.

MARKLE, ALVAN, JR.
Painter. Born in Hazleton, July 28, 1889. Pupil of H. N. Hooven. Member: Philadelphia Art Club; Grand Central Art Galleries. Address in 1929, 333 West Green Street, Hazleton, PA.

MARKOE, FRANCIS HARTMAN.
Painter, writer, lecturer, and teacher. Born in New York City, June 11, 1884. Pupil of Alden Weir. Member: National Society of Mural Painters; Architectural League. Address in 1929, 535 Park Avenue, New York, NY.

MARKS, ISSAC.
Sculptor. Born in Lithuania, July 17, 1859. Self-taught. Address in 1933, 202 East 154th St., Harvey, Ill.

MARKS, STELLA LEWIS.
Painter. Born in Melbourne, Australia, Nov. 27, 1892. Member: R.M.S., London; National Association of Women Painters and Sculptors; American Society of Miniature Painters. Work: "H. R. H. The Princess Patricia of Connaught," owned by the English Royal Family; miniature of "Maud Allen," National Gallery of Victoria, Melbourne, Australia. Address in 1929, Larchmont Hills Apts., Larchmont, NY.

MARKS, WILLIAM.
Illustrator, of Calumet, MI. Died Sept 7, 1906.

MARLATT, H. IRVING.
Landscape and portrait painter, illustrater. Born in Woodhull, NY, approximately 1867. Work in Mt. Vernon Public Library, NY. Paintings included many Indian subjects. Also painted many cover illustrations for the *Literary Digest*. Died in Mt. Vernon, NY, 1929.

MARLOW, HENRY.
Sculptor. Born in Liverpool, England, 1838. Died in New Rochelle, NY, December 28, 1911.

MARR, CARL.
Painter, illustrator, and teacher. Born in Milwaukee, WI, Feb. 14, 1858. Pupil of Weimar Academy under Schaus; Berlin Academy under Gussow; Munich under Seitz and Lindenschmit. Member: Academies of Munich, Berlin, Athens, etc.; National Institute of Arts and Letters. Awards: Gold medal, Prize Fund Exhibition, New York, 1886; medals, Vienna, Berlin, Munich, Dresden, Madrid, Salzburg, Barcelona, Antwerp, Budapest; first medal, Liege, 1905. Work: "Dusk," Museum of Art, Toledo; "Gossip" and "The Mystery of Life," MetropolitanMuseum, New York. Address in 1929, Solln II, C., Munich, Germany.

MARRON, EUGENIE MARIE.
Sculptor, painter, and teacher. Born in Jersey City, NJ, November 22, 1901. Studied: Columbia University, B.S., M.A.; and with Alexander Archipenko, Rudolph Belling, Fernand Leger. Member: National Association of Women Artists, New York. Awards: Prizes, American Artists Professional League, 1944; Montclair Art Museum, 1944; Montclair Art Association, 1944. Exhibited: Montross Gallery; Charles Morgan Gallery; Lilienfeld Gallery; Montclair Art Museum. Address in 1953, 152 West 57th Street, New York, NY.

MARS, ETHEL.
Painter, engraver and craftsman. Born in Springfield, IL. Member: Salon d'Automne, Paris; Societe Nationale des Beaux Arts, Paris. Represented in collection of the French Government. Specialty: Colored woodblock prints. Address in 1929, Vence, Alp. Mar., France.

MARSAC, HARVEY.
This name appears as an "engraver" in the New York Directory for 1834. As no work signed by him has been found by the compiler, it cannot be positively stated that he engraved on copper.

MARSCHNER, ARTHUR A.
Painter, illustrator, and etcher. Born in Detroit, MI, April 11, 1884. Pupil of J. P. Wicker. Member: Scarab Club. Award: Prize, Scarab Club, 1926. Address in 1929, 1479 Seyburn Avenue, Detroit, MI.

MARSDEN, EDITH FRANCES.
Painter, craftswoman, and teacher. Born in Utica, NY, Sept. 22, 1880. Pupil of Birge Harrison, Arthur Freedlander, Henry R. Poore, Harry Leith-Ross, George Pearse Ennis; NY School of Fine and Applied Art. Member: Springfield Art League; Springfield Artists Guild; Alliance; Eastern Arts Association. Address in 1929, High School of Commerce; h. 8 Buckingham Street, Springfield, MA.

MARSDEN, RUTH GLADYS.
Painter and teacher. Born in Pittsfield, MA, March 11, 1898. Pupil of NY School of Fine and Applied Art; Grand Central School of Art. Member: Springfield Art League; Springfield Artists Guild; Eastern Arts Association. Address in 1929, Artists Guild, Harrison Avenue; h. 8 Buckingham Street, Springfield, MA.

MARSH, ALICE RANDALL (MRS).
Miniature painter. Born in Coldwater, MI. Pupil of Art Institute of Chicago; also of Merson, Colin, Whistler and MacMonnies in Paris. Member: American Society of Miniature Painters. Address in 1926, Nutley, New Rochelle, NY.

MARSH, ANNE STEELE.
Painter and printmaker. Born in Nutley, New Jersey on Sept. 7, 1901. Studied: Cooper Union Art School. Award: Philadelphia Printmakers Club, 1952. Collections: Museum of Modern Art; Brooklyn Museum; New York Public Library; New Jersey State Museum; Library of Congress; Montclair Art Museum; Newark Public Library; Metropolitan Museum of Art; Collectors of American Art; Philadelphia Museum of Art. Exhibited: Metropolitan Museum of Art; Art Institute of Chicago; National Academy of Design; Society of American Graphic Artists; American Watercolor Society; others. Member: New York Society of Women Artists; Society of American Graphic Artists; National Association of Women Artists; Boston Society of Printmakers; Washington Society of Printmakers. Address in 1976, Pittstown, NJ.

MARSH, CHARLES HOWARD.
Painter, etcher, and teacher. Born in Magnolia, IA, April 8, 1885. Pupil of W. V. Cahill, Guy Rose, Clarence Hickle, Gorguet and Despujol in Paris, and Stickney Memorial School of Pasadena. Member: California Art Club; Laguna Beach Art Association; California Water Color Society. Award: First prize, Southern California Fair Exhibition, Riverside, CA, 1920. Address in 1929, Director, European School, Fort Wayne, IN.

MARSH, FRED DANA.
Painter. Born in Chicago, IL, April 6, 1872. Pupil of Art Institute of Chicago. Member: Society of American Artists, 1902; Associate National Academy of Design, 1906; NY Architectural League, 1902; National Society of Mural Painters, 1904, NY; New Rochelle Art Association; American Federation of Arts. Awards: Bronze medal, Paris Expo., 1900; Silver medal, Pan-Am. Expo., Buffalo, 1901; bronze medal, St. Louis Expo., 1904. Work: Steamer "Berkshire," Rochester Art Gallery; decorations in Hotel McAlpin, NY; United Engineering Societies Building; Museum of Safety, New York, NY; Automobile Club of America; Detroit Country Club. Pictorial maps in SS *Malolo* and many privately owned. Address in 1929, Wykagyl Park, New Rochelle, NY; Sakonnet Point, RI.

MARSH, HENRY.
Wood engraver. His work appeared in *The Riverside Magazine* published by Hurd & Houghton. He also executed the splendidly engraved wood-cuts of insects in Harris' "Insects Injurious to Vegetation." This work of patience, requiring remarkable eyesight, shows also true artistic skill, and evidences the great talent of the engraver.

MARSH, LUCILE PATTERSON (MRS.).
Illustrator. Born in Rapid City, SD, Oct. 21, 1890. Pupil of Art Institute of Chicago. Work: Advertising for Lux, Pet Milk, Post Toasties, Val Spar Paints, Ivory Soap, Jello, etc.; illustrations for *Woman's Home Companion; Saturday Evening Post; Good Housekeeping.* Address in 1929, 412 West 20th Street, New York, NY; summer, "The Sycamores," Torresdale, PA.

MARSH, MARY E.
(Mrs. Conrad Buff). Painter and writer. Born in Cincinnati, OH. Pupil of Birger Sandzen, Chicago Academy of Fine Arts, Cincinnati Art Academy. Member: California Art Club; Laguna Beach Art Association. Address in 1929, 1428 Holbrook Street, Eagle Rock, CA.

MARSH, REGINALD.
Painter, illustrator, and etcher. Born in Paris, France, on March 14, 1898. Attended Yale University where he began his career illustrating for the *Yale Record*; also studied with John Sloan and George Luks. Came to NY in 1920 and served as a staff artist for the *Daily News* and as a cartoonist at *The New Yorker*. Exhibited nationally and at 16 one-man shows at Rehn Gallery in NY. Best known for his painting of NY scenes, he was in demand for his magazine work and, later in his career, for book illustration. His work is in the Metropolitan Museum of Art, Whitney Museum, Springfield Museum, Addison Gallery of American Art, Penna. Academy of Fine Arts, Art Institute of Chicago, Boston Museum of Fine Arts, Hartford Atheneum, and many other museums and galleries. Awarded prizes from Corcoran Gallery of Art, National Academy of Design, The Kohnstamm prize and the Watson Blair prize from Chicago, and the Dana medal from Philadelphia. He drew cartoons for *Vanity Fair, Harper's Bazaar* and the *Daily News*, approx. 4,000 drawings in three years, and he illustrated *Anatomy for Artists* in 1945. Some notable paintings in oil include "Why Not Take The L?" 1930, found in the Whitney Museum, and "Negroes on Rockaway Beach," 1934. Was a member of the National Institute of Arts and Letters, National Academy of Design, Royal Society of Artists in London, and the

Southern Vermont Artists. Taught at the Art Students League in NY, and the Moore Institute of Art, Science, and Industry in Philadelphia. Address in 1953, 1 Union Square; h. 240 East 15th Street, New York, NY. Died in 1954.

MARSH, WILLIAM R.
Was engraving vignettes, advertising cards, etc., in New York, from 1833-43.

MARSHALL.
In Judge Marshall's *Life of George Washington*, published by C.P. Wayne, Philadelphia, 1804-07, one of the illustrative maps is signed "Marshall Sct." This map represents the relative positions of the American and British forces prior to the Battle of White Plains, Oct. 28, 1776.

MARSHALL, FRANK HOWARD.
Painter. Born in England, 1866. Pupil of Art Students League of NY; Chase School, New York; Julian Academy in Paris under Laurens; studied in Madrid and London. Member: Salma Club, 1910; American Federation of Arts. Address in 1929, Palo Alto, CA.

MARSHALL, FRANK WARREN.
Landscape painter, craftsman, and teacher. Born in Providence, RI, Sept. 24, 1866. Pupil of RI School of Design; Julian Academy, Paris. Member: Providence Art Club; Providence Water Color Club. Address in 1929, 652 Angell Street, Providence, RI.

MARSHALL, MacLEAN.
Sculptor. Born in New York City, May 2, 1912. Studied: Art Students League; University Virginia; Child-Walker School of Design; Yale University School of Fine Arts; and with George Bridgman, Kimon Nicolaides, George Demetrios. Awards: Prize, National Arts Club, New York, 1935; Telfair Academy, 1941. Member: Association of Georgia Artists; National Arts Club, New York; North Shore Arts Association. Work: Telfair Academy of Art. Exhibited: National Arts Club, New York; Penna. Academy of Fine Arts; Telfair Academy of Art; Savannah Museum of Art; Grand Central Art Galleries. Address in 1953, Rome, GA.

MARSHALL, MARGARET J.
Illustrator. Born in Philadelphia, PA, July 29, 1895. Pupil of Penna. Academy of Fine Arts. Member: Plastic Club; Fellowship Penna. Academy of Fine Arts. Awards: Cresson Traveling Scholarship, Penna. Academy of Fine Arts, 1918. Illustrated *Children of the Alps*, published by Lippincott & Co. Address in 1929, 223 S. Sixth Street, Torresdale, Philadelphia, PA.

MARSHALL, MARY E. (MRS.).
Painter. Born in Plainfield, PA. Pupil of Dow; Walter Sargent; Breckenridge. Member: Alumni

Philadelphia Museum School of Industrial Art; Fellowship Penna. Academy of Fine Arts; Philadelphia Art Alliance; Plastic Club; National Association of Women Painters and Sculptors; Eastern Art Association; North Shore Arts Association; American Federation of Arts. Special assistant in the department of art education, Philadelphia Public Schools, and director, School Art League, Philadelphia. Address in 1929, 111 South 21st Street, Philadelphia, PA; summer, Wonson's Dock, East Gloucester, MA.

MARSHALL, MAY CHISWELL.
Painter. Born in Markham, VA. Pupil of Chase, Webster, Critcher, Corcoran School of Art. Member: Society of Washington Artists; Southern States Art League; Washington Art Club; Provincetown Art Association. Address in 1929, 1701 K Street, N. W., Washington, D.C.; summer, 6 Priscilla Alden Road, Provincetown, MA.

MARSHALL, RACHEL.
See Hawks, Rachel Marshall.

MARSHALL, THOMAS W.
Landscape and genre painter. Born in 1850; died in 1874. Exhibited at National Academy, 1871, "Near Bellows Falls." His work showed much promise.

MARSHALL, WILLIAM EDGAR.
Painter and engraver. Born in New York, June 30, 1837. Employed by the American Bank Note Company in 1858, but subsequently painted portraits in oil and engraved large portraits in line. He settled in Boston, but in 1864-66 traveled in Europe, residing chiefly in Paris, where he exhibited in the Salons of 1865 and 1866. Among his more noteworthy achievements were engravings after Stuart's "Washington" and Da Vinci's portrait of Christ; his heroic ideal painting of Christ, which he also engraved; and also engravings of many distinguished persons, including Lincoln, Longfellow, Cooper, Garfield, Beecher, Grant, Sherman, Blaine, Hancock, Harrison, Mc Kinley, and Roosevelt, most of which were reproduced from oil paintings by himself. Represented at the National Gallery, in Washington, D.C., by his portrait of Longfellow, and self-portrait at the age of 23.

MARSHBURN, THERESA.
Watercolorist. Studied: New York University; Fairleigh Dickinson University, NJ; The Art Students League, NY. Awards: Marquette University, Milwaukee, Wisconsin, 1973; Flint Art Museum, Michigan, 1973; Wisconsin Festival of Arts, 1974. Exhibitions: Columbia University, NY, 1966; Artesaneos Festival, Albuquerque, NM, 1973; El Paso Museum of Art, TX, 1974.

MARSIGLIA, GERLANDO.
Portrait painter. Born in Italy in 1792, he arrived in New York about 1817. In 1826 he was elected a

member of the National Academy of Design. His copy of the portrait of General Von Steuben after Ralph Earl is owned by the City of New York. He died Sept 4, 1850, in NYC.

MARSTON, J. B.
Portrait painter, who worked in Boston in 1807. His portrait of Gov. Caleb Strong is in the Massachusetts Historical Society.

MARTIGNY, PHILIPPE.
Sculptor. Born in Alsace, France, 1859. Spent his boyhood in France working in various studios. Came to America in the early eighties, and became a pupil of St.-Gaudens. Executed many groups for World's Fair, Chicago; several pieces for Congressional Library, Washington; etc. Address in 1898, 50 Washington Sq., E., NYC.

MARTIN.
Portrait draftsman in crayons. Martin was an Englishman who came from Sheffield to NY about 1797. His work was in steady demand, and he worked there until 1808.

MARTIN, AGNES BERNICE.
Painter. Born in Macklin, Sask.,Canada, March 22, 1911. U.S. citizen. Studied: Columbia University; University of New Mexico. Collections: Wadsworth Atheneum; Whitney Museum of American Art; Museum of Modern Art; Solomon R. Guggenheim Museum; Tate Gallery, London; Stedelijk Museum, Amsterdam, Holland; Art Museum of Ontario, Canada. She has exhibited widely throughout the United States; Documenta 5, Germany, 1972; Retrospective, Heyward Gallery, London, 1977; Stedelijk Museum, 1977; others. Address in 1984, Lamy, New Mexico.

MARTIN, CHARLES.
Portrait painter. Born in 1820. He flourished about 1850, in Bristol, Rhode Island. In 1851 he exhibited at the National Academy in New York. Died April 5, 1906 in London, England.

MARTIN, D.
He engraved at least one portrait, and also some of the maps found in *The Monthly Military Repository*, published by G. Smith, New York, 1796. These are maps of military operations during the Revolution.

MARTIN, E.
In 1826 this man was engraving buildings, etc., for Cincinnati publishers.

MARTIN, EDNA M.
Painter and teacher. Born in Seekonk, MA, March 1, 1896. Pupil of RI School of Design. Member: Providence Water Color Club; Providence Handicraft Club; Providence Art Club. Represented in RI School

of Design Gallery. Address in 1929, 227 Fall River Avenue, Seekonk, MA.

MARTIN, GAIL WYCOFF.
Painter and designer. Born in Tacoma, Washington, April 19, 1913. Studied: John Herron Art School, B.F.A.; State University, Iowa, M.F.A., with Philip Guston, Fletcher Martin and Emil Ganso; Boston Museum Art School, with Karl Zerbe. Awards: Mary Millikan European traveling scholarship, John Herron Art School, 1937; Art Guild of St. Louis, 1943; New England Drawing Exhibition, 1958; mural competition, Gengras Campus Center, University of Hartford, 1968. Collections: Library of Congress; Wadsworth Atheneum, Hartford, CT; United States Post Office, Danville, Indiana; University of Hartford. Exhibited: Museum of Modern Art, 1942; Carnegie Institute, 1942, 43; Connecticut Academy of Fine Arts, 1947-57, 1962; Museum of American Art, New Britain, CT, 1968. Medium: Oil. Address in 1984, Newington, CT.

MARTIN, HOMER DODGE.
Painter and illustrator. Born in Albany, NY, on Oct. 28, 1836. He studied painting with William Hart, at the National Academy, and in 1878 was one of the founders of the Society of American Artists. In 1875 he was elected a National Academician. His early work followed the conventional lines of the Hudson River School, and he was, in a sense, the first American impressionist. His noted works, such as "Normandy Trees," "Adirondack Scenery," "River Scene" (Metropolitan Museum, New York), and "Old Church in Normandy," are among the most individual productions of American Art, and his work as a whole occupies a place by itself owing to its intrinsic beauty and admirable personal quality. He died Feb. 12, 1897, in St. Paul, MN.

MARTIN, JEROME.
Illustrator. Born in New York City in 1926. He studied at Cooper Union and NY University. His first piece appeared in *Fortune* in 1959, which led to assignments for *Sports Illustrated, Playboy, Life* and *The Saturday Evening Post*. Numerous awards from the American Institute of Graphic Arts and the Art Directors' Club, and a Gold Medal from the Society of Illustrators, are the results of his efforts in the profession. His artwork has been shown at the Museum of Modern Art, Whitney Museum, Metropolitan Museum of Art and in the Library of Congress.

MARTIN, JOHN.
Illustrator. Born in Camden, New Jersey in 1946. He graduated in 1968 from the Philadelphia College of Art. Among his instructors were Albert Gold, Jack Freas and Ben Eisenstat. After military service as an art director for the psychological operations group in Vietnam, he returned to NJ, whereupon he began

free-lancing. Among his clients are *Reader's Digest*, *Seventeen*, Nonesuch Records, Elektra Records and Bell Telephone Company, as well as book publishers. His wife, Nancy, is also an illustrator. Presently living in Pennsauken, New Jersey.

MARTIN, JOHN BLENNERHASSET.
Engraver. Born on Sept. 5, 1797 in Ireland. Several stipple portraits, fairly well engraved and published in Richmond, VA, in 1822, are signed "Engraved by J. B. Martin, Richmond." He drew upon stone a good quarto portrait of John Randolph, of Roanoke. This lithograph was printed by Cephas G. Childs, but is signed as "Drawn on Stone & Published by J. B. Martin, Richmond." Also painted portraits and miniatures. Died Oct. 22, 1857 in Richmond, VA.

MARTIN, KNOX.
Sculptor and painter. Born in Barranquilla, Colombia, February 12, 1923. Brought to U.S. when a child; became a U.S. citizen. Studied at the Art Students League, after World War II, for four years. Exhibited: Santa Barbara Museum of Art, CA, in 1964; Yale University Art Gallery, 1966; Whitney Museum of American Art, 1972; National Gallery, Yugoslavia, 1981; Ingber Gallery, NYC, 1981; and others. Awards: Creative Artists Public Service, 1978; Balloonist Award, Mat Wiedekehr, St. Paul, MN, 1972; National Endowment for the Arts, 1972. Commissions of his work include a nineteen story wall painting, for City Walls, Inc., NY; wall painting, Mercor, Inc., at the Merritt Complex in Ft. Lauderdale, FL, 1972; wall painting, Houston and Mac Dougal Streets, NYC, 1979; and another wall painting for Nieman Marcus, White Plains, NY, 1980. Represented in Museum of Modern Art, NY; Whitney; Corcoran; others. Address in 1982, 128 Ft. Washington Avenue, NYC.

MARTIN, MARIA.
(Mrs. Maria Bachman). Painter. Born in Charleston, South Carolina, on July 3, 1796. In 1831 she met the naturalist and artist John James Audubon. With instruction from Audubon, she began developing her artistic talent, and before long she was actively assisting him in his work by painting in backgrounds for his watercolor portraits of birds. A great many of the color plates in *Birds of America* and of those plates later issued separately in America featured her work, and it is possible that some of her watercolors of birds may have been touched up and used by Audubon as well. In this work she was one of his three principal assistants and the only woman. She also contributed a number of drawings to John Edwards Holbrook's *North American Herpetology*, 1836-1842. Audubon named the Maria's woodpecker - *Picus martinae* - a subspecies of hairy woodpecker, for her. Died in Columbia, South Carolina, on December 27, 1863.

MARTIN, MARSHALL B. (MRS.).
Painter. Member: Providence Water Color Club. Address in 1929, 1113 Turks' Head Bldg.; 336 Doyle Avenue, Providence, RI.

MARTIN, MARVIN B.
Sculptor and etcher. Born in Fort Worth, TX, July 28, 1907. Studied: Kansas City Art Institute. Member: American Artists Professional League; Denver Artists Guild. Awards: Prizes, Missouri State Fair, 1927, 32. Work: Fairmount Cemetery, Guldman Memorial, National Home for Jewish Children, Colorado Historical Society, Kirkland School of Art, Rosehill Cemetery, Police Building, all of Denver, CO; High School, Art Museum, Boulder, CO; U.S. Department of Interior monument, Ignacio, CO; University of Colorado; Kent School for Girls, Denver, CO. Exhibited: Missouri State Fair, 1927, 33; Kansas City Art Institute, 1933, 35, 38, 39; Denver Art Museum, 1933, 35, 36, 1938-41, one-man exhibition, 1935, 44; Cincinnati Museum Association, 1935; University of Colorado, 1937 (one-man); Architectural League, 1938; World's Fair, NY, 1939; University of Illinois Faculty Exhibition, 1945, 46, traveling exhibition, 1945. Taught: Instructor of Sculpture, Denver University, 1935-38; University of Illinois, Urbana, IL, from 1944. Address in 1953, Champaign, IL.

MARTIN, NANCY YARNALL.
Illustrator. Born in Camden, New Jersey in 1949. She studied at the Corcoran School of Art and Philadelphia College of Art under Ben Eisenstat and Albert Gold. Her work appeared in the Illustrators 18th Annual Exhibition at the Society of Illustrators. She and her husband, illustrator John W. Martin, presently live in Pennsauken, New Jersey.

MARTIN, ROBERT.
Born in Scotland. In 1860 this man produced some excellent line illustrations for Cooper's works, published in NY.

MARTIN, STEFAN.
Illustrator. Born in Elgin, Illinois, he studied for four years at the Art Institute of Chicago under Ben Shahn. His work appeared in *Natural History* magazine in 1960 and he has had assignments from book companies including E. P. Dutton, Coward-McCann, Scribner's and Grosset and Dunlap. Best known for his paintings and woodcuts, he has twice won awards from the American Institute of Graphic Arts. He is represented in the collections of the Philadelphia Museum, Library of Congress, Metropolitan Museum of Art and Art Institute of Chicago.

MARTIN, WILLIAM A. K.
Marine, landscape, and historical painter. Born in Philadelphia in 1817. He studied painting abroad, and portraiture under John Neagle, in Philadelphia.

The Wilstach Collection in Fairmount Park owns his picture "Bruce Defending the Path At Delrey." He painted many of the old "men-of-war" of the U.S. Navy. He died in Philadelphia in 1867.

MARTINELLI, EZIO.
Sculptor and painter. Born November 27, 1913, in West Hoboken, NJ. Studied: Academy of Fine Arts, Bologna, Italy, 1931; National Academy of Design, 1932-36; Barnes Foundation, Merion, PA, 1940; with Leon Kroll, Gifford Beal, Robert Aitken (sculpture), Ivan Olinsky. Work: Brooklyn Museum; Art Institute of Chicago; University of Illinois; Memphis (Brooks); Newark Museum; Philadelphia Museum of Art; Guggenheim; Seattle Art Museum; United Nations; Whitney Museum; University of Wisconsin; 30-ft. sculpture, General Assembly Building, UN (commission). Exhibited: The Willard Gallery, NYC, 1946, 47, 52, 55, 64, 66; Art Institute of Chicago; Penna. Academy of Fine Arts; Brooklyn Museum; Whitney Museum Annuals, 1948, 61, 62, 66; Walker, 1956; American Federation of Arts, Major Work in Minor Scale; Virginia Museum of Fine Arts; Carnegie; National Institute of Arts and Letters; Claude Bernard, Paris, Aspects of American Sculpture, 1960; Newark Museum, Survey of American Sculpture; Gallery of Modern Art, NYC; De Cordova. Awards: L. C. Tiffany Grant, 1936, 64; Guggenheim Foundation Fellowship, 1956-62; National Academy of Design, President's Award; Ford Foundation, 1963; National Institute of Arts and Letters Award, 1966. Appointed to the Jury of Selection, John Simon Guggenheim Memorial Foundation, 1963. Taught: Philadelphia Museum School, 1946-49; Sarah Lawrence College, 1947-75; Parsons School of Design; American Academy, Rome, Artist-in-Residence, 1964-65 (appointed Trustee, 1966); Skowhegan School of Painting and Sculpture, summer, 1969. Address in 1980, Saugerties, NY.

MARTINET, MARJORIE DORSEY.
Painter and teacher. Born in Baltimore, MD, Nov. 3, 1886. Pupil of Maryland Institute; Penna. Academy of Fine Arts; Chase; Cecilia Beaux. Member: Maryland Institute Alumni; Fellowship Penna. Academy of Fine Arts; Philadelphia Alliance; Baltimore Museum of Art. Awards: Cresson European Scholarship, Penna. Academy of Fine Arts; Thouron prize for composition, Penna. Academy of Fine Arts. Director, Martinet School of Art, Baltimore. Address in 1929, 10 East Franklin Street; h. 4102 Ridgewood Avenue, West Arlington, Baltimore, MD.

MARTINEZ, XAVIER.
(Timoteo Martinez y Orozco). Painter, etcher, and teacher. Born in Guadalajara, Mexico, Feb. 7, 1874. Pupil of Mark Hopkins Institute, San Francisco; Ecole des Beaux-Arts under Gerome and Carriere. Member: San Francisco Sketch Club; Bohemian Club. Awards: Gold medal, San Francisco Art Asso-

ciation, 1895; hon. mention, Paris Expo., 1900; gold medal, as collaborator in exhibition of California S. of Arts and Crafts, and hon. mention for etching, P. P. Expo., San Francisco, 1915. Address in 1929, 816 Scenic Avenue, Piedmont, CA.

MARTINI, HERBERT E.
Painter, illustrator, etcher, writer, and lecturer. Born in Brooklyn, NY, Jan. 8, 1888. Pupil of F. V. DuMond and Munich Royal Acad. under Angelo Jank. Member: Stowaways. Work: Illus. *Golden Treasury Readers* and *French Reader*; author, *Color*. Address 1929, 97 Harris Ave., LI City, NY.

MARTINO, ANTONIO PIETRO.
Painter. Born in Philadelphia, PA, April 13, 1902. Member: Philadelphia Sketch Club; Philadelphia Alliance. Awards: Honorable mention, Philadelphia Sketch Club, 1925; hon. mention, Philadelphia Art Club, 1925; Murphy Memorial prize, Nat. Academy of Design, 1926; medal, Philadelphia Sketch Club, 1926; bronze medal, Sesqui-Centennial Expo., Philadelphia, 1926; first Hallgarten prize, Nat. Academy of Design, 1927. Work: "Sunlight and Shadow," Reading Museum, Reading, PA. Address in 1929, 34 South 17th St.; h. 127 N. Gross St., Philadelphia, PA.

MARTINO, EVA E.
Sculptor and painter. Born in Philadelphia, PA. Studied at Gwynedd Mercy College; Montgomery County Community College; also with Giovanni Martino. Member of Artists Equity Association; National Forum of Professional Artists. Exhibitions: Reading Museum, PA, 1962; National Academy of Design, NY, 1965; Penna. Academy of Fine Arts, Philadelphia, 1966; Edinboro Teacher's College, PA, 1967; Butler Institute of American Art, Youngstown, OH, 1970; Audubon Artists, 1978. Awards: Bronze Medal, Da Vinci Alliance, 1953; First Prize, Plymouth Meeting Hall, 1967; Third Prize, Philadelphia Sketch Club, 1972; Second Prize, Greater Norristown Art League, 1976. Media: Oil and Wood. Address in 1982, Blue Bell, PA.

MARTINO, MICHEL.
Sculptor. Born in Alvignano, Casserta, Italy, February 22, 1889. Pupil of Lee Lawrie and H. Kitson. Award: English fellowship prize of Yale University for study abroad. Work: "Landing of Pilgrims," "Battle of Lexington," Strong School, New Haven; White Plains High School Memorial Tablet; commemorative medal, Am. Public Health Soc.; Mem. Flag Staff, Brooklyn, NY; Spanish War mem., New Haven; pediment for St. Anne Church, Hartford, CT. Address in 1929, 211 Clay St., New Haven, CT; h. 14 Myron St., Norris Cove, CT.

MARTINSEN, MONA.
Sculptor. Born in New York. Address in 1908, 15 Rue Bourgois, Paris, France.

MARTINY, PHILIP.
Sculptor. Born in Alsace, France, May 10, 1858, and came to America about 1876. He was a pupil of Augustus Saint-Gaudens and of Francois and Eugene Dock in France. Member: Society of American Artists, 1891; Associate Member of the National Academy of Design, 1902; New York Architectural League. He is represented by the World War Monument in Greenwich Village; McKinley Monument, Springfield, MA; statue of past Vice-President Garret A. Hobart, Paterson, NJ; sculpture on the Agricultural and Fine Arts Buildings at the World's Fair, Chicago; Soldiers' and Sailors' Monument, City Hall, Jersey City, NJ; in NYC by sculpture in the Hall of Records, doors for St. Bartholomew's Church, and two groups in the Chamber of Commerce. Address in 1926, Warburton Avenue, Bayside, L.I., NY. Died in NYC, June 26, 1927.

MARTMER, WILLIAM P.
Painter. Born in Detroit, MI, Sept. 25, 1939. Studied: Art School of Society of Arts & Crafts; Cranbrook Academy of Art; Wayne State University; University of Michigan. Work: Cranbrook Academy Museum; General Motors Corporation. Exhibitions: Cranbrook Art Academy Gallery; Northern Illinois University Art Department; Brooklyn Museum, Print Show; Wayne State University Alumni, Invitational; The Raven Gallery, Detroit, Michigan. Awards: Lewis Art Prize, Huntington Woods Annual; Popular Prize, Kalamazoo Art Center; Popular Prize, Scarab Club of Detroit; and others. Teaching: Instructor of art, Detroit Institute of Arts and Wayne State University. Member: Scarab Club, Detroit. Medium: Oil. Address in 1982, Coloma, MI.

MARULIS, ATHAN.
Painter. Born in Athens, Greece, in 1889. Pupil of Manos; Paul M. Gustin; Yasushi Tanaka. Member: Seattle Fine Arts Society. Address in 1926, 211 Fourth Avenue, North Seattle, WA.

MARWEDE, RICHARD L.
Painter. Born in New York, NY, Feb. 5, 1884. Pupil of Art Students League of NY. Member: Art Students League of NY; Alliance. Address in 1929, 976 Anderson Avenue, New York, NY.

MARYAN, HAZEL SINAIKO.
Sculptor, painter, and teacher. Born in Madison, WI, May 15, 1905. Studied: University of Wisconsin, B.S.; Art Institute of Chicago; and with E. Chassaing, A. Polasek, A. Archipenko, E. Simone. Member: Chicago Art Club; Artists Equity Association, New York. Exhibited: Art Institute of Chicago, 1930-32, 1937-41; Wisconsin Salon, 1932-65; Chicago No-Jury Exhibition, 1933, 34; Artists Equity Association, 1952, 65; Waterloo, Iowa Annual, 1965; others. Address in 1970, Madison, WI.

MARZOLLO, CLAUDIO.
Sculptor. Born in Milan, Italy, July 13, 1938; U.S. citizen. Studied at Columbia College, B.A. Work in Windsor Art Gallery, Ontario; Museum of Science and Industry, Chicago; Ft. Wayne Museum of Art, IN; others. Has exhibited at Everson Museum, Syracuse, NY; Toledo Museum of Art; National Academy of Science, Washington, DC; Whitney Museum of American Art, NY; Akron Art Institute, OH; others. Works in plexiglas and aluminum with various light sources, filters, and motors. Address in 1982, Cold Spring, NY.

MASE, CAROLYN CAMPBELL.
Landscape painter. Born in Matteawan, NY. Pupil of J. H. Twachtman. Member: Connecticut Academy of Fine Arts; National Association of Women Painters and Sculptors: Washington Art Club. Address in 1929, 1600 Genesee Street, Utica, NY.

MASON, ABRAHAM JOHN.
English engraver. Born on April 4, 1794 in London. He was best known for his wood engraving. Studied with Robert Branston. He came to this country in 1829 and settled in NY, and the following year he was elected an Associate of the National Academy of Design, and professor of wood engraving; he also lectured on this subject in Boston. Mason, finding his occupation unprofitable, returned to London in 1839. He died in England.

MASON, ALICE TRUMBULL.
Painter. Born in Litchfield, CT, November 16, 1904. Studied: In Italy, 1921-23, 29-30; National Academy of Design, 1923-27; with Arshile Gorky, 1928; in Greece, 1929-30. One-woman shows: Museum of Living Art, NY University, 1942; Hansa Gallery, NYC, 1959; numerous shows in oils, woodcuts, and etchings throughout the U.S. between 1936-57. Group exhibitions in U.S., Europe, South America, and Japan. Awards: Philadelphia Printmakers Club, 1945; Society of American Graphic Artists, 1946; Silvermine Guild, 1952; several purchase prizes and honorable mentions. Member: American Abstract Artists; Fed. of Modern Painters and Sculptors; 14 Painter-Printmakers. Collections: Philadelphia Museum of Art; Brooklyn Museum of Art; Whitney; Library of Congress, Washington, DC; Museum of Modern Art; New York Public Library; Berkshire Museum of Art; Solomon R. Guggenheim Museum of Art. Address in 1962, 334 W. 85th Street, New York, NY; studio, 78 E. 10th Street, New York, NY.

MASON, ALVA.
Engraver. About 1819 the firm of W. and A. Mason advertised as "Engravers of brass ornaments for book-binding, etc.; charter and Patent Medicine Seals, Embossing plates and Brass Engraving for Typographical Printing." Their establishment was located at No. 15 South 4th Street, Philadelphia.

MASON, C. D.
Sculptor. Born in France in 1830, and came to the U.S. when thirty years old. First work was on the old Vanderbilt mansion; he did some carvings on the Soldiers' and Sailors' Monument and the Angels of Art at the entrance to Greenwood Cemetery. He also worked on the Garden City Cathedral and in the Philadelphia and Chicago Expositions. Died in Mineola, LI, NY, July, 1915.

MASON, D. H.
The Philadelphia directories of 1805-18 contain the name of D. H. Mason, "music-engraver." In 1816 he executed vignettes for the bank-note engraving firm of Murray, Draper, Fairman Co., Philadelphia, and in 1830 Mason signed a certificate as "Architect and Engraver."

MASON, DORIS BELLE EATON.
(Mrs. Edward Files Mason). Sculptor. Born in Green River, Wyoming, June 29, 1896. Studied at University of Idaho, B.S., 1925, M.A., 1938; University of Iowa; University of Southern California, summer, 1945; Mills College, summer, 1949. Works: Spokane Art Association; Mt. Home Idaho Congregational Church. Exhibitions in NYC, Omaha, Chicago, Des Moines, and others. Awards: Iowa State Fair, 1937, 1938; second prize for sculpture, Iowa Art Salon, 1941; pottery prize, Des Moines Art Center, 1949; purchase prize, Spokane Art Association. Member: Iowa City Craft Guild; Des Moines Art Association; American Association of University Women. Address in 1962, Iowa City, IA.

MASON, ELEANOR.
Miniature painter. Exhibited at the Pennsylvania Academy of Fine Arts, Philadelphia, 1925. Address in 1926, 871 Beacon Street, Boston, MA.

MASON, FRANK HERBERT.
Painter. Born in Cleveland, Ohio, Feb. 20, 1921. Studied: National Academy of Design, NYC, with George Nelson, 1937-38; Art Students League, with Frank Vincent DuMond, 1937-51. Work: Butler Institute of American Art, Youngstown, Ohio; American Embassy, London; U.S. War Department; others. Paintings: St. Anthony of Padua, 11th Cert. Church of San Giovanni di Malta, Venice; Resurrection, Old St. Patrick's Cathedral, NYC; San Rocco, Church of Santa Vittoria, Italy; Murals, King Faisel Naval Academy, Saudi Arabia. Exhibited: Palais des Congres, Monaco, 1968; National Arts Club, NYC, 1973; Mood Gallery, San Francisco, 1977 & 79; Metropolitan Museum of Art, NYC, 1979. Awards: Nat. Acad. of Design; Popular Prize, Assoc. Artists of Pitts., Carnegie Insti.; Penn-Nat. Legionier; Prix du Nord, Expos Intercontinentale, Monaco; etc. Teaching: Art Students League, NYC, 1950-present. Member: Art Students League; National Society of Mural Painters; International Institute of Conservation of Historic and Artistic Works; Academician, National Academy of Design. Media: Graphics, watercolor. Address in 1982, 385 Broome Street, New York, NY.

MASON, GEORGE.
Limner and crayon portrait draftsman. He inserted an advertisement in the *Boston Chronicle* for June, 1768, stating that he drew "portraits in crayon for two guineas each." Died in 1773 in Boston.

MASON, JOHN.
Painter and designer. Born in New York, NY, 1868. Pupil of Julian Academy in Paris under Laurens and Constant. Member: Alliance. Award: Bronze medal, Paris Expo., 1889. Work: Decoration of dining room of Harmonic Club, New York; "Portrait of Admiral Dewey" and "Portrait of Major S. Ellis Briggs," in Armory, New York City; decorations, Wanamaker's; Gueting's Shoe Store; Louis Mark Shoe Store, Inc.; Blum Store and Dalsimer Shoe Store in Phila. Address in 1929, 1506 Sansom Street; h. 1608 Pine Street, Philadelphia, PA.

MASON, JOHN.
Sculptor. Born in Madrid, NE, March 30, 1927; raised in Nevada. Studied art at the Otis Art Inst., Los Angeles, CA, 1949-52; and the Chouinard Art Institute, Los Angeles, CA, 1953-54. Associated with sculptors Peter Voulkos and Kenneth Price during 1950's. Exhibitions: Several one-man shows including Pasadena Art Museum, CA, 1960 and 74; Whitney Museum of Modern Art, 1964, 73, and 76; Retrospective, Los Angeles Co. Museum of Art, 1966; National Museum of Modern Art, Kyoto, Japan, 1971; the now defunct Ferus Gallery, Los Angeles, CA, since 1961. Awards: Ford Foundation Award, 67th Am. Exhibition, Art Institute of Chicago, 1964; Univ. of CA Award, Creative Arts Institute, 1969-70. Commissions include the ceramic relief at Palm Springs Spa, CA; another ceramic relief for the Tishman Building in Los Angeles, CA, 1961; and ceramic doors for Sterling Holloway in So. Laguna, CA. Noted for his monumental wall reliefs and free standing unglazed sculpture. Taught: Pomona College, Claremont, CA; Univ. of CA., Irvine, 1967-73; Hunter College, NY, from 1974. Address in 1982, 1521 South Central Ave., Los Angeles, CA.

MASON, JONATHAN, JR.
Portrait painter. Born in 1795. Lived on Mt. Vernon Street, Boston. Exhibited portraits and figure subjects, 1828-34, at the Boston Athenaeum, among them his self-portrait. Died in 1884.

MASON, MARY STODDERT.
Sculptor. Born in Jackson, TN. Principal works, "Pilgrim Mother," "The Spirit of the New Era," and "Woman Triumphant." Address in 1926, Elmsford, Westchester County, NY. Died in 1934.

MASON, MARY TOWNSEND (MRS.).
(Mrs. Wm. Clarke Mason). Painter. Born in Zanesville, OH, March 21, 1886. Pupil of Chase and Breckenridge at Penna. Academy of Fine Arts; Maryland Institute, Baltimore. Member: Fellowship Penna. Academy of Fine Arts; Phila. Alliance; Plastic Club, 1917; Nat. Association of Women Painters and Sculptors; Am. Fed. of Arts; Southern States Art League. Awards: Cresson traveling scholarship, Penna. Academy of Fine Arts, 1909; Gold medal, Plastic Club, 1921 and 1924; Mary Smith prize, Penna. Academy of Fine Arts, 1922. Work: "Blue and Gold," Fellowship Penna. Academy of Fine Arts; "Still Life with Fruit," Penna. Academy of Fine Arts. Address in 1929, 8233 Seminole Avenue, Chestnut Hill, Philadelphia, PA.

MASON, MAUD M.
Painter, craftswoman, and teacher. Born in Russellville, KY, March 18, 1867. Pupil of Chase, Dow and Snell in New York; Brangwyn in London. Member: NY Society of Ceramic Artists; Boston Society of Arts and Crafts; National Association of Women Painters and Sculptors; National Arts Club; Pen and Brush Club; Society of Painters, NY; Allied Artists of America; American Water Color Society; NY Water Color Club; American Federation of Arts. Awards: Gold medal, P. P. Expo., San Francisco, 1915; bronze medal, National Arts Club, 1920; 1st prize, National Association of Women Painters and Sculptors, 1922. Address in 1929, 36 Gramercy Park, New York, NY; summer, New Canaan, CT.

MASON, ROBERT LINDSAY.
Illustrator, painter, and writer. Born in Knoxville, TN, June 5, 1874. Pupil of Howard Pyle. Member: East Tennessee Fine Arts Society; Wilmington Fine Arts Society. Award: Rush Strong medal, Southern Appalachian Expo. Work: Illustrations for books and magazines, *Harper's*, etc.; author of *The Lure of the Great Smokies* (Houghton Mifflin Co., Boston); author of short stories and articles on outdoor life in the Great Smoky Mountains, with illustrations. Address 1929, 230 East Church Ave., Knoxville, TN.

MASON, ROY M.
Painter. Born in Gilbert Mills, NY, March 15, 1886. Self-taught. Member: Buffalo Society of Artists; Salma. Club; American Fed. of Arts; Associate Nat. Academy of Design, 1930; Rochester Art Club; Am. Artists Professional League; Am. Water Color Society. Awards: First prize, Buffalo Society of Artists, 1928; hon. mention, Rochester, 1928; Plimpton prize, and Auction prize, Salma. Club, 1930; first prize, landscape, Rochester Art Soc., 1931; Zabriski prize, Am. Water Color Society, 1932. Work: "Big Starbuck," purchased with Ranger Fund, 1930, placed in Art Museum, Reading, PA; "Archie and the Guides," Univ. of Iowa, Iowa City. Address 1933, Turner Bldg.; h. 1 Richmond Ave., Batavia, NY.

MASON, W. SANFORD.
Painter, engraver, and copyist. He was working in Philadelphia about 1865. He made several copies of "The Washington Family, at Mount Vernon" after the painting by Savage.

MASON, WILLIAM ALBERT.
Painter and instructor. Born in Cambridge, MA, in 1885. Director of art education in the public schools of Philadelphia. Died Dec. 23, 1920 in Philadelphia.

MASON, WILLIAM G.
This line-engraver of buildings, etc., was located in Philadelphia in 1822-45, except during the years 1823-29. He made the illustrations for Joshua Shaw's "U. S. Architecture," and for other publications by the same author. Also painted landscapes.

MASSABO, JUSTIN.
Sculptor. Born in France in 1829. Listed as being in New York City in September of 1850.

MASSEE, CLARISSA DAVENPORT.
Sculptor, teacher. Pupil of Injalbert and Bourdelle in Paris. Address in 1909, Paris, France; Williston, North Dakota.

MASSEY, ROBERT JOSEPH.
Painter and educator. Born in Ft. Worth, Texas, May 14, 1921. Studied: Oklahoma State University, B.A., with Doel Reed; University of Havana; University of Michigan; Syracuse University, M.F.A.; University of Texas, Austin. Work: Dallas Museum of Fine Art; Syracuse Museum of Art; Society of American Graphic Artists; El Paso Museum of Art; University of New Mexico; and others, plus several commissions. Exhibited: National Small Painting Exhibition, University of the Pacific, Stockton, California; Annual Gulf Coast Exhibition, Mobile, AL; Small Painting Show, Albuquerque, NM; State Art Exhibition, Port Arthur, Texas; and others. Awards: Hon. mention, El Paso Art Annual; honorable mention, graphics, El Paso; John Chapman Purchase Award for painting, Syracuse; and others. Teaching: University of Texas at El Paso; and others. Medium: Egg Tempera. Address in 1982, 708 McKelligon, El Paso, TX.

MASSON, EMILE.
Crayon portrait draftsman who was working in Boston, MA, 1852-1856.

MASSON, RAYMOND.
Sculptor. Address in 1898, 27 Tremont Row, Boston, MA.

MAST, JOSEPHINE.
Painter and teacher. Born in New York City. Pupil of George Elmer Browne, Henry B. Snell, Hayley Lever. Member: NY Water Color Club (associate); Provincetown Art Association; National Association

of Women Painters Sculptors; National Arts Club. Address in 1929, 140 Halsey Street, Brooklyn, NY; summer, Provincetown, MA.

MASTERS, FRANK B.
Illustrator. Born in Watertown, MA, Sept. 25, 1873. Pupil of C. H. Woodbury and Howard Pyle. Member: Society of Illustrators, 1907; Salma. Club. Address in 1929, 1 Morris Crescent, Yonkers, NY.

MASTERSON, JAMES W.
Sculptor, painter, illustrator, and writer. Born in Hoard, Wisconsin, 1894. Studied at the Chicago Acad. of Fine Arts; Art Inst. of Chicago; San Jose Art School (CA). Work in Montana schools, banks, library; author and illustrator, *It Happened in Montana*. Inst. at Custer County Junior College. Received a fellowship in 1962. Specialty is Montana subjects. Died in 1970 in Miles City, Montana.

MATHEDI, ANGELO.
Sculptor. Born in Tuscany in 1836. In Philadelphia in 1860. Resided with and was presumably employed by Lorenzo Hardie. Medium: Plaster.

MATHEWS, ARTHUR FRANK.
Painter and teacher. Born in Wisconsin, Oct. 1, 1860. Pupil of Boulanger in Paris; also studied architecture. Member: Philadelphia Art Club. Award: Gold medal, murals American Institute of Architects, 1925. Work: Mural decoration (6 Panels), Oakland (CA) Library; mural paintings, California State Capitol Building; 4 triptych panels, University of California Library; Library of Stanford University; decorations, wall and dome of Commanding Hall, Masonic Temple, San Francisco; "California Landscape," Metropolitan Museum, New York. Director, California School of Design, 1890-1906. Address in 1929, 670 Fell Street, San Francisco, CA.

MATHEWS, FERDINAND SCHUYLER.
Painter, craftsman, illustrator, and writer. Born in New Brighton, SI, NY, May 30, 1854. Pupil of Cooper Union in NY; traveled in Italy. Author and illustrator: *Familiar Trees, Fieldbook of American Wild Flowers, Fieldbook of Wild Birds and Their Music, Fieldbook of American Shrubs and Trees, Book of Birds for Young People, Book of Wild Flowers for Young People*. Botanical artist on staff of Gray Herbarium, Harvard University. Specialty, landscape in water color and illumination. Address in 1929, 17 Frost Street, Cambridge, MA.

MATHEWS, LUCIA KLEINHANS.
(Mrs. Arthur F. Mathews). Painter, illustrator, and craftsman. Born in San Francisco, CA, August 29, 1882. Pupil of A. F. Mathews, Whistler. Award: Silver medal, P. P. Expo., San Francisco, 1915. Specialty, theatre decorations and furniture. Address in 1929, 670 Fell Street, San Francisco, CA.

MATHEWSON, FRANK CONVERS.
Painter. Born in Barrington, RI, May 12, 1862. Pupil of Laurens and National School of Decorative Art in Paris. Member: NY Water Color Club; Providence Art Club; Providence Water Color Club; Alliance; North Shore Arts Association. Award: Sullivan prize, Providence, 1903. Work: "Ogunquit Pasture," Rhode Island School of Design, Providence; "The Weisser Thurm," Boston Art Club. Address in 1929, 29 Waterman Street, Providence, RI; summer, Matunuck, South Kingston, RI.

MATHIE, GOLDIE (RALSTON).
Sculptor and painter. Born in Massillon, Ohio, August 18, 1884. Studied: With Miriam Cramer, Bernice Langton, Sister Matilda. Member: Akron Woman's Art League; Barberton Group Artists; Barberton Women's Club; Composers and Authors Association of America. Awards: Prizes, Canton, OH, 1943, 47. Exhibited: National Academy of Design, 1948; Miniature Painters, Sculptors and Gravers, Washington DC; Riverside Museum, NY; Newport Art Association; also in Canton, Massillon, Akron, Barberton, Ohio. One-man exhibition: Ashland, KY. Address in 1953, West Barberton, Ohio.

MATHIEU, HUBERT.
Illustrator and etcher. Born in Brookings, SD, Jan. 4, 1897. Pupil of Harvey Dunn and Henry Raleigh. Member: Society of Illustrators; Artists Guild of the Authors' League of America, NY; American Artists Professional League. Illustrator for magazines, newspapers, and advertising; pastels and watercolors; portraits. Address in 1929, 1931 Broadway, New York, NY; summer, Westport, CT.

MATHUS, HENRY.
Painter and craftsman. Born in Boston, MA, April 19, 1870. Pupil of RI School of Design. Member: Providence Art Club; Providence Water Color Club. Address in 1929, 39 Henry Street, Edgewood, Cranston, RI.

MATSON, GRETA (GRETA MATSON KHOURI).
Painter. Born in Claremont, VA, in 1915. Studied: Grand Central School of Art; and with Jerry Farnsworth. Awards: National Academy of Design, 1943, 1945; Southern States Art League, 1945, 1946; Virginia Artists, 1943, 1945, 1955; National Association of Women Artists, 1943, 1952, 1953, 1955-1958; State Teachers College, Indiana, PA, 1945, 1949, 1950; Norfolk Museum of Art, 1943, 1948, 1954; Am. Watercolor Society, 1950, 1951; Mississippi Art Association, 1951; Pen and Brush Club, 1948, 1951, 1952, 1954, 1956, 1958; Connecticut Academy of Fine Arts, 1952, 1953; New Orleans Art Association, 1949, 1952; Butler Art Institute, 1948; NJ Artists, 1948, 1951; Virginia Mus. of Fine Arts, 1957; NJ Society of Painters and Sculptors, 1957; Allied Artists of

America Gold Medal, 1962. Collections: Virginia Museum of Fine Arts; Norfolk Museum of Art, State Teachers College, Indiana, PA; New Britain Art Institute; Texas Technical College; William and Mary College; Texas College of Art and Industry; Mary Calcott School, Norfolk, VA; Florida Southern College; Longwood College, Farmville, VA; Little Rock Museum of Fine Arts; Seton Hall University. Exhibited: Art Inst. of Chicago; Carnegie Institute; National Academy of Design; Butler Art Institute; Virginia Museum of Fine Arts; American Watercolor Society; Society of American Graphic Artists; Audubon Artists; Allied Artists of Am.; National Association of Women Artists; others. One-man exhibitions: Pen and Brush Club; Norfolk Museum of Art; Virginia Museum of Fine Arts. Member: Audubon Artists; National Association of Women Artists; Allied Artists of America; American Watercolor Society. Media: Oil and watercolor. Address in 1982, Norfolk, VA.

MATTEI, MATTIS.
Sculptor. At Buffalo, New York, 1855.

MATTEI, VIRGILIO P.
Painter and illustrator. Born in Puerto Rico, June 30, 1897. Member: Society of Independent Artists. Award: First prize, Exhibition, Ponce, Puerto Rico, 1919. Address in 1929, Box 102; h. 49 Campos Street, Ponce, Puerto Rico.

MATTERSON, TOMKINS HARRISON.
See Matteson, Tomkins Harrison.

MATTESON, BARTOW VAN VOORHIS.
Painter and illustrator. Born in Buffalo, NY, Dec. 3, 1894. Pupil of School of Fine Arts of the Albright Art Gallery, Buffalo, NY; Art Students League of NY; Pratt Institute. Illustrator for *The Saturday Evening Post* and *The Country Gentleman*. Address in 1929, Van Dyck Studio Bldg., 939 Eight Avenue, New York, NY; summer, Sturgeon Point, Derby, NY.

MATTESON, IRA.
Sculptor and draftsman. Born in Hamden, CT, June 26, 1917. Studied at Art Students League, with Arthur Lee, 1937-42, also with William Zorach, 1946-51; National Academy, with John Flanagan, 1946-47. Work in Akron Art Institute, OH; Cleveland Museum of Art; Chrysler Museum, Provincetown, MA; others. Received Prix de Rome, American Academy in Rome, 1953-55, Louis Comfort Tiffany, 1956 and 60; others. Teaching at School of Art, Kent State University, Kent, from 1968. Works in wood and metal. Address in 1982, Kent, OH.

MATTESON, M. TOMKINS.
Signature of Tomkins Harrison Matteson. (See entry below.)

MATTESON, TOMKINS HARRISON.
Born in Peterborough, NY, May 2, 1813. In 1839 he began to paint portraits of merit, and was brought into notice by his "Spirit of '76" purchased by the Am. Art Union. His work was chiefly portraiture and historical painting. He became an Associate of the National Academy of Design in 1847. He died Feb. 2, 1884 in Sherburne, NY.

MATTHEWS, ANNA LOU.
Sculptor, painter, teacher, and illustrator. Born in Chicago, IL. Pupil of Taft and Vanderpoel at Art Institute of Chicago; Chicago Art Academy; Ecole des Beaux-Arts; and under Simon, Max Bohm, and Garrido in Paris; Brangwyn in London. Member: Association of Chicago Painters and Sculptors. Awards: Honorable mention, 1913; second sculpture prize, Minnesota State Art Comm., 1914; Rosenwald prize, Art Institute of Chicago, 1921; Harry A. Frank prize, Art Institute of Chicago, 1929; Municipal Art League, Chicago, 1932. Represented in St. Paul Institute of Art; Juvenile Court Room; murals, Walter Scott School, Rosenwald Collection, and City of Chicago Collection, Chicago, IL. Address in 1933, Green Bay, WI; summer, Big Suamico, WI.

MATTHEWS, ELIZABETH ST. JOHN (MRS.).
Sculptor. Born in Philadelphia, January 25, 1876. She studied with J. Liberty Tadd in Philadelphia, with Leon Girardet in Paris, and with Olin L. Warner in NY. She sculpted a bust of President Taft. Died in New York, April 27, 1911.

MATTHEWS, GEORGE BAGBY.
Painter. Born in Tappahannock, VA, in 1857. Studied art abroad, 1880-83; pupil of Carolus Duran, Paris. Among his historical paintings are "Lee and His Generals," "The Crucifixion," "Jefferson Davis," "John Paul Jones," "Stonewall Jackson," "Lee," "Daughter of the Confederacy," "Gen. Tyler," "Patrick Henry," "General Joe Wheeler," "Colonel John S. Mosby," "Battle of the Merrimac with the Monitor," "Last of the Wooden Navy." Address in 1926, Washington, D.C.

MATTHEWS, LESTER NATHAN.
Sculptor, painter, craftsman, and designer. Born in Pittsburgh, PA, August 8, 1911. Studied: California College of Arts and Crafts; with Sargent Johnson, M. Beckford Young, Worth Ryder. Member: San Francisco Art Association. Awards: Prize, San Francisco Art Association, 1939; American Academy in Rome, 1942. Work: Stockton (CA) Jr. College; Peter Burnett High School, San Jose, California; Salinas (CA) Jr. College; Ft. Ord, CA. Exhibited: Art Institute of Chicago; Oakland Art Gallery; San Francisco Museum of Art; Golden Gate Exposition, San Francisco, 1939; Sacramento Art Center; Los Angeles Museum of Art, 1946-48. Address in 1953, 1220 Third Ave., Los Angeles, CA.

MATTHEWS, WILLIAM.
Portrait painter. Born in Bristol, England, in 1821. Died in Washington, D.C., in 1905.

MATTHEWS, WILLIAM F.
Painter. Born in St. Louis, MO, 1878. Pupil of St. Louis School of Fine Arts. Member: St. Louis Artists Guild; 2 x 4 Society; Society of Ancients; Brooklyn Society of Artists; Kit-Kat Club; Painters and Sculptors; Architectural League of NY. Awards: Ives landscape prize, St. Louis Artists Guild, 1914 and 1915. Address in 1929, 103 Pierrepont Street, Brooklyn, NY.

MATTOCKS, MURIEL.
See Cleaves, Muriel Mattocks.

MATTSON, HENRY ELIS.
Painter. Born in Sweden, August 7, 1887. Pupil of Worcester Art Museum. Member: Woodstock Art Association. Work: "Wild Flowers," Phillips Memorial Gallery, Washington, D.C.; "Self Portrait," Municipal Art Gallery, Davenport, IA. Address in 1929, Woodstock, NY.

MATULKA, JAN.
Painter. Born in Czechoslovakia, 1890. Pupil of National Academy of Design. Studio in Paris. Collections: Whitney; NY Public Library; Penna. Academy of Fine Arts; San Francisco Museum of Art; Detroit Institute of Arts; Cincinnati Museum; Yale University Art Gallery. Instructor at Art Students League. Address in 1933, 439 East 89th Street, New York, NY.

MATZAL, LEOPOLD CHARLES.
Painter and teacher. Born in Vienna, Austria, Aug. 13, 1890. Studied in Austria. Award: Murray prize, Art Center, Orange, NJ, 1927. Work: "Portrait of Judge James F. Minturn" and "Portrait of Vice-Chancellor John T. Fallon," State House, Trenton, NJ; "Mayor P. R. Griffin," City Hall, Hoboken; "Librarian T. F. Hatfield," Public Lib., Hoboken; "Mayor Frank Hague," City Hall, Jersey City. Address in 1929, 660 Mt. Prospect Street, Newark, NJ.

MATZEN, HERMAN N.
Sculptor and teacher. Born in Denmark, July 15, 1861. Pupil of Munich and Berlin Academies of Fine Arts. Member: National Sculpture Society; National Arts Club, NY; Cleveland Society of Artists. Awards: Second medal, Berlin, 1895; first medal, Berlin Expo., 1896. Work: "War" and "Peace," Indianapolis Soldiers and Sailors Monument; "Schiller Monument," Detroit; "Law" and "Justice," Akron (OH) County Court House; "Wagner Monument," Cleveland; Burke Mausoleum; "Moses" and "Gregory," Cleveland Court House; "Cain and Abel," Lake County Court House; Tom L. Johnson monument, Cleveland Public Square; Holden Mausoleum and L.

E. Holden Memorial, Plain Dealer Building; Thomas White Memorial, Cleveland; Holden Mem. Tablet, Harvard Univ., Cambridge; Haserot Monument, Cleveland; Hatch Memorial, Western Reserve University, Cleveland. Address in 1933, 5005 Euclid Avenue; h. 2423 Woodmere Drive, Cleveland, OH. Died in 1938.

MATZINGER, PHILIP FREDERICK.
Painter, lecturer, and teacher. Born in Tiffin, OH in 1860. Pupil of John H. Vanderpoel, Art Institute of Chicago. Member: Fresno Art Association; Laguna Beach Art Association; Pasadena Society of Artists; American Federation of Arts. Address in 1929, 211 Patterson Building, Fresno, CA. Died in 1942.

MATZKE, ALBERT.
Painter and illustrator. Born in Indianapolis, IN, in 1882. Pupil of Art Students League of NY under Du Mond and George Bridgman. Address in 1926, 244 West 14th Street, New York, NY.

MATZKIN, MEYER.
Sculptor. Born in Russia, November 25, 1880. Address in 1921, 110 Tremont Street, Boston, MA; 29 Homestead Street, Roxbury, MA.

MAUCH, MAX.
Sculptor. Born in Vienna, Austria, February 6, 1864. In New York City, from 1891, and in Chicago, from 1893. Worked with Bitter and Bell. He exhibited at the National Sculpture Society, New York. He died in Chicago, IL, February 13, 1905.

MAULL, MARGARET HOWELL.
Illustrator. Born in Whitford, PA, June 22, 1897. Pupil of Henry McCarter. Member: Fellowship Penna. Academy of Fine Arts; Philadelphia Artists Guild. Address in 1929, 340 West 55th Street, New York, NY; h. 2227 DeLancey Place, Philadelphia, PA.

MAUNSBACH, GEORGE (HANS) ERIC.
Sculptor and painter. Born in Helsingborg, Sweden, January 5, 1890. Studied: Stockholm Academy with Anders Zorn; Royal Academy, with Sargent; Boston Museum of Fine Arts School, with Pape. Member: Alliance; Society of Independent Artists; Salons of America; American Artists Professional League; Scandinavian-American Artists. Work: "Portrait of Judge C. H. Duell," Court of Appeals, District of Columbia; "Portrait of Ossip Gabrilowitsch," Orchestra Hall, Detroit; "Portrait of Clara Clemens," for Detroit; "Portrait of Mr. and Mrs. P. A. Peterson," Swedish-American Hospital, Rockford, IL; portrait, Columbia University; Marywood College, Scranton, PA; World War Collection, Washington DC; American Society of Composers, Authors and Publishers, NY; Lincoln and Benjamin Franklin Hotels, NY; Court House, Easton, PA; Ft. Dix, NJ; Library of

Congress; Cavalry Armory, Brooklyn, NY; Ft. Jay; Ft. Slocum; Camp Upton; Lawrence University; Supreme Court, Schenectady, NY; etc. Exhibited: Brooklyn Museum; Art Institute of Chicago; National Academy of Design; Penna. Academy of Fine Arts; Paris Salon; Newport Art Association; etc. Lectures: "The Art of Portrait Painting." Address in 1953, 939 Eighth Avenue; h. 58 West 57th Street, New York, NY. Died in 1969.

MAURER, ALFRED HENRY.
Painter. Born in New York, April 21, 1868. Pupil of National Academy of Design under Ward; studied in Paris. Member: American Art Association of Paris; Paris Society of American Painters. Awards: Inness prize, Salma. Club, 1900; first prize ($1,500), Carnegie Institute, Pitts., 1901; first prize, Worcester, 1901; bronze medal, Pan-Am. Expo., Buffalo, 1901; silver medal, St. Louis, 1904; third medal, Liege Expo., 1905; gold medal International Expo., Munich, 1905. Represented in Memorial Hall Museum, Philadelphia, PA; Phillips Mem. Gallery, Washington, D.C.; Barnes Collection, Philadelphia, PA. Address in 1929, 404 West 43rd Street, New York, NY.

MAURER, LOUIS.
Painter. Born on Feb. 21, 1832 in Biebrich, Germany. Lived in New York and worked for Currier & Ives. His specialty was sporting and racing prints. Died July 19, 1932 in New York City.

MAURONER, FABIO.
Etcher. Born in Tisano, Italy, July 22, 1884. Pupil of E. M. Lynge. Member: Chicago Society of Etchers; Print Makers' Society of California. Work: "La Tiarretta," Public Library, New York, NY; "Cypress of Michelangelo," Art Institute of Chicago. Address in 1929, 1111 San Trovaso, Venice, Italy.

MAURY, CORNELIA FIELD.
Painter. Born in New Orleans, LA. Pupil of St. Louis School of Fine Arts; Julian Academy in Paris. Member: St. Louis Artists Guild. Awards: Bronze medal, Portland Expo., 1905; hon. mention, Kansas City Art Institute, 1923; second prize, St. Louis Artists' League, 1926; hon. mention, St. Louis Artists Guild, 1927. Represented in City Art Museum, and Public Library, St. Louis. Address in 1929, 5815 Pennsylvania Avenue, St. Louis, MO.

MAUVAIS, A.
Portrait painter in oil and miniatures, flourishing in 1776 in Savannah, Georgia. An excellent example of his work is the miniature of Maj. John Gedney Clark (1737-1784), a British Army officer, which is in the collection of the Essex Institute, Salem, MA.

MAVERICK, ANN.
This daughter of Dr. Alexander Anderson and the wife of Andrew Maverick was a capital wood-

engraver, somewhat later than 1830. Two other members of the Maverick family, Octavia and Catherine, were engaged in art work; the first named was a teacher of drawing in the Packard Institute, of Brooklyn; the other held a similar position in Madame Willard's School, in Troy, NY.

MAVERICK, EMILY.
Engraver. Born on April 3, 1803 in NYC. Daughter of Peter Maverick. Engraved stipple illustrations for an edition of Shakespeare, published about 1830. (See also Maverick, Maria). Member of the National Academy, and also a lithographer. Died in 1850.

MAVERICK, MARIA ANN.
Engraver. Born on May 15, 1805 in NYC. Daughter of Peter Maverick. She engraved several admirable stipple illustrations for an edition of Shakespeare, published about 1830, as did her sister Emily. Maria died Jan. 12, 1832 in NYC.

MAVERICK, PETER.
Engraver. Born in NYC, Oct. 22, 1780; died there June 7, 1831. Peter Maverick was the son and pupil of Peter Rushton Maverick, one of the early engravers of New York. In 1802 Peter Maverick was in business in New York as an engraver; but at a later period he removed to Newark, NJ, where he was the preceptor, and in 1817 the partner, of A. B. Durand. Maverick returned to NY and there conducted an extensive establishment as a general engraver and copperplate printer, and to this business he finally added lithography. Peter Maverick was one of the founders of the Nat. Acad. of Design in 1826, and the "Historic Annals of the Academy" refer to him as excelling in "letter engraving and bank-note work." A portrait of Peter Maverick is in existence, painted by John Neagle. He was a brother of Samuel Maverick.

MAVERICK, PETER, JR.
Born October 26, 1809, in New York City or Newark, NJ. The son of Peter Maverick, he learned engraving and lithography in his father's shops in NYC and Newark. The NY directories for 1832-45 give his occupation as "engraver and lithographer." Work: Reinagle-Maverick view of Wall St., 1834. Died 1845.

MAVERICK, PETER RUSHTON.
Engraver. Born in NY, April 11, 1755. Peter Rushton Maverick was probably originally a silversmith, and he advertised in the NY papers of the day that he was in the engraving, seal sinking, and copperplate printing business, and also engraved the tea table ware. In 1788 he represented the engravers of his city in the Federal Procession of that year. Peter R. Maverick had three sons - Samuel, Andrew and Peter. Samuel and Peter were also engravers and plate printers, and Andrew published prints in connection with Cornelius Tiebout. Died Dec. 12, 1811 in NYC.

MAVERICK, SAMUEL.
Born June 5, 1789 in NYC. This name is signed as engraver to book illustrations published in NY in 1824. The NY directories call Samuel Maverick a "copperplate printer," in 1805, and in 1819-37 the occupation becomes "Engraver and Copperplate printer." The name appears in these directories until 1847, although he died Dec. 4, 1845 in NYC.

MAVERICK, SAMUEL R.
Engraver and copperplate printer. Born on Feb. 19, 1812, probably in New York City. Second son of Samuel Maverick. Working in New York City in 1833. Went to New Orleans by 1837; employed there by engraver J. Lowe and printer D. G. Johnson. Died August 24, 1839, in New Orleans.

MAWICKE, TRAN J.
Illustrator. Born in Chicago, IL in 1911. He studied at the American Academy and Art Institute of Chicago. His career began in advertising in 1929 and later he had assignments from major magazines of the 1930's and 1940's. Among his clients were Pepsi-Cola, Phillips 66 and Camel Cigarettes. He began illustrating for book publishers in the late 1950's and has since worked for W. W. Norton, Putnam's and Grosset and Dunlap. A past president of the Society of Illustrators (1960-1961), he has participated in the U.S. Air Force Art Program and traveled overseas to record the Air Force Story. He has had many one-man shows and group exhibits across the United States.

MAX, PETER.
Painter and printmaker. Born in Berlin, Germany, Oct. 19, 1937; U.S. citizen. Studied: Art Students League; Pratt Institute; School of Visual Arts. Commissions: World's Fair U.S. Postage Stamp, Spokane, WA, 1974; Border Station Welcoming Billboards, GSA, Canadian and Mexican Borders, 1976; UNICEF International Flags Stamp Program, 1981; others. Exhibited: M. H. De Young Memorial Museum, San Francisco, 1970; London Arts Gallery Peter Max Exhibitions, travelling, 1970; Smithsonian, 1972-74; Corcoran Gallery, Washington, DC, 1981; others. Awards: American Institute of Graphic Arts; Society of Illustrators; International Poster Competition, Poland; others. Positions: Daly-Max Design Studio; General Foods; Elgin National Industries, Takashimaya Ltd., Japan; Van Heusen; UN; others. Address in 1982, Peter Max Enterprises, 118 Riverside Drive, New York, NY.

MAXON, CHARLES.
The NY directory for 1833 contains this name as "engraver." No copperplate is known so signed.

MAXWELL, CORALEE DeLONG.
Sculptor. Born in Ohio, September 13, 1878. Pupil of Herman Matzen. Member: Nat. Sculpture Society;

Cleveland Woman's Art Club; Cleveland Art Center; American Federation of Arts. Work: Fountain, Newark, OH. Award: Honorable mention, Cleveland Museum of Art, 1926; first prize, Bernards Gallery, NY, 1928. Address in 1933, Cleveland, OH. Died in 1937.

MAXWELL, GUIDA B.
Painter. Born in Philadelphia, PA. Pupil of Fred Wagner, Martha Walter. Member: Philadelphia Alliance; Lyceum Club, London. Address in 1929, 180 Manheim Street, Germantown, Philadelphia, PA.

MAXWELL, JOHN ALAN.
Illustrator. Born in Roanoke, VA, March 7, 1904. Pupil of Frank V. DuMond, George Luks, George B. Bridgman, Joseph Pennell. Illustrations in *The Crippled Lady of Peribonka*, *Off the Deep End*, and *The Seacoast of Bohemia* (Doubleday, Doran). Address in 1929, 841 West 177th Street, New York, NY.

MAY, BEULAH.
Sculptor. Born in Hiawatha, KS, June 26, 1883. Pupil of Lorado Taft, William Chase, Charles Grafly. Member: California Art Club; West Coast Arts, Inc.; California Sculptors Guild. Address in 1933, Santa Ana, CA.

MAY, EDWARD HARRISON.
Painter. Born in Croydon, England in 1824. He came to America as a boy of ten. He studied under Daniel Huntington, and his early work met with fair success in NY in the days of the Art Union. He painted portraits and historical scenes. Member of the National Academy of Design. He studied abroad, and came back to America for visits. The Union League Club of NY owns several of his portraits. He died May 17, 1887 in Paris.

MAY, PHIL.
Painter and illustrator. He was born in 1864, and died in 1903. He illustrated many books, magazines and other publications in NY.

MAYCALL, JOHN.
Sculptor. Born in Massachusetts, c. 1842. At Boston, 1860.

MAYER, BELA.
Painter. Born in Hungary, August 5, 1888. Pupil of C. Y. Turner, Olinsky and Ward. Member: Salma. Club; Guild of American Painters; Allied Artists of America. Address in 1929, 320 Fifth Avenue, New York, NY; summer, Beacon Hill, Port Washington, L.I., NY.

MAYER, CASPER.
Sculptor. Born in Bavaria, December 24, 1871. Pupil of J. Q. A. Ward; schools of Cooper Union; National

Academy of Design in NY. Award: Silver medal, St. Louis Expo., 1904. Maker of anthropological groups for American Museum of Natural History, and State Museum, Albany. Member: National Sculpture Society. Address in 1929, American Museum of Natural History, New York, NY; h. 24 Carver Street, Astoria, L.I., NY. Died in NY, 1931.

MAYER, CONSTANT.
Painter. Born on Oct. 3, 1832 in France. He studied under Cogniet, and came to NY in 1857. He was elected an Associate of the National Academy in 1866; he was also a member of the American Art Union. Mr. Mayer was best known for his genre pictures but he painted portraits of General Grant, General Sherman and many other prominent men. He died May 12, 1911 in Paris.

MAYER, FRANK BLACKWELL.
Portrait and genre painter. Born Dec. 27, 1827 in Baltimore, MD. Pupil of Alfred Miller in Baltimore, and of Gleyre and Brion in Paris. Painted in Paris, 1864-69. Received medal and diploma, Philadelphia, 1876; medal of Maryland Institute. Represented by "Leisure and Labor," at the Corcoran Gallery. Died July 28, 1899 in Annapolis, MD.

MAYER, HENRY (HY).
Caricaturist, illustrator, etcher, and author. Born at Worms-on-Rhine, Germany, July 18, 1868. Son of a London merchant; came to the U.S. in 1886. Work: "Impressions of the Passing Show," *New York Times*; editor of *Puck*. Contributor to many weeklies in the U.S. and Europe; originator of "Travelaughs" for moving pictures. Illustrator and author of *Autobiography of a Monkey*; *Fantasies in Ha-ha*; *A Trip to Toyland*; *Adventures of a Japanese Doll*; *Hy Mayer Puck Album*; *In Laughland*. Address in 1929, 300 Flax Hill Road, Norwalk, CT.

MAYER, LOUIS.
Sculptor and painter. Born in Milwaukee, WI, Nov. 26, 1869. Pupil of Max Thedy in Weimar; Paul Hoecker in Munich; Constant and Laurens in Paris. Member: Salma. Club; Wisconsin Painters and Sculptors. Awards: Bronze medal for sculpture, St. Paul Art Institute, 1915; silver medal, P.-P. Expo., San Francisco, 1915; hon. mention, sculpture, Art Insti. of Chicago, 1919; special mention, Milwaukee Art Institute, 1922. Work: State historical collections at Des Moines, IA, and Madison, WI; Public Library, Burlington, IA; Springer Collection, National Museum, Washington, DC; Milwaukee Art Institute; busts of Lincoln, Emerson and Whitman, Community Church, Theodore Roosevelt, Roosevelt House, Eugene V. Debs, Rand School of Social Science, New York City; bust of George F. Greer, and relief tablet to American Labor, National McKinley Birthplace Memorial, Niles, OH. Exhibited at Nat. Sculpture Society, 1923; National Academy of Design; Penna.

Academy of Fine Arts; Copley Society, Boston; Art Institute of Chicago; Milwaukee Art Institute. Address in 1953, Hopewell Junction, NY.

MAYER, MERCER.
Illustrator. Born in Little Rock, Arkansas in 1943. She attended the Honolulu Academy of Arts and the Art Students League. She illustrated *A Boy, A Dog and A Frog* for The Dial Press in 1967 and has worked for magazines and book publishers.

MAYFIELD, ROBERT BLEDSOE.
Painter and etcher. Born in Carlinville, IL, Jan. 1, 1869. Pupil of St. Louis School of Fine Arts; Julian Academy in Paris under Lefebvre and Constant. Award: First gold medal of New Orleans Art Association. Work: "In the Studio," "The Giant Oak," Delgado Mus. of Art, New Orleans, LA. Associate editor of the New Orleans Times-Picayune. Address in 1929, 8327 Sycamore Street, New Orleans, LA.

MAYHEW, NELL BROOKER.
Landscape painter, etcher and lecturer. Born in Astoria, IL. Pupil of University of Illinois under Newton A. Wells; Art Institute of Chicago under Johansen. Member: West Coast Art Club; Laguna Beach Art Association; Southern California Society of Arts and Crafts. Award: Medal for color etching, Alaska-Yukon Expo., Seattle, 1909. Represented by "Adobe," color etching in State Lib., Sacramento, CA; "Santa Inez Mission," color etching in Oregon State Museum, Salem; color etchings in Ambassador Hotels at Los Angeles, California, and Atlantic City, NJ. Address in 1929, 5016 Aldama St., Los Angeles, CA.

MAYNARD, GEORGE WILLOUGHBY.
Painter. Born on March 5, 1843, in Washington, DC. Studied at Royal Academy of Fine Arts, Antwerp. Had a studio in Paris in 1878, but later located in NY. Member: National Academy, in 1885; American Water Color Society; Society of American Artists. Died April 5, 1923 in NYC.

MAYNARD, RICHARD FIELD.
Painter, sculptor, and writer. Born in Chicago, IL, April 23, 1875. Studied: Cornell University; Harvard University; Art Students League; New York School of Art; and with William Chase, Irving Wiles, Joseph De Camp, and Robert Blum. Member: New York Water Color Club; MacDowell Club; New York Society of Painters; Allied Artists of America; Art Society, Old Greenwich; Artists Guild of the Authors' League of America; American Watercolor Society of New York. Exhibited: New York Watercolor Club; National Academy of Design; American Watercolor Society; National Arts Club, NY; Philadelphia Watercolor Club; Corcoran Gallery of Art; Art Institute of Chicago. Contributor: short stories to national magazines. Address in 1953, Old Greenwich, Conn.

MAYOR, HARRIET R. HYATT (MRS.).
(Mrs. Mayor). Sculptor, painter, and teacher. Born in Salem, MA, April 25, 1868. Pupil of Henry H. Kitson and Dennis Bunker at Cowles Art School in Boston. Member: Am. Federation of Arts; Boston Art Club. Award: Silver medal, Atlanta Expo., 1895. Work: Memorial tablet, Princeton Univ.; tablet, Carnegie Institute, Washington, DC; tablet to Alpheus Hyatt, Woods Hole, MA; historical tablet, Gloucester, MA; bust of Rear Admiral Goldsboro, Annapolis; statue, Mariner's Park, Newport News, VA. Exhibited at National Sculpture Society, 1923. Address in 1933, Annisquam, MA; winter, Princeton, NJ.

MAYORGA, GABRIEL HUMBERTO.
Painter and sculptor. Born in Colombia, South America, March 24, 1911; U.S. citizen. Studied: National Academy of Design, painting with Leon Kroll, Ivan Olinsky, etching with Aerobach-Levi, sculpture with Robert Aitkin; Art Students League, with Brackman; Grand Central Art School, NYC, with Harvey Dunn. Work: West Point Museum; Institute Ingenieros, Bogota, Colombia; Art Gallery of Barbizon Plaza, NYC, 1955; plus many painting and portrait commissions since 1955. Exhibitions: Institute Ingenieros, Bogota, Colombia; Art Gallery of Barbizon Plaza, NYC; Mayorga Art Gallery; International Expo., Paris; International Art Show, NYC. Art Positions: Instructor, Pan-American Art School, NYC; Art Director, Mannequins by Mayorga Inc., NYC; others. Media: Oil, watercolor; epoxy plastic, polyester plastic. Address in 1982, 331 W. 11 Street, New York, NY.

MAYR, CHRISTIAN.
Painter. Born in 1805 in Germany. He was painting portraits and figure pieces in NY in 1840. Also designer and daguerreotypist. He was elected a member of the National Academy of Design in 1849. His painting, "Reading the News," is in the permanent collection of the National Academy and was exhibited in their Centennial Exhibition of 1925. Died Oct. 19, 1851 in NYC.

MAYS, PAUL KIRTLAND.
Sculptor and painter. Born in Cheswick, PA, Oct. 4, 1887. Studied: Carnegie Inst.; Art Students League; Grande Chaumiere, Paris; pupil of Hawthorne, Johansen, Chase, Tack, Fraser; Massey in London; Ertz at the Academie Delecluse. Specialty: Decorative screens and mural panels. Work: Murals, the White House, Washington, DC; U.S. Post Office, Norristown, PA. Exhibited: Corcoran Gallery; Whitney; Grand Central Art Galleries; Penna. Academy of Fine Arts; Philadelphia Museum of Art; Dutchess County, NY; Carmel Art Association; others. Member: National Society of Mural Painters; Carmel Art Association. Address in 1953, Carmel, CA. Died in 1961.

MAZUR, WLADYSLAW.
Sculptor. Born in Poland, 1871. Pupil of Academy of Fine Arts at Vienna. Address in 1935, Cincinnati, OH.

MAZZANOVICH, LAWRENCE.
Landscape painter. Born in California, Dec. 19, 1872. Pupil of Art Institute of Chicago and Art Students League of NY. Member: Salma. Club, 1905; National Arts Club (life), 1913; American Federation of Arts. Represented in Hackley Gallery, Muskegon, MI, and Chicago Art Institute. Address in 1929, Tryon, NC.

MAZZONE, DOMENICO.
Sculptor and painter. Born in Rutigliano, Italy, May 16, 1927. Work: Museum of Foggia, Italy; monument in Rutigliano, Italy; monument in Barletta, Italy; bronze plaque in S. Fara Temple, Bari, Italy; UN Building, NYC. Exhibited: National Exhibition of Marble, Carrara, Italy; National Exhibition, San Remo, Italy; Gubbio, Italy; Silvermine Guild, CT; Italian Club Exhibition, UN Building, NYC, 1967. Awards: Silver medal, Carrara Exhibition; gold medal, Exhibition International Viareggio; Bronze Medal of Copernicus, 1972. Address in 1983, Jersey City, NJ.

McAULIFFE, JAMES J.
Painter. Born in St. Johns, Newfoundland, Canada, in 1848. He studied in the Boston Art School, and made a specialty of religious and marine subjects. His "Ecce Homo" and seventy-five life-size figures are in the Roman Catholic Cathedral in St. John, New Brunswick. He is also represented by "The Constitution" in the Parlin Library, Everett. He died at Medford, MA, Aug. 22, 1921.

McBRIDE, EDWARD J.
Cartoonist. Born in St. Louis, MI, March 10, 1889. Pupil of Berdanier; St. Louis Society of Fine Arts. Member: American Association of Cartoonists and Caricaturists; St. Louis Sketch Club. Award: First prize for book cover, World's Fair, St. Louis, 1904. Work: "The Night Rider," Congressional Gallery, Washington, D.C. Art Manager, New York Tribune Syndicate. Address in 1929, New York Tribune Syndicate, 225 West 40th Street,; h. 139 West 103rd Street, New York, NY; summer, Great Neck, L.I., NY.

McBRIDE, EVA ACKELY.
(Mrs. James H. McBride). Painter and etcher. Born in Wisconsin, Dec. 27, 1861. Pupil of H. J. Breuer and W. M. Chase. Member: California Art Club; Pasadena Society of Artists; La Jolla Art Club. Address in 1929, 489 Bellefontaine Street, Pasadena, CA.

McBRIDE, JAMES JOSEPH.
Painter. Born in Ft. Wayne, IN, May 19, 1923. Studied: Ft. Wayne Art Institute; Cape Cod School of

Art, Provincetown, MA; Penna. Academy of Fine Arts; Barnes Foundation of Modern Art, Merion, PA. Work: Regional collections. Exhibitions: Water Color U.S.A., Springfield, MO, 1962-70; American Society of Casein Painters, 1970-74; American Water Color Society, NYC, 1972, 75. Midwest Water Color Show, 1977; others. Awards: Best of Show, Indiana Artist Annual, 1978-79; Midwest Water Color Society, 1979. Teaching: Indiana University-Purdue University, Ft. Wayne, 1971 to present; others. Member: Hoosier Salon Association; Indiana Artists Club; National Society of Painters in casein and acrylic; others. Media: Watercolors. Address in 1980, Fort Wayne, IN.

McBURNEY, JAMES EDWIN.
Painter, illustrator, lecturer, and teacher. Born in Lore City, OH, Nov. 22, 1868. Studied: Pratt Institute Art School, Brooklyn, NY; with John Twachtman, Arthur W. Dow, Howard Pyle, Charles H. Davis; and in Paris. Member: Calif. Art Club; Cliff Dwellers, Chicago; Painters and Sculptors of Chicago; All-Illinois Society of Fine Arts. Award: Silver medal, Pan.-California Expo., San Diego, CA, 1915. Work: "The Mission Period" and "The Spanish Period," Southern California Counties' Commission, San Diego; eight panels, National Bank of Woodlawn, Chicago; historical panels, Federal Bank and Trust Co., Dubuque, IA, and Madison, WI; twenty panels, D.C. Wentworth School, Chicago; twelve industrial panels, State Agricultural Expo., Los Angeles; three panels, "Life of George Rogers Clark," Parkside School, Chicago; twelve panels, "Women Through the Ages," Women's League Building, University of Michigan, Ann Arbor, MI; fourteen panels, "Crafts and Trades," Tilden Technical High School, Chicago. Instructor, College of Fine and Applied Arts, A.E.F. Univ., Beaune, France, 1919. Exhibited: Chicago Galleries Association. Lecturer on History of Art, Art Institute of Chicago, 1920. Director, School Department, Art Institute of Peoria, 1925-1926. Address in 1953, 1521 East 61st Street, Chicago, IL.

McCABE, E.
This engraver of vignettes was seemingly working in NY about 1855.

McCAHILL, AGNES McGUIRE.
(Mrs. Daniel Wm. McCahill). Painter and sculptor. Born in New York. Pupil of Herbert Adams and Augustus Saint-Gaudens. Member: Art Students League of New York; New York Woman's Art Club. Address in 1910, 145 West 55th St.; h. 120 East 82nd St., NYC.

McCAIG, FLORA T. (MRS.).
Painter. Born in Royalton, NY in 1856. Pupil of Penna. Acad. of Fine Arts, B. F. Ferris, G. W. Waters and Carroll Beckwith. Work: "A Mothers' Meeting," Women's Union, Buffalo, NY; "First Lessons,"

Kindergarten Training School, Buffalo, New York. Address in 1929, R. 1, Box 415, La Canada, CA; 713 Michigan Avenue, Flintridge, CA.

McCALL, ROBERT T.
Illustrator. Born in Columbus, Ohio in 1919. He studied at the Columbus Fine Art School. After serving as a bombardier in World War II, he returned to his career, at first in Chicago, then NY, frequently illustrating for *Reader's Digest, Popular Science, Life* and *Collier's*. His first love, science fiction, led him to many interesting projects, most notable of which was an assignment to paint a mural at the National Air and Space Museum. He has designed postage stamps for the space program and has been invited to record several space shots including the recent Apollo-Soyuz mission.

McCALLUM, ROBERT HEATHER.
Painter and illustrator. Born in Rochester, NY, Aug. 28, 1902. Pupil of Lamorna Birch. Member: Scarab Club. Address in 1929, 1404 Maccabees Bldg.; h. 303 East Forest Avenue, Detroit, MI.

McCARTAN, EDWARD.
Sculptor. Born in Albany, NY, August 16, 1879. Pupil of Art Students League of New York; Ecole des Beaux-Arts in Paris; Pratt Institute; and with Herbert Adams, George Gray Barnard, Hermon MacNeil. Member: Associate of the Nat. Academy of Design; Academician National Academy of Design, 1925; National Sculpture Society, 1912; New York Architectural League; Beaux-Arts Institute of Design; American Federation of Arts; Nat. Institute of Arts and Letters; Concord Art Assoc. (president); American Academy of Arts and Letters; American Institute of Architects. Exhibited at Nat. Sculpture Society, 1923. Awards: Barnett prize for sculpture, National Academy of Design, 1912; Widener gold medal, Penna. Academy of Fine Arts, 1916, prize, 1931; medal of honor for sculpture, NY Architectural League, 1923; gold medal of honor, Concord Art Association; Pratt Prize, Grand Central Gallery, 1931; gold medal of honor, Allied Artists of America, 1933. Work: Fogg Museum of Art; Brookgreen Gardens, SC; Fine Arts Academy, Buffalo; Metropolitan Museum, New York; City Art Museum, St. Louis; Albright Gallery, Buffalo. Address in 1953, 225 East 67th Street, NYC.

McCARTER, HENRY.
Illustrator and teacher. Born in Norristown, PA, July 5, 1886. Pupil of Eakins in Philadelphia; Puvis de Chavannes, Bonnat and Alexander Harrison, Toulouse-Lautrec, M. Roll, M. Rixens, in Paris. Member: Fellowship Penna. Academy of Fine Arts. Awards: Bronze medal, Pan-Am. Expo., Buffalo, 1901; silver medal, St. Louis Expo., 1904; Beck prize, Philadelphia Water Color Club, 1906; gold medal for illustrations, second gold medal for decoration and

color, P.- P. Expo., San Francisco, 1915. Address in 1929, Pennsylvania Academy and Fine Arts Country School, Chester Springs, PA. Died in 1942.

McCARTHY.
A line-engraver of portraits, in the employ of J. C. Buttre, NY, from 1860-65.

McCARTHY, C. J.
Illustrator. Born in Rochester, NY, May 21, 1887. Pupil of F. Luis Mora and F. R. Gruger. Member: Artists Guild of the Authors' League of America, NY; Society of Illustrators. Address in 1929, 40 Gramercy Park; 143 East 21st Street, New York, NY; summer, Woodstock, NY. Died 1953.

McCARTHY, ELIZABETH WHITE.
Painter. Born in Lansdowne, PA, June 3, 1891. Pupil of Archambault; E. D. Taylor; H. L. Johnson. Member: Penna. Society of Miniature Painters; American Federation of Arts. Address in 1929, 1912 South Rittenhouse Square, Philadelphia, PA.

McCARTHY, HELEN K.
Painter. Born in Poland, OH, in 1884. Pupil of Philadelphia School of Design. Member: Plastic Club; Alumni of Penna. School of Design; International Society of Arts and Letters; National Association of Women Painters and Sculptors. Address in 1926, 1716 Chestnut Street, Philadelphia, PA.

McCARTNEY, EDITH.
Painter. Member: Washington Water Color Club. Address in 1929, 14 Christopher Street, New York, NY.

McCARTY, LEA FRANKLIN.
Sculptor, painter, and author. Probably born in California, 1905. Studied at the Chouinard Art School in Los Angeles; privately in California. Work includes sculpture, Jack London Square (Oakland); busts, Wyatt Earp plaque (tombstone); portrait series, "Gunslingers of the Old West." Specialty in painting was gunmen and portraits; in sculpture, statues and busts of Western subjects in bronze. Address in 1958, Santa Rosa, CA.

McCLAIN, HELEN CHARLETON.
Painter. Born in Toronto, Ontario, CN, May 25, 1887. Member: National Association of Women Painters and Sculptors. Award: National Arts Club prize, National Assoc. of Women Painters and Sculptors, 1918. Address in 1929, Care of Miss MacDonald, 92 Will's Hill Avenue, Toronto, CN.

McCLELLAND, D.
In 1850 this name appears on a map of the City of Washington, signed as "Eng. and pub. by D. McClelland, Washington, 1850."

McCLUNG, FLORENCE ELLIOTT.
Painter and educator. Born in St. Louis, Missouri, July 12, 1896. Studied: So. Methodist University; Texas State College for Women; Col. School of Fine Art; Taos, NM; and with Adolph Dehn, Alexandre Hogue, Frank Reaugh, Richard Howard and Frank Klepper. Awards: Dallas Allied Artists, 1942, 1943, 1944, 1946; National Assoc. of Women Artists, 1945; Pepsi-Cola, 1942. Collections: Met. Museum of Art; Dallas Mus. of Fine Arts; Library of Congress; Mint Mus. of Art; High Mus. of Art; Delgado Museum; Birmingham (AL) Library; Univ. of Kansas; Univ. of Texas; others. Exhibited: NY World's Fair; Penna. Academy of Fine Arts; Women Painters of Am.; Nat. Academy of Design; Nat. Assoc. of Women Painters; So. States Art League; San Francisco Art Museum; one-woman shows at Dallas Museum of Fine Arts, Santa Fe Art Museum, McMurray College, others. Member: Dallas Art Assoc.; Texas Printmakers; So. States Art League; Texas Fine Arts Assoc.; Nat. Assoc. of Women Painters; Nat. Audubon Society. Head of art dept., Trinity U., 1929-41. Address in 1962, Dallas, TX.

McCLURE, CAROLINE SUMNER.
(Mrs. G. G. McClure). Sculptor and writer. Born in St. Louis, MO. Pupil of Lorado Taft, Hermon MacNeil. Member: National Arts Club. Work: Figure of Victory for dome of the Missouri Building, St. Louis Exposition, 1904. Address in 1933, 640 Riverside Drive, New York, NY.

McCLURE, MAUD QUINBY.
Sculptor. Born in Mt. Morris, IL, October 4, 1884. Pupil of Art Institute of Chicago, and Lorado Taft in Chicago. Member: Alumni, Art Institute of Chicago; Chicago Art Club. Address in 1925, Eagle's Nest Camp, Oregon, IL.

McCLUSKEY, WILLIAM.
Some very well executed subject plates, signed by "Wm. McCluskey" as engraver, were published in *The New Mirror*, New York, about 1845.

McCOLL, MARY A.
Painter, craftswoman, writer, and teacher. Born in Forrest, Ontario, Can. Pupil of Cornoyer, Courtois, John Carlson, Hugh Breckenridge; Hans Hofmann in Munich. Member: St. Louis Artists Guild; St. Louis Art League; Western Art Association. Awards: First prize for figure painting, St. Louis Artists Guild, 1916, 1917, 1918; hon. mention for landscape, Black and White Competition, Chicago, 1929. Work: "Reflections" and "Still Life," Town Club, St. Louis, MO. Address in 1929, 3608 Castleman Avenue, St. Louis, MO; summer, Kimmswick, MO.

McCOMAS, FRANCIS.
Painter. Born in Fingal, Tasmania, Australia, Oct. 1, 1874. Member of the jury, Panama-Pacific Inter-

national Expo., 1915. Member: Philadelphia Water Color Club; American Water Color Society. Awards: Dana gold medal, Philadelphia Water Color Club, 1918; Hudnut prize, American Water Color Society, 1921; Philadelphia Water Color Club prize, 1921. Work: Two mural decorations on the Del Monte Lodge, Pebble Beach, CA; mural decorations, Del Monte Hotel, Del Monte, CA; and represented in the Metropolitan Museum of Art, NY, Park Museum of San Francisco and Portland Art Society. Address in 1929, Pebble Beach, CA.

McCOMB, MARIE LOUISE.
Illustrator and painter. Born in Louisville, KY. Pupil of Penna. Academy of Fine Arts. Member: Fellowship Penna. Acad. of Fine Arts. Award: Traveling Scholarship, Penna. Academy of Fine Arts, 1912. Address in 1929, 41 East 59th Street, New York, NY.

McCONAHA, LAWRENCE.
Painter. Born in Centerville, IN, August 8, 1894. Pupil of George H. Baker, Guy Wiggins. Member: Springfield Art Association; Palette Club of Richmond. Awards: Earlham College prize, Hoosier Salon, Chicago, 1927; Edward Rector Memorial prize, Hoosier Salon, Chicago, 1929. Address in 1929, 405 Pearl Street, Richmond, IN.

McCONNELL, GENEVIEVE KNAPP.
(Mrs. Guthrie McConnell). Painter, illustrator, and writer. Born in St. Louis, MO, March 18, 1876. Pupil of St. Louis School of Fine Arts. Member: Plastic Club; St. Louis Artists Guild. Author and illustrator of *The Seeing Eye* (Cornhill Publishing Co.). Author of children's stories in juvenile magazines. Address in 1929, 4915 Argyle Place, St. Louis, MO; summer, Easton, MD.

McCONNELL, GERALD.
Illustrator. Born in East Orange, NJ in 1931. He studied at the Art Students League under Frank Reilly, after which he apprenticed with Dean Cornwell. He began free-lancing in the mid-1950's, working for advertising agencies and publishers. He has served on the Board of Directors of the Society of Illustrators since 1963 and its Executive Committee since 1967. A founding member of Graphic Artists Guild in NYC, he has been on its Executive Committee since 1969. His works are in the collections of the Society of Illustrators, U.S. Air Force and National Park Service, and have been shown in the galleries of Master Eagle, Fairtree, Greengrass and the Society of Illustrators. He is best known for his three-dimensional art; his book on the subject, *Assemblage*, was published in 1976.

McCORD, GEORGE HERBERT.
Painter. Born on August 1, 1848 in NYC. He first exhibited at the National Academy in 1870. Among his most important works are "Sunnyside" (home of Washington Irving); "Cave of the Winds, Niagara" and "The Genesee Valley." Elected an Associate of the National Academy in 1880. He died in NYC on April 6, 1909.

McCORKLE, LOUIS W. (REVEREND).
Painter. Born in St. Louis, MO, in 1921. Studied: Largely self-taught; drawing lessons at School of Fine Arts, Washington University, St. Louis; art studies with Helen Mederos, Virginia McCloud. Ordained a Catholic priest, 1953. Work: Private collections; Missouri public collections of City of Hannibal, Diocese of Jefferson City, Order of Sisters of St. Francis of Maryville. Exhibited: Artist in Residence Exhibition, London, 1976; Grand Nat. Exhibition, NYC, 1976. Teaching: Art Inst., St. Thomas Seminary, Hannibal, MO, from 1970. Member: Am. Artists Professional League (life). Style and Technique: Florals executed in heavy impasto, brilliant color. Media: Oils. Address in 1983, P.O. Box 551, Hannibal, MO.

McCORMACK, NANCY.
See Cox-McCormack, Nancy.

McCORMICK, HOWARD.
Painter, illustrator, and engraver. Born in Indiana, August 19, 1875. Pupil of Forsyth and Chase; Laurens in Paris. Member: Salma. Club, 1907; Artists Guild of the Authors' League of America, NY. Work: Hopi, Apache and Navajo habitat group, American Museum of Natural History, New York; "Hopi World" (gesso), John Herron Art Institute; wood engravings in numerous magazines. Address in 1929, Leonia, NJ.

McCORMICK, KATHERINE HOOD.
Painter and illustrator. Born in Philadelphia, PA, Sept 17, 1882. Pupil of Penna. Academy of Fine Arts; Drexel Institute and Fred Wagner. Member: Fellowship Penna. Academy of Fine Arts; Philadelphia Alliance. Award: First hon. mention, Philadelphia Sketch Club, 1923. Address in 1929, 3416 Race Street, Philadelphia, PA; summer, Pocono Lake Preserve, Monroe Co., PA.

McCOSH, DAVID JOHN.
Painter, illustrator, etcher and teacher. Born in Cedar Rapids, July 11, 1903. Pupil of George Oberteuffer; Art Institute of Chicago; Art Students League of NY; Coe College. Member: Theta Chi Phi; American Association of University Professors. Work: "The Prodigal Son," Cedar Rapids Art Association; Seattle Art Museum; Portland Art Museum; Whitney Museum; IBM Collection; murals, U.S. Post Office, Kelso, WA, and Beresford, ND; Dept. of the Interior, Washington, DC. Exhibited: Carnegie Institute, 1936; Cincinnati Museum Association; Penna. Academy of Fine Arts, 1937; Art Institute of Chicago, 1929-38; Brooklyn Museum, 1937; Golden

Gate Expo., San Francisco, 1939; Whitney, 1939; Portland Art Museum, 1952 (one-man); Metropolitan Museum of Art; Seattle Art Museum, 1951 (one-man). Awards: Englewood Women's Club prize, Chicago Artists Exhibition, 1929; Traveling scholarship, Art Institute of Chicago, 1928, prize, International Water Color Club Exhibition, 1929; Tiffany Foundation Fellowship, 1930; honorable mention, Iowa State Fair, 1933. Address in 1953, Eugene, OR.

McCOUCH, D. W.
Painter. Exhibited at Penna. Academy of Fine Arts, Philadelphia, 1921; represented in "Exhibition of Paintings Showing the Later Tendencies in Art." Address in 1926, St. Martin's Lane, Chestnut Hill, Philadelphia, PA.

McCOUCH, GORDON MALLET.
Painter and etcher. Born in Philadelphia, PA, Sept. 24, 1885. Pupil of Howard Pyle in Wilmington; George Bridgman in NY; Heinrich von Zugel in Munich. Member: Zurcher Kunstgesellschaft; Gesellschaft Schweizerischer Maler, Bildhauer und Architekten. Address in 1929, Porto di Ronco, Switzerland. Died 1959.

McCREA, SAMUEL HARKNESS.
Landscape painter. Born in Palatine, Cook Co., IL, March 15, 1867. Studied in San Francisco, Chicago, New York, Paris and Munich. Member: Salma. Club. Address in 1929, Scraggycrag, Darien, CT.

McCREERY, FRANC ROOT.
(Mrs. Earl A. McCreery). Portrait painter, draftsman, and illustrator. Born in Dodge City, Kansas. Pupil of Buffalo School of Fine Arts; Students School of Art, Denver; Art Institute of Chicago. Member: Buffalo Society of Artists; League of American Penwomen; Guild of Allied Artists. Member of faculty of Buffalo School of Fine Arts. Address in 1929, 1110 Elmwood Avenue; h. 15 Elmview Place, Buffalo, NY. Died in 1957.

McCULLOUGH, LUCERNE.
(Mrs. C. E. Robert McCullough). Painter and illustrator. Born in Abilene, TX, December 6, 1916. Studied: Newcomb College, Tulane University, B. of Des.; Art Students League. Awards: Art Students League; Art Directors' Club, 1944; Direct Mail Advertising Association, 1941, 42, 44, 45; Silvermine Guild of Artists, 1954, 1956. Collections: Museum of Modern Art; San Angelo Museum of Art; National Academy of Design; United States Post Office, Booneville, NY; US Post Office, Thomaston, CT. Exhibited: Louisiana State Exhibition, 1938; Newcomb College, 1939; Direct Mail Advertising Association, 1941, 42, 44, 45; Art Directors' Club, 1944, 46; Silvermine Guild, 1952. Contributor of advertising and illustrations to *Ladies Home Journal, Life, Good Housekeeping, Vogue, Harpers Bazaar*, and other national magazines. Address in 1953, Westport, Connecticut; h. New Canaan, CT.

McCULLOUGH, MAX (MRS.).
(Mrs. Marshall McCullough). Painter and teacher. Born in Elmwood Plantation, Lee County, AR, Nov. 9, 1874. Pupil of Vincent Nowottney, L. H. Meakin, Emile Renard, LeFarge, Debillemont-Chardon. Member: Mississippi Art Association; Highland Park Society of Fine Arts, Dallas; Southern States Art League. Address in 1929, Corner Dixie and Plummer Sts.; h. 308 So. Dixie St., Eastland, TX.

McCUTCHEON, JOHN TINNEY.
Caricaturist. Born near South Raub, Tippecanoe County, IN, May 6, 1870. Pupil of Ernest Knaufft at Purdue University. Member: Society of Illustrators, 1911. On staff of *Chicago Tribune*, 1903; correspondent during Spanish War and World War I. Author: *Stories of Filipino Warfare, Bird Center Cartoons, In Africa*, etc. Address in 1929, Care of the Chicago Tribune, Tribune Tower, 31st Floor; h. 2450 Lakeview Avenue, Chicago, IL.

McDERMOTT, WILLIAM LUTHER.
Sculptor, painter, designer, craftsman, educator, and lecturer. Born in New Eagle, PA, February 21, 1906. Studied: Carnegie Institute, B.A.; University Pittsburgh, M.A.; Herron Art Institute; and with Joseph Ellis, J. P. Thorley, Frederick Nyquist. Member: Pittsburgh Society of Sculptors; Pitts. Art Association; American Artists Professional League; American Association of University Professors. Work: SS. Peter and Paul Church, St. Joseph Art School, De Paul Institute, all in Pitts.; Providence Normal School, PA; Mary Washington College, Fredericksburg, VA. Exhibited: Associated Artists of Pittsburgh, 1932-37; Pitts. Society of Sculptors, 1934-37; Virginia Museum of Fine Arts, Richmond. Lectures: Art Appreciation; Architecture and Sculpture. Taught: Professor of Art, Mary Washington College, Fredericksburg, VA, 1941-46. Address in 1953, Fredericksburg, VA.

McDONALD, ANN HEEBNER.
(Mrs. McDonald). Painter. Born in Philadelphia, PA. Pupil of Penna. Academy of Fine Arts; Hugh H. Breckenridge; Whistler School in Paris. Member: Fellowship Penna. Academy of Fine Arts; Philadelphia Alliance. Represented in the John Lambert Fund and Fellowship collections of the Penna. Academy of Fine Arts. Address in 1929, 8305 Seminole Avenue, Chestnut Hill, Philadelphia, PA.

McDONALD, WILLIAM PURCELL.
Painter. Born in Cincinnati, OH, Sept 18, 1863. Pupil of Cincinnati Art Acad. under Duveneck. Member: Cincinnati Art Club; Duveneck Society of Painters and Sculptors. On Rookwood Pottery staff from 1882. Address in 1929, Rookwood Pottery, Cincinnati, OH.

McDOUGAL, JOHN A.
Miniature painter, flourishing 1836-81 in NY and Newark.

McDUFFIE, JANE.
See Thurston, Jane McDuffie.

McENTEE, JERVIS.
Painter. Born July 14, 1828 in Rondout, NY. Specialty: Landscapes. Studied with F. E. Church. Elected an Associate of the National Academy, 1860; National Academy, 1861. Represented by "Eastern Sky at Sunset," at Corcoran Art Gallery, Washington, D.C. Was also draftsman for wood engravers. Died Jan. 27, 1891 in Rondout, N.Y.

McEWEN, KATHERINE.
Painter. Born in Nottingham, England, July 19, 1875. Pupil of Chase, Miller, Wicker and Woodbury. Member: Detroit Society of Arts and Crafts; Detroit Society of Women Painters; National Society of Mural Painters. Work: Water colors in Detroit Institute of Arts; frescoes in Christ Church, ceilings in Arts and Crafts Building, and murals in junior dining hall, School for Boys, Cranbrook, MI. Address in 1929, Seven Dash Ranch, Johnson, AZ.

McEWEN (or MacEWEN), WALTER.
Painter. Born in Chicago, IL, Feb. 13, 1860. Pupil of Cormon and Robert-Fleury in Paris. Member: Associate National Academy of Design, 1903; Paris Society of American Painters; National Institute of Arts and Letters. Counselor Cresson Scholarship, Penna. Academy of Fine Arts Students. Awards: Hon. Mention, Paris Salon, 1886; Silver medal, Paris Expo., 1889; first class gold medal, Berlin, 1891; medal Columbian Expo., Chicago, 1893; medal of honor, Antwerp, 1894; second class medal, Munich, 1897; silver medal, Paris Expo., 1900; first gold medal, Munich, 1901; first class medal, Vienna, 1902; Lippincott prize, Penna. Academy of Fine Arts, 1902; Harris prize, Art Institute of Chicago, 1902; gold medal, St. Louis Expo., 1904; first medal, Liege, 1905; hors concours (jury of awards), P.- P. Expo., San Francisco, 1915; Chevalier Legion of Honor, 1896, Officer, 1908; Order of St. Michael, Bavaria; Order of Leopold II Belgium, 1909; Proctor prize, National Academy of Design, 1919. Work: "Sunday in Holland," Luxembourg Museum, Paris; decorations in Library of Congress, Washington; "An Ancestor," Corcoran Gallery, Washington; "The Letter," Art Association, Indianapolis; "Lady in a White Satin Gown" and "The Judgement of Paris, "Art Institute of Chicago; "Phyllis," Pennsylvania Academy, Philadelphia; "Lady of 1810," Telfair Museum, Savannah; "Waiting," Honolulu Museum; "L'Absente," Musee, Liege, Belgium; "Enfant Hollandais," Musee, Budapest; "Famille Hollandais," Musee, Ghent, Belgium; "The Interlude," Los Angeles Museum; "The Ghost Story," Cleveland

Museum of Art. Address in 1929, 11 Rue Georges Berger; h. 59 Rue Galilee, Paris, France; Century Association, 7 West 43rd Street, New York, NY. Died 1943.

McEWEN, WILLIAM.
A little known landscape painter, friend and pupil of George Inness.

McFADDEN, SARAH YOCUM.
See Boyle, Sarah Yocum McFadden.

McFEE, HENRY LEE.
Painter and teacher. Born in St. Louis, MO., April 14, 1886. Member: New Society of Artists; Modern Artists of America, NY. Represented in Phillips Memorial Gallery, Washington, D.C. Address in 1929, Woodstock, Ulster County, NY. Died in 1953.

McGIBBON, JAMES.
He was a miniaturist and portrait painter who worked in Boston, MA, in 1801.

McGILLIVRAY, FLORENCE HELENA.
Painter. Born in Whitby, Ontario, CN, 1864. Pupil of Simon and Menard in Paris. Member: International Art Union, Paris; Nat. Assoc. of Women Painters and Sculptors; Ontario Soc. of Artists. Work: "Afterglow," and "Stack in Winter," owned by the Canadian Gov. Address in 1929, 292 Frank Street, Ottawa, Ont., CN; summer, Whitby, Ontario, CN.

McGINNIS, ROBERT E.
Illustrator. Born in Cincinnati, Ohio in 1926. He attended Ohio State University for four years and the Central Academy of Commercial Art. He began his career with *The Saturday Evening Post* in 1960 and has worked extensively for *Good Housekeeping* since then. As well as illustrating for paperback book publishers, he has also produced over 50 movie posters, most notably those for the James Bond movies in the 1960's. A member of the Society of Illustrators, he lived in Old Greenwich, CT.

McGOFFIN, JOHN.
Engraver. Born in Philadelphia, PA, in 1813. McGoffin was an excellent line-engraver of landscape and subject plates. He was a pupil of James W. Steel, of Philadelphia, and was in the employ of that engraver in 1834. He painted miniatures for some years, but he evidently continued to engrave, and was working at least as late as 1876.

McGRATH, BEATRICE (WILLARD).
Sculptor. Born in Dodge City, Kansas, November 28, 1896. Studied at Cleveland School of Art and with Herman N. Matzen. Award: Third prize, Garden Club Competition, Cleveland, Ohio, 1925. Member: Sculptors' Society of Cleveland. Address in 1933, 40 Wall St., New Haven, CT.

McGRATH, JOHN.
Etcher. Born in Ireland, Nov. 4, 1880. Self taught. Member: Baltimore Water Color Club; Charcoal Club. Address in 1929, 209 West Saratoga Street; 812 Cator Avenue, Baltimore, MD; summer, Pine Cove, Earleigh Heights, MD.

McGRATH, SALLIE TOMLIN.
Painter. Born in Galena, IL. Pupil of Christine Lumsdon. Member: Salons of America. Address in 1929, 1111 Carnegie Studio; h. 1065 Lexington Avenue, New York, NY.

McGREW, RALPH BROWNELL.
Painter, sculptor, and writer. Born in Columbus, Ohio, 1916. Studied with Lester Bonar at Alhambra, California (high school); Otis Art Institute, Los Angeles, with Ralph Holmes; also with Edouard Vysekal and E. R. Schrader. Worked as movie set decorator before turning to fine arts. Former member of Cowboy Artists of America; American Institute of Fine Art; National Academy of Western Art. Work in Anschutz Collection; Cowboy Hall of Fame; University of Santa Clara; Read Mullan Gallery of Western Art; Museum of Northern Arizona. Specialty is Indian subjects rendered in a style of poetic realism. Address in 1976, Guemado, New Mexico.

McHUGH, ARLINE B.
Painter and illustrator. Born in Owensboro, KY, March 9, 1891. Pupil of H. R. Ballinger; Alta W. Salisbury; Gerome De Witt. Member: New Rochelle Art Association; C. L. Wolfe Art Club. Address in 1929, 66 North Chatsworth, Larchmont, NY.

McILHENNEY, CHARLES M.
Painter and etcher. Born in Philadelphia in 1858. Studied at the Penna. Academy of Fine Arts in 1877. He established his studio in New York City. Among his pictures are "A Gray Summer Noon," "The Old Old Story," and "The Passing Storm." Elected an Associate of the National Academy in 1892. Member of the New York Etching Club. He died in 1904.

McINTIRE, KATHERINE ANGELA.
Painter and etcher. Born near Richmond, VA, in 1880. Pupil of Chase, Alice Beckington, George Bridgman in NY; also of Mme. La Farge and Guerin in Paris. Address in 1926, 160 Waverly Place, New York, NY.

McINTIRE, SAMUEL.
Sculptor and architect. Born in Salem, MA, in 1757. Apprenticed to his father's building trade, where he later began making decorative wood carvings. Working in that capacity for a wealthy Salem merchant, Elias Hasket Derby, by the 1790's. Performed decorative work for a number of Derby's ships, such as the Mount Vernon, 1798. Known primarily as an architect; proposed a design for the U.S. Capitol, but was rejected. In sculpture, he carved numerous eagles and reliefs, and occasional portrait busts, such as his busts of John Winthrop and Voltaire. Other works include four ornamental gateways for the Salem Common, 1802, including a relief medallion of George Washington. Many works have been attributed to McIntire, but few have been documented to his studio. Died in Boston, February 6, 1811.

McINTIRE, SAMUEL FIELD.
Carver. Born in Salem, MA, in 1780. Son of Samuel McIntire. Worked with his father; succeeded to the business in 1811. Died on September 27, 1819.

McINTOSH, PLEASANT R.
Painter. Born in New Salisbury, IN, Oct. 4, 1897. Pupil of Art Institute of Chicago. Member: Hoosier Salon. Award: Second Huntington prize, Columbus Gallery of Fine Arts, 1925; Erskine prize, Hoosier Salon, 1927; Chamber of Commerce medal, Peoria, Illinois, 1929. Director, School of the Art Institute of Peoria, and head of art department, Bradley Polytechnic Institute, Peoria, from 1926. Address in 1929, Art Institute of Peoria, Hamilton Boulevard and Randolph Street, Peoria, Illinois; New Salisbury, Indiana.

McKAY.
Painter. No work is known of this portrait painter except his painting of John Bush (1755-1816) and that of Abigail Bush (1765-1810) which are signed "McKay," and belong to the American Antiquarian Society of Worcester, MA.

McKEE, DONALD.
Illustrator and etcher. Born in Indianapolis, IN, March 1, 1883. Pupil of NY School of Art. Illustrations in Life, Judge, Saturday Evening Post and Collier's. Address in 1929, 66 King Street, Westport, CT.

McKEE, JOHN DUKES.
Illustrator. Born in Kokomo, IN, Dec. 4, 1899. Pupil of E. Forsberg. Awards: Third prize, Hoosier Salon, 1925; first prize, Hoosier Salon, 1926. Address in 1929, 185 N. Wabash Avenue, h. 6951 Ogleby Avenue, Chicago, IL.

McKEE, S. ALICE.
(Mrs. Charles Atherton Cumming). Painter and teacher. Born in Stuart, IA, March 6, 1890. Pupil of Charles A. Cumming. Member: Iowa Artists Guild; American Artists Professional League. Awards: Gold medal, Iowa State Fair, 1923, 1924; purchase prize, Des Moines Women's Club, 1925. Work in Des Moines Women's Club; Iowa State Historical Gallery. Address in 1929, Cumming School of Art, Des Moines, IA; San Diego, CA.

McKELLAR, ARCHIBALD.
Sculptor. Born in Paisley, Scotland, October 23, 1844. Worked for the Monumental Bronze Company, of NY, as its sculptor, and at the time of his death was superintendent of its works at Bridgeport and a director of the company. Works: Bronze statue of James A. Garfield, Wilmington, DE; "Defense of the Flag," which has been copied nearly 1,000 times. Died in Bridgeport, CT, July 4, 1901.

McKENZIE, ROBERT TAIT.
Sculptor, writer, and lecturer. Born in Almonte, Ontario, Canada, May 26, 1867. Member: Philadelphia Sketch Club; Fellowship Penna. Academy of Fine Arts; Century Association; Philadelphia Art Club; American Federation of Arts; Nat. Sculpture Society; Philadelphia Alliance. Exhibited at National Sculpture Society, 1923. Awards: Silver medal, St. Louis Expo., 1904; King's medal, Sweden, 1912; honorable mention, P.-P. Expo., San Francisco, 1915. Work: "Sprinter," Fitz William Mus., Cambridge, England; "College Athlete," Ashmoleam Museum, Oxford, England; "Juggler" and "Competitor," Metropolitan Museum, NY; "Competitor," Canadian National Gallery, Ottawa; "Onslaught," a group, and "Relay," statuette, Art Gallery, Montreal, CN; "The Plunger and the Ice Bird;" statuettes "Boy Scout" and "Blighty" and "Capt. Guy Drummond," memorial statue, Canadian War Museum, Ottawa, Canada; portraits in low relief of F. K. Huger and Crawford W. Long, University of Georgia; Dr. W. W. Keen, Brown Univ., Providence; "The Youthful Benjamin Franklin," bronze statue, Univ. of Pennsylvania campus; Newark Mus., "Portrait of Weir Mitchell," and medals for Franklin Institute, Philadelphia, University of Buffalo, Achilles Club, London; "Baron Tweedmouth" and "Lady Tweedmouth," Guisachan, Scotland; fountain with panel in high relief, "Laughing Children," Athletic Park Playground, Philadelphia; statues, "Provost Edgar F. Smith" and "Rev. George Whitefield," Triangle of the University of Pennsylvania dormitories, 1919; "Norton Downs, Aviator," St. Paul's School; Victory Memorial, Cambridge, England; memorial statue, Col. George Harold Baker, Parliament Buildings, Ottawa, CN; "William Cooper Proctor," and "Dean West," Princeton, NJ; "Flying Sphere," St. Louis Art Museum; Scottish-American War Mem., Edinburgh, Scotland; General Wolfe, Greenwich, England. Address in 1933, 2014 Pine Street, Philadelphia, PA; summer, Almonte, Ont. Died in 1938.

McKEOWN, WESLEY BARCLAY.
Illustrator. Born in Jersey City, in 1927. He graduated in 1950 from the Newark School of Fine and Industrial Arts. Shortly thereafter, his illustrations appeared in advertisements, magazines and books, as well as in technical and trade publications. A member of the Soc. of Illustrators, he contributed to the U.S. Air Force Art Program and was active on many committees before becoming President from 1968 to 1970. He was commissioned to produce a series of postage stamps on the metric system in 1974. Died in 1975.

McKERNAN, FRANK.
Painter and illustrator. Born in Philadelphia, PA, Sept. 19, 1861. Pupil of Penna. Academy of Fine Arts and of Howard Pyle. Member: Philadelphia Sketch Club; Fellowship Penna. Academy of Fine Arts. Address in 1929, Ridley Park, PA.

McKILLOP, EDGAR ALEXANDER.
Sculptor. Born in Balfour, North Carolina, June 8, 1878. Self-taught. Carved numerous objects in wood, such as clock housings, musical instruments, Victrolas, knives, and furniture. Only four of his works are known today, despite the volume of his work. Died in Balfour, North Carolina, August 4, 1950.

McKINNEY, GERALD T.
Painter and illustrator. Born in Garland, PA, Feb. 26, 1900. Pupil of E. M. Ashe; C. J. Taylor; H. S. Hubbell; Norwood MacGilvary. Member: Pittsburgh Art Association. Address in 1929, Youngsville, PA.

McKINNEY, ROLAND JOSEPH.
Painter, lecturer, and teacher. Born in Niagara Falls, NY, Nov. 4, 1898. Pupil of Leopold Seyffert and Wellington Reynolds. Member of Chicago Art Students League. Work: "The Ascension," mural painting, First Presbyterian Church, Davenport, IA. Address in 1929, care of Municipal Art Gallery; h. 2016 Main Street, Davenport, IA.

McKINSTRY, GRACE E.
Portrait painter, sculptor, and teacher. Born in Fredonia, NY. Pupil of Art Students League of NY; Art Institute of Chicago; Julian and Colarossi Academies; also with Raphael Collin in Paris. Member: American Artists Professional League; American Federation of Arts; National Arts Club. Work: Portraits in the Capitol, St. Paul, MN; Lake Erie College, Painesville, OH; Charleston College, Northfield, MN; Shattuck School, Faribault, MN; Army and Navy Club, Washington, DC; Woman's Club, Minneapolis; Cornell University; Beloit (WI) College; Pomona College, CA; etc. Address in 1933, Pen and Brush Club, New York, NY.

McKNIGHT, ROBERT J.
Sculptor and industrial designer. Born in Bayside, LI, NY, February 26, 1905. Studied: Yale College, Ph.B.; Yale School Fine Arts, B.F.A., and with H. Bouchard, Paris; Carl Milles. Awards: Lake Forest Scholarship, 1930; Prix de Rome, 1932; gold medal, Electronic Magazine (for industrial design), 1952. Work: Brookgreen Gardens, SC. Exhibited: Philadelphia Museum of Art; Carnegie Institute; Grand

Central Art Galleries; Robinson Gallery, NY; Brooks Memorial Art Gallery, Springfield Art Academy, 1946-52. Lectures: History of Art; Design. Positions: Director, Memphis Acad. of Art, 1936-41; Instructor of Design, Southwestern University, 1941-42; Army Aviation Engineers, 1942-45; Instructor Sculpture, Ceramics, Interior Decoration, Wittenberg College, Springfield, Ohio, 1948-51. Address in 1953, 648 East High St.; h. 1577 McKinley Ave., Springfield, Ohio.

McLAIN, MARY.
Miniature painter. Exhibited at the Pennsylvania Academy of Fine Arts, Philadelphia, 1925. Address in 1926, 111 East 56th Street, New York.

McLANE (or MacLANE), (M.) JEAN.
(Mrs. John C. Johansen). Portrait painter. Born in Chicago, IL, in 1878. Graduated from Art Institute of Chicago in 1897, with honors and prizes; also studied under Duveneck. Awards: Bronze medal, St. Louis Expo., 1904; first prize, International League, Paris, 1907, 08; Elling prize, NY Woman's Art Club, 1907, Burgess prize, 1908; Julia A. Shaw prize, National Academy of Design, 1912, third Hallgarten prize, 1913; Walter Lippincott prize, Penna. Academy of Fine Arts, 1914; silver medal, Panama-Pacific Expo., San Francisco, 1915; Harris silver medal and prize, Art Institute of Chicago, 1924. Represented in private galleries throughout U.S.; by "Girl in Green," Museum of Art, Syracuse, NY; "Virginia and Stanton," Art Institute of Chicago; "Portrait of a Boy," San Antonio Art Museum; "Girl in Gray," Toledo Museum of Art; "Queen Elizabeth of the Belgians," war collection of portraits, National Gallery of Art, Washington, DC; etc. Elected an Associate of the National Academy; also a member of the International Art League, Paris; MacDowell Club, New York; National Association of Portrait Painters. Address in 1926, 12 West 9th Street, New York, NY.

McLAUGHLIN, CHARLES J.
Painter, draftsman and decorator. Born Covington, KY, June 6, 1888. Pupil of Cincinnati Art Academy; Ecole des Beaux Arts, Fontainebleau and Duveneck; studied architecture in France, Belgium, Italy and Greece. Member: Cincinnati Art Club; MacDowell Club of Cincinnati; Cincinnati Architectural League. Designer at Rookwood Potteries, 1913-1920; teacher of architectural design, Department of Architecture, A. and M. College of Texas, College Station, 1926-1927. Address in 1929, Ferro Concrete Construction Co., Cincinnati, OH, 321 Front Street, Covington, KY.

McLAUGHLIN, MARY LOUISE.
Painter and etcher. Born in Cincinnati, OH, on Sept. 29, 1847. Pupil of Cincinnati Art Academy, and of Duveneck. She began making porcelain, called Losanti ware, in 1898; exhibited first in Paris Expo., 1900. Received silver medal for decorative metal work, Paris Expo., 1899; hon. mention for china painting, Chicago Expo. Represented by specimens of porcelain and pottery in the Cincinnati Museum and in the Pennsylvania Museum, Philadelphia. Member: Cincinnati Woman's Club (hon.); Woman's Art Club; National League of Mural Painters. Author of books entitled *China Painting, The Second Madame,* and *An Epitome of History.* Address 1926, 4011 Sherwood Ave., Annsby Place, Cincinnati, OH. Died in 1939.

McLAWS, VIRGINIA RANDALL.
Painter and teacher. Born in Augusta, GA, August 29, 1872. Pupil of Charcoal Club School, Baltimore; NY School of Fine and Applied Arts; Caro-Delvaille, Paris; summer schools of Penna. Academy of Fine Arts, Art Students League of New York. Member: Southern States Art League; College Art Association; American Federation of Arts. Address in 1929, Sweet Briar College, Sweet Briar, VA.

McLEAN, JAMES AUGUSTUS.
Painter and etcher. Born in Lincolnton, NC, May 2, 1904. Pupil of Daniel Garber, Joseph Pearson, Charles Garner. Member: Fellowship Penna. Academy of Fine Arts; Southern States Art League. Address in 1929, 406 East Main Street, Lincolnton, NC.

McLEAN, WILSON L.
Illustration. Born in Glasgow, Scotland in 1937. He had no formal art training. In 1969 his first illustration was published by *Woman's Own* magazine and he has since worked for *Sports Illustrated, Esquire, Oui, Playboy, Penthouse, McCall's,* and *Quest.* He has won a Gold Medal from the Art Directors' Club Show, Awards of Excellence from the Society of Illustrators, a Silver Medal from the One Show and a Clio for a TV commercial. The Greengrass Gallery has exhibited his work.

McLEARY, BONNIE.
See MacLeary, Bonnie.

McLELLAN, H. B.
About 1860 this stipple-engraver of portraits was located in Boston, MA.

McLELLAN, RALPH.
Painter, etcher, and teacher. Born in San Marcos, Texas, Aug. 27, 1884. Pupil of Philip Hale, Edmund Tarbell and Frank Benson in Boston. Member: Boston Museum Art Association; Texas Fine Art Association; Philadelphia Alliance; Southern States Art League; North Shore Arts Association. Awards: Dunham prize, Connecticut Academy of Fine Arts, 1917; Isidor medal, National Academy of Design, 1919; hon. mention, Southern States Art League, Houston, Texas, 1928. Represented in Southwest Texas Teachers College Museum. Instructor in

Pennsylvania School of Industrial Art. Address in 1929, 7906 Lincoln Drive, St. Martins; Pennsylvania Museum of Art, Pine and Broad Steets, Philadelphia, PA.

McLENEGAN, HARRY RICHARDSON.
Painter, craftsman, and teacher. Born in Milwaukee, WI, July 11, 1899. Pupil of Emma M. Church; Maybelle Key; Dudley Crafts Watson; Gerrit Sinclair; Charlotte Partridge. Member: Wisconsin Painters and Sculptors. Address in 1929, The Westlake, 394 Summit Avenue, South, Milwaukee, WI.

McMAHON, FRANKLIN.
Illustrator. Born in Chicago, IL in 1921. He attended the Art Institute of Chicago; Institute of Design; American Academy of Art; and the Chicago Academy of Art, from 1939-1950; he studied under E. W. Ball, Francis Chapin and Paul Weighardt. In 1939 he published his first illustration for *Collier's*. Aside from being an illustrator who has worked for all major magazines, he has done eight 16 mm documentaries on art, and in election years from 1964 to 1976 he made films for television on art and politics called *The Artist as a Reporter*. He has worked extensively for the American space program covering the launching of *Gemini III*, *Apollo X*, and *Apollo XI*, the first man on the moon.

McMAHON, MARK ANDREW.
Illustrator. Born in Chicago, IL, in 1950. He attended the North Shore Art League, Deerpath Art League and Adam State College. He has worked for many magazines, including *Chicago, US Catholic, The Uptowner* and *Chicago Tribune*. His on-the-spot illustrations have led to assignments covering tennis, skiing and rodeo events for TV and magazines. His work has been shown in many exhibits in Kentucky, Colorado and the Chicago area.

McMANHUS, BLANCHE.
See Mansfield, Blanche McManhus.

McMANHUS, GEORGE.
Illustrator. Member: Society of Illustrators. Address in 1929, International Features Service, 246 West 59th Street, New York, NY.

McMANHUS, JAMES GOODWIN.
Painter and teacher. Born in Hartford, CT, Feb. 5,1882. Pupil of C. N. Flagg, Robert B. Brandegee, W. G. Bunce, Montague Flagg and Walter Griffin. Member: Connecticut Academy of Fine Arts; Hartford Municipal Art Scoiety; Salma. Club; Springfield Art League; Lyme Art Association; New Haven Paint and Clay Club. Awards: Honorable mention, Connecticut Academy of Fine Arts, 1922; Alice C. Dunham prize and popular prize, 1923; honorable mention, 1928, and Cooper prize, 1929; hon. mention,

New Haven Paint and Clay Club, 1928; Bunce prize, Connecticut Academy of Fine Arts, 1930, 33. Work: "Portrait of Alfred E. Burr," Burr Grammar School, Hartford; "Dr. George C. Bailey," Brown School, and St. Francis' Hospital, Hartford; "Thomas Snell Weaver," Weaver High School, Hartford. Instructor at Hartford Public High School and the Connecticut League of Art Students. Address in 1929, 86 Pratt Street; P.O. Box 298; h. 843 New Britain Avenue, Hartford, CT. Died in 1958.

McMEIN, NEYSA MORAN.
(Mrs. John G. Baragwanath). Painter and illustrator. Born in Quincy, IL, Jan. 25, 1890. Pupil Art Institute of Chicago. Member: Society of Illustrators; Artists Guild of the Authors' League of America, NY. Work: Covers for *McCall's Saturday Evening Post, Woman's Home Companion*. Address in 1929, 1 West 67th Street, New York, NY.

McMILLAN, LAURA BROWN (MRS.).
Painter, writer, and teacher. Born in Malone, NY, April 23, 1859. Pupil of John Herron Art Institute; De Pauw University; Emma King; Edward Sitsman; George Innis, Jr. Member: Indiana Art Club; Art Department, Kokomo Woman's Club; Kokomo Art Association; Hoosier Salon. Work: "Autumn Time," Tipton Public Library; "Along the Stream," High School, Howard, IN; "Late Winter," Kokomo Women's Club House; "Morgan County Hills," Howard County Hospital; "Autumn Time," Y.W.C.A. Building. Address in 1933, 221 East Taylor Street, Kokomo, IN.

McMILLAN, MARY.
Painter. Born in Ilion, NY, March 29, 1895. Pupil of Mabel Welch. Member: Brooklyn Soc. of Miniature Painters; National Association of Women Painters and Sculptors; American Soc. of Miniature Painters; Penna. Society of Miniature Painters; National League of American Pen Women; Am. Federation of Arts. Address in 1929, 941 James Street, Syracuse, NY. Died 1958.

MCMILLEN, MILDRED.
Wood engraver. Born in Chicago, IL, in 1884. Studied in Chicago, NY, and Paris. Represented in the National Museum of Canada; Ottawa and New York Public Libraries. Address in 1926, 3 Central Street, Provincetown, MA.

McMURTRIE, EDITH.
Painter and teacher. Born in Philadelphia, PA. Pupil of Penna. Academy of Fine Arts. Member: Fellowship Penna. Academy of Fine Arts; Soc. of Independent Artists; Philadelphia Alliance; Plastic Club; Eastern Art Association; Philadelphia Art Teachers Association. Award: Cresson traveling scholarship, Penna. Academy of Fine Arts; Mary Smith prize, Penna. Academy of Fine Arts, 1929. Work: "The

Circus," Penna. Academy of Fine Arts. Instructor, William Penn High School. Address in 1929, 1430 South Penn Square; h. 5302 Knox St., Philadelphia, PA; summer, Orr's Island, ME. Died 1950.

McNAIR, WILLIAM.
Painter. Born in Oil City, PA, Sept. 24, 1867. Pupil of George de Forest Brush at Art Students League of New York. Member: American Federation of Arts. Address in 1929, 5 East 79th Street, New York, NY; summer, Bar Harbor, ME.

McNAMARA, MARY E.
Painter. Member: Society of Washington Artists. Address in 1929, 1711 Que Street, Washington, D.C.

McNEELY, JUANITA.
Painter. Born in St. Louis, MO in 1936. Studied: Washington University, St. Louis; Southern Illinois University, Carbondale; also studied in Mexico. Exhibitions: Prince Street Gallery, NYC; Westbeth Galleries, NYC; Philadelphia Museum of Art. Collections: National Museum of Art, China; Palacio De Las Bellas Artes, Mexico; St. Louis Art Museum.

McNEELY, STEPHEN THOMAS.
Sculptor and painter. Born in East Orange, NJ, November 17, 1909. Studied at the National Academy of Design; Beaux-Arts Institute of Design; also with Robert Aitken and Leon Kroll. Work: Newark Museum; Newark Public Library; Caldwell (NJ) Public Library. Exhibited: Corcoran Gallery, 1941; Carnegie, 1941; Penna. Academy of Fine Arts, 1942; National Academy of Design, 1942; Metropolitan Museum of Art, 1943. Awarded prize, National Academy of Design, 1942. Address in 1953, 538 East 83rd Street, NYC.

McNULTY, WILLIAM CHARLES.
Etcher. Born in Ogden, Utah, March 28, 1889. Member: Salma. Club. Address in 1929, 404 West 20th Street, New York, NY; summer, Rockport, MA. Died 1963.

McPHERSON, W. J.
Flourished in Boston, 1846-47, as a miniature painter.

McQUAID, MARY CAMERON.
Etcher and mural painter. Born in Jacksonville, FL, Nov. 21, 1886. Pupil of National Academy of Design; Art Students League; Cooper Union; Atelier of Ettore Cadorin. Member: Alliance. Address in 1929, 440 Riverside Drive, New York, NY.

McRAE, JOHN C.
This artist engraved portraits and subject plates, in both line and stipple, for New York publishers in 1855. He executed several large and excellent subject plates for framing, and was working in 1880. A portrait of John Wesley, in mezzotint, and published by Harper & Brother, New York, is signed "McRae sc." While inferior in execution to his other work, this may have been engraved by John C. McRae.

McRICKARD, JAMES P.
Painter. Born in Nov. 7, 1872. Pupil of Art Students League of NY; Douglas Volk; George de Forest Brush. Member: Salma. Club. Address in 1929, 39-15-215th Place, Bayside, L.I., NY.

McVEIGH, BLANCHE.
Etcher. Born in St. Charles, Missouri. Studied: St. Louis School of Fine Arts; Art Institute of Chicago; Penna. Academy of Fine Arts; Art Students League; with Daniel Garber, Doel Reed. Awards: Dallas Printmakers Club, 1942, 1944, 1947, 1948, 1950; Connecticut Academy of Fine Arts, 1941; Southern States Art League, 1945; Texas General Exhibition, 1944, 1945; Texas Fine Arts Association, 1946; 100 Prints, Chicago, 1936, 1938; Ft. Worth Art Association, 1948, 1950, 1952; Library of Congress, 1947. Collections: Museum of Fine Arts of Houston; Ft. Worth Art Association; Oklahoma Agricultural and Mechanical College; Dallas Museum of Fine Arts; Cincinnati Museum Association; Carnegie Institute; Library of Congress; University of Texas. Exhibited: Buffalo Print Club, 1938, 39; Connecticut Academy of Fine Arts, 1937-46; Chicago Society of Etchers, 1938-45; Texas Fine Arts Association, 1938; World's Fair, NY, 1939; Denver Art Museum, 1943, 45; Northwest Printmakers, 1940-42; California Print Society, 1940-44; National Academy of Design, 1943, 44; Penna. Academy of Fine Arts, 1941,42; Carnegie Institute, 1945; Southern States Art League; others. Member: California Print Society; Chicago Society of Etchers; Dallas Print Club; Southern States Art League; Prairie Printmakers. Address in 1953, 607½ Throckmorton Street; h. 3724 West Fourth St, Fort Worth, TX.

McVEY, LEZA S.
Ceramic sculptor and weaver. Born in Cleveland, OH, May 1, 1907. Studied at Cleveland School of Art; Colorado Fine Art Center; Cranbrook Academy of Art. Works: Smithsonian Institution; Syracuse Museum of Fine Arts; Cleveland Museum of Art; General Motors, Detroit, Michigan; Butler Institute of American Art. Awards: Syracuse Museum of Fine Arts, 1950, 51; Michigan Arts and Crafts, 1951; Cleveland Museum of Art, 1954-67; Butler Institute of American Art, 1958. Exhibited: Syracuse Museum and National Circuit, 1945-69; Smithsonian Institution, 1951-61; International Cong. Contemporary Ceramics, Ostend, Belgium, 1960; one-woman shows were held at the Cleveland Institute of Art, 1965; Albright-Knox Art Gallery, 1965; and the Penna. Academy, Pomona, CA. Medium: Clay. Address in 1984, 18 Pepper Ridge Road, Cleveland, OH.

McVEY, WILLIAM M.
Sculptor, lecturer, and teacher. Born in Boston, MA, July 12, 1905. Studied at Rice Univ.; Cleveland Inst. of Art; Academies Colarossi, Grande Chaumiere, and Scandinave, Paris, 1929-31; and with Despiau. Awards: Cleveland May Shows; Purchase Award, Butler Institute of American Art, Youngstown, OH, 1967, and Everson Museum, Syracuse, NY, 1951, 52. Member: Cleveland Sculptors' Club; College Art Association of America; fellowship, Nat. Sculpture Society; Associate Nat. Academy of Art. Exhibited at Grand Salon d'Automne; Penna. Academy of Fine Arts; Cleveland May Shows. Taught: Cleveland Museum, 1932; Houston Museum, 1936-38; University of Texas, 1939-53; head sculpture department, Cleveland Institute of Art, 1953-46; Cranbrook Academy, 1946-53. Media: Stone, bronze. Represented in Houston Art Mus., Houston, TX; Canton McKinley High School, Canton, OH; Cleveland Museum of Art; Smithsonian Institution; Ariana Museum, Geneva, Switzerland. Address in 1982, Cleveland, OH.

McVICKER, CHARLES T.
Illustrator. Born in Canonsburg, PA in 1930. He studied under John LaGatta at the Art Center College of Design for four years. His career began in 1957 with an assignment for *Good Housekeeping* and he has since worked for *Popular Mechanics, Family Circle* and the *American Journal of Nursing.* His illustrations are part of the collections of the National Historical Society and the United States Capitol. A member of the American Watercolor Society, he was elected President of the Society of Illustrators in 1976.

MEADE (or MEAD), LARKIN GOLDSMITH.
Sculptor. Born in Chesterfield, New Hampshire, on January 3, 1835. He studied under Henry Kirke Brown from 1983-55. Worked in Brattleboro, VT, for a few years; later in Italy as artist-correspondent for *Harper's Weekly* in 1861-62. His statue of Ethan Allen is in Washington, DC, and his statue of Abraham Lincoln is in Springfield, IL. In 1878 he resided in Washington, DC, and assisted the commission in the completion of the Washington Monument; designed sculptural dec. for Agricultural Building at Columbian Exposition. Address in 1910, Florence, Italy; and c/o W. M. Mead(e), 160 Fifth Avenue, NYC. He died in Florence, Italy, on October 15, 1910.

MEADOWS, CHRISTIAN.
Engraver. Born in 1814 in England. Engraver of portraits and buildings, signed himself thus at Windsor, VT. He was working about 1850-55.

MEADOWS, ROBERT MITCHELL.
A very well-executed stipple portrait of Edward Jenner, M.D., was engraved by R. M. Meadows and published in the *Analectic Magazine* for 1817.

Meadows also engraved a portrait of F. Asbury for an American publication, but it is not certain that either of these plates was necessarily engraved in the U.S. Nagler, in his *Kunstler-Lexicon,* refers to a Robert Meadows who flourished in the first quarter of the 19th century and engraved for the Shakespeare Gallery of London.

MEAGHER, MARION T.
Sculptor, painter, and teacher. Born in New York City. Pupil of National Academy of Design, of Chase, Beckwith, and R. Swain Gifford in New York; he also studied in Paris and Antwerp. Artist of the Department of Anthropology, Am. Museum of Natural History, and NY Ophthalmic Col. Address 1933, 939 Eighth Ave., NY, NY; summer, Fisher's Island, NY.

MEAKIN, LEWIS HENRY.
Landscape painter and etcher. Born in Newcastle, England. He came to this country as a child; studied art in Europe, and taught in Cincinnati. He is represented at the Cincinnati Museum. He was elected an Associate Member of the Nat. Academy of Design in 1913. Died August 14, 1917 in Boston, MA.

MEANCE.
French miniature painter, flourishing in New York, 1795. Portrait of N. G. Dufief, engraved by Edwin. (See Fielding, Edwin Catalogue, No. 60).

MEARS, HELEN FARNSWORTH.
Sculptor. Born in Oshkosh, WI, in 1876. Studied in New York and Paris. First success, "Genius of Wisconsin," exhibited at Chicago Expo., 1893; executed "The Fountain of Life," 1904; marble statue of Frances E. Willard, 1905, which was placed in the Capitol, Washington; portrait bust of George Rogers Clark; also bust of William L. G. Morton, M.D., placed in Smithsonian Institution; portrait reliefs of Augustus St.-Gaudens, Louis Collier Wilcox, and Edward A. McDowell. Awarded $500 prize from Milwaukee Women's Club, Columbian Expo., Chicago, 1893; silver medal, St. Louis Expo., 1904. Member of Nat. Sculpture Society. Address in 1910, 253 West 42nd Street, NYC. She died in NYC on February 17, 1916.

MEARS, HENRIETTA DUNN.
Painter and etcher. Born in Milwaukee, WI, Feb 28, 1877. Pupil of Art Students League of NY, Hawthorne and Pape. Member: Copley Society; Provincetown Art Association; West Coast Arts; Berkeley League of Fine Arts. Award: First prize, Minnesota State Fair, 1927. Address in 1929, Dodd Road, St. Paul, MN; summer, Provincetown, MA.

MEDAIRY & BANNERMAN.
This firm was engraving portraits and book-plates in Baltimore, MD, in 1828-29. The second member of

the firm was doubtless William W. Bannerman, already referred to.

MEDARY, AMIE HAMPTON.
Miniature painter. Born in Eastern Point, Groton, CT, July 24, 1903. Pupil of Penna. Academy of Fine Arts; School of Boston Museum of Fine Arts; and A. Margaretta Archambault. Address in 1929, 115 High Street, Taunton, MA; 383 Boylston Street, Boston, MA.

MEEDER, PHILIP.
Wood engraver. Born in Alsace, France. He came to the U.S. as a boy. He was associated with the wood-engraver Frederick Y. Chubb, under the firm name of Meeder and Chubb. He died in New York City, June 27, 1913.

MEEKER, JOSEPH RUSLING.
Landscape painter. Born in Newark, NJ, in 1827. He showed a special interest in southern scenery. Among his paintings are "The Indian Chief," "Louisiana Bayou," and "The Lotos Eaters."

MEEKS, EUGENE.
Born in New York in 1843. He spent much of his time abroad. Among his works are: "Gondola Party, Venice" and the "Halt at the Golden Lion."

MEER, JOHN.
He is included in Dunlap's list of artists and is described as an enamel painter. He was also a bank-note engraver, japanner and glass painter.

MEESER, LILLIAN B.
(Mrs. Spenser B. Meeser). Painter. Born in Ridley Park, PA, in 1864. Pupil of Penna. Academy of Fine Arts; Art Students League of NY; Worcester Art Museum. Member: Fellowship Penna. Academy of Fine Arts; Plastic Club; Philadelphia Alliance; North Shore Arts Association; Provincetown Art Association; American Federation of Arts; Detroit Society of Women Painters (founder). Awards: Hon. mention, 1921, and silver medal, 1922, Plastic Club; Mary Smith prize, Penna. Academy of Fine Arts, 1923; gold medal in decoration, Architectural League of NY, 1928. Represented in the Reading Museum; Pennsylvania State College Art Gallery; Fellowship Penna. Academy of Fine Arts. Work: Hotchkiss Memorial, St. Pauls Church, New Haven, CT; Altarpiece, Christ Church, Cranbrook, MI; Apse Dome, St. Bartholomew's Church, NY; three altars, Convent of the Sacred Heart, Overbrook, PA; floor, Baltimore Trust Co., Baltimore, MD. Address in 1933, 17 Dutton Street, Ridley Park, PA; summer, South Wellfleet, Cape Cod, MA.

MEGE, VIOLETTE (CLARISSE).
Sculptor and painter. Born in French Algiers, March 19, 1889. Pupil of Georges Rochegrosse, Ecole Nationale des Beaux Arts, Academie Julian, J. P. Laurens and Humbert, in Paris. Member: Societe des Artistes Francais; Society of Independent Artists. Awarded fellowship of French Government. Address in 1926, 119 West 87th Street, New York, NY.

MEIERE, HILDRETH.
Mural painter. Born in New York City. Pupil of F. V. DuMond; Kenneth H. Miller; Frank Van Sloan. Member: Art Students League of NY; National Society of Mural Painters, NY. Work: Rotunda dome, National Academy of Sciences, Washington, D.C.; domes, ceiling and floors, Nebraska State Capitol, Lincoln; Cowdin Memorial, St. Mark's Church, Mt. Kisco, NY; Cornell Memorial, St. Martin's Church, Providence, RI; Winthrop Memorial, St. John's Church, Beverly Farms, MA; Bennett Memorial, Christ Church Cathedral, Lexington, KY. Address in 1929, Rodin Studios, 200 West 57th Street; h. 620 Park Avenue, New York, NY. Died in 1961.

MEIERHANS, JOSEPH.
Painter. Born in Ober-Lunkhofen-Aargan, Switzerland, Feb. 22, 1890. Pupil of A. N. Lindenmuth, John Sloan. Member: Society of Independent Artists; Art Students League of NY. Address in 1929, 284 Garden Avenue, Mt. Vernon, NY.

MEINSHAUSEN, GEORGE F. E.
Painter, illustrator, and wood engraver. Born in Achim, Hanover, Germany, Jan. 6, 1855. Pupil of Cincinnati Art Academy. Award: Silver medal, St. Louis Expo., 1904. Work: Water colors, "The Phantom Ship" and "The Life Boat," and wood-engraving of same, Art Museum, Cincinnati; prints in Carnegie Institute, Pitts.; Library of Congress, Washington, D.C.; New York Lenox Public Library. Address in 1929, 4615 Station Avenue, Norwood, OH.

MEISSNER, ALFRED.
Portrait painter and illustrator. Born in Chicago in 1877. Pupil of Art Institute of Chicago. Address, 3057 North Christiana Avenue, Chicago, IL.

MEISSNER, LEO JOHN.
Painter. Born in Detroit, MI, June 28, 1895. Pupil of John Wicker; Detroit School of Fine Arts. Member: Print Club; Boston Society of Independent Artists; Springfield Art Association. Address in 1929, 96 Wadsworth Terrace, New York, NY; summer, Monhegan, ME.

MELCHER, BERTHA CORBETT (MRS.).
Illustrator and painter. Born in Denver, Colorado, in 1872. Pupil of Volk in Minneapolis; Pyle at Drexel Institute, Philadelphia. Specialty: Miniatures and illustrations for children's books. Address in 1926, Topanga, California.

MELCHERS, J. GARI.

Painter. Born in Detroit, MI, August 11, 1860. Pupil of Dusseldorf Academy, 1877-80; Lefebvre and Boulanger in Paris. Member: Associate National Academy of Design, 1904, Academician, 1906; Paris Society of American Painters; Societe Nationale des Beaux-Arts, Paris; International Society of Artists, London; Munich Secession (cor.); Berlin R. Academy; National Institute of Arts and Letters; New Society of Artists; National Arts Club; American Federation of Arts. Awards: Hon. mention, Paris Salon, 1886; first class medal, Amsterdam, 1887; 3rd class medal, Paris Salon, 1888; 1st class medal, Munich, 1888; grand prize, Paris Expo., 1889; first prize, Art Institute of Chicago, 1891; medal of honor, Berlin, 1891; gold medal, Art Club of Philadelphia, 1892; medal of honor, Antwerp, 1894; Temple gold medal, Penna. Academy of Fine Arts, 1896; 1st class medal, Vienna, 1898; gold medal, Pan-Am. Expo., Buffalo, 1901; gold medal, St. Louis Expo., 1904; second W. A. Clark prize, Corcoran Gallery, 1910; gold medal, Sesqui-Centennial Expo., Philadelphia, 1926; popular prize, Carnegie Institute Exhibition, 1927; popular prize, Corcoran Gallery, 1928. Knight of the Order of St. Michael of Bavaria; Chevalier of the Legion of Honor of France, 1895; Officer, 1904; Officer R. Prussian Order of Red Eagle, 1907. Work: Luxembourg Museum, Paris, France; Corcoran; Carnegie Institute; National Gallery; Institute of Arts, Detroit; Art Institute of Chicago; Metropolitan Museum of Art; Minneapolis Institute; RI School of Design; Penna. Academy, Philadelphia; Los Angeles Museum; City Art Museum, St. Louis; School of Design, Providence; and Toronto Mus. Address in 1929, 80 W. 40th St., New York, NY; Fredericksburg, VA.

MELCHERS, JULIUS THEODORE.

Sculptor, wood carver, and teacher. Born in Prussia, 1830. Came to U.S. after 1848. Worked in Detroit, from 1855. Media: Wood and stone. Died in 1903.

MELIODON, JULES ANDRE.

Sculptor and teacher. Born in Paris, France, June 1, 1867. Pupil of Falguiere, Fremiet, Barrau, and Message in Paris. Member: New York Architectural League; Societe des Artistes Francais; Societe des Professeurs Francais en Amerique; Alliance. Awards: Hon. mention, Paris Salon, 1902; Diploma of Officer of Academy, 1898; Diploma of Officer of Public Instruction, 1904; Master Craftsman, Philadelphia Building Congress, 1932. Work: "The Explorer Lesueur," Museum of Natural History, Paris; decorative sculpture on the reconstructed Sorbonne, Paris; Bahai's Vase (with Tiffany and L. Bourgeois, architect); Soldiers Monument, Bloomingdale, NJ; Roxy Theatre (in cooperation), NYC; bronze doors, Administration Bldg; statuary panels, Board of Ed., New Naval Hospital, Phila. Instructor at Univ. of Pennsylvania. Address in 1933, 1840 So. Bancroft St., Philadelphia, PA; summer, Lincoln Park, NJ.

MELLON, ELEANOR M.

Sculptor. Born in Narberth, PA, August 18, 1894. Pupil of V. D. Salvatore, Edward McCartan, A. A. Weinman, Robert Aitken, Charles Grafly, Harriet Frishmuth. Member: National Sculpture Society; American Federation of Arts. Exhibited at National Sculpture Society, 1921, 29, 43; Penna. Academy of Fine Arts; National Academy of Design; Art Institute of Chicago; Allied Artists of America; National Association of Women Artists; Society of Washington Artists; American Artists Professional League; North Shore Arts Association; Metropolitan Museum of Art, 1942; NY Jr. League. Awards: Prizes, National Academy of Design, 1927; NY Jr. League, 1942; medal, Society of Washington Artists, 1931; hon. mention, Nat. Association of Women Painters and Sculptors, 1932; American Artists Professional League, 1945. Position: Member of Council, National Sculpture Society, Secretary, 1936-40, 45; Board of Directors, Architectural League; 2nd V. Pres., 1942-44, Municipal Art Society. Address in 1953, 22 E. 60th St.; h. 133 East 64th, NYC. Died in 1979.

MELLOR, MARGARET W.

Painter. Exhibited water colors at the Penna. Academy of Fine Arts, Phila., 1925. Address 1926, 5203 McKean Ave., Germantown, Philadelphia, PA.

MELOSH, MILDRED E. (MRS.).

Painter, writer, lecturer, and teacher. Born in Jersey City, NJ, August 8, 1901. Pupil of Christine Lumsdon. Member: Salons of America; Jersey City Water Color Club; Society of Independent Artists. Address in 1929, Carnegie Hall, New York, NY; h. 145 Belmont Avenue, Jersey City, NJ; summer, Harrison, ME.

MELROSE, ANDREW.

Landscape painter. Born in 1836. Had studio in West Hoboken and Guttenberg, NJ, during the 1870's and 80's. Executed paintings of views in North Carolina, Hudson River Valley, Berkshires, New York City, Cornwall (England), Lake Killarney (Ireland), Tyrolese Alps. He died February 23, 1901, in West New York, New Jersey.

MELTON, CATHARINE PARKER.

Painter. Born in Nashville, TN. Pupil of Corcoran School of Art; Henry B. Snell. Member: Washington Art Club; C. L. Wolfe Art Club. Address in 1929, 1831 G. Street, N. W., Washington, D.C.

MELTZER, ARTHUR.

Painter. Born in Minneapolis, MN, July 31, 1893. Pupil of Robert Koehler; Penna. Academy of Fine Arts. Member: Fellowship Penna. Academy of Fine Arts; Philadelphia Sketch Club; Phila. Alliance; Mystic Society of Artists. Awards: Cresson traveling scholarship, Penna. Academy of Fine Arts, 1921; first hon. mention, Philadelphia Sketch Club, 1924; hon. mention, Minnesota State Fair, 1923; Fellowship

prize, Penna. Academy of Fine Arts, 1925; hon. mention, Philadelphia Art Club, 1926; hon. mention, Philadelphia Sketch Club, 1927. Represented in Carlisle Art Museum; Columbus Gallery of Fine Arts. Instructor, School of Design, Philadelphia. Address in 1929, Sterner Mill Road, Langhorne, PA; summer, Mystic, CT.

MELTZOFF, STANLEY.
Illustrator. Born in New York City, in 1917. He studied at the Institute of Fine Arts of NYC; Art Students League of NY; National Academy of Design. His first works appeared in *Stars and Stripes* prior to 1945, and in *Who* in 1946. In addition to his various poster and book illustrations, his pieces appeared in *Life, McCall's, The Saturday Evening Post, National Geographic* and *Sports Illustrated.* The Art Directors' Club and the Soc. of Illustrators in NY have awarded him many prizes for his paintings. His specialty as an art historian is Florentine Quattrocento painting.

MELVILL, ANTONIA (MRS.).
Portrait painter. Born in Berlin, Germany, Nov. 28, 1875. Came to America in 1894. Studied in London under W. P. Frith and at the Heatherley School of Art. Member: Society of Independent Artists of New York; American Federation of Arts; American Artists Professional League. Award: Prize, State Fair, Sacramento, CA, 1926. Work: "Portrait of Bishop J. H. Johnson," Good Samaritan Hospital, Los Angeles; "Portrait of Mrs. Dollard," Capitol at Pierre, SD; Public Library, Sacramento, CA; Portrait of Prof. Emery, Harvard Military School, Los Angeles; "Son of the Covenant," B'nai Brith Temple, Los Angeles; "Pierrot," Alhambra Theatre, Sacramento, CA. Address in 1929, 717 South Alvarado Street, Los Angeles, CA.

MELVILLE, FRANK.
Sculptor and etcher. Born in Brooklyn, December 28, 1832. Pupil of Henry K. Brown. Member: California Society of Etchers; Chicago Society of Etchers. Work: Library of Congress, Washington, DC; NY Public Library; Brooklyn Institute Museum; Walker Gallery, Liverpool, England. Address in 1916, 6 Montague Terrace, Brooklyn, NYC.

MENCHILLI, GEORGE G.
Sculptor. Born in Italy, 1800. Listed as living in Louisville, KY, in 1850. He employed his sons Achille and Francisco and his daughter Nicodema in his shop. Specialty was busts. Worked in plaster.

MENCONI, FRANK G.
Sculptor and designer. Born in Tuscany, Italy, April 24, 1884. He was educated abroad until his sixteenth year, when his parents immigrated to the United States. He was best known for his design of the Monumental Victory Arch, NY, for the homecoming

of American soldiers of the World War, and the Boston Memorial to Mrs. Mary Baker Eddy, founder of Christian Science. Several years ago he revived an ancient art known as "Graffito," a process of engraving on cement in colors, which was used on several public buildings in Washington, DC. Died in Union City, NJ, April 24, 1928.

MENCONI, RALPH JOSEPH.
Sculptor. Born in Union City, NJ, June 17, 1915. Studied: Yale University, B.F.A.; Hamilton College; National Academy of Design; Tiffany Foundation. Member: Century Association; National Sculpture Society; Municipal Art Society (director). Awards: Speyer award, National Academy of Design, 1941; Tiffany Foundation grant, 1947; National Jefferson Expansion Memorial (in collaboration with Caleb Hornbostel), 1947; Jefferson Competition, 1948. Work: Brookgreen Gardens, SC; St. Rose of Lima, Short Hills, NJ; St. Joseph's Catholic Church, Camden, NJ; medals, plaques, National Book Award; New York University Law Center; Kenyon College; Reader's Digest; General Electric; Buckley School; Grenfell Association, and many portrait commissions. Exhibited: National Academy of Design; National Sculpture Society; Medallic Art Co., 1950; International Competition, Imperial Palace, Addis Ababa; Government of Portugal, International Competition. Address in 1970, 154 West 55th St., NYC; h. Old School Lane, Pleasantville, NY. Died in 1972.

MENDENHALL, EARL (MRS.).
See Langley, Sarah.

MENDENHALL, EMMA.
Painter. Born in Cincinnati, OH. Pupil of Cincinnati Art Academy under Nowottny and Duveneck; Julian Academy in Paris; summer school under Mrs. Rhoda Holmes Nicholls, Woodbury and Snell. Member: Cincinnati Woman's Art Club; American Water Color Society; Nat. Association of Women Painters and Sculptors; Cincinnati MacDowell Club; NY Water Color Club; Washington Water Color Club. Address in 1929, 2629 Moorman Avenue, Walnut Hills, Cincinnati, Ohio.

MENEELEY, EDWARD.
Sculptor and painter. Born in Wilkes Barre, PA, December 18, 1927. Studied at Murray Art School, Wilkes Barre, 1952-56; School of Visual Arts, NYC, 1957-58; privately with Jack Tworkov, NYC, 1958-59. Work: Museum of Modern Art; Whitney; Chrysler Museum; Metropolitan Museum of Art. Exhibited: Donovan Gallery, Philadelphia, 1952-54; Parma Gallery, NYC, 1962; Frederick Teuscher Gallery, NYC, 1966; Whitney Museum, NYC, 1969; Museum of Modern Art, NYC, 1970; Victoria and Albert Mus., London, 1971; one-man exhibitions inc. the Susan Caldwell Gallery, NYC, 1976; a retrospective

at the Frank Marino Gallery, NYC, 1978; many others. Awards: Grant from the National Endowment for the Arts, Washington, DC, 1971; Arts Council Grant, London, 1971. Taught: St. Louis, MO, 1979; Art Students League, NYC, 1974, 79. Address in 1982, 201 Second Ave., NYC.

MENG, JOHN.
American portrait painter. Born about 1734 in Germantown, Philadelphia. He died in the West Indies in 1854. A few of his paintings are preserved in the old Germantown families and in the Penna. Historical Society of Philadelphia.

MENGARINI, FAUSTA VITTORIA.
Sculptor and teacher. Born in Rome, Italy, April 18, 1893. Studied with Edoardo Gjoia, Royal Academy of Arts, Rome. Work: War Memorial, and heroic size figures on Palace of Justice, Royal Italian Government, Rome, Italy; baptismal font, Montclair, NJ; Monumental Lighthouse, Massaua, Eritrea, Africa (Royal Italian Gov.). Awards: Nanna Matthews Bryant prize for sculpture, Nat. Academy of Women Painters and Sculptors, 1931; hon. mention, International Fair, Tampa, FL, 1931. Member: Nat. Acad. of Women Painters and Sculptors. Address 1933, 256 W 55th St.; h. 31 East 30th St., NYC; summer, c/o A. Tamburini, Rome, Italy.

MENNIE, FLORENCE.
Painter. Born in New York City. Pupil of George Bellows; Luis Mora. Member: Society of Independent Artists; Silvermine Guild of Artists; Salons of America. Address in 1929, R. F. D. 36, Wilton, CT.

MENTE, CHARLES.
Painter and illustrator. Born in NY. Pupil of Gabi and Loefftz in Munich. Member: American Water Color Society; Chicago Water Color Club. Awards: First prize, Chicago Society of Artists, 1893; gold medal, Art Club of Philadelphia, 1895; silver medal and hon. mention, Atlanta Expo., 1895; Evans prize, American Water Color Society, 1904. Address in 1929, Congers, NY.

MENTEL, LILLIAN A.
Painter, illustrator, and teacher. Born Cincinnati, OH, Nov. 2, 1882. Pupil of Cincinnati Art Academy and Pratt Institute. Member: Cincinnati Woman's Art Club. Address in 1929, Priscilla Apt. 9, Michigan Avenue, Hyde Park, Cincinnati, OH.

MENZEL, HERMAN E.
Painter. Born in Chicago, IL, Oct. 19, 1904. Pupil of William B. Owen, Jr. Address in 1929, 8332 South Green Street, Chicago, IL.

MENZLER-PEYTON, BERTHA S.
(Mrs. Alfred Conway Peyton). Landscape painter. Born in Chicago, IL. Pupil of Art Institute of Chicago; Merson, Collin and Aman-Jean in Paris. Member: Chicago Society of Artists; Chicago Water Color Club; National Association of Women Painters and Sculptors; NY Water Color Club; American Water Color Society; Allied Artists of America; Society of Painters, NY; North Shore Arts Association. Awards: Special prize, Art Institute of Chicago, 1903; Young Fortnightly prize, Art Institute of Chicago, 1909; Grower prize, Art Institute of Chicago, 1910; landscape prize, Nat. Association of Women Painters and Sculptors, 1926. Work: Union League Club, Chicago; Nike and Klio Clubs and West End Woman's Club, Chicago; Evanston (IL) Woman's Club; Mural decorations in Fine Arts Building, Chicago. Address in 1929, care of Budworth and Son, 424 West 52nd Street, New York, NY; summer, Reed Studio Bldg., East Gloucester, MA.

MERCER, GENEVA.
Sculptor. Born in Jefferson, Marengo Co., AL, January 27, 1889. Studied in Italy; also a pupil of G. Moretti. Exhibited: National Academy of Design; Gore Mansion, Boston, 1942; Penna. Academy of Fine Arts; Institute of Modern Art, Boston; Copley Society, Boston; others. Member: Alabama Art League; Institute of Modern Art, Boston; Pitts. Art Association; Copley Society, Boston. Work: "Rev. James L. Robertson," "Soldiers' Memorial," Bronxville (NY) Reformed Church; memorial to Florence McComb, Osceola School, Pittsburgh, PA; Museum of Fine Arts, Montgomery, AL; Alabama Memorial Building; numerous memorials in schools and churches. Awards: Philadelphia Art Week, 1925; San Remo, Italy, 1934; Massachusetts Horticultural Society, 1941. Address in 1953, Boston, MA.

MERCER, HENRY CHAPMAN.
Sculptor and worker in applied arts. Born in Doylestown, PA, June 24, 1856. Studied art at Harvard. Curator (1894-97) Prehistoric Archaeology, University of Pennsylvania. Grand prize for pottery, St. Louis Expo. 1904. Member of Boston Society of Arts and Crafts; Daedalus Association of Crafts, Philadelphia; Designers' and Artisans' Club, Baltimore; Detroit Assoc. of Crafts. Specialty: Pottery and color-printing. Address in 1910, Moravian Pottery; h. "Aldie," Doylestown, PA.

MERCER, WILLIAM.
Portrait painter. Born in 1773. Worked in oils and miniatures and painted historical scenes. Flourished in Philadelphia. A pupil of Charles Wilson Peale, he became an excellent portrait painter. Died in 1850.

MERCHANT, G. W.
A well-engraved plan of the floor of the Senate chamber, at Albany, NY, is signed "G. W. Merchant Engr. & Pub." The plan is used as a frontispiece to the "Legislative Manual of the State of New York, 1834," and it was published at Albany in that year.

MERFELD, GERALD LYDON.
Painter. Born in Des Moines, Iowa, Feb. 19, 1936. Studied: American Academy of Art, with William Mosby, 1954-57. Work: McDonough Collection of American Art; U.S. Navy Arch. Exhibited: Hope Show, Butler Institute of American Art, 1972, 74, 76, 78, 80; Allied Artists of America Annual, NYC, 1975-77; Knickerbocker Artists, NYC; National Academy of Western Art, 1979; and others. Awards: Seley Gold Medal, Salmagundi Club; Oklahoma Museum of Art Award; 1st Prize, Butler Institute of American Art; others. Combat Artist, U.S. Navy, Vietnam & Mediterranean; Art Instructor. Media: Oil, pastel, conte crayon. Address in 1982, 104 Oak St., New Lenox, IL.

MERINGTON, RUTH.
Painter and teacher. Born in London, England. Pupil of National Academy of Design and Art Students League in NY, under Edgar M. Ward, Bruce Crane and Birge Harrison; Julian Academy in Paris, under Constant. Address in 1929, 1 Wallace St., Newark, NJ.

MERKL, ELISSA F.
Painter. Born in Colorado Springs, July 2, 1949. Studied: Marymount College, Tarrytown, NY. Work: Collections of private individuals in U.S., England, Germany, Venezuela; SONY Corp., NJ; and more. One-person shows: Douglass Col. Center, NJ; Arnot Art Museum, Elmira, NY; Summit Art Center Members Gallery, NJ; and more. Exhibited: International Miniature Print Biennial, Space Group Art Gallery, Seoul, Korea; Garden State Arts Center, Holmdel, NJ; International Soc. of Artists, National Arts Club, NYC, and Foothills Art Center, Golden, Colorado; "American Artist" National Competition, Circle Gallery, NYC; Arts Club, Washington, DC; Zaner Gallery, Rochester, NY; Pratt Graphics Center. Awards: Grumbacher bronze medallion; purchase award, National Western Painting Exhibition, Bosque Art Gallery, NM; many others. Member: Pratt Graphics Center; Printmaking Council of NJ; other NJ associations. Media: Acrylic, serigraph. Address in 1983, 22 Fairview Road., Millburn, NJ.

MERO, LEE.
Illustrator. Born in Ortonville, MN, May 30, 1885. Pupil of Robert Koehler in Minneapolis; Robert Henri in NY. Member: Minneapolis Society of Fine Arts. Specialty: Design and decorative illustration, mottoes and greeting cards. Address in 1929, care of The Buzza Co., Minneapolis, MN.

MERRELS, GRAY PRICE (MRS.).
Miniature painter. Born in Topeka, KS, 1884. Pupil of Art Students League of NY under Shirley Turner. Member: Brooklyn Society of Miniature Painters. Address in 1934, 248 Oxford Street, Hartford, CT.

MERRILD, KNUD.
Painter, sculptor, writer, and block painter. Born in Odum, Denmark, May 10, 1894. Studied at Royal Academy of Fine Arts, Copenhagen, Denmark. Works: "Deer and Tiger" (sketch for fresco), "Man and Horse" and "Leaping Deer" (silk embroidery), Mus. of Art and Industry, Copenhagen, Denmark; mural decorations in hotels and buildings in Los Angeles, Studio Theatre Auditorium, Hollywood, California; Museum of Modern Art; Philadelphia Museum of Art; Los Angeles Museum of Art; San Diego Fine Arts Society; Pomona Gallery, Los Angeles, CA. Exhibited: Brooklyn Museum, 1936, 39, 43; Museum of Modern Art, 1936, 42; Golden Gate Expo., 1939; Art Institute of Chicago, 1940; Whitney, 1941; American Federation of Arts, 1942; Los Angeles Museum of Art, 1934-44; San Francisco Museum of Art (one-man), 1937; others. Author of *A Poet and Two Painters*, London, 1938, NY, 1939. Address in 1953, 2610 South Robertson Blvd., Los Angeles, California.

MERRILL, FRANK T.
Painter. Born in Boston in 1848. He studied art at the Lowell Institute, and at the Boston Museum of Fine Arts; he also studied in France and England. His water colors are free in wash and color, and he also was very successful with his etchings. Merrill's work has been used extensively for illustrating and may be found in Thackeray's *Mahogany Tree* and in Irving's *Rip Van Winkle*.

MERRILL, HIRAM CAMPBELL.
Painter and wood engraver. Born in Boston, MA, Oct. 25, 1866. Pupil of Douglas Volk; Art Students League of New York. Member: New York Water Color Club, 1914. Awards: Bronze medal, Pan Am. Exposition, Buffalo, 1901, and St. Louis Exposition, 1904, for wood engraving. Work: Carnegie Institute, Pittsburgh. Address in 1929, 1800 Mass. Avenue, Cambridge, MA.

MERRILL, KATHERINE.
Painter and etcher. Born in Milwaukee, WI. Pupil of Art Institute of Chicago; Brangwyn in London. Member: Chicago Society of Etchers; Brooklyn Society of Etchers; California Society of Etchers; Nat. Association of Women Painters and Sculptors. Represented in print collections of Library of Congress, Washington, D.C.; Corcoran Gallery of Art, Washington, DC; New York Public Library; Art Institute of Chicago; Milwaukee Art Institute; Newark Public Library; Springfield Public Library; art department of Beloit College, Beloit, WI; Hackley Gallery of Art, Muskegon, MI; Bibliotheque Nationale, Paris, France; collections of ex libris in bookplate collection of Metropolitan Museum of Art, New York; Widener Memorial Library; Harvard University; and the University of Chicago. Address in 1933, 107 East 73rd Street, New York, NY.

MERRIMAN, HELEN BIGELOW.
(Mrs. Daniel Merriman). Painter and writer. Born in Boston, MA, July 14, 1844. Pupil of Wm. Hunt. Member: Boston Water Color Club; Am. Federation of Arts. Address in 1929, 73 Bay State Road, Boston, MA; summer, Intervale, N.H.

MERRITT, ANNA LEA.
(Mrs. Henry Merritt). Painter and writer. Born in Philadelphia, PA, Sept. 13, 1844. Pupil of Henry Merritt in London. Awards: Centennial Expo., Philadelphia, 1876; hon. mention, Paris Expo., 1889; two medals (oil painting and mural decoration), Columbian Expo., Chicago, 1893; medal, Atlanta Expo., 1895; medal, Pan-Am. Expo., Buffalo, 1901. Work: "Love Locked Out," Nat. Gallery of British Art, London; "Piping Shepherd," Penna. Academy, Phila.; numerous portraits, including "James Russell Lowell," Memorial Hall, Harvard Univ., Cambridge, and "Mrs. Arnold Toynbee," Lady Margaret Hall, Oxford; eight mural paintings in St. Martin's Church, Wanersh, Guildford, Eng. Author of *Memoir of Henry Merritt, A Hamlet in Old Hampshire,* and *An Artist's Garden.* Address 1929, The Limes, Hurstbourne-Tarrant, Andover, Hampshire, Eng.

MERTON, OWEN.
Painter. Born in Christchurch, New Zealand, May 14, 1887. Pupil of Tudor-Hart in Paris. Represented in the National Gallery of New Zealand. Designs and color schemes for flower gardens. Address in 1929, 50 Virginia Road, Douglaston, Long Island, NY.

MERWIN, ANTOINETTE de FOREST (MRS.).
Painter and teacher. Born in Cleveland, OH, July 27, 1861. Pupil of Art Students League of NY; St. Paul School of Fine Arts under Burt Harwood; Merson; Courtois; Collin; and James McNeill Whistler. Member: California Art Club; Pasadena Society of Artists; Pasadena Fine Arts Society; San Diego Artists Guild. Award: Honorable mention, Paris Salon, 1900. Works: "Fisherfolk, Volendam Noord, Holland," owned by the Boston Art Club; "California Fruit and Flowers," Cuyamaca Club, San Diego, CA. Address in 1929, 1064 Armada Drive, Pasadena, CA.

MERWIN, HESTER.
(Mrs. Edward Lindsley Ayers). Painter. She is also known for her drawings. Born in Bloomington, IL. Studied: In Italy before attending the Chicago Art Institute; Pasadena Art Institute; and with Howard Giles, Andrew Dasburg, and Ward Lockwood. She has shown in leading NY galleries and in more than sixty one-man shows throughout the United States. She has made many drawing safaris in Africa, and has travelled also to Afghanistan, Mexico, South Pacific, and the British West Indies. Her drawings of the last few surviving Island Caribs on the island of Dominica are in the permanent collection of the Smithsonian Institution in Washington, D.C.

MESEROLE, WILLIAM HARRISON.
Sculptor. Born in Brooklyn, New York, December 28, 1893. Pupil of MacNeil. Address in 1918, 730 Rugby Rd., Brooklyn, NYC.

MESS, EVELYNNE B.
(Mrs. George Jo Mess). Etcher, painter, and teacher. Born in Indianapolis, Indiana, January 8, 1903. Studied: John Herron Art Institute; Butler University; Art Institute of Chicago; Ecole des Beaux-Arts, Fontainebleau, France; and with Andre Strauss and Despujols. Awards: Indiana State Fair, 1930, 1950, 1951, 1958; National Society of Arts and Letters, 1948; Indiana Artists, 1949, 1955; California Society of Etchers; Holcomb prize, John Herron Art Institute, 1958; Hoosier Salon, 1947, 48, 50, 53, 58; others. Collections: John Herron Art Institute; Library of Congress; De Pauw University; Ft. Wayne Art Museum. Exhibited: Soc. of American Graphic Artists; Los Angeles Mus. of Art; Penna. Academy of Fine Arts; Philadelphia Art Alliance; Hoosier Salon; Philadelphia Soc. of Etchers; Herron Art Institute; Seattle Art Museum; Indiana Society of Printmakers; others; one-woman shows include the John Herron Art Institute; Hoosier Salon; and Lieber Gallery. Member: National Society of Arts and Letters; California Society of Etchers; Indiana Art Club; Indiana Society of Printmakers; Indianapolis Art League (fellow); others. Positions: President, Indiana State Federation of Art Clubs, 1968-70; instructor of art, Indianapolis Art League. Address in 1970, Indianapolis, IN.

MESSO, DOMINICK.
Sculptor. Born in France in 1827. Was living in Philadelphia in August of 1860.

MESTROVIC, IVAN.
Sculptor, painter, and teacher. Born in the Slavonian village of Vrpolje, Yugoslavia, August 15, 1883. Studied with Otto Koenig in Vienna, 1899; four years at the Academy of Fine Arts in Vienna, 1900-04; with E. Hellmer, H. Bitterlich, Otto Wagner. Spent student years studying the styles of Rodin and the Vienna Secession, the results of which centered on a series of sculptures commissioned for the Kossovo Monument, a project never completed. Works: "The Crucifixion," 1917 (wood); "Lamentation," 1915; "Ashbaugh Madonna," 1917 (walnut); "Virgin and Child," 1919-22; "Amour and Psyche," 1918 (stone); "Distant Chords," 1918 (bronze); "The Raising of Lazarus," 1940 (walnut); "Study for the Monument of Marko Marulic," (plaster); "Woman with a Harp," 1924 (marble); "Woman with a Lute," 1924 (marble); "Waiting," 1929 (marble); "St. Luke the Evangelist," 1928 (bronze); "Indian with Bow," 1926 (bronze); "Mestrovic Family Memorial Chapel," 1926-31/1936-38 (stone); "Pieta," 1942 (marble); "Study of Moses," 1953 (plaster). Represented in Belgrade (National); Brooklyn Mus.; Albright; Art Institute of Chicago;

Detroit Institute; Snite Museum of Art; Congregation of the Holy Cross; Syracuse University; University of Minnesota Museum of Art; San Diego Fine Arts Museum; Wichita Art Museum; Louisiana Arts and Science Center, Baton Rouge; University of Notre Dame; and Mestrovic Gallery. Exhibited in Prague, Munich, Paris, Vienna, Zagreb, and the Victoria and Albert Museum, 1915; one-man show at the Metropolitan Museum of Art. Taught: Syracuse University, 1947-55, and University of Notre Dame, 1955-1962. Member of American Academy of Arts and Letters, 1953. Died January 17, 1962, in Notre Dame, IN.

METCALF, ELIAR.
Painter. Born in Franklin, MA, Feb. 5, 1785. He studied under Samuel Waldo. Metcalf resided and painted portraits in New Orleans, 1818-1823; they were considered excellent. He appears in the 1822 New Orleans directory as "portrait and miniature painter, 25 Magazine Street, above Common." In Sept., 1817, The *New York Commercial Advertiser* notes as follows: "E. Metcalf, Portrait and Miniature Painter, having recovered his health has returned to the city and resumed the exercise of his profession at No. 152, Broadway." He painted an excellent portrait of the artist Asher B. Durand, now in the New York Historical Society. Died Jan. 15, 1834, in NYC.

METCALF, JAMES.
Sculptor. Born March 11, 1925, in NYC. Studied: Dayton Art Institute School; Penna. Academy of Fine Arts, 1944-46; Central School of Arts and Crafts, London, 1950-53. Work: Univ. of Arizona; Museum 20 Jahrhunderts; New York Hilton Hotel; Yale University. Exhibited: Galerie Furstenberg, Paris, 1959; Galerie Europe, Paris, 1963; Albert Loeb Gallery, NYC, 1964; Dayton Art Institute, 1946; Cincinnati Art Museum; III Biennial of Spanish-American Art, Barcelona; V Sao Paulo Biennial; Exposition Internationale de la Sculpture, Paris, 1961; Un Demi-Siecle de la Sculpture, Paris, 1962; Actualite de la Sculpture, Paris, 1963; Documenta III, Kassel, 1964. Awards: Copley Foundation Grant, 1957; Clark Foundation Grant. Address in 1976, Yellow Springs, Ohio.

METCALF, WILLARD LEROY.
Painter. Born in Lowell, MA, in 1858; died in New York, March 9, 1925. Pupil of George L. Brown in Boston, and of Boulanger and Lefebvre in Paris. Hon. mention, Paris Salon, 1888; medal, Columbian Expo., Chicago, 1893; Temple gold medal, Penna. Academy of Fine Arts, 1904; gold medal and first prize, Corcoran Gallery of Art, Washington, 1907; Harris medal and prize, Art Institute of Chicago, 1910. Represented by "The Birches" and "My Pastoral," Boston Museum of Fine Arts, Boston, MA; also "May Night" at the Corcoran Art Gallery. Taught at Art Students League. Member of Nat. Inst. of Arts and Letters and Am. Water Color Society.

METEYARD, THOMAS BUFORD.
Painter. Born at Rock Island, IL, Nov. 17, 1865. Studied in Europe. Exhibited pictures at Paris Salon; Chicago Exposition; Society of American Artists, New York; Penna. Academy of Philadelphia; St. Louis Expo., 1904; and other exhibitions in U.S. Decorator for *Songs from Vagabondia* (by Bliss Carman and Richard Hovey) and numerous other books. Address in 1926, Moses Hill Farm, Fernhurst, Sussex, England. Died in Vaud, Switzerland on March 17, 1928.

METHVEN, H. WALLACE.
Painter and etcher. Born in Philadelphia, PA. Pupil of Henry F. Spread, Kenyon Cox, Beckwith and Laurens. Member: American Art Association of Paris. Address in 1929, 3 Rue Campagne Premiere, Paris, France.

METZGER, EVELYN BORCHARD.
Sculptor and painter. Born in NYC, June 8, 1911. Studied at Vassar College, A.B., 1932, with C. K. Chatterton; Art Students League, with George Bridgman and Rafael Soyer; also with George Grosz, sculpture with Sally Farnham, Guzman de Rojas in Bolivia and Demetrio Urruchua in Argentina. Works: Fine Arts Gallery of San Diego, Balboa Park, CA; Arizona State Museum, Tucson; Lyman Allyn Museum, New London, CT; University MO-Columbia; Butler Institute American Art, Youngstown, Ohio; also in over 40 museums, inc. Art in the Embassies Program. Exhibitions: One-woman shows, Galeria Muller, Buenos Aires, 1950, Gallerie Mex-Am. Cultural Institute, Mexico City, 1967; Van Diemen-Lilienfeld Gallery, NY, 1966. Member: American Federation of Arts; Artists Equity Association; others. Media: Oil, enamel, acrylics, and mixed media. Address in 1982, 815 Park Ave., NYC.

MEURER, CHARLES A.
Painter. Born in Germany, March 15, 1865. Pupil of Julian Academy, Bouguereau, Doucet and Ferrier in Paris. Member: Cincinnati Art Club. Specialty: Still life; also sheep and cattle. Address in 1929, Terrace Park, OH.

MEUX, GWENDOLYN D.
Painter. Member: Boulder Art Assoc.; Oklahoma Art Association. Award: Silver medal for painting, Kansas City Art Institute, 1923; hon. mention, Denver Museum Exhibition, 1928; Silver medal, drawing, Kansas City Art Institute, 1929. Address in 1929, care of University of Colorado, Boulder, CO.

MEWHINNEY, ELLA K. (MRS.).
Painter. Born in Nelsonville, TX, June 21, 1891. Pupil of George Bridgman; Robert Reid; Randall Davey. Member: Southern States Art League; Texas Fine Arts Association. Award: Hon. mention, Dallas Women's Forum, 1925; first prize, flower painting,

Southern States Art League, ($50); hon. mention, Davis competition ($100), 1928, third prize, Davis competition, Texas, ($500), 1929. Address in 1929, Holland, Texas.

MEYENBERG, JOHN CARLISLE.
Sculptor and craftsman. Born in Tell City, IN, February 4, 1860. Pupil of Cincinnati Art Academy under Thomas S. Noble and L. F. Rebisso; Beaux-Arts in Paris under Jules Thomas. Member: Cincinnati Art Club. Work: "Egbert Memorial," Fort Thomas, KY; "Pediment," Covington (KY) Carnegie Library; "Aunt Lou Memorial," Linden Grove Cemetery; Theodore F. Hallam, bust, Court House, Covington, KY; "Nancy Hanks," Lincoln Park entrance, State of Indiana; "Benn Pitman Memorial," Cincinnati Public Library. Exhibited at National Sculpture Society, 1923. Address in 1929, Tell City, IN.

MEYER, ALVIN (WILLIAM) (CARL).
Sculptor. Born in Bartlett, IL, December 31, 1892. Pupil of Maryland Institute; Penna. Academy of Fine Arts under Charles Grafly; Rinehart School of Sculpture in Baltimore, MD; American Academy in Rome. Member: Charcoal Club. Work: Peabody Institute, Maryland Institute, Baltimore; Chicago Daily News Building; Chicago Board of Trade; Archives Building, Springfield, IL; Natural History Building, Urbana, IL. Award: Cresson Traveling Scholarship, Penna. Academy of Fine Arts; Rinehart Traveling Scholarship from the Peabody Institute; Prize of Rome, American Academy in Rome, 1923. Exhibited at National Sculpture Society, 1923. Address in 1953, Chicago, IL.

MEYER, CHRISTIAN.
Landscape painter. Born in Germany in 1838, he came to this country as a young man. His paintings were shown at exhibitions of the Society of American Artists and at the National Academy of Design. He died in Brooklyn, NY, April 15, 1907.

MEYER, ENNO.
Sculptor, painter, illustrator, and etcher. Born in Cincinnati, OH, August 16, 1874. Pupil of Duveneck. Member: Cincinnati Art Club. Specialty is animals. Address in 1929, Milford, OH.

MEYER, ERNST.
Painter. Born in Germany in 1795. Pupil of Chase, Twachtman, Ward, Beckwith, DuMond, Turner. Member: Connecticut Academy of Fine Arts; Salma. Club. Address in 1929, Tylerville, CT. Died in Rome in 1861.

MEYER, GEORGE BERNHARD.
Miniature painter. Member: Charcoal Club. Address in 1929, 1230 St. Paul Street; East Pleasant Street, Baltimore, MD.

MEYER, HENRY HOPPNER.
Stipple engraver and portrait painter in oils and miniatures. Born in England in 1783. In 1830 he came to New York and engraved portraits and painted miniatures. Among his miniatures was one of President Jackson in 1833. He also engraved several plates for Longacre & Herring's "National Portrait Gallery," 1834. He died May 28, 1847, in London.

MEYER, HERBERT.
Painter and illustrator. Born in New York, NY, March 6, 1882. Pupil of Art Students League of NY; Twachtman; DuMond. Member: Salma. Club; NY Architectural League; Allied Artists of America; NY Water Color Club; American Water Color Society. Address in 1929, 108 East 82nd Street, New York, NY; Dorset, VT. Died 1960.

MEYERCORD, GRACE E.
Miniature painter. Exhibited at the Penna. Academy of Fine Arts, Philadelphia, 1925. Address in 1926, 329 West 84th Street, New York.

MEYEROWITZ, WILLIAM.
Painter and etcher. Born in Russia, July 15, 1889. Pupil of National Academy of Design. Member: Society of Independent Artists; Gloucester Society of Artists; Brooklyn Society of Etchers; North Shore Arts Association; Connecticut Academy of Fine Arts; Salons of America. Award: Honorable mention, Connecticut Academy of Fine Arts, 1923. Etchings in Public Library, Concord, MA, and Ralph Cross Johnson Collection, Washington, D.C.; painting in the Phillips Memorial Gallery, Washington, D.C.; "Fruit and Drapery," Albright Art Gallery, Buffalo, NY; "The Musician," Brooklyn Museum of Art. Address in 1929, 39 W 67th St., NY; summer, 44 Mt. Pleasant Avenue, East Gloucester, MA.

MEYERSAHM, EXENE REED (MRS.).
Painter. Born in Northville, MI. Pupil of RI School of Design; Boston Mus. of Fine Arts; Charles Hawthorne. Member: Providence Art Club; Nat. Arts Club. Address 1929, 508 Slade Bldg., 44 Washington St.; h. 111 Congress Ave., Providence, RI.

MEYLAN, PAUL JULIEN.
Illustrator and painter. Born in Canton of Vaud, Switzerland, May 17, 1882. Pupil of National Academy of Design in New York. Member: Society of Illustrators, 1907; American Art Society; Artists Guild of the Authors' League of America, NY. Illustrated: "Two Faces," by Marie Van Vorst; "The Poor Lady," by Mary E. Wilkins Freeman; "Sarolta," by Agnes and Egerton Castle; "Come Out of the Kitchen" and "Ladies Must Live," by Alice Duer Miller; "The Unexpected," by Elizabeth Jordan, etc. Address 1929, R.F.D. 3, Bethel, CT; 140 Wadsworth Avenue, New York, NY.

MEYNELL, LOUIS.
Sculptor and painter. Born in Cherryfield, ME, Sept. 22, 1868. Pupil of Otto Grundmann; F. H. Tompkins; and School of Boston Museum of Fine Arts (graduate, 1888). Address in 1910, 41 Commonwealth Ave., Chestnut Hill, MA.

MEYNER, WALTER.
Sculptor, painter, illustrator, and writer. Born in Philadelphia, PA, February 12, 1867. Pupil of Penna. Academy of Fine Arts. Member: Salma. Club; Fellowship Penna. Academy of Fine Arts; Society of Independent Artists; Allied Artists of America. Address in 1933, 150 Nassau St., NYC.

MEYRICK, RICHARD.
The *American Weekly Mercury*, Philadelphia, No. 516, 1729, contains the following advertisement: "Richard Meyrick, Engraver, removed from the Lock and Key in Chesnut Street to the Widow Walker's, in Front-Street Phila." Meyrick was probably an engraver for silversmiths.

MEYROWITZ, JENNEY DELONY RICE.
(Mrs. Paul A. Meyrowitz). Painter of portraits and miniatures. Born in Washington, Hempstead Cnty., AR. Studied at Cincinnati Art Academy, and took Medical School course in "Artistic Anatomy," St. Louis School of Fine Arts; pupil of Julian, Delance and Delecluse Academies, Paris. Studio in NY, 1900. Art Instructor, Virginia Female Institute, Roanoke, VA, 1893-94; Norfolk, Virginia, College; Director of Art, State University of AR, 1907-09. Exhibited at National Academy of Design; New York Water Color Club; National Arts Club; Woman's Art Club; Miniature Societies of New York, Boston and Philadelphia; etc. Painted portraits of Jefferson Davis; Mrs. Jefferson Davis; George G. William, president, Chemical National Bank, New York; Mrs. Hetty Green; Dr. George Taylor Stewart; etc. Member: Society of Women Painters and Sculptors. Address in 1926, 140 West 57th Street, New York.

MEYVIS, ALME LEON.
Painter. Born in St. Gilles - Waes, Belgium, May 17, 1877. Pupil of Mechanics' Institute, Rochester; Royal Academy, The Hague. Member: Rochester Art Club; Arti et Amici, Amsterdam. Awards: Hon. mention, Buffalo Society of Artists, 1903; silver medal, Ville de Paris, 1904; silver medal, Enghien-les-Bains, 1904; bronze medal, International Expo., Utrecht, Holland, 1909. Work: Modern Museum, The Hague, Holland; Sibley Hall Library, Rochester. Address in 1929, 22 Centennial Bldg.; h. 360 Main Street, East Rochester, NY.

MEZZARA, JOSEPH.
Sculptor. Born in NYC. Exhibited: Paris Salon, 1852, 1875. Works held: Chambery Museum, France.

MEZZARA, PIETRO.
Sculptor and stonecutter. Born in Italy c. 1823. In San Francisco c. 1856-78. Work: Statue of Lincoln, Lincoln Grammar School, San Francisco, 1865-66; statues and pediments, State Capitol, Sacramento, California, c. 1873; "Charity," Masonic Temple, San Francisco; "Romulus and Remus," Mechanics' Pavilion facade. Exhibited at Mechanics' Institute Industrial Exhibitions, San Francisco, 1857-78; San Francisco Art Association, 1872, 75. Received gold medals, Mechanics' Institute, San Francisco, 1865, 69, 71. Member of San Francisco Art Association. Considered San Francisco's first resident sculptor of note. Executed cameos, medallions, and portrait busts for city's social elite. Responsible for acquiring from the Louvre plaster casts of antique sculpture for San Francisco Art Association's School of Design. These influenced California's first generation of sculptors in the 1880's. Died in Paris in 1883.

MICHAEL, D. D. (MRS.).
See Wolfe, Natalie.

MICHELSON, LEO (LEIBA).
Portrait, figure, and landscape painter; sculptor; engraver. Born in 1887. Exhibited: Paris; NY; Baltimore; Berlin; Lisbon; Russia. Works held: Baltimore Museum; Paris Museum of Modern Art; Riga (Russia) Museum; San Diego Museum; Tel-Aviv, Israel; Jerusalem, Israel.

MICHNICK, DAVID.
Sculptor. Born in Gorinka, Ukraine, in 1892. Studied at the Art School of Odessa; at the Art Institute of Chicago; under Albin Polasek; and at the Beaux-Arts Institute of Design, NY. Works: Garden figure, private estate, Albany, NY; Nymph, private estate, Chicago, IL; overmantel, private residence, Forest Hills, LI; memorial panel, Isadora Duncan; statues, "Disarmament;" "Attic;" "Quiet Water." Awards: Medals, Beaux-Arts Institute of Design, NY.

MICHOD, SUSAN ALEXANDER.
Painter. Born on Jan. 3, 1945. Studied: Smith College, Northampton, MA; University of Michigan; Pratt Institute, Brooklyn. Awards: Artists Guild of Chicago, 1973; North Shore Art League, Chicago, 1971; Illinois State Museum, 1974. Collections: Illinois State Museum; Hastings College, NE. Media: Acrylic, watercolor.

MICKS, JAY RUMSEY.
Illustrator. Born in Baltimore, MD, Feb. 22, 1886. Pupil of Henry McCarter. Illustrations for *Everybodys, Scribner's, Harper's, Red Book*. Address in 1929, 53 Washington Sq., South, New York, NY; summer, 66 Cayuga Street, Seneca Falls, NY.

MIDDAUGH, ROBERT.
Painter. Born on May 12, 1935 in Chicago, IL. Earned BFA from Art Institute of Chicago, 1964.

Also studied at University of Chicago. Curator of art collection, first National Bank of Chicago. Taught at Chicago Academy of Fine Arts. Received Scholarships from University Club of Chicago. Exhibited at Art Institute of Chicago; Covenent Club, Chicago; Illinois State Fair; Penna. Academy of Fine Arts; and Virginia Museum of Fine Arts. In collections of Art Institute of Chicago; Phoenix Art Museum; Boston; Worcester Art Museum.

MIDDLETON, MARY P.
See Laessle, Mary P. Middleton.

MIDDLETON, STANLEY GRANT.
Painter. Born in Brooklyn, NY. Pupil of Jacquerson de la Chevreuse, Harpignies, Constant, Dagnan-Bouveret and Julian Academy in Paris. Member: Artists' Fund Society; Lotos Club; Salma. Club. Awards: Hon. mention, Pan-Am. Exposition, Buffalo, 1901; hon. mention, Charleston Exp., 1902. Work: "Normandy Fish Wife," Hamilton Club, Brooklyn; "En Costume de Bal," Lotos Club, New York; "Hon. Lynn Boyd," Capitol, Washington; "Hon. Andre D. White," National Gallery, Washington; "Col. William S. Gordon," West Point Library; "Theodore Connoly," City Hall, New York; "Albert S. Bickmore," Museum of Natural History, New York; "Hon. Carter Glass," Harvard University; "Woodrow Wilson," Princeton Library; "Hon. James J. Walker," Mayor of New York City; Gen. Robert Bullard, Gen. John F. O'Ryan, 27th Division, Gen. Robert Alexander, 77th Division, Gen. Farrington Austin, Bronx Armory, New York. Address in 1929, 1 West 67th Street, New York, NY.

MIDDLETON, THOMAS.
Engraver. Born on the family estate of Fanclure, Scotland, 1797; died in Charleston, S.C., Sept. 27, 1863. He was the third son of the Honorable Thos. Middleton of Charleston, SC. In the Middleton Records he is referred to as an amateur painter of considerable talent.

MIDENER, WALTER.
Sculptor, craftsman, and teacher. Born in Germany, October 11, 1912. Studied: Vereinigten Staats Schulen Fine and Applied Art; Berlin Academy, 1932-36; Wayne State University, M.A., 1950. Member: Michigan Sculpture Society; Michigan Academy of Arts and Letters. Awards: Tiffany grant, 1940; Honolulu, T.H., 1943; prize, Detroit Institute of Art, 1950; Scarab Club Gold Medal, 1960. Work: Whitney Museum of American Art; Flint Institute of Art; Detroit Institute of Art. Exhibited: Penna. Academy of Fine Arts, 1941, 48, 51, 59; Philadelphia Museum of Art, 1949; Whitney Museum of American Art, 1950, 51, 64; Metropolitan Museum of Art, 1951; Museum of Modern Art, 1950; Cranbrook Academy of Art, 1950; John Herron Art Institute, 1951; Detroit Institute of Art, 1946-51. Taught: Head of sculpture department, Art School,

Society of Arts and Crafts, Detroit, MI, 1946-66, assistant director, 1958-61, acting and associate director, 1961-67, dean of faculty, 1967-68; director, Center for Creative Studies, College of Art and Design, 1968-76, president, 1976-77, president emeritus and professor of sculpture, 1977-79. Media: Metal, wood, and clay. Address in 1982, East Jordan, MI.

MIELATZ, CHARLES F. W.
Etcher and painter. Born in Bredding, Germany, in 1864. Pupil of Chicago School of Design. Elected an Associate of the National Academy in 1906. Member of NY Etching Club. Died June 2, 1919 in NYC.

MIELZINER, JO.
Painter and draftsman. Born in Paris, France, March 19, 1901. Pupil of Leo Mielziner; National Academy of Design; Art Students League of NY; Penna. Academy of Fine Arts; American Federation of Arts; Joseph Urban; Robert Edmond Jones. Member: Salma. Club. Specialty: Stage Designs. Address 1929, 148 E 53rd St., New York, NY.

MIELZINER, LEO.
Sculptor, painter, illustrator, etcher, writer, and lecturer. Born in New York City, December 8, 1869. Pupil of Cincinnati Art Academy; Ecole des Beaux-Arts, Julian Academy, Colarossi Academy, Paris; Kroyer in Denmark. Member: Boston Art Club; Cincinnati Art Club; Salma. Club. Work: "Portrait of John Bassett Moore," Kent Hall, Columbia University, New York; University of Delaware and State Department, Washington, DC; "Portrait of Nathan Abbott," "Portrait of Harlan Fiske Stone," Kent Hall, Columbia University, NY; "Portrait of Solomon Schechter," Jewish Theological Seminary, NY; "Portrait of Moses Mielziner," Hebrew Union College, Cincinnati; "Portrait of Woodrow Wilson," Democratic Club, NY; "Portrait of Elizabeth Milbank Anderson," Barnard College, NY; miniature, "Mother and Child," Boston Art Museum; lithograph, "Boy in Fur Cap," Brooklyn Art Museum; silverpoint, "Arabesque," Worcester Art Museum, Worcester, MA; "Portrait of Louis Loeb," Metropolitan Museum of Art, NY; "Portrait of Isaac M. Wise," Cincinnati Art Museum; portraits of General Pershing, Woodrow Wilson, Theodore Roosevelt, New York Public Library. Address in 1933, 47 Fifth Ave., Washington Square, New York, NY; summer, Head O'Pamet, North Truro, MA. Died in 1935.

MIESTCHANINOFF, OSCAR.
Sculptor. Born in Vitebsk, Russia, 1884. Naturalized citizen of U.S. in 1949. Initially self-taught; later attended Odessa School of Fine Arts in Russia and the Ecole des Beaux-Arts in Paris. Exhibited many times in Paris until 1944 when he moved to NYC. One-man exhibits in NY, Wildenstein Galleries, Los Angeles County Museum, 1955. Died in NYC, 1956.

MIFFLIN, JOHN HOUSTON.
Born in 1807 in Pennsylvania. Miniature painter who flourished in New York, 1840-42. He is said to have painted portraits in Philadelphia in 1832. Died in 1888 in Columbia, PA.

MIGNOT, LOUIS REMY.
Painter. Born in Charleston, SC, in 1831. He studied in Holland and opened his studio in NY about 1855, as a landscape painter. He went to South America with Frederick E. Church and painted tropical scenes. Elected National Academician in 1859. He died in Brighton, England, Sept 22, 1870; after his death a collection of his paintings was exhibited there.

MIHALIK, JULIUS C.
Painter, craftsman, writer, lecturer, and teacher. Born in Budapest, Hungary, March 26, 1874. Pupil of Academy of Fine Arts, Budapest. Member: Art Teachers Guild, London (hon.); Etchers-Painters Society, Budapest (hon.); Boston Society of Arts and Crafts; American Federation of Arts. Address in 1929, 11480 Hessler Road, Cleveland, OH. Died 1943.

MIKELL, MINNIE.
(Mrs. Alexander B. Mikell). Painter and etcher. Born in Charleston, SC, Dec. 18, 1891. Pupil of Alfred Hutty; Joseph Pennell. Member: Southern States Art League; Charleston Etching Club; Carolina Art Assoc. Address 1929, R.F.D. No. 1, Charleston, SC.

MILAM, ANNIE NELSON (MRS.).
Painter. Born in Homer, LA, Nov. 20, 1870. Pupil of John Carlson. Member: El Paso Art Club; American Federation of Arts. Award: Second prize, Southwestern Expo., El Paso, 1924. Address in 1929, Canutillo, Texas. Died 1934.

MILBANK, MARJORIE R.
(Mrs. Albert G. Milbank). Painter. Born in Lynn, MA, June 15, 1875. Member: Nat. Assoc. of Women Painters and Sculptors. Address 1929, 480 Park Ave., NY; summer, Lloyd Harbour, Huntington, L.I., NY.

MILBOURNE, C.
English scene-painter, who was brought from London in 1793 by Wignell for the Chestnut Street Theatre. He painted some scenes of Phila., "View of Arch Street Wharf With Boats Sailing on the Delaware;" also a view, "Third and Market Sts., Phila.," both remarkable for their excellence. (First name may be Cotton.)

MILBURN, OLIVER.
Painter and etcher. Born in Toronto, Canada, Sept. 17, 1883. Pupil of Los Angeles Art Inst.; Chouinard School of Art. Member: California Art Club. Address in 1929, 536 North Las Palmas, Los Angeles, CA.

MILES, CYRIL.
Painter and instructor. Born in Boston, MA, June 13, 1918. Studied: Wayne State University. Work: Instituto Mexicano Northamericano de Relationes Culturales, Mexico; IBM, Southfield, MI; Michigan Academy of Arts & Sciences, Ann Arbor, MI; plus commissions. Exhibitions: Chicago Art Institute, International Watercolor Exhibition; Drawing U.S.A., St. Paul, MN; Northamerican Mex. Cult. Institute; Premier Invenaire Int'l. Poesie Elementaire, Paris. Awards: Citation, Mexican Government, 1979; Gold Medal, Acad. Italia Delle Arti, 1979; Michigan Art Education Association Award, 1978; others. Teaching: Detroit Institute of Art; Highland Park Comm. College. Member: Michigan Academy of Arts & Sciences; Michigan Water Color Society; National Art Education Association; Detroit Institute of Art Founders Society; others. Media: Acrylic, Collage. Address in 1982, Detroit, MI.

MILES, EDWARD.
Miniature painter and portrait artist in crayons. Born Oct. 14, 1752 in Yarmouth, England. He was employed by Sir Joshua Reynolds to make miniature copies of his portraits. He exhibited in the Royal Academy in 1775-79. In 1807 he settled in Philadelphia, where he died March 7, 1828. The directory entries list him both as a portrait painter and drawing teacher.

MILES, HAROLD W.
Painter and teacher. Born in Des Moines, IA, Sept. 2, 1887. Pupil of C. S. Cumming and J. F. Smith; Colarossi Academy in Paris. Member: California Art Club; California Water Color Club; Hollywood League of Architects. Work: Mural decorations in West Des Moines High School; illustrated "Girls of High Sierras." Art Director for "Dorothy Vernon of Haddon Hall," "What Price Glory," "King of Kings," etc. Instructor in art, University of Iowa; head of art department, Hollywood High School, for five years; instructor, Otis Art Institute, Los Angeles, for one year. Address in 1929, 6154 Glen Holly, Hollywood, CA.

MILES, JEANNE PATTERSON.
Painter and sculptor. Born in Baltimore, MD. Studied: George Washington University; Phillips Mem. Gallery, Washington, DC; Grande Chaumiere, Paris; Atelier Marcel Gromaire, Paris; NY University. Awards: C. C. Ladd Study Scholarship, 1939-40; American Institute of Arts and Letters Emergency Grant, 1969; Mark Rothko Foundation Grant, 1971. Collections: Mural (100 portraits), Ramon's, Washington, DC; Kentile Company, NY and Philadelphia, PA; Santa Barbara Museum of Art; Guggenheim Museum, NY; Munson-Williams-Proctor Museum, Utica, NY; Andrew D. White Museum, Cornell University. Exhibitions: Ten Years at Betty Parsons Gallery, NY, 1954; Whitney Museum, 1963;

American Federation of Arts, 1968-69; retrospective, Museum of Fine Arts, Springfield, MA, 1975; others. Member: Fine Arts Federation, NY; American Abstract Artists. Taught: Moravian College for Women, 1948-51; Guggenheim Museum, NY, 1951-52; Oberlin College, 1952-53; NY Inst. of Technology, 1968-69. Address in 1984, 463 West Street, New York, New York.

MILES, MAUD MAPLE (MRS.).
Sculptor, painter, and teacher. Born in Chariton, IA, February 11, 1871. Pupil of Art Institute of Chicago; Arthur Dow in New York. Address in 1910, 524 West 140th St., NYC.

MILIONE, LOUIS G., SR.
Sculptor and teacher. Born in Padua, Italy, Feb. 22, 1884. Studied: Spring Garden Institute; pupil of Charles Grafly, Herman Deigendesch, Porter, Alexander Calder, and William Chase; Philadelphia School of Industrial Art; and Penna. Academy of Fine Arts. Member: Fellowship, Penna. Academy of Fine Arts; American Federation of Arts; Alliance. Awards: Stewardson prize, 1904; Cresson Scholarship, Penna. Academy of Fine Arts, 1907, prize, 1904. Exhibited at Nat. Sculpture Society, 1923; National Academy of Design, 1910-30; Sculpture Society, 1940-43; Penna. Academy of Fine Arts, 1910-36; Philadelphia Museum of Art; others. Work: "Brig. Gen. Kirby Smith," Vicksburg, MI; Church of the Redeemer, Bryn Mawr; Germantown High School, Philadelphia; Fairmont Park, PA; Philadelphia Academy of Music; various memorials, reliefs, and busts. Specialized in sculpture in stone. Address in 1953, Havertown, PA.

MILLAR, ADDISON THOMAS.
Painter and etcher. Born in Warren, OH, on Oct. 4, 1860. Pupil of Chase in New York and of Constant in Paris. He is represented by paintings in Rhode Island School of Design, and in the Detroit Museum of Art. His etchings are in the New York Public Library and Congressional Library, Washington, D.C. He was killed in an automobile accident, Dec. 8, 1913.

MILLARD, C. E.
Painter and illustrator. Member: Artists Guild of the Authors' League of America, NY. Work: Illustrated *The Prince of Wails*, by Pauline F. Geffen (Simon and Schuster). Address in 1929, Greenley Arcade, 132 West 31st Street, New York, NY.

MILLBOURN, M. VAUGHN.
Painter, craftsman, and teacher. Born in Charlotte, MI, Sept. 8, 1893. Pupil of Art Institute of Chicago. Member: Artists Guild of the Authors' League of America, NY; Society of Typographic Arts. Address in 1929, Pittsfield Bldg., 55 E. Washington Street; h. 5311 Glenwood Avenue, Chicago, IL.

MILLER, ALFRED JACOB.
Painter. Born on Jan 2, 1810, in Baltimore. Studied first under Sully; visited Europe in 1833, studying in Paris, Rome and Florence. He accompanied Sir William Drummond Stewart, a Scotch Baronet, to the Rocky Mountains in 1837, making a series of sketches which were the groundwork of the very interesting gallery of pictures now in Murthely Castle. These pictures were reproduced in water colors for W. T. Walters, of Baltimore. Miller died June 26, 1874, in Baltimore, MD.

MILLER, ANNA HAZZARD.
(Mrs. Edward J. Miller). Painter and teacher. Born Minnesota, June 4, 1863. Pupil of Maurice Braun; Randall Davey; Ernest Lawson. Member: Oklahoma Art League; Oklahoma State Artists Association; MacDowell Club of Allied Arts. Work: "Mission Valley," University of Oklahoma. Address in 1929, 828 West 15th Street, Oklahoma City, OK.

MILLER, BARSE.
Painter. Born in New York City, Jan. 24, 1904. Pupil of National Academy of Design; Snell; Penna. Academy of Fine Arts; Breckenridge. Member: North Shore Arts Association; Fellowship Penna. Academy of Fine Arts; Calif. Art Club; Gloucester Art Association; California Water Color Society; Laguna Art Association. Awards: First Cresson Travelling Scholarship, Penna. Academy of Fine Arts, 1922; Second Cresson Travelling Scholarship to Europe, 1923; hon. mention, Arizona State Fair, 1925; second award for water color, Los Angeles County Fair, 1925; first landscape prize, Arizona State Fair, 1927; special award of honor, Springville Nat. Art Exhibition, Utah, 1928; second Purchase prize, Rocky Mt. Exhibition of Modern Art, Logan, UT, 1929. Represented in Fine Arts Gallery, San Diego, CA; Purchase Fund, Fellowship Penna. Academy of Fine Arts; Muncipal Collection, Phoenix, AZ; Bentley Collection, Boston; Logan Sr. High School, Logan, UT. Address in 1929, 828 So. Lucerne Boulevard, Los Angeles, CA; summer, care of Warren Hastings Miller, Grapevine Road, East Gloucester, MA.

MILLER, BENJAMIN.
Painter and wood-engraver. Born in Cincinnati, OH, in 1877. Pupil of Duveneck. Awards: First hon. mention, Print Club of Philadelphia, 1929. Represented in Bibliotheque Nationale, Paris; permanent collections, Cincinnati Art Museum, and Minneapolis Institute of Fine Arts. Address in 1929, 131 East 3rd Street, Cincinnati, OH.

MILLER, BURR (CHURCHILL).
Sculptor. Born in Wilkes-Barre, PA, April 3, 1904. Studied: Yale University, Ph.B.; Yale School of Fine Arts, with Robert Eberhard; in Paris, with Bouchard; and with Jose De Creeft and Paul W. Bartlett. Work:

Bishop Museum, Honolulu. Exhibited: Penna. Academy of Fine Arts, 1930, 39; National Academy of Design, 1931, 32, 35, 36, 46; Society of Independent Artists, 1938-42; Golden Gate Exposition, 1939; World's Fair, NY, 1939; Whitney, 1940; Conn. Academy of Fine Arts, 1933, 34, 36, 37; Anderson Gallery, 1939 (one-man). Member of Nat. Sculpture Society; Fed. of Modern Painters and Sculptors; Conn. Academy of Fine Arts. Received honorable mention, Paris Salon, 1907. Address in 1953, 17 MacDougal Alley; h. Gramercy Park, NYC.

MILLER, CHARLES HENRY.
Landscape painter and etcher. Born in New York, March 20, 1842. He first exhibited at the National Academy of Design in 1860; was elected an Associate in 1873, and an Academician, in 1875. Received a gold medal at Philadelphia, 1876; also exhibited in Boston and New Orleans exhibitions. Represented in Metropolitan Museum by "Sunset, East Hampton;" also by paintings in the Brooklyn Museum and the Rhode Island School of Design. Member of New York Etching Club. Died Jan. 23, 1922 in NYC.

MILLER, CORA E.
Painter. Born in Jenkintown, PA. Pupil of Penna. Academy of Fine Arts; Hugh Breckenridge; Fred Wagner. Member: Fellowship Penna. Academy of Fine Arts; Plastic Club. Address in 1929, 4524 Springfield Avenue, Philadelphia, PA.

MILLER, D. ROY.
Painter. Born in Mechanicsburg, Pennsylvania, February 8, 1891. Pupil of Garber, Breckenridge, Pearson. Award: European Traveling Scholarship, Pennsylvania Academy of Fine Arts, 1916. Resident Manager, Pennsylvania Academy of Fine Arts, Chester Springs. Address in 1929, Pennsylvania Academy of Fine Arts, Chester Springs, Chester County, PA.

MILLER, DELLE.
Painter, craftswoman, and teacher. Born in Independence, KS. Pupil of Kansas City Art Institute; Arthur W. Dow; Hugh Breckenridge; Art Students League of NY. Member: North Shore Arts Association; National Association of Women Painters and Sculptors; Western Art Association; Kansas City Society of Artists. Awards: Purchase prize, Kansas City Art Institute, 1922; hon. mention, Missouri-Kansas and Oklahoma Artists Exposition, 1923; prize, Kansas City Society of Artists, 1928. Work: "Morning Light of the Harbor," Kansas City Art Institute; "The Doorstep Garden," Greenwood School; "A New England Lane," Kansas City Public Library; "The Willows," Pittsburg, Kansas State Normal School; "Unconquered," N.W. Missouri St. Teachers College. Address in 1929, 3448 East 62nd Street, Kansas City, MO.

MILLER, DONALD RICHARD.
Sculptor and medalist. Born in Erie, PA, June 30, 1925. Studied at Dayton Art Institute, 1947-52; Pratt Institute, 1955-57; Art Students League, 1958-61; also with Ulysses A. Ricci, 1956-60. Work in Dayton Art Institute, OH; Medallic Art Co., NY; Division of Numismatics, Smithsonian Institution; two bronze reliefs, Cincinnati Zoo; Philadelphia Zoo; Washington Cathedral; others. Has exhibited at Allied Artists of America, from 1963; National Academy of Design, 1967-74; National Sculpture Society, from 1967; Soc. of Animal Artists, from 1968; others. Received Mrs. Louis Bennett Prize, Nat. Sculpture Soc. Teaching sculpture at Fashion Institute of Technology, from 1972. Member of National Sculpture Society (fellow); Society of Animal Artists; Am. Artists Prof. League (fellow); Allied Artists of America; Audubon Artists. Address 1982, Warwick, NY.

MILLER, ELEAZER HUTCHINSON.
Painter. Born in Shepherdstown, WV, in 1831. Painter in oils and water colors; also portraitist, etcher and illustrator. Visited Europe in 1875. Lived and worked in Washington after 1848. He was one of the organizers of the old Washington Art Club, and also aided in the organization of the Society of Washington Artists, of which he was three times the president. He was an etcher of prominence. Represented at Corcoran Art Gallery by "Moonrise and Twilight" (water color), painted in 1907. Died April 4, 1921, in Washington, D.C.

MILLER, ELIZABETH S.
Painter. Born in Lincoln, NE, in 1929. Studied: University of Nebraska, with Rudy Pozzatti, Walter Meigs, Kady Faulkner; Des Moines Art Center, with Louis Bouche; University of Colorado, with Carl Morris. Awards: Lincoln Art Guild, 1951; Iowa State Fair, 1956; Des Moines Art Center, 1956, 1958; Mulvane Art Museum, Topeka, 1958. Collections: Lincoln Art Guild; Lutheran Life of Christ collection, Des Moines Art Center; Mulvane Art Museum.

MILLER, EVYLENA NUNN (MRS.).
Painter, illustrator, lithographer, and teacher. Born in Mayfield, KS, July 4, 1888. Studied: Pomona College; University of California; Art Students League; also studied abroad. Awards: California State Fair, 1925; Women's Club, Hollywood, California, 1930; Festival Allied Artists, 1934; Los Angeles Museum of Art, 1937; Laguna Beach Art Association, 1953. Collections: Smithsonian Institution; Pomona College; Women's Christian College, Tokyo and Kobe, Japan; Chinese YMCA, California; Bowers Memorial Museum, Santa Ana, CA. One-woman exhibitions: Biltmore Art Salon; Ainslee Galleries, Los Angeles; Bowers Memorial Museum, Santa Ana, CA; Kievits Gallery, Pasadena. Group exhibitions: Los Angeles Museum; Southwest Museum; San Diego Art Museum; National Gallery of

Art, Washington, DC; San Francisco Legion of Honor; American Federation of Arts; Wichita Art Association; National Association of Women Artists. Member: Laguna Beach Art Association; National Association of Women Artists; Women Painters of the West; Society of Western Artists; Los Angeles Art Association. Address in 1962, Santa Ana, CA.

MILLER (or MILER), GEORGE M.
Sculptor and modeler. Born in Scotland; came to US towards the latter part of the eighteenth century. At Phila., 1798, and again from 1813; at Baltimore, c. 1810-12. He made busts of C. W. Peale, Bishop White, Commodore Bainbridge, Mrs. Madison, Mrs. Jerome Bonaparte, Jefferson, and, in 1798, of George Washington. He was a member of the Penna. Acad. of Fine Arts, exhibiting there from 1813-15, and the Columbian Society of Arts. He died in 1819.

MILLER, GODFREY.
Miniature painter, who flourished in New York, 1841-87.

MILLER, HARRIETTE G.
Sculptor and painter. Born in Cleveland, OH. Member: American Woman's Association; National Association of Women Painters and Sculptors; Alliance; Grand Central Art Galleries. Rep. in Whitney Mus., NYC; Corcoran Gallery, Washington, DC; and Grand Central Art Galleries. Address in 1933, Whimsy Farm, Arlington, VT; 17 rue de la Tour, Paris, France.

MILLER, IRIS MARIE ANDREWS.
(Mrs. Wm. N. Miller). Painter. Born in Ada, OH, March 28, 1881. Pupil of Chase, Henri, Breckenridge, Mora. Member: Detroit Society of Women Painters; National Association of Women Painters and Sculptors; National Arts Club; Am. Federation of Arts. Awards: Portrait prize, exhibition by Michigan Artists, 1923; Founders prize, Michigan Artists Exhibition, 1924; Scarab gold medal, Michigan Artists Exhibition, 1929. Address in 1929, 1135 Chicago Blvd., Detroit, MI.

MILLER, JOAN I.
Painter and printmaker. Born in Brooklyn, NY, Nov. 9, 1930. Studied: Tyler School of Art, Temple University, BFA; Brooklyn Museum; Parsons School; Ruth Leaf Studio (Etching). Work: Butler Institute, Youngstown, OH; Slater Memorial Museum, Norwich, CT; Philadelphia Museum of Art Lending Library. One-woman shows: Ocean Colony, Amagansett, NY; Phoenix Gallery, NYC, 1978, 81, 83; Artists Proof Gallery, East Hampton, LI, NY. Exhibited: Palazzo Vecchio, Florence; Philadelphia Print Club; Corcoran Gallery, Washington, DC; Brooklyn Mus.; National Arts Club; National Academy; Lever House; Architectural League; Guild Hall, East Hampton, LI, NY; and many others. Awards: National Arts

Club Award for Painting, Society of Painters in Casein; National Academy Award, National Association of Women Artists. Member: Phoenix Gallery, NYC; National Association of Women Artists. Address in 1983, 1192 Park Ave., NYC.

MILLER, JOSEPH MAXWELL.
Sculptor. Born in Baltimore, MD, December 23, 1877. Pupil of Maryland Institute School of Art and Design, Rinehart School of Sculpture and Charcoal Club in Baltimore; Julian Academy in Paris, under Verlet. Awards: Gold medal of honor, Maryland Institute School of Art and Design, 1897; Rinehart scholarship to Paris, 1901-05; honorable mention, Paris Salon, 1902; silver medal, St. Louis Expo., 1904; Officier d'Academie, 1912; honorable mention for medals, P.-P. Expo., San Francisco, 1915. Work: "Cardinal Gibbons," Penna. Academy of Fine Arts, and Metropolitan Museum, NY; "Ishmael," St. Louis Museum; "Separation of Orpheus and Eurydice," Peabody Institute, Baltimore; "Bust of Lady," Walters Gallery, Baltimore; monuments to French soldiers, Annapolis, MD; "School Children," Baltimore, MD; "Daniel Coit Gilmore Memorial," Johns Hopkins University, Baltimore. Exhibited at National Sculpture Soc., 1923. Address 1929, Baltimore, MD. Died in 1933, in Baltimore, MD.

MILLER, JOSEPH PINDYCK.
Sculptor. Born in NYC in 1938. Studied: Student apprentice to Alexander Archipenko, Woodstock, NY; Middlebury College, VT, B.A., 1960; Brooklyn Museum School of Art, NY, 1960-61; Silvermine Guild School of Art, New Canaan, CT, 1960-61. U.S. Army Illustrator, from 1961-63. One-man shows: Katonah (NY) Gallery, 1967; Sculpture 1972-1978, SUNY, Albany, 1978; Recent Steel Sculpture and Selected Work of the 70's, Bethel (CT) Gallery, 1979; Recent Sculpture & Wall Reliefs & Selected Work of 70's, Vassar College, Poughkeepsie, NY, 1981. Exhibitions: Katonah (NY) Gallery, 1966-78; Rose Fried Gallery, NYC, 1968; Phoenix Gallery, NYC, 1971; Gruenebaum Gallery, NYC, 1975; 28th Annual New England Exhibition, Silvermine Guild, CT, 1977; others. Address in 1983, Brewster, NY.

MILLER, JULIET SCOTT.
Painter, illustrator, and teacher. Born in Alexandria, VA, Dec. 12, 1898. Pupil of Boardman Robinson; G. P. du Bois; Minneapolis School of Art. Member: Art Students League of NY. Address in 1929, 51 East 9th Street, New York, NY.

MILLER, KATE RENO.
Painter. Born in Illinois. Pupil of Cincinnati Art Academy; Duveneck; Hawthorne. Member: Cincinnati Woman's Art Club. Instructor, Cincinnati Art Academy. Address in 1929, Art Academy; h. and studio, 4919 Ash Street, Norwood, Cincinnati, OH.

MILLER, KENNETH HAYES.
Painter, teacher, and etcher. Born in Kenwood, NY, March 11, 1876. Pupil of Art Students League of NY under Mowbray and Cox; New York School of Art under Chase. Work: "Interior" and "Woman in a Sculpture Gallery," Harrison Gallery, Los Angeles Museum; portrait of "Albert P. Ryder," "Apparition," "Consulting the Cards" and "White Kimono," Phillips Memorial Gallery, Washington, DC; figures with landscape, Metropolitan Museum; etchings, print collections, Public Library and Metropolitan Museum, New York; Whitney; Museum of Modern Art; Cleveland Museum. Instructor of painting and composition, Art Students League of NY, 1911-51. Address in 1929, care of F. K. M. Rehn Gallery, 693 Fifth Avenue; 30 East 14th Street, New York, NY. Died in 1952.

MILLER, LESLIE W(ILLIAM).
Painter, teacher, writer, and lecturer. Born in Brattleboro, VT, August 5, 1848. Pupil of Massachusetts Normal Art School and School of Boston Museum. Member: Philadelphia Art Club; Eastern Art Teachers' Association; T. Square Club (hon.); Boston Art Club; Fairmount Park Art Association; American Institute of Architects (hon.). Principal Emeritus, School of Industrial Art of the Pennsylvania Museum. Address in 1929, Oak Bluffs, MA.

MILLER, MARGUERITE C(UTTINO).
Painter and teacher. Born in Charleston, June 11, 1895. Pupil of Penna. Academy of Fine Arts. Member: Fellowship Penna. Academy of Fine Arts; Southern States Art League; Sketch Club of Carolina Art Association. Address in 1929, Studio 3, Gibbes Art Gallery; h. 138 Wentworth St., Charleston, SC; summer, 807 Flemming St., Hendersonville, NC.

MILLER, MAUDE ALVERA.
Painter, craftsman, and teacher. Born in Skylands, CA, July 31, 1883. Pupil of George Leykauf. Member: San Francisco Society of Women Artists. Award: Bronze medal, Panama-Pacific Expo., San Francisco, 1915. Address in 1929, 3412 Holly Avenue, Oakland, CA; h. 235 North Hancock Street, Los Angeles, CA.

MILLER, MILDRED BUNTING.
Painter and teacher. Born in Philadelphia, PA, June 21, 1892. Pupil of Anshutz, Vonnoh, Garber, Breckenridge and Violet Oakley. Member: Fellowship Penna. Academy of Fine Arts; Philadelphia Alliance; Plastic Club, Philadelphia. Awards: Two Cresson Scholarships, Penna. Academy of Fine Arts; Mary Smith prize, Penna. Academy of Fine Arts, 1920. Work: "Reflections," and "Paddock," Fellowship Penna. Academy of Fine Arts, Philadelphia; "Belgian Refugees," Mississippi Art Association, Jackson, MS; "Descending Night," Penna. Academy of Fine Arts. Address in 1929, Pennsylvania Academy of Fine Arts, Chester Springs, Chester Co., PA.

MILLER, MINNIE M.
Painter. Member: Plastic Club; Fellowship Penna. Academy of Fine Arts; American Federation of Arts; Phila. Alliance; Alumnae Phila. School of Design. Represented in Reading (PA) Mus. Address 1929, 3025 Queen Lane, Germantown, PA.

MILLER, OSCAR.
Painter. Born in New York, 1867. Pupil of Constant and Laurens in Paris. Member: NY Water Color Club. Address in 1929, Bristol Ferry, RI.

MILLER, REEVA A.
Painter. Born in Hollywood, CA, in 1912. Studied: Santa Monica City College; University of California at Los Angeles. Awards: Santa Monica Art Association, 1945, 1956. Collections: Dome, Al Jolson Memorial, Los Angeles; Beth Sholom Temple, Santa Monica (stained glass windows); Maarev Temple, Encino, Calif.; Temple Sinai, Oakland, California; Temples in Santa Monica, Inglewood, Long Beach and Burbank, California; Camp Shrader, Colorado.

MILLER, RICHARD E.
Painter and illustrator. Born in St. Louis, MO, March 22, 1875. Pupil of St. Louis School of Fine Arts; Constant and Laurens in Paris. Member: Associate Nat. Acad. of Design, 1913; Academician National Academy of Design, 1915; Nat. Association of Portrait Painters; St. Louis Artists Guild; Salma. Club; International Society of Painters, Sculptors and Gravers; American Art Association of Paris; Paris Society of American Painters; North Shore Arts Association. Awards: Third medal, Paris Salon, 1900; bronze medal, Pan-Am. Expo., Buffalo, 1901; silver medal, St. Louis Expo., 1904; second medal, Paris Salon, 1904; second medal, Liege Expo., 1905; Knight of the Legion of Honor, France, 1908; Temple gold medal, Penna. Academy of Fine Arts, 1911; Palmer gold medal, Art Institute of Chicago, 1914; Clark prize, National Academy of Design, 1915; medal of honor, P.- P. Expo., San Francisco, 1915. In collections of Luxembourg Gallery, Paris; Metropolitan Museum of Art; Gallery of Modern Art, Rome; Corcoran; City Art Museum, St. Louis; Albright; Penna. Academy of Fine Arts; Art Institute of Chicago; Detroit Institute; Cincinnati Museum; Queen City Art Club, Cincinnati; Carnegie; State Capitol, Jefferson City, MO; Royal Museum of Christiania; King of Italy's private collection; Museum of Fine Arts, Antwerp; Modern Gallery of the City of Venice; Musee du Petit Palais, Paris. Address in 1929, care of Grand Central Galleries, 15 Vanderbilt Avenue, New York, NY; Provincetown, MA.

MILLER, (RICHARD) GUY.
Sculptor. Born in Pittsburgh, PA. Studied at City and Guilds of London Art Council, with Ennis Fripps, 1958; Art Students League, NY, with Will Barnet, Robert Hale; Pratt Institute, Brooklyn, NY,

with Calvin Albert, M.F.A., 1965. Work in Pratt Institute, Brooklyn; stainless steel wall sculpture, New School, NY; others. Has exhibited at Guild Hall, East Hampton, NY; Heckscher Museum, Huntington, NY, 1975 and 81; Betty Parsons Gallery, NY, 1979, 80, and 81; others. Awards: Tiffany Foundation grant, 1966; MacDowell Colony Foundation fellowship, 1968; others. Member of Art Students League, NY. Works in stainless steel; lucite. Address in 1982, 25 Minetta Lane, NYC.

MILLER, RICHARD McDERMOTT.
Sculptor. Born April 30, 1922, in New Philadelphia, OH. Studied: Cleveland Institute of Art, 1940-42, 1949-51, grad., 51. Work: Butler Institute; Columbia, SC, Museum of Art; Massillon Museum; University of Nebraska; Whitney Museum; Canton Art Institute; Hirshhorn Museum, Washington, DC; University of Houston. Exhibited: Peridot Gallery, 1964, 66, 67, 69, Feingarten, Los Angeles, 1966; Duke University, 1967; Raleigh (NC) Museum of Art, 1967; Cleveland Museum of Art, 1968; Alwin Gallery, London, 1968; Whitney; National Institute of Arts and Letters; Baltimore Museum of Art; Butler, Sculpture Annual, 1970; Penna. Academy of Fine Arts, 1981; others. Awards: May Page Scholarship, Cleveland Institute of Art, 1951; Butler purchase prize, 1970; gold medals, National Academy of Design, 1974 and 81; Sculpture Award, American Academy and Institute of Arts and Letters, 1978. Taught at Queens College, NYC, from 1967. Address in 1983, 53 Mercer St., NYC.

MILLER, ROSE SHECHET.
Sculptor. Studied: Boston Museum of Fine Arts; Massachusetts College of Art. Awards: Brockton Art Association, 1965; Newport, RI, Art Association, 1974; Nat. Community Art Program, Washington, DC, 1974. Exhibitions: Eastern States Exposition, 1964; Boston Visual Artists' Union Gallery, 1975; M.I.T. Faculty Club, 1975.

MILLER, SUSAN BARSE (MRS.).
Painter. Born in Adrian, MI. Pupil of Colarossi Academie de la Grand Chaumiere, Paris; Hugh Breckenridge; William M. Chase. Member: North Shore Arts Association; Fellowship Penna. Academy of Fine Arts. Work: "The Tuareg Girl," Los Angeles Museum; "Zobieda," Pasadena Mus., Pasadena, CA. Address 1929, Grapevine Rd, East Gloucester, MA.

MILLER, WILLIAM.
Engraver. Born in New York, Dec. 3, 1850, of German parents; died Jan. 10, 1923. Started engraving on wood at Frank Leslie's publishing house, 1868; studied drawing, etc., in Germany, 1871-73; associated with Frederick Juengling, 1877-89. Exhibited in New York; Munich Salon; Paris Exposition, 1900. Received medals, Chicago Expo., 1893; Buffalo Expo., 1901.

MILLER, WILLIAM H.
Born 1820 in England. Miniature painter, who flourished about 1846-47, New York.

MILLER, WILLIAM HENRY.
Portrait painter. Born in Philadelphia, PA, in 1854. Pupil of Penna. Academy of Fine Arts under Eakins. Member: Fellowship of Penna. Academy of Fine Arts; Philadelphia Sketch Club. Instructor of drawing, Episcopal Academy, Philadelphia. Address in 1926, 102 West Montgomery Avenue, Ardmore, PA.

MILLES, CARL.
Sculptor and teacher. Born in Lagga, Sweden, 1875. Apprenticed to cabinet-maker in Stockholm in 1892. Studied at the Technical School, Stockholm; Ecole des Beaux-Arts, Paris. Became an assistant to Rodin in Paris. Taught at Royal Academy in Stockholm; Cranbrook Academy of Art in Michigan. Became a U.S. citizen in 1945. Work: Monuments, memorials, and figures, Whitney Museum of American Art; Cranbrook Academy of Art; City Hall, St. Paul, MN; Art Institute of Chicago; Tale Gallery, London; heroic figures, fountains, etc., in many cities in Sweden. Member: National Institute of Arts and Letters; National Sculpture Society. Awarded prize, Golden Gate Exposition, 1939. Address in 1953, Cranbrook Academy of Art, Bloomfield Hills, MI. Died in Lidingo, Sweden, 1955.

MILLESON, ROYAL HILL.
Landscape painter. Born in Batavia, OH, in 1849. Member: Chicago Society of Artists; Boston Art Club. Work: "Mt. Hood, Oregon," Herron Art Institute, Indianapolis. Author, "The Artist's Point of View." Address 1926, 2336 Osgood St., Chicago, IL.

MILLET, CLARENCE.
Painter and teacher. Born in Hahnville, LA, March 25, 1897. Pupil of George Bridgman; Art Students League of NY. Member: New Orleans Art Association; New Orleans Arts and Crafts Club; American Federation of Arts; Southern States Art League; Mississippi Art Association. Awards: Silver and gold ribbons, Mississippi Art Association, 1925-1926, and gold medal, 1927; purchase prize, Mississippi Fair Assoc., 1928; Wm. P. Silva prize ($100), Southern States Art League, 1929. Represented in Louisiana Polytechnic Institute, Ruston, LA; Municipal Art Gallery, Jackson, MS; Warren Easton High School, New Orleans. Address in 1929, 628 Toulouse Street; h. 1240 North Galvez Street, New Orleans, LA.

MILLET, FRANCIS DAVIS.
Painter. Born 1846 in Mattapoisett, MA. Graduated from Howard University, 1869. Awarded medal at Royal Academy of Antwerp. He was elected a National Academician in 1885, and served one or two terms as vice-president. His painting "At the Inn"

was exhibited at the Centennial Exhibition of the National Academy of Design in 1925. Died April 15, 1912 on the S. S. *Titanic*.

MILLET, GERALDINE R.
(Mme. Francois Millet). Painter. Born in America. Pupil of Alfred Stevens in Paris, and Maurice Denis. Studied fresco painting with Baudouin at Fontainebleau. Address in 1929, Barbizon, S. et M., France.

MILLET, THALIA W.
See Malcom, Thalia Westcott.

MILLETT, G. VAN.
Painter. Born in Kansas City, MO, April 5, 1864. Pupil of Royal Academy of Fine Arts in Munich, under Gysis and Loefftz. Award: Silver medal, Munich Academy. Represented in Kansas City Art Institute; Public Library and City Hall, Kansas City. Address in 1929, 520 Studio Bldg.; h. 421 West 61st Street Terrace, Kansas City, MO.

MILLIER, ARTHUR.
Etcher. Born in Weston-super-Mare, Somerset, England, Oct. 19, 1893. Pupil of California School of Fine Arts. Member: Chicago Society of Etchers; California Society of Etchers; Print Makers' Society of California; California Art Club. Award: Prize, Calif. Soc. of Etchers, 1922 and 1928. Represented by etchings in the Art Insti. of Chicago and the LA Museum. Editor of "Art and Artists" page, *Los Angeles Times*. Address in 1929, Los Angeles Times, 100 North Broadway, Los Angeles, CA.

MILLIGAN, GLADYS.
Painter. Studied: Western College for Women, Oxford, OH; Westminster College, New Wilmington, PA; Pratt Institute of Art School; Fontainebleau, France; and with George Luks, and Andre L'Hote in Paris. Coll: Phillips collection, Washington, DC.

MILLIS, CHARLOTTE (MELISSA).
Sculptor. Born in Palo Alto, CA, Dec. 23, 1906. Studied at University of Chicago, Ph.B.; Art Institute of Chicago, B.F.A.; Carnegie Art Center, University of Oregon. Works: International Business Machines collection; Church of the Redeemer, Chicago, IL. Exhibited: Art Institute of Chicago, 1935, 46-50; New York World's Fair, NYC, 1939; Oakland Art Gallery, 1942; Minneapolis Institute of Art, 1935-37, 39, 41, 42, 44; St. Paul Gallery, 1941-45; Syracuse Museum of Fine Art, 1950; and many others. Taught art at Macalester College, St. Paul, MN, 1944-45; and was assistant professor of art at George Williams College, Chicago, IL, from 1950. Member: Artists Equity Association; Renaissance Society; Midwest Sculptors and Potters. Awards: Minneapolis Institute of Art, 1935, 36, 41, 44; Minnesota State Fair, 1942; Walker Art Center, 1944. Address 1953, 5315 So. Drexel Ave.; h. 5744 Kenwood Avenue, Chicago, IL.

MILLMORE, JOSEPH.
Sculptor. Born in Ireland in 1842. Brother of Martin Millmore. He worked with his brother on the memorial to the Union dead in Mount Auburn Cemetery, Cambridge, MA. He died in Geneva, Switzerland, 1886.

MILLMORE, MARTIN.
Sculptor. Born in Ireland, 1845. He entered the studio of Thomas Ball in Charlestown in 1860. He soon took a studio and modeled busts of Longfellow and Sumner, and also executed marble statues for Horticultural Hall, Boston. Millmore executed a bust of George Ticknor for the Public Library, Boston; also busts of C.O. Whitmore, General Thayer, and an ideal bust of "Miranda." He died in Roxbury, MA, 1883.

MILLS, CLARK.
Sculptor. Born near Syracuse, NY, December 13, 1810/15. He lived in Charleston, SC, where he discovered a method of taking casts from the living face. He executed busts of a number of eminent South Carolinians. He designed the Jackson monuments in Washington and New Orleans; a scene in the battle of Princeton with a statue of Washington which was dedicated in Washington, DC, on February 22, 1860; also was commissioned to cast a bronze of Crawford's "Freedom" for the U.S. Capitol Dome. He died January 12, 1883, in Washington, DC.

MILLS, J. HARRISON.
Sculptor, painter, and poet. Born in Buffalo, New York, 1842. His early life was spent in Denver, CO. He was long a member of the New York Water Color Club. Works held at Buffalo Academy of Fine Arts. Died in Buffalo, NY, October 25, 1916.

MILLS, LOREN STURDEVANT (STURDY).
Sculptor and designer. Born in Atkinson, NE, January 8, 1915. Studied: Minneapolis School of Art; Kansas City Art Institute; University of Nebraska. Exhibited: Syracuse Museum of Fine Arts, 1940; Minneapolis Institute of Art, 1935; St. Paul Artists, 1935; Kansas City Art Institute, 1938-40; Nelson Gallery of Art, 1941; Missouri State Fair, 1938-41; Philbrook Art Center, 1940; Nebraska Art Museum, 1946; Lincoln Art Guild, 1946; Joslyn Art Museum, 1950. Taught: Instructor of Sculpture and Ceramics, Kansas City Art Institute, Kansas City, MO, 1938-40. Address in 1953, Lincoln, NE.

MILLS, THEODORE AUGUSTUS.
Sculptor. Born in Charleston, SC, in 1839. Eldest son of Clark and Eliza S. Mills. During his boyhood he pursued modeling as an amusement, without regular instruction, until 1860, when he entered the Royal Art Academy of Munich as a pupil. Received a prize for his composition "Penelope Presenting the Bow of Ulysses to the Suitors" at the academy. Returned to

United States and commenced work in the studio of his father, Clark Mills, then engaged in making a model for a proposed memorial in Washington to President Lincoln; was afterwards employed by the National Museum, Washington, and later at the Carnegie Institute, Pittsburgh. Noted for his Indian groups. He died December, 1916, in Pittsburgh, PA.

MILLS, THOMAS HENRY.
Painter, illustrator, etcher, and writer. Born in Hartford, CT. Pupil of Kenyon Cox and W. M. Chase. Member: North Shore Arts Association; American Federation of Arts. Address in 1929, Bass Rocks, Gloucester, MA.

MILNE, DAVID B.
Painter and illlustrator. Born in Paisley, Ontario, Canada, Jan. 8, 1882. Pupil of Art Students League of NY, under Du Mond, Reuterdahl and Bridgman. Member: NY Water Color Club; Philadelphia Water Color Club. Award: Silver medal, P.-P. Expo., San Francisco, 1915. Represented in Canadian War Memorials Collection, Ottawa. Address in 1929, care of Rene Clarke, 247 Park Avenue, New York, NY.

MILNE, MAY FRANCES.
Painter. Born in Brooklyn, NY, in 1894. Address in 1926, Boston Corners, Columbia County, NY.

MILSOM, EVA GRACE.
Painter, craftswoman, writer and teacher. Born in Buffalo, NY, Dec. 8, 1868. Studied with Bischoff, Rose Clark, J. H. Mills, and in Europe. Member: Buffalo Soc. of Artists; Buffalo Guild of Artists; Buffalo Soc. of Min. Painters; Buffalo Art Club. Chairman of Art, West. NY Fed. of Women's Clubs. Rep. in Albright Art Gallery, Buffalo. Died 1944. Address in 1929, Lake Shore, Angola, NY.

MIM, ADRIENNE C.
(ADRIENNE CLAIRE SCHWARTZ).
Painter and sculptor. Born in Brooklyn, NY, Feb. 4, 1931. Studied at Brooklyn Museum Art School and Brooklyn College, NY, 1950; Hofstra University, 1965. Work at Guild Hall, East Hampton, NY; Sculpturesites, Amagansett, NY. One-man shows: Fordham Univ., Lincoln Ctr., NY; Phoenix II Gallery; Guild Hall. Group shows: Heckscher Museum, Huntington, NY; Brooklyn Mus.; Parrish Mus., Southampton, NY; Pace Univ. Received Fellowship, MacDowell Colony; Helen B. Ellis Mem. Prize, Nat. Assoc. of Women Artists, 1980; Silver Medal, Audubon Artists, 1980. Member of Fed. of Modern Painters and Sculptors; Nat. Assoc. of Women Artists; Sculptors Guild. Works in fiberglas, steel; oil, mixed media. Address in 1982, East Hampton, NY.

MINAZZOLI, EDWARD A.
Sculptor. Born in Momo, Italy, August 16, 1887. Pupil of Art Students League of NY; Niehaus,

Fraser, Bartlett; Antonin-Mercie at Ecole des Beaux Arts in Paris. Member: American Art Association of Paris; American Federation of Arts. Awards: Chevalier order of Donilo, 1918; Chevalier of the Crown of Italy, 1922; hon. mention, Paris Salon, 1929, and medal, 1932; Officier d'Academie, 1932. Works: Groups, "Apparition N.D. de Lourdes" and "St. Theresa of Lisieux," at Cathedral of Chatillon, Loire, France; group, Fountain Garden, Poughkeepsie, NY; statue, West New York. Many notable portrait busts. Address in 1933, 18 Bld. Edgar Quinet; h. 17 bis Rue Campagne Premiere, Paris XIV, France; 60 19th Street, West New York, NJ.

MINER, EDWARD HERBERT.
Painter and illustrator. Born in Sheridan, NY, Jan. 23, 1882. Member: Salma. Club; Society of Illustrators. Work: Series of paintings of horses and of cattle, owned by the National Geographic Society. Address in 1929, Westbury, L.I., NY.

MINER, FRED R.
Painter and writer. Born in New London, CT, Oct. 28, 1876. Pupil of Art Students League of NY; William Wendt, John Carlson. Member: California Art Club; Laguna Beach Art Association; Society of Independent Artists. Award: Bronze medal, Expo., San Diego, 1915. Work: "The Old Oak," Union League Club, Los Angeles; "Late Afternoon, Garapatos Canon," Glendale Sanitarium, CA. Address in 1929, 1045 Stevenson Avenue, Pasadena, CA.

MINER, GEORGIA WATSON.
(Mrs. Lewis H. Miner). Painter, craftswoman, writer, lecturer, and teacher. Born in Springfield, IL, April 4, 1876. Pupil of C. A. Herbert and Dawson-Watson, Mabel Dibble, Matilda Middleton. Member: Chicago Artists Guild; Springfield Art Association. Awards: Illinois State Centennial medals, 1918, for best painting and work in ceramics. Represented in Springfield Art Association. Address in 1929, 1717 South 6th Street, Springfield, IL; summer, Old Mission, MI.

MINGO, NORMAN THEODORE.
Painter and illustrator. Born in Chicago, IL, Jan. 20, 1896. Pupil of Chicago Academy of Fine Arts; Art Institute of Chicago; Art Students League. Address in 1929, Lake Michigan Bldg., Chicago, IL; h. 740 Hinman Avenue, Evanston, IL.

MINISCI, BRENDA (EILEEN).
Sculptor and ceramist. Born in Gowanda, NY, June 15, 1939. Studied at Rhode Island School of Design, Rome, Italy, 1960-61, Providence, B.F.A., 1961; Cranbrook Academy of Art, Bloomfield Hills, MI, M.F.A., 1964; Provincetown Fine Arts Workshop, with Harry Hollander. Work in Everson Museum, Syracuse, NY; Fitchburg Art Mus., MA; fiberglas fountain sculpture and clear cast polyester resin

sculpture, University of Massachusetts, Amherst; others. Exhibited at Cranbrook Art Museum, Bloomfield Hills; Museum of Contemporary Crafts, NY; Smithsonian Institution; Everson Museum, Syracuse; Seven Sculptors, Boston City Hall Galleries, Massachusetts; others. Received award for sculpture, Providence Rhode Island Art Club; purchase prize for sculpture, Berkshire Museum, North Adams College; others. Taught ceramics and sculpture at University of Mass., Amherst, 1967-71; teaching ceramics and sculpture at Williston-Northampton School, Easthampton, MA, from 1971. Address in 1982, North Hatfield, MA.

MINKER, GUSTAVE, SR.
Painter. Born in Germany, May 18, 1866. Pupil of Westheld in Germany, F. Ballard Williams and Gustave Cimiotte. Member: Newark Art Club; Art Centre of the Oranges; Montclair Art Association; American Federation of Arts. Address in 1929, 187 Garden Avenue, Belleville, NJ.

MINOR, ANNE ROGERS.
(Mrs. George Maynard Minor). Painter. Born in East Lyme, CT, April 7, 1864. Pupil of Robert C. Minor. Member: American Federation of Arts; New Haven Paint and Clay Club; Connecticut Academy of Fine Arts. Address in 1929, Waterford, CT.

MINOR, ROBERT CRANNELL.
Painter and etcher. Born April 30, 1839 in New York. Died in Waterford, CT, August 3, 1904. Landscape painter. Pupil of Van Luppen in Antwerp; and of Diaz and Boulanger in Paris. Awards: Hon. mention, Paris Expo., 1900; silver medal, Pan-American Expo., Buffalo, 1901. Elected to National Academy, 1897; Society of Landscape Painters; New York Etching Club. Represented at Corcoran Art Gallery, Washington, D.C., by "Eventide."

MINOR, WENDELL GORDON.
Illustrator. Born in Aurora, Illinois, in 1944. He studied at the Ringling School of Art from 1963 to 1966. He worked as a designer for Hallmark Cards and his first works appeared in *Cards Magazine*. He was an art director and designer, both in Chicago and NY, before beginning a free-lance illustration career in 1970. His clients include *Bantam, Random House, Avon, Dell* and other book publishers. He has had exhibitions in NY at the Greengrass and Chisholm Galleries, and in NM at the Brandywine Gallery. He is a member of the faculty at Soc. of Visual Arts.

MIRANDA, FERNANDO.
Sculptor. Exhibited at National Sculpture Society, New York.

MIRKO (MIRKO BASALDELLA).
Sculptor. Born 1910 in Undine, Italy. Studied in Venice, Florence, and Rome. Director of Design

Workshop at Harvard University since 1957. Received awards from Sao Paulo Museum; the Carrara sculpture prize; and gold medal from Republic of Italy. Exhibited at Galleria La Cometa (Rome), 1935; Comet Gallery, NYC (1947, 49); RI School of Design; Institute of Contemporary Art (Boston); University of Illinois; many other international galleries.

MISH, CHARLOTTE (ROBERTA).
Sculptor, painter, illustrator, craftswoman, writer, and teacher. Born in Lebanon, PA, August 17, 1903. Pupil of W. L. Judson, F. Tadema, F. Vincent DuMond, Art Students League of NY; College of Fine Arts, University of So. California. Member: Portland Art Association; Oregon Society of Artists. Work: Music Box Theatre, Seattle. Address in 1933, Portland, OR.

MITCHAM, GEORGIA WHITMAN.
Sculptor. Born in Providence, RI, July 4, 1910. Studied at Slade School of Art, University of London; with Naum M. Los, NY. Works: American Museum of Natural History, NY; Smithsonian Institution, Washington, DC; Bennington Museum, VT; Norwich University, Northfield, VT; Harvard University, Cambridge, MA. Commissions: Two champion Angus bulls, commissioned by Gifford Cochrane, North Salem, NY; bas-relief of dinosaur. American Museum of Natural History; others. Exhibitions: One-man shows, Studio Guild, NY, 1938, Southern Vermont Art Center, Manchester, 1969 and Bennington Museum, 1972, 73; Child's Gallery, Boston, 1964. Awards: First for Sculpture, Northern Vt. Artist, 1963, Saratoga Art Festival, NY, 1964, and Norwich Show, Northfield, VT, 1975. Member of Southern Vermont Art Center and National League of American Pen Women. Media: Aluminum, lead, and iron. Address in 1980, Middlebury, VT.

MITCHELL, ALFRED R.
Painter and teacher. Born in York, PA, June 18, 1888. Pupil of Daniel Garber, Joseph T. Pearson, and Maurice Braun. Member: Fellowship Pennsylvania Academy of Fine Arts; San Diego Fine Arts Society; California Art Club. Awards: Silver medal, Panama-California Exposition, San Diego, 1915; Cresson Traveling Scholarship, Pennsylvania Academy of Fine Arts, 1920; Philadelphia prize, Pennsylvania Academy of Fine Arts, 1920; Art Guild prize, San Diego Fine Arts Society, 1926. Work: "In Mission Valley, San Diego," Reading Museum, Reading, Pennsylvania. Address in 1929, 1527 Granada Avenue, San Diego, CA.

MITCHELL, ARTHUR.
Painter. Born in Gillespie, IL, Feb. 5, 1864. Pupil of St. Louis School of Fine Arts. Member: 2 x 4 Society; St. Louis Artists Guild. Address in 1929, 4211 Castleman Avenue, St. Louis, MO.

MITCHELL, BENJAMIN T.
Sculptor. Born January 12, 1816 in Muncy, PA; settled in Nauvoo, IL, in 1841; moved to Utah in 1848. Cut the first capital for the Mormon Temple at Nauvoo, IL, about 1844. Died in Salt Lake City on March 9, 1880.

MITCHELL, CHARLES DAVIS.
Illustrator. Born in Wilmington, Delaware in 1887. He maintained a studio in Philadelphia throughout his career. His charcoal and pencil drawings, often of beautiful women, appeared for many years in *Redbook, McCall's, Delineator, Cosmopolitan,* and others. He was a member of the Artists Guild and Art Club of Philadelphia.

MITCHELL, E.
Engraver. Fenshaw, in his work on book-plates, says that this English book-plate engraver was working in the U.S. in 1790. American book-plates so signed have been found.

MITCHELL, GEORGE BERTRAND.
Painter, sculptor, illustrator, writer, and lecturer. Born in East Bridgewater, MA, April 18, 1872. Studied: Cowles Art School, Boston; Julian Academy, Ecole des Beaux-Arts, Paris, France. Work: Agricultural Dept., State of Connecticut; Marine Historical Association, Mystic, CT; Lyman Allyn Museum. Exhibited: American Watercolor Society, 1945, 46; Salmagundi Club, 1917-51; others. Awards: Honorable mention, Paris Salon, 1890. Member: American Watercolor Society; Salma. Club; Mystic Art Association; Rutherford Art Assoc.; American Artists Professional League; Marine Hist. Assoc. Address in 1953, Mystic, CT; h. Rutherford, NJ.

MITCHELL, GLADYS VINSON (MRS.).
Sculptor and painter. Born in Albuquerque, NM, March 1, 1894. Pupil of Boyer Gonzales and E. G. Eisenlohr. Member: Chicago Artists Guild. Award: Silver medal, Woman's Forum, Dallas Art Association, 1916. Work: "Snow Composition," Museum of Santa Fe; represented in collection of Houston Artists' League. Address in 1924, 139 So. Elmwood Ave., Oak Park, IL.

MITCHELL, GLEN.
Painter and illustrator. Born in New Richmond, IN, June 9, 1894. Pupil of Chicago Academy of Fine Arts; Art Institute of Chicago; AGC, Paris; additional studies in Spain, Italy, Egypt and Palestine. Awards: First Alumni Art Institute of Chicago prize, Art Inst. of Chicago, 1919, 1920, 1921; fellow, Guggenheim Mem. Found., 1926-1927. Work: "Sacrifice," First M. E. Church, New Richmond, IN; "Emigrants," Rotary Club, Chicago. Illustrated *The Heritage* (Scribner's); illustrations for *Liberty Weekly, Ladies Home Journal, Woman's Home Companion, Colliers Weekly.* Address in 1929, 2 East 12th Street, New York, NY.

MITCHELL, GUERNSEY.
Sculptor. He was a graduate of the Ecole des Beaux Arts in Paris. Worked and exhibited in Paris, where he won honorable mention in 1890. Among his best-known works are the statue of Martin B. Anderson, former president of the University of Rochester; "Aurora;" "The Young Botanist;" and "David and Goliath." Died in Rochester, NY, August 1, 1921.

MITCHELL, HARVEY.
Portrait painter. Born c. 1801 in Virginia. He was painting in 1830 at Charleston, SC.

MITCHELL, JAMES MURRAY.
Painter, illustrator, and etcher. Born Edisto Island, SC, Nov. 9, 1892. Member: Society of Illustrators. Address in 1929, 116 West 39th Street, New York, NY; h. 9429 210th Street, Queens Village, NY.

MITCHELL, JOHN.
Painter. Born in Hartford, CT, in 1811. Died in 1866 in NYC. His work was largely done in Hartford and in New London.

MITCHELL, JOHN BLAIR.
Painter. Born in Brooklyn, NY, Jan. 30, 1921. Studied: Pratt Institute, Cert. 1939-43; Pratt Institute School of Education, 1946-47; Columbia University Teachers College; Pratt Graphics Arts Center, with Edmondson, Rogalski, and Ponce de Leon; NYU School of Education, PhD, 1963. Work: Metropolitan Museum of Art; Baltimore Museum of Art; Library of Congress; Silvermine Guild Artists, CT; others. Exhibitions: Corcoran Gallery, Washington, DC; Library of Congress National Print Exhibition; Silvermine Guild; Baltimore Museum of Art; Johns Hopkins; and others. Awards: Silvermine Guild of Artists; Library of Congress; Corcoran Gallery of Art; MD State Arts Council; Works in Progress Grant. Teaching: Columbia University Teachers College, 1949-80; and others. Member: Artists Equity Association; Baltimore Print Club. Address in 1982, 9918 Finney Drive, Baltimore, Maryland.

MITCHELL, LAURA M. D.
Miniature painter. Born in Halifax, Nova Scotia, Can. Pupil of George Bridgman, Kenyon Cox, Alice Beckington at Art Students League of NY, Lucia Fairchild Fuller. Member: CA Soc. of Miniature Painters (president and founder); CA Art Club; Pasadena Soc. of Women Painters and Sculptors. Awards: First prize, C. L. Wolfe Art Club, NY, 1908; gold medal, Panama-Calif. Expo., San Diego, 1915; gold medal, Panama-Calif. International Expo., San Diego, 1916; popular prize, CA Soc. of Miniature Painters, 1923; hon. mention, CA Soc. of Miniature Painters, 1924, 25; special gold medal, Pac. Southwest Expo., 1928; Mrs. Oliver P. Clark Prize, CA Soc. of Miniature Painters, and Popular Vote Prize, 1929. Address in 1929, 307 South 4th St., Alhambra, CA.

MITCHELL, THOMAS JOHN.
Painter. Born in Rochester, NY, Feb. 22, 1875. Pupil of Rochester Art School. Member: Rochester Art Club; Buffalo Society of Artists; Geneseeans; Salma. Club. Address in 1929, 41 Heidelburg Street; 70 Reynolds Arcade, Rochester, NY.

MITTELL, SYBILLA.
See Weber, Sybilla Mittell.

MITTLEMAN, ANN.
Painter. Born January 15, 1898, in New York City. Studied: New York University; New School for Social Research; and with Philip Evergood, Robert Laurent, and Tchac Basov. Collections: Everhart Museum of Art; Seattle Art Museum; Zanesville, Ohio; Smith College; Jewish Museum; Hickory, North Carolina; New York University Museum; Richmond Indiana Art Association; Evansville, Indiana; Florence South Carolina Museum of Art; Delgado Museum of Art; Lowe Gallery of Art, Coral Gables; Birmingham Mus. of Art; others. Exhibited: Bodley Gallery; Wickersham Gallery, one-woman retrospective, University of Minn. Member: American Society of Contemporary Artists; Nat. Association of Women Artists; Artists Equity Association; fellow, Royal Society of Arts, London. Media: Oil. Address in 1976, 710 Park Avenue, New York, NY.

MIX, FLORENCE.
Painter of portraits and landscapes. She was born in Hartford, CT, in 1881. Died in Oct. 1922, in Glenwood, L.I., NY.

MOCHARNIUK, NICHOLAS (NIMO).
Sculptor, designer, and craftsman. Born in Philadelphia, PA, May 11, 1917. Studied: Girard College, Philadelphia, PA. Member: League of Present-Day Artists; Woodstock Art Association. Awards: Prize, Springfield Museum of Art, 1945. Work: Springfield (MO) Museum of Art. Exhibited: Marquie Gallery, 1943-46 (all one-man); Allied Artists of America, 1945; Audubon Artists, 1945; League of Present-Day Artists, 1946. Address in 1953, 318 Canal Street, New York, NY; h. Butternut Hill Farm, Gilboa, NY.

MOCHI, UGO.
Sculptor and painter. Born in Florence, Italy, in 1889. U.S. citizen. Studied: Academy of Fine Arts, in Florence, 1899; scholarship to the Art Academy, in Berlin, Germany, 1910; sculpture with August Gaul. Exhibited sculpture in London, 1922, where Queen Mary purchased Mochi's works for the Royal Collection at Windsor Castle; New York Museum of Science and Industry; Columbia University; College of New Rochelle; Albany Institute of History and Art (one-man), 1974; others. Exhibitions of outline art included Windsor Castle; Berlin Museum of Natural History; Metropolitan Museum of Art; and the Mus. of Natural History, New York City. Awards: Award for museum work, New York Zoological Society, 1969; first prize for graphics, Federation of Westchester Art Clubs, 1952, and Beaux Arts, White Plains, NY, 1971. Member: New York Society of Animal Artists (ranking officer); NY Zoological Soc.; Audubon Artists. Author of *African Shadows, Hoofed Mammals of the World, American Water and Game Birds*, others. Address in 1976, New Rochelle, NY. Died in 1977.

MOCK, GEORGE ANDREW.
Painter. Born in Muncie, IN, May 18, 1886. Pupil of Art Institute of Chicago. Member: Indiana Art Club; Brown Co. Group of Painters; Hoosier Salon. Address in 1929, R. F. D. No. 4, Muncie, IN.

MOCK, GLADYS AMY.
Painter, etcher and writer. Born in New York City. Studied: Art Students League, and with Kenneth Hayes Miller. Awards: National Association of Women Artists, 1946, 1954; Pen and Brush Club, 1946, 1955; Champlain Valley Exhibition, 1951. Collections: Penna. Academy of Fine Arts; Todd Museum, Kalamazoo, Michigan; Library of Congress; Kansas State College; Hays, Kansas; Metropolitan Museum of Art; Smithsonian Institution. Address in 1929, 10 MacDougal Alley, New York, NY.

MODEL, ELISABETH DITTMANN.
Painter and sculptor. Born in Bayreuth, Bavaria, in 1903. Became a U.S. citizen. Studied at College of Art, and with Walter Thor and Cericioli, Munich, Bavaria; Acad. of Art, Amsterdam, Holland; and in Paris with Kogan. Works: Corcoran Gallery of Art; Wadsworth Atheneum; Jewish Museum, New York; Rykspreuteu Cabinet, Amsterdam, Holland; others. Exhibitions: One-woman shows in Europe, NYC, Washington; Museum of Fine Arts, Philadelphia; Museum of Fine Arts, Boston; Brooklyn Museum; Stedelijk Museum, Amsterdam, Holland; plus many others. Awards: National Association of Women Artists, 1950, 51, 52; Brooklyn Society of Artists, 1953, 54. Member: Federation of Modern Painters and Sculptors (corr. sec.). Taught: Private lessons in Amsterdam, Holland, 1930-38, and in NYC, 1942-48. Address in 1982, 340 W. 72nd St., NYC.

MODJESKA, MARYLKA H.
Painter and etcher. Born in Chicago, IL, Jan. 22, 1893. Pupil of Art Institute of Chicago; Art Students League; Julian Academy; and of George Senseney, George Degorce, Jerry Farnsworth. Member of Chicago Society of Etchers; Alumni, Art Institute of Chicago; Provincetown Art Association; Palette and Brush Club. Work in Art Institute of Chicago. Address in 1953, Tucson, AZ.

MODRA, THEODORE.
Painter. Born in Poland, May 13, 1873. Pupil of Henri; Colarossi Academy, Paris; Groeber in Munich.

Member: National Arts Club; MacDowell Club: California Art Club; Allied Artists of America; Society of Independent Artists; California Water Color Society; Los Angeles PSC; Artland Club; Laguna Beach Art Association. Address in 1929, 2003 Canyon Drive, Hollywood, CA.

MOELLER, GUSTAVE.
Painter and teacher. Born in Wisconsin, April 22, 1881. Studied in Milwaukee, New York, Paris and Munich. Member: Wisconsin Painters and Sculptors. Awards: Hon. mention, Milwaukee Art Institute, 1917; hon. mention, Painters and Sculptors, 1922; silver medal, Milwaukee Art Inst., 1923; Milwaukee Journal Purchase prize, 1926. Director, Dept. of Art, State Teachers College, Milwaukee. Address in 1929, 1039 Third Street; h. 1079 39th Street; Milwaukee, WI.

MOELLER, HENRY NICHOLAS.
Sculptor and painter. Born in New York City, January 5, 1883. Pupil of Hinton, Curran, MacNeil, Aitken. Work: Memorial tablet to Elisha Kent Kane in the Grand Lodge of Masons of Cuba. Address in 1933, 140 West 88th Street, New York, NY.

MOELLER, LOUIS CHARLES.
Painter. Born in New York, Aug. 5, 1855. Pupil of National Academy of Design in New York; Diez and Duveneck in Munich. Member: Associate National Academy of Design, 1884, Academician National Academy of Design, 1894. Work: "Disagreement," Corcoran Gallery, Washington. Address in 1929, 714 Park Avenue, Weehawken, NJ.

MOELLER, SELMA M. D.
Miniature painter. Born in New York, Aug. 3, 1880. Pupil of Art Students League of NY under Cox, Chase, Birge Harrison, F. V. Du Mond; Lucia Fairchild Fuller and Alice Beckington for miniature painting. Member: National Association of Women Painters and Sculptors; Brooklyn Soc. of Miniature Painters. Award: Silver medal, P.- P. Expo., San Francisco, 1915. Address in 1929, 450 Riverside Drive, New York, NY; summer, Hickory Bluff, South Norwalk, CT.

MOEN, ELLA CHARLOTTE.
Painter and teacher. Born in Bottineau, ND, March 18, 1901. Address in 1929, 1439 Poplar Avenue, Fresno, CA.

MOERSCHEL, CHIARA.
Painter. Born in Trieste, Italy, Nov. 15, 1926. U.S. citizen. Studied: Lindenwood College, with Robert Hansen and Sandra Del Munch. Work: Mead Gallery, Amherst College, MA; Western Illinois University; Adams Mark, Houston; Adria Club, Trieste, Italy; several others here and abroad. Exhibitions: Springfield College, IL, 1971, Lynn Kottler Gallerie, NY,

1973, both one-man; numerous group shows including Spanish International Pavillion; Watercolor U.S.A., 1970; Springfield Art Museum; Trieste Corinta, Italy, 1976, 78, 80; many others. Awards: Gustave Geotch Memorial Prize, St. Louis Artists Guild; Lone Vasen Award; first prize for watercolor, American Bar Association, and Sesquicentennial Show, Northeast Missouri State College, 1971; many others. Member: Academy of Professional Artists; St. Louis Artists' Guild; St. Charles Artists' Guild; American Watercolor Society. Media: Oil, watercolor. Address in 1984, St. Charles, MO.

MOFFAT, J.
A fairly well-engraved line portrait of Robert Burns is signed as "Eng'd on Steel by J. Moffat." This print was published by Wm. Pearson, New York, 1830-35; but it is possibly the work of a Scotch engraver and the plate was brought over to Am. for publication.

MOFFETT, ANITA.
Painter. Member: Artists Guild of the Authors' League of America, NY; Washington Art Club. Address in 1929, 435 West 119th Street, New York, NY.

MOFFETT, ROSS E.
Painter. Born in Iowa, Feb. 18, 1888. Pupil Art Students League of NY; Art Institute of Chicago; Charles W. Hawthorne. Member: Chicago Galleries Association. Awards: Silver medal, Art Institute of Chicago, 1918; first Hallgarten prize, National Academy of Design, 1921; hon. mention, Carnegie Institute, 1921; French Memorial gold medal, Art Institute of Chicago, 1927. Work: "A Street in Provincetown," Pennsylvannia Academy of the Fine Arts, Philadelphia; "Dunes in Winter," Speed Memorial Museum, Louisville, KY; "Winter in Provincetown," Albright Art Gallery, Buffalo, NY; "The Red Dory," University Club Gallery, Lincoln, NE. Address in 1929, Provincetown, MA.

MOFFITT, JOHN M.
Sculptor. Born in England in 1837. He came to the United States as a youth. He designed the figures that represent the four ages of man at the entrance to Greenwood Cemetery, the reredos in the Packer Memorial Church, and many altars in the principal churches of New York. He died in 1887.

MOHN, CHERI (ANN).
Painter and instructor. Born August 12, 1936 in Akron, OH. Studied: Akron Art Institute, OH; Youngstown State Univ., B.A. Exhibited: Butler Institute of American Art Midyear Show, Youngstown, OH, 1970; John Young Invitational, Youngstown, 1972-81; Village Art Gallery, 1976 (one-woman); Trumbull Art Guild Art Show, 1979-81. Awards: One of *Mademoiselle* magazine's Top Twenty Women Artists in the USA, 1960; Gallerie

des Champignons Purchase Award, 1968; Butler Inst. of Am. Art purchase prize, 1970; others. Member: Soc. of North Am. Artists; Friends of Am. Art; Copley Soc. of Boston. Work in Butler Institute; Phoenix Gallery, Philadelphia; others. Dir. and inst. of fine arts, Cheri Mohn School of Arts, Youngstown, OH, 1963-67. Media: Watercolor and oil. Address 1984, Lima, OH.

MOHOLY-NAGY, LAZLO.
Sculptor, painter, and photographer. Born July 20, 1895, in Bacsbarsod, Hungary; came to U.S. in 1937. Studied: University of Budapest, 1913-14, LLB. Work: Art Institute of Chicago; Dayton Art Institute, Detroit Institute; Los Angeles County Museum of Art; Museum of Modern Art; San Francisco Museum of Art; Guggenheim. Exhibited: Stedelijk; Hamburg; Mannheim; Cologne; Budapest (National); Stockholm (National); The London Gallery, London, 1937; Harvard University, 1950; Zurich, 1953; Kunst Kabinett Klihm, 1956, 59, 62, 66; Kleemann Gallery, NYC, 1957; Dusseldorf, 1961; Guggenheim; Art Institute of Chicago; Whitney Museum; Yale University; Museum of Modern Art, The Machine as Seen at the End of the Mechanical Age, 1968; and others. Taught: Staatliche Bauhaus, Berlin, 1922; founding collaborator, with Gyorgy Kepes and Robert Wolff, of the Institute of Design, Chicago, 1938-42; director of the New Bauhaus, Chicago. Designed for State Opera and the Piscator Theatre, Berlin, 1928. Died November 24, 1946, Chicago, IL.

MOILAN, OTTO E.
Painter. Born in Finland. Pupil of Minnesota School of Art. Address in 1929, 422 Kasota Bldg.; 2621 Clinton Avenue, Minneapolis, MN.

MOIR, ROBERT.
Sculptor, painter, and teacher. Born in Chicago, IL, January 7, 1917. Studied: Art Institute of Chicago; Columbia Univ.; NYU; Art Students League. Work: Honolulu Acad. of Art; Whitney Mus.; Rittenhouse Savoy, Phila., PA. Exhibited: Art Inst. of Chicago, 1940, 41, 48; Whitney Mus., 1951-55, 56; Met. Museum of Art, 1951, 52; Sculpture Center, NY, 1951 (one-man); Sculptor's Guild, Lever House, NY, 1959, 60. Member: New Sculpture Group; Sculptors Guild. Address in 1980, 400 E 93rd St., New York, NY.

MOISE, THEODORE SYDNEY.
Portrait painter. Born in Charleston, SC, in 1806. He died in 1883 in Natchitoches, LA. In 1850 his studio was at 51 Canal Street, New Orleans, and he painted many portraits in Louisiana. He painted a standing portrait of Henry Clay now owned by the Metropolitan Gallery of New York.

MOLAND.
In 1839 the name "Moland Sc." is signed to fairly well-engraved script and sheet music, published in Philadelphia by George Willing.

MOLARSKY, ABRAHAM.
Painter. Born in Russia in 1879. Pupil of Chase in Philadelphia and of the Penna. Academy of Fine Arts. Address in 1926, 62 High Street, Nutley, NJ.

MOLARSKY, MAURICE.
Painter. Born in Kiev, Russia, May 25, 1885; American citizen. Studied at School of Industrial Art and Penna. Academy of Fine Arts, Philadelphia; and in France and England. Member: Allied Artists of America; American Artists Professional League; Philadelphia Alliance; Fellowship Penna. Academy of Fine Arts. Awards: Henry Thouron prize in comp. and Cresson Scholarship, Penna. Academy of Fine Arts; hon. mention, Philadelphia Art Club; Fellowship prize, Penna. Academy of Fine Arts; silver medal, P.-P. Expo., San Francisco, 1915; gold medal, Art Club of Philadelphia, 1919; silver medal, Sesqui-Centennial Expo., Philadelphia, 1926. Represented in Philadelphia Art Club collection; Jefferson College, Philadelphia; "Still Life," Butler Art Institute, Youngstown, OH; mural decorations in the Elks' Home, and in other public buildings, Philadelphia, PA. Address in 1929, 10 South 18th Street; h. 242 South 49th Street, Philadelphia, PA.

MOLIN, C. GUNNAR.
Painter, sculptor, and etcher. Born in Stockholm, Sweden. Pupil of Art Students League of NY. Member: Scandinavian-American Artists; Am. Artists Prof. League. Address 1933, 180 State St., Brooklyn, NY.

MOLINARY, MARIE M. SEEBOLD.
(Mrs. Andres Molinary). Painter. Born in New Orleans, LA, 1876. Pupil of William Chase and A. Molinary. Member: Art Association of New Orleans; New Orleans Arts and Crafts Club. Work in Delgado Museum, New Orleans. Address in 1929, 2619 St. Charles Avenue, New Orleans, LA.

MOLINEUX.
Engraver. In 1831 there was published by Luke Loomis & Co., of Pittsburgh, PA, a German work entitled "The Life and Works of Johann Friedrich Oberlin," with an introduction by prof. S. S. Schmucker, of the Theological Seminary at Gettysburg, PA. The frontispiece to this book is an engraved silhouette of Oberlin, signed "Molineux Sc. Pitt." The same Molineux engraved upon copper for this work a fairly well-executed portrait of Louis Schepler, and views of the residences of Oberlin and some of his fellow workers. No other examples of the engraved work of Molineux are known to Fielding in 1926.

MOLL, AAGE (PETER MARINUS).
Painter. Born in Ribe, Denmark, Feb. 9, 1877. Pupil of Charles Noel Flagg, James G. McManus. Member: Connecticut Academy of Fine Arts; Scandinavian American Artists; Gloucester Society of Artists. Address in 1929, 142 Freeman Street, Hartford, CT.

MOLYNEUX, EDWARD F(RANK).
Illustrator. Born in London, England, Feb. 29, 1896. Pupil of Pratt Institute, Brooklyn, NY. Member: Society of Illustrators; Art Directors' Club. Address in 1929, 16th Floor, 40 East 34th Street; h. 25 Fifth Avenue, New York, NY.

MOMBERGER, WILLIAM.
Painter. Born in Frankfurt, Germany, June 7, 1829. He came to the United States in 1848. He painted several landscapes, but gave much of his time to illustrating. Worked in NYC for many years.

MONACHISE, NICOLA.
Painter. Born in 1795 in Italy. Nothing is known of his work except that he painted historical pieces and portraits, and that his studio was at 98 Locust Street, Philadelphia. Died in 1851 in Philadelphia, PA.

MONAGHAN, GERTRUDE.
Painter. Born in West Chester, PA. Pupil of Philadelphia School of Design; Penna. Academy of Fine Arts. Member: Fellowship Penna. Academy of Fine Arts; Plastic Club; Print Club. Specialty: Mural decorations and lunettes. Address in 1929, 3309 Baring Street, Philadelphia, PA.

MONKS, EDWARD E.
Illustrator. Member: Society of Illustrators; Artists Guild of the Authors' League of America, NY. Address in 1929, 40 Gramercy Park, New York, NY.

MONKS, JOHN AUSTIN SANDS.
Painter and etcher. Born in Cold Spring-on-Hudson, NY, on Nov. 7, 1850. Studied wood engraving and etching in 1869. Pupil in painting of George Inness, 1875. Engaged in art work after 1874. His specialty was painting sheep. Member: Copley Society; Salma. Club; New York Etching Club; Boston Art Club. Died March, 1917 in Chicago, IL.

MONNIER, FRANCE X.
Sculptor. Born in Belfort, France, 1831. Worked: New York City; Detroit. Died in Detroit, April 5, 1912.

MONRAD, EMILY.
Painter, lecturer, and teacher. Born in Sweden, Jan. 30, 1877. Pupil of Viggo Johansen, Copenhagen. Member: New Haven Paint and Clay Club; Plainfield Art Association; New Educ. F. Address in 1929, Knox School, Cooperstown, NY; h. 166 Putnam Avenue, New Haven, CT.

MONRAD, MARGARET.
Sculptor and teacher. Born in New Zealand, June 10, 1879. Pupil of Royal Academy of Fine Arts, Copenhagen; studied sculpture in Italy. Member: National Association of Women Painters and Sculptors; New Haven Paint and Clay Club; Plainfield Art Assoc.

Teaching: Instructor, Industrial and Fine Arts Department, Hampton Institute, Virginia. Address in 1933, Hampton Institute, VA; 166 Putnam Avenue, Hamden, New Haven, CT.

MONTAGUE, HARRIOTTE LEE TALIAFERRO.
Painter. Pupil of George de Forest Brush and Twachtman in NY; Angelo Yank, Fehr, Hummel and Knurr in Munich; Simon in Paris. Member: Richmond Art Club. Work: "Portrait of Capt. Sallie Tompkins," Richmond Art Club; portrait in D.A.R. Hall, Washington, DC. Represented in Confederate Museum and the State Library in Richmond; also in Westmoreland (VA) Court House. Address in 1926, 1609 Hanover Avenue, Richmond, VA.

MONTANA, PIETRO.
Sculptor and painter. Born in Alcamo, Italy, June 29, 1890. U.S. citizen. Studied at Cooper Union Art School and the Mechanics Institute; pupil of George T. Brewster. Member: Fellow, National Sculpture Society, NY; National Academy of Design; Allied Artists of America (treasurer, 12 years); Artist's Fellowship (treasurer, 4 years); Hudson Valley Art Association; Architectural League of New York. Represented in Georgia Museum of Art, Athens; American Numismatic Society, NY; Brookgreen Gardens, SC; others. Work: "Doughboy Monument," NY; War Monument, Heisser Square, Brooklyn; "The Dawn of Glory," Highland Park, Brooklyn; "Mark Twain and Washington Irving," memorial tablet, New York City; "The Minute Man," East Providence, RI; "Mother Davison," Governor's Island, NY; War Memorial, Sicily, Italy; "Weisserberger Memorial," City Cemetery, Alliance, OH; Stations of the Cross, Fordham University, NY, 1947-52. Exhibited at National Academy of Design Annual, NY, 1921, 31; Allied Artists of America Annual, NY, from 1932; Hudson Valley Art Association, White Plains, NY, from 1937; National Sculpture Society, from 1923. Awards: Elizabeth M. Watrous gold medal, National Academy of Design, 1931; National Sculpture Society, 1962; Hudson Valley Art Association, 1962. Teaching: Instructor of sculpture, Master Institute of Arts, New York City, 1931-34; Fordham University, 1947-52. Address in 1976, Rome, Italy. Died in 1978.

MONTGOMERY, ALFRED.
Painter. His specialty was depicting farm life. He was born in 1857 and died in Los Angeles, CA, on April 20, 1922.

MONTGOMERY, R.
Engraver. The only example of the work of this engraver seen by Fielding is a book-plate of James Giles, signed "R. Montgomery, Sculp." The plate is armorial, with a cannon and American flag introduced into the decoration, and it is crude enough in

execution to have been the work of some apprentice or local engraver. Some collectors of "ex libris" asserted that the engraver of the plate was Gen. Richard Montgomery, who was killed at Quebec in 1775. This book-plate was probably engraved by Robert Montgomery, who advertised in the *New York Packet* in 1783, as "Watch-Maker, Clock Maker and Engraver."

MOONEY, EDWARD L.
Painter. Born March 25, 1813 in NYC. He began his art studies at the Academy of Design. He became a pupil of Henry Inman, and copied much of his work; later he studied with William Page. He painted many excellent portraits of prominent men; his picture of Gov. Wm. H. Seward was placed in the State House in Albany, and he painted several portraits of the Mayors of New York, for City Hall. He died in June, 1887, in NYC.

MOORE, ALLEN.
Painter, graphic designer, and lecturer. Born July 27, 1945, in Norfolk, VA. Studied: Pratt Institute; City University of NY at Hunter College; Tyler School of Art at Temple University; NYU; New School for Social Research; and with S. Green; H. Frankenthaler; L. Samaras; T. Smith; R. Morris; others. One-man exhibitions: School of Visual Arts Museum, NYC, 1971; O.K. Harris, NYC; Virginia Museum 618 Invitational, 1981, 82; Virginia State University, 1981; RI College, 1982; Virginia Center for Creative Arts, 1982; others. Group exhibitions: Brooklyn Museum, 1973; Mariners Museum, VA, 1974; Hansen Galleries, NYC, 1975; Whitney Museum Counterweight, 1977; 1708 Gallery, Richmond, 1982; others. Member: NY Art Directors' Club; Black Art Directors of NY; National Community of Art Workers. Awards: Scholarship, Pratt Institute, 1973; award, NJ State Museum Collection; Creative Artist Public Service Award/NYS Council on the Arts Grant, 1979-80; others. Taught at schools and universities. Address 1982, Poughkeepsie, NY.

MOORE, BENSON BOND.
Painter, etcher, and illustrator. Born in Washington, D.C., Aug. 13, 1882. Pupil of Corcoran School of Art, Washington. Member: Washington Society of Artists; Washington Water Color Club; Washington Landscape Club; Southern States Art League; Mississippi Art Association; New Haven Paint and Clay Club; Connecticut Academy of Fine Arts; New Orleans Art Association; Springfield Art League; Am. Federation of Arts. Represented by five etchings in Library of Congress; four drypoints in White House; drypoint in NY Public Library; two drypoints, Houston Museum of Fine Arts; drypoint, Bibliotheque Nationale, Paris; three drypoints, Philadelphia Art Alliance; three drypoints, Smithsonian Institution; drypoint, Washington Arts Club. Address in 1929, 105 R. Street, N.E., Washington, D.C.

MOORE, BETHUEL C.
Painter and teacher. Born in Barbourville, KY, June 15, 1902. Pupil of Charles Hawthorne; Olinsky; E. A. Jones. Member: Tiffany Foundation; Louisville Art Association; Louisville Art Club. Award: First prize, Louisville Art Association, 1928. Address 1929, 1116 Starks Bldg.; h. Weissinger Gaulbert, Louisville, KY.

MOORE, CECIL GRESHAM.
Painter, illustrator, craftsman, writer and teacher. Born in Kingston, Ontario, Canada, June 12, 1880. Pupil of Rochester Athenaeum and Mechanics Institute. Member: Rochester Art Club. Specialty: Decorations and color. Address in 1929, 86 State Street, Rochester, NY; summer, Rideau River, Kingston, Ontario, Canada.

MOORE, CLAIRE.
Printmaker. Studied: Siqueiros Workshop; The Art Students League, New York City; with Werner Drewes and Fernand Leger. Exhibitions: Museum of Modern Art; Metropolitan Museum of Art; Green Mountain Gallery, NYC. Collections: Newark Public Library, New Jersey; University Museum, Minneapolis, Minnesota. Publishes *The Children's Underground Press*. Noted for her experimentation with mimeograph-machine printing techniques.

MOORE, E. BRUCE.
Sculptor. Born in Bern, Kansas, August 5, 1905. Pupil of Penna. Academy of Fine Arts, with Charles Grafly, Albert Laessle. Member: Academician, National Academy of Design; National Sculpture Society; Fellowship Penna. Academy of Fine Arts; Wichita Art Guild. Award: Widener gold medal, Penna. Acad. of Fine Arts, 1929, Cresson traveling scholarship, 1925, 25; Guggenheim Fellowship, 1929-30, 30-31; prizes, National Academy of Design, 1935, 37; grant, National Institute of Arts and Letters, 1943; Henry Hering Memorial Medal, National Sculpture Society, 1968; others. Work: Whitney; Penna. Academy of Fine Arts; Brookgreen Gardens, SC; American Academy in Rome; two bronze tigers, Princeton University; portrait busts of Col. Thomas Fitch and Henry Wallenstein, Wichita Consistory; portrait bust of Dr. A. H. Fabrique, Wichita Medical Society; "Feline," High School, Wichita; sculptural designs and terra cotta decorations on high school, Wichita. Exhibited: Whitney Mus., 1942; National Institute of Arts and Letters, 1943; Virginia Museum of Fine Arts, 1958; Mostra Art Mod., Camaiore, Italy, 1968; others. Address in 1976, Washington, DC. Died in 1980.

MOORE, EDWIN A.
Painter. Born in Hartford, CT, in 1858. He was a son of Nelson A. Moore, and followed his father's profession of painting. Address in 1926, 901 West Lane, Kensington, CT. Died in 1925.

MOORE, ELLEN MARIA.
Miniature painter. Born in Kensington, CT. Pupil of Art Students League of New York; also of Mary and I. A. Josephi. Address, Kensington, CT.

MOORE, FRANK M(ONTAGUE).
Painter. Born Taunton, Somersetshire, Eng., 1877. Pupil of H. W. Ranger. Member: NY Water Color Club; Salma. Club; CA Water Color Soc.; Am. Fed. of Arts. Work: "Old Quarry in Moonlight," Honolulu Acad. of Arts. Address 1929, care of Boardman Bros., 32 Montgomery St., San Francisco, CA.

MOORE, H. W.
Painter. Member: Boston Art Club. Address in 1929, Main Street, Hingham, MA.

MOORE, H(ARRY) HUMPHREY.
Painter. Born in NYC, in 1844. Pupil of Bail in New Haven; S. Waugh in Philadelphia; Ecole des Beaux Arts in Paris, under Gerome, Boulanger and Yvon. Member: Rochester Art Club. His work is principally concerned with Moorish, Spanish, and Japanese subjects. Address in 1926, 75 Rue de Courcelles, Paris, France. Died Jan. 2, 1926 in Paris, France.

MOORE, ISAAC W.
Engraver, who was engraving good line portraits and historical plates in 1831-33 for Philadelphia periodicals.

MOORE, LOU WALL (MRS.).
Sculptor. Member: Chicago Soc. of Artists. Award: Bronze medal, St. Louis Exposition, 1904. Address in 1926, 5476 Ridgewood Court, Chicago, IL.

MOORE, MARTHA.
(Mrs. Charles H. Rathbone, Jr.). Sculptor. Born in New Britain, CT, December 30, 1902. Pupil of Archipenko and Heinz Warneke. Member: National Arts Club; Society of Independent Artists. Address in 1933, 75 Central Park West, New York, NY.

MOORE, MARY E.
Sculptor. Born in Taunton, MA. Studied at the school of the Boston Museum of Fine Arts, and was a pupil of Bela L. Pratt, Charles Grafly, and Frederick W. Allen. Works: Dudley Buck, Church of the Holy Trinity, Brooklyn, NY; W. W. Bond, Public Library, Hartford, CT; Rev. Charles F. Hoffman, Trinity College, Hartford, CT; relief, Charles M. Eliot; wall fountains, Huntington, LI, and Chestnut Hill, MA; iris fountain, Shrewsbury, MA; shell bird-bath; fountain figure; bust, H. T. Greene. Awards: Fairmount Park Art Association prize, Penna. Academy of Fine Arts, 1928; gold medal, Pennsylvania Horticultural Society, Philadelphia Art Alliance, 1928; medal, Concord Art Association, 1928. Membership: Guild of Boston Artists; Boston Society of Sculptors. Address in 1934, Cambridge, MA.

MOORE, MARY VIRGINIA.
Painter and teacher. Born in Brownsville, TN. Pupil of Chase; Henri; Timmons; Miller; NY School of Art; Art Institute of Chicago. Member: Western Art Association. Director of Art, Memphis Schools. Address in 1929, Board of Education Office, Goodwyn Institute; h. 1782 Peabody Avenue, Memphis, TN; summer, Brownsville, TN.

MOORE, NELSON AUGUSTUS.
Born in Connecticut, Aug. 2, 1824. He studied with Cummings, and later with Daniel Huntington. His pastoral scenes show great merit; "The Genius of Liberty" was also considered a great success.

MOORE, T.
This stippler-engraver of portraits signs himself on one of his plates "T. Moore (successor to Pendleton) Boston."

MOORE, WILLIAM A.
Sculptor and painter. Born in Glendale, CA, in 1936. Studied at Art Center College of Design, Los Angeles, 1956-58. Technical illustrator in missiles and aircraft industry; formed own graphic art and industrial design business; corporate art director. Turned to painting full-time in 1978. Specialty is subjects showing the history of early man and the wilderness. Sculpts in bronze. Represented by Riata Gallery, Virginia City, NV; Artists Co-op Gallery, Reno, NV. Address since 1968, Reno, NV.

MORA, DOMINGO.
Sculptor. Born in Catalonia, Spain. Studied in Barcelona and Madrid. Member of National Sculpture Society. Worked in Montevideo, Uruguay, where he is represented in museums. Exhibited at National Sculpture Society, NY. Address in 1910, Mountain View, Santa Clara, CA. Died in San Francisco, July 24, 1911.

MORA, FRANCIS LUIS.
Painter, illustrator, and teacher. Born in Montevideo, Uruguay, July 27, 1874. Pupil of School of Boston Museum, under Benson and Tarbell; Art Students League of NY under Mowbray. Member: Associate Nat. Acad. of Design, 1904; Academician National Academy of Design, 1906; Art Students League of NY; Salma. Club, 1899; Society of Illustrators, 1901; Society of American Artists, NY, 1905; NY Architectural League, 1903; American Water Color Society; NY Water Color Club; Allied Artists of America; National Arts Club; National Association of Portrait Painters, NY; American Federation of Arts. Awards: Gold medal, Art Club of Philadelphia, 1901; gold medal, American Art Society, 1902; 2 bronze medals, St. Louis Exposition, 1904; first Hallgarten prize, National Academy of Design, 1905; Beal prize, NY Water Color Club, 1907; Evans prize, Salma. Club, 1908; Shaw prize, Salma. Club, 1910;

gold medal for oil painting and gold medal for water color painting, P.-P. Exposition, San Francisco, 1915. Work: Decoration for Lynn (MA) Public Library; "Spanish Merrymakers," Museum of Art, Oakland, CA; "Jeanne Cartier," Toledo Museum; "Color Harmony," Newark Museum Association; "The Fortune Teller," Butler Art Institute, Youngstown, OH. Address in 1929, Cedar Hill, Gaylordsville, CT. Died in 1940.

MORA, JOSEPH JACINTO.
Sculptor. Born in Montevideo, Uruguay, October 22, 1876. Pupil of Domingo Mora; J. DeCamp; J. C. Beckwith. Member: National Sculpture Society. Work: "Cervantes Monument," San Francisco, CA; "Doughboy," San Raphael, CA; "Bret Harte Memorial," Bohemian Club, San Francisco, CA; "Junipero Serro Sarcophagus," Mission, San Carlos, Carmel, CA; heroic pediments, Don Lee Building and Stock Exchange, San Francisco, CA, and Pacific Mutual Building, Los Angeles; heroic figures, Scottish Rite Temple, San Jose, CA; four heroic bronzes, Ponca City, OK. Address in 1933, Pebble Beach, CA; h. Carmel, CA.

MORAHAN, EUGENE.
Sculptor. Born in Brooklyn, NY, August 29, 1869. Pupil of Augustus Saint-Gaudens. Member: Painters and Sculptors; Santa Monica Art Assoc.; National Sculpture Society. Work: Alfred Gwynne Vanderbilt memorial fountain, Newport, RI; Elks Memorial, Buffalo; Soldiers and Sailors Memorial, Carroll Park, Brooklyn, NY; Cuddy Memorial, St. Barnabas' Church, Bexhill, England; Gen. Samuel Welch Monument, Buffalo, NY. Address in 1933, Santa Monica, CA.

MORALES, ARMANDO.
Painter. Born Jan. 15, 1927 in Granada, Nicaragua. Also a printmaker. Studied at School of Fine Arts, Managua. Awards: Travelling Grant from American Council on Education, Washington, D.C.; Guggenheim, 1958; Organization of American States fellowship, 1962-64; Houston Museum of Fine Arts. Exhibited at Angellski Gallery, NYC, 1962; Pan Am. Union, Washington, D.C.; Sao Paulo, Brazil; Houston, TX; Museum of Modern Art; Carnegie; Guggenheim; University of Michigan; Phillips Exeter Academy; Time Life Building; Duke University; Mt. Holyoke; NY World's Fair, 1964; Cornell University; and many others. In collections of Houston; Guggenheim; Pan-Am. Union; Washington, D.C.; Museum of Modern Art; Caracas; Institute of Art, Detroit; and Philadelphia Museum of Art.

MORAN, EDWARD.
Painter. Born in England, Aug. 19, 1829. Came to the U.S. in 1844. Lived in New York and Philadelphia. Member: Penna. Academy of Fine Arts. Exhibited in Philadelphia in 1853. Painted fishermen at their

toil, and water scenes and vessels. Represented in Wilstach collection, Fairmount Park, Philadelphia. He died June 9, 1901 in NYC.

MORAN, EDWARD PERCY.
See Moran, Percy.

MORAN, JOHN LEON.
Painter. Born in Philadelphia, PA, Oct. 4, 1864. Studied art under his father, Edward Moran; at the National Academy of Design, NY; also in London and Paris. Returned to the U.S. in 1879 and established a studio in NY in 1883. He was a frequent exhibitor at the National Academy of Design, NY, and elsewhere. Received a gold medal, Art Club of Philadelphia, 1893; gold medal, American Art Society, 1902. Principal paintings: "Waylaid," 1885; "An Interrupted Conspiracy," 1886; "An Amateur," 1887; "The Duel," 1887; "An Idyll," 1888; "Eel Fishing," 1888; "Intercepted Dispatches;" "Madonna and Child;" "Between Two Fires." Address in 1929, 97 Mercer Avenue, Plainfield, NJ. Died in 1941 in Watchung, NJ.

MORAN, MARY NIMMO.
(Mrs. Thomas). Etcher. Born in 1842. Her plates as a rule are bold and direct and are marked by energetic emphasis. Her work stands high among the women etchers in this country. Member of New York Etching Club. Died Sept. 24, 1889.

MORAN, PERCY.
Painter and etcher. Born in Philadelphia, PA, July 29, 1862. Pupil of his father, Edward Moran; Penna. Academy of Fine Arts under S. J. Ferris; National Academy of Design, in New York; also studied four years in Paris and London. Member: American Water Color Society. Awards: First Hallgarten prize, National Academy of Design, 1886; first gold medal, American Art Association, NY, 1888. Work: "Castle Garden, NY," Wilstach Gallery, Phila., PA; "Washington and Betsy Ross," Masonic Hall, Chicago; "Signing the Compact on Mayflower," Plymouth Museum; "The Woodcutter's Daughter," Hamilton Club, Brooklyn. Address in 1929, Easthampton, Long Island, NY.

MORAN, PETER.
Painter and etcher. Born March 4, 1841 in Bolton, Lancashire, England. Studied with his brothers Thomas and Edward Moran; also in England, in 1863. Member: Philadelphia Art Club; NY Etching Club. President of the Society of Etchers. His paintings are principally of landscapes and animal subjects. Died Nov. 9, 1914 in Philadelphia, PA.

MORAN, THOMAS.
Painter and etcher. Born in Lancashire, England, Jan. 12, 1837, but was brought to the United States when a boy of seven. He began his art career as a

wood engraver in Philadelphia and in his hours of leisure taught himself to paint in water color and afterwards in oils. His brother, Edward Moran, gave him the benefits of the instruction he had himself received. In 1862, he went to England and made a study of the masters in the Nat. Gallery, receiving a strong impression from the work of J. Turner. In 1872, Mr. Moran established himself permanently in NY. He spent his summers at his country home at Easthampton, Long Island. He was elected a National Academician in 1884, and was a member of the Penna. Academy of Fine Arts; Artists' Fund Society; American Water Color Society; the New York Etching Club; and the Society of American Etchers. The subjects of his pictures were taken from one or another of the places he visited and studied, such as Venice, Yellowstone Park, Niagara, the luxuriant meadows of Kent and Sussex, and the quiet villages and pastures of Long Island. As a water color painter and as an etcher his skill and fertility of invention were equally notable. Died Aug. 26, 1926 in Santa Barbara, CA.

MORANGES.
Miniature painter who flourished in Baltimore, 1795.

MORAS, FERDINAND.
Engraver. Born in Germany in 1821, he studied lithography at Elberfeld. He established one of the first lithographic plants in this country, and was the first lithographer to attempt color printing with this process of engraving. In 1844 Thomas Moran became apprenticed to Moras in Philadelphia. In 1882 he published a book of poems of which he was the author, illustrator and engraver. He died in 1908.

MORCOS, MAHER NAGUIB.
Sculptor and painter. Born near Cairo, Egypt, February 23, 1946. Illustrating textbooks by age 15, he studied at Cairo University, receiving a degree in architecture and a degree in art (anatomy). Came to U.S. in 1972. Executed bust, Egyptian President Nasser, Ministry of Education, Cairo; mural, Valley National Bank, Scottsdale, AZ; other commissions. Has exhibited at Charles Russell Museum, Great Falls, MT; American Institute of Contemporary Art, San Dimas, CA; George Phippen Show, Prescott, AZ; others. Specialty is romantic Old West. Works in bronze; oil and watercolor. Member of American Indian and Cowboy Artists. Reviewed in *Southwest Art*, April 1978. Represented by Eagle Art Gallery, La Jolla, CA; and Circle Galleries, NYC. Address in 1982, San Diego, California.

MORE, THOMAS.
Ship carver. Active in Portsmouth, NH, in 1707; in Kittery, ME, in 1720; later lived in Boston with his son Samuel, also a carver. Executed lion figurehead while in Kittery.

MOREIN, J. AUGUSTUS.
Born c. 1810 in West Indies. Portrait painter in oils and miniatures who flourished in NY in 1841-42.

MORETTI, GIUSEPPE.
Sculptor. Born in Italy, 1859. Came to New York and exhibited at the National Sculpture Society. Died in 1935.

MOREY, BERTHA GRAVES.
Painter, etcher, craftswoman, illustrator, writer, and teacher. Born Ottumwa, IA, July 22, 1881. Pupil of Art Institute of Chicago. Award: Prize ($100) for Silk design, Art Alliance of America, 1918. Address in 1929, 327 West Fourth Street, Ottumwa, IA.

MORGAN, ALEXANDER CONVERSE.
Painter. Born in Sandusky, OH, July 1, 1849. Member: Artists' Fund Society (pres.); Century Association; Salma. Club. Address in 1929, 134 West 73rd Street, New York, NY.

MORGAN, ARTHUR C.
Sculptor, painter, designer, teacher, and writer. Born in Riverton Plantation, Ascension Parish, LA, August 3, 1904. Studied with Borglum, Korbel, McCarten; also at Beaux Arts Institute of Design. Work: Southwestern Institute of Art; bust of "Dr. James Monroe Smith," Louisiana State University, and bust of "Dr. George A. Sexton," Centenary College, Shreveport, LA; architectural bronzes and stone carvings, U.S. Post Office and Court House, Alexandria, LA; heroic figure, Chief Justice Edward Douglass White, U.S. Capitol, Washington, DC; A. J. Hodges Commemorative Bust, Hodges Gardens, Many, LA; "Don Quixote and Sancho Panza," "Thais," "Nymph and Faun," and "Satyr," Gorham Co., NYC. Exhibited: Louisiana State University, 1927; Southwestern Institute of Art, 1938; Louisiana State Exhibition, 1940, 50; Philbrook Art Center, 1952 (all one-man). Director of fine arts, instructor of sculpture, painting, drawing, and art history, Centenary College, Shreveport LA; director, Southwestern Institute of Art, Shreveport, LA, 1934-74. Media: Bronze, marble. Member: National Arts Club; Dartmouth House Club; Society of Medalists; New Orleans Art Association; American Federation of Arts. Address in 1953, 657 Jordan Street, Shreveport, LA.

MORGAN, EMMYLOU.
(Mrs. Ralph Depew Morgan). Painter. Born in Albany, NY, Sept. 10, 1891. Pupil of Urquhart Wilcox. Member: Buffalo Society of Artists; Guild of Allied Artists; National Arts Club; American Artists Professional League. Awards: First hon. mention, Albright Art Gallery, Buffalo, 1927, and Cary cash prize, 1928. Address in 1929, 27 Vernon Place, Buffalo, NY.

MORGAN, FRANCES MALLORY.
Sculptor. Born in Memphis, TN. Studied at Art Students League; National Academy of Design; Penna. Academy of Fine Arts; also with John Hovannes and Alexander Archipenko. Works: Memorial Art Gallery, Memphis; IBM Corporation. Commissions: Neely Grant (bronze), Mrs. Neely Grant, Memphis, 1934; Sen. Gilbert Hitchcock, 1945, and bronze fountain, 1949, Mrs. Gilbert Hitchcock, Washington, DC; bronze fountain, Vance Norfleet, Memphis, 1952; many portraits of children. Exhibitions: World's Fair, New York, 1939-40; Whitney Museum of American Art, NY, 1940; Metropolitan Museum of Art, NY, 1942; Philadelphia Art Alliance, 1946; Penna. Academy of Fine Arts, 1947. Awards: Anna Hyatt Huntington Award for Olympia, 1941; Prize for Peace Again, 1944, National Association Women Artists; Award for Fish, Audubon Artists, 1961. Media: Clay, stone, wood. Address in 1983, 50 Mendota Ave., Rye, NY.

MORGAN, FRANKLIN TOWNSEND.
Painter, illustrator, etcher and craftsman. Born in Brooklyn, NY, Dec. 27, 1883. Pupil of Bridgman, Carlsen. Member: Philadelphia Sketch Club; Philadelphia PC. Address in 1929, Moylan, Rose Valley, PA.

MORGAN, GEORGE T.
Engraver. Born in Birmingham, England, in 1845, was living in Philadelphia in 1892. Morgan studied at the art school in Birmingham and won a national scholarship in the South Kensington Art School, where he was a student for two years. He came to the U.S., and in 1875 he was made an assistant engraver in the U.S. Mint in Philadelphia, and remained there a number of years. He designed and executed the dies for the once famous "Bland Dollar."

MORGAN, GEORGIA WESTON.
Painter. Born in Virginia. Pupil of John Carlson; Daniel Garber; Joseph Pearson; Fred Wagner; Hugh Breckenridge; Art Students League of NY; Julian Academy, Beaux Arts and Mme. La Forge in Paris. Member: Southern States Art League; Gloucester North Shore Arts Association; Lynchburg Art Club (president); Fellowship Penna. Academy of Fine Arts. Work: Mural decorations in Euclid Avenue Christian Church, John Wyatt Pub. School, Garland-Rhodes Public School, R. E. Lee High School, Lynchburg, VA, and Lynchburg College. Head of Art Dept., Lynchburg College. Address in 1929, Lynchburg College, Lynchburg, VA.

MORGAN, HELEN BOSART.
(Mrs. Edwin M. Wagstaff). Sculptor. Born in Springfield, OH, October 17, 1902. Studied at Wittenberg College, A.B., 1923; Dayton Art Institute, 1940-42; Art Institute of Chicago, 1952-53. Exhibitions: Group shows, Springfield Art Association; Dayton Art

Institute, 1960; Columbus Gallery, 1960; Cincinnati (OH) Museum of Art; Butler Art Institute; National Academy of Design; Allied Artists of America; National Association of Women Artists; Syracuse Museum; Wichita Art Association; Newman Brown Gallery, Chicago, 1953; Cincinnati Museum of Art; many others. Awards: Springfield Co. Fair, 1951; Dayton Art Institute, 1945, 46, 48; Springfield Art Exhibition, 1946-48, 52, 54, 60, 71; Clark Co. Fair, 1951; Ohio State Fair, 1952; 2nd prize in sculpture, Columbus Art League, 1960; 2nd prize in sculpture, Ohio Religious Exhibition, 1960. Member: Fellow, International Institute of Arts and Letters; National Association of Women Artists; Dayton Art Institute; Association of University Women; Artists Equity Association; Columbus Art League. Media: Bronze, plastic. Address in 1982, Springfield, OH.

MORGAN, LOUIS.
American landscape painter. Born in Nov. 21, 1814, in Pennsylvania. Died in 1852 in Tennessee.

MORGAN, LYNN THOMAS.
Painter and illustrator. Born in Richmond, IN, April 24, 1889. Pupil of William Forsyth, Meakin, James Hopkins, George Bridgman. Member: Society of Illustrators; Alliance. Address in 1929, 49 West 45th Street, New York, NY; h. 156 23rd Street, Jackson Heights, L.I., NY.

MORGAN, M. DeNEALE.
Painter and etcher. Born in San Francisco, CA. Pupil of San Francisco Art Institute, and Chase. Member: San Francisco Art Association; Carmel Club Arts and Crafts; National Association of Women Painters and Sculptors; California Water Color Society; West Coast Arts. Work: Memorial Museum, Los Angeles; Del Monte Gallery; San Francisco Art Association; "Cypress and Cliffs," University of Texas; Stanford University; University of Southern California; "Tall Cypress," Lindsay High School; "Spring-Clouds," Salinas High School. Address in 1929, Box M, Carmel By the Sea, CA.

MORGAN, MATTHEW SOMERVILLE.
Painter. Born in London in 1839. He came to the United States in 1870 and worked in New York in 1880. He went to Cincinnati, and in 1883 founded there the Morgan Art Pottery Co. and Art Students League. He painted a series of large panoramic pictures of the battles in the Civil War, which were exhibited in Cincinnati in 1886. He died in NYC in 1890.

MORGAN, THEODORE J.
Painter. Born in Cincinnati, OH, Nov. 1, 1872. Member: Washington Society of Artists; Washington Art Club; National Arts Club; NY Water Color Club; Beachcombers; Washington Water Color Club; San Diego Art Association; San Antonio Art League; San

Antonio Palette Association. Awards: First prize ($1,500), Texas Wild Flower Competition, 1928; gold medal, most meritorious painting, Davis Wild Flower Competition, also hon. mention, 1929. Represented at University of Indiana, Bloomington, IN; Aurora (IL) Art Association; Women's Hospital, Cleveland, OH; Museum of Fine Arts, Houston, TX; Delgado Museum of Art, New Orleans, LA; Witte Memorial Museum, San Antonio, TX; Women's Building, Harlingen, TX. Address in 1929, 456 N. Street, S. W., Washington, D.C.; Provincetown, MA.

MORGAN, WALLACE.
Illustrator. Born in NYC in 1873. Studied at National Academy of Design. Member: Society of Illustrators; Artists Guild of the Authors' League of America, NY; National Academy of Design; Art Students League. Official artist with American Expeditionary Forces in France during World War I. Worked with NYC newspapers, *The Sun*. Taught at Art Students League. Died in 1948. Address in 1933, 1 West 67th Street, New York, NY.

MORGAN, WILLIAM.
Born in London, England, in 1826. He came to this country in his early life. He received his training in the schools of the Nat. Academy, of which he became an Associate in 1865. His works inc. "Emancipation;" "The Legend;" "Song without Words;" "Motherhood;" "Summer;" "Blowing Bubbles." He died in 1900.

MORIGI, ROGER.
Sculptor. Born in Bisyschio, Italy, October 4, 1907; U.S. citizen. Studied at Brera University, Milan, Italy, degree, 1927. Work in Washington National Cathedral; Supreme Court, Washington, DC; Post Office, Washington, DC; Rockefeller Church, Bronx, NY. Position, master carver, Washington National Cathedral, 1955-78. Address 1982, Hyattsville, MD.

MORIN, HAROLD N.
Painter. Born in Helsingborg, Sweden, Jan. 10, 1900. Pupil of Minnesota School of Art. Address in 1929, 3241-37th Avenue, South, Minneapolis, MN.

MORIN, JOHN F.
Engraver of maps, business cards, etc., who was working in NY in 1825-31, as shown by dates of publication on his few signed plates. In 1825 he engraved in connection with S. Maverick, and was then apparently in the employ of that engraver and copperplate printer. In 1831 Morin engraved a good map of New York City for *The Traveller's Guide through the State of New York*, published in New York in that year.

MORIN, THOMAS EDWARD.
Sculptor and educator. Born in September 22, 1934, in Malone, NY. Studied: Massachusetts College of Art, with Lawrence Kupferman, 1952-56, B.S.Ed.; Cranbrook Academy of Art, 1956-57, M.F.A.; Academy of Fine Arts, Florence, Italy, 1960-61; Brown University, basic metallic certificate, 1966, plastics technol. certificate, 1967. Work: Ogunquit, ME; NY State University, Oneonta; Brown Univ.; Virginia Museum of Fine Arts. Exhibited: Margaret Brown Gallery, Boston, 1954; Gallery Four, Detroit; Kanegis Gallery, Boston; Silvermine Guild; The Kornblee Gallery, NYC; De Cordova; Boston Arts Festival; Penna. Academy of Fine Arts; Detroit Institute Annuals; Whitney Museum Annual; Houston Museum of Fine Arts; Audubon Artists Annual; RI School of Design Museum of Art; Wadsworth Atheneum, Eleven New England Sculptors. Awards: Fulbright Fellowship, 1960; Silvermine Guild, first prize and best in show, 1960; Rhode Island Arts Festival, first prize, 1960; Rhode Island Art Festival, first prize; New Haven Art Festival, first prize, 1966. Taught: Cranbrook Academy of Art, 1957-58; Silvermine Guild, 1958-60; Rhode Island School of Design, from 1961. Address in 1982, Johnston, RI.

MORLEY, HUBERT.
Painter and etcher. Born in La Crosse, WI. Pupil of Art Institute of Chicago; Chicago Academy of Fine Arts. Member: Chicago Society of Etchers. Address in 1929, 162 East Superior Street, Chicago, IL.

MORLEY, RUTH KILLICK.
Sculptor, craftsman, and teacher. Born in London, England, June 8, 1888. Studied with Jean Dampt; Bourdelle. Member: Alliance. Address in 1933, 234 West 15th St., NYC.

MORO, PAOLO.
Painter. Exhibited at National Academy of Design, New York, 1925. Address in 1926, 2104 Vyse Avenue.

MOROSOFF, VADIM VLADIMIROVICH.
Painter. Born in Russia, April 9, 1874. Member: Society of Independent Artists. Address in 1929, care of Dr. R. Lerner, 1148 Eastern Parkway, Brooklyn, NY.

MORPURGO, VILNA JORGEN.
Painter. Born in Oslo, Norway in 1900. Studied: Maison Wateau, Paris; sculpture with Karl Eldh in Sweden. Collections: Gallery of Modern Art, Stockholm; in Royal collections in Sweden, Belgium and Italy.

MORRELL, IMOGENE ROBINSON.
Painter. Born in Attleboro, MA; died in Washington, DC, in 1908. Studied art under Gamphausen, and in Paris under Couture. Resided in Paris for several years and enjoyed the friendship of Meissonier, Bouguereau and other prominent artists of France. On her second visit to Paris she was accompanied by Elizabeth Jane Gardner, who became a pupil and

later the wife of W. A. Bouguereau. Mrs. Morrell's work was recognized by medals at the Mechanics' Institute in Boston and at the Centennial Exposition in Philadelphia. Among her important pictures are: "First Battle between the Puritans and the Indians," "Washington and his Staff Welcoming a Provision Train," and "David before Saul."

MORRELL, WILLETT H.
Shipcarver. Working in New York City from 1842 to 1851. Exhibited a full-size wood carving of a woman at the American Institute, with artist Winter Lindmark, 1842.

MORRIS, ADELAIDE.
Painter. Born in Brooklyn, NY, Jan. 11, 1898. Pupil of NY School of Fine and Applied Art; Art Students League of NY. Member: Society of Independent Artists. Address in 1929, Ardsley Studio, 110 Columbia Heights, Brooklyn, NY; summer, Scotland Hill Road, Spring Valley, NY.

MORRIS, CATHERINE WHARTON.
See Wright, Catherine Morris.

MORRIS, DAVID.
Sculptor. Born in Wales in 1817. Listed as living in Philadelphia in August of 1850. Medium: Plaster.

MORRIS, ELLWOOD.
Painter. Born in Richmond, IN, June 5, 1848. Member: Richmond Art Association; Richmond Palette Club. Work: "Autumn Tints and Shadows," Richmond Art Association. Address in 1929, Masonic Temple, 9th Street; h. 43½ South 19th Street, Richmond, IN. Died in 1940.

MORRIS, FLORENCE.
(Mrs. R. E. Morris). Painter. Born in Nevada, MO, March 5, 1876. Pupil of W. E. Rollins; A. J. Hammond; L. Brezoli. Member: New Mexico Archeological Society; American Federation of Arts; Society of Independent Artists. Award: First prize, Tri-State Fair, New Mexico, Texas, and Oklahoma, 1925. Work: "The Papoose," Museum of Art and Archeology, Santa Fe, NM; Portrait of Mrs. Virginia A. Stockard, Supreme National Board of P. E. O., Wesleyan College, Mt. Pleasant, IA. Exhibited: Galerie d'Art du Montparnasse, Paris, 1930; numerous exhibitions in the U.S. Address in 1953, Old Church Studio, 4th and Penn, Roswell, NM.

MORRIS, GEORGE FORD.
Sculptor, painter, illustrator, lecturer, writer, and critic. Born in St. Joseph, MO. Studied: Art Institute of Chicago; Julian Academy, Paris, France. Contributor: Illustrations for *Scribner's* and *Century* magazines. Specializes in painting famous horses, their owners and riders. Address in 1953, Fordacre, Shrewsbury, NJ.

MORRIS, GEORGE LOVETTE KINGSLAND.
Sculptor, painter, writer, lecturer, teacher, and designer. Born in New York, November 14, 1905/06. Studied: Yale University, B.A.; Art Students League; Academie Moderne, Paris, France. Member: American Abstract Artists; Federation of Modern Painters and Sculptors. Awards: Berkshire Museum, 1964; Temple Gold Medal, Penna. Academy of Fine Arts, 1967. Work: Metropolitan Museum of Art; Penna. Academy of Fine Arts; Philadelphia Museum of Art; Whitney Museum; U.S. State Department; Berkshire Museum; University of Georgia; Munson-Williams-Proctor Institute; Wichita Museum of Art; Yale School of Fine Arts; Encyclopedia Britannica Collection; New Art Circle, NY. Exhibited: Whitney Museum, 1938-46; Penna. Academy of Fine Arts, 1945, 46; Carnegie Institute, 1944-58; American Abstract Artists, 1936-58; Federation of Modern Painters and Sculptors, 1941-58; Virginia Museum of Fine Arts, 1946; Berkshire Museum, 1935, 38, 45; Century Association, NY, 1965; Corcoran Gallery, 1965. Contributor to: *Partisan Review*, with articles on abstract art. Position: Advisory Committee, Museum of Modern Art, New York, NY, 1933-40. Address in 1970, 1 Sutton Place, South, New York, NY. Died in 1975.

MORRIS, HILDA.
Sculptor and painter. Born in NYC, in 1911. Studied at Art Student League; Cooper Union Art School. Works: Memorial Art Gallery, Univ. of Rochester; Reed College, Portland, Oregon; Munson-Williams-Proctor Institute; Seattle Art Museum; Portland Oregon Art Museum; San Francisco Museum of Art; Walter Chrysler Collection, Virginia Museum. Exhibited: Metropolitan Museum of Art, 1951; 3rd Pacific Coast Biennial, Santa Barbara Museum of Art, 1960; Northwest Art Today, Seattle World's Fair, 1962; Brooklyn Museum, 1964; San Francisco Museum of Art. Received Ford Foundation Fellowship, 1960. Address in 1982, Portland, OR.

MORRIS, PAUL WINTERS.
Sculptor. Born in Du Quoin, IL, November 12, 1865. He studied with Saint-Gaudens and under D. C. French in New York. He died in New York, November 16, 1916.

MORRIS, ROBERT.
Sculptor. Born February 9, 1931, in Kansas City, MO. Studied: Kansas City Jr. College; Kansas City Art Institute, 1948-50; University of Kansas City; San Francisco Art Institute; Reed College, 1953-55; Hunter College, M.A., 1966. Work: National Gallery, Melbourne; Dallas Museum of Fine Art; Whitney; Tate; Modern Museum, Stockholm. Exhibited: Dilexi Gallery, San Francisco; Green Gallery, NYC; Dwan Gallery, Los Angeles; Leo Castelli Inc., NYC; Ileana Sonnabend Gallery, Paris; Sonnabend Gallery, Paris; Wadsworth Atheneum; Whitney Museum; Jewish

Museum, Primary Structures; Art Institute of Chicago; Walker; Detroit Institute, Color, Image and Form; Los Angeles Co. Museum of Art and Philadelphia Museum of Art, American Sculpture of the 60's; Museum of Modern Art, The 1960's; Torcuato di Tella, Buenos Aires; Eindhoven; Guggenheim, Guggenheim International; Albright; The Hague, Minimal Art; Foundation Maeght; Corcoran Gallery; Stedelijk Museum; Smithsonian Institution; others. Awards: National Council on the Arts; Art Institute of Chicago, 1966; Guggenheim, 1967, fellowship, 1969; Torcuato di Tella, Buenos Aires, 1967; Sculpture Award, Society of Four Arts, 1975. Address in 1982, c/o Castelli Gallery, NYC.

MORRIS, ROBERT C.
Painter. Born in Anderson, IN, Jan. 6, 1896. Member: Anderson Society of Artists. Address in 1929, 2609 Jackson Street, Anderson, IN.

MORRIS, VIRGINIA LEIGH.
Sculptor. Born in Norfolk, VA, October 16, 1899. Pupil of Solon Borglum, Harriet Frishmuth; Yale School of Fine Arts. Member: Norfolk Society of Artists; Society of Washington Artists; Washington Art Club; Southern States Art League. Awards: Florence K. Sloane prize, 1921 and 1926, and Elsie Stegman prize, 1921, Norfolk Society of Artists. Address in 1933, 596 Mowbray Arch, Norfolk, VA.

MORRISON, DAVID HERRON.
Painter. Born in Rawalpindi, Punjab, India, Nov. 15, 1885. Pupil of Kenneth Hayes Miller and George B. Bridgman. Member: NY Art Students League; Salons of America (director and treasurer). Instructor of drawing and painting, Allen Stevenson School, New York. Address in 1929, 28 Greenwich Avenue, New York, NY. Died in 1934.

MORRISON, MARK.
Sculptor. Born in King Fisher, OK, January 1, 1900. Studied: Univ. of Missouri; Art Students League; and with John Flanagan, Jose De Creeft, William Zorach. Member: Sculptors Guild; Architectural League; Audubon Artists. Awards: Prize, National Academy of Design, 1950. Exhibited: Metropolitan Museum of Art, 1942, 51; National Academy of Design, 1949, 50; Penna. Academy of Fine Arts, 1949, 50; Fairmount Park, Philadelphia, 1949; Whitney Museum of American Art, 1949, 50; Nebraska Fine Arts Association, 1946; Newark Museum, 1944; Wilmington Society of Fine Arts, 1946; Audubon Artists, 1947-50; Sculptors Guild, 1950, 51; New Britain, CT, 1947. Address in 1953, 8 West 13th Street, New York, NY.

MORRISON, ZAIDEE LINCOLN.
Portrait painter. Born in Skowhegan, ME, Nov. 12, 1872. Pupil of J. H. Twachtman, F. V. DuMond, Chase, R. H. Nicholls. Member: Art Students League

of NY; Alliance; NY Water Color Club (Assoc.); National Association of Women Painters and Sculptors; North Shore Arts Association. Work in Mary Lyon Room, Mount Holyoke College, MA; Colby University, Waterville, ME; Smithsonian Institution, Washington, D.C. Address in 1929, 58 West 57th Street, New York, NY; summer, East Gloucester, MA.

MORROW, JULIE.
(Mrs. Cornelius Wortendyke De Forest). Painter, writer, and teacher. Born in New York, NY. Pupil of Lie, Carlson and Hawthorne. Member: National Association of Women Painters and Sculptors; Provincetown Art Association; Marblehead Art Association; Cincinnati Art Club; American Artists Professional League; Laguna Beach Art Association; American Federation of Arts. Represented in Wadleigh Library, New York City. Address in 1929, Riverview Apartments, Cincinnati, OH.

MORSE & TUTTLE.
(Hazen Morse and Joseph Tuttle). In 1840 this firm was engraving maps in Boston, MA.

MORSE, ANNA G.
Painter, craftswoman, and teacher. Born in Leominster, MA. Pupil of Jules Lefebvre and T. Robert-Fleury in Paris. Member: Pen and Brush Club of NY; Alliance; C. L. Wolfe Art Club. Awards: Water color prize, Wanamaker's, Philadelphia, 1910; water color prize, C. L. Wolfe Art Club, New York, 1920. Address in 1929, 77 Irving Place, New York, NY. Died 1954.

MORSE, ANNE GODDARD.
Painter and illustrator. Born in Providence, RI, Jan. 17, 1855. Pupil of Massachusetts Normal Art School; NY Art Students League; Wyatt Eaton in NY; John La Farge for stained glass. Member: Providence Water Color Club. Address in 1929, Hope Hospital, 1 Young Orchard Avenue, Providence, RI.

MORSE, EDWARD LIND.
Painter and writer. Born in Poughkeepsie, NY, March 29, 1857. Studied at Royal Academy of Art, Berlin, 1884-88; Grand Ducal Academy of Art, Weimar, Germany, 1888-91; Julian Academy, Paris, 1891-92. Exhibited in Paris Salon, 1893; also at National Academy of Design; etc. Special exhibitions of work in Washington, New York, Chicago, St. Louis, etc. Member: American Federation of Arts. Died June 9, 1923, in Pittsfield, MA.

MORSE, HAZEN.
Engraver. In the *New England Palladium* of July 20, 1824, "Hazen Morse, Engraver," announced that he removed from No. 6 Congress Street to Congress Square, "a few doors south of the Exchange Coffee House," and he there "continues the business of

Copper Plate engraving, in its various branches." Copperplate printing was also done at the same place. For a time Hazen was in the employ of the Boston engraving firm of Annin & Smith. He was also with the firm of Morse and Tuttle, engravers of maps, in Boston, MA, 1840. According to the advertisement quoted above he seems to have been chiefly engaged in engraving doorplates, brass numbers for doors, coffin-plates, stencil-plates, etc. The only signed copperplate known to Fielding in 1926 is the "Carey" book-plate inscribed "H. Morse Sc."

MORSE, HENRY DUTTON.
Painter. Born in Boston, MA, April 20, 1826, where he continued to reside. He had no regular instruction in art and was not considered a professional artist; still, in his leisure hours, for many years, he painted pictures, generally of animals, that met with a ready sale in Boston. He was a member of the Boston Art Club, and the son of Hazen Morse. Died Jan. 12, 1888 in Jamaica Plains, MA.

MORSE, IRENE MILNER.
(Mrs. Norman K. Morse). Painter. Born in Philadelphia, PA, March 16, 1894. Pupil of Penna. Academy of Fine Arts. Member: Fellowship Penna. Academy of Fine Arts. Address in 1929, 6907 Henley Street, Mt. Airy, Phila., PA; summer, Avalon, NJ.

MORSE, JEAN H.
Sculptor and painter. Born in Derby, CT, September 7, 1876. Pupil of Yale Art School, Chase, Woodbury. Member: New Haven Paint and Clay Club; Northern Valley, NJ, Art Association; American Federation of Arts. Address in 1933, Englewood, NJ; summer, Cotuit, MA.

MORSE, MARY MINNS.
Painter. Born in Dorchester, MA, in 1859. Pupil of Ross Turner and Louis Ritter in Boston; of George Hitchcock in Holland. Member: Boston Water Color Club; Copley Society. Specialty: Landscape and marines in water colors. Address in 1926, 211 Savin Hill Avenue, Boston, MA.

MORSE, NATHANIEL.
Engraver. The only engraving by Nathaniel Morse found by Fielding is a portrait of Rev. Matthew Henry, engraved in line after a print by George Vertue. This portrait is the frontispiece to "The Communicant's Companion, etc.," by Matthew Henry, published in "Boston in New England, reprinted for T. Phillips at the Stationer's Arms, next to Mr. Dolbear, the Braziers, 1731." The Massachusetts Archives contain a copy of a bill of 1735, showing that Morse was paid for engraving and printing a plate for Massachusetts paper money. This bill is signed "Nat Mors," as is the engraving of Matthew Henry referred to above. Died in Boston, June 17, 1748.

MORSE, PAULINE HESTIA.
Painter. Born in Marlborough, MA. Pupil of Dante Ricci, Humann, Rice, Snell. Member: Society of Independent Artists; American Federation of Arts. Address in 1929, 15 Irving Street, Worcester, MA.

MORSE, SADIE MAY.
Painter, craftswoman and teacher. Born in Lexington, MA, May 5, 1873. Pupil of Massachusetts Normal Art School, Boston; also studied one year in Italy. Member: Hingham Arts and Crafts Society; Boston Society of Arts and Crafts; American Federation of Arts; Boston Painters in Water Color. Formerly educational director and reconstruction aide in occupational therapy, U.S. Veteran's Bureau. Address in 1929, Marblehead, MA.

MORSE, SAMUEL FINLEY BREESE.
Sculptor, figure and portrait painter, and inventor. Born in Charlestown, MA, April 27, 1791. He graduated from Yale in 1810; became a pupil of Washington Allston whom he accompanied the following year to London, where he studied under Benjamim West. Returned to America in 1815 and painted portraits in Boston, MA; Concord, NH; and Charleston, SC. Settled in New York in 1823, where, in 1826, he became one of the original founders of the National Academy of Design and its first president, serving from 1827-45 and again from 1861-62. Among his most important paintings is the full-length portrait of Lafayette in the New York City Hall, and the large picture of the old "House of Representatives by Candle Light," now in the Corcoran Gallery of Art, in Washington, DC. His model of a "Dying Hercules" was awarded a gold medal. From 1839 until his death he devoted his time to perfecting the invention of the telegraph. Died in NYC, April 2, 1872.

MORTON, CHRISTINA.
(Mrs. Benjamin A. Morton). Painter. Born in Dardanelle, AR. Member: Allied Artists of America; American Federation of Arts; National Association of Women Painters and Sculptors; MacDowell Club. Work: Paintings of Martinique reproduced in "The Veiled Empress," by B. A. Morton. Address in 1929, 27 West 67th Street, New York, NY.

MORTON, JOHN LUDLOW.
Painter. Born in 1792. He was a native of New York, and a son of General Morton. His best known painting was a historical scene from Scott's "Ivanhoe." He was elected an Academician in 1831. He died in New York on Aug. 1, 1871, having been active all his life from his student days in the National Academy of Design.

MORTON, JOSEPHINE A.
Painter. Born in Boston, MA, in 1854. Pupil of Eakins; of Laurens and Constant in Paris. Member:

Newport Artists' Association; Society of Independent Artists. Address in 1926, 144 Main Street, Williamstown, MA.

MORTON, KATHERINE GIBSON.
Sculptor and painter. Born in New York, NY, November 14, 1895. Studied with Boardman Robinson, Jonas Lie, Jerry Farnsworth. Work: Brookgreen Gardens, SC. Exhibited: National Academy of Design, 1941; Southern Vermont Artists, 1936-39; Norton Gallery, West Palm Beach, FL, 1944-46; Society of Four Arts, 1943-46; Tricker Gallery, 1939; one-woman exhibitions include the Arden Gallery, 1935, Ferargil Gallery, 1936, and the Worth Avenue Gallery, Palm Beach, FL, 1946. Illustrated special pamphlets, American Museum of Natural History, New York, NY. Address in 1953, Madison, CT.

MOSCHCOWITZ, PAUL.
Portrait painter and teacher. Born in Giralt, Hungary, March 4, 1876. Pupil of Art Students League in New York; Julian Academy in Paris. Member: Soc. of American Artists, 1901; Associate National Academy of Design, 1906. Awards: Silver medal, St. Louis Expo., 1904. Instructor, Pratt Inst., Brooklyn, NY. Address in 1929, 104 West 40th Street; h. 477 West 140th Street, New York, NY.

MOSE, CARL C.
Sculptor and teacher. Born in Copenhagen, Denmark, February 17, 1903. Studied: Art Institute of Chicago; Art Students League; Beaux-Arts Institute of Design; pupil of Lorado Taft, Albin Polasek, Leo Lentelli. Member: Society of Washington Artists; American Federation of Arts; St. Louis Art Guild; 2 x 4 Club; National Sculpture Society; National Society of Arts and Letters. Work: Corcoran Gallery; Minnesota State Historical Society; Ft. Sumter, NC; Meridian Hill Park, Washington, DC; U.S. Post Office, Maplewood, MO, and Salina, KS; figures of Apostles for the Washington Cathedral, Mt. St. Albans, Washington, DC; medal for the American Medical Assoc.; decorations on Y.M.C.A., Chicago, IL; eighteen decorative panels, exterior Potomac Electrical Power Company Building; others. Exhibited: Art Institute of Chicago, 1918-38; National Academy of Design; Royal Academy, Copenhagen, Denmark; one-man exhibitions include the Corcoran Gallery, Minneapolis Institute of Art, Society of Washington Artists, Chicago Galleries Association, St. Louis Art Guild, and the Museum of Fine Arts, Houston. Awards: Prizes, Minneapolis Institute of Art; St. Louis Art Guild, 1947, 49, 52; medal, Society of Washington Artists; others. Address in 1953, 4527 Olive Street; h. Maryland Avenue, St. Louis, MO.

MOSELEY, HELEN E.
Painter. Born Sept. 21, 1883, in Grand Rapids, MI. Exhibited at 33rd Annual Exhibition of National Assoc. of Women Painters and Sculptors, "Gloucester Moors." Studied at Art Institute of Chicago and with Robert Henri, Hugh Breckenridge & Charles Hawthorne. Member of National Association of Women Painters and Sculptors. Died April 22, 1928, in Boston, MA. Address in 1926, Grand Rapids, MI.

MOSELSIO, SIMON.
Sculptor, painter, and educator. Born in Russia, December 17, 1890. Studied: Kunstgewerbe Schule; Royal Academy of Fine Arts, Berlin, Germany. Member: National Sculpture Society; Architectural League. Awards: Medal, Paris International Exposition. Work: Whitney Mus.; University of Georgia; IBM; Bennington Historical Mus.; Weyhe Gallery. Exhibited: World's Fair, New York, 1939; Whitney Museum, 1934, 35, 39, 1940-43, 45, 46, 50; Art Institute of Chicago; Penna. Academy of Fine Arts; Weyhe Gallery (one-man); Fleming Museum of Art; Salons of America, 1925, 26; New York Art Center, 1926 (one-man); Brooklyn Museum, 1930; Research Institute Theatre, Saratoga Springs, New York; Philadelphia Museum of Art, 1940; Worcester Museum of Art, 1943, 51; Buchholz Gallery, 1941, 43, 45; Library of Congress, 1949; Albany Institute of History and Art; etc. Taught: Instructor of sculpture and art, Bennington College, Bennington, VT, from 1933; Director, Corp. of Yaddo. Address in 1953, Old Bennington, VT. Died in 1963.

MOSER, JAMES HENRY.
Painter. Born in Whitby, Ontario, Canada, in 1854. Landscape painter in oils and water colors. Pupil of John H. Witt and Charles H. Davis. Awards: Medal, Atlanta Exposition, 1895; first Corcoran prize, Washington Water Color Club, 1900; bronze medal, Charleston Expo., 1902, etc. Represented at the Corcoran Art Gallery, Washington, D.C., by "Winter Sunshine" (water color), painted in 1895; "The Mountain Road" (water color), painted in 1904. Died Nov. 10, 1913 in Washington, DC.

MOSER, JULON.
Painter. Born in Schenectady, NY, in 1900. Studied: Chouinard Art Institute; University of California; Scripps College; and with Millard Sheets, Glen Wessels, Frank Taylor Bowers. Awards: Greek Theatre, Los Angeles, 1951, 1955; Pasadena Art Institute, 1951; Women Painters of the West, 1938, 1940, 1942, 1944; Laguna Beach, 1953; Wilshire Ebell Club. Collection: Clearwater Museum of Art. Address in 1980, Dean Drive, Ventura, CA.

MOSES, ANNA MARY ROBERTSON.
"Grandma Moses." Painter. Born on September 7, 1860, in Greenwich, NY. In 1887 she married and, in 1905, moved to a farm near Eagle Bridge, Rensselaer County, NY, where she lived the rest of her life. In 1918 she tried painting a scene on the fireboard of her fireplace, but it was not until her late seventies, when arthritis forced her to give up making worsted

embroidery pictures, that she turned to oil paints to occupy her time. In October of 1939, three paintings were exhibited at the Museum of Modern Art in NYC in a show entitled "Contemporary Unknown Painters." In October, 1940, a one-man show of 35 paintings was held at Galerie St. Etienne in NYC. In November of that year, Gimbel's department store brought "Grandma" Moses to NYC on the opening day of a Thanksgiving exhibition of her works. Her paintings were shown throughout the U.S. and in Europe in some 150 one-man shows and 100 more group exhibits. Grandma Moses produced some 2,000 paintings in all, mainly on masonite board. She died on December 13, 1961, at the age of a hundred and one, in Hoosick Falls, New York.

MOSES, THOMAS G.
Landscape painter. Born in Liverpool, England, in 1856. Pupil of Art Institute of Chicago, and of R. M. Shurtleff. Member: Palette and Chisel Club; California Art Club; Laguna Beach Art Association; Salma. Club. Address 1929, 417 South Clinton St., Chicago, IL; h. 233 So. Euclid Ave., Oak Park, IL.

MOSKOWITZ, ROBERT.
Painter. Born June 20, 1935, in Brooklyn, NY. Studied at Pratt, 1955-57. Awards: Guggenheim fellowship, 1967; NYS Council on the Arts, 1973; National Endowment for the Arts, 1975. Exhibited at Leo Castelli Gallery, NYC, 1962; Museum of Modern Art; Albright-Knox; Brandeis; Wadsworth; La Jolla Museum of Contemporary Art (one-man); Margo Levin Gallery, Los Angeles (one-man). In collections of Whitney; Brandeis; Museum of Modern Art; Albright-Knox; and many private collections. Address in 1984, 81 Leonard Street, New York, NY.

MOSLER, HENRY.
Figure and genre painter. Born June 6, 1841, in New York. Pupil of James H. Beard in Cincinnati; Mucke and Kindler in Dusseldorf; Hebert in Paris; Wagner in Munich. Awards: Medal, Royal Academy, Munich, 1874; honorable mention, Paris Salon, 1879. Represented at the Corcoran Art Gallery by "Saying Grace," painted in 1897. Died April 21, 1920 in NYC.

MOSS, DONALD.
Illustrator. Born in Somerville, MA, in 1920. He studied at Pratt Institute and the Art Students League with such eminent instructors as Paul Rand, Will Burton and Howard Trafton. His first illustration was done for *Collier's* in 1948. He has specialized in sports art for many years and has worked for *Sports Illustrated* for over 20 years. In 1976 he designed the United States Olympic stamps.

MOSS, ELLA A.
Painter. Born in New Orleans in 1844. Studied in Europe, and opened her studio in NY. She painted many portraits of prominent people and exhibited in the National Academy in 1878.

MOSS, IRENE.
Painter. Born in Eperjes, Czechoslovakia. U.S. citizen. Studied: Brooklyn Museum School of Art; and with Moses Soyer and Dmitri Romanofsky. Exhibitions: Rochester Memorial Art Gallery, NY, 1968; Peter Rose Gallery, NYC; Bacardi Art Gallery, Miami, Florida, 1974; Suffolk Museum, Long Island, NY, 1971 (one-woman); Stamford Museum, CT, 1972; Philadelphia Civic Center Museum, 1974. Collections: Akron Art Institute, Akron, OH; Norfolk Museum, Norfolk, VA; Rose Art Museum, Brandeis University, MA; The New Britain Museum of American Art, New Britain, CT. Address in 1984, Floral Park, NY.

MOTE, ALDEN.
Portrait and landscape painter. He was born in West Milton, OH, on Aug. 27, 1840, and after 1880 lived in Richmond, IN. Represented by a portrait of Daniel G. Reid in the Reid Memorial Hospital, Richmond, IN. Died Jan. 13, 1917, in Richmond, IN.

MOTE, W. H.
This English portrait-engraver did a large amount of work in London in the first half of the 19th century. He engraved portraits of Charles Carroll, of Carrollton, Epes Sargent, and other Americans, and subject plates engraved by him were used in American publications; but no evidence was found by Fielding that Mote ever actually engraved in this country. The plates mentioned were probably brought over here for publication.

MOTHERWELL, ROBERT.
Painter. Born Jan. 24, 1915, in Aberdeen, WA. Received A.B., Stanford, 1936; studied at Harvard Graduate School, 1937, and Columbia, 1940. Taught at Univ. of Pennsylvania and Columbia. Awards: Guggenheim Museum, 1964; Belgian, 1966, and French, 1977; Penna. Academy of Fine Arts, 1979. Exhibited at Museum of Modern Art; Metropolitan Museum of Art; Phillips Gallery (Washington, D.C.); Tate; Guggenheim. Paintings hang internationally, including Addison at Andover, MA; Baltimore Museum of Art; Harvard; Cleveland; Yale; Museum of Modern Art; Metropolitan Museum of Art; Whitney; Museum de Arte Moderna in Rio; Tel Aviv; Art Gallery of Toronto. Murals in Kennedy Federal Building, Boston; University of Iowa Art Museum; National Gallery, Washington, D.C.

MOTLEY, ARCHIBALD JOHN, JR.
Painter. Born in New Orleans, LA, Oct. 7, 1891. Pupil of Karl Buehr. Member: Chicago Society of Artists; Illinois Academy of Fine Arts. Awards: Frank G. Logan medal and prize, Art Institute of Chicago, 1925; Joseph N. Eisendrath prize, Art Institute of Chicago, 1925; first Harmon Foundation award, gold medal and prize, New York, 1928. Address in 1929, 350 West 60th Street, Chicago, IL.

MOTLEY, ELEANOR W.

(Mrs. Thomas Motley). Painter. Member: Museum School Art Association; Guild of Boston Artists; Boston Society of Water Color Painters. Represented in Boston Museum of Fine Arts. Address in 1929, 22 Commonwealth Avenue, Boston, MA.

MOTT-SMITH, MAY.

(Mrs. Small). Sculptor, miniature painter, and craftswoman. Born in Honolulu, HI, March, 17, 1879. Pupil of Colarossi Academy; Van Der Weyden; Spicer-Simson; Robert Aitken. Member: California Art Club; Society of Independent Artists; California Society of Miniature Painters; California Sculptors Society; National Academy of Women Painters and Sculptors; American Numismatic Society; American Federation of Arts. Awards: Bronze medal for small relief, Panama-California Expo., San Diego, 1915; silver medal for jewelry, P.-P. Expo., San Francisco, 1915. Exhibited at National Sculpture Society, 1923. Address in 1933, c/o Harriman National Bank, New York City. Died in 1952.

MOTTET, JEANIE GALLUP.

(Mrs. Henry Mottet). Painter. Born in Providence, RI, in 1884. Pupil of Art Students League of NY; Chase; Richard E. Miller; E. Ambrose Webster. Member: National Association of Women Painters and Sculptors; Provincetown Art Association; National Arts Club; American Federation of Arts. Chairman of exhibition committee and curator of painting, Museum of French Art, New York, NY. Decorated Officier d'Academie by Minister of Beaux Arts, Paris, 1918, and Officier d'Instruction Publique, 1929. Represented in Musee du Luxembourg, Paris. Address in 1929, 47 West 20th Street, New York, NY.

MOTTO, JOSEPH C.

Sculptor. Born in Cleveland, OH, March 6, 1892. Pupil of Matzen, MacNeal, and Heber. Member: Cleveland Society of Artists; Cleveland Society of Sculptors. Award: First prize, Cleveland Museum of Art, 1922. Work: Shakespeare bust, City of Cleveland; bust of "Prof. Wilson," Western Reserve University, Cleveland; "Matzen" bust, Cleveland School of Art; "Lincoln" bust, Hawken School, South Euclid. Address in 1933, Hawken School, South Euclid, OH; h. 1536 East 41st Street, Cleveland, OH.

MOTTRAM, C.

Engraver. Born in 1817. A fine line-engraving, signed by C. Mottram as engraver, represents a view of the city of New York from the Brooklyn shore. It is made from a drawing executed by J. W. Hill, New York, 1855, and was published there that same year. John William Hill was the son of John Hill, the aquatint-engraver, who came to the United States in 1816 and died here in 1850.

MOTZ, RAY ESTEP (MRS.).

Painter, etcher, and teacher. Born in Whitsett, PA, May 27, 1875. Pupil of Carnegie Institute of Technology; Art Institute of Chicago; NY School of Fine and Applied Arts. Member: Associated Artists of Pittsburgh. Award: First prize for oil, Associated Artists of Pittsburgh, 1929. Address in 1929, 338 Oneida Street, Monessen, PA; summer, Shelburne Falls, MA.

MOTZ-LOWDON, ELSIE.

See Lowdon, Elsie Motz.

MOUGEL, MAX.

Sculptor and etcher. Born in New York, NY, April 21, 1895. Work: Brooklyn Museum; Library of Congress; U.S. Government Buildings. Exhibited: American Museum of Natural History; Soc. of American Graphic Artists, 1936, 1938-40, 44; Connecticut Academy of Fine Arts, 1936; Penna. Academy of Fine Arts, 1936; Philadelphia Print Club, 1940; Alden Gallery, 1940; Library of Congress, 1944; Carnegie Institute, 1944; Corcoran Gallery of Art, 1944-46; National Maritime Exhibition, 1945. Illustrator, architectural and travel magazines. Address in 1953, 574 C Minneford Avenue, City Island, New York, NY.

MOULD, J. B.

This name is signed as engraver to good stipple portraits published in New York about 1830, but as the portraits are those of foreigners it is possible that these plates were imported.

MOULTHROP, REUBEN.

Portrait and miniature painter. Born in 1763. He also modelled in wax. He died in East Haven, CT, in 1814. His portraits of Ezra Stiles and Jonathan Edwards are good examples of his work. Died July 29, 1814.

MOULTON, CLAXTON B.

Painter. Exhibited "Portrait of a Boy" at Penna. Academy of Fine Arts, Philadelphia, 1921. Address in 1926, 172 Townsend Street, Boston, MA.

MOULTON, SUE BUCKINGHAM (MRS.).

Painter. Born in Hartford, CT, Jan. 20, 1873. Pupil of Andrews, Moser, Frisbie. Member: Alliance; Ceramic League; American Federation of Arts. Award: Micherson memorial prize. Work: Mural painting in the Philomusian Club, Philadelphia. Specialty: Miniature painting. Address in 1929, 901 South 47th Street, Philadelphia, PA.

MOUNIER, LOUIS.

Sculptor, painter, and teacher. Born in France, December 21, 1852. Pupil of F. Sanzel in Paris (sculpture); F. Rondel in New York (painting). Address in 1910, Louisia Lodge, Vineland, NJ.

MOUNT, HENRY SMITH.
Painter. Born on Oct. 9, 1802, in Stony Brook, LI, NY. He was a brother of William S. and Shephard Alonzo. He was elected an Associate of the National Academy in 1832 and exhibited frequently. He died Jan. 20, 1841, in Setauket, LI, NY.

MOUNT, SHEPARD ALONZO.
Painter. Brother of W. S. Mount. Born July 17, 1804. He was a distinguished portrait painter. Became an Associate of the National Academy, 1831, and an Academician in 1842. He painted portraits of Martin Van Buren and other distinguished statesmen. Died Sept. 18, 1868, in Setauket, L.I, NY.

MOUNT, WARD.
(Pauline Ward Mount). Sculptor and painter. Born in Batavia, NY. Studied at NYU; Art Students League; private study with G. Gardner, K. H. Miller, A. P. Lucas, J. P. Pollia. Works: Designed bronze medal of honor for Painters and Sculptors Society, NJ, 1947; designed and executed The Bell of America, for Bell Association, 1950; Roosevelt Museum, Hyde Park, NY; Museum of Modern Art; Hudson River Museum; Delgado Museum. Exhibitions: Irvington Public Library; Delgado Museum; Hudson River Museum; Montclair Art Museum; Los Angeles Museum; Trenton State Mus.; Jersey City Mus.; National Academy of Design, 1944; Library of Congress; National Sculpture Society, 1945-48; New York Architectural League; NY Pub. Library; Municipal Art Gallery; Allied Artists of Am.; Riverside Mus.; Nat. Arts Club; Grand Central Palace; Audubon Artists, 1940-42; Penna. Academy of Fine Arts, 1949; Springfield Museum of Fine Arts; Smithsonian Inst., 1951; also represented in many collections. Awards: Jersey City Museum, 1941; Painters and Sculptors Society, 1943, 51; Montclair Art Museum, 1945; NJ Artists, 1945; Asbury Park Society of Fine Arts, 1946; Jersey City Museum, 1946; Kearney Museum, NJ, 1947; Jersey J. Woman of Achievement, 1971. Member: Founder, president, Painters and Sculptors Society of NJ; fellow, International Institute of Arts and Letters; Royal Society of Arts; NY Soc. of Painters; Artists Equity, NY; Painters and Sculptors Society of NJ; founding member, Audubon Artists. Address in 1984, Jersey City, NJ.

MOUNT, WILLIAM SIDNEY.
Painter. Born in Setauket, Long Island, NY, November 26, 1807. Most of his boyhood was spent at Stony Brook, Long Island. In 1824 he was apprenticed to his brother Henry at his sign-painting shop, where Mount commenced drawing. Two years later he entered the National Academy of Design for study. Also studied with Henry Inman. In 1831 he was elected an Associate of the National Academy of Design, and an Academician in 1832. Mount contributed regularly to the Academy's annual exhibitions for almost forty years after this. Except for short trips, he lived in Stony Brook from 1837. During the 1860's he travelled the country in a "portable studio" and much of his last sketching was done there. In 1868 he went to live with his brother, Nelson, in Setauket, where he died on November 19, 1868. Represented in the Metropolitan Museum of Art; National Gallery, Washington, DC; Suffolk Museum. Considered America's first important genre painter. His works include "Christ Raising the Daughter of Jairus;" "The Country Dance;" "The Sportsman's Last Visit;" "Farmers Nooning;" "Raffling for a Goose;" "Saul and the Witch of Endor;" "Rustic Dance after a Sleigh Ride;" "Cider Making;" "The Novice;" "The Bones Player;" "Catching Crabs;" and many others.

MOUNTFORT, ARNOLD.
Painter. Born in Eggbaston, England, in 1873. Pupil of Birmingham Municipal School of Art, England. Address in 1926, Sherwood Studios, 58 West 57th Street, New York, NY. Died Aug. 13, 1942.

MOUNTFORT, JULIA ANN.
Painter, illustrator, and writer. Born in Coaticooke, Canada, Jan. 14, 1892. Pupil of Fox Art School; Art Institute of Chicago; Chicago Academy of Fine Arts; Sargent; Townsley; etc. Member: Chicago No-Jury Society of Artists; Chicago Society of Artists; So. States Art League; South Shore Artists; All-Illinois Society of Artists. Address in 1929, Azalea Courts, Mobile, AL; summer, "House With Red Blinds," Bristol Road, Damariscotta, ME.

MOWBRAY, HENRY SIDDONS.
Painter. Born in Alexandria, Egypt, Aug. 5, 1858; brought to United States in 1859. Studied painting under Bonnat, Paris, 1878; in NY after 1878. Principal works include "A Lady in Black," Fine Arts Academy, Buffalo; "Idle Hours," National Gallery, Washington, D.C.; "Evening Breeze;" "Le Destin;" mural decorations in residences of F. W. Vanderbilt, C. P. Huntington, J. Pierpont Morgan, Appellate Court House, Morgan Library, NY, St. John's Episcopal Church, Washington, CT, and University Club Library, New York; residence of Larz Anderson, Washington; Federal Court Room, Cleveland. Member: Associate of the National Academy, 1888, Academician, 1891; Connecticut Academy of Fine Arts; National Institute of Arts and Letters; Society of American Artists, 1886; Artists' Fund Society; Century Association; National Commission of Fine Arts; and director of American Academy in Rome, 1903-04. Awards: Clarke prize, Nat. Academy of Design, 1888; medals at Atlanta, Boston, and Chicago; gold medal, Pan-Am. Expo., Buffalo, 1901. Address in 1926, Washington, CT. Died Jan 13, 1928.

MOWBRAY-CLARKE, JOHN FREDERICK.
Sculptor. Born in Jamaica, West Indies, August 4, 1869. Pupil of Lambeth School, London. Member:

American Painters and Sculptors. Represented in Metropolitan Museum, New York; Newark (NJ) Museum; British Museum, London. Address in 1933, "The Brocken," Pomona, Rockland Co., NY. Died 1953.

MOYERS, WILLIAM.
Sculptor and painter. Born in Atlanta, Georgia, December 11, 1916. Studied fine arts at Adams State College; Otis Art Institute, Los Angeles. Worked as a cowboy; in art at Walt Disney Studios; in New York City as an illustrator. Turned to fine art full-time around 1962. In collections of Gilcrease Institute, Tulsa, Oklahoma; National Cowboy Hall of Fame, Oklahoma City. Has exhibited in Cowboy Artists of America Shows since 1968; National Cowboy Hall of Fame, solo, Oklahoma City; Peking, China, Show; others. Received gold and silver medals, sculpture, Cowboy Artists of America Shows; others. Member of Cowboy Artists of America. Specialty is Western life; works in oils, watercolor, bronze. Bibliography includes *Southwest Art*, March 1980; *Cowboy in Art*, Ainsworth; *Western Americana*, Harmsen; *Bronzes of the American West*, Broder. Represented by Taos Art Gallery, Taos, NM; Trailside Galleries, Scottsdale, AZ. Address in 1982, Albuquerque, NM.

MOYNIHAN, FREDERICK.
Sculptor. Born in 1843 on Island of Guernsey, Great Britain. Student of the Royal Academy, London. Made a specialty of military figures of the Civil War period. Died January 9, 1910, in New York City.

MOZIER, JOSEPH.
Sculptor. Born in Burlington, VT, August 12, 1812. He studied sculpture for several years in Florence, and then went to Rome, where he spent the greater part of his professional career. Among his best works are "Esther," the "Wept of Wish-ton-Wish," "Tacite," "Truth," the "White Lady of Avenel," "The Peri," "Pocahontas," "Prodigal Son," "Rizpah," and "Il Penseroso" in marble; the last was transferred from the Capitol in 1888 to the Nat. Gallery, Washington, DC; works also at Mus. of Fine Arts, Philadelphia. Died in Faido, Switzerland, on October 3, 1870.

MUEDEN, MATHILDE.
See Leisenring, Mathilde Mueden.

MUELKE, ROBERT.
Sculptor, craftsman, illustrator and designer. Born in Buffalo, NY, April 3, 1921. Studied: Pratt Institute Art School; Art Institute, Buffalo. Member: Industrial Designers Institute. Exhibited: Albright Art Gallery, 1942. Position: Industry and Architectural Design, 1943-46, with Raymond Loewy, General Electric, Barnes and Reinecke, and others. Own design practice, from 1945. Address in 1953, Milford, CT.

MUELLER, ALEXANDER.
Painter, lecturer, and teacher. Born in Milwaukee, WI, Feb. 29, 1872. Pupil of Richard Lorenz in Milwaukee; Max Thedy in Weimar; Carl Marr in Munich. Member: Wisconsin Painters and Sculptors. Address in 1929, 2955 Monterey Road, San Marino, Los Angeles Co., CA. Died in 1935.

MUELLER, AUGUSTUS MAX JOHANNES.
Sculptor. Born in Meiningen, Germany, June 8, 1847. Pupil of the Royal Academies of Berlin and Munich. Address in 1910, 926 West College Ave.; h. 2314 Poplar St., Philadelphia, PA.

MUELLER, CARL.
Illustrator. Member: Society of Illustrators. Address in 1929, Westport, CT.

MUELLER (OR MILLER), CHARLES.
Sculptor. Born in Germany, about 1820. Worked in New York City from about 1856 into the 1860's. Exhibited at the National Academy, and the American Institute. Worked in bronze and marble.

MUELLER, HENRIETTA WATERS.
Painter and sculptor. Born in Pittsburgh, PA, April 13, 1915. Studied: Northwestern University; Art Institute of Chicago, with Helen Gardner, BFA, 1938; Art Students League; University of Wyoming, M.A., 1948, M.Ed., 1960; University of Colorado, with Wendell Black; and with Will Barnet, Ilya Bolotowsky, John Opper, and Geo. McNeil. Awards: Mary Griffiths Marshall Memorial fellowship, Alpha Chi Omega, 1952; Tri-State Exhibition, 1958; Cummington fellowship, 1954; Wilson Daly Prize, John Herron Art Institute, Indianapolis, 1952; Purchase Award, University Wyoming Art Museum, 1973. Collections: NY Public Library; Joslyn Art Museum; Henry Gallery, University of Washington; Nelson Gallery of Art; Woman's College, University of North Carolina. Exhibited at Phila. Mus.; San Francisco Museum of Art; Met. Museum of Art; Pioneer Museum, Stockton, CA, 1971; others. Member: Wyoming Artists' Assoc.; Artists Equity Assoc.; Laramie Art Guild. Media: Oil, watercolor, acrylic; steel and aluminium. Address 1982, Laramie, WY.

MUELLER, JOHN CHARLES.
Illustrator, craftsman, draftsman, and writer. Born in Cincinnati, OH, Nov. 3, 1889. Pupil of Nowottny, Duveneck, Meakin, Miller, Cincinnati Art Academy. Member: Cincinnati Art Club. Awards: Hon. mention for book cover, Advertisers Club of the World; first prize for emblem design, National Association Advertising Specialty Manufacturers. Designer of the official flag for the City of Norwood, OH. Address in 1929, 2042 Weyer Avenue, Norwood, OH.

MUELLER, LOUIS F.
Painter. Born in Indianapolis, IN, April 29, 1886. Pupil of Zugel, Habermann, and Marr in Munich.

Member: Royal Bavarian Akademie, Munich. Address 1929, 2209 Ashland Ave., Indianapolis, IN.

MUELLER, MICHAEL J.
Painter, craftsman, and teacher. Born in Durand, WI, Dec. 3, 1893. Pupil of Sergeant Kendall, Winter, Savage, E. C. Taylor, Rittenberg, Bridgman, DuBois. Address in 1929, Van Dyck Bldg., 939 Eighth Avenue, New York, NY; h. Cable, WI.

MUENDEL, GEORGE F.
Painter. Born in West Hoboken, NJ, 1871. Pupil of Ochtman and Art Students League of NY. Member: Connecticut Academy of Fine Arts; Silvermine Guild of Artists; American Federation of Arts. Awards: Prize ($100), Connecticut Academy of Fine Arts, 1914. Address in 1929, Rowayton, CT.

MUGFORD, WILLIAM.
Portrait painter. The Peabody Museum of Salem, MA, owns a crayon portrait by William Mugford.

MUHLHOFER, ELIZABETH.
Painter. Born in Maryland. Pupil of Corcoran School under Moser, Brooke, and Messer. Member: Wash. Water Color Club; Society of Washington Artists; Chicago Water Color Club. Address in 1929, 130 Eleventh Street, S. E., Washington, D.C.

MUIR, EMILY.
Painter. Born in Chicago, IL, in 1904. Studied: Vassar College; Art Students League with Richard Lahey, John Carroll, George Bridgman and Leo Lentelli. Collections: Brooklyn Museum; University of Maine; United States Gov.; Moore-McCormack Lines; American Caribbean Lines; American Scantic Lines; French Line; Pan-American Airways; Finnish Travel Bureau; Swedish Travel Bureau; Aluminum Corporation of America.

MULHAUPT, FREDERICK JOHN.
Painter. Born in Rockport, MO, March 28, 1871. Pupil of Art Academy in Kansas City; Art Institute of Chicago; Paris schools. Member: Associate National Acad. of Design; Palette and Chisel Club, Chicago; Salma. Club; American Art Association of Paris; National Arts Club (life); Allied Artists of America; North Shore Arts Association. Awards: Evans prize, Salma. Club; Proctor prize, Salma. Club, 1921; bronze medal for landscape, Philadelphia Art Week, 1925; popular vote, Allied Artists of America, 1925; Gedney Bunce prize, Connecticut Academy of Fine Arts, 1927. Represented in the John Herron Art Inst., Indianapolis; Reading (PA) Mus. of Fine Arts. Address 1929, 209 Bradford Bldg., Gloucester, MA; h. 9 Highland Ct., E. Gloucester, MA.

MULLEN, BUELL.
Painter. Born: Chicago, IL, on September 10, 1901. Studied: Tyler School of Art, Chicago; British Academy of Art; also with Petrucci and Lipinsky; in Belgium with Cucquier. Collections: Library of Congress (1st mural to be made of stainless steel); U.S. Naval Research Laboratory; Ministry of Public Works, Rio de Janeiro; Ministry of War, Buenos Aires; Great Lakes Naval Station; Dun & Bradstreet; Metal Research Laboratory, Niagara; Electronic Tower, International Telephone and Telegraph Company; General Motors Styling Administration, Detroit; U.S. Steel panels for private car; National Carbon Laboratory; Searle Laboratory; Inland Steel, Indiana Harbor; stainless steel mural, ceiling of North Adams Massachusetts Hospital; Sorg Paper, Middletown, OH; Gardner Board and Carton Co., Middletown; Allegheny Ludlum Steel Laboratory; John Woodman Higgins Armory, Worcester, MA; Republic Steel Co.; Physics Auditorium, Case Institute of Technology; American Society of Chemists, Washington, D.C.; Bowling Green State University; four panels, Paul Wolfe Chapel, Inter-American University, Puerto Rico, 1970; others. Exhibited: One-man shows at Findlay Gallery, Chicago, Smithsonian Institution, Washington, D.C., and Dayton Art Institute, OH; All-Illinois Society of Arts, Chicago. Award: All-Illinois Society of Arts Gold Medal. Member: National Society of Mural Painters; Royal Society of Arts, fellow; Architectural League; NY Federation of Fine Arts. Address in 1982, 233 E 70th Street, New York, NY.

MULLEN, RICHARD.
Wood engraver. Born in Germany in 1849. He came to this country when a boy and was educated at the Cooper Union, and at the National Academy of Design. He illustrated many of the early New York magazines with wood cuts until his work was replaced by the photo-engraving process. He died in Brooklyn on Nov. 17, 1915.

MULLER, HECTOR.
Dunlap noted him as a landscape painter, working in New York, 1828-53. Also painted portraits and miniatures.

MULLER, OLGA POPOFF (MRS.).
Sculptor. Born in New York City, December 1, 1883. Studied in Russia, Munich, and Paris. Member: National Association of Women Painters and Sculptors, NY. Awards: Cahn honorable mention, Art Institute of Chicago, 1911; McMillin prize, National Association of Women Painters and Sculptors, NY, 1914; medal of honor, Paris exhibition of women's works; bronze medals, P.-P. Expo., San Francisco, 1915; honorable mention, National Association of Women Painters and Sculptors, 1925. Address in 1933, Flushing, NY.

MULLER-URY, ADOLPH.
Portrait painter. Born Airolo Ct., Ticino, Switzerland, March 28, 1868. Came to U.S. in 1888. Pupil of

Royal Academy in Munich; Ecole des Beaux-Arts in Paris under Cabanel. Member: Lotos Club. Work: Portraits of President McKinley; General Grant; Senator and Mrs. Depew; Senator Hanna; and others. Address in 1929, 33 West 67th Street, New York, NY.

MULLIGAN, CHARLES J.
Sculptor. Born in Riverdale, Ireland, September 28, 1866. He came to America as a boy and worked with a stone cutter near Chicago. Studied at Chicago Art Institute, under Taft, and later under Falguiere, at the Ecole des Beaux-Arts in Paris. Among his statues are "The Three Sisters," at Springfield, Illinois; Lincoln, known as "The Rail Splitter;" and a statue of Col. Finnerty. Member of Society of Western Artists; Palette and Chisel Club (hon.). Address in 1910, Chicago, IL. He died March 25, 1916, in Chicago, IL.

MULLIKEN, JONATHAN.
Engraver. Born in Newburyport, MA, in 1746; died there June 1782. The only known copper-plate engraving by Mulliken is a very close copy of Paul Revere's "Massacre" plate, though there is no indication of the date of production. He was probably a self-taught engraver, producing some of his own metal clock faces, an accomplishment not rare among the early clockmakers. Died June 19, 1782.

MULLIKIN, MARY AUGUSTA.
Painter and lecturer. Born in Ohio. Pupil of Walter Beck in Cincinnati; Birge Harrison at Woodstock; Whistler in Paris. Member: China Society of Science and Arts; Am.Fed. of Arts. Work: Lasell Seminary, Auburndale, MA; Peking Inst. of Fine Arts; in collection of Ex-President Hsu Shih Chang of China. Address 1929, 397 Elfin Terrace, Tientsin, China.

MULLIN, CHARLES EDWARD.
Painter, sculptor, etcher, serigrapher, and teacher. Born in Chicago, IL, July 6, 1885. Studied: Chicago Academy of Fine Arts, with Wellington J. Reynolds; Art Institute of Chicago. Member: South Side Art Association; Ridge Art Association, Chicago. Award: Edward B. Butler purchase prize ($200), Art Institute of Chicago, 1929. Work: Chicago Public Schools. Exhibited: National Academy of Design, 1944, 45; Library of Congress, 1944, 45; Laguna Beach Art Association, 1945; Philadelphia Print Club, 1946; Los Angeles Museum of Art; Kansas City Art Institute; Baltimore Museum of Art; Springfield Museum of Art; Art Institute of Chicago, 1920, 28, 29, 30, 1932-34, 37. Address in 1953, Orland Park, IL.

MULLINS, FRANK.
Illustrator. Born in Springfield, MA, in 1924. He received his B.F.A. from Pratt Institute in 1959 and his M.A. from Columbia University in 1966. His first illustration was a portrait of Murray Rose done as a cover for *Sports Illustrated* in 1961.

MULRONEY, REGINA WINIFRED.
Sculptor, illustrator, writer, and teacher. Born in New York City, December 4, 1895. Pupil of Art Students League of New York; San Francisco Art School. Member: Catherine Lorillard Wolfe Club; Louis Comfort Tiffany Foundation; Philadelphia Alliance; Philadelphia Society of Artists; National Association of Women Artists; League of American Pen Women, 1934. Awards: Catherine Lorillard Wolfe prize for sculpture, 1929; League of American Pen Women, 1934. Position: Director, R. W. Mulroney School of Art, San Francisco, CA. Address in 1953, San Francisco, CA.

MULVANEY, JOHN.
Painter. Born in 1844, he came to this country when he was twenty. He specialized in painting Western, Indian, and army life and he was best known for his "Custer's Last Rally." He also painted many portraits, one of his last being that of Bishop McDonnell of Brooklyn. He died in New York in May, 1906.

MUMFORD, ALICE TURNER.
See Culin, Alice Mumford Roberts.

MUMFORD, EDWARD WILLIAM.
Engraver. Born in 1812. From 1835-40, Mumford was engraving landscapes and subject plates for Philadelphia publishers. Died in 1858.

MUMMERT, SALLIE BLYTH.
Painter. Born in Cisco, Texas. Pupil of Aunspaugh Art School, Dallas. Member: Society of Independent Artists; Fort Worth Art Association. Award: Linz medal for best figure, Woman's Forum Annual Art Exhibit, Texas. Address in 1929, 1308 South Adams Street, Fort Worth, Texas.

MUNDAY, ROSEMARY.
Painter. Exhibited at the Penna. Academy of Fine Arts, Philadelphia, 1914. Address in 1926, Norway, ME.

MUNDT, ERNEST KARL.
Sculptor, writer, lecturer, and educator. Born in Bleicherode, Germany, October 30, 1905. U.S. citizen. Studied: Berlin Institute of Technology, dipl. architecture, 1930; University of California, Ph.D., 1961. Member: College Art Association of America; San Francisco Art Association; Artists Equity Association. Work: San Francisco Museum of Art. Exhibited: Whitney Mus., 1951; Metropolitan Museum of Art, 1950; Detroit Inst. of Art, 1944; Nierendorf Gallery, 1945, 46; San Francisco Museum of Art, 1946; California Palace of the Legion Honor, 1949. Author, illustrator, *A Primer of Visual Art*, 1950; *Art Form and Society*, 1952. Contributor to *Arts and Architecture, College Art Journal*, and *Art Quarterly* magazines. Taught: Instructor, Brooklyn College, 1945-46; California School of Fine Arts, 1947-50,

director, 1950-55; assistant professor, California State University, San Francisco, 1955-76, emeritus professor, from 1976. Award: Gold Medal of Honor, American Institute of Architects, 1956. Address in 1982, San Francisco, CA.

MUNDY, ETHEL FRANCES.
Sculptor. Born in Syracuse, NY. Studied: Art Students League; Fontainebleau School of Art, France; Rochester Mechanics Institute; and with Amy M. Sacker, Twachtman, and Beckwith. Work: Syracuse Museum of Fine Arts; Frick Gallery, NY; J. B. Speed Memorial Museum; Louisville, Kentucky, Museum of Art. She discovered a new composition for use in wax portraiture and revived the art of wax portraiture which was known in Europe for 500 years before being lost in the 18th century. Member of ARMS, London; National Association of Women Artists; American Federation of Arts, NY; Society of Fontainebleau Artists. Exhibited: National Association of Women Artists; Carnegie Institute; Corcoran Gallery; Philadelphia Watercolor Club; Syracuse Museum of Fine Arts; Denver Art Mus.; Brooklyn Museum; Louisville Museum of Art; Montclair Art Museum; Royal Society of Miniature Painters. Address in 1953, Syracuse, NY.

MUNDY, JOHNSON MARCHANT.
Sculptor and portraitist. Born May 13, 1831, in New Brunswick, NJ. Served as apprentice to H. K. Brown for seven years. Later opened a studio in Rochester, NY, before moving to Tarrytown. Work: Statue, Washington Irving. Died in Tarrytown, NY, 1897.

MUNDY, LOUISE EASTERDAY.
Painter and teacher. Born in Nokomis, IL. Pupil of University of Nebraska; Art Institute of Chicago; Stout Institute; Chicago Academy of Fine Arts. Member: Nebraska Art Association; Lincoln Artists Guild. Address in 1929, University of Nebraska; h. 1507 R Street, Lincoln, NE.

MUNGER, ANNE WELLS.
(Mrs. W. L. C. Munger). Painter, sculptor, teacher, and craftswoman. Born in Springfield, MA, July 17, 1862. Pupil of Philip Hale, Woodbury and DeCamp in Boston; Brush in New York. Member: Boston Society of Arts and Crafts; Am. Fed. of Arts; New Orleans Art Assoc.; Provincetown Art Assoc.; So. States Art League; Gulf Coast Art Assoc.; Mississippi Art Assoc. Award: Prize for pastel, Gulf Coast Art Assoc., 1932. Address 1933, Pass Christian, MS; summer, South Wellfleet, MA. Died in 1945.

MUNGER, CAROLINE.
Miniature painter. Born May 15, 1808 in E. Guilford, CT. She was the daughter of George Munger. In 1831 she married Horace Wasburn, and exhibited miniatures at the National Academy of New York in 1841. She died Jan. 4, 1892 in Madison, CT.

MUNGER, GEORGE.
Engraver. Born Feb. 17, 1781, in Guilford, CT. Munger was a miniature painter of some merit, and the firm of N. & S. S. Jocelyn engraved plates after portraits painted by him. In 1816, N. Jocelyn and G. Munger, of New Haven, CT, published a large aquatint view of the Island of St. Helena. This plate is signed "G. Munger, Sculp.," but it is the only example of his engraved work found. Munger was some relation of Anson Dickinson, the miniature painter, also born in Connecticut. Two of Munger's daughters became artists. He died July 2, 1825.

MUNN, GEORGE FREDERICK.
Artist. Born in Utica, NY, in 1852. Studied in the National Academy, NY, and later in England in the studio of George F. Watts. He exhibited in many of the galleries. Died Feb. 10, 1907 in NYC.

MUNN, MARGUERITE CAMPBELL.
Painter. Born in Washington, D.C. Pupil of Henry B. Snell. Member: Society of Washington Artists; Washington Water Color Club; Washington Art Club; National Association of Women Painters and Sculptors; National Arts Club. Address in 1929, McLean Bldg., 1517 H Street; h. 1842 16th Street, N. W., Washington, D.C.

MUNRO, ALBERT A.
Painter and etcher. Born in Hoboken, NJ, in 1868. Address in 1926, Springfield, L.I., NY.

MUNROE, MARJORIE.
Painter. Born in New York, NY, in 1891. Pupil of Frank DuMond, E. Percy Moran, and of George Elmer Browne. Address in 1926, 12 East 30th Street, New York, NY.

MUNROE, SALLY C.
(Mrs. Vernon Munroe). Painter. Born in New York, Jan. 24, 1881. Pupil of Cox, Woodbury. Member: National Association of Women Painters and Sculptors; American Federation of Arts. Specialty: Landscape and figures. Address in 1929, 1172 Park Avenue, New York, NY; summer, Litchfield, CT.

MUNROE, SARAH SEWELL.
Painter. Born in Brooklyn, New York. Pupil of Hassam, Miller, Hawthorne. Awards: Corcoran prize, Washington Water Color Club; Society of Washington Artists, 1921, 1923. Member of Washington Society of Artists; National Association of Women Painters and Sculptors; Washington Water Color Club; American Federation of Arts. Address in 1929, 1905 N. Street, Washington, DC; summer, "Windover," Provincetown, MA.

MUNSELL, ALBERT HENRY.
Portrait painter. Born in Boston in 1858. Student of Ecole des Beaux Arts in Paris. Exhibited at Paris

Salon, 1886, 87, 88; also in Boston, New York, Chicago, and Pittsburgh. Instructor in Massachusetts Normal Art School after 1881; lecturer on artistic anatomy and color composition. He patented new instruments for color measurement, and invented a system of pigment colors, which was introduced in schools of Boston, NY, Baltimore, Mexico City, etc. Author: *Color Notation*, 1905; *Atlas of the Color System*, 1910. Address in 1926, 221 Columbus Avenue, Boston, MA.

MUNSELL, WILLIAM A. O.
Painter and architect. Born in Cold Water, OH, March 2, 1866. Member: American Institute of Architects; Society of Independent Artists; Laguna Beach Art Association; Allied Arch. Association. Represented in Los Angeles Museum; Scottish Rite Cathedral, Los Angeles; San Marino City Hall; hospital for tubercular soldiers, Soldiers' Home, CA. Address in 1929, Suite 631, 714 West 10th Street, Los Angeles, CA; h. 2405 Ridgeway Road, San Marino, CA.

MUNSON, LUCIUS.
Painter. Born in New Haven, CT, in 1796. In 1820 he visited South Carolina and painted many portraits. He had hopes of being able to study in Europe, but sickness prevented him from doing so, and he died in Turks Island, in 1823.

MUNSON, SAMUEL B.
Engraver. Born May 29, 1806, in Connecticut. From 1830-35 Munson was engraving in New Haven in conjunction with S. S. Jocelyn of that town, but about 1836 he removed to Cincinnati, OH, and was a member of the banknote engraving firm of Doolittle & Munson. For a time he was associated with G. K. Stillman in engraving and publishing prints. Died April 6, 1880 in Cincinnati, OH.

MUNZIG, GEORGE CHICKERING.
Portrait painter. Born in Boston in 1859. His specialty was portraits in crayon. Member of the Boston Art Club. He exhibited in Philadelphia, New York, Cleveland, and Boston. Died March 5, 1908 in NYC.

MURANYI, GUSTAVE.
Painter. Born in Temesvar, Hungary, Aug. 1, 1881. Studied in England. Specialty was portraits. Address in 1929, Room 1209, Carnegie Hall, New York, NY.

MURCH, WALTER TANDY.
Painter. Born in Toronto, Ontario, Canada, in 1907. Learned woodworking, architectural drafting at Toronto Technical High School; entered Ontario College of Art in 1925; formal art training, NYC, with Kenneth Hayes Miller; Arshile Gorky at Grand Central School. Worked as assistant stained-glass designer for NY company, and other jobs. Used a variety of discarded objects, such as machine parts, broken dolls, light bulbs, and car parts as subjects for the compositions for which he became well known. Died in 1967. Represented by Kennedy Galleries, NYC.

MURDOCH, DORA LOUISE.
Painter and craftswoman. Born in New Haven, CT, Sept. 14, 1857. Pupil of Lucien Simon, Courtois, Rixen and Boutet de Monvel in Paris. Member: NY Water Color Club; American Water Color Society; Baltimore Water Color Club; American Federation of Arts; Washington Water Color Club. Awards: Purnell prize, Baltimore Water Color Club, 1903; Baltimore water color prize, Peabody Institute, 1922. Address in 1929, 245 West Biddle Street, Baltimore, MD.

MURDOCH, FLORENCE.
Painter, craftswoman, and teacher. Born in Lakewood, NY, June 14, 1887. Pupil of Nowottny, Meakin, Ensign, and Carlson. Member: Cincinnati Women's Art Club; Alliance; Boston Society of Arts and Crafts; Ohio Water Color Society. Address in 1929, 2448 Maplewood Avenue, Cincinnati, OH.

MURDOCH, FRANK C.
Painter. Member: Pittsburgh Artists' Association. Address 1926, 5709 Woodmont St., Pittsburgh, PA.

MURPHY.
A crudely engraved line frontispiece, representing "Wisdom," is signed "Murphy Sculp." This plate was published in New York in 1807. The design shows Minerva armed with spear and shield standing in center, with a flying Cupid and palm tree to left and a lamb at her feet. No other example of Murphy's work has been seen.

MURPHY, ADA CLIFFORD.
(Mrs. J. Francis Murphy). Painter and illustrator. Pupil of Cooper Union and Douglas Volk in New York. Member: National Association of Women Painters and Sculptors; National Arts Club. Awards: Hallgarten prize, National Academy of Design, 1894; hon. mention, Pan-Am. Expo., Buffalo, 1901. Address in 1929, Arkville, NY.

MURPHY, CHRISTOPHER, JR.
Painter, etcher, and teacher. Born in Savannah, GA, Dec., 1902. Pupil of DuMond, Bridgman, Clark, Chadwick and Pennell; Art Students League of NY. Member: Savannah Art Association; Southern States Art League; Georgia Assoc. of Artists (treasurer). Award: Etching prize, Southern States Art League Exhibition, 1927. Address in 1929, 11 East Perry Street, Savannah, GA.

MURPHY, H. DUDLEY.
Painter, illustrator, etcher, craftsman, and teacher. Born in Marlboro, MA, Aug. 25, 1867. Pupil of

Boston Museum School; Laurens in Paris. Member: Copley Society, 1886; Boston Water Color Club; Salma. Club; Boston Society of Arts and Crafts; Guild of Boston Artists; National Arts Club; Boston Art Club; Boston Society of Water Color Painters; Massachusetts State Art Com.; Painters' and Sculptors' Gallery Association. Awards: Bronze medal, Pan-Am. Expo., Buffalo, 1901; silver medal for portrait and bronze medal for water color, St. Louis Expo., 1904; silver medal for oil painting and silver medal for water colors, P.- P. Expo., San Francisco, 1915; Peterson prize, Art Institute of Chicago, 1922. Work: "Mt. Monadnock," "Charles H. Woodbury," and portrait of H. O. Tanner, Art Institute of Chicago; "The Opal Sunset," Art Assoc., Nashville, TN; "Murano" and "Still Life," Albright Art Gallery, Buffalo, NY; "Moro Castle, San Juan," Dallas (TX) Museum of Fine Arts; "Tropic Castles," Cleveland Art Museum. Instructor in drawing and member of Faculty of Architecture, Harvard University. Address in 1929, Lexington, MA.

MURPHY, HENRY CRUSE, JR.
Painter, illustrator, and teacher. Born in Brooklyn, NY, Feb. 26, 1886. Self taught. Member: Salma. Club; Greenwich Society of Artists; Am. Federation of Arts. Work: "27th Division Breaking the Hindenburg Line," National Museum, Washington, DC. Specialty: Marine paintings and illustrations in color for reproduction purposes. Address in 1929, Cat Rock Road, Cos Cob, CT.

MURPHY, JOHN FRANCIS.
Landscape painter. Born in Oswego, NY, in 1853. He was largely self-taught. He first exhibited at the National Academy of Design in New York in 1876. He won many prizes, medals, and honors for his work in landscapes. His paintings are said to rank with Inness, Wyant and Homer Martin and are included in most of the prominent collections in America. He was elected a member of the National Academy in 1887. His studio was (for years) in New York. He died Jan. 29, 1921, in NYC.

MURPHY, JOHN J. A.
Painter. Member: Guild of Free Lance Association. Address in 1926, 21 Greenwich Avenue, New York, NY.

MURPHY, L. M.
Painter. Member: California Art Club. Address in 1926, 21 North Main Street, Los Angeles, CA.

MURPHY, MICHAEL THOMAS.
Sculptor. Born in Bantry, County Cork, Ireland, November 24, 1867. Apprenticed as marble carver in Cork; studied in School of Art, Cork, and later at Royal College of Art, London; also in Paris and Italy. Came to United States in 1912. Specialized in portraits and figure subjects in relief. Exhibited at Art Institute of Chicago, 1918. Principal works: Busts of Most Rev. George W. Mundelein and of Dr. John B. Murphy, of Chicago; "Aaron Blessing the Israelites," 4th Presbyterian Church, Lincoln Parkway, Chicago; heroic size figures representing an athlete and a student, University of Michigan, Ann Arbor; etc. Member: Western Society of Sculptors; Art Workers' Guild, Artists' Annuity Fund, London; Chicago Society of Artists. Address in 1926, 4 E. Ohio Street; h. 5739 Harper Avenue, Chicago, IL.

MURPHY, MINNIE B. HALL.
(Mrs. Edward Roberts Murphy). Painter, sculptor, writer, lecturer, and teacher. Born in Denver, CO, May 2, 1863. Pupil of Art Students League of New York; Art Institute of Chicago; Henry Read in Denver. Member: National Arts Club; Denver Art Club. Address in 1929, 805 Gaylord Street, Denver, CO.

MURPHY, NELLY LITTLEHALE.
(Mrs. H. Dudley Murphy). Painter, illustrator and etcher. Born in Stockton, CA, May 7, 1867. Pupil of Joseph De Camp and C. Howard Walker. Member: Copley Society; Boston Soc. of Water Color Painters; Guild of Boston Artists. Award: Purchase prize for water color, Boston Art Club, 1929. Represented in permanent collection, Boston Museum of Fine Arts. Address in 1929, Lexington, MA.

MURPHY, PETER.
Sculptor. Born in Ireland, c. 1825. Immigrated before 1846. At San Francisco, 1860. Worked in marble.

MURPHY, WILLIAM D.
Painter. Born in Madison County, AL, on March 11, 1834. In 1863 he received his first art education from William Cooper, a portrait painter, of Nashville, TN. Married Harriet Anderson, a pupil of Lorenz and William Morgan, in 1887. Since that time, Mr. and Mrs. Murphy were continuously engaged in portrait painting, their work being conducted jointly. The list of works from their studio contains the portraits of eminent public men, including those of President Lincoln, President McKinley, President Roosevelt, Admiral Dewey, Admiral Schley, and others.

MURRAY, GEORGE.
Born in Scotland. Dunlap said that Murray was a pupil of the well-known English engraver Anker Smith, and he was certainly engraving portraits, etc., in London in 1796. Murray appeared in Philadelphia in 1800, coming to that city from one of the So. States. He was prominent in the Philadelphia Society of Artists in 1810, and in 1810-11 he organized the banknote and general engraving firm of Murray, Draper, Fairman & Co. Died July 2, 1822 in Philadelphia, PA.

MURRAY, GRACE H.
(Mrs. A. Gordon Murray). Painter. Born in New York, Nov. 9, 1872. Pupil of Bouguereau and Gabriel Ferrier. Member: National Association of Women Painters and Sculptors; American Society of Miniature Painters (secretary); Pennsylvania Society of Miniature Painters (hon. life member). Address in 1929, 152 West 58th Street, New York, NY; summer, Pine Tree Farm, North Hampton, NH.

MURRAY, JOHN.
In Rivington's *Royal Gazette*, in 1776, we find the following: "John Murray, in the 57th Regiment from Edinburgh, engraves all manner of silver-plate, seals, coats of arms, etc."

MURRAY, RICHARD DEIBEL.
Sculptor and painter. Born in Youngstown, OH, December 25, 1921. Studied: University of Notre Dame, B.S., 1942; Georgetown University, MD, 1946; University of Pennsylvania, 1953. Work: American College of Surgeons; Mill Creek Park; and Youngstown Symphony Center. Exhibitions: Butler Art Institute, Youngstown; Kottler Galleries, NY; Canton Art Institute, Canton, OH; Galerie Int., NY, 1972; others. Awards: F. Punnell Award, Youngstown, OH, 1966; Citation, City of Youngstown, OH; others. Address in 1982, Youngstown, OH.

MURRAY, ROBERT (GRAY).
Sculptor and painter. Born March 2, 1936, in Vancouver, B.C., Can. Studied: Univ. of Saskatchewan with Arthur McKay, Roy Kiyooka, Kenneth Lochhead, R. Simmons, 1956-58; Emma Lake Artist's Workshops, University of Saskatchewan, with Will Barnet, 1957, Barnett Newman, 1959, John Ferren, 1960, Clement Greenberg, 1962, Jack Shadbolt. Traveled in Mexico and Canada. Work: Metropolitan Museum of Art; Walker Art Center; Hirshhorn Museum; Montreal Museum of Fine Arts; Ottawa (National); Aldrich; Toronto; Whitney Museum; and others. Exhibited: Betty Parsons Gallery, NYC; Jewish Museum; Ottawa (National); Whitney Museum; Toronto; Musee Cantonal des Beaux-Arts, Lausanne, Switzerland; Los Angeles County Museum of Art; Hayward Gallery; Walker Art Center; Philadelphia Mus. of Art; Guggenheim; Paris (Moderne); Tibor de Nagy Gallery, NY; Washington Square Gallery; others. Awards: Canada Arts Council Scholarship, 1960, grant, 1969; second prize, X Sao Paulo Biennial, Brazil, 1969; National Endowment Grant, 1969; National Council on the Arts, 1968. Media: Steel, aluminum. Address in 1982, 66 Grand Street, NYC.

MURRAY, SAMUEL.
Sculptor and teacher. Born in Philadelphia, PA, June 12, 1870. Pupil of Thomas Eakins. Awards: Diploma, Columbian Exposition, Chicago, 1893; gold medal, Art Club of Philadelphia, 1894; honorable mention, Pan-Am. Exposition, Buffalo, 1901; silver medal, St. Louis Exposition, 1904. Work: "Prophets," Witherspoon Building, Philadelphia; "Com. Barry," "Joseph Leidy," and J. H. Windrim portrait, Smith Memorial, Fairmount Park, Philadelphia; Pennsylvania State Monument, Gettysburg, PA; Corby statue, Notre Dame University, Notre Dame, IN; portrait, Dr. J. C. Wilson, Jefferson Medical College, Philadelphia; Bishop Shanahan Mem., St. Patrick's Cathedral; statue, Admiral George W. Melville, League Island Park, Philadelphia. Represented in Whitney Museum; Penna. Museum of Art; Met. Museum of Art; Univ. of Pennsylvania, Philadelphia. Address 1933, 3326 Lancaster Ave., Philadelphia, PA.

MUSGRAVE, ARTHUR FRANKLYN.
Painter. Born in Brighton, England, July 24, 1880. Pupil of Stanhope Forbes, Newlyn School of Art, Cornwall; Munich. Exhibited: Penna. Academy of Fine Arts; Corcoran; Stuart Gallery, Boston, MA; Museum of Fine Arts, New Mexico; Royal Academy, London. Member: Provincetown Art Association; Washington Water Color Club; Society of Washington Artists; NY Water Color Club. Address in 1953, Cape Cod, MA.

MUSGRAVE, EDITH.
Painter and writer. Born in New York City, Dec. 25, 1887. Pupil of E. M. Ashe; G. B. Bridgman; J. C. Johansen; Alon Bement; Art Students League of NY. Address in 1929, 534 East Third Street, Mt. Vernon, NY.

MUSGRAVE, HELEN GREENE.
Painter and teacher. Born in Cincinnati, OH, March 6, 1890. Pupil of Cincinnati Art Academy; Julian Academy in Paris; NY School of Fine and Applied Art. Member: Provincetown Art Assoc. Address in 1929, Truro, MA.

MUSSELMAN-CARR, MYRA V.
Sculptor. Born in Georgetown, KY, November 27, 1880. Studied with Bourdelle; Art Students League of NY; Cincinnati Art School. Work: Fountain, Kansas City; Roslyn, LI, NY; tablet, Pittsburgh, PA; fountain, Bronxville, NY. Member: Woodstock Art Association. Address in 1933, Woodstock, Ulster Co., NY.

MUTH, MARCIA.
Painter. Work in private collections and collection of Museum of New Mexico. One-woman shows include Diamond Art Gallery, Flint, MI, 1977; LaFarge Library, Santa Fe, NM, 1981; Mesa Public Library, Los Alamos, NM, 1982. Exhibited at The Gallery, Springfield, MO, 1978; J. Douglas Gallery, Santa Fe, NM, 1980; Rosequist Galleries, Tucson, AZ, 1981; San Francisco, CA; Sag Harbor, NY. Paintings used for cards by Sunstone Press and J. Douglas Gallery,

Santa Fe, NM. Represented by Yolanda Saul, Yolanda Fine Arts, 541 Lincoln, Winnetka, IL. Address in 1983, 140 Alamo Dr., Santa Fe, NM.

MYERS, ETHEL.
(Mrs. Jerome Myers). Sculptor and lecturer. Born in Brooklyn, NY, August 23, 1881. Studied at Hunter College; Columbia University; and with William M. Chase, Robert Henri, and Kenneth Hayes Miller. Member: NY Ceramic Society. Exhibited: National Academy of Design; Corcoran Gallery of Art; Penna. Academy of Fine Arts; Art Institute of Chicago; Whitney Museum of American Art; Brooklyn Museum; and others. Specialty: Small sculpture and drawing. Address in 1953, Carnegie Hall, West 57th Street, NYC; h. Carmel, NY. Died in 1960.

MYERS, LOUIS.
Illustrator. Born in Paris, France in 1915. He studied for many years at the New School for Social Research and the Art Students League. His first work, a children's book entitled *Clementina*, was published by Western Publishing. He has since illustrated many magazines and books in his unique cartoon style. He presently lives in Peekskill, NY.

MYERS, O. IRWIN.
Painter and illustrator. Born in Bananza, NE, in 1888. Pupil of Art Institute of Chicago and of Chicago Academy of Fine Arts. Member: Chicago Society of Artists; Chicago Art Club; Chicago Society of Independent Artists; Alumni Art Institute of Chicago. Address in 1926, Studio Bldg., 4 East Ohio Street, Chicago, IL.

MYRHL, SARAH.
Painter. Born in New York City in 1912. Studied: Hunter College; New School for Social Research; Columbia University; Art Students League; and with Brook, Zorach, and Kuniyoshi. Award: Metropolitan scholarship from Art Students League. Collections: Mural, La Guardia Sea Plane Base, New York; also in private collections in United States and Japan.

NADELMAN, ELIE.
Sculptor and etcher. Born in Warsaw, Poland, February 23, 1885. Studied at Art Academy, Warsaw, 1901; Academie Colarossi, Paris, 1904. Came to U.S. in 1914. Member: National Sculpture Society; New York Architectural League; Modern Artists Association; Salons of America; Society of Independent Artists; New Society Artists; Beaux-Arts Institute of Design; Municipal Art Society; American Federation of Arts. Exhibited in Paris at Gallery Drouant, Gallery Bernheim-Jeune, Salon d'Automne, etc.; in New York City at Scott and Fowles Gallery, Knoedler, Museum of Modern Art, Photo-Secession; Carnegie. In collection of Museum of Modern Art; Newark (NJ) Museum; Whitney. Address in 1934, Riverdale-on-Hudson, NY. Died in 1964.

NAEGELE, CHARLES FREDERICK.
Portrait painter. Born in Knoxville, TN, May 8, 1857. Pupil of William Sartain, Chase and C. Myles Collier. Member: Artists' Fund Society; Salma. Club, 1893; Lotos Club; Atlanta Art Association; National Arts Club; Artists Guild of the Authors' League of America, NY. Awards: Gold medal, Mechanics Fair, Boston, 1900; silver medal, Charleston Expo., 1902. Work: "Mother Love," National Gallery, Washington. Originated method of holding exhibitions by which system public collection of art works may be established. Died 1944. Address 1933, Marietta, GA.

NAGAOKA, SHUSEI S.
Illustrator. Born in Nagasaki, Japan in 1936. Studied: Musashino Art University for three years. In the 1960's he had his first illustration published in *Boys Magazine* in Tokyo and has since received awards from the American Institute of Graphic Arts and the Society of Illustrators in NY. His works are in Yokohama Marine Museum in Japan.

NAGEL, ELIZABETH and EDWARD.
Painters. Exhibited in Philadelphia, 1921, at "Exhibition of Paintings Showing the Later Tendencies in Art," Penna. Academy of Fine Arts. Address in 1926, 77 Washington Place, New York City.

NAGEL, HERMAN F.
Painter. Born in Newark, NJ, in 1876. Pupil of National Academy of Design. Member: Society of Independent Artists. Address in 1926, 23 Pennington Street, Newark, NJ.

NAGLER, EDITH KROGER.
Painter, illustrator, etcher and writer. Born in New York City, June 18, 1895. Pupil of Art Students League of NY; National Academy of Design Schools. Member: Am. Water Color Society; Springfield Art League; Bronx Artists Guild; Salons of America. Address in 1929, Spuyten Duyvil, NY; summer, Stone House, Huntington, MA.

NAGLER, FRED.
Painter, etcher and writer. Born in West Springfield, MA, Feb. 27, 1891. Pupil of Art Students League of NY. Award: Hallgarten prize, National Academy of Design, 1923; hon. mention, New Haven Paint and Clay Club, 1928. Address in 1929, Spuyten Duyvil, NY; summer, Huntington, MA.

NAHL, PERHAM W.
Painter, sculptor and teacher. Born in San Francisco, CA, Jan. 11, 1869. Work: Palace of Fine Arts; Municipal Art Gallery, Oakland; Univ. of California. Professor of Art, Univ. of California, Berkeley, CA. Died 1935.

NAKAMIZO, FUJI.
Painter and etcher. Born in Japan, Jan. 17, 1895. Pupil of Joseph Pennell, W. De Leftwich Dodge, Frank DuMond. Award: Honorable mention, Annual Arizona Art Exhibition, Arizona State Fair, 1927. Died in 1950. Address in 1929, Studio No. 1, 1270 Sixth Ave., New York, NY; summer, Branchville, CT.

NAKIAN, REUBEN.
Sculptor. Born August 10, 1897, in College Point, NY. Studied: Robert Henri School, with Homer Boss, A. S. Baylinson; Art Students League, 1912; apprenticed to Paul Manship, 1917-20, and Gaston Lachaise. Awards: Guggenheim Foundation Fellowship, 1930; Ford Foundation Grant, 1959 ($10,000); Sao Paulo, 1960; Rhode Island School of Design, 1979. Exhibited: The Downtown Gallery, NYC; Charles Egan Gallery, NYC; Sao Paulo, 1961; Los Angeles County Museum of Art, 1962; Washington Gallery of Modern Art; Felix Landau Gallery, LA; Museum of Modern Art; Salons of America, NYC, 1922; Whitney Studio Club, NYC; Art Institute of Chicago; Penna. Academy of Fine Arts; XXXIV Venice Biennial, 1968; Museum of Modern Art. Collections: Museum of Modern Art; NYU; Whitney; Art Institute of Chicago; Hirshhorn. Taught: Newark Fine Arts and Industrial Arts College; Pratt Institute, 1949. Address in 1982, Stamford CT.

NANKIVELL, FRANK ARTHUR.
Painter. Born in Maldon, Victoria, Australia, 1869. Studied art in Japan, 1891-94; in San Francisco,

1894-96. Published and illustrated fortnightly magazine *Chic*, and made drawings for *San Francisco Call*, *Examiner*, and *Chronicle*. Moved to New York in 1896, and illustrated daily papers; joined staff of *Puck*, May, 1896 , as cartoonist and caricaturist. He also studied portrait painting in New York and London; later occupied as painter, illustrator and etcher for *Ladies' Home Journal*. Member of Association of American Painters and Sculptors. Died in 1959. Address in 1926, 33 West 14th St., New York.

NASH, FLORA.
Illustrator. Member: Society of Illustrators; Artists Guild of the Authors' League of America, NY. Address in 1929, 19 Park Ave.; 73 Riverside Dr., New York, NY.

NASH, KATHERINE E.
Sculptor and educator. Born in Minneapolis, MN, in 1910. Studied: University of Minnesota; Minneapolis School of Art; Walker Art Center; University of New Mexico, computer graphics. Awards: National Delta Phi Delta Competition, 1932; Minnesota State Fair, 1941, 1942, 1944; Minneapolis Institute of Art, 1944; Swedish-American Exhibition, 1948; Lincoln Art Guild, 1950; Nebraska State Fair, 1951, 1952; Joslyn Art Museum, 1954; Nebraska Art Association, 1955; Walker Art Center, 1951; Sioux City, 1952. Collections: University Medical Building, Omaha; Buffalo, Minnesota, Court House; Walker Art Center; Lincoln (NE) Art Guild; Nebraska Art Association; Kansas State College; Concordia College; Minneapolis Public Library; Joslyn Art Museum; Omaha Association of Art. Memberships: Hon. member, Artist Equity Association, 1957-61; Sculptors Guild. Address in 1982, Excelsior, MN.

NASH, MARY HARRIET.
Painter and photographer. Born in Washington, DC, in 1951. Studied: George Washington University, B.A. in Painting, 1973; Washington State University, Pullman, M.F.A. in Painting, 1976, with G. Hansen, P. W. Siler, Robert Helm, Francis Ho. Work: Washington St. Univ.; The 2nd St. Gallery, Charlottesville, VA; MacDowell Colony, Peterborough, NH; George Washington Univ. Permanent Collection; Erie (PA) Art Center; Cleveland State University. One-woman shows: M.F.A. thesis, Washington State University, 1976; 2nd Street Gallery, Charlottesville, VA, 1978. Exhibited: Pyramid Gallery Ltd., Washington, DC, 1978; Janet Fleisher Gallery, Philadelphia, PA, 1979; Osuna Gallery, Washington, DC, 1979; Image Gallery, Stockbridge, MA, 1979; George Washington University, 1980; Southern Ohio Museum and Cultural Center, Portsmouth, OH, 1981; and others. Awards: MacDowell Colony Fellowship, Peterborough, NH, 1977; hon. mention, Southeastern Center for Contemporary Art, Winston-Salem, NC, 1979. Bibliography: Numerous reviews, articles. Member: College Art Association; MacDowell Colony

(fellowship); Women's Caucus for Art. Style: Folk art. Media: Oils, acrylic on canvas; ink on paper. Address in 1983, Vienna, VA.

NASH, WILLARD AYER.
Painter and etcher. Born in Philadelphia, PA, March 29, 1898. Pupil of John P. Wicker. Member: The Six Men; Scarab Club of Detroit. Died in 1943. Address in 1929, 566 Camino del Monte Sol, Sante Fe, NM.

NASON, GERTRUDE.
Painter and teacher. Born in Boston, MA, Jan. 7, 1890. Pupil of Joseph De Camp, Edmund Tarbell. Member: Copley Society; Pen and Brush Club; North Shore Arts Association; Connecticut Academy of Fine Arts. Died in 1969. Address in 1929, 405 Bleecker St., New York, NY; summer, Lyme, CT.

NASON, THOMAS W(ILLOUGHBY).
Illustrator. Born in Lowell, MA, Jan. 7, 1889. Award: Prize for best print, Philadelphia Print Club, 1929. Address in 1929, 34 Spring St., Reading, MA.

NAST, THOMAS.
Painter and illustrator. Born Sept. 27, 1840, at Landau, Bavaria, Germany. Studied at National Academy of Design. Lived chiefly in New York, and was famous as a caricaturist. Assignments in London and Sicily in 1860; reported for *Harper's* during Civil War and until 1886. His political cartoons were very influential. Credited with initiating the donkey and elephant as political symbols. His head of Christ painted in 1900 is in the Metropolitan Museum of New York. Died Dec. 7, 1902, at Guayaquil, Ecuador, where he was the American Consul-General.

NATHUKA, KURUMI.
Painter. Born in Tokyo, Japan, in 1940. Studied: Tokyo Art University; Univ. of Delaware; Vassar College. Exhibited: Silvermine Art Guild; Westchester Art Association; Boston Philharmonic Hall; Vassar College Art Gallery, Poughkeepsie, New York; Cary Arboretum, Millbrook, New York. Collection: Tokyo Art University. Many private collections throughout the East Coast. Media: Oil, acrylic, screen printing.

NAUMAN, F(RED) R(OBERT).
Painter, etcher and architect. Born in St. Louis, Jan. 7, 1892. Award: Landscape prize, St. Louis Artists Guild, 1919. Address in 1929, 3832 West Pine Blvd.; 107 Austin Place, Glendale, MO.

NAVE, ROYSTON.
Painter. Born in La Grange, Texas, Nov. 5, 1876. Pupil of Robert Henri. Member: Salma. Club. Exhibited "Norma" at the Penna. Academy of Fine Arts, Philadelphia, 1921. Address in 1926, 146 West 59th St., New York.

NAVIGATO, ROCCO D.
Painter. Member: Artists Guild of the Authors' League of America, NY; Palette and Chisel Club. Address in 1929, 2321 East 70th Pl., Chicago, IL.

NAYLOR, ALICE STEPHENSON.
Painter. Born in Columbus, TX. Studied: Witte Memorial Museum School of Art; San Antonio Art Institute; and with Charles Rosen, Etienne Ret, Andrew Dasburg, Xavier Gonzalez and Dan Lutz. Awards: River Art Group, 1953-1956; Texas Watercolor Society, 1953, 1958; Texas Art Mart, Austin, 1955; "Woman of the Year," 1953, San Antonio; Texas Fine Arts Association, 1957; Columbus Texas Art Fair, 1957-1958; Beaumont Art Museum, 1958. Address in 1980, 125 Magnolia Dr., San Antonio, TX.

NEAGLE, JAMES.
Engraver. Born c. 1769. The directories of Philadelphia contain his name for 1820-22, inclusive, as an "engraver." In 1819 he was engraving in Philadelphia, and a few well-executed portraits bear his name. His signed work is very scarce and he was possibly chiefly engaged in banknote work. Died June 24, 1822, "aged 53 years."

NEAGLE, JOHN.
Portrait painter. Born in Boston, Nov. 4, 1796; died in Philadelphia, Sept. 17, 1865. Born of Philadelphian parents during their residence in Boston; educated in Philadelphia, including some instruction with Pietro Ancora, a drawing-teacher. Also studied with Bass Otis, for two months. In 1818 he set up as a portrait painter, moving to Lexington, KY, but after two years spent there and at other points in the Mississippi Valley, he returned to Philadelphia and married a daughter of Thomas Sully, the artist. His first success was a portrait of the Rev. Dr. Joseph Pilmore, one of the pioneers of Philadelphia Methodism. His masterpiece, however, is a full-length of Patrick Lyon, the noted blacksmith, at his forge, which long hung in the galleries of the Academy of the Fine Arts. Other portraits may be seen at the Union League, the University of Pennsylvania, the Philadelphia Library and the rooms of the Philadelphia Law Association. He was one of the founders, and for eight years the president, of the Artist's Fund Society. An exhibition of his work was held at the Penna. Academy of Fine Arts in 1925. The catalogue included a memoir of the artist and a description of about 200 of his paintings, written by Mantle Fielding. John Neagle was elected an Honorary Member of the National Academy of Design in 1828.

NEAGLE, JOHN B.
Engraver. Born in England about 1796; died in Philadelphia in 1866. J. B. Neagle is said to have been the son of the English engraver John Neagle, born in 1760, and he was probably a pupil of his father. He came to Philadelphia when quite young, as he engraved, in 1815-18, a portrait of Dr. Caspar Wistar for "Delaplaine's Gallery." The father of Lewis Neagle, also an engraver.

NEAGLE, LEWIS.
Wood engraver. Born in Pennsylvania about 1837. Son of John B. Neagle. Worked in Philadelphia, 1860, with his father.

NEAL, DAVID.
Painter. Born in Lowell, MA, Oct. 20, 1838. He went to Europe in 1862; studied in Paris and Munich. He painted numerous historical romantic works, including "Mary Stuart and Riccio," "Oliver Cromwell Visits John Milton," "Nuns at Prayer," "James Watt in the Crypt," "Retour de Chasse," etc. His later work was portraiture, including portraits of Adolph Sutro; Rev. Mark Hopkins; Judge Hoffman of California; D. O. Mills; Teackle Wallis; Misses Gladys and Beatrice Mills (daughters of Ogden Mills); Prof. Henry Green; Whitelaw Reid; etc. Died May 2, 1915 in Munich, Germany.

NEAL, GRACE PRUDEN.
Sculptor and painter. Born in St. Paul, MN, May 11, 1876. Studied at Chicago Art Institute; Art Students League, NY; Grand Chaumiere, Paris, 1906-07. Works: Bronze relief, Corcoran Memorial Park, St. Paul; bronze group of symbolic figures presented to Great Britain, in London, 1924. Exhibitions: Corcoran Gallery, 1945; Smithsonian Institution, 1946; National Academy of Design, NY; Penna. Academy of Fine Arts, Philadelphia; Carnegie Institute, Pittsburgh; New York Architectural League; S. Coast art show, Ringling Museum, Sarasota, 1961; others. Award: First prize sculpture, Minnesota State Art Society, 1903, 04, 05. Member: Order Eastern Star. Taught: Instructor of art department, Minnesota State Univ., 1908-11; one-woman shows inc. Clearwater Art Group, Florida, 1952; Florida Gulf Coast Art Center; Chamber of Comm., Clearwater, 1954; Art Club of St. Petersburg, 1955; Tampa Art Inst., 1956. Address 1962, Dunedin, FL.

NEALE, MARGUERITE B.
Painter. Member: Washington Water Color Club. Address 1929, La Salle Apartments, Washington, DC.

NEANDROSS, LEIF.
Painter. Member: NY Water Color Club; National Sculpture Society (associate). Address in 1929, Ridgefield, NJ.

NEANDROSS, SIGURD.
Sculptor. Born in Stavanger, Norway, September 16, 1871; came to America at age of 10; U.S. citizen, 1894. Pupil of Cooper Union evening classes in New York; P. S. Kroyer and Stefan Sinding in Copenhagen. Member: National Sculpture Society.

Exhibited at National Sculpture Society, 1923. Award: Hon. mention, collaborative competition, New York Architectural League, 1915. Works include statues at Pottsville, PA, and Peekskill, NY. Address in 1933, Ridgefield, NJ. Died in 1958.

NEBEL, BERTHOLD.
Sculptor. Born in Basel, Switzerland in 1889. Studied sculpture at Mechanics Institute and Art Students League. Member: National Sculpture Soc. (assoc.); Associate National Academy, 1932. Award: Fellowship, American Academy at Rome, 1914-17; Virginia War Memorial Competition, 1926. Exhibited at National Sculpture Society, 1923. Work: Sculpture, U.S. Capitol, Washington, DC; Hartford State Capitol Building; others. Address in 1934, New York City. Died in 1964.

NED.
Carver. Black artist working in Charleston, SC, 1859. Known to have executed carvings on a hearse.

NEEBE, MINNIE HARMS.
Painter. Born in Chicago, IL, in 1873. Pupil of Hawthorne, Browne, Webster, Reynolds, Ufer. Member of Chicago Society of Artists. Address in 1926, 1320 Clybourn Ave., Chicago, IL.

NEEDHAM, A(LFRED) C(ARTER).
Painter. Born in Beechville, Canada, Jan. 28, 1872. Member: Copley Society; Rockport Art Association; Gloucester North Shore Arts Association. Address in 1929, 10 High St., Boston, MA; h. Manchester, MA.

NEEDHAM, CHARLES AUSTIN.
Sculptor, landscape painter, illustrator and craftsman. Born in Buffalo, NY, October 30, 1844. Pupil of August Will and Art Students League of New York. Member: New York Watercolor Club; American Water Color Society; Salmagundi Club, 1903. Awards: Medal and honorable mention, Atlanta International Expo., 1895; hon. mention, New York State Fair, Syracuse, 1898; bronze medal, Paris Expo., 1900; silver medal, Charleston Expo., 1902; bronze medal, St. Louis Expo., 1904. Represented in St. Louis Museum of Fine Arts, and in Annual Exhibition of American Water Color Society, 1906, 07, 08. Address in 1921, 145 East 23d St.; h. 218 East 19th St., NYC. Died November 24, 1923.

NEEL, ALICE.
Painter. Born in Merion Square, PA, January 28, 1900. Studied at Philadelphia School of Design for Women, 1921-25; Moore College of Art, Hon. Dr., 1971. Work in Museum of Modern Art and Whitney Museum, NY; Robert Mayer Collection, Winetka; Dillard Institute, New Orleans, LA; Graham Gallery, NY. Exhibitions include retrospectives, Moore College of Art, 1971, and Whitney Museum, 1974.

Awarded Longview Foundation Award, 1962; Amer. Academy of Arts and Letters Award, 1969; Benjamin Altman Figure Prize, National Academy of Design, 1971. Elected member of National Institute of Arts and Letters in 1976. Medium: Oil. Died on October 14, 1984.

NEELD, C(LARENCE) E(LLSWORTH).
Painter. Born in New Albany, IN, May 7, 1895. Pupil of Menoir, Claude Buck, James Topping. Member: Hoosier Art Patrons Assoc.; All-Illinois Society of Fine Arts. Address in 1929, 270 Bryant Ave., Glen Ellyn, IL.

NEGRON, WILLIAM.
Illustrator. Born in Bayonne, NJ, in 1925. Studied: Cooper Union, Society of Visual Arts, and the Pratt Graphics Workshop. For several years he held the position of art director for Clairol. His editorial illustrations have appeared in *The New York Times*, Exxon's magazine *The Lamp*, and in several travel books. In addition to his editorial work, he is active in advertising design and book illustration for such clients as Houghton Mifflin.

NEGUS, CAROLINE.
Painter. Born in 1814. Portrait painter in crayon and miniatures, working in Boston, MA, 1844-56. She shared a studio with her cousin, the artist George Fuller. Died in 1867.

NEHLIG, VICTOR.
Painter. Born in Paris in 1830. Pupil of Cogniet. He came to the United States in 1856, having resided for some time in Cuba. He settled in New York where he was elected an Associate of the National Academy in 1863, and an Academician in 1870. Many of his works are historical subjects; his "The Cavalry Charge" was in the New York Historical Society. Among his best known paintings are "Battle of Antietam," "Waiting for the Enemy," "Gertrude of Wyoming," and "The Artist's Dream." Died in 1909.

NEIBART, WALLY.
Illustrator. Born in Camden, NJ, in 1925. Studied for four years under Henry Pitz at the Philadelphia College of Art, where he later returned to teach drawing. Since 1952, the year of his first illustration for the *Philadelphia Inquirer*, he has worked for many major magazines including *Esquire, Playboy, Good Housekeeping* and *The New Republic*. His works are in several private collections and have been shown in exhibitions at the Philadelphia Art Alliance, Widmeir and Chelterham Art Center.

NEIDER, GUSTAVE.
Sculptor. Born in Bavaria in 1817. Active in Baltimore, 1860.

NEILL, FRANCIS ISABEL.
Painter, etcher and teacher. Born in Warren, PA, July 24, 1871. Studied in New York, Boston and Paris. Mem.: Nat. Assoc. of Women Painters and Sculptors; Buffalo Art Assoc.; MacDowell Club. Address in 1929, Harperley Hall, 1 West 64th St., NY, NY.

NEILL, JOHN R.
Illustrator. Member: Salma. Club; Fellowship Penna. Academy of Fine Arts. Address in 1929, 36 East 28th St.; 593 Riverside Drive, New York, NY.

NEILSON, RAYMOND P(ERRY) RODGERS.
Painter. Born in New York, 1881. Pupil of Art Students League of NY and Chase in New York; Laurens; Lucien Simon; Richard Miller in Paris. Member: Associate National Academy of Design, 1925; Salma. Club. Awards: Silver medal, Paris Salon, 1914; silver medal, P.-P. Expo., San Francisco, 1915. Work: "Le Chapeau Noir," owned by French Government. Died in 1964. Address in 1929, 114 East 66th St., New York, NY.

NEIMAN, LEROY.
Painter and printmaker. Born in St. Paul, MN, June 8, 1926. Studied: Art Institute of Chicago; University of Chicago; University of Illinois. Collections: Illinois State Museum; Joslyn Museum, Omaha; Wodham College, Oxford, England; National Museum of Sport in Art, NY; Hermitage, Leningrad, USSR; and others. Commissions: Murals, Continental Hotel, Chicago, 1963; Swedish Lloyd Ship, Stockholm, 1966; Sportsmen's Park, Cicero, IL, 1976; others. Exhibitions: O'Hana Gallery, London; Galerie O. Bosc, Paris. Group shows: Carnegie International, Pittsburgh; Corcoran, Washington, DC, 1957; Art Institute of Chicago, 1960; Hammer Galleries, NYC, 1979; Neiman-Warhol, Los Angeles Institute of Contemporary Art, 1981; others. Awards: Salon d'Art Moderne, Paris; Outstanding Sports Artist Award, Amateur Athletic Union; others. Positions: Sports Artist, NY Jets; ABC-TV; Major League Baseball Promotions, from 1971; Official Artist, Olympics, 1972 & 76; Teacher of Art Institute of Chicago, 1960-70; others. Media: Oil, enamel, serigraph, etching. Represented: Hammer Galleries, NYC. Address in 1984, 1 W. 67th, New York, NY.

NELL, ANTONIA (TONY).
Painter, sculptor, and illustrator. Born in Washington, DC. Studied: Denver School of Art; and with George Bellows, Chase and DuMond. Member: NY Water Color Club; Chicago Water Color Club; American Watercolor Society of New York; National Association of Women Artists; Baltimore Watercolor Club. Awards: Beal Prize, New York Watercolor Club, 1910; Harriet Brooks Jones Prize, Baltimore Watercolor Club, 1921; National Association of Women Artists, 1936. Work: Whitney Museum of American Art; Vassar College, Poughkeepsie, NY; Metropolitan Museum of Art; Ellis Island, New York. Exhibited: Art Institute of Chicago; National Academy of Design; Baltimore Watercolor Club; World's Fair, New York, 1939; Golden Gate Exposition, San Francisco, California, 1939; Penna. Academy of Fine Arts; and abroad. Illustrated national magazines. Address in 1953, 58 West 57th Street; h. 2 Riverview Terrace, New York, NY.

NELL, WILLIAM.
Painter. Exhibited a landscape at the Penna. Academy of Fine Arts, Philadelphia, 1921. Address in 1926, 106 South Troy Ave., Ventnor, NJ.

NELSON.
Dunlap records in his sketch of Chester Harding a portrait painter of that name who painted signs. Nelson had painted on his own sign a copy of Sir Joshua Reynolds' "Infant Artists." He painted portraits of Harding and his wife for $10 each, but refused to give the former any information about his method of working.

NELSON, G. PATRICK.
Illustrator. Member: Society of Illustrators; Artists Guild of the Authors' League of America, NY; Salma. Club. Address in 1929, 1947 Broadway, Rm. 622, New York, NY.

NELSON, GEORGE LAURENCE.
Painter and teacher. Born in New Rochelle, NY, Sept. 26, 1887. Pupil of National Academy of Design; Laurens in Paris. Member: Associate National Academy of Design, 1929; Allied Artists of America; Salma. Club; Amer. Water Color Society; Connecticut Academy of Fine Arts; NY Water Color Club; NY Architectural League (assoc.); Kent Art Association. Awards: Dunham portrait prize, Connecticut Academy of Fine Arts, 1918 and 1928; Isidor gold medal, National Academy of Design, 1921. Work: Portraits in New York Hospital and Mt. Sinai Hospital, New York; Reed Memorial Library, Carmel, NY; murals, "The Ideal School," School 55, the Bronx; "The Graduate," State Normal School, Plattsburgh, NY; portrait of Admiral Sims, Peace Palace, Geneva, Switzerland; "The Winged Book," mural, School 40, New York, NY. Instructor, National Academy of Design. Address in 1929, 15 West 67th St., New York, NY.

NEMOEDE, EDA.
See Casterton, Eda Nemoede.

NERI, MANUEL.
Sculptor and painter. Born in Sanger, California, April 12, 1930. Studied at Univ. of Calif., Berkeley; California College of Arts and Crafts, Oakland, 1952-53, 55-57; assist. to Peter Voulkos, Archie Bray Foundation, Helena, Montana, summer 1953; Calif.

School of Fine Arts, San Francisco, 1957-59. Also studied with Elmer Bischoff. Taught at California School of Fine Arts, 1959-64; University of California at Davis, from 1964. In collections of Oakland Museum; Museum of Art, San Francisco; others. Exhibited at Dilexi Gallery and Quay Gallery, San Francisco; Oakland Museum; Seattle Art Museum; Whitney, NYC; Sydney, Australia; San Francisco Museum of Modern Art; Everson, Syracuse; many others. Received sculpture prize, San Francisco Art Institute 82nd Annual; National Endowment for the Arts Grant; Nat. Art Foundation award; Guggenheim Fellowship. Has also exhibited and published drawings. Address in 1984, c/o Anne Kohs and Associates Inc., San Francisco, California.

NESBIT, ROBERT H.
Landscape painter. Elected an Associate of the National Academy of Design. His painting "The Hurrying River," at one time owned by the Telfair Academy of Savannah, GA, was exhibited at the Centennial Exhibition of the National Academy, 1925. Address in 1926, South Kent, CT.

NESBITT, LOWELL (BLAIR).
Painter and sculptor. Born in Baltimore, MD, Oct. 4, 1933. Studied: Tyler School of Fine Arts, Temple University, Philadelphia, B.F.A.; Royal College of Art, London. Work: National Collection of Fine Arts, Smithsonian Institution, Washington, DC; Corcoran Gallery, Washington, DC; Detroit Art Institute; Library of Congress, Washington, DC; Museum of Modern Art, NYC; Art Institute of Chicago; National Aeronautic and Space Administration (NASA); Philadelphia Museum; Yale University Art Gallery; Environmental Protection Agency, Washington, DC; National Gallery of Art, Washington, DC; many others in U.S.; Aachen, Germany; Wellington, New Zealand; Paris; Goteborg, Sweden; Monrovia; Tanzania; and Tel Aviv. One-man shows: Baltimore Museum of Art, 1958, 59-69; Corcoran Gallery, Washington, DC, 1964, 75; Rolf Nelson Gallery, Los Angeles, 1965, 66; Gertrude Kasle Gallery, Detroit, 1966, 67, 69, 70, 71, 73; Gallerie M.E. Thelen, Cologne, Germany, 1969, 70, 72; Andrew Crispo Gallery, NYC, 1975, 77; and many others in U.S., London, Zurich, Copenhagen, Brussels, Toronto, Caracas, Sweden (Goteborg and Malmo). Group exhibitions: Whitney; Ulrich Museum of Art, Wichita, KS; Kent State Univer.; New York World's Fair, 1964-65; Aldrich Mu., Ridgefield, CT; L.A. County Museum of Art; IX Sao Paulo Biennial. Awards: Purchase awards for oils and prints, Baltimore Museum of Art, 1956; award, National Collection of Fine Arts, 1969. Taught: Towson State College, 1966-67; Baltimore Museum of Art, 1967-68; Univer. of Miami, Univer. of Richmond, and Baltimore Museum of Art, 1968, 69, 71; School of Visual Arts, 1970-71. Medium: Oil on canvas. Address in 1984, c/o Andrew Crispo Gallery, 41 E 57th Street, New York, NY.

NESEMAN (or NESEMANN), ENNO.
Painter. Born in Maysville, CA, April 25, 1861. Pupil of Alfred Hart. Member: Society of Independent Artists. Work: "The First Discovery of Gold in California at Sutter's Mill," De Young Memorial Museum, San Francisco, CA. Address in 1926, 1635 Euclid Ave., Berkeley, CA. Died in 1949.

NESMITH, J. H.
Engraver. In 1805-18 this line-engraver was making illustrations for the encyclopedia published by S. F. Bradford, of Philadelphia. In 1824 his name as engraver is associated with that of J. B. Longacre, and in 1828 Nesmith was working for New Haven publishers.

NESSIM, BARBARA.
Illustrator. Born in NYC in 1939. Received a B.F.A. from Pratt Institute and taught at Society of Visual Arts from 1967 to 1975. Exhibitions: RI School of Design, 1966; Benson Gallery, Bridgehampton, Long Island, 1974; the Louvre; Mead Gallery; Whitney Museum; American Institute of Graphic Arts; Erotic Art Gallery. Awards: Society of Illustrators, 1961; Mead Library of Ideas Award, 1971; American Institute of Graphic Arts; Art Directors' Club. Collections: Westinghouse, Inc.; Shearson, Hamill and Company, Inc.; Moness, Williams, and Sidel, Inc.

NETTLETON, WALTER.
Landscape painter. Born in New Haven, CT, June 19, 1861. Pupil of Boulanger and Lefebvre in Paris. Member: Associate National Academy of Design, 1905; Society of American Artists, 1901. Awards: Hon. mention, Paris Salon, 1892; silver medal, St. Louis Expo., 1904; gold medal, American Art Society, 1907; bronze medal, Buenos Aires and Santiago Expo., 1910. Work: "December Sunshine," Yale Art Museum, New Haven; "A January Morning," Museum of Art, New Britain, CT; "The Beloved Physician," Jackson Library, Stockbridge, MA; "Waldesdammerung," Vassar College Art Gallery. Address in 1929, Stockbridge, MA.

NEUBAUER, FREDERICK AUGUST.
Landscape painter and illustrator. Born in Cincinnati, OH, in 1855. Pupil of Cincinnati Art Academy. Member: Cincinnati Art Club. Address in 1929, 22 Hulbert Block, Sixth and Vine Sts., Cincinnati, OH.

NEUFELD, PAULA.
Painter. Born in Berlin, Germany. Studied: Art Institute, Berlin; Berlin Academy of Art; and with von Koenig, Eugene Spiro, and Willy Jaekel; Colorado Springs Fine Arts Center. Award: Fellowship, Huntington Hartford Foundation, 1957, 59; prizes, Jewish Museum, Berlin, 1935; Kansas City Art Institute, 1942; Nelson-Atkins Museum, Kansas City, 1958. Collections: Bernheimer Memorial, Kansas

City, Missouri; Temple B'nai Jehudah, Kansas City; Mannheim Museum, Germany; Jewish Museum, Berlin; Jackson County Circuit Court; also in many private collections in U.S. and abroad. Group exhibitions: Kansas City Art Institute; Art Institute of Chicago; City Art Museum of St. Louis; William Rockhill Nelson Gallery. One-woman exhibitions: Denver Art Museum; Kansas City Public Library; Art Institute of Chicago; Jewish Center, Kansas City; Kansas City Art Institute; Lawrence Gallery, Kansas City (retrospective); Ben Uri Gallery, London. Address in 1970, Kansas City, MO.

NEUHAUS, EUGEN.
Painter, writer, lecturer and teacher. Born in Wuppertal, Germany, Aug. 18, 1879. Pupil of Royal Art School, Kassel; Institute of Applied Art, Berlin. Received hon. degree, Ph.D., University of Marburg, 1932. Member: San Francisco Art Association. Chairman of Western Advisory Committee and member of International Jury of Awards, Panama-Pacific Expo., San Francisco, 1915. Exhibited: Art Institute of Chicago, 1920-25; Penna. Academy of Fine Arts, 1921, 22; San Francisco Art Association, annually; Palace of the Legion of Honor, 1928, 30 (one-man). Professor of Art, University of California, Berkeley, from 1907. Author: "History and Ideals of American Art," 1931; "World of Art," 1934. Address in 1953, Berkeley, CA. Died in 1963.

NEUHAUSER, MARGUERITE PHILLIPS.
(Mrs. Roy L. Neuhauser). Painter. Born in North Arlington, VA, in 1888. Pupil of Bertha Perrie, George Noyes, Corcoran School of Art. Member: Society of Washington Artists; Washington Art Club; Southern States Art League; North Shore Arts Association. Address in 1929, 1847 Kalorama Rd., Washington, DC.

NEUMAN, ROBERT S.
Painter. Born Sept. 9, 1926 in Kellogg, Idaho. Studied at San Francisco Art Institute; California College of Arts and Crafts; California School of Fine Arts; University of Idaho; Mills College; and at the Academy of Fine Arts, Stuttgart, Germany, with Willi Baumeister. Taught at California College of Arts and Crafts, 1951-53; Brown University, 1961-63; Harvard University, 1964-65; Keene State College, NH, 1972-77. Awarded Fulbright grant, 1953; Guggenheim Fellowship, 1956-57; prize, San Francisco Museum of Art; award, Boston Arts Festival, 1961. One-man exhibitions: Gump's Gallery, San Francisco, 1952; Felix Landau Gallery, Los Angeles, 1954; Swetzoff Gallery, Boston, 1957, 58; Allan Stone Gallery, NYC, 1966; Pace Gallery, Boston, 1960, 62; De Cordova, 1963; others. Group exhibitions: Whitney, 1952, 58; Penna. Academy of Fine Arts, 1953; Seattle World's Fair, 1962; Denver Art Museum, 1952; Carnegie, 1961; Museum of Modern Art, 1964; others. In collections of Yale; Worcester

Art Museum; Museum of Modern Art; Institute of Contemporary Art; San Francisco Museum of Art; Boston Museum of Fine Arts; and Addison Gallery. Address in 1984, Waltham, MA.

NEVELSON, LOUISE.
Sculptor and printmaker. Born in Kiev, Russia, September 23, 1900. Studied in U.S., Europe and Central America; Art Students League, 1928-30; with Hans Hofmann, Munich, 1931; assistant to Diego Rivera, 1932-33. Collections: Museum of Fine Arts, Houston; Farnsworth Museum, Rockland, Maine; Brandeis University; Birmingham Museum of Art; Whitney Museum of American Art, Museum of Modern Art, St. Peter's Church, NY University, Queens College, all in NYC; Carnegie Institute; Riverside Museum, New York City; University of Nebraska; Brooklyn (NY) Museum. Exhibited: Brooklyn Museum; Nierendorf Gallery; Grand Central Moderns Gallery; Whitney; Museum of Modern Art; many others. She has been called "the most distinguished woman sculptor in America and one of the great sculptors of the world." Her wooden assemblage sculpture is usually painted black. Other media include stone, plaster, terra cotta, metals; other colors are white and gold. Address in 1983, 29 Spring St., NYC.

NEVIA, (JOSEPH SHEPPERD ROGERS).
Painter. Born in Washington, DC. Studied: Longfellow School, 1963, under Theodora Kané and Berthold Schmutzart; Greensboro College, B.A., 1967, under Irene Cullis, C. O. Braswell, and Mary Braeme Parker; University of North Carolina, Greensboro, M.F.A., 1969, under B. Carpenter, Andrew Martin, Peter Agostini, S. Antonakos, Will Insley, and W. Barker. Exhibited: The Art League, Alexandria, VA, 1979; Arts Club of Washington, DC, 1981; Galerie Geilsdorfer, Cologne, W. Germany, 1982, 84; Spectrum Gallery, Washington, DC, 1983; The Studios Gallery, Washington, DC, 1982; others. Awards: Best Oil, Miniature Show, Art League, Alexandria, VA, 1982; Hirshhorn Museum; Phillips Collection; others. Member: American Art League (vice-president, 1983-84); Northern Virginia Fine Arts Association; American Association Museum; Arts Club, Washington, DC; Artists Equity Association. Media: Oil, acrylic. Taught art at Corcoran School of Art, Washington, DC, and College Institute of Art, Columbia, MD, 1970-71. Address in 1984, Landover, MD.

NEVIN, BLANCHE.
Sculptor. Born in 1838 in Mercersburg, PA. Studied art in Philadelphia, and later in Italy. Pupil of J. A. Bailly. She executed many portrait busts, and her statue of Peter Muhlenberg was erected in the Capitol in Washington, DC. She died April 21, 1925, in Lancaster, PA.

NEWBY, RUBY WARREN (MRS.).

Painter, etcher, craftswoman and teacher. Born in Goff, KS, July 28, 1886. Studied: So. College, Lakeland, FL, B.S. Educ.; Teachers College, Columbia U.; pupil of Everett Warner, Kathryn Cherry, R. P. Ensign, Ernest Watson, Will Taylor, Gustave Cimiotti, Merlin Pease. Member: Orlando Art Assoc.; So. States Art League; Amer. Fed. of Arts; Florida Fed. of Arts. Awards: First and second prize, So. Florida Fair, 1927; Carnegie Scholarship, Harvard Univ., 1928-29; Orange County C. of C. prize, 1928 (landscape), Gainesville, FL. Work: "Woods Interior," Orlando Pub. Lib.; Yale Univ. Art Gallery; Art Inst. of Chicago; Utah Art Center. Exhibited: So. States Art League, 1928; Weyhe Gallery, 1940; Utah Art Center; NY Pub. Library; G. W. V. Smith Gallery of Art; Montclair Art Museum; Berkshire Museum of Art, 1941. Director of Art, Rollins College, Winter Park, FL. Address in 1933, Ringling School of Art, Sarasota, FL; summer, "Garfield Gables," Monterey, MA.

NEWCOMB, D.

This name as engraver appears upon vignettes on the title-page of books published in Boston, in 1820. Judging from his work, Newcomb was probably one of the banknote engravers then in business in Boston.

NEWCOMBE, GEORGE W.

Painter. Born Sept. 22, 1799 in England. He came to New York in 1829 and became a successful painter of portraits in oils and miniatures. He was elected an Associate of the National Academy in 1832. He died in New York, Feb. 10, 1845.

NEWELL, G(EORGE) GLENN.

Painter. Born in Berrien Co., MI, 1870. Pupil of National Academy of Design under F. C. Jones and Ward; Teachers College, NY, under Will S. Robinson, and W. H. Howe. Member: Associate Nat. Academy of Design; Salma. Club, 1898; Am. Water Color Society; Nat. Arts Club; Allied Artists of America; Am. Society of Animal Painters and Sculptors; NY Water Color Club; Am. Painters and Sculptors; Lotos Club; Aquarellists; Society of Painters, NY. Awards: Prize ($500), Salma. Club, 1906; Speyer prize, Nat. Academy of Design, 1923. Work: "Mists of the Morning," Nat. Gallery, Wash., DC; "Twilight," Detroit Institute; "My Pets" and "The Old Red Mill," Art Association, Dallas, TX; "The Unconquered," "Monarch of All He Surveys," "The Drovers' Inn," Butler Museum, Youngstown, OH. Rep. in Nat. Arts Club; Lotos Club; Salma. Club. Specialty, cattle and sheep. Died 1947. Address 1929, 57th St. and Seventh Ave., New York, NY.

NEWELL, GORDON B.

Sculptor. Born in Petaluma, Calif. 1905. Studied at Occidental College, LA; Univ. of Calif. at Berkeley; apprenticed to Ralph Stackpole, Pacific Coast Stock Exchange, San Francisco, 1929-32. Taught at Occidental; Chouinard Art Inst., LA, 1935-36; Sculpture Center, Monterey, Calif., c. 1965-72. Works include relief panel, "Banjo Player," Occidental College, LA, 1933; "Valley Landing," Fresno Mall, Calif., 1965; "Haupt Pools," White House Mall, Washington, DC, 1968; "Eagle," Public Library, Lompoc, CA, 1981-82. Exh. at CA-Pacific International Expo., San Diego, 1935; Feingarten Gall., NYC; Rutgers Univ., NJ, 1979. Cont. in the cut-direct stonework aesthetic of Stackpole; works in granite. His work in the 1930's made a significant contribution to modern Calif. idiom.

NEWELL, HUGH.

Born Belfast, Ireland, Oct. 4, 1830. He came to this country as a youth and resided for eight years in Pitts., PA, moving to Baltimore when he became connected with the Maryland Inst. and Johns Hopkins Univ. He was a member of the Am. Water Color Soc. Among his pictures are "The Country Musician," "The 13 Cottage Window," "In the Sugar Camp," and "Woods in Winter." Died in Bloomfield, NJ.

NEWELL, PETER SHEAD HERSEY.

Illustrator. Born March 5, 1862 in McDonough County, Illinois. Pupil of Art Students League of NY. He died in Little Neck, LI, Jan. 15, 1924. Most of his work was done for the Harpers publishing firm.

NEWER, THESIS.

Painter. Born in NY, January 6, 1918. Studied: Acad. Delle Belle Arte, Florence, 4 years; Pratt Inst. of Interior Design, graduate. Work: Private coll. only. Exhibited: Allied Artists of America; Am. Artists Prof. League; Knickerbocker Artists; Hudson Valley Art Assoc.; others. Awards: Nat. Art League Gold Medal, Nat. Arts Club, 1969, first prizes, 1972, 75; Am. Artists Prof. League; Best in Show, Catherine Lorillard Wolfe Art Club, 1968; and others. Member: Am. Artists Prof. League; Catharine Lorillard Wolfe Art Club; Nat. Art League; Allied Artists of America; others. Represented: Thomson Gallery, NYC. Address 1984, 876 Adams Ave., Franklin Square, NY.

NEWHALL, DONALD V.

Painter and illustrator. Born in England in 1890. Pupil of Penna. Academy of Fine Arts. Address in 1926, 140 West 57th St., New York.

NEWHALL, HARRIOT B.

Painter, etcher, teacher. Born Topeka, Kansas, June 23, 1874. Pupil of Benson, Tarbell, Hawthorne. Member: Copley Soc.; Provincetown Art Assoc. Address 1929, 157 Commercial St., Provincetown, MA.

NEWLIN, SARA JULIA.

See MacGregor, Sara Julia Newlin.

NEWMAN, ALLEN GEORGE.

Sculptor. Born in NY, August 28, 1875. Pupil of J. Q. A. Ward and National Acad. of Design. Member:

Assoc. Nat. Acad. of Design, 1926; Nat. Sculpture Soc., 1907; Beaux-Arts Institute; Nat. Arts Club; Numismatic Soc.; Am. Federation Arts. Award: Nat. Arts Club prize ($500) for design for "Valor Medal." Work: Marble figures; "Day and Night," Harriman Bank, NY; Henry Hudson Monument, NY; "The Hiker," Providence, RI; "Gate City Guard Peace Monument" and portrait on "Joel Chandler Harris Monument," Atlanta, GA; statue of "Governor Oates," Montgomery, AL; "Gen. Philip Sheridan Monument," Scranton, PA; "Doughboy Monument," Pitts., PA. Exhibited at Nat. Sculpture Society, 1923. Address 1929, 1947 Broadway; h. 263 W 71st St., NY, NY; summer, Marbletown, NY. Died 1940.

NEWMAN, ANNA MARY.
Painter, illustrator, teacher. Born in Richmond, IN. Pupil of Art Inst. of Chicago; School of Applied and Normal Art, Chicago; Overbeck School of Design and Pottery, Cambridge City, IN. Member: Alumni Art Inst. of Chicago; Chicago Art Students League; Richmond Art Assoc.; IN Art Club; Richmond Palette Club; Am. Fed. of Arts. Awards: Richmond Art Assoc. prize, 1908; Indiana State Fair prize, 1914. Work: "Old Irish Chain Quilt," Vanderpoel Memorial, Chicago; "William Mossman," Y.M.C.A., Fort Wayne, IN; "Chester T. Lane," High School, Fort Wayne, IN; "Judge Erwin," Supreme Court, Indianapolis. Instructor in art at Fort Wayne HS. Address in 1929, 25 North 16th St., Richmond, IN.

NEWMAN, B. P.
Newman was a very good engraver of landscape, working in New York in 1860.

NEWMAN, BARNETT.
Sculptor and painter. Born in NYC, Jan. 29, 1905. Studied at the Art Students League under John Sloan, Duncan Smith, Adolf Gottlieb and William Von Schlegell; also at Cornell University, 1922-26; City College of NY, B.A., 1927. Works: Noted for his "zip" paintings in which a single strip cuts vertically through a monochrome field; created his first one in 1950, entitled "Onement I." Also in 1950, he executed his first vertical strip sculpture, the two-strip "Here I," in plaster, cast in bronze in 1962. Other of Newman's sculptures of the same type are "Here II," 1965, three steel strips, each on a trapezoidal base on a platform, and "Here III," 1966. His largest sculpture was titled "Broken Obelisk," 1967, Houston, TX. Exhibited: Betty Parsons Gallery, 1947, 50, 51, Bennington College, 1958, French and Co., Inc., NYC, 1959, Guggenheim, 1966 (all one-man); Art Inst. of Chicago, 1948, 64; Minn. Inst. of Art, 1957; Mus. of Modern Art, 1958-59, 69; Carnegie Inst., 1958; Whitney, 1959, 63, 64; Documenta II, Kassel, Ger., 1959; Galleria dell'Ariete, Milan, 1960; Allan Stone Gallery, 1962; Seattle World's Fair, 1962; Onskemuseet, Moderna Museet, Stockholm, 1963; Brandeis Univ., 1963; LA, 1970; Kammerkunsthalle,

Berlin, 1970; Univ. of Washington, 1971; plus many others. Collections: Stedelijk, Amsterdam; Kunsthalle, Basel, Switzerland; Whitney Mus.; Met. Museum of Art; Wadsworth Atheneum; Tate Gallery, London; Mus. of Mod. Art; many private collections. Taught: Sub. in NYC pub. schools, 1931-39; University of Saskatchewan, 1959; Univ. of Penna., 1962-64. Co-founded a school called the "Subject of the Artist," along with William Baziotes, Robert Motherwell, and Mark Rothko. Address 1970, 685 West End Ave., New York, NY. Died NYC, July 4, 1970.

NEWMAN, BLOSSOM.
Sculptor. Studied: Pratt Institute, Brooklyn, NY; Univ. of Hartford Art School, Connecticut; Museum School, Boston, Mass.; Karlsruhe, Germany. Awards: Lowell Art, 1967; Sudbury Art, 1965. Exhibitions: Boston Center for Adult Education, 1974; Copley Society, Boston, 1974; Manchester Art Association, Massachusetts, 1974.

NEWMAN, CARL.
Painter. Born in 1858. Exhibited in Philadelphia in 1921, in "Exhibition of Paintings Showing the Later Tendencies in Art," Penna. Academy of Fine Arts. Address in 1926, Beth Ayres, PA. Died in 1932.

NEWMAN, CLARA G.
Painter and teacher. Born in Brownsville, NE, Sept. 10, 1870. Pupil of J. E. Forkner, Felix Mahony, Elizabeth Overbeck Potter, Randolph La Salle Coates. Member: Hoosier Salon; Richmond Art Association; Richmond Paint Club. Address in 1929, 59 South 17th St., Richmond, IN.

NEWMAN, ELIAS.
Painter, writer and teacher. Born in Poland, Feb. 12, 1903. Pupil of National Academy of Design; Educational Alliance Art School, New York. Member: Society of Independent Artists; Society of Palestine Artists. Work: "Vade Muserarah," Baltimore Museum of Art, Baltimore, MD. Address in 1929, 1604 49th St., Brooklyn, NY.

NEWMAN, HARRY W.
Painter and teacher. Born in London, England, June 26, 1873. Pupil of Bridgman, Henri. Member: Bronx Artists Guild; Salma. Club. Address in 1929, 3016 Bronx Blvd., Williamsbridge, New York, NY.

NEWMAN, HENRY.
Portrait painter. Born in 1843. Dealer in artists' supplies. He lived in Philadelphia for over fifty years. He died in 1921.

NEWMAN, HENRY RODERICK.
Painter. Born in New York City about 1833. He had his studio in New York State in 1861-69, and after that in Florence, Italy. He is noted for his water color

paintings of architectural subjects, landscapes and flower pieces. He was a friend of John Ruskin. Died in 1917 in Florence.

NEWMAN, ISIDORA.
Sculptor, painter, illustrator, craftswoman, writer, and lecturer. Born in New Orleans, LA, April 23, 1878. Author of "Fairy Flowers." Address in 1929, 2 West 89th St.; h. 285 Central Park West, New York, NY.

NEWMAN, JOSEPH.
Painter. Born in New York City, Sept. 4, 1890. Pupil of Pratt Institute; Whittaker. Member: Allied Artists of America; Salons of America; Painters and Sculptors; Brooklyn Society of Artists; Tiffany Foundation Alumni; NY Water Color Club. Represented in Newark Museum, Newark, NJ. Address in 1929, 609 Rutland Rd., Brooklyn, NY.

NEWMAN, ROBERT LOFTIN.
Painter. Born in Richmond, VA, in 1827. As a youth he read much about art, and in 1850 went to Europe with the intention of studying at Dusseldorf, but having stopped in Paris, he entered the atelier of Thomas Couture. After returning to Tennessee, he made a second trip to Paris in 1854, and formed the acquaintance of William M. Hunt, who introduced him to Jean Francois Millet. In 1882 and subsequently, he made several trips to Barbizon, and his work shows the influence of the group of masters who made that modest village a household word. He has been called the American Diaz on account of his poetic coloring. Died March 31, 1912 in NYC.

NEWMAN, WILLIE BETTY.
(Mrs. J. W. Newman). Painter. Born in Murfreesboro, TN. Pupil of Cincinnati Art School under T. S. Noble; Constant, Bouguereau, Bachet, Robert Fleury and Laurens in Paris; and in Holland and Italy. Awards: Hon. mention, Paris Salon, 1900; gold medal, Nashville Art Association; first prize, Tennessee State Fair, 1914-17. Work: "Fisherman's Daughter," Cincinnati Museum; "En Penitence," Nashville Art Association; "Le Pain Benite," Centennial Club, Nashville; "Reverie," Philadelphia Art Club; "Mrs. E. W. Cole," and "Bishop Galloway," Vanderbilt University; "Bishop Galloway," University of Mississippi; "Hon. John Bell," U.S. Capitol, Washington. Address in 1929, Hotel Tulane, Nashville, TN.

NEWMARK, MARILYN.
(Marilyn Newmark Meiselman). Sculptor. Born in NYC, July 20, 1928. Studied at Adelphi College; Alfred University; also with Paul Brown, Garden City, NY. Commissions: Hacking Home Trophy, Prof. Horseman's Association, 1971; Hobson Perpetual Trophy, Liberty Bell Race Track, PA, 1972; American Gold Cup Medallion Award, Appaloosa Horse Club Medallion Award, 1974; Triple Crown,

commission by Sam Lehrman, 1975; Affirmed, commissioned by Thoroughbred Racing Association, 1979; plus others. Exhibitions: Allied Artists of America, NY, 1970-81; National Sculpture Society, NY, 1970-73 and 75-81; National Art Museum of Sports, NY, 1971; James Ford Bell Museum of Natural History, Minneapolis, MN, 1971; National Academy of Design, NY, 1971, 72, 74, and 75. Awards: Anna Hyatt Huntington Gold Medal Award, Catharine Lorillard Wolfe Art Club, 1973; American Artists Professional League Gold Medal Award, 1974; Ellen P. Speyer Award; National Academy of Design, 1974; Pen and Brush Gold Medal, 1977; Gold Medal Award, Hudson Valley Art Association, 1979; Gold Medal Award, Allied Artists of America, 1981; plus others. Member: Fellow, National Sculpture Society; American Artists Professional League; Society of Animal Artists; Allied Artists of America. Medium: Bronze. Address in 1984, East Hills, NY.

NEWPORT, JAMES W.
Miniature painter, who flourished in Philadelphia, 1846-47, and exhibited at the Penna. Academy in 1847.

NEWSAM, ALBERT.
Lithographer. Born May 20, 1809, at Steubenville, Ohio; died near Wilmington, DE, Nov. 20, 1864. He was deaf and dumb at birth. His natural artistic bent was cultivated by placing him under the tuition of the artists George Catlin and Hugh Bridport. In 1927 Newsam was apprenticed to Cephas G. Childs to be taught engraving, and two examples of copperplate engraving are known to Fielding, signed "A. Newsam, sc. Deaf & Dumb, Childs dir." These are two good stipple-engravings of "Anna" and "Queen Dido," published in the *Casket* of Philadelphia. A catalogue of the "Lithograph Portraits of Albert Newsam" was written by Danl. Stauffer and published in the *Pennsylvania Magazine of History and Biography*, Oct. 1900-Jan. 1901, and April 1901.

NEWTON, EDITH WHITTLESEY.
Painter. Born in 1878. Exhibited at the 33rd Annual Exhibition of the National Association of Women Painters and Sculptors. Address in 1926, New Milford, CT.

NEWTON, FRANCIS.
Painter. Born in Lake George, NY, in 1873. Pupil of Howard Pyle in Wilmington, DE; Art Students League and Chase School, New York; Drexel Institute, Philadelphia; Colarossi Academy in Paris. Member: New York Architectural League, 1911; Wilmington Society of Fine Arts; American Artists Professional League; Mural Painters; New York Municipal Artists' Society; League of New York Artists. Died in 1944. Address in 1929, Easthampton, LI, NY.

NEWTON, GILBERT STUART.

Portrait painter. Born September 20, 1794 in Halifax, Nova Scotia, Canada; died August 5, 1835 in Chelsea, England. He was the nephew of Gilbert Stuart and studied for a while under his uncle. He went to France and England and arrived in London in company with C. R. Leslie in 1817. Dunlap, in his "History of the Arts of Design," gives an extended account of Newton, and quotes Washington Irving's recollections of the artist.

NEWTON, JOSEPHINE PITKIN.

(Mrs. R. C. Newton). Painter. Member: National Association of Women Painters and Sculptors. Address in 1929, Scarsdale, NY.

NEWTON, MARION CLEEVER WHITESIDE.

Painter, craftsman, illustrator and designer. Born in Boston, Massachusetts, March 23, 1902. Studied: Radcliffe College; Parsons School of Design; and with Ivan Olinsky, Lydia Field Emmet, and George Bridgman; also studied in Paris. Collections: Metropolitan Museum of Art; Museum of City of New York; Detroit Institute of Art; United States Lines; Baseball Hall of Fame, Cooperstown, New York; *Ladies Home Journal, Good Housekeeping*, and *McCalls'* magazines. Exhibitions: Salon des Artistes Francais, Paris; New York Water Color Club; New Haven Paint and Clay Club; Philadelphia Water Color Club; Baltimore Water Color Club; National Arts Club. Address in 1953, 1212 Fifth Avenue, New York, New York.

NEY, ELIZABETH.

Sculptor. Born in 1833 in Westphalia, Germany, and patronized by the "mad king" Ludwig II of Bavaria. She left her home for political reasons, and settled in Texas in 1873. Executed a fine memorial to General Albert Sidney Johnson for the cemetery at Austin, TX. Died June 30, 1907, in Austin, TX.

NEYLAND, HARRY.

Sculptor and painter. Born in McKean, Erie County, PA, in 1877. Pupil of New York Art Students League, and of schools in Paris. Works: Memorial tablets, Whaling Enshrined, Inc.; "Surf and Sunlight," Hudson Motor Car Co.; "The Wanderer," Pratt Institute, Brooklyn, New York; "Furled Sails," "Drying Sails," "The Huntress of the North," Country Club, New Bedford, MA. Illustrations for "Cap'n George Fred," published by Doubleday, Doran and Co. Address in 1933, New Bedford, MA; h. South Dartmouth, MA.

NICHOLDSON, J. D.

Engraver. As "J. D. Nicholdson sc," this name is signed to line work done for an encyclopedia published by E. Lucas, Jr., Baltimore, Maryland. The date is about 1830.

NICHOLLS, BURR H.

Painter. Born Dec., 1848, in Lockport, NY. He studied with Sellstedt in Buffalo, and with Carolus-Duran in Paris. Represented at Penna. Academy of Fine Arts by "Effect of Sunlight"; at Peabody Institute, Baltimore, by "Hunting Up a Quotation"; in Fine Arts Academy, Buffalo, by "A Group of Fowls." He died May 12, 1915, in Stamford, CT.

NICHOLLS, JOSEPHINE (LEWIS).

(Mrs. Burr H. Nicholls). Painter, writer and lecturer. Born in Hamilton, Ontario, Canada, Sept. 26, 1865. Pupil of Siddons Mowbray, George Bridgman, Lucius Hitchcock. Member: Alliance; Professional Artists' League; Guild of Allied Arts; Buffalo Society of Artists; League of American Pen Women. Award: Hon. mention, Pan-Am. Expo., Buffalo, 1901. Address in 1929, 188 Franklin St., Buffalo, NY.

NICHOLLS, RHODA CARLETON HOLMES.

(Mrs. Nicholls). Painter, illustrator, writer and teacher. Born in Coventry, England, March 28, 1854; came to America in 1884. Pupil of Bloomsbury School of Art in London; Cammerano and Vertunni in Rome. Member: Art Students League of NY; American Water Color Society; NY Water Color Club; American Society of Miniature Painters; Mac-Dowell Club; Woman's Art Association, Canada (hon.); Society of Painters, NY; National Association of Women Painters and Sculptors. Awards: Gold medal, Competitive Prize Fund Exhibition, NY; medal, Columbian Expo., Chicago, 1893; medal, Atlanta Expo., 1895; medal, Nashville Expo., 1897; medal, Boston; medal, Charlotte, NC; bronze medal, Pan-Am. Expo., Buffalo, 1901; bronze medal, Charleston Expo., 1902; bronze medal, St. Louis Expo., 1904. Work: "The Scarlet Letter," "Those Evening Bells," "Indian After the Chase," and "Searching the Scriptures," Boston Art Club; "Prima Vera, Venezia," and "Water Lilies," Boston Museum of Fine Arts. Living in New York in 1926. Address in 1929, Stamford, CT.

NICHOLS, EDWARD W.

Painter. Born April 23, 1819 in Orford, NH. He was elected an Associate of the National Academy in 1861. He died Sept. 21, 1871 in Peekskill, NY.

NICHOLS, FREDERICK B.

Engraver. Born in Bridgeport, CT, in 1824. Mr. Nichols learned to engrave with the New York firm of Rawdon, Wright, Hatch & Smillie, the last being his chief instructor. He then went into business for himself, and about 1846 he published "Nichols Illustrated New York," with views engraved by himself. In 1848 he invented a process for relief-engraving. Mr. Nichols was a good landscape engraver and did considerable work for the New York publishers, but in 1858 he abandoned engraving with the intention of promoting certain inventions of his own. Died in 1906 in Bridgeport.

NICHOLS, H(ARLEY) D(eWITT).
Landscape painter and illustrator. Born in Barton, Washington County, Wisconsin, February 3, 1859. Pupil of Hakel in Munich. Member: New York Water Color Club; Salma. Club; Artists Guild of the Authors' League of America, New York. Illustrated *French and English Furniture* and *Loves of Great Poets*. Did architectural illustrations for books and magazines, chiefly for *Harper's* and *Century*. Address in 1929, 189 Montague St.; h. 1208 Pacific Street, Brooklyn, NY.

NICHOLS, HENRY HOBART.
Landscape painter and illustrator. Born in Washington, DC, May 1, 1869. Pupil of Howard Helmick and Art Students League in Washington; Julian Academy and Castellucho in Paris. Member: Associate National Academy of Design, 1912; Academician National Academy of Design, 1920; Society of Washington Artists; Fellowship Pennsylvania Academy of Fine Arts; Washington Water Color Club; New York Water Color Club; Salma. Club; National Arts Club; Allied Artists of America; Lotos Club; Cosmos Club; Century Club; Connecticut Academy of Fine Arts; North Shore Arts Association. Awards: Second Corcoran prize, 1901, Parsons prize, 1904, first Corcoran prize, 1906, all from Washington Water Color Club; Parsons prize, Soc. of Washington Artists, 1902; Turnbull prize ($100), 1913, Evans prize ($100), 1915, Vezin prize, 1924, Salma. Club prize ($1,000), 1927, all from Salma. Club; bronze medal, 1915, silver medal ($300), 1920, from National Arts Club; 2nd Altman prize, 1923, first Altman prize, 1925, Club prize ($1,000), 1928, all from National Academy of Design. Assistant to Director of Fine Arts, United States Commission, Paris Exposition, 1900. Work: "Moonrise at Ogunquit," National Gallery, Washington; Museum of Natural History, New York; Corcoran Gallery of Art, Washington, DC; Metropolitan Museum, New York. President, National Academy of Design, New York, 1939-49, President Emeritus, from 1949; Vice-President and Director, Tiffany Foundation, New York. Died in 1962. Address in 1929, Lawrence Park, West, Bronxville, NY.

NICHOLS, JOHN W.
Etcher. Born in Keokuk, Iowa, August 1, 1881. Pupil of Charles A. Cumming; Scott Clifton Carbee; Ernest Haskell. Address in 1929, 520 Steinway Hall, New York, New York; home, 105-14 29th Ave., E. Elmhurst, New York; summer, Commonwealth Art Colony, Boothbay Harbor, ME.

NICHOLS, MARY PLUMB (MRS.).
Sculptor. Born in Vernon, Ohio, July 15, 1836. Pupil of Preston Powers. Medal and diploma, Columbian Expo., Chicago, 1893. Member Denver Art Club. Address in 1910, Denver, Colorado.

NICHOLS, PEGGY (MARTIN).
Sculptor and painter. Born in Atchison, Kansas, in 1884. Pupil of Cecilia Beaux and Chase. Member: California Art Club. Address in 1926, Los Angeles, California.

NICHOLS, SPENCER B(AIRD).
Painter and teacher. Born in Washington, DC, Feb. 13, 1875. Pupil of Art Students League in Washington under Howard Helmick; Corcoran Art School. Member: Associate National Academy of Design; Allied Artists of America; NY Architectural League; Washington Water Color Club; Society of Washington Artists; Salma. Club; NY Water Color Club; American Water Color Society; Grand Central Art Galleries. Award: Third Corcoran prize, Society of Washington Artists, 1901. Work: "Andrew Stephenson" and "John Marshall," House of Representatives, U.S. Capitol; "Holy City," mural in Fifth Avenue Presbyterian Church, New York; Ranger Fund Purchase, "The Bathers," Beloit, WI, Art Gallery. Died in 1950. Address in 1929, Kent, CT.

NICHOLS, WARD H.
Painter. Born in Welch, WV, July 5, 1930. Work: Springfield Museum of Art, MA; Huntington Gallery of Art, WV; others. Exhibitions: National Academy Galleries, NY; Museum of Fine Arts, Springfield, MA; Mississippi Museum of Art, Jackson, MS; others. Awards: Grumbacher Award of Merit, El Paso Museum of Art, TX; Merit Award, Mississippi Museum of Art, Jackson, MS; others. Medium: Oil. Address in 1982, Wilkesboro, NC.

NICHOLSON, DELOS CHARLES.
Illustrator, lecturer and teacher. Born in Edgerton, WI. Member: 2 x 4 Society; Faculty of St. Louis School of Fine Arts. Address in 1929, 864 Providence Ave., Webster Groves, MO.

NICHOLSON, ISABEL LEDCREIGH.
Sculptor and painter. Born in St. Louis, MO, March 28, 1890. Pupil of Tarbell; Richard Brooks; Lee Randolph; Ruth Ball; Bohnen and Loup in Lausanne. Member: National Association of Women Painters and Sculptors; San Diego Society Fine Arts; Carmel Society Arts and Crafts; American Federation of Arts. Address in 1929, Studio Building; h. La Playa Hotel, Carmel, CA.

NICHT, EDWARD W(ILLIAM).
Painter. Born in Auburn, NY, March 7, 1872. Pupil of H. R. Poore; Leith-Ross. Award: First prize for group of water colors, NY State Fair, Syracuse, 1912. Address in 1929, 135 Minerva St., Syracuse, NY.

NICKERSON, JENNIE RUTH (GREACEN).
Sculptor and teacher. Born in Appleton, WI, Nov. 23, 1905. Studied with Ahron Ben-Smuel, NYC; National Academy of Design; and at the Simcoe College

Institute, Ontario, Canada. Exhibitions: National Academy of Design, NYC, from 1932; Whitney Museum of American Art, NYC, 1934; Museum of Modern Art, NY, 1939; Artists for Victory, at the Metropolitan Museum of Art, NYC, 1942; Audubon Artists, 1981. Taught: Instructor in sculpture at the Roerich Museum, NYC, 1934-35; Westchester Art Workshop, 1945-47 and 48-69; instructor of modelling and sculpture, National Academy of Design School, NY, 1980-81. Commissions: Numerous portraits for private collectors, from 1932; "Learning," a stone group, for the Federal Art Project, Brooklyn, 1934; "Tympanum," for the Federal Government, New Brunswick Post Office, NJ, 1936; and numerous others. Major medium is stone. Address in 1982, White Plains, NY.

NICKERSON, REUBEN.
Sculptor. Born in Massachusetts in 1834. Active in Boston, June, 1860.

NICODEMUS, CHESTER ROLAND.
Sculptor, craftsman, and teacher. Born in Barberton, OH, August 17, 1901. Studied: Pennsylvania State College; Cleveland School of Art; University of Dayton; Ohio State University. Member: National Sculpture Society; Columbus Art League. Work: Tablet, Wilbur Wright High School, Dayton, OH; Columbus Gallery of Fine Arts; Unitarian Church, Columbus, OH; Butler Institute Medal; others. Exhibited: Syracuse Museum of Fine Arts, 1933-38, 40, 41; Columbus Art League, 1930-46, 63; Butler Institute of American Art, Youngstown, OH, 1965; others. Taught: Instructor of sculpture, Dayton Art Institute, 1925-30; instructor, sculpture and pottery, Columbus Art School, Columbus, Ohio, 1930-43. Address in 1982, Columbus, Ohio.

NICOLL, JAMES CRAIG.
Marine painter and etcher. Born November 22, 1847 in NYC. Elected an Associate of the National Academy of Design, 1880, and an Academician, 1885. He worked with M. F. H. de Haas. Represented by "Squally Weather" in the Metropolitan Museum of New York. He was awarded many mentions and medals for his marine painting and etchings, and his water colors were well known; among those exhibited were "On the Gulf of St. Lawrence," "Off Portland Harbor" and "Stormy Day at Block Island." Member of the New York Etching Club. Died July 25, 1918 in Norwalk, Connecticut.

NICOLOSI, JOSEPH.
Sculptor, painter, etcher, architect, writer, lecturer, and teacher. Born in Sicily, August 4, 1893. Came to U.S. in 1912. Pupil of Beaux-Arts Institute, Solon Borglum, Edward McCarten. Member: National Sculpture Society; New York Architectural League. Awards: Two bronze medals, 1917, 1919; five second-place medals, Beaux-Arts Institute. Work: Dr. M. B.

Heyman, Manhattan State Hospital; New Brighton, PA, War Memorial; World War Memorial, Morristown, New Jersey. Address in 1953, Los Angeles, California. Died in 1961.

NICOLSON, EDITH REYNAUD.
(Mrs. H. W. Nicolson). Illustrator. Born in Mount Vernon, New York, in 1896. Pupil of New York School of Applied Design for Women. Address in 1926, 4 Parmley Place, Summit, New Jersey.

NIEDECKEN, GEORGE MANN.
Mural painter, architect and decorator. Born in Milwaukee, Wisconsin, August 16, 1878. Pupil of Art Institute of Chicago, Mucha, Robert-Fleury, Lefebvre and Laurens in Paris. Address in 1933, 767 Jefferson Street; home 3205 Marietta Ave., Milwaukee, Wisconsin.

NIEHAUS, CHARLES HENRY.
Sculptor. Born in Cincinnati, OH, January 24, 1855. Pupil of McMicken School in Cincinnati; Royal Academy in Munich and Rome. Member: Associate National Academy of Design, 1902; Academician National Academy of Design, 1906; New York Architectural League, 1895; National Sculpture Society, 1893; Salmagundi Club, 1908; National Institute of Arts and Letters. Awards: Gold medal, Pan-Am. Expo., Buffalo, 1901; gold medal, Charleston Expo., 1902; gold medal, St. Louis Expo., 1904. Work: "Dr. Hahnemann" and "John Paul Jones," Washington, DC; "Garfield," Cincinnati, OH; Astor Memorial doors, Trinity Church, NY; "Caestus" and "The Scraper," Metropolitan Museum, New York; "Francis Scott Key," Baltimore; Soldiers and Sailors monuments, Hoboken, Newark and Hackensack, NJ; statues of Clay and McDowell, Statuary Hall, Capitol, Washington. Exhibited at National Sculpture Society, 1923. Address in 1933, Eagle Crest Studio, Grantwood, NJ. Died June 19, 1935.

NIELSON, HARRY A.
Painter. Born in Slagelse, Denmark, in 1881. Pupil of Art Institute of Chicago; Jean Mannheim. Member: California Art Club. Address in 1926, 701 California Terrace, Pasadena, CA.

NIEMEYER, JOHN H(ENRY).
Painter, teacher and lecturer. Born in Bremen, Germany, June 25, 1839; came to U.S. in 1843. Pupil of Gerome and Yvon at Ecole des Beaux-Arts, and of Jacquesson de la Chevreuse and Cornu in Paris. Member: Society of American Artists, 1882; Associate National Academy of Design, 1906; American Art Association of Paris; Connecticut Academy of Fine Arts; New Haven Paint and Clay Club. Award: Hon. mention, Pan-Am. Expo., Buffalo, 1901. Professor, Yale School of Fine Arts, 1871-1908; emeritus, after 1908. Represented in Smith College Art Gallery; Yale School of Fine Arts. Address in 1929, 251 Lawrence St., New Haven, CT.

NIEPOLD, FRANK.
Painter and craftsman. Born in Frederick, MD, Jan. 1, 1890. Pupil of Corcoran School of Art, Washington. Member: Washington Art Club; Society of Washington Artists. Address in 1929, 307 Seventh St., S.W.; h. 3321 Garfield St., N.W., Washington, DC.

NIGHT, EDWARD W.
Painter. Born in Auburn, NY, in 1872. Address in 1926, 105 Cook St., East Onondaga, Syracuse, NY.

NIIZUMA, MINORU.
Sculptor. Born in Tokyo, Japan, September 29, 1930. Studied at Tokyo University of Art, B.F.A. Work in Museum of Modern Art, NY; National Museum of Modern Art, Tokyo; Albright-Knox Gallery, Buffalo; Guggenheim Museum, NY; Hirshhorn Museum and Sculpture Garden, Washington, DC; others. Has exhibited at Mus. of Modern Art; Whitney Museum of American Art; Howard Wise Gallery, NY; Contemporary Sculpture Center, Tokyo; others. Member of Modern Art Association of Japan (permanent juror); Sculptors Guild. Taught sculpture at Brooklyn Museum Art School, 1964-69; teaching at Columbia University, from 1972. Address in 1982, 463 West St., NYC.

NILES, ROSAMOND.
Painter and etcher. Born in Portsmouth, NH, Nov. 5, 1881. Pupil of DuMond; Pennell; Andre L'hote; Edouard Leon. Member: National Association of Women Painters and Sculptors; National Arts Club; Southern States Art League. Address in 1929, 9 Gramercy Park; h. 15 Gramercy Park, New York, NY.

NIMMO, LOUISE EVERETT.
(Mrs. Ray E. Nimmo). Painter and sculptor. Born in Des Moines, IA, April 9, 1899. Pupil of Fursman; Charles W. Hawthorne; Julia Bracken Wendt; Otis Art Institute; Fontainebleau School of Fine Arts; Julian Academy; and Chouinard School of Art. Member: California Art Club; Women Painters of the West; Laguna Beach Art Association. Awards: Marine prize, Laguna Beach Art Association, 1923; silver medal for sculpture, Pacific Southwest Expo., Long Beach, CA, 1928; purchase prize, Beverly Hills Women's Club, 1933. Work: "Geraniums Red and Delphinium Blue," Smouse Opportunity School, Des Moines, IA; "Decorative Cactus," mural decoration, California Art Club, Los Angeles. Address in 1933, Los Angeles, CA.

NISBET, ROBERT H.
Painter and etcher. Born in Providence, RI, Aug. 25, 1879. Pupil of RI School of Design; Art Students League of NY. Member: Associate National Academy of Design, 1920; Academician National Academy of Design, 1928; NY Architectural League, 1912; Providence Art Club; Connecticut Academy of Fine Arts; National Arts Club (life); Salma. Club; Allied Artists of America; Lotos Club (artist life); Art Students League of NY; Academy of Fine Arts; Artists' Fund Society; Kent Art Association (president). Awards: Dunham prize, Connecticut Academy of Fine Arts, 1913; third Hallgarten prize, National Academy of Design, 1915; silver medal, P.-P. Expo., San Francisco, 1915; prize, Connecticut Society of Artists, 1915; Ranger Fund Purchase, National Academy of Design, 1923; Bryan prize, Los Angeles Museum, 1925; prize and medal, National Arts Club, 1927; hon. mention, Exhibition of Living American Etchers, 1927-28. Work: "Eve of St. John," National Arts Club, New York; "Earliest Spring," RI School of Design, Providence; "The Emerald Robe," Butler Art Institute, Youngstown, Ohio; "Falls at Bulls Bridge," Lotos Club; "Winter," Plantations Club, Providence, RI; "The Hurrying River," Telfair Academy, Savannah; "Promise of Spring," Rhode Island Hospital, Providence; "The Trout Stream," CT Agricultural College; etchings, Milwaukee Art Institute; Detroit Museum; Brooklyn Museum; University of Nebraska, Lincoln; Metropolitan Museum of Art; etchings, New York Public Library; Bibliotheque National, Paris, France. Exhibited: National Academy of Design; Connecticut Academy of Fine Arts; Kent Art Association; Society of American Etchers. Died April 19, 1961. Address in 1929, South Kent, CT.

NITZSCHE, ELSA KOENIG.
Painter, illustrator and lecturer. Born in Philadelphia, PA, in 1880. Pupil of Elliott Daingerfield, Dagnan Bouveret. Work: "Boy Blowing Bubbles," Art Club, Philadelphia; portrait in National Museum, Washington, DC. Author and illustrator of "Dickel and the Penguin." Died in 1952. Address in 1929, 1024 Westview Avenue, Germantown, Philadelphia, PA.

NIVEN, FRANK R.
Painter and illustrator. Born in Rochester, NY, in 1888. Pupil of S. C. Jones. Member: Rochester Art Club. Address in 1926, 402 Municipal Bldg., Rochester, NY.

NIVOLA, CONSTANTINO.
Sculptor. Born in Orani, Sardinia, July 5, 1911. Came to U.S. in 1939. Studied at Instituto Superiore d'Arte, Monaz, Italy, with Marino Marini, Marcello Nizzoli, 1930-36, M.A., 1936. Works: Museum of Modern Art; Whitney; Hirshhorn; Philadelphia Museum of Art; plus numerous commissions, including murals in Olivetti Showroom, NYC, gardens at 1025 Fifth Ave., NYC, sculpture at Yale University, sculpture for 19th Olympiad, Mexico City. Exhibitions: Tibor de Nagy Gallery, NYC; The Peridot Gallery, NYC; The Bertha Shaefer Gallery, NYC; NY Architectural League; American Federation of Arts; Brooklyn Museum; Rome National Art Quadrennial,

1950; Riverside Museum; Whitney; Carnegie; Museum of Contemporary Crafts; National Gold Medal Exhibition of the Building Arts, NYC; Museum of Modern Art. Awards: Philadelphia Decorators Club Award, 1959; Municipal Art Society of NY, Certificate of Merit, 1962; NY Architectural League, Silver Medal of Honor in Sculpture, 1962; Regional Exhibition of Figurative Art, Cagliari, Italy, Gold Medal; Federation of Graphic Arts, diploma; American Institute of Architecture, Fine Arts Medal, 1968. Member: NY Architectural League; National Institute of Arts and Letters. Taught: Director, Design Workshop of Harvard University Graduate School, 1953-57; Columbia University, 1961-63. Art Director, *Interiors* magazine, 1941-45. Address in 1982, East Hampton, NY.

NOBACK, GUSTAVE JOSEPH.
Sculptor, etcher, and lecturer. Born in New York, NY, May 29, 1890. Studied: Cornell University, B.S.; University of Minnesota, M.A., Ph.D.; and with W. C. Baker, Heinz Warneke, Wheeler Williams. Member: National Arts Club, New York; American Artists Professional League. Work: New York University; China Institute of America. Exhibited: Architectural League, 1938; Penna. Academy of Fine Arts, 1940, 42, 46; National Academy of Design, 1945, 46; Allied Artists of America, 1941-45; Clay Club, 1934, 35; Asbury Park Society of Fine Arts, 1939, 40; Montclair Art Museum, 1945; National Arts Club, 1944-46; Minneapolis Sculpture Exhibition, 1945. Lectures: Human Anatomy in Art. Taught: Professor of Anatomy, New York University, New York, NY, 1924-45. Address in 1953, 15 Gramercy Park, New York, NY; h. Forest Hills, NY.

NOBLE.
Painter. His picture of John Brown on his way from prison to the gallows, embracing the negro children, is well known. His painting of the "Slave Mart" attracted much attention in the days of the Civil War and was exhibited in Boston and at the Capitol in Washington, DC.

NOBLE, JOHN.
Painter. Born in Wichita, KS, March 15, 1874. Pupil of Cincinnati Academy of Fine Arts; Laurens and Julian Academy in Paris; Academy des Beaux Arts, Brussels. Member: Associate National Academy of Design, 1924; Academician National Academy of Design; Paris American Art Association; Society of Artists of Picardy; Independents of Paris; Allied Artists, London; Connecticut Academy of Fine Arts; Provincetown Art Association. Award: Salmagundi purchase prize ($1,000), 1922; W. A. Clark prize ($500) and hon. mention, Corcoran Gallery, Washington, DC, 1924; Athenaeum prize, Hartford, CT; Carnegie prize, National Academy of Design. Represented in Delgado Museum, New Orleans, LA; Academy of Design, RI; Dallas Museum, Dallas, Texas;

Wichita Museum, Wichita, KS. Died in 1934. Address in 1929, care of Milch Galleries, 108 West 57th St., New York, NY.

NOBLE, WILLIAM CLARK.
Sculptor and painter. Born in Gardiner, ME, February 10, 1858. Pupil of Pierce, Greenough, and Taft in London. Member: National Sculpture Society; National Arts Club. Work: Walters' Memorial, W. E. Channing and Soldiers and Sailors Monument, Newport, RI; memorial to Bishop Phillips Brooks in Church of the Incarnation, NY; portrait bust of Gen. Potter, Chamber of Commerce, NY; Challenge statue and General Christ statue, Antietam, MD; Gov. Curtin, Bellefonte, PA; jewelled crucifix in Church of St. Mary the Virgin; "Mother's Memorial," and "Major Pierre Charles L'Enfant Memorial," Washington, DC. Designed gold and silver money for Guatemala, 1925, and for Panama, 1930, 31. Address in 1929, Washington, DC. Died in 1938.

NOCI, ARTURO.
Painter, illustrator and teacher. Born in Rome, Italy. Pupil of Inst. of Fine Arts, Rome. Work: "Venetian Interior," Rochester Museum, Rochester, NY; "Riflesso d'oro" and "Nella Cabina," Galleria d'Arte Moderna, Rome, Italy.

NOCQUET, PAUL-ANGE.
Sculptor and painter. Born in Brussels, Belgium, April 1, 1877. He came to America in 1903. Pupil of Lambeaux, Antonin Mercie, and Gerome in Paris. His bronze "American Football" brought him recognition; it was presented to Columbia University. Awards: First grand prize for sculpture, Rome, Belgium, 1900; silver medal, St. Louis Expo. 1904. Member: Associate, Champs de Mars, Paris, 1902; Societe Nationale des Beaux-Arts, Paris; Society "Les Arts Reunis," Paris; Ste. Sillon, Brussels. Address in 1906, 55 East 59th St., NYC. Died in 1906.

NOGUCHI, ISAMU.
Sculptor. Born Nov. 17, 1904, in Los Angeles, CA. Studied at Columbia U. (premedical); with Gutzon Borglum; Leonardo da Vinci Art School, NYC; E. Side Art School, NYC; with Constantin Brancusi, Paris, 1927-29; and with Onorio Ruotolo. Designed stage sets for Martha Graham Dance Company. Received comm. in NYC, Boston, Fort Worth, TX, Paris, Jerusalem. In collections of Brooklyn Mus.; Guggenheim; LA Mus. of Art; Albright-Knox; Art Inst. of Chicago; Met. Mus. of Art; Mus. of Modern Art; Whitney; Tate; garden, Yale Library of Rare Books; IBM, Armonk, NY; many others. Exhibited at Penna. Academy of Fine Arts, 1926; Schoen Gallery, Sterner Gallery, Demotte Gallery, Harriman Gallery, all in NYC; Albright-Knox Art Gallery; San Francisco Mus. of Art; Carnegie Inst., 1959-61; Cordier and Ekstrom, NY, 1963, 68; Claude Bernard Gallery, Paris, 1964; Tate Gallery, London, 1964;

Whitney, retrospective, 1966, 68; Los Angeles County Museum of Art, 1967; Pace Gallery, 1975; Andre Emmerich Gallery, 1980; others. Received Guggenheim Foundation Fellowship, 1927; Logan Medal, Art Institute of Chicago; Bollingen Foundation Fellowship, 1950-51; Society of Four Arts Sculpture Award, 1975. Member: National Institute of Arts and Letters; Architectural League; National Sculpture Society. Address in 1984, 32-37 Tenth, Long Island City, NY.

NOLAND, KENNETH.
Painter. Born April 10, 1924 in Asheville, NC. Studied at Black Mt. College, 1946-48; and with the late sculptor, Ossip Zadkine, in Paris, 1948-49. Taught at Institute of Contemporary Arts, Catholic University in Washington, DC, and Bennington College. Awards: Inst. Torcuato Di Tella (Buenos Aires) prize, 1964; Brandeis University, 1965; and Corcoran award. Exhibited at Tibor de Nagy, NYC, 1956-58; Fogg Art Museum; Metropolitan Museum of Art, 1970; Guggenheim; Kootz Gallery, NYC; Whitney; Seattle World's Fair, 1962; Jewish Museum, 1962; Art Institute of Chicago, 1963; retrospective, Visual Arts Gallery, NY, 1975. In the collections of Detroit Institute of Arts; Whitney; Brandeis; Harvard; Albright-Knox Art Gallery, Buffalo; Museum of Modern Art; City Museum of St. Louis; Tate Gallery, London. Address in 1984, South Salem, NY.

NOLF, JOHN T(HOMAS).
Painter and illustrator. Born in Allentown, PA, July 23, 1871. Pupil of Art Institute of Chicago; Wellington Reynolds; Francis Smith; John Vanderpoel. Member: Chicago Galleries Association; Oak Park Art League; Chicago Association of Painters and Sculptors; Illinois Academy of Fine Arts. Award: Rosenwald Prize, Art Institute of Chicago, 1924; gold medal, Oak Park Art League, 1928; Wm. Ormond Thompson prize, 1929; purchase prize, Chicago Municipal Art League, 1929. Work: "Thunder Cloud," Chicago Public School Art Society; "Myrtle" and "Wizzard," Oak Park Public Schools; "The Wanderer," Northwestern University Fraternity, Chicago; "Little Joe," Kenilworth High School, Chicago; "Boys Plowing," Municipal Art League, Chicago. Died in 1954. Address in 1929, care of Oak Park Art League, Oak Park, IL; summer, Grand Detour, Dixon P.O., IL.

NOLL, ARTHUR HOWARD.
Engraver. Born in Caldwell, NJ, in 1855. Specialty: Bookplate engraving. Address in 1926, 608 Woodlaun St., Memphis, TN.

NORCROSS, ELEANOR.
Painter. Born in Massachusetts. Pupil of William M. Chase in New York; Alfred Stevens in Paris. She died in Paris in 1923, and a memorial exhibition of her painting was held in the Louvre by the French Government. Her studio had been in Paris for more than thirty years.

NORDBERG, C. ALBERT.
Painter and teacher. Born in Chicago, IL, Oct. 19, 1895. Pupil of Robert Reid, John F. Carlson, Birger Sandzen, Everett Warner. Member: Broadmoor Art Academy; Colorado Springs Society of Painters; Chicago Society of Painters; Denver Society of Painters; Society of American Painters. Work: Mural, "Indians of Pike's Peak Region," and "Towering Pine," Cheyenne School, Colorado Springs, CO; mural, "The Mesa," Richmond, IN; "The Peak," Vanderpoel Memorial Collection, Chicago. Address in 1929, 2700 Payne St., Evanston, IL; Broadmoor Art Academy, Colorado Springs, CO; Art Institute, Chicago, IL.

NORDELL, CARL JOHN.
Painter. Born in Copenhagen, Denmark in 1885. Pupil of Boston Museum School under Tarbell; Art Students League of NY under Bridgman and Du Mond; Julian Academy in Paris under Laurens; RI School of Design. Member: Art Students League of NY; Boston Art Club; Boston Water Color Club; Providence Art Club; North Shore Arts Association; Salma. Club; Print Makers' Society of California; Brooklyn Society of Etchers; Allied Artists of America. Awards: Fourth W. A. Clark prize ($500) and hon. mention, Corcoran Gallery, Washington, DC, 1912; silver medal, P.-P. Expo., San Francisco, 1915; first prize, Swedish-American Exhibition, Chicago, 1917. Address in 1929, Fenway Studios, 30 Ipswich St., Boston, MA.

NORDELL, EMMA PARKER.
(Mrs. Carl J. Nordell - "Polly Nordell"). Painter. Born in Gardner, MA. Pupil of S. R. Burleigh, Stacy Tolman, DuMond, Henri. Member: Providence Water Color Club; North Shore Arts Association; NY Water Color Club. Address in 1929, Fenway Studios, 30 Ipswich St., Boston, MA; summer, Reed Studios, East Gloucester, MA.

NORDFELDT, BROR JULIUS (OLSSON).
Painter, etcher, engraver and teacher. Born in Tulstorg, Scania, Sweden, April 13, 1878. Pupil of Art Institute of Chicago; Albert Herter in New York; Laurens in Paris; Frank M. Fletcher in Reading, England. Member: Taos Society of Painters; New Mexico Society of Painters; Chicago Society of Etchers; Brooklyn Society of Etchers. Awards: Silver medal, Milan, Italy, 1906, for wood block prints; silver medal for etching, P.-P. Expo., San Francisco, 1915; Logan medal, Art Institute of Chicago, 1926; bronze medal, Sesqui-Centennial Exposition, Philadelphia, 1926. Work in Sidney (Australia) Museum of Fine Arts; Chicago Art Institute; New York Public Library; Toledo Art Museum;

Bibliotheque des Arts et Archeologie, Paris; Nat. Museum, Christiania, Norway; Detroit Institute of Arts; Toronto Art Museum; Museum of New Mexico. Died in 1955. Address in 1929, Santa Fe, New Mexico.

NORDHAUSEN, A(UGUST) HENRY.
Painter, sculptor, and teacher. Born in Hoboken, NJ, Jan. 25, 1901. Pupil of Hugo von Habermann and Howard Giles. Member: Salmagundi Club; Springfield Art League; New Haven Paint and Clay Club. Awards: First prize for portrait, 1930, and hon. mention, 1931, Springfield Art League; hon. mention, New Haven Paint and Clay Club, 1931; fellowships at Tiffany Foundation, Oyster Bay, NY, Trask Foundation, Saratoga Springs, NY, and MacDowell Association, Peterborough, NH. Address in 1933, 46 East 9th Street, NYC.

NORDIN, PHYLLIS E.
Sculptor and designer. Born in Chicago, IL. Studied: Beloit College, WI; Wayne State University, 1954-56; Texas A and I; University of Toledo, B.S., 1962, B.A., 1974; Toledo Museum of Art School of Design. Commissions: "Family," bronze, Ohio Chamber of Commerce, Municipal Building, Sylvania, OH; "Into Thy Hands I Commit My Spirit," memorial, Epworth United Methodist Church, Toledo, OH; "Preceptor," bronze fountain, Univer. of Toledo, OH; "The Flame," corten steel, River East Corp. of Toledo, OH; "Triad," wall sculpture, Covenant Presbyterian Church, Toledo, OH; boulder font and glass altar, St. Joan of Arc Church, Maumee, OH; many others including works at Stranahan Arboretum, Toledo; Beloit College, WI; First Methodist Church, LaGrange, IL; Toledo Hospital, Toledo; and Reynolds Corner Branch Library, Toledo. Exhibitions: Butler Institute of Am. Art, Youngstown, OH, 1968-78; Allied Artists of Am. Annuals, National Academy Galleries, NY, 1978, 84; Interfaith Forum on Religion, Art and Architecture, Chicago, IL, 1981; Salma. Club Annual, National Club Galleries, NY, 1981; C. L. Wolfe Art Club Annuals National, National Arts Club Galleries, NY, 1981, 84; Liturgical Art National, McFall Gallery, Bowling Green State Univer., OH, 1981, 83; National Assoc. of Women Artists 94th Annual, NY, 1983, 85; North American Sculpture Exhibition, Golden, CO, 1984; others. Awards: Two 2nd prizes, three hon. mentions, Ohio State Fair, Columbus, OH, 1967, 69, 70, 74; 1st prize, 43rd Annual National Art Exhibition, Cooperstown, NY, 1978; certificate of merit, C. L. Wolfe Art Club Annual National, NY, 1982; first and second place winner, Invitational Competition, Univer. of Toledo, OH, 1980; 3rd prize, Shreveport Art Guild National Exhibition, Meadows Museum, LA, 1984; others. Member: Nat. Association of Women Artists; Ohio Designer Craftsmen; Liturgical Art Guild of Ohio; Arts Commission of Greater Toledo; others. Represented at Collectors Corner, Toledo Museum of Art,

Ohio, 1970-83. Liturgical art and designer consultant for many Ohio churches. Sculpts in various media. Address in 1985, Toledo, OH.

NORDQUIST, JUDY.
Sculptor and painter. Born in Oklahoma on July 31, 1949. Studied: Mesa College, CO, art major; Famous Artists School; anatomy under Jon Zahourek. Spent several successful years in the commercial art field before focusing complete attention on sculpture. Uses the lost wax process. Works: 35 editions including "Call My Name," bronze, commissioned by Dr. George Allen, Willomar; "Khemosabi," pastel, commissioned by Mr. Perry Perkins; "Cedardell Cameo & Foal," pastel, commissioned by Somerset Farm, Lee Romney; "The Wind is their Chariot," "Magic Moment," "Heritage," "The Chosen One," "Morning Mist," "Desert Warrior," all bronzes; many others, including collections in Canada, South America, Mexico, and Europe. Exhibited: Foothills Art Center, Golden, CO; Loveland High Plains Arts Council Sculpture Exhibition; International Arabian Horse Association; Scottsdale Arabian Horse Association. Award: Fifth place, North American Sculpture Exhibition, 1984. Associate member of the American Academy of Equine Artists. Subject: Arabian horses. Address in 1985, Evergreen, CO.

NORLING, ERNEST (RALPH).
Painter, illustrator and etcher. Born in Pasco, Wash., Sept. 26, 1892. Pupil of F. Tadema, E. P. Ziegler. Member: Seattle Art Institute; L. C. Tiffany Foundation. Address in 1929, 516 White Bldg.; h. 2453 22nd Ave., North, Seattle, WA.

NORMAN, DaLORIA.
Painter and craftswoman. Born in Leavenworth, KS, Nov. 18, 1872. Studied abroad. Work: "Ecclesiastes," "Song of Solomon," illuminations, New York Public Library; "Passing of the Seasons," mural fresco, Public Library, Teaneck, NJ. Specialties: Oil fresco, water color portraits, illuminations. Died in 1935. Address in 1929, Crossway Studio, Lyme, CT.

NORMAN, EMILE.
Sculptor and painter. Born in El Monte, CA, April 22, 1918. Work: San Francisco Museum of Art; Oakland Art Museum. Commissions: Mosaic window and marble relief, Masonic Memorial Temple, San Francisco; horse in wood, Crown Zellerbach Building, San Francisco; bronze of "St. Francis and Wood Inlay Mural," Bank of California, San Francisco. Exhibitions: Religious Art Show, de Young Museum, San Francisco, 1953; Society of Contemporary Art Annual, Art Institute of Chicago, 1960; design and aesthetics in wood, Lowe Art Center, Syracuse University, 1967; and others. Member: Carmel Art Association; National Society of Mural Painters. Media: Oil, acrylic; wood, precious metals. Address in 1982, Carmel, CA.

NORMAN, GEOFFREY R(ICH).
Painter and illustrator. Born in London, England, Feb. 21, 1899. Address in 1929, 400 East 59th St., NY, NY; summer, Crossway Cottage, Lyme, CT.

NORMAN, JOHN.
Engraver. Born c. 1748. According to the *New England Palladium and Commercial Advertiser*, in 1817, John Norman died in Boston "aged 69 years." That he was an Englishman is shown by his advertisement in the *Pennsylvania Journal* of May 11, 1774, which probably notes his first appearance in this country. A number of his plates are more or less modified copies of English originals. His chief claim to fame is the fact that he was probably the first engraver in America to attempt a portrait of Washington, about 1779.

NORRIS & KAIN.
Sculptors. Edward Norris and Francis Kain. Working in New York City, 1811-18.

NORRIS, S. WALTER.
Landscape painter and writer. Born in Philadelphia, PA, Jan. 12, 1868. Pupil of Penna. Academy of Fine Arts; Legros in Paris. Member: Philadelphia Sketch Club; Fellowship Penna. Academy of Fine Arts; Phila. Alliance; Phila. Art Club; Am. Fed. of Arts. Address in 1929, 1716 Chestnut St.; h. 135 South 18th St., Philadelphia, PA; summer, Ogunquit, ME.

NORRIS, W.J.
Illustrator and commerical designer. Born in Chicago, IL, Aug. 20, 1869. Member: Pen and Pencil Club, and Art League, Columbus, OH. Address in 1929, 56 East 8th Ave., Columbus, OH.

NORSTAD, MAGNUS.
Painter. Born in Norway, June 24, 1884. Pupil of National Academy of Design. Member: Artists Guild of the Authors' League of Am., NY. Awards: Hon. mention, Minn. State Art Exhibition, 1914; silver medal, St. Paul Inst., 1917; prize for group of four pictures at Minn. State Art Exhibition, 1917. Work: "The City on the Hill," St. Paul Inst. Address 1929, 303 Fifth Ave., NY, NY; Valhalla, NY.

NORTHCOTE, STAFFORD M(ANTLE).
Wood engraver. Born in Brooklyn, NY, July 7, 1869. Studied engraving with E. Heineman; drawing and painting at Art Institute, Brooklyn, under Boyle. Awards: Hon. mention, Pan-Am. Expo., Buffalo, 1901; bronze medal, St. Louis Expo., 1904. Died Nov. 15, 1949. Address in 1929, 288 Carlton Ave., Brooklyn, New York, NY.

NORTON, CLARA MAMRE.
Painter. Born in Burlington, CT. Exhibited water colors at the Penna. Academy of Fine Arts, Phila., 1925. Address in 1926, 49 Woodland St., Bristol, CT.

NORTON, ELIZABETH.
Sculptor, painter, and block printer. Born in Chicago, IL, December 16, 1887. Pupil of Art Institute of Chicago; Art Students League of New York; National Academy of Design. Exhibited: Golden Gate Expositions, San Francisco, CA, 1939; California Society of Etchers, annually; California Print Maker's Society, annually; National Academy of Design, 1942; Prairie Print Maker's Society, 1949-51; one-woman, California State Library, 1942; Stanford University, 1950. Member: Alliance; California Print Maker's Society; Palo Alto Art Club; San Francisco Society of Women Artists; American Federation of Arts. Work: Wall fountain in Detroit Athletic Club; Library of Congress and Smithsonian Institution, Washington, DC; Public Library, Springfield, MA; Metropolitan Museum of Art; Art Institute of Chicago; Fogg Museum of Art; Stanford University; others. Address in 1953, 353 Lowell Avenue, Palo Alto, CA.

NORTON, HELEN G(AYLORD).
Painter. Born in Portsmouth, Ohio, April 12, 1882. Pupil of Mills College; Jean Mannheim. Member: Laguna Beach Art Association; California Art Club. Awards: Second prize, Riverside Co. Fair, 1914; first prize, Southern California Fair, 1920, 22, 23, 2nd prize, 1921. Specialty: Landscapes and marines. Address in 1929, Laguna Beach, CA; h. 189 Magnolia Ave., Riverside, CA.

NORTON, JOHN WARNER.
Painter. Born in Lockport, IL, 1876. Pupil of Art Institute of Chicago. Member: Chicago Society of Artists. Award: Harris bronze medal ($300), Art Institute of Chicago, 1926. Instructor, Chicago Academy of Fine Arts. Work: Series of mural paintings in the Frank G. Logan Archaeological Museum, Beloit, WI. Died in 1934. Address in 1929, 10 East Ohio St., Chicago, IL; Lockport, IL.

NORTON, WILLIAM EDWARD.
Born June 28, 1843 in Boston, MA. Pupil of Lowell Institute, Boston; George Inness; Jacquesson, de la Chevreuse, and A. Vollon, in Paris. Awarded 3 gold medals in Amer.; hon. mention, Paris Salon, 1895. Exhibited at Paris Expo., 1900; also exhibited in Phila., Chicago, and St. Louis expositions. Regular exhibitor at the Royal Academy, London. Awarded Osborne prize for marine painting, 1905, and again in 1906. Died Feb. 25, 1916, in NYC.

NOTARO, ANTHONY.
Sculptor. Born in Italy, January 10, 1915; U.S. citizen. Studied: Rinehart School of Sculpture, Maryland Institute, Baltimore, 1935-39, with William Mark Simpson, Herbert Adams; also with Malvina Hoffman. Collections: The Hall of Fame for Great Americans; Student Center, Seton Hall University; National Commemorative Society; and many others.

Commissions: Wrestling group, Council American Artists Society; figure of "Winter," National Sculpture Society; portrait, Jimmy Carter; football players, Allied Artists of Amer.; others. Exhibitions: National Academy of Design; National Sculpture Society; Lever House; Allied Artists of America; Italian Cultural Center, Chicago; and many others. Awards: Bicentennial Exhibition, National Sculpture Society; Hudson Valley Art Association; plus many others. Member: Fellow, National Sculpture Society; American Artists Professional League; Allied Artists of America. Address in 1982, Mendham, New Jersey.

NOTHERMAN, G.
Engraver. A Harrison campaign badge issued in Baltimore in 1840 is signed as "Drawn & Eng. by G. Notherman, Jr." The work is well done in line. The badge was done by "Notherman & Mettee, Balt."

NOTMAN, HOWARD.
Painter. Born in Brooklyn, NY, April 20, 1881. Pupil of Constantin Herzberg, Brooklyn Polytechnic Institute. Member: Brooklyn Society of Artists; Society of Independent Artists; Brooklyn Society of Modern Artists; American Federation of Arts. Address in 1933, Circle Road, Dongan Hills, Staten Island, NY; summer, Keene Valley, Essex Co., NY.

NOURSE, ELIZABETH.
Painter. Born in Cincinnati, Ohio, 1860. Pupil of Art Academy in Cincinnati; Lefebvre, Henner and Carolus-Duran in Paris. Member: Societe Nationale des Beaux-Arts, 1901; Paris American Women's Art Association; National Association of Women Painters and Sculptors (hon.). Awards: Medal, Columbian Expo., Chicago, 1893; third class medal, Inst. de Carthage, Tunis, 1897; first class gold medal, Nashville Expo., 1897; silver medal, Paris Expo., 1900; silver medal, St. Louis Expo., 1904; gold medal, P.-P. Expo., San Francisco, 1915; Laetare medal, University of Notre Dame, South Bend, IN, 1921. Work: "Closed Shutters," Luxembourg Museum, Paris; "Peasant Woman of Borst" and "First Communion," Cincinnati Museum; "Twilight," Toledo Museum; "Happy Days," Detroit Institute; "Mother and Children," Art Institute, Chicago; "Fisher Girl of Picardy," National Gallery, Washington; "Under the Trees," Nebraska Museum; "Summer," Museum, Adelaide, Australia; "Summer Hours," Museum, Newark, NJ. Died in 1938. Address in 1929, 80 Rue d'Assas, Paris, France.

NOVANI, GUILIO C.
Sculptor. Born in Massa-Carrara, Italy, June 11, 1889. Pupil of Academy of Massa-Carrara and Beaux-Arts Institute in New York. Executed busts and medallions. Exhibited at National Sculpture Society, 1923. Address in 1929, 1347 Intervale Ave.; 126 East 75th St., New York, NY.

NOVELLI, JAMES.
Sculptor. Born in Sulmona, province of Aquila, Italy, in 1885. He came to NY in 1890. He returned to Italy in 1903 and studied under Julio Monteverde, Ettore Ferrari, and Silvio Sbricoli. He graduated at the Awards: Honorable mention, International Expo., Paris, 1906. Member: Nat. Sculpture Society, NY. Work: Motherhood group, and "Rock of Ages," Durham, NC; bronze crucifix, Holy Name Cemetery, Jersey City, NJ; bronze doors, Sigman mausoleum, and Schmuck mausoleum, Woodlawn Cemetery, NY; bronze door, Bigham mausoleum, Hawthorne, NY; bronze door, LaGioia mausoleum, Calvary Cemetery, NY; war memorials, Saratoga Park, Brooklyn, NY, and Pershing Field, Jersey City, NJ; Rowan panel, bronze, Woodlawn Cemetery, NY; Lamattina Guerriero memorial, of bronze and granite, Calvary Cemetery, NY; bronze busts; portrait reliefs in bronze and terra cotta. Exhibited at Nat. Sculpture Society, 1923.

NOVELLI, R(UDOLFO).
Painter. Born in Italy, Dec. 28, 1879. Pupil of Peters. Work: "Poppy," "Zinnias" and "Carnations," Funk and Wagnalls Co., New York. Address in 1929, 670 St. Ann's Ave., Bronx, NY.

NOXON, GRACE P.
Painter, writer, lecturer and teacher. Born in Ossining, NY. Pupil of Laurens; Ecole des Beaux-Arts; Chase at Art Students League of NY; NY School of Applied Design. Member: Society of Independent Artists. Address in 1929, 710 Carnegie Hall, 56th St. and 7th Ave., New York, NY.

NOYES, BERTHA.
Painter. Member: Soc. of Wash. Artists; Wash. Water Color Club; Wash. Art Club; Nat. Assoc. of Women Painters and Sculptors; Am. Fed. of Arts. Address 1929, 614 19th St., N.W., Washington, DC.

NOYES, GEORGE L.
Painter. Born in Canada. Pupil of Courtois, Rixen, Le Blanc and Delance in Paris. Member: Boston Art Club; Boston Society of Water Color Painters; Guild of Boston Artists. Award: Silver medal, P.-P. Expo., San Francisco, 1915. Work: "Gloucester Wharves," Museum of Fine Arts, Boston; "New Hampshire Hills," Des Moines Art Museum; "Road to Lisbon," Utah State Museum. Died in 1951. Address in 1929, 81 Chestnut St., Boston, MA.

NOYES, JOSIAH.
Engraver. Was working in 1799. He engraved a copper plate for the Social Friends' Library of Dartmouth College.

NUDERSCHER, FRANK BERNARD.
Painter, illustrator, etcher and teacher. Born in St. Louis, MO, July 19, 1880. Self-taught. Member: St.

Louis Artists Guild; Independent Artists, St. Louis; 2x4 Soc., St. Louis; Nat. Society of Mural Painters. Awards: 1st thumb-box prize, 1917; 1st prize, St. Louis Salon, 1916, 1921; 1st prize, Chamber of Commerce ($350) prize, 1919, 1921, 1926; prizes, City Art Mus. of St. Louis, 1945, 46; Missouri State Fair; Missouri State purchase prize. Work: Mississippi River scenes, in Chamber of Commerce, St. Louis, MO; Monday Club, Webster Groves, MO; "The Great Crossing," State Capitol, Jefferson City, MO; "The Eads Bridge," City Art Museum, St. Louis; Little Rock Art Mus.; Farmington (MO) Lib.; State Teachers College, Maryville, MO; murals, St. Louis Zoological Gardens; decorations, Hamburg-American Liner, St. Louis; others. Died 1959. Address in 1953, 406 Market St., St. Louis; h. 7408 Parkdale Ave., Clayton, MO.

NUHFER, OLIVE HARRIETTE.
Painter, sculptor, teacher, designer, and writer. Born in Pittsburgh, PA., Aug. 16, 1907. Studied: Univ. of Oklahoma, B.F.A.; Carnegie Inst. Member: Associated Artists of Pittsburgh. Work: Murals, U. S. Post Office, Westerville, Ohio; altar mural, St. John's Church, Norman, Oklahoma. Exhib.: Assoc. Artists of Pitts. Address 1953, Pittsburgh, PA.

NUNAMAKER, K. R.
Landscape painter. Exhibited at Nat. Academy of Design, NY, 1925. Address 1926, Center Bridge, PA.

NUNN, EVYLENA.
Painter. Born in Mayfield, KS, on July 4, 1888. Pupil of Art Students League of New York; Berkshire Summer School of Art; A. A. Hills; School of Art and Design of Pomona College. Also studied in Japan. Member: CA Art Club; Laguna Art Assoc.; West Coast Arts. Official artist, Arrow-Bear Park Assoc. Address 1926, 802 North Ross St., Santa Ana, CA.

NUNN, FREDERIC.
Painter. Born in Philadelphia, PA, Aug. 18, 1879. Pupil of Penna. Academy of Fine Arts under Anshutz, Breckenridge, Chase and Cecilia Beaux. Member: Fellowship Penna. Academy of Fine Arts; Atlantic City Art Assoc.; Phila. Alliance; Phila. Water Color Club; Society of Independent Artists. Represented in the collection of the Fellowship of the Penna. Academy of Fine Arts, Phila.; Reading (PA) Museum; LA Museum. Specialties: Marines and landscapes. Died in 1959. Address in 1929, R. F. D., Cape May Court House, NJ.

NURICK, IRVING.
Illustrator. Born in Brooklyn, NY, in 1894. He was trained at Pratt Institute, the Art Students League, and in Paris. His illustrations in *Ladies' Home Journal* for Elizabeth Woodward's *Sub Deb* articles were published for 15 years. The acclaim from this and other magazine work led to assignments from

such advertisers as Wesson Oil, Adams Hats, Sloane's Furniture and Kimberly Clark Products. A member of the American Watercolor Society, Artists and Writers, and a Life Member of the Society of Illustrators, he had one-man exhibitions in the U.S. and in Paris, where he lived for many years. The National Academy of Design awarded him the Ranger Prize in 1957 and the Samuel Finley Breese Morse Award in 1960. Died in 1963.

NUSE, R(OY) C(LEVELAND).
Painter and teacher. Born in Springfield, Ohio, Feb. 23, 1885. Pupil of Duveneck, Cincinnati Art Academy, Penna. Academy of Fine Arts. Awards: Cresson European Scholarship, Penna. Academy of Fine Arts, 1918; second Cresson, first Toppan and first Thouron prizes, Penna. Academy of Fine Arts, 1918; medal, Philadelphia Sketch Club, 1921. Represented in collection of Beaver College, PA. Director of Beechwood School of Fine Arts, Jenkintown, PA. Address in 1929, Rushland, PA.

NUYTTENS, J(OSEF) P(IERRE).
Painter and etcher. Born in Antwerp, Aug. 7, 1885. Studied at Antwerp Royal Acad., Ecole des Beaux-Arts in Paris and in Brussels. Awards: Bronze medal from Queen of Belgium, 1918; Chevalier of the Order of Leopold II. Member: Cliff Dwellers, Chicago; Alumni Art Inst. of Chicago. Work in Chicago Art Institute; White House, Wash., DC; Royal Palace, Brussels, Belgium; State House, Springfield, IL. Rep. in Vanderpoel Art Assoc. collection, Chicago. Address in 1933, 200 West 57th St., New York, NY.

NYE, E.
Portrait painter. Advertised as a "Portrait Painter" in the *Rural Visitor*, Burlington, NJ, March 25, 1811.

NYE, EDGAR.
Painter and teacher. Born in Richmond, VA, April 30, 1879. Pupil of Corcoran School of Art, Wash., and John Noble Barlow, Eng. Member: Wash. Soc. of Artists; Wash. Water Color Club; Wash. Landscape Club. Awards: Hon. mention, 1926, bronze medal, for landscape, 1927, for figure, 1933, Washington Soc. of Artists. Work: Picture in Plymouth Gallery, Eng. Specialty: Landscape. Died 1943. Address 1933, 1008 Taylor Street, N.E., Washington, DC.

NYE, ELMER L.
Etcher. Born St. Paul, MN, 1888. Member: Minn. Attic Club. Award: First prize, poster, Minn. Soc. of Artists. Address 1926, Grand Fords, Santa Fe, NM.

NYHOLM, ARVID FREDERICK.
Painter. Born in 1866 in Stockholm, Sweden. Pupil of Anders Zorn, and of Colarossi Academy in Paris. Rep. by "Captain John Ericson," National Gallery, Washington, DC, and "General Whipple," West Point Academy. Died Nov. 14, 1927 in Chicago, IL.

O

OAKES, W(ILBUR) L.
Painter. Born in Cleveland, Dec. 1, 1876. Pupil of F. C. Gottwald; A. T. Hibbard at Rockport, MA; Cleveland Society of Artists. Address in 1929, 1464 Lincoln Avenue, Lakewood, Cleveland, OH. Died in 1934.

OAKEY, MARIA R.
See Dewing, Maria Oakey.

OAKLEY, FRANK F.
Engraver and lithographer. About 1860 Oakley was engraving vignettes in line, and probably banknote work, at 204 Washington St., Boston. His work is very good, though very few signed pieces have been seen.

OAKLEY, GEORGE.
Painter. Born in 1793. He was elected an Associate of the National Academy in 1827. He died in 1869.

OAKLEY, THORNTON.
Illustrator, painter, writer, architect, lecturer, and teacher. Born in Pittsburgh, PA, 1881. Studied architecture at University of Pennsylvania, B.S., 1901, and M.S., 1902; pupil of Howard Pyle at Wilmington. Member: Philadelphia Water Color Club; Society of Illustrators, 1913; Fellowship Penna. Academy of Fine Arts; Philadelphia Alliance (director); Wilmington Society of Fine Arts. Awards: Brooke Memorial prize, University of Pennsylvania, 1902; Beck prize, Philadelphia Water Color Club, 1914; P.-P. Expo., San Francisco, 1915. Instructor in drawing, University of Pennsylvania, 1914-15; in charge, department of illustration, School of Industrial Art of the Pennsylvania Museum, 1914-19, from 21. Drawings of Hog Island adopted in 1918 by U.S. for Foreign News Service; lithographs, painting and drawings in Library of Congress; Boston Public Library; NY Public Library; Philadelphia Free Library; Newark Free Library; State Library of California; Seattle Public Library; St. Louis Public Library; Musee de la Guerre, Paris; British Museum, London; Library, Historical Society of Pennsylvania; Musee de Lourdes, France; National Library of Brazil; Milwaukee Art Institute; Luxembourg Museum, Paris. Books with Amy Oakley, *Hill Towns of the Pyrenees*, 1923, *Cloud-lands of France*, 1927, and *Enchanted Brittany*, 1930 (The Century Co.); with H. M. Lippincott, *Philadelphia*, 1926; illustrator, *Westward Ho!*, 1920; *Autobiography of Benjamin Franklin*, 1927; *Folk Tales of Brittany*, 1929. Industrial verse and drawings internationally distributed by American Federation of Labor. Work has appeared in *Harper's*, *Scribner's* and *Century* since 1904. Special lecturer, Curtis Institute, Philadelphia; Art Institute of Chicago; Metropolitan Museum of Art, NY. Died April, 1953, in Bryn Mawr, PA. Address in 1929, Villanova, PA.

OAKLEY, VIOLET.
Painter, sculptor, illustrator, and writer. Born in Jersey City, NJ, 1874. Studied at Art Students League; Penna. Academy of Fine Arts, with Joseph De Camp and Cecilia Beaux; Drexel Institute; with Howard Pyle; and with Aman-Jean, Collin and Lazar in Paris. Member: Academician of National Academy of Design; Philadelphia Art Alliance; American Institute of Architects (hon.); Philadelphia Water Color Club. Awards: Hon. degree, D. Litt., Delaware College, Newark, DE; medal, Penna. Academy of Fine Arts, 1905; St. Louis Expo., 1904; Panama-Pacific Expo., San Francisco, 1915; Architectural League, 1916; prizes, Penna. Academy of Fine Arts, 1922, 32, 40. Work: All Angels Church, NY; Penna. State Capitol; panel, "The Constitutional Convention," Cuyahoga Co. Court House, Cleveland, OH; 9 panels, "The Creation and Preservation of the Union," Senate Chamber, Harrisburg; USO Officer's Club, Philadelphia; Penna. Academy of Fine Arts; portraits, Victoria and Albert Museum, London; Alumnae House, Vassar College; Fleischer Memorial, Philadelphia; League of Nation's Library. Exhibited: National Academy of Design; Architectural League; Penna. Academy of Fine Arts; Corcoran Gallery of Art; Philadelphia Art Alliance; Woodmere Art Gallery; Yale University; and extensively in Europe. Author, illustrator, *The Holy Experiment*, 1922; *Law Triumphant*, 1932; and other books. Address in 1953, Philadelphia, PA. Died in 1960.

OBERHARDT, WILLIAM.
Illustrator, sculptor, painter, and lithographer. Born in Guttenberg, NJ, September 22, 1882. Studied at National Academy of Design, 1897-1900; Royal Academy, Munich, 1900-03, the pupil of Carl Marr and Ludwig V. Herterich; also with Edgar Ward and George Maynard. Member: Art Directors' Club (hon.); Associate National Academy of Design; Society of Illustrators; New Rochelle Art Association. Work in New York Public Library; Library of Congress; War Department; Commission of Fine Arts. Specialty was portraits, including hundreds of celebrities from 1908 to 1956, such as President Harding, Thomas A. Edison, Henry Cabot Lodge, J. G. Cannon, Chief Justice Taft, Mrs. Fisk, Rachmaninoff, Luther Burbank, Hudson Maxim, C. D. Gibbson, Joseph Pennell, Maj. Gen. James G. Harboard; portrayed for government, 1919, twenty-five

members, Division of Pictorial Publicity for records of archives, Washington, D.C. Lithograph subjects included cowboys. Illustrator for leading magazines. Exhibited: National Acad. of Design; World's Fair, NY, 1939; Art Directors' Club, annually; Society of Illustrators. Address in 1953, 41 Union Square, New York, NY; h. 538-2nd Ave., North Pelham, NY. Died probably in Pelham, New York, in 1958.

OBERTEUFFER, GEORGE.
Painter. Born in Philadelphia, PA, 1878. Pupil of Chase, Anshutz. Member: Salon d'Automne; Salon des Independents; Chicago Galleries Association; Painters and Sculptors of Chicago. Awards: Gold medal, Wisconsin Painters and Sculptors, 1922; Sesnan medal, Penna. Academy of Fine Arts, 1922; Logan medal ($750), Art Institute of Chicago, 1926; third prize ($500), Chicago Galleries Association, 1927. Works: "Stevenson's Moret," and "Eglise St. Roch," Brooklyn Museum; "Springtime, Paris," National Gallery of New South Wales; "Winter," owned by French Government. Represented in Phillips Gallery, Washington; Grand Rapids Museum; Milwaukee Art Institute; Columbus, OH, Art Museum. Instructor, Penna. Academy of Fine Arts and Chicago Art Institute, 1924-25. Address in 1929, Tree Bldg., 9 E. Ontario Street, Chicago, IL.

OBERTEUFFER, HENRIETTE AMIARD.
Painter. Born in Havre, France, 1878. Pupil of Laurens and Constant. Member: Salon d'Automne; Salon des Independents; Chicago Galleries Association. Work: Still life owned by French Government; represented in Duncan Phillips Gallery, Washington, D.C. Awards: Medal of honor, Milwaukee Art Institute; Brower prize ($300), Art Institute of Chicago, 1926; Logan medal ($750), Art Institute of Chicago, 1927. Died in 1962. Address in 1929, 9 E. Ontario Street, Chicago, IL.

O'BRIEN, CATHERINE C.
Painter. Born in New York. Pupil of Granbury, Walter Shirlaw, Arthur W. Dow. Member: Society of Independent Artists. Address in 1929, Butler Hall, 400 West 119th Street, New York, NY; summer, Southampton, LI, NY.

O'BRIEN, JOHN.
Sculptor. Born in Ireland in 1834. Executed monument to Commodore Perry at Cleveland, OH. Lived in Galveston, TX, from 1882 until he died on Dec. 20, 1904.

O'BRIEN, R.
Portrait engraver. Worked for many years for the NY engraver, A. H. Ritchie.

O'BRIEN, SEUMAS.
Sculptor and writer. Born in Glenbrook, Co. Cork, Ireland, in 1880. Instructor in art, Cork School of Art,

Mt. St. Joseph's Monastery, Cork; Queenstown Technical School; Metropolitan School of Art, Dublin, until 1912; Abbey Theatre dramatist and lecturer, 1913-17. Exhib. at Royal Hibernian Academy. Awarded silver medal (sculpture) by Board of Education, in 1926, 117 W. 90th St., NYC.

O'BRIEN, SMITH.
Painter, etcher and architect. Born in Cork, Ireland. Pupil of California School of Fine Arts; Andre L'hote Academy, Paris. Member: California Society of Etchers (president); San Francisco Art Association; San Francisco Beaux Art Club. Award: Hon. mention-picture, San Diego, 1927. Address in 1929, 110 Sutter St.; h. 2032 Baker St., San Francisco, CA.

O'BRIEN, THOMAS.
Sculptor. Born in Ireland, 1834. Died in Galveston, TX, 1904. See also O'Brien, John.

O'CALLAHAN, C(LINTON) C(LEMENT).
Painter. Born in Hartford, CT, Feb. 19, 1890. Pupil of Charles Noel Flagg, Charles Guerin. Member: American Art Association of Paris. Address in 1929, American Art Association, 4 Rue Joseph Bara, Paris, France.

O'CALLAHAN, KEVIN B.
Designer, graver, and craftsman. Born in Buffalo, NY, Feb. 14, 1902. Studied at Cornell University; Carnegie Institute. Exhibited: National Academy of Design, 1936-38, 41, 42, 44, 46; Philadelphia Printmakers Club, 1937, 38, 40-44; San Francisco Museum of Art, 1941-43; Penna. Academy of Fine Arts, 1936, 38, 40, 41, 43; Northwest Printmakers, 1942-44; Society of American Etchers, 1937, 40, 42; Albright Art Gallery, 1934, 35, 37-41, 43-46; others. Work: Albright Art Gallery; Farnsworth Museum, Rockland, ME; Library of Congress. Member of Buffalo Printmakers Club. Address in 1953, Buffalo, NY.

OCHTMAN, DOROTHY.
Painter. Born in Riverside, CT, May 8, 1892. Pupil of National Academy of Design and Ochtman. Member: Associate National Academy of Design, 1929; Allied Artists of America; Greenwich Society of Artists; National Association of Women Painters and Sculptors; Society of Painters, NY; Painters' and Sculptors' Gallery Association. Awards: Shaw prize, National Academy of Design, 1921; third Hallgarten prize, National Academy of Design, 1924; hon. mention, Exposition of Women's Arts and Industries, 1926, and first prize, 1927; Guggenheim European Scholarship, 1927; first hon. mention, Greenwich Society of Artists, 1928-1929. Died in 1971. Address in 1929, Cos Cob, CT.

OCHTMAN, LEONARD.
Landscape painter. Born in Zonnemaire, Holland, Oct. 21, 1854; came to Albany, NY, in 1866. Self-

taught. Member: Society of American Artists, 1891; Associate National Academy of Design, 1898; Academician National Academy of Design, 1904; American Water Color Society; NY Water Color Club; Brooklyn Art Club; Artists' Fund Society; Artists Aid Society; Salma. Club, 1901; Lotos Club; National Arts Club; National Institute of Arts and Letters; Greenwich Society of Artists; American Federation of Arts. Awards: Prize, Brooklyn Art Club, 1891; medal, Columbian Expo., Chicago, 1893; gold medal, Art Club of Philadelphia, 1894; silver medal, Pan-Am Expo., Buffalo, 1901; silver medal, Charleston Expo., 1902; Morgan prize, 1902, Evans prize, 1903, 07, Inness prize, 1906, all from Salma. Club; Shaw Fund prize, 1902, Webb prize, 1904, Society of American Artists; Inness gold medal, National Academy of Design, 1903; 2 gold medals, St. Louis Expo., 1904; second Corcoran prize, Society of Washington Artists, 1905; medal of second class, Knoxville Expo., 1911; silver medal, P.- P. Expo., San Francisco, 1915; 1st People's Prize, Greenwich Society of Artists, 1929. In collections of Metropolitan Museum of Art; Brooklyn Institute Museum; City Art Museum, St. Louis; Columbus Gallery of Art; Corcoran Gallery and National Gallery, both in Washington, D.C.; Museum of Art, Fort Worth, TX; Brooklyn Institute Museum; Dallas Art Association; Hackley Art Gallery, MI; Butler Art Institute, OH; Albany Institute. Address in 1933, "Grayledge," Cos Cob, CT. Died in 1934.

OCHTMAN, MINA FUNDA.
(Mrs. Leonard Ochtman). Painter. Born in Laconia, NH, in 1862; died in 1924. She was a member of the American Water Color Society and the National Association of Women Painters and Sculptors. Her pictures have been shown in exhibitions throughout the country.

O'CONNOR, ANDREW.
Sculptor. Born in Lanarkshire, Scotland, April 18, 1846; came to America at the age of five. Pupil of C. H. Heminway in Providence, RI; studied in Rome. Address in 1910, Holden, MA.

O'CONNOR, ANDREW, JR.
Sculptor. Born in Worcester, MA, June 7, 1874. Pupil of his father; also of Daniel Chester French. Member: Associate National Academy of Design, 1919; National Institute of Arts and Letters. Awards: Bronze medal, Pan-Am. Expo., Buffalo, 1901; gold medal, Paris Salon, 1906; silver medal, Barcelona, Spain, 1907. Work: Central Porch, St. Bartholomew's Church, NY; Liscurn Memorial, Arlington; Thomas Memorial, Tarrytown; "Inspiration," St. Louis; "Justice," Newark; "Lawton," Indianapolis; "Wallace," Washington, DC; "1898," Worcester; "Lincoln," Springfield; "Roosevelt Memorial," Glen View, IL; "Lafayette," Baltimore; "Justice," The Hague; "1917," Boston; statues in the Luxembourg; Musee

des Arts Decoratifs, Paris; bust of Lincoln at Met. Mus. of Art; "Adam and Eve," marble, Corcoran Gall. of Art, Wash., DC. Exhibited at Nat. Sculpture Soc., 1923. Died 1941. Address 1929, Paxton, MA.

O'CONNOR, HENRY M.
Painter and etcher. Born in Brookline, MA, March 5, 1891. Pupil of Massachusetts Normal Art School and Boston Museum School. Member: Boston Society of Etchers; Copley Soc.; Chicago Soc. of Etchers. Address 1929, 58 Putnam Avenue, Cambridge, MA.

ODDIE, WALTER M.
Landscape painter. Born in 1808. He was elected an Associate of the National Academy of Design in 1833. He died in 1865.

O'DONOVAN, WILLIAM RUDOLPH.
Sculptor. Born in Preston County, VA, in 1844. Self-taught in art. He established a studio in New York and executed many important portrait busts and bas-reliefs. Works: William Page, National Academy, which was presented to the National Academy of Design; Arthur Quartly, National Academy; Thomas Eakins, National Academy; Edmund Clarence Stedman; busts of Walt Whitman and Gen. Joseph Wheeler; equestrian statues of Lincoln and Grant for Soldiers' and Sailors' Arch, Prospect Park, Brooklyn; reliefs for Oriskany battle monument; statue of Archbishop Hughes, St. John's College, Fordham; memorial tablet to Bayard Taylor, Cornell University; a statue to the captors of Major Andre, Tarrytown, NY. O'Donovan was one of the four founders of the famous Title Club; also a member of the Hudson-Fulton Commission. Elected an Assoc. of the Nat. Academy, 1878. Member: Society of Am. Sculptors; Architectural League. Died in 1920.

OEHLER, BERNICE (OLIVIA).
Painter, illustrator, writer, lecturer, and teacher. Born in Lake Mills, WI. Member: Art Institute of Chicago Alumni Artists. Formerly instructor of drawing, HS Madison, WI; formerly instructor in art, Univ. of Wis. Illustrated series of Lincoln School Readers; *General Language*, by S. A. Leonard; *The Dance*, by Margaret H. Doubler; *Educational Story Plays and School Room Games*, by Emily Elmore and Marie Carus; *Tales of Leather Stocking*, by Annie Marble; *The Juniors' Own Composition Book*, by Leonard and McFadden; *Chico, the Circus Cherub*, by Stella Burke May; *Books VII and VIII of Real Life Readers*, Leonard-Theisen; author and illustrator of *A Series of Decorative Figures from the Dance* and *Figure Sketching*. Permanent artist for Ruth St. Denis. Address in 1929, Lake Mills, WI; 125 E. 30th Street, New York, NY.

OERTEL, JOHANNES ADAM SIMON.
Painter, sculptor, engraver. Born in Furth, near Nuremberg, Germany, November 3, 1823. Oertel was

apprenticed to J. M. E. Muller, a well-known engraver of Nuremberg; but as a result of the German revolution of 1848 he came to America and settled in Newark, NJ. He at first tried painting and then resorted to engraving, doing much work for the banknote companies. He finally attained success with his pictures of army life done from studies made in Virginia during the Civil War. He was rector of a number of churches at various times and was professor in an art school in St. Louis for two years. All of this time he was busy painting, especially in the line of Christian art, and carving church decorations. About 1857 he assisted in decorating the Capitol at Washington, DC. Died Dec. 9, 1909, in Vienna, VA.

OESTERMANN, MILDRED (CAROLINE).
Painter, etcher, and craftsman. Born in San Francisco, CA, Aug. 23, 1899. Pupil of Gertrude Partington Albright; Lee F. Randolph; Constance L. Macky; E. Spencer Macky. Member: California Society of Etchers; San Francisco Society of Women Artists; Am. Artists Professional League. Address in 1929, 1462 7th Avenue, San Francisco, CA.

OF, GEORGE FERDINAND.
Painter. Born in New York, NY, Oct. 16, 1876. Pupil of Art Students League of NY; Weinhold in Munich; Delecluse Academy in Paris. Address in 1929, 1030 Lydig Ave., New York, NY.

OFFICER, THOS. S.
Miniature painter. Born in Carlisle, PA, in 1820. He had his studio in New Orleans, Philadelphia and New York, but passed the last years of his life in California. His work is remarkable for crisp, fresh color and artistic delicacy. He died in 1860.

OGDEN, HELENA EASTMAN.
See Campbell, Helena Eastman Ogden.

OGDEN, HENRY ALEXANDER.
Illustrator. Born in Philadelphia, PA, July 17, 1856. Pupil of National Academy of Design; Art Students League of NY. Member: Society of Illustrators, 1911; American Federation of Arts. Work: Collection of uniforms of the U.S. Army, 1775-1906, made by order of Quarter-Master General's Department. Author and illustrator of *The Boy's Book of Famous Regiments*, etc. Specialty: Military and historical subjects. Died June 13, 1936. Address 1929, 200 Fifth Ave., NY, NY; Englewood Club, Englewood, NJ.

OGDEN, LYMAN GARFIELD.
Painter and illustrator. Born in Walton, NY, in 1882. Pupil of Thomas Anshutz; Robert Henri. Address in 1926, East St., Walton, NY.

OGILVIE, CLINTON.
Painter. Born in NYC, 1838. He studied painting under James Hart. He went abroad for four years

and on his return was elected an Associate of the National Academy of Design. He has since exhibited "Among the Adirondacks," "The Mountain Brook," "Lake Como." He died Nov. 29, 1900, in NYC.

O'HANLON, HARRY.
Sculptor and painter. Born in Edmonton, Alberta, Canada, in 1915; lived in Montana. Began painting portraits of Blackfoot Indians in 1956. In mid 1960's he turned to sculpture. Specialty is Blackfoot subjects, including hunting, camp life, religious practices. Sculpts in bronze. Work is in museums in England and Canada (Glenbow-Alberta Institute of Calgary); created "Trailing the Buffalo Hunters," given by Blackfoot to English monarchy, 1977. Reviewed in Art West, spring, 1979. Represented by Gainsborough Gallery, Calgary, Alberta, Canada. Address in 1982, High River, Alberta, Canada.

O'HANLON, RICHARD E.
Sculptor and painter. Born in Long Beach, CA, October 7, 1906. Studied at California College of Arts and Crafts, 1926-27; California School of Fine Arts, 1930-1933; also in Europe, India, Japan, and Mexico. Works: Addison Gallery, Andover, MA; Baltimore Museum of Art; University of California, Davis; Denver Art Museum; San Francisco Museum of Art; Smith College; Whitney; Walker; Worcester Art Museum. Exhibitions: The Willard Gallery, NYC; San Francisco Museum of Art; Carnegie; Baltimore Museum of Art; Santa Barbara Museum of Art, 1969. Taught: Univ. of CA, 1948-74; emeritus professor from 1974. Address 1982, Mill Valley, CA.

O'HARA, DOROTHEA WARREN.
Sculptor. Born in Malta Bend, MO. Pupil of Royal College of Art, London; School of Design, Munich. Exhibited: Paris Salon; Metropolitan Museum of Art; Harlow Gallery; Grand Central Art Gallery; Pen and Brush Club; and in London, Stockholm, and Tokyo. Member: National Arts Club; Pen and Brush Club; Silvermine Guild of Artists; Darien Guild of Artists. Awards: Medal, Panama-Pacific Exposition, 1915. Work: Large carved white bowl, Met. Museum of Art, NY, NY. Address 1970, Darien, CT.

O'HARA, ELIOT.
Painter. Born in Waltham, MA, June 14, 1890. Pupil of Russell T. Hyde; Charles Hopkinson; Andre L'hote. Member: American Water Color Society; American Federation of Arts. Award: Fellowship, Guggenheim Memorial Foundation, 1928. Address in 1929, 44 Greenwood Lane, Waltham, MA.

O'HARA, SUSAN.
Miniature painter, who flourished in 1834, in NY.

O'KEEFFE, GEORGIA.
Painter. Born in Sun Prairie, Wisconsin, Nov. 15, 1887. Studied: Art Institute of Chicago, with John

Vanderpoel 1905-06; Art Students League, with Wm. M. Chase, 1907-08; University of Virginia, with Alon Bement, summer 1912; Columbia University, with Arthur Dow, Alon Bement, 1914-16; Mills College, 1952; Randolph-Macon Women's College, 1966; Hon. DFA, William and Mary College, 1938, University of New Mexico, 1964, Brown University, 1971, and Minneapolis College of Art and Design, 1972; Hon. Litt.D., University of Wisconsin, 1942, and Mt. Holyoke College, 1971; Hon. LHD, Columbia University, 1971. Work: Metropolitan Museum of Art, Museum of Modern Art, Whitney Museum, all in NYC; Brooklyn Museum, NY; Art Institute of Chicago; Detroit Institute; Springfield Museum of Art; Cleveland Museum of Art; Boston Museum of Fine Arts; Philadelphia Museum of Art; Newark Museum; John Herron Art Institute; others. Paintings first exhibited by Alfred Stieglitz at "291" in 1916-17. Exhibited: One-woman retrospectives, Art Institute of Chicago, 1943, Museum of Modern Art, 1946, Worcester Museum of Art, 1960, Museum of Fine Arts Houston, 1966, Whitney Museum, 1970; Guggenheim Museum, NYC; plus many other national exhibitions. Awards: Creative Arts award, Brandeis University, 1963; gold medal, painting, National Institute of Arts and Letters, 1970; M. Carey Thomas Award, Bryn Mawr College, 1971; Edward Mac Dowell Medal, Bryn Mawr College, 1972; and others. Member: National Institute of Arts and Letters; American Academy of Arts and Letters; American Academy of Arts and Sciences. Address in 1982, Abiquiu, New Mexico.

O'KELLY, ALOYSIUS.
Painter. Born in Dublin, Ireland, in 1853. Pupil of Bonnat and Gerome at the Ecole des Beaux Arts in Paris. Member: New York Water Color Club. Address in 1926, 402 Clermont Ave., Brooklyn, NY.

O'KELLY, STEPHEN J.
Sculptor. Born in Dublin, Ireland, 1850. Died October 21, 1898.

OKEY, SAMUEL.
Engraver. Born in 1765. John Chaloner Smith, in his "British Mezzotints," says that Samuel Okey, an engraver in mezzotint, was awarded premiums in 1765 and 1767 by the London Society of Arts, presumably for his engravings. Soon after the date mentioned, Samuel Okey must have sailed for America. In 1773, '74 and '75 he was engraving and publishing portraits in mezzotint in Newport, RI, his business partner being Charles Reak.

OKON, MEJO.
Illustrator. Born in Indianapolis, IN, in 1953. Studied: Rochester Institute, Syracuse University, and Herron School of Art until 1975. She began her career in Indianapolis with *Young World Magazine* in 1976. She has won a gold medal from the Indian-

apolis Art Directors' Club and her work was accepted for the Society of Illustrators Annual Exhibition in 1976.

OLAND, CHARLES.
Sculptor. Born in Italy in 1800. Working in NYC in 1850.

OLBRES, ZEIGMUND ANTHONY (ZIGMONT D. OLBRYS).
Painter, sculptor, designer, and craftsman. Born in Clinton, MA, April 1, 1915. Studied at Worcester Art School; Boston Museum of Fine Arts School. Work: Murals, Casablanca, French Morocco; Caserta, Italy. Exhibited: NY World's Fair, 1939; Army Art Exhibition, Algeria, North Africa. Address in 1953, Clinton, MA.

OLDENBURG, CLAES THURE.
Sculptor. Born in Stockholm, Sweden, January 28, 1929. Studied: Yale University, 1950, B.A.; Art Institute of Chicago School, 1952-55, with Paul Wieghart. Work: Brandeis University; Albright-Knox Art Gallery, Buffalo; Museum of Modern Art; Walker; Art Gallery of Ontario, Toronto; Art Institute of Chicago; Whitney; many others. Commissions: Oberlin College, OH; City of St. Louis, MO, 1971; Yale University, 1974; Walker Art Center, MN, 1974; Hirshhorn Museum, Washington, DC, 1975; others. One-man exhibitions: Judson Gallery, NY, 1959; Reuben Gallery, NY, 1960; Green Gallery, NY, 1962; Dwan Gallery, Los Angeles, 1964; Sidney Janis Gallery, NY, 1964, 66; Museum of Contemporary Arts, Dallas, TX, 1962; University of Chicago, 1962; Ileana Sonnabend Gallery, Paris, 1964; Richard Feigen Gallery, Chicago, 1969. Group exhibitions: Martha Jackson Gallery, NY, 1960; Wadsworth Atheneum, Hartford, 1962; Art Institute of Chicago, 1962, 63; Sidney Janis Gallery, NY, 1962-67; Museum of Modern Art, 1963; Cincinnati Art Museum, 1963; Dallas Museum of Fine Arts; Museum of Modern Art, NYC, 1963; Gallery of Modern Art, Washington, DC, 1963; Stedelijk Museum, Amsterdam, 1963, 64; Tate, 1964; The Hague, 1964; Whitney, 1965, 68, 69; Metropolitan Museum of Art, NYC; Rhode Island School of Design, 1966; Walker, 1966; Los Angeles County Museum of Art, 1967; IX Sao Paulo Biennial, 1967; Guggenheim, 1967; Carnegie, 1967; Pasadena Art Museum, CA; Kunsthalle, Tubingen, Germany; Expo '70, Osaka, Japan; Seattle Art Museum; and others in U.S., Amsterdam, Baden-Baden, London, Stockholm, New Delhi, etc. Author and illustrator of "Store Days," 1967. Address in 1982, 556 Broome St., NYC.

OLDS, ELIZABETH.
Painter and printmaker. Born Dec. 10, 1896 in Minneapolis, MN. Studied architecture at University of Minnesota, 1916-18; Minneapolis School of Art, 3 years; Art Students League, 2 years; also with

George Luks, Paris, 2 years, and George Bridgman, 1920-23. Awards: First woman to receive a Guggenheim Fellowship for the study of painting abroad, 1926-27; medal, Kansas City Art Institute, 1934; first prize for lithograph, Philadelphia Print Club, 1937, and Art Alliance, 1938; Museum of Modern Art, 1941; third prize for watercolor, Baltimore Museum of Art, 1944; Baltimore Museum of Art, 1953; others. Employed on WPA Federal Art Project, 1935-40. Work: Metropolitan Museum of Art: Museum of Modern Art; NY Public Library; Seattle Art Museum; Baltimore Museum of Art; Hirshhorn; San Francisco Museum of Art; Brooklyn Museum; Philadelphia Museum of Art; others. Exhibitions: Artists for Victory, Metropolitan Museum of Art, 1942; Museum of Modern Art, 1940's; Whitney Museum of American Art, 1945-47, 56; Brooklyn Museum, 1949, 53, 55, 57; Vassar College, Poughkeepsie, NY, 1976; Smithsonian Institution, 1977; Berkshire Museum; Munson-Williams-Proctor Institute; many one-woman shows in New York. Author and illustrator of several books. Address in 1984, Sarasota, FL.

OLINSKY, IVAN GREGOROVITCH.
Painter. Born in Russia in 1878. Studied at National Academy of Design, and in France and Italy. Member: Associate National Academy of Design, 1914; Academician National Academy of Design, 1919; National Society of Mural Painters, NY; NY Architectural League, 1912; Salma. Club; American Art Society; Allied Artists of America; Lotos Club; American Federation of Arts. Awards: Clarke prize ($300), National Academy of Design, 1914; Shaw purchase prize, Salma. Club, 1919; purchase prize, Lyme Art Association, 1922; Eaton purchase prize, Lyme Art Association, 1926. Work: "Ada," Omaha Society of Fine Arts; "Young Girl," Detroit Art Club; "Gossip," Dallas (TX) Art Association; "Old Fashioned Gown" and "Two Girls," Detroit Institute; portraits of Mr. Stambaugh and Mr. J. G. Butler; "Springtime," "Fairy Tales," Butler Art Institute, Youngstown, OH; "Adoration," Art Association, Norfolk, VA. Address in 1929, 27 West 67th Street, New York, NY.

OLITSKI, JULES.
(Known also as Jules Demikov). Sculptor and painter. Born in Snovsk, Soviet Union, March 27, 1922. Emigrated to U.S. in 1924 with his family; became a U.S. citizen in 1946. Studied at the National Academy of Design, 1939-42; Beaux-Arts Institute, NYC, 1940-42; Academie de la Grande Chaumiere, Paris, 1949-50; Zadkine School of Sculpture, Paris, 1949; NY University, NYC, B.A., 1952, M.A., 1954; privately with Chaim Gross. Work: Corcoran Gallery of Art, Washington, DC; Art Institute of Chicago; Whitney Museum of American Art; Museum of Modern Art. Exhibited: Galerie Huit, Paris, 1950; Alexander Iolas Gallery, NY, 1959, 60, 69; Poindexter Gallery, NYC, 1961, 62; New Gallery,

Bennington College, VT, 1963; Whitney Museum of American Art, 1962, 64, 67, 69, 72; Los Angeles County Museum of Art, 1964; Corcoran Gallery, 1967; Pasadena Museum, 1967; Metropolitan Museum of Art, NY, 1969; Art Institute of Chicago, 1970; Albright-Knox Art Gallery, Buffalo, NY, 1970; Boston Mu. of Fine Arts, 1972, 77; Mu. of Fine Arts, Houston, 1974; Hirshhorn, 1977; and others. Awards: Second prize for painting, Pittsburgh International Painting and Sculpture, 1961; first prize for painting, Taught: State University of NY, College at New Paltz, 1954-55; C. W. Post College, Long Island University, 1956-63; Bennington College, 1963-67. Wrote "Painting in Color," catalogue of 33rd Biennial of Art (Venice), 1966; and "On Sculpture," in the Metropolitan Museum of Art Bulletin, NYC, April, 1969. Address in 1984, Meredith, NH.

OLIVER, FREDERICK W.
Painter. Born in New York, Sept 4, 1876. Pupil of DeCamp, Major, S. C. Carbee. Member: Boston Art Club; Copley Society. Address in 1929, Fenway Studios, 30 Ipswich Street, Boston, MA; h. 27 Mountford Road, Newton Highlands, MA.

OLIVER, JEAN NUTTING.
Painter, teacher, and writer. Born in Lynn, MA. Pupil of Boston Museum School; C. H. Woodbury; Philip Hale. Member: Copley Society, 1883; National Association of Women Painters and Sculptors; Guild of Boston Artists; Connecticut Academy of Fine Arts; Concord Art Association; Provincetown Art Association; North Shore Arts Association. Awards: Hudson prize, Penna. Academy of Fine Arts, 1916; "People's Prize," Boston Women Painters Exhibition, 1917. Address in 1929, Studios, 30 Ipswich St., Boston, MA; summer, East Gloucester, MA.

OLIVER, L.
Sculptor. Active 1859. Exhibited at the National Academy of Design, NY, in 1859 (plaster medallion).

OLIVER, MYRON ANGELO.
Painter and craftsman. Born in Fulton, Kansas, June 16, 1891. Pupil of Chase, DuMond, Poor. Member: Salma. Club; Laguna Beach Art Association. Address in 1929, 110 Main Street; h. 502 Pierce Street, Monterey, CA.

OLSEN, CHRIS E.
Painter, sculptor, craftsman, architect, and lecturer. Born in Copenhagen, Denmark, April 8, 1880. Studied at Allen's Art School, Perth Amboy, NJ; Mechanics Institute; and with Peter Eggers. Member: Scandinavian-American Artists. Awards: Prize, Mechanics Institute. Work: American Museum of Natural History Hall of Ocean Life; Boston Museum of Science, Science Hall; and in many other museums and colleges in the U.S. Exhibited: National Academy of Design; High Museum of Art; Scandinavian-

American Artists; American Museum of Natural History; Staten Island Museum of Art and Science; Arnot Art Gallery. Arranged numerous marine exhibitions in museums. Specialized in undersea painting. Contributor to scientific entomological publications. Position: Artist, Modeler, American Museum of Natural History, New York City, 1916-52. Address in 1953, West Nyack, New York.

OLSEN, HARRY EMIL.
Painter. Born in 1887. Exhibited water colors at the Penna. Academy of Fine Arts, Philadelphia, 1925. Address in 1926, 2 Glenada Place, New York.

OLSON, ALBERT BYRON.
Painter and craftsman. Born in Montrose, CO, May 3, 1885. Pupil of Penna. Academy of Fine Arts under Chase, Anshutz and McCarter. Member: Denver Art Club. Represented in collection of Denver Art Museum; St. Mark's Church; murals in St. Martin's Chapel and Ilyria Branch Library, Denver. Died in 1940. Address in 1933, 817 Pearl Street, Denver, CO.

OLSON, CARL GUSTAF THEODORE.
Painter, sculptor, craftsman, and teacher. Born in Sweden, June 7, 1875. Pupil of Peter Roos. Member: Copley Society. Address in 1929, Belmont, MA.

OLSON, HERBERT VINCENT (HERB OLSEN).
Painter, sculptor, illustrator, designer, teacher, and lecturer. Born in Chicago, IL, July 12, 1905. Studied at Art Institute of Chicago. Member: Philadelphia Water Color Club. Awards: Prizes, Swedish-American Exhibition, Detroit, 1941, 42; Chicago Free Lance Art Exhibition, 1939, 40. Exhibited: Penna Academy of Fine Arts, 1942, 43; Art Institute of Chicago, 1939, 40; Rockford, IL, 1946; Bloomington, IL, 1946; Racine, WI, 1946; one-man exhibitions include the O'Brien Gallery, Findlay Gallery, and Chicago Galleries Association, all in Chicago. Position: Instructor of illustration, Chicago Professional School of Art, 1938-40; American Academy of Art, Chicago, IL, from 1940. Died in 1973. Address in 1953, Glenview, IL.

OLSON, JOSEPH OLAF.
Painter, sculptor, etcher, craftsman, writer, and lecturer. Born in Buffalo, MN, January 28, 1894. Pupil of F. Tadema, George Bellows. Exhibited: One-man shows, Corcoran Gallery, Washington, DC; Carnegie Institute, Pittsburgh; Chicago Art Institute. Member: Salmagundi Club; Painters and Sculptors Gallery Association; New York Water Color Club. Work: "Pyrenees Mountains," Baltimore Museum. Address in 1982, Mystic, CT.

OLSON-MANDLER, SUE POSPESCHIL.
Painter and printmaker. Born in Janesville, WI, June 17, 1941. Studied: University of Wisconsin at Whitewater, 1961-62; with Prof. Robert Raushenberger, University of Illinois; with Maryalice Wells, T. Palmerton, and Robert A. Nelson at University of Nebraska, Omaha, and Creighton workshops; S. Buchanan, University of Nebraska, Omaha; workshops with H. Walkinshaw, 1980, D. Kingman and C. Croney, 1981; Bellevue (NE) College, 1982. Work: Collections of Bob Hope, Gerald Ford, many Nebraska corporations and institutions. Exhibited: Numerous shows at universities and museums in Nebraska. Commissions: Record album and magazine covers, book illustrations, architectural renderings, silhouettes, portraits in ink, and pen and ink note cards. Awards: Many awards in local and state exhibitions and competitions, 1976-83. Member: University of Nebraska, Omaha, Fine Arts Advisory Committee, 1975-83; National Watercolor Club. Media: Ink/wash architectural drawings and portraits; oils, acrylic, watercolor, pastel; cut silhouettes. Address in 1983, Bellevue, NE.

OLSSON, AXEL ELIAS.
Sculptor. Born in Sweden, April 17, 1857. Pupil of Stockholm Academy of Fine Arts. Address in 1910, Chicago, IL.

OLSTOWSKI, FRANCISZEK.
Sculptor, painter, illustrator, and teacher. Born in Zaborowo, Poland, March 25, 1901. Pupil of his father. Member: NY Painters and Sculptors; Buffalo Society of Artists; Chicago No-Jury Society of Artists; Society of Independent Artists; Salons of America; Alliance. Work: "Abraham Lincoln," Newspaper Men's Club, NYC; "Don Basco Group," Salesian School, New Rochelle, NY; "Madonna Christiana," St. Mary's Church, NYC; "The Great America," Foreign Affairs Building, Warsaw, Poland; "John E. Kellerd as Mephisto," Theatre League, Buffalo; "Marguerite Olstowski," Gardner Dancing School, Toledo, OH; lion heads, Courthouse, Hackensack, NJ. Address in 1933, Matawan, NJ.

O'MALLEY, POWER.
Painter, illustrator, etcher, and lecturer. Born in County Waterford, Ireland, in 1870. Pupil of Shirlaw, Henri, National Academy of Design. Award: First prize, Cronach Sailteen, Dublin, 1924. Represented in Phillips Memorial Gallery, Washington, D.C. Address in 1934, Scarborough, NY.

O'MEALLIE, KITTY.
Painter and printmaker. Born in Bennettsville, SC, October 24, 1916. Studied: Newcomb Art School, B.F.A. (design), 1937; advanced painting under Xavier Gonzalez, Pat Trivigno, John Taylor, Edward Corbett, and George Rickey, 1954-59. Primarily a nature painter but also executed group paintings of human face and figure, semi-abstract compositions in oil, acrylic, charcoal and mixed media. Awards: Gulf Coast Annual Exhibition, Pass Christian, MS;

Masur Museum of Art's 5th Monroe Annual, Monroe, LA; Edgewater Plaza 5th Art Exhibit, Gulfport-Biloxi, MS; Biloxi Art Association's Annual Tri-State Show; 2nd Greater New Orleans National Exhibition; Annual Art Auction Award, WYES Public Television, New Orleans, 1979. Collections: New Orleans Museum of Art; Tulane University, New Orleans; Meridian Museum of Art, MS; Masur Museum of Art, Monroe, LA; Wake Forest University, Winston-Salem, NC; St. Martin's Protestant Episcopal School, Metairie, LA; Downtown Gallery, New Orleans, LA; New Orleans Public Library, 1977; others. Exhibitions: Southeastern Center of Contemporary Art, Winston-Salem, NC, 1971; New Orleans Museum of Art, 1973; Masur Museum of Art, 1979 (one-woman); Meridian Museum of Art, 1981 (one-woman); many others. Member: Artists Equity Association; New Orleans Women's Caucus of Art; National Women's Caucus of Art. Media: Acrylic, mixed media; silkscreen. Address in 1984, New Orleans, LA.

ONDERDONK, ELEANOR.
Painter and teacher. Born in San Antonio, TX, Oct. 25, 1886. Pupil of DuMond; Johansen; Lucia Fuller; Alice Beckington; George Bridgman; John F. Carlson. Address in 1929, 128 West French Place, San Antonio, TX.

ONDERDONK, JULIAN.
Painter. Born in 1882 in San Antonio, TX. Pupil of Chase; Henri; and of his father R. J. Onderdonk. Represented by "Springtime," Dallas Art Association, and "Morning Sunlight" in the San Antonio Art League. Died Oct. 27, 1922 in San Antonio, TX.

ONDERDONK, ROBERT JENKINS.
Painter. Born in Baltimore, MD, on Jan. 16, 1853. He studied under Chase and Wyant in NY. Specialty: Flower painting. He died in San Antonio, TX, July 2, 1917.

O'NEILL, JOHN A.
Engraver. Born in NJ. He worked chiefly in the city of New York, engraving portraits and historical subjects. During the Cleveland administration, O'Neill was chief engraver to the Treasury Department at Washington, DC. In 1876 he was mayor of Hoboken, NJ.

O'NEILL, R. E.
Painter. Born in Trenton, NJ, in 1893. Pupil of A. W. Dow; Lachman; Angel Zarrago; and of C. H. Martin. Member: Society of Independent Artists. Address in 1926, 331 Johnston Ave., Trenton, NJ.

O'NEILL (or O'NEIL), ROSE CECIL.
Illustrator. Born in Wilkes-Barre, PA, 1875. Self-taught, she wrote and illustrated the unpublished novel *Calesta* at age 19. Shortly thereafter she came to NY where she worked for *Truth, Life, Collier's* and *Harper's* publications. She married in 1896 and became a staff artist for *Puck*. Five years later she was divorced, left *Puck*, and was soon married to its editor, Leon Wilson. In 1904 she wrote *The Loves of Edwy* for *Harper's* and illustrated her husband's novels. Early in 1908 she divorced Wilson and moved to Bonniebrook in Missouri, where she originated the Kewpies, the cherubic creatures that made her famous. The Kewpies first appeared in *Ladies' Home Journal* in 1909 and were later seen in *Woman's Home Companion, Good Housekeeping*, and as a comic strip in *The New York Journal* in the 1930's. The ubiquitous use of her characters culminated in the creation of the Kewpie Doll in 1912. Died in 1944.

ONTHANK, NATHAN B.
Portrait painter, who flourished in Boston from 1850 to 1879. The Gallery in Independence Hall, Philadelphia, has a copy of the portrait of Samuel Adams by Copley that was painted by Onthank.

OPERTI, ALBERT (JASPER LUDWIG ROCCABIGILERA).
Painter, sculptor, and illustrator. Born in Turin, Italy, March 17, 1852. Studied abroad. Works: Historical pictures, "Rescue of the Greeley Party" and "Farthest North," for army and navy departments, Washington, DC; also "The Schwatka Search," "Finding De Long in the Lena Delta (Jeanette);" "Dr. Kane;" portrait of Comdr. Peary; mural paintings in American Museum of Natural History, New York, and in the Pittsfield, MA, Museum. Awards: Medals and diplomas as official artist, U.S. Government exhibits, Chicago and San Francisco Expositions. Member: Palette Club; Tile Club. Scenic artist in New York theatres; illustrator of books on arctic subjects, having made two voyages to the arctic regions with Rear Admiral Peary. Address in 1926, American Museum of Natural History, West 77th St., New York, NY.

OPPENHEIM, DENNIS A.
Sculptor. Born in Mason City, WA, September 6, 1938. Moved to California in 1940. Studied at California College of Arts and Crafts, Oakland; Stanford University, California. Taught at Yale; Art Institute of Chicago School; SUNY Stony Brook; Pratt Institute; California College of Arts and Crafts; others. In collections of Museum of Modern Art; Oakland Art Museum; Stedelijk, Amsterdam; Tate, London; commissions in Tobago, West Indies, and Aspen, Colorado. Exhibited at John Gibson Gallery, NYC (many times); Museum of Modern Art; Reese Palley Gallery, San Francisco; Tate; Sonnabend Gallery, NYC; Stedelijk; Cranbrook Academy of Art; Whitney annuals and biennials; MIT; Museum of Contemporary Art, Chicago; New Museum, NYC; and many others, including galleries and museums in Dusseldorf, Montreal, Basel, Bern, Turin, Kassel,

Venice, Jerusalem, Paris, Stockholm, and Stuttgart. Received Newhouse Foundation Grant, Stanford University, 1965; John Simon Guggenheim Foundation Fellowship, 1971-72; National Endowment for the Arts Grant for Sculpture, 1974. Address in 1982, 54 Franklin Street, NYC.

OPPER, FREDERICK BURR.
Cartoonist. Born in Madison, Lake Co., OH, Jan. 2, 1857. Member: Society of Illustrators, 1910. On staff of Journal since 1899. Illustrated *Mark Twain, Mr. Dooley.* Address in 1929, 62 Circuit Road, New Rochelle, NY.

OPPER, LAURA.
Portrait painter. Studied at National Academy of Design under Chase and Beckwith; also studied abroad. Member of Art Students League, New York. She died in New York City on Sept. 18, 1924.

ORB, OVAN (JOHN CARBONE).
Sculptor, painter, lecturer, and teacher. Born in Cranston, RI, March 2, 1911. Studied at Rhode Island School of Design; Beaux-Arts Institute of Design; and with Leo Lentelli, Edward McCartan, Ossip Zadkine. Member: Rhode Island Abstract Artists; Providence Art Club; A. and W. Union, Rhode Island. Awards: Prize, Rhode Island School of Design, 1928; Rhode Island College of Education, 1941. Work: Sculpture, Technical High School Library, Providence, RI; Roger Williams Park, Jamestown, RI; Rhode Island School of Design. Exhibited: Providence Art Club, 1937-41; Rhode Island School of Design, 1927-43; Brown University, 1941; Rhode Island College of Education, 1940; Contemporary Art Gallery, 1944. Lectures: Sculpture. Address in 1953, 35 West 20th St., NYC; h. Providence, RI.

ORD, JOSEPH BIAYS.
Portrait painter. Born in 1805 in Philadelphia; also well known in Philadelphia as a still-life and religious painter. He was a member of the first Council of the Artists' Fund Society in 1835. His portrait of his father, the ornithologist, is owned by the Academy of Natural Sciences. Died in Phila. in 1865.

ORDWAY, ALFRED.
Portrait and landscape painter. Born in 1819. Resident of Boston and founder of the Boston Art Club in 1854. Among his best known works were "On the Charles River," "Newton Lower Falls," and "Arline." He died on Nov. 17, 1897, in Boston.

OREN, MAURY.
Born in Pasadena, CA, Aug. 6, 1930. Work: Stanley Marcus, Dallas; Mrs. Harcourt Amory, Jr., NYC. Exhibited: York Gallery, NY; Litchfield Gallery, CT; Bramante Gallery, London; Oliva Gallery, NYC; Norma Clark Gallery, London; Fairmount Gallery, Dallas, TX. Address, 315 East 56th, New York, NY.

ORENTLICHERMAN, ISAAC HENRY.
Painter. Born in Russia, Nov. 3, 1895. Pupil of Sergeant Kendall; Laurens and Lapparra in Paris. Member: Meriden Society of Arts and Crafts; Society of Independent Artists. Address in 1929, 545 Miller Avenue, Brooklyn, NY.

ORFUSS, ELSIE.
Painter and etcher. Born in Harrisburg, PA, on October 4, 1913. Studied: Grand Central Art School; Hans Hofmann School of Fine Arts; Art Students League; also in Europe. Award: Bronze medal, 1956, 60, National Association of Women Artists; included in Prize Awards, 1960, 62. Work: Chrysler Collection; Jewish Museum, NY. Exhibited: National Association of Women Artists, 1956-64; Argent Gallery, NY, 1957-59; Audubon Artists; Detroit Institute of Arts; Penna. Academy of Fine Arts; Philadelphia Museum of Art; Staten Island Institute of Arts and Sciences; Jewish Museum, 1960 (one-woman). Member: Art Students League; National Association of Women Artists; American Federation of Arts; Provincetown Art Association. Address in 1970, 55 E. 10th Street; h. 7 Cooper Road, New York, NY.

ORGAN, MARJORIE.
(Mrs. Robert Henri). Caricaturist. Born in New York, NY, Dec. 3, 1886. Pupil of Dan McCarthy and Robert Henri. Member: Society of Independent Artists; NY State Women Artists. Work: "Reggie and the Heavenly Twins," "The Man Haters' Club," "Strange What a Difference a Mere Man Makes," in New York *Journal*; caricatures of stage, etc., for New York *World*. Died in 1931. Address in 1929, 10 Gramercy Park, New York, NY.

ORLOFF, GREGORY.
Painter. Born in Russia, March 17, 1890. Pupil of Ivan Olinsky, K. Buer; Kokenev in Russia. Member: Chicago Society of Artists; Chicago No-Jury Society of Artists; South Side Art Association. Address in 1929, 59 East Van Buren Street, Chicago, IL

ORMSBY, WATERMAN LILLY.
Engraver. Born in Hampton, Windham County, CT, in 1809; died in Brooklyn, NY, in 1883. Ormsby was a student in the National Academy of Design, in 1829; and though his preceptor in engraving is unknown, he was engraving over his own name in Albany, NY, at an early date; he was also engraving for Carter, Andrew & Co., of Lancaster, MA. Being of a decided mechanical turn of mind, he invented a ruling-machine, a transferpress, and a "grammagraph," a device for engraving on steel, directly from medals and medallions. Died Nov. 1, 1883.

ORR, ALFRED EVERITT.
Painter and illustrator. Born in New York in 1886. Pupil of New York Art Students League; W. M. Chase; the Royal Academy, London. Author of poster

"For Home and Country" (5th Liberty Loan). Address in 1926, 14 West 72nd Street, New York, NY.

ORR, ELEANOR MASON.
Painter. Born in Newton Centre, MA, Aug. 15, 1902. Pupil of Boston Museum School of Fine Arts. Member: Copley Society. Address in 1929, 66 Pleasant Street, Newton Centre, MA.

ORR, FRANCES MORRIS.
Painter. Born in Springfield, MO, in 1880. Pupil of G. A. Thompson. Address in 1926, Woodland Road, Sewickley, PA.

ORR, JOHN WILLIAM.
Wood engraver, who was born in Ireland, March 31, 1815. He was brought to this country as a child. He studied engraving on wood in New York, and later established there the most important engraving business in that section of the country. He produced the frontispieces for *Harper's Illustrated Shakespeare*. He died on Mar. 4, 1887, in Jersey City, NJ.

ORR, LOUIS.
Painter and etcher. Born in Hartford, CT, May 19, 1879. Pupil of Laurens in Paris; Knight of the Legion of Honor. Work: Mural decorations in State Bank, Hartford, CT; 22 original pencil drawings, "Rheims Cathedral, 1917," and 11 etchings in the Luxembourg, Paris; one etched copper plate in the Louvre, Paris; one plate in New York Public Library; two etchings in Oakland (CA) Museum; etching in Strasbourg Museum; 3 etchings of Rheims Cathedral, National American Red Cross; 2 plates in French Government collection. Address in 1933, 5 Rue Mazarine Paris, France.

ORTIZ, RAFAEL MONTANEZ.
Sculptor and educator. Born in NYC, January 30, 1934. Studied at Brooklyn Museum Art School; Art Students League; Pratt Institute, B.S. and M.F.A.; Columbia University. Work in Museum of Modern Art, NY; Whitney Museum of American Art, NY; Syracuse Museum of Contemporary Art, NY. Has exhibited at Museum of Modern Art, NY; Whitney Museum of American Art, NY; Everson Museum, Syracuse, NY; San Antonio Museum, TX; Palacia de Mineria, Mexico City; others. Received John Hay Whitney Fellowship Grant, 1965. Teaching art at Rutgers, from 1972. Works in mixed media. Address in 1982, Highland Park, NJ.

ORTLIEB, ROBERT EUGENE.
Sculptor and graphic artist. Born in San Diego, CA, July 4, 1925. Studied at University of Southern California, with Merrell Gage, Francis de Erdely, and Glen Lucens, B.F.A. and M.F.A. Work in California Palace of Legion of Honor Museum, San Francisco; Laguna Beach Art Museum; wood head of Christ, Congregation, First Presbyterian Church,

Culver City, CA; others. Has exhibited sculpture at Los Angeles Co. Museum, California; sculpture, Western States Exhibition, Denver Art Museum, CO; Dallas Museum of Fine Arts; Long Beach Museum of Art, CA; others. Taught sculpture at Riverside Art Center, University of California, 1962-75; others. Works in stone, wood carving, bronze, and plexiglas. Address in 1982, Garden Grove, CA.

ORTLIP, AIMEE E.
(Mrs. H. W. Ortlip). Painter. Born in Philadelphia, PA, April 21, 1888. Pupil of William M. Chase, Sergeant Kendall, Henry McCarter. Address in 1929, Old Palisade Road, Fort Lee, NJ.

ORTLIP, H. WILLARD.
Painter. Born in Norristown, PA, March 28, 1886. Pupil of William M. Chase, Sergeant Kendall, Henry McCarter. Award: Popular vote prize ($100), Woman's Club, Patterson, NJ, 1928. Work: Decorations featuring historic incidents, Hotel Huntington, LI, NY. Address in 1929, Old Palisade Road, Fort Lee, N.J.

ORTMAN, GEORGE EARL.
Painter and sculptor. Born Oct. 17, 1926 in Oakland, CA. Studied at Berkeley, 1947-48; Hans Hofmann School, NY, 1950-51; Academie Andre L'Hote, Paris, 1950; Arizona State University; California College of Arts and Crafts; Atelier 17, NY. Taught at School of Visual Arts (NYC); NYU; Princeton; Fairleigh Dickinson College, summer, 1964; and now at Cranbrook Academy of Art. Awarded Guggenheim Fellowship, 1965; Birmingham Museum of Art Religion in Art prize, 1966; NJ State Museum Second Annual prize, 1967. Exhibited at Tanger Gallery, NYC, 1954, Stable Gallery, NYC, 1953-61, Wittenborn Gallery, NYC, 1956, Howard Wise Gallery, NY, 1962-64, Walker, 1965, Dallas Museum of Fine Arts, 1966, Akron Art Institute, 1966, University of Chicago, 1967 (all one-man); San Francisco Museum of Art, 1952, 63; Seattle World's Fair, 1962; Fairleigh Dickinson University, 1963 (retrospective); Jewish Museum, NYC, 1963; Stedelijk, 1963; Museum of Modern Art, NYC, 1963-64; Carnegie Institute, 1960, 64, 67; Art Institute of Chicago Annuals, 1961, 62; Whitney, many times. In collections of Whitney Museum and Museum of Modern Art, both in NYC; Joslyn Memorial Museum, Omaha, NE; De Cordova Art Museum, Lincoln, MA; Albright-Knox Art Gallery, Buffalo, NY; New York University; Walker Art Center; Worcester Art Museum; and private collections. Address in 1984, Castine, ME.

ORTMAYER, CONSTANCE.
Sculptor and educator. Born in NYC on July 19, 1902. Studied: Royal Academy of Fine Arts, and Royal Academy of Master School, Vienna, Austria. Exhibited: Vienna Secession, 1932; National Association of Women Painters and Sculptors, NY, 1935;

Allied Arts, Brooklyn Museum, 1936; National Sculpture Society, Whitney Museum of American Art, NYC, 1940; Penna. Academy of Fine Arts, 1941. Awards: Anna Hyatt Huntington Prize, National Association of Women Painters and Sculptors, 1935; Henry O. Avery Architectural Prize, National Sculpture Society, 1940; Award of Merit, Florida Federation of Art, 1948; Rollins Decoration of Honor, Rollins College, 1947. Collections: Brookgreen Gardens, South Carolina; American Numismatic Society, NY; U.S. Post Office, Arcadia, Florida; U.S. Post Office, Scottsboro, Alabama. Member: Emeritus member, National Sculpture Society; Florida Federation of Art; Morristown Art Association. Teaching: Professor of sculpture, Rollins College, from 1937 (also chairman of art department); emeritus professor, from 1968. Address in 1984, Morristown, TN.

ORWIG, LOUISE.
Painter. Born in Mifflinburg, PA. Pupil of William M. Chase, Henry McCarter and Daniel Garber. Member: Fellowship Penna. Academy of Fine Arts; Des Moines Academy of Fine Arts (secretary); Des Moines Sketch Club; Iowa Art Club. Awards: Cresson scholarship, Penna. Academy of Fine Arts, 1911; prize ($100), 1911, first prize, 1919 and 1920, gold medal and $100 purchase prize, 1921, $100 purchase prize, 1923, hon. mention, 1927, all from the Women's Club of Des Moines. Address in 1929, Public Library, Des Moines, IA.

OSBORN, FRANK C.
Painter and craftsman. Born in Altamont, NY, June 13, 1888. Member: Society of Independent Artists; Salons of America; Alliance. Address in 1929, 20 West 22nd Street; h. 1 Fifth Ave., New York, NY; summer, West Georgetown, ME.

OSBORN, M.
This stipple-engraver of portraits was working in Baltimore, MD, in 1812. In 1820 Osborn was located in Philadelphia.

OSBORN, MILO.
Born c. 1810 in Massachusetts. In 1836 this very clever line-engraver of portraits and landscape was employed in New York. He was later working for Philadelphia magazines. One of his contemporaries says that he became dissipated and disappeared.

OSBORNE, LILLIE.
(Mrs. Lithgow Osborne). Sculptor. Born in Aalholm, Denmark, March 8, 1887. Studied in Copenhagen, Rome, and Paris. Specialty: Portrait-statuettes of children and animals. Address in 1933, Auburn, NY.

OSGOOD, CHARLES.
Portrait painter. Born Feb. 25, 1809, in Salem, MA. In 1827 he opened his studio in Boston, and in 1828 he returned to Salem where he lived until his death. His portraits hang in the historical societies in Boston and Worcester, and in the Peabody Museum of Salem. Died in 1890.

OSGOOD, HARRY H.
Painter and etcher. Born in Illinois, 1875. Pupil of Julien and Colarossi Academies in Paris. Address in 1926, 1538 East 57th St., New York.

OSGOOD, SAMUEL TILLMAN.
Portrait painter. Born June 9, 1808, in New Haven, CT. Studied art in Europe, and settled in New York. The New York Historical Society owns a number of his portraits. He is said to have died in California in 1885.

OSNIS, BENEDICT A.
Portrait painter. Born in Russia in 1872. Pupil of Penna. Academy of Fine Arts. Address in 1926, The Art Club, Philadelphia, PA.

OSSORIO, ALFONSO A.
Painter and sculptor. Born August 2, 1916, in Manila, Philippines. Studied at Harvard, B.A., 1938; and Rhode Island School of Design, 1938-39. U.S. citizen. Commissions: Murals, Church of St. Joseph, Victorias, Negros, Philippines, 1950-51 and Washington Square Village, New York City, 1954; large circular assemblage, New York Hilton Hotel, 1964. Exhibited: Wakefield Gallery, NYC, 1941-61; Galerie Paul Facchetti, Paris, 1951; Betty Parsons Gallery, Cordier and Warren, Museum of Modern Art, and Whitney Museum, all in NYC; Documenta, Kassel, Germany, 1964; plus numerous others. In private collections, and in those of the Guggenheim; Philadelphia Museum of Art; New York University; Whitney; and Museum of Modern Art. Address in 1982, Wainscott, NY.

OSTER, JOHN.
Painter, craftsman, and teacher. Born in Heidelberg, Germany, Sept. 14, 1873. Pupil of Douglas Volk; National Academy of Design. Work: Stained glass windows, Harvard University Museum, Cambridge, MA; John Singer Sargent stained glass window, Boston, MA. Address in 1929, 279 Columbia Avenue, Jersey City, NJ.

OSTHAUS, EDMUND.
Painter. Born at Hildesheim, Germany, in 1858. Pupil of Andreas Muller, Peter Jansen, E. V. Gebhardt, E. Deger and C. Kroner. He came to the United States in 1883 and was called to Toledo, Ohio, as principal of the Toledo Academy of Fine Arts, 1886. This school was later abandoned and he then devoted his entire time to pictures; he painted principally pictures of shooting and fishing, hunters and dogs being the general subjects. Address in 1926, 27 Bedford Road, Summit, NJ. Died Jan. 30, 1928 in Jackson County, FL.

OSTRANDER, PHILLIP.
Landscape engraver. Worked in New York, and later in Cincinnati, OH, from 1850-55.

OSTRANDER, WILLIAM CHEESEBOROUGH.
Painter. Born New York, NY, March 5, 1858. Pupil of Carl Hecker, Murphy, Scott and Venino. Member: Salma. Club, 1897; Artists' Fund Society; NY Society of Craftsmen; Amer. Institute of Graphic Arts; Amer. Federation of Arts. Address in 1929, c/o J. Ross Mackenzie, 3472 E. Hill St., Huntington Park, CA.

OSTROM, CORA CHAMBERS.
Painter. Born in Harrison, AR, Sept. 2, 1871. Pupil of Maria Brown; Wells; Arpa. Member: San Antonio Art League; Southern States Art League. Address in 1929, 305 Ceylon Street, Eagle Pass, TX.

OSTROWSKY, ABBO.
Painter, etcher, and teacher. Born in Russia, Oct. 23, 1889. Studied in Russia; pupil of National Academy of Design; Turner; Maynard. Member: Society of Independent Artists; American Artists Professional League; Salons of America; Paris Society of Independent Artists. Work: Bibliotheque Nationale, Paris; Gregg Collection, University of Nebraska. Founder and Director, Educational Alliance Art School, New York. Address in 1929, Alliance, 197 East Broadway; h. 31 Gramercy Park, New York, NY.

OSTROWSKY, SAM.
Painter, lecturer, and teacher. Born in Russia, May 5, 1885. Pupil of Harry Wolcott and Art Institute of Chicago; Laurens and Academie Julian in Paris. Member: Society of Independent Artists. Award: Hon. mention, Art Institute of Chicago. Address in 1929, 1868 South Central Park Avenue, Chicago, IL.

OSZE, ANDREW E.
Sculptor. Born in Nagykanizsa, Hungary, January 14, 1909; U.S. citizen. Studied at Academy of Art, Budapest; Academy D'Ungheria, Rome, fellowship, 1947-49. Work in Denver Art Museum; Museum of Budapest; fountain, Rome; T. S. Eliot relief, St. Louis; others. Has exhibited at Far Gallery, NY, 1964, 70; De Young Museum, San Francisco, 1973; Denver Art Museum, 1975; others. Member of College Art Association of America. Works in stone, bronze, and wood. Address in 1982, Vero Beach, FL.

OTIS, AMY.
Miniature painter, teacher. Born in Sherwood, NY. Pupil of Phila. School of Design and Penna. Acad. of Fine Arts; Colarossi Academy, Courtois and Garrido in Paris. Member: Plastic Club; Phila. Water Color Club; Penna. Soc. of Min. Painters; Fellowship Penna. Acad. of Fine Arts. In charge, Art Dept., Wheaton College. Address 1929, Wheaton Col., Norton, MA.

OTIS, BASS.
Painter and engraver. Born July 17, 1784, in Bridgewater, MA. Made the first lithograph in the United States. Apprenticed as a youth to a scythemaker, it is not known from whom he gleaned instruction in art, but in 1808 he was painting portraits in New York and four years later settled in Philadelphia. His well-known portrait of President Jefferson was engraved for Delaplaine's "Portrait Gallery," and many other celebrities sat for him. One of his best works is a portrait of himself, painted shortly before his death. In 1815 he invented the perspective protractor, which was well-received by his co-workers in art, and in 1819, for the July issue of the *Analectic Magazine*, he produced the first lithograph in this country. The design was made on a stone brought from Munich and he did the printing himself. Only one composition from his brush is known - a large interior of a smithy, possibly the one in which he served his apprenticeship. This was first exhibited at the Pennsylvania Academy of the Fine Arts in 1819, and was afterwards presented to that institution. In 1815 he painted a delightful portrait of John Neagle, at the age of nineteen, who worked in his atelier. Died Nov. 3, 1861 in Philadelphia.

OTIS, GEO(RGE) D(EMONT).
Painter. Born Sept. 21, 1877. Pupil of John Carlson, R. Schmidt, Reynolds, Poole, Vanderpoel, Robert Henri. Member: California Art Club; Los Angeles Painters and Sculptors; Palette and Chisel Club of Chicago; Laguna Beach Art Association; Cliff Dwellers. Award: State prize, Sacramento, CA, 1925. Work: "Little Blue House," Art Institute of Chicago; "Pigeon Hill," Hackley Gallery of Fine Arts, Muskegon, MI. Address in 1933, 304 Avon Street, Burbank, CA.

OTIS, SAMUEL DAVIS.
Painter, sculptor, illustrator, and teacher. Born in Sherwood, NY, July 4, 1889. Pupil of Henry Mc Carter. Member: Silvermine Guild of Artists; Artists Guild of the Authors' League of America, NY. Illustrated "Cyrano de Bergerac" and "Francesca da Rimini;" illustrations for *Harpers Bazaar*. Address in 1933, Norwalk, CT.

OTNES, FRED.
Illustrator. Born in Junction City, Kansas, in 1926. He attended the Art Institute of Chicago and the American Academy. Since 1946 his illustrations, exhibiting his fine draftsmanship, have appeared in many publications, including *True, The Saturday Evening Post*, and *Reader's Digest*. Recently he has concentrated on intricate and superbly crafted assemblages and elegant illustrations utilizing new photographic and printing techniques. He has received over 100 honors, including the Hamilton King Award from the Society of Illustrators, and is a founding member of the Illustrators Workshop.

OTT, PETERPAUL.

Sculptor, craftsman and teacher. Born in Pilsen, Czechoslovakia, June 4,1895. Studied: Emerson University, Los Angeles, CA; in Dresden, Germany; Cooper Union Art School, NY; pupil of Karl Albiker and Alexander Archipenko. Awards: First prize, 1919, first mention, 1920, state medal, 1921, Dresden Academy of Art, Germany; gold medal, Kunstverein, Chemnitz, Saxony, 1922; first prizes, National Small Sculpture Competitions, 1930, 31; Chicago Art Group, 1932; Evanston, IL, 1934-36, 38; Art Institute of Chicago, 1934; Laguna Beach Art Association, 1943, 44; numerous awards in Germany. Works include war memorials: Infantry Regiment 35, Regiment Hall, Pilsen, Czechoslovakia; Student Society, Academy of Art, Dresden; Church of the City of Pinow, Silesia; College Hall of Honor, College of the City of Aue, Saxony; College Hall, College of the City of Schoenberg, Saxony; metal emblem, Infantry Regiment 35, Pilsen, Czechoslovakia; medal, Schaffen and Koennen der Deutschen Frau, Chemnitz, Germany; "Torso," male, and "Torso," female, Gorham Bronze Company Collection, NYC; plaque of Rear Admiral Byrd, Antarctic Ship, Century of Progress Exposition, Chicago, IL; entire sculptural interior decoration, St. George Playhouse, Brooklyn, NY; entire exterior decoration, Greater New York Savings Bank, Brooklyn, NY; entire interior and exterior decoration, Post Office Building, Oak Park, IL. Exhibited: Architectural League; Society of Independent Artists; Montclair Art Museum; National Academy of Design; National Arts Club; Palace of the Legion of Honor; Penna. Academy of Fine Arts; Art Institute of Chicago; College Art Association of America; Carnegie Institute; Laguna Beach Art Association; Philadelphia Museum of Art; many others. Member: Laguna Beach Art Association. Address in 1953, 117 Canyon Acres Drive; h. 119 Canyon Acres Drive, Laguna Beach, CA.

OTT, RALPH C.

Painter. Born in Springfield, MO. Pupil of Constant and Laurens. Member: Philadelphia Art Club. Represented in State Capitol, Jefferson City, MO; Public Library, Springfield, MO; City Art Museum and Masonic Lodge, St. Louis, MO. Address in 1929, 809 East Grand Avenue, Springfield, MO.

OTTER, THOMAS.

Painter. Resided in Philadelphia. Represented by his picture "Moonlight," painted in 1860, in the Wilstach Collection, Fairmount Park, Philadelphia. Also an engraver.

OTTIANO, JOHN WILLIAM.

Sculptor and jeweler. Born in Medford, MA, July 23, 1926. Studied: Massachusetts College of Art; Boston University; Pennsylvania State University. Work: University of Western Illinois; Pennsylvania State University; Glassboro State College, NJ; commissions for Glassboro State College and NJ Art Education Association; private collections. Exhibitions: Penna. Academy of Fine Arts, PA; The Speed Art Museum, KY; National Academy Galleries, NYC; and others. Teaching: Glassboro State College, NJ; and others. Member: Am. Assoc. of Univ. Professors; New Jersey Art Educ. Assoc.; NJ Designer-Craftsmen Assoc.; Artists Equity Assoc.; Nat. Art Educ. Assoc. Media: Bronze, gold, silver. Address 1982, Pitman, NJ.

OURDAN, JOSEPH JAMES PROSPER.

Engraver. Born in Marseilles, France, in March, 1803; died in Washington, DC, Oct. 25, 1874. Joseph J. P. Ourdan came to New York in 1821, moved later to Philadelphia, and having learned to engrave through instruction by his son, Joseph P. Ourdan, he became an expert letter engraver. In this capacity he was employed by the United States Treasury Department, at Washington, from 1866 until his death.

OURDAN, JOSEPH PROSPER.

Engraver. Born in New York City, Feb. 16, 1828; died in Washington, DC, May 10, 1881. Joseph P. Ourdan was the son of Joseph James Prosper Ourdan, and served his apprenticeship as an engraver with W. L. Ormsby, of NY. Over his own name he engraved in line some good portraits and illustrative works for the book publishers, and the firm of Packard and Ourdan produced portraits in mezzotint, but he early became interested in banknote work and was in the employ of the Continental and the National banknote companies, of New York, and of the American Bank Note Company, of Philadelphia.

OURDAN, VINCENT LE COMTE.

Engraver. Born in Brooklyn, NY, in 1855. He served his apprenticeship as an engraver with the Columbian Bank-Note Company, of Washington, DC, from 1875 to 1878; for some time he was employed in the Bureau of Engraving and Printing, and then returned to the Columbian Company and was with the latter until it went out of business. In 1882 Mr. Ourdan went to the United States Hydrographic Office, in Washington, and there created the Mechanical Engraving Department.

OUREN, KARL.

Painter. Born in Fredrikshald, Norway, Feb. 5, 1882. Studied in Copenhagen; at Art Inst. of Chicago; with Hans Larvin at Palette and Chisel Club, Chicago. Member: Palette and Chisel Club; Art Inst. of Chicago Alumni; Scandinavian-Amer. Artists; Chicago Galleries Assoc. Award: Gold medal, Palette and Chisel Club, 1919. Rep., Milwaukee Art Inst. Died 1943. Address 1929, 2334 No. Sawyer Ave., Chicago, IL.

OURLAC, JEAN NICOLAS.

Painter. Born in New Orleans, LA, in 1789; died in 1821 in Paris. The subjects of his paintings are mostly taken from Amer. scenery.

OUTBANK, NAHUM BALL.
Painter. Born in 1823. Lived in Boston from 1856-79. He painted portraits of John Brown, Wendell Philips, and others of his friends. Died in 1888.

OUTCAULT, RICHARD FELTON.
Comic illustrator. Born Jan. 4, 1863 in Lancaster, OH. Studied at McMicken University; Cincinnati, OH. Created 1st full page color comic ever published, "Hogan's Alley." Syndicated work. Also created "The Yellow Kid" and the very popular "Buster Brown," based on his son Richard, Jr. On staff of the *New York Journal* since 1905. Member: Salmagundi Club. Painted last 10 years of his life. Address in 1926, 245 Madison Avenue, Flushing, Long Island, NY. Died Sept. 25, 1928, in Flushing, Long Island, NY.

OVERBECK, MARY FRANCIS.
Painter and craftsman. Born in Cambridge City, IN, Jan. 28,. 1878. Pupil of Arthur Dow at Columbia University, New York. Member: Cincinnati Woman's Art Club; Indiana Artists' Club. Specialty: Overbeck Pottery. Represented by Overbeck Pottery at John Herron Art Institute, Indianapolis, IN; and General Federation of Woman's Clubs, Washington, D.C. Address in 1929, Cambridge City, IN.

OVRYN, BENJAMIN S.
Painter. Born in Russia, Oct. 3, 1892. Pupil of Ladisenski. Member: Society of Independent Artists; Alliance; Salons of America. Address in 1929, 17 Cook Street; h. 890 Flushing Ave., Brooklyn, NY; summer, Piermont, NY.

OWEN, ESTHER S. D. (MRS.).
(Mrs. Charles H. Owen). Painter. Born Sept. 19, 1843 in Boston, MA. Pupil of Votin, Geary and Tuckerman. Member: Connecticut Academy of Fine Arts. Represented in Worcester Art Museum. Died Sept. 20, 1927 in Hartford, CT.

OWEN, MICHAEL G., JR.
Sculptor, painter, illustrator, and craftsman. Born in Dallas, Texas, May 2, 1915. Studied at Dallas Art Institute. Member: Society of Washington Artists. Work: Sculpture, Southern Methodist University, Dallas, Texas. Exhibited: Kansas City Art Institute, 1938; Society of Washington Artists, 1944; *Times-Herald* Art Fair, 1944; Baltimore Museum of Art, 1945. Address in 1953, Greenbelt, MD.

OWINGS, THOMAS BOND.
Painter. Member: Baltimore Water Color Club. Address in 1929, 1215 John Street, Baltimore, Maryland.

OZERSKY, J. W.
Sculptor. Born in Russia in 1890. Studied in NY at the Beaux-Arts Institute of Design under A. A. Weinman and Jo Davidson, and also at the National Academy of Design. Work: Dormir.

P

PACH, WALTER.
Painter. Born in New York, July 11, 1883. Pupil of Leigh Hunt, Chase and Henri in New York. Member: Societe des Artistes Independants, Paris; Society of Independent Artists. Represented in Metropolitan Museum of Art; Cleveland Museum of Art; Newark Museum. Articles in *Scribner's, Century, Harper's, La Gazette des Beaux Arts.* Author of *The Masters of Modern Art, Georges Seurat, Modern Art in America* and *Ananias or the False Artist.* Died in 1958. Address in 1929, 48 West 56th St., New York.

PACKARD, DAVID.
Sculptor. Born in Albany, NY, May 29, 1928. Studied at Penna. Academy of Fine Arts, with Walker Hancock, 1946-48; Syracuse University, with Ivan Mestrovic, 1951-56, B.F.A. Works: Milwaukee; Syracuse University. Exhibitions: Main St. Gallery, Chicago; Penna. Academy of Fine Arts; Audubon Artists; Ravinia Festival, Highland Park, IL; New Horizons in Sculpture, Chicago; Ball State Teachers College, Drawings and Sculpture Annual. Awards: Copley Foundation Grant, 1962; New Horizons in Sculpture, first prize ($2,000), Chicago, 1962; Wisconsin Painters and Sculptors Annual, cash award, 1965; University of Illinois summer fellowship, 1966. Taught: Layton School of Art, 1964-65; University of Illinois, 1965-67; and privately. Died Feb. 2, 1968, Chicago, IL.

PACKARD, MABEL.
Miniature painter. Born in Iowa. Pupil of Art Institute of Chicago; Colarossi Academy and Mme. La Forge in Paris. Member: Chicago Society of Artists. Award: Bronze medal, St. Louis Expo., 1904. Address in 1929, 2031 Berkshire Ave., South Pasadena, CA.

PACKER, FRANCIS HERMAN.
Sculptor. Born in 1873. Pupil of Martiny and Saint Gaudens. Member: National Sculpture Society, 1905. Sculptor of "Nebraska." Address in 1929, Rockville Center, LI, NY. Died in 1957.

PACKMAN, FRANK G.
Painter, illustrator and etcher. Born in England, June 5, 1896. Pupil of John P. Wicker, Paul Honore. Member: Scarab Club; Michigan Academy of Science, Arts and Letters. Address in 1929, 1512 Book Tower, Detroit, MI; h. 2822 Benjamin Ave., Royal Oak, MI; summer, Petoskey, MI.

PADDOCK, ETHEL LOUISE.
Painter. Born in New York City, April 19, 1887. Pupil of New York School of Art, and Henri. Member: Society of Independent Artists; National Association of Women Painters and Sculptors; Pen and Brush Club of New York; NY Society of Women Artists; Salons of America.

PADDOCK, JOSEPHINE.
Painter. Born in New York, NY, April 18, 1885. Studied: Art Students League; with Robert Henri, Kenyon Cox, William M. Chase, and John Alexander; Barnard College, B.A. Exhibited at the Penna. Academy of Fine Arts, Philadelphia, 1914; National Academy of Design; Corcoran Gallery of Art; Connecticut Academy of Fine Arts; American Watercolor Society of New York, NY; Brooklyn Museum; Allied Artists of America; New Haven Paint and Clay Club; Paris Salon, 1951; Royal Institute, London. Work: Barnard College Club, NY; Wesleyan College; National Bible Institute; Colgate University. Portraits include "Miss Trelawney" and "The Sealskin Muffs." Awards: Prizes, Brooklyn Museum, 1935; New Haven Paint and Clay Club, 1935; Connecticut Academy of Fine Arts, 1937; American Watercolor Society of New York, 1946. Member: American Watercolor Society; Allied Artists of America; New Haven Paint and Clay Club; Connecticut Academy of Fine Arts; Springfield Art League. Address in 1953, 115 East 86th St., New York, NY.

PADDOCK, WILLARD DRYDEN.
Sculptor and painter. Born in Brooklyn, NY, October 23, 1873. Pupil of Herbert Adams in New York; Pratt Institute in Brooklyn; Courtois and Girardot in Paris. Member: Associate National Academy of Design; New York Architectural League; Salma. Club, 1904; MacDowell Club; Fellow, National Sculpture Society, 1915; Artists' Aid Society; Allied Artists of America; Washington Art Club; Century Association. Works: Orr and Jessup relief, New York Chamber of Commerce; The Whittier and Grant memorials, Saginaw, MI; George Seward memorial; Noah Webster memorial, Amherst College, MA; Alfred Noble memorial, Engineering Societies Building, New York City; Edward C. Mershon memorial fountain; numerous busts, figures, fountains, sundials and statuettes. Exhibited at National Sculpture Society, 1923. Address in 1953, South Kent, Connecticut. Died in 1956.

PADELFORD, MORGAN.
Sculptor, painter, and teacher. Born in Seattle, Washington, October 10, 1902. Pupil of Hopkinson, Isaacs, etc. Member: Seattle Art Institute; Northwest Print Maker's Society. Award: First prize, oil, Northwest Artists Exhibition, 1923. Work: Symbolic bas-

relief in cast stone, Chamber of Commerce Building; four portraits, University of Washington, Seattle, WA. Address in 1933, Claremont, CA; h. 4710 20th Street, N.E., Seattle, WA.

PAEFF, BASHKA.
(Mrs. Bashka Paeff Waxman). Sculptor and teacher. Born in Minsk, Russia, August 12, 1893. Pupil of Bela Pratt; Massachusetts Normal Art School; School of Boston Museum of Fine Arts. Member: Boston Guild of Artists; Detroit Society of Arts and Crafts; Mac Dowell Colony; fellow, National Sculpture Society. Work: Massachusetts Chaplains' War Memorial, Hall of Fame, State House, Boston; World War Memorial, State of Maine, Kittery, ME; bronze bas-relief of "Dr. Elmer E. Southard," Harvard Medical Library; John E. Warren memorial bronze fountain, Westbrook, ME; Julius Rosenwald fountain, Ravina, IL; bronze bas-relief of "Dr. E. Fernald," Fernald State School, Waverly, MA; "Boy and Bird" fountain, Stoughton, MA; "Judge Manly B. Allen" for City of Birmingham, AL; bronze bas-relief, "Ellen H. Richards," Massachusetts Institute of Technology; bronze bas-relief, C. H. Hovey Co., Boston, MA; life-size bas relief of Justice Oliver Wendell Holmes, Harvard Law Library; bronze relief of Dr. Martin Luther King, Jr., Boston University; also in Boston Museum of Fine Arts; and other collections. Exhibited at National Academy of Design; National Sculpture Society; and others. Address in 1976, Cambridge, MA. Died in 1979.

PAGE, GROVER.
Illustrator and cartoonist. Born in Gastonia, NC, Nov. 10, 1892. Pupil of Art Institute of Chicago; Chicago Academy of Fine Arts. Member: Louisville Art Association. Specialty: Cartoons. Died in 1958. Address in 1929, Louisville Courier-Journal, Louisville, KY; h. 1703 DePauw Pl., New Albany, IN.

PAGE, H. C.
Marble cutter, carver, and engraver. Worked in Charleston, SC, 1830.

PAGE, KATHERINE S(TUART).
Painter. Born in Cambridge, MD. Pupil of Philadelphia School of Design for Women; Margaretta Archambault. Member: Philadelphia Paint Club. Specialty: Miniatures. Address in 1929, 1524 - 28th St., NW, Washington, DC; summer, South Boston, VA.

PAGE, MARIE D(ANFORTH).
(Mrs. Calvin G. Page). Portrait painter. Born in Boston, MA. Pupil of School of the Boston Museum of Fine Arts. Member: Associate National Academy of Design; Copley Society; Concord Art Association; Guild of Boston Artists; American Federation of Arts. Awards: Bronze medal, P.-P. Expo., San Francisco, 1915; Bok prize, Penna. Academy of Fine Arts,

1916; first prize and honorable mention, Duxbury Art Association, 1920; Greenough prize, Newport Art Association,1921; Isidor prize, National Academy of Design, 1923; bronze medal, Sesqui-Centennial Exposition, Philadelphia, 1926; Thomas R. Proctor prize, National Academy of Design, 1928; Harold H. Swift prize, Grand Central Gallery, 1928. Died in 1940. Address in 1933, 128 Marlborough St., Boston, MA.

PAGE, WALTER GILMAN.
Painter and writer. Born in Boston in 1863. Pupil of Boston Museum School; Boulanger and Lefebvre in Paris. Member: Boston Museum School Alumni Association; Portland Society of Artists (life); Springfield Art Society; American Federation of Arts; Massachusetts State Art Commission. Work: "A Head," Toledo Museum of Art; "Lillian," Art Museum, Portland, ME; portraits in Massachusetts State House; Portland (ME) City Hall; Bowdoin College; Maine Historical Society; Colby College, Maine; Vermont State House; Worcester Public Library; Fall River Public Library; Lowell City Hall; Dracut Public Library; Tufts College, MA. Died in 1934. Address in 1929, Nantucket, MA.

PAGE, WILLIAM. *1811*
Painter. Born Jan. 23, ~~1911~~ in Albany, NY. He moved with his family to New York City in 1820 and entered the law office of Frederick De Peyster when quite a young man, but soon devoted himself entirely to art, studying under Professor Morse, and in the Schools of the National Academy. He painted portraits in Albany, 1828-29, returned to New York, and, later, opened a studio in Boston, where he remained until he went to Europe. He was for many years considered the leading American portrait painter in Rome. Elected a member of the National Academy in 1836, and delivered lectures which were highly esteemed to the Academy students. Among his earlier works are a "Holy Family," belonging to the Boston Athenaeum; a portrait of Governor Marcy, in the City Hall, New York; and "The Infancy of Henry IV." His exhibits in the National Academy include "Antique Timbrel Player," 1871; "Farragut's Triumphant Entry into Mobile Bay," 1872; "Shakespeare," 1874; "Shakespeare, from the German Death Mask," 1876. He was much impressed with the death mask of Shakespeare and wrote several articles in support of its authenticity. He painted a head of "Christ" which attracted much attention, because of the deep religious sentiment it expressed. A number of Page's pictures were on exhibition in New York in the winter of 1877, including his "Shakespeares" and his celebrated "Venus," painted in Rome, 1859, and exhibited in London and other cities, including Philadelphia. The Penna. Academy has an interesting genre painting by Page, of excellent qualities, but in curious condition as to color, it being possibly one of the experi-

ments in color which the artist was reputed to be fond of trying. He died at his home on Staten Island, Oct. 1, 1885.

PAGES, JULES.
Painter and teacher. Born in San Francisco, CA, 1867. Pupil of Constant, Lefebvre and Robert-Fleury in Paris. Awards: Hon. mention, Paris Salon, 1895; third medal, Paris Salon, 1899; second medal, Paris Salon, 1905; Knight of the Legion of Honor, 1910. Instructor at the Julian Academy night class since 1902; life class since 1907. Member: International Society of Paris Sculptors and Painters. Represented in Museum of Pau, France; Museum of Toulouse, France; the Luxembourg, Paris; Golden Gate Park Museum and Art Institute, San Francisco; Municipal Art Gallery, Oakland, CA. Died May 22, 1946. Address in 1929, 42 Rue Fontaine, Paris, France.

PAGET-FREDERICKS, J(OSEPH) (ROUS-MARTEN).
Painter, illustrator, writer and lecturer. Born in San Francisco, CA, Dec. 22, 1903. Studied: University of California; in Europe; pupil of Leon Bakst, John Singer Sargent. Work: Mills College, Oakland, CA; University of California; collections in London, Paris, Rome, and Venice. Exhibited: Special memorial exhibition of Pavlova College, San Francisco, CA, 1951, for Sadler's Wells Ballet; Art Institute of Chicago; NY Public Library; in Europe and South America. Awards: Stanford University, 1935; Berlin, Germany, 1936. Member: Los Angeles Museum Patrons Association; American Society of Painters and Sculptors. Author and illustrator of *Green Pipes, Miss Pert's Christmas Tree, Pavlova Impressions, Atlantis, These Younger Years, Red Roofs and Flowerpots,* and other books. Illustrator of *The Collected Poems of Edna St. Vincent Millay, The Macaroni Tree, Sandra and the Right Prince,* others. Lectures on "Creative Imagination in the Arts," "The Russian Ballet," others. Instructor of color and design, California College of Arts and Crafts; assistant director, San Francisco Art Center. Address in 1953, Berkeley, CA. Died in 1963.

PAGON, KATHERINE DUNN.
(Mrs. William Watters Pagon). Painter. Born in Chestnut Hill, Philadelphia, PA, Dec. 25, 1892. Pupil of Penna. Academy of Fine Arts; Hugh Breckenridge. Member: Fellowship Penna. Academy of Fine Arts; Maryland Institute Alumni Association (associate); Friends of Art; Baltimore Society of Independent Artists; American Federation of Arts. Address in 1929, 114 St. John's Road, Roland Park, Baltimore, MD.

PAIN, LOUISE (CAROLYN).
Sculptor. Born in Chicago, IL, July 14, 1908. Pupil of Emil Robert Zettler. Award: Chicago Woman's Aid prize, Thirty-seventh Annual Exhibition by Artists of Chicago and Vicinity, Art Institute of Chicago, 1933. Address in 1933, 6837 Oleander Parkway, Chicago, IL.

PAINE, MAY.
Painter. Born in Charleston, SC, May 7, 1873. Pupil of Leith-Ross; Frank Chase; Gruppe; Alfred Hutty; Ivan Summers. Member: Southern States Art League. Award: First prize, Southern States Art League. Address in 1929, 47 Meeting St., Charleston, SC.

PAINE, RICHARD G.
Sculptor. Born in Charleston, SC, February 15, 1875. Pupil of Amateis and Kemeys. Address in 1926, East Falls Church, VA.

PAINE, T. O.
Sculptor. Born in Maine about 1825. Was living in Bangor, Maine, in 1850 and in Boston, Massachusetts, in 1852.

PALANSKY, ABRAHAM.
Painter and sculptor. Born in Lodz, Poland, July 1, 1890. Studied at Art Institute of Chicago. Member: Los Angeles Water Color Society; No-Jury Society, Chicago. Awards: Prize, Art Institute of Chicago, 1941, 45; Pasadena Art Institute, 1952. Exhibited: National Art Week, Chicago, 1940; Art Institute of Chicago, 1940-45, 49; Illinois State Museum, 1940; No-Jury Society, 1941, 42; Los Angeles Museum of Art, 1944 (one-man), 1943, 45, 48, 49, 52; Oakland Art Gallery, 1944; San Francisco Museum of Art, 1944; Riverside (CA) Museum, 1946, 48; Madonna Festival, Los Angeles, 1949; Chicago Board of Jewish Education, 1950; Pasadena Art Institute,1947-50; Greek Theatre, Los Angeles, 1946, 47, 48, and 51. Address in 1953, Los Angeles, CA.

PALAU, FLEUR.
Sculptor. Born September 5, 1953. Studied: National Academy of Design, New York City, with Gaetano Cecere, Adolph Block, Charles Salerno, 1972-77; privately with sculptor Jurio Vivarelli, Pistoia, Italy, 1978; with Rino Giannini, Univ. of Carrara, Italy, 1980-81. Work: In private collections in U.S. and Italy; contractor working for sculptor Harry Jackson, Camaiore, Italy, 1979-80; subcontractor, terracotta bas-relief for Toronto subway, 1981-82; freelance, small sculptures for Austin Productions, Inc., NYC, 1983. Exhibitions: National Academy Galleries 52nd Annual, NYC, 1977; Allied Artists and Audubon Artists, National Academy Galleries, NYC; Museum of Modern Art Annual Exhibition, Forte dei Marmi, Italy, 1981, 82; Versilia Show of Foreign Artists Living Abroad, Pietrasanta, Italy (catalogue published), 1982; Pen and Brush Club Annual Sculpture Exhibition, 1983; Salma. Club Annual Sculpture Exhibition, 1983. Awards: Helen Smith prize, 1972, Certificate of Merit, 1973, Ralph

Weiler prize, 1975, Catherine Lorillard Wolfe prize, 1976, all at National Academy of Design, NYC. Media: Clay, bronze, and marble. Address in 1983, Northport, NY.

PALL, AUGUSTIN G.
Painter. Born in Hungary in 1882. Member: Chicago Society of Artists. Address in 1926, 19 East Pearson St., Chicago, IL.

PALLADINI, DAVID.
Illustrator. Born in Roteglia, Italy, in 1946. Studied art from 1964 to 1968 at Pratt Institute under Jacob Landau and Gabriel Laderman. He produced a poster for Lincoln Center's Vivian Beaumont Theatre in 1965 and has worked for many major magazines and book companies. He has exhibited illustrations at the American Institute of Graphic Arts, Society of Illustrators and Saks Fifth Avenue Galleries; his works are also in the collection of the Museum of Warsaw, Poland.

PALLENLIEF, ANDREW.
Sculptor. Born in Switzerland in 1824. Working in San Francisco in July 1860.

PALLISON.
A landscape painter, noted in Tuckerman's "American Artist Life."

PALMER, ADELAIDE.
Painter. Born in Orford, NH. Pupil of John J. Enneking. Member: Copley Society, 1893. Address in 1929, 739 Boylston St., Boston, MA; summer, Piermont, NH.

PALMER, ELIZABETH V.
See Bradfield, Elizabeth V. P.

PALMER, ERASTUS DOW.
Sculptor. Born April 2, 1817, in Pompey, Onondaga County, NY. He first executed cameo portraits and later undertook sculpture. Did cameo-cutting in Utica, NY; later modeling in clay. Moved to Albany in 1846 where he had a studio for more than 25 years. All his knowledge was acquired in America, and it was not until he had become famous that he visited Europe. Exhibited: National Academy, 1851. Member: National Academy. Among his best known works are "The Indian Girl," "White Captive," and "Morning and Evening." He was also known for his portrait busts, reliefs, and memorials. One of his pupils was Launt Thompson. He died in Albany, NY, March 9, 1904.

PALMER, FRANCES (FANNY)
FLORA BOND.
(Mrs. Edward S. Palmer). Painter. Born in Leicester, England, in 1812. Came to NYC in early 1840's; worked for Currier & Ives from 1849 for many years. Her specialty was sporting scenes; well known for land and townscapes. Her lithographs were also published by Nathaniel Currier. She was the only woman in her field and was considered one of the best American lithographers. Died Aug. 20, 1876, in New York.

PALMER, FREDRIKKE S(CHJOTH).
Painter. She was born in Drammen, Norway, May 26, 1860. Pupil of Knut Bergslien in Christiania; Carl Gussow in Berlin. Member: New Haven Paint and Clay Club. Staff artist for *Woman's Journal*. Address in 1929, 1450 Kewalo St., Honolulu, HI.

PALMER, HATTIE VIRGINIA YOUNG.
(Mrs. C. F. Palmer). Painter and teacher. Born in Ripley, OH. Pupil of the Cincinnati Art Academy. Member: Houston Art League; Indiana Art Association; Indiana State Ceramic Club; Texas Fine Arts Association; American Artists Professional League; Southern States Art League. Address in 1929, 2616 Albany St., Houston, TX.

PALMER, HERMAN.
Sculptor, painter, illustrator, and etcher. Born in Farmingham, UT, March 17, 1894. Pupil of Mahonri Young. Member: NY Water Color Club. Illustrated *Hidden Heroes of the Rockies*. Address in 1929, 961 Madison Ave., New York, NY.

PALMER, J.
A number of large and fairly well-executed Bible illustrations, published in New York in 1826, are signed "J. Palmer, Sc."

PALMER, JESSIE A.
(Mrs. Carl E. Palmer). Painter, sculptor, and teacher. Born in Lawrence, TX, October 19, 1882. Studied at Dallas Technical College; Broadmoor Art Academy; and with Frank Reaugh, Martha Simkins, and John Carlson. Member: Southern States Art League; Texas Fine Arts Association; Reaugh Art Club; Amarillo Art Association. Awards: Evert Medal, Dallas Woman's Forum, 1924; 1st prize, Texas-Oklahoma Fair, 1926, 27. Work: "Bluebonnets," Travis School, Dallas, TX; "In Colorado," Dallas Woman's Forum. Exhibited: Southern States Art League, 1928, 34, 44, 45; Texas Fine Arts Association, 1930-40; Elisabet Ney Museum, 1935 (one-man); Texas State Fair, 1934; Frank Reaugh Art Exhibition, 1925-46; Dallas Art Association, 1940. Position: Secretary, Frank Reaugh Art Club, Dallas, TX, 1944-46. Address in 1953, Dallas, TX.

PALMER, LEMUEL.
Illustrator, draughtsman and lecturer. Born in Portland, ME, Nov. 1, 1893. Pupil of Richard Andrews; Massachusetts School of Art. Awards: Strathmore award, Springfield Artists Guild, 1927; Milton Bradley award, Springfield Artists Guild, 1928. Address

in 1929, Studio Bldg., 215 Dwight St.; h. 11 Priscilla St., Springfield, MA.

PALMER, LUCIA A.
Painter. Born in Dryden, NY. Prize winner in Paris Exposition, 1900. Member: Woman's National Press Association, Washington, DC. Address in 1926, Park Hill-on-Hudson, New York.

PALMER, MARGARET LONGYEAR.
Sculptor, craftsman, and teacher. Born in Detroit, MI, Aug. 19, 1897. Pupil of John Wilson. Member: Detroit Society of Arts and Crafts; Detroit Society of Women Painters. Award: First prize, Michigan State Fair, 1921. Address in 1933, 2 McKinley Pl., Grosse Pointe Farm, MI; 8103 Agnes Ave., Detroit, MI; summer, Huron Mountain Club, Huron Mountain, MI.

PALMER, PAULINE.
(Mrs. Albert E. Palmer). Painter. Born in McHenry, IL. Pupil of Art Institute of Chicago, Chase, Miller and Hawthorne; Collin, Prinet, Courtois and Simon in Paris. Member: Painters and Sculptors of Chicago (president); Rockford Art Association; Chicago Water Color Club; Chicago Municipal Art League; Chicago Art Guild; Chicago Art Club; Cordon Club; Chicago Alliance; Alumnae Art Institute of Chicago; Painters and Sculptors Gallery Association; Chicago Society of Artists; Illinois Academy of Fine Arts; Grand Central Gallery. Awards: Bronze medal, St. Louis Expo., 1904; Young Fortnightly prize, 1907, Marshall Field prize, 1907, Thompson portraiture prize, 1914, Cahn hon. mention, 1916, Rosenwald purchase prize, 1916, Carr prize, 1917, Butler Purchase Prize, 1920, Fine Arts Building prize ($500), 1924, Rosenwald prize ($300), 1926, all from Art Institute of Chicago; participant in Fine Arts prize, Society of Women Artists, 1915; hon. mention, Chicago Artists Guild, 1915; silver medal, Chicago Society of Artists, 1920; silver medal, Peoria, IL, 1921; hon. mention, National Association of Women Painters and Sculptors, 1924; purchase prize ($500), Chicago Galleries Association, 1928, and prize ($400), 1929. Represented in permanent collections of West End Woman's Club, Municipal Art League collection at Art Institute of Chicago, Nike Club, Klio Association and Arche Club, all of Chicago; public school collection of Decatur, IL; Muncie (IN) Art Association; "Village by the Sea" and "The Gingham Girl," Chicago Municipal Commission; Aurora (IL) Art Association; Rockford (IL) Art Association; Rogers Park Woman's Club; Springfield (IL) Art Association; Delgado Museum of Art, New Orleans; Aurora (IL) Art League; San Diego Museum; Academy of Fine Arts, Elgin, IL. Died in 1938. Address in 1929, 4 East Ohio St., Chicago, IL; summer, 5 Webster Pl., Provincetown, MA.

PALMER, WALTER L(AUNT).
Landscape painter. Born in Albany, Aug. 1, 1854; son of the sculptor, Erastus Dow Palmer. Pupil of F. E. Church at Hudson, NY; Carolus-Duran in Paris. Member: Society of American Artists, 1881; Associate National Academy of Design, 1887; Academician National Academy of Design, 1897; NY Water Color Club; American Water Color Society; Salma. Club, 1901; Pastel; Century Association; American Federation of Arts; Union Inter. des Beaux-Arts et des Lettres; NY State Fine Arts Commission. Awards: Second Hallgarten prize, National Academy of Design, 1887; medal, Columbian Expo., Chicago, 1893; gold medal, Art Club of Philadelphia, 1894; Evans prize, American Water Color Society, 1895; second prize, Tennessee Centennial Expo., Nashville, 1897; hon. mention, Paris Expo., 1900; silver medal for water color, Pan.-Am. Expo., Buffalo, 1901; silver medal for water color, Charleston Expo., 1902; silver medal for water color and bronze medal for oil, St. Louis Expo., 1904; silver medal, Philadelphia, 1907; bronze medal, Buenos Aires Expo., 1910; Butler prize, Art Institute of Chicago, 1919; Du Pont prize, Wilmington, 1926 and 1928. Specialty: Winter landscapes. Work: "Sundown At Walpole, NH," Buffalo Fine Arts Academy, Buffalo, NY; "The Pasture Fence," Public Gallery, Richmond, IN; "Lingering Oak Leaves," Omaha (NE) Art Society; "Under the Pines," Memorial Art Gallery, Rochester, NY; "Silent Dawn," and "La Salute at Noon," Metropolitan Museum of Art; "The Dell," Art Museum, Youngstown, OH; "An Upland Stream," Museum of Fine Arts, Boston, MA. Address in 1929, 409 State Street, Albany, NY. Died April 16, 1932 in Albany, NY.

PALTENGHI, A.
Sculptor. Worked at New Orleans, 1854-56; San Francisco, 1856-60.

PALULIAN, DICKRAN P.
Illustrator. Born in Pontiac, Michigan, in 1938. Studied for two years at the Society of Arts and Crafts in Detroit and began his career there in 1958. The recipient of awards from the Michigan Watercolor Show, Detroit Art Directors' Club and Graphic Artists Guild of Detroit, he has illustrated for many magazines and has often exhibited his work in the Detroit area.

PANCOAST, HENRY B., JR.
Painter. Exhibited "Landscape" at the Penna. Academy of Fine Arts, Philadelphia, PA, 1924. Address in 1926, 2201 Chestnut St., Philadelphia, PA.

PANCOAST, MORRIS HALL.
Painter and illustrator. Born in Salem, NJ, April 27, 1877. Pupil of Penna. Academy of Fine Arts under Anshutz; Julian Academy under Laurens in Paris. Member: Fellowship Penna. Academy of Fine Arts;

Salma. Club; Philadelphia Alliance; North Shore Arts Association; Connecticut Academy of Fine Arts. Award: Gold medal, Fellowship Penna. Academy of Fine Arts, 1924. Work: "Pennsy Train Shed," Penna. Academy of Fine Arts, Philadelphia; "Easter Snow Storm," Municipal Art League, Williamsport, PA; "The Edge of a New England Village," Houston Art Museum; "Portuguese Hill," Museum of Fine Arts, Reading, PA; drawings in Milwaukee Art Institute. Address in 1929, 47 Fifth Ave., New York, NY; summer, Rockport, MA.

PANDICK, JOHN.
Painter. Exhibited at Philadelphia, PA, 1921, in "Exhibition of Paintings Showing Later Tendencies in Art." Address in 1926, Fanwood, NJ.

PAOLO, CARTAINO S.
Sculptor. Born in Italy in 1882. Pupil of American Academy in Rome. Work: Bust of Ex-Governor MacCall in Boston State House; Cardinal O'Connell in Boston Cathedral; marble memorial in Cathedral of St. John the Divine, New York. Address in 1926, 80 Washington Square, New York City.

PAPASIAN, JACK CHARLES.
Sculptor and artist. Born in Olympia, Greece, June 27, 1878. Pupil of Antonio Dal Zotto of Venice and Ettore Ferrari of Rome. Member: National Sculpture Society. Work: "The Golden Age of Greece," property of the Greek Government. Address in 1933, 243 East 24th St.; h. 93 Lexington Avenue, NYC. Died in 1957.

PAPE, ALICE MONROE.
(Mrs. Eric Pape). Painter. Born in Boston, MA. Died May 17, 1911 in Manchester, MA.

PAPE, ERIC.
Painter and illustrator. Born in San Francisco, CA, Oct. 17, 1870. Pupil of Emil Carlsen in NY; Ecole des Beaux-Arts in Paris under Gerome, Constant, Lefebvre, Doucet and Delance. Member: United Arts Club, London; Royal Society of Arts, London; Atlantic Union, London; North British Academy; Players Club, NY. Director, Eric Pape School of Art, 1898 to 1913. Awards: Five medals and diplomas at various exhibitions. Illustrations for *The Fair God, The Scarlet Letter, The Life of Napoleon Bonaparte, Life of Mahomet, Poetical Works of Madison Cawein,* portraits for *The Memoirs of Ellen Terry.* Monument at Stage Fort Park, Gloucester, commemorating founding of Massachusetts Bay Colony, 1623. Director of pageants, "The Canterbury Pilgrims," Gloucester, MA, 1908, and "The Flowers of the Sea," Lookout Hill, MA, 1912. Died in 1938. Address in 1929, "The Plains," Manchester by-the-Sea, MA; and the Players, Gramercy Park, NY.

PAPPRILL, HENRY.
This engraver in aquatint produced at least two very large plates. One shows New York as seen from Governor's Island; the other is a most interesting and detailed view over the city from the steeple of St. Paul's Church. The first was engraved from a sketch made by F. Catherwood, and the other from a drawing by J. W. Hill. These plates were published in New York in 1849, and the view from St. Paul's steeple was reissued in 1855 with many changes in the buildings shown. There were also several editions of the other plate.

PAQUET, ANTHONY C.
Engraver. Born in Hamburg, Germany, in 1814; died in 1882 in Philadelphia, PA. Paquet came to the United States in 1848 and found employment here as a die-sinker. From 1857 until 1864 he was assistant engraver of the U.S. Mint in Philadelphia. He engraved the dies for medals of Buchanan, Everett, Grant, and Johnson, among others.

PARADISE, JOHN.
Painter. Born Oct. 24, 1783 in New Jersey. He became a member of the National Academy of Design upon its formation in 1826. He painted many portraits of Methodist divines, his drawings being correct but his ability as an artist not very high. His son John W. Paradise was an admirable engraver of portraits. Died Nov. 26, 1833/34 in NYC or Springfield, NJ.

PARADISE, JOHN WESLEY.
Engraver and portrait painter. Born in Hunterdon County, New Jersey in 1809. John W. Paradise was the son of John Paradise, an American portrait-painter who was born in 1783 and died in 1833 or 1834. The son was a pupil of Asher B. Durand and in time became an admirable line-engraver of portraits. He was one of the founders of the National Academy in 1826. Later in life, John W. Paradise was chiefly employed as a banknote engraver, and he was working in this branch of his profession up to the time of his death. Died August 17, 1862, in NYC.

PARADISE, PHILIP HERSCHEL.
Painter, sculptor, illustrator, graphic artist and teacher. Born in Ontario, Oregon, 1905. Studied at Chouinard Art Institute, Los Angeles; with F. Tolles Chamberlain, Rico Lebrun, and Leon Kroll. Taught at Chouinard, 1932-40; film art director at Paramount Studios, 1941-48; lecturer at University of Texas at El Paso, and Scripps College; director of the Cambria Summer Art School. Illustrated for magazines, including *Fortune, Westways, True.* Work in Library of Congress; Penna. Academy of Fine Arts; Cornell University; Spokane Art Association. Member: National Academy (aquarellist). Specialties include Western subjects. Address in 1976, Cambria, California.

PARAMINO, JOHN FRANCIS.
Sculptor and writer. Born in Boston, December 25, 1888. Pupil of Augustus Saint-Gaudens and Bela L. Pratt; Boston Museum of Fine Arts School. Member: Boston Guild of Artists; Copley Society, Boston. Awards: Medal, Massachusetts Horticultural Society, 1929. Work: Sculpture, bas-reliefs, memorials, monuments, busts: State House, Boston, MA; World War II Memorial, Four Freedoms Memorial, Boston; A. Platt Andrew Memorial, Gloucester, MA; Plymouth, MA; Hall of Fame, New York University; Boston Commons; Cambridge, MA; Boston University Law School; Harvard University; others. Publications: "Sculpture as a Medium of Expression," 1945. Address in 1953, Wellesley Hills, MA.

PARCELL, L. EVANS.
Illustrator. Member: Society of Illustrators. Address in 1929, 116 Duncan Ave., Washington, PA.

PARCELL, MALCOLM (STEPHENS).
Painter and etcher. Born Jan. 1, 1896. Pupil of Carnegie School of Fine Arts. Member: Pittsburgh Art Association. Awards: Saltus gold medal, National Academy of Design, 1920. Work: "In a Pensive Mood," "Old Gate, Trinity Hall," Butler Art Institute, Youngstown, Ohio. Address in 1929, care of the Macbeth Galleries, 450 Fifth Ave., New York, NY; Casino Bldg., Main St., Washington, PA.

PARIS, HAROLD PERSICO.
Sculptor. Born in Edgemere, NY, Aug. 16, 1925. Studied at Atelier 17, NYC, 1949; Creative Graphic Workshop, NYC, 1951-52; Academy of Fine Arts, Munich, 1953-56. Works: California Palace; University of California; Art Institute of Chicago; Library of Congress; Museum of Modern Art; NY Public Library; Oakland Art Museum; Ottawa (National); Brooks Memorial Art Gallery, Memphis, TN; Philadelphia Museum of Art; San Francisco Museum of Art; Whitney; La Jolla Museum; Art Institute of Chicago; others. One-man exhibitions: Hansen Gallery, San Francisco; Mills College, Oakland, CA; Reed College, Portland, OR; Sally Judd Gallery, Portland, OR; Studio Marconi, Milan, Italy. Group exhibitions: Argent Gallery, NYC; Philadelphia Art Alliance; Village Art Center, NYC; Wittenborn Gallery, NYC; Pratt Graphic Art Center; Paul Kantor Gallery, Beverly Hills, CA; Bolles Gallery, 1962 (two-man, with Angelo Ippolito); Metropolitan Museum of Art; Boston Museum of Fine Arts; Vienna Sezession; The Hague; Amerika Haus, Munich; California Palace; Baltimore Museum of Art; Smithsonian; Delgado; Pasadena Art Museum; Brooklyn Museum; Penna. Academy of Fine Arts; Galerie Kunst der Gengenwart, Salzburg; Museum of Modern Art; Philadelphia Museum of Art; San Francisco Museum of Art; III Biennial of Spanish-American Art, Barcelona; Salon de las Jeune Sculpture, Paris; Whitney; France (National); San Fran-

cisco Art Institute; New School for Social Research; M. Knoedler & Co., Art Across America; Los Angeles County Museum of Art; others. Awards: L. C. Tiffany Grant, 1949; Guggenheim Foundation Fellowship, 1953; Fulbright Fellowship (Germany), 1953; San Francisco Art Association, 1963, 64; University of California, Creative Arts Award and Institute Fellowship, 1967-68. Member: San Francisco Art Association; Society of American Graphic Artists, NY. Address in 1970, Oakland, CA.

PARIS, WALTER.
Painter. Born Feb. 28, 1842 in London, England. Specialty: Water color painting. He died in Washington, DC, on Nov. 26, 1906.

PARIS, W(ILLIAM) FRANCKLYN.
Mural painter, architect, writer and lecturer. Born in New York. Pupil of Art Students League of NY; Julian Academy in Paris; Salvi in Rome. Member: NY Architectural League, 1898; National Sculpture Society (lay); Century Association; Museum of French Art (board of trustees); Artists Aid Society; Alliance; Societe Histoire d'Art Francaise; Societe Gens de Lettres de France; hon. fellow for life, Metropolitan Museum of Art, NY. Awards: Legion of Honor of France; Knight of the Crown of Belgium; made "Knight of the Crown of Italy," 1924. Author: *Rodin as a Symbolist; Biography of Albert Besnard; The French Institute and American Art; Modern Gobelin Tapestries; Decorative Elements in Architecture; The House That Love Built;* etc. Lecturer at University of Pennsylvania; Vassar College; St. John's College; University of Maryland; Cornell University. U.S. Commissioner of Decorative Art, Paris Expo., 1900. Address in 1929, 7 East 48th St.; h. 11 East 68th St., New York, NY.

PARISSEN, OTTO.
Engraver. Born in 1723. A silversmith and engraver on silver, he also designed the ornaments on the silverware he made. He was a native of Prussia and resided in New York City. His son painted miniatures. Died Jan. 17, 1811, in New Rochelle, NY.

PARISSEN, PHILIP.
Miniature painter, silhouettist, silversmith, and hairworker. Flourished in 1798-1812 in New York. He was the son of a silversmith, Otto Parissen, who came from Prussia. Visited Charleston, SC, 1795, as a drawing teacher. Died in 1822. Also listed as Parisen and Parisien.

PARISSEN, WILLIAM D.
Miniature and portrait painter. Born in February, 1800 in NYC. Son of Philip Parissen. Exhibited at the American Academy in 1816. In Charleston, SC, 1818-19; ran a drawing academy in 1819 with a Mr. Hinckley. Spent the rest of his life in NYC, exhibiting occasionally at the American Academy and the National Academy. Died April 9, 1832.

PARK, ASA.
Portrait painter, who flourished about 1800, and died in 1827, in Lexington, Kentucky. Also painted still life.

PARK, MADELEINE F.
Sculptor. Born in Mt. Kisco, NY, July 19, 1891. Studied at Blair Academy; Art Students League, 1909; also with Frederick V. Guinzburg, Alexander P. Proctor, Naum Los, and Lawrence T. Stevens. Awards: 1st Prize, American Women's Association, 1933; 1st prize, Hudson Valley Art Association, 1944, 52, 53; Malvina Hoffman Award, Pen and Brush Club, 1938; Anna Hyatt Huntington first prize, 1954; 1st prize, Catherine Lorillard Wolfe Art Club, 1957; honorable mention, National Academy of Design, 1958; 1st prize, American Artists Professional League, 1959; others. Specialized in wild and domestic animal sculpture. Work: F. D. Roosevelt Library, Hyde Park, NY; Rochester Memorial Museum, Rochester, NY; National Hall of Fame for Famous American Indians, Anadarko, OK; Brookgreen Gardens, SC; Gertrude Vanderbilt Whitney Gallery of Western Art, Cody, WY; Racing Museum, Goshen, NY; Somers Historical Society Circus Museum, Somers, NY. Exhibited: Paris Salon; National Academy of Design; Pennsylvania Academy of Fine Arts; Art Institute of Chicago; San Francisco Museum of Art; Whitney; Metropolitan Museum of Art; Speed Memorial Museum; Arnot Art Gallery; many more; one-woman exhibitions in Paris, France; Rome, Italy; Memphis, TN; Oxford, MA; Gainesville, FL; Spartanburg, SC; Charlotte, NC; Louisville, KY; Buffalo, Rochester, Utica, and Cortland, NY; Springfield, IL; many more. Member: National Sculpture Society (fellow), 1936; National Association of Women Artists; Allied Artists of America; Associate National Academy of Design, 1960; Pen and Brush Club, 1933; others. Address in 1953, Katonah, NY. Died in April, 1960.

PARK, RICHARD HENRY.
Sculptor. Born in NYC, 1832. Worked in Florence, Italy, in 1890. In collections of the Metropolitan Museum of Art, NYC. Died after 1890.

PARKE, JESSIE BURNS.
Painter, illustrator, and etcher. Born in Paterson, NJ, Dec. 2, 1889. Pupil of Mary Morgan in Paterson, NJ; School of Applied Design for Women, New York; School of the Boston Museum of Fine Arts. Member: Alliance; American Federation of Arts. Work: Portrait of Dean Roscoe Pound of Harvard Law School, Northwestern University, Evanston, IL. Address in 1929, 121 Newbury St., Boston, MA; h. Robbins Road, Arlington Heights, MA.

PARKER, ALFRED CHARLES.
Illustrator. Born in St. Louis, MO, in 1906. Studied at the St. Louis School of Fine Arts of Washington University and came to NY in the mid-1930's. His illustrations depicting mothers and daughters for *Cosmopolitan* and *Ladies' Home Journal* were trendsetters of the era. Since his first assignment in 1933 for *Woman's Home Companion*, his illustrations have appeared in women's magazines and have earned him a number of awards, including election to the Society of Illustrators Hall of Fame in 1965. He has served as president of the Westport Artists and as a founding faculty member of the Famous Artists School. His artwork has been exhibited in the U.S. and Canada and is in many major collections. A longtime resident of NY and Westport, he now resides in Carmel Valley, CA.

PARKER, A(NNA) B(ENEDICT).
(Mrs. Neilson T. Parker). Painter. Member: National Association of Women Painters and Sculptors; National Arts Club. Address in 1929, Woodstock, NY.

PARKER, CHARLES H.
Engraver. Born in Salem, MA, about 1795; died in Philadelphia in 1819. Parker was a pupil of Gideon Fairman. He worked in Europe for a time, and about 1812 he was in business as an engraver in Philadelphia. He is referred to as the "best engraver of script, maps and ornament of his time." He was the engraver of the beautiful script on the title-page of the *Analectic Magazine*, of Philadelphia, and did considerable work of this character.

PARKER, CORA.
Painter and illustrator. Born in Kentucky. Pupil of Cincinnati Art School; Julien Academy in Paris. Member: Greenwich Society of Artists. Work: "Blue Waters of Gloucester," Kansas City (MO) Art Club; "Prune Orchard, California," Nebraska Art Association, Lincoln. Address in 1933, Coral Gables, FL.

PARKER, CUSHMAN.
Illustrator. Born in Boston, MA, April 28, 1881. Pupil of Laurens and Carl Marr. Member: Society of Illustrators; Artists Guild of the Authors' League of America, NY. Designer of covers for *Saturday Evening Post, McCall's, Collier's*, etc. Address in 1929, Woodstock, Ulster Co., NY; Onset, MA.

PARKER, EDGAR.
Portrait painter. Born in Framingham, Massachusetts in 1840. He spent his professional life in Boston. Three of his portraits are in Faneuil Hall (Sumner-Wilson and Winslow); Whittier gave him sittings in 1875. He painted "Embarkation of the Pilgrims," after Weir.

PARKER, EMMA ALICE.
Painter and illustrator. Born in Gardner, MA, in 1876. Pupil of Sydney R. Burleigh, Robert Henri, F. V. DuMond and of H. R. Poore. Member: Providence Water Color Club. Address in 1926, 42 College St., Providence, RI.

PARKER, GEORGE.

Engraver. Born in England, he was engraving excellent stipple portraits in London in 1832. He came to the United States about 1834 to work for Longacre and Herring on "The National Portrait Gallery" plates, and he seems to have remained continuously in this country until his death, which occurred about 1868. Parker engraved a considerable number of good portraits.

PARKER, GEORGE WALLER.

Painter, craftsman, designer, and teacher. Born in Gouverneur, New York, NY, Sept. 17, 1888. Pupil of Brown University, Ph.B.; Art Students League; Grande Chaumiere, Paris, France. Member: Salma. Club; Portland Art Society; Societe Coloniale des Artistes Francaise; Audubon Artists; Allied Artists of America; Fine Arts Federation of NY. Award: Plaquette de Grand Prix, Exposition Coloniale, Strasbourg, 1924. Work: "Village Indigene, Tougourt," Memorial Art Gallery, Rochester; "Moonlight in Andalusia," Newark Museum, Newark, NJ; "Three Birches," Portland Museum, Portland, ME; L. D. M. Sweat Memorial Museum; NY Historical Society; Saranac Lake Public Library; U.S. Navy Building, Washington, DC; Baltimore Museum of Art; others. Exhibitions: National Academy of Design; Penna. Academy of Fine Arts; Kansas City Art Institute; Paris Salon; Springfield Museum of Art; Art Institute of Chicago; Rochester Memorial Art Gallery; numerous one-man exhibitions including those in New York, Cincinnati, Chicago, Cleveland, etc. Address in 1953, Salmagundi Club, 47 Fifth Avenue, New York, NY.

PARKER, HARRY HANLEY.

Sculptor and mural painter. Born in Philadelphia, PA, on November 29, 1869. Studied at Penna. Academy of Fine Arts. Member: Fellowship Penna. Academy of Fine Arts; Philadelphia Sketch Club; T Square Club. Died March 16, 1917, in Philadelphia, PA.

PARKER, JOHN ADAMS.

Painter. Born Nov. 29, 1829, in New York City. He was elected an Associate of the National Academy in 1869. Mountain scenery has claimed his attention, and the Adirondacks, Catskills, and White Mountains have furnished him subjects for most of his pictures. Died c. 1905.

PARKER, JOHN F.

Sculptor and painter. Born in New York City, May 10, 1884. Pupil of Henri in New York; studied in England; and with Laurens and Steinlen in Paris. Member: Artists Guild of America; Alliance; Salma. Club. Award: Whitney prize, Labor Competition. He directed a pageant of the City History Club, NY, 1916; also the Westfield 200th Anniversary Pageant; etc. Represented in National Gallery, Washington, DC; Valley Forge Museum of American History. Address in 1926, 401 Convent Ave., NYC.

PARKER, LAWTON S.

Portrait painter and teacher. Born in Fairfield, MI, Aug. 7, 1868. Pupil of Gerome, Laurens, Constant, Besnard and Whistler in Paris; Chase in NY. Instructor, St. Louis School of Fine Arts, 1892; director of fine arts, Beloit College, 1893; president, NY School of Art, 1898-89; director of Parker Academy, Paris, 1900; non-resident professor, Art Institute of Chicago, 1902; president, Chicago Academy of Fine Arts, 1902. Member: Associate National Academy of Design, 1916; Chicago Society of Artists; American Art Association of Paris; National Arts Club. Awards: John Armstrong Chandler five-year European Scholarship, 1896; hon. mention, Paris Salon, 1900; third medal, Paris Salon, 1902; silver medal, St. Louis Expo., 1904; gold medal, International Expo., Munich, 1905; hon. mention, Carnegie Institute, Pittsburgh, 1907; first medal, Chicago Society of Artists, 1908; Cahn prize, Art Institute of Chicago, 1909; gold medal, Paris Salon, 1913; medal of honor, P.-P. Expo., San Francisco, 1915; Altman prize, National Academy of Design, 1916. Work: President Harry Pratt Judson and Martin A. Ryerson, Chicago University; Judge Peter S. Grosscup and Judge James G. Jenkins, U.S. Court of Appeals, Washington; "Portrait of a Lady," Art Institute of Chicago; "The Masquerader," "Sous Bois," Harrison Gallery, Los Angeles Museum. Address in 1933, Chateaux d'Andecy, Pailly 'Oise, France.

PARKER, LIFE, JR.

Portrait painter, sculptor, marble and stone engraver. Born c. 1822. Active 1837. Employed by Major Benjamin Day in Lowell, MA, between 1837 and 1847.

PARKER, NEILSON R. (MRS.).

See Steele, Zulma.

PARKER, RAYMOND.

Painter. Born in Beresford, SD, August 22, 1922. Studied: University of Iowa, B.A., 1946, M.F.A., 1948. Work: Museum of Modern Art; Whitney Museum; Guggenheim; Metropolitan Museum of Art; Brandeis University; Albright-Knox Art Gallery, Buffalo, NY; Art Institute of Chicago; Wadsworth Atheneum; Los Angeles County Museum of Art; Aldrich Museum, Ridgefield, CT; Tate Gallery, London, England; many others. One-man exhibitions: Walker Art Center, Minneapolis, MN, 1950; Brooks Memorial Art Gallery, Memphis, TN, 1953; Paul Kantor Gallery, Beverly Hills, CA, 1953, 56; J. B. Speed Art Museum, Louisville, KY, 1954; Dwan Gallery, 1960, 62; Kootz Gallery, NY, 1960-66; Guggenheim Museum, 1961; others. Group exhibitions: Metropolitan Museum of Art, 1950; Walker Art Center, 1955, 60; Seattle World's Fair, 1962; Corco-

ran, 1963; Jewish Museum, 1963; Wadsworth Athenaeum, 1964; Art Institute of Chicago, 1964; Dayton Art Institute, OH, 1965 (retrospective); San Francisco Museum of Art, CA, 1967; School Of Visual Arts, NY, 1971; Museum of Modern Art, NY, 1968, 71; others. Awards: Ford Foundation Purchase Award, Corcoran Biennial, 1963; National Council on the Arts Award, 1967; Guggenheim Fellowship, 1967, 81. Teaching art at Hunter College, from 1955. Media: Oils. Address in 1984, 101 Prince Street, New York, NY.

PARKER, ROBERT ANDREW.
Illustrator. Born in Norfolk, VA, in 1927. Attended the Art Institute of Chicago and Atelier 17 in NY before beginning his career in 1954. His watercolors and etchings have since appeared in *Fortune, Sports Illustrated, Travel and Leisure,* and *The Lamp.* In 1976 he produced a poster, entitled "Third Century," for Mobil Oil. His paintings have been part of exhibitions at the Whitney Museum, Museum of Modern Art and Los Angeles County Museum.

PARKER, STEPHEN HILLIS.
Portrait painter. Born in 1852. He was a friend of John Singer Sargent and a fellow-pupil in Paris. He made his home for years in New York City, but lived in Italy and France for the last thirteen years of his life, and did little or no painting. He died in Florence, Italy on May 17, 1925.

PARKER, THOMAS H.
Miniature painter. Born in Sag Harbor, Long Island, in 1801. He studied under Rogers in New York, and later removed to Hartford, CT, where he became most popular in his profession; he was painting there in 1829. He died after 1851.

PARKER, WENTWORTH.
Painter and etcher. Born in Terre Haute, IN, Oct. 11, 1890. Pupil of William Forsyth. Address in 1929, 815 South 6th St.; Terre Haute, IN.

PARKHURST, ANITA.
(Mrs. Willcox). Painter and illustrator. Born in Chicago, Nov. 11, 1892. Pupil of Art Institute of Chicago. Member: Artists Guild of the Authors' League of America, NY; Society of Illustrators. Covers for *Saturday Evening Post, Collier's,* etc. Address in 1929, Box 44, Tompkinsville, SI, NY; Ocean Terrace, Dongan Hills, SI, NY.

PARKHURST, C. E.
Illustrator. Born in Toledo, OH, in 1885. Pupil of Vanderpoel, Freer and Armstrong. Member: New York Architectural League. Award: Three honorable mentions, Art Institute of Chicago, 1906. Address in 1926, 63 East 59th St., New York, NY.

PARKHURST, THOMAS SHREWSBURY.
Landscape painter and illustrator. Born Aug. 1, 1853 in Manchester, England. Self-taught. Member: Toledo Tile Club; National Arts Club. Work: "October Skies" and "The Spirit of the Maumee," Toledo Museum of Art; "Landscape," Grand Rapids Art Association; "Chariot of the Sky," Oakland (CA) Art Museum; represented in Lima (OH) Art League; Des Moines (IA) Art Club; Oklahoma Art League. Died in Carmel, CA, in 1923.

PARKMAN.
A landscape painter noted in Tuckerman's "American Artist Life."

PARKS, CHARLES CROPPER.
Sculptor. Born in Onancock, VA, June 27, 1922. Studied: Penna. Academy of Fine Arts. Work: Commissions for H. B. du Pont, Wilmington, DE; Byrnes Foundation, Columbia, SC; Brandywine River Museum; Mystic Seaport Museum; Equitable Building, NYC. Exhibitions: National Sculpture Society Annual, 1962-77; National Academy of Design, 1965-77; and others. Awards: Wemys Foundation Travel Grant, Greece, 1965; American Artists Professional League, gold medal, 1970; National Sculpture Society, gold medal, 1971; others. Member of Advisory Committee, John F. Kennedy Center, from 1968; Fellow National Sculpture Society (president, 1976-78); Allied Artists of America; National Academy of Design; Delaware State Arts Council. Address in 1984, Wilmington, DE.

PARKYNS, GEORGE ISHAM.
Born c. 1750. This English artist and designer for engravers came to Philadelphia about 1795. His only known print is a large and good aquatint view of Mount Vernon. He is said to have been employed by T. B. Freeman, the Philadelphia publisher of books and prints. Died c. 1820.

PARRISH, CLARA WEAVER.
(Mrs. Wm. P. Parrish). Painter and etcher. Born in Selma, AL. Pupil of Art Students League of New York, under Chase, Mowbray, Cox and J. Alden Weir; under Collin in Paris. Member: New York Water Color Club; National Association of Women Painters and Sculptors; National Arts Club. Awards: Watrous prize, NY Women's Art Club, 1902 and 1913; silver medal, Appalachian Exposition, Knoxville, 1910; silver medal, Panama-Pacific Exposition, San Francisco, 1915. Died Nov. 13, 1925 in NYC.

PARRISH, MAXFIELD FREDERICK.
Painter and illustrator. Born in Philadelphia, PA, July 25, 1870; son of Stephen Parrish. Pupil of Haverford College; Penna. Academy of Fine Arts; and with Howard Pyle. Had studio in Philadelphia for many years. Member: Society of American Artists, 1897; Associate National Academy of Design,

1905; Academician National Academy of Design, 1906; Fellowship Penna. Academy of Fine Arts; Philadelphia Water Color Club (hon.). Awards: Hon. mention, Paris Expo., 1900; silver medal for drawings, Pan-Am. Expo., Buffalo, 1901; Beck prize, Philadelphia Water Color Club, 1908; gold medal, NY Architectural League, 1917. Illustrated for magazines; did advertisements; illustrated Arizona desert life for *The Century*; later worked on landscape murals. Designed own home in Windsor, VT. Died in 1966. Address in 1929, Windsor, VT.

PARRISH, STEPHEN WINDSOR.
Painter and etcher. Born in Philadelphia, PA, July 9, 1846. Member: Royal Society of Painter-Etchers, London; NY Etching Club. Work: "The Break-up of Winter, Cornish, NH," painting, Toledo Museum of Art; "Winter at Trenton, NJ," Carnegie Institute, Pittsburgh. Died in 1938. Address in 1929, Windsor, VT.

PARROTT, WILLIAM SAMUEL.
Painter of western scenery. Born in 1844 in Missouri. He went West in 1847, and died at Goldendale, Washington, in May, 1915.

PARSELL, ABRAHAM.
Miniature painter, who flourished in 1825-47 in New York. Born c. 1792 in New Jersey. Probably the father of John H. Parsell.

PARSELL, JOHN H.
Miniature painter, who flourished in 1846-47 in New York.

PARSHALL, De WITT.
Landscape painter. Born in Buffalo, NY, Aug. 2, 1864. Pupil of Cormon; Alexander Harrison; Julian Academy, Paris; Hobart College. Member: Associate National Academy of Design, 1910; Academician National Academy of Design, 1917; Allied Artists of America; Society of Men Who Paint the Far West; International Society of Arts and Letters; Lotos Club (life); Century Association; National Arts Club (hon.); MacDowell Club; California Art Club; Society of Independent Artists; Painters of the West; American Federation of Arts. Awards: Gold medal, Painters of the West, 1928; prize, All-California Exhibition, 1934. Work: "Catskills" and "Great Abyss," Metropolitan Museum of Art, New York; "Granite Gorge," Toledo (OH) Museum of Art; "Isis Peak," Syracuse (NY) Museum of Fine Arts; "Hermit Creek Canyon," Worcester Museum of Art; "Grand Canyon," Detroit Institute of Arts; "Platform Rock," Hackley Gallery of Fine Arts, Muskegon, MI; "Night - Grand Canyon," Fine Arts Gallery, San Diego, CA; Seattle Art Museum. Address in 1953, Santa Barbara, CA. Died in 1956.

PARSHALL, DOUGLASS EWELL.
Painter. Born in New York, NY, Nov. 19, 1899. Pupil of De Witt Parshall. Member: Associate National Academy of Design, 1927; California Art Club; Painters of the West. Awards: Silver medal, Painters of the West; second Hallgarten prize, National Academy of Design, 1924 and 1927; gold medal, Painters of the West, Los Angeles, 1926; first hon. mention, Painters and Sculptors, Los Angeles Museum, 1927. Represented by "Marine," Syracuse Museum; "Troops Entering Arras," National Gallery, Washington, DC; "Great Surge," Reading (PA) Museum; "Fiesta at Taos," Kansas City Museum; "Freight Yards," San Diego Museum; "Sycamore and River," Detroit Museum. Address in 1929, Santa Barbara, CA.

PARSONS, CHARLES.
Born in Hampshire, England on May 8, 1821. He came to this country at an early age. Studied with George Endicott in NYC. He painted in oil and water color, besides having learned the art of lithograpy. He was elected an Associate Member of the National Academy of Design, and of the New York Water Color Society. Died Nov. 9, 1910, in Brooklyn, NY.

PARSONS, DAVID GOODE.
Sculptor, painter, illustrator, teacher, and lecturer. Born in Gary, IN, March, 2, 1911. Studied at Art Institute of Chicago; University of Wisconsin, B.S. in Art Education, M.S. in Art Education. Member: Wisconsin Painters and Sculptors; Wisconsin Art Federation. Awards: Prizes, Wisconsin Salon, 1938, 44, 45; Hoosier Salon, 1939; Wisconsin Painters and Sculptors, 1941; Virginia Museum of Fine Arts, 1943. Exhibited: Art Institute of Chicago, 1935-40, 46; Penna. Academy of Fine Arts, 1940, 46; NY World's Fair, 1939; Grand Rapids Art Gallery, 1939; Carnegie Institute, 1940; Wisconsin Salon, 1934-41, 43, 45; Wisconsin Painters and Sculptors, 1933, 36-41; Virginia Museum of Fine Arts, 1943; Hoosier Salon, 1935, 38, 39; University of Wisconsin, 1940; Houston Museum of Fine Arts, 1953, 54; Joslyn Art Museum, Omaha, 1967; others. Lectures: Contemporary American Sculpture. Position: Surgical Artist for Plastic Surgery, U.S. Army, 1944-47; professor of sculpture and drawing, Rice University, from 1953. Address in 1982, Houston, TX.

PARSONS, EDITH BARRETTO STEVENS.
Sculptor. Born in Houston, VA, July 4, 1878. Pupil of Art Students League of New York under French and Barnard. Member: National Association of Women Painters and Sculptors; National Sculpture Society. Work: Memorial fountain to John Galloway, Public Park, Memphis; figures for Liberal Arts Building, St. Louis; memorial monument, St. Paul; "Duck Girl," Metropolitan Museum; Monument to Soldiers of World War, Summit, NJ. Address in 1933, 13 Van Dam St., New York, NY; summer, Quogue, LI, NY. Died in 1956.

PARSONS, ETHEL M.
Painter. Member: National Society of Mural Painters, NY. Address in 1929, 2 East 81st St., New York, NY.

PARSONS, THEOPHILUS.
Painter and writer. Born in New York, NY, June 20, 1876. Pupil of John Carlson. Member: Washington Society of Artists; Washington Art Club. Address in 1933, 1620 P St., N.W., Washington, DC; summer, Nonquitt, MA.

PARTEE, McCULLOUGH.
Illustrator, designer, painter, cartoonist, and teacher. Born in Nashville, TN, Feb. 19, 1900. Studied: Chicago Academy of Fine Arts; Art Institute of Chicago; Art Students League; National Academy of Design; Grand Central School of Art; pupil of Pruett Carter, Dunn, Reynolds, and Hawthorne. Illustrations for *Liberty; Colliers; Country Gentlemen; People's Home Journal.* Art editor, *Southern Agriculturist,* Nashville, TN, from 1935. Address in 1953, 1523 Broad Street; h. 2116 West Linden Avenue, Nashville, TN.

PARTINGTON, RICHARD L.
Painter. Born in England in 1868. Member of San Francisco Art Association. Address in 1926, 1713 Sansom St., Philadelphia, PA.

PARTON, ARTHUR.
Landscape painter. He was born at Hudson, NY, March 26, 1842, and studied in Philadelphia under William T. Richards. In 1869 he visited Europe and obtained some effective studies of Scotch and English scenery. He was elected a National Academician in 1884, and was a member of the American Water Color Society. Represented in the Metropolitan Museum; also exhibited in Paris, in 1889. He died March 7, 1914, in Yonkers, NY.

PARTON, ERNEST.
Landscape painter. Born in Hudson, NY, March 17, 1845. Member: Artists Fund Society; Royal Institute of Painters, London. Awards: Honorable mention, Paris Exposition, 1889, 1900. Has resided in England since 1873. Died September 16, 1933. Address in 1929, 86 Goldhurst Terrace, London, NW, England.

PARTON, HENRY WOODBRIDGE.
Painter. Born in Hudson, NY, in 1858. Member: Academician National Academy of Design; Painters and Sculptors Gallery Association; Salma. Club, 1889; Century Association; American Federation of Arts; National Arts Club. Awards: Small picture prize, National Arts Club, 1928; William C. Gregg purchase prize, National Arts Club, 1929. Represented in University of Nebraska, Lincoln, NE; Reading Museum, Reading, PA. Address in 1929, 119 East 19th St., New York, NY.

PARTRIDGE, CHARLOTTE RUSSELL.
Painter, lecturer and teacher. Born in Minneapolis, MN. Pupil of Emma M. Church, John Carlson, Art Institute of Chicago. Member: American Federation of Arts. Director, Layton Art Gallery. Founder and director, Layton School of Art. Address in 1929, Layton Art Gallery, 438 Jefferson St.; h. 802 Frederick Ave., Milwaukee, WI.

PARTRIDGE, JOSEPH.
Painter. He painted a portrait of Rev. Stephen Gano of Providence, RI, which was engraved and published by Pekenino in 1822.

PARTRIDGE, ROI.
Etcher. Born in Centralia, Washington, Oct. 14, 1888. Pupil of National Academy of Design in NY. Member: California Print Maker's Society; Chicago Society of Etchers; Brooklyn Society of Etchers; California Society of Etchers. Awards: Two silver medals, Alaska-Yukon-Pacific Expo., Seattle, 1909; medal, National Academy of Design, 1910; prizes, Brooklyn, NY, 1921; Logan medal, Art Institute of Chicago, 1921; H. W. O'Melveney prize, California Print Maker's Society, 1922; San Francisco, 1921; Los Angeles, CA, 1922, 25, medal, 1929; Buma Prize, California Print Maker's Society, 1925; Library of Congress, 1943; New York, 1947. Work in New York Public Library; Newark (NJ) Public Library; Library of Congress, Washington, DC; Palace of Legion of Honor, San Francisco, CA; Worcester (MA) Art Museum; Art Institute of Chicago; Walker Art Gallery, Liverpool, England; Toledo Museum of Art; Carnegie Institute, Pittsburgh; California State Library, Sacramento; Los Angeles Museum of Art; Toronto Art Gallery; Academy of Arts, Honolulu; San Francisco Museum of Art; Museum of Modern Art; Brooklyn Museum; National Gallery of Art, Washington, DC. Has exhibited nationally. Instructor of art and professor of art, Mills College, Oakland, CA, 1921-46. Has contributed articles to art and photographic magazines. Address in 1953, Oakland, CA.

PARTRIDGE, W(ILLIAM) H.
Painter. Born in Wheeling, WV, Sept. 21, 1858. Pupil of Massachusetts School of Art; Boston Museum of Art. Member: Boston Art Club; Springfield Art League; Gloucester Society of Artists; Business Men's Art Club of Boston. Work: "Old House, France," Library, Wellesley, MA. Address in 1929, 39 Pine St., Wellesley Hills, MA.

PARTRIDGE, WILLIAM ORDWAY.
Sculptor and writer. Born in Paris, France, April 11, 1861. Studied in New York, Paris, Florence and Rome. Member: Lotos Club; New York Architectural League. Work: Equestrian statue of Gen. Grant, Union League Club, Brooklyn; statue of Alexander Hamilton, Brooklyn; "Shakespeare,"

Lincoln Park, Chicago; "Pocahontas," Jamestown, VA; "Nathan Hale," St. Paul, MN; font, Cathedral of St. Peter and St. Paul, Washington, DC; Schermerhorn Memorial, Columbia University, New York. Author: *Art for America, The Song of Life of a Sculptor, The Technique of Sculpture.* Address in 1929, Cosmos Club, Washington, DC. Died in 1930.

PASCHKE, EDWARD.
Illustrator. Born in Chicago, IL, in 1939. Studied at the Art Institute of Chicago, where he received both his B.F.A. and M.F.A. He has exhibited his work at the Whitney Museum, Museum of Contemporary Art in Chicago, Washington, and Mexico City and the Darthea Speyer Gallery in Paris. The Art Institute of Chicago, Brooklyn Museum, Museum of Modern Art in Vienna, Austria, and Museum Boymans in Rotterdam own his work. He has taught painting, drawing, and design at the School of the Art Institute of Chicago, Barat College in Illinois and Columbia College in Chicago.

PASCIN, JULES.
Painter. Born in Bulgaria, 1885. Studied in Vienna. Died in 1930. Address in 1929, care of Bernheim Jeune and Co., Paris, France.

PASCUAL, MANOLO.
Sculptor and instructor. Born in Bilbao, Spain, April 15, 1902; U.S. citizen. Studied at Academy of Fine Arts, San Fernando, Madrid, Spain, M.A. Work in Museum of Fine Arts, Santo Domingo; Emily Lowe Gallery, Coral Gables, FL; Miami University, FL; Hofstra University, NY; Museum, World University, Tucson, AZ; sculpture, Government of Santo Domingo; others. Has exhibited at International Art, Paris; Royal Academy of Fine Arts, Madrid; National Academy of Fine Arts, Santo Domingo; Hofstra University, NY; many others. Taught sculpture at National Academy of Fine Arts, Santo Domingo, 1940-50; teaching sculpture at New School for Social Research, NY, from 1951. Works in iron and stone. Address in 1982, Jamaica, NY.

PASKELL, WILLIAM FREDERICK.
Painter. Born in England, October 5, 1866. Studied in Boston, MA, under J. F. DeBlois and Sanderson. Exhibited at the Boston Art Club and at the Charitable Mechanics Association in Boston, 1884-1906. Worked in Cape Ann, Nantucket, and New Hampshire. Travelled to Europe, late 1880's. Died in Boston in 1951.

PASZTHORY, ARPAD.
Painter of "A Negro Newsboy," standing, three-quarter length, wall background. Sold in New York Auction.

PATIGIAN, HAIG.
Sculptor. Born in Armenia, January 22, 1876. Self-taught; criticism from Marquet in Paris. Member:

National Sculpture Society; Societe des Artistes Francais; National Institute of Arts and Letters; Jury of Awards, Panama-Pacific International Exposition, San Francisco, 1915. Work: "Ancient History," Bohemian Club, and "Gen. Funston," City Hall, San Francisco; monument to Dr. Rowell, Fresno, California; marble bust, Helen Wills, California Palace of Legion of Honor; bust of John Keith, Memorial Museum, San Francisco; pediment for Metropolitan Life Building, San Francisco; allegoric figures and tympanum for Memorial Museum; "Gen. Pershing" monument, and "Lincoln" monument, San Francisco; bronze bust, Herbert Hoover, White House; many statuettes, bas-reliefs, busts, and figures. Address in 1933, 3055 Webster St., San Francisco, California. Died in 1950.

PATTEE, ELSIE DODGE.
Painter, illustrator, lecturer and teacher. Born in Chelsea, MA, Sept. 4, 1876. Pupil of Julian Academy in Paris. Member: American Society of Miniature Painters; National Association of Women Painters and Sculptors. Awards: Silver medal, Panama-Pacific Expo., San Francisco, 1915; hon. mention, Concord Art Association, 1921; hon. mention, National Association of Women Painters and Sculptors, 1921; first Balch prize, California Society of Miniature Painters, 1927. Address in 1929, 1186 Lexington Ave., New York.

PATTERSON, AMBROSE.
Painter and teacher. Born in Daylesford, Victoria, Australia. Member: California Print Maker's Society; Salon d'Automne, Paris. Works: "Boulevard Waterloo, Brussels," National Gallery, Adelaide, Australia; "Collins St., Melbourne," National Gallery, Sydney, Australia; portrait C. C. Kingston, Australian Commonwealth Government. Address in 1929, Dept. of Painting, University of Washington, Seattle, WA.

PATTERSON, CATHERINE NORRIS H.
Miniature painter. Born in Philadelphia, PA. Studied at the Penna. Academy of Fine Arts, Philadelphia. She has exhibited at the Penna. Academy of Fine Arts Exhibitions and in other places. Address in 1926, 2200 St. James Place, Philadelphia, PA.

PATTERSON, CHARLES ROBERT.
Marine painter. Born in England, July 18, 1878. Member: National Arts Club; Salma. Club; Allied Artists of America; American Water Color Society; NY Society of Painters. Work: "Journeys' End," Royal Victoria Museum, Halifax; "Rounding the Buoy," Butler Art Institute, Youngstown, Ohio; "Old Ironsides," Museum of Fine Arts, Boston, MA; "Slipping Away from the Land," Museum, Trenton, NJ. Address in 1929, 344 West 72nd St., New York, NY.

PATTERSON, CHARLES WESLEY.
Painter and teacher. Born in Belle Vernon, PA, Aug. 5, 1870. Pupil of Penna. Academy of Fine Arts. Member: Pittsburgh Art Association. Awards: Second honor, Pittsburgh Art Association, 1914; prize, Friends of Pittsburgh Art, 1921; prize, Pittsburgh Art Society, 1924. Represented, 100 Friends of Art, Pittsburgh, PA. Died in 1938. Address in 1929, Woodbine and Stanton Ave., Pittsburgh, PA.

PATTERSON, HOWARD A(SHMAN).
Painter, lithographer, designer, and teacher. Born in Philadelphia, PA, Sept. 13, 1891. Pupil of Philadelphia Museum School of Industrial Art; Penna. Academy of Fine Arts, with Henry McCarter; Art Students League of NY. Member: American Veterans Society of Artists; Fellowship Penna. Academy of Fine Arts; Philadelphia Sketch Club; New Mexico Painters. Work: "Lines and Patches," Fellowship of the Penna. Academy of Fine Arts, Philadelphia; "Flox," Luxembourg Museum, Paris. Exhibited: Penna. Academy of Fine Arts; Art Institute of Chicago; National Academy of Design; Carnegie Institute; Palace of the Legion of Honor; Cleveland Museum of Art. Address in 1953, 65 Irving Place, New York, NY.

PATTERSON, MARGARET (JORDAN).
Painter and illustrator. Born in Soerabaija, Java. Pupil of Pratt Institute under Arthur Dow in Brooklyn; Charles H. Woodbury in Boston; Castellucho in Paris. Member: Boston Society of Water Color Painters; American Federation of Arts; Copley Society, 1900; Philadelphia Water Color Club; National Association of Women Painters and Sculptors; California Print Maker's Society; Print Society of England; Providence Water Color Club. Award: Hon. mention for etching, P.-P. Expo., San Francisco, 1915. Work: "Basque Fishing Boats," Museum of Fine Arts, Boston; represented in Oakland (CA) Art Museum; Metropolitan Museum; University of California; Smith College; Cleveland Art Museum; Springfield (MA) Public Library; Victoria and Albert Museum, Kensington, England; print collection, Museum, Genoa, Italy. Director, art department, Dana Hall School, Wellesley, MA. Address in 1929, Trinity Court, Boston, MA.

PATTERSON, REBECCA BURD PEALE.
Painter. Born in Philadelphia, PA. Pupil of Pennsylvania Museum and School of Industrial Art, Philadelphia; Rebecca Van Trump and W. J. Whittemore, New York; A. Margaretta Archambault. Member: Pennsylvania Society of Miniature Painters. Died in Sept., 1952. Address in 1933, 5522 Morris St., Germantown, Philadelphia, PA.

PATTERSON, ROBERT.
Illustrator. Born in Chicago, IL, in 1898. Pupil of Harvey Dunn, Walt Louderback, Carl Erickson.

Had studio in Chicago. Moved to NYC in 1922; received fashion illustration assignments. Assignment in Paris in 1924 for *Judge*. Began work for *Vogue* in Paris in 1927. Returned to U.S. in 1934; worked for *McCall's*, *Good Housekeeping*, *Ladies' Home Journal*, etc. Instructor, Famous Artists School. Member: Society of Illustrators; Artists Guild of the Authors' League of America, NY. Address in 1929, 44 West 10th St., New York, NY.

PATTERSON, RUSSELL.
Painter and illustrator. Born in Omaha, NE, Dec. 26, 1896. Pupil of Monet. Studed at McGill University, Canada; Art Institute of Chicago; Academy of Fine Arts. Worked in Hollywood and on Broadway in 1930's; designed costumes for Ziegfield, windows for Macy's, hotel lobbies, restaurants; illustrated for advertisements and magazines. Member: Society of Illustrators; Chicago Art Club; Chicago Artists Guild. Died in 1977. Address in 1933, 730 Fifth Avenue; h. 2 West 67th Street, New York, NY.

PATTERSON, VIOLA.
(Mrs. Ambrose Patterson). Painter, illustrator, craftsman and teacher. Born in Seattle, WA, May 20, 1898. Member: Seattle Art Institute; North West Print Maker's Society. Awards: First prize, Black and White Exhibition, Phoenix, AZ, 1928; Katherine B. Baker memorial prize, Seattle Art Institute, 1928. Address in 1929, 4725 Fifteenth St., NE Seattle, WA.

PATTISON, ABBOTT.
Sculptor and painter. Born in Chicago, Illinois, May 15, l916. Studied at Yale College and Yale School of Fine Arts. In collections of Whitney; Israel State Museum; Art Institute of Chicago; San Francisco Museum; others. Exhibited at Art Institute of Chicago, 1940-69; Metropolitan Museum of Art; Whitney; Sculpture Center, NYC; others. Taught at Art Institute of Chicago, 1946-52; Skowhegan; sculptor in residence, University of Georgia. Address in 1982, Winnetka, IL.

PATTISON, JAMES WILLIAM.
Painter. Born in Boston, MA, on July 14, 1844. Painter of figures, domestic animals, landscapes, marines, etc. Exhibitor at Paris Salon, 1879-81; at National Academy, New York, for many years; at American Water Color Society, New York, 15 years; Penna. Academy of Fine Arts; at Art Institute of Chicago, many times; Chicago Exposition, 1893; St. Louis Exposition, 1904; also medal at Boston, 1882; was a constant exhibitor at art galleries all over the country. Director of School of Fine Arts, Jacksonville, IL, 1884-96; faculty lecturer on the collections, Art Institute of Chicago, after 1896; editor, Fine Arts Journal, Chicago, in 1910. Ex-president, Chicago Society of Artists; member of the Municipal Art League of Chicago; also of Society of Western Artists. Died on May 29, 1915 in Asheville, NC.

PATTISON, SIDNEY (MRS.).
See Modjeska, Marylka H.

PATTON, ELIZABETH.
Painter. Exhibited "Landscape" at the Penna. Academy of Fine Arts, 1926. Address in 1926, 1522 Chestnut St., Philadelphia, PA.

PATTON, KATHARINE.
Painter. Born in Philadelphia, PA. Pupil of Cox, Hawthorne and Snell in New York; Frank Brangwyn in London. Member: National Association of Women Painters and Sculptors; Philadelphia Water Color Club; Fellowship Penna. Academy of Fine Arts; Plastic Club; Philadelphia Alliance; American Federation of Arts. Awards: Silver medal for water color, Knoxville (TN) Expo., 1913; prize for landscape, National Association of Women Painters and Sculptors, 1918; Mary Smith prize, Penna. Academy of Fine Arts, 1921; special award of honor, National Art Exhibition, Springville, UT, 1926. Work: "The Maple Woods," Penna. Academy of Fine Arts; "Wood Interior," Fellowship, Penna. Academy of Fine Arts, Philadelphia; "Through the Old Window Screen," South High School, Philadelphia, PA; "The Wooded Path, September," Municipal Collection, Trenton, NJ. Address in 1929, 1522 Chestnut St., Philadelphia, PA.

PATTON, ROY EDWIN.
Painter, etcher, lecturer and teacher. Born in Springfield, OH, April 7, 1878. Pupil of Catlin, Erickson, Cross. Member: Erie Art Club; Fine Art Palette Club; American Artists Professional League. Address in 1933, 131 West 18th St., Erie, PA.

PATTY, W(ILLIAM) A(RTHUR).
Painter and teacher. Born in New Hartford, CT, March 17, 1889. Studied: National Academy of Design; Julian Academy, Paris; and with Charles Noel Flagg, Robert B. Brandegee, Edgar M. Ward. Member: Brooklyn Society of Artists; Society of Independent Artists; Brooklyn Water Color Club; Brooklyn Painters and Sculptors; Connecticut Academy of Fine Arts; American Artists Professional League; Laguna Beach Art Association; Allied Artists of America. Work: Murals in St. Petersburg, FL; Phoenix, AZ; Miami, FL; Los Angeles, CA; Trinidad, BWI. Exhibited: Naitonal Academy of Design; Corcoran; Penna. Academy of Fine Arts; Connecticut Academy of Fine Arts; Wilmington Society of Fine Arts; Witte Memorial Museum; Brooklyn Museum. Died in 1961. Address in 1953, North Hollywood, CA.

PAUL, CHARLES R.
Illustrator. Born in Indiana, PA, in 1888. Pupil of Anshutz, Chase and McCarter. Member: Philadelphia Sketch Club. Address in 1926, 17th St. and the Parkway, Philadelphia, PA. Died in 1942.

PAUL, EUGENE.
Engraver. Born c. 1830 in France. The only known print engraved by this man is a large and excellent mezzotint portrait of Henry Clay, published by R. A. Bachia, New York, 1855. This print is signed "Eng'd by E. Paul."

PAUL, HORACE A.
Painter. Exhibited at the Penna. Academy of Fine Arts, Philadelphia, 1924. Address in 1926, 2160 North Van Pelt St., Philadelphia, PA.

PAUL, JEREMIAH, JR.
Portrait, figure, and animal painter. Painted portraits from 1791 to about 1820. His studio was No. 35, South Fourth St., Philadelphia, PA. Appeared first in Philadelphia, 1795, as one of the founders of the Columbianum. Worked under the name of Pratt, Rutter and Company in 1796; under the name of Paul, Rutter and Clarke a few months later when Pratt dropped out of the group. Painted miniatures and traced profiles at Charleston, SC, in 1803; from 1806-08 he was in Baltimore, and in 1814 he was at Pittsburgh, PA, painting signs and portraits. Spent his last years painting theatrical scenery in the West. Exhibited: "Venus and Cupid," in Philadelphia, 1811. Work: Portrait of Mrs. Rachel West Clarkson, bust, wears cap tied under chin, arms crossed in lap, owned by Worcester Art Museum; portrait of Tench Coxe, bust to left, owned by Brinton Coxe, Philadelphia. Died July 13, 1820 in St. Louis, MO.

PAULDING, JOHN.
Sculptor. Born in Darke County, OH, April 5, 1883. Pupil of Art Institute of Chicago. Member: Alumni, Art Institute of Chicago; Chicago Galleries Association; Cliff Dwellers; Chicago Painters and Sculptors. Address in 1933, 1600 Monroe Building, 104 South Michigan Avenue, Chicago, IL; h. Park Ridge, IL. Died in 1935.

PAULIN, TELFORD.
Painter. Member: National Society of Mural Painters, NY. Address 1929, 111 East 10th St., New York, NY.

PAULUS, CHRISTOPHER DANIEL.
Sculptor, painter, illustrator, and teacher. Born in Wuertemburg, Germany, April 11, 1848. Pupil of Ernst Kaehnel in Dresden. Address in 1908, 1110 Main St., Newton, KS.

PAULUS, FRANCIS PETRUS.
Painter and etcher. Born in Detroit, MI, March 13, 1862. Pupil of Penna. Academy of Fine Arts; Royal Academy in Munich under Loefftz; Ecole des Beaux-Arts in Paris under Bonnat. Member: Chicago Society of Etchers; National Arts Club; La Gravure Originale en Noir; Societe International des Beaux-Arts et des Lettres. Work: "Alley in Bruges," Herron

Art Institute, Indianapolis; "Low Tide," "Fish Market," "Shimmering Sea," "Old Bridge, Bruges," and set of etchings, Detroit Institute; "Old Canal," Bruges, McGregor Library, Highland Park, MI. Etchings in: New York Public Library; Library of Congress, Washington, DC; Oakland (CA) Museum; Musee Moderne, Bruges; Royal Academy of Fine Arts, Munich. Died in 1933. Address in 1929, 917 E. Jefferson Ave., Detroit, MI.

PAUS, HERBERT ANDREW.
Illustrator. Born in Minneapolis, MN, in 1880. Studied at the Art Students League under George Bridgman. His first illustration, an editorial cartoon, appeared in 1896; after this he did many covers for *The Saturday Evening Post, Woman's Home Companion, Collier's, Popular Science,* and *Redbook*. In World War I he did the poster *Over the Top* and later worked on many book illustrations, such as *The Children's Blue Bird* by Madame Maurice Maeterlinck. In 1913 he designed the stage set for *The Betrothal* by Maeterlinck. Address in 1934, Mamaroneck, NY. Died in 1946.

PAUSCH, EDUARD LUDWIG ALBERT.
Sculptor. Born in Copenhagen, Denmark, Sept. 30, 1850. Pupil of Carl Conrads and Karl Gerhart in Hartford; Domenico Mora in NY. Address in 1910, corner of Delaware and Delavan Aves., Buffalo, NY; and Westerly, RI.

PAVAL, PHILIP.
Sculptor, painter, craftsman, and lecturer. Born in Nykobing Falster, Denmark, April 20, 1899. Studied at Borger School; Technical School of Design, Denmark. Member: California Art Club: Painters and Sculptors Club, Los Angeles Museum of Art Association; Scandinavian-American Art Association; Sociedade Brasileira de Belas Artes, Brazil; and other organizations abroad and in South America. Awards: Many awards in local and national exhibitions. Work: Metropolitan Museum of Art; Los Angeles Museum of Art; Philbrook Art Center; Wichita Art Association; Newark Museum; Pasadena Art Institute; Devi Palace, Vizianagaram, South India; Presidential Palace, Quito, Ecuador; Le Grand Palais, Paris, France; Buckingham Palace, London; and others. Exhibited: Golden Gate Expo., 1939; Wichita Art Association; Santa Barbara Museum of Art; Los Angeles Museum of Art; California Palace of the Legion of Honor; Philbrook Art Center; Newark Museum; and many others. Address in 1953, Hollywood, CA.

PAXON, EDGAR SAMUEL.
Illustrator and painter. Born in East Hamburg, NY, in 1852. Specialty: Indians and American pioneers. Work: Eight murals in Missoula County Court House; six murals in Montana Capitol; "Custer's Last Fight," exhibited in many cities. Address in 1926, 611 Stephens Ave., Missoula, MT.

PAXSON (or PAXTON), ETHEL.
(Mrs. Clement Esmond Paxson). Painter, sculptor, illustrator, blockprinter, writer and teacher. Born in Meriden, CT, March 23, 1885. Studied: Corcoran School of Art, 1905-09; Penna. Academy of Fine Arts, 1909-11; pupil of Cecilia Beaux, William Chase, Hugh Breckenridge, Poore, others. Work: American Embassy, Rio de Janeiro, Brazil. Exhibited: National Academy of Design; National Association of Women Artists; Allied Artists of America; American Water Color Society, 1945, 46; American Museum of Natural History; New Haven Paint and Clay Club, annually; Argent Gallery (one-man). Awards: Prize, Meriden Arts and Crafts Association. Member: National Association of Women Artists; Catherine Lorillard Wolfe Art Club; New Haven Paint and Clay Club; American Artists Professional League; Meriden Arts and Crafts Association; Art League of Nassau County; American Water Color Society. Address in 1962, 2400 Sedgwick Avenue, New York, NY.

PAXSON, MARTHA KELSO DUNING.
Painter, sculptor, and teacher. Born in Philadelphia, PA, 1875. Pupil of William Sartain and Elliott Daingerfield. Address in 1908, 2108 Bellevue St., Philadelphia, PA.

PAXTON, ELIZABETH OKIE (MRS.).
Painter. Born in Providence, RI. Pupil of W. M. Paxton. Member: Guild of Boston Artists; North Shore Arts Association. Award: Silver medal, Panama-Pacific Expo., San Francisco, 1915; Alice Worthington Ball Prize, North Shore Arts Association, 1927. Address in 1929, 19 Montvale Rd., Newton Centre, MA.

PAXTON, W. A.
Painter. Member: California Art Club. Address in 1926, 955 Edgeware Road, Los Angeles, CA.

PAXTON, WILLIAM M(cGREGOR).
Painter and teacher. Born in Baltimore, MD, June 22, 1896. Pupil of Ecole des Beaux-Arts in Paris under Gerome; Dennis M. Bunker in Boston. Member: Associate of the National Academy of Design, 1917; Copley Society, 1894; Guild of Boston Artists; St. Botolph Club, Boston; Philadelphia Art Club; Allied Artists of America; American Federation of Arts. Awards: Hon. mention, Pan-Am. Expo., Buffalo, 1901; bronze medal, St. Louis Expo., 1904; Lippincott prize, Penna. Academy of Fine Arts, 1915; hors concours (jury of awards), P.-P. Expo., San Francisco, 1915; popular prize, Corcoran Gallery, Washington, DC, 1919; Philadelphia prize and Stotesbury prize, Penna. Academy of Fine Arts, 1921; Carroll Beck portrait prize, Penna. Academy of Fine Arts, 1928. In collections of Pennsylvania Academy, Philadelphia; Metropolitan Museum of Art; Corcoran; Museum of Fine Arts, Boston; Cincinnati

Museum; Detroit Institute of Arts; Wadsworth Atheneum, Hartford; and Butler Art Institute, Youngstown, OH. Mural: Army and Navy Club. Died May 13, 1941 in Boston. Address in 1929, 19 Montvale Road, Newton Centre, MA; Riverway Studios, 120 Riverway, Boston, MA.

PAYNE, EDGAR ALWIN.
Painter. Born in Washburn, MO, March 1, 1882. Pupil of Art Institute of Chicago; chiefly self-taught. Member: Salma. Club; Allied Artists of America; International Society of Arts and Letters; California Art Club; 10 Painters of Los Angeles; Laguna Beach Art Association; Alumni Art Institute of Chicago; Chisel Club, 1913. Awards: Gold medal, Sacramento State Fair, 1918; silver medal, Sacramento, 1919; Cahn prize, Art Institute of Chicago, 1920; first prize ($250), Southwest Museum, 1921; hon. mention, Paris Salon, 1923; gold and bronze medals, Los Angeles Museum, 1926. Works: Mural decorations, American and Empress Theatres, Chicago; Northern Hotel, Billings, MT; Clay County Court House, Brazil, IN; Hendricks County Court House, Danville, IN; Queen Theatre, Houston, TX; "Hills of El Toro," Nebraska Art Association, Lincoln; "The Hills of Marin," Peoria (IL) Society of Allied Arts; "Pleasant Valley," Chicago Municipal Art Commission purchase; "The Restless Sea," Herron Art Institute, Indianapolis; "Topmost Peaks," Janesville (WI) Art Association; "High Sierras," Southwest Museum, Los Angeles; "Fifth Lake," National Academy of Design, New York. Died in 1947. Address in 1933, Los Angeles, CA.

PAYNE, ELSIE PALMER.
(Mrs. Edgar A. Payne). Painter, lecturer and teacher. Born in San Antonio, TX, Sept. 9, 1884. Pupil of A. W. Best in San Francisco and of Chicago Fine Arts School. Member: Laguna Beach Art Association; West Coast Arts, Inc.; Los Angeles Water Color Society. Address in 1929, Netherlands Ave., New York, NY; Stendahl Galleries, Ambassador Hotel, Los Angeles, CA; summer, Laguna Beach, CA.

PAYNE, EMMA LANE.
Painter, illustrator and teacher. Born in Canada, May 5, 1874. Pupil of F. C. Gottwald; Leonard Ochtman. Member: Cleveland Woman's Art Club; Cleveland Society of Artists. Address in 1933, Studio Stop, 14 RFD, Euclid, OH.

PAYNE, GEORGE KIMPTON.
Designer, illustrator, painter, sculptor, and craftsman. Born in Springville, NY, May 23, 1911. Studied at Art Students League, with George Bridgman, Allen Lewis, Thomas Benton. Contributor to *New Yorker* magazine. Position: Scientific Artist, National Zoo Park, Washington, DC, 1936; Advertising Artist, 1937-43; USNR Terrain Map Model Maker,

1943-45; Supervisor of Displays, Woodward and Lothrop, Washington, DC, 1946-50; Assistant Manager in Charge of Displays, from 1950. Address in 1953, Arlington, VA.

PAYNE, JEANNE.
See Johnson, Jeanne Payne.

PEABODY, AMELIA.
Sculptor. Born in Marblehead Neck, MA, July 3, 1890. Pupil of Boston Museum of Fine Arts School, with Charles Grafly; Archipenko School of Art; Northeastern University, hon. D.F.A. Exhibited: Penna. Academy of Fine Arts; World's Fair, NYC, 1939; Art Institute of Chicago; Whitney Museum, 1940; Carnegie Institute, 1941; Boston Museum of Fine Arts, 1950, 51; National Academy of Design, 1952; National Association of Women Artists, 1953; others. Member: Guild of Boston Artists; Copley Society; Boston Sculpture Society; Marblehead Art Association; American Federation of Arts; National Sculpture Society; National Association of Women Artists; American Artists Professional League; North Shore Arts Association. Work: "End of an Era," marble, Museum of Fine Arts, Boston, MA; baptismal font, church, Oxford, MA; Victory Medal, Joslin Clinic, Boston, MA; portraits, medals, garden and architectural sculpture, in bronze, stone, and pottery. Awards: Mrs. Oakleigh Thorne Medal, Garden Club of America. Address in 1982, Boston, MA.

PEABODY, EVELYN.
Sculptor. Exhibited at the Penna. Academy of the Fine Arts, Philadelphia, 1924. Address in 1926, 1620 Summer St., Philadelphia, PA.

PEABODY, M. M.
Engraver. The earliest plate by this engraver is a very large and crudely executed engraving of "The Unjust Sentence of the Jews against Jesus Christ the Saviour of the World." This print was engraved and published in 1823. Place of publication unknown, but in 1835 M. M. Peabody was located in Utica, NY, where he engraved maps in line, and general book illustrations in stipple. A few portraits, signed "M. Peabody," were probably his work also.

PEABODY, MARIAN LAWRENCE.
Sculptor and painter. Born in Boston, MA, May 16, 1875. Pupil of Hale, Benson, Tarbell, Allen, Recchia. Work: Portrait head, Lawrence College, Appleton, WI; portrait head, Groton School, Groton, MA; portrait, Episcopal Theological School, Cambridge, MA; portrait, University of Kansas, Lawrence, KS. Address in 1933, 27 Mechanic St., Roxbury; h. 302 Berkeley St., Boston, MA; summer, Devon, Bar Harbor, ME.

PEABODY, RUTH EATON.
Sculptor, painter and teacher. Born in Highland Park, IL. Pupil of Art Institute of Chicago. Member:

California Art Club; Laguna Beach Art Association; San Diego Artists Guild. Awards: Gold medal, West Coast Artists, Los Angeles, CA, 1926; third prize, California State Fair, Sacramento, 1926; first prize, Laguna Beach Art Association, 1927; first prize, Riverside Co. Fair, 1928, 30; special water color prize, 1928, P. F. O'Rourke prize ($500), 1929, and Evelyn N. Lawson water color purchase prize, 1931, Fine Arts Society, San Diego; hon. mention, Pasadena Art Institute, 1930; hon. mention, 1930, first prize, 1931, Hatfield gold medal, 1932, California Art Club; second prize, Los Angeles Co. Fair, 1931; second prize, Sacramento State Fair, 1932. Work: Kerr Memorial, bronze fountain, Laguna Beach, CA; oil and water color, Fine Arts Gallery, San Diego, CA. Exhibited at Penna. Academy of Fine Arts; Art Institute of Chicago; Golden Gate Expo., San Francisco, 1939; Laguna Beach Art Association; San Diego Fine Arts Society; Oakland Art Gallery; California Art Club; California State Fair; others. Address in 1953, Laguna Beach, CA.

PEACEY, JESS.
See Lawson-Peacey, Jess M. (Mrs.).

PEACOCK.
An early New England portrait painter of whom little is known. The American Antiquarian Society of Worcester, MA, has two portraits of John and Mrs. Charles Bush which are attributed to "Peacock."

PEAK, ROBERT.
Illustrator. Born in Colorado, in 1928. Received his art training at the Art Center College of Design. After his arrival in NY, he was given assignments from advertising clients and periodicals such as *Cosmopolitan* and *Newsweek*. His deceptively simple style and innovative techniques have placed him in great demand among major magazines. A regular contributor to *TV Guide* and *Sports Illustrated*, he has also illustrated posters for movies such as "Rollerball," "Mame," and "The Missouri Breaks." Among his many citations are Artist of the Year in 1961 from the Artists Guild of NY and from the Society of Illustrators, and the Hamilton King Award in 1968, in addition to several awards of excellence and gold medals from the Annual Exhibitions.

PEALE, ANNA CLAYPOOLE.
Painter. Daughter of James Peale, and grandchild of James Claypoole. She was born in Philadelphia on March 6, 1791. She painted still-life subjects, and later took to miniature painting. She painted Gen. Lallemand, President James Monroe, Maj.-Gen. Jackson, and Commodore Bainbridge. Exhibited frequently at the Penna. Academy of Fine Arts between 1811-42. Died Dec. 25, 1878 in Philadelphia, PA.

PEALE, CHARLES WILLSON.
Painter and engraver. Born in Queen Anne's Co., MD, on April 15, 1741. Peale is said to have been apprenticed to a saddler in Annapolis, MD, but he went to Boston to study art, possibly with J. S. Copley, in 1765. Went to London where he was a pupil of Benjamin West and studied painting miniatures, engraving in mezzotint, molding in wax, and plaster work. Was in Philadelphia in 1775 and took part in the Revolution and state politics. Painted portraits of many men prominent at the time in military affairs, including many of George Washington, as well as doing much work in ordinary portraiture. Established the famous Peale Museum in Independence Hall in 1786, to which he devoted the rest of his life. In 1794, Peale established a short-lived association for the encouragement of the fine arts, The Columbianum. Peale was influential in founding, in 1806, the Penna. Academy of Fine Arts, and lived to contribute to seventeen of its annual exhibitions. Father of Rembrandt Peale, who, after his return from Paris in 1805, gave his father considerable instruction in the methods of the French school which he himself had studied there, which may explain the difference in style of Peale's late works. A memorial exhibition of Peale's work was held at the Penna. Academy of Fine Arts in 1923. Died on February 27, 1827, in Philadelphia, PA.

PEALE, EMMA CLARA.
Painter. Born in November, 1814. Daughter of Rembrandt Peale. Exhibited at the Artists' Fund Society, 1840, and the American Academy, 1835.

PEALE, FRANKLIN.
Medallist. Born October 15, 1795, in Philadelphia, PA. Son of Charles Willson Peale. Ran a cotton mill near Philadelphia after the War of 1812; later assisted his father and brothers at the Peale Museum. Later employed at the U.S. Mint; served as Chief Coiner from 1840-54. Executed President Polk's Indian medal. Died May 5, 1870 in Philadelphia, PA.

PEALE, JAMES.
Miniature, portrait, and still life painter. Younger brother of Charles Willson Peale, born at Chestertown, MD, in 1749. As a youth he lived with his brother and learned the trade of chaisemaker. At about the time Charles Willson Peale returned from London, and chiefly due to his instruction and influence, James Peale gave up his trade to become a painter. He devoted some attention to portraiture, executed some landscapes, and even attempted some historical composition, but it is as a miniature painter that he is best known. During the Revolutionary War, James Peale, like his brother Charles, served as an officer in the Continental Army under Washington, first as an Ensign in the Maryland Battalion, Colonel Smallwood commanding, in 1776; then as a First Lieutenant of the First Battalion of Maryland

Regulars, Colonel John H. Staul commanding, in 1777, being later (1778) promoted to a captaincy in the First Maryland Regiment of the Continental Line. He was a good soldier and bore an enviable military record. James Peale painted two portraits of Washington, one of which is owned by the City of Philadelphia and hangs in the National Portrait Gallery at Independence Hall; the other is owned by the New York Historical Society. Most of his lifetime was spent in Philadelphia, though he worked and resided for a time in the Southern States. He was married and had six children, all but one of whom were girls. Of these children, James, Jr., Anna and Sarah were painters. He was a member of the Maryland Society of the Cincinnati. James Peale died in Philadelphia, PA on May 24, 1831.

PEALE, JAMES, JR.
Marine, landscape, and still life painter. Born March 6, 1789, in Philadelphia, PA. He was the son of James Peale, who was born in 1749 and died in 1831. He exhibited paintings at the Penna. Academy of Fine Arts, 1825-47. His sisters were also painters. Died Oct. 27, 1876 in Philadelphia, PA.

PEALE, MARGARETTA ANGELICA.
Still life and portrait painter. Born October 1, 1795, in Philadelphia, PA. Daughter of James Peale. Exhibited at the Artists' Fund Society and the Penna. Academy of Fine Arts. Died January 17, 1882.

PEALE, MARIA.
Still life painter. Daughter of James Peale. Born in 1787. She commenced painting still-life subjects about 1810. Exhibited at the Penna. Academy of Fine Arts in 1811. Died March 27, 1866 in Philadelphia, PA.

PEALE, MARY JANE.
Portrait and still life painter. Born Feb. 16, 1827. She was the daughter of Rubens Peale and a grand-daughter of Charles Willson Peale. She died in Pottsville, PA, in November, 1902.

PEALE, RAPHAELLE.
Portrait, miniature and still-life painter. He was the eldest son of Charles Willson Peale and was born Feb. 17, 1774 in Annapolis, MD. Collaborated with his brother Rembrandt Peale on many portraits including the famous "Staircase Group," exhibited at the Columbianum in 1795. The two brothers ran a museum in Baltimore from 1797-1800, after which Raphaelle returned to Philadelphia to become his father's chief assistant. In 1801 he advertised as a portrait painter with his studio at No. 28 Powel St., Philadelphia, PA. Went into the profile cutting business in 1803. Eventually turned from portrait painting to still life painting. He died March 5, 1825, in Philadelphia, PA.

PEALE, REMBRANDT.
Portrait, miniature, and historical painter. Son of Charles Willson Peale, born in Bucks County, PA, Feb. 22, 1778. His father instructed him from an early age. At 17 he obtained a sitting from George Washington. This portrait, painted in 1823, is not the familiar Rembrandt Peale portrait, a composite head known as the Porthole portrait, of which he made many copies. About 1795, Charles Willson Peale retired from portrait painting and recommended his son to the public as his successor. The younger Peale, however, did not meet with the success anticipated, and left Philadelphia for Charleston, SC, with his brother Raphaelle, during the winter of 1795-96 to commence his career as an artist. The two opened a museum in Baltimore in 1797. In 1801, Peale went to England to study under Benjamin West and at the Royal Academy. He painted a few portraits, and, because of ill health, decided to abandon art for agriculture and so returned to the U.S in 1803. To his surprise, he found his services as a painter in great demand, and in 1804 established a studio in Philadelphia, where he showed great improvement in his style. In 1807, he went to Paris, where he painted eminent Frenchmen, including Jacques Louis David, Dominique Vivant Denou, and Jean Antoine Houdon, now owned by the Penna. Academy of Fine Arts. He later returned to Baltimore where he opened another museum. His most important work, "The Court of Death," was painted in Philadelphia in 1820. In 1822, he moved to New York and again visited Europe in 1829-30, returning later to Philadelphia, where he spent the remainder of his life. He was one of the first in the U.S. to make lithographic drawings, one of the founders of the Penna. Academy of Fine Arts, and one of the original members of the National Academy of Design. In 1923 a Memorial Exhibition of Peale's work was held at the Penna. Academy of Fine Arts. Died October 3, 1860, in Philadelphia, PA.

PEALE, REMBRANDT (MRS.).
(Harriet Cany Peale). Painter. Born c. 1800. Wife of Rembrandt Peale. Exhibited portraits, still lifes, and copies at the Penna. Academy of Fine Arts and the Artists' Fund Society. Died January 12, 1869.

PEALE, ROSALBA CARRIERA.
Copyist. Born July 28, 1799. Daughter of Rembrandt Peale. Exhibited at the Artists' Fund Society, 1840. Was an Artist, 1827, and Honorary Member, and a Professional, 1828, of the National Academy. Died November 15, 1874.

PEALE, RUBENS.
Still life and animal painter. Born May 4, 1784 in Philadelphia, PA. Son of Charles Willson Peale. He painted in an indifferent manner. Chiefly involved in museum management. In charge of the Philadelphia Museum, founded by his father, 1810-22; had a

museum in Baltimore, 1822-25; and managed the Peale Museum in NYC, 1825-37. Died July 17, 1865.

PEALE, SARAH MIRIAM.
Painter. Born in Philadelphia, PA, on May 19, 1800. Sister of Anna Claypoole Peale. Exhibited "Portrait of a Lady" at the Penna. Academy of Fine Arts, 1818; portraits and still lifes at the Penna. Academy of Fine Arts, 1819. At Charles W. Peale's studio in Washington, DC, briefly; then launched an independent career as a portraitist, working mainly in Philadelphia. Elected to the Penna. Academy of Fine Arts in 1824, exhibited there annually until 1831, when she moved to Baltimore. Moved to St. Louis, MO, in 1845; leading portraitist there for 32 years. Also painted still lifes. Returned to Philadelphia in 1878 to live with her sister, with whom she often shared a studio. Her portraits are distinctive for detailed furs, laces, and fabrics. Subjects included Thomas Hart Benton, Caleb Cushing, Daniel Webster, Marquis de Lafayette (1825), and others. She died on February 4, 1885 in Philadelphia, PA.

PEALE, TITIAN RAMSAY.
Born Nov. 17, 1799 in Philadelphia, PA. Son of Charles Willson Peale. He was best known as a student of natural history, and in his artistic labors he has devoted himself to animal life. Served as artist-naturalist with Long's exploring expedition to the Upper Mississippi, 1818-21. Became the assistant manager of the Peale Museum in Philadelphia; succeeded his brother Franklin Peale as manager, 1833. Participated in the Charles Wilkes' expedition to the Pacific from 1838-41, after which he went to Washington to work in the Patent Office from 1849-73. Returned to Philadelphia and died there March 13, 1885. He executed most of the plates for Charles L. Bonaparte's work on "American Ornithology," and did important work on entomology. He has also exhibited water color drawings of animals in the Penna. Academy of Fine Arts. Died March 13, 1885 in Philadelphia, PA.

PEALE, WASHINGTON.
Landscape painter. Born on February 9, 1825. Son of James Peale, Jr. In New York City, 1860. Exhibited at the National Academy. Died in 1868.

PEANO, FELIX ACHILLES.
Sculptor. Born in Parma, Italy, June 9, 1863. Studied at Albertina Academy of Art, Turin; University of Turin; Paris; and Rome. Lived in Oakland, CA; in Los Angeles from 1902. First important sculptor to arrive in the Los Angeles area. Known primarily for architectural sculpture and small bronzes. Combined figurative and floral imagery. Works include sculpture for bridges in Venice, CA; gardens and sculpture at house in Hawthorne, CA; bronze "Door of Life." Died in Hawthorne, CA, Jan. 10, 1949.

PEARCE, CHARLES SPRAGUE.
Painter. Born in Boston, MA on Oct. 13, 1851. Studied under Bonnat in Paris. Awards: Silver medals, Boston, 1878, 1881; gold medal, 1884, for best figure picture, Penna. Academy of Fine Arts, 1881; Temple gold medal, 1885; honorable mention, Paris Salon, 1881. Elected an Associate of the National Academy of Design. Represented in Chicago Art Institute by "The Beheading of John the Baptist." Died May 18, 1914, in Paris, France.

PEARCE, EDGAR LEWIS.
Painter and etcher. Born in 1885. Pupil of Chase and Weir. Represented in Penna. Academy of Fine Arts; National Academy of Design, New York; Carnegie Institute of Pittsburgh. Address in 1926, 3620 Washington Blvd., St. Louis, MO.

PEARLMAN, CHARLOTTE FRANK.
Painter. Born in Washington, DC, Aug. 12, 1925. Studied at University of Maryland; de Burgos School of Art; American University, Washington, DC. Exhibited at 5th Annual Area Exhibition, Corcoran; Memorial Show, Gallery of Northern Virginia Art League; Washington Women's Art Center; Maryland Park and Planning Commission; others. Received awards from Virginia Art League; Montgomery County Art Association; Maryland Federation of Arts; etc. Member of Artists Equity Association; others. Living in Bethesda, MD, in 1982.

PEARLSTEIN, PHILIP.
Painter. Born May 24, 1924 in Pittsburgh, PA. Studied: Carnegie Institute of Technology, with Sam Rosenberg, Robert Lepper and Balcomb Greene, B.F.A., 1949; Institute of Fine Arts, NYU, M.A., 1955. Taught: Pratt, 1959-63; Yale; and Brooklyn College, since 1963. Awarded Fulbright Fellowship, 1958-59; National Endowment Arts Grant, 1969; Guggenheim Fellowship, 1971-72. Exhibited at Harcus Krakow Gallery, Boston, Gimpel Fils Gallery, London, Galerie Jallenbeck, Koln, Germany, Carnegie Mellon University, Reed College, Portland, OR (all one-man); Tanager Gallery, NYC, 1955; A. Frumkin Galleries in NYC and Chicago, many times since 1960; SUNY/Purchase; Penna. Academy of Fine Arts; MIT; Smithsonian; Yale; Des Moines Art Center; Whitney; Helsinki; and Japan. In collections of Corcoran Gallery, Washington, DC; University of Nebraska/Lincoln; Syracuse University; Whitney; Art Institute of Chicago; Museum of Modern Art; Vassar College; and R.P.I. Address in 1984, 163 W. 88th Street, New York, NY.

PEARSON, EDWIN.
Sculptor. Born near Yuma, Colorado, December 20, 1889. Pupil of Art Institute of Chicago with Harry Walcott; Munich Royal Academy; Hermann Hahn. Work: Bust of William Shakespeare, Munich Theater Museum and State Library, Weimar, loaned

by Shakespeare Society; portrait of Professor Franz Jacobi, Clara Zeigler Museum, Munich. Exhibited: Penna. Academy of Fine Arts; Art Institute of Chicago. Address in 1953, Hyde Park, New York.

PEARSON, JOSEPH O.
Painter and engraver. He served in the Civil War, and lived in Brooklyn for twenty years. Died in Little Falls, NJ, July 12, 1917. Specialty: Title pages and covers for music.

PEARSON, JOSEPH T., JR.
Painter and teacher. Born in Germantown, Feb. 6, 1876. Pupil of J. Alden Weir and Wm. M. Chase. Member: Associate National Academy of Design; Academician National Academy of Design, 1919; Fellowship Penna. Academy of Fine Arts. Award: Second Hallgarten prize, National Academy of Design, 1911; hon. mention, Carnegie Institute, Pittsburgh, 1911; Sesnan medal, Penna. Academy of Fine Arts, 1911; Inness medal, National Academy of Design, 1915; gold medal, P.-P. Expo., San Francisco, 1915; Harris silver medal and prize ($500), Art Institute of Chicago, 1915; Temple gold medal, Penna. Academy of Fine Arts, 1916; Stotesbury prize, Penna. Academy of Fine Arts, 1916; Beck gold medal, Penna. Academy of Fine Arts, 1917; Saltus gold medal, National Academy of Design, 1918; Potter Palmer gold medal ($1,000), Art Institute of Chicago, 1918; gold medal, Sesqui-Centennial Expo., Philadelphia, 1926. Instructor, Penna. Academy of Fine Arts. Died in 1951. Address in 1929, Huntingdon Valley, Montgomery Co., PA.

PEARSON, MARGUERITE S(TUBER).
Painter. Born in Philadelphia, PA. Pupil of Boston Art Museum School, under William James and Frederic Bosley; Rockport Summer School, under H. Leith-Ross and A. T. Hibbard. Member: North Shore Arts Association; Allied Artists of America; Connecticut Academy of Fine Arts; Rockport Art Association; American Artists Professional League; American Federation of Arts. Address in 1929, 401 Fenway Studios, 30 Ipswich St., Boston, MA; 369 Broadway, Somerville, MA; summer, Rockport, MA.

PEARSON, RALPH M.
Etcher. Born in Angus, IA, May 27, 1883. Pupil of Art Institute of Chicago under C. F. Browne and Vanderpoel. Member: Art Students League of Chicago; Chicago Society of Etchers; NY Society of Etchers; California Art Club; California Print Makers' Society; California Society of Etchers; Brooklyn Society of Etchers. Awards: Prize, Chicago Society of Etchers, 1914; silver medal for etching, P.-P. Expo., San Francisco, 1915; first prize for bookplate, American Bookplate Society, 1917; California Print Makers' Society, 1922. Work: NY Public Library; Library of Congress, Washington, DC; Mechanics' Institute, Rochester, NY; Art Institute of Chicago; Museum of Fine Arts, Los Angeles; Avery Library, Columbia University, NY; portfolio of twelve original etched book plates published by American Bookplate Society. Author of *How to See Modern Pictures*, Dial Press, 1925; *Fifty Prints of the Year*, John Day Co., for the American Institute of Graphic Arts, 1927; "Woodcuts," Encyclopaedia Brittanica, 1929; "Seeing Pictures," series in *Forum Magazine*. Died in 1958. Address in 1929, 10 East 53rd St., New York, NY.

PEASE, C. W.
Miniature painter who flourished in Providence, RI, in 1844.

PEASE, ERNEST SHERMAN.
Painter in water colors. A son of the engraver J. I. Pease. Born in Philadelphia, PA, in 1846. His specialty was painting birds and animals.

PEASE, JOSEPH IVES.
Engraver. Born Aug. 9, 1809 in Norfolk, CT. In his early youth Pease showed very considerable mechanical ability, and among other things he designed and built a power-loom and also invented a propeller for boats. He finally became an apprentice with the Hartford engraver Oliver Pelton, and remained with him until 1830. In 1835 Pease located himself in Philadelphia and engraved portraits for the National Portrait Gallery and did a considerable amount of work for the *Annuals*; these small plates are the best examples of his skill as an engraver in line. In 1848 he went to Stockbridge, MA, and finally settled on the farm where he died. He practically devoted the later portion of his life to banknote engraving and crayon portraits. Died at Twin Lakes (near Salisbury), CT, on July 2, 1883.

PEASE, RICHARD H.
Engraver. Born Feb. 19, 1813, in Norfolk, CT, he was living in 1869. He was a brother of Joseph Ives Pease, engraver. R. H. Pease apparently began business as a wood engraver in Albany, NY, though he also engraved in a rather labored manner upon copper. He furnished many illustrations for publications of the state of New York.

PEASLEY, A. M.
A map engraver working at Newburyport, MA, in 1804. Examples of his work are to be found in *The American Coast Pilot*, by Capt. Lawrence Furlong, printed for Ed. M. Blount, Boston. He also engraved at least one portrait, that of Sauvin, executed in line combined with roulette work.

PEBBLES, FRANK M.
Painter. Born Oct. 16, 1839 in Wyoming Co., NY. Pupil of National Academy of Design, and of G. A. P. Healy in Chicago. Address in 1926, 1160 Bay St., Alameda, CA.

PECK, ANNE MERRIMAN.
(Mrs. Frank E. Fite). Painter, illustrator and writer. Born in Piermont, NY, July 21, 1884. Pupil of Robert Henri and Irving R. Wiles. Specialty: Children's portraits and woodcuts. Author and illustrator, *Storybook Europe*, Harper Brothers; *A Vagabond's Provence*, Dodd Mead and Co. Illustrated for Harper Brothers, MacMillan Co., and Minton Balch Co. Address in 1933, Croton-on-Hudson, NY.

PECK, CLARA ELSENE.
(Mrs. J. Scott Williams). Painter, illustrator and etcher. Born in Allegan, MI, April 18, 1883. Studied: Minneapolis School of Fine Arts; Penna. Academy of Fine Arts, with William Chase. Member: Society of Illustrators, 1912 (associate); NY Water Color Club; American Water Color Society; Women Painters and Sculptors Society; Fellowship Penna. Academy of Fine Arts; Artists Guild of the Authors' League of America, NY; American Artists Professional League. Exhibited: American Water Color Society traveling exhibition of illustrations; NY Arts Club; Laguna Beach Art Association; Architectural League; National Arts Club; Brooklyn Museum; Penna. Academy of Fine Arts; others. Awards: Watrous prize, NY Women's Painters and Sculptors, 1921, and poster prize, 1922. Illustrator of children's books and text books. Contributor: Covers and illustrations to national magazines. Address in 1962, Gettysburg, PA.

PECK, HENRY J(ARVIS).
Painter, illustrator, etcher and writer. Born in Galesburg, IL, June 10, 1880. Pupul of Eric Pape and Howard Pyle; Rhode Island School of Design. Member: Providence Art Club; North Shore Arts Association. Address in 1929, 5 East 14th St., New York, NY; h. 259 Benefit St., Providence, RI.

PECK, NATALIE.
Painter. Born in Jersey City, NJ, Feb. 27, 1886. Pupil of Kenneth Hayes Miller. Member: Salons of America; Springfield Art Association. Work: "Storm Clouds," in the Penna. Academy of Fine Arts. Address in 1929, 12 West 92nd St., New York, NY.

PECK, ORIN.
Painter. Born in Delaware County, NY, in 1860. He was in charge of the artistic work planned for the ranch of W. R. Hearst in northern California, and had painted several portraits of the Hearst family. He was awarded a gold medal at the Columbian Exposition, Chicago, 1893, for his "Scene in the Garden of the Santa Barbara Mission." He died in Los Angeles, CA, January 20, 1921.

PECKHAM.
A landscape painter noted in Tuckerman's "American Artist Life."

PECKHAM, MARY C.
(Mrs. F. H. Peckham). Painter. Born in Providence, RI, Oct. 26, 1861. Pupil of Mary C. Wheeler, Raphael Collin, Abbott Thayer. Member: Providence Art Club; Providence Water Color Club; American Federation of Arts. Address in 1929, Handicraft Club, 42 College St.; h. 96 Lloyd Ave., Providence, RI.

PECKHAM, ROBERT.
Portrait painter. Born in Massachusetts, Sept. 10, 1785. He traveled mostly in the country districts of New England, but established himself for a while in Boston. Most of his portraits are flat, hard and stiff. Peckham painted John Greenleaf Whittier in 1833. Died June 29, 1877 at Westminster, MA.

PECKHAM, ROSA F.
Nothing is known of this artist except that in the Phillips Academy, Exeter, NH, there is a portrait of Rev. Aug. Woodbury, which is signed "Rosa F. Peckham."

PECORINI, (COMTESSA) MARGARET B.
Painter. Born in Philadelphia, PA, Aug. 18, 1879. Pupil of Julian Academy, Paris. Specialty: Children's portraits. Address in 1929, 70 bis rue Notre Dames des Champs, Paris, France; h. 114 East 84th St., New York, NY; summer, Morgan & Co., 14 Place Vendome, Paris, France.

PEDDLE, CAROLINE.
See Ball, Caroline Peddle.

PEEBLES, ROY B.
Painter. Born in Adams, MA, Aug. 9, 1899. Pupil of Gustave Cimoitti, Ernest W. Watson, Clinton Balmer, Will Taylor, Norwood MacGillverary. Member: Society of Independent Artists; Salons of America. Died in 1957. Address in 1933, 34 Main St., North Adams, MA.

PEELE, JOHN THOMAS.
Painter. Born in April 11, 1822 in England, he came to this country as a child. He settled in New York, and in 1846 was elected an Associate of the National Academy. He painted portraits and genre subjects. Among his works are "Children of the Woods," "Highland Supper," "The Village School" and "The Birds' Nest." Died May 19, 1897 in London, England.

PEETS, ORVILLE HOUGHTON.
Painter and etcher. Born in Cleveland, OH, Aug. 13, 1884. Pupil of Baschet and Laurens in Paris. Member: Salma. Club. Award: Hon. mention, Paris Salon, 1914. Painting owned by French Government in the Luxembourg, Paris; represented in the Hispanic Museum, New York; and by etchings and woodcuts in Museum of Art, Cleveland, OH. Died in 1968. Address in 1929, 683 Lake View Road, Cleveland, OH; Woodstock, NY.

PEIRCE, ALZIRA.

Painter and sculptor. Born in New York City, January 31, 1908. Pupil of Bourdelle and Boardman Robinson. Work includes murals, U.S. Post Office, Ellsworth, South Portland, ME. Exhibited at Penna. Academy of Fine Arts; Carnegie; Federation of Modern Painters and Sculptors. Address in 1933, 225 Cedar St., Bangor, ME. Living in New York City in 1953.

PEIRCE, H. WINTHROP.

Painter and illustrator. Born in Boston, MA, Nov. 25, 1850. Pupil of Boston School under Grundmann and Rimmer; Bouguereau and Robert-Fleury in Paris. Member: Copley Society, 1879; Boston Society of Water Color Painters; North Shore Arts Association; Springfield Art Association. Work: John-Esther Gallery, Andover; Phillips Academy, Andover, MA; Bowdoin College, Brunswick, ME; Public Library, Malden, MA. Died in 1935. Address in 1929, West Newbury, MA.

PEIRCE, THOMAS MITCHELL.

Painter. Born in Grand Rapids, MI, in 1864. Address in 1926, Bartholdi Building, Madison Square, New York.

PEIRCE, WALDO.

Painter. Born in 1884. He exhibited "La Sevilliana" at the Penna. Academy of Fine Arts in Philadelphia, 1915. Address in 1926, Hotel Ansonia, New York, NY. Died in 1970.

PEIRSON, ALDEN.

Painter. Born in Baltimore in 1873. Began his work in Baltimore, MD, 1894; art manager of the *American Magazine* since 1912; art manager of the Caxton Advertising Co. Address in 1926, 64 East 34th St., New York, NY.

PEIXOTTO, ERNEST C(LIFFORD).

Painter, illustrator and writer. Born in San Francisco, CA, Oct. 15, 1869. Pupil of Constant, Lefebvre and Doucet in Paris. Member: Associate of the National Academy of Design, 1909; National Society of Mural Painters (president); NY Architectural League, 1911; Society of Illustrators, 1906; Salma. Club; MacDowell Club; Allied Artists of America; American Federation of Arts; Societe des Artistes Francais. Awards: Hon. mention, Paris Salon, Chevalier of the Legion of Honor, 1921; Officer, 1924. Work: Scenes from "Le Morte d'Arthur" in Library of Henry A. Everett, near Cleveland, Ohio; represented in National Gallery, Washington, DC; Hispanic Museum, New York, NY; murals in Seaman's Bank, Bank of NY, and Embassy Club, NYC; illustrations for Roosevelt's *Life of Cromwell; Wanderings*, by Clayton Hamilton (Doubleday Doran & Co.). Author: *By Italian Seas, Romantic California, Our Hispanic Southwest, The American Front*, etc.

Official Artist, American Expeditionary Forces, 1918; Director, Atelier of Painting, A.E.F. Art Training Center, Bellevue, France, 1919; Director, Department of Mural Painting, Beaux Arts Institute, New York; Chairman, American Committee, Fontainebleau School of Fine Arts. Died in 1940. Address in 1929, 137 East 66th St., New York, NY; and Credit Lyonnais, Paris, France.

PEIXOTTO, GEORGE DA MADURO.

Painter, sculptor, architect, and mural decorator. Born in Cleveland, OH. Pupil of Meissonier and Munkacsy. Member: Societe des Artistes Francais. Award: Silver medal, Royal Academy, Dresden. Represented in Eastnor Castle, England; Corcoran Gallery, Washington, DC; Widener Memorial Library, Harvard University; murals in New Amsterdam Theater, and Park National Bank, NY. Address in 1929, "The Chalet," Crestwood, Westchester Co., NY; summer, Martha's Vineyard, MA.

PEIXOTTO, MARY H.

(Mrs. Ernest Peixotto). Painter. Born in San Francisco, CA. Pupil of San Francisco Artists' Association; Emil Carlsen; Atelier Delecluse, Paris. Member: National Association of Women Painters and Sculptors; MacDowell Club; NY School of Design. Address in 1929, 137 East 66th St., New York, NY.

PEKENINO, MICHELE.

Engraver, who appears to have been in New York in 1820, and his latest prints are dated in 1822, so that his stay there was a comparatively short one, though he engraved about thirty plates while in the United States. He was located in Philadelphia in 1821-22. That he was an intimate friend of A. B. Durand is shown by each having engraved the other's portrait and adding very friendly inscriptions, but Dunlap's story that Durand taught Pekenino to engrave is very dubious, to say the least. Durand was a line-engraver, and Pekenino's portrait of Durand, done evidently soon after his arrival in New York, is executed in stipple and is a most excellent piece of work, showing the touch of a master rather than that of an apprentice.

PELBY, MRS.

Wax modeler. Exhibited collection of scriptural wax statuary in NYC, 1848; in Boston, 1849; in Philadelphia, 1851.

PELHAM, HENRY.

Engraver, portrait and miniature painter. Born Feb. 14, 1749 in Boston; accidentally drowned in Ireland in 1806. Henry Pelham was the son of Peter Pelham and his second wife, Mary Singleton Copley; he was thus the half-brother of John Singleton Copley. The late Wm. H. Whitmore says that Henry Pelham certainly engraved a picture of "The Finding of

Moses," but he neither describes the print nor does he give his authority. The late Paul Leicester Ford also prints a letter of March 29, 1770, from H. Pelham to "Mr. Paul Revere," in which he says, "When I heard that you was cutting a plate of the late Murder, I thought it impossible as I knew you was not capable of doing it unless you copied it from mine, etc." In another letter to Charles Pelham written May 1, 1770, Henry Pelham says: "Inclosed I send you two of my prints of the late Massacre." No such prints by Pelham are known, but several water color copies of the Massacre picture have been preserved which are exactly the same in design as the Revere plate, but much superior to it as to details and in the expression of the faces. Some claim that these water colors are the work of Henry Pelham, and are the "prints" referred to, and that Revere used one of these as the original of his plate, and hence the complaint of Pelham to Revere. Exhibited at the Royal Academy in 1777, 78.

PELHAM, PETER.
Portrait painter and engraver. Born in 1697 in London, England. Between 1720-1726 he produced 25 or more mezzotint portraits of prominent persons. He came to Boston with his wife and family in 1727. Upon the death of his first wife in 1734, he married his second wife, and a child was born in Newport, RI. Returned to Boston by 1737. In 1748, he married again, the widow of Richard Copley, whose son John Singleton Copley, then eleven years of age, was destined to become celebrated as a portrait painter, and must have acquired the rudiments of art from his step-father. Had a son, Henry Pelham, in 1749. In the Antiquarian Society at Worcester is the portrait painted by Peter Pelham of the Rev. Increase Mather, who died in 1728. He painted other portraits that are known, and was the earliest mezzotintist in America. His works in mezzotint are highly esteemed, a number of which are engraved from portraits by Smibert. He died in Boston in December, 1751.

PELIKAN, A(LFRED) G(EORGE).
Painter, writer, lecturer and teacher. Born in Breslau, Germany, March 5, 1893. Studied: Carnegie Institute, B.A.; Columbia University, M.A.; Art Students League; in England; pupil of H. S. Hubbell, Hawthorne, Bicknell, E. Savage. Member: American Artists Professional League; Wisconsin Society of Arts and Crafts; Wisconsin Painters and Sculptors (hon.); Wisconsin Designer-Craftsman (hon.); Seven Arts Society (hon). Represented: The Kent Scientific Museum, South Sea Islands. Awards: Fellowship, Royal Society of Arts, London; Milwaukee Journal prize, 1931; Helen F. Mears prize, 1936. Positions: Educational Staff, Bureau of University Travel; Supt. of Fine Arts Galleries, Wisconsin State Fair; Director, Milwaukee Art Institute; Director of Art Education, Milwaukee Public Schools; others.

Author: "The Graphic Aids" series; "The Art of the Child," 1931. Contributor to art, design, education, and other magazines. Address in 1953, School Administration Building, 1111 North 10th Street; h. 7845 North Links Circle, Milwaukee, WI.

PELL, ELLA FERRIS.
Painter, sculptor, and illustrator. Born in St. Louis, MO, January 18, 1846. Pupil of Cooper Union in New York under Rimmer; Laurens, Ferdinand Humbert and Gaston St. Pierre in Paris. Work: "Salome," painting owned by Boston Art Club; "Andromeda," heroic statue. Address in 1929, Beacon, NY.

PELLEGRINI, ERNEST G.
Sculptor. Born in Verona, Italy, August 18, 1889. Studied: Academy of Verona. Member: Boston Sculpture Society; Copley Society; North Shore Arts Association; National Sculpture Society. Work: Reredos, St. Luke's Cathedral, Portland, ME; panels and triptychs in churches in Cambridge, Boston, Brighton, Lenox, MA; NYC; Washington, DC; Chicago; Portland, ME; St. Michael and All Angels Church, Cincinnati, OH. Exhibited: North Shore Arts Association; Pennsylvania Academy of Fine Arts; Detroit Institute of Art; others. Address in 1953, Boston, MA. Died in 1955.

PELTON, AGNES.
Painter. Born in Stuttgart, Germany, of American parents, Aug. 22, 1881. Pupil of Pratt Institute under Dow; W. L. Lathrop, Hamilton E. Field; and in Rome. Member: National Association of Women Painters and Sculptors; Associated Artists of Long Island; American Federation of Arts. Work: Portraits of Henry Leslie Perry, Henry Leslie Perry Memorial Library; and of William Wright Abbot, First National Bank, Louisville, GA. Died in 1961. Address in 1929, Hay Ground Windmill, Water Mill, Long Island, NY.

PELTON, OLIVER.
Engraver. Born Aug. 31, 1798 in Portland, CT. He was first a pupil and then a partner of Abner Reed, in Hartford, CT. In 1827 he was established in business as an engraver in Boston, and in 1836 the firm of Pelton and Terry was engraving banknotes in the same city. His son, Edward B. Pelton, was born in Boston in 1840, and was later a publisher in New York. Oliver Pelton was a fairly good line engraver of portraits and worked at his profession up to within a few years of his death. He also engraved a number of small subject-plates for the *Annuals*. Died Aug. 15, 1882 in E. Hartford, CT.

PEMBER, ADA HUMPHREY.
Painter. Born in Shopiere, WI, in 1859. Pupil of W. M. Clute and F. Fursman. Member: Janesville Art League; Wisconsin Painters and Sculptors. Address in 1926, 103 Jackson St., Janesville, WI.

PEMBROOKE, THEODORE KENYON.
Landscape painter. Born in Elizabeth, NJ, in 1865; died Sept. 22, 1917 in New York City.

PENCZNER, PAUL JOSEPH.
Painter. Born in Hungary, Sept. 17, 1916; U.S. citizen. Studied in Hungary and Austria. Work: The Vatican; Sir Winston Churchill's family; University of Tennessee; other university, institutional, and private collections. Exhibited: Penna. Academy of Fine Arts; Brooks Memorial Art Gallery, Memphis, TN; Smithsonian Institution; Delgado Museum, New Orleans; Kottler Gallery, New York; and others. Member: National Society of Painters in Casein; Tennessee Watercolor Society; American Artists Professional League; Southern Watercolor Society. Address in 1982, Memphis, TN.

PENDLETON, JOHN B.
Lithographer. Born in 1798 in New York City. While traveling in France he became interested in lithographs and studied the art under the best masters in Paris. On returning to America, he settled in Boston with his brother, William S. Pendleton, a copperplate printer. Established a lithographing establishment in 1825 in Boston, working there with his brother until about 1828, after which John Pendleton spent a short time in Philadelphia, and from 1829-34 he worked as a lithographer in NYC. Died March 10, 1866.

PENDLETON, W(ILLIAM) L(ARNED) MARCY.
Painter. Born in Paris of American parents, Feb. 19, 1865. Pupil of Carolus-Duran. Member: Society of Independent Artists; Salons of America. Award: Honorable mention, Paris Salon, 1888.

PENDLETON, WILLIAM S.
Engraver and lithographer. Born in New York City, January 27, 1795, of English parents. Older brother of John B. Pendleton. Worked with his brother in 1826 as an engraver in Boston, MA. Continued there as a lithographer until 1836, at which time he sold out to Thomas Moore, his bookkeeper. William then did banknote engraving and worked in the hardware business in Philadelphia. Settled in Staten Island, NY after the Civil War. Died there January 22, 1879.

PENFIELD, EDWARD.
Painter and illustrator. Born in Brooklyn, NY, in 1866. Pupil of Art Students League of New York. Member: Society of Illustrators, 1901. Specialty: Posters and cover designs. Author and illustrator of "Holland Sketches" and "Spanish Sketches;" decorations for Rochester Country Club; editor for *Harper's*, 1890-1901; instructor, Art Students League. Had profound impact on American illustration. He died Feb. 8, 1925, in Beacon, NY.

PENFOLD, FRANK C.
Born in Buffalo, NY. Received honorable mention in Paris Salon, 1889, for his painting, "Stormy Weather, North Sea."

PENMAN, EDITH.
Painter. Member of National Association of Women Painters and Sculptors. Exhibited in Annual Exhibition, 1923-24. Address in 1926, 939 Eighth Ave., New York.

PENNELL, JOSEPH.
Etcher, lithographer, illustrator and author. Born in Philadelphia, PA, July 4, 1860. Pupil of Penna. Academy of Fine Arts, and Penna. School of Industrial Art. Taught at Art Students League. Awards: 1st class gold medal, Paris Exposition, 1900; Dresden, 1902; Grand Prize, St. Louis Exposition, 1904; gold medal, Liege, 1905; Grand Prix, Milan, 1906; Barcelona, 1907; Brussels, 1910; Diplome d'Honneur, Amsterdam, 1912; 2 medals, London, 1913; Florence, 1914; commemorative medal, same, 1915. Represented in the Luxembourg, and in the collection of the city of Paris; also in Cabinet des Estamps (France); Uffizi Gallery (Florence); British Museum; S. Kensington Museum; Guildhall Gallery, London; Library of Congress, Washington; Penna. Academy, Philadelphia; Carnegie Institute, Pittsburgh; and in many state and municipal collections in Europe and the United States. Elected an Associate of the National Academy in 1907, and an Academician in 1909. Member of the New York Etching Club. Author of *Lithography and Lithographers*, 1900; *The Authorized Life of J. McN. Whistler* (with Mrs. Pennell), 1910. Pictures of War Work in America, 1918; he also illustrated a great number of books; contributor to the leading magazines. Address in 1926, Century Club, New York, NY. Died April 23, 1926, in Brooklyn, NY.

PENNEY, L. P.
Miniature painter, who flourished in Boston, 1845.

PENNIMAN, H. A. F.
Painter. Born in New York, NY, in 1882. Pupil of Twachtman, Beckwith, S. E. Whiteman, Everett L. Bryant and Anshutz; also studied in Germany. Member: Society of Independent Artists. Address in 1926, 609 Cathedral St., Baltimore, MD.

PENNIMAN, JOHN RITTO.
Painter. Born Jan. 30, 1783 in Milford, MA. Lived and worked for many years in Roxbury, MA. He was married in Boston in 1805. He painted a well-executed picture of the Boston Common and other views in and about Boston. Died in 1830.

PENNIMAN, LEONORA NAYLOR.
Painter. Born in Minneapolis, MN, April 2, 1884. Pupil of Emma Siboni. Member: Santa Cruz Art

League; San Francisco SWA; League of American PW; Women Painters of the West. Awards: Hon. mention, Santa Cruz Annual, 1928; 1st prize, water color, National Exhibition, League of American PW, San Francisco, 1931; hon. mention, Chicago, 1933. Represented in public schools at Santa Cruz, Soquel, and Aptos, CA. Address in 1933, 317 Water St., Santa Cruz, CA; summer, Brookdale, CA.

PENNINGTON, HARPER.
Painter. Born in Newport, RI, in 1854. Pupil of Gerome at the Ecole des Beaux Arts, and of Carolus-Duran and Whistler, 1874-86, during which period he also spent some time in Italy. Died March 15, 1920 in Baltimore, MD.

PENNOYER, A(LBERT) SHELDON.
Painter. Born in Oakland, CA, April 5, 1888. Pupil of Ecole des Beaux-Arts, Academies Julian and Grande Chaumiere, Rene Menard and Lucien Simon in Paris; Naum Los in Rome, Giuseppe Casciaro and Carlandi in Italy; Harold Speed in London; Penna. Academy of Fine Arts. Member: American Water Color Society; American Federation of Arts; Brooklyn Society of Artists; Century Association. Work: "Church of the Espiritu Santo, Ronda," Metropolitan Museum of Art. Died in 1957. Address in 1933, 114 East 66th St., New York, NY; summer, Litchfield, CT.

PEPLOE, FITZGERALD CORNWALL.
Sculptor. Born in England in 1861. Died in Purchase, NY, January 30, 1906.

PEPPER, BEVERLY.
Sculptor and painter. Born in Brooklyn, NY, December 20, 1924. Studied at Pratt Institute; Art Students League; and in Paris under Andre L'hote and Fernand Leger. Exhibited: Albright-Knox Art Gallery, 1968; San Francisco Museum of Art, CA, 1976; Seattle Museum of Contemporary Art, 1977; Princeton Art Museum, 1978; Andre Emmerich Gallery, 1979; International Sculpture Conference, Washington, DC, 1980; Smithsonian Institution, Washington, DC, 1980. Work: "Excaliber" (painted steel), commissioned by the San Diego Federal Courthouse, CA, 1974; "Thel" (site sculpture), commissioned by Dartmouth College, 1977; Fogg Art Museum, Cambridge, MA; Massachusetts Institute of Technology; Albright-Knox Art Gallery, Buffalo, NY; Walker Art Center, Minneapolis, MN; others. Awards: Best Art in Steel, Iron and Steel Institute, 1970; two grants from the National Endowment for the Arts, 1975, 79; and a General Services Administration Grant, 1975. Used primary forms and large geometric metal forms for her sculpture in the 1960's and early 1970's. Media: Cast steel, cast iron. Address in 1984, Torre Gentile Di Todi, Italy.

PEPPER, CHARLES HOVEY.
Painter. Born in Waterville, ME, Aug. 27, 1864. Pupil of Chase in New York; Constant, Laurens and Aman-Jean in Paris. Member: NY Water Color Club; Boston Water Color Club; Copley Society, 1900; Boston Art Club; New Haven Paint and Clay Club; Concord Art Association; Boston Society of Water Color Painters. Died in 1950. Address in 1929, Fenway Studios, 30 Ipswich St., Boston, MA; h. Concord, MA.

PEPPER, ROBERT RONALD.
Illustrator. Born in Portsmouth, NH, in 1938. Attended Los Angeles City College and received a B.A. in advertising illustration from Art Center College of Design. Since his first published work for *The Saturday Evening Post* in 1964, he has won awards from the Society of Publication Designers, Mead Library of Ideas and the Society of Illustrators. His covers for Ace, Ballantine, Avon, Dell, and the New American Library won him an award from Fantasy/Science Fiction Readers. He has also produced several posters and illustrated for major magazines.

PERARD, VICTOR S(EMON).
Illustrator and etcher. Born in Paris, France, Jan. 16, 1870. Pupil of National Academy of Design and Art Students League of New York; Ecole des Beaux-Arts in Paris, under Gerome. Member: Society of Illustrators. Instructor at Cooper Union. Specialty: Character sketches. Died July 9, 1959 in Bellport, LI, NY. Address in 1929, 55 Charles St., New York, NY.

PERATEE, SEBASTIAN.
Image maker. Worked in NYC in 1819.

PERCIVAL, EDWIN.
Painter. Born in Kensington, CT, in 1793. In 1830 he went to Hartford to study art. He was gifted but very eccentric. His drawing was good and the coloring of his pictures pleasing. He excelled in ideal sketches; the "Three Daughters of Job" was his best known work. He went to Albany in 1833 and was in partnership with Henry Bryant. He later went to Troy, NY, and died of depressing melancholy, starving to death.

PERCY, ISABELLE CLARK.
(Mrs. George Parsons West). Illustrator. Born in Alameda, CA. Pupil of Mark Hopkins Institute, San Francisco; Dow and Snell in New York and Europe; Brangwyn in England. Member: Women's Art Association; San Francisco Art Association. Awards: Hon. mention, Paris Salon, 1911; hon. mention, California bookplate and poster competitions; bronze medal for lithography, P.-P. Expo., San Francisco, 1915. Professor of design and composition, California School of Arts and Crafts, Oakland. Address in 1929, 220 Spencer St., Sausalito, CA.

PERDUE, W. K.
Painter, craftsman and writer. Born in Minerva, OH, May 17, 1884. Pupil of Dr. Esenwein. Address in 1929, 2915 Tenth St., N.W., Canton, OH.

PERELLI, ACHILLE.
Sculptor and painter. Born in Milan, Italy, in 1822. Studied at the Academy of Arts, Milan. Moved to the U.S. and settled at New Orleans. Was Louisiana's first sculptor in bronze. Painting subjects were fish and game. Died in New Orleans, Oct. 9, 1891.

PERELLI, CESAR.
Sculptor. Associated with Achille Perelli, New Orleans, 1853.

PERERA, GINO.
Painter and sculptor. Born in Siena, Italy, August 2, 1872. Pupil of Royal Academy, Rome; School of Boston Museum; H. D. Murphy, Birge Harrison, and Ochtman. Member: Boston Art Club; St. Botolph Club; Copley Society of Boston; Salma. Club. Address in 1933, 382 Commonwealth Ave., Boston, MA.

PEREZ, FRANCISCO.
Sculptor. Born in New York City, Aug. 24, 1934. Work: Private collections, including H. F. Guggenheim, J. P. Morgan; many public collections. Exhibitions: Loeb Student Center, NYU, NY; Brooklyn Museum, NY; Museum of Fine Arts, MA; and others. Address in 1970, Patchogue, NY.

PERFILIEFF, VLADIMIR.
Painter. Born in Russia, Dec. 20, 1895. Pupil of Snell, Garber, Breckenridge, McCartan, Carrois, Joseph Pearson, Schouhaieff, Andre L'hote. Member: Fellowship Penna. Academy of Fine Arts; Philadelphia Alliance; Philadelphia Sketch Club. Address in 1929, 2116 Chancellor St., Philadelphia, PA.

PERINE, GEORGE EDWARD.
Engraver. Born in South Orange, Essex County, NJ, on July 9, 1837. Mr. Perine was of Huguenot and Dutch descent, his ancestors having settled on Staten Island and in Ulster County prior to the Revolution. On May 25, 1852, he commenced engraving under Thomas Doney, of New York, and in 1856-58 he was with W. W. Rice, an excellent line and bank-note engraver of Scotch Plains. During this time, and before he was nineteen years old, he engraved in mezzotint his large plate of "The Signing of the Compact in the Cabin of the Mayflower." In 1858-60 Mr. Perine was in the employ of New York engravers, and in the latter year he began engraving on his own account and established, in time, an extensive and very successful business in NYC. Portrait engraving formed the chief part of his work; and while he employed many engravers in his establishment he is said to have finished every plate himself. Died Feb. 3, 1885 in Brooklyn, NY.

PERKES, LINNETTE MOENCH.
Painter, graphic artist, and illustrator. Born in Chicago, IL. Studied at the University of Utah. Studied privately with Alvin Gittenes, Howard Sanden and Daniel Green. Awards include 1st and 2nd prize in All-Utah Commercial Art Exhibition; 2nd and 3rd Prizes in Southern California Exhibition. Media: Oils, charcoal, pastels, pen and ink. Address in 1983, 1583 Lime Grove Rd., Poway, CA.

PERKINS, CHARLES CALLAHAN.
Born in Boston in 1823. President of the Boston Art Club, 1871. Honorary life member of the Metropolitan Art Museum of New York. Though not a professional artist, he drew and etched the plates to illustrate a number of the books on art and artists of which he was the author. Died in 1886.

PERKINS, E. G.
A line portrait of no particular merit, published by Samuel W. Wheeler, of Providence, RI, in 1831, is signed "E. G. Perkins, Sc."

PERKINS, GRANVILLE.
Born Oct. 16, 1830 in Baltimore, MD. He studied in Philadelphia under James Hamilton. He devoted himself to scene painting and illustrating. He was a member of the Water Color Society, and exhibited frequently at the National Academy of Design. Died April 17, 1895 in New York City.

PERKINS, HARLEY.
Portrait painter. Pupil of DeCamp; Tarbell; Benson; Massachusetts Normal Art School; Boston Museum School. Member: Boston Art Club. Art editor and critic for Boston *Evening Transcript*. Address in 1929, Fenway Studios, 30 Ipswich St., Boston, MA.

PERKINS, JACOB.
Born in Newburyport, MA, in 1776; died in London, England, in 1849. Perkins was not known to have been an engraver on copperplate, but his influence upon the development of bank-note engraving was so marked that he deserves mention among engravers. As a silversmith in his native town he made the dies for the Massachusetts copper coinage of 1787, and he was early prominent as an inventor of machines for various purposes. In 1810 he found means for the important substitution of steel for copper plates in engraving bank-notes, thus greatly prolonging the life of the plate.

PERKINS, JOHN U.
Painter. Born in Washington, DC, in 1875. Pupil of Chase. Member of Society of Washington Artists. Address in 1926, 815 A St., N.E., Washington, DC.

PERKINS, JOSEPH.
Engraver. Born Aug. 19, 1788 in Unity, NH. Joseph Perkins graduated from Williams College in 1814; in

1818 he went to Phila. and there learned script engraving. He established himself in business in that city, but in 1825 he removed to New York and with A. B. Durand he became a member of the bank-note engraving firm of Durand, Perkins & Co. Died April 27, 1842 in New York City.

PERKINS, LUCY FITCH.
(Mrs. Dwight H. Perkins). Illustrator and teacher. Born in Maples, IN, July 12, 1865. Pupil of Boston Museum School. Author and illustrator of *A Book of Joys, The Goose Girl, The Dutch Twins, The Scotch Twins, Dandelion Classics, Cornelia,* and other books for children. Died in 1937. Address in 1929, 2319 Lincoln St., Evanston, IL.

PERKINS, MARY SMYTH.
(Mrs. William F. Taylor). Painter. Born in Phila., PA. Pupil of Penna. Acad. of Fine Arts; Robert Henri; Phila. School of Design under Wm. Sartain; Lawton Parker School, Cottet and Simon in Paris. Member: Nat. Assoc. of Women Painters and Sculptors. Award: Mary Smith prize, Penna. Acad. of Fine Arts, 1907. Work: "Portrait of James L. Miles," City Hall, Phila., PA. Address 1929, Lumberville, PA.

PERKINS, MISS.
Portrait draughtsman in pastel. She was a sister of Dr. Perkins. Portraits in pastel (probably by Miss Perkins) of Caleb Perkins, Lucy Perkins, and Sarah Perkins are owned by the Connecticut Historical Society. She was working in Connecticut about 1790.

PERKINS, WILLARD.
Painter, who exhibited water colors at the Penna. Academy of Fine Arts, Philadelphia, PA, 1925. Address in 1926, Fort Washington, PA.

PERL, A.
Sculptor. In New Orleans, LA, 1857.

PERO, LORENZO.
Image maker. Born in Tuscany, 1837. In Phila. in 1860, working and living with Lorenzo Hardie. Medium: Plaster.

PEROT, JAMES.
Engraver. He was one of the Huguenot settlers of New Rochelle, NY, and was a silversmith of that place, and later of Bermuda and Phila. He was a brother-in-law of Robert Elliston of NY. He was probably the founder of the Perot family in Phila., and the father of Elliston Perot, a prominent merchant of Phila., about 1790. A Chippendale bookplate of James Perot with a wide engraved border is said to have been engraved by Perot himself.

PERRETT, A. LOUISE.
Painter, illustrator and teacher. Born in Chicago, IL. Pupil of Art Institute of Chicago; Howard Pyle; John Carlson. Member: Chicago Society of Artists; Oak Park, River Forest and Austin Art League. Instructor, Art Institute of Chicago. Address in 1929, 150 North Scoville Ave., Oak Park, IL.

PERRETT, GALEN JOSEPH.
Painter and illustrator. Born in Chicago, IL, Sept. 14, 1875. Pupil of Art Institute of Chicago; Munich Art Academy, Germany; Colarossi and Julian Academies in Paris. Member: Salma. Club; NY Water Color Club; American Federation of Arts. Represented in Newark, NJ, Museum. Address in 1929, 51 West 10th St., New York, NY; h. 492 Mt. Pleasant Ave., Newark, NJ; Rockport, MA.

PERRINE, VAN DEARING.
Painter. Born in Garnett, KS, Sept. 10, 1869. Self-taught. Member: Associate National Academy of Design; New Society of Artists. Awards: Silver medal, Charleston Expo., 1902; honorable mention, Carnegie Institute of Pittsburgh, 1903; silver medal, P.-P. Expo., San Francisco, 1915. Experiments with color music. Represented in Phillips Memorial Gallery, Washington, DC. Died Dec. 10, 1955 in Stamford, CT. Address in 1929, 42 Prospect Ave., Maplewood, NJ.

PERRY, CLARA FAIRFIELD.
(Mrs. Walter Scott Perry). Painter and lecturer. Born in Brooklyn, NY. Pupil of Walter Scott Perry, Henry B. Snell, Ettore Caser. Member: Meridian Club; Brooklyn Society of Artists; Brooklyn Painters and Sculptors. Died in 1941. Address in 1929, 56 Cambridge Pl., Brooklyn, New York, NY; summer, Elmcroft, Stoneham, MA.

PERRY, CLARA GREENLEAF.
Sculptor, painter, and lecturer. Born in Long Branch, NJ, August 22, 1871. Pupil of Robert Henri. Member: Copley Society; National Academy of Design; Women Painters and Sculptors; Washington Art Club. Address in 1933, care of Mrs. David Perry, The Wyoming, Washington, DC; summer, Chavaniac-Lafayette, Haute Loire, France.

PERRY, EDITH DEAN WEIR.
(Mrs. James DeWolf Perry). Miniature painter. Born in New Haven, CT, August 17, 1875. Pupil of Yale School of Fine Arts under her father, John F. Weir; of Lucia Fairchild Fuller; and Adele Herter. Member: Providence Art Club. Award: Hon. mention, Pan-Am. Expo., Buffalo, 1901. Work: "Virgin and Child," St. Paul's Church, New Haven, CT; tabernacle door, Christ Church, West Haven, CT. Specialty: Portrait miniatures. Address 1929, Bishops House, Providence, RI.

PERRY, EMILIE S.
Sculptor and medical illustrator. Born in New Ipswich, NH, December 18, 1873. Pupil of School of

the Boston Museum; Massachusetts Normal Art School; Max Broedel. Member: Ann Arbor Art Association. Work: Panel in bas relief, The Women's Club, Hollywood; panel, Hollywood Library; bust of Prof. Gordon, College of Garvanza, Los Angeles, CA. Address in 1929, Ann Arbor, MI. Died in 1929.

PERRY, ENOCH WOOD, JR.
Genre, portrait, and landscape painter. Born July 31, 1831 in Boston, MA. Came to New Orleans in 1848; went to Europe and studied in Dusseldorf with Leutze and in Paris with Couture, 1852 and 1853; then to Rome and Venice, 1856 to 1858; returned to the U.S. in the latter year. In 1860 he had a studio at 108 St. Charles Street, New Orleans. He painted the splendid lifesize portrait of U.S. Senator John Slidell, now in the Louisiana State Museum. In 1861 he painted Jefferson Davis, using the map of the Conf. States as a background. He traveled extensively and was a famous international portrait painter, having painted many of the great men of his time. Among his important figure compositions is "Signing the Ordinance of the Secession of Louisiana," painted in 1861. In 1865 he settled in NY. He was elected an Associate of the National Academy of Design in 1868, and a full Academician in 1869; he was also a member of the American Water Color Society. Died Dec. 14, 1915, in NY.

PERRY, IONE.
Painter. Born in New York City in 1839. Student of the Cooper Institute, and pupil of Henry Loop. Among her best known paintings are "Hypatia," "Romola," "Consuelo" and "Elsa, at the Coming of Lohengrin." Mother of Roland Hinton Perry.

PERRY, J(AMES) R(AYMOND).
Painter. Born in Northfield, MA, April 20, 1863. Self taught. Member: Chicago Society of Artists; Business Men's Art Club; South Side Art Association; Chicago Municipal Art League; All-Illinois Society of Fine Arts; Illinois Academy of Fine Arts; American Federation of Arts. Represented in Chicago Public Schools. Address in 1929, 5221 Cornell Ave., Chicago, IL.

PERRY, JOHN D.
Sculptor. Born in Swanton, VA, in 1845. He lived in New York, 1869-70, but passed the rest of his professional life in Italy and Boston. He made many portrait busts, and his statuette of Sumner was highly praised.

PERRY, LILLA CABOT.
(Mrs. Thomas S. Perry). Painter and writer. Born c. 1848 in Boston, MA. Pupil of Cowles Art School under D. M. Bunker and R. W. Vonnoh in Boston; Julian and Colarossi academies and at Alfred Stevens' studio in Paris. Member: American Federation of Arts; Guild of Boston Artists; Societe des Artistes Independants, Paris; International Society of Arts and Letters; Women's International Art Club, Paris and London; Nippon Bijitsu-in, Tokyo; Concord Art Association; Connecticut Academy of Fine Arts. Awards: Silver medal, Boston, 1892; bronze medal, St. Louis Expo., 1904; bronze medal, P.-P. Expo., San Francisco, 1915. Work: "The Young 'Cellist," Boston Museum of Fine Arts; "Portrait of Worthington Ford," NY Public Library; "Pair of Blue Eyes," American Federation of Women's Clubs, Washington, DC; "After the First Snow," Carolina Art Association, Charleston. Author of *The Heart of the Weed, From the Garden of Hellas, Impressions, The Jar of Dreams*. Died in 1933 in Hancock, NH. Address in 1929, Fenway Studios, 30 Ipswich St.; h. 312 Marlborough St., Boston, MA.

PERRY, MAEBLE CLAIRE.
Sculptor. Born in Idaho, February 11, 1902. Pupil of Albin Polasek. Award: Alliance, 1931. Work: "Jeff," Art Institute of Chicago. Address in 1933, 1142 Maple Ave., Evanston, IL.

PERRY, OSWALD.
Sculptor. He exhibited in Chicago and Cincinnati. Active in Cincinnati, OH, in 1925.

PERRY, RAYMOND K.
Painter, illustrator, and designer. Born in Sterling, IL, 1876 or 1886. Pupil of Art Institute of Chicago. Member: Salma. Club, 1908; American Water Color Society (life); NY Water Color Club. Windows in St. Andrews Church, Pittsburgh; Memorial Library, Hanover, PA; portraits, "W. H. Shelton," "Jumel Mansion," "Maj. Barnard," 7th Regiment Armory, and drawing, Fraunces Tavern, New York, NY; Press Club, Baltimore, MD; Poe Cottage, Philadelphia, PA. Died in 1960. Address in 1929, 145 East 34th St., New York, NY.

PERRY, RAYMOND W.
Painter. Born in Natick, MA, July 28, 1883. Pupil of A. K. Cross, W. D. Hamilton, Munsell, Vojtech Preissig; Massachusetts School of Art (grad.). Member: Providence Art Club; Providence Water Color Club; Massachusetts Normal Art Association; Eastern Arts Association. Address in 1933, 175 Evergreen St., Providence, RI; summer, West Dennis, MA.

PERRY, ROLAND HINTON.
Sculptor and portrait painter. Born in New York, Jan. 25, 1870. Pupil of Gerome, Delance, Callot, Chapu and Puech in Paris; Ecole des Beaux-Arts, Academie Julien, Paris; Art Students League, NY. Member: National Sculpture Society; American Federation of Arts. Work: "Fountain of Neptune," Library of Congress, Washington; Langdon doors, Buffalo Historical Society; frieze, New Amsterdam Theatre, New York; "Pennsylvania" on dome of

Capitol, Harrisburg; "Gen. Greene" and Gen. Wadsworth" at Gettysburg; "New York State Memorial," Andersonville; "Gen. Curtis," Ogdensburg; "Gen. Castleman," Louisville; "New York Monument," Chattanooga; "Benjamin Rush Monument," and Lions, Conn. Ave. Bridge, Washington; monument to 38th Infantry, Syracuse, NY. Exhibited at National Sculpture Society in 1923. Address in 1933, 51 West 10th St., New York, NY. Died October 27, 1941.

PERRY, W. A.
Painter. Born in Wasepi, MI. Pupil of San Francisco School of Art and of W. V. Cahill and John Rich. Address in 1926, 6172 Chabot Road, Oakland, CA.

PERRY, WALTER SCOTT.
Painter, sculptor, teacher, writer, and lecturer. Born in Stoneham, MA. Pupil of Langerfeldt, Higgins and Pierre Millet; Massachusetts Normal Art School; studied abroad. Member: Nat. Arts Club; Alliance; Eastern Arts Association; Western Art Association; Rembrandt Club. Supervisor of drawing and art education, public schools, Fall River, MA, 1875-79; and Worcester, MA, 1879-87. Director, School of Fine and Applied Arts, Pratt Institute, since its organization, from 1887 to 1928. Author of *Egypt, the Land of the Temple Builders; With Azir Girges in Egypt*; textbooks on art education. Lecturer on architecture, sculpture, painting and decoration. Address in 1929, 56 Cambridge Pl., Brooklyn, New York, NY; summer, Elmcroft, Stoneham, MA.

PERSICO, E. LUIGI.
Sculptor, miniature and portrait painter. Born in Naples, 1791. Came to America in 1818. At Lancaster, Harrisburg, and Philadelphia, PA, 1819, 20. At Philadelphia, 1824-25. Executed sculpture for the U.S. Capitol at Washington, including colossal "War" and "Peace" for the east portico. Project completed in 1834. Exhibited at the Boston Athenaeum and the Artists' Fund Society of Philadelphia, 1834-55. Later settled in Europe; died in 1860 at Marseilles.

PERSICO, GENNARINO.
Miniature painter. He was the brother of Luigi Persico, the sculptor. He came from Naples. See "Lancaster Historical Society Papers." Exhibited at the Penna. Academy, 1827. Died c. 1859.

PESCHERET, LEON R(ENE).
Etcher, craftsman, designer, painter, illustrator, architect, writer and teacher. Born in Chiswick, England, March 15, 1892. Pupil of Fleury; Millet; Art Institute of Chicago; Royal College of Engraving, Kensington, England. Member: Palette and Chisel Club; Chicago Society of Etchers; American Color Print Society; Printmakers' Society of California; Society of American Printmakers'; others. Work: British Museum; Library of Congress; Cabinet du Roi, Brussels; NY Public Library; Art Institute of Chicago; American Color Print Society; decoration in Drake Hotel, Chicago; Peoria Country Club; interior of Memorial Union Building, Univ. of Wisconsin. Exhibited: Buck Hills Art Association, 1948, 49; Chicago Galleries Association, 1951. Award: Lila Mae Chapman award, 1936, 37. Author and illustrator of *Principle and Practice of Interior Decorating*, and *An Introduction to Color Etching*; illustrator, *The Spirit of Vienna*, and *Chicago Welcomes You*. Contributor of color etchings to *American Artists* and *Arizona Highways* magazines. Died in 1961. Address in 1953, Whitewater, WI.

PETERDI, GABOR F.
Painter and printmaker. He was born Sept. 17, 1915 in Budapest, Hungary. Citizen of U.S. Studied at Hungarian Academy, Budapest; Academie Julian, Atelier 17 with Hayter, and Academie Scandinave, Paris; Academy of Fine Arts, Rome. Taught at Brooklyn Museum Art School; Hunter College; Yale (prof. of art since 1960). Awards: Prix de Rome, 1930; Museum of Western Art, Tokyo, 1964; Guggenheim fellowship, 1964-65; Penna. Academy of Fine Arts; Boston Printmakers; Seattle Art Museum; and others. Exhibited at Levy Gallery, NYC; Philadelphia Art Alliance; Smithsonian; Brooks Memorial Art Gallery; Brooklyn Museum; Cleveland Museum; Salt Lake City Art Center; NY Public Library; Yale; Corcoran; Silvermine Guild; Aldrich Art Museum; Kanegis Gallery, Boston; Wesleyan; Berkeley; University of Kentucky; over 100 one-man shows and 22 retrospectives. In collections of University of Georgia (Athens); Wesleyan College; Harvard; Addison; University of Michigan; Albright-Knox; Art Institute of Chicago; Vassar College, Poughkeepsie, NY; Cleveland Museum of Art; Brown University; Smithsonian; Clarkson College; Whitney; Boston Museum of Fine Arts; Museum of Modern Art; Yale; Wadsworth; University of North Carolina; Rijks Museum, Amsterdam; Museum of Prague, Czechoslovakia; and many others internationally. Member: Silvermine Guild of Artists; National Drawing Society; Florentine Academy of Design. Media: Oil; intaglio. Address in 1984, Rowayton, CT.

PETERS, CARL W(ILLIAM).
Painter. Born in Rochester, NY, Nov. 14, 1897. Pupil of Rosen, Ross and Carlson. Member: Rochester Art Club; Buffalo Society of Artists; Springfield Art Association; American Federation of Arts. Award: Fairchild Gift of 1924 from the University of Rochester; silver medal, Rochester Art Club, 1925, first prize, 1927-28; third Hallgarten prize, National Academy of Design, 1926, and second Hallgarten prize, 1928; hon. mention, Buffalo Society of Artists, 1927. Address in 1929, Jefferson Ave., Fairport, NY.

PETERS, CHARLES F.
Illustrator and etcher. Born in Christiania, Norway, in 1882. Work: Cartoons in *Life*; illustrations in

Scribner's, Harper's, and *Century.* Address in 1926, 412 East 50th St., New York, NY. Died June 21, 1948.

PETERS, CHARLES ROLLO.
Painter. Born in California in 1862. Pupil of Virgil Williams in San Francisco; Ecole des Beaux Arts under Gerome, and of Boulanger and Lefebvre in Paris. Member: Lotos Club; Salmagundi Club, 1901. Awards: Bronze medal, Pan.-American Exposition, Buffalo, NY, 1901; silver medal, St. Louis Exposition, 1904. Address in 1926, Monterey, CA. Died c. 1928.

PETERS, DEWITT CLINTON.
Painter, illustrator and teacher. Born in Baltimore, MD, June 11, 1865. Pupil of Ecole des Beaux-Arts under Gerome, and of Lefebvre, Boulanger and Collin in Paris. Award: Bronze medal, Paris Exp., 1889. Specialty: Portraits. Founder and principal instructor, Clinton Peters Art Classes, New York. Address in 1929, Class Studio 606, 1947 Broadway; h. Apt. 7D, 145 West 55th St., New York, NY.

PETERSEN, CHRISTIAN.
Sculptor. Born in Dybbol, North Slesvig, Denmark, February 25, 1885. Pupil of Newark Technical School; Art Students League of New York; RI School of Design; and H. H. Kitson. Member: Attleboro Chapter, American Federation of Arts; Chicago Galleries Association; East Orange Art Association. Work: "Battery D Memorial," New Bedford, MA; "Spanish War Memorial," Newport, RI; "Rev. John W. Moore," St. John's College, Brooklyn, NY; "Governor George W. Clarke" and "Henry C. Wallace, Secretary of Agriculture," State of Iowa; "Niels Bukh," Bukh's School, Ollerup, Denmark. Address in 1933, Buchanan Street, Belvidere, Illinois.

PETERSEN, EUGEN H.
Painter, designer, lecturer and teacher. Born in Bluefields, Nicaragua, Feb. 16, 1894. Studied: Pratt Institute Art School, Brooklyn, NY; NY University, B.A.; pupil of John F. Carlson and George Elmer Browne. Exhibited: National Academy of Design; Brooklyn Museum; Salma. Club. Member: Brooklyn Society of Artists; Swedish-American Artists. Instructor, supervisor, and professor of art, Pratt Institute Art School, Brooklyn, NY, from 1921. Address in 1953, 345 Park Avenue, Manhasset, NY.

PETERSEN, JOHN ERIK CHRISTIAN.
Painter. Born in Denmark in 1839; died in Boston, MA, in 1874. In 1864 he settled in this country and opened his studio in Boston, and devoted himself mainly to marine painting. His work is strong and effective. Among his paintings are "After the Collision," "Making Sail after the Gale," and "The Phantom Ship."

PETERSEN, MARTIN.
Painter. Born in Denmark, Nov. 23, 1870. Pupil of National Academy of Design. Member: NY Water Color Club; Salma. Club, 1906. Awards: Third Hallgarten prize, National Academy of Design, 1905; Beal prize, NY Water Color Club, 1906; Inness prize, Salma. Club, 1907. Address in 1929, 437 West 59th St., New York, NY; h. 325 Hillside Ave., West Nutley, NJ.

PETERSON, C.
American marine painter.

PETERSON, ELSA KIRPAL.
(Mrs. R. M. Tower Peterson). Sculptor. Born in New York, NY, June 16, 1891. Pupil of Edith Woodman Burroughs; J. E. Fraser; Hans Schwegerle in Munich. Member: Art Alliance of America; Art Students League of NY. Address in 1933, 67 Hillside Ave.; h. 140 Barclay St., Flushing, NY.

PETERSON, GEORGE D.
Sculptor. Born in Wilmington, Delaware, 1862. Specialty: Animals.

PETERSON, JANE.
(Mrs. M. Bernard Philipp). Painter. Born in Elgin, IL. Pupil of Pratt Institute Art School, Brooklyn, NY; and of Brangwyn, Blanche, L'Hote and Sorolla. Member: Fellow, National Academy of Design; NY Water Color Club; American Water Color Society; National Association of Women Artists; Society of Painters of NY; Connecticut Academy of Fine Arts; Pen and Brush Club; National Arts Club; Art Alliance of America; Hartford Art Association; Gloucester Society of Artists; Audubon Artists; Allied Artists of America; American Federation of Arts; Washington and Philadelphia Water Color Clubs; North Shore Arts Association; Federation Francaise des Artistes, Paris; Turkish American Painters Assoc., Constantinople; others. Awards: Water color prize, Girls' Art Club, Paris; hon. mention, Connecticut Academy of Fine Arts, 1916; Flagg prize ($100), Connecticut Academy of Fine Arts, 1917; hon. mention, National Association of Women Artists, 1919, 27; Florida Society of Artists, 1938; Washington Water Color Club, 1940. Work: "Glimpse of the Grand Canal," Art Association, Grand Rapids, MI; Girls' Art Club, Paris; Brooklyn Athletic Club; Public Schools, Evanston, IL; Country Club, Torrington, CT; Y.M.C.A., Elgin, IL; Boise (Idaho) Public Library; Brooklyn Museum; Syracuse Art Museum; Wichita Art Museum; Wesleyan College. One-woman exhibitions: Syracuse Museum of Fine Arts; Springfield Museum of Fine Arts; Philbrook Art Center; Wichita Art Association; Crocker Art Gallery, Sacramento, California; Santa Barbara Museum of Art; others. Group exhibitions: Corcoran; Penna. Academy of Fine Arts; National Academy of Design; National Association of Women Artists;

American Water Color Society; Washington and Philadelphia Water Color Clubs; Binghamton Museum of Art; Montclair Art Museum; Princeton University; Brooks Memorial Art Gallery; J. B. Speed Memorial Museum; Butler Art Institute; many others. Author of *Flower Painting*. Instructor at Art Students League, 1914-19. Died in 1968. Address in 1953, 1007 Fifth Ave., New York, NY.

PETERSON, LARRY D.
Painter. Born in Holdrege, NE, Jan. 1, 1935. Studied: Kearney State College, 1958; Northern Colorado University, 1962; University of Kansas, Ed.D., 1975. Work: University of Minn.; commissions, First Methodist Church, and State Bank, Kearney, NE; many private collections. Exhibitions: Joslyn Art Museum, Omaha, NE, 1974, 75; Annual American National Miniature Exhibition, Laramie, WY, 1977, 80, 81; Augustana College, Sioux Falls, SD, 1980; 10th Annual National Fall Art Fete, Scottsbluff, NE, 1980-81; others. Awards: America's Outstanding Names and Faces, Scholastics, 1978; Governor's Art Award, State of Nebraska, 1981. Teaching: Kearney (NE) State College, 1967 to present. Member: National Art Education Association; Nebraska Art Teachers Association; Association of Nebraska Art Clubs; National Art Fraternity. Media: Watercolor, acrylic. Address in 1984, Kearney, NE.

PETERSON, PERRY.
Illustrator. Born in Minneapolis, MN, in 1908. Received his art training through the Federal Schools Course and later at the Art Institute of Chicago. His career began with advertising assignments in Chicago and Detroit, but he soon moved to NY, where he worked at the Byron Musser Studio. His free-lance career began in 1942, and he illustrated for *The Saturday Evening Post, Liberty, Good Housekeeping* and others. Died in 1958.

PETHEO, BELA FRANCIS.
Painter and printmaker. Born Budapest, Hungary, May 14, 1934; U.S. citizen. Studied: University of Budapest, M.A., 1956; Academy of Fine Arts, Vienna, 1957-59, with A. P. Gueterslogh; University of Vienna; University of Chicago, M.F.A., 1963. Work: Hungarian State Museum of Fine Arts, Budapest; Kunstmuseum, Bern, Switzerland; University of Minnesota permanent collect.; others. Commissions: Assoc. of Austrian Boy Scouts; Hall of Education, NY World's Fair, 1964; others. Exhibitions: Hamline University; University of Chicago; Coffman Gallery, University of Minnesota; Biennale Wisconsin Printmakers; Tweed Museum of Art, MN; and others. Awards: Academy of Fine Arts, Vienna; University of Chicago, Graphic Prize; Rockefeller Foundation Scholarship; purchase award, Pillsbury Invitational; and others. Art Positions: Artist in residence at St. John's University; lecturer at Museum of Fine Arts, Budapest. Illustrator and author of many articles on

art. Member: College Art Association of America; Los Angeles Printmaking Society. Media: Lithograph, oil, acrylic. Address in 1982, Saint John's University, Department of Art, Collegeville, MN.

PETO, JOHN FREDERICK.
Painter. Born in Philadelphia, PA, in 1854. Self-taught, with one year at the Penna. Academy of Fine Arts, 1878. Moved to Island Heights, NJ, 1889; visited the West twice; never traveled to Europe. With the exception of one exhibit at the Penna. Academy, he had no major shows until the 1950's. Painted "Trompe l'oeil" still lifes characterized by asymetrical arrangement of banal subjects such as string, tin cups, tattered books, umbrellas, torn postcards. His use of light and color are said to be reminiscent of Vermeer. Died in 1907. Represented by Kennedy Galleries, NYC.

PETREMONT, CLARICE MARIE.
Painter, illustrator, craftsman and teacher. Born in Brooklyn, New York. Pupil of Marshall Fry and Paul Cornoyer. Member: New Haven Paint and Clay Club; Bridgeport Art League; Boston Society of Arts and Crafts; American Artists Professional League. Died in 1949. Address in 1929, Shelton, CT.

PETROVITS, MILAN.
Painter. Born in Vienna, Austria, Jan. 17, 1892. Pupil of Arthur C. Sparks. Member: Pittsburgh Art Association. Award: Third prize, 1922, first prize for group paintings, 1923, first prize, 1924, Pittsburgh Art Association. Work: "Portrait of An Old Man," "Girl with Guitar," and "Evening," Public School Collection, Pittsburgh, PA. Address in 1929, 723 Liberty Ave., Pitts., PA; h. Verona Rd., Verona, PA.

PETRUCCELLI, ANTONIO.
Illustrator. Born in Fort Lee, NJ, in 1907. Attended the Master School of United Arts in NY in the early 1920's. He began his career in 1929 with a *House Beautiful* cover and has since illustrated many books for *Time-Life*, as well as many magazines, over a 40-year period. His posters have won awards from *House Beautiful*, the American Society for Cancer Control, and International Press Exhibition in Cologne, 1928. He designed the postage stamp for the Steel Centenary in 1957 and an award-winning medal for the Franklin Mint in 1973.

PETRY, VICTOR.
Painter, illustrator, etcher, teacher. Born in Phila., PA, Oct. 9, 1903. Pupil of Frederick Waugh. Work: "White-Tailed Deer," Brooklyn Museum, Brooklyn, NY. Died July 1924 in NYC. Address 1929, 29 Cedar Ln., Douglaston, LI, NY; summer, Ogunquit, ME.

PETTICOLAS, EDWARD F.
Portrait painter in oils and miniatures. Born in 1793 in Pennsylvania, the son of Philip Petticolas. He

practiced in Richmond, VA, in 1805-34, after studying with Thomas Sully in Philadelphia. His portrait of John Buchanan is owned by the Virginia State Library, Richmond, VA. A miniature of Elihu Etting, signed on front "E. F. Petticolas 1799," was presented in 1886 by Mr. Etting to the Penna. Academy of Fine Arts. Died c. 1853.

PETTICOLAS, PHILIP A.
Miniature painter, who was born in 1760 in France. He painted for years in Richmond, Virginia, and died in Virginia in August, 1841. It is claimed that Washington gave him sittings for a miniature in Philadelphia in 1796. He also made several miniatures of Washington from Gilbert Stuart's first portrait.

PETTINGILL, LILLIAN ANNIN.
(Mrs. C. K. Pettingill). Painter and teacher. Born in Le Roy, NY, Feb. 4, 1871. Pupil of Irving R. Wiles; L. M. Wiles; Rhoda Holmes Nicholls, Chase School; Art Students League of NY. Address in 1929, 319 South 8th St., La Crosse, WI.

PETTRICH, FERDINAND (or FRIEDRICH) AUGUST.
Sculptor. Born at Dresden, Germany, December 3, 1798. Came to U.S. in 1835. Residing in Rio de Janeiro, Brazil, in 1847; Court Sculptor to Emperor Dom Pedro II. Probably in Philadelphia, 1850. Works include bronze statue of Washington, New York Customs House, plaster replica at National Museum, Washington, DC; tomb, Laurel Hill Cemetery, Philadelphia; marble portrait of Hoel Poinsett, Secretary of War, National Museum; portraits of Henry Clay and Martin Van Buren; others. Honorary professional member of Nat. Acad. of Design, NYC, 1838-60. Exhibited at Penna. Academy, 1843-1870.

PETTY, MARY.
Illustrator. Born in Hampton, NJ, in 1899. Her works appeared in *The New Yorker* from 1927 until 1966, during which time she illustrated 38 covers, her last on Mother's Day in 1966. Her artwork was often satirical, preying on rich dowagers. In 1927 she married a NY cartoonist, Alan Dunn. Died in 1976.

PEUGEOT, GEORGE I(RA).
Painter, craftsman. Born Buffalo, NY, Nov. 26, 1869. Pupil of Peter Gowans. Member: Buff. Soc. of Artists. Address 1929, 120 Highland Ave., Buffalo, NY.

PEW, GERTRUDE L.
Miniature painter, who exhibited at the Penna. Academy of Fine Arts, Philadelphia, 1925. Address in 1926, 48 East 49th St., New York.

PEYRAUD, ELIZABETH K.
(Mrs. F. C. Peyraud). Painter and illustrator. Born in Carbondale, IL. Pupil of Art Institute of Chicago; F.

C. Peyraud. Member: Painters and Sculptors of Chicago; Chicago Water Color Club; Cordon Club; Alumni Art Institute of Chicago; Chicago Galleries Association. Address in 1929, 1230 Judson Ave., Highland Park, IL.

PEYRAUD, FRANK C.
Painter. Born in Bulle, Switzerland, 1858. Pupil of Art Institute of Chicago; Ecole des Beaux-Arts, Bonnet, Friburg, Paris. Member: Painters and Sculptors of Chicago; Chicago Water Color Club; National Arts Club; American Federation of Arts. Awards: Fortnightly prize, 1899, Butler prize, 1912, Chicago Society of Artists medal, 1912, Carr prize, 1913, Grower prize, 1915, Martin B. Cahn prize, 1921, all from Art Institute of Chicago; bronze medal, P.-P. Expo., San Francisco, 1915; silver medal, Hamilton Club, Chicago, 1920. Work: Union League Club, Chicago; Art Institute of Chicago (Municipal Art League collection); fresco in Peoria Public Library; "After Rain, Chicago," Friends of American Art, Chicago, IL; "Late Afternoon," Museum at Bulle, Switzerland. Died May 31, 1948. Address in 1929, 1608 Monroe Bldg.; 1230 Judson Ave., Highland Park, IL; Ravinia, IL.

PEYTON, ALFRED CONWAY.
Painter and illustrator. Born in Dera Doon, British India, Nov. 9, 1875. Pupil of South Kensington Schools, London, England. Member: American Water Color Society; NY Water Color Club; North Shore Arts Association. Awards: Silver medals at Bombay and Madras, British India. Died in 1936. Address in 1929, Budworth and Son, 424 West 52nd St., New York, NY; summer, Reed Studio Bldg., East Gloucester, MA.

PEYTON, ALFRED CONWAY (MRS.).
See Menzler-Peyton, Bertha S.

PEYTON, ANN MOON.
(Mrs. Philip B. Peyton). Painter and illustrator. Born in Charlottesville, VA, in 1891. Pupil of George Bellows. Address in 1926, 3804 Locust Street, Philadelphia, PA.

PFEIFER, HERMAN.
Painter and illustrator. Born in Milwaukee, WI, Nov. 24, 1879. Pupil of Howard Pyle. Member: Society of Illustrators. Illustrations for *Harper's, Century, McClure's, Ladies' Home Journal, Good Housekeeping*, etc. Address in 1929, 424 East 57th St., New York, NY; summer, Arrochar, Staten Island, NY.

PFEIFFER, FRITZ (WILHELM).
Painter, illustrator, craftsman and writer. Born in Adams County, PA, June 3, 1889. Pupil of Henri, Chase, Anschutz and Breckenridge. Died in 1960. Address in 1929, 151 Richmond Hill Ave., Kew Gardens, Long Island, NY.

PFEIFFER, HEINRICH (HARRY R.).
Painter and teacher. Born in Hanover, PA, Oct. 19, 1874. Pupil of Penna. Academy of Fine Arts, with Hugh Breckenridge, Henry McCarter; Art Students League of NY, with John Carlson. Exhibited: Penna. Academy of Fine Arts; Art Institute of Chicago; Corcoran. Member: Northeastern Soc. of Contemporary Artists. Address in 1953, 18 Aviles Street, St. Augustine, FL; summer, 244 Commercial Street, Provincetown, MA.

PFEIFFER, JUSTUS.
Painter. Exhibited in Phila., 1921, in "Exhibition of Paintings Showing the Later Tendencies of Art." Address in 1926, care of Preston Dickinson, Long Island, New York.

PFISTER, JEAN JACQUES (MR.).
Painter and teacher. Born in Switzerland. Studied at Hopkins School of Fine Arts, San Francisco; with Wayman Adams; and at Art School of Bremen, Germany. Member: National Arts Club; American Water Color Society; Salma. Club; NY Water Color Society; Laguna Beach Art Association; Yonkers Art Association; Westfield Art Association; New Rochelle Art Association. Work: Portraits, Winter Park, FL; Vermont Historical Museum, Old Bennington, VT; Capistrano, CA; Columbia University Chapel, New York, NY; Elk Temple, Passaic, NJ. Died in 1949. Address in 1933, Rollins College, Winter Park, FL; h. 1358 Richmond Road, Winter Park, FL.

PFLAUMER, PAUL GOTTLIEB, II.
Painter, illustrator and craftsman. Born in Philadelphia, Aug. 9, 1907. Pupil of Thornton Oakley, Luigi Spizzirri, John Dull. Member: Philadelphia Alliance. Address in 1933, 6965 Ogontz Ave., Philadelphia, PA.

PHEARSON, JUDY.
Painter. Born on March 18, 1943, in Boise, Idaho. Studied under many private instructors. Exhibited: Ellensburg Nat. Western Art Show, WA; Oregon Trail National Art Show; Western Masters, Scottsdale, AZ; Great Falls, Russell Show, Trails West Gallery; Ducks Unlimited, various cities; Favell Anniversary Invitational, Klamath Falls, OR; others. Member: Society of Western Artists; League of Women Artists, OR; Wildlife Artists of the World; National Wildlife Association. Awards: Best of Show, Southern Oregon Show, 1981; Best of Show, Rogue Valley Benefit, 1983; Best of Show, Favell Museum Anniversary, Klamath Falls, OR, 1983. Specializes in wildlife and western subjects. Media: Oil, tempera, pencil. Address in 1983 (studio), Klamath Falls, OR.

PHELAN, ELIZABETH SIMON.
Sculptor. Born in St. Louis, MO, Dec. 9, 1896. Studied at Columbia, 1919-21; Washington University, 1939, 40. Exhibitions: Art Mart, Clayton, MO, 1953 (one-woman), 1958; John Burroughs School, 1959 (one-woman); St. Louis Artists' Guild, 1955; Bernandy Architectural Office, 1952; 3rd Sculpture International, Philadelphia, 1949; National Academy of Design, 1948; Penna. Academy of Fine Arts, 1951. Awards: First prize, St. Louis Artists' Guild, 1948, 55; 2nd prize, 1950, 51; purchase prize for wood sculpture, Mid-American Annual Exhibition, 1952; Martha Love prize, St. Louis City Art Museum, 1952; prize for sculpture, St. Louis Church Federation, 1957. Member: St. Louis Artists' Guild; Missourians. Address in 1962, St. Louis, MO.

PHELAN, HAROLD L.
Painter. Born in New York in 1881. Address in 1926, 67 West 67th St., New York City.

PHELAN, LINN LOVEJOY.
Sculptor, craftsman, designer, and teacher. Born in Rochester, New York, August 25, 1906. Studied at Rochester Institute of Technology; Ohio State University, B.F.A.; Alfred University, M.S. (Educ.), 1955. Award: Prize, Arts and Crafts Festival, Abingdon, VA, 1950; NY State Fair awards, 1975. Work: Convalescent Hosp. for Children, Rochester, NY; Cranbrook Academy of Art; Dartmouth College. Exhibited: Philadelphia Art Alliance, 1937-42, 45, 52; Syracuse Museum of Fine Arts, 1932-36, 42, 46, 47, 51; Columbus Gallery of Fine Art, 1931-33; NY Soc. of Ceramic Art, 1934, 36; Rochester Memorial Art Gallery, 1929, 30, 32, 35, 38, 47-52; Wichita Art Association, 1946; Dartmouth College, 1945; Albright-Knox, Buffalo, 1951; others. Contributor to *Design, Craft Horizons* magazines. Position: Owner, "Linwood Pottery," Almond, NY; ceramic instructor, School for American Craftsmen, Alfred, NY, 1944-50; art supervisor, Alfred-Almond Central School, Almond, NY, 1950-67; lecturer, Alfred University, 1967-72. Address in 1982, Almond, NY.

PHELIPS, EMILY BANCROFT (MRS.).
Painter. Born in England, July 1, 1869. Pupil of St. Louis School of Fine Arts and Hugh Breckenridge. Member: Artists Guild of the Authors' League of America, NY. Awards: Honorable mention, Portland Expo., 1905; gold medal, Sedalia, 1913 and 1918. Address in 1933, Kimmswick, MO.

PHELPS, EDITH CATLIN.
(Mrs. Stowe). Painter, etcher. Born in NYC, April 16, 1879. Pupil of Hawthorne; Julian in Paris. Member: Conn. Acad. of Fine Arts; Nat. Assoc. of Women Painters and Sculptors; Springfield Art Assoc.; Am. Fed. of Arts. Awards: Hon. mention, Conn. Academy of Fine Arts, 1920, 1922. Died in 1961. Address in 1929, 161 E 74th St., New York, NY; summer, Provincetown, MA.

PHELPS, HELEN WATSON.
Painter. Born in Attleboro, MA. Pupil of Julian Academy and Collin in Paris. Member: National

Association of Women Painters and Sculptors; Providence Art Club; Society of Painters of NY; Yonkers Art Association; Newport Art Association; Pen and Brush Club; National Arts Club. Awards: Hon. mention, Pan.-Am. Expo., Buffalo, 1901; NY Woman's Art Club prize, 1907, Elling prize, 1909; Watrous figure prize, National Association of Women Painters and Sculptors, 1914, prize, 1915. Died in 1944. Address in 1929, 1 West 64th St.; 58 West 57th St., New York, NY.

PHELPS, W. P.
Painter. Born in New Hampshire, he began life as a sign painter in Lowell, MA. He was sent abroad for study and on his return he exhibited his paintings "Morning," "Evening," and "Forest Scene near Munich," at the National Academy in New York in 1878.

PHILBRICK, ALLEN E.
Painter, etcher, lecturer and teacher. Born in Utica, NY, Nov. 19, 1879. Pupil of Art Institute of Chicago; Laurens in Paris. Member: Painters and Sculptors of Chicago; Chicago Society of Etchers. Award: Butler prize, Art Institute of Chicago, 1923. Work: Mural decoration, "Morning, Noon and Night," People's Trust and Savings Bank, Cedar Rapids, IA; Brown Memorial Window, Lake View High School, Chicago. Address in 1929, care of the Art Institute, Chicago, IL; h. 982 Elm St., Winnetka, IL; summer, R.F.D. No. 2, Montague, MI.

PHILBRICK, OTIS.
Painter. Born in Mattapan, MA, Oct. 21, 1888. Pupil of Major and De Camp. Member: Boston Society of Water Color Painters. Instructor, life drawing, Massachusetts School of Art. Died in 1973. Address in 1929, 10 Hillcrest Parkway, Winchester, MA.

PHILIP, WILLIAM H.
Sculptor. At New York City, 1858-59.

PHILIPP, M. BERNARD (MRS.).
See Peterson, Jane.

PHILIPP, ROBERT.
Painter and etcher. Born in New York, Feb. 2, 1895. Pupil of Art Students League of NY, under Du Mond and Bridgman; and National Academy of Design, under Volk and George Maynard. Awards: Third Hallgarten prize, 1917, second Hallgarten prize, 1922, prizes, 1947, 51, all from National Academy of Design; Laguna Beach Art Association; medal, prize, Art Institute of Chicago, 1936; Carnegie Institute, 1937; Corcoran, 1939; IBM, 1939. Work: Whitney; Brooklyn Museum; Museum of Fine Arts of Houston; Corcoran; High Museum of Art; Dallas Museum of Fine Arts; Joslyn Art Museum; IBM; others. Exhibited: Nationally. Taught at High Museum of Art, 1946; Univ. of Illinois, 1940; Art Students League

of New York; National Academy of Design. Member: Academician National Academy of Design; Lotos Club. Address in 1953, 200 West 57th Street, New York, NY.

PHILLIBROWNE, THOMAS.
Engraver. Born in London. He is said to have been a pupil of the Findens in that city. He was engraving admirable portraits in pure line in London in 1834, and came to the United States prior to 1851, as in that year he engraved a full-length portrait of Louis Kossuth for Boston publishers. Mr. Alfred Jones says that Phillibrowne was a very eccentric character, peculiar in appearance, and he claimed that his personal friend Hablot Knight Brown, or "Phiz," had used him as a model for the familiar "Mr. Pickwick" in his original illustrations to that story of Dickens.

PHILLIPS, AMMI.
Portrait painter, limner. Born in Coalbrook, CT, on Aug. 24, 1788. Had begun his career by 1811, working chiefly in western parts of Connecticut and Massachusetts and in neighboring counties of upstate NY. Latest known commission, 1862. In collections of Albany (NY) Institute; Fogg Art Museum, Boston; Metropolitan Museum of Art, American Wing; Abby Aldrich Rockefeller Folk Art Center, Williamsburg, VA; others, including private collections. Bibliography: *Ammi Phillips: Portrait Painter 1788-1865*, by Holdridge and Black (NY, 1969); *American Folk Portraits*, Rockefeller Folk Art Center (Williamsburg, VA, 1981); Columbia County, NY, exhibition catalogue, Ruth Piwonka and R. H. Blackburn. Died in Curtisville, Berkshire County, MA, July 11, 1865.

PHILLIPS, BERT GREER.
Painter, illustrator and teacher. Born in Hudson, NY, July 15, 1868. Pupil of National Academy of Design and Art Students League in New York; Constant and Laurens in Paris. Member: Taos Society of Artists; Salma. Club; Chicago Galleries Association. Specialty: Indian subjects. Work: Mural decorations, Polk County Court House, Des Moines, IA; mural decoration, San Marcos Hotel, Chandler, AZ; three panels, State Capitol, Jefferson City, MO. Died in 1956. Address in 1929, Taos Co., NM.

PHILLIPS, BLANCHE (HOWARD).
Sculptor. Born in Mt. Union, PA, February 26, 1908. Studied at Cooper Union Art School; Art Students League; Stienhofs Institute of Design; California School of Fine Arts; also with Zadkine and Hofmann. Works: Whitney Museum of Am. Art. Exhibited: San Francisco Museum of Art, 1942, 43, 45-47, 49; Oakland Art Museum, 1946, 48; Los Angeles Museum of Art, 1949; Whitney, 1952, 57; Boston Museum of Fine Arts, 1958; Museum of Fine Arts of Houston, 1958; Riverside Museum, 1958, 62; Stable Gallery, NY, 1959, 60; Silvermine Guild, 1963, 64; one-woman shows at San Francisco Museum of Arts, Crocker

Art Gallery, New Gallery (Provincetown, MA), Silvermine Guild, Galerie Internationale (NY), others. Awards: National Association of Women Artists, 1963, 64. Member: Sculptors Guild; Chrysler Museum, Provincetown, MA; Norfolk Museum of Arts and Sciences. Address in 1970, Upper Nyack, NY.

PHILLIPS, C. HOLMEAD.
Painter. Exhibited at the Penna. Academy of Fine Arts, Philadelphia, 1926. Address in 1926, 58 West 57th St., New York, NY.

PHILLIPS, CHARLES.
This excellent engraver of portraits in stipple was located in New York, in 1842, and was an Englishman by birth. Very little work is signed by him, and it is said that he went into the employ of the Government at Washington, DC.

PHILLIPS, J. CAMPBELL.
Painter. Born in New York, Feb. 27, 1873. Pupil of Art Students League of NY, under Clinedinst and Mowbray; Chase. Member: Salma. Club, 1905; Lotos Club. Awards: Isidor portrait prize, Salma. Club, 1914. Work: "The First Born," Corcoran Gallery, Washington, DC; "The Age of Wonder," Albright Gallery, Buffalo, NY; "Paradise Bay, Lake George," Cleveland Museum; "Hon. Wm. J. Gaynor," City Hall, New York; "Hon. William G. McAdoo," "Sen. Carter Glass," U.S. Treasury Building; "Mrs. Cumming Story," Daughters of Am. Revolution, Washington, DC; "Dr. John A. Wyeth," Academy of Medicine, New York; "Judge John J. Brady," Bronx Co. Court House, New York City; also represented in State Capitol, Trenton; Real Estate Board of New York; Cornell University, Ithaca, NY; "Dr. Nicholas Smith," Metropolitan Museum of Art. Died in 1949. Address in 1929, 1108 Carnegie Hall; h. 480 Park Murray Butler," Lotos Club, New York; "Dr. Stephen Ave., New York, NY.

PHILLIPS, JOHN HENRY.
Etcher. Born in Wisconsin in 1876. He has executed mural decorations in theatres. Address in 1926, 681 Fifth Ave., New York.

PHILLIPS, MARJORIE.
(Mrs. Duncan Phillips). Painter and teacher. Born in Bourborn, IN, Oct. 25, 1895. Pupil of K. H. Miller, Boardman Robinson, and Gifford Beal. Member: Society of Washington Artists. Represented in Phillips Memorial Gallery, Washington, DC. Address in 1929, 1600 21st Street, Washington, DC; summer, Ebensburg, PA.

PHILLIPS, S. G.
Painter. Exhibited the "Little Nude" at the Penna. Academy of Fine Arts, Philadelphia, 1921. Address in 1926, 1520 Chestnut St., Philadelphia, PA.

PHILLIPS, W(ALTER) J(OSEPH).
Painter, etcher, craftsman, lecturer and teacher. Born in Barton-on-Humber, England, Oct. 2, 1884. Pupil of E. R. Taylor. Member: Print Makers' Society of California; Boston Society of Arts and Crafts. Awards: Storrow prize, Los Angeles, 1926; medal, Graphic Arts Club, Toronto, 1926. Work: "Water Baby," National Gallery of Canada; "Lake of the Woods," Toronto Gallery; 13 color woodcuts, British Museum; 12 color woodcuts, Victoria and Albert Museum; color woodcuts, California State Library and Los Angeles Museum. Died in 1963. Address in 1929, 104 Wellington Crescent, Winnipeg, Canada.

PHILLIPS, WINIFRED E.
Painter, etcher, craftsman and teacher. Born in Claybanks, WI, Nov. 1, 1881. Pupil of Alex Mueller, Gustave Moeller, George Oberteuffer, Henry B. Snell. Member: Wisconsin Painters and Sculptors; National Association of Women Painters and Sculptors. Address in 1933, Art Department, State Teachers College, Milwaukee, WI; h. 1523 Alice St., Wauwatosa, WI.

PHOENIX, LAUROS M(ONROE).
Mural painter. Born in Chicago, IL, Feb 23, 1885. Pupil of Art Institute of Chicago; Woodstock Summer School; and with John Vanderpoel, Thomas Wood Stevens, Louis W. Wilson, John F. Carlson, and others. Member: National Society of Mural Painters; Art Students League of Chicago; New Rochelle Art Association. Work: "Rip Van Winkle," Grill Room, St. Paul Hotel; "Aesculapius," "The Fountain of Youth" and "Old Herb Woman," Lobby of Lowry Doctors' Building, St. Paul, MN; "Minnehaha," L. S. Donaldson Building; "Nine Fairy Stories," New Grand Theatre; "Robin Hood," Elks Club, Minneapolis, MN. Director and instructor, NY-Phoenix School of Design, New York, NY. Address in 1953, 160 Lexington Avenue, New York, NY; h. 14 Alden Place, Bronxville, NY.

PIAI, PIETRO.
Sculptor. Born in Vittorio, Treviso, Italy, March 31, 1857. Pupil of Stella at Vittorio; Academy in Turin under C. Tabacchi. Address in 1903, 131 Houston St., NY.

PIATTI, ANTHONY.
Sculptor. Worked in NYC, 1849-57. Exhibited at the National Academy of Design, NY, in 1850.

PIATTI, EMILIO F.
Sculptor. Born in NYC, December 18, 1859. Pupil of his father, Patrizio Piatti, and also of Cooper Union. Assistant to Saint-Gaudens. Works include "Grief," for the Mausoleum of George Westcott; a statue of General Spinola; and a bust of Bertha Galland. Died in Englewood, NJ, Aug. 22, 1909.

PIATTI, PATRIZIO.
Sculptor. Born near Milan, Italy, 1824. Came to America and settled in NY in 1850. Address in 1903, 229 West 23rd St., NY.

PIAZZONI, GOTTARDO F. P.
Painter, sculptor, and etcher. Born in Intragna, Switzerland, April 14, 1872. Pupil of San Francisco Art Association School of Fine Arts; Julian Academy and Ecole des Beaux-Arts, Paris. Member: San Francisco Art Association; California Society of Etchers; Bohemian Club; Club Beaux Arts, San Francisco; Am. Federation of Arts. Represented in the Walter Collection, San Francisco Art Association; California Palace of the Legion of Honor; Golden Gate Park Museum, San Francisco; Oakland (CA) Art Gallery; Municipal Gallery, Phoenix, AZ; Mills College Art Gallery, Oakland, CA. Address in 1933, 446 Lake St., San Francisco, CA. Died in 1945.

PICART, B.
This apparently fictitious signature, either as designer or engraver, is signed to a large and poorly engraved plate published by H. D. Robinson, New York, seemingly about 1800. The print is entitled "Church and State," and is a caricature dealing with the doctrines of Thomas Paine.

PICCHI, FREDERICK.
Sculptor. In New Orleans, 1860-61.

PICCIRILLI, ATTILIO.
Sculptor. Born in Massa, Italy, May 16, 1866. Pupil of Accademia San Luca, Rome. Came to U.S., 1888. Member: Associate National Academy of Design, 1909; New York Architectural League, 1902; Allied Artists of America. Awards: Bronze medal, Pan.-Am. Exposition, Buffalo, 1901; silver medal, St. Louis Exposition, 1904; hon. mention, Paris Salon, 1912; gold medal, P.-P. Exposition, San Francisco, 1915; Widener gold medal, Penna. Academy of Fine Arts, 1917; Saltus gold medal, National Academy of Design, 1926. Work: "Maine Memorial," New York; "MacDonough Monument," New Orleans; "Dancing Faun" and "Head of a Boy," Fine Arts Academy, Buffalo; pediment, Frick House, NYC; bust of Jefferson, Virginia Capitol. Exhibited at National Sculpture Society, 1923. Address in 1933, 467 East 142nd St., New York, NY. Died in 1945.

PICCIRILLI, BRUNO.
Sculptor. Born in NYC, March 30, 1903. Studied at the National Academy of Design, and at the Beaux-Arts Institute of Design, NY; American Academy in Rome. Works: Fountain figure, Pan; head, Mimi; bust, Modern Amazon; statuette, Orpheus; exterior and interior sculpture, Riverside Church, NYC; Brookgreen Gardens, SC; Mount Carmel School, Poughkeepsie, NY; others, including many portraits, fountains, etc., in private collections. Exhibited at

National Academy of Design, 1930-32; Architectural League, 1945; National Sculpture Society; Metropolitan Museum of Art; American Academy in Rome; F. D. Roosevelt Library, Hyde Park, NY; Albany Institute of History and Art; others. Member of National Sculpture Society; Architectural League; Dutchess County Art Association. Instructor of sculpture, Beaux-Arts Institute of Design, NYC; Vassar College, Poughkeepsie, NY. Address in 1970, Vassar College, Poughkeepsie, NY. Died in 1976.

PICCIRILLI, FURIO.
Sculptor. Born in Massa, Italy, March 14, 1868. Pupil of Accademia San Luca, Rome. Came to U.S. in 1888. Member: Associate National Academy of Design; New York Architectural League, 1914 (associate). Awards: Honorable mention, Pan.-Am. Exposition, Buffalo, 1901; silver medal, St. Louis Exposition, 1904; silver medal, P.-P. Exposition, San Francisco, 1915. Exhibited at National Sculpture Society, 1923. Address in 1933, 467 East 142nd St.; h. 1 Beach Terrace, Bronx, New York, NY. Died in 1949.

PICCIRILLI, GUISEPPE.
Sculptor. Born in Rome, Italy, 1843. Settled in NYC in 1888 and opened a studio there. Assisted by his sons, he executed marble decorations for the New York Customs House, Chamber of Commerce, County Court House and Stock Exchange Buildings, all in NYC. Died in New York City, January 20, 1910.

PICCIRILLI, HORACE.
Sculptor. Born in Massa, Italy, in 1872. Studied in NYC under Roine. Award: Speyer Memorial prize ($300), National Academy of Design, 1926. Works: Interior decorations on the Frick house, New York City; decorations in marble, stone, and majolica on the Clark house, New York City; models for the exterior decorations of the New Court House, NYC. Exhibited at National Sculpture Society, 1923. Address in 1933, 467 East 142nd St., New York, NY.

PICCIRILLI, MASO.
Sculptor. Address in 1929, 467 East 142nd St., New York, NY.

PICCIRILLI, ORAZIO.
Sculptor. Address in 1929, 467 East 142nd St., New York, NY.

PICCIRILLI, VIVIAN LUSH.
See Lush, Vivian.

PICCOLI, GIROLAMO.
Sculptor. Born in Palermo, Sicily, May 9, 1902. Pupil of Wisconsin School of Art; Frank Vittor; Lorado Taft. Awards: Milwaukee Art Institute medal, 1922; hon. mention, Wisconsin Painters and Sculptors, 1924. Work: Sculpture on the Eagles Club Building, Milwaukee, WI; fountain, "Boy With Duck," Lake

Park, Milwaukee. Taught: Instructor of Sculpture, Layton School of Art, Milwaukee. Address in 1933, 216 East 17th St., New York City.

PICKENS, ALTON.
Sculptor, painter, and instructor. Born in Seattle, WA, January 19, 1917. Studied: Reed College, Portland, OR, 1936-38, influenced there by calligrapher and printer Lloyd J. Reynolds; Portland Art Museum, one semester; New School for Social Research, NYC, 1939, with Seymour Lipton, sculpture; solitary study at Mus. of Modern Art and Met. Museum of Art. Work: Mus. of Modern Art; Hirshhorn Mus. and Sculpture Garden, Wash., DC; numerous private coll. One-man exhibitions: ACA Gallery, NY, 1956, 60; Indiana Univ. Art Mus., 1956; Vassar College Art Gallery, 1956, 61, 77. Group exhibitions: Met. Museum of Art, NYC, 1942; Mus. of Modern Art, 1943, 46; Art Inst. of Chicago, 1945, 46, 51, 54; Carnegie Inst., 1945, 46, 47; Whitney Museum, 1946, 48, 49, 50, 55; John Herron Art Museum, Indianapolis, 1947, 49; Inst. of Contemporary Arts, London, 1950; Corcoran Gallery, Washington, DC, 1951; Bienal du Museu de Arte Moderna, Sao Paulo, 1951, 53; Galerie "Kunst der Gegenwart," Salzburg, 1952; ACA Gallery, NYC, 1964; Rutgers Univ. Art Gallery, 1977; Phila. Art Mus.; Penna. Academy of Fine Arts; Nat. Inst. of Arts and Letters; and many more. Teaching: Prof. of art, Vassar College, 1956-83, retired. Bibliography: Books, reviews, exhib. catalogues. Media: Oils, pen and ink, woodcut, lithograph, etching, aquatint, charcoal, pastel, watercolor; bronze. Address in 1984, Poughkeepsie, NY.

PICKERING, SIMEON HORACE.
Painter. Born in Salt Lake City, UT, Oct. 18, 1894. Pupil of Art Institute of Chicago; Grand Central Art School; Wayman Adams; J. Wellington Reynolds. Member: Society of Independent Artists; Salons of America. Address in 1929, 21 Minetta Lane, New York, NY; h. Centerville, UT.

PICKNELL, GEORGE W.
Painter. Born in Springfield, VT, June 26, 1864. Pupil of Lefebvre and Constant. Member: Salma Club; American Federation of Arts. Work: "Stock Yard in Winter," Detroit Institute of Arts. Died in 1943. Address in 1929, Norwalk, CT.

PICKNELL, WILLIAM LAMB.
Painter. Born in Massachusetts in 1853; died in Marblehead, MA, in 1897. Landscape painter. Pupil of George Inness in Rome, and of Gerome in Paris; painted in Brittany for several years under Robert Wylie. Awarded honorable mention, Paris Salon, 1880. Member of Society of American Artists; was elected an Associate of the National Academy of Design; Society of British Artists. Represented by "The Road to Concarneau," painted 1880, in the Corcoran Art Gallery, Washington, DC.

PIERCE, ANNA HARRIET.
Painter and illustrator. Born in South Britain, CT, May 17, 1880. Pupil of F. C. Jones, George Maynard, Mora, K. H. Miller, John F. Weir, Niemeyer, E. C. Taylor; Yale School of Fine Arts; National Academy of Design; NY School of Art; Commonwealth Colony, Boothbay Harbor, ME. Member: New Haven Brush and Palette Club (associate); New Haven Paint and Clay Club. Address in 1933, 1378 Boulevard, New Haven, CT; summer, South Britain, CT.

PIERCE, CHARLES FRANKLIN.
Paitner. Born in New Hampshire on April 26, 1844. Specialty: Landscapes. Member of Boston Art Club and Boston Water Color Society. Died March 5, 1920 in Brookline, MA.

PIERCE, DIANE.
Painter and sculptor. Studied at Cleveland Institute of Art; Western Reserve University. Exhibited: National Audubon Society, 1977, 79, 80; National Wild Turkey Federation, 1977; Cleveland Museum of Natural History, 1978; National Wildlife Federation, 1980; Game Conservation International Convention and Show, TX, 1979; Salisbury Wildfowl Festival, MD, 1976, 77, 79; Easton Waterfowl Festival, MD, 1977, 78, 79; Society of Animal Artists, NYC, 75, 76, 78, 79. Awards: Sculpture, Catherine Lorillard Wolfe Art Club, NYC, 1978; painting, National Wildlife Show, MO, 1978; painting, Midwest Wildlife Art Show, MO, 1978; sculpture and painting, Tulsa Wildlife Art Show, OK, 1979; Indiana State Waterfowl Stamp Contest, 1979; Long Island Waterfowl Stamp Contest, 1980. Member: Society of Animal Artists; International Platform Association; Salmagundi Club. Specialty: Birds. Media: Bronze; oil, watercolor, scratchboard, and pastel. Address in 1983, Mentor, OH.

PIERCE, GLENN M.
Illustrator. Member: Society of Illustrators. Address in 1929, 2326 Grove St., Brooklyn, NY.

PIERCE, WILLIAM H. C.
Painter. Born in Hamilton Co., NY. Pupil of Lowell School of Design; Massachusetts Institute of Technology; also studied in Paris. Member: San Diego Artists Guild. Award: Bronze medal, P.-P. Expo., San Francisco, 1915. Address in 1929, 124 Brooks Ave., San Diego, CA.

PIERPONT, BENJAMIN, JR.
Pierpont engraved upon copper the music and words of "The Singing Master's Assistant; or Key to Practical Music. By William Billings, Author of the New England Psalm-Singer, etc. Boston, (New England), Printed by Draper and Folsom, 1778." This singing-book is an oblong quarto, and on the last page of music the engraver signs himself thus: "Engrav'd by Benj. Pierpont Junr. Roxbury, 1778."

PIETERSZ, BERTUS.
Painter, writer and teacher. Born in Amsterdam, Holland, Sept. 13, 1869. Studied in Rotterdam, and under Harry W. Ranger. Member: American Federation of Arts. Work: "Campanilo," Springfield (MA) Art Museum. Died in 1938. Address in 1929, Hancock, NH.

PIETRO, CARTAINO di SCIARRINO.
Sculptor. Born in Palermo, Italy, Dec. 25, 1886. Mainly self-taught, but studied for a time in Rome. Member: Boston Arts Club. Awards: Hon. men., P.-P. Expo., San Francisco, 1915. Represented by statues of John Burroughs and Charles S. Sargent, American Museum of Natural History, NYC; marble fountain for Hackensack, NJ, Court House; bust of Elihu Root for Hamilton College, and in Pan.-American Union, Washington, D.C.; bust of John Muir, University of Wisconsin, Madison, WI; bust of W. H. Taft, Hague Peace Palace, Hague, Holland; bust of General William Booth, Memorial College, Philadelphia, PA. Died in Pelham, NY, Oct. 9, 1918.

PIETZ, ADAM.
Sculptor and medalist. Born in Offenbach, Germany, July 19, 1873. Studied at Penna. Academy of Fine Arts; Art Institute of Chicago; and in Germany. Member: Philadelphia Sketch Club; Fellow Penna. Academy of Fine Arts; American Numismatic Society; NY Numismatic Society. Work in Chicago Art Institute; Memorial Hall, Philadelphia; Navy Yard, Philadelphia; Huston Club, University of Pennsylvania; Philadelphia Museum of Art; Philadelphia Sketch Club; National Museum, Washington, DC; Vanderpoel Memorial Collection, Chicago; British Museum; and American Numismatic Society. Exhibited at National Sculpture Society, 1923. Award: Bronze medal, Madrid, Spain, 1951. Position: Assistant Engraver, U.S. Mint, 1927-46, retired. Address in 1953, Drexel Hill, PA.

PIGALLE.
Rough line engravings signed "Pigalle" are found with other plates evidently engraved by Scoles for the same work. The date is about 1800.

PIGOTT, FRANK E.
Painter. Member: Rochester Art Club. Address in 1926, care of Steck and Spelrein Lithographic Company, 65 West Houston St., New York, NY.

PIKE, CHARLES J.
Sculptor. Member of New York Architectural League, 1902. Address in 1910, 151 West 23rd St., NYC.

PILLARS, CHARLES ADRIAN.
Sculptor. Born in Rantoul, IL, July 4, 1870. Pupil of Taft, French, and Potter; Art Institute of Chicago. Work: Memorial group to Florida's dead in the World War, Jacksonville; Bryan Memorial, Battleship *Florida*; Memorial Flag Staff Standard, St. Augustine; statue of Gen. Kirby Smith and statue of Dr. John Gorrie, United States Capitol, Washington, DC; statue, W. B. Barnett, Barnett National Bank, Jacksonville, FL. Address in 1933, Sarasota, FL. Died in 1937.

PIMSLER, ALVIN J.
Illustrator. Born in NYC in 1918. Attended Pratt Institute and the Art Students League, where he studied under Howard Trafton. His first published illustration in 1940, for L. Bamberger Company, led to his successful career as a fashion artist, his work appearing in ads for Saks Fifth Avenue for 25 years. Represented in the USAF Museum; Smithsonian Institution; Portraits, Inc.; and Gallery of Sports. He has taught at the Society of Visual Arts; Parsons School of Design; Fashion Institute of Technology; also served for two years as president of the Society of Illustrators.

PINE, ROBERT EDGE.
Portrait and historical painter. Born in 1730 in London, son of John Pine, the engraver. He gained the premium of the Society for the Encouragement of Arts, etc., for the best historical design in 1760, and again in 1762. Established himself as a portrait painter and went to Bath in 1772, and remained there until 1779. Made an exhibition in London, 1782, of a collection of pictures painted by himself in illustration of scenes in Shakespeare. He came to this country in 1784, bringing his family, and taking up his residence in Philadelphia. He painted Washington at Mt. Vernon in 1785, belonging now to J. Carson Brevoort, Esq., of New York. The Honorable Joseph Hopkinson, second Pres. of the Academy, writing to Mr. Dunlap in 1833, says: "I remember his arrival in this country. He brought letters of introduction to my father, whose portrait was the first he painted in America. It is now in my possession . . . it bears the date of 1785, and is now as fresh in color as it was on the day it was painted . . . Robert Morris, who patronized him, built a house in Eighth Street suitable to his objects. I remember a large picture in his gallery, of Medea murdering her children, and several others, some from Shakespeare - Prospero and Miranda, in *The Tempest*, I particularly recollect. Many of his pictures are scattered about in Virginia, where he went occasionally to paint portraits . . . P.S. He brought with him a plaster cast of the Venus, which was kept shut up in a case, and only shown to persons who particularly wished to see it, as the manners of our country at that time would not tolerate the public exhibition of such a figure." Rembrandt Peale in his "Reminiscences" mentions seeing him in London. In Phila. he painted the "Congress Voting Independence," but died before it was completed; Edward Savage later finished it. Died Nov. 19, 1788 in Philadelphia, PA.

PINEDA, MARIANNA (or MARIANA).
Sculptor. Born in Evanston, IL, May 10, 1925.
Studied at Bennington College; Univ. of California,
Berkeley; privately with George Stanley in Los
Angeles (sculpture); Cranbrook Acad. of Art, with
Carl Milles; privately with Raymond Puccinelli in
San Francisco, with Oronzio Maldarelli in NY, and
Ossip Zadkine in Paris; scholarship, Radcliffe Inst.
for Independent Study, 1962-64. Works: Addison
Gallery, Andover, MA; Boston Mus. of Fine Arts;
Bowdoin Col.; Dartmouth Col.; Wadsworth Athe-
neum; Harvard U.; Walker; Williams College. Ex-
hibitions: Walker; The Swetzoff Gallery, Boston; De
Cordova; Museum of Modern Art; Albright; Whit-
ney; Met. Museum of Art; Art Inst. of Chicago;
Boston Arts Festival; NY World's Fair, 1964-65.
Awards: Albright, 1948; Walker; Boston Arts Festi-
val, 1957, 60. Address 1982, Boston, MA.

PINELES, CIPE (MISS).
Painter and illustrator. Born in Vienna, Austria,
June 23, 1908. Pupil of Anna Fisher. Address in 1929,
934 Carroll St., Brooklyn, NY.

PINKNEY, ELLIOTT.
Painter, printmaker and sculptor. Born in Bruns-
wick, GA, January 9, 1934. Studied: Woodbury
University, Los Angeles, BA; Art Instruction Inc.,
Minneapolis, MN. Work: Murals in Watts Towers
Arts Center, Los Angeles; Church of God in Christ,
Los Angeles; other work in private and institutional
collections. Commissions: Watts Community Hous-
ing Corporation; Los Angeles Department of Parks
and Recreation; Watts Alcoholic Rehabilitation Cen-
ter; etc. Exhibited: Black Artists Invitational, Los
Angeles County Museum of Art, 1972; Environ-
mental Billboard Art, Los Angeles, 1973; Merabash
Mus., NJ, 1975; Watts Towers Arts Center Gallery,
Los Angeles, 1977; Compton (CA) College Gallery,
1981; Calif. Black Printmakers, 1983; many more.
Member: International Soc. of Artists; Bunker Hill
Art League. Awards: Latham Found. International
Poster Award; Theatre Guild Am. Theatre Soc. and
Council of Living Theatre Award; Calif. Arts Council
Grant. Address in 1983, Compton, CA.

PINKNEY, JERRY.
Illustrator. Born in Phila., PA, in 1939. Studied at the
Phila. Mus. College of Art and went to school with
Roger Hane. His first illus. was done in Boston for
Little, Brown in 1963. He has since won many
awards and illustrated for *Seventeen, Post, Boys' Life,*
and *Essence Magazine.* His work has been shown at
the Brooklyn Mus., Soc. of Illustrators, Brandeis
Univ. in Mass., and the Studio Museum in Harlem.

PINKOVITZ, H. A.
Painter. Exhibited "Anna Perry" at the Penna.
Academy of Fine Arts, Philadelphia, 1921. Address
in 1926, 721 Walnut St., Philadelphia, PA.

PINTNER, DORA.
Painter. Born in Hooley Hill, England. Studied in
England, Scotland, and in the U.S. Member: Art
Alliance of America. Address in 1929, 45 Coolidge
Hill Road, Cambridge, MA.

PINTO, JODY.
Sculptor. Born in NYC, April 8, 1942. Studied:
Penna. Academy of the Fine Arts, 1964-68, Cresson
fellowship, 1967, 68; Philadelphia College of Art,
1971-73, B.F.A. Exhibited: Artpark, Lewiston, NY,
1975; Nexus Gallery, Philadelphia, 1976; Whitney
Museum, NYC; Bard College, Annandale, NY, 1984;
Philadelphia Museum of Art; Penna. Academy of
Fine Arts. One-man exhibitions, Hal Bromm, NYC,
1978, 79, 80, 83; 112 Greene Street Gallery, NYC;
Richard Demarco Gallery, Edinburgh, Scotland.
Works: Philadelphia Museum of Art; Penna. Acad-
emy of Fine Arts; Whitney; Art Institute of Chicago;
Wildlife Preserve, Cape May, NJ, 1974; "Finger
Span: For Climber's Rock," Fairmount Park, Phila.,
1984; "Landmarks," Bard College, Annandale-on-
Hudson, NY, 1984; many others. Awards: National
Endowment for the Arts Grant, 1979-80; Penna.
Council on the Arts Grant, 1980-81; New Jersey
Council on the Arts Grant, 1980-81; Hazlett Memo-
rial Award, PA, 1983. Taught: University of Guelph,
Canada, 1977; Penna. Academy of Fine Arts, from
1980; Rhode Island School of Design, from 1980.
Works in industrial materials (building). Address in
1982, 28 W. 69th St., NYC.

PIPPIN, HORACE.
Painter. Born in 1888 in Pennsylvania. Left school at
14, became a farm laborer, and entered the Army
during WWI. He returned from the war partially
paralyzed in his right arm and embittered by his war
experiences. Untrained in drawing, Pippin drew
since childhood but took it up seriously after the war
using the right hand with the aid of the left. His first
major painting is a primitive oil called "End of the
War: Starting Home." Many of his pictures depict
Bible scenes and Negro family life. He began to be
taken seriously when he was 50. He was acclaimed as
the best Negro painter. One of his better known
paintings is "John Brown Going to His Hanging,"
1942. Died in 1946.

PISANI, F. AND C. (BROTHERS).
Sculptors. At San Francisco, CA, 1860.

PITKIN, CAROLINE W.
Painter, sculptor, craftsman, and teacher. Born in
New York City, June 12, 1858. Pupil of Chase,
DuMond, Harrison, Woodbury, Brenner. Member:
Pen and Brush Club of New York; Art Alliance of
America; National Association of Women Painters
and Sculptors. Address in 1933, 550 West 157th St.,
New York, NY. Died before 1940.

PITMAN, HARRIETTE RICE.
(Mrs. Stephen Minot Pitman). Painter. Born in Stetson, ME. Pupil of Pratt Institute in Brooklyn, NY. Circuit supervisor of art instruction, Corning, Ithaca and Jamestown, NY, 1891-92; director of art instruction, Providence Public School, 1894-1904; museum instructor at Museum of the RI School of Design during 1926. Member: Providence Water Color Club; Providence Art Club. Address in 1929, 1 Congdon St., Providence, RI.

PITMAN, SOPHIA L.
Painter and teacher. Born in Providence, RI. Member: Providence Art Club; Providence Water Color Club; Copley Society. Address in 1929, 227 Benefit St.; Moses Brown School, 156 Pitman St., Providence, RI.

PITTMAN, HOBSON.
Painter, etcher and teacher. Born in Tarboro, NC, Jan. 14, 1898. Pupil of Albert W. Heckman; Doris Rosenthal; Emile Walters. Member: Society of Independent Artists; Salons of America. Address in 1929, 4107 Locust St., Philadelphia, PA; summer, Woodstock, NY.

PITZ, HENRY CLARENCE.
Painter, illustrator, teacher and writer. Born in Philadelphia, PA, June 16, 1895. Studied: Philadelphia Museum School of Industrial Art; Spring Garden Institute, Philadelphia; pupil of Maurice Bower and Walter Hunt Everett. Member: Associate National Academy of Design; American Water Color Society; Audubon Artists; Society of Illustrators; Philadelphia Sketch Club; Art Alliance of Philadelphia; Society of Illustrators; Artists Guild; American Federation of Arts; Alumni Association, Philadelphia Museum School of Industrial Art; Philadelphia Water Color Club; others. Work: "Apple Gathering" and "The Edge of the Meadow," West Philadelphia High School; Los Angeles Museum of Art; National Academy of Design; Cleveland Museum of Art; Penna. Academy of Fine Arts; NY Public Library; Philadelphia Museum of Art; Denver Art Museum; National Gallery Collection, Washington, DC; others. Exhibited: National Academy of Design; Art Institute of Chicago; Los Angeles Museum of Art; Penna. Academy of Fine Arts; Philadelphia Museum of Art; American Water Color Society; Brooklyn Museum; Baltimore Museum of Art; Paris Salon; World's Fair, NY, 1939; others. Awards: Los Angeles Museum of Art; Penna. Academy of Fine Arts; Philadelphia Museum School of Industrial Art; Philadelphia Art Alliance; Paris Salon; American Water Color Society; National Academy of Design; Butler Art Institute; Salma. Club; Philadelphia Sketch Club; Society of Illustrators; Audubon Artists; others. Co-Author, with Edward Warwick, *Early American Costume*; author, *The Practice of Illustration; Pen, Brush and Ink*; many others. Illustrated over 150 books; also did illustrations for *Readers Digest, Colliers, Gourmet,* and other magazines. Director, department of illustration, Philadelphia Museum School of Industrial Art, 1934-60; taught at Penna. Academy of Fine Arts, University of Pennsylvania, and Carnegie Institute. Address in 1976, Philadelphia, PA. Died in 1976.

PIZZUTI, MICHELE.
Painter. Born in Naples, Italy, Nov. 29, 1882. Pupil of Domenico Morelli. Address in 1929, 165 East 60th St., New York, NY.

PLACE, VERA CLARK.
Painter. Born in Minneapolis, MN, Feb. 5, 1890. Pupil of Chase, Dufner, Richard Miller, Antonio de la Gandere. Member: Attic Club, Minneapolis; Alumni Minneapolis School of Art; Minn. Soc. of Fine Arts. Awards: First and second prizes, Minnesota State Art Exhibit. Address in 1929, 741 Kenwood Parkway, Minneapolis, MN.

PLACKETT, EBENEZER.
Portrait and figure painter. Born in Wisconsin, 1844, he settled in New Milford in 1871.

PLANTOU, ANTHONY (MRS.).
Portrait painter in oils and miniatures; also historical painter. She painted portraits in Washington, DC, about 1820. In 1821 she moved to Philadelphia. Her portrait of Bishop Conwell, painted in 1825, is well known from the engraving.

PLASCHKE, PAUL A.
Painter and illustrator. Born in Berlin, Germany, Feb. 2, 1880. Pupil of Cooper Union and Art Students League of NY. Member: Society of Independent Artists; Louisville Art Association; Louisville Art Club; Indiana Art Association; Southern States Art League; American Federation of Arts. Award: Hon. mention, Richmond (IN) Art Association, 1917; landscape prize, Nashville Art Association, 1925; Joseph H. Defrees prize, Hoosier Salon, 1929. Represented in Attica (IN) Library; Lexington (KY) Library; J. B. Speed Memorial Museum; Children's Free Hospital, Louisville, KY. Cartoonist and caricaturist for Louisville *Times*; caricaturist for Sunday Courier-Journal since 1913; humorous drawings in *Life, Puck, Judge,* and other periodicals. Address in 1929, care of Louisville Times, Louisville, KY; h. 326 Beharrel Ave., New Albany, IN.

PLASSMAN, ERNST.
Sculptor. Born June 14, 1823, in Westphalia, Germany. Studied in Germany and Paris. He came to NY in 1853, where the following year he opened "Plassman's School of Art," which he carried on until his death. He executed many models, carvings, and sculptures; his statue of Franklin is in Printing-House Square, NY, and his figure of "Tammany" is

on Tammany Hall, NY. Also a woodcarver. Author of *Modern Gothic Ornaments*, 1875; *Designs for Furniture*, 1877. He died in New York City on November 28, 1877.

PLATT, ALETHEA HILL.
Painter. Born in Scarsdale, NY. Pupil of Henry B. Snell; Ben Foster; Art Students League of NY; Delecluse Academy in Paris. Member: American Federation of Arts; NY Water Color Club; American Water Color Society; National Association of Women Painters and Sculptors; National Arts Club; Pen and Brush Club; Society of Painters of NY; Yonkers Art Association; Allied Artists of America; Connecticut Academy of Fine Arts. Awards: First prize for water color, NY Women's Art Club, 1903; first prize, Minnesota Art Association, Faribault, 1909; first prize, National League of Art, Chapter American Pen Women, 1928. Work: "Old World Work Shop," Public Library, Faribault, MN; "An Old Garden," Anderson (IN) Art Gallery; portrait of Judge Lewis C. Platt, Court House, White Plains, NY; "A Devonshire Cottage," Museum, St. Joseph, MO. Address in 1929, 939 Eighth Ave., New York, NY; h. Sharon, CT.

PLATT, CHARLES ADAMS.
Painter, architect, landscape architect, etcher and writer. Born in New York, Oct. 16, 1861. Pupil of National Academy of Design and Art Students League in New York; Boulanger and Lefebvre in Paris. Member: Society of American Artists, 1888; Associate National Academy of Design, 1897; Academician National Academy of Design, 1911; American Academy of Arts and Letters; American Water Color Society; NY Etching Club; London Society of Painter-Etchers; Fellow, American Institute of Architects; Century Association; American Federation of Arts. Awards: Webb prize, Society of American Artists, 1894; bronze medal, Paris Expo., 1900; silver medal, Pan-Am. Expo., Buffalo, 1901; medal of honor, Architectural League of NY, 1913. Author: *Italian Gardens*. Died in 1933. Address in 1929, 131 East 66th St., New York, NY.

PLATT, ELEANOR.
Sculptor. Born in Woodbridge, NJ, May 6, 1910. Studied at Art Students League; also under Arthur Lee. Noted work: "Louis D. Brandeis," bronze head, in collection of Metropolitan Museum of Art. Also represented at Boston Museum of Fine Arts; Supreme Court Building, Washington, DC; New York Bar Association; Museum of the City of NY; Carnegie Corporation; Harvard University Law School Library; others. Executed awards medals, bas-reliefs, plaques, busts. Awards: Chaloner Scholarship, 1939-41; Grant, American Academy of Arts and Letters, 1944; Guggenheim Fellowship, 1945. Member of National Sculpture Society. Living in Santa Barbara, CA, in 1953. Address in 1970, 50 West 77th St., NYC. Died in 1974.

PLATT, H.
Engraver. A well-executed stipple portrait of Samuel Thomson, botanist, is prefixed to his "New Guide to Health, Boston, 1832." This plate is simply signed "H. Platt," and while this signature is assumed to be that of the engraver, it may also indicate the painter. No other engraved work of Platt is known.

PLEADWELL, AMY M(ARGARET).
Painter and teacher. Born in Taunton, MA, Sept. 15, 1875. Pupil of Massachusetts Normal Art School, Boston; Grand Chaumiere and Colarossi Academies in Paris. Member: American Federation of Arts; Copley Society; National Association of Women Painters and Sculptors; Lyceum Club of Paris. Address in 1929, 82 Chestnut St., Boston, MA; summer, American Woman's Club, Paris, France.

PLEISSNER, OGDEN MINTON.
Painter and etcher. Born in Brooklyn, NY, April 29, 1905. Studied: Art Students League; pupil of F. J. Boston, George Bridgman, and Frank V. DuMond. Member: Art Students League of NY; Salma. Club; National Arts Club; Brooklyn Society of Artists; Century Association. Awards: Second prize, 1928, 1st prize, 1929, medal, 1952, National Arts Club, New York; Baltimore Water Color Club, 1949; Allied Artists of America, 1951; National Academy of Design, 1952; Concord Art Association, 1950; Connecticut Academy of Fine Arts, 1950. Work: "Morning Mass," University of Nebraska, Lincoln; Brooklyn Museum; Lyman Allyn Museum of Art; University of Georgia; Philbrook Art Center; Syracuse Museum of Fine Arts; Whitney; National Academy of Design; University of Maine; others. Exhibited: American Watercolor Society; Allied Artists of America; Connecticut Academy of Fine Arts; National Academy of Design; Baltimore Water Color Club; Philadelphia Water Color Club; Whitney; Metropolitan Museum of Art; Penna. Academy of Fine Arts; Art Students League; many others. Address in 1953, 33 West 67th Street; h. 35 East 9th Street, New York, NY.

PLETCHER, GERRY.
Painter and printmaker. Born in State College, PA. Studied: Edinboro State College; George Peabody College, Nashville, TN; Pennsylvania State University; also with Montenegro, Carol Summers, Harold Altman, Nelson Sandgren, Shobaken. Work: Evansville Museum of Arts and Sciences; Watkins Art Institute, TN; Fisk University; Jacksonville State University, AL; Tennessee Botanical Gardens and Art Museum; others. Exhibited: Gallery of Contemporary Art, Winston-Salem, NC, 1969; Graphics USA - 1970, National Art Exhibition, Dubuque, IA; National Academy of Design, 145th Annual, NYC, 1970; Women in Art, Springfield (IL) National Exhibition, 1979; Summer Lights Art Exhibition, Nashville, TN, 1983; plus others. Awards: 22nd

Annual Mid-States Art Exhibition, Evansville Museum of Arts and Sciences, 1969; Tennessee All-State, 1973; others. Media: Etchings, woodcuts, acrylic, oil. Address in 1984, Nashville, TN.

PLEUTHNER, WALTER C.
Painter, architect and writer. Born in Buffalo, NY, Jan. 24, 1885. Pupil of DuMond and Mòra. Member: Society of Independent Artists; Am. Camouflage; Art in Trades Club; NY Architectural League. Designed Emerson Phonograph Galleries, New York. Address in 1929, 137 East 45th St., New York, NY; Scarsdale, NY.

PLOCHER, JACOB J.
Engraver. A landscape engraver, Plocher had an engraving establishment from 1815-18 in Philadelphia (in the Shakespeare Building), but before this date he did considerable work for the encyclopedia published by S. F. Bradford, Philadelphia, 1808-11. He engraved at least one meritorious large plate, a view of the "Upper Ferry Bridge Over the Schuylkill River, Philadelphia." Died on Dec. 27, 1820 in Philadelphia, PA.

PLOCHMANN, CAROLYN GASSAN.
Painter and graphic artists. Born in Toledo, OH, May 4, 1926. Studied at Toledo Museum Art School of Design, 1943-47; University of Toledo, B.A., 1947; State University of Iowa, M.F.A., 1949; with Alfeo Faggi, 1950; Southern Illinois University, 1951-52. Works in Evansville Museum of Arts and Science, IN; Fleishmann Foundation Collection, Cincinnati, OH; Rodman Collection, Oakland, NJ; Butler Institute of American Art, Youngstown, OH; and others. Exhibited at Toledo Museum of Art, 1941 (first show, age 15), 1968; Witte Museum, San Antonio, Texas, 1968; print and drawing annual, Penna. Academy of Fine Arts, 1969; Philadelphia Water Color Club, 1969; Kennedy Galleries, NY, 1983; and many others. Awards: G. W. Stevens Fellow, Toledo Museum, 1947-49; Tupperware Art Fund First Award, 1953; Lowe Foundation Competition Award, 1958. Member of Silvermine Guild of Artists; Woodstock Art Association; Philadelphia Water Color Club; Toledo Federation of Art Societies. Media: Oil, acrylic, graphics. Represented by Kennedy Galleries, NYC. Address in 1984, Carbondale, IL.

PLOWMAN, GEORGE T(AYLOR).
Illustrator and etcher. Born in Le Sueur, MN, Oct. 19, 1869. Pupil of Douglas Volk in Minneapolis; Eric Pape in Boston; studied at Royal College of Art, South Kensington, London; and in Paris. Member: Chicago Society of Etchers; NY Society of Etchers; Salma. Club; Boston Society of Etchers; California Society of Etchers; National Arts Club; Print Makers' Society of California; Brooklyn Society of Etchers. Award: Bronze medal for etching, P.-P. Exposition, San Francisco, 1915. Work: Etchings in

Boston Museum of Fine Arts; New York Public Library; Library of Congress, Washington, DC; British Museum; South Kensington Museum; Nat. Museum, Washington, DC; Luxembourg Museum; Newark Public Library; Sacramento State Museum; Albany Art Museum; Southport Museum, England; Metropolitan Museum of Art. Author: *Etchings and Other Graphic Art*, 1914; *Manual of Etching*, 1924 (Dodd Mead and Co.). Address in 1929, 9½ Madison St., Cambridge, MA.

PLUMB, H(ENRY) G(RANT).
Painter and teacher. Born in Sherburne, NY, April 15, 1847. Pupil of National Academy of Design in New York; Ecole des Beaux-Arts in Paris, under Gerome. Member: Salma. Club; Artists' Fund Society; American Federation of Arts. Award: Hon. mention, Paris Expo., 1889. Died in 1936. Address in 1929, 195 Claremont Ave., New York City; summer, Sherburne, NY.

PLUMMER, ETHEL McCLELLAN.
(Mrs. Norman Jacobsen). Painter and illustrator. Born in Brooklyn, NY, March 30, 1888. Pupil of Henri and Mora. Member: Society of Illustrators. Illustrated for *Vanity Fair, Vogue, Life, Shadowland, New York Tribune*; painted portrait sketches. Died in 1936. Address in 1929, 21 East 10th St., New York, NY.

PODESTA, STEPHEN.
Plaster image maker. Born in Italy, 1810. Living in Boston in 1860; in Massachusetts from at least 1843.

PODOLSKY, HENRY.
Sculptor. Exhibited "The Old Rabbi" at the Penna. Academy of Fine Arts, Philadelphia, 1921. Address in 1926, 1335 Greenmount Ave., Baltimore, MD.

PODWIL, JEROME.
Illustrator. Born in NY in 1938. Attended Pratt Institute and the Art Students League from 1955 to 1960. He has illustrated for many major magazines, especially *Playboy*, and has received several awards, including a gold medal from the Society of Illustrators Annual Exhibition, awards of excellence from Chicago, 1974 and 1976, and a medal from the Communication Arts Annual.

POE, HUGH M.
Painter. Born in Dallas, TX, Dec. 14, 1902. Pupil of R. L. Mason; Forsyth; Charles Hawthorne. Member: Knoxville Sketch Club; Indiana Art Club; East Tennessee Society of Fine Arts; Hoosier Salon. Awards: Art Association prize, 1923, certificate of merit, 1924, Herron Art Institute; Cunningham prize, Hoosier Salon, Marshall Field's, Chicago, 1925. Represented at Herron Art Institute, Indianapolis, IN; and Knoxville (TN) Sketch Club. Address in 1929, 25½ West Washington Street, Indianapolis, IN.

POGANY, WILLIAM ANDREW (WILLY).
Painter, designer, sculptor, illustrator, etcher, and craftsman. Born in Hungary, August 24, 1882. Studied in Budapest. Member: Salma. Club; Architectural League; Royal Society of Arts, London. Awards: Gold medals, Leipzig, and Budapest Expo.; gold medal, Panama-Pacific Expo., San Francisco, 1915. Work: Twelve paintings, Hungarian National Gallery, Budapest; mural paintings for Heckscher Foundation and Peoples House, NY; ceiling murals for Italian Renaissance Room, Park Central Hotel, NY; ceiling painting for Ritz Towers, New York; mural for Niagara Falls Power Co., Buffalo; stage design for Broadway productions and Metropolitan Opera Company; others. Author of numerous books. Address in 1953, 1 West 67th St., NYC. Died in 1955.

POHL, DENNIS.
Illustrator. Born in Milwaukee, WI, 1941. Received his B.A. from the University of Wisconsin and his M.F.A. from Pratt Institute in Brooklyn, NY. He studied under Dore Ashton and Arthur Okamura and his first published illustration, entitled Vatican Library, was done for ESP Disk in 1972. He has designed numerous album covers for RCA, Columbia, London, Arista, and Savoy.

POHL, HUGO DAVID.
Painter, illustrator, etcher, and teacher. Born in Detroit, MI, March 11, 1878. Pupil of Jean Paul Laurens. Work: "Founding of San Antonio" and "Mayor Callaghan," City of San Antonio, TX; "Pleading for World Peace" and "The Problem of Time," Atelier Art Gallery, San Antonio. Died in 1960. Address in 1933, San Antonio, TX.

POIDIMANI, GINO.
Sculptor and teacher. Born in Rosolini, Italy, Jan. 2, 1910. Studied at Royal School of Art, Siracusa, Italy; Royal Liceo Artistico of Rome; Royal Academy of Fine Arts, Rome. Member: International Artistic Association, Rome; Artistic and Culture Club; Siracusa, Italy; National Sculpture Society; Allied Artists of America. Awards: Government scholarship to Royal Academy of Fine Arts, Rome; gold medal for sculpture, Tripoli, 1929. Work: Statues, bas-reliefs, Cathedral of Messina, Rome; St. Joseph's Catholic Church, Rosolini, Italy; Monumental Cemetery, Milan, and others; numerous portrait busts in private collections. Exhibited: Florence, 1942; San Remo prize exhibition, 1937, 39, 40; Venice Biennale, 1941; Rome, 1947 (one-man); Audubon Artists, 1947, 50-52; Penna. Academy of Fine Arts, 1948; Fairmount Park, Phila., 1949; Nat. Sculpture Soc., 1951, 52; Argent Gallery, 1951; Allied Artists of Am., 1951. Address 1953, 121 Bank St., NYC.

POINCY, PAUL.
Painter. Born March 11, 1833 in New Orleans; died there in 1909. Poincy studied at the Ecole des Beaux Arts, Paris, and at the Julien Academy, Paris. He was a portrait, religious, and genre painter of merit, and his street scenes are well executed, full of poetry and charm. As a teacher and painter he had much to do with furthering interest in local art.

POINTER, AUGUSTA L.
Sculptor. Born in Durango, CO, May 10, 1898. Pupil of Henry Hering. Award: Avery prize, Architectural League of New York, 1928. Address in 1933, care of Henry Hering, 10 West 33rd St., New York, NY; h. Lincoln Park, NJ.

POLASEK, ALBIN.
Sculptor and teacher. Born in Frenstat, Czechoslovakia, February 14, 1879. Pupil of Charles Grafly at Penna. Academy of Fine Arts; American Academy in Rome. Member: Associate, National Academy of Design; National Sculpture Society, 1914 (associate); NY Architectural League; Southwest Soc.; Chicago Society of Artists; Cliff Dwellers; American Federation of Arts; Alumni Association of the Fellowship of the American Academy in Rome. Awards: Prix de Rome, American Academy in Rome, 1910; hon. mention, Paris Salon, 1913; Widener gold medal, Penna. Academy of Fine Arts, 1914; silver medal, P.-P. Expo., San Francisco, 1915; Logan medal ($1,500), Art Inst. of Chicago, 1917; Hearst prize, Art Inst. of Chicago, 1917; medal, Milwaukee Art Inst., 1917; Shaffer prize, Art Inst. of Chicago, 1917; Logan medal ($500), Art Inst. of Chicago, 1922; silver medal, Chicago Soc. of Artists, 1922; Fairmount Park Art Assoc. prize ($500), Penna. Acad. of Fine Arts, 1925; Chicago Galleries Assoc., 1937. Work: "Fantasy," Met. Museum, NY; "F. D. Millet" bust, Penna. Academy of Fine Arts, Phila.; "Sower," "Unfettered," busts of Charles Hawthorne, Charles L. Hutchinson, Frank G. Logan, Art Inst. of Chicago; "Aspiration," Detroit Inst. of Art; Richard Yates Memorial, Springfield, IL; J. G. Batterson Mem., Hartford, CT; Theodore Thomas Mem., Chicago; Woodrow Wilson Mem., Prague, Czechoslovakia, 1928, for which he received order of the White Lion, awarded by the Gov. Head of Sculpture Dept., Chicago Art Inst. Address 1953, Winter Park, FL. Died in 1965.

POLK, CHARLES PEALE.
Painter. Born March 17, 1767 in Maryland. He was the son of Charles Willson Peale's sister, Elizabeth Digby Peale, who married Capt. Robt. Polk of Virginia. At the age of 18, young Polk went to live with his artist uncle in Phila. He painted portraits of Gen. Washington, Rochambeau, and other noted men of the Am. Revolution, and at one time held office under the Gov. He died in 1822.

POLK, FRANK FREDERICK.
Sculptor. Born in Louisville, Kentucky, September 1, 1908. Self-taught in art, except for some study with

Hughlette Wheeler, George Phippen, and J. R. Williams. Worked as a cowboy, in rodeos, on ranches, and as a stunt man in cowboy films. Work in Colorado Springs Fine Arts Center; private collections. Has exhibited at Cowboy Artists of America Show, Cowboy Hall of Fame, Oklahoma City; Phoenix Art Museum; Kennedy Galleries, New York City; others. Won Golden Spur Award, bronze, National Rodeo Cowboy's Association; silver medal, George Phippen Memorial Annual Art Show, Prescott, Arizona. Member of Cowboy Artists of America. Specialty is statuettes of cowboys from 1918 to the present. Works in bronze. Bibliography includes *Bronzes of the American West*, Broder. Address in 1982, Mayer, Arizona.

POLK, GEORGE.
Portrait painter. The collection of paintings at Independence Hall in Philadelphia has a portrait of Rev. George Duffield painted by George Polk.

POLK, MARY ALYS.
Painter, illustrator and teacher. Born in Greenwood, IN, Aug. 29, 1902. Pupil of William Forsyth. Award: Earlham Alumni prize, Hoosier Salon, 1927. Member: Indiana Art Club. Address in 1929, 3029 Blvd. Pl., Indianapolis, IN.

POLLACK, REGINALD MURRAY.
Sculptor and painter. Born in Middle Village, Long Island, NY, July 29, 1924. Studied with Moses Soyer, Boardman Robinson, Wallace Harrison; Academie de la Grande Chaumiere, Paris. Awards: Maurice Fromke scholarship, Spain, 1951; Prix Neumann, Paris, 1952; Prix des Peintres Etrangers-Laureate, Paris, 1958; Ingram-Merrill Foundation grants in painting, 1964, 70-71. Work: Mint Museum of Art; Whitney; Museum of Modern Art; Brooklyn; Tel Aviv; many others, including private collections. Exhibited: Salon de Mai, 1949, 51, Salon d'Automne, 1949, 50, 52, both in Paris, France; Joslyn Art Museum, 1951; Peridot Gallery, NY, 1949-69; Felix Landau Gallery, Los Angeles, CA, 1977; Dwan Gallery, Los Angeles, CA; Museum of Modern Art; Carnegie; Whitney; Art Institute of Chicago; Penna. Academy of Fine Arts; University of Illinois; others. Taught: Yale; Cooper Union; UCLA; and elsewhere. Has written and illust. numerous books. Address 1953, Paris, France; address 1982, Great Falls, VA.

POLLAK, VIRGINIA MORRIS.
Sculptor, educator, and museum consultant. Born in Norfolk, VA, Oct. 16, 1898. Studied at Yale; Art Students League, NYC; Harriet Whitney Frishmuth Studio; Borglum School of Am. Sculpture; and abroad. Awards: Elsie Stegman prize; Florence K. Sloan award; Pres. citation for work, World War II. Member: Am. Fed. of Arts; Soc. Am. Archaeology. Co-founder, Alva Studios, mus. sculpture reproductions. Address 1962, 502 Park Ave., NYC. Died 1968.

POLLEY, FREDERICK.
Painter and etcher. Born in Union City, IN, Aug. 15, 1875. Pupil of Corcoran Art School, Washington, DC; Herron Art Inst., Indianapolis, IN, under William Forsyth. Member: Indiana Art Club; Indianapolis Art Association; Brown Co. Art Association; Salma. Club; Chicago Galleries Association. Instructor of art at Technical High School, Indianapolis, IN. Died in 1958. Address in 1929, 371 South Emerson Avenue, Indianapolis, IN.

POLLIA, JOSEPH P.
Sculptor and painter. Born in Italy, 1893. Studied at Boston Museum of Fine Arts School. Member: Conn. Academy of Fine Arts; National Sculpture Society; Architectural League. Work: Statues, memorials, figures, monuments, Commonwealth of Virginia; courthouse, Elizabeth, NJ; Indiana University; West Side Park, Jersey City, NJ; Sheridan Square, NYC; others in White Plains, Gloversville, Lake Placid, Tarrytown, Troy, all in New York; Greenfield, Stoneham, Lynn, Franklin, and Barre, all in Massachusetts; many others. Address in 1953, 1947 Broadway, New York, NY. Died in 1954.

POLLOCK, JACKSON.
Painter. Born in Cody, Wyoming, Jan. 28, 1912. His family settled in So. CA in 1925. Studied at Manual Arts High School, Los Angeles, CA, 1925-29; Art Students League of NY, with Thomas Benton, 1929-31. Settled in NYC in 1935. Worked in Fed. Arts Project, 1938-42. Exhibited at McMillan Gall., NYC, 1940; Peggy Guggenheim's Art of This Century Gallery, NYC, 1943, 45, 46, 47; Betty Parson's Gallery, NYC, yearly, 1948-51; Met. Museum of Art, 1943; Venice Biennale, 1950; Sidney Janis Gallery, NYC, 1952; Mus. of Mod. Art, NY, 1952; Bennington Col., 1952; Williams Col., 1952; Kunsthaus, Zurich, 1953; Sidney Janis Gallery, 1952, 54, 55. In coll. of Peggy Guggenheim (shown in Venice, Florence, Milan, Amsterdam, Brussels, Zurich), 1948; Mus. of Mod. Art; San Francisco Mus. of Art; Stedelijk Mus., Amsterdam; Addison Gallery of Am. Art; Baltimore Mus. of Art; Albright Art Gallery, Buffalo, NY; Art Inst. of Chicago; Dallas Mus. of Fine Arts; LA County Mus.; Solomon R. Guggenheim Mus.; Met. Mus. of Art; Whitney; Joslyn Mem. Art Mus., Omaha, NE; Carnegie; others. Address 1953, E. Hampton, LI, NY. Died Aug. 11, 1956.

POLLOCK, THOMAS.
Engraver. In 1839 Pollock was engraving portraits in line in Providence, RI. He was apparently a member of the NY engraving firm of Pollock and Doty.

POMAREDE, LEON.
Portrait painter. Born c. 1807 in Tarbes, France. He opened a studio in New Orleans in 1837. Died in 1892 in St. Louis, MO.

POMEROY, FLORENCE W.
(Mrs. Ralph B. Pomeroy). Painter. Born in East Orange, NJ, July 9, 1889. Pupil of Bellows; Johansen; Nordfeldt; Homer Boss. Member: NY Society of Craftsmen; Guild of Book Workers. Address in 1929, Llewellyn Park, West Orange, NJ.

POMEROY, LAURA SKEEL (MRS.).
(Laura Skeel Hofmann). Sculptor. Born in New York, 1833; grew up in Poughkeepsie. NY. She executed a bust of Matthew Vassar, which still stands in Vassar College. Died in the Bronx, NYC, August 23, 1911.

POND, EMMA McHENRY.
Painter and teacher. Born in San Francisco, CA. Pupil of William Keith. Member: San Francisco Society of Women Artists. Address in 1929, 2621 Ridge Rd., Berkeley, CA.

POND, THEODORE HANFORD.
Painter, craftsman, writer, lecturer and teacher. Born in Beirut, Syria, September 27, 1873. Pupil of Herbert Adams, F. V. Du Mond, and Pratt Institute in NY; also studied in Paris and London. Member: Boston Soc. of Arts and Crafts; Providence Art Club; NY Arch. League, 1902; Art Alliance of America; Am. Assoc. of Mus.; Assoc. of Art Mus. Directors; Am. Fed. of Arts; College Art Assoc. Director, Akron Art Inst., OH. Address in 1929, Akron Art Institute, Akron, OH.

POOKE, MARION LOUISE.
(Mme. Bernard S. Duits). Painter, illustrator and teacher. Born in Natick, MA. Pupil of Massachusetts Normal Art School, Boston; School of the Museum of Fine Arts, Boston; De Camp, Tarbell, Benson, Woodbury. Member: Connecticut Academy of Fine Arts. Awards: Silver medal, P.-P. Expo., San Francisco, 1915; Hudson prize, Connecticut Academy of Fine Arts, 1917; hon. mention, National Association of Women Painters and Sculptors, 1921. Instructor in art at Abbot Academy, Andover, MA; and Walnut Hill School, Natick, MA, 1915-23. Address in 1929, 11 rue Chateaubriand; h. 5 rue Lyautey, Paris, France.

POOLE, ABRAM.
Painter. Born in Chicago, Jan., 1883. Pupil of Carl Marr, Simon. Member: Chicago Soc. of Artists. Awards: Silver medal, Royal Acad., Munich; hon. mention, Chicago Art Inst., 1922; fourth Clark prize and Corcoran hon. mention, Corcoran Gallery of Art, Wash., DC, 1926; medal of honor, Concord, MA, 1926; Holmes prize, Art Inst. of Chicago, 1926. Work: "Portrait," Chicago Art Inst. Died May 25, 1961. Address 1929, 134 E 47th St., NY, NY.

POOLE, BERT.
Painter, illustrator and writer. Born in North Bridgewater (now Brockton), MA, Dec. 28, 1853.

Pupil of Tommaso Juglaris and evening art schools in Boston. Member: Copley Society; American Artists Professional League. Work: "Twentieth Century Boston," Boston Pub. Lib.; "Intermediate Thoroughfare," City Hall, Boston; "City of Cambridge, Mass.," City Hall. Specialty: Panoramic paintings and landscapes. Died before 1940. Address in 1929, 306 Edgehill Road, East Milton, MA.

POOLE, EARL LINCOLN.
Illustrator, painter, sculptor, lecturer, educator, and museum director. Born in Haddonfield, NJ, October 30, 1891. Studied at Philadelphia Museum School of Industrial Art; Penna. Academy of Fine Arts; University of Pennsylvania. Member: Reading Teachers Association; Pennsylvania State Education Association; National Education Association. Awards: Fellowship, Penna. Academy of Fine Arts; hon. degree, Sc.D., Franklin and Marshall College, 1948. Work: University of Michigan; sculpture, Reading Museum Park, Reading, PA. Exhibited: Penna. Academy of Fine Arts; University of Michigan; Library of Congress; Los Angeles Museum of Art; Harrisburg (PA) Art Association; City Art Museum of St. Louis; American Museum of Natural History. Illustrated: *Birds of Virginia*, 1913; *Mammals of Eastern North America*, 1943; and other books. Lectures: Symbolism in Art. Position: Director of art education, Reading School Dist., 1916-39; assistant director, 1926-39, director, 1939-57, Reading (PA) Public Museum. Died in 1972. Address in 1970, West Reading, PA.

POOLE, FREDERIC VICTOR.
Painter, illustrator, craftsman and teacher. Born in Southampton, Hants, England. Pupil of Frederick Brown in London. Member: Chicago Society of Artists; Painters and Sculptors of Chicago; Chicago Galleries Association. Award: Brower prize, Art Inst. of Chicago, 1928. Work: "Portrait of President Lowden," Toronto Univ. Illustrated for magazines. Died in 1936. Address in 1929, 469 Deming Pl.; 65 East Elm St., Chicago, IL.

POOLE, H(ORATIO) NELSON.
Painter, illustrator and etcher. Born in Haddonfield, NJ, Jan. 16, 1885. Pupil of Penna. Academy of Fine Arts. Member: California Society of Etchers; Chicago Society of Etchers; California Book Plate Society; San Francisco Art Association. Award: First prize, Graphic Section, San Francisco Art Association, 1922; prize, California Society of Etchers, 1926; special medal of first award, San Francisco Art Association, 1927. Address in 1929, 728 Montgomery St., San Francisco, CA.

POONS, LARRY.
Painter. Born in Tokyo, Japan, Oct. 1, 1937. Studied at the Boston Museum of Fine Arts School, 1958. Exhibited: Art Institute of Chicago, 1966; Corcoran

Gallery of Art, 1967; Carnegie Inst., 1967; Documenta IV, Kassel, West Germany, 1968; Whitney Museum of American Art Annual, 1968 and 72; and the Whitney Biennial, 1973; plus numerous others. Taught: NY Studio School, 1967. Authored a book titled *The Structure of Color*, 1971. Address in 1984, 831 Broadway, New York, NY.

POOR, HENRY VARNUM.
Painter and teacher. Born in Kansas, September 30, 1888. Pupil of Slade School and of Walter Sickert in London; Julian Academy in Paris. Member: San Francisco Society of Artists; California Art Club; San Francisco Art Association. Award: Walter purchase prize ($300), San Francisco Art Association, 1918. Represented in Metropolitan Museum. Died in 1970. Address in 1929, care of the Montross Gallery, 26 East 56th St., New York, NY.

POORE, HENRY R(ANKIN).
Painter, illustrator, writer and teacher. Born in Newark, NJ, March 21, 1859. Pupil of Peter Moran and Penna. Academy of Fine Arts in Philadelphia; National Academy of Design in New York; Luminais and Bouguereau in Paris. Member: Associate National Academy of Design, 1888; Philadelphia Sketch Club; Art Club of Philadelphia; Salma. Club; Lotos Club; Union International des Beaux-Arts et des Lettres; Fellowship Penna. Academy of Fine Arts, 1916; MacDowell Club; Nat. Arts Club; Connecticut Academy of Fine Arts; American Society of Animal Painters and Sculptors; American Federation of Arts. Awards: 1st prize ($2,000), American Art Association; second Hallgarten prize, Nat. Academy of Design, 1888; bronze medal, Pan.-American Expo., Buffalo, 1901; silver medal, St. Louis Expo., 1904; gold medal, American Art Society, Philadelphia, 1906; gold medal, Buenos Aires, 1910; silver medal, P.-P. Exposition, San Francisco, 1915. Work: "Night of the Nativity," Fine Arts Academy, Buffalo; "The Shore," City Art Mus., St. Louis; "In the Meadow," "Hounds in Sunlight," Art Association, Indianapolis; "Old English Stage Hound," Worcester Museum; "Royal Buck Hounds," Philadelphia Art Club; "Grace Before Meat," Rittenhouse Club; "The Favorite," Madison Art Association; "Marshland Harvest," Tacoma Art Club; "The Far Hills," government purchase, Brazil; "New England Wastes," National Museum, New Zealand. Author: *Pictorial Composition; The Pictorial Figure; The Conception of Art; Art Principles in Practice*. Died in 1940. Address in 1933, 61 Ridge St., Orange, NJ; summer, Lyme, CT.

POPE, ALEXANDER.
Sculptor and painter. Born in Boston, MA in 1849. Member: Copley Society, 1893; Boston Art Club. Published *Upland Game Birds and Water Fowl of the United States*. At the beginning of his career he painted and modeled animals; after 1912 he was chiefly a portrait painter. He died September 1924, in Hingham, MA.

POPE, MARION HOLDEN (MRS.).
Painter, etcher and lithographer. Born in San Francisco, CA. Pupil of A. Mathews; Whistler; Colarossi Academy; Mark Hopkins School of Art. Member: San Francisco Art Association; Northern California Art Association; California Society of Etchers; Kingsley Art Club, Sacramento, CA; American Federation of Arts. Work: Three mural decorations in the Carnegie Library, Oakland, CA; Library of Congress; San Francisco Museum of Art; Crocker Art Gallery; Seattle Art Museum; California State Capitol; California State Library. Award: Medal, Mark Hopkins School of Art. Died c. 1957. Address in 1953, 3948 Jay St., Sacramento, CA.

POPE, WILLIAM FREDERICK.
Sculptor. Born in Fitchburg, MA, in 1865. He lived for a time in Boston, MA. He died in Paris or Boston, October 22, 1906.

PORTANOVA, JOSEPH DOMENICO.
Portrait sculptor and designer. Born in Boston, Massachusetts, May 16, 1909. Studied with Cyrus Dallin. In collections of Smithsonian; California Institute of Technology; Orthopaedic Hospital, Los Angeles; Los Angeles Memorial Coliseum; others. Exhibited at Los Angeles Co. Museum of Art; Laguna Beach Art Association; National Academy of Design; others. Member of California Art Club; American Institute of Fine Arts. Worked in bronze. Address in 1976, Pacific Palisades, CA. Died in 1979.

PORTER, BENJAMIN CURTIS.
Portrait painter. Born in Melrose, MA, Aug. 29, 1845. Pupil of Dr. Rimmer and of A. H. Bicknell, in Boston; also studied in Europe. Awards: Bronze medal, Paris Exposition, 1900; silver medal, Pan.-American Exposition, Buffalo, 1901; silver medal, St. Louis Exposition, 1904. Elected an Associate of the National Academy, 1878; Academician National Academy of Design, 1880; Society of American Artists; National Sculpture Society; National Institute of Arts and Letters. Died April 2, 1908 in NYC.

PORTER, BRUCE.
Sculptor, mural painter, and writer. Born in San Francisco, CA, February 23, 1865. Studied in England and France. Member: American Painters and Sculptors. Award: Chevalier of the Legion of Honor of France. Work: Designed "Stevenson Memorial," San Francisco; stained glass and mural paintings in churches and public buildings of California; gardens, "Filoli" and "New Place." Author: "The Arts in California," etc. Address in 1933, Santa Barbara, CA.

PORTER, DORIS L(UCILE).
Painter, lecturer and teacher. Born in Portsmouth, VA, Feb. 7, 1898. Pupil of Hugh Breckenridge; Penna. Academy of Fine Arts; Hans Hofmann in Munich. Member: North Shore Arts Association; Southern States Art League; Art Corner, Norfolk, VA; fellowship Penna. Academy of Fine Arts. Awards: Prize for landscape, Norfolk Society of Art, 1925, 26, 27, 29; prize for portrait, Norfolk Society of Art, 1929. Work: "Portrait of John Marshall," Wythe House, Williamsburg, VA; St. Mary's Hall, Burlington, NJ; "Still Life," Penna. Academy of Fine Arts. Address in 1933, 124 Dinwiddie St., Portsmouth, VA.

PORTER, ELMER J(OHNSON).
Painter, etcher and teacher. Born in Richmond, VA, May 5, 1907. Pupil of Art Institute of Chicago. Work: Murals, Shrine Temple diningroom, Cedar Rapids, IA. Member: Western Art Association; Alumni Art Institute of Chicago. Awards: First hon. mention, Foulke Richmond prize, Richmond, 1929; Indianapolis Art Association, Indiana Exhibition, Herron Art Institute, 1929. Address in 1933, 108 South 9th St., Richmond, IN.

PORTER, J. T.
In 1815 this line-engraver of historical plates signed himself as of Middletown, CT. The only plates to be found are in the *Narrative of John R. Jewett*, etc., published by Loomis and Richards, Middletown, CT, in 1815.

PORTER, JAMES TANK.
Sculptor. Born in Tientsin, China, October 17, 1883. Studied: Pomona College, B.A.; Art Students League; and with George Bridgman, Gutzon Borglum, Robert Aitken. Member: Art Students League of NY; San Diego Artists Guild; Contemporary Artists of San Diego; San Diego Friends of Art. Award: Prize, San Diego Fine Arts Society, 1924. Work: "Portrait bust of James W. Porter," "Portrait relief of my Mother," owned by Beloit College, WI; portrait of Prof. Chester Lyman, Yale University; Ellen B. Scripps testimonial, La Jolla, CA; "Portrait bust of Pres. James A. Blaisdell," Pomona College, CA; "Portrait of a Young Man," San Diego Fine Arts Gallery; "Portrait bust of the late Bishop Bashfold," M. E. Church of North China, Peking; San Diego Museum of Natural History. Exhibited: National Academy of Design; Penna. Academy of Fine Arts; San Diego Fine Arts Society, 1923-41; Golden Gate Expo., 1939. Address in 1953, La Mesa, CA.

PORTER, JOHN S.
Miniature painter in Boston, MA, in 1832-33.

PORTER, M(ARY) K(ING).
Miniature painter. Born in Batavia, IL, June 9, 1865. Pupil of Volk; Art Students League of Washington, DC; Bertha Perrie; Snell. Member: Washington Water Color Club; Washington Art Club; American Federation of Arts. Died in 1938. Address in 1933, 1761 Q St., Washington, DC; summer, Charmian, PA.

PORTER, RAYMOND AVERILL.
Sculptor. Born in Hermon, NY, February 18, 1883. Member: Boston Society of Arts and Crafts; Copley Society. Work: Memorial to President Tyler, Richmond, VA; statue, "The Green Mountain Boy," Rutland, VT; Victory Memorial, Salem, MA; World War Memorial, Commonwealth Armory, Boston, MA. Address in 1933, Massachusetts Normal Art School, Boston; h. Dana Hill Apts., 331 Harvard St., Cambridge, MA. Died April 2, 1949.

PORTER, S. C. (MRS.).
Painter. Born in Hartford, CT. Studied in art schools in New York and Paris. She exhibited in the Paris Salon of 1875 her "Head of a Girl;" it was also exhibited at the Centennial exhibition in Philadelphia.

PORTNOFF, ALEXANDER.
Sculptor, painter, and teacher. Born in Russia in 1887. Pupil of Charles Grafly; Penna. Academy of Fine Arts. Member: Fellowship, Penna. Academy of Fine Arts; American Federation of Arts; Philadelphia Alliance. Awards: Cresson European Scholarship, Penna. Academy of Fine Arts, 1912, 13; hon. mention, P.-P. Expo., San Francisco, 1915. Exhibited: National Sculpture Society. Represented in Milwaukee Art Institute; Brooklyn Museum; Voks Museum, Moscow; and in private collections. Address in 1933, 718 Locust St., Philadelphia, PA; High Point, Long Beach Island, NJ. Died in 1949.

POSEY, LESLIE THOMAS.
Sculptor. Born in Harshaw, Wisconsin, January 20, 1900. Pupil of E. Clausen, H. Schuetze, Fred Koenig; also at Penna. Academy of Fine Arts, with Albert Laessle; Art Institute of Chicago, with Albin Polasek; Wisconsin School of Fine and Applied Arts. Award: Medal, Milwaukee Art Institute, 1923; others. Work: "The Frontiersman," Women's Alliance, Merrill, WI; "Beethoven," Wildwood Park, WI; decorative cast stone, Church of the Redeemer, Sarasota, FL; garden figure, National Council of Garden Clubs; others. Exhibited at Milwaukee Art Institute; Chicago Art Institute; Hoosier Salon; others. Works in stone and bronze. Address in 1924, 810 East Main St., Merrill, WI; address in 1982, Sarasota, FL.

POSSELWHITE, GEORGE W.
Engraver. Born in England about 1822. He was living in New York in 1899. Posselwhite was an admirable engraver of landscape and subject plates. He came to the United States about 1850 and was largely employed in New York and Philadelphia.

POST, CHARLES JOHNSON.

Painter and journalist. Born in New York in 1873. Since 1893 he was engaged as an artist-journalist and editorial writer with the Associated Press, *New York Daily News, Recorder, World, Journal, Herald* and *Globe.* Illustrated for *American, New York Times, Philadelphia Inquirer, Century Magazine, Pearson's, Cosmopolitan, Harper's Weekly, Harper's Magazine, Everybody's* and *Outing.*

POST, MAY AUDUBON.

Painter and illustrator. Born in New York City. Pupil of Penna. Academy of Fine Arts under Chase, Beaux, Grafly and Breckenridge; of Drexel Institute under Howard Pyle; of Lucien Simon in Paris. Member: Fellowship, Penna. Academy of Fine Arts. Award: Traveling scholarships, Penna. Academy of Fine Arts; gold medal, Art Club of Philadelphia, 1903. Address in 1926, 4446 Sansom St., Philadelphia, PA.

POST, W(ILLIAM) MERRITT.

Landscape painter. Born in Brooklyn, NY, Dec. 11, 1856. Pupil of Frost Johnson; Art Students League of NY under Beckwith. Member: Associate National Academy of Design, 1910; American Water Color Society; NY Water Color Club; Artists' Fund Society; Salma. Club, 1900; Connecticut Academy of Fine Arts; NY Society of Painters. Award: Hon. mention, Pan.-Am. Expo., Buffalo, 1901. Work: "Landscape," Newark Museum Association. Died in 1935. Address in 1933, Bantam, CT.

POSTGATE, MARGARET J.

Painter and sculptor. Born in Chicago, IL. Pupil of Art Institute of Chicago; Art Students League; Robert Ryland; Mahonri Young. Member: College Art Association; Illinois Academy of Fine Arts. Awards: Second prize, 1924, 3rd prize, 1927, 1st prize, 1928, National Small Sculpture Competition, New York; medal, murals, Beaux-Arts, 1924; Harper's Sketch Contest, 1931. Address in 1933, 388 Park Pl., Brooklyn, NY.

POTTER, AGNES SQUIRE.

Painter and teacher. Born in London, Oct. 31, 1892. Pupil of NY School of Fine and Applied Art; Minneapolis Art Institute; Hawthorne; Breckenridge. Member: Chicago Art Club; Cordon Club; Chicago Society of Artists; Cor Ardens. Award: Hinsdale Woman's Club prize, Art Institute of Chicago, 1922. Work: "Coronado Beach," owned by the City of Chicago Schools. Address in 1933, 1542 East 57th St.; h. 5515 Woodlawn Ave., Chicago, IL.

POTTER, BERTHA HERBERT.

(Mrs. Edward Potter, Jr.). Painter. Born in Nashville, TN, March 12, 1895. Pupil of L. Pearl Saunders; E. Ambrose Webster; Hugh Breckenridge; Van D. Perrine; Edmund Greacen; Sidney Dickinson.

Member: Southern States Art League; North Shore Arts Association; American Federation of Arts. Address in 1929, 1709 West End Ave.; h. 3828 Whitland Ave., Nashville, TN.

POTTER, BESSIE O.

See Vonnoh, Bessie (Onahotema) Potter.

POTTER, EDWARD CLARK.

Sculptor. Born in New London, CT, on November 26, 1857. Studied sculpture under Mercie and Fremo, Paris. Collaborated with D. C. French in sculpture for Chicago Exposition, 1892-93; executed equestrian statues of Grant at Philadelphia, 1894; one of Washington, at Paris, 1898; Hooker, at Boston, 1904; Derens, at Worcester, MA, 1905; Slocum, at Gettysburg; De Soto, at St. Louis Exposition, 1904; also statues in Fulton Library, Washington. Elected to National Academy of Design, 1906. Member: National Institute of Arts and Letters; National Sculpture Society; Architectural League. Died in 1923, in New London, CT.

POTTER, H(ARRY) S(PAFFORD).

Illustrator. Born in Detroit, MI, 1870. Pupil of Constant, Laurens and Jules Simon in Paris. Member: Society of Illustrators, 1910. Address in 1929, 539 West 112th St., New York, NY.

POTTER, LOUIS McCLELLAN.

Sculptor and etcher. Born in Troy, NY, November 14, 1873. Pupil of Luc Olivier Merson, Jean Dampt, and Charles Flagg. Member: NY Municipal Art Society. "The Snake Charmer" attracted favorable comment at the Pan.-American Exposition, while his busts "A Tunisian Jewess" and "A Young Bedouin" were highly praised. Address in 1910, 18 East 23d St., NYC. Died in Seattle, WA, in 1912.

POTTER, MARTHA J(ULIA).

Painter and teacher. Born in Essex, CT, Jan. 14, 1864. Pupil of J. H. Niemeyer; John F. Weir; A. W. Dow; Marshall Fry. Member: New Haven Paint and Clay Club; Connecticut Academy of Fine Arts; American Federation of Arts. Address in 1929, 224 Park St., New Haven, CT.

POTTER, MARY K.

Painter and writer on art. Pupil of Metropolitan Museum and of the Art Students League of New York; also of the Julien Academy, Paris. Address in 1926, 184 Boylston St., Boston, MA.

POTTER, NATHAN DUMONT.

Sculptor and painter. Born in Enfield, MA, April 30, 1893. Son of Edward Clark Potter, sculptor. Pupil of D. C. French and E. C. Potter. Work: World War Memorial Column, Westfield, NJ; Equestrian Statue, William Jackson Palmer, Colorado Springs, CO. Address in 1933, Lyme, CT. Died in 1934.

POTTER, WILLIAM J.

Painter and teacher. Born in Bellefonte, PA, July 14, 1883. Pupil of Penna. Academy of Fine Arts; Walter Sickert in London. Work: "Balearic Isles," Brooklyn Museum; "Villa Rosa and Pasquala Harbor," Hispanic Museum, New York; Memorial Art Gallery, Rochester, NY; "Porto Pi Balearics," Herron Art Institute, Indianapolis, IN; "Cornwall Coast," Sydney, Australia Museum; also represented in Cincinnati Museum of Art; Exposition Park Museum, Los Angeles, CA; Museum of Rouen, France. Died in 1964. Address in 1933, 40 Bush Avenue, Greenwich, CT.

POTTHAST, EDWARD HENRY.

Painter and illustrator. Born in Covington, KY, June 10, 1857. Studied at McMicken School, with Thomas Noble and Duveneck; Cincinnati Art Academy; in Antwerp, with Polydore Beaufaux and Charles Verlat; in Munich, with Nikolous Gysis, Ludwig von Loefftz, Carl von Marr, and Alexander von Wagner; and in Paris, with Boulanger and Lefebvre at the Academie Julian, and with Laurens. Member: American Water Color Society, 1895; Salma. Club, 1895; Society of Western Painters, 1897, 98; Art Club of Philadelphia, 1898; Associate National Academy of Design, 1899; Society of American Artists, 1900; NY Water Color Society, 1900; National Institute of Arts and Letters, 1905; Academician National Academy of Design, 1906; Fine Arts Federation of New York, 1910-17; Society of Men Who Paint the Far West, 1911-20; Lotos Club, 1912 (life-member); League of American Artists, 1921; Allied Artists of America, 1922; Cincinnati Art Club (hon.); Painters and Sculptures Gallery Association; Society of Painters of NY; National Arts Club (life member). Awards: Clarke prize, National Academy of Design, 1899; Evans prize, 1901, gold medal, 1902, Griscom Prize, 1926, Osborn Purchase Prize, 1927, American Water Color Society; Inness prize, Salma. Club, 1903, 06; silver medal, St. Louis Expo., 1904; Hudnut prize ($200), American Water Color Scoiety, 1914; silver medal, P.-P. Expo., San Francisco, 1915. Work: "Dutch Interior," Cincinnati Museum; "On the Beach" and "Bathers," Brooklyn Institute Museum; "The Pilot," Hackley Art Gallery, Muskegon, MI; "A Holiday," Chicago Art Institute; mural, Chicago National Bank. One-man exhibitions: Montross Gallery, NYC; Traxel Art Gallery, Cincinnati, OH; Young's Art Gallery, Chicago; Katz Galleries, NYC; Macbeth Galleries, NY; Corcoran Gallery; Feragil Galleries; Brooks Memorial Art Museum, Memphis, TN; Grand Central Art Galleries, NY. Retrospectives and memorials: Hirschl and Adler Galleries, NY; Cincinnati Art Museum; Butler Institute; Taft Museum; Corcoran Gallery; Los Angeles County Museum; others. Address in 1925, 222 Central Park South, New York, NY. Died March 10, 1927 in NYC.

POTTHAST, EDWARD HENRY, JR.

(Also listed as Potthast, Edward Henry, II). Painter. Born about 1880 in Cincinnati, OH. Studied under his uncle, Edward Potthast. Travelled to Holland in 1904-05. Returned to America in 1905. Lived in New York City; later moved to Cincinnati with his wife and daughter. Taught commercial art at the Ohio Mechanics Institute during the 1920's and 30's. Exhibited at the American Water Color Society; Annual Exhibitions of American Art, Cincinnati Art Museum, 1911, 12, 13, 14, 15, 25, 26. Address in 1914, 222 Central Park South, New York, NY; address in 1925, Gordon Avenue, Cincinnati, OH. Died in 1941.

POTTS, DON.

Sculptor and lecturer. Born in San Francisco, CA, October 5, 1936. Studied at San Jose State College, B.A., 1936, M.A., 1965; University of Iowa, 1963. Work in Joslyn Art Museum, Omaha; La Jolla Museum of Art, CA; Oakland Museum, CA; San Francisco Museum of Art; others. Has exhibited at Denver Art Museum; Walker Art Center, Minneapolis, MN; Whitney Museum of American Art, NY; Museum of Modern Art, NY; San Francisco Museum of Modern Art, CA; Documenta, Kassel, Germany; Institute of Contemporary Art, Boston; Stedelijk Museum, Amsterdam; others. Received National Endowment for the Arts Fellowship Grant, 1970; Louis Comfort Tiffany Foundation Grant, 1973-74; others. Address in 1982, c/o Hansen Fuller Goldeen Gallery, San Francisco, CA.

POTTS, SHERMAN.

Portrait painter and miniature painter. Born in Millburn, NJ, July 29, 1876. Pupil of C. N. Flagg in Hartford; Penna. Academy of Fine Arts; Laurens and Constant in Paris. Member: Connecticut Academy of Fine Arts; American Society of Miniature Painters; Mystic Society of Artists. Award: Dunham portrait prize, Connecticut Academy of Fine Arts, 1929. Address in 1929, 45 East 59th St., New York, NY; summer, Noank, CT.

POTTS, WILLIAM S.

Engraver. Born in New Jersey; died in St. Louis in 1852. In 1824 Potts was an engraver in a New York office, working with William Chapin, but he later studied for the ministry and became a prominent Presbyterian clergyman, and in 1837 was president of the Marion College.

POUPARD, JAMES.

Engraver, portrait painter, jeweler and goldsmith. Born in Martinique. Was an actor early in his life. Advertised in the *Pennsylvania Gazette*, Philadelphia, PA, in 1772. The earliest engraving by Poupard of which we have any note is mentioned in the *Gazette* of June 29, 1774. James Humphreys, Jr., announces the publication of "The Search after Happiness, a Pastoral Drama, by Miss More (embellished with an

elegant Copperplate Frontispiece, engraved by James Poupard, of this City)." In 1775 Poupard engraved the portrait of Dr. Goldsmith for the *Pennsylvania Magazine*; in 1788-89 he was engraving diagrams, etc., for the *Transactions of the American Philosophical Society*; and as a "seal and die engraver" his name appears continuously in the Philadelphia directories for 1793-1807, inclusive. Poupard then moved to NY, and was engraving on wood for New York publishers in 1814. A fairly well executed portrait of John Wesley may be ascribed to this latter period.

POUSETTE-DART, NATHANIEL J.
Painter, sculptor, etcher, teacher, and lecturer. Born in St. Paul, MN, September 7, 1886. Pupil of St. Paul Art School; Henri and MacNeil in New York; Penna. Academy of Fine Arts. Member: Artists' Society, St. Paul Institute; Gargoyle Club; Fellowship Penna. Academy of Fine Arts; Society of Independent Artists; Art Directors' Club. Awards: Cresson Scholarships, 1909 and 1910, Toppan prize, 1910, both from Penna. Academy of Fine Arts; hon. mention for painting and second prize for etching, 1913, third prize for painting and first prize for etching, 1914, from Minnesota State Art Society; hon. mention for painting, St. Paul Institute, 1915; first prize for painting, Minnesota State Art Society, 1916. Director of art department at St. Catherine's College, St. Paul, MN; St. Benedict's College, St. Joseph, MN; and Minnesota College, Minneapolis, MN. Address in 1929, Valhalla, NY. Died in 1965.

POWELL, ARTHUR JAMES EMERY.
Painter. Born in Vanwert, OH, Dec. 11, 1864. Pupil of San Francisco School of Design; St. Louis School of Fine Arts; Julian Academy, Toulouse and Ferrier in Paris. Member: Associate National Academy of Design, 1921; Salma. Club, 1904; American Art Association of Paris; Artists' Fund Society; Allied Artists of America; National Arts Club (life); NY Water Color Club. Awards: Vezin prize ($100), Salma. Club, 1913; Ranger Purchase prize, National Academy of Design, 1921. Died in 1956. Address in 1929, 59 East 59th St., New York, NY.

POWELL, CAROLINE A(MELIA).
Wood engraver. Born in Dublin, Ireland. Pupil of W. J. Linton and Timothy Cole; studied drawing at Cooper Union and National Academy of Design in New York. Member: Society of American Wood Engravers. Awards: Bronze medal, Columbian Expo., Chicago, 1893; silver medal, Pan.-Am. Expo., Buffalo, 1901. Work: Boston Museum of Fine Arts; New York Public Library; Springfield (MA) Public Library; Carnegie Institute, Pittsburgh. Died in 1935. Address in 1929, 1034 Third St., Santa Monica, CA.

POWELL, JENNETTE M.
Painter, etcher, craftsman and teacher. Born in Kingston, Canada. Studied with Chase, Henri, Hawthorne, Parsons, Sandzen, and in Paris. Address in 1929, 202 N 23rd St., Camp Hill, PA; winter, "House in the Pines," Norton, MA.

POWELL, LESLIE J.
Painter, sculptor, teacher, designer, and lithographer. Born in Fort Sill, OK, March 16, 1906. Studied at University of Oklahoma; Chicago Academy of Fine Arts; Art Students League; NY University; Columbia University, B.F.A., M.A. Work: University of Arizona; Columbia University; Lehigh University; University of Oklahoma; Brooklyn Museum; Matthews Museum of Theatre Arts; Cooper Union Museum; Newark Museum of Art. Exhibited: New Orleans Arts and Crafts, 1926, 31, 45; Delgado Museum of Art, 1927; Morgan Gallery, NY, 1939, 40; Lehigh University, 1943; Carlebach Gallery, NY, 1948; Monmouth (IL) College, 1949; Norlyst Gallery, 1949; Third St. Gallery, Los Angeles, 1950; Avery Library, Columbia University, 1950; Mercersburg (PA) Art Gallery, 1951; Philbrook Art Center, 1957; Galerie Raymond Duncan, Paris, 1966; Springfield (MA) Museum, 1964, 65; Audubon Artists, 1969; one-man shows in various galleries. Address in 1970, 39½ Washington Sq. S., NYC.

POWELL, LUCIEN WHITING.
Painter. Born in Virginia, Dec. 13, 1846. Pupil of Penna. Academy of Fine Arts; London School of Art; studied in Rome, Venice and Paris. Member: Society of Washington Artists; Washington Water Color Club. Award: Parsons prize, Society of Washington Artists, 1903. Work: "The Afterglow," and "Grand Canyon, Arizona," Corcoran Gallery, Washington; "Grand Canyon of the Yellowstone River," National Gallery, Washington, DC. Died Sept. 27, 1930. Address in 1929, Round Hill, VA.

POWELL, WILLIAM HENRY.
Portrait and historical painter. Born Feb. 14, 1823 in NYC. Represented in the Capitol, Washington, DC, by "De Soto Discovering the Mississippi River" and by the "Battle of Lake Erie." A replica of this picture is in the State Capitol of Ohio. In the painting of his "Battle of Lake Erie," persons then employed about the Capitol were used as models. For many years he occupied a studio in New York. His "Landing of the Pilgrims" was purchased by Marshall O. Roberts, and his portraits of Gen. McClellan and Maj. Anderson are in the City Hall, New York. Died Oct. 6, 1879 in New York City.

POWERS, HIRAM.
Sculptor. Born in Woodstock, VT, July 29, 1805. Raised in Cincinnati, OH. Initiated his studies by modelling figures for a wax museum in Cincinnati. Modelled wax figures of Dante's *Inferno*. In 1834,

made several portrait busts in Washington, DC. Nicholas Longworth, patron of Powers, sent him to Florence, Italy, in 1837 to study sculpture; he remained there until his death. Works during the Italian period include "Greek Slave," 1843; "The Fisher Boy," 1848; "California," 1950; and other portrait busts and ideal figures. Other works are statues of Adams, Jackson, Webster, Calhoun, Longfellow, Gen. Sheridan. Exhibited at the Crystal Palace Exhibition, London, 1851; National Academy of Design; works also exhibited at Metropolitan Museum, and Cincinnati Art Museum, posthumously. In collections of Metropolitan Museum; de Young Museum, San Francisco; other museums and private collections. Member: National Academy of Design. Worked in marble. Died in Florence, Italy, June 27, 1873.

POWERS, JOHN M.
Illustrator. Member: Society of Illustrators. Address in 1929, 154 Nassau St., New York, NY.

POWERS, LONGWORTH.
Sculptor. Son of Hiram Powers. Resided in Florence, Italy, for many years and died there in 1904.

POWERS, MARION.
(Mrs. W. A. Kirkpatrick). Painter. Born in London, England, of American parents. Pupil of Garrido in Paris. Member: National Association of Women Painters and Sculptors; Copley Society; Artists' Guild of the Authors League of America, NY. Awards: Lippincott prize, Penna. Academy of Fine Arts, 1907; silver medal, Buenos Aires Expo., 1910; gold medal, P.-P. Expo., San Francisco, 1915. Work: "Tresors," in Luxembourg, Paris, bought from Salon, 1904; mural decoration for Canadian Pacific Railway, Hotel Vancouver, BC; "Little Housewife," Rhode Island School of Design. Address in 1929, Fenway Studios, 30 Ipswich St., Boston, MA; summer, Friendship, ME.

POWERS, PRESTON.
Sculptor and portrait painter. Son of Hiram Powers. Born in Florence in 1843. He practiced his profession in Boston, MA, Washington, DC, and in Portland, ME. His life-bust of Whittier is in the library at Haverhill, MA.

POWRIE, ROBERT.
Sculptor and painter. Born in 1843. His chief work is the memorial to General John Gibbons in Arlington Cemetery. Died December 13, 1922.

PRADOS, MADAME.
Miniature portrait painter, working in New Orleans about 1800.

PRAHAR, RENEE.
Sculptor. Born in New York City, October 9, 1880. She studied in Paris with Bourdelle, Injalbert, and at

the Beaux Arts. Exhibited: The Salon, Paris; National Sculpture Society, NYC, 1923. Honors: Prize for sculpture, National Association of Women Painters and Sculptors, 1922. Works: Impression; Jaguars (unfinished); bronze, A Russian Dancer, Metropolitan Museum of Art, New York City. Member: National Association of Women Painters and Sculptors. Address in 1933, 309 4th Street, New York, NY. Died in 1962.

PRASUHN, JOHN G.
Sculptor. Born near Versailles, OH, Dec. 25, 1877. Pupil of Mulligan, Taft, Art Institute of Chicago. Member: Indiana Art Club; Indianapolis Art Association. Award: Mildred Veronese Beatty prize, 1927. Work: Bronze tablet, Northern Illinois State Normal School, De Kalb; bronze bust of "Dr. F. W. Gunsaulus," Field Museum of Natural History; marble music group, Lincoln Park Band Stand, Chicago; two lions on Columbus Memorial Fountain, Washington, DC. Publication: Author of article "Cement," in *Scientific American*, 1912. Address in 1933, 1310 Hiatt St., Field Museum of Natural History, Dept. of Anthropology, Indianapolis, IN.

PRATHER, RALPH CARLYLE.
Illustrator and writer. Born in Franklin, PA, Nov. 4, 1889. Specialty: Animals and nature for advertising, illustration and design. Author, in collaboration with Claire McCullough Prather, of articles in *Nature Magazine*, etc. Address in 1929, P.O. Box 71, Drexel Hill, PA.

PRATT, BELA LYON.
Sculptor. Born in Norwich, CT, on December 11, 1867. Studied with Saint-Gaudens, Chase and Cox in New York; in Paris with Falguiere. Represented by statue of Nathan Hale at Yale University; "The Seasons," in the Congressional Library, Washington, DC; and many war monuments and memorials. Died in Boston, MA, May 18, 1917.

PRATT, DUDLEY.
Sculptor, educator, and writer. Born in Paris, France, June 14, 1897. Studied: Yale University; Boston Museum of Fine Arts School; Grande Chaumiere, Paris; and with E. A. Bourdelle, Charles Grafly. Member: Artists Equity Association (president, Seattle Chapter). Work: Seattle Art Museum; IBM Collection; architectural sculpture, Civic Auditorium, Henry Art Gallery, Doctors Hospital, University of Washington Medical School, all in Seattle, WA; Women's Gymnasium, Social Science Building, University of Washington; Hoquiam (WA) City Hall; Bellingham City Hall; Washington State College Library; etc. Exhibited: Seattle Art Museum, 1929-41, 1935 (one-man); Oakland Art Gallery, 1940; NY World's Fair, 1939; Sculpture Center, NY, 1957-69; Penna. Academy of Fine Arts; Detroit Institute of Art, 1958; others. Lectures: History of Sculpture.

Position: Assistant, Associate Professor of Sculpture, University of Washington, Seattle, WA, 1925-42; Ed.-in-Chief, handbooks, 1942-47, Boeing Aircraft Co., Seattle, WA. Died in 1975. Address in 1953, Seattle, WA; in 1970, San Miguel de Allende, Mexico.

PRATT, HARRY E(DWARD).
Painter, illustrator and teacher. Born in North Adams, MA, May 21, 1885. Address in 1929, 125 Hall St., North Adams, MA; summer, Jacksonville, VT.

PRATT, HELEN L.
(Mrs. Bela L. Pratt). Sculptor. Born in Boston, MA, May 8, 1870. Pupil of School of the Boston Museum of Fine Arts. Address in 1915, 30 Lakeville Place, Jamaica Plain, MA.

PRATT, HENRY CHEEVES.
Landscape painter. Born June 13, 1803 in Orford, NH. He also painted a bust-portrait of Longfellow. Died Nov. 27, 1880 in Wakefield, MA.

PRATT, JULIA D.
Painter and lecturer. Born in North Collins, NY. Pupil of Otto Schneider, Buffalo Fine Arts Academy; Cooper Union; NY Independent Art School. Member: Buffalo Independent Artists; Buffalo Allied Artists of America; Chicago No-Jury Society of Artists; Society of Independent Artists; Buffalo Society of Fine Arts. Formerly art supervisor in Buffalo public schools. Address in 1933, 94 Glenwood Ave., Buffalo, NY; summer, North Collins, NY.

PRATT, MATTHEW.
Painter. Born in Philadelphia, PA, Sept. 23, 1734. He was the son of Henry Pratt (goldsmith), a friend of Doctor Franklin and one of his famous Junto. His mother's brother, James Claypole, "limner and painter in general," had the distinction, until recently, of being the earliest native-born American artist (1720) recorded, and it was he who gave his nephew the first instruction he received in art, "from whom," to use Pratt's language, "I learned all the different branches of painting from ten years of age." His earliest work apparently is the portrait of his father's friend, Franklin, painted circa 1756, now in the Manor House collection at Yonkers, NY, which is also the earliest known portrait of the philosopher. In the summer of 1764, Pratt sailed for London, having under his protection his kinswoman, the fiancee of Benjamin West, who a few months later Pratt gave in marriage to the future President of the Royal Academy of Arts in London. For two and a half years Pratt lived in the household of West and was West's first student. It was during this period that he painted the picture of "The American School" - West's painting-room, now in the Museum of Modern Art, NY, and portraits of West and Mrs. West in the Penna. Academy of Fine Arts, Philadelphia. Matthew Pratt died Jan. 9, 1805, and was buried in Christ Church burying ground at 5th and Arch Streets, Philadelphia. He was the father of Henry Pratt, who built the famous "yellow mansion" which stood at Broad and Walnut Streets, Philadelphia, for so many years, and he was the progenitor of many families of prominence in that city. He also painted a full-length portrait of Cadwalader Colden belonging to the NY Chamber of Commerce, for that body, in 1772, at a cost of thirty-seven pounds. The Spring Garden Institute of Philadelphia owned at one time a full-length portrait of Gov. James Hamilton, painted by Pratt, but it has been lost for years.

PRATT, PHILIP H(ENRY).
Painter, illustrator and teacher. Born in Kansas City, MO, Aug. 10, 1888. Pupil of St. Louis School of Fine Arts; Philadelphia Industrial Art School; South Kensington, London. Member: 2x4 Society; St. Louis Artists' Guild; Camera Club. Work: Mural panels for Wisconsin State Capitol.

PRATT, ROBERT M.
Portrait and genre painter. Born in 1811 in Binghamton, NY. He was a pupil of Morse and Ingham. Member of the National Academy of Design. He also painted a number of miniatures. The New York Historical Society owns his portraits of Richard Hildreth and Nicholas Triest. He died Aug. 31, 1880 in New York City.

PRATT, VIRGINIA CLAFLIN.
(Mrs. Dudley Pratt). Sculptor and teacher. Born in Littleton, MA, June 1, 1902. Studied: Boston Museum of Fine Arts School; Grande Chaumiere, Paris. Work: Numerous portrait heads. Exhibited: Seattle Art Museum. Position: Head of art department, Helen Bush School, Seattle, WA, 1926-38. Address in 1953, Seattle, WA.

PRELLWITZ, EDITH MITCHILL.
Painter. Born in 1865 in South Orange, NJ. Pupil of Art Students League under Brush and Cox; Julian Academy in Paris. Member: Society of American Artists, 1898; Associate National Academy of Design, 1906; NY Woman's Art Club. Awards: Second Hallgarten prize, National Academy of Design, 1894; Dodge prize, National Academy of Design, 1895; medal, Atlanta Expo., 1895; bronze medal, Pan.-Am. Expo., Buffalo, 1901; Shaw prize, National Academy of Design, 1929. Died in 1944. Address in 1933, Peconic, Long Island, NY; 333 East 41 St., New York, NY.

PRELLWITZ, HENRY.
Painter and teacher. Born in New York, Nov. 13, 1865. Pupil of T. W. Dewing and Art Students League in New York; Julian Academy in Paris. Member: Society of American Artists, 1897; Associate National Academy of Design, 1906; Academician National Academy of Design, 1912; Salma. Club,

1903; Century Association; American Federation of Arts. Awards: Third Hallgarten prize, National Academy of Design, 1893; bronze medal, Pan.-Am. Expo., Buffalo, 1901; silver medal, St. Louis Expo., 1904; Clarke prize, National Academy of Design, 1907. Died in 1940. Address in 1929, Peconic, Long Island, NY; 333 East 41st St., New York, NY.

PRENDERGAST, CHARLES E.
Sculptor, painter, and teacher. Born in Boston, MA, May 27, 1868. Member: Copley Society; Society of Independent Artists; Mural Painters; New Society of Artists; others. Represented: Barnes Foundation, Philadelphia, PA; Phillips Memorial Gallery, Washington, DC; International House, NYC; Addison Museum of American Art, Andover, MA. Address in 1933, 219 West 14th St.; 50 Washington Sq., New York, NY. Died in 1948.

PRENDERGAST, MAURICE BRAZIL.
Painter. Born in 1859. Brought to Boston in 1861 from St. John's, Newfoundland; lived there until 1914 when he moved to NY. Went to England in 1886; was in France from about 1891-95 where he studied at the Academie Julien, Academie Colarossi, and with Laurens and Blanc in Paris. Made two more trips to Paris and Italy. Worked in NYC and Boston. Represented at Metropolitan Museum of Art; a collection of his sketchbooks is at the Museum of Fine Arts, Boston. Awarded medal at Buffalo Exposition in 1901, and at Corcoran Art Gallery, Washington, DC, in 1923, for his "Landscape with Figures." Died in New York, Feb. 1, 1924.

PRENTISS, TINA.
Painter. Studied: Harvard University's Carpenter Center for the Visual Arts; Massachusetts College of Art. Awards: Cambridge Art Association, 1967; SPCA Bronze Medal, Boston Tea Party Poster Award, 1973. Exhibitions: Concord Art Association, 1973; Cambridge Art Association, 1973. U.S. Department of Labor, Women's Bureau, Washington, DC, 1974. She is represented in the collection of Paramount Pictures.

PRESCOTT, KATHARINE T.
Sculptor. Born at Biddeford, ME. Pupil of E. Boyd, Boston, and of F. E. Elwell, New York. Member: Boston Art Students' Association; Copley Society, Boston. Exhibited at Art Institute, Chicago; National Sculpture Society; National Academy of Design, New York; Penna. Academy of Fine Arts, Philadelphia; Boston Art Club. Address in 1926, 59 5th Ave., New York.

PRESCOTT, PRESTON L.
Sculptor, teacher, and designer. Born in Ocheyedan, Iowa, Aug. 10, 1898. Studied at Minneapolis Institute of Art; Otis Art Institute; Art Students League; and with Gutzon Borglum, David Edstrom. Member:

California Art Club; Laguna Beach Art Association. Awards: Prizes, California Art Club, 1935, 36; Laguna Beach Art Association, 1936; Los Angeles Chamber of Commerce, 1927-29. Work: Sculpture portraits, California State Building, Los Angeles; memorial, Arcadia, CA. Exhibited: Los Angeles Museum of Art, 1937; California Art Club, 1935, 36; Ebell Salon, 1935-37; Stendahl Gallery, Los Angeles, 1937; Laguna Beach Art Association, 1936-38; Metropolitan Museum of Art (AV), 1942. Position: Instructor of sculpture, Sheridan Memorial School of Art, Ben Lomond, CA, 1953. Address in 1953, Santa Cruz County, CA.

PRESSOIR, ESTHER (ESTELLE).
Painter, illustrator, etcher, craftsman and teacher. Born in Philadelphia, PA, Oct. 4, 1905. Pupil of Hawthorne; K. Miller; Kuhn; B. Robinson; Kunstgewerbeschule in Munich. Member: National Association of Women Painters and Sculptors; Providence Water Color Club. Work: "Still Life," Penna. Academy of Fine Arts. Address in 1929, 8 E. 15th St., New York, NY.

PRESTINI, JAMES LIBERO.
Sculptor and designer. Born in Waterford, CT, January 13, 1908. Studied at Yale University, B.S., 1930, School of Education, 1932; University of Stockholm, 1938, with Carl Malmsten; Institute of Design, Chicago, 1939, with L. Moholy-Nagy; also studied in Italy, 1953-56. Work in Smithsonian Institution, Washington, DC; San Francisco Museum of Art; Brooklyn Museum, NY; others. Has exhibited at San Francisco Museum of Art; Art Institute of Chicago; Museum of Modern Art, NY; Metropolitan Museum of Art, NY; others. Received Guggenheim Fellowship for Sculpture, 1972-73; others. Life fellow, Metropolitan Museum of Art, NY. Works in steel, aluminum, and wood. Address in 1982, Berkeley, CA.

PRESTON, ALICE BOLAM.
(Mrs. Frank Preston). Illustrator and draughtsman. Born in Malden, MA, March 6, 1888. Pupil of Massachusetts School of Art; Vesper L. George; Albert H. Munsell; Anson K. Cross; Felicie Waldo Howell; Henry Snell. Exhibited: Boston Art Club; Copley Society; Pen and Brush Club; J. B. Speed Memorial Museum; Rockport Art Associaiton; North Shore Arts Association. Member: North Shore Arts Association; Rockport Art Association; Copley Society, Boston; Rockport Art Association; Boston Art Club; Pen and Brush Club of NY; others. Awards: Hon. mention, 1924, first prize ($500), 1925 and 1926, special prize ($250), 1927, prize, 1928, *House Beautiful* magazine cover competitions. Illustrated: *The Valley of Color Days, The Little Man with One Shoe, Seven Peas in the Pod, Adventures in Mother Goose-land* (Little Brown and Co.); *Peggy in Her Blue Frock* and *Humpty Dumpty House* (Houghton Mifflin Co.);

and other children's books. Died in 1958. Address in 1929, 807 Hale St., Beverly Farms, MA.

PRESTON, JAMES.
Landscape painter. Born in 1873. He exhibited at the Penna. Academy of Fine Arts in Philadelphia, 1915. Address in 1926, 22 West 9th St., New York. Died in 1962.

PRESTON, JESSIE GOODWIN.
Painter. Born in East Hartford, CT, Sept. 9, 1880. Pupil of William M. Chase; Robert Henri. Member: Connecticut Academy of Fine Arts; Springfield Art League; Gloucester Art Society; New Haven Paint and Clay Club; American Federation of Arts. Award: Hon. mention, Connecticut Academy of Fine Arts, 1924. Address in 1929, 984 Main St., East Hartford, CT.

PRESTON, MAY WILSON.
(Mrs. James M. Wilson). Illustrator. Born in New York in 1873. Pupil of Art Students League of New York; National Academy of Design; Whistler School in Paris. Member: Society of Illustrators, 1904. Award: Bronze medal, Panama-Pacific Exposition, San Francisco, CA, 1915. Died in 1949. Address in 1926, 22 West 9th St., New York, NY.

PREZZI, WILMA A. M.
Portrait and creative painter, sculptor and muralist. Born in Astoria, Long Island, NY, Sept. 2, 1915. Studied at State Education Department, Teachers College, 1940; Philathea College, London, Ontario, 1954; Ph.D. (hon.), St. Andrew's Ecumenical University, London, England, 1957; and Metropolitan Art School, 1932. Works: Reproduced in many publications, dailies, magazines, art and news periodicals in the U.S. and abroad; Messiah, 1954; Gallery C. T. Loo, 1949; Knoedler Gallery, NYC, 1945; Southampton Museum, 1945; Carnegie Institute, 1946-47; China Institute in America, 1947; Studio Gallery, NYC, 1941; Allied Artists of America, 1944, 45, 46; Arthur Harlow Galleries Water Colors, 1948; NY Architectural League Member Shows, 1950, 51; Adam Mickiewicz Museum, Warsaw (Poland) Centennial International, 1956-57. Awards: Numerous international awards; gold medal, International Fine Arts Council; Architectural League of NY; others. Member of International Institute of Arts and Letters; International Fine Arts Council; American International Academy; others. Taught: Costume Design at School of Industrial Arts, NYC, 1943-44; also a fashion designer. Address in 1962, Hotel des Artistes, 1 W. 67th St., New York, NY.

PRICE, ANNA G.
Painter and teacher. Born in New York. Pupil of Art Students League of NY; NY School of Art. Member: National Association of Women Painters and Sculptors; Pen and Brush Club. Address in 1929, 145 Greenway South, Forest Hills, NY.

PRICE, CHESTER B.
Illustrator, etcher, sculptor and artist. Born in Kansas City, MO, June 11, 1885. Pupil of Umbdenstock in Paris; Donn Barber in New York. Member: American Institute of Architects; Architectural League of NY; NY Artists Guild. Specialized in architectural illustration for magazines. Co-author, illustrator of *Portraits of Ten Country Houses Designed by Delano and Aldrich*. Died in 1962. Address in 1929, 201 East 40th St., New York, NY; h. 69 Kensington Rd., Bronxville, NY.

PRICE, CLAYTON S.
Woodcarver and painter. Born in Bedford, IA, 1874. Studied: St. Louis School of Fine Art, Missouri, 1905-06. Visited San Francisco, CA, 1915; lived in Monterey, CA, 1918-29; moved to Portland, OR, 1929. One-man shows: Beaux Arts Galerie, San Francisco, CA, 1925; Portland Art Museum, OR, 1942, 51; The Fine Arts Patrons of Newport Harbor, Pavilion Gallery, Balboa, CA, 1967. Group exhibitions: Frontiers of American Art, M. H. de Young Memorial Museum, San Francisco, 1939; Romantic Painting in America, The Museum of Modern Art, NY, 1943; Fourteen Americans, The Museum of Modern Art, NY, 1946; San Francisco Museum of Modern Art, 1976; and Smithsonian Institution, 1977. In collections of Portland Art Museum, OR; Hirshhorn Museum and Sculpture Garden, Washington, DC. Sculpture includes miniature woodcarvings of animals and farm workers. Died in 1950 in Portland, OR.

PRICE, EDITH BALLINGER.
Painter, illustrator and writer. Born in New Brunswick, NJ, April 26, 1897. Pupil of P. L. Hale, A. R. James, Helena Sturtevant, George Maynard and Thomas Fogarty. Member: Newport Art Association. Work: Author and illustrator of *Blue Magic; Silver Shoal Light; Us and the Bottleman; The Happy Venture; The Fortune of the Indies; Garth, Able Seaman; John and Susanne; My Lady Lee; Ship of Dreams; The Four Winds; Gervaise of the Garden.* Address in 1929, 7 Arnold Ave., Newport, RI; summer, "The Acorn," Wakefield, RI.

PRICE, EUGENIA.
Painter. Born in Beaumont, TX, in 1865. Pupil of St. Louis School of Fine Arts; Art Institute of Chicago; Julien Academy in Paris. Member: Alumni, Art Institute of Chicago; Chicago Art Club; Texas Fine Arts Society; Chicago Society of Miniature Painters. Died in 1923 in Los Angeles, CA.

PRICE, GEORGE.
Born in England in 1826. This landscape engraver was a pupil of the Findens in London. Price came to the United States in 1853, did considerable work here, and returned to England in 1864.

PRICE, HENRY.
Sculptor. Awards: Bronze medal, St. Louis Expo., 1904. Address in 1906, London, England.

PRICE, LLEWELLYN.
Painter. Exhibited water colors at the Penna. Academy of Fine Arts, Philadelphia, 1925. Address in 1926, Bryn Athyn, PA.

PRICE, M. ELIZABETH.
Painter and teacher. Born in Martinsburg, WV. Pupil of Philadelphia Museum School of Industrial Art; Penna. Academy of Fine Arts; and with William L. Lathrop. Member: Fellowship Penna. Academy of Fine Arts; Painters and Sculptors; American Woman's Association. Exhibited: National Academy of Design, 1932-34; Penna. Academy of Fine Arts, 1932-43; Corcoran, 1933, 35, 37, 39; Grand Central Art Galleries; Ferargil Gallery. Lectures: Art Appreciation. Address in 1953, New Hope, PA.

PRICE, MARGARET EVANS.
Painter and illustrator. Born in Chicago, IL, March 20, 1888. Pupil of Massachusetts Normal Art School, DeCamp and Major. Work: Murals in Aurora Theatre; illustrated *Once Upon a Time*; author and illustrator of *Enchantment Tales for Children* and *A Child's Book of Myths*. Address in 1929, 201 Main St., East Aurora, NY.

PRICE, NORMAN (MILLS).
Illustrator. Born in Brampton, Canada, April 16, 1877. Pupil of Cruickshank, Jean Paul Laurens, Richard Miller. Member: Society of Illustrators; Artists Guild of the Authors' League of America, NY. Illustrated: *Lambs Tales from Shakespeare* (T. C. and E. C. Jack, Edinburgh); *The Children's Tennyson* (Froude, Hodder and Stoughton, London); *Chopin, Wagner, Mendelsohn, Scott, Kingsley, E. B. Browning, Xmas Bells, A Legend of Jerusalem, The Joy of the Lord* (Hodder and Stoughton, London); *The Derelict, A Servant of Reality, The Boomerang, The Return of the Soldier* (Century Co.); *The Greater Glory* and *The Wall Between* (Little Brown and Co.). Died in 1951. Address in 1929, 370 Riverside Drive, New York, NY.

PRICE, SAMUEL W., GENERAL.
Portrait painter. Born Aug 5, 1828 in Nicholasville, KY. Died Jan. 22, 1918 in St Louis, MO.

PRICHARD, SIDNEY.
Painter. Exhibited water colors at the Penna. Academy of Fine Arts, Philadelphia, 1925. Address in 1926, Stockton Springs, ME.

PRIEST, T.
(Theresa Khoury Struckus). Painter and printmaker. Born in Worcester, MA, Jan. 20, 1928. Studied: Worcester Art Museum School; University of Massachusetts. Exhibitions: Assumption College, Worcester, MA; DeCordova Museum, Lincoln, MA; Young American Up-coming Artists, Nashua, NH. Collections: Aldrich Museum of Contemporary Art, Ridgefield, CT; Honeywell Corporation, Boston, MA; Bundy Art Center, Waitsfield, VT. Media: Acrylic and oil on canvas. Address in 1982, 5 Pratt St., Worcester, MA.

PRIME, WILLIAM COWPER.
Painter. Born in 1825. He died in New York City in 1905.

PRINCE, WILLIAM MEADE.
Illustrator. Born in Roanoke, VA, July 9, 1893. Pupil of NY School of Fine and Applied Art. Worked in advertising art in Chicago; moved to Connecticut and illustrated for major NYC magazines. Noted for Roark Bradford's Negro stories, *Collier's*. Head, Art Department, University of North Carolina. Member: Artists Guild of the Authors' League of America, NY; Salma. Club. Died in 1951. Address in 1929, Box 159, Westport, CT.

PRIOR, CHARLES M.
Painter, sculptor, illustrator, etcher, and teacher. Born in NY, December 15, 1865. Pupil of National Academy of Design under Edgar M. Ward. Awards: Tiffany gold medal, 1884. Specialty: Etching on silver. Member: Society of Independent Artists; Eastern Arts Association; Art Alliance of America; American Artists Professional League; American Federation of Arts. Address in 1908, 24 East 21st St., New York, NY; address in 1933, 571 West 139th St., New York, NY.

PRITCHARD, J. AMBROSE.
Painter. Born April 11, 1858 in Boston, MA. Died Feb. 5, 1905 in Boston, MA.

PROBST, THORWALD (A.).
Painter, illustrator and teacher. Born in Warrensburg, MO, July 18, 1886. Pupil of Iner Olsen, Viggo Langer. Member: California Art Club; Laguna Beach Art Association; Artland Club. Works: Illustrations for *Poems of California Missions*. Address in 1929, 1555 Altivo Way, Los Angeles, CA.

PROCTOR, ALEXANDER PHIMISTER.
Sculptor and painter. Born in Bozanquit, Ontario, Canada, September 27, 1862. Pupil of National Academy of Design and Art Students League in New York; Puech and Injalbert in Paris. Member: Associate National Academy of Design, 1901, Academician National Academy, 1904; Society of American Artists, 1895; American Water Color Society; NY Architectural League, 1899; National Sculpture Society, 1893; National Institute of Arts and Letters; Artists Aid Society; Century Association; National Arts Club; American Society of Animal Painters and

Sculptors. Awards: Medal, Columbian Expo., Chicago, 1893; Rinehart scholarship to Paris, 1896-1900; gold medal, Paris Expo., 1900; gold medal for sculpture and bronze medal for painting, St. Louis Expo., 1904; NY Architectural League medal, 1911; gold medal, P.-P. Expo., San Francisco, 1915. Specialty: Western subjects. Exhibited at National Sculpture Society, 1923. Work: "Panthers," Prospect Park, Brooklyn, NY; "Puma," "Fawn," "Dog with Bone," and "Fate," Metropolitan Museum, NY; "Indian Warrior," Brooklyn Museum; "Tigers," Princeton University; buffaloes and tigers on bridges, Washington, DC; "Moose," Carnegie Institute, Pittsburgh; "Pioneer," University of Oregon, Eugene; lions, McKinley monument, Buffalo; "Circuit Rider," State House, Salem, OR; equestrian statue of Col. Roosevelt, Portland, OR, and Minot, NH; "Bronco Buster" and "On War Trail," Civic Center, Denver, CO; heroic Indian fountain, Lake George, NY; "Pioneer Mother," Kansas City, KS; bronze tablet markers for Pony Express Trail. Address in 1933, New York City. Died in 1950.

PROHASKA, RAY.
Illustrator. Born in Muo Dalmatia, Yugoslavia, in 1901. Attended the California School of Fine Art in San Francisco for four years. His first published illustration was a watercolor done for the *Delineator* in 1930 and later he illustrated the books *Eddie No Name* (Pantheon, 1963) and *Who's Afraid* (Crowell Collier, 1963). He was an artist-in-residence at Washington and Lee University from 1964 to 1969, and at Wake Forest University from 1969 to 1975. His works are owned by the New Britain Museum of American Art and the Guild Hall in East Hampton, NY.

PROPHET, NANCY ELIZABETH.
Sculptor. Born in Orctic Center, RI, March 19, 1890. Pupil of RI School of Design (grad.); L'Ecole des Beaux Arts. Member: Newport Art Association; College Art Association. Awards: Otto H. Kahn prize, exhibition of work of Negro Artists, 1929; Greenough prize, Newport Art Association, 1932. Work: "Silence" and "Discontent," Museum of the Rhode Island School of Design, Providence; "Congolais," Whitney Museum of American Art, New York. Address in 1933, 147 rue Broca, Paris, France.

PROSPER.
Sculptor, marble cutter, engraver, and teacher. Worked in New Orleans in 1825 and 1837.

PROTIN & MARCHINO.
Sculptors and carvers. Worked in NYC, 1850. Victor Protin and Frederick Marchino.

PROW, HALLIE P(ACE) (MRS.).
Painter. Born in Salem, IN, April 25, 1868. Pupil of John Herron Art Institute; L. O. Griffith. Member:

Indiana Art Association; Federation of Indiana Art Clubs. Work: "A Salem Bouquet," Public Library, Salem, IN. Died in 1945. Address in 1929, 1015 North College Ave., Bloomington, IN.

PRUD'HOMME, JOHN FRANCIS EUGENE.
Engraver. Born on the island of St. Thomas, West Indies, Oct. 4, 1800; died in Georgetown, DC, June 22, 1892. His parents came to the United States in 1807 and settled in New York in 1809. About 1814 Prud'Homme was apprenticed to his brother-in-law Thomas Gimbrede to learn engraving, and was engraving over his own name in New York in 1821. He became a reputable engraver of portraits in stipple, though his best work is represented by his small plates executed for the *Annuals*, about 1839. Among these "The Velvet Hat" and "Friar Puck" are to be especially admired. In 1852 Prud'Homme became interested in bank-note work, and from 1869 to 1885 he was employed by the Treasury Department at Washington, DC. Prud'Homme was made an Academician of the National Academy of Design in 1846, and in 1834-53 he was the curator of the Academy.

PUCCIARELLI, MARIO.
Born in Buenos Aires, Argentina, in 1928. Traveled and studied in England, France, and Italy. Exhibitions: Teatro Candilejas, Buenos Aires, 1957; Galeria Balatea, Buenos Aires, 1958; Galeria Pizarro, Buenos Aires, 1960. Group exhibitions: Museo Sivori, Pizarro Gallery, Van Riel Gallery, Buenos Aires, 1959; Isaac Delgado Museum of Art, New Orleans, 1960; The Solomon R. Guggenheim Museum, New York, 1960; and many others.

PUCCINELLI, RAYMOND (RAIMONDO).
Sculptor and graphic artist. Born in San Francisco, CA, May 5, 1904. In California, 1904-48. Studio in Florence, Italy, from 1960. Studied at California School of Fine Arts, San Francisco, 1919; Rudolph Schaeffer School of Design, San Francisco, 1924-27; with woodcarvers, stone cutters and master plasterers in Italy and France, 1927-28; assistant to J. Vieira, San Francisco, 1928. Taught at Mills College, 1938-47; Berkeley (University of California), 1942-47; Queen's College, NYC, 1948-51; Rinehart School of Sculpture, Baltimore, MD, 1958-60. In collections of Columbia University Music Library; Fresno (CA) Mall; Stadt Theatre Museum, Schleswig, Germany; City of San Francisco Hospital; Duke University; museums and galleries throughout Germany; Hirshhorn, Washington, DC; Jerusalem Music Center; numerous commissions. Exhibited at Oakland Art Gallery, California; California Palace of Legion of Honor, San Francisco, 1939, 46; San Francisco Museum of Art; de Young, San Francisco; Institute of Arts and Letters, NYC; Galleria Schneider, Rome; galleries in Milan, Paris, and Florence; California-Pacific International Exposition, San Diego; NY

World's Fair, 1939; Golden Gate International Exposition, San Francisco; Philadelphia Museum; Detroit Institute of Art; Grand Palais, Paris; Salon d'Automne, 1978-82; Whitney; Corcoran; and others. Received many awards, including sculpture prize, San Francisco Museum of Art and Los Angeles County Museum of Art; gold medal, Florence, Italy. Works in granite, porphyry, bronze, polished diorite, terracotta, etc. Lives in Florence, Italy.

PUGH, MABEL.
Painter, illustrator and etcher. Born in Morrisville, NC, Nov. 1, 1891. Pupil of Art Students League of NY; Penna. Academy of Fine Arts. Member: Fellowship Penna. Academy of Fine Arts; Plastic Club; Southern States Art League; Art Students League of NY. Award: Cresson Traveling Scholarship, Penna. Academy of Fine Arts, 1919; gold medal, Plastic Club, Philadelphia, 1926. Illustrated in *Ancient Albemarie*, by Catherine Albertson; *The Adventures of Paul Bunyan* (Century Co., 1927); *Blackbeard's Treasure* (Crowell Co., 1927); *Twelve Bad Men* (Crowell Co., 1929). Address in 1929, 106 W. 57th St., New York, NY.

PUGLIESE, CARL J.
Sculptor and illustrator. Born in New York City in 1918. Studied at School of Visual Arts, New York City. Specialty is statuettes of historical Western subjects, including Indian and military figures. Works in bronze. In collections of West Point Museum of the U.S. Military Academy. Has exhibited at Western Heritage Sale, Houston, Texas; National Sculpture Society; Grand Central Art Galleries, New York City; Grizzly Tree Gallery, Gunnison, CO. Won award at Society of American Historical Artists show, 1982. Member: Society of American Historical Artists (founding); Historical Arms Society of New York; fellow, Company of Military Historians. Illustrated many books, including *Confederate Edged Weapons*, *Classic Bowie Knives*, *Literary Places: New England and New York*. Has lectured on American illustration. Address in 1982, Yonkers, New York.

PULFREY, DOROTHY LING.
Painter. Born in Providence, RI, April 16, 1901. Pupil of John Sharman, Arthur Heintzelman. Member: Providence Water Color Club. Address in 1929, 19 Greystones Ave., Sheffield, England.

PULLINGER, HERBERT.
Painter and illustrator. Born in Philadelphia, PA, Aug. 5, 1878. Pupil of Penna. Academy of Fine Arts under McCarter and Anshutz. Member: Fellowship Penna. Academy of Fine Arts; Philadelphia Sketch Club; Philadelphia Water Color Club; American Federation of Arts. Address in 1929, 1430 South Penn Square, Philadelphia, PA.

PULSIFER, J(ANET) D.
Painter. Born in Auburn, ME. Pupil of Art Students League of NY; Delance, Courtois, Aman-Jean in Paris. Address in 1929, 32 Argyle Park, Buffalo, NY: summer, Scituate, MA.

PUNCHATZ, DON IVAN.
Illustrator. Born in Hillside, NJ, in 1936. Attended the School of Visual Arts and Cooper Union. He worked as an art director for several years before beginning free-lance illustration in 1966. His studio, The Sketch Pad, was organized in 1970. His work for magazines such as *Playboy*, *Oui*, *Penthouse*, *Esquire*, *True*, and *Time* has earned him awards from the Society of Illustrators and from many Art Directors' Clubs.

PUNDERSON, LEMUEL S.
This excellent engraver of portraits in stipple was working in New York in 1850-55.

PURCELL, JOHN WALLACE.
Sculptor, craftsman, teacher, and writer. Born in New Rochelle, NY, January 3, 1901. Studied at Cornell University, A.B.; Art Institute of Chicago. Awards: Medal, 1946, Ryerson traveling scholarship, 1930, Art Institute of Chicago; prize, Evanston and North Shore Artists, 1935, 39. Work: Art Institute of Chicago. Exhibited: NY World's Fair, 1939; Art Institute of Chicago, 1933-46; Evanston and North Shore Artists, 1933-46. Position: Instructor of sculpture, Art Institute of Chicago, 1925-44; Evanston (IL) Art Center, 1944-46. Address in 1953, Evanston, IL.

PURDIE, EVELYN.
Miniature painter. Born in Smyrna, Asia Minor, 1859. Pupil of Boston Museum School, under Grundmann; Carolus-Duran, Henner and Mme. Debillemont-Chardon in Paris. Member: Woman's International Art Society, London and Paris; Copley Society; Pennsylvania Society of Miniature Painters; Guild of Boston Artists. Died in 1943. Address in 1929, 383 Harvard St., Cambridge, MA.

PURDY, MAUD H.
Painter and illustrator. Born in Philadelphia, PA, Nov. 29, 1874. Pupil of Amy Cogswell; Whitaker; etc. Member: Brooklyn Art Society. Illustrated *Fundamentals of Botany*, etc., by Dr. Gager. Specialty: Miniatures. Address in 1929, 151 Linden Blvd., Brooklyn, NY; summer, Pomona, Rockland Co., NY.

PUREFOY, HESLOPE.
Miniature painter. Born in Chapel Hill, NC, June 17, 1884. Pupil of Alice Beckington and Lucia Fairchild Fuller. Member: Pennsylvania Society of Miniature Painters. Address in 1929, 27 Charlotte St., Asheville, NC.

PURINTON, J.
Miniature painter who flourished in 1802, in Salem, MA.

PURRINGTON, HENRY J.
Ship carver, musician, and amateur actor. Born in Mattapoisett, MA, 1825. Employed at New Bedford, MA, 1848-1900. Still living in the 1920's.

PURSELL, HENRY.
Engraver. In the *New York Mercury*, in 1775, Henry Pursell advertises that he has removed "from Broadway to Dock Street, near the Old Coffee House, where he carries on the Engraving business in its different branches, viz., Copperplates of all kinds, Arms, crests, cyphers, etc., on plate. Ditto on watches. Ditto on seals of any metals. Types, Free Mason Medals. Gun furniture, Harness ditto, Cyphers, etc., on whips. Morning rings, Door plates, Dog Collars, etc."

PURVES, AUSTIN, JR.
Sculptor, mural painter, craftsman, and educator. Born in Chestnut Hill, PA, Dec. 31, 1900. Studied at Penna. Academy of Fine Arts; with Daniel Garber; Julian Academy, American Conservatory, Fontainebleau, and with Baudouin in France. Member: Architectural League; National Society of Mural Painters; Century Association; Fellowship Penna. Academy of Fine Arts. Work: Illuminated Litany Service, St. Paul's Church, Philadelphia, PA; coats-of-arms, St. Michael's Church, Jersey City, NJ; reredos, St. Paul's Church, Duluth, MN; Grace Church, Honesdale, PA; mosaic ceiling, Bricken Building, NY; memorial, Washington, DC; fresco, St. Michael's Church, Torresdale, PA; sculpture, map, design, S.S. *America*; other work, Firestone Memorial Library, Princeton University; American Battle Monuments Comm.; S.S. *United States*; Federal Reserve Bank of Boston; Washington Hall Barracks Complex, West Point, NY; others. Award: Honorable mention, Architectural League of NY, 1926. Position: President, National Society of Mural Painters; Advisory Board, Cooper Union Art School, NYC, Director, 1931-38; taught at Yale School of Fine Arts, National Academy of Design, and Bennington College (1940-42). Address in 1970, Litchfield, CT.

PUSHMAN, HOVSEP.
Painter. Pupil of Lefebvre, Robert-Fleury and Dechenaud in Paris. Member: California Art Club; American Art Association of Paris; Salma. Club. Awards: Bronze medal, Paris Salon, 1914; Ackerman prize, California Art Club, 1918; silver medal, Paris Salon, 1921. Represented in Milwaukee Art Institute; Layton Art Gallery, Milwaukee; Minneapolis Art Museum; Rockford (IL) Art Guild; Norfolk Art Association, Norfolk, VA. Died in 1966. Address in 1929, 154 West 57th St., New York, NY.

PUTHUFF, HANSON (DUVALL).
Painter. Born in Waverly, MO. Pupil of University Art School, Denver, CO. Member: California Art Club; Laguna Beach Art Association (life); Los Angeles Water Color Society; Berkeley LFA (hon.). Awards: Two silver medals, Pan.-Calif. Expo., San Diego, CA, 1916; first prize, California Art Club, 1916; gold medal, State Fair, Sacramento, CA, 1918; silver medal, State Fair, Sacramento, CA, 1919; 1st prize, Laguna Beach Art Association, 1920-21; 2nd prize, Southwest Museum, Los Angeles, CA, 1921; first prize, Springville, UT, 1924; silver medal, Painters of the West, 1927, and silver medal, 1929. Represented in the Municipal Collection of Paintings, Denver; Los Angeles County Collection, Los Angeles Museum. Died in 1972. Address in 1929, 2744 Altura Ave., La Crescenta, CA.

PUTNAM, ARTHUR.
Sculptor. Born in Waveland, MS, September 6, 1873. Member: National Sculpture Society, 1913. Award: Gold medal, P.-P. Expo., San Francisco, CA, 1915. Work: "Snarling Jaguar," Metropolitan Museum, New York. Address in 1929, care of Bohemian Club, San Francisco, CA; care of American Express Company, Paris, France. Died in 1930.

PUTNAM, BRENDA.
Sculptor and teacher. Born in Minneapolis, MN, June 3, 1890. Studied: Boston Art Museum School under E. C. Messer; Art Students League; also a pupil of Bela Pratt, J. E. Fraser, Mary Moore and Charles Grafly. Member: National Sculpture Society; National Academy of Design; National Association of Women Painters and Sculptors; American Federation of Arts; others. Awards: Hon. mention, Chicago Art Institute, 1917; Helen Foster Barnett prize, National Academy of Design, 1922, 29; Widener medal, Penna. Academy of Fine Arts, 1923; Avery prize, New York Architectural League, 1924. Represented in Dallas Museum, Dallas, Texas; Hispanic Museum, New York; Rock Creek Cemetery, Washington, DC; Brookgreen Gardens, SC; private estates. Exhibited at National Sculpture Society, 1923. Publications: Author and illustrator, *The Sculptor's Way*, 1939; *Animal X-Rays*, 1947. Address in 1953, Wilton, CT. Died in 1975.

PUTNAM, STEPHEN G(REELEY).
Wood engraver. Born in Nashua, NH, Oct. 17, 1852. Studied drawing at Brooklyn Art Association and Art Students League of NY; pupil of H. W. Herrick, Frank French and E. J. Whitney. Awards: Bronze medal, Paris Expo., 1889; medal, Columbian Expo., Chicago, IL, 1893; bronze medal, Paris Expo., 1900; silver medal, Pan-Am. Expo., Buffalo, NY, 1901. Address in 1929, College Point, Queens, New York, NY.

PYE, FRED.
Painter and illustrator. Born in Hebden Bridge, Yorkshire, England, Dec. 1, 1882. Pupil of Julian Academy, Colarossi Academy, Paris. Member: Nassau County Art League; Salma. Club; American Art Association of Paris; Cincinnati Art Club. Work: "Mer Agiteo," Luxembourg Museum, Paris, France. Address in 1933, Cincinnati, OH.

PYE, CLIFFORD C(OLTON).
Painter and illustrator. Born in Missouri, Oct. 24, 1894. Pupil of Pedro Lemos; Lee Randolph; Spencer Mackey; Gertrude Albright; Rudolph Schaeffer. Illustrator and designer of books and textiles. Represented in Metropolitan Museum of Art. Address in 1929, John-Martin Bldg., 33 West 49th St., New York, NY.

PYLE, HOWARD.
Painter and illustrator. Born in Wilmington, DE, March 5, 1853. Began art studies at age 16 under Belgian Professor Van der Weilen in Philadelphia; went to NYC in 1876 and studied at Art Students League. Stories and illustrations appeared in *Scribner's* and *St. Nicholas* magazine and established his reputation. Returned to Wilmington in 1879. His work in color reproduction techniques led to a new era in illustration. Major contribution as teacher, at Drexel Institute from 1894; summer classes at Chadds Ford, PA; opened own studio in Wilmington, where he taught many major illustrators from 1901 to 1910. He was the author of the text and illustrations for *The Merry Adventures of Robin Hood*, and *The Wonder Clock*; also illustrated many books of juvenile fiction. He was elected a member of the National Academy of Design in 1911. Died Nov. 9, 1911, in Florence, Italy, while travelling in Europe.

QUANCHI, LEON WILLIAM.
Painter. Born in New York City, Sept. 23, 1892. Pupil of George de Forest Brush; F. C. Jones; Douglas Volk. Member: Society of Independent Artists. Address in 1929, 1560 Broadway, New York, NY; h. 406 Palmer Ave., Maywood, NJ.

QUARRE, F.
Engraver. He was also a lamp-shade manufacturer located in Philadelphia, PA, in 1850, and possibly earlier. Executed an oval-shaped engraving of lace, printed in white on a brown ground. Centered in the oval is an embossed view of New York, seemingly taken from Hoboken. Below is "New York," in white on the brown ground. This view was used as a magazine illustration.

QUARTLEY, ARTHUR.
Painter. Born in France in 1839; son of Frederick William Quartley. He settled in New York in 1851. He painted signs and later devoted his time to marine painting. He was elected an Associate of the National Academy in 1879 and an Academician in 1886. His most important pictures are "View of North River," "Trinity from the River," "Lofty and Lowly," and "Morning in New York Harbor." He died in New York in 1886.

QUARTLEY, FREDERICK WILLIAM.
Engraver and painter. Born July 5, 1808, in Bath, England. He became a wood engraver in 1852, then came to New York, where he lived his professional life. His best known work is "Picturesque America" and "Picturesque Europe." His paintings include "Niagara Falls," "Catskill Falls," and "Butter-Milk Falls." Died May 19, 1866, in NYC.

QUASTLER, GERTRUDE.
(Mrs. Henry Quastler). Printmaker, wood engraver and painter. Born in Vienna, Austria, on February 10, 1909. Came to America in 1939; naturalized, 1945. Studied: Columbia University; University of Illinois; Chicago Institute of Design. Collections: Museum of Modern Art; Farnsworth Museum of Art; Art Institute of Chicago; Boston Museum of Fine Arts; Fogg Museum of Art; Boston Public Library; Philadelphia Free Library; Library of Congress; Rhode Island School of Design; University of Delaware; University of Nebraska; University of Maryland; Wadsworth Athenaeum. One-woman exhibitions: Palmer House Gallery, Chicago, 1949; Ruth Dickens Gallery, 1951, 52; Print Club, Phila., 1951; Boston Print Makers, 1953; Art Institute, Decatur, IL, 1954. Group exhib.: Penna. Academy of Fine

Arts, 1949, 50; Brooklyn Museum, 1951; Denver Art Museum, 1948-52; others. Member: Audubon Artists; Philadelphia Color Pr. Society; Boston Print Makers. Address in 1962, Brookhaven, Long Island, NY.

QUEBY (or QUELY), JOHN.
Sculptor. Born in Florida, 1808. Worked in NYC in 1850.

QUESNAY, ALEXANDRE-MARIE.
Portrait painter in miniature and portrait draughtsman in crayon. Born Nov. 23, 1755, at Saint-Germain-en-Viry, France. Arrived in Virginia in 1777 and assisted the Continental Army, but retired in 1778 due to ill health. Went to Philadelphia in 1780 and ran a school for four years there. Moved to New York in 1784; numerous extended advertisements inserted in the New York newspapers during 1784, concerning his Academy for Dancing and Drawing there, are reprinted in W. Kelby's "Notes on American Artists." Returned to Virginia in 1785 and opened a school in Richmond; went back to France in 1786. Remained there for the rest of his life, except for a brief period during the French Revolution. Died Feb. 8, 1820, in Saint Maurice, Seine, France.

QUEST, CHARLES FRANCIS.
Painter, sculptor, illustrator, and teacher. Born in Troy, NY, June 6, 1904. Studied: Washington University School of Fine Art; Europe; also a pupil of Fred Carpenter, Edmund Wuerpel. Member: St. Louis Artists Guild; Society of American Graphic Artists; others. Awards: Edward Mallinckrodt watercolor prize, St. Louis Artists Guild, 1924; Letticia Parker Williams prize, St. Louis Artists Guild, 1926, 1929; George Warren Brown prize, St. Louis Artists Guild, 1928; Black and White prize, St. Louis Art League, 1928; National Print Exhibition, Library of Congress; Society of American Graphic Artists, 1971; others. Work: Mural decoration, Hotel Chase, St. Louis, MO. Teaching: Institute of Arts, St. Louis Public Schools, MO, 1929-44; professor of art, Washington University School of Fine Arts, 1944-71, emeritus professor, from 1971. Address in 1980, 200 Hillswick Road, Tryon, NC.

QUIDOR, JOHN.
Painter. Born Jan. 26, 1801, in Tappan, NY. He studied with Inman, and was a pupil of John Wesley Jarvis in his New York studio. Charles Loring Elliott studied with Quidor. Quidor painted imaginative subjects, often inspired by Washington Irving's tales. He painted "Rip Van Winkle" and "Ichabod Crane." He died Dec. 13, 1881, in Jersey City, NJ.

QUINAN, HENRY B(REWERTON).
Artist and designer. Born in Sitka, AK, Nov. 10, 1876. Pupil of Laurens in Paris. Member: Salma. Club; Society of Illustrators; Art Directors; American Federation of Arts. Art editor of *Woman's Home Companion*. Address in 1929, 250 Park Ave.;h. 321 East 43rd St., New York, NY.

QUINCY, EDMUND.
Painter and teacher. Born in Biarritz, France, May 15, 1903. Pupil of George Noyes, Albert Herter, Fred Whiting, Georges Degora. Member: Springfield Art League; Boston Art Club; Salons of America; Art Alliance of America; Provincetown Art Association. Award: Hon. mention, Springfield Art League, 1929. Address in 1929, 4 Charles River Sq., Boston, MA; summer, 5 rue de Bagneaux, Paris, France.

QUINER, JOANNA.
Portrait sculptor. Born in 1801. Worked in Beverly, Massachusetts. Exhibited at Boston Athenaeum, 1846-48. Died in 1873.

QUINLAN, WILL J.
Painter and etcher. Born in Brooklyn, NY, June 29, 1877. Pupil of J. B. Whittaker at Adelphi College; National Academy of Design in New York under Maynard and Ward. Member: Salma. Club; Brooklyn Society of Etchers; Brooklyn Society of Artists; Yonkers Art Association. Awards: Shaw black and white prize, Salma. Club, 1913; Shaw etching prize, Salma. Club, 1913 and 1914. Work: New York Public Library; Oakland (CA) Public Museum. Address in 1929, 333 Warburton Ave., Yonkers, NY.

QUINN, EDMOND THOMAS.
Sculptor and painter. Born in Philadelphia, PA. Pupil of Eakins in Philadelphia; Injalbert in Paris. Member: Associate of the National Academy; National Sculpture Society, 1907; New York Architectural League; National Institute of Arts and Letters. Exhibited at National Sculpture Society, 1923. Award: Silver medal, P.-P. Exposition, San Francisco, 1915. Work: Statue, "John Howard," Williamsport, PA; statue, "Zoroaster," Brooklyn Institute of Arts and Sciences; reliefs on "Kings' Mountain (SC) Battle Monument;" bust of Edgar Allan Poe, Fordham University, NYC; "Nymph," statuette, Metropolitan Museum, NYC; statue of Major General John E. Pemberton, Vicksburg (MS) National Military Park; statue of Edwin Booth as "Hamlet," Gramercy Park, New York; bust of Professor Hooper, Brooklyn Museum. Address in 1926, 207 East 61st St., NYC. Died in 1929.

QUINN, STEPHEN C.
Painter and sculptor. Studied at Ridgewood School of Fine Arts and Design. Work at Am. Museum of Natural History involves research, design, and fabrication of museum exhibits (painting, illustrations, murals, dioramas, sculpture, taxidermy, models). Member: Society of Animal Artists. Collections: Models and paintings on permanent display at American Museum of Natural History. Taught: Animal drawing and animal anatomy at the American Museum of Natural History. Publications: Harper and Row's *Complete Field Guide To North American Wildlife; New York Times Magazine; Animal Kingdom Magazine*. Media: Bronze; oil, watercolor. Specialty: Birds. Address in 1983, Ridgefield Park, New Jersey.

QUINTON, W. W. (MRS.).
See Sage, Cornelia Bentley.

QUIRT, WALTER W.
Painter and teacher. Born in Iron River, Missouri, Nov. 24, 1902. Pupil of Layton School of Art. Member: Wisconsin Painters and Sculptors. Address in 1929, 453 Jefferson Street, Milwaukee, Wisconsin.

QUISGARD, LIZ WHITNEY.
Sculptor and painter. Born in Philadelphia, Pennsylvania, October 23, 1929. Studied at Maryland Institute College of Art, dipl., 1949, B.F.A. (summa cum laude), 1966; also with Morris Louis, 1957-60; Rinehart School of Sculpture, M.F.A., 1966. Works: University of Arizona, Ghallager Memorial Collection, Tucson; Lever House, NY; University of Baltimore, Maryland; Johns Hopkins University; Hampton School, Towson, Maryland; William Fell School, Baltimore, Maryland, 1978. Exhibitions: Corcoran Biennial American Painting, Corcoran Gallery of Art, Washington, DC, 1963; University of Colorado Show, 1963; American Painting and Sculpture Annual, Pennsylvania Academy of Fine Arts, Philadelphia, 1964; Art Institute of Chicago Annual, 1965; one-woman shows, Jefferson Place Gallery, Washington, DC, 1961, Emmerich Gallery, New York, 1962, University of Maryland, 1969, Gallery 707, Los Angeles, 1974, South Houston Gallery, New York 1974, and Arts and Science Center, Nashua, New Hampshire, 1975. Awards: Artists Prize, Baltimore Museum Regional Exhibition, 1958; Rinehart Fellowship, Maryland Institute, 1964-66; Best in Show, Loyola College, 1966. Teaching: Instructor in painting and color theory, Maryland Institute, Baltimore, from 1965. Address in 1976, Baltimore, Maryland.

QUISTGAARD, J(OHANN) W(ALDEMAR).
Portrait painter. Born in Denmark, February 9, 1877. Member: Salma. Club. Work: Portraits of Joseph Choate, Chauncey M. Depew, in New York Genealogical Society; Honorable David F. Houston, U.S. Treasury Department; Honorable David Meredith, U.S. Agricultural Department. Died in 1962. Address in 1929, 130 West 57th Street, New York, New York; summer, Bankers' Trust Company, Place Vendome, Paris, France.

R

RAAB, GEORGE.
Sculptor, block painter, and teacher. Born in Sheboygan, WI, Feb. 26, 1866. Pupil of Richard Lorenz in Milwaukee; C. Smith in Weimar; Courtois in Paris. Member: Milwaukee Art Soc.; Wisconsin Painters and Sculptors. Award: Medal, Milwaukee Art Institute, 1917. Work: "The Lone Pine," St. Paul Institute; "The Veil of Snow" and "Mother," Milwaukee Art Institute. Educational Director of Decatur Institute of Art. Address in 1933, Art Institute, Decatur, IL.

RAB, SHIRLEE.
Sculptor and jeweler. Studied: Traphagen School of Design, NYC; New School for Social Research, NYC; Philadelphia Museum of Art; Moore College of Art, jewelry major; Philadelphia College of Art; Fleisher Art Memorial; Cheltenham Township Art Center; Rutgers University, special program for selected artists; Princeton Atelier, masters course, bronze casting; summer study, Florence, Italy. Work: In private collections. Exhibited throughout U.S. since 1962; Trenton (NJ) State Museum; National Academy of Design, NYC; Philadelphia Art Alliance; Squibb Gallery, Princeton, NJ. Awards: National Academy of Design, NYC; New School, NYC; Chestnut Hill Academy; Atlantic City Inauguration Exhibition; Fleisher Art Memorial; others. Currently designing jewelry; teaching sculpture at Cherry Hill, Moorestown, Philadelphia, PA.

RABILLON, LEONCE.
Sculptor and teacher. Born in Baltimore, MD, 1814. Executed two portrait busts for the Peabody Institute, Baltimore, in the early 1870's. Died in 1886.

RABUT, PAUL L.
Illustrator. Born in NYC in 1914. Attended City College of NY; Art Students League; and Grand Central School of Art. In 1935 his first illustration was published for *Ainslee's Magazine*. His work has been shown at the Metropolitan Museum of Art; National Academy of Design in NY; International Watercolor Show in Chicago; and Penna. Academy of Fine Arts in Philadelphia. Not only an advertising illustrator for Gen. Motors, Ford, Western Electric, General Electric, Shell Oil, and U.S. Steel, but also an expert on primitive art who has lectured at Pratt Institute, Newark School of Art, and the Society of Illustrators.

RACHMIEL, JEAN.
Painter. Born in Haverstraw-on-Hudson, NY, in 1871. Art pupil under his father; later under George de Forest Brush, NY; went to Paris, 1890; studied under Jules Lefebvre; entered Ecole des Beaux Arts and studied with Leon Bonnat. Exhibitor in Paris Salon, annually, since 1898.

RACKLEY, MILDRED.
(Mrs. Mildred Rackley Simon). Serigrapher and painter. Born in Carlsbad, NM, October 13, 1906. Studied: University of Texas; New Mexico Normal Univ.; Kunstgewerbe Schule, Hamburg, Germany; and with Walter Ufer and George Grosz. Awards: Diablo Art Festival, 1958; Concord, CA, 1958. Collections: Met. Museum of Art; Philadelphia Museum of Art; Springfield Art Museum; Princeton Printmakers Club. Exhibitions: Springfield Art League; Denver Art Museum; Newport Art Association; Laguna Beach Art Association; Seattle Art Museum; Mint Museum of Art; Museum of Modern Art; National Serigraph Society; Oakland Art Gallery; Art Institute of Chicago; Audubon Artists; Phila. Printmakers Club; Library of Congress; Carnegie Institute; Northwest Print Makers. Address in 1953, Lafayette, CA.

RACKOW, LEO.
Illustrator. Born in Spring Valley, NY in 1901. Attended Parsons School of Design, then Grand Central School of Art as a student of Harvey Dunn, and studied in Paris under Leger. Over the years he has received a number of NY Art Directors' Club awards and several of his posters are in the Library of Congress collection. His illustrations have appeared in *New Yorker*, *Liberty*, *Collier's*, and *True*. The Museum of Modern Art, Dudensir.g Gallery and Harlow Gallery have all exhibited his work.

RADCLIFFE, C.
Was a stipple-engraver of portraits and vignettes, located in Philadelphia, PA, as early as 1805.

RADER, ISAAC.
Painter. Born in Brooklyn, NY, Oct. 5, 1906. Pupil of Abramovsky; Kappes; Niles; Wicker; Jean Marchand; Andre L'hote. Member: Detroit Art Club. Awards: Libbey first prize, Toledo Painters, 1921; Hecker prize, Detroit Insti. of Arts, 1926; Whitcomb Traveling Scholarship, Detroit, 1927; hon. mention, annual exhibition, Toledo Museum of Art, 1930. Address in 1933, Detroit, MI.

RADITZ, LAZAR.
Painter. Born in Dvinsk, Russia, April 15, 1887. Pupil of Chase and Tarbell. Member: Fellowship Penna. Academy of Fine Arts; Philadelphia Art Club; Philadelphia Alliance; American Federation

Arts. Awards: Bronze medal, P.-P. Expo., San Francisco, 1915; second Hallgarten prize, National Academy of Design, 1918. Work: Self portrait, Penna. Academy of Fine Arts, Philadelphia; "Dr. I. M. Hays," American Philosophical Society, Philadelphia; "Mrs. R.," Reading (PA) Museum; "Judge Mayer Sulzberger," Dropsie College, Philadelphia; "Dr. Hobert M. Hare," University of Pennsylvania, Philadelphia; "Daniel Baugh," Baugh Institute of Anatomy, Philadelphia; "Dr. S. G. Dixon," Academy of Natural Science, Philadelphia; "Dr. Walton Clark," Franklin Institute, Philadelphia; "John C. Woods," Brown Univ., Providence; "Mr. Sterling," Yale University, New Haven; "Dr. William J. Taylor," College of Physicians, Philadelphia, PA; "Wayne W. Babcock," Temple Univ., Philadelphia; "Hampton L. Carson," Free Library of Philadelphia. Instructor, Graphic Sketch Club. Address in 1933, 1520 Chestnut Street; h. 143 North 20th Street, Philadelphia, PA.

RADITZ, VIOLETTA C.
Painter. Exhibited water colors at the Penna. Academy of Fine Arts, Philadelphia, 1925. Address in 1929, 143 North 20th Street, Philadelphia, PA.

RAE, JOHN.
Illustrator, painter, and writer. Born in Jersey City, NJ, July 4, 1882. Pupil of Howard Pyle and F. V. Du Mond. Member: Society of Illustrators, 1912; Artists Guild of the Authors' League of America; American Federation of Arts. Illustrated *The Girl I Left Behind Me, Historic Houses of New Jersey, The Big Family, Pies and Pirates, Why, Fables in Rhyme, American Indian Fairy Tales, Fairy Tales From France.* Author and illustrator of *New Adventures of Alice, Grasshopper Green and the Meadow Mice; Granny Goose; Lucy Locket.* Represented in Library of Congress, Washington, DC. Address 1933, Caldwell, NJ; summer, North Stonington, CT.

RAEMISCH, WALDEMAR.
Sculptor and teacher. Born in Berlin, Germany, August 19, 1888. Studied: In Germany. Member: National Sculpture Society; Providence Art Club. Awards: Medal, Penna. Academy of Fine Arts, 1946. Work: Cranbrook Academy of Art; Fogg Museum of Art; Providence Art Museum. Exhibited: Art Institute of Chicago, 1942; Penna. Academy of Fine Arts, 1946; Phillips Acad., Andover, MA, 1941; Worcester Museum of Art, 1942; Buchholz Gallery, 1941, 45. Taught: Instructor of Sculpture, Rhode Island School of Design, Providence, RI, from 1939. Address in 1953, 52 Boylston Avenue, Providence, RI. Died in 1955.

RAHMING, NORRIS.
Painter, etcher and educator. Born in New York City, May 1, 1886. Studied: National Academy of Design; Art Students League; NY School of Art;

pupil of H. G. Keller, Emil Carlsen, William M. Chase, Robert Henri. Member: College Art Association of America; Columbus Art League; Cleveland Society of Artists. Awards: Second prize for landscape, 1926, hon. mention, 1928, hon. mention, 1929, Cleveland. Work: "Mt. Chocorua, NH," Newark Mus. of Art, Newark, NJ; "The Bridge, Avignon," Cleveland Mus. of Art, Cleveland, OH; "Carcassone," Mary Warner Fund, City of Cleveland; Senate Office Building, Washington, DC; murals, U.S. Post Office, Gambier, OH; others. Exhibited: Penna. Academy of Fine Arts; Corcoran; City Art Museum of St. Louis, 1925-37; Great Lakes Exhibition, 1937; Columbus Art League, 1938, 39. Director, department of art, Kenyon College, Gambier, OH, from 1936. Address in 1953, Gambier, OH. Died in 1959.

RAKEMANN, CARL.
Mural painter and illustrator. Born in Washington, DC, April 27, 1878. Pupil of academies in Munich, Dusseldorf and Paris. Member: X Painters of Washington. Award: Gold medal, Sesqui-Centennial Expo., Philadelphia, PA, 1926. Work: Four lunettes in room of Senate Committee on Military Affairs and four paintings in lobby of House of Representatives, U.S. Capitol, Washington, DC; portrait of ex-Speaker Henderson, U.S. Soldiers Home, Tennessee; portraits for the State House, Columbus, OH; Ohio State Archaeological and Historical Soc., Kenyon College, OH; Hayes Memorial, Fremont, OH; murals, U.S. Court House, Dallas, TX. Exhibited: Corcoran; Society of Washington Artists. Address in 1953, Chevy Chase, MD.

RALEIGH, HENRY.
Illustrator, etcher, lithographer, portrait painter. Born in Portland, OR, on Nov. 23, 1880. Pupil of Hopkins Academy, San Francisco, CA. Member: Art Alliance of America; Artists Guild of the Authors' League of Am.; Salma. Club; Society of Illustrators; Coffee House Club. Award: Shaw prize for illustration, Salma. Club, 1916; gold medal for Advertising Art in America, 1927. Worked for all major magazines. Address in 1929, 1 Sheridan Square, New York, NY. Died June 8, 1945.

RALPH, W.
Line-engraver of views, etc. He was working in Philadelphia, PA, in 1794-1808, and engraved at least one plate for the *New York Magazine.*

RAMAGE, JOHN.
English miniature painter. Born c. 1748 in Dublin, Ireland. He was living in Boston, Massachusetts, 1775, and in New York in 1777. He painted a miniature of George Washington. He became involved in debt and fled to Canada in 1794. He died in Montreal on October, 24, 1802, and was buried in the Protestant Cemetery there. (See Strickland's *Dictionary of Irish Artists.*)

RAMSDELL, FRED W.
Painter of landscapes and portraits. Born in 1865. Studied at Art Students League, NY, and with Collin in Paris. He had a studio at Lyme, Ct. He died in 1915.

RAMSEY, LEWIS A.
Landscape and portrait painter, muralist, sculptor and teacher. Born in Bridgeport, IL, March 24, 1873; settled in Utah. Studied with John Hafen; at Art Institute of Chicago; Julien Academy, Paris, under Bouguereau and Laurens from 1897-1903; and under Douglas Volk. His work can be seen in Latter-Day Saints temples and public buildings, Utah. Worked in Boston and NYC as a calligrapher and photo retoucher. Member of Society of Utah Artists. Taught at Latter-Day Saints University from 1903-05. In the early 1930's he moved to Hollywood where he painted portraits of movie stars for art cards. Died there in 1941.

RAMUS, MICHAEL.
Illustrator. Born in Naples, Italy, in 1917. Attended Exeter Academy at Yale University and the Art Students League, with additional training under Harry Sternberg, Howard Trafton, and Elliot O'Hara. He has worked for *Life, Sports Illustrated, Smithsonian,* and *American Heritage,* among others, and received the Award for Distinctive Merit in the 29th Annual Exhibition of the Art Directors' Club.

RAND, ELLEN G. EMMET.
(Mrs. William Blanchard Rand). Painter. Born in San Francisco, CA, March 4, 1876. Studied in NY and Paris. Member: Associate National Academy of Design, 1926; Nat. Association of Women Painters and Sculptors; Nat. Association of Portrait Painters; American Federation of Arts. Awards: Silver medal, St. Louis Expo., 1904; gold medal, P.-P. Expo., San Francisco, 1915; bronze medal, Buenos Aires Expo., 1910; Beck gold medal, Penna. Academy of Fine Arts, 1922; Gould prize ($250), Women Painters and Sculptors, 1927. Work: "Portrait of Augustus Saint-Gaudens" and of "Benjamin Altman," Metropolitan Museum, New York. Address in 1933, 320 East 57th Street, New York, NY; Salisbury, CT. Died Dec. 18, 1941, in Salisbury, CT.

RAND, HENRY ASBURY.
Painter. Born in Philadelphia, PA, April 1, 1886. Pupil of Penna. Academy of Fine Arts under Chase, Anshutz and Breckenridge. Member: Philadelphia Sketch Club; Fellowship Penna. Academy of Fine Arts. Work: "Snow Shadows," Penna. Academy of Fine Arts, Philadelphia. Address in 1933, Holicong, Bucks Co., PA.

RAND, MARGARET ARNOLD.
Painter and teacher. Born in Dedham, MA, Oct. 21, 1868. Pupil of Emily D. Norcross; Clara Goodyear; Geo. H. Smillie; and Henry W. Rice. Member: Copley Society, 1894. Work: "Pansies," Boston Art Club. Address in 1929, 49 Kirkland Street, Cambridge, MA.

RAND, PAUL.
Painter and designer. Born on Aug. 15, 1914 in Brooklyn, NY. Studied at Pratt Institute; Art Students League with George Grosz; Parsons School of Design. Work: Museum of Modern Art; Library of Congress. Exhibitions: IBM Gallery, and American Institute of Graphic Arts Gallery (both one-man); Pratt Institute; Art Directors' Club of New York. Awards: Gold medal, American Institute of Graphic Arts, 1966; Art Directors' Hall of Fame, 1972; DFA, Philadelphia College of Art, 1979. Member: American Institute of Graphic Arts; Art Directors' Club of New York; Benjamin Franklin fellow, Royal Society of Arts and Science, London. Instructor, Pratt Institute, Brooklyn, NY, 1946; Cooper Union Art School, New York, NY, 1942; NY Design Laboratory, 1941; professor, Yale University, from 1956. Art director of *Esquire* magazine, 1937-41; was also the art director for the Weintraub Advertising Agency, and worked as a design consultant for IBM, Westinghouse and Cummins Engine Company. Author of *Thoughts on Design* and *The Trademark of Paul Rand;* illustrated several other books. Address in 1984, Weston, CT.

RANDALL, ASA GRANT.
Painter and teacher. Born in Waterboro, ME, 1869. Pupil of Howard Helmick; Arthur Dow; A. H. Munsell; and Pratt Institute. Member: Providence Water Color Club. Founder, Commonwealth Art Colony, Boothbay Harbor, ME. Specialty: Landscape painting and block printing. Address in 1929, 32 Summer Street, Providence, RI; summer, Boothbay Harbor, ME.

RANDALL, D. ERNEST.
Painter and illustrator. Born in Rush County, IN, in 1877. Pupil of Art Institute of Chicago. Address in 1934, San Francisco, CA.

RANDALL, DARLEY (MRS.).
See Talbot, Grace Helen.

RANDALL, (LILLIAN) PAULA.
Sculptor and designer. Born in Plato, MN, Dec. 21, 1895. Studied at Minneapolis Institute of Arts; University of Southern California; Otis Art Institute, Los Angeles. Works: Western Division, Nat. Audubon Society, Sacramento, CA; Official Tournament of Roses, Pasadena, CA. Exhibitions: All California Exhibition, Laguna Beach Art Museum, California, 1964; University of Taiwan, Formosa, 1964; Brandeis University Exhibition, Granada Hills, CA, 1967; Form and the Inner Eye Tactile Show, California State University, Los Angeles and Pierce College,

San Fernando, CA, 1972; one-person show, Galerie Vallombreuse, Biarritz, France, 1975. Awards: Laguna Beach Art Museum Award, All California Show, 1964; Special Achievement Award, All California Exhibition, Indio, 1966; Pasadena Society of Artists Special Award, 1971. Media: Wood, stone, plastics, welded metals. Address in 1984, Sierra Madre, CA.

RANDALL, PAUL A.
Landscape painter. Born in Warsaw, IN, Sept. 29, 1879. Pupil of William Forsyth and C. A. Wheeler. Member: Indiana Art Club. Address in 1929, care of the Herron Art Institute; 3204 Bellefontaine Street, Indianapolis, IN.

RANDOLPH, GLADYS CONRAD.
Painter and writer. Born in Whitestone, Long Island, NY. Studied: NY School of Fine and Applied Art; Terry Art Institute; Portland (OR) Art Museum; University of Pennsylvania; NY University; also studied with Hobson Pittman and Revington Arthur. Work: Lowe Gallery of Art; Columbus Museum of Art, GA. Exhibited: League of American Pen Women, 1950; Florida Southern College, 1952; American Artists Professional League; Ringling Museum of Art, FL; Miami Art League; others. Awards: Miami Art League; Blue Dome; Florida Federation of Artists; Terry Art Institute; National League of American Pen Women; American Artists Professional League. Member: Miami Watercolor Society; Artists Equity Association; Florida Federation of Artists; Arts Council, Inc., Miami (art chairman); others. Contributor to various publications and newspapers. Address in 1976, Miami, FL.

RANDOLPH, INNES.
Portrait sculptor. Born Oct. 25, 1837. Lived and worked in Baltimore, MD. About 1873, he executed a bust of George Peabody, founder of the Peabody Institute in Baltimore. Died April 28, 1887.

RANDOLPH, JAMES THOMPSON.
Portrait sculptor and wood carver. Born in Bound Brook, NJ, 1817. Lived and worked in Baltimore. With firm of Harold & Randolph, ship carvers, 1839; headed firm of Randolph & Seward, ship carvers, 1853-60. Executed a bust of John T. Randolph, 1858; the McDonough Monument in Greenmount Cemetery, 1865. Died in 1874.

RANDOLPH, LEE F.
Painter, etcher, and landscape architect. Born in Ravenna, OH, June 3, 1880. Pupil of Cincinnati Art Academy; Art Students League of NY under Cox; Ecole des Beaux-Arts and Julian Academy in Paris. Member: Chicago Society of Etchers; California Society of Etchers; San Francisco Art Association. Awards: Bronze medal for painting, P. P. Expo., San Francisco, 1915; silver medal for painting, San Francisco Art Association, 1919. Work in Luxembourg, Paris. Director of California School of Fine Arts. Address in 1929, care of California School of Fine Arts, San Francisco, CA.

RANGER, HENRY WARD.
Landscape painter. Born in Jan., 1859 in Syracuse, NY; he died in New York City on Nov. 7, 1916. He studied in this country; also in France, England and Holland. He was elected an Associate of the National Academy, 1901, and an Academician in 1906. Represented in Corcoran Art Gallery by the "Top of the Hill," and in the Metropolitan Museum of Art by "High Bridge" and "Spring Woods."

RANKIN, ELLEN HOUSER.
Sculptor. Born in Atlanta, IL, 1853. Pupil of Art Institute of Chicago and Fehr School, Munich. Address in 1898, Chicago, IL.

RANNELLS, WILL.
Illustrator, painter and teacher. Born in Caldwell, OH, July 21, 1892. Pupil of Cincinnati Art Academy. Member: Artists Guild of the Authors' League of America. Exhibited: Philadelphia Water Color Club; American Water Color Society. Work: Cover designs and illustrations for *Life, Judge, Country Gentleman, Farm and Fireside, McClures, Outing, Sportsmen's Digest,* and *The People's Home Journal;* calendar designs and backs for Congress playing cards. Illustrated *Dog Stars, Waif, the Story of Spe, Animals Baby Knows, Farmyard Play Book,* others; author and illustrator of *Animal Picture Story Book.* Specializes in portraits of dogs. Associate Professor of Fine Arts, Ohio State University, Columbus, OH. Address in 1953, Columbus, OH.

RANNEY, WILLIAM.
Painter. Born May 9, 1813, in Middletown, CT. Represented by "Duck-Shooting" in Corcoran Art Gallery, Washington, DC. Elected an Associate of the National Academy in 1850. His work is mainly connected with the life of hunters and trappers in the West. Died Nov. 18, 1857, in W. Hoboken, NJ.

RANSOM, ALEXANDER.
Painter. Noted in Tuckerman's "American Artist Life." A portraitist.

RANSOM, CAROLINE L. ORMES.
Born in Newark, OH, in 1838. She was taught by her mother in drawing and painting in water colors, and received some help from an itinerant portrait painter, who visited her father's home and painted portraits of the family. She afterwards went to NY, and studied landscape painting under A. B. Durand, and portrait painting under Thomas Hicks and Daniel Huntington. Visited Europe later, where she was for some time a pupil of Kaulbach, at Munich. Her first work of note was painted in her studio in

Cleveland, OH; she afterwards worked in NY, prior to her coming to Washington, DC, where she maintained a studio at 915 F. Street, N.W., for many years. Among her works are portraits of Maj. Gen. McPherson, Salmon P. Chase, Senator Benjamin F. Wade, Joshua R. Giddings, Alexander Hamilton, John A. Dix, John W. Taylor, James A. Garfield, and Thomas Jefferson. Died February 12, 1910, in Washington, DC.

RANSON, NANCY SUSSMAN.
Painter and serigrapher. Born in NYC on Sept. 13, 1905. Studied: Pratt Institute School of Art and Design, B.F.A.; Art Students League; Brooklyn Museum Art School; and with Laurent, Charlot, Brook, and Brackman. Awards: Critic's Choice Exhibition, 1947; National Association of Women Artists, 1952, 53, 56, 58; National Serigraphic Society, 1953; Grumbacher award in Casein, 1954; American Color Printmakers Soc., 1955; Brooklyn Society of Artists, 1955; Audubon Artists, 1958; MacDowell Foundation Fellowship, 1964; first prize in graphics, American Society of Contemporary Artists, 1970; award of merit, American Society of Contemporary Artists, 1981. Collections: Fogg Museum of Art; Butler Institute of American Art; Smithsonian Institution; Brandeis Univ.; Mexican Government Tourist Commission; Key West Art and Historical Society; Reading Public Museum; Free Library, Philadelphia, PA; Museum of the City of NY; Nat. Art Gallery, Sydney, Australia. Exhibited: Brooklyn Museum; Whitney; NJ State Museum; Penna. Academy of Fine Arts; American Institute and Academy of Arts and Letters; Brooklyn Public Library, Main Branch (one-woman); others. Member: American Society of Contemporary Artists; Audubon Artists; National Association of Women Artists. Media: Oil, acrylic; serigraphy. Address in 1984, 400 Rugby Road, Brooklyn, NY.

RAPHAEL, JOSEPH.
Painter. Born in Jackson, Amador Co., CA, in 1872. Pupil of San Francisco Art Association; Beaux-Arts, Julian Academy, and Laurens in Paris. Awards: Hon. mention, Paris Salon, 1915; silver medal, P.-P. Expo., San Francisco, 1915; first purchase prize, San Francisco Art Assoc.; gold medal, San Francisco Art Association, 1918. Work in Golden Gate Park Museum, San Francisco; San Francisco Art Association. Died in 1950. Address in 1933, care of Art Association, 800 Chestnut Street, San Francisco, CA; 41 Rue Engeland, Uccle, Belgium.

RASARIO, ADA.
See Cecere, Ada Rasario.

RASCHEN, CARL MARTIN.
Painter and illustrator. Born Dec. 17, 1882. Pupil of Rochester Athenaeum; Mechanics Institute; Gilbert Gaul. Member: Rochester Art Club; Rochester

Picture Painters' Club; St. Louis Brush and Pencil Club; Geneseeans. Died in June, 1962.

RASKIN, SAUL.
Painter, illustrator, etcher, craftsman, writer, and lecturer. Born in Russia, Aug. 15, 1878. Member: NY Water Color Club; American Water Color Society (associate). Author of *Palestine in Word and Pictures.* Address in 1929, 96 Fifth Ave.; 1475 Grand Concourse, New York, NY.

RASMUSSEN, BERTRAND.
Painter. Born in Arendal, Norway, in 1890. Pupil of Laurens in Paris. Member: Society of Independent Artists; Brooklyn Water Color Club; League of New York Artists. Address in 1926, 468 60th Street, Brooklyn, New York, NY.

RATH, HILDEGARD.
Painter and lecturer. Born Freudenstadt, Germany in 1909. Awards: Stuttgart, Germany; Salon of the 50 States, NY; Prix de Paris, France. Collections: Library of Congress, Washington, DC; Metropolitan Museum of Art; NY Public Library. Address in 1980, P.O. Box 298, Manchester Center, VT.

RATHBONE, CHARLES H., JR.
Painter and etcher. Born in New York, Nov. 25, 1902. Pupil of Art Students League of NY; Hayley Lever. Member: National Arts Club; "The Fifteen;" Society of Independent Artists; Salma. Club; Artists Fellowship Association; Union Artistique de la Bretagne, France. Repr. by "Valley of St. Paul," Brooklyn Museum; also numerous private collections in U.S. and France. Died in 1936. Address in 1933, 75 Central Park, West, New York, NY; summer, Concarneau, Finistere, France.

RATHBONE, CHARLES H., JR. (MRS.).
See Moore, Martha.

RATLIFF, BLANCHE COOLEY.
(Mrs. Walter B. Ratliff). Painter. Born in Smithville, Texas, May 26, 1896. Pupil of O. B. Jacobson; Dura B. Cockrell. Member: Les Beaux-Arts, Norman, OK; Fort Worth Painters. Work in Univ. of Oklahoma. Address in 1933, Atlanta, GA.

RATTERMAN, W. G.
Painter. Member: Artists Guild of the Authors' League of America. Address in 1929, 67 West 67th Street, New York, NY.

RATTNER, ABRAHAM.
Painter. Born July 8, 1895 in Poughkeepsie, NY. Studied at Corcoran School of Art; George Washington University; Pennsylvania Academy of Fine Arts; Ecole des Beaux Arts; Academie Ransom, Paris; Academie Grande Chaumiere; Sorbonne. Taught at New School for Social Research, 1947-55; Brooklyn

Museum Art School; Yale, 1951-53; Columbia; American Academy in Rome; Penna. Academy of Fine Arts; and Skowhegan School of Art, ME. Lived in Paris and NYC. Awarded Cresson Fellowship from the Penna. Academy of Fine Arts, 1945; hon. mention, Carnegie, 1949; citation and gold medal, Temple University, Philadelphia, 1955; gold medal, Art Directors' Club, Philadelphia, 1956; others. Exhibited: Penna. Academy of Fine Arts; Corcoran Gallery; Art Institute of Chicago; Carnegie Institute; University of Illinois; Bonjean Galleries, Paris, 1935; Renaissance Society, University of Chicago, 1957; Downtown Gallery, NYC, multiple times; Vassar, 1948; Stendahl Gallery; Kennedy Gallery, 7 exhibitions, 1969-79; others. Work: Museum of Modern Art; Whitney; Penna. Acad. of Fine Arts; Albright-Knox Art Gallery, Buffalo; Yale; Vassar; Washington University; New School for Social Research; Arizona State; Baltimore; Art Institute of Chicago; Newark Museum; Musee du Jeu de Paume, Paris; plus many commissions. Address in 1976, 830 Greenwich Street, New York, NY. He died Feb. 14, 1978.

RAU, WILLIAM.
Painter and illustrator. Born in New York, NY, 1874. Pupil of Chase and Edgar M. Ward; National Academy of Design. Member: International Society of Arts and Letters; American Artists Professional League; Nassau County Society of Artists. Work: Eight mural paintings, Douglas Co. C. H., Omaha, NE; lunette in St. Matthews' Church, Hoboken, NJ; panels in Melrose Public Library, and High Bridge Public Library, New York, NY; Patio Theatre, Brooklyn, NY; Keith Theatre, Richmond Hill, NY; Pt. Washington Theatre, Pt. Washington, NY; Fantasy Theatre, Rockville Center, Long Island, NY; Bliss Theatre, Woodside, Long Island, NY. Address in 1933, 104 W. 42nd St., New York, NY; h. 8636 107th St., Richmond Hill, LI, NY.

RAUGHT, JOHN WILLARD.
Painter. Born in Dunmore, PA. Pupil of National Academy of Design; Julian Academy in Paris. Member: Salma. Club, 1902; American Federation of Arts. Address in 1929, Dunmore, PA.

RAUL, HARRY LEWIS.
Sculptor, museum administrator, designer, lecturer, and writer. Born in Easton, PA, in 1883. Pupil of NY School of Art; F. E. Elwell; Art Students League of NY under F. V. Du Mond; Penna. Academy of Fine Arts under Grafly. Member: American Artists Professional League; American Association of Museums; Miniature Painters, Sculptors, and Gravers Society, Washington, DC; Art Centre of the Oranges (president); Mystic Society of Artists; American Federation of Arts. Work: "Green Memorial Statue," Easton, PA; "Monument to Martyrs of the Maine" (Hail, Martyrs' statue), Northampton Co., Penna.;

"Soldiers' Monument" (Old Glory Statue), West Chester, Pennsylvania; "Portrait, Ex-Mayor Rudolph Blankenburg," Philadelphia; Englewood (NJ) World War Mem. ("America, 1917-1918" statue); Manton B. Metcalf memorial, Rosedale Cemetery, Orange, NJ; Wilson Borough Pennsylvania World War monument; "The Face of Lincoln," Lincoln Trust Co. Building, Scranton, PA; Julia-Dykman Andrus memorial group, Yonkers, NY; Herbermann memorial, Sea Girt, NJ; Williams-Coolidge memorial, Easton, PA; Herbermann memorial, Jersey City, NJ; War Mothers' memorial, Philadelphia, PA; heroic statue, "Christ the King," Loyola House Retreats, Morristown, NJ; "Venture," prize statuette, NJ State Federation of Women's Clubs, Asbury Park, NJ; Montclair Art Museum. Author, "The Celtic Cross for Modern Usage." Exhibited: National Sculpture Society, 1923; Architectural League; Nat. Academy of Design; Corcoran; Pan.-Pacific Expo., 1915; Penna. Academy of Fine Arts; Baltimore Museum of Art; Montclair Art Museum; Newark Museum; Ferargil Gallery; others. Administrator, Museum of the U.S. Department of the Interior, Washington, DC, from 1938. Address in 1953, Museum of the U.S., Dept. of the Interior; h. 2115 Huidekoper Place, NW, Washington, DC.

RAUL, JOSEPHINE GESNER.
(Mrs. Harry Lewis Raul). Painter. Born in Linden, NJ. Pupil of National Academy of Design; Art Students League of NY; G.A. Thompson. Member: Mystic Society of Artists; American Federation of Arts; Plainfield Art Association; Art Centre of the Oranges; National League of American Pen Women; American Artists Professional League; National Association of Women Painters and Sculptors. Awards: National Association of Women Painters and Sculptors, 1930; National League of American Pen Women, 1930; Art Centre of the Oranges, 1931; Kresge Art Exhibition, 1933. Address in 1933, 312 Highland Ave., Orange, NJ; summer, Groton Long Point, CT.

RAUSCHENBERG, ROBERT.
Painter, sculptor and photographer. Born in Port Arthur, TX, Oct. 22, 1925. Studied briefly at the University at Austin, TX (pharmacy); Kansas City Art Institute and the School of Design, 1946-47; Academie Julian, Paris, 1947; studied under Josef Albers at Black Mountain College, NC, 1948-49; Art Students League, 1949-50, under Morris Kantor and Vaclav Vytlacil. Returned to Black Mountain College in 1952 and became associated with performance musician John Cage and dancer-choreographer Merce Cunningham. Exhibited at Mus. of Modern Art, 1968; Milwaukee Art Center, 1968; Whitney, annuals, 1969, 70, 73; Guggenheim; Copenhagen; Baltimore; Munich; Tate, London; Pompidou Center, Paris; numerous other group and solo shows in U.S. and abroad. Received Grand Prix d'Honneur, 13th

International Exhibition of Graphic Art, Ljubljana, Yugoslavia; gold medal, Oslo; Officer of the Order of Arts and Letters, France; others. In collections of Albright-Knox, Buffalo; Whitney; White Museum, Cornell University; Tate; Museum of Modern Art; many others. Among the many types of execution, the artist designed sets, costumes, and lighting for Cunningham's Dance Company for over ten years. Address in 1982, c/o Leo Castelli Gallery, 420 West Broadway, NYC.

RAUSCHNER, HENRY.
Wax miniaturist. Advertised in Charleston, SC, in November, 1810 and April, 1811. Possibly the same as John Christian Rauschner.

RAUSCHNER, JOHN CHRISTIAN.
Wax portraitist. Born in Frankfurt, Germany, 1760. In NYC 1799-1808; travelled and worked from Massachusetts to Virginia or farther south. In Philadelphia, 1801, 1810-11; in Boston and Salem, MA, 1809-10. Work at NY Historical Society; Maryland Historical Society.

RAVENSCROFT, ELLEN.
Painter, craftsman, and teacher. Born in Jackson, MI. Pupil of Chase; Henri; Castellucho in Paris. Member: National Association of Women Painters and Sculptors; NY Soc. of Women Artists; Province-town Art Association. Awards: Portrait prize, C. L. Wolfe Art Club, 1908; landscape prize, and hon. mention, Kansas City Art Institute, 1923. Died in 1950. Address in 1929, 17 East 59th Street, New York, NY; summer, Provincetown, MA.

RAVLIN, GRACE.
Painter. Born in Kaneville, IL. Pupil of Art Institute of Chicago; Penna. Academy of Fine Arts under Chase; Simon and Menard in Paris. Member: Associee Societe Nationale des Beaux-Arts, Paris, 1912, and Peintres Orientalists Francais; Societaire Salon d'Automne. Awards: Third medal, Amis des Arts, Toulon, 1911; silver medal, P.-P. Expo., San Francisco, 1915; Field and Butler prizes, Art Institute of Chicago, 1918; Peterson prize, Art Institute of Chicago, 1922. Work: "Procession of the Redentore, Venice," Art Institute of Chicago; "Arab Women in the Cemetery Tangier," Luxembourg, Paris; four paintings owned by French Government and two by City of Chicago; "Blue Doors," Arche Club, Chicago; "The Plaza," Newark Museum; "Market Day, Grand Socco," Harrison Gallery, Los Angeles Museum; Vanderpoel Art Association Collection, Chicago. Address in 1933, 134 Lexington Avenue, New York, NY.

RAWDON, FREEMAN.
Engraver. Born c. 1801 in Tolland, CT. He was a pupil of his brother, Ralph Rawdon, an engraver, then of Albany, NY. In 1828 he was the Rawdon of the NY engraving firm of Rawdon, Wright, & Co., and of Rawdon, Wright, Hatch, and other combinations of a later date. These firms conducted an extensive bus. in general and bank-note engraving, and employed many engravers. Freeman Rawdon signed very little work. Died Sept. 21, 1859 in NYC.

RAWDON, RALPH.
Engraver. In 1813 Ralph Rawdon was engraving in a very crude manner in Cheshire, CT. He was associated in this work with Thomas Kensett, the father of the American Artist. About 1816 Rawdon removed to Albany, NY, where he engraved stipple portraits over his own name, and with his brother and A. Willard he was in the bank note and general engraving business in that city.

RAWSON, CARL WENDELL.
Painter. Born in Des Moines, IA, Jan. 28, 1884. Pupil of Cumming Art School; National Academy of Design; Minneapolis School of Art. Member: Attic Club; Minneapolis Art Society; Minnesota State Art Society; Palette and Chisel Club, Chicago. Represented by portrait in Minneapolis Institute of Arts; landscapes in Minekahda Club, Minneapolis Golf Club Galleries and Winona Country Club, Library Bldg., Douglas School, Northwestern Bank Bldg., Minneapolis; portraits, State Capitol, Bismarck, ND; State Historical Department, and Library, Des Moines, IA; University of Minnesota; Public Library, Mayo Clinic, University Club, Rochester, MN; College of Surgeons, Chicago, IL; State College, Ames, IA. Address in 1933, 637 Kenwood Parkway, Minneapolis, MN.

RAY, MAN.
Sculptor and painter. Born in Philadelphia, PA, Aug. 27, 1890; grew up in NYC. Studied at National Academy of Design; Art Students League; and Ferrer Art Center, NYC. Early career involved with painting, photography, and mixed media. First sculptures produced in 1920's in bronze, entitled "By Itself I" and "By Itself II;" later turned toward sculpture with "found" objects, an early example being a nineteen inch high wood skyscraper held in a C-clamp, titled "NY 17," and others, such as his "Cadeau," an iron with nails protruding outward from its bottom. Founded, in collaboration with Marcel Duchamp and Katherine S. Dreier, the Societe Anonyme, a society involved with the collection of modern art in the U.S. Published, in conjunction with Duchamp, the first and only issue of *New York Dada* in 1921. Later travelled to Paris. Member: Parisian Dada Group. In 1923, he made his first film and exhibited in the first Surrealist exhibition held at the Galerie Pierre, Paris, 1925. Other exhibitions include one-man shows and retrospectives at the Los Angeles County Museum in 1966 and the NY Cultural Center, 1975; numerous galleries in Paris, London, Cologne, California, NYC;

also exhibited at Brooklyn Museum; Museum of Modern Art; Whitney; Yale University. In collection of Museum of Modern Art. Address in 1971, Paris, France. Died in 1976.

RAYMOND, FRANK WILLOUGHBY.
Etcher and engraver. Born in Dubuque, IA, 1881. Pupil of Art Institute of Chicago. Member: California Society of Etchers; Chicago Society of Etchers; Palette and Chisel Club; Artists Guild of the Authors' League of America. Work: Art Institute of Chicago; Toledo Museum of Art. Address in 1933, 1012 North Dearborn Street, Chicago, IL.

RAYMOND, GRACE RUSSELL.
Painter and teacher. Born in Mt. Vernon, OH, May 1, 1877. Pupil of Art Institute of Chicago; School of Applied Design, NY; Corcoran School, Washington, DC; studied in Paris and Rome. Member: Washington Water Color Club; American Federation of Arts. Instructor of drawing and painting, Southwestern College, Winfield, KS. Address 1933, 923 Mansfield Street, Winfield, KS; Piazza Monte d'Oro 29, Rome, Italy.

RAYMOND, LEONE EVELYN.
Sculptor and teacher. Born in Duluth, MN, March 20, 1908. Studied at Minneapolis School of Art; also studied with Charles S. Wells. Works: Bas-relief, International Falls (MN) Stadium; wood carvings, Sebeka (MN) High School; Farmer's Exchange Building, St. Paul; Hall of Statuary, Washington, DC; Lutheran Church of the Good Shepherd, Minneapolis; Church of St. Joseph, Hopkins, MN.; interior of St. George's Episcopal Church, St. Louis Park, MN. Awards: Prizes, MN State Fair, 1941, 43, 44; Minneapolis Insti. of Art, 1944; Walker Art Center, 1944, 45. Exhibitions: Annually at local and regional exhibitions. Contributor to school arts magazines. Director, Evelyn Raymond Clay Club, Minneapolis, MN. Address 1953, Minneapolis, MN.

RAYNAUD, LOUIS.
Painter and teacher. Born in New Orleans, LA, June 18, 1905. Member: New Orleans Art Association; Southern States Art League; New Orleans Arts and Crafts Club. Award: Prize, San Antonio Art League, San Antonio, Texas, 1929; first popular prize, New Orleans Art League, 1933. Address in 1933, 2539 Esplanade Avenue, New Orleans, LA.

RAYNOR, GRACE HORTON.
Sculptor. Born NY, NY, Sept. 20, 1884. Member: Art Workers Club. Work: Plaque, Public Library, Glen Ridge, NJ; fountain, Cherry Valley Club, LI. Specialty: Portrait statuettes and heads.

REA, GARDENER.
Illustrator. Born in Ironton, OH, in 1892. Attended Ohio University in 1914, and later, the Columbus Art

School. A free-lance cartoonist and writer, he worked for *Judge, Life,* and *The New Yorker.* His cartoons were exhibited in museums all over the world and he was author and illustrator of the books *The Gentleman Says It's Pixies,* 1944, and *Gardener Rea's Sideshow,* 1945. He lived in Brookhaven, Long Island, for many years. Died in 1966.

REA, JAMES EDWARD.
Painter, sculptor, designer, lecturer, teacher, and illustrator. Born in Forsyth, Montana, January 14, 1910. Studied: St. Paul School of Art; American Academy of Art, Chicago; University of Minnesota, B.S.; University of Redlands; Claremont College. Member: Twin City Puppetry Guild. Awards: Prizes, Minnesota State Fair, 1933, 34. Work: Custer State Park Museum, SD; Hotel Lenox, Duluth, MN; Lowry Medical Building, St. Paul, MN; Harding High School, St. Paul, MN. Exhibited: Grumbacher Exhibition, 1935; Minnesota State Fair; Minneapolis Institute of Art, 1932-42. Lectures: History of Art. Address in 1953, San Bernardino, CA.

REA, JOHN LOWRA.
Sculptor, writer, and teacher. Born Beekmantown, NY, Jan. 29, 1882. Pupil of H. A. MacNeil; J. E. Fraser; F. V. Du Mond. Work: Bronze tablet to George H. Hudson, State Normal School, Plattsburgh, NY. Address in 1933, Plattsburgh, Clinton Co., NY.

READ, ADELE VON HELMOLD.
Painter. Born in Philadelphia, PA. Pupil of Chase, Anshutz, Penna. Academy of Fine Arts. Member: Fellowship Penna. Academy of Fine Arts; Art Alliance of Philadelphia; Plastic Club; Pennsylvania Museum and School of Industrial Art; American Federation of Arts. Address in 1933, Presser Bldg., 1714 Ludlow St., Philadelphia, PA; h. 74 Lincoln Ave., Lansdowne, PA.

READ, ELMER JOSEPH.
Painter. Born in Howard, Steuben Co., NY, June 19, 1862. Pupil of College of Fine Arts, Syracuse University; Fremiet in Paris. During winter, painted in West Indies. Works in many private collections. Address in 1933, 11 Washington Street, Palmyra, NY.

READ, FRANK E.
Painter, etcher, and architect. Born in Austinburg in 1862. Pupil of W. M. Hunt. Member: Seattle Fine Arts Society. Address in 1926, 232 Harvard, North, Seattle, WA.

READ, HENRY.
Painter, writer, teacher, lecturer, and draftsman. Born in Twickenham, England, Nov. 16, 1851. Member: National Academy A. (regent); Colorado Chapter American Institute of Architects (hon.);

American Federation of Arts. Director, Denver Students' School of Art. Work in Denver Art Museum. Died in 1935. Address in 1929, 1311 Pearl Street; h. 1360 Corona Street, Denver, CO.

READ, THOMAS BUCHANAN.
International portrait and historical painter, sculptor, illustrator, and poet. Born in Chester County, PA, March 12, 1822; moved to Cincinnati. Painted signs, itinerant portraits, and canal boats, and played female parts in a theatrical troupe. Employed by Shobal Vail Clevenger as a stonecutter in Cincinnati. Nicholas Longworth provided him a studio in Cincinnati in 1839. He went to Boston in 1841 where he was friends with Longfellow and Allston, and went to Philadelphia in 1846. He was known as a poet as well as an artist. In 1850 he went to Europe, working and studying in Florence and Rome, finally making the latter city his home, with occasional visits to the U.S. Works include a portrait bust of General Sheridan and a painting of General Harrison. Represented in Peabody Insti. (Baltimore); Pennsylvania Academy of Fine Arts; Cincinnati Art Museum; Smithsonian Institution. Member: Colony of American Artists in Rome. A portrait of himself is owned by the Nat. Gallery of Washington, DC. Specialty: Indian and historical subjects. Died in NYC, May 11, 1872.

READ, WILLIAM.
Portrait painter. Born in 1607 in Batcombe, Eng. He came over in 1635 and settled in Weymouth, MA. He lived in Boston until 1674, and died at Norwich, CT, in 1679. In 1641 he painted the portrait of Richard Bellingham, Governor of Massachusetts. The picture is inscribed "Govr. R. Bellingham, Effiegies Delin, Boston Anno Dom, 1641. Aetatis 49, W. R." This is supposed to be the earliest known portrait painted in this country.

READIO, WILFRED A.
Painter and teacher. Born in Florence, MA, Nov. 27, 1895. Pupil of Alfred Vance Churchill; Carnegie Institute of Technology. Member: Pittsburgh Art Association; L. C. Tiffany Artists Guild. Award: First honors, Pittsburgh Art Association, 1921. Work: "Curtained Window," Public Schools of Pittsburgh. Died in 1961. Address in 1933, Carnegie Institute of Technology, Pittsburgh, PA.

REAM, CARDUCIUS, P.
Painter. Born in Lancaster, OH, in 1837. He is represented in the Chicago Art Institute. Died June 20, 1917 in Chicago, IL.

REAM, VINNIE (MRS.).
(Mrs. Hoxie). Sculptor. Born Madison, WI, on Sept. 25, 1847. Studied sculpture under Clark Mills and Luigi Majoli. Work: Several busts of congressmen, including bust of President Abraham Lincoln from life. Received a $10,000 commission from Congress in August, 1866, to make a full-size marble statue of Lincoln for Capitol Rotunda. Other busts included Gustave Dore and Pere Hyacinthe. Died Washington, DC, on Nov. 20, 1914.

REARDON, MARY A.
Painter, etcher, and muralist. Born in Quincy, MA, 1912. Studied: Radcliffe College; Yale University School of Fine Arts; and in Mexico. Collections: St. Theresa's, Watertown, MA; Good Shepherd Convent, NY; Radcliffe College; Cardinal Spellman High School, Brockton, MA; Boston College; St. Francis Xavier Chapel, Boston, MA; St. Peter and St. Paul Church, Boston; St. John's Seminary, Boston; Maryknoll and Brookline Chapel, Boston; Children's Medical Center, Boston; Boston State Teachers College; triptych, U.S. Ship *Wasp*. Address in 1980, 12 Martin's Lane, Hingham, MA.

REASER, WILBUR AARON.
Painter and lecturer. Born in Hicksville, OH, Dec. 25, 1860. Pupil of Mark Hopkins Institute in San Francisco; Constant and Lefebvre in Paris. Member: San Francisco Art Association. Awards: Gold and silver medals, California Expo., 1894; first Hallgarten prize, National Academy of Design, 1897. Specialty: Portraits. Work: "Mother and Daughter," Carnegie Gallery, Pitts.; "Old Man and Sleeping Child," Art Gallery, Des Moines, IA; portrait of "Senator W. B. Allison," U.S. Senate Lobby, Washington, DC; "Senator C. S. Page," The Capitol, Charleston, WV; "Bishop Lewis," State Historical Society, Des Moines, IA. Died in 1942. Address in 1933, City Club, New York, NY.

REASON, P. H.
Engraver. This very clever, Black engraver of portraits in stipple was educated and apprenticed to an engraver by certain members of the antislavery party in New York City. He engraved a few good portraits, but early in the 1850's racial prejudice compelled him to abandon engraving for other employment.

REAUGH, FRANK M.
Painter. Born near Jacksonville, IL, Dec. 29, 1860. Pupil of St. Louis School of Fine Arts; Julien Academy in Paris under Doucet. Member: Dallas Art Association (hon.); American Federation of Arts. Work: "Driving the Herd," Dallas (TX) Art Association; "The Road to the Brazog," Dallas Public Library. Specialty: Texas cattle and western landscape. Address in 1933, Oak Cliff, TX.

REBECK, STEVEN AUGUSTUS.
Sculptor. Born in Cleveland, OH, May 25, 1891. Pupil of Karl Bitter; Carl Heber; Cleveland School of Art; National Academy of Design, NY; Beaux-Arts Institute of Design, NY. Member: Cleveland Sculpture

Society; Cleveland Society of Artists; Nat. Sculpture Society (associate). Awards: Medal for portrait bust, Cleveland Museum of Art, 1922; award for sculpture, Cleveland Mus. of Art, 1923. Work: "Shakespeare," Cleveland, OH; Soldiers' Memorial, Alliance, OH; heroic statue, Sphinx, Civil Court House, St. Louis, MO. Exhibited at National Sculpture Society, 1923. Address 1953, Cleveland Heights, OH. Died in 1975.

REBISSO, LOUIS T.
Sculptor. Born in 1837 in Genoa, Italy. Settled in Boston, MA, in 1857. He taught modeling for years in the Art Academy of Cincinnati. His equestrian statue of Gen'l. McPherson is in Washington and his Gen'l. Grant is in Chicago. Associated with Thomas Dow Jones. Died May 3, 1899, in Cincinnati, OH.

RECCHIA, RICHARD HENRY.
Sculptor. Born in Quincy, MA, November 20, 1885. Studied: Boston Museum of Fine Arts School; and in Paris and Italy. Member: Academician National Academy of Design; American Artists Professional League; National Sculpture Society; Guild of Boston Artists; Copley Society; Boston Sculpture Society (Founder); Boston Art Club; North Shore Arts Association; Gloucester Society of Artists; Rockport Art Association; Art Alliance of Philadelphia. Awards: Bronze medal, P.-P. Expo., San Francisco, 1915; National Sculpture Society, 1939; International Expo., Bologna, Italy, 1931; National Academy of Design, 1944. Work: Bas-relief portrait of Gov. Curtis Guild, Boston State House; "Architecture," figure panel on Boston Museum; Red Cross panel in Musee de l'Armee, Gallery Foch, Paris; Memorial to Gov. Oliver Ames, North Easton, MA; Sam Walter Foss Memorial panel, John Hay Library, Brown University, RI; Phi Beta Kappa tablet, Harvard University; "Disaster Relief" model, American Red Cross Museum, Washington, DC; George E. Davenport, portrait tablet, Davenport School, Malden, MA; William Hoffman, portrait tablet, Brown University, Providence, RI; "Youth," J. B. Speed Memorial Museum, Louisville, KY; Brookgreen Gardens, SC. Exhibited: National Sculpture Society, 1939-46; Art Institute of Chicago; National Academy of Design, annually; Corcoran, 1928; Boston Museum of Fine Arts; many one-man exhibitions. Address in 1953, Hardscrabble, Rockport, MA.

RECKLESS, STANLEY LAWRENCE.
Painter. Born in Philadelphia, PA, Aug. 22, 1892. Pupil of Pennsylvania Academy of Fine Arts; and Julian in Paris. Member: Graphic Sketch Club, Philadelphia; Fellowship Pennsylvania Academy of Fine Arts; American Art Association of Paris. Awards: Cresson Traveling Scholarship, Pennsylvania Academy of Fine Arts, 1915-1916; First Toppan prize, Pennsylvania Academy of Fine Arts, 1916. Address in 1933, New Hope, Bucks County, PA.

REDER, BERNARD.
Painter and sculptor. Born in Czernowitz, Bukovina, Austria, June 29, 1897. Came to U.S. in 1943. Studied at Academy of Fine Arts, Prague, 1919, with Peter Bromse, Jan Stursa. Works: Baltimore Museum of Art; Brooklyn Museum; Art Institute of Chicago; Harvard University; Jewish Museum; Metropolitan Museum of Art; Museum of Modern Art; NY Public Library; National Gallery; Philadelphia Museum of Art; Sao Paulo. Exhibitions: Manes Gallery, Prague, 1935; Galerie de Berri, Paris, 1940; Lyceum Gallery, Havana, 1942; Weyhe Gallery, 1943; Art Alliance of Philadelphia; Tel-Aviv; Grace Borgenicht Gallery Inc., NYC; Art Inst. of Chicago; The Contemporaries, NYC; Palazzo Torrigiani, Florence, Italy; World House Galleries, NYC; Whitney; Philadelphia Museum of Art; Museum of Modern Art. Awards: International architectural competition to house the monument to Christopher Columbus in Santo Domingo, 1927; Ford Foundation Grant, Program in Humanities and the Arts ($10,000), 1960. Died Sept. 7, 1963, NYC.

REDERUS, S. F.
Painter. Born in the Netherlands in 1854. Pupil of R. Wynkoop, Bridgeport, CT. Member: Milwaukee Art Insti.; Dubuque Artists' Society. Work represented in Presbyterian Church, Nortonville, KS. Address in 1926, 18 South Glen Oak Avenue, Dubuque, IA.

REDFIELD, EDWARD WILLIS.
Landscape painter. Born in Bridgeville, DE, Dec. 19, 1869. Pupil of Penna. Academy of Fine Arts; Bouguereau and Robert-Fleury in Paris. Member: Society of American Artists, 1903; National Institute of Arts and Letters; Art Club of Philadelphia; Fellowship Penna. Academy of Fine Arts; Salma. Club; American Federation of Arts. Awards: Art Club of Philadelphia, 1896; Paris Expo., 1900; Pan-Am. Expo., Buffalo, 1901; Temple medal, 1903, Sesnan gold medal, 1905, gold medal of honor, 1907, Lippincott prize, 1912, Stotesbury prize, 1920, from Penna. Academy of Fine Arts; St. Louis Expo., 1904; Society of American Artists, 1904, 06; Carnegie Institute, Pittsburgh, 1905, 14; Corcoran Art Gallery, 1907, 08; Paris Salon, 1908, 09; second Harris medal, 1909, Palmer gold medal, 1913, from Art Institute of Chicago; Buenos Aires Expo., 1910; Washington Society of Artists, 1913; Wilmington Society of Fine Arts, 1916; second Hallgarten prize, 1904, Carnegie prize, 1918 and 1922, Altman prize, 1919, Saltus medal, from National Academy of Design, 1927; P.-P. Expo., San Francisco, 1915; Springfield Art Association, 1930. In collections of Luxembourg Museum, Paris; Corcoran; Cincinnati Museum; Carnegie; Boston Museum; Penna. Academy of Fine Arts; Brooklyn Institute Museum; Herron Art Institute, Indianapolis; Art Inst. of Chicago; Minneapolis Institute of Art; RI School of Design; Metropolitan Museum of Art; National Gallery of Art; Butler Art

Institute; Kansas City Art Museum; St. Louis Art Museum; Philadelphia Art Club; Los Angeles Museum; Delgado Museum, New Orleans; others. Died in 1965. Address in 1953, New Hope, PA.

REDFIELD, HELOISE GUILLOU.
Miniature painter. Born in Philadelphia, PA, 1883. Pupil of Penna. Academy of Fine Arts under Chase and Cecilia Beaux; Mme. La Forge and Delecluse in Paris. Member: Ameri. Soc. of Miniature Painters; Pennsylvania Society of Miniature Painters. Awards: Hon. mention, Buffalo Society of Artists; silver medal, P.-P. Expo., San Francisco, 1915. Address in 1933, Barnstable, MA; Wayne, PA.

REDMAN, HENRY N.
Painter. Exhibited a landscape at the Pennsylvania Academy of Fine Arts, 1926. Address in 1926, Boston, MA.

REDMOND, GRANVILLE.
Painter. Born in Philadelphia, PA, March 9, 1871. Pupil of Mathews and Joullin; Constant and Laurens in Paris. Member: San Francisco Art Association; California Art Club. Awards: Hon. mention and W. E. Brown gold medal at San Francisco Art Association; silver medal, Alaska-Yukon-Pacific Expo., Seattle, 1909. Represented in the Wash. State Capitol, Olympia; "A California Landscape," Jonathan Club, Los Angeles. Died in 1935. Address in 1933, care of the Charlie Chaplin Film Co., 1416 North La Brea Ave., Los Angeles, CA.

REDMOND, MARGARET.
Painter and craftsman. Born in Philadelphia, PA. Pupil of Penna. Academy of Fine Arts; Twachtman in NY; Simon and Menard in Paris. Member: Fellowship Penna. Academy of Fine Arts; Philadelphia Water Color Club; Copley Society; Boston Society of Arts and Crafts; Society of Independent Artists; Art Alliance of Philadelphia; American Federation of Arts. Specialty: Stained glass. Address in 1929, 45 Newbury Street, Boston, MA; h. Cheshan, NH.

REECE, DORA.
Painter. Born in Philipsburg, PA. Pupil of Daingerfield; Snell; Seyffert; Breckenridge; Hale; Pearson; Garber; etc. Member: Fellowship Penna. Academy of Fine Arts; Plastic Club; Art Alliance of Phila.; Philadelphia Society of Arts and Letters; American Federation of Arts; Pennsylvania Soc. of Miniature Painters. Address in 1933, 1540 North 55th Street, Philadelphia, PA.

REED, ABNER.
Engraver, painter and printer. Born in E. Windsor, CT, in 1771; died in Toledo, OH. Abner Reed was apprenticed to a saddler and commenced engraving by working upon the engraved metal nameplates then used on saddles. In 1797 he was in NYC, and in 1803 he settled in Hartford, CT, and regularly engaged in the business of engraving, plate printing, and sign painting. In 1811 he returned to East Windsor, and became largely interested in banknote engraving for U.S. and Canadian Banks. From 1821-24 he was in Hartford with Samuel Stiles. He was one of the earliest banknote engravers in this country, having engraved the plates for the Hartford Bank of 1792. Among the apprentices in his employ at East Windsor were William Mason, later a well-known wood engraver of Philadelphia, Asaph Willard, later of NY, Oliver Pelton, Alfred Daggett, Vistus Balch, Fred Bissell, Ebenezer F. Reed and Lewis Fairchild, wood engravers, and William Phelps, a plate printer. Died Feb. 25, 1866 in Toledo, OH.

REED, DOEL.
Painter and printmaker. Born in Logansport, Indiana, May 21, 1895. Pupil of Cincinnati Art Academy, with Meakin, Hopkins, and Wessel. Member: Cincinnati MacDowell Society; Cincinnati Art Club; Indiana Art Club; Brown Co. Group of Artists; Hoosier Salon; Society of Independent Artists; Oklahoma Art Association; National Academy of Design; Allied Artists of America; Audubon Artists; Society of American Graphic Artists; National Society of Painters in Casein. Work: "Along the Ohio," Cincinnati Art Club; "Muted Strings," A. and M. College Library, Stillwater, OK; "On the Banks of the Loing" and "Along the Cimarron," Oklahoma Art League; Metropolitan Museum of Art; Pennsylvania Academy of Fine Arts; Victoria and Albert Museum, London; others. Exhibited: National Academy of Design; Allied Artists of America; Audubon Artists; Society of American Graphic Artists; National Society of Painters in Casein. Awards: Audubon Artists, 1951, 54; National Academy of Design, 1965. Professor of art, chairman of department, Oklahoma State University, 1924-59, emeritus professor, from 1959. Address in 1984, Taos, New Mexico.

REED, EARL H.
Etcher and sculptor. Born in Geneva, Illinois, July 5, 1863. Self-taught. Member: Chicago Society of Artists. Work: Toledo Museum of Art; Library of Congress, Washington, DC; Chicago Art Institute; New York Public Library; Saint Louis Art Museum; Milwaukee Art Institute. Author: *Etcher: A Practical Treatise; The Voices of the Dunes and Other Etchings; The Dune Country; Sketches in Jacobia; Sketches in Duneland; Tales of a Vanishing River;* and *The Silver Arrow.* Address in 1929, Chicago, Illinois.

REED, GRACE ADELAIDE.
Painter and teacher. Born in Boston, MA, July 14, 1874. Pupil of Woodbury, Denman Ross, Francis Hodgkins; Delecluse and Menard in Paris; Mass. Normal Art School. Member: Copley Society. Address in 1933, 91 Pinckney Street, Boston, MA.

REED, HELEN.
Sculptor and painter. She began her professional career in Boston by drawing portraits in crayon. Later she went to Florence where she studied sculpture under Preston Powers, sending to America bas-reliefs in marble which have been exhibited at the Boston Art Club and in NY.

REED, LILLIAN R.
Painter and teacher. Born in Philadelphia, PA. Pupil of Lathrop and Daingerfield. Member: Plastic Club; Fellowship Penna. Academy of Fine Arts; Philadelphia Art Teachers' Association; Art Alliance of Philadelphia; College Art Association; American Federation of Arts. Award: Georgine Shillard gold medal, Plastic Club. Address in 1933, 1800 N. Park Avenue, Philadelphia, PA.

REEVS, GEORGE M.
Portrait painter. Born in Yonkers, NY, 1864. Pupil of Constant; Laurens; Gerome. Member: Salma. Club; Artists' Fund Society. Award: Portrait prize, Salma. Club, 1906. Address in 1929, 35 West 14th Street, New York, NY.

REGESTER, CHARLOTTE.
Painter, craftsman, and teacher. Born in 1883 in Baltimore, MD. Pupil of Rose Clark; Urquhart Wilcox; Maude Robinson; Attilio Piccirilli; W. M. Chase; Robert Henri; Buffalo Art Students League; NY Art Students League; Albright Art School; Columbia University; Greenwich House. Member: National Association of Women Artists; Buffalo Society of Artists; Pen and Brush Club; Catherine L. Wolfe Art Club; NY Ceramic Society. Awards: Portrait prize, Catherine L. Wolfe Club, 1929; Pen and Brush Club, 1939. Has held positions at the Todhunter School, NY; Dalton School, New York; Westchester Workshop of Arts and Crafts, White Plains, NY; City College of NY; Studio Workshop for Painting and Ceramics, Rockport, MA. Died in 1964. Address in 1953, Rockport, MA.

REHBERGER, GUSTAV.
Illustrator. Born in Riedlingsdorf, Austria, in 1910. He came to the U.S. at age 13 and attended the Art Institute of Chicago and the Art Instruction School in Minneapolis, as a scholarship student. In 1949 he was awarded the Most Creative Painting from the Audubon Artists, and in 1966 he received the Stern Award. He has done a number of movie posters, such as "The Command," "Moby Dick," "Defiant Ones," and "Animal World." He currently teaches and lectures at the Art Students League in figure drawing, composition, and painting.

REIBEL, BERTRAM.
Sculptor and wood engraver. Born in New York, NY, June 14, 1901. Studied: Art Institute of Chicago; and with Alexander Archipenko. Member: Artists Equity Assoc.; Am.-Jewish Art Club. Exhibited: National Academy of Design; International Print Makers; Penna. Academy of Fine Arts; Metropolitan Museum of Art; Cincinnati Museum Association; Oakland Art Gallery; Northwest Print Makers; Art Institute of Chicago; Kansas City Art Institute; Detroit Institute of Art; Southern Print Makers; Buffalo Print Club; Denver Art Museum; Phila. Print Club; San Francisco Museum of Art; Library of Congress. Address in 1982, Chappaqua, NY.

REIBER, R(ICHARD) H.
Sculptor, painter, etcher, designer, lecturer and teacher. Born in Crafton, PA, October 2, 1912. Studied: Cornell University; and with Kenneth Washburn, Olaf Brauner, Walter Stone. Member: Pittsburgh Art Assoc.; Pittsburgh Architectural Club; Pittsburgh Print Club. Lectures: "Process of Etching." Address in 1953, 434 Fifth Avenue; h. 5516 Woodmont Street, Pittsburgh, PA.

REICH, JACQUES.
Painter and etcher. Born in Hungary, Aug. 10, 1852. Studied art in Budapest; came to U.S., 1873; continued studies at National Academy of Design, NY; Penna. Academy of Fine Arts, Philadelphia; and in Paris. Located in NY in 1885. Made most of pen portraits for Scribner's *Cyclopaedia of Painters and Paintings*, and for Appleton's *Cyclopaedia of American Biography*. He etched on copper a series of portraits of American and English authors; engaged in etching and publishing a series of etched portraits of famous Americans, inc. Washington, Jefferson, Alexander Hamilton, Benjamin Franklin, Daniel Webster, Abraham Lincoln, Roosevelt, Cleveland, McKinley, Paul Jones, Andrew Carnegie, George William Curtis, Andrew Jackson, U. S. Grant, James Madison, John Marshall, President Taft, Gen. Robert E. Lee, Dr. Andrew D. White, James Abbott McNeill Whistler, Woodrow Wilson, etc.; among many private plates etched are portraits of Whitelaw Reid, E. H. Harriman, H. H. Rogers, John W. Mackay, Gov. Winthrop, Mark Hanna, Charles B. Alexander, Nelson Wilmarth Aldrich and Gen. Thomas Hamlin Hubbard. Died July 8, 1923 in Dumraven, NY.

REICH, JOHN.
Engraver. Born in 1768 in Bavaria, Germany. In 1806 John Reich was a die-sinker of considerable merit, and he was frequently employed by Robert Scot, engraver of the US Mint in Philadelphia, to prepare the dies for national coin. He engraved the dies for several fine medals, including Washington, after Stuart; Franklin, from the Houdon bust; a Peace medal of 1783, and a Tripoli medal presented to Com. Edward Preble in 1806. John Reich was one of the founders of the Society of Artists, organized in Philadelphia in 1810, and is entered on the list of Fellows of the Society as "die-sinker at the United States Mint." Died in 1833 in Albany, NY.

REICHE, F.
This German engraver was executing crude line work in Philadelphia in 1795. He was engraving portraits on wood in 1800.

REICHMANN, JOSEPHINE (MRS.).
Painter. Born in Louisville, KY, March 24, 1864. Pupil of Art Institute of Chicago; Art Students League of NY. Member: Chicago Society of Artists; Chicago Art Club; Cordon Club; North Shore Arts Association; National Association of Women Painters and Sculptors; Southern States Art League. Died in 1939. Address in 1929, 7136 Crandon Avenue, Chicago, IL.

REID, ALBERT TURNER.
Illustrator. Born in Concordia, KS, Aug. 12, 1873. Pupil of NY School of Art and Art Students League of NY. Member: Artists Guild of the Authors' League of America; Society of Illustrators. Work in newspapers, magazines and books. Owner of The Albert T. Reid Syndicate. Died in 1955. Address in 1929, Forest Hills, L.I., NY.

REID, AURELIA WHEELER.
Painter and writer. Born in Beekman, Dutchess Co., NY. Pupil of Delecluse Academy in Paris; Cooper Union, NY School of Art; Otis Art Institute of Los Angeles. Member: California Miniature Society. Address in 1933, 252 West 11th Street, San Pedro, CA.

REID, JEAN ARNOT.
Miniature painter. Born in Brooklyn, NY, July 22, 1882. Pupil of Robert Brandegee; American School of Miniature Painting; Art Students League of NY. Member: National Association of Women Painters and Sculptors; American Society of Miniature Painters; Yonkers Art Association. Address in 1929, care of Bankers' Trust Co., 57th Street and Madison Ave., New York, New York; h. 955 Lexington Avenue, New York, New York; summer, Struan Farms, Monterey, Massachusetts.

REID, MARIE CHRISTINE WESTFELDT.
Painter and teacher. Born in New York City. Pupil of J. Alden Weir; Douglas Volk; G. Wharton Edwards; F. Edwin Elwell. Member: National Association of Women Painters and Sculptors; College Art Association; Salons of America. Address in 1929, Box 7, South Bristol, ME.

REID, OLIVER RICHARD.
Painter and teacher. Born in Eaton, GA, Feb. 27, 1898. Pupil of Daniel Garber. Member: Salons of America. Award: Honorable mention, Harmon Foundation, NY, 1928. Work: "Portrait of Dr. Henry Goddard Leach," New York Public Library. Address in 1933, 169 St. Nicholas Avenue, New York, NY.

REID, PEGGY.
Sculptor and painter. Born in Liverpool, England, June 7, 1910. Pupil of Robert J. Kuhn. Address in 1933, Westford, NY; Skowhegan, ME.

REID, ROBERT.
Painter. Born in Stockbridge, MA, in 1862. Studied at Museum of Fine Arts, Boston, 1880 (for 3 yrs. was assistant instructor in same); Art Students League, NY, 1885-89; Academie Julian, under Boulanger and Lefebvre. Exhibited annually in the Salon, and in the Paris Exposition, 1889; returned to NY, 1889; he was one of the NY artists who painted frescoes of the domes of the Liberal Arts Building, Chicago Exposition; formerly instructor in painting, Art Students League and Cooper Institute. Awarded Clarke prize, 1897; 1st Hallgarten prize, 1898, National Academy of Design; gold and silver medals, Paris Exposition, 1900. He painted mural decorations for many public and private buildings, including the Library of Congress, Washington, DC; Appellate Court House, NY; Massachusetts State House, Boston; Paulist Fathers Church, NY; Fine Arts Palace, San Francisco. Represented in Metropolitan Museum of Art; Corcoran Gallery; and National Gallery of Art, Washington, D.C.; museums of Minnesota, Omaha, Cincinnati, Indianapolis, Brooklyn; Albright Gallery, Buffalo; Nebraska Art Association, Lincoln, NE; Art Assoc., Richmond, IN; etc. Elected to National Academy, 1906; member of National Institute of Arts and Letters, and "Ten American Painters." Address in 1926, Colorado Springs, CO. Died in 1929.

REIFFEL, CHARLES.
Landscape painter. Born in 1862 in Indianapolis, IN. Self-taught. Member: Allied Artists of America; Contemporary Group; International Society of Arts and Letters; Connecticut Society of Artists; Salma. Club; Connecticut Academy of Fine Arts; Buffalo Society of Artists; Silvermine Guild of Artists; Washington Art Club; North Shore Arts Association; Hoosier Salon; Chicago Galleries Association; San Diego Artists Guild; California Art Club; Laguna Beach Art Association. Awards: Fellowship prize, Buffalo Society of Artists, 1908; Harris silver medal, Art Institute of Chicago, 1917; hon. mention, Conn. Academy of Fine Arts, 1920; hon. mention, International Expo., Pittsburgh, 1922; Hannah prize, Indiana Hoosier Salon, Chicago, 1925; Butler prize, Hoosier Salon, Chicago, 1926; Harrison prize, Los Angeles Museum, 1926; Art Guild prize, San Diego Fine Art Gallery, 1926; Tri Kappa Sorority prize, Hoosier Salon, 1927; Fine Arts Gallery purchase prize, San Diego, 1927; John C. Shaffer grand prize, Hoosier Salon, Chicago, 1928; Hatfield gold medal, California Art Club, 1928; third prize Sacramento, CA, 1928; second landscape prize, Phoenix, AZ, 1928; Mrs. Kieth-Spalding prize, Los Angeles Museum, 1929; grand prize, State Exhibition, Santa Cruz, CA,

1929; Independent Art Association prize, John Herron Art Institute, 1929; Folke prize, Richmond (IN) Art Association, 1930; first landscape prize, Sacramento, CA, 1930; Butler Memorial prize, Hoosier Salon, 1931; prize, 13th annual Los Angeles Exhibition, 1932. Work: "Railway Yards - Winter Evening," Corcoran Gallery, Washington; "In the San Filepe Valley," San Diego Fine Art Gallery; "In Banner Valley," Santa Cruz (CA) Art League; "Cuyamaca," Municipal Gallery, Phoenix, AZ. Died in 1942. Address in 1933, PO Box 412, East San Diego, CA.

REINA, SALVATORE.
Sculptor. Born in Santo Stefano, Girgenti, Italy, April 8, 1896. Pupil of Beaux-Arts Institute of Design, NY. Work: "Memory," Lake View Cemetery, East Hampton, CT; "Crucifix," Gate of Heavenly Rest Cemetery, NY. Member: Salons of America. Address in 1933, 128 East 23rd Street, New York, NY; h. South Beach, Staten Island, NY.

REINAGLE, HUGH.
Landscape, genre, and scene-painter. He was the son of Frank Reinagle, the lessee of the Chestnut St. Theater, Philadelphia. He was born in Philadelphia before 1790. Reinagle studied scene-painting with John J. Holland; he also painted landscapes, among which are "A View of the City of NY," "Niagara Falls," and several views on the Hudson River, NY. He worked in both water colors and oils. Died May 23, 1834, in New Orleans, LA.

REINDEL, EDNA.
Sculptor. Born in Detroit, MI, in 1900. Studied: Pratt Institute Art School. Awards: Art Directors' Club, 1935; fellowship, Tiffany Foundation, 1926, 1932; Beverly Hills Art Festival, 1939. Collections: Metropolitan Museum of Art; Dallas Museum of Fine Arts; Whitney Museum of American Art; Ball State Teachers College; Canajoharie Art Gallery; *Life* magazine collection; New Britain Art Institute; Labor Building, Washington, DC; Fairfield Court, Stamford, CT; Governor's House, St. Croix, Virgin Islands; U.S. Post Office, Swainsboro, Georgia. Address in 1953, Santa Monica, CA.

REINDEL, WILLIAM GEORGE.
Painter and etcher. Born in Fraser, Macomb Co., MI, June 25, 1871. Studied in America and Europe; largely self-taught. Member: Cleveland Society of Artists; Chicago Society of Illustrators. Represented in NY Public Library; British Museum; Victoria and Albert Museum; Metropolitan Museum; Cleveland Museum; Butler Art Institute, Youngstown, OH. Died in 1948. Address in 1933, Euclid, OH.

REINHARD, SIEGBERT.
Illustrator. Born in Germany in 1941. Began his career in 1959 and two years later came to the U.S.

He has had his illustrations published in *Oui* magazine, as well as accepted in several Society of Illustrators Annual Exhibitions. Known for his incredibly intricate paper sculptures, he has utilized this skill in the design of many sets for television productions. He is presently working in Los Angeles, CA.

REINHART, BENJAMIN FRANKLIN.
Painter. Born in Pennsylvania, Aug. 29, 1829. He studied in the National Academy, NY. He was elected an Associate in 1871. Among his works, many of which have been engraved, are "Cleopatra," "Evangeline," "Young Franklin and Sir William Keith," and "Washington Receiving the News of Arnold's Treason." He died May 3, 1885 in Phila., PA.

REINHART, CHARLES STANLEY.
Painter. Born in Pittsburgh, PA, in 1844; died in 1896. Genre painter and illustrator. Employed by Harper and Brothers. Studied in Paris, and at the Royal Academy, Munich, under Professors Streyhuber and Otto. Awards: Second medal, Paris Exposition, 1889; Temple gold medal, Penna. Academy of Fine Arts, 1888. Member of Art Clubs in Munich, Pittsburgh, and NY; NY Etching Club. Represented at Corcoran Art Gallery, Washington, DC.

REINHART, STEWART.
Sculptor, painter, and etcher. Born in Baltimore, MD, in 1897. Pupil of Edward Berge and Maxwell Miller. Address in 1926, 45 Washington Square, New York, NY.

REINHART, WILLIAM HENRY.
See Rinehart, William Henry.

REISNER, IRMA VICTORIA.
(Mrs. Ferdinand Betzlmann). Portrait painter. Born in Budapest, Hungary, Dec. 24, 1889. Pupil of Max Klinger; Audubon Tyler. Member: North Shore Art League; Chicago No-Jury Society of Artists; All-Illinois Society of Fine Arts; American Artists Professional League; American Federation of Arts. Address in 1933, "Casa del Sol," Hibbard Road N. of Lake Avenue, Wilmette, IL.

REISS, FRITZ WINOLD.
Painter, int. architect, and teacher. Born Germany. Pupil of Franz Von Stuck; Royal Academy, Munich. Member: Architectural League of NY; American Union of Decorative Artists and Craftsmen. Work: Apollo's Theatre, South Sea Island Ballroom of Hotel Sherman, Chicago; Restaurants Crillon, Elysee, Robert, Bonaparte, Rumpelmeyer, Caprice, New York City; Tavern Club, Chicago; Hotel St. George, Brooklyn, NY; mosaic murals, Cincinnati Union Terminal. Special work: Collection portraits of eighty-one Indians for Great Northern R. R.,

exhibited in principal art institutes and museums in U.S., also in Munich, Paris and Stockholm. Assistant professor of mural painting, New York University. Address in 1933, 108 W. 16th Street, New York, NY.

REISS, HENRIETTE.
Painter, sculptor, designer, lecturer, and teacher. Born in Liverpool, England, May 5, 1890. Studied: In Switzerland, Germany, England, and with Schildknecht in Germany. Member: Artists Equity Association. Exhibited: Metropolitan Museum of Art; Whitney Museum of American Art; Art Institute of Chicago; Boston Museum of Fine Arts; Brooklyn Museum; Cleveland Museum of Art; American Museum of Natural History; Newark Museum; Philadelphia Museum of Art; City Art Museum of St. Louis; American Federation of Arts, New York; Carnegie Institute; Dayton Art Institute; Cincinnati Museum Association; Baltimore Museum of Art; American Design Gallery; Anderson Gallery; Grand Central Palace; Rochester Memorial Art Gallery; American Women's Assoc. One-woman exhibitions: Toledo Museum of Art; Cleveland Museum of Art; University of Nebraska; University of Kentucky; Univ. of Delaware; Hackley Art Gallery; Fashion and Industrial Exhibition; many in Europe. Contributor to national magazines. Taught special classes in design for supervisors, public and high school teachers of Board of Education, New York, NY; instructor, Fashion Institute of Technology, Textile Design Department, New York, NY, 1953. Address in 1953, 10 Fifth Avenue, New York, NY.

REISS, LIONEL S.
Painter, illustrator, etcher, writer, and lecturer. Born in Austria, Jan. 29, 1894. Studied in NY, Paris and Berlin. Member: Society of Independent Artists. Illustrated *Ethnic Studies of Jewish Types, The Forum.* Lecturer on "The Jew in Art." Address in 1929, 55th St., NY, NY; summer, Provincetown, MA.

REISS, ROLAND.
Sculptor. Born in Chicago, IL, in 1929. Went to California in 1941. Studied at Univ. of California at Los Angeles. Taught at University of Colorado, 1957-71; Claremont (CA) Graduate School, from 1971. Exhibited at Los Angeles Co. Museum of Art; Ace Gallery, Venice, California; Whitney, NYC; San Francisco Museum of Modern Art; Fort Worth (TX) Art Museum; Hirshhorn Museum and Sculpture Garden, Washington, DC; Documenta VII, Kassel, Germany; Los Angeles Institute of Contemporary Art; others.

REITER, FREDA LEIBOVITZ.
Painter and graphic artist. Born in Philadelphia, PA, September 21, 1919. Studied: Moore Institute of Design; Penna. Academy of Fine Arts; Barnes Foundation; Graphic Sketch Club; San Carlos Academy, Mexico. Award: Graphic Sketch Club,

1938, 40. Work: Library of Congress; Carnegie Institute; Philadelphia *Inquirer* newspaper. One-woman exhibitions: Carlin Galleries; Philadelphia Print Club; Warwick Galleries; 20th Century Club; others. Group exhibitions: Metropolitan Museum of Art; Carnegie Mus.; National Academy of Design; Pittsburgh Academy of Fine Arts. Member: Artists Equity; National Women Artists. Address in 1962, Haddonfield, NJ.

REITZEL, MARQUES E.
Painter, etcher, lecturer, and teacher. Born in Fulton, IN, March 13, 1896. Pupil of Seyffert; J. A. St. John; Kroll; Norton; Carl Buehr; Foster. Member: Chicago Society of Artists; Painters and Sculptors of Chicago; Chicago Galleries Association; Hoosier Salon; College Art Association; American Artists Professional League; American College Society of Print Collectors; Cliff Dwellers. Awards: Butler purchase prize, Art Institute of Chicago, 1927 and 1928; Logan prize and medal, Art Institute of Chicago, 1927; Muncie Star prize, Hoosier Salon, 1929. Work: "Queen Anne's Lace," Chicago Municpl. Collection for public schools; "Morning Route," "His First Circus," Chicago Public Schools Art Society; "Six o'Clock," Hobart (IN) High School, Rockford, IL; "July Afternoon," Rockford College; "The Last Cover," Dakota Boys Sch., Dakota, IL; "Swimmers," Rockford Public Schools Collection. Professor of Fine Arts, Rockford College. Director, Rockford Art Museum. Address in 1933, Rockford College, Rockford, IL.

RELYEA, CHARLES M.
Illustrator and painter. Born in Albany, NY, April 23, 1863. Pupil of Penna. Academy of Fine Arts under Thomas Eakins; F. V. Du Mond in NY and Paris. Member: Salma. Club; Allied Artists of America; Art Alliance of America; Players' Club; Artists Guild of the Authors' League of America; Fellowship Penna. Academy of Fine Arts. Address in 1929, 15708 Quince Avenue, Flushing, Long Island, NY.

REMBSKI, STANISLAV.
Painter. Born in Sochaczew, Poland, Oct. 8, 1896. Member: Brooklyn Society of Artists. Work: "Nude," Newark Museum, Newark, NJ; "Portrait of Father James O. S. Huntington," Kent School, Kent, CT; "Portrait of Emanuel Swedenborg," Church of the Neighbor, Brooklyn, New York; "Portrait of Sister Catherine," St. John's Hosp.; "Portrait of Professor Brace Chittenden," Brooklyn Polytechnic Institute, Brooklyn, NY; mural, St. Bernard of Clairvaux, St. Bernard's School, Gladstone, NJ; "Portrait of Dr. Frank D. Blodgett," Adelphi College, Garden City, L.I.; "Portrait of Professor Adelaide Nutting," Columbia University, New York, NY. Address in 1933, Carnegie Hall, New York, NY; summer, Deer Isle, ME.

REMICK, CHRISTIAN.
Painter. Born on April 8, 1726 in Eastham, MA. An early Boston artist who painted views of Boston Harbor and of the Boston Commons at the time of the Revolution.

REMINGTON, DEBORAH WILLIAMS.
Painter. Born in Haddonfield, NJ, June 25, 1935. Studied: San Francisco Art Institute, B.F.A., 1957; also in Asia, 1957-59. Exhibited: Bykert Gallery, NY, 1967, 69, 72, 74, Hamilton Gallery, NY, 1977, Portland Center for the Visual Arts, OR, 1977 (all one-woman); Whitney, 1972; 71st Am. Exhibition, Art Institute of Chicago, 1974; Inst. of Contemporary Art, Boston, 1975; retrospective, Oakland Museum of Art, California, 1984; others. Work: National Museum of American Art; Whitney; Art Institute of Chicago; others. Awards: Fellowship, Tamarind Institute, Albuquerque, 1973; National Endowment Fellowship, 1979-80. Media: Oil; lithography. Address in 1984, 309 W. Broadway, New York, NY.

REMINGTON, FREDERIC SACKRIDER.
Sculptor, painter, etcher, and illustrator. Born in Canton, NY, Oct. 4, 1861. Studied one year at Yale Art School, under John Henry Niemeyer, 1871, and later at the Art Students League, but otherwise was self-taught. Owing to ill health he went West and, after clerking in a general store, became a cowboy and later a stockman on a ranch. From the knowledge he gained in these connections and from his own experiences sprang the inspiration for his remarkably vivid and faithful portrayal of life on the Western plains and in the mining camps, for which he became so justly renowned. He came back East in 1886 and settled in New Rochelle, NY, and for some years Remington occupied a large studio there. In 1888, *The Century* published his illustrated edition of *Teddy Roosevelt's Ranch Life and the Hunting Trail*. Studied at the Art Students League, but after a cool reception of his oil paintings in 1892, stopped painting for about ten years and toured Russia, Germany and North Africa with Poultney Bigelow. In 1897, 98 he travelled with Roosevelt's Roughriders to Cuba as artist-correspondent and sketched incidents of the Spanish-American War. He turned to modeling when he stopped painting. Remington moved to Ridgefield, CT, about six months before his death, on December 26, 1909. His first commission, executed in the early eighties, was an Indian picture based on "Geronimo's Campaign." He produced a large number of oil paintings, about fifteen bronzes, and was the author of several books. He received a silver medal for sculpture at the Paris Expo. in 1889; he was an associate of the National Academy of Design, and a member of the National Institute of Arts and Letters. Works: Amon Carter Museum, TX; Whitney Gallery of Western Art; Metropolitan Museum of Art; Institute of Albany; Museum of St. Louis; Brookgreen Gardens, SC; Amherst College;

Philbrook Art Museum, Tulsa, OK; Fairmount Park, Philadelphia; Museum of Arts, Toledo; National Gallery, Washington, DC; Corcoran Gallery; Remington Art Memorial, Ogdensburg, NY.

REMSEN, HELEN Q.
Sculptor. Born in Algona, IA, March 9, 1897. Studied: University of Iowa; Northwestern Univ.; Grand Central School of Art; also studied with Georg Lober and John Hovannes. Awards: Society of Four Arts, Palm Beach, Florida, 1942; Norton Gallery of Art, 1944; Dallas Museum of Fine Arts, 1944; Florida Federation of Artists, 1941, 42, 44; National Sculpture Exhibition, Sarasota, 1953; Smithsonian Institution, 1954; New Orleans Art Association, 1955, 57; National Sculpture Soc., 1961. Work: Fountains, Jungle Gardens, Sarasota; St. Boniface Church, Sarasota; Three Marys (marble), Grace and Holy Trinity Cathedral, Kansas City, MO; memorial sculpture, Algona (IA) Public Library; and others. Exhibited: National Academy of Design; Penna. Academy of Fine Arts; Society of Four Arts; Norton Gallery of Art; Allied Artists of America; Florida Federation of Artists; New Orleans Art Association; Silvermine Guild of Artists; National Sculpture Society; Sarasota Art Association; others. Instructor in sculpture, Sarasota, FL, for 25 years. Address in 1970, Sarasota, FL.

REMUS, PETER.
Sculptor. Born in France in 1824. Living in Pittsburgh, PA, in Sept. 1850.

RENAUD, PHIL.
Illustrator. Born Edmonton, Can., 1934. He studied first at the Chicago Academy of Fine Arts and then, after a brief stint in a Chicago studio, attended the Art Center College of Design, studying under John LaGatta and Eugene Edwards. Returning to Chicago, he received many assignments from book publishers such as Scott, Foresman Co., Harper & Row, and Rand McNally. *Playboy, Atlanta,* and *Chicago* have featured his editorial work. Recently he has been concentrating on fine art painting.

RENAULT, JOHN FRANCIS.
Allegorical and historical painter. His "Triumph of Liberty" was advertised in NYC in 1795 by D. F. Launy, and again in 1797 by Verger and Renault. In 1819 he published an engraving of the British officers surrendering their arms to Washington at Yorktown. The "Surrender of Cornwallis," engraved by Tanner, Vallance, Kearny & Co., after a drawing by J. F. Renault, published in 1824, was sold to subscribers. It might be interesting to note that the original painting of the "Surrender of Cornwallis" by J. F. Renault was exhibited by him throughout the United States previous to 1824. In a prospectus published by Benjamin Tanner in the *New England Palladium & Commercial Advertiser* for Feb. 10,

1824, we are told that "The Engraving is executed by Tanner, Vallance, Kearney & Co. from an Original Drawing by J. F. Renault."

RENCH, POLLY MARY.
Miniature painter. Working in Philadelphia before the Revolution, according to Charles Willson Peale, who instructed her in painting. Also mentioned in a letter from C. W. Peale to his son Rembrant in 1812 (published in Sartain's *Reminiscences*). She married William Rush, modeler and carver.

RENEZETTI, AURELIUS.
Sculptor. Executed a portrait bust of the late N. W. Ayer. Address in 1926, Philadelphia, PA.

RENIER, JOSEPH EMILE.
Sculptor. Born on August 19, 1887. Studied at Art Students League under George Bridgman, Kenyon Cox and Herman A. MacNeil; Ecole de la Grande Chaumiere and Academie Colarossi in Paris; American Academy in Rome; also with Victor Rousseau and Adolf Weinman. Work: Decorative panels, home of Seward Johnson, Esq., New Brunswick, NJ; "Boy with Snails," Brookgreen Gardens, SC; Great Star of Texas, State of Texas Building, Dallas, TX; statue, "Speed," New York World's Fair, 1939; Mattituck Museum, Waterbury, CT; medal for Medallic Art Society; triptych, Citizens' Commission for the Army and Navy, 1945; bronze war memorial plaque, Ozone Park, NY, 1947; Ross Memorial medal, for American Tuberculosis Association, 1952; panels for the main entrance of the Domestic Relations Court, Brooklyn, NY; others. Had exhibited at Penna. Academy of Fine Arts; Mattituck Museum, Waterbury, CT; National Arts Club, NY; New Haven Paint and Clay Club. Member: Fellow, National Sculpture Society; Architectural League; Fellow, American Academy in Rome; National Arts Club. Award: Prix de Rome, 1915; prize, Garden Club of America, 1928, 29; received medals from the NY State Chapter of American Artists Professional League, 1959; National Arts Club, 1960; National Academy, Samuel F. B. Morse Award, 1962, Elizabeth N. Watrous Award, 1965, and the Daniel Chester French Award, 1966. Taught: Associate Professor, Life Drawing, Yale University, 1927-41. Address in 1953, NYC. Died October 8, 1966, in New York City.

RENIERS, PETER.
Sculptor. Executed small bust of Elisha Kent Kane (1820-1857). Piece is signed and dated Phila., 1857.

RENWICK, HOWARD CROSBY.
Painter. Member: Allied Artists of America. Address in 1929, 33 West 67th Street, New York, NY.

RESLER, GEORGE EARL.
Etcher. Born in Waseca, MN, Nov. 12, 1882. Member: Chicago Society of Etchers. Awards: First prizes, 1913 and 1923, and second prize, 1914, MN. Art Commission; bronze medal for etching, St. Paul Institute, 1918. Represented in the print collections of the Chicago Art Institute; Smithsonian Institution, Washington, DC; Municipal Art Gallery, Tampa; St. Paul Institute. Address in 1929, 45 W. 4th Street; h. 2136 Lincoln Avenue, St. Paul, MN.

RETTIG, JOHN.
Painter. Born in 1860 in Cincinnati, OH. Pupil of Cincinnati Art School, Duveneck and Potthast; Collin, Courtois and Prinet in Paris. Member: Salma. Club; Cincinnati Art Club (hon.); Amer. Federation of Arts. Died in 1932. Address in 1929, 2227 Kemper Lane, Walnut Hills, Cincinnati, OH.

RETTIG, MARTIN.
Painter. Born in Cincinnati, OH. Pupil of Frank Duveneck. Member: Cincinnati Art Club. Address in 1929, 127 East 3rd Street; h. 110 Findlay Street, Cincinnati, OH.

REUTERDAHL, HENRY.
Naval painter. Born in Malmo, Sweden, in 1871. Served as correspondent during Spanish-American War, and also during the first part of the European War, 1914. Contributor to leading magazines. He was attached to the battleship *Minnesota* during the fleet's cruise around South America, and during the cruise to the Mediterranean, 1913. He was present during the Vera Cruz campaign, 1914. Represented in permanent collection at the United States Naval Academy by paintings of this cruise, presented to the Navy by George Von L. Meyer, Secretary of Navy; also in the National Museum, Washington, DC; Naval War Collection, Newport; Toledo Museum. Awarded a silver medal for painting, Panama-Pacific Expo., 1915. Painted panels for steam yachts *Noma*, Vincent Astor, owner; *Viking*, G. F. Baker, Jr., owner; for schooner *Vagrant*, Harold S. Vanderbilt, owner. Formerly instructor of Art Students League. Member: Architectural League; Artists' Fund Society of NY; associate member of U.S. Naval Institute; Society of Naval Architects and Marine Engravers. Club: New York Yacht. Address in 1925, 800 Boulevard, Weehawken, NJ. Died Dec. 20, 1925 in Washington, DC.

REVERE, PAUL.
Engraver. Born Jan. 1, 1735 in Boston, MA. The father of Paul Revere came from the Island of Guernsey and established himself in Boston as a goldsmith. In this business the son was trained in Boston, and he there learned to engrave upon silverplate. Aside from some possible book-plates, his best known engraved plates may be noted as follows: "Portrait of Jonathan Mahew," "The Repeal of the Stamp Act" (1766); the caricature of the seventeen Rescinders; "The Landing of the British Troops" (1768); also his famous "Boston Massacre" of 1770.

For the *Royal American Magazine* of 1774-75, Revere engraved a number of plates. His work is exceedingly crude in execution and is only valuable for its historical interest. See "Paul Revere and His Engraving," by William Loring Andrews. Died May 10, 1818 in Boston, MA.

REVEREND, T. OR J.
Sculptor. Born in Philadelphia, PA. Exhibited at the Penna. Academy in 1859.

REYNARD, CAROLYN COLE.
Painter and instructor. Born in Wichita, KS on Aug. 6, 1934. Award: Nine awards in state, local, and regional exhibitions. Collections: Wichita State University Gallery. Address in 1980, 110 College Ave., Poughkeepsie, NY.

REYNARD, GRANT TYSON.
Painter, illustrator, and etcher. Born in Grand Island, NE, Oct. 20, 1887. Pupil of Art Institute of Chicago; Chicago Academy of Fine Arts; C. S. Chapman; and Harvey Dunn. Member: Salma. Club; Society of Illustrators. Died in 1967. Address in 1929, 312 Christie Hgts., Leonia, NJ.

REYNERSON, JUNE.
Sculptor, painter, and craftsman. Born in Mound City, KS, February 21, 1891. Pupil of Pratt Institute and Columbia University. Member: Western Art Association; Pen and Brush Club; Hoosier Salon; Art Section, Women's Department Club, Terre Haute. IN. Position: Professor Emeritus of Art, Indiana State Teachers College, Terre Haute, IN. Address in 1953, Terre Haute, IN.

REYNOLDS, FREDERICK THOMAS.
Etcher and mezzotint engraver. Born in London, Feb. 19, 1882. Studied in London. Settled in NYC. Member: Brooklyn Society of Etchers; Salma. Club. Address in 1929, 17 East 14th Street; h. 602 West 157th Street, New York, NY. (Bibliography: *Frederick Reynolds, An Amer. Master of Mezzotint*, by W. H. Nelson; Vol. I, *The Print Connoisseur*.)

REYNOLDS, HARRY REUBEN.
Painter, craftsman, lecturer, and teacher. Born in Centerburg, OH, Jan. 29, 1898. Pupil of Art Institute of Chicago; Lee Randolph; Birger Sandzen. Member: Oakland Art League; Alumni Art Institute of Chicago; Delta Phi Delta. Award: Harper Brothers gold medal, Art Institute of Chicago, 1923. Address in 1933, Utah Agricultural College, Logan, UT.

REYNOLDS, THOMAS.
In the *New York Daily Advertiser*, 1786, Thomas Reynolds advertises that he has established a "seal manufactory in Philadelphia; where he engraves on stone arms, descents, etc.; and he likewise cuts on brass all sorts of state and public seals."

REYNOLDS, WELLINGTON JARARD.
Portrait painter and teacher. Born in Chicago, IL, April 9, 1866. Pupil of Laurens and Constant in Paris; Royal Academy in Munich. Member: Chicago Soc. of Artists; Cliff Dwellers; Chicago Galleries Assoc. Awards: Medal, Marshall Field Ex., 1908; medal of honor, Chicago Society of Artists, 1910; composition prize, Art Institute of Chicago, 1920, and Norman W. Harris medal, 1921; second prize, Paris Salon, 1925; bronze medal, Sesqui-Centennial Expo., Philadelphia, 1926. Work: Portrait of Mr. Hitchcock, University of Chicago; "The Coquette," Golden Gate Park Museum, San Francisco; "A Votre Sante," Piedmont Gallery, Oakland, CA; "Les Miserables," Springfield (IL) State Mus.; "Portrait Decorative," City Museum, Laurel, MI. Address in 1929, 3 E. Ontario Street, Chicago, IL.

RHEAD, LOIS WHITCOMB.
Sculptor and craftsman. Born in Chicago, IL, Jan. 16, 1897. Pupil of F. H. Rhead; L. V. Solon. Exhibited: National Association of Women Painters and Sculptors, NYC, 1924. Member: National Association of Women Painters and Sculptors; American Ceramic Society. Address in 1929, E. Liverpool, OH; summer, Santa Barbara, CA.

RHEAD, LOUIS JOHN.
Painter and illustrator. Born in Etruria, Staffordshire, England, November 6, 1857. Came to United States in 1883. Painter in oil and water colors, exhibiting in America and in European galleries. Pupil of Edward J. Poynter and Alphonse Legros in London. Work: Illustrations for Harper's Juvenile Classics. Awarded gold medal, Boston, 1895, for artistic posters; hon. mention, Pan.-Am. Expo., 1901; gold medal, St. Louis Exposition, 1904. Member: NY Architectural League, 1902; NY Water Color Club. Address in 1926, "Seven Oaks," Amityville, NY. Died there July 29, 1926.

RHETT, ANTOINETTE FRANCESCA.
Painter and etcher. Born in Baltimore, MD, Oct. 7, 1884. Pupil of Alfred Hutty. Member: Charleston Etching Club; Artists of Charleston (associate); Southern States Art League. Address in 1929, 9 Logan Street, Charleston, SC.

RHETT, HANNAH McCORD.
Painter and teacher. Born in Columbia, SC, Feb. 28, 1871. Pupil of Art Students League in NY; Collin and Laurens in Paris. Member: Art Students League of NY; Carolina Art Association (associate); Society of Independent Artists. Awards: Bronze and silver medals, American Art Society. Address in 1929, Brevard, N.C.

RHIND, JOHN MASSEY.
Sculptor. Born in Edinburgh, Scotland, July 9, 1860. Pupil of his father, John Rhind, R.S.A.; Dalou in

Paris. Came to U.S. in 1889. Member: National Sculpture Society, 1893; NY Architectural League, 1894; NY Municipal Art Society; National Arts Club; Salma. Club; Allied Artists of America; Brooklyn Society of Artists. Awards: Scholarship, $2,000, Scottish Academy; nat. scholarship, So. Kensington, London; gold medal, St. Louis Expo., 1904. Work: Astor door, Trinity Church, NY; equestrian, "George Washington," Newark, New Jersey; "Stephen Girard," Phila., PA; "Peter Stuyvesant," Jersey City; "Robert Burns," Pittsburgh; McKinley Mem., Niles, OH; "Apollo," "Minerva," "J. G. Butler, Jr.," "Wisdom," "Authority," Butler Art Institute, Youngstown, OH; numerous decorations for federal and municipal buildings. Address in 1933, 208 East 20th St.; h. 34 Gramercy Park, NYC. Died in 1936.

RHODEN, JOHN W.
Sculptor. Born in Birmingham, AL, in 1918. Studied under Hugo Robus, William Zorach, and Oronzio Maldarelli at Columbia University Sch. of Painting and Sculpture; also with Richmond Barthe in 1938. Exhibited: Metropolitan Museum of Art; Penna. Academy of Fine Arts; Audubon Annuals; American Academy of Art; National Academy of Design; numerous others. Awards: Rockefeller Grant, 1959; Guggenheim Fellowship, 1961; others. Commissions: Monumental Abstraction for the Metropolitan Hosp., 1968; Monumental Bronze for Bellevue Hospital, NYC, 1975; Monumental Sculpture for the Afro-American Museum, Philadelphia, PA, 1976; and others. Address in 1982, Brooklyn, NY.

RHODES, HELEN NEILSON.
Painter and teacher. Born in Milwaukee, WI. Pupil of Arthur W. Dow. Member: Seattle Art Institute; Northwest Print Makers (president); Pacific Art Association. Awards: First prizes, 1923 and 1925, and second prize, 1924, Seattle Art Institute; first prize and gold medal, International Salon of Water Colors, Provincial Exhibition, New Westminster, B.C., 1928; second prize and silver medal, Provincial Exhibition, 1929; first prize in water colors, Northwest Artists Annual Exhibition, Seattle Art Institute, 1930, and first hon. mention, 1932; third prize, State Fair, 1932. Author of articles on university problems in design. Illustrated *Paul Bunyan Comes West* (Houghton Mifflin Co.), 1928. Died in 1938. Address in 1933, Fine Arts Dept., University of Washington; h. Malloy Apts., Seattle, WA.

RIBCOWSKY, DEY DE.
Marine painter. Born in Bulgaria in 1880. Studied in Paris. Address in 1935, Los Angeles, CA.

RICCI, ULYSSES ANTHONY.
Sculptor. Born in NYC, May 2, 1888. Studied: Art Students League; also with James Earle Fraser. Work: Medals, American Numismatic Society; sculpture, Plattsburgh, NY; Department of Commerce Building, Washington, DC; and others. Exhibited: Penna. Academy of Fine Arts; Metropolitan Museum of Art, 1942; and others. Member: National Sculpture Society, 1914. Address in 1953, New York, NY. Died in 1960.

RICCIARDI, CAESARE.
Painter. Born in Italy in 1892. Pupil of Academy of Fine Arts, Philadelphia. Address in 1926, Art Alliance, 1823 Walnut Street, Philadelphia, PA.

RICE, E. A.
This portrait engraver in mezzotint was working for Baltimore engravers about 1845.

RICE, JAMES R.
Engraver. Born in Syracuse, NY, in 1824. He studied engraving under his brother W. W. Rice, of Rawdon, Wright, Hatch, & Co., of NY. He moved to Phila. in 1851, and as late as 1876 was engraving portraits there in connection with J. Earle.

RICE, MARGHUERITE SMITH.
(Mrs. Fred Jonas Rice). Sculptor. Born in St. Paul, MN, June 11, 1897. Pupil of Edward Pausch. Work: Portrait bust, Bishop Charles Harry Brent, mem. in Phillipines. Member: Buffalo Society of Artists; Guild of Allied Artists; League of American Pen Women. Address in 1933, Buffalo, NY.

RICE, W. W.
Engraver of portraits and subject plates, who was a member of the firm of Rawdon, Wright, Hatch & Co., of NY in 1846. He was engraving over his own name as late as 1860.

RICE, WILLIAM CLARKE.
Sculptor and painter. Born in Brooklyn, NY, April 19, 1875. Pupil of George de Forest Brush. Graduate of NY City College, 1897. Also painted mural decorations, including those at Park Central Hotel, NYC. Taught art and design in NYC schools. Member of Architectural League; National Society of Mural Painters. Address in 1926, 145 East 23rd Street, NYC. Died in NYC, Feb. 13, 1928.

RICE, WILLIAM MORTON JACKSON.
Portrait painter. Born in Brooklyn in 1854. Studied painting in Paris under Carolus-Duran, in 1881-84. Elected an Associate of the National Academy in 1900. He died Oct. 13, 1922.

RICE, WILLIAM SELTZER.
Painter, illustrator, craftsman, writer, and teacher. Born in Manheim, PA, June 23, 1873. Pupil of Philadelphia School of Industrial Art; and of Howard Pyle at Drexel Institute, Philadelphia. Member: California Society of Etchers; California Print Makers; San Francisco Art Association; Oakland Art Association; Pacific Art Association. Work: "The

Salmon Fleet - Oakland Estuary," California State Library; "Windswept Cypress" and "Old Adobe - Monterey," California School of Arts and Crafts, Oakland; "Glacier High Sierras," Golden Gate Park Museum, San Francisco. Illustrator for *Philadelphia Times*, 1885-89; teacher of art and drawing, California Public Schools, 1900-28; head of art department, Fremont High School, Oakland, CA, 1914-29. Address in 1929, 2083 Rosedale Avenue, Oakland, CA.

RICE-MEYEROWITZ, JENNY DELONY.
Painter, illustrator, writer, lecturer, and teacher. Born in Washington, AR. Pupil of Cincinnati Art Academy; St. Louis School of Fine Arts; William M. Chase; Julian, De Launce and Delecluse Academies in Paris. Member: National Arts Club; National Association of Women Painters and Sculptors; Fine Arts Club of Arkansas (hon). Work: Portraits of "Jefferson Davis," "Gov. George W. Donaghey" and "Gov. Thomas C. McRae," Arkansas State Capitol; "Mrs. Jefferson Davis," Confederate Museum, Richmond, VA; "George G. Williams," NY Clearing House, New York City; "Dr. George T. Stewart," Metropolitan Hospital, New York City; "Rt. Rev. Bishop H. N. Pierce," Trinity Cathedral, Little Rock, AR; and other public portraits. Address in 1933, 140 West 57th Street, New York, NY.

RICH, FRANCES L.
Sculptor and draftsman. Born in Spokane, WA, on Jan. 8, 1910. Studied: Smith College; Cranbrook Academy of Art; Claremont College; Columbia University; with Malvina Hoffman, Carl Milles, Millard Sheets, and Alexander Jacovleff. Collections: Army and Navy Nurse Memorial, Arlington National Cemetery; Purdue University; Wayside Chapel of St. Francis, Grace Cathedral, San Francisco; Mt. Angel Abbey, St. Benedict, OR; Hall of Fame, Ponca City, OK; Smith College; St. Peters Church, Redwood City, CA; University of Calif., Berkeley; Madonna House, Combermere, Ontario, Canada; Carl Milles Museum Garden, Stockholm; Univ. of Oklahoma; science medal, Dr. Jonas Salk. Medium: Bronze. Address in 1980, Palm Desert, CA.

RICH, JOHN HUBBARD.
Painter. Born in Boston, MA, March 5, 1876. Pupil of Art Students League of NY; School of Boston Museum of Fine Arts. Member: California Art Club; Salma. Club. Awards: Paige traveling scholarship from School of Boston Museum of Fine Arts, 1905-07; silver medal, San Diego Expo., 1915; second prize, California Art Club, 1916; Black prize, California Art Club, 1917; Ackerman prize, California Art Club, 1919; silver medal, Panama-California Expo., San Diego, 1916; Harrison prize, Los Angeles Museum, 1922; Phoenix, AZ, 1928; Sacramento, CA, 1928; purchase prize, Santa Monica Art Association, 1932. Represented at Los Angeles Museum; Utah

Art Institute; University Club, San Diego; Pomona College; Scripps College; University of Southern California; California State Federation of Women's Clubs. Address in 1933, 2262 San Marco Drive, Hollywood, CA.

RICHARD, BETTI.
Sculptor. Born in NYC on March 16, 1916. Studied: Art Students League with Mahonri Young, Paul Manship. Awards: National Academy of Design, 1947; Pen and Brush Club, 1951; gold medal, Allied Artists of America, 1956; National Sculpture Society, 1960. Collections: Doors, Oscar Smith Mausoleum; Church of the Immaculate Conception, NY; Pieta Skouras Memorial, NY; Bellingrath Gardens, Mobile, AL; monument to race horse "Omaha" at Ak-Sar-Ben Track, Omaha; figure, Austrian Legation, Tokyo; figure, Sacred Heart Rectory, Roslindale, MA; House of Theology, Centerville, OH; statue, St. Francis of Assisi Church, New York; busts at Metropolitan Opera House, Lincoln Center, NYC. Exhibited at Allied Artists of America annuals; National Academy of Design; National Sculpture Society. Member: Nat. Sculpture Society (secretary, from 1971); Architectural League of NY; Allied Artists of America; Audubon Artists. Works in bronze, stone, and wood. Address in 1980, 131 East 66th St., NYC.

RICHARDS, DAVID.
Sculptor. Born in North Wales, 1829; came to U.S. and settled in Utica, NY. Works: "President Grant," "General Harding," "The Confederate Soldier," at Savannah, GA; "Love" and "Boy Gathering Shells." Died in Utica, NY, November 28, 1897.

RICHARDS, ELLA E.
Painter. Born in Virginia. Pupil of Lefebvre, Collin and Robert Fleury in Paris. Member: Pen and Brush Club. Specialty: Portrait and genre painting. Address in 1929, 1009 Carnegie Hall, New York, NY.

RICHARDS, FREDERICK DE BERG.
Painter and etcher. Born in 1822. Lived for years in Philadelphia. He died there in 1903.

RICHARDS, FREDERICK THOMPSON.
Painter. Born in Philadelphia, May 27, 1864. Pupil of the Penna. Academy of Fine Arts; Thomas Eakins; Edmund B. Bensell; and of the Art Students League, New York. Exhibited at the Paris Expo., 1900. On staff of *Life* since 1889, also *Collier's Weekly*; cartoonist for *New York Herald*, 1901-02, also for *New York Times*, *New York Evening Mail*, Philadelphia *Press* and the Philadelphia *North American*. Author: "The Royal Game of Gold" (series of color prints); "Color Prints from Dickens" (portfolio); and "The Blot Book." Address, 110 West 48th Street, New York, NY. Died July 8, 1921 in Philadelphia, PA.

RICHARDS, GEORGE MATHER.

Painter and illustrator. Born in Darien, CT, Sept. 3, 1880. Pupil of Douglas John Connah; Robert Henri; Edward Penfield. Member: Salma. Club; Silvermine Guild; NY Architectural League. Illustrator for *The Golden Book*, McMillan Co. Address in 1929, New Canaan, CT.

RICHARDS, GLENORA.

Miniature painter. Born in New London, OH, February 18, 1909. Studied: Cleveland School of Art. Awards: American Society of Miniature Painters, 1947; Pennsylvania Society of Miniature Painters, 1947; National Association of Women Artists, 1953; Washington Miniature Painters and Sculptors Society, 1956, 57. Collections: Philadelphia Museum of Art. Exhibitions: National Collection of Fine Arts, Smithsonian Institution; Nat. Academy of Design; Philadelphia watercolor show with Pennsylvania Society of Miniature Painters, Philadelphia Museum of Art; California Society of Miniature Painters; Royal Society of Miniature Painters; others. Member: American Society of Miniature Painters; National Association of Women Artists. Address in 1962, New Canaan, CT.

RICHARDS, HARRIET ROOSEVELT.

Painter and illustrator. Born in Hartford, CT. Pupil of Yale School of Fine Arts; Frank Benson in Boston; Howard Pyle in Wilmington, DE. Member: Paint and Clay Club of New Haven. Illustrated holiday edition of books by Louisa Alcott and W. D. Howells, etc. Died in 1932. Address in 1929, 422 Whitney Ave., New Haven, CT.

RICHARDS, JEANNE HENON.

Painter and etcher. Born in Aurora, IL, in 1923. Studied: University of Illinois; Colorado Springs Fine Arts Center; Iowa State University; also studied with Wm. S. Hayter, Mauricio Lasansky. Awards: Fulbright fellowship, 1954-55; Des Moines Art Center, 1953; University of Southern California, 1954; Bradley University, 1954; Nelson Gallery of Art, 1954. Collections: Society of American Graphic Artists; Des Moines Art Center. Address in 1980, 9526 Liptonshire, Dallas, TX.

RICHARDS, LEE GREENE.

Sculptor, painter, and illustrator. Born in Salt Lake City, July 27, 1878. Pupil of J. T. Harwood; Laurens; and Bonnat. Member: Salon d'Automne; American Art Association of Paris; Utah Society of Artists; National Arts Club. Award: Honorable mention, Paris Salon, 1904. Address in 1933, Salt Lake City, UT. Died in 1950.

RICHARDS, LUCY CURRIER.

(Mrs. F. P. Wilson). Sculptor. Born in Lawrence, MA. Pupil of Boston Museum School; Kops in Dresden; Eustritz in Berlin; Julian Academy in Paris. Member: Copley Society; Boston Guild of Artists; National Association of Women Painters and Sculptors; MacDowell Club. Address in 1933, Silvermine, Norwalk, CT.

RICHARDS, MYRA REYNOLDS.

Sculptor and painter. Born in Indianapolis, IN, Jan 31, 1882. Pupil of Herron Art Institute under Otis Adams, Rudolf Schwartz and George Julian Zolnay. Member: Hoosier Salon; Indianapolis Sculpture Society. Address in 1929, Indianapolis, IN. Died in 1934.

RICHARDS, N.

Sculptor and stone cutter. Worked in New Orleans, LA, 1841-46.

RICHARDS, OREN C.

Painter. Born in South Boston in 1842. In 1860 he studied under George Innes at Medford, MA. He painted scenery at nearly all the Boston theaters, and easel-pictures of still-life in oils.

RICHARDS, THOMAS ADDISON.

Painter. Born Dec. 3, 1820 in London, England. He came to America in 1831, his early years being passed in Georgia and the Carolinas. He painted landscapes and views of Lake George and the White Mountains. He became secretary of the National Academy of Design and had his studio in NY. He also was well known as an author and illustrator of books on art and travel. He died at Annapolis, MD, June 29, 1900.

RICHARDS, WALTER DuBOIS.

Illustrator. Born in Penfield, OH, in 1907. Studied at the Cleveland Institute of Art under Henry G. Keller, Frank Wilcox, and Carl Gaertner. In 1930 his first published illustration was done in dry brush for *Child Life* magazine. He won the highest award in lithography from the Cleveland Museum, the Lily Saportas Award from the American Water Color Society in 1962, and a Special Award from the U.S. Air Force in 1964. He has done extensive book, magazine, and poster illustrations since 1940, and his work appeared in the 200 Years of Watercolor Painting exhibition in 1966 at the Metropolitan Museum of Art.

RICHARDS, WILLIAM TROST.

Marine painter. Born in Philadelphia, PA, Nov. 14, 1833. Pupil of Paul Weber; later studied in Florence, Rome and Paris. Awards: Medal, Centennial Expo., Philadelphia, 1876; Temple medal, Pennsylvania Academy of the Fine Arts, 1885; bronze medal, Paris Expo., 1889. Member: American Water Color Society; honorary member, National Academy of Design. Represented by "On the Coast of NJ," painted to order for the Corcoran Art Gallery, 1883; also "On the Coast of New England," painted in 1894.

See "Life of William T. Richards," by Harrison S. Morris, Philadelphia, 1912. Died Nov. 8, 1905 in Newport, RI.

RICHARDSON, ANDREW.
Born 1799 in Scotland. This man is noted in Tuckerman's "Artists Life" as painting landscapes about 1860. The National Academy of Design elected Andrew Richardson a member in 1833. He died in 1876, in NYC.

RICHARDSON, CATHERINE PRIESTLY.
Painter. Born in New York City, Nov. 22, 1900. Pupil of Philip L. Hale. Member: National Association of Women Painters and Sculptors. Award: First prize in open competition of life drawings, Boston, 1921. Address in 1933, 11 Welch Road, Brookline, MA.

RICHARDSON, CLARA VIRGINIA.
Painter, etcher, and teacher. Born at Philadelphia, PA, April 24, 1855. Pupil of Ferris; Moran; Daingerfield; and Snell. Member: Plastic Club; Art Alliance of Philadelphia; Alumnae of the Philadelphia School of Design for Women. Address in 1929, "The Sherwood," Portland, ME.

RICHARDSON, CONSTANCE COLEMAN.
Painter. Born in Indianapolis, IN, on Jan. 18, 1905. Studied: Vassar College; Penna. Academy of Fine Arts. Collections: John Herron Art Institute; Detroit Institute of Art; Penna. Academy of Fine Arts; Saginaw Museum of Art; Grand Rapids Art Museum; New Britain Institute. Address in 1980, 285 Locust St., Philadelphia, PA.

RICHARDSON, FRANCIS HENRY.
See Richardson, Frank Henry.

RICHARDSON, FRANK HENRY.
Painter. Born in Boston, MA, July 4, 1859. Pupil of Julian Academy in Paris under Boulanger and Lefebvre. Member: Salma. Club, 1901; Gloucester Society of Artists; North Shore Arts Association. Awards: Hon. mention, Paris Salon, 1899; bronze medal, American Art Society, 1902. Work: "Hauling Seaweed," Boston Art Club; "Breton Widow at Prayer," Lasell Seminary, Auburndale, Mass.; "Portrait of Rear Admiral George F. F. Wilde," Town Hall, Braintree, MA; "Dr. William C. Collar," Roxbury Latin School, Boston, MA. Died in 1934. Address in 1933, County Road, Ipswich, MA.

RICHARDSON, FREDERICK.
Illustrator, painter, and teacher. Born in Chicago, IL, Oct. 26, 1862. Pupil of St. Louis School of Fine Arts; Doucet and Lefebvre in Paris. Member: Century Association; Society of Illustrators, 1905; American Federation of Arts. Died in 1937. Address in 1933, Century Association, 7 West 43rd Street, New York, NY; Cliff Dwellers, Chicago, IL.

RICHARDSON, GRETCHEN.
Sculptor. Born in Detroit, MI, in 1910. Studied: Wellesley College; Art Students League with Wm. Zorach; Academy Julian, Paris. Awards: National Association of Women Artists, 1952, 55; Knickerbocker Artists. Exhibited at Penna. Academy of Fine Arts; Audubon Artists; Knickerbocker Artists. Represented by Bodley Gallery, NYC. Address in 1982, 530 Park Ave., NYC.

RICHARDSON, HELEN ELY.
Sculptor. Exhibited at the Penna. Academy of the Fine Arts, Philadelphia, 1924. Address in 1926, Detroit, MI.

RICHARDSON, MARGARET F.
Painter. Born in Winnetka, IL, Dec. 19, 1881. Pupil of DeCamp; Ernest L. Major; Tarbell. Member: American Federation of Arts. Awards: Harris bronze medal and prize ($300), Art Institute of Chicago, 1911; Maynard portrait prize ($100), Nat. Academy of Design, 1913; second prize, Duxbury Art Association, 1920. Work: Self portrait, Penna. Academy of Fine Arts. Address in 1933, Fenway Studios, 30 Ipswich Street, Boston, MA.

RICHARDSON, MARION.
Painter and etcher. Born in Brooklyn, NY, Jan. 24, 1877. Pupil of Chase; Du Mond; Senseney; others. Member: California Print Maker's Society; National Association of Women Painters and Sculptors; American Federation of Arts. Died December, 1952. Address in 1933, 169 East 78th Street, New York, NY.

RICHARDSON, MARY CURTIS (MRS.).
Painter. Born in NY, April 9, 1848. Pupil of Benoni Irwin; Virgil Williams; William Sartain. Member: American Federation of Arts. Awards: Norman Dodge prize, National Academy of Design, 1887; medals for figure painting, California State Fair, 1887, 1916, 17, 19, and Industrial Expo., San Francisco, 1915. Work: Golden Gate Park Museum, San Francisco; Music and Art Assoc., Pasadena, CA; California Palace of the Legion of Honor, San Francisco. Address in 1929, 1032 Vallejo Street, San Francisco, CA.

RICHARDSON, MARY NEAL.
Portrait painter. Born in Mt. Vernon, ME, Feb. 17, 1859. Pupil of Boston Museum School; Colarossi Academy and A. Koopman in Paris. Member: Copley Society, 1897. Work: "Prof. Charles C. Hutchins," Walker Art Gallery, Bowdoin College, Brunswick, ME. Address in 1933, 309 Fenway Studios, 30 Ipswich Street, Boston, MA; summer, Canton, ME.

RICHARDSON, S.
This man was a bookplate engraver apparently working about 1795, but with no indication of

locality. The one known example of his work represents a woman with left hand on an anchor, with ships in the distance. In the base is a blank tablet surmounted by an urn. On the tablet is written in ink "I. H. Swale, 1795." The plate is signed "S. Richardson Sculpsit."

RICHARDSON, SAM.
Painter and sculptor. Born in Oakland, CA, July 19, 1934. Studied at California College of Arts and Crafts, Oakland. Taught there, 1959-60; at Oakland City College, 1960-61; art director, American Craftsmen's Council, Museum of Contemporary Crafts, NYC, 1961-63; California State University at San Jose, from 1963. In collections of Fort Worth Museum of Art, Texas; Whitney, NYC; Milwaukee; others. Exhibited at Hansen-Fuller Gallery, San Francisco; Martha Jackson Gallery, NYC; San Francisco Museum of Art; Cranbrook; Denver Art Museum; M. H. de Young Memorial Museum, San Francisco; Janus Gallery, Los Angeles; Santa Barbara Museum of Art; Museum of Contemporary Crafts, NYC; Whitney, NYC; Museum of Modern Art; Hudson River Museum, Yonkers, NY; Honolulu Academy of Arts; many more. Address in 1982, Oakland, CA.

RICHARDSON, THEODORE.
Landscape painter. Born in Readfield, ME, in 1855. For years he made a specialty of Alaskan scenery. He died Nov. 1914, in Minneapolis, MN.

RICHERT, CHARLES HENRY.
Painter. Born in Boston, MA, July 7, 1880. Pupil of De Camp, Andrew and Major in Boston. Member: Boston Society of Water Color Painters; Connecticut Academy of Fine Arts; Boston Art Club; American Water Color Society. Address in 1933, 10 Linden Street, Arlington Heights, MA; summer, Ellsworth, ME.

RICHEY, OAKLEY E.
Painter, craftsman, writer, lecturer, and teacher. Born in Hancock Co., IN, March 24, 1902. Studied: John Herron Art Institute; Grand Central School of Art; Art Students League; and with DuMond, Purves, Forsyth, Hadley, Pogany, Stuart Walker, Kimball, G. Bridgman. Member: Indiana Art Association; Richmond Art Association; Indiana State Teachers Association; National Education Association. Awards: Prizes, Hoosier Salon, 1948, 50; Indiana State Fair, 1950. Work: Mural decorations in schools, Lafayette and Connersville, IN; Richmond (IN) Art Association; Pittsburgh (KS) Pub. Library. Positions: Art director, Stuart Walker Repertory Co., 1921-23; instructor, John Herron Art School, 1924-35; instructor of art, from 1935, head of art department, from 1942, Arsenal Technical Schools, Indianapolis, IN. Writer and director of numerous pageants and masques, including "Ages of Beauty," "Masque of Legends," "Masque of the Hours," "Pageant of the Palette," etc. Address in 1953, Arsenal Technical Schools, 1500 East Michigan Street; h. 3738 Colorado Avenue, Indianapolis, IN.

RICHMOND, AGNES M.
(Mrs. Winthrop Turney). Painter. Born in Alton, IL. Pupil of Art Students League of NY; St. Louis School of Fine Arts. Member: National Association of Women Painters and Sculptors; Allied Artists of America; Brooklyn Society of Artists; Brooklyn Modern Artists; Gloucester Society of Artists; Conn. Academy of Fine Arts; Brooklyn Painters and Sculptors; Fifteen Gallery. Awards: Watrous figure prize, 1911, water color prize, 1922, hon. mention, portrait, 1930, National Association of Women Painters and Sculptors; Jacobson prize, New Rochelle, 1932. Address in 1933, 211 Greene Ave., Brooklyn, NY; summer, Mountainville, NY.

RICHTER, WILMER SIEGFRIED.
Illustrator. Born in Philadelphia, PA, Jan. 20, 1891. Pupil of School of Industrial Art, Philadelphia, PA. Member: Philadelphia Sketch Club. Address in 1929, 1214 Walnut Street, Philadelphia, PA; h. 39 Pennsylvania Ave., Brookline Manor, Delaware Co., PA.

RICKETSON, WALTON.
Sculptor. Born May 27, 1839, in New Bedford, MA. Engaged as a sculptor since 1870. Among his notable works are portrait busts of A. B. Alcott, Louisa May Alcott, Henry D. Thoreau, George William Curtis, R. W. Emerson; also intaglios, bas-reliefs. He was the designer of the Gesnold memorial tower on the Island of Cuttyhunk, MA, in 1902. Address in 1926, New Bedford, MA.

RICKEY, GEORGE W.
Sculptor. Born in South Bend, IN, June 6, 1907. Studied at Trinity College, Glenalmond, Scotland, 1921-26; Balliol College, Oxford University, B.A., 1926-29, M.A. with honors, 1941; Ruskin School of Drawing and of Fine Art, Oxford University, 1928-29; Academie Andre L'hote and Academie Moderne, Paris, 1929-30; NY University, 1945-46; State University of Iowa, 1947, with Mauricio Lasanky; Insti. of Design, Chicago, 1948-49. Works: Addison Gallery, Andover, MA; Baltimore Museum of Art; Albright; Dallas Museum of Fine Art; Dartmouth College; Hamburg; Kansas City (Nelson); Museum of Modern Art; Tate; Hirshhorn Sculpture Garden, Washington, DC; Whitney; Walker; plus many commissions, inc. Rijksmuseum Kroller-Muller and the Singer Company. Exhibited: Denver Art Museum; Herron Art Institute; The Little Gallery, Louisville; Kraushaar Galleries, NYC; Amerika Haus, Hamburg; Santa Barbara Museum of Art; Hyde Park Art Center, Chicago; Dartmouth College; Staempfli Gallery, NYC; Walker; Corcoran; Salon

des Artistes Independants, Paris; Metropolitan Museum of Art, Nat. Sculpture Exhibition; Whitney; Penna. Academy of Fine Arts; Art Institute of Chicago; Museum of Modern Art; Stedelijk, Art in Motion; Battersea Park, London, International Sculpture Exhibition; Documenta III & IV, Kassel; Palais des Beaux-Arts, Brussels; Staatliche Kunsthalle, Baden-Baden; Los Angeles Co. Museum of Art; Carnegie; XXXIV Venice Biennial; Guggenheim; Albright-Knox. Awards: Guggenheim Foundation Fellowship, 1960, 61; Am. Institute of Architects, 1972. Taught: Groton School, 1930-33 (history department); Knox College, 1941, 1946-48; University of Washington, 1948; Indiana University, 1949-55; Tulane University, 1955-62; University of California, Santa Barbara, 1960; Rensselaer Polytechnic Institute, 1961-65; director of Kalamazoo Institute, 1939-40. Address in 1984, East Chatham, NY.

RIDDELL, ANNETTE IRWIN (MRS.).
Painter. Born in Oswego, NY. Pupil of Vanderpoel; Freer; Art Institute of Chicago; Collin; Courtois; Girardot; Royer and Prinet at Julian Academy in Paris. Member: Laguna Beach Art Association; Alumni Art Institute of Chicago. Address in 1933, Riddell Studio, Coast Blvd. at Diamond St., Laguna Beach, CA.

RIDDELL, WILLIAM WALLACE.
Painter. Born in Chicago, IL, March 21, 1877. Pupil of Art Institute of Chicago; Constant and Laurens in Paris. Member: Palette and Chisel Club; Laguna Beach Art Association; American Federation of Arts. Address in 1929, Riddell Studio, Laguna Beach, CA.

RIDDLE, ALICE L.
See Kindler, Alice L. Riddle.

RIDER, ALEXANDER.
Historical and miniature painter, who flourished 1810-25 in Philadelphia, PA. Rider came to the United States with his countryman Krimmel from Germany, and in 1811 he is listed as a "Fancy Painter," and in 1812 as a "Miniature Painter." There was a Rider in Charleston, SC, in 1819, but it is not certain that he was the same man.

RIDER, CHARLES JOSEPH.
Painter, sculptor, designer, lecturer and teacher. Born in Trenton, NJ, Jan 21, 1880. Pupil of W. M. Chase; S. Macdonald-Wright. Member: American Society of Bookplate Collectors and Designers. Address in 1933, San Pedro, CA.

RIDGWAY, W.
This excellent engraver of historical subjects in line was working in New York in connection with Wm. Wellstood, and was engraving for NY publishers at a much later date.

RIEKER, ALBERT GEORGE.
Sculptor. Born in Stuttgart, Germany, October 18, 1889. Pupil of Academy of Fine Arts, Munich; Royal Academy of Fine Art, Stuttgart. Exhibited: Art Institute of Chicago, 1929; Penna. Academy of Fine Arts, 1929, 30, 37. Awards: Prize, Stuttgart, 1910; Nuremberg, 1911; New Orleans Art Association, 1934, 40, 41; others. Member: New Orleans Arts and Crafts Club; New Orleans Art Association; Southern States Art League. Work: E. V. Mente Monument, Mente Park, New Orleans; Joseph Sinai memorial, Masonic Temple, New Orleans; Colonel William Temple Withers monument, Vicksburg National Military Park, Vicksburg, MS; Rabbi Max Heller memorial, Temple Sinai, New Orleans; bas-reliefs, "Life and Death," Vaccaro Mausoleum, Metairie Cemetery, New Orleans. Address in 1953, New Orleans, LA. Died in 1959.

RIES, GERTA.
Sculptor. Exhibited a portrait of John Cotton Dana at the Annual Exhibition of the National Academy of Design, 1925. Address in 1926, Brooklyn, New York.

RIESENBERG, SIDNEY.
Painter and illustrator. Born in Chicago, IL, Dec. 12, 1885. Pupil of Art Institute of Chicago. Address in 1929, 739 Palisade Avenue, Yonkers, New York.

RIFFLE, ELBA LOUISA.
(Mrs. Elba Riffle Vernon). Painter and sculptor. Born in Winamac, IN, January 3, 1905. Studied: John Herron Art Institute; Indiana University; Purdue University; and with Myra Richards, Forsythe. Member: Hoosier Salon; Indiana Art Club. Awards: Prizes, Northern Indiana Artists, 1931; Midwestern Exhibition, Wichita, KS, 1932; Hoosier Salon, 1934; Indiana State Fair, 1930-32, 34, 35, 38. Work: Christian Church, High School, Public Library, Winamac, Indiana; Public Library, Tipton, Indiana; Indiana University; Woman's Club House, Clay City, Indiana. Address in 1953, Nashville, IN; home, Indianapolis, IN.

RIGBY, F. G. (MRS.).
Portrait painter. Died in New York. Her husband, also a portrait painter, is deceased.

RIGGS, ROBERT.
Painter. Born in Illinois in 1896. Studied at Academie Julian, Paris; Art Students League, NY. Work: Library of Congress, Washington, DC; Museum of Modern Art; Brooklyn Museum; Whitney. Exhibited water colors at the Penna. Academy of Fine Arts, Philadelphia, 1925. Address in 1926, 218 Walnut Street, Philadelphia, Pennsylvania. Died in 1972.

RIGNEY, FRANCIS JOSEPH.
Painter, illustrator, and writer. Born in Waterford, Ireland, January 20, 1882. Member: Nat. Arts Club.

Illustrated: "The Clipper Ship" and "Ships of the Seven Seas," by Daniel Hawthorne. Art Editor, *Boy's Life Magazine*. Address in 1929, 62 East 90th Street, New York, NY.

RIIS, ANNA M.
Designer, craftsman, and teacher. Born in Norway. Pupil of Royal and Imperial School for Art and Industry, Vienna; Royal Art School of Christiania. Member: Cincinnati Woman's Art Club; Crafters; Cincinnati Ceramic Club. Address in 1929, care of Art Academy; h. 3325 Burnet Ave., Cincinnati, OH.

RILEY.
This name, as "Riley, Engraver," is signed to poorly engraved music and words published by J. & M. Paff, City Hotel, Broadway, New York. The date is apparently about 1800.

RILEY, FRANK H.
Painter. Born in St. Joseph, MO, June 15, 1894. Pupil of Louis Ritman; Jean Marchand; and Andre L'hote. Address in 1933, Highland Park, IL.

RILEY, GARADA CLARK.
Painter. Born in Chicago, IL, April 22, 1894. Pupil of Jean Marchand; Andre L'hote; and Leon Kroll. Address in 1933, Highland Park, IL.

RILEY, KENNETH.
Illustrator. Born in Waverly, MO, 1919. Studied at Kansas City Art Institute and the Art Students League, where he was taught by Harvey Dunn, DuMond, Benton, and George Bridgman. He illustrated *The Greatest Story Ever Told*, by Anthony Trollope, and he has done work for *The Saturday Evening Post, Life, National Geographic, Reader's Digest*, and *McCall's*. His work is owned by the Custer Museum, West Point Museum and the White House Collection.

RILEY, MARY G.
Painter. Born in Washington, D.C. in 1883. Pupil of Birge Harrison and Henry B. Snell. Member: Society of Washington Artists; National Association of Women Painters and Sculptors; Washington Art Club; National Arts Club; American Federation of Arts. Award: Bronze medal, Society of Washington Artists, 1923; purchase prize, National Arts Club, 1928; Penman Memorial prize, National Association of Women Painters and Sculptors, 1930; landscape medal, Washington Society of Artists, 1932. Died in 1939. Address in 1929, 2141 Le Roy Place, Washington, D.C.

RILEY, NICHOLAS F.
Illustrator. Born in Brooklyn, NY, in 1900. Attended Pratt Institute and Mr. Scott School in Paris. His first illustration was a full color oil done for the *West Point Year Book* in 1928. *Good Housekeeping, The Saturday Evening Post, Woman's Home Companion*, and *Field and Stream* are some of the magazines for which he illustrated. His portrait work was selected and hung at the Paris Grand Salon in 1925. Died in 1944.

RIMMER, WILLIAM.
Sculptor and painter. Born February 20, 1816, in Liverpool, England. He came to Canada in 1818; to Boston in 1826. At 15, assisted his family in painting portraits and signs. Began sculpture career after 1855, working in granite, clay, and marble. In 1860, modeled the "Falling Gladiator," now in the Boston Museum of Fine Arts. He painted a number of other pictures besides producing numerous works of sculpture. It is, however, as an art teacher that Dr. Rimmer is best known: School of Drawing and Modelling in Boston, 1864-66; Director of the School for Design for Women at Cooper Institute, NYC, 1866-70; re-opened his school and taught there until 1876; Boston Museum of Fine Arts, 1876-79. Died in South Milford, MA, August 20, 1879.

RINEHART, WILLIAM HENRY.
Sculptor. Born in Frederick, MD, Sept. 13, 1825. He worked with a stone cutter and studied drawing in Baltimore. In 1855 he went to Italy to study and while there executed the bas-reliefs of "Night" and "Morning." In 1857 he opened his studio in Baltimore, but soon returned to Italy. His best known statues are "Clytie," owned by the Peabody Institute; "Rebecca" in the Corcoran Art Gallery; and "Latona and Her Daughters," at the Metropolitan Museum of Art, NYC. He executed many portrait busts. His statue of Chief Justice Taney, ordered by the State of Maryland, was unveiled at Annapolis in 1872. Died Oct. 28, 1874, in Rome, Italy.

RINES, FRANK M.
Landscape painter and pencil artist. Born in Dover, NH, in 1892. Studied: Eric Pape Art School; Fenway School of Illustration; Massachusetts College of Art. Member: Rockport Art Association; Rockport Art Galleries; North Shore Art Association; Copley Society; South Shore Art Association; Washington Water Color Society. Work: Fogg Art Museum; Boston Museum of Fine Arts; Library of Congress; New England Life Insurance Company collection. Exhibited: North Shore Art Association; Copley Society; Washington Water Color Society; South Shore Art Association; Rockport Art Galleries; Boston Art Club; Boston Architectural Club; Jordan Marsh exhibits; Casson Galleries; Fitchburg Art Center; Twentieth Century Association; Ross Gallery; New England Life Insurance Company; Copley Square Library; Boston Arts Festival; Currier Galleries; Ogunquit Gallery; others. Director of the Copley Society and the Boston Center for Adult Education. Author: *Pencil Sketches; Tree Drawing; Drawing in Lead Pencil; Landscape Drawing with Pencil*; others.

Represented in *A Complete Guide to Drawing, Illustration, Cartooning and Painting* (Simon and Schuster, NY). Taught: Cambridge School of Architecture; Harvard and Massachusetts College of Art; Boston University; Boston Center for Adult Education. Died in 1962.

RING, ALICE BLAIR.
Painter. Born in Knightville, MA. Pupil of Laurens, Julian Dupre, Hitchcock, Mme. La Forge and Meichers in Paris; Art Students League of NY; also studied in Washington. Member: Cleveland Woman's Art Association; Laguna Beach Art Association; California Society of Miniature Painters; American Fed. of Arts. Award: First prize for oil painting, Pomona, 1922; hon. mention, miniature, Long Beach, CA, 1928. Address in 1933, 225 East Pasadena Street, Pomona, California.

RINGIUS, CARL.
Painter, craftsman, and writer. Born in Bastad, Sweden, December 3, 1879. Pupil of Charles Noel Flagg and Robert B. Brandegee at Hartford. Member: Connecticut Academy of Fine Arts; Soc. of Graphic Art, Stockholm; Chicago Artists Guild; Gloucester Society of Artists; Provincetown Art Association; Scandinavian American Artists; Springfield Art League; Salma. Club; Springfield (Illinois) Art Association; Art Alliance of America; North Shore Arts Association; Illinois Academy of Fine Arts; Swedish-American Art Association; American Artists Professional League. Represented in Vanderpoel Art Association, Chicago; "Sweden in Foreign Lands," Museum, Gothenburg; "Evening Gold," State Museum, Springfield, Illinois. Address in 1933, 62 Vernon Street, Hartford, Connecticut; summer, East Gloucester, Massachusetts.

RIOPELLE, JEAN PAUL.
Born in Montreal, Canada, in 1923. Largely self-taught. Since 1947 he has lived in Paris, France. Exhibitions: Galerie Greuse, Paris, 1950; Galerie Springer, Berlin, 1951; Galerie Fachetti, Paris, 1952; Galerie Henriette Niepoe, Paris, 1952; Galerie Pierre Loeb, Paris, 1953; Galerie Evrard, Lille, France, 1954; Pierre Matisse Gallery, New York, 1954; Galerie Rive Droite, Paris, 1954; Gimpel Fils Gallery, London, 1956; Galerie Jacques Dubourg, Paris, 1956, 60; Galerie Kolnischer Kunstverein, Cologne, 1958; Galerie Kestner Gesellschaft, Hannover, 1958; Galerie Kunst und Museumsverein, Wuppertal, Germany, 1958; Kunsthalle, Galerie Richentor, Basel, 1959; Galerie Ann Abels, Cologne, 1959. Group exhibitions at the Venice Biennale d'arte, 1954; Museu de Arte Moderna de Sao Paulo, Brazil, 1955, 61; Leverkusen, Holland, 1956; the Galerie Charpentier, Paris, 1956-58; Bonn, Germany, 1957; Arthur Tooth & Sons, London, 1957; The National Gallery of Canada, Ottawa, 1957, 63; Galerie Kleber, Paris, 1957; Palais des Beaux Arts, Brussels, 1958; Kassel,

Germany, 1959; Krakow, Poland, 1959; Walker Art Center, Minneapolis, 1959; Warsaw, Poland, 1959; Goteborg, Sweden, 1960; Kyoto, Japan, 1960; the Salon de Mai, Grand Palais, Paris, 1960; Tokyo, Japan, 1960; Kolnischer Kunstverein, Cologne, 1962.

RIPLEY, AIDEN LASSELL.
Painter. Born in Wakefield, MA, Dec. 31, 1896. Pupil of the School of the Museum of Fine Arts, Boston, MA. Member: Boston Guild of Artists; Boston Water Color Society; Copley Society. Awards: Logan purchase prize and medal, Art Institute of Chicago, IL, 1928; co-winner, first Dacre Bush prize, Boston Water Color Society, 1929. Work: "Swedish Peasant Girls," Art Institute of Chicago. Died in 1969. Address in 1929, 98 Chestnut Street, Boston, MA.

RIPLEY, LUCY PERKINS.
Sculptor. Born in Minnesota. Pupil of Saint-Gaudens; Daniel C. French; and Rodin. Member: National Association of Women Painters and Sculptors; National Sculpture Society. Awards: Barnett prize, National Association of Women Painters and Sculptors, 1919; bronze medal, St. Louis Expo., 1904. Exhibited at National Sculpture Society, 1923. Address in 1933, 9 East 17th Street; 12 West 10th Street, New York, NY. Died Sept. 5, 1949.

RISQUE, CAROLINE EVERETT.
Sculptor. Born in St. Louis, MO, 1886. Pupil of St. Louis School of Fine Arts under Zolnay; Colarossi Academy in Paris under Injalbert and Paul Bartlett. Member: St. Louis Artists Guild. Exhibited at National Sculpture Society, 1923. Awards: Western prize ($50), St. Louis Artists Guild, 1914; Halsey C. Ives Prize, St. Louis Artists Guild, 1922; thumbbox prize, St. Louis Art League, 1924; small sculpture prize, St. Louis Artists Guild, 1924. Represented in Museum of New Orleans; St. Louis Artists Guild. Specialty: Decorative work and small bronzes. Address in 1933, Clayton, MO.

RISWOLD, GILBERT P.
Sculptor. Born in Sioux Falls, SD, in 1881. Pupil of Lorado Taft and of Charles Mulligan. Work: "Statue of Stephen A. Douglass," Springfield, IL; "Mormon Pioneer Monument," Salt Lake City, UT. Address in 1926, Chicago, IL.

RITCHIE, ALEXANDER.
Painter. Born in Scotland, Feb. 19, 1863. Pupil of RI School of Design. Member: Soc. of Independent Artists; Brooklyn Soc. of Artists. Address in 1933, 51 Harrison Ave., Hicksville, LI, NY.

RITCHIE, ALEXANDER HAY.
Born Jan. 14, 1822, Glasgow, Scotland. He studied drawing in Edinburgh under Sir Wm. Allan, and came to NY in 1841. He apparently learned to engrave after he reached this country, but he

ultimately established an extensive general engraving business in NY, his earlier prints being issued about 1847. Ritchie himself was a very clever engraver of portraits in mezzotint, and it is claimed that he finished every plate that went out of his establishment. He also painted in oils. He began exhibiting at the Academy in 1848, was an Associate Member in 1863, and an Academician in 1871. Died Sept. 19, 1895 in New Haven, CT.

RITMAN, LOUIS.

Painter. Born in Russia, Jan. 6, 1889. Pupil of William Chase; John Vanderpoel; W. J. Reynolds. Awards: Silver medal, Panama-Pacific International Expo., San Francisco, 1915; first prize, Chicago Artists Guild, 1915. Work: "Early Morning," Chicago Municipal Art League; "Sun Spots" and "Spring Morn," Des Moines Gallery, Des Moines, IA. Died in 1963. Address in 1933, 1826 South Millard Ave., Chicago, IL; Paris, France.

RITSCHEL, WILLIAM.

Marine Painter. Born in Nuremberg, Germany, July 11, 1864. Pupil of F. Kaulbach and C. Raupp in Munich; came to U.S. in 1895. Member: Associate National Academy of Design, 1910; Academician National Academy of Design, 1914; NY Water Color Club; American Water Color Society; Salma. Club, 1901; Artists' Fund Society; National Arts Club; Kunstverein, Munich; Allied Artists of America; California Water Color Society. Awards: Hon. mention, Salma. Club; hon. mention, Carnegie Institute, Pittsburgh, 1912; Carnegie prize, 1913, Ranger purchase prize, 1921, National Academy of Design; gold medal and $1,000, National Arts Club, 1914; gold medal, P.-P. Expo., San Francisco, 1915; gold medal, State Fair, Sacramento, CA, 1916; gold medal, Philadelphia Art Club, 1918; Isidor medal, Salma. Club, 1923; Harris prize, Art Institute of Chicago, 1923; first prize, Santa Cruz, first prize, Pomona, CA, 1930; third prize, Dallas, TX, 1930. Work: "Rocks and Breakers," Penna. Academy of Fine Arts; "Across the Plains, Arizona," Ft. Worth (TX) Museum; "Desert Wanderers," Art Institute of Chicago; "Fog and Breakers," Detroit Art Club; "Rockbound Coast," City Art Museum, St. Louis, "Evening Tide, California," Smithsonian Institution, Washington, DC; "Carmel-by-the-Sea and Point Lobos," Los Angeles Museum; "Inrush of the Tide," Albright Art Gallery, Buffalo. Died in 1949. Address in 1933, care of the Milch Galleries, 108 West 57th Street, New York, NY.

RITTENBERG, HENRY R.

Painter and teacher. Born in Libau, Russia, Oct. 2, 1879. Pupil of W. M. Chase at Penna. Academy of Fine Arts; Bavarian Academy; Ludwig Heterich in Munich. Member: Academician National Academy of Design; Fellowship Penna. Academy of Fine Arts; Philadelphia Art Club; Salma. Club; National Arts Club; Allied Artists of America; Washington Art Club; MacDowell Club of NY; Painters and Sculptors Gallery Association; Beaux Arts Institute of Design; Art Alliance of America; Artists' Fund Society; Artists' Fellowship Inc. Awards: Cresson Traveling Scholarship, Penna. Academy of Fine Arts, 1904; hon. mention, Art Club of Philadelphia, 1906; Maynard portrait prize, National Academy of Design, 1920; Harris prize, Art Institute of Chicago, 1925; Proctor portrait prize, National Academy of Design, 1926. Work: "Caroline Augusta," "Still Life Fish," Butler Art Institute, Youngstown, OH; University of Pennsylvania, College of Physicians, Union League, Philadelphia Art Club, Hahnemann College, Poor Richard's Club, College of Pharmacy, Philadelphia Bar Association, Philadelphia Public Library, Jefferson College, N. E. Manual Training High School, Southern Manual Training High School, Federal Court, all in Philadelphia, PA; Capitol, Harrisburg, PA; Columbia University, NY; University of Virginia; Skidmore College, Saratoga Springs, NY; University of Panama; NY County Bar Association; National Arts Club; Salma. Club; others. Instructor, Art Students League of NY; Beaux Arts Institute of Design. Address in 1933, 222 W. 59th Street, New York, NY.

RITTER, ALONZO W.

Painter. Born in Hagerstown, MD, Jan. 7, 1898. Pupil of D. M. Hyde. Member: Baltimore Society of Independent Artists; NY Society of Independent Artists; American Artists Professional League; Washington Art League. Award: First hon. mention, Cumberland Valley Artists, Hagerstown Museum of Fine Arts, 1932. Address in 1933, 863 Dewey Ave., Hagerstown, MD.

RITTER, ANNE GREGORY.

(Anne Gregory Van Briggle). Painter, sculptor, and craftswoman. Born in Plattsburgh, NY, July 11, 1868. Pupil of Charles Melville Dewey and Robert Reid; Colarossi Academy in Paris under Prinet and and Girardot; Victoria Lyceum in Berlin. Member: Boston Society of Arts and Crafts; National Society of Craftsmen; American Federation of Arts. Awards: Bronze medal for pottery, St. Louis Expo., 1904; first prize, Boston Society of Arts and Crafts, 1907. Work: "Anne in the Garden," Broadmoor Art Academy; "March Landscape," Denver Art Museum. President and art director, Van Briggle Pottery Co. Address in 1929, 1152 York Street, Denver, CO.

RIVERA, SOPHIE.

Photographer. Studied: Educational Alliance, New York City; Apeiron Workshops, Inc., Millerton, New York; New School for Social Research, NYC. Exhibitions: Crossroads Gallery, NYC, 1974; Third Eye Gallery, New York City, 1973; Women's Interart Center, NYC, 1973, 74, 75. Collections: Apeiron Workshops, Inc.; Women's Interart Center, NYC.

RIVERS, LARRY.
Painter and sculptor. Born in NYC, 1923. Studied at Juilliard School of Music, NYC, 1944-45; Hofmann School, 1947-48; NY University, 1947-48. Works: Brooklyn Museum; Art Institute of Chicago; Corcoran; Kansas City (Nelson); Metropolitan Museum of Art; Museum of Modern Art; Minneapolis Institute; SUNY New Paltz; Parrish Museum; Tate; Munson-Williams-Proctor Institute, Utica, NY; Victoria and Albert Mu.; Whitney. Exhibitions: Tibor de Nagy Gallery, NYC; Martha Jackson Gallery, NYC; Dwan Gallery, NYC; Galerie Rive Droite, 1962; Gimpel Fils Ltd., London; Marlborough-Gerson Gallery Inc., NYC; Whitney; Museum of Modern Art; Sao Paulo; Carnegie; II Inter-American Paintings and Prints Biennial, Mexico City; Seattle World's Fair, 1962; Penna. Academy of Fine Arts; Flint Institute, I Flint Invitational; Herron Art Institute; San Francisco Museum of Art; Documenta IV, Kassel; Virginia Museum of Fine Art; plus many more. Awards: Corcoran, Third Prize, 1954. Professional jazz musician; began sculpture in 1953. Represented by Marlborough Gallery, NYC. Illustrated *When the Sun Tries to Go On*. Address in 1982, Southampton, NY.

RIX, JULIAN.
Painter. Born in Peacham, VT, in 1850; died in NY in 1903. Landscape painter. Self-taught. Commenced painting at the age of twenty-two as a sign and decorative painter in San Francisco; afterward came East and settled in NY. Represented by "Pompton Plains, New Jersey," painted in 1898, at the Corcoran Gallery.

ROBB, ELIZABETH B.
Painter. Member: Pittsburgh Art Association; American Federation of Arts. Awards: Third prize, Art Association of Pittsburgh, 1914; first prize, Art Association of Pittsburgh, 1915. Address in 1933, 24 Herron Ave., Emsworth, PA.

ROBB, SAMUEL ANDERSON.
Sculptor. Born in NYC, Dec. 16, 1851. Apprenticed as a ship carver to Thomas V. Brooks; later with William Demuth. Studied part-time at the National Academy of Design, 1869 to 1873; studied at the "Free Night School of Science and Art" at Cooper Union. Opened his own carving studio in 1876 on Canal St., Manhattan. Moved his shop to 114 Centre St. in Manhattan, where he was one of NY's most prolific carvers; made scores of cigar-store Indians, carousel houses, and circus wagons. Went to Philadelphia in 1917, where he was employed by the Ford Motor Company until 1919. Returned to NYC and died there May 5, 1928.

ROBBINS, ELLEN.
Painter in water colors, and pupil of the New England School of Design. Was born in 1828 and died in 1905. She is spoken of by Tuckerman in his "American Artists Life" as receiving many orders for exquisite water color painting of flowers and autumn leaves.

ROBBINS, FREDERICK (GOODRICH).
Painter, etcher, lecturer, and teacher. Born in Oak Park, IL, May 8, 1893. Pupil of Carl N. Werntz; Spencer Mackey; Lee Randolph; Breckenridge; Meryman; Constance Mackey; Hendrick de Rooy. Address in 1929, 1923 Callowhill Street, Philadelphia, PA.

ROBBINS, HORACE WOLCOTT.
Born Oct. 21, 1842 in Mobile, AL. He was elected an Associate of the National Academy in 1864, and an Academician in 1878, and in 1882 became recording secretary. He worked both in oil and water colors, his pictures being chiefly landscapes of mountain and lake scenery. Among his works are "New England Elms," "Lake Katahdin, Maine," and "Views of Jamaica." In 1865 he visited the West Indies with Frederick E. Church. Member of the New York Etching Club. He died Dec. 14, 1904, in NYC.

ROBBINS, JOHN WILLIAMS.
Painter and etcher. Born in Windham, CT, Feb. 16, 1856. Studied in Boston and at New York art schools. Member: Connecticut Academy of Fine Arts. Inventor of "The Bruleprint" and "Brulechrome." Died in 1939. Address in 1929, 20 Rockland Ave., Dorchester, Boston, MA.

ROBBINS, THERESA REYNOLDS.
Painter. Born in Boston, May 8, 1893. Pupil of Philip L. Hale; Rosamond Smith. Member: Gloucester Society of Artists. Address in 1929, 22 Carlton Street, Brookline, MA; summer, Cottage Inn, Pearl Street, Nantucket, MA.

ROBERTS.
Engraver. Some rather poor line book illustrations published in NY in 1841 are thus signed.

ROBERTS, ALICE MUMFORD.
See Culin, Alice Mumford Roberts.

ROBERTS, BISHOP.
Portrait painter and engraver, who was working in Charleston, SC, in 1735. His advertisement appears in the *South Carolina Gazette* of May, 1735. Died in October, 1739.

ROBERTS, BLANCHE G.
Sculptor. Exhibited "Beatrice" at the Penna. Academy of Fine Arts in Philadelphia, 1915. Address in 1926, 284 Reservoir Place, Bronx, NY.

ROBERTS, EDITH ADELINE.
Painter and craftsman. Born in Germantown, PA, June 8, 1887. Pupil of NY School of Fine and Applied

Arts; Penna. Academy of Fine Arts; and of Cecil Chichester, John Carlson, Charles Rosen, Henry McFee, and Andrew Dasburg. Member: Art Alliance of America; Woodstock Art Association. Address in 1929, Woodstock, NY.

ROBERTS, ELIZABETH WENTWORTH.
Painter. Born in Philadelphia, PA, in 1871. Pupil of Elizabeth Bonsall and of H. R. Poore in Philadelphia; of Bouguereau, Robert-Fleury, Lefebvre and Merson in Paris. Member: Penna. Academy of Fine Arts. Awards: Mary Smith prize, Penna. Academy of Fine Arts, 1889; honorable mention, Paris Salon, 1892. Work: "The Boy with the Violin," Pennsylvania Academy, Philadelphia; "The Madonnas of Marks," Asilo Giovanni in Bragora, Venice, Italy; "Reflections," Public Library, Concord, MA; "Concord March," Fenway Court, Boston. Address in 1926, Concord, MA. Died March 12, 1927 in Concord, MA.

ROBERTS, GILROY.
Sculptor and engraver. Born in Philadelphia, PA, March 11, 1905. Studied: Corcoran School of Art; and with John R. Sinnock, Paul Remy, Eugene Weis, and Heinz Warneke. Member: National Sculpture Society. Awards: Gold medal, Madrid Exhibition of Medals, 1951; gold medal, Numismatic Association, 1956. Work: Medals, Drexel Institute, 1936; Brandeis Lawyers' Society, 1948; Einstein award medal, 1950; Schaefer Brewing Co. Achievement Award, 1951; American Medical Association, Dr. Hektoen Medal, 1952; Dr. Albert Hardt Memorial, 1950; Lewis N. Cassett Foundation, 1950; Theodore Roosevelt High School, 1952; Valley Forge Patriots Memorial, 1952; U.S. Mint, Philadelphia; Smithsonian; Kennedy half dollar, U.S. Mint, 1963; others. Exhibited: Penna. Academy of Fine Arts, 1930, 34, 45, 46; International Exhibition of coins and medals, Paris, France, 1949, Madrid, Spain, 1951; Corcoran, 1942; National Sculpture Society; many others. Banknote Engraver, Bureau of Engraving and Printing, Washington, DC, 1938-44; chief sculptor and engraver, U.S. Mint, Philadelphia, PA, 1948-64; chief sculptor and chairman, Franklin Mint, from 1964. Address in 1982, Newtown Square, PA.

ROBERTS, HOWARD.
Sculptor. Born in Philadelphia, PA, April, 1843. He studied art at the Penna. Academy of Fine Arts. Modeled statuettes of Hawthorne's "Scarlet Letter," "Hypathia" and "Lucille," and numerous portrait busts. His statue of Robert Fulton is in the Capitol in Washington, DC. He died in Paris in April, 1900.

ROBERTS, JOHN.
Painter and engraver. Born in Scotland in 1768; died in NY in 1803. He came to NY in 1793, says Wm. Dunlap. Roberts was engraving views, script, etc., in NY in 1796, and his name as an engraver appears in the directories of 1802-03. He visited Charleston, SC, during the winter of 1796-97, and possibly was in Portsmouth, NH, in March of 1801. Dunlap describes him as a sort of universal genius, ready to do anything, but erratic and incapable of turning his advantages to personal account. A small mezzotint portrait by him, of Washington, exists, which is extremely rich in effect and shows fine execution. Dunlap says this was engraved by Roberts in NY, in 1799, from a miniature portrait by Benjamin Trott. Owing to some misunderstanding between the painter and the engraver, Roberts deliberately destroyed the copperplate and a few proof impressions alone remain. He painted miniatures, drew portraits in crayon, and was a musician of no mean skill, but he abused his gifts, and died.

ROBERTS, JOHN TAYLOR.
Sculptor. Born in Germantown, Pennsylvania, 1878. Address in 1915, Philadelphia, Pennsylvania.

ROBERTS, JOSEPHINE SEAMAN.
Painter, writer, lecturer and teacher. Born in Los Angeles, CA. Member: So. Cal. Water Color Society; Calif. Painters and Sculptors; Pacific Arts Assoc. Address in 1933, 2341 Scarff Street, Los Angeles; summer, "Casa Madre," Idyllwild, CA.

ROBERTS, MORTON.
Illustrator. Born in Worcester, MA, in 1927. Graduated from Yale Univ. School of Fine Arts. He illustrated for many major magazines, most notably *Life*, for which he painted a series on *The History of Russia* and *The Story of Jazz*. Among his many awards was the Edward Austin Abbey Fellowship from the Nat. Academy of Design. He was an instructor of life drawing at Pratt Inst. Died in 1964.

ROBERTS, NORMAN L.
Painter. Born in Ironia, New Jersey, August 8, 1896. Pupil of Henry G. Keller. Work: "Forgotten Days," Junior League Club, Cleveland, Ohio; "The Golden Fleece," Public Library, Cleveland, Ohio. Address in 1929, 3 West 108th Street, New York, New York.

ROBERTS, VIOLET KENT (MRS.).
Painter, illustrator, and writer. Born in The Dalles, OR, November 22, 1880. Pupil of Pratt Institute Art School; Boston Museum of Fine Arts School; and with Benson, Beck, Moschcowitz, Prellwitz, George Eggers. Exhibited: Washington Water Color Club, 1945; Washington Miniature Society, 1945; Washington Art Club, 1946. Member: Alumni Pratt Institute. Illustrator, First Book of Religion. On staff of Corcoran Gallery of Art, Washington, DC, from 1944. Address in 1953, 3037 Dent Place, N. W., Washington, D.C. Died in 1958.

ROBERTSON.
Engraver. A large and well engraved front piece, apparently intended for an edition of Cook's Voyages,

of about 1815, is signed "Robertson Sc." While this plate bears some indication of American origin, it may be English.

ROBERTSON, ALEXANDER.
Miniature painter. Born May 13, 1768. He also worked in water colors, chiefly in landscape. Like his brother Archibald, he was well known as a teacher. He died in 1841, in NYC.

ROBERTSON, ARCHIBALD.
Miniature and portrait painter, designer and etcher. Born May 8, 1765 in Moneymusk, near Aberdeen, Scotland. He studied art in Edinburgh and London from 1782 to 1791. In the latter year, he came to the U.S., bringing with him from his patron, the Earl of Buchan, and for presentation to General Washington, a box made of the oak that sheltered Sir William Wallace after the battle of Falkirk. At the request of the Earl of Buchan, Washington sat for his portrait to Robertson. From 1792 to 1821 he followed his profession in NY as a painter, largely in water colors, and was a teacher of drawing. Proprietor, with his brother Alexander, of the Columbian Academy of Painting. He designed for engravers and the early lithographers of NY, and drew a number of large views of NY, which were engraved. Robertson was one of the founders and a director of the American Academy of Art. Died Dec. 6, 1835 in NYC.

ROBERTSON, MADELEINE NIXON.
Sculptor, painter, and teacher. Born in Vancouver, B.C., Canada, August 14, 1912. Studied: Moore Institute of Design for Women; Penna. Academy of Fine Arts. Awards: Cresson traveling scholarship, Penna. Academy of Fine Arts, 1942; Ware Fellow, 1943; prize, Alumnae, American Academy in Rome, 1943. Work: Swedish Museum, Philadelphia; Philadelphia Sketch Club; Stevens Institute, Hoboken, NJ. Exhibited: Penna. Academy of Fine Arts, annually; Moore Institute of Design for Women. Address in 1953, Philadelphia, PA.

ROBERTSON, W.
Engraver. This man was a script engraver employed in New York in 1831.

ROBERTSON, WALTER.
Born in Dublin, 1793. He sailed with Gilbert Stuart for the United States. He worked in Philadelphia and New York, copying some of Stuart's portraits in miniature, and painting a number of miniatures of his own composition. Died in 1802 in India.

ROBESON, EDNA AMELIA.
Miniature painter. Born in Davenport, IA, Jan. 25, 1887. Pupil of Frank Phoenix and Art Students League of NY. Member: Pennsylvania Society of Miniature Painters. Address in 1929, Bettendorf, IA; Woodstock, NY.

ROBIN, AUGUSTUS.
Engraver. Born in New York of French parentage. This good engraver of portraits and subject plates was in the employ of J. C. Buttre, of New York, for nearly forty years.

ROBINS, SUSAN P. B.
Painter. Born in Boston, 1849. Pupil of John Johnston, Ross Turner and F. Crowninshield; also of the Boston Museum School under Philip Hale. Member: Copley Society, 1894. Address in 1926, 95 Mount Vernon St., Boston, Massachusetts.

ROBINSON.
Engraver. This name is signed to a number of small, wonderfully designed but poorly engraved plates illustrating an edition of Weems' "Life of Washington," published in 1815 by Matthew Carey, of Philadelphia, Pennsylvania.

ROBINSON, ADAH MATILDA.
Painter, artist, writer, lecturer, and teacher. Born in Richmond, Indiana, July 13, 1882. Pupil of John F. Carlson; George Elmer Browne; Art Institute of Chicago. Member: Oklahoma Art Association; Tulsa Art Association; American Federation of Arts; College Art Association; Prairie Print Maker's Society; National League of American Pen Women. Address in 1933, 1119 South Owasso, Tulsa, Oklahoma.

ROBINSON, ALEXANDER.
Painter and teacher. Born in Portsmouth, New Hampshire, May 11, 1867. Pupil of Lowell School of Design (Boston Museum of Art); Academie Julian, Paris, under Doucet and Constant. Member: New York Water Color Club; Philadelphia Water Color Club; Chicago Water Color Club; American Water Color Society; Salma. Club; Societe Nationale des Aquarellistes; Societe des Artistes Independents and Societe des Artistes Coloniale in Paris; Cercle d'Art, Tournai and Bruges, Belgium; United Arts Club, London. Award: Silver medal, P.-P. Expo., San Francisco, 1915. Work: "Church Interior" and group of 11 pastels, Toledo Art Museum; "Falling Leaves," Rockford (Illinois) Art Association; "Canal Venice," Mississippi Art Association, Jackson; "Jehaun-Ara," Pennsylvania Academy of Fine Arts; ten paintings and nine aquarelles, Delgado Museum, New Orleans; "Dordrecht" and "Spanish Coast," five aquarelles and twelve drawings, Newcomb Art Gallery, Tulane University, New Orleans; twenty-seven Italian water colors, Desmond Fitzgerald Art Gallery, Brookline, Massachusetts; "La Dame aux Tulipes" and "Summer," Museum d'Ixelles; "Autumn, England," Moscow (Russia); and in collections at Glasgow, Dundee, London, and Manchester (England). Address in 1929, 235 Faubourg Street, Honore, Paris, France; 18 Aldworth Street, Jamaica Plain, Boston, Massachusetts.

ROBINSON, ALONZO CLARK.
Sculptor and writer. Born in Darien, CT, Sept. 3, 1876. Member: Societe Internationale des Beaux-Arts et des Lettres. Address in 1929, Paris, France.

ROBINSON, BOARDMAN.
Painter, illustrator, lithographer and teacher. Born in Somerset, Nova Scotia, Canada, September 6, 1876. Studied at the Massachusetts Normal Art School and in Paris. Member: National Society of Mural Painters. Award: Gold medal of honor, NY Architectural League, 1930. Work: Illustrations, "Cartoons of the War," Dutton, 1915; "Rhymes of If and Why," by Betty Sage, published by Duffield; "The War in Eastern Europe," by John Reed; Dostoevsky's *The Brothers Karamazov*, in 1933, and *The Idiot*, in 1916, both published by Random House. Murals: "A History of Commerce," Kaufmann's Department Store, Pittsburgh, PA; "Man and his Toys," R. K. O. Building, Rockefeller Center, New York City. Director, Broadmoor Art Academy, Colorado Springs, CO. He worked as an art editor and illustrator for several magazines. Exhibited: Penna. Academy of Fine Arts, 1926. Address in 1934, Broadmoor Art Academy, Colorado Springs, CO. Died in 1952.

ROBINSON, CHARLES DORMAN.
Landscape and marine painter. Born in Vermont in 1847. Pupil of William Bradford, 1862; of George Inness and M. F. H. DeHaas, 1863; of Gignoux and Cropsey, Newport, VT, 1866-67; studied under Boudin; also studied methods of Segantini, 1900, Paris. Resided in Vermont, 1861-73; in Clinton, IA; San Francisco since 1874 (except in Paris, France, 1899-1901). Dean of Pacific Coast Artists. Received first diploma, Mechanics' Fair, San Francisco, 1860; money award, Sacramento State Agricultural Society, 1878, gold medal, 1903. Spent 19 seasons in the Yosemite and the High Sierras; has 84 paintings, mostly of the Yosemite Valley, in Great Britain. Member: San Francisco Art Association.

ROBINSON, DAVID.
Sculptor, painter, and illustrator. Born in Warsaw, Russian Poland, July 31, 1886. Studied in US, France, and Germany. Member: Palette and Chisel Club; Society of Illustrators, 1910; Salmagundi Club; Society of Independent Artists; Artists' Guild; Silvermine Guild of Artists; American Federation of Arts. Address in 1933, Silvermine, CT.

ROBINSON, FLORENCE VINCENT.
Painter. Born in Boston, MA, Nov. 18, 1874. Pupil of Vignal in Paris. Member: Societe des Aquarellists, Paris; American Water Color Society. Work: In Harvard University, Cambridge; Cleveland School of Art; Government collection of France; "Chateau de Versailles," Boston Museum of Fine Arts; 12 water colors of Spain, Hispanic Museum, New York;

Brooklyn Museum of Fine Arts. Died in 1937. Address in 1929, 139 East 66th Street, New York, New York.

ROBINSON, HELEN AVERY.
Sculptor. Born in Louisville, KY. She studied under Solon H. Borglum. Exhibited at National Sculpture Society, 1923. Address in 1926, 200 West 58th Street, New York.

ROBINSON, IRENE BOWEN.
(Mrs. W. W. Robinson). Painter. Born in South Bend, WA, Nov. 27, 1891. Pupil of John F. Carlson; Otis Art Institute. Member: California Art Club; Laguna Beach Art Association; California Water Color Society; West Coast Arts, Inc.; "Younger Painters." Awards: Prize, oils, California Art Club, 1931; hon. mention, Ebell Club, Los Angeles, 1932; hon. mention, Los Angeles County Fair, 1933. Address in 1933, 2310 Palm Grove Avenue, Los Angeles, California.

ROBINSON, JOHN.
Miniature painter. Born c. 1774. He was an English artist who settled in Philadelphia in 1817; died there about 1829. He showed a miniature of West, with picture of "Christ Rejected" in the background, and said that Benjamin West had sat for it. A miniature of Samuel Milligan is signed "J. R. 1819."

ROBINSON, KATHLEEN BEVERLEY.
Sculptor and teacher. Born in Aurora, Ontario, Canada, 1882. Pupil of Art Institute of Chicago under Taft. Member: Chicago Society of Artists. Instructor, Art Institute of Chicago. Award: Shaffer prize ($100), Art Institute of Chicago, 1913. Work: Brooklyn Institute Museum. Address in 1916, Chicago, IL.

ROBINSON, L. S. MONA.
Painter. Exhibited in the Annual Exhibition of the Penna. Acad. of Fine Arts, Philadelphia, 1924. Address in 1926, Paoli, PA.

ROBINSON, NANCY BELL.
Painter and teacher. Born Big Cove, Pennsylvania. Pupil of Deigendeisch and School of Industrial Art, Philadelphia. Member: Art Alliance of Philadelphia; Plastic Club. Add. in 1933, Presser Bldg., 1714 Chestnut St.; h. 2012 Mt. Vernon St., Phila., PA.

ROBINSON, NORA B.
Miniature painter. Exhib. at Penna. Acad. of Fine Arts, PA., 1925. Address in 1926, 9 Cedar Ave., Rockville Centre, L.I., NY.

ROBINSON, RUTH C.
See Treganza, Ruth C. Robinson.

ROBINSON, THEODORE.
Painter of landscapes and figures subjects. Born in Irasburg, VT., 1852; died in New York in 1896. Pupil

of Carolus-Duran and of Gerome. Awarded the Webb prize, 1890; Shaw prize, 1892. Represented by "Valley of the Seine from Giverny Heights," in the Corcoran Art Gallery. See *Scribner's Magazine*, "Field of Art" by Eliot Clark.

ROBINSON, THOMAS.
Painter. Born in Nova Scotia, Aug. 23, 1834. The Worcester Art Museum owns his painting "Fowls in Yard." He also painted a portrait group of five dogs that attracted much attention. Died March 1, 1888 in Providence, RI.

ROBINSON, VIRGINIA CAROLYN.
Painter. Born in Maryville, MO. Studied: William Woods College; Northwest Missouri State College; Columbia University. Awards: Kappa Pi, 1955. One-woman shows: Mississippi State College for Women, 1955; Delta Art Association, Greenwood, MS, 1955, 59; Meridian (MS) Art Association, 1955; Clarksdale (MS) Public Library, 1956; Gilmer Hotel, Columbus, MS, 1956; Lauren Rogers Gallery of Art, 1956; Mississippi Historical Society, Natchez, 1957; Allison's Wells Art Colony, Way, MS, 1957; William Carey College, 1958. Group shows: Municipal Art Gallery, Jackson, MS; Brooks Memorial Gallery, Memphis, TN; Delgado Museum; others. Collections: Mississippi Department of Archives and History, Jackson; Mississippi State College for Women; Blue Ridge Assembly, Black Mountain, North Carolina. Member: Long Beach Art Association; Laguna Beach Art Association; Birmingham (AL) Art Association; National Audubon Society; Allison's Wells Art Colony; American Association of University Women; Palette and Brush Club; Kappa Pi (hon.); others. Address in 1962, Columbus, MS.

ROBINSON, W.
Engraver. Born between 1825-30, this W. Robinson etched in a fairly good style a Masonic certificate published by R. D. Desilver, of Philadelphia.

ROBINSON, WILLIAM S.
Painter. Born in East Gloucester, MA, Sept. 15, 1861. Pupil of Massachusetts Normal Art School in Boston; Julian Academy in Paris. Member: Associate National Academy of Design, 1901, Academician, 1911; NY Water Color Club, 1891; American Water Color Society, 1897; Salma. Club, 1896 (life); Lotos Club, 1900 (life); Artists' Fund Society, 1889; National Arts Club, 1917 (life); Allied Artists of America, 1919. Awards: Hon. mention, Paris Expo., 1900; hon. mention, Pan-Am. Expo., 1900, 01; Newhouse prize ($500), Salma Club, 1901; bronze medal, St. Louis Expo., 1904; Carnegie prize ($500), National Academy of Design, 1910; silver medal, Buenos Aires Expo., 1910; silver medal, P.-P. Expo., San Francisco, 1915; bronze medal, Dallas (TX) Exhibition, 1915; Turnbull prize, Salma. Club, 1917; fourth W. A. Clark prize ($500), and hon. mention, Corcoran

Gallery, Washington, DC, 1919; James W. Porter prize, Salma. Club, 1922; Museum purchase prize ($500), 1925; Woodhull Adams Memorial sketch prize, 1927; prize ($300), Lyme Art Association, 1928; 1st Altman prize, best landscape ($1,000), National Academy of Design, 1929. Work: "The Golden Bough," Carnegie Institute, Pittsburgh; "Golden Days," Art Museum, Dallas, TX; "Monhegan Headland," National Gallery, Washington, D.C.; Museum of Art, Cleveland, OH. Instructor, National Academy of Design schools, 1920; Connecticut College, New London, CT, from 1928. Died in 1945. Address in 1933, Old Lyme, CT.

ROBINSON, WILLIAM T.
Painter. Born in Somerville, MA, Sept. 17, 1852. Pupil of George N. Cass in Boston; Ecole des Beaux-Arts, Ecole de Medecine, Gobelin Tapestry Schools, Bouguereau and Diogene Maillart in Paris. Member: National Arts Club (life). Represented in the Henry Gallery, Seattle, WA. Address in 1933, Dowling Bldg., Malden, MA.

ROBUS, HUGO.
Sculptor and painter. Born May 10, 1885, in Cleveland, OH. Studied at Cleveland School of Art; National Academy of Design; Academie de la Grande Chaumiere, with Bourdelle. Began career in painting, switched to sculpture in 1920. Work: Cleveland Museum of Art; Corcoran; Metropolitan Museum of Art; Museum of Modern Art; Whitney; Munson-Williams-Proctor Institute. Exhibited: Grand Central Art Galleries, NYC; Whitney, annually; Penna. Academy of Fine Arts, annually; Metropolitan Museum of Art; Sculptors Guild, annually; Corcoran; Museum of Modern Art; Carnegie Institute; World's Fair of NY, 1939. Awards: Artists for Victory, second prize, Metropolitan Museum of Art, 1942; Penna. Academy of Fine Arts, Widener gold medal, 1950, Alfred G. B. Steel Memorial prize, 1953; National Institute of Arts and Letters citation and grant, 1957. Member: Sculptors Guild; Shilling Fund Jury; Artists Equity Association (board of directors). Taught: Columbia University (summers); Munson-Williams-Proctor Institute; Brooklyn Museum School. Address in 1953, 37 East 4th Street, New York City. Died Jan. 14, 1964, in New York City.

ROCHE.
Engraver. Several of the plates of the American edition of Maynard's "Josephus," published in New York in 1791, are signed "Roche sc." No other plates are known.

ROCHE, M. PAUL.
Painter, etcher, sculptor, lithographer, and lecturer. Born in Cork, Ireland, January 22, 1888 (or 1885). Studied: St. John's College; Pratt Institute Art School; National Academy of Design, with Charles Hawthorne. Awards: Prizes, National Academy of

Design; Brooklyn Society of Etchers; National Arts Club, New York; Art Institute of Chicago. Work: Brooklyn Museum; Cleveland Museum of Art; Chicago Art Institute; Detroit Institute; Library of Congress; California State Library; New York Public Library; murals, Washington College, Chestertown, MD; Enoch Pratt Library, Catholic Cathedral, St. Joseph's Church, all of Baltimore, MD. Exhibited: National Academy of Design. Member: Brooklyn Society of Etchers; Salma. Club; American Federation of Arts. Lectures: American Mural Painting. Address in 1953, Baltimore, MD.

ROCKEY, ABRAHAM B.
Nothing is known about this painter except that he was born in Mifflinburg, PA, in 1799. He moved to Philadelphia where he began painting about 1825; he was active there until after 1860. He worked in that city for many years painting portraits and copying pictures, and also worked in Delaware painting portraits. He exhibited at the Artists' Fund Society; Pennsylvania Academy. The Pennsylvania Historical Society owns several of his portraits.

ROCKWELL, EVELYN ENOLA.
Painter. Born in Chicago, 1887. Pupil of Penna. Academy of Fine Arts; Art Students League of NY; Woodbury; and Chase. Member: National Association of Women Painters and Sculptors; C. L. Wolfe Art Club. Specialty: Portraits of children in pastel. Address in 1933, 40 Deepdene Road, Forest Hills Gardens, LI, NY.

ROCKWELL, FREDERICK (FRYE).
Sculptor and painter. Born in Brooklyn, NY, January 12, 1917. Studied: Columbia University; National Academy of Design; Tiffany Foundation; and with Oronzio Malderelli, Arnold Blanch, George Grosz, William Zorach, and others. Member: Audubon Artists. Award: Fellow, Tiffany Foundation, 1948. Work: U.S. Marine Hospital, Carville, LA. Exhibited: NY World's Fair, 1939; American Watercolor Society of New York, 1939, 42, 43; Art Institute of Chicago, 1940, 43, 44; Penna. Academy of Fine Arts, 1943, 46; National Gallery of Art, 1941; Whitney Museum of American Art, 1941; Portland Museum of Art, 1944; Ogunquit Art Center, 1945; Audubon Artists, 1945, 1949-52; Metropolitan Museum of Art, 1952; Farnsworth Museum, 1949; Morton Gallery, 1941 (one-man), 1943; National Sculpture Society, 1956, 57; many others. Address in 1970, East Boothbay, ME.

ROCKWELL, NORMAN.
Illustrator. Born in NYC, Feb. 3, 1894. Pupil of George Bridgman and Thomas Fogarty. Member: Salma. Club; New Rochelle Art Assoc.; Artists Guild of the Authors' League of America; Society of Illustrators. Famous for his illus. for *Saturday Evening Post* and other magazines, including *American* *Magazine* and *Ladies Home Journal*. Captured F.D. Roosevelt's war aims in *Four Freedoms* posters; *Freedom of Speech* poster is in collection of Metropolitan Museum of Art. Collections at Rockwell Museum, Stockbridge, MA. Living in New Rochelle, NY, in 1929. Died in 1978, in Stockbridge, Massachusetts.

ROCKWELL, ROBERT HENRY.
Sculptor. Born in Laurens, New York, October 25, 1885. Represented in the Brooklyn Museum by small bronzes of animals.

ROCLE, MARGARET K.
Painter. Born in Watkins, New York, March 6, 1897. Pupil of Robert Henri; Bredin; Wiles. Member: San Diego Artists Guild; Society of Independent Artists; Salons of America; San Diego Fine Arts Society; Laguna Beach Art Association. Awards: Honorable mention, Southern California Artists, 1931; second prize, Santa Cruz Annual, 1932; honorable mention, San Diego Annual, 1933. Address in 1933, 899 Fourth Avenue, Chula Vista, California.

ROCLE, MARIUS ROMAIN.
Painter. Born in Brussels, Belgium, June 6, 1897. Member: San Diego Artists Guild; Society of Independent Artists; Salons of America; San Diego Fine Arts Society; Laguna Beach Art Association. Award: First prize, San Diego Artists Guild, in 1931. Address in 1933, 8998 Fourth Avenue, Chula Vista, California.

RODDY, EDITH JEANNETTE.
Painter and etcher. Born in Meadville, Pennsylvania. Studied: Boston Museum of Fine Arts School; with Charles Hawthorne, George Pearse Ennis, and others; and in Europe. Awards: Florida Federation of Arts, 1938; Clearwater Art Association, 1946; Sarasota Federation of Arts. Collections: Syracuse Museum of Fine Arts. Exhibited: Florida Art Association; Sarasota Art Association; Clearwater Art Association; Palm Beach Art League; Gulf Coast Group. Member: National Association of Women Artists; Florida Federation of Arts; Sarasota Art Association; Clearwater Art Association. Contributor of covers for *Literary Digest*. Lectures: Art History and Art Appreciation. Address in 1953, Sarasota, Florida.

RODEWIG, DORIS.
Illustrator. Born in Westfield, New Jersey, in 1927. Attended Pratt Institute and began her career as an illustrator in 1949. Since then she has shown her work in the National Arts Club, Society of Illustrators, where she is a member, and the Salmagundi Club, which gave her the Best in Show award in 1975. Her work hangs in the Pentagon and the Smithsonian Institution. Currently living in New York City, she is active in book illustration.

RODINA, K. MICHALOFF.
Sculptor. Exhibited at Pennsylvania Academy of Fine Arts, Philadelphia, in 1915. Address in 1926, 439 Sixteenth Street, Brooklyn, New York.

ROE, ROBERT (MRS.).
See Stohr, Julie.

ROECKER, HENRY LEON.
Painter. Born in Burlington, IA. Pupil of Academy of Design in Chicago; Gysis at Royal Academy in Munich. Member: Chicago Society of Artists; Chicago Water Color Club; "The Cliff Dwellers;" "Cor Ardens." Awards: Hon. mention, Munich, 1889; Yerkes prize, Art Institute of Chicago, 1894; Arche Club prize, Art Institute of Chicago, 1897; Chicago Society of Artists medal, 1909; Carr prize, Art Institute of Chicago, 1911. Address in 1933, Winthrop Harbor, IL.

ROEHLK, ERNST.
Painter. Member: Chicago Society of Artists. Address in 1929, 115 East 30th Street, New York, NY.

ROENNEBECK, ARNOLD.
See Ronnebeck, Arnold.

ROERICH, NICHOLAS KONSTANTIN.
Painter. Born in 1874 in Russia. He came to America about 1920. Has painted Western scenes, also coast and lake views in Maine. In 1921 he organized the "Master Institute of United Arts" in New York City. Address in 1926, 310 Riverside Drive, New York City. He died in 1947.

ROESEN, SEVERIN.
Still life painter, porcelain and enamel painter. Born c. 1815, probably in German Rhineland. Came to United States in 1848, settled in New York City. Between 1848-50, the American Art-Union in New York City purchased eleven of his still lifes. Listed in directories there from 1850-57. About 1857 he went to Philadelphia and later Harrisburg, Pennsylvania; in Huntington, Pennsylvania, in 1860; lived in Williamsport, Pennsylvania, from at least 1862, for about 10 years. Exhibited a flower painting at Cologne in 1847; work also shown at Maryland Historical Society, Baltimore, 1858; Pennsylvania Academy of Fine Arts, 1863; Brooklyn Art Association, 1873. Date of death uncertain; references show a death date of 1871, but Gerdts, in *Painters of the Humble Truth*, mentions a painting executed by Roesen in 1872. Most of his known paintings are still owned in Williamsport and Lycoming County.

ROGALL, WILHELMINE.
Painter. Member: National Association of Women Painters and Sculptors. Address in 1929, 115 East 30th Street, New York, New York.

ROGERS, ADELE (MRS.).
Painter. Born in Mount Vernon, New York, July 7, 1861. Pupil of Cooper Union; Wm. M. Chase; Charles Hawthorne. Member: Provincetown Art Association; Fellowship Penna. Academy of Fine Arts; Southern States Art League; Penna. Academy of Fine Arts. Address in 1929, East Palatka, Florida; summer, Provincetown, MA.

ROGERS, BARKSDALE (MISS).
Illustrator, painter and sculptor. Born in Macon, GA. Pupil of Steinlen in Paris; also studied in Munich. Member: Greenwich Society of Artists; Society of Illustrators. Work: Illustrations for *Judge, The New York Sunday World, Scribners*, and *Puck*. Address in 1934, New York.

ROGERS, CHARLES.
Miniature painter who flourished in Boston about 1846.

ROGERS, FRANCES.
Painter and illustrator. Born in Grand Rapids, MI. Pupil of Howard Pyle. Member: Artists Guild of the Authors' League of America. Illustrations for current magazines. Address in 1929, 350½ West 24th Street, New York, NY; summer, Bearsville, NY.

ROGERS, FRANKLIN WHITING.
Born in Cambridge, MA, in 1854. Pupil of J. Foxcroft Cole in 1874. He has devoted himself especially to the painting of dogs. Among his works are "The Two Friends," "Steady" and "Resignation."

ROGERS, GRETCHEN W.
Painter. Member: Guild of Boston Artists; American Federation of Arts. Award: Silver medal, P.-P. Expo., San Francisco, 1915. Exhibited portrait entitled "Young Girl" at Penna. Academy of Fine Arts (1914). Address in 1929, 210 Fenway Studios, Boston, MA.

ROGERS, HENRY W.
Miniature portrait painter who flourished in Salem about 1782.

ROGERS, HOWARD.
Illustrator. Born in Medford, Oregon, in 1932. Studied at the Art Center College of Design, where he graduated with honors in Advertising Illustration. Before becoming a free-lance illustrator, he worked for McNamara Studio, Graphic House and New Center Studio in Detroit. He has won several awards including an Award of Excellence from the Society of Illustrators.

ROGERS, JANE.
Painter. Born in New York, August 1, 1890. Member: Society of Independent Artists; Salons of America. Address in 1929, 28 West 63rd Street; home 210

West 70th Street, New York, New York; summer, Woodstock, New York.

ROGERS, JOHN.
Engraver. Born in England about 1808; died in New York about 1888, says Mr. Samuel Hollyer. Rogers came to NY in 1850-51, and he engraved for the book publishers a large number of portraits and some subjects plates. He generally worked in line and was a very good engraver.

ROGERS, JOHN ARTHUR.
Etcher and architect. Born in Louisville, KY, April 12, 1870. Pupil of Art Institute of Chicago; Mass. Institute of Technology; Ralph Seymour. Member: Southern States Art League. Died in 1934. Address in 1929, 508 Bellevue Ave., Daytona Beach, FL.

ROGERS, JOHN H.
Sculptor and modeler. Born in Salem, MA, October 30, 1829. Studied in Paris and Rome. Began sculpture after 1858; gave it up for a short period; later received notoriety for humorous genre subjects in Chicago. Opened own studio in NYC where he produced over 80 groups; over 80,000 casts of his work have been made. His well-known "Rogers Groups" were familiar subjects connected with the Civil War. His best-known group of the "Slave Auction" was done in 1859. Rogers also executed the equestrian statue of General Reynolds which stands before the City Hall in Philadelphia. He was elected a member of the National Academy of Design in 1863, and belonged to the National Sculpture Society. Died in New Canaan, CT, July 26, 1904.

ROGERS, JOSEPH SHEPPERD.
See Nevia (Joseph Shepperd Rogers).

ROGERS, LOUISE DE GIGNILLIET.
Painter and etcher. Born in Macon, GA. Pupil of Steinlen, Paris; Robert Henri; also studied in Munich. Member: Brooklyn Soc. of Etchers; CT. Soc. of Artists. Painted portraits of Ex-Vice-President Marshall, William Jennings Bryan, Senator Tillman and others. Add. in 1929, Greenwich, CT.

ROGERS, MARGARET ESTER.
Painter. Born in Birmingham, England, May 1, 1872. Pupil of F. L. Heath; L. P. Latimer; A. L. Bower. Member: Women Painters of the West; West Coast Arts; Santa Cruz Art League; Berkeley League of Fine Arts; San Francisco Society of Women Artists; Oakland Art League. Award: Hon. mention, Statewide Exhib., Santa Cruz, 1928. Died in 1961. Add. in 1933, 99 Pilkington Ave., Santa Cruz, CA.

ROGERS, MARY.
Sculptor and painter. Born in Pittsburgh, Pennsylvania, May 7, 1882. Pupil of Robert Henri; Simon and Menard in Paris. Member: Society of Independent Artists. Address in 1918, 430 Lafayette St.; h. 1 West 85th St., New York City.

ROGERS, NATHANIEL.
Painter. Born in Bridgehampton, Long Island, NY, 1788. He went to NY in 1811 and became a pupil of Joseph Wood, and soon took high rank as a painter of miniatures, among which were those of Fitz-Greene Halleck and Joseph Rodman Drake. He was one of the founders of the National Academy of Design in New York. Died Dec. 6, 1844 in Bridgehampton, Long Island, NY.

ROGERS, RANDOLPH.
Sculptor. Born in Waterloo, NY, on July 6, 1825. About 1848 he went to Italy to study art in Florence and Rome, where he produced the well-known statue "Nydia." Returned to U.S. in 1853 and opened his studio in New York. In 1858 he designed the bronze doors for the Capitol in Washington. He also executed portrait statues of Abraham Lincoln for Philadelphia and of William H. Seward for New York. He resided in Italy from 1860 and was an important figure in the American colony at Rome. Died in Rome, January 15, 1892.

ROGERS, RICHARD (MRS.).
(Mary Bean). Painter. Born in Norristown, PA, August 20, 1904. Pupil of Breckenridge School of Painting; Penna. Academy of Fine Arts; Philadelphia Museum School of Industrial Art. Member: Plastic Club. Address in 1933, Sumneytown, PA.

ROGERS, WILLIAM ALLEN.
Illustrator and writer. Born in Springfield, OH, May 23, 1854. Member: Society of Illustrators (hon.); Artists Guild of the Authors' League of America (hon.); Chevalier of the Legion of Honor, 1921. Work: Poster, "Paid for in Full," Smithsonian Institution, Washington, D.C.; cartoons of war in *New York Herald*. Author of "A World Worth While." Died in 1931. Address in 1929, 1404 29th Street, N. W. Washington, D.C.

ROHL-SMITH, CARL.
See Smith, Carl Rohl.

ROHM, ROBERT.
Sculptor. Born in Cincinnati, OH, Feb. 6, 1934. Studied at Pratt Institute, B. Industrial Design, 1956; Cranbrook Academy of Art, with Berthold Schewitz, M.F.A., 1960. Works: Columbus Gallery of Fine Art; Finch College Museum; Pennsylvania State University; Museum of Modern Art; Whitney. Exhibitions: Aspen (CO) Art Gallery; Whitney; DeCordova; Fogg; Boston Museum of Fine Art; Aldrich Museum of Contemporary Art; others. Awards: Penna. Academy of Fine Arts, honorable mention, 1959; Columbus, Sculpture Prize, 1957, 59; Guggenheim Foundation Fellowship, 1964; University of

Rhode Island Research Grant-in-Aid, 1965, 66, 69; Cassandra Foundation, 1966; National Endowment for the Arts Award, 1974; Artpark, Lewiston, NY, 1977. Member: Sculptors Guild. Taught: Columbus College of Art and Design, 1956-59; Pratt Institute, 1960-65; University of Rhode Island, from 1965. Address in 1984, Wakefield, RI.

ROHN, RAY.
Illustrator. Member: Society of Illustrators. Address in 1929, 218 Walnut Street, Philadelphia, PA.

ROINE, JULES EDOUARD.
Sculptor. Born in Nantes, France, in 1857. Work: "Dawn of the Twentieth Century," Metropolitan Museum, NY. Member: Salmagundi Club, 1906; National Sculpture Society, 1907. Address in 1916, 139 East 23rd Street, NYC. Died in 1916.

ROLLE, A. H. O.
Painter. Born in Minnesota, March 30, 1875. Pupil of Corcoran School of Art, Washington, D.C. Member: Society of Washington Artists; Washington Landscape Club; Washington Water Color Club; American Federation of Arts; Washington Art League. Address in 1929, 1422 Buchanan Street, N. W., Washington, D.C.

ROLLER, MARION BENDER.
Sculptor and painter. Born in Boston, MA. Studied at Vesper George School of Art, dipl.; Art Students League, with John Hovannes; Greenwich House, with Lu Duble; Queens College, B.A.; also watercolors with Edgar Whitney. Commissions: Head of child, Nassau Center for Emotionally Disturbed Children, Woodbury, NY, 1968; portrait of Margaret Sussman, Pen and Brush Club, 1983-84; sculpture of woman and youth, St. Mary of Angels Home, Syosset, NY, 1984; many private commissions. Exhibitions: Allied Artists of America, 1959-74; National Academy of Design, NY, 1962-69; American Artists Professional League, 1965, 66, and 68; National Sculpture Society, from 1969; Audubon Artists, 1973; Catherine Lorillard Wolfe Art Club, 1979-81; Sculpture Center Gallery, 1979-81; Allied Artists of America, 1980-81; many others. Awards: Mrs. John Newington Award, American Artists Professional League, 1965; Archer Milton Huntington Award, 1968; Knickerbocker Artists Prize for Sculpture, 1966; gold medal, 1971, honorable mention for sculpture and watercolor, 1975, Brush Award for etching, 1975, bronze medal, 1980, Tallix Foundry Award, 1983, from Pen and Brush Club; Kalos Kagathos Foundation Prize, National Sculpture Society, 1980. Member: National Sculpture Society; Pen and Brush Club; Allied Artists of America; Catharine Lorillard Wolfe Art Club; Hudson Valley Art Association; others. Has taught at the Sculpture Center, since 1977, and the Traphagen School, since 1973. Address in 1984, 1 West 67th Street, NYC.

ROLLINSON, CHARLES.
Engraver. Born c. 1793. Also a copperplate printer, living in New York in 1808-1832. He was probably a son, or other near relative, of William Rollinson, as he worked with him from about 1808-32, and his address for a considerable time was No. 28 John St., the same as that of Wm. Rollinson. The only plates found by the compiler, and signed by C. Rollinson as engraver, consist of architectural subjects, diagrams, etc. Died Jan. 19, 1833 in Boston, MA.

ROLLINSON, WILLIAM.
Engraver and miniaturist. Born in Dudley, Staffordshire, England, April 15, 1762; died in NY on Sept. 21, 1842. Rollinson was probably a silversmith and learned to engrave upon plate. He came to the United States in 1788 and arrived in New York City on February 15, 1789. He is credited with having ornamented the silver button on the coat worn by Washington at his inauguration as President. His earliest work upon copperplate appears in the American edition of Brown's family Bible, published in NY in 1792. This work is crude, though his small profile of Washington, executed in 1791, according to Wm. Dunlap, is a much better piece of work. Rollinson rapidly progressed in the art of engraving, and about 1796 he changed his style to stipple and furnished some very good portrait plates for the Analectic and other magazines. His large plate of Alexander Hamilton is said to have been commenced in 1800 and published by Rollinson and the painter Archibald Robertson in 1805. He also did banknote work in collaboration with William S. Leney.

ROLPH, JOHN A.
Engraver. Born 1799 in Essex, England. This reputable landscape engraver was working in NY, 1834-46, and probably later. Also a painter. Died in 1862.

ROLSHOVEN, JULIUS.
Painter and teacher. Born in Detroit, MI, Oct. 28, 1858. Pupil of Cooper Union, New York; Hugo Crola at Dusseldorf; Loefftz in Munich; Frank Duveneck in Florence; Robert-Fleury in Paris. Member: Associate National Academy of Design; Societe National des Beaux-Arts, Paris; Secession, Munich; Detroit Fine Arts Society (hon.); International Art Congress; Paris Society of Arts and Letters; Scarab Club, Detroit; Foreign Arts Club, Florence; Bene Merensa Societa di Belle Arte, Florence; Taos Society of Artists; National Arts Club. Awards: Second medal, Paris Expo., 1889; hon. mention, Paris Expo., 1900; bronze medal, Pan.-Am. Expo., Buffalo, 1901; medals, Munich, Berlin, Brussels and Chicago; silver medal, St. Louis Expo., 1904; Hors Concours, Societe Francaise, Paris. Work: "Chioggia Fishing Girl," and two etchings, Cincinnati Museum; "The Refectory of San Damaino, Assisi," Detroit Institute. Represented in Minneapolis Museum; Brooklyn Museum; Detroit Athletic Club; San Francisco

Bohemian Club; Union League Club of Chicago; Baltimore Museum; Montclair Museum; Santa Fe Museum. Died Dec. 7, 1930 in NYC. Address in 1929, 140 West 57th Street, New York, NY; 21 Viale Michelangelo, Florence, Italy.

ROMANO, CLARE CAMILLE.
Painter, lithographer, and printmaker. Born in Palisade, NJ, August 24, 1922. Studied: Cooper Union Art School; Ecole des Beaux-Arts, Fontainebleau, France; Instituto Statale d'Arte, Florence, Italy. Work: Whitney; Library of Congress; Museum of Modern Art; National Collection of Fine Arts, Washington, DC; Metropolitan Museum of Art; NY Public Library; Rochester Memorial Art Gallery; Pennsylvania State University; others. Exhibited: Museum of Modern Art, 1953; Brooklyn Museum, 1951-53, 56-58; Metropolitan Museum of Art, 1953; Library of Congress, 1951, 52, 55; Philadelphia Print Club, 1956, 58, 67 (one-woman); Carnegie; Penna. Academy of Fine Arts; Society of American Graphic Artists; Whitney; Cincinnati Museum of Art Print Exhibition, 1968; Philadelphia Art Alliance, 1969 (one-woman); 1st Biennial American Graphic Art, Colombia, South America, 1971; 2nd Triennial International Exhibition of Woodcuts, Ugo Carpi Museum, Italy, 1972; Amer. Prints, U.S. Information Agency, Australian National Museum, Canberra, 1972; others. Awards: Fulbright fellowship, 1958-59; Tiffany Foundation, 1952; prizes, Brooklyn Museum, 1951; Audubon Artists, 1962, 66; Society of American Graphic Artists, 1962, 67, 68; Boston Print Maker's Society, 1967; others. Member: Print Club of Philadelphia; Society of American Graphic Artists; Modern Painters and Sculptors; Associate National Academy of Design. Has taught at the New School for Social Research; Manhattanville College; Pratt Graphic Arts Center; Pratt Institute. Address in 1984, Englewood, NJ.

ROMANO, NICHOLAS.
Painter, sculptor, craftsman, and writer. Born in Montoro, Italy, Dec. 6, 1889. Pupil of Albert Laessle. Award: Honorable mention, Art Institute of Chicago, 1928. Represented in Penna. Academy of Fine Arts; Philadelphia Art Alliance; Graphic Sketch Club of Philadelphia; Albright Gallery, Buffalo; Memorial Gallery, Rochester. Address in 1933, Philadelphia, PA.

ROMANO, UMBERTO ROBERTO.
Painter, sculptor, engraver and teacher. Born in Italy, Feb. 26, 1905. Pupil of National Academy of Design; American Academy in Rome. Awards: Pulitzer Prize, Columbia University, 1926; Tiffany Fellowship, 1926; honorable mention, 1928, and Peabody prize, 1931, Art Institute of Chicago; Art Guild medal, Tiffany Foundation, NY, 1931; prize, best modern, Springfield Art Club, 1930; first prize, Springfield Art League, 1931, best portrait, 1932;

Atheneum prize, Connecticut Academy of Fine Arts, 1931; Crowninshield prize, Stockbridge, MA, 1932; Carnegie Award, National Academy of Design, 1954; gold medal of honor, Century Association, 1969. Represented in National Collection of Fine Arts, Washington, DC; Whitney Museum; Corcoran Art Gallery; Penna. Academy of Fine Arts; National Academy of Design; Smithsonian Institution; Brandeis University; Ohio University; Roosevelt Library, Hyde Park, NY; Worcester Art Museum; Smith College Museum of Art, Northampton, MA; Rhode Island School of Design, Providence; Fogg Art Museum, Cambridge, MA; Museum of Fine Arts, Springfield, MA; many others, including private collections in U.S. and abroad. Commissions: Mural, Springfield Post Office; Hyde Park Library; Munic. Court House, NY; Allen Stevenson School, NY. Exhibited: Nationally, and in Europe, South America, and the Orient. One-man exhibitions: Rehn Gallery; Whitney; Springfield Museum of Fine Arts; Associated American Artists, Chicago; Rochester, NY; Chicago, IL; Krasner Gallery; Birmingham Museum of Art; Wellfleet Art Gallery, Cape Cod; others. Member: National Society of Mural Painters; National Academy of Design (council member, 1963; chairman of the School Committee, 1965); Audubon Artists (vice-president, 1963); Century Association (exhibition committee, from 1970); Rockport Art Association; National Mural Society (director, from 1962). Teaching: Worcester Art Museum School, 1933-40; privately in NYC and Chatham, Massachusetts, from 1950. Address in 1984, 162 E. 83rd Street, New York City.

ROMANS, BERNARD.
Engraver. Born in Holland about 1720; died at sea in 1784. Romans was educated in England, and about 1755 he came to the American Colonies. At the outbreak of the Revolution he entered the service of the American Colonies, and was present at Lexington and Bunker Hill, according to the statement made in connection with his published proposals for issuing his view of the Battle of Bunker Hill and his map of Boston. Romans is referred to in the *New York Mercury* of 1775 as "The most skillful draughtsman in all America," though his view of the battle of Bunker Hill is anything but artistic in its composition. He engraved this view on a large scale, and it was published by Nicholas Brooks, of Philadelphia, in September and October, 1775, "An Exact View of the Late Battle of Charlestown, June 17, 1775," to give the plate its full title. It was re-engraved by Robert Aitken on a small scale and published in the *Pennsylvania Magazine* for 1775.

ROMNEY, MILES.
Wood carver. Born in Dalton, Lancashire, England, July 13, 1806. Came to Nauvoo, Illinois, in 1841; moved to Utah in 1850. Worked on Mormon Temple at Nauvoo, Illinois, in the mid-1840's. Died at St. George, Utah, in May 1877.

ROMOSER, RUTH AMELIA.
Painter and sculptor. Born in Baltimore, MD, April 26, 1916. Studied at Baltimore Art Institute, grad.; sculpture with Xavier Corbera, Barcelona, Spain; Robert Motherwell Workshop; graphics with Joseph Ruffo; Individual Artist Fellowship, Division of Cultural Affairs of Florida, 1980-81. Works: Miami Museum of Modern Art, FL; Lowe Museum, University of Miami; Miami Herald; National Cardiac Hospital, Miami; International Gallery, Baltimore, MD. Commissions: Two paintings for 12 productions, Actors Studio M, Coral Gables, FL, 1963-64. Exhibitions: Ringling Southeast National Art Show, Sarasota, FL, 1961-63; National Drawing Exhibition, Cheltenham, PA, 1964; Four Arts Plaza National, Palm Beach, 1966; Hortt Memorial Regional, Ft. Lauderdale Museum of Arts, 1966; Norton Gallery, Palm Beach, FL; one-woman show, National Design Center, NY, 1967. Awards: Eighth Annual Hortt Memorial Award, Ft. Lauderdale Museum of Arts, 1967; Design Derby Award, Designers-Decorators Guild, 1969; Artspo 70, Coral Gables, 1970; Major Florida Artists, 1976-77; Dade County Council of Arts and Science Award, 1979; Florida House of Representatives Purchase Award, 1979. Member: Blue Dome Art Fellowship; Women's Caucus of Art; Florida Artists Group; Lowe Museum. Media: Oil and acrylic. Address in 1984, Miami, FL.

RONDONI, ROMOLO.
Sculptor. Exhibited at the Penna. Academy of Fine Arts, Philadelphia, 1914. Address in 1926, 35 East 30th Street, New York City.

RONNEBECK, ARNOLD.
Sculptor, lithographer, teacher, writer and lecturer. Born in Nassau, Germany, May 8, 1885. Pupil of Aristide Maillol and Emile Bourdelle in Paris. Awards: Silver medal, Kansas City, MO, 1928; Fine Arts medal, City Club, Denver, 1928; gold medal, Kansas City Art Institute, 1929; hon. mention, Annual Exhibition, Denver, 1931. Work: Sixteen panels, "The History of Money," Denver National Bank; "Madonna and Angels," St. John's Cathedral; reredos of "The Ascension," Church of the Ascension, Denver, CO; Friezes of Indian Ceremonial Dances, La Fonda, Santa Fe, NM; bronze portrait bust, Denver Museum. Represented in various European and American museums and private collections. Director, Denver Art Museum. Address in 1933, Denver, CO.

RONNEBECK, LOUISE EMERSON.
Painter. Born in Germantown, PA, in 1901. Studied: Columbia, B.A., 1922; Barnard College; Art Students League, 1922-26; American School, Fontainebleau, France, summer, 1923; also studied with George Bridgman and Kenneth Hayes Miller. Collections: County Hospital, Greeley, CO; Morrey Junior High School, Denver, CO; Children's Hospital, Denver, CO; Sloanes Lake Club House, Denver, CO; Bermuda High School for Girls; Bermuda Department of Agriculture; U.S. Post Office, Worland, WY, Grand Junction, CO; children's chapel, St. John's Cathedral, Denver; others. Exhibited: Denver Art Museum; San Diego Museum; Los Angeles Museum; Fine Arts Center, Colorado Springs, CO; Corcoran Gallery; others. Member: Art Students League, NY; Artists Equity; National Society of Mural Painters; Bermuda Society of Arts. Address in 1962, Beckshill, Harrington Sound, Bermuda.

ROOD, JOHN.
Sculptor, painter, writer, lecturer and educator. Born in Athens, OH, February 22, 1906. Studied: Ohio University; self-taught in art. Traveled extensively. Works: Addison Gallery, Andover, Massachusetts; Corcoran; Cranbrook; Minneapolis Institute; University of Minnesota; Ohio University; Walker; plus commissions for Minneapolis Public Library; Wellesley College; St. Marks Cathedral, Minneapolis; and Hamline University. Exhibitions: Nationally, including Passedoit Gallery, NYC; Durand-Ruel Gallery, NYC; Newark Museum; Minneapolis Institute; Ward Eggleston Gallery, Chicago, 1949; Whitney; University of Minnesota; Walker; Corcoran; Cranbrook; and in Milan and Rome, Italy, 1956. Member: Artists Equity Association (national president, from 1959); Minnesota Art Association. Awards: Minneapolis Institute of Art; Minnesota State Fair; San Francisco Museum of Art; others. Author: *Wood Sculpture*, 1940; *Sculpture in Wood*, 1950; *Sculpture with a Torch*, 1961. Address in 1970, c/o Weintraub Gallery, New York City. Died in Minneapolis, Minnesota, 1974.

ROOK, EDWARD FRANCIS.
Painter. Born in New York, NY, 1870. Pupil of Constant and Laurens in Paris. Member: Associate National Academy of Design, 1908; Academician National Academy of Design, 1924; Lotos Club; Lyme Art Association. Awards: Temple gold medal, Penna. Academy of Fine Arts, 1898; bronze medal, Pan.-Am. Expo., Buffalo, 1901; two silver medals, St. Louis Expo., 1904; bronze medal, Carnegie Institute, Pittsburgh, 1910; silver medal, Buenos Aires Expo., 1910; gold medal, P.-P. Expo., San Francisco, 1915; third W. A. Clark prize ($1,000), and bronze medal, Corcoran Gallery, Washington, DC, 1919. Work: "Deserted Street - Moonlight," Penna. Academy, Philadelphia; "Pearl Clouds - Moonlight" and "Wisteria," Cincinnati Museum; represented in Boston Art Club and in Lotos Club, New York, and Portland Art Museum. Died in 1960. Address in 1929, Old Lyme, CT.

ROOS, PETER.
Painter and teacher. Born in Sweden, February 22, 1850. Member: Boston Art Club. Award: Medal, Boston, 1874. Specialty: Landscape. Address in 1929, 24 Sacramento Street, Cambridge, Massachusetts.

ROOSEVELT, SAMUEL MONTGOMERY.
Portrait painter. Born July 20, 1863 in New York City. Pupil of Art Students League of New York; Academie Julian, Paris. Painted portraits of Theodore Roosevelt, Bishop James H. Darlington, Oliver Belmont, Hudson Maxim, Henry F. Shoemaker, Earl of Kintare, etc. Member: National Association of Portrait Painters; Artists' Fund Society; Chevalier Legion of Honor, France. Died Aug. 19, 1920 in NYC.

ROOT, ORVILLE HOYT.
Painter. Exhibited at the Penna. Academy of Fine Arts, Philadelphia, 1914. Address in 1926, Paris, France.

ROOT, ROBERT MARSHALL.
Painter and illustrator. Born in Shelbyville, IL, March 20, 1863. Pupil of Constant, Laurens and Lefebvre. Member: Brown County (IN) Art Association; Springfield (IL) Art Association; All-Illinois Society of Fine Arts. Award: State Centennial Medal, Springfield, 1918. Work: Historical painting "Lincoln and Douglass Debate, 1858," Springfield; "Portrait Lt. Gov. Barat O'Harra," Lt. Governor's office, Springfield; "The Power, The Wisdom, The Justice of the Law," in Atty. General's office, Springfield. Address in 1929, Syndicate Bldg., Shelbyville, IL.

ROPER, MURRAY J.
Sculptor and painter. Born in David City, NE, Feb. 2, 1910. Studied: University of Nebraska; PAFA; Art Students League; Beaux-Arts Institute of Design. Exhibited: PAFA; Putnam County Art Association. Address in 1940, Yonkers, NY.

RORIMER (or RORHEIMER), LOUIS.
Sculptor, architect, craftsman, lecturer, and teacher. Born in Cleveland, Sept. 12, 1872. Pupil of Puech, Constant, Widaman, LeBlanc. Member: Cleveland Society of Artists; Salmagundi Club; Arts in Trade Club. Died November 30, 1939.

ROSATI, JAMES.
Sculptor. Born in Washington, PA, 1912. Works: Colby College; NY Univ.; Rockefeller Univ.; Whitney; Yale Univ.; Albright-Knox; Hirshhorn. Exhibited: The Peridot Gallery, NYC; Ninth St. Exhibition, NYC; Whitney Annuals, 1952, 53, 54, 60, 62, 66; Carnegie; Claude Bernard, Paris; American Federation of Arts, Contemporary Sculpture; International Outdoor Sculpture Exhibition, Otterlo, Holland; Art Institute of Chicago; Seattle World's Fair, 1962; Battersea Park, London, International Sculpture Exhib.; New York World's Fair, 1964-65; Flint Institute; Colby College; Museum of Contemporary Crafts. Awards: Brandeis University, Creative Arts Award, 1960; Art Institute of Chicago, Logan Medal and Prize, 1962; Carborundum Major Abrasive Marketing Award, 1963; Guggenheim

Foundation Fellowship, 1964. Taught: Cooper Union; Pratt Inst.; Yale Univ., 1960-64, from 1968; Dartmouth Col., 1963. Violinist with the Pittsburgh Symphony. Address 1982, 56 7th Ave., NYC.

ROSE, LEATRICE.
Painter and instructor. Born in NY, NY. Studied: Cooper Union, 1945; Art Students League, 1946; Hans Hofmann School, 1947. Exhibited: Artists Annual, Whitney Mus. of Am. Art, 1950; Zabriskie Gallery, 1965 (one-woman); Landmark Gallery, 1974 (one-woman); Tibor de Nagy Gallery, 1975, 81 (one-woman); Penna. Acad. of Fine Arts Annual, 1966; NY Cultural Center, 1973; Nat. Academy of Design, 1974-76; Whitney Mus. of Am. Art, 1978; Met. Museum of Art, 1979; Nassau County Mus. of Fine Arts, 1980. Awards: Creative Artists Public Service Grant, 1974; Am. Assoc. of Univ. Women Grant, 1975-76; Nat. Endowment for the Arts Grant, 1977. Dealer: Tibor de Nagy Gallery, NY, NY. Address 1984, 463 West St., New York, NY.

ROSE, RUTH STARR.
Sculptor and painter. Born in Eau Claire, WI, July 12, 1887. Studied: Vassar College; Art Students League of NY; and with Hayley Lever. Exhibited: Nat. Academy of Design, 1945, 46; Nat. Assoc. of Women Artists, 1944, 45, 49, 50; one-woman shows at Rehoboth Art League; Farnsworth Museum of Art, Rockland, ME, 1954; Howard Univ., 1958; City Hall, Alexandria, VA, 1964; others. Member of Southern States Art League; Montclair Art Assoc.; Nat. Arts Club, NY. Awards: Nat. Assoc. of Women Artists, 1937, 44; State of NJ, 1944; Wash. Printmakers, 1951; Norfolk Mus. of Arts and Science, 1950; Corcoran Gallery of Art, 1951; VA Printmaker, 1957; Wash. Area Printmakers, 1957; Art Fair, Alexandria and Washington, 1957; Religious Art Fair, 1958. Collections: Library of Congress; Met. Museum of Art; Wells Col.; Williams Col.; Milliken Col.; Norfolk Mus. of Arts and Science. Address 1970, Alexandria, VA.

ROSE, THOMAS ALBERT.
Sculptor. Born in Wash., DC, Oct. 15, 1942. Studied at Univer. of Wis-Madison, 1960-62; Univ. of IL, Urbana, B.F.A., 1965; Univ. of CA, Berkeley, M.A., 1967, study grant to Univ. of Lund, Sweden, 1967-68. Work in Library of Congress, Wash., D.C.; Minneapolis Inst.; Brooklyn Mus., NY; others. Exhibited at Walker Art Center; Downtown Whitney, NY; Hirshhorn Mus., Washington, DC; others. Taught sculpture at Univ. of MN, Minneapolis, 1972-81, assoc. prof. from 1981. Address in 1982, Minneapolis, MN.

ROSEBERRY, HELEN K.
Sculptor. Born 1932. Studied: East TN State Univ., Johnson City, TN. Awards: Sinking Creek Film Celebration, Nashville, TN., 1973; TN Arts Comm., 1974. Exhibitions: Beech Galleries, Beech MT., NC, 1972; Milligan Col., TN, 1973; TN Drawings, 1974.

ROSELAND, HARRY.
Painter. Born in Brooklyn, NY, May 12, 1868. Pupil of J. B. Whittaker in Brooklyn; Beckwith in NY. Member: Brooklyn Art Club; Salma. Club, 1896; Brooklyn Painters and Sculptors; Brooklyn Society of Artists. Awards: Gold medal, Brooklyn Art Club, 1888; second Hallgarten prize, National Academy of Design, 1898; silver medal, Boston, 1900; bronze medal, Charleston Expo., 1902; silver medal, American Art Society, 1902; gold medal, Boston, 1904; gold medal, American Art Society, 1907. Work: "The Blessing," "Toilers of the Field," Brooklyn Institute of Arts and Sciences; Charleston Art Museum; Huntington Art Museum. Specialty: Negro subjects. Address in 1929, Ovington Studios, 246 Fulton Street; h. 389 Bergen Street, Brooklyn, NY.

ROSEN, CHARLES.
Painter. Born in Westmoreland Co., PA, April 28, 1878. Pupil of National Academy of Design and NY School of Art under Chase, Du Mond and F. C. Jones. Member: Associate National Academy of Design, 1912, Academician National Academy of Design, 1917; National Arts Club. Awards: Third Hallgarten prize, National Academy Design, 1910; first Hallgarten prize, National Academy of Design, 1912; Shaw purchase prize ($500), Salma. Club, 1914; hon. mention, Carnegie Institute, Pittsburgh, 1914; silver medal, P.-P. Expo., San Francisco, 1915; Inness gold medal, National Academy of Design, 1916; Altman prize ($1,000), National Academy of Design, 1916; first prize, Columbus Art League, 1925; Sesnan gold medal, Penna. Academy of Fine Arts, 1926. Work: "Washed Out Bottomlands," Minneapolis Society of Fine Arts; "Late Sunlight," Duluth Fine Arts Association; "Frozen River," Delgado Museum, New Orleans, LA; "Winter Sunlight," Butler Art Institute, Youngstown, OH; "North Haven," City Art Museum, St. Louis, MO; "Ice Bound Coast," University of Michigan, Ann Arbor; "Tivoli Ferry," "Car Shops," Whitney Museum of American Art, New York, NY. Died in 1950. Address in 1933, Woodstock, NY.

ROSEN, KAY.
Sculptor. Born in Corpus Christi, TX, in 1943. Studied: Newcomb College, New Orleans; Northwestern University; Art Institute of Chicago. Exhibitions: Del Mar College, Texas; University of Chicago; ARC Gallery, Chicago, 1975.

ROSENBAUER, WILLIAM WALLACE.
Sculptor, craftsman, and teacher. Born in Chambersburg, Pennsylvania, June 12, 1900. Studied: St. Louis School of Fine Arts; Alexander Archipenko. Member: Kansas City Society of Artists. Awards: Silver medal, Kansas City Art Institute, 1925, 26 and 29; gold medal, Kansas City Art Institute, 1927, prizes, 1935, 36, 39, 40; first sculpture awards, Second Missouri Art Exhibition, St. Louis, 1929. Address in 1953, Danbury, CT.

ROSENBERG, HENRY MORTIKAR.
Painter. Born in New Brunswick, NJ, Feb. 28, 1858. Pupil of Royal Academy in Munich; studied in Florence and Venice. Member: Salma. Club; vice-president, Nova Scotia College of Art, Halifax. Died in 1947. Address in 1929, Hotel Citronelle, Citronelle, AL; Halifax, N.S.; h. Dartmouth, N.S.

ROSENBERG, JAMES N.
Painter. Born in Allegheny City, PA, Nov. 20, 1874. Member: National Arts Club; Society of Independent Artists; Washington Art Club; American Federation of Arts. Died in 1970. Address in 1929, 165 Broadway; 27 West 67th Street, New York, NY.

ROSENBERG, LOUIS C.
Illustrator and etcher. Born in Portland, OR, May 6, 1890. Pupil of Massachusetts Institute of Technology; American Academy in Rome; Royal College of Art, London. Member: Philadelphia Society of Etchers; Brooklyn Society of Etchers; Chicago Society of Etchers; Royal Society of Painters, Etchers and Engravers. Awards: Silver medal, California Print Maker's Society, 1924; Logan medal, Chicago Society of Etchers, 1925 and 1927. Prints in Smithsonian Institution and Congressional Library, Washington, DC; Victoria and Albert Museum, London; British Museum, London; New York Public Library. Address in 1929, Greenfield Hill, Fairfield, CT.

ROSENBERG, MANUEL.
Illustrator, cartoonist, writer, lecturer, and teacher. Born in New Orleans, Jan. 29, 1897. Pupil of Duveneck; Meakin; Carl Werntz; John Maynard. Member: Commercial Art Club of Cincinnati; Western Art Association. Author of *Newspaper Art, Practical Art, Cartooning and Drawing, Art in Advertising* (Harper Bros., 1929). Art Editor of *The Cincinnati Post*. Chief artist, The Scripps-Howard League of Newspapers. Address in 1929, The Cincinnati Post; Artists' Bldg., 35 East Third Street; h. 3592 Bogart Ave., Avondale, Cincinnati, OH.

ROSENBERG, SAMUEL.
Painter and etcher. Born in Philadelphia, PA, June 28, 1896. Studied: Carnegie Institute, B.A.; pupil of Collens, Sparks, Volk. Member: Associated Artists of Pittsburgh; College Art Association of America; Abstract Group. Award: 1st prize, Pittsburgh Art Association, 1920; prizes, Carnegie, 1945; Associated Artists of Pittsburgh, 1917, 20, 21, 30, 36, 46, 48; Pittsburgh Society of Artists, 1928, 29; Butler Art Institute, 1939, 43, 47; others. Represented in Pittsburgh public schools; Carnegie Institute; Butler; Slippery Rock (PA) State Teachers College; Pennsylvania State College. Exhibited: Carnegie; Whitney; John Herron Art Institute; University of Illinois; Butler. One-man exhibitions: Bucknell University; University of Tennessee; Butler; Boston Museum of Fine Arts School; Cheltenham Art Center, Phila.;

Jewish Community Center; others. Professor of Drawing and Painting, Carnegie Institute, Pittsburgh, PA. Address in 1953, Carnegie Institute, Fine Arts College; h. 340 Coltart Ave., Pittsburgh, PA.

ROSENBERG, SAMUEL MARTIN.
Painter and teacher. Born in Washington, D.C., December, 1893. Pupil of Henry Seldon. Member: Springfield Art League; Springfield Artists Guild. Award: Springfield Art League, 1927. Address in 1933, 767 Armory Street, Springfield, MA.

ROSENBLUM, REGINA.
Painter. Born in Poland in 1948. Studied: School of the Art Institute of Chicago; Northwestern University. Awarded a Ford Foundation Fellowship in 1970-72. Exhibitions: Lever House, NYC, 1968; Women Choose Women Show, Wabash Transit Gallery, Chicago, 1973; ARC Gallery, Chicago, 1974.

ROSENBLUM, RICHARD STEPHEN.
Sculptor. Born in New Orleans, LA, December 31, 1940. Studied: California School of Art; Cleveland Institute of Art; Cranbrook Academy of Art. Work in Columbus Museum of Art. Has exhibited at Addison Gallery of American Art, Andover, MA; National Academy of Design Annual, NY; Edwin Ulrich Museum of Art, Wichita, KS; others. Works in bronze. Represented by Coe Kerr Gallery, NYC. Address in 1982, Newton, MA.

ROSENBLUM, SADIE SKOLETSKY.
Painter, printmaker and sculptor. Born in Odessa, Russia, Feb. 12, 1899; U.S. citizen. Studied at Art Students League; New School for Social Research; also with Raphael Soyer, Kunioshr, Ben-Zion, and Samuel Adler. Works: Philadelphia Museum of Art; Ohio University; El Paso Museum of Art; Brandeis University Museum; Lowe Art Museum, University of Miami. Exhibitions: Museum of Modern Art, NY; Corcoran Gallery of Art, Washington, DC; one-woman shows, Museum of Arts, Ft. Lauderdale, FL, 1962 and 65, Lowe Art Museum, University of Miami, 1964; Columbia Museum, SC, 1972. Medium: Oil. Address in 1982, Miami Beach, FL.

ROSENFELD, MORT.
Illustrator. Born in Brooklyn, NY, in 1928. Attended the School of Industrial Art and the Art Students League. His first published illustration, an advertisement for US Rubber, appeared in *Life* magazine in 1948. Though primarily concentrating on editorial work, he has also illustrated books, including *Eight Bailed Out* (1952) and *Where Love Has Gone* (1960). The Silvermine Guild and New Haven Paint and Clay Gallery have exhibited his work.

ROSENGREN, HERBERT.
Painter, sculptor and etcher. Born in Kewanee, IL, Dec. 8, 1908. Member: Rockford Art Association;

Iowa Art Club. Awards: First prize in etching and water color, Iowa State Fair, 1931; first prize, sculpture, Iowa Art Club, 1931. Address in 1933, Rockford, IL; summer, The Little Gallery, Cedar Rapids, IA.

ROSENKRANZ, CLARENCE C.
Painter. Born in Hammondsport, NY. Pupil of John Ward Stimson, W. M. Chase and Walter Shirlaw. Member: Buffalo Society of Arts; Duluth Art Association; Minnesota State Art Association. Awards: First hon. mention, 1909, fellowship prize, 1911, second hon. mention, 1912, Buffalo Fine Arts Academy; first prize, 1911, second hon. mention, 1912, Buffalo Fine Arts Academy; first prize, Minn. Art Committee, 1913. Work: "New England Winter," Minn. Art Society; Hibbing and Buhl (MN) Public Libraries. Instructor, Minnesota Art School, St. Paul. Address in 1933, 48 East 4th Street, St. Paul, MN.

ROSENMEYER, BERNARD JACOB.
Painter and illustrator. Born in New York in 1870. Pupil of Art Students League of NY under Mowbray; Constant and Laurens in Paris. Member: Society of Illustrators, 1902. Work: Carnegie Institute, Pittsburgh; Print Department of NY Public Library. Address in 1929, 140 Wadsworth Ave., New York, NY.

ROSENQUIST, JAMES.
Painter. Born in Grand Forks, ND, Nov. 29, 1933. Studied: Minneapolis School of Art, 1948; University of Minnesota, with Cameron Booth, 1952-54; Art Students League, 1955. From 1954-60, he worked as a billboard painter. Involved with the Aspen Institute of Humanist Studies, Colorado, Eastern philosophy and history, 1965. Exhibited: Six Painters and the Object, Solomon R. Guggenheim Museum, NYC, 1963; Mixed-Media, 1963 and Kid Stuff, 1971, at the Albright-Knox Art Gallery, Buffalo, NY; Americans 1963, Around the Automobile, 1965; The 1960's, 67 and Works from Change, 1974, all at the Museum of Modern Art, NYC; Whitney Museum of Art, NYC; Documenta IV, Kassel, West Germany, in 1968; Los Angeles County Museum of Art, 1971; Portland Art Center, OR, 1973; and others. Taught: Visiting lecturer at Yale University, New Haven, CT, 1964. First fine art piece he painted was "Zone," 1961; in 1963, painted a mural for the NY World's Fair. Another later work is "F-111," 1964-65, a work which is 86 feet wide and shows the fuselage of an airliner which is broken up by smaller pictures such as images of spaghetti, a lightbulb, and a child's face. Works are in oil. Address in 1982, Leo Castelli Gallery, 420 West Broadway, NYC.

ROSENSHINE, ANNETTE.
Sculptor. Born in San Francisco, CA, April 14, 1880. Pupil of California School of Fine Arts and Henri

Matisse. Member: San Francisco Society of Women Artists. Address in 1933, San Francisco, CA.

ROSENTHAL, ALBERT.
Painter, etcher, lithographer and writer. Born in Philadelphia, PA, Jan. 30, 1863. Pupil of his father, Max Rosenthal, and of Penna. Academy of Fine Arts; Ecole des Beaux-Arts in Paris under Gerome; studied in Munich. Member: Fellowship Penna. Academy of Fine Arts; Charcoal Club, Baltimore; Washington Art Club; Salma. Club; Locust Club, Philadelphia; American Federation of Arts. Awards: Bronze medal, St. Louis Expo., 1904; bronze medal, P.-P. Expo., San Francisco, 1915. Represented in Brooklyn Museum; Butler Art Institute, Youngstown, OH; Los Angeles Museum; Kansas City Art Institute; Detroit Institute; St. Louis Museum; Dallas (TX) Art Association; Rhode Island School of Design; Newport Art Association. Died in 1939. Address in 1929, 10 South 18th Street, Philadelphia, PA; summer, New Hope, PA.

ROSENTHAL, DAVID.
Painter and illustrator. Born in Cincinnati, OH, in 1876. Studied in Italy. Address in 1926, 30 Hurbert Block, Cincinnati, OH. Died in 1949.

ROSENTHAL, DORIS.
Painter, lithographer, designer and teacher. Born in Riverside, CA. Studied: Teachers College, Los Angeles, CA; Columbia University; Art Students League with George Bellows and John Sloan. Awards: Guggenheim fellowship, 1932, 36; prize, Northwest Printmakers; Nat. Academy of Design, 1952; American Academy of Arts and Letters grant, 1952. Collections: Metropolitan Museum of Art; Addison Gallery of American Art; Museum of Modern Art; Colorado Springs Fine Arts Center; Rochester Memorial Art Gallery; Toledo Museum of Art; University of Arizona; Library of Congress; San Diego Fine Arts Gallery; Davenport Municipal Art Gallery; Cranbrook Academy of Art. Exhibited: Museum of Modern Art, Paris, 1938; Whitney; Virginia Museum of Fine Arts; Rhode Island School of Design; Art Institute of Chicago; Dallas Museum of Fine Arts; Golden Gate Expo., 1939; Midtown Gallery (one-woman); Latin America traveling exhibition, Metropolitan Museum of Art; Nat. Academy of Design; Dayton Art Institute; Baltimore Museum of Art (one-woman); Slater Memorial Museum (one-woman); others. As a lithographer, she was a compiler on the Encyclopedia Britannica. Address in 1970, c/o Midtown Galleries, 11 East 57th Street, New York, NY; h. Porfirio Diaz 1220, Oaxaca, Oax., Mexico.

ROSENTHAL, LOUIS CHATEL.
Sculptor. Born in Lithuania, Feb. 5, 1888. Came to U.S. in 1907. After studying with Ephraim Keyser in Baltimore, he won a scholarship to study abroad.

Exhibited: Palace of the Legion of Honor, 1929; Philadelphia Art Alliance, 1930; Baltimore Museum of Art, 1923. Member: Royal Society of Miniature Painters and Sculptors, England; National Sculpture Society; College Art Association; Charcoal Club, Baltimore. Address in 1953, Baltimore, MD. Died in 1964.

ROSENTHAL, MAX.
Etcher and lithographer. Born in Turek, Russian Poland, November 23, 1833. Mr. Rosenthal studied drawing and painting in Paris. He came to Philadelphia in 1849 and there continued his studies at the Penna. Academy of Fine Arts. Having been a pupil of the famous Thurwanger in Paris and in Philadelphia, in connection with his brother, Mr. Rosenthal established himself in the lithographic business in the latter city, and he made notable progress in developing the then new art of Chromo-lithography in this country In 1884, Mr. Rosenthal turned his attention to etching, and in connection with his son, Albert Rosenthal, issued a series of portraits of men prominent in American history. In 1890 he took up the work of engraving in mezzotint, and as he was already a reputable painter of portraits and historical subjects, his artistic training led him to produce mezzotint portraits of merit. Died Aug. 8, 1918, in Philadelphia, PA.

ROSENTHAL, MICHAEL.
Painter. Born in Russia, 1885. Pupil of Robert Henri. Address in 1926, 1947 Broadway, New York City. Died in 1941.

ROSENTHAL, MILDRED.
(Mrs. Hyman Rosenthal). Painter. Born in Panama. Pupil of California School of Fine Arts. Member: San Francisco Society of Women Artists; San Francisco Art Association. Address in 1933, 76 Sixth Ave., San Francisco, CA.

ROSENTHAL, TOBY EDWARD.
Painter. Born in New Haven, CT, in 1848. Studied drawing under Henri Bacon, and painting under Fortunato Arriola, San Francisco; student at Royal Academy, Munich, under Straehuber, Carl Raupp and Carl von Piloty, 1865-72. Professionally engaged as a painter since leaving the Academy, having classes in painting and composition. He painted chiefly figural compositions and genre work; also painted many portraits in California, England and Germany. Medals at Centennial Expo., Philadelphia, 1876; Royal Academy, Munich; International Exposition, Munich. Died in 1917, in Berlin.

ROSENTHAL, TONY (BERNARD).
Sculptor. Born in Highland Park, IL, Aug. 9, 1914. Studied at University of Michigan, 1936, B.A.; Art Institute of Chicago School; Cranbrook Academy of Art, with Carl Milles. Works: Baltimore Museum of

Art; Albright; University of Illinois; Herron; De Cordova; Long Beach Museum of Art; Los Angeles County Museum of Art; Museum of Modern Art; University of Michigan; Milwaukee; National College of Fine Art; NY University; Newark Museum; Santa Barbara Museum of Art; UCLA; Whitney; Guggenheim Museum; Museum of Modern Art; Albright-Knox Art Gallery. Commissions: Museum of Science and Industry, Chicago, 1941; New York World's Fair, 1939; RKO Studios, Hollywood; University of Michigan; Temple Beth-El, Birmingham, MI, 1973; Cranbrook, 1980. Exhibited at San Francisco Museum of Art; Long Beach Museum of Art; Carnegie; The Kootz Gallery, NYC; M. Knoedler & Co., NYC; Metropolitan Museum of Art; Museum of Modern Art; Sao Paulo Biennial; Brussels World's Fair, 1958; Art Institute of Chicago; Penna. Academy of Fine Arts; Sculptors Guild; Audubon Artists; Walker; Yale University; Whitney; Boston Museum of Fine Arts; Krannert Art Museum, University of Illinois, Champaign; Aldrich Museum of Contemporary Arts, Ridgefield, CT. Received San Francisco Museum of Art Sculpture Award, 1950; Los Angeles Co. Museum of Art, 1950; Los Angeles All-City Show, sculpture prize, 1951; Audubon Artists, sculpture award, 1953; Penna. Academy of Fine Arts, honorable mention, 1954; Los Angeles County Museum of Art, sculpture award, 1957; American Institute of Architects, Southern California Chapter, honor award, 1959; Ford Foundation, 1963; Tamarind Fellowship, 1964; Univ. of Michigan, outstanding achievement award, 1967; Carborundum Major Abrasive Marketing Award, 1969. Address in 1982, 173 E. 73rd St., NYC.

ROSENZWEIG, LIPPA.
Sculptor. Exhibited at Penna. Academy of Fine Arts, Phila., 1926. Address in 1926, Philadelphia, PA.

ROSEY, ALEXANDER P.
(Abraham Rosenstein). Sculptor. Born in Baltimore, MD, July 4, 1890. Studied: National Academy of Design; Beaux-Arts Institute of Design, New York. Awards: Medal, National Academy of Design; Beaux-Arts Institute of Design. Exhibited: Penna. Academy of Fine Arts; Corcoran Gallery of Art; National Academy of Design; Baltimore Museum of Art. Address in 1953, 185 McClellan Street, New York, NY.

ROSIN, HARRY.
Sculptor and teacher. Born in Philadelphia, PA, December 21, 1897. Studied: Philadelphia Museum School of Industrial Art, Phila.; Penna. Academy of Fine Arts; and in Paris, France. Awards: Cresson traveling scholarship, 1926, medal, 1939, 40, prize, 1941, Penna. Academy of Fine Arts; grant, American Academy of Arts and Letters, 1946; medal, Philadelphia Museum of Art, 1951; prize, Audubon

Artists, 1956. Work: Penna. Academy of Fine Arts; Philadelphia Mus. of Art; Papeete, Tahiti; memorial, Fairmount Park, Philadelphia. Exhibited: World's Fair, Chicago, 1934; Texas Centennial, 1936; Golden Gate Expo., 1939; NY World's Fair, 1939; Art Institute of Chicago, 1934, 46; Whitney Museum of American Art; Penna. Academy of Fine Arts, 1933-46, 58, 60; Carnegie Institute; Modern American Art, Paris, 1932; Salon de L'Oeuvre Unique, Paris, 1932; Metropolitan Museum of Art, 1951; Detroit Institute of Art, 1958. Taught: Instructor, Sculpture and Drawing, Penna. Academy of Fine Arts, Philadelphia, PA, from 1939. Address in 1970, New Hope, PA. Died in 1973.

ROSS, ALEX.
Illustrator. Born in Dunfermline, Scotland, in 1908. He came with his family to America and settled in the Pittsburgh area. He attended Carnegie Institute of Technology and later received an honorary degree from Boston College. His art career began in Pennsylvania, but he soon came to NY and worked in advertising. In 1942 he painted the first of 130 covers for *Good Housekeeping*. He has contributed to the U.S. Air Force Art Program and his works are in the collections of the New Britain Museum of American Art, the Mormon Church, six murals exhibited at the NY World's Fair, and Fairfield University, where he is on the board of trustees.

ROSS, CHARLES.
Environmental artist and sculptor. Born in Philadelphia, PA, December 17, 1937. Studied: University of Calif., A.B., 1960, M.A., 1962. Works: Indianapolis Museum of Art; William Rockhill Nelson Gallery of Art, Kansas City, MO; Whitney. Exhibitions: Dilexi Gallery, San Francisco; Cornell University; Dwan Gallery, NYC; Musee Cantonal des Beaux-Arts, Lausanne, II Salon International de Galeries Pilotes, 1966; Paris Biennial; NY Architectural League; American Federation of Arts; Aldrich; Nelson Gallery of Art, Kansas City; Newark Museum; Milwaukee Art Center; Flint Institute; Whitney Sculpture Annual; Hudson River Museum; Castelli Gallery, NYC. Awards: University of California, James D. Phelan Traveling Scholarship, 1962; American Institute of Graphic Arts Award, 1976. Taught: Univ. of CA, 1962, 65; Cornell Univ., 1964; Univ. of Kentucky, Artist-in-Residence, 1965; School of Visual Arts, NYC, 1967, 79, 71; Herbert Lehman College, 1968; Artist-in-Residence, MIT, 1977. Dance Theater: Judson Dance Theater, NYC, A Collaborative Event (with the Judson Dancers), 1963. Co-director and collaborator, Dancers Workshop Company, San Francisco, 1964-66; Dance Theater work, NYC. Address in 1982, 383 W. Broadway, NYC.

ROSS, DENMAN WALDO.
Painter, writer, lecturer, and teacher. Born in Cincinnati, OH, Jan. 10, 1853. Member: Copley

Society, 1892; Boston Society of Arts and Crafts (life); American Federation of Arts; Boston Society of Architects; Architectural Club; Fellow American Academy of Arts and Letters; Trustee, Museum of Fine Arts, Boston. Lecturer on "Theory of Design" at Harvard University. Died in 1935. Address in 1929, 24 Craigie Street, Cambridge, MA.

ROSS, LAUREL BERGER.
Painter. Born in Youngstown, OH, on Dec. 12, 1947. Studied: Carnegie-Mellon University; Art Institute of Chicago. Exhibitions: University of Illinois, Medical Center; ARC Gallery, Chicago. Address in 1980, 1841 Halekoa Dr., Honolulu, HI.

ROSS, RAYMOND L.
Painter. Born in Cattaraugus, NY, April 6, 1880. Member: Washington Water Color Club. Address in 1933, 3212 17th Street, N. E., Washington, D.C.

ROSSE, HERMANN.
Painter, illustrator, architect, craftsman, lecturer and teacher. Born in The Hague, Holland, Jan. 1, 1887. Studied in Holland. Member: Kunstkring of The Hague; Cliff Dwellers, Chicago. Award: Medal of honor, P.-P. Expo., San Francisco, 1915. Work: Painting in dome of the Peace Palace, The Hague; mural decorations in Salt Lake City Orpheum Theatre. Illustrated *Wonder Tales from Windmill Lands*, by F. J. Olcott (Longmans, Green and Co.). Address in 1929, Pomona, NY; summer, 20 Niewe Uitleg, The Hague, Holland.

ROSSEAU, PERCIVAL LEONARD.
Painter. Born in Point Coupee parish, LA, Sept. 21, 1859. Pupil of Lefebvre, Herman Leon, and Robert-Fleury in Paris. Member: Lyme Art Association; Lotos Club. Awards: Hon. mention, Paris Salon, 1900; third class medal, Paris Salon, 1906. Died in 1937. Address in 1929, Grassy Hill, Old Lyme, CT.

ROSSITER, THOMAS P.
Portrait, religious and historical painter. Born Sept. 29, 1818, in New Haven, CT. Pupil of Nathaniel Jocelyn at New Haven. Went to Europe with Kensett, Durand, and Casilear in 1840; spent the next six years studying in London, Paris, and Rome, as well as travelling to Italy, Germany, and Switzerland. In 1846 he returned to America and opened his studio in New York with Kensett and Louis Lang. Returned to Europe in 1853; studied in Paris for three years. Upon his return to New York City in 1856, he devoted himself mainly to historical and religious painting. He was elected an Associate of the National Academy in 1840, and an Academician in 1849. He painted "Washington's Entry into Trenton," and a series of pictures on the "Life of Christ." His "Washington and Lafayette at Mount Vernon" is at the Metropolitan Museum of Art. He died at Cold Spring, NY, on May 17, 1871.

ROST, CHRISTIAN.
Engraver. Born in Germany. He studied in Paris and in London, and in the latter city he made the drawings and engraved on wood for a work describing the exhibits at the London World's Fair of 1850. It is not known when Mr. Rost came to the U.S., but he was engraving very good portraits and subject plates in line in New York in 1860. In 1865, he was in the employ of George E. Perrine, and at a later date he was employed by the American Bank Note Co. He died at Mount Vernon, NY.

ROSZAK, THEODORE J.
Sculptor. Born in Poznan, Poland, May 1, 1907. Studied at Columbia University, 1925-26; Chicago Art Institute School, 1922-29, with John W. Norton, Boris Ainsfeld; National Academy of Design, 1925-26, with C. W. Hawthorne. Works: Baltimore Museum of Art; Art Institute of Chicago; Cleveland Museum of Art; University of Illinois; Industrial Museum, Barcelona; Museum of Modern Art; University of Michigan; Penna. Academy of Fine Arts; Guggenheim; Sao Paulo; Smithsonian; Tate; Whitney; Walker; University of Wisconsin; Yale University; plus commissions, including MIT (spire and bell tower), American Embassy, London, and New Public Health Lab, NYC. Exhibitions: Albany Institute; Artists' Gallery, NYC; Julien Levy Gallery, NYC; Pierre Matisse Gallery, NYC; XXX Venice Biennial, 1960; Art Institute of Chicago, 1929-31, 33, 34, 38, 41, 47, 48, 51, 61; Whitney, 1932-38, 41-45, 46-52, retrospectives, 1956, 59; Museum of Modern Art; Penna. Academy of Fine Arts; American Federation of Arts; Documenta I & II, Kassel, 1955, 59; Brussels World's Fair, 1958; Carnegie; National Institute of Arts and Letters; Tate; Seattle World's Fair, 1962; Silvermine Guild, 1962; Cleveland Museum of Art. Awards: World's Fair, Poland, 1930, silver medal; Art Institute of Chicago, Joseph N. Eisendrath prize, 1934, Logan medal, 1947, 51, Campagna Award, 1961; I Sao Paulo Biennial, 1951; Tate, International Unknown Political Prisoner Competition, 1953; Penna. Academy of Fine Arts, George D. Widener memorial gold medal, 1958; Ball State Teachers College, Griner Award, 1962. Elected to the National Institute of Arts and Letters. Member: Commission of Fine Arts, Washington, DC (appointed for 1963-67); Advisory Committee on the Arts, U.S. State Department (appointed for 1963-67); National Adv. Committee, National Council on Arts and Goverment. Taught: Chicago Art Institute School, 1927-29; Design Lab., NYC, 1938-40; Sarah Lawrence College, 1940-56; lectured at many museums and universities. Address in 1980, 1 St. Lukes Place, NYC. Died in 1981.

ROTH, ERNEST DAVID.
Painter and etcher. Born in Stuttgart, Germany, Jan. 17, 1879. Pupil of National Academy of Design in NY; etching under James D. Smillie. Member:

Associate National Academy of Design; NY Water Color Club; Salma. Club; Chicago Society of Etchers; NY Society of Etchers; California Society of Etchers; American Water Color Society; Washington Water Color Club; Allied Artists of America; California Print Maker's Society. Awards: Third Shaw prize for black and white, Salma. Club, 1911; first Shaw prize for black and white, Salma. Club, 1912; first prize for architectural subject, Chicago Society of Etchers, 1914; Vezin thumb-box prize, Salma. Club, 1915; bronze medal for painting and silver medal for etching, P.-P. Expo., San Francisco, 1915; J. Sanford Saltus prize, Salma. Club, 1917; first hon. mention, Chicago Art Institute, 1917; Shaw prize, Salma. Club, 1918; Bryan prize, California Painters and Sculptors, 1922. Prints in: New York Public Library; Boston Museum of Art; Library of Congress, Washington, DC; Public Library, Newark, NJ; Chicago Art Institute; Minneapolis Institute of Art; Uffizi Gallery, Florence, Italy. Address in 1929, 5 East 14th Street; 5 Bank Street; 222 East 71st Street, New York, NY.

ROTH, FRANK.
Painter. Born Feb. 22, 1936, in Boston, MA. Studied at Cooper Union, 1954; and Hans Hofmann School, 1955. Awards: Chaloner prize, 1960; Ford Foundation purchase award, 1962; Guggenheim Fellowship, 1964; Ford Foundation Artist-in-Residence, University of Rhode Island, 1966; National Endowment for the Arts, 1977. Taught at State University of Iowa, summer, 1964; School of Visual Arts, NYC, since 1963; University of California, Berkeley, 1968, Irvine, 1971. Group exhibitions: Carnegie, 1959; American Federation of Arts; Baltimore Museum of Art; National Institute of Arts and Letters; Corcoran; University of Illinois; Whitney; University of Nebraska; University of Colorado; Toledo Museum of Art; Amherst; Lehigh University; Ulster Museum, Belfast, Ireland; Philadelphia Art Alliance; Virginia Museum of Fine Arts; Indianapolis Museum of Art; Louise Himmelfarb Gallery, Bridgehampton, NY; others. One-man exhibitions: The Artists Gallery, NY; Grace Borgenicht Gallery, NY; American Gallery, NY; Hamilton Galleries, London; Galerie Anderson-Mayer, Paris; others. In collections of Albright-Knox; Tate; Santa Barbara Museum of Art; Baltimore Museum of Art; Michigan State University; Walker Art Center; Chase Manhattan Bank; Whitney; Manufacturers Hanover Trust Company, NY; others. Address in 1984, East Hampton, NY.

ROTH, FREDERICK GEORGE RICHARD.
Sculptor. Born in Brooklyn, NY, April 28, 1872. Pupil of Edmund von Hellmer and Meyerheim in Vienna. Also studied at Academy of Fine Arts in Berlin. Member: Associate National Academy Design, 1906, Academician, 1906; New York Architectural League, 1902; National Institute of Arts and

Letters; Society of American Artists, 1903; National Sculpture Society, 1910; New Society of Artists; Society of Animal Painters and Sculptors. Awards: Silver medal, St. Louis Expo., 1904; silver medal, Buenos Aires Expo., 1910; gold medal, P.-P. Expo., San Francisco, 1915; Ellen Speyer memorial prize, National Academy of Design, 1924; National Arts Club prize, 1924; William O. Goodman prize, 1928; medal, National Arts Club, 1931. Represented in Metropolitan Museum, NY; Detroit Institute of Arts; Cincinnati Museum; Children's Museum, Boston; San Francisco Museum; Museum, Newark, NJ; Equestrian, Washington, Morristown, NJ. Exhibited at National Sculpture Society, 1923. Address in 1929, Englewood, NJ. Died in 1944.

ROTH, HERBERT.
Illustrator. Member: Society of Illustrators, 1912. Address in 1933, 28 Huguenot Drive, Larchmont, NY.

ROTHBORT, SAMUEL.
Sculptor and painter. Born in Wolkovisk, Russia, November 25, 1882. Member: Society of Independent Artists; Brooklyn Society of Artists; Nassau Art League; Brooklyn Society of Modern Artists. Awards: Two blue ribbons, 1932, 33 (painting of postage stamps), Brooklyn and Long Island Stamp Exhibition. Author: *Out of Wood and Stone*. Director, Rothbort Home Museum of Direct Art, Brooklyn, NY, exhibiting work in paint, wood, glass, etc., by Samuel and Lawrence Rothbort. Address in 1953, Brooklyn, NY.

ROTHERMEL, PETER FREDERICK.
Born in Nescopeck, PA, July 8, 1817. He was an eminent American historical painter, one of the greatest colorists this country has produced, and a master of composition involving the management of large masses of figures. He began the active practice of his profession in 1840 by painting portraits in Philadelphia, having received instructions from Bass Otis; he went to Europe in 1856, spending some time in the art centers of the Continent, and painting his first historical picture. He was an active member of the Artists' Fund Society of Philadelphia, of which he was elected Vice-President in 1844, and was made a Director of the Penna. Academy of Fine Arts in 1847-55. Among his best-known works are "St. Agnes," painted in 1858, and now in Russia; "Patrick Henry before the Virginia House of Burgesses," engraved by Alfred Jones for the American Art Union of Philadelphia, 1852; "St. Paul, on Mars Hill;" "Amy Robsart interceding for Leicester," property of Mrs. Blanchard; also the colossal picture of the Battle of Gettysburg, ordered by the Legislature of Pennsylvania, and finished in 1871. The last-named picture, which has been engraved by John Sartain, is preserved in Memorial Hall, Fairmount Park, Phila., PA. He died near Linfield, PA on Aug. 15, 1895.

ROTHKO, MARK.
Painter. Born on Sept. 25, 1903 in Dvintka, Russia. Studied at Yale College, 1921-23; Art Students League, 1925, with Max Weber. He taught at the Center Academy, Brooklyn, 1929-52; California School of Fine Arts, summers, 1947, 49; Brooklyn College, 1951-54; University of Colorado, 1955; Tulane University, 1956. Co-founder of the group The Ten in 1935. Worked on the Federal Arts Project, from 1936-37. One-man exhibitions: Art of This Century, NYC, 1945; Santa Barbara Museum of Art, 1946; Betty Parsons Gallery, 1946-51; Rhode Island School of Design, 1954; Art Institute of Chicago, 1954; Houston Museum of Fine Arts, 1957; XXIX Venice Biennial, 1958; Museum of Modern Art, 1961; Whitechapel Art Gallery, London, 1961; Palais des Beaux-Arts, Brussels, 1962; others. Group exhibitions: Penna. Academy of Fine Arts, 1940; Whitney, 1945-50; XXIV Venice Biennial, 1948; Museum of Modern Art, 1951, 52, 69, circa. Europe, 1958-59; Carnegie, 1958, 61; Documenta II, Kassel, 1959; Walker, 1960; Cleveland Museum of Art, 1966; others. Collections are held at the Baltimore Museum of Art; Museum of Modern Art; Tate; Albright-Knox; Brooklyn Museum; Chicago Art Institute; Kunstsammlung Nordrhein-Westfalen, Dusseldorf; Vassar College; Whitney; others. Member: Federation of Modern Painters and Sculptors. Address in 1970, 118 E. 95th Street, New York, NY. Died by suicide, February 25, 1970 in NYC.

ROTHSCHILD, AMALIE (ROSENFELD).
Sculptor and painter. Born in Baltimore, MD, January 1, 1916. Studied at Maryland Institute College of Art, diploma; NY School of Fine and Applied Art; and with Herman Maril. Work in Corcoran Gallery of Art; Baltimore Museum of Art; Peale Museum, Baltimore; others. Has exhibited at Jewish Museum, NY; Corcoran Gallery of Art; Baltimore Museum of Art; National Academy of Science; others. Received prize for painting, Baltimore Museum of Art; award for painting, Corcoran Gallery of Art; others. Works in particle board, metal leaf; acrylic. Address in 1982, Baltimore, MD.

ROTHSCHILD, LINCOLN.
Sculptor, painter, writer, etcher, and lecturer. Born in NYC, August 9, 1902. Studied: Columbia University, A.B., A.M.; NY University Institute of Fine Arts; Art Students League, with K. H. Miller, B. Robinson, A. Tucker. Member: College Art Association of America; Artists Equity Association; Art Students League. Work: Metropolitan Museum of Art; Whitney. Awards: Prize, Village Art Center, 1948. Author: *Sculpture Through the Ages*, 1942; *Style in Art*, 1960; *To Keep Art Alive*, 1974; *Forms and their Meaning in Western Art*, 1976. Contributor to *Saturday Review of Lit.*, *World Book Encyclopaedia*, *Collier's Encyclopaedia*, others. Positions: Instructor of Fine Arts Dept., Columbia University, 1925-35; Director, NY Unit of American Design, 1938-40; Assistant Professor, Chairman of Art Department, Adelphi College, Garden City, NY, 1946-50; Lecturer, Art Students League, 1948-51; Executive Director, Artists Equity Association, NYC, 1951-57. Address in 1982, Dobbs Ferry, NY.

ROTHWELL, ELIZABETH L.
Painter. Born in California, PA. Pupil of Chase; Beaux. Member: Pittsburgh Art Association. Award: Third prize, Pittsburgh Art Association, 1915, second prize, 1918, Smith prize, 1928. Work: "The White Parasol," owned by Hundred Friends of Art, Pittsburgh, PA. Address in 1933, 6432 Darlington Road, Pittsburgh, PA.

ROTHWELL, J.
Engraver. This man was engraving book illustrations, in a crude line manner, in New York in 1841.

ROTHWELL, VIOLET HAMILTON (MRS.).
Painter. Born in New York City, March 27, 1890. Pupil of Christine Lumsdon; Academie de Passy in Paris. Address in 1929, Carnegie Hall; h. 311 West 95th Street, New York, NY; summer, "Woods Hollow," Remsenburg, LI, NY.

ROUDEBUSH, JOHN HEYWOOD.
Sculptor. Born in New York. Awarded honorable mention, Paris Salon, 1898; bronze medal at the Paris Expo. of 1900; silver medal, Pan-American Expo., Buffalo, 1901, for his group, "The Wrestlers." Address in 1910, 80 Irving Place, NYC.

ROUGERON, MARCEL JULES.
Landscape painter. Born in Paris, France, Oct. 6, 1875; son of the artist, Jules James Rougeron. Pupil of Julian Academy; Ecole des Beaux-Arts; Gerome; J. G. Vibert; L. Van den Bergh. Member: National Arts Club; Lotos Club; Washington Art Club; Salma. Club; American Artists Professional League; American Art Association of Paris; American Federation of Arts; Montreal Art Club; Societe des Artistes Francais; Societe Royale Artistes Belges. Awards: Officier d'Academie, 1900; hon. mention, Paris, 1902; Officier of Public Instruction, France, 1910; Chevalier of the Order of Leopold, 1931, Belgium. Represented in Brooklyn Museum; Art Institute of Chicago; Toledo Museum of Art, Toledo, OH; City Hall, New York; Art Museum, Montreal; William Rockhill Nelson Gallery of Art, Kansas City, MO; many important collections. Specialty: Restoration of Paintings. Address in 1933, 101 Park Ave., New York, NY.

ROULAND, ORLANDO.
Painter and teacher. Born in Pleasant Ridge, IL, Dec. 21, 1871. Pupil of Max Thedy in Germany; Julian Academy in Paris under Laurens and Constant. Member: Salma. Club, 1901; American Art

Association of Paris; Lotos Club; Allied Artists of America; MacDowell Club; Art Alliance of America; North Shore Arts Association; Springfield Art Association; American Federation of Arts. Award: Popular prize ($50), Duxbury Art Association, 1921. Work: Yale University, New Haven, CT; Trinity College, Cambridge University, England; University of Texas; Historical Society, St. Paul, MN; Wheaton Seminary, Norton, MA; Carnegie Institute, Washington, DC; Engineers Club and Society of Mining Engineers, New York, NY; City Club, Boston; Art Museum, Montclair, NJ; National Gallery, Washington, DC; Public Library, Lexington, KY; Amherst College; Art Club, Erie, PA; Columbia University and Lotos Club, NY; Rollins College, Winter Park, FL; American Academy of Arts and Letters. Died June 26, 1945. Address in 1929, 130 West 57th Street, New York, NY; summer, 5 Lookout Court, Marblehead, MA.

ROWE, CLARENCE HERBERT.
Illustrator and etcher. Born in Philadelphia, PA, May 11, 1878. Pupil of Max Bohm; Penna. Academy of Fine Arts; Bouguereau and Ferrier in Paris. Member: Salma. Club; Society of Illustrators; California Print Maker's Society; Artists Guild of the Authors' League of America. Died in 1930. Address in 1929, Cos Cob, CT.

ROWE, CORINNE FINSTERWALD.
Painter. Born in Marion, WI, Nov. 5, 1894. Pupil of John P. Wicker and Guy Rowe. Member: National Association of Women Painters and Sculptors. Died in 1965. Address in 1933, Hampton, CT.

ROWE, J. STAPLES.
Portrait painter. Born in 1856. He studied in Boston and New York, and painted life-size portraits and miniatures. He died in New York.

ROWE, WILLIAM B.
Painter, sculptor, teacher, and lecturer. Born in Chicago, IL, May 25, 1910. Studied: Cornell University; Buffalo Art Institute; and with Edwin Dickinson. Member: Buffalo Society of Artists; The Patteran. Awards: Prizes, Buffalo Society of Artists, 1935; Albright Art Gallery, 1937. Work: Smithsonian Institution; Rochester Memorial Art Gallery; murals, Bennett High School, Marine Hospital, Buffalo, NY; Youngstown, NY. Exhibited: Metropolitan Museum of Art, 1938; Riverside Museum, 1937, 1941; Golden Gate Exposition, San Francisco, 1939; Corcoran Gallery of Art, 1935; Great Lakes traveling exhibition, 1937; Baltimore Watercolor Club, 1938; Kansas City Art Institute, 1941; Rochester Memorial Art Gallery, 1942; Syracuse Museum of Fine Arts, 1934; Albright Art Gallery, 1934-44; Art Institute, Buffalo, 1951; University of Illinois, 1952. Taught: Instructor, president, Buffalo Art Institute, Buffalo, New York, 1941-45. Address in 1953, Buffalo, NY.

ROWELL, FANNY.
(Mrs. Horace C. Wait Taylor). Painter. Born in Princeton, NJ, May 11, 1865. Pupil of J. B. Whittaker in Brooklyn; Colarossi Academy in Paris; Trager at Sevres. Taught arts and crafts to mountain children near her summer home, Tamasee, NC. Member: National Arts Club; New York Municipal Artists' Society. Address in 1926, National Arts Club, 14 Gramercy Park, New York, NY. Died on April 22, 1928.

ROWLAND, W. E.
Painter and illustrator. Born in Trinidad, CO. Pupil of Art Institute of Chicago. Member: California Art Club; Laguna Beach Art Association. Award: Second prize, Woman's Club, Phoenix, AZ, 1923. Address in 1929, 3448 Gardenside Lane, Los Angeles, CA.

ROWLAND, WILLIAM.
Miniature painter. Flourished about 1777 in NY. He came from Glasgow, Scotland and settled in New York.

ROWSE, SAMUEL WORCESTER.
Painter and engraver. Born January 29, 1822 at Bath, ME; died May 26, 1901, at Morristown, NJ. After a brief period in Augusta, ME, as an engraver, Samuel W. Rowse came to Boston in 1852 and worked for a lithographic firm. He soon after established himself as an excellent crayon portrait draughtsman. At the Studio Building where he lived in 1861 and worked for a number of years, he had as a friend Eastman Johnson. In 1872, with his friend Chauncey Wright, he visited London and was frequently the guest of Charles Eliot Norton; also met Ruskin there. About 1880 he moved to NY. With his friend Eastman Johnson he again visited London in 1891. He is represented in the large portrait by Eastman Johnson, called "Two Men," now at the Metropolitan Museum and reproduced in the *World's Work*, in 1906. He finally settled in Morristown, NJ, where he died, leaving a considerable estate. His work was regularly in demand and in later years he was well-paid. His portraits are in black crayon and are quite large.

ROX, HENRY.
Sculptor, etcher, designer, and illustrator. Born in Berlin, Germany, March 18, 1899. Studied: University of Berlin; Julian Academy, Paris, France. Member: Associate of the National Academy of Design; National Sculpture Society; College Art Association of America; Springfield Art League. Awards: Prizes, Springfield Art League, 1941, 43, 45, 47, 49; Architectural League, 1949; Silvermine Guild, 1950, 52; Art Directors' Club, 1950; Audubon Artists, medal, 1951; National Academy of Design, medal, 1952. Work: Springfield Museum of Fine Arts; Mt. Holyoke College; Addison Gallery of American Art; John Herron Art Institute; Dartmouth College; Syracuse

Museum of Fine Arts; Faenza, Italy; Liturgical Art Society. Group exhibitions: Penna. Academy of Fine Arts; Whitney Museum; Philadelphia Museum; National Institute of Arts and Letters; Syracuse Museum of Fine Arts; Yale University; Art Directors' Club; Addison Gallery of American Art; Wadsworth Atheneum; Metropolitan Museum of Art; Smith College; Institute of Contemporary Art, Boston; Worcester Museum of Art; Boston Art Festival; and in Europe. One-man exhibitions: Concord State Library, 1945; Art Headquarters Gallery, NY, 1945; Springfield Museum of Fine Arts, 1945; Kleeman Gallery, 1946; DeYoung Memorial Museum, 1947; Worcester Museum of Art, 1948; University of New Hampshire, 1950; Dartmouth College, 1950. Author of numerous children's books. Taught: Associate professor of art, Mount Holyoke College, 1939-64; instructor of sculpture, Worcester Art Museum, Worcester, MA, 1946-52. Address in 1970, South Hadley, MA.

ROYCE, ELIZABETH R.
Sculptor. Member of the National Association of Women Painters and Sculptors. Address in 1926, 11 Greycourt, Ithaca, NY.

ROYER, JACOB S.
Painter and craftsman. Born in Waynesboro, PA, Nov. 9, 1883. Pupil of Dayton Art Institute; Robert Oliver; T. C. Steele. Member: Dayton Artists Guild; American Artists Professional League. Work: "September Evening," Dayton Art Institute. Address in 1933, 917 Manhattan Ave., Dayton, OH.

RUBENSTEIN, LEWIS.
Painter and printmaker. Born in Buffalo, NY, Dec. 15, 1908. Studied: Harvard University, A.B., 1930; Bacon traveling fellowship, 1931-33; painting with Leger and Ozenfant, Paris; fresco with Rico Lebrun; lithography with Emil Ganso, NY; sumi with Keigetsu, Tokyo. Work: Fogg Art Museum, Boston; Museum, Rhode Island School of Design; Vassar College Art Gallery; Ford Foundation; Butler Institute of American Art, Youngstown, OH; Tokyo University of Arts. Commissions: Frescoes, Busch-Reisinger Museum, Harvard University; murals, U.S. Post Office, Wareham, MA; Jewish Center, Buffalo; etc. Exhibited: Fogg Art Museum, 1936, 37; Whitney, 1938, 41; Vassar College, 1940, 45, 52, 59, 65; Corcoran, 1942, 44; National Academy of Design, 1946, 52, 56, 63; Library of Congress, 1952-55, 61; Society of American Graphic Artists, NYC, 1952-81; American Watercolor Society, NYC, 1955, 64; Provincetown Art Association, 1959, 60, 62, 64; Audubon Artists, 1961; Barrett House, Poughkeepsie, NY, 1979; others. Awards: Traveling Fellowship, Harvard University, 1931-33; Fulbright Grant, Japan, 1957-58; State Department Grant, South America, 1961; Society of American Graphic Artists, 1952, 54; Silvermine Guild of Artists, 1959; Empire State

Architects Award - Mural Painting. Member: Society of American Graphic Artists; Dutchess County Art Association. Taught: Instructor, fresco painting, Boston Museum School of Art, 1937-38; professor of painting, Vassar College, Poughkeepsie, NY, 1939-74. Address in 1984, Poughkeepsie, NY.

RUBIN, DONALD VINCENT.
Sculptor. Born in NYC, July 10, 1937. Exhibitions: (One-man shows) Brass Door Galleries, Houston, TX, 1977; Hunter Gallery, San Francisco, CA, 1977; Indian Paint Brush, Vail, CO, 1975, 76, 77, 78, 79; Huntsville Museum of Art, AL, 1978; (two-man show) Burk Gallery, Boulder City, NE, 1977; (three-man shows) Hobe Sound Galleries, Hobe Sound, FL, 1980; Kennedy Galleries, NYC; National Sculpture Society, 1980; Society of Animal Artists, San Antonio, TX, 1980; National Academy of Design, NYC, 1982; Knickerbocker Artists, NYC, 1982. Works: Numerous sculptures in bronze, "First Bull Riding Event," 1974, "Too Much Slack," 1974, "Spring Spirit," 1974; "Freedom Lost;" "Rhythm" (nude), 1973; "Bathing" (nude), 1975; others. Awards: 2nd prize sculpture, 1975, Salmagundi Club, Richman sculpture award, 1975, 76, 77; honorable mention, sculpture, Grand National Exhibition, American Artists Professional League, 1979; Elliot Liskin sculpture prize, Knickerbocker Artists, NYC, 1981; numerous others. Member: Salmagundi Club, NYC, from 1974; Society of Animal Artists, NYC, 1975; American Artists Professional League, NYC, from 1977; and Artists Fellowship Inc., NYC, from 1977. Taught: Lecturer, "Western Bronzes and the Art of Bronze Casting," Oct. 17, 1978, Huntsville Museum of Art, Huntsville, AL. Address in 1983, Huntsville, AL.

RUBINS, DAVID KRESZ.
Sculptor, lithographer, and teacher. Born Sept. 5, 1902. Studied: Dartmouth College; Beaux-Arts Institute of Design, NY; Ecole des Beaux-Arts, Julian Academy, Paris; and with James E. Fraser. Awards: Fellowship, American Academy in Rome, 1928; prize, Architectural League, 1932; National Institute of Arts and Letters Grant for Sculpture, 1954. Work: Minneapolis Institute of Art; John Herron Art Institute; Indiana University; Archives Building, Washington, DC (in collaboration). Exhibited: Architectural League, 1933; National Academy of Design, 1933; Indiana Artists Annual, 1936-70. Taught: Professor emeritus, sculpture, anatomy, drawing, John Herron Art School, Indianapolis, IN, from 1935. Address in 1982, Indianapolis, IN.

RUBINS, HARRY W.
Painter, etcher and decorator. Born in Buffalo, NY, Nov. 25, 1865. Pupil of Art Institute of Chicago. Member: Chicago Society of Etchers; Minneapolis Society of Fine Arts. Work: NY Public Library; painted decorations in Blake School Library,

Minneapolis; Chapel, St. Marks Church, Minneapolis; Nazareth Hall, St. Paul, MN; Northwestern National Life Building, Minneapolis; Children's Hospital, Cincinnati. Address in 1933, 712 Fourth Ave. South; h. 224 Ridgewood Ave., Minneapolis, MN. Died in 1934.

RUCKSTULL, FREDERIC WELLINGTON.
Sculptor, lecturer, and writer. Born in Breitenbach, Alsace, May 22, 1853. Pupil of Boulanger and Lefebvre, Julian Academy, Paris; and with Mercie, at the Rollins Academy. Member: National Sculpture Society, 1893; NY Architectural League, 1894; National Institute of Arts and Letters; NY Municipal Art Society; Brooklyn Society of Artists. Awards: Hon. mention, Paris Salon, 1888; medal, Columbian Expo., Chicago, 1893. Positions: Sec., committee for erection of Dewey Arch, 1898; chief of sculpture, St. Louis Expo., 1904. Work: "Evening," life-size marble, Metropolitan Museum, NY; equestrian statue, "Gen. J. F. Hartranft," Harrisburg, PA; "Gen. Wade Hampton," Columbia, SC; "Confederate Monument," Baltimore; "Defense of the Flag," Little Rock, AR; "Women's Monument," Columbia, SC; "John C. Calhoun," "Wade Hampton," and "U. M. Rose," the Capitol, Washington; "Solon," "Goethe," "Franklin," "Macaulay," Lib. of Congress, Washington, DC; "Wisdom" and "Force," Appellate Court, NY; "Three Partisan Generals Monument," Columbia, SC; "Confederate Monument," Salisbury, NC; "Soldiers' Monument," Jamaica, New York City; "Mercury Teasing Eagle of Jupiter," St. Louis; Penn. Soldier Mon., Petersburg, VA; "Phoenicia," NY Customs House; "Minerva," Liberty Monument, Battlefield of Long Island; "America Remembers," Civil War Monument, Stafford Springs, CT. Address in 1933, Brooklyn, NY. Died in 1942.

RUDD, EMMA R.
Painter. Exhibited at the 33rd Annual Exhibition of the National Association of Women Painters and Sculptors, New York. Address in 1926, Lyons, NY.

RUDDER, STEPHEN CHURCHILL DOUGLAS.
Painter, illustrator, etcher, craftsman, writer, and lecturer. Born in Salem, IN, May 12, 1906. Pupil of Art Institute of Chicago. Member: Art Students League of Chicago; Alumni Art Inst. of Chicago; Hoosier Salon; Indiana Art Assoc. Address in 1929, The Judas Tree, 403 Charlestown Rd, Salem, IN.

RUDERSDORF, LILLIAN.
Painter. Born in Clarkson, NE, in 1882. Pupil of Univ. of Nebraska; Art Inst. of Chicago. Address in 1926, 21 East Van Buren Street, Chicago, IL.

RUDOLPH, PAULINE DOHN (MRS.).
Painter. Born in Chicago. Pupil of Penna. Academy of Fine Arts; Boulanger, Lefebvre, Lasar and

Couture in Paris. Member: Palette Club; Cosmopolitan Club, Chicago; Chicago Society of Artists; American Federation of Arts. Award: First Yerkes prize, Chicago Society of Artists. Address in 1929, Winnetka, IL.

RUDY, CHARLES.
Sculptor. Born in York, PA, Nov. 14, 1904. Studied: Penna. Academy of Fine Arts; pupil of Charles Grafly and Albert Laessle. Member: Fellowship, Penna. Academy of Fine Arts; National Sculpture Society; National Academy of Design. Awards: Cresson Traveling Fellowship, Penna. Academy of Fine Arts, 1927 and 1928; Guggenheim Foundation Fellowship, 1942; gold medal, National Sculpture Society, 1973; others. Work: Pennsylvania Museum of Fine Arts; Brookgreen Gardens; Philadelphia Museum, PA; Carnegie; Metropolitan Museum of Art, NY; Edgar Fahs Smith Memorial, Public School of York, PA; Shipley Memorial, Masonic Temple, York, PA; plus many commissions. Exhibited: Penna. Academy of Fine Arts, 1928-68; Whitney, 1936-53; Metropolitan Museum of Art, 1950; National Academy of Design, 1950-71; Art Institute of Chicago, 1939-52; others. Taught: Head of sculpture dept., Cooper Union, 1931-41; instructor of sculpture, Penna. Academy of Fine Arts, 1950-52; Philadelphia Museum College of Art, 1960-62. Address in 1982, Ottsville, PA.

RUDY, MARY E.
Painter. Born in Burlington, IA, in 1861. Pupil of Art Institute of Chicago. Address in 1926, 4516 Lake Park Avenue, Chicago, IL.

RUFFINS, REYNOLD.
Illustrator. Born in NYC in 1930. Graduated from Cooper Union in 1951, the year his first illustration was published. An early member of Push Pin Studios, he has worked in advertising agencies and been a partner in his own studio. A regular contributor to *Family Circle*, he designed and illustrated several children's books for Charles Scribner's Sons. The Amer. Institute of Graphic Arts, Art Directors' Club, Society of Illustrators, and *The New York Times Book Review* have all presented him with awards.

RUGGLES, E., JUN'R.
This man was a book-plate engraver, apparently working between 1790 and 1800 somewhere in New England. The only plate seen is that for Walker Lyon, in reality a label with peculiarly conventionalized peacock feathers used as borders.

RUGGLES, EDWARD (DR.).
Painter of small landscapes and miniature views and an amateur marine painter. He painted many studies in the White Mountains. His views and landscapes met a ready sale, where the so-called "Ruggles

Gems" were in much demand. Exhibited French and Italian views at the American Art-Union and the National Academy, 1851-60. Honorary member, National Academy.

RUGGLES, THEO ALICE.
See Kitson, Theo Alice Ruggles.

RUHL, JOHN.
Sculptor. Born in NY, April 14, 1873. Pupil of Metropolitan Museum Art School; John Ward Stimson; and F. E. Elwell in NY. Address in 1910, 1389 Washington Ave.; h. 463 East 136th St., NYC.

RUHNKA, ROY.
Painter. Exhibited water colors at the Penna. Academy of Fine Arts, Philadelphia, 1925. Address in 1925, 3616 Walnut Street, Philadelphia, PA.

RULE, FAY SHELLEY (MRS.).
Miniature painter. Born in Chattanooga, TN, Nov. 30, 1889. Pupil of Lucia F. Fuller; Mabel Welch; Alice Beckington; F. V. DuMond. Member: Chattanooga Art Association. Address in 1929, 1026 East 10th Street, Chattanooga, TN.

RUMBOLD-KOHN, ESTELLE.
Painter. Award: Spalding prize ($1,000), Art Inst. of Chicago, 1925. Address 1929, 40 W 59th St., NY, NY.

RUMMELL, JOHN.
Painter, writer, lecturer, and teacher. Born in Springville, NY, Aug. 24, 1861. Pupil of L. B. C. Josephs; John F. Carlson; F. V. Du Mond; and George Bridgeman. Awards: First hon. mention, Buffalo Society of Artists, 1917; second hon. mention, Buffalo Society of Artists, 1918 and 1919; Fellowship prize ($50), Buffalo Society of Artists, 1921. Address in 1933, 68 Greenfield Street, Buffalo, NY.

RUMMLER, ALEX J.
Painter and illustrator. Born in Dubuque, IA, July 25, 1867. Pupil of Laurens in Paris. Member: Salma. Club, 1900; American Federation of Arts. Address in 1929, 25 Bettswood Road, Norwalk, CT.

RUMSEY, CHARLES CARY.
Sculptor. Born Buffalo, NY, 1879. Studied in Boston Art School; later in Paris; and with Bela Pratt and Paul Wayland Bartlett. Exhibited at Nat. Sculpture Soc., 1923. He worked principally in bronze, and modeled many statues of race horses. Nephew of Seward Cary, the sculptor. In collections of Whitney; Brooklyn; Cleveland; friezes at approach to Manhattan Bridge and Pelham Bay Park, NYC; Victory Statue, Brooklyn, NY. Died in LI, NY, Sept. 21, 1922.

RUNGIUS, CARL (CLEMENS MORITZ).
Painter, sculptor and engraver. Born in Berlin, Germany, Aug. 18, 1869. Studied painting at Berlin Art School; School of Applied Arts; Academy of Fine Arts; pupil of Paul Meyerheim in Berlin. Came to U.S. in 1894. Member: Associate, National Academy of Design, 1913; National Academy of Design, 1920; Salmagundi Club; National Arts Club; Society of Men Who Paint the Far West; Society of American Animal Painters and Sculptors; Am. Federation of Arts. Exhibitions: National Academy of Design, 1898-43; Penna. Academy of Fine Arts, 1910-34; Art Institute of Chicago; Society of American Artists. Awards: Vezin prize, Salmagundi Club, 1922; Plimpton prize, Salmagundi Club, 1923; Speyer Memorial prize, National Academy of Design, 1925; Carnegie prize, National Academy of Design, 1926, and Saltus medal, 1929. Specialty: American big game painting. Address in 1953, 33 West 67th St., NYC; summer, Banff, Alberta, Canada. Died in 1959.

RUSH, JOHN.
Carver. Born in 1782. Son of William Rush. Worked with him carving figureheads. Active in Philadelphia, PA. Died there on January 2, 1853.

RUSH, OLIVE.
Painter. Born in Fairmount, IN. Studied in NY, Paris, etc. Member: NY Water Color Club; Wilmington Society of Fine Arts. Awards: Hon. mention, Richmond Art Association, 1919; first prize, Herron Art Institute, 1919; Tri Kappa prize, $400, Hoosier Salon, 1931; hon. mention, annual exhibition, Denver, 1931. Work: "The Gospel," altar panels, St. Andrew's Church, Wilmington, DE; "Fairyland in Books and in Nature," Nathaniel Hawthorne School, Indianapolis, IN; murals, La Fonda Hotel, Santa Fe, NM. Represented in Phillips Mem. Gallery, Washington; Herron Art Institute, Indianapolis; Art Museum, Worcester, MA; Brooklyn Museum. Address in 1933, 630 Canon Road, Santa Fe, NM.

RUSH, WILLIAM.
Sculptor. Born in Philadelphia, PA, July 4, 1756. Apprenticed as a maker of figure-heads for ships under Edward Cutbush. Notable among these were the figures "Genius of the U.S." and "Nature," for the frigates *U.S.* and *Constellation*, and of celebrities such as Rousseau, Franklin and Penn for other vessels. The figure of the "Indian Trader" for the Ship William Penn excited great admiration in London, where carvers sketched it and made casts of the head, while the figure of a river-god, carved for the ship *Ganges*, is said to have been worshipped by the Hindus on her calls to Indian ports. His "Tragedy" and "Comedy," done for the first Chestnut Street Theater, may now be seen at the Forrest Home in Philadelphia; his "Leda and the Swan," originally placed before the first water-works on the site of the City Hall, was later moved to Fairmount, where a bronze replica--he himself worked in nothing but wood and clay--has since replaced it. For the first

Custom House he designed the much admired figure of "Commerce;" for the permanent bridge at Market Street those of "Commerce" and "Agriculture;" for St. Augustine's Church a representation of the Crucifixion. Also carved portrait busts, anatomical models and ideal figures, such as the well-known "Nymph of the Schuylkill." Among a large number of statues executed by him, the most notable was that of Washington, purchased by the city in 1814 and still on exhibition in Independence Hall, Philadelphia. He served in the Revolutionary Army. Died in Philadelphia, January 17, 1833.

RUSHTON, ROBERT.
Painter. Exhibited water colors at the Penna. Academy of Fine Arts, Philadelphia, 1925. Address in 1926, 5238 Carlisle Street, Philadelphia, PA.

RUSS, HORACE ALEXANDER.
Sculptor, painter, craftsman, and teacher. Born in Logtown, MS, Jan. 25, 1887. Studied: Tulane University; Louisiana State University; Columbia University; also a pupil of Penna. Academy of Fine Arts. Member: Southern States Art League; New Orleans Art Association; New Orleans Art League; New Orleans Arts and Crafts Club; Gulf Coast Art Association. Address in 1953, New Orleans, LA.

RUSSELL, CHARLES MARION.
Painter, sculptor, illustrator and writer. Born March 19, 1864, in St. Louis, MO. Moved to Montana in 1880. Self-taught. An experienced cowboy, he created many thousands of paintings, over 100 bronzes, and illustrated scores of books and magazine articles. Had 28 one-man shows in NYC; Chicago; London. In collections of Amon Carter Museum of Western Art, Fort Worth, TX; Buffalo Bill Cody Center, WY; Montana Hist. Soc.; The Trigg-C. M. Russell Gallery, Great Falls; Norton Gallery, Shreveport; Woolaroc Mus., Bartlesville. Created mural, State Capitol, Helena, MT. Wrote books, inc., *Trails Plowed Under*. Died Oct. 24, 1926, in Great Falls, MT.

RUSSELL, H.B.
Painter. Member: Boston Art Club. Address in 1929, 9 Park Street, Boston, MA.

RUSSELL, JAMES.
Painter. Born in New Albany, IN, 1873. Member of Louisville Art League. Address in 1926, 201 East Market Street, New Albany, IN.

RUSSELL, M. B.
Miniature painter. Born c. 1810 in New England. Flourishing in Boston in 1834. Also painted portraits. Died in 1884.

RUSSELL, W. C.
Miniature painter. Flourished in New York about 1837.

RUSSELL, WALTER.
Sculptor, painter, and writer. Born in Boston, May 19, 1871. Pupil of Albert Munsell and Ernest Major in Boston; Howard Pyle at Wilmington; Laurens in Paris. Member: Spanish Academy of Arts and Letters; Society of Arts and Sciences (president). Award: Special mention, Turin Exposition, Italy, 1900. Specialty: Portraits of children. Work: "The Might of Ages," an allegory, "A Southern Rose," Dallas Museum of Art. Art editor, *Collier's Weekly*, 1897. War correspondent and illustrator for *Collier's* and *Century*. Author and illustrator of *The Sea Children; The Bending of the Twig; The Age of Innocence; The Universal One; Salutation to the Day; The New Electric Theory;* and *Russell Genero-Radiative Concept.* Address in 1933, Washington, CT. Died May 19, 1963.

RUSSIN, ROBERT I.
Sculptor, painter, craftsman, and teacher. Born August 26, 1914. Studied: Beaux-Arts Institute of Design; College of City of NY. Member: Sculptors Guild; American Institute of Architects (associate); Audubon Artists; National Sculpture Society; American Association of University Professors. Awards: Prizes, Arizona Fine Arts Fair, 1947, 49; Wyoming State Fair, 1950; Lincoln Sesquicentennial Medal, U.S. Congress, 1959; Charles G. B. Steel Sculpture Award, Penna. Academy of Fine Arts, 1966; Order of Duarte, Sanchez, and Mella, by President Joachim Balaguer, Dominican Republic, 1977. Work: U.S. Post Office, Evanston, IL, Conshohocken, PA; carvings and plaques for numerous buildings at University of Wyoming; mural, Park Hotel, Rock Springs, WY. Exhibited: Art Institute of Chicago; Denver Art Museum; Joslyn Art Museum; Nelson Gallery of Art; Kansas City Art Institute; Penna. Academy of Fine Arts; Colorado Springs Fine Arts Center; National Academy of Design; New Orleans Arts and Crafts; Architectural League; Fairmount Park, Philadelphia; Philadelphia Art Alliance; NY World's Fair, 1939; Oakland Art Gallery; Syracuse Museum of Fine Arts; Penna. Academy of Fine Arts Sculpture Biennial, Philadelphia, 1966; others. Position: Associate Professor of Art, University of Wyoming, Laramie, WY. Address in 1982, Laramie, WY.

RUSSMANN, FELIX.
Painter. Born in New York City, Aug. 2, 1888. Pupil of National Academy of Design; Munich Royal Academy. Member: Chicago Society of Artists; No-Jury Society of Artists, Chicago. Award: Third Hallgarten prize, National Academy of Design, 1918. Address in 1929, 3538 Lake Park Ave., Chicago, IL.

RUST, EDWIN C.
Sculptor, etcher, and art administrator. Born in Hammonton, CA, Dec. 5, 1910. Studied: Cornell University; Yale Univ., B.F.A.; and with Archipenko

and Milles. Member: National Sculpture Society. Work: College of William and Mary; St. Regis Hotel, NY; U.S. Court House, Washington, DC. Exhibited: Whitney Museum, 1940; Carnegie Institute, 1940; Metropolitan Museum of Art, 1942; Virginia Museum of Fine Arts, 1938; Philadelphia Museum of Art, 1940, 49; Brooks Memorial Museum, 1950, 52. Taught: Associate professor of sculpture, 1936-43, head of fine arts department, 1939-43, College of William and Mary, Williamsburg, VA; director, Memphis Academy of Arts, 1949-75, emeritus director, from 1975. Address in 1982, Memphis, TN.

RUTHERFORD, ALEXANDER W.
Born in 1826 in Vermont. He is spoken of by Tuckerman in his "American Artist Life" as a "genre painter of promise who died young." Died in 1851 in London.

RUTHRAUFF, FREDERICK G.
Painter and writer. Born in Findlay, OH, Aug. 6, 1878. Pupil of William V. Cahill; William H. Claff; Henri Morrisett in Paris. Member: Berkeley L. Fine Arts; California Art Club; Ogden Art Society. Address in 1929, 2586 Polk Ave., Ogden, UT.

RUTMAN, HERMAN S.
Sculptor, painter, designer, and teacher. Born in Russia, June 1, 1889. Studied: Philadelphia Museum School of Industrial Art; Penna. Academy of Fine Arts; Temple University; Barnes Foundation. Awards: Fellow, Penna. Academy of Fine Arts. Work: City Hall, Philadelphia, PA. Exhibited: National Academy of Design, 1940; Penna. Academy of Fine Arts, 1936-46; Butler Art Institute; Woodmere Art Gallery. Address in 1953, Phila., PA.

RUYL, LOUIS H.
Illustrator and etcher. Born in Brooklyn, NY, Nov. 13, 1870. Member: Artists Guild of the Authors' League of America; Stowaway Club. Illustrations for *Cape Cod, Old and New; Old Post Road, from Boston to Plymouth; From Provincetown to Portsmouth.* Address in 1929, 45 Prospect Place, New York, NY; summer, Hingham, MA.

RUZICKA, RUDOLPH.
Illustrator, etcher, draftsman, and wood engraver. Born in Bohemia, June 29, 1883. Pupil: Art Institute of Chicago; NY School of Art. Work: Illustrated *Fountains of Papal Rome; NY; Newark; Notes of Travel in Europe,* by Washington Irving; examples in Art Inst. of Chicago; Carnegie Inst., Pitts.; Met. Museum, NY; Library of Congress, Washington; Brooklyn Inst. of Arts and Sciences; Cleveland Mus. of Art. Address in 1929, Dobbs Ferry, NY.

RYDEN, HENNING.
Sculptor, draftsman, and painter. Born in Sweden, Jan. 21, 1869. Pupil of Art Institute of Chicago;

studied in Berlin and London. Member: Salmagundi Club, 1908; American Federation of Arts. Award: Honorable mention, P.-P. Expo., San Francisco, 1915. Work: American Numismatic Society. Address in 1933, NYC. Died in 1939.

RYDER, ALBERT PINKHAM.
Painter. Born on March 19, 1847 in New Bedford, MA. Pupil of William E. Marshall, the engraver, and of the National Academy of Design, NY. Among his works, "Death on a Pale Horse," "The Pasture," "The Curfew Hour," "Pegasus," "The Flying Dutchman," "Launcelot and Elaine," and "Jonah and the Whale." He was elected a Member of the National Academy in 1906 (see *International Studio* for July, 1925). Died in Almhurst, NY, on March 28, 1912.

RYDER, CHAUNCEY FOSTER.
Painter. Born in Danbury, CT, Feb. 29, 1868. Pupil of Art Institute of Chicago; Julian Academy, Collin and Laurens in Paris. Member: Associate National Academy of Design, 1914; Academician National Academy, 1920; American Water Color Society; Allied Artists of America; Salma. Club; NY Water Color Club; Lotos Club; Nat. Arts Club; Brooklyn Soc. of Etchers; Chicago Society of Etchers; Am. Fed. of Arts. Awards: Hon. mention, Paris salon, 1907; silver medal, P.-P. Expo., San Francisco, 1915; Baltimore Water Color Club prize, 1920; first prize, Central State Fair, Aurora, 1922; first prize, Salma. Club; Members prize, Brooklyn Soc. of Etchers. Work: Art Inst. of Chicago; Delgado Mus., New Orleans, LA; Washington State Art Assoc., Seattle, WA; Corcoran Gallery, Washington, D.C.; Nat. Exhibition Assoc., Toronto, Canada; Artists Club, Denver, CO; Engineers Club, NY, NY; Societe des Arris des Arts, Douai, France; City Art Museum, St. Louis; Butler Art Inst., Youngstown, OH; Minn. Inst. of Arts; Nat. Gallery, Washington, DC; Wilmington Society of Fine Arts; Randolph Macon Woman's College, Lynchburg, VA; Quinnipiac Club, New Haven; Dayton Mus. of Arts; Macon (GA) Art Assoc.; Met. Mus.; Rochester (NY) Mem. Art Gallery; Springfield (IL) Art Assoc.; Brooks Mem. Art Gallery, Memphis, TN; NY Pub. Lib.; Art Inst. of Chicago; Dept. of Prints and Drawing, British Mus., London; Dept. of Engraving, Victoria and Albert Mus., So. Kensington; Graphic Arts Dept., Smithsonian Inst., Washington, D.C.; Print Dept., Brooklyn Mus.; Art Assoc. of Indianapolis, John Herron Art Inst.; Hartford (CT) Athenaeum; Art Assoc., New Britain, CT; Cabinet des Estampes, Bibliotheque Nationale, Paris; others. Died in 1949. Address in 1929, 171 W 12th Street, New York, NY; summer, Wilton, New Hampshire.

RYDER, MARILLA.
Painter. Exhibited at Penna. Academy of Fine Arts, Phila., 1924. Address in 1926, 2940 Washington Street, Roxbury, MA.

RYDER, PLATT P.
Portrait and genre painter. Born in 1821 at Brooklyn, NY; died in 1896. Pupil of Bonnat in Paris, also studied in London. Elected in 1868 an Associate of the National Academy. His portrait of Geo. P. Putnam, painted in 1872, is in the Metropolitan Museum; he also painted "Clean Shave," "Reading the Cup," "Spinning Wheel" and "Watching and Waiting."

RYDER, WORTH.
Painter, etcher, writer, lecturer, and teacher. Born in Kirkwood, IL, Nov. 10, 1884. Pupil of University of California; Royal Academy, Munich; Hofmann Sch., Munich. Member: Beaux Arts Group, San Francisco. Award: Silver medal for etching, P.-P. Expo., San Francisco, 1915. Landscape, figure and fresco painter. Associate professor of art, University of California. Died in 1960. Address in 1929, 2772 Hilgard Ave., Berkeley, CA.

RYERSON, MARY McILVAINE.
Painter and etcher. Born in Morristown, NJ, Sept. 15, 1886. Pupil of Robert Henri and Charles W. Hawthorne. Member: Wash. Water Color Club; Brooklyn Society of Etchers; CA Print Maker's Soc.; Grand Central Art Galleries; Allied Artists of Am.; Provincetown Art Assoc. Award: Emil Fuchs prize, Brooklyn Society of Etchers, 1924. Etchings in permanent college of Smithsonian Institute, Washington, D.C.; Cleveland Museum of Art. Address 1929, Sherwood Studios, 58 West 57th Street, New York, NY.

RYERSON, MARGERY (AUSTEN).
Sculptor. Born in Philadelphia, PA. Pupil of Saint-Gaudens, Solon Borglum and Fraser. Died in 1936. Address in 1929, Sherwood Studios, 58 West 57th Street, New York, NY.

RYLAND, L. H. (MRS.).
See Hamilton, Hildegarde.

RYLAND, ROBERT KNIGHT.
Mural painter and illustrator. Born in Grenada, MI, Feb. 10, 1873. Pupil of Art Students League and Nat. Academy of Design in NY. Member: Nat. Soc. of Mural Painters; Salma. Club; Artists Guild of the Authors' League of Am.; Alumni Am. Academy in Rome. Awards: Lazarus European Scholarship, 1903-1905; Altman prize, Nat. Academy of Design, 1924; hon. mention, Art Inst. of Chicago, 1926. Died in 1951. Address 1929, 61 Poplar St., Brooklyn, NY; Russellville, KY.

SAALBURG, LESLIE.
Illustrator. Born in 1902. Having studied briefly at the Art Students League, he continued his self-education at various studios. His style, often color washes over line drawings, portrayed the old genteel manners of the elegant and was much in demand for editorial and advertising clients. His work appeared in *Collier's*, *Vogue*, *Town and Country*, and in several portfolios for *Esquire*. *Ford Motor Company*, *Cannon Mills*, and *Hiram Walker Distillers* were among his many advertising clients, earning him two awards from the New York Art Directors' Club. Died in 1975.

SABATINI, RAPHAEL.
Painter, sculptor and teacher. Born in Philadelphia, PA, November 26, 1898. Studied: Penna. Academy of Fine Arts; also under Fernand Leger, Antoine Bourdelle, Constantin Brancusi, and Charles Grafly. Member: Fellowship, Penna. Academy of Fine Arts; Artists Equity Association. Commissions include a frieze for the Fine Art Building in Philadelphia, 1926; Mother Mary Drexel Chapel, Langhorne, PA, 1929. Exhibited: Sesquicentennial, at Philadelphia, 1926; Golden Gate Exposition, San Francisco; Penna. Academy of Fine Arts Annual. Taught: Professor of painting and sculpture, Tyler School of Art, Temple University, 1936-66, professor emeritus, from 1966. Awards: Limback Foundation Award for distinguished teaching, 1962; 400th Anniversary of Michelangelo Award, American Institute of Italian Culture. Address in 1982, Melrose Park, PA.

SABIN, JOSEPH F.
Etcher and illustrator. Born in 1846, he was long a resident of NY. Member of the NY Etchers' Society. He made the illustrations for "Shakespeare's House." His "John Falstaff," after George Cruikshank, is well-known. Address in 1926, Nassau St., New York City. Died in 1927.

SABO, IRVING.
Sculptor and designer. Born in New York City, March 27, 1920. Studied at Cooper Union School, 1940. Has exhibited at Walker Art Center, Minneapolis, Minnesota, 1957; New England Annual, Silvermine Guild of Artists, New Canaan, Connecticut, 1974, 76-79; Aldrich Museum, Ridgefield, Connecticut, 1978; others. Awards from Olivetti Foundation; Silvermine Guild; others. Member of Sculptors Guild; Silvermine Guild; others. Taught at Cooper Union Art School, 1947-50; Brooklyn Museum Art School, 1950-54. Works in wood. Address in 1982, Westport, Connecticut.

SACHEVERELL, JOHN.
Engraver. The *Pennsylvania Gazette*, Philadelphia, March 15-22, 1732-33, contains an advertisement for the sale of "A quantity of white metal, or pewter, teapots, teaspoons, etc. These are of the newest Fashion, and so very neat, as not easily to be distinguished from Silver." The importer, John Scheverell, adds to his notice that he "performs all Sorts of Engraving or Carving in Gold, Silver, Brass, Copper, or Steel, after the newest and neatest manner."

SACKER, AMY M.
Illustrator, craftsman, lecturer, and teacher. Born in Boston, July 17, 1876. Pupil of DeCamp, Joseph Lindon Smith, and C. Howard Walker; studied in Rome and Athens. Member: Boston Society of Arts and Crafts; Copley Society; American Federation of Arts. Award: Bronze medal for book covers, Pan.-Am. Expo., Buffalo, 1901. Art director in motion pictures. Principal of School of Design and Interior Decoration. Address in 1929, 739 Boylston St.; h. 64 Charlesgate East, Boston, MA.

SACKETT, CLARA E(LISABETH).
Portrait painter and teacher. Born in Westfield, NY. Pupil of Art Students League of NY; Aman-Jean and Delecluse and Vitti Academies in Paris. Member: Buffalo Society of Artists; Buffalo Guild of Allied Artists; Copley Society; Guild of Boston Artists; Art Students League of NY. Award: Prize, Buffalo Society of Artists. Represented in Buffalo Historical Society. Address in 1929, Studio 104 East 30th St., New York, NY; summer, Westfield, NY.

SACKS, CAL O.
Illustrator. Born in Brookline, Massachusetts, in 1914. Studied with Kimon Nicolaides. Beginning his career in 1933, he has worked for the American Heritage Publishing Company, illustrated many books, and had shows with General Electric, the U.S. Air Force, and Society of Illustrators, of which he is a member. He has two married children and resided with his wife, who is also an illustrator, in Westport, Connecticut.

SACKS, JOSEPH.
Painter. Born in Shavli, Russia, in 1887. Pupil of the Penna. Academy of Fine Arts, under Anshutz, Chase and Kendall. Member: Fellowship, Penna. Academy of Fine Arts; Philadelphia Sketch Club; Philadelphia Art Alliance. Exhibited a portrait, "The Red Headed Boy," at the Penna. Academy of Fine Arts, Philadelphia, 1924.

SADD, HENRY S.

Born in England. He was engraving good portraits in mezzotint in NY in 1840. He produced a number of plates in this country, but Mr. Alfred Jones says that he went to Australia after a comparatively short stay in the United States.

SAECKER, AUSTIN.

Painter. Born in Appleton, WI, Feb. 13, 1896. Member: Wisconsin Painters and Sculptors; Fellowship Penna. Academy of Fine Arts. Award: Medal, Milwaukee Art Institute, 1924; Business Men's Art Club prize, Wisconsin Painters and Sculptors, Milwaukee, 1926; Fawsett prize, Wisconsin Painters and Sculptors, Milwaukee, 1927. Address in 1929, 110 East College Ave.; h. 414 North Union St., Appleton, WI.

SAGE, CORNELIA BENTLEY.

(Mrs. W. W. Quinton). Painter and writer. Born in Buffalo, NY, Oct. 3, 1876. Pupil of Buffalo Art Students League; Art Students League of NY under Twachtman, Beckwith, Wiles and Reid. Member: Buffalo Society of Artists; Buffalo Art Students League; American Association of Museums; Buffalo Guild of Allied Arts; California Art Club; Los Angeles Art Association; Guild of Boston Artists; Archaeological Society of America; School Art Association; cor. member, Hispanic Society of Artists; Western Association of Art Museum Directors. Awards: Decoration of L'Officier de l'Instruction Publique, Paris, 1917; Decoration Palme d'Academique, 1917; Cross of the Legion of Honor, 1921; Sorolla medal, 1925. Director, Albright Art Gallery, 1910-24, and of the School of the Albright Art Gallery, 1910-1916; member of the National Advisory Committee, Sesqui Centennial Expo., Philadelphia, 1926; elected honorary advisor, Roerich Museum, NY, 1926; Archaeological Institute of America, 1927. Appointed "Patron of American Group of Painters and Sculptors in Paris," 1927. Director, California Palace of the Legion of Honor, 1924-30. Address in 1933, 1775 No. Las Palmas Avenue, Hollywood, California.

SAGE, KAY (TANGUY).

Painter. Born in Albany, NY, June 25, 1898. Awards: Art Institute of Chicago, 1945; Corcoran Gallery of Art, 1951; Connecticut Development Commission, 1951. Collections: Art Institute of Chicago; California Playhouse; Connecticut Development Commission. Exhibited: Whitney Museum of American Art; Metropolitan Museum of Art; Museum of Modern Art; Walker Art Center; Carnegie; Toledo Museum of Art; University of Illinois; John Herron Art Institute; Los Angeles Museum of Art; Brooklyn Museum; Detroit Institute of Art; San Francisco Museum of Art (one-man); Julien Levy Gallery (one-man); others, including exhibitions abroad. Author and illustrator of "Piove in Giardino," 1937. Address in 1953, Woodbury, CT.

SAHLER, HELEN GERTRUDE.

Sculptor. Born in Carmel, NY, in 1877. Pupil of Art Students League of New York; Enid Yandell and H. A. MacNeil. Exhibited: Architectural League; New York Municipal Art Society; National Academy of Design; National Sculpture Society; Panama-Pacific International Expo., 1915; Penna. Academy of Fine Arts. Work: Relief of Dr. George E. Brewer, Medical Centre, medal of Edward P. York, Numismatic Museum, NYC; relief, Dr. Percy S. Grant, St. Mark's Church, Fall River, MA; Brush Memorial, Hackley Chapel, Tarrytown, NY. Member: National Association of Women Painters and Sculptors; MacDowell Club; NY Municipal Art Society; Connecticut Academy of Fine Arts; Art Workers Club; Art Alliance of America; American Federation of Arts. Address in 1933, 1088 Park Ave., NYC. Died in 1950.

SAINT, LAWRENCE.

Etcher, craftsman, writer, and lecturer. Born in Sharpsburg, PA, Jan. 29, 1885. Pupil of Penna. Academy of Fine Arts; Chase; Beaux; Poore; Sergeant Kendall; and in Europe. Member: Fellowship Penna. Academy of Fine Arts. Work in Victoria and Albert Museum, London; Carnegie Institute, Pittsburgh; Bryn Athyn Church, Bryn Athyn, PA; NY Public Library; Cleveland Museum of Art; Metropolitan Museum of Art; stained glass windows, Washington Cathedral, Washington, DC; murals, Kemble Park Church, Philadelphia, PA; others. Illustrator of "Stained Glass of the Middle Ages in England and France;" author and illustrator of "A Knight of the Cross." Was director of the Stained Glass Department, Washington Cathedral, Washington, D.C. Died in 1961. Address in 1953, Huntingdon Valley, PA.

SAINT-GAUDENS, ANNETTA JOHNSON.

(Mrs. Louis Saint-Gaudens). Sculptor. Born in Flint, OH, September 11, 1869. Pupil of Columbus Art School; Art Students League of New York under Twachtman and Saint-Gaudens. Exhibited: Penna. Academy of Fine Arts, 1924. Member: National Association of Women Painters and Sculptors. Awards: McMillin prize, National Association of Women Painters and Sculptors, 1913; honorable mention and silver medal, Pan.-California Expo., San Diego, 1915. Work in Boston Museum of Art; Columbus Gallery of Fine Arts. Address in 1933, Windsor, VT. Died in 1943.

SAINT-GAUDENS, AUGUSTUS.

Sculptor. Born in Dublin, Ireland, March 1, 1848. Family moved to U.S. in the same year. At age 13, he was apprenticed to a stone cameo cutter and studied drawing at Cooper Institute. In 1864 he changed employment to Jules LeBrethon and changed art schools to the National Academy of Design, where he began to model from life. In 1867 he went to Paris to study at Petite Ecole, and later Ecole des Beaux-Arts

under Jouffroy; cut cameos to earn a living. Spent about 4 years studying in Rome. Located in NYC in 1873, anxious to complete the Farragut statue. In 1876 he was engaged on his portrait bust of Chief Justice Taney for the Supreme Court Room. By 1885, Saint-Gaudens had tested his abilities and had tasted success, after earlier years of poverty. He was an officer of the Legion of Honor and taught at the Art Students League, 1889-90, 91/92 and 93-98. Prominent works include the Shaw Memorial, Boston; the Lincoln Statue, Chicago; The Puritan; memorial to Mrs. Henry Adams; Peter Cooper, Cooper Union Square, NYC; Sherman Memorial, Central Park, NYC; and many other important works. Represented in permanent collections of Metropolitan Museum of Art; Penna. Academy of Fine Arts; Corcoran Art Gallery; Luxembourg, Paris; Brookgreen Gardens; etc. Memorial collection of casts of his works in Cornish, NH, presented by Mrs. Saint-Gaudens to the State of New Hampshire and open to the public. Died in Cornish, August 3, 1907.

SAINT-GAUDENS, CARLOTTA.
(Mrs. Homer Saint-Gaudens). Miniature and water color painter. Born in Rochester, NY, 1884. Pupil of Penna. Academy of Fine Arts; Art Students League of NY. Address 1926, Windsor, VT. Died 1927.

SAINT-GAUDENS, LOUIS.
Sculptor. Born in New York on January 1, 1854. His early training was as a cameo cutter. He joined his brother, Augustus, at his studio in Paris in 1878, studied at the Ecole des Beaux-Arts and then returned with his brother to NYC and helped him with his work there. Between 1898-1900, he lived and worked in Flint, OH, and then moved to Cornish, NH, where he lived a mile away from his brother's studio. Modeled a "Faun" and "St. John" for the Church of the Incarnation, NY; and other statues and works, including lions at Boston Public Library; facade (6 statues), Union Station, Washington, DC; Homer, Library of Congress; Pipes of Pan, Metropolitan Museum of Art; Samuel Brearley, Brearley School, NYC; painting, City Art Museum, St. Louis; relief of angels, Church of the Ascension, NYC. Awarded silver medal, Pan.-American Exposition, Buffalo, 1901. Member: National Sculpture Society. Died March 8, 1913.

SAINT-GAUDENS, PAUL.
Sculptor, craftsman, and writer. Born in Flint, OH, June 15, 1900. Pupil of Frank Applegate, O. L. Bachelor, Arnold Ronnebeck, Archipenko; also Boston Museum of Fine Arts School; British Academy, Rome; Julian Academy, Grande Chaumiere, Paris, France. Exhibited: Nationally and internationally. Contributor to Craft Horizons. Member: Boston Soc. of Arts and Crafts; N.Y. Soc. of Craftsmen; Chicago Artists Guild; Am. Fed. of Arts. Address in 1953, Windsor, VT.

SAINT-LANNE, LOUIS.
Sculptor. Born in France, 1871. Member: National Sculpture Society, 1907. Address in 1933, 432 West 22nd St., New York, NY.

SALA, RAFAEL.
Painter. Exhibited in Philadelphia, PA, 1921, in "Exhibition of Paintings Showing the Later Tendencies in Art." Address in 1926, 216 West 50th St., New York City.

SALAZAR, JOSE DE (JOSEPH D.).
Portrait painter. Had his studio in New Orleans about 1792. He painted a portrait of Daniel W. Coxe, which was exhibited at the Loan Exhibition of Historic Portraits at the Penna. Academy of Fine Arts in 1887.

SALDIBAR, P.
Sculptor. Born in 1907. Address in 1934, West Haven, Connecticut.

SALDUTTI, DENISE.
Illustrator. Born in Newark, NJ. Attended Parsons School of Design, where she studied under Maurice Sendak. In 1974 she began illustrating and was selected to appear in the Society of Illustrators Annual Show in 1975 and 1976.

SALEMME, ANTONIO.
Painter and sculptor. Born in Gaeta, Italy, November 2, 1892. U.S. citizen. Student at Boston Museum of Fine Arts, and afterwards abroad; with Angelo Zanelli; Artists Equity. Member of National Sculpture Society; New York Architectural League. Exhibited at National Sculpture Society, 1923; General International Exhibition, Salon des Tuileries, Paris, France, 1932, 34, 35; Penna. Academy of Fine Arts, 1930-50; Art Institute of Chicago; Whitney; Metropolitan Museum of Art; Weintraub Gallery, NY, 1964; Schoelkopf Gallery, 1964 (one-man); Yellow Box Gallery, NYC, 1980; others. Works: Bronze statue, "Prayer," Newark Public Library; portrait, Mr. W. A. Read, Robert Stein and Stanley Kimmel; Metropolitan Museum of Art; Newark Museum; Syracuse Museum of Fine Arts; Columbia University; Yale University; others. Media: Oil, watercolor; bronze, terracotta. Address in 1982, Easton, PA.

SALERNO, CHARLES.
Sculptor and teacher. Born in Brooklyn, NY, August 21, 1916. Studied at the Academie Grande Chaumiere, Paris; Escuela Pintura Y Escultura, Mexico City; State University, NY, teaching certificate. Exhibited: Museum of Modern Art, 1950; American Pavilion, at the Brussels World's Fair, Belgium, 1958; New York World's Fair, 1964; a one-man show at the Weyhe Gallery, NY; and a retrospective at the Sculpture Center, NY, 1975. Awards: Purchase Prize, Staten Island Museum, 1959; Louis Comfort

Tiffany Foundation Fellowship for Sculpture, 1948; Margaret Hirsch-Levine Prize in sculpture, Audubon Artists Annual, 1971. Member: National Sculpture Society; National Academy of Design; Audubon Artists (director). Taught: Assistant professor of sculpture at City College, NYC, 1961-74, and the National Academy of Design, 1978-80. Works primarily in stone. Address in 1982, Melbourne, FL.

SALERNO, VINCENT.
Sculptor and illustrator. Born in Sicily, Italy, February 10, 1893. Pupil of A. Stirling Calder, Francis C. Jones, Hermon A. MacNeil; National Academy of Design; Beaux Arts Institute. Awards: Bronze medal, Louisiana Purchase Exposition, St. Louis, MO, 1904; silver medal, Panama-Pacific International Exposition, San Francisco, CA, 1915. Works: Portraits, Justice Hendrick, Supreme Court, NYC; John B. Stanchfield, NYC. Specialty: Portraiture. Exhibited at National Sculpture Society, 1923. Address in 1929, 50 East 34th Street; h. 1919 Seventh Ave., New York, NY.

SALING, HENRY (FREDERICK).
Painter. Born in Hartford, CT, March 3, 1901. Pupil of Paul E. Saling; Michel Jacobs. Member: Connecticut Academy of Fine Arts; Springfield Art League. Address in 1929, 147 Fairfield Ave.; h. 248 Fairfield Ave., Hartford, CT.

SALING, PAUL E.
Painter. Born in Germany, July 19, 1876. Studied in Germany; with Charles Noel Flagg and A. Bunce; Connecticut League of Art Students. Member: Salma. Club; Connecticut League of Art Students; Springfield Art League; American Federation of Arts. Award: Hon. mention, Connecticut Academy of Fine Arts, 1915. Represented in Gallery of Storrs College, Storrs, CT; East Hartford Trust Co.; Odd Fellows Temple, Hartford, CT; Elks Temple, New London, CT. Died in 1936. Address in 1929, 147 Fairfield Ave., Hartford, CT; summer, Lyme, CT.

SALISBURY, A(LTA) W(EST) (MRS.).
Painter. Born in Darnestown, MD. Pupil of Corcoran School of Art; Cullen Yates and Leon Dabo; and in Dresden. Member: National Association of Women Painters and Sculptors; Brooklyn Society of Artists; Wolfe Club; New Rochelle Art Association; Connecticut Academy of Fine Arts. Address in 1929, 75 Ellenton Ave., New Rochelle, NY.

SALMON, ROBERT W.
Marine painter. Born c. 1775 of Scottish descent. Worked in England as early as 1800; at Liverpool, 1806-12; at Greenock (Scotland), 1812-21; later at North Shields. Came to this country in 1828. He was painting in Boston as late as 1841. His painting, "The Wharves of Boston," hangs in the old Boston State House. "Rocks at Nahant," and a list of his paintings are preserved at the Boston Museum of Fine Arts. Died c. 1842.

SALTONSTALL, ELIZABETH.
Lithographer, painter and teacher. Born in Chestnut Hill, MA, on July 26, 1900. Studied: Boston Museum of Fine Arts School; with Andre L'Hote in Paris; also with Stow Wengenroth and Frank Swift Chase. Collections: Boston Museum of Fine Arts; Boston Public Library; Library of Congress; Yale University; Farnsworth Art Gallery, Rockland, ME. Exhibited: Library of Congress; Brooklyn Museum; Audubon Artists; National Association of Women Artists; Pen and Brush Club; Print Club of Albany; Boston Print Maker's Society; Society of Washington Print Makers. Member: Audubon Artists; Artists Equity Association; National Association of Women Artists; Pen and Brush Club; Springfield Art League. Address in 1980, 231 Chestnut Hill Rd., Chestnut Hill, MA.

SALTZMAN, WILLIAM.
Painter and sculptor. Born in Minneapolis, MN, July 9, 1916. Studied at University of Minnesota, B.S., 1940. Work in Minneapolis Institute of Art; Walker Art Center; Joslyn Museum, Omaha; welded sculpture and candelabra, B'nai Abraham Synagogue, Minneapolis; copper relief sculptures, Adath Jeshurun Synagogue, Minneapolis; others. Has exhibited at Art Institute of Chicago; Whitney Museum of American Art; San Francisco Art Association; Carnegie Institute; Philbrook Museum, Tulsa, OK (one-man); Joslyn Art Museum; many others. Member of National Society of Mural Painters and Sculptors. Awards: Best in Painting award, 48th Annual Minnesota State Fair, 1959; American Institute of Architects Assoc. Art award, 1973. Has taught at University of Minnesota; St. Olaf College; University of Nebraska; Macalester College. Address in 1982, Minneapolis, MN.

SALVATORE, VICTOR D.
Sculptor, painter, and teacher. Born in Italy, July 7, 1885. Pupil of Charles Niehaus and A. Phimister Proctor. Member: National Sculpture Society, 1913; Artists Aid Society; Architectural League of NY; Century Association. Awards: Bronze medal, St. Louis Expo., 1904; silver medal, P.-P. Expo., San Francisco, 1915; Barnett prize, National Academy of Design, 1919; honorable mention, Art Institute of Chicago, 1919; honorable mention, Concord Art Association, 1920. Work: Head of a Child, Metropolitan Museum of Art; Head of Child, Brooklyn Museum of Art; Head of Girl, Museum of Art, Portland, OR; James Fenimore Cooper, Hall of Fame, NY. Exhibited at National Sculpture Society, 1923. Address in 1933, 8 MacDougal Alley; h. 25 Washington Square, North, New York, New York; h. "Swanswick," Springfield Centre, Otsego County, New York. Died in 1965.

SAMERJAN, GEORGE E.
Sculptor, painter, designer, teacher, and lecturer. Born in Boston, MA, May 12, 1915. Studied at Otis Art Institute, 1940-41; Chouinard Art Institute, 1933; and with Alexander Brook and Willard Nash. Member: California Water Color Society; Art Directors' Club, Los Angeles. Awards: Prizes, American Institute of Graphic Arts, 1941; Los Angeles Advertising Club, 1940; Art Fiesta, San Diego, 1938; California Water Color Society, 1943; Santa Cruz Art League, 1942; medal, Oakland Art Gallery, 1940. Work: San Diego Fine Arts Society; hospital, Lexington, KY; American Red Cross; murals, U.S. Post Office, Maywood, Culver City, CA. Exhibited: National Academy of Design, 1941; Virginia Museum of Fine Arts, 1940, 42, 43; Penna. Academy of Fine Arts, 1938-40, 43; American Water Color Society, 1941, 42; California Water Color Society, 1938-42; Denver Art Museum, 1941, 42; San Francisco Art Association, 1940-42; San Diego Fine Arts Society, 1938-42; Los Angeles Museum of Art, 1939, 41, 42; New Haven Paint and Clay Club, 1941; Washington Water Color Club; Corcoran Gallery of Art; Riverside Museum; Oakland Art Gallery; Los Angeles County Fair, 1938, 39, 41; California State Fair, 1939-41; Santa Paula, California, 1942-45; Santa Barbara Art Museum; Laguna Beach Art Association; Grand Central Art Gallery; Seattle Art Museum; Los Angeles Art Association; Santa Cruz Art League; California Institute of Technology; Liege, Belgium; Paris, France. Position: Art Director, *Los Angeles Times*, from 1946. Address in 1982, Katonah, NY.

SAMMONS, FREDERICK HARRINGTON C.
Painter. Born in Bath, England in 1838. He lived in America for many years, and was connected with the Chicago Art Institute. He was also a skillful restorer of paintings. Died in 1917, in Chicago, IL.

SAMPLE, PAUL.
Illustrator. Born in Kentucky on Sept. 14, 1896. Received his art training from Jonas Lie. During his long career as an editorial and advertising illustrator, he earned a reputation for painting country landscapes. Among his clients were Maxwell House Coffee and Ford Motor Company. His works were exhibited at the 1940 NY World's Fair and at the Golden Gate International Exposition. A long-time resident of New Hampshire, he was artist-in-residence at Dartmouth College and a member of the National Academy of Design. Died in 1974.

SAMPSON, ALDEN.
Painter. Born in Manchester, ME, in 1853. Address in 1926, 168 East 51st Street, New York, NY.

SAMPSON, CHARLES A. L.
Sculptor. Born in Boston, MA, 1825. Apprenticed as a ship carver in Bath, ME, by G. B. McLain; opened his own shop in 1852 which thrived after the Civil War. Personally carved over thirty figureheads, only four of which are known to survive. Died in Bath, ME, Jan. 1, 1881.

SANBORN, EARL EDWARD.
Painter and teacher. Born in Lyme, N.H., May 21, 1890. Pupil of Burbank; Tarbell; Benson; and Paxton. Member: Boston Art Club; Stained Glass Assoc. of Am.; Rockport Art Assoc. Awards: Paige European traveling scholarship from the Boston Museum of Fine Arts, 1914-16; gold medal, still life, Boston Tercentenary Exhib., 1931. Work: Stained glass, National Cathedral, Washington, DC; Trinity College, Chapel, Hartford, Conn.; Boston College Library, Boston, MA. Still lifes and portraits in private collections. Address in 1933, Hearthstone, Dennison Farm, Annisquam, MA. Died in 1937.

SANDEFUR, JOHN COURTNEY.
Etcher. Born in Indiana, May 26, 1893. Pupil of Allen E. Philbrick. Member: Chicago Society of Etchers; Illinois Academy of Fine Arts. Award: Frank Cunningham prize, Hoosier Salon, Chicago, 1928. Address in 1929, 524 West 72nd Street, Chicago, Illinois.

SANDER (or SANDERS), A. H. (MRS.).
Sculptor. Born in 1892. Work in Dallas Museum of Fine Art. Executed pair of bronze bookends titled "Indian Head," cast by Griffoul, Newark, New Jersey. Address in 1948, Fort Worth, Texas.

SANDERS, ADAM ACHOD.
Sculptor, painter, teacher and writer. Born in Sweden, June 15, 1889. Pupil of Beaux Arts Institute of Design, New York; Cooper Union Art School. Exhibited: National Sculp. Society. Member: Brooklyn Society of Artists; Bronx Artists Guild; Society of Independent Artists; Brooklyn Painters and Sculptors Society; Am. Fed. of Arts. Work: "Abraham Lincoln," Lincoln Mem. Collection, Washington, DC; "Beethoven," Library of the Friends of Music, NY; Schubert medal, commemoration Schubert Centenary, presented to Arthur Bodanzky, conductor of the Metropolitan Opera House, New York; College of the City of New York; Brooklyn College; Tel-Aviv Museum, Israel. Published: *The Theory of Altoform*, 1945; *Cosmogony*, 1950. Address in 1953, Brooklyn, N.Y.

SANDERSON, CHARLES WESLEY.
Painter. Born in Brandon, Vermont, in 1838. He studied in Vermont and later went to Paris and studied at Julian's. On his return to this country he painted landscapes in water colors. His studio was in Boston, and he died there on March 8, 1905.

SANDERSON, RAYMOND PHILLIPS.
Sculptor. Born in Bowling Green, Missouri, July 9, 1908. Studied at Art Institute of Chicago; Kansas

City Art Institute; and with Raoul Josset, in Chicago, IL. Work: Monument, Bisbee, AZ; carvings, U.S. Maritime Commission vessels; Hotel Westward Ho, Hotel Adams, Phoenix, AZ. Exhibited: New York World's Fair, 1939; Denver Art Museum, 1939-42; Tempe (AZ) State Teachers College, 1946 (one-man); retrospective, Arizona State University, 1973. Taught: Associate professor of sculpture, Arizona State College, 1947-53. Media: Bronze and wood. Address in 1982, Oroville, CA.

SANDHAM, HENRY.
Painter. Born in Montreal in 1842. He worked in Canada until 1880 when he went to England, and on his return from abroad he established his studio in Boston. His best work was done in historical painting and portraiture, and he had success with marine painting. His portraits of Dr. Duryea and Robert Swan are in Boston. He was a member of the Boston Art Club. Died Jan. 6, 1912, in London, England.

SANDMAN, JO.
Painter. Born in Boston, MA, in 1931. Studied: Hans Hofmann School of Fine Arts, Provincetown, MA; University of California at Berkeley; Radcliffe College, Cambridge, MA. Exhibitions: DeCordova Museum, Lincoln, MA, 1952; Nexus Gallery, Boston, 1958, 61; O. K. Harris Works of Art, NYC, 1975. Collections: Massachusetts Institute of Technology, Cambridge; Addison Gallery of American Art, Andover, MA; Brockton Art Center, Lincoln, MA.

SANDONA, MATTEO.
Painter. Born in Schio, Italy, April 15, 1881. Pupil of Nani and Bianchi. Member: San Francisco Art Association; Bohemian Club, San Francisco; American Federation of Arts. Awards: Silver medal, Lewis and Clark Expo., Portland, 1905; silver medal, Sacramento, 1917; first prize, Sacramento State Fair, 1926; second prize, Chicago Galleries Association, 1926. Member: International Jury of Awards for Paintings, Panama Pacific Expo., San Francisco, 1915. Work: "Portrait of Mary Pickford," National Gallery, Washington, DC; "Chrysanthemums," Golden Gate Park Memorial Museum, San Francisco; "Portrait of Hon. Sanford B. Dole," Punahou College, Honolulu, Hawaii; several etchings and dry points, Palace of the Legion of Honor, San Francisco; "Amber Beads," Mills College, California; "Reflections," High School, Salt Lake City, UT. Address in 1929, 471 Buena Vista Ave., San Francisco, CA.

SANDOR, MATHIAS.
Painter. Born in Hungary in 1857; died in NYC on Nov. 3, 1920. Educated at Art Students League of NY, 1885-86; Academie Julian, Paris, 1889-90, under Francois Flameng and Gabriel Ferrier. Came to the U.S. in 1881 and began making designs for commercial purposes and painting portraits. He became a portrait, miniature and landscape painter. Member

of Artists' Fund Society; American Federation of Arts. He exhibited in all important exhibitions.

SANDS, J.
An engraver of music on copper, working in Baltimore about 1824. He signed his name "J. Sands Sc."

SANDZEN, SVEN BIRGER.
Painter, etcher, engraver, lithographer, block printer, teacher, writer, and lecturer. Born in Bildsberg, Sweden, Feb. 5, 1871. Pupil of Stockholm Artists' League under Zorn, Erlandsson and Bergh; Aman Jean in Paris; came to U.S. in 1894. Member: NY Water Color Club; California Water Color Society; Philadelphia Water Color Club; Prairie Print Maker's Society; Chicago Society of Etchers; Smoky Hill Art Club. Awards: First Moore prize ($100), Artists of Kansas City and vicinity, 1917; Philadelphia Water Color Club prize, 1922. Work: National Museum, Stockholm; Lund Museum, Sweden; NY Public Library; Library of Congress, Washington, DC; Chicago Art Institute; Brooklyn Museum; Yale Art Museum; Art Museum of Gothenburg, Sweden; Art Museum of Santa Fe, NM; Bibliotheque Nationale, Paris; department of prints and drawings, British Museum, London. Author, *With Brush and Pencil*. Head of School of Art, Bethany College, Lindsborg, KS. Died in 1954. Address in 1953, Bethany College, Lindsborg, KS.

SANFORD, EDWARD FIELD, JR.
Sculptor. Born in NY, April 6, 1886. Studied: Art Students League of New York; National Academy of Design; Julian Academy in Paris; Royal Academy in Munich. Member: National Sculpture Society; Beaux Arts Institute; National Arts Club. Exhibited at National Sculpture Society, 1923. Work: "Pegasus," bronze statuette, Rhode Island School of Design, Providence; Charles Francis Adams Memorial, Washington and Lee University, Lexington, VA; Commemorative Tablet, Columbia University; Core Memorial, Norfolk, VA; 2 pediments, 4 colossal figures and 20 bas-relief panels, State Capitol, Sacramento, CA; finial figure and 3 colossal Gothic figures for the Alabama Power Co. Building; colossal figure, Yale University Gymnasium, New Haven, CT; 2 colossal groups, Bronx County Court House; animal frieze, New York State Roosevelt Memorial, NY. Director, department of sculpture, Beaux Arts Institute of Design, 1923-25. Noted for his monumental sculpture. Address in 1933, 15 West 67th Street, New York, NY. Died in 1951.

SANFORD, ISAAC.
Engraver. As early as 1783 Sanford engraved a music book entitled "Select Harmony, containing the Necessary Rules of Psalmody, together with a Collection of Approved Psalm Tunes, Hymns and Anthems," by Oliver Brownson. Mr. James Terry, in referring to this book, in his "Ex Libris Leaflet, No.

4," describes the title as contained in a circle of music, and the whole within an engraving of an elaborate church interior covering the entire page. The plate is signed by "I. Sanford, Sculp. 1783." On his business card Sanford advertised himself as "Miniature Painter and Engraver," and he was engraving and publishing fairly well-executed stipple portraits and book illustrations in Hartford, CT, as late as 1822. Died c. 1842, in Philadelphia, PA.

SANFORD, MARION.
Sculptor. Born in Guelph, Ontario, Canada, February 4, 1904. Studied: Pratt Institute Art School; Art Students League; and with Brenda Putnam. Awards: Guggenheim fellowship, 1941-43; National Academy of Design, 1943, 47; Allied Artists of America, 1945; Meriden, CT, 1949; American Artists Professional League, 1945; Springfield (MA) Museum of Art, 1957. Collections: Penna. Academy of Fine Arts; Corcoran Gallery of Art; Brookgreen Gardens, SC; Warren (PA) Public Library; Haynes Collection, Boston; Norton Hall, Chautauqua, NY; Warren General Hospital, PA; Cosmopolitan Club, NY; Trinity Memorial Church, Warren, PA; St. Mary's Chapel, Faribault, MN; U.S. Post Office, Winder, GA. Exhibited: Whitney Museum, 1940; Penna. Academy of Fine Arts, 1943-46; National Academy of Design, 1938-46; Allied Artists of America, 1944, 45; National Association of Women Artists; Audubon Artists, 1945. Illustrated *The Sculptor's Way*, 1942. Address in 1953, NYC.

SANGER, ANTHONY.
Sculptor. Born in Wuerttemberg, 1835. Living in Boston in 1860.

SANGER, GRACE H. H. (COCHRANE).
Painter and illustrator. Born in Newark, NJ, June 15, 1881. Pupil of Howard Pyle; W. M. Chase; Hugh Breckenridge. Member: North Shore Arts Association; Baltimore Water Color Club. Represented by portraits in public schools of Maryland. Illustrator of *Eve Dorre* (Dorran & Co.). Address in 1929, Ruxton, MD.

SANGER, I. J.
Painter, illustrator, draftsman, and lithographer. Born in Port Republic, VA, Jan. 8, 1899. Pupil of Arthur W. Dow; Columbia University. Award: Joint prize for best print, The Print Club, Philadelphia, PA, 1929. Address in 1929, 408 West 130th Street, New York, NY.

SANGER, WENDOLIN.
Sculptor. Born in Wuerttemberg, 1838. Living in Boston in 1860.

SANGER, WILLIAM.
Painter and etcher. Born in Berlin, Germany, of American parents, Nov. 12, 1875. Pupil of Art Students League of NY; Artists and Artisans Institute of NY. Represented by "City of Vigo," Hispanic Society of America, New York; entire cycle of figures of the Gate of Glory, Santiago Cathedral, Spain; "Seal Cove, Grand Manan," Newark Museum; "South Bridge, Eastport," "Surf," Brooklyn Museum; "The Wreck," "Eastport Harbor," Whitney Museum of American Art; painting, Avery Library, Columbia University, New York, NY. Address in 1933, State Building, Albany, NY.

SANGERNEBO, ALEXANDER.
Sculptor. Born in Esthonia, Russia, May 1, 1856. Member: Indiana Art Club. Work: Murat Temple, Lincoln Hotel, Union Station, Guaranty Building, Blind Institution, St. Joan of Arc Church, Ayres Building, Indiana National Guard Armory, and Indiana Theatre, Indianapolis; County Court House, Lebanon, IN. Address in 1929, Indianapolis, IN. Died there in 1930.

SANGERNEBO, EMMA EYLES.
(Mrs. Alexander Sangernebo). Sculptor and painter. Born in Pittsburgh, PA, Janury 23, 1877. Pupil of William Forsyth. Member: Indiana Art Club; National League of American Pen Women; American Artists Professional League; Hoosier Salon. Work: Figure panels, Loew's Theatre, historic panel, Washington High School, Indianapolis; Elizabeth Bartnett Hitt memorial portrait tablet, Indianapolis (IN) Woman's Department Club; Garfield Park, Indianapolis; Union Building, Bloomington, IN. Address in 1953, Indianapolis, IN.

SANIN, FANNY.
Painter. Born in Bogota, Colombia. Now living and working in NYC. Studied: University of the Andes, Bogota; University of Illinois, Urbana, IL; Chelsea School of Art, London. Awards: I Edinburgh Open 100, Edinburgh, Scotland, 1967; II Coltejer Art Biennale, Medellin, 1970. Exhibitions: Modern Art Gallery, Monterey, Mexico, 1964; Pan-American Union Gallery, Washington, DC, 1969; Union Carbide Building, NYC, 1975. Collections: Museum of Modern Art of Bogota, Colombia; Museum of Contemporary Art, Bogota; Museum of Fine Arts of Caracas, Venezuela.

SANSAM, EDITH (MISS).
Painter. Born in Evanston, IL. Studied in School of New Orleans Artists Association. President of the Black and White Club. Won Pinckney Smith medal for sketches, and Artists Association medal for landscape in oil.

SANTORE, CHARLES.
Illustrator. Born in Philadelphia, in 1935. Attended the Philadelphia College of Art. He began his career in 1959 with an illustration for *The Saturday Evening Post* after studying with Henry Pitz and Albert Gold.

He has illustrated for most major magazines and was awarded gold medals from the Philadelphia Art Directors' Club. In 1972, he received an Award of Excellence from the Society of Illustrators and the Hamilton King Award.

SARDEAU, HELENE.
(Mrs. George Biddle). Sculptor. Born in Antwerp, Belgium, July 7, 1899. Studied: Art Students League; New York School of American Sculpture. Member: Sculptors Guild. Award: Architectural League, 1934. Collections: Croton-on-Hudson High School; U.S. Post Office, Greenfield, MA; Fairmount Park, Philadelphia, PA; National Library, Rio de Janeiro; Supreme Court, Mexico City; Whitney Museum of American Art; Tel-Aviv Museum, Israel. Exhibited: Salon d'Automne, Paris, 1928; Museum of Modern Art, 1940; Art Institute of Chicago, 1941; Carnegie Institute, 1941; Penna. Academy of Fine Arts, 1946; Metropolitan Museum of Art, 1940; Carlen Gallery, 1946; many others. Address in 1953, Croton-on-Hudson, NY. Died in 1968.

SARG, TONY.
Painter, illustrator, craftsman, writer, and lecturer. Born in Guatemala, Central America, April 24, 1880. Member: Salma. Club; Society of Illustrators; Artists Guild of the Authors' League of America. Illustrated *Speaking of Operations* and *Fiddle D. D.*, by Irvin S. Cobb. Creator of Tony Sarg's Marionettes and of motion picture shadowgraph productions; Tony Sarg's Almanac. Died in 1942. Address in 1929, 54 West 9th Street, New York, NY; h. 24 Ivanhoe Terrace, East Orange, NJ.

SARGEANT, CLARA McCLEAN.
Painter. Born in Washington, IA, June 24, 1889. Pupil of Cleveland School of Art; Art Students League of NY; Corcoran School, Washington, D.C. Member: Woman's Art Club, Cleveland. Awards: Third portrait prize, 1922, and hon. mention, 1924-28, Cleveland Museum of Art. Address in 1929, 2258 Euclid Ave., Cleveland, OH; 15706 Grovewood Ave., Northeast, Cleveland, OH.

SARGEANT, GENEVE RIXFORD.
Painter. Born in San Francisco, CA, in 1868. Pupil of Emil Carlsen; Andre L'hote. Member: San Francisco Art Association; Chicago Society of Artists. Award: Cahn prize, Art Institute of Chicago, 1903. Address in 1929, 115 rue Notre Dame des Champs, Paris VI, France.

SARGENT, HENRY.
Painter. Born in Gloucester, MA, in 1770. He copied the work of Copley and other early American Artists. In 1790 Trumbull commended his work, and in 1793 Sargent went to London with letters to West, but returned to Boston in 1797. He received several military commissions. He studied in Gilbert Stuart's studio in Boston about 1806, with whom he was very friendly. He became an Honorary Member of the National Academy in 1840, and was elected first president of the Artists' Association of Boston. Many of his paintings will be found in Boston. Colonel Sargent died in that city on Feb. 21, 1845.

SARGENT, JOHN SINGER.
Painter. Born of American parents in Florence, Italy, in 1856. Educated in Florence, Rome, and Nice; went to Paris in 1874, where he entered studio of Carolus Duran, then the most popular portrait painter. Spent five years there at the studio, assisting his master at times with murals, and traveled to Italy and Spain, where he studied the work of Velazquez. Painted portrait of Carolus Duran, considered one of his greatest pictures. Moved to London in 1884; yet spent much time in U.S. painting many fine portraits in NY and Boston. Received commissions from Public Library of Boston and Boston Museum of Fine Arts to paint mural decorations for their buildings. Works include portraits of Henry G. Marquand and Wm. M. Chase, Metropolitan Museum of Art; "Daughters of Edward Boit," Boston Museum of Fine Arts; "Mr. and Mrs. Field," Penna. Academy of Fine Arts; portraits of Edwin Booth and Joseph Jefferson, Players' Club of NY; "Dr. Pangloss," "President Lowell," of Harvard, Harvard University. A retrospective of important works was held February-March, 1924, at Grand Central Art Galleries, NY. Memorial Exhibition held January-February, 1926, at Metropolitan Museum of Art, showing 59 oil paintings and 62 watercolors. Biographies include "Sargent," T. Martin Wood; "John S. Sargent, His Life and Works," William Howe Downes (1925). Died in London, April 15, 1925.

SARGENT, MARGARET W.
Sculptor. Born in Wellesley, MA, August 31, 1892. Pupil of Woodbury and Borglum. Member: National Association of Women Painters and Sculptors. Address in 1933, c/o Mrs. L. A. S. McKean, Prides Crossing, MA; Wellesley, MA.

SARGENT, MARY F.
(MRS. WILLIAM DUNLAP).
Etcher and sculptor. Born in Somerset, PA, July 4, 1875. Studied at Pennsylvania College for Women; Art Students League; Teachers College, Columbia University; in Paris and London; and with William P. Robbins, Paul Bornet, St. Gaudens, Wickey, and others. Member: Connecticut Academy of Fine Arts; National Association of Women Artists; Silvermine Guild of Artists. Awards: Medal, Pennsylvania College for Women. Work: Metropolitan Museum of Art; Library of Congress; Brooklyn Museum; Brooks Memorial Art Gallery; G. W. V. Smith Art Museum. Exhibited: Library of Congress, 1944; National Academy of Design, 1943; National Association of Women Artists, 1942, 43; Silvermine Guild Artists, 1940-43;

Connecticut Academy of Fine Arts, 1940-42, 46; New England Print Association, 1941; Society of Liberal Arts, Omaha, NE, 1944; Morton Gallery, 1939 (one-woman); Studio Guild, 1940. Illustrated in *House Beautiful* magazine. Lectures: History and Appreciation of Etching. Address in 1953, Westport, CT.

SARGENT, PAUL T(URNER).
Painter. Born in Hutton, IL, July 23, 1880. Member: Brown County Art Association of Indiana; Hoosier Salon. Address in 1929, Charleston, IL.

SARGENT, WALTER.
Painter. Born in Worcester, MA, in 1868. Pupil of Colarossi and Delecluse Academies in Paris. Address in 1929, University of Chicago, Chicago, IL. Died Sept. 19, 1927 in North Scituate, MA.

SARKA, CHARLES NICOLAS.
Mural painter and illustrator. Born in Chicago, IL, Dec. 6, 1879. Member: Aquarellists. Awards: Collaborative prize, NY Architectural League, 1913; first prize for poster cover, St. Louis Pageant, 1914. Address in 1929, 680 Madison Ave, New York, NY; summer, Canada Lake, NY.

SARKADI, LEO (SCHULLER).
Painter, writer, and illustrator. Born in Budapest, Hungary, May 24, 1879. Member: Green Room Club; Society of Independent Artists; American Federation of Arts. Address in 1929, 200 West 57th Street; h. 256 Seaman Ave., New York, NY.

SARNOFF, LOLO (MS.).
Sculptor and collector. Born in Frankfurt, Germany, January 9, 1916; U.S. citizen, 1943. Studied: Reimann Art School, Berlin, Germany, graduate, 1936; art history at Universities of Berlin and Florence, 1934-37. Work: Corning (NY) Museum of Glass; National Academy of Science, Washington, DC; The David Kreeger College, Washington, DC; Joseph H. Hirshhorn, Washington, DC; many other public and private collections in U.S. and abroad. Commissions: "The Flame," J. F. Kennedy Center; "The Spiral Galaxy," National Air and Space Museum; "Today and Tomorrow," Federation of National Mortgage Association, all in Washington, DC. Exhibited: Agra Gallery, Washington, DC, solo, 1968; Corning (NY) Museum, solo, 1970; National League of American Pen Women, Washington, DC, 1977; Gallery Two, Woodstock, VT, 1977; Alwin Gallery, London, solo, 1981; Gallery von Bartha, Basel, Switzerland, solo, 1982; many other group and solo shows in U.S. and abroad, from 1968 to present. Awards: "Medaglia d'Oro," Accademia Italia Delle Arti e del Lavoro; American Artists of Renown; many other honors. Member: Artists Equity Association; American Pen Women; Washington Women's Art Center; Trustee, Corcoran Gallery, Washington, DC. Collector of 20th century drawing, painting, sculpture; 18th century

Faience; 18th century porcelain. Author of many scientific articles. Media: Light sculpture, plexiglas, fiberoptics, acrylic. Dealer: Gallery K, Washington, DC; Gallery Two, Woodstock, VT; Gallery von Bartha, Basel, Switzerland. Address in 1983, 7507 Hampden Lane, Bethesda, MD.

SARONY, NAPOLEON.
Artist. Born March 9, 1821 in Quebec. Identified with lithographic printing houses since his thirteenth year. Also drew portraits in charcoal. He signed some pieces himself, executed in a graceful and smooth manner. Died Nov. 9, 1896, in NYC.

SARTAIN, EMILY.
Engraver. Born in Philadelphia, PA, in 1841. The daughter of John Sartain, she learned to engrave under the tuition of her father; she also studied art under Scheussele, in Philadelphia, and under Luminais, in Paris, in 1871-75. She engraved and signed a few mezzotint portraits. In 1881-83, Emily Sartain was the art editor of *Our Continent*, and in 1886 she became principal of the Philadelphia School of Design for Women. Miss Sartain is also a painter of portraits and genre subjects, and exhibited at the Paris Salon in 1875 and 1883. Address in 1926, 1346 N. Broad Street, Philadelphia, PA. Died June 18, 1927 in Philadelphia.

SARTAIN, HARRIET.
Landscape painter. Born in Philadelphia, PA. Pupil of Philadelphia School of Design for Women, and of Teachers College, NY. Member of Plastic Club; National Association of Women Painters and Sculptors; Philadelphia Art Alliance; and Dean of Philadelphia School of Design for Women. Address in 1926, 1346 North Broad St., Philadelphia, PA.

SARTAIN, JOHN.
Engraver and portraitist. Father of Samuel Sartain. Born in London, October 24, 1808. Apprenticed in February, 1823, to John Swain, a London engraver. First significant plates were line illustrations for "The Early Florentine School," by Wm. Young Ottley, London, 1826. In 1827-28, apprenticed to Henry Richter of London; while in Richter's employ he engraved his first mezzotint plate, "Omphale." Engraved "The Tight Shoe," which he brought to U.S. and sold in 1830 to Mr. Littell, Philadelphia publisher. At the termination of his apprenticeship, he commenced his own business in London, engraved a portrait of Sir Charles Wilkins, and some small Annual plates for the Ackermans. Moved to Philadelphia, 1830; executed mezzotint plate after "Old Age," a painting by John Neagle; and line plate, "Deer," in a landscape, after a painting by Thomas Doughty. In 1843 became proprietor of *Campbell's Foreign Semi-Monthly Magazine.* In 1841-48, he was engraving for *Graham's Magazine*. After the collapse of that journal in the latter year, he became half

owner of *Sartain's Union Magazine*, discontinued in 1852. Sartain was art manager and engraver for all these magazines. After 1852, he devoted himself to general engraving. Total output of engraved plates is approximately 1,500. Executed large portrait mezzotint plates and also painted miniatures. For life of Sartain see "The Reminiscences of a Very Old Man," by John Sartain. Died in Philadelphia, Oct. 25, 1897.

SARTAIN, SAMUEL.
Engraver, portrait and genre painter. Born Oct. 8, 1830 in Philadelphia, PA. Samuel Sartain studied engraving under his father, John Sartain, and became an admirable engraver of mezzotint portraits. About 1851 he commenced business on his own account in Philadelphia, and did much work for the publishers of that period. His best plates were after the paintings of Peale, Sully and Neagle. Died Dec. 20, 1906 in Philadelphia, PA.

SARTAIN, WILLIAM.
Engraver. Born in Philadelphia, PA, in 1843. William Sartain, the son of John Sartain, studied mezzotint engraving with his father and issued and signed a few portrait plates. He then studied art in Paris under Bonnat, and at the Ecole des Beaux Arts, and became a reputable painter of landscapes. Died in Oct. 1924, in NYC. Mr. Sartain was one of the founders of the Society of American Artists, and became an Associate of the National Academy of Design. He was president of the NY Art Club, and was later a teacher in the life class of the Art Students League of NY. Member of the New York Etching Club. He died in 1924. He is represented in the Metropolitan Museum of NY, and in the Corcoran Art Gallery of Washington, D.C.

SARTELLE, MILDRED E.
Sculptor. Exhibited at the Penna. Academy of Fine Arts, Philadelphia, 1924. Address in 1926, Wellesley, MA.

SARTORI, GIOVANNI.
Sculptor. Worked in Italy c. 1774-1793; in Philadelphia about 1794.

SATRE, AUGUST.
Painter. Born in Norway, Feb. 19, 1876. Member: Providence Water Color Club. Address in 1929, 22 Pullis Ave., Middle Village, Long Island, NY.

SATTERLEE, WALTER.
Born in Brooklyn, NY, in 1844. He was a pupil of the National Academy; and of Edwin White and Leon Bonnat. Member of the New York Etching Club; elected an Associate of the National Academy in 1879, and in 1886 he gained the Clarke prize. Among his works are "Contemplation," owned by Smith College; "Autumn," "The Cronies," and "The Fortune Teller." He died May 28, 1908, in NY.

SAUER, LEROY D.
Etcher, craftsman, and teacher. Born in Dayton, OH, Feb. 17, 1894. Pupil of Peixotto; Hopkins; Meakin; Wessel; Keller; Orr; Lachman. Member: Dayton Society of Etchers; Dayton Guild of Fine Arts. Address in 1929, Mutual Home Bldg.; h. 506 Volusia Ave, Dayton, OH.

SAULNIER, H. E.
A script and letter engraver working in Philadelphia, 1830-40. He engraved one of the early certificates of membership of the Franklin Institute, of that city.

SAULTER, LEON.
Sculptor. Born in Wilno, Poland, March 31, 1908. Member: Council of Allied Artists. Work: Horace Mann Jr. High School; Sierra Bonita High School; memorial, Hollywood Cemetery. Exhibited: Los Angeles Museum of Art, annually; Contemporary Art Gallery; University of California at Los Angeles; Occidental College. Address in 1953, Los Angeles, CA.

SAUNDER, KENDALL.
Painter. Born at Templeton, MA, in 1886. Pupil of Julian Academy under Laurens, in Paris. Address in 1926, 47 Fifth Ave., New York, NY, or Westport, CT.

SAUNDERS, CLARA R(OSSMAN).
Painter. Member: Washington Water Color Club; Washington Society of Artists; Washington Art Club. Died in 1951. Address in 1929, 808 17th Street, N. W.; 2900 O St., Washington, D.C.

SAUNDERS, HENRY DMOCHOWSKI.
Sculptor. Born in Vilna, Lithuania, October 14, 1810. Educated in Vilna; studied sculpture in Paris about 1846. Lived in London before coming to America. Lived in Philadelphia, 1853-57; in Washington, DC, 1857-60. Works include busts of Kosciuszko and Pulaski, now in the Capitol, Washington, DC. Exhibited at Pennsylvania Academy, 1853-57. Died in Poland in 1863.

SAUNDERS, L. PEARL.
Painter, illustrator, and teacher. Born in Tennessee. Pupil of Chase in Italy; Hawthorne; Art Students League of NY. Member: Southern States Art League; Nashville Art Association; Chicago Artists Guild; Society of Independent Artists; Art Alliance of America; National Association of Women Painters and Sculptors. Awards: First prize, war poster, New Orleans, 1916; first prize, Southeastern Fair Association; first prize, Tennessee State Fair; Chase prize, Italy; second prize, Nashville Museum of Art, 1928; first prize, North Carolina State Fair, 1928. Represented in collections of Art Association and Centennial Club, Nashville; Murfreesboro Women's Club; Continental Hall, D. A. R., Washington, DC;

Jackson Woman's Club. Author of *Make Your Own Posters*. Address in 1933, 108 33rd Ave. S., Nashville, TN.

SAUNDERS, SOPHIA.
Miniature painter. Flourished in 1851-52 in New York City.

SAUTER, GEORGE.
Painter. Born in 1866. Exhibited at the Penna. Academy of Fine Arts, Philadelphia, 1915. Address in 1929, 1 Holland Park Ave., London, England. Died in 1937.

SAVAGE, DOROTHY L.
Painter. Exhibited water colors at the Penna. Academy of Fine Arts, Philadelphia, 1925. Address in 1926, 300 Goodwood Road, Baltimore, MD.

SAVAGE, EDWARD.
Painter. Born Nov. 26, 1761, in Princeton, Worcester County, MA. The father of Edward, Abraham Savage, had been driven from France by the revocation of the Edict of Nantes. Edward Savage was originally a goldsmith, and was a portrait painter at age 28 when he left Massachusetts. As his first commission he painted a portrait of President Willard of Harvard College. He moved to Philadelphia, and in 1791 sailed for London where he studied under Benjamin West and probably learned something of the art of engraving in stipple and in mezzotint. His engraved portraits of General Knox and of Washington were issued in London, 1791, 92, 93. In 1794, Savage returned to the U.S., living in Philadelphia. In 1795 he exhibited the first panorama ever shown in that city, of London and Westminster, and a newspaper states that it was painted "in a circle and looks like reality." Savage apparently remained in Philadelphia until 1801, then went to NY, Boston, and Princeton. In NY, Savage joined forces with Daniel Bowen, in the NY Museum. Dunlap, in his "History of the Arts of Design," calls it "a mingled establishment, half painting gallery, half museum." In 1795 these collections were transferred to Boston, and presented at "The Head of the Mall" as the Columbia Museum. The engraving of the Washington Family was published by Savage in 1798. David Edwin, the engraver, was assisting Savage at this time. It has always been more or less a question as to what extent Edwin and other engravers assisted Savage. John Sartain, the engraver, said "Savage drew the outlines on copper, but Edwin did a large part of the engraving." This is corroborated in part by the painter, James R. Lambdin, who wrote, "The Group of the Washington family by Savage was engraved by Edwin at Burlington, NJ, during the prevalence of the yellow fever in Philadelphia in 1798." Besides his portraits of Washington, Savage painted portraits of Generals Wayne and Knox; also of Robert Morris, Dr. William Handy, Benjamin

Rush, and John Langdon, and many others prominent at that time. Died July 6, 1817 in Princeton, MA.

SAVAGE, EUGENE F(RANCIS).
Painter and teacher. Born in Covington, IN, 1883. Pupil of Corcoran Art Gallery; Art Institute of Chicago; American Academy in Rome; and with Reynolds and Henderson. Member: Associate National Academy of Design, 1924; Academician National Academy of Design, 1926; Century Association; Painters and Sculptors Gallery Association; Alumni American Academy in Rome; National Society of Mural Painters. Awards: American Academy in Rome Fellowship, 1912-15; gold medal, NY Architectural League, 1921; Clarke prize ($300) and Saltus medal, National Academy of Design, 1922; French Memorial gold medal, Art Institute of Chicago, 1922; Harris silver medal, Art Institute of Chicago, 1923; second Altman prize ($500), 1923; Isidor gold medal, National Academy of Design, 1924; Logan bronze medal ($1,500), 1924; Schaffer prize ($500), 1925; Clark prize ($1,000), Grand Central Gallery, 1929. Work: "Arbor Day," Art Institute of Chicago; "Expulsion," City Art Museum of St. Louis; "Armistice" and "Paths to Peace," Elks' Memorial, Chicago; Los Angeles Museum of Fine Arts; Nebraska State Museum; Herron Art Institute; Yale University; Columbia University; others. Leffingwell professor of painting, Yale University School of Fine Arts. Address in 1953, New Haven, CT.

SAVAGE, MARGUERITE DOWNING (MRS.).
Painter and illustrator. Born in Bay Ridge, Long Island, Sept. 6, 1879. Studied in U.S. and Europe; pupil of E. C. Messer; E. L. Morse; Richard Miller. Work: Portrait of Bishop Arthur C. Coxe, Coxe Hall, Hobart College, Geneva, NY; portrait of Alfred Eels, Alpha Delta Phi Fraternity House, Cornell University, Ithaca, and Leland Stanford University, CA; Union Seminary, NY; Worcester (MA) Polytechnic Institute. Exhibited: Whitney; one-woman exhibitions in Boston, MA, and Cleveland, OH. Illustrator for *Harper's* magazine. Address in 1953, Encino, CA; summer, Prouts Neck, ME.

SAVAGE-JONES, TRUDI.
Portrait sculptor. Born in Roselle Park, NJ, in 1908. Studied at Grand Central School of Art; Penna. Academy of Fine Arts; Clay Club, NY. Award: Penna. Academy of Fine Arts, 1930.

SAVIER, HELEN.
See DuMond, Helen Savier.

SAVILLE, BRUCE WILDER.
Sculptor and teacher. Born in Quincy, MA, March 16, 1893. Pupil of Boston Normal Art School under Dallin, and of Mr. and Mrs. Kitson. Member: Copley Society; Boston Art League; Boston Art Club;

National Sculpture Society; NY Architectural League; National Arts Club; American Federation of Arts. Work: "John Hancock Statue," Quincy, MA; 3 memorials to Civil War veterans, Vicksburg (MS) National Park; Collingwood Memorial, Kansas City, MO; Potter Memorial, Annapolis; Memorial Angel, Quincy High School; Memorial Tablet to Unknown Dead of World War, Quincy; Canadian Infantryman, St. John's; Victory figure, in collaboration with Mossman at Chicopee, MA; Forrester Memorial, Worcester, MA; memorial of 3 wars at Palmyra, ME; Memorial to 104th Infantry, 16th Division, Westfield, MA; World War Memorial, Upton, MA; World War Memorial, Ravenna, OH; Peace memorial, Civil War, State House grounds, Columbus, OH; Mack Memorial, Ohio State University; 3 panels, Jeffrey Manufacturing Co. Office Building and Ohio State World War Memorial, Columbus, OH; World War Memorials at Glens Falls, NY and Quincy, MA; John Quincy Adams Memorial, Wollaston, MA; Anthony Wayne Memorial, Toledo, OH; memorial group, "Until the Dawn" and "Progress of Aviation," White Chapel Memorial Park, Detroit, MI; Goddard Memorial, Worcester, MA; memorial to Gen. Leonard Wood, City Hospital, Boston, MA; memorial to "First Flight Around World," Boston Airport. Exhibited at National Sculpture Society, 1923. Instructor at Ohio State University and Columbus (OH) Art School. Address in 1933, Santa Fe, NM. Died in 1938.

SAVORY.
This name is appended as engraver to a somewhat crudely executed line engraving of the "Trinity Church, Pittsburgh, Founded A. D. 1824." The plate is signed "Savory Sc. Pitt." There is no date, but appearances would indicate that the work was done about 1830-40.

SAWRIE, MARY B. (MRS).
Miniature painter. Born in Nashville, TN, 1879. Pupil of Chase; Vanderpoel; Dow; and Julien in Paris. Address in 1926, 710 Russell St., Nashville, TN.

SAWTELLE, A. ELIZABETH.
Painter. Pupil of School of Design for Women and Drexel Institute, Philadelphia; Corcoran Art School, Washington; Ingram Summer School, Cornwall, England; Woodbury. Member: Washington Water Color Club; Washington Society of Artists; Providence Water Color Club; Washington Art Club. Address in 1929, 2102 O St., Washington, DC; summer, Ogunquit, ME.

SAWTELLE, MARY BERKELEY.
(Mrs. Charles G. Sawtelle). Painter. Born Washington, DC, Aug. 24, 1872. Pupil of Corcoran School of Art in Washington; Delecluse and Colarossi Academies in Paris; Edwin Scott in Paris; Irving Wiles and Charles Hawthorne in NY. Member:

Washington Water Color Club; Washington Society of Artists; Southern States Art League. Work: "Alice by the Sea," Isaac Delgado Museum, New Orleans, LA. Director, Asheville School of Art. Address in 1929, 147 East 37th Street, New York, NY; summer, care of the Asheville School of Art, Asheville, NC.

SAWYER, EDITH.
Painter. Born in South Coventry, CT. Pupil of Adelphi School; Art Students League of NY. Member: Pennsylvania Society of Miniature Painters; Brooklyn Society of Miniature Painters; Brooklyn Artists Guild; National Association of Women Painters and Sculptors; New Haven Paint and Clay Club. Specialty: Miniatures. Address in 1929, Ovington Bldg., 246 Fulton St., Brooklyn, New York, NY; summer, Columbia, CT.

SAWYER, EDWARD WARREN.
Sculptor. Born in Chicago, IL, March 17, 1876. Pupil of J. P. Laurens, Injalbert, R. Verlet, Fremiet, A. Rodin; Art Institute of Chicago; Academie Julien. Awards: Bronze medal, St. Louis, 1904; prize, Pan.-Pacific, 1914; silver medal, Ghent, 1913; honorable mention, Paris Salon, 1914. Work: Medallions, "American Indians," American Numismatic Society, NY; Art Institute of Chicago; Massachusetts Historical Society, Boston; U.S. Mint, Philadelphia; Musee Luxembourg, Paris. Exhibited at National Sculpture Society, 1923. Address in 1929, Clos Vert, La Palasse, Toulon, Var. France. Died in 1932.

SAWYER, HELEN.
(Helen Sawyer Farnsworth). Painter and writer. Born in Washington, DC in 1900. Studied: Masters School, Dobbs Ferry; National Academy of Design; and with Charles Hawthorne. Awards: Hudson Valley Art Institute, 1935, 36; Fine Prints of the Year, 1937; Ringling Museum of Art Circus Exhibition, 1950, 51; Florida Federation of Artists, 1956, 57; Art Institute of Chicago; Atlanta Museum. Collections: Library of Congress; Toledo Museum of Art; Indianapolis Museum; Whitney Museum of American Art; John Herron Art Institute; Penna. Academy of Fine Arts; Vanderpoel Collection; Miami University, Oxford, OH; International Business Machines; Chesapeake and Ohio Railroad; National City Bank, NY; High Museum of Art, Atlanta, GA. Exhibitions: Metropolitan Museum of Art; Century of Progress, Chicago; Carnegie; San Francisco World's Fair; New York World's Fair; plus various one-woman shows. Member: National Academy of Design; National Association of Women Painters and Sculptors; Florida Artists Group; Audubon Artists. Media: Oil, watercolor. Address in 1980, 3842 Flamingo, Sarasota, FL.

SAWYER, PHIL(IP) (AYER).
Painter and lecturer. Born in Chicago, IL, June 18, 1877. Pupil of Leon Bonnat in Paris. Member:

Detroit Society of Independant Artists; Scarab Club. Work: Mural, "Progress," Gary School, Chicago; etching, "'L' Bridge," Library of Congress, Washington, DC and NY Public Library; portraits in France and America. Died in 1949. Address in 1933, care of B. N. Stevens, Tiskilwa, IL.

SAWYER, WELLS M.
Painter and illustrator. Born in Iowa, Jan. 31, 1863. Pupil of Art Institute of Chicago; Washington Art Students League; Corcoran Art School; J. O. Anderson and Howard Helmick. Member: Washington Society of Artists; Yonkers Art Association; Salma. Club. Represented in Museum of the City of NY; Smithsonian Institution, Washington, DC; School Collection, Yonkers, NY; "Hilltops," Vanderpoel Gallery, Chicago. Commissioner, Museum of Science and Arts, Yonkers. Died in 1961. Address in 1933, 47 Fifth Ave., New York, NY.

SAXON, CHARLES DAVID.
Illustrator and cartoonist. Born in NYC, Nov. 13, 1920. Studied at Columbia University; Hamilton College. In collections of Library of Congress; Columbia University. Received gold medal, Art Directors' Club, NY; Venice Film Festival special award; National Cartoonist Society award. Author and illustrator, *One Man's Fancy*. Lives in New Canaan, CT.

SAXTON, JOHN G(ORDON).
Landscape painter. Born in Troy, NY, 1860. Pupil of Lefebvre, Merson and Robert Fleury in Paris. Member: Lotos Club. Awards: Hon. mention, Paris Expo., 1900; hon. mention, Pan.-Am. Expo., Buffalo, 1901; bronze medal, St. Louis Expo., 1904. Address in 1929, Seaford, Long Island, NY.

SAXTON, JOSEPH.
Born in Huntington, PA, in 1790; died in Washington, D.C., in 1873. Saxton was not an engraver, though he devised a medal ruling machine, among his many other inventions. While he was the constructor and curator of the standard weighing apparatus in the U.S. Mint, in Philadelphia, in 1842, he produced two beautifully executed portraits by means of this machine. These are portraits of Franklin Peale and of Dr. R. M. Patterson. They are inscribed "Modelled by J. G. Chapman; electrotyped by Franklin Peale; engraved with the Medal-ruling machine by Jos. Saxton, Mint of the United Sates, 1842." They are admirable pieces of work of this type. Previous to this date, medal ruling had been done directly from the original medal, with the disadvantage of copying all its dents, scratches, or other imperfections, and there was the possibility of injuring a valuable medal by scratching it with the tracer; then a shellac cast of the orginal was copied by the machine, but this device failed, owing to the shellac model being liable to puncture by the tracing point, thus producing false lines upon the plate being

engraved. To avoid these difficulties, inherent in the older methods, Saxton made an electrotype copy of the original and used that as a model in the machine. As this model was copper, it could not be punctured, and any imperfections in the original could be corrected in the model; it provided a smooth, hard and true surface for the tracing point, and produced a perfect copy.

SAYEN, HENRY LYMAN.
Sculptor and painter. Born in Philadelphia, PA, April 25, 1875. Pupil of Penna. Acad. of Fine Arts. Member: Phila. Sketch Club. Specialty: Mural decorations. Address in 1903, 206 South 43rd St., Philadelphia, PA. Died on April 28, 1918 in Philadelphia.

SAZEGAR, MORTEZA.
Painter. Born in Teheran, Iran, Nov. 11, 1933; U.S. citizen. Studied at University of Texas, El Paso; Baylor University Medical College; Cornell. In collections of Whitney; San Francisco Museum of Art; Corcoran; others. Exhibited at Poindexter Gallery, NYC; Art Institute of Chicago; Whitney; Corcoran. Represented by Poindexter Gallery, NYC. Address in 1982, Cochranville, PA.

SAZEVICH, ZYGMUND.
Sculptor. Born in Kovno, Russia, 1899. Went to the San Francisco Bay area in 1923. Studied at University of Kazan, Russia; University of California at Berkeley, c. 1923; California School of Fine Arts, San Francisco. Exhibited: San Francisco Museum of Art; Mills College; San Francisco Art Association Annuals; Golden Gate International Exposition, San Francisco; Museum of Modern Art, Sao Paulo, Brazil; others. Taught: California School of Fine Arts, c. 1947-65; Mills College, Oakland, c. 1947-58. Much of his early work was direct-carved in wood. Died in San Francisco in 1968.

SCACKI, FRANCISCO.
Engraver. This name is signed to a large but very crudely drawn and etched view of the Battle of New Orleans. It apparently was contemporaneous with the battle in date, and the only impression known has the second state of the plate printed on the back of the first impression. It is difficult to determine, however, whether Scacki is the engraver or the publisher of the plate, or both. The form of the signature is as follows: "Francisco Scacki Copy Right Secured."

SCALELLA, JULES.
Painter and etcher. Born in Philadelphia, March 31, 1895. Pupil of Albert Jean Adolphe. Member: North Shore Arts Association. Address in 1929, 21 East Turnbull Ave., South Ardmore, PA.

SCARAVAGLIONE, CONCETTA.
Sculptor. Born in NYC, July 9, 1900. Pupil of Boardman Robinson and Robert Laurent; National

Academy of Design; Art Students League. Awards: Prix de Rome, 1947-50; Penna. Academy of Fine Arts; American Academy of Arts and Letters. Exhibited: Museum of Modern Art; Art Institute of Chicago; Fairmount Park, Philadelphia, PA; World's Fair, 1964; Vassar College, Poughkeepsie, NY; others. In collections of Whitney; Penna. Academy of Fine Arts. Exhibited: New York World's Fair, 1939. Member: National Association of Women Painters and Sculptors; Salons of America; National Sculpture Society. Address in 1970, NYC. Died in 1975.

SCARBOROUGH, JOHN.
Painter. Flourished about 1830.

SCARPITTA, G. SALVATORE CARTAINO.
Sculptor. Born in Palermo, Italy, Feb. 28, 1887; settled in NY in 1910. Studied at Instituto di Belli Arti, Palermo; and in Rome. Member: National Sculpture Society; Allied Artists of America; New York Architectural League; New York Numismatic Society; decorated by Japanese and Cuban governments. Awards: Barnett prize, National Academy of Design, 1914; second mention, collaborative competition, New York Architectural League, 1913; honorable mention, Art Institute of Chicago, 1923; O'Rourke prize, Fine Arts Gallery, San Diego, 1933. Work: Sculpture in Church of St. John the Evangelist, Los Angeles, CA. Address in 1933, Los Angeles, CA.

SCARPITTA, SALVATORE.
Sculptor and painter. Born in NYC, 1919. Studied in Italy, 1936-59. Work in Stedelijk Museum, Amsterdam, Holland; Albright-Knox Art Gallery, Buffalo, NY; Los Angeles Co. Museum of Art; Museum of Modern Art, NY; private collections; others. Has exhibited at Galleria Gaetano Chiurazzi, Rome, 1949 (one-man); Galleria La Tartaruga, Rome, 1955 (one-man); Houston Museum of Fine Arts, 1961; Corcoran Gallery of Art, Washington, DC, 1963; Art Institute of Chicago, 1964; Leo Castelli Gallery, NYC, 1959, 60, 63, 65 (one-man); Columbus Gallery of Fine Arts, OH; L'umo e l'arte, Milan, 1974; Vassar College, 1976; Portland Center for Visual Arts, 1978; The New Museum, New York, 1979; others. Taught: Visiting critic, Maryland Institute, College of Art, from 1966. Address in 1984, c/o Leo Castelli Gallery, Maryland Institute, College of Art, NYC.

SCHAAF, ANTON.
Sculptor. Born in Milwaukee, WI, February 22, 1869. Pupil of Shirlaw, Cox, Beckwith, Saint-Gaudens, Dewing; Cooper Union; National Academy of Design under Ward. Member: National Sculpture Society; Architectural League of NY; American Federation Arts. Work: Statue of General Ord, Vicksburg National Military Park; Glendale Monument and Ridgewood Monument, Brooklyn, NY; Shaw Memorial, Woodlawn Cemetery, NY; Meredith portrait tablet, Tompkins Avenue Church, Central Congregational Church War Memorial, 14th Inf. soldiers monument and Ridgewood monument, all in Brooklyn, NY; Glendale Brooklyn War Memorial; Ericson Memorial, NY. Exhibited at National Sculpture Society, 1923. Address in 1933, 1931 Broadway, New York, NY; h. 397 East 17th St., Brooklyn, NY. Died in 1943.

SCHAARE, HARRY J.
Illustrator. Born in NYC in 1922. Attended NYU School of Architecture and Pratt Institute. His career began in 1949 with cover art for Bantam Books and he has since worked for most major book publishers and magazines, including *The Saturday Evening Post, True, Reader's Digest, and Rolling Stone.* He has done many posters for movies and advertising and has exhibited in the Smithsonian Institution, the Pentagon, Grand Central Gallery, Society of Illustrators, of which he is a member, and in numerous other galleries. The U.S. Air Force has given him assignments in America, Europe, and Asia.

SCHABACKER, BETTY BARCHET.
Painter, sculptor and lecturer. Born in Baltimore, MD, August 14, 1925. Studied: Dominican College, San Rafael, CA; Connecticut College, New London; Marian Carey Art Association, Newport, RI; Coronado School of Fine Arts, CA, with Monty Lewis; and with Gerd and Irene Koch, Ojai, CA. Work: B. K. Smith Gallery, Lake Erie College, Painesville, OH; Western Union, NY; Midland Capital Corporation, NY; Erie Zoo, PA; corporate and gallery collections. Exhibitions: Museum of Modern Art, Paris, 1961-63; Butler Institute, annuals, 1964-77; Chautauqua Exhibition of American Art, 1966-74; Audubon Artists, 1967-79; National Academy of Design, solos and 150th annual; Artists Equity, Philadelphia; California National Watercolor Society Membership Show, 1975; Academy of Natural Science, Philadelphia, 1981-82; others. Member: National Watercolor Society; Audubon Artists; Society of Animal Artists; Artists Equity Association; others. Media: Watercolor; cloth collage. Address in 1984, Erie, PA.

SCHABELITZ, R(UDOLPH) F(REDERICK).
Illustrator. Born in Stapleton, Staten Island, NY, June 10, 1884. Pupil of Carl Marr in Munich, and others. Member: Society of Illustrators; Salma. Club; Artists Guild of the Authors' League of America. Address in 1929, 123 West 74th Street, New York, NY.

SCHAEFER, GAIL.
Sculptor. Born in NJ, June 11, 1938. Studied at Art Students League with Kaz-Simon, 1977-80; Ramapo College, NJ, B.A., 1979; National Academy of Design, Lucchesi scholarship, 1980-82. Has exhibited at Catherine Lorillard Wolfe National Arts Club,

NY; National Academy Galleries, NY; American Academy and Institute of Arts and Letters; Salmagundi Club, NY; National Academy of Design; others. Received trustee awards, American Artists Professional League, 1978-80; honorable mention, Salmagundi Club, NY, 1980; William Auerbach-Levy Award, National Academy of Design, 1981; Anna Hyatt Huntington Award, Catherine Lorillard Wolfe Art Club, 1983; others. Member of Allied Artists of America; Painters and Sculptors Society of New Jersey; Portrait Society of New Jersey. Works in clay. Address in 1984, Oradell, NJ.

SCHAEFER, HANS.
Sculptor. Born in Sternberg, Czechoslovakia, February 13, 1875. Pupil of Kunstgewerbeschule, Vienna, Austria. Member: Chicago Modelers and Sculptors League. Address in 1933, 284 West 12th Street, NYC.

SCHAEFER, MATHILDE.
(Mrs. Mathilde Schaefer Davis). Sculptor, craftsman, teacher. Born in New York City, March 20, 1909. Studied with Raoul Josset; Walter Lemcke. Works: International Business Machines; Museum of Northern Arizona; Katherine Legge Memorial, Hinsdale, Illinois. Exhibited: Art Institute of Chicago, 1938; World's Fair, New York, 1939; San Francisco Museum of Art, 1938-40; Denver Art Museum, 1938, 39; one-woman shows include Santa Barbara Museum of Art, 1942, Museum of Northern Arizona, 1943, University of New Mexico, 1940, Dallas Museum of Fine Arts, 1947. Address in 1953, Scottsdale, AZ.

SCHAEFFER, MEAD.
Illustrator. Born in Freedom Plains, New York, July 15, 1898. Pupil of Dean Cornwell. Member: Society of Illustrators. Illustrated *Moby Dick, Typee,* and *Omoo,* by Herman Melville; *Les Miserables,* by Victor Hugo; *Wings of the Morning,* by Louis Tracy; *Sans Famille,* by Hector Malot; *King Arthur and His Knights,* published by Rand, McNally & Co.; *Jim Davis,* by John Masefield; *The Wreck of the Grosvenor,* by W. Clark Russell. Address in 1929, Bellerose, LI, NY.

SCHAEFFER, WILLIAM G.
Painter. Member of the Washington Water Color Club. Address in 1926, 95 Madison Ave., New York.

SCHAEFFLER, LIZBETH.
Sculptor, craftsman, painter, teacher and commercial artist. Born in Somerville, MA, October 27, 1907. Studied at Pratt Institute Art School; National Academy of Design; Art Students League; Clay Club, NY; also with Mahonri Young. Works: Church of the Highlands, White Plains, NY. Exhibited: National Sculpture Society, 1936-38, 57, 58, 65; Clay Club; New Rochelle Art Association; Nantucket Art Association (one-woman); New York Society of

Ceramic Artists; Kenneth Taylor Gallery, 1962-64. Award: New Rochelle Art Association. Director of Kenneth Taylor Gallery, Nantucket, MA. Address in 1970, 78 Irving Place, New Rochelle, NY; s. Nantucket, MA.

SCHAETTLE, LOUIS.
Mural painter. Born in Chicago, IL; died in New York City on June 21, 1917. He painted mural decorations in Georgian Court, Lakewood, NJ.

SCHAFER, GEORGE L(ESLIE).
Illustrator and draftsman. Born in Wilmington, DE, Jan. 26, 1895. Pupil of Penna. Academy of Fine Arts; Bellevue Art Training Center in Paris. Member: Fellowship Penna. Academy of Fine Arts; Wilmington Society of Fine Arts. Address in 1929, 404 South Broome St., Wilmington, DE.

SCHALLINGER, MAX.
Painter, sculptor and craftsman. Born in Ebensee, Austria, September 26, 1902. Studied at Academy of Fine Art, Vienna; Academy of Fine Art, Munich; Bauhaus, Dessau. Member: Baltimore Artists Guild. Work: Baltimore Museum of Art; American University, Washington, DC. Exhibited: International Craft Exhibition, Paris, 1926; Salzburg, Austria, 1930; Baltimore Museum of Art, 1938, 45 (one-man); ACA Gallery, 1947 (one-man). Position: Instructor, Hood College, Frederick, MD, 1944-47. Address in 1953, 170 East 63rd St., NYC.

SCHAMBERG, MORTON L.
Painter. Born in Philadelphia in 1881. Pupil of Wm. M. Chase. Member: Society of Independent Artists. Address in 1926, care of W. Pach, 13 East 14th St., New York City. Died in 1918.

SCHANZENBACHER, NELLIE.
Painter. Born in Louisville, KY. Pupil of William M. Chase; Robert Henri; Luis Mora. Member: Louisville Art Association; Art Students League of NY. Work: Mural, "Christ Blessing the Multitude," St. Paul's Evangelical Church, Louisville. Address in 1929, 1016 South Jackson, Louisville, KY.

SCHAPIRO, MIRIAM.
Painter and collage artist. Born in Toronto, Canada, November 15, 1923. U.S. citizen. Attended Hunter College, 1942-44; University of Iowa where she received B.A., M.A., and M.F.A. degrees, 1944-49. Work: Whitney Museum of American Art; Illinois Wesleyan University; St. Louis City Art Museum; Albion College; IBM; University of Iowa; Museum of Modern Art; Stanford University; Hirshhorn Museum; United Nations; Williams College; Carnegie; New York University; and others. One-woman exhibitions: Univer. of Missouri, Columbia, 1950; Illinois Wesleyan Univer., Bloomington, 1951; Emmerich Gallery, NY, 1958, 60, 61, 63, 65. Group exhibitions:

Stable Gallery, NY, 1954, 55, 56; Museum of Modern Art, NY, 1957, 61, 67; Nottingham University, England, 1958; Whitney Museum of American Art, NY, 1959; Carnegie Institute, Pittsburgh, 1958; International Biennial Exhibition of Paintings, Tokyo, Japan, 1959; San Francisco Museum of Art, 1963; Denver Art Museum; Penna. Academy of Fine Arts, 1963, 64; Jewish Museum, NY; Museum of Contemporary Art, Chicago, 1979; Galerie Rudolf Zwirner, Cologne, Germany, 1981; Art Institute of Chicago, 1981; others. Awards: Ford Foundation Tamarind Fellowship, 1964; National Endowment for the Arts, 1976; Skowhegan Award, 1981. Taught at College Institute of Arts, 1973-75; Bryn Mawr, 1977; Amherst, 1978. Address in 1984, 393 W. Broadway, New York, NY.

SCHAR, A(XEL) E(UGENE).
Painter and teacher. Born in Oslo, Norway, April 12, 1887. Pupil of Fritz Taulow. Member: Duluth Art Association. Address in 1929, 2024 West Superior St.; h. 728 West Third St., Duluth, MN.

SCHARBACH, B. K. (MS.).
Sculptor and watercolorist. Born in Louisville, KY, in 1936. Studied at University of Louisville; University of Kentucky; Parsons School of Design; Art Students League; Silvermine Guild; University of Hartford, (CT) Art School. Exhibitions: NY Council for the Arts Sponsored Show, 1971; Webb and Parsons Gallery, New Canaan, CT, 1979, 80, 82; New England Annual, Silvermine Guild, 1981; SOHO 20 Gallery, NYC, 1981, 82, 83; Lever House, NYC, 1982; others. Received Amidar Memorial Award, Silvermine Guild. Address in 1983, Darien, CT.

SCHATTENSTEIN, NIKOL.
Portrait painter. Born in Poniemon, Russia, Aug. 10, 1877. Studied at Vienna Akademie. Member: Kunstlerhaus, Vienna; Allied Artists of America. Awards: Two gold medals, International Expo., Vienna; hon. mention, Paris; Knight Cross of the Francis Josef Order. Work: "Prisoners," National Museum, Krakow; "Portrait of Ina Claire," Empire Theater, New York City; also represented in the Artillerie Museum, Vienna. Address in 1929, Atelier Bldg., 33 West 67th St., New York, NY.

SCHAUER, MARTHA K.
Painter, writer, lecturer, and teacher. Born in Troy, OH, Feb. 13, 1889. Pupil of Pratt Institute. Member: Ohio Water Color Society; Ohio Born Women Artists. Specialty: Flower studies and still life in water color. Address in 1929, 356 Kenilworth Ave., Dayton, OH.

SCHEFFLER, RUDOLF.
Painter. Born in Zwickau, Saxony, Dec. 5, 1884. Pupil of the Dresden Akademie; Prof. Otto Gussman; and Prof. Hermann Prell. Member: Brooklyn Society of Modern Artists. Awards: Grand Prix de Rome; gold and silver medals of the government and Royal Academy, Dresden. Work owned by German government and museums; mural and mosaics in Cathedral of St. Louis, and churches in Detroit, Chicago, Los Angeles, New Orleans, etc. Address in 1929, 106 Columbia Heights, Brooklyn, NY.

SCHEIBNER, VIRA McILRATH (MRS.).
Painter. Born in Cleveland, OH, Aug. 12, 1889. Pupil of Robert Spencer; Charles Rosen; Edouard Van Waeyenberge in England. Member: Fellowship Penna. Academy of Fine Arts; National Association of Women Painters and Sculptors. Address in 1933, 20 Aviles St., St. Augustine, FL; summer, New Hope, PA.

SCHELER, ARMIN A.
Sculptor and educator. Born in Sonneberg, Germany, May 20, 1901. Studied at State School of Applied Art, State Academy of Fine Arts, Munich, Germany. Member: National Sculpture Society; Louisiana Teachers Association; New Orleans Art Association. Awards: Prizes, Switzerland, 1923; Delgado Museum of Art; National Sculpture Competition, 1939; medal, Paris Expo., 1936; New Rochelle, NY, 1938. Work: Government Office Building, New Orleans, LA; Government Printing Office, Washington, DC; U.S. Post Office, Evanston, IL; Mattawan, NJ. Exhibited: National Academy of Design; Whitney Museum of American Art; Penna. Academy of Fine Arts; Paris Exposition, 1937; Delgado Museum of Art, 1943-46; New Orleans Society of Arts and Crafts, 1946. Lectures: "The Meaning and Study of Sculpture." Address in 1953, Baton Rouge, LA.

SCHELL, DOROTHY ROOT.
Painter. Member: Plastic Club. Address in 1926, Middle City Building, Philadelphia, PA; 5027 Newhall St., Germantown, Philadelphia, PA.

SCHELL, F. CRESSON.
Illustrator and writer. Born in Philadelphia, PA, in 1857. Pupil of Thomas Eakins and Thomas P. Anshutz. Member: Artists' Aid Soc.; Fellowship Penna. Academy of Fine Arts; Philadelphia Art Alliance; Philadelphia Sketch Club; Fairmount Park Art Association; Artists' Fund Society. Address 1926, 5215 Archer St., Germantown, Phila., PA.

SCHENCK, FRANKLIN LEWIS.
Painter. Born 1855. Pupil of Thomas Eakins, who founded the Phila. Art Students League and appointed Schenck as curator. Represented by paintings in Brooklyn Chamber of Comm. and in the Pratt Library. Add. in 1926, East Northport, L.I., NY.

SCHENCK, MARIE (PFEIFFER).
(Mrs. Frank Schenck). Sculptor and art director. Born in Columbus, OH, February 3, 1891. Studied at

Cleveland School of Art; Columbus Art School; and with Hugo Robus, John Hussey, Bruce Saville, and others. Member: Columbus Art League; Miami Art League; American Society for Aesthetics. Exhibited: Columbus Art League; Miami Art League. Positions: Art Instructor, Coburn School, Miami, FL, 1938-40; Art Director, City of Miami Beach, Miami Art Center, 1942, and from 46. Address in 1953, Miami Beach, FL.

SCHETKY, CAROLINE.
Miniature painter and water color artist. Born March 3, 1790, in Edinburgh, Scotland. Formerly flourished in Philadelphia and Boston. She married Samuel Richardson and exhibited at the Boston Athenaeum under that name; she also painted landscapes and flowers. Died March 14, 1852, in Boston, MA.

SCHEVILL, W(ILLIAM) V.
Portrait painter. Born in Cincinnati, OH, March 2, 1864. Pupil of Loefftz, Lindenschmitt and Gysis in Munich. Member: Century Association; Salma. Club; Kuenstler Genossenschaft; St. Louis Guild of Artists; American Federation of Arts. Award: Bronze medal, St. Louis Expo., 1904. Work: "In Love," Cincinnati Museum, Cincinnati; portrait sketch, Prince Henry of Prussia, Herron Art Institute, Indianapolis; Leipsic Art Museum; portrait of Chancelor Hall, Robert Brookings and Judge Hitchcock, Washington University, St. Louis; portrait of Ex-President Taft, War Department, Washington, D.C., and St. Louis Art Museum. Address in 1933, 205 East 68th Street, New York, NY; summer, Charlevoix, MI.

SCHICK, FRED G.
Painter and illustrator. Born in 1893. Pupil of Wilcox; M. B. Cox. Member of the Buffalo Art Club, Buffalo, NY. Address in 1926, 546 Main St., Buffalo, NY.

SCHIFFER, ETHEL BENNETT.
(Mrs. W. B. Schiffer). Illustrator, etcher, and engraver. Born in Brooklyn, NY, March 10, 1879. Pupil of Yale School of Fine Arts; Art Students League of NY. Member: New Haven Paint and Clay Club; Society of Independent Artists; National Association of Women Painters and Sculptors; New Haven Brush and Palette Club (president); Springfield Art League; American Artists Professional League; American Federation of Arts. Address in 1929, 357 Elm Street, New Haven, CT.

SCHILDKNECHT, E(DMUND) G(USTAV).
Painter and teacher. Born in Chicago, IL, July 9, 1899. Pupil of Wisconsin School of Arts; Penna. Academy of Fine Arts; Academie Julien; Academie de la Grande Chaumiere; George Oberteuffer. Address in 1929, Arsenal Technical Schools, Indianapolis, IN; h. 4709 Lloyd St., Milwaukee, WI.

SCHILLE, ALICE.
Painter. Born in Columbus, OH. Pupil of Columbus Art School under Chase and Cox; Prinet, Collin, Courtois and Colarossi Academie in Paris. Member: American Water Color Society (associate); NY Water Color Club; Boston Water Color Club; National Association of Women Painters and Sculptors; Chicago Water Color Club; Philadelphia Water Color Club. Awards: Corcoran prize, Washington Water Color Club, 1908; NY Women's Art Club prize, 1908 and 1909; participant, Fine Art Building prize, SWA, 1913; gold medal for water colors, P.-P. Expo., San Francisco, 1915; Philadelphia water color prize, Penna. Academy of Fine Arts, 1915; first prize ($200), Columbus Art League, 1919; Stevens prize, Columbus Art League, 1920; Fine Arts prize, National Association of Women Painters and Sculptors, 1929. Work: "The Melon Market," Herron Art Institute, Indianapolis; "Mother and Child," Art Club, Philadelphia; "The Market Place," Columbus (OH) Gallery of Fine Arts. Address in 1929, 1166 Bryden Road, Columbus, OH.

SCHILLING, ALEXANDER.
Painter and etcher. Born in Chicago, IL, in 1859. Pupil of G. S. Collis. Member of American Water Color Society, NY; Salmagundi Club, 1908; New York Etching Club. Awarded gold medal, Art Club, Philadelphia, PA, 1901; silver medal, St. Louis Expo., 1904. Specialty: Landscapes. Address in 1910, 939 Eighth Ave., NYC; h. Leonia, NJ.

SCHILLING, A(RTHUR) O(SCAR).
Painter, illustrator, lecturer and writer. Born in Germany, May 14, 1882. Studied in Chicago, Buffalo, Rochester, and Germany. Member: Buffalo Art Club; Rochester Art Club. Animal illustrations and landscapes. Address in 1933, 1057 Main St., E.; h. 285 Laurelton Road, Rochester, NY.

SCHIMMEL, WILHELM.
Woodcarver. Born in 1817. Lived and worked in the area of Carlisle, Newburg, and occasionally Lancaster, Pennsylvania. Made toys, figures, animals, birds; small eagles for mantel and table decorations, larger ones as exterior ornaments. Represented in Abby Aldrich Rockefeller Collection, Williamsburg, VA. Died in Carlisle, Pennsylvania, in 1890.

SCHLADERMUNDT, HERMAN T.
Mural painter. Born in Milwaukee, WI, Oct. 4, 1863. Member: NY Architectural League, 1893; National Society of Mural Painters; Century Association. Awards: Allied Arts prize, Architectural League; medal, Columbian Expo., Chicago, 1893. Work: Stained glass windows in Flagler Memorial Church, St. Augustine, FL; stained glass dome lights, Emigrants Industrial Bank, New York; mosaic vaults, Congressional Library, Washington, DC; decorations, Grand Jury Room, Court House, Newark, NJ;

Directors' Room, General Motors Co., New York; Museum of Thomas F. Ryan, New York; mosaic glass windows, House of Representatives, Missouri, Capitol, Jefferson City, MO; U.S. Post Office, Denver, CO. Died in 1937. Address in 1929, Lawrence Park, Bronxville, NY.

SCHLAFF, HERMAN.
Sculptor and painter. Born in Odessa, Russia, December 19, 1884. Pupil of School of Fine Arts, Odessa, Russia. Member: American Federation of Arts. Address in 1929, Philadelphia, PA.

SCHLAG, FELIX OSCAR.
Sculptor. Born in Frankfurt-on-Main, Germany, September 4, 1891. Studied at Academy of Art, Munich, Germany. Work: Champaign (IL) Jr. High School; Bloom Township High School, Chicago Heights, IL; U.S. Post Office, White Hall, Illinois; designed Jefferson nickel, United States Mint, Washington, DC. Exhibited: Art Institute of Chicago; Detroit, MI; New York City; and abroad. Address in 1953, Owosso, MI.

SCHLAIKJER, J(ES) W(ILLIAM).
Painter and illustrator. Born September 22, 1897. Pupil of E. A. Forsberg; Harvey Dunn; and Dean Cornwell. Member: Associate National Academy of Design, 1932; Society of Illustrators; Salma. Club; Scandinavian American Artists; Grand Central Gallery; American Federation of Arts. Award: First Hallgarten prize, National Academy of Design, 1926, first Altman prize, 1928, second Hallgarten prize, 1932. Represented in Ranger Fund; Vassar College Collection. Address in 1933, Sherwood Studios, 58 West 57th Street, New York, NY.

SCHLECHT, CHARLES.
Engraver. Born in Stuttgart, Germany, in 1843; living in NY in 1905. Charles Schlecht was brought to the U.S. by his parents in 1852, and was apprenticed to the Am. Bank Note Company in 1859; he also received instruction in his profession from Charles Bush and Alfred Jones. Mr. Schlecht made bank note engraving his principal occupation, working in NYC and at the Bureau of Engraving and Printing in Washington, DC, but he also produced some admirable portrait and subject plates for the publishers. Two of his large plates, executed in pure line, are especially worthy of note. These are "Eyes to the Blind," after a painting by A. F. Bellows, and "The Wish," after a painting by Percy Moran.

SCHLEGELL, GUSTAV VON.
Painter and teacher. Born in St. Louis, Missouri, September 16, 1877. Pupil of Robert Koehler in Minneapolis; Carl Marr in Munich; Laurent and Laurens in Paris. Member: 2 x 4 Society. Work: St. Louis Artists Guild. Address in 1929, 1921 Carrol Street, St. Paul, Minneapolis.

SCHLEIN, CHARLES.
Painter, etcher, and teacher. Born in Russia, April 5, 1900. Pupil of Leon Kroll. Member: Art Alliance of America. Address in 1933, 306 East 15th Street, New York, NY.

SCHLEINKOFER, DAVID J.
Illustrator. Born in Philadelphia, in 1951. Attended Bucks County Community College and the Philadelphia College of Art. His first published illustration appeared in 1974 and he has since been illustrating paperback books and doing editorial work for *Cue* and *Cosmopolitan*. His artwork was selected for Society of Illustrators Annual Shows in 1975 and 1976.

SCHLEMMER, F(ERDINAND) LOUIS.
Painter and teacher. Born in Crawfordsville, IN, Sept. 26, 1893. Pupil of Hawthorne; H. M. Walcott; Art Institute of Chicago. Member: Indiana Art Society; Hoosier Salon. Work: "Sacred Vase," Miami Conservatory of Art, Miami, Florida; "Old Codger," "J. H. Osborne" (portrait), Wabash College, Crawfordsville, IN. Awards: Hon. mentions, Indiana Artists, John Herron Art Institute, 1927-31; first portrait prize, Indiana State Fair, 1930; Foulke prize, Richmond (IN) Art Association, 1929. Address in 1929, 319 South Green St., Crawfordsville, IN; summer, Provincetown, MA.

SCHLEMOWITZ, ABRAM.
Sculptor and educator. Born in NYC, July 19, 1911. Studied at Beaux-Arts Institute of Design, NYC, 1928-33; Art Students League, 1934; National Academy of Design, 1935-39. Works: University of California, Berkeley; Chrysler Museum of Art, Provincetown, MA; others. Exhibitions: The Howard Wise Gallery, NYC; Claude Bernard, Paris; The Stable Gallery, Sculpture Annuals; Museum of Contemporary Crafts, Collaboration: Artist and Architect; Riverside Museum, 12 NY Sculptors; New School for Social Research, Humanists of the 60's; Museum of Modern Art, Art in Embassies, circ. internationally, 1963-64. Award: Guggenheim Foundation Fellowship, 1963. Taught: Contemporary Art Center, YMHA, NYC, 1936-39; Pratt Institute, 1962-63; University of California, Berkeley, 1963-64; distinguished lecturer, Kingsborough College, City University of New York, from 1970. Address in 1982, 139 W. 22nd St., NYC.

SCHLESINGER, LOUIS.
Sculptor. Born in Bohemia in 1874. Member of NY Architectural League. Address in 1926, 51 West 10th Street, New York.

SCHLEY, M(ATHILDE) G.
Painter, illustrator, teacher, and writer. Born in Horicon, WI, May 14, 1874. Pupil of Richard Lorenz. Member: Society of Independent Artists; Chicago

Artists; Salons of America. Address in 1933, Schley Apts.; h. 1102 N. 15th Street, Milwaukee, WI; summer, Beaver Dam, WI.

SCHMAND, J. PHILLIP.
Portrait painter. Born in Germania, PA, Feb. 24, 1871. Pupil of Mary Cox; Lucius Hitchcock; H. S. Mowbray; Vonnoh; A. P. Lucas. Member: Nat. Arts Club; Washington Art Club; Salma. Club; National Assoc. of Women Painters and Sculptors (assoc.); Am. Fed. of Arts. Award: Albright Scholarship, Buffalo, 1896. Work: Portraits of Blackstone, Pitt, Mansfield, and John Marshall in Lawyers' Club, NY; "Portrait of Charles S. Green," Green Free Library, Wellsboro, PA; "Portrait of John R. Patterson," owned by the National Cash Register Co., Dayton, OH; "Portrait of Warren C. Hubbard," Rochester (NY) Consistory; decoration, "The Dauntless," Osage Inn, Essex, CT. Address in 1933, Hotel des Artistes, 1 West 67th St., New York, NY; summer, Lyme, CT.

SCHMEDTGEN, WILLIAM HERMAN.
Painter. Born in Chicago in 1862. Studied at the Art Institute of Chicago. Pioneer in newspaper illustrating in Chicago; commercial art work, *Chicago Mail*, 1883; and also in St. Louis and the South; head of art department, *Chicago Record*, 1886-1901; now on staff of Chicago *Record Herald*. Illustrator for many art books and magazine articles on outdoor sports; field artist for *Record*, in Spanish American war, in camp before Santiago; traveled and sketched for newspaper articles in Mexico and Cuba; traveled in Spain, Italy and Northern Africa for the *Record*, 1900. Address in 1926, Record Herald, Chicago, Illinois. Died in 1936.

SCHMID, RUPERT.
Sculptor. Born in Munich, Germany, in 1864. Studied at Royal Academy, Munich, in the early 1880's. Came to California c. 1889; active in San Francisco from about 1892. Instructor and director at Mark Hopkins Insti. of Art, San Francisco. Works include a marble group symbolizing CA for World's Columbian Exhibit, Chicago, 1893; "California Venus," now in Oakland Art Mu., 1894; Memorial Arch, Stanford Univer., 1900; McKinley Monument, St. James Park, San Jose, CA; Ulysses S. Grant statue, Golden Gate Park, San Francisco, 1908. Exhibited at Mechanics' Insti. Industrial Exhibitions, San Francisco, 1889-95; World's Columbian Exhib., Chicago, 1893; others. Executed portrait busts and statues; worked in bronze and marble. Died Alameda, CA, in 1932.

SCHMIDT, AUGUST.
Sculptor. Born in Germany, 1809. Living in Philadelphia, PA, in 1850.

SCHMIDT, JULIUS.
Sculptor. Born June 2, 1923, in Stamford, Connecticut. Earned B.F.A. (1952) and M.F.A. (1955)

from Cranbrook Academy of Art, MI; studied with Ossip Zadkine in Paris, 1953; Academy of Fine Arts, Florence, 1954. Taught at Cranbrook; Kansas City Art Institute; Rhode Island School of Design; Berkeley; University of Iowa, from 1970. Awarded Guggenheim Foundation Fellowship, 1963. Exhibited at Silvermine Guild, New Canaan, CT, 1953; Santa Barbara Museum of Art; Penna. Academy of Fine Arts; Art Institute of Chicago; Walker; Museum of Modern Art; Rhode Island School of Design; Carnegie; Battersea Park, London, England; others. In collections of Art Institute of Chicago; Whitney; University of Illinois; Washington University; Museum of Modern Art; SUNY/Oswego and Buffalo; Albright-Knox Art Gallery. Works in cast bronze and iron. Address in 1982, University of Iowa, Iowa City, IA.

SCHMIDT, KARL.
Painter and teacher. Born in Worchester, MA, Jan. 11, 1890. Self-taught. Member: Salma. Club; National Society of Mural Painters. Address in 1929, Silvermine, CT; care of Rookwood Pottery, Cincinnati, OH; 1 Melville St., Worcester, MA.

SCHMIDT, KATHERINE.
Painter. Born in Xenia, OH, Aug. 15, 1898. Studied: Art Students League; pupil of K. H. Miller. Member: Salons of America; Brooklyn Society of Modern Artists. One-woman exhibitions: Whitney Museum; Metropolitan Museum of Art; Newark Museum; University of Nebraska. Died in 1978. Address in 1953, 19 West 12th Street, New York, NY.

SCHMIDT, OSCAR F.
Painter. Exhibited at the National Academy of Design, New York, 1925. Address in 1926, 301 West 24th Street, New York.

SCHMIDT, OTTO.
Painter, illustrator, craftsman, lecturer, teacher and writer. Born in Philadelphia, PA. Pupil of Penna. Academy of Fine Arts under Anshutz, Thouron and Chase; National Academy of Design under Emil Carlsen and Henry Ward. Member: Fellowship Penna. Academy of Fine Arts. Work: Mural, Northeast High School, Philadelphia; represented in collections of Fellowship of the Penna. Academy of Fine Arts, Philadelphia, and John H. Vanderpoel Art Association, Chicago, IL; decorations and illustrations for *Judge, Farm Journal, Saturday Evening Post*, etc. Died in 1940. Address in 1933, 3139 Belgrade St., Philadelphia, PA; summer, Lindenwold, NJ.

SCHMITT, ALBERT F(ELIX).
Painter. Born in Boston, MA, June 14, 1873. Pupil of Massachusetts Normal Art School; Cowles Art School; Boston Museum School; also studied abroad. Member Copley Society; American Water Color

Painters; Washington Art Club; Societe Academique d'Historie Internationale, Paris, decoration Etoile d'or et cravate. Award: Silver medal, P.-P. Expo., San Francisco, 1915. Work: City Art Museum, St. Louis; Rhode Island School of Design, Providence; Museum of Fine Arts, Boston; Musee du Luxembourg, Paris; Musee de Pan B. P. France; Musee de Lisbon, Portugal. Address in 1933, Studio Pavillon Primerose rue des Rochers, Biarritz, B. P. France.

SCHMITT, CARL.
Painter. Born in Warren, Ohio, May 6, 1889. Pupil of National Academy of Design under Carlsen; Solon Borglum; and in Florence, Italy. Member: Architectural League of New York. Work: "The Mill," Butler Institute of American Art, Youngstown, OH. His mural painting of "The Nativity" was exhibited at Brooklyn Exhibition of mural painters. Address in 1929, Silvermine, Norwalk, CT.

SCHMITT, HENRY.
Sculptor. Born in Mainz, Germany, July 8, 1860; came to America in 1884. Studied in Munich. Member: German Society of Christian Arts, Munich; Buffalo Society of Artists. Most of his work was done in Roman Catholic churches in Buffalo. Specialty: Ecclesiastical subjects. Died in Buffalo, New York, May 1, 1921.

SCHMITZ, CARL LUDWIG.
Sculptor. Born in Metz, France, September 4, 1900. Studied in Europe; Beaux-Arts Institute of Design; and with Maxim Dasio, Joseph Wackerle, and others. Member: Associate of the National Academy of Design; National Sculpture Society; Architectural League; Audubon Artists; Allied Artists of America. Awards: Prizes, Syracuse Museum of Fine Arts, 1939; National Sculpture Society, 1934, 40; Our Lady of Victory Comp., 1945; Allied Artists of America, 1951; Meriden, CT, 1952; medal, Paris, France, 1937; Penna. Academy of Fine Arts, 1940; Guggenheim Fellow, 1944; American Academy of Arts and Letters grant, 1947. Work: Syracuse Museum of Fine Art; IBM; New York Municipal College; Justice Building, U.S. Post Office Department Building, Federal Trade Commission Building, all in Washington, DC; Federal Building, Covington, KY; U.S. Post Office, York, PA; design, Delaware Tercentenary half-dollar and medal for City Planning; Bar Association medal; Electro-chemical Society medal; other work, Parkchester, NY; Michigan State College. Exhibited: Penna. Academy of Fine Arts, 1934-52; Whitney Museum of American Art, 1936, 38-42, 44; Art Institute of Chicago, 1936-40; Syracuse Museum of Fine Arts, 1938-41, 46-51; Corcoran Gallery of Art, 1936, 39; Audubon Artists, 1945, 50, 51; San Francisco Museum of Art, 1935, 36, 41; National Academy of Design, 1934, 35, 42, 44, 48-51; Architectural League, 1936, 42, 44, 49-50; National Sculpture Society, 1934, 39-41, 43, 44, 46-52; Allied Artists

of America, 1951. Position: Instructor of Sculpture, Michigan State College, 1947; Art Workshop, NYC, from 1948. Address in 1953, 2231 Broadway; h. 517 East 84th St., New York City. Died in 1967.

SCHMITZ, ELIZABETH T.
Painter. Born in Philadelphia, Pennsylvania. Pupil of Pennsylvania Academy of Fine Arts. Address in 1926, 1710 Chestnut St., Philadelphia, Pennsylvania.

SCHMOHLE, FRED C.
Sculptor. Born in Wurtemburg, Germany, 1847. Died in Los Angeles, CA, 1922.

SCHNABEL, DAY.
Sculptor and painter. Born in Vienna, Austria, March 1, 1905. Studied painting at the Vienna Academy of Fine Arts; in Paris with Malfray, Maillol and Zadkine; architecture and sculpture in Holland and Italy. Exhibitions: Betty Parsons Gallery, NYC, 1947, 51; Denise Rene, 1948; Salon des Realites Nouvelles, Paris, 1948, 49; Stedelijk Museum, Amsterdam, 1949; Whitney Museum Annual, New York City, 1949, 50, 52, 53; Jardin du Musee Rodin, Paris, 1948, 51, 52, 53; Salon de Mai, Paris, 1949, 50, 51, 52, 53; Third Open Air Biennial, Brussels, 1953; Palais des Beaux Arts, Brussels, 1953; Ministry of Reconstruction, Paris, 1954. Member: Artists Equity Association. Address in 1953, 969 Park Avenue, New York City.

SCHNACKENBERG, ROY.
Painter. Born Jan. 14, 1934 in Chicago, Illinois. Earned B.F.A. from Miami University (Oxford, Ohio). Award from Copley Foundation, 1967; Art Institute of Chicago, 1964. Exhibited at Main St. Gallery, Chicago; Art Institute of Chicago; Whitney Recent Acquisitions Show, and Whitney Annuals; Department of the Interior Bicentennial Exhibition, Corcoran; many other group and one-man shows. In collections of Art Institute of Chicago and Whitney. Address in 1982, Chicago, Illinois.

SCHNAKENBERG, HENRY ERNEST.
Painter and etcher. Born in New Brighton, New York, Sept. 14, 1892. Pupil of Kenneth Hayes Miller; Staten Island Academy. Member: Art Students League of New York; Society of Independent Artists; National Institute of Arts and Letters. Award: Hon. degree, D.F.A., University of Vermont. Work: "Still Life," owned by the Pennsylvania Academy of Fine Arts; "Mullen Plant," San Francisco Museum; "Quarry," Wadsworth Atheneum, Hartford, Connecticut; "Betty as a Gypsy," Highland Park Gallery, Dallas, Texas; "Air Plants," "Pears," "Conversation," Whitney Museum; "Ronda," Art Institute of Chicago; "Earth and Sky," Museum of Fine Arts, Springfield, Massachusetts; Brooklyn Museum; Montclair Art Museum; Addison Gallery of American Art; Newark Museum; Wichita Art Gallery;

Minneapolis Institute of Art; Palace of the Legion of Honor; many others. Exhibited: Nationally. Taught at Art Students League, 1923-25. Became president of the Art Students League in 1932. Contributor of articles and criticisms to The Arts magazines. Died in 1970. Address in 1953, Newtown, CT.

SCHNEIDER, ARTHUR.
Painter and illustrator. Address in 1926, 939 Eighth Avenue, New York, NY.

SCHNEIDER, FREDERICK.
Illustrator. Born in Los Angeles, CA, in 1946. Studied at Pratt Institute, Society of Visual Arts, and Parsons School of Design in NY with Jacob Lawrence and Seymour Chwast. His first job appeared in *Crawdaddy* magazine in 1974 and he has since illustrated book covers, film strips, theater posters, and editorial pieces for *Cue, Psychology Today,* and *The New York Times.* He received an Award of Excellence from the Society of Illustrators in 1976 and has had his artwork exhibited in Battle Creek, MI.

SCHNEIDER, OTTO J.
Painter, illustrator, and etcher. Born in Atlanta, IL, 1875. Member: Chicago Society of Artists; Chicago Society of Etchers. Work: Etching in Art Institute of Chicago; Toledo Museum of Art. Died in 1946. Address in 1929, 1259 Thorndale Ave., Chicago, IL.

SCHNEIDER, ROSALIND.
Artist/film-maker. Studied: Syracuse Univer. School of Fine Arts; Art Students League, NYC. Exhibitions: Corcoran Gallery, Washington, DC; Butler Insti. of Am. Art, Ohio; Brooklyn Museum, NY. Film Festivals: Womens' International Film Festival, NYC; Museum of Modern Art, Paris; Museum of Graz, Austria; Artists' Space, NYC. Awarded a film retrospective at the Whitney Museum of Am. Art, 1973. She is a founder-member of "Women/Artist/Film-makers" and a charter member of the "Association of Independent Film-makers."

SCHNEIDER, SUSAN HAYWARD.
(Mrs. Karl Schneider). Painter. Born in Pana, IL. Studied: Phila. Mu. School of Industrial Art; Smith College; and with Fred Wagner, Wayman Adams, Henry Rittenberg, Carl Leopold Voss in Munich. Member: Phila. Alliance; Am. Artists Professional League; Plastic Club; Am. Federation of Arts. Work: Langhorne (PA) Library. Exhibited: Phila. Art Club, 1936-40; Indiana Art Club, 1936; Penna. Academy of Fine Arts, 1940; Reading Mu., 1940; one-man exhibitions at New Century Club, Women's City Club, and Plastic Club, all of Phila., PA. Address in 1953, Glenlake Farms, Langhorne, PA.

SCHNEIDER, THEOPHILE.
Painter. Born in Freiburg, Germany, Dec. 5, 1872. Pupil of Monks; Noyes; Davol; Boss; Hofmann;

Hawthorne. Work: Brooklyn Museum; Master Institute, NY; Boston Art Club. Exhibited: Penna. Academy of Fine Arts; Brooklyn Museum; Boston Art Club; NY Water Color Club. Member: Boston Art Club; Salma Club; National Arts Club; Brooklyn Society of Artists. Award: Prize, Boston Art Club, 1924. Address in 1953, 1 Union Square, West, New York, NY; h. 38 Livingston Street, Brooklyn, NY.

SCHNEIDERHAN, MAXIMILAN.
Sculptor. Born in Europe, 1844. Came to U.S. in 1870. Worked: Washington, DC; Louisville, KY; St. Louis, MO. Died in St. Louis, MO, 1923.

SCHNELLE, WILLIAM G.
Painter and teacher. Born in Brooklyn, NY, January 29, 1897. Pupil of Pratt Institute; Art Students League of NY; Walter Beck and Henry B. Snell. Member: Society of the Five; National Arts Club. Address in 1929, 8502 89th Street, Woodhaven, LI, NY.

SCHNIER, JACQUES.
Sculptor. Born in Roumania, December 25, 1898. Studied: Stanford University, A.B.; University of California, M.A.; California School of Fine Arts. Awards: First sculpture award, San Francisco Art Association, 1928; first sculpture prize, North Western Art Exhibition, Seattle, WA, 1928; Oakland Art Museum, 1936, medal, 1940, 48; Los Angeles Art Museum, 1934; Institute for Creative Art, University of California, 1963-64; Artist of the Year Award, San Francisco Art Commission, 1979. Work: Fountain, San Francisco Playground Commission; Berkeley High School; Ann Buemer Memorial Library, San Francisco; Stanford University Museum; Santa Barbara Museum of Art; Hebrew University, Jerusalem; Oakland Art Museum; Crocker Art Gallery, Sacramento, CA; Smithsonian Institution; designed half-dollar commemorating San Francisco-Oakland Bay Bridge. Publications: Contributor of articles on psychoanalysis and art to *Journal of Aesthetics, Art Criticism, Journal of Psychoanalysis*; others. Exhibited: Seattle Fine Arts Institute, 1927; Art Institute of Chicago; San Francisco Museum of Art, 1934, 36, 39, 50; M. H. de Young Memorial Museum, 1947, 60; National Academy of Design; National Sculpture Society; Philadelphia Museum, 1949; Santa Barbara Museum of Art, 1963; Crocker Art Gallery, Sacramento, 1963; Rutgers University Museum, 1979; and many more. Taught: California College of Arts and Crafts, Oakland; University of California, Berkeley. Works in bronze and acrylic. Address in 1982, Lafayette, CA.

SCHNITTMANN, SASCHA S.
Sculptor. Born in NYC on September 1, 1913. Studied: Cooper Union Art School; National Academy of Design; Beaux-Arts Institute of Design; Columbia University; Ecole des Beaux-Arts, Paris;

and with Attilio Piccirilli, Robert Aitken, Olympio Brindesi, and others. Commissions: Martin Luther King, Jr., heroic memorial portrait bust four times life size, 1968; Elvis Presley Monument, 1978. Awards: Society of Independent Artists, 1942; City Art Museum of St. Louis, 1942; Junior League Missouri Exhibition, 1942; Kansas City Institute, 1942; Art Institute of Chicago, 1943; Pan.-American Architectural Society, 1933; Fraser medal, 1937. Collections: Pan.-American Society; American Museum of Natural History; Dayton Art Institute; Moscow State University, Russia; Memorial Plaza, St. Louis, MO; Dorsa Building, St. Louis, MO. Media: Marble and bronze. Address in 1980, San Jose, CA.

SCHOENER, J.
Portrait painter in oils and miniature. He exhibited at the Pennsylvania Academy, in 1817, and was working in Philadelphia until 1827.

SCHOENFELD, FLORA.
Painter. Exhibited in Philadelphia, PA, 1921, in "Exhibition of Paintings Showing the Later Tendencies in Art." Address in 1926, 5024 Ellis Ave., Chicago, IL.

SCHOFF, P. R.
Engraver. An excellent portrait in pure line, of Robert Baird, after a painting by G. P. R. Healy, is thus signed. No other work has been found signed by this man, and it is possible that the signature is a letter engraver's error for the name below.

SCHOFF, STEPHEN ALONZO.
Engraver. Born Jan. 16, 1818 in Danville, VT. At the age of about eight his parents moved first to Bradford, on the Merrimack, and later to Newburyport, MA. Stephen Alonzo Schoff was one of a family of six children and when he was sixteen years old he was sent to Boston and there indentured for 5 years to Oliver Pelton, an engraver of that city. Dissatisfied with the progress he was making, at the end of about 3 years, and with the consent of Mr. Pelton, Mr. Schoff became a pupil of Joseph Andrews and to this admirable line engraver, says Mr. Schoff in a personal letter, "I owe more than can ever be repaid." With Mr. Andrews he went to Paris in 1840, and both young men there worked for a time in the studio of Paul Delarocher, drawing from the nude. Mr. Schoff returned to the U.S. in 1842, and was at once employed by a bank note engraving company in NY. Died May 6, 1904 in Norfolk, CT.

SCHOFIELD, FLORA.
Painter and sculptor. Born in Chicago, IL, March 6, 1880. Studied at Art Institute of Chicago; and in Paris, France. Member: Chicago Society of Artists; Chicago Art Club; New York Society of Women Artists. Awards: Prizes, Art Institute of Chicago, 1929, 31; Wichita Museum of Art, 1939. Work:

Detroit Institute of Art. Address in 1953, Chicago, Illinois.

SCHOFIELD, LOUIS SARTAIN.
Engraver. Born in 1868; a grandson of John Sartain. He is an expert line engraver and a designer of great ability, and for some years has been in the employ of the Bureau of Engraving and Printing, at Washington, D.C.

SCHOFIELD, W(ALTER) ELMER.
Landscape painter. Born in Philadelphia, PA, Sept. 9, 1867. Pupil of Penna. Academy of Fine Arts; Bouguereau, Ferrier, Doucet and Aman Jean in Paris. Member: Society of American Artists, 1904; Associate National Academy of Design, 1902; Academician National Academy of Design, 1907; National Institute of Arts and Letters; Art Club of Philadelphia; Fellowship Penna. Academy of Fine Arts; Century Association; National Arts Club; Salma. Club; Royal Society of British Artists; Chelsea Arts Club, London. Awards: Hon. mention, Art Club of Philadelphia, 1898; Webb Prize, Society of American Artists, 1900; hon. mention, Paris Expo., 1900; hon. mention, Carnegie Institute, Pittsburgh, 1900; first Hallgarten prize, National Academy of Design, 1901; silver medal; Pan.-Am. Expo., Buffalo, 1901; Sesnan gold medal, St. Louis Expo., 1904; Inness gold medal, National Academy of Design, 1911; gold medal and $1,000, National Arts Club, 1913; Temple gold medal, Penna. Academy of Fine Arts, 1914; medal of honor, P.-P. Expo., San Francisco, 1915; Altman prize ($1,000), National Academy of Design, 1920; Mrs. Keith Spalding prize, Art Institute of Chicago ($1,000), 1921; silver medal, Sesqui Centennial Expo., Philadelphia, 1926. Work: "Sand Dunes near Lelant," Metropolitan Museum, NY; "Morning After Snow," "Cliff Shadows," Corcoran Gallery, Washington, DC; "Midwinter Thaw, Morning" and "Landing Stage Boulogne," Cincinnati Museum; "Across the River," Carnegie Institute, Pittsburgh; "Autumn in Brittany," "The Crossroads," Albright Art Gallery, Buffalo; "Winter," Penna. Academy, Philadelphia; "Old Mills on the Somme," Herron Art Institute, Indianapolis; "The White Frost," Memorial Gallery, Rochester, NY; "The Coffer Dam," Art Institute of Chicago; "The Spring Thaw," National Arts Club, New York; "The Rapids," Brooklyn Museum; "June Morning," Des Moines City Library; "Autumn in Cornwall," Harrison Gallery, Los Angeles Museum, Museum of Art, Norfolk, VA. Died in 1944. Address in 1929, 119 East 19th St.; care of the Grand Central Art Galleries, 15 Vanderbilt Ave., New York, NY; 6816 Quincy St., Mt. Airy, Philadelphia, PA.

SCHONGUT, EMANUEL.
Illustrator. Born in Monticello, NY, in 1936. Received his B.F.A. and M.F.A. from Pratt Institute where he was a classmate of James McMullan. This start in the illustration field was in 1963 with book covers for

Macmillan. Doubleday, Dodd, Mead, *New York Magazine, Sesame Street* and *Electric Company Magazine* have all utilized his illustrating skills. He has several posters to his credit as well.

SCHONHARDT, HENRI.
Sculptor, painter, and teacher. Born in Providence, RI, April 24, 1877. Pupil of Julian Academy under Puech, Dubois and Verlet; Ecole des Arts Decoratifs under David and Chevinard. Member: Providence Art Club. Award: Honorable mention, Paris Salon, 1908. Work: "Elisha Dyer Memorial," St. Stevens Church, Providence, RI; "Henry Harrison Young Memorial," City Hall Park, Providence; "Clytie" and "Cadmus," RI School of Design Museum, Providence; "Soldiers' and Sailors' Monument," Bristol, RI; "Col. Sissons Monument," Little Compton, RI. Address in 1933, Providence, RI.

SCHONLU, W. A.
Painter. Exhibited "Snow Mountain" at the Penna. Academy of Fine Arts, Philadelphia, 1924. Address in 1926, 173 Pleasant St., Arlington, MA.

SCHOOK, F. DE FOREST.
Painter and teacher. Born in Michigan, 1872. Pupil of Art Institute of Chicago; H. O. Tanner, Menard and Simon in Paris. Member: Chicago Society of Artists; Chicago Water Color Club; Chicago Artists Guild. Instructor of painting and composition, Chicago Art Institute. Died in 1942. Address in 1929, Lombard, IL; care of the Art Institute of Chicago, IL.

SCHOONMAKER, W(ILLIAM) P(OWELL).
Etcher. Born in New York City, Nov. 14, 1891. Pupil of George B. Bridgman. Member: Philadelphia Sketch Club; Print Club; American Institute of Graphic Arts; Artists Guild of the Authors' League of America; Art Directors' Club; Philadelphia Artists Guild. Address in 1929, 1211 Walnut St.; Hotel Gladstone, Philadelphia, PA.

SCHOONOVER, FRANK E(ARLE).
Painter and illustrator. Born in Oxford, NJ, Aug. 19, 1877. Pupil of Drexel Institute, Philadelphia, under Howard Pyle. Member: Society of Illustrators, 1905; Fellowship Penna. Academy of Fine Arts (associate); Wilmington Society of Fine Arts. Specialty: American Indians and Canadian trappers. Illustrator and writer of books, 1912-18, and illustrator of children's classics, 1920-30. Designed stained glass windows. Landscapist since 1937. Died in 1972. Address in 1929, 1616 Rodney St.; h. 2003 Bayard Ave., Willington, DE; summer, Bushkill, PA.

SCHOTTLAND, MIRIAM.
Illustrator. Born in Brooklyn, NY, in 1935. Attended Pratt Institute; the New School; and Art Students League. Her free-lance work includes children's books, trade publications, corporate and editorial illustrations, as well as the 1975 International Women's Year stamp and courtroom drawings for the ABC coverage of the Ellsberg hearings. The recipient of many awards, she was given the Society of Illustrators Hamilton King Award in 1970.

SCHOULER, WILLARD C.
Painter. Born in Arlington, Nov. 6, 1852. Pupil of Henry Day and William Rimmer. Specialty: Western and Arabian scenes. Address in 1919, 173 Pleasant Street, Arlington, MA.

SCHOYER, RAPHAEL.
A copperplate printer living in Baltimore, MA, in 1824; in 1826 he was engraving some indifferently executed portraits in NY. His album of wood engravings is at the Metropolitan Museum of Art.

SCHRAM, A(BRAHAM) J(OHN).
Sculptor, painter and teacher. Born in Heidenheim, Wuerttemberg, Germany, December 22, 1867. Pupil of Gruenenwald; Schrandolph; Kraeutle; McNeil; Arangi. Member; Progredi Art Club. Address in 1906, 46 West 28th St., NYC.

SCHRANKER, LOUIS.
Sculptor, painter and printmaker. Born in New York City, July 20, 1903. Studied at Educational Alliance, NYC; Cooper Union; Art Students League. Works: Brooklyn Museum; Art Institute of Chicago; Metropolitan Museum of Art; University of Michigan; New York Public Library; Newark Museum; Philadelphia Museum of Art; Phillips; Toledo Museum of Art; Utica; Wesleyan University. Exhibitions: Contemporary Arts Gallery, NYC; Kleemann Gallery, NYC; New School for Social Research; Artists' Gallery, NYC; Brooklyn Museum, 1943; The Willard Gallery, NYC; Hacker Gallery, NYC; Grace Borgenicht Gallery Inc., NYC; Walker; Whitney; Metropolitan Museum of Art; Utica; Art Institute of Chicago; University of Michigan. Taught: New School for Social Research, 1940-60; Bard College, 1949-64; University of Colorado, 1953; University of Minnesota, 1959. Living in CT in 1970. Died in 1981.

SCHRECKENGOST, DON.
Sculptor, painter, designer, craftsman, and educator. Born in Sebring, OH, September 23, 1911. Studied at Cleveland School of Art; and with Alexander Blazys, N. G. Keller. Member: American Ceramic Society; U.S. Potters Association; Boston Society of Arts and Crafts; The Patteran. Awards: Medal, American Ceramic Society, 1946; prizes, Syracuse Museum of Fine Arts, 1941; Graphic Art Exhibition, NY, 1940; Albright Art Gallery, 1938; Finger Lakes Exhib., Rochester, NY, 1940. Work: Rochester Memorial Art Gallery; IBM Collection; Universitaria de Bellas Artes, San Miguel, Mexico. Exhibited: Nationally and internationally. Contributor to: *American Artist* magazine. Lectures: History of Ceramics; Design;

etc. Position: Professor, Industrial Ceramic Design, Alfred University, 1935-45; Art Director, Homer Laughlin China Co., Newell, WV, from 1953. Address in 1953, East Liverpool, OH.

SCHRECKENGOST, VIKTOR.
Sculptor and craftsman. Born in Sebring, OH, June 26, 1906. Pupil of Cleveland School of Art; Julius Mihalik; and Michael Powolny. Exhibited: Century of Progress, Chicago, San Francisco, and New York World's Fair; Paris Exposition. Member: Cleveland Society of Artists; New York Architectural League; American Watercolor Society; others. Awards: Annual Exhibition of Work by Cleveland Artists and Craftsmen, Cleveland Museum of Art, first prize, 1931, special prize for outstanding excellence, 1932. Work: Ceramics, five pieces, Cleveland Museum of Art. Teaching: Instructor, Cleveland School of Art, from 1930. Address in 1982, Cleveland Heights, OH.

SCHREIBER, GEORGES.
Sculptor and painter. Born in Brussels, Belgium, April 25, 1904. Studied at Academy of Fine Arts, Berlin and Dusseldorf, Germany; also in London, Rome, Paris, and Florence. Work: Philbrook Art Center; Maryland Institute; Rutgers University; Whitney; Syracuse Museum of Fine Arts; Springfield (MA) Museum of Art; Brooklyn Museum; Metropolitan Museum of Art; White House Library, Washington, DC; Library of Congress; Bibliotheque Nationale, Paris, France; Newark Museum of Art; Montclair (NJ) Art Museum; University of Minnesota; others. Member: Art Alliance of America. Awards: Tuthill prize, Twelfth International Exhibition of Water Colors, Art Institute of Chicago, 1932; Museum of Modern Art, 1939; medal, Art Directors' Club, 1943; prize, Springville Museum, UT, 1963. Author and illustrator of *Portraits and Self Portraits*, 1936, *Bombino the Clown*, 1947; illustrator of *Ride on the Wind*, 1956, *That Jud!*, 1957, others. Instructor, New School for Social Research, Art Department, New York, NY, from 1959. Address in 1970, 8 West 13th Street, New York, NY.

SCHREYVOGEL, CHARLES.
Painter, sculptor, illustrator, and lithographic artist. Born in NYC, January 4, 1861. Studied in Newark, NJ; later in Munich with Carl Marr and Frank Kirchbach. Worked as an office boy, carved meerschaum, was apprenticed to a gold engraver, and became a die sinker and later a lithographer. Traveled in the West, sketching various scenes. Award: National Academy, 1900. Work in Metropolitan Museum of Art; C. R. Smith Collection; Harmsen Collection; Anschutz Collection. Associate member of National Academy, 1901. Works include "Dead Sure," 1902 (oil); "A Beeline for Camp" (oil); "The Last Drop" (bronze); "My Bunkie" (oil); etc. Known chiefly as genre painter; specialty was Western military life. Died in Hoboken, NJ, January 27, 1912.

SCHRIER, JEFFREY A.
Illustrator. Born in Cleveland, OH, in 1943. Educated at the Cleveland Insti. of Art, CA Institute of the Arts, and the New School for Social Research in NY. Although he began his career doing fashion illustrations in California in 1967, his range of work includes album covers for Warner Brothers, book covers for Ballantine and Bantam, editorial art for major magazines, and several posters. Galleries in LA and NY, including the Society of Illustrators Annual Exhib. in 1976, have exhibited his artwork.

SCHROFF, ALFRED HERMANN.
Painter, craftsman, and teacher. Born in Springfield, MA, Dec. 26, 1863. Pupil of De Camp; Major; Chominski; Cowles Art School. Member: Boston Art Club; Boston Archit. Club; Laguna Beach Art Assoc.; Pacific Art Assoc.; Oakland Art League; Society of Oregon Artists; Carmel Art Association; Copley Society. Awards: Medal for stained glass, Columbian Expo., Chicago, 1893; 1st prize, Seattle, 1923; 1st prize, Springville, Utah, 1923; diploma, Beaux Arts, Fontainebleau, 1924; others. Died in 1939.

SCHROTH, DOROTHY L.
Painter and craftsman. Born in San Francisco, California, May 9, 1906. Pupil of Marian Hartwell; Rudolph Schaeffer; Lucian Lebaudt. Member: San Francisco Society of Women Artists. Address in 1933, 325 Laguna Honda Boulevard, San Francisco, California.

SCHULENBERG, ADELE.
(Mrs. Charles K. Gleeson). Sculptor. Born in St. Louis, MO, Jan. 18, 1883. Pupil of George J. Zolnay; St. Louis School of Fine Arts; Grafly; studied in Berlin at Secessionist School with Funcke. Member: St. Louis Artists' Guild. Received bronze medal at Alaska-Yukon-Pacific Expo., Seattle, 1901. Exhib. at Nat. Sculpture Society, 1923. Address in 1933, Kirkwood, MO.

SCHULER, HANS.
Sculptor and painter. Born in Alsace-Lorraine, Germany, May 25, 1874. Pupil of Raoul Verlet in Paris. Member: National Sculpture Society, 1908; Charcoal Club. Awards: Rinehart scholarships in sculpture, 1900, Paris, 1901-05; third class medal, Paris Salon, 1901; silver medal, St. Louis Exposition, 1904; Avery prize, NY Archit. League, 1915. Work: "Ariadne," Walters Gallery, Baltimore, MD; "Johns Hopkins Monument," Baltimore; statue, James Buchanan, Meridian Hill, Washington, DC. Exhib. at Nat. Sculp. Society, 1923. Director, Maryland Insti. Address in 1929, care of Maryland Institute, Mt. Royal Ave.; h. 5 E. Lafayette Ave., Baltimore, MD.

SCHULLER, GRETE.
Sculptor. Born in Vienna, Austria; U.S. citizen. Studied at Academy of Art; Vienna Lyzeum; Vienna

Kunstakademie; Art Students League; sculpture with W. Zorach; Sculpture Center, NY. Works: Norfolk Museum of Arts and Science, VA; Museum of Natural History, NY; Museum of Science, Boston. Exhibitions: One-man shows, Sculpture Center; group shows, Allied Artists of America; Audubon Artists; Academy of Design; Des Moines Art Center; National Association of Women Artists; National Sculpture Society; Academy of Arts and Letters, 1955; University of Notre Dame, 1959; Detroit Institute of Arts, 1959-60; Penna. Academy of Fine Arts, Philadelphia, 1959-60; 150 Years of American Art, New Westbury Garden, NY, 1960; plus many others. Awards: Sculpture house prize, National Association of Women Artists, 1953; bronze medal of honor from the Knickerbocker Artists, 1959; Silvermine Guild, 1960; first prize for sculpture, 1956; bronze carving prize for sculpture, Art League of Long Island; Pauline Law Prize, Allied Artists of America, 1972; Roman Bronze Foundry Prize, National Sculpture Society, Lever House, 1973, Bronze Medal, 1975; Goldie Paley Prize, National Association of Women Artists, 1975; plus others. Member: Fellow National Sculpture Society; Allied Artists of America; Audubon Artists; Sculptors League; National Assoc. of Women Artists; George Society; Natural History Museum Club; New York Architectural League. Medium: Stone. Address in 1982, 8 Barstow Road, Great Neck, New York.

SCHULMAN, A. G.
Painter. Born in Koenigsberg, Germany, in 1881. Pupil of S. J. Woolf and of the National Academy of Design, New York. Instructor, College of the City of New York. Address in 1926, 24 East 59th Street, New York, NY.

SCHULTE, ANTOINETTE.
Painter. Born in NYC. Studied: Art Students League with George Bridgman, Homer Boss; Fontainebleau School of Fine Arts, Paris; and with Lopez Mezquita. Awards: Salons of America, 1931. Collections: Benjamin West Museum; Brooklyn Museum; Corcoran Gallery of Art; Newark Museum; Montclair Art Museum; Cincinnati Museum of Art; Metropolitan Museum of Art; French Government. Collection: Aix-en-Provence, France.

SCHULTZ, GEORGE F.
Painter. Born in Chicago, Illinois, April 17, 1869. Award: Tuthill prize, Art Institute of Chicago, 1918. Work: "By the Sea," Union League Club, Chicago; "Among the Birches," Cliff Dwellers, Chicago; "Twilight Shadows," Arche Club, Chicago; "Autumn Weather," City of Chicago Collection; "Rocky Cove," Mt. St. Claire College, Clinton, IA; "Elephant Rock," Muscatine (IA) Art Association; "After the Rain," "Autumn Gold," Muskogee (OK) Public Library. Specialty: Landscapes and marines. Address in 1929, 1900 Newport Ave., Chicago, IL.

SCHULTZ, HARRY.
Painter. Born in Sebastopol, Russia, Jan. 1, 1900. Pupil of John Sloan; Kenneth Miller. Mem.: Society of Independent Artists; Museum of Art Culture in Russia, Leningrad. Address in 1929, 2607 Jerome Ave., New York, NY.

SCHULTZ, ISABELLE.
Sculptor, lecturer, and teacher. Born in Baltimore, MD, April 20, 1896. Pupil of Ephraim Keyser and J. Maxwell Miller. Member: Baltimore Handicraft Club. Work: Memorial tablet to W. E. Kellicott, Goucher College, Baltimore; memorial tablet to John T. King, Medical and Chirurgical Building, Baltimore; testimonial tablet, Buckingham School, Frederick, MD; portrait relief, Dr. G. W. Carver, Tuskegee Institute, AL; and John Gardner Murray, Protestant Episcopal Cathedral, Baltimore, MD. Address in 1933, Baltimore, MD.

SCHULTZ, SUSETTE.
See Keast, Susette Schultz.

SCHUMACHER, WILLIAM E.
Painter. Born in Boston, MA, in 1870. Studied in Paris. Exhibited in the "Autumn Salon," Paris, until the exhibitions were discontinued; retrospective, Ferargil Gallery, NYC, 1931; other exhibitions. One of the earliest painters of the Woodstock School, he was also a gifted teacher. Held classes in NYC, and from 1913 until his death he taught at Byrdcliffe, Woodstock, NY. Died August 30, 1931, in Kingston, NY.

SCHUPBACH, MAE ALLYN.
Painter, block printer, and teacher. Born May 13, 1895, in Moberly, MO. Studied: NY School of Fine and Applied Arts; and with J.F. Carlson, G. Wood and B. Sandzen. Exhibited: Tulsa Art Assoc., 1934. Member: Tulsa Art Assoc.; Assoc. of Oklahoma Artists; others. Address in 1940, Tulsa, OK.

SCHUSSELE, CHRISTIAN.
Painter. Born Aug. 16, 1824 in Alsace, France. He studied in Paris, and came to Philadelphia, PA, about 1848. He exhibited his work at the Penna. Academy of Fine Arts, and was elected professor of drawing and painting at the Academy, where he served until his death in 1879. Many of his paintings were engraved by John Sartain. He painted "Benjamin Franklin before the Council, London, 1773," and other American historical scenes; painted a number of portraits of prominent Americans. Died August 21, 1879 in Merchantville, New Jersey.

SCHUSTER, DONNA N.
Painter. Pupil of Art Institute of Chicago; Tarbell; and Chase. Member: CA Art Club; Society of Independent Artists; West Coast Arts; California Water Color Society. Awards: Gold medal, Minn. State Art Exhib., 1913; prize for painting ($100), Minn.

State Art Exhib., 1914; silver medal for water colors, P.-P. Expo., San Francisco, 1915; silver medal, Pan.-Calif. Expo., San Diego, 1915; first prize for water colors, Phoenix, AZ, 1918 and 1919; hon. mention, Wisconsin Painters and Sculptors, 1919; first prize for oil painting, Phoenix, AZ, 1920; Ackerman prize ($100), CA. Art Club, 1921; first prize, CA. Water Color Society, 1926; first prize, West Coast Arts, Inc., 1926; first prize, 1927-28, second prize, 1930, LA County Fair; first prize, 1929, second prize, 1930, Riverside County Fair; second prize, Orange County Fair, 1930; first hon. mention, State Wide Exhib., Santa Cruz, 1931; Fisher prize, CA. Art Club, 1931; first prize in oils, AT Assoc., L.A. County, 1933. Address in 1933, 2672 Glendower Ave., L.A., CA.

SCHUTZ, ANTON (JOSEPH) (FRIEDRICH).
Etcher. Born in Berndorf, Rhineland, April 19, 1894. Pupil of Academie of Fine Arts, Munich, under Groeber and Peter von Halm; Art Students League of NY with Joseph Pennell; studied architecture at Technical Univer., Munich. Member: Brooklyn Society of Etchers; Chicago Society of Etchers; American Fed. of Arts. Represented by etchings in Brooklyn Mu.; NY Public Library; Art Inst. of Chicago; Library of Congress, Washington, DC; Cleveland Museum of Art; St. Louis Public Library; Bibliotheque Nationale, Paris. Died 1977. Address in 1929, 340 West 86th St., New York, NY.

SCHUYLER, REMINGTON.
Painter, illustrator, lecturer, and writer. Born in Buffalo, NY, July 8, 1887. Pupil of George B. Bridgman; Howard Pyle; Jean Paul Laurens; Edmund Bashet. Member: Society of Ill.; Silvermine Guild; Westport Art Market. Works: "George Washington, the Surveyor," Washington School, New Rochelle, NY; "Siwanoy Indians," New Rochelle High School; "Approach Sign (Siwanoy Indians)," owned by the City of New Rochelle; six Indian panels, Clyde Line Steamship Company. Died in 1955. Address in 1933, Lane off Wright St., Westport, CT.

SCHWAB, EDITH FISHER.
(Mrs. C. Schwab). Painter. Born in Cincinnati, OH, in 1862. Member of National Association of Women Painters and Sculptors. Address in 1926, 310 Prospect St., New Haven, CT.

SCHWAB, ELOISA.
Painter. Born in Havana, Cuba, July 4, 1894. Pupil of Kenneth Hayes Miller at Art Students League of NY; Julian Academy in Paris. Member: Salons of America; Art Students League of NY; Society of Independent Artists. Address in 1929, Charmont Ct., 817 West End Ave., New York, NY.

SCHWABE, HENRY AUGUST.
Painter. Born in Oberweisbach, Germany, in 1843. Learned drawing and china decorating, and at the age of 18 worked as a painter and designer of stained glass in Stuttgart; studied in Polytechnic School, Royal Academy of Fine Arts, Munich; also in Cologne. He came to the United States in 1871, and later studied at the old Academy of Design, NY, and under William Chase; also at Munich, Paris and in the Julian Academy. He has designed and painted church windows in NY, Pittsburgh, Chicago, etc. Awarded gold medal for stained glass design and execution, St. Louis Exposition, 1904; exhibited at NY Academy of Design; Art Association. He was also a portrait figure painter. Was president of the Newark Art League, and a member of the Newark Museum Association. Address in 1926, 917 Broad St., Newark, New Jersey. Died Feb. 8, 1916, in South Orange, New Jersey.

SCHWANKOVSKY, FREDERICK JOHN DE ST. VRAIN, JR.
Painter, writer, lecturer, and teacher. Born in Detroit, MI, Jan. 21, 1885. Pupil of Penna. Academy of Fine Arts; Art Students League of NY. Member: California Art Club; Laguna Beach Art Association; Pacific Art Association; Southwest Art Association of Los Angeles; Central California Art Association; Fresno Art League. Work: Mission Beach (CA) Art Gallery; Manual Arts High School, Los Angeles, CA. Head of art department, Manual Arts High School, Los Angeles. Address in 1953, Laguna Beach, California.

SCHWARCZ, D. R.
Painter. Born in Brooklyn, New York, in 1893. Pupil of Kenneth Hayes Miller; C. W. Hawthorne; Jonas Lie; R. S. Bredin. Member: National Association of Women Painters and Sculptors; League of New York Artists. Address in 1926, 272 West 90th St., New York, New York.

SCHWARM, WESLEY A.
Painter. Born in Lafayette, Indiana, in 1883. Pupil of Pratt Institute; also of Henri. Member of Society of Independent Artists. Address in 1926, 130 East 19th Street, Brooklyn, New York.

SCHWARTKOFF, EARL C.
Painter and illustrator. Born in Ohio in 1888. Member of Toledo Tile Club. Address in 1926, care of Willys Overland Company, Toledo, Ohio.

SCHWARTZ, ANDREW (THOMAS).
Mural painter. Born Louisville, KY, Jan. 20, 1867. Pupil of Duveneck in Cincinnati; Art Students League of NY under Mowbray. Member: National Society of Mural Painters; NY Architectural League, 1904; American Water Color Society; Circolo Artistica of Rome; Allied Artists of America; Salma. Club; American Federation of Arts; Fellow, American Academy in Rome. Award: Lazarus scholarship to Italy, 1899-1902. Decorations: Kansas City Life

Insurance Co., Kansas City, MO; "Christ the Good Shepherd," Baptist Church, South Londonderry, VT; represented in Cincinnati Art Museum and Utica (NY) Public Library; eleven murals, Atkins Museum of Fine Arts, Kansas City, MO. Died in 1942. Address in 1933, 246 Fulton Street, Brooklyn, NY.

SCHWARTZ, C.
In 1814 this stipple engraver of portraits was working in Baltimore, MD. His signed work is rare, but his large plate of Bishop James Kemp, published in Baltimore, is a capital piece of work.

SCHWARTZ, DANIEL.
Illustrator. Born in NYC in 1929. Went to Rhode Island School of Design and Art Students League under scholarship. He studied with Yasuo Kuniyoshi and John Frazier, and in 1953 he published his first illustration for *Theatre Arts*. He has won seven gold medals from the Society of Illustrators and the purchase prize from the Childe Hassam Fund of the American Academy of Arts and Letters. He has had numerous one-man shows and illustrates for all national magazines.

SCHWARTZ, ELIZABETH.
(Mrs. Charles Neyland). Painter. Member of National Association of Women Painters and Sculptors. Address in 1926, 3337 North 17th St., Philadelphia, PA.

SCHWARTZ, MANFRED.
Painter, illustrator, teacher, lecturer and writer. Born in Lodz, Poland, Nov. 11, 1909. Studied: Art Students League; National Academy of Design; pupil of John Sloan, George Bridgman. Member: Federation of Modern Painters and Sculptors; Art Students League of NY. Awards: Silvermine Guild, 1965, 67; Sesnan gold medal, Penna. Academy of Fine Arts. Work: Guggenheim Museum; Museum of Modern Art; NY Public Library; Metropolitan Museum of Art; Whitney; Brooklyn Museum; Philadelphia Museum of Art; Newark Museum; others. Group Exhibitions: Carnegie; Whitney; Virginia Museum of Fine Arts; Penna. Academy of Fine Arts; Brooklyn Museum; Metropolitan Museum of Art; Butler Art Institute; Art Institute of Chicago; Portland (OR) Museum of Art; Museum of Modern Art; Denver Art Museum; Baltimore Museum of Art; City Art Museum of St. Louis; others. One-man exhibitions: Durand-Ruel Gallery; Brooklyn Museum; Albert Landry Gallery; New School, NY. On faculty, Brooklyn Museum Art School, NY, and New School for Social Research, NY. Address in 1970, 22 East 8th Street, New York, NY. Died in 1970.

SCHWARTZ, WILLIAM S.
Painter and lithographer. Born in Russia, Feb. 23, 1896. Pupil of Vilna Art School, Russia; Art Institute of Chicago. Awards: First Kahn prize, Detroit, MI, 1925; first Temple Beth El Sisterhood prize, Detroit, 1926; Holmes prize, Art Institute of Chicago, 1927, M. V. Kohnstamm prize, 1928, Shafer prize, 1930. Work: "Friendly Enemies," Chicago Public Schools Collection. Represented in University of Nebraska, Lincoln; University of Missouri, Columbia; University of Wisconsin, Madison; Cincinnati Public Library; Public Art Gallery, Dallas, TX; Municipal Gallery, Davenport, IA. Address in 1933, 29 East Ohio St., Chicago, IL.

SCHWARZ, FRANK HENRY.
Painter. Born in New York City, June 21, 1894. Pupil of H. M. Walcott and C. W. Hawthorne. Member: Salma Club; Architectural League of NY; National Society of Mural Painters; Silvermine Guild of Artists. Awards: Fellowship American Academy in Rome, 1921-24; Fellowship Guggenheim Memorial Foundation research in painting, 1926; Isidor prize (drawing), Salma. Club. Work: Drawing, Brooklyn Museum of Fine Arts, NY; drawing, University of Nebraska, Lincoln; main reredos, Church of the Ascension, Montreal, Canada, and St. John's Church, Seattle, WA; stone floor design, Pioneer Monument, Harrodsburg, KY. Died in 1951. Address in 1929, 114 East 28th Street, New York, NY; h. Norwalk, CT.

SCHWARZ, MARGARET.
Sculptor. Born in NYC in 1900. Studied sculpture with Solon Borglum and Frederic V. Guinzburg in New York. Works: Dough Boy; portraits of H. S., Jimmy and Herbert; bird fountain, private estate, NY; also dancing figures, in private collections.

SCHWARZ, RUDOLF.
Sculptor. Born in Germany, he settled in Indianapolis, IN. In 1902 he won the competition for a statue of Governor Pingree, of Michigan. Address in 1910, Herron Art Institute, IN.

SCHWARZ, WILLIAM T(EFFT).
Painter and illustrator. Born in Syracuse, NY, July 27, 1889. Pupil of Charles Hawthorne; studied in France and Spain. Work: Murals for the Onondaga Hotel, Syracuse; Utica Hotel, Utica, NY; Pontiac Hotel, Oswego, NY; Fulton National Bank, Lancaster, PA; Hotel Dennis, Atlantic City, NJ; Gen. Price Auditorium, Valley Forge, PA; Girl Scout mural for Scout Headquarters. Illustrations in *The Saturday Evening Post, The Spur, World's Work*, etc. In charge of the Art Unit for the History of Surgery during the World War. Address in 1929, 343 Sycamore Ave., Merion, PA.

SCHWARZBURGER, CARL.
Engraver. Born in Leipzig, Germany, in 1850. Studied in Leipzig and Berlin; came to America in 1874. Went to Australia, 1886-89, to illustrate the books

Picturesque Australia. Exhibited at Chicago; also the Paris Exposition, 1900. Received a medal, Buffalo Exposition, 1901. Address in 1926, 595 McDonough St., Brooklyn, NY.

SCHWARZOTT, MAXIMILIAN.
Sculptor. Born in 1898. He exhibited at the National Sculpture Society. Died in New York, 1926.

SCHWEISS, RUTH KELLER.
Sculptor and designer. U.S. citizen. Studied at Washington University, St. Louis, fine arts certificate; Cranbrook Art Academy, Bloomfield Hills, MI, three year international fellowship, sculpture with Carl Milles. Works: Cranbrook Art Museum; plus many private collections. Commissions: Life size garden sculpture, commission by Lawrence Roos, St. Louis, 1965; bear for pool garden, commission by J. A. Baer, II, St. Louis, 1970; Blachette (six foot bronze), Founder Monument, St. Charles, MO, 1972; Children in the Rain, German Council, Hamm, Germany, 1973; Sons of Founders (bronze reliefs), Stix, Baer, and Fuller, St. Louis, 1975. Exhibitions: National Academy of Design, NY, 1943; Detroit Art Museum Regional Show, MI, 1943; Pacific Show, Hawaiian Art Museum, Honolulu, 1944; International Art Show, Rotunda Gallery, London, 1973; Ars Longa Gallery, Houston, TX, 1974. Awards: Museum Purchase Prize, Cranbrook Art Museum, 1942; Ruth Renfrow Sculpture Prize, St. Louis Art Museum, 1945; Thalinger Sculpture Prize, St. Louis Artists Guild, 1950. Media: Bronze casting of limited editions from any carved or modeled medium. Address in 1982, St. Louis, MO.

SCHWEITZER, GERTRUDE.
Sculptor and painter. Born in NYC in 1911. Studied: Pratt Institute Art School; National Academy of Design; Julian Academy, Paris. Awards: Philadelphia Watercolor Club, 1936; Norton Art Gallery, 1946, 47; Montclair Art Museum, 1947, 52; Society of Four Arts, 1947, 48, 50, 51; Miami, FL, 1951; American Artists Professional League, 1934, 53, 56, 57; American Watercolor Society, 1933. Collections: Brooklyn Museum; Canajoharie Gallery of Art; Toledo Museum of Art; Atlanta Art Association; Norton Gallery of Art; Hackley Art Gallery; Davenport Municipal Art Museum; High Museum of Art; Witte Memorial Museum; Museum of Modern Art, Paris; Museum of Albi, France; Montclair Art Museum; Philadelphia Art Alliance, 1969; Hokin Gallery, Palm Beach, 1971; numerous others. Address in 1980, Stone Hill Farm, Colts Neck, NJ.

SCHWEIZER, J. OTTO.
Sculptor. Born in Zurich, Switzerland, March 27, 1863. Pupil of Tuiller in Paris; Royal Academy of Fine Arts, and Schilling in Dresden; Art School, Zurich; and in Rome and Florence. Member: National Sculpture Society; American Federation of Arts. Exhibited at National Sculpture Society, 1923. Works: "Gen. P. Muhlenberg," and "James B. Nicholson," Philadelphia; "Gen. F. W. Steuben," Utica, NY, and Valley Forge Military Park, Valley Forge, PA; statues of Abraham Lincoln and Generals Gregg and Pleasanton, Pennsylvania State Memorial; statues of Generals Humphrey, Geary and Hays for Pennsylvania and Gen. Wells for Vermont, Gettysburg, PA; statue of Lincoln with allegorical reliefs and portraits of Generals Grant, Meade, Sherman, Sheridan, Gregg, Farragut, and Hancock, for Lincoln Memorial Room, Union League of Philadelphia; "Senator Clay," Marietta, GA; Henry Melchior Muhlenberg, patriot of the Lutheran Faith, statue and heroic size relief groups, Germantown, PA; statues of Adj. Gen. Stewart, and Senator George Oliver, Capitol, Harrisburg, PA; equestrian statue of Major Gen. F. W. von Steuben, Milwaukee, WI; symbolic group with James J. Davis and two children, Moosehart, IL; East Germantown War Memorial; Central High School War Memorial, Memorial for the Colored Solidery, busts of Senator James J. Davis and G. P. Morgan, all at Philadelphia; medals of Gov. Brumbaugh and of Gov. Sproul of Pennsylvania; Mexican War medal and World War medal for the State of Pennsylvania; National Guard, State of New Jersey; Thompson Hoadley Landon, Military Academy, Bordentown, NJ; Charles Edmund Dana, Numismatic Society; others. Address in 1953, Philadelphia, PA. Died in 1955.

SCHWIEDER, ARTHUR I.
Painter, illustrator and teacher. Born in Bolivar, MO, Dec. 2, 1884. Pupil of Art Institute of Chicago. Illustrated: *Grey Face, Bat Wing, Yellow Shadows, The Dream Detective, The Winning Game, The Mansion of Unrest* (Doubleday, Doran & Co.). Address in 1933, 80 West 40th Street, New York, NY.

SCOFIELD, WILLIAM BACON.
Sculptor. Born in Hartford, CT, Feb. 8, 1864. Pupil of Gutzon Borglum. Member: American Federation of Arts. Work: "Good and Bad Spirit," bronze, Worcester Art Museum. Author of "Verses," and "Poems of the War;" "A Forgotten Idyl;" "Sketches in Verse and Clay." Address in 1929, Worcester, MA.

SCOLES, JOHN.
This engraver of portraits and subject plates was located continuously in NY from 1793 until 1844. He probably died in the latter year, as he is then registered "John Scoles, late engraver." Scoles worked in both line and stipple, but with indifferent success. He engraved many of the views appearing in the *New York Magazine,* in 1793-96.

SCOMA, MARIO.
Sculptor. Exhibited "The Birthday" in Annual Exhibition, 1915, of the Penna. Academy of Fine Arts, Philadelphia. Address in 1926, Brooklyn, NY.

SCOT.
Painter. Nothing is known of this artist, except the mention in the diary of Rev. Wm. Bentley, Oct. 3, 1803. "At Mr. Scot's saw several full lengths of Washington which pleased me, excepting the faces so different from those I saw. Several paintings did honor to this young painter; the head of Dr. Lathrop was complete, Mr. Adams I readily knew, Mr. Murray, the Universalist not so much, Gov. Strong too full faced."

SCOT, ROBERT.
Engraver. Born in England. He was originally a watchmaker. He appears in Philadelphia about 1783, and in that year he engraved a frontispiece for a Masonic sermon preached by Wm. Smith, D.D., and published by Hall & Sellars. He advertised himself as "Late Engraver to the State of Virginia," and in 1785 he was paid 16 pounds for engraving done for the State of Pennsylvania. Scot engraved a few fairly well-executed line portraits, including one of Washington, over his own name. In 1793, Robert Scot was appointed engraver to the newly established United States Mint in Philadelphia, and he is credited with having made the dies for the copper cent of 1793.

SCOTT, ANNA PAGE.
Painter. Born in Dubuque, IA. Pupil of Anshutz; Arthur Dow; and of the Colarossi Academy, Paris. Represented by the "Shores of the Pacific," Carnegie Library, Dubuque. Address in 1926, 1212 Locust St., Dubuque, IA. Died Oct. 13, 1925 in Dubuque.

SCOTT, BERTHA.
Painter, writer, and teacher. Born in Frankfort, March 25, 1884. Pupil of Anson K. Cross; Andrene Kauffmann; Gerrit A. Beneker. Member: Louisville Art Club; Louisville Art Association. Author and illustrator of articles for *House Beautiful* and other garden magazines. Died in 1965. Address in 1933, "The Attic Studio," 402 Shelby St., Frankfort, KY.

SCOTT, CHARLES THOMAS.
Sculptor and painter. Born in Chester County, PA, in 1876. Pupil of Penna. Museum School of Industrial Art, Philadelphia. Address in 1926, Philadelphia, PA.

SCOTT, COLIN A.
Painter. Born in Ottawa, CN, 1861. Member of Providence Art Association. Address in 1926, College St., South Hadley, MA.

SCOTT, EMILY MARIA SPAFORD.
Flower painter. Born in Springwater, NY, on Aug. 27, 1832. She studied at the Art Students League of NY, and in Paris. She is represented by paintings in the Metropolitan Museum and in the Brooklyn Institute Museum. She died on April 9, 1915, in NYC.

SCOTT, ERIC G(LIDDEN).
Painter, etcher, and teacher. Born in Bega, Australia, July 5, 1893. Pupil of Julian Ashton; Henri Royer; Jules Pages. Member: Chicago Soc. of Etchers; Australian Painter-Etchers; CA Soc. of Etchers. Represented by etching in Art Insti. of Chicago. Address in 1929, 37 rue Froidevaux, Paris XIV, France.

SCOTT, GERALDINE ARMSTRONG.
Painter. Born in Elkhart, IN, Oct. 1, 1900. Studied: Northwestern Univ.; NY School of Fine and Applied Arts. Exhibited: Hoosier Salon; Indiana Art Club. Address in 1953, Kokomo, IN.

SCOTT, JAMES.
Painter. Born in Racine, WI, Sept. 3, 1889. Pupil of Art Students League of NY; Julian Academy, Colarossi and Grande Chaumiere in Paris. Member: Salma. Club; New York Society of Craftsmen. Award: Silver medal, Panama-Pacific Expo., San Francisco, 1915. Work: Mural, American Expeditionary Forces University, France. Address in 1933, Milton, NY.

SCOTT, JEANNETTE.
Painter and teacher. Born in Kincardine, Ontario, CN, Sept 26, 1864. Pupil of Penna. Academy of Fine Arts and Philadelphia School of Design for Women; also studied in Paris. Member: American Federation of Arts. Work in Syracuse Museum of Fine Arts. Professor of painting, Syracuse University, since 1895; professor emeritus, A.F.D., 1927. Died in 1937. Address in 1933, Skaneateles, NY.

SCOTT, JOHN WHITE ALLEN.
Landscape painter. Born in Roxbury, MA, in 1815. His best-known paintings are scenes in the Catskills and White Mountains. He died March 4, 1907, in Cambridge, MA.

SCOTT, JOSEPH T.
Engraver (an especially good map engraver), working in Philadelphia as early as 1795. He published an atlas of the United States, printed in Philadelphia in 1796 by Francis and Robert Bailey. Scott drew and engraved the maps.

SCOTT, JULIAN.
Painter. Born VT, Feb. 15, 1846. He entered the army at the breaking out of the Civil War. He afterwards became a pupil of the Nat. Acad. and studied under Leutze to 1868. Work consists chiefly of pictures of Army life; "Battle of Cedar Creek," "Charge at Antietam," "The Recall" and the "Blue and the Gray." He died July 4, 1901, Plainfield, NJ.

SCOTT, KATHERINE H(ALL).
Portrait and miniature painter. Born in Burlington, IA. Pupil of Art Institute of Chicago, Vanderpoel and

Chase, Snow-Froelich School of Industrial Art. Member: Alumni Art Institute of Chicago; Chicago Artists Guild; Eastern Arts Association; American Federation of Arts. Work: Portraits in Des Moines County Court House; Public Library and Merchants National Bank, Burlington, IA. Art Supervisor, State Teachers College, West Chester, PA. Address in 1929, 313 South High St., West Chester, PA.

SCOTT, MONA DUGAS.
Painter. Born in Augusta, GA. Pupil of Leon Foster Jones. Member: Nat. Assoc. of Women Painters and Sculptors. Add. 1929, 106 Morris St., Yonkers, NY.

SCOTT, R(ALPH) C.
Painter, illustrator, and teacher. Born in Elliston, Newfoundland, Oct. 6, 1896. Pupil of Josph De Camp; Ernest L. Major; Aldro T. Hibbard. Member: Providence Art Club; Providence Water Color Club; Rockport Art Association. Work: "South Court Street," Plantation Club, Providence. Address in 1929, "The Arlington," 41 Angell Street, Providence, RI; summer, Rockport, MA.

SCOTT, WILLIAM EDOUARD.
Painter. Born in Indianapolis, IN, 1884. Pupil of Art Institute of Chicago; Julian and Colarossi Academies, Paris; H. O. Tanner in France. Member: Hoosier Salon; Alumni, Art Institute of Chicago; Chicago Art League. Award: Municipal Art League Traveling Scholarship; Frederick Magnus Brandt prize; special gold medal and Harmon award, Harmon Foundation; Jesse Binga prize, and Eames MacVeagh prize, Chicago Art League. Represented by mural decorations in Evanston, IL; Herron Art Institute, Indianapolis; Fort Wayne (IN) Court House; Lafayette (IN) Court House; Springfield (Illinois) State House; Schools in Institute, WV, and Charleston, WV; First Presbyterian Church, Chicago; Chicago Defender Newspaper Lobby; Binga State Bank, Chicago; Anthony Hotel, Fort Wayne, IN; Edwardsville (IL) National Bank; South Park M. E. Church, Chicago; Paris Salon; Royal Acad., London, England; First National Bank and High School, Michigan City, IN; Peoples Finance Corp. Bank, St. Louis, MO; mural, "Jean Baptiste De Saible," John Shoop School, and mural, Betsy Ross Junior High School, Chicago; one painting owned by the Argentine Government; twelve paintings, City of Port au Prince, Haiti; mural decoration, Century of Progress Exposition, Chicago, IL. Address in 1933, 612 E. 51st Street, Chicago, IL.

SCOTT, WILLIAM J.
Painter. Exhibited water colors at the Penna. Academy of Fine Arts, Philadelphia, 1925. Address in 1926, Compo Road, Westport, CT.

SCOTT, WILLIAM WALLACE.
Painter in water colors. Born in 1819. Died Oct. 6, 1905, in New Rochelle, NY.

SCRIVER, ROBERT MACFIE.
Sculptor. Born in Browning, MT, August 15, 1914. Studied: Vandercook School of Music, M.A. Became a taxidermist; established his own Museum of Montana Wildlife, including a gallery for his clay sculpture and dioramas. Began casting in bronze in 1962; turned to sculpture full-time in 1967. Opened Bighorn Foundry. Work in Glenbow Foundation, Calgary; Whitney Gallery of Western Art, Cody; Montana Historical Society, Helena; Cowboy Hall of Fame, Oklahoma City; Panhandle Plains Museum, Canyon, TX. Awards: Gold medals, Cowboy Hall of Fame, 1969-71, silver medal, 1972; silver medal, National Academy of Western Art, 1973. Specialty is Western animals; commissions of heroic bison and cowboy figures. Member: Cowboy Artists of America; National Sculpture Society; National Academy of Western Art. Medium: Bronze. Address in 1976, Browning, MT.

SCRUGGS, MARGARET ANN.
(Mrs. Carruth Scruggs). Etcher. Born in Dallas, TX, Feb. 18, 1892. Member: Texas Fine Arts Association; Highland Park Art Association; Dallas Art Association; Reaugh Art Club; Southern States Art League; American Federation of Arts; American Artists Professional League; Society of Medalists. Address in 1929, 3715 Turtle Creek Blvd., Dallas, TX; summer, Indian River, MI.

SCRYMSER, CHRISTABEL.
Painter. Born in Brooklyn, NY, May 12, 1885. Pupil of Whittaker, Twachtman, Metcalf, Beck, Fisher; Cooper Union; Pratt Institute. Member: Brooklyn Society of Miniature Painters. Specialty: Miniature painting. Address in 1929, 34 Lewis Place, Rockville Center, NY.

SCUDDER, (ALICE) RAYMOND.
Painter and craftsman. Born in New Orleans, LA. Pupil of Newcomb Art School; New York School of Applied Design; Chase and Mora. Member: New Orleans Artists; American Federation of Arts. Address in 1929, 478 South Grand Avenue, Pasadena, California.

SCUDDER, JANET.
Sculptor. Born in Terre Haute, IN, October 27, 1875. Pupil of Cincinnati Art Academy under Rebisso; Taft in Chicago; MacMonnies in Paris; Academies Vitti and Colarossi in Paris. Member: Associate National Academy of Design; National Sculpture Society, 1904; National Association of Women Painters and Sculptors; National Arts Club; American Federation of Arts. Exhibited at National Sculpture Society, 1923. Awards: Medal, Columbian Expo., Chicago, 1893; honorable mention, Sun Dial Competition, NY, 1898; medal, St. Louis Expo., 1904; honorable mention, Paris Salon, 1911; sculpture prize, National Association of Women Painters and

Sculptors, 1914; silver medal P.-P. Expo., San Francisco, 1915; Chevalier de la Legion d'Honneur, 1925. First American woman to have sculpture bought for the Luxembourg, Paris. Work: Seal for the Association of the Bar of the City of NY; "Japanese Art," facade of Brooklyn Institute Museum; "Frog Fountain," Metropolitan Museum, NY; "Fighting Boy Fountain," Art Institute of Chicago, IL; 3 medallions in gold and 3 in silver, Art Association of Indianapolis, IN; portrait medallions in Congressional Library, Washington, DC; Metropolitan Museum, NY; Musee du Luxembourg, Paris; medal of Indiana Centennial, Minneapolis Institute; "Medal," Rhode Island School of Design, Providence; "Tortoise Fountain," Peabody Institute, Baltimore; "Seated Fawn," Brooklyn Museum; fountain, Public School, Richmond, IN. Fountains in many private estates. Publication: *Modeling My Life*. Address in 1933, Square de Vergennes 279 rue de Vaugirard, Paris, France; c/o The Colony Club, New York, NY. Died in Rockport, MA, June 9, 1940.

SCURIS, STEPHANIE.
Sculptor and educator. Born in Lacedaemonos, Greece, January 20, 1931. Studied at School of Art and Architecture, Yale University, B.F.A. and M.F.A., with Josef Albers. Work: Jewish Community Center, Baltimore; West View Center, Baltimore. Commissions: Sculpture, Bankers Trust Co., New York; lobby sculpture, Cinema I and II, NY. Exhibitions: New Haven Art Festival, 1958-59; Art: USA Traveling Exhibition, 1958, 60; Museum of Modern Art, New York, 1962; Whitney Museum of American Art, New York, 1964; plus others. Awards: Winterwitz Award, Prize for Outstanding Work and Alumni Award, Yale University; Peabody Award, 1961-62; Rinehart Fellowship, 1961-64. Address in 1976, Baltimore, Maryland.

SEABORNE, WILLIAM.
Sculptor. Born in 1849. Died in New York City, March, 1917.

SEABURY, ROXOLI (MRS.).
Painter. Born in 1874. Pupil of D. W. Ross; Robert Reid; and of Knirr in Munich. Student of School of Boston Museum of Fine Arts. Address in 1926, Broadwater Art Academy, Colorado Springs, CO.

SEAGER.
Sculptor. Active in Salem and New Bedford, MA, in 1834, making bronze portrait medallions.

SEAGER, MRS. (SARA) AND MISS.
Miniature and portrait painters. Flourished in NY, in 1834.

SEALEY (or SEALY), ALFRED.
Engraver. Born c. 1815 in NY. He is said to have died about 1868. Sealey was an admirable line engraver and devoted himself to bank note work in his later life. He was active in New York City, 1838-68; with Sealey and Smith, about 1858-60; with the American Bank Note Company, after 1860. In 1860 some very good line illustrations to Cooper's novels are signed "Sealey & Smith Sculpt."

SEAMAN, CHARLES.
Portrait painter in oils and miniatures. Flourished in NY about 1834.

SEAMAN, ELAYNE.
Printmaker. Born on October 27, 1929. Work: Private collections, U.S. and Europe. Commissions: 12 drawings, Scafa-Tornabene Art Publishing Co.; Lithograph, Book-of-the-Month Club's Fine Arts 260 Series. One-man shows: Cary Arboretum, NY Botanical Garden, Millbrook, NY; Bloomingdale's Gallery, Stamford, CT; Hansen Galleries, NYC; Lewis Gallery, Woodstock, NY; Eisenhower Hall, U.S. Military Academy, West Point, NY; Bardavon 1869 Opera House, Poughkeepsie, NY. Exhibited: Rainbow Graphics Gallery, Woodstock, NY; Gallery East, Amagansett, NY; Hansen Galleries, NYC; Uptown Gallery, NYC; Henri Bendel Gallery, NYC; Galerie Mouffe, Paris and Biarritz, France; Salon des Artistes Francais, Grand Palais, Paris; Vassar College, Poughkeepsie, NY; Faber Birren Award Exhibition, Stamford, CT; Berkshire Art Association, Pittsfield, MA; Summergroup Gallery, Mid-Hudson Arts and Science Center, Poughkeepsie, NY; and many more. Address in 1983, Poughkeepsie, NY.

SEARCY, ELISABETH.
Landscape painter and etcher. Born in Memphis, TN. Member: Pen and Brush Club of NY; Southern States Art League; Am. Federation of Arts. Work: Etchings in the Library of Congress, Washington, D.C. Address in 1929, 353 Orleans St., Memphis, TN.

SEARLE, ALICE T.
Miniature painter. Born in Troy, NY, in 1869. Pupil of Art Students League of NY and of the Colarossi Academy, Paris. Member of Brooklyn Artists Guild. Address in 1926, 241 Fenimore St., Brooklyn, NY.

SEARLES, STEPHEN.
Sculptor, designer, and teacher. Born in NYC, June 10, 1914. Studied at Art Students League, with George Bridgman, Frank DuMond, and Reginald Marsh; Grand Central School of Art; Corcoran School of Art; Fontainebleau, France. Member: Salma. Club; Copley Society; North Shore Arts Association; American Veterans Society of Art; American Artists Professional League; American Federation of Arts. Work: Sculpture, Grassy Gallery, Biarritz, France; Army Medical Museum, Washington, DC; many portrait busts. Exhibited: Corcoran Gallery of Art; Grand Central Art Gallery; Montclair Art Museum, 1938-52; Ogunquit Art Center; California Palace of

the Legion of Honor; Allied Artists of America, 1950, 51. Awards: Salmagundi Club, 1952; American Artists Professional League, 1976, 77; others. Position: Instructor, Newark School of Fine and Industrial Arts, Newark, NJ, at present. Address in 1982, Boston, MA.

SEARS, ELINOR LATHROP.
Sculptor and painter. Born in Hartford, CT, September 26, 1899. Pupil of Hale; Logan; Mora; and Calder. Member: Hartford Art Society. Address in 1933, Old Lyme, CT.

SEARS, PHILIP SHELTON.
Sculptor of busts, memorials, and statues. Born in Boston, MA, November 12, 1867. Pupil of Daniel C. French and Boston Museum of Fine Arts School; studied law at Harvard Law School. Work: Indian statue, Boston Museum of Fine Arts; State House, Boston; American Indian Museum, Harvard; County Court House, NY; Harvard Varsity Club, Cambridge, MA; Harvard Medical School, Cambridge, MA; White House, Washington, DC; Royal Academy of Art, London; parks in Manchester, MA, San Francisco, CA, and Philadelphia, PA. Member: Boston Guild of Artists; North Shore Arts Association; Boston Sculpture Society; American Federation of Arts; Copley Society, Boston; National Sculpture Society. Turned to sculpture in 1919. Address in 1953, Brookline, MA. Died in Brookline, MA, March 1953.

SEARS, SARAH C(HOATE).
(Mrs. J. Montgomery Sears). Painter. Born in Cambridge, MA, May 5, 1858. Pupil of Ross Turner; Joseph De Camp; Dennis M. Bunker; Edmund C. Tarbell; George de Forest Brush. Member: NY Water Color Club; Copley Society, 1891; National Arts Club; Philadelphia Water Color Club; Boston Water Color Club; Boston Society of Arts and Crafts (life). Awards: Evans prize, American Water Color Society, 1893; medal, Columbian Expo., Chicago, 1893; hon. mention, Paris Expo., 1900; bronze medal for water color, Pan.-Am. Expo., Buffalo, 1901; silver medal for water color, Charleston Expo., 1902; silver medal, St. Louis Expo., 1904. Died in 1935. Address in 1929, 12 Arlington St., Boston, MA.

SEARS, TABER.
Mural painter. Born in Boston, MA, 1870. Pupil of Boston Museum School; Julian Acad. in Paris under Constant, Laurens, and Merson. Member: NY Archit. League, 1899; NY Water Color Club; American Water Color Society; National Society of Mural Painters; Artists Aid Society; NY Municipal Art Society; Century Association; MacDowell Club. Award: Bronze medal, St. Louis Expo., 1904; Delano prize, American Water Color Society, 1926. Work: Altar paintings, Chapel of the Intercession, St. Thomas's Church, St. James Church, First Presbyterian Church, New York City; and in Trinity Church, Buffalo, NY. Mural paintings, Grace Church Choir School, NY, and City Hall, New York; Church of the Nativity and Church of the Holy Innocents, Brooklyn, NY. Died Oct. 18, 1950, in NYC. Address in 1929, 96 Fifth Ave.; h. 1060 Park Ave., New York, NY.

SEATON, C. H.
Painter. Born in Monson, MA, in 1865. Self-taught. Member: Washington Society of Artists; Washington Landscape Club. Address in 1926, Glencarlyn, VA.

SEAVEY, THOMAS.
Figurehead carver. Active in Bangor, ME, during the first half of the 19th century. In partnership with his son, William L. Seavey, by 1843.

SEAVEY, WILLIAM L.
Figurehead carver. Active in Bangor, ME, 1843, with his father, Thomas Seavey.

SEAWELL, H(ENRY) W(ASHINGTON).
Painter, illustrator, and teacher. Born in San Francisco, CA. Pupil of Laurens and Constant in Paris. Member: American Art Association of Paris; Bohemian Club, San Francisco; Pacific Art Association of California. Address in 1929, 1617 California St., San Francisco, CA.

SEDGWICK, FRANCIS (or FRANCES) MINTURN.
Sculptor and museum official. Born in New York City, 1904. Studied at Harvard University and at Trinity College (Cambridge University). Works: Pioneer Monument, Colma, California; heroic statue of cowboy, Earl Warren Showgrounds, Santa Barbara, California; others in England, San Francisco, and Washington. Specialty: Western monuments. Vice president of the Museum of Art in Santa Barbara, California. Address in 1968, Santa Ynez Valley, California.

SEEBOLD, MARIE M.
See Molinary, Marie M. Seebold.

SEGAL, GEORGE.
Sculptor. Born in NYC, November 26, 1924. Studied at NYU, 1950, B.S.; Rutgers University, 1963, M.F.A. Works: Stedelijk; Albright; Mint Museum of Art, Charlotte, NC; Art Institute of Chicago; Museum of Modern Art; Newark Museum; National Gallery of Canada, Ottawa; Moderna Museet, Stockholm, Sweden; Art Gallery of Toronto, Canada; Whitney; Walker. Exhibitions: Hansa Gallery, NYC; Ileana Sonnabend Gallery, Paris; Sidney Janis Gallery, NYC; Art Gallery of Toronto, 1967 (three-man, with Jim Dine, Claes Oldenburg); Boston Arts Festival, 1956; Jewish Museum; Whitney; American Federation of Arts; VII & IX Sao Paulo Biennials, 1963, 67; Moderna Museet, Stockholm, Sweden,

American Pop Art; Corcoran Biennial; Palais des Beaux-Arts, Brussels, 1965; Guggenheim; Rhode Island School of Design, Recent Still Life, 1966; Art Institute of Chicago; Walker; L.A. County Museum of Art, American Sculpture of the 60's; Museum of Modern Art, the 1960's; Carnegie; Trenton State, Focus on Light. Awards: Walter K. Gutman Foundation Grant, 1962; Art Insti. of Chicago, 1st Prize, 1966. Represented by Sidney Janis Gallery, NYC. Address in 1982, South Brunswick, NJ.

SEIBEL, FRED O.
Cartoonist. Born in Durhamville, NY, Oct. 8, 1886. Pupil of Kenyon Cox; Albert Sterner; Frank V. DuMond. Died in 1968. Address in 1929, Times Dispatch, 107 South 7th Street; h. 414 North Sheppard St., Richmond, VA.

SEIBERT, EDWARD.
Sculptor. Worked in New York City, 1856.

SEIDEL, EMORY P.
Sculptor. Member: Illinois Academy of Fine Arts; Oak Park Art League; Chicago Painters and Sculptors; Chicago Gallery of Art; Palette and Chisel Club. Award: John C. Shaffer prize, Art Institute of Chicago, 1925; Charles Worcester prize, Palette and Chisel Club, 1926; gold medal, Palette and Chisel Club, 1927; gold medal, Oak Park Art League, 1929. Address in 1933, Chicago, IL; h. River Forest, IL.

SEIDEN, ART.
Illustrator. Born in Brooklyn, NY, in 1923. Received his B.A. degree from Queens College. His first published illustration was for a children's book, *Three Mice and a Cat*, which was published in 1957 by Grosset and Dunlap. His work has been on display at the Lotos Club in NYC, University of Minnesota (Kerlan Collection), and the Watercolor Society at the National Academy of Design, where he is a member.

SEIDENECK, GEORGE J.
Painter. Born in Chicago, Illinois, in 1885. Pupil of Walter Thor and von Marr. Member: Chicago Art Club; Chicago Society of Artists; Chicago Palette and Chisel Club. Work: "Portrait of Judge Seaman," Federal Building, Chicago. Address in 1926, Tree Studio Building, 4 East Ohio St., Chicago, Illinois.

SEIDLER, DORIS.
Painter, etcher, and engraver. Born in London, England, in 1912. Studied with Stanley W. Hayter. Awards: National Assoc. of Women Artists; Washington Watercolor Club; Chicago Society of Etchers. Coll.: Seattle Art Museum; Library of Congress; Hofstra College, NY; Philadelphia Museum of Art.

SEIPP, ALICE.
Painter and illustrator. Born in 1889, in New York, New York. Pupil of Art Students League of New York; and of Ossip Linde, Douglas Volk, B. W. Clinedinst and Jane Peterson. Member: National Association of Women Painters and Sculptors; N.Y. Water Color Club; Pen and Brush Club; Am. Fed. of Arts. Art editor and artist of The Woman's Insti. Address in 1929, care of The Woman's Institute, Scranton, PA.

SEISSER, MARTIN B.
Painter. Born in Pittsburgh, PA., in 1845. He went to Europe in 1868 and studied in Munich. On his return he opened his studio in Pittsburgh and painted many portraits. His picture, "The Crusaders," painted in 1875, was stolen in 1878 at an auction sale in Philadelphia, PA.

SEKULA, SONIA.
Painter. Born in Lucerne, Switzerland, April 8, 1918. Studied: Art Students League; in Italy; and with Morris Kantor and Kurt Roesch. Collections: San Francisco Mu. of Art; Brooklyn Mu.; and in private collections. Exhibited: Brooklyn Museum; Santa Barbara Museum of Art; Nebraska Art Assoc., 1949; Museum of New Mexico, 1951; University of IL. 1952; Paris, France, 1948; Sao Paulo, Brazil, 1948; Betty Parsons Gallery, 1948, 49, 51, 52 (one-woman). Address in 1953, 206 East 51st Street, New York, New York.

SEL, JEAN B.
Portrait painter in oils and miniatures. Flourished in 1820-1830 in New Orleans. A portrait in oil by Sel of Gov. A. B. Romans is in the Louisiana State Museum. Died January 28, 1832.

SELDEN, DIXIE (MISS).
Portrait and landscape painter and illustrator. Born in Cincinnati, OH. Pupil of Cincinnati Art Academy under Duveneck; W. M. Chase; H. B. Snell. Member: Cincinnati Woman's Art Club; National Association of Women Painters and Sculptors; Cincinnati MacDowell Society. Awards: Eagan prize, landscape, National Association of Women Painters and Sculptors, 1929. Died in 1936. Address in 1933, No. 5, The Deventer Bldg.; 1203 East McMillan St., Walnut Hills, Cincinnati, OH.

SELDEN, HENRY BILL.
Painter, etcher, and teacher. Born in Erie, Pennsylvania, Jan. 24, 1886. Pupil of Art Students League of NY; Charles Woodbury and Birge Harrison. Member: Lyme Art Association; American Water Color Society; New York Water Color Club; Allied Artists of America; Artists' Fund Society; Connecticut Academy of Fine Arts; National Arts Club; St. Botolph; Salma. Club. Award: Flagg prize, Connecticut Academy of Fine Arts, 1929, honorable mention, 1931. Professor of Fine Arts, Connecticut College. Died in 1934. Address in 1933, 38 Chapel St., New London, Connecticut.

SELETZ, EMIL.
Sculptor. Born in Chicago, IL, February 12, 1909. Studied briefly with Jo Davidson and George Grey Barnard. Work: Einstein (heroic bronze), Albert Einstein College of Medicine, NY; heroic bust of Lincoln, San Jose Court House, CA; Franklin Roosevelt (heroic bust), President L. B. Johnson Library, TX. Exhibited at Painters and Sculptors Club, 1952-68; California Art Club, 1955-68; University of Southern California, 1968 (one-man); others. Awards: Gold medal, Artists of the SW, 1952, 68; first in sculpture, Painters and Sculptors Club of California, 1970. Member: California Art Club; Painters and Sculptors Club of California; Artists of the SW. Works in bronze. Address in 1982, Los Angeles, CA.

SELEY, JASON.
Sculptor. Born in Newark, NJ, May 20, 1919. Studied at Cornell University, 1936-40, B.A.; Art Students League, with Ossip Zadkine, 1943-45; Ecole National Superieur des Beaux-Arts, Atelier Gaumond. Works: University of California; Dartmouth College; Museum of Modern Art; Newark Museum; National Gallery of Canada, Ottawa; Aldrich Museum of Contemporary Art; Everson Museum of Art, Syracuse, NY; Art Gallery of Toronto, Toronto, Canada; Whitney. Exhibited: American-British Art Center, NYC; AAA Gallery, NYC; Barone Gallery, NYC; The Kornblee Gallery, NYC; Whitney Sculpture Annuals, 1952, 53, 62, 64, 66, 68-69; Newark Museum; Guggenheim; Festival of Two Worlds, Spoleto, Italy, 1962; Battersea Park, London, International Sculpture Exhibition, 1963; Documenta III, Kassel, West Germany, 1964; Museum of Modern Art. Awards: U.S. State Department Grant, 1947-49; Fulbright Fellowship (France), 1949; Silvermine Guild, First Prize for Sculpture, 1962. Member: Federation of Modern Painters and Sculptors; Sculptors Guild; College Art Association of America; New Sculpture Group. Taught: Le Centre d'Art, Port-au-Prince, Haiti, 1946-49; Hofstra University, 1953-65; NYU, 1963-67; Dartmouth College, 1968; Cornell University, from 1968. Address in 1982, Ithaca, NY.

SELIGER, CHARLES.
Painter. Born June 3, 1926, in NYC. Studied at Works Progess Adm. Art School, Jersey City, NJ. Exhibited at Art of this Century Gallery, NYC, 1945; Jersey City Museum; Virginia Museum of Fine Arts, Richmond; Art Institute of Chicago; Newark Museum; Brooklyn Museum; Museum of Modern Art, NY; Smithsonian Institution; Munson-Williams-Proctor Institute; Cornell; Whitney; Albright-Knox Art Gallery, Buffalo, NY; Jacksonville Art Museum; Nassau Community College; Crispo Gallery, NYC, and Makler Gallery, Philadelphia (both one-man); others. Work: Seattle Art Museum; Whitney; Munson-Williams-Proctor Institute; Baltimore Museum of Art; Museum of Modern Art; Vassar College; the Hague; Hirshhorn Museum; Metropolitan Museum

of Art; and private collections. Taught at Mt. Vernon Art Center, 1951. Media: Oil, acrylic. Address in 1984, Mt. Vernon, NY.

SELIGMAN, ALFRED L.
Sculptor. Born in New York, January 29, 1864. Pupil of Paul Nocquet. Address in 1910, 59 East 59th St.; h. 16 East 60th St., NYC.

SELINGER, JEAN PAUL.
Painter. Born in 1850. His painting "The Water Seller" is in the Boston Museum of Fine Arts. He died on Sept. 11, 1909, in Boston, MA.

SELLERS, MARY (OR MINNIE).
Painter. Born in Pittsburgh, PA, Nov. 23, 1869. Pupil of Alexander Robinson and August Hennicott in Holland. Member: Associ. Artists of Pittsburgh; Nat. Assoc. of Women Painters and Sculptors. Address in 1929, 6216 Howe St., Pittsburgh, PA.

SELLSTEDT, LARS GUSTAF.
Painter. Born on April 30, 1819, at Sundsvall, Sweden. He came to the U.S. in 1834 and settled in Buffalo, NY, in 1842. He devoted himself chiefly to portraiture, and his works include portraits of G. W. Clinton, M. Fillmore, B. Fitch, and G. Cleveland. He was elected an associate member in 1871 of the National Academy, and an Academician in 1874. For his life see "From Forecastle to Academy," published in Buffalo, NY, in 1904. Died June 4, 1911 in Buffalo, NY.

SELTZER, ISADORE.
Illustrator. Born in St. Louis, MO, in 1930. Attended Art Center College of Design and Chouinard Art Institute. He illustrates for *McCall's*, *Playboy*, *Redbook*, *Cosmopolitan*, *Seventeen*, *Leisure*, and others. His works have been exhibited at the Louvre, the Whitney Museum and Benson Museum in Bridgehampton, NY.

SELTZER, OLAF CARL.
Painter. Born in Copenhagen, Denmark, August 14, 1877. Studied at Technical Institute of Copenhagen. Came to Great Falls, MT, in 1892. Worked on a ranch; apprentice machinist for Great Northern Railroad; worked as railroad and locomotive repairman until 1926. Met Charles Russell, who taught and encouraged him. Stayed in NYC, 1926 and 27, studying paintings in museums and galleries. Executed over 2,500 oils and water colors, largely of Western subjects. In collections of Gilcrease Institute of Art, Tulsa, OK; Montana Historical Society; Great Falls Clinic, MT; Harmsen Collection. Died in Great Falls, MT, in December, 1957.

SENAT, PROSPER L.
Painter. Born in Germantown, Philadelphia in 1852. Studied in Philadelphia, NY, London and Paris.

Specialty: Landscapes in water colors. For years he painted on the Brittany coast and at Cornwall, England. Died in Sept. 1925, in Germantown.

SENCE, LEONARD.
Sculptor in plaster and marble. Worked in New York City from 1848-52. With Victor Flagella from 1848-50. Media: Plaster and marble.

SENCE & FLAGELLA.
Sculptors. Active in NYC, 1848-50. Exhibited plaster statuary at the American Institute, 1848 and 1849; won diploma in 1848. Worked in plaster and marble.

SENECAL, RALPH L.
Painter and illustrator. Born in Bolton, Canada, Aug. 3, 1883. Pupil of National Acad. of Design. Member: CT Society of Artists; Springfield Art Club; Springfield Art League; Connecticut Academy of Fine Arts. Address in 1929, 35 Squier St., Palmer, MA.

SENSENEY, GEORGE.
Painter and etcher. Born in Wheeling, WV, Oct. 11, 1874. Pupil of Corcoran Art School in Washington, under Howard Helmick; Laurens and Constant in Paris. Member: Chicago Society of Etchers; Salma. Club; Societe des Graveurs en Couleurs; Brooklyn Society of Etchers. Award: Silver medal, P. P. Expo., San Francisco, 1915. Work: Library of Congress, Washington, DC; South Kensington Museum, London. Died 1943. Address in 1929, The Marvellum Co., Holyoke, MA; 65 New South St., Northampton, MA.

SENYARD, GEORGE.
Painter. Died Jan. 18, 1924, in Olmstead Falls, OH. He toured the country with Lincoln, and made many sketches and drawings of him during his political debates.

SEPESHY, ZOLTAN L.
Painter and teacher. Born in Kassa, Hungary, Feb. 24, 1898. Studied in Acad. of Fine Arts, Budapest, Hungary, M.F.A.; and in Vienna and Paris. Member: Scarab Club; Nat. Soc. of Mural Painters; American Artists Prof. League; Scarab Club, Detroit, MI. Awards: Prizes, Carnegie Inst., 1947; Detroit Inst. of Art, 1925, 30, 36, 38, 40, 45; The Patteran, 1939; Am. Acad. of Arts and Letters, 1946; medal, Penna. Acad. of Fine Arts, 1946; National Acad. of Design, 1952. Represented by 2 murals, General Motors Building, Detroit; six murals, High School, Fordson, MI; paintings, Art Institute of Detroit; Art Inst. of Chicago; Toledo Mu. of Art; Albright Art Gallery; Wichita Art Mu.; San Diego Fine Arts Society; City Art Mu. of St. Louis; Butler Art Inst.; Penna. Acad. of Fine Arts; Dallas Museum of Fine Arts; Walker; Flint Institute; Cranbrook Acad. of Art Mu.; many others. Exhibited: Penna. Acad. of Fine Arts; Whitney; Art Inst. of Chicago; Detroit Inst. of Art; Toledo Mus. of Art; Carnegie. Author and illus., *Tempera*,

1946; contributor to art magazines. Resident instructor of painting and drawing, Cranbrook Acad. of Art, from 1932. Address in 1953, 3 Academy Road, Bloomfield Hills, MI; summer, Bridgewater, CT.

SERGEANT, EDGAR.
Painter. Born in NYC, Nov. 25, 1877. Pupil of Du Mond; George Pearse Ennis; Gifford Beal. Member: Salma. Club; American Fed. of Arts. Address in 1929, 160 Satterthwaite Ave., Nutley, NJ; summer, North Hatley, P.Q., Canada.

SERPELL, SUSAN WATKINS.
(Mrs. Goldsborough Serpell). Painter. Born in CA in 1875. In 1912 she was elected an Assoc. of the Nat. Acad. of Design, and received many medals and awards. Died June 18, 1913.

SERRAO, LUELLA VARNEY (MRS.).
Sculptor. Born in Angola, NY, 1865. Work: "An Archbishop of Odessa," in Roman Catholic Cathedral, Odessa, Russia; "Bust of Senator Rice," State Capitol of Minnesota; "Bust of Archbishop Wigger," Seaton Hall, Newark, NJ; busts of Mark Twain and Mr. Brett, Cleveland Public Library; "Monument of Archbishop Rappe," Catholic Cathedral, Cleveland, OH. Address in 1926, Cleveland, OH.

SERRON HYPPOLITE, VICTOR VALINTIN.
Painter. Born Aug. 21, 1801, in Camdebec, Florence. Painted landscapes and river views in and about New Orleans. Died Sept. 1, 1897, in Paris, France.

SERVER, J. WILLIAM.
Painter. Born PA, 1882. Pupil of Deigendesch; Chase; and Colarossi. Mem.: Art Students League, Philadelphia. Address in 1926, 43 South 18th Street, Philadelphia, PA.

SERZ, JOHN.
Born c. 1810 in Bavaria. Died in Philadelphia about 1878, as the result of a fall. Serz came to Philadelphia about 1850; he engraved several large historical plates and furnished a number of subject plates for *Sartain's Magazine* and other publications of that city.

SETON, ERNEST THOMPSON.
Sculptor, painter, illustrator, and writer. Born Ernest Thompson in South Shields, England, August 14, 1860; lived in Canada. Studied at Toronto Collegiate Institute; the Royal Academy in London; in Paris, pupil of Bouguereau, Ferrier, Mosler and Gerome, 1890-96. Work in Museum of New Mexico. Member: National Institute of Arts and Letters. Author and illustrator of *Mammals of Manitoba*, 1886; *Birds of Manitoba*, 1891; *Wild Animals I Have Known*, 1898; *The Birchbark Roll*, 1906; *Indian Lore*, 1912; *Woodcraft Indians*, 1915; *Gospel of the Red Man*, 1936; *Art Anatomy of Animals*; others. Illustrator of the *Century*

Dictionary; lectured on Indians and woodcraft. Served as Chief Scout of the Boy Scouts, to 1915; founded the College of Indian Wisdom near Santa Fe; Chief of Woodcraft League of America. Specialty was animal subjects. Address in 1929, Greenwich, CT. Died near Santa Fe, NM, in 1946.

SEVERANCE, JULIA GRIDLEY.
Sculptor, etcher, and teacher. Born in Oberlin, OH, Jan. 11, 1877. Pupil of Art Students League of NY. Member: Cleveland Woman's Art Club; Florida Society of Arts and Sciences. Work: "Rice Memorial Tablet," Oberlin Conservatory of Music, Oberlin College, OH; etching in Print Department, Library of Congress, Washington, DC; Cobb Memorial Tablet, Warner Hall, Oberlin, Ohio; Leffingwell Tablet, St. Mary's School, Knoxville, Illinois; portrait of "Prof. G. F. Wright," Allen Memorial Museum, Oberlin, Ohio. Address in 1953, San Diego, California.

SEWALL, BLANCHE HARDING.
(Mrs. Cleveland Sewall). Painter. Born in Ft. Worth, Texas, May 12, 1889. Pupil of J. C. Tidden and Fred Wagner. Member: Southern States Art League. Address in 1929, 7B The Beaconfield, Houston, Texas.

SEWARD, C. A.
Painter, etcher, lecturer, and lithographer. Born in Chase, KS, March 4, 1884. Pupil of Reid, Stone, and Sandzen; mostly self-taught. Member: Wichita Art Association; Wichita Artists Guild; California Print Maker's Society. Award: First prize, Kansas City Art Institute, 1924; silver medal, Mid West Artists, 1927; gold medal, Mid West Artists, 1928. Work: "The Acropolis," Kansas Masonic Grand Lodge; "Wichita in 1869," Sedgwick Co. Historical Society; lithographs in Los Angeles Museum of History and Art; Springfield (MA) Public Library; Smoky Valley Art Club, Lindsborg, KS; High School Art Club, Twentieth Century Club, Wichita, KS; California State Library; Kansas Federation of Women's Clubs; New Mexico Federation of Women's Clubs; Vanderpoel Memorial High School, Chicago; Mulvane Art Museum, Topeka, KS; Bibliotheque Nationale, Paris. Died in 1939. Address in 1929, 1534 North Holyoke Ave., Wichita, KS.

SEWELL, AMANDA BREWSTER.
Painter. Born in Essex County, New York. Studied at Art Students League of New York; Julian and Carolus Duran, Paris. Began painting in Paris in 1886; exhibited at Paris Salon, 1886, 87, 88; awarded Dodge prize, National Academy of Design, 1888; Clarke prize, same, 1903; bronze medal, Chicago Exposition. Principal works: Portraiture in the style and spirit of the early English masters. Elected an Associate of the National Academy of Design. Address in 1926, 33 West 67th Street, New York City.

SEWELL, AMOS.
Illustrator. Born in San Francisco, CA, in 1901. Went to the California School of Fine Arts before moving East to attend the Art Students League and Grand Central School of Art, where he studied under Harvey Dunn. His career began in 1936 with an illustration for *Country Gentleman*. He contributed for over 20 years to *The Saturday Evening Post*; his work was very popular in the 1940's and 1950's, earning him several awards from the Society of Illustrators and Art Directors' Club. His painting entitled, "What It Is Like to Die," won a Special Art Award in 1944.

SEWELL, HELEN MOORE.
Painter, etcher, and illustrator. Born in Mare Island, CA, June 27, 1896. Pupil of Frederick Baker; Otto Beck; Mac Herrmann; C. W. Hawthorne; and A. Archipenko. Member: New Haven Paint and Clay Club; NY Water Color Club. Died in 1957. Address in 1929, 52 Heights Road, Ridgewood, NJ; summer, Burnt Hill, NY.

SEWELL, ROBERT VAN VORST.
Painter. Born in New York in 1860. Studied under Lefebvre and Boulanger, Paris, 1883-87. Won 1st Hallgarten prize, National Academy of Design, 1888; silver medal, Buffalo Exposition, for exhibit of designs of mural paintings, etc. His mural painting, "The Canterbury Pilgrims," in the great hall of Georgian Court, Lakewood, and several others are widely known; he painted "The Story of Psyche," a series of lunette decorations in the Palm Room of the St. Regis Hotel, NY. Elected Associate of the National Academy in 1902. Member of Society of Mural Painters; Architectural League of NY. Died Nov. 18, 1924, in Florence, Italy.

SEXTON, FREDERICK LESTER.
Painter, sculptor, illustrator, etcher, lecturer, and teacher. Born in Cheshire, CT, September 13, 1889. Studied: Yale School of Fine Arts, B.F.A.; also a pupil of Sergeant Kendall and Edwin Taylor. Member: New Haven Paint and Clay Club; Lyme Art Association; Salma. Club; CT Academy of Fine Arts. Awards: Winchester traveling fellowship, Yale University, 1915; second prize, New Haven Paint and Clay Club, 1923; Meriden Arts and Crafts Club, 1941; CT Academy of Fine Arts, 1927, 38; Carney Prize, Hartford, CT, 1944. Exhibited: National Acad. of Design; Salma. Club; Lyme Art Association; Meriden Arts and Crafts Club; Lyman Allyn Museum; Bridgeport Art Association; New Haven Paint and Clay Club; East Hampton (Long Island) Art Association. Address in 1953, New Haven, CT.

SEYFFERT, HELEN F.
(Mrs. L. Seyffert). Painter. Member of Fellowship of the Penna. Academy of Fine Arts. Address in 1926, care of Chicago Art Institute, Chicago, IL.

SEYFFERT, LEOPOLD (GOULD).
Painter. Born in California, MO, Jan. 6, 1887. Studied at Penna. Academy of Fine Arts; pupil of William M. Chase. Member: Associate National Academy of Design, 1916; Academician National Academy of Design, 1925; National Association of Portrait Painters; American Federation of Arts; Philadelphia Sketch Club. Awards: Fellowship prize ($100), Penna. Academy of Fine Arts, 1913; hon. mention, 1913, popular prize, 1930, Carnegie Institute, Pittsburgh; gold medal, Philadelphia Art Club, 1915; silver medal, P.-P. Expo., San Francisco, 1915; Beck gold medal, 1918, Temple gold medal, 1921, Stotesbury gold medal, 1926, Lippincott prize, 1929, Penna. Academy of Fine Arts; Altman prize ($500), and first Hallgarten prize, 1918, Proctor prize, 1921, Isidor medal, National Academy of Design; Palmer gold medal, 1923, Logan gold medal, 1924, Hearst prize, 1924, Art Institute of Chicago; silver medal, Municipal Art League of Chicago; gold medal, Sesqui Centennial Expo., Philadelphia, 1926. Work: "Model Resting," Art Institute of Chicago; "Portrait of John G. Johnson" and "Myself," Corcoran Gallery, Washington, DC; "An Old Spanish Woman," Metropolitan Museum of Art; "Dr. Holland," Carnegie Institute, Pittsburgh; "Lacquer Screen," Penna. Academy of Fine Arts; "Myself," Detroit; "Myself," Chicago; "Nude with Oriental Background," Harrison Gallery, Los Angeles Museum; "In My Studio," Ranger purchase, Brooklyn Museum. Has exhibited nationally. Died in 1956. Address in 1953, 1 West 67th Street, New York, NY; h. Easton, CT.

SEYLER, DAVID WOOD.
Craftsman, sculptor, painter, designer, lithographer, and educator. Born in Dayton, KY, July 31, 1917. Studied at Cincinnati Art Academy; Art Institute of Chicago, B.F.A.; University of Chicago; and with William Hentschel, Francis Chapin, Emil Zettler and others. Member: Modern Art Society; Crafters Club, Cincinnati, OH; Nebraska Arts Council; Nebraska Art Association; College Art Association of America; fellow, International Society of Arts and Letters. Awards: Prizes, Syracuse Museum of Fine Arts, 1938; Trebilcock prize, 1938; Wood Foundation Travel Grant, Italy, 1959-60; University of Nebraska Foundation Grant, England, 1971-72. Work: University of Chicago; Syracuse Museum of Fine Arts; Cincinnati Museum Association; murals, Philippine Island Base, U.S. Navy; Great Lakes Naval Station; designer and sculptor, Nebraska State Centennial Medal and University of Nebraska Centennial Medal; tapestry, Grace United Methodist Church, Lincoln, NE. Exhibited: Syracuse Museum of Fine Arts, 1938-41; Art Institute of Chicago, 1939, 44 (one-man); NY World's Fair, 1939; Loring Andrew Gallery, Cincinnati, 1943 (one-man); Cincinnati Museum Association, 1939-46. Lectures: Contemporary Ceramics. Positions: Sculptor, designer, Rookwood Pottery, Cincinnati, OH, 1936-39; president and director,

Kenton Hills Porcelains, Erlanger, KY, 1939-45; art director, S. Belvedere Pottery, Lake Geneva, WI, 1945-49; professor of sculpture and head of crafts department, Univer. of NE, Lincoln, from 1948. Address in 1982, Lincoln, NE.

SEYMOUR, JOSEPH H.
Engraver. Probably related to Samuel Seymour. Joseph H. Seymour was in the employ of Isaiah Thomas, at Worcester, MA, as early as 1791. The Bible published by Thomas in that year contains thirty-two plates by Seymour, variously signed J. H., Jos. and J. Seymour, and in the printer's advertisement Thomas writes: "These plates were engraved in his Office (Thomas's) in this town in 1791. . . and the Editor doubts not but a proper allowance will be made for work engraved by an artist who obtained his knowledge in this country, compared with that done by European Engravers who have settled in the U.S." Seymour was thus evidently trained to his art in the U.S. and must have been really at work in Worcester previous to 1791.

SEYMOUR, RALPH FLETCHER.
Illustrator, etcher, and teacher. Born in Milan, IL, 1876. Pupil of Nowottny and Meakin, Cincinnati; also studied in Paris. Member: Chicago Society of Illustrators; Cliff Dwellers; National Arts Club. Award: Cunningham prize for best group of etchings. Etchings in various art museums. Represented in Bibliotheque Nationale, Paris. Instructor, decorative illustration, Chicago Art Institute, 1909-18. Address in 1929, 410 Michigan Blvd., Chicago, IL; home, Ravinia, Lake County, IL.

SEYMOUR, SAMUEL.
Engraver of portraits, located in Philadelpia, Pennsylvania between 1797-1882. In 1823, as a draftsman, he accompanied Major Stephen H. Long on his exploring expedition into the Yellowstone region, and nothing later is known of him.

SGOUROS, THOMAS.
Illustrator. Born in Chicago, IL, 1927. Went to the MA College of Art for a year and completed his studies at the R.I. School of Design under Joseph J. C. Santoro, John Frazier, and Harvey Stein. His first piece was published in 1949 while he was still a student. Since that time his artwork has earned him many awards and been shown in major museums nationwide. The Museum of Fine Arts in Jacksonville, FL, and the R.I. School of Design Museum of Fine Arts have his work in their permanent collections. A participant in the Lecture Series at the Society of Illustrators, he is currently the chairman of the design division at R.I. School of Design.

SHACKLEFORD, SHELBY.
Painter and etcher. Born in Halifax, VA, 1899. Pupil of Ross Moffett and Othon Friesz. Member: Society of

Independent Artists; Provincetown Art Association. Awards: Two scholarships, Maryland Institute, Baltimore. Represented in print division, New York Public Library; Fifty Prints of the Year, 1932. Address in 1933, 439 West 123rd Street, New York, NY; summer, Provincetown, MA.

SHAFER, L. A.
Painter, etcher, and illustrator. Born in Geneseo, IL, Nov. 17, 1866. Pupil of Art Institute of Chicago. Member: Society of Illustrators, 1911; American Federation of Arts. Illustrator of *The Shock of Battle*, by Vaux; *The Road to Glory*, by Powell; *Heading North*, by Barbour; posters of the Great War. Address in 1933, 67 Perth Avenue, New Rochelle, NY.

SHAFTENBENG, LEWIS.
Miniature painter. Flourished in 1783, in Baltimore, MD.

SHAGIN, ALEX.
Sculptor and medallist. Born in USSR, c. 1948. Emigrated to U.S., 1979. Studied: Leningrad Fine and Decorative Art School, USSR, 1966-72. Exhibited: Numerous group shows in USSR, 1974-77; Young Leningrad Artists, Finland, 1977; Olympic Designs, Montreal, Canada, 1976; Leningrad Artists, Gdansk, Poland, 1977; Los Angeles Art Festival for Russian Newcomers, 1980; one-man show, Santa Barbara University, 1982; FIDEM Medallic Art Congress, Florence, Italy, 1983; Numismatic Society, NYC, 1983; American Medallic Sculpture Association Show, NYC, 1983. Commissions: "Peter the Great—1972," "Decembrists—1825-1975," "Victory Day—1945-1975," "Space Mission Apollo-Sojuz 1975," "Michelangelo-500," 1975, "Titian-400," 1976, "Rubens," 1977, all commemorative medals for The Leningrad Mint; designed commemorative coins for 1980 Moscow Olympics, 1975-77; three medals designed for FIDEM-77 in Budapest, Hungary; three medals, "Prophets Awards," for Greater Los Angeles Federation Council, 1980-82; "Anatoly Shcharanscky," medal, 1983; "Solidarnosc" (Solidarity), medal, 1983; "1984 Olympic Games," Los Angeles, 1983-84. Address in 1984, Los Angeles, CA.

SHAHN, BEN.
Illustrator. Born in Kovno, Lithuania, in 1898. Came to America in 1906. He worked as a lithographer's apprentice until 1930 when he completed his formal education at NYU, City College of NY, and the National Academy of Design. One of America's most renowned artists, a traveler of Africa and Europe, his work is in private collections and museums around the world. He has earned innumerable prizes, including many gold medals from the Art Directors' Club. His illustrations have appeared in *Fortune*, *Time*, *Seventeen*, *Esquire*, and *Harper's*, on posters for the Office of War Information and at Syracuse

University, where his famous interpretation of the Sacco-Vanzetti trial has been translated into a wall-sized mosaic. Died in 1969.

SHALER, FREDERICK.
Painter. Born at Findlay, OH, on December 15, 1880. Studied with Chase in NY and had a studio for years in that city. He died December 27, 1916, in Taormina, Italy.

SHALLUS, FRANCIS.
Engraver. Born in Philadelphia, PA, in 1773. He was the son of Jacob Shallus, an officer in the Revolutionary War. As a young man Francis Shallus was prominent in local politics, and in 1805 he was captain of the First Light Infantry, of Philadelphia. His profession is given as engraver from 1797 to 1821. He died in Philadelphia in 1821.

SHANE, FREDERICK.
Painter and teacher. Born in Kansas City, MO, Feb. 2, 1906. Pupil of Randall Davey. Member: Kansas City Society of Artists; Society of Independent Artists; Salons of America. Award: Bronze medal, Mid-Western Exhibition, Kansas City, 1927; Post Dispatch prize, St. Louis, 1929. Address in 1933, 917 West 38th Street, Kansas City, MO.

SHANNON, HOWARD J(OHNSON).
Painter and illustrator. Born in Jamaica, NY, May 30, 1876. Pupil of Pratt Institute under Herbert Adams and F. V. Du Mond. Illustrated nature and science sections, *Century Dictionary*; Zoological Society Bulletins; writer and illustrator of science articles in *St. Nicholas*, *Harper's Magazine*, *Scientific Monthly*, and *Journal of the American Museum of Natural History*. Address in 1933, 88-60 162nd St., Jamaica, Queens Borough, New York, N.Y.

SHANNON, JAMES JEBUSA.
Painter. Born in Auburn, NY, in 1862. He resided for many years in England. Studied at South Kensington Schools, London, under Edward Poynter. Awards: Gold medal, Paris Exposition, 1889; first class medal, Berlin; first medal, Carnegie Institute, Pittsburgh, 1897; Lippincott prize, Penna. Academy of Fine Arts, 1899; silver medal, Paris Expo., 1900; gold medal, Pan.-Am. Expo., Buffalo, 1901. Elected an Associate of the Royal Academy, 1897; Royal Academy, 1909; Associate, National Academy, 1908. His painting, "Girl in Brown," is in the Corcoran Art Gallery, Washington, DC. Died March 6, 1923, in London, England.

SHANNON, W.
Sculptor. At San Francisco, California, 1858.

SHAPIRO, JOEL (ELIAS).
Sculptor. Born in NYC, September 27, 1941. Studied at NY University, B.A. and M.A. Work at Fogg Art

Museum; Metropolitan Museum; Museum of Modern Art, NY; Whitney Museum of American Art, NY; Albright-Knox Art Gallery, Buffalo; Stedelijk Museum, Amsterdam. Has exhibited at Museum of Contemporary Art, Chicago; Albright-Knox Art Gallery; Akron Art Institute, OH; Institute of Contemporary Art, Boston; Whitney Museum of American Art; Aldrich Museum of Contemporary Art, CT; High Museum of Art, Atlanta, GA; others. Address in 1982, c/o Paula Cooper, 155 Wooster St., NYC.

SHAPLEIGH, FRANK HENRY.
Born in Boston, MA, in 1842. He studied under Emile Lamton in Paris, and spent his professional life in Boston. His paintings include "Yosemite Valley," "Mount Washington," the "White Mountains" and the "Old Mill in Seabrook." Died in 1906.

SHARADIN, HENRY W(ILLIAM).
Painter, craftsman, lecturer and teacher. Born in Kutztown, PA, Dec. 22, 1872. Pupil of Carrol Beckwith; School of Industrial Arts, Philadelphia; Metropolitan Art School, NY; Tudor-Hart in Paris; Nordi in Rome. Member: National Arts Club; American Federation of Arts; Eastern Arts Association. Work: Education, Chapel of State Teachers College, Kutztown. Address in 1929, State Teachers College; h. College Hill, Kutztown, PA.

SHARE, HENRY PRUETT.
Illustrator and etcher. Born in 1853; died in 1905. Member of the New York Etching Club.

SHARMAN, FLORENCE M.
Sculptor. Born in Bloomington, IL, March 27, 1876. Pupil of St. Louis School of Fine Arts under Robert P. Bringhurst. Member: St. Louis Artists' Guild. Address in 1906, 1820 Locust St., St. Louis, MO.

SHARMAN, JOHN.
Painter and teacher. Member: Philadelphia Art Club; Guild of Boston Artists; Connecticut Academy of Fine Arts. Award: Flagg prize ($100), Connecticut Academy of Fine Arts, 1922. Instructor, Massachusetts School of Art and School of the Museum of Fine Arts, Boston. Address in 1933, 80 Somerset Street, Belmont, Massachusetts.

SHARP, EVERETT H(ILL).
Painter and illustrator. Born in Foster, KY, February 22, 1907. Pupil of Wayman Adams; George Pearse Ennis; George Luks. Awards: Culver Military Acad. prize, Hoosier Salon, Chicago, IL, 1928; Kiwanis Club Prize, Hoosier Salon, 1929. Specialty: Portraits. Address in 1933, 523 South Council St., Muncie, Indiana; summer, Eastport, Maine.

SHARP, J(OSEPH) H(ENRY).
Painter, illustrator, and teacher. Born in Bridgeport, Ohio, September 27, 1859. Pupil of Royal Academy in Munich, and under Marr; Julian Academy in Paris under Laurens and Benjamin-Constant; Verlat in Antwerp; Duveneck in Spain. Member: Cincinnati Art Club; California Art Club; Salma. Club; Taos Society of Artists; California Print Maker's Society; American Federation of Arts. Ten years on faculty, Cincinnati Art Academy. Awards: Silver medal, Department of Ethnology, Pan.-American Exposition, Buffalo, 1901; first portrait prize, Cincinnati Art Club, 1901; gold medal, Pan.-California Exposition, San Diego, 1915 and 1916; first prize ($500), California Art Exhibition, Pasadena Art Institute, 1930. Specialty: Types of Indians. Work: "Harvest Dance--Pueblo Indians," "Old Dog--Crow Indian Chief," and "Strikes His Enemy Pretty," Cincinnati Museum; "Chief Flat Iron," Herron Art Institute, Indianapolis; "The Great Sleep," and nearly 100 portraits of Indians and Indian pictures, University of California; 11 Indian portraits, Smithsonian Institution, Washington, DC; "1920 Ration Day on the Reservation," "A Young Chief's Mission," Butler Museum, Youngstown, Ohio; "Voice of the Great Spirit," and 15 Indian genre pictures, Smithsonian Institution, Washington, DC; two Indian portraits, Museum of Santa Fe, New Mexico. Address in 1933, winter, Crow Agency, Montana; summer, Taos, New Mexico; permanent, 1481 Corson Street, Pasadena, California.

SHARPE, C. W.
This line engraver of portraits and book illustrations was working in Philadelphia in 1850. There are some indications that he originally came from Boston to that city.

SHARPE, CORNELIUS N.
Ship carver. Worked in New York City. Associated with Sharpe and Ellis, 1810-12; with Dodge and Sharpe, 1814-28. Died in 1828.

SHARPE, JAMES C.
Illustrator. Born in Vernon, TX, in 1936. Attended Texas Tech. University and graduated from the Art Center College of Design where he was taught by John LaGatta. An illustration published in *Ford Times* in 1966 was his first, and he has since worked for Bantam, Dell, Fawcett, Warner, and Berkley doing cover art. As well as illustrating books for the Franklin Library and numerous *Reader's Digest Condensed Books*, his work has appeared editorially in major magazines, including many *Time* and *TV Guide* covers. He is a member of the Society of Illustrators, and his illustrations have been selected for their Annual Exhibitions.

SHARPE, JULIA GRAYDON.
Painter, draughtsman and writer. Born in Indianapolis, IN. Pupil of Art Students League of NY; W. M. Chase, IN School of Art; J. Ottis Adams; William Forsyth; H. Siddons Mowbray; Saint-Gaudens. Member

Art Students League of NY; Indiana Society of Artists. Represented in the Indianapolis (IN) Univer. Club and Herron Art Insti.; MacDowell Club, New York; Richmond (IN) Art Club; memorials in the Second Presbyterian Church and the Caroline Scott Harrison Chapter House, D.A.R., Indianapolis. Specialty: Portraits and landscapes; also bookplates and designing. Writer of short stories. Died in 1937. Address in 1933, 1234 No. Alabama St., Indianapolis, IN; summer, Idylwilde, Harbor Springs, MI.

SHARPLES, FELIX THOMAS.
Pastel artist. Son of James Sharples. Born in England c. 1786; he died in North Carolina after 1824. The pastel portrait of Alexander Hamilton owned by the NY Historical Society is done by Felix T. Sharples after the original by his father.

SHARPLES, JAMES.
Portrait painter in pastels. Born in England in 1752. He came to America in 1796, and traveled through the country painting portraits chiefly in pastels on thick gray paper. A large collection of his work is in Independence Hall, Philadelphia, PA, and in Bristol, England. In 1796 he drew his pastel portrait of Washington, which was frequently copied by his wife and sons. Died Feb. 26, 1811, in NYC.

SHARPLES, JAMES, JR.
Portrait draughtsman in pastel. Born in 1789, England. The younger son of James Sharples. He frequently copied his father's work. He returned to England with his mother and sister after his father's death. Died Aug. 10, 1839, in Bristol, England.

SHARPLES, JAMES (MRS.).
(Ellen Sharples). Portrait draughtsman in pastel. Born in 1769, in Birmingham, England; died in 1849, in Bristol, England. Mrs. Sharples frequently copied her husband's portraits very faithfully in the exact size. After her husband's death she returned to England and settled in Bristol. In 1845 she gave two thousand pounds for the founding of the Bristol Fine Arts Academy. In her will she left, in 1849, 3,465 pounds more. At this institution there is today the "Sharples Collection" of ninety seven pictures by her husband, herself, James Junior and Rolinda. Her daughter Rolinda (1794-1838) was born in NY, but none of her paintings were made in this country. (See *Century Magazine*, Feb., 1894, also *Magazine of American History*.).

SHATTUCK, AARON DRAPER.
Painter. Born in Francestown, NH, on March 9, 1832. In 1850 he became a pupil of Alexander Ransom in Boston. In 1852 he entered the school of the Academy of Design in NY and in 1861 was elected an Academician. Among his works are "White Mountains in October," "Cattle," "Peaceful Days," and "Granby Pastures." Inventor of Shattuck

Stretcher key for canvases. Died July 30, 1928, near Granby, CT.

SHAVER, JAMES ROBERT.
Painter and illustrator. Born in Evening Shade, AR, March 27, 1867. Pupil of St. Louis School of Fine Arts. Member: Salma. Club. Author of *Little Shavers*. Specialty: Drawings of children. Died in 1949. Address in 1929, 13 West 23rd St., New York, NY.

SHAW, ANNIE CORNELIA.
Landscape painter. Born in West Troy, NY, in 1852. She studied in Chicago, and was elected an Associate of the Chicago Academy of Design in 1873. Her principal works are "On the Calumet," "In the Clearing," "Fall Ploughing," and "The Russet Year." Died in 1887.

SHAW, ELSIE BABBITT.
Sculptor and painter. Born in Charlotte, North Carolina, December 6, 1929. Studied: Salem Academy, 1948; Mt. Vernon Junior College, 1949; Rollins College, B.A., 1951; studied with Hilton Leech, Jerry Farnsworth, and Syd Solomon. Awards: Mint Museum, Charlotte, North Carolina, 1964; Juried Arts National, Tyler Museum of Art, Texas, 1969; Salmagundi Club Prize, National Academy of Design, 1971. Collections: Mint Museum of Art; Wachovia National Bank, Charlotte, North Carolina; American National Bank, Chattanooga, TN; Tyler Museum of Art, TX; others. Exhibited: National Academy of Design, 1963, 67, 71; Butler Art Institute, 1966-68; Allied Artists of America, 1966 and 67; Isaac Delgado, New Orleans, LA, 1964. Address in 1982, De Land, FL.

SHAW, ERNEST CARL.
Sculptor. Born in NYC, April 17, 1942. Exhibited: Storm King Art Center, Mountainville, NY, 1977; Contemporary Reflections, at the Aldrich Museum of Contemporary Art, 1977; one-man shows, Storm King Art Center, 1978; Hamilton Gallery of Contemporary Art, 1978; Allentown Art Museum, 1981; Wichita Art Museum, 1981; Huntington Galleries, WV, 1981; Sculpture Now, NYC, 1978; Hamilton Gal. of Contemporary Art, 1978; and others. Commission: Orlando International Airport, Reading, PA. In collections of Aldrich Museum, Ridgefield, CT; Wichita Art Museum, KS; and others. Medium: Steel. Address 1982, New Paltz, NY.

SHAW, FREDERICK A.
Sculptor. Born in 1855. Died in Brookline, MA, March 8, 1912.

SHAW, H(ARRIETT) M(CCREARY) (MRS.).
Painter, writer, lecturer, and teacher. Born in Fayetteville, AR, March 17, 1865. Pupil of University Art School, Denver; Art Institute of Chicago; Magda Heuermann; Samuel Richards, Munich; Charles P.

Adams in Denver, CO. Awards: Silver medal for ivory miniature, and gold medal, figure on porcelain, St. Louis Expo., 1904; two gold and silver medals for life portraits, Seattle Expo., 1909; Guggenheim Fellowship. Member: American Federation of Arts; Seattle Fine Arts Society. Work: Portrait of Rev. J. B. Jones, William Woods College. Author of *Outlines of American Painting.* Specialty: Portraits. Died in 1934. Address in 1933, 1528 Fifth Ave., West, Seattle, WA.

SHAW, HARRY H.
Painter. Exhibited at the Penna. Academy of Fine Arts, Philadelphia, 1926. Address in 1926, 1809 Callowhill St., Philadelphia, PA.

SHAW, HELEN ADELE LERCH.
Sculptor, lecturer, teacher of art and dancing. Born in Chicago, IL, September 28, 1891. Studied at Lewis Institute, Chicago, 1910-11; Wheaton (IL) College, 1911-13; graduate of the Chicago Art Institute, 1917. Works include the sculptured head of American Manhood, presented to government, 1944; plaque, Marie and Pierre Curie, 1949, to commemorate 50th anniversary of radium discovery. Awards: Gold medal, 1938, first awards and honors for poems and sculpture, 1938-44. Member: Chicago Art Institute Alumni; Illinois Society of Fine Arts. Teacher of art and dancing, Experimental School, Peterboro, NH, 1917-18; private classes, art and dancing, 1920-30. Illustrator and author of children's stories; also poems and articles. Address in 1962, 655 62nd Street S., St. Petersburg, FL.

SHAW, JOSHUA.
English landscape painter. Born in 1776, in Bellingborough, Lincolnshire, England. He practiced his profession in Philadelphia for many years. He came to this country in 1817, bringing with him West's picture of "Christ Healing the Sick." He died Sept. 8, 1860, in Burlington, NJ.

SHAW, RICHARD BLAKE.
Sculptor. Born in Hollywood, CA, September 12, 1941. Studied at Orange Coast College, 1961-63; San Francisco Art Institute, B.F.A., 1965; Alfred University, 1965; University of California, Davis, Massachusetts, 1968. Work in Oakland Museum, California; San Francisco Museum; National Museum of Art, Tokyo; Stedelijk Museum, Amsterdam, Holland; Whitney Museum of American Art, NY. Has exhibited at Dilexi Gallery, San Francisco; San Francisco Museum of Art; Alan Frumkin Gallery, NY; Whitney Museum of American Art, NY; International Ceramics, 1972, Victoria and Albert Museum, London; Painting and Sculpture in California Modern Era, National Collection of Fine Arts, Washington, DC; others. Member of Order of Golden Brush; International Society of Ceramists. Works in ceramics, mixed media. Award: National Endowment for the Arts, from 1970, and crafts grant, 1974.

Address in 1982, c/o Braunstein Gallery, San Francisco, CA.

SHAW, STEPHEN WILLIAM.
Director and instructor of art at the Boston Athenaeum. He was born Dec. 15, 1817, in Windsor, VT, and died Feb. 12, 1900, in San Francisco, CA.

SHAW, SYDNEY DALE.
Painter and craftsman. Born in Walkley, England, Aug. 16, 1879. Pupil of Art Students League of NY; Academie Colarossi and Ecole des Beaux Arts in Paris. Member: California Art Club; American Water Color Society; Salma. Club. Awards: Silver medal, Pan.-California Expo., San Diego, 1915; hon. mention, Los Angeles, 1916; Hudnut prize, American Water Color Society, NY, 1917; Auction Prize, Salma. Club, 1929. Died in 1946. Address in 1933, 4030 Bronx Blvd., New York, NY.

SHEAFER, FRANCES B(URWELL).
(Mrs. Samuel Waxman). Painter, craftsman, and writer. Born in Pennsylvania. Pupil of Penna. Academy of Fine Arts; Philadelphia School of Design for Women; and with William Sartain. Member: Plastic Club; Copley Society. Award: Special silver medal, St. Louis Expo., 1904; silver medal, Horticultural Society of Massachusetts, 1931. Address in 1933, 21 Foster St., Cambridge, MA; summer, Greenbush, Plymouth Co., MA.

SHEAFER, FRANK W.
Painter. Born in Pottsville, Pennsylvania, in 1867. Pupil of Penna. Academy of Fine Arts. Exhibited "Harbor Lights" at Penna. Academy of Fine Arts, 1915. Address in 1926, 908 Pine Street, Philadelphia, PA.

SHEAN, CHARLES M.
Portrait and mural painter. Born in Brooklyn, NY. Studied at Art Students League of NY and in Paris. Member of National Society of Mural Painters; Architectural League of NY. Medal for mural painting, St. Louis Expo., 1904. Author of "A Plea for Americanism in the Decoration of Public Buildings," 1901; "Mural Painting from the American Point of View." He died in October, 1925, in Brooklyn, NY.

SHEBL, JOSEPH J.
Sculptor. Born in Crete, NE, 1913. Specialty is Western subjects, particularly historical and animals. Works in bronze. Also a medical doctor. Address in 1968, Salinas, CA.

SHECTMAN, ADELE.
Painter. Born in Cambridge, MA, in 1927. Studied: Vesper George School of Art; Boston University; Boston Museum School. Exhib.: Childrens' Art Center, Boston, 1967; Psychoanalytic Society and Institute, Boston, 1974; Goethe Institute, 1975. Collections:

Leonard Morse Hospital, Natick, MA; Boston University.

SHEELER, CHARLES R., JR.
Painter and lithographer. Born in Philadelphia, PA, in 1883. Pupil of Philadelphia Museum School of Industrial Art; Penna. Academy of Fine Arts; and William Chase. Work: Boston Museum of Fine Arts; Whitney; Art Institute of Chicago; Penna. Academy of Fine Arts; Museum of Modern Art; Newark Museum; Palace of the Legion of Honor; Fogg Museum of Art; Cleveland Museum of Art; University of Nebraska; Detroit Institute of Art; others. Exhibitions: Modern Gallery, NY, 1918 (one-man); retrospectives, Museum of Modern Art, 1939, University of California, Los Angeles, 1954, Allentown Art Museum Retrospective, 1961, Massachusetts Institute of Technology, 1959; others. Awards: Harris Prize, Chicago Art Institute, 1945; Alumni Award, Penna. Academy of Fine Arts, 1957; Award of Merit Medal, American Academy of Arts and Letters, 1962. Position: Artist in residence, Phillips Academy, Andover, MA, 1946; Currier Gallery of Art, Manchester, NH, 1948. Address in 1953, Irvington-on-Hudson, NY. Died in 1965.

SHEERER, MARY G.
Painter, craftsman, and teacher. Born in Covington, KY. Pupil of Cincinnati Art Academy; Penna. Academy of Fine Arts; Art Students League of NY. Member: New Orleans Art Association; Louisiana Art Teachers Association; New Orleans Arts and Crafts Club; American Ceramic Society; American Federation of Arts. Instructor, School of Art, Newcomb College, New Orleans. Assistant Director, Newcomb Pottery. Address in 1929, 1404 Audubon St.; Newcomb School of Art, New Orleans, LA; summer, Ogunquit, ME.

SHEETS, MILLARD.
Painter. Born in Pomona, CA, June 24, 1907. Pupil of Chouinard School of Art, Los Angeles, CA. Awards: Second prize, California Water Color Show, 1927; third prize, Riverside County Fair, Riverside, CA, 1928; first prize, Los Angeles County Fair, 1928, 30; first landscape purchase prize, Arizona State Fair, 1928, water color prize, 1929, second prize, landscape, 1930; prize ($1,750), Texas National Competition, San Antonio, 1929; second prize, landscape, California State Fair, 1930; first prize, water color, Ebell Club, Los Angeles, 1930; first prize, water color, Santa Cruz Art League, 1931; first prize, landscape, California State Fair, 1932; first prize, water color, Los Angeles Museum, 1932; second prize, California Water Color Society, 1933. Work: "Market Place, San Jose, Guatemala," San Diego Museum; "The Goat Ranch," Arizona State Fair Permanent Collection; "The Russian Processional," Museum of Art, Fort Worth, TX; "The Market Basket," Albany Institute of History and Art;

"Fishermen of Laigueglia," M. H. deYoung Memorial Museum, San Francisco; "Angel's Flight," Los Angeles Museum, CA. Member: California Art Club; California Water Color Society. Address in 1933, 2509 West Seventh St., Los Angeles, CA.

SHEETS, NAN.
(Mrs. Fred C. Sheets). Painter, etcher and teacher. Born in Albany, IL. Pupil of John Carlson; Robert Reid; E. L. Warner; Birger Sandzen; Nellie Knopf; Kathryn E. Cherry; Hugh Breckenridge; A. Thayer. Member: Oklahoma Art Association; Art League of Oklahoma City; MacDowell Club; North Shore Arts Association; National Association of Women Painters and Sculptors; Southern States Art League; American Federation of Arts. Awards: Birger Sandzen prize, Broadmoor Art Academy, 1924; purchase prize, Kansas City Art Institute, 1924; landscape prize, Southern States Art League, 1929. Represented in permanent collection of the Kansas City Art Institute; Art Museum, Springfield, IL; Art Gallery, Oklahoma University, Norman, OK; John H. Vanderpoel Art Association, Chicago, IL. Address in 1933, "The Elms," 2810 North Walker, Oklahoma City, OK.

SHEFFER, GLEN C.
Painter. Born in Angola, IN, in 1881. Pupil of Art Institute of Chicago and Chicago Academy of Fine Arts. Member: Palette and Chisel Club; Chicago Galleries Association. Specialty: Painting figure and decorative composition. Died in 1948. Address in 1933, 1138 Lake Shore Drive, Chicago, IL.

SHEFFIELD, ISAAC.
Painter. Born in Guilford, CT, in 1798. He painted portraits and figure pieces in and about New London, CT. Most of his portraits are of sea captains, very red faced, with telescope in hand, standing before a red curtain. He died in 1845.

SHEGOGUE, JAMES HAMILTON.
Painter. Born Feb. 22, 1806, in Charleston, NC. Devoted himself principally to portraiture, but he did produce some landscapes, genre pieces, and historical scenes. He first exhibited at the National Academy of Design, NY, in 1835, and became an Associate in 1841, and an Academician in 1843. He painted a number of prominent men and several of his portraits are owned by the city of NY. He died April 7, 1872, in Warrenville, CT.

SHEIRR, OLGA.
Painter, printmaker, and teacher. Studied: Brooklyn College, B.A., 1953, with Rothko, Reinhardt, and Still; NY Institute of Fine Arts, graduate studies, 1954; NYU Intaglio Workshop, 1961-64, with Callapai; Pratt Graphic Center, 1964-72, with Michael Ponce de Leon; Board of Education, NYC, lic. teacher of Fine Arts, 1970. Work: NYU Hospital;

Greenville (SC) County Museum; private collections. Exhibited: Noho Gallery, NYC, solo, 1975, 76, 78, 79, 80; International Art Exchange, NYC, solo, 1962, 63; International Art Exchange, Paris & Trouville, France, 1963; 46th Annual Print Exhibition, AAA Gallery, NYC, 1965; 4th International Miniature Print Exhibition, AAA Gallery, NYC, 1971-74; Silvermine Guild, 1966, 1976; NY Artists Equity Association, NYC, 1981; many other invitational, juried shows in NYC, 1963 to present. Member: Noho Gallery, NYC; NY Artists Equity; etc. Bibliography: Numerous articles and interviews. Address in 1983, 360 First Ave., NYC.

SHELDON, CHARLES MILLS.
Painter. Born at Lawrenceburg, IN, in 1866. Studied in Paris under Constant and Lefebvre, and at the Academie Julian, 1890-91. Traveled through the Southern States, illustrating articles for the Associated Press, 1889; illustrator on *Pall Mall Budget*, 1892-95; artist and correspondent for *Black and White*, London, in South Africa during time of Jamieson raid; through Dongola Expedition, Sudan, 1896; artist correspondent of *Frank Leslie's* and *Black and White* in Cuba, 1898. Died March 15, 1928 in London.

SHELLHASE, GEORGE.
Sculptor and painter. Exhibited water colors at the Penna. Academy of Fine Arts, Philadelphia, 1925; White Plains, New York, 1933. Address in 1926, 720 Locust St., Philadelphia, PA.

SHELTON, WILLIAM HENRY.
Painter and etcher. Born in 1840; died in 1932. He was a librarian for the Salmagundi Club, and a member in 1871. Also a member of the New York Etching Club.

SHEPHARD, CLARENCE.
Painter and architect. Born in Cortland, NY, Oct. 27, 1869. Pupil of Keith and Griffin. Member: Kansas City Society of Artists; Mid-Western Artists; American Institute of Architects; Architectural League of NY. Address in 1929, 412-15 Huntzinger Building, Kansas City, MO; summer, Fryeburg, ME; Bemis Pt., NY.

SHEPHERD, CHESTER GEORGE.
Painter and illustrator. Born in Lathrop, MI, April 28, 1894. Pupil of Art Institute of Chicago. Member: Palette and Chisel Club; Alumni Association of Art Institute of Chicago; Association of Arts and Industries. Address in 1929, 1258 Columbia Ave., Chicago, IL.

SHEPHERD, J. CLINTON.
Painter, sculptor, and teacher. Born in Des Moines, IA, Sept. 11, 1888. Studied at University of Missouri; Kansas City School of Fine Arts; Art Institute of Chicago; Beaux-Arts Institute of Design; with Walter Ufer and Harvey Dunn. Exhibited: National Academy of Design; Penna. Academy of Fine Arts; Silvermine Guild. Member: Palm Beach Art League; Society of Four Arts; National Arts Club; Whitney Studio Club; Society of Illustrators; Artists Guild of the Authors' League of America. Awards: Miami Art League, 1940; Palm Beach Art League, 1941. Collection: Herron Art Institute; memorial, Westport, CT. Address in 1953, Palm Beach, FL.

SHEPHERD, THOMAS S.
Miniature painter. Flourished 1845-46 in NY.

SHEPPARD, WARREN W.
Painter, illustrator, and writer. Born in Greenwich, NJ, April 10, 1858. Pupil of Hertzberg; de Haas. Work: "The Restless Sea," Albright Art Gallery, Buffalo; "The Trackless Ocean," Toledo Museum; "The Sea," Public Library, Springfield, MA; "Clipper Ship, Young America," "South Street, New York, in the Eighties," Addison Gallery, Phillips Academy, Andover, MA; "Clipper Ship, Flying Cloud," India House, New York. Author of "Practical Navigation" and "A Tale of the Sea." Died in 1937. Address in 1933, 1130 Bergen Street, Brooklyn, NY; summer, Lincoln Park, NJ, and Isles of Shoals, NH.

SHEPPARD, WILLIAM LUDWELL.
Sculptor, watercolorist, and illustrator. Born in Richmond, VA, in 1833. Painted series of watercolors of army life in the Civil War (Confederate Museum in Richmond). Died in Richmond, VA, March 27, 1912.

SHERBELL, RHODA.
Sculptor, consultant and collector. Born in Brooklyn, NY. Studied at Art Students League, with William Zorach; Brooklyn Museum Art School, with Hugo Robies; in Italy and France. Works: The Dancers, Oklahoma Museum of Art, Oklahoma City; The Flying Acrobats, Colby College Art Museum, Waterville, ME; Sculpture Garden, Stony Brook Museum, NY. Commissions: Marguerite and William Zorach Bronze, National Arts Collection, Smithsonian Institution, Washington, DC, 1964; Casey Stengel, Country Art Gallery of Long Island, and Baseball Hall of Fame, Cooperstown, NY; Yogi Berra, commissioned by Percy Uris; others. Exhibited: Penna. Academy of Fine Arts and Detroit Institute of Art, 1960; American Academy of Arts and Letters, 1960; Brooklyn Museum Art Award Winners, 1965; National Academy of Design and Heckscher Museum Show, 1967; Retrospective Sculpture and Drawing Show, Huntington Hartford Gallery, NY, 1970; Catherine Lorillard Wolfe Club; National Sculpture Society; Sculptors Guild; Salma. Club; many others. Awards: American Academy of Arts and Letters and National Institute of Arts and Letters Grant, 1960; Ford Foundation Purchase Award, 1965; Louis Comfort Tiffany Foundation Grant, 1966; H. F. Bennett prize,

National Academy of Design; National Sculpture Society; many more. Member of National Academy; National Sculpture Society; National Association of Women Artists; Sculptors Guild; Allied Artists of America; Art Students League. Medium: Bronze. Address in 1983, Westbury, NY.

SHERER, RENSLOW PARKER.
Sculptor and painter. Born in Chicago, IL, Oct. 13, 1888. Studied at University of Chicago. Exhibited: Art Institute of Chicago, 1937, 39, 40, 44; Milwaukee Art Institute. Address in 1953, Highland Park, Illinois.

SHERIDAN, FRANK J., JR.
Illustrator. Member: Society of Illustrators. Address in 1929, care of Sheridan, Shawhan and Sheridan, 30 East 34th Street, New York, NY.

SHERIDAN, JOHN E.
Painter and illustrator. Born in Tomah, Wisconsin. Member: Society of Illustrators, 1912. Address in 1929, 35 East 49th Street, New York, New York; h. Port Washington, LI, New York.

SHERIDAN, JOSEPH MARSH.
Sculptor, painter, illustrator, writer, lecturer, and etcher. Born in Quincy, IL, March 11, 1897. Studied at Beloit College, B.A.; Art Students League; Art Institute of Chicago; University of California, M.A.; and with Norton, Hofmann, and Archipenko. Member: San Francisco Art Association; San Diego Artists Guild; Art Congress. Awards: Prizes, Minneapolis Institute of Art, 1931. Work: San Francisco Museum of Art; Berkeley (CA) Public Library; Oakland Public Library; University of California; Beloit College, University of Minnesota; A. F. of L. Building, San Francisco, CA; University of Arizona; Mills College; Westminster College, PA; Oakland (CA) High School; Piedmont (CA) High School. Exhibited: Minneapolis Institute of Art, 1930; European and American Abstractionists Exhibition, 1933; Oakland Art Gallery, 1932-45; San Francisco Museum of Art, 1932-45; Art Institute of Chicago, 1931, 33; many one-man exhibitions in U.S. Position: Instructor of art, University of Minnesota, 1928-30; assistant professor of art, University of Arizona, 1944-45; acting head, department of art, Westminster College, New Wilmington, PA, 1945-46. Address in 1953, New Wilmington, PA.

SHERINYAN, ELIZABETH.
Painter, craftsman, and teacher. Born in Armenia. Studied in Europe, Asia and Africa; Worcester Museum School and Massachusetts Normal Art School; pupil of Hale, H. D. Murphy, Major, Greenwood, and Cornoyer. Member: Connecticut Academy of Fine Arts; Springfield Art League; American Federation of Arts. Died in 1947. Address in 1929, 11 St. Elmo Road, Worcester, Massachusetts.

SHERMAN, ELLA BENNETT.
(Mrs. John Sherman). Painter. Born in New York, NY. Pupil of Douglas Volk; W. M. Chase; Robert Henri. Member of Washington Water Color Club; Washington Society of Artists. Address in 1926, 500 Powers Building, Rochester, NY.

SHERMAN, GAIL.
See Corbett, Gail Sherman.

SHERMAN, STOWELL B(RADFORD).
Painter and etcher. Born in Providence, Rhode Island, Jan. 22, 1886. Pupil of Rhode Island School of Design. Member: Providence Art Club; Providence Water Color Club. Address in 1929, 147 Lorimer Avenue, Providence, Rhode Island; summer, Rockport, Massachusetts.

SHERMAN & SMITH.
(George Sherman and John Calvin Smith). Engravers. This firm was designing and engraving plates for the *NY New Mirror* in 1841. In 1838-39, the firm of Stiles, Sherman and Smith was engraving in the same city.

SHERRATT, THOMAS.
About 1870, a portrait engraver of this name was working for Detroit publishers.

SHERWOOD, MARY CLARE.
Painter and teacher. Born in Lyons, May 18, 1868. Pupil of Art Students League of NY under Weir, Chase and Cox; Conrad Fehr and Curt Hermanns in Berlin; F. Edwin Scott in Paris. Member: National Association of Women Painters and Sculptors; Mississippi Art League; Southern States Art League; American Federation of Arts. Died in 1943. Address in 1929, All Saints College, Vicksburg, MI; summer, Lyons, NY.

SHERWOOD, ROSINA EMMET.
(Mrs. Arthur M. Sherwood). Painter. Born in New York, Dec. 13, 1854. Pupil of Chase in NY; Julian Academy in Paris. Member: Society of American Artists, 1886; Associate National Academy of Design, 1906; NY Water Color Club; American Water Color Society. Awards: Silver medal for painting, Paris Expo., 1889; medal, Columbian Expo., Chicago, 1893; bronze medals for water color and for drawing, Pan.-Am. Expo., Buffalo, 1901; silver medal, St. Louis Expo., 1904. Died Jan. 19, 1948. Address in 1929, Stockbridge, MA.

SHERWOOD, RUTH.
(Mrs. Albin Polasek). Sculptor and teacher. Born in Chicago, IL, in 1889. Pupil of Albin Polasek; Art Institute of Chicago; University of Chicago, B.S. Member: Alumni, Art Institute of Chicago; Chicago Painters and Sculptors. Awards: Lathrop foreign fellowship, 1921; Adams Foreign Fellowship, Art

Institute of Chicago, 1921; honorable mention, Art Institute of Chicago, 1922; prizes, Chicago Woman's Aid; Chicago Galleries Association, 1928, 30; Mrs. John C. Shaffer prize, Art Institute of Chicago, 1929; Municipal Art League, 1936; Association of Chicago Painters and Sculptors, 1939. Work: Memorial tablet, River Forest Women's Club; memorial tablet to James V. Blake, Evanston, IL; safety trophy, Portland Cement Association; Lake Shore Bank medal for architecture; Johns Hopkins University; University of Chicago; others. Exhibited at National Sculpture Society, 1923; Century of Progress, Chicago, 1933, 34; Chicago Art Club; Penna. Academy of Fine Arts; San Francisco Museum of Art; others. Address in 1953, Winter Park, FL; summer, Chautauqua, NY. Died in 1953.

SHERWOOD, WILLIAM (ANDERSON).
Painter and etcher. Born in Baltimore, MD, Feb. 13, 1875. Member: Societe Royale des Beaux-Arts Belge; Societe Royale des Aqua-Fortists de Belgique; Chicago Society of Etchers; California Print Maker's Society; American Federation of Arts; Chevalier de l'Ordre de la Couronne, (Belgique). Work: Etchings owned by Queen of Belgium; etchings in Royal Library at Brussels, Musee Plantin-Moretus, Antwerp, and Library of Congress at Washington, DC; Cleveland Public Library; Detroit Public Library; Worcester Free Library; Chicago Art Institute; California State Library; City Library of Sacramento. Died in 1951. Address in 1933, Lac d'amour, Bruges, Belgium.

SHIELDS, CHARLES.
Illustrator. Born in Kansas City, KS, in 1944. Received his B.F.A. from the University of Southern California, his M.F.A. from the Art Directors' Club, and he later taught painting at Colorado Mountain College. His first illustration was done for the *Saturday Review of the Arts* in 1972, and he has since illustrated for *Rolling Stone, Sesame Street, Genesis, City of San Francisco, Human Behavior,* and others. He has received awards from the Society of Illustrators.

SHIELDS & HAMMOND.
Engravers. This first name is signed to some good landscape plates published in New Orleans, in 1845. Hammond is noticed elsewhere.

SHIFF, E. MADELINE.
See Wiltz, E. Madeline Shiff.

SHILLING, ALEXANDER.
Landscape painter and etcher. Born in Chicago, IL, in 1859. Pupil of G. S. Collis. Member: Am. Water Color Society; NY Etching Club; Salma. Club; Century Association. Awards: Gold medal, Philadelphia Art Club, 1901; silver medal, St. Louis Expo., 1904; Shaw etchings prize, Salma. Club, 1913. Represented

by painting in Metropolitan Museum of Art and in Print Collection, Public Library, New York. Died in 1937. Address in 1929, 939 Eighth Ave., New York, NY.

SHINDLER, A. ZENO.
Portrait draughtsman in crayons. Born c. 1813 in Germany. He was working in Philadelphia about 1855-60.

SHINN, EVERETT.
Mural painter and illustrator. Born Nov. 6, 1873 or 78, in Woodstown, NJ. Studied art at Penna. Academy of Fine Arts, Philadelphia. Moved to NYC in 1900; worked for *The Herald* and *The World*. City life illustrations appeared in *Harper's, McClure's,* and *Scribner's*. Painted the mural decorations for the Stuyvesant Theater, New York, NY. Known as one of The Eight or Ashcan School. Exhibited at the American Artists Professional League, 1964, 65; with The Eight, 1908. Represented in Metropolitan Museum of Art; Whitney; Phillips Memorial Gallery, Washington, DC. Was a member of the National Academy and taught at the Art Students League in 1906/07. Died in 1953. Address in 1926, 19 East St., New York, NY.

SHINN, FLORENCE SCOVEL.
Illustrator. Born in Camden, NJ, in 1869. Studied at the Penna. Academy of Fine Arts. She became well known for her book illustrations in line and watercolor, such as those done for the series *Mrs. Wiggs of the Cabbage Patch* and *Lovely Mary,* by Hegan Rice in 1903. She died in her home in NYC in 1940.

SHIPMAN, CHARLES.
Engraver. In the New York Mercury in 1768 is the following: "Charles Shipman, Ivory and Hard Wood Turner, . . . engraves Copper Plate, Seals, etc."

SHIPPEN, ZOE.
Painter. Born in Boston, MA, Nov. 12, 1902. Pupil of Leslie P. Thompson; Phillip Hale; William Hazelton; John P. Wicker. Member: North Shore Arts Association; Gloucester Society of Artists; Copley Society; Boston Society of Independent Artists. Specialty: Portraits. Address in 1929, 6 Arlington St., Annisquam, MA; h. 39 Pilgrim Road, Boston, MA.

SHIRK, JEANNETTE C(AMPBELL).
Painter and illustrator. Born in Middletown, PA, April 16, 1898. Pupil of Eugene F. Savage; Charles J. Taylor; George Sotter. Member: Pittsburgh Art Association; Buffalo Society of Artists. Award: Third Anonymous Graphic Arts prize, Pittsburgh Art Association, 1927. Address in 1929, Glenshaw, PA.

SHIRLAW, WALTER.
Painter and engraver. Born in Paisley, Scotland on Aug. 6, 1838. He was brought to the United States

when two years old. He studied art at the Royal Academy, Munich, and was a pupil of Raab, Wagner, Ramberg, and Lindenschmidt at Munich; also studied at the National Academy. Worked at bank note engraving for some time, but had a decided talent for painting. His "Sheep Shearing in the Bavarian Highland" received honorable mention at the Paris Exhibition of 1878. Awarded medals, Royal Academy, Munich; Philadelphia Expo., 1876; Lotos Club Fund prize, National Academy of Design, 1895. His "Susannah and the Elder" (a study) is owned by the Boston Museum of Fine Arts. He was elected a member of the National Academy in 1888 and was a member of the New York Etching Club, American Water Color Soc., Architectural League, Society of Mural Painters, and first president of the Society of Amer. Artists. He died Dec. 26, 1909, in Madrid, Spain.

SHIRLEY, ALFARETTA DONKERSLOAT.
Craftsman, sculptor and teacher. Born in NJ, August 2, 1891. Studied: Parsons School of Design; Columbia University, B.S., M.A.; Alfred University, with Charles F. Binns. Member: College Art Association of America; National Association of Art Education; American Association of University Women; New York Ceramic Society; National Education Association; New Jersey Educational Association; Newark Art Club. Exhibited: Syracuse Museum of Fine Arts; Architectural League; Montclair Art Museum; Newark Museum; New York Ceramic Society traveling exhibition; Rutgers University. Position: Instructor, Ceramics, Newark School of Fine and Industrial Arts, 1921-34; Instructor, Art and Art History, Barringer High School, Newark, NJ, from 1935. Address in 1953, Short Hills, NJ.

SHISLER, CLARE SHEPARD.
Miniature painter. Pupil of Carlotta Vanatta and Lillian Pettingill. Member: California Society of Miniature Painters; Pennsylvania Society of Miniature Painters; West Coast Arts, Inc. Awards: Medal, Yukon Pacific Expo., 1909; silver medal, P.-P. Expo., San Francisco, 1915; prize, Seattle Fine Arts Society, 1913; prize, West Coast Arts, Inc., 1923; fourth Balch prize, California Society of Miniature Painters, 1929. Address in 1929, 581 Mountain View St., South Pasadena, CA; 1605 East Madison St., Seattle, WA.

SHIVA, R(AMON).
Painter. Born in Spain, Oct. 17, 1893. Member: Cor Ardens; Art Institute of Chicago Alumni; Chicago Society of Artists; Palette and Chisel Club. Awards: Eisendrath prize, Art Institute of Chicago, 1921; hon. mention, Art Institute of Chicago, 1923. Address in 1929, 1311 North Dearborn St., Chicago, IL.

SHOEMAKER, EDNA COOKE.
(Mrs. Orlando Shoemaker). Illustrator. Born in Philadelphia, PA, June 19, 1891. Pupil of Hugh Breckenridge

and Henry McCarter. Member: Philadelphia Alliance; Fellowship Penna. Academy of Fine Arts; Plastic Club. Illustrated stories by Mrs. J. H. Ewing, Mrs. Milsworth Duffield; *East o' the Sun and West o' the Moon; Mother Goose* and other Nursery Rhymes; *Rip Van Winkle; Hans Brinker or The Silver Skates; Heidi; The Legend of Sleepy Hollow*; and stories for many magazines. Address in 1929, 4049 Locust St., Philadelphia, PA.

SHOKLER, HARRY.
Painter. Born in Cincinnati, OH, April 27, 1896. Pupil of Herman Wessel; Daniel Garber; Howard Giles. Address in 1929, 99½ W. 3rd Street, New York, NY.

SHONNARD, EUGENIE FREDERICA.
Sculptor, painter, and teacher. Born in Yonkers, NY, April 29, 1886. Pupil of Bourdelle and Rodin in Paris; New York School of Applied Design for Women, with Mucha. Member: Art Alliance of America; National Sculpture Society (associate); National Association of Women Painters and Sculptors. Commissions: Decorative wooden panels for Waco (TX) Post Office, and U.S. Treasury Department; decoration in terra cotta for Ruth Hanna Memorial Wing, Presbyterian Hospital, Albuquerque, NM; bronze portrait plaque, Supreme Court Building, Santa Fe, NM; many others. Exhibited many times in Paris, up to 1923; at National Sculpture Society, 1923; Art Inst. of Chicago; Penna. Acad. of Fine Arts; Museum of Modern Art; Whitney Mu. of American Art; Brooklyn Mu.; many others. Moved to Santa Fe, NM, in 1928. In collections of Museum of Modern Art; Brookgreen Gardens, SC; NY Zoological Society; and private collections. Address in 1976, Santa Fe, NM.

SHOPE, HENRY B.
Etcher. Born in Baltimore, MD, in 1862. Member of Brooklyn Society of Etchers. Represented by etchings in NY Public Library. Address in 1926, 28 East 21st St., New York, NY.

SHORE, HENRIETTA M.
Painter, lithographer, lecturer and teacher. Born in Toronto, Canada. Pupil of Henri, Chase, Hayes Miller in NY; studied in London. Mem.: Soc. of Independent Artists; Nat. Assoc. of Women Painters and Sculptors. Awards: Silver medal, Panama-California Expo., San Diego, 1915; silver medal, Panama-California Expo., San Diego, 1916; prize, Graphic Arts, San Francisco Art Assoc., 1930. Work: "Negro Woman and Children," National Gallery of Canada, Ottawa; three lithographs, Gallery of Fine Arts, San Diego, CA; lithograph, Univ. of Washington, Seattle. Address in 1933, Carmel-by-the-Sea, CA.

SHORE, ROBERT.
Illustrator. Born in NYC in 1924. Attended Cranbrook Academy in Michigan and Pratt Institute. In

1952 he was awarded a Fulbright Fellowship in painting. His clients have included *Esquire, Collier's, Seventeen, Woman's Day,* CBS, NBC, and *The New York Times*, as well as many book publishers and advertisers. The Detroit Institute of Fine Arts, Smithsonian Institution and National Gallery in Washington, DC, have all exhibited his artwork. In 1967 he was awarded a gold medal from the Society of Illustrators for book illustration.

SHOREY, GEORGE H.
Painter, illustrator, and teacher. Born in Hoosick Falls, NY, Sept. 9, 1870. Pupil of Walter Shirlaw. Director, Artist-Artisan Institute, 1898-1903. Work: Illustrations for "Cathedral of St. John the Divine," "New York Parks," "Old Kingston," etc.; "The Ascension," Soldiers bronze memorial tablet, Trinity Episcopal Church, Grantwood, NJ. Director of art department, Browning School, New York, NY. Died in 1944. Address in 1929, 52 East 62nd St., New York, NY; h. Grantwood, NJ; summer, Burnt Hills, NY.

SHORTER, EDWARD S(WIFT).
Painter, etcher, and writer. Born in Columbus, GA, July 2, 1900. Pupil of Corcoran School of Art; Breckenridge School; W. L. Stevens, at Rockport, MA; M. F. Browne; Emile Renard, Paris. Member: North Shore Arts Association; Washington Society of Artists; Washington Society of Water Color Painters; Southern States Art League; Society of Independent Artists; Washington Art Club; Atlanta Art Association; American Artists Professional League; Chicago Art League; American Federation of Arts; Georgia Society of Artists (president). Award: Blue ribbon for drawing, Southern Art Exhibition, Nashville, TN, 1926; hon. mention, Georgia Artists Exhibition, 1928, 32. Author of bi-weekly column on the arts in *Macon News*, entitled "Palette Scrapings;" contributor to *Macon Telegraph* and magazines. Address in 1929, 130 Georgia Ave., Macon, GA.

SHOTWELL, FREDERIC VALPEY.
Painter, illustrator, etcher, lecturer, and teacher. Born in Detroit, MI, Sept. 22, 1907. Pupil of Berninghaus; Carpenter; Pennell; Dodge; Bridgman; Sepeshy. Member: Detroit Society of Etchers; Scarab Society. Work: Assisted execution of murals for the Library of Fordson School, Fordson, MI; General Motors Building, Detroit. Address in 1929, 236 Holybrook, Detroit, MI; summer, Bay View, MI.

SHOTWELL, H. C.
In 1853 this landscape engraver was working for publishers in Cincinnati, OH.

SHOTWELL, HELEN HARVEY.
Painter and photographer. Born in New York City, April 21, 1908. Studied sculpture with Bruno Zimm; oils with Edwin Scott, a student of Whistler, in Paris; water color with Poveda in Rome; pictorial photography with Flora Pitt-Conrey; still life with Henry Lee McFee and Judson Smith, both noted Woodstock artists; portrait with Alexander Brook at the Art Students League. Also worked with her mother, painter Margaret Harvey Shotwell, in their Woodstock and NYC studios. She travelled widely in Europe, the Orient, and Latin America, using her camera to record many themes. In collections of Arthur M. Watson; Corcoran; Art Students League; IBM; China Institute, NY; Fitchburg (MA) Art Museum; others. Exhibited at Argent Galleries, NYC (one-woman); Dayton Art Institute; San Francisco Museum of Art; World's Fair of NY, 1939; High Museum, SC; Fitchburg (MA) Art Center (one-woman); Carnegie Institute; Montclair (NJ) Art Museum; Apollo Gallery, Poughkeepsie, NY; Corcoran, Washington, DC; Penna. Academy of Fine Arts; Shuster Gallery, NY (one-woman); international salons in Spain, India, New Zealand, Iceland, South America, U.S.; others. Also known for her work with the Woodstock Guild of Craftsmen. Member: Woodstock Art Association (life); National Association of Women Artists; International Society of Arts and Letters (life); Jackson Heights Art Club. Address in 1970, Woodstock, NY; 257 West 86th Street, New York, NY.

SHOTWELL, MARGARET HARVEY.
Painter. Born in Wyoming, Ontario, CN, October 14, 1873. Studied at University of Toronto; Sorbonne, Paris; Universities of Geneva and Rome; with Edwin Scott, a pupil of Whistler, and with Leon Dabo, in France. Travelled widely with her husband, James Thomson Shotwell, author and historian of international stature. Exhibited in U.S. and abroad, including Paris Salon d'Automne, 1911, 13; Shuster and Argent Galleries, Cosmopolitan Club, 1951, Columbia University, 1957-59, all in NYC; Woodstock, NY; Apollo Gallery, Poughkeepsie, NY. One of the earliest settlers in the Woodstock art colony, founded in 1902, she painted and taught there and in NYC. Awards include honorable mention in the Paris Salon d'Automne, 1911, at which Mary Cassatt had also worked. Life member of the Woodstock Art Association. Address in 1962, Woodstock, NY; 257 West 86th Street, New York, NY. Died in 1965.

SHOVER, EDNA M(ANN).
Illustrator, writer, and teacher. Born in Indianapolis, IN. Pupil of Faber; Deigendesch; Thomas Scott; Philip Muhr; J. F. Copeland. Member: Alumni Association, Pennsylvania Museum School of Industrial Art; Indiana Art Club; American Federation of Arts. Award: Gold medal, Alumni Association, Pennsylvania Museum School of Industrial Art, 1931. Author of *Art in Costume Design*, published by Milton Bradley Company. Principal, Art School of the Herron Art Institute. Address in 1933, Art School of the Herron Art Institute; h. 1468 North New Jersey St., Indianapolis, IN.

SHOWE, LOU ELLEN (MRS.).
See Chattin, Lou Ellen.

SHRADER, E(DWIN) ROSCOE.
Painter, illustrator, lecturer, and teacher. Born in Quincy, IL, Dec. 14, 1879. Pupil of Art Institute of Chicago and Howard Pyle. Member: California Art Club; Wilmington Society of Fine Arts. Died in 1960. Address in 1929, Otis Art Institute, 2401 Wilshire Blvd., Los Angeles, CA; h. 1927 Highland Ave., Hollywood, CA.

SHRADY, HENRY MERVIN.
Sculptor. Born in NYC in 1871. He was self-taught in sculpture. Member: National Sculpture Society; New York Architectural League; National Academy of Design, associate; National Institute of Arts and Letters. Works: Grant Memorial, Washington, DC; equestrian statues, General Washington at Valley Forge, Brooklyn, NY; General Williams, Detroit, MI; General Robert Lee, Charlottesville, VA; William the Silent, Holland Society; Jay Cooke, Duluth, MN; life-size bas-relief portrait, Dr. St. John Roosa; portrait bust, General Grant; numerous statuettes and bas-relief portraits. Exhibited at National Sculpture Society, 1923. Died April 12, 1922, in New York City.

SHRAMM, PAUL H.
Sculptor and illustrator. Born in Heidenheim, Germany, in 1867. Pupil of Claudinso, Schrandolph and Jacob Grunenwald in Stuttgart; of MacNeil at Pratt Institute, Brooklyn, NY. Member of NY Society of Cartoonists. Address in 1926, Buffalo, NY.

SHUFF, LILY.
(Lillian Shir). Painter and engraver. Born in NYC. Studied: Hunter College; Art Students League; Brooklyn Academy of Fine Arts; Farnsworth School of Art; Columbia University; and with Jon Corbino. Awards: Brooklyn Society of Artists, 1953, 57, 62; NJ Society of Painters and Sculptors, 1956; Caravan Gallery, 1958; Connecticut Academy of Fine Arts, 1956; National Association of Women Artists, 1958, 59; Grumbacher award, 1960, 65; Painters in Casein, 1957, 63, 65, 66, 67; American Society of Contemporary Artists, 1966, 68; others. Collections: Library of Congress; Metropolitan Museum of Art; Butler Institute of American Art; Pakistan Consulate, NY; Lane College, NY; James Fenimore Cooper High School; Georgia Museum of Fine Arts; Yale University; Mueller Collection, Paris, France; others, including private collections in U.S. and abroad. Exhibited: National Arts Club; Brooklyn Museum; Library of Congress; Audubon Artists; Connecticut Academy of Fine Arts; National Academy of Design; American Federation of Arts traveling exhibition; National Association of Women Artists; NY Society of Women Artists; Butler Institute; Whitney; Silvermine Guild; Smithsonian; Boston Museum of Fine Arts; plus many one-woman exhibitions. Member: Artists Equity Association; National Association of Women Artists; Silvermine Guild of Artists; Connecticut Academy of Fine Arts; NY Society of Women Artists; Audubon Artists; others. Address in 1980, 155 W. 68th St., New York, NY.

SHULGOLD, WILLIAM (ROBERT).
Painter, etcher, and teacher. Born in Russia. Pupil of Sparks; Sotter; Levy; Hawthorne. Member: Pittsburgh Art Association; Pittsburgh Palette Club; Tiffany Foundation. Work: "Sketching" and "Self Portrait," gift of Hundred Friends of Art to Pittsburgh Public Schools. Address in 1933, 229 Halket Street, Pittsburgh, PA.

SHULL, DELLA.
Portrait painter. Exhibited portrait of Mrs. Robert Henri at Annual Exhibition, 1923, of Penna. Academy of Fine Arts. Address in 1926, 39 West 67th St., New York.

SHULL, J(AMES) MARION.
Painter, illustrator, and writer. Born in Clark County, OH, Jan. 23, 1872. Pupil of Art Students League of NY. Member: Washington Art Club. Work: 1,350 color drawings, U.S. Department of Agriculture; illustrations for *Country Life* and *Ladies Home Journal*. Died in 1950. Address in 1929, Agricultural Department, 14th and B. Streets, Washington, D.C.; h. 207 Raymond St., Chevy Chase, MD.

SHULZ, ADA WALTER.
(Mrs. Adolph R. Shulz). Painter. Born in Terre Haute, IN, on Oct. 21, 1870. Pupil of Art Institute of Chicago; Vitti Academy in Paris. Member of Chicago Society of Artists; Wisconsin Painters and Sculptors. A founder of Brown Colony of Artists, IN. Work: "Motherhood," Milwaukee Art Institute; "Mother and Child," Art Institute of Chicago. Specialty: Children. Address in 1929, Nashville, Brown County, IN. Died May 4, 1928 near Nashville, IN.

SHULZ, ADOLPH R(OBERT).
Landscape painter and teacher. Born in Delavan, WI, June 12, 1869. Pupil of Art Institute of Chicago; Art Students League of NY; Julian Academy in Paris under Lefebvre, Constant and Laurens. Member: Indiana Art Club. Awards: Young Fortnightly prize, Art Institute of Chicago, 1900; Grower prize, Art Institute of Chicago, 1908; Municipal Art League purchase, Art Institute of Chicago, 1904; Milwaukee Art Institute medal, 1918. Work: "Frost and Fog," Art Institute of Chicago. Address in 1929, Nashville, Brown Co., IN.

SHUMACKER, ELIZABETH WIGHT.
(Mrs. Ralph Shumacker). Painter and instructor. Born in Chattanooga, TN, on Sept. 25, 1912. Studied: University of Chattanooga with Frank Baisden; also

with Stuart Purser, Wiemer Purcell, George Cress, and Joe Robertson; studied graphics with Carolyn Hilton; also studied at the Hunter Gallery of Art with Phillips, James Watson, and Alan Kuzmickie. Collections: High Museum, Atlanta; Brooks Memorial Gallery, Memphis; Atlanta Art Association Museum; First National Bank of Little Rock; New York *Times*; South Central Bell, Birmingham. Exhibitions: High Museum; Butler Institute, Youngstown, OH; Brooks Memorial Gallery; Smithsonian Institution, Washington, DC; Heal's Art Gallery, London, England; others; one-woman exhibitions at Chattanooga, TN; Rome, GA; Oak Ridge, TN; others. Member of Chattanooga Art Association. Address in 1980, 1400 Riverview Rd., Chattanooga, TN.

SHUMWAY, HENRY COLTON.
Miniature painter. Born July 4, 1807, in Middletown, CT. He came to NY in 1827 and entered as a student in the National Academy of Design. He began painting professionally in 1829. Among the prominent men who sat for him were Henry Clay, Daniel Webster, and Prince Napoleon (afterwards Napoleon III). Died May 6, 1889, in NYC.

SHURTLEFF, ELIZABETH.
Painter. Born in Concord, NH, Sept. 3, 1890. Pupil of Phillip Hale and Frank Benson. Work: Series of mural decorations showing seven countries, Raymond Whitcomb Co., Boston, MA. Address in 1929, 86 Mt. Vernon St., Boston, MA.

SHURTLEFF, ROSWELL MORSE.
Painter. Born June 14, 1838, at Rindge, NH. Graduate of Dartmouth College, 1857. He took charge of architect's office, Manchester, NH, in 1857; worked at lithography in Boston, drawing on wood and attending evening classes, Lowell Institute, in 1859; worked as an illustrator and attended Academy of Design, NY. He was an illustrator for magazines and books in NY for several years. He began to paint in oils in 1870, at first animal pictures, and later landscapes, in both oils and water colors. Elected an Associate of the National Academy of Design in 1881; Academician National Academy, 1890; was also a member of the American Water Color Society. Among his works are "The Wolf at the Door," "A Race for Life," and "Views Among the Adirondacks." Died Jan. 6, 1915, in NYC.

SHUSTER, WILLIAM HOWARD.
Painter, etcher, sculptor, artist, and illustrator. Born in Philadelphia, PA, November 26, 1893; moved to Santa Fe, NM, in 1920. Studied electrical engineering, Drexel Institute, Philadelphia; with J. William Server in Philadelphia; with John Sloan, etching and painting, in Santa Fe. Work: "The Corn Dance, Santo Domingo," Museum of New Mexico, Santa Fe, NM; "The Rain Prayer," Newark Museum; "Carlsbad Cavern," Brooklyn Museum; Anschutz Collection,

Denver, CO; New York Public Library; sculpture at Carlsbad Caverns (NM) National Park. Member: Society of Independent Artists; Los Cinco Pintores; Santa Fe Arts Club. Illustrator of a frontier biography. Address in 1933, Camino del Monte Sol, Santa Fe, NM. Died in Albuquerque, NM, 1969.

SHUTTLEWORTH, CLAIRE.
Painter and teacher. Born in Buffalo, NY. Pupil of Buffalo Art Students League; DuMond and Bridgman; Merson, Collin and Leroy in Paris. Member: Buffalo Society of Artists; National Association of Women Painters and Sculptors; Rockport Art Association; American Federation of Arts. Award: Fellowship prize, Buffalo Society of Artists, 1910 and 1929; special award of honor, Springville (UT) High School Art Association, 1927. Work: "The Horse Shoe Falls from Table Rock," Arnot Art Gallery, Elmira, NY; "Flags A Flying," Buffalo Historical Society. Address in 1929, 508 Franklin St., Buffalo, NY; summer, "Minglestreams," Chippawa, Ontario, Canada.

SIBBEL, JOSEPH.
Sculptor. Born in Germany. Sculpted ecclesiastical statuary. Died July 10, 1907, in NYC.

SIBONI, EMMA.
Miniature painter. Born in 1877. Exhibited at the Penna. Academy of Fine Arts, Philadelphia, 1926. Address in 1925, 1115 Maples St., South Pasadena, CA.

SICKLES, NOEL.
Illustrator. Born in 1911. His early career as a newspaper artist and cartoonist was the basis for his predisposition for clean, expressive line drawing. Having created his adventure strip, "Scorchy Smith," he produced editorial and advertising illustrations. After instructional assignments from the Army and Navy Departments he produced a series of drawings of World War II for *Life*. American history illustration, his specialty, appeared in *The Saturday Evening Post, This Week, Life,* and the *Reader's Digest.*

SIEBER, EDWARD E.
Painter. Born in Brooklyn, NY, in 1862. Pupil of National Academy of Design; also studied in Paris. Specialty: Landscape and cattle. Address in 1926, 9 West 14th St., New York, NY.

SIEBERN, E.
Sculptor. Exhibited at the Annual Exhibition, 1923, Penna. Academy of Fine Arts, Philadelphia. Address in 1926, 99 Sixth Ave., New York. Died June 14, 1942, in NYC.

SIEBERT, EDWARD S(ELMAR).
Painter, etcher, and teacher. Born in Washington, D.C., July 1, 1856. Pupil of Baur in Weimar; Carl

Hoff in Karlsruhe; Willian von Diez in Munich. Award: Hon. mention and one prize, Rochester, NY. Work: "Flute Player," Corcoran Gallery of Art, Washington, D.C. Address 1929, 37 East Ave., Rochester, NY.

SIEGEL, DINK.
Illustrator. Born in Birmingham, AL, in 1915. Attended the National Academy of Design; Art Students League; and American Academy of Art. His editorial work was first seen in *Good Housekeeping*, and this led to many years of assignments from other magazines and the subsequent appearance of his illustrations in *Playboy* and *Field and Stream*. Arrow Shirts, Ford Motor Company, and film studios have used his advertising art. He is a life member of the Society of Illustrators and presently lives in NY.

SIEGLER, MAURICE.
Painter. Born 1896. Exhib. water colors at the Penna. Acad. of Fine Arts, Phila., 1925. Address 1926, care of Penna. Acad. of Fine Arts, Phila.

SIEVERS, FREDERICK WILLIAM.
Sculptor. Born in Fort Wayne, IN, October 26, 1872. Studied in Richmond, VA; Royal Academy of Fine Arts in Rome, under Ferrari; and Julian Academy in Paris. Exhibited: National Sculpture Society; Virginia Museum of Fine Arts. Work: Equestrian statue of Gen. Lee and group at Gettysburg, PA; equestrian statue of Stonewall Jackson, Richmond, VA; Confederate Monuments at Abingdon and Leesburg, VA; Matthew Fontaine Maury monument, Richmond, VA. Address in 1953, Forest Hill, Richmond, VA.

SILBERMAN, SARAH GETTLEMAN.
Sculptor. Born in Odessa, Russia, September 10, 1909. Pupil of Albert Laessle and Walker Hancock. Member: Fellowship Penna. Academy of Fine Arts. Award: Cresson Traveling Fellowship, Penna. Academy of Fine Arts, 1931. Address in 1933, 12 South Brighton Ave., Atlantic City, NJ.

SILEIKA, JONAS.
Painter and teacher. Born in Lithuania, July 2, 1883. Studied at Art Institute of Chicago; Royal Academy, Munich. Member: American Federation of Arts (active); Art Society of Lithuania. Award: Joseph N. Eisendrath prize, Art Institute of Chicago, 1920. Work: Portrait of "Prof. J. Naujalis," "Winter in Lithuania" and "An Old Man and His Cottage," Gallery of (Tchur Lionis) Ciur Lionis, Kaunas, Lithuania. Address in 1929, Art Institute, Meno Mokykla, Lithuania; h. Jedagoniu K., P. ag. Lekeciai, Lithuania.

SILSBEE, MARTHA.
Painter. Born in Salem, MA, in 1858. Member: Boston Water Color Club. Address in 1926, 82 Chestnut Street, Boston, MA.

SILSBY, CLIFFORD.
Painter and etcher. Born in New Haven, CT, Aug. 15, 1896. Pupil of Duchenaud; Royer; Laurens; Pages. Address in 1929, 1411 West Calumet Ave., Los Angeles, CA.

SILVA, FRANCIS AUGUSTUS.
Painter. Born in 1835. He worked as a sign painter until the opening of the Civil War when he entered the National Army; at the close of the war he settled in NY and devoted himself to painting marine subjects. Among his works are "Gray Day at Cape Ann," "Sunrise in Boston Harbor," and "Near Atlantic City." Member of the Hudson River School and Watercolor Society. His most important and highly valued works were his last few marine views. He died in 1886.

SILVA, WILLIAM PASEY.
Painter. Born in 1859 in Savannah, GA. Pupil of Julian Academy in Paris under Laurens and Royer; Chauncey Ryder at Etaples, France. Member: Society of Washington Artists; Mississippi Art Association; American Art Association of Paris; Southern States Art League; New Orleans Art Association; American Federation of Arts. Awards: Silver medal, Appalachian Expo., Knoxville, 1910; silver medal, Pan-Cal. Expo., San Diego, 1915; gold medal, Mississippi Art Association, 1916; hon. mention, Salon Artists Francais, Paris, 1922; Southern States Art League prize, 1925; grand prize, Georgia-Alabama Exhibition, Nashville, 1926; popular prize, New Orleans Art Assoc., 1926; first prize, Mississippi State Fair, 1926; popular prize, Southern States Art League, 1927; special mention of honor, Springville, UT, 1927; Davis National prize, San Antonio, TX, 1928; popular prize, state-wide exhib., Santa Cruz, 1929; hon. mention, Davis National Competition, San Antonio, 1929; purchase prize, Springville (UT) High School Art Assoc., 1929. Work: "Pines of Picardy," Carnegie Public Library, Chattanooga, TN; "Pine and Its Shadow," "Fog, Isle of Palms," Gibbes Gallery, Charleston, SC; "Fog Coming In - Ogunquit," and 10 sketches around Fort Worth, Forth Worth (TX) Art Association; "Poplars at Twilight," 19th Century Club, TN; "Foggy Day, Ogunquit," and "The Harvest Moon," Delgado Museum, LA; "A Street in Carmel," Public Library, Palo Alto, CA; "Afternoon, Venice," Huntington Club, Savannah, GA; "Into the Mist," Janesville (WI) Art League; "Springtime in the South," Mississippi Art Gallery, Jackson, MI; "The Swelling Tide," Milwaukee Art Institute; "Breezy Day, Gloucester," Centennial Club, Nashville, TN; "Georgia Pines," "The Magic Pool," "Mists of Morning," Nashville (TN) Art Association; "Wind Swept Cypress," Kansas State Teachers' College, Emporia, KS; "The Nation's Landmark," Union High School, Monterey, CA; "Morning, Washington, D.C.," Union High School, Salinas, CA; "Dusk, Point Lobos," Union

High School, Ft. Worth, TX; "Wisteria and Azaleas," purchased by French Government for State Collecton, 1926; "Springtime in the Low Country," Carey Art Club, Jackson, MI; "The Palmetto Shore," "Sea Island Marshes," "The Little Bridge, Magnolia," "Path by the Lake, Magnolia," Columbia College Art Department, SC; "Twilight Glow in the Garden of Dreams," High School Art Association, Springville, UT; "Garden of Dreams," Tennessee Pen Womens' Club, Look Out Mountain; "Moonrise Magnolia," Woman's Club, Fort Worth, TX; "The Swirl of Foam," Union High School, King City, CA; "The Timeless Cypress," Chatham Academy, Savannah, GA; Art Appreciation Club, Meridian, MI; Boise Art Association, ID; others. Died in 1948. Address 1933, Carmel-by-the-Sea, CA.

SILVEIRA, BELLE.
(Mrs. W. O. Gorski). Sculptor, painter, and illustrator. Born in Erie, PA, September 21, 1877. Pupil of John Vanderpoel; William Chase; and Fred Richardson. Address in 1903, 202 East 57th St., Chicago, IL.

SILVER, ROSE.
Painter and illustrator. Born in New York City, May 8, 1902. Pupil of the University of Washington; Rudolf Schaeffer. Member: Art Club, University of Washington. Award: Silver cup from *Judge* for cover, 1922. Illustrates for *The New Yorker*, etc. Address in 1933, 2014 East Cherry St., Seattle, WA.

SILVER, THOMAS C.
Sculptor and educator. Born in Salem, OR, May 27, 1942. Studied at San Francisco Art Institute, 1960-61, with Joan Brown; California State College, Long Beach, B.A., 1966; University of Kansas, M.F.A., with Elden Tefft. Exhibited: Oakland Museum, CA; Corcoran Gallery of Art, Washington, DC; Virginia Museum of Fine Arts, 1971-73; Cleveland Museum of Art, OH, 1972-77; others. Taught sculpture at Virginia Commonwealth University, 1965-72; teaching sculpture at Cleveland State University, OH, from 1972. Works in bronze. Address in 1982, Cleveland Heights, OH.

SILVERBERG, E. MYER.
Portrait painter. Born in Russia, in 1876. Studied in Royal Academy of Fine Arts, Munich. Member of Pittsburgh Artists' Association. Work in high schools and other public institutions, Pittsburgh, PA. Address in 1926, 58 West 57th Street, New York, NY.

SILVERMAN, BURTON PHILIP.
Illustrator. Born in Brooklyn, NY, in 1928. Trained at Columbia University and intermittently attended the Art Students League. Among his teachers were Reginald Marsh and Julian Levi. In 1955 he began working for *The New York Post* and since that time his illustrations have appeared in most national and international publications. A gold medal from the Art Directors' Club One-Show was awarded to him in 1973; he also won six prizes from the National Academy of Design Annual Exhibition. His work has been shown in many galleries as well as being presented in 14 one-man shows. The Philadelphia Museum, the Brooklyn Museum, and the New Britain Museum of American Art all own his artwork.

SILVERMAN, MEL (MELVIN FRANK).
Painter, engraver, illustrator and writer. Born Jan. 26, 1931, in Denver, CO. Earned B.F.A. and B.A.E. from Art Insti. of Chicago. Awarded traveling fellowship, Art Institute of Chicago, 1954; prize, NJ Graphics, 1959. Exhibited at American Fed. of Arts; Philadelphia Printmakers' Club; Brooklyn Museum; Denver Museum of Art; Art: USA; one-man exhibitions at Butler Institute of American Art, Zanesville Museum of Art, Artists Gallery, NY, Ein Harod, Israel; others. In collections of Butler Institute of American Art; University of Minnesota; Philadelphia Museum of Art; Allentown Art Museum; U.S. Information Agency, Washington, DC; Public Library, Washington, DC; and others. Address in 1962, c/o World Publishing Co., 119 West 57th St., New York, NY. Died Sept. 16, 1966.

SILVERS, HERBERT (FERBER).
Sculptor and painter. Born in NYC, April 30, 1906. Address in 1933, 145 West 14th St., NYC.

SIMEON, NICHOLAS.
Painter. Born in Switzerland in 1867. Address in 1926, 109 West 54th Street, New York City.

SIMES, MARY JANE.
Miniature painter. Born April 1, 1807, in Baltimore, MD. She flourished 1826-31. Died May 16, 1872.

SIMKHOVITCH, SIMKHA.
Painter. Born in Petrograd, Russia, May 21, 1893. Pupil of Royal Academy of Russia, Petrograd. Member: Brooklyn Society of Artists; Painters and Sculptors. Award: First prize given by First Soviet Government in 1918 for "Russian Revolution." Works: "Victory in Death," Museum of the Winter Palace, Petrograd; "Sawing Wood" and "Under the Apple Tree," Museum of Art, Petrograd; "Head of a Woman," Krakow Museum, Poland. Address in 1933, 65 Orchard Place, Greenwich, CT.

SIMKINS, MARTHA.
Painter. Born in Texas. Pupil of Art Students League of NY and Chase. Member: National Association of Women Painters and Sculptors; Pen and Brush Club. Address in 1929, 939 Eighth Ave., New York, NY; summer, Woodstock, Ulster Co., NY.

SIMMANG, CHARLES, JR.
Sculptor, engraver, and craftsman. Born in Serbin, TX, February 7, 1874. Pupil of Charles Stubenrauch.

Member: American Federation of Arts; San Antonio Artists' League. Specialty: Steel relief engraving. Address in 1929, San Antonio, TX.

SIMMONS, EDWARD E.
Mural painter and craftsman. Born in Concord, MA, Oct. 27, 1852. Pupil of Boulanger and Lefebvre in Paris. Member: Ten American Painters; National Institute of Arts and Letters. Awards: Hon. mention, Paris Salon, 1882; bronze medal, Paris Expo., 1889; gold medal, Pan.-Am. Expo., Buffalo, 1901; collaborative prize, NY Architectural League, 1912. Work: "The Battle of Concord" and "Restoration of Battle Flags," Massachusetts State House, Boston; "The Muses," nine panels, Library of Congress, Washington, DC; "Justice," "The Fates" and "Liberty, Equality, Fraternity," Criminal Court, NY; four pendentives, dome, Minnesota State Capitol, Pierre, SD; and in Court House, Mercer, PA; Astor Gallery, Astoria, NY; Court House, Des Moines, IA; Appellate Court, NY; Memorial Hall, Harvard College. Address in 1929, 16 Gramercy Park, New York, NY.

SIMMONS, FRANKLIN.
Sculptor. Born on January 11, 1839, in Lisbon, ME. Studied in Boston with John Adams Jackson. He executed a bust of President Lincoln; also statues of Roger Williams and William King for the state of Maine. Worked in Providence, RI, Maine and Washington, DC. Specialties were portrait busts, ideal figures, Civil War monuments. Died in Rome, December 6, 1913, where he had lived from 1867.

SIMMONS, JOSEPH.
Engraver. *The Pennsylvania Gazette* for Jan. 3, 1765, contains the following advertisement: "Joseph Simmons, Engraver, from London, Cuts Coats of Arms and Cyphers in Stone, Silver or Steel, for Watches. He is to be spoke with at Mr. Robert Porter's Saddler, in Market street, Opposite the Prison. N. B. As there is no other Person of the same business on the Continent, he hopes to meet with Encouragement." Simmons was evidently a seal cutter; and special interest lies in his claim to be the only one then in business in the country.

SIMMONS, WILL.
Painter, writer, etcher, and sculptor. Born in Elche, Spain, June 4, 1884. Pupil of Julian Academy, Lefebvre and Alexander Harrison in Paris; Edward Simmons in America. Member: Chicago Society of Etchers; Brooklyn Society of Etchers; California Printmakers. Represented in NY Public Library; Smithsonian Institution, Washington, D.C. Specialty: Natural History. Died in 1949. Address in 1929, New Milford, CT.

SIMON, BERNARD.
Sculptor and teacher. Born in Russia, January 6, 1896. Studied art at the Educational Alliance and

Art Workshop, NY. Exhibited: Audubon Artists; Silvermine Guild; American Society of Contemporary Artists; Boston University; ACA Gallery, NY; Ruth White Gallery, NY (one-man); Arwin Gallery, Detroit (one-man); plus others. Work: Slater Memorial Museum, Norwich, CT; Norfolk Museum of Arts and Sciences; private collections. Awards: Prizes, Knickerbocker Artists; prizes, Artists Equity Association; Audubon Artists; and New Jersey Soc. of Painters and Sculptors. Member: Brooklyn Society of Artists; Audubon Artists; Artists Equity Assoc.; Silvermine Guild; New Jersey Society of Painters and Sculptors. Taught: Instructor at the Museum of Modern Art, NY; New School for Social Research; and the Bayonne Art Center. Media: Wood and marble. Address in 1982, 490 West End Ave., NYC.

SIMON, EUGENE J.
Painter. Born in Hungary, May 8, 1889. Pupil of Kenneth Hayes Miller. Member: Society of Independent Artists; Woodstock Art Association; Bronx Artists Guild. Address in 1929, 665 East 242nd St., New York, NY; summer, Woodstock, NY.

SIMON, HOWARD.
Engraver, illustrator and painter. Born in New York, July 22, 1902. Member: California Society of Etchers. Work: "Mother Earth," Museum of the Legion of Honor, San Francisco, CA; wood engraving, "Rabelais" and "Mme. du Maupin," Baltimore Museum of Art, Baltimore, MD. Illustrated *History of California Pathfinders* (Powell Pub. Co.). Died in 1979. Address in 1933, 664 West 163rd St., New York, NY; summer, Possum Trot, Hollis, AR.

SIMON, SIDNEY.
Sculptor and painter. Born in Pittsburgh, PA, June 21, 1917. Studied at Carnegie Institute of Technology; Penna. Academy of Fine Arts, with George Harding, B.F.A.; University of Pennsylvania, B.A.; Barnes Foundation. Works: Century Association; Chautauqua Institute; Colby College; Metropolitan Museum of Art; The Pentagon; U.S. State Department; plus many commissions, including Downstate Medical Center, Brooklyn; Temple Beth Abraham, Tarrytown, NY; Walt Whitman High School, Yonkers, NY; stage and film sets; and others. Exhibitions: Penna. Academy of Fine Arts; Niveau Gallery, NYC; Grand Central Moderns, NYC; Grippi Gallery, NYC; Pittsburgh Plan for Art; Yale University; New School for Social Research; National Academy of Design Annuals, 1944-60; Penna. Academy of Fine Arts, 1948-53, 62; Metropolitan Museum of Art, American Painters Under 35, 1950; Whitney; International Biennial Exhibition of Paintings, Tokyo; Brooklyn Museum; Corcoran; Museum of Modern Art; American Federation of Arts, Educational Alliance Retrospective; others. Awards: Penna. Academy of Fine Arts, Cresson Fellowship; Edwin Austin Abbey Fellowship, 1940; Art Institute of

Chicago, Posner Painting Prize; Penna. Acad. of Fine Arts, Fellowship, 1960; Chautauqua Institute, Babcock Memorial Award, 1963; Century Assoc., gold medal for sculpture, 1969. Member: Artists Equity; Century Assoc.; New York Architectural League; Provincetown Art Assoc.; others. Taught: Cooper Union, 1947-48; Brooklyn Mu. School, 1950-52, 54-56; Parsons School of Design, 1962-63; Skowhegan School, 1946-58, 75-76, acad. director, from 1981; Art Students League, from 1973. Media: Wood and bronze. Address in 1982, 95 Bedford St., New York, NY.

SIMOND, L.
Designer of book plates. The engraving "Christ Blessing Children," done for an orphan asylum after his design, was engraved by Leney.

SIMONDS, CHARLES FREDERICK.
Sculptor and architect. Born in NYC, Nov. 14, 1945. Studied at Univer. of CA., Berkeley, B.A., 1967; Rutgers Univer., Douglass College, New Brunswick, NJ, M.F.A., 1967. Work in Museum of Modern Art, NY; Walker Art Center, Minneapolis; Centre Georges Pompidou, Paris; others. Has exhibited at Whitney Biennial; Art Institute of Chicago; Walker Art Center; Stedelijk Mu., Amsterdam; Mu. of Modern Art, NY; Albright-Knox Art Gallery, Buffalo; Fort Worth Art Mu.; Los Angeles County Mu. of Art; others. Address in 1982, 26 E. 22nd St., NYC.

SIMONE, EDGARDO.
Sculptor. Born in Brindisi, Italy, 1890. Came to U.S. in 1924. Studied at the Institute of Fine Arts in Rome; University of Rome; and the Art Institute in Naples, Italy. Work: Bronze bust of Theodore Dreiser, 1944, Metropolitan Museum of Art; worked on decorative sculpture for Century of Progress Exposition in Chicago, 1933. Exhibited at Los Angeles County Museum; Cal. Art Club, Los Angeles; Los Angeles Public Library. Died in Los Angeles, CA, 1948.

SIMONET, SEBASTIAN.
Painter, illustrator, and writer. Born in Stillwater, MN, Oct. 19, 1898. Pupil of University of Minnesota, School of Art; National Academy of Design; Art Students League of NY. Award: First prize, Minnesota State Fair, 1921; first prize for painting, NY State Fair, 1922. Represented by "The Caulker of Oakum," Stillwater, MN. Died in 1948. Address in 1933, 612 South 4th Street, Stillwater, MN.

SIMONNE, T.
Engraver. In 1814-16 Simone was engraving a very few but good plates for the NY publishers David Longworth and T. C. Fay.

SIMONS, AMORY COFFIN.
Sculptor. Born in Charleston, SC, April 5, 1869. Studied: Penna. Academy of Fine Arts; with Rodin,

Dampt, and Puech in Paris. Went to California in the late 1920's; lived first in Hollywood and later in Santa Barbara. Works: High Museum of Art; Baltimore Museum of Art; Brookgreen Gardens, SC; Charleston Museum; Buffalo Bill Museum, Cody, WY; Metropolitan Museum of Art; Santa Barbara Public Library; Santa Barbara Museum of Art; Museum of Natural History, NY; Musee de l'Armee, Paris; others. Awards: Honorable mention, Paris Expo., 1900; honorable mention, Pan.-Am. Expo., Buffalo, 1901; silver medal, St. Louis Expo., 1904; honorable mention, Paris Salon, 1906; honorable mention, P.-P. Expo., San Francisco, 1915; Speyer memorial prize, National Academy of Design, 1922. Exhibited: National Sculpture Society, 1923; Baltimore Museum, 1924; Museum of Natural History, NYC, 1947. Member: American Federation of Arts; American Art Association of Paris; National Sculpture Society (fellow). Specialty: Sculptures of horses. Address in 1953, Santa Barbara, CA. Died in 1959.

SIMONT, JOSEPH.
Illustrator. Member: Society of Illustrators; Artists Guild of the Authors' League of America. Address in 1933, 54 West 74th Street, New York, NY.

SIMPSON, C. HELEN.
See Whittemore, C. Helen Simpson.

SIMPSON, CLARA DAVIDSON (MRS.).
See Davidson, Clara D.

SIMPSON, EDNA HUESTIS (MRS.).
(Mrs. Simpson). Miniature painter. Born in Troy, NY, Nov. 26, 1882. Pupil of Emma Willard Art School; Cornell University; Art Students League of NY. Member: Pennsylvania Society of Miniature Painters; American Federation of Arts. Address in 1929, 333 East 68th St., New York, NY.

SIMPSON, M.
This stipple-engraver designed and engraved a portrait of Washington in the center of an elaborate script memorial. This print was published in 1855 and is signed as "Designed and Engraved by S. Simpson, NY."

SIMPSON, MARIAN.
(Mrs. Lesley Simpson). Painter. Born in Kansas City, Missouri, July 12, 1899. Pupil of H. G. Keller. Member: Club Beaux Arts, San Francisco, California. Awards: Hon. mention for water color, 1923 and 1924, first prize for pastel and second prize for oil, 1924, Cleveland Artists; honor. mention, San Francisco, 1927; prize, water colors, San Francisco Art Association, 1930. Work: "Luisita," owned by the Ward Fund, Cleveland; "Hills," Mills College Gallery, Oakland, California; wall decoration, YWCA, San Francisco. Address in 1929, 976 Miller Ave., Berkeley, California.

SIMPSON, MAXWELL STEWART.
Painter, etcher, and lithographer. Born in Elizabeth, NJ, Sept. 11, 1896. Pupil of National Academy of Design. Member: Chicago Society of Etchers; Society of Independent Artists. Works: "Etelka," "New Jersey Landscape," "Self Portrait," and etchings and lithographs in print collections, New York Public Library; two watercolors, Newark Museum, NJ; portraits, "Foster M. Voorhees, Ex-Governor of New Jersey," Rutgers University; "Gen. Winfield Scott," Winfield Scott Hotel, Elizabeth, NJ; water color, "Moret at Evening," Art Institute of Detroit; three water colors, oils, "Gray Pitcher" and "Oriental Head," and two lithographs, Newark Museum, Newark, NJ; oil and water color, Museum Collection, Briarcliff School, NY. Address in 1933, 1147 East Jersey St.; h. 431 Madison Ave., Elizabeth, NJ.

SIMPSON, ROSLYNN MIDDLEMAN.
Painter. Born in Philadelphia, PA, in 1929. Studied: NJ College for Women; Newark School of Fine and Industrial Arts; with W. Benda; also studied with R. Nakian and B. Gussow. Collections: Metropolitan Museum of Art; Whitney Museum of American Art; Newark Museum of Art.

SIMPSON, WILLIAM MARKS, JR.
Sculptor. Born in Norfolk, VA, August 24, 1903. Pupil of J. Maxwell Miller; Rinehart School of Sculpture; Maryland Institute. Member: Norfolk Society of Artists. Awards: Sloane prizes, 1920, 21, 23, 24, and Ferguson prize, 1923, Norfolk Society of Artists. Work: Portrait bust of Patrick Henry in Patrick Henry School, Norfolk; athletic sketches, V. M. I., Lexington. Address in 1933, 1109 Graydon Ave., Norfolk, VA.

SIMS, AGNES.
Painter, sculptor and craftsman. Born in Rosemont, PA, October 14, 1910. Studied: Philadelphia School of Design for Women; Philosophical Society grant, 1949; Neosho grant, 1952; Penna. Academy of Fine Arts. Collections: Museum of New Mexico; Colorado Springs Fine Arts Center; Denver Art Museum; others. Exhibited: Mus. of NM; Philadelphia Art Alliance; Washington Art Club; Santa Barbara Museum of Art. Address in 1970, Santa Fe, NM.

SIMS, SAMUEL.
(Simms or Syms). Plaster modeler. Worked in NYC, 1844-46. Exhibited plaster medallion of Andrew Jackson, American Institute, 1845-46; unidentified plaster bust, 1844.

SINAIKO, ARLIE.
Sculptor and collector. Born in Kapule, Russia, October 1, 1902; U.S. citizen. Studied at University of Wisconsin, B.S.; Northwestern University, M.D.; Art Institute of Chicago; Sculpture Center, NY; Art Students League; Atelier, with Archipenko, Lassaw,

and Harkavy. Work in Phoenix Art Museum, AZ; Witte Memorial Museum, San Antonio, TX; Delgado Museum, New Orleans; Penna. Academy of Fine Arts; Chrysler Museum; Brooks Memorial Museum; Denver Art Museum; others. Has exhibited at Penna. Academy of Fine Arts; Detroit Institute of Fine Arts; Riverside Museum, NY; Provincetown Art Association, MA; Brooklyn Society of Artists; Bodley Gallery, NY (one-man); New Gallery, Provincetown (one-man); others. Received purchase prize, Penna. Academy of Fine Arts, 1961; honorable mention for sculpture, Audubon Artists; others. Member of American Society of Contemporary Artists; Artists Equity Association; Audubon Artists; Sculptors League. Address in 1982, 115 Central Park W., New York, NY.

SINCLAIR, ARCHIE.
Painter and craftsman. Born in Pitlochry, Perthshire, Scotland, Feb. 19, 1895. Pupil of John H. Dixon and Clyde Leon Keller. Member: Society of Independent Artists; Chicago No-Jury Society of Artists; Salons of America. Represented by two landscapes, Normal School, North Adams, MA; church decorations and stained glass windows. Address in 1933, 969 Multnomah St., Portland, OR.

SINCLAIR, GERRIT V.
Painter and teacher. Born in Grand Haven, MI, May 1, 1890. Pupil of Chicago Art Institute. Member: Wisconsin Painters and Sculptors (president); Chicago Galleries Association; Chicago Society of Artists. Awards: Medal, 1921-28, landscape prize, 1924, figure prize, 1926, Milwaukee Journal purchase prize, 1929, Wisconsin Painters and Sculptors. Work: Murals, "Christ Before Temple," St. James Church, Milwaukee; "La Salle and Tonty," Sherman Park, Chicago. Died in 1955. Address in 1933, Layton School of Art; h. 3274 Newhall Street, Milwaukee, WI.

SINDELAR, THOMAS A.
Illustrator. Born in Cleveland, OH, in 1867. Pupil of Mucha in Paris. Address in 1926, 15 Maiden Lane, New York, NY.

SINGER, BURR (BURR LEE FRIEDMAN).
Painter and lithographer. Born in St. Louis, MO. Studied: St. Louis School of Fine Arts; Art Institute of Chicago; Art Students League; and with Walter Ufer. Awards: Marineland Exhibition, 1955; Los Angeles County Fair, 1951, 53. Collection: Warren Flynn School, Clayton, MO; Library of Congress; Beverly-Fairfax Jewish Community Center, Los Angeles; Child Guidance Clinic, Los Angeles. Exhibited: World's Fair of NY, 1939; Golden Gate Expo., 1939; Audubon Artists; Denver Art Museum; California Water Color Society; Santa Barbara Museum of Art; Library of Congress; Philadelphia Printmakers' Club; Oakland Art Museum; California Water Color

Society Exhibition, Los Angeles; Kramer Gallery, Los Angeles (one-man); Esther Robles Gallery, Los Angeles (one-man); others. Member: Artists Equity Association; Los Angeles Art Association; California Water Color Society. Address in 1976, Los Angeles, CA.

SINGER, WILLIAM H., JR.
Painter. Born in Pittsburgh, PA, July 5, 1868. Studied at Julian Academy, Paris. Member: Associate National Academy of Design, 1916; Pittsburgh Art Society; American Federation of Arts; Allied Artists of America; St. Lucas Society of Art, Amsterdam, Holland. Awards: Silver medal, P.-P. Expo., San Francisco, 1915; Cahn hon. mention, Art Institute of Chicago, 1916. Royal Order of St. Olaf, conferred by King of Norway, 1929. Represented in the Portland Museum; Stedelijk, Amsterdam; Royal Museum, Antwerp; Musee de Luxembourg; Milwaukee Art Institute; Carnegie Public Library, Fort Worth; Delgado Museum, New Orleans, LA; Pinakothek Museum, Munich, Germany; Metropolitan Museum; Brooklyn Museum; Brooks Memorial Art Gallery, Memphis, TN; City Museum of the Hague, Holland; Washington County Museum of Fine Arts, Hagerstown, MD; Curtis Institute of Music, Philadelphia, PA; Walker Gallery, Brunswick, ME; National Gallery, Oslo, Norway; Museum des Beaux Arts, Brussels, Belgium. Died in 1943. Address in 1933, 58 West 57th Street, New York, NY.

SINNOCK, J(OHN) R(AY).
Painter, medallist, and teacher. Born in Raton, NM, July 8, 1888. Pupil of Penna. Museum and School of Industrial Art for 10 years. Member: Boston Art Club; Philadelphia Sketch Club; Philadelphia Alliance; National Sculpture Society (associate); American Federation of Arts. Work: Mural decorations in several Philadelphia public schools. Designed and modeled the special commemorative coins for the Sesqui-Centennial Expo., Philadelphia, 1926; special Congressional Medal of Honor, to Thomas A. Edison, 1928, and to Ellsworth Nobile Amundsen for North Pole flight in dirigible Norge; Yangtse Service Medal, Navy Department; Order of Military Merit, War Department. Portrait medals from life of Presidents Coolidge, Hoover, and Franklin D. Roosevelt. Represented in Luxembourg Museum, Paris. Died in 1947. Address in 1933, Mint of the U.S.; h. and studio, 2022 Spring Garden St., Philadelphia, PA.

SINZ, WALTER A.
Sculptor and teacher. Born in Cleveland, OH, July 13, 1881. Studied: Cleveland School of Art; Julian Academy, Paris; also pupil of Herman N. Matzen; Landowski in Paris. Exhibited: Whitney Museum of American Art, 1941; Penna. Academy of Fine Arts, 1935; Cleveland Museum of Art, annually; Jewish Museum, NY, 1953; Butler Art Institute, 1954; Cleveland Society of Artists, 1958 (one-man). Member: Cleveland Society of Artists; National Sculpture Society. Awards: Cleveland Museum of Art, 1938, 41, 43, 48-50. Work: Cleveland 125th Anniversary Medal; fountain, Y.M.C.A., Cleveland; Cleveland Flower Show Medal; sculpture group, St. Luke's Hospital, Cleveland; Case Institute of Technology; Mount Union College, Alliance, OH; portrait busts of prominent persons; others. Instructor of sculpture, emeritus, Cleveland Institute of Art, from 1912. Address in 1962, Cleveland, OH; h. University Heights, OH. Died in 1966.

SISSON, FREDERICK R.
Painter, etcher, and teacher. Born in Providence, RI, Sept. 5, 1893. Pupil of Rhode Island School of Design; Boston Museum of Fine Arts; Abbott H. Thayer. Member: Providence Art Club; Providence Water Color Club. Address in 1929, 128 North Main St.; h. 24 Thayer St., Providence, RI.

SITZMAN, EDWARD R.
Painter, lecturer, and teacher. Born in Cincinnati, OH, March 31, 1874. Pupil of Duveneck; H. Farney; Cincinnati Art Academy. Member: Indiana Art Club; Indianapolis Art Association; Chicago Galleries Association. Address in 1929, Columbia Securities Bldg., Room 310; h. 1422 North Dearborn St., Indianapolis, IN.

SKELTON, LESLIE JAMES.
Painter. Born in Montreal, Canada, in 1848. Studied in Paris several years. Pupil of Iwill. Landscapes in oil and pastel exhibited: Salon, Paris, 1901; Liverpool Autumn Exhibition, 1902; British and Colonial Exhibition, at time of King Edward's Coronation, 1902; Royal Academy, London, 1904; National Academy of Design; Denver Artists' Club; Montreal Art Assoc.; Colorado Springs Art Society. Represented in the permanent collections of Colorado College, Colorado Springs; in National Gallery, Ottawa, Canada. One of his most noted productions entitled "Gathering Storm in Ester Park" was reproduced in colors in *Brush and Pencil*, 1903. President of Coburn Library Book Club, Colorado Springs; Winter Night Club, 1911; Colorado Springs Art Society, 1913. Address in 1926, 1225 N. Tejon St., Colorado Springs, CO.

SKELTON, RALPH FISHER.
Painter and etcher. Born in Port Byron, IL, Feb. 4, 1899. Pupil of Henry Tonks; W. W. Russell; Sir William Orpen. Address in 1929, Italian Court, 145 East Ontario St., Chicago, IL; summer, 40 Dover St., London, England.

SKEU, SIGURD.
Painter. Exhibited water colors at the Penna. Academy of Fine Arts, Philadelphia, 1925. Address in 1926, 51 Popular St., Brooklyn, NY.

SKIDMORE, LEWIS PALMER.
Painter, etcher, and illustrator. Born in Bridgeport, Connecticut, September 3, 1877. Pupil of J. H. Niemeyer; Laurens and Bonnat in Paris. Member: Brooklyn Society of Artists; Brooklyn Water Color Club; New Haven Paint and Clay Club; Georgia Art Association; American Art Association of Paris. Died in 1955. Address in 1933, Director, High Museum of Art, Atlanta, Georgia; summer, Port Jefferson, LI, NY.

SKIDMORE, THORNTON D.
Painter and illustrator. Born in Brooklyn, NY, June 2, 1884. Pupil of Howard Pyle; Eric Pape. Member: Society of Illustrators; Artists Guild of the Authors' League of America. Address in 1929, 1947 Broadway, New York, NY; h. 95 28th St., Jackson Heights, Elmhurst, LI, NY.

SKILES, JACQUELINE.
Sculptor, printmaker, and videotape artist. Born in St. Louis, MO, in 1937. Studied: Washington University, St. Louis; University of Wisconsin, Madison; New School for Social Research, NYC. Exhibitions: Vis-a-Vis Gallery, NYC; University of Bridgeport, CT; Ramapo College of NJ; Women's Interart Center, NYC. Publications: *Documentary History of Women Artists in Revolution; Columbus Started Something.* Posters: Threat to the Peace; For Life on Earth; Liberation; Rise Up Sisters; Arising. She has been very active in the women artists movement.

SKILLIN, JOHN.
Ship carver. Born in Boston, MA, in 1746. Son of Simeon Skillin, Sr. Worked in Boston from about 1767 until his death. Carved the figurehead for the *Confederacy*, a Continental frigate. In partnership with his brother, Simeon Skillin, Jr., c. 1780-1800. Died in Boston, January 24, 1800.

SKILLIN, SAMUEL.
Ship carver. Son of Simeon Skillin, Sr. Active in Boston from about 1780 to 1816. Died in 1816.

SKILLIN, SIMEON.
Ship carver. Worked in NYC, active 1799-1822; after 1822, dealt in crockery and earthenware. Any relationship to the Boston Skillins is uncertain. In partnership with Charles Dodge, 1810.

SKILLIN, SIMEON, JR.
Ship carver. Born in Boston, MA, in 1756. Son of Simeon Skillin, Sr. Active in Boston from 1776-1806; in partnership with his brother John. Carved first figurehead of the U.S. *Constitution*; bust of Milton; four figures for the garden of Elias Hasket Derby in Salem. The partnership was well known from Salem to Philadelphia for their figureheads and ship carvings. Also specialized in ornamental and garden figures. Did relief carving for Badlam chest of drawers, Yale Univer. Garvan Collection; Corinthian capitals, State House, Boston, 1797; capitals, Derby mansion, Salem, 1799; ornament, "Plenty" (attributed), from the Bolles secretary, Metropolitan Museum of Art; other attributed works at Old State House, Boston, and Winterthur Museum. Died 1806.

SKILLIN, SIMEON, SR.
Sculptor and wood-carver. Born in Boston, MA, in 1716. Active in Boston, MA, by 1738. Did ship carving and figureheads, such as the "Minerva" for the brig Hazard, for about forty years. Three sons, John, Simeon Jr., and Samuel, became ship carvers. Died in Boston, 1778.

SKILLIN, SIMEON, 3rd.
Ship carver. Born in Boston, MA, in 1766. Probably a son of Samuel Skillin. Active in Boston and in Charlestown, MA, in 1829. Died in 1830.

SKILLIN & DODGE.
Ship carvers. Worked in New York City, 1810. Probably Charles Dodge and Simeon Skillin.

SKINNER, CHARLES.
This excellent bank note engraver, in the employ of The American Bank Note Company, was working in NY at least as early as 1867. He engraved in line a few portraits for the book publishers.

SKINNER, CHARLOTTE B.
(Mrs. William Lyle Skinner). Painter and etcher. Born in San Francisco, California, June 17, 1879. Pupil of California School of Art. Member: San Francisco Society of Women Artists. Address in 1933, 16 Pleasant Street, San Francisco, California.

SKINNER, ORIN E(NSIGN).
Painter, craftsman, writer, and lecturer. Born in Sweden Valley, PA, Nov. 5, 1892. Pupil of Herman J. Butler; Frank Von der Lancken. Member: Boston Art Club; Boston Society of Arts and Crafts; Boston Architectural Club. Address in 1929, 9 Harcourt St., Boston, MA; h 37 Walden St., Newtonville, MA.

SKODIK, ANTONIN.
Sculptor. Pupil of Art Students League and sculptor of "Montana."

SKOOG, KARL FREDERICK.
Sculptor and painter. Born in Sweden, November 3, 1878. Pupil of Bela L. Pratt. Member: Connecticut Academy of Fine Arts; Boston Sculpture Society; Boston Art Club. Awards: Prize, Rochester, NY, 1908; honorable mention, Society of American Artists, 1912; honorable mention, Connecticut Academy of Fine Arts, 1915, 18; first prize, Society of American Artists, 1918; first prize, Swedish American Artists, 1918, 21, honorable mention, 1912, 20; honorable mention, Chicago Society of American Artists,

1920; first prize for sculpture, Connecticut Academy of Fine Arts, 1930. Work: Bust of John Ericsson in K. of P. Building, Brockton, MA; bronze tablet in Home for Aged Swedish People, West Newton, MA; Perry Monument, Forest Dale Cemetery; relief, J. A. Powers, Elks Building, Malden, MA; medallion, R. W. Emerson, Museum of Numismatic Society, NY; Soldiers Monument, Cambridge, MA; Soldiers World War Monument, Cromwell, CT; "On Guard," Angell Memorial Hospital, Boston; memorial relief to A. N. Pierson, Cromwell Gardens, Cromwell, CT; "Light" and "Charity," bronze doors, Masonic Temple, Goshen, IN; memorial relief to A. P. Peterson, John Morton Memorial Museum, Philadelphia, PA. Address in 1933, Boston, MA. Died in 1934.

SKORA, MARIE.
Printmaker. Born in Arkansas City, KS. Studied: New Mexico Highlands University; private studio in Caracas, Venezuela. Exhibitions: Chula Vista, CA, 1954; Center of Fine Arts, Maracaibo, Venezuela, 1964; National League of American Pen Women, Washington, DC, 1973. Collections: Smithsonian Institution, Washington, DC; Museum of Fine Arts, Caracas, Venezuela; Rockville Civic Center Gallery, Maryland.

SKOU, SIGURD.
Painter. Exhibited at the National Academy of Design, NY, 1925. Address in 1926, 19 West 50th Street, New York.

SLACKMAN, CHARLES B.
Illustrator. Born in NYC in 1934. Began his career in 1959 for *Esquire* and has worked for almost every national magazine, some of which include *New York Magazine, The New York Times, Playboy, Audience, Evergreen Review, National Lampoon,* and *Time.* His work has appeared in numerous shows and galleries and was the subject of a feature article in *Communication Arts.* He has been an instructor with R. O. Blechman at the Society of Visual Arts since 1963. He and his wife, a ballerina, live in NYC.

SLADE, C. ARNOLD.
Painter. Born in Acushnet, MA, Aug. 2, 1882. Pupil of F. V. Du Mond; Laurens; Schomer; and Bachet. Member: Philadelphia Art Club; Paris Art Association; Allied Artists of London; Grand Rapids Art Club; Springfield (IL) Art Club; New Bedford Art Association; Philadelphia Sketch Club. Work: "Sardine Boats, Brittany," Springfield (IL) Art Club; "Venice," Philadelphia Art Club; "The Reapers," Attleboro (MA) Public Collection; 3 paintings, Isabella Stewart Gardner Museum, Boston; "Sea Waifs," New Bedford (MA) Public Library; "Vender of Cocoa Water," Milwaukee Art Institute; "Christ on the Mountain," Bethany Church, Philadelphia, PA; "Nubian Card Players," Fitzgerald Gallery, Brookline, MA. Represented in Paramount Theatre, New York, John Wanamaker, and Elkins Collections, Philadelphia, and portraits of Hon. Charles A. Dawes, Att. Gen. Sargent, Senators Borah, McNary, Brookhart, Sec. Agriculture Hyde, etc. Address in 1933, Truro, MA.

SLADE, CORA L.
(Mrs. Abbott E. Slade). Painter. Pupil of Robert S. Dunning. Member: Providence Art Club; Newport Art Association; Fall River Art Club; American Federation of Arts. Died in 1937. Address in 1929, 863 High St., Fall River, MA.

SLATER, EDWIN CROWEN.
Painter, illustrator, and craftsman. Born in NJ, Dec. 22, 1884. Pupil of William Chase; Cecilia Beaux; Thomas P. Anshutz; Hugh Breckenridge; Birge Harrison; Charles Grafly; Herman D. Murphy; Henry R. Poore; George Bridgman; Walter Priggs. Member: Salma. Club; Copley Society; Fellowship Penna. Academy of Fine Arts. Address in 1933, 5 Lenox Ave., Greenwich, CT; care of Morgan & Cie, 14 Place Venome, Paris, France.

SLAVET, RUTH.
Sculptor. Studied: Bennington College, Bennington, VT; Boston University, School of Fine Arts; Impression Workshop, Boston. Exhibitions: Boston Summerthing Traveling Art Exhibit, Boston, 1968; Brockton Art Center, Brockton, MA, 1972, 73; Hayden Gallery, MA; Institute of Technology, 1973.

SLEETH, L. MACDONALD.
(Mrs. Francis V. Sleeth). Sculptor, painter, and teacher. Born in Croton, IA, October 24, 1864. Pupil of Whistler; MacMonnies; Emil Carlsen. Member: San Francisco Art Association; Washington Water Color Club; Society of Washington Artists; Washington Art Club; Laguna Beach Art Assoc. Work: Portrait busts in marble of "Brig. Gen'l. John M. Wilson," Corcoran Gallery of Art; "Martha Washington," Memorial Continental Hall, and "Rt. Rev. Bishop Henry T. Satterlee," Cathedral Foundation, all in Washington, DC. Address in 1933, Cathedral School for Girls, Washington, DC.

SLOAN, J(AMES) BLANDING.
Painter, illustrator, etcher, craftsman, writer, and teacher. Born in Corsicana, TX, Sept. 19, 1886. Pupil of Chicago Academy of Fine Arts; B. J. O. Nordfeldt; George Senseney. Member: Chicago Society of Etchers. Address in 1929, 120 North 15th Street, Corsicana, TX.

SLOAN, JOHN.
Painter, etcher, lithographer, illustrator, and teacher. Born in Lock Haven, PA, Aug. 2, 1871. Studied: Art Students League, with Thomas Anschutz and Robert Henri; Penna. Academy of Fine Arts. Member: Society of Independent Artists; New Society of

Artists; American Institute of Arts and Letters; Art Students League of NY. Awards: Hon. mention, Carnegie Institute, Pittsburgh, 1905; bronze medal for etching, P.-P. Expo., San Francisco, 1915; gold medal, Sesqui-Centennial Expo., Philadelphia, 1926; Beck gold medal for portraiture, Penna. Academy of Fine Arts, 1931. Work: NY Public Library; Newark (NJ) Public Library; Cincinnati Museum of Art; Carnegie Institute, Pittsburgh; Metropolitan Museum of Art; Brooklyn Museum; Museum of New Mexico; Phillips Memorial Gallery, Washington; Pennsylvania State College; Barnes Foundation; Newark (NJ) Museum of Art; Detroit Institute of Arts; Harrison Gallery, San Diego; Art Institute of Chicago; Whitney. Died in 1951. Address in 1933, 53 Washington Square, New York, NY; summer, Santa Fe, NM.

SLOAN, MARIANNA.
Landscape and mural painter. Born in Lock Haven, PA, September 21, 1875. Pupil of Robert Henri and Elliott Daingerfield in Philadelphia; Philadelphia School of Design for Women. Member: Fellowship Penna. Academy of Fine Arts, 1916; American Federation of Arts. Award: Bronze medal, St. Louis Expo., 1904. Work: "Landscape," St. Louis Club; "Rocky Beach," Penna. Academy of Fine Arts, Philadelphia; mural decorations in Church of the Annunciation, Philadelphia, and chancel, St. Thomas Church, Whitemarsh, PA. Died in 1954. Address in 1953, 5314 Germantown Avenue; h. 44 Queen Lane, Germantown, PA.

SLOANE, ERIC.
Illustrator and writer. Born in NYC, February 27, 1910. Studied at Art Students League, NYC; School of Fine Arts, Yale University; NY School of Fine and Applied Art. Represented in Sloane Museum of Early American Tools, Kent, CT; commissions include Willett's Memorial at American Museum of Natural History, NYC, National Air and Space Museum in Washington, DC, others. Received gold medal, Hudson Valley Art Association, 1964; Freedom Foundation Award, 1965; gold medal, National Academy of Design. Author and illustrator of many books, including *Skies and the Artist*, *Return to Taos*, *Reverence for Wood*, *I Remember America*, and many more. Member of National Academy of Design; Salmagundi Club; Lotos Club; others. Address in 1982, Cornwall Bridge, CT.

SLOANE, MARIAN PARKHURST.
(Mrs. George Sloane). Painter. Born in Salem, Massachusetts. Pupil of Boston Museum School. Member: National Association of Women Painters and Sculptors; Copley Society; Connecticut Academy of Fine Arts; Guild of Boston Artists; Grand Central Galleries Association. Died in 1955. Address in 1929, Fenway Studios, 30 Ipswich Street, Boston, Massachusetts.

SLOBODKIN, LOUIS.
Sculptor, writer, illustrator, lecturer, and teacher. Born in Albany, NY, February 19, 1903. Studied: Beaux-Arts Institute of Design. Work: Madison Square Post Office, New York; memorial tower, Philadelphia, PA. Exhibited: Whitney, 1935-44; Pennsylvania Academy of Fine Arts, 1941-45; World's Fair, NY, 1939; Art Institute of Chicago, 1939-43; Sculptors Guild, traveling exhibition; Metropolitan Museum of Art, 1942, 44; others. Award: Caldecott medal, 1943. Member: Sculptors Guild; Artists Equity Association; others. Author of *Sculpture Principles and Practice*, 1949, *First Book of Drawing*, 1958; illustrator, *Tom Sawyer*, 1946, *Robin Hood*, 1946, and many others. Positions: Head of sculpture department, Maser Institute, NYC, 1934-37; and NYC Art Project, 1941-42; board of directors, Sculptors Guild, 1940-45. Address in 1970, 209 West 86th Street, NYC. Died in 1975.

SLOBODKINA, ESPHYR.
Sculptor, painter, illustrator, writer, designer, and craftsman. Born in Tcheliabinsk, Russia, September 22, 1914. Studied: National Academy of Design; and abroad. Member: American Abstract Artists; Federation of Modern Painters and Sculptors. Work: Philadelphia Museum of Art; Whitney; Corcoran; others. Exhibited: Whitney Museum; John Heller Gallery; Federation of Modern Painters and Sculptors, NYC, 1983; American Abstract Artists. Awarded Yaddo Fellowships and MacDowell Fellowships. Author, illustrator, *The Little Fireman*; *Little Cowboy*; *Caps for Sale*; and other books. Address in 1953, 20 West Terrace Road, Great Neck, NY; home, 108 East 60th St., New York, NY.

SLOCUM, ANNETTE MARCELLUS.
Sculptor. Born in Cleveland, OH. Studied at Penna. Acad. of Fine Arts, and with Edward Lanteri; also at Royal College of Arts, London. Exhib. at National Sculpture Society, 1923. Specialty: Portraiture. Address in 1926, 250 W. 154th St., NY.

SLOCUM, SAMUEL GIFFORD.
Sculptor and architect. Born in Leroy, New York, 1854. Pupil of Cornell University. Member: Salma. Club. Address in 1906, 1170 Broadway, NYC.

SLOCUM, VICTOR VAUGHAN.
Sculptor. Exhibited portraits in the Pennsylvania Academy of Fine Arts, 1924, Philadelphia, PA. Address in 1926, Philadelphia, PA.

SLOMAN, JOSEPH.
Painter, illustrator, sculptor, and craftsman. Born in Philadelphia, PA, on Dec. 30, 1883. Pupil of Howard Pyle; B. W. Clinedinst and Clifford Grayson. Works: Art Dome, Town Hall, West New York, NJ; "Martin Luther," Church of St. John, West New York, NJ; fourteen memorial windows in Hoboken, NJ; mural,

"Sir Philip Carteret Entering the Province of NJ, 1650," Elizabeth Carteret Hotel, Elizabeth, NJ; work in synagogue at Athens, GA. Exhibited: Philadelphia Art Club; Penna. Academy of Fine Arts; National Academy of Design; others. Illustrated *In Many Islands, A Declaration of Dependence, Billy Glen of the Broken Shutter, Deer Jane, The Escape of the Magruder,* and *Alias Kitty Kasey.* Address in 1953, Union City, NJ.

SLOPER, NORMA (WRIGHT).
Painter. Born in New Haven, CT, Jan. 12, 1892. Pupil of A. E. Jones; Lucien Simon and Rene Menard in Paris. Member: Society of Connecticut Painters; Connecticut Academy of Fine Arts. Award: Dunham prize, Connecticut Academy of Fine Arts, 1922. Address in 1929, 301 West Main St., New Britain, CT.

SLUSSER, JEAN PAUL.
Painter, craftsman, writer, and teacher. Born in Wauseon, OH, Dec. 15, 1886. Pupil of John F. Carlson; Wm. M. Paxton; Philip Hate; Henry L. McFee; Hans Hofmann. Awards: Walker Memorial prize, Art Institute, Detroit, 1928; prize, etching, Detroit Museum of Art Founders Society, 1931; etching purchase prize, Detroit Institute of Art, 1931. Work: "People's Houses," Detroit Institute of Art; "The Green Cottage," Ann Arbor (MI) Art Association. Member: Detroit Society of Arts and Crafts. Address in 1933, 1324 Pontiac St., Ann Arbor, MI.

SLUTZ, HELEN BEATRICE.
Painter. Born in Cleveland, OH, April 15, 1886. Pupil of Cleveland School of Art. Member: California Society of Miniature Painters; Artland Club of Los Angeles; American Federation of Arts; All-Illinois Society of Artists. Address in 1933, 736 Monroe Street, Evanston, IL.

SMALL, HANNAH L.
Sculptor. Born in New York City, January 9, 1908. Studied at Art Students League. Works: University of Nebraska. Award: Art Institute of Chicago, 1940. Exhibited at Fairmount Park, Philadelphia; Art Institute of Chicago; Whitney; Woodstock Art Association; Passedoit Gallery. Address in 1953, Woodstock, NY.

SMALL, MAY MOTT-SMITH.
See Mott-Smith, May.

SMALL, NEAL.
Sculptor and designer. Born in NYC, August 4, 1937. Studied at Museum of Modern Art School; Texas A & M School of Architecture, 1954-56; West Virginia Wesleyan, 1956-58. Work at Museum of Modern Art, NY; Brooklyn Museum; Philadelphia Museum of Art; Albright-Knox Art Gallery, Buffalo; Dallas Museum of Fine Arts. Has exhibited at Brooklyn Museum, Excellence in Design; Smithsonian Institution, Washington, DC; Museum of Science and Industry, Chicago; AIR Gallery; others. Received awards for excellence of design, Annual Design Reviews, Industrial Design, 1968, 69, 70. Works in acrylic, bronze, and collage. Address in 1982, 178 Fifth Ave., NYC.

SMALLEY, JANET LIVINGSTON.
(Mrs. Alfred Smalley). Illustrator. Born in Philadelphia, PA, May 16, 1893. Pupil of Penna. Academy of Fine Arts. Award: Cresson traveling scholarship, Penna. Academy of Fine Arts, 1915. Member: Fellowship Penna. Academy of Fine Arts. Illustrated for children's publications. Died in 1965. Address in 1929, 223 East Washington Square, Philadelphia, PA; 309 Yale Ave., Swarthmore, PA.

SMART, ANNA M. (MISS).
Painter. Born in 1847; died in 1914, in New York City. Specialty: Water colors.

SMEDLEY, WILL LARYMORE.
Painter, sculptor, engraver, craftsman and designer. Born in Sandyville, OH, November 10, 1871. Studied: Case School of Applied Science. Member: Society of Artists and Illustrators; Cleveland Society of Artists; National Craftsmen. Exhibited: National Academy of Design; American Miniature Painters Society; Penna. Academy of Fine Arts; American Watercolor Society of New York; Albright Art Gallery; Art Institute of Chicago; many others. Address in 1953, Chautauqua-on-the-Lake, New York. Died in 1958.

SMEDLEY, WILLIAM THOMAS.
Painter. Born in Chester County, PA, on March 26, 1858. Studied engraving in Philadelphia and art in the Penna. Academy of Fine Arts; went to New York, 1878, and later to Paris; studied under Jean Paul Laurens; opened studio, New York, 1880; then became actively engaged as illustrator for *Harper's* and other standard periodicals. In 1882 he was engaged by publishers of *Picturesque Canada* to travel with Marquis of Lorne through West and Northwest Canada and to illustrate the work; he made several sketchings tours in the United States, and in 1890 he went around the world. He exhibited at the Paris Salon, 1888. Several of his principal productions are: "An Indiscreet Question," "A Thanksgiving Dinner," "A Summer Occupation." Elected a member of the National Academy, 1905. Died March 26, 1920 in Bronxville, NY.

SMIBERT, JOHN.
Painter. Born March 24, 1688 in Edinburgh, Scotland. One of the earliest of the American portrait painters. His influence may be seen in the work of many of those who immediately followed him, and it is thought that Copley may have received instruction

in his studio. Born in Scotland in 1688, Smibert was first a common house painter. Later he worked for coach painters in London and afterward copied painters for dealers until he succeeded in gaining admittance to an art academy. He returned briefly to Edinburgh in 1717, after which he spent 3 years in Italy copying Raphael and other "Old Masters." He spent from 1720-28 working in London and in 1728 came to America with the Rev. George Berkeley. A portrait of "Rev. George Berkeley with His Family," by Smibert, signed and dated 1729, is preserved at Yale University. Smibert married and left 2 children, one a son, Nathaniel (1734-56), who became a portrait painter, and a portrait of John Lovell, a product of his brush, is now at Harvard University, Cambridge, MA. John Smibert worked mostly in Providence, RI, and in Boston after 1728. He died in Boston on April 2, 1751.

SMIBERT, NATHANIEL.
Painter. Born Jan. 20, 1735. Son of the artist John Smibert. He died in his 22nd year having showed a great talent for portraiture, and, had his life been spared, he would doubtless have achieved much success. His portrait of John Lowell is owned by Harvard. He died Nov. 3, 1756, in Boston, MA.

SMILLIE, GEORGE F(REDERICK) CUMMING.
Engraver. Born in New York, NY, Nov. 23, 1854. Pupil of the National Academy of Design and of his uncle, James D. Smillie, in the American Bank Note Company. Principal engraver, U.S. Bureau of Engraving, 1894 to 1922; chief work, the so-called "picture notes" ($2 and $5 silver certificates of 1895); back of $100 Federal Reserve notes; large portraits of Presidents Grant, McKinley, Roosevelt, Taft, and Wilson. Address in 1929, 2631 Connecticut Ave., N. W., Washington, DC.

SMILLIE, GEORGE HENRY.
Painter and etcher. Born December 29, 1840. A son of James Smillie, the celebrated line engraver, and brother of James D. Smillie, National Academy, George H. Smillie was born in the city of New York in 1840. He is one of the most widely known of American landscape painters, and his pictures are characterized by poetic sentiment and technical skill of a high order. He was a pupil of James M. Hart, National Academy. He made sketching trips in the Rocky Mountains, the Yosemite Valley, and Florida, but the most popular of his subjects are those he found in picturesque spots in the interior and along the shores of Long Island. He was elected a member of the American Water Color Society in 1868, and a National Academician in 1882, and was also a member of the New York Etching Club. He is represented in the Metropolitan Museum, New York; Corcoran Art Gallery, Washington, DC; Rhode Island School of Design; Union League Club, of

Philadelphia. Died November 10, 1921 in Bronxville, New York.

SMILLIE, HELEN SHELDON JACOBS.
(Mrs. George H.). Painter. Born in New York in 1854. Studied under Joseph O. Eaton and James D. Smillie. Painter of genre pictures in oils and water colors. Member of American Water Color Society. Address in 1926, 136 East 36th St., New York, NY. Died July 30, 1926, in NYC.

SMILLIE, JAMES.
Engraver. Born Nov. 23, 1807, in Edinburgh, Scotland. Died Dec. 4, 1885, in Poughkeepsie, NY. He was the son of a silversmith and he was first apprenticed to James Johnston, a silver engraver of his native city, and he also received some instruction from Edward Mitchell, a portrait engraver. In 1821 he came with his family to Quebec, Canada, where his father and elder brother established themselves in business as jewelers, and James worked with them for some time as a general engraver. In 1827, under the patronage of Lord Dalhousie, he was sent to London and to Edinburgh for instruction in engraving, but he returned to Quebec after a short time, and in 1829 he went to NY. His first plate to attract attention was done after Robert W. Weir's painting of the "Convent Gate," and in 1832-36 he engraved a series of plates for the *NY Mirror* after paintings by Weir. In 1832 he was made an Associate of the National Academy, and in 1851 he became an Academician. James Smillie was an admirable line engraver of landscape, and worked largely from his own drawing, but from 1861 until his death he devoted himself almost solely to bank note engraving, and he did much to bring that art to its present high repute.

SMILLIE, JAMES DAVID.
Painter and engraver. Born on Jan. 16, 1833, in NY. James David Smillie was a son of James Smillie, and was trained by his father as an engraver on steel. While his principal work was bank note engraving, he produced some excellent general work, including a series of illustrations for Cooper's novels, after designs by F. O. C. Darby. He was an excellent etcher and a founder of the NY Etching Club, and later its president. In 1864, after a visit to Europe, James D. Smillie turned his attention to painting, and in the same year he exhibited at the Academy of Design, in NY, and was made an Associate of the National Academy in 1865; he was made an Academician in 1876. As a painter in oils and water colors he obtained reputation. He was one of the founders and the president (1873-79) of the American Water Color Society. Died Sept 14, 1909 in NYC.

SMILLIE, WILLIAM CUMMING.
Engraver. Born in Edinburgh, Scotland on Sept. 23, 1813. Wm. C. Smillie was a brother of James Smillie

and came to Canada with his father's family in 1821. After working at silver engraving for a time in Quebec, he came to NY in 1830. He early turned his attention to bank note engraving and was connected with several bank note companies, the last of which, "Edmonds, Jones & Smillie," was later absorbed by the American Bank Note Co. In 1866 he secured a contract to engrave the paper currency of the Canadian government, and for this purpose he established a bank note engraving company in Ottawa. In 1874 he retired from his business, but in 1882 he again established an engraving company in Canada, and he was still at the head of that company in 1889. Died in 1899.

SMILLIE, WILLIAM MAIN.
Engraver. Born in NY in 1835; died there in 1888. Wm. M. Smillie was a son of James Smillie, and was early known as an expert letter engraver. He was long employed by one of the firms that in 1857 was merged into the old American Bank Note Company, and he was connected with the old and newer American company until his death, having been general manager of the newer organization for some years.

SMITH, A.
Dunlap notes an artist of this name as having painted in NY in 1834.

SMITH, ALBERT D(ELMONT).
Painter. Born in New York, NY, Feb. 14, 1886. Pupil of Art Students League under DuMond and Chase. Member: Chelsea Art Club, London; Salma. Club; Century Association. Work: "Portrait of Childe Hassam," Toledo Museum of Art; "Self Portrait," Detroit Institute of Arts; "Portrait of John Drew," owned by the Village of East Hampton; portrait of "Lionel Atwill as Deburau," City Art Museum, St. Louis. Died in 1962. Address in 1929, 58 West 57th St., New York, NY; summer, East Hampton, LI, NY.

SMITH, ALBERT E.
Painter and illustrator. Born in Waterbury, CT. Pupil of Yale School of Fine Arts. Member: Salma. Club. Address in 1929, "Cherryledge," Cos Cob, CT.

SMITH, ALFRED EVERETT.
Portrait painter. Born in Lynn, MA, in 1863. Pupil of School of Boston Museum of Fine Arts; Julien Academy in Paris, under Boulanger, Lefebvre, and Constant. Member of the Copley Society, Boston. Address in 1926, Boylston Street, Boston, MA. Died in 1955.

SMITH, ALICE R(AVENEL) HUGER.
Painter and teacher. Born in Charleston, SC, July 14, 1876. Member: Southern States Art League; Carolina Art Association; American Federation of Arts.

Work: "Solitude," Delgado Art Museum; "The Coming of Night at Kecklico," Carolina Art Association; "The Ashepoo Swamp," Atlanta Art Association. Illustrator and joint author of *The Dwelling Houses of Charleston*, *The Life of Charles Frasier* and *The Pringle House*. Work: "The White Heron," Brooklyn Institute of Arts and Sciences; "A Snowy Heron Amid the Lotus," Albany Institute of History and Art. Address in 1929, 8 Atlantic St.; h. 69 Church St., Charleston, SC.

SMITH, ALLEN (JR.).
Portrait, genre and landscape painter. Born in 1810 in Rhode Island. He lived in Cleveland from 1841 to 1883, painting many excellent portraits of prominent citizens. In his later years he painted landscapes. His work compares with that of Healy, Huntington, and Elliott, who lived during the same period. He was an Associate of the National Academy of Design. He died in 1890, in Cleveland, OH.

SMITH, ANDRE.
Sculptor, painter, architect, etcher and writer. Born in Hong Kong, China, 1880. Studied: Cornell University, B.S. in Architecture, M.S. in Architecture. Founder and director, The Research Studio, Maitland, FL, an art center for the development of modern art. Died in 1959. Address in 1953, Maitland, FL.

SMITH, ANITA M(ILLER).
Painter and craftsman. Born in Torresdale, Pennsylvania, October 20, 1893. Pupil of Carlson and New York Art Students League. Member: National Association of Women Painters and Sculptors; Art Alliance of America; Art Students League of New York; Woodstock Art Association. Work: "Houses in the Dunes," Penna. Academy of Fine Arts. Address in 1929, Lake Hill, Ulster County, New York; Woodstock, NY.

SMITH, ANNE FRY.
Painter. Born in Philadelphia, PA, Jan. 25, 1890. Pupil of Fred Wagner; Penna. Academy of Fine Arts. Member: Plastic Club; Philadelphia Alliance. Work: "The Covered Bridge," Pennsylvania State College. Address in 1929, Bridge St., Oreland, Pennsylvania.

SMITH, ARCHIBALD CARY.
Marine painter. Born in New York in 1837 and lived his professional life in that city. Pupil of M. F. H. DeHaas. He exhibited frequently at the National Academy, New York, and painted many pictures of private yachts.

SMITH, BELLE PATTERSON.
(Mrs. Myron O. Smith). Painter. Member: Washington Water Color Club. Address in 1929, 2121 F. Street; 720 21st Street, N. W., Washington, DC.

SMITH, C. H.

In 1855-60 this capital line engraver of portraits and book illustrations was working in Philadelphia and in NY.

SMITH, CARL ROHL.

(Also Rohl-Smith). Sculptor. Born in Copenhagen, Denmark, April 3, 1848. He studied at Academy of Copenhagen, 1865-70; also travelled to Berlin, Italy, and Vienna. He was in NY, St. Louis, and Chicago 1886-1900. His studio was for years in Washington, DC, where he designed the Sherman Monument in front of the Treasury Building. His work is also in Memphis, TN, and Copenhagen. He died in Copenhagen, on August 20, 1900.

SMITH, CATHERINE N.

Fancy wax worker. Born in Philadelphia, PA, 1785. Still living there in 1860.

SMITH, CHARLES L. A.

Painter. Born in New York, Jan. 11, 1871. Self-taught. Member: Boston Art Club; California Art Club; California Water Color Club; Chicago Society of Artists; Society of Western Artists. Represented in Lawrence (MA) Art Museum. Address in 1933, 3440 Atwater Ave., Los Angeles, CA.

SMITH, CHARLES W(ILLIAM).

Illustrator, craftsman, and writer. Born in Lofton, VA, June 22, 1893. Pupil of Richard N. Brooke; Sergeant Kendall; M. Ligeron in Paris. Member: Artists Guild of the Authors' League of America; American Institute of Graphic Arts Leaders Exhibition, 1926. Author of book on block printing. Address in 1929, 1207 West Franklin St., Richmond, VA; summer, Waynesboro, VA.

SMITH, DAN.

Illustrator. Born in 1864. Member: Society of Illustrators, 1912. Died in 1934. Address in 1929, NY World, New York, NY.

SMITH, DAVID.

Sculptor. Born in Decatur, IN, in 1906. Studied at Ohio University, 1924; Art Students League, 1926-30, with John Sloan, Jan Matulka. Works: Baltimore Museum of Art; Brandeis University; Carnegie; Cincinnati Art Museum; Art Institute of Chicago; Detroit Institute; Metropolitan Museum of Art; Museum of Modern Art; University of Michigan; University of Minnesota; San Francisco Museum of Art; City Art Museum, St. Louis; Munson-Williams-Proctor Institute, Utica; Whitney; Walker. Exhibitions: The Willard Gallery, NYC; Kalamazoo Institute; Walker; Buchholz Gallery, NYC; Cooling Gallery, London; Munson-Williams-Proctor Institute, Utica; Philbrook Art Center, Tulsa, OK; The Kootz Gallery, NYC; Cincinnati Art Museum; Otto Gerson Gallery, NYC; Everett Ellin Gallery, Los Angeles; Harvard Univer.; Tate; Guggenheim; XXIX Venice Biennial, 1958; Museu de Arte Moderna, Sao Paulo, 1959; Documenta II & III, Kassel, 1959, 64; Whitney; Art Inst. of Chicago; Carnegie; Museum of Modern Art. Awards: Guggenheim Foundation Fellowship, 1950, 51; Brandeis Univer., Creative Arts Award, 1964. Taught: Sarah Lawrence College, 1948; Univer. of Arkansas, 1953; Indiana Univer., 1954; Univer. of Mississippi, 1955. Died May 5, 1965, in Bennington, VT.

SMITH, DE COST.

Painter. Member: Salma. Club, 1891. Died in 1939. Address in 1929, Amenia, NY; 146 West 55th St.; h. 144 West 73rd St., New York, NY.

SMITH, DUNCAN.

Mural painter and illustrator. Born in Virginia, 1877. Pupil of Cox; Twachtman; DeCamp. Member of National Society of Mural Painters. Instructor in Art Students League of NY. Address in 1926, 42 Washington Square, New York. Died in 1934.

SMITH, (EDWARD) GREGORY.

Painter. Born in Grand Rapids, MI, 1880. Member: CT Academy of Fine Arts; Allied Artists of America; New Society of Am. Artists. Work: "Winter Nocturne," Grand Rapids Art Mu.; "Summer," Lincoln (NE) Art Mu. Address in 1929, Old Lyme, CT.

SMITH, EDWARD HERNDON.

Sculptor and painter. Born in Mobile, AL, July 9, 1891. Pupil of Weir; Tack; and Yale School of Fine Arts. Member: Brooklyn Society of Modern Artists. Address in 1933, Mobile, AL.

SMITH, EDWARD ROBINSON.

Sculptor. Born Beirut, Syria, Jan. 3, 1854. Pupil of William Rimmer and Frank Duveneck. Member: NY Architectural League, 1910; NY Municipal Art Society; Archaeological Institute of America; American Numismatic Society; American Library Associ. Librarian, Avery Architectural Library, Columbia Univer. Died in Stamford, CT, March 21, 1921.

SMITH, ELIZA LLOYD.

Painter. Born in Urbana, OH, July 1872. Pupil of Corcoran Art School, Washington, DC. Member: Washington Water Color Club. Address 1929, 3511 Porter St.; 3702 Macomb St., Washington, DC; Bluemont, MD.

SMITH, ELIZABETH.

Painter. Member: Baltimore Water Color Club. Address in 1929, 1702 Bolton St., Baltimore, MD.

SMITH, ELLAS B.

Painter. Exhibited "The Long Wharf" at the Penna. Academy of Fine Arts, Philadelphia, 1915. Address in 1926, 307 Fenway Studios, Boston, MA.

SMITH, E(LMER) BOYD.
Illustrator. Born in St. John's, NB, Canada, May 31, 1860. Member: Boston Art Club. Author and illustrator: "The Story of Noah's Ark," "The Chicken World," "Pocahontas and Captain John Smith," "The Story of Our Country," etc. Died in 1943. Address in 1929, 140 West 57th St., Wilton, CT.

SMITH, EMMA J.
Painter. Member: Washington Water Color Club. Address in 1929, The Wyoming, Washington, DC.

SMITH, ERNEST BROWNING.
Painter. Born in Brimfield, MA, Nov. 30, 1866. Self-taught. Member: California Art Club; Laguna Beach Art Association. Awards: Prize, Sacramento State Fair, 1925; hon. mention, Pomona, CA, 1925 and 1928. Work: "Sycamores in Spring," Los Angeles Museum; "The Sentinel," San Francisco Museum. Address in 1929, 2416 Loma Vista Pl., Los Angeles, CA.

SMITH, ERWIN E.
Sculptor, sketch artist, and photographer. Born in Honey Grove, TX, 1888. Studied modeling in Chicago with Lorado Taft; in Boston with Bela Pratt. Specialty was cowboy and Indian subjects. Sculpture titles include "Sioux Indians" and head of "Nez Perce Indian." Photographs illustrated Western stories of George Patullo; also collected in *Life on the Texas Range*, 1952, by J. Evetts Haley. Died at Bermuda Ranch, Bonham, TX, 1947.

SMITH, ESTHER.
Portrait painter. Born in Connecticut. She studied under Edwin White in New York. She resided in Hartford, Connecticut, and there painted portraits of Theo. D. Judah, Col. G. T. Davis, Judge T. B. Butler and many others. Her specialty was the portraiture of children.

SMITH, F. CARL.
Portrait painter. Born in Cincinnati, OH, Sept. 7, 1868. Pupil of Bouguereau, Ferrier and Constant in Paris. Member: Society of Washington Artists; Washington Water Color Club; American Art Association of Paris; California Art Club; Pasadena Fine Arts Club; Laguna Beach Art Association (life). Awards: Hon. mention for water color, American Art Society, 1902; second figure prize, Southwest Museum, 1921. Work: "Mrs. Charles W. Fairbanks" and "Mrs. John Ewing Walker," D. A. R. Continental Hall, Washington; former speaker "Joseph Cannon," Public Library, Minneapolis; "Samuel P. Langley," Allegheny (PA) Observatory; "Governor Shafroth," The Capitol, Denver; portraits of Governor Willis of Ohio in Capitol, Columbus, and Speaker Clark, The Capitol, Washington, DC. Address in 1929, 217 Oakland Ave., Pasadena, CA; summer, Laguna Beach, CA.

SMITH, F. STANLEY.
Painter. Member: Philadelphia Water Color Club. Address in 1929, R. F. D., North Shirley, MA.

SMITH, F(RANCIS) BERKELEY.
Illustrator and writer. Born in Astoria, LI, NY, Aug. 24, 1868; son of F. Hopkinson Smith. Studied architecture at Columbia University, and practiced until 1896. Author and illustrator: "The Real Latin Quarter," and "Budapest, the City of the Magyars." Address in 1929, 16 Place de la Madeleine, Paris, France.

SMITH, FRANCIS DREXEL.
Painter. Born in Chicago, IL, June 11, 1874. Pupil of John Vanderpoel, John F. Carlson, Everett L. Warner; studied at Art Institute of Chicago; Broadmoor Art Academy. Member: National Arts Club; Denver Art Association; Buffalo Society of Artists; Broadmoor Art Academy (president); Brooklyn Society of Artists; Mississippi Art Association; Washington Art Club; Connecticut Academy of Fine Arts; Chicago Galleries Association; Dubuque (IA) Art Association; New Haven Paint and Clay Club; American Federation of Arts; Springfield Art Association; Illinois Academy of Fine Arts. Awards: Hon. mention, Seattle Fine Arts Society, 1923; purchase prize, Kansas City Art Institute, 1924; hon. mention, Buffalo Society of Artists, 1925; hon. mention, Denver Art Museum, 1927-28; hon. mention, Colorado Springs, 1929, 30, 32; second prize, Seattle Art Institute, 1929; bronze medal, Mississippi Art Association, 1932; Colorado State Fair, 1949; New Orleans Art Association, 1940. Represented in Kansas City (MO) Art Institute; Broadmoor Art Academy, Colorado Springs, CO; Vanderpoel Collection, Chicago; Denver Art Museum; Dubuque Art Association; Museum of Fine Arts, Montgomery, AL; Mississippi State College for Women. Exhibited: Carnegie; National Academy of Design; Denver Art Museum; Oakland Art Gallery; New Orleans Art Association; Kansas City Art Institute; others. Died in 1956. Address in 1953, Colorado Springs, CO.

SMITH, FRANCIS HOPKINSON.
Painter and author. Born in Baltimore, MD, Oct. 23, 1838. Has done much landscape work in water colors, also portraits, charcoal work and illustrations. Represented in Walter's Gallery, Baltimore; Marquand collection, etc. Lecturer on art subjects. Awarded bronze medal, Buffalo Expo., 1901; silver medal, Charleston Expo., 1902; gold medal, Philadelphia Art Club, 1902; gold medal, American Art Society, 1902; Commander Order of the Mejidieh, 1898, and of the Order of Osmanieh by Sultan of Turkey, 1900. Member of the American Academy of Arts and Letters; American Society; Civil Engineers; American Water Color Society; Philadelphia Art Club; Cincinnati Art Club. Address in 1926, 16 Exchange Place, New York, NY. Died April 7, 1915, in NYC.

SMITH, FRANK HILL.
Painter. Born in Boston, MA, in 1841. He studied in Boston and later in Paris under Bonnat. He painted portraits, figure pieces, landscapes, and mural paintings. He died in 1904.

SMITH, FREDERICK.
Sculptor. Born in Germany c. 1807. Active in Washington, DC, 1850-55.

SMITH, G.
This name is signed to well executed script billheads, etc., published in 1790-1800. The work was done in NY.

SMITH, GEORGE GIRDLER.
Born Sept. 8, 1795, in Danvers, MA. He was probably a pupil of Abel Bowen, the Boston engraver, as he was in Bowen's employ in 1815 as an engraver. Little is known about G. G. Smith until 1830, when, in connection with William B. Annin, he was in the general engraving business in Boston, working under the firm name of Annin & Smith. Mr. Smith was early interested in lithography, and visited Paris for instruction and materials, but for some reason he failed in his efforts to establish himself in that business. Later he was engaged in the bank note engraving business with Terry and Pelton, and when that firm was absorbed by another company, Smith resumed the general engraving business with two of his former pupils, Knight and Tappan. G. G. Smith engraved portraits chiefly, in both line and stipple, and he did some good work. Died December 18, 1878, in Boston, MA.

SMITH, GEORGE ROBERT, JR.
Painter. Born in New York City, Sept. 1889. Pupil of Art Students League of NY; West End School of Art; George Elmer Browne. Member: Provincetown Art Association; Society of Independent Artists; Bronx Artists Guild. Address in 1929, 340 East 198th St., Bronx, New York, NY.

SMITH, GEORGE W(ASHINGTON).
Painter and architect. Born in East Liberty, PA, Feb. 22, 1879. Studied in Paris and Rome; Architectural School, Harvard University. Member: American Art Association of Paris; National Arts Club; California Art Club; American Institute of Architects. Address in 1929, 17 Mesa Road, Santa Barbara, CA.

SMITH, GERTRUDE ROBERTS (MRS.).
Painter, craftsman, and teacher. Born in Cambridge, MA, May 11, 1869. Pupil of Massachusetts Normal Art School; Chase School; Colarossi Academy, Paris. Member: Southern States Art League; New Orleans Art Association; New Orleans Arts and Crafts Club; Needle and Bobbin Club. Award: Gold medal, New Orleans Art Association ($150), Delgado Art Museum. Represented in Newcomb College Art Gallery, New Orleans. Address in 1933, H. Sophie Newcomb College, New Orleans, LA.

SMITH, GLADYS K.
Painter, sculptor, and teacher. Born in Philadelphia, PA, April 30, 1888. Pupil of Philadelphia School of Design; Penna. Academy of Fine Arts. Member: Fellowship Penna. Academy of Fine Arts; Plastic Club; Alumni, Philadelphia School of Design; Eastern Arts Association. Instructor in art, Shaw Junior High School, West Philadelphia. Address in 1933, Philadelphia, PA; summer, Locust Valley, LI, NY.

SMITH, GRACE P.
Painter and illustrator. Born in Schenectady, NY. Member: Artists Guild of the Authors' League of America. Address in 1929, 144 West 11th St., New York, NY.

SMITH, HARRIET F(RANCES).
Painter and teacher. Born in Worcester, Massachusetts, July 28, 1873. Pupil of Massachusetts Normal Art School; and of Denman W. Ross, E. W. D. Hamilton, Henry B. Snell, C. H. Woodbury, Philip Hale. Member: Copley Society; Eastern Arts Association; New York Water Color Club; American Federation of Arts; Boston Art Club. Art Supervisor, Boston Public Schools. Died in 1935. Address in 1933, 1991 Centre Street, West Roxbury, Massachusetts; summer, Lincolnville, ME.

SMITH, HARRY KNOX.
Painter. Born in Philadelphia, PA, April 24, 1879. Pupil of Penna. Academy of Fine Arts; Art Students League of NY. Member of NY Architectural League, 1910. Address in 1933, 555 Edgecombe Ave., New York, NY.

SMITH, HASSEL W., JR.
Painter. Born April 24, 1915, in Sturgis, MI. Studied: California School of Fine Arts, with Maurice Sterne; earned B.S. from Northwestern University, taught there and at San Francisco State, University of Oregon, California School of Fine Arts, Presidio Hill School in San Francisco, and Berkeley. Awarded Abraham Rosenberg Fellowship, 1941. One-man exhibitions: California Palace, San Francisco; New Arts Gallery, Houston; Andre Emmerich Gallery, NYC; University of Minnesota; Santa Barbara Museum of Art; others. Group exhibitions: San Francisco State College; Whitney; David Stuart Gallery, NYC; Los Angeles County Museum of Art; San Francisco Museum of Art; University of California, Berkeley; others. In collections of Washington University; Tate; Albright-Knox; Baltimore; Pasadena Art Museum; Whitney; SUNY/New Paltz; City Art Museum, St. Louis; Corcoran. Address in 1971, c/o Andre Emmerich Gallery, NYC; c/o David Stuart Gallery, NYC.

SMITH, HELEN L.
Painter, craftsman, and teacher. Born in Frederick, Maryland, Jan. 21, 1894. Pupil of Maryland Institute. Member: Frederick Art Club. Work: "Justice," owned by Frederick County, MD. Address in 1929, 311 North Market Street; home, McCardell Apartments, Frederick, Maryland.

SMITH, HENRY PEMBER.
Landscape painter. Born in Waterford, Connecticut, on February 20, 1854. He painted New England scenes and views of Venice; these were his most frequent subjects. He was a member of the American Water Color Society and the Artists' Fund Society of NY. He died Oct. 16, 1907, in Asbury Park, NJ.

SMITH, HENRY T.
A portrait and genre painter of Philadelphia. He was a member of the Artists' Fund Society and chairman of its Executive Committee in 1867. Was a regular exhibitor at the Philadelphia Academy, 1861-67. Painted portraits of Henry C. Carey at the Pennsylvania Historical Society, and of Joseph Harrison, Philadelphia.

SMITH, HEZEKIAH WRIGHT.
Engraver. Born in Edinburgh, Scotland, in 1828. He disappeared from Philadelphia in 1879 and was never heard of afterward. Smith was brought to NY when about 5 years old, and was later apprenticed to an engraver in that city. He continued his studies under Thomas Doney and became a most meritorious engraver of portraits, in line and in stipple. In 1850 he was associated with Joseph Andrews in Boston, and employed in NY, 1870-77. In 1877 H. W. Smith established himself in Philadelphia and did work there, but in April, 1879, he suddenly abandoned engraving, sold all his effects, left that city and was never heard of again. His more important plates include a full length portrait of Daniel Webster, after the painting by Chester Harding; a three-quarter length of Edward Everett; and his head of "Washington" after the Athenaeum head, by Stuart, said to be the best engraving of this famous portrait.

SMITH, HOLMES.
Painter, teacher, writer, and lecturer. Born in Keighley, England, May 9, 1863. Member: St. Louis Artists Guild; College Art Association; 2x4 Society; Archaeological Inst. of Am.; St. Louis Chapter of American Institute of Architects (hon.); American Federation of Arts. Professor of drawing and history of art, Washington University, St. Louis. Specialty: Water colors. Died before 1940. Address in 1929, Washington Univer.; h. 5440 Maple Ave., St. Louis, MO; summer, Magog, Quebec, Canada.

SMITH, HOPE.
Painter. Born in Providence, RI, May 10, 1879. Pupil of Woodbury and Chase; Rhode Island School of Design; also studied in Paris. Member: Providence Art Club; So. County Art Association. Specialty: Landscapes in oil and water color. Address in 1933, 165 Hope St., Providence, RI.

SMITH, HOWARD EVERETT.
Painter and teacher. Born in West Windham, NH, April 27, 1885. Pupil of Howard Pyle and E. C. Tarbell; Art Students League of NY. Member: Associate National Academy of Design, 1921; Guild of Boston Artists; Boston Art Club; Rockport Art Association; North Shore Arts Association. Awards: Paige Traveling Scholarship, School of the Museum of Fine Arts, Boston; bronze medal for painting, P.-P. Expo., San Francisco, 1915; first Hallgarten prize, National Academy of Design, 1917; Isidor Medal, National Academy of Design, 1921; Peabody prize, Art Institute of Chicago, 1923; Maynard portrait prize, National Academy of Design, 1931. Work: "Portrait of Col. W. H. Osborn," Treasury Building, Washington, DC; "Portrait of Ex-Gov. Eugene Foss," State House, Boston, MA; "Captain's Widow," Pennsylvania Academy of Fine Arts; portraits in Brown University, Providence, RI, and Rand School of Social Science, NY. Address in 1933, Art Studio Bldg., 31 Newbury St., Boston, MA; summer, 11 High St., Rockport, MA.

SMITH, ISABEL E.
(Mrs. F. Carl Smith). Miniature painter. Born in Smith's Landing, near Cincinnati, OH. Pupil of L'hermitte, Delance and Callot in Paris. Member: Paris Woman's Art Club; Pasadena Fine Arts Club. Died in 1938. Address in 1929, 217 Oakland Ave., Pasadena, CA.

SMITH, ISHMAEL.
Painter, sculptor and illustrator. Born in Barcelona, Spain, July 16, 1886. Studied at Ecole Nationale des Arts Decoratifs, Paris; in schools of Rafael Atche, Baixas, Querol, Benlliure. Member: Salmagundi Club; American Federation of Arts; Art Alliance of America; American Numismatic Society. Works: Monument to Pablo Torull, Caja de Ahorros de Sabadell, Catalunya; portrait of Mila Y Fontanals, Institute des Estudies Catalans; portrait of Alphonse Maseras and group in sculpture, Museum of Barcelona, Spain. Represented in British Museum, London; Hispanic Museum, NY; Cleveland Museum; "Blessed Teresa," Carmelite Fathers, Washington, DC. Awards: Medal at International Exposition, Belgium, 1910, and International Exposition, Barcelona. Exhibited at National Sculpture Society, 1923. Address in 1933, 173 Riverside Drive, New York City.

SMITH, J. ANDRE.
Etcher and painter. Award: Gold medal for etching, P.-P. Expo., San Francisco, 1915. Member: Brooklyn Society of Etchers. Address in 1929, care of Arthur

E. Harlow Co., 712 Fifth Ave., New York, NY; Pine Orchard, CT.

SMITH, J. FRANCIS.
Painter and teacher. Born in Chicago, IL. Pupil of Gregori; Boulanger; Lefebvre; and Constant. Member: American Art Association of Paris; Chicago Society of Illustrators; California Art Association. Address in 1929, 290 East 72nd St., New York, NY; summer, Dublin, NH.

SMITH, JACK W(ILKINSON).
Painter. Born in Paterson, NJ, 1873. Studied at Cincinnati Art Academy; Art Institute of Chicago. Member: California Art Club; Allied Artists of America; Salma. Club; Laguna Beach Art Association. Awards: Silver medal, San Diego Expo., 1915; bronze medal, San Diego Expo., 1916; silver medals, Sacramento Expo., 1917 and 1918; first prize, Los Angeles Liberty Expo., 1918; Black prize, California Art Club, 1919; gold and bronze medals, Sacramento Expo., 1919; second prize, Phoenix (AZ) Expo., 1920; first prize, Phoenix, AZ, 1922. Represented in Phoenix Municipal collection. Died in 1949. Address in 1929, 16 Champion Pl., Alhambra, CA.

SMITH, JACOB GETLAR.
Painter. Born in New York City, Feb. 3, 1898. Pupil of National Academy of Design. Awards: Hon. mention, Art Institute of Chicago, 1926; Guggenheim Fellowship, 1930; Logan prize ($750), Art Institute of Chicago, 1930. Work: "Approaching Storm," "Self Portrait," Whitney Museum of American Art, NY. Died in 1958. Address in 1933, 3970 45th Street, Sunnyside, LI, NY.

SMITH, JAMES CALVERT.
Illustrator. Member: Society of Illustrators; Artists Guild of the Authors' League of America; Salma. Club. Address in 1929, 114 East 56th St., New York, NY.

SMITH, JAMES P.
Miniature and portrait painter. Born in 1803, and resided in Philadelphia, PA. He died in Philadelphia in 1888. Contemporary with Thomas Sully. He attained great proficiency in his art. Sully invariably sought his approval of portraits he painted before he let them leave his studio. He painted several miniatures of Washington, after the portraits painted by Gilbert Stuart.

SMITH, JESSIE WILLCOX.
Illustrator and painter. Born in Philadelphia, PA. Pupil of Penna. Academy of Fine Arts; Drexel Institute under Howard Pyle. Member: Plastic Club; Philadelphia Water Color Club; Fellowship Penna. Academy of Fine Arts; Society of Illustrators, 1904 (associate); NY Water Color Club; Philadelphia Alliance; American Federation of Arts. Awards: Bronze medal, Charleston Expo., 1902; Mary Smith prize, Penna. Academy of Fine Arts, 1903; silver medal, St. Louis Expo., 1904; Beck prize, Philadelphia Water Color Club, 1911; silver medal, water colors, P.-P. Expo., San Francisco, 1915. Specialty: Paintings and illustrations of children. Died in 1935. Address in 1929, "Cogshill," Allen Lane, Philadelphia, PA.

SMITH, JOHN.
Sculptor. Born c. 1805 in Ireland. Came to New York before 1831. Located: New York City, 1850.

SMITH, JOHN ROWSON.
Scenic and panoramic artist. Born May 11, 1810, in Boston, MA. Son of John Rubens Smith. Studied under his father. Working in Philadelphia, St. Louis, New Orleans and elsewhere, after 1832. By the late 1830's, he took up panorama painting. His work includes a panorama of the Mississippi, 1844, exhibited here and in Europe. Lived in Carlstadt, NJ; died in Philadelphia, PA, March 21, 1864.

SMITH, JOHN RUBENS.
Engraver, miniaturist, lithographer and topographical painter. Born Jan. 23, 1775, in London, England. Tuckerman, in his "Book of the Artists," says that John Rubens Smith was the son of the famous English engraver John Raphael Smith (1740-1811). A pupil of his father, he exhibited several portraits at the Royal Academy, 1796-1811. John R. Smith was working as an engraver in Boston in 1811, and in 1816 he was in NY, painting portraits, engraving, and conducting a drawing school. He remained in NY until 1826, and then possibly went to Philadelphia, as he was engraving and teaching drawing in that city in 1835-37. He again appears in NY in 1845 and once more opened his school. Among his known pupils were Sully, Agate, Cummings, DeRose, Metcalf, Leutze and Swain R. Gifford. In noting his death, the Historic Annals of the National Academy of Design describes Smith as "Short in figure, with a large head, peculiar one-sided gait and an indescribable expression of countenance." As an engraver, he worked in stipple, aquatint and mezzotint, chiefly upon portraits, and he was an experienced engraver. Died Aug. 21, 1849, in NYC.

SMITH, JOSEPH LINDON.
Painter, lecturer, and teacher. Born in Pawtucket, RI, Oct. 11, 1863. Pupil of Boston Museum School under Crowninshield and Grundmann; Julian Academy, in Paris, under Boulanger and Lefebvre. Member: National Society of Mural Painters; Boston Society of Arts and Crafts; Copley Society, 1882; Century Association; American Federation of Arts. Award: Beck Prize, Philadelphia Water Color Club, 1905. Work: Mural paintings in Boston Public Library and Horticultural Hall, Philadelphia. Made studies from sculpture in Italy, Egypt, Turkey,

Mexico, Guatemala, Java, India, China, Sudan, Cambodia, Siam, Greece, Honduras, Yucatan and Japan for Museums in U.S. Represented in Corcoran Gallery and Smithsonian Institution, Washington; Chicago Art Institute; Boston Museum; Harvard University; Rhode Island School of Design; Gardner Collection, Boston; Dartmouth College; Fogg Art Museum, Cambridge, MA; Musee Guimet, Paris; Louvre School, Paris. Died in 1950 in Dublin, NH. Address in 1929, 132 East 72nd St., New York, NY; summer, Dublin, NH.

SMITH, KATHARINE ENGLISH.
Painter. Born in Wichita, KS, March 12, 1899. Pupil of Emma M. Church; Birger Sandzen; Charles Hawthorne; Robert Reid; George B. Bridgman. Member: Wichita Art Associ.; Smoky Hill Art Club. Address 1929, 520 N. Lorraine St., Wichita, KS.

SMITH, LAWRENCE BEALL.
Painter, sculptor and illustrator. Born in Washington, DC, October 2, 1909. Studied at the Art Institute of Chicago, University of Chicago, PhB, 1931; also under Ernest Thurn, Gloucester, MA; Harold Zimmerman, and Charles Hopkinson, both in Boston. Exhibited: Carnegie Institute, Pittsburgh, PA, 1941; Whitney Museum of American Art, 1960; National Academy of Design Annuals, NYC, 1974 and 75; and many others. Illustrated *Robin Hood*, for Grossett, 1954; *Girls are Silly*, Odgen Nash, Watts, 1962; *Tom Jones*, by Henry Fielding, 1964; and others. In collections of Fogg, Cambridge, MA; Metropolitan Museum; Wichita Art Museum, KS; Herron Art Institute; Brandeis University, NY; Addison Gallery, Andover, MA; Library of Congress, Washington, DC; University of Chicago; others. Commissions include portraits of Harold Swift and Charles Merrill, Jr., Boston, and Robert Hutchins, University of Chicago. Sculpture work is in stone. Address in 1982, Cross River, NY.

SMITH, MARCELLA.
(Claudia Heber). Painter and teacher. Born in East Molesey, Surrey, England, March 6, 1887. Pupil of Delecluse in Paris; Fred Milner at Royal British Academy in London; Corcoran School of Art, Washington; Philadelphia School of Design. Member: A. R. B. A.; Society of Washington Artists. Address in 1929, 1320 New Hampshire Ave., Washington, DC.

SMITH, MARGERY HOFFMAN.
Painter and craftsman. Born in Portland, OR, Aug. 30, 1888. Pupil of F. G. Wentz; K. H. Miller; A. B. Dow; Herman Rosse. Member: Portland Art Association; Portland ACS. Address in 1929, 705 Davis St., Portland, OR.

SMITH, MARSHALL J.
Native of New Orleans. Died in Covington, LA. Studied under R. Clague. Specialty: Louisiana landscapes and portraits. Represented in Louisiana State Museum, New Orleans, Louisiana.

SMITH, MAY MOTT.
See Mott-Smith, May.

SMITH, MINNA WALKER.
Painter. Born in New Haven, Connecticut, March 29, 1883. Pupil of Yale School of Fine Arts. Member: New Haven Paint and Clay Club, Connecticut; New Haven Brush and Palette Club, Connecticut; New York Water Color Club; American Federation of Arts. Award: Water color prize, Ogunquit Art Club, 1932. Address in 1933, 531 Edgewood Avenue, New Haven, Connecticut.

SMITH, OLIVER PHELPS.
Painter. Born in Hartford, Connecticut, December 18, 1867. Pupil of National Academy of Design. Member: New York Water Color Club. Specialty: Stained glass and mural decoration. Died in 1953. Address in 1933, 550 East Lincoln Avenue, Mt. Vernon, New York.

SMITH, R. K.
Engraver. A weak stipple portrait of Rev. John Flavel is signed "Engraved by R. K. Smith from an Original." This plate appears as a frontispiece to "The Fountain of Life Opened, Etc.," by Rev. John Flavel, and it was published by Joseph Martin, Richmond, VA, 1824. No other example of the work of the engraver has been found.

SMITH, ROSAMOND L.
See Bouve, Rosamond Smith.

SMITH, RUSSELL.
Painter. Born April 26, 1812, in Glasgow, Scotland. Came to this country in 1819 and studied art with James R. Lambdin, Philadelphia artist and father of Alfred C. Lambdin, the well known local journalist. For 6 years after 1834 he worked at the Chestnut and Walnut street theaters as a scene painter, but after his marriage to a fellow artist, he took to landscape painting in which he met with great success. Also became noted as a scientific draughtsman, employed by Sir Charles Lyell and other naturalists, and did similar work for geological surveys of Pennsylvania and Virginia. When the Academy of Music was in the process of building the foremost structure of its type in America, he was engaged to paint scenery, and the drop curtain which he produced, with its handsome landscape, brought him many commissions of the sort from managers in this and other cities. His "Cave at Chelten-Hills" was admired at the Centennial Expo. He also was a panoramist and portraitist. He contributed to the exhibitions of the Penna. Academy of Fine Arts for more than half a century. Died Nov. 8, 1896 in Edge Hill, Montgomery County, or Glenside, PA.

SMITH, SHARON.
Painter and graphic artist. Studied: California State University at Long Beach, CA. Exhibitions: San Luis County Art Show, 1968; Honolulu Academy of Art, 1974; Hallway Gallery, Bishop Museum, Hawaii, 1975. Collections in the City and County of Honolulu.

SMITH, SIDNEY L.
Engraver, painter, and etcher. Born in Foxboro, MA, in 1845. In 1847 his father moved to Canton, MA. In 1863, Sidney L. Smith was placed with Reuben Carpenter, a commercial engraver, to learn that business, but in the early part of 1864, Mr. Smith enlisted in the Union army and saw some service at the close of the Civil War. Upon returning to peaceful pursuits, he entered the engraving establishment of Joseph Andrews, in Boston. Smith and Thomas D. Kendricks reproduced on steel the original etchings, and the original woodcuts as well, issued in England for an edition of Dickens' works. As Mr. Andrews was not an etcher and had little liking for this class of work, the young men were left much to their own devices in a task which occupied them for about 2½ years. Upon the completion of this work, Smith opened an engraving establishment of his own, and for some time was engaged with such work as he could secure. In 1877 Mr. John LaFarge, who had previously tried to induce Mr. Smith to abandon engraving for painting, invited the latter to assist him in the decoration of Trinity Church, in NY, and as an assistant to Mr. LaFarge, Mr. Smith was engaged in this work until 1883; from then till 1887 he was chiefly employed in the designing of stained glass windows and in work of decorative character. In 1887 Mr. Smith made some etchings for Mr. Clarence Cook, and finding that others desired work of a similar character he continued etching and designing for engravers, etc., since that date. Though Mr. Smith has produced exceptionally good and artistic work as an etcher, his experience along this line was confined to the early part of his professional career, and covers a comparatively brief period.

SMITH, T. HENRY.
A portrait and genre painter of Phila. He was a member of the Artists' Fund Society, and Chairman of its Exhibition Comm. in 1867. He exhibited reg. in the Penna. Acad. exhibitions from 1861-67.

SMITH, THOMAS HERBERT.
Painter. Born in NYC, Oct. 31, 1877. Pupil of George Bellows. Member: National Arts Club; Brooklyn Soc. of Artists; Silvermine Guild of Artists; Soc. of Independent Artists; Salons of Am.; Am. Fed. of Arts; New Rochelle Art Assoc. Address in 1929, Wilton, CT.

SMITH, THOMAS LOCHLAN.
Painter. Born December 31, 1835, in Scotland. He came to this country at an early age, and was a pupil of George H. Boughton in Albany, NY. He devoted himself chiefly to painting winter scenes. His "Deserted House" and "Eve of St. Agnes" were exhibited at the Centennial in Philadelphia, 1876. He died Nov. 5, 1884 in NYC.

SMITH, THOMAS M.
Painter. Smith was a sea captain who travelled from Bermuda to Boston, MA, in 1650. His works include a portrait of a Dr. Ames, 1680, paid by Harvard College; a portrait of Maria Catherine Smith, 1683, belonging to the Clapp family of Dorchester, MA; "Self-Portrait," c. 1690, Worcester Museum, noted for its accessories, which include a naval battle in the distance, and a skull and poem on the table which suggest the mortality of man. A number of other late 17th-century New England portraits have also been attributed to him.

SMITH, TONY.
Sculptor. Born in South Orange, NJ, 1912. Studied at the Art Students League, 1934-35; New Bauhaus, Chicago, for architectural study, in 1937-38; architectural apprentice of Frank Lloyd Wright, 1938-40. Gave up architecture for sculpture, in 1960, of geometric forms. His works concentrate on unifying architecture, painting, and sculpture, exemplified by his "Gracehoper," 1961, the cubic piece "Black Box," 1962, and "The Snake is Out," 1962. Larger pieces include his "Smoke," based on a space grid. Noted for his cave-like sculpture executed for 1970 World's Fair at Osaka, Japan. Exhibited: Wadsworth Atheneum, Hartford, CT, 1964, 67, and 74; Philadelphia Institute of Contemporary Art, 1967; Whitney Museum of American Art Annual, 1970-73; Metropolitan Museum of Art, NY, 1970; Los Angeles Co. Museum of Art, 1971; San Francisco Museum of Art, 1971; Seattle Art Museum Pavilion, Washington, 1973; Cleveland Museum of Art, 1974; Painting and Sculpture Today 1974, Indianapolis Museum of Art, 1974; Art Institute of Chicago, 1974; Walker Art Center, Minneapolis, MN, 1974; New Orleans Museum of Art, LA, 1976; and others. Taught: New York University, 1946-50; at Cooper Union, Pratt Institute, Bennington College, and Hunter College, from 1962. Associated with Barnett Newman, Clyfford Still, Jackson Pollock, and Mark Rothko. Address in 1982, c/o The Pace Gallery, New York City.

SMITH, TWIGG.
Painter. Born in Nelson, New Zealand, in 1882. Pupil of Art Institute of Chicago; also of Harry M. Walcott. Member of Hawaiian Society of Artists; Chicago Art Students League. Address in 1926, 122 Bates St., Honolulu, Hawaii.

SMITH, VIOLET THOMPSON (MRS.).
Miniature painter. Born in Annapolis, Maryland, July 28, 1882. Pupil of Archambault. Member: Art

Alliance of America. Address in 1929, 100 Kings Highway, West Haddonfield, New Jersey.

SMITH W. HARRY.
Painter, illustrator, and etcher. Born in Brent, Devon, England, Dec. 23, 1875. Member: Boston Society of Water Color Painters; Chicago Society of Etchers; Boston Society of Arts and Crafts; Whistler Art Club. Award: Prize, Chicago Society of Etchers, 1926. Address in 1929, Concord Road, Billerica, MA.

SMITH, W. LINFORD.
Painter. Born in Pittsburgh, PA, in 1869. Pupil of Chris Walters. Member of Pittsburgh Artists Association. Address in 1926, 5029 Amderson Place, Pittsburgh, PA.

SMITH, W(ALTER) GRANVILLE.
Painter and illustrator. Born in S. Granville, NY, Jan. 26, 1870. Pupil of Walter Satterlee; Carroll Beckwith; Willard Metcalf; Art Students League of NY; studied in Europe. Member: Associate National Academy of Design, 1908; Academician National Academy of Design, 1915; American Water Color Society; Salma. Club, 1918; Society of Painters, NY; Allied Artists of America; Greenwich Society of Artists; National Arts Club; American Federation of Arts; Grand Central Art Galleries. Awards: Third Hallgarten prize, National Academy of Design, 1900; bronze medal, Charleston Expo., 1902; Evans prize, American Water Color Society, 1905; first prize, Worcester, 1906; hon. mention, Carnegie Institute, Pittsburgh, 1907; Inness gold medal, National Academy of Design, 1908; bronze medal, Buenos Aires Expo., 1910; Vezin prize, Salma. Club, 1911; Shaw purchase prize ($500), Salma. Club, 1913; Hudnut prize ($200), American Water Color Society, 1916; Isidor prize, Salma. Club, 1918, Turnbull prize, 1922, Auction Exhibition prize, 1925; prize ($300) and bronze medal, 1925, National Arts Club; Carnegie prize ($500), National Academy of Design, 1927; Purchase prize ($1,000), Salma. Club, 1928; second Altman prize, National Academy of Design, 1929, first Altman prize ($1,000), 1933. Work: "Grey Day," Smithsonian Institution, Washington, DC; "The Willows," Butler Art Institute, Youngstown, OH; "South Haven Mill," Museum, Toledo, OH; permanent collections in Salma. Club, National Arts Club, Lotos Club, Fencers Club of New York, and Art Club of Philadelphia. Address in 1933, 96 Fifth Ave., New York, NY; Bellport, LI, NY.

SMITH, WILLIAM.
Modeler of wax. Presumably American. Modelled a wax portrait of John Paul Jones.

SMITH, WILLIAM A.
Illustrator. Born in Toledo, OH, in 1918. Studied art in Toledo, Paris, and NY. At the age of 13, he began his career as an illustrator working for the *San Francisco Chronicle*. His reputation as a printmaker, muralist, and painter began with national advertising assignments in the early 1940's. In 1943 he began working for magazines, especially *Cosmopolitan*, and later illustrated books by Pearl Buck and Carl Sandburg, as well as designing a number of U.S. postage stamps. His works are in the collections of the Metropolitan Museum of Art, Library of Congress, and Los Angeles County Museum.

SMITH, WILLIAM D.
Engraver. Born c. 1800. In 1829 this capital line engraver was working in Newark, NJ, and he was possibly a pupil of Peter Maverick. From 1835 to 1850, Wm. D. Smith was in business as a general engraver in NYC.

SMITH, WILLIAM GOOD.
Portrait painter in oils and miniatures. Flourished 1842-1844 in NY. Exhibited a drawing at the American Institute, 1842.

SMITH, WUANITA.
Etcher, block printer, painter and illustrator. Born in Philadelphia, PA, Jan. 1, 1866. Pupil of Penna. Academy of Fine Arts; Philadelphia School of Design for Women; and Howard Pyle. Member: Plastic Club; Fellowship Penna. Academy of Fine Arts; Art Alliance of America; American Federation of Arts. Award: Hon. mention, Wilmington Art Association. Illustrated: *The Four Corner Series*, *The Admiral's Granddaughter*, *Grimm's Fairy Tales*, *Gulliver's Travels*, *Washington Square Classics*, etc. Address in 1933, 1010 Clinton Street, Philadelphia, PA.

SMITHBURN, FLORENCE BARTLEY.
Painter and teacher. Born in New Augusta, IN. Pupil of William Forsyth; John Herron Art School, Indianapolis. Member: Hoosier Salon; Indiana Art Association. Awards: Two second prizes, Indiana State Fair, 1929; water color prize, Hoosier Salon, Chicago, 1929. Address in 1929, New Augusta, IN.

SMITHER, JAMES (or JAMES, JR.).
Engraver. According to data available, this engraver in line, and in a somewhat peculiar stipple manner, was born in England in 1741; he first appears in this country in Philadelphia in 1768, when he was engraving for Robert Bell, a publisher and book seller of that city. He advertised his business as follows in the *Pennsylvania Journal* of 1768: "James Smither. Engraver. At the first house in Third street, from the Cross-Keys, corner of Chestnut-street, Philadelphia. Performs all manner of Engraving in gold, silver, copper, steel and all other metals: coats of arms, and seals, done in the neatest manner. Likewise cuts stamps, brands and metal cuts for printers, and ornamental tools for book-binders. He also ornaments guns and pistols, both engraving and inlaying silver, at the most reasonable rates." This ad

would seem to justify the tradition that he was originally an ornamenter of guns and a gunsmith, working in the Tower of London previous to his arrival in Philadelphia, Pennsylvania. He did considerable engraving for Robert Bell, mentioned above; also engraved bookplates and bill heads, and he is credited with having engraved the plates for some of the paper money of the province of Pennsylvania, and then having counterfeited this money for the use of the enemy during the British occupation of Philadelphia. A proclamation was issued by the Supreme Executive Council of Pennsylvania, on June 25, 1778, accusing Smither and others of having "knowingly and willingly aided and assisted the enemies of this state and the United States of America," and declaring all of them "attainted with high treason." Smither evidently left Philadelphia with the British troops, as he was working for Hugh Gaine in NY in 1777, and he advertises himself as an engraver, "late of Philadelphia," in Rivington's *Royal Gazette* of May 22, 1779. He returned to Philadelphia, as in 1786 he was engraving for publishers of that city, and the name of "James Smither, engraver and seal-cutter" appears in the Philadelphia directories for 1791-1800, 1802-19 and 1823-24. Unfortunately, there was a James Smither (3rd), also an engraver, and the directories make no distinction between the father and son. Probably died September, 1797, in Philadelphia, Pennsylvania, although a James Smither was listed in the above directories after 1800.

SMITHER, JAMES, JR.
Engraver. Working in Philadelphia, 1794-1824. May be the same as, or a son of, James Smither, listed above.

SMITHER, JAMES, 3rd.
Engraver. Born in 1772; died in 1793. There is some difficulty in disentangling these 2 names. The evidence of the existence of a "James Smither, 3rd" (signed Jr.), lies in the occurrence of this name among the professional members of the Philadelphia Association of Artists, organized on Dec. 28, 1794, and plates of birds so signed are among the illustrations in Dobson's edition of Rees' Encyclopedia, published in Philadelphia in 1794-1803. In the same work, however, plates almost identical in character are signed "James Smither" and "James Smither, Jr." The directories make no distinction between father and son and give no clue. James Smither the 3rd, son of James Smither, died during the yellow fever epidemic in Philadelphia, Pennsylvania in 1793, the father outliving the son, hence the confusion in the dates of their work.

SMITHWICK, J. G.
Wood engraver. Worked for *Harper's* and *Scribner's*; he afterwards formed a partnership with Frank French.

SMOLEN, FRANCIS (FRANK).
Painter, illustrator, sculptor, designer, craftsman, and teacher. Born in Manor, PA, January 8, 1900. Studied at Fed. School, Inc.; Carnegie Institute; and with Bicknell, Readio, Ashe, and others. Member: Friends of Art, Youngstown, OH. Awards: Prizes, Sharon Art Association, 1935, 39, 43. Work: Buhl Girls Club, Sharon, PA. Exhibited: Devoe and Raynolds Exhibition, 1940; Associated Artists of Pittsburgh, 1928, 31-34; Butler Art Institute, 1935, 36, 38, 41, 43; Sharon Art Association, 1938-42, 45; Albright Art Gallery, 1949; Alliance College, Cambridge Springs, PA, 1951. Address in 1953, Sharon, PA.

SMOOT, MARGARET.
Sculptor. Born in Lakeport, CA, August 29, 1907. Pupil of Charles Grafly and Albert Laessle. Member: Fellowship Penna. Academy of Fine Arts. Awards: Cresson Traveling Fellowship, Penna. Academy of Fine Arts, 1930 and 1931. Address in 1933, Altamonte Springs; h. Route 2, Maitland, FL.

SMYTH, DAVID RICHARD.
Sculptor. Born in Washington, DC, December 2, 1943. Studied at Corcoran School of Art, Washington, DC, 1962-64; Art Institute of Chicago, B.F.A., 1967, M.F.A., 1969. Work at Whitney Museum of American Art, NY; others. Has exhibited at Art Institute of Chicago; Universities of Illinois and Pennsylvania; Whitney Museum of American Art, NY; Museum of Contemporary Art, Chicago; Prints, Brooklyn Museum; others. Received George D. Brown Traveling Fellowship, Art Institute of Chicago, 1969, and Richard Rice Jenkins Award; others. Address in 1982, c/o Ronald Feldman Fine Arts Inc., NYC.

SMYTH, MARGARITA PUMPELLY.
Painter. Born in Newburgh, NY, in 1873. Pupil of Abbott H. Thayer. Address in 1926, Belmont St., Watertown, MA.

SMYTH, S(AMUEL) GORDON.
Etcher, block printer, illustrator, painter and teacher. Born in Holmesburg, Philadelphia, PA, Nov. 21, 1891. Pupil of Harry Lachman; Walter H. Everett. Work: Series of historical paintings in National Shawmut Bank, Boston; illustrations for *Saturday Evening Post, Collier's*. Address in 1933, 2442 Linden Dr., Merwood Park, Upper Darby, PA; summer, Quebec, Canada.

SMYTHE, ROBERT L.
Sculptor. Born in Ireland, 1820. Worked in New York City in 1850.

SNEAD, LOUISE W(ILLIS).
(Mrs. Harry Vairin Snead). Miniature painter, illustrator, writer, and lecturer. Born in Charleston, SC.

Pupil of Chase; Art Students League of NY, under Theodora Thayer; studied in Palestine and Egypt. Awards: Hon. mention, Charleston Expo., 1902; prize for seal for a South Carolina city in 1915; first prize for miniatures at Mineola, LI, 1911 and 1912. Work: Portrait of "Capt. Henry M. Shreve," Shreveport (LA) Memorial Library; "Rebecca Mott," D. A. R. Building, Charleston, SC. Author and producer of Oriental plays and pageants, designing the stage settings and costumes under the name of "Gulnare el Nahdir." Lectures on Oriental rugs and Fine Arts. Author and illustrator of *History of Stamford, CT; Silver and Gold*, for Stamford Trust Co. Illustrator of *Suburban Life of Stamford*, for Stamford Chamber of Commerce, 1919. Address in 1929, Hotel Brevoort, New York, NY; "Ye Olde King's Highway," Noroton, CT.

SNEDEN, ELEANOR ANTOINETTE (MRS.).
Sculptor. Born in New York, 1876. Pupil of Mlle. Genevieve Granger in Paris. Specialty: Portrait medallions. Address in 1913, Avon-by-the-Sea, NJ.

SNELGROVE, WALTER H.
Painter. Born in Seattle, WA, March 22, 1924. Studied: University of Washington, 1941-43; California School of Fine Arts, with Hassel Smith, Antonio Sotamayor, James Weeks; University of California, Berkeley, B.A., 1947, M.A., 1951, with James McCray, M. O'Hagen. Work: Whitney, NYC; Oakland (CA) Museum; California Palace of Legion of Honor; others. Exhibited: Carnegie Institute; Art Institute of Chicago; Whitney; Albright-Knox, Buffalo, NY; California Palace; others. Awards: Oakland Museum; San Francisco Museum of Art; California Palace of the Legion of Honor. Member: San Francisco Art Association. Address in 1976, Berkeley, CA.

SNELL, FLORENCE FRANCIS.
(Mrs. Henry B. Snell). Painter. Born in London, England. Pupil of Art Students League of NY. Member: NY Water Color Club; American Water Color Society; National Association of Women Painters and Sculptors; National Arts Club. Awards: McMillin landscape prize, National Association of Women Painters and Sculptors, 1913; National Arts Club prize, National Association of Women Painters and Sculptors, 1915. Died Jan. 20, 1946. Address in 1929, New Hope, PA.

SNELL, HENRY B(AYLEY).
Marine painter and teacher. Born in Richmond, England, Sept. 29, 1858. Pupil of Art Students League of NY. Member: Associate National Academy of Design, 1902; Academician National Academy of Design, 1906; NY Water Color Club; American Water Color Society; Society of American Artists, 1905; Salma. Club, 1903; Lotos Club; Fellowship Penna. Academy of Fine Arts, 1916 (associate); National Arts Club; Allied Artists of America.

Awards: Gold medal, Art Club of Philadelphia, 1896; 1st prize, Nashville Expo., 1897; hon. mention, Paris Expo., 1900; silver medal, Pan-Am. Expo., Buffalo, 1901; silver medal, St. Louis Expo., 1904; first prize ($300), Worcester Museum, 1905; Beal prize, NY Water Color Club, 1905; silver medal for oil painting and gold medal for water color, P.-P. Expo., San Francisco, 1915; hon. mention, Philadelphia Art Club, 1916; Shaw Purchase Prize, Salma. Club, 1918. Assistant director of Fine Arts, U.S. Commission, Paris Expo., 1900. Work: "The Citadel at Quebec," Albright Art Gallery, Buffalo; "Entrance to the Harbor of Polperro," Worcester Museum; "Nightfall," Herron Art Institute, Indianapolis; "Lake Como," Metropolitan Museum, NY; "The Windjammer," Harrison Gallery, Los Angeles Museum. Died January, 1943. Address in 1933, New Hope, PA.

SNELSON, KENNETH D.
Sculptor. Born in Pendleton, OR, June 29, 1927. Studied at University of Oregon, with Jack Wilkinson; Black Mountain College, with Josef Albers, Buckminster Fuller, Willem de Kooning; Academie Montmartre, Paris, with Fernand Leger. Works: Museum of Modern Art; Whitney; Stedelijk Museum, Amsterdam; Hirshhorn. Exhibited: Pratt Institute; New York World's Fair; Dwan Gallery, NYC; Dwan Gallery, Los Angeles; Bryant Park, NYC; Rijksmuseum Kroller-Muller; Stadtische Kunsthalle, Dusseldorf; Museum of Modern Art, NYC; Milan Triennial, 1964; Whitney Sculpture Annual, 1966-69; Los Angeles County Museum of Art; Art Institute of Chicago; Albright; Philadelphia Museum of Art. Award: Milan Triennial, Silver Medal, 1964. Taught: Cooper Union; Pratt Institute; School of Visual Arts, NYC; Southern Illinois University; Yale University. Address in 1982, 140 Sullivan St., NYC.

SNOWDEN, ELSIE BROOKE.
Painter. Born in Ashton, MD, March 4, 1887. Pupil of Corcoran School of Art, Washington, DC; Penna. Academy of Fine Arts. Award: Cresson Traveling Scholarship, Penna. Academy of Fine Arts, 1914. Specialty: Figure. Address in 1929, 2200 16th St., N.W., Washington, DC; Ashton, MD.

SNOWDEN, GEORGE HOLBURN.
Sculptor. Born in NY, Dec. 17, 1902. Studied at Yale School of Fine Arts; Ecole des Beaux-Arts; pupil of A. A. Weinman. Awards: Prix de Rome, 1927; New Haven Paint and Clay Club, 1926; Otis Elevator Prize, Beaux-Arts Institute, NYC, 1926. Work: Law groups, Bronx County, NY; pediments, Drink Hall, Saratoga Springs, NY; Yale Memorial, Pershing Hall, Paris. Address in 1933, 154 West 55th St., NYC.

SNVERNIZZI, PROSPER.
Sculptor. Exhibited in the Penna. Academy of Fine Arts, Philadelphia, 1926. Address in 1926, 500 West 178th Street, New York, NY.

SNYDER, CLARENCE W.
Painter. Born in Philadelphia, PA, March 10, 1873. Member: Penna. Academy of Fine Arts; Drexel Institute; Fellowship Penna. Academy of Fine Arts; Philadelphia Art Club. Address in 1933, Barker Bldg., 1520 Chestnut St.; h. 5016 Hazel Ave., Philadelphia, PA.

SNYDER, CORYDON GRANGER.
Illustrator, designer, etcher, painter, writer, and teacher. Born in Atchison, KS, February 24, 1879. Studied: Art Institute of Chicago; Minneapolis Institute of Art; Toronto Art Institute. Member: Chicago No-Jury Society of Artists. Work: St. Paul Historical Society, MN. Exhibited: Palette and Chisel Academy, 1931 (one-man); Chicago No-Jury Society of Artists, 1951. Author and illustrator: *Fashion Illustration*, 1916; *Pen and Ink Technique*, 1920; others. Address in 1953, 1935 South Michigan Ave.; h. 61 East Grand Ave., Chicago, IL.

SNYDER, HENRY W.
Engraver. Snyder was engraving in NY in 1797-1805, and in 1811 he made some good stipple portraits for the "Polyanthus," of Boston. He usually signed his plates "Snyder," but one plate, published in Boston in 1807, is signed as above. As "H. W. Snyder," he also made a number of the line illustrations in "The American Builder's Companion," published in Boston in 1816.

SOBLE, JACK.
Painter, etcher, and teacher. Born in Russia, Jan. 14, 1893. Pupil of Charles C. Curran and Francis C. Jones. Work: Character studies of Maurice Schwartz, Yiddish Art Theatre Galleries. Address in 1929, Clinton Bldg., 107th West 47th Ave., New York, NY; h. 1685 Morris Ave., Bronx, NY; summer, Totem Lodge, Averill Pk., Albany, NY.

SODERBERG, YNGVE EDWARD.
Etcher. Born in Chicago, IL, Dec. 21, 1896. Member: Chicago Society of Etchers. Work: Etching, "Jibbing Around Buoy," Art Institute of Chicago. Address in 1935, Mystic, CT.

SODERSTON, HERMAN.
Painter. Born in Sweden, July 12, 1862. Pupil of Royal Academy of Fine Arts, Stockholm. Member of New Haven Paint and Clay Club; Society of Independent Artists. Represented in Memorial Hall, Hartford; Sheffield Scientific Hall, New Haven, CT. Address in 1926, 840 Chapel St., New Haven, CT. Died July 3, 1926 in New Haven, CT.

SOELLNER, OSCAR D(ANIEL).
Painter and etcher. Born in Chicago, IL, April 8, 1890. Member: Chicago Palette and Chisel Club; Chicago Painters and Sculptors; Austin, Oak Park, and River Forest Art Leagues; American Federation of Arts; American Artists Professional League; Illinois Academy of Fine Arts; All-Illinois Society of Artists. Work: "River Wharf," public schools of Oak Park and River Forest; "Heroes Memorial," Oglesby, IL; "Deserted Farm," State Capitol Building, Springfield, IL. Address in 1933, Grand Detour, Dixon, IL; h. 31 Keystone Ave., River Forest, IL.

SOHIER, ALICE RUGGLES.
Painter. Born in Quincy, MA, Oct. 21, 1880. Studied in Buffalo; School of Boston Museum of Fine Arts under Tarbell; and in Europe as holder of Paige Traveling Scholarship. Member: Guild of Boston Artists; Concord Art Association. Award: Bronze medal, P.-P. Expo., San Francisco, 1915. Address in 1933, Concord, MA.

SOKOLSKY, SULAMITH.
Painter. Born in NY in 1889. Pupil of Cooper Union of the National Academy of Design, NY. Address in 1926, 2103 Vyse Ave., Bronx, New York, NY.

SOLDWEDEL, FREDERIC.
Painter. Born in 1886. Painter of marine and yachting subjects. His water colors of yachts are considered his best works.

SOLOMON, MAUDE BEATRICE.
(Mrs. Joseph Solomon). Sculptor, painter, and illustrator. Born in Seattle, WA, June 6, 1896. Pupil of Liberty Todd; Hugh Breckenridge. Member: Fellowship Penna. Academy of Fine Arts. Illustrated *Aristocrats of the North*. Address in 1933, NYC.

SOLOMON, MITZI.
Sculptor, designer and teacher. Born in NY, January 1, 1918. Studied: Columbia University, B.S., M.A.; Art Students League; and with Oronzio Maldarelli, Anne Goldthwaite, and others. Member: National Association of Women Artists; New York Society of Women Artists; Audubon Artists; Springfield Art League. Awards: Prizes, Smith Art Gallery, Springfield, MA, 1940, 43, 45; Irvington (NJ) Public Library, 1944. Exhibited: Syracuse Museum of Fine Arts, Philadelphia Art Alliance, M. H. de Young Memorial Museum, Milwaukee Art Institute, Brooks Memorial Art Gallery (all one-man); Whitney Museum of American Art, 1945, 46; Art Institute of Chicago, 1942; Cincinnati Museum Association, 1939, 41; Metropolitan Museum of Art, 1942; Denver Art Museum, 1942-44; National Association of Women Artists, 1943-46; Connecticut Academy of Fine Arts, 1940; North Carolina Artists, 1943, 44; Newport Art Association, 1944, 45; Springfield Art League, 1941-44, 46. Address in 1953, 2 Columbus Circle; h. 115 Central Park West, NYC.

SOLOMON, ROSALIND.
Photographer. Born in Highland Park, IL, in 1930. Studied: Goucher College and with Lisette Model in

NYC. Awards: Hunter Museum of Art, 1974; Atlanta Arts Festival, 1974; Arkansas Fine Arts Center, 1971. Exhibitions: Birmingham Museum of Art, Alabama, 1975; Neikrug Galleries, NYC, 1975; Slocumb Gallery, Johnson City, TN, 1975. Her one-person show, *Israel: Radishes and Roses*, toured the eastern United States. Collections: Museum of Modern Art, NYC; Metropolitan Museum of Art, NYC; Arkansas Fine Arts Center. She is noted for her photographs of Union Depot, Chattanooga, TN, and First Monday, Scottsboro, AL.

SOLOMON, SYD.
Painter. Born on July 12, 1917 at Uniontown, PA. Studied at L'Ecole des Beaux Arts, Paris, 1945; Chicago Art Institute School, 1934. Taught at Ringling School of Art; Famous Artists Schools, Inc.; University of Illinois; Sarasota School of Art; New College. Received Ford Foundation Purchase Award, 1965; Audubon Artists, gold medal, 1957; Florida State Fair, first prize; American Institute of Architects, medal of honor, 1959; Butler Institute of American Art, first purchase prize, 1957; Silvermine Guild, 1962; others. Exhibited at Lowe Art Gallery, Coral Gables, FL; Stetson University; University of Florida; A.A.A. Gallery, NYC; American Federation of Arts, NYC; Metropolitan Museum of Art; Museum of Fine Arts, Houston; University of Illinois; Dallas Museum of Fine Arts; Butler Institute of American Art; Art Institute of Chicago; NY Coliseum, 1959; Boca Raton Center for Arts; Whitney Museum; National Academy of Design; American Academy of Arts and Letters; Genesis Gallery, NYC; McDowell Gallery, Toronto; others. In collections at Baltimore Museum of Art; Wadsworth; Philadelphia Museum of Art; Brandeis; Ryder College, Trenton, NJ; Whitney; Guggenheim Museum; Adelphi University; Mead Corporation; Butler Institute of American Art, Youngstown, OH. Address in 1984, Sarasota, FL.

SOLON, HARRY.
Painter. Born in San Francisco, June 5, 1873. Pupil of California School of Design, San Francisco; Art Institute of Chicago; Julian Academy in Paris; Henri Royer; Richard Miller. Member: American Federation of Arts. Work: "Portrait of Dr. Bennett Mitchell," Capitol Building, Des Moines; also at Morningside University, Sioux City. Address in 1929, 1 West 67th Street, New York, NY.

SOLON, LEON VICTOR.
Painter, designer, illustrator, craftsman, and writer. Born in Stoke-on-Trent, England, April 17, 1872. Studied at Royal College of Art, London. Member: Royal Society of British Artists; National Sculpture Society; Architectural League; National Society of Mural Painters. Awarded medal, American Institute of Architects; Architectural League; others. Represented in Victoria and Albert Museum, London;

Rockefeller Center, NYC; Fairmount Park Museum, Philadelphia; others. Exhibited in Europe. Living in NYC in 1934. Address in 1953, Lakeland, FL.

SOMERBY, J. E.
Engraver. The only record of this man as an engraver is found in the American Coast Pilot, by Capt. Lawrence Furlong, edited by Edmund M. Blunt, Newburyport, 1804. He engraved two or three maps in this work, the rest being engraved by A. M. Peasley.

SOMMER, EDWIN G.
Painter, illustrator, etcher, and craftsman. Born in Roseville, NJ, June 29, 1899. Pupil of William Sommer. Member: Kokoon Art Club. Awards: First prize for illustration, second prize for water color, 1923, and second prize for illustration, 1924, Cleveland Museum of Art. Work: "The Shower," "The Return" and "The Castle on the Moon," Cleveland Museum of Art; "The Lost Prince," Cleveland Public Schools; mural decoration in the Embassy Club, Cleveland. Address in 1929, 2121 East 21st St.; h. Elderhood Ave., East Cleveland, OH; summer, Route No. 3, Macedonia, OH.

SOMMERBURG, MIRIAM.
Painter and sculptor. Born in Hamburg, Germany, October 10, 1910. U.S. citizen. Studied with Friedrich Adler and Richard Luksch in Germany. Works: Florida Southern College; Metropolitan Museum of Art; Butler Institute; Springfield (MO) Art Museum. Exhibitions: Florida Southern College, 1952; Village Art Center, 1948, 49, 50, 51, 57; Creative Art Gallery, 1950; NJ Painters and Sculptors, 1955; Edinburgh, Scotland, 1963; Palazzo Vecchio, Florence, Italy, 1972; National Association of Women Artists; Brooklyn; Whitney; others. Awards: First, second and third prizes, Sculpture and Graphics, Village Art Center, 1946-60; medal, Audubon Artists, 1966. Member: National Association of Women Artists; Audubon Artists; Artists Equity; others. Media: Stone, wood, stained glass. Address in 1976, 463 West St., New York, NY.

SOMMERS.
He painted "Westward Ho! or Crossing the Plains." It is now in the Capitol, Washington, DC.

SONED, WARREN.
Painter, designer, sculptor, teacher, and lecturer. Born in Berlin, Germany, September 15, 1911. Studied at Fine Arts Academy, Duesseldorf, Germany; Beaux-Arts Institute, Grande Chaumiere, Paris, France; University of Miami, B.A. Member: Mural Artists Guild; Society of Independent Artists. Awards: Prize, National Army Exhibition, 1945. Work: Murals, U.S. Post Office, Hapeville, GA; New York Telephone Building: Pildes Optical Co., NY; Barbizon School of Fashion Modeling, NY; Walter

Reed Hospital, Washington, DC. Exhibited: Society of Independent Artists; Army Art Exhibition, Dallas, TX, 1945; Lowe Gallery, University of Miami, 1952; and in Europe. Position: Instructor and lecturer, University of Miami, FL, from 1950. Died in 1966. Address in 1953, Miami Beach, FL.

SONN, ALBERT H.
Painter and illustrator. Born in Newark, NJ, Feb. 7, 1867. Pupil of National Academy of Design. Member: Salma. Club, 1900; American Water Color Society; Artists' Fund Society; NY Water Color Club; American Federation of Arts. Author: "Early American Wrought Iron." Died in 1936. Address in 1929, 282 Parker St., Newark, NJ.

SONNICHSEN, YNGVAR.
Painter, illustrator, etcher, and teacher. Born in Christiania, Norway, March 9, 1875. Graduate of Polytechnic School of Christiania, Norway, in mechanical engineering, 1894. Studied in Antwerp, Brussels; at Julian's under Bouguereau and Constant in Paris. Member: Board of Fine Arts, Christiania, Norway; Seattle Art Institute; American Federation of Arts. Awards: 1st prize, International Exhibition, St. John, N. B., Canada, 1906; gold and silver medals, Alaska-Yukon-Pacific Expo., Seattle, 1909; hon. mention, Northwest Artists' Annual Expo., Seattle, 1920. Decorations for Norway Hall, Seattle; portraits in municipal galleries of Christiania, Arendal, and Laurvik, Norway; Free Mason's Lodge, St. John, N. B., Canada; "The Moon, Alaska," Vanderpoel Art Association, Chicago; Norwegian Club, Brooklyn, NY. Died in 1938. Address in 1929, 520 13th Ave., North, Seattle, WA.

SONNIER, KEITH.
Sculptor and painter. Born in Mamou, LA, 1941. Studied at the Univer. of Southwestern Louisiana, 1959-63, B.A.; Rutgers Univer., 1965-66, M.F.A., where he met artists Robert Morris, Gary Kuehn, and Robert Watts. Painted during a year in France. Exhibited: Douglass College, New Brunswick, NJ, 1966; Galerie Rolf, Inc., 1968, 71, 72, 75, 76, 78, 79; ACE Gallery, Los Angeles, CA, 1970, 75, 77; Creigh Gallery, Coronado, 1974, 76; Rosamund Felsen Gallery, Los Angeles, 1978; The Clocktower, NYC, 1978; Galerie Michele Lachowsky, Brussels, 1979; Eric Fabre Gallery, Paris, 1979; American Abstract Artists, 1968; Washington Univer., Here and Now, 1969; Mu. of Modern Art, Information, 1971; Dusseldorf/Kunsthalle, Prospect '71, 1971; and many others. Noted early in career for his soft sculptures of inflatable boxes run by motors; also his use of neon tubing, latex, string, and glass in his non-sculptural works. He has also executed works using sound recordings and videotape in conjunction with other materials. Awards include first prize, Tokyo Print Biennial, 1974; Guggenheim Foundation Fellowship, 1974. Address in 1982, 33 Rector Street, NYC.

SONTAG (or SONNTAG), WILLIAM LOUIS.
Landscape painter. Born March 2, 1822 at East Liberty, PA, near Pittsburgh. Worked in Cincinnati from 1842 to 1855 or 56, and then went to Italy to study in Florence. Upon his return to America about a year later, he worked and lived in New York City until his death on January 22, 1900. He was elected an Associate of the National Academy in 1860 and an Academician two years later. His principal works are "Morning in the Alleghenies," "View on Licking River, KY," "Sunset in the Wilderness," "Fog Rising off Mount Adams" and "Spirit of Solitude." He also painted a panorama of Milton's *Paradise Lost* and *Paradise Regained*.

SOOY, LOUISE PINKNEY.
Painter, writer, lecturer, and teacher. Born in Blairstown, IA, Aug. 9, 1889. Pupil of Arthur W. Dow. Member: California Painters and Sculptors; The Seven, Honolulu; Arthur Wesley Dow Association; Pacific Art Association. Author of articles on art education for "Dark and Light." Address in 1929, 855 Vermont Ave., Los Angeles, CA; h. 2013 Pelham Road, Sawtelle, CA.

SOPER, J. H. GARDNER.
Painter. Born in Flint, MI, in 1877. Awarded bronze medal, Louisiana Purchase Exposition, St. Louis, 1904. Address in 1926, 12 Gramercy Park, New York, NY.

SOPER, RICHARD F.
Engraver. Born c. 1810 in England. This meritorious engraver of portraits in stipple was employed by NY publishers as early as 1831; he worked largely for J. C. Buttre, of the same city, at a later period. Died c. 1862.

SOREL, EDWARD.
Illustrator. Born in NYC in 1929. Attended Cooper Union and began his career as a founding member of Push Pin Studios in 1953. Five years later he started free-lancing as a political satirist and his work has appeared in *Ramparts*, *Esquire*, *Atlantic*, *Time*, and *New York Magazine*, for the last of which he is a contributing editor. He has done several books and illustrates weekly in the *Village Voice*. In 1973 Cooper Union awarded him their Augustus St. Gaudens Medal for professional achievement.

SORENSEN, CARL SOFUS WILHELM.
Sculptor and painter. Born in Denmark, September 25, 1864. Pupil of the Academy of Fine Arts and of P. S. Kroyer in Copenhagen. Specialty: Modeling in wax. Address in 1913, 3241 Pierce Place, Chicago, IL.

SORENSEN, REX.
Sculptor. Born in Omaha, NE, 1908. Address in 1934, Oak Grove, OR.

SORENSON-DIEMAN, CLARA LEONARD.
Sculptor. Born in Indianapolis, IN, in 1877. Pupil of Lorado Taft and Victor Brenner. Member: Chicago Society of Artists; Indiana Society of Artists; Alumnae, Chicago Art Institute. Work: Memorial Tablet, Shortridge High School, Indianapolis; Memorial Tablet, YMCA, Cedar Rapids, IA; Memorial Tablet, Art Association, Cedar Rapids, IA. Address in 1926, Cedar Rapids, IA.

SOTHERN, E. A.
Painter. "Alpine View" was painted by the elder Sothern (actor), and presented by him to Alfred Sutliffe, editor of the *San Francisco Chronicle*.

SOTTEK, FRANK.
Painter, illustrator, etcher, and writer. Born in Toledo, OH, Oct. 10, 1874. Member: Artklan; Toledo Federation of Art Societies. Award: First prize, Toledo Federation of Art Societies, 1924. Died in 1939. Address in 1929, 381 South Detroit Ave., Toledo, OH.

SOTTER, GEORGE W.
Painter and craftsman. Born in Pittsburgh, PA, Sept. 25, 1879. Pupil of Chase; Anshutz; Redfield; H. G. Keller. Member: Pittsburgh Art Association; Connecticut Academy of Fine Arts; Salma. Club; Fellowship Penna. Academy of Fine Arts. Awards: Silver medal, P.-P. Expo., San Francisco, 1915; first prize, Pittsburgh Associated Artists, 1917; art society prize, Pittsburgh Associated Artists, 1920; hon. mention, Connecticut Academy of Fine Arts, 1921; Flagg prize, Connecticut Academy of Fine Arts, 1923; hon. mention, Connecticut Academy of Fine Arts, 1926. Works: "The Hill Road," Reading Museum; "Pennsylvania Country," State College, State College, PA. Stained glass windows in church of Our Lady of Lourdes, New York; St. Agnes Church, St. Pauls Monastery, Sacred Heart Church, Pittsburgh; Kenrick Seminary, St. Louis; St. Mark's Church, St. Paul; St. Mary Magdalene Cathedral, Salt Lake City; St. Joseph's Cathedral, Wheeling, WV; New Jersey State Museum, Trenton. Died in 1953. Address in 1929, Holicong, Bucks Co., PA.

SOUDEIKINE S(ERGEI) (YURIEVICH).
Painter, illustrator, and teacher. Born in Russia in 1886. Pupil of Moscow Art School; St. Petersburg Imp. Academy. Member: Mir Isskustva, Salon D'Automne Union; Russian Artists. Work: "Les Fiancees de Moscow," Luxembourg Museum, Paris; "Promenade Landscape," Morosoff Gallery, Moscow; "Pastorale," Girshman Gallery, Moscow, etc. Mural decorator and scenic artist. Died in 1946. Address in 1929, 1 W. 67th St., New York, NY.

SOULEN, HENRY J.
Illustrator. Born in Milwaukee, WI, in 1888. Studied at the Chicago Academy of Fine Arts and later with Howard Pyle. He illustrated for most of the major magazines and received the Peabody Award for his magazine cover designs. During World War II he gave free art lessons to veterans at the Valley Forge Military Hospital. His illustrations were known for their strong patterns and rich colors.

SOUTHER, LYNA CHASE.
(Mrs. Latham T. Souther). Painter, sculptor and writer. Born in St. Louis, MO, October 14, 1880. Pupil of Edmund Wuerpel; Boris Lovet-Lorski; Klasstorner. Member: Springfield Art Association; Illinois Academy of Fine Arts. Address in 1933, Springfield, IL.

SOUTHWARD, GEORGE.
Landscape, still life, portrait and miniature painter. Born in 1803. Studied in Boston under Ames, and accompanied that artist to Rome. At one time he was a pupil of Thomas Sully. On his return from his studies abroad, he settled in Salem, MA, and died there Feb. 19, 1876.

SOUTHWARD, NATHANIEL.
Miniature painter. Born January 8, 1806 in Scituate, Massachusetts. He worked in Boston from 1842-48, visited Europe, and on his return lived in New York and Pennsylvania. Died April 25, 1858 in Dorchester, Massachusetts. The name is sometimes spelled "Southworth."

SOUTHWICK, JEANIE LEA.
Painter, teacher, writer, and lecturer. Born in Worcester, Massachusetts. Pupil of Art Students League of NY; Boston Museum of Fine Arts School. Member: Alumni, Boston Museum of Fine Arts School; American Federation of Arts; Corporate member, Worcester Art Museum. Lecturer on Arts and Crafts of Japan, Java, etc. Specialty: Water colors. Address in 1929, 6 Home Street, Worcester, Massachusetts.

SOUTHWICK, KATHERINE.
Painter and illustrator. Born in Buxton, ME, Jan. 9, 1887. Pupil of Chicago Academy of Fine Arts; Art Institute of Chicago; Penna. Academy of Fine Arts. Member: Fellowship Penna. Academy of Fine Arts. Awards: Cresson traveling scholarship, Penna. Academy of Fine Arts, 1911-1913. Address in 1934, Scarsdale, NY; Stevens Point, WI.

SOUTHWORTH, F(RED) W.
Painter. Born in Canada, Feb. 7, 1860. Self-taught. Member: Tacoma Fine Arts Association; North West Art Association; Chicago Brush and Palette Club. Work: "Sunlight on the Sea," Ferry Museum, Tacoma. Died in 1946. Address in 1929, 609 North I St., Tacoma, WA.

SOUTHWORTH, NATHANIEL.
See Southward, Nathaniel.

SOUTHWORTH, WILLIAM.
An American painter whose name is mentioned by writers on art in this country about 1850.

SOWINSKI, JAN.
Sculptor and painter. Born in Opatow, Poland, October 2, 1885. Studied at Beaux-Arts Institute of Design; and in Poland. Works: St. Stephen's Church, Paterson, NJ; Trinity Church, Utica, NY. Award: Beaux-Arts Institute of Design. Member: Modelers and Sculptors of America and Canada. Address in 1953, Long Island City, NY.

SOYER, MOSES.
Painter. Born on Dec. 25, 1899, in Borisoglebsk, South Russia. Emigrated to U.S. with his family in 1913, settling in Philadelphia, PA, and then in New York City. Studied at Cooper Union Art School; National Academy of Design School of Art with George W. Maynard; Beaux-Arts Institute of Design; Art School with Robert Henri and George Bellows; Educational Alliance. Taught at Educational Alliance; Contemporary School of Art; New School for Social Research, from 1927-34. Work: Newark Museum; Toledo Museum of Art; Metropolitan Museum of Art; Whitney; Brooklyn Museum; National Institute of Arts and Letters; Detroit Institute of Arts; others. Exhibitions were held at Kleeman Galleries, NY, in 1936; Boyer Gallery, Philadelphia, PA, in 1936, 37; Little Gallery, Washington, DC, in 1939-40; Reading Museum, 1968; Albrech Gallery Museum of Art, St. Joseph, MO, in 1970; Loch Haven Art Center, Orlando, FL, in 1972; others, nationally. Published: Author of *Painting the Human Figure*, 1964. Address in 1970, 70 West 3rd Street; h. 356 West 21st Street, New York, NY. Died in 1974.

SOYER, RAPHAEL.
Painter. Born in Russia, Dec. 25, 1899. Studied at the Art Students League under Guy Pene du Bois; Cooper Union; National Academy. One-man show was held in 1929. Exhibited: Whitney Museum of American Art, 1967; Associated American Artists, 1967; National Collection of Fine Arts, 1977; Carnegie; California Palace of the Legion of Honor, San Francisco; Pennsylvania Museum of Fine Arts. Work: Whitney; Museum of Modern Art; Metropolitan Museum of Art; Philadelphia Museum of Art. Awards: W. A. Clark prize from the Corcoran Gallery of Art in Washington, DC; Temple gold medal from the Penna. Academy of Fine Arts; Kohnstann prize and Harris gold medal from the Art Institute of Chicago. Taught painting, Art Students League; American Art School; New School for Social Research. Member: American Academy of Arts and Letters; National Academy of Design. Media: Oil, graphic. Address in 1982, 88 Central Park W, New York, NY.

SPACKMAN, CYRIL (SAUNDERS).
Painter, sculptor, etcher, engraver, lithographer, lecturer, teacher, and writer. Born in Cleveland, OH, August 15, 1887. Pupil of Henry G. Keller in Cleveland; Kings College Architectural Studio, London. Member: Royal Society of British Artists; American Federation of Arts; Society Graphic Arts; Cleveland Society of Artists; Chicago Society of Etchers. Represented in Cleveland Museum; Chicago Art Institute; Print Room of the British Museum; permanent collection of the City of Hull; The Nativity, The Crucifixion, The Ascension, altar panels in 13th Century Church, Grosmont, Monmouthshire; Crucifix in stone, Sanctuary of William Lillico Memorial Church of All Saints' at Selhurst, Surrey. Designed medal of Masonic Million Memorial. Art Editor of *The Parthenon*. Address in 1933, East Croydon, Surrey, England.

SPADER, WILLIAM EDGAR.
Painter and illustrator. Born in Brooklyn, NY. Pupil of H. Siddons Mowbray; Joseph H. Boston. Member: American Water Color Society; Brooklyn Painters and Sculptors; Brooklyn Society of Artists. Work: "For the Feast," Museum of Art, Fort Worth, TX. Address in 1929, 32 Union Square, New York, NY; h. 22 Lake St., Jamaica, NY.

SPAETH, CAROLA HAUSCHKA (MRS.).
Portrait painter. Born in Philadelphia, PA, April 29, 1883. Pupil of Penna. Academy of Fine Arts; Graphic Sketch Club, Philadelphia. Member: Fellowship Penna. Academy of Fine Arts; Philadelphia Alliance. Specialty: Children. Died in 1948. Address in 1929, 1819 Green St., Philadelphia, PA.

SPAETH, MARIE HAUGHTON.
(Mrs. J. Duncan Spaeth). Painter. Born in Hanover, NH. Pupil of Penna. Academy of Fine Arts; Pennsylvania School of Design; studied in Spain, France, and Italy. Member: Fellowship Penna. Academy of Fine Arts (hon.); National Association of Women Painters and Sculptors; Catherine L. Wolfe Art Club; American Federation of Arts. Specialty: Portraits of children. Work: "Apennine Village," Penna. Academy of Fine Arts; portrait of Dr. Theodore Hunt, Princeton University. Died in 1937. Address in 1929, 32 Edgehill Street, Princeton, NJ.

SPAFARD, MYRA B.
Painter and teacher. Born in Manchester, MI. Pupil of Art Students League; Teachers College; and Mrs. E. M. Scott, in NY. Member: National Association of Women Painters and Sculptors. Address in 1929, 2181 Hulbert Ave., Detroit, MI; and Manchester, MI.

SPALDING, ELISABETH.
Landscape painter. Born in Erie, PA in 1870. Pupil of Art Students League of NY; Penna. Academy of Fine Arts. Member: Washington Water Color Club; NY Water Color Club; Erie Art Club; Providence Water Color Club; American Federation of Arts. Awards: First prize, Erie Art Club, 1900; C. E. Kremer prize for water color, Art Institute of Chicago, 1921. Work: "Rain," Erie (PA) Art Club;

(PA) Art Club; "Twilight Shower, Manoach," Denver Art Association. Died in 1954. Address in 1929, 853 Washington St., Denver, CO.

SPALDING, GRACE.
Painter. Exhibited at the Penna. Academy of Fine Arts, Philadelphia, PA, 1924. Address in 1926, New York, NY.

SPANFELLER, JAMES JOHN.
Illustrator. Born in Philadelphia, PA, in 1930. Studied at the Philadelphia College of Art; Penna. Academy of Fine Arts. His first published illustration appeared in *Seventeen* in 1956. He has worked for most major magazines and illustrated over 40 books. He was voted Artist of the Year in 1964 and has received gold medals from the Art Directors' Clubs of NY and Washington, and the Society of Illustrators, where he is a member. He won the *New York Herald Tribune* Children's Book Award and was also nominated for the National Book Award. He currently teaches at Parsons School of Design.

SPARHAWK-JONES, ELIZABETH.
Painter. Member: Fellowship Penna. Academy of Fine Arts. Awards: Mary Smith prize, Penna. Academy of Fine Arts, 1908 and 1912; honorable mention, Carnegie Institute, Pittsburgh, 1909; Mary Smith prize, Penna. Academy of Fine Arts, 1912; Kohnstamm prize ($250), Art Institute of Chicago, 1926. Work: "Shop Girls," Art Institute of Chicago. Address in 1929, 2046 Rittenhouse St., Philadelphia, PA.

SPARK, JOSEPH.
Painter, illustrator, and etcher. Born in Jersey City, NJ, Dec. 23, 1896. Pupil of Percy Ives, Paul Honore, Leon Kroll; Art Institute of Chicago. Member: Scarab Club. Address in 1929, Scarab Club, 217 Farnsworth; h. 8724 Smart Street, Detroit, MI.

SPARKS, ARTHUR WATSON.
Painter. Born in Washington, DC, in 1870. Studied at Julien Academy and Ecole des Beaux Arts, Paris, France, under Laurens, Cormon, Bouguereau, Thaulow, Mucha, Ferrier and Courtois. Exhibited at Paris Salon; Carnegie Institute; Penna. Academy of Fine Arts; National Academy of Design; Art Institute, Chicago; Corcoran Gallery; others. Awarded bronze medal, San Francisco Expo., 1915; 2nd prize, Associated Artists of Pittsburgh. Principal works: "The Steel Mills;" "Under the Birches;" "Grand View Arizona Canyon;" "Clemance and Cora;" "The Model at Rest;" etc. Professor of painting at Carnegie Institute. Member of Associated Artists of Pittsburgh. Died Aug. 6, 1919 in Philadelphia, PA.

SPARKS, H. L.
Illustrator. Member: Society of Illustrators. Address in 1929, National Park Bank, 214 Broadway, New York, NY.

SPARKS, WILL.
Painter, etcher, writer, and lecturer. Born in St. Louis, MO, Feb. 7, 1862. Pupil of St. Louis School of Fine Arts; Julian Academy in Paris. Member: Bohemian Club, San Francisco; American Federation of Arts. Work: Murals, including "The Home," Bohemian Club, San Francisco; "Delores," and "Cypresses," Plaza Hotel, San Francisco; "Stormy Day," Golden Gate Park Museum, San Francisco; oil paintings, including "A Christmas Allegory," Bohemian Club, San Francisco; "Soledad Mission," Toledo Art Museum; a portrait in St. Louis Museum. Died in 1937. Address in 1929, 163 Sutter Street, Room 408, San Francisco, CA.

SPARLING, JOHN EDMOND (JACK).
Illustrator, cartoonist, painter, and sculptor. Born in Winnipeg, Canada, June 21, 1916. Studied at Arts and Crafts Club, New Orleans, LA; Corcoran School of Art. Member: Society of Illustrators; Cartoonists Society, NY. Awards: Treasury Dept. Citations, 1944, 45. Work: Hyde Park Collection. Created, wrote, and produced "Hap Hopper, Washington Correspondent," United Features Syndicate, 1939-43; "Claire Voyant," *Chicago Sun* and PM newspaper Syndicate, 1943-46. Position: Editorial Cartoonist, *New Orleans Item Tribune*, 1935-37; *Washington Herald*, 1937-39. Address in 1953, Freeport, NY.

SPARROW, LOUISE WINSLOW KIDDER.
(Madame Paul E. H. Gripon). Sculptor and writer. Born in Malden, MA, January 1, 1884. Pupil of Eric Pape; Bush-Brown; Ulric Dunbar; Frederick Allen; Bela Pratt; also studied in Europe. Member: Society of Washington Artists; Fellow, Royal Society of Artists; Scarsdale Art Association. Awards: Medal, Society of Washington Artists, 1930; Diplome d'Honneur, Coloniale Internationale, Paris, 1931. Work: Bust of Capt. James F. Gilliss, U.S. Government and in University of Chile, and U.S. Naval Observatory; statue of Col. Archibald Gracie, IV, National Gallery of Art, Washington, DC, and Museum, Montgomery, AL; bust of Senator Theodore Burton, Oberlin College and Western Reserve Historical Society, Cleveland, OH; U.S. Military Academy at West Point; U.S. Naval Academy at Annapolis, MD; U.S. Senate, Washington, DC; bust of General Gorgas, Smithsonian Institution, Washington, and University of Alabama; Cornell University; Vassar College; NY State Maritime Academy, Ft. Schuyler, NY; others. Exhibited at Corcoran; National Gallery of Art, Washington, DC; Washington Art Club (one-man); Newport Art Association; others. Specialties: Busts, statues, memorial tablets. Author of *The Last Cruise* of the U.S.S. *Tacoma*. Address in 1953, 1661 Crescent Place, N.W., Washington, DC; Salies-du-Salat, Hte, Garonne, France.

SPARROW, THOMAS.
Engraver. Born c. 1746. Plates for Maryland paper money, issued in 1770-74, are conspicuously signed "T. Sparrow, Sculp." Sparrow also engraved upon

copper the title page to *The Deputy Commissary's Guide of Maryland*, published by Anne Catherine Green & Son, Annapolis, MD, 1774. Sparrow was chiefly a wood engraver, and thus made book plates, head and tail-pieces, bill-heads, etc. He was located in Annapolis, MD, and Mr. Charles Dexter Allen, in his "American Book-Plates," says that he worked there between 1765-80. This same man was apparently employed in Boston at a possibly earlier date, judging solely from the period of the designer, after whom he engraved a somewhat curious advertisement for the music dealer, John Ashton, of 197 Washington St., Boston.

SPAULDING, GRACE.
(Mrs. A. M. John). Painter and etcher. Born in Battle Creek, MI, Feb. 10, 1890. Member: Tiffany Foundation. Work: "Spring Comes to Bayou," Houston Museum; portrait of "Miss Aloysius Larchmiller," State Capitol, Oklahoma City. Address in 1929, 1306 Barbee Ave., Houston, TX.

SPAULDING, HENRY P(LYMPTON).
Painter. Born in Cambridge, MA, Sept. 16, 1868. Pupil of Ross Turner and Blummers. Member: Boston Art Club; Copley Society; American Federation of Arts. Address in 1933, 32 Salisbury Road, Brookline, MA.

SPAVENTA, GEORGE.
Sculptor. Born in NYC, February 22, 1918. Studied at Leonardo da Vinci Art School; Beaux-Arts Institute of Design; Academie de la Grande Chaumiere, Paris. Exhibited at Carnegie Institute; Museum of Modern Art traveling exhibition. Taught at New York Studio School; Skowhegan School of Painting and Sculpture; Maryland Institute of Art. Address in 1976, 463 West St., NYC.

SPEAKMAN, ANNA W(EATHERBY PARRY).
(Mrs. T. Henry Speakman). Illustrator. Born in Springfield, IL. Pupil of Penna. Academy of Fine Arts. Member: Fellowship Penna. Academy of Fine Arts; Plastic Club; National Association of Women Painters and Sculptors; Philadelphia Alliance. Died in 1937. Address in 1929, 524 Walnut St., Philadelphia, PA.

SPEAKMAN, ESTHER.
A portrait painter of Philadelphia exhibiting about 1843-61. Daughter of John Speakman. She painted a portrait of John Speakman, half length. He was Treasurer of the Academy of Natural Sciences, Philadelphia, PA.

SPEAR, ARTHUR P(RINCE).
Painter. Born in Washington, DC, September 23, 1879. Studied: George Washington University; Art Students League; Julian Academy, Paris; pupil of Laurens in Paris. Member: Associate National Academy of Design; St. Botolph's Club; Allied Artists of America; Guild of Boston Artists. Awards: Medal,

Pan-Am. Expo., 1915; prize, National Academy of Design, 1922. Died in 1959. Address in 1953, Friendship, ME.

SPEICHER, EUGENE E.
Painter. Born in Buffalo, NY, April 5, 1883. Studied in Buffalo, NY, and Europe. Member: Associate National Academy of Design, 1912; Academician National Academy of Design, 1927; National Society of Portrait Painters; National Arts Club; Contemporary Group; International Society of Painters, Gravers and Sculptors; New Society of Artists; Century Club; Boston Art Club. Awards: Proctor prize, National Academy of Design, 1911, third Hallgarten prize, 1914, first Hallgarten prize, 1915; Isidor portrait prize, Salma. Club, 1913; silver medal, P.-P. Expo., San Francisco, 1915; Beck gold medal, Penna. Academy of Fine Arts, 1920; third class medal, 1921, Carnegie Institute, second class medal, 1922; Potter Palmer gold medal ($1,000), Art Institute of Chicago, 1926. Work: "Morning Light" and "Polly," Metropolitan Museum, NY; "Mountain Landscape," Art League, Galveston, TX; "Portrait of an Old Lady," Decatur (IL) Museum; "Mlle. Jeanne Balzac," Cleveland Museum of Art; "Portrait of a Girl," Phillips Memorial Gallery, Washington, DC; "Portrait of Col. Charles Clifton," Albright Art Gallery, Buffalo, NY; "Portrait of Clinton Morrison," Minneapolis Museum; "Lois," Brooklyn Museum; "Torso of Hilda," Detroit Art Institute; "Lilya," Cincinnati Art Museum; "Girl with Gold Shawl," Worcester Art Museum; "Girl's Head," Fogg Museum, Cambridge, MA; "Nude," Museum of Fine Art, Des Moines, IA; "Babette," Carnegie Institute, Pittsburgh, PA; "Lucia," Whitney Museum of American Art, NY. Died in 1962. Address in 1933, 165 East 60th St., New York, NY; Woodstock, NY.

SPEIGHT, FRANCIS.
Painter. Born in 1896. Exhibited in Penna. Academy of Fine Arts, Philadelphia, 1926. Address in 1926, The Penna. Academy of Fine Arts, Philadelphia.

SPELLMAN, COREEN MARY.
Etcher, lithographer, painter, illustrator, craftsman, and teacher. Born in Forney, TX, March 17, 1909. Studied: Texas State College for Women, B.S.; Columbia University, M.A.; University for Women; Columbia University; Art Students League; University of Iowa, M.F.A.; and with Charles Martin. Awards: West Texas Art Exhibition, 1940, 42, 45, 46; University of Iowa, 1942; Texas Printmakers Exhibition, 1942, 43, 45; Texas Fine Arts Association, 1943, 45; Texas General Exhibition, 1943; Dallas Museum of Fine Arts, 1951; Southern States Art League, 1944. Exhibited: National Exhibition of American Artists, 1937; World's Fair, NY, 1939; Philadelphia Art Alliance, 1939; Whitney, 1941; American Federation of Arts traveling exhibition, 1944-45; Associated American Artists, 1946; Denver Art Museum, 1944-46; Kansas City Art Institute, 1936, 37, 42; Southern States Art League, 1932, 36,

37, 44; Texas Fine Arts Association, 1932, 33, 40, 43-46; Texas State Fair, 1938, 39; others. Illustrated "Dona Perfecta," 1940; "El Mundo Espanol," 1942; others. Instructor of Art, Texas State Teachers College, Denton, TX. Address in 1962, Denton, TX.

SPELMAN, JOHN A.
Painter. Born in Owatonna, MN, Sept. 30, 1880. Pupil of Art Institute of Chicago. Member: Chicago Painters and Sculptors; Chicago Society of Artists: Palette and Chisel Club; Chicago Artists Guild; Oak Park and River Forest Art Leagues; Chicago Galleries Association; Duluth Art League; All-Illinois Society of Fine Arts; Illinois Academy of Fine Arts. Awards: Englewood Woman's Club prize ($100), Art Institute of Chicago, 1926; two prizes ($300), Chicago Galleries Association, 1927, and prize ($250), 1928; gold medal, Association of Chicago Painters and Sculptors, at Art Institute of Chicago; first prize, Chicago Galleries Association ($1,000), 1929; gold medal, Oak Park Art League, 1930. Represented in the collections of the Springfield Art Association; the Chicago Athletic Club; the University of Nebraska; State Museum, Springfield, IL. Address in 1933, 731 Woodbine Ave., Oak Park, IL; summer, Spruce Point Lodge, Hovland, MN.

SPENCELEY, J. WINFRED.
Engraver. Born in Boston, MA, in 1865; living there in 1905. Mr. Spenceley learned to engrave with J. A. Lowell & Co., of Boston, and was with that firm in 1882-87, doing lettering and ornamental steel and copper-plate engraving with the intention of devoting himself to bank-note work. At the same time he attended the art school of Tomasso Juglaris, in Boston. In 1887 he went into business for himself, and while perfecting himself in freehand drawing, he took up etching. In 1901-03 he was with the Western Bank-Note Co., of Chicago, and he was later associated with the bank-note company of E. Bouligny, of the city of Mexico. While in the employ of J. A. Lowell & Co., Mr. Spenceley worked upon several bookplates, including one for Oliver Wendell Holmes. The freedom of design and the variety incidental to bookplate work appealed to him, and he later made a specialty of this branch of engraving, designing as well as engraving the plates. Among the more important book-plates made by Mr. Spenceley may be noted the following: The plate for the Boston Public Library and those for Harvard, Dartmouth, Michigan, Ohio State, and Missouri Universities. In addition to these he designed and engraved about 150 plates for other libraries and for private individuals. A descriptive catalogue of Mr. Spenceley's book-plates has been published by W. P. Tonesdell, Boston, 1905.

SPENCER, ASA.
Engraver. Born circa 1805 in Pennsylvania; died in England in 1847. Spencer was a member of the bank-note engraving firm of Murray, Draper, Fairman & Co., of Phila. He invented a process for applying lathe work to bank-note engraving, made improvements in the medal-ruling machine, and introduced other devices connected with the manufacture of bank notes. He accompanied Fairman and Perkins to England in 1817, but Spencer returned to Philadelphia, and later he published a few book illustrations made by his medal-ruling machine.

SPENCER, EDNA ISBESTER.
Sculptor, painter, and lecturer. Born in St. John, N. B., Canada, November 12, 1883. Pupil of Bela Pratt and Robert Aitken; Boston Museum of Fine Arts School; Art Students League. Award: Honorable mention, Concord Art Association, 1919; Paris Salon, 1929; Miami Art League, 1940. Exhibited at Paris Salon, 1926; Pennsylvania Academy of Fine Arts; Miami Art League; others. Address in 1953, Waban, Massachusetts.

SPENCER, FREDERICK R.
Painter. Born in Madison County, New York, on the 7th of June, 1806. His parents were from the New England states - his father, General Ichabod S. Spencer, from Massachusetts, and his mother from Connecticut. Mr. Spencer experienced the usual boyhood inclination to imitate prints, and at the age of 15, being with his father in Albany, he saw, for the first time, a gallery of portraits. In 1825, he came to New York to study art, where he drew from the casts of the American Academy, and had the favor of the President, and received instruction in the methods he was to pursue. In 1827 he commenced painting professionally at a village in the neighborhood. He painted for a time in Utica, New York, but finally made the city of New York his headquarters where he continued painting until his death on April 3, 1875. Among his many portraits, he painted Henry A. Ingalls; Robert Hunter Morris (mayor of New York, painted for the city in 1846) and Frances L. Morris, painted in 1838. Member of the National Academy in 1846. Died on April 3, 1875, in Wampsville, New York.

SPENCER, H(ENRY) C(ECIL).
Painter and teacher. Born in Mangum, Oklahoma, March 5, 1903. Pupil of Ernest Blumenschein; Art Students League of New York. Member: Southern States Art League; American Artists Professional League. Work: "Blind Beggar," Sociology Department, Baylor University, Waco; "Portrait of Dr. S. P. Brooks," Baylor University, Waco; "Portrait of Dr. A. J. Armstrong," Browning Collection, Waco. Instructor of drawing, Agricultural and Mechanical College of Texas. Address in 1933, College Station, Texas.

SPENCER, HOWARD B(ONNELL).
Painter. Born in Plainfield, New Jersey. Pupil of F. V. DuMond; Art Students League of New York; A. P. Lucas; Walt Kuhn. Member: Barnard Club; Salma. Club; Yonkers Art Association; Lime Rock Art Association; Ogunquit Art Club. Address in 1933, 103 East 86th Street, New York, New York.

SPENCER, HUGH.
Illustrator and craftsman. Born in St. Cloud, MN, July 19, 1887. Studied: Chicago School of App. and Normal Arts; NY Evening School of Industrial Art; Art Students League; pupil of Charles S. Chapman, Harvey Dunn, Arthur Covey. Member: Boston Society of Arts and Crafts; Society of Connecticut Craftsmen; Meriden Arts and Crafts; others. Died in 1975. Address in 1970, Chester, CT.

SPENCER, JOB B.
Painter of fruit, flowers and animals. Born in Salisbury, CT, in 1829. He settled in Scranton, PA.

SPENCER, JOSEPH B.
See Spencer, Job B.

SPENCER, MARGARET F(ULTON).
Painter and artist. Born in Philadelphia, PA, Sept. 26, 1882. Pupil of Birge Harrison; Robert Spencer. Work: "Still Life and Flowers," Alexander Simpson Collection, Philadelphia, PA. Address in 1933, New Hope, PA.

SPENCER, MARY.
Painter and teacher. Born in Fitchburg, MA. Pupil of Herbert Adams, Henry B. Snell, Arthur Dow, and Richard Miller; Pratt Institute. Member: National Association of Women Painters and Sculptors; Art Alliance of America; American Federation of Arts. Died in 1923. Address in 1929, 1062A Sterling Place, Brooklyn, New York, NY.

SPENCER, MARY.
Painter. Born in Springfield, OH, in 1835. Pupil of C. T. Webber in Cincinnati. Member of Cincinnati Woman's Art Club. Work: "Fruit," Cincinnati Museum. Address in 1926, 3612 Woodbridge Place, Cincinnati, OH.

SPENCER, MRS.
In Tuckerman's "Book of the American Artists" he notes that a Mrs. Spencer was painting genre subjects with decided merit.

SPENCER, NILES.
Painter. Born in Pawtucket, RI, May 16, 1893. Pupil of RI School of Design; also studied in NY and Paris. Represented in the Newark Museum; Phillips Memorial Gallery, Washington, DC; Albright Memorial Gallery, Buffalo, NY. Died in 1952. Address in 1929, The Daniel Gallery, 600 Madison Ave., New York, NY.

SPENCER, ROBERT.
Painter. Born in Harvard, NE, Dec. 1, 1879. Pupil of Chase; DuMond; Henri; and Garber. Member: Associate National Academy of Design, 1914; Academician National Academy of Design, 1920; Salma. Club; National Arts Club (life); Century Association. Awards: Second Hallgarten prize, National Academy of Design, 1913; hon. mention, Philadelphia Art Club, 1913, 23; Sesnan medal, Penna. Academy of Fine Arts, 1914; Inness medal, National Academy of Design, 1914; Boston Art Club medal and purchase prize ($1,000), 1915; gold medal, P.-P. Expo., San Francisco, 1915; Norman Wait Harris bronze medal, Art Institute of Chicago, 1919; hon. mention, Carnegie Institute, 1920, third prize, 1926; Altman prize ($500), National Academy of Design, 1920 and 1921; Members' Purchase prize, Salma. Club, 1921; Mrs. Wm. K. du Pont prize ($100), Wilmington Society of Fine Arts, 1921; gold medal, Sesqui-Centennial Expo., Philadelphia, 1926; Isidor gold medal, National Academy of Design, 1928; gold medal, Philadelphia Art Club, 1928. Work: Metropolitan Museum of Art; Boston Art Club; Detroit Institute of Arts; Art Institute of Chicago; National Arts Club, NY; Corcoran; Salma. Club; Brooks Memorial Art Gallery, Memphis; National Academy of Design; Philadelphia Art Club; Carnegie Institute; Union League Club, Chicago; Brooklyn Museum; Newark Museum Association; Albright-Knox Art Gallery; Society of Fine Arts, Wilmington, DE; Phillips Memorial Gallery, Washington. Died in 1931. Address in 1929, New Hope, Bucks Co., PA.

SPENCER, W. H.
This engraver of landscapes, in line, was working in NY in 1825.

SPENS, NATHANIEL.
Woodcarver, primitive painter, and decorator. Born in Edinburgh, Scotland, 1838; came to U.S. in 1862; settled in Utah about 1865. Self-taught in art. Lived in American Fork, UT, about 1865-90; moved to Mountainville in 1890. Was a farmer as well as an artist. His decorations are in Latter-Day Saints Temples. Died in Mountainville, UT, 1916.

SPERRY, REGINALD T.
Landscape painter and designer. Born in Hartford, CT, in 1845. In 1874 he moved to Brooklyn, NY.

SPERRY, THEODORE S.
Landscape painter. Born in Bozrahville, CT, in 1822. He painted theatrical scenery and lived for years in Hartford, CT. Died c. 1878 in Hartford, CT.

SPICER-SIMSON, THEODORE.
Sculptor and painter. Born in Havre, France, June 25, 1871. Studied in England and Germany; at the Ecole des Beaux-Arts and Academie Julian in Paris; and with Dampt. Exhibited: National Sculpture Society, 1923. Member: Societe Nationale des Beaux-Arts, 1928; Century Association; National Sculpture Society, 1911. Awards: Highest award for medals, Brussels Expo., 1911, and Ghent Expo., 1915; bronze medal for medals, P.-P. Expo., San Francisco, 1915. Work: Metropolitan Museum and Numismatic Museum, NY; Chicago Art Institute; Detroit Institute; New Mexico Museum of Art; City Museum of Art, St. Louis; the Luxembourg, Paris; Victoria and Albert Mu., London; in Holland, Belgium, Germany,

Austria, and Czecho-Slovakian Museums. Address in 1953, Miami, FL. Died in 1959.

SPICUZZA, FRANCESCO J.
Painter. Born in Sicily, July 23, 1883. Member: NY Water Color Club; Wisconsin Painters and Sculptors. Awards: Bronze medal, St. Paul Institute, 1915; silver medal, St. Paul Institute, 1917; Snyder prize, Wisconsin Painters and Sculptors, 1919; gold medal ($100), Milwaukee Art Institute, 1922; Milwaukee Journal purchase prize, 1927; Hammersmith prize, 1930. Represented in St. Paul (MN) Institute; Milwaukee (WI) Art Institute. Address in 1933, 125 East Well Street, Fine Arts Building; h. 1316 South 36th Street, Milwaukee, WI.

SPIERS, HARRY.
Painter. Born in Selsey, Sussex, England, Oct. 15, 1869. Pupil of Academie Julian in Paris. Member: Boston Society of Water Color Painters; Boston Art Club; Dedham ACS. Work: "As the Sunlight Bursts," Boston Museum of Fine Arts; "At the Trough" and "Passing of an Autumn Day," Ontario Government Gallery, Toronto. Address in 1933, 30 Pemberton Sq., Boston, MA; 150 Cedar St., Dedham, MA.

SPINGARN, AMY.
(Mrs. J. E. Spingarn). Painter. Born in NY, Jan. 29, 1883. Pupil of K. H. Miller. Member: Society of Independent Artists. Address in 1929, 9 West 73rd St., New York, NY; summer, Amenia, NY.

SPITZMILLER, WALTER.
Illustrator. Born in St. Louis, MO, in 1944. Attended Washington University. He began his career there and in 1974 was awarded a gold medal from the St. Louis Art Directors' Club. His editorial work has appeared in *McCall's*, *Redbook*, *Golf Digest*, and *Sports Illustrated*. Exhibitions of his work have been held in colleges in Quebec City, Atlanta, St. Louis, and in the Society of Illustrators Annual Exhibition. He presently lives in Connecticut.

SPIZZIRRI, LUIGI.
Painter. Born in Spezzano, Grand Prov. of Cosenza, Italy, Oct. 23, 1894. Pupil of Chase; Emil Carlsen; Vonnoh; Pearson; Daniel Garber; Philip Hale. Member: Fellowship Penna. Academy of Fine Arts. Address in 1933, h. 825 Wharton St., Philadelphia, PA; summer, Summerdale Park, Camden, NJ.

SPOHN, CLAY.
Sculptor and painter. Chiefly painter. Born in 1898 in San Francisco. Studied at University of California at Berkeley; California School of Fine Arts; New York Art Students League; Academie Moderne, Paris. Exhibited at San Francisco Museum of Art; Mobiles and Articulated Sculpture, California Palace of the Legion of Honor, 1948; Oakland Museum; others. Executed "junk constructions" in San Francisco, late 1940's. Address in 1977, NYC. Died in 1977.

SPOLLEN, CHRIS JOHN.
Illustrator. Born in NYC, in 1952. Studied at Parsons School of Design. His first job was an etching for *Crawdaddy* magazine in 1973. Awards for his work include the Society of Publication Designers Award of Merit, Second Place in the Society of Illustrators Scholarship Competition and Second Place in the Staten Island Museum Spring Show. Illustrating for *Redbook*, *Viva*, and *Emergency Medicine*, as well as other major publications, he has shown his work in many galleries in the NY area.

SPONENBURGH, MARK.
Sculptor and art historian. Born in Cadillac, MI, June 15, 1916. Studied at Cranbrook Academy of Art, scholarship, 1940; Wayne State University; Ecole des Beaux-Arts, Paris, France; University of London; University of Cairo. Work in Detroit Institute of Art; Portland Art Museum; Museum of Modern Art, Egypt; architectural sculpture, Corvallis Methodist Church, OR; others. Has exhibited at Penna. Academy of Fine Arts; Paris Salon, France; Institute of Fine Arts, Cairo; others. Received Fulbright Foundation fellowship, 1951-53. Member of International Association of Egyptologists; Royal Society of Artists; Royal Society of Antiquaries. Taught at University of Oregon, 1946-56; Oregon State University, from 1961, distinguished professor, 1981; others. Works in wood and stone. Address in 1982, Department of Art, Oregon State University, Corvallis, OR.

SPOTH-BENSON, EDA.
Painter and sculptor. Born in Brooklyn, March 25, 1898. Pupil of Dabo and Eggleston. Member: Lime Rock Art Assoc.; Brooklyn Society of Artists; Palm Beach Art League. Awards: Hon. mention, Lime Rock Art Assoc., CT, 1929; first prize, Florida Fed. of Arts, Miami Beach, 1930-31. Address in 1933, 140 West 57th St., NYC; h. Pine Villa Park, West Cornwall, CT.

SPRAGUE, FLORENCE.
Sculptor and teacher. Born in Paullina, IA. Pupil of Charles Mulligan and Albin Polasek. Member: Iowa Art Club; Des Moines Association of Fine Arts; College Art Association. Work: "Frog Mountain," Des Moines Water Works; bas-relief, "Harvest," Public Library, Des Moines. Head of Art Dept., Drake University. Address in 1933, Department of Fine Arts, Drake University; h. 3518 Grand Avenue, Des Moines, IA.

SPRAGUE-SMITH, ISABELLE DWIGHT.
(Mrs. Charles Sprague-Smith). Painter and teacher. Born in Clinton, NY, Nov. 11, 1861. Pupil of Art Students League of NY; studied in Paris. Member: MacDowell Club; Archeology Society of America. Died in 1951. Address in 1933, 1200 Fifth Avenue,

New York, NY; h. Anchor to Windward, Seal Harbor, ME.

SPREAD, HENRY FENTON.
Painter. Born in Ireland in 1844. He studied and travelled in England, Germany and Australia, and in 1870 he came to the United States. He had his studio in Chicago, where he founded "Spread's Art Academy." Among his works are "Chicago Arising from her Ashes" and "Sad News."

SPRINCHORN, CARL.
Painter. Born in Broby, Sweden, May 13, 1887. Studied: NY School of Art; pupil of Robert Henri. Member: Brooklyn Society of Modern Artists; Society of Independent Artists; Salons of America; Artists Equity Association. Represented in Brooklyn Museum; Philadelphia Museum of Art; Fogg Museum of Art; Metropolitan Museum of Art; RI School of Design; Dayton Art Institute; others. Exhibited: Corcoran, 1943; Art Institute of Chicago, 1932, 43; Whitney, 1936; Walker Art Center, 1943; Cincinnati Museum Association, 1932; Worcester Museum of Art (one-man); Chicago Art Club (one-man); others. Address in 1970, c/o Babcock Gallery, 805 Madison Ave., and Jas. Graham and Sons, 1014 Madison Ave.; h. Beaver Dam Road, Selkirk, NY. Died in 1971.

SPRING, EDWARD ADOLPHUS.
Sculptor. Born in New York City in 1837. He studied with Henry K. Brown, John Q. A. Ward, and William Rimmer; also in France and England. He modeled many terra cotta panels. He established the Perth Amboy Terra Cotta Co. and the Eagleswood Art Pottery in 1877. Also lectured and taught.

SPRINGER, CARL.
Painter. Born in Fultonham, OH, Nov. 4, 1874. Member: Art Students League of NY; Columbus Pen and Pencil Club; Columbus Art League; Scarab Club. Awards: Prize, Scarab Club, Detroit, 1913 and 1916; hon. mention, Ohio State Expo., 1920; first prize, Columbus Art League, 1920, second prize, 1924; Pitts Flateau prize, Columbus Art League, 1926. Represented in Gallery of Fine Arts, Columbus, OH. Died in 1935. Address in 1929, Brevort, MI.

SPRINGER, CHARLES H.
Sculptor, painter, designer, and illustrator. Born in Providence, RI, July 15, 1857. Pupil of Art Students League in New York; Hugo Breul in Providence; Frederick W. Freer (for water color); studied architecture in Providence. Member of Providence Art Club; Rhode Island School of Design. Teacher of modeling and wood carving, Pawtucket, RI. Specialty was woodcarving and furniture design. Address in 1919, 211 Lenox Avenue, Providence, RI. Died there in 1920.

SPRINGER, EVA.
Painter. Born in 1882 in Cimarron, NM. Studied: Columbia University; Highlands University, Las Vegas, NM, B.A.; Julian Academy and Grande Chaumiere, Paris; Art Students League of NY; pupil of W. H. Foote and Kenneth H. Miller in NY, and of Delecluse, Mme. LaForge and Richard Miller in Paris. Member: Washington Water Color Club; National Association of Women Painters and Sculptors; Pennsylvania Society of Miniature Painters; Brooklyn Society of Miniature Painters; Pen and Brush Club; Washington Society of Miniature Painters, Sculptors and Gravers; Art Students League; National Arts Club. Exhibited: Washington Water Color Club; Penna. Academy of Fine Arts; National Arts Club; Brooklyn Museum; Grand Central Art Galleries; National Academy of Design; Corcoran; others. Died in 1964. Address in 1962, Santa Fe, NM.

SPRINGWEILER, ERWIN FREDERICK.
Sculptor and craftsman. Born in Pforzheim, Germany, January 10, 1896. Studied: Artcraft School, Pforzheim; Academy of Fine Arts, Munich; assistant to Paul Manship, Herbert Hazeltine. Member: National Sculpture Society; Associate, National Academy of Design; Allied Artists of America; McDowell Colony. Awards: National Sculpture Society, 1937; National Academy of Design, 1938, 49; Architectural League, 1949; National Arts Club, 1956. Work: Congressional gold medals of George M. Cohan and General W. L. Mitchell; statues, Washington Zoo and Detroit, MI; reliefs, Washington Zoo, USPO, Chester, PA, and Manchester, GA. Exhibited: National Academy of Design; Penna. Academy of Fine Arts; Art Institute of Chicago; and other major exhibitions. Address in 1962, Wyandanch, LI, NY. Died in 1968.

SPRUANCE, BENTON MURDOCH.
Lithographer, painter and etcher. Born on June 25, 1904 in Philadelphia, PA. Attended the University of Pennsylvania School of Fine Arts; Penna. Academy of Fine Arts. Founding member of the Philadelphia Chapter of Artists Equity; also a member of the National Academy of Design; Philadelphia Art Alliance; Society of American Graphic Artists; Philadelphia Printmakers Club. Served on the City of Philadelphia Arts Commission from 1953 until his death. In 1928 and 1929 he was awarded the Cresson Travelling Scholarship by the Penna. Academy of Fine Arts; in 1950 and 1962-63 he received grants from the Guggenheim Foundation. Taught at Beaver College and the Philadelphia College of Art. Work: Penna. Academy of Fine Arts; Library of Congress; Carnegie Institute; Philadelphia Museum of Art; NY Public Library; many others. Exhibitions: National print shows; Penna. Academy of Fine Arts and the Philadelphia Museum of Art shortly following his sudden death. Address in 1962, Philadelphia, PA. Died in 1967.

SPRUNGER, ART(HUR) (L.).
Painter. Born in Berne, IN, April 25, 1897. Pupil of William Forsyth. Member: Hoosier Salon; Northern Indiana Art League. Awards: Hon. mention, Artists' League of Northern Indiana, South Bend, 1929; first prize, Friends of Art, South Bend, 1929. Address in 1929, 213 Cottage Ave., Goshen, IN.

SQUIER, JACK LESLIE.
Sculptor. Born in Dixon, IL, February 27, 1927. Studied at Oberlin College; Indiana University, with Robert Laurent, Leo Steppat, 1950, B.S.; Cornell University, with John Hartell, 1952, M.F.A. Works: Cornell University; Ithaca College; Instituto de Arte Contemporaneo, Lima, Peru; Everson Museum of Art, Syracuse; Whitney; Museum of Modern Art; Hirshhorn. Exhibitions: The Alan Gallery, NYC; Cornell University; Instituto de Arte Contemporaneo, Lima, Peru; Whitney; Museum of Modern Art; Houston Museum of Fine Arts; Addison Gallery, Andover, MA; Boston Museum of Fine Arts; Brussels World's Fair, 1958; University of Illinois; Art Institute of Chicago; Boston Arts Festival; Carnegie; Claude Bernard, Paris; Albright-Knox Art Gallery, Buffalo. Taught: Cornell, since 1958. Member: International Association of Artists; Sculptors Guild. Works in resin and fiberglas. Address in 1982, Ithaca, NY.

SQUIRE, MAUD H(UNT).
Illustrator, painter, and etcher. Born in Cincinnati, OH. Pupil of Cincinnati Art Club. Member: NY Water Color Club; Chicago Society of Etchers; Societe du Salon d'Automne, Paris. Work: "Concarneau Fisherman" and "At the Well," Herron Art Institute, Indianapolis; South Kensington Museum, London; Corcoran Gallery, Washington, D.C. Address in 1933, Vence, Alp. Mar., France.

SQUIRES, C. CLYDE.
Illustrator. Born in Salt Lake City, UT, Aug. 29, 1883. Pupil of Henri; Miller; Du Mond; Mora; Pyle; NY School of Art. Member: Artists Guild of the Authors' League of America; Society of Illustrators, 1911. Published first illustration in 1906 for *Life* magazine; worked with *Woman's Home Companion*, *Western Romances*, *Western Monthly*. Best known for romantic depiction of the West. Died in 1970. Address in 1929, 48 Morton St., New York, NY; summer, Little Neck, LI, NY.

ST. CLAIR, GORDON.
Painter. Exhibited "Pavilion on the Moon," Penna. Academy of Fine Arts, 1915, Philadelphia. Address in 1926, 26 Studio Building, Chicago, IL.

ST. JOHN, J. ALLEN.
Painter and illustrator. Born in Chicago, IL, in 1872. Pupil of Art Students League of NY under Mowbray, Chase, Beckwith and Du Mond; Jean Paul Laurens in Paris. Member: Chicago Painters and Sculptors; Cliff Dwellers; Chicago Galleries Association. Instructor, Art Institute of Chicago; Business Men's Art Club of Chicago. Address in 1933, Tree Studio Bldg., Chicago, IL.

ST. JOHN, LOLA ALBERTA.
Painter and craftsman. Born in Albany, IN, July 16, 1879. Pupil of H. R. McGinnis; Cincinnati Art Academy under Nowottny and Meakin; J.O. Adams and Brandt Steele at Indianapolis. Work: "October Morning," Montpelier (IN) Library; "Iron Weed and Bone Set," Tipton Art Association. Member: Art Alliance of America; Hoosier Salon; Indiana Art Club. Address in 1934, Albany, IN.

ST. MEMIN, CHARLES BALTHAZAR JULIEN FEVRET DE.
Engraver, watercolor portraitist and landscapist. Born March 12, 1770, in Dijon, France. At the outbreak of the French Revolution, he went to Switzerland, then to Canada in 1793, and soon after he came to NY. As a means of supporting himself in this country he introduced here the engraving of portraits by means of the "Physionotrace," a machine invented by Edme Queneday, of Paris, and intended to exactly reproduce on a reduced scale the human profile. St. Memin made some improvements upon this device, and with it he made on a tinted paper a profile a little less than life size; this he finished by hand and with crayons directly from the sitter. With this finished crayon drawing as a guide he used a pantograph of special design to still further reduce the profile so that it would go inside a circle of about 2" in diameter, faintly scratching the reduced drawing directly on the copperplate. This copper was now etched and finished in aquatint, with some assistance with the roulette. The result was a soft, pleasing print. For the original crayon, which was ready for framing, for the plate, and for 12 impressions from the plate, St. Memin charged $33. These small portraits became very popular, and St. Memin, traveling from North to South over the country, produced about 800 of them. He kept for himself 2 sets of proof impressions; after his death these sets were purchased from his executors and are now in the U.S., one in the Corcoran Gallery in Washington, DC, and the other was lately in the hands of a Philadelphia collector. Besides these portraits, St. Memin etched 2 large views of the city of NY, a map of the siege of Savannah, published in *The Monthly Military Repository*, C. Smith, NY, 1796, and a beautiful etched business card of Peter Mourgeon, "Copperplate printer from Paris," of NY. Died June 23, 1852.

STACEY, ANNA LEE.
(Mrs. John F. Stacey). Painter. Born in Glasgow, Missouri. Pupil of Art Institute of Chicago; Delecluse Academy, Paris. Member: Chicago Painters and Sculptors; Chicago Water Color Club. Awards: Young Fortnightly prize, Art Institute of Chicago, 1902; Cahn prize, Art Institute of Chicago, 1902; $200 prize, Field Exhibition, 1907; Carr Landscape prize, Chicago Society of Artists, 1912; Logan bronze medal, Art Institute of Chicago, 1921. Work: "A Spanking Breeze," Chicago Woman's Club; "Moonlight in the Guidecca Venice," Kenwood Club, Chicago; "Trophies of the Fields," Union League Club,

Chicago; Chicago Art Commission purchase, 1914 and 1924. Address in 1929, 6 East Ohio Street; Studio Bldg., Ohio and State Streets, Chicago, IL.

STACEY, J. GEORGE.
Painter. Born in Fayette, NY, Feb. 8, 1863. Pupil of Art Students League; Charles W. Hawthorne; Susan Ricker Knox. Member: American Artists Professional League; Rochester Art Club; American Federation of Arts; Provincetown Art Association. Awards: First popular award, 1927, and second popular award, 1928, Rochester, NY. Address in 1933, 112 Jay Street, Geneva, NY; summer, Provincetown, RI.

STACEY, JOHN FRANKLIN.
Painter and teacher. Born in Biddeford, ME, 1859. Pupil of Mass. Normal School in Boston; Boulanger, Lefebvre and Julian Academy in Paris. Member: Chicago Painters and Sculptors; Cliff Dwellers. Awards: Bronze medal, St. Louis Expo., 1904; $100 prize, Field Exhibition, 1907; bronze medal, Buenos Aires, 1910; Grower prize, Art Inst. of Chicago, 1911; Logan medal, Art Institute of Chicago, 1924; Municipal Art League purchase prize ($500), Art Institute of Chicago, 1928; prize, Chicago Galleries Association, 1931. Work: "Church Spires of a New England Village," Mu. of Fine Arts, Santiago, Chile; "Across the Hills," Union League Club, Chicago; "Valley of the Darro, Granada, Spain," Herron Art Institute, Indianapolis, IN; purchase, Chicago Art Commission, 1922. Address in 1933, Studio Bldg., Ohio and State St., Chicago, IL.

STACKEL, ALIE (ANN L.).
Sculptor, painter and teacher. Born in NYC, September 28, 1909. Studied at National Academy of Design; NYU; and with Joseph Boston, Carnegie Hall Studios, and Professor Feldman, of Austria. Member of Brooklyn Society of Artists. Exhibited at Brooklyn Museum; Riverside Museum; National Sculpture Society; New School for Social Research; Medallic Art Exhibition; others. Works: Educational Art School, Port Hope, Ontario, Canada. Address in 1953, Brooklyn, NY.

STACKPOLE, RALPH.
Sculptor, etcher, craftsman, and teacher. Born in Williams, OR, May 1, 1885. Pupil of Arthur Putnam; G. Piazzoni; Mercie; Ecole des Beaux-Arts, Paris. Member: California Society of Etchers. Awards: Honorable mention, P.-P. Expo., San Francisco, 1915; gold medal, San Francisco Art Association, 1918; gold medal, San Francisco Art Association, 1920. Work: "Portrait bust of Prof. Hilgard," University of California; "Portrait bust of Prof. Flugel," Stanford University, CA; "Portrait bust of Judge Seawell," City Hall, San Francisco; two groups, "Mother Earth" and "Man and His Inventions," Stock Exchange, San Francisco. Address in 1933, Paris, France; San Francisco, CA.

STADELMAN, HENRYETTE LEECH.
Painter and teacher. Born in Brownsville, PA, Dec. 5, 1891. Pupil of Hugh Breckenridge; Hawthorne; Penna. Academy of Fine Arts. Member: Plastic Club; Wilmington Society of Fine Arts; Fellowship Penna. Academy of Fine Arts; American Federation of Arts. Exhibited: Penna. Academy of Fine Arts, 1924. Address in 1929, 710 Blackshire Road, Wilmington, DE.

STAFFORD, MARY.
(Mrs. John R. Frazier). Portrait painter. Born in Chicago, IL, Feb. 4, 1895. Pupil of Art Institute of Chicago; Academy de la Grande Chaumiere; Charles W. Hawthorne. Member: Chicago Galleries Association; Chicago Painters and Sculptors; Providence Art Club. Awards: Hearst prize, 1925, Thompson prize, 1927, Art Institute of Chicago. Address in 1929, 74 N. Main St.; h. 37 Field St., Providence, RI.

STAFFORD, P. SCOTT.
Painter. Born in Brooklyn, NY. Pupil of Robert Henri. Member of Pen and Pencil Club of Columbus, OH. Address in 1926, 1947 Broadway, NY.

STAGG, CLARENCE ALFRED.
Painter. Born in Nashville, TN, Aug. 16, 1902. Pupil of Charles W. Hawthorne. Member: Southern States Art League. Awards: First prize for still life, Nashville, 1927; first prize for self-portrait, Nashville, 1928. Address in 1933, 185-8th Ave., No. Nashville, TN; h. 1709 Simkin St., Nashville, TN.

STAGG, JESSIE A.
Sculptor, craftsman, and teacher. Born in Burnage, England, April 10, 1891. Pupil of Art Students League of New York; Robert Aitken; C. McClure; also studied in London and Rome. Member: National Association of Women Painters and Sculptors; New York Society of Ceramic Arts; American Federation of Arts; NY Society of Craftsmen. Address in 1929, 17 East 62nd St.; 1160 Fifth Ave., New York, NY; summer, Woodstock, NY. Living in Woodstock in 1953. Died in 1958.

STAGI, PIETRO.
Sculptor. Born in Italy. Worked in Carrara and Leghorn, 1783-93; in Philadelphia, 1795-99.

STAHL, M. LOUIS.
Painter. Born in Cincinnati, OH. Pupil of Cincinnati Art Academy under Meakin and Nowottny; Art Students League of NY under Volk, Mowbray and Blum; also of Chase in NY and Spain; Hawthorne and Webster in Provincetown, MA; and of Gaspard at Taos, NM. Member: Cincinnati Women's Art Club; Provincetown Art Association: American Federation of Arts. Address in 1929, Ohio University, Athens, OH.

STAHR, PAUL C.
Illustrator. Born in New York, NY, Aug. 8, 1883. Pupil of John Ward and National Academy of Design. Member: Society of Illustrators; Artists Guild of the Authors' League of America. Work: Illustrations for *Life, Collier's Weekly, American Magazine, Harpers Bazaar* and *Woman's Home Companion.* Illustrated *The Hornet, The Mask, The Sear,* etc. Address in 1933, 510 West 183rd Street, New York, NY.

STAIGG, RICHARD MORRELL.
Painter. Born Sept. 7, 1817, in Leeds, England. He came to the U.S. in 1831 and settled in Newport, RI. He was elected a member of the National Academy of Design in 1861. See Tuckerman's *Book of the Artists* for general biographical details. Died Oct. 11, 1881, in Newport, RI.

STAIR, IDA M. (MRS.).
Sculptor. Born in Logansport, IN, February 4, 1857. Was a pupil of Preston Powers; Chase in NY; and Taft at the Art Institute of Chicago. Awarded a medal at the Omaha Exposition in 1898. Member of the Artists' Club of Denver and an instructor at the Art Students Class of the Women's Club in Denver. Modeled statues of Myron Reed and Ex-Governor Gilpin for parks in Denver; executed busts of Judge Merrick A. Rogers, John Clark Ridpath, and others. Died in Denver, CO, March 27, 1908.

STALKER, E.
Well-engraved vignettes so signed are found in Philadelphia publications of 1815. There was an E. Stalker engraving in London in 1801, and again in 1823; it is possible that he was located in Philadelphia for a short time. Several of the plates noted are designed by C. R. Leslie.

STAMATO, FRANK.
Sculptor. Born in the U.S., January 16, 1897. Pupil of Charles Grafly and Albert Laessle. Member: Fellowship Penna. Academy of Fine Arts; Art Alliance of America; Graphic Sketch Club. Awards: Two Cresson Traveling Scholarships, and Stewardson prize, Penna. Academy of Fine Arts. Work: "Pandora," Reading Art Museum; "Head of an Old Man," "Wounded Dog," "Billy Goat," Graphic Sketch Club; painting, "St. Anne France," Penna. Academy of Fine Arts, Philadelphia. Address in 1933, 123 S. 16th Street; h. 1316 South Warnock Street, Philadelphia, PA. Died in 1939.

STAMOS, THEODOROS.
Painter. Born December 31, 1922, in NYC. Has lived in Greece. Studied at American Artists School, NYC. Taught at Art Students League of NY; Cummington School of Fine Arts; Black Mountain College; Columbia; Brandeis. Awards: Tiffany Foundation Scholarship, 1951; National Institute of Arts and Letters, 1956; Brandeis University, 1959; National Arts Foundation, 1967. One-man exhibitions: Wakefield Gallery; Brandt Gallery, NYC; Philadelphia Art Alliance; Brandeis University; Phillips Gallery, Washington, DC; Emmerich Gallery; others. Group exhibitions: Museum of Modern Art; Metropolitan Museum of Art; Carnegie; Whitney; Guggenheim; Documenta II, Kassel; others. In collections of Wadsworth; Detroit Institute of Fine Arts; Vassar College; Tel-Aviv Museum of Art, Israel; Phillips Gallery, Washington, DC; Museum of Modern Art; Art Institute of Chicago; Corcoran; Yale; Metropolitan Museum of Art; Baltimore Museum of Art; California Palace of the Legion of Honor; NY University; Walker Art Center; Butler Institute of American Art, Youngstown, OH; others. Address in 1971, 37 West 83rd Street, NYC.

STANCLIFF, J. W.
Marine painter. Born in Chatham, CT, in 1814. Pupil of J. B. Flagg. Later he became president of the Connecticut School of Design.

STANCZAK, JULIAN.
Painter. Born Nov. 5, 1928, in Borownica, Poland. U.S. citizen. Studied in London, Africa, and Uganda; earned B.F.A., Cleveland Institute of Art, 1954, and M.F.A., Yale, 1956, with Albers and Marca-Relli. Taught at Art Academy of Cincinnati; at Cleveland Institute of Art, since 1964; Dartmouth College. Awards: Contemporary Arts Center, Cincinnati; Dayton Art Institute; Cleveland Fine Arts Award; Ohio Arts Council Award. Exhibited at Dayton Art Institute, 1964; Martha Jackson Gallery, NYC; Kent State University; Corcoran; Museum of Modern Art; Dartmouth; Ohio State University; Butler Institute of American Art, Youngstown; Cleveland Art Institute; Whitney; Museum of Modern Art; Brooklyn Museum; Albright-Knox Art Gallery; Larry Aldrich Museum; others. In collections of Larry Aldrich Museum, Ridgefield, CT; Dayton Art Institute; Baltimore Museum; Penna. Academy of Fine Arts; San Francisco Museum of Art; Cleveland Museum of Art; Albright-Knox; others, including many international collections. Member of American Abstract Artists. Address in 1982, Seven Hills, OH.

STANFIELD, MARION BAAR.
Painter. Born in New York City, Sept. 22, 1895. Pupil of Du Mond; Johansen; Henri. Member: National Association of Women Painters and Sculptors; American Artists' Association; North Shore Arts Association. Address in 1933, 225 Broadway, New York, NY; summer, Westport, CT.

STANGE, EMILIE.
Painter. Born in Jersey City, NJ, in 1863. Member of Salmagundi Club. Address in 1926, North Hackensack, NJ. Died in 1943.

STANKIEWICZ, RICHARD PETER.
Sculptor. Born Oct. 18, 1922, in Philadelphia, PA. Studied at Hans Hofmann School, 1949; with Fernand Leger and Ossip Zadkine in Paris. Taught at Maryland Institute, Baltimore; University of Pennsylvania; Skowhegan School, Maine; School of Visual Arts, NYC; Syracuse; Princeton; SUNY/Albany. Awards from Ford Foundation; Brandeis University; and National Council on the Arts. Exhibited at Museum of Modern Art, Stockholm; Carnegie; Stable Gallery, NYC; in Sao Paulo; Whitney; Hansa Gallery, NYC; Walker; Guggenheim; Penna. Academy of Fine Arts; Art Institute of Chicago; many others. In collections of Guggenheim; Museum of Modern Art, NY; Albright-Knox Art Gallery, Buffalo; Whitney; Harvard; Washington University in St. Louis; Stockholm Museum of Modern Art; and private collections. Was an organizer of Hansa Gallery in NYC. Living in Huntington, MA, in 1982.

STANLAWS, PENRYHN.
(Penryhn Stanley Adamson). Illustrator, painter, etcher and writer. Born in Dundee, Scotland, March 19, 1877. Pupil of Julian Academy, Benjamin-Constant and Laurens in Paris. Work: "August Heckscher, Esq.," Heckscher Park Art Museum, Huntington, NY; "The End of the Hunting," "Instinct," plays; "The Little Minister" and other motion pictures. Member: Society of Illustrators, 1913. Address in 1933, 15 West 67th St., New York, NY; summer, Riversville Road, Greenwich, CT.

STANLEY, GEORGE M.
Sculptor. Born in Acadia Parish, LA, April 26, 1903. Lived and worked in Los Angeles, CA. Studied at Otis Art Institute, Los Angeles, 1923-26; Santa Barbara School of the Arts, CA, 1927. Taught at Otis Art Institute, c. 1940. Works include the "Oscar" statuette for Academy of Motion Picture Arts and Sciences, 1927; three figures, Muses of Music, Dance, and Drama, Hollywood Bowl, c. 1938-40; bas-reliefs at Bullock's Wilshire, and Telephone Building, Los Angeles; "Dancer;" "Enigma;" "Bird-woman;" "Head of a Young Woman." Exhibited: Los Angeles County Museum; California Palace of the Legion of Honor, San Francisco; California Pacific International Expo., San Diego, 1935; Golden Gate International Expo., San Francisco, 1939. Awards: Maintenance scholarship to study sculpture and bronze casting at the School of the Arts, Santa Barbara, CA. Died in 1977.

STANLEY, HARVEY.
Stonecutter. Born in Vermont, December, 1811. Worked on sun-face capitals of Mormon Temple, Nauvoo, IL, mid-1840's. Later lived in Missouri and Iowa.

STANLEY, IDAHLIA.
Painter. Studied: Brandeis University; Harvard University; The Art Students League, NY. Exhibitions: Institute of Contemporary Art, Boston, 1972; Philadelphia Art Alliance, PA, 1974; Sketch Club, Philadelphia, 1975.

STANLEY, JANE C. (MAHON).
(Mrs. Louis Crandall Stanley). Painter. Born in Detroit, MI, July 21, 1863. Member: Detroit Society of Women Painters and Sculptors; American Water Color Society; Washington Water Color Club; American Water Color Society; Ann Arbor Art Association; National Association of Women Painters and Sculptors; American Federation of Arts. Address in 1933, care of George M. Stanley, Geology Dept., University of Michigan, Ann Arbor; summer, Belvedere Cottage 122, Charlevoix, MI.

STANLEY-BROWN, RUDOLPH.
Painter, illustrator, etcher, artist, and teacher. Born in Mentor, OH, April 9, 1889. Pupil of Col. School of Arch.; Ecole des Beaux-Arts, Paris. Member: American Institute of Architects; Soc. of Beaux-Arts Architects; Cleveland Print Club. Represented by etchings in Cleveland Museum of Art; Yale University, New Haven. Address in 1929, 1899 E. 87th St., Cleveland, OH.

STANSON, GEORGE CURTIN.
Sculptor and painter. Born in Briscout, France, in 1885. Member of Archaeological Institute of America; California Art Club. Work: 4 murals in the Biological Museum of the University of California, La Jolla, California; "After the Rain" (mural), in Golden Gate Park Museum, San Francisco; "On the Trail" in Museum of Archeology, Santa Fe, NM. Address in 1926, Los Angeles, CA.

STANTON, ELIZABETH C(ADY).
(Mrs. Wm. H. Blake). Painter and teacher. Born in New York, NY, Dec. 31, 1894. Pupil of F. Luis Mora; George Bridgman; Albert Sterner; Cecilia Beaux. Member: National Association of Women Painters and Sculptors; Barnard Club; Louis Comfort Tiffany Foundation; American Federation of Arts. Address in 1929, 35 Claremont Ave., New York, NY; summer, Silver Beach, North Falmouth, MA; and Grandview-on-Hudson, Nyack, NY.

STANTON, GIDEON TOWNSEND.
Painter. Born in Morris, MN, July 14, 1885. Member: New Orleans Art Association; New Orleans Art League; Southern States Art League; New Orleans Arts and Crafts Club. Award: Silver medal, New Orleans Art Association, 1911, Presidents' prize, 1925; first prize in oil, New Orleans Art League, 1932. Address in 1933, 1314 Jackson Ave., New Orleans, LA.

STANTON, LUCY MAY.
Portrait painter and teacher. Born in Atlanta, GA, May 22, 1875. Pupil of Colarossi Academy; Lucien Simon; Emile Blanche; La Gandara; and A. Koopman in Paris. Member: Pennsylvania Society of Miniature Painters; American Society of Miniature Painters; National Association of Women Painters and Sculptors; Washington Water Color Club; Guild of Boston Artists; Copley Society; Concord Art Association. Awards: Medal of honor, Pennsylvania Society of Miniature Painters, Penna. Academy of Fine Arts, 1917; medal of honor, Concord Art Association, 1923; hon. mention, National Association of Women Painters and Sculptors, 1925. Represented by oil painting in Capitol, Washington, DC; miniature, Lincoln Memorial Museum, Milton, MA; miniature, Concord Art Association; miniature, "Self Portrait," Philadelphia Museum. Died in 1931. Address in 1929, 552 Cobb St., Athens, GA; 98 Chestnut St., Boston, MA.

STANWOOD, GERTRUDE.
Painter. Born in West Newbury, MA, in 1874. Pupil of Joseph De Camp; Ernest Major; and Lasar. Member of Society of Independent Artists. Address in 1926, 1015 Cathedral St., Baltimore, MD.

STAPLES, EDNA FISHER STOUT.
(Mrs. Arthur Chase Staples). Sculptor, painter and teacher. Born in Philadelphia, PA, 1871. Pupil of Philadelphia School of Design, under Elliott Daingerfield, H. B. Snell, and Marianna Sloan. Award: Prize, Wanamaker competition, 1904. Member: Alumni, Philadelphia School of Design. Specialty: Landscapes in water color. Address in 1910, 2030 Cherry St., Philadelphia, PA.

STARK, FORREST F.
Painter, sculptor and teacher. Born in Milwaukee, WI, May 29, 1903. Studied: Art Students League; Milwaukee State Teachers College; Penna. Academy of Fine Arts; pupil of Charles Grafly, Albert Laessle, Leon Kroll, George Harding, George Oberteuffer, and Boardman Robinson. Awards: Cresson traveling scholarship, Penna. Academy of Fine Arts, 1927; first sculpture prize, Twenty-fifth Annual Indiana Artists' Exhibition, John Herron Art Institute, 1932; prizes, Hoosier Salon, 1932; first sculpture prize, Twentieth Annual Exhibition, Wisconsin Painters and Sculptors, Milwaukee Art Institute, 1933. Work: "David Jung," sculptured head, Art School of the John Herron Art Institute. Exhibited at Penna. Academy of Fine Arts, 1938; Indiana Artists; others. Member: Indiana Art Club. Instructor of sculpture, Art School of the John Herron Art Institute, Indianapolis, IN; instructor of art, Ft. Wayne Art School and Museum, Ft. Wayne, IN. Address in 1933, Mukwonago, WI. Living in Fort Wayne, IN, 1953.

STARK, OTTO.
Painter and illustrator. Born in Indianapolis, IN, in 1859. Pupil of Lefebvre, Boulanger and Cormon in Paris. Member: International Society of Arts and Letters. Awarded first Holcomb prize, Herron Art Institute, 1915. In charge of art department, Manual Training High School, and art department, Technical High School, Indianapolis; instructor, Herron Art School, Indianapolis, IN. Work: "Two Boys" and "The Indian Trail," Herron Art School, Indianapolis; "River Valley and Hill," Cincinnati Art Museum; mural decoration, City Hospital, Indianapolis, and mural decorations in the public schools of Indianapolis; "Portrait of Gen. George Rogers Clark," Indiana State House. Address in 1926, 1722 N. Delaware St., Indianapolis, IN. Died April 14, 1926, in Indianapolis.

STARKWEATHER, WILLIAM E. B.
Painter, teacher and writer. Born in Edinburgh, Scotland, 1879. Pupil of Art Students League of NY; Colarossi Academy in Paris; Sorolla in Madrid, followed by 3 years study in Italy. Member: New Haven Paint and Clay Club; Hispanic Society of America (cor.); American Water Color Society; Salma. Club; NY Water Color Club; Allied Artists of America. Awards: Mrs. William K. Vanderbilt prize, joint water color exhibition, NY, 1925; hon. mention with popular vote for oil painting, New Haven, 1924; Dana gold medal, Penna. Academy of Fine Arts, 1925; Jones prize for water color, Baltimore, 1926; Philadelphia prize, water color, Penna. Academy of Fine Arts, 1929. Author of "Paintings and Drawings by Francisco Goya in the collection of the Hispanic Society of America, 1916." Represented in the Metropolitan Museum of Art; Brooklyn Museum; San Diego Museum; University of Pennsylvania Collection; Randolph-Macon College, Lynchburg, VA; Institute de Valencia de Don Juan, Madrid. Died in 1969. Address in 1933, 82 State Street, Brooklyn, NY.

STARR, IDA M. H.
Painter and writer. Born in Cincinnati, OH, July 11, 1859. Pupil of Myra Edgerly; Lillian Adams; Howard Schultze. Member: Society of Independent Artists of NY, Chicago and Buffalo. Address in 1929, Hope House, Easton, MD.

STARR, LORRAINE WEBSTER.
(Mrs. William Starr). Painter. Born in 1887. Member: Baltimore Water Color Club. Address in 1929, Hope House, Easton, MD.

STARR, MAXWELL B.
Painter, sculptor and teacher. Born in Odessa, Russia, February 6, 1901. Studied at National Academy of Design; Beaux-Arts Institute of Design; pupil of Kenyon Cox, Charles W. Hawthorne, Ivan G. Olinsky. Member: Tiffany Artists Guild; Architec-

tural League; National Society of Mural Painters; Allied Artists of America. Work: American Museum of Numismatics; murals in U.S. Customs Office, NYC; others. Exhibited at National Academy of Design; Pennsylvania Academy of Fine Arts; Art Institute of Chicago; Whitney; Museum of Modern Art; Boston Museum of Fine Arts; World's Fair, NY, 1939; others. Address in 1953, 54 West 74th St., New York, NY.

STARR, SIDNEY.
Painter. Born in Kingston-upon-Hull, Yorkshire, England, in 1857; died in NY in 1925. Pupil of Poynter and of Legros. Awarded bronze medal, Universal Expo., Paris, 1889. Work: Mural decorations, Grace Chapel, New York City; 24 figures in Congressional Library, Washington, DC. Address in 1926, 256 West 85th Street, New York, NY.

STASACK, EDWARD ARMEN.
Painter and printmaker. Born Oct. 1, 1929, in Chicago, IL. Received B.F.A., M.F.A., 1956, from University of Illinois. Taught: Professor of art, University of Hawaii, since 1969. Awards: Society of American Graphic Artists, 1956, 57, 61; San Francisco Museum of Art, 1958; Springfield Art League, 1956, 57; Hawaii State and U.S. Bicentennial Commission, 1976; Tiffany Foundation grant, 1957, 63; Rockefeller Foundation fellowship, 1959; McDowell Colony Foundation fellowships, 1971, 75; others. Exhibited at Fort Sheridan, IL, 1954; Cromer and Quint Gallery, Chicago; Honolulu Academy of Arts; University of Illinois; Cleveland Institute of Art; Downtown Gallery, NYC; Carnegie; Library of Congress; Washington Water Color Club; San Francisco Museum of Art; Smithsonian Institution; others. In collections of Seattle Art Museum; Addison Gallery; Butler Institute of American Art; Bradley University; Library of Congress; Philadelphia Museum of Art; Metropolitan Museum of Art; Cincinnati Museum Association; Art Institute of Chicago; plus others, including commissions. Member: Honolulu Printmakers; Hawaii Artists League; Society of American Graphic Artists; others. Address in 1982, Honolulu, HI.

STATTLER, GEORGE.
Ship carver. Born in Charleston, SC. In 1798 carved a figurehead of General Charles C. Pinckney.

STAUCH, ALFRED.
Sculptor. Born c. 1836 in Germany. Exhibited: Pennsylvania Academy, 1860-69. Worked: Philadelphia, c. 1860's.

STAUCH, EDWARD.
Sculptor. Born c. 1830 in Germany. Worked: Philadelphia, c. 1855-70. Exhibited: Pennsylvania Academy.

STAUFFER, EDNA (PENNYPACKER).
Painter, illustrator, teacher, and etcher. Born in Phoenixville, Chester Co., PA, Oct. 12, 1887. Pupil of Chase, Beaux, Anshutz, and Dow; Andre L'hote, Friesz, and Academie Moderne in Paris. Member: Fellowship Penna. Academy of Fine Arts. Instructor, Hunter College, NY. Died in 1956. Address in 1933, 158 East 61st Street, New York, NY; 1900 Rittenhouse Square, Philadelphia, PA.

STEA, CESARE.
Sculptor and painter. Born in Bari, Italy, August 17, 1893. Studied: National Academy of Design; Cooper Union; Beaux-Arts Institute; Italian-American Art Association; Grande Chaumiere; pupil of Hermon MacNeil, Victor Salvatore, Carl Heber, Stirling Calder. Exhibited at National Sculpture Society, 1923; California Palace of Legion of Honor; Hispanic Museum; Penna. Academy of Fine Arts, 1944; Brooklyn Museum, 1941; Metropolitan Museum of Art, 1942; Whitney; others. Member: Italian-American Art Association. Awards: Medal from Beaux-Arts for relief in Educational Building, San Francisco, 1915; prize for trophy cup, National Defense Society; Barnett prize, National Academy of Design, 1926. Work in Whitney Museum of American Art; others. Address in 1953, NYC. Died in 1960.

STEADHAM, TERRY EVAN.
Illustrator. Born in Indianapolis, IN, in 1945. Attended the John Herron School of Art and began his career in 1968. He received the Gold Award for Illustration of the Indiana Art Directors' Club in 1970 and has been represented in the Society of Illustrators Annual Shows of 1974, 75, and 76. Though he started working in advertising, he is currently free-lancing out of NYC, doing editorial work for children's magazines and other publications.

STEADMAN, L. ALICE TUTTLE.
(Mrs. Harold Steadman). Sculptor, painter and teacher. Born in Stokes County, NC, March 10, 1907. Studied at Meredith College, Raleigh; Penna. Academy of Fine Arts; and with Breckenridge, O'Hara, and others. Awards: Margaret Graham silver cup, 1935; Raleigh Studio Club, gold medal, 1936; Ethel Parker silver cup, 1937; Blowing Rock, North Carolina, 1957, 58; Mint Museum of Art, 1958. Member: American Association of University Women; North Carolina State Art Society. Instructor of art, Mint Museum School of Art, Charlotte, NC, from 1936, Queens College, 1953-54. Work includes many bas-relief and portrait commissions and is in many private collections. Address in 1962, Charlotte, NC.

STEARNS, JUNIUS BRUTUS.
Painter. Born July 2, 1810, in Arlington, VT. Pupil of the National Academy of Design. He became an Associate in 1848, and an Academician in the follow-

ing year. His work is mainly portraiture but he also painted genre and historical subjects; his 5 paintings representing Washington as citizen, farmer, soldier, statesman and Christian are considered his best. His "Millennium" is in the New York Academy of Design, and several of his portraits hang in the City Hall there. He died in Brooklyn, NY, on Sept. 17, 1885.

STEBBINS, EMMA.
Painter and sculptor. Born in NYC, September 1, 1815. For years she devoted herself to painting in oil and water color. In 1857 she went to Italy and began to model under Italian masters, also with Paul Akers until 1870. Moved to NYC. She produced the figure in the Central Park fountain, "Angel of the Waters;" also a statue of Horace Mann, Boston, 1860; and numerous other portrait busts and statues. She was a friend of the actress Charlotte Cushman. She exhibited at the Penna. Academy and the National Academy. Associate of the National Academy. She died October 25, 1882, in NYC.

STEBBINS, ROLAND STEWART.
Painter and illustrator. Born in Boston, MA, in 1883. Pupil of DeCamp in Boston; Hackl in Munich. Member: Boston Art Club. Illustrator of "At the King's Pleasure."

STEDMAN, JEANETTE.
Portrait painter. Born in 1880/81. She studied in Paris early in her career. Her body was found in Lake Michigan, Chicago, IL, on March 8, 1924. She had lived in Chicago, IL, for years.

STEDMAN, WILFRED (HENRY).
Painter, sculptor, illustrator, blockprinter, and teacher. Born in Liverpool, England, July 6, 1892. Pupil of Gustav Goetsch; Lauros M. Phoenix; Harvey Dunn; Luis Mora; Frank V. DuMond; John F. Carlson; Birger Sandzen; Robert Reid; and Charles S. Chapman. Member: Houston Artists' Gallery; Texas Fine Arts Association. Work: "Freighters" and "Loading Coffee," paintings, James M. Lykes Shipping Co.; bronze memorial tablet, South End Christian Church; volumes, "Rice Campanile," Rice Institute, all in Houston, TX; bronze memorial tablet, Catholic Tubercular Hospital, Colorado Springs, CO; "Portrait of Col. Parsons," New York Engineering Society. Address in 1933, Houston, TX. Died in 1950.

STEEL, ALFRED B.
This engraver of subject plates was working for *Sartain's Magazine* in 1850.

STEEL, J.
In 1850 J. Steel was doing very good work for *Sartain's Magazine*. He was an engraver of buildings, etc.

STEEL, JAMES W.
Engraver. Born in Philadelphia, PA, in 1799. Steel was a pupil of the Philadelphia engravers Benjamin Tanner and George Murray, and for a time he was engaged in bank note engraving for Tanner, Vallance, Kearney & Co. Later he became an accomplished line engraver producing a number of portraits, landscape and *Annual* plates. Steel was working under his own name in 1820; at a later period in his professional life he was employed chiefly upon bank-note work. Died June 30, 1879, in Philadelphia.

STEELE, BRANDT (THEODORE).
Painter and architect. Born in Battle Creek, MI, Nov. 16, 1870. Pupil of his father, T. C. Steele; Aman-Jean in Paris. Member: Indianapolis Arch. Association; Indiana Art Club. Instructor, Herron Art Institute. Address in 1929, 811 East Drive, Woodruff Place, Indianapolis, IN.

STEELE, FREDERIC DORR.
Illustrator. Born in Marquette, MI, Aug. 6, 1873. Pupil of National Academy of Design and Art Students League in NY. Member: Society of Illustrators, 1902. Award: Bronze medal, St. Louis Expo., 1904. Illustrated: *The Return of Sherlock Holmes*, and other tales by Doyle; books by R. H. Davis, Mark Twain, Myra Kelly, Gouverneur Morris, Mary Roberts Rinehart, Kipling, Conrad, Bennett, Tarkington, etc. Died in 1944. Address in 1929, care of The Players, 16 Gramercy Park, New York, NY.

STEELE, IVY NEWMAN.
Sculptor. Born in St. Louis, MO, April 15, 1908. Studied at Wellesley College, B.A.; Washington University Art School, St. Louis; Art Institute of Chicago; with Cosmo Campoli, Chicago. Work: Wellesley Art Museum, MA; Highland Park Hospital, IL; Covenant Methodist Church, Evanston, IL. Exhibitions: Paul Theobald Gallery, 1938; American Institute of Architects, Chicago, 1959; Art Institute of Chicago, 1935-52; Oakland Art Gallery, CA, 1936; Oklahoma Art Center, Oklahoma City, 1939. Member: Chicago Society of Artists; Chicago Art Institute; Artists Equity Association; College Art Association of America; others. Taught: Instructor of art, Francis W. Parker School, Chicago, 1941-45; instructor of art, Hull House Art School, 1945-54; others. Media: Bronze, wood, resins. Address in 1976, Chicago, IL.

STEELE, THEODORE CLEMENT.
Painter. Born in Owen County, IN, in 1847. Pupil of Royal Academy in Munich under Benczur and Loefftz. Elected an Associate of the National Academy, 1914. Awarded honorable mention, Paris Exposition, 1900; Fine Arts Corporation prize, 1910. Work: "Gordon Hill," Cincinnati Museum; "Oaks at Vernon," "Portrait of Rev. N. A. Hyde," "The River,"

"Winter Sunlight," Herron Art Institute, Indianapolis; "Landscape," St. Louis Museum; "Whitewater Valley," Richmond (IN) Art Association. Address in 1925, Bloomington, IN. Died July 24, 1926 in Bloomington, IN.

STEELE, ZULMA.
(Mrs. Neilson T. Parker). Painter. Born in Appleton, WI, July 7, 1881. Pupil of Pratt Institute, Brooklyn; Art Students League of NY. Member: National Association of Women Painters and Sculptors; Washington Art Club; Society of Independent Artists. Address in 1933, Woodstock, Ulster Co., NY.

STEENE, WILLIAM.
Painter and sculptor. Born in Syracuse, NY, August 18, 1888. Studied: National Academy of Design; Art Students League of NY; Beaux Arts, Colarossi and Julian Academies, Paris; pupil of Henri, Jones, Cox, and Chase. Member: National Society of Mural Painters. Work: 3 murals, "History of Galveston," City Hall, Galveston, TX; "Commerce," Court House, Tulsa, OK; "The Coming of the Traders," Tulsa, OK; War Memorial to Cherokee Indians, Tahlequah, OK; war memorial, Washington County Court House, AR; portraits of "Pres. Denny," University of Alabama; "Gov. Whitfield," Governor's mansion, and "Judge Cambell," Historical Society, Jackson, MS; "Col. Woodward," Georgia Military Academy, Atlanta; "Melville R. Grant," Masonic Hall, Greenville, MS; "Mayor Williams," City Auditorium, Macon, GA; "The Caravan," Macon Art Association; "Melody," Mississippi Art Association; "O. Henry Memorial," Asheville, NC; "Dr. and Mrs. D. B. Johnson," Winthrop College, Rock Hill, SC; "Dr. Alexander Graham," Central High School, Charlotte, NC; "Pres. W. M. Sparks," G.S.C.W., Milledgeville, GA; "Pres. Angold Shamlee," Tift College, Forsyth, GA; "Pres. M. M. Walker," A. and M. College, Starkville, MS; "Pres. J. P. Fant," M.S.C.W., Columbus, MS; "Early Traders," mural, high school, Tulsa, OK. Address in 1933, Tryon, NC. Died in 1965.

STEEPER, JOHN.
Engraver. According to an advertisement in the *Pennsylvania Gazette,* in 1762, John Steeper was engraving "in all its branches" in Philadelphia. Westcott, in his "Philadelphia," says that the first important copperplate published in Philadelphia in 1755 was "A Southeast Prospect of the Pennsylvania Hospital with the elevation of the intended plan." He goes on to say that Montgomery and Winters drew it. It was engraved by J. Steeper and H. Dawkins, and was printed and sold by Robert Kennedy, of Philadelphia.

STEERE, LORA WOODHEAD.
Sculptor. Born in Los Angeles, CA, March 13, 1888. Studied: University of Southern California; Boston Museum of Fine Arts School, with Bela Pratt; Stanford University, B.A.; George Washington University, M.A.; California School of Fine Arts; pupil of Albert Toft in Berlin; Lentelli and Ralph Stackpole in San Francisco; Florence Wyle in Toronto, Canada. Member: San Diego Artists Guild; California Art Club; Southern California Sculptors Guild. Award: First prize, Clatsop County (OR) Expo., 1917. Work: "Ifugao Fire Dancer," marble bust of Pearl Keller, and "Dance of Pan," Pearl Keller School of Dramatic Arts, Glendale, CA; Los Angeles Museum of History, Science and Art; bronze bas-relief, David Starr Jordan High School, Los Angeles; bust of Abraham Lincoln, Lincoln Memorial University, TN; bronze of Dr. Geo. F. Bovard, Bovard Hall, USC; bronze bust of L. E. Behymer, Los Angeles Museum; Stanford University; others. Exhibited: Art Institute of Chicago; Penna. Academy of Fine Arts; Los Angeles Museum of Art; Mission Gallery, Riverside, CA, 1933; San Francisco Museum of Art. Teaching at Los Angeles high schools; Idyllwild School of Music and Art, Idyllwild, CA. Address in 1953, Hollywood, CA.

STEES, SEVILLA L.
Painter. Born in Philadelphia, PA. Pupil of Penna. Academy of Fine Arts; Woman's School of Design. Member: Fellowship, Penna. Academy of Fine Arts; Plastic Club. Address in 1929, 1806 North Park Ave., Philadelphia, PA.

STEGAGNINI (or STEGNANI), LOUIS.
Sculptor and marble mason. Worked: Philadelphia, 1823-40. Specialty was ornamental work.

STEICHEN, EDWARD J.
Painter. Born in Milwaukee, WI, in 1879. Represented in Metropolitan Museum, NY, by "Nocturne, Temple d'Amour;" in Toledo Museum by "Across the Marshes." His mural paintings are to be seen at the Luxembourg, Paris. Address in 1926, care of Knoedler & Co., New York City, NY. Died in 1973.

STEIG, WILLIAM.
Sculptor and cartoonist. Born in NYC, November 14, 1907. Studied at City College, NY, 1923-25; National Academy of Design, 1925-29. Work: Wood sculpture, Rhode Island Museum of Art, and Smith College; paintings, Brooklyn Museum. Exhibitions: Downtown Gallery, NY, 1939; others. Published several books of his drawings, including *The Lonely Ones, About People, Till Death Do Us Part;* and *Dreams of Glory.* Contributor to New Yorker and other magazines. Awards: Caldecott Medal, 1970; William Allen White Award, 1975; others. Sculpts in wood. Address in 1982, Kent, CT.

STEIGER, HARWOOD.
Painter, illustrator, and teacher. Born in Macedon, NY, Jan. 2, 1900. Pupil of Daniel Garber; Hugh Breckenridge. Member: Fellowship Penna. Academy of Fine Arts. Awards: Hon. mention, 1928, and

first prize for water color, 1929, 30, and 31, Memorial Art Gallery, Rochester. Work: "Trout Stream," "Abandoned Village" and "Evening," Memorial Art Gallery, Rochester, NY. Address in 1933, 150 West 4th Street, New York, NY; h. 16 West Church St., Fairport, NY; summer, Parker's Cove, Annapolis Co., Nova Scotia.

STEIN.
Dunlap notes that a portrait painter of that name was born in Washington, VA, but painted principally in the region beyond the Alleghenies. He was said to have skill, and in 1820 painted a number of portraits at Steubenville, OH. Stein died when he was a young man.

STEIN, EVALEEN.
Painter. Born in Lafayette, IN. Studied art at Art Institute of Chicago. Became decorative designer and illuminator, and exhibited illuminated manuscripts at the Arts and Crafts Society in Chicago; also in Indianapolis, etc. Contributor of verse to Indianapolis *Journal*, 1886-1900. Contributor: Society of Decorative Art, NY and Chicago. Address in 1926, 708 Hitt St., Lafayette, IN.

STEIN, RONALD JAY.
Sculptor. Born in NYC, September 15, 1930. Studied at Cooper Union, certificate of fine art, with Will Barnet; Yale University, with Joseph Albers, B.F.A.; Rutgers University, M.F.A. Work at Carnegie Institute, Pittsburgh; Guggenheim Museum, NY; Hirshhorn Collection, Washington, DC; Wadsworth Atheneum, Hartford, CT; others. Has exhibited at Carnegie International; Institute of Contemporary Art, Boston; Art Institute of Chicago; Museum of Modern Art, NY; others. Works in plastic and all media. Address in 1982, 76 E. 79th St., New York, NY.

STEINBERG, NATHANIEL P.
Etcher, painter and illustrator. Born in Jerusalem, Palestine, Feb. 15, c. 1893. Pupil of Art Institute of Chicago; also of A. Sterba, W. Reynolds, Seyffert and H. Walcott. Member: Palette and Chisel Academy; Chicago Society of Etchers. Work: Smithsonian Institution; Federal Court, Chicago; others. Exhibited in many galleries and museums in U.S., Paris, and London. Awards: Society of American Graphic Artists, 1950; Chicago Society of Etchers, 1935, 49; Palette and Chisel Club, 1953, 59; Chicago Artists Guild, 1955; others. Address in 1962, Chicago, IL.

STEINKE, WILLIAM (BILL).
Illustrator, cartoonist, writer, and lecturer. Born in Slatington, PA, Nov. 25, 1887. Pupil of George McManus; "Vet" Anderson. Member: American Association of Cartoonists and Caricaturists. Address in 1929, Industrial Bldg., 1060 Broad St., Newark, NJ; h. 1383 Clinton Ave., Irvington, NJ.

STEKETEE, SALLIE HALL.
(Mrs. Paul Frederick Steketee). Painter. Born in Brazil, IN, Sept. 11, 1882. Pupil of Cincinnati Art Academy. Member: National Association of Women Painters and Sculptors; Hoosier Salon. Awards: Ball prize, Hoosier Salon, Chicago, 1926; Daughters of Indiana prize and Tri Kappa prize, Hoosier Salon, 1928; Progress Club of South Bend prize, Hoosier Salon, 1929, and Ball prize, 1931. Work: "Summer Flowers," Daughters of Indiana, Chicago. Address in 1933, 432 Washington St., S. E., Grand Rapids, MI.

STELLA, FRANK.
Painter. Born in Malden, MA, May, 1936. Studied: Phillips Academy, with Patrick Morgan; Princeton University, with William Seitz and Stephen Greene. Work: Museum of Modern Art; Whitney; Pasadena Art Museum; Albright-Knox Art Gallery, Buffalo, NY; Walker Art Center, Minneapolis, MN. Exhibited: Corcoran, 1967; Museum of Modern Art, 1969-70; Philadelphia Museum of Art, 1968; Whitney, 1969, 72; Contemporary Arts Center, Cincinnati, 1970; Carnegie, 1971; Museum of Fine Arts, Houston, 1974; Virginia Museum of Fine Arts, 1974; Walker Art Center, Minneapolis, 1974; and many more. Awarded first prize, International Biennial Exhibition of Paintings, Tokyo, 1967. Represented: Lawrence Rubin Gallery, NYC. Address in 1982, 29 E. 73rd St., New York, NY.

STELLA, JOSEPH.
Painter, writer, etcher, lecturer, and teacher. Born in Italy, May 13, 1880. Self-taught. Member: Societe Anonyme; Modern Art Association; Salons of America. Died in 1946. Address in 1929, 457 West 24th Street; 43 East 57th Street, New York, NY.

STELLAR, HERMINE.
Painter. Born in Austria. Pupil of Art Institute of Chicago; Sorolla in Spain; Bellows. Member: Chicago Society of Artists; Chicago Art Club. Award: Traveling scholarship from Tuesday Art and Travel Club, 1911. Formerly instructor, Art Institute of Chicago. Head of Department of Drawing and Painting, University of Nebraska. Address in 1929, 6732 Oglesby Ave., Chicago, IL.

STELZER, MICHAEL.
Sculptor. Born in Brooklyn, NY, January 6, 1938. Studied at Pratt Institute, 1956; Art Students League, 1960-62; National Academy School of Fine Arts, Edward Mooney traveling scholarship, 1966, and National Sculpture Society Joseph Nicolosi grant, 1967; and with Nathaniel Choate, 1964, Michael Lantz, 1964-67, and Donald DeLue, 1968-69. Exhibited at American Artists Professional League Grand National, 1963, 76-77; National Arts Club, 1963-64; National Academy of Design, 1964-67, 70-71 and 74-77; National Sculpture Society Annual Exhibition, 1968-81; others. Awards: Helen Foster

Barnett Prize, National Academy of Design, 1966; gold medal, Grand National Exhibition, American Artists Profesional League, 1976. Member: National Sculpture Society; American Artists Professional League; Allied Artists of America; others. Address in 1982, Brooklyn, New York.

STEMLER, OTTO ADOLPH.

Painter and illustrator. Born in Cincinnati, OH, in 1872. Student of Cincinnati Art Academy. Specialty: Biblical pictures. Address in 1926, Kennedy Ave., Cincinnati, OH.

STENGEL, G. J.

Painter. Born in Newark, NJ, Sept. 26, 1872. Pupil of Art Students League of NY; Julian Academy, Paris, France. Member: Salma. Club; Yonkers Art Association; Allied Artists of America; American Federation of Arts; Silvermine Guild; Guild of American Painters; American Artists Professional League. Award: Hon. mention, Allied Artists of America, 1930. Work: "The Cathedral," property of Mexican Government, President's Palace, Chapultepec, Mexico. Died in 1937. Address in 1933, 34 Main St., Ridgefield, CT.

STEPHAN, ELMER A.

Painter and illustrator. Born in Pittsburgh, PA, Jan. 31, 1892. Pupil of Joseph Greenwood. Member: Pittsburgh Art Association; Pittsburgh Teachers Art Club. Illustrated *Practical Art Drawing Books*, published by Practical Art Co., Dallas, TX. Director of Art Education, Pittsburgh Public Schools. Died in 1944. Address in 1929, 209 Gladstone Road, Pittsburgh, PA.

STEPHENS, ALICE BARBER.

(Mrs. Charles H. Stephens). Illustrator, wood engraver and teacher. Born near Salem, NJ, July 1, 1858. Pupil of Penna. Academy of Fine Arts; Philadelphia School of Design for Women; Julian and Colarossi Academies in Paris. Member: Plastic Club; Fellowship Penna. Academy of Fine Arts. Awards: Mary Smith prize, Penna. Academy of Fine Arts, 1890; bronze medal, Atlanta Expo., 1895; gold medal, London, 1902. Numerous illustrations for *Harper's* and *Century*, and wood engravings for *Scribner's*. Address in 1929, Moylan, PA.

STEPHENS, CHARLES H.

Illustrator. Member: Fellowship Penna. Academy of Fine Arts. Address in 1929, Moylan, Delaware Co., PA.

STEPHENS, C(LARA) J(ANE).

Painter and writer. Pupil of Kenyon Cox; W. M. Chase; F. V. DuMond. Member: Society of Independent Artists; American Federation of Arts. Awards: First prize for figure, 1920, and West Seattle prize, Seattle Fine Arts Society, 1925. Address in 1933, 12 Mulkey Bldg., Portland, OR.

STEPHENS, D(ANIEL) OWEN.

Painter and architect. Born in Philadelphia, PA, Aug. 5, 1893. Pupil of William Lathrop and N. C. Wyeth. Member: Philadelphia Alliance; Fellowship Penna. Academy of Fine Arts. Specialty: Night landscapes in oil. Died in 1937. Address in 1933, 4335 Dakota Street, Pittsburgh, PA.

STEPHENS, FRANK L.

Painter. Born in Philadelphia, PA, in 1824. He spent most of his professional life in New York City. He was an illustrator and cartoonist and was known for his caricatures; he also painted in water colors. He died in 1882.

STEPHENS, GEORGE FRANK.

Sculptor and craftsman. Born in Rahway, NJ, December 28, 1859. Pupil of Penna. Academy of Fine Arts. Member: Fellowship Penna. Academy of Fine Arts; Philadelphia Sketch Club; Art Club of Philadelphia; National Arts Club. Taught modeling in several art schools. Was instructor at Drexel Institute. Worked on sculptures for City Hall, Philadelphia. Address in 1929, Arden, DE. Died in 1935.

STEPHENSON, JOHN H.

Sculptor. Born in Waterloo, IA, October 27, 1929. Studied: University of Northern Iowa, Cedar Falls, B.A.; Cranbrook Academy of Art, M.F.A. Exhibitions: Michigan Artists Exhibition, Detroit Institute of Arts; Michigan Artists, Grand Rapids Art Museum; All-Michigan II, Flint Institute of Arts, 1973; Objects USA, Smithsonian Institution; Focus, Detroit Institute of Arts, 1974-75; Everson Museum of Art, Syracuse, 1979-80; others. Collections: Alfred University; Oklahoma University; Parrish Museum of Art; Faenza Museum, Italy; Detroit Institute of Arts; Everson Museum, Syracuse, NY; others. Awards: Gold medal, City of Faenza, Italy; Rackham Research Grants (3). Taught: Cleveland Institute of Art, 1958-59; University of Michigan, Ann Arbor, from 1959. Address in 1982, Ann Arbor, MI.

STEPHENSON, PETER.

Sculptor and cameo portraitist. Born August 19, 1823, in Yorkshire, England; came to U.S. in 1827. Worked: Buffalo, New York; Boston, MA, from 1843. Work held: American Antiquarian Society. Exhibited at Boston Atheneum. Specialty was cameos; also executed portrait busts and ideal figures. Died c. 1860.

STERBA, ANTONIN.

Painter, etcher and teacher. Born in Hermanec, Czechoslovakia, Feb. 11, 1875. Pupil of Art Institute of Chicago; Smith Art Academy, Chicago; Julian Academy, and Laurens and Constant in Paris. Work: Portraits, Northwestern University; Baylor University; DePauw University. Exhibited: Penna. Academy of Fine Arts; Corcoran; Chicago Galleries Asso-

ciation; one-man shows at Chicago, IL, Nashville, TN, Little Rock, AR, San Antonio, TX, others. Member: Chicago Painters and Sculptors; Cliff Dwellers; Bohemian Art Club; Chicago Galleries Association. Awards: Gold medal, Bohemian Art Club, 1923; Association of Chicago Painters and Sculptors, 1943; others. Instructor at Art Institute of Chicago. Specialty: Portraits. Address in 1962, Chicago, IL.

STERCHI, EDA (ELISABETH).
Painter. Born in Olney, IL. Pupil of Art Institute of Chicago; Lucien Simon, Menard and Prinet in Paris; Institute de Carthage, Tunisia. Member: Chicago Society of Artists; Chicago Art Club; Inst. de Carthage. Address in 1933, 214 Fair St., Olney, IL; 10 rue Medersa Slimania, Tunis, Tunisia.

STERLING, LINDSEY MORRIS (MRS.).
Sculptor. Born in Mauch-Chunk, PA, November 8, 1876. Pupil of George Brewster at Cooper Union and James Fraser at Art Students League; Bourdelle and Bartlett in Paris. Member: National Sculpture Society; National Association of Women Painters and Sculptors; New Haven Paint and Clay Club; Allied Artists of America. Awards: Bronze medal, P.-P. Expo., San Francisco, 1915; prize, National Association of Women Painters and Sculptors, 1916; Joan of Arc medal, National Association of Women Painters and Sculptors, 1923. Exhibited at National Sculpture Society, 1923. Works include "Blown by the Winds of Destiny;" "The Afternoon of the Faun." Address in 1929, Edgewater, NJ; summer, Jay, Essex County (Adirondack Mts.), NY. Died in 1931.

STERN, GERD.
Sculptor. Born in Saarbrucken, Germany, October 12, 1928. Studied at Black Mountain College, with M. C. Richards. Works: Associated Coin Amusement Co.; Immaculate Heart College; San Francisco Museum of Art; commission for Whitney. Exhibitions: San Francisco Museum of Art; University of British Columbia; Dwan Gallery, NYC; University of Rochester; Los Angeles County Museum of Art; International Arts Festival, Newport, RI; Jewish Museum; Museum of Modern Art; Brooklyn Museum; Whitney; Eindhoven; Walker Art Center. Awards: New York State Council on the Arts; National Council on the Arts. Address in 1970, Cambridge, MA.

STERN, LUCIA.
Painter, sculptor and craftswoman. Born in Milwaukee, WI, December 20, 1900. Member: Wisconsin Painters and Sculptors Society; Springfield Art League; Wisconsin Designer Craftsmen. Awards: Prizes, Milwaukee Art Institute, 1945, 46. Work: Smith College Museum; Milwaukee Art Institute; Museum of Non-Objective Painting, NY. Exhibited: Museum of Non-Objective Painting, 1944-52;

Springfield Art League, 1945-51; Salon des Realites Nouvelles, Paris, France, 1948, 51, 52; Detroit Institute of Art, 1945; Milwaukee Art Institute, 1942. Address in 1953, Milwaukee, WI.

STERN, MILDRED B.
Painter. Exhibited portrait of "Miss B." at Penna. Academy of Fine Arts, Philadelphia, 1915. Address in 1926, 4535 Pine St., Philadelphia, PA.

STERNBERG, HARRY.
Etcher. Born in NY, July 19, 1904. Pupil of Harry Wickey. Address in 1929, 20 West 49th St., New York, NY; h. 106 Arlington Ave., Brooklyn, NY.

STERNE, HEDDA.
Painter. Born August 4, 1916, in Bucharest, Rumania. U.S. citizen since 1944. Studied in Bucharest, Paris and Vienna. Extensive travel abroad. Awarded second prize, Art Institute of Chicago, 1957; Fulbright Fellowship, 1963; purchase award from Childe Hassam Fund, 1971. Taught at Carbondale College, 1964. Exhibited at Wakefield Gallery, 1943; Betty Parsons Gallery, many from 1947-75; Vassar College, 1956; Sao Paulo, Brazil, 1953; Arts Club of Chicago, 1955; Museum of Modern Art, 1955; Corcoran, 1955, 56, 58, 63; Virginia Museum of Fine Arts, 1958; Roswell (NM) Museum; Smithsonian, 1956; Carnegie, 1955, 58, 61, 64; Penna. Academy of Fine Arts; Finch College; Westmoreland Museum, 1969; Montclair Museum of Art, 1977; others. In collections of Art Institute of Chicago; Museum of Modern Art; Albright-Knox Art Gallery; Penna. Academy of Fine Arts; Montclair Museum of Art; Whitney; Chase Manhattan Bank; Metropolitan Museum of Art; Virginia Museum of Fine Arts; others. Address in 1982, c/o Betty Parsons Gallery, 24 W. 57th Street, New York, NY.

STERNE, MAURICE.
Painter and craftsman. Born at Libau, Russia, July 13, 1878. Came to NY at age of 12. Studied: National Academy of Design and other schools in NY; also with Thomas Eakins. Traveled extensively in Europe; special study of the people of Bali. Member: New Society of Artists; National Academy of Design; National Institute of Arts and Letters; Sculptors Guild. Awards: Logan medal and prize, $750, Art Institute of Chicago, 1928; Golden Gate Expo., San Francisco, CA, 1939; Penna. Academy of Fine Arts; National Academy of Design; others. Work: Carnegie Institute, Pittsburgh; Rhode Island School of Design, Providence; Whitney; Museum of Modern Art; Metropolitan Museum of Art, NY; Boston Museum of Fine Arts; Detroit Institute of Arts; Fairmount Park, Philadelphia; Los Angeles Museum; Kaiser Friedrich Museum, Berlin; Cologne Museum; Tate Gallery, London; others. Has exhibited nationally. Taught at Art Students League, 1919-20, 1921-22. Died in 1957. Address in 1953, Mt. Kisco, NY.

STERNER, ALBERT EDWARD.
Painter, etcher, lithographer, and writer. Born in London, England, March 8, 1863, of American parents. Studied at Birmingham, England; pupil of Julian Academy, Paris, under Boulanger, Lefebvre and Gerome. Member: Associate National Academy of Design, 1910; American Water Color Society; Lotos Club; American Institute of Arts and Letters; New Society of Artists. Awards: Hon. mention, Paris Salon, 1891; bronze medal, Paris Expo., 1900; silver medal for water color and bronze medal for drawings, Pan-Am. Expo., Buffalo, 1901; gold medal, Munich, 1905. Illustrated: "Prue and I," by George W. Curtis; "Fenwick's Career," by Mrs. Ward, etc. Work: "Portrait of Martin Birnbaum," Carnegie Institute, Pittsburgh; "The Blue Stocking," Metropolitan Museum of Art, NY; "The Gray Cape," Toronto Museum of Fine Arts; "Nude," Brooklyn Museum; "Amour Mort," South Kensington Museum, London; drawings and 6 lithographs, K. G. L., Kupferstich Kabinet Pinakothek, Munich; drawings and 6 lithographs, K. G. L., Kupferstich Kabinet, Dresden; 6 lithographs, Royal Print Collecton of Italy; 6 lithographs, NY Public Library; "John B. Deaver and His Clinic," group portrait of 25 figures, for Lankenau Hospital, Philadelphia, PA. Died in 1946. Address in 1933, 1801 Wolcott Avenue, Astoria, Long Island, NY; summer, RFD. 1, Pittsfield, MA.

STERNFELD, EDITH A.
Painter, sculptor, lecturer, and educator. Studied at Northwestern University, B.A.; Art Institute of Chicago, B.A.E.; University of Iowa, M.A.; Cranbrook Academy of Art; Claremont Graduate School; and with Eliot O'Hara, Grant Wood, Jean Charlot. Member: College Art Association; American Association of University Women. Awards: Prizes, All-Iowa Exhibition, 1937; Joslyn Memorial, 1937, 40; Iowa Water Color Exhibition, 1945; numerous prizes in regional exhibition. Exhibited: Art Institute of Chicago; Wisconsin Painters and Sculptors; American Water Color Society; Philadelphia Water Color Club; Baltimore Water Color Club; California Water Color Society; Washington Water Color Club; Kansas City Art Institute; Joslyn Memorial; New York World's Fair, 1939; Iowa Water Color Exhibition, since 1945; Des Moines, Iowa; Denver Art Museum; Mid-American Artists; Springfield (MO) Art Museum; several one-woman exhibitions. Lectured on painting. Address in 1953, Grinnell, IA.

STERNGLASS, ARNO.
Illustrator. Born in Berlin, Germany, in 1926. Attended Pratt Institute from 1944 to 1947. His illustrations have appeared in *Esquire, Look, Vogue, Redbook, Glamour, Seventeen, Horizon, The New York Times Magazine*, and others. He has won awards in NY from the Art Directors' Club, American Institute of Graphic Arts, and the Society of Illustrators.

STERRETT, CLIFF.
Cartoonist. Born in Fergus Falls, MN, Dec. 12, 1883. Pupil of Chase School of Art. Member: Society of Illustrators. Award: William Randolph Hearst cash prize for industrious cartoonists, NY. Illustrated *Polly and Her Pals* for Hearst Publications. Died in 1964. Address in 1929, 316 W. 72nd St., New York, NY.

STETCHER, KARL.
Painter. Born in Germany in 1832, he came to NY as a youth and spent most of his life in that city where he painted a number of portraits, besides staining the windows in Trinity Church, NY. He died in Wichita, KS, January, 1924.

STETSON, CHARLES WALTER.
Painter. Born on March 25, 1858 in Tiverton, RI. Exhibited "Twilight, Pasadena, Cal." His studio was in Boston, MA. In 1906 he was in Rome, Italy, and he died there on July 21, 1911.

STETSON, KATHERINE BEECHER.
(Mrs. Katherine Beecher Stetson Chamberlin). Sculptor, painter, and teacher. Born in Providence, RI, March 23, 1885. Pupil of da Pozzo, Sabate, Noel and Breck in Rome; Penna. Academy of Fine Arts under Chase, Kendall and Beaux; also studied under H. D. Murphy, Birge Harrison, Leonard Ochtman and F. Tolles Chamberlin. Member: MacDowell Memorial Association; Sculptors Guild of Southern California; California Art Club; Pasadena Society of Artists. Awards: Gold medal for sculpture, California Art Club, 1925; medal, Los Angeles Museum of Art, 1925; honorable mention, San Diego Fine Arts Gallery, 1926; prizes, Los Angeles Co. Fair, 1927; Pasadena Society of Artists, 1940. Exhibited: Penna. Academy of Fine Arts, 1912, 14, 15, 16, 19, 26; National Academy of Design, 1914-16, 19, 25; Pasadena Society of Artists, 1924-51. Address in 1953, Pasadena, CA.

STETTHEIMER, FLORINE.
Painter. Born in NY in 1871. Studied in NY, Paris, Rome, Munich. Member: Society of Independent Artists. Died in 1944. Address in 1929, 80 West 40th St., New York, NY.

STEUART, M. LOUISA.
Painter and teacher. Born in Baltimore, MD. Pupil of Hugh Newell; Julius Rolshoven; William Chase; Courtois. Member: Baltimore Water Color Club. Address in 1933, Ardmore Apts., 609 Somerset Road, Baltimore, MD; summer, Cascade P. O., MD.

STEVENS, CLARA HATCH (MRS.).
Painter, illustrator, writer, lecturer, and teacher. Born in Harrodsburg, KY, April 22, 1854. Pupil of J. Carroll Beckwith; William Chase; R. M. Shurtleff; Puvis de Chavannes. Member: All-Illinois Society of

Fine Arts; Chicago Municipal Art League; Chicago Society of Artists; North Shore Arts League. Work: Frieze in Hall of Honor, Women's Building, World's Columbian Expo., Chicago, 1893; panel, Hall of Science, Century of Progress Exposition, Chicago, 1933. Address in 1929, 561 Moffett Road, Lake Bluff, IL.

STEVENS, DOROTHY.
Etcher and painter. Born in Toronto, Canada, in 1888. Pupil of Slade School in London. Member of Chicago Society of Etchers. Awarded silver medal for etching, Panama Pacific Expo., San Francisco, 1915. Address in 1926, 2 Spadina Gardens, 145 West Wellington St., Toronto, Canada. Died in 1966.

STEVENS, EDITH BARRETTO.
See Parsons, Edith Barretto Stevens.

STEVENS, EDITH BRISCOE.
Painter. Born in Philadelphia, PA. Pupil of A. E. Jones; Harry Leith-Ross; George Elmer Browne. Member: Connecticut Academy of Fine Arts; New Haven Paint and Clay Club; Springfield Art League; Gloucester Society of Artists; Rockport Art Association. Work: "Gloucester Wharf," Beach Memorial Collection, Storrs, CT. Address in 1929, 6 Regent St., Hartford, CT.

STEVENS, EDWARD DALTON.
Illustrator. Born in Goochland Co., VA, Dec. 6, 1878. Pupil of Vanderpoel in Chicago; Chase School, NY. Illustrated *Mary Regan*, by Leroy Scott; *The Crystal Stopper*, by Leblanc; *Peter Rough*. Illustrations for *Cosmopolitan, Red Book, McCalls, Liberty*, etc. Died in 1939. Address in 1929, Tenth St. Studio Bldg., 51 West 10th St., New York, NY; h. 153 Chestnut Ave., Metuchen, NJ.

STEVENS, ESTHER.
(Mrs. Walter T. Barney). Painter. Born in Indianapolis, IN, in 1885. Pupil of Robert Henri; also studied at Art Students League of NY. Address in 1926, Pt. Loma, San Diego, CA.

STEVENS, GEORGE W.
Miniature painter. Flourished in Boston about 1842.

STEVENS, GEORGE WASHINGTON.
Painter. Born in Utica, NY, in 1866. Pupil of J. Francis Murphy in NY. Member of Salmagundi Club; was an Associate of Museum Directors. Director, Toledo Museum of Art, since 1903. Address in 1926, Museum of Art, Toledo, OH.

STEVENS, HELEN B.
(Mrs. T. W. Stevens). Etcher. Born in Chicago, IL, Feb. 8, 1878. Pupil of Art Institute of Chicago; Frank Brangwyn in England. Member: Chicago Society of Etchers; Pittsburgh Art Association. Award: Bronze

medal, P.-P. Expo., San Francisco, 1915. Instructor in etching and assistant curator of prints, Art Institute of Chicago, 1909-1912. Address in 1929, care of Art Institute of Chicago, Chicago, IL.

STEVENS, JOHN CALVIN.
Landscape painter and architect. Born in Boston, MA, Oct. 8, 1855. Member: Boston Society of Architects; NY Architectural League; Portland Society of Artists; Salma. Club; American Federation of Arts; others. Died in 1940. Address in 1933, 711 Chapman Bldg.; h. 31 Craigie St., Portland, ME.

STEVENS, LAWRENCE TENNEY.
Sculptor, painter, etcher, and teacher. Born in Brighton, MA, July 16, 1896. Studied: Boston Museum of Fine Arts School; American Academy in Rome; and with Charles Grafly and Bela Pratt. Member: National Sculpture Society; Society of Medalists; Architectural League of New York; others. Award: American Prix de Rome, 1922. Work: "Baptism of Christ" (marble), Congregational Church, Brighton, MA; statue, "John Harrison," Fairmount Park, Philadelphia; "Triptych," polychromed wood carving, St. Mathews Church, Bedford, NY; Brookgreen Gardens, SC; University of Pennsylvania; Brooklyn Museum; Will Rogers Memorial, Claremore, OK; others. Exhibited at Penna. Academy of Fine Arts, 1929; Grand Central Art Galleries; Boston Museum of Fine Arts; Philbrook Art Center; National Academy of Design; others. Address in 1953, Tulsa, OK. Died in 1972.

STEVENS, MARION.
Painter. Member: Washington Society of Artists. Address in 1929, 1332-21st St., N. W., Washington, DC.

STEVENS, THOMAS WOOD.
Mural painter, etcher, and writer. Born in Daysville, IL. Pupil of Art Institute of Chicago; Armour Institute of Technology, Chicago; Frank Brangwyn in London; Sorolla y Bastida. Head of drame department and director, Goodman Theatre, Art Institute of Chicago, 1924-30. Address in 1933, care of Art Institute of Chicago, Chicago, IL.

STEVENS, VERA.
Painter. Born in Hustontown, PA, Aug. 5. 1895. Pupil of George Elmer Browne. Member: Springfield Art League; Connecticut Academy of Fine Arts; New Haven Paint and Clay Club; National Association of Women Painters and Sculptors; Provincetown Art Association. Awards: Honorable mention, portrait, National Association of Women Painters and Sculptors, 1933. Address in 1933, Provincetown, MA.

STEVENS, WILL HENRY.
Landscape painter, designer, teacher, and potter. Born in Vevay, IN, Nov. 28, 1887. Pupil of Cincinnati

Academy under Caroline Lord; Nowottny, Duveneck and Meakin; Jonas Lie and Van Dearing Perrine in NY. Member: International Society of Arts and Letters; Cincinnati Art Club; New Orleans Art Association; Southern States Art League; New Orleans Arts and Crafts Club; New Orleans Art Association. Award: Foulke prize, Richmond, IN, 1914; hon. mention, Southern States Art League, 1925. Represented in art galleries, Des Moines, IA; Oklahoma University, Norman, OK; Shreveport, LA; J. B. Speed Memorial Museum, Louisville, KY. Instructor of painting, Newcomb School of Arts, New Orleans. Decorator at Rookwood Pottery. Director, Natchitoches (LA) Art Colony. Instructor, Texas Artists' Camp, San Angelo, TX. Address in 1933, Newcomb School of Art, Tulane University, New Orleans, LA.

STEVENS, WILLIAM CHARLES.
Landscape painter. Born in 1854 in Barre, MA; died in 1917. The Worcester Museum of Fine Arts owns several of his paintings. Address in 1926, 13 West 29th Street, New York, NY.

STEVENS, W(ILLIAM) D(ODGE).
Illustrator. Born in Tidioute, PA, Sept. 13, 1870. Pupil of Art Institute of Chicago, under Vanderpoel and Grover; also studied in Paris. Member: Artists Guild of the Authors' League of America. Address in 1929, 51 West 10th St., New York, NY; h. Metuchen, NJ.

STEVENS, W(ILLIAM) LESTER.
Painter and teacher. Pupil of Parker S. Perkins, Boston Museum School. Member: NY Water Color Club; North Shore Arts Association; Guild of Boston Artists. Awards: Fourth Clark prize, Corcoran Gallery, Washington, DC, 1921; Gedney Bunce prize, Connecticut Academy of Fine Arts, 1924; landscape prize, Springfield, MA, 1925; second Altman prize, National Academy of Design, 1927; Wm. A. Delano Purchase prize, American Water Color Society, 1928; Mansfield prize, New Haven Paint and Clay Club, 1929; special award of honor, Springville, UT, 1931; patrons' prize, Springfield Art League, 1932; medal, Quincy Art League, 1932; Club prize, New Haven Paint and Clay Club, 1933. Works: "Winter Gray Day," Boston Art Club; "Winding Road," Boston City Club; Art Museum, Louisville, KY; "Winter Woods," Public Library, Birmingham, AL; "Quarry Workers," High School, Gloucester, MA; "Rockport Quarry," High School, Rockport, MA. Address in 1933, 2 Mill Lane, Rockport, MA.

STEVENSON, BEULAH.
Painter and etcher. Born in Brooklyn, NY. Pupil of John Sloan. Member: National Association of Women Painters and Sculptors; Society of Independent Artists. Award: Prize for painting, National Association of Women Painters and Sculptors, 1930. Address in 1933, 246 Fulton St.; h. 178 Emerson Place, Brooklyn, New York, NY.

STEVENSON, GORDON.
Painter and etcher. Born in Chicago, IL, Feb. 28, 1892. Pupil of Sorolla. Member: Salma. Club; American Water Color Society. Represented in the Brooklyn Museum. Address in 1933, 222 West 23rd St., h. 1 Lexington Ave., New York, NY; summer, Willowemoc, NY.

STEVENSON, MARGARET PARIS.
Photographer and graphic artist. Born in Roxboro, NC, in 1937. Studied: University of North Carolina; American University, Washington, DC; Corcoran School of Art, Washington, DC. Exhibitions: Ikon Gallery, Washington, DC; Martin Luther King Memorial Library, Washington, DC; Smithsonian Institution, Washington, DC.

STEWARDSON, EDMUND AUSTIN.
Sculptor. Pupil of Penna. Academy of Fine Arts. Elected a member of the Society of American Artists in 1891. He died in 1892 at Newport, RI.

STEWART, ALBERT T.
Sculptor, painter, and illustrator. Born in Kensington, England, April 9, 1900. Studied: Beaux-Arts Institute of Design; Art Students League; also with Paul Manship. Member: Animal Painters and Sculptors; National Sculpture Society; National Academy of Design. Works: "Dolphins," Seamen's Church Institute, NY; "Memorial Tablet," Amherst College; "Memorial Tablet," Williams College, Williamstown, MA; "Louis Pope Gratacap Memorial," American Museum of Natural History, NY; "Hawk," Metropolitan Museum of Art; many others, including tablets, memorials, panels, doors, fountains. Won prizes at National Academy of Design; Pasadena Art Institute; others. Address in 1982, Claremont, CA.

STEWART, CATHERINE T.
Painter. Exhibited water colors at the Penna. Academy of Fine Arts, Philadelphia, 1925. Address in 1926, 2206 Locust Street, Philadelphia, PA.

STEWART, CHARLES.
Engraver. In 1841 Stewart engraved a small but exceedingly fine mezzotint portrait of Peter Stuyvesant, printed by A. King, who was the publisher of some of Durand's plates. A pencil memorandum on the print says that it was engraved for the NY Historical Society.

STEWART, GRACE BLISS (MRS.).
Painter and writer. Born in Atchison, KS, April 18, 1885. Pupil of Art Students League of NY; Hawthorne Summer Art School. Member: National Arts Club; National Association of Women Painters and Sculptors; North Shore Arts Association; Pen and

Brush Club; American Federation of Arts; Gloucester Society of Artists. Author of *In and Out of the Jungle, Jumping into the Jungle,* and *The Good Fairy,* (Reily-Lee, Chicago). Address in 1933, 50 West 45th St., New York, NY; summer, Spofford, NH.

STEWART, JOSEPH.
Painter. Born about 1750. He graduated from Dartmouth College in 1780. His portraits of Rev. Eleazer Wheelock, first president of Dartmouth College, and of John Phillips are signed "J. Steward." He painted a portrait of John Kemble, engraved by H. Houston, published in 1796. He became a Congregationalist minister and was said to have been the first instructor of S. L. Waldo.

STEWART, JULIUS L.
Painter. Born in Philadelphia, PA, in 1855. Pupil of J. L. Gerome and R. de Madrazo. Hon. mention, Salon, Paris, 1885; 3rd class medal, Salon, 1890; gold medal, Berlin International Art Exhibition, 1891; grand gold medal, Berlin, 1895; Munich, 1897. Decorated with Order of Leopold of Belgium, Antwerp, 1894; Cross of Legion d'Honneur, 1895. Elected associate member of Societe Nationale des Beaux Arts, 1895; elected member of Societe des Beaux Arts, 1899; member of International Jury, Paris Expo., 1889; member of jury of selection, Chicago Expo., 1893; grand gold medal, Munich, 1901; promoted officer of Legion d'Honneur, 1901; member of advisory and executive committee for St. Louis Expo., 1904. Member: Paris Society of American Painters; Societe Nationale, Berlin, 1895; Munich, 1897. Exhibited at Paris Expo., 1900; Paris Club de France; Philadelphia Club, Philadelphia; delegate for the fine arts, U.S. sect., to the Liege Exhibition, 1905. Died in Paris.

STEWART, LE CONTE.
Painter and illustrator. Born in Glenwood, UT, in 1891. Pupil of Art Students League of NY; Carlsen. Awarded second prize, landscape, Utah State Fair, 1914, first prize, landscape, 1915. Work: Represented in Utah State collection; mural decorations in the Hawaiian Temple at Laie; Cardston Temple, Cardston, Alberta, Canada. Address in 1926, Cardston, Alberta, Canada.

STEWART, ROBERT B.
Painter. Member: Society of Illustrators; Artists Guild of the Authors' League of America. Address in 1929, 1947 Broadway, New York, NY; 721 Walnut St., Philadelphia, PA.

STEWART, T. J. (MRS.).
See Horton, Dorothy E.

STEWART, THOMAS KIRK.
Sculptor and portraitist. Born in New York City in 1848. Died in Kansas City, MO, 1879.

STICKROTH, HARRY I.
Mural painter. Born in 1844; died in Chicago, 1922. Instructor in mural and decorative painting in Chicago Art Institute. He was associated with Barry Faulkner in the mural work on the Cunard Building, New York.

STIERLIN, MARGARET E.
Sculptor, craftswoman, designer, and teacher. Born in St. Louis, MO, December 28, 1891. Studied at University of Missouri, A.B.; Art Institute of Chicago; and with Emil Zettler. Member: Chicago Art League; Chicago Potters Guild. Awards: American traveling scholarship, Art Institute of Chicago, 1932. Work: Springfield (IL) Museum of Art. Exhibited: Art Institute of Chicago, 1935, 36, 40, 41, 43; Syracuse Museum of Fine Arts, 1940; Springfield Museum of Art, 1941. Position: Instructor, modeling, Jr. Department, Art Institute of Chicago, 1932-38; instructor, ceramics, Hull House, Chicago, IL, from 1939. Address in 1953, Chicago, IL.

STIHA, VLADIN.
Sculptor and painter. Born in Belgrade, Yugoslavia, 1908. Studied art in Yugoslavia; Academy of Fine Arts, Vienna; privately in Rome. Lived in Argentina and Brazil before coming to U.S. (Beverly Hills) in 1968; settled in Santa Fe, NM. Painting specialty is Pueblo Indians and New Mexico landscape; sculpts figures of Indian children in action. Paints in oil; sculpts in bronze. Reviewed in *Southwest Art,* summer 1973, August 1979. Has his own gallery. Address since 1970, Santa Fe, NM.

STILES, SAMUEL.
Engraver and portrait painter. Born on July 15, 1796 in East Windsor, CT. He served his apprenticeship as an engraver with Abner Reed at East Windsor, and in 1824 he removed to Utica, NY, and formed a partnership in the banknote and general engraving business with Vistus Balch. He was also a pupil of Abner Reed. In 1828 he moved to NY as a banknote engraver. He married Charlotte Sophia Reed in 1825, the daughter of his old preceptor Abner Reed. Died April 3, 1861 in NYC.

STILL, CLYFFORD.
Painter. Born in Grandin, ND, November 30, 1904. Studied: Spokane University, B.A., 1933; Washington State College, M.A. Work: Albright-Knox Art Gallery; Phillips Collection, Washington, DC; Baltimore Museum of Art; Whitney; Museum of Modern Art; San Francisco Museum of Art; others. Exhibited: Museum of Modern Art; Albright-Knox Art Gallery; San Francisco Museum of Art (one-man); Betty Parsons Gallery, NY (one-man); others. Taught: Washington State College, 1933-41; College of William and Mary, 1943-45; California School of Fine Arts, 1946-50; Hunter College, 1952; University of Pennsylvania, 1962; others. Address in 1980, New Windsor, MD.

STILLSON, BLANCHE.
Painter and teacher. Born in Indianapolis, IN. Pupil of Forsyth; Hawthorne. Member: Indiana Artists' Club; Hoosier Salon. Address in 1929, 4245 North Meridian St., Indianapolis, IN.

STILSON, ETHEL M.
Painter. Member: National Association of Women Painters and Sculptors; Cleveland Woman's Art Club. Address in 1929, 1962 East 79th St.; 2259 Cedar Ave., Cleveland, OH.

STILWELL-WEBER, SARAH S.
Illustrator. Born in 1878. Studied art at Drexel Institute under Howard Pyle, from 1894 to 1900, and later attended his summer classes at Chadds Ford, PA. *The Saturday Evening Post* covers which she painted in the 1910's and 1920's earned her distinction in the magazine cover field. She is best known for her illustrations of children. Died in 1939.

STIMSON, ANNA KATHARINE.
Sculptor. Born in New York City, November 14, 1892. Pupil of Charles Grafly. Member: Philadelphia Alliance; Fellowship Penna. Academy of Fine Arts; Philadelphia Water Color Club. Address in 1933, Philadelphia, PA; summer, Bolton Landing, NY.

STIMSON, JOHN WARD.
Painter, illustrator, teacher, writer, and lecturer. Born in Paterson, NJ, Dec. 16, 1850. Pupil of Ecole des Beaux Arts in Paris under Cabanel and Jacquesson de la Chevreuse. Studied in England, Belgium, Holland, and Italy. Director, Metropolitan Museum School, NY, for 5 years; founder of Artist-Artisan Institute, NY, and of the School of Fine and Industrial Arts, Trenton. Author of *The Gate Beautiful, The Love of the Three Primaries, Wandering Chords.* Associate Editor of *Arena*; art lecturer at leading universities, etc. Address in 1929, Corona, CA.

STINSON, HARRY EDWARD.
Sculptor and teacher. Born in Wayland, IA, January 3, 1898. Pupil of Cumming, Aitken, Hawthorne, Olinsky, Bridgman; studied at University of Iowa, B.A., M.F.A.; Cumming School of Art; National Academy of Design; Art Students League. Member: American Association of University Professors; College Art Association of America; Iowa Artists Guild. Exhibited at National Academy of Design; Penna. Academy of Fine Arts; Kansas City Art Institute; Grand Central Palace; Nebraska Art Association; others. Address in 1953, Hunter College, 695 Park Ave.; h. 446 East 66th Street, New York, NY.

STIRNWEISS, SHANNON.
Illustrator. Born in Portland, OR, in 1931. Graduated from Art Center College of Design in Los Angeles where he studied under John LaGatta, Reynold Brown, and Pruett Carter, and shared classes with

Jack Potter, Phil Hays, and Chuck McVicker. He received a gold medal from the New Jersey Art Directors' Club and the Book Writers Award for the best illustrated dog book. He has illustrated 25 books and many magazines, including *Field and Stream, Boys' Life, Reader's Digest, Argosy,* and *Show,* have used his talents. His work has been shown in many galleries, including the Society of Illustrators, where he was president from 1972 to 1974.

STITT, HOBART D.
Painter. Born in Hot Springs, AR, in 1880. Pupil of Howard Pyle, Robert Spencer, and Fred Wagner at Penna. Academy of Fine Arts. Member: Salma. Club; Wilmington Society of Fine Arts; American Artists Professional League; Southern States Art League. Work: Wilmington Society of Fine Arts; Art Museum, Little Rock, AR; Princeton University. Address in 1933, Sudbrook, Pikesville, MD.

STIVERS, HARLEY ENNIS.
Illustrator and etcher. Born in Nokomis, IL, Nov. 25, 1891. Pupil of Art Institute of Chicago. Member: Society of Illustrators; Artists Guild of the Authors' League of America. Illustrated for *Saturday Evening Post, Ladies' Home Journal, Cosmopolitan, Photoplay, Red Book,* etc. Address in 1933, 55 West 42nd Street, New York, NY; 20 Edgewood Place, Scarsdale, NY; summer, Belmar, NJ.

STOCKBRIDGE, DANA W.
Painter. Born in Haverhill, MA, on Jan. 29, 1881. Pupil of School of Fine Arts at Harvard University and of the Eric Pape School of Arts. He died Nov. 24, 1922.

STOCKMAN, HELEN PARK (MRS.).
Painter, sculptor and teacher. Born in Englewood, NJ, October 16, 1896. Pupil of Jonas Lie; Luis Mora; Robert Henri. Member: Palisade Art Association. Address in 1933, Sherwood Place, Englewood, NJ.

STODART, G.
Engraver. A well-engraved portrait of David Stoner, in stipple, is signed "G. Stodart." It was apparently published about 1835, but as G. Stodart also engraved a portrait of Washington, published in London, he may have been an English engraver. David Stoner, however, seems to have been an American.

STODDARD, ALICE KENT.
Painter. Born in Watertown, CT, in 1893. Pupil of Penna. Academy of Fine Arts. Member: Fellowship Penna. Academy of Fine Arts; Plastic Club. Awards: Mary Smith prize, Penna. Academy of Fine Arts, 1911 and 1913; hon. mention, Philadelphia Art Club, 1913; Fellowship prize, Penna. Academy of Fine Arts, 1916; Isidor medal, National Academy of Design, 1917; Carol Beck medal, Penna. Academy of Fine Arts, 1926; Clark prize, 1928. Work: Pennsyl-

vania Academy, Philadelphia; Delgado Museum, New Orleans, LA; Reading (PA) Museum. Address in 1929, 7930 Crefield St., St. Martin's, Philadelphia, PA.

STODDARD, ELIZABETH M. (MRS.).
Painter. Member: Hartford Art Society. Address in 1929, 30 Farmington Ave., Hartford, CT.

STODDARD, FREDERICK L(INCOLN).
Mural painter and illustrator. Born in Coaticook, P. Q., Canada, March 7, 1861. Pupil of St. Louis School of Fine Arts; Constant and Laurens in Paris. Member: North Shore Arts Association; St. Louis Artists Guild; Salma. Club; NY Architectural League, 1911. Award: Silver medal, St. Louis Expo., 1904. Work: City Hall, St. Louis; High School, St. Louis; Hebrew Technical School for Girls, NY; "Birth and Development of Education," and War Workers Memorial, Eastern District High School, NY; "The Transfiguration," Memorial Church, Baltimore, MD. Died in 1940. Address in 1933, 107 Mt. Pleasant Ave., Gloucester, MA.

STODDARD, MUSETTE OSLER (MRS.).
Painter, craftsman, lecturer, and teacher. Born in Carson, IA. Pupil of Art Institute of Chicago; Ralph Johonnot; E. A. Webster; Charles W. Hawthorne; Maud Mason. Member: Indiana Art Club; Brown County Art Galleries Association; Indiana Art Club; Hoosier Salon; Indiana Weaver's Guild. Award: Silver medal and diploma, Panama-Pacific Expo., San Francisco, 1915. Address in 1953, Nashville, IN.

STOHR, JULIA COLLINS.
(Mrs. Peter C. Stohr). Painter. Born in Toledo, OH, Sept. 2, 1866. Pupil of Cooper Union and Art Students League in NY under Beckwith, Chase, J. Alden Weir, Freer, and W. L. Lathrop; also studied in Paris. Member: Art Workers' Guild of St. Paul; Minnesota State Art Society; Chicago Water Color Club; National Association of Women Painters and Sculptors. Address in 1929, "Conifer," Lovell, ME.

STOHR, JULIE.
(Mrs. J. S. Roe). Painter. Born in St. Paul, MN, March 19, 1895. Pupil of Simon and Menard in Paris; Henri and Bellows in NY. Member: Art Students League of NY; Society of Independent Artists. Address in 1929, 512 Pierce St., Monterey, CA.

STOKES, FRANK WILBERT.
Painter and sculptor. Born in Nashville, TN. Pupil of Penna. Academy of Fine Arts under Thomas Eakins; Ecole des Beaux-Arts in Paris under Gerome; Colarossi Academy under Collin; Julian Academy under Boulanger and Lefebvre. Award: Medaille d'Argent, Prix de Montherot de Geographie de Paris. Specialty: Arctic and antarctic scenes. Member of Peary Greenland Expedition, 1892 and 1893-94; Swedish Antarctic Expedition, 1901-02; artist member of Amundsen Ellsworth Expedition, 1926. Member: Fellowship, Penna. Academy of Fine Arts. Work: Mural decorations, Museum of Natural History, NY. Address in 1933, 3 Washington Square N., New York, NY.

STOLL, FREDERICK H.
Sculptor. Exhibited at the Annual Exhibition, 1923, at the Penna. Academy of Fine Arts, Philadelphia. Address in 1926, American Museum of Natural History, New York.

STOLL, JOHN THEODOR EDWARD.
Sculptor, painter, illustrator, and etcher. Born in Goettingen, Hanover, Germany, September 29, 1889. Studied at Academy of Fine Art, Dresden; California School of Fine Art; otherwise self-taught. Member: San Francisco Art Association; California Society of Etchers. Represented in Art Museum of Legion of Honor, San Francisco; San Francisco Museum of Art; memorial mural and sculpture, Sailors Union of the Pacific; others. Exhibited at Detroit Institute of Arts; Art Institute of Chicago; San Francisco Museum of Art; Carnegie; others. Address in 1953, San Francisco, CA.

STOLL, R(OLF).
Painter, illustrator, and teacher. Born in Heidelberg, Germany, Nov. 11, 1892. Pupil of Academie of Fine Arts in Karlsruhe; Academie of Fine Arts in Stuttgart, Germany. Member: Cleveland Society of Artists; Kokoon Art Club. Awards: First prize, Cleveland Museum of Art, 1925; first and second prizes, Cleveland Museum of Art, 1926; hon. mention, Cleveland Museum of Art, 1927. Represented by decorative panels in the Public Library and Administration Building of Board of Education, Cleveland, OH; Dayton Art Institute, Toledo Museum of Art, OH; oil paintings, Gallery of Fine Arts, Columbus, OH; Nebraska Arts Association, Lincoln, NE. Address in 1933, 1851 Hillside Ave., East Cleveland, OH.

STOLOFF, IRMA.
(Mrs. Charles I. Stoloff). Sculptor. Born in NYC. Studied at Art Students League, 1921; and with Alexander Stirling Calder, Boardman Robinson, Howard Giles, Yasuo Kuniyoshi, and Alexander Archipenko. Exhibitions: Salons of America, 1931; Painters and Sculptors Guild, 1932; Woodstock Gallery, 1934; Argent Gallery, 1947, 54, 58; National Academy of Design Galleries, 1947-53, 55, 57, 66; Art Students League Centennial, 1950; Artists Equity, 1952; Painters and Sculptors Society of NJ, 1955; Silvermine Guild of Artists, CT; National Association of Women Artists, 1970, 72; others. Award: National Association of Women Artists, 1953; honorable mention, Painters and Sculptors Society, NJ, 1959; C. L. Wolfe Art Club, 1969; Audubon Artists,

1971; others. Member: National Association of Women Artists (sculpture jury, 1952-74, 77-79); Art Students League (life); Artists Equity; League of Present Day Artists; Silvermine Guild of Artists; Audubon Artists; others. In collections of Butler Institute of American Art; Norfolk (VA) Museum; Wichita Art Museum; others. Address in 1982, 46 East 91st St., NYC.

STOLTENBERG, H(ANS) J(OHN).
Painter and teacher. Born in Flensburg, Germany, April 8, 1879. Pupil of Dudley Crafts Watson. Member: Wisconsin Painters and Sculptors. Award: Hon. mention, Milwaukee Art Institute, 1920. Work: "The Birches," Milwaukee Technical High School; "Winter Landscape," Public Library, and "Morning Shadows," High School, Wauwatosa, WI; "Open Stream in Winter," Milwaukee Art Institute. Address in 1929, Lovers Lane, Wauwatosa, WI.

STONE, ALICE BALCH.
(Mrs. Robert Bowditch Stone). Painter, sculptor and craftsman. Born in Swampscott, MA, July 12, 1876. Pupil of Caroline Rimmer; Wilbur Dean Hamilton; John Wilson. Member: Copley Society; Art Alliance of America; Boston Society of Arts and Crafts; National Association of Women Painters and Sculptors; American Federation of Arts. Work: Pottery plaque, Judson Memorial Building, Boston Floating Hospital. Address in 1933, Jamaica Plain, MA; summer, Chocorua, NH.

STONE, ANNA B.
Painter. Born in DeWitt, IA, Jan. 8, 1874. Pupil of Edgar Forkner. Member: Seattle Art Institute. Died in 1949. Address in 1929, Olympian, 16th and Madison; h. 1605 East Madison, Seattle, WA.

STONE, BEATRICE.
(Mrs. J. C. Stone). Sculptor. Born in NYC, December 10, 1900. Studied at Smith College; in Paris; also with Heinz Warneke, Oronzio Maldarelli, Jacques Loutchansky. Works: Ethical Culture Society; Hudson Guild; Aluminum Corporation of America. Awards: Huntington award, 1943; Scarsdale Art Association; Westchester Arts and Crafts Association; National Association of Women Artists, 1942. Exhibited at de Young Memorial Museum, San Diego Fine Arts Society, Atlanta Art Association (all one-woman); Penna. Academy of Fine Arts; National Academy of Design; Art Institute of Chicago; Philadelphia Museum of Art; Whitney; Connecticut Academy of Fine Arts; Audubon Artists; others. Member of National Association of Women Artists; National Sculpture Society; Allied Artists of America; others. Address in 1953, 375 Park Avenue, NYC. Died in 1962.

STONE, DAVID K.
Illustrator. Born in Reedsport, OR, in 1922. Attended the University of Oregon, graduating after serving in World War II. He studied art at the Art Center College of Design in Los Angeles and also studied in Mexico. His career began in 1949 in NY with editorial work, and he has won several awards since then from the Society of Illustrators and the Art Directors' Clubs of St. Louis and Richmond. Was president of the Society of Illustrators.

STONE, FRANK FREDERICK.
Sculptor. Born in London, England, March 28, 1860. Pupil of Richard Belt. Awards: First prize for sculpture, San Antonio State Fair; gold medal, Alaska-Yukon-Pacific Expo., 1909. Work: "Gladstone," Treasury Office, London; "Mark Twain Medallion," Sacramento State Library. Address in 1933, Los Angeles, CA.

STONE, GILBERT LEONARD.
Illustrator. Born in Brooklyn, NY, in 1940. Graduated with honors from Parsons School of Design after receiving scholarships there and at the Brooklyn Museum. Three years after his first illustration appeared in *Seventeen*, he was awarded the Prix de Rome. He has been the recipient of four gold medals from the Society of Illustrators for his work in *Sports Illustrated*, *McCall's*, *Seventeen*, and *Steelways*. His art is part of the permanent collection of the Brooklyn Museum and the Smithsonian Institution.

STONE, HENRY.
Engraver. In 1826 this line engraver was also doing work in Washington, DC. He was doubtless connected with the Mr. and Mrs. William J. Stone here referred to, possibly a son. Henry Stone drew upon stone for lithographers of Washington, DC.

STONE, HORATIO.
Sculptor. Born in Jackson, NY, December 25, 1808. Originally trained as a physician, practicing from 1841-47. At an early age he attempted wood carving. Began sculpting professionally after 1848 and lived in Washington, DC. Instrumental in the organization of the Washington Union Art Association, he was elected its president. This organization presented a memorial to Congress requesting recognition of American artists in the decoration of the Capitol, and as a result, the Art Commission of 1859, consisting of H. K. Brown, James R. Lambdin, and John F. Kensett, was appointed by President Buchanan. Stone was also significant in the establishment of the National Gallery of Art. He visited Italy twice in the study of his work as a sculptor. In 1857, he received the medal of the Maryland Institute for his busts of Benton and Taney, and exhibited his works in the National Academy of Design in 1849 and 1869. He is also credited with models for statues of Prof. Morse, Admiral Farragut, and Dr. Harvey, the discoverer of the circulation of blood. Died in Carrara, Italy, August 25, 1875.

STONE, J. M.
Painter. Born in Dana, MA, in 1841. He studied in Boston, and later in Munich. He spent his professional life in Boston, where he became an instructor at the School of the Museum of Fine Arts. He painted a number of portraits.

STONE, M. BAINBRIDGE.
Painter. Member: Baltimore Water Color Club. Died in 1939. Address in 1929, 223 West Lanvale St., Baltimore, MD.

STONE, MAYSIE.
Sculptor. Born in NYC. Studied at Cornell University; University of Wisconsin; Penna. Academy of Fine Arts; and with Albert Laessle and Charles Grafly. Exhibited at Penna. Academy of Fine Arts; National Academy of Design; Architectural League of New York; Salon de Printemps, Paris; Smithsonian; Artists Equity Association. Address in 1953, 2 East 23rd Street; h. 414 West 118th Street, NYC.

STONE, SEYMOUR M.
Painter. Born in Poland, June 11, 1877. Came to U.S. at the age of six. Pupil of the Art Institute of Chicago; Royal Academy in Munich under De Loeftz, also of Jank in Munich; Zorn in Sweden; Lefebvre in Paris; John Singer Sargent in London. Member: American Federation of Arts; American Artists Professional League; Knight Commander of Merit of the Constantinian Order of St. George, Italy, 1921. Painted royalty and nobility in Europe for 11 years. Work: Portraits, President Hamilton Holt, Rollins College, Winter Park, FL; Bishop Ferris of Rochester, Chauncey M. Depew, Charles C. Paulding, Gallery Military Academy, Peekskill, NY; Dr. P. Faunce, Sayles Hall, Brown University, Providence, RI; Admiral Byrd and Governor Byrd, University of Virginia; Major-General Henry T. Allen and Lieutenant-General Robert Lee Bullard, Smithsonian Institution, Washington, and State House, Montgomery, AL; "General John J. Pershing With His Horse," Army and Navy Club, NY; "Parsifal," Munich, Germany. Address in 1933, 39 West 67th Street, New York, NY.

STONE, VIOLA PRATT.
(Mrs. Joseph H. Stone). Sculptor and painter. Born in Omaha, NE. Pupil of J. Laurie Wallace; Kansas City Art Institute; Edna Kelly. Member: Long Beach Art Association. Awards: Prizes, Long Beach Art Association; Ebell Club, 1934. Address in 1953, Long Beach, CA.

STONE, WALTER KING.
Illustrator and painter. Born in Barnard, NY, March 2, 1875. Pupil of Pratt Institute, Brooklyn, NY, under Arthur Dow. Member: Salma. Club. Work: "The Walter Garden," and "Blue Shadows," Memorial Gallery, Rochester, NY; overmantel decorations in many private homes. Assistant professor of painting, Cornell University. Died June 21, 1949. Address in 1933, The Byway, Forest Home, Ithaca, NY.

STONE, WILLIAM J.
In 1822 this excellent engraver of portraits in stipple and etcher of buildings, etc., was located in Washington, DC, possibly in Government employ. A map of Washington, published in 1840 by Wm. D. Morrison, is signed "Eng'd by Mrs. W. J. Stone." There is an excellent engraved portrait of Wm. J. Stone.

STONE, WILLIAM OLIVER.
Portrait painter. Born Sept. 26, 1830, at Derby, CT. Studied with Nathaniel Jocelyn at New Haven in 1851, and then moved to NY. In 1856 he was elected an Associate of the National Academy, and in 1859 an Academician. He painted portraits of Bishops Williams, Littlejohn and Kip. The NY Historical Society owns his portrait of Thomas J. Bryan and the Metropolitan Museum owns his portrait of Miss Rawle. Died Sept. 15, 1875, in Newport, RI.

STONER, HARRY.
Painter, sculptor and illustrator. Born in Springfield, OH, January 21, 1880. Member: New York Architectural League; Artists Guild of the Authors' League of America; Society of Illustrators; American Artists Professional League. Work: Design for glass mosaic curtain, executed by Tiffany Studios for the National Theatre of Mexico, Mexico City. Exhibited: American Water Color Society; National Academy of Design; Penna. Academy of Fine Arts; Philadelphia Water Color Club; Corcoran Gallery of Art; Chicago Water Color Club; Architectural League; American Institute of Architects; Toledo Museum of Art; Society of Illustrators; American Federation of Arts traveling exhibition. Address in 1953, c/o The Artists Guild, Inc., 129 East 10th St., NYC.

STONER, OLIVE.
Painter and teacher. Born in Pleasantville, PA. Pupil of Snell, Breckenridge, Garber, Arthur B. Carles, Fred Wagner; Philadelphia School of Design for Women; Penna. Academy of Fine Arts. Member: Fellowship Penna. Academy of Fine Arts; Philadelphia Alliance; Artists Guild of Tiffany Foundation. Address in 1929, 3408 Baring St., Philadelphia, PA.

STOOPS, HERBERT MORTON.
Illustrator. Born in Idaho in 1888. Attended Utah State College before joining the staff of the *San Francisco Call*. He later worked at the *Chicago Tribune* while attending the Art Institute of Chicago. His career as an illustrator of Western scenes began in NY with *Bluebook*, for which he was a frequent contributor. His illustrations also appeared in *Collier's* and *Cosmopolitan*. A member of several professional organizations and president of the Artists Guild, he was awarded the Isidor Medal from the Salmagundi Club. Died in 1948.

STORER, MARIA LONGWORTH.
Sculptor and potter. Born in Cincinnati, OH. Studied: Cincinnati Art School, which her father, Joseph Longworth, endowed. Awarded a gold medal at the Paris Exposition, 1900. She was appointed United States Minister to Belgium in 1897, and later, Ambassador to Austria. In 1880, after working four years at the Dallas White Ware Pottery, she opened the Rookwood Pottery.

STOREY, ROSS BARRON.
Illustrator. Born in Dallas, TX, in 1940. Studied at the Famous Artists School, the Society of Visual Arts, under Robert Weaver, and the Art Center College of Design in Los Angeles where he is presently chairman of the illustration department. His career began in 1959 in Dallas and his artwork soon began appearing in the *Sunday Magazine* of *The New York Journal American*. He has since illustrated for many magazines, including *Esquire, Life, This Week*, and recently, *Time*. He has won awards from the Society of Illustrators, along with others.

STORM, ANNA ALFRIDA.
Painter, craftsman, and teacher. Born in Sweden, July 2, 1986. Pupil of Down. Member: Chicago No-Jury Society of Artists. Award: First prize, Seattle Fine Arts Society, 1923. Address in 1929, Northwestern University, 1888 Sheridan Road, Evanston, IL; summer, State Teachers College, Greeley, CO.

STORM, G. F.
Engraver. Born in England and came to Philadelphia about 1834. Storm was an admirable engraver of portraits in stipple; he was also a good etcher. Though his stay in the U.S. is said to have been a short one, he engraved a considerable number of American portraits.

STORRS, FRANCES HUDSON.
(Mrs. William M. Storrs). Painter. Born in NY. Pupil of Chase; Hawthorne; and Hale. Member: Connecticut Academy of Fine Arts; North Shore Arts Association; Springfield Art Association. Work: "Summer Flowers," Morgan Memorial, Hartford. Address in 1933, 1034 Prospect Ave., Hartford, CT; summer, Hawthorne Inn, East Gloucester, MA.

STORRS, JOHN.
Sculptor and etcher. Born in Chicago, IL, June 29, 1885. Pupil of Grafly; Bartlett; Rodin. Member: Societe Anonyme; Chicago Art Club; Cliff Dwellers. Awards: Second Logan medal and $1,500, Art Institute of Chicago, 1929; third Logan prize ($750), Art Institute of Chicago, 1931. Represented by eleven panels, Hall of Science, Century of Progress Exposition, Chicago. Address in 1934, Chicago, IL. Died in 1956.

STORY, GEORGE HENRY.
Painter. Born Jan. 22, 1835, in New Haven, CT. Studied in NY and Paris. In 1875 he was elected an Associate of the National Academy of Design, and in 1876 he received a medal at the Centennial Expo., Philadelphia. He painted several portraits of Lincoln, and is represented at the Metropolitan Museum by "Self Portrait," and "The Young Mother." He died Nov. 24, 1923, in NYC.

STORY, JULIAN RUSSELL.
Portrait painter. Born in 1857, in Walton-on-Thames, England. He was the son of William Wetmore Story (poet and sculptor). Pupil of Frank Duveneck, Boulanger and Lefebvre, Paris. Awards: Third class medal and honorable mention, Paris Salon, 1889; gold medal, Berlin, 1891; silver medal, Paris Exposition, 1900; made Chevalier of Legion d'Honneur, France, 1900. Elected an Associate of the National Academy in 1906. He died Feb. 23, 1919, in Philadelphia, PA.

STORY, THOMAS C.
This general engraver of portraits and historical plates was in business in NY during the period 1837-44. The firm of Story and Atwood was engraving in the same city in 1843.

STORY, THOMAS WALDO.
Sculptor. Son of William Wetmore Story. Born in Rome, Italy, in 1855. He was a pupil of his father. His work includes a statue of Sir William Vernon Harcourt, in the House of Commons, London; the bronze door of the Morgan Library, NYC; and a drinking fountain given by General Draper to the town of Hopedale, MA. His studio was in Rome. He died in NYC, October 23, 1915.

STORY, WILLIAM WETMORE.
Sculptor. Born February 12, 1819, in Salem, MA. Graduated from Harvard College in 1838, law degree, 1840; he adopted art as a profession and about 1848 went to Italy for study in order to prepare himself for the execution of a memorial to his father, U.S. Supreme Court Justice Joseph Story. Returned to America to practice law; from 1856 he lived in Italy, sculpting full time. His statues of Josiah Quincy, Edward Everett, and Colonel Shaw are well known. He died October 7, 1895, in Vallombrosa, Italy.

STOUFFER, J. EDGAR.
Sculptor. Member: Charcoal Club. Award: Rinehart Scholarship to Paris, 1907-1911. Address in 1933, Baltimore, MD.

STOUT, GEORGE H.
Engraver. Born in 1807 in NYC. The NY directories for 1830-50, inclusive, contain this name as an "engraver of cards, seals and door plates." Died Jan. 26, 1852.

STOUT, IDA McCLELLAND.
Sculptor. Born in Decatur, IL. Pupil of Albin Polasek. Work: "Goose Girl Fountain," Mary W. French School, Decatur, IL; "Princess Badoura," Hillyer Gallery, Smith College; others. Member of Chicago Artists Guild; Alumni Art Institute of Chicago; Chicago Galleries Association; MacDowell Club. Address in 1926, Chicago, IL. Died in Rome, Italy, September 2, 1927.

STOUT, JAMES DEFORREST.
Engraver. Born July 22, 1783, in NYC. This man was a map engraver about 1813, apparently living in New York. Died July 8, 1868 in NYC.

STOUT, JAMES VARICK.
Engraver. Born in 1809, in NYC. In business in NY from 1834-38 as a general engraver and die sinker. He also engraved some good landscape plates. Son of James D. Stout. Died April 26, 1860, in NYC.

STOVER, ALLAN JAMES.
Painter and illustrator. Born in West Point, MI, Oct. 9, 1887. Pupil of Cleveland School of Art. Work: Decoration of Masonic Temple, Corvallis, OR. Illustrated *Oregon's Commercial Forests.* Address in 1933, 2626 Arnold Way, Corvallis, OR.

STOVER, NANCY.
Painter. Born on November 21, 1921. Studied at Vassar College, B.A., 1943; Columbia Graduate School, 1945-47; painting with Alton Pickens and Rosemary Beck at Vassar College, 1955-57. One-woman exhibitions: Three Arts, 1958, Barrett House, Dutchess Co. Art Association, 1979, Bardavon Theatre Gallery, 1980, Vassar College Center, 1980, all in Poughkeepsie, NY; Institute for the New Age, NYC, 1982; Institute on Man and Science, Rensselaerville, NY, 1982. Group exhibitions: NYC Center Art Gallery, 1960; Mid-Hudson Arts and Science Center, Poughkeepsie, NY, 1982; Phoenix Gallery, NYC, 1982; Vassar College Center, Poughkeepsie, NY, 1983. Awarded first prize, NYC Center Art Gallery, 1960. Address in 1984, 150 College Ave., Poughkeepsie, NY.

STOVER, WALLACE.
Painter and illustrator. Born in Elkhart, IN, Jan. 5, 1903. Pupil of William Forsyth; Clifton Wheeler; Paul Hadley; Myra Richards. Member: Indiana Art Club; Herron Art School Alumni; Hoosier Salon. Award: First prize, Herron Art Institute, IN, 1925, and third prize, 1927. Specialty: Portraits and illustrations. Address in 1933, 1018 South Second St., Elkhart, IN.

STOWELL, M. LOUISE.
Painter, illustrator, craftsman, and teacher. Born in Rochester, NY. Pupil of Art Students League of NY and Arthur W. Dow. Member: Rochester Society of Arts and Crafts; NY Water Color Club. Specialty: Water colors. Address in 1929, 714 Ins. Bldg., Main St.; h. 29 Atkinson St., Rochester, NY.

STRAHAN, ALFRED W(INFIELD).
Painter and illustrator. Born in Baltimore, MD, June 24, 1886. Pupil of S. Edwin Whiteman and Harper Pennington. Member: Charcoal Club. Address in 1933, 214 Chamber of Commerce Bldg., Baltimore, MD; h. St. James Road, Woodlawn, MD.

STRAIN, D. J.
Painter. Born in New Hampshire, he entered Julien's studio in Paris in 1877. In 1883 he opened his studio in Boston. He painted a number of portraits, that of General N. P. Banks perhaps his greatest achievement. Address in 1926, 278 Boyleston Street, Boston, MA.

STRAIN, FRANCES.
Painter. Born in Chicago, IL, Nov. 11, 1898. Pupil of Art Institute of Chicago. Member: Society of Independent Artists; Chicago Society of Artists; The Ten; Chicago No-Jury Artists; Salons of America. Address in 1933, 5644 Harper Ave.; h. 5200 Dorchester Ave., Chicago, IL.

STRASBURGER, CHRISTOPHER.
Sculptor. Worked in Troy, New York, 1859.

STRATER, HENRY.
Painter. Born in Louisville, KY, Jan. 21, 1896. Pupil of Penna. Academy of Fine Arts; Art Students League of NY; Charles Grafly; Hamilton Easter Field; Vuillard; Maurice Dennis; also studied in Madrid, Paris and Florence. Member: Salons of America; Louisville Art Association; Southern States Art League. Address in 1933, Ogunquit, ME.

STRAUS, MITTELDORFER.
Painter and illustrator. Born in Richmond, VA, Jan. 21, 1880. Pupil of Art Students League of Washington; studied in Europe and Africa. Member: American Art Association of Paris; NY Water Color Club; Society of Independent Artists; Art Alliance of America; Society of Illustrators. Award: Scholarship, Art Students League of Washington, to Pratt Institute. Address in 1933, 245 Fifth Ave., New York, NY; 2025 Monument Ave., Richmond, VA.

STRAWBRIDGE, ANNE W(EST).
Painter. Born in Philadelphia, PA, March 20, 1883. Pupil of W. M. Chase. Member: Fellowship Penna. Academy of Fine Arts; Plastic Club; Philadelphia Alliance; Society of Independent Artists; American Federation of Arts. Address in 1933, 6711 Wissahickon Ave., Mt. Airy, Philadelphia, PA; summer, care Messrs. Brown, Shipley and Co., 123 Pall Mall, London, England.

STREAN, MARIA JUDSON.
Painter. Born in Washington, PA. Pupil of Art Students League of NY under Cox and J. Alden Weir; under Prinet and Dauchez in Paris. Member: New York Water Color Club; American Society of Miniature Painters; Allied Artists of America; National Association of Women Painters and Sculptors. Awarded honorable mention, Panama-American Expo., Buffalo, 1901. Address in 1926, 140 West 57th Street, New York, NY.

STREATFIELD, JOSEPHINE.
Portrait painter. Born in London, England, May 31, 1882. Pupil of Slade School in London, under Fred Brown. Member: Philadelphia PC; Society of Women Artists, London; Art Alliance of America. Specialty: Pastel and oil portraits, copies of old oil paintings. Address in 1933, 135 West 81st St., New York, NY.

STREATOR, HAROLD A.
Painter. Born in Cleveland, OH. Pupil of Art Students League of NY; Boston Museum School. Member: Salmagundi Club, 1906. Address in 1926, Box 345, Morristown, NJ.

STRECKER, HERMAN.
Sculptor, naturalist, and author. Born March 24, 1836, in Philadelphia, PA. Died November 30, 1901, in Reading, PA.

STREET, FRANK.
Illustrator. Born in Kansas City, MO, in 1893. Attended the Art Students League; also studied with Charles Chapman, Harvey Dunn in Leonia, NJ. Editorial illustrations in *Saturday Evening Post, Ladies' Home Journal, Cosmopolitan*. Active portrait and landscape artist. Member: Society of Illustrators; Salma. Club. Died in 1944. Address in 1933, 505 Grand St., Leonia, NJ.

STREET, ROBERT.
Painter of portraits and historical subjects, who was for many years a resident of Philadelphia. He was born Jan. 17, 1796 in Germantown, PA, and exhibited in the Penna. Academy of Fine Arts during the period between 1815-1817. In 1824 his portraits were shown in Washington, DC, where he painted several well-known men. In 1835 Dunlap records the death of Street, and the artist had the most unique experience of calling the author's attention to such a grave error. Dunlap corrects his error with many apologies in the February 28, 1835 issue of the *NY Mirror*. In 1840, Robert Street held 200 oil paintings of historical subjects, landscapes and portraits. Catalogues of this exhibition are accessible, but unfortunately they give little valuable information regarding the portraits, as they are frequently recorded as merely "A Portrait of a Lady" or "A Portrait of a Gentleman." This exhibition opened on Nov. 18, 1840, in Philadelphia.

STREETER, JULIA ALLEN.
(Mrs. George L. Streeter). Painter. Born in Detroit, MI, June 19, 1877. Pupil of Detroit Art School under Joseph Gies and F. P. Paulus. Member: Baltimore Water Color Club; Arundell Club; American Federation of Arts. Award: Hon. mention, Baltimore Charcoal Club, 1924. Address in 1933, 2022 Eutaw Place, Baltimore, MD; summer, Green Lake P.O., Fulton Co., NY.

STREETER, TAL.
Sculptor. Born in Oklahoma City, OK, Aug. 1, 1934. Studied at University of Kansas, B.F.A., M.F.A.; Colorado Springs Fine Arts Center, with Robert Motherwell; Colorado College; and with Seymour Lipton. In collections of Museum of Modern Art; San Francisco Museum of Art; Wadsworth Atheneum; Smithsonian; Storm King Art Center, Mountainville, NY; others. Commissions in Little Rock, AR; Atlanta, GA; NYC; Trenton, NJ. Exhibited at Aldrich Museum, Ridgefield, CT; Storm King Art Center, Mountainville, NY; American Cultural Center, Seoul, Korea; Contemporary Arts Museum, Houston; Corcoran (drawings); MIT; many others. Well-known for his work with kites. Has taught at numerous institutions, including SUNY Purchase, from 1973. Address in 1982, Millbrook, NY.

STREETT, TYLDEN WESTCOTT.
Sculptor and educator. Born in Baltimore, MD, November 28, 1922. Studied at Johns Hopkins University; St. John's College; Maryland Institute College of Art, with Sidney Waugh and Cecil Howard, B.F.A. and M.F.A.; also assistant to Lee Lawrie. Work: Architectural sculpture, West Point, NY; architectural sculpture, National Cathedral, Washington, DC; 8 ft. bronze portrait statue, O'Donnell Square, Baltimore; others. Has exhibited at Corcoran Gallery of Art; Baltimore Museum of Art; others. Received Ford Foundation Grant, 1980; others. Member: National Sculpture Society; Artists Equity Association. Teaching sculpture at Maryland Institute College of Art, Baltimore, from 1959. Address in 1982, Baltimore, MD.

STRICKLAND, WILLIAM.
Painter and engraver. Born in Philadelphia, PA, in 1787 (Navesink, NJ, in 1788 according to some sources). Strickland studied architecture under Benjamin H. Latrobe, but in 1809 he took up portrait painting, designing for engravers and engraving in aquatint. In this manner he produced a few portraits and a number of views illustrating events in the War of 1812. About 1820 Strickland resumed practice as an architect and among the buildings designed by him in Philadelphia were the Masonic Hall, United States Mint, Bank of the U.S., the new Chestnut Street, the Arch Street theatres and the Merchants' Exchange. Died April 6, 1854, in Nashville, TN.

STRINGFIELD, VIVIAN F.
Painter, illustrator, craftsman, and teacher. Born in California. Pupil of Mark Hopkins Institute; Pratt Institute; Douglas Donaldson; Ralph H. Johonnot. Member: Southern California Art Teachers Association; Boston Society of Arts and Crafts; Chicago Artists Guild. Award: Bronze medal, Panama-California Expo., San Diego, 1915. Address in 1929, 229 South Normandie Ave., Los Angeles, CA.

STROHL, CLIFFORD.
Painter. Born in South Bethlehem, PA, in 1893. Pupil of Jules Dieudonne and of Orlando G. Wales; also studied at the Penna. Academy of Fine Arts. Member of Salmagundi Club. Address in 1926, 416 Avenue E, Bethlehem, PA.

STRONG, CONSTANCE GILL.
Painter and teacher. Born in New York City, May 13, 1900. Pupil of Pratt Institute; University of Pennsylvania. Member: Palette and Pencil Club. Awards: First and second prizes for water color, Lake County Fair, Crown Point, IN, 1926, 27, 28. Address in 1929, 768 Vermont St., Gary, IN.

STROTHER, COL. DAVID HUNTER.
Portrait painter. Born Sept. 26, 1816, in Martinsburg, VA. Studied in Europe. In 1844, he returned to U.S. as an illustrator, especially for *Harper's Magazine*. Died March 8, 1888 in Charleston, WV.

STROTHMANN, FRED.
Painter and illustrator. Born in New York, Sept. 23, 1879. Pupil of Carl Hecker; studied in Berlin and Paris. Member: Society of Illustrators. Illustrated books by Mark Twain, Carolyn Wells, Brubacker, Ellis P. Butler, Lucille Gulliver. Died in 1958. Address in 1929, 562 West 190th St., New York, NY; summer, Long Beach, LI, NY.

STROUD, CLARA.
Painter, draftsman, and teacher. Born in New Orleans, LA, Nov. 4, 1890. Pupil of Cimiotti; Mary Lantry; Otto W. Beck; Ethel F. Shaurman; Ethel Traphagen; Jay Hambridge; Ralph Johonnot. Member: National Association of Women Painters and Sculptors. Contributor to *Design* and *Every Day Art*. Address in 1933, Pt. Pleasant, NJ.

STROUD, IDA WELLS (MRS.).
Painter and draftsman. Born in New Orleans, LA, Oct. 19, 1869. Pupil of Pratt Institute; Art Students League of NY. Member: National Association of Women Painters and Sculptors; NY Water Color Club. Instructor: Painting, drawing, and design at Newark School of Fine and Industrial Art, Newark, NJ. Address in 1933, 85 North 7th St., Newark, NJ.

STRUBING, LOUISA HAYES.
Painter, sculptor and craftsman. Born in Buffalo, NY, January 15, 1881. Pupil of Buffalo Albright Art School; Robert Reid. Member: Buffalo Society of Artists; Buffalo Guild of Allied Artists. Address in 1933, Eggertsville, NY.

STRUNK, HERBERT.
Sculptor. Born in Shakopee, MN, April 9, 1891. Pupil of St. Paul Institute School of Art. Member: St. Paul Art Society. Awards: Silver medal, St. Paul Institute, 1915; first prize, Nassau County Art League, 1932. Work: "Chief Shakopee," model in St. Paul Institute Gallery. Address in 1933, Lava, NY. Died in 1950.

STRUVEN, GERTRUDE STANWOOD (MRS.).
Painter and etcher. Born in West Newbury, MA, March 2, 1874. Pupil of Joseph DeCamp; Charles Lasar in Paris. Member: North Shore Arts Association; Gloucester Society of Artists. Address in 1929, Wilmette, IL.

STRYCKER, JACOBUS GERRITSEN.
Artist. Born in 1619. Farmer, trader, magistrate, and "limner." Was born at Ruinen, province of Drenthe, in the Netherlands. His wife was Ytie Huybrechts, possibly related to the lady of the same surname, whose daughter at about the same time married Titus van Rijn, the son of a greater "limner," Rembrandt. Strycker came to New Netherland in 1651, a gentleman of considerable means and decided culture, and after a successful career died in 1687. We knew something of his office holding; he was Burgher in 1653 and afterwards Alderman of New Amsterdam, also Attorney General Sheriff of the Dutch towns on Long Island up to August, 1673. Very little of his work as an artist is known. Three of his portraits have been identified. He left a son, Gerrit, who became Sheriff of King's County in 1688, and a brother, Jan, who also left descendants.

STUART, F. T.
This good engraver of portraits was working in 1850, and at a much later date he was located in Boston, MA.

STUART, GILBERT (CHARLES).
Portrait painter. Born in North Kingston or Narragansett, RI, Dec. 3, 1755. Considered the greatest American portrait painter, and among the great artists of the world. Stuart was educated in Newport and early showed great promise when he painted portraits of the prominent men of Newport. In 1770 Stuart received instruction from Cosmo Alexander, a Scotch gentleman then residing in Newport. Sailed to England in 1775. Painted in the studio of Benjamin West in London for several years. Opened own studio in London in 1788 and became one of the most sought after portrait painters in England. There he painted portraits of artists Benjamin West, Sir Joshua Reynolds, Gainsborough, Copley, W. Grant skating in St. James Park (considered one of his finest works); also portraits of John Philip Kemble, the actor; the Duke

of Northumberland; and Admiral Sir John Jarvis. In 1790 he went to Ireland, where he painted important personages, including the Duke of Leinster, Lord Fitzgibbon, and Hon. John Beresford. Stuart was hopelessly in debt during his stay in Ireland and sailed to NY in 1792, remaining there for some time painting portraits. He moved to Philadelphia in 1794 to paint portraits of George Washington. There are 124 portraits of Washington listed as painted by Stuart. He remained in Philadelphia until 1803, when he moved to Washington to paint a portrait of President Jefferson and other prominent men of his time. In 1805 he moved to Boston. Elected a member of the American Academy in 1795 and an honorary member of the National Academy of Design in 1827. A memorial exhibition of his portraits was held in Boston in 1880 and his portraits are in collections of many prominent galleries; the Penna. Academy of Fine Arts owns probably the finest collection of his works. Painted over 1,000 portraits. Died in Boston, July 9th, 1828. Biographies include *Mason's Life and Works of Stuart* (a catalogue of portraits), and a list of 200 portraits by Stuart not noted in Mason's list, published in the *Pennsylvania Magazine* of the Historical Society, by Mantle Fielding.

STUART, JAMES E(VERETT).
Painter. Born near Dover, ME, March 24, 1852. Pupil of Virgil Williams and R. D. Yelland in San Francisco School of Design. Member: San Francisco Art Association; American Artists Professional League. Work: "Sunset Glow, Mt. Takoma" and "Sacramento River," Kalamazoo (MI) Art Association; "Showers Among the Trees, New Jersey" and "Sunset Glow, Mt. Jefferson," Omaha Public Library; "Sunset, Sacramento River," Reno Arts and Crafts Club; "Showers, Napa Valley," Oakdale Public Library; "Morning, Mt. Hood," "Mt. Tallac, Lake Tahoe," Los Angeles Museum of History, Science and Art. Originator of a new method of painting on aluminum and wood. Died in 1941. Address in 1933, 684 Commercial St., San Francisco, CA.

STUART, JANE.
Painter. Daughter of Gilbert Stuart. Born about 1812, in Boston, MA. She followed her father's profession for many years. She was a skillful copyist and reproduced many of her father's paintings, especially his portraits of Washington. She died in Newport, RI, April 27, 1888. She published several articles in *Scribner's Monthly Magazine* of 1877 about her father and his work.

STUART, MICHELLE.
Painter and sculptor. Born in Los Angeles, CA, February 10, 1919. Studied at Chouinard Art Institute, Los Angeles; New School for Social Research; apprenticed to Diego Rivera, Mexico. Has exhibited

at Museum of Modern Art; Drawings of the Seventies, Art Institute of Chicago; Albright-Knox Art Gallery, Buffalo; Hirshhorn Museum and Sculpture Garden, Washington, DC; Walker Art Center; others. Received Guggenheim Memorial Foundation Fellowship, 1975; National Endowment for the Arts Fellowship for Individual Artists, 1974, 77 and 80; MacDowell Fellowship, 1974; others. In collections of Aldrich Museum, Ridgefield, CT; Allen Memorial Art Museum, Oberlin College; Power Institute Museum, Sydney, Australia; others. Address in 1984, 152 Wooster St., NYC.

STUBBS, LU.
Sculptor. Born in NYC in 1925. Studied: Boston Museum of Fine Arts; Academia di Belle Arti, Perugia, Italy. Awards: Providence Art Club, 1972; Art Association of Newport, RI, 1972. Exhibitions: Milton Academy, Milton, MA, 1968; Thayer Academy, Braintree, MA, 1972; The American Woman, Jordan Marsh, 1975. Collections: Boston Center for Adult Education; Community Systems by Perini, Boston.

STUBBS, MARY H(ELEN).
Painter, illustrator, craftsman, and teacher. Born in Greenville, OH, Oct. 31, 1867. Pupil of Cincinnati Art Academy; Academie Julien in Paris. Member: Cincinnati Woman's Art Club; Cincinnati Ceramic Club. Award: Hon. mention, Columbian Expo., Chicago, 1893. Address in 1929, 4429 Ellis Ave., Chicago, IL.

STUBER, DEDRICK B(RANDES).
Painter. Born in NY, May 4, 1878. Pupil of Bridgman; Julian Onderdonk; Clinton Peters; Art Students League of N.Y. Member: Los Angeles Painters and Sculptors; Laguna Beach Art Association; Glendale Art Association. Address in 1933, Kelton Ave., Westwood, Los Angeles, CA.

STUEVER, CELIA M.
Etcher and painter. Born in St. Louis, MO. Pupil of St. Louis School of Fine Arts; Academie Julien in Paris, under Bouguereau and Ferrier; also studied in Vienna and Munich. Member: Chicago Society of Etchers; California Society of Etchers; NY Society of Etchers; California Printmakers. Work: City Art Museum, St. Louis; Library of Congress, Washington, DC; New York Public Library. Address in 1929, 3444 Russell Ave., St. Louis, MO.

STURDEVANT, S.
A practically unknown American engraver, only one example of his work being catalogued. It was published in Lexington, KY, in 1822. The portrait is very crude and occurs in a privately printed volume of sermons. It is the earliest known signed portrait engraved west of the Allegheny Mountains.

STURGEON, RUTH B.
Painter and etcher. Born in Sterling, KS, in 1883. Address in 1926, 115 Pearl St., Council Bluffs, IA.

STURGES, DWIGHT CASE.
Painter and etcher. Born in Boston, MA, in 1874. Pupil of Cowles Art School in Boston. Member: Chicago Society of Etchers; Canadian Society of Etchers; Brooklyn Society of Etchers; Concord Art Association; American Federation of Arts. Awards: Lamont prize, Chicago Society of Etchers, 1915; silver medal for etching, P.-P. Expo., San Francisco, 1915; Logan medal, Art Institute of Chicago, 1924; member's prize, Chicago Society of Etchers, 1926; Huntington prize, California Print Maker's Society, 1927. Work: Boston Museum of Fine Arts; Chicago Art Institute; Oakland (CA) Museum; Library of Congress, Washington, DC; NY Public Library; Toledo Museum of Art. Died in 1940. Address in 1933, Melrose, MA.

STURGES, KATHARINE.
Painter and illustrator. Member: Artists Guild of the Authors' League of America. Work: Illustrated *Little Pictures of Japan*, edited by O. K. Miller (Bookhouse for Children). Address in 1933, Main St., Roslyn, LI, NY.

STURGES, LEE.
Etcher. Born in Chicago, IL, Aug. 13, 1865. Pupil of Art Institute of Chicago; Penna. Academy of Fine Arts; Chicago Society of Etchers; California Print Maker's Society; Brooklyn Society of Etchers; American Federation of Arts; Print Society of England. Award: Logan medal, Art Institute of Chicago, 1923. Address in 1929, 280 Cottage Hill Ave., Elmhurst, IL.

STURGES, LILLIAN.
Painter, illustrator, writer, and teacher. Born in Wilkes-Barre, PA. Member: Pittsburgh Art Association. Author and illustrator of *The Runaway Toys*, and several other books for children; illustrated new editions of *Fairy Tales; Little Black Sambo; Aladdin; Eugene Field's Poems*; first child's picture book in the Arabic; *Bible ABC Book for Little Ones*. Address in 1933, 2956 Belrose Ave., Pittsburgh, PA.

STURGIS, MABEL R(USSELL).
Painter and craftsman. Born in Boston, MA, July 17, 1865. Pupil of Boston Museum of Fine Arts School; Woodbury. Member: Copley Society; American Federation of Arts; North Shore Arts Association. Address in 1933, 63 Beacon St., Boston, MA; summer, Manchester, MA.

STURM, JUSTIN.
Sculptor and writer. Born in Nehawka, NE, April 21, 1899. Studied at Yale University, A.B. Work: Many portrait busts of prominent people. Author:

The Bad Samaritan, 1926. Contributor to: *Harper's, Collier's, Pictorial Review, Redbook* magazines. Address in 1953, Redding, CT; h. Westport, CT.

STURTEVANT, EDITH LOUISE.
Painter and teacher. Born in Utica, NY, Dec. 23, 1888. Pupil of Penna. Academy of Fine Arts under McCarter, Breckenridge, Garber, and Pearson. Member: Plastic Club; Penna. Academy of Fine Arts. Address in 1933, 107 McCartney St., Easton, PA.

STURTEVANT, HELENA.
Painter and teacher. Born in Middletown, RI, Aug. 9, 1872. Pupil of Boston Museum School under Tarbell; Colarossi Academy in Paris under Blanche and Lucien Simon. Member: International Society of Arts and Letters; National Association of Women Painters and Sculptors; Newport Art Association; American Federation of Arts; others. Director, School of Art Association, Newport, RI. Died in 1946. Address in 1933, Second Beach Road, Newport, RI.

STURTEVANT, LOUISA C(LARK).
Painter and designer. Born in Paris, France, Feb. 2, 1870. Pupil of Boston Museum School under Tarbell; Collin and Simon in Paris. Member: Newport Art Association; American Federation of Arts. Award: Silver medal, P.-P. Expo., San Francisco, 1915. Address in 1933, Second Beach Road, Newport, RI.

STUSSY, JAN.
Painter and educator. Born Aug. 13, 1921, in Benton County, MO. Earned B.A. from UCLA, 1944; M.F.A., University of Southern California, 1953; also studied with Stanton MacDonald-Wright. Teaching at UCLA since 1946. Received awards from Los Angeles County Museum; San Francisco Art Association; Critics Award, Best One-Man Show, Santiago, Chile, 1968; University of California, Los Angeles Fine Arts Council Award, 1970; others. Exhibited at Ohio State; University of Nebraska; UCLA; Phoenix Art Museum; Krannert Art Museum, IL; Fresno Arts Center; Santa Barbara Museum; Mulvane Art Center, Topeka, KS; Penna. Academy of Fine Arts; Library of Congress; Museum of Modern Art; Stanford University; and others. Work: San Francisco Museum of Art; Museum of Modern Art; Santa Barbara Museum of Art; Los Angeles Museum of Art; and in private collections. Media: Oil, acrylic. Address in 1984, Los Angeles, CA.

STYLES, GEORGE C(HARLES).
Etcher, artist, and craftsman. Born in York, England, June 14, 1892. Pupil of Richard Windass, York School of Art. Awards: Kings prize in architecture, 1911; National scholarship in architecture, 1912; Assoc. Royal College of Art, 1914. Address in 1929, 75 Stratfield Road, Bridgeport, CT.

STYLES, GEORGE W(ILLIAM).
Painter and block printer. Born in Sutton, England, Nov. 11, 1887. Pupil of George Elmer Browne; School of Arts and Crafts in London. Member: Scarab Club; American Federation of Arts. Award: Walter C. Piper prize ($500), Detroit, 1927. Work: "Low Tide," Dearborn Public Library, Dearborn, MI; "Quiet," High School, Fordson, MI; "Cornish Coast," Scarab Club, Detroit, MI; "The Little Harbor," "Detroit Skyline," Southeastern High School, Detroit, MI. Designed and executed medal awarded to Mrs. Evangeline Lindbergh by the Detroit Board of Education. Died in 1949. Address in 1933, 37 Marston Ave., Detroit, MI.

SUARES, JEAN CLAUDE.
Illustrator. Born in Alexandria, Egypt, in 1942. Attended Sarola Suizzera di Genova and Pratt Institute. His first published work appeared in *The Realist* in 1965, and the NY Art Directors' Club awarded him a Special Gold Medal in 1971. A specialist in pen-and-ink editorial art, he has written several books on illustration and his works have been shown in the Musee des Beaux Arts in Bordeaux as well as the Musee des Arts Decoratifs in the Louvre.

SUGARMAN, GEORGE.
Sculptor and painter. Born in NYC, May 11, 1912. Studied: Atelier Zadkine, Paris, 1951; City College of New York, B.A. Works: Basel, Switzerland; Geigy Chemical Corporation; Kalamazoo Institute; MIT; Museum of Modern Art; Museum Schloss Marberg; NYU; City Art Museum, St. Louis; Walker; Art Institute of Chicago. Exhibitions: Stephen Radich Gallery, NYC, Philadelphia Art Alliance, and Kunsthalle, Basel, 1969 (all one-man); American Federation of Arts, Sculpture in Wood, circ. 1941-42; Salon de la Jeune Sculpture, Paris; Salon des Realites Nouvelles, Paris; Silvermine Guild; Claude Bernard, Paris; Carnegie; Seattle World's Fair, 1962; Wadsworth Atheneum; Art Institute of Chicago; VII Sao Paulo Biennial, 1963; Walker; Jewish Museum; New York World's Fair, 1964-65; NYU; Flint Institute; Whitney; Los Angeles County Museum of Art, American Sculpture of the Sixties; Foundation Maeght, l'Art Vivant, circ. French museums, 1968; XXXIV Venice Biennial, 1968; Museum of Modern Art; Stedelijk; retrospective, Joslyn Art Museum, 1981; others. Awards: Longview Foundation Grants, 1961-63; Carnegie, second prize, 1961; Ford Foundation, 1965; National Council on the Arts, award, 1966. Taught: Hunter College, 1960-70; Graduate School of Art and Architecture, Yale University, 1967-68. Works in metal and acrylic. Address in 1982, 21 Bond St., NYC.

SUGDEN, THOMAS D.
Wood engraver. Pupil of T. W. Strong. He was connected for years with the engraving department of the Century Company. He wrote a volume on wood engraving, *Remarks on Wood Engraving by One-o'-them*, 1904.

SUHR, FREDERIC J.
Illustrator. Born in Brooklyn, NY, Feb. 15, 1885. Studied: Art Students League of NY; Pratt Institute; pupil of Bridgman, Fogarty, and Dufner. Member: Salma Club; Society of Illustrators; Art Directors' Club. Died in 1941. Address in 1933, 320 Fifth Ave., New York, NY.

SULLIVAN, ARTHUR B.
Painter. Member: Salma. Club; Society of Illustrators. Address in 1929, care of the Hill-Winsten Co., 25 West 44th St., New York, NY.

SULLIVAN, D. FRANK.
Painter, etcher, and teacher. Born Oct. 17, 1892. Pupil of Vesper George; E. L. Major; Richard Andrew. Member: Pittsburgh Art Association; American Federation of Arts. Work: "Olde King Cole," City of Brownsville, PA; "The Keeper of the Garden," public schools of Pittsburgh. Address in 1929, College of Fine Arts, Carnegie Institute of Technology; h. 5546 Pocusset St., Pittsburgh, PA; summer, 622 Columbia Road, Dorchester, MA.

SULLIVAN, FRANCES.
Portrait painter. Born in 1861; died in 1925 in NYC. Among his portraits are T. C. DuPont, J. B. McLean and F. W. Woolworth.

SULLIVAN, JAMES AMORY.
Painter. Born in Boston, MA, in 1875. Pupil of Laurens and of Alexander Harrison. Address in 1926, 98 Chestnut Street, Boston, MA.

SULLIVAN, LOUIS H.
Sculptor, architect, and writer. Born in Boston, MA, 1856. Studied at Massachusetts Institute of Technology and Ecole des Beaux-Arts in Paris for architecture. Wrote numerous articles on architecture, as well as his autobiography, *The Autobiography of an Idea*. Noted for the rediscovery of the aesthetic principle "form follows function," previously espoused by Horatio Greenough. One of Sullivan's most famous students was Frank Lloyd Wright. In collections of Metropolitan Museum of Art; Art Institute of Chicago; bronze door, Getty Tomb, Graceland Cemetery in Chicago. Died in Chicago, IL, 1924.

SULLIVAN, LOUISE KARRER.
(Mrs. William Sullivan). Painter. Born in Port Huron, MI, March 15, 1876. Pupil of Phillip L. Hale; Boston Museum of Fine Arts School. Member: Rockport Art Association; Copley Society; American Federation of Arts. Address in 1933, 2 Arlington Street, Boston, MA.

SULLIVAN, PAT.
Cartoonist. Born in Sydney, Australia, Feb. 2, 1887. Pupil of Pasquin in Sydney. Originator of "Felix the Cat." Address in 1929, 46 West 63rd St.; h. Hotel Alamac, New York, NY.

SULLIVANT, THOMAS S.
Illustrator. Born in Columbus, OH, in 1854. Pupil of Penna. Academy of Fine Arts. Address in 1926, 1911 Pine Street, Philadelphia, PA.

SULLY, ALFRED.
Painter. Born May 22, 1820, in Philadelphia, PA. Son of Thomas Sully. Graduated from West Point in 1841. He painted in water colors, and his views of the western forts where he was stationed are of artistic and historic interest. He died April 27, 1879.

SULLY, JANE COOPER.
(Jane Sully Darley). Born in 1807. She was the daughter of Thomas Sully, and married W. H. W. Darley. She painted a number of portraits before and after her marriage. In the register of paintings noted by her father, he mentions "finishing several paintings begun by Jane." She died in 1877.

SULLY, KATE.
Painter. Member: Rochester Art Club. Address in 1929, 393 Westminster Road, Rochester, NY.

SULLY, LAWRENCE.
Miniature painter. Born Dec. 28, 1769, in Kilkenny, Ireland. He was the eldest brother of Thomas Sully and came to this country with his father in 1792, settling in Charleston, SC. He later moved to Virginia where he painted first in Norfolk and then in Richmond. He died there in 1804. His brother, Thomas Sully, married his widow.

SULLY, ROBERT MATTHEW.
Portrait painter. Born July 17, 1803, in Petersburg, VA. He was a nephew of Thomas Sully and studied with him. He visited London in 1824, painting there until 1828, when he returned to Virginia. He died in Buffalo, NY, on Oct. 16, 1855, as he was enroute to Madison, WI, to execute commissions for portraits. Represented in the Corcoran Art Gallery, Washington, DC, by his portrait of Chief Justice John Marshall.

SULLY, THOMAS.
Portrait painter. Born at Horncastle in Lincolnshire, England, on June 19, 1783. His parents were actors who came to this country in 1792, bringing their family with them and settling at Charleston, SC. In 1801 he sailed for Norfolk, VA, where he joined his elder brother Lawrence, the miniature painter. In 1801 he began his professional career as a portrait painter, and in 1806 he moved to NYC where he received instructions from the painters Trumbull and Jarvis. Early in 1808 he moved from New York to Philadelphia, where he made his permanent home, although he made frequent visits to all the principal cities for the practice of his profession, besides making two trips to England. Sully also received a certain amount of criticism and instruction from Gilbert Stuart, whose studio he visited in Boston in 1807 when that artist was at the height of his fame. In 1809 Sully visited London for study, and there he settled down with the Newport artist C. B. King in a course of drawing and painting. He was much impressed by the work of Sir Thomas Lawrence whose paintings he followed in many particulars. He returned to Philadelphia in 1810 and painted there many of his finest portraits during the next quarter of the century. In 1838 he revisited London to paint the portrait of Queen Victoria for the St. George Society of Philadelphia. The painting is still owned by the society in Philadelphia, a replica being presented by the artist to the St. Andrew Society of Charleston, SC, and another portrait of the Queen being in the Wallace collection in London. Mr. Sully was a very rapid and industrious painter, and there are over 2,000 listed portraits from his brush, besides miniatures and some 500 subject paintings. He also painted a number of historical subjects, his best-known canvas being "Washington Crossing the Delaware." He served for 15 years as a Director of the Penna. Academy of Fine Arts. His kindness and sympathy to young artists was well known and he had many pupils and assistants. He died in Philadelphia, loved and respected, on Nov. 5, 1872, in his 90th year.

SULLY, THOMAS WILCOCKS.
Portrait and miniature painter. Born in Philadelphia, PA, January 3, 1811; died there on April 18, 1847. He was the fourth child of the artist Thomas Sully and followed his father's profession. His fondness for the stage caused him to paint a series of portraits of prominent actors of his day, and these were lithographed by Newsam but unfortunately lettered "Thomas Sully." Thomas Wilcocks Sully later changed his signature to "Thomas Sully, Jr." Exhibited at the Penna. Academy and the Artists' Fund Society.

SUMICHRAST, JOEZEF.
Illustrator. Born in Hobart, IN, in 1948. Spent two years at the American Academy of Art. He has recently done a number of books, having written as well as illustrated *Onomatopoeia*. He has many posters to his credit, including those for *Graphics*, 1975 and 1977. *Communication Arts* and *Art Direction* have featured this artist and his work, examples of which are part of the permanent collections of the Library of Congress and the Chicago Historical Society.

SUMMA, E(MILY) B. (MRS.).
Painter. Born in Mannheim, Germany, Sept. 20, 1875. Pupil of St. Louis School of Fine Arts; Bissell; Dawson-Watson. Member: St. Louis Artists Guild; St. Louis Art League. Award: Frederick Oakes Sylvester prize for landscape, St. Louis Artists Guild Exhibition, 1917. Address in 1929, 5059 Raymond Ave., St. Louis, MO.

SUMMERS, DUDLEY GLOYNE.
Painter and illustrator. Born in Birmingham, England, Oct. 12, 1892. Studied at New School of Design, Boston; Art Students League, with T. Fogarty, Charles Chapman, F. R. Gruger; also with George Bridgman, D.J. Connah. Published in *MacLean's*, Canada; and most American magazines. Taught: American School of Design, NYC; VanAmburg School of Art, Plainfield, NJ. Member: Society of Illustrators; Artists Guild of the Authors' League of America. Died in 1975. Address in 1929, 191 West 10th Street, New York, NY; living in NJ at the time of his death.

SUMMERS, IVAN F.
Painter and etcher. Born in Mt. Vernon, IL. Pupil of Art Students League of NY; St. Louis School of Fine Arts. Member: Salma. Club. Award: Ives landscape prize, St. Louis Artists Guild, 1916; landscape prize, Art Students League of NY, 1916. Address in 1933, Woodstock, NY.

SUMNER, L. W. Y.
Painter. Born in Middletown, CT. Pupil of Van Dearing Perrine. Member: Pen and Brush Club; Palisade Art Association; Silvermine Guild of Artists. Address in 1933, Round Hill Road, Greenwich, CT; summer, Watch Point, Raquette Lake, NY.

SUNDBERG, WILDA REGELMAN.
Painter. Born in Erie, PA, in 1930. Studied: Albright Art School, University of Buffalo, NY. Awards: Edinboro Summer Gallery, 1969, 71; Chautauqua National, 1971. Exhibitions: Ashtabula Winter Show, OH, 1969; Springfield (MO) Art Museum, 1971, 72; William Penn Museum, PA, 1971. She is represented in the collection of the Erie Public Library.

SUNDGAARD, ERIK.
Illustrator. Born in New Haven, CT, in 1949. Attended the Paier School of Art, where he studied with Rudolf Zallinger and Ken Davies. In 1970, his first published illustration appeared in *Yankee* magazine. His work has been hung in the John Slade Ely House in New Haven and the Society of Illustrators Annual Show in 1976.

SURLS, JAMES.
Sculptor and educator. Born in Terrell, TX, 1943. Studied at Sam Houston State College, B.S., 1966; Cranbrook Academy of Art, M.F.A., 1969. Work at Solomon R. Guggenheim Museum, NY; Fort Worth Art Museum, TX; others. Has exhibited at Fort Worth Art Museum; San Francisco Museum of Modern Art; Solomon R. Guggenheim Museum, NY; Whitney Museum of American Art Biennial, NY; others. Received National Endowment for the Arts individual artist's fellowship, 1979. Works in wood. Address in 1982, Splendora, TX.

SUSAN, ROBERT.
Portrait painter. Born in 1888. Student of the Penna. Academy of Fine Arts. Member of Penna. Academy of Fine Arts Fellowship and California Art Club. Address in 1926, 1520 Chestnut Street, Philadelphia, PA.

SUTCLIFFE, RITA JEAN.
Sculptor. Studied: University of Michigan, B.A., 1968, B.F.A., 1970, M.A., 1971; also at the Ecole Nationale d'Art Decoratif, Nice, France. Exhibitions: Cheekwood Galleries, Nashville, TN, 1973; Parthenon Galleries, Nashville, TN, 1974; Harbor Gallery, Cold Spring Harbor, NY, 1978; Meridith Hunter Gallery, Tesuque and Santa Fe, NM, 1980, 81; Taos Spring Arts Celebration, Taos, NM, 1983; Stables Gallery, Taos, NM. Grants received from Yaddo, Saratoga Springs, NY, 1976, 77; Ossabaw Island Project, Ossabaw Island, GA, 1978, 80, 82; The Helene Wurlitzer Foundation, Taos, NM, 1979, 83. Works: Several large commissions in hollow concrete in Michigan, Texas, and Virginia. Taught: Volunteer State Community College, Gallatin, TN, 1972-76; numerous workshops on experimental concrete sculpture techniques in Tennessee, New York, Washington, DC, New Mexico, and elsewhere. Media: Hollow concrete, bronze, and clay. Address in 1984, Taos, NM.

SUTTON, EILEEN RAUCHER.
Painter. Born on July 28, 1942. Studied: Brooklyn (NY) Museum Art School, 1958-59; Art Students League, NYC, 1961-63; Hunter College, NYC, B.A., Art, 1963; Brooklyn College, M.S., Art, 1971. One-woman exhibitions: Women in the Arts, Selected Artists Exhibition, Broome St., NYC, 1978; Cicchinelli Gallery, NYC, 1979; Ward-Nasse Gallery, NYC, 1982; others. Group exhibitions: Azuma Gallery, NYC, 1975; Baron's Art Center, Woodbridge, NJ, 1978; Lever House, NYC, 1980; Phoenix Gallery, NYC, 1982; Middlesex Co. Museum, Piscataway, NJ, 1982; many other solo, group, and museum shows in NY, NJ, FL, and PA. Awards: Watercolor award, Somerset (NJ) Tri-State Juried Exhibition, 1978; water color award, Artists League of Central NJ, 1979. Member: Artists Equity Association; Mensa; Women's Caucus on the Arts; Women in the Arts. Address in 1983, 15 Pleasant Valley Road, Old Bridge, NJ.

SUTTON, GEORGE MIKSCH.
Painter, illustrator, writer, and lecturer. Born in Lincoln, NE, May 16, 1898. Pupil of Louis Agassiz Fuertes. Illustrated "Birds of Florida," "Birds of Minnesota," "Birds of Pennsylvania," and others. Illustrated in *Bird Lore, The Wilson Bulletin, Outdoor Life, The Auk*, etc. Professor of Zoology, University of Oklahoma, Norman, OK. Address in 1953, University of Oklahoma, Norman, OK.

SUTTON, HARRY, JR.
Painter. Born in Salem, MA, April 21, 1897. Pupil of Museum of Fine Arts School, Boston; Julian in Paris. Member: Copley Society; Boston Society of Water Color Painters; Guild of Boston Artists; American Federation of Arts. Address in 1933, 85 Newbury St., Boston, MA.

SUTTON, RUTH HAVILAND.
Painter. Born in Springfield, MA, Sept. 10, 1898. Pupil of Henry B. Snell. Member: Art Alliance of America; Connecticut Academy of Fine Arts; Springfield Art League; Springfield Artists Guild; National Association of Women Painters and Sculptors. Awards: Hon. mention, Springfield Art League, 1927; prize, Springfield Art League, 1928; hon. mention, Connecticut Academy of Fine Arts, 1929. Died in 1960. Address in 1929, 142 Thompson St., Springfield, MA.

SUYDAM, E(DWARD) H(OWARD).
Painter, illustrator, and etcher. Born in Vineland, NJ, Feb. 22, 1885. Pupil of Thornton Oakley; School of Industrial Art, Philadelphia. Member: Philadelphia Water Color Club; Philadelphia Print Club; Philadelphia Sketch Club; Philadelphia Society of Applied Arts; Philadelphia Alliance. Awards: John Wanamaker prize for illustration, 1916; John Wanamaker prize for water color, 1917. Illustrations for *Harper's Monthly, Designer*, and *Delineator*. Died in 1940. Address in 1929, 1430 South Penn Square; h. 1305 71st Ave., Oak Lane, Philadelphia, PA.

SUYDAM, JAMES AUGUSTUS.
Landscape painter. Born in New Hampshire or NYC, March 27, 1819. Studied with Durand and Kensett. He was elected an honorary member of the National School of Design in 1858, and an Academician in 1861. He was most successful with his coast views; his "View on Long Island" and "Hook Mountain on the Hudson" are well known. He died Sept 15, 1865, in North Conway, NH.

SVENDSEN, CHARLES C.
Painter. Born in Cincinnati, OH, Dec. 7, 1871. Pupil of Cincinnati Art Academy; Julian Academy, Bouguereau, Ferrier, and Colarossi Academy in Paris. Member: Cincinnati Art Club; American Artists Professional League; Scandinavian-American Artists. Award: Bronze medal, St. Louis Expo.,

1904. Represented by "Lock Vale," John H. Vanderpoel Association, Chicago; mural, St. Xavier Church, Cincinnati, OH. Exhibited: Art Institute of Chicago; City Art Museum of St. Louis; Detroit Institute of Arts; Penna. Academy of Fine Arts; in Egypt and Palestine. Specialty: Figure and pastoral scenes. Address in 1953, 555 Elberon Ave., Price Hill, Cincinnati, OH.

SVOBODA, J(OSEF) C(ESTMIR).
Illustrator. Born in Bohemia, Czechoslovakia, July 28, 1889. Pupil of Antonin Sterba; Ralph Clarkson; Hanz Larwin. Member: American Federation of Arts; Bohemian Art Club, Chicago. Awards: First hon. mention, Bohemian Art Club, 1924; first and second prizes, Arizona State Exhibition, 1926. Address in 1933, 320 East 42nd Street, New York, NY.

SWAIN, FRANCIS W(ILLIAM).
Painter and etcher. Born in Oakland, CA, March 24, 1892. Pupil of Frank Duveneck and Frank Van Sloun. Member: Cincinnati Art Club; California Society of Etchers. Work: Decoration in Westwood School, Cincinnati, OH. Died in 1937. Address in 1929, Southern Railway Bldg.; h. 1028 Underwood Place, Cincinnati, OH; summer, 2799 Clay St., San Francisco, CA.

SWAIN, WILLIAM.
Painter. Born Dec. 27, 1803, in NYC. He was elected an Associate of the National Academy of Design in 1836. He died in NYC, on Feb. 18, 1847. Self-portrait exhibited in Centennial Exhibition of National Academy, New York, 1925-26.

SWALLEY, JOHN F.
Painter and etcher. Born in Toledo, OH, Sept. 5, 1887. Pupil of Arthur W. Dow; Wilder Darling; Ernest Dean; Karl Kappes. Member: Toledo Print Club; Dayton Society of Etchers; Artklan-Toledo. Address in 1933, 2407 Glenwood Ave., Toledo, OH.

SWALLOW, WILLIAM WELDON.
Sculptor, painter, and teacher. Born in Clark's Green, PA, September 30, 1921. Studied at the Philadelphia Museum School of Industrial Art; University of Pennsylvania. Work: "As the Earth Sings - Pennsylvania Dutch Family" (terra cotta), 1942, Metropolitan Museum of Art; Syracuse Museum of Fine Arts; Scranton Museum of Art; others. Exhibited at Penna. Academy of Fine Arts, 1941-45; National Academy of Design, 1943-45; Audubon Artists, 1945; Wichita Art Association, 1946; Syracuse Museum of Fine Arts, 1940, 41; others. Received awards from National Sculpture Society; Audubon Artists; Philadelphia Museum School of Industrial Art; Syracuse Museum of Fine Arts; others. Member of Audubon Artists; Philadelphia Watercolor Club; others. Address in 1953, Allentown, PA.

SWAN, FLORENCE (WELLINGTON).
Draftsman and teacher. Born in Cambridge, MA, July 13, 1876. Pupil of Amy M. Sacker. Member: Boston Society of Arts and Crafts (master). Work: Memorial tablets in Beneficent Congregational Church, Providence; St. James' Church, Salem. Address in 1929, 6 Rollins Place, Beacon Hill, Boston, MA.

SWAN, PAUL.
Sculptor and painter. Born in Illinois. Studied drawing under John Vanderpoel and sculpture under Taft. Later he studied in NY and Paris. He exhibited his paintings and sculpture in the National Academy of Design, New York. Exhibited paintings at Paris Salon, 1922, and sculpture ("Douleur") at National Sculpture Society, 1923. Address in 1926, Jackson Heights, NYC.

SWANSON, BENNET A.
Painter. Born in Winthrop, MN, April 26, 1899. Studied: St. Paul Institute of Art; Art Students League; and with Andre L'Hote, Paris. Work: Minneapolis Institute of Art; Walker Art Center; others, including numerous schools, hospitals and public buildings throughout the U.S. Exhibited: Paris Salon, 1927; Art Institute of Chicago, 1942; Milwaukee, WI, 1944. Member: St. Paul Art Society. Awards: Hon. mention, State Exhibit, 1920; second award for painting, second award for black and white, Minnesota State Art Society Exhibit, 1922; hon. mention for prints and drawings, State Exhibit, 1923; hon. mention for prints and drawings, Minneapolis Art Institute, 1923; second prize for prints and drawings, Minnesota State Art Society, 1924. Address in 1953, St. Paul, MN.

SWANSON, JONATHAN M.
Painter, sculptor and illustrator. Born in Chicago, IL, July 21, 1888. Pupil of John Vanderpoel at Art Institute of Chicago. Member: Art Institute of Chicago Alumni; American Numismatic Association; NY Numismatic Club. Work: Medals and portraits in low relief; portaits of former presidents J. Sanford Saltus, D. W. Valentine, and George H. Blake, of the New York Numismatic Club; three portrait medals, French Mint Exhibit. Exhibited at National Sculpture Society, 1923. Address in 1933, 63 Washington Square South, NYC.

SWARTZ, HAROLD.
Sculptor, writer, lecturer, and teacher. Born in San Marcial, NM, April 7, 1887. Studied in Berlin, Paris. Member: Sculptors Guild of Southern California; California Art Club; California Painters and Sculptors; Municipal Art Commission. Awards: First prize, Arcadia Expo., 1923; first prize, Pomona Expo., 1923; gold medal, Pacific Southwest Expo., 1928; first prize, California Art Club, 1932. Represented in Los Angeles Museum. Instructor of sculp-ture, Chouinard Art School. Address in 1933, 3827 Ronda Vista Place, Los Angeles, CA.

SWARZ, SAHL.
Sculptor, painter, and teacher. Born in NYC, May 4, 1912. Studied at Art Students League. Member: Connecticut Academy of Fine Arts; Clay Club, NY. Work: Brookgreen Gardens, SC; Court House, U.S. Post Office, Statesville, NC; U.S. Post Office, Linden, NJ; Buffalo, NY; Whitney; Minneapolis Institute of Fine Arts; others. Exhibited: Syracuse Museum of Fine Arts, 1938, 40; Connecticut Academy of Fine Arts, 1938; Penna. Academy of Fine Arts, 1949-58; Clay Club, 1934-46; Brooklyn Museum, 1936; Whitney Museum of American Art, 1947-62; Fairmount Park, Philadelphia, 1949; Berkshire Museum, 1941; Rochester Memorial Art Gallery, 1940; Springfield Museum of Art, 1936; Lyman Allyn Museum, 1939; Plainfield (NJ) Art Association, 1943; Newark Museum, 1944. Position: Associate Director, Clay Club, Sculpture Center, NYC, 1931-46. Awards include American Academy of Arts and Letters grant; Guggenheim Memorial Foundation grants; others. Address in 1953, 167 East 69th St., NYC; living in Japan in 1980.

SWAYNE, H(UGH) N(ELSON).
Painter, etcher, and teacher. Born in Hickman, KY, July 22, 1903. Pupil of Will H. Stevens; C. M. Saz; George Pearse Ennis; John Costigan. Member: Louisville Art Association; Southern States Art League; Natchitoches Art Colony. Awards: Prize, Louisville Art Association, 1928; prize, Baton Rouge, LA, 1929. Address in 1933, Hickman, KY.

SWAYNE, WILLIAM MARSHALL.
Sculptor. Born in 1828, Chester County, PA. Worked: Washington, 1859-62; Chester County, PA. Died in 1918, in Chester County. Executed busts of Lincoln and other sitters.

SWEENEY, NORA.
(Mrs. S. Gordon Smyth). Illustrator. Born in Philadelphia, PA, June 17, 1897. Pupil of Walter H. Everett. Illustrator of juvenile subjects. Address in 1929, 2442 Linden Dr., Greenwood Park, Upper Darby, PA; summer, Conshohocken, PA.

SWEEZEY, NELSON.
Sculptor and designer of monuments. At New York City, 1849-52.

SWENSON, GOTTFRIDA.
Painter. Born in Sweden, June 19, 1882. Pupil of Knute Heldner and Delecluse, Paris, France. Member: Duluth Art Society. Award: Hon. mention and second prize, Duluth Art Society; popularity prize and third prize, Arrowhead Exhibition. Address in 1929, 2001 Jefferson St., Duluth, MN.

SWENSON, HOWARD WILLIAM.
Sculptor and designer. Born in Rockford, IL, June 30, 1901. Studied at Corcoran School of Art. Member: Rockford Art Association; Potters Guild of Greater Chicago. Work: Library of Congress; Masonic Cathedral, Rockford, IL. Exhibited: Society of Washington Artists; Corcoran Gallery of Art; Philadelphia Print Club; Rockport Art Association. Address in 1953, Rockford, IL. Died in 1960.

SWERGOLD, MARCELLE M.
Sculptor. Born in Antwerp, Belgium, September 6, 1927; U.S. citizen. Studied at New York University, painting with Aaron Berkman and Henry Kallem; Art Students League, with John Hovannes and Jose de Creeft, wax with Harold Caster. Work in New Britain Museum of American Art, CT; others. Has exhibited at Cork Gallery, Philharmonic Hall, Lincoln Center, NY; Allied Artists, National Academy Galleries, NY; Audubon Artists Annual, NY; others. Member of New York Society of Women Artists; Artists Equity Association, NY; Contemporary Artists Guild. Works in bronze and stone. Address in 1982, 450 West End Ave., NYC.

SWETT, CYRUS A.
Engraver. As a copperplate engraver this name appears on a "Descent from the Cross," a frontispiece to *Helps to Young Christians*, published in Portland in 1839. The plate is signed as "engraved by C. A. Swett, Portland." He later engraved a plan of the city of Boston, published in 1862.

SWETT, WILLIAM OTIS, JR.
Landscape painter. Born in Worcester, MA, May 5, 1859. Pupil of Whistler and H. G. Dearth; studied in Munich, Paris, Belgium, and Holland. Member: Salma. Club, 1903; Chicago Artists Guild; Society of Independent Artists. Specialty: Marines and landscapes. Died in 1939. Address in 1933, Dover Plains, NY; care of Salmagundi Club, 47th Fifth Ave., New York, NY; and Deerfield, MA.

SWEZEY, AGNES.
Painter. Exhibited at National Academy of Design, New York, 1925. Address in 1926, 39 West 9th Street, New York.

SWIFT, HOMER (MRS.).
See MacRae, Emma Fordyce.

SWIFT, IVAN.
Painter, writer, and lecturer. Born in Wayne, MI, June 24, 1873. Studied: Art Institute of Chicago; pupil of Freer, Von Sulza, Ochtman and Chase. Member: National Arts Club. Work: "A Michigan Home," Detroit Institute of Arts; "Indian Summer," "Toward the Light," and "In the Shadow of the Hill," Detroit Library; "Lakeland," Michigan Fair Gallery; "The Hooker," Harbor Springs High School;

"Lodges," Michigan State Library; "Jesuits' Landing," "Park and River," Utley Branch Library; "Lake Michigan," Lochmoor Club, Detroit; "Sheds," University of Nebraska. Author of books of verse, *Fagots of Cedar*, and *The Blue Crane and Shore Songs*; essays, *Nine Lives in Letters*. Died in 1945. Address in 1933, 1001 E. Jefferson Ave., Detroit; summer, Chippewa Cove Woods, Harbor Springs, MI.

SWIFT, S(TEPHEN) (TED).
Illustrator and etcher. Pupil of Pedro J. Lemos and Lorenzo P. Latimer; California School of Arts and Crafts. Specialty: Wood block printing and etching. Staff artist, *School Arts Magazine*. Address in 1929, Museum, Stanford University, CA.

SWINDELL, BERTHA.
Miniature painter. Born in Baltimore, MD, Dec. 2, 1874. Pupil of Chase, Hawthorne, Bridgman, and Breckenridge; La Forge at Julian Academy in Paris. Member: Baltimore Water Color Club; North Shore Arts Association; Pennsylvania Society of Miniature Painters. Died in 1951. Address in 1933, Professional Building, 330 N. Charles Street, Baltimore, MD.

SWINNERTON, JAMES.
Painter. Born in 1875. Painted Southwestern scenery; his specialty was the American desert lands. He was born in California, and studied in NY. Among his best-known paintings are "Coming Storm, Mojave Desert," "Clouds in Monument Valley, North Arizona," and "Here Ends the Trail."

SWISHER, ALLAN.
Portrait and figure painter. Born in Gypsum, KS, Oct. 2, 1888. Pupil of H. M. Walcott and Laurens. Address in 1929, University of Kentucky; h. 119 Bassett Court, Lexington, KY.

SWOPE, H. VANCE.
Painter. Born in southern Indiana, in 1879. Pupil of Academie Julien in Paris under Constant. Member: Circle of American Painters and Sculptors; Salmagundi Club; NY Architectural League. Represented in Public Library, Seymour, MN. Address in 1926, Van Dyck Studios, 939 Eighth Ave., New York, NY. Died Aug. 10, 1926.

SWOPE, KATE F. (MRS.).
Painter. Born in Louisville, KY. Pupil of National Academy of Design, NY. Awarded gold medal, Southern Art League, 1895; highest award, Louisville Art League, 1897. Member of Louisville Art League. Address in 1926, 939 Eighth Ave., New York, NY.

SWOPE, VIRGINIA VANCE.
Painter. Born in Louisville, KY. Pupil of DuMond; Mora; Carlson; Penfield; and Bridgman. Address in 1926, 939 Eighth Avenue, New York, NY.

SWORD, JAMES BRADE.
Painter. Born Oct. 11, 1839, in Philadelphia, PA. His early life was spent in Macao, China, and he engaged in art as a profession about 1863. He was a founder of the Art Club of Philadelphia and served for a number of years as its vice president and director, and as president of the Philadelphia Society of Artists and the Artists' Fund Society of Philadelphia. He is represented by portraits and paintings in many public institutions and by his portrait of John W. Jones in the House of Representatives, Washington, DC. Died Dec. 1, 1915, in Philadelphia.

SYKES, ANNIE G. (MRS.).
Painter. Born in Brookline, MA. Pupil of Boston Museum School; Cincinnati Art Academy under Duveneck. Member: Cincinnati Woman's Art Club; National Association of Women Painters and Sculptors. Address in 1929, 3007 Vernon Place, Vernonville, Cincinnati, OH. Died in 1931.

SYKES, CHARLES HENRY.
Cartoonist. Born in Athens, AL, November 12, 1882. Pupil of B. West Clinedinst, Drexel Institute of Philadelphia. Member: Philadelphia Sketch Club. Address in 1934, Philadelphia, PA.

SYKES, S. D. GILCHRIST.
Painter. Born in Cheshire, England. Pupil of Boston Museum Art School. Member: Copley Art Society; North Shore Arts Association; Rockport Art Association. Address in 1933, 100 Winchester St., Brookline, MA.

SYLVESTER, FREDERICK OAKES.
Mural and landscape painter. Born in Brockton, MA, Oct. 8, 1869. He was a member of the Society of Western Artists. He died March 2, 1915, in St. Louis, MO.

SYMONS, (GEORGE) GARDNER.
Painter. Born in Chicago, IL, 1863. Pupil of Art Institute of Chicago; studied in Paris, Munich, and London. Member: Associate National Academy of Design, 1910, Academician National Academy, 1911; Royal Society of British Artists; Union International des Beaux-Arts et des Lettres; Salma. Club, 1900; National Arts Club (life); Chicago Society of Artists; Century Association; California Art Club; Institute of Arts and Letters; Chicago Galleries Association; American Federation of Arts. Awards: Carnegie prize, National Academy of Design, 1909; Evans prize, Salma. Club, 1910; bronze medal, Buenos Aires Expo., 1910; National Arts Club prize and gold medal, 1912; third W. A. Clark prize ($1,000) and bronze Corcoran medal, 1912; Saltus medal, National Academy of Design, 1913; Altman prize ($500), National Academy of Design, 1919. Work: "The Opalescent River," Metropolitan Museum, NY; "Snow Clouds," Corcoran Gallery, Washington; "Sorrow," Cincinnati Museum; "Snow-Clad Fields in Morning Light," Toledo Museum; "The Top of the Hill and Beyond," and "The Winter Sun," Art Institute of Chicago; "Through Snow-Clad Hills and Valley," City Art Museum, St. Louis; "Through Wooded Hills," Art Association, Dallas, TX; "Deerfield River," Brooklyn Institute Museum; "River in Winter," Minneapolis Institute of Arts; "November, Dachau, Germany," Carnegie Institute, Pittsburgh; "Sunlight in the Woods," Fort Worth (TX) Museum; "Silence and Evening Light," Butler Art Institute, Youngstown, OH; "The Bridge," Harrison Gallery, Los Angeles Museum. Also represented in National Arts Club, NY; Des Moines Art Association; Lincoln Art Association, NE; Cedar Rapids Art Association, IA; Museum of Art, Erie, PA; Rochelle Art Association, IN; Union League Club, Chicago; Hyde Park Art Association, Chicago. Address in 1929, care of Grand Central Galleries, 15 Vanderbilt Ave.; Arts Club Bldg., 119 East 19th St., New York, NY.

SZAFRAN, GENE.
Illustrator. Born in Detroit, MI, in 1941. Trained at the Art School of the Society of Arts and Crafts. Receiving his start in studios in Detroit, he produced many auto advertisements in addition to freelance assignments. Among his many clients since his move to NY in 1967 are Bantam Books, New American Library, *Cosmopolitan*, *Fortune*, and *Playboy*. He has exhibited his works in group shows at the General Electric and Master Eagle Galleries and has held a one-man exhibition at the Society of Illustrators.

SZATON, JOHN J.
Sculptor. Born in Ludlow, MA, November 18, 1907. Studied at Chicago Academy of Fine Arts; Chicago School of Sculpture; Art Institute of Chicago; and with Edouard Chassaing and Lorado Taft. Works include panels, plaques, and decorations: Recreation Building, Hammond, IN; Pilsudski plaque, Springfield, MA; Lincoln Memorial, Vincennes, IN; Northwest Armory, Chicago. Exhibited: Art Institute of Chicago, 1935; Penna. Academy of Fine Arts, 1940; National Academy of Design, 1941; Cincinnati Museum Association, 1941; Polish Art Club, Chicago, 1942; Society for Sanity in Art, 1940. Address in 1953, Chicago, IL.

T

TAAKE, DAISY.
Sculptor and teacher. Born in St. Louis, MO, March 21, 1886. Pupil of Art Institute of Chicago; St. Louis School of Fine Arts; Lorado Taft. Member: St. Louis Art League. Winner of St. Louis Art League Fountain Competition. Work: Eight-foot decorative figure at Washington University; several large fountains privately owned. Address in 1933, St. Louis, MO.

TACK, AUGUSTUS VINCENT.
Painter and teacher. Born in Pittsburgh, PA, Nov. 9, 1870. Pupil of Mowbray and La Farge in NY; Merson in Paris. Member: Art Students League of NY (life); Connecticut Academy of Fine Arts; New Haven Paint and Clay Club; Century Association; International Society of Arts and Letters. Represented in Metropolitan Museum; Phillips Gallery, Washington; Legislative Chamber, New Parliament Buildings, Winnipeg; Cleveland Art Museum; Newark Museum; Speed Memorial Museum, Louisville, KY; Paulist Church, NY; Chapel of The Cenacle Convent, Newport, RI; St. James Church, South Deerfield, MA; decoration for Governor's Reception Room, Nebraska State Capitol, Lincoln. Died July 21, 1949 in NYC. Address in 1933, 15 Vanderbilt Ave., New York, NY; and Deerfield, MA.

TADAMA, FOKKO.
Painter. Born in 1871 in India. Represented in San Francisco Art Museum. Address in 1926, 2012 Laurelshade Ave., Seattle, WA.

TADASKY.
See Tadasuke, Kuwayama.

TADASUKE, KUWAYAMA.
Painter. Born Aug. 24, 1935 in Nagoya, Japan. Studied at Art Students League; Brooklyn Museum School. Resides in NYC. Exhibited at Kootz Gallery, NYC, 1965; Museum of Modern Art, 1965; Albright-Knox, 1965; University of Illinois, 1965; NY State Fair, 1967; in Japan at National Museum of Modern Art, 1965, and Gutai Museum, 1967; others. In collections of Museum of Modern Art; Albright-Knox; CBS; Brandeis; Baltimore Museum of Art; Aldrich Museum of Contemporary Art; Ohara Museum, Japan; Gutai Museum, Japan; Houston Museum of Fine Arts; and in private collections. Address in 1970, 142 Fulton Street, New York, NY.

TAFFS, C. H.
Illustrator. Member: Society of Illustrators; Artists Guild of the Authors' League of America. Address in 1929, 29 West 67th St., New York, NY.

TAFLINGER, ELMER E.
Painter. Born in Indianapolis, Indiana, March 3, 1891. Pupil of Art Students League of New York; George Bridgman. Award: Lontz prize, Indiana Painters, 1930. Address in 1933, 46 North Pennsylvania Street; h. 925 North Dearborn Street, Indianapolis, IN.

TAFT, LORADO ZADOC.
Sculptor, writer, and lecturer. Born in Elmwood, Illinois, April 29, 1860. Pupil of Ecole des Beaux-Arts in Paris under Dumont, Bonnassieux, and Thomas. Member: National Sculpture Society, 1893; Associate National Academy of Design, 1909; Academician National Academy of Design, 1911; National Academy of Arts and Letters; Chicago Painters and Sculptors; American Federation of Arts; American Institute of Architects (hon.), 1907; Illinois State Art Commission; National Commission Fine Arts, 1925-29. Taught: Instructor, Chicago Art Institute, 1886-1906; lecturer, Chicago Art Institute, 1886-1929; lecturer on art, University of Chicago; non-resident professor of art, University of Illinois. Awards: Designers' medal, Columbian Exposition, Chicago, 1893; silver medal, Pan.-Am. Expo., Buffalo, 1901; gold medal, St. Louis Expo., 1904; Montgomery Ward prize, Art Institute of Chicago, 1906; silver medal, P.-P. Expo., San Francisco, 1915. Author: *History of American Sculpture, Modern Tendencies in Sculpture*. Work: "Solitude of the Soul," Art Institute, Chicago; Metropolitan Museum of Art; "Washington Monument," Seattle, Washington; "Fountain," Paducah, KY; "Trotter Fountain," Bloomington, IL; "Columbus Memorial Fountain," Washington; Ferguson "Fountain of the Great Lakes," Chicago; "Thatcher Memorial Fountain," Denver, CO; "Blackhawk," Ogle Co. Soldiers' Memorial, Oregon, IL; "Fountain of Time," Chicago; Danville (IL) Soldiers' Monument; "Lincoln," Urbana, IL; "Pioneers," Elmwood, IL; "Alma Mater," University of Illinois, Urbana, IL; "Hackley Memorial," Muskegon, MI; "Charles Page Memorial," Sand Springs, OK; "The Crusader," memorial to Victor Lawson, Chicago; two colossal pylons, main entrance, Louisiana State Capitol, Baton Rouge. Exhibited at National Sculpture Society, 1923. Address in 1933, 6016 Ingleside Avenue; h. 5801 Dorchester Avenue, Chicago, Illinois; summer, "Eagle Nest Camp," Oregon, Illinois. Died in Chicago, IL, October 30, 1936.

TAGGART, EDWIN LYNN.
Painter, sculptor, illustrator, and etcher. Born in Richmond, IN, April 23, 1905. Studied: California

School of Arts and Crafts; pupil of R. L. Coates, F. F. Brown, B. Waite. Member: Indiana Art Club; Junior Art Association. Awards: Five prizes at Wayne County Fair; U. C. T. Art Medal, 1925. Work: Murals in Morton High School, Richmond, IN. Address in 1933, San Mateo, CA; h. Richmond, IN.

TAGGART, GEORGE H(ENRY).
Portrait painter. Born in Watertown, NY, March 12, 1865. Pupil of Julian Academy, Bouguereau, Ferrier and Lefebvre in Paris. Member: Societe International des Beaux-Arts et des Lettres; Buffalo Society of Artists; Society of Independent Artists. Awards: Medal of honor and cash prize, Utah State Exhibition; hon. mention, Salon d'Automne, Paris; hon. mention, Expo. Toulouse, France. Represented in private collection of Royal Palace, Berlin, Germany; Palace of Governor, City of Mexico; Mormon Temple, Brigham Young University and City Hall, Salt Lake City; City Hall, Watertown, NY; Tusculum College, Greeneville, TN; Chemists Club, NY; Welch Memorial Library, Baltimore, MD. Address in 1953, 11 Hillside Ave., Port Washington, Long Island, NY.

TAGGART, LUCY M.
Painter. Born in Indianapolis, IN. Pupil of Forsyth, Chase, and Hawthorne; studied in Europe. Member: National Arts Club (life); Art Workers' Club for Women; North Shore Arts Association; National Association of Women Painters and Sculptors; American Federation of Arts; Grand Central Art Galleries. Represented in the John Herron Art Museum, Indianapolis, IN. Address in 1933, 15 Gramercy Park, New York, NY; h. 1331 North Delaware St., Indianapolis, IN.

TAIRA, FRANK.
Painter and sculptor. Born in San Francisco, CA, August 21, 1913. Studied: California School of Fine Arts, 1935-38; Columbia University, 1945; Art Students League, 1956; New School for Social Research, 1957. Exhibited: San Francisco Museum of Arts, 1939; National Arts Club, 1968; Knickerbocker Artists, 1968; National Academy of Design, 1976; Allied Artists of America, 1976; Horizon Galleries, 1982; and others. Awards: First prize, painting, California School of Fine Arts, 1940; first prize, portrait, Cambridge, MA, 1943; National Arts Club, 1968; honorable mention, Knickerbocker Artists, 1968; Accademia Italia delle Arti e del Lavoro, 1981. Member: Artists Equity Association of NY. Media: Oil, watercolor; bronze. Address in 1983, 135 W. 106th St., NYC.

TAIT, ARTHUR FITZWILLIAM.
Painter. Born Aug. 5, 1819 in England. Came to the United States in 1850 and was most successful with paintings of animals. Elected an Associate of the National Academy in 1853, and an Academician in 1858. Sketched in the Adirondack Mountains. Works:

"Quail and Young," Corcoran Art Gallery, Washington, DC; "Duck and Her Young;" "Racquette Lake;" "Ruffled Grouse;" "Portage. "Many of his paintings were reproduced in lithograph by Currier & Ives. Died April 28, 1905 in Yonkers, NY.

TAIT, JOHN ROBINSON.
Painter. Born Jan. 14, 1834 in Cincinnati, OH. Graduated from Bethany College, VA, 1852, then spent three years in Europe sketching and writing. Returned to Europe in 1859 and studied painting at Dusseldorf, remaining there for twelve years. Visited Germany for the third time in 1873 and from 1876 resided in Baltimore, MD. Works: "Lake of Four Cantons," in the Cincinnati Art Museum; his "Landscape and Cattle" was exhibited in the Centennial in Philadelphia in 1876. Died July 29, 1909, in Baltimore, MD.

TAJIRI, SHINKICHI.
Sculptor and teacher. Born in Los Angeles, CA, December 7, 1923. Studied at the Art Institute of Chicago, under Ossip Zadkine; with F. Leger in Paris; Academie Grande Chaumiere, Paris; trained at San Diego under American sculptor Donald Hord. In collections of Stedelijk, Amsterdam; Museum of Modern Art; Carnegie Institute; museums in Paris and Copenhagen. Exhibited: Stedelijk Museum, 1960-67; Venice Biennial, 1962; Andre Emmerich Gallery, NY, 1965; Kunsthalle, Lund, Sweden, 1971; Kunsthalle, Basel, Switzerland, 1969. Awards: Golden Lion, 8th International Festival Amateur Films, Cannes, France, 1955; Mainichi Shibum prize for Sculpture, Tokyo Biennial, 1963. Taught: Minneapolis College of Art and Design, 1964-65, as guest professor of sculpture; and at the Hochschule der Kunste, West Berlin, Germany, 1969. Published *The Wall*, 1970; *Mayday*, 1970; and *Land Mine*, 1970; others. Address in 1982, Castle Scheres, Baarlo, Netherlands.

TAKSA, DESHA A. MILCINOVIC.
Painter, sculptor, serigrapher, designer, and teacher. Born in Zagreb, Yugoslavia, March 3, 1914. Studied in Europe; also with Ivan Mestrovic. Member: American Artists Professional League; Greenwich Society of Artists. Work: Greenwich (CT) Library; Witte Memorial Museum, San Antonio, TX. Exhibited: American Artists Professional League, 1940-42; Art Directors' Club, traveling exhibition, 1930-36; Arden Gallery, 1943; Dance International, NY, 1940; Witte Memorial Museum, 1944 (one-man); Kansas City, MO; Oakland Art Gallery, 1943; Dallas Museum of Fine Arts, 1944; Library of Congress, 1946; Morgan Library, New Haven, CT, 1946; Greenwich, CT, 1946. Illustrated *Adventures in Monochrome*. Address in 1953, 158 West 58th St., NYC.

TALABA, LINDA.
See Cummens, Linda.

TALBOT, CORNELIA BRECKENRIDGE.
Painter. Born in Natrona, PA, in 1888. Pupil of Penna. Academy of Fine Arts. She died in 1924. Address in 1924, Talbot Hall, Norfolk County, VA.

TALBOT, GRACE HELEN.
(Mrs. Darley Randall). Sculptor. Born in North Billerica, MA, September 3, 1901. Pupil of Harriet W. Frishmuth. Member: National Association of Women Painters and Sculptors; National Sculpture Society. Awards: Avery prize, Architectural League, 1922; Joan of Arc medal, National Association of Women Painters and Sculptors, 1925. Exhibited at National Sculpture Society, 1923. Address in 1953, Syosset, LI, NY.

TALBOT, HENRY S.
Painter. Member: Boston Art Club. Work: "Morning in Mid Ocean," Minneapolis Institute of Arts. Address in 1926, 387 Washington St., Boston, MA.

TALBOT, WILLIAM H. M.
Sculptor. Born in Boston, MA, January 10, 1918. Studied at Penna. Academy of Fine Arts, 1936-38, 1940-41, with Walker Hancock; privately with George Demetrios, Boston, 1938-39; Academie des Beaux-Arts, Paris, 1945-46, with Marcel Gaumont. Works: Bryn Mawr College; The Cambridge School; Earlham College; Rumsey Hall School; St. Lawrence University; Whitney; Washington University. Exhibitions: Carroll-Knight Gallery, St. Louis; Andrew-Morris Gallery, NYC; Hartford (CT) Jewish Community Center; Federation of Modern Painters and Sculptors Annuals; Fairmount Park Association, Philadelphia, Sculpture International; Boston Arts Festival; Whitney; Philadelphia Museum of Art; City Art Museum, St. Louis; Dallas Museum of Fine Arts; De Cordova; Phillips Academy, Addison Gallery of American Art, Andover, MA; New York World's Fair, 1964-65; Penna. Academy of Fine Arts; Wadsworth Atheneum; Arts Club, Chicago; Sculptors Guild. Awards: Penna. Academy of Fine Arts, Cresson Fellowship, 1941; Connecticut Academy of Fine Arts, Howard Penrose Prize, 1950; National Institute of Arts and Letters Award, 1975. Member: Sculptors Guild; Federation of Modern Painters and Sculptors; New York Architectural League. Media: Concrete, stained glass with electronic components. Lived in Connecticut. Died in 1980.

TALBOTT, KATHARINE.
Sculptor. Born in Washington, DC, January 18, 1908. Pupil of H. P. Camden; Avard Fairbanks; Robert Laurent. Award: First prize for portrait, Exhibition of Oregon Artists, Sculptors and Designers, Portland Museum of Art, 1932. Address in 1933, 644 San Luis Road, Berkeley, CA.

TALCOTT, ALLEN B.
Landscape painter. He had a studio on the Connecticut River, near Lyme, and painted in water colors. Died in New York City, c. 1925.

TALCOTT, DUDLEY VAILL.
Sculptor, illustrator, painter and writer. Born in Hartford, CT, June 9, 1899. Exhibited: Art Institute of Chicago, 1940; Valentine Dudensing Gallery, 1927; Museum of Modern Art, 1930; Whitney Museum of American Art, 1937; Grace Horne Gallery, Boston; Phillips Academy, Andover, MA. Author and illustrator of *Noravind*, 1929; *Report of the Company*, 1936. Address in 1953, Farmington, CT.

TALCOTT, SARAH WHITING.
Painter. Born in West Hartford, CT, April 21, 1852. Pupil of Chase and Cox in NY; Bouguereau and Robert Fleury in Paris. Member: Connecticut Academy of Fine Arts; Hartford Art Club. Address in 1933, Elmwood, CT.

TALEN, W. A.
Sculptor and carver. Worked: New Orleans, 1858-66.

TALLMADGE, THOMAS EDDY.
Etcher. Born in Washington, DC, April 24, 1876. Pupil of Massachusetts Institute of Technology, Boston. Member: Cliff Dwellers; Chicago Society of Etchers; National Arts Club; Art Institute of Chicago Alumni; California Society of Etchers; Federated Council on Art Education; Art Com., City of Evanston, IL (president); Governing Life Member, Art Institute of Chicago. Award: Chicago Architectural Club Traveling scholarship, 1904. Author, *Story of Architecture in America*. President, Summer School of Painting, Saugatuck, MI; Hon. Professor of Architectural History, Armour Institute of Technology. Address in 1929, 19 East Pearson St.; Burnham Bldg., Chicago, IL.

TALLMAN, M(ARTHA) G(RIFFITH).
(Mrs. Walter B. Tallman). Painter. Born in Llanidloes, North Wales, Sept. 22, 1859. Pupil of F. S. Church; National Academy of Design; Art Students League of NY; Mrs. Coman; and Jane Peterson. Member: Fellow National Academy of Design; Pen and Brush Club; NY Water Color Club (associate); National Association of Women Painters and Sculptors; American Federation of Arts. Address in 1929, 780 Riverside Drive, New York, NY; studio, Kent, CT.

TAM, REUBEN.
Painter and educator. Born Jan. 17, 1916, in Kapaa, Hawaii. Earned B. A. in Education, University of Hawaii, 1937. Studied at California School of Fine Arts; New School for Social Research; Columbia University, with Meyer Schapiro; and with Hans Hofmann. Taught: Brooklyn Museum Art School,

1946-75; Oregon State University, summer, 1966; others. Awards: Honolulu Academy of Arts; Guggenheim fellowship, 1948; Brooklyn Museum; St. Paul Gallery; National Academy of Design Annual, 1974, 77; Amer. Academy and Institute of Arts and Letters, 1978. Exhibited at Alan Gallery, NYC; Whitney; New School for Social Reseach; Metropolitan Museum of Art; Corcoran; Carnegie; University of Illinois; Colby College (ME); California Palace of the Legion of Honor (one-man); Wichita Art Association, Kansas (one-man); and others. In collections of Albright-Knox Art Gallery; Newark Museum; Whitney; Brooklyn; Wichita Art Museum; Temple University; Museum of Modern Art; Metropolitan Museum of Art; Bowdoin College. Address in 1984, Kapaa, HI.

TANBERG, ELLA HOTELLING.
Painter. Born in Janesville, WI. Member: West Coast Arts; Janesville Art League; Chicago Art Club; California Art Club; Laguna Beach Art Association. Work: "Lily Pond, Lincoln Park," owned by Janesville Art League. Address in 1926, Laguna Beach, CA.

TANDLER, RUDOLPH (FREDERICK).
Painter and teacher. Born in Grand Rapids, MI, March 22, 1887. Pupil of George Bellows; John Sloan; Andrew Dasburg. Member: Society of Independent Artists; Scarab Club; Woodstock Art Association. Award: Gold medal, Detroit Art Institute, 1930. Address in 1933, The Principia College, St. Louis, MO; summer, Woodstock, NY.

TANEJI, MOICHIRO TSUCHIYA.
Painter. Born in Ogaki City, Japan, in 1891. Studied in Japan. Member of Penguins. Address in 1926, 61 West 37th St., New York, NY.

TANIA (SCHREIBER).
Sculptor and painter. Born in Warsaw, Poland, January 11, 1924. Studied at McGill University, 1941-42, M. A.; Columbia University, 1942-44; Art Students League, 1948-51, with Yasuo Kuniyoshi, Morris Kantor, Vaclav Vytlacil, Harry Sternberg, 1948-51. Work: Brandeis University; Morgan State College; New York University. Exhibitions: San Francisco Museum of Art, 1963; Albert Landry, NYC; Bertha Schaefer Gallery, NYC; New York University, 3 Artists; University of Illinois; University of Virginia, Color and Space, 1964, 68; Guggenheim, 1963; Oakland Art Museum; World House Galleries, NYC, International, 1964; Milwaukee Art Institute, 1965; Museum of Modern Art, 1969; others. Taught: NYU, 1963-69. Address in 1976, c/o Bertha Schaefer Galleries, 41 E. 57th St., NYC.

TANNAHILL, MARY H.
Painter and block printer. Born in Warrenton, NC. Pupil of Weir, Twachtman, Cox and Mowbray in NY. Member: Pennsylvania Society of Miniature Painters; National Association of Women Painters and Sculptors; Provincetown Art Association; NY Society of Women Artists; Salons of America. Award: Prize for best group, National Association of Women Painters and Sculptors, 1914, best water color, 1932. Represented in Newark (NJ) Museum; Bibliotheque Nationale, Paris. Address in 1933, 423 West 120th Street, New York, NY; summer, Provincetown, MA.

TANNAHILL, SALLIE B.
Painter, teacher, and draftsman. Born in New York, Oct. 25, 1881. Pupil of Arthur W. Dow; V. Preissig. Professor, Art Department, Teachers College, Columbia University. Author of *Ps and Qs* (Doubleday, Doran & Co.). Address in 1929, 400 West 118th Street, New York; summer, Lake Mahopac, NY.

TANNER, BENJAMIN.
Engraver. Born March 27, 1775 in New York City. Tanner's master is unknown, but he was engraving in New York in 1792, and was possibly a pupil of Peter R. Maverick. Remained in New York until 1805, and in that year his name first appeared in Philadelphia directories. He remained there until 1845, when he moved to Baltimore. In 1811, with his brother Henry S. Tanner, he was a general engraver and map publisher; in 1837 he changed his business to "stereographer," using steel plates for production of checks, drafts, notes and other mercantile paper. In 1816-24 he was member of the engraving firm of Tanner, Vallance, Kearny & Co. Tanner worked in both line and stipple. He produced excellent large plates of portraits and historical subjects, especially views relating to the American Revolution and the War of 1812. Engraved some plates in connection with W. R. Jones. Died Nov. 14, 1848 in Baltimore, MD.

TANNER, H(ENRY) O(SSAWA).
Painter. Born in Pittsburgh, PA, June 21, 1859. Pupil of Penna. Academy of Fine Arts under Eakins; Laurens and Constant in Paris. Member: Associate National Academy of Design, 1909; Academician National Academy of Design, 1927; Paris Society of American Painters; Societe International de Peinture et Sculpture; Fellowship Penna. Academy of Fine Arts. Awards: Hon. mention, Paris Salon, 1896-97, third class medal, 1897, second class medal, 1906; Lippincott prize, 1900; silver medal, Paris Expo., 1900; silver medal, Pan-Am. Expo., Buffalo, 1901; silver medal, St. Louis Expo., 1904; Harris prize, Art Institute of Chicago, 1906; gold medal, P.-P. Expo., San Francisco, 1915; Clark prize, Grand Central Galleries, 1930. Specialty: Biblical subjects. Work: "The Raising of Lazarus," and "The Disciples at Emmaus," Luxembourg Museum, Paris; "Christ at the Home of Mary and Martha," Carnegie; "Nicodemus," Penna. Academy of Fine Arts; "The Two

Disciples at the Tomb" and "The Three Marys," Art Institute of Chicago; "L'Annonciation," Wilstach Collection, Philadelphia; "Holy Family," Hackley Art Gallery, Muskegon, MI; "Christ Walking on the Water," Des Moines Association of Fine Arts; "Daniel in the Lions' Den," and "Moonlight, Walls of Tangiers," Harrison Gallery, Los Angeles Museum. Died May 25, 1936. Address in 1933, 15 rue St. Jacques, XIV, Paris, France; summer, "Edgewood," Trepied, par Etaples, Pas-de-Calais, France.

TANNER, HENRY SCHENCK.
Engraver. Born in 1786 in New York City. In 1811 he was in business in Philadelphia with his brother Benjamin. Engraved outline illustrations for some magazines of that city, though he was chiefly engaged upon map and chart work. The "Port Folio" of 1815 credits him with inventing a process of banknote engraving which was intended to increase the difficulties of counterfeiting. He produced effects by white lines on a black ground, varied in form and intricate in character. In 1843 he moved to New York. Engraved and published maps, charts, etc. Contributed geographical and statistical articles to various periodicals, and published guide-books for a half dozen regions of the United States. He was a member of the geographical societies of London and Paris, when this distinction was rare among Americans. Died May 17, 1858 in New York City.

TAPPAN, W. H.
An engraver of portraits in mezzotint about 1840; also engraved some line plates, in conjunction with Joseph Andrew, in Boston. Was partner of George C. Smith in the engraving business in Boston.

TARBELL, EDMUND C(HARLES).
Painter and teacher. Born in West Groton, MA, April 26, 1862. Pupil of Boston Museum School; Boulanger and Lefebvre in Paris. Member: Ten American Painters; Associate National Academy of Design, 1904; Academician National Academy of Design, 1906; National Institute of Arts and Letters; Guild of Boston Artists; Art Club of Philadelphia. Awards: Clarke prize, National Academy of Design, 1890, first Hallgarten prize, 1894, Saltus medal, 1908, Isidor medal and purchase through Ranger Fund, 1929; Shaw fund, Society of American Artists, 1893; medal, Columbia Expo., Chicago, 1893; Lippincott prize, Penna. Academy of Fine Arts, 1895, Temple gold medal, 1895, second Elkins prize, 1896, medal of honor, 1908, Beck gold medal, 1911; gold medal, Art Club of Philadelphia, 1895; hon. mention, Tennessee Expo., Nashville, 1897; first prize, Worcester Museum, 1900; three medals, Boston Charitable Mechanics' Association; bronze medal, Paris Expo., 1900; first prize, Worcester Museum, 1904; Harris prize, Art Institute of Chicago, 1907; third prize, Carnegie Institute, Pittsburgh, 1901, second prize, 1904, first prize ($1,500), 1909, popular prize, 1928-

29; first W. A. Clark prize, Corcoran Artists Guild, 1910; P.-P. Expo., San Francisco, 1915. Work: Corcoran; Cincinnati Museum; Rhode Island School of Design; Boston Museum of Fine Arts; Worcester (MA) Museum; Penna. Academy of Fine Arts; Wilstach Collection, Philadelphia, PA; War Department, Washington, DC; State House, Boston; Smith College, Northampton, MA; Butler Art Institute; Buffalo Academy of Fine Arts. Chairman of the Faculty and Chairman of Administrative Council of the School of the Museum of Fine Arts, Boston. Died in 1938. Address in 1929, Fenway Studios, Boston, MA; New Castle, NH.

TARDO, (MANUEL) RODULFO.
Sculptor. Born in Matanzas, Cuba, February 18, 1919; U. S. citizen. Studied at National Fine Arts School, Havana, Cuba (sculpture and drawing); Clay Club and Art Students League, scholarship. Work in National Museum of Cuba; Cathedral of St. John the Divine, NY; bust, Mother Cabrini Park, Newark, NJ; outdoor bronze sculpture, Church Immaculad Corazon de Maria, Elizabeth, NJ; others. Has exhibited at Philadelphia Museum of Art; National Museum of Modern Art, Paris; Brooklyn Museum; Metropolitan Museum of Art; others. Received honorable mention, Audubon Artists; gold medal, Tampa University, 1952. Address in 1982, Long Island City, NY.

TARLETON, MARY LIVINGSTON.
Landscape and miniature painter, sculptor. Born in Stamford, CT. Pupil of Childe Hassam; Charles W. Hawthorne; W. M. Chase; Art Students League of New York. Member of National Association of Women Painters and Sculptors. Awarded Guggenheim Fellowship, 1933. Address in 1934, Great Neck, Long Island, New York.

TATERKA, HELENE.
Painter and sculptor. Born in Breslau, Germany, December 2, 1901. Studied at Munich Art and Craft School, Breslau, Germany, 3 years; Academy Fine Art, Breslau, Germany, 1 year; also sculpture with Harold Castor and painting with Revington Arthur, US. Works: Alfred Khouri Memorial Collection, Norfolk Museum Arts and Science, VA; Smithsonian Institution. Exhibitions: Audubon Artists Annual, NY; National League American Pen Women Biennial, Smithsonian Institution; Painters and Sculptors of New Jersey Annual; Silvermine Guild of Artists Annual; Sculptors League Annual, NY. Awards: Julia Ford Pew Award for Sculpture, National Association of Women Artists, 1964; Bronze Medal for Creative Sculpture, Audubon Artists, 1965; Mary and Gustave Kellner Award for Sculpture, American Society of Contemporary Artists, 1970. Media: Bronze, lost wax; polymer, watercolor. Address in 1976, 140 West End Avenue, NYC.

TATNALL, HENRY LEE.
Painter. Born in Brandywine Village, DE, in 1829. Specialty: Marine and landscape painting. Elected president of the Delaware Artists' Association. Died in September, 1885, in Wilmington, DE.

TATTI, BENEDICT MICHAEL.
Sculptor, painter, and teacher. Born in NYC, May 1, 1917. Studied at Art Students League, with William Zorach and O. Zadkine; Masters Institute, Roerich Museum, with Louis Slobodkin; State University of NY; Hans Hofmann Art School; Da Vinci Art School, with A. Piccirilli. Member: Sculptors League; American Society of Contemporary Artists; Painters and Sculptors Society of New Jersey (vice-president); Brooklyn Society of Artists. Awards: Prizes, Brooklyn Society of Artists, 1944; Soldier Art Exhibition, National Gallery of Art, 1945; medal of honor for sculpture, Painters and Sculptors Society of New Jersey, 1972. Exhibited: Metropolitan Museum of Art, 1942; National Gallery of Art, 1945; Brooklyn Society of Artists, 1943-46; Tribune Art Gallery, 1946 (one-man); Penna. Academy of Fine Arts, 1950-54; Museum of Modern Art, 1960; Roko Gallery, NY, 1967. Work: Harper's Row, Mr. and Mrs. Cass Canfield, NY; sundial, R. W. Bliss for Dumbarton Oaks, Washington, DC, 1952; medallions of D. Sarnoff, D. Eisenhower and Mark Twain, Newell and Lennon, NY; others. Taught: Instructor of sculpture and head of department, High School of Art and Design; instructor of sculpture, Craft Students League, 1966-67. Address in 1984, 214 E. 39th Street, NYC.

TAUCH, WALDINE AMANDA.
Sculptor and collector. Born in Schulenburg, TX, January 28, 1894. Pupil of Pompeo Coppini. Work: Oldest inhabitant fountain, San Antonio, TX; Henderson Memorial, Winchester, KY; Witte Memorial Museum, San Antonio, TX; Indiana monument to Civil and World War heroes and pioneers, Bedford, IN; "Baptismal Font," Grace Lutheran Church, San Antonio, TX; Wesleyan Museum, GA; "General Douglas MacArthur," Howard Payne College, Brownwood, TX; fountain, Pelham Manor, New York, NY; Baylor University Library; others. Exhibited: National Sculpture Society Traveling Show, 1931; Women Painters and Sculptors, NY, 1932; Witte Memorial Museum; National Academy of Design; Coppini Academy of Fine Arts, from 1954. Member: Fellow, National Sculpture Society; American Academy of Arts and Letters; fellow, American Artists Professional League; Coppini Academy of Fine Arts. Address in 1982, San Antonio, TX.

TAUSZKY, D(AVID) ANTHONY.
Portrait painter. Born in Cincinnati, OH, Sept. 4, 1878. Pupil of Art Students League of NY under Blum; Julian Academy in Paris under Laurens and Constant. Member: Salma. Club, 1907; Connecticut Academy of Fine Arts; Allied Artists of America; Laguna Beach Art Association; Southern California Painters and Sculptors; Pasadena Society of Artists; Grand Central Art Galleries. Awards: Sargent prize, Art Institute, Pasadena, 1928; first prize, Santa Ana, 1928; first hon. mention, Allied Artists of America, 1929; sketch prize, Salma. Club, 1929; first hon. mention, Connecticut Academy of Fine Arts, 1931. Work: Portrait of Emp. Franz Josef I, Criminal Court, Vienna; portrait of George W. Wingate, Wingate School, New York, NY; portrait of Mrs. J. F. Brown, Denver Art Museum, Denver, CO. Address in 1933, 47 Fifth Ave., New York, NY; 511 Garfield, S. Pasadena, CA.

TAVSHANJIAN, ARTEMIS.
(Mrs. Charles A. Karagheusian). Painter and sculptor. Born in Englewood, NJ, June 18, 1904. Pupil of Mabel R. Welch; Robert G. Eberhard. Awards: Sterling Prize, National Association of Women Painters and Sculptors, 1933; Boardman Prize, 34th Annual Miniature Exhibition, Grand Central Galleries, 1933. Member: National Association of Women Painters and Sculptors. Address in 1933, 91 Central Park West, New York, NY.

TAYLOR.
Miniature painter. Flourished in Philadelphia about 1760. He copied a miniature of Oliver Cromwell, among other works.

TAYLOR, ALEX H.
Portrait painter. Flourished in 1849-50 in New York.

TAYLOR, ANNA HEYWARD.
Painter and craftsman. Born in Columbia, SC, Nov. 13, 1879. Pupil of Chase; Lathrop; Hawthorne; Nordfeldt; Meijer. Member: National Arts Club; Washington Art Club; Charleston Art Association; Columbia Art Association; Columbia Sketch Club; Southern States Art League; Society of Independent Artists; National Association of Women Painters and Sculptors. Address in 1929, 79 Church St., Charleston, SC.

TAYLOR, BEATRICE M.
Painter. Member of Pittsburgh Artists' Association. Address in 1926, 306 South Craig St., Pittsburgh, PA.

TAYLOR, CECELIA EVANS.
Sculptor. Born in Chicago, IL, July 23, 1897. Pupil of Arthur Lee. Member: Buffalo Society of Artists. Awards: Honorable mention, Albright Art Gallery, 1932, 33. Address in 1933, Sheridan Dr., Williamsville, NY.

TAYLOR, CHARLES JAY.
Painter and illustrator. Born in New York in 1885. Pupil of Art Students League, National Academy of

Design and Eastman Johnson in New York; also studied in London and Paris. Member: Society of Illustrators, 1910; Pittsburgh Art Association; Pittsburgh Architectural Club; The Players; Philadelphia Art Club. Awards: Honorable mention for drawing, Pan.-Am. Exposition, Buffalo, 1901; bronze medal and hors concours, P.-P. Exposition, San Francisco, 1915. Represented in Carnegie Institute of Technology. Instructor in Carnegie Technical Schools, Pittsburgh, from 1911. Address in 1926, "The Players," 16 Gramercy Park, New York, NY.

TAYLOR, EDGAR J.
Painter and illustrator. Born in Brooklyn, NY, in 1862. Pupil of National Academy of Design; Art Students League of New York under Beckwith; Brooklyn Artists Guild under Eakins. Member: Brooklyn Art Club; Connecticut Society of Artists; Society of Independent Artists. Address in 1926, Westbrook, CT.

TAYLOR, EDWIN C.
Painter and teacher. Born in Detroit, MI, March 10, 1874. Pupil of Art Students League of NY and Kenyon Cox. Member: New Haven Paint and Clay Club. Address in 1933, Yale School of Fine Arts; h. 352 Townsend Ave., New Haven, CT; summer, Liberty, ME.

TAYLOR, ELIZABETH.
Painter. Member: Chicago Society of Artists; Society of Independent Artists; Provincetown Printers. Work: "Flowers," Detroit Institute. Address in 1933, New Berlin, IL; summer, Provincetown, MA.

TAYLOR, EMILY (HEYWARD) DRAYTON.
(Mrs. J. Madison Taylor). Miniature painter and writer. Born in Philadelphia, PA, April 14, 1860. Pupil of Cecile Ferrere in Paris; Penna. Academy of Fine Arts. Member: Pennsylvania Society of Miniature Painters; Fellowship Penna. Academy of Fine Arts; Plastic Club; Art Alliance of America; American Federation of Arts. Awards: Gold medal, Earl's Court Expo., London, 1900; gold medal for services on Jury, Charleston Expo., 1902; silver medal, P.-P. Expo., San Francisco, 1915; medal of honor, Penna. Academy of Fine Arts, 1919; Lea prize ($50), Penna. Academy of Fine Arts, 1920; special award of $100, Penna. Academy of Fine Arts, 1924, for miniature of Cardinal Mercier. Collaborated with Miss Wharton in writing *Heirlooms in Miniature*. Work: Portraits of President and Mrs. William McKinley, Dr. S. Weir Mitchell, George Hamilton and Cardinal Mercier. Died June 19, 1952. Address in 1929, 1504 Pine St., Philadelphia, PA.

TAYLOR, ETHEL C.
Painter. Born in Taylor's-on-Schroon, NY. Pupil of Kenneth Hayes Miller. Member: Artists Guild of the Authors' League of America. Illustrated for *Vanity*

Fair, Vogue, Town and Country, Scribner's, Harper's, etc., and for the *Theatre Magazine, Times, Sun* and *Herald Tribune* of NY. Address in 1933, 247 Lexington Ave., New York, NY.

TAYLOR, F. WALTER.
Painter. Born in Philadelphia, PA, in 1874. Studied at Penna. Academy of Fine Arts, 1896 (awarded traveling scholarship); studied independently in Paris. Established studio in Philadelphia, 1898. Member: Fellowship of Penna. Academy of Fine Arts; Society of Illustrators. Illustrator of various books. Received medal of honor, Panama P. I. Exposition, 1915. Contributed numerous short stories to leading magazines. Died in 1921.

TAYLOR, H. WESTON.
Illustrator. Born in Chester, PA, May 11, 1881. Pupil of McCarter and Anshutz. Member: Fellowship Penna. Academy of Fine Arts. Illustrations for *Saturday Evening Post, Red Book, Ladies' Home Journal, Elks Magazine, American Boy, MacLean's*, etc. Address in 1933, 1012 Walnut St., Philadelphia, PA; h. 2 Seminary Ave., Chester, PA.

TAYLOR, HENRY FITCH.
Painter. Born in Cincinnati, OH in 1853. Studied art at Academie Julien, Paris. Exhibited three paintings at the Armory Show of 1913, and also exhibited in London, Paris, Rome, New York, Philadelphia, Chicago and San Francisco. Member of Association of American Painters and Sculptors. Inventor of "The Taylor System of Organized Color," a device for indicating harmonious color relations. Died in New York in 1925.

TAYLOR, HENRY W(HITE).
Painter, teacher and lecturer. Born in Otisville, NY, Aug. 22, 1899. Pupil of Penna. Academy of Fine Arts; Hugh H. Breckenridge. Member: Fellowship Penna. Academy of Fine Arts; Philadelphia Sketch Club; Chester County Art Association; Philadelphia Alliance; North Shore Arts Association; East Gloucester Society of Artists. Award: Second prize, water color, Chester County Art Association Annual, 1932. Address in 1933, End of Biddle Road, Paoli, PA.

TAYLOR, IDA C.
Painter. Born in Le Roy, NY. Pupil of W. M. Hunt; Julian Académy in Paris. Member: American Artists Professional League; American Federation of Arts. Work: Portrait, The Rt. Rev. W. D. Walker, Historical Museum of Buffalo; "Old Trinity College," Alpha Chapter House, Trinity College, Hartford, CT; "Rev. Dr. Pierre Cushing," Episcopal Church, Le Roy, NY; three portraits, Masonic Temple, Le Roy, NY; portrait, Rev. N. Barrows, De Veaux School, Niagara Falls, NY. Address in 1933, 55 Wolcott St., Le Roy, NY.

TAYLOR, JOSEPH RICHARD.
Sculptor and teacher. Born in Wilbur, WA, February 1, 1907. Studied at University of Washington, B. F. A., 1931, M. F. A., 1932; University of Oklahoma; Columbia University, 1940. Work at Philbrook Museum, Tulsa; walnut figure, Seattle Art Museum, Seattle, WA. Has exhibited at Kansas City Art Institute; New York World's Fair, 1938-39; San Francisco World's Fair, 1940; Museum of Modern Art, NY. Awards: Bronze medal, Annual Mid-Western Exhibition, Kansas City Art Institute, 1932; Annual Northwest Art Exhibition, Seattle Art Museum, grand award, 1932, and honorable mention, 1933; Oklahoma Hall of Fame, 1960. Professor of art and head of sculpture department, 1932-63, emeritus professor, from 1971, University of Oklahoma, Norman, OK. Works in bronze, wood, and stone. Address in 1982, Norman, OK.

TAYLOR, MARIE.
Sculptor. Born in St. Louis, MO, February 22, 1904. Studied at Art Students League; Washington University School of Art, 1923-24. Works: St. Louis Art Museum; also in many private collections. Commissions: Main altar, St. Paul's Church, Peoria, IL, 1960; Jefferson Memorial National Expansion, St. Louis Riverfront, for Mansion House, St. Louis, 1967. Exhibitions: Five one-woman shows, Betty Parsons Gallery, NY; Penna. Academy of Fine Arts; Whitney; Southern Illinois University, Carbondale, 1952; Brooks Memorial Art Gallery, Memphis, TN, 1955; Sculpture, 1969, Span International Pavillion, 1969; Joslyn Museum of Art; Kansas City Art Institute; others. Awards: Prizes, Cleveland Art Museum, St. Louis Artists Guild and National Association of Women Artists; others. Member: National Society of Arts and Letters; Sculptors Guild, NY. Address in 1982, St. Louis, MO.

TAYLOR, MARY PERKINS.
See Perkins, Mary Smyth.

TAYLOR, RALPH.
Painter. Born in Russia, Jan. 18, 1896. Pupil of Penna. Academy of Fine Arts. Member: Fellowship Penna. Academy of Fine Arts; Sketch Club; Philadelphia Alliance; American Artists Professional League. Award: European scholarship, Penna. Academy of Fine Arts. Work: "The Studio," Penna. Academy of Fine Arts; "Reflections," and "The Reading Lessons," Graphic Sketch Club; "The Clinic," Fellowship, Penna. Academy of Fine Arts; "An Outing" and "The Sculptor," La France Art Institute, Philadelphia. Address in 1929, 113 S. 19th St., Philadelphia, PA.

TAYLOR, ROLLA S.
Painter and teacher. Born in Galveston, TX, Oct. 31, 1874. Pupil of Jose Arpa; A. W. West. Member: Texas Fine Arts Association; Society of Independent Artists; Chicago No-Jury Society of Artists; San Antonio Art League; San Antonio Artists Guild; American Federation of Arts. Address in 1933, 503 West Euclid Ave., San Antonio, TX.

TAYLOR, T.
Engraver. Good landscape plates, done in line and published in New York in 1860, are so signed. Possibly a bank-note engraver, as little of his signed work is found.

TAYLOR, WILL S.
Mural painter. Member: National Society of Mural Painters; Salma. Club; NY Architectural League; American Institute of Architects; Allied Artists of America. Work: Sixteen panels relating to early life of Alaskan and British Columbian Indians, Museum of Natural History, NY; religious mural for the City Park Chapel, Brooklyn. Associate Professor of Art and Curator of Art Collection, Brown University. Address in 1933, Brown University, Providence, RI; summer, Lyme, CT.

TAYLOR, WILLIAM FRANCIS.
Painter and illustrator. Born in Hamilton, Ontario, Canada, March 26, 1883. Pupil of W. L. Lathrop; Albert Sterner. Member: Salma. Club. Awards: Hon. mention, Salma. Club, 1924; hon. mention, Philadelphia Art Club, 1924; club prize, Salma. Club, 1932. Represented in Philadelphia Art Alliance. Address in 1933, Lumberville, Bucks Co., PA.

TAYLOR, WILLIAM LADD.
Painter and illustrator. Born in Graftson, MA, in 1854. Studied at art schools in Boston and New York; under Boulanger and Lefebvre in Paris, 1884-85. Later painted and illustrated in the United States. Works: "Selections from Longfellow's Poems" (series of pictures illustrating the 19th century in New England); series of pictures of the "Pioneer West;" "Old Songs Series," 1908-09; "Our Home and Country," a book of pictures of American life, 1908; "Pictures from American Literature," 1910; "Pictures from the Old Testament," 1913. Exhibited one oil painting and drawings at the 1913 Armory Show. Address in 1926, Wellesley, MA. Died in 1926.

TAYLOR, WILLIAM N(ICHOLSON).
Painter and architect. Born in Cincinnati, OH, Jan. 22, 1882. Pupil of Louis Bernier. Member: National Society of Mural Painters; National Sculpture Soc.; Beaux-Arts Institute of Design; Beaux-Arts Architects; Society des Architects diplomes par le Gouvernement Francais; Lyme Art Association. Address in 1933, Harvard Club, 127 West 44th St., New York, NY.

TEAGUE, DONALD.
Illustrator. Born in Brooklyn, NY, Nov. 27, 1897. Studied at Art Students League; also in England.

Member: Society of Illustrators; American Artists Professional League; Artists Guild of the Authors' League of America. Awards: Murphy Memorial prize, National Academy of Design, 1932. Address in 1933, 2 Division St.; h. 38 Locust Ave., New Rochelle, NY.

TEAGUE, WALTER DORWIN.
Lecturer and draftsman. Born in Decatur, IN, Dec. 18, 1883. Pupil of George Bridgman. Member: Society of Illustrators; Artists Guild of the Authors' League of America. Designer of advertising and products for Eastman Kodak Co.; National Carbon and Carbide Co.; Turner Glass Co.; Welte Mignon Corp.; etc. Address in 1929, 210 Madison Ave., New York, NY; h. Forest Hills, NY.

TEE-VAN, HELEN DAMROSCH.
(Mrs. John Tee-Van). Painter, illustrator, and writer. Born in New York City, May 26, 1893. Pupil of George de Forest Brush; Jonas Lie. Member: Art Alliance of America. Work: Color plates of the Flora and Fauna of British Guiana, for the Tropical Research Station of the NY Zoological Society and for the Arcturus, Haitian, and Bermuda Oceanographic Expeditions under the direction of William Beebe; illustrated *A Birthday Greeting and Other Songs*, and other children's books; illustrator and author of stories of South American Indian and animal life; numerous landscapes. Address in 1933, 120 East 75th St., New York, NY.

TEEL, E.
Engraver. Born in the United States about 1830; died in Hoboken, NJ, before 1860. An excellent line-engraver of portraits and landscape. After being employed for some time in New York, he worked for Cincinnati publishers in 1854.

TEESDALE, CHRISTOPHER H.
Painter. Born in Eltham, England, April 6, 1886. Member: Southern States Art League; Texas Fine Arts Association; Cleburne Art Association. Work: Portrait of Professor Emmett Brown, Cleburne Public Schools; portrait of J. E. Scott, Masonic Temple, Cleburne; landscape, Ft. Worth Public Schools, TX. Address in 1933, 310 North Walnut; Box 121, Cleburne, TX.

TEFFT, CARL (or CHARLES) EUGENE.
Sculptor. Born September 22, 1874 in Brewer, ME. Studied with Blankenship and Ruckstall, Artist-Artisan Institute, NYC. Also taught there. He was an apprentice of J. Q. A. Ward and was influenced by Saint-Gaudens. His figure of "Lake Superior" was acclaimed at the Buffalo Exposition. Works also include a fountain, N.Y. Botanical Garden; war memorial, Belleville, NJ; statue, American Museum of Natural History, NYC; statue, Bangor, ME; statue, Brookgreen Gardens, SC. He was chosen as director of sculpture for the Sesqui-Centennial Exposition, Philadelphia, 1926. Tefft's studio was established at Tompkinsville, Staten Island, NY, and later at Guilford, ME. Died September 20, 1951, in Presque Isle, ME.

TEFFT, ELDEN CECIL.
Sculptor and educator. Born in Hartford, KS, December 22, 1919. Studied at University of Kansas, B. F.A., 1949, M.F.A., 1950; Cranbrook Academy of Art, 1951-52; with Bernard Frazier and William McVey. Has exhibited at Philbrook Art Center, Tulsa, OK; San Francisco Museum of Art; Carnegie Museum, Pittsburgh, PA; Joslyn Art Museum, NE; Denver Art Museum, CO; others. Teaching sculpture at University of Kansas, Lawrence, from 1950. Works in bronze and stone. Address in 1982, Lawrence, KS.

TEICHMAN, SABINA.
Sculptor and painter. Born in NYC in 1905. Studied at Columbia University, B.A., M.A.; also with C. J. Martin and A.J. Young. Works: Carnegie Institute; Brandeis University; Fogg Art Museum; Tel-Aviv Museum, Israel; San Francisco Museum of Art; Whitney Museum of American Art; Butler Institute of American Art; Museum of the University of Puerto Rico; Living Arts Foundation Collection, NY. Exhibited at Argent and Phoenix Galleries, NYC; New York Cultural Center; Audubon Artists Annual; many others. Award: Women's Westchester Center, 1950. Media: Watercolor, oil; clay. Address in 1982, 1120 Fifth Avenue, NYC.

TELLANDER, FRED.
Painter. Member: Chicago Painters and Sculptors; Chicago Galleries Association. Award: Fine Arts Building Purchase prize, ($500), Art Institute of Chicago, 1927; purchase prize ($1,000), Chicago Galleries Association, 1930, prize ($500), 1931. Address in 1933, 202 South State St.; 7460 Greenview Ave., Chicago, IL.

TELLER, JANE (SIMON).
Sculptor. Born in Rochester, NY, in 1911. Studied at RIT; Skidmore College; Barnard College, B.A.; and with Aaron Goodelman and Ibram Lassaw. Exhibited extensively throughout Pennsylvania; Newark Museum, NJ; Skidmore College, Saratoga Springs, NY; Whitney Museum; Princeton University; Museum of Modern Art, NYC, 1975; others. Member: Sculptors Guild; Artists Equity Association. Awards: Purchase Awards, New Jersey State Museum, 1971, and Trenton State College, NJ, 1972-79; Philadelphia Art Alliance. Address in 1983, 200 Prospect Avenue, Princeton, NJ.

TELLING, ELISABETH.
Etcher. Born in Milwaukee, WI, July 14, 1882. Pupil of W.P. Henderson; George Senseney; H.E. Field;

also studied in Munich. Member: Chicago Society of Etchers; California Print Makers. Work: "'Uncle William' Creech," California State Library, Pasadena; Associate print for California Print Makers. Address in 1929, 2120 Lincoln Park, West, Chicago, IL.

TEN EYCK, JOHN (ADAMS).
Painter, etcher, and teacher. Born in Bridgeport, CT, Oct. 28, 1893. Pupil of NY School of Fine and Applied Art; Art Students League of NY under F. Luis Mora, Kenneth Hayes Miller, Joseph Pennell, Charles Hawthorne and Bror J.O. Nordfeldt. Member: Society of Illustrators, 1922; Salma. Club, 1926; Societe des Artistes Independents, Paris; Society of Independent Artists, 1918; NY Architectural League, 1928; Brooklyn Society of Modern Artists. Instructor of landscape and etching, Kihn-Ten Eyck Art School, Stamford, CT. Address in 1929, 51 West 10th Street, New York, NY; h. Shippan Pt., Stamford, CT; summer, P.O. Box 540, Westerly, RI.

TENNANT, ALLIE VICTORIA.
Sculptor. Born in St. Louis, MO. Studied at Art Students League; also with George Bridgman and Edward McCartan. Works: State of Texas Building, Dallas; Brookgreen Gardens, SC; Hockaday School, Southwest Medical College, Aquarium, Museum of Fine Arts, and Woman's Club, all of Dallas, TX; memorial, Corsicana, TX; memorial, Bonham, TX; U.S. Post Office, Electra, TX. Exhibited: Penna. Academy of Fine Arts, 1935; Art Institute of Chicago, 1935; Texas Centennial, 1936; Architectural League, 1938; World's Fair, NY, 1939; Whitney, 1940; National Sculpture Society, 1940; Carnegie Institute, 1941; others. Member: National Sculpture Society; Dallas Art Association. Awards: Dallas Art Association, 1936; Southern States Art League, 1932, 33, 36. Address in 1953, Dallas, TX. Died in 1971.

TENNEY.
In Tuckerman's Book of the Artists he is noted as painting miniatures.

TERKEN, JOHN.
Sculptor. Born in Rochester, NY, January 11, 1912. Studied at Beaux-Arts Institute of Design, with Chester Beach, Lee Lawrie and Paul Manship; New York School of Fine and Industrial Arts; Columbia School of Fine Arts. Work: Roswell Museum, NM; Eagle Fountain, Salisbury Park, East Meadow, NY; others. Exhibited: National Academy of Design, NY, 1968; National Arts Club, New York, 1970; National Sculpture Society, New York, 1972; and others. Member of the National Sculpture Society, fellow; Hudson Valley Art Association, fellow; and others. Awards: Lindsey Morris Memorial Prize, 1965, National Sculpture Society; Louis C. Tiffany Foundation Award, 1949; American Artists Professional League, 1972; others. Works in bronze. Address in 1982, East Meadow, NY.

TERRELL, ALLEN TOWNSEND.
Sculptor, painter, and writer. Born in Riverhead, NY, November 2, 1897. Studied at Columbia University; Art Students League, with Edward McCartan; Julian Academy, Ecole des Beaux-Arts, and Fontainebleau, in France; Penna. Academy of Fine Arts, with Albert Laessle; and with Charles Despiau. Member: Fellow, National Sculpture Society; Allied Artists of America; National Arts Club; American Watercolor Society; Municipal Art Society; Fontainebleau Association. Awards: Prizes, Ernest Piexotto award, NY, 1941; Village Art Center, 1943, 49, 54; IBM, 1945; bronze medal of honor for sculpture, National Arts Club, 1959; Greer prize for sculpture, National Academy of Design, 1972. Work: Metropolitan Museum of Art; Smithsonian Institution; Brooklyn Museum, NY; York Club, NY; IBM Collection; murals, S.S. America; Aluminum Corporation of America, Garwood, NJ; modeled Vermilye medal, Franklin Institute, Philadelphia. Group exhibitions: Salon d'Automne, 1931; National Academy of Design, 1932-34, 37, 61, 62, 72; Penna. Academy of Fine Arts, 1933, 34, 36; American Watercolor Society, 1942-51, 61, 62; Whitney Museum, 1954; Allied Artists of America, 1965. One-man exhibitions: Decorators' Club, NY, 1939; Stendahl Gallery, 1944; Pasadena Art Institute, 1944; Village Art Center, 1943, 55, 56, 58; National Arts Club, 1975. Author: "Drawing for Sculpture," National Sculpture Review, 1974. Address in 1982, 42 Stuyvesant St., NY.

TERRIL, ISRAEL.
Engraver. He arranged the music, engraved the title-page and music, and printed and sold a music-book entitled "Vocal Harmony, No. 1, Calculated for the Use of Singing Schools and Worshipping Assemblies." The imprint is "Newhaven, West Society, Engrav'd Printed and Sold by the Author (Israel Terril)," and the work was copyrighted "21 Aug. in 30th year of Independence," or in 1806.

TERRILL BROS.
These twin brothers were mezzotint engravers and came from Canada to the United States about 1868. Returned to England about two years later. Pupils of Simmons of London. Engraved large plates of fancy subjects.

TERRIS, ALBERT.
Sculptor and calligrapher. Born in New York, NY, November 10, 1916. Studied with Aaron J. Goodelman, 1933; Work Progress Administration Art School, NY; Beaux Arts Institute of Design, NY, 1933-34; City College of NY, 1936-39, B.S.S., 1939, with George W. Eggers; Institute of Fine Arts, NY University, 1939-42, with Walter Friedlander, Richard Krautheimer, A. Phillip McMahon. Has exhibited at Allan Stone Gallery, NY (one-man); Museum of Art, Carnegie International, Pittsburgh; Brooklyn Museum Biennial, NY; Museum of Mod-

ern Art, NY; Sculpture Center of NY; others. Received first prize, Brooklyn Museum Biennial, 1960. Teaching sculpture and theory of art at Brooklyn College, NY, from 1954. Works in steel, plaster, terra cotta, and acrylic. Address in 1982, Freeport, NY.

TERRIZZI, ANTHONY T.
Sculptor. Award: Collaborative Competition prize, New York Architectural League, 1915. Address in 1916, 401 East 56th St., NYC.

TERRY, LUTHER.
Painter. Born on July 18, 1813 in Enfield, CT. Studied in Hartford, and in 1838 he went to Italy where he lived for years. Painted portraits and historical compositions. Married the widow of Thomas Crawford, the sculptor, in 1861. His paintings are rarely seen in the U.S. Died in 1869.

TERRY, WILLIAM D.
Engraver. Worked in Providence, RI, 1830-36. In 1836, with Olive Pelton, Terry founded the Bank Note Company of Boston. Terry, Pelton & Co. also did general engraving in Boston. Terry himself was a bank-note engraver, and some of his early vignettes were signed at Providence, RI. He died probably late in 1858 or early in 1859.

TESSIN, GERMAIN.
Sculptor. Born in France, 1829. Worked in New Orleans in 1860.

TETLEY, WM. BIRCHALL.
Portrait painter in oils and miniatures. Born in London; came to U.S. in 1774. Flourished in New York about 1774. Taught painting, drawing, and dancing.

TEW, DAVID.
Engraver. The Journals of the Continental Congress record that on Oct. 28th, 1788, they owed him the sum of 213 50/90 dollars, for engraving three copperplates for bills of exchange, and for repairing two other plates.

TEW, MARGUERITE R.
Sculptor. Born in Magdalena, NM, January 6, 1886. Pupil of Penna. Museum School of Industrial Art; Penna. Academy of Fine Arts, under Grafly. Member: California Art Club; Fellowship of Penna. Academy of Fine Arts; National Association of Women Painters and Sculptors. Awards: Cresson European Scholarship, Penna. Academy of Fine Arts, 1913; first sculpture prize, California Art Club, 1924. Work: Mayan ornament on portal of South West Museum, Los Angeles. Address in 1933, Los Angeles, CA.

TEWKSBURY, FANNY W(ALLACE).
Painter and teacher. Born in Boston, MA. Pupil of School of Design; Massachusetts Institute of Tech-

nology and Ross Turner in Boston. Member: NY Water Color Club. Address in 1929, 11 Maple Ave., Newton, MA.

THACHER, ELIZABETH.
Painter. Born in Brookline, MA, Feb. 13, 1899. Pupil of Leslie Thompson; Philip Hale; William James; Frederick Bosley. Member: Springfield Art League. Award: Hon. mention, Junior League, Boston, 1929. Address in 1933, 21 Dwight St., Brookline, MA; summer, Cohasset, MA.

THACKARA.
This signature as engraver is signed to a crude copperplate frontispiece to "The Instructor, or Young Man's Best Companion, etc," by George Fisher, published by Isaac Collins, Burlington, NJ, 1775. No other example has been seen of this man's work, and it is barely possible that the plate referred to was engraved by the sailor father of James Thackara.

THACKARA, JAMES.
Engraver. Born in Philadelphia, PA, March 12, 1767; died there August 15, 1848. Son of James Thackara, Sr., who settled in Philadelphia in 1764, after having served many years as a seaman in the British navy. Young James was apprenticed to James Trenchard, and later married his daughter. From 1791 to about 1797, Thackara was a partner of John Vallance in the engraving business in Philadelphia, and Thackara's name as engraver appears in directories from 1791 to 1833. He later worked with his son William Thackara. His work was done entirely in line and confined to subject plates. For some time after 1826 he was the keeper of the Penna. Academy of Fine Arts. A three quarter length seated oil portrait of James Thackara was in the possession of his grandson, James Thackara, Lancaster, PA.

THACKARA, WILLIAM W.
Engraver. Born in Philadelphia, PA, February 9, 1791. Son of James Thackara and a pupil of his father. Active in Philadelphia, 1818-1824. In 1832 he and his father had the firm of Thackara & Son, general engravers in Philadelphia. This firm published, in 1814, *Thackara's Drawing Book, for the Amusement and Instruction of Young Ladies and Gentlemen.* Died April 19, 1839.

THAIN, HOWARD A.
Painter. Born in Dallas, TX, Nov. 16, 1891. Pupil of Samuel Ostrowsky; Antonin Sterba; F.V. DuMond; Robert Henri; Vivian Anspaugh; F. De Forest Schook; Jay Hambidge. Member: Society of Independent Artists; Bronx Artists Guild; Art Students League of NY; Southern States Art League. Address in 1933, 327 West 22nd St., New York, NY.

THAL, SAMUEL.
Etcher, sculptor, and painter. Born in NYC, May 4, 1903. Studied at Art Students League; National Academy of Design; Beaux-Arts Academy; Boston Museum of Fine Arts School. Member: Boston Architectural Club. Awards: Prizes, Connecticut Academy of Fine Arts, 1943; Library of Congress, 1945; National Academy of Design. Work: Boston Museum of Fine Arts; Library of Congress; Bibliotheque Nationale, Paris; Boston Public Library; Carnegie Institute; Pennsylvania State University; Metropolitan Museum of Art; others. Exhibited: Doll and Richards, Boston; Rockport Art Association; Institute of Modern Art, Boston; Library of Congress; U.S. National Museum. Address in 1962, Boston, MA.

THALINGER, E. OSCAR.
Painter. Born in Alsace-Lorraine, France, March 20, 1885. Pupil of St. Louis School of Fine Arts under Wuerpel, Stoddard and Campbell; Gruber in Munich. Member: St. Louis Artists Guild; 2 x 4 Society. Awards: Thumb box group prize, 1926; St. Louis Artists Guild group prize, 1926; Halsey C. Ives landscape prize, 1926, best work prize, 1928; prize, 1927, best industrial picture, 1930, 32, best landscape, 1931, St. Louis Chamber of Commerce; bronze medal, Kansas City, 1931. Registrar, City Art Museum, St. Louis, MO. Address in 1933, St. Louis, MO.

THALINGER, FREDERIC JEAN.
Sculptor. Born in St. Louis, MO, August, 28, 1915. Studied at Antioch College, A.B.; Washington University; Art Institute of Chicago; and with Grant Wood. Awards: Prizes, Syracuse Museum of Fine Arts, 1937; Beaux-Arts Exhibition, 1939; Traveling Fellowship, Washington University, St. Louis, MO, 1939. Work: Syracuse Museum of Fine Arts; Illinois State Museum; Antioch College, Yellow Springs, OH; sculpture, U.S. Post Office, Jenkins, KY; Francis Cabrini Housing Project, Chicago, IL. Exhibited: Kansas City Art Institute, 1937; Art Institute of Chicago, 1940, 41; City Art Museum of St. Louis, 1943; Syracuse Museum of Fine Arts, 1937; New-Age Gallery, NY, 1946. Address in 1953, 205 Main St., Ossining, NY; h. Croton-on-Hudson, NY.

THAW, FLORENCE.
(Mrs. Alex. Blair Thaw). Painter. Born in New York City, Feb. 17, 1864. Pupil of Abbott Thayer and Birge Harrison; Julian Academy in Paris. Member: Washington Society of Artists; NY Cosmopolitan Club; American Federation of Arts. Address in 1933, 3255 N. St., Washington, DC; summer, Little River Farm, North Hampton, NH.

THAXTER, EDWARD R.
Sculptor. Born in Maine. Died in Naples, Italy, 1881.

THAYER, ABBOTT HANDERSON.
Painter. Born in Boston, MA, August 12, 1849. Went to Paris and entered the atelier of Gerome, and from this studio went to Ecole des Beaux Arts, where his great ability as a draftsman was recognized. On his return home from Europe, he painted cattle-pieces and animal studies. Their backgrounds were indicative of the mastery he was later to achieve in his landscapes. After his return to the U.S., he dedicated himself to ideal figure pictures. His painting of a nude is shown in his great picture "Figure Half-Draped," which shows well the commanding exercise of his technique. Painted the first of his "Winged Figures" in 1889, later owned by Smith College, then painted the "Caritas" and the "Virgin," Freer Gallery, Smithsonian, also the "Virgin Enthroned," and other angel paintings. Executed the mural decoration at Bowdoin College. Although he painted few landscapes, his profound knowledge of the truth of nature and his great skill can be seen in those he did. The "Winter Sunrise on Monadnock," in the Metropolitan Museum of Art, the "Sketch of Cornish Headlands" and "Winter Dawn on Monadnock," in the Freer Gallery, Smithsonian Institution, are among the finest examples of American landscapes. Died in 1921. In 1922 a memorial exhibition of his work was held at the Metropolitan Museum of Art where 78 paintings and many drawings and sketches were shown.

THAYER, EMMA B.
(Mrs. Abbott Thayer). Painter. Born in 1850. Specialty: Flower studies in oil and pastel. Died in 1924.

THAYER, ETHEL R(ANDOLPH).
Painter. Born in Boston, MA, Nov. 8, 1904. Pupil of Philip Hale. Member: Guild of Boston Artists; National Association of Women Painters and Sculptors. Award: First Hallgarten prize, National Academy of Design, NY, 1929. Address in 1933, 77 Bay State Road, Boston, MA; summer, Wier River Farm, Hingham, MA.

THAYER, GERALD H.
Painter. Born in Cornwall-on-Hudson, NY, in 1883. Pupil of Abbott H. Thayer, his father. Work: "Partridge," Metropolitan Museum of Art; "Rabbit," Brooklyn Museum of Art. Author of *Concealing Coloration in the Animal Kingdom; The Nature-Camouflage Book; The Seven Parsons and the Small Iguanodon*. Address in 1926, Monadnock, NH.

THAYER, GLADYS.
(Mrs. David Reasoner). Painter. Born in South Woodstock, CT, in 1886. Pupil of her father, Abbott H. Thayer. Address in 1926, Monadnock, NH.

THAYER, GRACE.
Painter. Born in Boston, MA. Pupil of Boston Museum School; also of Mme. Hortense Richard in Paris. Member of Copley Society, 1885. Address in 1926, 845 Boylston St., Boston, MA.

THAYER, RAYMOND L.
Painter. Born in Sewickley, PA, November 16, 1886. Pupil of Kenneth Hayes Miller. Member: Artists Guild of the Authors' League of America; Society of Illustrators; American Water Color Society. Address in 1933, 149 West 45th St., New York, NY.

THAYER, SANFORD.
Portrait painter of Syracuse, NY. Born in Coto, NY, on July 19, 1820. Died in December, 1880, in Syracuse, NY.

THAYER, THEODORA W.
Miniature painter. Born in Milton, MA, in 1868. Studied with Joseph De Camp in Boston, MA. Instructor in NY School of Art, and at Art Students League of NY. Her fine portrait of Bliss Carman is considered one of the memorable achievements in American miniature painting. Died in 1905.

THEIS, GLADYS HULING.
Sculptor. Born in Bartlesville, OK, August 24, 1903. Studied at Oklahoma Agricultural and Mechanical College; Cincinnati Art School; Corcoran School of Art; and with Miller, Malfrey, and Despiau; also in Paris. Works: Tulsa High School, Tulsa University, Boston Avenue Church, all in Tulsa; Oklahoma Agricultural and Mechanical College; University of New Mexico; Cincinnati Museum Association; Daufelser School of Music. Awards: Society of Washington Artists, 1931; National League of American Pen Women, 1950, 52; Albuquerque, NM. Exhibited: Society of Washington Artists, 1931, 32; Southwestern Art Exhibition, 1940; New Mexico Art League, 1937; Albuquerque, NM, 1937 (one-woman). Address in 1953, Albuquerque, NM.

THEISS, J(OHN) W(ILLIAM).
Painter and writer. Born in Zelienople, PA, Sept. 20, 1863. Pupil of Lorenzo P. Latimer and Anthony Anderson. Member: Springfield Art League. Address in 1933, 29 Glenwood Ave., Springfield, OH.

THEOBALD, ELIZABETH STURTEVANT.
(Mrs. Samuel Theobald, Jr.). Sculptor and painter. Born in Cleveland, OH, July 6, 1876. Pupil of Chase; Mora; Hawthorne; F. C. Gottwald; Herman Matzen. Member: National Association of Women Painters and Sculptors. Address in 1933, 42 Barrow St., New York, NY. Died in 1939.

THEOBALD, SAMUEL, JR.
Painter, etcher and teacher. Born in Baltimore, MD, Oct. 23, 1872. Pupil of Castaigne and National Academy of Design. Address in 1933, 42 Barrow Street, New York, NY.

THEODORE, PAN.
Sculptor and teacher. Born in Lemnos, Greece, February 5, 1905. Studied at DaVinci Art School; Beaux-Arts Institute of Design; Art Students League. Work: Numerous portrait busts. Exhibitions: Penna. Academy of Fine Arts, 1942; National Academy of Design, 1944; Society of Independent Artists, 1943. Address in 1953, 62 West 11th St., New York, NY.

THERIAT, CHARLES JAMES.
Painter. Born in NY in 1860; student of Jules Lefebvre and Boulanger in Paris. Awards: Honorable mention, Paris Expo., 1899; Salon, 1896, and Paris Expo., 1900; bronze medal, Buffalo Expo., 1901. Member of Paris Society of American Painters. Address in 1926, Le Mee, Melum, Seine et Marne, France.

THEUERKAUFF, CARL R.
Painter. Born in Germany in 1875. Member of Rochester Art Club. Address in 1926, Cornwall Bldg., Chicago, IL.

THEUS, JEREMIAH.
Portrait painter. Born c. 1719. One of three brothers who came to South Carolina from Switzerland c. 1735. He established a studio and painted portraits in Charleston, SC, where he settled c. 1739, and worked as a limner and decorative painter until his death. His work has frequently been attributed to Copley. Died at Charleston, SC, May 17, 1774, after painting for about 35 years in that city.

THEW, (R.) GARRET.
Painter and sculptor. Born in Sharon, CT, October 13, 1892. Pupil of Edward Penfield; John Carlson; Walter Biggs. Member: Artists Guild of the Authors' League of America. Represented in the Newark Museum. Address in 1933, Westport, CT.

THEW, ROBERT.
Engraver. Born in England. Came to U.S. about 1850, and returned to England about 1865. Worked in NY and in Cincinnati. Engraver of landscapes.

THIEBAUD, (MORTON) WAYNE.
Painter and educator. Born Nov. 15, 1920 in Mesa, AZ. Studied: San Jose State College; earned B.A. and M.A. from Sacramento State College. Produced many educational films. Received awards at California State Fair, Art Film Festival, first prize, 1956; Columbia Records Award, 1959; Scholastic Art Awards, 1961; others. Taught at San Francisco Art Institute; Sacramento City College; Sacramento State College; California School of Fine Arts; Yale University; University of California, Davis, since

1960; others. Created mosaic mural, 1959, Sacramento Municipal Utility Building. Exhibited at Crocker Art Gallery, Allan Stone Gallery, M. H. de Young Memorial Museum, San Francisco Museum of Art, Galleria Schwarz (Milan), Stanford University (all one-man); Institute of Contemporary Arts, London; Guggenheim; Wadsworth; Brandeis; Art Institute of Chicago Annual; Los Angeles County Museum of Art; California Palace of the Legion of Honor; IX Sao Paulo Biennial, 1967; Denver Art Museum; The Hague; Whitney Annual; others. In collections of Metropolitan Museum of Art; Albright-Knox Art Gallery; Newark Museum; Stanford University; Museum of Modern Art; Bryn Mawr College; University of Miami; Wadsworth; Corcoran; Whitney; Crocker Art Gallery; others, including many private collections. Address in 1984, Department of Art, University of California, Davis, CA.

THIEDE, HENRY A.
Illustrator. Born in Germany, Oct. 27, 1871. Member: Palette and Chisel Club. Award: Prize, Palette and Chisel Club, 1929. Address in 1929, North American Bldg., Chicago, IL; h. 2749 Woodbine Ave., Evanston, IL.

THIEM, HERMAN C.
Painter, architect, and illustrator. Born in Rochester, NY, Nov. 21, 1870. Studied: Mechanics' Institute; pupil of Seth Jones and Carl M. Raschen. Member: Rochester Art Club; Picture Painters' Club. Address in 1933, 1589 St. Paul St.; summer, Stop 16, Sumerville Blvd., Rochester, NY.

THIEME, A(NTHONY).
Painter, designer and teacher. Born in Rotterdam, Holland, Feb. 20, 1888. Pupil of George Hacker; Academie of Fine Arts, The Hague, Holland; Garlobini, Guardaciona, Mancini, in Italy. Member: Boston Art Club; Providence Water Color Club; Boston Society of Arts and Crafts; North Shore Arts Association; Salma. Club; Springfield Art League; Rockport Art Association; NY Water Color Club; Art Alliance of America; American Artists Professional League; Gloucester Society of Artists; American Water Color Society; Art Alliance of Philadelphia; Connecticut Academy of Fine Arts; National Arts Club. Awards: Second prize, 1927, and first prize, 1928, Springfield Art League; first landscape prize, Gloucester Art Association, 1928; hon. mention, Springville, UT, 1928; Shaw prize, Salma. Club, 1929, 31; Delano prize, NY Water Color Club, 1930; marine prize, North Shore Arts Association, 1930; Atheneum prize, Connecticut Academy of Fine Arts, 1930; hon. mention, Tercentenary Exhibition, Boston, 1930; hon. mention, Ogunquit Art Centre, 1930; Mr. and Mrs. Burton Mansfield prize, New Haven Paint and Clay Club, 1931; Lucien Powell Memorial award, Washington Water Color Club, 1931; purchase prize, Los Angeles Museum, 1931; purchase

prize, Springville, UT, 1931. Work: Boston Museum of Fine Arts; Dayton Art Institute; Albany Institute of History and Art; Los Angeles Museum of Fine Arts; permanent collection of City of New Haven, CT; Metropolitan Museum of Art; Seattle Art Museum; Pittsfield Museum; art collection, Springville, UT; permanent collection of Iowa State University; others. Exhibited: Art Institute of Chicago; National Academy of Design; Penna. Academy of Fine Arts; Los Angeles Museum of Art; Corcoran; City Art Museum of St. Louis; Detroit Institute of Arts; others, including exhibitions in Brussels, France, and Holland. Address in 1953, Rockport, MA; winter, St. Augustine, FL.

THIESSEN, CHARLES LEONARD, JR.
Designer, painter, sculptor, graphic artist, lecturer, and teacher. Born in Omaha, NE, May 3, 1902. Studied at University of Nebraska; School of Royal Academy, Stockholm, Sweden; Heatherley's School of Art, London; Grande Chaumiere, Paris; Creighton University, honorary D.F.A., 1972. Work: Nebraska Historical Society, Lincoln, 1952-53; Nebraska Art Association; Artists Guild, Lincoln, NE; Alfred East Memorial Gallery, Kettering, England; University of Nebraska; University of Omaha; Joslyn Art Museum; others. Exhibited: Royal Society of British Artists, London, 1949; Young Contemporaries, London, 1949; Midwest Biennial, Joslyn, 1952; Mid-America, Kansas City, 1953. Member of Artists Equity Association. Position: Art consultant, State Historical Society, Lincoln, NE, from 1951; instructor, painting, Joslyn Art Museum, Omaha, NE, from 1951; executive director, Nebraska Arts Council. Address in 1970, Nebraska Arts Council; h. Omaha, NE.

THOBURN, JEAN.
Painter and teacher. Born in Calcutta, India, Nov. 27, 1887. Pupil of Frank A. Parsons; H. S. Stevenson; A. W. Dow. Member: Pittsburgh Art Association. Art teacher, Peabody High School, Pittsburgh, PA. Address in 1933, 6759 Penn Ave., Pittsburgh, PA; 12 Cookman Ave., Chautauqua, NY.

THOELE, LILLIAN (CAROLINE) (ANNE).
Painter and illustrator. Born in St. Louis, MO, Aug. 12, 1894. Pupil of St. Louis School of Fine Arts; Penna. Academy of Fine Arts. Member: St. Louis Artists Guild; St. Louis Art League; Society of Independent Artists of St. Louis. Work: "The Vision of Christian Leadership," Assembly Hall, and "The Lost Trail," "I Saw the Shining Sea," "Memorial to Kinji," Tipiwakan Building, American Youth Foundation Camp, Shelby, MI. Address in 1933, 4025 Shreve Ave., St. Louis, MO.

THOM, JAMES.
Sculptor. Born in Ayrshire, Scotland, 1799. Exhibited at the British Institute, in London, 1815. Work-

ing in New Orleans by 1834; lived in Newark, NJ, after 1836; later settled on a farm near Ramapo, NJ. Group illustrating Burns's "Tam O'Shanter" in the collection of the Franklin Institute in Philadelphia and exhibited at the Pennsylvania Academy, 1850-70. Died in NYC on April 17, 1850.

THOM, JAMES CRAWFORD.
Painter. Born in New York in 1835. Son of James Thom. He studied at the National Academy; also went abroad for study and exhibited in London, where he earned several medals. Among his paintings are "By the River-side," "The Monk's Walk," "Forgotten Cares," "The Old Farm House," and a number of landscapes painted along the Hudson River. Exhibited at the National Academy of Design; Royal Academy; Boston Athenaeum; Pennsylvania Academy. Died February 16, 1898, at Atlantic Highlands, NJ.

THOMAS, ALLAN A. F.
Designer and illustrator. Born in Jackson, MI, Feb. 15, 1902. Pupil of George Harding; Penna. Academy of Fine Arts. Awards: First Cresson European Scholarship, 1925, second Cresson European Scholarship, 1927; first Lea prize, Penna. Academy of Fine Arts, 1926; medal, Philadelphia Water Color Club, 1929. Work: Penna. Academy of Fine Arts; murals, Upjohn School, Kalamazoo, MI; St. John's Church, Jackson, MI; U.S. Post Office, Crystal Falls and Clare, MI, and Wabasha, MN; others. Exhibited: Philadelphia Water Color Club; Art Institute of Chicago; Architectural League; Detroit Institute of Arts; others. Illustrator for national magazines and leading publishers. Address in 1953, 440 Main St.; h. 527 North Michigan Ave., Stevens Point, WI.

THOMAS, C. B.
Painter. Member: National Society of Mural Painters. Address in 1929, 132 East 19th St., New York, NY.

THOMAS, C. H.
Miniature painter. Flourished in NY in 1838-39.

THOMAS, CONRAD ARTHUR.
Painter. Born in Dresden, Germany, April 28, 1858. Pupil of Hofmann; Grosse; Schilling. Member: American Federation of Arts; New Rochelle Art Association. Work: Allegorical murals, City Hall, St. Louis; Court House, Auburn, IN; Sinton Hotel, Cincinnati, OH; historical murals, "La Salle," Court House, South Bend, IN; "Daniel Boone," Seelbach Hotel, Louisville, KY; "Radisson," Radisson Hotel, Louisville, KY; "Adoration of the Magi," Saints Peter and Paul Cathedral, Philadelphia. Address in 1929, 116 4th St., Pelham, NY.

THOMAS, EMMA W(ARFIELD).
Painter. Born in Philadelphia, PA. Pupil of Beaux; Chase; Thomas P. Anshutz; Hugh H. Breckenridge.

Member: Fellowship Penna. Academy of Fine Arts; Art Alliance of Philadelphia; Plastic Club. Specialty: Portraits and landscapes. Address in 1933, 3409 Hamilton St., Philadelphia, PA.

THOMAS, ESTELLE (L.).
Painter, illustrator, and teacher. Born in New York City. Pupil of Martin Borgard; John Sloan; Charles Hawthorne. Member: Pittsburgh Art Association; Gloucester Society of Artists. Address in 1933, 512 North Euclid Ave., Pittsburgh, PA.

THOMAS, HENRY.
Portrait painter. Pupil of John Neagle. Worked in Philadelphia. His portrait of the actor Junius Brutus Booth was exhibited in the Loan Collection of Historic Portraits, Philadelphia, 1887.

THOMAS, ISAIAH.
Engraver. Born Jan. 19, 1749 in Boston, MA. Served as apprentice to Zachariah Fowle. In 1770, in partnership with Fowle, Thomas published the *Massachusetts Spy*. About this time he tried engraving on type metal. To this later well-known printer and publisher are credited some very crude cuts signed "I.T.," appearing in "The History of the Holy Jesus, etc., 15th edition, printed by I. Thomas for L. Fowle." Died April 4, 1831 in Worcester, MA.

THOMAS, JOHN.
Painter and printmaker. Born Feb. 4, 1927 in Bessemer, AL. Earned B.A. from New School for Social Research, 1951; studied at University of Georgia, 1946-48; University of Stranieri, Perugia, Italy, 1954; earned M.A. from NYU, 1954. Taught at State University of Iowa; University of Hawaii in Manoa and Hilo; University of Washington. Awards: Yaddo Foundation; Tuscon Art Center; grant from National Endowment for the Arts, 1977; Hawaii Artists League Juror's Award, Annual Exhibition, Honolulu, 1978. Exhibited at Birmingham Museum of Art; Oklahoma Art Center; University of Arizona; Seattle Art Museum; Denver Art Museum; State University of Iowa; Whitney; Wichita Art Museum; University of Nebraska; Kootz Gallery, NYC; California Palace; Contemporary Art Center, Hawaii; Santa Barbara Museum; Virginia Museum of Fine Arts; Honolulu Academy of Arts; others. Work: Smithsonian; Capitol Building, Honolulu; Hirshhorn Collection; Contemporary Art Center of Hawaii, Honolulu; others, including many private collections. Member: Hawaii Artists League; Komohana Artists Association. Media: Oil, watercolor. Address in 1984, Kailua, Kona, HI.

THOMAS, MARJORIE.
Painter. Exhibited at the Annual Exhibition of the Penna. Academy, Philadelphia, 1924. Address in 1926, Scottsdale, AZ.

THOMAS, PAUL KIRK MIDDLEBROOK.
Painter, sculptor, writer, lecturer, and teacher. Born in Philadelphia, PA, January 31, 1875. Pupil of Penna. Academy of Fine Arts; and with Cecilia Beaux, William M. Chase, and Charles Grafly. Awards: First and second Toppan prize, Penna. Academy of Fine Arts; Bronze medal, St. Louis Exposition, 1904. Member: Fellowship, Penna. Academy of Fine Arts; American Artists Professional League; Lotos Club; New Rochelle Art Association. Work: Portraits, Bryn Mawr College; University of Chicago; Williams College; Western Reserve University; Nippon Club, NY; Yale University; Smith College; University of Pennsylvania. Address in 1953, New Rochelle, NY.

THOMAS, RICHARD.
Sculptor and craftsman. Born in Philadelphia, PA, September 4, 1872. Pupil of Charles Grafly; August Zeller; Ed Maene. Member: Trenton (NJ) Art Association. Address in 1929, Memorial Art Studio, Crosswich St.; h. Elizabeth St., Bordentown, NJ.

THOMAS, ROLAND.
Painter. Born in Kansas City, MO, in 1883. Pupil of William Chase; Robert Henri; Frank Vincent DuMond. Member: Kansas City Arts and Crafts; American Artists, Munich. Awarded landscape prize, Missouri State Art Exhibit, 1912. Work: "Autumn," Elverhoj Art Gallery, Milton, NY; "Winter Dachaon," American Artists' Club, Munich; mural decoration in Curtiss Building, Kansas City, MO. Address in 1926, 409 East 10th St., Kansas City, MO.

THOMAS, RUTH.
Painter. Born in Washington, DC, Oct. 10, 1893. Studied: Corcoran School of Art; pupil of Albert Sterner; John Elliot; Helena Sturtevant; Cecilia Beaux. Member: Newport Art Association. Award: Davidson prize, black and white, National Association of Women Painters and Sculptors, 1933. Specialty: Portrait drawings. Address in 1933, 62 Ayrault St., Newport, RI.

THOMAS, RUTH F.
See Felker, Ruth Kate.

THOMAS, S. SEYMOUR.
Painter. Born in 1868 in San Augustine, TX. Studied at Art Students League, NY, 1886-88; Julian Academy and Ecole des Beaux Arts, Paris. Work was principally portraiture. Awards: Honorable mention, Salon, Paris, 1895; gold medals, Salon, 1901; 2nd gold medal, Hors Concours, 1904; bronze medal, Paris Expo., 1900; gold medal, Munich, 1901; Chevalier de la Legion d'Honneur, 1905. Member International Jury of Awards, St. Louis Expo., 1904; Paris Society of American Painters. Painted Hon. James Bryce, Cardinal William Henry O'Connell, Gen. Lew Wallace; President Woodrow Wilson for the White House, and one for the State House of NJ; "Portrait of a Lady and Dog," acquired by the Metropolitan Museum, 1915. Address in 1926, 11 Impasse Rousin, Paris, and 80 West 40th St., New York, NY. Died Feb. 29, 1956.

THOMAS, STEFFEN WOLFGANG GEORGE.
Sculptor and painter. Born in Furth, Germany, January 7, 1906. U.S. citizen. Pupil of Zink School of Fine Arts, Nuremburg; Academy of Fine Arts, with Herman Hahn, Bernhart Bleeker, and Josef Wakerle, Munich, Germany; and University of Bavaria, Munich. Member: Atlanta Art Association; Verein Student Haus, Munich; Deutscher Reichbund Der Kuenstler, Berlin. Work: "Head of Youth," "Baby" (fountain), City of Furth, Bavaria, Germany; "Bust of Dr. George H. Denny," University of Alabama; bronze bust, Judge John S. Candler, Emory University, GA; High Museum, Atlanta, GA; bronze monument of Gov. Eugene Talmadge, State Capitol Grounds, Atlanta; "Mother and Child," Fulton County Court House garden, Atlanta; others. Exhibited: Smithsonian Institution, 1952; High Museum, 1936; W. C. Hill Gallery, Atlanta, 1979; Kraskin Galleries, Atlanta and Washington, DC, 1980; others. Awards: Honorable mention, Fine Arts Academy, Munich, 1928; first prize and purchase prize, City of Furth, 1925. Media: Bronze; painting, graphics. Address in 1982, Atlanta, GA.

THOMAS, VERNON (MRS.).
Painter, illustrator, and etcher. Born in Evanston, IL, Sept. 12, 1894. Pupil of Ralph Clarkson; Charles Hawthorne; W. J. Reynolds. Member: National Arts Club; Chicago Society of Etchers; Cordon Club. Represented by "The Cut Outs" in collection of the City of Chicago. Specialty: Painting and etching of children. Address in 1933, 1400 Lake Shore Drive, Chicago, IL.

THOMASON, FRANCIS Q.
Painter. Exhibited at the Penna. Academy of Fine Arts, Philadelphia, 1914.

THOMPSON.
Some poorly drawn and badly engraved subject plates are thus signed. They were published in NY in 1834.

THOMPSON, ALBERT.
Painter. Born in Woburn, MA, in 1853. He became a pupil of William E. Norton in 1880-81; he also studied in Paris. His work was mainly landscapes and cattle. Among his paintings are "After the Shower," "Clearing Up," "Changing Pasture," and "An October Afternoon."

THOMPSON, ALFRED WADSWORTH.
Painter. Born in Baltimore, MD, May 26, 1840. Studied in Paris. His paintings cover a wide range of

subjects. Specialty: Landscapes. Member of National Academy of Design in 1875. The NY Historical Society owned "The Parting Guests." Died August 28, 1896 in Summit, NJ.

THOMPSON, ARAD.
Painter. Born in Dec. 1786 in Massachusetts. Graduated from Dartmouth College in 1807. Lived and painted portraits in Middleboro, MA. Died April 23, 1843 in Middleboro, MA.

THOMPSON, CEPHAS GIOVANNI.
Landscape and portrait painter. Born in Middleborough, MA, August 3, 1809. At 18 years he painted portraits in Plymouth, MA, and afterwards in Providence, RI. Had a studio in NY in 1837-47. Resided in Italy, 1852-60, and returned to NY. He was an Associate of the National Academy. Painted portraits of many American authors. The collection is now owned by the NY Historical Society. Died Jan. 5, 1888.

THOMPSON, D. GEORGE.
Engraver. Born in England; died in NY about 1870. He spent a considerable part of his early life in India with a brother who held some official position in that country. Was engraving portraits and landscapes in NYC in 1856. Also a watercolor artist.

THOMPSON, EDITH BLIGHT (MRS.).
Painter. Born in Philadelphia, PA, April 27, 1884. Pupil of F. V. DuMond and Luis Mora. Member: Newport Art Association. Specialty: Interiors. Award: Hon. mention, Paris Salon, 1927. Address in 1933, Westbury, Long Island, NY; summer, 20 Belgrave Square, London, England.

THOMPSON, ERNEST THORNE.
Etcher, lithographer, illustrator, painter, and teacher. Born in Saint John, N. B., Canada, Nov. 8, 1897. Pupil of Massachusetts School of Art, under Major, Hamilton and Andrew; School of Boston Museum, under Bosley; European study. Member: Indiana Art Association; Hoosier Salon; American Federation of Arts; Society of Illustrators; Chicago Society of Etchers; others. Awards: McCutcheon prize, Hoosier Salon, 1927; Cunningham prize, 1929; Fifty prints of The Year, 1928. Work: "The Sacred Heart," mural, St. Patrick's Church, McHenry, IL; "Madonna of Sorrows," mural, Holy Cross Seminary, Notre Dame, IN; "Decorative Landscape," Palmer Lodge, Detroit, MI; "Stations of the Cross," and Football Championship memorial, bronze, also world war memorial, bronze and mural, University of Notre Dame; "Indiana Snows," Wightman Memorial Gallery, Notre Dame; "Adventures of Don Quixote," murals, Oliver Hotel, South Bend, IN; "Net Mender's Yard," Bibliotheque Nationale, Paris. Author of "Technique of the Modern Woodcut," "New England, Twelve Woodcuts;" works also reproduced by principal magazines. Director, School of Fine Arts, University of Notre Dame, 1922-29. Address in 1933, School of Art, College of New Rochelle, New Rochelle, NY; summer, Bristol, ME.

THOMPSON, F. LESLIE.
Etcher. Member: Chicago Society of Etchers; Print Makers' Society of California. Address in 1929, Fenway Studios, Boston, MA; 4700 North Lawndale Ave., Chicago, IL.

THOMPSON, FRED D.
Painter. Member: Providence Water Color Club. Address in 1929, 184 Alabama Ave., Providence, RI.

THOMPSON, FREDERIC LOUIS.
Painter and sculptor. Born in Chilmark, MA, in 1868. Pupil of George H. McCord. Member: Salmagundi Club; Societe des Beaux Arts. Address in 1926, 126 East 75th St., New York, NY.

THOMPSON, G(EORGE) A(LBERT).
Painter, teacher, and draftsman. Born in New Haven, CT, July 1, 1868. Pupil of Yale School of Fine Arts, Yale University; John La Farge in NY; Merson, Blanc, Courtois and Girardot in Paris. Member: Connecticut Academy of Fine Arts; Paint and Clay Club of New Haven; Salma. Club, 1909; Mystic Art Association; Mystic Society of Artists. Award: Cooper prize, landscape, Connecticut Academy of Fine Arts, 1928. Work: "Nocturne, the Quinnipiack," National Gallery, Uruguay, S.A. Address in 1929, 12 Ashbey Street, Mystic, CT.

THOMPSON, HANNAH.
Painter and etcher. Born in Philadelphia in 1888. Pupil of William M. Chase. Member of California Art Club and Society of Etchers. Address in 1926, 415 Oakland Ave., Pasadena, CA.

THOMPSON, HARRY IVES.
Painter. Born in West Haven, CT, January 31, 1840. Died there in 1906. First painted under the instruction of Benjamin Coe, a water colorist of New Haven, CT, whom he succeeded as instructor in the drawing school. While his landscape and figure work was well received, his best work was that of a portrait painter. At the Fifty-second Annual Exhibition of the National Academy of Design, he exhibited a large portrait of governors of Connecticut, later in the library of the State Capitol. His portrait of Jonathan Trumbull was in the U.S. Capitol.

THOMPSON, J. D.
In 1860 this capital line-engraver of landscapes was working in NY. Probably a bank-note engraver.

THOMPSON, JEROME.
Painter. Born in 1814. Brother of Cephas G. Thompson. Painted portraits at an early age at Cape Cod.

Had a studio in NYC and went to Europe in 1852 to study. Painted landscapes and figures. His "Land of Beulah," "Hiawatha's Journey" and "The Voice of the Great Spirit" were well-known. Died in 1886.

THOMPSON, JOHN EDWARD.
Painter, draftsman, and teacher. Born in Buffalo, NY, Jan. 3, 1882. Pupil of Art Students League of Buffalo and New York; and of Laurens, Blanche, Cottet, and Tudor-Hart in Paris. Member: Denver Art Association; Cactus Club. Award: Medal for murals, Denver Club, 1929. Represented by decorations in National Bank Building, Polo Club, St. Martin's Chapel, and in Art Museum, Denver. Instructor at University of Denver. Patron at "Atelier" (branch of Beaux Arts). Address in 1933, 1985 South Pennsylvania Street, Denver, CO.

THOMPSON, JULIET.
Portrait painter. Born in New York. Pupil of Corcoran Art School and Art Students League in Washington; Kenneth Hayes Miller; Julian Academy in Paris. Member: National Arts Club; Society of Washington Artists; Washington Water Color Club; Society of Independent Artists. Award: Medal, Brown-Bigelow Competition, 1925. Address in 1933, 48 West 10th St., New York, NY.

THOMPSON, KATE E.
Painter. Born near Middletown, Orange Co., NY, June 8, 1872. Studied: Art Students League of NY; pupil of Kenneth Hayes Miller and George Bridgman. Work: Mural, "Sisterhood," Montclair (NJ) Unitarian Church; "The Law," New Jersey Department of Public Highways. Specialty: Small murals for homes. Address in 1929, Pompton Plains, NJ.

THOMPSON, LAUNT.
Sculptor. Born in Abbeyleix, County Leix, Ireland, February 8, 1833. Came to America in 1847. Pupil of Erastus Dow Palmer. Produced several portrait busts and later opened a studio in New York. Elected an Associate of the National Academy of Design in 1859 and an Academician in 1862. Work: Statues of Pierson, at Yale College; Bryant, at the Metropolitan Art Museum, NY; and Edwin Booth, as Hamlet. Died September 26, 1894, in Middletown, NY.

THOMPSON, LESLIE P(RINCE).
Painter. Born in Medford, March 2, 1880. Pupil of Boston Museum School under Tarbell. Member: Associate National Academy of Design; Guild of Boston Artists; St. Botolph Club; Newport Art Association. Awards: Bronze medal, St. Louis Expo., 1904; third Hallgarten prize, National Academy of Design, 1911; H. S. Morris prize, Newport Art Association, 1914; silver medal, P.-P. Expo., San Francisco, 1915; Beck gold medal, Penna. Academy of Fine Arts, 1919; silver medal, Sesqui-Centennial Expo., Philadelphia, 1926; Stotesbury prize, Penna. Academy of Fine Arts, 1927; purchase prize, Boston Art Club, 1928. Address in 1933, 308 Fenway Studios, 30 Ipswich St., Boston, MA.

THOMPSON, MARGARET WHITNEY.
(Mrs. Randall Thompson). Sculptor. Born in Chicago, IL, February 12, 1900. Pupil of Penna. Academy of Fine Arts; Charles Grafly; Schukieff in Paris. Member: Philadelphia Alliance; Fellowship, Penna. Academy of Fine Arts. Address in 1929, Wellesley Hills, MA.

THOMPSON, MARVIN FRANCIS.
Painter, block printer and etcher. Born in Rushville, IL, March 14, 1895. Studied: Chicago Academy of Fine Arts; pupil of Louis Ritman, Dorothy Vicaji. Member: Chicago Society of Artists; Illinois Academy of Fine Arts. Work: "Hunters," Pere Marquette Hotel, Peoria, IL. Painter, etcher, wood engraver of the American Indian. Address in 1933, 6933 Stewart Ave., Chicago, IL.

THOMPSON, MILLS.
Mural painter and writer. Born in Washington, DC, Feb. 2, 1875. Pupil of Corcoran Art School in Washington; Art Students League of Washington; Art Students League of NY. Member: Society of Washington Artists; Washington Water Color Club; Art Club of Philadelphia. Address in 1929, 44 Old Military Road, Saranac Lake, NY.

THOMPSON, MYRA.
Sculptor and painter. Born in Maury Co., TN, November 23, 1860. Pupil of A. Saint-Gaudens; French; Injalbert; Eakins. Address in 1916, Spring Hill, TN.

THOMPSON, NELLIE LOUISE.
Painter and sculptor. Born in Jamaica Plain, Boston, MA. Pupil of Sir James Linton and South Kensington School under Alyn Williams and Miss Ball Hughes, in London; Cowles Art School, in Boston, under De Camp; Henry B. Snell. Studied sculpture under Roger Noble Burnham, Bela Pratt, John Wilson, Cyrus Dallin. Member: Copley Society, 1893; allied member, MacDowell Club; North Shore Arts Association; Gloucester Society of Artists; Boston Sculpture Society. Address in 1933, Boston, MA.

THOMPSON, WALTER W.
Painter and teacher. Born in Newton, MA, Jan. 10, 1881. Pupil of W. T. Robinson; John Enneking; C. W. Reed. Member: Darien Guild of Seven Arts; Jacksonville Fine Arts Society; American Federation of Arts; Association of Georgia Artists; Savannah Art Club. Address in 1933, care of Ainslie Galleries, Inc., 677 Fifth Ave., New York, NY; Biltmore Hotel, Atlanta, GA.

THOMPSON, WILLIAM JOHN.
Portrait and genre painter. Born 1771 in Savannah, GA. Painted miniatures. In 1812 he moved to Edinburgh, Scotland, and died there in 1845.

THOMPSON, WOODMAN.
Painter and draftsman. Born in Pittsburgh, PA, Nov. 19, 1889. Pupil of Arthur W. Sparks; George Sotter; Ralph Holmes. Member: Pittsburgh Art Association. Founded Department of Stagecraft at Carnegie Institute of Technology. Specialty: Stage scene designs and mural paintings. Address in 1933, Booth Theater, 222 West 45th St., New York, NY.

THOMPSON, WORDSWORTH.
Painter. His picture "Passing the Outpost" was owned by the Union League Club of NY. Elected a member of the National Academy of Design in 1875. Died in 1896.

THOMSEN, SANDOR VON COLDITZ.
Sculptor, lawyer, and philanthropist. Born in Chicago, IL, 1879. He was a pupil of Lorado Taft. Died in Chicago, IL, December 7, 1914.

THOMSON, FRANCES LOUISE.
Painter, lecturer, and teacher. Born in Hagerstown, MD, Feb. 22, 1870. Pupil of Art Students League of NY; Maryland Institute; Jean Paul Laurens. Member: Washington Society of Artists; Washington Water Color Club. Work: "Portrait of Admiral Schley," Maryland Historical Society, Baltimore.

THOMSON, GEORGE.
Painter. Born in Claremont, Ontario, Canada, Feb. 10, 1868. Pupil of F. V. DuMond; W. L. Lathrop; H. R. Poore. Member: Connecticut Academy of Fine Arts; New Haven Paint and Clay Club. Award: Hon. mention, Connecticut Academy of Fine Arts, 1915. Address in 1933, 591 8th St., East, Owen Sound, Ontario, Canada.

THOMSON, H(ENRY) G(RINNELL).
Painter. Born in New York, NY, Nov. 24, 1850. Pupil of National Academy of Design; Art Students League of NY; Chase. Member: Society of Independent Artists; Salma. Club; Silvermine Guild of Artists; American Artists Professional League; American Federation of Arts. Address in 1933, Wilton, Fairfield Co., CT.

THOMSON, RODNEY.
Illustrator and etcher. Born in San Francisco, CA, October 2, 1878. Pupil of Partington School of Illustration. Member: Society of Illustrators; Artists Guild of the Authors' League of America; American Federation of Arts. Address in 1929, 280 Riverside Drive, New York, NY.

THOMSON, W(ILLIAM) T.
Portrait painter and illustrator. Born in Philadelphia, PA, Oct. 5, 1858. Pupil of Penna. Academy of Fine Arts. Member: Fellowship Penna. Academy of Fine Arts; Art Club of Philadelphia; Philadelphia Sketch Club; American Art Society; Philadelphia Art Association. Address in 1933, 1020 Chestnut St.; h. 252 North 16th St., Philadelphia, PA.

THORBERG, TRYGVE.
Sculptor. Born in 1884. Specialty: Busts of children and adults.

THORNDIKE, GEORGE QUINCY.
Painter. Born in 1825. Graduated from Harvard in 1847 and went abroad to study art. On his return he settled in Newport, RI. His work showed the French influences of his training. Elected an Associate of the National Academy of Design in 1861. Among his works are "The Wayside Inn," "The Lily Pond," "The Dumplings" and "Newport, RI." Died in 1886.

THORNE, ANNA LOUISE.
Painter, etcher, writer, and lecturer. Born in Toledo, OH, December 21, 1878. Pupil of Art Institute of Chicago; Chicago Academy of Fine Arts; Art Students League of NY; with William Chase and Naum Los; Delacluse, M. Castolucio and Andre L'hote in Paris. Member: Detroit Society of Women Painters; Ohio Women Artists; Toledo Society of Women Artists; Athena Society. Awards: Prizes, Toledo Museum of Art, 1937. Work: Toledo Zoo; mural, Toledo Public Library. Exhibited: Detroit, MI (one-woman); Toledo Museum of Art. Address in 1953, Toledo, OH.

THORNE, THOMAS ELSTON.
Painter, sculptor, engraver, art historian, and illustrator. Born in Lewiston, ME, October 5, 1909. Pupil of Portland School of Fine and Applied Art; Yale School of Fine Arts, B.F.A., 1940; Art Students League, with Reginald Marsh. Work: "Crucifixion," "Last Supper," St. Lawrence Church; mural, "The Circus," children's ward, Maine General Hospital, Portland, ME; College of William and Mary, Williamsburg, VA; Colonial Williamsburg Foundation, VA. Exhibited: Penna. Academy of Fine Arts Watercolor Show, Philadelphia, 1930; New York Watercolor Club, 1940; Irene Leehe Memorial Exhibition, Norfolk, 1962. Taught: From instructor to professor of painting, College of William and Mary, 1940-75, head of fine arts department, 1943-69, professor emeritus, from 1975. Address in 1976, Williamsburg, VA.

THORNE, WILLIAM.
Painter. Born in Delavan, WI, 1864. Pupil of Constant, Lefebvre and Laurens in Paris. Member: Associate National Academy of Design, 1902; Academician National Academy of Design, 1913; Society

of American Artists, 1893. Awards: Medal, National Academy of Design, 1888; hon. mention, Paris Salon, 1891; bronze medal, Pan.-Am. Expo., Buffalo, 1901. Work: "The Terrace," Corcoran Gallery, Washington, DC. Address in 1933, Delavan, WI.

THORNHILL.
He was a music engraver on copper. Located in Charleston, SC, early in the last century.

THORNTON, WILLIAM.
Born May 20, 1759 in Tortola, West Indies. Educated as a physician. Lived in England and Scotland from 1781-83. Came to Philadelphia, and was elected a member of the American Philosophical Society of that city in 1787. A skilled architect. Designed the Philadelphia library building, completed in 1790, and superintended erection of the Capitol in Washington. In 1802 appointed first superintendent of U.S. Patent Office and held that office until his death. While in England, Thornton made a serious attempt at mezzotint engraving. One of his mezzotints, in the Library of Congress and dated 1781, is an enlarged copy of an engraved gem representing Caesar Augustus, fairly well executed, and signed "Thornton" in Greek characters. Assisted Thomas Jefferson with the plans for the University of Virginia buildings. A collection of his manuscripts, including personal notes, is in the Library of Congress. He also copied the profile crayon drawing that Gilbert Stuart made of Jefferson in "Swiss Crayon." Died in March, 1828, in Philadelphia.

THORPE, FREEMAN.
Portrait painter. Born in 1844; died in Hubert, MN, in 1922. Painted many portraits of Government officials in Washington, DC.

THORSEN, LARS.
Painter. Born in Norway, November 30, 1876. Member: Springfield Art Association; Connecticut Academy of Fine Arts; Mystic Art Association; Gloucester Society of Artists. Work: "Port Jackson," Louise Crombie Beach Memorial Collection, Storrs, CT; painting, "John Bertram," New York, New Haven and Hartford Railway Co.; murals, Mariner's Savings Bank, New London, Ct; represented in Art Museum, Norway. Address in 1933, Noank, CT.

THORWARD, CLARA SCHAFER (MRS.).
Painter and craftsman. Born in South Bend, IN, June 14, 1887. Pupil of Cleveland School of Art; Art Institute of Chicago; Henry G. Keeler. Member: Hoosier Salon; Artists League of Northern Indiana; Boston Society of Arts and Crafts; Philadelphia Society of Arts and Crafts. Award: First prize for batiks, Cleveland Museum of Art, 1926. Address in 1929, 31 West Mosholu Parkway, New York, NY.

THOURON, HENRY J.
Painter. Studied at the Penna. Academy of Fine Arts and later in Paris. On his return to this country he painted a number of altar pictures. Was instructor at the Penna. Academy of Fine Arts for several years. Died in 1915 in Rome.

THRASH, DOX.
Painter, etcher, lithographer, sculptor, writer, lecturer, and designer. Born in Griffin, GA, March 22, 1892. Studied at Art Institute of Chicago; Philadelphia Graphic Sketch Club; and with H. M. Norton and Earl Horter. Member: Philadelphia Print Club. Work: Library of Congress; Baltimore Museum of Art; Lincoln University; Philadelphia Museum of Art; Bryn Mawr College; West Chester (PA) Museum of Fine Arts; New York Public Library; U.S. Government. Exhibited: New York World's Fair, 1939; Philadelphia Museum of Art; Philadelphia Art Alliance, 1942 (one-man). Contributor to: *Magazine of Art; Art Digest*. Lectures: Modern Art Appreciation. Address in 1953, 2409 West Columbia Ave.; h. 2340 West Columbia Avenue, Philadelphia, PA.

THRASHER, HARRY
(or HENRY) DICKINSON.
Sculptor. Born in Plainfield, NH, May 24, 1883. Pupil of Augustus Saint-Gaudens. Member: National Society of Mural Painters; National Sculpture Society, 1917; Alumni Association of the American Academy in Rome. Awarded the scholarship offered by the American Academy in Rome, 1911-14. Address in 1917, Baltic, CT. Died in France, August 11, 1918.

THRASHER, LESLIE.
Painter and illustrator. Born in Piedmont, WV, Sept. 15, 1889. Pupil of Pyle; Chase; Anshutz. Member: Wilmington Society of Fine Arts; Society of Illustrators; Artists Guild of the Authors' League of America; Salma. Club. Address in 1933, 34 West 67th Street, New York, NY; summer, Setauket, Long Island, NY.

THROCKMORTON, CLEON (FRANCIS).
Painter and lecturer. Born in Atlantic City, NJ, Oct. 3, 1897. Member: Washington Art Club. Work: Scenic designs for *Emperor Jones, Hairy Ape, Desire Under the Elms, Rosmersholm, Romeo and Juliet, Rain, The Verge, Patience, Wings of Chance, Thrills, All God's Chilluns Got Wings, Take a Chance, Criminal at Large, Alien Corn, In Abraham's Bosom* (Pulitzer prize), etc. Address in 1933, 102 West 3rd St.; h. 1 Fifth Avenue, New York, NY.

THROOP, BENJAMIN F.
Engraver and plate printer. Born in Washington, DC, c. 1837/38. Son of John Peter Vannes Throop. Working in Washington, from 1858.

THROOP, DANIEL SCROPE.

Born in Oxford, Chenango County, NY, January 14, 1800; died at Elgin, IL. Son of Major Dan Throop (1768-1824) of Norwich, CT, and younger brother of John Peter Vannes and Orramel H. Throop. He engraved a good stipple portrait of Lafayette in 1824, evidently made for a Lafayette badge. This plate is signed "D. S. Throop, Sc., Utica, NY." In Hamilton, NY, in 1830; moved to Elgin, IL, and died there.

THROOP, J. V. N.

He was an engraver of portraits, in line and stipple, working in NY and in Baltimore in 1835. Possibly a brother of, or the same as, John Peter Vannes Throop.

THROOP, JOHN PETER VANNES (or VAN NESS).

Engraver and lithographer. Born April 15, 1794, in Oxford, NY. Brother of, or possibly the same as, J. V. N. Throop. Older brother of Daniel S. and Orramel H. Throop. Engraver of portraits working in Baltimore, MD, in 1835. Settled in Washington, DC, and worked there until his death, c. 1861.

THROOP, ORRAMEL HINCKLEY.

Engraver. Born in 1798 at Oxford, NY. In 1825, O. H. Throop, an engraver of landscape and vignettes, had his office at 172 Broadway, New York City. Working in New Orleans, 1831-32.

THULSTRUP.

See DeThulstrup, Thure.

THUM, PATTY PRATHER.

Painter. Born in Louisville, KY. Graduated from Vassar College; studied painting with Henry Van Ingen at Vassar and later at Art Students League of NY. Honorable mention for book illustrations, Chicago Expo., 1893. Member: Louisville Art League. Contributor to art magazines. Address in 1926, 654 4th St., Louisville, KY.

THURBER, ALICE HAGERMAN.

(Mrs. Thomas L. Thurber). Painter, craftsman, and teacher. Born in Birmingham, MI, June 21, 1871. Pupil of Joseph Gies; Detroit Commercial Art School; Art Institute of Chicago under St. Pierre; Frederick Fursman; W. W. Kreghbeil; Frank L. Allen. Member: Detroit Society of Women Painters and Sculptors; Chicago No-Jury Society of Artists; Detroit Society of Independent Artists; Michigan Academy of Science, Arts and Letters; NY Society of Independent Artists. Awards: First and second prizes for water color, 1915, and first and second prizes for posters, 1916, first miscellaneous water color, 1928, at Michigan Institute of Art, State Fair. Represented by "The Old Red Tree," Community House, Birmingham, MI. Address in 1933, 664 Oak St., Birmingham, MI.

THURBER, CAROLINE.

(Mrs. Dexter Thurber). Portrait painter. Born in Oberlin, OH. Studied in Italy, Germany, England and France. Member: Copley Society; Guild of Boston Artists (associate). Work: Portraits for Mt. Holyoke College; Western College for Women, Oxford, OH; Oberlin College; Boston University; Supreme Courts of Iowa and Rhode Island; portraits of Angelo Patri, Robert Andrews Millikan, Margaret Deland, Dallas Lore Sharp, Dorothy George, and other professional people. Address in 1933, 320 Tappan St., Brookline, MA.

THURLOW, HELEN.

Painter. Member: Fellowship Penna. Academy of Fine Arts; Artists Guild of the Authors' League of America. Address in 1933, 10 Gramercy Park, New York, NY.

THURN, ERNEST.

Painter, etcher, writer, lecturer, and teacher. Born in Chicago, IL, July 23, 1889. Pupil of Hans Hofmann and Munich Academy; Julian Academy in Paris. Member: North Shore Arts Association; Gloucester Art Association. Writer and lecturer on "The Modern Movement in Art." Director, Thurn School of Modern Art. Address in 1933, East Gloucester, MA.

THURSTON, JANE McDUFFIE (MRS.).

Painter, etcher and sculptor. Born in Ripon, WI, January 9, 1887. Studied: Art Institute of Chicago; in Europe; pupil of Townsley, Mannheim, Miller. Member: California Watercolor Society; California Art Club; Laguna Beach Art Association; West Coast Arts; Pasadena Society of Artists. Work: Pasadena Art Institute. Exhibited: Los Angeles Museum of Art, 1945, 46; California Watercolor Society, 1946; Pasadena Society of Artists, 1946; Pomona (CA) College, 1946; San Gabriel Valley Exhibition, 1949, 51. Awards: Taft prize, West Coast Arts, 1923; honorable mention, California Art Club, 1925. Address in 1953, Pasadena, CA.

TIDDEN, JOHN C(LARK).

Painter and teacher. Born in Yonkers, NY, Feb. 10, 1889. Pupil of Penna. Academy of Fine Arts. Member: Southern States Art League. Awards: Cresson European Scholarship, Penna. Academy of Fine Arts; second Toppan prize, Penna. Academy of Fine Arts, 1914. Work: "Autumn, 1918," and 4 portraits, University Club, Houston, TX; "Portrait of Josiah Jackson," Pennsylvania State University, Philadelphia. Address in 1929, 143 East 62nd St., New York, NY; h. 1110 Dennis Ave., Houston, TX.

TIEBOUT, CORNELIUS.

Engraver. Born c. 1773. The first American-born professional engraver to produce really meritorious work. Apparently died in obscurity in Kentucky about 1832. The date of his birth is equally uncertain.

Some biographers state he was born in NY in 1777, but existing plates show that he was doing creditable work in 1789. Descended from a Huguenot family, from Holland, which held lands on the Delaware as early as 1656 and owned property in Flatbush, Long Island, in 1669. He was apprenticed to John Burger, silversmith of NY, where he learned to engrave on metal. Was engraving maps and subject plates for NY publishers in 1789-90, and line portraits in 1793. Went to London to study and learned to engrave in stipple manner. In 1794, in London, a large and well executed stipple plate engraved by Tiebout, after a painting by J. Green, was published. In 1796 Tiebout published in London his quarto portrait of John Jay, probably the first good portrait engraved by an American-born professional engraver (the mezzotint work of the artist Edward Savage not coming under this category). In November, 1796, he was again in NY, engraving and publishing prints with his brother, Andrew Tiebout. His name disappears from the NY directories in 1799. He went to Philadelphia about that time and conducted an extensive business as an engraver. He was a member of the banknote engraving firm of Tanner, Kearney and Tiebout. Sources say he moved to either Kentucky or New Harmony, IN, about 1825, and died c. 1832.

TIEBOUT, MADEMOISELLE.
French miniature painter. Flourished in NY about 1834.

TIFFANY, LOUIS C(OMFORT).
Painter and craftsman. Born in New York, Feb. 18, 1848. Pupil of George Inness and Samuel Colman in NY; Leon Bailey in Paris. Member: Associate National Academy of Design, 1871; Academician National Academy of Design, 1800; Society of American Artists; American Water Color Society; NY Architectural League, 1889; Century Association; National Arts Club; NY Society of Fine Arts; NY Municipal Art Society; American Institute of Graphic Arts; National Sculpture Society; American Federation of Arts; NY Etching Club; Societe Nationale des Beaux Arts. Awards: Gold medal for applied arts, Paris Expo., 1900; Chevalier of the Legion of Honor of France, 1900; gold medal, Dresden Expo., 1901; grand prize, Turin Expo. of Decorative Art, 1901; special diploma of honor, St. Louis Expo., 1904; gold medal, P.-P. Expo., San Francisco, 1915; gold medal, Sesqui Expo., Philadelphia, 1926. In painting, made specialty of Oriental scenes; originator of what is known as Favrile glass. Art director of Tiffany Studios. In 1918 established the Louis Comfort Tiffany Foundation for art students at Oyster Bay, LI, and deeded to it his art collections, gallery, chapel and country estate. Died Jan. 17, 1933 in NYC. Address in 1933, 391 Madison Ave; 46 West 23rd St.; h. 27 E. 72nd St., NY; summer, Laurelton Hall, Oyster Bay, LI, NY.

TIFFANY, MARY A.
Painter in oils and watercolors. Born in Hartford, CT. Pupil of Tryon at Connecticut School of Design.

TIFFANY, WILLIAM SHAW.
Painter and illustrator. Born in 1824. He was from Baltimore, MD. Known as an accomplished draughtsman whose pencil illustrations of Tennyson and Longfellow were remarkable for truth and refined conception. His best known paintings are "Lenore" and "St. Christopher Bearing the Christ Child." Died in New York City, September 27, 1907.

TILDEN, ALICE F(OSTER).
Portrait painter. Born in Brookline, MA. Pupil of Boston Museum School; Wm. M. Chase, in NY; Lucien Simon. Member: Copley Society, 1898. Address in 1929, 30 Walnut St., Milton, MA.

TILDEN, ANNA MEYER.
Painter. Born in Waupun, WI, July 9, 1897. Pupil of Albin Polasek. Member: Chicago Painters and Sculptors; Austin, Oak Park, and River Forest Art Leagues. Work: World War memorial, River Forest, IL. Address in 1933, Hinsdale, IL.

TILDEN, DOUGLAS.
Sculptor. Born in Chico, CA, May 1, 1860. Pupil of National Academy of Design under Ward and Flagg; Gotham Students League under Mowbray; Chopin in Paris. Awarded honorable mention, Paris Salon, 1890; bronze medal, Paris Expo., 1900; gold medal, Alaska-Yukon-Pacific Expo., Seattle, 1909; commemorative gold medal, St. Louis Expo., 1904. Work: "The Tired Boxer," Art Institute of Chicago; "Baseball Player," Golden Gate Park, San Francisco; memorial monuments at Portland (OR), Los Angeles, San Francisco, etc. Address in 1926, Oakland, CA. Died in Berkeley, CA, in 1935.

TILLER, ROBERT.
There were two engravers of this name in Philadelphia, father and son. The father was an engraver of landscape, working in line in 1818-25. The son engraved portraits in stipple and subject plates in line in 1828-36.

TILLINGHAST, MARY E.
Painter. Born in NY. Pupil of John La Farge in NY; of Carolus Duran and Henner in Paris. Specialty: Designs for stained glass.

TILLOTSON, ALEXANDER.
Painter. Born in Waupun, WI, July 9, 1897. Pupil of Frederick Fursman; Maurice Sterne; Max Weber; others. Member: Wisconsin Painters and Sculptors. Award: Gold medal, Milwaukee Art Institute, 1926. Director of art department, South Division High School, Milwaukee. Address in 1933, 2118 E. Edgewood Ave., Milwaukee, WI.

TILTON, JOHN ROLLIN.
Painter. Born in Loudon, NH, June 8, 1828. Landscape painter, largely self-taught. Settled in Rome in 1852. The *London Daily News* wrote of him, "He was the first American painter since Benjamin West to receive special commendation from the President of the Royal Academy." Recipient of honorary degrees of M.A. and Ph.D. from Dartmouth College. Represented by "Venetian Fishing Boats" at Corcoran. Died March 22, 1888, in Rome, Italy.

TILTON, OLIVE.
Painter. Born in 1886 in Mountain Station, NJ. Pupil of Collin and Delecluse in Paris; also studied in Munich and London. Address in 1926, 24 West 59th St., New York, NY.

TILYARD, PHILLIP THOMAS COKE.
Portrait painter. Born January 10, 1785, in Baltimore, MD. Studied sign and ornamental painting. Began portrait painting about 1814. Died December 21, 1830.

TIMMONS, EDWARD J. FINLEY.
Painter. Born in Janesville, WI, 1882. Pupil of Art Institute of Chicago; Ralph Clarkson, Gari Melchers, Sorolla; also studied in England, Holland, France, Italy and Spain. Member: Chicago Society of Artists; Chicago Art Students League; Association of Chicago Painters and Sculptors; Illinois Academy of Fine Arts. Award: Prize, Municipal Art League; portrait, Art Institute of Chicago, 1929. Work: Portraits in University of Chicago, University of Arkansas, University of Illinois, Beloit College, State Capitol at Des Moines, Janesville Art League, San Diego Museum of Fine Arts, National Bank of Mattoon, IL; Mt. Clair (IL) Community House; State Capitol, Cheyenne, WY; Municipal Art Collection, Chicago; Polytechnic Institute, Blacksburg, VA; Meyer Memorial, Michael Reese Hospital, Chicago. Instructor, Art Institute of Chicago. Address in 1933, care of Art Institute of Chicago, Chicago, IL.

TIMONTE, ALPHONSE.
Sculptor. Located: Buffalo, New York, 1858.

TIMOSHENKO, MARINA.
Painter. Exhibited water colors at the Penna. Academy of Fine Arts, Philadelphia, 1925. Address in 1926, 1620 Summer St., Philadelphia, PA.

TINDALE, EDWARD H.
Painter. Born in Hanson, MA, March 21, 1879. Studied at Munich Academy under Carl Marr, Hans von Hayeck, Loeftz. Address in 1929, 3 Hampton Road, Brockton, MA; summer, S. Hanover, MA.

TISCHLER, MARIAN CLARA.
Painter. Member: Cincinnati Woman's Art Club. Address in 1926, 453 Riddle Road, Cincinnati, OH.

TISDALE, ELKANAH.
Engraver, designer and miniature painter. Born in Lebanon, CT, c. 1771, and was living there in 1834. In 1794-98, and in 1809-10, Tisdale was in NY as an engraver, illustrator and miniature painter, but moved to Hartford, CT, where he founded the Hartford Graphic and Bank Note Engraving Co., an association of engravers, though he was the designer of vignettes rather than their engraver. Dunlap says that he remained in Hartford until 1825, designing and engraving plates for Samuel F. Goodrich of that city, in 1820. Tisdale worked in both line and stipple. The earliest dated plates by Tisdale are full page illustrations to Trumbull's *McFingal*, published in NY in 1795. Tisdale was a better designer than engraver.

TITCOMB, M. BRADISH.
Painter and illustrator. Born in NH. Pupil of Boston Museum School under Tarbell, Benson and Hale. Member: Copley Society, 1895; NY Water Color Club; National Association of Women Painters and Sculptors; Connecticut Academy of Fine Arts. Award: Honorable mention, Connecticut Academy of Fine Arts, 1917. Represented in the White House, Washington, DC. Address in 1929, Fenway Studios, Ipswich St., Boston, MA.

TITCOMB, VIRGINIA CHANDLER.
(Mrs. John Abbot Titcomb). Painter, sculptor and writer. Born in Otterville, IL. Exhibited at National Academy of Design. Founder, 1884, and president of the Patriotic League of the Revolution. Memorialized 57th Congress for recognition of services rendered by Theodore R. Timby, the inventor of the revolving turret as used on the *Monitor* and all battleships of the U.S. after the Civil War. Contributor to *Harper's Bazaar*, *Demorest's Magazine*, *Brooklyn Eagle*, etc. Specialty: Bas-reliefs. Address in 1926, 101 Lafayette Avenue, Brooklyn, NY.

TITLOW, HARRIET W(OODFIN).
Painter. Born in Hampton, VA. Pupil of Robert Henri. Member: National Association of Women Painters and Sculptors; Pen and Brush Club; NY Society of Women Artists; National Arts Club. Address in 1933, 117 Kensington Ave., Jersey City, NJ.

TITSWORTH, JULIA.
Painter. Born in Westfield, MA, 1878. Pupil of Art Institute of Chicago; R. Collin in Paris. Member: National Association of Women Painters and Sculptors; American Federation of Arts. Address in 1929, Bronxville, NY.

TITTLE, WALTER (ERNEST).
Painter and etcher. Born in Springfield, OH, Oct. 9, 1883. Pupil of Chase, Henri and Mora in NY. Member: Royal Society of Arts, London, England; Society of American Etchers; Chicago Society of

Etchers; Print Makers' Society of California. Author and illustrator: *Colonial Holidays, The First Nantucket Tea Party*, etc. Awards: Arts Committee prize, National Arts Club, 1931; silver medal, International Exhibition of California Print Makers, 1933. Etchings in Art Institute of Chicago; Cleveland Art Museum; Library of Congress and National Gallery, Washington, DC; NY Public Library; Brooklyn Museum; California State Library; British Museum; Victoria and Albert Museum, London; Fitzwilliam Museum, Cambridge, England; National Portrait Gallery, London, England; oil portrait of President Amos, Johns Hopkins University, Baltimore, MD; oil portrait, Joseph Conrad, National Portrait Gallery, London. Address in 1933, 123 E. 77th St., New York, NY; summer, National Liberal Club, London, England.

TITUS, AIME BAXTER (MR.).
Painter, illustrator, and teacher. He was born in Cincinnati, OH, April 5, 1882. Studied: Art Students League of NY; San Francisco Institute; pupil of Harrison, Mora, Bridgman, DuMond, and Chase. Award: Silver medal, P.-P. Expo., San Francisco, 1915. Director, Fine Arts Society of San Diego. Address in 1933, 2924 Juniper St., San Diego, CA.

TITUS, FRANCIS (FRANZ M).
Sculptor and carver. Born c. 1829, in Bavaria. Worked: New York City, c. 1854-60. Died c. 1862.

TOBEY, MARK.
Painter. Born Dec. 11, 1890 in Centerville, WI. Studied at the Art Institute of Chicago; also with Teng Kwei, Shanghai. His work has been exhibited at the Metropolitan Museum of Art, NY; Whitney Museum of American Art; Museum of Modern Art, NY; Seattle Art Museum, WA. He was awarded the Grant National Prize for Painting, Venice Biennial, 1958; first prize for painting, Carnegie Institute, Pittsburgh, PA, 1961. Media: Oil and tempera. Address in 1976, 40 Willard Gallery, 29 E. 72nd Street, NYC.

TOBIAS, JULIUS.
Sculptor and instructor. Born in New York City, August 27, 1915. Studied: Atelier Fernand Leger, Paris, France, 1949-52. Exhibitions: Provincetown Art Association Exhibition, MA, 1946; Galerie Creuze, Paris, 1958; Allan Stone Gallery, NYC, 1962; Whitney Annual, NYC, 1968; Bard College, Annandale, NY (with Christopher Gianakos); 55 Mercer Street Gallery, NYC; Esther Stuttman Gallery, NYC, 1959; Bleecker Gallery, NYC, 1961; 10 Downtown, NYC, 1968; Max Hutchinson Gallery, NYC, 1970, 71, 72; Penna. Academy of Fine Arts, 1958; Museum of Modern Art Traveling Exhibition, Tokyo, 1959; New England Exhibition, Silvermine, CT, 1960; others. Awards: Creative Artists Public Service Program Grant, NYC, 1971; Guggenheim

Memorial Foundation Fellowships, 1972-73, 78; Mark Rothko Foundation Grant, NYC, 1973; National Endowment for the Arts Grant, Washington, DC, 1975-76. Taught: Instructor in painting, NY Institute of Technology, 1966-71; instructor of sculpture, Queens College, NY, 1971-74; visiting artist, Indiana University (Bloomington), University of Minnesota (Minneapolis), University of North Carolina (Greensboro). Address in 1982, 9 Great Jones Street, NYC.

TOBIN, GEORGE T(IMOTHY).
Painter and illustrator. Born in Weybridge, VT, July 26, 1864. Pupil of George De Forest Brush. Member: Art Students League of NY; American Federation of Arts. Address in 1929, 528 Main St., New Rochelle, NY.

TODD, A.
Engraver. Etched a small bust of Washington for the Washington Benevolent Society, Concord, 1812. The firm of Gray & Todd engraved astronomical plates published in Philadelphia in 1817. A. Todd may have been a partner.

TODD, CHARLES STEWART.
Painter. Born in Owensboro, KY, Dec. 16, 1885. Pupil of Cincinnati Art Academy; Albert Herter in NY. Member: Cincinnati Art Club; Cincinnati Mac Dowell Society; Boston Society of Arts and Crafts. Address in 1929, 2513 Park Ave., Cincinnati, OH.

TODD, HENRY STANLEY.
Portrait painter, working in NYC in 1902. Painted the portrait of Judge Emott in that year for the City Hall, NY.

TODHUNTER, FRANCIS.
Painter, illustrator, etcher, and teacher. Born in San Francisco, CA, July 29, 1884. Pupil of National Academy of Design; California School of Design. Member: California Society of Etchers; San Francisco Art Association; Bohemian Club. Address in 1929, 2424 Larkin St., San Francisco; summer, Belmont, CA.

TOERRING, HELENE.
Miniature painter. Exhibited at the Penna. Academy of Fine Arts, Philadelphia, 1925. Address in 1926, 6399 Woodbine Ave., Overbrook, PA.

TOFEL, JENNINGS.
Painter. Exhibited in Philadelphia in 1921, in "Exhibition of Paintings Showing the Later Tendencies in Art." Address in 1926, 61 Colben St., Newburgh, NY.

TOFFT, CARLE EUGENE.
Sculptor. Born in Brewer, ME, September 22, 1874. Pupil of Blankenship and Ruckstuhl. Member: Na-

tional Sculpture Society. Address in 1903, 4 West 18th St., NY.

TOLERTON, DAVID.
Sculptor. Born in Toledo, OH. Went to California c. 1915. Studied at Stanford University; California School of Fine Arts, San Francisco; studied ironwork in Europe, 1929-30. Taught at San Francisco Art Institute; University of Minnesota; ornamental ironwork, Berkeley Metal Arts, CA, and Allied Arts Guild, Menlo Park, CA; with Tolerton Potteries, Los Gatos, CA. Exhibited at Paul Kantor Gallery, Beverly Hills, CA; de Young Museum, San Francisco; Golden Gate International Exposition, San Francisco; Denver (CO) Art Museum; Museum of Modern Art, Sao Paulo; Contemporary Arts Museum, Houston, TX; other California museums.

TOLLES, SOPHIE MAPES.
Painter. Began studies in Philadelphia in 1864 with Peter F. Rothermel. Later studied in France and Italy. Her first exhibit in America was a portrait at the National Academy in 1876. In 1878 she exhibited several flower pieces. Among her best known portraits is one of Linda Gilbert of Chicago.

TOLMAN, JOHN.
Portrait painter. Lived in Pembroke, MA. Painted in Boston and Salem about 1816. He evidently travelled throughout the country as a portrait painter.

TOLMAN, R(UEL PARDEE).
Painter, restorer, etcher, and teacher. Born in Brookfield, VT, March 26, 1878. Pupil of Los Angeles School of Art and Design; Mark Hopkins Institute of Art; Corcoran School of Art, Washington, DC; Art Students League of NY; National Academy of Design; J. C. Beckwith. Member: Society of Washington Artists; Washington Water Color Club; American Federation of Arts. Assistant curator in charge, Divison of Graphic Arts, United States National Museum, Washington, DC. Address in 1929, 3451 Mt. Pleasant St., Washington, DC.

TOLMAN, STACY.
Portrait painter and teacher. Born in Concord, MA, January, 1860. Pupil of Otto Grundmann in Boston; Boulanger, Lefebvre and Cabanel in Paris. Member: Providence Art Club; Providence Water Color Club; Boston Art Club. Instructor of anatomy, RI School of Design. Address in 1929, 7 Thomas St., Providence, RI; h. 1182 Mineral Spring Ave., Pawtucket, RI.

TOLPO, CARL.
Painter, sculptor, writer, and lecturer. Born in Ludington, MI, December 22, 1901. Studied at Augustana College, Rock Island, IL; University of Chicago; Art Institute of Chicago; and with Frank O. Salisbury, in London, England; also with Gutzon Borglum. Awards: Prizes, Southtown, Chicago, Na-

tional Portrait Competition and Exhibition, 1952; Illinois Abraham Lincoln Memorial Commission, 1955. Member of American Artists Professional League. Work: Augustana College; Augustana Hospital, Chicago; Swedish-American Historical Museum, Philadelphia, PA; Municipal Court, City of Chicago; Institute of Medicine; Marshall Law School, Chicago; Illinois State Capitol Building; two Lincoln bronze busts, Lincoln Room, Illinois State Historical Museum, Springfield; others. Exhibited: Five one-man exhibitions, 1938-44; National Sculpture Society, 1967. Address in 1970, Barrington, IL; Stockton, IL.

TOLSON, MAGDALENA WELTY.
(Mrs. Norman Tolson). Painter, craftsman, and teacher. Born in Berne, IN, Feb. 15, 1888. Member: Kansas City Society of Artists. Awards: Hon. mention and Sweeney purchase prize, Kansas City Art Institute, 1922. Address in 1933, 510 Roscoe Street, Chicago, IL.

TOLSON, NORMAN.
Painter, etcher and teacher. Born in Distington, Cumberland, England, March 25, 1883. Pupil of Angelo von Jank, Munich; Art Institute of Chicago. Member: Chicago Society of Artists; Kansas City Society of Artists; Illinois Society of Artists. Awards: Edward B. Butler prize, Art Institute of Chicago, 1917; first prize, Kansas City Art Institute, 1921; hon. mention, Kansas City Art Institute, 1924; first purchase prize, All-Illinois Society of Fine Arts, 1929. Work: Decorative panels in La Salle Hotel, Chicago; murals, Stevens Hotel, Chicago. Address in 1933, 510 Roscoe Street, Chicago, IL; summer, Lake George, Clare Co., MI.

TOMASO, RICO.
Painter and illustrator. Born in Chicago, IL, Feb. 21, 1898. Pupil of Dean Cornwell; Harvey Dunn; J. Wellington Reynolds. Member: Society of Illustrators. Illustrated: *Son of the Gods*, by Rex Beach; *The Parrot*, by Walter Duranty; and *Tagoti*, by Cynthia Stockley. Address in 1929, 206 East 33rd St., New York, NY.

TOMEI, LUCILLE V.
Sculptor, painter, and teacher. Born in St. Joseph, MO, May 11, 1904. Studied at University of Kansas; Kansas City Art Institute; University of Pittsburgh; and with Charles Sasportas, Jane Heidner. Member: Associated Artists of Pittsburgh. Awards: Prizes, Kansas City Art Institute, 1937, 38. Work: Immaculata High School, Ft. Leavenworth Museum, Ft. Leavenworth, KS; Churchill Country Club, Cathedral of Learning, Pittsburgh, PA; Kansas Historical Museum; Max Adkins Studios, Pittsburgh, PA. Address in 1953, Pittsburgh, PA.

TOMKINS, FRANK HECTOR.
Painter. Born in Hector, NY, in 1847; died in Brookline, MA, in 1922. Pupil of Art Students League. Represented at the Penna. Academy of Fine Arts by "The Penitent," and in the Boston Museum by "The Young Mother."

TOMLIN, BRADLEY WALKER.
Painter and illustrator. Born in Syracuse, NY, August 19, 1899. Pupil of Jeannette Scott; Academie Colarossi; Le Grande Chaumiere. Member: Louis Comfort Tiffany Foundation. Work: Decorations in Children's Room, Memorial Hospital, Syracuse, NY; Brooklyn Museum; Penna. Academy of Fine Arts, Philadelphia. Address in 1933, 317 East 51st St., New York, NY; summer, Woodstock, NY.

TOMLINSON, ANNA C.
Painter. Exhibited water colors at the Penna. Academy of Fine Arts, Philadelphia, 1925. Address in 1926, 281 Heath St., Boston, MA.

TOMLINSON, HENRY W(ELLING).
Painter. Born in Baltimore, MD, Sept. 18, 1875. Pupil of E. S. Whiteman in Baltimore; Art Students League of NY under Cox and Brush. Address in 1929, Taconic, CT.

TOMPKINS, CLEMENTINA M. G.
Painter. Born in Washington, DC. Lived in Paris, studying with Bonnat. Specialties were portraits and figure pieces. Exhibited in this country in 1876-78.

TOMPKINS, LAURENCE.
Sculptor and painter. Born in Atlanta, GA, February 18, 1897. Studied at Beaux-Arts Institute of Design; Art Students League; Slade School, London; Grande Chaumiere, Paris. Member: National Sculpture Society. Work: Monuments, Augusta, Ocilla, Atlanta, GA; Luxembourg Museum, Paris, France. Exhibited: Royal Academy, London; Paris Salon, 1924; Penna. Academy of Fine Arts; National Academy of Design. Address in 1953, 114 East 66th St., NYC. Died in 1972.

TONETTI, FRANCOIS MICHEL LOUIS.
Sculptor. Born in Paris, France, April 7, 1863. Came to U.S. in 1899. Studied: Ecole des Beaux-Arts, Paris, under Falguiere; also with Noel and MacMonnies. His work at the Chicago Fair in 1893 received an award; also received honorable mention, Paris Salon, 1892; bronze medal, St. Louis Expo., 1904. Represented by "Bust of General Charles C. Cook," Luxembourg, Paris; and his most recent work, the "Battle of the Marne." He worked on the fountain at the Chicago World's Fair, 1893; on the New York Custom House; New York Public Library; and others. Collaborated with Saint-Gaudens in work on the Congressional Library in Washington, DC. Member of New York Architectural League, 1901. Address in 1919, 135 East 40th Street, NYC. Died in NYC, May 2, 1920.

TONETTI, MARY LAWRENCE.
(Mrs. F. Michel Tonetti). Sculptor. Address in 1908, 57 East 25th St., New York, NY.

TOPCHEVSKY, MORRIS.
Painter, etcher, and teacher. Born in Poland, Oct. 17, 1898. Pupil of Art Institute of Chicago; Albert Krehbiel, San Carlos Academy, Mexico City. Member: Chicago Society of Artists; Illinois Academy of Fine Arts; John Reed College. Address in 1933, Abraham Lincoln Centre, 700 Oakwood Blvd., Chicago, IL.

TOPHAM.
Engraver. Well-executed landscape plates published in Cincinnati in 1852 are thus signed.

TOPPAN, CHARLES.
Engraver. Born in Newburyport, MA, February 10, 1796. Pupil of Gideon Fairman, engraver. Was with him in Philadelphia in 1814. After some general engraving on his own, on the death of Fairman in 1827, became partner in bank note company of Draper, Toppan, Longacre & Co. The firm later became Toppan, Carpenter, Casilear & Co., and in 1854 was Toppan, Carpenter & Co. Having moved to NYC, he became president of the then American Bank Note Co. in 1858-60. Died Nov. 20, 1874 in Florence, Italy.

TOPPING, JAMES.
Painter and lithographer. Born in Cleator Moor, England, in 1879. Studied: In England; Art Institute of Chicago. Member: Palette and Chisel Club; Painters and Sculptors of Chicago; Oak Park Art League; Chicago Litho. Club; Illinois Academy of Fine Arts. Awards: Municipal Art League prize, 1923; Robert Rice Jenkins prize, Art Institute of Chicago, 1924; Palette and Chisel Club, gold medal, 1924; Cahn prize, Art Institute of Chicago, 1926; Perkins prize, Chicago Galleries Association, 1926; Bontoux prize, Palette and Chisel Club, 1927; prize, Business Men's Art Club, Chicago, 1929; bronze medal, Oak Park Art League, 1930. Represented in State Museum, Springfield, IL. Address in 1933, 541 Forest Ave., Oak Park, IL.

TORRENS, ROSALBA.
Landscape painter, who was practicing her art in Charleston, SC, in 1808.

TORREY, CHARLES CUTLER.
Engraver. Born July 9, 1799. According to *The Annals of Salem* (Salem, MA, 1849), Charles Cutler Torrey was brought to Salem by his parents as an infant. Studied engraving in Philadelphia about 1815, and in 1820 he established himself in business

in Salem. Engraved a few portrait plates and some general illustrations for publishers, but his notable work of this period is a large, well-executed plate showing a "North East View of the Several Halls of Harvard College," published in Boston, in 1823, by Cummings, Hilliard & Co. A companion plate, "South View of the Several Halls of Harvard College," was engraved by Annin & Smith and published by the same Boston firm. Torrey left Salem in 1823 for Nashville, TN, where he died of a fever, February 9, 1827. Brother of Manasseh Cutler Torrey, portrait and miniature painter of Salem.

TORREY, ELLIOT (BOUTON).
Painter. Born in East Hardwick, VT. Studied in Florence and Paris. Member: Salma. Club; Society of American Artists; San Diego Fine Arts Society; Laguna Beach Art Association. Award: Guild prize, San Diego, 1929. Represented in Chicago Art Institute; Cleveland Museum of Art; Art Institute, Akron, OH; Fine Arts Museum, San Diego, CA. Address in 1929, 4716 Panorama St., San Diego, CA.

TORREY, FRANKLIN.
Sculptor. Born on October 25, 1830, probably in Scituate, MA. Studied: Rome. Worked: Italy. Died November 16, 1912, in Florence, Italy.

TORREY, FRED M.
Sculptor. Born in Fairmont, WV, July 29, 1884. Pupil of Art Institute of Chicago; Charles J. Mulligan; Lorado Taft. Member: Chicago Society of Painters and Sculptors; Western Society of Sculptors. Work: Rosenberger medal for the University of Chicago; Susan Colver medal of honor for Brown University; memorial tablet for Theta Delta Chi, Champaign, IL; Hutchinson memorial tablet for Hutchinson Hall, Chicago University; sculpture decorations for Paradise Theatre, Chicago; Esperson portrait bust, Houston, TX; C. C. Linthicum Foundation medal, Northwestern University, Evanston, IL; Beta Sigma Omicron medal, Denver, CO; Lincoln's Tomb, Springfield, IL; busts, Swedish Hall of Fame, Philadelphia, PA; panels, State Capitol, Baton Rouge, LA; others. Address in 1953, Chicago, IL.

TORREY, GEORGE BURROUGHS.
Portrait painter. Born in NY in 1863. Exhibited at Paris Salon, 1900 and after. Painted portraits of William Howard Taft and Theodore Roosevelt. Decorated by the King of Greece with the Grecian Order of the Savior, 1904. Address in 1926, 27 East 35th St., New York, NY.

TORREY, MABLE LANDRUM.
Sculptor and teacher. Born in Sterling, CO, June 23, 1886. Pupil of Charles J. Mulligan. Member: Chicago Society of Painters and Sculptors; Chicago Galleries Association; Alumni Art Institute of Chicago; Cordon Club. Work: "Wynken, Blynken and Nod Fountain,"

City and County of Denver; "Buttercup—Poppy and Forget-me-not," South Bend (IN) Library; "Stanley Matthews," Children's Hospital, Cincinnati, OH; University of Chicago; State Normal College, Greeley, CO; many portraits of children. Exhibited: Art Institute of Chicago; Chicago Galleries Association. Awards: Prize, Chicago Galleries Association. Address in 1953, Chicago, IL.

TORREY, MANASSEH C.
Portrait and miniature painter. Born in 1807 in Salem, MA. Flourished about 1830-37 in NY, Philadelphia, and Salem. Died Sept. 24, 1837, in Pelham, VT.

TOTTEN, VICKEN VON POST.
(Mrs. George Oakley Totten). Sculptor and painter. Born in Sweden, March 12, 1886. Pupil of the Academie Beaux-Arts, Stockholm. Member: Grand Central Art Galleries; Woman's Society of Painters and Sculptors, Stockholm; Painters and Sculptors Gallery Association; National Association of Women Painters and Sculptors. Represented in Metropolitan Museum; Church of the Immaculate Conception, Washington, DC; eleven panels, U.S. Post Office, Waterbury, CT. Address in 1933, Washington, DC.

TOVISH, HAROLD.
Sculptor and educator. Born in NYC, July 31, 1921. Studied at WPA Art Project, with Andrew Berger; Columbia University, 1940-43, with Oronzio Maldarelli; Zadkine School of Sculpture, Paris, 1949-50; Academie de la Grande Chaumiere, 1950-51. Works: Phillips Academy, Addison Gallery of American Art, Andover, MA; Boston Museum of Fine Arts; Art Institute of Chicago; Minneapolis Institute; University of Minnesota; Philadelphia Museum of Art; Guggenheim; Whitney; Walker; Worcester Art Museum; Hirshhorn. Exhibitions: Walker; The Swetzoff Gallery, Boston; Terry Dintenfass, Inc., NYC; Phillips Academy; Guggenheim; Metropolitan Museum of Art; Toledo Museum of Art; San Francisco Museum of Art; Minneapolis Institute; Whitney; Denver Art Museum; Carnegie; Art Institute of Chicago; Museum of Modern Art; Venice Biennial; De Cordova; Penna. Academy of Fine Arts; Boston University Art Gallery; others. Awards: Minneapolis Institute, first prize, sculpture, 1954; Boston Arts Festival, first prize for drawing, 1958, first prize for sculpture, 1959; American Institute of Arts and Letters Grant, 1960, 71; Guggenheim Fellowship, 1967. Member: Artists Equity. Taught: New York State College of Ceramics, 1947-49; University of Minnesota, 1951-54; Boston Museum School, 1957-66; University of Hawaii, 1964-70; Boston University, from 1971. Medium: Bronze. Address in 1982, Boston, MA.

TOWN, HAROLD BARLING.

Painter and writer. Born in Toronto, Canada, June 13, 1924. Graduated from the Ontario College of Art, Toronto, in 1944, continued with post graduate study there in 1945; York University, hon. LHD, 1966. Exhibitions: L'Actuelle Gallery, Montreal, 1957; Loranger Gallery, Ottawa, 1957; Gallery of Contemporary Art, Toronto, 1957; Jordan Gallery, Toronto, 1958; Jerrold Morris International Gallery, Toronto, 1962; Galeria Bonino, Ltd., New York, 1964. Group Exhibitions: Riverside Museum, New York, 1956; Venice Biennale d'arte, 1956; Moderna Galerja, Ljubljana, Yugoslavia, 1957, 59, 61, 63; in Milan, Italy, 1957; at the Museum of Art, Carnegie Institute, Pittsburgh, 1961; J. B. Speed Art Museum, Louisville, 1962; The Museum of Modern Art, Pratt Graphic Art Center, Pratt Institute, New York, 1962; Guggenheim, 1963; others. Work: Museum of Modern Art, NY; Stedelijk Museum, Amsterdam, Holland; Tate Gallery, London; Guggenheim Museum; others. Awards: Founders College, York University; medal of merit, City of Toronto, 1979. Address in 1982, Toronto, Ontario, Canada.

TOWNE, CONSTANCE (GIBBONS).

(Mrs. F. T. Towne). Portrait painter and sculptor. Born in Wilmington, DE, September 9, 1868. Address in 1918, "Brick House," Norton, CT.

TOWNLEY, HUGH.

Sculptor and printmaker. Born in West Lafayette, IN, February 6, 1923. Studied at University of Wisconsin, 1946-48; privately with Ossip Zadkine, Paris, 1948-49; Central School of Arts and Crafts, London, 1949-50, with Victor Passmore. Works: Phillips Academy, Addison Gallery of American Art, Andover, MA; Boston Museum of Fine Arts; Brandeis University; Brown University; Fogg Art Museum; Kalamazoo Institute; De Cordova; Museum of Modern Art; Milwaukee Art Center; Rhode Island School of Design; San Francisco Museum of Art; Munson-Williams-Proctor Institute, Utica, NY; Whitney; Williams College; Wrexham Foundation, New Haven, CT. One-man exhibitions: Studio 40, The Hague, 1950 (two-man); Gallerie Apollinaire, London, 1951; Milwaukee, 1957; The Swetzoff Gallery, Boston, 1958, 59; The Pace Gallery, Boston, 1960, 64, NYC, 1964; Yale University; De Cordova. Group exhibitions: San Francisco Museum of Art; Museum of Modern Art; Art Institute of Chicago; Walker; Whitney; Carnegie; Boston Arts Festival, 1958, 61, 64; Silvermine Guild; Institute of Contemporary Art, Boston; Wadsworth Atheneum; M. Knoedler & Co., NYC; National Institute of Arts and Letters; Worcester Art Museum, MA, 1980; Flint Institute of Art; Wingspread Gallery, ME, 1977. Awards: San Francisco Museum of Art Annual, 1952; Art Institute of Chicago, Exhibition Momentum, 1952, 53; MIT, Summer Fellowship, 1956; Institute of Contemporary Art, Boston, View, 1960;

Institute of Contemporary Art, Boston, Selections, 1961; Berkshire Art Association Annual, 1961, 63; Brown University, hon. M.F.A., 1962; Rhode Island Arts Festival, 1962, 63; Silvermine Guild, 1963; Yaddo Fellowship, 1964; Kalamazoo Art Center, Lithographic Workshop, Fellowship, 1964; National Institute of Arts and Letters, 1967; Tamarind Fellowship, 1969. Member: Artists Equity, Boston, 1961. Taught: Layton School of Art, 1951-56; Beloit College, 1956-57; Boston University, from 1961; University of California, Berkeley, 1961, Santa Barbara, 1968; Harvard University, 1967. Media: Wood, concrete; lithography. Address in 1982, Bristol, RI.

TOWNSEND, ERNEST N.

Painter, illustrator and teacher. Born in NY, June 26, 1893. Pupil of Paul Cornoyer; George Maynard; C. Y. Turner; Thomas Fogarty. Member: Salma. Club; Yonkers Art Association; Allied Artists of America; American Artists Professional League; American Water Color Society. Address in 1933, 45 East 59th St., New York, NY.

TOWNSEND, ETHEL HORE.

(Mrs. John Townsend). Miniature painter. Born in Staten Island, NY, Sept. 26, 1876. Pupil of Henry B. Snell and Orlando Rouland in NY. Member: NY Water Color Club; Artists' Fellowship. Address in 1933, 63 Hillside Ave., Glen Ridge, NJ.

TOWNSEND, HARRY E(VERETT).

Painter, illustrator, etcher, and craftsman. Born in Wyoming, IL, March 10, 1879. Pupil of Art Institute of Chicago; Howard Pyle; studied in Paris and London. Member: Society of Illustrators, 1911; Allied Artists of America; Society of American Etchers; Artists Guild of the Authors' League of America; Salma. Club; Silvermine Guild of Artists. Official artist with the A. E. F. during World War I. Work: Drawings and paintings of the war at War College; and in the Smithsonian Institution, Washington, DC; prints in the Metropolitan Museum of Art, NY; paintings and prints in the NY Public Library. Address in 1933, 5 Stevens St., Norwalk, CT.

TOWNSEND, LEE.

Illustrator. Born in Wyoming, IL, August 7, 1895. Pupil of Harvey Dunn and Art Institute of Chicago. Member: Society of Illustrators; Salma. Club. Specialty: Magazine illustrations. Address in 1933, Westport, CT.

TOWNSLEY, C. P.

Painter. Born in Sedalia, MO, in 1867. Pupil of Julian and Delecluse Academies in Paris; under Chase in NY. Member: Salma. Club; California Art Club. Director, Chase European classes; London (EN) School of Art; Otis Art Institute. Address in 1926, care of Frank Brangwyn, Temple Lodge, London, England.

TRACY, GLEN.
Painter, illustrator, and teacher. Born in Hudson, MI, Jan. 24, 1883. Pupil of Nowottny; Meakin; Duveneck. Member: Cincinnati Art Club. Represented in Detroit Art Institute. Specialty: Crayon sketches. Address in 1933, Mt. Washington, Cincinnati, OH.

TRADER, EFFIE CORWIN.
Miniature painter. Born in Xenia, OH, Feb. 18, 1874. Pupil of Cincinnati Art Academy; T. Dube in Paris. Member: Cincinnati Woman's Art Club; Cincinnati MacDowell Club. Address in 1933, 3000 Vernon Place, Cincinnati, OH.

TRAIN, DANIEL N.
Ship carver. Pupil of William Rush. Worked in New York City from 1799 to about 1811. Did carving for the war ships *Adams* and *Trumbull*, 1799.

TRAIN, H. SCOTT.
Illustrator. Member: Society of Illustrators. Address in 1933, 352 Singer St., Astoria, Long Island, NY.

TRAKAS, GEORGE.
Sculptor. Born in Quebec, Canada, May 11, 1944. Studied at Brooklyn Museum Art School; Hunter College, New York University, B.S. Work in Solomon R. Guggenheim Museum. Has exhibited at Museum of Modern Art, NY; Guggenheim Museum, NY; Detroit Institute of Art; Documenta 6, Kassel, West Germany; Walker Art Center; Whitney Museum of American Art, NY; others. Awards: Fellowship, National Endowment for the Arts, 1979. Address in 1982, P.O. Box 395, NYC.

TRAKIS, LOUIS.
Sculptor and educator. Born in NYC, June 22, 1927. Studied at Cooper Union, B.F.A.; Columbia University; Art Students League; Politechneion, Athens, Greece; Fulbright grants, Academy of Fine Arts, Rome, Italy, 1959-60 and 60-61. Has exhibited at Penna. Academy of Fine Arts, Philadelphia; Metropolitan Museum of Art, Tokyo; Corcoran Gallery, Washington, DC; Brooklyn Museum, NY; others. Received Louis Comfort Tiffany Foundation Award for Sculpture, 1961 and 63. Address in 1982, Brooklyn, NY.

TRAQUAIR, JAMES.
Stonecutter and portrait sculptor. Born in 1756. Worked in Philadelphia from about 1802. Died there April 5, 1811.

TRAVER, GEORGE A.
Painter. Member: National Arts Club; Salma. Club. Work: "Intervale," Brooklyn Institute Museum, Brooklyn, NY. Address in 1926, 109 West 11th St., New York, NY.

TRAVER, MARION GRAY.
Painter. Born in Elmhurst, Long Island, NY, June 3, 1896. Pupil of George A. Traver. Member: National Association of Women Painters and Sculptors; C. L. Wolfe Art Club; Allied Artists of America; Three Arts Club. Awards: McCarthy prize, National Academy of Design, 1931; honorable mention, Allied Artists of America, 1932. Address in 1933, 205 West 57th Street, New York, NY.

TRAVER, WARDE.
Painter. Born in Ann Arbor, MI, in 1880. Pupil of Royal Academy, Munich, under Marr; also of Millet and Snell. Address in 1926, Central Park Studios, 15 West 67th St., New York, NY.

TRAVIS, OLIN H(ERMAN).
Painter. Born in Dallas, TX, Nov. 15, 1888. Pupil of Art Institute of Chicago; Charles Francis Browne; Kenyon Cox. Member: Chicago Society of Artists; Texas Fine Arts Association; Highland Park Art Association; American Artists Professional League; Southern States Art League; American Federation of Arts. Work: "Ozark Hills" and "Negro Head," Dallas Public Art Gallery; "Trump Thornton," Elisabet Ney Museum, Austin, TX. Awards: Haverty and popular prizes, best landscape, Southern States Art League, 1932. Director, Dallas Art Institute. Address in 1933, 2224 Alice Street, Dallas, TX.

TRAVIS, PAUL BOUGH.
Painter, etcher, lithographer and teacher. Born in Wellsville, OH, January 2, 1891. Studied: Cleveland School of Art; pupil of H. G. Keller. Awards: First prize and Penton medal, 1921, first prize for etching and for portraiture, third prize for still-life, 1922, second prize for lithography, 1925, hon. mention for water color, 1928, first prize for landscape, hon. mention for figure and water colors, 1929, hon. mention for water color and landscape, 1930, first prize for figure painting and third prize for landscape, 1931, others, all from Cleveland Art Association; Butler Art Institute, 1940. Member of American Society for Aesthetics. Work: Seven etchings, three lithographs, five drawings, two water colors, one oil, Cleveland Museum of Art; lithograph, NY Public Library; three oils, Cleveland Museum of Natural History; water color, Brooklyn Museum, Brooklyn, NY; Butler Art Institute; others. Exhibited: Museum of Modern Art; Art Institute of Chicago; Penna. Academy of Fine Arts; Carnegie; Corcoran; Brooklyn Museum; Butler Art Institute; others. Instructor of drawing and painting at Cleveland School of Art, from 1920. Address in 1953, Cleveland, OH; h. Cleveland Heights, OH.

TREASE, SHERMAN.
Painter and illustrator. Born in Galena, KS, March 22, 1889. Pupil of School of Applied Art; A. H. Knott. Member: Joplin Artists Guild; San Diego Artists

Guild. Awards: First landscape prize, Joplin Spring Exhibition, 1922; grand prize and first landscape prize, Joplin Fall Exhibition, 1922. Represented in the Joplin Art League Gallery, Joplin, MO; Fine Arts Society of San Diego. Address in 1933, 3545 Bear Drive, San Diego, CA.

TREBILCOCK, PAUL.
Painter. Born in Chicago, IL, Feb. 13, 1902. Pupil of Art Institute of Chicago; Seyffert. Member: Associate National Academy of Design, 1932; Chelsea Art Club, London; Painters and Sculptors of Chicago; Cliff Dwellers. Awards: Cahn prize, Art Institute of Chicago, 1925; Hearst prize, Art Institute of Chicago, 1926; first prize ($1,000), Chicago Galleries Association, 1926; Logan medal, Art Institute of Chicago, 1928; French gold medal, Art Institute of Chicago, 1929; first Hallgarten prize, National Academy of Design, 1931; prize, Newport Art Association, 1931. Work: "Old London Coachman," Albright Art Gallery; "President David Kinley," University of Illinois; "Dean Shailer Mathews," University of Chicago; "Portrait of a Painter," Art Institute of Chicago; "Judge A. A. Bruce," "Dean Peter C. Lutkin," "President Walter Dill Scott," Northwestern University; "Dr. W. G. MacCallum," Johns Hopkins University, Baltimore, MD; "President Franklin D. Roosevelt," Columbia University, NY. Address in 1933, 141 East Ontario St., Chicago, IL; h. 554 Ashland Ave., River Forest, IL.

TREFETHEN, JESSIE B.
Painter, lecturer, and teacher. Born in Peak's Island, ME. Pupil of Henry McCarter; Penna. Academy of Fine Arts. Member: Fellowship Penna. Academy of Fine Arts. Address in 1929, 35 South Professor St., Oberlin, OH; summer, Trefethen, ME.

TREGANZA, RUTH C. ROBINSON.
Painter, architect, designer, and teacher. Born in Elmira, NY, March 30, 1877. Pupil of J. M. Hewlett; L. C. Tiffany; Arthur W. Dow; H. W. Corbett. Member: National Association of Women Painters and Sculptors; American Federation of Arts. Address in 1929, Teachers College, Columbia University; 230 West 120th St., New York, NY.

TREGO, JONATHAN.
Painter. Born in March, 1817, in Pennsylvania. Father of William Trego. Painted many of the families of Bucks County, PA, in a rather stiff and formal manner.

TREGO, WILLIAM T.
Painter. Born in Yardley, Bucks County, PA, in 1859. Studied with his father Jonathan Trego. In 1879 he entered the schools of the Penna. Academy of Fine Arts; he later studied in Paris under Fleury and Bouguereau. Died in North Wales, PA, in 1909.

TREIMAN, JOYCE WAHL.
Painter and sculptor. Born May 29, 1922, in Evanston, IL. Earned B.F.A. from State University of Iowa, 1943. Awards: Graduate fellowship to State University of Iowa, 1943; Tiffany Grant, 1947; Tupperware Art Fund, 1955; Tamarind Lithography Fellowship, 1962; Ford Foundation, 1960, 63; Logan prize, Art Institute of Chicago, 1951, Palmer Prize, 1953, Cahn Award, 1949, 60; Los Angeles Sculpture Prize, All-City Show, 1964; others. Los Angeles Times Woman of the Year for Art, 1965. Taught at UCLA; Los Angeles Art Center School; University of Illinois; San Fernando Valley State College; California State University. One-man exhibitions: Paul Theobald Gallery, Chicago, 1942; Art Institute of Chicago; Fairweather-Garnett Gallery, IL; Felix Landau Gallery; Cliff Dwellers Club, Chicago; others. Group exhibitions: Whitney; Stanford University; Museum of Modern Art; Metropolitan Museum of Art; San Francisco Museum of Art; Watkins Gallery, Washington, DC; Milwaukee Art Center; Denver Art Museum; Penna. Academy of Fine Arts; others. In collections of Ball State Teachers College; Pasadena Art Museum; University of Oregon; Abbott Laboratories Collection; Art Institute of Chicago; Los Angeles County Museum; Museum of Modern Art; International Minerals and Chemical Corporation; Whitney; Denver Art Museum; others. Address in 1984, Pacific Palisades, CA.

TRENCHARD, E. C.
Engraver. A well-executed stipple portrait of Count Rumford is signed "Drawn and Engraved by E. C. Trenchard," as a frontispiece to "The Essays of Count Rumford," published by D. West, Boston, 1798. There is difficulty in locating this E. C. Trenchard, who engraved for Boston publishers in 1798. An Edward Trenchard signed an agreement in Philadelphia in 1794 to establish a school of architecture, sculpture and painting. The biography of Capt. Edward Trenchard, a naval officer in the War of 1812, says that he was born in Salem, NJ, c. 1777; studied art with his uncle, James Trenchard, the Philadelphia engraver, and went to England to complete his education. But in 1800 this Edward Trenchard entered the U.S. Navy. He died in Brooklyn, NY, November 3, 1824. The signer of the Philadelphia Agreement of 1794, and the Edward Trenchard who studied with his uncle before 1793, when James Trenchard left the U.S., might well have been the engraver of the "Count Rumford" in 1798, but the alleged birthdate of the naval officer, Edward Trenchard, is 1784, and the engraving is almost too well done for a 14 year old. However, this date of 1784 may be an error, and the later naval officer may have engraved the portrait in question and his own book plate.

TRENCHARD, EDWARD.
Painter. Born in Philadelphia, PA, in 1850. Studied with Peter Moran and at the National Academy of

Design. Work: "The Passing Shower;" "The Old Wreck;" "Sea, Sand and Solitude;" "The Surf." Specialty: Marine painting. Died in 1922.

TRENCHARD, JAMES.
Engraver. Born in 1747. According to Trenchard's grandson, James Thackara, Trenchard came to Philadelphia from Penns Neck, Salem County, NJ. Was in the city as engraver and seal-cutter as early as 1777. In 1787 was artistic member of the firm that established the *Columbian Magazine* in Philadelphia. In 1793 he went to England and remained there. Dunlap stated that Trenchard learned to engrave with J. Smither, in Philadelphia. He engraved a few portraits and views in and about Philadelphia. Also a die-sinker. Made the dies for the medal of the Agricultural Society of Philadelphia, 1790. Possibly a son or nephew of George Trenchard, Salem, NJ, who was Attorney General of West New Jersey in 1767.

TRENHOLM, GEORGE F(RANCIS).
Designer, craftsman, and teacher. Born in Cambridge, MA, Oct. 23, 1886. Pupil of Charles E. Heil; Vojtech Preissig. Member: Artists' Guild; Stowaways; American Institute of Graphic Arts; Boston Society of Painters. Work: Designer of type designs, including Trenholm Old Style, Trenholm Italic, Trenholm Bold, Trenholm Ornament, owned by Barnhart Brothers and Spindler, Chicago. Address in 1929, Little Bldg., 80 Boylston St., Boston, MA; h. Ox Bow Road, Weston, MA.

TRENTANOVE, GAETANO.
Sculptor. Born in 1858 in Florence, Italy. Educated at the Fine Arts Academies of Florence and Rome. Knighted by King Humbert of Italy. Became an American citizen in 1892. Works: Statue of James Marquette, Statuary Hall, United States Capitol; statue of Daniel Webster, Washington, DC; statue of Albert Pike, Washington, DC; Kosciuszko equestrian statue, Milwaukee, WI; "The Last of the Spartans," Layton Art Gallery, Milwaukee, WI; Soldiers' Monument, Oshkosh, WI; Chief Oshkosh Statue, Oshkosh, WI; monument to Confederate soldiers, Springfield, MO; Soldiers' Monument, Appleton, WI; and in private collections. Address in 1900, Washington, DC.

TREVITTS, J.
Painter. Pupil of Penna. Academy of Fine Arts. Member of Fellowship Penna. Academy of Fine Arts. Awarded Cresson traveling scholarship, Penna. Academy of Fine Arts. Address in 1926, Manistee, MI.

TRICCA, MARCO A.
Sculptor and painter. Born in Italy, March 12, 1880. Awards: Shilling award, 1944, 48. Work: Art Institute of Chicago; Whitney Museum of American Art.

Exhibited: Whitney Studio Club, Whitney Museum of American Art, Contemporary Artists, 1940 (all one-man); Corcoran Gallery of Art, 1935; Art Institute of Chicago, 1935-38; Penna. Academy of Fine Arts, 1933-37; Mortimer Brandt Gallery, 1944; Brooklyn Museum. Address in 1953, 337 East 10th St., NYC.

TRICKER, FLORENCE.
Painter, sculptor and teacher..Born in Philadelphia, PA. Pupil of Elliott Daingerfield; Henry B. Snell; Daniel Garber; Charles Grafly; Samuel Murray; Albert Laessle. Member: Philadelphia Alliance; Plastic Club; Fellowship Penna. Academy of Fine Arts; Alumni Philadelphia School of Design for Women. Awards: Gold medal, Graphic Sketch Club; silver medal, first prize, and honorable mention, Plastic Club; first prize, Tampa Art Institute; Douglas prize, Tampa Art Institute, 1927. Work: "Across the River," and "Apple Blossoms," Graphic Sketch Club. Instructor: Stage Design, Mary Lyon School, Swarthmore, PA. Address in 1933, Tricker School of Art, 405 Dartmouth Avenue; h. 250 Haverford Avenue, Swarthmore, PA.

TRIEBEL, FREDERIC ERNEST.
Painter and sculptor. Born in Peoria, IL, December 29, 1865. Pupil of Augusto Rivalta. Studied at Royal Academy in Florence, Italy. Member: Academician of Merit, Roman Royal Academy, San Luca, Rome, Italy. Awards: Galileo silver medal, Museo Nazionale di Antropologia, Florence, 1889, 91. Works: Soldiers' Monument, Peoria, IL; Iowa State Monument, Shiloh, TN; Mississippi State Monument, Vicksburg; Robert G. Ingersoll Statue, Peoria, IL; statues of late Senator George L. Shoup and late Senator Henry M. Rice, Statuary Hall, Washington, DC; Otto Pastor Monument, Petrograd, Russia; bronze, "Mysterious Music," Imperial Museum, Japan; educational Dante medal, Sons of Italy; Dante bronze plaque, various high schools and public libraries. Exhibited at National Sculpture Society, 1923. Superintendent of Sculpture and Secretary for International Jury on Awards, Columbian Expo., Chicago, 1893. Address in 1933, Long Island, NY.

TRINCHARD, J. B.
Sculptor. Worked in New Orleans, 1841-42, 1846.

TRIPLER, H. E.
About 1850-52 this engraver of portraits and historical plates was working for NY publishers. He engraved for *Sartain's Magazine*, of Philadelphia, with John Bannister.

TRISCOTT, SAMUEL PETER ROLT.
Painter. Born in Gosport, England, in 1846. Studied in England. Came to U.S. in 1871. Represented at Boston Museum of Fine Arts. Died in 1925.

TROBAUGH, ROY (B.).
Painter. Born in Delphi, IN, Jan. 21, 1878. Pupil of Art Students League of NY; J. H. Twachtman. Member: Indiana Art Club. Address in 1929, 424 Summit St., Delphi, IN.

TROCCOLI, GIOVANNI BATTISTA.
Painter and craftsman. Born in Lauropoli, Italy, Oct. 15, 1882. Pupil of Denman Ross and Julian Academy. Member: Copley Society; Boston Society of Arts and Crafts; Guild of Boston Artists; American Federation of Arts. Awards: Hon. mention, Carnegie Institute, Pittsburgh, 1911; Harris silver medal ($500), Art Institute of Chicago, 1913; gold medal, P.-P. Expo., San Francisco, 1915; Thomas R. Proctor prize ($200), National Academy of Design, 1922. Represented in the Detroit Institute of Arts. Address in 1929, 21 Morseland Ave., Newton Center, MA.

TROMMER, MARIE.
Painter and writer. Born in Russia. Studied: Cooper Union; pupil of Wayman Adams, S. Halpert, Barile. Member: Salons of America; Society of Independent Artists; C. L. Wolfe Art Club; Brooklyn Society of Modern Artists; Brooklyn Water Color Club. Work: "Still Life" and "Portrait," Corona Mundi, New York, NY. Address in 1929, 1854 62nd St., Brooklyn, NY.

TROSKY, HELENE ROTH.
Printmaker. Born in Monticello, NY, Nov. 23, 1917. Studied: Manhattanville College, B.A., 1964, with John Ross, Garner Tullis, Al Blaustein; New School for Social Research, with Kuniyoshi and Egas. Work: Staten Island Museum; Wichita Museum; Hudson River Museum; Tampa Museum. Exhibited: Wichita Art Museum, 1977, Hudson River Museum, Yonkers, NY, 1969, Silvermine Guild, New Canaan, CT, Long Island University, all one-woman; Wadsworth; National Academy; Musee des Beaux Arts, Orleans, France; Butler Institute, OH; others. Awards: Northern Westchester Award, 1968; award, National Association of Women Artists, 1969, 82. Member: Artists Equity Association; Hudson River Contemporary Artists; National Association of Women Artists; Connecticut Academy of Fine Arts; Westchester Art Society (executive director and chairman of board, from 1960); Council for the Arts, Westchester (founder); Silvermine Guild; others. Taught: Manhattanville College; Westchester Art Workshop; Westchester County Music and Arts Camp; lecturer, Brandeis University for Women, Westchester Community College. Position: Arts editor, Westchester Women's News. Address in 1984, Purchase, NY.

TROTT.
A copperplate engraver, who signed his plates "Trott, sp. Boston." The date of publication was 1800 to 1820.

TROTT, BENJAMIN.
Miniature and portrait painter. Born c. 1770 in Boston, MA. Considered one of the greatest miniaturists of his day. Divided the honors of his profession with Malbone and the Peales. Pupil of Gilbert Stuart. Worked with Thomas Sully in Philadelphia in 1808. Working in Baltimore in 1796. His miniatures suggest the treatment of Richard Cosway, especially in the use of clouds and blue sky backgrounds. Miniatures by Benjamin Trott were placed in the Metropolitan Museum of Art and Rhode Island School of Design, and in many collections in the U.S. Died in November 27, 1843, in Washington, DC.

TROTTER, NEWBOLD HOUGH.
Painter. Born in Philadelphia, PA, in 1827. Studied at the Academy of the Fine Arts. Painted animals. His most important works include "The Range of the Bison"; "Grizzly Bears"; "The Last Stand"; "The Young Bull"; "The Barnyard" (signed and dated Philadelphia, 1866). Died at Atlantic City, NJ, in 1898.

TROUARD.
Sculptor. Born in Louisiana. Worked: New Orleans, 1848; Paris, 1850.

TROUBETZKOY, PAUL.
Sculptor. Born in Lake Intra, Lake Maggiore, Italy, February 16, 1866. Studied in Italy, Russia, and France. Award: Grand prize, Paris Expo., 1900. Bronzes in the Luxembourg in Paris; National Gallery in Rome; National Gallery in Venice; Museum of Alexander III in Petrograd; Treliakofsky Gallery in Moscow; National Gallery in Berlin; Royal Gallery in Dresden; Leipzig Gallery; Chicago Art Institute; Detroit Institute; Toledo Museum; Buffalo Fine Arts Academy; Golden Gate Park Museum; Museum in Buenos Aires; Brera Museum, Milan. Address in 1933, Paris, France; Lago Maggiore, Italy. Died February 12, 1938.

TROUBETZKOY, PIERRE.
Painter. Born in Milan, Italy, April 19, 1864. Pupil of Ranzoni and Cremona. Works: Portrait of "Gladstone," National Gallery of Edinburgh; portrait of Gladstone, National Portrait Gallery, London; "Marquis of Dufferin and Ava as Warden of the Cinq Ports," Town Hall of Dover; "Mr. Archer Huntington," Institute de Valencia de Don Juan, Madrid; "De Philip Bruce," University of Virginia, Charlottesville. Address in 1933, Castle Hill, Cobham, Albemarle Co., VA.

TROUT, (ELIZABETH) DOROTHY BURT.
Painter, illustrator, and teacher. Born in Fort Robinson, NE, June 3, 1896. Pupil of E. C. Messer; Bertha Perrie; Catherine Critcher; Howard Giles; C. W. Hawthorne; E. A. Webster. Member: Society of

Washington Artists; Provincetown Art Association. Address in 1933, 2713 Ontario Road, Washington, DC.

TROVA, ERNEST TINO.
Sculptor and painter. Born in St. Louis, MO, February 19, 1927. Self-taught in art. Works: Museum of Modern Art; City Art Museum, St. Louis; Whitney; Hirshhorn; Guggenheim. Exhibitions: Oakland Art Museum, Pop Art USA; Art Institute of Chicago; Guggenheim; Walker; San Francisco Museum of Art; Whitney; Virginia Museum of Fine Arts; University of Illinois; Dallas Museum of Fine Arts; Museum of Modern Art; Documenta IV, Kassel; Hirshhorn; many galleries. Represented by Pace Gallery, NYC. Address in 1982, St. Louis, MO.

TROWBRIDGE, HELEN FOX.
Sculptor. Born in New York, September 19, 1882. Address in 1918, 18 Lincoln St., Glen Ridge, NJ.

TROWBRIDGE, VAUGHAN.
Painter. Born in NY in 1869. Abandoned business life in 1897, and took up art studies in Paris with Jean Paul Laurens and Benjamin Constant. Exhibited paintings and etchings in Paris Salons, 1900-13, and etchings printed in color at St. Louis Expo., 1904. Illustrated "Paris and the Social Revolution," by Alvan F. Sanborn, 1905. Address in 1926, 15 Ave. Libert, Draveil, Seine-et-Oise, France. Died in 1945 in Paris, France.

TROYE, EDWARD.
Painter. Born in Switzerland in 1808. Came to U.S. c. 1828. In Philadelphia he worked on *Sartain's Magazine* as an animal painter. As a painter of race horses he was most successful, and was styled "The Landseer of America." His equestrian portrait of General Winfield Scott was purchased by the Government. Died in Georgetown, KY, in July, 1874.

TRUAX, SARAH E.
Painter. Born in Iowa. Pupil of Art Institute of Chicago. Member: Art Students League of Chicago; Art Guild Members of Fine Arts Club of San Diego; Baltimore Water Color Club; American Artists Professional League. Awards: Silver and bronze medals, Pan.-Pacific Expo., San Diego, CA, 1915; hon. mention, Los Angeles County Fair, Pomona, CA, 1928. Work: "Cacti," Fine Arts Gallery, San Diego; decoration of table tops, Helping Hand Children's Home, San Diego; Baptistry Window, First Baptist Church, Breckenridge, MN. Address in 1933, 3620 Fairmount Ave., San Diego, CA.

TRUCKSESS, FREDERICK CLEMENT.
Painter and teacher. Born in Brownsburg, IN, Aug. 16, 1895. Pupil of William Forsyth; E. C. Taylor; Eugene Savage. Member: Boulder Artists Guild; Prospectors; Delta Phi Delta. Awards: Second prize

for pastel, Indiana State Fair, 1922; hon. mention, Denver Art Museum, 1933. Work: "Woman and Cows," Jefferson School, Lafayette, IN; stage curtain and mural, "Dramatic Masks," University of Colorado. Address in 1933, 600 Spruce Street, Boulder, CO.

TRUDEAU, JUSTINIAN.
Sculptor. Born c. 1827, Louisiana. Worked: New Orleans, 1849-54.

TRUE, ALLEN TUPPER.
Painter and illustrator. Born in Colorado Springs, CO, May 30, 1881. Pupil of Howard Pyle; Corcoran Art School in Washington; Brangwyn in London. Member: Denver Art Association; National Society of Mural Painters; NY Architectural League. Assisted Frank Brangwyn with decorations for Panama-Pacific Exposition, 1915, and decorations in dome of Missouri State Capitol. Mural decorations in Wyoming State Capitol; Denver Public Library; Montana National Bank, Billings, MT; open air Greek Theater, Civic Center, Denver; Voorhees Memorial Arch, Denver, CO; pendentives in dome, Missouri State Capitol, Jefferson City, MO; "Mother Goose" frieze, Taylor Day Nursery, Colorado Springs; decorations in Colorado National Bank, and in Mountain States Telephone Building, Denver; Indian pottery design applied to barrel vault ceiling, U.S. National Bank Building, Denver. Address in 1933, Littleton, CO.

TRUE, GRACE H(OPKINS).
(Mrs. E. D. A. True). Painter. Born in Frankfort, MI, May 2, 1870. Pupil of John P. Wicker; Frederic Fursman. Member: Detroit Society of Women Painters and Sculptors; Tampa Federation of Artists. Award: First prize, Tampa Federation of Artists, 1930. Address in 1933, Melbourne Beach, Melbourne City, FL; summer, 5981 Woodward Ave., Detroit, MI.

TRUE, VIRGINIA.
Painter and educator. Born in St. Louis, MO, Feb. 7, 1900. Studied: John Herron Art Institute, B.A.E.; Cornell University, M.F.A.; pupil of William Forsyth, Daniel Garber, R. S. Meryman, Hugh Breckenridge, Charles Grafly. Member: College Art Association of America; Artists Equity Association; Indiana Art Club; Hoosier Salon; National Association of Women Artists; Cornell Club, NY; others. Awards: Prize, Indiana State Fair; prizes, Denver Art Museum, 1932, 33; Kansas City Art Institute, 1935; Rochester Memorial Art Gallery, 1939. Work: University of Colorado; Cornell University; State College of Agriculture, Ft. Collins, CO. Exhibitions: National Association of Women Artists, Carnegie Institute; Kansas City Art Institute; Denver Art Museum; American Water Color Society; Rochester Memorial Art Gallery; others. Taught: John Herron

Art Institute, 1926-28; University of Colorado, 1929-36; Cornell University, from 1936. Address in 1962, Cornell University; h. Ithaca, NY; South Yarmouth, Cape Cod, MA.

TRUESDELL, EDITH P(ARK).
Painter and teacher. Born in Derby, CT, Feb. 15, 1888. Pupil of Tarbell; Benson; Hale; Bosley. Member: California Art Club; Laguna Beach Art Association. Awards: First prize, Laguna Beach Anniversary Exhibition, 1924; third prize, Los Angeles County Exhibition, Pomona, CA, 1928; Dalzell Hatfield gold medal and prize, California Art Club, Los Angeles, 1930; second prize, graphic arts, Los Angeles Fiesta Exhibition, 1931. Represented in Denver Art Museum. Address in 1933, 6310 Franklin Circle, Los Angeles, CA.

TRUESDELL, GAYLORD SANGSTON.
Painter. Born in Waukegan, IL, in 1850; died in NY in 1899. Pupil of Penna. Academy of Fine Arts, Philadelphia; also of A. Morot and Cormon, in Paris. Awards: Bronze medal, Exposition Universelle, 1889; second class medal, Paris Salon, 1892; Hors Concours, Salon des Champs Elysees. His painting "Going to Pasture," painted in 1889, was in the Corcoran Art Gallery. Specialty: Animals.

TRUITT, ANNE (DEAN).
Sculptor. Born in Baltimore, MD, March 16, 1921. Studied at Bryn Mawr College, B.A., 1943; Institute of Contemporary Art, Washington, DC, 1948-49; Dallas Museum of Fine Arts, 1950. Works: University of Arizona Museum of Art, Tucson; National Collection of Fine Arts, Washington, DC; Museum of Modern Art; Whitney Museum of American Art; Walker Art Center. Exhibitions: Andre Emmerich Gallery, NYC, 1963, 65, 69, 75, 80; Baltimore Museum of Art, 1969, 74; Pyramid Gallery, 1971-73, 75-77, 79; Whitney Museum of American Art, 1974; Corcoran Gallery of Art, 1974; others. Awards: Guggenheim Fellowship, 1971; National Endowment for the Arts, 1972, 77. Media: Wood and acrylic. Address in 1982, Washington, DC.

TRUMBULL, GURDON (or GORDON).
Painter. Born in Stonington, CT, in 1841. Pupil of F. S. Jewett and of James M. Hart in NY. Specialty was painting game fish. Resided for years in Hartford, CT, and died there in 1903.

TRUMBULL, JOHN (COLONEL).
Born in Lebanon, CT, June 6, 1756. Graduated from Harvard in 1773. After college he painted "The Death of Paulus Emilius at Cannae," his first attempt at composition. Was Revolutionary War adjutant. His skill as a draughtsman attracted the attention of Washington, who made him an aide-de-camp and his military secretary. Afterwards joined army of General Gates, as adjutant, but in 1777, dissatisfied with his commission as deputy adjutant-general, he resigned and resumed art studies. In 1778 he joined General John Sullivan as a volunteer aide-de-camp in the plan to recover Rhode Island from the British. In May, 1780, he sailed for France, and then to London, with a letter from Benjamin Franklin to Benjamin West, under whom he wanted to study art. He was arrested for treason while pursuing his studies and held in prison for eight months, and was then released on the condition of leaving the kingdom. After the war, in 1784, he was again enabled to visit London to study under Ben West. He also visited Paris at this time and came under the influence of David and Vigee-LeBrun. From 1789 to 1794 he was in America. Executed historical paintings of "The Declaration of Independence," "The Battle of Bunker Hill," "The Death of General Montgomery," "The Surrender of Burgoyne," "The Sortie from Gibraltar," several portraits of Washington, and others. In 1794 he went to England, as secretary to Hon. John Jay. Returned to U.S. in 1804 and had a studio in New York City. Returned to England once more in 1808 until 1816, when he went back to New York City. Painted historical portraits, but these not meeting with ready sales, he contracted with Yale to present the collection in return for an annuity of $1,000. It now forms an important historical gallery. His most important works include four paintings for the Capitol: "Declaration of Independence," "Surrender of General Burgoyne," "Surrender of Lord Cornwallis," and "General Washington Resigning his Commission." Thirty-six of the figures in "Declaration" were painted from life in 1791; nine figures were from memory and from portraits by other artists. Small sizes of the four works were hung in the School of Fine Arts at Yale. His "Death of Montgomery" is considered one of the most spirited battle-pieces ever painted. His portraits of Gen. Washington are of great interest, and his Alexander Hamilton might be called his best work. Elected president of the American Academy of Fine Arts in 1817 and re-elected to this office for years. Died Nov. 10, 1843, in NYC.

TRUMP, R(ACHEL) B(ULLEY).
(Mrs. Charles C. Trump). Painter. Born in Canton, OH, May 3, 1890. Pupil of Syracuse University. Member: National Association of Women Painters and Sculptors; Philadelphia Alliance; Plastic Club. Work: "Judge Knapp," United States Circuit Court of Appeals, Richmond, VA. Address in 1933, 503 Baird Road, Merion, PA.

TRYON, BENJAMIN F.
Painter. Born in 1824 in New York City. Studied with Richard Bengough and James H. Cafferty. Subjects were chiefly landscapes. Resided for years in Boston, where he exhibited at the Boston Art Club. Among his works are "New England Scenery," "Conway Valley" and "A Quiet Nook."

TRYON, DWIGHT W.

Landscape painter. Born in Hartford, CT, in 1849. Studied in Paris in the atelier of Jacquesson de la Chevreuse; also studied from nature out of doors with Daubigny and Harpignies. Returned to U.S. and received immediate recognition and many medals. In 1886 his painting "Daybreak" received the gold medal at the Prize Fund Exhibition, American Art Association. Other awards include a prize at the National Academy in 1895; gold medal at Munich in 1898; and first prize at the Carnegie Institute. In 1891 elected a member of the National Academy of Design. Member of Society of American Artists and the American Water Color Society. Represented in Metropolitan Museum of Art by "Moonrise at Sunset," "Early Spring," and "Evening, New Bedford Harbor." Also in principal galleries in America and abroad. (See *American Masters of Painting*, by Charles Caffin). Died in 1925.

TRYON, HORATIO L.

Sculptor and marble worker. Born c. 1826 in New York State. Worked: New York City, from 1852.

TSAI, WEN-YING.

Sculptor and painter. Born in Amoy, China, October 13, 1928; U.S. citizen. Studied at University of Michigan, M.E., 1953; Art Students League, 1953-57; New School for Social Research, 1956-58. Work at Tate Gallery, London; Centre Nationale d'Art Contemporain, Paris; Albright-Knox Art Gallery, Buffalo; Whitney Museum of American Art, NY; others. Has exhibited at Corcoran Gallery of Art, Washington, DC; Museum of Modern Art, NY; Institute of Contemporary Arts, London; Carnegie Institute Museum of Art; others. Received Whitney Fellowship, 1963; Center for Advanced Visual Studies Fellowship, Massachusetts Institute of Technology, 1969-71; others. Works in water, fiber optics, fiberglas, and stainless steel. Address in 1982, 565 Broadway, NYC.

TSCHAEGLE, ROBERT.

Sculptor, curator, teacher, writer, and lecturer. Born in Indianapolis, IN, January 17, 1904. Studied at Art Institute of Chicago; University of Chicago, Ph.D., A.M.; University of London; and with Lorado Taft. Member: College Art Association of America. Exhibited: Art Institute of Chicago; Hoosier Salon; John Herron Art Institute; National Academy of Design. Contributor to Herron Art Institute Bulletins. Positions: Instructor, History of Art, University of Missouri, 1935-36; Assistant Curator, John Herron Art Museum, Indianapolis, IN, 1937-41. Address in 1953, Indianapolis, IN.

TSCHUDI, RUDOLF.

Painter. Born in Switzerland in 1855. Member of Cincinnati Art Club. Represented by "Surrender of Lee," and portraits of Jefferson and Lincoln. Died in Cincinnati in 1923.

TSCHUDY, H(ERBERT) B(OLIVAR).

Painter and illustrator. Born in Plattsburg, OH, Dec. 28, 1874. Pupil of NY Art Students League. Member: Brooklyn Society of Modern Artists; Brooklyn Water Color Club; Philadelphia Water Color Club; American Federation of Arts; American Water Color Society; others. Work: Decorative panels, four water colors, Brooklyn Museum; water color, State Museum, Santa Fe, NM. Address in 1933, Brooklyn Museum, Brooklyn, NY.

TSENG, YU-HO.

(Betty Tseng Yu-Ho Ecke). Painter. She was born Nov. 29, 1924, in Peking, China, where she earned degree in art at Fu-jen University, 1942. Also studied at the University of Hawaii, M.A., 1966; Institute of Fine Arts, NY University, Ph.D., 1972. U.S. citizen. Awarded Rockefeller Scholarship, 1953, used for study of U.S. collections; American Artists of the Western States Award, Stanford Art Gallery; NY University Founders Day Award for Outstanding Scholarship, 1972. Taught at Honolulu Academy of Art, 1950-63, where she is now a consultant on Chinese art; University of Hawaii, associate professor, 1963-66, program chairman of art history, from 1971, professor of art, from 1973. Exhibited at De Young Memorial Museum, San Francisco, 1947; Smithsonian; Downtown Gallery, NYC; Carnegie; University of Illinois; Walker Art Center; in Paris and Germany; others. Work: Various commissions in Hawaii and elsewhere; Cornell University; Munson-Williams-Proctor Institute; Art Institute of Chicago; Walker Art Center; Williams College; Honolulu Academy of Arts; Stanford Art Gallery; and others internationally. Address in 1984, Honolulu, HI.

TUCKER, ALLEN.

Painter, architect, writer, and teacher. Born in Brooklyn, New York, June 29, 1866. Pupil of Columbia University; Art Students League of New York. Represented in Providence Museum; Brooklyn Museum; Metropolitan Museum of Art; Albright Gallery, Buffalo; Phillips Memorial Gallery, Washington, DC; Whitney Museum of American Art. Instructor, Art Students League of New York. Author: *Design and the Idea; There and Here*. Died in 1939. Address in 1933, 133 East 80th Street; care of Rehn Gallery, 693 Fifth Avenue, New York, New York.

TUCKER, BENJAMIN.

Portrait painter. Born in 1768. Worked in Newbury, CT.

TUCKER, CORNELIA.

Sculptor. Born in Loudonville, New York, July 21, 1897. Pupil of Grafly; Pennsylvania Academy of Fine Arts. Member: Fellowship Pennsylvania Academy of Fine Arts. Address in 1933, Sugar Loaf, NY.

TUCKER, WILLIAM E.
Engraver. Born in Philadelphia, PA, in 1801; died there in 1857. Pupil of Francis Kearny in Philadelphia. Also studied in England, evidenced by prints signed "Engraved in London by W. E. Tucker." Tucker's name as an engraver appeared continuously in the directories of Philadelphia from 1823 to 1845. He was an excellent engraver in line and stipple, but his best signed work is among his small *Annual* plates. Later devoted himself almost entirely to bank-note engraving.

TUCKERMAN, LILIA (McCAULEY).
(Mrs. Wolcott Tuckerman). Painter. Pupil of George S. Noyes; Charles H. Woodbury; De Witt Parshall. Member: California Art Club; Society of Washington Artists; San Francisco Art Association; National Arts Club; National Association of Women Painters and Sculptors; Boston Art Club; Minnesota State Art Society; San Diego Artists Guild; Santa Barbara Art League; American Federation of Arts. Work: Background for Elk Group in Santa Barbara Museum of Natural History. Address in 1933, Foothill Road, Carpinteria, CA.

TUCKERMAN, STEPHEN SALISBURY.
Painter. Born in Boston, MA, in December 8, 1830. Studied in England but returned to Boston and taught there until 1864. Noted for his marine views, which he exhibited in many galleries abroad. His painting of the "U.S. Frigate Escaping from the British Fleet in 1812" was in the Boston Museum of Fine Arts. Also a landscapist. Died March, 1904, in Standsford, England.

TUDOR, ROSAMOND.
Painter, etcher, and teacher. Born in Buzzards Bay, MA, June 20, 1878. Pupil of Boston Museum School under Benson and Tarbell; W. H. W. Bicknell. Member: North Shore Arts Association; American Artists Professional League. Work: "Portrait of Father Zahm," Library University of Notre Dame, Notre Dame, IN. Address in 1933, c/o Portrait Painters' Gallery, 570 Fifth Ave., New York, NY; Redding, CT.

TUKE, (ELEANOR) GLADYS.
Sculptor and potter. Born in Linwood, WV, November 19, 1899. Studied at International Correspondence Schools, 1920-22; Corcoran School of Art, 1931-32; Penna. Academy of Fine Arts, 1932-33; sculpture with Albert Laessle, 1933-37; pottery with Charles Tennant, Wm. Scott, 1940-41; and with Maxwell Miller. Exhibitions: Penna. Academy of Fine Arts; Philadelphia Art Alliance; Woodmere Galleries, Washington, Charleston, WV, Cincinnati, NYC, Philadelphia, and others. Member: Southern Appalachian Botanical Club; Southern Highland Handicraft Guild. Taught: Art, Germantown (PA) YWCA, 1937-40; Steven's School, 1940-42; Ashford General Hospital, 1943-46; private studio, White Sulphur Springs, VA, 1946-52, and at present. Address in 1962, White Sulphur Springs, WV.

TULLOCH, W(ILLIAM) A(LEXANDER).
Painter, teacher and writer. Born in Venezuela, South America, Jan. 3, 1887. Pupil of William Turner. Member: Salons of America; Society of Independent Artists. Address in 1933, 114-116 East 28th Street, New York, NY.

TULLY, CHRISTOPHER.
Engraver. The *Pennsylvania Magazine* for 1775 contains a copperplate of a machine for spinning wool, which the text said was "drawn and engraved by Christopher Tully, who first made and introduced this machine into this country." The plate was evidently made in connection with the work of the Society for Promoting American Manufactures, organized in Philadelphia in 1775. To this society C. Tully and John Hague submitted models of machines for spinning wool and cotton goods; these two machines were so similar in design, the committee appointed to examine them decided to divide the prize of 30 pounds offered by the society between the two inventors.

TUNIS, EDWIN B(URDETT).
Illustrator, painter, sculptor, and writer. Born in Cold Spring Harbor, NY, Dec. 8, 1897. Studied: Maryland Institute; pupil of Joseph Lauber, C. Y. Turner, Hugh Breckenridge. Work: Murals, Mc Cormick & Co., Baltimore, MD; Title Guarantee Co., and City Hospital, Baltimore. Awards: Gold medal, Boys' Club of America, 1956; Edison Foundation Award, 1957. Illustrated *Eat, Drink and Be Merry in Maryland*, 1932. Author and illustrator of *Oars, Sails and Steam*, 1952; *Wheels*, 1955; *Colonial Living*, 1957; *Frontier Living*, 1961 (runner-up for Newberry Medal); *Shaw's Fortune*, 1966; others. Contributor to *House Beautiful* and *Better Homes and Gardens*, with garden landscape and architectural illustrations. Address in 1970, Reisterstown, MD. Died in 1973.

TUPPER, ALEXANDER G(ARFIELD).
Painter and writer. Born in Gloucester, MA, Oct. 25, 1885. Pupil of Twachtman. Member: National Arts Club; Gloucester Society of Artists; North Shore Arts Association. Address in 1933, 126 East 54th Street, New York, NY; 81 Mt. Pleasant Ave., East Gloucester, MA.

TURANO, DON.
Sculptor and medalist. Born in New York, NY, March 9, 1930. Studied at School of Industrial Art, with Albino Cavalido; Corcoran School of Art, with Heinz Warneke; Skowhegan School of Painting and Sculpture, with H. Tovish; Rinehart School of Sculpture, with R. Puccinelli. Work: Carved oak panels, First Presbyterian Church, Royal Oak, MI; lime-

stone figures, Cathedral of St. Peter and St. Paul, Washington, DC; four arks (locust wood), Temple Micah, Washington, DC; others. Exhibited: Penna. Academy of Fine Arts, Philadelphia; St. Louis Museum, MO; Audubon Annual, National Academy of Design Galleries; others. Member of the National Sculpture Society. Awards: Mrs. Lindsey Bennett Prize, 1964; honorable mention, National Sculpture Society; first prize, Corcoran Gallery of Art, 1966; others. Taught sculpture at George Washington University and Corcoran School of Art, 1961-65. Works in bronze and wood. Address in 1982, Washington, DC.

TURCAS, JULES.
Landscape painter. Born in Cuba in 1854; died in Boston in 1917. Exhibited in the NY and Philadelphia galleries.

TURINO (or TURINI), GIOVANNI.
Sculptor. Born in Italy, May 23, 1841. Works: Statue of Garibaldi, Washington Square, NYC. Died in U.S., August 27, 1899.

TURKENTON, NETTA CRAIG (MRS.).
Painter and teacher. Born in Georgetown, DC, October 23, 1884. Pupil of Penna. Academy of Fine Arts; Corcoran School of Art; William M. Chase. Member: Society of Washington Artists. Address in 1933, 1513-33rd St., N.W., Washington, DC.

TURLE, SARAH A.
Painter. Exhibited miniatures at the Penna. Academy of Fine Arts, Philadelphia, 1925. Address in 1926, 2216 East Superior St., Duluth, MN.

TURMAN, WILLIAM T.
Painter and teacher. Born in Graysville, IN, June 19, 1867. Studied: Art Institute of Chicago; Chicago Academy of Fine Arts; Penna. Academy of Fine Arts; pupil of J. Francis Smith, A. F. Brooks, Sterba, A. T. Van Laer. Member: Terre Haute Art Association; Indiana Art Association; Hoosier Salon; American Federation of Arts; Pen and Brush Club, Terre Haute. Work: High School, Columbia City, IN; Public Library, Thorntown, IN; Indiana State Teachers' College; Turman Township High School, Graysville, IN; High School, Jasonville, IN; Sara Scott and McClain Junior High Schools, Montrose Grade School, Wiley High School, and Woman's Dept. Club, Terre Haute, IN. Award: Rector Memorial prize, Hoosier Salon, 1932. Address in 1933, Terre Haute, IN.

TURNBULL, GALE.
Painter and etcher. Born in Long Island City, NY, Dec. 19, 1889. Pupil of Guerin; Preissig; Lasar. Member: American Art Association of Paris; Salma. Club; Groupe des Peintres et Sculpteurs Americains de Paris. Represented in the Luxembourg Museum,

Paris; Brooklyn Museum, New York. Address in 1933, 51 Blvd. St. Jacques, Paris, France; summer, Pont Croix, Finistere, France.

TURNBULL, GRACE HILL.
Painter, sculptor, lecturer, and writer. Born in Baltimore, MD, December 31, 1880. Studied at Art Students League with Joseph De Camp; Penna. Academy of Fine Arts with Chase and Cecilia Beaux; Maryland Institute of Art; also painting with Willard Metcalf. Works: Metropolitan Museum of Art; Corcoran Gallery of Art; Baltimore Museum of Art; monument, Eastern High School, Baltimore. Awards: Whitelaw Reid first prize, Paris, France, 1914; Huntington prizes, National Association of Women Artists, 1932, 44; Baltimore Museum of Art, 1945, 47; purchase prize, Metropolitan Museum of Art, 1942; Gimbel award, Philadelphia, 1932; Phi Beta Kappa, Southwestern University, 1956; others. Exhibited at National Sculpture Society, many times; National Association of Women Artists, many times; Salon des Beaux Arts, Paris, 1914; Corcoran; Penna. Academy of Fine Arts, many times; Art Institute of Chicago, 25th Annual, 1912; Metropolitan Museum, 1942-43; National Academy of Design; Architectural League; World's Fair, NY, 1939; Detroit Institute of Arts; and others. Member: National Association of Women Artists; Baltimore Museum of Art; Fellow, National Sculpture Society. Author: *Tongues of Fire* (Macmillan Co.), 1929; *Chips from my Chisel*, 1951; others. Media: Marble, wood; oil, pastel. Address in 1976, Baltimore, MD. Died in 1976.

TURNBULL, RUTH.
Sculptor. Born in New City, NY, January 25, 1912. Pupil of Ella Buchanan. Address in 1929, Hollywood, CA.

TURNER, ALFRED M.
Painter and teacher. Born in England, Aug. 28, 1851. Pupil of his father, Edward Turner. Member: American Water Color Society. Work: "Chancellor McCracken" and "Dean Brush," New York University.

TURNER, CHARLES YARDLEY.
Painter and etcher. Born in Baltimore, MD, in 1850. Went to NYC in 1872 and entered the school of the National Academy of Design, where he studied for three years and received awards. Went to Paris and studied under Laurens, Munkacsy and Leon Bonnat. In Holland he found the subject of his famous painting "The Grand Canal at Dordrecht." Was assistant director of decorations at the Columbia Expo. in Chicago in 1893. Elected an Associate of the National Academy of Design in 1883, and an Academician in 1886; he was also a member of the NY Etching Club. One of his murals was in the Baltimore Court House, the subject being the incident of the

brig *Peggy Stuart* entering the harbor of Annapolis in 1774. Also painted many Puritan subjects. Some of his work was in the Capitol at Madison, WI; also in many buildings in NY. Towards the last of his life he concentrated on etching. Died in 1918.

TURNER, FRANCES LEE.
(Mrs. E. K. Turner). Painter and teacher. Born in Bridgeport, AL, Nov. 5, 1875. Studied: Corcoran Art School; Art Students League of NY; pupil of Kenyon Cox, George Elmer Browne, Daniel Garber, George Pearse Ennis. Member: Southern States Art League; Atlanta Art Association; Georgia Art Association. Award: Prize, Atlanta Art Association, 1923. Address in 1933, Emory University, Atlanta, GA.

TURNER, HELEN M.
Painter. Born in Louisville, KY, 1858. Pupil of Art Students League of NY under Cox. Member: Associate National Academy of Design, 1913; Academician National Academy of Design, 1921; NY Water Color Club; National Association of Portrait Painters; National Arts Club; American Federation of Arts; American Artists Professional League; Southern States Art League. Awards: Elling prize for landscape, NY Woman's Art Club, 1912; Agar prize, National Association of Women Painters and Sculptors; Shaw memorial prize, National Academy of Design, 1913; Altman prize ($500), National Academy of Design, 1921; second prize ($400), National Arts Club, 1922; gold medal ($300), National Arts Club, 1927; Maynard prize, National Academy of Design, 1927. Work: Miniature, Metropolitan Museum, NY; "Girl with the Lantern," Corcoran Gallery, Washington, and in Detroit Institute; Delgado Museum, New Orleans, LA; National Arts Club, New York; Phillips Memorial Gallery, Washington, DC; "Two Women," Houston Art Museum, TX; "Lilies, Lanterns and Sunshine," Norfolk Museum, VA; "Golden Hours," Newark Art Museum; "A Young Girl," Highland Park Society of Arts, Dallas, TX. Address in 1933, 343 Broadway, New Orleans, LA; 15 Gramercy Park, NY, NY; summer, Cragsmoor, Ulster Co., NY.

TURNER, JAMES.
Engraver. This name first appears in Boston, MA, signed to a view of Boston which appears in *The American Magazine* for 1744. In the *Boston Evening Post* of 1745, he advertised as follows: "James Turner, Silversmith & Engraver, near the Town-House in Cornhill Boston. Engraves all sorts of Stamps in Brass or Pewter for the common Printing Press, Coats of Arms, Crests, Cyphers, &c., on Gold, Silver, Steel, Copper, Brass or Pewter. He likewise makes Watch Faces, makes and cuts Seals in Gold, Silver, or Steel: or makes Steel Faces for Seals, and sets them handsomely in Gold or Silver. He cuts all sorts of Steel Stamps, Brass Rolls and Stamps for Sadlers and Bookbinders, and does all sorts of work in Gold

and Silver. All after the best and neatest manner and at the most Reasonable Rates." In Boston he engraved the three large folding maps used in a "Bill in the Chancery of New Jersey," published in NY in 1747 by James Parker, and also engraved a fairly good portrait of the Rev. Isaac Watts. About 1758 James Turner was in Philadelphia as an engraver and print-dealer on Arch Street, and he was probably there earlier as he engraved the large map "Province of Pennsylvania," published by Nicholas Scull in Philadelphia in 1759. Engraved book-plates for residents of Philadelphia, and the Penn coat of arms for the headline of *The Pennsylvania Gazette*. Died in December, 1759, in Philadelphia.

TURNER, JEAN (LEAVITT).
(Mrs. Leroy C. Turner). Painter, sculptor, illustrator, teacher, and lecturer. Born in NYC, March 5, 1895. Studied at Pratt Institute Art School; Cooper Union Art School; and with Ethel Traphagen. Member: American Artists Professional League; League of American Pen Women. Exhibited: Palace of the Legion of Honor, 1938-39; American Artists Professional League, 1940-46; League of American Pen Women, 1940, 41. Illustrated Progress Books (grades 1, 2, 3), 1926. Lectures: Art in War. Address in 1953, Victorville, CA.

TURNER, LESLIE.
Illustrator. Born in Cisco, TX, Dec. 25, 1900. Illustrations for *The Saturday Evening Post, Ladies Home Journal, Pictorial Review*. Address in 1929, Westport, CT.

TURNER, MATILDA HUTCHINSON.
Painter. Born in Jerseyville, IL. Pupil of Drexel Institute under Steinmetz; Hugh Breckenridge; William M. Chase; Cecilia Beaux; Sergeant Kendall; Margaretta Archambault. Exhibited at Penna. Academy of Fine Arts. Member: Fellowship Penna. Academy of Fine Arts; Illinois Academy of Fine Arts. Address in 1933, 3717 Hamilton St., Philadelphia, PA.

TURNER, RAYMOND.
Sculptor. Born in Milwaukee, WI, May 25, 1903. Studied at Milwaukee Art Institute; Wisconsin Normal School; Layton School of Art; Cooper Union Art School; Beaux-Arts Institute of Design. Work: Smithsonian Institution, Washington, DC; Baseball Hall of Fame, Cooperstown, NY; numerous commemorative coins. Exhibited: National Academy of Design, 1932, 33, 35, 67; Penna. Academy of Fine Arts, 1936, 40; New York World's Fair, 1939; Salon d'Automne, Paris, 1928; National Sculpture Society, 1949, 50, 72; Medallic Art Co., 1950; Argent Gallery, 1951; Sports of the Olympics, National Art Museum of Sports, NYC, 1972; NYC WPA Art Exhibit, Parsons School of Design, 1977. Awards: August Helbig Prize for Man, Detroit Art Institute, 1927;

Guggenheim Foundation Fellowship, 1928; Pauline Law Prize for Girl, Allied Artists of America, 1966. Address in 1983, 51 Seventh Ave., South, NYC.

TURNER, ROSS STERLING.
Painter and illustrator. Born in Westport, Essex County, NY, in 1847. Began artistic career after 1873. Studied in Europe, mostly in Germany (Munich) and Italy, 1876-80-82. Among his oils and watercolors are "A Small Court, Mexico;" "El Jardin Modesto;" "A Painted Ship;" "The Flying Dutchman;" and "A Bermuda Wedding." Professor at Normal Art School, Boston, MA, in 1909. Author: "Water Colors;" "Art for the Eye;" "School Room Decorations;" and others. Published reproduction of the "Golden Galleon" picture, *Century Magazine*, 1899. Died in 1915.

TURNER, WILLIAM GREENE.
Sculptor. Born in Newport, RI, in 1833. Went abroad for study and spent much of his life in Italy. Exhibited in Philadelphia in 1876. Died in Newport, RI, December 22, 1917.

TURNEY, AGNES RICHMOND.
See Richmond, Agnes M.

TURNEY, OLIVE.
Painter. Born in Pittsburgh, PA, August 4, 1847. Pupil of Pittsburgh School of Design for Women. Member: American Artists Professional League; American Federation of Arts. Award: Gold medal, 1872. Address in 1933, 322 Amber St., Pittsburgh, PA; summer, Scalp Level, PA.

TURNEY, WINTHROP DUTHIE.
Painter. Born in New York, NY. Pupil of Loeb, DuMond and Brush; Art Students League of NY. Member: National Society of Mural Painters; Brooklyn Society of Modern Artists; Artists' Fellowship, Inc.; Fifteen Gal.; others. Represented in the Brooklyn Museum. Address in 1933, 211 Greene Ave., Brooklyn, NY.

TUROFF, MURIEL PARGH.
Sculptor and painter. Born in Odessa, Russia, March 1, 1904; U.S. citizen. Studied at Art Students League; Pratt Institute; University of Colorado. Work: Smithsonian Institution Portrait Gallery, Washington, DC; Jewish Museum, NY. Commissions: Enamel on copper artifacts, commission by St. James Lutheran Church, Coral Gables, FL, 1974. Exhibitions: Syracuse Museum of Art, NY, 1945; Museum of Natural History, NY, 1958; Cooper Union Museum, NY, 1960; Lowe Museum Beaux Arts, Miami, FL, 1968; YM-YWHA, Miami, FL, 1971. Awards: Blue Ribbon for best in show, Blue Dome Art Fellowship, 1966 and 1973; second prize, YM-YWHA, 1971. Member: Artists Equity Association; Florida Sculptors; others. Media: Metal and enamel.

Address in 1982, 517 Gerona Avenue, Coral Gables, FL.

TUTHILL, WILLIAM H.
Engraver and lithographer. In 1825 Tuthill was designing for the early New York lithographer Imbert. In 1830-31 he engraved portraits, landscape and book illustrations for NY publishers. The engraving firm of Tuthill & Barnard was later working in NY. The small etching of "Mr. Robert as Wormwood," published in NY, is signed "Tuthill fec't."

TUTTLE, ADRIANNA.
Painter. Born in Madison, NJ, Feb. 6, 1870. Pupil of Chase. Member: Pennsylvania Society of Miniature Painters; National Association of Women Painters and Sculptors; American Society of Miniature Painters. Specialty: Portraits on ivory. Address in 1933, 2 Orchard St., Newark, NJ.

TUTTLE, H(ENRY) E(MERSON).
Etcher. Born in Lake Forest, IL, Dec. 10, 1890. Member: Brooklyn Society of Etchers; Chicago Society of Etchers; American Federation of Arts. Work: "The Goshawk," Art Institute of Chicago; "The Goshawk," "Old Raven," "Saw-Whet Owl No. 1," "Great Horned Owl," and "Sharp-Shinned Hawk No. 1," British Museum, London; "Afternoon," Memorial Art Gallery, Rochester, NY; "Old Raven," Bibliotheque Nationale, Paris; twenty-five prints, Museum of Fine Arts, Yale University, New Haven, CT. Address in 1929, 87 Trumbull St., New Haven, CT.

TUTTLE, MACOWIN.
Painter, illustrator, engraver, teacher, writer, and lecturer. Born in Muncie, IN, Nov. 3, 1861. Pupil of William M. Chase; Duveneck; Laurens and the Julian Academy in Paris. Member: National Arts Club; Salma. Club; American Art Association of Paris. Represented in Metropolitan Museum and Museum of the City of New York, NY; National Gallery of Art and the Library of Congress, Washington, DC; group of twenty-four blocks of Yale University, showing technique of American School of Wood Engraving, 1875-1895. Specialty: Engravings on wood direct from nature. Address in 1933, 50 Central Park, South; h. 47 Fifth Ave., New York, NY.

TUTTLE, MARY McARTHUR THOMPSON.
Painter and author. Born at Hillsboro, Highland County, OH, in 1849. Portrait and landscape painter. In 1895 and after, she lectured on "Color" in schools, colleges, etc. Painted portrait of her mother exhibited in W.C.T.U. exhibit, St. Louis Expo., 1904, and in Tremont Temple, Boston; portraits of Prof. Tuttle in Historical Seminary Room, Cornell University, and Billings Library. Author of *Chronological Chart of the Schools of Painting*.

TUTTLE, MILDRED JORDAN (MRS.).
Painter, etcher, and teacher. Born in Portland, ME, Feb. 26, 1874. Pupil of Yale School of Fine Arts; W. M. Chase. Member: New Haven Paint and Clay Club; Pennsylvania Society of Miniature Painters. Work: "Bishop Samuel Senbury," Yale University. Address in 1933, Clinton, CT.

TUTTLE, RICHARD.
Painter and sculptor. Born in Rahway, NJ, July 12, 1941. Studied: Trinity College, CT, 1963, B.A., where he met artist Agnes Martin; Cooper Union. Worked as an assistant at the Betty Parsons Gallery. In collections of Corcoran; Kaiser-Wilhelm Museum, Germany; National Gallery, Canada; others, including private and public collections. Exhibited: Betty Parsons Gallery, 1965; Galeria Schmela, Dusseldorf, 1968, NY, 1970; Museum of Fine Arts, Dallas, 1971; Nicholas Wilder Gallery, Los Angeles, 1969; Albright-Knox Art Gallery, Buffalo, NY, 1970; Museum of Modern Art, NY, 1972; Whitney Museum of American Art, 1969, Retrospective, 1975; Corcoran Gallery of Art 31st Biennial, 1969; Documenta, Kassel, West Germany, 1972; others. Address in 1982, c/o Betty Parsons Gallery, 24 West 57th Street, New York, NY.

TUTTLE, RUEL CROMPTON.
Portrait and mural painter. Born in Windsor, Sept. 24, 1866. Pupil of Art Students League of NY under Mowbray and J. Alden Weir. Member: Art Students League of NY; Connecticut Academy of Fine Arts; Washington Water Color Club; NY Water Color Club; American Federation of Arts. Lecturer on History of Art, Amherst College. Address in 1933, Greenfield, MA.

TWACHTMAN, JOHN HENRY.
Landscape painter and etcher. Born in Cincinnati, OH, in 1853. Pupil of School of Design of Cincinnati, under Frank Duveneck; National Academy of Design, NY; later studied in Munich, and in Paris at the Academie Julien under Boulanger and Lefebvre. Awarded Webb prize from the Society of American Artists in 1888; Temple gold medal from the Penna. Academy of Fine Arts, 1895. Member of the American Art Club of Munich; New York Etching Club; honorary member of the Art Students League of NY. Taught at the Art Students League, NY, 1889-1902. In 1898 founded the organization named "Ten American Painters." Exhibited two oil paintings at the Armory Show, 1913. Ranks among the greatest American landscape painters. Showed great skill in natural scenery, particularly in representing snow upon tree branches. Probably the first American artist to employ blue shadows. A great master of values. Died in 1902 in Gloucester, MA.

TWIBILL, GEORGE W.
Portrait painter. Born in Lampeter, Lancaster County, PA, c. 1806. Pupil of Henry Inman in 1828. Elected an Associate of the National Academy in 1832 and an Academician in 1833. The NY Historical Society has his copy of the portrait of Fitz-Greene Halleck which was painted by his master Henry Inman in 1828. The National Academy of Design has his portrait of Colonel John Trumbull in its permanent collection. Died February 15, 1836.

TWIGG-SMITH, W.
Painter and illustrator. Born in Nelson, New Zealand, Nov. 2, 1883. Pupil of Art Institute of Chicago; Harry M. Walcott. Member: Hawaiian Society of Artists; Chicago Art Students League. Address in 1933, 122 Bates St., Honolulu, HI.

TWORKOV, JACK.
Painter and teacher. Born August 15, 1900, in Biala, Poland. In U.S. since 1913; became a U.S. citizen in 1928. Studied at Columbia University, 1920-23; National Academy of Design, 1923-25, with Ivan Olinsky, C. W. Hawthorne; Art Students League, 1925-26, with Guy Du Bois, Boardman Robinson; privately with Ross Moffett, 1924-25. Taught at Queens College; Pratt Institute; Yale University; Columbia; others. Awards: William A. Clark Prize and Corcoran Gold Medal, Corcoran Gallery, 1963; Guggenheim, 1970; hon. doctorates from Maryland Institute, Columbia, Rhode Island School of Design. Exhibited at Charles Egan Gallery, NYC, 1947, 49, 52, 54 (one-man); University of Mississippi; Holland Gallery, Chicago; Baltimore Museum of Art, 1948 (one-man); Walker Art Center, 1957 (one-man); Carnegie, 1961; Whitney, 1964; Yale (one-man); Ohio State; UC/Santa Barbara; Penna. Academy of Fine Arts, 1929; Museum of Modern Art; Guggenheim; Seattle World's Fair, 1962; Rice University; Corcoran, 1963; others. In collections of Metropolitan Museum of Art; SUNY/New Paltz; Union Carbide Corporation; Museum of Modern Art; Rhode Island School of Design; Yale; Kent State University; Baltimore Museum of Art; Albright-Knox Art Gallery; Whitney; Wadsworth Atheneum; Newark Museum; Chase Manhattan Bank; others. Member: New England Society of Contemporary Art. Address in 1971, 161 West 22 Street, New York, NY.

TYLER, BAYARD H(ENRY).
Portrait painter. Born in Oneida, Madison Co., NY, April 22, 1855. Pupil of Syracuse University; Art Students League; National Academy of Design, NY. Member: Lotos Club; Salma. Club; Yonkers Art Association; NY Water Color Club. Award: Hon. mention, Washington Society of Artists, 1913; first purchase prize, Yonkers Art Association, 1927. Represented in the Corcoran Gallery of Art, Washington, DC; State Collection, Albany, NY; Banking Department, Albany; Insurance Underwriters, NY; Aetna Insurance Company, NY; North River Insurance Company, NY; Standard Club, Chicago; Holden Memorial, Clinton, MA; Hackley Memorial School,

Tarrytown; Albright Memorial Library, Scranton; Wells College, Aurora; Twenty-second Regiment Armory, NY; Woman's College, New London. Address in 1929, 26 Marshall Road, Yonkers, NY; Hearts Content Camp, R.F.D. 1, Catskill, NY.

TYLER, CAROLYN D.
Miniature painter. Born in Chicago, IL. Pupil of Art Institute of Chicago under Mrs. Virginia Reynolds. Member: Chicago Society of Artists; Chicago Water Color Club; Chicago Society of Miniature Painters; Alumni Art Institute of Chicago; Chicago Art Club; Cordon. Address in 1933, 1401 East 53d St., Chicago, IL.

TYLER, ERNEST F(RANKLIN).
Painter, architect and designer. Born in New Haven, CT, April 13, 1879. Pupil of Yale School of Fine Arts. Member: Society of Beaux-Arts Architects; NY Architectural League; Century Association. Work in association with Edgar W. Jenney - decorations in main banking room, Sun Life Assurance Society, Montreal, Canada; ceilings in Woolworth Building, NY; Wisconsin State Capitol Building, Madison; Union Central Life Building, Cincinnati; decorations, Hibernia Bank and Trust Co., New Orleans, LA; Houses of Parliament, Ottawa, CN; ceiling in Seamen's Bank for Savings, NY; First National Bank, Jersey City, NJ; hall of Standard Oil Company Building, New York; New Palmer House Hotel, Chicago; New Aeolian Company Building, New York; National Academy of Sciences Building, Washington, DC; War Memorial Building, Nashville, TN; Union Planters Bank, Memphis; dining hall, Columbia University, NY; Baptistry, Cathedral of St. John the Divine, NY. Address in 1933, 142 East 30th St.; h. 131 East 66th St., New York, NY.

TYLER, GEORGE WASHINGTON.
Painter. Born in 1803 in NYC. Died in March, 1833, in NYC.

TYLER, HUGH C.
Painter. Exhibited at the Penna. Academy of Fine Arts, Philadelphia, 1914. Address in 1926, 1115 West Clinch Ave., Knoxville, TN.

TYLER, JAMES G(ALE).
Marine painter, illustrator, and writer. Born in Oswego, NY, Feb. 15, 1855. Pupil of A. Cary Smith. Member: Brooklyn Art Club; Salma. Club, 1893; Artists' Fund Society; Greenwich Society of Artists. Some of his prominent works are: "Abandoning the Jeannette" (painted to order for James Gordon

Bennett); "The New World;" "Do Not Abandon Me;" "The Constitution." Contributed illustrations and marine art studies for L. Prang, *Harper's, Century, Truth* and other magazines. Died in 1931. Address in 1929, Greenwich, CT.

TYLOR, STELLA ELMENDORF (MRS.).
Sculptor. Member: Wisconsin Painters and Sculptors. Address in 1928, 242 Maple Ave., Oak Park, IL; 310 North Murray Ave., Madison, WI.

TYNG, GRISWOLD.
Painter, designer, illustrator, educator and lecturer. Born in Dorchester, MA, August 13, 1883. Pupil of De Camp; Pyle; Massachusetts School of Art. Member: Boston Art Club. Author: *History of the Engraving Processes*, 1941. Co-author and illustrator of specialty publications used in public relations and promotional work. Contributor to national magazines, advertising campaigns, etc. Address in 1962, 1011 Centre St., Jamaica Plain, MA.

TYNG, MARGARET FULLER.
Painter. Member: Guild of Boston Artists. Address in 1929, 1011 Centre St., Jamaica Plain, MA.

TYRE, PHILIP S.
Painter, etcher and architect. Born in Wilmington, DE, July 14, 1881. Pupil of Anshutz; Henry R. Poore. Member: Fellowship Penna. Academy of Fine Arts; American Institute of Architects; Philadelphia Art Club; American Federation of Arts. Address in 1933, Bonbright Building, 1520 Locust Street, Philadelphia, PA; 1100 Oak Lane Ave., Oak Lane P. O., Philadelphia, PA.

TYSON, CARROLL SARGENT, JR.
Sculptor and painter. Born in Philadelphia, PA, November 23, 1878. Pupil of Penna. Academy of Fine Arts under Chase, Anshutz, and Beaux; Carl Marr and Walter Thor in Munich. Member: Art Club of Philadelphia; Fellowship Penna. Academy of Fine Arts; Society of Independent Artists. Awards: Sesnan gold medal, Penna. Academy of Fine Arts, 1915; bronze medal, P.-P. Expo., San Francisco, 1915; gold medal, Philadelphia Art Club, 1930. Work: Art Club of Philadelphia; State College of Pennsylvania; Pennsylvania Museum of Art, Philadelphia. Address in 1933, Philadelphia, PA. Died March 19, 1956.

TYSON, GEORGE (MRS.).
Painter. Member: Boston Water Color Club. Address in 1929, 314 Dartmouth St., Boston, MA.

U

UBALDI, MARIO CARMELO.
Sculptor and designer. Born in Monarch, WY, July 16, 1912. Studied: Industrial Museum of Art, Rome, Italy; Art Institute of Chicago. Member: Renaissance Society, University of Chicago. Awards: Medal, 1943, prize, 1944, Art Institute of Chicago. Work: Pasteur School, Chicago; Chicago Commons Settlement House. Exhibited: Art Institute of Chicago; World's Fair, New York, 1939; Corcoran Gallery of Art; University of Chicago; Marc Gallery, New Orleans, LA; Palmer House, Chicago, 1952 (one-man). Address in 1953, Chicago, IL.

UERKVITZ, HERTA.
Painter. Born in Wisconsin in 1894. Work: "Summer Sunset," Seattle Fine Arts. Address in 1926, 3030 Hoyt Avenue, Everett, WA.

UEYAMA, TOKIO.
Painter. Born in Wakayama, Japan, Sept. 22, 1890. Pupil of Penna. Academy of Fine Arts. Represented by portrait in State College, PA. Address in 1929, 214 North Mott Street, Los Angeles, CA.

UFER, WALTER.
Painter. Painted American Indian and Western subjects. Born in Louisville, KY, July 22, 1876. Pupil of Royal Applied Art Schools and the Royal Academy in Dresden; Art Institute of Chicago; J. Francis Smith Art School, Chicago; Walter Thor in Munich. Member: Associate National Academy of Design, 1920; Academician National Academy of Design, 1926; Chicago Society of Artists; Salma. Club; Taos Society of Artists; Boston Art Club (hon.); National Arts Club (life); Allied Artists of America; Fellow Royal Society of Artists; Connecticut Academy of Fine Arts; New Mexico Painters; Modern Society of Artists, Los Angeles. Awards: Cahn prize, Art Institute of Chicago, 1916; first Logan medal ($500), Art Institute of Chicago, 1917; Clarke prize, National Academy of Design, 1918; hors concours, Illinois Painters, 1918; third class medal, International Exhibition, Carnegie Institute, Pittsburgh, 1920; first Altman prize ($1,000), National Academy of Design, 1921; hon. mention, Conn. Academy of Fine Arts, 1922; gold medal, Philadelphia Art Club, 1922; Temple gold medal, Penna. Academy of Fine Arts, 1923; French gold medal, Art Institute of Chicago, 1923; first prize, Kentucky Painters, Nashville, 1925; second Altman prize ($500), National Academy of Design, 1926; Isidor gold medal, National Academy of Design, 1926. In collections of Chicago Art Institute; Springfield (IL) State House; Brooklyn Institute; Penna. Academy of Fine Arts; Maryland Institute, Baltimore; Museum of History, Science and Art, LA; Chicago Municipal Collection; Corcoran; Tulsa (OK) Art Association; Rockford (IL) Art Association; Joliet (IL) Art Association; National Arts Club; Union League Club of Chicago; Metropolitan Museum of Art; Houston Museum of Fine Arts; Wichita (KS) Art Association; Dubuque (IA) Art Association. Died in 1936. Address in 1933, Taos, NM.

UHL, EMMY.
Sculptor. Born in Bremen, Germany, May 10, 1919; U.S. citizen. Works: Hudson River Museum, Yonkers, NY. Exhibitions: Yonkers Art Association Annual, NY, 1967-70; Westchester Art Society Annual, NY, 1969-71; North Shore Community Arts Center, NY, 1970; Knickerbocker Artists Annual, NY, 1970-72; Audubon Artists, NY, 1971. Awards: Armbruster Award, Yonkers Art Association, 1967; Knickerbocker Artists Award of Merit, 1972. Address in 1976, Mt. Vernon, NY.

UHLE, BERNHARD.
Painter. Born in Chemnitz, Saxony, in 1847. He was brought by his parents to the U.S. in 1851, and received his first instruction in art from his father. He entered the Penna. Academy at fifteen. Between 1867 and 1875, he devoted most of his time to photography. Went to Munich from 1875 to 1877, studying in the Academy there, under Prof. F. Barth (drawing) and Prof. Alexander Wagner (painting); he also traveled to Italy, visiting the principal art galleries there. He opened his studio as a portrait painter in Philadelphia in 1877. Made a second trip to Europe in 1879, which was exclusively devoted to the study of the Old Masters in Munich and Paris. After his return to Philadelphia in 1880, Uhle was constantly employed in painting portraits.

ULBER, ALTHEA.
Painter, designer, craftsman, sculptor and teacher. Born in Los Angeles, CA, July 28, 1898. Studied: Chouinard Art Institute; pupil of Arthur D. Rozaire, F. Tolles Chamberlin, Hans Hofmann, Joseph Binder, Stanton McDonald-Wright. Member: National Society of Mural Painters; California Art Club; Art Teachers Association of Southern California. Award: Prize, Los Angeles Museum of Art. Work: Los Angeles Museum of Art; high school, Los Angeles, CA. Exhibited at Los Angeles Museum of Art. Taught: Children's Department, Chouinard Art Institute, Los Angeles, CA, 1921-41, and from 1952. Address in 1953, Chouinard Art Institute, Los Angeles, CA; h. La Crescenta, CA.

ULBRICHT, ELSA E(MILIE).

Craftsman, designer, lithographer, painter and teacher. Born in Milwaukee, WI, March 18, 1885. Studied: Wisconsin School of Art; Milwaukee State Teachers College; Pratt Institute; pupil of Frederick F. Fursman, Alexander Mueller, Francis Chapman, Walter Marshall Clute, George Senseney. Member: Wisconsin Designer-Craftsmen; Western Art Association; Wisconsin Painters and Sculptors; Milwaukee Art Institute; Wisconsin Society of Applied Arts. Awards: Prizes, Wisconsin Union, Madison, WI; Milwaukee Art Institute. Work: University of Minnesota; Milwaukee Art Institute. Exhibited: Wisconsin Painters and Sculptors; Milwaukee Art Institute; Wisconsin Designer-Craftsmen; others. Contributor to *Design* magazine. Taught: Wisconsin State College, Milwaukee; Saugatuck, MI. Address in 1962, Milwaukee, WI.

ULKE, HENRY.

Painter. Born in Frankenstein, Germany, January 29, 1821; died in Washington, DC, February 17, 1910. Pupil of Professor Wach, court painter in Berlin. He emigrated to the United States and reached New York in 1849, where he found employment as an illustrator and designer. Went to Washington, DC, where he resided for the remainder of his life. Among his patrons were many distinguished people, including Charles Sumner, Salmon P. Chase, Chief Justice Taney, James G. Blaine, John Sherman, W. W. Corcoran, Carl Schurz, A. R. Shepherd, Secretary Stanton, Robert G. Ingersoll and Mrs. Jefferson Davis. His portraits of different secretaries of war are in the war department, and his portraits of the secretaries of the treasury in the treasury department. His portrait of General Grant is in the White House. Over one hundred portraits were produced by this artist while in Washington. As a naturalist he was very celebrated and is credited with having made the largest known collection of American beetles, now on exhibition in the Museum of Natural History, Carnegie Institute, Pittsburgh, PA.

ULLBERG, KENT.

Sculptor. Born in Goteborg, Sweden, July 15, 1945. Studied at Swedish State School of Art, Stockholm; Swedish Museum of Natural History, anatomy; Museum of Natural Science, Orleans, France. Worked as a merchant marine, taxidermist, and safari hunter in Botswana, Africa; curator, Botswana National Museum and Art Gallery, and Denver Museum of Natural History. Exhibited: National Academy of Design, NYC; Los Angeles County Museum, CA; Denver Museum of Natural History, CO; Salon d'Automne, Paris, France; National Sculpture Society, NYC; National Art Gallery, Botswana, Africa; National Cowboy Hall of Fame, Oklahoma City, OK; Society of Animal Artists, NYC; Museum of Natural History, Goteborg, Sweden; numerous others. Awards: Barnett Prize for Sculpture, National Academy of Design; Percival Dietsch Award, 1979, Joel Meisner Award, 1981, both from National Sculpture Society; medals for sculpture, 1979, 80, 82, Society of Animal Artists, NYC; gold medals for sculpture, National Academy of Western Art; others. Member: Associate National Academy of Design, NYC; National Sculpture Society, NYC; Society of Animal Artists, NYC; National Academy of Western Art, Oklahoma City, OK; others. Major works include "Puma" (bronze), Museum of Natural History, Goteborg, Sweden, 1980; "Lincoln Centre Eagle," Dallas, 1981; "Watermusic" (polished stainless steel and black granite), Corpus Christi National Bank, TX, 1981; "Genesee Eagle" (bronze and stone), Genesee County Museum, Rochester, NY, 1983; Los Angeles County Museum; National Academy of Design; National Cowboy Hall of Fame. Specialty is wildlife; works in bronze and steel. Reviewed in *Southwest Art*. Represented by Sportsman's Edge Gallery, NYC; Trailside Gallery, Scottsdale, AZ; Grand Central Gallery, NYC. Address in 1983, Corpus Christi, TX.

ULLMAN, ALICE WOODS.

(Mrs. Eugene P. Ullman). Painter and illustrator. Born in Goshen, IN. Member: National Association of Women Painters and Sculptors; National Arts Club. Address in 1926, 39 Commercial St., Provincetown, MA.

ULLMAN, ALLEN.

Sculptor. Born in Paris, 1905. Works held: Brooklyn Museum. Exhibited: Paris.

ULLMAN, EUGENE PAUL.

Painter. Born in New York, March 27, 1877. Pupil of William M. Chase. Member: Salon des Jeunes, Paris; American Art Association of Paris; Salon des Independents, Paris; New Society of Artists; Paris Society of American Painters; Salma. Club, 1902; Groupe des Peintres et Sculpteurs Americains de Paris. Awards: Bronze medal, St. Louis Expo., 1904; first class medal, Orleans, France, 1905; second prize, Worcester, 1906; Temple gold medal, Penna. Academy of Fine Arts, 1906; silver medal, P.-P. Expo., San Francisco, 1915; hon. mention, John Herron Art Institute. Work: "Portrait of Madam Fisher" and "The Sea," Herron Art Institute, Indianapolis, IN; represented in French Government Collection, Brooklyn Institute. Died April 20, 1953, in Paris. Address in 1929, 24 rue Denfert Rochereau, Paris, France.

ULLRICH, ALBERT H.

Painter. Born in Berlin, Germany, April 24, 1869. Pupil of Art Institute of Chicago under Charles E. Boutwood; Frederick Freer; Gari Melchers; Duveneck; and in Rome, Munich and Paris. Member: Palette and Chisel Club, Chicago; Chicago Painters and Sculptors; Chicago Society of Artists; Chicago

Art Club. Address in 1933, 925 Lake Ave., Wilmette, IL.

ULP, CLIFFORD M(cCORMICK).
Painter, illustrator and teacher. Born in Olean, NY, Aug. 23, 1885. Studied: Art Students League of NY; Mechanics Institute, Rochester; pupil of William M. Chase; F. Walter Taylor. Member: Board of Directors of the Memorial Art Gallery, Rochester; Rochester Art Club; Iroquois Art Association. Work: "Adoration of the Magi," altar painting, St. Monica's Church, Rochester, NY; mural decorations, Eastman Dental Dispensary, Rochester, NY; "Gen. Allenby in Palestine," National Gallery, Washington. Director, School of Applied Art, Mechanics Institute, Rochester, NY. Address in 1933, 56 South Washington St., Rochester, NY.

ULREICH, EDUARD BUK.
Painter, sculptor, illustrator, and designer. Born in Austria-Hungary. Studied: Kansas City Art Institute; Penna. Academy of Fine Arts; pupil of Mlle. Blumberg. Member: Artists Guild of the Authors' League of America; Architectural League of NY; Fellowship Penna. Academy of Fine Arts; Chicago Art Club; NY Architectural League. Exhibited: Anderson Gallery, NY (one-man); Dudensing Gallery, 1930; Philadelphia Art Alliance, 1939; and in Paris, France; Vienna, Austria. Works: Decorations, Denishawn Studios, CA, and Edgewater Beach Hotel, Chicago; painted wall hangings, Chicago Temple Building; U.S. Post Offices, Columbia (MO) and Tallahassee (FL); marble mosaic, Industrial Arts Building, Century of Progress Exposition, Chicago. Awards: Prizes, Art Directors' Club, 1927, medal, 1932; Chicago Exposition, 1933. Address in 1953, 145 East 40th Street; h. 143 East 40th Street, New York.

ULREICH, NURA WOODSON.
(Mrs. Eduard Buk Ulreich). Sculptor, painter, illustrator, and lithographer. Born in Kansas City, MO. Address in 1933, 145 East 40th St., New York, NY. Died October 25, 1950.

ULRICH, CHARLES FREDERIC.
Painter. Born in New York, Oct. 18, 1858. He studied at the school of the National Academy of Design in New York and later with Loefftz and Lindenschmidt in Munich. In 1884 he was the first recipient of the Clark prize at the National Academy of Design; the prize picture, "In the Land of Promise (Castle Garden)," belongs to the Corcoran Art Gallery of Washington, DC. His painting, "The Glass Blowers of Murano," is in the Metropolitan Museum, New York. He resided for many years in Venice, Italy. His pictures are known for their exquisite technique, purity of color and strength of character. Died May 15, 1908, in Berlin, Germany.

UMLAUF, CHARLES.
Sculptor. Born in South Haven, MI, July 17, 1911. Studied at the Art Institute of Chicago, with Albin Polasek; Chicago School of Sculpture, with Viola Norman. Work: Krannert Art Museum, University of Illinois, Urbana; Oklahoma Art Center; Museum of Fine Arts, Houston; nine other Texas museums; "Horse" (stone), 1953, Metropolitan Museum of Art; others. Commissions include marble reredos relief, St. Michael and All Angels Church, Dallas, TX, 1961; Torch Bearers (bronze), University of Texas, Austin, 1963; Family Group (bronze), Houston Museum of Natural Science, TX, 1972. Exhibited: Valley House Gallery, Dallas, TX; Denver Art Museum; Passedoit Gallery, NYC; Metropolitan Museum of Art; Everson Museum, Syracuse; Penna. Academy of Fine Arts; thirty solo exhibitions, including NY and Italy; others. Awards: Guggenheim grant, 1949-50; Ford Foundation grant, 1979. Member: Sculptors Guild. Taught sculpture at University of Texas, Austin, from 1952. Works in bronze and marble. Address in 1982, Austin, TX.

UNDERHILL, KATHARINE.
Sculptor. Born in New York City, March 3, 1892. Pupil of Elizabeth Norton. Address in 1918, 307 West 93rd St., NYC; summer, South Ashfield, MA.

UNDERWOOD, CLARENCE F.
Painter. Born in Jamestown, NY, in 1871. Studied at Art Students League, New York; Julian Academy, Paris, under Constant, Jean Paul Laurens and Bouguereau. Executed illustrations for *Century*, *Studio, McClure's*, and other publishers in New York and London. Illustrator for *Harper's*; illustrated *London News*, Frederick A. Stokes & Co. (New York), *Saturday Evening Post*, Philadelphia, etc. Address in 1926, 106 West 55th St., New York, NY.

UNDERWOOD, ELISABETH KENDALL.
Decorative sculptor and portrait painter. Born in Gerrish Island, ME, September 22, 1896. Pupil of Lee Lawrie; Yale School Fine Arts, 1913-19; Art Students League, 1933. Exhibitions: Playhouse Gallery, Ridgefield, CT (one-woman); George Washington University Library; New York Watercolor Society; National Academy of Design; Newport Art Association; New Haven Paint and Clay Club. Work: Stations of the Cross, permanently installed in the chapel of the Convent of the Cenacle, Newport, RI. Address in 1962, 2459 P St., Washington; summer, Shadow Green, South Salem, NY. Died in 1976.

UNDERWOOD, GEORGE CLAUDE LEON.
Painter, sculptor, illustrator, etcher, writer, and lecturer. Born in London, December 25, 1890. Award: Honorable mention, Carnegie Institute, 1923. Work: "Machine Gunners," Manchester Art Gallery, Manchester, England; watercolor drawings, Whitworth Art Gallery, Manchester; etchings,

British Museum and the Victoria and Albert Museum, London. Illustrated: *The Music from Behind the Moon*, by James Branch Cabell (John Day Co.); wood engravings and verses for *Animalia* (Payson & Clarke). Address in 1929, in care of Brentano's, 225 Fifth Ave., New York, NY; h. London, England; summer, in care of Brentano's, London, England.

UNDERWOOD, THOMAS.
Engraver. Born about 1795; died at Lafayette, IN, in 1849. Underwood was a good bank-note engraver working in Philadelphia in 1829. He was a member of the bank-note company of Fairman, Draper, Underwood & Co., and after 1841, of Underwood, Bald, Spencer & Hufty.

UNTHANK, ALICE GERTRUDE.
Painter, craftsman, teacher and lecturer. Born in Economy, IN, Oct. 26, 1878. Studied: Earlham College; Teachers College, Columbia University; University of Nebraska, A.B.; University of Chicago, M.A.; pupil of J. E. Bundy, Martha Walter, C. C. Rosenkranz, Knute Heldner, Pedro de Lemos, Friez and Eric Scott, Paris. Member: Hoosier Salon; Arrowhead Art Association; Western Art Association; American Artists Professional League; College Art Association of America; Superior Art Association; others. Awards: Second prize, still life, Arrowhead Exhibition, Duluth, MN, 1928; hon. mention, pastel, landscape, West Duluth, MN, 1929; American Library Color Slides, 1940. Work: "Oil-Fishing Boats, Honfleur," Carroll College, Waukesha, WI; Wisconsin State College. Exhibited: Terry Art Institute, 1952; Hoosier Salon; Indiana traveling exhibition, 1929-30; Douglas County Historical Museum, Superior, WI, 1945 (one-man). Positions: Superior (WI) State Teachers College; National Education Association; Western Art Association State Publicity Chairman. Address in 1956, Androy Hotel, Superior, WI.

UNVER, GEORGE.
Painter. Award: Bronze medal for portrait, Kansas City Art Institute, 1923. Address in 1929, 5838 East 14th St., Kansas City, MO.

UPJOHN, ANNA MILO.
Painter. Member: National Association of Women Painters and Sculptors. Address in 1929, care of American Red Cross, Washington, DC; care of Credit Lyonnais, Paris, France; 11 Central Ave., Ithaca, NY.

UPTON, FLORENCE K.
Painter and illustrator. Born in NYC. Pupil of Kenyon Cox. Died Oct. 16, 1922, in London, England.

URBAITIS, ELENA.
Painter and sculptor. Born in Kaunas, Lithuania. U.S. citizen, 1956. Studied: Akademie der Bildenden Kunste, Munich, Germany, 1946-48; Ecole des Arts et Metier, Freiburg in Br., Germany, degree, 1950; Fellowship, French Ministry of Cultural Affairs, Paris, France, 1950; two years academic scholarship to the U.S., 1950; Art Students League, NY; Columbia University, NY, M.A., 1960. Received Award of Excellence, Heckscher Museum, Huntington, NY, 1975; gold medal, Lithuanian Cultural Center, NY, 1977. One-woman exhibitions: Ruth Sherman Gallery, New York City, 1960; Phoenix Gallery, New York City, 1978, 79, 80, 82, 84; Concordia College, Bronxville, NY, 1980; Merrick Wing Gallery, Merrick, Long Island, NY, 1978. Group exhibitions: Columbia University, New York City; Annual Long Island 20th Art Exhibition, Heckscher Museum; Work on Paper - Women Artists, Brooklyn Museum, NY; Fairleigh Dickinson University, NJ; Adelphi University, Garden City, Long Island, NY; SUNY Binghamton, NY; Lehigh University, PA; Phoenix Gallery, New York City (many times); First Annual Open Juried Exhibition of Fine Arts, Nassau Museum of Fine Arts, Roslyn, NY; Emily Lowe Gallery, Hofstra University, Hempstead, NY; Port of History Museum, Philadelphia, PA; Long Beach Museum of Art, NY; others. Member: New York Artists Equity; Women's Caucus for Art; National Association of Women Artists. Address in 1985, Wantagh, NY.

URBANI, F.
Sculptor and carver. Worked: Charleston, SC, 1850. His specialties were busts and statues; repairing marble statues; bronzing; imitation iron work.

URIBE, GUSTAVO ARCILA.
Sculptor and painter. Born in Bogota, Colombia, March 2, 1895. Pupil of Silvanus Cuellas; Dioicis Cortes; and J. A. Cano. Address in 1924, 2970 Ellis Ave., Chicago, IL.

URICH, LOUIS J.
Sculptor and teacher. Born in Paterson, NJ, July 4, 1879. Pupil of Art Students League of New York; Cooper Union; Beaux-Arts Architects. Award: Barnett prize, National Academy of Design, 1914. Address in 1934, Elmhurst, Long Island, NY.

URNER, JOSEPH (WALKER).
Sculptor, painter, and etcher. Born in Frederick, MD, January 16, 1898. Studied: Baltimore Polytechnic Institute; Maryland Institute; and with Ettore Cadorin, Dwight Williams. Member: Southern States Art League. Awards: Prize, Cumberland Valley Artists, 1939. Work: Alabama monument, Gettysburg, PA; Taney monument, Frederick, MD; Cedar Lawn Memorial; presentation portrait, General A. A. Vandergrift, USMC. Exhibited: Cumberland Valley Artists, annually. Address in 1953, 215 East Second Street; 110 West Patrick Street; h. Frederick, MD.

USHER, LEILA.
Sculptor and painter. Born in Onalaska, La Crosse Co., WI, August 26, 1859. Pupil of G. T. Brewster in Cambridge, MA; Art Students League of New York under Augustus Saint-Gaudens; H. H. Kitson in Boston; also studied in Paris. Member: American Artists Professional League; American Federation of Arts. Awards: Bronze medal, Atlanta Exposition, 1895; honorable mention for medals, P.-P. Exposition, San Francisco, 1915. Work: Bronze portraits in Harvard University; Bryn Mawr College; Rochester University; Bowdoin College; Johns Hopkins University; Royal Danish Mint and Medal Collection, Copenhagen; bas-relief, Fogg Museum of Art, Cambridge, MA; bas-relief portrait, National Museum, Washington, DC; Smithsonian Institution; "Portrait of John Wesley Powell," Powell Monument, Grand Canyon, AZ; portrait in bas-relief, Agassiz Museum, Cambridge, MA. Address in 1953, 105 West 55th Street, NYC. Died in 1955.

UTESCHER, GERD.
Sculptor and designer. Born in Germany; U.S. citizen. Studied drawing, graphics, and sculpture with Professor Wadim Falileef; Academy of Fine Arts, Berlin, M.A. Work in Fleisher Art Memorial, Philadelphia; Lafayette College, Easton, PA; bronze, Philadelphia General Hospital; others. Has exhibited at Philadelphia Art Alliance; Philadelphia Museum of Art; Penna. Academy of Fine Arts; Detroit Art Institute; others. Member of Artists Equity; Philadelphia Art Alliance. Taught sculpture at Penna. Academy of Fine Arts, 1960-64; Philadelphia Museum of Art, 1962-69; sculpture and three-dimensional design, Philadelphia College of Art, 1962-68. Received a Special Arts Award from the Philadelphia Association for the Blind for teaching sculpture to the blind. Works in plaster, wax, bronze, and terra cotta. Address in 1982, Alassio, Italy.

UTZ, THORNTON.
Sculptor and painter. Born in Memphis, TN, 1915. Lived in Chicago and Connecticut. Studied briefly at American Academy of Art, Chicago. Free-lance illustrator; did more than fifty covers for *The Saturday Evening Post*. Specialties are portraits of children, nudes, animals in motion. Reviewed in *Southwest Art*, July, 1981. Prints published by Mill Pond Press, Venice, FL. Represented by Conacher Galleries, Venice, FL; and Brubaker Gallery, Sarasota, FL. Address since 1949, Sarasota, FL.

V

VACCARINO, ROBIN.
Sculptor and painter. Born in Seattle, WA, August 14, 1928. Studied at Los Angeles City College; Los Angeles Valley College; University of California, Los Angeles; Otis Art Institute, M.F.A., 1966. Work in Los Angeles County Museum; Santa Barbara Museum; Library of Congress, Washington, DC; De Cordova Museum; others. Has exhibited at Long Beach Museum of Art; Otis Museum, Los Angeles; Library of Congress National Print Exhibition, Washington, DC; Santa Barbara Museum; others. Received National Endowment for the Arts individual fellowship, 1980-81; others. Teaching painting at Otis Art Institute, currently. Works in aluminum; oil and acrylic. Address in 1982, Studio City, CA.

VAGIS, POLYGNOTOS GEORGE.
Sculptor. Born on the Island of Thasos, Greece, January 14, 1894. Studied: Cooper Union Art School; Beaux-Arts Institute of Design; pupil of Gutzon Borglum, Leo Lentelli, John Gregory. Works include "Greek Soldier," "The Defender," and "The Dreamer." Represented in Brooklyn Museum; Whitney; Art Students League; Toledo Museum of Art; Tel-Aviv Museum, Israel. Group exhibitions: National Academy of Design; Penna. Academy of Fine Arts; National Sculpture Society; Corcoran Gallery, 1934, 37; Museum of Modern Art Gallery, Washington, DC, 1938; World's Fair, NY, 1939; Carnegie Institute, 1940, 41; Boston Museum of Fine Arts, 1944; Wadsworth Atheneum, 1945; Brooklyn Museum, 1932, 38; Sculptors Guild, 1938-42; Philadelphia Museum of Art, 1940; Metropolitan Museum of Art, 1942, 52; Museum of Fine Arts of Houston, 1947; Museum of Modern Art, 1951; Whitney, 1950, 52; others. One-man exhibitions: Painters and Sculptors Gallery, 1932; Kraushaar Gallery, 1934; Valentine Gallery, 1938; Hugo Gallery, 1946. Member of Artists Equity Association; Federation of Modern Painters and Sculptors. Awards: Shilling prize, 1945; Levittown Art Festival, 1951. Address in 1953, Bethpage, Long Island, NY. Died in 1965.

VAGO, SANDOR.
Painter, teacher and lecturer. Born in Hungary, Aug. 8, 1887. Pupil of the Royal Academie of Budapest and the Royal Academie of Munich. Member: Founder-Member, National Salon, Royal Art Association, and Royal Academie, Budapest; Royal Academie, Munich; Budapest Royal Art Association; Cleveland Society of Artists; American Artists Professional League. Awards: Hon. mention, 1913, Budapest; prizes, Cleveland Museum of Art, 1926; Newark Museum, 1926. Work: National Salon, Budapest; Cleveland Public Library; Cleveland Hermit Club; Bluffton (OH) College; Cleveland Museum of Art; Union Trust Co., Cleveland; others. Exhibited: Corcoran; Penna. Academy of Fine Arts; Newark Museum; Cleveland Museum of Art; Allied Artists of America; Albright Art Gallery; Rochester Memorial Art Gallery. Address in 1933, 3920 Euclid Ave., Cleveland, OH.

VAIL, ARAMENTA DIANTHE (MISS).
Miniature painter. Worked 1837-47. Lived in Newark, NJ, 1837-38; in New York City, 1839-45. Exhibited at American Institute; National Academy; Apollo Association.

VAIL, EUGENE.
Marine and figure painter. Born in Saint-Servan, France, of an American father, September, 1857. Pupil of NY Art Students League under Beckwith and Chase; Ecole des Beaux-Arts, Paris, under Cabanel, Dagnan-Bouveret and Collin. Awards: Honorable mention, 1886, and third class gold medal, 1888, Paris Salon; first class gold medal, Paris Exposition, 1889; Grand Diploma of Honor, Berlin; second medal, Munich; first class medal, Antwerp; silver medal, St. Louis Expo., 1904; first medal, Liege Expo., 1905; Legion of Honor, 1894. Represented by "Ready About," painted in 1888, at the Corcoran Art Gallery, Washington, D.C. Died in 1934.

VAILLANT, LOUIS D(AVID).
Mural painter. Born in Cleveland, OH, Dec. 14, 1875. Pupil of Art Students League of NY under Mowbray. Member: Art Students League of NY; Architectural League, 1902; National Society of Mural Painters; NY Municipal Art Society; Century Association; Salma. Club; American Federation of Arts. Award: Second Hallgarten prize, National Academy of Design, 1910. Work: Stained glass windows in Meeting House, Ethical Culture Society, NY; ceiling decoration, First National Bank, Titusville, Pennsylvania. Address in 1933, 219 East 61st Street, New York, New York; summer, Washington, Connecticut.

VAILLANT, MADAME.
Miniature painter. Working in NY in 1825.

VALAPERTA, GIUSEPPE.
Sculptor. Born in Milan, Italy. Worked in Genoa; in Madrid for Joseph Bonaparte, King of Spain; and in France at the palace of Malmaison before 1815. Came to Washington, DC, in 1815; employed as sculptor there until 1817. Executed eagle on the

frieze of the south wall of Statuary Hall. Carved in ivory and modeled red wax portraits of Jefferson, Gallatin, Madison, Monroe, and Jackson. Presumably died in March, 1817.

VALDENUIT, THOMAS BLUGET DE.
Engraver and crayon portraitist. Born 1763. Opened a drawing school in Baltimore in Nov., 1795. Moved to New York City in 1796, where he became a partner of Saint-Memin. Some of the portrait plates issued by Saint-Memin, previous to 1797, are signed "St. Memin & Valdenuit, No. 12 Fair St., N. York." An aquatint portrait of a man is signed "Drawn by Gimaldi, Engraved by Valdenuit, NY," in February, 1797. He probably returned to France sometime after that. Died in 1846.

VALENTIEN (or VALENTINE), ANNA MARIE.
(Mrs. A. R. Valentien). Sculptor, painter, and illustrator. Born in Cincinnati, OH, February 27, 1862. Pupil of Cincinnati Art Academy under Rebisso; Rodin, Injalbert, and Bourdelle in Paris. Member: San Diego Art Guild; La Jolla Art Association. Awards: Gold medal, Atlanta Expo., 1895; collaborative gold medal, Pan.-Calif. Expo., San Diego, 1915; two gold medals, Pan.-Calif. Expo., San Diego, 1916; highest award and cash prize, Sacramento State Fair, 1919; bronze medal, San Diego Fine Arts Society, 1931. Address in 1953, San Diego, CA.

VALENTINE, ALBERT R.
Painter. Born in Cincinnati, OH, May 11, 1862. Studied in this country, and in Europe with Duveneck. Exhibited in the Paris Salon in 1900. His specialty was the painting of wild flowers, grasses, etc. Died August 5, 1925.

VALENTINE, DE ALTON.
Illustrator. Born in Cleveland, OH, June 6, 1889. Pupil: Ufer; J. Wellington Reynolds. Member: Society of Illustrators; Artists Guild of the Authors' League of America; Players. Address in 1929, 32 Union Sq.; h. 135 West 16th Street, New York, NY.

VALENTINE, EDWARD VIRGINIUS.
Sculptor. Born Richmond, VA, Nov. 12, 1838. Pupil of Couture and Jouffroy in Paris; Bonanti in Italy; August Kiss in Berlin; also painting under William James Hubard. Member: Richmond Art Club (ex-president); president, Valentine Mu., Richmond, VA. Work: Made numerous busts and statues of Confederate heroes; "Gen. Robert E. Lee," Memorial Chapel, Lexington, VA, and U.S. Capitol, Washington; "Thomas Jefferson," Richmond; "Gen. Hugh Mercer," Fredericksburg, VA; "J. J. Audubon," New Orleans, LA; "Jefferson Davis," Richmond, Virginia. Address in 1929, 809 E. Leigh St.; home 109 North

Sixth Street, Richmond, Virginia. Died October 19, 1930.

VALENTINE, ELIAS.
Valentine was a copperplate printer and engraver living in NY in 1810-18, according to the directories. As an engraver he seems to have done very little work.

VALENTINE, JANE H.
Painter and etcher. Born in Bellefonte, Pennsylvania. Pupil of William M. Chase; Cecilia Beaux. Member: Art Alliance of Philadelphia; Fellowship Penna. Academy of Fine Arts; Philadelphia Print Club. Work: "Market in Venice," Albright Art Gallery, Buffalo, N.Y. Died in 1934. Address in 1933, 127 West Springfield Ave., Chestnut Hill, Philadelphia, Pennsylvania.

VALENTINE, WILLIAM.
Portrait painter. Born in England in 1798; died in 1849. He visited Boston in 1826.

VALK, ELLA SNOWDEN.
Miniature painter. Member of National Association of Women Painters and Sculptors, NY. Address in 1926, 58 West 57th Street, NY.

VALLANCE, JOHN.
Engraver. Born in Scotland, c. 1770; died in Philadelphia, June 14, 1823. Vallance apparently came to Philadelphia about 1791, as his name as an engraver appears in that city in 1791-99, and in 1811-23. It cannot be stated where he was in the interval between 1800-10. In 1794, as a member of the firm of Thackara & Vallance, he was engraving in Philadelphia, and Edwin ascribes to Vallance the portrait of John Howard signed by this firm. The stipple portrait of Hugh Blair, signed by Vallance alone, is an excellent engraving and example of his work. He engraved a large number of encyclopedia plates and other general work. He was one of the founders of the Association of Artists in America, organized in Philadelphia in 1794, and in 1810 he became treasurer of the Society of Artists in Philadelphia. A member of the engraving firm of Tanner, Vallance, Kearny & Co., of Philadelphia. An excellent script engraver. Good early bank-notes bear his name.

VALLE, MAUDE RICHMOND FLORENTINO.
Painter, illustrator, writer, and teacher. Pupil of Art Students League of New York, under Cox, Chase, Brush and Beckwith; Academie Julien under Lefebvre, Constant and Beaury-Sorel; Academie Delecluse under Delance and Callot in Paris. Member: Artists Guild. Illustrations for *Collier's; Life; Churchman; Cosmopolitan.* Art critic for *Rocky Mountain News.* Address in 1933, summer, "Mt. Falcon," Mt. Morrison, CO.

VALLEE, JEAN FRANCOIS DE.
Miniaturist and silhouettist. Came to Philadelphia by 1794. At Charleston, South Carolina, 1803, 05, 06; at New Orleans, 1810, 1815, where he was painting fine miniatures. He painted a miniature of General Andrew Jackson about 1815, which the general pronounced the best portrait of him extant, and then presented to Edward Livingston. Also known for his portrait painting. In 1826 he visited Boston, and in 1828 was painting portraits there.

VAN ALLEN, GERTRUDE E.
Painter and teacher. Born in Brooklyn, New York, October 15, 1897. Pupil of G. L. Nelson; Anna Fisher; Lewis Skidmore; W. Taylor; Henriette Reiss. Member: Nassau County Art League. Address in 1933, 20 Fairview Avenue, Port Washington, Long Island, NY.

VAN BEEST, ALBERT.
Marine painter and landscapist. Born on June 11, 1820, in Rotterdam, Holland. His "Engagement between the Constitution and the Guerriere" was sold in New York City. Died in NYC, October 8, 1860.

VAN BOSKERCK, ROBERT WARD.
Landscape painter. Born in Hoboken, NJ, Jan. 15, 1855. Pupil of R. Swain Gifford and A. H. Wyant in NY. Member: Associate National Academy of Design, 1897; Academician National Academy of Design, 1907; Society of American Artists, NY, 1887; Lotos Club; Artists' Aid Society. Awards: Silver medal, Pan.-Am. Expo., Buffalo, 1901; silver medal, St. Louis Expo., 1904. Represented in Union League and Lotos Club, New York; Layton Art Gallery, Milwaukee; Hamilton Club, Brooklyn. Died April 24, 1932. Address in 1929, 53 West 57th Street, New York, NY.

VAN BRIGGLE, ANNE GREGORY.
See Ritter, Anne Gregory.

VAN BUREN, RAEBURN.
Illustrator. Born in Pueblo, CO, Jan. 12, 1891. Attended Art Students League in 1913. Sketch artist for *Kansas City Star*; illustrated over 350 stories for *The Saturday Evening Post*; contributed to *Redbook, The New Yorker, Esquire, McCalls, McClure's Syndicate, King Features Syndicate*; created comic strip, *Abbie and Slats*. Member: Society of Illustrators; Artists Guild of the Authors' League of America. Address in 1929, 21 Clover Drive, Great Neck, L.I., NY.

VAN BUREN, RICHARD.
Sculptor. Born in Syracuse, NY, 1937. Studied: San Francisco State College; The University of Mexico; Mexico City College. Exhibitions: Bay Area Artists, San Francisco Museum of Art, CA, 1964; Whitney Museum, NYC, 1968, 70; Walker Art Center,

Minneapolis, 1971; Jewish Museum, New York City, 1966; Aldrich Museum Contemporary Art, Ridgefield, Connecticut, 1968; Musee d'Art Moderne, Paris, 1970; Albright-Knox Gallery, Buffalo, NY, 1971; Museum of Modern Art, NYC, 1973; Fogg Art Museum, 1973; Virginia Museum of Fine Arts, Richmond, 1974; numerous other group and individual shows. Teaching at School of Visual Arts, New York City, in 1976. Address in 1982, in care of Paula Cooper Gallery, 155 Wooster St., NYC.

VAN CLEVE, HELEN.
(Mrs. Eric Van Cleve). Painter, sculptor and writer. Born in Milwaukee, WI, June 5, 1891. Studied: Univer. of Calif.; Boston Museum of Fine Arts School; Grande Chaumiere, Paris; and with Bela Pratt, E. Withrow, Eliot O'Hara, Oscar Van Young, Frederic Taubes. Member: Western Artists; Pacific Palisades Art Assoc.; Westwood Village Art Assoc. Work: California Palace of the Legion of Honor; San Diego Public Library. Exhibited: San Diego Fine Arts Society, 1932; Montclair Art Museum, 1934; Kennebunk Village, 1934; Gump's, San Francisco; Rockefeller Center, 1934; Santa Barbara Museum of Art, 1940, 44, 45; California Palace of the Legion of Honor, 1940-45; Laguna Beach Art Assoc., 1944; Oakland Art Gallery, 1948; Westwood Village Art Assoc., 1949-52; de Young Memorial Museum, 1949-51; Springville, UT, 1951, 52; Pacific Palisades Art Assoc., annually. Address 1953, Pacific Palisades, CA.

VAN COTT, DEWEY.
Painter, illustrator, craftsman, lecturer, and teacher. Born in Salt Lake City, UT, May 12, 1898. Pupil of Chicago Academy of Fine Arts; Julian Academy, Paris; Yale University. Member: Artists Guild, UT. Work: "Literature" and "History," Washington School, New Britain, CT. Civic Art Director, New Britain, CT. Address in 1929, Walnut Hill Bldg., New Britain, CT.

VAN COTT, FERN H.
(Mrs. Dewey Van Cott). Painter and craftswoman. Born Feb. 6, 1899. Pupil of Dewey Van Cott. Member: Springfield Painters. Work: "Springtime," Art Institute, Springfield. Address 1933, Walnut Hill; 101 Monroe St., New Britain, Connecticut; h. Salt Lake City, UT.

VAN DEN BERGHEN, ALBERT LOUIS.
Sculptor. Born in the city of Vilvorde, Belgium, of American descent, September 8, 1850. Came to America in 1876. Studied in Brussels, New York City, and Chicago. Address in 1903, 390 Fulton Street, Chicago, Illinois; h. River Forest, Illinois.

VAN DEN HENGEL, WALTER.
Painter. Exhibited water colors at the Penna. Academy of Fine Arts, Philadelphia, 1925. Address

in 1926, 2095 North 63rd Street, Philadelphia, Pennsylvania.

VAN DER VEER, MARY.
Painter. Born in Amsterdam, NY, Sept. 9, 1865. Pupil of Chase; Penna. Academy of Fine Arts; National Academy of Design; Whistler in Paris. Member: NY Water Color Club; National Association of Women Painters and Sculptors. Awards: Bronze medal, St. Louis Expo., 1904; Shaw memorial prize, National Academy of Design, 1911. Address in 1933, 1 Arnold Avenue, Amsterdam, NY.

VAN DER VELDE, HANNY.
(Mrs. A. W. Van der Velde). Painter. Born in Rotterdam, Holland, Sept. 19, 1883. Pupil of Rotterdam Acad. of Fine Arts. Member: Nat. Assoc. of Women Painters and Sculptors; Detroit Society of Women Painters. Awards: Rotterdam, 1910; Detroit, 1910, 24; three first prizes, MI State Show, 1926; Arts Club prize for "Best Painting executed in 1926," Detroit Institute of Art, 1927. Represented: Detroit Institute of Arts; Grand Rapids Art Assoc.; Vanderpoel Art Association, Chicago, IL. Address in 1933, 1108 E. 12 Mile Road, Royal Oak, MI.

VAN DER WEYDEN, HARRY.
Painter. Born in Boston, MA, 1868. Pupil of Laurens, Lefebvre and Constant in Paris; Fred Brown in London. Member: Paris Society of American Painters; American Art Association of Paris; Institute of Oil Painters, London. Awards: Third class medal, Paris Salon, 1891; second medal, International Expo., Antwerp, 1894; gold medal, Atlanta Expo., 1895; bronze medal, Paris Expo., 1900; second gold medal, Munich, 1901; gold medal, Vienna, 1902; third medal, Liege Expo., 1905. Work: "Christmas Eve," Art Institute of Chicago; pictures purchased by French Government, 1906, 08. Address in 1929, Rye, Sussex, England.

VAN DRESSER, WILLIAM.
Etcher and painter. Born in Memphis, TN, Oct. 28, 1871. Pupil of F. Luis Mora; George Bridgman; Walter Appleton Clark. Member: Society of Illustrators, 1911; Bronx Artists Guild, American Artists Professional League. Specialty: Portraits. Address in 1933, 447 Park Ave., New York, NY; h. Palm Beach, FL.

VAN DUZEE, KATE KEITH.
Painter and craftswoman. Born in Dubuque, IA, Sept. 18, 1874. Pupil of Arthur Dow; John Johansen; Adrian J. Dornbush; Charles Woodbury. Member: Iowa Artists Club; Dubuque Art Association. Awards: Medals for water color, Iowa State Fair, 1917, 18; hon. mention for water color, St. Paul Institute, 1918; medal for monochromes and water

colors, Iowa State Fair, 1919, 20, 22, 23; medal and prize sweepstakes, water color, and pastel, 1929, and first prize in black and white, 1929-30, Iowa State Fair; first prize, water color and pastel, Iowa artists, State Federation of Women's Clubs, 1931. Work: Oil painting and drawing in Dubuque Public Library. Address in 1933, 1471 Main Street, Dubuque, IA.

VAN ELTEN, HENDRICK D. K.
Landscape painter. Born in Holland in 1829. He came to NY in 1865. Elected to the National Academy of Design in 1883. Died July 12, 1904, in Paris, France.

VAN EMPEL, JAN.
Painter and writer. Born in Amsterdam, Holland. Pupil of Robert Henri; Roman Kryzanowsky. Work: "The Resurrection," St. Peter's Church, Seward, AK; "The Canadian Rockies," Canadian National Railroad. Address in 1929, Profile Farm, Franconia, NH.

VAN EVEREN, JAY.
Painter. Member: National Society of Mural Painters. Died in 1947. Address in 1929, 509 East 77th Street, New York, NY.

VAN GORDER, L. EMERSON.
Painter and illustrator. Born in Pittsburgh, PA, 1861. Pupil of Chase and C. Y. Turner in NY; Ecole des Beaux Arts in Paris under Carolus-Duran; also studied in London. Member: NY Water Color Club; Toledo Tile Club. Work: "Quai Aux Fleurs," Museum of Art, Toledo. Address in 1926, 504 Euclid Ave., Toledo, OH.

VAN HOOK, NELL.
Painter, sculptor and teacher. Born in VA, Oct. 29, 1897. Studied: National Academy of Design; Art Students League of NY; pupil of Calder and Rittenberg. Member: Atlanta Art Association; Southern States Art League; Georgia State Art Association; Three Arts Club. Award: Sculpture prize, Atlanta Art Association, 1928. Work: "Rev. John Patterson Knox," Erskine College, Due West, SC; "The Resurrection" and "Madonna," Peachtree Christian Church; "In Memoriam," Westminster Presbyterian Church; "Dr. Virgil Gibney," Gibney Foundation, all in Atlanta, GA; "Richard March Hoe," Dean Russel, Columbia University, New York, NY. Address in 1933, 52 Inman Circle, Atlanta, GA.

VAN INGEN, WILLIAM BRANTLEY.
Mural painter. Born in Philadelphia, PA, Aug. 30, 1858. Pupil of Penna. Academy of Fine Arts under Schussele and Eakins; La Farge in NY; Bonnat in Paris. Member: NY Architectural League, 1889; National Society of Mural Painters; Fellowship Penna. Academy of Fine Arts; Artists' Aid Society; Art Club of Philadelphia; Nat. Arts Club; Lotos Club;

Artists' Fund Society. Award: Hon. mention, Pan.-Am. Expo., Buffalo, 1901. Work: "The Divine Law," "Signing of the Magna Charta," "Socrates Discussing the Nature of Justice," "Cicero Speaking from the Roman Forum," "The Origin of Circuit Courts," "The Signing of the Constitution of the United States," "Lincoln as a Law Student" and "Lincoln as President," eight panels in U.S. Court House, Chicago; "Justice and Mercy," "An Appeal to Justice," U.S. Court House, Indianapolis; eleven panels representing "Coinage," four panels, "Gold Mining," U.S. Mint, Philadelphia; fourteen panels representing the "Early Settlers of Pennsylvania," State Capitol, Harrisburg, PA; sixteen panels, "Industries of New Jersey," State Capitol, Trenton; "The Departments," six panels in Congressional Library, Washington; "Construction of the Canal," five panels in Administration Building, Panama Canal Zone, 1914-15. Address in 1933, 17 West 10th Street, New York, NY.

VAN LAER, ALEXANDER THEOBALD.
Painter and lecturer. Born Feb. 9, 1857, in Auburn, NY. Studied art at National Academy of Design, NY; Art Students League, with R. Swain Gifford; and with George Poggenbeek of Holland. Exhibited at the leading American exhibitions, and received bronze medal at Charleston Expo. Lectured on art history at Chautauqua, NY, for seven years; lectured at Brooklyn Institute and at schools and colleges. Member: Jury of Selection and International Jury of Awards, St. Louis Exposition, 1904. Elected an Associate of National Academy, 1902, and National Academy, 1909. Member: American Water Color Society; New York Water Color Club. Specialty: Landscapes. Died March 12, 1920, in Indianapolis, IN.

VAN LAER, BELLE.
Miniature painter. Born in Philadelphia, PA, in 1862. Pupil of S. J. Ferris. Address in 1926, Johnsville, Bucks County, PA.

VAN LESHOUT, ALEXANDER J.
Etcher and teacher. Born in Harvard, IL, May 16, 1868. Studied: Art Students League of NY; Art Institute of Chicago; pupil of Carroll Beckwith, Frederick Freer, John H. Vanderpoel; also studied in Holland and Paris. Member: Southern States Art League; Chicago Society of Etchers; Louisville Art Association. Director, Louisville School of Art Dept., Conservatory of Music. Address in 1929, Louisville School of Art; h. 1732 Shady Lane, Louisville, KY.

VAN LEYDEN, ERNST OSCAR MAURITZ.
Painter and sculptor. Born in Rotterdam, Holland, May 16, 1892. Awards: Medals, expositions in Brussels, Paris, Amsterdam, The Hague; prizes, Venice, Italy, 1932; Los Angeles Museum of Art. Work: Tate Gallery, London; and in museums throughout Europe. Exhibited: Virginia Museum of Fine Arts, 1946; Pepsi-Cola, 1946; Los Angeles Museum of Art; Santa Barbara Museum of Art; San Diego Fine Arts Society; Syracuse Museum of Fine Arts; San Francisco Museum of Art; and extensively in Europe. Creator of special glass-tile technique for murals. Address in 1953, Los Angeles, CA.

VAN LOEN, ALFRED.
Sculptor and educator. Born in Oberhausen-Osterfeld, Germany, September 11, 1924; US citizen. Studied at Royal Academy of Art, Amsterdam, Holland, 1941-46. Work in Metropolitan Museum of Art; Museum of Modern Art; Brooklyn Museum; National Museum, Jerusalem, Israel; others. Has exhibited at Whitney Museum of American Art Annual, NY, 1967; Heckscher Museum, Huntington, NY, 1971, 74; Stony Brook Museum, 1968; others. Received Louissa Robbins Award, Silvermine Guild of Artists; first prize for sculpture, American Society of Contemporary Artists. Taught: Hunter College; North Shore Community Art Center, NY; C. W. Post College, Long Island University. Works in ivory, wood, bronze, hammered brass and aluminum, stone; acrylic. Address in 1982, Huntington Station, NY.

VAN NESS, BEATRICE WHITNEY (MRS.).
See Whitney, Beatrice.

VAN PAPPELENDAM, LAURA.
Painter. Born near Donnellson, Lee County, IA. Studied: Art Institute of Chicago; pupil of Sorolla, George Bellows, Nicholas Roerich. Member: Chicago Society of Artists; Chicago Galleries Association; Illinois Academy of Fine Arts. Represented in the Vanderpoel Art Association Collection, Chicago. Awards: Brower prize, Art Institute of Chicago, 1932, Logan prize, 1933. Address in 1933, 1418 E. 54th Street; Art Institute, Chicago, IL.

VAN REUTH, EDWARD C.
Painter. Born in Holland in 1836; died near Baltimore, MD, in 1924.

VAN ROEKENS, PAULETTE.
(Victorine Jeanne). Painter. Born in Chateau-Thierry, France, Jan. 1, 1898. Pupil of Henry B. Snell; Leopold G. Seyffert; Joseph Pearson; C. Grafly. Member: Fellowship Penna. Academy of Fine Arts; Art Alliance of America; National Association of Women Painters and Sculptors. Awards: Gold medal, Plastic Club, 1920; Philadelphia Sketch Club, gold medal, 1923; hon. mention, National Association of Women Painters and Sculptors; Penna. Academy of Fine Arts Fellowship prize, 1928. Works: "15th St. from Broad St. Station," Pennsylvania State College; "The New Boulevard," Graphic Sketch Club; "Treat 'Em Rough," Penna. Academy of Fine Arts; "Gray Towers," Reading Museum; represented in collections of Alumnae of Philadelphia School of Design

and of Fellowship of Penna. Academy of Fine Arts. Instructor, School of Design, Philadelphia. Address in 1933, Sterner Mill Road, Langhorne, PA.

VAN SCIVER, PEARL AIMAN.
Painter and teacher. Born in Philadelphia, PA. Studied: Penna. Academy of Fine Arts; Moore Institute; pupil of Leopold Seyffert, Violet Oakley. Exhibited water colors at the Penna. Academy of Fine Arts, Philadelphia, 1925; National Academy of Design; Corcoran. Work: Allentown Museum; University of Pennsylvania; Rochester Memorial Art Gallery. Awards: Medal, Chestnut Hill, PA; prize, Penna. Academy of Fine Arts; Philadelphia Plastic Club. Member: National Association of Women Painters and Sculptors; Philadelphia Plastic Club; League of American Pen Women. Address in 1953, 1406 East Willow Grove Ave., Chestnut Hill, Philadelphia, PA.

VAN SHECK, SIDNEY W. JIROUSEK.
Painter, lecturer, and teacher. Born in Prague, Czechoslovakia. Pupil of Julian Academy and L'Ecole des Beaux-Arts, Paris. Member: Boston Society of Independent Artists; Alabama Art League. Work: Mural paintings, H. Burroughs Newsboy Foundation; portrait of President T. G. Masaryk, Czechoslovakian government, Prague; portrait of Mrs. T. G. Masaryk, National Gallery, Prague; murals, Richmond Theatre, North Adams, MA. Instructor, Massachusetts School of Art, Boston; professor, Alabama Polytechnic Institute, Auburn, AL. Address in 1933, Auburn, AL.

VAN SLOUN, FRANK J.
Painter, etcher, and teacher. Born in St. Paul, MN. Award: Bronze medal, P.- P. Expo., San Francisco, 1915. Died in 1938. Address in 1933, 1617 California St.; h. 946 Central Ave., San Francisco, CA.

VAN SLYCK, WILMA LUCILE.
Painter. Born in Cincinnati, OH, July 8, 1898. Pupil of H. H. Wessel; J. R. Hopkins; J. E. Weis; Hawthorne; I. C. Olinsky. Represented in Circulating Gallery of the Dayton Art Institute. Member: Society of Independent Artists; Salons of America; Cincinnati Art Club. Address in 1933, 328 Rockdale Ave., Cincinnati, OH.

VAN SOELEN, THEODORE.
Painter. Born at St. Paul, MN, Feb. 15, 1890. Pupil of Penna. Academy of Fine Arts; St. Paul Art Institute. Member: New Mexico Painters; Associate National Academy of Design, 1933. Awards: Bronze medal, Sesqui-Centennial Expo., Philadelphia, PA, 1926; J. Francis Murphy memorial prize, 1927, and first Altman prize for landscape, 1930, National Academy of Design; May Audubon Post prize, Fellowship Penna. Academy of Fine Arts, 1931. Work: "Summer Morning," Penna. Academy of Fine Arts; "Last Snow," Ranger Fund purchase, Everhart Museum, Scranton, PA. Died in 1964. Address in 1933, Tesuque Valley, Santa Fe, NM.

VAN SOLUN, FRANK J.
Painter and etcher. Born in St. Paul, Minnesota. Address in 1926, 1617 California Street, San Francisco, California.

VAN TYNE, PETER.
Painter. Born in Flemington, New Jersey, October 24, 1857. Pupil of Art Students League of New York; Pennsylvania Academy of Fine Arts. Member: Fellowship Penna. Academy of Fine Arts; American Federation of Arts. Awards: First prize ($50) for still life, Trenton Fair, 1926. Address in 1929, Trenton Junction, New Jersey.

VAN VEEN, PIETER J. L.
Painter. Born in The Hague, Holland, Oct. 11, 1875. Studied in Holland and France. Member: Salma. Club; National Arts Club; NY Municipal Art Society; Allied Artists of America. Award: Cross of Legion of Honor by French Government for series of oil paintings of Cathedral of France, 1929. Represented in Museum, Seattle, Washington; Butler Art Institute, Youngstown, OH; collection of H. M. Queen of Belgium, with "The Mission of San Juan Capistrano, California;" H. C. Henry Collection, Washington University, Seattle. Address in 1933, 58 West 57th Street, New York, NY; summer, care of Equitable Trust Co., Paris, France.

VAN VRANKEN, ROSE.
See Hickey, Rose Van Vranken.

VAN WART, AMES.
Sculptor. Born in New York. Pupil of Hiram Powers. Member of Century Association, NY. Address in 1926, care of the Century Association, 7 West 43rd Street, New York, NY.

VAN WERVEKE, GEORGE.
Illustrator. Member: Society of Illustrators; Artists Guild of the Authors' League of America. Address in 1933, 27 West 67th Street, New York, NY.

VAN WOLF, HENRY.
Sculptor and painter. Born in Regensburg, Bavaria, April 14, 1898. U.S. citizen. Studied: Munich Art School, 1912-16; sculpture and bronze technique with Ferdinand von Miller, 1919-22, 23-26. Work: California Art Club Medal; Professional Artists Guild Medal; bronze statue of Ben Hogan, Golf Writer's Association of America; bronze memorial bust, Einstein Memorial Foundation; bronze Madonna, St. Timothy Church, West Los Angeles; sculptured group, Garden Grove (CA) Community Church; many others. Exhibited: Brooklyn Museum, NY; Springfield Museum of Art; Allied Artists of America;

Architectural League; Artists of the Southwest; International Exhibition of Contemporary Sculptured Medals, Athens, Greece, 1966, Paris, 1967; others. Awards: Los Angeles City Art Exhibition, 1949, 66, 70; National Award, National Sculpture Society, 1962; seven awards, Valley Artists Guild, 1948-72; Artists of the Southwest, 1950, 51, 53, 54; many more. Member: National Sculpture Society; fellow, American Institute of Fine Arts; Valley Artist's Guild (founder and past president). Address in 1982, Van Nuys, CA.

VAN WYCK, MATILDA (MRS.).
See Browne, Matilda.

VAN ZANDT, HILDA (MRS.).
Painter and teacher. Born in Henry, IL, June 18, 1892. Member: California Water Color Society; California Art Club. Represented in the Woman's Club, Baldwin Park, CA. Address in 1933, 3740 Bluff Place, San Pedro, CA.

VANCE, FRED NELSON.
Mural painter. Born in Crawfordsville, IN, in 1880. Pupil of Art Institute of Chicago; Smith Academy in Chicago; Julien, Colarossi and Vitti Academies in Paris; pupil of Max Bohm, in Paris, and E. Vedder, in Rome. Address in 1926, corner Plumb and Jefferson Streets, Crawfordsville, IN. Died Sept. 21, 1926 in Nashville, IN.

VANDER SLUIS, GEORGE J.
Sculptor, painter, and educator. Born in Cleveland, OH, December 18, 1915. Studied at Cleveland Institute of Art, 1934-39; Colorado Springs Fine Arts Center, 1939-40, with Boardman Robinson; Fulbright Scholarship, Italy, 1951-52. Works: Cleveland Museum of Art; Colorado Springs Fine Arts Center; Nelson Gallery of Art, Kansas City; Everson Museum of Art, Syracuse; Munson-Williams-Proctor Institute, Utica. Exhibitions: Columbia University; Galleria d'Arte Contemporanea, Florence, Italy; Everson Museum of Art, Syracuse; Cleveland Institute of Art; Munson-Williams-Proctor Institute, Utica; Cleveland Museum of Art; Smithsonian Institution; Art Institute of Chicago; San Francisco Art Association Annuals; Metropolitan Museum of Art; Corcoran; Penna. Academy of Fine Arts; Museum of Contemporary Crafts, NY; Whitney. Awards: Fulbright Fellowship, Italy, 1951-52; Jurors' Award, Rochester Memorial Art Gallery, 1958, 69. Taught: Colorado Fine Arts Center, 1940-42, 45-47; Syracuse University, from 1947. Address in 1982, Syracuse University, Syracuse, NY.

VANDERCOOK, MARGARET METZGER.
Sculptor. Born in New York City, April 7, 1899. Pupil of Georg Lober in New York; Aristide Rousaud in Paris. Member: National Association of Women Painters and Sculptors. Address in 1933, 32 Union Square; h. 13 Gramercy Park, NY. Died in 1936.

VANDERLYN, JOHN.
Portrait, history and landscape painter. Born in Kingston, NY, Oct. 15, 1775. Grandson of Pieter Vanderlyn and son of Nicholas Vanderlyn. Pupil of the Columbian Academy of Archibald Robertson. Employed by Thomas Barrow, the earliest art dealer in the city. Vanderlyn attracted attention of Aaron Burr, who encouraged him to pursue his art studies. About this time Gilbert Stuart returned to his native country and among his first portraits were those of Aaron Burr and Egbert Benson, which Vanderlyn was allowed to copy. Vanderlyn studied with Stuart for about one year. Returned to NY to begin a career. Painted Citizen Adet, the French Minister, one of Albert Gallatin, and Theodosia Burr, the daughter of his patron. In 1796 Vanderlyn went to France to become a pupil of Vincent, exhibiting several portraits in the Paris Salon for the first time in 1800. A self-portrait hangs in the Metropolitan Museum of Art. After five years in Paris, he returned to the U.S., and then returned to Europe in 1803. There he met Washington Allston with whom he travelled and lived in Rome. There he painted his first historical picture, "The Massacre of Miss McCrea," exhibited in the Salon in 1804, and which is in the Wadsworth Athenaeum, Hartford, CT. Exhibited "Caius Marius amidst the Ruins of Carthage" in the Salon in Paris, 1808, which earned a medal of honor from Napoleon. In Paris he next painted what is perhaps his greatest painting, "Ariadne Asleep in the Island of Naxos," exhibited in the Paris Salon of 1810 and considered then the finest nude painted by an American; it is now at the Penna. Academy of Fine Arts. Vanderlyn returned to America in 1815. He painted portraits for City Hall, NY, and private commissioners. The portrait of Abraham Hasbrouck is considered one of his finest. He was commissioned to paint a panel, "The Landing of Columbus," in the rotunda of the Capitol at Washington in 1837. Also devoted himself to the paintings and executions of panoramas, that of Versailles being preserved in his home town as a memorial to his honor. He returned to Paris once more for several years and then came back to his native town. His work has frequently been confused with that of his master, Stuart. Died Sept. 23, 1852, in Kingston, NY.

VANDERLYN, JOHN (2nd).
Painter. Nephew of the artist and named for him. He was born in 1805. Worked at Savannah, Georgia, 1833; possibly at Charleston, South Carolina, 1836, with J.P. Sherwood; at Kingston, NY, 1859. Died in 1876.

VANDERLYN, NICHOLAS.
Portrait, sign and house painter. Father of John Vanderlyn. Working in Kingston, NY, 1776.

VANDERLYN, PIETER.
Portrait painter. Member of one of the early Dutch families in New York State. Born in 1676 or 1687 in Holland; came to the Province of New York, c. 1718. There is some question as to whether or not this man was a portrait painter; however, several New York portraits have been attributed to him. In 1719 he painted a portrait of Johannes Van Vechten. Lived in Albany, NY, 1720's; moved to Kingston, NY, where he settled. About forty of his portraits have been recognized as those of descendents of early Dutch families in this country. He was the grandfather of John Vanderlyn (1775-1852), the noted portrait painter. Died in 1778.

VANDERPOEL, EMILY NOYES.
(Mrs. John A. Vanderpoel). Painter, craftswoman and writer. Born in NY. Pupil of R. Swain Gifford and William Sartain. Member: NY Water Color Club; National Association of Women Painters and Sculptors; National Arts Club; American Federation of Arts; Fellow National Academy of Design. Award: Bronze medal, Columbian Expo., Chicago, 1893. Author of *Color Problems; Chronicles of a Pioneer School; More Chronicles of a Pioneer School; American Lace and Lace Makers; Ypres, 1919*, Washington Museum of Army and Navy Relics of the Great War. Died in 1939. Address in 1933, 22 Gramercy Park, New York, NY; summer, Litchfield, CT.

VANDERPOOL, MATILDA.
Painter and teacher. Born in Holland. Pupil of Art Institute of Chicago; David Ericson. Member: Chicago Water Color Club; Chicago Society of Artists; Cordon Club; Illinois Academy of Fine Arts. Address in 1933, 9431 Pleasant Avenue, Chicago, Illinois; summer, Gold Hill, Colorado.

VANDEVELDE, PETRO.
Sculptor. Worked: New York City. Exhibited: American Institute, 1850, "Slave in Revolt."

VANDINE, ELIZABETH.
Engraver. The Journals of the Continental Congress for June 7, 1776 indicate that this woman was a counterfeiter, the first on record in the colonies. With her husband, Henry Vandine, of Morris Co., NJ, she was arrested for an attempt to counterfeit bills of credit emitted by Congress. She confessed that "with privity of her said husband she counterfeited several bills of the Continental Currency." For this offense and for passing the same, she and her husband were confined in Morris County Jail.

VANDYCK, JAMES.
Miniature painter. Flourished about 1806-35.

VANNUCHI, F. OR S.
Wax modeller. Born in Italy, c. 1800. Exhibited wax figures in Charleston, South Carolina, in 1845; also

"cosmorama" or collection of paintings of American views and historical scenes in New York City and Philadelphia, 1847. Settled in New Orleans by 1852; opened the American Museum and Waxworks.

VARIAN, DOROTHY.
Painter. Born in New York, April 26, 1895. Member: Salons of America; NYS Women Artists; American Society of Painters, Sculptors and Engravers. Work: "Fruit on a Red Table," "Plants and Artichokes," "Still Life," Whitney Museum of American Art, New York; "Red Plums," Phillips Memorial Gallery, Washington, DC. Address in 1933, Woodstock, Ulster County, NY.

VARIAN, GEORGE EDMUND.
Painter. Born Oct. 16, 1865, in Liverpool, England. Studied at Brooklyn Art Guild and Art Students League, NY. Illustrated for various magazines and books. Commissioned by McClure's to visit Mont Pelee at time of destruction of St. Pierre. He accompanied Ray Stannard Baker to Europe and made illustrations for his book, *Seen in Germany;* also illustrated George Kennan's *The Tragedy of Pelee.* Exhibited at Paris Salon, 1907. Died April 13, 1923, in Brooklyn, NY.

VARIAN, LESTER E.
Etcher, artist, and teacher. Born in Denver, CO, Oct. 20, 1881. Pupil of Donn Barber and Chifflot. Member: Denver Art Club; American Institute of Architects. Address in 1929, 565 Gas and Electric Bldg.; h. 464 Williams Parkway, Denver, CO.

VARNUM, WILLIAM HARRISON.
Painter, writer, and teacher. Born in Cambridge, MA, Jan. 27, 1878. Studied: Massachusetts School of Art; pupil of De Camp; Major; Woodbury. Member: Eastern Art Association; Western Art Association; Wisconsin Painters and Sculptors. Author of texts: *Industrial Arts Design; Pewter Design and Construction; Art in Commemorative Design.* Chairman and professor, Department of Art Education, University of Wisconsin. Address in 1933, Art Educational Building, University of Wisconsin; h. 207 Forest St., Madison, WI; summer, Monhegan, ME.

VAUDECHAMP, JEAN JOSEPH.
Painter. Born in France, 1790; died there in 1866. He exhibited in the Salon, Paris, 1817, and afterward. He resided in New Orleans for several years during the 1830's and painted many fine portraits. In 1833 he had a studio as portrait painter at 147 Royal Street, New Orleans, LA.

VAWTER, JOHN WILLIAM.
Painter, illustrator, and etcher. Born in Boone County, VA, April 13, 1871. Member: Hoosier Salon. Award: Prize of $100 for "Our Alley," Exhibition of Indiana Artists, Marshall Field Gallery, 1925. Work:

Illustrated the Riley Series of books. Address in 1933, Nashville, IN.

VAWTER, MARY H. MURRAY (MRS.).
Painter. Born in Baltimore, MD, June 30, 1871. Pupil of Edwin S. Whiteman; Irving Wiles; Charcoal Club, Baltimore; Art Students League of NY. Member: Indiana Art Club; Hoosier Salon; American Federation of Arts. Specialty: Portraits and landscapes. Address in 1933, Nashville, IN.

VAYANA, NUNZIO.
Painter, illustrator, and lecturer. Born in Castelvetrano, Italy, August 28, 1887. Pupil of Grosso; Morelli; Pisani. Awards: Selective prize, Venice Art Club, Venice, 1921; popular prize, Connecticut Academy of Fine Arts, 1924; hon. mention, I. E., Rome, 1925; William G. Bunce prize, Connecticut Academy of Fine Arts, 1926. Address in 1933, Ogunquit, ME.

VECCHIO, LOUIS.
Sculptor, painter, and teacher. Born in New York, August 24, 1879. Pupil of Walter Shirlaw and National Academy of Design. Address in 1910, 105 East 14th St.; h. 2114 Prospect Ave., NYC.

VEDDER, ELIHU.
Painter, sculptor, mural painter, illustrator, and writer. Born in NYC, February 26, 1836. Studied art under T. H. Mattison at Sherburne, NY; then Paris, in the atelier of Picot; also studied in Italy. Spent time in Florence and Rome and returned in 1861 to New York, where he remained five years. Made sketches there for *Vanity Fair*. Returned to Paris for one year; finally settled in Rome in 1867. Works: Five panels in the Library of Congress in Washington and one in Bowdoin College; "The Pleiades" and "African Sentinel," Metropolitan Museum of Art, NY; "The Keeper of the Threshold," Carnegie Institute, Pittsburgh; "The Lair of the Sea Serpent," "Lazarus," "The Sphinx," Boston Museum of Fine Arts; "Storm in Umbira," Art Institute of Chicago; Brooklyn Institute Museum; Rhode Island School of Design. His "Greek Actor's Daughter" was shown at the Centennial Exhibition in Philadelphia in 1876. Best known for illustrations of *The Rubaiyat of Omar Khayyam*. Was made a National Academician in 1865. Member of Society of American Artists; American Society of Mural Painters; National Institute of Arts and Letters; The Century Society, NY. Received honorable mention, Paris Exposition, 1889; gold medal, Pan.-Am. Exposition, Buffalo, 1901. Exhibited at National Sculpture Society, 1923. Publication: *The Digressions of V.*, his autobiography. Died in Rome, Italy, January 29, 1923.

VEDDER, SIMON HARMON.
Painter, illustrator and sculptor. Born in Amsterdam, NY, October 9, 1866. Pupil of Metropolitan Museum School in New York; Julian Academy in Paris under Bouguereau and Robert-Fleury; Ecole des Beaux-Arts under Gerome; and of Glaize. Awarded honorable mention, Paris Salon, 1899; second class medal, Crystal Palace, London. Address in 1918, Haverstock Hill, London; 253 West 42nd Street, NYC.

VEILER, JOSEPH.
Sculptor. Worked: New Orleans, 1840's. Presumably the same as J. H. Veilex.

VELSEY, SETH M.
Sculptor, painter, teacher, and designer. Born in Logansport, IN, September 26, 1903. Studied: University of Illinois; Art Institute of Chicago; pupil of Lorado Taft, Albin Polasek. Awards: Mrs. Keith Spalding prize, Hoosier Salon, Chicago, 1928; Indiana Artists, 1931; Hickox prize, 1934; medal, Paris Salon, 1937. Work: Dayton Art Institute; Wright Field, Dayton, OH; U.S. Post Office, Pomeroy, OH; St. Peter and Paul's Church, Reading, OH; others. Address in 1953, Yellow Springs, OH.

VER BECK, FRANK.
Illustrator. Born in Belmont Co., OH, 1858. Illustrator and author of *A Short Little Tale from Bruintown; Timothy Turtle's Great Day; The Donkey Child; The Little Cat Who Journeyed to St. Ives; Ver Beck's Book of Bears; Little Black Sambo and the Baby Elephant*; etc. Designer of the Ver Beck earthenware models. Address in 1929, care of Curtis Brown, Ltd., 6 Henrietta St., Covent Garden, London, England.

VER BRYCK, CORNELIUS.
Landscape, historical and portrait painter. Born in Yaugh Paugh, NJ, on Jan. 1, 1813. He studied under Samuel F. B. Morse, and in 1839 he visited London. In 1833 his portrait was painted by Thomas Sully. Academician, National Academy of Design. He died May 31, 1844, in Brooklyn, NY.

VER STEEG, FLORENCE B(IDDLE).
Painter. Born in St. Louis, MO, Oct. 17, 1871. Pupil of St. Louis School of Fine Arts; Richard Miller; Hugh Breckenridge. Member: St. Louis Artists' Guild; North Shore Arts Association; American Federation of Arts; St. Louis Art League; Boston Art Club; All-Illinois Society of Fine Arts; Illinois Academy of Fine Arts; Southern States Art League; Independent Artists of St. Louis. Award: Hon. mention, Kansas City Art Institute, 1923; purchase prize, St. Louis Art League, 1928; Missouri Society of Artists, 1928. Address in 1933, 4646 Lindell Blvd., St. Louis, MO.

VERBEEK, GUSTAVE.
Painter and etcher. Born in Nagasaki, Japan, in 1867. Pupil of Constant; Laurens; Girardot; Blanc; Brush. Died in 1937.

VERGER, P. C.

Engraver. The only known plate of Verger is "The Triumph of Liberty," a folio plate signed "Engraved by P. C. Verger" in 1796. Fielding believed that this plate may have actually been engraved in France for an American market, and brought over here by Verger and published by him in New York, Verger not being a copperplate engraver himself. He was an "engraver upon fine stone," an art demanding a very different training and entirely different methods from those required in engraving upon copper. The plate referred to is very well engraved and evidently the work of an expert engraver. Nagler, in his *Kunstler-Lexicon*, in speaking of Claude du Verger, a landscape painter of 1780, refers to "a younger Verger" who was an engraver on precious stones, working in Paris in 1806.

VERGER, PETER C.

Sculptor, engraver, and hair worker. Born in Paris. Active in NYC from 1795 to 1797 and Paris in 1806. Worked with John Francis Renault on his "Triumph of Liberty" print. Possibly the same as P.C. Verger or the "younger Verger" mentioned in the above entry.

VERHAEGEN, LOUIS M.

Sculptor. Worked: NYC, 1851-60. With Verhaegen and Peeiffer, 1851. Exhibited: American Institute, 1856, plaster figure of Tom Thumb, marble bust of Daniel Webster.

VERHAGEN & PEEIFFER. [sic]

Sculptors. Worked in NYC in 1851. Louis Verhaegen and an unidentified Peeiffer or Pfeiffer were their parties.

VERHEYDEN, FRANCOIS (ISIDORE).

Painter, etcher, and teacher. Born in Hoeylaert, Belgium, April 8, 1880. Pupil of Royal Academy of Brussels. Address in 1926, Provincetown, MA.

VERMILYE, ANNA JOSEPHINE.

Etcher, block printer, painter, craftswoman, writer, and lecturer. Born in Mt. Vernon, NY. Pupil of John F. Carlson; George Bridgman; John C. Johansen; Robert Henri; B. J. Nordfeldt; Allen Lewis. Member: American Federation of Arts; National Association of Women Painters and Sculptors; Art Students League of NY; Plainfield Art Association; Westfield Art Association; Provincetown Art Association. Address in 1933, 428 Lenox Ave., Westfield, NJ.

VERNER, ELIZABETH O'NEILL.

(Mrs. E. Pettigrew Verner). Etcher, writer, and lecturer. Born in Charleston, SC, Dec. 21, 1884. Pupil of Penna. Academy of Fine Arts. Member: Charleston Etching Club; Southern States Art League; Carolina Art Association; American Federation of Arts. Address in 1929, 3 Atlantic St., Charleston, SC; summer, Verner's Lodge, Brevard, NC.

VERNON, THOMAS.

Engraver. Born in Staffordshire, England, c. 1824, where he learned to engrave and worked for the *London Art Journal*, before he came to NY, about 1853. Vernon was chiefly employed here by the bank-note engraving companies, and he returned to England in 1856-57. Died January 23, 1872, in London.

VERREES, J. PAUL.

Painter and illustrator. Born in Turnhout, Belgium, May 24, 1889. Pupil of Julien de Vriendt, and Francois Lauwers; Royal Academy of Fine Arts, Antwerp, and Higher Institute of Fine Arts, Belgium. Member: Brooklyn Society of Etchers; Chicago Society of Etchers. Award: Mr. and Mrs. Frank G. Logan medal, Art Institute of Chicago, 1921. Prints in Art Institute, Chicago; State Library of California; Smithsonian Institution, Washington, D.C.; New York Public Library; Museum of Fine Arts, Boston. Address 1929, Scherpenberg, Westmalle, Belgium.

VERSTILLE, WILLIAM.

Miniaturist and portrait painter. Born about 1755; he died in Boston, MA, Dec. 6, 1803. He painted miniatures in Philadelphia in 1782 and later in Boston and Salem, MA. His miniatures are recognized in nearly every instance by the piercing black eyes given to his subjects.

VETTER, CORNELIA C. (MRS.).

Painter and etcher. Born in Hartford, CT, in 1881. Pupil of Robert Henri; of Andrada in Paris and Spain. Member of Connecticut Academy of Fine Arts, Hartford. Address in 1926, 29 Huntington Street, Hartford, CT.

VEZIN, CHARLES.

Painter and writer. Born in Philadelphia, PA, April 9, 1858. Pupil of Art Students League of NY under Du Mond, Chase, George Elmer Browne, John Carlson, F. Luis Mora; also of Helen M. Turner and George M. Bruestle. Member: Art Students League of NY; Salma. Club, 1902; Municipal Art Society; Yonkers Art Association; Brooklyn Society of Artists; Philadelphia Art Club; National Arts Club; Century Association; Lyme Art Association; Society of Painters, NY; Allied Artists of America; American Federation of Arts; Springfield Art League. Awards: Hon. mention, Society of Washington Artists, 1914; hon. mention, Connecticut Academy of Fine Arts, 1925; popular prize, Lyme Art Association, 1927; popular vote, Hudson Valley Art Association. Represented in High Museum, Atlanta, GA. Address in 1933, Century Club, 7 West 43rd Street, New York, NY; summer, Old Lyme, CT.

VIANELLO, FRANCO.

Sculptor. Born in Venice, Italy, 1937; came to United States in 1959. Worked in foundry and as sculptor's

apprentice; received M.A., Institute of Arts, Venice. Works include 18-foot monument, bronze, World's Fair, Seattle, 1962; heroic replica, Remington's "Coming through the Rye," Cowboy Hall of Fame, 1981. Specialty is statuettes and statues of Western figures. Works in bronze. Represented by Hunter Gallery, San Francisco, CA; Meinhard Gallery, Houston, TX. Address in 1982, Napa, CA.

VIAVANT, GEORGE.
Painter. Native of New Orleans. Studied in Southern Art Union under Parelli. Diploma, New Orleans Cotton Centennial Expo., 1884. Specialized in water color sketches of native birds and animals. Represented in Louisiana State Museum. Died in 1925 in New Orleans, LA.

VIBBERTS, EUNICE WALKER (MRS.).
Painter. Born in New Albany, IN, Aug. 8, 1899. Pupil of Anna Fisher; Frank V. DuMond. Member: Louisville Art Association; National Association of Women Painters and Sculptors. Address in 1929, 5 Glenwood Rd., Scarsdale, NY.

VICE, HERMAN STODDARD.
Painter and illustrator. Born in Jefferson, Indiana, 1884. Pupil of Chicago Academy of Fine Arts. Member: Hoosier Salon; Illinois Academy of Fine Arts; South Side Art Association; Romany Club. Address in 1933, 7037 Merrill Avenue, Chicago, Illinois.

VICKERS, S. J.
Painter. Born in Middlefield, Otsego County, New York, in 1872. Among other things, he designed subway stations and ornamental elevated structures of the rapid-transit system of New York. Address in 1926, Grand-View-on-Hudson, New York.

VICTOR, SOPHIE.
Painter. Exhibited at the Penna. Academy of Fine Arts, Philadelphia, 1924.

VIETH, CARL VALDEMAR.
Sculptor. Born in Copenhagen, Denmark, 1870. Worked: Bridgeport, Connecticut. Died in Meriden, Connecticut, 1922.

VIGNA, GLORIANO.
Painter, sculptor, illustrator, architect, writer, and teacher. Born in Paterson, New Jersey, August 20, 1900. Pupil of Bridgman; Du Mond; Fratelli Vigna in Turin, Italy. Decorator to the King and Queen of Italy. Address in 1933, 156 East 49th Street, New York, New York; h. 30 Ward St., Paterson, New Jersey.

VIGNIER, A.
Dunlap recorded him as painting landscapes in Philadelphia in 1811.

VINCENT, H(ARRY) A(IKEN).
Painter. Born in Chicago, IL, Feb. 14, 1864. Self-taught. Member: Associate National Acad. of Design; Salma. Club; Allied Artists of America; NY Water Color Club; North Shore Arts Association. Award: Shaw prize, Salma. Club, 1907; Isidor prize, Salma. Club, 1916; Turnbull prize, Salma. Club, 1918; Porter prize, 1925; Wm. Church Osborne prize, and Paul L. Hammond prize, NY Water Color Club. Work: "Rockport Harbor," Butler Art Institute, Youngstown, OH; IL State Univer. Address in 1929, care of Casson Galleries, 575 Boylston St., Boston, MA.

VINCENTI, FRANCIS.
Sculptor. Born in Italy. Employed at the Capitol in Washington, 1853-58. Modeled busts of visiting Indians; anatomical models for other Capitol sculptors. Worked for Edward V. Valentine in Richmond, VA; returned to Europe and Paris.

VINTON, FREDERICK PORTER.
Painter. Born on Jan. 29, 1846, in Bangor, ME. His specialty was portraiture. Pupil of William Hunt and Dr. Rimmer in Boston, and of Bonnat and Laurens in Paris. Also studied at the Royal Academy of Bavaria under Mauger and Dietz. Honorable mention in Paris Salon, 1890. Elected a member of the National Academy of Design in 1891. A memorial exhibition of 124 of his paintings, including 50 portraits, was held in 1911 at the Boston Museum of Fine Arts. Many statesmen, jurists, authors, and professional men were among his sitters. For life of Frederick P. Vinton, see *New England Artists*, by Frank T. Robinson. Died May 19, 1911, in Boston, MA.

VINTON-BROWN, PAMELA (MRS.).
Painter. Born in Boston, MA, Jan. 28, 1888. Pupil of Collin and Courtois in Paris; Edwin Whiteman in Baltimore. Member: French Miniature Society; Deutscher Werkbund; Pennsylvania Society of Miniature Painters; American Society of Miniature Painters. Awards: Hon. mention, miniature section, Exhibition of American Woman's Work, Paris, 1914; hon. mention, Baltimore Water Color Club, 1920. Represented by two drawings in Cleveland Museum of Art; miniature, Brooklyn Museum. Address in 1933, Woodstock, NY.

VITTOR, FRANK.
Sculptor. Born in Italy, January 6, 1888. Pupil of Bistolfi. Member: Academy of Brera, Milan, Italy; Washington Art Club. Work: Bronze bust of President Wilson in White House; heroic group, "The Human Vision," dedicated to Woodrow Wilson; Pittsburgh Chamber of Commerce. Address in 1918, 140 West 57th Street, NYC.

VIVASH, RUTH ATHEY (MRS.).
Painter, illustrator, craftswoman, and teacher. Born in St. Louis, MO, March 26, 1892. Pupil of Pratt

Institute; Mary Langtry; Ralph Johonnot; O. W. Beck; Ida Haskell; Ethelyn Schaurman; Ethel Traphagen. Member: Art Alliance of America; Brooklyn Water Color Club; American Artists Professional League. Address in 1933, 326 St. John's Place, Brooklyn, NY.

VIVIAN, CALTHEA (CAMPBELL).
Painter, etcher, and teacher. Born in Fayette, MO. Pupil of Arthur Mathews; Lazar and Colarossi Academies in Paris. Member: San Francisco Art Association; San Francisco Society of Etchers; Laguna Beach Art Association; California Art Association; California Art Club. Represented in Palace of Fine Arts, San Francisco; Arkansas Auditorium Gallery. Address in 1933, Berkeley, CA.

VODICKA, RUTH KESSLER.
Sculptor. Born in New York City in 1921. Studied at City College of NY; with O'Connor Barrett; Sculpture Center, New York; Art Students League; New York University; New School for Social Research; Empire State College Program. Exhibited at the Whitney Museum Annual, New York City, 1952-57; Galerie Claude Bernard, Paris, 1960; Hudson River Museum, Yonkers, New York, 1973; plus many solo shows. Work: Norfolk Museum, Virginia; Montclair State College, New Jersey; others. Member: American Society of Contemporary Artists; Audubon Artists; National Association of Women Artists; Sculptors Guild (executive board, 1975); Women in Arts. Awards: National Association of Women Artists, 1954, 57, 66; National Academy of Design, 1955; Audubon Artists, 1957, 60; Silvermine Guild of Artists, 1957, 58; Painters and Sculptors Society, New Jersey, 1962. Taught: Instructor, sculpture, Queens Youth Center, Bayside, 1953-56; Emanuel Midtown YMHA and YWHA, New York, 1966-69; Great Neck Arrandal School, 1969-70. Media: Brass, bronze, and wood. Address in 1982, 97 Wooster Street, New York City.

VOGNILD, EDNA.
(Mrs. Enoch M. Vognild). Painter. Born in Chicago, Illinois. Studied: Art Institute of Chicago; Colarossi and Delecluse Academies in Paris; pupil of Hawthorne, J. C. Johansen, H. B. Snell. Address in 1929, 231 E. Superior Street, Chicago, Illinois.

VOGNILD, ENOCH M.
Painter. Born in Chicago, Illinois, in 1880. Pupil of Art Institute of Chicago under Johansen and Vanderpoel; in summer under Woodbury; also studied in Julien and Delecluse Academies in Paris. Member: Art Students League of Chicago; The Round Table; Chicago Art Club; Chicago Arts and Crafts; Chicago Society of Artists. Awarded Municipal Art League prize, 1906. Address in 1926, 22 Tooker Place, Chicago, Illinois. Died in 1928 in Woodstock, New York.

VOGT, L. C.
Painter. Born in Cincinnati, OH, in 1864. Pupil of H. Siddons Mowbray and Frank Duveneck. Member: Cincinnati Art Club. Represented by three water colors in Cincinnati Museum. Address in 1926, 141 East Fourth Street, Cincinnati, OH.

VOIGHT, CHARLES A.
Illustrator. Member: Society of Illustrators, 1913; New Rochelle Art Association. Address in 1929, New York Tribune, New York, NY; 514 Rochelle Terrace, Pelham Manor, NY.

VOISIN, ADRIEN.
Sculptor. Born in Islip, NY, 1890. Lived in Newport, RI. Worked with a taxidermist; apprenticed to a French woodcarver; studied painting with Sargent Kendall, Yale School of Fine Arts; at Academie Colarossi, 1912, and Ecole National des Beaux-Arts, Paris. Saw Buffalo Bill Cody Show in Paris; inspired him to sculpt. Returned to U.S. in 1916. After 1918 received commissions for sculpture on public buildings, including Hearst Castle; also memorial busts of public figures. Moved to Browning, MT, 1929; sculpted Indian subjects. Went to Paris in 1930, where his works were cast in bronze. Exhibited: Exposition Coloniale, Paris. Awarded: Diplome d'Honneur; gold medal, International Art Exhibition, Paris, 1932. Returned to U.S., lived and worked in San Francisco. In collection of Museum of Native American Culture, Spokane, WA; also in Harmsen Collection of American Western Art. Living in Southern California in 1977.

VOLCK, FREDERICK.
Sculptor. Born in 1833, in Bavaria. Worked: Baltimore. Work held: Peabody Institute. Died in 1891.

VOLK, DOUGLAS.
Painter, teacher, lecturer, and writer. Born in Pittsfield, MA, Feb. 23, 1856. Son of the sculptor, Leonard W. Volk. Pupil of Gerome in Paris. Member: Associate National Academy of Design, 1898; Academician National Academy of Design, 1899; Society of American Artists, 1880; National Arts Club; Artists' Fund Society; Artists' Aid Society; National Society of Portrait Painters; NY Architectural League, 1912; Century Association; International Society of Arts and Letters; National Society of Mural Painters; Society of Illustrators; Washington Art Club; American Federation of Arts. Awards: Medal, Columbian Expo., Chicago, 1893; Shaw Purchase, Society of American Artists, 1899; first prize, Colonial Exhibition, Boston, 1899; silver medal, Pan-Am. Expo., Buffalo, 1901; silver medal, Charleston Expo., 1902; Carnegie prize, Society of American Artists, 1903; silver medal, St. Louis Expo., 1904; gold medal, Carolina Art Association, 1907; Proctor portrait prize, National Academy of Design, 1910; Saltus gold medal, National Academy of Design, 1910; gold

medal, National Arts Club, 1915; Maynard portrait prize, National Academy of Design, 1915; gold medal, P.-P. Expo., San Francisco, 1915; Beck gold medal, Penna. Academy of Fine Arts, 1916. Cross of officer of the Order of Leopold II, 1921. Organized handicraft movement at Centre Lovell; director, Minneapolis School of Fine Arts, 1886 to 1893; instructor, National Academy of Design and Cooper Union. Work: "Father Hennepin" and "Battle of Missionary Ridge," mural decorations, St. Paul Capitol, St. Paul, MN; "Puritan Mother and Child," Carnegie Institute, Pittsburgh; "Portrait of Dr. Felix Adler" and "Little Mildred," Metropolitan Museum, NY; "Accused of Witchcraft," Corcoran Gallery, Washington; "Boy with the Arrow," National Gallery, Washington; "Maiden's Reverie," Pittsfield (MA) Museum; "Fur Trading Period," mural decoration, 1913, for Court House, Des Moines, IA; "Reverie," Art Museum, Montclair, NJ; "The Artist's Daughter," Memorial Art Gallery, Rochester, NY; "Among the Lilies," National Arts Club, NY; "Adoration," Hackley Art Gallery, Muskegon, MI; "By the Pond," Omaha Art Gallery; portraits of King Albert, Lloyd George, Gen. Pershing, National Gallery, Washington, DC; "Gov. A. E. Smith," Capitol, Albany; "Lincoln," Albright Gallery, Buffalo (NY), and Memorial Art Museum, Portland, ME; portrait, Maj. Gen. John G. Frost, U.S. Military Academy, West Point, NY. Address in 1933, 119 E. 19th St., New York, NY; summer, Centre Lovell, ME. Died Feb. 7, 1935.

VOLK, LEONARD WELLS.
Sculptor. Born in Wellstown (now Wells), New York, November 7, 1828. In 1855 he was sent abroad for study. On returning in 1857 he settled in Chicago, Illinois. Executed many busts and statues of prominent men. Among his works are the life-size statue of Stephen Douglass in marble, and a portrait bust of Abraham Lincoln. Died August 19, 1895, in Osceola, Wisconsin.

VOLKERT, EDWARD C(HARLES).
Painter. Born in Cincinnati, Ohio, September 19, 1871. Pupil of Duveneck in Cincinnati; Art Students League of New York. Member: Associate National Academy of Design; New York Water Color Club; American Water Color Society; Allied Artists of America; Salma. Club; Union International des Beaux-Arts et des Lettres; Cincinnati MacDowell Society; American Society of Animal Painters and Sculptors; National Arts Club (life); Connecticut Academy of Fine Arts; American Federation of Arts. Awards: Hudnut prize, NY Water Color Club, 1919; Cooper prize, CT Academy of Fine Arts, 1925; Gedney Bunce prize, Connecticut Academy of Fine Arts, 1929; Mansfield prize, New Haven Paint and Clay Club, 1930; Goodman prize, Lyme Art Association, 1932. Specialty: Cattle. Address in 1933, Lyme, Connecticut. Died March 4, 1935.

VOLKMAR, CHARLES.
Painter, sculptor, craftsman, etcher, and teacher. Born in Baltimore, MD, August 21, 1841. Pupil of Barye (sculptor) and Harpignies (painter). Member of National Society of Craftsmen; New York Architectural League, 1890; Salma. Club, 1880; National Arts Club. Exhibited at American Water Color Society, 1898; New York Etching Club. At first a landscape and animal painter, but later a maker of pottery. Address in 1910, Metuchen, NJ. Died in Metuchen, NJ, February 6, 1914.

VOLLMER, GRACE LIBBY.
Painter. Born in Hopkinton, MA. Pupil of Martinez; Edward Vysekal; Roscoe Shrader. Member: Pasadena Art Assoc.; CA Art Club; Laguna Beach Art Assoc. Address in 1933, 77 N. Coast Blvd., Laguna Beach, CA.

VOLLMER, RUTH.
Sculptor. Born in Munich, Germany, 1903. U.S. citizen. Work: Museum of Modern Art; National Collection of Fine Arts, Washington, DC; New York University; Riverside Museum; Whitney Museum; Guggenheim; others. Exhibitions: Betty Parsons Gallery, NYC, many times; Brussels World's Fair, 1958; Penna. Academy of Fine Arts; American Abstract Artists Annuals, 1963-68; C. Ekstrom Gallery, NY, 1964; Whitney Annuals, 1964-70; Sculptors Guild, 1964-68; Musee Cantonal des Beaux-Arts, Lausanne, II Salon International de Galeries Pilotes, 1966; Everson Museum of Art, Syracuse, NY, 1974; others. Member: Sculptors Guild; American Abstract Artists; American Craftsmen's Council. Media: Plastic, metal. Address in 1980, 25 Central Park West, NYC. Died in 1982.

VOLLMERING, JOSEPH.
Painter. Born in Anhalt, Germany, in 1810; died in New York City in 1887. He studied in Amsterdam. In 1847 he moved to New York and opened his studio. Elected an Associate of the National Academy in 1853. Exhibited at the National Academy and at the American Art-Union. Landscape and winter-scene in the Bryan Collection, New York Historical Society.

VOLOZON, DENIS A.
Landscape painter and portrait draftsman in crayons. Volozon was a Frenchman who settled in Philadelphia, exhibited at the Academy and taught drawing there. He also made historical compositions. His crayon of George Washington is in the Penna. Academy of Fine Arts. He was working in Philadelphia, 1811-20.

VOLPE, ANTON.
Sculptor. Born in 1853. His home was in Philadelphia, Pennsylvania. Died in New York, May 26, 1910.

VOLZ, GERTRUDE.
(Gertrude V. Crosby). Painter and sculptor. Born in NYC, Oct. 27, 1898. Pupil of Art Students League of New York. Address in 1933, 40 Fifth Ave., New York, NY.

VON AUW, EMILIE.
Painter, sculptor, designer, writer, craftswoman, and lecturer. Born in Flushing, LI, NY, September 1, 1901. Studied: New York School of Fine and Applied Arts; Columbia University, B.A., M.A.; University of New Mexico, B.F.A.; Grande Chaumiere, Paris; Ecole des Beaux-Arts, Fontainebleau, France; Academy of Art, Florence, Italy; etc. Member: New Mexico Art League; National League of American Pen Women; Sculpture Center, NY; National Society of Arts and Letters; American Craftsmen's Council; others. Award: Prizes, New Mexico State Fair; New Mexico Art League, 1961. Exhibited: National Gallery of Art, Washington, DC; Terry Art Institute; Albuquerque Artists; New Mexico Art League; New Mexico State Fair; Plaza Gallery; Ramage Gallery; Albuquerque; others. Taught: Professor of Art, University of New Mexico, 1940-45; director, Studio Workshop, Albuquerque, NM. Address in 1962, Albuquerque, NM.

VON DER LANCKEN, FRANK.
Painter, sculptor, illustrator, craftsman, teacher and lecturer. Born in Brooklyn, New York, September 10, 1872. Pupil of Pratt Institute under Herbert Adams; Art Students League of New York under Mowbray; Julian Academy in Paris under Constant and Laurens. Member: Tulsa Art Association; Art Students League in New York; Salma. Club; Rochester Art Club. Awards: Medal, Kentucky Federation of Women's Clubs, 1925; medal of first class, Rochester Exposition, 1926. Positions: Director of School of Applied and Fine Arts of the Mechanics Institute, Rochester, New York; lecturer on art at the University of Rochester; professor, Evening Art Classes, Tulsa University; director, Chautauqua School of Arts and Crafts. Address in 1933, Tulsa, OK; summer, Chautauqua, New York. Died in January, 1950.

VON EISENBARTH, AUGUST.
Painter and illustrator. Born in Hungary, November 15, 1897. Pupil of Royal Hungarian Academy; Art Students League of New York. Member: National Salon, Budapest; Art Alliance of America; American Water Color Society. Work: "Biedermeyer Doll," National Salon, Budapest, Hungary; "Portrait of a Young Lady," "Spanish Dancers," American Water Color Society, NY. Specialized in water colors, commercial advertising and textile designs. Executed series of silk prints: "Indo-chi," for Corticelli Silk Company, etc. Address in 1933, 1441 Broadway, New York; h. 59 Eton Road, Fleetwood-Knolls, Bronxville, New York.

VON HOFSTEN, HUGO OLOF.
Painter and illustrator. Born in Sweden, June 20, 1865. Pupil of Royal Academy at Stockholm under M. E. Winge; O. Aborelius; A. Larson. Organizer of the Forestry Painters of Chicago. Award: First water color prize, Swedish American Artists, 1919. Address in 1929, Winnetka, IL.

VON MEYER, MICHAEL.
Sculptor and teacher. Born in Russia, June 10, 1894. U.S. citizen. Studied: California School of Fine Arts, San Francisco, CA. Member: San Francisco Art Association. Awards: Medal, San Francisco Art Association, San Francisco, 1934; prize, Women's Art Association, 1926; bronze medal, Oakland Art Gallery, 1934. Work: San Francisco Museum of Art; Palace of Legion of Honor; *Daily Californian* newspaper building, Salinas, CA; University of California Hospital; San Francisco City Hall; House Office Building, Washington, DC; U.S. Post Office, Santa Clara, CA. Exhibited: Oakland Art Gallery; Corcoran Gallery of Art, 1936; Whitney Museum, 1936; CA Art Assoc.; Palace of Legion of Honor; de Young Memorial Museum; Pomeroy Galleries, San Francisco, 1966; San Francisco Museum of Art. Received bronze medal, Oakland Art Gallery, 1934. Contributor to *Asia, Art News, Pencil Points*, and other publications. Address in 1982, San Francisco, CA.

VON NEUMANN, ROBERT.
Painter, engraver, block printer, lithographer, teacher and lecturer. Born in Rostock, Mecklenburg, Germany, Sept. 10, 1888. Studied: Kunstgewerbe Schule, Rostock, Germany; Royal Academy, Berlin, M.A.; and with Hans Hofmann, Emil Topler, Frans Burke. Member: Wisconsin Painters and Sculptors; Chicago Society of Etchers; Society of American Etchers; Milwaukee Print Makers. Awards: Hon. mention, Wisconsin Painters and Sculptors, Milwaukee, 1926; Madison Art Association, 1934; Art Institute of Chicago, 1936; Milwaukee Art Institute, 1938; Society of American Etchers, 1942; Library of Congress, 1943; Penna. Academy of Fine Arts, 1944; Herron Art Institute; medal, Milwaukee Art Institute, 1941; others. Work: Milwaukee Art Institute; University of Wisconsin; Library of Congress; American Institute of Graphic Arts; Berlin, Germany. Exhibited: National Academy of Design; World's Fair, NY, 1939; Art Institute of Chicago; Carnegie Institute; Milwaukee Art Institute; Penna. Academy of Fine Arts; Corcoran; Golden Gate Expo., San Francisco, 1939; others. Contributor to art magazines. Taught: Art Institute of Chicago; Wisconsin State College, Milwaukee. Address in 1962, Wisconsin State College; h. 1050 West River View Drive, Milwaukee, WI. Died in 1976.

VON RINGELHEIM, PAUL.
Sculptor. Born Vienna, Austria, 1934. Studied at the Brooklyn Museum Art School, 1952-56; with Picasso

at the Villa Californie, Cannes, 1958. Taught at Brooklyn Museum Art School, 1957-58; Art Students League of NY, 1958-59. Works: Fairleigh Dickinson University; Metropolitan Museum of Art; Art Institute of Chicago; Whitney; and many private collections. Exhibitions: Fairleigh Dickinson Univer., Rutherford, NJ, 1959; Guenther Franke, Munich, 1963; Rose Fried Gallery, NY, 1964; Felix Landau Gallery, NY, 1965. Group Exhibitions: The Brooklyn Museum, NY, 1958-1959; Berlin and Hamburg, Germany, 1961; Guenther Franke, Munich, 1961; NY World's Fair, 1964; and others.

VON RYDINGSVARD, URSULA.
Sculptor. Born in Deensen, Germany, July 26, 1942. Studied at University of Miami, Coral Gables, FL, B.A., 1964, M.A., 1965; University of California, Berkeley, 1969-70; Columbia University, NY, M.F.A., 1975. Work at Aldrich Museum of Contemporary Art, Ridgefield, CT; others. Has exhibited at Corcoran Gallery, Washington, DC; Aldrich Museum of Contemporary Art, Ridgefield, CT; Rosa Esman Gallery, NYC; others. Awards: Fulbright-Hays Travel Grant, 1975; National Endowment for the Arts, 1979. Taught: Pratt Institute, Brooklyn, NY, from 1977; Parsons School of Design, from 1979. Works in wood. Address in 1982, 210 Spring St., New York, NY.

VON SALTZA, CARL F.
Portrait painter. Born in Sweden in 1858. Studied in Paris. He came to the United States in 1891, and for years was an instructor and teacher. Later he spent some time in Cleveland painting portraits. Died in NY in 1905.

VON SCHLEGELL, DAVID.
Sculptor. Born in St. Louis, Missouri, May 25, 1920. Studied at University of Michigan, 1940-42; Art Students League, with William Von Schlegell (his father) and Yasuo Kuniyoshi, 1945-48. Works: Phillips Academy, Addison Gallery of American Art, Andover, Massachusetts; Carnegie; Lannan Foundation; MIT; University of Massachusetts; Ogunquit; Aldrich Museum of Contemporary Art, Ridgefield, Connecticut; Whitney; Hirshhorn; Yale Art Gallery; R. W. Godard Memorial, Worcester, MA; Indiana University, Indianapolis. Exhibitions: The Swetzoff Gallery; Poindexter Gallery, NYC; Stanhope Gallery, Boston; New York University (three-man); Whitney Annuals, 1960-68; Institute of Contemporary Art, Boston; Wadsworth Atheneum; Jewish Museum; Art Institute of Chicago; Los Angeles County Museum of Art, American Sculpture of the Sixties; Walker Art Center; Carnegie; others. Awards: Rhode Island Arts Festival, first prize, 1962; Carnegie, 1967; National Council on the Arts, $5,000 award, 1968; Guggenheim, 1974. Address in 1982, 190 Dromara Road, Guilford, Connecticut.

VON SCHMIDT, HAROLD.
Painter, illustrator, lecturer and teacher. Born in Alameda, CA, May 19, 1893. Studied at California College of Arts and Crafts, 1912-13; Grand Central Art School, with Harvey Dunn, 1924; San Francisco Art Institute, 1915-18; and with M. Dixon and W. Ryder. Member: Society of Illustrators; Artists Guild of the Authors' League of America; American Artists Professional League. Exhibited at Society of Illustrators. Work: National Cowboy Hall of Fame; California State Capitol; West Point Museum; others. Illustrated *Song of Songs, December Night*, others; illustrated for over 30 major magazines; painted posters during WWI & II. Awarded Trustees' Gold Medal, Cowboy Hall of Fame and Western Heritage Center. Teacher/founder of Famous Artists School, Westport, CT. Known for beautiful, realistic depiction of the West. Address in 1933, Evergreen Road, Westport, CT; summer, Taos, N.M.

VON SCHNEIDAU, CHRISTIAN.
Painter and teacher. Born Smaland, Sweden, March 24, 1893. Studied: Academy of Fine Arts, Sweden; Art Institute of Chicago; pupil of J. Wellington Reynolds, K. A. Buehr, H. M. Walcott, C. W. Hawthorne, Richard Miller. Member: Art Students League of Chicago; Chicago Swedish Art Club; California Art Club; Laguna Beach Art Association; Beachcombers Club, Provincetown; Painters and Sculptors Club, Los Angeles; CA Water Color Society; Scandinavian-American Art Society. Awards: First prize, Art Institute of Chicago, 1915, John Quincy Adams Traveling Scholarship, 1916; second prize for portrait, Minn. State Fair, 1915; first prize for portrait, Swedish-American Exhibition, Chicago, 1917; gold medal, CA State Fair, 1919, second prize, 1920, first prize for portraits, 1923, prize, 1925, 26; second prize, Swedish Club, Chicago, 1920; first prize, Southwest Museum, 1921; hon. mentions, Exposition Park Museum, 1921, and Pomona (CA) Fair, 1925, 27; Los Angeles Museum of Art, 1939; Scandinavian-American Art Society, 1940, 41, 43, 45; Society of Western Artists, 1947; Painters and Sculptors Club, Los Angeles, 1945, 47, 50-52; Golden Gate Expo., San Francisco, 1939; others. Works include portraits and murals in many churches, theatres, hotels, etc., throughout the U.S. and abroad. Has exhibited nationally. Director of Von Schneidau School of Art in Los Angeles and Palm Springs, California. Address 1962, Los Angeles, CA; h. Laguna Beach, California. Died January 6, 1976, in Orange, CA.

VON SCHOLLEY, RUTH.
Painter. Exhibited at the Penna. Academy of Fine Arts, Philadelphia, 1924. Address in 1926, 132 Riverway, Boston, MA.

VON WESTRUM, MRS.
See Baldaugh, Anni.

VONDROUS, JOHN C.

Painter, illustrator, and etcher. Born in Bohemia, Europe, January 24, 1884. Pupil of National Academy of Design in NY under E. M. Ward, G. Maynard, F. C. Jones, James D. Smillie. Member: S. V. U. Manes; Graphic Arts Society; "Hollar," of Prague, Czechoslovakia; Chicago Society of Etchers; Print Makers' Society of California. Awards: Bronze medal for etching, P.-P. Expo., San Francisco, 1915; Logan prize, Chicago Society of Etchers, 1917, 18 and 19; bronze medal, Sesqui-Centennial Expo., Philadelphia, 1926. Work: Modern Gallery of Prague; Art Institute of Chicago; NY Public Library; Fogg Museum, Cambridge, MA; Congressional Library, Washington, D.C.; Victoria and Albert Museum, and British Museum, London; Kupferstich Kabinett, Berlin. Address in 1929, Prague-Stresovice, Vorechovka, 486, Czechoslovakia; h. East Islip, L.I., NY.

VONNAH, BESSIE (ONAHOTEMA) POTTER.

(Mrs. Robert W. Vonnoh). Sculptor and painter. Born in St. Louis, MO, August 17, 1872. Pupil of Art Institute of Chicago; Lorado Taft, 1895; and Florence, 1897. Member: Associate National Academy of Design, 1906; Academician National Academy of Design, 1921; National Sculpture Society, 1898; National Institute of Arts and Letters; National Society of Portrait Painters; Allied Artists of America. Awards: 2nd prize, Nashville Exposition, 1897; bronze medal, Paris Exposition, 1900; honorable mention, Pan.-American Exposition, Buffalo, 1901; gold medal, St. Louis Exposition, 1904; silver medal, P.-P. Exposition, San Francisco, 1915; Watrous gold medal, National Academy of Design, 1921; Art Alliance of Philadelphia, 1928. Specialty: Small groups. Work: "The Young Mother," and eleven statuettes, Metropolitan Museum of Art, NY; eleven statuettes, Art Institute of Chicago; thirteen statuettes, Brooklyn Institute Museum; "Girl Dancing," Carnegie Institute, Pittsburgh; two statuettes, Corcoran Gallery, Washington; two statuettes, Philadelphia Academy; two statuettes, Newark Museum; two statuettes, Cincinnati Museum; two statuettes, Detroit Institute; Roosevelt Memorial Bird Fountain, Oyster Bay, Long Island, NY; Burnette Fountain, Central Park, NYC; Brookgreen Gardens, SC; American Museum of Natural History, NY; Penna. Academy of Fine Arts; Ft. Worth Museum of Arts; others. Exhibited at National Sculpture Society, 1923. Address in 1953, 33 West 67th St., New York, NY; summer, Lyme, CT. Died in NY, 1954.

VONNOH, ROBERT.

Painter and teacher. Born in Hartford, CT, Sept. 17, 1858. Pupil of Massachusetts Normal Art School in Boston; Julian Academy in Paris, under Boulanger and Lefebvre. Member: Associate National Academy of Design, 1900; Academician National Academy of Design, 1906; Society of American Artists, 1892; National Arts Club; NY Architectural League; National Society of Portrait Painters (associate); Lotos Club; Salma. Club, 1904; Fellowship Penna. Academy of Fine Arts; Allied Artists of America; Munich Secession; Connecticut Academy of Fine Arts; Gamut Club of Los Angeles; American Art Association of Paris; L. C. Tiffany Foundation; Lyme Art Association. Awards: Gold medal for portraiture, Massachusetts Charitable Mechanics Association, Boston, 1884; hon. mention, Paris Salon, 1889; bronze medal, Paris Expo., 1889 and 1900; medal, Pan.-Am. Expo., Buffalo, 1901; gold medal, Charleston, 1902; Proctor portrait prize, National Academy of Design, 1904; gold medal, P.-P. Expo., San Francisco, 1915; Charles Noel Flagg prize, Connecticut Academy of Fine Arts, 1920; prize, Newport Art Association, 1920. In collections of Penna. Academy of Fine Arts; College of Physicians, Philadelphia; Buffalo Club, Buffalo, NY; Union League Club, Philadelphia; Department of Justice, Washington, DC; Post Office Dept., Washington, DC; Brown University; Massachusetts Historical Society, Boston; White House; Metropolitan Museum of Art; Butler Art Institute; Brooklyn Museum; Harrison Gallery, Los Angeles Museum; Capitol, Hartford, CT; Ft. Worth (TX) Museum; American Philosophical Society, Philadelphia; Cleveland Museum. Taught: Massachusetts Normal Art School; Thayer Academy, Boston; Cowles Art School; Boston Museum of Fine Arts School; Penna. Academy of Fine Arts; others. Lived in New York City, Connecticut, and France. Died Dec. 28, 1933, in Nice, France.

VOORHEES, CLARK G(REENWOOD).

Painter and etcher. Born in New York, New York, May 29, 1871. Pupil of Julian Academy in Paris, with Constant and Laurens; Columbia; Yale; and with I. Wiles in New York City. Member: Connecticut Academy of Fine Arts; Lyme Art Association; Century Club, New York; Massachusetts Art Association; Grand Central Art Association, 1923 (founder). Awards: Bronze medal, St. Louis Expo., 1904; third Hallgarten prize, National Academy of Design, 1906; Eaton purchase prize, Lyme Art Association, 1923. Address in 1929, Lyme, Connecticut; winter, Somerset, Bermuda. Died July 17, 1933, in Old Lyme, Connecticut.

VOORHEES, HOPE HAZARD.

Sculptor, painter, block printer, and teacher. Born in Coldwater, Michigan, January 28, 1891. Pupil of Detroit School of Design; Dickinson; Roerich Institute. Member: Detroit Society of Women Painters and Sculptors; Provincetown Art Association. Address in 1933, 8100 East Jefferson Ave., Detroit, Michigan.

VOORHEES, JAMES P.

Sculptor. Born in 1855. Active in Washington, DC.

VORIS, MILLIE ROESGEN.
Painter, writer, lecturer and teacher. Born in Dudley Town, IN, Aug. 23, 1869. Pupil of L. C. Palmer; Jacob Cox; Chase; A. Berger; Lotta Griffin; others. Member: Indiana Art Association; Columbus Art League; Palette Club, Chicago; National Society of Arts and Letters; American Federation of Arts; Chicago Art Association. Award: Hon. mention, Columbian Exposition, Chicago, 1893; prize, Chicago World's Fair. Work: "Autumn in Brown County" and "Happy Youth," Art Museum, Berlin, Germany. Exhibited: Chicago World's Fair; Hoosier Salon; John Herron Art Institute; Indiana Art Association; others. Address in 1956, Columbus, IN.

VOS, HUBERT.
Painter. Born in Maastricht, Holland, Feb. 17, 1855. Pupil of Academy of Fine Arts in Brussels; Cormon in Paris. Awards: Gold medals at Paris, Amsterdam, Munich, Dresden, Brussels, etc. Specialty: Types of aboriginal races, portraits and interiors. Address in 1933, 15 West 67th St., New York, NY; Newport, RI.

VOULKOS, PETER.
Sculptor. Born in Bozeman, Montana, on January 29, 1924. Studied at Montana State University, B.S., 1968; California College of Arts and Crafts, M.F.A. Works: Baltimore Museum of Art; Archie Bray Foundation; Los Angeles County Museum of Art; Museum of Modern Art; Museum of Contemporary Crafts; Oakland Art Museum; Pasadena Art Museum; San Francisco Museum of Art; Santa Barbara Museum of Art; Smithsonian; Everson Museum of Art, Syracuse; Whitney; Wichita Art Museum. Exhibitions: Gump's Gallery; Felix Landau Gallery; Art Institute of Chicago; Pasadena Art Museum; Los Angeles County Museum of Art; Hansen Gallery, San Francisco; Metropolitan Museum of Art; Everson Museum of Art, Syracuse; Brussels World's Fair, 1958; de Young Memorial Museum; Seattle World's Fair, 1962; Whitney; Denver Art Museum; Smithsonian; Los Angeles County Museum of Art; Battersea Park, London, International Sculpture Exhibition; Detroit Institute of Art; Braunstein Gallery, San Francisco, CA. Awards: Richmond (CA) Art Center, first prize; National Decorative Art Show, Wichita, KS, first prize; Portland (OR) Art Museum, Northwest Craft Show, first prize; Pacific Coast Ceramic Show, first prize; Denver Art Museum; Cranbrook Academy of Art; Smithsonian; Los Angeles County Fair; Pasadena Art Museum; Ford Foundation; International Ceramic Exhibition, Cannes, France, Gold Medal; I Paris Biennial, 1959, Rodin Museum Prize in Sculpture; San Francisco Museum of Art, Ford Foundation; others. Taught: Archie Bray Foundation, Helena, MT; Black Mountain College; Los Angeles County Art Institute; Montana State University; University of California, Berkeley, from 1959; Greenwich House Pottery, New York City; Teachers College, Columbia University. Address in 1982, 1306 Third Street, Berkeley, California.

VREELAND, ELIZABETH L. W.
(Mrs. F. K. Vreeland). Painter. Born in India in 1896. Studied in New York, London, Paris and Norway. Address in 1926, 228 Orange Road, Montclair, NJ.

VREELAND, FRANCIS WILLIAM.
Painter. Born in Seward, NE, March 10, 1879. Studied: Julian Academy in Paris; pupil of O. W. Beck, Vincent Nowottny, George Bridgman. Member: National Society of Mural Painters; NY Architectural League; California Art Club; Artists Council of Los Angeles; Oklahoma Art League; Art and Education Committee, Los Angeles Chamber of Commerce; Chairman, Art Commission, Hollywood Chamber of Commerce. Address in 1933, Franmar, 2206 Live Oak Drive, Hollywood, CA.

VUCHINICH, VUK.
Sculptor, painter, and etcher. Born in Yugoslavia, December 9, 1901. Pupil of Charles Curran; Robert Aitken; Francis Jones; Mestrovic. Member: National Sculpture Society; Kit Kat Club. Address in 1933, 54 West 74th Street, New York, NY.

VUILLEMENOT, FRED A.
Painter, designer, sculptor and illustrator. Born in Ronchamps, France, Dec. 17, 1890. Studied: Ecole des Beaux-Arts, France; Ecole des Arts Decoratifs, Paris; pupil of Hector Lemaire, E. Deully, David, Rouard. Member: Art Alliance of America; Art Decoratif; others. Awards: Prize for clock design, Cloister Clock Corp., 1923; Prix de Rome at David's; Prix du Ministre, France; honorable mention, Toledo Museum of Art. Work: Silver plaquette, Gravereaux Museum, France. Address in 1933, 2441 West Brook Dr., Toledo, OH. Died on February 26, 1952.

VYSEKAL, EDOUARD A(NTONIN).
Painter. Born in Kutna Hora, Czechoslovakia, March 17, 1890. Studied: Art Institute of Chicago; pupil of J. H. Vanderpoel, Harry M. Walcott, S. Macdonald-Wright. Member: California Art Club; Chicago Palette and Chisel Club; California Water Color Society. Awards: Harrison prize, California Painters and Sculptors, 1922; Ackerman prizes, California Art Club, 1922, 23, 24; hon. mention, Western Painters Association, 1924; bronze medal, Society of Western Artists, 1925; gold medal, California Art Club, 1926; hon. mention, Painters and Sculptors Society, 1927; first prize, California Water Color Society, 1927; first prize, Pomona Water Color Society, 1927; hon. mention, Painters and Sculptors of the West, 1927; first water color prize, Santa Cruz, 1927; special prize, San Diego Annual, 1929; first water color prize, Santa Cruz, 1929; prize, 13th Los Angeles Exhibition, 1932; first prize, 12th annual, California Water Color Society, 1932. Work: "The Conquest of

the Desert," Barbara Worth Hotel, El Centro, CA; "Korean," Mission Inn, Riverside, CA. Instructor, Otis Art Institute, Los Angeles. Address in 1933, 1978 Lucile Ave., Los Angeles, CA. Died December 2, 1939.

VYSEKAL, LUVENA BUCHANAN.
(Mrs. E. A. Vysekal). Painter. Born in Le Mars, IA. Studied: Art Institute of Chicago; pupil of S. Macdonald-Wright, Harry M. Walcott, J. H. Vanderpoel, Ralph Clarkson. Member of California Art Club; California Water Color Society. Work: Portrait of Christian Hoffman, in State Historical Building, Topeka, KS; murals, Barbara Worth Hotel, El Centro, CA; Los Angeles Art Institute; Kansas State Capitol. Exhibited: Los Angeles, San Francisco, Sacramento, and Oakland, CA, 1914-46. Awards: Prizes, Los Angeles Museum of Art, 1924; prize, Federation of Women's Clubs, 1924; first hon. mention, Pomona, 1927, 28; first hon. mention, Hollywood Chamber of Commerce, 1927; second prize, Santa Cruz, 1929; first prize, Laguna Beach Art Association, 1929; hon. mention, Riverside, 1929; hon. mention, Pomona, 1931; first prize, California Painters and Sculptors, 1932; first prize, California Water Color Society, 1932; hon. mention, Los Angeles Water Color Club Exhibition, 1933. Address in 1953, Los Angeles, California.

VYTLACIL, ELIZABETH FOSTER.
(Mrs. Vaclav Vytlacil). Painter and teacher. Born in St. Paul, MN, March 5, 1899. Pupil of Minneapolis Institute of Art; with L'hote in Paris; Hans Hofmann in Munich. Awards: Third prize, Minnesota State Fair; hon. mention, Minnesota State Art Society. Address in 1933, 7 Villa Brune, Paris, France.

VYTLACIL, VACLAV.
Painter, lecturer and teacher. Born in New York, NY, November 1, 1893. Pupil of Art Institute of Chicago; Art Students League of NY; Hans Hofmann in Munich. Work: Milwaukee Art Institute; Municipal Collection, Chicago; others. Member: American Abstract Artists. Awards: Chicago Society of Artists; Art Institute of Chicago, 1913. Represented in Milwaukee Art Institute, Milwaukee, WI; Museum Dessau, Germany. Taught: Art Students League, NY; Florence Cane School of Art, NY. Address in 1933, 7 Villa Brune, Paris, France.

W

WAANO-GANO, JOE.
Painter, sculptor and lecturer. Cherokee Indian, born in Salt Lake City, UT, March 3, 1906. Studied at T. N. Lukits Academy of Art; Hanson Puthuff Art School; University of Southern California; Von Schneidau School of Art, 1924-28; extension courses and private instruction; also with Dean Cornwell. Worked as commercial artist; decor designer, Western Air Lines. Work: Represented in Southwest Museum, Los Angeles; History and Art Museum, Los Angeles; Bureau of Indian Affairs, Washington, DC; plus others; commissions for Western Air Lines, ticket offices (murals); Los Angeles General Hospital (mural); others. Exhibited at Philbrook Museum, Tulsa, OK, American Indian Artists National Exhibition; National American Indian Exhibition, Scottsdale, AZ; American Indian and Cowboy Artists National Exhibition, San Dimas, CA; many others. Has won numerous awards. Member of Valley Artists Guild; Artists of the Southwest; fellow, American Artists Professional League; fellow, American Institute of Fine Art; others. Author and illustrator, *Art of the American Indian; Amerindian's; The Herbalist*. Bibliography includes *American Indian Painters*, Snodgrass; *Desert Magazine*, March, 1977. Has own gallery. Address in 1982, Los Angeles, CA.

WACHTEL, ELMER.
Painter. Born in Baltimore, MD, in 1864. Member: "Ten Painters," of Los Angeles, CA. Address in 1926, Los Angeles, CA. Died in 1929.

WACHTEL, MARION KAVANAUGH.
(Mrs. Elmer Wachtel). Painter. Born in Milwaukee, WI, June 10, 1875. Pupil of Art Institute of Chicago and Chase. Member: "Ten Painters" of Los Angeles; NY Water Color Club; California Water Color Society; Pasadena Society of Painters. Work: "Eucalyptus at Evening," California State Building; "San Gabriel Canon," Friday Morning Club, Los Angeles; "San Jacinto Canon," Woman's Club, Hollywood, CA; Cedar Rapids (IA) Museum; Vanderpoel Collection; State Building, Los Angeles, CA; others. Awards: Prizes, Pasadena Society of Artists, 1942, 44. Died in 1954. Address in 1953, 1155 Lida St., Pasadena, CA.

WACK, H(ENRY) W(ELLINGTON).
Painter, designer, writer and lecturer. Born in Baltimore, MD, Dec. 21, 1867 or 1875. Pupil of Leon Dabo; N. R. Brewer; H. Salem Hubbell; Frank Spenlove. Member: American Artists Professional League; NY League of Painters; Brooklyn Society of Artists; Salma. Club; Salons of Am.; Am. Fed. of Arts. Represented in Newark Art Mu.; Whistler House, Lowell, MA; Vanderpoel Collection, Chicago; Fort Worth (TX) Art Museum; Penna. Academy of Fine Arts; Salisbury (CT) Public Library; Mary Washington College, Univer. of VA. Author of *In Thamesland; Story of the Congo*; others. Founder and first editor of *Field and Stream* magazine. Specialty: Landscapes. Address in 1953, Santa Barbara, CA. Died in 1954.

WACKERMAN, DOROTHY.
Painter. Born in Cleveland, OH, in 1899. Specialties: Landscapes and mural paintings. Address in 1926, 1615 Fourth St., Minneapolis, MN.

WADDELL, MARTHA E.
Painter, writer, and teacher. Born Ontario, Canada, Feb. 27, 1904. Pupil of Butler Art Institute. Member: National Association of Women Painters and Sculptors; Cleveland Art Center; Columbus Art League; Youngstown Alliance. Address in 1933, City Club, 505 Wick Ave., Scienceville, Youngstown, OH.

WADE, CAROLINE D.
Painter. Born in Chicago, 1857. Pupil of Art Insti. of Chicago; Courtois in Paris. Mem.: Am. Fed. of Arts. Address in 1929, 57 E. Jackson Blvd., Chicago, IL.

WADE, J. H.
Portrait painter. From 1810-1823 he was painting in Cleveland, OH, and throughout the southern states.

WADSWORTH, ADELAIDE E.
Painter. Born Boston, MA, in 1844. Pupil of Wm. M. Hunt; Frank Duveneck; Twachtman; Woodbury; Arthur Dow. Member: Copley Society, Boston, 1894.

WADSWORTH, FRANK RUSSELL.
Painter. Born in Chicago, IL, in 1874. Pupil of Chicago Art Institute where he received several prizes. He was a member of the Chicago Society of Artists. Died in Madrid, Spain, on Oct. 9, 1905, where he was painting with William Chase's summer class.

WADSWORTH, WEDWORTH.
Landscape painter and illustrator. Born in Buffalo, NY, 1846. Member: NYWCC; Salma. Club, 1890; Brooklyn Art Club. Author and illustrator of *Leaves from an Artist's Field Book;* illustrated *The Song of the Brook, A Winter's Walk with Cowper, Under the Greenwood Tree with Shakespeare*, others. Address in 1926, Durham, CT. Died there Oct. 22, 1927.

WADSWORTH, WILLIAM.
Wood engraver and designer. Worked in Hartford, CT. His work appeared in Noah Webster's *American Spelling Book* and *The Cannibal's Progress*.

WAGANER, ANTHONY.
Sculptor. At New York City, 1834-35.

WAGEMAN, MICHAEL.
Portrait painter. At Newark, NJ, 1857-59.

WAGENHALS, KATHERINE H.
Painter. Born in Ebensburg, PA, in 1883. Pupil of Art Department of Smith College; Art Students League of New York; Academie Moderne in Paris. Award: Art Association prize, Herron Art Institute, 1916. Work: "The Visitor," Herron Art Institute, Indianapolis. Address in 1926, 2124 Sunset Blvd., San Diego, CA.

WAGER-SMITH, CURTIS.
Portrait painter, illustrator, and writer. She was born in Binghamton, NY. Pupil of Emily Sartain; Alice Barber Stephens; Henry McCarter, in Philadelphia. Member: Plastic Club; Society of Arts and Letters; City Parks Association; Women's Press Association. Award: Silver medal, Dallas Expo., 1890. Illustrated *Rhymes for Wee Sweethearts, Story Without an End*, and other children's books. Address in 1933, "By-the-Way," Willow Grove, Montgomery Co., PA.

WAGNER, BLANCHE COLLET.
Painter, craftswoman, writer and lecturer. Born in Grenoble, France, Oct. 26, 1873. Pupil of Clinton Peters in NY; H. Gazan in Paris; Alfonso Grosso in Seville, Spain. Member: Los Angeles Art Association; League of American Pen Women; Carmel Art Association; Laguna Beach Art Association; West Coast Art Association; Springfield Art Association. Awards: Prizes, League of American Pen Women, 1939; San Francisco, CA, 1939; Los Angeles, CA, 1946. Exhibited: Santa Ana (CA) Museum, 1935, 36; Southwest Museum, Los Angeles, CA. Author and illustrator of *Tales of Mayaland*. Address in 1956, San Marino, CA. Died in 1958.

WAGNER, EDWARD Q.
Painter and sculptor. Born in 1855. Did work for Chicago World's Fair, 1904. Died in Detroit, MI, 1922.

WAGNER, FRANK HUGH.
Painter, sculptor and illustrator. Born in Milton, Wayne Co., IN, January 4, 1870. Pupil of Freer; Vanderpoel; Von Salza. Member: Indiana Art Association; Richmond Art Association; Indiana Traveling Art Association; Alumni Association, Art Institute of Chicago; Hoosier Salon. Work: "Adoration of the Magi," St. Joseph's Chapel, West Pullman, IL; "Portrait of C. W. Hargrave," and "Portrait of A. Kate Huron," Chapel Hall, Danville, Indiana. Address in 1933, 1445 Plaisance Court, Chicago, Illinois.

WAGNER, FRED.
Painter and teacher. Born in Valley Forge, Pennsylvania, on December 20, 1864. Pupil of Pennsylvania Academy of Fine Arts. Member: Philadelphia Sketch Club; Fellowship Pennsylvania Academy of Fine Arts; Philadelphia Water Color Club. Awards: Fellowship prize, Pennsylvania Academy of Fine Arts, 1914; honorable mention, Carnegie Institute Outdoor Painting. Address in 1933, 1520 Chestnut Street, Philadelphia, Pennsylvania. Died in 1940.

WAGNER, GEORGE.
Sculptor. Born in the United States. Pupil of Dumont in Paris. Specialty: Statuettes of silver, gold, ivory, and precious stones. Address in 1908, 40 Rue de la Prevoyance, Vincennes (Seine), France.

WAGNER, MARY NORTH.
Miniature painter, sculptor, illustrator, writer, and lecturer. Born in Milford, Indiana, on December 24, 1875. Pupil of John Vanderpoel; Charles Francis Browne; Mary S. West; Louis J. Millet; C. J. Mulligan and W. M. Chase. Member: Indiana Society of Artists; Richmond Art Association; Hoosier Salon; Indiana Art Association; Alumni Association, Art Institute of Chicago and Independent Society of Artists. Work: Four drawings for the *Second Brownie Book*, by Mrs. Alpha B. Benson. Address in 1933, 1445 Plaisance Court, Chicago, Illinois.

WAGNER, ROB.
Painter, illustrator, and writer. Born in Detroit, Michigan, August 2, 1872. Pupil of Julian Academy in Paris. Member: California Art Club. Awards: Silver medal, Alaska-Yukon Pacific Exposition, Seattle, 1909; bronze medal, P.-P. Exposition, San Francisco, 1915. Writer and illustrator for *Saturday Evening Post, Collier's, Liberty*; editor of *Rob Wagner's Script*. Motion picture director. Address in 1933, Beverly Hills, California. Died in California in 1942.

WAGNER, ROSA.
Painter. Member: Washington Water Color Club. Address in 1929, Rockville, Maryland.

WAGNER, S. PETER.
Painter, etcher and teacher. Born in Rockville, MD, May 19, 1878. Studied: Corcoran School; Art Students League of New York; Grande Chaumiere Academy, Paris; pupil of Paul Pascal. Member: Washington Water Color Club; Pensacola Art Club; Society of Washington Artists; St. Petersburg Art Club; Washington Art Club; Southern States Art

League; American Federation of Arts; American Water Color Society; Salma. Club; Baltimore Water Color Club; others. Awards: Hon. mention, Tampa Art Institute, 1928; first prize, Florida Federation of Arts, 1928, 31, 32; medal, Landscape Club, Washington, DC, 1943, 45. Address in 1953, Rockville, Maryland.

WAGNER, WILLIAM.
Seal-engraver. Lived York, Pennsylvania, in 1820-35. He made a few crude engravings on copper; his plates included a portrait of Rubens and a view of York Springs. He was treasurer of NY High School in 1835.

WAGONER, HARRY B.
Painter and sculptor. Born in Rochester, Indiana, November 5, 1889. Pupil of Homer Pollock. Member: Pasadena Society of Painters; Hoosier Salon; International Society of Sculptors, Painters and Gravers. Address in 1933, El Mirador Hotel, Palm Springs; home, 2737 Page Drive, Altadena, California; summer, 9220 Pleasant Avenue, Chicago, Illinois.

WAITE, CHARLES W.
Painter. Studied at Ohio Mechanics' Institute and under Duveneck. Member: Cincinnati Art Club. Address in 1929, 1355 Locust St., Walnut Hills, Cincinnati, OH.

WAITE, EMILY BURLING.
(Mrs. Arthur Williams Manchester). Painter. Born in Worcester, Massachusetts, July 12, 1887. Studied: Art Students League of New York; Boston Museum of Fine Arts School; Worcester Museum of Art School; pupil of F. Luis Mora, Frank DuMond, Philip Hale, others; also studied in England, France, Belgium, Holland, Germany, Austria, Italy and Spain. Member: Concord Art Association; Newport Art Association; North Shore Arts Association; Washington Water Color Club; Washington Art Club; Society of American Etchers; Chicago Society of Etchers; League of American Pen Women; Boston Society of Arts and Crafts. Awards: Silver medal, P.-P. Expo., San Francisco, 1915; traveling scholarship, Boston Museum of Fine Arts School; prizes, League of American Pen Women. Work: Tufts College; Clark University; Episcopal Theological School, Cambridge; Worcester Art Museum School; Boston Museum of Fine Arts; Metropolitan Museum of Art; Fogg Museum of Art. Exhibited: Pennsylvania Academy of Fine Arts; National Academy of Design; Chicago Society of Etchers, 1945; Society of American Etchers, 1946; Corcoran; Newport Art Association, 1946; Boston Society of Arts and Crafts. Address in 1953, Worcester, Massachusetts.

WAITT, BENJAMIN FRANKLIN.
Sculptor, wood engraver and lithographer. Born March 3, 1817, in Malden, MA. Worked: Philadelphia, c. 1845-84.

WAKEMAN, ROBERT CARLTON.
Sculptor. Born in Norwalk, Oct. 26, 1889. Pupil of Lee Lawrie; Yale School of Fine Arts. Member: National Arts Club; Silvermine Guild of Artists. Exhibited at National Sculpture Society, 1923. Awards: First prize in competition, National Aeronautic Association, Washington, DC; first prize in competition, Brown and Bigelow medal. Work: "Dr. W. S. Lively," Southern School of Photography, McMinnville, TN; Dotha Stone Prineo Memorial, Thomas Balcom Memorial, Norwalk Public Library; Com. John Rogers Memorial, U.S. Naval Academy, Annapolis, MD. Supervisor of carving, Bok Singing Tower, Mountain Lake, FL. Address in 1933, 93 Main Street; h. 3 Ward St., Norwalk, Connecticut. Died in 1964.

WAKEN, MABEL (J.).
Painter. Born in Chicago, IL, March 13, 1879. Pupil of Charles Hawthorne; Hugh Breckenridge; Randall Davey. Member: Chicago Art Club; Washington Art Club; American Federation of Arts. Address in 1933, 1120 Lake Shore Drive, Chicago, IL; summer, East Gloucester, MA.

WALCOTT, ANABEL ("BELLE") HAVENS.
(Mrs. Harry M. Walcott). Painter. Born in Havens Corners, Franklin Co., OH, Sept. 21, 1870. Studied: Art Students League of NY; Colarossi Academy; pupil of W. M. Chase, Whistler. Award: Third Hallgarten prize, National Academy of Design, 1903. Represented in St. Louis Club. Address in 1933, 46 The Terrace, Rutherford, NJ; summer, Newark, OH.

WALCOTT, H(ARRY) M(ILLS).
Painter and teacher. Born in Torrington, CT, July 16, 1870. Pupil of National Academy of Design in NY; Julian Academy, under Constant, in Paris. Member: Associate National Academy of Design, 1903; Society of American Artists, 1902. Awards: Hon. mention, Paris Salon, 1897; bronze medal, Pan-Am. Expo., Buffalo, 1901; Shaw Fund, Society of American Artists, 1902; first Hallgarten prize, National Academy of Design, 1903; Clarke prize, National Academy of Design, 1904; hon. mention, Carnegie Institute, Pittsburgh, 1904; silver medal, P.-P. Expo., San Francisco, 1915. Work: "Hare and Hounds," Richmond (IN) Art Association; "The Contest," Erie (PA) Art Association; portrait at Ohio State University, Columbus; portrait at Ohio Wesleyan University, Delaware; "School's Out," H. C. Frick Collection. Address in 1933, 46 The Terrace, Rutherford, NJ. Died November 4, 1944.

WALCUTT, WILLIAM.
Sculptor and portraitist. Born in 1819, in Columbus, OH. Studied: Columbus; New York City; Washington; Cleveland; London; Paris. Had studio in New York City; also worked in Cleveland, OH, 1859-60.

Executed monument to Oliver Hazard Perry, Cleveland. Died 1882 or 1895.

WALD, SYLVIA.
Painter, sculptor and serigrapher. Born in Philadelphia, PA, October 30, 1914. Studied at Moore Institute of Art, Science and Industry, Philadelphia, 1931-35. Awards: Museum of Modern Art, 1941; Library of Congress, 1944; National Association of Women Artists, 1949; Serigraph Gallery, 1948, 49, 50; Brooklyn Museum, 1951, 54; others. Collections: Allen R. Hite Museum; J. B. Speed Memorial Museum; Whitney Museum; New York Public Library; Metropolitan Museum of Art; Munson-Williams-Proctor Institute; National Gallery, Canada; Philadelphia Museum of Art; Museum of Modern Art; Brooklyn Museum; Library of Congress; Princeton University; Walker Art Center; Philadelphia Museum of Art; Worcester Art Museum; others. One-woman exhibitions: Benson Gallery, Bridgehampton, Long Island, NY; Amerika Haus, Munich, Germany; Aaron Berman Gallery, NY; ACA Gallery; New School for Social Research; others. Group exhibit.: Carnegie; Whitney; Brooklyn Museum; Museum of Modern Art; Smithsonian Institution; National Sculpture Society; Pennsylvania Academy of Fine Arts Annuals; Library of Congress; Art Institute of Chicago; Philadelphia Museum of Art; others, including exhibitions abroad. Member of American Federation of Arts; Artists Equity Association. Address in 1982, 417 Lafayette Street, New York City.

WALDECK, C(ARL) G(USTAVE).
Painter. Born in St. Charles, Missouri, March 13, 1866. Pupil of Constant and Laurens in Paris. Member: St. Louis Artists Guild; 2 x 4 Society, St. Louis. Awards: Bronze medal, St. Louis Expo., 1904; silver medal, Lewis and Clarke Expo., Portland, Oregan, 1905; gold medal, Missouri State Expo., 1913; Betty Brown prize ($50), St. Louis Artists Guild, 1914; Fine Arts Prize, Society of Western Artists, Indianapolis, 1914; first prize, St. Louis Art League, 1915; first prize for best group of paintings, St. Louis Artists Guild, 1923; second prize, City Art Museum, St. Louis, 1923; Officier d'Academie, Paris, 1904. Address in 1929, 103 Edwin Avenue, Kirkwood, Missouri.

WALDECK, NINA V.
Painter, illustrator, etcher, and teacher. Born in Cleveland, Ohio, January, 1868. Pupil of Chase; Max Bohm; Julian Acad., Paris. Member: Orlando Art Assoc.; Cleveland Woman's Art Club. Work: Portrait of Jane Elliot Snow, Woman's Club, Cleveland; portrait of Bishop Schram, Ursuline Acad., Cleveland. Died 1943. Address in 1933, River St., Olmsted Falls, OH.

WALDEN, LIONEL.
Marine painter. Born in Norwich, CT, May 22, 1861. Pupil of Carolus-Duran in Paris. Member: American Federation of Arts; National Institute of Arts and Letters; Paris Society of American Painters; Societe International de Peinture et Sculpture, Paris. Awards: Second class medal, Crystal Palace Exhibition, London; hon. mention, Paris Salon, 1899; silver medal, Paris Expo., 1900; third class medal, Paris Salon, 1903; silver medal, St. Louis Expo., 1904; silver medal, P.-P. Expo., San Francisco, 1915. Chevalier of the Legion of Honor, France, 1910. Work: "Fishing in the Roadstead," Wilstach Collection, Philadelphia; "Cardiff Docks," Luxembourg Gallery, Paris. Represented in Cardiff Museum, Wales; Honolulu Academy of Arts, Honolulu, HI. Address in 1929, P. O. Box 2953, Honolulu, HI. Died July 12, 1933, in Chantilly, France.

WALDO & JEWETT.
Portrait painters. Samuel L. Waldo was born in 1783 and died in 1861; William Jewett was born c. 1795 and died in 1873/74. Worked in New York City from 1820-54. Work owned by the city of NY; Metro. Museum; and a number of prominent art galleries in the U.S. Exhibited at the American Academy; National Academy; Apollo Association; Artists' Fund Society of Philadelphia.

WALDO, RUTH M(ARTINDALE).
Painter. Born in Bridgeport, CT, Jan. 18, 1890. Pupil of Jonas Lie; F. V. DuMond; Charles Hawthorne. Member: Plainfield Art Association. Address in 1933, 640 West Eighth Street, Plainfield, NJ.

WALDO, SAMUEL LOVETT.
Portrait painter. Born in Windham, CT, April 6, 1783. Studied with Stewart, a portrait painter, at Hartford, CT, and practiced at Charleston, SC. In 1806 he went to London and studied at the Royal Academy and with West and Copley. In 1809 he settled in NY, and in 1812, William Jewett came to him as a pupil and later formed a partnership with him to paint portraits jointly. Represented at the Metropolitan Museum of Art by a self portrait; his portrait of his wife Deliverance Mapes Waldo, painted 1826; and by his life sketch of General Andrew Jackson, painted in 1817. Also painted George Washington Parke Custis, David C. Colden, William Steele, Joseph M. White and R. G. Livingston De Peyster. Died Feb. 16, 1861, in New York City.

WALDRON, ANNE A.
Painter. Exhibited water colors at the Penna. Academy of Fine Arts, Philadelphia, 1925. Address in 1926, Bishop Place, New Brunswick, NJ. Died in 1954.

WALDRON, VANIS ROY.

Painter. Born on September 19, 1936. Graduated from the Art Institute of California, Berkeley; also studied at the Sergei Bongart School of Art. Work in galleries throughout California, including Carmel, Monterey, Half Moon Bay, San Francisco, Alameda, and San Leandro, and in numerous collections throughout the world. Has received many national and regional awards. Address and studio in 1983, San Leandro, CA.

WALES, GEORGE CANNING.

Etcher, lithographer and painter. Born in Boston, MA, Dec. 23, 1868. Pupil of Paxton. Member: Brooklyn Society of Etchers; Guild of Boston Artists; American Federation of Arts. Etchings in Library of Congress and the U.S. National Museum, Washington, DC; New York Public Library; Peabody Museum, Salem; Old Dartmouth Historical Society; British Museum, London; Victoria and Albert Museum, London; Marine Museum, Boston; Museum at Stavanger, Norway. Died in 1940. Address in 1929, 1064 Beacon St., Brookline, MA.

WALES, JAMES ALBERT.

Caricaturist and engraver. Born in 1852; died in 1886. After leaving school he studied with a wood-engraver in Toledo, but being talented at portraiture he began drawing for newspapers; some of his best work appeared in *Puck* and *Judge*. He was a founder and chief cartoonist of the latter periodical.

WALES, ORLANDO G.

Painter and teacher. Born in Philadelphia, PA. Pupil of Wm. M. Chase and Alphonse Mucha; Penna. Academy of Fine Arts. Member: Salma. Club, 1908. Address in 1933, 832 Hamilton St., Allentown, PA.

WALES, SUSAN M. L.

Landscape painter. Born in Boston, MA, in 1839. Pupil of Boston Museum School; Vincente Poveda in Rome; under Bloomers in Holland. Member of Boston Water Color Club. Address in 1926, 341 Marlboro St., Boston, MA.

WALINSKA, ROSA NEWMAN.

Sculptor, writer, and lecturer. Born in Russia, December 25, 1890. Studied: Art Students League; and with Robert Laurent, Alexander Archipenko. Member: National Association of Women Artists; American Artists Professional League; League of Present-Day Artists. Work: Plaque, Women's Peace Society, NY; memorial, Lynn, MA. Exhibited: World's Fair, 1939; Independents; American-British Art Center; National Association of Women Artists; Riverside Museum; New School for Social Research; Anderson Gallery; Delphic Art Gallery, 1939 (one-woman). Author: *Ink and Clay*, 1942. Lectures: Modern Art and Poetry. Address in 1953, 875 West End Avenue, New York, NY.

WALKER, A(LANSON) B(URTON).

Illustrator. Born in Binghamton, NY, Nov. 19, 1878. Pupil of Kenyon Cox; Bryson Burroughs; Charles Curran; F. V. DuMond. Member: Society of Illustrators. Illustrations and humorous drawings for *Life; Judge; Harper's Weekly; Harper's Bazaar; Scribner's; Century; Harper's Magazine; The American Golfer; St. Nicholas*; etc. Died in 1947. Address in 1933, The Playhouse; h. 225 South Main St., New Canaan, CT; summer, Morningside, Milford, CT.

WALKER, CHARLES ALVAH.

Painter, engraver and etcher. Born in 1848, in Loudon, NH. He engraved on wood and steel, his plate after Daubigny being exhibited at the Paris Salon. Later he turned to painting in water color and oil. He exhibited in the Boston Art Club, and served as its vice-president. He died April 11, 1920, in Brookline, MA.

WALKER, DUGALD STEWART.

Illustrator, painter, and lecturer. Born in Richmond, VA. Studied under Anne Fletcher and Harriotte Taliaferro Montague in Richmond; Graham Cootes at Summer School of University of Virginia; at the NY School of Art; Art Students League of NY. Work: Illustrated *Hans Anderson's Fairy Tales, Stories for Pictures, The Gentlest Giant*, etc. Address in 1933, 304 Carnegie Hall, New York, NY. Died February 26, 1937.

WALKER, F. R.

Painter. Member: Cleveland Society of Artists. Address in 1929, 1900 Euclid Beach Park, Cleveland, OH.

WALKER FAMILY.

Gravestone sculptors. Worked: Charleston, SC, 1790's-1830's. Family included Thomas Walker, his sons James E., Robert D. W., and William S. Walker; also A. W. and C. S. Walker.

WALKER, FERDINAND GRAHAM.

Painter. Born in Mitchell, IN, in 1859. Pupil of Dagnan-Bouveret, Puvis de Chavannes, Blanche and Merson in Paris. Member: Society of Indiana Artists; Louisville Artists' Association; Chicago Arts and Crafts. Portraits in Kentucky State Historical Collection; University of Kentucky at Lexington; Berea College; Agricultural College of Michigan; Lincoln Institute, Simpsonville, KY; Kentucky State Collection at Frankfort; State House, Indianapolis, IN; Public Library, Jefferson Davis Memorial, New Albany, IN, and in other places; also represented by landscapes in the public galleries at New Albany, IN, and Lexington, KY, and by two murals in St. Peter's Church, Louisville, KY. Address in 1926, 308 Commercial Building, Louisville, KY. Died June 1, 1927, in New Albany, IN.

WALKER, GEORGE W.
Painter. Member: Cleveland Society of Artists. Address in 1929, Euclid Beach Park, Cleveland, OH.

WALKER, HAROLD E.
Painter. Born in Scotch Ridge, OH, Nov. 6, 1890. Pupil of Almon Whiting; Karl Kappes; Frederick Trautmann; Wilder M. Darling; Ross Moffett. Member: Toledo Artklan; Beachcombers. Awards: First prize, 1922, and hon. mention, 1923, Toledo Museum of Art. Work: "Overhauling the Nets," permanent collection, John H. Vanderpoel Art Association, Chicago. Address in 1933, Madison Court, Toledo, OH.

WALKER, HENRY OLIVER.
Painter. Born in Boston, MA, in 1843. He began in commercial pursuits in that city, but later turned to art, and went to Paris in the early eighties to become a pupil of M. Bonnat. Returning to the U.S., he took a studio in Boston, and held a very successful exhibition. A few years later he came to NY and was well-known to the art public. Was a member of the National Academy of Design; in 1895 he was awarded the Clarke prize for "A Morning Vision." In 1894 at the Society of American Artists he earned the Shaw Fund prize for "The Singers." These compositions, like "The Boy and the Muse," another celebrated work, show graceful, accurate drawing, refined color quality, and beauty of ensemble. Also well-known for important achievements in mural painting. Executed a series of compositions and single figures illustrative of lyric poetry for the Congressional Library at Washington, and an important piece of work for the Appellate Court building, New York. Received medal and diploma for work exhibited at the World's Fair, Chicago, 1893. Studio in NY. Address in 1926, Belmont, MA. Died January 14, 1929, in Belmont, MA.

WALKER, HOBART A(LEXANDER).
Painter and architect. Born in Brooklyn, NY, Nov. 1, 1869. Member: American Institute of Architects; NJ Society of Architects; American Water Color Society. Address in 1933, 360 Main St., East Orange, NJ; h. Maplewood, NJ.

WALKER, HORATIO.
Painter. Born in Listowel, Ontario, Canada, 1858; came to NY in 1885. Member: Associate National Academy of Design, 1890; Academician National Academy of Design, 1891; Society of American Artists, NY, 1887; National Institute of Arts and Letters; Royal Institute of Painters in Water Colors, England; American Water Color Society; Salma. Club; Artists' Fund Society; Artists' Aid Society; Rochester Art Club; National Arts Club. Awards: Gold medal, competitive exhibition, at American Art Galleries, NY, 1887; Evans prize, American Water Color Society, 1888; bronze medal, Paris Expo., 1889; gold medal and diploma, Columbian Expo., Chicago, 1893; gold medal, Pan.-Am. Expo., Buffalo, 1901; gold medal, Charleston Expo., 1902; gold medal for oil and gold medal for water colors, St. Louis Expo., 1904; gold medal of honor, Penna. Academy of Fine Arts, 1906; first prize, Worcester, 1907; gold medal, P.-P. Expo., San Francisco, 1915; Hudnut prize, American Water Color Society, 1920. Work: "The Harrower - Morning," "The Harrower," and "The Sheepfold," Metropolitan Museum, NY; "Ave Maria," Corcoran Gallery, Washington; "The Wood Cutter" and "Milking - Evening," City Art Museum, St. Louis; "Sheep Shearing," Albright Art Gallery, Buffalo; "Sheepyard - Moonlight," National Gallery, Washington; "Moonrise - A Canadian Pastoral," Carnegie Institute, Pittsburgh. Died in 1938. Address in 1933, Ile d'Orleans, Quebec, Canada; care of Ferargil Galleries, 37 East 57th St., New York, NY.

WALKER, JAMES.
Painter. Born in England, June 3, 1819. He was brought to NYC as a child, where he resided for most of his life. When a young man he resided one winter in New Orleans. At the outbreak of the Mexican War he was a resident of the city of Mexico, where he remained hidden for six weeks after the Mexican commander had issued an edict banishing all American residents to a 300-mile distance in the interior. Afterwards escaping to the lines of the American Army, he served as an interpreter, returning with the Army to the city of Mexico. He remained there during occupation of the Mexican capital by the U.S. After eight years he returned to NY, in 1848. Visited South America and established a studio in NY in 1850. In 1857-58 he was in Washington, and again for a brief period in 1883. In 1884 he moved to San Francisco, CA, to execute a large French battle picture. Work was principally large battle paintings. Among the most prominent of these are the "Battle of Chapultepec," "Battle of Lookout Mountain" and "Battle of Gettysburg." The commission for the "Battle of Lookout Mountain" was given by Gen. Hooker. His painting "The Battle of Chapultepec" is in the Capitol in Washington, D.C. Died Aug. 29, 1889 in Watsonville, CA.

WALKER, MARGARET MCKEE.
Painter, designer, and lecturer. Born September 12, 1912. Studied: Northwestern University; Art Students League; Art Institute of Chicago; also with L'hote. Exhibited: Art Institute of Chicago, 1934, 35, 36, 38; Salon des Tuileries, Paris, 1939. Work: Patten Gymnasium, Northwestern University. Address in 1940, Wilmette, IL.

WALKER, MARIAN D. BAUSMAN.
(Mrs. Otis L. Walker). Sculptor. Born in Minneapolis, Minnesota, June 21, 1889. Studied in Minneapolis. Member: Minneapolis Society of Fine Arts. Award: Honorable mention, Minnesota State Art Society, 1914. Address in 1933, Casper, Wyoming.

WALKER, NELLIE VERNE.
Sculptor. Born in Red Oak, IA, December 8, 1874. Pupil of Art Institute of Chicago under Lorado Taft. Member: National Sculpture Society, 1911; Chicago Society of Artists; Society of Western Sculptors; Chicago Painters and Sculptors. Awards: First Chicago Municipal Art League prize, 1907; second Grover prize, Art Institute of Chicago, 1908; Shaffer prize, Art Institute of Chicago, 1911. Work: "Stratton Memorial," Colorado Springs, CO; portrait statue of "Senator Harlan," U.S. Capitol, Washington; "Her Son," ideal group, Art Institute of Chicago; "Chief Keokuk," IA; Sen. Issac Stephenson, monument, Marinette, WI; memorial group at Cadillac, MI; two panels in library, State College, Ames, IA; two bronze panels, Roger Sullivan, Jr. High School, Chicago. Exhibited at National Sculpture Society, 1923. Address in 1933, The Midway Studios, 6016 Ingleside Ave., Chicago, IL. Died in 1973.

WALKER, SOPHIA A.
Painter, sculptor and etcher. Born in Rockland, MA, in 1855. Pupil of Lefebvre in Paris; Mowbray and Chase in New York. Member of National Arts Club. Painted "Portrait of E. B. Woodward," State Normal School, Bridgewater, MA. Address in 1926, 70 West 49th St., New York, NY.

WALKER, WILLIAM AIKEN.
Portrait and genre painter. Born in Charleston, SC, c. 1838, where, at the age of twelve, he exhibited his first works. Studied later in Dusseldorf, West Germany. Spent most of his life in Charleston, although he executed some work in Florida and Louisiana which was lithographed by Currier and Ives in the 1880's. Died Jan. 3, 1921, in Charleston, SC.

WALKER, WILLIAM (HENRY).
Cartoonist, portrait and landscape painter. Born in Pittston, PA, Feb. 13, 1871. Pupil of Art Students League of NY. Member: Society of Illustrators, 1909; Artists Guild of the Authors' League of America; American Federation of Arts. Contributor to *Life* since 1898. Specialty: Policital subjects. Address in 1933, 336 Sanford Ave., Flushing, Long Island, NY; summer, Duxbury, MA. Died in 1938.

WALKINSHAW, JEANIE WALTER.
(Mrs. Robert Walkinsaw). Painter and illustrator. Born in Baltimore, MD. Pupil of Charcoal Club, Baltimore; Edwin Whiteman; Lucien Simon and Rene Menard in Paris; Robert Henri in New York. Member: National Association of Women Painters and Sculptors; National League of American Pen Women; Pac.-NW Academy of Art; Southern States Art League; Women Painters of Washington; Portraits, Inc. Work: University of Washington, Seattle; Seattle Historical Society; Temple of Justice, Olympia, WA; others. Specialty: Portraits. Address in 1962, 936 12th Ave., East, Seattle, WA.

WALKLEY, DAVID B.
Painter. Born in Rome, OH, in 1849. Pupil of Julian Academy; Penna. Academy of Fine Arts. Member of Salma. Club, 1903, New York. Address in 1926, Rock Creek, OH.

WALKOWITZ, ABRAHAM.
Painter, graphic artist and illustrator. Born in Tuiemen, Siberia, Russia, March 28, 1880. Pupil of National Academy of Design under Ward, Maynard and F. C. Jones, in New York; Julian Academy under Laurens, in Paris. Work: Metropolitan Museum of Art; Whitney Museum; Boston Museum of Fine Arts; Museum of Modern Art; Brooklyn Museum; Addison Gallery of American Art; Philadelphia Museum of Art; Newark Museum; Library of Congress; NY Public Library; others. Has exhibited nationally. Author of *Isadora Duncan; From the Objective to the Non-Objective*. Member: American Art Association of Paris. Was director and vice-president of the Society of Independent Artists, NY. Address in 1962, 1469 53rd Street, Brooklyn, NY. Died January 27, 1965.

WALL, A. BRYAN.
Painter. Born in Allegheny City, PA. Pupil of his father, A. Wall. Member: Pittsburgh Society of Artists; Art Club of Philadelphia. Award: Gold medal, American Art Society, 1907. Address in 1933, 814 Arch St., Pittsburgh, PA. Died c. 1937.

WALL, WILLIAM ALLEN.
Painter. Born on May 19, 1801, in New Bedford, MA. He was apprenticed to a watchmaker, but early turned his attention to painting. Studied with Thomas Sully. Went to Europe in 1831. Returned to New Bedford in 1833. In about 1840 he copied Stuart's "Lansdowne Washington." His portrait of N. P. Willis, painted in Italy, is in the New York Historical Society. Several of his portraits are owned by Dartmouth College, Hanover, NH. He died in New Bedford, MA, Sept. 6, 1885.

WALL, WILLIAM GUY.
Painter. Born in Scotland or Dublin, Ireland, in 1792. He came to NY in 1818 where he began his career as an artist, living there for the next ten years and receiving wide recognition for his paintings of the Hudson River and New York City. He was a founder and member of the National Academy, New York, and exhibited there as well as at the Pennsylvania Academy and the Apollo Association. After 1828 he moved to Newport, RI, and lived there until about 1834, when he went to New Haven, CT. He was in Brooklyn, NY, in 1836, and after this he returned to Dublin where he lived and exhibited his work; he also exhibited once in London during this time. He returned to America in 1856 and lived in Newburgh, but again returned to Dublin and was still living there in 1864.

WALLACE, FREDERICK E(LLWOOD).
Painter and teacher. Born in Haverhill, Massachusetts, October 19, 1893. Studied: Massachusetts Normal Art School; Julian Academy, Paris; pupil of Joseph DeCamp and E. L. Major. Member: Guild of Boston Artists; Rockport Art Association; North Shore Arts Association. Awards: Prize, New England Contemporary Artists, 1944. Work: Dartmouth College; Massachusetts State House; Bridgewater Normal School; others. Exhibited: Rockport Art Association; North Shore Arts Association; New England Contemporary Artists. Died in 1958. Address in 1953, 30 Ipswich Street, Boston, Massachusetts.

WALLACE, JAMES.
Sculptor. At New Orleans, 1852-56. Worked in marble.

WALLACE, J(OHN) LAURIE.
Painter, sculptor and teacher. Born in Garvagh, Ireland, July 29, 1864. Pupil of Thomas Eakins. Member: Omaha Artists Guild (president). Work: University of Nebraska; Federal Court, Omaha, NE; Joslyn Memorial, Omaha; NYC Athletic Club; Creighton Medical School, Omaha; others. Address in 1933, 5804 Leavenworth St., Omaha, NE.

WALLACE, LUCY.
(Mrs. Lucy Wallace de Lagerberg). Painter, craftswoman, designer and teacher. Born in Montclair, New Jersey, November 13, 1884. Studied: New York School of Fine and Applied Arts; Art Students League of New York; pupil of Kenneth Hayes Miller, John R. Koopman. Member: NY Society of Craftsmen; Boston Society of Arts and Crafts. Award: Prize, New Haven Paint and Clay Club, 1923. Exhibited: American Water Color Society; Philadelphia Water Color Club; Paris Salon; Corcoran; City Art Museum of St. Louis; Montclair Art Museum; Suffolk Museum, Stony Brook, Long Island, New York; Parrish Museum of Art; others. Address in 1962, Wading River, Long Island, New York.

WALLACE, THOMAS J.
Sculptor. Born in Schenectady, NY, March 10, 1851. Pupil of Plassman and Elwell. Address in 1910, 112 McClellan St., Schenectady, New York.

WALLER, FRANK.
Painter. Born in NY in 1842. Formerly engaged as an architect; became a painter after 1903. Fellow of Academy of Design, New York; president of Art Students League of NY, which he incorporated; honorable secretary, Egypt Exploration Fund Society and of Ur Exploration Society; honorable life fellow, Metropolitan Museum of Art. Wrote: "Report on Art Schools," 1879; also first report, Art Students League, 1886. Died March 9, 1923, in Morristown, NJ.

WALLEY, ABIGAIL B. P.
Painter. Born in Boston, MA. Pupil of Sanderson; Langerfeldt; Bensa; Rice. Member: Copley Society; American Federation of Arts. Specialty: Landscapes and gardens in watercolors and pastels. Address in 1929, Hampton Court, 1223 Beacon St., Brookline, MA.

WALSH, ELIZABETH M.
Painter. Born in Lowell, MA. Pupil of Boston Museum of Fine Arts. Member of Concord Art Association. Address in 1926, 419 Andover St., Lowell, MA.

WALTER, ADAM B.
Engraver. Born in Philadelphia, PA, in 1820. A pupil of Thomas B. Welch, he was associated with Welch in the engraving business until 1848. An excellent engraver of portraits, chiefly executed in mezzotint. Died in Philadelphia, October 14, 1875.

WALTER, CHRISTIAN J.
Painter and craftsman. Born in Pittsburgh, PA, Feb. 11, 1872. Member: Associated Artists of Pittsburgh (president). Awards: Third prize, 1913, Roland prize ($200), 1915, Arts Society prize ($100), 1921, drawing and print prize, 1927, Associated Artists of Pittsburgh. Represented in the St. Petersburg (FL) permanent collection; John H. Vanderpoel Art Association, Chicago; Pennsylvania State College; collection, One Hundred Friends of Art, Pittsburgh, PA. Specialty: Stained glass. Died in 1938. Address in 1933, McCance Block, Pittsburgh, PA; summer, Ligonier, PA.

WALTER, EDGAR.
Sculptor. Born in San Francisco, CA, in 1877. Studied at the Mark Hopkins Institute of Art, San Francisco; under Cormon and Perrin, in Paris. Exhibited at the Paris Salon, 1899 and subsequently; National Sculpture Society, 1923. Awards: Honorable mention, Paris Salon, 1901; honorable mention, Panama-Pacific International Exposition, San Francisco, CA, 1915. Works include "Nymph and Bears;" "Primitive Man." Represented at Metropolitan Museum of Art; Toledo Museum of Art; others. Address in 1926, 1803 Franklin St., San Francisco, CA. Died in 1938.

WALTER, JEANIE.
See Walkinshaw, Jeanie Walter.

WALTER, JOHN.
Sculptor. At New Orleans, 1846.

WALTER, JOSEPH.
Painter. Born in Galtuer, Austria, July 5, 1865. Pupil of Loefftz; S. Herterich; J. Hackl in Munich; Gripenkerl in Vienna. Work: Murals, Catholic Church, Madison, NE; six murals, Peter and Paul's Church,

Petersburg, IA; three murals, St. Joseph's Church, Peoria, IL; mural, St. Patrick Church, Dubuque, IA; four paintings in Church, Sherrills, IA. Address in 1933, 2625 Carroll Street, Dubuque, IA.

WALTER, MARTHA.
Painter. Born in Philadelphia, PA. Pupil of Penna. Academy of Fine Arts; Julian Academy in Paris. Member: Fellowship Penna. Academy of Fine Arts. Awards: Cresson scholarship, Penna. Academy of Fine Arts, 1903; Mary Smith prize, Penna. Academy of Fine Arts, 1909; prize, National Association of Women Painters and Sculptors, 1915; gold medal, Fellowship Penna. Academy of Fine Arts, 1923. Work: "Anne," Toledo Museum; "Dorothy Lee Bell," Penna. Academy of Fine Arts; "Umbrellas on the Beach," Norfolk Society of Art; "Baby," Fellowship, Penna. Academy of Fine Arts; "Beach Scene," Art Institute, Milwaukee, WI; "La Cape Ecossaise," Luxembourg; "Sleepy Child," Little Gallery, Cedar Rapids, IA; "Southern Baby and Nurse," "Jane," and six water colors of Spanish and Moorish subjects, Art Institute of Chicago. Specialty: Figures and portraits. Address in 1933, care of Fifth Avenue Bank, New York, NY; 7535 Mill Road, Melrose Park, PA.

WALTER, VALERIE HARRISSE.
Sculptor. Born in Baltimore, MD, February 15, 1892. Studied: Mrs. Lefebvre's School; Maryland Institute, Baltimore; Art Students League; Hunter College; College of Notre Dame, MD; McCoy College, Johns Hopkins University; pupil of Ephraim Keyser, Augustus Lukeman. Awards: Prize, Corcoran Art Gallery, 1934; first prize, sculpture, Society of Washington Artists Annual. Work includes many commissions; executed portrait busts of Dr. Nicholas Sbarounis Tricorphos, Riccardo Bertelli, Marie Blandin, Robert Underwood Johnson, others; statues of Youth, Madonna and Child, Struggle, The Dip, Law, others; bas-reliefs of Genevieve Lymans, Walter Walkinshaw, Jim the Master, and others. Also executed life-size bronze gorillas, Johns Hopkins University and Baltimore Zoo. Exhibited at National Sculpture Society, 1923; Corcoran; National Academy of Design; Baltimore Museum of Art; Detroit Institute of Art; Penna. Academy of Fine Arts; Paris Salon; San Francisco Museum of Art. Address in 1982, Baltimore, MD.

WALTERS, CARL.
Ceramic sculptor and craftsman. Born in Ft. Madison, IA, June 19, 1883. Studied at Minneapolis School of Art; and with Robert Henri. Awards: Prize, Metropolitan Museum of Art, 1940; Guggenheim Fellowship, 1935, 36. Work: Museum of Modern Art; Whitney Museum of American Art; Metropolitan Museum of Art; Art Institute of Chicago; Davenport Municipal Art Gallery; Cincinnati Museum; Minneapolis Institute of Art. Exhibited: Copenhagen, Denmark, 1927; Stockholm, Sweden, 1928; Metro-

politan Museum of Art; Whitney Museum of American Art, 1929-45, 51, 52; Art Institute of Chicago, 1932-45; Penna. Academy of Fine Arts, 1938-45, 51; Musee du Jeu de Paume, Paris, 1938; Syracuse Museum of Fine Arts traveling exhibition to Denmark, Sweden, and Finland, 1937. Address in 1953, Woodstock, NY. Died in 1955.

WALTERS, EMILE.
Painter. Born in Winnipeg, Canada, Jan. 31, 1893. Pupil of Art Institute of Chicago; Penna. Academy of Fine Arts; and Tiffany Foundation. Member: Salma. Club; Art Students League of Chicago; Fellowship Penna. Academy of Fine Arts; Pittsburgh Art Association; Tiffany Foundation Art Club; Philadelphia Art Club. Awards: Goodwin prize, Chicago Art Institute, 1918, 19, 21; municipal prize, Chicago, 1918; Tiffany Foundation Scholarship ($2,000); Murphy Memorial prize, National Academy of Design, 1924; first hon. mention, National Art Exhibition, Springville, UT, 1926; second prize, Springville, 1927. Work: "Springtime Blossoms," State College (PA) Museum; "Early Spring," Hundred Friends of Art, Pittsburgh; "Birches in Winter," Houston (TX) Museum of Fine Arts; four canvases, National Museum of Iceland; "Harvest Time in the Nittany Valley," Centre Hills Country Club, State College, PA; "Roosevelt"s Haunts," National Gallery of Art, Washington, DC; "Blossom Time," Brooklyn Museum; "Spring Blossoms," Los Angeles Museum; "Late Winter," Fogg Museum, Harvard University, Cambridge; "Winter Haze," Museum of Rouen, France; "Depth of Winter," Heckscher Park Art Museum, Huntington, LI; "February Thaw," Art Institute, Altoona, PA; "Day in May," Art Club of Philadelphia; "The Passing Storm," Uniontown Friends of Art; "Springtime," Canadian Club of NY; "Morning Light," University of Saskatchewan, Canada; "The Village in Spring," Museum of Fine Arts, Edmonton, Canada; "Winter-Apple Blossoms," Nutana Collegiate Institute, Saskatoon, CN; Smithsonian Institution; Seattle Art Museum; Vanderpoel Collection; Municipal Gallery of Modern Art, Dublin, Ireland; National Museum, Helsinki, Finland; Palace of the Legion of Honor; others. Exhibited: Nationally and internationally. Instructor at summer session of Pennsylvania State College, State College, PA. Address in 1962, Poughkeepsie, NY.

WALTERS, JOHN.
Miniature painter and engraver who flourished about 1784, in Philadelphia. In partnership with John Norman in 1779; partner of Thomas Bedwell by 1782.

WALTHER, CHARLES H.
Painter and teacher. Born in Baltimore, MD, Feb. 10, 1879. Pupil of Maryland Institute; Blanche, Simon, Cottet and Laurens in Paris. Member: Charcoal Club; Municipal Art Society. Died in 1937.

Address in 1933, 4000 Pimlico Road, Baltimore, Maryland.

WALTMAN, HARRY FRANKLIN.
Painter. Born in Ohio, April 16, 1871. Pupil of Constant and Laurens in Paris. Member: Associate National Academy of Design, 1917; Salma. Club, 1897; Allied Artists of America; National Arts Club. Awards: Isidor prize, Salma. Club, 1916; prize, National Arts Club, 1927. Work: "Vermont Woods in Winter," Butler Art Institute, Youngstown, OH. Died January 23, 1951. Address in 1933, Dover Plains, NY.

WALTON, FLORENCE L.
Painter. Born in East Orange, NJ, in 1889. Pupil of George Bellows. Address in 1926, 18 East 8th St., New York, NY.

WALTON, MARION.
(Marion Walton Putnam). Sculptor. Born in New Rochelle, NY, November 19, 1899. Studied at Art Students League; Grande Chaumiere, Paris, with Antoine Bourdelle; Borglum School of Sculpture; Bryn Mawr College. Work: University of Nebraska; World's Fair, NY, 1939; numerous private collections in U.S. and Europe plus many commissions. Exhibited: Museum of Modern Art; Metropolitan Museum of Art; Whitney; Art Institute of Chicago; Penna. Academy of Fine Arts; Rodin Museum, Paris; Carnegie; San Francisco Museum of Art; Weyhe Gallery, NYC; and others. Received gold medal, Biennial International, Ravenna, Italy, 1979. Member of Sculptors Guild; Artists Equity Association. Works in marble and bronze. Address in 1982, 49 Irving Place, New York, NY.

WALZ, JOHN.
Sculptor. Born in Wuertemberg, Germany, August 31, 1844; came to America in 1859. Pupil of Aime Millet in Paris; Tilgner in Vienna. Address in 1910, 407 Liberty St., E., Savannah, GA.

WAMALINK, H. J.
Painter. Member: Cleveland Society of Artists. Address in 1929, 2630 Payne Ave., Cleveland, OH.

WAMSLEY, FRANK C.
Sculptor. Born in Locust Hill, MO, September 12, 1879. Pupil of C. J. Mulligan; Albin Polasek; Art Institute of Chicago; Beaux-Arts Institute of Design; Solon Borglum; John Gregory; Edward McCarten. Member: Artland Club (life); Painters and Sculptors of Los Angeles. Work: "Meditation," Hackley Art Gallery, Muskegon, MI; urn at Hollywood Crematory; Douglas Memorial Tablet, Covina, CA. Address in 1933, 1928 Hillhurst Avenue, Hollywood, CA.

WANDS, ALFRED J(AMES).
Painter, illustrator, and teacher. Born in Cleveland, OH, February 19, 1902. Studied: Cleveland School of Art; John Huntington Institute; pupil of F. N. Wilcox and H. G. Keller; also studied in Europe. Member: Chicago Galleries Association; Denver Artists Guild; Cleveland Society of Artists; Cleveland Art Center; Ohio Water Color Society; Baltimore Water Color Club. Awards: Prize for painting, 1923; prize for drawing, 1926, Cleveland Museum; Chaloner prize, NY, 1926; first prize in lithograph, second prize in figure composition, hon. mention in landscape and in drawing, Cleveland Museum of Art, 1929; prize for print, Colorado Contemporary Exhibition, 1932. Work: "The Last Load," and "Seated Nude," Cleveland Museum of Art; "Alttenha Valley," Cleveland Public Schools; Brooklyn Museum; Denver Art Museum. Address in 1933, Colorado Woman's College, Denver, CO.

WARBOURG, EUGENE.
Sculptor. Born in New Orleans, LA, in 1825. This black artist worked in New Orleans, 1840's-50's, and in Europe, from 1852. Executed busts and cemetery sculpture; a work entitled "Ganymede Offering a Cup of Nectar to Jupiter;" and bas-reliefs based on *Uncle Tom's Cabin*, commissioned by Duchess of Sutherland. Died January 12, 1859, in Rome, Italy.

WARD, ALBERT PRENTISS.
Painter, sculptor and illustrator. Pupil of S. Seymour Thomas; Whistler. Address in 1910, 317 Park Ave., Rochester, NY.

WARD, EDGAR MELVILLE.
Genre and landscape painter. Born in Urbana, OH, Feb. 24, 1839. Younger brother of John Quincy Adams Ward. Studied in the National Academy in 1870, and in Paris, 1872-78. His best known paintings were "Paternal Pride, "Lace Makers," and "Brittany Washerwomen," which was shown at the Paris Salon, 1876, and in the Philadelphia Centennial. His studio was in NY. Made an Academician of the National Academy in 1883; taught there in 1889. He died May 15, 1915, in NYC.

WARD, EDMUND F.
Painter and illustrator. Born in White Plains, NY, in 1892. Pupil of Edward Dufner; George Bridgman; Thomas Fogarty. Member of Guild of Free Lance Artists. Made illustrations for *Saturday Evening Post, Pictorial Review, Red Book, Woman's Home Companion*. Address in 1926, 33½ Court St., White Plains, NY.

WARD, ELSIE.
See Hering, Elsie Ward.

WARD, HERBERT T.
Sculptor and explorer. American born in London, 1862. Died in Neuilly, France, August 2, 1919.

WARD, IRVING.
Portrait and landscape painter. Born in 1867. Member of Baltimore Charcoal Club. He died at his home in Baltimore, MD, April 17, 1924.

WARD, J. STEPHEN.
Painter. Born in St. Joseph, MO, April, 1876. Pupil of Nicholas Brewer; Maurice Braun. Member: California Art Club; Artland Club; Los Angeles Painters and Sculptors; Glendale Art Association; Oregon Society of Artists. Awards: Hon. mention, State Fair, Phoenix, AZ, 1923; hon. mention, Witte Memorial Museum, San Antonio, TX, 1929; first prize, Oregon State Fair, 1930. Work: "Retreating Snow," Fairfax High School, Hollywood, CA; "Oak Creek Canyon, Arizona" and "Blue Bonnet," Clubb Collection, Kaw City, OK. Address in 1933, Jacksonville, OR.

WARD, JOHN QUINCY ADAMS.
Sculptor. Born June 29, 1830, near Urbana, OH. Studied with Henry K. Brown in Brooklyn, NY, remaining in his studio for seven years. Assisted Brown with the casting of the Union Square "Washington." From 1857-60 he was in Washington working as a portrait sculptor. In 1857 he made his first sketch for "The Indian Hunter," now in Central Park, NY. In 1861, he opened his studio in NY. Elected an Associate of the National Academy of Design in 1862, an Academician the following year, and president in 1874; also a member of the National Institute of Arts and Letters. First president of the National Sculpture Society. Member of original board of trustees of the Metropolitan Museum of Art, NYC. In 1866, he executed the group of "The Good Samaritan," in Boston; "The Freedman," Boston Athenaeum, Cincinnati Art Museum, and the American Academy of Arts and Letters; bronze portrait statue of George Washington, 1883, Wall Street, NYC; statue of Henry W. Beecher in Brooklyn; of Commodore Oliver H. Perry in Newport, RI; Israel Putnam at Hartford, CT; William Gilmore Simms in Charleston; equestrian statue of General Hancock, Philadelphia; other noted statues, including those of Horace Greeley, Lafayette, President Garfield, and the equestrian statue of General Thomas at Washington, DC; Ward also executed marble pediment figures (with P. W. Bartlett) for NY Stock Exchange; others. Died May 1, 1910 in NYC.

WARD, NINA B.
Painter. Born in Rome, GA. Pupil of St. Louis School of Fine Arts; NY School of Art; Penna. Academy of Fine Arts. Member of Fellowship, Penna. Academy of Fine Arts. Awards: Cresson European scholarship, Penna. Academy of Fine Arts, 1908 and 1911; first Toppan prize, Penna. Academy of Fine Arts, 1912; Mary Smith prize, Penna. Academy of Fine Arts, 1914. Address in 1926, 1515 Arch St., Philadelphia, PA.

WARD, RICHARD, JR.
Illustrator, sculptor, cartoonist, and craftsman. Born in New York City, April 30, 1896. Studied at Margate College, England; Beaux-Arts. Member: Society of Illustrators. Work: Free lance. Address in 1953, 270 Park Ave.; h. 51 West 10th St., New York City.

WARD, WILLIAM.
Sculptor. Born in Leicester, England. Came to U.S. about 1852. Worked: Utah and St. Louis. Taught: University of Utah, from 1892. Executed work for Washington Monument, Washington, DC; lion, Brigham Young's house; served as assistant architect, Mormon Temple, Salt Lake City.

WARD, WINIFRED.
Sculptor. Born in Cleveland, OH, in 1889. Pupil of Charles Grafly. Member: Fellowship, Penna. Academy of Fine Arts; Plastic Club; National Association of Women Painters and Sculptors; Society of Independent Artists. Address in 1926, 2006 Mt. Vernon St., Philadelphia, PA.

WARE, EDWARD THOMPSON, JR.
Painter. Address in 1926, 127 East Third St., Cincinnati, OH.

WARE, ELLEN PAINE.
(Mrs. J. W. Ware). Painter. Born in Jacksonport, AR, Nov. 12, 1859. Pupil of St. Louis School of Art; Cincinnati School of Design. Member: Memphis Art Association. Awards: Prizes, Memphis Art Association, 1920, 21. Address in 1929, Route 4, Station G, Memphis, TN.

WARE, JOSEPH.
Sculptor. Born in 1827. Exhibited: Boston Athenaeum, 1846, marble bas-relief of St. John.

WAREHAM, JOHN HAMILTON DEE.
Painter and craftsman. Born in Grand Ledge, MI. Pupil of Duveneck and Meakin. Member: Cincinnati Municipal Art Society. Award: Bronze medal, St. Louis Expo., 1904. Decorations in Fort Pitt Hotel, Pittsburgh; Seelbach Hotel, Louisville; Hotel Sinton, Cincinnati; Poli's Theatre, Washington, D.C. Address in 1933, Rookwood Pottery Co.; h. 3329 Morrison Ave., Clifton, Cincinnati, OH.

WARHANIK, ELIZABETH C.
(Mrs. C. A. Warhanik). Painter. Born in Philadelphia, PA, Feb. 29, 1880. Pupil of Paul Gustin; Edgar Forkner; Charles Woodbury. Member: Seattle Fine Arts Society; Seattle Art Museum; Women Artists of Washington (president). Award: Third prize for oil, Northwest Artists, Seattle, 1917; hon. mention, University of Washington, 1930. Address in 1933, 6052 Fifth Ave., N. W., Seattle, WA.

WARHOL, ANDY.
Painter, sculptor, craftsman, designer, illustrator and graphic artist. Born in Cleveland, OH, August 8, 1931. Studied at Carnegie Institute of Technology. Exhibited at Museum of Modern Art, 1967; Documenta IV, Kassel, Germany; Milwaukee Art Center; Guggenheim Museum; Oakland Art Museum; Stedelijk Museum, Amsterdam; Rochester Memorial Art Gallery; Rhode Island School of Design; Moderna Museet, Stockholm; Baltimore Museum of Art; Art Institute of Chicago; Whitney Museum; Metropolitan Museum of Art, NYC; Ronald Feldman Fine Arts, NYC; plus many more. Received Sixth Film Cultural Award, 1964; Los Angeles Film Festival Award, 1964. In collections of Albright-Knox Art Gallery, Buffalo; Los Angeles County Museum of Art; Museum of Modern Art; Whitney, NYC; Walker Art Center, Minneapolis; others. Member of Film Co-op. Represented by Leo Castelli Gallery, NYC. Address in 1982, Andy Warhol Enterprises, 860 Broadway, NYC.

WARING, LELIA.
Miniature painter. Member: Southern States Art League; Charleston Etching Club; Carolina Art Association; American Federation of Arts. Address in 1933, 2 Atlantic St., Charleston, SC.

WARNACUT, CREWES.
Painter and etcher. Born in Osman, IL, June 1, 1900. Pupil of William Forsyth; Charles Hawthorne. Member: All-Illinois Society of Fine Arts; Hoosier Salon; League of Northern Indiana. Awards: First prizes, All-Illinois Society of Fine Arts and League of Northern Indiana, 1929. Address in 1933, Inwood, IN.

WARNEKE, HEINZ.
Sculptor. Born in Bremen, Germany, June 30, 1895. U.S. citizen. Studied: Academy of Fine Arts in Berlin; Kunstschule, Bremen; Staatliche Kunstgewerbe Schule and Academy; with Blossfeld, Wakele, and Haberkamp. Awards: Prizes, St. Louis Artists Guild, 1925, 26; Logan medal and $2500, Art Institute of Chicago, 1930; Widener gold medal, Penna. Academy of Fine Arts, 1935; others. Work: Eagle facade, Masonic Temple, Fort Scott, KS; memorial tablet, Medical Society, St. Louis; memorial tablet, YMCA Building, St. Louis; "Wild Boars," granite, Art Institute of Chicago; "Prodigal Son," granite, National Cathedral, Washington, DC, as well as tympanum and clerestory decoration; elephant group, Philadelphia Zoological Gardens; Fairmount Park, Philadelphia; Brookgreen Gardens, SC; Corcoran Gallery; Addison Gallery of American Art; many others. Exhibited at Salon des Tuileries, Paris, 1929; Art Institute of Chicago Annual; Museum of Modern Art Annuals, 1936-46; Whitney Annuals; others. Taught at Corcoran School of Art, 1943-68; George Washington University, 1943-68; others. Member of National Academy of Design; fellow, National Sculpture Society; life fellow, International Institute of Arts and Letters; Connecticut Academy of Fine Arts; others. Address in 1982, East Haddam, CT. Died on August 16, 1983.

WARNER, C. J.
Engraver. The only known plate of this man is a fairly well-executed stipple portrait of Gen. Anthony Wayne. It was published by C. Smith, NY, 1796, and probably appeared in *The Monthly Military Repository*, published by Smith in that year.

WARNER, EVERETT LONGLEY.
Painter, etcher, teacher, lecturer and writer. Born in Vinton, IA, July 16, 1877. Pupil of Art Students League in Washington and NY; Julian Academy in Paris. Member: Associate National Academy of Design, 1913; Academician National Academy of Design; NY Water Color Club; American Water Color Society; National Arts Club (life); Washington Water Color Club; Connecticut Academy of Fine Arts; Society of Washington Artists; Associated Artists of Pittsburgh; Salma. Club, 1909; American Art Association of Paris. Awards: First Corcoran prize, Washington Water Color Club, 1902; Sesnan medal, Penna. Academy of Fine Arts, 1908; silver medal, Buenos Aires Expo., 1910; second Hallgarten prize, National Academy of Design, 1912; Evans prize, Salma. Club, 1913; bronze medal, Society of Washington Artists, 1913; Vezin prize, Salma. Club, 1914; silver medal for painting and bronze medal for etching, P.-P. Expo., San Francisco, 1915; hon. mention, Connecticut Academy of Fine Arts, 1917; hon. mention, Art Institute of Chicago, 1919; museum purchase prize, Lyme Art Association, 1924; National Academy of Design, 1937; World's Fair, NY, 1939; Associated Artists of Pittsburgh, 1940. Work: "Broadway on a Rainy Evening," Corcoran Gallery, Washington; "A February Day," "Quebec," Penna. Academy of Fine Arts, Philadelphia; "Amsterdam," Erie (PA) Public Library; "December Hillside," Museum of Fine Arts, Syracuse, NY; "Along the River Front, New York," and six etchings, Toledo Art Museum; "The Frozen Brook," Rhode Island School of Design, Providence; "A Mountain Village, Tyrol," City Art Museum, St. Louis; "The Guardian Elm," National Arts Club, New York; "Snowfall in the Woods," Art Institute of Chicago; "Falling Snow," Gibbes Art Gallery, Charleston, SC; "Autumn Afternoon," Oklahoma Art League, Oklahoma City; Boston Museum of Fine Arts; NY Historical Society; others. Has exhibited nationally. Taught: Associate professor, Carnegie Institute, Pittsburgh, PA, 1924-42. Died in 1963. Address in 1962, Westmoreland, NH.

WARNER, GEORGE D.
Engraver. This name is signed to a botanical plate published in the *New York Magazine* for December,

1791. The book-plate of George Warner is signed "Warner sculpt," and is probably the work of this engraver.

WARNER, LILY G. (MRS.).
Painter and illustrator. Born in Hartford, CT. Painted flower-pieces and illustrated for *St. Nicholas Magazine*.

WARNER, MARGARET.
Illustrator and writer. Born in Mabbettsville, NY, Dec. 5, 1892. Pupil of Corcoran School of Art; Abbott School of Art, Washington, DC; NY School of Fine and Applied Art; Berkshire Summer School of Art. Address in 1929, 1624 Eye St., N.W.; h. 3409 Newark St., N.W., Washington, D.C.

WARNER, MARY LORING (MRS.).
Painter. Born in Sheffield, MA, Sept. 2, 1860. Pupil of Frank de Haven; Charles Warren Eaton. Member: Connecticut Academy of Fine Arts; New Haven Paint and Clay Club. Address in 1933, 344 Washington St., Middletown, CT.

WARNER, MYRTLE LOUISE.
Painter, sculptor, illustrator, craftswoman, and teacher. Born in Worcester, MA, June 25, 1890. Address in 1925, Sterling, MA; summer, Cliff Island, ME.

WARNER, NELL WALKER.
Painter. Born in Nebraska, April 1, 1891. Pupil of Paul Lauritz; Los Angeles School of Art and Design. Member: California Art Club; Glendale Art Association; West Coast Artists; Laguna Beach Art Association; Artland Club; California Water Color Society; Women Painters of the West. Awards: Four gold and silver medals, California Eisteddfod, 1925; first prize, Southern California Fair, 1925; prize, Santa Cruz Annual, 1930; first prize, California State Annual, 1931; prize, Phoenix (AZ) Annual, 1931; two awards, Ebell Club, purchase prize, Los Angeles Museum, 1933; others. Represented in Municipal Art Gallery, Phoenix, AZ; Los Angeles Museum. Address in 1933, 2436 Orange Ave., La Crescenta, CA.

WARNER, OLIN LEVI.
Sculptor. Born in Suffield, CT, in 1844. Raised in Amsterdam, NY, and Brandon, VT. Studied in Paris at Ecole des Beaux-Arts, 1869; studio assistant to Augustus Saint-Gaudens. Returned to U.S. in 1872 and opened his studio in NY. Elected an Associate of the National Academy in 1888; also a member of the National Sculpture Society, Society of American Artists, and the Architectural League of New York. Designed silverware and bronze gas fixtures; souvenir half dollar for World's Columbian Exposition in 1893; executed bronze doors for Library of Congress. Represented in collection of the Metropolitan Museum of Art, NYC. His portrait busts of Gov. William

A. Buckingham and William Lloyd Garrison and his statuettes of "Twilight" and the "Dancing Faun" were well known. Died in 1896 in NY.

WARNER, WILLIAM, JR.
Engraver. Born in Philadelphia, PA, about 1813. Warner was a portrait-painter and a self-taught engraver in mezzotint. He made comparatively few plates, but his large plates are fine examples of mezzotint work. Exhibited at the Pennsylvania Academy; Apollo Association; and the Artists' Fund Society. Died in Philadelphia in 1848.

WARNICKE, JOHN G.
Engraver. In 1811-14, and again in 1818, Warnicke was engraving in Philadelphia. The only portrait known is that of Franklin. Died December 29, 1818.

WARR, JOHN.
Engraver. Born c. 1798 in Scotland. There were two men of this name in Philadelphia in 1821-45 working as "general engravers." The older man was seemingly engraving in 1821-28, and the younger man, John Warr, Jr., was engraving in 1825-45. Their work consisted chiefly of vignettes, business-cards, etc., but these were well-engraved. Father of William Warr, born c. 1828, who was also an engraver.

WARR, W. W.
Engraver. This W. W. Warr was a script engraver working in Philadelphia about 1830. He usually signed plates in connection with John Warr as "Engraved by J. & W. W. Warr."

WARREN, A. W.
Marine and landscape painter. Born on a farm in Coventry, NY. He studied under T. H. Matteson and in 1863 was elected an Associate of the National School of Design. At Coventry, NY, 1855, 1857; working in New York City, 1858-60. The Brooklyn Institute owns his "Rocky Shore, Mt. Desert." Died in 1873, probably in New York City.

WARREN, ASA.
Portrait and miniature painter. Flourished about 1846-47 in Boston.

WARREN, ASA COOLIDGE.
Engraver, illustrator and painter. Born March 25, 1819, in Boston, MA. Son of Asa Warren, a portrait and miniature painter. Was apprenticed in 1833 to Bigelow Brothers, jewelers, of Boston. Showing an inclination toward engraving, he was placed with the Boston engraver George G. Smith. At the end of his apprenticeship, Warren spent another year with Joseph Andres and he became a reputable line-engraver of vignettes and book illustrations. Employed by New England Bank Note Co. and the Boston publishers, Ticknor & Field. Abandoned engraving for about five years, and in this interval he

drew upon wood for other engravers. In 1863 Mr. Warren moved to NY and engraved for the Continental Bank Note Co. and book publishers. In June, 1899, he lost the sight of one eye and was compelled to abandon his profession. He occupied his later years in painting. Died Nov. 22, 1904, in NYC.

WARREN, CHARLES BRADLEY.
Sculptor. Born in Pittsburgh, PA, December 19, 1903. Studied: Carnegie Institute; Beaux-Arts Institute of Design. Member: Architectural League; Associated Artists of Pittsburgh; Society of Sculptors, Pittsburgh. Awards: Prize, Carnegie Institute, 1936, 41. Work: North Carolina State College; Greek Catholic Seminary, Pittsburgh; Department of Justice, Raleigh, NC; County Building, High Point, NC; Stevens School, Pittsburgh; Scott Township School, PA; Stephen Foster Memorial medal; St. Athanasius Church, West View, PA; Kaufmann tablet, Pittsburgh. Exhibited: Associated Artists of Pittsburgh, 1930-41, 50, 52; Architectural League, 1940-42; Society of Sculptors, Pittsburgh, 1935-45, 50, 51; National Sculpture Society, 1952. Address in 1953, Pittsburgh, PA.

WARREN, CONSTANCE WHITNEY.
Sculptor and poster artist. Born in NYC, 1888. Began designing and sketching posters. Exhibited: Many times at the Paris Salon, and won numerous honorable mentions there. Noted for her modeling of horses and dogs. In 1926, she produced a life-size equestrian statue of a cowboy for the State Capitol in Oklahoma City. Work in collection of Metropolitan Museum of Art, NYC. Died in Paris, France, 1948.

WARREN, DUDLEY THOMPSON.
Sculptor. Born in East Orange, NJ, Febuary 17, 1890. Member: Richmond Academy of Arts. Work: "Age of Endearment," Church Home and Infirmary of the City of Baltimore, MD. Address in 1933, Roanoke, VA.

WARREN, ELISABETH B(OARDMAN).
(Mrs. Tod Lindenmuth). Painter, illustrator and etcher. Born in Bridgeport, CT, Aug. 28, 1886. Studied: Massachusetts School of Art; Vesper George School of Art; pupil of W. H. W. Bicknell; Charles Simpson in England. Member: Provincetown Art Association; Copley Society; St. Augustine Art Club; Palm Beach Art League; Rockport Art Association. Awards: Prizes, Florida Federation of Arts. Exhibited: Chicago Society of Etchers; Society of American Etchers; California Printmakers; St. Augustine Art Association; Rockport Art Association; Palm Beach Art League; Society of Four Arts; Philadelphia Art Alliance; others. Illustrated school readers for Ginn & Co.; Silver, Burdett & Co. Illustrated story books for Lothrop, Lea and Shepard; Bobbs Merrill; Pilgrim Press. Specialties: Etchings and dry points. Address in 1953, Aviles Street, St. Augustine, FL; Rockport, MA; h. St. Augustine, FL.

WARREN, FERDINAND E.
Painter. Born in Independence, MO, Aug. 1, 1899. Member: Kansas City Society of Artists; L. C. Tiffany Artists Guild. Award: Bronze medal, Kansas City Art Institute, 1923; bronze medal for illustrations, Grand Central School of Art, 1928. Address in 1933, 10 Hooga Studios, 51 Poplar St., Brooklyn, NY.

WARREN, HAROLD B(ROADFIELD).
Landscape painter, illustrator, and craftsman. Born in Manchester, England, Oct. 16, 1859. Pupil of Charles H. Moore and Charles Eliot Norton at Harvard University. Member: Copley Society, 1891; Boston Society of Architects (associate); Boston Society of Water Color Painters; American Federation of Arts; Boston Society of Arts and Crafts (master). Specialty: Water color. Work: "The Parthenon," "The Propylaea," "Aegina from the Parthenon" and "Northwest Corner of the Parthenon," Boston Museum of Fine Arts; "The Parthenon," Cleveland Art Museum. Instructor in water color, School of Architecture, Harvard University. Died in 1934. Address in 1933, 8 Craigie Circle, Cambridge, MA.

WARREN, H(ENRY).
Painter. Born c. 1793 in England. Worked in Philadelphia from c. 1822 to 1860, or after. In the exhibition held in 1847 at the Penna. Academy of Fine Arts, in Philadelphia, "View on the Delaware near Trenton Bridge" is noted as for sale by the artist, "H. Warren." He also exhibited at the Artists' Fund Society and the Apollo Association. A view of the Washington Monument was engraved after a drawing by "H. Warren."

WARREN, HENRY.
According to an advertisement appearing in the *Virginia Gazette* for the year 1769, "Henry Warren, limner who is now at Williamsburg has had the satisfaction of pleasing most gentlemen who have employed him."

WARRICK, META VAUX.
(Mrs. Fuller). Sculptor, illustrator, craftsman, teacher and lecturer. Born in Philadelphia, PA, June 9, 1877. Studied at the Philadelphia Museum School of Industrial Art, with Paul Lachenmeyer; Penna. Academy of Fine Arts, with C. Grafly; Colarossi Academy, Paris; pupil of Collin, Carles, Injalbert, Gauqui, and Rodin. Member: Alumni Association, Philadelphia School of Industrial Art; Fellowship Penna. Academy of Fine Arts; Boston Art Club. Represented in Cleveland Art Museum; New York Public Library. Exhibited at Cleveland Art Museum; San Francisco Museum of Art; New York Public Library. Address in 1953, 31 Warren Road, Framingham, MA.

WARSAW, ALBERT T(AYLOR).
Painter and illustrator. Born in New York, Oct. 6, 1899. Pupil of National Academy of Design. Address

in 1933, 333 Seventh Avenue, New York; 3532 157th Street, Flushing, Long Island, NY.

WARSHAWSKY, ABRAHAM (or ABEL) GEORGE.
Painter. Born in Sharon, PA, Dec. 28, 1883. Pupil of Mowbray and Loeb in NY; Winslow Homer. Member: American Art Association of Paris; Salon d'Automne; Cincinnati Art Club; Salma. Club; American Artists Professional League. Chevalier of the Legion of Honor of France. Work: Mural decoration, "The Dance," Rorheimer and Brooks Studios, Cleveland, OH; Cleveland Museum of Art; Minneapolis Art Institute; drawings, Art Institute of Chicago; Corcoran; Luxembourg Museum and Petit Palais, Paris; others. Exhibited: National Academy; Penna. Academy of Fine Arts; Carnegie Institute; Salon d'Automne; American Art Association; Reinardt Gallery, 1938. Address in 1933, 7 rue Antoine Chantin, Paris, France. Died May 30, 1962, in California.

WARSHAWSKY, XANDER (or ALEXANDER).
Painter. Born in Cleveland, OH, March 29, 1887. Pupil of National Academy of Design. Member: American Art Association of Paris; Group X. Y. Z., Paris. Work: "Overlooking the Mediterranean," Cleveland Museum; "La Gaude," Los Angeles Museum. Address in 1933, 16 Villa Seurat, Paris, France.

WARTHEN, FEROL SIBLEY.
Painter and block printer. Born May 22, 1890. Studied at Columbus School of Art; Art Students League, 1911-13; and with W.M. Chase, K.H. Miller, K. Knaths, and B. Lazzell.

WARTHOE, CHRISTIAN.
Sculptor and writer. Born in Salten, Denmark, June 15, 1892. Studied at the Royal Academy of Fine Arts, Copenhagen, Denmark; Minneapolis School of Art; Art Students League; Beaux-Arts Institute of Design. Member: National Sculpture Society; American Veterans Society of Arts. Work: Grand View College, Des Moines, IA; in Denmark and Germany; memorial, Chicago, IL. Exhibited: American Veterans Society of Arts; National Sculpture Society; National Academy of Design; Sculptors Guild. Contributor to Danish American Press. Address in 1953, Chicago, IL. Died in 1970.

WARWELL.
"Limner." Came to Charleston, SC, from London in 1765. Died in Charleston, May 29, 1767.

WARWICK, EDWARD.
Painter, craftsman, lecturer, and teacher. Born in Philadelphia, PA, Dec. 10, 1881. Pupil of J. Frank Copeland and Charles T. Scott. Member: Philadelphia Sketch Club; Art Alliance of Philadelphia; Philadelphia Print Club; Philadelphia Water Color Club. Address in 1929, School of Industrial Art, Broad and Pine Streets; h. 222 West Hortter St., Germantown, Philadelphia, PA.

WARWICK, ETHEL HERRICK (MRS.).
Painter. Born in New York, NY. Pupil of W. M. Chase; Fred Wagner; Hugh Breckenridge; H. B. Snell. Member: Plastic Club; Art Alliance of Philadelphia; Fellowship Penna. Academy of Fine Arts; Philadelphia Print Club; Philadelphia Water Color Club. Address in 1933, 222 West Hortter St., Germantown, Philadelphia, PA.

WASEY, JANE.
Sculptor. Born in Chicago, IL, June 28, 1912. Studied with Simon Moselsio and John Flanagan in NY; with Paul Landowski in Paris; and with Heinz Warneke in Connecticut. Awards: Lighthouse Exhibition, NY, 1951; National Association of Women Artists, 1951; Guild Hall, East Hampton, Long Island, 1949-56; Architectural League, 1955; Parrish Art Museum, Southampton. Collections: Whitney Museum of American Art; Penna. Academy of Fine Arts; University of Nebraska; Arizona State University, Tempe; University of Colorado; City Art Museum of St. Louis. Exhibitions: Art Institute of Chicago; Brooklyn Museum; Detroit Institute of Arts; Philbrook Art Center (one-woman); Kraushaar Galleries, NYC, 1956, 71 (one-woman); others. Member: National Sculpture Society; National Association of Women Artists; Audubon Artists; Sculptor's Guild. Address in 1982, Lincolnville, ME.

WASHBURN, CADWALLADER.
Painter, etcher, and writer. Born in Minneapolis, MN, October 31, 1866. Pupil of architecture of Massachusetts Institute of Technology, Boston; Art Students League of NY; Mowbray and Chase in NY; Sorolla in Spain; Besnard in Paris; Gallaudet College, B.A., D.Sc.; Bowdoin College, L.H.D. Member: National Arts Club; Washington Art Club; American Federation of Arts; American Artists Professional League; Associate National Academy of Design; others. Awards: Second prize, American Art Association of Paris; gold medal, P.-P. Expo., San Francisco, 1915. Work: Luxembourg Museum, Bibliotheque Nationale, Paris; Victoria and Albert Museum, British Museum, London; Rijksmuseum, Amsterdam; Metropolitan Museum of Art; NY Public Library; Museum of Fine Arts of Houston; Library of Congress; others. Exhibited: Massachusetts Institute of Art; M. H. de Young Memorial Museum; Atlanta Art Association; Bowdoin College; others. Died in 1965. Address in 1962, Brunswick, ME.

WASHBURN, KENNETH (LELAND).
Painter and educator. Born in Franklinville, NY, January 23, 1904. Studied at Cornell University,

B.F.A., M.F.A. Member: American Water Color Society. Awards: Prizes, Cortland County (NY) State Exhibition, 1945; Finger Lakes Exhibition, Auburn, NY, 1944. Work: Springfield (IL) Museum of Art; Binghamton (NY) Museum of Art; IBM Collection; murals, plaque, U.S. Post Office, Binghamton, NY; Moravia, NY. Exhibited: Texas Centennial, 1934; New York World's Fair, 1939; National Academy of Design, 1942-44; American Watercolor Society, 1942-45; Penna. Academy of Fine Arts, 1940, 41, 46; Rochester Memorial Art Gallery, 1943-46; Finger Lakes Exhibition, 1941-46; etc. Positions: Instructor of fine arts, 1928-34, assistant professor of fine arts, 1934-44, associate professor of art, 1944-50, Cornell University, Ithaca, NY; San Mateo Jr. College, San Mateo, CA, from 1950. Address in 1953, San Carlos, CA.

WASHBURN, MARY N(IGHTINGALE).
Painter. Born in Greenfield, MA, 1861. Pupil of D. W. Tryon; H. G. Dearth; Smith College Art School; Art Students League of NY. Member: Springfield Art League; National Association of Women Painters and Sculptors. Address in 1929, 451 Main St., Greenfield, MA.

WASHBURN, MARY S.
Sculptor. Born in Star City, IN. Pupil of Art Institute of Chicago; Edwin Sawyer in Paris. Awards: Bronze medal, P.-P. Expo., San Francisco, 1915. Work: "Statue of Gen. Milroy," Milroy Park, Rensselaer, IN; medal in Carnegie Institute, Pittsburgh, PA; memorial to Lt. Joseph Wilson, Logansport, IN; monument, Waite Memorial, Rock Creek, Washington, DC; character sketch medallions, Berkeley League of Fine Arts; bust of Dr. Byron Robinson, Medical Library, Chicago. Address in 1929, 2321 Haite St., Berkeley, CA.

WASHBURN, MRS.
Painter. Daughter of the miniature painter George Munger of New Haven. Produced a few very delicate miniature portraits on ivory.

WASHBURN, ROY E(NGLER).
Painter. Born in Vandalia, IL, Jan. 10, 1895. Pupil of Duveneck; Meakin; J. R. Hopkins. Member: Cleveland Society of Artists. Address in 1933, Room 424, 910 S. Michigan Ave., Chicago, IL; 809 Judson St., Evanston, IL.

WASHINGTON, ELIZABETH FISHER.
Landscape and miniature painter. Born in Siegfried's Bridge, PA. Studied: Penna. Academy of Fine Arts; Philadelphia Museum School of Industrial Art; pupil of Hugh Breckenridge and Fred Wagner. Member: American Water Color Society; Fellowship Penna. Academy of Fine Arts; Plastic Club; Art Alliance of Philadelphia; Pennsylvania Society of Miniature Painters; North Shore Arts Association.

Awards: Prizes, Penna. Academy of Fine Arts, 1912, 17, 34; Fellowship prize, Penna. Academy of Fine Arts, 1917; Springville, UT, 1927. Represented in Fellowship Penna. Academy of Fine Arts Collection, Philadelphia; Pierce Business College, Philadelphia; Smith College, Northampton, MA; New Century Club, Philadelphia; Municipal Collection, Trenton, NJ; High School Collection, Springville, UT; Philadelphia Museum of Art; Allentown (PA) Gallery. Exhibited: Carnegie Institute, 1920-22; Penna. Academy of Fine Arts, 1918-42, 44; Corcoran; National Academy of Design, 1930; City Art Museum, St. Louis; Pan.-Pacific Expo., 1915; Art Alliance of Philadelphia; American Federation of Arts; Plastic Club; Philadelphia Sketch Club; others. Address in 1953, 1714 Chestnut St.; h. 214 South 43rd St., Philadelphia, PA.

WASHINGTON, JAMES W., JR.
Painter and sculptor. Born in Gloster, MI, November 10, 1909. Studied painting privately with Mark Tobey in Seattle; National Landscape Institute; graduate, Theological Union Center of Urban Black Studies, Berkeley, CA. Works: Oakland Art Museum; San Francisco Museum of Art; Seattle Art Museum; Seattle Public Library; others. Exhibitions: Vicksburg (MI), YMCA; Hall-Coleman Gallery, Seattle; National Collection of Fine Arts, Washington, DC; Lee Nordness Gallery, NYC, 1962; Frye Art Museum, Seattle; Expo '70, Osaka, Japan; Museum of History and Industry, Seattle (one-man); others. Awards: San Francisco Museum of Art; Oakland Art Museum, 1957; Seattle World's Fair, 1962, second prize; Governor's Sculpture Award, 1970. Member: Sculptors Institute. Changed from painting to sculpture in 1956. Media: Marble, granite; tempera, oil. Address in 1982, Seattle, WA.

WASSON, GEORGE SAVARY.
Painter and author. Born in Groveland, MA, in 1855. He began his career as a marine artist in Boston and built a house and studio at Kittery Point, ME, 1889, in order to study the sea. Author: *Cap'n Simeon's Store*, 1903; *The Green Shay*, 1905; *Home from the Sea*, 1908. Contributor to leading magazines. Address in 1926, Kittery Point, ME.

WATERMAN, MARCUS.
Painter. Born Sept. 1, 1834, in Providence, RI. Worked in NY, 1857-70. Visited Algiers, 1879-83. He exhibited at Centennial, Philadelphia, 1876. Principal works: "Fountain, Algiers;" "Arab Girl;" "Roc's Egg" (1886); "Journey to the City of Brass" (1888); also numerous American forest scenes and Arabian subjects. He was an Associate of the National Academy. Died April 2, 1914, in Moderno, Italy.

WATERS, GEORGE FITE.
Sculptor and teacher. Born in San Francisco, CA, October 6, 1894. Pupil of Elwell of Art Students

League of New York; Rodin in Paris; also studied in Italy and London. Member: American Art Association of Paris; Societe Moderne; Societe des Artistes Landais. Work: Portrait of President Cosgrave, Dublin Art Gallery; "Valdimir Rosing," Eastman School of Music, Rochester, NY; "Dr. Gordon Hewitt," Ottawa National Gallery; statue of Abraham Lincoln, Portland, OR; "James K. Hackett," University of New York; "Capt. Sir Bertram Towse, V. C.," St. Dustan's, London; statue, "John Brown," John Brown Memorial State Park, Osawatomie, KS; bust, "Pirandello," Osso Films, Inc.; bust, "Gen. John J. Pershing," owned by French Government; others. Received honorable mention, Salon des Artistes Francais, 1932. Address in 1933, Hossegor (Landes), France. Died in 1961.

WATERS, GEORGE W.
Painter. Born in Coventry, Chenango Co., NY, in 1832. He studied art in NY and later in Dresden and Munich. He exhibited a landscape, "Franconia Notch," in 1876, at the Centennial Exhibition. His portrait of Joseph Jefferson as "Rip Van Winkle" attracted much attention; he also painted three portraits of Walt Whitman. Art director for many years at Elmira College, NY. He died in Elmira in 1912.

WATERS, R. KINSMAN.
Painter, craftsman, and teacher. Born in Columbus, OH, July 21, 1887. Member: NY Water Color Club. Address in 1933, 1241 Lincoln Road, Columbus, OH.

WATKINS, CATHERINE W. (MRS.).
Painter, lecturer and writer. Born in Hamilton, Ontario. Pupil of Art Institute of Chicago; Dauchez, Simon, Menard, Miller in Paris; Brangwyn in London. Member: National Association of Women Painters and Sculptors; International Art Union, and American Women's Art Association, Paris. Address in 1933, Hershey Arms Hotel, 2600 Wilshire Blvd., Los Angeles, CA.

WATKINS, FRANKLIN CHENAULT.
Painter. Born in NY, NY, Dec. 30, 1894. Studied: University of Virginia; University of Pennsylvania; Penna. Academy of Fine Arts; Whitney; Museum of Modern Art; Corcoran; Smith College; murals, Rodin Museum, Philadelphia. Exhibited at Penna. Academy of Fine Arts, Philadelphia, 1924. Taught: Painting, Penna. Academy of Fine Arts. Address in 1970, Harvey Cedars, NJ. Died in 1972.

WATKINS, SUSAN.
Painter. Born in California in 1875. Pupil of Art Students League, NY, and of Collin in Paris. She received honorable mention in the Paris Salon of 1889 and third gold medal in the Salon of 1901. Her painting entitled "The Fan" was well known.

WATKINS, WILLIAM REGINALD.
Designer, painter, lithographer and teacher. Born in Manchester, England, Nov. 11, 1890. Studied: Maryland Institute; pupil of C. Y. Turner, Edward Berge, Hans Schuler, Maxwell Miller. Member: Charcoal Club; Alumni Association, Maryland Institute; Baltimore Water Color Club; Baltimore Art Directors' Club; others. Exhibited: Peabody Gallery, 1916-24; Penna. Academy of Fine Arts, 1930; Baltimore Museum of Art, 1927-33; Municipal Museum, Baltimore, 1941-45; Maryland Institute (one-man); Baltimore Water Color Club, 1950-52; Grand Central Art Galleries; Baltimore Charcoal Club (one-man); others. Work in the Univer. of Maryland. Instructor: Maryland Institute; University of Maryland. Address in 1953, 3120 Weaver Avenue, Baltimore, MD.

WATROUS, ELIZABETH SNOWDEN NICHOLS.
Painter and writer. Wife of the painter Harry W. Watrous. She was born in NY in 1858. Member: Pen and Brush Club; NY Woman's Art Club; Soc. of Women Painters and Sculptors; Professional Women's League. Died on Oct. 4, 1921, in NYC.

WATROUS, HARRY W(ILLSON).
Painter. Born in San Francisco, CA, Sept. 17, 1857. Pupil of Bonnat, Boulanger and Lefebvre in Paris. Member: Associate National Academy of Design, 1894; Academician National Academy of Design, 1895; Society of American Artists, 1905; Artists' Aid Society; Lotos Club; Century Association; National Arts Club; Salma. Club; Society of Painters, NY; American Federation of Arts. Awards: Clarke prize, National Academy of Design, 1894; bronze medal, Pan.-Am. Expo., Buffalo, 1901; special commemorative gold medal, St. Louis Expo., 1904; first Altman prize, $1,000, for figure, National Academy of Design, 1929; medal, National Arts Club, 1931; Carnegie prize, National Academy of Design, 1931. Work: "Passing of Summer," Metropolitan Museum, NY; "A Vision of Love," Montpelier (VT) Museum; "A Study in Black," City Art Museum, St. Louis; "An Auto Suggestion," Buffalo Fine Arts Academy; "The Drop Sinister," and "Moon Lace," Portland (ME) Museum; "A Couple of Girls," Brooklyn Museum; "Three Goats," Fort Worth Museum; "Portrait of My Mother," Corcoran Gallery, Washington, DC. Served as president of the National Academy of Design, 1933. Address in 1933, 58 West 57th St.; h. 17 East 89th St., NY, NY; summer, Hague, Warren Co., NY.

WATSON, ADELE.
Painter. Born in Toledo, OH, April 30, 1873. Pupil of Art Students League of NY and Raphael Collin in Paris. Member: Pen and Brush Club; National Association of Women Painters and Sculptors; Society of Independent Artists. Died in 1947. Address in 1933, 283 South Grand Avenue, Pasadena, CA.

WATSON, AMELIA MONTAGUE.

Painter, illustrator, and teacher. Born in East Windsor Hill, March 2, 1856. Member: Southern States Art League. Specialty: Southern scenery. Cover and frontispiece in color for *The Carolina Mountains*, by Margaret W. Morley; color illustrations for Thoreau's *Cape Cod; Thousand Mile Walk to the Gulf*, by John Muir. Exhibited at the American Water Color Society; New York Water Color Club; Boston Art Club. Taught at Martha's Vineyard Summer Institute for many years. Died in 1934. Address in 1933, "Wild Acres," East Windsor Hill, CT.

WATSON, CHARLES R.

Painter. Born in Baltimore, MD, in 1857. He was a member of the Baltimore Water Color Club and specialized in marine painting. Died in 1923.

WATSON, DUDLEY CRAFTS.

Painter, teacher, writer and lecturer. Born in Lake Geneva, WI, April 28, 1885. Studied: Art Institute of Chicago; Beloit College, B.F.A.; in Madrid and Valencia, Spain, and in Paris and London; pupil of Sorolla and Sir Alfred East. Member: Wisconsin Painters' and Sculptors' Society; Cliff Dwellers Club, Chicago; Tavern Club, Chicago; Chicago Art Club; associate, Boston Guild of Artists; Chicago Society of Artists; Chicago Water Color Club. Awards: First prize, water color, Art Students League, Chicago, 1907; hon. mention for water colors, Art Institute of Chicago, 1911; hon. mention, Wisconsin Painters and Sculptors, 1922; Florence B. Fawcett prize for flower painting, Milwaukee Art Institute, 1923; Art Institute of Chicago, 1926. Exhibited at Art Institute of Chicago, annually; Grand Central Art Galleries. Work: "Monsalvat" and "Hollyhocks," Milwaukee Art Institute; "Parliament Tower, London," Burlington (IA) Public Library; "Flower Panels," Public High School, Milwaukee, WI, La Mars, IA; "Marines," Milwaukee Yacht Club; "Delphinium," Layton Art School, Milwaukee; others. Author: *Nineteenth Century Art; Twentieth Century Art; History of Interior Decoration for Delphian Society*. Art editor, Milwaukee *Journal*, for five years. Originator of the Music-Picture Symphonies; official director of pageantry, City of Milwaukee, 1914-1920; director, Milwaukee Art Institute, 1914-1924; educational director of Minneapolis Institute of Arts, 1922-1923; Rockford (IL) Art Club, 1923-25; Springfield (IL) Art Association; director of art education, Minnesota State Fair, 1915-29; lecturer on art, St. Paul Institute, 1920-21; lecturer, Art Institute of Chicago, 1926-55, special lecturer, 1955-60; official art lecturer, Century of Progress Exposition, 1933. Conductor of art pilgrimages to Europe each year. Address in 1962, Highland Park, IL.

WATSON, ELIZABETH H.

Painter. Pupil of Penna. Academy of Fine Arts. Member: Fellowship Penna. Academy of Fine Arts. Award: Mary Smith prize, Penna. Academy of Fine Arts, 1896. Address in 1933, 126 South 18th St., Philadelphia, PA.

WATSON, ELIZABETH V. TAYLOR.

Painter. Born in New Jersey. Pupil of Tarbell; DeCamp; Boston Museum of Fine Arts School. Member: Copley Society; Connecticut Academy of Fine Arts; Gloucester Society of Artists; Duxbury Artists. Awards: Bronze medal, Tennessee Centennial Expo., Nashville, 1897; hon. mention, Springfield Art League. Address in 1933, 404 Fenway Studios, Ipswich St., Boston, MA; summer, Clark's Island, Plymouth, MA.

WATSON, ERNEST W.

Illustrator, lecturer, and teacher. Born in Conway, MA, Jan. 14, 1884. Pupil of Massachusetts Art School, Boston; Pratt Institute, Brooklyn. One of the founders and directors of The Berkshire Summer School of Art. Instructor and supervisor at Pratt Institute. Member: Print Makers' Society of California; American Institute of Graphic Arts; Boston Society of Arts and Crafts. Specialty: Block prints in color. Address in 1929, Pratt Institute; h. 181 Emerson Place, Brooklyn, NY; summer, "Greywold," Monterey, MA.

WATSON, EVA AULD.

Painter, illustrator, and craftsman. Born in Texas, April 4, 1889. Studied: Pittsburgh School of Design; Pratt Institute, Brooklyn; pupil of M. O. Leisser. Member: Boston Society of Arts and Crafts. Award: Hon. mention, P.-P. Expo., San Francisco, 1915. Author: *Coptic Textile Motifs*. Address in 1929, 181 Emerson Place, Brooklyn, NY; summer, Monterey, MA.

WATSON, HENRY S(UMNER).

Illustrator. Born in Bordentown, NJ, 1868. Pupil of Thomas Eakins in Philadelphia; Laurens in Paris. Member: Society of Illustrators, 1904. Specialty: Outdoor subjects. Address in 1929, 2 East 12th Street, New York, NY.

WATSON, JESSIE NELSON.

Painter. Born in Pontiac, IL, in 1870. Address in 1926, 1004 Chemical Building, St. Louis, MO.

WATSON, JOHN.

Painter. Born on July 28, 1685, in Scotland. Came to the Colonies in 1714/15 and set up his easel in the capital of New Jersey, Perth Amboy. William Dunlap, in his *History of the Arts of Design*, Vol. 1, devotes four pages to the career of the artist John Watson. In 1731 Watson painted his portrait of Sir Peter Warren, who through his marriage into the de Lancey family had connections living in Perth Amboy, NJ, the home of the artist. This portrait was exhibited at the Union League Club, NY, in 1925. Died Aug. 22, 1768, in New Jersey.

WATSON, MINNIE.
Painter. She was a pupil of D. W. Tryon in Hartford, Connecticut, in 1875. Later she studied in NY. Painted excellent still-life subjects true in line and color.

WATT, BARBARA HUNTER.
Painter, illustrator, etcher, block printer, teacher, lecturer, and writer. Born in Wellesley, MA. Pupil of Albert H. Munsell; V. L. George; J. De Camp; D. J. Connah. Member Brush and Chisel Club; Springfield Art League; Springfield Artists Guild; Wellesley Art Association; Baltimore Water Color Club; Alumni Association of the Massachusetts Normal Art School; Copley Society. Work: Mural decoration, "Pan," Massachusetts Art School, Boston; Public Library Branch, Wellesley, MA. Address in 1933, 39 Grantland Road, Wellesley Hills, MA.

WATT, WILLIAM G.
Wood engraver. Born in New York in 1867. Pupil of E. Heinemann; Emile Clement; National Academy of Design. Member of Salma. Club in 1903. Work: "The Harvest," after L'Hermitte; "The Pool," after own painting; "A Music Party," after Metsu; "The Trousseau," by C. W. Hawthorne; "Magnolia," by J. J. Shannon. Work represented in New York Public Library; Carnegie Institute, Pittsburgh; Public Library, Newark, NJ; Metropolitan Museum Library, NY; Salma. Club. Elected an Associate of the National Academy in 1922. Died in New York in 1924.

WATTS, JAMES W.
Engraver. Born in 1895. About 1850 Watts was a line-engraver of landscape in Boston. He later etched some portraits and was also a banknote engraver. He died March 13, 1895, in West Medford, MA.

WATTS, WILLIAM CLOTHIER.
Painter. Born in Philadelphia, PA. Pupil of Penna. Academy of Fine Arts. Member: Fellowship Penna. Academy of Fine Arts; Philadelphia Sketch Club; Philadelphia Water Color Club; California Water Color Society. Address in 1933, Carmel, Monterey Co., CA.

WAUGH, ALFRED S.
Portrait sculptor, portrait and miniature painter, profiler writer, and lecturer on the fine arts. Born in Ireland. Studied modelling in Dublin in 1827; toured Europe. Working in Baltimore, MD, by 1833; in Raleigh, NC, 1838; Alabama, 1842; Pensacola, FL, 1843; Mobile, AL, 1844; Missouri from 1845; visited Santa Fe, 1846; moved to St. Louis in 1848. Died in St. Louis, MO, on March 18, 1856.

WAUGH, COULTON.
Painter, cartoonist, lithographer, engraver, educator, lecturer, and writer. Born in St. Ives, Cornwall County, England, March 10, 1896. Studied: Art Students League; pupil of George Bridgman, Douglas Volk, Frederick J. Waugh, and Frank DuMond. Member: Boston Society of Arts and Crafts; Beachcombers Club. Exhibited: Penna. Academy of Fine Arts; National Academy of Design; Carnegie Institute; Golden Gate Expo., 1939; Provincetown Art Association. Work: Marine drawings and maps reproduced in *Country Life, House Beautiful, House and Garden, American Home, American Sketch, Harper's,* and others; mural, "New York and Long Island in Days of the Revolution," New York Board of Education; drawing, "Principal Rigs of Deep Water Sailing Ships," Peabody Museum, Salem, MA; map of "Old Cape Cod," Memorial Hall, Plymouth, MA; maps in National Geographic Society and in many libraries; Toledo Museum of Art; Wave Crest on the Hudson Museum, Hyde Park, NY; Davenport Municipal Art Gallery; Syracuse Univer., Coulton Waugh Collection; Cooperstown Art Association. Author and illustrator of the comic strip *Dickie Dare.* Taught: Bethlehem Art Center; Cornwall (NY) Central School; Orange County Community College; Storm King Art Center, Cornwall, NY; Art Instruction Schools, Minneapolis, MN. Address in 1970, Newburgh, NY. Died in 1973.

WAUGH, FREDERICK J(UDD).
Painter and illustrator. Born in Bordentown, NJ, September 13, 1861. He was the son of Samuel B. Waugh, portrait painter, and Mary Eliza Young Waugh. Pupil of the Penna. Academy of Fine Arts, Philadelphia; Julian Academy, Paris. He resided at various places in Europe between 1892-1907. Member: Associate National Academy of Design, 1909; Academician National Academy of Design, 1911; Royal Academy of the West of England, Bristol; Salma. Club, 1908; National Arts Club; Lotos Club; Connecticut Academy of Fine Arts; Fellowship Penna. Academy of Fine Arts; Boston Art Club; North Shore Arts Association; American Federation of Arts; Washington Art Club. Illustrated for *Graphic* and London papers and exhibited in the Salon, Paris, previous to 1892, and later in the Royal Academy in London. Awards: Clarke prize, National Academy of Design, 1910; gold medal, Buenos Aires Expo., 1910; $100 prize, Boston Art Club; Harris bronze medal and $300, Art Institute of Chicago, 1912; prize ($100), Connecticut Academy of Fine Arts, 1915; silver medal, P.-P. Expo., San Francisco, 1915; gold medal, Philadelphia Art Club, 1924; Palmer Memorial prize, $1,000, National Academy of Design, 1929. Work: "Roaring Forties" and "The Great Deep," Metropolitan Museum, NY; "The Coast," Museum of Art, Toledo, "Breakers at Floodtide," Butler Art Institute, Youngstown, OH; "After a Northeaster," "Knight of the Holy Grail," and "Southwesterly Gale, St. Ives," National Gallery, Washington, DC; "Under the Full Moon," Brooklyn Institute Museum; "Evening, Coast of Maine," Art

Museum, Montclair, NJ; "The Outer Surf" and "Surf and Fog, Monhegan," Art Institute of Chicago; "The Blue Gulf Stream," Penna. Academy of Fine Arts, Philadelphia; "Surf and Headlands," Currier Gallery, Manchester, NH. Also represented by paintings in the Bristol Academy, England; Wave Crest on the Hudson Museum, Hyde Park, NY; Museum of Modern Art; Delgado Art Museum, New Orleans; Walker Art Gallery, Liverpool; Durban Art Gallery, Natal, South Africa; Dallas Art Association; Austin (TX) Art League; City Art Museum, St. Louis. His work consists chiefly of marines. Author of *The Clan of Munes*. Address in 1933, Kent, CT; 74 Commercial Street, Provincetown, MA. Died in 1940.

WAUGH, IDA.
Painter. Born in Philadelphia, PA. Daughter of Samuel B. Waugh. Pupil of Penna. Academy of Fine Arts, Philadelphia; in Paris at L'Academie Julien and L'Academie Delecluse, 1880 and 1891-92. Principal painting, "Hagar and Ishmael." Received the Norman W. Dodge prize, National Academy of Design for portrait of Dr. Paul J. Sartain, 1896. Exhibited in Paris Salon; World's Fair (Chicago), 1893; New York; Philadelphia; California; Cincinnati; and other places. Member of Historical Society of Pennsylvania; Penna. Academy of Fine Arts. Died Jan. 25, 1919 in NYC.

WAUGH, (MARY) ELIZA YOUNG.
Miniature painter. Married the artist Samuel B. Waugh and was the mother of Frederick J. Waugh.

WAUGH, SAMUEL BELL.
Portrait painter. Born in Mercer, PA, in 1814. Studied drawing while a boy under J. R. Smith, Philadelphia; also studied the works of the old masters in Italy, Paris and England, without a teacher. Spent eight years in Italy prior to 1841. After this he lived mainly in Philadelphia, where he was one time the president of the Artists' Fund Society; also an Associate (1845), and an Honorary Member, Professional (1847) of the National Academy of Design, NY. Working in New York City, 1844-45; Bordentown, NJ, 1853. His Italian panorama was exhibited in Philadelphia in 1849 until as late as 1855. Represented in the Wave Crest on the Hudson Museum, Hyde Park, NY. Died in 1885 in Janesville, WI.

WAUGH, SIDNEY.
Sculptor and designer. Born in Amherst, MA, January 17, 1904. Studied: Amherst College; MIT; Ecole des Beaux-Arts, Paris; American Academy in Rome. Member: Academician National Academy of Design (vice-president, 1952-54); National Sculpture Society (president, 1948-50); Century Association; National Arts Club; National Institute of Arts and Letters. Awards: Paris Salon, 1928, 29; Prix de Rome, 1929; Saltus award, American Numismatic Society, 1954;

others. Work: Metropolitan Museum of Art; Victoria & Albert Museum, London; Cleveland Museum of Art; Toledo Museum of Art; Art Institute of Chicago; Herron Art Institute; monument, Richmond, TX; Corning Building, NY; Smith College; Buhl Planetarium, Pittsburgh, PA; Federal Trade Commission Building, Washington, DC; Department of Justice Building, Washington, DC; Mellon Memorial fountain, Washington, DC; battle monument, Florence, Italy, and others; portrait statues, Johns Hopkins University; Parsons School of Design; American Institute of Architects; others. Author: *The Art of Glassmaking*, 1938. Address in 1962, 101 Park Ave., New York, NY. Died in 1963.

WAWRYTKO, MARY FRANCES.
Painter and sculptor. Born in Sandusky, OH, April 28, 1950. Studied: Cleveland Institute of Art in sculpture and enameling, B.F.A. Studied lost wax bronze casting under Ron Dewey at the Studio Foundry in Cleveland. Exhibitions: Cleveland Natural History Museum's Art Society, 1978; three-person exhibit at Wichita Art Association, 1979; two-woman exhibit at Women's City Club, Cleveland, 1978; 45th Annual National Sculpture Society Show, 1978; Ohio Invitational Enameling Exhibition. Awards: Purchase prize for sculpture, Butler Institute of American Art Annual Ceramic and Sculpture Show, 1977, 78; Nancy Hine Dunn Memorial Scholarship Award, Cleveland Institute of Art, 1977; sculpture prize, Massillon Museum, 1978. Permanent collections: Butler Institute of American Art, Youngstown, OH; numerous religious institutions and private collections. Member: New Organization of Visual Art, OH; Ohio Designer Craftsmen; Natural History Art Society, OH; Artists Equity; American Crafts Council; Society of Animal Artists. Expeditions: Study and travel in Europe. Specialties: Reviving the lost art of enameling on specially alloyed bronze castings (from the Ming and Ching Dynasties 15th-17th c.). Media: Bronze and terracotta; enamel on copper. Address in 1983, Cleveland, OH.

WAXMAN, FRANCES S.
See Sheafer, Frances Burwell.

WAY, ANDREW JOHN HENRY.
Painter. Born in Washington, D.C., April 27, 1826. He studied in Baltimore with Alfred J. Miller and in Cincinnati with John P. Frankenstein, and then went to Paris in 1850 and studied there and in Florence. Returned to the U.S. after four years and lived in Baltimore, MD. His work was portraiture, still-life, and landscapes, his fruit-pieces attracting special attention. Among his works are "A Christmas Memory," "Albert Grapes" and "Flora and Pomona." Several of his paintings have been lithographed. He died Feb. 7, 1888, in Baltimore, MD.

WAY, GEORGE BREVITT.
Painter. Son of the artist Andrew John Henry Way. He was born in Baltimore in 1854 and educated at the U.S. Naval Academy. He later studied in Paris. Among his paintings are "Twilight on the Susquehanna," "On the Upper Potomac," and "Sunset."

WAY, MARY (MISS).
Portrait and miniature painter of New London, CT. In the *New York Evening Post*, in 1811, it notes "Takes Likenesses upon Ivory & Glass, in colors or gold. Also landscapes or views of country Seats. Paintings not approved may be returned without charge at her painting-room No. 95 Greenwich Street, New York." Exhibited at the American Academy in 1818.

WEAR, J. F.
Portrait painter. The collection of historic portraits at Independence Hall, Philadelphia, has a portrait of a signer of the Declaration of Independence, painted by J. F. Wear after the portrait painted by John Trumbull.

WEAVER, B. MAIE.
Painter, sculptor and teacher. Born in New Hartford, CT, Dec. 12, 1875. Studied: Massachusetts School of Art; Julian Academy, Grande Chaumiere, Paris; pupil of Ross Turner; Mme. La Forge; George T. Collins; M. Simone. Awards: Prizes, Julian Academy, Paris. Member: Springfield Art League; Holyoke Art Club. Work: Portraits of Ex-Governors Woodruff, Templeton, Holcomb and Weeks, State of Connecticut; State Library, Hartford, CT. Exhibited at the Paris Salon; Springfield (MA) Museum of Art; others. Address in 1953, New Hartford, CT.

WEAVER, BEULAH B(ARNES).
Painter, sculptor and teacher. Born in Washington, D.C., July 8, 1882. Studied: Corcoran School of Art; Art Students League; pupil of Peppino Mangravite, Karl Knaths, others. Member: Society of Washington Artists. Awards: Prizes, Corcoran; Washington Woman's Club; Independent Artists Exhibition, Washington, DC. Work: Townsends Corner, Phillips Memorial Gallery, Washington, DC. Exhibited: Anderson Gallery, New York; Phillips Memorial Gallery; Corcoran; National Gallery of Art, Washington, DC; Washington Woman's Club. Director and art teacher, Madeira School, Greenway, Virginia. Address in 1953, The Madeira School, Greenway, Virginia; 2133 Wisconsin Avenue, Washington, D.C.

WEAVER, MARGARITA (WEIGLE).
(Mrs. John Weaver). Painter. Born in Brandon, VT, Nov. 24, 1889. Pupil of Forsyth in Indianapolis; Lucien Simon, Henri Morriset, and Bourdelle in Paris. Member: Hoosier Salon; Chicago Art Club. Awards: Purdue Alumni prize ($100), exhibit of Hoosier Artists, Marshall Field's, 1925. Address in 1933, Brandon, VT.

WEAVER, P. T.
Dunlap notes his painting of small portraits in oil, in a hard manner. His portrait of Alexander Hamilton attracted attention by its strong likeness. He often painted portraits in profile on wood panels, and signed several "P. T. Weaver."

WEBB, A. C.
Painter, illustrator, architect and etcher. Born in Nashville, Tennessee, April 1, 1888. Pupil of Art Institute of Chicago; Art Students League of New York. Member: Beaux Arts Architects; American Art Association of Paris. Award: Municipal Arts prize in Architecture, New York, 1917. Work: Etchings owned by City of Paris; French Government. Address in 1929, Rue de Alfred Stevens, Montmartre, Paris, France.

WEBB, EDNA DELL.
See Hinkelman, Edna Webb.

WEBB, JACOB LOUIS.
Painter. Born April 24, 1856, in Washington, DC. He was elected an Associate of the National Academy of Design in 1906. Address in 1926, 32 East 42nd St., New York, NY. Died December 24, 1928, in New York City.

WEBB, MARGARET ELY.
Illustrator and etcher. Born in Urbana, IL, March 27, 1877. Pupil of Twachtman and Cox in New York. Member: Boston Art Club; American Society of Bookplate Collectors and Designers; Internatonal Bookplate Association. Illustrated *The House of Prayer*, by F. C. Converse; *Aldine First Reader*, *Under Greek Skies*, etc. Address in 1929, 26 West Micheltorena St., Santa Barbara, CA.

WEBB, WARREN.
Marine painter. Specialty is oil paintings of sailing ships.

WEBBER, CHARLES T.
Painter, sculptor and teacher. Born in Cayuga Lake, NY, or Cincinnati, OH, December 31, 1825; settled in Ohio in 1844. Charter member of the Cincinnati Sketch Club, 1860; Art Club, 1890. Organized McMicken School of Art and Design, 1869. Paintings include "The Underground Railroad" and group portrait of Major Daniel McCook and his nine sons. Specialties: Portraits, landscapes, and historical subjects. Died in Cincinnati, OH, 1911.

WEBBER, WESLEY.
Painter. Born in Gardiner, ME, in 1841. Had a studio in Boston and in New York. Painted landscapes and scenes of the Civil War. Died Nov. 4, 1914, in Boston, MA.

WEBER, AUGUST J(AMES).
Painter. Born in Marietta, OH, Oct. 21, 1889. Pupil of Meakin and Duveneck in Cincinnati. Member: Cincinnati Art Club; Valley of the Moon Society of Painters; Ohio Water Color Society. Address in 1933, 127 East 3rd St., Cincinnati, OH; h 419-4th Street, Marietta, OH.

WEBER, CARL.
Landscape painter. Born in Philadelphia, PA, in 1850 or 55. Son of Paul Weber. Studied in Germany. Represented in many galleries and collections of paintings. Died Jan. 24, 1921, in Ambler, PA.

WEBER, FREDERICK (THEODORE).
Painter, sculptor, etcher and writer. Born in Columbia, SC, March 9, 1883. Studied: Ecole des Beaux-Arts and Julian Academy, Paris; pupil of Jean Paul Laurens and Paul Richer. Member: Southern States Art League; New York Water Color Club; Brooklyn Society of Etchers (president); American Artists Professional League; National Arts Club; American Water Color Society. Collections: Etchings in the Library of Congress, Washington, DC; New York Public Library; Smithsonian Institution, Washington, DC; Bibliotheque Nationale, Paris; Metropolitan Museum of Art; Brooklyn Museum; Museum of the City of New York; University of Vermont; University of South Carolina; others. Exhibited: Corcoran; National Academy of Design; Detroit Institute of Arts; Art Institute of Chicago; Penna. Academy of Fine Arts; New Haven Paint and Clay Club; American Water Color Society; City Art Museum, St. Louis; Washington Water Color Club; Baltimore Water Color Club; U.S. National Museum, 1930 (one-man); High Museum of Art, 1931 (one-man); others. Author, article on "Portrait Painting," *Encyclopedia Britannica*. Address in 1953, Jackson Heights, New York. Died in 1956.

WEBER, MAX.
Painter, sculptor, teacher and lecturer. Born in Bialystok, Russia, April 18, 1881. Studied: Pratt Institute, New York City, 1898-1900, with Arthur Wesley Dow; Julian Academy, Paris; travelled throughout Europe, 1905-08; associated closely with Henri Rousseau; studied with Henri Matisse, 1907; also with Jean Paul Laurens. Work: Metropolitan Museum of Art; Museum of Modern Art; Whitney; Wichita Art Museum; Brooklyn Museum; Jewish Theological Seminary of America; Art Institute of Chicago; Los Angeles Art Museum; California Palace of Legion of Honor; Santa Barbara Museum of Art; Walker Art Center; others. Awards: Prizes, Art Institute of Chicago, 1928, 41; Penna. Academy of Fine Arts, 1941, 56; Corcoran, 1941; others. Works include "The Geranium," 1911; "Chinese Restaurant," 1915; "Adoration of the Moon," 1944; "Figure in Rotation," (bronze); "Still Life." Taught at the Art Students League, 1919-21, 25-27. Honorary member,

Art Students League; member, American Painters, Sculptors and Gravers. Published: *Essays on Art*, 1916; *Primitives*, 1926. Address in 1956, Great Neck, Long Island, New York. Died in 1961.

WEBER, PAUL.
Landscape and animal painter. Born in Darmstadt, Germany, in 1823. Studied in Frankfurt, Germany. Came to America in 1848 and settled in Philadelphia. Travelled in Scotland and Germany in 1857; returned to America for a short time; went to Darmstadt in 1858 and was appointed court painter. His American work was generally pure landscape, of which one of the finest examples is his "Evening," in the permanent collection of the Academy of Fine Arts. The Corcoran Gallery has "Scene in the Catskills," painted in 1858. His later work was primarily of animal life. Died in 1916 in Philadelphia, Pennsylvania.

WEBER, SYBILLA MITTELL.
Painter and etcher. Born in New York, May 30, 1892. Pupil of Alfons Purtscher in Munich; Pennell in N.Y. Member: National Association of Women Painters and Sculptors; National Arts Club; American Federation of Arts. Work: Painting of "Pointer," Westminster Kennel Club, NY; "Great Dane," Berlin Museum; "Hackney Pony," "Contented" and "Alert," New Pinakothek, Munich. Died in 1957. Address in 1933, Van Dyck Studios, 939 Eighth Avenue; h. 40 West 67th Street, New York, NY.

WEBSTER, E. AMBROSE.
Painter and teacher. Born in Chelsea, MA, Jan. 31, 1869. Pupil of Boston Museum under Benson and Tarbell; Laurens, Benjamin-Constant and Albert Gleizes in Paris. Member: Provincetown Art Association. Director and instructor, Webster Art School, Provincetown. Author of a booklet on color and lecturer on modern art. Address in 1933, Provincetown, MA. Died in 1935.

WEBSTER, FREDERICK RICE.
Sculptor. Born in Grand Rapids, MI, November 12, 1869. Pupil of Royal Academy, Munich. Member of Chicago Water Color Club; Chicago Society of Artists. Address in 1919, Evanston, IL.

WEBSTER, H. DANIEL.
Sculptor. Born at Frankville, IA, April 21, 1880. Pupil of Barnard and DuMond in New York. Represented by "Minute Man" (bronze), Campo Beach, Saugatuck, CT; General W. H. Beadle (marble), State Capitol, Pierre, SD; the bronze doors for American National Bank Building, Austin, TX. Member of Art Students League of New York; Silvermine Guild. Died in 1912, in Westport, CT.

WEBSTER, HAROLD TUCKER.
Cartoonist. Born in Parkersburg, WV, Sept. 21, 1885. Member: Society of Illustrators; Dutch Treat Club. Author of "Our Boyhood Thrills and other Cartoons;" "Boys and Folks;" cartoon series entitled "Our Boyhood Ambitions;" "The Thrill That Comes Once in a Lifetime;" "Life's Darkest Moment;" "The Beginning of a Beautiful Friendship;" "How to Torture Your Wife." Died in 1952. Address in 1929, The New York World, New York Club, NY; h. "Crest Hill," Shippan Pt., Stamford, CT; summer, Meddybemps, ME.

WEBSTER, HERMAN A(RMOUR).
Painter-etcher. Born in New York, NY, April 6, 1878. Pupil of Laurens in Paris. Member: Royal Society of Painter-Etchers, London; Societe National des Beaux Arts, Paris; American Art Association of Paris; Chelsea Art Club. Awards: Gold medal, P.-P. Expo., San Francisco, 1915; Chevalier de la Legion d'Honneur, 1927. Work: Luxembourg, Paris; South Kensington, London; British Museum; Darmstadt; Library of Congress, Washington; Art Institute, Chicago; Metropolitan Museum, NY; Fogg Museum, Cambridge; etc. Address in 1933, care of Frederick Keppel and Co., 16 E. 57th St., New York, NY.

WEBSTER, MARY HORTENSE.
Sculptor, painter, and teacher. Born in Oberlin, OH. Pupil of Cincinnati Art Academy under Barnhorn and Nowottny; Injalbert, Verlet, and Waldmann in Paris; Hitchcock in Holland; Hawthorne in Provincetown; Lorado Taft in Chicago. Address 1933, Midway Studios, 6016 Ingleside Ave., Chicago, IL.

WEDDERSPOON, R(ICHARD) G(IBSON).
Painter. Born in Red Bank, NJ, Oct. 15, 1889. Pupil of Daniel Garber and Henry McCarter. Member: Fellowship Penna. Academy of Fine Arts; Chicago Society of Artists; Chicago Art Club. Awards: European scholarship, Penna. Academy of Fine Arts, 1915, 16; first Toppan prize, Penna. Academy of Fine Arts, 1917; Jenkins prize, Art Institute of Chicago, 1922. Represented in Chicago Civic Committee, DePauw University. Professor of fine arts, Syracuse University. Address in 1929, Syracuse University, College of Fine Arts; h. 301 Marshall St., Syracuse, NY; summer, New Hope, PA.

WEEDELL, HAZEL (ELIZABETH).
(Mrs. Gustav F. Goetsch). Painter, etcher, craftsman, and teacher. Born in Tacoma, WA, Jan. 26, 1892. Pupil of Gustave F. Goetsch; Robert Koehler; Ernest Batchelder. Member: Alumni, Minn. School of Art; St. Louis Artists Guild. Address in 1929, 20 Elm Ave., Glendale, MO.

WEEKS, CAROLINE.
Portrait painter. The collection of Colonial portraits in Independence Hall, Philadelphia, has a copy by Caroline Weeks of John Trumbull's portrait of Josiah Bartlett of New Hampshire. She painted most of her pictures from 1860 to 1870.

WEEKS, EDWIN LORD.
Painter. Born in Boston, MA, in 1849. Landscape and figure painter. Pupil of the Ecole des Beaux-Arts; also of Bonnat and Gerome in Paris. Sketched and painted in Cairo, Jerusalem, Damascus, and Tangiers, and is noted for paintings of Eastern life. Awards: Honorable mention, Paris Salon, 1884, medals, 1889; Paris Exposition, 1889; Art Club, Philadelphia, 1891; London Exposition, 1896; Dresden, 1897; Munich, 1897; Pan.-American Exposition, Buffalo, 1901. Member: Paris Society of American Painters; Boston Art Club; Chevalier of the Legion of Honor, 1896; officer, Order of St. Michael of Bavaria. Died in 1903.

WEEKS, JAMES (DARRELL NORTHRUP).
Painter and educator. Born December 1, 1922, in Oakland, CA. Studied at California School of Fine Arts, 1940-42, 46-48; Nebraska State Teachers College, 1943; Marian Hartwell's School of Design, San Francisco, 1946-47; Escuela de Pintura y Escultura, Mexico City, 1951; U.S. Army Air Force, 1942-45. Awarded Rosenberg fellowship, 1952; National Endowment for the Arts grant, 1978; California Palace, 1961, 62; Howard University, 1961; purchase award, American Institute of Arts and Letters, 1980. Taught at San Francisco Art Institute; UCLA; Brandeis; Boston University; others. Exhibited at Labaudt Gallery, San Francisco; California Palace, San Francisco; Poindexter Gallery; Felix Landau Gallery; Oakland Museum; Corcoran; Stanford University; Art Institute of Chicago; Boston University; Scripps College; Brown University; Houston Museum of Fine Arts; Los Angeles County Museum of Art; Carnegie Institute; Brandeis University; others. In collections of San Francisco Museum of Art; Corcoran; Howard University; Boston Museum of Fine Arts; New England Mutual Life; many private collections. Commissions: Painting, U.S. Department of the Interior traveling exhibition, 1976; painting, Boston 200 Bicentennial Exhibition, 1976. Address in 1982, Bedford, MA.

WEEMS, KATHARINE LANE.
Sculptor. Born in Boston, MA, February 22, 1899. Studied at the Boston Museum Fine Arts School; also studied with Charles Grafly, Brenda Putnam, George Demetrios, and Anna Hyatt Huntington. Awards: Sesqui-Centennial Exposition, Philadelphia, 1926; Boston Tercentenary Exhibition, 1930; Penna. Academy of Fine Arts, 1927; Paris Salon, 1928; National Association of Women Painters and Sculptors, 1928; Grand Central Art Gallery, 1929; National Academy of Design, 1931, 32, 60, 63, 73, 75; Architectural League, 1942; National Association of Women Artists, 1948; National Arts Club gold

medal, 1961; others. Work: Boston Museum of Fine Arts; Reading Museum; Penna. Academy of Fine Arts; Brookgreen Gardens, SC; Baltimore Museum of Art; carvings, bronzes, doors, Harvard University; fountain, Boston, MA; many Medals for Merit, U.S. Government; others. Has exhibited at the National Sculpture Society Exhibition, 1981, and the National Academy of Design. Member: National Academy of Design; National Sculpture Society; National Institute of Arts and Letters; NY Architectural League; Boston Guild of Artists. Address in 1984, Manchester, MA.

WEHN, JAMES A.
Sculptor and teacher. Born in Indianapolis, IN. Pupil of R. N. Nichols; Will Carson; August Hubert. Member: Seattle Art Institute; American Numismatic Society. Work: Monument, Seattle, WA; Meriwether-Lewis relief, Court House, Chehalis, WA; series of historical medallions, University of Washington; Henry L. Yesler medallion, Yesler Library, Seattle; medal, Garden Club, Seattle; Morgan relief, Northern Life Tower, Seattle; great seal of U.S. and large stone eagles, U.S. Post Office, Longview, Washington; several memorials in Alaska. Address in 1933, 710 29th Avenue, South, Seattle, Washington; summer, Crescent Beach, WA.

WEIL, ARTHUR.
Sculptor. Born in Strasbourg, Alsace-Lorraine, June 8, 1883. Studied in Italy. Work: "Marshall Foch," owned by the Canadian Government. Address in 1919, 2519 Sheridan Road, Evanston, IL.

WEIL, CARRIE H. (MRS.).
Sculptor. Born in New York, August 17, 1888. Pupil of P. Hamaan in New York and Paul Landowski in Paris. Member: National Association of Women Painters and Sculptors. Specialty: Portrait busts. Address in 1933, 125 East 50th Street; h. Hotel Beverly, New York, NY.

WEILAND, JAMES.
Portrait painter. Born in Toledo, OH. Pupil of National Academy of Design; Royal Academy, Munich; Delecluse and Colarossi Academies in Paris. Member: Salma. Club; Allied Artists of America; Provincetown Art Association. Represented in the National Museum, Washington, D.C.; State Capitol Library, Hartford, CT. Address in 1933, Lyme, CT.

WEILL, EDMOND.
Painter, etcher and lithographer. Born in New York, NY, July 29, 1877. Pupil of National Academy of Design under Edgar M. Ward. Member: Brooklyn Society of Modern Artists; Brooklyn Water Color Club; Society of Independent Artists; Salma. Club; Putnam County Art Association; Salons of America; American Water Color Society. Represented in Brooklyn Museum; College of the City of New York;

Middletown (NY) Library. Exhibited: Corcoran; Penna. Academy of Fine Arts; Art Institute of Chicago; Carnegie; Boston Museum of Fine Arts; Whitney. Address in 1953, 756 East 9th Street, Brooklyn, New York, NY; summer, Brewster, NY.

WEIN, ALBERT W.
Sculptor, painter, designer and educator. Born in New York, NY, July 27, 1915. Studied: With Hans Hofmann at the Beaux-Arts Institute of Design; National Academy of Design; Grand Central School of Art; Maryland Institute. Exhibited: Whitney Museum of American Art Annual, NYC, 1950; Metropolitan Museum of Art, 1951; The San Francisco Museum of Art Annual, 1957; Heritage Gallery, Los Angeles (one-man); 30 year retrospective, Palm Springs Desert Museum, 1969; National Arts Club; National Academy of Design; Argent Gallery (one-man); Canton Art Institute (one-man); others. Awards: Prizes, Prix de Rome, 1947, 48; Tiffany Foundation grant, 1949; Hudson Valley Art Association, 1948; National Sculpture Society, 1942, 46, Henry Hering medal, 1976; Artists Fund prize, 1976, and a gold medal for sculpture, 1979, National Academy of Design; others. Member: Fellow, National Academy of Design; fellow, International Institute of Arts and Letters; Huntington Hartford Foundation; fellow, National Sculpture Society; fellow, American Academy in Rome; Allied Artists of America; others. Taught: Sculpture at the University of Wyoming, 1965-67; National Academy of Design, 1977-78; and Pace University, 1979. Work: Vatican Museum Numismatic Collection; Jewish Museum; Brookgreen Gardens, SC; medal, Society of Medalists; U.S. Post Office, Frankfort, NY; Gramercy Park Memorial Chapel, NY; plus numerous commissions. Address in 1982, Scarborough, NY.

WEINBERG, ELBERT.
Sculptor and educator. Born in Hartford, CT, May 27, 1928. Studied at Hartford Art School; Rhode Island School of Design, 1951, B.F.A.; Yale University, 1955, M.F.A. Works: Phillips Academy, Addison Gallery of American Art, Andover, MA; Brandeis University; Colgate University; 405 Park Ave., NYC; Wadsworth Atheneum; Jewish Museum; Rhode Island School of Design; Museum of Modern Art; Whitney; Yale University; others, including numerous commissions. Exhibitions: Grace Borgenicht Gallery Inc., NYC; Whitney; Phillips Academy; Silvermine Guild; Jewish Museum; Institute of Contemporary Art, Boston; Wadsworth Atheneum; American Academy of Arts and Letters; Carnegie; Museum of Modern Art; Art Institute of Chicago; Munson-Williams-Proctor Institute, Utica, NY; Boston Arts Festival; Penna. Academy of Fine Arts; Smithsonian; others. Awards: Prix de Rome, 1951-53; Institute of Contemporary Art, Tate, International Unknown Political Prisoner Competition, hon. mention, 1953; silver medal for achievement in the

arts, Yale University, 1959; Guggenheim Foundation Fellowship, 1960; sculpture award, American Institute of Arts and Letters, 1969. Taught: Rhode Island School of Design; Yale University; Cooper Union; Boston University; Tyler School of Art; Union College, Schenectady, NY. Address in 1982, c/o Grace Borgenicht Gallery, NYC.

WEINBERG, E(MILIE) SIEVERT (MRS.).
Painter. She was born Chicago, IL. Pupil of Art Institute of Chicago and William M. Chase. Member: San Francisco Art Association; California Art Club; Oakland Art Association; Alumni Association, Art Institute of Chicago; San Francisco Society of Women Artists. Address in 1933, 1801 California St., San Francisco, CA.

WEINBERG, LOUIS.
Sculptor, educator, and designer. Born in Troy, KS, June 19, 1918. Studied at University of Kansas, B.F.A. Member: Artists Equity Association; American Association of University Professors. Work: Philbrook Art Center. Exhibited: Penna. Academy of Fine Arts, 1949; Joslyn Art Museum; Denver Art Museum; Dallas Museum of Fine Arts; Philbrook Art Center; Delgado Museum of Art; Syracuse Museum of Fine Arts; Wichita Art Association; Nelson Gallery of Art; others. Address in 1953, Tulsa, OK.

WEINDORF, ARTHUR.
Painter. Born in Long Island City in 1885. Member of Society of Independent Artists. Address in 1926, Woolworth Building, NY.

WEINEDEL, CARL.
Miniature and portrait painter. Born in 1795. He was working in New York in 1834; in 1839 he was elected an Associate of the National Academy of Design. He died May 11, 1845, in NYC.

WEINER, EGON.
Sculptor, educator and lecturer. Born in Vienna, Austria, July 24, 1906. U.S. citizen. Studied: School of Arts and Crafts, Academy of Fine Arts, Vienna. Work: Syracuse Museum of Fine Arts; Augustana College, Rock Island, IL; Salem Church, Chicago; Chicago Airport; University of Wisconsin; Gary (IN) Public Library; Vatican collection; numerous sculpture busts; others. Exhibited: Art Institute of Chicago; Art Institute of Oslo Annual Exhibition; Penna. Academy of Fine Arts; Oakland Museum of Art; University of Chicago; Syracuse Museum of Fine Arts; City Art Museum, St. Louis; Metropolitan Museum of Art; Denver Museum of Art; Seattle World's Fair, 1962; NY World's Fair, 1964-65; University of Illinois; Portland (OR) Art Museum; others. Awards: Prizes, Grand Prix, Paris, 1925; Municipal Art League, Chicago, 1948, gold medal, 1969; Syracuse Museum of Fine Arts, 1949; American Institute of Architects, 1955, citation, 1962; medals, Art Institute of Chicago, 1949, prize, 1959; Oakland Art Museum, 1945, 51; gold medal, Society of Arts and Letters, 1970; others. Member: National Institute of Arts and Letters; life fellow, International Institute of Arts and Letters; Municipal Art League, Chicago; Cliff Dwellers of Chicago; others. Taught: Art Institute of Chicago; Augustana College. Contributor to *American-German Review; Frontiers; Figure.* Media: Stone, wood, steel, and bronze. Address in 1982, Evanston, IL.

WEINER, LAWRENCE CHARLES.
Sculptor. Born in Bronx, NY, February 10, 1940. Self-taught. Exhibited: Mill Valley, CA, 1960; Seth Siegelaub, NYC, 1964, 65; Galerie Folker Skulima, Berlin, 1970; Modern Art Agency, Naples, 1973; Max Protetch Gallery, Washington, DC, 1974; Leo Castelli Gallery, NYC, all individual shows; group shows at Museum of Modern Art, NYC; Jewish Museum; Art Institute of Chicago; Museum of Contemporary Art, Chicago; many more. Awards from der Deutscher Akademische Austauschdienst, Berlin, 1975-76; National Endowment for the Arts Fellowship, 1976-77. In collections of Museum of Modern Art, NYC; Centre Georges Pompidou, Paris; National Gallery of Australia; others. Address in 1982, c/o Leo Castelli, 420 W. Broadway, New York, NY.

WEINERT, ALBERT.
Sculptor. Born in Leipzig, Germany, June 13, 1863. Pupil of Ecole des Beaux-Arts in Brussels. Member: National Sculpture Society, 1909; Society of Independent Artists. Work: "Lake George Memorial," Lake George, NY; "McKinley Monument," Toledo, OH; "Statue of Lord Baltimore," Baltimore, MD; marble groups in vestibule of Hall of Records, NYC; "Stevens T. Mason Monument," Detroit, MI; historical tablets for Sons of the Revolution and Society of Colonial Wars; work at Panama-Pacific Exposition, San Francisco, CA; architectural sculpture, Congressional Library, Washington, DC. Address in 1926, 256 West 55th Street, New York, NY.

WEINMAN, ADOLPH ALEXANDER.
Sculptor. Born in Karlsruhe, Germany, December 11, 1870; came to U.S. in 1880. Studied: Cooper Union; Art Students League of NY; pupil of Augustus Saint-Gaudens and Philip Martiny. Assistant to Niehaus, Warner, and French. Opened his own studio in 1904. Member: Society of American Artists, NY, 1903; National Academy, Associate, 1906, Academician, 1911; National Sculpture Society, 1900 (president); NY Architectural League, 1902; American Academy of Arts and Letters, 1932; National Institute of Arts and Letters; Century Association; American Numismatic Society; American Federation of Arts; International Jury for Sculpture, P.-P. Exposition, San Francisco, 1915; New York City Art

Commission, 1924-27; National Commission of Fine Arts, 1929-33. Awards: Honorable mention, Pan-Am. Exposition, Buffalo, 1901; silver medal, St. Louis Exposition, 1904; silver medal, Brussels Exposition, 1910; gold medal of honor for sculpture, NY Architectural League, 1913; Saltus Medal for medal, American Numismatic Society, 1920; gold medal of honor in sculpture, Architectural League of New York; Widener gold medal at the Penna. Academy of Fine Arts, 1924; Fine Arts medal, American Institute of Architects, 1930. Work: Lincoln memorials at Hodgenville, KY, and Madison, WI; "General Macomb Monument," Detroit; "Abraham Lincoln," statuette, and "The Rising Sun," Metropolitan Museum, NY; "Chief Black Bird," Brooklyn Institute Museum; plaque, "Adelaide," Carnegie Institute, Pittsburgh; "Descending Night," Kansas City Museum; "Alexander J. Cassatt," New York; "The Rising Sun" and "Descending Night," Houston Museum, TX; "Fountain of the Tritons," Missouri State Capitol Grounds; pediment sculpture, Wisconsin State Capitol; pediment sculpture, Missouri State Capitol; frieze and bronze groups, facade of Elks National Memorial Headquarters Building, Chicago; all sculpture on exterior and interior of Pennsylvania Railway Station, NY; sculpture on facade and top of tower, Municipal Building, NY; sculpture for Post Office Department Building, Washington, DC; monumental frieze for U.S. Supreme Court Room, U.S. Supreme Court, Washington, DC. Designer of half dollar and dime for U.S. Goverment, Victory Button for U.S. Army and Navy. Trustee and chairman of Art Committee, Brookgreen Gardens, SC. Address in 1933, Forest Hills, NY. Died August 8, 1952.

WEIR, CHARLES E.
Portrait and genre painter. Born c. 1823. Painted many cabinet heads as noted in an early Art-Union Exhibition. Died June 20, 1845 in NYC.

WEIR, EDITH DEAN.
See Perry, Edith Dean Weir.

WEIR, JOHN FERGUSON.
Sculptor and painter. Born in West Point, NY, August 28, 1841. Elected an Associate of the National Academy of Design in 1864, and Academician in 1866. He was director of the Yale School of Fine Arts, 1869-1913. Principal works in sculpture: Statues of Presidents Woolsey and Professor Silliman, of Yale. Executed many portraits and other works in painting, notably "The Gun Foundry," "The Forging of the Shaft," "The Confessional," "An Artist's Studio," "Christmas Eve," "Tapping the Furnace," "Rain and Sunshine," "The Column of St. Mark's, Venice." Author of *John Trumbull and His Works*, 1902. Address in 1926, Yale University, New Haven, CT. Died in 1926.

WEIR, JULIAN ALDEN.
Painter, etcher and teacher. Born in West Point, NY, August 30, 1852. Pupil of his father, Robert W. Weir, at West Point, and of Gerome in Paris. Awards: Hon. mention, Paris Salon, 1882; silver medal for painting and bronze medal for drawing, Paris Expo., 1889; American Art Association, NY, 1889; medal, Carnegie Institute, Pittsburgh, 1897; bronze medal, Paris Expo., 1900; gold medal for paintings and silver for engravings, Pan.-Am. Expo., Buffalo, 1901; gold medal, National Academy of Design, 1906; Lippincott prize, Penna. Academy of Fine Arts, 1910; Harris silver medal, Chicago Art Institute, 1912; Beck medal, Penna. Academy of Fine Arts, 1913; first William A. Clark prize and Corcoran gold medal, Corcoran Gallery of Art, 1914. Elected Associate, National Academy, 1885, Academician, 1886, and became its president, 1915-17. Member: American Water Color Society; Ten American Painters; National Institute of Arts and Letters; New York Etching Club; honorary member, Art Students League; Century Association; Lotos Club; others. Work: Corcoran; Art Institute of Chicago; Penna. Academy of Fine Arts; Carnegie; Rhode Island School of Design; Whitney; Metropolitan Museum of Art; Cincinnati Museum; others. A memorial exhibition was held at the Century Club, NY, of about forty of his best known paintings. Exhibited twelve paintings and several etchings at the Armory Show, 1913. Taught at the Art Students League, 1885-87, 90-98; Cooper Union Art School. Died December 9, 1919, in New York City.

WEIR, ROBERT WALTER.
Painter. Born in New Rochelle, NY, June 18, 1803. Father of John Ferguson Weir and Julian Alden Weir. Pupil of Jarvis. Studied at Florence, Italy, under Benvenuti; also in Rome, Italy. Became a professional painter at the age of 20. In 1829 he became a member of the National Academy of Design and in 1832 was made professor of drawing at West Point. Among his works are: "The Bourbons' Last March;" "Landing of Henry Hudson;" "Indian Captives;" "Christ and Nicodemus;" "Taking the Veil;" "Child's Evening Prayer;" "The Portico of the Palace of Octavia, Rome;" "Our Lord on the Mount of Olives;" and "Last Communion of Henry Clay." His "Embarkation of the Pilgrims," in the rotunda of the Capitol, Washington, was injured during the building of the new dome of the Capitol. Professor Weir repaired this injury in 1861. His portrait of General Winfield Scott is owned by the Metropolitan Museum of Art. Died on May 1, 1889 in New York City.

WEIR, WILLIAM (JOSEPH).
Painter, illustrator, and etcher. Born in Ballina, Ireland, June 8, 1884. Pupil of Art Institute of Chicago; Chicago Art Academy; Julian Academy, Paris. Member: Chicago Palette and Chisel Club; Illinois Academy of Fine Arts. Work: "The Road to

Lake Ripley," "Fishermen's Houses," "Frogland," State Museum, Springfield, Illinois. Address in 1929, Palette and Chisel Club, 1012 North Dearborn Street; home, 1312 Byron Street, Chicago, IL.

WEIS, JOHN E(LLSWORTH).
Painter, writer, and teacher. Born in Higginsport, Ohio, September 11, 1892. Pupil of Duveneck; Meakin; Hopkins; Wessel. Member: Cincinnati Art Club; Cincinnati MacDowell Club; Duveneck Society of Painters and Sculptors. Address in 1933, Art Academy, Cincinnati, Ohio; home, 2155 Fulton Avenue, W.H., Cincinnati, OH.

WEIS, S(AMUEL) W(ASHINGTON).
Painter. Born in Natchez, Mississippi, August 8, 1870. Member: New Orleans Art Association; Salma. Club; Business Men's Art Club, Chicago; Palette and Chisel Club, Chicago; North Shore Art League, Winnetka; Southern States Art League. Address in 1929, Drake Hotel, Chicago, Illinois; summer, Glencoe, IL.

WEISBROOK, FRANK S.
Painter. Award: Bronze medal for water color, St. Paul Institute, 1918. Address in 1929, 713 East 13th St., Davenport, IA.

WEISEL, DEBORAH DELP.
Painter, craftsman, lecturer, and teacher. Born in Doylestown, PA. Studied: Philadelphia Museum School of Industrial Art; Penna. Academy of Fine Arts; Columbia; pupil of Breckenridge and DeVoll. Member: Fellowship Penna. Academy of Fine Arts; Alumni Association, Philadelphia Museum School of Industrial Art; Friends of Art, Springfield, MO; American Federation of Arts; Ozark Art Association; College Art Association; Southern States Art League; others. Head of art department, Teachers College; secretary, Springfield Art Museum; teacher, Southwest Missouri State College, from 1921. Address in 1933, Teachers College, Springfield, MO; summer, "Gray Gables," Moorestown, NJ. Died December 16, 1951.

WEISENBORN, RUDOLPH.
Painter. Member: Chicago No-Jury Society of Artists; Cor Ardens; Chicago Society of Artists. Award: Hon. mention, Art Institute of Chicago, 1928. Address in 1933, 1501 North La Salle St., Chicago, IL.

WEISENBURG, HELEN M(ILLS).
Painter. Pupil of Philadelphia Museum School of Industrial Art; Penna. Academy of Fine Arts; Hugh Breckenridge. Member: Plastic Club; Fellowship Penna. Academy of Fine Arts; Art Alliance of Philadelphia. Awards: Fellowship prize, Penna. Academy of Fine Arts, 1927; gold medal, Plastic Club, Philadelphia, 1929. Address in 1933, 5211 Spring Lake Way, Baltimore, MD.

WEISS, HARVEY.
Sculptor. Born in New York, NY, April 10, 1922. Studied at National Academy of Design; Art Students League; and with Ossip Zadkine, Paris. Work in Albright-Knox Art Gallery; Krannert Museum; Silvermine Guild Collection; Nelson Rockefeller Collection; Joseph H. Hirshhorn Collection; and others. Has exhibited at Silvermine Guild; Sculptors. Guild Annual Shows; and others. Received three Ford Foundation purchase awards; Olivetti Award, New England Annual Exhibition, 1969; National Institute of Arts and Letters Grant, 1970. Member of Sculptors Guild; Silvermine Guild of Artists. Teaching sculpture at Adelphi University, Garden City, NY. Works in bronze and welded brass. Address in 1982, Greens Farms, CT.

WEISS, LEE (ELYSE C. WEISS).
Painter. Born in Inglewood, CA, May 22, 1928. Studied: California College of Arts and Crafts, 1946-47; with N. Eric Oback and Alexander Nepote. Exhibitions: California Palace of the Legion of Honor, 1962, Madison Art Center, 1967, 73, Milwaukee Art Center, 1965, Walker, 1960 (all one-woman); Allied Artists of America; American Watercolor Society; Audubon Artists; Butler Institute; Madison Art Center; Penna. Academy of Fine Arts, 1965, 68; Phillips Gallery Invitational, 1972; Smithsonian Institution, 1978; Canton Art Institute, 1979; many others. Work: National Academy of Design; Madison Art Center; Milwaukee Art Center; National Collection of Fine Arts, Smithsonian Institution; Springfield Museum of Art; others. Awards: Numerous from American Watercolor Society, California National Water Color Society, Watercolor USA, and Philadelphia Watercolor Club; Best of Show, Madison Art Center, 1963, award, 1966; first award, Illinois Seven-State Regional Exhibition, Springfield, 1964, second award, 1965; first award, National Watercolor Society, 1982; certificate of merit, National Academy of Design; others. Commissions: One of 40 American artists chosen for the U.S. Department of Interior's Bureau of Reclamation Art Project, 1971; one painting selected for White House, 1972; artist for space shuttle launch, NASA, 1984. Member: American Watercolor Society; National Watercolor Society; Wisconsin Painters and Sculptors; Wisconsin Watercolor Society. Media: Watercolor. Address in 1984, Madison, WI.

WEISS, MARY L.
Painter. Exhibited at the Penna. Academy of Fine Arts, Philadelphia, 1924. Address in 1926, East Gloucester, MA.

WEISS, WILLIAM L.
Painter. Exhibited at the Penna. Academy of Fine Arts, Philadelphia, 1924. Address in 1926, East Gloucester, MA.

WEISSER, LEONIE.
(Mrs. Fred Weisser). Painter. Born in Guadalupe County, TX, Oct. 5, 1890. Pupil of Minnie Stanford; William Jenkins; R. J. Onderdonk. Member: San Antonio Art League; Southern States Art League. Awards: First prize, Hays County (TX) Fairs, 1922, 23, 24; hon. mention, Edgar B. Davis competitive exhibition, San Antonio, 1929; hon. mention, Texas Federation of Women's Club, 1931. Address in 1933, 211 Kennedy Ave., San Antonio, TX.

WEISTROP, ELIZABETH N.
Sculptor. Member of the National Sculpture Society. Award: Lindsey Morris Memorial Prize, 1974, National Sculpture Society. Address in 1982, Half Moon Bay, CA.

WEISZ, EUGEN.
Painter. Born in Hungary. Pupil of Corcoran School of Art; Penna. Academy of Fine Arts; Albright School of Fine Arts. Member: Society of Washington Artists. Award: Bronze medal, Society of Washington Artists, 1927. Instructor, Corcoran School of Art. Address in 1933, 515 20th Street, Washington, D.C. Died in 1954.

WELCH, JOHN.
Wood carver. Born in Boston, MA, August 19, 1711. Probably carved codfish in the House of Representatives, Old State House, Boston. Also a notable ship and ornamental carver and chairmaker. Died in Boston, February 9, 1789.

WELCH, LIVINGSTON.
Sculptor and painter. Born in New Rochelle, NY, August 8, 1901. Studied at Hunter College. Exhibited at Wellons Gallery, Caravan Gallery, World House Gallery, Shuster Gallery, Galeria International, all in NYC. Worked in lead and brass. Address in 1970, c/o Shuster Gallery, 536 Third Avenue, New York, NY. Died in 1976.

WELCH, MABEL R.
Painter and teacher. Born in New Haven, CT. Pupil of Art Students League of NY under Cox and Reid; Van der Weyden, Garrido, Lazar and Scott in Paris. Member: National Association of Women Painters and Sculptors; American Society of Miniature Painters; Pennsylvania Society of Miniature Painters; Brooklyn Society of Miniature Painters; MacDowell Club of NY. Awards: Silver medal, P.-P. Expo., San Francisco, 1915; medal of honor, Penna. Academy of Fine Arts, 1920; medal, Pennsylvania Society of Miniature Painters, 1920; first prize, Brooklyn Society of Miniature Painters, 1933; medals, American Society of Miniature Painters, 1935, 40; medal, California Society of Miniature Painters, 1937; National Association of Women Artists, 1938; Penna. Academy of Fine Arts, 1938. Represented in Brooklyn Museum; Penn. Museum of Art, Philadelphia; Corcoran. Address in 1953, care of Van Dyke Studios, 939 Eighth Ave., New York, NY; summer, North Wilbraham, MA. Died Jan. 1, 1959.

WELCH, THOMAS B.
Engraver. Born in Charleston, SC, in 1814. Welch was a pupil of James B. Longacre in Philadelphia and apparently soon after his release from his apprenticeship he formed a business with A. B. Walter. Over his own name he produced some good portraits in stipple and some large ones in mezzotint. For the *Annuals* he engraved some admirable pure line plates. About 1861 Welch abandoned engraving and went abroad to study art; he remained in Paris for many years. The Philadelphia directories of 1841-45 give his occupation as "portrait painter." Died in Paris, on November 5, 1874.

WELDON, C(HARLES) D(ATER).
Illustrator and painter. Born in Ohio. Pupil of Walter Shirlaw in NY; Munkacsy in Paris. Member: Associate National Academy of Design, 1889, Academician National Academy of Design, 1897; American Water Color Society; Century Association. Award: Bronze medal, Charleston Expo., 1902. Died August 9, 1935. Address in 1933, 51 West 10th Street, New York, NY.

WELFARE, DANIEL.
Painter. Born in 1796 in North Carolina. He was a student of Thomas Sully, who gave him letters of introduction to many artists in this country and abroad, where he travelled and studied. Later settled in Salem, NC, where he painted for years. His son was named Thomas Sully Welfare and Sully painted a self-portrait for his namesake. Exhibited at the Pennsylvania Academy, 1825. He died in Salem, NC, in 1841.

WELLIVER, LES.
Sculptor, woodcarver, and painter. Born in North Dakota about 1920; raised in Montana. Has worked as a bartender, cook, farm hand, and roughneck. Specialties: Wildlife; Indian and western subjects. Prefers woodcarving; works in cottonwood, juniper, other woods. Address in 1969, Kalispell, MT.

WELLIVER, NEIL G.
Painter, teacher and critic. Born in Millville, PA, July 22, 1929. Studied at the Philadelphia Museum College of Art, 1948-52; Yale University, with Josef Albers, Burgoyne Diller, and James Brooks, 1953-1954. Taught at Yale University; University of Pennsylvania; University of Santo Thomas, Manila, Republic of the Philippines. Exhibitions: American Federation of Arts traveling exhibition, 1960, 68; National Arts Club, 1959; Penna. Academy of Fine Arts, 1965, 77; Whitney Museum of American Art, New York, 1963, 72, 73; Art Institute of Chicago, 1975; DeCordova Museum, Lincoln, MA, 1975; North

Carolina Museum of Art, Raleigh, 1977; Museum of Modern Art, New York; one-man shows at the Stable Gallery, 1964, 66, Tibor de Nagy Gallery, NY, 1968, 69, in Philadelphia, 1953, and Boston, 1959; others. Work: Museum of Modern Art; Penna. Academy of Fine Arts; Hirshhorn Museum; Metropolitan Museum of Art; Whitney; Vassar College. Awarded the Morse Fellowship, 1960-61. Critic of painting: Cooper Union Art School; Yale University; University of Pennsylvania; Maryland Institute College of Art. Address in 1982, Lincolnville, ME.

WELLMORE (or WILLMORE), EDWARD.
Portrait painter, crayon portraitist, and engraver in stipple and in line. He was a pupil of James B. Longacre in Philadelphia and over his own name he engraved some of the portraits in *The National Portrait Gallery* of 1834-35. Working in Baltimore, 1837-67. At a later period he was engraving book illustrations in New York and is said to have later become a clergyman. Wellmore was also a miniature painter, as we find engravings and lithographs done after portraits painted by E. Wellmore.

WELLS, ALICE RUSHMORE (MRS.).
Painter. Born May 21, 1877. Studied: Art Students League; pupil of Mme. Debillemont-Chardin, R. Collin. Member: American Society of Miniature Painters; Pennsylvania Society of Miniature Painters; National Association of Women Painters and Sculptors. Address in 1933, 226 East Ninth St., Plainfield, NJ.

WELLS, AMY W(ATSON).
Painter, designer, block printer, lithographer, teacher and lecturer. Born in Lynchburg, VA, Dec. 21, 1898. Studied: School of Industrial Art, Trenton, NJ; Penna. Academy of Fine Arts; Teachers College, Columbia University, B.S.; Chicago School of Design; pupil of Hans Hofmann, Charles Hawthorne. Member: Fellowship Penna. Academy of Fine Arts; Art Students League of Trenton, NJ; Morrisville-Trenton Artists Group. Represented in Longfellow School, Philadelphia; State Capitol, Trenton, NJ. Exhibited: Montclair Art Museum, 1945; Contemporary Club, Trenton, NJ, 1946 (one-woman); Morrisville-Trenton Artists Group, 1945. Taught and lectured at the School of Industrial Art, Trenton, NJ, from 1930. Address in 1953, 455 West State Street, Trenton, NJ.

WELLS, CHARLES S.
Sculptor and teacher. Born in Glasgow, Scotland, June 24, 1872. Pupil of Karl Bitter; Augustus Saint-Gaudens; George G. Barnard. Work: Fountain, Gateway Park, City of Minneapolis; Anna T. Lincoln Memorial, Northfield, MN. Taught at Minneapolis School of Art. Address in 1933, Minneapolis, MN.

WELLS, ELOISE LONG (MRS.).
Painter. Born in Alton, IL, May 3, 1875. Pupil of St. Louis Art School. Member: St. Louis Artists Guild; American Fed. of Arts; Chicago Art Club. Award: Bronze medal for still life painting and gold medal for graphic art, Kansas City Art Institute, 1923. Address 1933, 4905 Argyle Place, St. Louis, MO.

WELLS, FRANCIS MARION.
Sculptor. Born in 1848. Sculptor of the giant figure of "Progress" which crowns the dome of the City Hall, San Francisco, CA. Designed Marshall Monument at Coloma, CA. Co-founder of Bohemian Club of San Francisco. Died July 22, 1903, in San Francisco, CA.

WELLS (or WELL), HENRY.
Ship carver. Worked in Norfolk, VA. Carved figureheads for the brigs *Norfolk* and *Tetsworth*. Active 1748-1800.

WELLS, J.
Engraver. The only information obtainable is that J. Wells was a map engraver working in NY in 1836.

WELLS, LUCY D.
(Mrs. William A. Wells). Painter and teacher. Born in Chicago, IL, September 4, 1881. Studied: Art Institute of Chicago; pupil of Vanderpoel, Ralph Clarkson, Randall Davey, Ernest Lawson. Member: Northwest Print Makers; Texas Fine Arts Association; Art Institute of Chicago; Spokane Art Association; National Association of Women Painters and Sculptors. Address in 1933, 17237 Greenwood Avenue, Seattle, WA.

WELLS, NEWTON ALONZO.
Painter, sculptor, architect, craftsman, and teacher. Born in Lisbon, St. Lawrence Co., NY, April 9, 1852. Pupil of Constant and Laurens in Paris. Member: National Society of Mural Painters, 1905; Architectural League of America; Chicago Society of Etchers; American Art Association of Paris. Instructor in painting, University of Illinois, from 1899. Exhibited at Paris Salon and various national and municipal exhibitions. Work: Mural decoration in library of University of Illinois; Sangamon County Court House, Springfield, IL; Colonial Theater, Boston; Englewood High School, Chicago; designed Soldiers' Monument, Tuscola, IL; series of historical mural paintings in Gayoso Hotel, Memphis, TN. Taught: Instructor of drawing and geometry, Union College, NY, 1877-79; professor of drawing, Syracuse University; professor of art, University of Illinois, from 1899. Address in 1926, 1630 Monroe Building, Chicago, IL.

WELLS, RACHEL.
Wax portraitist. Lived in Bordentown, NJ. Moved to Philadelphia. Executed full-length figure of the Rev. George Whitefield, given to Bethesda College, GA,

but it was later destroyed in a fire. Her work was chiefly small profile bas-reliefs in wax; the portraits were well-modeled and frequently finished in color. A sister of Patience Lovell Wright, who was the wife of Joseph Wright. He painted portraits of Washington in 1790.

WELLSTOOD, JAMES.
Engraver. Born in Jersey City, NJ, in 1855; died there in 1880. Son of William Wellstood and pupil of his father. He became a successful and promising engraver. At the time of his death he was a member of the engraving firm of William Wellstood & Co. His principal plates were "The Pointer" and "Safe in Port," the latter after a painting by Thomas Moran.

WELLSTOOD, JOHN GEIKIE.
Engraver. Born in Edinburgh, Scotland, January 18, 1813; was still living in 1889. Brother of William Wellstood. Wellstood came to NY in 1830. Employed by Rawdon, Wright & Co., where he remained until 1847, when he began business for himself. In 1858 his firm was merged into what became the American Bank Note Company, until 1871. In that year he founded the Columbian Bank Note Company in Washington, D.C., and while president of that company he designed and partially engraved the backs of the U.S. Treasury notes issued at that time. When the printing of United States notes passed into the hands of the Treasury Department, he returned to NY and was still employed in 1889 as a script engraver by the American Bank Note Company. Made many improvements in the manufacture of bank-notes. Died January 21, 1893, in Greenwich, CT.

WELLSTOOD, WILLIAM.
Engraver and etcher. Born in Edinburgh, Scotland, December 19, 1819. William was a brother of John G. Wellstood and came to NY with his parents in 1830. Began work there as a letter engraver, but later devoted himself to landscape and pictorial work. From 1846 to 1871 he was employed by the Western Methodist Book Concern in Cincinnati, OH, and by New York firms. A good line engraver. Produced a large amount of work. Died September 19, 1900, in New York City.

WELP, GEORGE L.
Illustrator and art director. Born in Brooklyn, NY, March 30, 1890. Studied: Art Students League; Pratt Institute; pupil of Walter Biggs. Member: Society of Illustrators; Salma. Club; Art Directors' Club. Address in 1929, Chanin Bldg., 122 East 42nd St., New York, NY; h. 157-48 Quince Ave., Flushing, Long Island, NY.

WELPLEY, CHARLES.
Painter and etcher. Born in Washington, D.C., June 11, 1902. Pupil of Burtis Baker; Daniel Garber. Address in 1929, 1912 H. St., N. W., Washington, D.C.

WELSCH, PAUL.
Painter. Born at Strasbourg, July 26, 1889. Pupil of Maurice Denis; Charles Guerin; Bernhard Naudin in Paris. Represented in: Chicago Art Institute; Musee de Mulhouse and Musee du Chateau des Rohans in Strasbourg. Address in 1933, 152 rue Broca, Paris, France.

WELSH, B. F.
Engraver. The American engraver William Chapin, in his autobiography, says that in 1824 he worked in a NY office with an engraver by this name. Welsh afterward became a prominent Baptist clergyman.

WELSH, HERBERT.
Painter. Born in Philadelphia, PA, 1851. Pupil of Bonnat in Paris; F. Auguste Ortmanns in Fontainebleau; Onorato Carlandi in Rome. Member of Fellowship Penna. Academy of Fine Arts. Address 1926, 814 Carpenter Lane, Mt. Airy Station, Philadelphia, PA.

WELSH, HORACE DEVITT.
Illustrator, painter and etcher. Born in Philadelphia, PA, March 2, 1888. Pupil of Thomas Anshutz; William M. Chase; Joseph Pennell. Member: Philadelphia Sketch Club; Fellowship Penna. Academy of Fine Arts; Society of Illustrators; Philadelphia Water Color Club; Art Directors' Club; Philadelphia Art Week Association; Society of Allied Artists. Work: Etching of Rembrandt's "Mill," and "St. Paul," Widener Collection, Philadelphia; etchings of the White House for President Wilson; etching of "The Lock," by Constable, Elkins Collection, Philadelphia; eight prints, British Museum. Assistant secretary of division of pictorial publicity during World War. Chairman, executive committee, Joseph Pennell Memorial Exhibition, Philadelphia, 1926. Special member, Anglo-American Archaeological Association of Mexico D.F. Died in 1942. Address in 1929, 80 West 40th St., New York, NY.

WELSH, ROSCOE.
Painter. Born in Laclede, MO, in 1895. Pupil of Eugene, California. Address in 1926, 445 Garfield Ave., Chicago, IL.

WELSH, WILLIAM P.
Painter and illustrator. Born in Lexington, KY, Sept. 20, 1889. Pupil of Mary Kinkead; Delecluse, Baschet and Royer in Paris; Du Mond in New York. Member: Artists Guild of the Authors' League of America; Chicago Society of Artists; Chicago Art Club. Awards: Third prize, Harry Payne Whitney mural competition, 1910; first prize, First International Water Color Exhibition, 1921; second prize, Tribune mural competition, 1922; first and third prizes, Inst. Poster Competition for Chicago World's Fair poster; medal, Annual Exhibition, Advertising Art for black and white drawing, 1930, and for poster, New York,

1931. Work: "Prisoners of War," Chicago Art Institute; mural decorations for the Men's Cafe, Palmer House Hotel, Chicago. Address in 1933, 19 East Pearson Street, Chicago, IL.

WENDEL, THEODORE.
Painter. Studied: McMicken School of Art; at Giverny, summers of 1886-87. Member: Guild of Boston Artists. Awards: Sesnan medal, Penna. Academy of Fine Arts, 1909; silver medal, P.-P. Expo., San Francisco, 1915. Work: "Landscape," Cincinnati Museum; "Winter at Ipswich," Pennsylvania Academy, Philadelphia. Awards: Medal, Penna. Academy of Fine Arts, 1909; medal, P.-P. Expo., San Francisco, 1915. Address in 1933, Ipswich, MA.

WENDT, JULIA M. BRACKEN.
See Bracken, Julia M.

WENDT, WILLIAM.
Painter. Born in Germany, Feb. 20, 1865; settled in Chicago in 1880. Self-taught. Member: Associate National Academy of Design, 1912; Chicago Society of Artists; National Arts Club; California Art Club; Ten Painters of Los Angeles; Laguna Beach Art Association; American Federation of Arts. Awards: Second Yerkes prize, Chicago, 1893; Young Fortnightly prize, Art Institute of Chicago, 1897; bronze medal, Pan.-Am. Expo., Buffalo, 1901; Cahn prize, Art Institute of Chicago, 1904; silver medal, St. Louis Expo., 1904; hon. mention, Chicago Society of Artists, 1905; silver medal, Wednesday Club, St. Louis, 1910; Cahn hon. mention, Art Institute of Chicago, 1910; Fine Arts Building prize, Society of Western Artists, 1912; Kirchberger prize, Art Institute of Chicago, 1913; silver medal, P.-P. Expo., San Francisco, 1915; Black prize, California Art Club, 1916; Spalding prize and second Balch purchase prize, Art Institute of Chicago, 1922; Pan.-Am. Exhibition, Los Angeles, 1925; special gold medal and diploma of honor, Pacific Southwest Expos., Long Beach, CA, 1928; second prize, Pasadena Art Institute, 1930. Work: "To Join the Brimming River," Cincinnati Museum; "When All the World is Young" and "The Silence of Night," Art Institute of Chicago; "Marine," Herron Art Institute, Indianapolis; "Hills in Springtime," Hibbard High School, Richmond, IN; "Montecito," Cliff Dwellers Club, Chicago; "Where Peace Abides," Des Moines Association of Fine Arts; "To Mountain Heights and Beyond," Harrison Gallery, Los Angeles Museum. Address in 1933, 2814 N. Sichel St., Los Angeles, CA; Laguna Beach, CA. Died December 29, 1946.

WENGER, JOHN.
Painter and designer. Born in Russia, June 16, 1891. Pupil of Imperial Art School of Odessa; National Academy of Design. Member: Salma. Club; Grand Central Art Galleries; Audubon Artists; American Water Color Society; NY Water Color Club. Awards:

Bronze medal, Sesqui-Centennial Expo., Philadelphia, 1926; Tel-Aviv Museum. Work: Decorative curtains, Theatre Masque and the Town Hall, New York; designer of moving scenery in "Good Boy," Hammerstein Theatre, New York; scenic designer for talking picture, "Paramount on Parade," Hollywood, CA; art director for Roxy Theatre, New York; Museum of the City of New York; Tel-Aviv Museum, Palestine. Exhibited: Corcoran, 1935; Penna. Academy of Fine Arts; American Water Color Society; Art Institute of Chicago; Audubon Artists, 1945, 53, 54, 56; Metropolitan Museum of Art, 1949; Museum of Modern Art; Museum of the City of New York; National Society of Painters in Casein, 1954, 55; others; one-man exhibitions at the Ferargil Gallery, 1925; Montross Gallery, 1931-34; Grand Central Art Galleries, 1929, 35, 38, 40, 44, 50, 56. Address in 1962, 252 West 76th Street, New York, NY.

WENIGER, MARIA P.
Sculptor. Born in Bevensen, Germany, in 1880. Studied in Munich with von Debschitz and Vierthaler, and with Maria Cacer. Member of Art Alliance of America. Work: Miniature bronzes, "Dancers." Exhibited at National Sculpture Society, 1923. Address in 1926, 442 East 58th Street, New York, NY.

WENTWORTH, ADELAIDE E.
Etcher, craftsman, lecturer and teacher. Born in Wakefield, NH. Pupil of D. W. Ross; W. S. Robinson; Arthur Dow. Member: Cincinnati Woman's Art Club; Crafters Co. Address in 1929, 17 The Somerset, Avondale, Cincinnati, OH; summer, Kittery Depot, ME.

WENTWORTH, CECILE DE (MRS.).
Painter. Born in New York City. Studied: Sacred Heart Convent; pupil of Alexander Cabanel and Edward Detaille, Paris. Exhibited at Paris Salon, since 1889, received hon. mention there, 1891; received gold medal, Lyons; gold medal, Turin; first gold medal, National Exhibition, Tours; exhibited at the Paris Expo., 1900, receiving a medal for portrait of Pope Leo XIII. Represented at Musee du Luxembourg, Paris; Vatican Musee, Rome; Senate Chamber, Paris; Metropolitan Museum of Art; Corcoran Gallery, Washington, D.C.; others. Has made portraits of Theodore Roosevelt, William H. Taft, Archbishop Corigan, and many notable people in Europe. Was Officier d'Academie, Paris, 1894; Officier de l'instruction Publique; Chevalier Legion d'Honneur, 1901. Address in 1910, 15 Avenue des Champs-Elysees, Paris, France; 15 West 67th Street, New York, NY.

WENTWORTH, D(ANIEL) F.
Painter. Studied in Munich, but largely self-taught. Member: Connecticut Academy of Fine Arts (president emeritus). Award: Popular prize, Connecticut

Academy of Fine Arts, 1922. Work: "Evening after Snow," Storrs College. Exhibited at American Water Color Society; Connecticut Academy of Fine Arts; Brooklyn Art Club. Died May 31, 1934. Address in 1933, Whittlesey Ave., New Milford, CT.

WENTWORTH, (THOMAS HANFORD).
Portrait painter in oils and miniature, landscapist, engraver, and lithographer. Born March 15, 1781 in Norwalk, CT. Father of William Henry Wentworth. He was working about 1815 in Utica, NY. He also made profile portraits in pencil and published several lithographs of Niagara Falls. Died December 18, 1849 at Oswego, NY.

WENTZ, HENRY FREDERICK.
Painter, craftsman, lecturer and teacher. Born in The Dalles, OR. Pupil of Art Students League of NY. Work: "Sand Dune, Neahkahmie," Portland Art Association. Address in 1933, Worcester Building, Portland, OR; summer, Neah-kah-mie Mt., Nehalem, OR.

WENZELL, ALBERT BECK.
Illustrator and painter. Born in Detroit, MI, in 1864. Pupil of Strahuber and Loefftz in Munich; Boulanger and Lefebvre in Paris. He painted the mural panels in the New Amsterdam Theater, NY. Member: National Society of Mural Painters; Architectural League, 1913. Awards: Medal, Pan.-Am. Expo., Buffalo, 1901; St. Louis Expo., 1904. Died in Englewood, NJ, on March 4, 1917.

WENZLER, H(ENRY) A(NTONIO), JR.
(or ANTHON HENRY).
Portrait, landscape, miniature, still life, and genre painter. Was of Danish birth but came to the U.S. at an early age and settled in NY. Worked there from 1838 until after 1860. He exhibited at the Penna. Academy, National Academy, and the Apollo Association. He was elected an Associate of the National Academy in 1848 and an Academician in 1860. Died in New York in 1871.

WERBE, ANNA LAVICK.
Painter and teacher. Born Jan. 2, 1888. Pupil of John H. Vanderpoel; Frederick Freer; Martha Baker. Exhibited at the Penna. Academy of Fine Arts, 1925. Member: Alumni Art Institute of Chicago; Chicago Art Club. Address in 1933, 2950 Webb Avenue, Detroit, MI.

WERNTZ, CARL N.
Painter, illustrator and teacher. Born in Sterling, IL, July 9, 1874. Pupil of J. H. Vanderpoel, Frederick Freer, Lawton Parker, Jeanette Pratt, Orson Lowell, A. Mucha and Robert Reid in America; Richard Miller in Paris; Onorato Carlandi in Rome; Seti Mizuno and Kaho Kawatika in Japan. Member: Western Art Association; Palette and Chisel Club;

American Federation of Arts; Illinois Manual Art Association. Formerly cartoonist on *Chicago Record*. Illustrated books and magazine articles. Founder, director and president, Chicago Academy of Fine Arts. Address in 1933, 18 South Michigan Ave., Chicago, IL. Died October 27, 1947, in Mexico City.

WERTMULLER, ADOLPH ULRIC.
Painter. Born in Stockholm, Sweden, February 18, 1751. Made first studies in art at home; went to Paris where he studied and practiced painting several years. Elected a member of the Royal Academies of Sculpture and Painting in Paris and Stockholm and became the first court painter to King Gustaf III of Sweden in 1787. He came to Philadelphia in May, 1794. Washington is said to have given him a single sitting for the portrait which was engraved by H. B. Hall for Irving's *Life of Washington*, the picture then in possession of Charles Augustus Davis of NY. The artist made several copies of this picture. He remained in this country until the autumn of 1796, when he returned to Stockholm. Came again to Philadelphia in 1800, and in the following year married a granddaughter of Hesselius, pastor of the Swedish congregation at Wilmington, DE. Shortly after, he purchased a farm below Marcus Hook on the Delaware, where he died in 1811. His portait of Marie Antoinette was exhibited in the Salon of 1785. After his death his pictures were sold at auction, a small copy of his "Danae" bringing $500.

WESCOTT, SUE MAY.
Miniature painter. Born January 14, 1893, in Sabinal, TX. Studied at Penna. Academy of Fine Arts; Denver Museum School. Exhibited portrait miniatures at the Penna. Academy of Fine Arts, Philadelphia, 1922. Address in 1926, 5970 Woodbine Ave., Overbrook, PA.

WESSEL, BESSIE HOOVER.
(Mrs. H. H. Wessel). Painter. Born in Brookville, IN, January 7, 1889. Pupil: Cincinnati Art Academy; Frank Duveneck. Work: Christian College, Columbia, MO; National Academy of Design; Anderson House, Washington, DC; American Legion Auxiliary Headquarters, Indianapolis, IN. Exhibited: Cincinnati Museum Association, 1944; annually at Cincinnati Professional Artists, Woman's Art Club, and the Hoosier Salon. Awards: Prizes, Cincinnati Woman's Art Club, 1937, 39, 40, 48, 50; Hoosier Salon, 1943, 45, 47. Member: Cincinnati Professional Artists; Cincinnati Woman's Art Club. Address in 1953, Cincinnati, OH.

WESSEL, HERMAN HENRY.
Painter, etcher, and teacher. Born in Vincennes, IN, January 16, 1878. Pupil: Cincinnati Art Academy, with Frank Duveneck; Julian Academy, Paris, with Jean Paul Laurens. Awards: Fine Arts prize, Society of Western Artists, 1915; first portrait prize,

Columbus, 1922; first prize, Atlanta, 1920. Member of Cincinnati Art Club; Cincinnati Professional Artists. Represented in Cincinnati Museum Association; Engineering College, University of Cincinnati; murals in Scioto Co. Courthouse, OH; Federal Reserve Bank Branch and Holmes Memorial Hospital, Cincinnati; Ohio State Office Building, Columbus. Address in 1953, h. 2152 Alpine Place, Cincinnati, OH.

WESSELHOEFT, MARY FRASER.
Craftsman, designer, painter, illustrator, and lecturer. Born in Boston, MA, Feb. 15, 1873. Pupil of Boston Museum of Fine Arts School, with C. H. Woodbury and D. Ross; von Habermann in Munich. Member: Copley Society, 1892; Salons of America; Society of Independent Artists; Santa Barbara Com. Art Association; Santa Barbara Art League. Exhibited at California Water Color Society, Los Angeles. Work: Natural History Museum; Fogg Museum of Art; Grace Church, Kansas City; Unitarian Church, Santa Barbara. Specialty: Stained glass and water colors. Address in 1929, 914 Santa Barbara St., Santa Barbara, CA. Died 1971.

WESSELMANN, TOM.
Painter. Born in Cincinnati, OH, Feb. 23, 1931. Studied: Art Academy of Cincinnati; Hiram College; University of Cincinnati, B.A.; Cooper Union, NYC, in the late 1950's. One-man exhibitions: Green Gallery, 1962, 64, and 65; Sidney Janis Gallery, NYC, 1966, 68, 70, 72, 74, 76, 79, 80; DeCordova Museum, 1969; Ehrlich Gallery, 1979; others. Group exhibitions: Museum of Modern Art; Contemporary Art Association, Houston; Oakland Art Museum; Sonnabend Gallery, Paris; Carnegie Institute; Dayton Art Institute; Des Moines Art Center; Rochester Memorial Gallery; Moderna Museet, Stockholm; Milwaukee Art Center; Whitney; Worcester Museum of Art; Larry Aldrich Museum of Contemporary Art, CT; NY University; Rhode Island School of Design; Detroit Institute of Art; Museum of Contemporary Art, Chicago, IL; DeCordova Museum, Lincoln, MA; American Federation of Arts; numerous others. Early work was in collages, many depicting interior domestic scenes. Work: Museum of Modern Art, NY; Whitney; Albright-Knox Art Gallery; Suermondt Museum, Aachen, Germany; Brandeis University; Worcester Museum of Art; Dallas Museum of Fine Arts; others. Many of his works are interspersed with depictions of the female nude, often as sex objects, emphasizing breasts, mouths, and genitalia. Address in 1982, Long Eddy, NY.

WEST, BENJAMIN.
Painter. Born Oct. 10, 1738, in Springfield, PA, on what is now the campus of Swarthmore. Showed great artistic talent in drawing and painting. Said to have been supplied his first colors by an Indian chief. He later received some instruction and materials from William Williams, an English artist then in Philadelphia. West went to Lancaster and made his first attempt at portraiture, painting a likeness of his friend William Henry, and a historical scene, "The Death of Socrates." Became a pupil of Provost William Smith, graduating as a member of the class of 1757 of the University of Pennsylvania. Left America to study in Rome in 1760, and made a study of the methods employed by Titian and other Italian painters while there. After three years of study, at the age of 25, he went to England and opened a studio in London. Was presented to George III, who ordered a canvas depicting "The Departure of Regulus from Rome." In 1772 he was appointed historical painter to the king, who, in 1765, founded the Royal Academy, and Joshua Reynolds became its first president. After Reynold's death in 1792, West served as president almost uninterruptedly from 1792-1815. In 1764 he married Elizabeth Shewell, whom he had known in Philadelphia and who had crossed the sea to her artist lover. West painted four classes of pictures: portraits, minor historical scenes, great historical scenes, and religious subjects. In his painting of the death of Wolfe at Quebec, he repudiated traditions of the classical school, clothing his characters in the dress of the time. He said that "this battle took place in the year of 1758, out in the wilds of Canada. That Indian who was there with his scalping knife and tomahawk knew nothing about a toga, and it is inappropriate." This painting brought about a revolution in art. Work: "Christ Healing the Sick," British National Gallery (a replica sent by West hangs in the Pennsylvania Hospital, Philadelphia); a large painting, "Death on the Pale Horse" (1817), Philadelphia Museum of Art; "Penn's Treaty with the Indians," Independence Hall, Philadelphia; self-portrait, "Hagar and Ishmael," and "Apollo and Hyacinthus," Metropolitan Museum of Art; "Una and the Lion," Wadsworth Athenaeum; "Woodcutters in Windsor Park," Herron Institute, Indianapolis; "Death of General Wolfe," National Gallery of Canada, Ottawa; and others. West taught Charles Willson Peale, Gilbert Stuart, Thomas Sully, Washington Allston, John Trumbull, John Singleton Copley and Samuel Morse. He was painted by most of them, but the most pleasing portrait is that painted as a young man by his friend Matthew Pratt. *The Life and Studies of Benjamin West*, by John Galt, published in 1816, was written during West's lifetime; its title page states that it is compiled from material furnished by himself. The Pennsylvania Historical Society, in Philadelphia, has many of West's paintings and drawings, besides a large collection of his letters; large collections of his drawings are also owned by Swarthmore College, the Boston Museum of Fine Arts, and Mr. H. Margary, Bagshot, Surrey, England. In 1817, after the death of his wife, West's strength began to fail, though his mental faculties remained unimpaired. Died in London on March 10, 1820, and was buried in St. Paul's Cathedral.

WEST, BERNICE DELMAR.
(Mrs. Robert A. Beyers). Sculptor. Born in Bronxville, NY, April 26, 1906. Studied: Art Students League, 1928-30; The Bennett School, Millbrook, NY, 1925; pupil of Archipenko, E. Amateis, Lu Duble, W. Zorach, W. Reiss. Works: Heroic Osceola, Silver Springs, FL; bronze statue of Dr. Fred H. Albee in Venice Bank, FL; bas-relief of Theodore L. Mead in Mead Botanical Gardens, Winter Park, FL; Wadsworth Atheneum; Mint Museum; cork mural in lobby of Little Theatre, Charlotte, NC; garden sculpture, Rockefeller Center, New York City; portraits of R. Werrenrath, R. Coleman, A. Bodanzky, and A. Corwin. Exhibitions: Contemporary Artists, 1931, Midtown Gallery, 1932, Ferargil Gallery, 1933, Federal Art Gallery, St. Petersburg, FL, 1936 (all one-woman); Southern States Art League, 1938-41; Southern Vermont Artists, 1938-40; Mint Museum, Charlotte, NC, 1940, 41, 45, 46; National Academy of Design, 1941; Connecticut Academy of Fine Arts, 1941-52; National Association of Women Artists, 1932; others. Awards: National Association of Women Artists, 1932; second prize, Southern States Art League, 1940; first prize, Connecticut Academy Annual, 1943; first prize, Bronxville (NY) Federation of Art Exhibit, 1955. Trustee, Dallas Museum of Fine Arts. Member: Connecticut Academy of Fine Arts; National Association of Women Artists; Pen and Brush Club; Dallas Art Association; Southern Vermont Artists; Mid-Vermont Artists; American Artists Professional League; Dallas Museum League; Southern States Art League; others. Address in 1962, Dallas, TX.

WEST, CHARLES MASSEY, JR.
Painter, sculptor and teacher. Born in Centreville, MD, Dec. 5, 1907. Studied at Penna. Academy of Fine Arts; Univer. of Iowa; John Herron Art Institute, B.F.A. Member: Wilmington Society of Fine Arts. Awards: Cresson traveling scholarship, Penna. Academy of Fine Arts, 1934; prizes, Indiana Art Association, 1940, 41; Hoosier Salon, 1942; Delaware Artists, 1942, 43. Exhibited: Corcoran Gallery of Art, 1941, 43; Art Institute of Chicago, 1942; Penna. Academy of Fine Arts, 1941; Baltimore Museum of Art, 1941; Delaware Artists, 1939-46; Cincinnati Museum Association, 1942. Position: Instructor of Painting, John Herron Art Institute, Indianapolis, IN, 1939-43. Address in 1953, Centreville, MD.

WEST, GEORGE PARSONS (MRS.).
See Percy, Isabelle Clark.

WEST, GLADYS (M. G.).
Painter and teacher. Born in Philadelphia, PA, Aug. 24, 1897. Pupil of Penna. Academy of Fine Arts, with Merriman, Vonnoh, Breckenridge, Hale, and Pearson. Member: Fellowship Penna. Academy of Fine Arts; Art Alliance of Philadelphia. Work: "St. Michael and the Cripples," St. Michael and All Angels, Philadelphia; altar, pulpit and tabernacle door decorations, Church of the Nativity, Philadelphia; decoration, Oak Lane Review Club, Philadelphia. Address in 1933, 34 South 17th St., Philadelphia, PA.

WEST, LEVON.
Etcher, painter, writer and teacher. Born in Centerville, SD, February 3, 1900. Studied: Art Students League; University of Minnesota; pupil of Joseph Pennell. Award: Charles M. Lea prize, Philadelphia, 1928. Work: "The Mountain Ranger," Philadelphia Museum, Philadelphia, PA; "Blackfoot Glacier," New York Public Library; "Pine and Sapling," Brooklyn Museum, Brooklyn, NY; "Portrait of Alfonso XIII," Hispanic Museum, New York City; Boston Museum of Fine Arts; Metropolitan Museum of Art; University of Minnesota Art Gallery; Honolulu Academy of Arts; others. Illustrator of *Masters of Etching; Making an Etching; Catalogue of the Etchings of Levon West*; others. Address in 1929, 342 Madison Ave., New York, NY; summer, Mayville, ND. Died in 1968.

WEST, PETER.
Animal painter. Born in England in 1833. He came to this country and maintained studios in several cities. In 1878 he was settled in Cleveland, OH, where he painted many of the fine horses of that section of the country; he also painted still-life and genre subjects.

WEST, WILLIAM EDWARD.
Historical painter and portrait painter in oils and miniature. Born December 8, 1788 in Lexington, KY. West painted miniatures several years before he studied in Philadelphia with Thomas Sully in about 1807. In 1819 he went to Natchez. In 1820 he sailed for Europe. At Leghorn he painted a portrait of Shelley from life. In 1824 he was in Paris, from 1825-39 in London, then he sailed for Baltimore. In 1840 he was in NY where he lived until 1855, when he moved to Nashville. See: *Century Magazine*, October, 1905; *Putnam's Magazine*, September, 1907; Tuckerman, *Book of the Artists*. Died Nov. 2, 1857, in Nashville.

WESTERMAN, HARRY JAMES.
Cartoonist, painter, illustrator, teacher, and writer. Born in Parkersburg, WV, August 8, 1876 or 77. Pupil of Columbus Art School. Member: Columbus Pen and Brush Club; League of Columbus Artists; Society of Independent Artists; Chicago No-Jury Society of Artists; League of American Artists. Cartoonist, McClure Newspaper Syndicate. Address in 1929, 1661 Franklin Park, South, Columbus, OH. Died June 27, 1945.

WESTERMANN, HORACE CLIFFORD.
Sculptor. Born in Los Angeles, CA, December 11, 1922. Studied at Chicago Art Institute School,

1947-54, with Paul Wieghardt. Works: Art Institute of Chicago; Wadsworth Atheneum; Los Angeles County Museum of Art; Pasadena Art Museum; Whitney; Walker. One-man exhibitions: Allan Frumkin Gallery, Chicago and NYC; Dilexi Gallery, Los Angeles, 1962, San Francisco, 1963; William Rockhill Nelson Gallery of Art, Kansas City, MO; Los Angeles County Museum of Art (retrospective). Group exhibitions: Houston Museum of Fine Arts; Wadsworth Atheneum; American Federation of Arts; Museum of Modern Art; Tate; The Hague; Rhode Island School of Design; Art Institute of Chicago; Worcester Art Museum; Walker; Carnegie; Documenta IV, Kassel, Germany, 1968; Whitney traveling exhibition; others. Awards: Art Institute of Chicago, Campana Prize, 1964; National Council on the Arts, 1967; Tamarind Fellowship, 1968. Media: Metals, woods. Address in 1980, Brookfield Center, CT. Died in 1981.

WESTFELDT (or WESTERFELDT), PATRICK MCLOSKY.
Painter. Born in New York, NY, May 25, 1854. Studied with Carl Hecker and William Prettyman. Specialty: Landscapes, mostly in water color. Died in New Orleans, or Asheville, NC, June 2, 1907.

WESTOBY, M.
Portrait painter. The portrait of Lindley Murray, published in (Longacre and Herring) *National Portrait Gallery*, is noted as engraved by Gimber after the portrait by Westoby.

WESTON, FRANCES M.
Painter. Exhibited water colors at the Penna. Academy of Fine Arts, Philadelphia, 1922. Address in 1926, Haddonfield, NJ.

WESTON, HAROLD.
Painter. Born in Merion, PA, February 14, 1894. Studied: Harvard University, B.A. Member: Artists Equity Association; Federation of Modern Painters and Sculptors. Work: "Trees in Winter," Memorial Gallery, Rochester, NY; "Catalan Kitchen," Penna. Academy of Fine Arts, Philadelphia; "The New Stove," "The Melon," "Loneliness," "Arena" and "Asleep," "Breakfast Table," "Resting," "Purring Pussywillow," "Pyrenees - Spring," "Self Portrait," Phillips Memorial Gallery, Washington, DC; San Francisco Museum of Art; Museum of Modern Art; Fogg Museum of Art; Yale University. Exhibitions include twelve one-man shows in New York; others. Award: Prize, Golden Gate Expo., San Francisco, 1939. Position: President, Federation of Modern Painters and Sculptors, 1953-55, 55-57; consultant, NY State Council on the Arts; liaison officer, U.S. Commission, International Association of Plastic Artists, 1958, 60, president, from 1961; others. Died in 1972. Address in 1962, 282 Bleecker Street, New York, NY; s. St. Hubert's, NY.

WESTON, HARRY ALAN.
Painter and teacher. Born in Springfield, IL, Dec. 11, 1885. Pupil of Art Institute of Chicago; Grand Central School of Art in New York. Member: Salma. Club; American Water Color Society; Allied Artists of America; NY Water Color Club; American Artists Professional League. Awards: Porter prize, Salma. Club, New York, 1828; hon. mention, American Water Color Society and NY Water Color Club, New York, 1929. Address in 1929, 170 East 78th St., New York, NY; summer, Idlehour Artist Colony, Oakdale, Long Island, NY. Died March 26, 1931.

WESTON, HENRY W.
Weston was engraving maps, Bible illustrations, etc. in Philadelphia, 1803-06, for Mathew Carey, book-publisher of that city.

WESTON, MARY PILLSBURY (MRS.).
Miniature, portrait, religious, and landscape painter. Born Jan. 5, 1817, in Hebron, NH. Exhibited at the National Academy in 1842. Died in May, 1894, in Lawrence, KS.

WESTON, MORRIS.
Painter, sculptor, writer, and teacher. Born in Boston, MA, Nov. 19, 1859. Member: League of Am. Artists. Exhibited at the National Academy of Design, 1925. Address 1926, 127 E. 59th St., NY, NY.

WESTWOOD, CHARLES.
Engraver. Born in Birmingham, England. He came to the United States in 1851 with John Rogers, the engraver. Westwood was a talented general engraver. Committed suicide about 1855.

WETHERALD, HARRY H.
Painter, designer, and illustrator. Born in Providence, RI, April 3, 1903. Studied: Rhode Island School of Design; National Academy of Design; pupil of Frazier and Hawthorne. Member: Providence Water Color Club; Providence Art Club; Salma. Club; Boston Art Directors' Club. Exhibited: Art Institute of Chicago; American Federation of Arts traveling exhibition, 1924-27; Baltimore Museum of Art; Philadelphia Water Color Club. Died June 4, 1955. Address in 1953, 42 Pine Street; h. 353 Olney Street, Providence, RI.

WETHERBEE, GEORGE.
Painter. Born in Cincinnati, OH, in 1851. Educated in Boston; studied at Royal Academy of Arts, Antwerp; also in London. Travelled and resided in West Indies, France, Germany, Italy, Belgium; finally settled in London. Member: Royal Institute of Painters in Water Colors; Royal Society of Oil Painters; Royal British Colonial Society of Artists; New Gallery Society, London. Award: Medal, St. Louis Expo., 1904. Work in Albright Art Gallery, Buffalo, NY. Address in 1926, 18 Redington Road, Hampstead, N.W., London, England.

WETHERILL, ELISHA KENT KANE.
Painter and etcher. Born September 1, 1874, in Philadelphia, PA. Studied: Penna. Academy of Fine Arts, with Anshutz; University of Pennsylvania; in Paris with Laurens and Whistler. Work in the Luxembourg Museum, Paris; Philadelphia Art Club. Member: Associate, National Academy of Design, 1927; Salma. Club; Allied Artists of America; Brooklyn Society of Etchers; Sketch Club. Awards: Gold medal, P.-P. Expo., San Francisco, 1915; silver medal, Sesqui-Centennial Expo., Philadelphia, 1926. Exhibited at the National Academy of Design, New York, 1925. Address in 1927, 143 East 23rd St.; 47 Fifth Avenue, New York, NY; summer, Phoenicia, NY. Died March 9, 1929, in Aberdeen, NC.

WETHERILL, ROY.
Painter and teacher. Born in New Brunswick, NJ, May 11, 1880. Pupil of R. L. Lambdin and of Norman Tolson. Taught at the Kansas City Art Institute. Address in 1926, Kansas City Art Institute, Kansas City, MO.

WETMORE, MARY MINERVA.
Painter. Born in Canfield, OH. Pupil of Cleveland Art School; Art Students League of NY, with Fox, Mowbray, Chase; School of Design, Philadelphia; Art School, San Francisco; Hopkins Art Institute; Chase in Spain and California; Julian Academy, with Laurens, Constant, and Collin; Colarossi Academy, with Courtois. Member: Chicago Society of Artists; Chicago Art Club; NY Women's Art Club. Address in 1933, 511 West Church St., Champaign, IL.

WETZEL, GEORGE J(ULIUS).
Painter. Born in New York City, Feb. 8, 1870. Pupil of Art Students League of NY under Mowbray, Beckwith, Cox and Chase. Member: Art Students League of NY (life); Salma. Club; National Fine Arts Society; American Federation of Arts; Art League of Nassau County. Awards: Hon mention, Art Club, Philadelphia; hon mention, Salma. Club. Died c. 1935. Address in 1933, 302 Forest Road, Douglas Manor, Douglastown, Long Island, NY.

WEYAND, CHARLES L. (MRS.).
See Cockcroft, Edith Varian.

WEYL, MAX.
Painter. Born Dec. 1, 1837, in Muhlen-on-Neckar, Germany. Studied in Europe. Came to America in 1853. Represented in the Corcoran Gallery; National Art Gallery, Washington, DC; Albright-Knox Art Gallery, Buffalo, NY; and in many private collections. Member: Society of Washington Artists. Awards: Prizes, Society of Washington Artists, 1901, 04. He died on July 6, 1914, in Washington, DC.

WEYRICK, JOSEPH LEWIS.
Painter. Specialty: Water colors. He died in Baltimore, MD, in 1918.

WHALEN, JOHN WILLIAM.
Painter, illustrator and teacher. Born in Worcester, MA, February 25, 1891. Pupil of Chase; Pape; Emerson; Brett; Spear. Member of Pittsfield Art League. Address in 1926, 29 Richards St., Worcester, MA.

WHALEY, E(DNA) REED.
(Mrs. M. S. Whaley). Painter, writer, and teacher. Born in New Orleans, LA, March 31, 1884. Pupil of Newcomb College, Tulane University. Member: Columbia Art Association (president); Carolina Art Association; Southern States Art League; Columbia Sketch Club. Awards: First prize for water color, Columbia Art Association, 1924; honorable mention for still-life in oil, Southern States Art League, February, 1921. Work: Illustrated "The Old Types Pass," by M. S. Whaley; represented in Vanderpoel Collection. Exhibited: South Carolina Artists Guild, 1951; Artists Guild of Columbia. Address in 1953, 4908 Colonial Drive, Columbia, SC.

WHARTON, PHILIP FISHBOURNE.
Painter. Born in Phila., PA, in 1841. Studied at the Penna. Academy of Fine Arts and in Paris. Best known works: "Perdita," which received a medal at the Centennial in 1876; "Eventide;" "Uncle Jim;" "Waiting for the Parade." Died in 1880.

WHARTON, T. H.
According to Dunlap this artist was painting in NY in 1834.

WHEATLEY, THOMAS JEFFERSON.
Sculptor, painter, and craftsman. Born in OH, Nov. 22, 1853. Pupil of C. Arter and T. C. Lindsay. Member: Cincinnati Art Club; Cincinnati Arts and Crafts Club; National Society of Craftsmen. Specialized in pottery. Address 1908, 2518 Highland Ave., Cincinnati, OH.

WHEELAN, ALBERTINE RANDALL.
Painter, illustrator, and craftsman. Born in San Francisco, CA, May 27, 1863. Pupil of Virgil Williams; San Francisco School of Design. Member: American Federation of Arts. Designer of character and costume sketches for David Belasco; illustrator; designer of book plates and stained glass windows; originator of the newspaper cartoons, "The Dumbunnies." Address in 1929, care of American Express, Paris, France.

WHEELER, CLEORA CLARK.
Designer, illuminator, craftsman, writer and lecturer. Born in Austin, MN. Studied: Univer. of Minnesota, B.A.; NY School of Fine and Applied Arts; pupil of Julie Gauthier. Member: Minnesota State Art Society; Am. Society of Bookplate Collectors and Designers; National League of Am. Pen Women. Award: First award in design, Minn. State

Art Society, 1913; National League of American Pen Women, 1942, 50. Exhibited: American Bookplate Society, annually, 1916-25; Grolier Club; NY Times Book Fair, 1937; Bookplate Assoc. International Exhibition, 1926, 31-36; National League of American Pen Women, 1936, 38, 40, 44, 46, 48, 50, 52, 54, 56, 60; Minnesota State Art Society; Minneapolis Institute of Art; U.S. National Museum, 1946, 48, 50, 52, 54, 56, 60; St. Paul Institute; others, including many one-woman exhibitions. Work: Minnesota State Historical Society; Minneapolis Institute of Art; Library of Congress; Yale Club, NY; Los Angeles Public Library; Am. Library in Paris; libraries of many colleges and universities, including Vassar, Harvard, Brown, Princeton, Yale, Radcliffe, Wells, etc. Has held various positions with the National League of Am. Pen Women between 1936-56. Specialty: Bookplate designs. Address in 1962, St. Paul, MN.

WHEELER, CLIFTON A.
Painter and teacher. Born in Hadley, IN, Sept. 4, 1883. Studied: Columbia Univer.; Butler University; pupil of Forsyth in Indianapolis; Henri, Miller and Chase in NY; also studied in Europe. Awards: Richmond (IN) prize, 1917; Holcomb prize, Herron Art Institute, 1921, 23; Art Association prize, 1924; Franklin College prize, 1926; Rector Memorial prize, 1927, 32; Indiana University, prize, 1928. Work: Paintings in Herron Art Institute, Indianapolis; Thorntown (IN) Public Library; Swope Art Gallery; Mooresville (IN) Public Library; Indiana University, Bloomington; Purdue University, Lafayette; Rose Polytechnic Institute, Terre Haute; Syracuse (IN) Public Library; mural paintings in Indianapolis City Hospital; St. Joseph's Convent, Tipton, IN; Circle Theatre, Indianapolis; Brookside and Whittier Schools, Indianapolis; others. Exhibitions: Penna. Academy of Fine Arts; World's Fair of NY, 1939; American Water Color Society; Virginia Museum of Fine Arts, 1938; Golden Gate Expo., 1939; Hoosier Salon; John Herron Art Institute; Indiana Art Club; Swope Art Gallery; others. Member: Indiana Art Club. Instructor of drawing and painting, Herron Art Institute, Indianapolis; summer school, University of Colorado. Died in 1953. Address in 1953, 5317 Lowell Ave., Indianapolis, IN.

WHEELER, DORA.
See Keith, Dora Wheeler.

WHEELER, E. KATHLEEN.
(Mrs. W. R. H. Crump). Sculptor. Born in Reading, England, October 15, 1884. Studied under Esther M. Moore and Frank Calderon; also at the Slade School, London. Came to America in 1914. Exhibited at the Paris Salon, 1906; Royal Academy, 1910; National Sculpture Society, 1923. Member: Society of Washington Artists; Guild of Boston Artists; Art Alliance of Philadelphia. Awards: Prize, Art Institute of Chicago; prize, Society of Washington Artists. Work:

"Death and Sleep," Harvey's Museum, St. John's Wood, London, England; Hackley Art Gallery, Muskegon, MI; "The Roundup," Canadian Pacific Railway, London. Specialized in animals and made portraits in bronze of the leading horses of America. Address in 1953, Chevy Chase, MD.

WHEELER, HELEN CECIL.
Painter. Born in Newark, NJ, September 10, 1877. Pupil of John C. Johansen. Member of Art Students League of New York. Address in 1926, 6 Kirk Place, Newark, NJ.

WHEELER, JANET D.
Portrait painter. Born in Detroit, MI. Pupil of Penna. Academy of Fine Arts; Julian Academy, Bouguereau and Courtois, Paris. Exhibited at the Salon, Paris; Penna. Academy of Fine Arts, Philadelphia; Philadelphia Art Club; St. Louis Expo. Awards: Toppan prize, Penna. Academy of Fine Arts, Mary Smith prize, 1901; gold medal, Philadelphia Art Club, 1902; silver medal, St. Louis Expo., 1904. Member: Plastic Club; American Federation of Arts; Art Alliance of Philadelphia; Fellowship Penna. Academy of Fine Arts. Address in 1933, The Barclay, 2607 E. Ocean Avenue, Long Beach, CA. Died Oct. 25, 1945.

WHEELER, LAURA B.
Portrait painter, illustrator, craftsman, and teacher. Born in Hartford, CT. Pupil of W. M. Chase, Henry McCarter, and Violet Oakley. Illustrated *The Shadow, The Upward Path.* Address in 1929, Brinton Cottage, Cheyney, PA; summer, 589½ Lafayette Ave., Brooklyn, New York, NY.

WHEELER, WILLIAM R.
Portrait painter, miniaturist and landscapist. Born in Scio, MI, in 1832. Started painting professionally when he was 15. Studied under Alvah Bradish in Detroit, c. 1850. In about 1862 he moved to Hartford, CT, and had a studio there until 1893. Specialized in children's portraits. Died c. 1894.

WHEELOCK, MERRILL G.
Landscape and portrait painter and architect. Born in 1822 in Calais, VT. In *Tuckerman's American Artist Life*, the water color studies of the White Mountain scenery by Wheelock are noted as skillful. Working in Boston, 1853, as an architect; worked as a portrait painter in watercolors between 1858-61. Illustrated *The White Hills, Their Legends, Landscape, and Poetry*, by Thomas Starr King, 1860. Died in 1866.

WHEELOCK, WARREN (FRANK).
Painter, sculptor, craftsman, teacher and writer. Born in Sutton, MA, January 15, 1880. Pupil of Pratt Institute Art School, Brooklyn. Member: Society of Independent Artists; Sculptors Guild; An American Group. Award: Honorable mention, Pan.-American

Exhibition, Los Angeles, CA, 1925. Work: "Old Man and Child," Los Angeles Museum of Art; Whitney; Art Institute of Chicago; IBM collection; Bartlett High School, Webster, MA; others. Exhibited at Musee du Jeu de Paume, Paris, 1938; Museum of Modern Art, New York City, 1939; Philadelphia Museum of Art, 1940; Carnegie, 1941; Art Institute of Chicago, 1942; Whitney, 1932-46; Metropolitan Museum of Art, 1942; Penna. Academy of Fine Arts, 1932, 34, 44-46; Denver Art Museum, 1941; Brooklyn Museum, 1938; Sculptors Guild, annually; others. Taught: Pratt Institute Art School, Brooklyn, 1905-10; Cooper Union Art School, New York, NY, 1940-45. Address in 1953, 400 East 57th Street, NYC.

WHELAN, BLANCHE.
Painter. Born in Los Angeles, CA. Pupil of Los Angeles School of Art and Design; Stanford University, A.B.; Art Students League of NY; pupil of Boardman Robinson and Nicholas Haz. Member: California Art Club; Laguna Beach Art Association; West Coast Arts, Inc.; American Federation of Arts; Women Painters of the West. Award: Prize, Arizona State Fair, 1931. Address in 1962, 386 South Burnside Avenue, Los Angeles, CA.

WHELPLEY, PHILIP M.
Engraver and landscapist, in New York City, active 1845-52. He engraved portraits in mezzotint of such people as William H. Seward, Richard Yeadon, and Robert Toombs for the *Whig Portrait Gallery*, 1852. Exhibited at the American Art-Union.

WHETSEL, GERTRUDE P. (MRS.).
Painter. Born in McCune, KS, Sept. 21, 1886. Pupil of Clyde Leon Keller. Member: Oregon Art Society; Portland Art Association. Awards: First prize for marine, second prize for landscape, Oregon State Fair, 1922. Address in 1933, 1683 West Blvd., Los Angeles, CA.

WHISLER, HOWARD F(RANK).
Painter. Born in New Brighton, PA, Jan. 25, 1886. Studied: Art Students League of NY; Penna. Academy of Fine Arts; pupil of Breckenridge and McCarter. Member: Fellowship Penna. Academy of Fine Arts; Architectural League of NY; North Shore Arts Association; Art Students League of NY. Awards: Cresson European Scholarships, Penna. Academy of Fine Arts, 1910-12. Address in 1933, 548 Riverside Drive, New York, NY.

WHISTLER, JAMES ABBOTT McNEILL.
Painter, etcher, lithographer, writer and teacher. Born in Lowell, MA, July 10, 1834. Raised in Lowell and in Russia, where his father was employed. Probably received his early training from his father, George Washington Whistler. He also studied at the Imperial Academy of Fine Arts, St. Petersburg, Russia. Returned to the U.S. in 1849. Studied at Pomfret, CT, 1849-51; West Point Military Academy, 1851-54. Traveled to Europe in 1855 to pursue his artistic career. Settled in Paris and entered the studio of Gleyre, and became acquainted with Degas, Bracquemond, Legros, Faintin-Latour, and other well-known artists, poets and critics. Executed the "Little French Set" of etchings, published in 1858. Whistler was in London in 1859 and two of his etchings were exhibited at the Academy in this year, probably two of the Thames Series, which were produced between 1859 and 1861, though not published until many years later. After this, he shared a studio with George Du Maurier, spent some time at Wapping, where he worked on paintings and etchings, and finally settled in Lindsay Row, Chelsea. His first important picture, "At the Piano," was hung at the Royal Academy in 1860. Following this, in the next year, was his picture "La Mere Gerard," and for several years after this paintings and etchings by Mr. Whistler appeared in the Academy Exhibitions. In 1863, "The White Girl" was sent to the Salon but rejected; however, it was hung in the Salon des Refuses and it there aroused great enthusiasm among the critics. Whistler visited Valparaiso in 1865-66, where he painted several pictures of the harbor. He returned to Chelsea, England and settled there, where he painted "The Thames in Ice" and "The Last of Old Westminster," along with other famous pictures of the Thames; pictures showing Japanese influence, including "La Princesse du Pays de la Porcelaine," "Die Lange Leizen of the Six Marks," "The Gold Screen," "The Little White Girl," "Symphony in White No. 3," and "The Balcony." Went to Venice, Italy in 1879, where he executed etchings and pastels. Returned to Chelsea in 1880. In 1887, he published his first collection of lithographs under the title of "Notes." On subsequent travels in Europe and North Africa he worked largely in pastel, watercolor, and graphic media. Lived in Paris, c. 1893-95, where he produced a large number of lithographs. He opened the Academie Carmen (briefly called the Academie Whistler) in Paris, in 1889, with the help of F. MacMonnies, and it drew many students while Whistler was there, but closed in 1901. Returned to England in 1895 and spent some time at Lyme Regis, where he executed a group of paintings, including "The Master Smith" and "The Rose of Lyme Regis," as well as a number of lithographs. Whistler was back in London in 1896 and continued to produce lithographs, including the magnificent series of the Thames Embankment done from the Savoy Hotel. His "Nocturne" lithographs are among the best ever produced. Whistler was still working up to the time of his death in London, 1903. Exhibited at the Royal Academy, London; Salon des Refuses, Paris, 1863; gallery in Pall Mall, 1874, Grosvernor Gallery, 1877, 79, 82, 84, Fine Arts Society's Gallery, 1880, 81, 95, Dowdeswells' Gallery, 1883, 84, 86, all in London; Working Women's College, Queen's Square, 1888; Goupil's Gallery,

London, 1892; Armory Show, 1913. In collections of Taft Museum, Cincinnati, OH; National Gallery of Art, Washington, DC; Detroit Institute; Louvre, Paris; decorations for Peacock Room, 1876-77, Freer Gallery of Art, Washington, DC; Metropolitan Museum, NYC; Tate; Art Institute of Chicago; Philadelphia Museum of Art; others. Awards: Medals, Paris Salon, 1883, 89, 1900; medal, Munich International Expo., 1892; gold medal, Penna. Academy of Fine Arts, 1894; others. Elected a member of the Royal Society of British Artists, 1884, president 1886; first president of the International Society of Sculptors, Painters, and Gravers, 1898-1903; Officer of Legion of Honor, France; member of Societe Nationale des Artistes Francais; Commander of the Order of the Crown of Italy; Chevalier of the Order of St. Michael of Bavaria; honorary member of Royal Academies of Bavaria, Dresden, and of St. Luke in Rome. Died in London, July 17, 1903. See also *The Art of James McNeill Whistler*, by T. R. Way and G. R. Dennis, and *Life and Works of James McNeill Whistler*, by E. R. and J. Pennell.

WHITE, ALDEN.
Etcher. Born in Acushnet, MA, April 11, 1861. Pupil of V. Preissig; Haskell. Member: Chicago Society of Etchers. Address in 1929, R. F. D. No. 1, New Bedford, MA.

WHITE, BELLE CADY.
Painter. Born in Chatham, NY. Studied: Pratt Institute in Brooklyn; pupil of Snell, Woodbury, and Hawthorne. Member: Brooklyn Water Color Club; American Water Color Society (life); National Association of Women Painters and Sculptors; Brooklyn Society of Artists. Award: Popular prize, Brooklyn Society of Artists, 1932. Represented in Rollins College, FL; public schools, St. Louis, MO. Director of the Ashland (OR) School of Art. Instructor at Pratt Institute. Address in 1933, 150 Steuben St., Brooklyn, NY; summer, Chatham Center, NY. Died February 26, 1945, in Hudson, NY.

WHITE, C(LARENCE) SCOTT.
Painter. Born in Boston, MA, March 14, 1872. Pupil of Charles H. Woodbury. Member: Boston Society of Water Color Painters; Copley Society; Boston Art Club. Exhibited: Boston Museum of Fine Arts; Boston Society of Water Color Painters. Address in 1953, 97 Somerset St., Belmont, MA.

WHITE, EDWIN.
Painter. Born in South Hadley, MA, in 1817. He studied in Paris and in Dusseldorf. His studio was in New York. Elected to the National Academy of Design in 1849. Best known for his American historical pictures. "Washington Resigning His Commission" was painted for the State of Maryland. Died at Saratoga Springs, NY, in 1877.

WHITE, ELIZABETH.
Etcher, painter, illustrator, teacher and lecturer. Born in Sumter, SC, Nov. 22, 1893. Studied: Penna. Academy of Fine Arts; Columbia University; pupil of Wayman Adams and Alfred Hutty. Member: Fellowship Penna. Academy of Fine Arts; Carolina Art Association; Tiffany Foundation; Southern States Art League. Awards: First prize for flower painting, Southern States Art League, Houston, TX, 1926. Work: Carnegie Library, Sumter, SC; Library of Congress. Exhibited: Prize, Southern States Art League, Houston, 1926; Smithsonian Institution, 1939 (one-man); World's Fair of NY, 1939; Venice, Italy, 1940; Chapin Memorial Library, 1951 (one-man); Asheville Museum of Art, 1950 (one-man). Illustrated *Crossin' Over*, 1938. Address in 1953, 421 North Main St., Sumter, SC.

WHITE, EMMA L(OCKE) R(IANHARD).
(Mrs. F. Winthrop White). Painter. Born in New Brighton, Staten Island, NY, Nov. 21, 1871. Studied: Art Students League; pupil of Twachtman; Cox; Mowbray; Brandegee; Chase; others. Member: Artists Equity Association; Kent Art Association; National Association of Women Artists; Kent Art Association; American Artists Professional League. Exhibited: Staten Island Museum of Arts and Sciences, 1943 (one-woman); also in Maine, California, New York, and Connecticut. Address in 1953, New Brighton, Staten Island, NY; summer, New Preston, CT. Died September 7, 1953.

WHITE, G. I.
This good line-engraver of portraits was working about 1825-30 in this country, but his prints give no indication of locality.

WHITE, GEORGE F.
Painter. Born June 1, 1868, in Des Moines, IA. Studied at the Art Students League; also in Munich, with A. Azbe and R. Frank. Exhibited water colors at the Penna. Academy of Fine Arts, Philadelphia, 1922. Address in 1926, 3 S. W. 9th St., Des Moines, IA.

WHITE, GEORGE H.
Engraver. Some fairly good portraits, engraved in a mixed manner in about 1870, are thus signed.

WHITE, HELENE MAYNARD.
Sculptor and portrait painter. Born in Baltimore, MD, May 26, 1870. Studied: Art Students League; Penna. Academy of Fine Arts; Drexel Institute; pupil of Moran, Chase, Cecilia Beaux, Grafly; also studied in Paris. Professional portrait painter since 1895. Member: Fellowship Penna. Academy of Fine Arts; Harmonic Society; Plastic Club; Lyceum Club, London; International Society. Work: "Last Mohicans" (sculpture), Roosevelt, AZ; "William H. Carpenter," Union National Bank; "Hugh Clarke" (sculpture),

University of Pennsylvania; "Robert Lee Jarvis," Bethany College Church; murals, St. Andrew's, Philadelphia; modeled heroic figure, "Chingachgook," for Mohican Lodge, Red Bank, NJ; "Liberty," San Francisco; painted portraits of many notable people. Exhibited: St. Louis Exposition; Philadelphia Art Club; leading art institutions. Awards: Hon. mention, St. Louis Exposition, 1904; prize, Philadelphia Art Club; silver medal, International Society; medal, California. Address in 1929, Southeast corner, Walnut at 16th Street, Philadelphia, PA; summer, Overbrook, PA.

WHITE, HENRY C(OOKE).
Painter, teacher and writer. Born in Hartford, CT, Sept. 15, 1861. Pupil of D. W. Tryon; Art Students League of NY, with K. Cox; George De Forest Brush. Member: Connecticut Academy of Fine Arts; Fellowship, National Academy of Design; NY Water Color Club; The Pastellists; American Federation of Arts. Exhibited: Penna. Academy of Fine Arts; Art Institute of Chicago; American Water Color Society; National Academy of Design; Connecticut Academy of Fine Arts; The Pastellists; Lyman Allyn Museum; in Hartford and New London, CT. Work: Wadsworth Atheneum; Phillips Memorial Gallery; Morgan Memorial Gallery, Hartford, CT. Taught at Hartford Art School, 1897; trustee, Lyman Allyn Museum, New London, CT. Address in 1933, Waterford, CT. Author of *Life and Art of Dwight William Tryon*, 1930. Died September 28, 1952.

WHITE, J(ACOB) C(AUPEL).
Designer, painter, illustrator, etcher and commercial artist. Born in New York, NY, Oct. 1, 1895. Pupil of National Academy of Design; Academie Julien, Paris. Member: American Federation of Arts; Advertising Club, NY. Awards: Fellowship, Tiffany Foundation, 1920; prize, cartoon competition, *Liberty* magazine. Works: "The Library" and "The Hall," Tiffany Foundation Art Gallery. Exhibited: Salon de Tunis; National Academy of Design; Tiffany Foundation. Address in 1962, 408 West 34th Street, New York, NY.

WHITE, JOHN BLAKE.
Painter. Born Sept. 2, 1781, near Eutaw Springs, SC. In 1803 he went to London and studied under Benjamin West. Returned to America in 1803 and worked in Charleston and Boston. Turned to law after meeting with little success in his painting and started practicing in Charleston in 1808. After this, he continued to paint at leisure. Lived in Columbia, SC, c. 1831; spent the rest of his life in Charleston. He excelled as an historical painter. He was also an author, and was a member and director of the South Carolina Academy of Fine Arts. Painted "Genl. Marion Inviting British Officers to Dinner;" also painted "The Battle of New Orleans" and "Grave Robbers." Exhibited at the Apollo Association;

National Academy; Boston Athaeneum. Was an honorary member of the National Academy, 1837. Died Aug. 24, 1859, in Charleston, SC.

WHITE, MARGARET WOOD.
(Mrs. V. G. White). Painter. Born in Chicago, IL, March 4, 1893. Pupil of Biloul; Humbert; Richard Miller; Johansen; Bridgeman. Member: National Association of Women Painters and Sculptors. Work: Portrait, President F. D. Roosevelt. Address in 1933, 58 West 57th St., NY; Woodmere, Long Island, NY.

WHITE, NELSON C(OOKE).
Painter. Born in Waterford, CT, June 11, 1900. Pupil of Henry C. White and National Academy of Design. Member: Connecticut Academy of Fine Arts. Exhibited: American Water Color Society; National Academy of Design. Trustee, Lyman Allyn Museum, New London, CT; Wadsworth Atheneum, Hartford, CT. Author of *The Life and Art of J. Frank Currier*, 1936; *Abbott H. Thayer - Painter and Naturalist*, 1951. Contributor to *Art in America; Art & Archaeology*. Address in 1962, Waterford, CT.

WHITE, NONA L.
Painter, writer, critic, lecturer, and teacher. Born in Illinois, Oct. 4, 1859. Pupil of Art Institute of Chicago. Member: Laguna Beach Art Association; Pasadena Society of Artists; Laguna Beach Art Association; Women Painters of the West. Art critic on "Los Angeles Evening News." Director of art in South Pasadena Women's Club. Address in 1933, 1134 Wabash St., Pasadena, CA. Died March 11, 1937.

WHITE, ORRIN A(UGUSTINE).
Painter. Born in Hanover, IL, Dec. 5, 1883. Pupil of Philadelphia School of Applied Art, 1906. Member: California Art Club. Awards: Silver medal, Panama-California Expo., San Diego, 1915; Mrs. Henry E. Huntington prize, California Art Club, 1921. Work: "Sierra Peaks," Los Angeles Museum; "Mountain Ranch," State Museum, Springfield, IL; Cleveland Museum of Art; Montclair Museum. Address in 1933, 2036 Linda Vista Ave., Pasadena, CA. Died April 28, 1969.

WHITE, RICHARDSON.
Sculptor. Born in Cohasset, MA, 1904. Studied: Harvard College, 1927; apprenticed for several years under the Boston sculptor Joseph Coletti. Exhibited: Boston Tercentenary Fine Arts Exhibition at Horticultural Hall; numerous one-man exhibits, including Doll and Richards Gallery, Boston, MA; Fitchburg Art Museum, Andover Academy; Chicago Livestock Show; Dartmouth College; Harvard College; Sotheby Parke Bernet; Animal Artists Society. Awards: National Sculpture Society for his "Guernsey Bull;" Maurice Hexter award for "Redring Clydesdale;" Chilmark award for small scale study entitled "Fave-Gaited Horse," 1981. Member: Animal Artists

Society; New England Sculpture Association; National Sculpture Society. Address in 1983, Holly Hill Farm, Cohasset, MA.

WHITE, THOMAS GILBERT.
Painter, decorator, lecturer, teacher and writer. Born in Grand Haven, MI, July 18, 1877. Studied: Julian Academy under Constant and Laurens; Beaux-Arts; pupil of Whistler and MacMonnies. Member: American Artists Professional League; Societe Internationale. Honors: Officier de la Legion d'Honneur; Officier de l'Academie; Order of the Purple Heart. Work: Murals, Kentucky State Capitol; Federal Building, Gadsden, AL; Utah State Capitol; County Court House, New Haven, CT; Peninsula Club, Grand Rapids, MI; portrait, "Gov. McCreary of Kentucky," Pan.-American Building, Washington, DC; murals, Oklahoma State Capitol; McAlpin Hotel, New York; Agricultural Building, Washington, DC. Represented in Locust Club, Philadelphia; Houston Museum; Brooklyn Museum; University Club; Corcoran; City of Paris Museum; Luxembourg Gallery, Paris; drawings, University of Washington, Seattle; University of Oklahoma, Norman. Address in 1933, care of Michigan Trust Co., Grand Rapids, MI; 5 bis rue Jadin, Paris, France. Died February 17, 1939.

WHITE, THOMAS STURT.
The *New England Weekly Journal*, for July 8, 1734, contains the following notice of a possible early engraver and printer of copperplates: "Engraver from London, not having met with such success as he expected since he came to Boston; hereby gives Notice that he intends sailing for London in the Fall, unless he meets with sufficient encouragement to oblige him to stay. This therefore is to inform all Gentlemen, Goldsmiths, and others, that they may have all manner of Engraving either on Gold, Silver, Copper or Pewter; likewise Rolling Press Printing, as well and cheap as is performed in London. N. B. The said White lives at the Second Door on the Right Hand in Williams Court, in Cornhill."

WHITE, VICTOR GERALD.
Painter and teacher. Born in Dublin, Ireland, Feb. 27, 1891. Studied: Art Students League, with Henri, Chase and Bellows; Julian Academy; Grande Chaumiere, Paris; pupil of Laurens, Simon, Biloul. Member: National Society of Mural Painters. Exhibited at the Architectural League, 1945. Work: Murals, Waldorf-Astoria Hotel, New York; ITT Building, New York; U.S. Post Office, Rockville Centre, NY; Grumman Corporation; frieze, Theatre Guild, NY. Address in 1953, Cedarhurst, Long Island, NY. Died in April, 1954.

WHITE, WALTER CHARLES LOUIS.
Painter, teacher and lecturer. Born in Sheffield, Yorkshire, England, Sept. 15, 1876. Studied: Pratt Institute; Teachers College, Columbia University, B.S., M.A.; pupil of Carlson, Beck, Dow, Hawthorne. Member: Brooklyn Society of Artists; Salma. Club; New Haven Paint and Clay Club; Mississippi Art Association; Brooklyn Water Color Club; Art Alliance of America; Springfield Art League; NY Water Color Club; American Water Color Society; Nassau County Art League. Awards: Hon. mention, 1925; gold medal, Mississippi Art Association, 1926; prize, Nassau County Art League, 1929, 34, 37. Work: Vanderpoel Collection; John Adams High School, St. Albans, NY. Exhibited: Sesqui-Centennial Expo., Philadelphia, PA, 1926; World's Fair of NY, 1939; Washington Water Color Club; Toledo Museum of Art; Brooklyn Museum; American Water Color Society, 1948-51; American Federation of Arts traveling exhibition; Salma. Club, 1948-51; Mississippi Art Association; New Haven Paint and Clay Club; Brooklyn Society of Artists, 1950; Nassau County Art League; National Arts Club, 1950-52; Art Institute of Chicago; Cincinnati Museum Association. Instructor at the Brooklyn Institute of Arts and Science. Address in 1962, St. Albans, Long Island, NY. Died c. 1964.

WHITE, WILLIAM FLETCHER.
Painter and illustrator. Born in Hudson, NY, July 2, 1885. Pupil of Twachtman, Mowbray, Cox, Bridgman. Member: Society of Illustrators; Artists Guild of the Authors' League of America. Address in 1933, 66 West 11th Street, New York, NY.

WHITECHURCH, ROBERT.
Engraver. Born in London in 1814. Came to the United States about 1848 and lived in Philadelphia until 1872. Worked for the treasury department after this in Washington, DC. Engraver of portraits in line, stipple and mezzotint. Died c. 1880.

WHITEHAM, EDNA MAY.
Painter and illustrator. Born in Scribner, NE, January 18, 1887. Student: Art Institute of Chicago; University of Nebraska, with Hayden and Seymour. Member: Lincoln Art Club; Awards: Prizes, Nebraska State Fair. Address in 1926, 9 Westmoreland Ave., Takoma Park, MD.

WHITEHEAD, MARGARET VAN CORTLANDT.
Painter. Member: Pittsburgh Art Association; National Association of Women Painters and Sculptors; American Federation of Arts. Award: First prize, Pittsburgh Art Association, 1912. Exhibited: National Association of Women Painters and Sculptors, 1936-38; Pittsburgh Art Association, 1912. Address in 1933, "The Maples," 80 West Putnam Ave., Greenwich, CT.

WHITEHEAD, WALTER.
Painter, illustrator and teacher. Born in Chicago, IL, Sept., 2, 1874. Pupil of Art Institute of Chicago and

Howard Pyle. Member: Society of Illustrators, 1911; Salma. Club; Art Directors' Club. Instructor, Chicago Academy of Fine Arts. Address in 1953, Dare, VA. Died January 31, 1956.

WHITEHORN, JAMES.
Painter. Born in Rutland Co., VT, in 1787. He was made a member of the National Academy. Specialty was portraiture. His painting of Silas Wright is in the City Hall, New York. Also designed the well-known mezzotint engraving of "Henry Clay Addressing the Senate," published about 1846. Died in 1830.

WHITEHURST, CAMELIA.
Painter. Born in Baltimore, MD, April 9, 1871. Pupil of Chase, Beaux. Member: Fellowship Penna. Academy of Fine Arts; National Association of Women Painters and Sculptors; Southern States Art League; North Shore Arts Association; Society of Washington Artists; Grand Central Art Galleries. Awards: First prize, All Southern Exhibition, Charleston, SC, 1921; hon. mention, National Association of Women Painters and Sculptors, 1920; first prize, Memphis, 1922; Delgado prize, New Orleans, 1923; second prize, National Association of Women Painters and Sculptors, 1923; bronze medal, Washington Society of Artists, 1925, and first prize, portraiture, 1929; first prize, portraiture, Springfield, MA, 1929; gold medal, Jackson, MI, 1929. Work in Delgado Museum, New Orleans; Baltimore Friends of Art. Address in 1933, 218 Chancery Road, Baltimore, MD. Died June 23, 1936.

WHITEMAN, SAMUEL EDWIN.
Landscape painter and teacher. Born in Philadelphia, PA, in 1860. Pupil of Boulanger, Constant and Lefebvre in Paris. Instructor at Johns Hopkins University. Member of Charcoal Club of Baltimore, MD. Award: Prize, Paris Expo., 1889. Director and teacher at the Charcoal Club; also taught at John Hopkins University. Died Oct. 27, 1922.

WHITESIDE, FRANK REED.
Landscape painter and teacher. Born in Philadelphia, PA, August 20, 1866. Pupil of Penna. Academy of Fine Arts; also Laurens and Constant in Paris. Member: Philadelphia Sketch Club; Fellowship, Penna. Academy of Fine Arts; Philadelphia Water Color Club; Art Alliance of Philadelphia. Exhibited: Philadelphia Sketch Club, 1929; Phoenix Art Museum, 1971 (retrospective). Address in 1926, 1010 Clinton St., Philadelphia, PA. Died September 19, 1929.

WHITFIELD, EMMA M(OREHEAD).
Painter and teacher. Born in Greensboro, NC, Dec. 5, 1874. Pupil of Art Students League of NY; Raphael Collin in Paris. Work: Portraits in State Library, Richmond, VA; University of Richmond, VA; Car-

negie Library, Greensboro, NC; State Capitols of Raleigh, NC, and Jackson, MI; Guilford County Court House, Greensboro, NC; Confederate Battle Abbey, Confederate Memorial Museum and the Executive Mansion, Richmond, VA; Woman's Club, Raleigh, NC; Mississippi College, Clinton, MI; portrait of "Mrs. R. D. Johnson, Founder," Boys Industrial School, Birmingham, AL. Address in 1929, 1800 Grove Ave., Richmond, VA. Died May 6, 1932.

WHITFIELD, JOHN S. (OR W.).
Portrait painter, sculptor and cameo portraitist. Active in Cambridge, MA, 1828; Philadelphia, 1829; Patterson, NJ, 1848; and NYC, 1849-1851.

WHITING, ALMON C(LARK).
Painter, etcher and designer. Born in Worcester, MA, March 5, 1878. Studied: Massachusetts Normal Art School in Boston; Julian Academy; pupil of Constant, Laurens and Whistler in Paris. Member: Paris Art Association; Salma. Club. Director and founder of the Toledo Museum of Art, 1901-03. Work: "Notre Dame, Paris," Toledo Museum of Art. Address in 1962, c/o Salmagundi Club, 47 Fifth Avenue, New York, NY.

WHITING, JOHN DOWNES.
Painter, illustrator, writer and lecturer. Born in Ridgefield, CT, July 20, 1884. Studied: Yale School of Fine Arts, B.F.A.; pupil of John H. Niemeyer, G. A. Thompson, Clifton S. Carbee, Lucius W. Hitchcock. Member: New Haven Paint and Clay Club; Society of Illustrators; Connecticut Academy of Fine Arts; Rockport Art Association; Meriden Arts and Crafts Society. Work: Municipal Collection, New Haven, CT; National Library of Color Slides, Washington, DC. Exhibited: Hartford, CT (one-man); Rockport Art Association; Connecticut Academy of Fine Arts; New Haven Paint and Clay Club; Connecticut Water Color Society; Meriden Arts and Crafts Society. Author and illustrator of *Practical Illustration*, 1920; others. Has done covers and illustrations for book and magazine publishers. Address in 1962, 254 Laurence Street; h. 291 Edwards St., New Haven, CT.

WHITLOCK, M(ARY) URSULA.
Painter, craftsman, and teacher. Born in Great Barrington, MA. Studied: Art Students League; Julian Academy in Paris; pupil of J. Alden Weir. Member: National Association of Women Painters and Sculptors; California Society of Miniature Painters; Pennsylvania Society of Miniature Painters; Riverside Art Association. Work: White House; Los Angeles Museum of History, Science and Art. Address in 1929, care of MacDowell Club, 166 East 73rd St., New York, NY; summer, care of Cecilia Beaux, Gloucester, MA. Died December 7, 1944.

WHITMAN, PAUL.
Painter, lithographer and etcher. Born in Denver, CO, April 23, 1897. Studied: Washington University, St. Louis; pupil of Armin Hansen. Award: Prize, International Society of Etchers, Los Angeles, 1928. Member: Carmel Art Association; International Society of Etchers, Los Angeles. Awards: Prize, International Society of Etchers, Los Angeles, 1928. Work: California State Library; Stanford University; Del Monte (CA) Hotel. Position: Teacher, Douglas School, Pebble Beach. Address in 1929, San Luis Avenue, Carmel, CA.

WHITMAN, SARAH DE ST. PRIX WYMAN.
(Mrs. William Whitman). Born in Baltimore, MD, in 1842. Pupil of William M. Hunt of Boston; Couture in Paris. Represented by "Gloucester Harbor," "Sunset," portrait of Martin Brimmer, "Warm Night," "Edge of Evening," "Rhododendrons," "Roses," Boston Museum of Fine Arts; "Brooks Memorial Window," Trinity Church, Boston, 1895. Member: Society of American Artists, 1880; honorary member, Copley Society; committee member, Boston Museum of Fine Arts School, 1885-1904. Has exhibited in many Boston galleries; Boston Art Club; St. Botolph Club; National Academy of Design; Pan.-Am. Expo.; Columbian Expo. Awards: Medal, Columbian Expo., Chicago, 1893; medal, Pan.-Am. Expo., 1901. Author: *Robert Browning in his Relation to the Art of Painting*, 1889; a tribute to William M. Hunt, *International Review*, 1879; article, "Stained Glass," *Handicraft*, 1903. Died in July, 1904, in Boston, MA.

WHITMER, HELEN C(ROZIER) (MRS.).
Painter and teacher. Born in Darby, PA, Jan. 6, 1870. Studied: Philadelphia School of Design for Women; pupil of Breckenridge, Anshutz, Henri, Thouron, Vonnoh. Member: Associated Artists of Pittsburgh; Society of Independent Artists; Dutchess County Art Association. Exhibited: Penna. Academy of Fine Arts; Dutchess County Art Association; Associated Artists of Pittsburgh. Address in 1953, La Grangeville, NY.

WHITMORE, ROBERT HOUSTON.
Painter, etcher, engraver, craftsman, illustrator, and teacher. Born in Dayton, OH, Feb. 22, 1890. Studied: Art Institute of Chicago; Cincinnati Art Academy; pupil of H. M. Walcott, James R. Hopkins. Member: Dayton Society of Etchers; Art Students League of Chicago; Dayton Society of Painters and Sculptors. Awards: Goodman prize, Art Students League of Chicago, 1920; prize, Art Institute of Chicago, 1921; Springfield Art Association, 1950-52; International Print Makers' Exhibition, Los Angeles, CA, 1924. Represented in Dayton Art Institute; Steel High School, Dayton; Normal School, Dayton; Los Angeles Museum of Art; Antioch College, Yellow Springs, OH; Vanderpoel Collection; Coshocton (OH) Public Library. Exhibited: Library of Congress, 1944; National Academy of Design, 1944; Philadelphia Print Club, 1945; Dayton Art Institute, 1936-52; Northwest Print Makers' Society, 1947; Wichita, KS, 1947; Terry Art Institute, 1952; Butler Art Institute, 1942; Dayton Society of Etchers, 1921-42. Instructor of painting, 1925-27, assistant professor, 1927-32, associate professor, from 1932, Antioch College. Address in 1962, Yellow Springs, OH.

WHITNEY, ANNE.
Sculptor and poet. Born in Watertown, MA, September 2, 1821 or 22. Studied sculpture in Rome, Munich, and Paris, from 1859-64. Set up a sculpture studio in Watertown, NY, 1860. In 1873 she established a studio in Boston, which she maintained until her death. Her works include a statue of Samuel Adams for the Capitol in Washington, of which a bronze replica is in Adams Square, Boston; Harriet Martineau at Wellesley College; Leif Eriksen, in bronze, in Boston and Milwaukee; "Roma" in Albany, Wellesley, St. Louis and Newton; Calla Fountain in Franklin Park, Philadelphia; seated statue of Charles Sumner, Harvard Law School; Boston Museum of Fine Arts; others. Died in Boston, MA, January 23, 1915.

WHITNEY, BEATRICE.
(Mrs. Van Ness). Painter. Born in Chelsea, MA, March 24, 1888. Pupil of Tarbell; Benson; Hale; Pratt. Awards: Julian A. Shaw prize, National Academy of Design, 1914; silver medal, P.-P. Expo., San Francisco, 1915. Address in 1933, 91 Francis St., Brookline, MA.

WHITNEY, CHARLES FREDERICK.
Painter and teacher. Born in Pittston, ME, June 18, 1858. Pupil of Massachusetts State Normal Art School. Author of *Blackboard Sketching*, published by the Milton Bradley Co.; *Blackboard Drawing*, published by the Prang Co.; *Indian Designs and Symbols*, published by C. F. Whitney, Danvers; *Chalk Talks for the Teacher*, published by the Practical Drawing Co., Dallas. Taught at The Wheelock School, Boston. Address in 1933, The Wheelock School, 100 Riverway, Boston, MA; h. 29 Pine St., Danvers, MA; summer, Camp Vision, Tamworth, NH.

WHITNEY, DANIEL WEBSTER.
Painter. Born in Catonsville, MD, May 3, 1896. Pupil of C. Y. Turner; Daniel Garber; Hugh Breckenridge; Joseph Pearson. Address in 1929, Catonsville, MD.

WHITNEY, ELIAS JAMES.
Wood engraver and painter. Born February 20, 1827. Living in Brooklyn, NY, in 1874. Exhibited at the American Institute as early as 1842 and at the National Academy in the 1850's. He succeeded Benjamin F. Childs as superintendent of engraving for

the Tract Society. His engraving of the designs of the Englishman Gilbert is among his best work and can be compared to the engraving of Dalziel. He illustrated largely for Putnam & Co., NY. See *History of Wood Engraving in America*, by W. J. Linton.

WHITNEY, FRANK.
Painter, sculptor and illustrator. Born in Rochester, MN, April 7, 1860. Pupil of Julian Academy in Paris, under Puech, Bouguereau, and Ferrier. Specialty: Animals. Address in 1910, Hubbardwoods, IL.

WHITNEY, GERTRUDE VANDERBILT.
(Mrs. Harry Payne Whitney). Sculptor. Born c. 1876 in NYC. Pupil of James E. Fraser, Harry Anderson at Art Students League; Andrew O'Connor in Paris. Member: National Association of Women Painters and Sculptors; National Sculpture Society; National Association of Portrait Painters; Newport Art Association; New Society of Artists; National Arts Club. Awards: Honorable mention, Paris Salon, 1913; National Arts Club prize, National Association of Women Painters and Sculptors, 1914; bronze medal, P.-P. Expo., San Francisco, 1915; bronze medal of honor, American Art Dealers' Association, 1932. Founded Whitney Club, forerunner of the Whitney Museum. Awarded the Grand Cross, Order of King Alfonso II of Spain. Works: Aztec fountain, Pan.-American building, Washington, DC; El Dorado fountain, San Francisco Exposition; two panels for Triumphal Arch, NYC; Soldiers memorial, Washington Heights, NYC; fountain, McGill University, Montreal; *Titanic* memorial statue, Washington, DC. Exhibited at National Sculpture Society, 1923. Address in 1933, 8 West 8th Street, 19 Macdougal Alley; h. 871 Fifth Avenue, New York, NY; summer, Old Westbury, Long Island, NY. Died on April 18, 1942.

WHITNEY, HELEN REED.
(Mrs. P. R. Whitney). Painter and designer. Born in Brookline, MA, July 1, 1878. Pupil of Boston School of Drawing and Painting under Hale, Benson and Tarbell. Member: Plastic Club; Art Alliance of Philadelphia; Fellowship Penna. Academy of Fine Arts; Philadelphia Water Color Club; Philadelphia Print Club. Work: Pennsylvania State College. Awards: Prize, Wanamaker Exhibition, 1915; prize, Newtown Square, PA, 1935. Address in 1953, The Homestead, Evanston, IL.

WHITNEY, ISABEL LYDIA.
Mural painter and craftsman. Born in Brooklyn, NY. Pupil of Arthur Dow; Howard Pyle; Hayley Lever. Member: Brooklyn Water Color Club; National Arts Club; Society of Independent Artists; Brooklyn Society of Modern Artists; Salons of America. Work: Brooklyn Museum. Specialty: Watercolors. Died February 2, 1962. Address in 1933, 337 Fourth Ave., New York, NY; h. 114 Remsen St., Brooklyn, NY.

WHITNEY, JOSEPHA.
Painter and teacher. Born in Washington, DC, September 27, 1872. Pupil of Messer; Chase; Ennis; Perrie; Cherouzet. Member: New Haven Paint and Clay Club; National Association of Women Painters and Sculptors; American Water Color Society. Address in 1933, 433 West 21st Street, New York, NY; h. 188 Bishop Street, New Haven, CT; summer, Woodstock, NY.

WHITNEY, MARGARET Q.
See Thompson, Margaret Whitney.

WHITNEY, PHILIP RICHARDSON.
Painter, craftsman, architect and teacher. Born in Council Bluffs, IA, Dec. 31, 1878. Studied: Massachusetts Institute of Technology, B.S. in architecture; also a pupil of Fred Wagner. Member: Philadelphia Art Club; Art Alliance of Philadelphia; Philadelphia Water Color Club. Work: "Winter," in Pennsylvania State College. Exhibited: Philadelphia Water Color Club; Penna. Academy of Fine Arts; Baltimore Water Color Club; Philadelphia Art Club. Professor, School of Fine Arts, University of Pennsylvania, retired in 1936. Address in 1956, Swarthmore, PA. Died c. 1960.

WHITTAKER, JOHN BERNARD.
Painter. Born in 1836, in Ireland. A painter of decided merit who worked in New York, from 1957. He painted several portraits of prominent men for the city of New York. Mr. Whittaker's portrait of John W. Hunter (Mayor of Brooklyn), painted in 1876, hangs in the old City Hall. Exhibited at the National Academy. Was a member of the Salma. Club, 1897, and worked as art director at Adelphi College.

WHITTEMORE, FRANCES D(AVIS).
(Mrs. L. D. Whittemore). Painter, writer, lecturer, and teacher. Born in Decatur, IL. Studied: Art Students League of NY; Art Institute of Chicago; pupil of J. Alden Weir, Kenyon Cox, Walter Shirlaw. Member: American College Art Association; Washington Art Club; Topeka Artists Guild; American Federation of Arts. Author of *George Washington in Sculpture*, Marshall Jones Co., 1933. Address in 1933, 1615 College Ave., Topeka, KS.

WHITTEMORE, GRACE CONNER.
(Mrs. George A. Whittemore). Painter, craftsman, and teacher. Born in Columbia County, PA, Oct. 29, 1876. Studied: Philadelphia School of Design for Women; Penna. Academy of Fine Arts; pupil of Daingerfield and Snell. Member: Art Center of the Oranges; Essex Water Color Club. Awards: Prizes, NJ State Federation of Women's Clubs, 1942, 43; Woman's Club, Orange, NJ. Exhibited: Art Center of the Oranges; Essex Water Color Club; Woman's Club, Orange, NJ; Montclair Art Museum; others. Address in 1953, 6 Morse Ave., East Orange, NJ.

WHITTEMORE, HELEN SIMPSON.

(Mrs. William J. Whittemore). Painter. Born in Horsham, England. Pupil of Chase, Colin, Merson, Garrido. Member: NY Water Color Club; National Association of Women Painters and Sculptors; American Water Color Society; Allied Artists of America. Work: Guild Hall, East Hampton, Long Island, NY. Address in 1956, 58 West 57th St., New York, NY; summer, East Hampton, Long Island, NY. Died c. 1958.

WHITTEMORE, WILLIAM J(OHN).

Painter and teacher. Born in New York, NY, March 26, 1860. Studied: National Academy of Design, with W. M. Hart and L. Wilmarth; Art Students League, under Beckwith; Julian Academy; pupil of Lefebvre and Constant in Paris. Member: Associate National Academy of Design, 1897; American Water Color Society; NY Water Color Club; American Society of Miniature Painters; Salma. Club, 1890; Lotos Club; California Society of Miniature Painters; Allied Artists of America; Society of Painters of NY; Century Club; American Federation of Arts. Awards: Silver medal, Paris Salon, 1889; bronze medal, Atlanta Expo., 1895; bronze medal, Charleston Expo., 1902; Proctor prize, National Academy of Design, 1917; Griscom prize, American Water Color Society, 1927; Isidor prize, Salma. Club, 1927; Weyrich Memorial prize, Baltimore, 1928; Philadelphia Society of Miniature Painters, 1934; California Society of Miniature Painters, 1942. Work: Columbia University; State House, Montpelier, VT; State House, Trenton, NJ; Boston Art Club; Franklin Institute, Philadelphia, PA; Brooklyn Museum; Lotos Club, New York City; Essex Club, Newark, NJ; Detroit Club; Metropolitan Museum of Art; San Diego Fine Arts Society. Address in 1953, East Hampton, Long Island, NY. Died February 7, 1955.

WHITTREDGE, THOMAS WORTHINGTON.

Painter. Born in Springfield, OH, May 22, 1820. Studied landscape and portrait painting in Cincinnati. Going abroad in 1849, he continued his studies in Dusseldorf under Andreas Achenbach, and in Rome, London, Paris and Antwerp. Upon his return to America in 1859, he settled in New York City and opened a studio there, making a specialty of landscapes, and actively participated in art matters. Whittredge remained in New York until 1880, when he moved to Summit, NJ. He travelled to Colorado various times, but is best known for his New England landscapes. He was elected an Associate and, in 1861, an Academician of the National Academy of Design, of which he was president in 1865 and 1874-77. Also a member of the Artists' Fund Society and the Century Association. He received a bronze medal at the Centennial Exhibition, Philadelphia, 1876; honorable mention at the Paris Expo., 1889; silver medals at the Pan.-American Expo., 1901, and the St. Louis Expo., 1904. His work is in the Whitney Museum; Cincinnati Art Museum; Newark Museum; Brooklyn Museum; Metropolitan Museum of Art. Died Feb. 25, 1910, in Summit, NJ.

WHORF, JOHN.

Painter. Born in Winthrop, MA, January 10, 1903. Studied: Boston Museum of Fine Arts School; Grande Chaumiere and Ecole des Beaux-Arts, Paris; pupil of Charles Hawthorne, Miller, and Bohm. Member of American Watercolor Society, 1948-58; Academician National Academy of Design; Florida Water Color Society. Works: Brooklyn Museum; Whitney; John Herron Art Institute; Boston Museum of Fine Arts; Toledo Museum of Art; Montclair Art Museum; Art Institute of Chicago; Rhode Island School of Design; New Britain Museum of Art; National Museum, Stockholm, Sweden; Delgado Museum of Art; Los Angeles Museum of Art; Museum of Modern Art; Fogg Museum of Art; City Art Museum, St. Louis; Yale University; others. Exhibited at the National Academy of Design, 1945-56, 58-59; work included in "200 Years of Watercolor Painting in America," at the Metropolitan Museum of Art, 1966-67; also exhibited nationally. Awarded an honorary M.A. degree from Harvard, in 1938; medal, 1939, prize, 1943, Art Institute of Chicago. Subjects included harbor, yachting, and beach scenes; landscapes; ducks. Address in 1956, c/o Milch Galleries, 55 East 57th Street, New York, NY; h. Provincetown, MA. Died in Provincetown, MA, February 13, 1959.

WICKER, MARY H. (MRS.).

Painter and sculptor. Born in Chicago, IL. Studied: Julian Academy in Paris; pupil of Brangwyn, Hawthorne, Pushman, Gaspard, Browne, Szukalski. Member: National Arts Club; American Artists Professional League; Illinois Academy of Fine Arts; Chicago Painters and Sculptors; Chicago Art Club; Hoosier Salon Patrons Association. Awards: American Artists Exhibition, Art Institute of Chicago, 1923 and 1924. Address in 1933, 450 St. James Pl., Chicago, IL.

WICKES, WILLIAM JARVIS.

Painter and sculptor. Born in Saginaw, MI, May 26, 1897. Pupil of Art Institute of Chicago. Member: Art Alliance of America. Address in 1929, 1016 Genesee Ave., Saginaw, MI.

WICKEY, HARRY HERMAN.

Etcher, sculptor, and printmaker. Born in Stryker, OH, Oct. 14, 1892. Studied: Detroit School of Fine Arts; Ferrer Modern School, NY; School of Industrial Art, NY. Member: Salma. Club; Brooklyn Society of Illustrators; Society of American Graphic Artists; Academician National Academy of Design. Awards: Logan prize, Chicago Society of Etchers; Shaw prize, Salma. Club, 1925; bronze medal, Sesqui-Centennial Expo., Philadelphia, 1926; Noyes

prizes, Society of American Etchers, 1934; Guggenheim Fellowship, 1939, 40; American Institute of Arts and Letters Grant, 1949. Work: "Midsummer Night," "Snug Harbor" and "The Park," Metropolitan Museum of Art, New York; "Midsummer Night," Art Institute of Chicago; Boston Museum of Fine Arts; Whitney; NY Public Library; Library of Congress; Carnegie; Wichita Museum of Art; Art Students League; Newark Museum; Addison Gallery of American Art. Exhibited: Victoria & Albert Museum, London; Bibliotheque Nationale, Paris; many Canadian galleries; major U.S. print exhibitions. Taught: Art Students League; Orange County Community College; Storm King School, Cornwall, NY. Address in 1962, Cornwall Landing, NY.

WICKEY, HELEN REED.
Painter. Exhibited water colors at the Penna. Academy of Fine Arts, Philadelphia, 1925. Address in 1926, 163 West 23rd St., NYC.

WICKHAM, JULIA M.
Painter. Member: National Association of Women Painters and Sculptors; Pen and Brush Club. Exhibited: National Association of Women Painters and Sculptors, 1935-38. Address in 1929, Cutchogue, Long Island, NY.

WICKS, HEPPIE EN EARL.
Portrait painter, lecturer, and teacher. Born in Le Roy, Genesee Co., NY. Pupil of L. M. Wiles, Irving R. Wiles, C. Y. Turner, Cecilia Beaux; Julian Academy and Ecole des Beaux-Arts in Paris. Address in 1933, 14 Trigon Park, Leroy, NY.

WICKWIRE, JERE R(AYMOND).
Painter. Born in Cortland, NY, July 3, 1883. Pupil of W. M. Chase. Represented by portraits of William Lyon Phelps and Dr. James M. Taylor in Vassar College, Poughkeepsie, NY. Member: Salma. Club; Associate National Academy of Design, 1936; Allied Artists of America. Awards: Allied Artists of America, 1934. Address in 1933, 130 West 57th St.; summer, Cortland, NY.

WIDFORSS, G(UNNAR) (MAURITZ).
Painter. Born in Stockholm, Sweden, Oct. 21, 1879. Studied: Stockholm Institute of Technology. Member: California Water Color Society; Scandinavian-American Artists. Awards: First prize, California Water Color Society, 1928; third prize, California State Fair, 1930. Work: "The Three Patriarchs," National Museum, Washington, D.C. Specialty: Views of the Grand Canyon. Address in 1933, 1845 Gough Street, San Francisco, CA. Died December 2, 1934, Grand Canyon, AZ.

WIDSTROM, EDWARD FREDERICK.
Sculptor. Born in Wallingford, CT, November 1, 1903. Studied: Detroit School of Art; Art Students League; and with Arthur Lee, William Zorach. Commissions: 36 Presidents of U.S., International Silver Co., Meriden, 1939-70; portrait reliefs, St. Stevens School, Bridgeport, CT, 1950; Municipal Building, Meriden, 1966; Marionist School, Thompson, CT, 1968. Work: Brookgreen Gardens, SC; New Haven Paint and Clay Club, CT; Meriden Arts and Crafts Association, CT; private collections. Member: Connecticut Academy of Fine Arts; New Haven Paint and Clay Club; Meriden Arts and Crafts Association; National Sculpture Society; American Artists Professional League; others. Awards: Prizes, Meriden Arts and Crafts Association, 1937, 46; American Artists Professional League, 1970; silver medal, National Sculpture Society, 1972, John Spring award, 1973, C. P. Dietsch award, 1975. Exhibited: National Academy of Design, 1940-75; Penna. Academy of Fine Arts, 1939, 40; Fairmount Park, Philadelphia, 1940; Connecticut Academy of Fine Arts, 1934-46; New Haven Paint and Clay Club, 1939-46; Meriden Arts and Crafts Association, 1936-46; National Sculpture Society, NY, 1960-81; American Artists Professional League, NY, 1969-71; others. Address in 1982, Meriden, CT.

WIEBKING, EDWARD.
Painter. Address in 1926, 104 Mason St., Cincinnati, OH.

WIECHMANN, MARGARET HELEN.
Sculptor. Born in NY, September 29, 1886. Studied: Art Students League; National Academy of Design; pupil of A. Phimister Proctor. Specialty: Small bronzes of animals. Address in 1926, Wainscott, Long Island, NY.

WIECZOREK, MAX.
Painter. Born in Breslau, Germany, Nov. 22, 1863. Studied in Italy and Germany; pupil of Ferdin, Keller, and Max Thedy. Member: California Art Club; Laguna Beach Art Association (life); California Water Color Society; NY Water Color Club; Painters of the West; Chicago Galleries Association; American Water Color Society; American Federation of Arts; Artland Club (life); Foundation of Western Art (president). Awards: Silver medal, Pan.-California Expo., San Diego, 1915; Harrison popular prize, California Art Club, 1918, A. J. Ackerman prize, 1920; merit prize, Arizona State Fair, 1920, 22; merit prize, Laguna Beach Art Association, 1920; H. E. Huntington prize, California Water Color Society, 1923; merit prize, International Bookplate Association, 1926; second prize, California State Fair, 1927; gold medal, Pacific Southwest Expo., Long Beach, 1928. Work: "Portrait of George Chaffey," Library Union Chaffey High School, Ontario, California; "The Old Sycamore," Engineers' Club, New York, NY; "Foothills," Los Angeles Athletic Club; portrait of "Ruth St. Denis," portrait of "Ted Shawn," Denishawn School of Dancing, New York, NY; "Boy

Listening," Los Angeles Museum; "Portrait of Jay B. Millard," Library of Virgil Junior High School; portrait of F. W. Blanchard, City Hall, Los Angeles. Address in 1933, 1007 South Grand Ave., Los Angeles, CA. Died September 25, 1955.

WIEDERSHEIM, GRACE GEBBIE.
See Drayton, Grace Gebbie Wiedersheim.

WIEGAND, GUSTAV (ADOLPH).
Painter. Born in Bremen, Germany, Oct. 2, 1870. Pupil of Dresden Royal Academy under Eugene Bracht; Chase in New York. Member: Salma. Club; Allied Artists of America; NY Society of Painters; National Arts Club (life). Awards: Bronze medal, St. Louis Expo., 1904; second Hallgarten prize, National Academy of Design, 1905; prize, Allied Artists of America, 1937. Work: "Stars Above Home," National Arts Club, New York; Newark Museum; Brooklyn Museum. Has exhibited extensively throughout the U.S. Address in 1953, Summit, NJ. Died Nov. 3, 1957, in Old Chatham, NY.

WIEGHORST, OLAF.
Painter. Born in Denmark, April 30, 1899. Self-taught. Work: National Cowboy Hall of Fame, Oklahoma City; Whitney Museum Cody, WY. One-man exhibitions: Cowboy Hall of Fame, Oklahoma City, 1974; San Diego Fine Art, California, 1980; Tucson Museum of Art, AZ, 1981; Gilcrease, Tulsa, OK. Noted for cowboy paintings in oil. Address in 1982, El Cajon, CA.

WIESSLER, WILLIAM, JR.
Painter and teacher. Born in Cincinnati, OH, June 14, 1887. Pupil of Frank Duveneck; L. H. Meakin; Vincent Nowottny. Member: Cincinnati Art Club; Valley of the Moon Society of Painters; Duveneck Society of Painters and Sculptors. Address in 1933, 131 East Third St., Cincinnati, OH.

WIGAND, ADELINE ALBRIGHT.
(Mrs. Otto Wigand). Painter. Born in Madison, NJ. Studied: Academie Julien, with Bouguereau; pupil of William M. Chase and Robert-Fleury. Member: National Association of Women Painters and Sculptors; Society of Painters, NY; Staten Island Art Association; Staten Island Institute of Arts and Science. Awards: NY Women's Art Club prize, 1905, 08; Shaw memorial prize, National Academy of Design, 1909; Simpson prize, NY Women's Art Club, 1909; National Arts Club prize, NY Woman's Art Club, 1912; prize, National Association of Women Painters and Sculptors, 1920. Work: Staten Island Institute of Arts and Science; Rhode Island School of Design; Little Gallery, Cedar Rapids, IA. Address in 1933, Woodside Ave., Stapleton, Staten Island, NY. Died March 30, 1944.

WIGAND, OTTO CHARLES.
Painter. Born in New York, June 8, 1856. Studied: Art Students League of NY; Academie Julien, with Boulanger and Lefebvre, in Paris. Member: NY Water Color Club; Salma. Club, 1899; Staten Island Institute of Arts and Science; president, Staten Island Art Association. Work: Boston Art Club. Address in 1933, Woodside Ave., Stapleton, Staten Island, NY. Died July 17, 1944.

WIGGIN, J.
This is a fraudulent signature. A portrait of Benjamin Rush in line was engraved by J. Akin and published by him in Philadelphia in 1800. A later impression of this plate is found with the name of the engraver and a long dedicatory address erased; it is relettered "Engraved by J. Wiggin."

WIGGIN, JESSIE DUNCAN.
Sculptor. Born in Boston, MA, 1872. Address in 1934, New York.

WIGGINS, CARLETON.
Painter. Born in Turner's, Orange Co., NY, March 4, 1848. Father of Guy Wiggins. Pupil of National Academy of Design and George Inness in NY; in Paris, 1880-81. Member: Associate National Academy of Design, 1890; Academician National Academy of Design, 1906; Society of American Artists, 1887; American Water Color Society; Salma. Club, 1898; Lotos Club; Brooklyn Art Club; Artists' Fund Society; Artists' Aid Society; American Society of Animal Painters and Sculptors; Connecticut Academy of Fine Arts; Lyme Art Association; American Federation of Arts. Awards: Gold medal, Prize Fund Exhibition, NY, 1894; bronze medal, Pan.-Am., Expo., Buffalo, 1901. Work: "A Holstein Bull," Metropolitan Museum, New York; "The Plow Horse," Lotos Club, NY; "The Wanderers," Hamilton Club, Brooklyn, NY; "October," Corcoran Gallery, Washington; "Evening after a Shower," National Gallery, Washington, DC; "Cattle in Pond" and "Sheep and Landscape," Brooklyn Institute Museum; "Lake and Mountains" and "Moonrise on the Lake," Art Institute of Chicago; "Sheep and Landscape," Newark Museum. Specialized in landscapes with cattle. Died June 11, 1932. Address in 1929, Riverwood, Lyme, CT.

WIGGINS, GUY.
Painter, teacher and lecturer. Born in Brooklyn, NY, Feb. 23, 1883. Studied: National Academy of Design in NY; pupil of his father, Carleton Wiggins. Member: Associate National Academy of Design, 1916; Academician National Academy of Design, 1935; Salma. Club; Connecticut Academy of Fine Arts (president, 1927-30's); Lotos Club; Lyme Art Association; Kit Kat Club; National Arts Club; New Haven Paint and Clay Club. Awards: Dunham prize, Connecticut Academy of Fine Arts, 1916, Flagg prize,

1918, 31, Cooper prize, 1926, Atheneum prize, 1933; Turnbull prize, Salma. Club, 1916, Isidor prize, 1919; Harris bronze medal and prize ($300), Art Institute of Chicago, 1917; hon. mention, Philadelphia Art Club, 1917; J. Francis Murphy Memorial prize, Rhode Island School of Design, 1922; grand prize, New Rochelle (NY) Society, 1929; prize, New Haven Paint and Clay Club, 1930; Lotos Club, 1938. Work: "The Metropolitan Tower," Metropolitan Museum, New York; "Columbus Circle—Winter" and "Gloucester Harbor," National Gallery, Washington, DC; "Berkshire Hills—June," Brooklyn Institute Museum; "Old North Docks," Hackley Art Gallery, Muskegon, MI; "Snow-crowned Hills" and "Lightly Falling Snow," Chicago Art Institute; "Fifth Avenue, Winter," Dallas Art Association; "Opalescent Days," Lincoln (NE) Art Association; "Winter Morning," Newark (NJ) Museum; "Through the Storm," Lotos Club; "Madison Square," National Arts Club; "On Wintry Hills," Wadsworth Athenaeum, Hartford, CT; "Winter Symphony," Beach Memorial Gallery, Storrs, CT; "Valley and the Hills," Detroit Athletic Club; "Winter, New York," Denton College, TX; "Light of the Morning," Cincinnati Club, Cincinnati, OH; also represented in Syracuse Museum of Fine Arts; Reading Museum; Heckscher Park Art Museum, Huntington, NY; University of Nebraska Art Gallery; Amherst College. Director, Guy Wiggins Art School, New Haven and Lyme, CT. Address in 1953, Essex, CT. Died April 25, 1962, in St. Augustine, FL.

WIGGINS, MYRA ALBERT.
Painter, designer, photographer, writer and teacher. Born in Salem, OR, Dec. 15, 1869. Studied: Willamette University, Salem, OR; Mills College; Art Students League of NY, with William M. Chase, Kenyon Cox, Frank DuMond, others; NY School of Art. Member: Seattle Art Museum; American Artists Professional League; American Federation of Arts; Women Painters of Washington State (founder and past president); National Association of Women Artists; American Artists Group; National League of American Pen Women; Pacific Coast Association of Painters and Sculptors. Awards: Prizes, Art Institute of Chicago, 1933; San Francisco, CA, 1939; prize, League of American Pen Women, 1939; first national award for achievement in art, Washington, DC, 1948, 52; General Federation of Women's Clubs; Seattle, WA, 1951. Work: YMCA, YWCA, Yakima, WA; State Library and Public Library, Olympia, WA. Exhibited: Argent Gallery, NY; Seattle Art Museum; Art Institute of Chicago (photography); Vancouver (B.C.) Art Gallery (one-man); Albright Art Gallery; Rochester Memorial Art Gallery; Portland Art Museum; League of American Pen Women; in Los Angeles, New Orleans, London, Paris, Toronto, and others. Specialty: Pictorial photography and still life in oils. Address in 1953, Seattle, WA. Died January 14, 1956.

WIGGINS, SIDNEY M(ILLER).
Painter, decorator and designer. Born in New Haven, NY, Jan 12, 1883. Pupil of Robert Henri; E. J. Sloane. Member: Salma. Club; Yonkers Art Association; NY Water Color Club; American Water Color Society; Allied Artists of America. Died in 1940. Address in 1933, 797 North Broadway, Yonkers, NY.

WIGGLESWORTH, FRANK.
Painter and sculptor. Born in Boston, MA, February 7, 1893. Pupil of Charles Grafly. Member: Boston Society of Sculptors; Boston Art Club; North Shore Arts Association; Gloucester Society of Artists. Address in 1933, Boston, MA.

WIGHT, MOSES.
Painter. Born in Boston, MA, April 2, 1827. Studied in Boston and later in Paris under Herbert and Leon Bonnat; also in Europe and Rome. Upon his return from Rome, he had his studio in Boston from 1854-73; made trips to Paris in 1860 and 1865; settled in Paris in 1873. In 1852, at the age of 82, he painted a portrait of Alexander von Humbolt, now in the collection of the Boston Museum of Fine Arts. Also represented in the American Antiquarian Society. Specialized in interior scenes. Died in 1895.

WIGHTMAN, THOMAS.
Engraver. He was in New England prior to 1806 as *Dean's Analytical Guide to Penmanship* was published in Salem in 1802, illustrated by twenty-five copperplates. These plates were "Collected by Henry Dean and correctly engraved by Thomas Wightman." Wightman also engraved some of the plates for a mathematical text-book published in 1806 by Professor Webber, of Harvard College. In 1814 he was in the employ of the Boston engraver Abel Bowen, and he engraved for "The Naval Monument," published by Bowen that year. The portraits executed by Wightman are fairly well done in stipple. Publication dates indicate he was working until 1820. Wightman engraved some of the plates in *The American Builder's Companion*, by A. Benjamin and D. Raynerd, Boston, 1806. Some book plates bear his name as engraver.

WIKEN, DICK.
Sculptor, craftsman, designer, writer, teacher, and lecturer. Born in Milwaukee, WI, April 11, 1913. Studied: University of Wisconsin Extension Division; largely self-taught. Member: Wisconsin Painters and Sculptors. Awards: Prizes, Milwaukee Art Institute, 1934, medal, 1935; Wisconsin Painters and Sculptors, 1935; Madison Salon, 1935, 37. Work: Public School, Milwaukee, WI; Soldier's Field, Administration Building, Chicago; many sculptured portraits. Exhibited: Wisconsin Painters and Sculptors, 1934, 35, 37, 39-41; Madison Salon of Art, 1935, 37, 39, 40; Washington, DC, 1936, 37; Rockefeller Center, NY, 1934, 38; NY World's Fair, 1939; Penna. Academy of

Fine Arts, 1940; Mississippi Valley Artists, 1941; Art Institute of Chicago, 1941; Syracuse Museum of Fine Arts, 1939; National Exhibition of American Artists, NY, 1937, 38. Lectures: Woodcarving; Ceramic Sculpture; etc. Address in 1953, Milwaukee, WI.

WILBUR, DOROTHY THORNTON.
Painter and illustrator. Born in Fincastle, VA. Pupil of Frederick F. Fursman; Julius Golz; Alice Schille. Award: Second prize for painting, Minnesota Society of Artists, 1924. Illustrated and designed *Stars*. Address in 1953, 18 Fourth St., Washington, DC.

WILCOX, FRANK NELSON.
Painter, etcher, illustrator, writer, teacher and lecturer. Born in Cleveland, OH, Oct. 3, 1887. Studied: Cleveland School of Art; pupil of H. G. Keller and F. C. Gottwald. Member: Cleveland Society of Artists; NY Water Color Club; Philadelphia Water Color Club. Award: Penton medal, Cleveland, 1920; prize, Cleveland Museum of Art Annual, 1932. Work: "The Old Market," Cleveland Museum of Art; Brooklyn Museum; Toledo Museum of Art; dioramas, Western Reserve Historical Society. Author and illustrator of *Ohio Indian Trails*. Instructor of art, Cleveland Institute of Art, Cleveland, OH; John Huntington Polytechnic Institute. Address in 1957, Cleveland Institute of Art, Cleveland, OH; h. 1879 Page Avenue, East Cleveland, OH.

WILCOX, JARVIS GEER, JR.
Painter. Born in Houston, TX, July 18, 1942. Studied: Yale University, B.A., 1964; with Arthur Stern, 1964-65. Work: Museum of the City of NY; Chrysler Museum, VA; Academy of Arts, MD. Exhibited: American Painters in Paris, 1975; Silvermine Guild of Artists, 1978; Audubon Artists Show, NYC, 1978; American Artists Professional League, NYC, 1977-81. Awards: A. Congor Goodyear Prize for Excellence in Art History, Yale University, 1964. Member: Salma. Club. Media: Oil, conte. Represented: Audrey Leeds, NYC. Address in 1982, 412 W. 110th St., NYC.

WILCOX, JOHN ANGEL JAMES.
Engraver and portrait painter. Born in Portage, NY, Aug. 21, 1835; living in Boston in 1908. In 1856 Wilcox entered the office of J. C. Kellogg, of Hartford, CT, and there learned to engrave. In 1860 he moved to Boston and was working there as an engraver until 1913. Though originally taught to engrave in strict line, he worked in stipple, mezzotint and etching with equal facility, engraving portraits, historical and subject plates, and landscapes. Also designed book plates and title pages and painted portraits.

WILCOX, LOIS.
Painter, lithographer, craftsman, teacher and writer. Born in Pittsburgh, PA, January 11, 1889.

Studied: Art Students League, with F. V. DuMond; Boston Museum of Fine Arts School, with Philip Hale; pupil of Charles Hawthorne, Raphael Collin, Willard L. Metcalf, Galemberti and Venturini-Papari in Rome; also studied in Paris. Exhibited: National Academy of Design; Corcoran Gallery; Architectural League; Century of Progress, Chicago; Fifty Prints of the Year, 1939. Member: College Art Association of America; many national exhibitions of lithographs. Taught at Sweet Briar College, VA, 1933-46. Contributor to *Magazine of Art*. Address in 1953, Woodstock, NY.

WILCOX, URQUHART.
Painter and teacher. Born in New Haven, CT, 1876. Pupil of Art Students League of Buffalo. Awards: Fellowship prize, Buffalo Society of Artists, 1906, Hengerer prize (first award), 1911, Fellowship prize, 1913. Director, School of Fine Arts, Albright Art Gallery, Buffalo, NY. Work: "A Song," Albright Art Gallery, Buffalo. Address in 1929, 85 North Pearl St., Buffalo, NY. Died May 16, 1941.

WILCOX, WILLIAM H.
See Willcox, William H.

WILDE, HAMILTON GIBBS.
Painter. Born in 1827, in Boston, MA. Studied in this country and abroad. Principally a genre painter, but also painted portraits and landscapes. Work: "Girl and Doves;" "Sultana;" "Roman Peasant." Exhibited at the Boston Athenaeum; Penna. Academy; National Academy. Died in 1884.

WILDE, IDA M.
Miniature painter. Exhibited at the Penna. Academy of Fine Arts, Philadelphia, 1925; Brooklyn Society of Miniature Painters, 1934, 35; Pennsylvania Society of Miniature Painters, Penna. Academy of Fine Arts, 1934, 35, 39; Washington Society of Miniature Painters, Sculptors, and Engravers, 1939. Address in 1929, Brooklyn, NY.

WILDE, JENNY (MISS).
Painter. Native of New Orleans. She was a member of the Artists' Association of New Orleans and of the Art League of New York. Did landscape, genre and portrait work, and for many years was engaged in designing tableux and floats for the New Orleans Carnival Organization. Represented in the Louisiana State Museum.

WILDENHAIN, FRANS RUDOLPH.
Sculptor, painter, ceramic craftsman, and teacher. Born in Leipzig, Germany, June 6, 1905. Studied: Bauhaus, Weimar, Germany; also with Walter Gropius, Klee, Kandinsky, Moholy-Nagy, Josef Albers, and others. Member: Boston Society of Arts and Crafts. Awards: Prizes, International Expo., Paris, 1939; Exhibition of Art, Los Angeles, 1949;

California State Fair, 1949; Wichita Art Association, 1951; Rochester Memorial Art Gallery, 1951; Albright Art Gallery, 1952; Brussels World's Fair. Member: American Crafts Council; World Crafts Council. Work: Stedelijk Museum, Amsterdam; Smithsonian Institution; Rochester Memorial Art Gallery, NY; Everson Museum, Syracuse, NY; Stoke-Upon-Trent, England; Mons, Belgium; Faenza and Milan, Italy; Portland Art Museum; Seattle Art Museum; Scripps College; Baltimore Museum of Art; Indianapolis Art Association; Art Institute of Chicago; commission for Rochester Institute of Technology; others. Exhibited: Metropolitan Museum of Art, 1929; San Francisco Museum of Art, 1949; de Young Memorial Museum, 1948; Portland Art Museum, 1949; San Diego Art Gallery; Art Institute of Chicago; Walker Art Center; Des Moines Art Center; Virginia Museum of Fine Art; University of California at Los Angeles; Dallas Museum of Fine Arts; Ft. Worth Art Association; University of Redlands; Henry Gallery, Seattle; Wichita Art Association; Baltimore Museum of Art; Syracuse Museum of Fine Arts, 1952; Museum of Contemporary Crafts, 1956, 62-64; Brussels World's Fair, 1958; American Crafts Council Gallery, NY; others. Contributor of ceramic designs to *Art and Architecture, House Beautiful, Craft Horizons*, and other publications. Position: Instructor, ceramics, School for American Craftsmen, Rochester, NY, from 1953. Address in 1976, Pittsford, NY. Died in 1980.

WILDENRATH, JEAN A(LIDA).
Painter and sculptor. Born in Denmark, November 3, 1892. Studied: Cooper Union; National Academy Design; pupil of George Ford Morris, Joshua Dupont. Address in 1933, 2707 Sedgwick Ave., New York, NY.

WILDER, ARTHUR B.
Landscape painter. Born in Poultney, VT, April 23, 1857. Pupil of Art Students League of NY; Brooklyn Art Guild School; T. Eakins. Member: Boston Art Club; American Federation of Arts. Work in the Woodstock Inn, Vermont. Address in 1933, Woodstock, VT.

WILDER, BERT.
Painter, etcher and teacher. Born in Taunton, MA, Sept. 17, 1883. Pupil of Cooper Union in NY; Academie Julien in Paris; Massachusetts School of Art; School of the Boston Museum of Fine Arts. Member: Kit Kat Club. Instructor, art group, Paterson, NJ. Address in 1933, Homer, NY.

WILDER, LOUISE HIBBARD.
(Mrs. Bert Wilder). Sculptor, etcher, and teacher. Born in Utica, NY, October 15, 1898. Pupil of George T. Brewster. Member: National Association of Women Painters and Sculptors; Society of Medalists. Award: Honorable mention, National Garden Show,

New York, 1929. Work: Relief, Court House, Newark, NJ; memorial fountain, Home for Indigent Aged, Washington, DC. Taught: Instructor, School of Sculpture and Painting, Paterson, NJ. Address in 1933, Homer, NY.

WILDHACK, ROBERT J.
Illustrator and painter. Born in Pekin, IL, Aug. 27, 1881. Pupil of Robert Henri in NY; Otto Stark in Indianapolis. Member: Society of Illustrators, 1910; Salma. Club; Artists Guild of the Authors' League of America. Specialties: Posters and humorous line drawings. Address in 1929, La Crescenta, CA.

WILES, GLADYS (LEE).
(Mrs. W. R. Jepson). Painter. Born in New York, NY. Pupil of Cox; Chase; Johansen; Wiles. Member: Audubon Artists; National Association of Women Painters and Sculptors; MacDowell Club; Allied Artists of America; American Federation of Arts; Associate National Academy of Design; American Artists Professional League. Award: Medal of French Museum, National Association of Women Painters and Sculptors, 1919. Address in 1962, Peconic, NY.

WILES, IRVING R(AMSEY).
Portrait painter. Born in Utica, NY, April 8, 1861. Pupil of his father, L. M. Wiles; of Chase and Beckwith in NY; Academie Julien under Lefebvre; Carolus-Duran in Paris. Member: Associate National Academy of Design, 1889; Academician National Academy of Design, 1897; Society of American Artists, 1887; American Water Color Society; National Institute of Arts and Letters; National Association of Portrait Painters; Allied Artists of America; Century Association; Lotos Club; American Art Association of Paris; National Arts Club; American Federation of Arts; American Artists Professional League; Architectural League, 1897; NY Water Color Club, 1904. Awards: Third Hallgarten prize, National Academy of Design, 1886, Clarke prize, 1889, Proctor portrait prize, 1913, Maynard portrait prize, 1919, Palmer Memorial Prize, 1931, prize, 1936; hon. mention, Paris Expo., 1889; medal, Columbian Expo., Chicago, 1893; Evans prize, American Water Color Society, 1897; medal, Tennessee Centennial, Nashville, 1897; Shaw prize, Society of American Artists, 1900; bronze medal, Paris Expo., 1900; gold medal, Pan.-Am. Expo., Buffalo, 1901; first Corcoran prize, Society of Washington Artists, 1901; gold medal, St. Louis Expo., 1904; silver medal, Appalachian Expo., Knoxville, 1910; gold medal, Buenos Aires Expo., 1910; gold medal, P.-P. Expo., San Francisco, 1915; Morris prize, Newport Art Association, 1917; first prize, Duxbury Art Association, 1921; Lippincott prize, Penna. Academy of Fine Arts, 1922. Work: Four portrait panels, Hotel Martinique, NY; "Ex-Mayor Schieren," City Hall, Brooklyn, NY; "The Student,"

Corcoran Gallery, Washington, DC; "The Brown Kimono," "Russian Tea," portraits "John Gellatly" and "My Daughter," National Gallery, Washington, DC; "General Guy V. Henry," Military Academy, West Point, NY; "L. M. Wiles" and "George A. Hearn," Metropolitan Museum, NY; portrait of Mrs. Gilbert, "The Sonata," Butler Art Institute, Youngstown, OH; "President Roosevelt," University of Berlin, Germany; "William J. Bryan," State Department, Washington, DC; "Albert H. Wiggin," Chase Bank; "A. Barton Hepburn," Banker's Club, NY; Columbia University, NY; Lotos Club. Well-known for his portraits, figure-pieces, genre and outdoor scenes. Illustrator for *Scribner's; Harpers; Century.* Taught at the Art Students League; Chase School of Art; Wiles Summer School, Peconic, NY. Address in 1933, 130 West 57th Street, New York, NY; summer, Peconic, Long Island, NY. Died April 8, 1948.

WILES, LEMUEL MAYNARD.
Landscape painter and teacher. Born at Perry, NY, October 21, 1826. Studied: NY State Normal College, 1847; Ingham University, LeRoy, NY, 1848; Albany Academy, with William M. Hart; also a pupil of J. F. Cropsey. He was the father of Irving R. Wiles. Work: Ingham University, NY; Perry Public Library, NY. Director, College of Fine Arts, Ingham; director of art department, University of Nashville; taught at Albany, NY, and Washington, DC. Died in New York City, Jan. 28, 1905.

WILEY, CATHER.
Painter. Exhibited at the National Academy, NY, 1925. Address in 1926, Knoxville, TN.

WILEY, FREDERICK J.
Painter. Member: Century Association; Lotos Club; National Society of Mural Painters. Award: Bronze medal, St. Louis Expo., 1904. Address in 1933, c/o Paris and Wiley, 7 East 48th Street; 139 West 55th Street, NY.

WILEY, HEDWIG.
Painter and teacher. Born in Philadelphia, PA. Studied: Penna. Academy of Fine Arts; University of Pennsylvania, B.S.; pupil of Chase, Beaux, Dow, Breckenridge, and Snell. Member: Philadelphia Plastic Club; Art Alliance, Philadelphia; Philadelphia Print Club; Fellowship Penna. Academy of Fine Arts; American Federation of Arts. Exhibited: Philadelphia Art Club; Penna. Academy of Fine Arts; Philadelphia Print Club; Philadelphia Plastic Club; others. Address in 1953, Philadelphia, PA.

WILFORD, LORAN FREDERICK.
Painter, illustrator, and teacher. Born in Wamego, KS, Sept. 13, 1892. Studied: Kansas City Art Institute; pupil of Charles Wilimovsky and George Pearse Ennis. Member: Society of Independent Artists;

Artists Guild of the Authors' League of America; Salons of America; NY Water Color Club; American Water Color Society; Salma. Club; NY Artists Guild. Awards: Hon. mention, California Print Makers' Society, 1922; silver medal, Kansas City Art Institute, 1922; Gallatin prize, NY Water Color Club, 1929; Zabriskie prize, American Water Color Society, 1929, J. T. McGowan prize, 1930, Osborne prize, 1933; Isidor prize, Salma. Club, 1930, Shaw prize, 1931; Philadelphia Water Color Club prize, 1931; Audubon Artists, 1945. Represented in permanent collection of woodcuts, New York Public Library; murals, Holmes Public School, Darien, CT; Toledo Museum of Art. Exhibited: Corcoran Gallery; Penna. Academy of Fine Arts; Carnegie Institute; National Academy of Design; Golden Gate Expo., San Francisco, 1939; others. Address in 1953, Stamford, CT.

WILFRED, THOMAS (RICHARD EDGAR LOVSTROM).
Sculptor. Born in Naestved, Denmark, June 18, 1889. Studied at Sorbonne. Works: Clairol Inc.; Cleveland Museum of Art; Honolulu Academy; Metropolitan Museum of Art; Museum of Modern Art; Joslyn Art Museum, Omaha. Exhibitions: Museum of Modern Art; Moderna Museet, Stockholm; Eindhoven, Kunst-Licht-Kunst; Walker Art Center and Milwaukee Art Center, Light Motion Space; Trenton State, Focus on Light; The Howard Wise Gallery, NYC, Lights in Orbit, and Festival of Lights; Worcester Art Museum, Light and Motion. Awards: Philadelphia College of Art, honorary Ph.D., 1968. Died in West Nyack, NY, August 15, 1968.

WILGUS, (WILLIAM) JOHN.
Painter. Born January 28, 1819, in Troy, NY. He was a pupil of Samuel F. B. Morse, 1833-36, and was in New York City until about 1841. After this he moved to Buffalo, NY. He was elected an honorary member of the National Academy of Design in 1839. His painting of an Indian chief was exhibited in the Centennial Exhibition of the National Academy of Design, 1925. Died July 23, 1853, at Buffalo, NY.

WILHELM, ARTHUR L.
Painter. Born in Muscatine, IA, December 14, 1881. Pupil of Art Institute of Chicago; C. C. Rosenkranz. Award: Special mention, Minnesota State Exhibition, 1916. Address in 1927, 2312 Alden Street, St. Paul, MN.

WILIMOVSKY, CHARLES A.
Etcher, engraver, painter, block printer, and teacher. Born in Chicago, IL, September 10, 1885. Studied: Art Institute of Chicago; pupil of J. C. Johansen, and Wm. M. Chase. Member: Chicago Art Students League; Alumni Art Institute of Chicago; Chicago Society of Etchers; California Print Makers' Society; Chicago Painters and Sculptors; Society of American Graphic Artists; Chicago Galleries Asso-

ciation. Awards: Dean prize ($50), Kansas City Art Institute, 1916, prize ($100), 1920, purchase prize, 1923; silver medal, Oklahoma Artists, 1917; Rosenwald purchase prize, Art Institute of Chicago, 1924, Clyde M. Carr prize, 1929, prize, 1937. Represented in Lindsborg University, KS; Kansas City Club; Kansas City Art Institute; City Library, Springfield, MA; collection of the City of Chicago; Art Institute of Chicago; Art Association, Cedar Rapids, IA; Bibliotheque Nationale, Paris; Honolulu Academy of Art; Modern Gallery, Prague. Exhibited in Paris, Brussels, Rome, Florence, and nationally. Taught at the Art Center School, Los Angeles, CA. Address in 1953, Los Angeles, CA.

WILKE, WILLIAM H(ANCOCK).
Designer, illustrator, etcher, block printer, and teacher. Born in San Francisco, CA. Studied: Mark Hopkins Institute of Art, San Francisco, CA; Julian Academy, Paris; pupil of A. F. Mathews; Laurens and Blanche in Paris. Work: American Institute of Graphic Arts; etchings in many privately printed books. Member: California Society of Etchers; California Print Makers' Society; San Francisco Federation of Arts. Designer-manager, Shreve and Company, Silversmiths; illustrator and industrial designer, Henry Kaiser Company. Award: Gold medal, P.-P. Expo., San Francisco, 1915. Address in 1953, Berkeley, CA.

WILKINSON, EDWARD.
Painter, illustrator, architect, craftsman, teacher, and writer. Born in Manchester, England, Jan. 22, 1889. Studied: Rice Institute; pupil of James Chillman, J. C. Tidden. Member: Texas Fine Arts Association; Southern States Art League. Award: Hon. mention, Nashville, TN, 1929. Work: Houston Public Library; historical dioramas for museums in Houston and Huntsville, TX; Capitol, Texas. Address in 1933, Garden Villas, Houston, TX.

WILL, BLANCA.
Sculptor, painter, illustrator, and teacher. Born in Rochester, NY, July 7, 1881. Studied: Rochester Mechanics Institute; Grande Chaumiere, Paris; pupil of Herbert Adams, James Fraser, G. G Barnard, D. W. Tryon, John Alexander, H. Hofmann; Tyrohn in Karlsruhe; Luhrig in Dresden; Castellucho in Paris. Awards: Prizes, Rochester Memorial Art Gallery, 1932, 33; Fairchild award and first prize, figure painting, 19th Annual Exhibition, Rochester Artists, 1934; New Mexico State Fair, 1938-40. Represented in Memorial Art Gallery, Rochester, NY; University of Arkansas; New School for Social Research; numerous oil portraits and sculptured busts, including Herman Le Roy Fairchild, University of Rochester. Exhibited: Penna. Academy of Fine Arts; National Academy of Design; University of New Mexico; Museum of New Mexico, Santa Fe, NM (one-man); Rochester, NY (one-man); Albuquerque, NM; Coro-

nado, CA; traveling exhibition of bronzes, U.S. and Canada; University of Arkansas (one-man). Director of art instruction, Memorial Art Gallery, Rochester, NY. Address in 1953, Blue Hill, ME.

WILLARD, ASAPH.
Engraver. Born December 24, 1786 in Wethersfield, CT. Studied engraving under Deacon Abner Reed of East Windsor. As early as 1816 Willard was in business in Albany, NY, as a member of the firm of Willard & Rawdon, bank-note and general engravers. In 1817-19 he was a member of the Hartford Graphic and Bank Note Engraving Company. An engraver of maps, portraits, subject plates, etc. His plates had little merit. Willard is mentioned as having been the first preceptor of John Cheney. Died July 14, 1880 in Hartford, CT.

WILLARD, HOWARD W.
Lithographer, illustrator, and painter. Born in Danville, IL, Sept. 3, 1894. Pupil of Art Students League of N.Y. Member: Artists Guild of the Authors' League of America. Work: Illustrated *The Silverado Squatters*, by Robert Louis Stevenson (Scribner's). Exhibited: Fifty Best Books of the Year, 1931. Specialized in lithographs of Chinese. Address in 1929, 74 Washington Place, New York, NY.

WILLARD, SOLOMON.
Carver in stone and wood, architect, and teacher. Born in Petersham, MA, June 26, 1783. Learned carpenter's trade there. Settled in Boston in 1804. Began wood carving in 1809; turned to figurehead carving in 1813. Executed the figure for the frigate *Washington*. Became a leading architect in Boston, after 1820; also taught drawing and sculpture. Designed the Bunker Hill Monument, and supervised its erection. Died in Quincy on February 27, 1861.

WILLCOX (or WILCOX), WILLIAM H.
Landscape painter and illustrator. Born c. 1831 in New York State. Studied: Penna. Academy of Fine Arts; pupil of J. L. Williams. Living in Williamsburgh, Long Island, in 1849, at which time he exhibited two pencil drawings at the American Institute. Moved to Philadelphia by 1850; active there until 1868 or after. In 1853 he painted several views of the lakes in New York State, especially of Lake Champlain. Exhibited at the Penna. Academy. Was a member of the Artists' Fund Society. Address in 1917, Germantown, PA.

WILLENBECHER, JOHN.
Sculptor and painter. Born in Macungie, PA, May 5, 1936. Studied at Brown University, with William Jordy, George Downing, B.A., 1958; NYU Institute of Fine Arts, with Craig Hugh Smyth, 1958-61. Works: Albright-Knox Art Gallery, Buffalo, NY; Aldrich, Ridgefield, CT; Whitney; Hirshhorn Museum and Sculpture Garden; Guggenheim; others.

Exhibitions: Feigen-Herbert Gallery, NYC; Feigen-Palmer Gallery, Los Angeles; Richard Feigen Gallery, NYC and Chicago; Albright-Knox Art Gallery; Rhode Island School of Design; Whitney; Stedelijk Museum, Eindhoven, Holland; Everson Museum of Art, Syracuse, NY; Arts Club, Chicago; others. Member of the Art Commission of New York. Address in 1982, 145 W. Broadway, NYC.

WILLET, ANNE LEE.

(Mrs. William Willet). Painter, craftsman, designer, decorator, teacher, lecturer and writer. Born at Bristol, PA, Dec. 15, 1866. Studied: Penna. Academy of Fine Arts; also studied in France and England; pupil of Anshutz, Richardson, W. Willet. Member: Fellowship Penna. Academy of Fine Arts; Art Alliance of Philadelphia; Stained Glass Association of America; MacDowell Club; American Federation of Arts. Author of articles on stained glass. Work: Designer and maker, in collaboration with William Willet, of all windows, West Point Military Chapel; Great West Window, Post Graduate College, Princeton; Mather Memorial, Trinity Cathedral, Cleveland; Guthrie Memorial, St. John's Church, Locust Valley, Long Island; St. Paul's Cathedral, Pittsburgh; Medallion, Sanctuary and Lady, Chapel Window, Calvary Church, Pittsburgh; Harrison Memorial, Calvary Church, Germantown; mural paintings in St. Alvernia's Convent, Pittsburgh; Harbison Memorial, Presbyterian Hospital Chapel; Mellon Memorial; Thaw Memorial, Third Presbyterian Church, Pittsburgh; Buchanan Memorial, St. Nathanael's Church, Philadelphia; Herbert Hugh Riddle Memorial, Chicago; all windows in Greenwood Cemetery Chapel, NY; Victory Window, Trinity Church, Syracuse; St. Paul's Church, Halifax, N.S.; Crucifixion Window, Holy Trinity Church, Philadelphia. In collaboration with Henry Lee Willett; Sanctuary and Transept windows, Grace P. E. Church, Oak Park, IL; the James Memorial, Doyleston; Ryers Memorial Baptismal Font, Rose Window and Bronze; The Sanctuary, Jesse Tree Window and entire fenestration, Church of the Most Blessed Sacrament, Detroit; Berry Memorial and entire fenestration, Jefferson Avenue Presbyterian Church; Journeyings of the Pilgrims, lounge, Hilton Memorial, the Chapel, the Library, and all glass, Theological Seminary, Chicago; John B. Murphy Memorial, College of Surgeons, Chicago; Sanctuary window, Epiphany Church, Germantown, PA; Colonial Dames, Whitefield Memorial, Bethesda at Savannah, GA; all windows, Grosse Pointe Memorial Church, Grosse Point, MI; Johnson Memorial, Prince of Peace Episcopal Church, Philadelphia; Patton Memorial, Lake Vineyard, San Gabriel, CA; Royster Memorial, First Presbyterian Church, Norfolk, VA; reredos and transept and McWilliams Chapel, First Presbyterian Church, Chicago. Address in 1929, 226 South 11th St.; h. 2116 De Lancy St., Philadelphia, PA. Died January 18, 1943.

WILLET, HENRY LEE.

Craftsman and lecturer. Born December 7, 1899, in Pittsburgh, PA. Studied: University of Pennsylvania; Princeton; in Europe; pupil of W. Willet. Member: Architectural League; American Federation of Arts; American Institute of Architects; Stained Glass Association of America (national president, 1942-44); Fairmount Park Art Association; T. Square Club; Pennsylvania Museum of Art; Art Alliance of Philadelphia. Exhibited in leading galleries throughout the U.S. His work includes stained glass windows for churches and chapels including the National Cathedral, Washington, DC; Chicago Theological Seminary; Northwestern University; West Point Military Academy; Wilmington, DE; Longport, NJ; Columbia, SC; Grosse Pointe, MI; Muskegon, MI; Buffalo, NY; Ardmore, PA; Baltimore, MD; Winter Park, FL; San Juan, Puerto Rico; many others. Other works in St. Paul's Episcopal Cathedral, Detroit; Martin Luther Church, Youngstown; epic window, McCartney Library, Geneva College, Beaver Falls, PA; Valley Forge Military Academy; Trinity Episcopal Church, Swarthmore, PA; Great West Window, St. Mary's School, Glens Falls, NY; First Unitarian Church, New Orleans; Presbyterian Church, Rye, NY; others. Co-author of "Stained Glass," *Encyclopaedia Americana*. Contributor to *Stained Glass Quarterly; Architectural Forum; Religion in Life*; other magazines. President, Willet Stained Glass Company. Address in 1962, Philadelphia, PA; h. Ambler, PA.

WILLET, WILLIAM.

Mural painter, craftsman, lecturer, and writer. Born in NYC, November 1, 1868. Studied: Mechanics' and Tradesmen's Institute, NY; pupil of Van Kirk, Chase, John La Farge, Whittaker; also studied in France and England. Member: National Society of Mural Painters; NY Architectural League, 1910; Boston Society of Arts and Crafts; St. Dunstan's Club, Boston; Fellowship Penna. Academy of Fine Arts; Art Alliance of Philadelphia. His work included Sanctuary Window, West Point Military Academy; window in Proctor Hall, Princeton; Mather Memorial, Trinity Cathedral, Cleveland; Guthrie Memorial, St. John's Church, Locust Valley, Long Island; St. Paul's Cathedral, Pittsburgh; Harrison Memorial, Calvary Church, Germantown; mural paintings in St. Alvernia's Convent, Pittsburgh; Presbyterian Hospital Chapel, Pittsburgh; Thaw Memorial, Third Presbyterian Church, Pittsburgh; memorial in Greenwood Cemetery Chapel, NY; Trinity Church, Syracuse; St. Paul's Church, Halifax, N.S. Author of *Stained Glass in Our Churches*. Died in Philadelphia, PA, March 29, 1921.

WILLETT, ARTHUR R(EGINALD).

Mural painter and decorator. Born in England, Aug. 18, 1868. Studied: With E. H. Blashfield; H. S. Mowbray; F. Lathrop; in London. Member: NY

Architectural League, 1897; National Society of Mural Painters; Artists' Aid Society; American Federation of Arts. Work: Foreign Relations Committee Room, U.S. Capitol; courthouse, Youngstown, OH; capitol, St. Paul, MN. Address in 1933, 15 East 59th St., New York, NY.

WILLETT, JACQUES I.
Painter. Born in Petrograd, Russia, June 22, 1882. Studied: The Imperial Academy of Art, Petrograd; also in Munich and Paris. Member: Allied Artists of America; Brooklyn Society of Artists; Salons of America; Society of Independent Artists; Contemporary Artists. Work: "Evening Breeze," Newark Museum, Newark, NJ; "Autumn Afternoon," University Club, Chicago, IL. Address in 1933, 115 West 57th Street; h. 25 Sickles St., New York, NY. Died May 19, 1958.

WILLIAMS, ADELE.
Painter. Member: NY Water Color Club; National Association of Women Painters and Sculptors; American Water Color Society; Plastic Club. Award: Prize, Pittsburgh Art Association, 1912. Exhibited: Pittsburgh Art Association, 1912; National Association of Women Painters and Sculptors, 1936-38. Address in 1929, 1009 West Ave., Richmond, VA.

WILLIAMS, ALYN (MR.).
Painter, writer, lecturer, and teacher. Born in Wrexham, Wales, England, August 29, 1865. Studied: Slade School of Art, London; pupil of Laurens and Constant in Paris. Member: Royal British Colonial Society of Artists; Royal Society of Miniature Painters, Sculptors, and Gravers (president); Imperial Art League; Pennsylvania Society of Miniature Painters; Royal Cambrian Academy, Wales; Washington Art Club; American Federation of Arts; Miniature Painters, Sculptors, and Gravers Society, Washington, DC. Work: Miniatures of King Edward VII and Queen Alexandra in Guildhall (London) Art Gallery; miniatures in Rome of the Pope, Cardinal Garquet, Cardinal Archbishop Bourrie, Premier Mussolini; also Queen Mary; H. R. H. Princess Marie Jose of Belgium; Cardinal Gibbons; President Taft and President Coolidge, Smithsonian Institution. Exhibited: Royal Academy, London; New Water Color Society, London; Paris Salon; in U.S., mainly between 1890-1914. Address in 1933, 1724 Connecticut Ave., Washington, D.C.; Barrack's Hill, Plimpton, Sussex, England. Died in 1955.

WILLIAMS, BALLARD.
Painter. Exhibited at the Penna. Academy of Fine Arts, Philadelphia, 1924. Address in 1926, 27 West 67th St., New York, NY.

WILLIAMS, CAROLINE GREENE (MRS.).
Painter and etcher. Born in Fulton, NY, May 9, 1855. Pupil of Cleveland School of Art, under Henry Keller; Cullen Yates, Clara McChesney, Michel Jacobs. Member: Cleveland School of Art Alumni; Cleveland Women's Art Club. Address in 1933, 1858 Marloes Ave., East Cleveland, OH.

WILLIAMS, CHARLES D.
Illustrator. Born in New York City, Aug. 12, 1880. Member: Society of Illustrators; Artists Guild of the Authors' League of America. Address in 1933, 152 West 42nd St., New York, NY; h. 10 Stonelea Place, New Rochelle, NY.

WILLIAMS, CHARLES SNEED.
Painter. Born in Evansville, IN, May 24, 1882. Studied in Louisville, New York and London; Allan Fraser Art College, Arbroath, Scotland. Member: Union Internationale des Beaux-Arts; Louisville Art Association (hon. life member); Louisville Art Club; Chicago Association of Painters and Sculptors; Cercle de L'Union Artistique, Paris; Art Institute of Chicago (life); American Federation of Arts; Hoosier Salon; Chicago Galleries Association. Award: Four year resident scholarship at Allan Fraser Art College, Scotland, 1902. Portraits in Confederate Museum, Richmond, VA; Kentucky State Capitol, Frankfort; U.S. Capitol, Washington, D.C.; Speed Memorial Museum, Louisville, KY; American College of Surgeons, Chicago; Vanderpoel Art Association, Chicago; Shomberg House, London; Northwestern University, Evanston, IL; Legion Auxiliary Headquarters, Indianapolis. Exhibited: Royal Society of Portrait Painters, London; Paris Salon; Glasgow Institute; National Academy of Design; Penna. Academy of Fine Arts; Art Institute of Chicago; National Gallery of Art; Corcoran; Belfast (Ireland) Art Museum; others, including one-man exhibitions in New York, Chicago, and London. Address in 1953, 408 South Michigan Ave., Chicago, IL; h. The Dartmouth, Louisville, KY.

WILLIAMS, CHARLES WARNER.
See Williams, Warner.

WILLIAMS, CLARA ELSENE.
See Peck, Clara Elsene.

WILLIAMS, DWIGHT.
Landscape painter and teacher. Born in Camillus, Onondaga Co., NY, April 25, 1856. Pupil of John C. Perry. Member: Central NY Society of Artists; American Federation of Arts. Work: "Landscape," Hamilton College; "Landscape," Cazenovia Public Library; Phillips Memorial Gallery, Washington, DC. Positions: Director of art, Norfolk College, 1889-92; National Park School, Washington, 1894-98; teacher, Utica Seminary. Address in 1929, 44 Albany St., Cazenovia, NY.

WILLIAMS, E. G. & BRO.
This engraving firm was producing portraits in New York in 1880.

WILLIAMS, EDWARD K.

Painter. Born in Greensburg, PA, June 5, 1870. Pupil of Art Institute of Chicago. Member: NY Water Color Club (associate); American Water Color Society (associate); Alumni Art Institute of Chicago; Brown County Art Association; Hoosier Salon; Chicago Society of Artists; Indiana Art Club; Chicago Galleries Association. Awards: Business Men's Art Club purchase prize, $300, Art Institute of Chicago, 1928; Davis Memorial prize ($200), Hoosier Salon, 1930, Tri Kappa purchase prize ($400), 1932, prizes, 1934, 37, 38, 40, 41; Brown County Art Association, 1939; Indiana Art Club, 1939, 40, 41; Chicago Galleries Association, 1940. Address in 1933, Nashville, IN. Died in 1948.

WILLIAMS, ELEANOR PALMER.

(Mrs. Carroll R. Williams). Painter. Born in Baltimore, MD. Studied: Maryland Institute, Baltimore; pupil of George H. Smillie, B. West Clinedinst, Hugh Newell; Margaret Lippincott in Philadelphia. Member: Philadelphia Water Color Club; Plastic Club; Art Alliance of Philadelphia (life); Print Club; Philadelphia Museum School of Industrial Art; American Federation of Arts. Address in 1933, 250 South 18th St., Philadelphia, PA.

WILLIAMS, FLORENCE WHITE.

Painter, designer, illustrator, teacher, lecturer, and writer. Born in Putney, VT. Studied: Art Institute of Chicago; Chicago Academy of Fine Arts; pupil of Henry B. Snell, Frederick Grant, John F. Carlson, Ames Aldrich, Carl Krafft. Member: South Side Art Association; Chicago Galleries Association; Illinois Academy of Fine Arts; American Federation of Arts; Chicago Painters and Sculptors; All-Illinois Society of Fine Arts; Deerfield Valley Art Association. Awards: First prize, Art Students League, 1924; second prize, Boston Line Greeting Card Contest; prize, Chicago Galleries, 1927; Mrs. John B. Hall prize ($350), 1927; silver medal, All-Illinois Society of Fine Arts, 1932; prizes, Illinois Federation of Women's Clubs; Art Institute of Chicago. Works: "Down on the Coast of Maine," owned by the Commission for Encouragement of Local Art; Springfield Museum of Art; represented in three public schools, Chicago; illustrations for children's books and magazines, such as *St. Nicholas*, *Little Folks*, children's page in the *Christian Science Monitor*, *Child Life*; designed wallpaper for leading manufacturers. Exhibited: Corcoran Gallery; Art Institute of Chicago; Baltimore Water Color Club; Detroit Institute of Arts; Milwaukee Art Institute; others. Address in 1953, Greenfield, MA. Died May 17, 1953.

WILLIAMS, FREDERIC ALLEN.

Sculptor, lecturer, writer and teacher. Born in West Newton, MA, April 10, 1898. Studied: Columbia University; National Academy of Design; Beaux-Arts Institute of Design; pupil of Robert Aitken. Member: American Veterans Society of Artists (president); American Artists Professional League. Work: Sundial, "The Arrow Maker," Arkell Museum, Canajoharie, NY; Columbia Dental College, Medical Center, NY; NY Public Library; American Academy of Arts and Letters; Heye Foundation, NY; Yale University; Phillips Museum, Bartlesville, OK; Gilcrease Foundation. Exhibitions: National Academy of Design, 1926, 28, 31, 33, 35, 36, 42-44; Penna. Academy of Fine Arts, 1926, 27; Architectural League, 1929, 36; National Sculpture Society, 1929; American Veterans Society of Artists, 1938-56; Artists of the Southwest, Santa Fe, NM, 1926-45; Brooklyn Museum, 1930; Metropolitan Museum of Art, 1942; Jersey City Museum. Specialized in Indians and Southwest life. Address in 1956, 58 West 57th Street, New York, NY. Died December 6, 1958.

WILLIAMS, F(REDERICK) BALLARD.

Painter. Born in Brooklyn, NY, Oct. 21, 1871. Studied: Cooper Union Art School and National Academy of Design in New York; pupil of J. W. Stimson, C. Y. Turner, W. H. Gibson, E. M. Ward; also studied in England and France. Member: Associate National Academy of Design, 1907, Academician National Academy of Design, 1909; NY Water Color Club; Lotos Club; Salma. Club, 1898; National Arts Club; Montclair Art Association; American Federation of Arts; NY Society of Painters; American Artists Professional League. Awards: Bronze medal, Pan.-American Expò., Buffalo, 1901; Inness prize, Salma. Club, 1907; Isidor gold medal, National Academy of Design, 1909; gold medal, American Artists Professional League. Work: "A Glade by the Sea" and "Conway Hills," National Gallery, Washington, DC; "Happy Valley" and "L'Allegro," Metropolitan Museum, New York; "Vivacetto," Albright Art Gallery, Buffalo; "Chant d'Amour" and "Spring," Brooklyn Museum; "Old Viaduct at Little Falls, NJ" and "Sea Echoes," Art Museum, Montclair, NJ; "Grand Canyon," Hackley Art Gallery, Muskegon, MI; "A Glimpse of the Sea," City Art Museum, St. Louis; "Somewhere in Arcadia," Harrison Gallery, Los Angeles Museum; also represented in collections of Dallas Art Association; Lotos Club, NY; National Arts Club, NY; Quinnipiack Club, New Haven; Milwaukee Art Institute; Chicago Art Institute; Grand Rapids Art Association; Los Angeles Museum; New Britain (CT) Art Association; Engineers Club, NY; National Academy of Design; Arnot Art Gallery. Exhibited in London; Paris; Venice; Rome; Lima; as well as nationally. Address in 1953, Glen Ridge, NJ. Died December 11, 1956.

WILLIAMS, FREDERICK DICKINSON.

Painter and teacher. Born in 1829 in Boston, MA. He studied at Harvard and later in Paris. He devoted his time to landscapes and figure-pieces. He was active in Boston in the 1850's and 1860's, taught drawing in public schools, and exhibited in 1878. Died Jan. 27, 1915 in Brookline, MA.

WILLIAMS, GARTH MONTGOMERY.
Illustrator, designer, cartoonist, sculptor, painter, and writer. Born in NYC, April 16, 1912. Studied at the Westminster School of Art and the Royal College of Art, London, England. Awards: Prix de Rome, Society of Rome Scholars, London, 1936. Exhibited: British Royal Academy, 1933-35, 38; American-British Art Center, 1942. Illustrated *Stuart Little*, 1945; *In Our Town; Little Fur Family; Wait 'Til the Moon is Full; Charlotte's Web*, 1952; the *Little House* books; several Golden Books. Author and illustrator of *The Adventures of Benjamin Pink*, 1951; *The Rabbit's Wedding*, 1958. Contributed cartoons to *New Yorker* and *Tomorrow* magazines. Address in 1982, Guanajuato, Mexico.

WILLIAMS, GEORGE ALFRED.
Painter, illustrator and craftsman. Born in Newark, NJ, July 8, 1875. Studied under Chase and Cox. Member: NY Society of Keramic Artists. Award: Silver medal, P.-P. Expo., San Francisco, 1915. Work: "The Drama of Life—The Marginal Way," Art Institute of Chicago; six decorative paintings, "Tristan and Isolde," in Newark Museum. Illustrator of Dickens' characters. Address in 1929, Beachwood Road, Kennebunkport, ME. Died February 29, 1932.

WILLIAMS, GLUYAS.
Illustrator, cartoonist, writer. Born in San Francisco, CA, July 23, 1888. Studied: Harvard University, A.B. Work: Library of Congress. Exhibited: Boston Museum of Fine Arts, 1946. Illustrated *Of All Things, Pluck and Luck* and *The Early Worm*, by Robert Benchley; *Daily Except Sunday*, 1938; *People of Note*, 1940; *Father of the Bride*, 1949; author of *The Gluyas Williams Book*, 1929. Contributor to *New Yorker* magazine. Address in 1953, West Newton, MA.

WILLIAMS, HENRY.
Engraver, painter and wax modeler. Born in Boston in 1787. Stipple portraits are signed as both painted and engraved by H. Williams. In 1814, Williams published in Boston *The Elements of Drawing*, illustrated by twenty-six copperplate engravings. As late as 1824, H. Williams advertised as a portrait and miniature painter in the *New England Palladium* with a studio at No. 6 School Street, Boston. This notice says that "He also continues to paint from the dead in his peculiar manner by Masks, etc." He died Oct. 21, 1830.

WILLIAMS, ISAAC L.
Painter. Born in Philadelphia, PA, June 24, 1817. At the age of 15 he became the pupil in drawing of John R. Smith; he afterwards practiced painting with John Neagle. Lived and followed his profession in Philadelphia. He was president of the Artists' Fund Society and a member in 1860. Until 1844 he devoted himself to portrait painting, but later gave equal or greater attention to landscape; he was also a figure painter. In 1866, at the invitation of an English gentleman, he visited Great Britain to paint his homestead. He travelled in France and Italy, and painted historic pictures. He returned to Philadelphia and taught drawing in schools and also had private pupils; he was the first preceptor of the late Henry E. Hubley. Painted a series of historic mansions of Philadelphia, now in the possession of the State Historical Society. He visited Lancaster in 1854 with a commission to paint the portrait of Rev. Bernard Keenan. Died April 23, 1895, in Philadelphia.

WILLIAMS, JAMES ROBERT.
Painter, sculptor and cartoonist. Born in Halifax, Nova Scotia, Canada, March 30, 1888. Studied at Mt. Union College in Alliance, OH. Worked as a fireman on the Pennsylvania Railroad; as a ranch hand in New Mexico; as a Fort Sill muleskinner with the Apaches in Oklahoma; in the U.S. Cavalry; in factories as a machinist. As a cartoonist he created *Out Our Way*, sold to newspaper syndicate in 1922 along with many other cartoons. Painting and sculpture subjects were Western. Died probably in San Marino, CA, 1957.

WILLIAMS, JOHN A(LONZO).
Painter and illustrator. Born in Sheboygan, WI, March 23, 1869. Pupil of Art Students League of NY and Metropolitan Museum of Art School. Member: Society of Illustrators, 1910; Salma. C.; Artists Guild of the Authors' League of America; NY Architectural League; American Water Color Society; NY Water Color Club; American Artists Professional League; Artists' Fund Society. Awards: Yabriski prize, American Water Color Society-NY Water Color Club; prizes, Salma. Club, 1937, 39. Address in 1933, 401 West End Avenue, New York, NY.

WILLIAMS, J(OHN) SCOTT.
Painter, illustrator, etcher, craftsman, and teacher. Born in Liverpool, England, Aug. 18, c. 1877. Pupil of Art Institute of Chicago. Member: Associate National Academy of Design, 1935; Academician National Academy of Design, 1937; American Water Color Society; NY Water Color Club; Salma. Club; National Society of Mural Painters; Society of Illustrators; NY Architectural League; Philadelphia Sketch Club; Artists Guild of the Authors' League of America; Alumni Association, Art Institute of Chicago. Awards: Shaw black and white prize, Salma. Club, 1912, Vezin prize, 1914, Isidor prize, 1919, etching prize, 1928; water color prize, Art Institute of Chicago, 1924; Delano purchase prize, combined water color exhibition, American Water Color Society and NY Water Color Club, 1925 and 27. Represented by mural and glass work in Bush Terminal Sales Building, New York, NY; water

color in the permanent collection of the Art Institute of Chicago; murals, Park Central Hotel, Thomas Cook and Sons, and Hemphill-Noyes, New York, NY; glass work, Johns Hopkins University; University of Illinois; Indiana State Library and Historical Building, Indianapolis; Memphis Museum; Yale University; 102 maps in porcelain enamel, American Battle Monuments Commission, 1957; U.S. Post Office, Newcastle, DE. Taught at University of Wyoming. Address in 1962, Mt. Vernon, NY.

WILLIAMS, KATE A.

Painter. Member: National Association of Women Painters and Sculptors; Washington Water Color Club; American Water Color Society; National Arts Club; American Artists Professional League; Artists branch, American Pen Women; American Federation of Arts. Address in 1933, 1264 Boston Road, New York, NY. Died August 8, 1939.

WILLIAMS, KEITH SHAW.

Painter, etcher, and teacher. Born in Marquette, Michigan, Oct. 7, 1906. Studied: Penna. Academy of Fine Arts; National Academy of Design; pupil of Daniel Garber, Ivan G. Olinsky, Charles Hawthorne. Member: Associate National Academy of Design, 1939; Academician National Academy of Design, 1942; National Arts Club; American Water Color Society; American Artists Professional League; Salma. Club; Society of American Etchers; Allied Artists of America; Chicago Society of Etchers; Artists' Fellowship. Award: Purchase prize ($100) for water color, National Arts Club, New York, 1928; water color prizes, Junior Artists, 1930, 31, and oil, 1932; National Academy of Design, 1935; Salma. Club; Library of Congress, 1946; medal, Allied Artists of America, 1938, 40; medal, Montclair Art Museum, 1941; medal, American Artists Professional League, 1941. Work: National Academy of Design; Library of Congress; NY Historical Society; Salma. Club; Rollins Museum Library. Taught: Grand Central School of Art. Address in 1933, 18 West 16th Street, New York, NY. Died February 10, 1951.

WILLIAMS, L(AWRENCE) S.

Painter. Born in Columbus, OH, July 24, 1878. Pupil of Carroll Beckwith; William M. Chase; F. V. Du Mond. Member: Salma. Club. Address in 1933, 121 Engle St., Tenafly, NJ.

WILLIAMS, LOUISE H(OUSTON).

Painter, lithographer, block printer and teacher. Born in Garnett, KS, April 9, 1883. Studied: Kansas City Art Institute; Kansas University; pupil of Randall Davey. Member: Boston Art Club; Northwest Print Makers; Pacific Coast Artists; American Society of Arts and Science; Women Artists of Washington; Seattle Art Institute. Taught at Union Jr. College, Mount Vernon; private school, Anacortes. Address in 1933, 1310 Fifth Street, Anacortes, WA.

WILLIAMS, MAY.

Painter, craftsman, designer and teacher. Born in Pittsburgh, PA. Pupil of Carnegie College of Fine Arts, Pittsburgh; NY School of Fine and Applied Art; Ecole des Beaux-Arts; Fontainebleau School of Fine Arts, France. Member: Pittsburgh Art Association; American Federation of Arts; Pennsylvania Craftsmen's Guild; Pittsburgh Art Center; Fontainebleau Alumni Association. Work: Pittsburgh Art Center; Carnegie Institute. Instructor, Arts and Crafts, Shady Side Academy, and Winchester-Thurston Schools, Pittsburgh, PA. Address in 1962, Pittsburgh, PA.

WILLIAMS, MILDRED EMERSON.

Painter and lithographer. Born in Detroit, MI, Aug. 9, 1892. Studied: Penna. Academy of Fine Arts; Art Students League; pupil of Robert Henri, George Luks, Mahonri Young, H. McCarter, C. Locke; also studied in Paris. Member: Society of Independent Artists; Detroit Society of Women Painters; Artists Equity Association; Michigan Academy of Sciences, Arts and Letters, Ann Arbor. Awards: Detroit Institute of Arts, 1923, 34, 39, 40; prizes, Penna. Academy of Fine Arts, 1928. Work: Penna. Academy of Fine Arts; Detroit Institute of Arts; NY Public Library; McGregor Library, Highland Park, MI; many private collections. Exhibited: Penna. Academy of Fine Arts, 1925, 26, 28; Art Institute of Chicago, 1935; Corcoran Gallery, 1936; American Federation of Arts traveling exhibition; Carnegie Institute, 1941; Birmingham (MI) Art Association; Detroit Institute of Arts, 1956, 57; American Institute of Graphic Arts, 1935; Michigan Academy of Sciences, Arts and Letters. Address in 1962, Birmingham, MI.

WILLIAMS, PAULINE BLISS.

(Mrs. Ronald Lloyd Croft). Painter and lecturer. Born in Springfield, MA, July 12, 1888. Studied: Art Students League; Henri School of Art; pupil of Du Mond, Bellows, Mora, Hayes-Miller. Member: Springfield Art League; Springfield Artists Guild; National Association of Women Artists; North Shore Arts Association; Gloucester Society of Artists; Brooklyn Society of Miniature Painters; Art Students League (life); American Artists Professional League; Pennsylvania Society of Miniature Painters; Boston Art Club. Awards: Hon. mention, National Association of Women Painters and Sculptors, 1926; popular prize, Springfield Artists Guild, 1932; Society for Sanity in Art, Chicago, 1941; Art Institute of Chicago, 1941. Exhibited: National Association of Women Artists; National Society of Mural Painters; North Shore Arts Association; Pennsylvania Society of Miniature Painters; Brooklyn Society of Miniature Painters; others. Address in 1962, Rockport, MA; Daytona Beach, FL.

WILLIAMS, RAMOND HENDRY.

Painter, sculptor, writer and teacher. Born in Ogden, UT, October 31, 1900. Studied: Art Institute of

Chicago; University of Chicago; pupil of Mabel Frazer, Charles J. Martin, William Varnum, and Arthur Gunther. Awards: Prize, Delta Phi Delta National Exhibition, Kansas City, 1936. Member: Utah Artists Guild; Lincoln Artists Guild; Madison Art Association. Work: "Southern Utah," Logan Junior High School, Logan, UT; Joslyn Memorial, Omaha, NE. Taught at Texas Technical College. Address in 1933, 300 Morrill Hall, University of Nebraska; h. 721 North 24th St., Lincoln, NE.

WILLIAMS, REED.
Etcher. Born in Pittsburgh, PA. Member of the Los Angeles Print Makers' Association. Address in 1926, 1111 Central Building, Los Angeles, CA.

WILLIAMS, TODD.
Sculptor and painter. Born in Savannah, GA, January 6, 1939. Studied at City College of New York; School of Visual Arts, New York, certificate and scholarship, 1964. Work in Smithsonian Institution, Washington, DC; sculpture, Mexican Government, Olympic Village, Mexico City, 1968; wall painting, New York Parks Department, Brooklyn, 1970; others. Has exhibited at Oakland Art Museum, Colored Sculpture, 1965; Witte Memorial Museum, Madison, WI, 1966; Cranbrook Academy of Art, Bloomfield Hills, MI, 1966; Jewish Museum, New York, 1969; Contemporary Black Artists, Whitney Museum of American Art, 1971; Banners, National Museum, Singapore, and Hirshhorn Museum, Washington, DC, 1976; others. Teaching sculpture at Columbia University, New York, from 1976. Received John Hay Whitney Foundation Fellowship, 1965; Adolph and Clara Obrig Prize, National Academy of Design, 1972; and others. Address in 1982, Brooklyn, New York.

WILLIAMS, WALTER REID.
Sculptor. Born in Indianapolis, IN, November 23, 1885. Pupil of Charles Mulligan, Bela Pratt; Paul Bartlett and Mercie in Paris. Member: Chicago Galleries Association; Hoosier Salon. Represented by "Goal," bronze, Woman's Athletic Club, Chicago. Director, Clay Arts Studio, Ridge Park Field House, Chicago. Address in 1933, Chicago, IL.

WILLIAMS, WARNER.
Sculptor, designer and lecturer. Born in Henderson, KY, April 23, 1903. Studied at Berea College; Herron Art Institute; Art Institute of Chicago, B.F.A.; Butler University; pupil of Zettler, Polasek, Ianelli. Work: Martin Luther King, bas-relief portrait, King Memorial, Atlanta, GA; Albert Schweitzer medallion, Schweitzer Memorial Museum, Switzerland; Thomas Edison Commemorative Medal, Smithsonian Institution, and Edison Museum, East Orange, NJ; Court House, Frankfort, IN; Spaulding School, Chicago; Chicago Public Library; Logansport (IN) Public School; City Church, Gary, IN;

Court of States, Century of Progress Expo., Chicago; F. E. Clark Memorial, Winnetka, IL; Kalamazoo (MI) Public Library; Ball State Teachers College, Muncie, IN; John Herron Art Institute, Indianapolis; Purdue University; Three Arts Club, Chicago; others, including many other memorials, medals, medallions, bas-reliefs, busts. Received awards from Hoosier Salon, 1928-42; North Shore Arts Association, 1937, 38; Art Institute of Chicago, 1941; others. Member of Chicago Art Club; Chicago Art Association; Hoosier Salon; National Sculpture Society; All-Illinois Society of Fine Arts; Association of Chicago Painters and Sculptors; Chicago Galleries Association. Artist-in-residence, Culver Military Academy, Culver, IN, 1940-68. Address in 1982, Geodesic Dome Studio, Culver, IN.

WILLIAMS, WAYNE FRANCIS.
Sculptor. Born in Newark, NY, July 22, 1937. Studied at Syracuse University, B.F.A., 1958, M.F.A., 1962, Chaloner Foundation fellowship, 1958 and 59; Skowhegan School of Painting and Sculpture, summer, 1956-57, with Harold Tovish. Work at Wichita Museum, KS; Whitney Foundation Collection, Cornell University; NY State University College at Albany; others. Has exhibited at Belgium Salon des Beaux Arts, Museum voor Schone Kunsten, Ghent, Belgium; Frank Rehn Gallery, NY; NY Art Dealers Exhibition, Parke Bernet Gallery, NY; and others. Received Louis Comfort Tiffany Foundation Award for Sculpture, 1964. Taught at Syracuse University; Community College of Finger Lakes. Works in metals. Address in 1982, Newark, NY.

WILLIAMS, WHEELER.
Sculptor, painter, architect, writer, teacher, and lecturer. Born in Chicago, IL, November 3, 1897. Studied: Yale University, Ph.B.; Ecole des Beaux-Arts, Paris, France; Harvard University School of Architecture, M. Arch.; pupil of John Wilson in Boston and Jules Coutan in Paris. Member: Academician National Academy of Design; New York Architectural League; National Sculpture Society; American Institute of Fine Arts (fellow); American Artists Professional League (president); Municipal Art Society of NY; Audubon Artists; Beaux-Arts Institute of Design; others. Work: Tablet to French Explorers and Pioneers, Michigan Avenue Bridge, Chicago, IL; bust of Clifford Holland, entrance to Holland Tunnel, NYC; San Diego Fine Arts Society; Art Institute of Chicago; Hackley Art Gallery; Brookgreen Gardens, SC; U.S. Naval Academy, Annapolis; over-entrance, Parke Bernet Gallery, NY; Department of Interstate Commerce Building, Washington, DC; Regents Park, London; Reader's Digest Tower, Pleasantville, NY; garden facade, Brooks Memorial Art Gallery, Memphis, TN; many architectural and monumental works, portrait busts, reliefs, garden sculptures, medals, and statues throughout U.S., South Africa, and Canada; others.

Exhibited: Salon des Artistes Francais, 1923-27; Salon d' Automne, Paris; Penna. Academy of Fine Arts; Art Institute of Chicago; National Academy of Design; California Palace of the Legion of Honor; Golden Gate Expo., San Francisco, 1939; National Sculpture Society; Ferargil Gallery (one-man); Society of Four Arts (one-man); others. Awards: Prize, National Academy of Design, 1936; gold medal, National Arts Club, 1956; medal, Paris Expo., 1937; American Artists Professional League, 1957; others. Author of *Monograph on Sculpture*, 1947. Address in 1970, 15 West 67th Street, New York, NY; Madison, CT. Died in 1972.

WILLIAMS, WILLIAM JOSEPH.
Portrait painter. Born in New York City, November 17, 1759. Worked in New York City, from 1779 to c. 1792; was in Virginia c. 1792 and then went to Philadelphia until 1797; in South Carolina in 1798 and 1804; in New Bern, NC, from 1804-07; back in New York City, 1807-1817; and from 1817 until his death in 1823 he was in New Bern. In 1792 he painted in Philadelphia a portrait from life of Washington in Masonic regalia at the request of the Masonic Lodge of Alexandria, VA. The original pastel portrait is in Alexandria, and a copy by Miss Burke is in the Masonic Hall in Philadelphia. Williams died Nov. 30, 1823.

WILLIAMSON, ADA C.
Painter and illustrator. Born in Camden, NJ, September 15, 1880. Studied: Penna. Academy of Fine Arts; Drexel Institute; pupil of William Chase, Cecilia Beaux, others. Member: Fellowship Penna. Academy of Fine Arts; Art Alliance of Philadelphia; Plastic Club; Ogunquit Art Association; Philadelphia Printmakers' Club. Awards: Shillard-Smith gold medal, Plastic Club, 1913; Fellowship Penna. Academy of Fine Arts, 1922, 45, Spaulding prize, 1948; Cosmopolitan Club, 1945. Exhibited: Penna. Academy of Fine Arts, 1924, 41-45. Address in 1953, Ogunquit, ME. Died October 31, 1958.

WILLIAMSON, J. MAYNARD, JR.
Painter and illustrator. Born in Pittsburgh, PA, June 7, 1892. Pupil of F. V. DuMond. Member: Pittsburgh Art Association. Award: Prize, Pittsburgh Art Association, 1911. Address in 1926, 514 S. Linden Ave., Pittsburgh, PA.

WILLIAMSON, JOHN.
Painter. Born April 10, 1826, at Toll Cross, near Glasgow, Scotland. He was brought to this country as a child and lived in Brooklyn, NY. Began exhibiting at the National Academy in 1850 and also exhibited in Brooklyn, Washington, and Boston. In 1861, he was elected an Associate of the National Academy of Design. Many of his paintings are scenes on the Hudson River and in the Catskill Mountains, as well as other scenes in New England, New York, and

Pennsylvania. Died May 28, 1885, at Glenwood-on-the-Hudson.

WILLIAMSON, SHIRLEY.
(Mrs. Edward Lincoln Williamson). Painter and craftsman. Born in New York. Pupil of Arthur Dow, Art Students League in NY; Constant and Rodin in Paris. Member: National Association of Women Painters and Sculptors; San Francisco Society of Women Artists; Palo Alto Art Club. Exhibited: Golden Gate Expo., 1939. Taught at Palo Alto High School; instructor in dramatics, Summer School, Stanford University, CA. Address in 1933, 521 Addison Avenue, Palo Alto, CA.

WILLING, J(OHN) THOMSON.
Painter, craftsman, writer, and lecturer. Born in Toronto, Canada, August 5, 1860. Pupil of Ontario School of Art. Member: Salma. Club, 1897; American Institute of Graphic Arts; Royal Canadian Academy (associate); Art Directors' Club; Society of Illustrators. Specialty: Bookplate designs. Editor, Gravure Service Corporation; art manager, *The North American*. Address in 1929, 25 West 43rd St., New York, NY; h. 5909 Wayne Ave., Germantown, PA; summer, Henryville, Monroe Co., PA.

WILLIS, ALBERT PAUL.
Landscape painter and teacher. Born in Philadelphia, PA, Nov. 15, 1867. Studied: Philadelphia Museum School of Industrial Art; pupil of Frank V. DuMond. Member: Philadelphia Water Color Club; Philadelphia Sketch Club. Address in 1929, 2332 North Park Ave., Philadelphia, PA; summer, Bailey Island, Casco Bay, ME.

WILLIS, EOLA.
Painter, craftsman, writer, and lecturer. Born in Dalton, GA. Pupil of Mrs. J. S. D. Smillie, Chase at Art Students League of NY; studied in Paris. Member: Carolina Art Association; Charleston Sketch Club; Charleston Art Commission; Southern States Art League. Author of *The Charleston Stage in the XVIII Century* and *Henrietta Johnston, First Woman Painter in America*. Work: "A Carolina Vista," Gibbes Memorial Art Gallery, Charleston, SC. Awards: Charleston Expo., 1902. Address in 1933, 72 Tradd St., Charleston, SC.

WILLIS, R(ALPH) T(ROTH).
Painter, sculptor, illustrator, and etcher. Born in Leesylvania, Freestone Point, VA, March 1, 1876. Pupil of Corcoran School of Art; Art Students League of NY; Academie Julien. Member: National Society of Mural Painters; California Art Club. Works: Murals of twelve naval engagements, Second Battalion Armory, and murals in 22nd Regiment Armory, N.Y.N.G., NYC; decorations, Library of Congress, Washington, DC; murals, Pomona Building Loan Association, Pomona, CA; and Angeles

Temple, Los Angeles, CA; Brock Jewelry Store, Los Angeles. Address in 1933, Encinitas, CA.

WILLNER, TOBY S.
Painter and printmaker. Born on Sept. 17, 1932. Studied: UCLA; Art Center College of Design; California State at Northridge (print and glass). Work: Hospital Corporation of America, Nashville, TN; Disney Foundation, Burbank, CA; Warner Brothers Records, Burbank, CA; IBM, San Francisco, Los Angeles, and NY; Northrup Aviation, Torrance, CA; Hilton Hotels, Los Angeles and Baltimore; Capital Hilton, Washington, DC; Columbia Pictures and MGM, Los Angeles; American Institute of Banking, Dallas; Lloyds Bank, Los Angeles; many others. Commissions: Davey "C's," Toronto, Canada. Award: Walt Disney Foundation, 1977. Address in 1983, 6317 Maryland Dr., Los Angeles, CA.

WILLOUGHBY, ALICE ESTELLE.
Painter. Born in Groton, NY. Pupil of Washington Art League; Corcoran Art School. Member: Washington Water Color Club; Washington Art Club. Address, The Rockingham, Washington, DC. Died Oct. 28, 1924, in Washington, DC.

WILLSON, EDITH DERRY.
Painter and etcher. Born in Denver, CO, Jan. 20, 1899. Pupil of Joseph Pennell; Art Students League of NY. Member: Chicago Society of Etchers; NY Society of Women Painters and Sculptors. Work: Etchings in National Gallery, Munich, Germany; Cincinnati Library; Los Angeles Library, Los Angeles, CA; Cleveland Museum of Art; Art Institute of Chicago; Detroit Museum of Art. Address in 1929, Kleeman-Thorman Galleries, 575 Madison Ave., New York, NY; h. 1803 Wilshire Blvd., Los Angeles, CA.

WILLSON, JAMES MALLORY.
Painter, etcher and teacher. Born in Kissimmee, FL, Dec. 28, 1890. Studied: Academie Colarossi, Paris; Rollins College; Art Students League; National Academy of Design; pupil of Bridgman, Maynard, Henri, Johansen, and Fogarty. Member: NY Water Color Club (associate); Art Students League (life); Chicago Society of Etchers; Florida Art Group. Award: Prize, Society of Four Arts, Palm Beach, FL, 1941. Work: Library of Congress. Exhibited: Society of American Graphic Artists, 1940, 45; National Academy of Design, 1944-46; Library of Congress, 1943, 45; Society of Four Arts, 1939, 46; Palm Beach Art League, 1939, 46; Norton Gallery, 1944-45. Taught drawing and painting at the Norton School of Art, West Palm Beach, FL, from 1946. Address in 1962, West Palm Beach, FL.

WILLSON, MARTHA B(UTTRICK).
(Mrs. Howard D. Day). Painter, miniaturist, and lecturer. Born in Providence, RI, August 16, 1885.

Studied: Rhode Island School of Design; Julian Academy, Paris; pupil of Lucia Fairchild Fuller. Member: Providence Art Club; American Federation of Arts; American Society of Miniature Painters; Brooklyn Society of Miniature Painters; Pennsylvania Society of Miniature Painters. Award: Prize, Penna. Academy of Fine Arts, 1932. Exhibited: American Society of Miniature Painters, annually; Pennsylvania Society of Miniature Painters, annually. Lectures: Miniatures. Address in 1953, Providence, RI.

WILMARTH, LEMUEL EVERETT.
Painter and teacher. Born in Attleboro, MA, March 11, 1835. Studied drawing in the Penna. Academy of Fine Arts, Philadelphia, 1854; went to Europe, 1858; studied at the Royal Academy, Munich, with Kaulbach, 1859-62; also at Ecole des Beaux-Arts, Paris, with Gerome, 1863-67. Settled in New York City in 1867 and became the director of the schools of the Brooklyn Academy of Design, 1868-70. Professor in charge of schools of National Academy of Design, 1870-90. Was an associate of the National Academy of Design in 1871, an Academician in 1873, and a member of the Artists' Aid Society. Married Emma B. Barrett in 1872. Among his best known pictures are "The Pick of the Orchard;" "Ingratitude;" "Left in Charge;" "Sunny Italy;" "Captain Nathan Hale." Died July 27, 1918 in Brooklyn, NY.

WILMER, WILLIAM A.
Engraver. Wilmer was a pupil of James B. Longacre in Philadelphia, and engraved some excellent portrait plates in stipple for the "National Portrait Gallery." Died 1855.

WILMES, FRANK.
Painter and craftsman. Born in Cincinnati, OH, Oct. 4, 1858. Pupil of L. H. Meakin; Vincent Nowottny; Frank Duveneck. Member: Cincinnati Art Club. Address in 1929, 1560 Elm St., Cincinnati, OH.

WILMOT, ALTA E.
Painter and teacher. Born in Ann Arbor, MI. Pupil of J. Alden Weir; Gustave Courtois, Prinet, etc., in Paris. Member: Society of Painters, NY; Pennsylvania Society of Miniature Painters; American Federation of Arts. Specialty: Miniatures. Address in 1929, 939 Eighth Ave., New York, NY.

WILSHIRE, FLORENCE L.
Painter. Member: New Haven Paint and Clay Club. Address in 1929, 97 Livingston St., New Haven, CT.

WILSON, ALBERT.
Ship and ornamental carver. Born in Newburyport, MA, June 29, 1828. Worked in Newburyport with his father, Joseph Wilson, and his brother, James Warner Wilson, from c. 1850 until his death on November 26, 1893.

WILSON, ALEXANDER.
Engraver and sketcher. Born in Paisley, Scotland, July 6, 1766. Came to America in 1794. Taught school in Pennsylvania and New Jersey for about ten years. Began work on American birds after meeting William Bartram. Wilson was taught to draw, color and etch by his friend Alexander Lawson, the engraver, and he rapidly attained a marked degree of proficiency in delineating birds. His great work *American Ornithology* included two plates etched by Wilson from his own drawings, as well as etchings by Lawson. In 1804 Wilson made a sketch of Niagara Falls which was engraved for *Port Folio* in March 1810. He died in Philadelphia, PA, August 23, 1813.

WILSON, ASHTON (MISS).
Painter. She was born in Charleston, WV, April 1, 1880. Studied: Academie Colarossi, Paris; pupil of Chase, Hawthorne, Beaux, Twachtman, Borglum, Felicie, Howell. Member: National Association of Women Painters and Sculptors; Pen and Brush Club. Work: Washington, DC; capitol, West Virginia. Illustrated *Gardens of Virginia*. Address in 1933, 137 East 66th Street, New York, NY; summer, "Fenton," White Sulphur Springs, WV.

WILSON, CLAGGETT.
Painter. Born in Washington, DC, August 3, 1887. Studied: Art Students League of NY; pupil of F. Luis Mora, Richard Miller; Julian Academy and under Laurens in Paris. Member: Society of Independent Artists; Salons of America; American Federation of Arts. Work: "The Corner," "Gypsy Dancer," and "Basque Fishermen," Brooklyn Museum. Represented in Metropolitan Museum, New York. Died in 1952. Address in 1933, 11 Hereford Street, Boston, MA.

WILSON, EDWARD ARTHUR.
Illustrator, lithographer and painter. Born in Glasgow, Scotland, March 4, 1886. Studied at the Art Institute of Chicago; pupil of Howard Pyle. Began his career in New York City in the early 1920's. Illustrated advertising campaigns for LaSalle-Cadillac and Victrola; illustrated his *Iron Men and Wooden Ships*, 1924; illustrated *Robinson Crusoe, Treasure Island, Around the World in 80 Days, Jane Eyre, Ivanhoe, Dr. Jekyll and Mr. Hyde, A Journey to the Center of the Earth*, and others. Exhibited: Rhode Island School of Design, 1953; Society of Illustrators, 1954; Pratt Institute, 1954. In collections of Metropolitan Museum of Art; Library of Congress; NY Public Library. Awards: Medal, Art Directors' Club, NY, 1926, 30; prizes, Salma. Club, 1926, 42. Member: Fellow, Royal Society of Artists; Society of Illustrators, 1912; Salma. Club; Artists Guild of the Authors' League of America; Associate National Academy of Design; American Institute of Graphic Arts; Players Club. Address in 1962, Truro, MA. Died in 1970.

WILSON, EDWARD N.
Sculptor. Born in York, England. Pupil of Dalon. Address in 1898, Princeton, NJ.

WILSON, EMILY L(OYD).
Painter. Born in Altoona, PA, November 2, 1868. Pupil of Philadelphia School of Design for Women; William Sartain. Member: Plastic Club. Work: Charcoal portrait of Charles Johnson, Museum of the Historical Society, St. Augustine. Address in 1929, Second St., Beach Haven, NJ; winter, 280 St. George Street, St. Augustine, FL.

WILSON, GILBERT BROWN.
Painter, sculptor and illustrator. Born in Terre Haute, IN, March 4, 1907. Studied: Indiana State Teachers College; Art Institute of Chicago; Yale School of Fine Arts; pupil of Lucy Arthur Batten, W. T. Turman, E. L. Coe, Eugene Savage, E. A. Forsberg. Member: Terre Haute Pen and Brush Club; Art League of America. Awards: Culver Military Academy prize, Hoosier Salon, Chicago, 1929, 33; second prize, Beaux-Arts Institute of Design, 1930; prize, Indiana State Kiwanis, Hoosier Salon, 1933. Work: Murals, Woodrow Wilson Jr. High School, Terre Haute, IN; Indiana State Teachers College; Antioch College, Yellow Springs, OH. Address in 1953, 245 East 36th St., New York, NY; h. 1201 North 4th St., Terre Haute, IN.

WILSON, HENRIETTA.
Painter and teacher. Born in Cincinnati, OH. Pupil of Cincinnati Art Academy. Member: Cincinnati Woman's Art Club; Ohio-Born Women Artists; Ohio Water Color Society. Instructor, Cincinnati Art Academy. Address in 1933, Art Academy, Cincinnati, OH; h. 2215 Monroe Ave., Norwood, OH.

WILSON, HENRY.
Marble cutter and painter. Worked in Chicago, 1849-60. Awarded a prize, together with his partner Oliver Wilson, for animal painting exhibited at the Illinois State Fair, 1855.

WILSON, JAMES WARNER.
Ship and ornamental carver. Born in Newburyport, MA, July 2, 1825. Son of Joseph Wilson and brother of Albert Wilson. Worked in Newburyport with his father and later with his brother, Albert. Died in Newburyport on October 19, 1893.

WILSON, JOHN ALBERT.
Sculptor. Born in New Glasgow, Nova Scotia, April 10, 1878. Pupil of H. H. Kitson and B. L. Pratt in Boston. Address in 1910, 19 Grundmann Studios, Boston, MA.

WILSON, JOHN T.
Portrait painter. Flourished about 1844 to 1860 in NY.

WILSON, JOSEPH.
Ship and ornamental carver. Born in Marblehead, MA, November 2, 1779. Worked in Chester, NH, 1796-98; at Newburyport, MA, from 1798. Carved portrait statues and animal figures for the grounds of Timothy Dexter's house in Newbury. Subjects of these works include Washington, Jefferson, Adams, Napoleon, Dexter, Lord Nelson, and other prominent persons, along with four lions, a lamb, dog, unicorn, eagle, horse, Adam and Eve, Fame, and a traveling preacher. Assisted by his sons, Albert and James Warner Wilson, after c. 1850. Died in Newburyport, MA, March 25, 1857.

WILSON (or WILLSON), JOSEPH.
Sculptor. Born in Canton, NY, 1825. Active 1842-57. Studied portrait painting with Salathiel Ellis in Canton. Worked in cameo cutting and die sinking in NYC, 1842-48; in Washington, DC, 1848-51; studied sculpture in Italy, 1851-54. Exhibited at the National Academy of Design, NY. Died in NYC, September 8, 1857.

WILSON, KATE.
Painter, sculptor and teacher. Born in Cincinnati, OH. Pupil of Louis Rebisso at Cincinnati Art Academy. Member: Cincinnati Women's Art Club. Teacher of drawing in public schools. Address in 1929, 2215 Monroe Ave., Norwood, OH.

WILSON, LUCY ADAMS (MRS.).
Painter. Born in Warren, OH, 1855. Studied: Herron Art Institute, Indianapolis; Art Students League of NY; pupil of William Forsyth and T. C. Steele. Member: Chicago Water Color Club; Miami League of Artists; Tropical League of Artists; Southern States Art League; American Federation of Arts. Represented in Herron Art Institute, Indianapolis, IN; Zion Park Inn, Asheville, NC; Conservatory of Art and Music, Miami, FL. Address in 1933, 227 Northwest 3rd St., Miami, FL.

WILSON, MATTHEW.
Portrait painter in oils and miniature. Born in London, July 17, 1814. He came to this country in 1832, settled in Philadelphia, and became a pupil of Henry Inman. Went to Paris in 1835 to study under Dubufe. Returned to America and settled in Brooklyn. First exhibited miniatures in Philadelphia. Elected an Associate of the National Academy of Design in 1843. He was in New Orleans, 1845; in Baltimore, 1847, for two or more years; probably in Ohio in the early fifties; in Boston, 1856-60; in Hartford, CT, 1861-73, where he had a studio; finally settled in Brooklyn. Also spent some time in Washington, DC, where he painted portraits of prominent men, including Lincoln. He died February 23, 1892, in Brooklyn, NY.

WILSON, MAY.
Sculptor. Born in Baltimore, MD, September 28, 1905. Works: Whitney Museum of American Art, NY; Baltimore Museum; Goucher College, Baltimore; Corcoran Gallery of Art, Washington, DC; Dela Banque de Pariset, Brussels, Belgium. Exhibitions: New Idea, New Media Show, Martha Jackson Gallery, NY, 1960; Museum of Modern Art Traveling Assemblage, NY, 1962; American Federation of Arts Patriotic Traveling Show, NY, 1968; Human Concern Show, 1969, and Whitney Sculpture Annual, 1970, Whitney Museum of American Art. Awards: Baltimore Museum Art Show Awards, 1952, 59. Address in 1982, 208 West 3rd Street, NYC.

WILSON, MELVA BEATRICE.
Sculptor, mural painter, poet, and lecturer. Born in Madison, IN, in 1866. Studied: Cincinnati Art Museum; Cincinnati Art Academy, with Nowottny, Rebisso, Nobel; in Paris, with Rodin. Awarded an honorable mention, Paris Salon, in 1897. Works: Corcoran Art Gallery, Washington, DC; State of NY; Tiffany & Company, NYC; Farley Memorial Chapel at Calvary, Long Island, NY; St. Louis Cathedral, St. Louis, MO. She was awarded the largest commission given any woman sculptor up to that time for the decoration of the buildings of the St. Louis Exposition. Specialty: Decorative religious subjects. Address in 1903, 467 Central Park West, NYC. Died in NYC, June 2, 1921.

WILSON, MRS.
Sculptor. Born near Cooperstown, NY. Active about 1840-1850, in Cincinnati, OH. Work includes stone bust of her husband, Dr. Wilson; and other sculpture portraits.

WILSON, OLIVER.
Sculptor and marble cutter. Worked: Chicago, 1850's. Partner of Henry Wilson, with whom he was awarded a prize for animal painting in oils, Illinois State Fair, 1855.

WILSON, ROBERT BURNS.
Portrait and marine painter. Born in Parker, PA, in 1851. Exhibited at the Southern States Art League, at Henderson, KY, c. 1900, where he was awarded a medal. Settled in Frankfort, KY, and lived there for almost 30 years. Specialty: Animals. Address in 1915, New York City. Died March 31, 1916, in Brooklyn, NY.

WILSON, SOL(OMON).
Painter, printmaker and etcher. Born in Vilno, Poland, August 11, 1896. Studied: Cooper Union Art School; National Academy of Design; Beaux-Arts Institute of Design, New York, NY; pupil of Ivan G. Olinsky, George Maynard, Robert Henri, George Bellows. Member: Artists Equity Association; Provincetown Art Association; Audubon Artists;

Cape Cod Art Association; An American Group; others. Work: Brooklyn Museum; Library of Congress; Baltimore Museum of Art; Metropolitan Museum of Art; Newark Museum; Delgado Museum of Art; Seattle Art Museum; University of Minnesota; City Art Museum, St. Louis; Living Arts Foundation, NY; Ball State University; Bezalel and Ain Harod Museums, Israel; Syracuse University; Norfolk Museum of Arts and Science; Provincetown Art Association; Smithsonian Institution; Brandeis University; others. Exhibited: Penna. Academy of Fine Arts, 1934, 35, 40, 45; Corcoran, 1934, 43, 45; Art Institute of Chicago, 1935, 43, 45; National Academy of Design, 1938, 40, 45, 46; Whitney, 1945; Virginia Museum of Fine Arts, 1942, 44, 46; Library of Congress, 1944; Pepsi-Cola, 1944, 45; City Art Museum, St. Louis, 1939; others. Awards: Prizes, American Red Cross, 1942; Pepsi-Cola, 1944; Audubon Artists, 1947, 49, 63; Carnegie, 1947; Corcoran, 1947; American Academy of Arts and Letters, 1950; National Society of Painters in Casein, 1955; National Academy of Design, 1958, Carnegie prize, 1966; others. Taught at American Artists School; School of Art Studies; Art Students League. Address in 1973, 200 West 72nd Street, New York, NY.

WILTZ, ARNOLD.
Painter and engraver. Born in Berlin, Germany, June 18, 1889. Self-taught. Member: Brooklyn Society of Modern Artists; Woodstock Art Association. Represented in Cincinnati Museum; Helena Rubenstein Collection, Paris; Phillips Memorial Gallery, Washington, DC; Whitney Museum of American Art, NY. Address in 1933, Woodstock, NY. Died March 13, 1937.

WILTZ, E. MADELINE SHIFF.
(Mrs. Arnold Wiltz). Painter and craftsman. Born in Denver, CO. Studied at Adelphi College, B.A.; Art Students League; pupil of J. B. Whittaker, F. V. Du Mond, William Chase, H. E. Field. Member: Salons of America; Brooklyn Society of Miniature Painters; Woodstock Art Association. Award: Charlotte Ritchie Smith Memorial prize, Baltimore Water Color Club, 1923. Work: "Wiltz at Work," Whitney Museum of American Art. Exhibited: Rudolph Gallery, Woodstock; Coral Gables, FL. Address in 1962, Woodstock, NY.

WILTZ, LEONARD, JR.
Sculptor. At New Orleans, 1846-53. Worked in marble.

WIMAR, CHARLES (KARL FERDINAND).
Painter. Born in Siegburg, near Bonn, West Germany, Feb. 20, 1828. Emigrated to U.S. in 1843. Studied under Leon Pomarede, 1846-51, in St. Louis; also apprenticed to him on a trip up the Mississippi River. Trained in Duesseldorf, Germany, 1851-56, studying under Emanuel Gottlieb Leutze. Returned to St. Louis where he made at least three trips up the Missouri River for artistic material. Painting subjects were of American Indians, hunting, war scenes, buffalo, and wide, highly panoramic plains views. Celebrated works are his "Indians Pursued by American Dragoons," 1853, Noonday Club, St. Louis, and "Indians Approaching Fort Benton," 1859, Washington University, St. Louis. Also executed some portrait pictures and in 1861 painted mural decorations in the rotunda of the St. Louis Court House, those murals being almost completely destroyed. Four American sketchbooks have been preserved and approximately fifty of his finished works have been identified. Took many photographs of American Indians. Died in St. Louis, MO, Nov. 28, 1862.

WINANS, WALTER.
Painter, sculptor and illustrator. Born in St. Petersburg, Russia, of American parents, April 5, 1852. Pupil of Volkoff, Paul, Georges and Corbould. Member: Peintres et Sculpteurs du Cheval; Allied Artists of America. Work: Sculpture in Marble Palace, St. Petersburg; "Pegasus Alighting" and "Indian Fight," Hartsfeld House, London. Awarded Chevalier, Imperial Russian Order. Specialized in the horse. Worked in U.S. Died in London, August 12, 1920.

WINCHELL, ELIZABETH BURT.
(Mrs. John Patten Winchell). Painter, craftsman, designer, lecturer, and teacher. Born in Brooklyn, NY, June 20, 1890. Studied: Moore Institute of Design, Philadelphia; Philadelphia Museum School of Industrial Art; Penna. Academy of Fine Arts; pupil of Elliott Daingerfield, Henry B. Snell, Daniel Garber, W. W. Gilcrist, Jr., Samuel Murray, Harriet Sartain. Member: Haylofters, Portland, ME; Portland Water Color Society; C. L. Wolfe Art Club; Freeport Art Club; American Artists Professional League; Maine Craft Guild. Awards: First prize, Wanamaker Exhibition, Philadelphia, 1910-11; first prize, Flower Show Exhibition, Philadelphia, 1911; 2nd and 3rd prizes, Flower Show Exhibition, Philadelphia, 1928; hon. mention, C. L. Wolfe Art Club, New York, 1928. Work: Moore Institute of Design; Camden (ME) Municipal Collection; Brunswick (ME) Savings Banks. Exhibited: Brooklyn Museum; Portland Society of Artists; Penna. Academy of Fine Arts; Freeport Art Club, 1940-46; Lincolnville, ME; Providence, RI; Farnsworth Museum; Portland Art Museum. Taught at Bailey School, Bath, ME, 1939-46. Address in 1962, Yarmouth, ME.

WINDISCH, MARION LINDA.
(Mrs. Alden Cody Bentley). Sculptor. Born in Cincinnati, OH, June 20, 1904. Pupil of Clement J. Barnhorn and Edward McCartan. Awards: First and second prizes, Three Arts Club, and honorable mention, Women's City Club, Cincinnati, OH. Address in 1933, 47 East 61st St., Apt. 8B, NYC.

WINEBRENNER, HARRY FIELDING.
Painter, sculptor, illustrator, lecturer, and teacher. Born in Summersville, WV, January 4, 1885. Studied at University of Chicago; Art Institute of Chicago; British Academy in Rome, Italy; Grande Chaumiere, Paris; Academie Julien, Paris; pupil of Taft, Mulligan, Sciortino. Member: Chicago Society of Artists; California Art Club; Sculptors Guild of Southern California; Society for Sanity in Art. Work: "Italian Boy" and "The Passing of the Indian," Oklahoma State Historical Society; "Fountain of Education," "Statue of Welcome," "The Soul of a Dancer," Venice; Northern Oklahoma Jr. College; Carmel School, Avranches, France; Municipal Art Gallery, Oklahoma City, OK; Oklahoma Art Museum. Exhibited: Oakland Art Gallery, 1948; Paris, France, 1950 (one-man). Art director, City of Venice, and head of art department, Venice Union Polytechnic High School. Author and illustrator of *Practical Art Education*. Address in 1962, Chatsworth, CA.

WINES, JAMES N.
Sculptor and environmental artist. Born June 27, 1932, in Oak Park, IL. Earned B.A. at Syracuse University School of Art, 1955; studied with Ivan Mestrovic. Lived in Rome. Taught at School of Visual Arts, NYC; NY University; Cornell; SUNY/Buffalo; Jersey School of Architecture, Newark, NJ; Cooper Union, NY. Awarded Pulitzer Fellowship, 1953; Prix de Rome, 1956; Guggenheim Fellowship, 1962; Ford grant, 1964; National Endowment for Architecture, 1973; National Endowment for Arts, 1974. Exhibited at Everson Museum, Syracuse; Baltimore Museum of Art; Walker Art Center; Museum of Modern Art; Sao Paulo Biennial; Galleria Trastevere di Topazia Alliata, Rome; Los Angeles County Museum of Art; Walker Art Center, Minneapolis, MN; Whitney; Museum of Modern Art; Art Institute of Chicago; Carnegie; Stedelijk Museum; Pompidou Center, Paris; CAYC Museum, Buenos Aires; others. In collections of Whitney; Albright-Knox Art Gallery; Currier Gallery, NH; Everson Museum of Art, Syracuse; Stedelijk Museum, Amsterdam; Colgate University; NY University; Art Institute of Chicago; Cleveland Museum of Art; Herron Art Institute, Indianapolis; Los Angeles County Museum of Art; Tate Gallery, London; Munson-Williams-Proctor Institute, Utica, NY; Walker Art Center; plus many others. Positions: Director of Site, Inc., New York, from 1969, and currently president; member of Federal Design Assembly, Washington, DC, 1972; member, Arts Advisory Council, Bicentennial Celebration, Washington, DC, 1972; others. Address in 1984, c/o SITE, 83 Spring Street, New York, NY.

WINGATE, ARLINE (HOLLANDER).
Sculptor. Born in New York City, October 18, 1906. Studied at Smith College; in Europe; and with Alexander Archipenko. Works: Syracuse University Museum; Birmingham Museum of Art; National Museum, Stockholm, Sweden; Newark Museum; Ghent Museum, Belgium; Hirshhorn. Awards: National Association of Women Artists, 1945; Amelia Peabody award, 1956; Easthampton Guild Hall, 1958. Exhibitions: Metropolitan Museum of Art; Whitney Museum, NYC; Wadsworth Atheneum; San Francisco Museum; Art Institute of Chicago; Penna. Academy of Fine Arts; National Association of Women Artists; Brooklyn Museum; National Academy of Design; Golden Gate Expo.; World's Fair of NY, 1939; Midtown Gallery; Wildenstein Gallery; others in U.S. and abroad. Member: National Association of Women Artists; Federation of Modern Painters and Sculptors. Address in 1983, East Hampton, NY.

WINGATE, CARL.
Painter and etcher. Born in Brooklyn, NY, December 9, 1876. Pupil of Walter Shirlaw; National Academy of Design. Specialty: Etching. Work: Museum, City of NY. Address in 1929, 22 Curtis Road, Boston, MA.

WINGERD, LOREEN.
Painter, illustrator, and teacher. Born in Delphi, IN, August 2, 1902. Pupil of William Forsyth; John Herron Art Institute. Address in 1929, 51 East Market; h. 217 West North St., Delphi, IN.

WINGERT, EDWARD OSWALD.
Painter. Born in Philadelphia, PA, February 29, 1864. Studied: Penna. Academy of Fine Arts; pupil of Hovenden, Anshutz and Porter in Philadelphia. Member: Fellowship Penna. Academy of Fine Arts; American Artists Professional League. Represented in Graphic Sketch Club, Philadelphia, PA; Youngstown Art Institute. Address in 1933, Oak Lane, Philadelphia, PA.

WINKEL, NINA.
Sculptor. Born in Westfalen, Germany, May 21, 1905. U.S. citizen. Studied in Germany. Works: War memorial, Seward Park High School, NY; monument, Charlotte, North Carolina; wall panel, Keene Valley Library, NY; numerous others. Awards: National Academy of Design, 1945, 64, 78, 79; Avery award, 1958; purchase prize, National Sculpture Society, 1981. Exhibited at Fairmount Park, Philadelphia; American Academy of Arts and Letters; Newark Museum; many exhibitions at National Academy of Design; retrospective, Sculpture Center, 1972. Member: Fellow, National Sculpture Society; National Academy of Design; Sculptors Guild; Sculpture Center. Address in 1983, Keene Valley, NY.

WINKLER, AGNES CLARK.
(Mrs. G. A. M. Winkler). Painter, craftsman, writer, and lecturer. Born in Cincinnati, OH, April 8, 1893. Studied: Art Institute of Chicago; pupil of Leon

Lundmark, Watson and Mary Helen Stubbs. Member: Allied Artists of America; Chicago No-Jury Society of Artists; All-Illinois Society of Fine Arts; Hoosier Salon; Woman's Art Club, Cincinnati; Renaissance Art Society, University of Chicago; Illinois Academy of Fine Arts; Chicago Society of Artists. Died January 15, 1945. Address in 1933, 4468 Lake Park Ave., Chicago, IL.

WINKLER, JOHN W.
Painter and etcher. Member: Chicago Society of Illustrators; Brooklyn Society of Etchers; Associate National Academy of Design, 1936; Academician National Academy of Design; American Society of Etchers; Societe des Graveurs en Noir, Paris. Awards: Logan prize, Chicago Society of Etchers, 1918; purchase prize, California Society of Etchers, 1919; honorable mention, Concord Art Association, 1920; Society of American Etchers, 1937. Work in Chicago Art Institute; NY Public Library; Library of Congress; Musee du Luxembourg, Paris. Address in 1929, 3026 Benvenue Ave., Berkeley, CA.

WINN, JAMES HERBERT.
Painter, sculptor, jeweler, engraver, designer, craftsman, writer, and teacher. Born in Newburyport, MA, September 10, 1866. Pupil of Art Institute of Chicago. Member: Cliff Dwellers Club; Alumni, Art Institute of Chicago; Association of Arts and Industries. Awards: Arthur Heun prize, Art Institute of Chicago, 1910; first prize and gold medal, Women's Conservation Exhibition, Knoxville, TN, 1913; prize, California State Fair, Pomona, 1931. Instructor, Jewelry and Metal Work, Art Institute of Chicago. Address in 1929, Fine Arts Building, 410 South Michigan Ave.; h. 9522 Longwood Drive, Chicago, IL.

WINNER, MARGARET F.
Painter, illustrator, and teacher. Born in Philadelphia, PA, Oct. 21, 1866. Pupil of Penna. Academy of Fine Arts and Howard Pyle. Member: Plastic Club; Fellowship Penna. Academy of Fine Arts; Philadelphia Alliance. Represented at Dickinson College, Carlisle, PA. Died December 21, 1937. Address in 1933, 1706 North 16th St., Philadelphia, PA.

WINNER, WILLIAM E.
Portrait, genre, historical and religious painter. Born c. 1815 in Philadelphia, PA. Worked there from 1836, probably until his death; also visited Charleston, SC, 1848. Member of the Board of Control of the Artists' Fund Society from 1843. Exhibitor at the Penna. Academy of Fine Arts, until 1881; Boston Athenaeum; National Academy; Apollo Association; American Art Union. Died in 1883.

WINSLOW, EARLE BARTRUM.
Illustrator, lithographer, painter and teacher. Born in Northville, MI, February 21, 1884. Pupil of Detroit Fine Arts School; Art Students League of NY; Art Institute of Chicago; student of George Bellows, Andrew Dasburg, John Sloan. First published illustration, *Judge* magazine, 1919. Illustrated the *Gospel of St. Mark* for Conde Nast, 1932; *Robbin's Journal*, 1931; *Fire Fighters*, 1939; others. Originated newspaper cartoon *Bingville Bugle*. Member: Society of Illustrators (life); Art Directors' Club; Artists Guild of the Authors' League of America; Woodstock Art Association; Salma. Club. Exhibited: Macbeth Gallery (one-man); International Water Color Society; College Art Association of America; Society of Illustrators; Penna. Academy of Fine Arts. Died in 1969. Address in 1962, Woodstock, NY.

WINSLOW, ELEANOR C. A. (MRS.).
Painter and illustrator. Born in Norwich, CT, May, 1877. Pupil of Art Students League of NY; Whistler in Paris. Award: Third Hallgarten prize, National Academy of Design, 1907. Member: National Association of Women Painters and Sculptors; Connecticut Academy of Fine Arts; Norwich Art Association. Address in 1933, 125 East 62nd Street, New York, NY.

WINSLOW, HENRY.
Painter, etcher, and engraver. Born in Boston, MA, July 13, 1874. Pupil of Whistler in Paris. Member: Chicago Society of Etchers; American Institute of Graphic Arts. Work: British Museum, London; Bibliotheque Nationale, Paris; Boston Museum of Fine Arts; New York Public Library. Exhibited: Royal Academy, London; Paris Salon. Address in 1933, 24 Marlborough Place; 10 Fitzroy St., London, England. Died in the 1950's.

WINSLOW, LEON LOYAL.
Teacher and writer. Born in Brockport, NY. Pupil of Pratt Institute. Member: American Federation of Arts. Author of *Organization and Teaching of Art, Elementary Industrial Arts, Essentials of Design*. Contributor to art and educational journals. Address in 1929, Carrollton and Lafayette Avenues, Baltimore, MD.

WINSTANLEY, JOHN BREYFOGLE.
Painter, writer, and illustrator. Born in Louisville, KY, October 23, 1874. Studied: Penna. Academy of Fine Arts; University of Pennsylvania; Purdue University; pupil of W. M. Chase. Member: NY Water Color Club. Award: Bronze medal, P. P. Expo., San Francisco, 1915. Work: Rochester Memorial Art Gallery. Address in 1933, 644 Minneford Ave., City Island, New York, NY. Died December 5, 1947.

WINSTANLEY, WILLIAM.
An English artist who came to America during the last decade of the eighteenth century. He made many good copies of Gilbert Stuart's portraits of George Washington. Returned to England and exhibited

three Virginia landscapes in London at the British Institution in 1806.

WINTER, ALICE BEACH.
(Mrs. Charles Allan Winter). Painter, sculptor, illustrator, and teacher. Born in Green Ridge, MO, March 22, 1877. Studied: St. Louis School of Fine Arts; Art Students League of New York; pupil of George de Forest Brush, Joseph De Camp, John Twachtman, and others. Member: North Shore Arts Association; Business and Professional Women's Club, Gloucester; National Association of Women Painters and Sculptors. Awards: Medal, St. Louis School of Fine Arts. Specialty: Childhood subjects. Exhibited: National Academy of Design; Penna. Academy of Fine Arts; Carnegie Institute; City Art Museum of St. Louis; National Association of Women Artists; Los Angeles Museum of Art; Contemporary New England Artists; North Shore Arts Association. Child-life illustrator of covers and stories for national magazines. Address in 1953, 134 Mt. Pleasant Ave., East Gloucester, MA.

WINTER, ANDREW.
Painter. Born in Sindi, Estonia, April 7, 1892. Studied: National Academy of Design; Cape Cod School of Art; Tiffany Foundation. Work: National Academy of Design; Penna. Academy of Fine Arts; Mint Museum of Art; Cranbrook Academy of Art; National Arts Club; Rochester Memorial Art Gallery; High Museum of Art; IBM Collection; others. Exhibited: National Academy of Design, New York, 1925; Penna. Academy of Fine Arts; Corcoran; Art Institute of Chicago; Carnegie; American Federation of Arts traveling exhibition; Golden Gate Expo., 1939; World's Fair of NY, 1939; Salma. Club; National Arts Club; Herron Art Institute; Toledo Museum of Art; Montclair Art Museum; others. Awards: Medal, National Academy of Design, 1924, 35, prizes, 1931, 40-42; prizes, National Arts Club, 1931; Salma. Club, 1934, 37, 38, 40, 41, 42, 45, 48, 49; Allied Artists of America, 1933, 39; Ogunquit Art Center, 1948; Currier Gallery, 1941; others. Member: American Water Color Society; National Arts Club; Salma. Club; Academician National Academy of Design; Allied Artists of America; others. Address in 1956, Monhegan Island, ME. Died October 27, 1958, in Brookline, MA.

WINTER, CHARLES A(LLAN).
Painter and illustrator. Born in Cincinnati, OH, October 26, 1869. Pupil of Cincinnati Art Academy, under Noble and Nowottny; Julian Academy in Paris, under Bouguereau and Ferrier. Work: University of Wyoming; City Hall, Gloucester, MA; High School, Gloucester, MA. Award: Foreign Scholarship from Cincinnati Art Academy, 1894. Illustrations and covers for *Collier's* and other magazines. Address in 1933, 134 Mt. Pleasant Ave., East Gloucester, MA. Died September 23, 1942.

WINTER, CLARK.
Sculptor. Born in Cambridge, MA, April 4, 1907. Studied: Harvard University, B.A.; Indiana University, M.F.A.; Art Students League; Cranbrook Academy of Art; Fontainebleau Academy of Art; pupil of Robert Laurent; M. Saulo in Paris. Work: Carnegie Institute; Aldrich Museum of Contemporary Art; Carnegie-Mellon University. Member: Artists Equity Association; Society of Sculptors; Mid-American Artists. Awards: Florida Southern College, 1952; Wichita Art Association; prizes, Oakland Art Museum; Western Penna. Society of Sculptors, 1956-60; others. Exhibited: Metropolitan Museum of Art; Penna. Academy of Fine Arts; Carnegie Institute (one-man); Audubon Artists; John Herron Art Institute; Sculpture Center, NY; Whitney; Philadelphia Museum of Art; Kansas City Art Institute (one-man); Carnegie College of Fine Arts (one-man). Position: Head of sculpture department, Kansas City Art Institute, Kansas City, MO, 1949-53; associate professor of sculpture, Carnegie-Mellon University, 1955-72, emeritus professor, from 1972; others. Address in 1980, San Rafael, CA.

WINTER, EZRA (AUGUSTUS).
Painter and illustrator. Born in Manistee, MI, March 10, 1886. Pupil of Chicago Academy of Fine Arts; American Academy in Rome. Member: Associate National Academy of Design, 1924; Academician National Academy of Design, 1931; National Society of Mural Painters; NY Architectural League; Salma. Club; Players Club; American Federation of Arts. Awards: American Academy at Rome Scholarship, 1911-14; medal of honor, NY Architectural League, 1922; gold medal, NY Society of Architects, 1923. Work: Decorations in Great Hall and Vestibule, Cunard Building, NY; Kilburn Hall and Eastman Theatre, Rochester, NY; Trading Room, NY Cotton Exchange; Willard Straight Hall, Cornell University, Ithaca, NY; ceiling decorations, National Chamber of Commerce, Washington, D.C.; children's room frieze and delivery room frieze, Public Library, Birmingham, AL; ceiling and mosaic panel, Rochester Savings Bank, Rochester, NY; 3 domes, Industrial Trust Building, Providence, RI; stained glass window, Straus Bank, Chicago; decorations in the Monroe County Savings Bank, Rochester, NY; fairy story decorations, NY Life Building Restaurant, NY; mosaic panel and decorative map, Union Trust Building, Detroit, MI; mural, Grand Foyer, International Music Hall, Rockefeller Centre, NY. Address in 1933, 15 Vanderbilt Ave., New York, NY. Died April 7, 1949.

WINTER, GEORGE.
Painter. Born June 10, 1810, in Portsea, England. Working in New York in 1834. Died February 1, 1876, in Lafayette, IN.

WINTER, LUMEN MARTIN.
Sculptor and painter. Born in Ellery, IL, December 12, 1908. Studied at Grand Rapids Jr. College; Cleveland School of Art; National Academy of Design; also studied in France and Italy. Work in Library of Congress, Washington, DC; Vatican, Rome; mosaic and bas-relief sculpture for chapels, U.S. Air Force Academy, Colorado Springs, CO; bas-relief frieze, Gerald R. Ford Center, Grand Rapids, MI; others. Has exhibited at National Academy of Design, NY; American Watercolor Society Annual and Traveling Shows; American Academy Institute of Arts and Letters, NY; others. Received Purchase Ranger Fund Award, National Academy of Design; William A. White Award, Salma. Club; others. Member of Salma. Club; American Watercolor Society; National Society of Mural Painters. Works in marble and bronze; watercolor and oil. Address in 1982, New Rochelle, NY.

WINTER, MILO.
Illustrator. Born in Princeton, IL, in 1888. Pupil of Art Institute of Chicago; American Water Color Society; Cliff Dwellers, Chicago. Illustrated *Nights with Uncle Remus, Aesop's Fables, Alice in Wonderland, Bill Pop-Gun*, etc. Address in 1926, 621 Sheridan Road, Evanston, IL.

WINTERHALDER, ERWIN.
Sculptor. Born in Zurich, Switzerland, in 1879. Studied in Paris, France, 1903-05; in Italy, 1905-07; in Munich; and from 1908-13 in Zurich. Settled in San Francisco in 1913. Worked under Stirling Calder, 1914-15. During the past years he has been actively engaged in sculptural works in different parts of California on private and public buildings. Works: Statue, "Despair"; four panels, State Buildings, Sacramento, CA. Address in 1918, 1160 Page Street, San Francisco, CA.

WINTERHALDER, LOUIS A.
Painter and pen and ink artist. Native of New Orleans. He studied at the Art Union and under Molinary, Perrelli and Buck. Exhibited at New Orleans and at the Academy of Fine Arts, Chicago. Specialty: Landscapes. Represented in Louisiana State Museum.

WINTERICH, JOSEPH.
Sculptor. Born in Neuwied, Germany, 1861. Active in Cleveland, OH, 1920. Work: Church decorations in St. Cyril, St. Methodine, St. Ignatius, and Our Lady of Good Counsel churches, Cleveland, OH. Died in Coblenz, Germany, November 16, 1932.

WINTERS, JOHN (RICHARD).
Painter and sculptor. Born in Omaha, NE, May 12, 1904. Studied at Chicago Academy of Fine Arts; Art Institute of Chicago; pupil of Frederick Poole, J. Allen St. John. Work: Murals, Steinmetz High School, Chicago; Northwest Airlines, Seattle; Cook County Hospital, IL; Hatch School, Oak Park, IL; Brookfield (IL) Zoo; mural, United States Post Office, Petersburg, IL. Exhibited: Corcoran Gallery of Art, 1934; Denver Art Museum; Wichita Art Association; Kansas State College; Tulsa Art Association; Topeka Artists Guild; Salina (KS) Art Association; Art Institute of Chicago, 1935, 36, 38, 40, 44; Springfield (MA) Museum of Art, 1938; Little Gallery, Chicago; Chicago Woman's Club, 1938. Address in 1953, Chicago, IL.

WINTERS, PAUL VINAL.
Sculptor and painter. Born in Lowell, MA, September 8, 1906. Studied at Massachusetts State School of Art; pupil of Raymond A. Porter, Leo Toschi. Work: Statue, Monohoi, PA; bust, Boston Public Library. Exhibited: Robbins Memorial Town Hall, Arlington, MA. Address in 1953, Norwood, MA.

WINTRINGHAM, FRANCES M.
Painter. Born in Brooklyn, NY, March 15, 1884. Pupil of George Bellows; Kenneth Hayes Miller; Robert Henri; John Sloan; and Charles Hawthorne. Member: Art Students League. Address in 1933, 168 Hicks St., Brooklyn, NY.

WIRE, MELVILLE T(HOMAS).
Painter. Born in Austin, IL, Sept. 24, 1877. Pupil of Marie Craig Le Gall and Mrs. Eva Cline-Smith. Member: Oregon Society of Artists. Award: Second prize, landscape, Oregon Society of Artists, 1931. Address in 1933, 128 West 3rd Street, Albany, OR.

WIREMAN, EUGENIE M.
Painter and illustrator. Born in Philadelphia, PA. Pupil of Penna. Academy of Fine Arts; Howard Pyle. Member: Art Alliance of Philadelphia. Address in 1933, Haworth Bldg., 1020 Chestnut St.; h. 3601 Walnut St., Philadelphia, PA.

WIRES, MRS. ALDEN CHOATE.
Painter. Born in Oswego, NY, February 16, 1903. Member: Tiffany Foundation; Rockport Art Association. Address in 1933, Rockport, MA.

WIRTH, ANNA M(ARIA).
Illustrator and writer. Born in Johnstown, PA, November 12, 1868. Pupil of Penna. Academy of Fine Arts; Philadelphia School of Design for Women; Philadelphia School of Miniature Painting. Member: California Society of Miniature Painters; Fellowship Penna. Academy of Fine Arts. Illustrated *Progressive Pennsylvania*, by J. M. Swank. Author and illustrator of The King's Jester. Address in 1933, 2025 Ruho Court, Altadena, CA; h. 248 Barron Ave., Johnstown, PA. Died c. 1939.

WIRTZ, WILLIAM.
Painter, sculptor, and teacher. Born in The Hague, Holland, May 9, 1888. Pupil of Fritz Jansen and

W.A. van Konijnenburg. Address in 1928, 2322 Eutaw Pl., Baltimore, MD. Died April 20, 1935.

WISE, ETHEL BRAND.
(Mrs. L. E. Wise). Sculptor. Born in New York City, March 9, 1888. Pupil of James Earle Fraser; Harry Trasher; Arthur Lee. Member: Syracuse Associated Artists; Syracuse Art Club Guild. Work: Plaisted Memorial, Masonic Temple, Syracuse, NY; Teachers Memorial, Wichita Falls, TX; "Repose," permanent collection, University of Missouri, Columbia; St. Johns Military Academy, Manlius, NY; others. Address in 1929, 201 Clarendon St., Syracuse, NY. Died August 14, 1933.

WISE, FLORENCE B(ARAN) (MRS.).
Painter and lecturer. Born in Farmingdale, Long Island, NY, January 27, 1881. Studied: Rhode Island School of Design; pupil of F. C. Jones, George W. Maynard, George Bridgman. Member: Springfield Art League; Providence Water Color Club. Work: Copy of Gilbert Stuart's "George Washington," Ambassador Hotel, Chicago, IL; "Philanthropy," Vacation Home for Crippled Children, Spring Valley, NY; "Victory," Rhode Island Post 23, Providence. Address in 1933, 90 Sefton Drive, Cranston, RI.

WISE, LOUISE WATERMAN.
(Mrs. Stephen Wise). Portrait painter and writer. Born in New York. Pupil of Kenyon Cox; Robert Henri; George Bellows; K. H. Miller. Exhibited: Penna. Academy of Fine Arts; National Association of Women Painters and Sculptors; Corcoran. Member: National Association of Women Painters and Sculptors. Address in 1933, 300 Central Park, West, New York, NY. Died December 10, 1947.

WISELTIER, JOSEPH.
Painter, craftsman, and teacher. Born in Paris, France, October 6, 1887. Pupil of Dow; Bement; Snell. Member: Art Alliance of America; Eastern Arts Association (president); Connecticut Art Association; Hartford Arts and Crafts Club; American Federation of Arts; American Artists Professional League. State Director of Art Education for Connecticut. Address in 1929, 107 Washington Circle, West Hartford, CT. Died in 1933.

WISEMAN, ROBERT W.
Painter of animals. Exhibited at the National Academy. His studio was in New Haven, CT.

WISER, GUY BROWN.
Painter and teacher. Born in Marion, IN, February 10, 1895. Pupil of Despujols; Gorguet; Hugh H. Breckenridge; Charles Hawthorne; J. R. Hopkins. Member: Hoosier Art Patrons Association; Columbus Art League; Northern Indiana Art League; American Artists Professional League. Awards:

Walter Lippincott prize, Penna. Academy of Fine Arts, Philadelphia, 1927; Union Trust prize, Northern Indiana Art League, 1927; prizes, Hoosier Salon, Chicago, 1927, 29-34; Art Association prize, Richmond, IN, 1928; first prize, Columbus Art League, 1929; Col. Buckingham prize, 1930; hon. mention, John Herron Art Institute, 1930. Represented in Muskingum College, New Concord, OH. Address in 1933, 100 West Duncan Street, Columbus, OH.

WITHERSTINE, DONALD F(REDERICK).
Etcher, block printer and painter. Born in Herkimer, NY, February 9, 1896. Pupil of Art Institute of Chicago; Penna. Academy of Fine Arts; George Elmer Browne. Member: Salma. Club; Beach Combers; Fellowship Penna. Academy of Fine Arts; Boston Art Club. Works: "Devant le Mosque," Peoria Art Institute; "The Old Wharf in Moonlight," Bloomington Art Association; "Andorra - Pyrenees," University of Illinois. Address in 1933, 47 Commercial St., Provincetown, MA. Died in 1961.

WITKIN, ISAAC.
Sculptor and instructor. Born in Johannesburg, South Africa, May 10, 1936; U.S. citizen. Studied at St. Martins School of Art, London, with Anthony Caro; also with Henry Moore, England. Work in Joseph Hirshhorn Museum, Washington, DC; Tate Gallery, London; sculpture, Storm King Art Center, Mountainville, NY; others. Has exhibited at Marlborough Gallery, NYC, from 1963; Paris Bienale, Museum of Modern Art; Primary Structures, Jewish Museum, NY; Condition of Sculpture, Hayward Gallery, London, 1975; others. Received Guggenheim fellowship, 1981. Teaching sculpture at Bennington College, from 1965; sculpture at Parsons School of Design, from 1975. Works in steel and bronze. Address in 1982, c/o Hamilton Gallery of Contemporary Art, NYC.

WITT, JOHN HENRY (or JOHN HARRISON).
Painter. Born in Dublin, Wayne County, IN, May 18, 1840. A machinist and wagon painter in a small agricultural implement factory owned by his uncles. Studied art in Cincinnati with Joseph O. Eaton. Began portrait painting at an early age and adopted it as a profession about 1862. From 1862 to c. 1879 he had a studio in Columbus, OH. Painted portraits of a great many governors and other prominent public men of Ohio until about 1879, when he moved to NYC. Elected an Associate of the National Academy of Design and was a member of various clubs. Died Sept. 13, 1901 in NYC.

WITTERS, NELL.
Painter, illustrator, etcher, and craftsman. Born in Grand Rapids, MI. Studied: Art Institute of Chicago; Penna. Academy of Fine Arts; Art Students League

of NY; Teachers College, Columbia University; pupil of John C. Johansen, Eliot O'Hara, George Elmer Browne. Member: Art Alliance of America; Art Institute of Chicago Alumni; Pen and Brush Club; Wolfe Art Club; Brooklyn Society of Artists; American Artists Professional League. Awards: Logan medal for arts and crafts, Art Institute of Chicago, 1919; first prize for cotton dress goods design and first prize for wall paper design, Art Alliance of America, 1919; prize, Wolfe Art Club, 1935; Pen and Brush Club, 1937. Designs for textiles. Address in 1953, 609 West 137th Street, New York, NY.

WOELFLE, ARTHUR WILLIAM.
Painter, lecturer and teacher. Born in Trenton, NJ, December 17, 1873. Pupil of Art Students League of NY under Mowbray, Beckwith, Cox and Twachtman; National Academy of Design under Will Low and C. Y. Turner; Carl Marr and Diez in Munich; also in Paris. Member: Associate National Academy of Design, 1929; National Arts Club (life); Art Students League of NY; Salma. Club, 1902; Artists Guild of the Authors' League of America; Grand Central Art Galleries; Allied Artists of America; American Federation of Arts. Awards: Hon. mention, Munich, 1897; scholarship, Brooklyn Institute; silver medal, Allied Artists of America, 1928. Work: Murals in Court House at Youngstown, OH; Court House of Coshocton, OH; also ten portraits of judges in the Court House at Youngstown, OH. Taught at Mechanics Institute; Grand Central School of Art; Castle School; Kingsley School. Address in 1933, 36 West 9th Street, New York, NY. Died March 6, 1936, Brooklyn, NY.

WOHR, DONNA.
Sculptor. Born in Arlington, MA, August 18, 1926. Studied at Massachusetts College of Art; Bard College, Annandale, NY; Dutchess Community College, Poughkeepsie, NY; State University of NY at New Paltz; Vassar College. Exhibited at Seaman Studio Gallery, Poughkeepsie, NY, 1976; Voltaire's Gallery, New Milford, CT, 1976; The Craft Connection, Jenkintown, PA, 1977; Vassar College Center, 1978; Barrett House Invitationals, 1979, 80, 81; Mid-Hudson Arts and Science Center (one-woman), 1982; Cunneen-Hackett Gallery (one-woman), 1983; others. Work in private collections in U.S., Holland, and France. Awarded purchase prize and honorable mention, Maine Annual Sidewalk Show, 1969; merit for sculpture, 1969, best in sculpture, 1970, 73, merit for drawing, 1972, first in soft sculpture, 1977, Dutchess County Art Association. Member of Empire State Crafts Alliance; Dutchess County Art Association; others. Address in 1984, Poughkeepsie, NY.

WOICESKE, RONAU W(ILLIAM).
Painter, etcher, painter and designer. Born in Bloomington, IL, October 27, 1887. Pupil of John Carlson and St. Louis School of Fine Arts. Member: New Haven Paint and Clay Club; American Federation of Arts; Society of American Etchers; California Printmakers Club; Philadelphia Printmakers Club; Chicago Society of Etchers; Connecticut Academy of Fine Arts. Awards: Second prize, St. Louis Art League; prize, Southern Printmakers, 1936. Work: NY Public Library; Los Angeles Museum of Art; Library of Congress; murals and stained glass windows in many churches. Exhibited: Philadelphia Printmakers Club; Chicago Society of Etchers; Carnegie; Society of American Etchers; others. Specialty: Etching and stained glass designing. Address in 1953, Woodstock, NY. Died July 21, 1953.

WOISERI, J. L. BOUQUET
(or BOQUETA DE WOISERI, J. L.).
Engraver and painter. As early as 1803 this man was working in New Orleans. Engraved a plan and a view of New Orleans with well-executed aquatint vignettes and views of buildings, and a large aquatint view of Boston. In the *General Advertiser* in Philadelphia, in 1804, Woiseri advertises his two New Orleans plates "for $10 for both colored." He dedicates his plates "by permission to President Thomas Jefferson." Called himself a "designer, drawer, geographer, and engineer." He worked six years on the New Orleans plates and lived in New Orleans for many years.

WOLCHONOK, LOUIS.
Painter, etcher, designer and teacher. Born in New York, NY, January 12, 1898. Studied: National Academy of Design; Cooper Union Art School; City College of NY, B.S.; Julian Academy, Paris. Work: University of Nebraska; Cleveland Museum of Art; Bibliotheque Nationale, Paris. Group exhibitions: Art Institute of Chicago; Whitney, 1934; National Academy of Design; Penna. Academy of Fine Arts; Tate Gallery, London; Los Angeles Museum of Art. One-man exhibitions: ACA Gallery; Newhouse Gallery; Milch Gallery; Ainslie Gallery. Member: Brooklyn Society of Artists; NY Water Color Club; Society of American Etchers; NY Society of Craftsmen. Taught: Drafting, City College of NY, from 1930; Design, Painting and Etching, Craft Students League, YWCA, New York, NY, from 1932. Address in 1953, 60 West 76th Street, New York, NY.

WOLCOTT, FRANK.
Painter, sculptor, etcher, and craftsman. Born in McLeansboro, IL. Pupil of Art Institute of Chicago. Member: Chicago Society of Artists. Address in 1925, 1504 East 17th Street, Chicago, IL.

WOLCOTT, KATHERINE.
Painter and sculptor. Born in Chicago, IL, April 8, 1880. Studied: Art Institute of Chicago; Art Students League of New York; Chicago Academy of Fine Arts; pupil of L. Parker, H. B. Snell, V. Reynolds, F. Grant,

O. White; Mme. La Forge, Benjamin-Constant and Auguste Rodin in Paris. Member: Art Institute of Chicago; Illinois Academy of Fine Arts; The Cordon; North Shore Arts Association; Chicago Art Club; South Side Art Association; Chicago Society of Miniature Painters; American Federation of Arts. Address in 1933, c/o The Cordon, 410 S. Michigan Ave., Chicago, IL.

WOLCOTT, ROGER AUGUSTUS.
Designer, painter, sculptor, craftsman, and teacher. Born in Amherst, MA, August 25, 1909. Studied at Massachusetts College of Art; NY School of Fine and Applied Arts; pupil of Richard Andrew, Joseph Cowell, Ernest Major. Member: Rockport Art Association; Springfield Artists Guild. Work: Springfield Museum of Natural History. Position: Instructor of Art, Springfield Museum of Fine Arts, Springfield, MA, 1933-40; Industrial Design Research, Angler Research, Inc., Framingham, MA, 1940-43; Design Research, Nikor Products, Springfield, MA, 1943-46; Industrial Design Consultant, 1946-51; Assistant Professor, Visual Education, University of Massachusetts, Amherst, MA. Address in 1953, Agawam, MA.

WOLF, HAMILTON A(CHILLE).
Painter, illustrator, writer, lecturer, and teacher. Born in New York City, September 11, 1883. Studied: Columbia University; National Academy of Design; Art Students League; in Paris; pupil of Robert Henri, William M. Chase, Edward McCartan. Work: Pastel, Huntington Library and Art Gallery, San Marino, CA; mural, Shell Laboratories, Emeryville, CA. Exhibited: Golden Gate Expo., 1939; World's Fair of NY, 1939; Carnegie Institute, 1941; M. H. de Young Memorial Museum, 1943; Palace of the Legion of Honor, 1945, 46; San Francisco Art Association; Stanford University; others. Awards: Prizes, Seattle Art Society, 1917; Oakland Art Gallery, 1929, 50; California State Exhibition, 1930, 34, 40; San Francisco Art Association, 1939, 44. Member: San Francisco Art Association. Taught: Los Angeles School of Art, 1911-16; University of California Extension Division, 1929-38; California College of Arts and Crafts, Oakland, CA, from 1929; others. Address in 1953, Oakland, CA. Died May 2, 1967.

WOLF, HENRY.
Painter and wood engraver. Born August 3, 1852, in Eckwersheim, Alsace. Pupil of Jacques Levy, artist-engraver of Strasbourg. Exhibited at Paris Salon; Chicago Expo.; Paris Expo.; St. Louis Expo.; Columbian Expo., Chicago; P.-P. Expo., San Francisco. Awards: Paris Salon, 1888, 1895; silver medal, Fine Arts Expo., Rouen, France, 1903; diploma and grand medal of honor for distinguished services in promoting the art of engraving, St. Louis Expo., 1904; Paris Expo., 1889, 1900; Columbian Expo., Chicago, 1893; P.-P. Expo., San Francisco, 1915. Member of advi-

sory committee, and later of International Jury of Awards, St. Louis Expo., 1904; Jury Selection and Awards, Pan.-Am. Expo., Buffalo, 1901; International Society of Sculptors, Painters and Gravers; Associate National Academy of Design, 1905, Academician National Academy of Design, 1908; Lotos Club; American Federation of Arts; Alliance Francaise; Union Internationale des Beaux Arts et des Lettres, Paris, France. Principal works: Engravings illustrating American Artist Series, and Gilbert Stuart Series of Men and Women in *Century Magazine*. Original engravings: "The Morning Star;" "The Evening Star;" "A Duck Pond;" "Morning Mists;" "Lower New York in a Mist;" "The Scattering of the Mists;" "Portrait of Thomas Jefferson;" "Portrait of Thomas Carlyle;" "My Mother;" "Miss Alexander, after Whistler;" "Portrait of Robert Louis Stevenson;" "William Makepeace Thackeray;" "Masterpieces of the Metropolitan Museum of Art, New York;" "Portrait of Ladies," and "American Artist Series" which appeared in *Harper's Magazine*; also represented in the Library of Congress and the NY Public Library. Contributor to other magazines. See "History of Wood Engraving in America," by W. J. Linton. Died March 18, 1916, in NYC.

WOLF, MAX (DR.).
Painter and etcher. Born in Vienna, Austria, October 22, 1885. Member: Physicians Art Club; American Bookplate Society. Address in 1929, 85 East 79th St., New York, NY; summer, Millwood, NY.

WOLFE, ANN (ANN WOLFE GRAUBARD).
Sculptor. Born in Mlawa, Poland, November 14, 1905. U.S. citizen. Studied at Hunter College, B.A.; in Paris with Despiau and Vlerick at Academie Grande Chaumiere; and in Manchester, England. Works: College of the City of New York; Museum of Art, Jerusalem; Hamline University; Colgate University; Museum of Western Art, Moscow; Mt. Zion Temple, St. Paul; University of Minnesota; others. Awards: Allied Artists of America, 1936; Society of Washington Artists, 1944, 45; Minnesota State Fair, 1949; Minneapolis Institute of Arts, 1951; Minneapolis Women's Club, 1954. One-man exhibitions: Walker Art Center, Minneapolis; Grace Horne Gallery, Boston; Minneapolis Institute of Art; Worcester Museum; Philadelphia Museum of Art; others. Group exhibitions: Penna. Academy of Fine Arts; Allied Artists of America; Whyte Gallery, Washington, DC; Addison Gallery, Andover, MA; others. Address in 1982, Minneapolis, MN.

WOLFE, NATALIE.
(Mrs. D. D. Michael). Sculptor. Born in San Francisco, CA, March 16, 1896. Pupil of Ferrea and California School of Fine Arts. Member: National League of American Pen Women (fine arts department). Work: Bust of M. H. de Young, San Francisco Memorial Museum. Address in 1933, 107 Sutter St., San Francisco, CA. Died in 1939.

WOLFF, GUSTAVE H.

Painter and sculptor. Born in Germany, March 28, 1863. Came to America in 1866. Pupil of St. Louis School of Fine Arts under Paul Cornoyer; also studied in Europe. Member: Buffalo Society of Artists. Awards: Silver medal, Portland, OR, 1905; first Dolph prize, Competitive Exhibition, St. Louis, 1906; Wednesday Club silver medal, Society of Western Artists, 1907. Work: "The Brook," City Art Museum, St. Louis. Address in 1933, 503 West 175th Street, New York, NY. Died in Berlin, 1935.

WOLFF, OTTO.

Painter and illustrator. Born in Cologne, Germany, July 30, 1858. Studied in Paris. Member: Chicago Society of Artists; Chicago Art Club. Award: Honorable mention, Paris Salon, 1888. Address in 1926, 245 West North Ave., Chicago, IL.

WOLFF, ROBERT JAY.

Painter, sculptor, educator, designer, writer, and lecturer. Born in Chicago, IL, July 27, 1905. Studied at Yale University; Ecole des Beaux Arts, Paris, pupil of Georges Mouveau; also a pupil of Viola Norman. Work: Guggenheim Museum; Art Institute of Chicago; Tate; Wadsworth Atheneum. Member: American Abstract Artists. Group exhibitions: Art Institute of Chicago, 1934, 38, 46; American Abstract Artists, 1938-50; Penna. Academy of Fine Arts Annual; Corcoran Gallery, Washington, DC, 1958; Whitney Annual, 1958; others in U.S. and abroad. One-man exhibitions: Art Institute of Chicago; Guggenheim Museum; Quest and Kuh Gallery, Chicago; Reinhardt Gallery; Nierendorf Gallery; Kleemann Gallery, NY. Author and illustrator, *Elements of Design*, 1945. Contributor to numerous art magazines. Position: Dean, head of painting and sculpture department, School of Design, Chicago, IL, 1938-42; professor of art, Brooklyn College, City University of New York, 1946-71; visiting professor of design, MIT, 1961. Awards: Jenkins memorial prize, Annual Exhibition by Artists of Chicago and Vicinity; Art Institute of Chicago, 1933, 34. Address in 1976, New Preston, CT. Died there in 1978.

WOLFS, WILMA DIENA.

Sculptor, painter, illustrator, graphic artist, educator, and lecturer. Born in Cleveland, OH. Studied at Western Reserve University, B.A., B.S.; Cleveland School of Art; University of Minnesota; Ecole du Louvre; Radcliffe College, A.M.; Ecole des Beaux-Arts, Paris; Hans Hofmann School (Munich & St. Tropez); and with Henry Keller and Rolf Stoll. Works: University of Arkansas; Hendrix College, Conway, AR; sculpture, Catholic Church, Winter Park, FL; Research Studio, Maitland, Florida. Exhibited: Corcoran Gallery; Cleveland Museum of Art; Butler Art Institute; Philbrook Art Museum; Ecole des Beaux Arts; Grand Central Palace; Institute of Fine Arts, NYU; Studio Guild, NYC; Wichita Art Museum; Dayton Art Institute; Toledo Museum of Art; many others. Awards: Museum of Fine Arts, Little Rock, Arkansas, 1939; Arkansas Watercolor Society, 1938; Carnegie Scholarships for study in Paris, France, and at New York University, Harvard University, and University of Pennsylvania. Head of art department, Hendrix College, Conway, AR, 1936-37; State Teachers College, Keene, NH, 1937-38; assistant professor of art, Florida State College for Women, Tallahassee, FL, 1939-40; others. Address in 1962, Lakewood, OH.

WOLFSON, IRVING.

Painter, etcher, and teacher. Born December 10, 1899. Address in 1929, 399 Grand Street, New York, NY.

WOLFSON, SIDNEY.

Sculptor and painter. Born in NYC, June 18, 1914. Studied at Art Students League; Cooper Union Art School; Pratt Institute. Work in Whitney; Wadsworth Atheneum; others. Exhibited at Carnegie Institute; Whitney; Berkshire Museum, retrospective, 1960; The Contemporaries Gallery, NYC, sculpture (one-man); IBM Gallery, NY, painting (one-man); Bennett College, 1966 (one-man); others. Address in 1970, Salt Point, NY. Died in 1973.

WOLFSON, WILLIAM.

Lithographer, painter, illustrator and etcher. Born in Pittsburgh, PA, October 26, 1894. Studied: Carnegie Institute; National Academy of Design; Art Students League; pupil of A. W. Sparks, G. W. Maynard, Du Mond. Member: Pittsburgh Art Association. Exhibited: Fifty Prints of the Year, 1928-29, 31. Work: NY Public Library; Bibliotheque Nationale, Paris. Author and illustrator of *Going Places*, 1940; contributor to *Readers Digest* and *Coronet*. Address in 1953, 9922-64th Road, Forest Hills, Long Island, NY.

WOLINSKI, JOSEPH.

Painter. Born July 13, 1873. Pupil of Royal Art Society of New South Wales; also of Colarossi in Paris. Member: Royal Art Society, New South Wales. Work: "After Life's Fitful Fever He Sleeps Well;" "An Interior," two head studies in charcoal; and "Summer" in National Art Gallery of New South Wales. Address in 1926, 32 Moore Park Road, Sydney, Australia.

WOLLASTON, JOHN.

English portrait painter. He visited the Colonies in the middle of the eighteenth century, and painted many portraits in NY, Philadelphia, and the South from 1750 to 1767. His best portraits seem to have been painted in NY between 1751 and 1757. Among his portraits were those of Martha Dandridge Custis (Mrs. Washington) and the Custis children, Sir Charles Hardy, Governor of NY, William Allen of Claremont, and Clara Walker Allen.

WOMRATH, A(NDREW) K(AY).
Painter, illustrator, and draftsman. Born in Frankford, Philadelphia, PA, October 25, 1869. Pupil of Art Students League of NY under Twachtman and J. Alden Weir; Grasset and Merson in Paris; Westminster School of Art, London. Member: NY Architectural League, 1902; National Arts Club. Address in 1933, 7 Square Port-Royal, Paris, France; h. Kent, CT.

WONNER, PAUL (JOHN).
Painter. Born April 24, 1920, in Tucson, AZ. Studied: California College of Arts and Crafts, B.A., 1942; Art Students League, 1947; University of California at Berkeley, B.A., 1952, M.A., 1953, M.L.S., 1955. Taught at Berkeley; UCLA; Otis Art Institute. Exhibited: M. H. de Young Memorial Museum, San Francisco; Guggenheim; Museum of Modern Art; Walker; Denver Art Museum; Carnegie; Art Institute of Chicago; Whitney; others. Work: University of Nebraska; Oakland Art Museum; Guggenheim; San Francisco Museum of Art; National Collection of Fine Arts; many private collections. Address in 1982, San Francisco, CA.

WOOD, EDITH LONGSTRETH.
(Mrs. William S. Wood). Painter and lithographer. Born in Philadelphia, PA. Pupil of Penna. Academy of Fine Arts; Bryn Mawr College, A.B.; Scandinavian Art Academy in Paris. Member: Art Alliance of Philadelphia; Plastic Club; Fellowship Penna. Academy of Fine Arts; Philadelphia Printmakers Club; North Shore Arts Association. Awards: Fellowship, Penna. Academy of Fine Arts; medal, Philadelphia Plastic Club, 1933; Cresson traveling scholarship, Penna. Academy of Fine Arts. Work: Philadelphia Art Alliance; Penna. Academy of Fine Arts. Exhibited: Penna. Academy of Fine Arts, 1932-46; National Academy of Design. Address in 1953, Studio 354, 34 South 17th Street; h. 2139 Cypress Street, Philadelphia, PA.

WOOD, E(LLA) MIRIAM.
Painter. Born in Birmingham, AL, February 18, 1888. Studied: Newcomb College, Tulane University; Penna. Academy of Fine Arts; pupil of Ellsworth Woodward, Henry McCarter, Hawthorne, Chase, Garber. Member: New Orleans Artists Guild; New Orleans Arts and Crafts Club. Award: Second prize, Mississippi Art Association, Jackson; prize, Newcomb Art School. Work: Mural, altarpieces, St. Augustine Church, New Orleans; portrait, Newcomb College; "The Fisherman's Dory," Mississippi Art Association. Exhibited: New Orleans Arts and Crafts Club; Delgado Museum of Art; Louisiana State Exhibition, Baton Rouge, LA. Address in 1953, New Orleans, LA.

WOOD, ETHELWYN A.
Painter. Born in Germantown, PA, January 10, 1902. Pupil of Philadelphia Museum School of Industrial Art; Penna. Academy of Fine Arts. Member: Fellowship Penna. Academy of Fine Arts; West Palm Beach Art League. Work: Painting, Fellowship of the Penna. Academy of Fine Arts, Philadelphia, PA. Address in 1933, 903 North N St., Lake Worth, FL.

WOOD, FRANKLIN T.
Etcher and painter. Born in Hyde Park, MA, October 9, 1887. Studied at Cowles Art School; Art Students League of NY; and abroad. Member: Chicago Society of Etchers; Society of American Etchers. Award: Bronze medal, P.-P. Expo., San Francisco, 1915. Represented in Art Institute of Chicago; Boston Museum of Fine Arts; Smithsonian; Library of Congress. Address in 1929, Rutland, MA. Died May 22, 1945.

WOOD, GEORGE BACON, JR.
Painter. Born in Philadelphia, PA, January 6, 1832. Studied at the Penna. Academy of Fine Arts. Member: Philadelphia Sketch Club; Artists' Fund Society of Philadelphia. Exhibited: Penna. Academy of Fine Arts. Represented in Wilstach Collection, Fairmount Park, Philadelphia, by landscape "Winter Twilight." The Penna. Academy of Fine Arts owns his painting of "Dr. Tyson's Library." Died in Massachusetts in 1910.

WOOD, GRANT.
Painter and sculptor. Born in Anamosa, IA, February 13, 1892. Pupil of Art Institute of Chicago; Minneapolis Handicraft Guild; Iowa State University; Julian Academy in Paris. Work: "Democracy," mural painting, Harrison School, Cedar Rapids; life membership medal, bas-relief, and paintings, "Woman with Plants" and "Doorway at Periguex," for Cedar Rapids Art Association; decoration in National Masonic Research Building, Anamosa, IA; war memorial window, Memorial Building, Cedar Rapids, IA; "American Gothic," Art Institute of Chicago; "Stone City," Art Institute of Omaha, NE; "Paul Revere's Ride," Metropolitan Museum of Art; Whitney; "Arnold Comes of Age," Nebraska Art Association; Dubuque Art Association; Cincinnati Art Museum; others. Award: Harris bronze medal and $300, Art Institute of Chicago, 1930. Address in 1933, No. 5 Turner Alley, Cedar Rapids, IA. Died February 12, 1942, in Iowa.

WOOD, HARRIE (MORGAN).
Painter and illustrator. Born in Rushford, NY, April 28, 1902. Pupil of Pratt Institute; Art Students League of NY. Member: NY Water Color Club; American Water Color Society; Mystic Art Association; Tiffany Foundation. Represented in Lyman Allyn Museum, New London, CT. Illustrated *The Boy Who Was*; also *Made in America, Something Perfectly Silly*, and *Lucian Goes A-Voyaging*, Knopf; *Made in England*, Thomas Nelson, 1932; also contributed illustrations and designs for magazines and

advertising. Address in 1933, 211 East 35th Street, New York, NY; summer, Bethel, CT.

WOOD, JESSIE PORTER.
Painter and illustrator. Born in Syracuse, NY, February 27, 1863. Pupil of J. Carroll Beckwith; George de Forest Brush; Walter Shirlaw; J. Ward Stimson; others. Address in 1926, 2005 Columbia Road, Washington, DC.

WOOD, JOSEPH.
Miniature and portrait painter. Born in Clarkstown, NY, about 1778; died in Washington, DC, in 1830. Largely self-taught, he earned his living with his violin in the summer in order to study in the winter. In 1804 formed partnership with John Wesley Jarvis, painting miniatures. Dunlap records a visit he made with Malbone to their studio during 1805-06. Both artists received some assistance from Malbone at the time. The partnership was dissolved in 1809. Wood had a studio at 160 Broadway during 1812-13. Went to Philadelphia in 1813 and had a studio at 93 South Third Street. His name occurs in the Philadelphia directories until 1817. Exhibited at Penna. Academy of Fine Arts. Moved later to Washington and in 1827 had a studio on the north side of Pennsylvania Avenue between 9th and 10th Streets. An extended account of the artists appeared in *The Port-Folio*, 1811. Died June 15, 1830 or 1852, in Washington, DC.

WOOD, KATHERYN LEONE.
Painter and writer. Born in Kalamazoo, MI. Pupil of Frederick Freer; Lawton Parker; others. Member: American Federation of Arts. Work: Miniature of Mrs. J. C. Burrows, Continental Memorial Hall, Washington, D.C.; portrait of Judge Severens, U.S. District Court, Cincinnati, OH. Address in 1933, 1605½ South Main Street, Los Angeles, CA. Died c. 1935.

WOOD, M. LOUISE.
See Wright, M. Louise Wood.

WOOD, MARY EARL.
Painter. Born in Lowell, MA. Pupil of Boston Museum School under Tarbell, Benson and DeCamp. Member: Copley Society. Address in 1929, 404 Fenway Studios, 30 Ipswich St., Boston, MA.

WOOD, NAN.
(Mrs. Charles Morgan Wood). Painter. Born in Dayton, OH, February 11, c. 1874. Pupil of Hugh Breckenridge; Art Students League of NY; L'Hote in Paris. Member: North Shore Arts Association; Tucson Pen and Brush Club; Boston Art Club. Work: Dayton Art Institute. Exhibited: State Museum of Tucson, 1943-46. Address in 1953, Tucson, AZ.

WOOD, STAN.
Painter. A San Francisco water color artist who exhibited in the New York galleries in 1925.

WOOD, THOMAS WATERMAN.
Painter and etcher. Born November 12, 1823, in Montpelier, VT. Studied portrait painting under Chester Harding in Boston; in Dusseldorf, with Hans Gude, 1858-60; and in London. Established his studio in NY. Wood depicted black Americans and their development during the Civil War. Elected an Associate of the National Academy of Design, 1869, and an Academician in 1871; also a member of the New York Etching Club; American Water Color Society; National Arts Club; Artists' Aid Society. Painted a number of portraits of prominent men in New York City. Represented by over 200 paintings in the Wood Art Gallery, Montpelier, VT. He died April 14, 1903, in NYC.

WOOD, VIRGINIA HARGRAVES.
(Mrs. C. F. Goddard). Painter, etcher, and teacher. Born near St. Louis, MO. Studied: Cooper Union Art School; Yale; pupil of Chase, Du Mond, and Hawthorne; also studied abroad. Member: National Association of Women Painters and Sculptors; Art Alliance of America; American Federation of Arts; National Society of Mural Painters. Exhibited: National Association of Women Painters and Sculptors, 1935-38. Awards: Liturgical Art Society, NY, 1937. Work: Mural decorations in Broadway Cafe; Liturgical Art Society, NY; WPA murals, Federal Court Room, Scranton, PA; illustrated several books. Founded Virginia Fine Arts Society. Address in 1929, 601 Madison Ave., New York, NY; h. Ivy Depot, Albemarle County, VA.

WOOD, WILLIAM REUBEN CLARK.
Landscape painter. Born April 15, 1875, in Washington, DC. Pupil of S. E. Whiteman in Baltimore. Member: President, Baltimore Water Color Club; Charcoal Club, Baltimore; Baltimore Municipal Art Club. Died April 30, 1915, in Baltimore, MD.

WOODBURY, CHARLES H(ERBERT).
Marine painter, etcher, teacher and writer. Born in Lynn, MA, July 14, 1864. Pupil of Massachusetts Institute of Technology in Boston; Julian Academy in Paris, under Boulanger and Lefebvre. Member: Society of American Artists, 1899; Associate National Academy of Design, 1906; Academician National Academy of Design, 1907; American Water Color Society; Boston Water Color Club; NY Water Color Club; St. Botolph Club; Copley Society, 1900; Guild of Boston Artists; North Shore Arts Association; Boston Water Color Club. Awards: Third prize, Boston Art Club; gold medal, Atlanta Expo., 1895; second prize, Tennessee Centennial, Nashville, 1897; 2 medals, Mechanics' Fair, Boston; bronze medal, Paris Expo., 1900; bronze medal, Pan.-Am. Expo., Buffalo, 1901;

first prize, Worcester Museum, 1903; silver medal, St. Louis Expo., 1904; hon. mention, Carnegie Institute, Pittsburgh, 1905; second prize, Worcester, 1907; silver medal, Buenos Aires Expo., 1910; Evans prize, American Water Color Society, 1911; second W. A. Clark prize ($1,500) and Corcoran silver medal, 1914; gold medal for oil painting and medal of honor for water colors, P.-P. Expo., San Francisco, 1915; Dana gold medal, Penna. Academy of Fine Arts, 1924; Henry B. Swope prize, Brooklyn, 1931; first Palmer Memorial Prize, National Academy of Design, 1932. In collections of Carnegie Institute; Rhode Island School of Design; Museum of Fine Arts, Boston; Worcester Museum; Herron Art Institute; City Art Museum, St. Louis; Corcoran; Detroit Institute; Metropolitan Museum of Art; Gardner Collection, Boston; Fitzgerald Collection, Brookline; State of Utah Collection; Telfair Academy, Savannah, GA; Collection of Queen of Italy. Illustrator for *Century* and *Harper's*. Address in 1933, 132 Riverway, Boston, MA; Ogunquit, ME. Died January 22, 1940, in Jamaica Plain, MA.

WOODBURY, J. C.
Painter. Member: Providence Water Color Club. Address in 1929, 155 Medway St., Providence, RI.

WOODBURY, LLOYD.
Sculptor. Born in Baggs, WY, 1917. Worked on railroad in Seattle until he moved to New York City to work on museum commissions of mounted animal groups. Opened own taxidermy studio on return to Wyoming, and later in Texas. Turned full-time to sculpture in 1974. Specialty is statuettes of horses, cowboys, cattle, wildlife of past and present West. Works in bronze. Represented by Shidoni Gallery and Foundry, Tesuque, NM. Reviewed in *Paint Horse Journal*, January 1982. Address in 1982, Center Point, TX.

WOODBURY, MARCIA OAKES.
(Mrs. Charles H. Woodbury). Painter. Born June 20, 1865, in South Berwick, ME. Student of Woman's Art Club, New York; also with Lassar in Paris. Member: NY Woman's Art Club; NY Water Color Club; Boston Water Color Club. Awards: Mechanics' Fair, Boston; Atlanta Expo., 1895; Boston Art Club; Tennessee Centennial, Nashville, TN, 1897. Represented in Boston Museum of Fine Arts by "Triptych" and "Mother and Daughter." Died November 7, 1913, in Ogunquit, ME.

WOODCOCK, T. S.
Engraver. Born in Manchester, England. Came to NY about 1830, and in 1836 was working in Philadelphia, PA. A portrait of Andrew Jackson, published in NY in 1834, is engraved with a ruling-machine and is signed by Woodcock. About 1840 Woodcock was located in Brooklyn as an engraver and print publisher, and about this time we find some beautiful plates of butterflies engraved by Woodcock & Harvey, Brooklyn. Woodcock later returned to England.

WOODHOUSE, BETTY BURROUGHS.
(Mrs. Thomas F. Woodhouse). Sculptor and teacher. Born in Norwich, CT, August 17, 1899. Studied at Art Students League, NY; also studied in Paris, France, 1921, 25, 27. Member: Archeology Institute of America; College Art Association; National Sculpture Society; Art Students League; American Society of Painters, Sculptors and Gravers. Work: Whitney Museum of American Art. Taught: Art and history of art, Birch Wathen School, NY, 1935-45; head of art department, Cambridge School, Weston, MA, 1945-51; curator of education, Rhode Island School of Design Museum, Providence, until 1961. Editor, *Vasari's Lives of the Painters*, 1946. Address in 1962, Little Compton, RI.

WOODROFFE, ELEANOR G.
Painter. Member: National Association of Women Painters and Sculptors. Address in 1929, Box 166, Niantic, CT; 9 Jane Street, New York, NY.

WOODRUFF, CLAUDE WALLACE.
Illustrator. Member: Society of Illustrators. Address in 1933, care of The North American Society of Arts, 461 Eighth Avenue, New York, NY; h. Decatur, IL.

WOODRUFF, CORICE.
(Mrs. Henry S. Woodruff). Sculptor and painter. Born in Ansonia, CT, December 26, 1878. Pupil of Minneapolis School of Fine Arts under Robert Koehler; Knute Akerberg; Art Students League of New York. Member: Artists Guild, Chicago; Attic Club, Minneapolis. Awards: First prize for sculpture, Minnesota State Art Society, second prize, 1914; hon. mention for sculpture, St. Paul Institute, 1916. Specialty: Small sculpture, bas-relief portraits and portrait busts. Address in 1933, 2017 Pleasant Avenue; h. 2431 Pleasant Avenue, Minneapolis, MN.

WOODRUFF, JOHN KELLOGG.
Painter, sculptor, and teacher. Born in Bridgeport, CT, September 6, 1879. Studied: Yale School of Fine Arts; Artist-Artisan Institute, NY; Teachers College, Columbia University; pupil of Walter Shirlaw, Arthur W. Dow, John Niemeyer, Charles J. Martin. Represented in Brooklyn Museum. Member: Society of Independent Artists; Salons of America. Exhibited: Marie Sterner Gallery, Babcock Gallery, Dudensing Gallery, Argent Gallery, Findlay Gallery (all one-man); Brooklyn Museum. Address in 1953, Nyack, NY. Died June 14, 1956.

WOODRUFF, WILLIAM.
Engraver of portraits and landscapes. He was in business in Philadelphia in 1817-24. He worked quite well in both line and stipple. After 1824 he apparent-

ly removed to Cincinnati, as we find prints by him engraved in that city. Died February 26, 1852.

WOODS, LILLA SORRENSON.
(Mrs. E. B. Woods). Painter. Born in Portage, WI, April 27, 1872. Pupil of Lydia Ely in Kilburn, WI; Art Institute of Chicago; summer class at Delavan, WI; Miss Hawley at Rijsvard in Holland; Laurens in Paris; Corcoran School of Art in Washington; Helen Todd Hammon in Boston. Member: Gloucester Society of Artists. Address in 1933, 30 Occon Ridge, Hanover, NH.

WOODSIDE, JOHN ARCHIBALD (SR.).
Painter. Born in Philadelphia, PA, in 1781. Flourished in the middle of the last century. He painted many portraits, historical, allegorical, animal and still-life subjects, and was noted as the decorator of the hose carriages and engines of local fire companies, and the first locomotive. He was painting in Philadelphia before 1817. Died February 26, 1852, in Philadelphia.

WOODSON, MARIE L.
Painter, craftsman, and teacher. Born in Selma, AL, September 9, 1875. Pupil of Art Institute of Chicago; Ochtman; NY School of Fine and Applied Art. Member: Alumni Association, Art Institute of Chicago; Denver Art Association; American Federation of Arts; Art Committee, City and County of Denver. Award: Prize for "Welcome Arch" for Denver. Work: Mural decoration in Denver Public Library; illustrated "Tunes for Tiny Tots," by Antoinette Freneauff. Director of Art Education, Denver Public Schools. Address in 1933, 832 South Pearl Street, Denver, CO.

WOODVILLE, RICHARD CATON, SR.
Painter. Born in Baltimore, MD, April 30, 1825. He had access to the pictures of Robert Gilmore, then one of the best collections in the country, and he copied many of the figure-pieces among them. He went to Dusseldorf in 1845 and stayed there for about six years studying. During this time he sent several paintings to American exhibitions. He lived mainly in Paris and London after 1851, until his premature death in London on September 30, 1856. His painting "Reading the News" is owned by the National Academy of Design and has been engraved.

WOODWARD, DEWING (MISS).
Painter, writer, illustrator, lecturer, and teacher. Born in Williamsport, PA, June 6, 1876. Studied: Penna. Academy of Fine Arts; Julian Academy, Paris; pupil of Robert-Fleury, Lefebvre, Dechamps, Jacques Blanche, Raffaelli. Member: Femmes Peintres Et Sculpteurs de France; Washington Art Club; Blue Dome Fellowship; American Federation of Arts; Florida Federation of Arts. Awards: Gold medal, International, Marseilles, 1897; silver medal,

Nantes, 1904; League of American Pen Women, 1936; others. Work: "Wings," College of Music of the University of Miami; "Waiting," Museum of the Julian Academy; "Morning Song of the Pines," Woman's Club of Miami; silver point portrait, Judge Wyman, City Hall, Coral Gables; Baltimore Museum of Art; State College for Women, Tallahassee, FL. Director of School of Fine Arts, University of Miami. Address in 1933, 172 Avenue Alcazar, Coral Gables, FL.

WOODWARD, E. F.
Engraver of maps and small vignettes of events in American history. In a school atlas published in Hartford, CT, in 1839, these engravings are signed "as Engraved by E. F. Woodward."

WOODWARD, ELLSWORTH.
Painter, illustrator, etcher, craftsman, teacher, and lecturer. Born in Bristol County, MA, July 14, 1861. Pupil of Rhode Island School of Design in Providence; Carl Marr in Munich. Member: Art Association of New Orleans; Boston Society of Arts and Crafts; Louisiana State Art Teachers' Association; Southern States Art League (president); Providence Art Club (hon.); Providence Water Color Club; Round Table Club (president). Awards: Gold medal, Art Association of New Orleans; gold medal, Mississippi Art Association; bronze medal of honor, Boston Society of Arts and Crafts; Alice Huger Smith water color prize, Southern States Art League. Work: Allegory, "Administration of Justice," Municipal Court House; Delgado Museum of Art, New Orleans; Newcomb College Art Gallery, New Orleans; Jackson Art Association, MS; Charleston Museum, SC; Brooklyn Museum of Art; Houston Museum of Fine Arts. Director of Art Education, Newcomb College, since 1890. Address in 1933, 1316 Pine St., New Orleans, LA. Died February 28, 1939.

WOODWARD, HELEN M.
Painter, sculpture, craftsman, and teacher. Born in Newton Stewart, IN, July 28, 1902. Studied: John Herron Art Institute; Butler University; Indiana University; pupil of William Forsyth, Charles Hawthorne, Wayman Adams, and Eliot O'Hara. Member: Indiana Art Club; Contemporary Club, Indianapolis. Awards: Prizes, Indiana State Fair, 1926, 27, 28; prize, Hoosier Salon, Chicago, 1928, 29; Herron Art Institute, 1939; Indiana Art Club. Work: Painting, Bedford High School, Bedford, IN. One-woman exhibitions: Ball State College, Muncie, IN; Indiana University; Hoosier Salon; H. Lieber Gallery, Indianapolis. Address in 1953, Indianapolis, IN.

WOODWARD, LELLA GRACE.
Painter and teacher. Born in Coldwater, MI, May 2, 1858. Studied in Boston, Chicago, England, Holland, Rome, and Venice; pupil of Du Mond, Merson, Collin and Whistler in Paris. Address in 1929, National Park Seminary, Forest Glen, MD.

WOODWARD, MABEL MAY.
Painter. Born in Providence, RI, September 28, 1877. Pupil of Chase, Du Mond, and Cox in NY. Member: Providence Art Club; Providence Water Color Club; South County Art Association; Ogunquit Art Association. Represented in Providence Art Club, Providence, RI. Exhibited: Providence Art Club, 1939 (one-woman). Address in 1933, 36 Belvedere Blvd., Providence, RI; summer, Ogunquit, ME. Died August 14, 1945.

WOODWARD, ROBERT STRONG.
Painter. Born in Northampton, MA, May 11, 1885. Studied: Boston Museum of Fine Arts School; pupil of Edmund Tarbell, Philip Hale; mostly self-taught. Member: Salma. Club; American Federation of Arts; Guild of Boston Artists; NY Water Color Society; Boston Art Club; Springfield Art League; Pittsfield Art League; Grand Central Art Galleries. Awards: First Hallgarten prize, National Academy of Design, 1919; hon. mention, Concord Art Association, 1920; first landscape prize, Springfield Art League, 1927, special honor medal, 1932; gold medal of honor, Tercentenary Exhibition, Boston, 1930; second prize with bronze medal, Boston Art Club, 1932; Albany Institute of History and Art, 1937; Ogunquit Art Center, 1948. Represented in Springfield (MA) Art Museum; Forbes Library, Northampton, MA; Public Library, Stockbridge, MA; Syracuse Museum of Fine Arts, Syracuse, NY; Boston Museum of Fine Arts; Stockbridge Public Library; Yale University; Pasadena Art Institute; San Diego Fine Arts Society; Mount Holyoke College; others. Exhibited: Carnegie; Corcoran; Art Institute of Chicago; National Academy of Design; Penna. Academy of Fine Arts; World's Fair of NY, 1939; Golden Gate Expo., 1939; Boston Museum of Fine Arts; Springfield Art Association; others. Address in 1953, Shelburne Falls, MA; h. Buckland, MA. Died in 1960.

WOODWARD, STANLEY W(INGATE).
Painter, illustrator, etcher, writer, and teacher. Born in Malden, MA, December 11, 1890. Pupil of Eric Pape School of Art; School of the Boston Museum of Fine Arts; Penna. Academy of Fine Arts. Member: Chicago Society of Etchers; Washington Water Color Club; Audubon Artists; Society of American Etchers; Concord Art Association; Brooklyn Society of Etchers; Copley Society; Fellowship Penna. Academy of Fine Arts; Boston Society of Water Color Painters; Boston Art Club; Salma. Club; Allied Artists of America; NY Water Color Club; Guild of Boston Artists; Connecticut Academy of Fine Arts; North Shore Arts Association; New Haven Paint and Clay Club; Philadelphia Water Color Club; Springfield Art League; American Federation of Arts. Awards: Hon. mention, Concord Art Association, 1919; second Hallgarten prize, National Academy of Design, 1925; Hammond purchase prize ($150), NY Water Color Club and American Water Color Society, 1927; prize ($100) Baltimore Water Color Club, 1927; anniversary prize, Springfield Art League ($250), 1928; gold medal, water color, and gold medal, "October Moonlight," Tercentenary Exhibition, Boston, 1930; Crowninshield prize, Stockbridge, MA, 1931; New Haven Paint and Clay Club; Rockport Art Association, 1940, 47; Washington Water Color Club, 1940; North Shore Arts Association, 1941; Meriden Art Association, 1950. Represented in University of Michigan; Boston Museum of Fine Arts; Vanderpoel Collection; Malden Public Library; Concord Art Association; Walker Gallery, Bowdoin College, Brunswick, ME; St. Marks School, Groton, MA; Public Library, Wellesley Hills, MA; Fort Worth Museum of Art, TX. Exhibited: Corcoran; Art Institute of Chicago; National Academy of Design; Boston Museum of Fine Arts; City Art Museum of St. Louis. Illustrator for *Ford Times* and *Collier's* magazines. Author of *Adventure in Marine Painting*, 1948. Address in 1953, 36 Main Street; h. 27 South Street, Rockport, MA. Died in 1970.

WOODWARD, WILLIAM.
Painter, architect, craftsman and teacher. Born in Seekonk, MA, May 1, 1859. Pupil of Rhode Island School of Design in Providence; Massachusetts Normal Art School in Boston; Boulanger in Paris. Member: Louisiana Chapter, American Institute of Architects; Art Association of New Orleans; American Institute of Architects, 1897 (hon.); Southern States Art League; Gulf Coast Art Association; Mississippi Art Association; American Federation of Arts; Laguna Beach Art Association. Awards: Gold medal, Gulf Coast Art Association, 1927 and 1929; prize, best work in any medium, Mississippi Federation of Women's Club, 1931; prize, best etching, New Orleans Art Association, 1932, prize, 1936; Southern States Art League, 1936. Work: "Rainy Day," New Orleans Art Association; "Orleans Alley," Delgado Art Museum, New Orleans; "Midway Point, Carmel, California," High Museum of Art, Atlanta, GA; "Hawaiian Landscape," Rogers Art Gallery, Laurel, MS; portraits of faculty, Tulane University, New Orleans; mural, United Fruit Company. Professor of drawing and painting (emeritus), Tulane University, New Orleans. Address in 1933, Kensington Drive, Biloxi, MI. Died November 17, 1939.

WOOLF, S(AMUEL) J(OHNSON).
Portrait painter, illustrator and writer. Born in New York, February 12, 1880. Pupil of Art Students League; National Academy of Design, under Cox and Brush. Awards: Third Hallgarten prize, National Academy of Design, 1904; St. Louis Expo., 1904; medal, Appalachian Expo., Knoxville, 1910; Paris Salon, 1937. Work: "Dr. Finley," College of the City of NY; "Mark Twain," Brook Club; "Dr. Hunter," Normal College; "Cardinal Logue," Catholic Club, NY; also represented in Metropolitan Museum; New

York Public Library; University of Michigan; others. Exhibited: National Academy of Design; Penna. Academy of Fine Arts; Carnegie; Corcoran; St. Louis Expo. As special correspondent with American Expeditionary Force, painted portraits of Joffre, Pershing, and other commanders. Author and illustrator of *Here Am I*, 1942; *Drawn from Life*, 1932; others. Address in 1933, 160 West 73rd Street; h. 210 West 101st St., New York, NY. Died December 3, 1948.

WOOLLETT, ANNA PELL.
(Mrs. Sidney Woollett). Sculptor and painter. Born in Newport, RI. Pupil of Boston Museum School under Bela Pratt. Address in 1909, 1 Park Place, Jamaica Plain, MA.

WOOLLEY.
An English painter who divided his time between Philadelphia and NY about 1757. He painted small portraits in oil; also signs and other pictures.

WOOLLEY, VIRGINIA.
Painter, etcher, and teacher. Born in Selma, AL, August 27, 1884. Pupil of Jacques Blanche; Lucien Simon; Richard Miller; F. W. Freer. Member: Atlanta Art Association; Southern States Art League; Laguna Beach Art Association. Work: "Provincetown Street," Atlanta Art Association. Award: Landscape prize, Southern States Art League, 1932. Address in 1933, Laguna Beach, CA. Died February 15, 1971.

WOOLLEY, WILLIAM.
Engraver in mezzotint and portrait painter. An Englishman, he came to America in about 1797 and worked in Philadelphia and New York. Produced two portraits of George Washington and a companion plate of Mrs. Washington. These plates were published by David Longworth at the Shakespeare Gallery, No. 11 Park Place, New York, probably about 1800. The larger memorial plate bears the inscription "David Longworth Direxit. Woolley - Pinxit et Sculpsit." While this might suggest American origin, it is possible that David Longworth suggested the design, ordered a painting and engraving made in London, and then imported both and published the print in New York. No other plates by Woolley are known and the majority of the Washington portraits by Woolley owned by American collectors were purchased in London. They apparently had a very limited sale in this country. The plate was printed later in a reduced, altered state.

WOOLRYCH, BERTHA HEWIT.
(Mrs. F. Humphry W. Woolrych). Painter and illustator. Born in Ohio in 1868. Pupil of St. Louis School of Fine Arts; Morot, Collin and Courtois in Paris. Member: St. Louis Artists Guild; St. Louis Art Students' Association. Awards: Medal, Lewis and Clark Expo., Portland, 1905; gold and silver medals, St. Louis School of Fine Arts; silver medal, 1908, St. Louis District, General Federation of Women's Clubs. Address in 1933, 3855 Hartford Street, St. Louis, MO. Died in 1937.

WOOLRYCH, F. HUMPHRY W.
Painter and illustrator. Born in Sydney, Australia, 1868. Pupil of Royal Academy, Berlin; Ecole des Beaux-Arts, Colarossi Academy, Collin, Courtois and Puvis de Chavannes in Paris. Member: Hellas Art Club, Berlin; St. Louis Artists Guild; Brush and Pencil Club; 2 x 4 Society; St. Louis Architectural Club. Awards: Bronze medal, Portland Exposition, 1905; medal for portrait, Missouri State Fair, Sedalia, 1913. Work: Water color in St. Louis Public Library; lunette, "Wealth of the North," Museum of Natural Resources; State Capitol, Jefferson City, MO; also represented in University of Missouri, Columbia, MO. Address in 1933, 3855 Hartford Street, St. Louis, MO.

WOOLSEY, C(ARL) E.
Painter. Born in Chicago Heights, IL, April 24, 1902. Self-taught. Awards: McCutcheon award for landscape, Hoosier Salon, Chicago, 1928, Butler award for landscape, 1929, prizes, 1935, 37; third Hallgarten prize, National Academy of Design, 1931. Work: "Taos Housetops," Art Association, Kokomo, IN. Address in 1933, Taos, NM.

WOOLSEY, WOOD W.
Painter. Born in Danville, IL, June 29, 1899. Self-taught. Work: "El Paseo," High School, Danville, IL; "Part of Taos," Art Association, Kokomo, IN; "Carriers of Water," Federation of Women's Clubs, Kokomo, IN; others. Awards: Best figure composition, Hoosier Salon, 1931, outstanding painting, 1932; first prize, Phoenix Art Association, 1932. Address in 1933, Taos, NM.

WORCESTER, ALBERT.
Painter and etcher. Born in West Campton, NH, January 4, 1878. Pupil of Luc Olivier Merson and of Jean Paul Laurens in Paris. Address in 1926, 467 West Canfield Avenue, Detroit, MI.

WORDEN, LAICITA WARBURTON.
(Mrs. Kenneth Gregg Worden). Painter, sculptor and illustrator. Born in Philadelphia, PA, September 25, 1892. Pupil of Penna. Academy of Fine Arts. Member: Fellowship, Penna. Academy of Fine Arts. Address in 1926, Belle Haven, Greenwich, CT; 4141 North Broad St., Philadelphia, PA.

WORES, THEODORE.
Painter, illustrator, and teacher. Born in San Francisco, CA, August 1, 1860. Pupil of A. Wagner and Duveneck in Munich. Member: Century Association. Award: Gold medal, Alaska Yukon Expo., 1909.

Instructor at San Francisco Art Institute, 1907-1912. Work: Los Angeles Museum of Art. Address in 1929, Bohemian Club; h. 1722 Buchanan St., San Francisco, CA. Died in 1939.

WORKMAN, DAVID TICE.
Etcher. Born in Wahpeton, ND, October 18, 1884. Studied: Hamline University, St. Paul, MN; Boston Museum of Fine Arts School; pupil of Benson and Hale in Boston; under Pyle in Wilmington; Brangwyn and Swan in London. Member: Chicago Society of Etchers; Attic Club, MN; Minneapolis Society of Artists. Award: First prize, Minnesota State Art Commission, 1914. Work: Mural decorations, Irving School, and East Side High School, Minneapolis, MN; Lincoln High School, Hibbing, MN; Public Library, Ely, MN; St. George's Church and St. James' Church, St. Louis; others. Address in 1953, Excelsior, MN.

WORRELL, JAMES.
An early Virginia portrait painter who painted a portrait of Judge John Tyler, who was a Governor of Virginia, 1808-11. The portrait is at the College of William and Mary at Williamsburg, VA.

WORSWICK, LLOYD.
Sculptor, craftsman, and teacher. Born in Albany, NY, May 30, 1899. Pupil of Urich; Cedarstrom; Brewster; Olinsky; Weinman; Bufano. Member: American Federation of Arts. Address in 1933, 136 East 93rd St.; h. 19 East 94th St., NYC; summer, Washingtonville, New York, NY.

WORTH, KAREN.
Sculptor. Born in Philadelphia, PA, March 9, 1924. Studied at Tyler Art School, Temple University; Penna. Academy of Fine Arts; Academie de la Grande Chaumiere, Paris. Work: Smithsonian Institution; West Point Academy, NY; American Jewish Historical Association, Boston; Jewish Museum, NY; Israel Government Coins and Medals Division, Jerusalem. Exhibited: National Academy, NY, 1965; Lever House, NY, from 1966; Ceramic Sculpture of Western Hemisphere. Awards: Second Place for Sculpture, Ceramic Sculpture Western Hemisphere, 1941; Penna. Academy of Fine Arts Award for Sculpture, 1942; Allied Artists of America Award for Sculpture, 1965. Member: Fellow, National Sculpture Society; Fine Arts Federation of New York. Media: Clay, bronze. Address in 1982, 19 Henry Street, Orangeburg, NY.

WORTH, PETER JOHN.
Sculptor, historian, and educator. Born in Ipswich, England, March 16, 1917. U.S. citizen. Studied at Ipswich School of Art, 1934-37; Royal College of Art, London, with E. W. Tristram, Roger Powell, Paul Nash, Edward Bawden, Douglas Cockerell. Member: Institute of Contemporary Art, London; College

Art Association of America. Exhibited: San Francisco Museum of Art, 1950; Art Institute of Chicago, 1951; Walker Art Cent., 1951, 52, 56; Mid-American Art, 1951; Denver Art Museum, 52, 53, 55-57, 60-63. Worked as photographer on *Life Library of Photography*. Position: Professor of art history, University of Nebraska, Lincoln, NE. Address in 1982, University of Nebraska, Lincoln, NE.

WORTHINGTON, MARY E.
Painter. Born in Holyoke, MA. Studied with Constant, Laurens and F. V. DuMond in Paris; with Henry Read in Denver. Member: Denver Art Museum. Address in 1929, 1455 Humboldt St., Denver, CO.

WORTHLEY, CAROLINE BONSALL.
(Mrs. Irving Tupper Worthley). Painter and craftsman. Born in Cincinnati, OH, December 25, 1880. Studied: Cincinnati Art Academy; Philadelphia Museum School of Industrial Art; pupil of Fred Wagner, J. F. Copeland. Member: Plastic Club; Art Alliance of Philadelphia. Address in 1933, R.F.D. No. 3, Phoenixville, PA. Died in 1944.

WORTMAN, JOHANN HENDRICK PHILIP.
Sculptor. Born at The Hague, 1872. Award: Prize from The Hague Academy of Fine Arts. Exhibited: "Calabrian Peasant," 1897. Work: Bust of Queen Wilhelmina. Died in Italy, September 3, 1898.

WRAY, HENRY RUSSELL.
Painter, etcher and writer. Born October 3, 1864, in Philadelphia, PA. Member: Philadelphia Sketch Club; Salma. Club; Players Club; Colorado Springs Art Society. Address in 1926, 33 West Willamette Ave., Colorado Springs, CO. Died July 29, 1927, in CO.

WRENN, CHARLES L(EWIS).
Painter and illustrator. Born in Cincinnati, OH, September 18, 1880. Pupil of Chase and Art Students League of NY. Member: Society of Illustrators; Salma. Club. Specialty: Portraits. Address in 1929, 18 East 8th Street, New York, NY; Wilson Point, South Norwalk, CT. Died in October, 1952.

WRENN, ELIZABETH JENCKS.
Sculptor. Born in Newburgh, NY, December 8, 1892. Studied: Maryland Institute; pupil of Abastenia Eberle, George Bridgman, Mahonri Young. Member: Norfolk Society of Artists; Baltimore Friends of Art; Provincetown Art Association; American Artists Professional League; Municipal Art Society, Baltimore. Award: Irene Leach Memorial prize, Norfolk Society of Artists, 1922. Work: City Hall, Baltimore, MD. Exhibited: World's Fair of NY, 1939. Address in 1933, 202 Belvedere Avenue, Baltimore, MD; summer, Wellfleet, MA.

WRIGHT, ALICE MORGAN.

Sculptor. Born in Albany, NY, October 10, 1881. Studied: Art Students League; Academie Colarossi, Paris; Smith College, A.B.; St. Agnes School, Albany, NY; Russell Sage College, L.H.D.; Ecole des Beaux-Arts, Paris; pupil of MacNeil, Gutzon Borglum, Fraser, Injalbert in Paris. Member: National Association of Women Artists; Society of Independent Artists; fellow, National Sculpture Society; Silvermine Guild of Artists. Awards: National Association of Women Artists; National Arts Club prize, 1923; National Academy of Design. Work: Portrait reliefs of President L. Clark Seelye, Professor Mary A. Jordan and John Doleman, Smith College, Northampton, MA; "Lady Macbeth," Newark Museum; "Faun," Bleecker Hall, Albany, NY, and National Academy of Design; National Museum, Washington, DC; Brookgreen Gardens, SC; Folger Shakespeare Museum, Washington, DC. Exhibited: National Sculpture Society, 1923; Penna. Academy of Fine Arts; Art Institute of Chicago; National Academy of Design; National Association of Women Artists; Paris Salon; Salon d'Automne; Salon des Beaux-Arts, Paris; others. Contributor to *Harper's*. Address in 1953, Albany, NY. Died in 1976.

WRIGHT, ALMA BROCKERMAN (MR.).

Painter and teacher. He was born in Salt Lake City, UT, November 22, 1875. Studied: L. D. S. College, 1892-95; Ecole des Beaux-Arts, Julian and Colarossi Academies in Paris; pupil of Bonnat and Laurens. Member: Society of Utah Artists; American Art Association of Paris; Salt Lake City Art Commission; Laguna Beach Art Association; American Artists Professional League. Awards: State prize, 1904; medal of honor, Utah Art Institute, 1905. Work: Mural decorations in L. D. S. Temples at Honolulu and Cardston, Alberta, Canada; Senate Chamber, Utah State Capitol; terra cotta panels, Mormon Temple, Mesa, AZ, in collaboration with the sculptor. Head of art department, L. D. S. University, Salt Lake City, UT. Address in 1929, L.D.S.U., Salt Lake City, UT. Died in 1952.

WRIGHT, BERTHA EUGENIE STEVENS.

(Mrs. Lawrence Wright). Painter. Born in Astoria, Long Island, NY. Member: Society of Independent Artists; Salons of America; American Artists Professional League. Address in 1933, 2 East Merrick Road, Merrick, Long Island, NY.

WRIGHT, CATHERINE WHARTON MORRIS (MRS.).

(Mrs. Catherine Morris Wright). Painter, writer, lecturer and teacher. Born in Philadelphia, PA, January 26, 1899. Studied: Moore Institute of Art; Philadelphia School of Design for Women; pupil of Henry B. Snell, Leopold Seyffert. Member: Associate National Academy of Design; NY Water Color Club; American Water Color Society; Philadelphia Water Color Club; Allied Artists of America; Audubon Artists; Philadelphia Society of Miniature Painters; Newport Art Association; American Federation of Arts; Baltimore Water Color Club; others. Awards: Honorable mention, Philadelphia Art Club, 1924; National Academy of Design; Penna. Academy of Fine Arts; Allied Artists of America; Newport Art Association; Germantown Art League. Work: Allentown Museum; Penna. Academy of Fine Arts; Woodmere Art Gallery; University of Pennsylvania; Moore Institute of Art; Philadelphia Museum of Art. One-woman exhibitions: Syracuse Museum of Fine Arts; de Cordova Museum; New Britain Art Institute; Mt. Holyoke College; Fitchburg (MA) Museum of Art. Exhibited: National Academy of Design; Penna. Academy of Fine Arts; Corcoran; Art Institute of Chicago; Carnegie Institute; Allied Artists of America; Audubon Artists; Newport Art Association; others. Contributor to *Scribners, Saturday Evening Post, Atlantic Monthly.* Founder and instructor, Fox Hill School of Art, Jamestown, RI. Address in 1953, Fox Hill Farm, Jamestown, RI; h. Endsmeet Farm, Wyncote, PA.

WRIGHT, CHARLES CUSHING.

Engraver. Born in Damariscotta, ME, May 1, 1796. Wright was orphaned at an early age and adopted by Charles Cushing, whose name he later assumed. After some service as a soldier in the War of 1812, he settled in Utica, NY, and engaged in business as a watchmaker. In 1824 he was associated with A. B. Durand, in New York, doing etching, engraving, and making the dies for a number of medals awarded by the National and State Governments. One of the founders of the National Academy of Design in NY in 1826. Living in Savannah in 1820, and engraving in Charleston, SC, in 1824. Wright attempted line-engraving without much success; his best work was his etched portraits. Died June 7, 1854, in New York.

WRIGHT, CHARLES H.

Painter and illustrator. Born in Knightstown, IN, November 20, 1870. Pupil of Art Students League of NY. Member: Society of Illustrators, 1914; Salma. Club; NY Water Color Club; Artists Guild of the Authors' League of America; New Rochelle Art Association; Indiana Artists. Died in 1939. Address in 1929, Room 309, 1931 Broadway, New York, NY; 27 Willow Ave., Larchmont, NY.

WRIGHT, CHARLES LENNOX.

Painter, illustrator and teacher. Born in Boston, MA, May 28, 1876. Pupil of Art Students League of NY; under Dagnan-Bouveret in Paris. Address in 1926, Bayside, Long Island, NY.

WRIGHT, F. E.

Painter. Born in South Weymouth, MA, in 1849. Studied in Paris under Bonnat, Boulanger, Chapu and Lefebvre.

WRIGHT, FRED W.
Portrait painter. Born in Crawfordsville, IN, October 12, 1880. Pupil of Julian Academy and P. Marcel-Beronneau in Paris; J. Ottis Adams; Art Students League and Robert Reid in NY. Member: Salma. Club; Artists' Fund Society; Artists' Fellowship, Inc. Represented in NY State Capitol, Albany; National Democratic Club, Union Club, and Catholic Club, NY; James Jerome Hill Reference Library, St. Paul, MN; Columbia University; College of Industrial Arts, Denton, TX; Law School, Albany. Address in 1933, 33 West 67th Street, New York, NY; Cambridge, MD.

WRIGHT, G.
Engraver of vignettes, etc. He was working in Philadelphia in 1837. About this date the engraving firm of Wright & Balch was producing line portraits in NY. The Wright of this firm was probably G. Wright.

WRIGHT, GEORGE FREDERICK.
Portrait painter. Born in Washington, CT, December 19, 1828. Student at the National Academy, New York, and later spent 2 years abroad. He painted most of his portraits in Hartford and they are remarkable for their natural flesh tints and accuracy of likeness. Died in 1881, in Hartford, CT.

WRIGHT, GEORGE H(AND).
Painter and illustrator. Born in Fox Chase, PA, August 6, 1872. Pupil of Penna. Academy of Fine Arts and Spring Garden Institute. Member: Society of Illustrators, 1901; Salma. Club; Artists Guild of the Authors' League of America; Society of Independent Artists. Died in 1951. Address in 1933, Salmagundi Club, 47 Fifth Ave., New York, NY; h. Westport, CT.

WRIGHT, GLADYS YOAKUM (MRS.).
Painter. Born in Greenville, TX. Pupil of McLeod School of Art in Los Angeles. Address in 1926, 606 West Third St., Fort Worth, TX.

WRIGHT, GRANT.
Painter and illustrator. Born in Decatur, MI, September 1, 1865. Pupil of National Academy of Design; Ed Ward. Member: Bronx Artists Guild (founder). Work: Museum of the City of New York. Illustrated *Yazzo Valley Tales*, by Ed F. Younger. Address in 1933, 327 Park Avenue, Weehawken, NJ. Died October 20, 1935.

WRIGHT, JAMES HENRY.
Portrait, marine, still-life and landscape painter. Born in 1813. His studio was at 835 Broadway, New York City. Died in Brooklyn in 1883. Painted the portrait of Daniel Webster. The New York Historical Society owns his view of Donagham Manor.

WRIGHT, JOSEPH.
Portrait painter and etcher. Son of Joseph Wright and Patience Lovell, born in Bordentown, NJ, July 16, 1756. After the death of his father, his mother took the family to London. She became famous as a modeler in wax, and gave her son a good education. Received instruction from West and Hoppner, the latter marrying his sister. Before leaving England, Wright painted a portrait of the Prince of Wales, afterward George IV. Exhibited at the Royal Academy in 1780 and 1782. Went to Paris in 1782. Came to America soon after. Painted the portrait of Washington who gave him several sittings at Rocky Hill, near Princeton, NJ, in 1783. Painted two others of Washington about this time, and in 1790 drew his profile likeness. In 1787 Wright had a studio in Pearl Street, NY, and married Miss Vandervoort. Moved to Philadelphia and painted portraits, modeled in clay, and practiced die sinking. This latter accomplishment gained for him, shortly before his death, the appointment of die sinker to the U.S. Mint. Made the design for a cent of 1792, though it is not known that this design was ever executed. Modeler in clay and wax, portrait painter, medalist, die sinker, and etcher.

WRIGHT, JOSEPHINE M.
Miniature painter. Exhibited miniatures at the Penna. Academy of Fine Arts, Philadelphia, 1925. Address in 1926, 1010 North Stoneman Ave., Alhambra, CA.

WRIGHT, M. LOUISE WOOD.
(Mrs. John Wright). Painter and illustrator. Born in Philadelphia, PA, 1875. Pupil of Penna. Academy of Fine Arts; Whistler and Julian Academy in Paris; F. W. Jackson in England. Member: Philadelphia Water Color Club; NY Water Color Club; Fellowship, Penna. Academy of Fine Arts; Concord Art Association; American Federation of Arts. Award: Bronze medal, St. Louis Expo., 1904. Address in 1933, 12 St. Mary Abbott Place, London, England.

WRIGHT, MARGARET HARDON.
(Mrs. James Hayden Wright). Etcher. Born in Newton, MA, March 28, 1869. Pupil of Massachusetts Institute of Technology in Boston; Wellesley; W. H. W. Bicknell; Merson in Paris. Member: Chicago Society of Etchers; Copley Society; Boston Society of Etchers; American Artists Professional League. Specialties: Bookplates; etchings; Christmas cards. Represented in NY Public Library; Library of Congress, Washington, DC. Address in 1929, 28 Copley St., Newton, MA. Died January 12, 1936.

WRIGHT, MARSHAM E(LWIN).
Painter, illustrator, etcher and craftsman. Born in Sidcup, Kent, England, March 27, 1891. Studied: Minneapolis School of Art; pupil of Leo A. Henkora, Cameron Booth. Member: American Artists Profes-

sional League. Awards: Minneapolis Institute of Art, 1929, 31; Minnesota State Fair, 1931, 32. Address in 1929, 1435 East Franklin Avenue; h. 4440 Xerxes Avenue, South Minneapolis, MN.

WRIGHT, PATIENCE LOVELL.
Sculptor and wax modeler. Born in Bordentown, NJ, 1725. No formal training. Known for her small bas-relief portraits. Opened a waxworks in NYC with her sister; moved to England January 30, 1772 and opened a waxworks in London. She had great success in producing profile relief portraits of the upper middle class and aristocracy, including the king and queen. Portraits range in size from two to ten inches. Her most celebrated works are those of Benjamin Franklin and George Washington, the latter being in the collection of the Maryland Historical Society. Lovell's wax statue of Lord Chatham was placed in Westminster Abbey. She intended to return to America, but she never did. Her daughter married portrait painter John Hoppner, and her son, Joseph, began studying with Benjamin West. Died in London, March 23, 1786.

WRIGHT, (PHILIP) CAMERON.
Illustrator and designer. Born in Philadelphia, PA, June 11, 1901. Studied: Pratt Institute; Art Students League of NY; pupil of Max Herman, W. de Leftwich Dodge, George B. Bridgman, Enrico Arcioni at the British Academy of Arts in Rome. Member: Artists Guild of the Authors' League of America. Illustrated *Two Fables*, by Christopher Morley; book jackets for Century Co., Longmans, Green and Co., Bobbs Merrell; Christmas cover for *Country Life*, 1925, and full color insert, *Country Life*, Christmas, 1926; *Plymouth, 1620*, by Walter Prichard Eaton; *Stonewall*, by Julia Davis Adams; juvenile and educational books for Appleton and Co., Harcourt Brace and Co., Random House, E. P. Dutton and Co., and others. Address in 1933, 3520-82nd Street, Jackson Heights, NY.

WRIGHT, RUFUS.
Portrait and figure painter, lithographer and teacher. Born in 1832 in Cleveland, OH. He was a pupil of the National Academy of Design. His portraits include those of Roger B. Taney, Edward M. Stanton and Wm. H. Seward; among his other works are "The Morning Bouquet" and "Feeding the Birds." Exhibited at the National Academy of Design. Represented in Oakland Museum of Art; Chicago Historical Society. Taught at Brooklyn Academy of Design, 1866-72.

WRIGHT, SARA GREENE.
Sculptor. Born in Chicago, IL, 1875. Pupil of Art Institute of Chicago; F. M. Charpentier and F. MacMonnies in Paris. Address in 1906, 27 West 67th Street, New York, NY.

WRIGHT, STANTON MACDONALD.
See MacDonald-Wright, Stanton.

WRIGHT, W. LLOYD.
Painter. Member: Society of Illustrators. Address in 1929, 16 West 67th Street; 146 West 55th Street, New York, NY.

WRIGHTSON, J.
Engraver. Born in England. He came to the United States about 1854. A reputable line-engraver of landscape and book illustrations. Worked in Boston and in New York. Soon after 1860 he returned to England, and died there in 1865.

WU, LINDA YEE CHAU.
Sculptor. Born in Canton, China, July 4, 1919. U.S. citizen. Studied at the California School of Fine Arts, 1939-42; National Academy of Design, 1942-44; School of Painting and Sculpture, at Columbia University, 1944-50. Exhibited: National Academy of Design Annuals; Philadelphia Art Museum, 1949; Audubon Artists Annuals; National Sculpture Society Annuals; Allied Artists of America Annuals, from 1947. Awards: Gold medal of honor for sculpture, Allied Artists of America, 1973; Dessie Greer Prize for Sculpture, National Academy of Design, 1965; Anna Hyatt Huntington gold medal, Catharine Lorillard Wolfe Art Club, 1968. Member of Allied Artists of America; National Academy of Design; and National Sculpture Society (fellow). Address in 1982, Studio 209-10, 185 Canal St., New York, NY.

WUERMER, CARL.
Painter and etcher. Born in Munich, Germany, August 3, 1900. U.S. citizen. Studied: Art Institute of Chicago; Art Students League; pupil of Wellington J. Reynolds. Member: Art Institute of Chicago Alumni; Artists' Fellowship, Inc.; Allied Artists of America; Springfield Art League; Illinois Academy of Fine Arts; Grand Central Galleries; Salons of America; Connecticut Academy of Fine Arts; Hudson Valley Art Association. Awards: Hon. mention, Art Institute of Chicago, 1926, Eisendrath prize ($200), 1927, Kohnstamm prize ($250), 1927; J. Francis Murphy Memorial prize ($150), National Academy of Design, 1928; Springfield Art League prize ($50), 1928; Golden State prize ($500), Grand Central Art Galleries, 1929, prize, 1945; Buck Hill Falls (PA) Art Association; Carnegie Institute, 1949; hon. mention, Allied Artists of America 58th Annual, 1971. Work: Municipal Collection, Chicago; Buck Hill Art Association; Amherst College; IBM Collection. Exhibited nationally; one-man exhibitions include Anderson Gallery, Chicago, 1925, 26; Art Institute of Chicago, 1928; Grand Central Art Galleries, 1930, 34, 38, 43, 47, 48. Address in 1982, Escondido, CA. Died in 1983.

WUERPEL, EDMUND H(ENRY).
Painter, teacher, writer, and lecturer. Born in St. Louis, MO, May 13, 1866. Studied: Washington

University, St. Louis; St. Louis School of Fine Arts, Julian Academy and Ecole des Beaux-Arts in Paris under Bouguereau, Robert Fleury, Gerome, Ferrier and Aman-Jean. Member: St. Louis Artists Guild; St. Louis Municipal Art League; 2 x 4 Society; American Art Association of Paris (hon). Awards: Bronze medal, Nashville Expo., 1897; hors concours, St. Louis Expo., 1904; silver medal, Missouri Building, Lewis and Clarke Expo., Portland, OR, 1905; hon. mention, Buenos Aires Expo., 1910; St. Louis Artists Guild life membership prize, 1914; hors concours (jury of awards), P.-P. Expo., San Francisco, 1915. In collections of City Art Museum, St. Louis; Herron Art Institute, Indianapolis; high school and public library, St. Louis; Buenos Aires Museum; State Capitol, Jefferson City, MO; Church of Unity, St. Louis; murals in Missouri Athletic Club and Carpenter Branch Library, St. Louis, MO. Exhibited: Carnegie; Penna. Academy of Fine Arts; Corcoran; Pan.-Pacific Expo., 1915; City Art Museum of St. Louis; 2 x 4 Society; St. Louis Artists Guild; St. Louis Expo. Dean emeritus, Washington University; instructor, acting director, dean, St. Louis School of Fine Arts. Address in 1953, Washington University, St. Louis, MO; h. 7717 Walinca Terrace, Clayton, MO. Died February 24, 1958.

WUERTZ, EMIL H.
Sculptor. Born in 1856 in Germany or St. Albans. Studied in Paris with Rodin, Chapu, and Mercie. Awards: World's Columbian Expo., 1893; Tennessee Centennial Expo., 1897. Taught at Art Institute of Chicago. Resided for years in Chicago. Died July 4, 1898.

WULFF, TIMOTHY MILTON.
Painter. Born in San Francisco, CA, October 13, 1890. Pupil of Frank Van Sloun. Member: San Francisco Art Association. Work: "The Laughing Buffoon," in the Palace of Fine Arts, San Francisco. Address in 1933, 2245 Turk Street, San Francisco, CA.

WUNDER, ADALBERT.
Portrait painter and draughtsman in oils, crayon and ink. Born in Berlin, Germany, February 5, 1827. Began studying art at the age of 16; spent two years at the Dresden Academy. In 1855 he came to America and opened his studio in Hartford, CT. Went to Hamilton, Ontario, in 1869.

WYAND, CHARLES L. (MRS.).
See Cockcroft, Edith Varian.

WYANT, ALEXANDER HELWIG.
Landscape painter. Born in Evans Creek, OH, January 11, 1836. Devoted himself in early life to painting photographs and portraits in Cincinnati. At 21 he visited George Inness, whose influence is shown in many of his most important works. Studied at the

National Academy of Design; pupil of Hans Gude in Karlsruhe and a student of the works of Turner and Constable in London. Exhibited first at the National Academy of Design in 1865. Elected a member of the National Academy, 1869. One of the founders of the American Water Color Society. His studio was in NY. Represented by paintings in the Metropolitan Museum of Art; Corcoran Art Gallery; National Gallery, Washington, DC; Brooklyn Museum; Montclair Art Museum. Died November 29, 1892, in NYC.

WYCKOFF, JOSEPH.
Painter and teacher. Born in Ottawa, KS, July 9, 1883. Studied: Art Institute of Chicago; Penna. Academy of Fine Arts; Art Students League of NY; NY School of Fine and Applied Arts; pupil of Jay Hambridge, Howard Giles. Member: American Artists Professional League. Address in 1933, 248 Sherman Ave., New York, NY.

WYCKOFF, MARJORIE ANNABLE.
Sculptor. Born in Montreal, Quebec, Canada, September 23, 1904. Pupil of Arthur Lee. Address in 1933, 61 Oakland Place; h. 240 Middlesex Road, Buffalo, NY.

WYETH, ANDREW NEWELL.
Painter. Born July 12, 1917, in Chadds Ford, PA. Studied with N.C. Wyeth, his father; received hon. D.F.A. from Colby College, Harvard, Swarthmore, Dickinson, Tufts, Princeton, University of Pennsylvania, Amherst, and from others. Awards from Penna. Academy of Fine Arts, 1947; Carnegie Institute; American Water Color Society. Many group and one-man exhibitions, including Macbeth Gallery, NYC; Doll and Richards, Boston; Penna. Academy of Fine Arts; Carnegie; University of Illinois; City Art Museum of St. Louis; Museum of Modern Art; Whitney; Tate Gallery; Albright-Knox Art Gallery, Buffalo, NY; Santa Barbara Museum of Art; Corcoran; Fogg Art Museum; National Museum of Modern Art, Tokyo, Japan; Royal Academy, London; others. In collections of Museum of Modern Art; Montclair (NJ) Art Museum; Metropolitan Museum of Art; Joslyn (Omaha) Art Museum; Munson-Williams-Proctor Institute, Utica; Addison Gallery, Andover, MA; National Gallery, Oslo; Boston Museum of Fine Arts; California Palace of the Legion of Honor; Art Institute of Chicago; Dallas Museum of Fine Arts; others. Member: Audubon Artists; American Watercolor Society; National Academy of Design; others. Media: Watercolor, tempera. Address in 1984, c/o Frank Fowler, Lookout Mountain, TN.

WYETH, JAMES BROWNING (JAMIE).
Painter. Born in Wilmington, DE, July 6, 1946. Studied with Carolyn Wyeth and with his father Andrew Wyeth; received hon. D.F.A. from Elizabethtown College. In collections of Smithsonian,

Washington, DC; Museum of Modern Art; Joslyn Art Museum, Omaha; Delaware Art Museum, Wilmington; others. Exhibited at Knoedler Gallery, NYC; Penna. Academy of Fine Arts, 1980; Amon Carter Museum, Fort Worth, TX, 1981; State Museum, Alaska, 1983; others. Member of National Academy of Design, NYC; American Watercolor Society; National Endowment for the Arts. Media: Oil, watercolor. Address in 1984, c/o Frank Fowler, Lookout Mountain, TN.

WYETH, NEWELL CONVERS.
Painter, illustrator and teacher. Born in Needham, MA, October 22, 1882. Pupil of Howard Pyle; also studied at Mechanics Art School, Boston; Normal Art High School; Eric Pape School of Art, with C. W. Reed, H. Pyle, G. L. Noyes. Travelled West and executed many drawings of cowboys, cattle, landscapes; on return, commissioned by all major magazines and book publishers. Illustrated Stevenson's *Treasure Island*, 1911, and *Kidnapped*, 1913; Verne's *Mysterious Island*, 1918; Cooper's *The Deerslayer* and *Last of the Mohicans;* Defoe's *Robin Hood* and *Robinson Crusoe*; others. Member: Salma. Club, 1908; Society of Illustrators, 1912; Philadelphia Sketch Club; Fellowship Penna. Academy of Fine Arts; Wilmington Society of Fine Arts; American Federation of Arts; National Academy of Design. Awards: Beck prize, Philadelphia Water Color Club, 1910; gold medal, P.-P. Expo., San Francisco, 1915; bronze medal, Washington Society of Artists, 1931; fourth Clark prize and hon. mention, Corcoran Gallery, 1932. Murals in Missouri State Capitol; Hotel Traymore, Atlantic City; Reading Museum of Fine Arts; Federal Reserve Bank of Boston; NY Public Library; Hotel Utica, Utica, NY; National Cathedral, Washington, DC; Roosevelt Hotel Dining Room, New York; Penn Mutual Life Insurance Building, Philadelphia; others. Address in 1933, Needham, MA; Chadd's Ford, PA. Died October 19, 1945, in a railroad accident near his home in Chadds Ford, PA.

WYLIE, ROBERT.
Genre painter and sculptor. Born on the Isle of Man, England, in 1839; family moved to U.S. and settled in Philadelphia. Studied at the Penna. Academy, 1859-62; exhibited work in ivory and clay there. Sent by its directors to France to study in 1863 and lived there the rest of his life. Entered the Ecole des Beaux-Arts and worked under Gerome. Known chiefly as a painter of Breton peasant scenes. Awarded second class medal, Paris Salon, 1872. Died in Brittany, France, February 4, 1877.

Y

YALE, LEROY MILTON (DR.).
Painter and etcher. Born at Vineyard Haven, MA, February 12, 1841. He was a founder, along with Robert S. Gifford and James D. Smillie, of the New York Etching Club and produced several hundred plates. His collection is in the New York Public Library. Died September 12, 1906.

YANDELL, ENID (MISS).
Sculptor and teacher. Born in Louisville, KY, October 6, 1870. Pupil of Cincinnati Art School; Philip Martiny in NY; MacMonnies and Rodin in Paris. Member: National Sculpture Society, 1898; New York Municipal Art Society; New York Water Color Club; National Arts Club. Awards: Designer's medal, Columbian Expo., Chicago, 1893; silver medal, Tennessee Expo., Nashville, 1897; honorable mention, Pan.-American Expo., Buffalo, 1901; bronze medal, St. Louis Expo., 1904; Officier de l'Academie, French Government, 1906. Organized, 1907, Branstock Summer School of Art at Edgartown. Work: "Carrie Brown Memorial Fountain," Providence; bust, "Dr. W. T. Bull," College of Physicians and Surgeons, NY; "Emma Willard Memorial," Albany, NY; "Hogan Fountain" and "Boone Monument," Louisville, KY; "Indian and Fishes," Watch Hill, RI. Address in 1933, 219 Beacon St., Boston, MA; summer, Edgartown, MA. Died June 12, 1934.

YATES, ELIZABETH M.
Painter and teacher. Born in Stoke-on-Trent, Staffordshire, England, May 13, 1888. Pupil of Pratt Institute Art School. Member: Buffalo Guild of Allied Artists. Address in 1929, 374 McKinley Parkway, Buffalo, NY.

YATES, JULIE NICHOLLS.
Sculptor. Born in St. Louis, MO. Studied: St. Louis School of Fine Arts in America; pupil of George Zolnay, Rodin and Bourdelle in Paris. Member: National Arts Club of New York; Art Association in Paris; Artists Guild of St. Louis; National Association of Women Painters and Sculptors. Has exhibited in many of the most prominent exhibitions, including the Paris Salon. Specializes in portraits and garden figures.

YATES, RUTH.
Sculptor. Born in Greenville, OH, December 31, 1896. Studied at Cincinnati Art Academy; Art Students League; Grand Central Art School; Academie Julien; pupil of Jose de Creeft. Work: Norfolk Museum of Arts and Science; Brookgreen Gardens, SC. Exhibited: National Academy of Design, 1931; Penna. Academy of Fine Arts, 1942, 43; National Sculpture Society, 1940, 49, 52; Whitney Museum; National Arts Club; National Association of Women Artists, 1931, 32, 38-43, 49, 51, 52; Pen and Brush Club, 1945-49; Metropolitan Museum of Art, 1942; one-woman show, NYC, 1939. Awards: National Association of Women Artists, 1939, 51; Pen and Brush Club, 1945, 49; Artists for Democratic Living award, 1951; Anna Hyatt Huntington prize, 1939. Member: Fellow, International Institute of Arts and Letters; National Sculpture Society (recording secretary, 1943-46, 49-50); Artists Equity Association; Artists for Victory (recording secretary, 1945-46); National Association of Women Artists (president, 1949-51, treasurer, 1952, past corresponding secretary and chairman of sculpture); Pen and Brush Club (vice-president, chairman of sculpture, 1946-50); New York Architectural League; Art Students League; Hudson Valley Art Association. Address in 1962, 58 West 57th Street, New York, NY. Died in 1969.

YEATS, JOHN BUTLER.
Painter and writer. Born in Ireland in 1839. Father of the poet William Butler Yeats and the artist Jack B. Yeats. Painted numerous portraits of well-known people. Member of the Society of Independent Artists. Died February 3, 1922, in New York City.

YELLAND, RAYMOND DABB.
Painter. Born in London, England, in 1848. He came to this country in 1851 and studied at the National Academy. Also a pupil of James R. Brevoort, L. E. Wilmarth, and William Page. Among his paintings are "Half-moon Beach;" "Mount Hood;" "The Columbia River." Exhibited at the National Academy of Design, 1882-88. Was assistant director of the California School of Design, 1877. Died July 27, 1900, in Oakland, CA.

YELLIN, SAMUEL A.
Craftsman. Born in Poland, March 2, 1886. Studied: Philadelphia Museum School of Industrial Art; also in Europe. Member: American Institute of Architects; American Federation of Arts; NY Architectural League; Art Alliance of America; T. Square Club; Fairmount Park Art Association; Art Alliance of Philadelphia; Beaux-Arts Institute of Design; others. Awards: Medal, Art Institute of Chicago, 1918; medal, Boston Society of Artists, 1920; medal, American Institute of Architects, 1920; gold medal, Architectural League of NY, 1922; Philadelphia Book Award, 1925; prize, Philadelphia Museum School of Industrial Art, 1930. Work: Main entrance,

golden door and all other metal work, Bok Carillon Tower, Mountain Lake, FL; main entrance, gates and other metal work, Harkness Memorial Quadrangle, Yale University; metal work, Washington Cathedral, Washington, DC; wrought iron pupil, Mercersburg Academy, Mercersburg, PA; wrought iron pulpit, St. Mary's Church, Detroit, MI; wrought iron work, St. George's Chapel, Newport, RI; wrought iron work, Federal Reserve Bank, Equitable Trust Co. and Central Savings Bank, New York, NY; Seattle Art Museum; Art Institute of Chicago; Metropolitan Museum of Art; others. Address in 1929, 5520 Arch Street, Philadelphia, PA; h. 331 East Lancaster Pike, Wynnewood, PA. Died October 3, 1940, in New York City.

YENS (or JENS), KARL (JULIUS HEINRICH).
Mural and portrait painter, illustrator, etcher and teacher. Born in Altona, Germany, January 11, 1868. Pupil of Max Koch in Berlin; Constant and Laurens in Paris. Member: California Art Club; California Water Color Society; Laguna Beach Art Association; Artland Club; Los Angeles Painters and Sculptors Club; Long Beach Art Association; International Bookplate Association; American Federation of Arts; American Artists Professional League; San Diego Fine Arts Society; others. Awards: Bronze and silver medals, Pan.-California International Expo., San Diego, 1915; second Black prize, California Art Club, 1919; hon. mention, Laguna Beach Art Association, 1921, first Stevens prize, 1922, silver medal, 1924, grand prize, 1925, second prize, 1927; first Huntington prize, California Water Color Society, 1922; first prize, Southern California Fair, Riverside, 1922; hon. mention, Southwest Museum, 1922; first Harrison prize, Painters and Sculptors exhibition, Los Angeles, 1923; hon. mention, Arizona State Fair, Phoenix, 1923; third prize, Orange County Fair, CA, 1923, special award, 1925, first prize, 1927; first prize, Los Angeles County Fair, 1924, 28; special award, Orange County Fair, CA, 1925; first prize, Artists of Southern California, San Diego, 1926; bronze medal, Biltmore Salon, Los Angeles, 1926; first prize, International Bookplate Association, 1927; hon. mention, Arizona State Fair, 1927, hon. mention, 1928; popular vote, mention, Sacramento (CA) State Fair, 1927; hon. mention, Fine Arts Gallery, San Diego, 1928; first gold medal, Pacific Southwest Expo., Long Beach, 1928; first prize, Southern Counties Fair, Riverside, 1928; bronze medal, Los Angeles Painters and Sculptors, 1928; others. Work: Mural decorations in City Hall, Altona, Germany; Country Club House, Brookline, MA; Duquesne Club, Pittsburgh, PA; Astor Theatre, New York. Represented in the Los Angeles Museum of History, Science and Art; Fine Arts Gallery, San Diego; John H. Vanderpoel Art Association, Chicago; U.S.S. *California*; San Pedro High School, CA. Address in 1933, Laguna Beach, CA. Died April 13, 1945.

YEOMANS, WALTER C(URTIS).
Etcher, illustrator and craftsman. Born in Avon, IL, May 17, 1882. Studied: University of Illinois; Art Institute of Chicago; pupil of Fursman, Senseney, Bicknell. Member: Chicago Society of Etchers; Palette and Chisel Club; American Federation of Arts. Address in 1929, Cornwall Bridge, CT.

YERKES, LANE HAMILTON.
Illustrator. Born in Philadelphia, PA, in 1945. He attended the Philadelphia College of Art for five years. His first published illustration was for *Today Magazine* in Pennsylvania in 1962. His work has been shown at the Commercial Museum and he has illustrated for *Macmillan, Penthouse, Smithsonian Magazine* and *The Philadelphia Inquirer*.

YERUSHALMY, DAVID.
Sculptor. Born in Jerusalem, Palestine, October 15, 1893. Pupil of Franz Barwig, Joseph Mullner, and Franz Zelzny in Vienna. Member: Around the Palette; All-Illinois Society of Fine Arts. Award: Honorable mention, Annual Exhibition by Artists of Chicago and Vicinity, Art Institute of Chicago, 1931. Address in 1933, 2828 Prairie Avenue; h. 2720 Prairie Avenue, Chicago, IL.

YEWELL, GEORGE HENRY.
Painter and etcher. Born in Havre-de-Grace, MD, January 20, 1830. Studied: National Academy of Design, 1851-56; in Paris, 1856-61, in atelier of Thomas Couture; pupil of Thomas Hicks. Resided in Rome, Italy, 1867-78, and for one winter in Cairo, Egypt; after 1878 in New York. Elected an Associate of the National Academy, 1862, Academician, 1880; member of the Artists' Fund Society; patron, Metropolitan Museum of Art, NY. Exhibited at the NY Etching Club, 1888. His work was chiefly portraits, which included those of Isaac Davis, Alexander Mitchell, Frederick Layton and Robert Lucas. Represented in the Metropolitan Museum of Art; Wadsworth Athenaeum, Hartford; Louisville Art Gallery; Presbyterian Building, New York City; others. He died September 26, 1923, at Lake George, NY.

YOCHIM, LOUISE DUNN.
Painter, sculptor, teacher, writer, and craftsman. Born in Jitomir, Ukraine, July 18, 1909. U.S. citizen. Studied at Art Institute of Chicago, certificate, 1932, B.A.E., 1942, M.A.E., 1952; University of Chicago, 1956. Member: National Art Education Association; Western Art Education Association; Artists Equity Association; Chicago Society of Artists (president, 1972-82). Work: Hebrew Theological College, Skokie, IL; Bernard Horwich Center, Chicago; Northeastern Illinois University, Chicago; A. Werbe Gallery, Detroit; others, including many private collections. Exhibited: Art Institute of Chicago, 1935-37, 41, 42, 44; Detroit Institute of Arts, 1945; Chicago Fine Arts

Gallery, 1945; University of Chicago, 1946; Todros Geller Gallery, Chicago, 1947, 51, 52; Associated Artists Gallery, 1949; Riverside Museum, 1951; Kansas City, MO, 1948; Terry Art Institute, 1952; McKerr Gallery, 1962 (one-woman); Chicago Teachers College, 1964 (one-woman); Northeastern Illinois University, 1972; Spertus Museum, Chicago, 1979-81; others. Awards: Chicago Society of Artists, 1953, 78; Todros Geller award for painting, American Jewish Art Club, 1948-61. Positions: Instructor of art, Chicago Public High School, 1934-50, Academy of Fine Arts, Chicago, 1952, and Chicago Teachers College, 1960-61; supervisor of art, Chicago Public Schools, 1950-71; consultant on art, elementary and high schools, 1971-74, Rand McNally Publications, from 1967, and *Encyclopaedia Britannica*, from 1968. Author of *Building Human Relationships Through Art*, 1954; *Art in Action*, 1969; *Role and Impact: The Chicago Society of Artists*, 1979; others. Address in 1982, Evanston, IL.

YOHN, FREDERICK COFFAY.
Illustrator. Born in Indianapolis, IN, February 8, 1875. Studied: Indianapolis Art School; Art Students League of NY, under Mowbray. He began his career in 1894 working for *Harper's*; illustrated for many book publishers and extensively for *Scribner's* and *Collier's*; for Henry Cabot Lodge's *The Story of the Revolution*; others. Member: Society of Illustrators, 1901; Artists Guild of the Authors' League of America. Permanent collection in Library of Congress. Commissioned to paint several historical scenes for the Massachusetts Bay Tercentenary. Specialty: Battle scenes. Address in 1929, Norwalk, CT. Died June 5, 1933, in Norwalk.

YOKOI, RITA.
Sculptor and painter. Born in NYC, August 26, 1938. Studied at Alfred New York State College of Ceramics, Alfred University, 1956-59; San Francisco Art Institute, Agnes Brandenstein Memorial Scholarship, 1959-61, B.F.A., 1961; Tokyo University of Japan, Fulbright Fellowship for Ceramics, 1962-63; University of California at Berkeley, 1966-70, M.A., 1970. Exhibited: Museum of Contemporary Crafts, NYC, 1962; M. H. de Young Memorial Museum, San Francisco, 1968; one-woman show at Kirk de Gooyer Gallery, Los Angeles, 1981; Santa Barbara Arts Forum, CA, 1981; others. Taught: Fresno City College, CA, 1972; California State University, Fresno, 1971-73; Otis Art Institute, 1973-75; Mt. St. Mary's College, 1975-76; California State University, 1978; others. Awarded National Endowment for the Arts, 1981. Noted for her ceramic sculpture and assemblage. Address in 1982, Los Angeles, CA.

YOUNG, ARTHUR (ART).
Cartoonist and writer. Born in Orangeville, Stephenson County, IL, January 14, 1866. Studied: Art Institute of Chicago, with Vanderpoel; Art Students

League; Julian Academy, with Bouguereau, in Paris. Exhibited at the Armory Show, 1913. Cartoons and illustrations in *Life; Collier's Weekly; The Masses; The Nation; Saturday Evening Post; New Yorker*; etc. Author of *Trees at Night; The Best of Art Young; On My Way*; others. Specialized in radical socialist cartoons. Address in 1929, 9 East 17th Street, New York, NY; summer, Bethel, CT. Died December 29, 1943.

YOUNG, ARTHUR R(AYMOND).
Painter, illustrator, graphic artist, etcher, lecturer, and teacher. Born in New York, NY, July 10, 1895. Studied: Art Students League of NY; National Academy of Design. Work: "Athlete" and "Woman Dressing Her Hair," British Museum, London. Exhibited: Brooklyn Museum; one-man exhibitions at Weyhe Gallery, Daniels Gallery, and Pan-Hellenic Engineers Club. Contributor to *Art Education Today* and other art and art education magazines. Professor of painting and graphics, Teachers College, Columbia University, New York, NY, 1927-60, professor emeritus, from 1960; chairman, National Committee on Art Education, 1961. Address in 1962, 420 West 118th Street, New York, NY.

YOUNG, C(HARLES) JAC.
Painter and etcher. Born in Bavaria, December 21, 1880. Studied: National Academy of Design, with E. M. Ward and C. Y. Turner. Member: Brooklyn Society of Etchers; California Printmakers; Salma. Club; Chicago Society of Etchers; Yonkers Art Association; Provincetown Art Association. Awards: Kate W. Arms Memorial prize, etching, Brooklyn Society of Etchers, 1928; purchase prize, painting, Yonkers Art Association, 1929; Newark Art Club, 1931, 33, 35; Northern NJ Artists, Newark, 1932, 33; Montclair Art Association, 1922, 33; Philadelphia Print Club, 1933; Salma. Club, 1929; others. Represented in Los Angeles Museum of Art; Newark Public Library; Art Gallery, Toronto, Canada; NY Public Library; etchings, University of Nebraska; Art Institute of Peoria, IL; Art Alliance of Philadelphia; Art Institute of Milwaukee; Corcoran Art Gallery, Washington; Hackley Gallery of Art, Muskegon, MI; Library of Congress; Print Club of Philadelphia; Smithsonian Institution; painting, Museum of Science and Art, Yonkers, NY; Art Institute of Chicago; Brooklyn Museum; Albany Institute of History and Art; others. Address in 1933, 114 Highpoint Ave., Weehawken Heights, NJ. Died March 4, 1940.

YOUNG, CHARLES MORRIS.
Landscape painter and etcher. Born in Gettysburg, PA, September 23, 1869. Pupil of Penna. Academy of Fine Arts; Colarossi Academy in Paris. Member: Associate National Academy of Design; Philadelphia Art Club. Awards: Toppan prize, Penna. Academy of Fine Arts; hon. mention, Pan.-Am. Expo., Buffalo,

1901; silver medal, St. Louis Expo., 1904; gold medal, Art Club of Philadelphia, 1908; hon. mention, Carnegie Institute, Pittsburgh, 1910; silver medal, Buenos Aires Expo., 1910; gold medal, P.-P. Expo., San Francisco, 1915; Sesnan gold medal, Penna. Academy of Fine Arts, 1921; Stotesbury prize ($500), Penna. Academy of Fine Arts, 1925; gold medal, Amsterdam, Holland, 1929. Work: "Winter Morning after Snow," Penna. Academy of Fine Arts, Philadelphia, PA; "The North Wind," Corcoran Gallery, Washington, DC. Represented in Boston Art Club; St. Louis Art Club; Budapest National Gallery; Albright Art Gallery, Buffalo; Rochester Art Gallery; National Gallery, Santiago, Chile; Reading Art Museum; Philadelphia Museum of Art; Allentown Art Gallery; Sandhurst Military Academy, England; private collections. Died in 1964. Address in 1962, Radnor, PA; s. Drifton, PA. Died November 14, 1964.

YOUNG, DOROTHY O.
(Mrs. Jack J. Sophir). Sculptor, painter, teacher and craftsman. Born in St. Louis, MO, June 22, 1903. Studied at St. Louis School of Fine Arts, Washington University; Art Students League; and with E. Wuerpel, Leo Lentelli, and George Bridgman. Works: Office, St. Louis Council, Boy Scouts of America; Rockwoods (MO) Museum; Jackson Park School, St. Louis. Exhibited: St. Louis Artists Guild, 1925-52 (one-woman, 1946); Kansas City Art Institute, 1923-32, 34; Society of Independent Artists, St. Louis, 1930-52; Joslyn Art Museum, 1939, 41, 44; Springfield Art Museum, 1943; City Art Museum, 1939-46, 49; William Rockhill Nelson Gallery of Art, 1947. Awards: St. Louis Artists Guild, 1925, 49; Society of Independent Artists, 1937, 40, 43, 44, 45, 47-49, 50, 52, 53, 55; Henry Shaw Cactus Society, 1955; St. Louis County Fair, 1947. Address in 1953, University City, MO.

YOUNG, ELIZA MIDDLETON COXE.
(Mrs. C. M. Young). Painter. Born in Philadelphia, PA, in 1875. Studied: Penna. Academy of Fine Arts; pupil of Anshutz and Charles Morris Young. Work: "Garden Study," Herron Art Institute, Indianapolis. Address in 1929, Radnor, PA.

YOUNG, ELLSWORTH.
Painter and illustrator. Born July 8, 1866. Member: Chicago Society of Artists; Chicago Painters and Sculptors; Chicago Galleries Association; Oak Park Art League; All-Illinois Society of Fine Arts. Work: "Passing Cloud," State Museum, Springfield, IL; "Road to Fourmile," Tolleston Public School, Gary, IN; Illinois State Teachers College, Bloomington, IL. Address in 1933, 726 Woodbine Avenue, Oak Park, IL.

YOUNG, ESTHER CHRISTENSEN.
(Mrs. Charles J. Young). Illustrator, etcher, craftsman, and writer. Born in Milwaukee, WI, May 10, 1895. Studied: Art Students League; Milwaukee-Downer College; pupil of Groom, Aiken, Sinclair. Member: Wisconsin Painters and Sculptors. Awards: Hon. mention, Wisconsin Painters and Sculptors, 1924; second prize, Women's Arts and Industries Expo., NY, 1925. Address in 1933, 226 Golf View Road, Ardmore, PA.

YOUNG, EVA H.
Miniature painter. Exhibited at the Penna. Academy of Fine Arts, Philadelphia, 1922. Address in 1926, 115 West 16th Street, New York, NY.

YOUNG, GLADYS G.
Painter. Born in Vevey, Switzerland, June 11, 1897. Studied: Art Students League; in Paris with Andre L'hote. Exhibited watercolors at the Penna. Academy of Fine Arts, Philadelphia, 1925; Corcoran Gallery, 1941; Gallery 460 Park Avenue, NY, 1941 (one-woman); Ferargil Gallery, 1945 (one-woman); Riverside Art Museum, New York, NY, 1938. Member: NY Society of Women Artists; Audubon Artists. Award: Prize, National Association of Women Artists, 1951. Address in 1962, 9 East 63rd Street, New York, NY.

YOUNG, GRACE.
Painter. Member: Cincinnati Woman's Art Club; American Federation of Arts. Address in 1929, Art Academy, Cincinnati, OH.

YOUNG, JAMES H.
Engraver. In Philadelphia, PA, from 1817-45. At times he was a member of the firms of Kneass & Young, and of Young & Delleker, both in business in Philadelphia. The only plates found signed by Young alone are early encyclopedia plates in line.

YOUNG, JAMES HARVEY.
Painter. Born June 14, 1830, in Salem, MA. Moved his studio to Boston in 1848. Worked largely in portraiture. Work: "Wm. Warren" (actor), painted in 1867; "Dr. Peabody" (Exeter Academy); "Mrs. John H. Holmes;" "Horace Mann;" "Edward Everett." Represented in American Antiquarian Society; Essex Institute, Salem. Member: Boston Art Club. Died in 1918 in Brookline, MA.

YOUNG, MAHONRI MACKINTOSH.
Painter, sculptor, etcher, writer and teacher. Born in Salt Lake City, UT, August 9, 1877. Pupil of Art Students League in NY; Academies Julien, Colarossi, and Delacluse in Paris; also with J. T. Harwood. Member: Associate, National Academy of Design, 1912; National Academy of Design, 1923; National Sculpture Society, 1910; Paris Art Association; Society of Utah Artists; New York Architectural League, 1911; Chicago Society of Etchers; New York Water Color Club; New York Society of Etchers; National Institute of Arts and Letters; New Society of Artists;

Society of American Etchers; American Water Color Society; Century Association; National Arts Club; American Society of Painters, Sculptors and Gravers. Awards: Honorable mention for etching, American Art Association of Paris; Barnett prize, National Academy of Design, 1911; silver medal for sculpture, P.-P. Expo., San Francisco, 1915; first medal, sculpture, Olympic Games, Los Angeles, CA, 1932; Maynard prize, portrait, National Academy of Design, 1932; Society of American Etchers. Work: "Etchings," "Man with Pick," and "Stevedore," Metropolitan Museum, NY; Hopi, Navajo and Apache groups, American Museum of Natural History, NY; bronzes, "A Laborer" and "The Rigger," and etchings, Newark Museum; etchings, New York Public Library; "Sea Gull Monument," Salt Lake City; bronze, Peabody Institute, Baltimore, MD; Rhode Island School of Design, Providence; painting and sculpture, Art Institute of Utah, Salt Lake City; Whitney; Corcoran; Brooklyn Museum; Baltimore Museum of Art; Brookgreen Gardens, SC; Cleveland Museum of Art; Addison Gallery of American Art; others. Exhibited at the Armory Show, 1913; National Sculpture Society, 1923; nationally. Instructor, School of American Sculpture and Art Students League, NY. Contributor to *Encyclopaedia Britannica*. Address in 1953, Ridgefield, CT. Died in Norwalk, CT, November 2, 1957.

YOUNG, MARY ELIZA.
See Waugh, (Mary) Eliza Young.

YOUNG, SUSANNE BOTTOMLEY.
(Mrs. Benjamin Swan Young). Painter and decorator. Born in New York, NY, December 28, 1891. Pupil of Alexander; George de Forest Brush. Work: Frieze in Club Royal, New York; ceiling in Le Paradis, Washington, DC. Address in 1933, 73 Hilton Avenue, Garden City, Long Island, NY.

YOUNG, THOMAS.
Portrait and miniature painter. Native of Providence, RI, where he produced numerous portraits. The portraits of Thomas Cole and John Matthewson Eddy by Young were in the Providence Athenaeum. Also painted a portrait of Nehemiah Knight, Governor of Rhode Island.

YOUNG, WILLIAM CRAWFORD.
Illustrator. Born in Cannonsburg, MI, March 26, 1886. Pupil of Art Institute of Chicago; Chicago Art Academy. Member: Silvermine Guild of Artists.

Staff contributor to *Judge* and King Features Syndicate. Address in 1929, Comstock Hill, Norwalk, CT.

YOUNG-HUNTER, JOHN.
Painter. Born in Glasgow, Scotland, October 29, 1874. Came to U.S. in 1913. Pupil of Royal Academy Schools under Sargent, Alma-Tadema and others. Member: Chelsea Artists, London; National Arts Club; Salma. Club; American Water Color Society; Connecticut Academy of Fine Arts; Allied Artists of America. Awards: Hon. mention, Paris Salon, 1910; silver medal, Paris Salon, 1914; Dunham prize, Hartford, 1925; gold medal, Allied Artists of America, 1932; medal, Luxembourg Museum, Paris; prizes, National Gallery, London. Work: "My Lady's Garden," National Gallery of British Art, London; "The Dream," Luxembourg, Paris; "Two Voices," Walker Art Gallery, Liverpool, England; "Judith Shakespeare," Art Museum, Wellington, New Zealand; "Portrait, Pres. King," Oberlin (OH) Museum; portrait study, Dayton Museum; "Raymond Henniker-Heaton," Worcester Museum; "Duke of Argyll," Government House, Ottawa, Canada; "J. Scott Skinner," Art Museum, Dundee, Scotland; Worcester Museum of Art; Harvard University; Princeton University; others. Exhibited: National Academy of Design; Allied Artists of America; Art Institute of Chicago; Kansas City Art Institute; Royal Academy of Art, London; Museum of New Mexico, Santa Fe; Audubon Artists; Taos, NM; Albuquerque, NM. Address in 1953, Taos, NM. Died August 9, 1955.

YOUNGERMAN, JACK.
Painter and sculptor. Born in Louisville, KY, March 25, 1926. Studied: University of North Carolina, Chapel Hill, 1944-46; University of Missouri, A.B., 1947; Ecole des Beaux-Arts, Paris, 1947-48. Work: Whitney Museum; Museum of Modern Art; Guggenheim; Hirshhorn Museum, Washington, DC; Art Institute of Chicago. Commissions include First Pennsylvania Bank, Philadelphia, 1969; "The Ohio" (fiberglas), Pittsburgh Plate Glass, 1977; others. Exhibitions: Betty Parsons Gallery, 1958, 60, 61, 65; Guggenheim, NYC, 1961, 66; Whitney, 1965; Jewish Museum; NYU; Carnegie Institute, Pittsburgh, 1971; Hirshhorn Museum, 1980; Haus der Kunst, Munich, 1981; others. Awards: National Council on Arts and Science award, 1966; National Endowment for the Arts award, 1972; fellow, Guggenheim Foundation, 1976. Taught at Yale University, 1974-75; Hunter College, 1981-82; NYU, from 1982-83. Represented in Washburn Gallery, NYC. Address in 1982, 130 West 3rd Street, NYC.

Z

ZAIDENBERG, ARTHUR.
Sculptor and writer. Born in New York, NY, 1908. Studied at Art Students League; National Academy of Design, NY; Beaux Arts, Paris; also in Rome and Munich. Work at Metropolitan Museum; Brooklyn Museum; New York Public Library; Albany Museum; SS *Rotterdam* (mural), Holland American Line; and others. Exhibitions include one-man shows at the Albany Museum, 1965; Bellas Artes, Mexico, 1972, 78. Received Sally Jacobs Award, Woodstock Artists Association, 1969. Member of Woodstock Artists Association. Taught drawing at NY University, 1963-65; drawing at Institute of San Miguel, Mexico, 1972-73. Works in welded steel and oil. Address in 1982, San Miguel Allende, Mexico.

ZAIKINE, ZAK (VICTOR EUGENE).
Sculptor and painter. Born in Queens, NY, September 7, 1941. Studied: Pratt Institute, 1959-64, sculpture with Charles Ginnever, painting with Nicholas Buhalis. Work: Wright State University Museum, OH; Brooklyn Automotive High School, NY; others. One-man exhibitions: Miller Gallery, OH; Goldsmith's, Washington, DC; Baldenhofer Gallery, CA; The Art Works Gallery, CA; Lincoln Arts Gallery, CA; Ulster County Council of the Arts, Kingston, NY; Work of Art Gallery, Saugerties, NY; Paramour Fine Arts, MI; others. Group exhibitions: National Arts Club, NY; Cooperstown Art Association, NY; Silvermine Guild Center for the Arts, New Canaan, CT; Laguna Gloria Art Museum, Austin, TX; Heckscher Museum, Huntington, NY; Empire State Plaza, Albany, NY; Parsons School of Design, New York City; Schenectady Museum, Schenectady, NY; 14 Sculptors Gallery, New York City; Kleinert Art Center, Woodstock, NY; others. Awards: Fiesta de Artes, Los Gatos, CA, 1976; Washington Square Village Art Exhibition, 1980, 81. Member: Woodstock Arts Association, Inc.; Cooperstown Art Association, Inc.; Woodstock Guild Craftsmen, Inc. Address in 1984, Woodstock, NY.

ZAJAC, JACK.
Sculptor and painter. Born December 13, 1929, in Youngstown, OH. Began as a painter. Studied at Scripps College; American Academy in Rome; pupil of Millard Sheets, Henry McFee, and Sueo Serisawa. Taught at Dartmouth and Pomona. Awards: Butler Institute of American Art, Youngstown, OH, 1950; Pasadena Art Museum, 1951; American Academy of Arts and Letters grant; California State Scholarship, 1950; Los Angeles County Museum of Art, 1953, 58; Guggenheim fellowship, 1959; Limited Editions Club etching prize, 1959; Prix de Rome, 1954, 56, 57;

Sarasota Art Association, 1959; National Religious Art Exhibition, Birmingham, MI, 1962. Exhibited at Felix Landau Gallery (one-man, many times); Pasadena Art Museum (one-man); Scripps College (one-man); Virginia Museum of Fine Arts; University of Illinois; Whitney Museum; Museum of Modern Art; Guggenheim Museum; Art Institute of Chicago; Santa Barbara Museum of Art, CA; Smithsonian Institution; Temple University, Rome (retrospective); others. In collections of University of Nebraska at Lincoln; Los Angeles County Museum; Penna. Academy of Fine Arts; California Federal Savings and Loan Association; Museum of Modern Art; others. Represented by Forum Gallery, NYC. Address in 1982, c/o Forum Gallery, 1018 Madison Ave., New York, NY.

ZAKHEIM, BERNARD BARUCH.
Painter, sculptor, craftsman, designer, and teacher. Born in Warsaw, Poland, April 4, 1898. Studied at San Francisco School of Fine Arts; and in Europe. Award: Medal, San Francisco Art Association, 1935. Work: San Francisco Museum of Art; frescoes, Coit Memorial Tower, Jewish Community Center, University of California Medical School, University of California Hospital, all in San Francisco; murals, U.S. Post Office, Mineola, TX. Exhibited: San Diego traveling exhibition, 1940; U.S. Treasury Department, 1940; San Francisco Museum of Art, annually; Golden Gate Expo., 1939; Palace of the Legion of Honor. Position: Instructor, adult department, San Francisco Public School; instructor, occupational therapy, Presidio, San Francisco, CA. Address in 1953, San Francisco, CA; h. Sebastopol, CA.

ZEIDLER, AVIS.
Painter, sculptor, etcher, craftsman, and lecturer. Born in Madison, WI, December 12, 1908. Pupil of Labault; Boynton; Stackpole; DuMond. Member: San Francisco Society of Women Artists. Address in 1933, 745 Forty-seventh Ave., San Francisco, CA.

ZEISLER, CLAIRE (BLOCK).
Sculptor. Born in Cincinnati, OH, April 18, 1903. Studied: Institute of Design, Chicago, with Lazlo Moholy-Nagy; also under Alexander Archipenko. Exhibited: Textile Objekte, Kunstgewerbe Museum, Berlin, Germany, 1975; Museum of Contemporary Art, Chicago, 1976; Renwick Gallery of the National Collection, Washington, DC, 1977; National Museum of Modern Art, Kyoto, Japan, 1977; others. One-woman shows include a retrospective at the Art Institute of Chicago, 1979; St. Louis Art Museum, 1980. Work: Stedelijk Museum, Amsterdam; Art

Institute of Chicago; Milwaukee Art Center; Museum des Arts Decoratifs, Nantes, France. Medium: Fiber. Address in 1982, c/o Young Hoffman Gallery, 215 West Superior, Chicago, IL.

ZEITLIN, ALEXANDER.
Sculptor. Born in Tiflis, Russia, July 28, 1872. Pupil of Falguiere at Ecole des Beaux-Arts in Paris. Member: Art Alliance of America; Painters and Sculptors; Brooklyn Society of Artists. Work: Senator Birarelli's heroic size statue, City of La Valence, France; Richard Hudnut's monument, Woodlawn Cemetery, NY; George Backer's monument, Betholom Fields Cemetery, Brooklyn. Address in 1933, 41 Gramercy Park, NYC.

ZELLER, AUGUST.
Sculptor. Born in Bordentown, NJ, March 7, 1863. Pupil of Franklin Institute of Philadelphia; Penna. Academy of Fine Arts under Eakins; Ecole des Beaux-Arts in Paris under Thomas; studied and worked with Rodin. Taught: Instructor, Carnegie Technical Schools and Art Students League of Pittsburgh, PA. Member: Pittsburgh Art Association. Work: "Last Supper," Episcopal Church, Fox Chase, PA; Schuylkill Co. military monument, Pottsville, PA; etc. Address in 1914, Carnegie Institute, Pittsburgh, PA. Died January 11, 1918.

ZENNER, ROSE.
Painter. Member: Cincinnati Woman's Art Club. Address in 1929, 2947 Gilbert Avenue, Cincinnati, OH.

ZETTLER, EMIL ROBERT.
Sculptor. Born March 30, 1878, in Chicago, IL. Studied at Art Institute of Chicago; Royal Academy of Berlin; Julian Academy in Paris. Awards: Honorable mention, Art Institute of Chicago, 1912, silver medal, 1915, Potter Palmer gold medal, 1916, Logan medal, 1917, Harry A. Frank prize, 1921, and French memorial gold medal, 1925, all from Art Institute of Chicago; medal, Chicago Society of Artists, 1915; bronze medal, P.-P. Expo., San Francisco, 1915. Work: Municipal Art Collection, Chicago. Taught: Professor and head of School of Industrial Art, Art Institute of Chicago; assistant professor, Armour Institute of Technology. Address in 1933, Chicago, IL. Died January 10, 1946.

ZIEGLER, EUSTACE PAUL.
Painter, etcher, engraver, block printer, illustrator, teacher and lecturer. Born in Detroit, MI, July 24, 1881. Studied: Yale School of Fine Arts, with Ida Marie Perrault; Detroit School of Fine Arts. Member: Puget Sound Group of N. W. P. Awards: First prize, 11th, 12th, 14th and 16th Annual Northwest Artists Exhibitions, popular prize, 17th Annual, 1932. Work: Mural decorations in Alaska Steamship Offices, Seattle; Steamship *Alaska*; mural decorations in Olympic Hotel, Seattle, WA, and in Dayton Clinic, Dayton, OH; "Fish Pirates," Seattle Art Museum; mural, "Masterbuilders of the Northwest," Broadway High School, Seattle. Address in 1933, 5514 White Building, Seattle, WA.

ZIEGLER, FREDERICK J.
Sculptor. Born in New York, 1886. Address in 1935, Woodmere, Long Island, New York.

ZIEGLER, SAMUEL P.
Painter, lithographer and teacher. Born in Lancaster, PA, January 4, 1882. Studied: Penna. Academy of Fine Arts under Chase, Anshutz and Breckenridge; Texas Christian University, B.A., M.A. Member: Southern States Art League; American Artists Professional League; Ft. Worth Art Association; Fellowship Penna. Academy of Fine Arts; Texas Fine Arts Association; American Federation of Arts. Awards: Cresson traveling scholarship, Penna. Academy of Fine Arts, 1912; Bailey gold medal, Dallas, 1924; first still-life prize, Nashville, TN, 1927; first lithograph prize, Southern States Art League, 1929. Work: University Club, Ft. Worth; "A Texas Acropolis," Burnett Library, Texas Christian University, Ft. Worth; "Winter Landscape," Ft. Worth Museum of Art. Exhibited: Southern States Art League; regional and local annual exhibitions. Head of art department, Texas Christian University, Ft. Worth, TX, 1926-53, professor emeritus and advisor, from 1953. Address in 1933, Ft. Worth, TX. Died in 1967.

ZILVE, ALIDA.
Sculptor. Born in Amsterdam, Holland. Pupil of Allen G. Newman; Earl Stetson; Crawford. Work: Bas-reliefs, "Four Master Schooner," Seaman's Savings Bank, New York; "Pioneer," Oil City, PA; "David H. Burrell," YMCA, Little Falls, NY; "John A. Collier," Canastota Memorial Hospital, Canastota, NY; "John S. Schofield," Macon, GA; "Herman Mahnkin," YWCA, Bayonne, NJ; "Woodrow Wilson," Independent Memorial Building, United Daughters of the Confederacy, Independence, MO; "Mayor Newman," Elks Club, Paterson, NJ; "Benjamin Franklin" and "Edw. V. Walton," Roselle High School, NJ; "George Washington," Hempstead, LI; "Lafayette," Junior High School, Elizabeth, NJ; "Theodore Roosevelt," Vocational School, Perth Amboy, NJ; "General John J. Pershing," Independence Memorial Building, Independence, MO. Address in 1933, 80 Winthrop Street, Brooklyn, New York, NY. Died November 14, 1935.

ZIM, MARCO.
Etcher, painter, and sculptor. Born in Moscow, Russia, January 9, 1880. Pupil of Art Students League of New York under George Grey Barnard; National Academy of Design under Ward and Maynard; Ecole des Beaux-Arts in Paris under Bonnat.

Member: Artland Club, Los Angeles; Los Angeles Painters and Sculptors Club; Society of American Etchers. Works: Library of Congress; NY Public Libary; Art Institute of Chicago. Address in 1933, 54 West 74th Street, New York, NY.

ZIMM, BRUNO LOUIS.
Sculptor. Born in New York, December 29, 1876. Pupil of J. Q. A. Ward; Augustus Saint-Gaudens; Karl Bitter. Member: National Sculpture Society. Awards: First mention, collaborative competition, New York Architectural League, 1913; silver medal, Paris Expo., 1900. Work: Slocum Memorial and Memorial Fountain, NY; Finnegan Memorial, Houston; Murdoch Memorial, Wichita; sculpture in rotunda of Art Building, San Francisco; bust of Robert E. Lee, Baylor College, Belton, TX; panels of Sergt. York and Paul Revere, Seaboard National Bank, New York; Edward C. Young tablet, 1st National Bank, Jersey City; sculptures, St. Pancras Church, and St. Thomas Church, Brooklyn, NY; Stations of the Cross, St. Clement's Church, Philadelphia, PA. Exhibited at National Sculpture Society, 1923. Address in 1933, Woodstock, NY. Died November 21, 1943.

ZIMMELE, MARGARET SCULLY (MRS.).
Painter, sculptor and illustrator. Born in Pittsburgh, PA, September 1, 1872. Pupil of Chase, Shirlaw, Whittemore, Lathrop, Carlson, Hawthorne. Member: Society of Washington Artists; Pittsburgh Art Association; Washington Art Club; National League of American Pen Women. Address in 1933, Washington, DC; summer, Great Barrington, MA.

ZIMMERMAN, EUGENE ("ZIM").
Caricaturist. Born in Basel, Switzerland, May 25, 1862. On staff of *Puck*, from 1882; *Judge*, from 1884-1913. Author of *This and That About Caricature; Cartoons and Caricatures; Home Spun Philosophy.* Conducted correspondence school of caricature, cartooning and comic art. Address in 1929, Horseheads, Chemung Co., NY. Died March 26, 1935.

ZIMMERMAN, FREDERICK ALMOND.
Painter, sculptor and teacher. Born in Canton, OH, October 7, 1886. Studied: University of Southern California; pupil of Victor D. Brenner. Member: Scarab Club; California Art Club; Laguna Beach Art Association; Pasadena Society of Artists; Southern California Society of Arts and Crafts; American Federation of Arts; American Artists Professional League. Work: Pasadena Public Library; John Muir Public School, Seattle, WA; Monrovia (CA) High School. Exhibited: Pasadena Society of Artists; Los Angeles Museum of Art; Detroit Institute of Arts. Taught: Instructor, Pasadena Art Institute. Address in 1962, Pasadena, CA. Died November 27, 1974, in Arcadia, CA.

ZIMMERMAN, LILLIAN HORTENSE.
Sculptor. Born in Milwaukee, WI. Pupil of Art Institute of Chicago; Art Students League of New York. Member: Wisconsin Painters and Sculptors. Award: Medal and prize for sculpture, Milwaukee Art Institute, 1924. Address in 1933, Milwaukee, WI.

ZIMMERMAN, MARCO.
See Zim, Marco.

ZIMMERMAN, M(ASON) W.
Painter and block printer. Born in Philadelphia, PA, August 4, 1861. Pupil of Julian Academy; John Wesley Little. Member: Philadelphia Water Color Club; Philadelphia Sketch Club; Salma. Club; Art Alliance of Philadelphia; American Water Color Society; Washington Water Color Club; Baltimore Water Color Club; Philadelphia Society of Etchers. Awards: Dana gold medal, Penna. Academy of Fine Arts, 1920; bronze medal, Sesqui-Centennial, Philadelphia, 1926; best Philadelphia print, Philadelphia Print Club, 1931. Address in 1933, 1518 Waverly Street, Philadelphia, PA; h. Rydal, PA.

ZINSER, PAUL R.
Painter, sculptor, illustrator, and craftsman. Born in Wildbad, Germany, April 4, 1885. Pupil of J. Hopkins Adam. Member: Cincinnati Arts Club. Work: "Evening," Cincinnati Art Museum. Address in 1924, 3229 Sheffield Avenue; Highland Apts., Chicago, IL.

ZIROLI, ANGELO.
Sculptor, craftsman, and writer. Born in Italy, August 10, 1899. Pupil of Albin Polasek; Antonin Sterba; Vittorio Gigliotti. Member: Chicago Gallery of Artists; Illinois Academy of Fine Arts; All-Illinois Society of Fine Arts; Society of Medalists. Awards: Dunham prize, 1923, Shaffer prize, 1924, Art Institute of Chicago; first prize for sculpture, Society of Washington Artists, Washington, DC, 1928; Barnett prize, National Academy of Design, 1931. Author of *The Life of a Chicago Sculptor.* Work: Memorial, Randhill Park Cemetery, Arlington Heights, IL; memorial, East Chicago. Exhibited: Penna. Academy of Fine Arts; Detroit Institute of Arts; Chicago Galleries Association; Art Institute of Chicago; National Academy of Design; others. Address in 1933, 717 South Racine Ave., Chicago, IL. Died November 15, 1948.

ZOGBAUM, WILFRID.
Sculptor. Born in Newport, RI, September 10, 1915. Studied at Yale University, 1933-34; with John Sloan, NYC, 1934-35; Hofmann School, NYC and Provincetown, 1935-37 (class monitor). Works: University of California; International Institute for Aesthetic Research; New School for Social Research; San Francisco Museum of Art; Whitney. Exhibitions: Walker; Staempfli Gallery, NYC; Obelisk

Gallery, Washington, DC; Dilexi Gallery, San Francisco; Grace Borgenicht Gallery, Inc., NYC; Oakland Art Museum; Baltimore Museum of Art; Museum of Modern Art; Seattle World's Fair, 1962; Whitney Annuals; Art Institute of Chicago; Carnegie. Awards: Guggenheim Fellowship for Painting, 1937; University of California Institute for Creative Work in the Arts, 1963. Member: American Welding Society; Sculptors Guild. Taught: University of California, Berkeley, 1957, 1961-63; University of Minnesota, 1958; Pratt Institute, 1960-61; Southern Illinois University, 1961. Died in NYC, January 7, 1965.

ZOLNAY, GEORGE JULIAN.
Sculptor and teacher. Born July 4, 1863. Came to the U.S. in 1892. Pupil of Imperial Academy of Fine Arts in Vienna; National Academy of Bucharest. Member: National Arts Club; St. Louis Artists Guild; Washington Art Club; Union International des Arts et Sciences, Paris; Society of Washington Artists; Circolo Artistico, Rome; Tineremia Romana, Bucharest. Awards: Gold medal, St. Louis Expo., 1904; gold medal, Portland Expo., 1905. Decorated by the King of Romania with the Order "Bene Merenti" first class. Work: "Pierre Laclede Monument," and Confederate monument, St. Louis, MO; "Winnie Davis" and "Jefferson Davis" monuments, Richmond, VA; "Soldiers Monument" and "Sam Davis Monument," Nashville, TN; "Gen. Bartow" and "Gen. McLaws" monuments, Savannah, GA; "Soldiers Monument," Owensboro, KY; "Edgar Allan Poe Monument," University of Virginia, Charlottesville, VA; colossal, "Lions," on City Gates, University City, MO; main group, U.S. Customs House, San Francisco, CA; labor monument, New Bedford, MA; Sequoyah statue, U.S. Capitol, Washington; war memorial, and sculpture of the Parthenon, Nashville, TN. Represented in the Bucharest Royal Institute; St. Louis Museum; Herron Art Institute, Indianapolis. Address in 1933, Washington, DC; 15 Gramercy Park, New York, NY.

ZORACH, MARGUERITE THOMPSON.
(Mrs. William Zorach). Painter and craftsman. Born in Santa Rosa, CA, September 25, 1887. Studied in Paris. Member: NY Society of Women Artists; American Society of Painters, Sculptors and Gravers. Awards: Medal, Pan.-Pacific Expo., 1915; medal, Art Institute of Chicago, 1920. Work: Metropolitan Museum of Art; Whitney; Museum of Modern Art; Newark Museum; Brooklyn Museum; murals, U.S. Post Office, Peterborough, NH, and Ripley, TN.

Exhibited: Paris Salon, 1908, 11; Armory Show, NY, 1913; Forum Exhibition, New York City, 1916; Kraushaar Gallery, 1953, 57 (one-woman); Whitney, 1952. Address in 1953, 276 Hicks Street, Brooklyn, NY. Died June 27, 1968.

ZORACH, WILLIAM.
Sculptor, painter, writer, teacher, and lecturer. Born February 28, 1887, in Eurburick-Kovno, Russia. Came to U.S. in 1891. Lived in New York City and Maine. Studied at Cleveland School of Art; National Academy of Design; in Paris. Member: Sculptors Guild; American Society of Painters, Sculptors and Gravers. Taught at Des Moines Art Center; Art Students League, New York City, 1929-66. Awards: Hon. M.F.A., Bowdoin Club; D.F.A., Colby Club; Widener Memorial Medal; National Institute of Arts and Letters gold medal; New York Architectural League, honorable mention, 1937; prize, Art Institute of Chicago, 1931, medal and purchase prize, 1932; others. Exhibited at Taylor Gallery, New York; Downtown Gallery, NY (one-man); Whitney Museum; Queens College; Brooklyn Museum; Zabriskie Gallery, New York; Art Institute of Chicago; Art Students League; New York Architectural League; McNay Art Institute (one-man); Dayton Art Institute (one-man); Dallas Museum of Fine Arts (one-man); Palace of the Legion of Honor; Bowdoin College Museum of Art (one-man); Contemporary Arts Center, Cincinnati, OH; others. In collections of Phillips Academy, Andover, MA; Metropolitan Museum of Art; Museum of Modern Art; Berkshire Museum; Wichita Art Museum; Swope Art Gallery; Munson-Williams-Proctor Institute; Newark Museum; Webb Gallery, VT; Butler Institute, Youngstown, OH; Boston Museum of Fine Arts; Brooklyn Museum; Art Institute of Chicago; University of Nebraska, Lincoln; Whitney Museum; Columbia University; others. Contributor to *Magazine of Art; Creative Arts; National Encyclopaedia*; and other publications. Author of *Zorach Explains Sculpture*. Address in 1953, 276 Hicks Street, Brooklyn, NY. Died in Bath, ME, November 15, 1966.

ZYLINSKI, ANDREW.
Painter and teacher. Born May 29, 1869, in Zaile, Lithuania. Studied: Warsaw (Poland) School of Design; pupil of Wojciech and Gerson. Member: St. Louis Art League. Work: "Early Morning," Delgado Art Museum; "Mark Twain," Commercial Club, Hannibal, MO. Address in 1926, Ebenezer, NY.

BIBLIOGRAPHY

A

Addison, Julia de Wolf. *The Art of the National Gallery.* Boston: 1909.

Addison, Julia de Wolf. *The Boston Museum of Fine Arts.* Boston: 1910.

Allen, Charles D. *Classified List of Early American Book-Plates.* Accompanied by an exhibition at the Grolier Club, October, 1894. New York: 1894.

Allston, Washington. "Correspondence." *Century Magazine.*

Allston, Washington. "Exhibition of Pictures at Harding's Gallery, School Street." *North American Review,* 50 (April 1840).

Allston, Washington. *Outlines and Sketches.* Boston: 1850.

Allston, Washington. "Pictures in 1839." Record of impressions produced by the exhibition. Remarks on the progress and present state of the fine arts in the United States. *Analectic Magazine,* 6 (Nov. 1815).

"Allston's Lectures." *New Englander,* 8 (Aug. 1850).

American Academy of the Arts. Charter and by-laws. With an account of the statues, etc., belonging to the Academy. New York: American Academy of the Arts, 1815.

American Academy of the Fine Arts. Catalogues of annual exhibitions. New York: American Academy of the Fine Arts, 1816-.

American Art Annual. 37 vols. Washington, DC: American Federation of Arts, 1898-1948.

American Art Directory. New York: R. R. Bowker Co. for the American Federation of Arts, 1952-.

American Art News. New York: Weekly.

American Magazine of Art. Formerly *Art and Progress.* New York.

Amory, Martha B. *Domestic and Artistic Life of John Singleton Copley.* Boston: 1882.

Amory, Martha B. "John Singleton Copley, R. A." *Scribner's Monthly,* 21 (Mar. 1881).

Andrews, William L. "Essay on the Portraiture of the American Revolutionary War." New York: 1896.

Andrews, William L. *New Amsterdam, New Orange, New York.* A chronologically arranged account of engraved views of the city from MDCLI until MDCCC. New York: 1897.

Andrews, William L. *Paul Revere and his Engraving.* New York: 1901.

Appleton, John. "Alleged Portrait of Rev. John Wilson, with Notices of Other Early Painters." *M. H. S. Proc.,* 10 (1867).

Armstrong, William. "Some New Washington Relics." From the collection of Mrs. B. W. Kennon. *Century,* 40 (May 1890).

Artists/USA. The Buyer's Guide to Contemporary Art. Philadelphia: Artists/USA, Inc., 1970.

Arts Monthly, The. New York City.

Atlee, Samuel Y. "Hiram Powers, Sculptor." *Living Age,* Sept. 1854.

Audubon, Lucy. *The Life of John James Audubon.* New York: 1869.

Avery, Samuel P. Account of the "Gibbs-Channing" portrait of George Washington, painted by Gilbert Stuart. New York: 1900.

B

Baigell, Matthew. *Dictionary of American Art.* New York: Harper and Row Publishers, 1982.

Baker, William S. *American Engravers and Their Works.* Philadelphia: 1885.

Baker, William S. "History of a Rare Washington Print." *Pennsylvania Magazine,* 13 (1892).

Baker, William S. *Medallic Portraits of Washington.* Philadelphia: 1885.

Baker, William S. *The Engraved Portraits of Washington.* With Biographical Sketches of the Painters. Philadelphia: 1880.

Balch, Edwin S. "Art in America Before the Revolution." *Society of Colonial Wars in . . . Pennsylvania,* 2, part 1 (1908).

Bartlett, Ellen S. "John Trumbull, the Patriot Painter." *North East Magazine,* 13 (Jan. 1896).

Bates, Albert C. *An Early Connecticut Engraver (Richard Brunton) and His Work.* Hartford: 1906.

Baxter, Sylvester. "Handbook of the Boston Public Library." Boston: 1916.

Bayley, Frank W. *Life and Works of John Singleton Copley.* Boston: 1915.

Bayley, Frank W. *Little-Known Early American Portrait Painters.* 3 vols. Boston: 1915-17.

Benezit, Emmanuel, ed. *Dictionnaire Critique et Documentaire des Peintres, Sculpteurs, Dessinateurs et Graveurs.* New ed., 10 vols. Paris: Grund, 1976.

Benjamin, Samuel G. W. *Art in America.* A critical and historical sketch. New York: 1880.

Benjamin, Samuel G. W. "Early American Art." *Harper's Magazine,* 59 (Nov. 1879).

Benjamin, Samuel G. W. "Fifty Years of American Art, 1828-1878." 3 articles. *Harper's Magazine,* 59 (1879).

Berry, Rose V. S. "John Singer Sargent: Some of His American Work." *American Architect and Architectural Review,* Sept. 1924, pp. 83-112.

Biddle, Edward, and Charles H. Hart. *Memoirs of the Life and Works of Jean Antoine Houdon.* Philadelphia: 1911.

Biddle, Edward, and Mantle Fielding. *Life and Works of Thomas Sully.* Including catalogue of 2631 of his paintings. Philadelphia: 1921.

Blackall, C. H. "Sargent Decorations in the Boston Museum of Fine Arts." *American Architect and Architectural Review,* 29 Mar. 1922.

Blashfield, Edwin H. *Mural Painting in America.* New York: 1913.

Bolton, Ethel S. *Wax Portraits and Silhouettes.* Boston: 1914.

Bolton, Theo. *Early American Miniature Painters.* 1921.

Boston Art Club. *Report of . . . Memorial Meeting in Honor of the Late Mr. Joseph Andrews (Engraver).* Boston: Boston Art Club, 1873.

Boston Athenaeum. *Catalogue at 1st (to 50th) Exhibition of Paintings and Sculpture at the Athenaeum Gallery.* Boston: Boston Athenaeum, 1827-73.

Boston Public Library. List of books and magazine articles on American engraving, etching and lithography. *Boston Public Library Monthly Bulletin,* 9 (Dec. 1904).

Boston Public Library. List of portraits of Benjamin Franklin owned by the Public Library of City of Boston. *Boston Public Library Monthly Bulletin,* 11 (July 1892).

Bowdoin College. Catalogue of art collection. Compiled by Henry Johnson. Brunswick: 1906.

Bowen, Clarence W. *History of the Centennial Celebration of the Inauguration of George Washington.* New York: 1892.

Bowen, Clarence W. "The Inauguration of Washington." *Century,* 37 (Apr. 1889).

Bowles, Samuel. "Chester Harding." *Atlantic,* 19 (Apr. 1867).

Bradley, Joseph P. "Saint-Memin's Portrait of Marshall." *Century,* 38 (Sept. 1889).

Breck, Joseph. "Two Portraits by Charles Willson Peale." *Art in America,* 2 (Oct. 1914).

Brewer, Thomas M. "Reminiscences of John James Audubon." *Harper's Magazine,* 61 (Oct. 1880).

Brinton, Christian. "Sargent and His Art." *Munsey's Magazine,* Dec. 1906.

Brinton, Christian. *Modern Artists.* New York: 1908.

Brookgreen Gardens. *Brookgreen Gardens.* Sculpture pamphlets. Brookgreen, SC: Brookgreen Gardens, 1937.

Brooklyn Institute of Arts and Sciences. *Early American Paintings.* Catalogue of an exhibition, February 3-March 12, 1917. New York: Brooklyn Institute of Arts and Sciences, 1917.

Brown, William G. *List of Portraits in the Various Buildings of Harvard University.* Cambridge: Harvard University Library, Bibliographical Contributions, No. 53, 1898.

Browne, Nina E., and William Coolidge Lane. *A. L. A. Portrait Index.* Index to Portraits Contained in Printed Books and Periodicals. New York: Burt Franklin.

Bryan, Michael. *Bryan's Dictionary of Painters and Engravers,* G. C. Williamson, ed. 5 vols. London: 1903-05.

Bryant, Lorinda M. *American Pictures and Their Painters.* New York: 1917.

Budd, Henry. "Thomas Sully." *Pennsylvania Magazine,* April 1918.

Burch, R. M. *Color Printing and Color Printers.* New York: 1920.

Burr, Frederic M. *Life and Works of Alexander Anderson, M.D., the First American Wood Engraver.* New York: 1893.

C

Caffin, Charles H. *American Masters of Painting.* New York: 1902.

Caffin, Charles H. "Drawings by John S. Sargent." *Metropolitan Magazine,* July 1909, pp. 413-418.

Caffin, Charles H. "John S. Sargent, the Greatest Contemporary Portrait Painter." *World's Work,* Nov. 1903, pp. 4099-4116.

Caffin, Charles H. *The Story of American Painting.* New York: 1907.

Carrington, Fitzroy. *Prints and Their Maker.* New York: Century Co., 1912.

Carson, Hampton L. *Life and Works of Benjamin West.*

Carson Sale. "Collection of Engraved Portraits (Belonging to Hampton L. Carson)." Compiled by S. V. Henkels. 4 vols. Philadelphia: 1904.

Cary, Elizabeth L. "The Gallery of National Portraiture in the Pennsylvania Academy." *Scrip,* 2 (Aug. 1907).

Catlin, George. *Catalogue Descriptive and Instructive of Indian Cartoons.* New York: 1871.

Champlin, John D., Jr., and Charles C. Perkins. *Cyclopedia of Painters and Paintings.* 4 vols. New York: 1886-1887.

Cheney, Ednah D. *Memoir of John Cheney, Engraver.* Boston: 1889.

Cheney, Ednah D. *Memoir of Seth W. Cheney, Artist.* Boston: 1881.

Cheney, John, and Seth Wells. *Catalogue of the Engraved and Lithographed work by Sylvester R. Koehler.* Boston: 1891.

Clark Sale. *Catalogue of the Dr. Charles E. Clark Collection of American Portraiture.* Sold January 15-17, 1901. Boston: 1901.

Clay Sale. *Rare and Valuable Collection of Portraits and Choice Engravings Gathered by J. Henry Clay.* Sold December 3-4, 1897. Philadelphia: 1897.

Clement, Clara E. "Early Religious Painting in America." *North East Magazine,* 11 (Dec. 1894).

Clement, Clara E., and Laurence Hutton. *Artists of the Nineteenth Century and Their Works.* Boston: 1880.

Clement, Clara Erskine. *Painters, Sculptors, Architects, Engravers and Their Works.* 13th ed. Boston: 1895.

Cleveland, Edith R. "Archibald Robertson and His Portraits of the Washingtons." *Century,* 40 (May 1890).

Cleveland Museum of Art. *Catalogue of the Inaugural Exhibition, June 6 to September 20, 1916.* Cleveland: 1916.

Cline, I. M. *Artists of New Orleans.*

Coad, Oral S. *William Dunlap.* A study. New York: 1917.

Coburn, Frederick W. "The Sargent Decorations in the Boston Public Library." *American Magazine of Art,* Feb. 1917.

Coffin, William A. "The Sargent Loan Exhibition in Boston." *New York Sun,* Feb. 1917.

Colden, Cadwallader D. *Life of Robert Fulton.* New York: 1817.

Collins, Jim, and Glenn B. Opitz. *Women Artists in America.* 18th Century to the Present. 1790-1980. Poughkeepsie, New York: Apollo, 1980.

Colonial Dames of America. *Ancestral Records and Portraits.* A compilation from the archives of Chapter I. 2 vols. New York: Colonial Dames of America, 1910.

Conant, Samuel S. "Progress of the Fine Arts." *First Century of the Republic,* pp. 399-415. New York: 1817.

Cope, Edward R. *Sale of Engravings.* Catalogue compiled by S. V. Henkels. Philadelphia: May 1896.

Copley, John S., and Henry Pelham. *Letters and Papers, 1739-1776.* Vol. 71. Boston: Massachusetts Historical Society, Collections, 1914.

Copley, Stuart and Allston. "Exhibition at the Boston Athenaeum." *Old and New,* 4 (Dec. 1871).

Copley Society, Boston. Catalogues of loan exhibitions. Boston: Various dates.

Cortissoz, Royal. "John S. Sargent." *Scribner's Magazine,* various dates.

Cortissoz, Royal. "Sargent, the Painter of Modern Tenseness." *Scribner's Magazine,* March 1924, pp. 345-352.

Cox, Kenyon. *Old Masters and New.* New York: 1905, pp. 145, 146, 244, 255, 265.

Cox, Kenyon. "Two Ways of Painting." *Scribner's Magazine,* 52.

Craven, Wayne. *Sculpture in America From the Colonial Period to the Present.* New York: T. Y. Crowell, 1968.

Cummings, Paul. *Dictionary of Contemporary American Artists.* New York: St. Martin's Press, 1971.

Cummings, Thomas S. *Historical Annals of the National Academy of Design.* Philadelphia: 1865.

Cunningham, Allan. *Lives of the Most Eminent British Painters and Sculptors.* 6 vols. London: 1829-1837.

Cunningham, Henry W. *Christian Remick, An Early Boston Artist.* Boston: 1904.

Currier, John J. "History of Newburyport, Mass., 1764-1909." *Authors, Artists and Engravers,* vol. 2, chap. 24. Newburyport: 1909.

Custis, George W. Parke. "Recollections and Private Memoirs of Washington." *Portraits of Washington,* chap. 27. New York: 1860.

D

Dalton, Charles H. Letter to Winthrop Murray Crane, with some account of Houdon's statue of Washington and of Stuart's original portrait. Cambridge: 1906.

Darrach, Charles G. "Christian Gobrecht, Artist and Inventor." *Pennsylvania Magazine,* 30 (1906).

Davol, Ralph. "Early American Artists." *North East Magazine,* 45 (Jan. 1912).

Dawdy, Doris Ostrander. *Artists of the American West.* 3 vols. Chicago: The Swallow Press, 1974.

Delaplaine, Joseph. *Delaplaine's Repository of the Lives and Portraits of Distinguished American Characters.* Philadelphia: 1815.

Detroit Institute of Arts. *Michigan Artists 80-81.* Catalogue. Detroit: Detroit Institute of Arts.

Dexter, Arthur. "The Fine Arts in Boston." *Memorial History of Boston,* Justin Winsor, ed., vol. 4, pp. 383-414. Boston: 1880-1881.

Dexter, J. Reynolds. "Notable Paintings From Old Salem." *North East Magazine,* 39 (Dec. 1908).

Dickinson, H. W. *Robert Fulton, Engineer and Artist.* London: 1913.

Dodge, Pickering. *Painting - Its Rise and Progress*. Boston: 1846.

Downes, William H. "Boston Painters and Paintings." *Atlantic*, 6 articles (1 and 2), 62 (1888).

Downes, William H. *John S. Sargent, Life and Works*. Boston: 1925.

Downes, William H. "Stuart's Portraits of Washington." *North East Magazine*, 9 (Feb. 1894).

Downes, William H. *Winslow Homer, Life and Works*. Boston: 1911.

Downes, William H., and Frank T. Robinson. "Our American Old Masters." *North East Magazine*, 13 (Nov. 1895).

Downes, William Howe. *Twelve Great Artists*, pp. 165 et seq. Boston: 1900.

Dunlap, William. Address to the students of the National Academy of Design, 18th of April, 1831. New York: 1831.

Dunlap, William. Description of Dunlap's Painting of Christ Rejected by the High Priest, Elders and People. Norfolk: 1820.

Dunlap, William. *History of the Rise and Progress of the Arts of the Design in the United States*. New York: 1834 (2 vols.), 1918 (3 vols., revised edition).

Durand, John. "John Trumbull." *American Art Review*, 2 (1881).

Durand, John. *Life and Times of Asher B. Durand*. New York: 1894.

E

Earle, Alice M. *Two Centuries of Costume in America*. 2 vols. New York: 1903.

Edes, Henry H. "Chief Justice Martin Howard and his Portrait by Copley." *Colonial Society of Massachusetts Publications*, 6 (Mar. 1900).

Ehrich Galleries. *One Hundred Early American Paintings*. New York: 1918.

Ekdahl, Janis. *American Sculpture*. A Guide to Information Sources. Detroit: Gale Research Co., 1977.

Essex Institute. *Historical Collections*. 52 vols. Salem: Essex Institute, 1859-1916.

Etting, Frank M. *Historical Account of the Old State House of Pennsylvania*. Boston: 1876.

Etting, Frank M. "Portraiture of William Penn." *Scribner's Monthly*, 12 (May 1876).

F

Fairman, Charles E., compiler. *Works of Art in the United States Capitol Building, Including Biographies of the Artists*. Washington: 1913.

Falk, Peter Hastings. *Who Was Who in American Art*. Madison, CT: Sound View Press, 1985.

Federation of Modern Painters and Sculptors, Inc. *35th Anniversary Exhibition*. Catalogue. New York: The Federation of Modern Painters and Sculptors, Inc.

Felt, Joseph B. *Annals of Salem*. 2 vols., 2nd ed. Salem: 1845-1849.

Fenollosa, Ernest F. *Mural Paintings in the Boston Public Library*, pp. 19-28. Boston: 1896.

Fevret de Saint-Memin, Charles B. J. *The St. Memin Collection of Portraits*. New York: 1862.

Fielding, Mantle. *American Engravers Upon Copper and Steel*. A supplement to Stauffer's American engravers. Philadelphia: 1917.

Fielding, Mantle. *Catalogue of the Engraved Works of David Edwin*. Philadelphia: 1905.

Fielding, Mantle. "Edward Savage and His Washington Family." *Pennsylvania Magazine of History and Biography*.

Fielding, Mantle. "Joseph Andrews." *Pennsylvania Magazine*, 31 (1907).

Fielding, Mantle. *Memoir and Catalogue of Paintings by John Neagle for Memorial Exhibition at Penna. Academy of Fine Arts*. Philadelphia: 1925.

Fielding, Mantle. "Portraits Not Mentioned in Mason's *Life and Works of Gilbert Stuart*." *Pennsylvania Magazine*, 38 (1914).

Fielding, Mantle. *Portraits of George Washington by Gilbert Stuart*. Philadelphia: 1923.

Flagg, Jared B. *Life and Letters of Washington Allston*. New York: 1892.

Ford, Paul L. "Some Pelham-Copley Letters" *Atlantic*, 71 (Apr. 1893).

Foster, Joshua J. *Miniature Painters, British and Foreign, With Some Account of Those Who Practiced in America in the Eighteenth Century*. 2 vols. New York: 1903.

Fowler, Frank. "Metropolitan Museum of Art." The American School. Some early painters. *Scribner's Magazine*, 42 (July 1907).

Fowler, Frank. "The Sully Portraits at the U.S. Military Academy, West Point." *Scribner's Magazine*, 43 (Jan. 1908).

Fowler, Frank. "The Work of John S. Sargent." *Bookman*, Jan. 1904, pp. 537-539.

Fraser, Charles. *Catalogue of Miniature Portraits, Landscapes, etc*. Accompanied by a life of the artist. Charleston: 1857.

French, Harry W. *Art and Artists of Connecticut*. Boston: 1879.

G

Galt, John. *Life, Studies and Works of Benjamin West*. London: 1820.

Gardiner Greene Hubbard Collection. *Catalogue of the Gardiner Greene Hubbard Collection of Engravings*. Presented to the Library of Congress. Catalogue compiled by Arthur J. Parsons. Washington: 1905.

Gavin, William J., III, and Robert F. Perkins, Jr., ed. *The Boston Athenaeum Art Exhibition Index 1827-1874*. Boston: The Boston Athenaeum, 1980.

Gilliams, E. Leslie. "A Philadelphia Sculptor: William Rush." *Lippincott's Magazine*, 52 (Aug. 1893).

Goodwin, Daniel, Jr. "Early Painters of Bostonians." *Proceedings on Presentations of Portrait of Gen. Henry Dearborn*, pp. 5-8. Chicago: Calumet Club, 1886.

Goss, Elbridge H. *Life of Colonel Paul Revere*. 2 vols. Boston: 1891.

Graves, Algernon. *Dictionary of Artists*. 8 vols. London: 1905-06.

Green, Samuel A. *John Foster, the Earliest American Engraver*. Boston: 1909.

Green, Samuel A. "John Foster, the Earliest Engraver in New England." *M. H. S. Proc.*, 19, 2nd ser. (1905).

Green, Samuel A. Remarks on an original portrait of Rev. Increase Mather, D.D., and on some of the engravings taken from it. Cambridge: 1893.

Green, Samuel A. Remarks on *The Boston Magazine* and John Norman, engraver. Cambridge: 1904.

Greenough, Henry. "Washington Allston as a Painter." *Scribner's Magazine*, 11 (Feb. 1892).

Greenwood, Isaac J. "Remarks on the Portraiture of Washington." *Magazine of American History*, 2 (Jan. 1878).

Griswold, Rufus W. *The Republican Court*. American Society in the Days of Washington. New York: 1867.

Groce, George C., and David H. Wallace. *The New York Historical Society's Dictionary of Artists in America*. 1564-1860. New Haven and London: Yale University Press, 1957.

Grohmann, Will, ed. *Art of Our Time*. Painting and Sculpture Throughout the World. London: Thames and Hudson, 1966.

Grolier Club. *Catalogue of Exhibition on Lithography*. Grolier Club, 1796-1896.

Grolier Club. *Catalogue of the Engraved Work of Asher B. Durand*. Exhibited April, 1895. New York: Grolier Club, 1895.

Grolier Club. *Exhibition of Engraved Portraits of Washington, December 14, 1899, to January 6, 1900*. New York: Grolier Club, 1895.

H

Haddon, Rawson W. "The Roger Morris House, or Jumel Mansion, New York City." *Arch. Record*, 42 (1917).

Hale, Edward E. "The Early Art of Thomas Cole." *Art in America*, 4 (Dec. 1915).

Halsey, R. T. H. "Malbone and His Miniatures." *Scribner's Magazine*, 47 (May 1910).

Halsey Sale. *The Frederic R. Halsey Collection of Prints*. Part I, Americana. Sold November 1-3, 1916. New York: 1916.

Hamerton, Philip Gilbert. *Etching and Etchers*. Boston: 1876.

Hardie, James. *New Universal Biographical Dictionary*. 4 vols. New York: 1805.

Harding, Chester. *My Egotistography*. Cambridge: 1866.

Harrison, C. C. "Home and Haunts of Washington." *Century*, Nov. 1887.

Harrison, Constance C. "Washington at Mount Vernon after the Revolution." *Century*, 37 (Apr. 1889).

Harrison, Constance C. "Washington in New York in 1789." *Century*, 37 (Apr. 1889).

Hart, Charles H. *An Etched Profile Portrait of Washington by Joseph Hiller, 1794*. Essex Institute Historical Collection, 43 (1907).

Hart, Charles H. "An Original Portrait of Dr. Franklin, Painted by Joseph Wright." *Pennsylvania Magazine*, 32 (1908).

Hart, Charles H. "An Unpublished Life Portrait of Washington." *McClure's Magazine*, 8 (Nov. 1896).

Hart, Charles H. "Anthony Wayne." Presentation of His Portrait (by Henry Elouis). *Pennsylvania Magazine*, 35 (1911).

Hart, Charles H. *Catalogue of the Engraved Portraits of Washington*. New York: 1904.

Hart, Charles H. "Jouett's Kentucky Children." *Harper's Magazine*, 101 (June 1900).

Hart, Charles H. "Life Portraits of Alexander Hamilton." *McClure's Magazine*, 8 (Apr. 1897).

Hart, Charles H. "Life Portraits of Andrew Jackson." *McClure's Magazine*, 9 (July 1897).

Hart, Charles H. "Life Portraits of Benjamin Franklin." *McClure's Magazine*, 8 (Jan. 1897).

Hart, Charles H. "Life Portraits of Daniel Webster." *McClure's Magazine*, 8 (Feb. 1897).

Hart, Charles H. "Life Portraits of George Washington." *McClure's Magazine*, 8 (Feb. 1897).

Hart, Charles H. "Life Portraits of Thomas Jefferson." *McClure's Magazine*, 9 (Sept. 1897).

Hart, Charles H. "Original Portraits of Washington." *Century*, 37 (Apr. 1889).

Hart, Charles H. "Original Portraits of Washington." *Century*, 40 (May 1890).

Hart, Charles H. "Portrait of Abraham Hasbrouck by John Vanderlyn." *Art in America*, 5 (Feb. 1917).

Hart, Charles H. "Portrait of Jacques Louis David by Rembrandt Peale." *Art in America*, 3 (Aug. 1915).

Hart, Charles H. "Portrait of Jean Antoine Houdon by Rembrandt Peale." *Art in America*, 3 (Feb. 1915).

Hart, Charles H. "Portrait of John Grimes by Matthew Harris Jouett." *Art in America*, 4 (Apr. 1916).

Hart, Charles H. "Portrait of Richard Mentor Johnson by John Neagle." *Art in America*, 4 (Aug. 1916).

Hart, Charles H. "Portrait of Thomas Dawson, Viscount Cremorne, by Mather Brown." *Art in America*, 5 (Oct. 1917).

Hart, Charles H. *Portraits of Patrick Henry*. Philadelphia: Numismatic and Antiquarian Society of Philadelphia, 1911.

Hart, Charles H. "The Wilson Portrait of Franklin." *Pennsylvania Magazine*, 30 (1906).

Hart, Charles H. "Thomas Mifflin and Sarah Morris Mifflin by John Singleton Copley." *Art in America*, 5 (June 1917).

Hart, Charles H. "Unknown Life Masks of Great Americans." *McClure's Magazine*, 9 (Oct. 1897).

Hart, Charles H. "Washington Portraits." *American Historical Association Annual Report*, 1 (1896).

Havelice, Patricia Pate. *Index to Artistic Biography*. 2 vols., supplement. Metuchen, NJ: The Scarecrow Press, Inc., 1973.

Hazelton, John H. "The Historical Value of Trumbull's Declaration of Independence." *Pennsylvania Magazine*, 31 (1907).

Healy, George P. A. *Reminiscences*. Chicago: 1894.

Henderson, Helen W. *The Art Treasures of Washington*. Boston: 1912.

Henkels, S. V. *Engraved Portraits of Washington and Other Notable Americans*. Sale catalogue. Philadelphia: 1906.

Hensel, William U. "Jacob Eichholtz, Painter." *Pennsylvania Magazine*, 37 (1913).

Heraldic Journal. Recording the armorial bearings and genealogies of American families. 4 vols. Boston: 1865-68.

Herrick, Francis H. *Audubon the Naturalist*. 2 vols. New York: 1917.

Hesselius, Gustavus. "The Earliest Painter and Organ-Builder in America." *Pennsylvania Magazine*, 29 (1905).

Hind, A. M. *History of Engraving and Etching*. Boston: 1908.

Historical Society of Pennsylvania. *Pennsylvania Magazine of History and Biography*. 41 vols. Philadelphia: Historical Society of Pennsylvania, 1877-1917.

Hitchcock, J. Ripley W. *Etching in America*. New York: 1886.

Hoeber, Arthur. "The Story of Art in America." *Bookman*, 30-31, 4 articles (1-3) (1910).

Hoeber, Arthur. *The Treasures of the Metropolitan Museum of Art*. New York: 1899.

Holden Sale. *Catalogue of the Collection of Americana and Engravings Formed by Edwin Babcock Holden*. Sold April 21 to May 5, 1910. Compiled by Robert Fridenberg. New York: 1913.

Howe, Winifred E. *History of the Metropolitan Museum of Art*. With a chapter on the early institutions of art in New York. New York: 1913.

Hubard, William J. "A National Standard for the Likeness of Washington." *Magazine of American History*, 4 (Feb. 1880).

Hunter, Sam. *Modern American Painting and Sculpture*. New York: Dell Publishing Co., 1959.

Huntington, Daniel. *A. B. Durand*. A memorial address. New York: 1887.

Hyde, Charles C. "John Trumbull - A Historian in Color." *Magazine of American History*, 28 (Oct. 1892).

I

Independence Hall, Philadelphia. *Catalogue of the National Portraits*.

International Directory of Arts. 16th and 17th ed. 2 vols. New York: R. R. Bowker Co., 1984, 85.

Isham, Samuel. *History of American Painting*. New York: 1905.

Isham, Samuel. "Two Portraits by Gilbert Stuart." *McClure's Magazine*, June 1908.

J

Jackson, Henry E. *Benjamin West*. His Life and Works. Philadelphia: 1900.

Jackson, Joseph. "Bass Otis, America's First Lithographer." *Pennsylvania Magazine*, 37 (1913).

Jognston, Elizabeth B. *Original Portraits of Washington*. Boston: 1882.

K

Karpel, Bernard, ed. *Arts In America*. A Bibliography. 4 vols. Washington: Smithsonian Institution Press, 1979.

Kent, Henry W., and Florence N. Levy. *Judson-Fulton Celebration*. Catalogue of Art Exhibition at the Metropolitan Museum, 1909. New York: 1909.

Kepple, Frederick. *The Golden Age of Engraving*. New York: 1910.

Kimball, Fiske. "The Genesis of the White House. *Century*, 95 (Feb. 1918).

Kimball, Fiske. "Thomas Jefferson and the First Monument of the Classical Revival in America." *American Institute of Architects, Journal*, 3 (1915).

Kip, William I. "Recollections of John Vanderlyn, the Artist." *Atlantic*, 19 (Feb. 1867).

Koehler, Sylvester R. *American Painters*. London: 1883.

Koehler, Sylvester R. *Catalogue of the Engraved and Lithographed Work of John Cheney and Seth Wells Cheney*. Boston: 1891.

Koehler, Sylvester R. "Painting in America." *English Painters*, by Harry J. W. Buxton, pp. 185-222. London: 1883.

Krannert Art Museum. *Twelfth Exhibition of Contemporary American Painting and Sculpture*. Catalogue. March 7 through April 11, 1965. Urbana: University of Illinois Press, 1965.

L

Lake, Carlton, and Robert Maillard. *Dictionary of Modern Painting*. New York: Tudor Publishing Co.

Lamb, Martha J. "Benjamin West." *Magazine of American History*, 27 (Mar. 1892).

Lamb, Martha J. "The Ingham Portrait of De Witt Clinton." *Magazine of American History*, 27 (May 1892).

Lamb, Martha J. "Unpublished Washington Portraits." Some of the Early Artists. *Magazine of American History*, 19 (Apr. 1888).

Latrobe, John H. B. *The Capitol and Washington at the Beginning of the Present Century*. Baltimore: 1881.

Lee, Hannah F. *Familiar Sketches of Sculpture and Sculptors*. 2 vols. Boston: 1854.

Leslie, Charles R. *Autobiographical Recollections*. 2 vols. London: 1860.

Lester, Charles E. *Artists of America*. New York: 1846.

Lester, Charles E. "Charles Loring Elliott." *Harper's Magazine*, 38 (Dec. 1868).

Levis, Howard C. *Bibliography of American Books Relating to Prints and the Art and History of Engraving*. London: 1910.

Lincoln, N. L. Engraved Portraits of American Patriots by Saint-Memin.

Linton, William J. *History of Wood Engraving in America*. Boston: 1882.

Linton, William J. *The Masters of Wood Engraving*. New Haven: 1889. "Lithography." With an original lithograph by Bass Otis. *Analectic Magazine*, 14 (July 1819).

"Lithography." With lithograph by T. Edwards. *Boston Monthly Magazine*, 1 (Dec. 1825).

Longacre, James B., and James Herring. *National Portrait Gallery of Distinguished Americans*. 4 vols. New York: 1834-1839.

Lossing, Benson J. *The Home of Washington (or Mount Vernon and its Associations)*. Hartford: 1870.

Lossing, Benson J. "The National Academy of the Arts of Design and its Surviving Founders." *Harper's Magazine*, 66 (May 1883).

Lounsbery, Elizabeth. "American Miniature Painters." *The Mentor*, No. 123, 15 January 1917.

Low, Will H. "A Century of Painting in America; Fathers of Art in America." *McClure's Magazine*, 20 (Feb. 1903).

Lucas, E. V. *Edwin Abbey - Life and Works*. 2 vols. London: 1921.

M

Macbeth Gallery, New York. *Paintings by American Artists*. Colonial portraits. New York: 1914.

"Malbone, Edward G." Biographical notice of. *Analectic Magazine*, 6 (Sept. 1815).

Mallett, Daniel Trowbridge. *Mallett's Index of Artists*. 1 vol., supplement. New York: Peter Smith, 1948.

Mason, George C. *Life and Works of Gilbert Stuart*. New York: 1879.

Massachusetts Historical Society. "List of Portraits in the Hall of the Historical Society." *Massachusetts Historical Society Collections*, 3rd ser., 7 (1838).

McCall, Dewitt Clinton, III. *California Artists 1935 to 1956*. Jones and McCall Enterprises, 1981.

McCracken, Harold. *Portrait of the Old West*. New York: McGraw-Hill Book Company, Inc., 1952.

McGlauflin, Alice Coe. *Dictionary of American Artists*. 19th and 20th Century. Poughkeepsie, NY: Apollo, 1982.

McRae, Sherwin. *George Washington*. His person as represented by the artists. Richmond: 1873.

McSpadden, J. Walter. *Famous Painters of America*. New York: 1907.

Metropolitan Museum of Art. *Catalogue of an Exhibition of Colonial Portraits, November 6 to December 31, 1911*. New York: 1911.

Metropolitan Museum of Art. Catalogues. New York: various dates.

Michigan State Library. *Biographical Sketches of American Artists*. 3rd ed. Lansing: 1915.

Mitchell Sale. *Unequaled Collection of Engraved Portraits . . . Belonging to James T. Mitchell*. Sold January 18, 1906, to February 27, 1908. Compiled by S. V. Henkels. 6 vols. Philadelphia: 1906-1908.

Montgomery, Walter, editor. *American Art and American Art Collections*. 2 vols. Boston: 1889.

Morgan, John H. *Early American Painters*. In New York Historical Society.

Morgan, John H. "The Work of M. Fevret de Saint-Memin." *Brooklyn Museum Quarterly*, 5 (Jan. 1918).

Morris, Harrison S. *Memoir of William T. Richards*.

Morse, Edward L., ed. *Samuel F. B. Morse - Letters and Journals*. 2 vols. Boston: 1914.

Munn, Charles A. *Three Types of Washington Portraits*. New York: 1908.

Murdock, Kenneth B. *Portraits of Increase Mather*.

Museum of Fine Arts. *Descriptive Catalogue of an Exhibition of Early Engraving in America, December 12, 1904, to February 5, 1905.* Cambridge, 1904.

Museum of Fine Arts. *Exhibition of Portraits Painted by Gilbert Stuart, May 4, 1880.* Boston: 1880.

Museum of Fine Arts. *Exhibition of the Works of Washington Allston, July 18, 1881.* Boston: 1881.

Muther, Richard. *History of Modern Painting.* 4 vols. New York: 1896.

N

National Academy of Design. *Catalogue of Centennial Exhibition, 1925.*

National Academy of Design. Catalogues of annual exhibitions (1st, 1826). New York: Various dates.

National Academy of Design. *1825-1975 - A Century and a Half of American Art.* New York: National Academy of Design, 1975.

National Cyclopaedia of American Biography. 15 vols. New York: James T. White and Co., 1898-1908.

National Sculpture Society. *American Sculpture Exhibition.* Catalogue. New York: National Sculpture Society, 1923.

National Sculpture Society. *Membership 1980-81-82.* Catalogue. New York: National Sculpture Society.

Naylor, Maria, ed. *The National Academy of Design Exhibition Record 1861-1900.* 2 vols. New York: Kennedy Galleries, 1973.

New International Encyclopaedia. 23 vols. New York: 1914-1916.

New York Art Commission. *Catalogue of the Works of Art Belonging to the City of New York.* New York: 1909.

New York Historical Society. *Gallery of Art.* Catalogue. New York: 1915.

New York Public Library. "Check List of Engraved Views of the City of New York in the New York Public Library." *New York Public Library Bulletin,* 5 (1901).

New York Public Library. *Historical Prints and Early Views of American Cities.* Catalogue of loan exhibition, April to October, 1917. New York: 1917.

Noble, Louis L. *Life and Works of Thomas Cole.* 3rd edition. New York: 1856.

O

Olana's Guide to American Artists. A Contribution Toward a Bibliography. 2 vols. Riverdale, NY: Olana Gallery, 1978.

Opitz, Glenn B., ed. *Dictionary of American Sculptors.* New York: Apollo, 1984.

Ord, George. *Sketch of the Life of Alexander Wilson.* Philadelphia: 1828.

Ormsby, Waterman L. *Description of the Present System of Banknote Engraving.* New York: 1852.

Osgood, Samuel. *Thomas Crawford.* New York: 1875.

P

Paine, Nathaniel. "Early American Engravings . . . in the Library of the American Antiquarian Society." *Antiquarian Society Proc.,* N. S., 17 (Apr. 1906).

Park, Lawrence. "Joseph Badger, 1708-1765, and a Descriptive List of Some of His Works." *M. H. S. Proc.,* 51 (1918).

Parkman, Francis. "Report on the Alleged Sharpless Portraits of Washington." *M. H. S. Proc.,* 2nd ser., 3 (Jan. 1887).

Peacock, Virginia T. *Famous American Belles.* Philadelphia: 1901.

Peale, Charles W. "Extracts From Correspondence Relative to Establishment of the Academy of the Fine Arts, Philadelphia." *Pennsylvania Magazine,* 9 (1885).

Peale, Rembrandt. *Catalogue of Original Paintings.* Sold Nov. 18, 1862. Philadelphia: 1862.

Peale, Rembrandt. *Peale's "Court of Death."* Biographical sketch and history of the painting. New York: 1845.

Peale, Rembrandt. *Portrait of Washington* (testimonials). Philadelphia: 1824.

Peale, Rembrandt. "Washington Portraits." Four letters. *Magazine of American History,* 5 (Aug. 1880).

Peck, Grace B. "Amateur Art in Early New England." *Harper's Magazine,* 104 (May 1902).

Pennell, E. R. and J. *Life of James McNeill Whistler.* Philadelphia: 1907.

Pennell, Joseph. *Adventures of an Illustrator.* Boston: 1925.

Pennell, Joseph. *The Illustration of Books.* New York: Century Co.

Pennsylvania Academy of the Fine Arts. *Catalogues of Annual Exhibitions.* Philadelphia: Pennsylvania Academy of the Fine Arts, 1811-.

Pennsylvania Academy of the Fine Arts. *Descriptive Catalogue of the Permanent Collection, Philadelphia.* Philadelphia: Pennsylvania Academy of the Fine Arts, various dates.

Perkins, Augustus T. "Additional Notes on the Portraits by Blackburn and Smibert." *M. H. S. Proc.,* 17 (May 1879).

Perkins, Augustus T. *Sketch of the Life of John Singleton Copley.* Boston: 1873.

Perkins, Augustus T. "Sketches of the Artists Blackburn and Smibert." *M. H. S. Proc.,* 16 (Dec. 1878).

Philadelphia Museum. *Historical Collection of Paintings.* Philadelphia, 1813.

Piers, Harry. "Artists in Nova Scotia." *Nova Scotia Historical Society Collection,* 18 (1914).

Poland, William C. *Robert Feke, the Early Newport Painter, and the Beginnings of Colonial Painting.* Providence: 1907.

Pousette-Dart, Nathaniel. *Memoir of Robert Henri.*

Pratt, Herbert L. *Catalogue of American Paintings.*

Pratt, Matthew. "Autobiographical Notes of Matthew Pratt, Painter." *Pennsylvania Magazine,* 19 (1895).

Preyer, David C. *The Art of the Metropolitan Museum of New York.* Boston: 1909.

Price, Samuel W. *Old Masters of the Bluegrass.* Louisville.

Prince, S. Irenaeus. *Life of S. F. B. Morse.* New York: 1875.

Print Collector's Quarterly. 12 vols.

Print Connoisseur. 1921, 22, 23.

Proske, Beatrice Gilman. *Brookgreen Gardens.* Sculpture. Brookgreen, SC: Brookgreen Gardens, 1943.

R

Rathbun, Richard. *The National Gallery of Art.* 2nd ed. Washington: 1916.

Redgrave, Richard, and Samuel Redgrave. *A Century of Painters of the English School.* 2nd ed. London: 1890.

Redwood Library, Newport. *Catalogue of Art Collection.* Newport: 1885.

Reigart, J. Franklin. *Life of Robert Fulton.* Philadelphia: 1856.

Richter, Emil H. *Prints and Their History.* Boston: 1914.

Robinson, Frank T. *Living New England Artists.* Boston: 1888.

Robinson, Jeanie F. J., and Henrietta C. Bartlett, editors. *Genealogical Records . . . From Family Bibles.* New York: 1917.

Rogers, Edmund L. "Some New Washington Relics, II." From the collection of Edmund Law Rogers. *Century,* 40 (May 1890).

Rogers, Edmund Law. *Sale of Engravings.* Catalogue compiled by S. V. Henkels. Philadelphia: 1896.

Rubinstein, Charlotte Streifer. *American Women Artists.* From Early Indian Times to the Present. Boston and New York: G. K. Hall and Co., and Avon Books, 1982.

S

Sachse, Julius F. *Portraits and Busts in the Collection of the American Philosophical Society.* Philadelphia: 1898.

Samuels, Peggy and Harold. *Contemporary Western Artists.* New York: Bonanza Books, 1985.

Samuels, Peggy and Harold. *The Illustrated Biographical Encyclopedia of Artists of the American West.* Garden City, NY: Doubleday and Company, Inc., 1976.

Sanborn, Franklin B. "Thomas Leavitt and His Artist Friend, James Akin." *Granite Monthly,* 25 (Oct. 1898).

Sanderson, John, and Robert Wain, editors. *Biography of the Signers of the Declaration of Independence.* 9 vols. Philadelphia: 1823-1827.

Sartain, John. "Benjamin West." *Sartain's Magazine.*

Sartain, John. *Reminiscences of a Very Old Man, 1808-1897.* New York: 1899.

Scharf, J. Thomas, and Thompson Westcott. *History of Philadelphia, 1609-1884.* 3 vols. Philadelphia: 1884.

Schevill, F. *Biography of Karl Bitter.*

Seguier, Frederick P. *Critical and Commerical Dictionary of the Works of Painters.* London: 1870.

Sellers, Horace W. "Charles Willson Peale, Artist-Soldier." *Pennsylvania Magazine,* 38 (1914).

Selz, Peter. *New Images of Man.* With statements by the artists. New York: Museum of Modern Art, 1959.

Shackleton, Robert. "A Benvenuto of the Backwoods (Chester Harding)." *Harper's Magazine,* 133 (July 1916).

Sharples. *Portraits of Washington.* History and descriptive details of Middleton's portraits of Mary, the mother of Washington, and Mary Phillipse. Boston: 1886.

Shedd, Julia A. *Famous Painters and Paintings.* 4th ed. Boston: 1896.

Sheldon, George W. *American Painters, with 83 Examples of Their Work.* New York: 1879.

Slade, Denison R. "Henry Pelham, the Half-Brother of John Singleton Copley." *Colonial Society of Massachusetts Publications,* 5 (Feb. 1898).

Smibert, John. "Smibert-Hoffatt Letters." *M. H. S. Proc.,* 49 (1915).

Smith, Alice R. Huger. "Charles Frazer, the Friend and Contemporary of Malbone." *Art in America,* 3 (June 1915).

Smith, Ralph Clinton. *A Biographical Index of American Artists.* New York: Olana Gallery.

Spencer, Edwina. "Story of American Painting." *Chautauquan,* 5 articles, 48-49 (1907-1908).

Spooner, Shearjashub. *Anecdotes of Painters, Engravers, Sculptors and Architects.* 3 vols. New York: 1865.

Spooner, Shearjashub. *Biographical History of the Fine Arts.* 2 vols. New York: 1865.

Stauffer, David McN. *American Engravers Upon Copper and Steel.* 2 vols. New York: 1907.

Stauffer, David McN. "Lithographic Portraits of Albert Newsam." 4 articles. *Pennsylvania Magazine,* 24-26 (1900-1902).

Stuart, Gilbert C. *Catalogue of an Exhibition of Portraits Painted by the Late Gilbert Stuart.* Boston: 1828.

Stuart, Gilbert C. "Portrait of James Ward, R. A., by Gilbert Stuart." *Art in America,* 4 (1916).

Stuart, Jane. "Anecdotes of Gilbert Stuart." *Scribner's Monthly,* 14 (July 1877).

Stuart, Jane. "The Stuart Portraits of Washington." *Scribner's Monthly,* 12 (July 1876).

Stuart, Jane. "The Youth of Gilbert Stuart." *Scribner's Monthly,* 13 (Mar. 1877).

Sully, Thomas. *Hints to Young Painters, and the Process of Portrait Painting as Practiced by the Late Thomas Sully.* Philadelphia: 1873.

Sweetser, M. Foster. *Life of Washington Allston.* Cambridge: 1876.

T

Taft, Lorado. *History of American Sculpture.* New York: 1903.

Thieme, Ulrich, and Felix Becker, eds. *Allgemeines Lexikon der Bildenden Kunstler.* 37 vols. Leipzig, Germany: W. Engelmann, 1907-50.

Trowbridge, John. *Samuel Finley Breese Morse.* Boston: 1901.

Trumbull, John. *Autobiography, Reminiscences and Letters.* New York: 1841.

Trumbull, John. *Catalogue of Paintings by Colonel Trumbull.* 5th ed. New Haven: 1864.

Trumbull, John. *Catalogue of the Collection of Studies and Sketches Made by Col. John Trumbull.* Sold December 14, 1896. Compiled by S. V. Henkels. Philadelphia: 1896.

Trumbull, John. "Painting of the Declaration of Independence." *Pennsylvania Magazine,* 31 (1907).

Tuckerman, Henry T. *Art in America.* Its History, Condition and Prospects. 1858.

Tuckerman, Henry T. *Book of the Artists.* New York: James F. Carr, 1967.

Tuckerman, Henry T. *The Character and Portraits of Washington.* New York: 1859.

V

Van Dyke, John C. *American Painting and Its Traditions.* New York: 1919, pp. 243-270.

Van Dyke, John C. "John S. Sargent, Portrait Painter." *Outlook,* 2 May 1903, pp. 31-39.

Van Dyke, John C. *Text-book of the History of Painting.* New York: 1894.

Van Rensselaer, Mariana G. "Washington Allston, Hon. N. A. D." *Magazine of Art,* 12 (1889).

Vollmer, Hans, ed. *Allgemeines Lexikon der Bildenden Kunstler des XX. Jahrhunderts.* 6 vols. Leipzig, Germany: Seemann, 1953-62.

W

Walter, James. *Memorials of Washington and of Mary, His Mother, and Martha, His Wife.* From letters and papers of Robert Cary and James Sharples. New York: 1887.

Walton, William. "American Paintings in the Metropolitan Museum." *Scribner's Magazine,* 42 (Nov. 1907).

Ward, Townsend Alexander Lawson, Engraver. *Pennsylvania Historical Society Magazine.*

Ware, William. *Lectures on the Works and Genius of Washington Allston.* Boston: 1852.

Watson, John F. *Annals of Philadelphia and Pennsylvania.* Enlarged by Willis P. Hazard. 3 vols. Philadelphia: 1877-1879.

Wead, Charles Kasson. "The Portraits of St. Memin." *Appleton's Magazine,* July 1906.

Weir, John F. *Brief Sketch of the Life of John Trumbull*, to which is added a catalogue of his works. New York: 1901.

Weir, Robert W. *Catalogue of Oil Paintings and Water Colors by Robert W. Weir*. Sold at auction, February 19. New York: 1891.

Weitenkampf, Frank. *American Graphic Art*. New York: 1912.

Weitenkampf, Frank. *How to Appreciate Prints*.

Weitenkampf, Frank. "The Fine Arts in New York City." *Memorial History of the City of New York*, 4, pp. 344-370. New York: 1893.

West, Benjamin. Description of the Picture "Christ Healing the Sick in the Temple," by John Robinson. Philadelphia: 1818.

West, Benjamin. Description of the Picture "Death on the Pale Horse." London: 1818.

West, Benjamin. *Gallery of Pictures Painted by Benjamin West*. Engraved in outline by Henry Moses. London: 1811.

West, Benjamin. "Unpublished Letters of Benjamin West." *Pennsylvania Magazine*, 32 (1908).

West's Gallery. *Catalogue of Pictures and Drawings by the Late Benjamin West*. London: 1824.

Wharton, Anne H. *Heirlooms in Miniatures*. Philadelphia: 1898.

Wharton, Anne H. *Salons, Colonial and Republican*. Philadelphia: 1900.

Wharton, Anne H. *Social Life in the Early Republic*. Philadelphia: 1902.

Whelen Sale. *Important Collection of Engraved Portraits of Washington . . . (and Franklin) belonging to Henry Whelen, Jr.* Sold April 27, 1909. Catalogue compiled by S. V. Henkels. Philadelphia: 1900.

White, Margaret E., ed. *Sketch of Chester Harding, Artist, Drawn by His Own Hand*. Boston: 1890.

Whitmore Sale. *Catalogue of the Private Library of William H. Whitmore*. Sold November 11-14, 1902. Boston: 1902.

Whitmore, William H. *Abel Bowen, Engraver*. Boston: 1884.

Whitmore, William H. *Notes Concerning Peter Pelham . . . and His Successors*. Cambridge: 1867.

Whitmore, William H. "The Early Painters and Engravers of New England." *M. H. S. Proc.*, 9 (May 1866).

Who Was Who. Vol. VII, 1971-1980. New York: St. Martin's Press, 1981.

Who Was Who in America. Historical Volume, 1607-1896. Revised ed. Chicago: Marquis-Who's Who, Inc., 1967.

Who's Who in America. Vols. 1 to 13. Marquis-Who's Who, Inc.

Who's Who in American Art. New York: R. R. Bowker Co., and the American Federation of Arts, 1953-1984.

Who's Who of American Women. Vol II. Chicago: The A. N. Marquis Company, 1961.

Williams, George A. "Robert Havell, Junior, Engraver of Audubon's 'The Birds of America.'" *Print-Collector's Quarterly*, 6 (Oct. 1916).

Willing, J. Thomson. "Makers of American Art." *The Mentor*, No. 45, 22 Dec. 1913.

Wilson, Robert. "Art and Artists in Provincial South Carolina." *City of Charleston Year Book*, 1899, pp. 137-147.

Wilson, Rufus R. "America's First Painters." *North East Magazine*, 26 (Mar. 1902).

Winsor, Justin. "Portraits of Washington." *Narrative and Critical History of America*, 7, pp. 563-582. Boston: 1888.

Winsor, Justin. "Savage's Portrait of Washington." *Harvard Graduates Magazine*, 3 (June 1895).

Woolsey, Theodore S. "The American Vassari (William Dunlap)." *Yale Review*, N. S., 3 (July 1914).

Worcester Art Museum. *Bulletin*. Print Connoisseur, 1910.

Y

Yale College. *Catalogue of Paintings Belonging to Yale College*. New Haven: 1852.

Young, Stark. "The Sargent Exhibition." *New Republic*, 19 Mar. 1924.

Young, William. *A Dictionary of American Artists, Sculptors and Engravers*. From the beginnings through the turn of the Twentieth Century. Cambridge: William Young and Co., 1968.

PERCY ALBEE

H. PIPPIN

GF Wetherbee.

Ridgway Knight

Whistler

Sion L. Wenban.

BABCOCK
BEQUEST

Karl Knaths

E.L. WEEKS.

Hans Hofmann

R. Peale

Jo DAVIDSON

mary Cassatt

Fred Elwell

B. West
1800

Herbert Peacock

Eugene Paul Ullman

A. West

Walt Kuhn